DUST TRACKS ON A ROAD

DUST TRACKS ON A ROAD

THE RESTORED TEXT ESTABLISHED BY THE
LIBRARY OF AMERICA

ZORA NEALE HURSTON

WITH A FOREWORD BY MAYA ANGELOU
SERIES EDITOR: HENRY LOUIS GATES, JR.

AMISTAD

An Imprint of HarperCollins*Publishers*

First Harper Perennial edition published 1996.
First Harper Perennial Modern Classics edition published 2006.

Designed by Cassandra J. Pappas

Library of Congress Cataloging-in-Publication Data
Hurston, Zora Neale.
 Dust tracks on a road : an autobiography / Zora Neale Hurston ; with a foreword by Maya Angelou.— 1st Harper Perennial Modern Classics ed.
 p. cm.
 "Originally published in 1942 by J. B. Lippincott, Inc. The restored text was published in 1995 by the Library of America as part of Folklore, memoirs & other writings"—T.p. verso.
 "First Harper Perennial edition published 1996"—T.p. verso.
 ISBN-10: 0-06-085408-1
 ISBN-13: 978-0-06-085408-9
 1. Hurston, Zora Neale. 2. Authors, American—Twentieth century—Biography. 3. African American women—Southern States—Biography. 4. Southern States—Social life and customs. 5. Folklorists—United States—Biography. 6. African American authors—Biography. 7. African Americans—Southern States. 8. Harlem Renaissance. I. Title.

PS3515.U789Z465 2006
813'.52—dc22
[B] 2005052616

21 ❖/LSC 21

CONTENTS

FOREWORD

There is an eerie, sometimes pathetic, ofttimes beautiful urge that prevails in Black American lore, lyrics and literature. The impulse, simply put, is to tell the story . . . to tell one's own story . . . as one has known it, and lived it, and even died it.

From 1619, with the off-loading of nineteen Africans at Jamestown, Virginia, until this age of innocuous television series featuring Black characters, a large number of white writers have felt they were not only capable but called upon to write the "Black person's story."

It is rather astounding that so many noninformed, or at best partially informed, yet otherwise learned personages have felt and still feel that although they themselves could not replicate the grunts, moans and groans of their Black contemporaries, they could certainly explain the utterances and even give descriptions, designs and desires of the utterers. Black Americans often have found themselves in disagreement with many who have cavalierly drawn their portraits.

Langston Hughes captured the protest in his poem "Note on Commercial Theatre":

> You've taken my blues and gone—
> You sing 'em on Broadway

. . . And you fixed 'em
So they don't sound like me.
Yes, you done taken my blues and gone.

You also took my spiritual and gone.
. . . But someday somebody'll
Stand up and talk about me,
And write about me—
Black and Beautiful—
And sing about me,
And put on plays about me!
I reckon it'll be
Me myself!

Yes, it'll be me.

Zora Neale Hurston chose to write her own version of life in *Dust Tracks on a Road.* Through her imagery one soon learns that the author was born to roam, to listen and to tell a variety of stories. An active curiosity led her throughout the South, where she gathered up the feelings and sayings of her people as a fastidious farmer might gather eggs. When she began to write, she used all the sights she had seen, all the people she had encountered and the exploits she had survived. One reading of Hurston is enough to convince the reader that Hurston had dramatic adventures and was a quintessential survivor. According to her own account in *Dust Tracks on a Road,* a hog with a piglet and an interest in some food Hurston was eating taught the infant Hurston to walk. The sow came snorting toward her, and Zora, who had never taken a step, decided that the time had come to rectify her reluctance. She stood and not only walked but climbed into a chair beyond the sow's inquisitive reach.

That lively pragmatism which revealed itself so early was to remain with Hurston most of her life. It prompted her to write and rewrite history. Her books and folktales vibrate with tragedy, humor and the real music of Black American speech. In a letter to a friend, she wrote that she wanted to "show a Negro preacher who is neither funny nor an imitation puritan

ramrod in his pants. Just the human being and poet he must be to succeed in a Negro pulpit." Thus, her first novel, *Jonah's Gourd Vine,* published in 1934, clearly told the story of John Hurston, her father, who could build houses, uproot trees, fight victoriously, love women and preach the color blue out of the sky.

Hurston was born in Eatonville, Florida, the only incorporated, all-Black town in America. Her father, with whom she rarely shared a peaceful hour, had been the town's alderman, three times its mayor, and had written many of the laws in the late 1800s, which are still observed in the 1990s.

In this autobiography Hurston describes herself as obstinate, intelligent and pugnacious. The story she tells of her life could never have been told believably by a non-Black American, and the details in even her own hands and words offer enough confusions, contusions and contradictions to confound the most sympathetic researcher.

Her mother, whom she seemed to have pitied but only glancingly loved, died when Hurston was nine years old. Her father remarried, and the antipathy between them was exacerbated by the presence and actions of a thick-skinned and malicious stepmother. Hurston found her first personal power at the expense of her father's wife.

The primeval in me leaped to life. Ha! This was the very corn I wanted to grind. Fight! Not having to put up with what she did to us through Papa! . . . If I died, let me die with my hands soaked in her blood. I want her blood, and plenty of it. That is the way I went into the fight, and that is the way I fought it. . . .

She scratched and clawed at me, but I felt nothing at all. In a few seconds, she gave up. I could see her face when she realized that I meant to kill her. She spat on my dress, then, and did what she could to cover up from my renewed fury. She had given up fighting except for trying to spit in my face, and I did not intend for her to get away.

This puzzling book was written during 1940 and 1941 but for the most part deals with the early part of the twentieth century. Hurston, who claimed to have been born in 1901, but whose records show her birth year was a decade earlier, most certainly lived through the race riots and other atrocities of her time. However, she does not mention even one unpleasant racial incident in *Dust Tracks on a Road*. The southern air around her most assuredly crackled with the flames of Ku Klux Klan raiders, but Ms. Hurston does not allude to any ugly incident.

Her silence over these well-known issues gives rise to many questions: Why did Hurston write *Dust Tracks on a Road?* Whose song was she singing? And to whose ears was she directing her melody? Is this book a tale or a series of tales meant to appease a white audience? Does Hurston mean to show herself as a sleeping princess who will awaken to grandeur with the slightest kiss from a white prince?

Hurston does imply that the nicest people she met in her youth were whites who showed her kindness. It was a white man, who, discovering her mother in labor, delivered Hurston into the world and afterward took a proprietary interest in her. Hurston recalls how the kindly crusty old man took the eight-year-old Black girl fishing and gave her advice that might have been William Shakespeare's from the mouth of a Faulknerian Polonius.

> He called me Snidlits, explaining that Zora was a hell of a name to give a child.

> "Snidlits, don't be a nigger," he would say to me over and over. "Niggers* lie and lie! Any time you catch folks lying, they are skeered of something. Lying is dodging. People with guts don't lie. They tell the truth and then if they have to, they fight it out. You lay yourself open by lying. The other fellow knows right off that you are skeered of him and he's more'n apt to tackle you. If he don't do nothing, he starts to looking down on you from

then on. Truth is a letter from courage. I want you to grow
guts as you go along. So don't you let me hear of you
lying. You'll get 'long all right if you do like I tell you.
Nothing can't lick you if you never get skeered."

*[Hurston's footnote.] The word Nigger used in this sense does not mean
race. It means a weak, contemptible person of any race.

That was a knowledge not given to many southern Black
girls—or boys for that matter. In fact, few southerners of any
race or sexual persuasion would have deduced that the old
white man meant anything other than "don't be Black, if you
possibly can, for your greater good and the general wealth and
welfare of everyone, be or at least act white."

Two white women whom Hurston describes as gracious and
beautiful gave her candies, clothes and books to read. She says
of them:

They had shiny hair, mostly brownish. One had a looping
gold chain around her neck. The other one was dressed all
over in black and white with a pretty finger ring on her left
hand. But the thing that held my eyes were their fingers.
They were long and thin, and very white, except up near
the tips. There they were baby pink. I had never seen such
hands. It was a fascinating discovery for me. I wondered
how they felt. . . .
 First thing, the ladies gave me strange things, like stuffed
dates and preserved ginger, and encouraged me to eat all
that I wanted. Then they showed me their Japanese dolls
and just talked. . . .

Is it possible that Hurston, who had been bold and boda-
cious all her life, was carrying on the tradition she had begun
with the writing of *Spunk* in 1925? That is, did she mean to
excoriate some of her own people, whom she felt had ignored
or ridiculed her? The *New Yorker* critic declared the work a
"warm, witty, imaginative, rich and winning book by one of
our few genuine grade A folk writers."

There is, despite its success in certain quarters, a strange

distance in this book. Certainly the language is true and the dialogue authentic, but the author stands between the content and the reader. It is difficult, if not impossible, to find and touch the real Zora Neale Hurston. The late Larry Neal in his introduction to the 1971 edition of *Dust Tracks on a Road* cited, "At one moment she could sound highly nationalistic. Then at other times she might mouth statements which in terms of the ongoing struggle for Black liberation were ill conceived and were even reactionary."

There is a saying in the Black community that advises: "If a person asks you where you're going, you tell him where you've been. That way you neither lie nor reveal your secrets." Hurston had called herself the "Queen of the Niggerati." She also said, "I like myself when I'm laughing." *Dust Tracks on a Road* is written with royal humor and an imperious creativity. But then all creativity is imperious, and Zora Neale Hurston was certainly creative.

MAYA ANGELOU

CHAPTER 1

MY BIRTHPLACE

Like the dead-seeming, cold rocks, I have memories within that came out of the material that went to make me. Time and place have had their say.

So you will have to know something about the time and place where I came from, in order that you may interpret the incidents and directions of my life.

I was born in a Negro town. I do not mean by that the black back-side of an average town. Eatonville, Florida, is, and was at the time of my birth, a pure Negro town—charter, mayor, council, town marshal and all. It was not the first Negro community in America, but it was the first to be incorporated, the first attempt at organized self-government on the part of Negroes in America.

Eatonville is what you might call hitting a straight lick with a crooked stick. The town was not in the original plan. It is a by-product of something else.

It all started with three white men on a ship off the coast of Brazil. They had been officers in the Union Army. When the bitter war had ended in victory for their side, they had set out for South America. Perhaps the post-war distress made their

1

native homes depressing. Perhaps it was just that they were young, and it was hard for them to return to the monotony of everyday being after the excitement of military life, and they, as numerous other young men, set out to find new frontiers.

But they never landed in Brazil. Talking together on the ship, these three decided to return to the United States and try their fortunes in the unsettled country of South Florida. No doubt the same thing which had moved them to go to Brazil caused them to choose South Florida.

This had been dark and bloody country since the mid-seventeen hundreds. Spanish, French, English, Indian, and American blood had been bountifully shed.

The last great struggle was between the resentful Indians and the white planters of Georgia, Alabama, and South Carolina. The strong and powerful Cherokees, aided by the conglomerate Seminoles, raided the plantations and carried off Negro slaves into the Spanish-held Florida. Ostensibly they were carried off to be slaves to the Indians, but in reality the Negro men were used to swell the ranks of the Indian fighters against the white plantation owners. During lulls in the long struggle, treaties were signed, but invariably broken. The sore point of returning escaped Negroes could not be settled satisfactorily to either side. Who was an Indian and who was a Negro? The whites contended all who had negro blood. The Indians contended all who spoke their language belonged to the tribe. Since it was an easy matter to teach a slave to speak enough of the language to pass in a short time, the question could never be settled. So the wars went on.

The names of Oglethorpe, Clinch and Andrew Jackson are well known on the white side of the struggle. For the Indians, Miccanopy, Billy Bow-legs and Osceola. The noble Osceola was only a sub-chief, but he came to be recognized by both sides as the ablest of them all. Had he not been captured by treachery, the struggle would have lasted much longer than it did. With an offer of friendship, and a new rifle (some say a beautiful sword) he was lured to the fort seven miles outside of St. Augustine, and captured. He was confined in sombre

2

Fort Marion that still stands in that city, escaped, was recaptured, and died miserably in the prison of a fort in Beaufort, South Carolina. Without his leadership, the Indian cause collapsed. The Cherokees and most of the Seminoles, with their Negro adherents, were moved west. The beaten Indians were moved to what is now Oklahoma. It was far from the then settlements of the Whites. And then too, there seemed to be nothing there that White people wanted, so it was a good place for Indians. The wilds of Florida heard no more clash of battle among men.

The sensuous world whirled on in the arms of ether for a generation or so. Time made and marred some men. So into this original hush came the three frontier-seekers who had been so intrigued by its prospects that they had turned back after actually arriving at the coast of Brazil without landing. These young men were no poor, refuge-seeking, wayfarers. They were educated men of family and wealth.

The shores of Lake Maitland were beautiful, so they chose the northern end and settled. There one of the old forts—built against the Indians, had stood. It had been commanded by Colonel Maitland, so the lake and the community took their names in memory of him. It was Mosquito County then and the name was just. It is Orange County now for equally good reason. The men persuaded other friends in the north to join them, and the town of Maitland began to be in a great rush.

Negroes were found to do the clearing. There was the continuous roar of the crashing of ancient giants of the lush woods, of axes, saws and hammers. And there on the shores of Lake Maitland rose stately houses, surrounded by beautiful grounds. Other settlers flocked in from upper New York state, Minnesota and Michigan, and Maitland became a center of wealth and fashion. In less than ten years, the Plant System, later absorbed into the Atlantic Coast Line Railroad, had been persuaded to extend a line south through Maitland, and the private coaches of millionaires and other dignitaries from North and South became a common sight on the siding. Even a president of the United States visited his friends at Maitland.

3

These wealthy homes, glittering carriages behind blooded horses and occupied by well-dressed folk, presented a curious spectacle in the swampy forests so dense that they are dark at high noon. The terrain swarmed with the deadly diamond-back rattlesnake, most potent reptile on the North American continent. Huge, centuries-old bull alligators bellowed their challenge from the uninhabited shores of lakes. It was necessary to carry a lantern when one walked out at night, to avoid stumbling over these immense reptiles in the streets of Maitland.

Roads were made by the simple expedient of driving buggies and wagons back and forth over the foot trail, which ran for seven miles between Maitland and Orlando. The terrain was as flat as a table and totally devoid of rocks. All the roadmakers had to do was to curve around the numerous big pine trees and oaks. It seems it was too much trouble to cut them down. Therefore, the road looked as if it had been laid out by a playful snake. Now and then somebody would chop down a troublesome tree. Way late, the number of tree stumps along the route began to be annoying. Buggy wheels bumped and jolted over them and took away the pleasure of driving. So a man was hired to improve the road. His instructions were to round off the tops of all stumps so that the wheels, if and when they struck stumps, would slide off gently instead of jolting the teeth out of riders as before. This was done, and the spanking rigs of the bloods whisked along with more assurance.

Now, the Negro population of Maitland settled simultaneously with the White. They had been needed, and found profitable employment. The best of relations existed between employer and employee. While the White estates flourished on the three-mile length of Lake Maitland, the Negroes set up their hastily built shacks around St. John's Hole, a lake as round as a dollar, and less than a half mile wide. It is now a beauty spot in the heart of Maitland, hard by United States Highway Number 17. They call it Lake Lily.

The Negro women could be seen every day but Sunday,

squatting around St. John's Hole on their haunches, primitive style, washing clothes and fishing, while their men went forth and made their support in cutting new ground, building, and planting orange groves. Things were moving so swiftly that there was plenty to do, with good pay. Other Negroes in Georgia and West Florida heard of the boom in South Florida from Crescent City to Cocoa and they came. No more back-bending over rows of cotton; no more fear of the fury of the Reconstruction. Good pay, sympathetic White folks and cheap land, soft to the touch of a plow. Relatives and friends were sent for.

Two years after the three adventurers entered the primeval forests of Mosquito County, Maitland had grown big enough, and simmered down enough, to consider a formal city government.

Now, these founders were, to a man, people who had risked their lives and fortunes that Negroes might be free. Those who had fought in the ranks had thrown their weight behind the cause of Emancipation. So when it was decided to hold an election, the Eatons, Lawrences, Vanderpools, Hurds, Halls, the Hills, Yateses and Galloways, and all the rest including Bishop Whipple, head of the Minnesota diocese, never for a moment considered excluding the Negroes from participation. The Whites nominated a candidate and the Negroes, under the aggressive lead of Joe Clarke, a muscular, dynamic Georgia Negro, put up Tony Taylor as their standard-bearer.

I do not know whether it was the numerical superiority of the Negroes, or whether some of the Whites, out of deep feeling, threw their votes to the Negro side. At any rate, Tony Taylor became the first Mayor of Maitland with Joe Clarke winning out as town Marshal. This was a wholly unexpected turn, but nobody voiced any open objections. The Negro Mayor and Marshal and the White City Council took office peacefully and served their year without incident.

But during that year, a yeast was working. Joe Clarke had asked himself, why not a Negro town? Few of the Negroes were interested. It was too vaulting for their comprehension.

5

A pure Negro town! If nothing but their own kind was in it, who was going to run it? With no White folks to command them, how would they know what to do? Joe Clarke had plenty of confidence in himself to do the job, but few others could conceive of it.

But one day by chance or purpose, Joe Clarke was telling of his ambitions to Captain Eaton, who thought it a workable plan. He talked it over with Captain Lawrence and others. By the end of the year, all arrangements had been made. Lawrence and Eaton bought a tract of land a mile west of Maitland for a town site. The backing of the Whites helped Joe Clarke to convince the other Negroes, and things were settled.

Captain Lawrence at his own expense erected a well-built church on the new site, and Captain Eaton built a hall for general assembly and presented it to the new settlement. A little later, the wife of Bishop Whipple had the first church rolled across the street and built a larger church on the same spot, and the first building was to become a library, stocked with books donated by the White community.

So on August 18, 1886, the Negro town, called Eatonville, after Captain Eaton, received its charter of incorporation from the state capital at Tallahassee, and made history by becoming the first of its kind in America, and perhaps in the world. So, in a raw, bustling frontier, the experiment of self-government for Negroes was tried. White Maitland and Negro Eatonville, have lived side by side for fifty-five years without a single instance of enmity. The spirit of the founders has reached beyond the grave.

The whole lake country of Florida sprouted with life— mostly Northerners, and prosperity was everywhere. It was in the late eighties that the stars fell, and many of the original settlers date their coming "just before, or just after the stars fell."

CHAPTER 2

MY FOLKS

Into this burly, boiling, hard-hitting, rugged-individualistic setting, walked one day a tall, heavy-muscled mulatto who resolved to put down roots.

John Hurston, in his late twenties, had left Macon County, Alabama, because the ordeal of share-cropping on a southern Alabama cotton plantation was crushing to his ambition. There was no rise to the thing.

He had been born near Notasulga, Alabama, in an outlying district of landless Negroes, and Whites not too much better off. It was "over the creek," which was just like saying on the wrong side of the railroad tracks. John Hurston had learned to read and write somehow between cotton-choppings and cotton-picking, and it might have satisfied him in a way. But somehow he took to going to Macedonia Baptist Church on the right side of the creek. He went one time, and met up with dark-brown Lucy Ann Potts, of the land-owning Richard Potts, which might have given him the going habit.

He was nearly twenty years old then, and she was fourteen. My mother used to claim with a smile that she saw him looking and looking at her up there in the choir and wondered what

he was looking at her for. She wasn't studying about *him*. However, when the service was over and he kept standing around, never far from her, she asked somebody, "Who is dat bee-stung yaller nigger?"

"Oh, dat's one of dem niggers from over de creek, one of dem Hurstons—call him John I believe."

That was supposed to settle that. Over-the-creek niggers lived from one white man's plantation to the other. Regular hand-to-mouth folks. Didn't own pots to pee in, nor beds to push 'em under. Didn't have no more pride than to let themselves be hired by poor white trash. No more to 'em than the stuffings out of a zero. The inference was that Lucy Ann Potts had asked about nothing and had been told.

Mama thought no more about him, she said. Of course, she couldn't help noticing that his grey-green eyes and light skin stood out sharply from the black-skinned, black-eyed crowd he was in. Then, too, he had a build on him that made you look. A stud-looking buck like that would have brought a big price in slavery time. Then, if he had not kept on hanging around where she couldn't help from seeing him, she would never have remembered that she had seen him two or three times before around the cotton-gin in Notasulga, and once in a store. She had wondered then who he was, handling bales of cotton like suitcases.

After that Sunday, he got right worrisome. Slipping her notes between the leaves of hymn books and things like that. It got so bad that a few months later she made up her mind to marry him just to get rid of him. So she did, in spite of the most violent opposition of her family. She put on the little silk dress which she had made with her own hands, out of goods bought from egg-money she had saved. Her ninety pounds of fortitude set out on her wedding night alone, since none of the family except her brother Jim could bear the sight of her great come-down in the world. She who was considered the prettiest and the smartest black girl was throwing herself away and disgracing the Pottses by marrying an over-the-creek nigger, and a bastard at that. Folks said he was a certain white man's

8

son. But here she was, setting out to walk two miles at night by herself, to keep her pledge to him at the church. Her father, more tolerant than her mother, decided that his daughter was not going alone, nor was she going to walk to her wedding. So he hitched up the buggy and went with her. Nobody much was there. Her brother Jim slipped in just before she stood on the floor.

So she said her words and took her stand for life, and went off to a cabin on a plantation with him. She never forgot how the late moon shone that night as his two hundred pounds of bone and muscle shoved open the door and lifted her in his arms over the door-sill.

That cabin on a white man's plantation had to be all for the present. She had been pointedly made to know that the Potts plantation was nothing to her any more. Her father soon softened and was satisfied to an extent, but her mother, never. To her dying day her daughter's husband was never John Hurston to her. He was always "dat yaller bastard." Four years after my mother's marriage, and during her third pregnancy, she got to thinking of the five acres of cling-stone peaches on her father's place, and the yearning was so strong that she walked three miles to get a few. She was holding the corners of her apron with one hand and picking peaches with the other when her mother spied her, and ordered her off the place.

It was after his marriage that my father began to want things. Plantation life began to irk and bind him. His over-the-creek existence was finished. What else was there for a man like him? He left his wife and three children behind and went out to seek and see.

Months later he pitched into the hurly-burly of South Florida. So he heard about folks building a town all out of colored people. It seemed like a good place to go. Later on, he was to be elected Mayor of Eatonville for three terms, and to write the local laws. The village of Eatonville is still governed by the laws formulated by my father. The town clerk still consults a copy of the original printing which seems to be

the only one in existence now. I have tried every way I know how to get this copy for my library, but so far it has not been possible. I had it once, but the town clerk came and took it back.

When my mother joined papa a year after he had settled in Eatonville, she brought some quilts, her feather bed and bedstead. That was all they had in the house that night. Two burlap bags were stuffed with Spanish moss for the two older children to sleep on. The youngest child was taken into the bed with them.

So these two began their new life. Both of them swore that things were going to better, and it came to pass as they said. They bought land, built a roomy house, planted their acres and reaped. Children kept coming—more mouths to feed and more feet for shoes. But neither of them seemed to have minded that. In fact, my father not only boasted among other men about "his house full of young'uns" but he boasted that he had never allowed his wife to go out and hit a lick of work for anybody a day in her life. Of weaknesses, he had his share, and I know that my mother was very unhappy at times, but neither of them ever made any move to call the thing off. In fact, on two occasions, I heard my father threaten to kill my mother if she ever started towards the gate to leave him. He was outraged and angry one day when she said lightly that if he did not want to do for her and his children, there was another man over the fence waiting for his job. That expression is a folk saying and Papa had heard it used hundreds of times by other women, but he was outraged at hearing it from Mama. She definitely understood, before he got through carrying on, that the saying was not for her lips.

On another occasion Papa got the idea of escorting the wife of one of his best friends, and having the friend escort Mama. But Mama seemed to enjoy it more than Papa thought she ought to—though she had opposed the idea when it was suggested—and it ended up with Papa leaving his friend's wife at the reception and following Mama and his friend home, and marching her into the house with the muzzle of his Winchester

rifle in her back. The friend's wife, left alone at the hall, gave both her husband and Papa a good cussing out the next day. Mama dared not laugh, even at that, for fear of stirring Papa up more. It was a month or so before the two families thawed out again. Even after that, the subject could never be mentioned before Papa or the friend's wife, though both of them had been red-hot for the experiment.

My mother rode herd on one woman with a horse whip about Papa, and "spoke out" another one. This, instead of making Papa angry, seemed to please him ever so much. The woman who got "spoken out" threatened to whip my mother. Mama was very small and the other woman was husky. But when Papa heard of the threats against Mama, he notified the outside woman that if she could not whip him too, she had better not bring the mess up. The woman left the county without ever breaking another breath with Papa. Nobody around there knew what became of her.

So, looking back, I take it that Papa and Mama, in spite of his meanderings, were really in love. Maybe he was just born before his time. There was nothing then to hinder impulses. They didn't have these zippers on pants in those days, guaranteed to stay locked no matter what the strain. From what I can learn, those button-up flies were mighty tricky and betraying. Maybe if I ask around, somebody will tell me what modern invention has done for a lot of morals.

We lived on a big piece of ground with two big chinaberry trees shading the front gate . . . Cape jasmine bushes with hundreds of blooms on either side of the walks. I loved the fleshy, white, fragrant blooms as a child but did not make too much of them. They were too common in my neighborhood. When I got to New York and found out that the people called them gardenias, and that the flowers cost a dollar each, I was impressed. The home folks laughed when I went back down there and told them. Some of the folks did not want to believe me. A dollar for a Cape jasmine bloom! Folks up north there must be crazy.

There were plenty of orange, grapefruit, tangerine, guavas and other fruits in our yard. We had a five acre garden with things to eat growing in it, and so we were never hungry. We had chicken on the table often; home-cured meat, and all the eggs we wanted. It was a common thing for us smaller children to fill the iron tea-kettle full of eggs and boil them, and lay around in the yard and eat them until we were full. Any leftover boiled eggs could always be used for missiles. There was plenty of fish in the lakes around the town, and so we had all that we wanted. But beef stew was something rare. We were all very happy whenever Papa went to Orlando and brought back something delicious like stew-beef. Chicken and fish were too common with us. In the same way, we treasured an apple. We had oranges, tangerines and grapefruit to use as hand-grenades on the neighbors' children. But apples were something rare. They came from way up north.

Our house had eight rooms, and we called it a two-story house; but later on I learned it was really one story and a jump. The big boys all slept up there, and it was a good place to hide and shirk from sweeping off the front porch or raking up the back yard.

Downstairs in the dining room there was an old "safe," a punched design in its tin doors. Glasses of guava jelly, quart jars of pear, peach and other kinds of preserves. The leftover cooked foods were on the lower shelves.

There were eight children in the family, and our house was noisy from the time school turned out until bedtime. After supper we gathered in Mama's room, and everybody had to get their lessons for the next day. Mama carried us all past long division in arithmetic, and parsing sentences in grammar, by diagrams on the black-board. That was as far as she had gone. Then the younger ones were turned over to my oldest brother, Bob, and Mama sat and saw to it that we paid attention. You had to keep on going over things until you did know. How I hated the multiplication tables—especially the sevens!

We had a big barn, and a stretch of ground well covered

12

with Bermuda grass. So on moonlight nights, two-thirds of the village children from seven to eighteen would be playing "hide and whoop," "chick-mah-chick," "hide and seek," and other boisterous games in our yard. Once or twice a year we might get permission to go and play at some other house. But that was most unusual. Mama contended that we had plenty of space to play in; plenty of things to play with; and, furthermore, plenty of us to keep each other's company. If she had her way, she meant to raise her children to stay at home. She said that there was no need for us to live like no-count negroes and poor white trash—too poor to sit in the house—had to come outdoors for any pleasure, or hang around somebody else's house. Any of her children who had any tendencies like that must have got it from the Hurston side. It certainly did not come from the Pottses. Things like that gave me my first glimmering of the universal female gospel that all good traits and leanings come from the mother's side.

Mama exhorted her children at every opportunity to "jump at de sun." We might not land on the sun, but at least we would get off the ground. Papa did not feel so hopeful. Let well enough alone. It did not do for Negroes to have too much spirit. He was always threatening to break mine or kill me in the attempt. My mother was always standing between us. She conceded that I was impudent and given to talking back, but she didn't want to "squinch my spirit" too much for fear that I would turn out to be a mealy-mouthed rag doll by the time I got grown. Papa always flew hot when Mama said that. I do not know whether he feared for my future, with the tendency I had to stand and give battle, or that he felt a personal reference in Mama's observation. He predicted dire things for me. The white folks were not going to stand for it. I was going to be hung before I got grown. Somebody was going to blow me down for my sassy tongue. Mama was going to suck sorrow for not beating my temper out of me before it was too late. Posses with ropes and guns were going to drag me out sooner or later on account of that stiff neck I toted. I was going to tote a hungry belly by reason of my forward

13

ways. My older sister was meek and mild. She would always get along. Why couldn't I be like her? Mama would keep right on with whatever she was doing and remark, "Zora is my young'un, and Sarah is yours. I'll be bound mine will come out more than conquer. You leave her alone. I'll tend to her when I figger she needs it." She meant by that that Sarah had a disposition like Papa's, while mine was like hers.

Behind Mama's rocking chair was a good place to be in times like that. Papa was not going to hit Mama. He was two hundred pounds of bone and muscle and Mama weighed somewhere in the nineties. When people teased him about Mama being the boss, he would say he could break her of her headstrong ways if he wanted to, but she was so little that he couldn't find any place to hit her. My Uncle Jim, Mama's brother, used to always take exception to that. He maintained that if a woman had anything big enough to sit on, she had something big enough to hit on. That was his firm conviction, and he meant to hold on to it as long as the bottom end of his backbone pointed towards the ground—don't care who the woman was or what she looked like, or where she came from. Men like Papa who held to any other notion were just beating around the bush, dodging the issue, and otherwise looking like a fool at a funeral.

Papa used to shake his head at this and say, "What's de use of me taking my fist to a poor weakly thing like a woman? Anyhow, you got to submit yourself to 'em, so there ain't no use in beating on 'em and then have to go back and beg 'em pardon."

But perhaps the real reason that Papa did not take Uncle Jim's advice too seriously, was because he saw how it worked out in Uncle Jim's own house. He could tackle Aunt Caroline, all right, but he had his hands full to really beat her. A knock-down didn't convince her that the fight was over at all. She would get up and come right on in, and she was nobody's weakling. It was generally conceded that he might get the edge on her in physical combat if he took a hammer or a trace-chain to her, but in other ways she always won. She

14

would watch his various philandering episodes just so long, and then she would go into action. One time she saw all, and said nothing. But one Saturday afternoon, she watched him rush in with a new shoe box which he thought that she did not see him take out to the barn and hide until he was ready to go out. Just as the sun went down, he went out, got his box, cut across the orange grove and went on down to the store.

He stopped long enough there to buy a quart of peanuts, two stalks of sugar cane, and then tripped on off to the little house in the woods where lived a certain transient light of love. Aunt Caroline kept right on ironing until he had gotten as far as the store. Then she slipped on her shoes, went out in the yard and got the axe, slung it across her shoulder and went walking very slowly behind him.

The men on the store porch had given Uncle Jim a laughing sendoff. They all knew where he was going and why. The shoes had been bought right there at the store. Now here came "dat Cal'line" with her axe on her shoulder. No chance to warn Uncle Jim at all. Nobody expected murder, but they knew that plenty of trouble was on the way. So they just sat and waited. Cal'line had done so many side-splitting things to Jim's lights of love—all without a single comment from her— that they were on pins to see what happened next.

About an hour later, when it was almost black dark, they saw a furtive figure in white dodging from tree to tree until it hopped over Clarke's strawberry patch fence and headed towards Uncle Jim's house until it disappeared.

"Looked mightily like a man in long drawers and nothing else," Walter Thomas observed. Everybody agreed that it did, but who and what could it be?

By the time the town lamp which stood in front of the store was lighted, Aunt Caroline emerged from the blackness that hid the woods and passed the store. The axe was still over her shoulder, but now it was draped with Uncle Jim's pants, shirt and coat. A new pair of women's oxfords were dangling from the handle by their strings. Two stalks of sugar cane were over her other shoulder. All she said was, "Good evening, gentle-

15

men," and kept right on walking towards home.

The porch rocked with laughter. They had the answer to everything. Later on when they asked Uncle Jim how Cal'line managed to get into the lady's house, he smiled sourly and said, "Dat axe was her key." When they kept on teasing him, he said, "Oh, dat old stubborn woman I married, you can't teach her nothing. I can't teach her no city ways at all."

On another occasion, she caused another lady who couldn't give the community anything but love, baby, to fall off of the high, steep church steps on her head. Aunt Cal'line might have done that just to satisfy her curiosity, since it was said that the lady felt that anything more than a petticoat under her dresses would be an incumbrance. Maybe Aunt Caroline just wanted to verify the rumor. The way the lady tumbled, it left no doubt in the matter. She was really a free soul. Evidently Aunt Caroline was put out about it, because she had to expectorate at that very moment, and it just happened to land where the lady was bare. Aunt Caroline evidently tried to correct her error in spitting on her rival, for she took her foot and tried to grind it in. She never said a word as usual, so the lady must have misunderstood Aunt Caroline's curiosity. She left town in a hurry—a speedy hurry—and never was seen in those parts again.

So Papa did not take Uncle Jim's philosophy about handling the lady people too seriously. Every time Mama cornered him about some of his doings, he used to threaten to wring a chair over her head. She never even took enough notice of the threat to answer. She just went right on asking questions about his doings and then answering them herself until Papa slammed out of the house looking like he had been whipped all over with peach hickories. But I had better not let out a giggle at such times, or it would be just too bad.

Our house was a place where people came. Visiting preachers, Sunday school and B.Y.P.U. workers, and just friends. There was fried chicken for visitors, and other such hospitality as the house afforded.

Papa's bedroom was the guest room. Store-bought towels

would be taken out of the old round-topped trunk in Mama's room and draped on the wash-stand. The pitcher and bowl were scrubbed out before fresh water from the pump was put in there for the use of the guest. Sweet soap was company soap. We knew that. Otherwise, Octagon laundry soap was used to keep us clean. Bleached-out meal sacks served the family for bath towels ordinarily, so that the store-bought towels could be nice and clean for visitors.

Company got the preference in toilet paper, too. Old newspapers were put out in the privy house for family use. But when company came, something better was offered them. Fair to middling guests got sheets out of the old Sears, Roebuck catalogue. But Mama would sort over her old dress patterns when really fine company came, and the privy house was well scrubbed, lime thrown in, and the soft tissue paper pattern stuck on a nail inside the place for the comfort and pleasure of our guests. It was not that regular toilet paper was unheard of in our house. It was just unthought of. It was right there in the catalogue for us to see. But as long as we had Mr. Sears, Roebuck's catalogue, we had no need for his toilet paper.

CHAPTER 3

I GET BORN

This is all hear-say. Maybe, some of the details of my birth as told me might be a little inaccurate, but it is pretty well established that I really did get born.

The saying goes like this. My mother's time had come and my father was not there. Being a carpenter, successful enough to have other helpers on some jobs, he was away often on building business, as well as preaching. It seems that my father was away from home for months this time. I have never been told why. But I did hear that he threatened to cut his throat when he got the news. It seems that one daughter was all that he figured he could stand. My sister, Sarah, was his favorite child, but that one girl was enough. Plenty more sons, but no more girl babies to wear out shoes and bring in nothing. I don't think he ever got over the trick he felt that I played on him by getting born a girl, and while he was off from home at that. A little of my sugar used to sweeten his coffee right now. That is a Negro way of saying his patience was short with me. Let me change a few words with him—and I am of the word-changing kind—and he was ready to change ends. Still and all, I looked more like him than any child in the house.

19

Of course, by the time I got born, it was too late to make any suggestions, so the old man had to put up with me. He was nice about it in a way. He didn't tie me in a sack and drop me in the lake, as he probably felt like doing.

People were digging sweet potatoes, and then it was hog-killing time. Not at our house, but it was going on in general over the country, like, being January and a bit cool. Most people were either butchering for themselves, or off helping other folks do their butchering, which was almost just as good. It is a gay time. A big pot of hasslits cooking with plenty of seasoning, lean slabs of fresh-killed pork frying for the helpers to refresh themselves after the work is done. Over and above being neighborly and giving aid, there is the food, the drinks and the fun of getting together.

So there was no grown folks close around when Mama's water broke. She sent one of the smaller children to fetch Aunt Judy, the mid-wife, but she was gone to Woodbridge, a mile and a half away, to eat at a hog-killing. The child was told to go over there and tell Aunt Judy to come. But nature, being indifferent to human arrangements, was impatient. My mother had to make it alone. She was too weak after I rushed out to do anything for herself, so she just was lying there, sick in the body, and worried in mind, wondering what would become of her, as well as me. She was so weak, she couldn't even reach down to where I was. She had one consolation. She knew I wasn't dead, because I was crying strong.

Help came from where she never would have thought to look for it. A white man of many acres and things, who knew the family well, had butchered the day before. Knowing that Papa was not at home, and that consequently there would be no fresh meat in our house, he decided to drive the five miles and bring a half of a shoat, sweet potatoes, and other garden stuff along. He was there a few minutes after I was born. Seeing the front door standing open, he came on in, and hollered, "Hello, there! Call your dogs!" That is the regular way to call in the country because nearly everybody who has anything to watch, has biting dogs.

Nobody answered, but he claimed later that he heard me spreading my lungs all over Orange County, so he shoved the door open and bolted on into the house.

He followed the noise and then he saw how things were, and being the kind of a man he was, he took out his Barlow Knife and cut the navel cord, then he did the best he could about other things. When the mid-wife, locally known as a granny, arrived about an hour later, there was a fire in the stove and plenty of hot water on. I had been sponged off in some sort of a way, and Mama was holding me in her arms.

As soon as the old woman got there, the white man unloaded what he had brought, and drove off cussing about some blankety-blank people never being where you could put your hands on them when they were needed.

He got no thanks from Aunt Judy. She grumbled for years about it. She complained that the cord had not been cut just right, and the belly-band had not been put on tight enough. She was mighty scared I was going to have a weak back, and that I would have trouble holding my water until I reached puberty. I did.

The next day or so a Mrs. Neale, a friend of Mama's, came in and reminded her that she had promised to let her name the baby in case it was a girl. She had picked up a name somewhere which she thought was very pretty. Perhaps, she had read it somewhere, or somebody back in those woods was smoking Turkish cigarettes. So I became Zora Neale Hurston.

There is nothing to make you like other human beings so much as doing things for them. Therefore, the man who grannied me was back next day to see how I was coming along. Maybe it was pride in his own handiwork, and his resourcefulness in a pinch, that made him want to see it through. He remarked that I was a God damned fine baby, fat and plenty of lung-power. As time went on, he came infrequently, but somehow kept a pinch of interest in my welfare. It seemed that I was spying noble, growing like a gourd vine, and yelling bass like a gator. He was the kind of a man that had no use for puny

things, so I was all to the good with him. He thought my mother was justified in keeping me.

But nine months rolled around, and I just would not get on with the walking business. I was strong, crawling well, but showed no inclination to use my feet. I might remark in passing, that I still don't like to walk. Then I was over a year old, but still I would not walk. They made allowances for my weight, but yet, that was no real reason for my not trying.

They tell me that an old sow-hog taught me how to walk. That is, she didn't instruct me in detail, but she convinced me that I really ought to try.

It was like this. My mother was going to have collard greens for dinner, so she took the dishpan and went down to the spring to wash the greens. She left me sitting on the floor, and gave me a hunk of corn bread to keep me quiet. Everything was going along all right, until the sow with her litter of pigs in convoy came abreast of the door. She must have smelled the corn bread I was messing with and scattering crumbs about the floor. So, she came right on in, and began to nuzzle around.

My mother heard my screams and came running. Her heart must have stood still when she saw the sow in there, because hogs have been known to eat human flesh.

But I was not taking this thing sitting down. I had been placed by a chair, and when my mother got inside the door, I had pulled myself up by that chair and was getting around it right smart.

As for the sow, poor misunderstood lady, she had no interest in me except my bread. I lost that in scrambling to my feet and she was eating it. She had much less intention of eating Mama's baby, than Mama had of eating hers.

With no more suggestions from the sow or anybody else, it seems that I just took to walking and kept the thing a'going. The strangest thing about it was that once I found the use of my feet, they took to wandering. I always wanted to go. I would wander off in the woods all alone, following some inside urge to go places. This alarmed my mother a great deal. She used to say that she believed a woman who was an enemy

of hers had sprinkled "travel dust" around the doorstep the day I was born. That was the only explanation she could find. I don't know why it never occurred to her to connect my tendency with my father, who didn't have a thing on his mind but this town and the next one. That should have given her a sort of hint. Some children are just bound to take after their fathers in spite of women's prayers.

THE INSIDE SEARCH

Grown people know that they do not always know the why of things, and even if they think they know, they do not know where and how they got the proof. Hence the irritation they show when children keep on demanding to know if a thing is so and how the grown folks got the proof of it. It is so troublesome because it is disturbing to the pigeon-hole way of life. It is upsetting because until the elders are pushed for an answer, they have never looked to see if it was so, nor how they came by what passes for proof to their acceptances of certain things as true. So, if telling their questioning young to run off and play does not suffice for an answer, a good slapping of the child's bottom is held to be proof positive for anything from spelling Constantinople to why the sea is salt. It was told to the old folks and that had been enough for them, or to put it in Negro idiom, nobody didn't tell 'em, but they heard. So there must be something wrong with a child that questions the gods of the pigeon-holes.

I was always asking and making myself a crow in a pigeon's nest. It was hard on my family and surroundings, and they in turn were hard on me. I did not know then, as I know now,

that people are prone to build a statue of the kind of person that it pleases them to be. And few people want to be forced to ask themselves, "What if there is no me like my statue?" The thing to do is to grab the broom of anger and drive off the beast of fear.

I was full of curiosity like many other children, and like them I was as unconscious of the sanctity of statuary as a flock of pigeons around a palace. I got few answers from other people, but I kept right on asking, because I couldn't do anything else with my feelings.

Naturally, I felt like other children in that Death, destruction and other agonies were never meant to touch me. Things like that happened to other people, and no wonder. They were not like me and mine. Naturally, the world and the firmaments careened to one side a little so as not to inconvenience me. In fact, the universe went further than that—it was happy to break a few rules just to show me preferences.

For instance, for a long time I gloated over the happy secret that when I played outdoors in the moonlight, the moon followed me, whichever way I ran. The moon was so happy when I came out to play, that it ran shining and shouting after me like a pretty puppy dog. The other children didn't count.

But, I was rudely shaken out of this when I confided my happy secret to Carrie Roberts, my chum. It was cruel. She not only scorned my claim, she said that the moon was paying me no mind at all. The moon, my own happy private-playing moon, was out in its play yard to race and play with her.

We disputed the matter with hot jealousy, and nothing would do but we must run a race to prove which one the moon was loving. First, we both ran a race side by side, but that proved nothing because we both contended that the moon was going that way on account of us. I just knew that the moon was there to be with me, but Carrie kept on saying that it was herself that the moon preferred. So then it came to me that we ought to run in opposite directions so that Carrie could come to her senses and realize the moon was mine. So we both stood

with our backs to our gate, counted three and tore out in opposite directions.

"Look! Look, Carrie!" I cried exultantly. "You see the moon is following me!"

"Aw, youse a tale-teller! You know it's chasing me."

So Carrie and I, parted company, mad as we could be with each other. When the other children found out what the quarrel was about, they laughed it off. They told me the moon always followed them. The unfaithfulness of the moon hurt me deeply. My moon followed Carrie Roberts. My moon followed Matilda Clarke and Julia Mosely, and Oscar and Teedy Miller. But after a while, I ceased to ache over the moon's many loves. I found comfort in the fact that though I was not the moon's exclusive friend, I was still among those who showed the moon which way to go. That was my earliest conscious hint that the world didn't tilt under my foot-falls, nor careen over one-sided just to make me glad.

But no matter whether my probings made me happier or sadder, I kept on probing to know. For instance, I had a stifled longing. I used to climb to the top of one of the huge Chinaberry trees which guarded our front gate, and look out over the world. The most interesting thing that I saw was the horizon. Every way I turned, it was there, and the same distance away. Our house then, was in the center of the world. It grew upon me that I ought to walk out to the horizon and see what the end of the world was like. The daring of the thing held me back for a while, but the thing became so urgent that I showed it to my friend, Carrie Roberts, and asked her to go with me. She agreed. We sat up in the trees and disputed about what the end of the world would be like when we got there—whether it was sort of tucked under like the hem of a dress, or just was a sharp drop off into nothingness. So we planned to slip off from our folks bright and soon next morning and go see.

I could hardly sleep that night from the excitement of the thing. I had been yearning for so many months to find out about the end of things. I had no doubts about the beginnings.

27

They were somewhere in the five acres that was home to me. Most likely in Mama's room. Now, I was going to see the end, and then I would be satisfied.

As soon as breakfast was over, I sneaked off to the meeting place in the scrub palmettoes, a short way from our house and waited. Carrie didn't come right away. I was on my way to her house by a round-about way when I met her. She was coming to tell me that she couldn't go. It looked so far that maybe we wouldn't get back by sundown, and then we would both get a whipping. When we got big enough to wear long dresses, we could go and stay as long as we wanted to. Nobody couldn't whip us then. No matter how hard I begged, she wouldn't go. The thing was too bold and brazen to her thinking. We had a fight, then. I had to hit Carrie to keep my heart from stifling me. Then I was sorry I had struck my friend, and went on home and hid under the house with my heartbreak. But, I did not give up the idea of my journey. I was merely lonesome for someone brave enough to undertake it with me. I wanted it to be Carrie. She was a lot of fun, and always did what I told her. Well, most of the time, she did. This time it was too much for even her loyalty to surmount. She even tried to talk me out of my trip. I couldn't give up. It meant too much to me. I decided to put it off until I had something to ride on, then I could go by myself.

So for weeks I saw myself sitting astride of a fine horse. My shoes had sky-blue bottoms to them, and I was riding off to look at the belly-band of the world.

It was summer time, and the mocking birds sang all night long in the orange trees. Alligators trumpeted from their stronghold in Lake Belle. So fall passed and then it was Christmas time.

Papa did something different a few days before Christmas. He sort of shoved back from the table after dinner and asked us all what we wanted Santa Claus to bring us. My big brothers wanted a baseball outfit. Ben and Joel wanted air rifles. My sister wanted patent leather pumps and a belt. Then it was my turn. Suddenly a beautiful vision came before me. Two things

could work together. My Christmas present could take me to the end of the world.

"I want a fine black riding horse with white leather saddle and bridles," I told Papa happily.

"You, what?" Papa gasped. "What was dat you said?"

"I said, I want a black saddle horse with . . ."

"A saddle horse!" Papa exploded. "It's a sin and a shame! Lemme tell you something right now, my young lady; you ain't white.* Riding horse!! Always trying to wear de big hat! I don't know how you got in this family nohow. You ain't like none of de rest of my young'uns."

"If I can't have no riding horse, I don't want nothing at all," I said stubbornly with my mouth, but inside I was sucking sorrow. My longed-for journey looked impossible.

"I'll riding-horse you, Madam!" Papa shouted and jumped to his feet. But being down at the end of the table big enough for all ten members of the family together, I was near the kitchen door, and I beat Papa to it by a safe margin. He chased me as far as the side gate and turned back. So I did not get my horse to ride off to the edge of the world. I got a doll for Christmas.

Since Papa would not buy me a saddle horse, I made me one up. No one around me knew how often I rode my prancing horse, nor the things I saw in far places. Jake, my puppy, always went along and we made great admiration together over the things we saw and ate. We both agreed that it was nice to be always eating things.

I discovered that I was extra strong by playing with other girls near my age. I had no way of judging the force of my playful blows, and so I was always hurting somebody. Then they would say I meant to hurt, and go home and leave me. Everything was all right, however, when I played with boys. It was a shameful thing to admit being hurt among them. Further-

*That is a Negro saying that means "Don't be too ambitious. You are a Negro and they are not meant to have but so much."

29

more, they could dish it out themselves, and I was acceptable to them because I was the one girl who could take a good pummeling without running home to tell. The fly in the ointment there, was that in my family, it was not lady-like for girls to play with boys. No matter how young you were, no good could come of the thing. I used to wonder what was wrong with playing with boys. Nobody told me. I just mustn't, that was all. What was wrong with my doll-babies? Why couldn't I sit still and make my dolls some clothes?

I never did. Dolls caught the devil around me. They got into fights and leaked sawdust before New Year's. They jumped off the barn and tried to drown themselves in the lake. Perhaps, the dolls bought for me looked too different from the ones I made up myself. The dolls I made up in my mind, did everything. Those store-bought things had to be toted and helped around. Without knowing it, I wanted action.

So I was driven inward. I lived an exciting life unseen. But I had one person who pleased me always. That was the robust, grey-haired, white man who had helped me get into the world. When I was quite small, he would come by and tease me and then praise me for not crying. When I got old enough to do things, he used to come along some afternoons and ask to take me with him fishing. He said he hated to bait his own hook and dig worms. It always turned out when we got to some lake back in the woods that he had a full can of bait. He baited his own hooks. In between fishing business, he would talk to me in a way I liked—as if I were as grown as he. He would tell funny stories and swear at every other word. He was always making me tell him things about my doings, and then he would tell me what to do about things. He called me Snidlits, explaining that Zora was a hell of a name to give a child.

"Snidlits, don't be a nigger," he would say to me over and over.* "Niggers lie and lie! Any time you catch folks lying, they are skeered of something. Lying is dodging. People with

*The word Nigger used in this sense does not mean race. It means a weak, contemptible person of any race.

30

guts don't lie. They tell the truth and then if they have to, they fight it out. You lay yourself open by lying. The other fellow knows right off that you are skeered of him and he's more'n apt to tackle you. If he don't do nothing, he starts to looking down on you from then on. Truth is a letter from courage. I want you to grow guts as you go along. So don't you let me hear of you lying. You'll get 'long all right if you do like I tell you. Nothing can't lick you if you never get skeered.''

My face was all scratched up from fighting one time, so he asked me if I had been letting some kid lick me. I told him how Mary Ann and I had started to fighting and I was doing fine until her older sister Janie and her brother Ed, who was about my size, had all doubleteened me.

"Now, Snidlits, this calls for talking. Don't you try to fight three kids at one time unlessen you just can't get around it. Do the best you can, if you have to. But learn right now, not to let your head start more than your behind can stand. Measure out the amount of fighting you can do, and then do it. When you take on too much and get licked, folks will pity you first and scorn you after awhile, and that's bad. Use your head!''

"Do de best I can,'' I assured him, proud for him to think I could.

"That's de ticket, Snidlits. The way I want to hear you talk. And while I'm on the subject, don't you never let nobody spit on you nor kick you. Anybody who takes a thing like that ain't worth de powder and shot it takes to kill 'em, hear?''

"Yessir.''

"Can't nothing wash that off, but blood. If anybody ever do one of those things to you, kill dead and go to jail. Hear me?''

I promised him I would try and he took out a peanut bar and gave it to me.

"Now, Snidlits, another thing. Don't you never threaten nobody you don't aim to fight. Some folks will back off of you if you put out plenty threats, but you going to meet some that don't care how big you talk, they'll try you. Then, if you can't back your crap with nothing but talk, you'll catch hell. Some folks puts dependence in bluffing, but I ain't never seen one

31

that didn't get his bluff called sooner or later. Give 'em what you promise 'em and they'll look up to you even if they hate your guts. Don't worry over that part. Somebody is going to hate you anyhow, don't care what you do. My idea is to give 'em a good cause if it's got to be. And don't change too many words if you aim to fight. Lam hell out of 'em with the first lick and keep on lamming. I've seen many a fight finished with the first lick. Most folks can't stand to be hurt. But you must realize that getting hurt is part of fighting. Keep right on. The one that hurts the other one the worst wins the fight. Don't try to win no fights by calling 'em low-down names. You can call 'em all the names you want to, after the fight. That's the best time to do it, anyhow."

I knew without being told that he was not talking about my race when he advised me not to be a nigger. He was talking about class rather than race. He frequently gave money to Negro schools.

These talks went on until I was about ten. Then the hard-riding, hard-drinking, hard-cussing, but very successful man, was thrown from his horse and died. Nobody ever expected him to die in bed, so that part was all right. Everybody said that he had been a useful citizen, just powerful hot under the collar.

He was an accumulating man, a good provider, paid his debts and told the truth. Those were all the virtues the community expected. Any more than that would not have been appreciated. He could ride like a centaur, swim long distances, shoot straight with either pistol or guns, and allowed no man to give him the lie to his face. He was supposed to be so tough, it was said that once he was struck by lightning and was not even knocked off his feet, but that lightning went off through the woods limping. Nobody found any fault with a man like that in a country where personal strength and courage were the highest virtues. People were supposed to take care of themselves without whining.

For example, two men came before the justice of the peace over in Maitland. The defendant had hit the plaintiff three

times with his fist and kicked him four times. The justice of the peace fined him seven dollars—a dollar a lick. The defendant hauled out his pocketbook and paid his fine with a smile. The justice of the peace then fined the plaintiff ten dollars.

"What for?" he wanted to know. "Why, Mr. Justice, that man knocked me down and kicked me, and I never raised my hand."

"That is just what I'm fining you for, you yellow-bellied coudar!* Nobody with any guts would have come into court to settle a fist fight."

The community felt that the justice had told him what was right. In a neighborhood where bears and alligators raided hog-pens, wild cats fought with dogs in people's yards, rattle-snakes as long as a man and as thick as a man's forearm were found around back doors, a fist fight was a small skimption. As in all frontiers, there was the feeling for direct action. Decency was plumb outraged at a man taking a beating and then swear-ing out a warrant about it. Most of the settlers considered a courthouse a place to "law" over property lines and things like that. That is, you went to law over it if neither party got too abusive and personal. If it came to that, most likely the heirs of one or the other could take it to court after the funeral was over.

So the old man died in high favor with everybody. He had done his cussing and fighting and drinking as became a man, taken care of his family and accumulated property. Nobody thought anything about his going to the county seat fre-quently, getting drunk, getting his riding-mule drunk along with him, and coming down the pike yelling and singing while his mule brayed in drunken hilarity. There went a man!

I used to take a seat on top of the gate post and watch the world go by. One way to Orlando ran past my house, so the carriages and cars would pass before me. The movement made me glad to see it. Often the white travelers would hail me, but

*A coudar is a fresh-water terrapin.

more often I hailed them, and asked, "Don't you want me to go a piece of the way with you?"

They always did. I know now that I must have caused a great deal of amusement among them, but my self-assurance must have carried the point, for I was always invited to come along. I'd ride up the road for perhaps a half mile, then walk back. I did not do this with the permission of my parents, nor with their foreknowledge. When they found out about it later, I usually got a whipping. My grandmother worried about my forward ways a great deal. She had known slavery and to her, my brazenness was unthinkable.

"Git down offa dat gate post! You li'l sow, you! Git down! Setting up dere looking dem white folks right in de face! They's gowine to lynch you, yet. And don't stand in dat doorway gazing out at 'em neither. Youse too brazen to live long."

Nevertheless, I kept right on gazing at them, and "going a piece of the way" whenever I could make it. The village seemed dull to me most of the time. If the village was singing a chorus, I must have missed the tune.

Perhaps a year before the old man died, I came to know two other white people for myself. They were women.

It came about this way. The whites who came down from the North were often brought by their friends to visit the village school. A Negro school was something strange to them, and while they were always sympathetic and kind, curiosity must have been present, also. They came and went, came and went. Always, the room was hurriedly put in order, and we were threatened with a prompt and bloody death if we cut one caper while the visitors were present. We always sang a spiritual, led by Mr. Calhoun himself. Mrs. Calhoun always stood in the back, with a palmetto switch in her hand as a squelcher. We were all little angels for the duration, because we'd better be. She would cut her eyes and give us a glare that meant trouble, then turn her face towards the visitors and beam as much as to say it was a great privilege and pleasure to teach lovely children like us. They couldn't see that palmetto hickory in her hand behind all those benches, but we

34

knew where our angelic behavior was coming from.

Usually, the visitors gave warning a day ahead and we would be cautioned to put on shoes, comb our heads, and see to ears and fingernails. There was a close inspection of every one of us before we marched in that morning. Knotty heads, dirty ears and fingernails got hauled out of line, strapped and sent home to lick the calf over again.

This particular afternoon, the two young ladies just popped in. Mr. Calhoun was flustered, but he put on the best show that he could. He dismissed the class that he was teaching up at the front of the room, then called the fifth grade in reading. That was my class.

So we took our readers and went up front. We stood up in the usual line, and opened to the lesson. It was the story of Pluto and Persephone. It was new and hard to the class in general, and Mr. Calhoun was very uncomfortable as the readers stumbled along, spelling out words with their lips, and in mumbling undertones before they exposed them experimentally to the teacher's ears.

Then it came to me. I was fifth or sixth down the line. The story was not new to me, because I had read my reader through from lid to lid, the first week that Papa had bought it for me.

That is how it was that my eyes were not in the book, working out the paragraph which I knew would be mine by counting the children ahead of me. I was observing our visitors, who held a book between them, following the lesson. They had shiny hair, mostly brownish. One had a looping gold chain around her neck. The other one was dressed all over in black and white with a pretty finger ring on her left hand. But the thing that held my eyes were their fingers. They were long and thin, and very white, except up near the tips. There they were baby pink. I had never seen such hands. It was a fascinating discovery for me. I wondered how they felt. I would have given those hands more attention, but the child before me was almost through. My turn next, so I got on my mark, bringing my eyes back to the book and made sure of my place. Some

35

of the stories, I had reread several times, and this Greco-Roman myth was one of my favorites. I was exalted by it, and that is the way I read my paragraph.

"Yes, Jupiter had seen her (Persephone). He had seen the maiden picking flowers in the field. He had seen the chariot of the dark monarch pause by the maiden's side. He had seen him when he seized Persephone. He had seen the black horses leap down Mount Aetna's fiery throat. Persephone was now in Pluto's dark realm and he had made her his wife."

The two women looked at each other and then back to me. Mr. Calhoun broke out with a proud smile beneath his bristly moustache, and instead of the next child taking up where I had ended, he nodded to me to go on. So I read the story to the end where flying Mercury, the messenger of the Gods, brought Persephone back to the sunlit earth and restored her to the arms of Dame Ceres, her mother, that the world might have springtime and summer flowers, autumn and harvest. But because she had bitten the pomegranate while in Pluto's kingdom, she must return to him for three months of each year, and be his queen. Then the world had winter, until she returned to earth.

The class was dismissed and the visitors smiled us away and went into a low-voiced conversation with Mr. Calhoun for a few minutes. They glanced my way once or twice and I began to worry. Not only was I barefooted, but my feet and legs were dusty. My hair was more uncombed than usual, and my nails were not shiny clean. Oh, I'm going to catch it now. Those ladies saw me, too. Mr. Calhoun is promising to 'tend to me. So I thought.

Then Mr. Calhoun called me. I went up thinking how awful it was to get a whipping before company. Furthermore, I heard a snicker run over the room. Hennie Clark and Stell Brazzle did it out loud, so I would be sure to hear them. The smart-aleck was going to get it. I slipped one hand behind me and switched my dress tail at them, indicating scorn.

"Come here, Zora Neale," Mr. Calhoun cooed as I reached the desk. He put his hand on my shoulder and gave me little

pats. The ladies smiled and held out those flower-looking fingers towards me. I seized the opportunity for a good look.

"Shake hands with the ladies, Zora Neale," Mr. Calhoun prompted and they took my hand one after the other and smiled. They asked me if I loved school, and I lied that I did. There was *some* truth in it, because I liked geography and reading, and I liked to play at recess time. Whoever it was invented writing and arithmetic got no thanks from me. Neither did I like the arrangement where the teacher could sit up there with a palmetto stem and lick me whenever he saw fit. I hated things I couldn't do anything about. But I knew better than to bring that up right there, so I said yes, I *loved* school.

"I can tell you do," Brown Taffeta gleamed. She patted my head, and was lucky enough not to get sandspurs in her hand. Children who roll and tumble in the grass in Florida, are apt to get sandspurs in their hair. They shook hands with me again and I went back to my seat.

When school let out at three o'clock, Mr. Calhoun told me to wait. When everybody had gone, he told me I was to go to the Park House, that was the hotel in Maitland, the next afternoon to call upon Mrs. Johnstone and Miss Hurd. I must tell Mama to see that I was clean and brushed from head to feet, and I must wear shoes and stockings. The ladies liked me, he said, and I must be on my best behavior.

The next day I was let out of school an hour early, and went home to be stood up in a tub of suds and be scrubbed and have my ears dug into. My sandy hair sported a red ribbon to match my red and white checked gingham dress, starched until it could stand alone. Mama saw to it that my shoes were on the right feet, since I was careless about left and right. Last thing, I was given a handkerchief to carry, warned again about my behavior, and sent off with my big brother, John, to go as far as the hotel gate with me.

First thing, the ladies gave me strange things, like stuffed dates and preserved ginger, and encouraged me to eat all that I wanted. Then they showed me their Japanese dolls and just talked. I was then handed a copy of *Scribner's Magazine,* and

asked to read a place that was pointed out to me. After a paragraph or two, I was told with smiles, that that would do.

I was led out on the grounds and they took my picture under a palm tree. They handed me what was to me then, a heavy cylinder done up in fancy paper, tied with a ribbon, and they told me goodbye, asking me not to open it until I got home.

My brother was waiting for me down by the lake, and we hurried home, eager to see what was in the thing. It was too heavy to be candy or anything like that. John insisted on toting it for me.

My mother made John give it back to me and let me open it. Perhaps, I shall never experience such joy again. The nearest thing to that moment was the telegram accepting my first book. One hundred goldy-new pennies rolled out of the cylinder. Their gleam lit up the world. It was not avarice that moved me. It was the beauty of the thing. I stood on the mountain. Mama let me play with my pennies for a while, then put them away for me to keep.

That was only the beginning. The next day I received an Episcopal hymn-book bound in white leather with a golden cross stamped into the front cover, a copy of *The Swiss Family Robinson,* and a book of fairy tales.

I set about to commit the song words to memory. There was no music written there, just the words. But there was to my consciousness music in between them just the same. "When I survey the Wondrous Cross" seemed the most beautiful to me, so I committed that to memory first of all. Some of them seemed dull and without life, and I pretended they were not there. If white people liked trashy singing like that, there must be something funny about them that I had not noticed before. I stuck to the pretty ones where the words marched to a throb I could feel.

A month or so after the two young ladies returned to Minnesota, they sent me a huge box packed with clothes and books. The red coat with a wide circular collar and the red tam pleased me more than any of the other things. My chums pretended not to like anything that I had, but even then I

knew that they were jealous. Old Smarty had gotten by them again. The clothes were not new, but they were very good. I shone like the morning sun.

But the books gave me more pleasure than the clothes. I had never been too keen on dressing up. It called for hard scrubbings with Octagon soap suds getting in my eyes, and none too gentle fingers scrubbing my neck and gouging in my ears.

In that box was Gulliver's Travels, Grimm's Fairy Tales, Dick Whittington, Greek and Roman Myths, and best of all, Norse Tales. Why did the Norse tales strike so deeply into my soul? I do not know, but they did. I seemed to remember seeing Thor swing his mighty short-handled hammer as he sped across the sky in rumbling thunder, lightning flashing from the tread of his steeds and the wheels of his chariot. The great and good Odin, who went down to the well of knowledge to drink, and was told that the price of a drink from that fountain, was an eye. Odin drank deeply, then plucked out one eye without a murmur and handed it to the grizzly keeper, and walked away. That held majesty for me.

Of the Greeks, Hercules moved me most. I followed him eagerly on his tasks. The story of the choice of Hercules as a boy when he met Pleasure and Duty, and put his hand in that of Duty and followed her steep way to the blue hills of fame and glory, which she pointed out at the end, moved me profoundly. I resolved to be like him. The tricks and turns of the other Gods and Goddesses left me cold. There were other thin books about this and that sweet and gentle little girl who gave up her heart to Christ and good works. Almost always they died from it, preaching as they passed. I was utterly indifferent to their deaths. In the first place I could not conceive of death, and in the next place they never had any funerals that amounted to a hill of beans, so I didn't care how soon they rolled up their big, soulful, blue eyes and kicked the bucket. They had no meat on their bones.

But I also met Hans Andersen and Robert Louis Stevenson. They seemed to know what I wanted to hear and said it in a way that tingled me. Just a little below these friends was Rud-

yard Kipling in his Jungle Books. I loved his talking snakes as much as I did the hero.

I came to start reading the Bible through my mother. She gave me a licking one afternoon for repeating something I had overheard a neighbor telling her. She locked me in her room after the whipping, and the Bible was the only thing in there for me to read. I happened to open to the place where David was doing some mighty smiting, and I got interested. David went here and he went there, and no matter where he went, he smote 'em hip and thigh. Then he sung songs to his harp a while, and went out and smote some more. Not one time did David stop and preach about sins and things. All David wanted to know from God was who to kill and when. He took care of the other details himself. Never a quiet moment. I liked him a lot. So I read a great deal more in the Bible, hunting for some more active people like David. Except for the beautiful language of Luke and Paul, the New Testament still plays a poor second to the Old Testament for me. The Jews had a God who laid about Him when they needed Him. I could see no use waiting till Judgment Day to see a man who was just crying for a good killing, to be told to go and roast. My idea was to give him a good killing first, and then if he got roasted later on, so much the better.

In searching for more Davids, I came upon Leviticus. There were exciting things in there to a child eager to know the facts of life. I told Carrie Roberts about it, and we spent long afternoons reading what Moses told the Hebrews not to do in Leviticus. In that way I found out a number of things the old folks would not have told me. Not knowing what we were actually reading, we got a lot of praise from our elders for our devotion to the Bible.

Having finished that and scanned the Doctor Book, which my mother thought she had hidden securely from my eyes, I read all the things which children write on privy-house walls. Therefore, I lost my taste for pornographic literature. I think that the people who love it, got cheated in the matter of privy-houses when they were children.

40

In a way this early reading gave me great anguish through all my childhood and adolescence. My soul was with the gods and my body in the village. People just would not act like gods. Stew beef, fried fat-back and morning grits were no ambrosia from Valhalla. Raking back yards and carrying out chamber pots, were not the tasks of Hercules. I wanted to be away from drabness and to stretch my limbs in some mighty struggle. I was only happy in the woods, and when the ecstatic Florida springtime came strolling from the sea, trance-glorifying the world with its aura. Then I hid out in the tall wild oats that waved like a glinty veil. I nibbled sweet oat stalks and listened to the wind soughing and sighing through the crowns of the lofty pines. I made particular friendship with one huge tree and always played about its roots. I named it "the loving pine," and my chums came to know it by that name.

In contrast to everybody about me, I was not afraid of snakes. They fascinated me in a way which I still cannot explain. I got no pleasure from their death.

I do not know when the visions began. Certainly I was not more than seven years old, but I remember the first coming very distinctly. My brother, Joel, and I had made a hen take an egg back and been caught as we turned the hen loose. We knew we were in for it and decided to scatter until things cooled off a bit. He hid out in the barn, but I combined discretion with pleasure, and ran clear off the place. Mr. Linsay's house was vacant at the time. He was a neighbor who was off working somewhere. I had not thought of stopping there when I set out, but I saw a big raisin lying on the porch and stopped to eat it. There was some cool shade on the porch, so I sat down, and soon I was asleep in a strange way. Like clearcut stereopticon slides, I saw twelve scenes flash before me, each one held until I had seen it well in every detail, and then be replaced by another. There was no continuity as in an average dream. Just disconnected scene after scene with blank spaces in between. I knew that they were all true, a preview of things to come, and my soul writhed in agony and shrunk away. But I knew that there was no shrinking. These things

41

had to be. I did not wake up when the last one flickered and vanished, I merely sat up and saw the Methodist Church, the line of moss-draped oaks, and our strawberry patch stretching off to the left.

So when I left the porch, I left a great deal behind me. I was weighed down with a power I did not want. I had knowledge before its time. I knew my fate. I knew that I would be an orphan and homeless. I knew that while I was still helpless, that the comforting circle of my family would be broken, and that I would have to wander cold and friendless until I had served my time. I would stand beside a dark pool of water and see a huge fish move slowly away at a time when I would be somehow in the depth of despair. I would hurry to catch a train, with doubts and fears driving me and seek solace in a place and fail to find it when I arrived, then cross many tracks to board the train again. I knew that a house, a shot-gun built house that needed a new coat of white paint, held torture for me, but I must go. I saw deep love betrayed, but I must feel and know it. There was no turning back. And last of all, I would come to a big house. Two women waited there for me. I could not see their faces, but I knew one to be young and one to be old. One of them was arranging some queer-shaped flowers such as I had never seen. When I had come to these women, then I would be at the end of my pilgrimage, but not the end of my life. Then I would know peace and love and what goes with those things, and not before.

These visions would return at irregular intervals. Sometimes two or three nights running. Sometimes weeks and months apart. I had no warning. I went to bed and they came. The details were always the same, except in the last picture. Once or twice I saw the old faceless woman standing outdoors beside a tall plant with that same off-shape white flower. She turned suddenly from it to welcome me. I knew what was going on in the house without going in, it was all so familiar to me.

I never told anyone around me about these strange things. It was too different. They would laugh me off as a story-teller. Besides, I had a feeling of difference from my fellow men, and I did not want it to be found out. Oh, how I cried out to be just as everybody else! But the voice said no. I must go where I was sent. The weight of the commandment laid heavy and made me moody at times. When I was an ordinary child, with no knowledge of things but the life about me, I was reasonably happy. I would hope that the call would never come again. But even as I hoped I knew that the cup meant for my lips would not pass. I must drink the bitter drink. I studied people all around me, searching for someone to fend it off. But I was told inside myself that there was no one. It gave me a feeling of terrible aloneness. I stood in a world of vanished communion with my kind, which is worse than if it had never been. Nothing is so desolate as a place where life has been and gone. I stood on a soundless island in a tideless sea.

Time was to prove the truth of my visions, for one by one they came to pass. As soon as one was fulfilled, it ceased to come. As this happened, I counted them off one by one and took consolation in the fact that one more station was past, thus bringing me nearer the end of my trials, and nearer to the big house, with the kind women and the strange white flowers.

Years later, after the last one had come and gone, I read a sentence or a paragraph now and then in the columns of O. O. McIntyre which perhaps held no meaning for the millions who read him, but I could see through those slight revelations that he had had similar experiences. Kipling knew the feeling for himself, for he wrote of it very definitely in his *Plain Tales from the Hills.* So I took comfort in knowing that they were fellow pilgrims on my strange road.

I consider that my real childhood ended with the coming of the pronouncements. True, I played, fought and studied with other children, but always I stood apart within. Often I was in some lonesome wilderness, suffering strange things and ago-

nies while other children in the same yard played without a care. I asked myself why me? Why? Why? A cosmic loneliness was my shadow. Nothing and nobody around me really touched me. It is one of the blessings of this world that few people see visions and dream dreams.

CHAPTER 5

FIGURE AND FANCY

Nothing that God ever made is the same thing to more than one person. That is natural. There is no single face in nature, because every eye that looks upon it, sees it from its own angle. So every man's spice-box seasons his own food.

Naturally, I picked up the reflections of life around me with my own instruments, and absorbed what I gathered according to my inside juices.

There were the two churches, Methodist and Baptist, and the school. Most people would say that such institutions are always the great influences in any town. They would say that because it sounds like the thing that ought to be said. But I know that Joe Clarke's store was the heart and spring of the town.

Men sat around the store on boxes and benches and passed this world and the next one through their mouths. The right and the wrong, the who, when and why was passed on, and nobody doubted the conclusions. Women stood around there on Saturday nights and had it proven to the community that their husbands were good providers, put all of his money in

his wife's hands and generally glorified her. Or right there before everybody it was revealed that he was keeping some other woman by the things the other woman was allowed to buy on his account. No doubt a few men found that their wives had a brand new pair of shoes oftener than he could afford it, and wondered what she did with her time while he was off at work. Sometimes he didn't have to wonder. There were no discreet nuances of life on Joe Clarke's porch. There was open kindnesses, anger, hate, love, envy and its kinfolks, but all emotions were naked, and nakedly arrived at. It was a case of "make it and take it." You got what your strengths would bring you. This was not just true of Eatonville. This was the spirit of that whole new part of the state at the time, as it always is where men settle new lands.

For me, the store porch was the most interesting place that I could think of. I was not allowed to sit around there, naturally. But, I could and did drag my feet going in and out whenever I was sent there for something to allow whatever was being said to hang in my ear. I would hear an occasional scrap of gossip in what to me was adult double talk, but which I understood at times.

There would be, for instance, sly references to the physical condition of women, irregular love affairs, brags on male potency by the parties of the first part, and the like. It did not take me long to know what was meant when a girl was spoken of as "ruint" or "bigged." For instance somebody would remark, "Ada Dell is ruint, you know." "Yep, somebody was telling me. A pitcher can go to the well a long time, but its bound to get broke sooner or later." Or some woman or girl would come switching past the store porch and some man would call to her, "Hey Sugar! What's on de rail for de lizard?" Then again I would hear some man say that "I got to have my ground-rations. If one woman can't take care of it, I gits me another one." One man told a woman to hold her ear close, because he had a bug to put in her ear. He was sitting on a box. She stooped over to hear whatever it was he had to whisper to her. Then she straightened up sharply and pulled

46

away from him. "Why, you!" she exclaimed. "The idea of such a thing! Talking like dat to me, when you know I'm a good church-worker, and you a deacon!" He didn't seem to be ashamed at all. "Dat's just de point I'm coming out on, sister. Two clean sheets can't dirty one 'nother, you know." There was general laughter, as the deacon moved his foot so that I could get in the store door. I happened to hear a man talking to another in a chiding manner and say, "To save my soul, I can't see what you fooled with her for. She'd have a shake if somebody was to hold his head for her! I'd just as soon pick up a old tin can out of the trash pile." The other one stroked his chin and said, "On de average, I'd say de same thing. But last night, I had de feeling dat anything hot and hollow would do. Just like Uncle Bud."

One afternoon my oldest brother was on the store porch with the men. He was proudly stroking two or three hairs on his top lip. A married man in his late twenties was giving him some advice about growing a big, thick mustache. I went on inside. When I was coming out, I heard something about getting his finger wet from a woman and wiping it on his lip. Best mustache-grower God ever made. They all grew theirs that way. It was a good thing my brother let them know so he could be told the inside secret. I emerged from the door and the porch fell silent. Later on, I asked my brother what they were talking about, and he slapped me all over the place. He and my second brother, John, were in secret session upstairs in their room. I went on down and crept back to listen and heard John asking how old the woman had to be? It seemed that Bob was not sure. He had forgotten to ask. But it was evident that some great discovery had been made, and they were both most eager to grow big, manly moustaches. It was still mysterious to me. I was out of college and doing research in Anthropology before I heard all about it. Then I heard that a man's moustache was given him by a woman anyway. It seems that Adam came to feel that his face needed more decoration than it had. Eve, obligingly, took a spot of hair from where she had no particular use for it—it didn't show

anyway, and slapped it across Adam's mouth, and it grew there. So what Bob was being told, was regular knowledge he was supposed to get when he approached manhood. Just as I learned at puberty that a girl is supposed to catch water-beetles and let one bite her on each breast if she wants a full bosom. There was another way, of course. You could let a boy— anywhere from sixteen to sixty—do what the boys call, "steal a feel" on you, but of course that would not be nice. Almost as bad as having a baby, and not being married.

But what I really loved to hear was the menfolks holding a "lying" session. That is, straining against each other in telling folk tales. God, Devil, Brer Rabbit, Brer Fox, Sis Cat, Brer Bear, Lion, Tiger, Buzzard, and all the wood folk walked and talked like natural men. The wives, of the story-tellers I mean, might yell from backyards for them to come and tote some water, or chop wood for the cook-stove and never get a move out of the men. The usual rejoinder was, "Oh, she's got enough to go on. No matter how much wood you chop, a woman will burn it all up to get a meal. If she got a couple of pieces, she will make it do. If you chop up a whole boxful, she will burn every stick of it. Pay her no mind." So the story telling would go right on. And I often hung around and listened while Mama waited on me for the sugar or coffee to finish off dinner, until she lifted her voice over the tree tops in a way to let me know that her patience was gone: "You Zora-a-a! If you don't come here, you better!" That had a promise of peach hickories in it, and I would have to leave. But I would have found out from such story-tellers as Elijah Moseley, better known as "Lige," how and why Sis Snail quit her husband, for instance. You may or may not excuse my lagging feet, if you know the circumstances of the case:

One morning soon, Lige met Sis Snail on the far side of the road. He had passed there several times in the last few years and seen Sis Snail headed towards the road. For the last three years he had stepped over her several times as she crossed the road, always forging straight ahead. But this morning he found her clean across, and she seemed mighty pleased with

herself, so he stopped and asked her where she was headed for.

"Going off to travel over the world," she told him. "I done left my husband for good."

"How come, Sis Snail? He didn't ill-treat you in no ways, did he?"

"Can't exactly say he did, Brother Lige, but you take and take just so much and then you can't take no more. Your craw gits full up to de neck. De man gits around too slow to suit me, and look like I just can't break him of it. So I done left him for good. I'm out and gone. I gits around right fast, my ownself, and I just can't put up with nobody dat gits around as slow as he do."

"Oh, don't leave de man too sudden, Sis Snail. Maybe he might come to move round fast like you do. Why don't you sort of reason wid de poor soul and let him know how you feel."

"I done tried dat until my patience is all wore out. And this last thing he done run my cup over. You know I took sick in de bed—had de misery in my side so bad till I couldn't rest in de bed. He heard me groaning and asked me what was de matter. I told him how sick I was. Told him, 'Lawd, I'm so sick!' So he said 'If youse sick like dat, I'll go git de doctor for you.' I says, 'I sho would be mighty much obliged if you would.' So he took and told me, 'I don't want you laying there and suffering like dat. I'll go git de doctor right away. Just lemme go git my hat.'

"So I laid there in de bed and waited for him to go git de doctor. Lawd! I was so sick! I rolled from pillar to post. After seven I heard a noise at de door, and I said, 'Lawd, I'm so glad! I know dats my husband done come back wid de doctor.' So I hollered out and asked, 'Honey, is dat you done come back wid de doctor?' And he come growling at me and giving me a short answer wid, 'Don't try to rush me. I ain't gone yet.' It had done took him seven years to git his hat and git to de door. So I just up and left him."

Then one late afternoon, a woman called Gold, who had

come to town from somewhere else, told the why and how of races that pleased me more than what I learned about race derivations later on in Ethnology. This was her explanation:

God did not make folks all at once. He made folks sort of in His spare time. For instance one day He had a little time on his hands, so He got the clay, seasoned it the way He wanted it, then He laid it by and went on to doing something more important. Another day He had some spare moments, so He rolled it all out, and cut out the human shapes, and stood them all up against His long gold fence to dry while He did some important creating. The human shapes all got dry, and when He found time, He blowed the breath of life in them. After that, from time to time, He would call everybody up, and give them spare parts. For instance, one day He called everybody and gave out feet and eyes. Another time He give out toe-nails that Old Maker figured they could use. Anyhow, they had all that they got up to now. So then one day He said, "Tomorrow morning, at seven o'clock *sharp,* I aim to give out color. Everybody be here on time. I got plenty of creating to do tomorrow, and I want to give out this color and get it over wid. *Everybody* be 'round de throne at seven o'clock tomorrow morning!"

So next morning at seven o'clock, God was sitting on His throne with His big crown on His head and seven suns circling around His head. Great multitudes was standing around the throne waiting to get their color. God sat up there and looked, east, and He looked west, and He looked north and He looked Australia, and blazing worlds were falling off His teeth. So He looked over to His left and moved His hands over a crowd and said, "Youse yellow people!" They all bowed low and said, "Thank you, God," and they went on off. He looked at another crowd, moved His hands over them and said, "Youse red folks!" They made their manners and said, "Thank you, Old Maker," and they went on off. He looked towards the center and moved His hand over another crowd and said, "Youse white folks!" They bowed low and said, "Much obliged, Jesus," and they went on off. Then God

50

looked way over to the right and said, "Look here, Gabriel, I miss a lot of multitudes from around the throne this morning." Gabriel looked too, and said, "Yessir, there's a heap of multitudes missing from round de throne this morning." So God sat there an hour and a half and waited. Then He called Gabriel and said, "Looka here, Gabriel, I'm sick and tired of this waiting. I got plenty of creating to do this morning. You go find them folks and tell 'em they better hurry on up here and they expect to get any color. Fool with me, and I won't give out no more."

So Gabriel run on off and started to hunting around. Way after while, he found the missing multitudes lying around on the grass by the Sea of Life, fast asleep. So Gabriel woke them up and told them "You better get up from there and come on up to the throne and get your color. Old Maker is might wore out from waiting. Fool with Him and He won't give out no more color."

So as the multitudes heard that, they all jumped up and went running towards the throne hollering, "Give us our color! We want our color! We got just as much right to color as anybody else." So when the first ones got to the throne, they tried to stop and be polite. But the ones coming on behind got to pushing and shoving so till the first ones got shoved all up against the throne so till the throne was careening all over to one side. So God said "Here! Here! Git back! Git back!" But they was keeping up such a racket that they misunderstood Him, and thought He said "Git black!" So they just got black, and kept the thing agoing.

In one way or another, I heard dozens more of these tales. My father and his preacher associates told the best stories on the church. Papa, being moderator of the South Florida Baptist Association, had numerous preacher visitors just before the Association met, to get the politics of the thing all cut and dried before the meetings came off. After it was decided who would put such and such a motion before the house, who would second it, and whom my father would recognize first and things like that, a big story-telling session would get under

way on our front porch, and very funny stories at the expense of preachers and congregations would get told.

No doubt, these tales of God, the Devil, animals and natural elements seemed ordinary enough to most people in the village. But many of them stirred up fancies in me. It did not surprise me at all to hear that the animals talked. I had suspected it all along. Or let us say, that I wanted to suspect it. Life took on a bigger perimeter by expanding on these things. I picked up glints and gleams out of what I heard and stored it away to turn it to my own uses. The wind would sough through the tops of the tall, long-leaf pines and said things to me. I put in the words that the sounds put into me. Like "woo woo, you wooo!" The tree was talking to me, even when I did not catch the words. It was talking and telling me things. I have mentioned the tree, near our house that got so friendly I named it "the loving pine." Finally all of my playmates called it that too. I used to take a seat at the foot of that tree and play for hours without any other toys. We talked about everything in my world. Sometimes we just took it out in singing songs. That tree had a mighty fine bass voice when it really took a notion to let it out.

There was another tree that used to creep up close to the house around sundown and threaten me. It used to put on a skull-head with a crown on it every day at sundown and make motions at me when I had to go out on the back porch to wash my feet after supper before going to bed. It never bothered around during the day. It was just another pine tree about a hundred feet tall then, standing head and shoulders above a grove. But let the dusk begin to fall, and it would put that crown on its skull and creep in close. Nobody else ever seemed to notice what it was up to but me. I used to wish it would go off somewhere and get lost. But every evening I would have to look to see, and every time, it would be right there, sort of shaking and shivering and bowing its head at me. I used to wonder if sometime it was not going to come in the house.

When I began to make up stories I cannot say. Just from one

fancy to another, adding more and more detail until they seemed real. People seldom see themselves changing. It is like going out in the morning, or in the springtime to pick flowers. You pick and you wander till suddenly you find that the light is gone and the flowers are withered in your hand. Then, you say that you must turn back home. But you have wandered into a place and the gates are closed. There is no more sharp sunlight. Gray meadows are all about you where blooms only the asphodel. You look back through the immutable gates to where the sun still shines on the flowered fields with nostalgic longing, but God pointed men's toes in one direction. One is surprised by the passage of time and the distance travelled, but one may not go back.

So I was making little stories to myself, and have no memory of how I began. But I do remember some of the earliest ones.

I came in from play one day and told my mother how a bird had talked to me with a tail so long that while he sat up in the top of the pine tree his tail was dragging the ground. It was a soft beautiful bird tail, all blue and pink and red and green. In fact I climbed up the bird's tail and sat up the tree and had a long talk with the bird. He knew my name, but I didn't know how he knew it. In fact, the bird had come a long way just to sit and talk with me.

Another time, I dashed into the kitchen and told Mama how the lake had talked with me, and invited me to walk all over it. I told the lake I was afraid of getting drowned, but the lake assured me it wouldn't think of doing *me* like that. No, indeed! Come right on and have a walk. Well, I stepped out on the lake and walked all over it. It didn't even wet my feet. I could see all the fish and things swimming around under me, and they all said hello, but none of them bothered me. Wasn't that nice?

My mother said that it was. My grandmother glared at me like open-faced hell and snorted.

"Luthee!" (She lisped.) "You hear dat young'un stand up here and lie like dat? And you ain't doing nothing to break her of it? Grab her! Wring her coat tails over her head and

53

wear out a handful of peach hickories on her back-side! Stomp her guts out! Ruin her!''

"Oh, she's just playing," Mama said indulgently.

"Playing! Why dat lil' heifer is lying just as fast as a horse can trot. Stop her! Wear her back-side out. I bet if I lay my hands on her she'll stop it. I vominates (abominate) a lying tongue.''

Mama never tried to break me. She'd listen sometimes, and sometimes she wouldn't. But she never seemed displeased. But her mother used to foam at the mouth. I was just as sure to be hung before I got grown as gun was iron! The least thing Mama could do to straighten me out was to smack my jaws for me. She outraged my grandmother scandalously by not doing it. Mama was going to be responsible for my downfall when she stood up in judgment. It was a sin before the living justice, that's what it was. God knows, grandmother would break me or kill me, if she had her way. Killing me looked like the best one, anyway. All I was good for was to lay up and wet the bed half of the time and tell lies, besides being the spitting image of dat good-for-nothing yaller bastard. I was the punishment God put on Mama for marrying Papa. I ought to be thrown in the hogslops, that's what. She could beat me as long as I last.

I knew that I did not have to pay too much attention to the old lady and so I didn't. Furthermore, how was she going to tell what I was doing inside? I could keep my inventions to myself, which was what I did most of the time.

One day, we were going to have roasting-ears for dinner and I was around while Mama was shucking the corn. I picked up an inside chuck and carried it off to look at. It was such a delicate, blushy green. I crawled under the side of the house to love it all by myself.

In a few minutes, it had become Miss Corn-Shuck, and of course needed some hair. So I went back and picked up some corn silk and tied it to the pointed end. We had a lovely time together for a day or two, and then Miss Corn-Shuck got lonesome for some company.

I do not think that her lonesomeness would have come

down on her as it did, if I had not found a cake of sweet soap in Mama's dresser drawer. It was a cake of Pear's scented soap. It was clear like amber glass. I could see straight through it. It delighted my senses just as much as the tender green corn-shuck. So Miss Corn-Shuck fell in love with Mr. Sweet Smell then and there. But she said she could not have a thing to do with him unless he went and put on some clothes. I found a piece of red and white string that had come around some groceries and made him a suit of clothes. Being bigger in the middle than he was on either end, his pants kept falling off— sometimes over his head and sometimes the other way. So I cut little notches in his sides around the middle and tied his suit on. To other people it might have looked like a cake of soap with a bit of twine tied around it, but Miss Corn-Shuck and I knew he had on the finest clothes in the world. Every day it would be different, because Mr. Sweet Smell was very particular about what he wore. Besides he wanted Miss Corn-Shuck to admire him.

There was a great mystery about where Mr. Sweet Smell came from. I suppose if Mama had been asked, she would have said that it was the company soap, since the family used nothing but plain, yellow Octagon laundry soap for bathing. But I had not known it was there until I happened to find it. It might have been there for years. Whenever Miss Corn-Shuck asked him where his home was, he always said it was a secret which he would tell her about when they were married. It was not very important anyway. We knew he was some very high-class man from way off—the farther off the better.

But sad to say, Miss Corn-Shuck and Mr. Sweet Smell never got married. They always meant to, but before very long, Miss Corn-Cob began to make trouble. We found her around the kitchen door one day, and she followed us back under the house and right away started her meanness. She was jealous of Miss Corn-Shuck because she was so pretty and green, with long silky hair, and so Miss Corn-Cob would make up all kinds of mean stories about her. One day there was going to be a big party and that was the first time that the Spool People came

to visit. They used to hop off of Mama's sewing machine one by one until they were a great congregation—at least fifteen or so. They didn't do anything much besides second the motion on what somebody else did and said, so they must have been the common people.

Reverend Door-Knob was there, too. He used to live on the inside of the kitchen door, but one day he rolled off and came under the house to be with us. Unconsciously he behaved a lot like Mayor Joe Clarke. He was roundish and reddish brown, and used to laugh louder than anything when something funny happened. The Spool People always laughed whenever he laughed. They used to cry too, whenever Mr. Sweet Smell or Miss Corn-Shuck cried. They were always doing whatever they saw other people do. That was the way the Spool People were.

When Mr. Sweet Smell left his fine house in the dresser drawer that day, he came through the kitchen and brought a half can of condensed milk for the refreshments. Everybody liked condensed milk for refreshment. Well, Miss Corn-Cob sneaked around and ate up all the refreshments and then she told everybody that Miss Corn-Shuck ate it. That hurt Mr. Sweet Smell's feelings so bad till he went home and so he didn't marry Miss Corn-Shuck that day. Reverend Door-Knob was so mad with Miss Corn-Cob that he threw her clear over the house and she landed in the horse trough, which everybody said, served her just right.

But not getting married that day sort of threw Mr. Sweet Smell in a kind of fever. He was sick in the bed for several days. Miss Corn-Shuck went to see him every day, and that was very nice. He rubbed off some of his smell on her because she was so nice to come to see him.

Some people might have thought that Miss Corn-Shuck's green dress had faded and her silky hair all dried up. But that was because they didn't know any better. She just put on a brownish cloak over it, so it wouldn't get dirty. She would let me see it any time I wanted to. That was because she liked me better than anyone else except Mr. Sweet Smell. She lay under

the mattress of my bed every night. Mr. Sweet Smell always went home to the dresser drawer. The Spool People slept on the sill under the house because Reverend Door-Knob used to sleep there. They couldn't do a thing unless they saw somebody else doing it. They wore a string around their waist, trying to dress up like Mr. Sweet Smell.

Miss Corn-Cob played a very mean trick once. Miss Corn-Shuck and Mr. Sweet Smell were going to get married down by the lake. The lake had kindly moved into the wash-basin for the occasion. A piece of cold cornbread had turned into a magnificent cake. Plenty of egg-nogg had come out of a cake of shaving soap. The bride and groom were standing side by side and ready. Then what did Miss Corn-Cob do? She shoved Reverend Door-Knob into the lake, because she knew he couldn't swim. Here everybody was waiting and nobody would have known where the preacher was if one of the Spool People had not seen him kicking down at the bottom of the lake and rescued him.

While he was getting dry and putting on a fresh suit of clothes, Miss Corn-Cob sent our old dominecker rooster to steal the wedding cake. So the wedding had to be put off until Christmas because then there would be plenty of cake for everybody. The Spool People said they were glad of it, because there ought to be enough cake to go around if you wanted a really nice wedding. The lake told everybody good-bye, jumped out in the yard and went on home. It could not stay off too long, because it would be missed and people would not know what to think.

Miss Corn-Cob went and hid down a gopher hole for a whole week. Every night she used to cry so loud, that we could hear her at the house. You see she was scared of the dark. Her mama gave her a good whipping when she got back home and everybody stood around and said "Goody! Goody! Goody! Goody! Goody!" Because that makes everybody feel bad. That is, no child likes to hear another one gloating "Goody!" when he is in trouble.

They all stayed around the house for years, holding funerals

and almost weddings and taking trips with me to where the sky met the ground. I do not know exactly when they left me. They kept me company for so long. Then one day they were gone. Where? I do not know. But there is an age when children are fit company for spirits. Before they have absorbed too much of earthy things to be able to fly with the unseen things that soar. There came a time when I could look back on the fields where we had picked flowers together but they, my friends, were nowhere to be seen. The sunlight where I had lost them was still of Midas gold, but that which touched me where I stood had somehow turned to gilt. Nor could I return to the shining meadow where they had vanished. I could not ask of others if they had seen which way my company went. My friends had been too shy to show themselves to others. Now and then when the sky is the right shade of blue, the air soft, and the clouds are sculptured into heroic shapes, I glimpse them for a moment, and believe again that the halcyon days have been.

When inanimate things ceased to commune with me like natural men, other dreams came to live with me. Animals took on lives and characteristics which nobody knew anything about except myself. Little things that people did or said grew into fantastic stories.

There was a man who turned into an alligator for my amusement. All he did was live in a one-room house by himself down near Lake Belle. I did the rest myself. He came into the village one evening near dusk and stopped at the store. Somebody teased him about living out there by himself, and said that if he did not hurry up and get married, he was liable to go wild.

I saw him tending his little garden all day, and otherwise just being a natural man. But I made an image of him for after dark that was different. In my imagination, his work-a-day hands and feet became the reptilian claws of an alligator. A tough, knotty hide crept over him, and his mouth became a huge snout with prong-toothed, powerful jaws. In the dark of the night, when the alligators began their nightly mysteries

58

behind the cloaking curtain of cypress trees that all but hid Lake Belle, I could see him crawling from his door, turning his ugly head from left to right to see who was looking, then gliding down into the dark waters to become a 'gator among 'gators. He would mingle his bellow with other bull 'gator bellows and be strong and terrible. He was the king of 'gators and the others minded him. When I heard the thunder of bull 'gator voices from the lake on dark nights, I used to whisper to myself, "That's Mr. Pendir! Just listen at him!"

I kept adding detail. For instance, late one afternoon, my mother had taken me for a walk down around Lake Belle. On our way home, the sun had set. It was good and dark when we came to the turning-off place that would take us straight home. At that spot, the trees stood apart, and the surface of the lake was plain. I saw the early moon laying a shiny track across the water. After that, I could picture the full moon laying a flaming red sword of light across the water. It was a road of yellow-red light made for Mr. Pendir to tread. I could see him crossing the lake down this flaming road wrapped in his awful majesty, with thousands on thousands of his subject-'gators moving silently along beside him and behind him in an awesome and mighty convoy.

I added another chapter to the Pendir story when a curious accident happened in the village. One old woman, Mrs. Bronson, went fishing in Blue Sink late one afternoon and did not return. The family, who had opposed the idea of a woman of Mrs. Bronson's age going off to Blue Sink to fish so late in the day, finally became worried and went out to hunt for her. They went around the edge of the lake with lanterns and torches and called and called, but they could not see her, and neither did she answer. Finally, they found her, though people were beginning to be doubtful about it. Blue Sink drops down abruptly from its shores, and is supposed to be bottomless. She was in the lake, at the very edge, still alive, but unable to crawl out. She did not even cry out when she heard herself being called and could discern the moving lanterns. When she was safely home in bed, she said that she had sat there till sundown

59

because she knew the fish would begin to bite. She did catch a few. But just as black dark came on, a terrible fear came on her somehow, and something like a great wind struck her and hurled her into the water. She had fallen on the narrow inside rim of the lake, otherwise she would have sunk into the hidden deeps. She said that she screamed a few times for help, but something rushed across Blue Sink like a body-fied wind and commanded her to hush-up. If she so much as made another sound, she would never get out of that lake alive. That was why she had not answered when she was called, but she was praying inside to be found.

The doctor came and said that she had suffered a stroke. One whole side of her body was paralyzed, so when she tumbled over into the lake, she could not get out. Her terror and fear had done the rest. She must have had two or three horrible hours lying there in the edge of the water, hard put to it to keep her face above water, and expecting the attack of an alligator, water moccasin, gar fish, and numerous other creatures which existed only in her terrified mind. It is a wonder that she did not die of fright.

Right away, I could see the mighty tail of Mr. Pendir slapping Old Lady Bronson into the lake. Then he had stalked away across the lake like the Devil walking up and down in the earth. But when she had screamed, I pictured him recrossing to her, treading the red-gold of his moon-carpet, with his mighty minions swimming along beside him, his feet walking the surface like a pavement. The soles of his feet never even being damp, he drew up his hosts around her and commanded her to hush.

The old woman was said to dabble in hoodoo, and some said that Pendir did too. I had heard often enough that it was the pride of one hoodoo doctor to "throw it back on the one that done it." What could be more natural then than for my 'gator-man to get peeved because the old lady had tried to throw something he did back on him? Naturally, he slapped her in to the lake. No matter what the doctor said, I knew the real truth of the matter.

I told my playmates about it and they believed it right away. I got bold and told them how I had seen Mr. Pendir turning into a 'gator at night and going down into the lake and walking the water. My chums even believed part of it in a way. That is they liked the idea and joined in the game. They became timid in the presence of the harmless little man and on the sly, would be looking for 'gator signs on him. We pretended a great fear of him. We might meet him in 'gator form some night and get carried off into the lake, and die on that terrible road of light.

I told them how he couldn't die anyway. That is, he couldn't die anymore. He was not a living man. He had died a long time ago, and his soul had gone to the 'gators. He had told me that he had no fear of death because he had come back from where other folks were going.

The truth of the matter was, that poor Mr. Pendir was the one man in the village who could not swim a lick. He died a very ordinary death. He worked too long in the hot sun one day, and some said on an empty stomach, and took down sick. Two days later he just died and was buried and stayed where he was put. His life had not agreed with my phantasy at any point. He had no female relatives around to mourn loud and make his funeral entertaining, even, and his name soon ceased to be called. The grown folks of the village never dreamed what an exciting man he had been to me. Even after he was dead and buried, I would go down to the edge of Lake Belle to see if I could run across some of his 'gator hides that he had sloughed off at daybreak when he became a man again. My phantasies were still fighting against the facts.

CHAPTER 6

WANDERING

I knew that Mama was sick. She kept getting thinner and thinner and her chest cold never got any better. Finally, she took to bed.

She had come home from Alabama that way. She had gone back to her old home to be with her sister during her sister's last illness. Aunt Dinky had lasted on for two months after Mama got there, and so Mama had stayed on till the last.

It seems that there had been other things there that worried her. Down underneath, it appeared that Grandma had never quite forgiven her for the move she had made twenty-one years before in marrying Papa. So that when Mama suggested that the old Potts place be sold so that she could bring her share back with her to Florida, her mother urged on by Uncle Bud, Mama's oldest brother, refused. Not until Grandma's head was cold, was an acre of the place to be sold. She had long since quit living on it, and it was pretty well run down, but she wouldn't, that was all. Mama could just go on back to that yaller rascal she had married like she came. I do not think that the money part worried Mama as much as the injustice and spitefulness of the thing.

Then Cousin Jimmie's death seemed to come back on Mama during her visit. How he came to his death is an unsolved mystery. He went to a party and started home. The next morning his headless body was found beside the railroad track. There was no blood, so the train couldn't have killed him. This had happened before I was born. He was said to have been a very handsome young man, and very popular with the girls. He was my mother's favorite nephew and she took it hard. She had probably numbed over her misery, but going back there seemed to freshen up her grief. Some said that he had been waylaid by three other young fellows and killed in a jealous rage. But nothing could be proved. It was whispered that he had been shot in the head by a white man unintentionally, and then beheaded to hide the wound. He had been shot from ambush, because his assailant mistook him for a certain white man. It was night. The attacker expected the white man to pass that way, but not Jimmie. When he found out his mistake, he had forced a certain Negro to help him move the body to the railroad track without the head, so that it would look as if he had been run over by the train. Anyway, that is what the Negro wrote back after he had moved to Texas years later. There was never any move to prove the charge, for obvious reasons. Mama took the whole thing very hard.

It was not long after Mama came home that she began to be less active. Then she took to bed. I knew she was ailing, but she was always frail, so I did not take it too much to heart. I was nine years old, and even though she had talked to me very earnestly one night, I could not conceive of Mama actually dying. She had talked of it many times.

That day, September eighteenth, she had called me and given me certain instructions. I was not to let them take the pillow from under her head until she was dead. The clock was not to be covered, nor the looking-glass. She trusted me to see to it that these things were not done. I promised her as solemnly as nine years could do, that I would see to it.

What years of agony that promise gave me! In the first place, I had no idea that it would be soon. But that same day near

sun-down, I was called upon to set my will against my father, the village dames and village custom. I know now that I could not have succeeded.

I had left Mama and was playing outside for a little while when I noted a number of women going inside Mama's room and staying. It looked strange. So I went on in. Papa was standing at the foot of the bed looking down on my mother, who was breathing hard. As I crowded in, they lifted up the bed and turned it around so that Mama's eyes would face the east. I thought that she looked to me as the head of the bed was reversed. Her mouth was slightly open, but her breathing took up so much of her strength that she could not talk. But she looked at me, or so I felt, to speak for her. She depended on me for a voice.

The Master-Maker in His making had made Old Death. Made him with big, soft feet and square toes. Made him with a face that reflects the face of all things, but neither changes itself, nor is mirrored anywhere. Made the body of Death out of infinite hunger. Made a weapon for his hand to satisfy his needs. This was the morning of the day of the beginning of things.

But Death had no home and he knew it at once.

"And where shall I dwell in my dwelling?" Old Death asked, for he was already old when he was made.

"You shall build you a place close to the living, yet far out of the sight of eyes. Wherever there is a building, there you have your platform that comprehends the four roads of the winds. For your hunger, I give you the first and last taste of all things."

We had been born, so Death had had his first taste of us. We had built things, so he had his platform in our yard.

And now, Death stirred from his platform in his secret place in our yard, and came inside the house.

Somebody reached for the clock, while Mrs. Mattie Clarke put her hand to the pillow to take it away.

"Don't!" I cried out. "Don't take the pillow from under Mama's head! She said she didn't want it moved!"

I made to stop Mrs. Mattie, but Papa pulled me away. Others were trying to silence me. I could see the huge drop of sweat collected in the hollow at Mama's elbow and it hurt me so. They were covering the clock and the mirror.

"Don't cover up that clock! Leave that looking-glass like it is! Lemme put Mama's pillow back where it was!"

But Papa held me tight and the others frowned me down. Mama was still rasping out the last morsel of her life. I think she was trying to say something, and I think she was trying to speak to me. What was she trying to tell me? What wouldn't I give to know! Perhaps she was telling me that it was better for the pillow to be moved so that she could die easy, as they said. Perhaps she was accusing me of weakness and failure in carrying out her last wish. I do not know. I shall never know.

Just then, Death finished his prowling through the house on his padded feet and entered the room. He bowed to Mama in his way, and she made her manners and left us to act out our ceremonies over unimportant things.

I was to agonize over that moment for years to come. In the midst of play, in wakeful moments after midnight, on the way home from parties, and even in the classroom during lectures. My thoughts would escape occasionally from their confines and stare me down.

Now, I know that I could not have had my way against the world. The world we lived in required those acts. Anything else would have been sacrilege, and no nine-year-old voice was going to thwart them. My father was with the mores. He had restrained me physically from outraging the ceremonies established for the dying. If there is any consciousness after death, I hope that Mama knows that I did my best. She must know how I have suffered for my failure.

But life picked me up from the foot of Mama's bed, grief, self-despisement and all, and set my feet in strange ways. That moment was the end of a phase in my life. I was old before my time with grief of loss, of failure, of remorse of failure. No matter what the others did, my mother had put her trust in me. She had felt that I could and would carry out her wishes, and

I had not. And then in that sunset time, I failed her. It seemed as she died that the sun went down on purpose to flee away from me.

That hour began my wanderings. Not so much in geography, but in time. Then not so much in time as in spirit.

Mama died at sundown and changed a world. That is, the world which had been built out of her body and her heart. Even the physical aspects fell apart with a suddenness that was startling.

My oldest brother was up in Jacksonville in school, and he arrived home after Mama had passed. By then, she had been washed and dressed and laid out on the ironing board in the parlor.

Practically all of the village was in the front yard and on the porch, talking in low tones and waiting. They were not especially waiting for my brother Bob. They were doing that kind of waiting that people do around death. It is a kind of sipping up the drama of the thing. However, if they were asked, they would say it was the sadness of the occasion which drew them. In reality it is a kind of feast of the Passover.

Bob's grief was awful when he realized that he was too late. He could not conceive at first that nothing could be done to straighten things out. There was no ear for his excuse nor explanation—no way to ease what was in him. Finally it must have come to him that what he had inside, he must take with him wherever he went. Mama was there on the cooling board with the sheet draped over her blowing gently in the wind. Nothing there seemed to hear him at all.

There was my sister Sarah in the kitchen crying and trying to quiet Everett, who was just past two years old. She was crying and trying to make him hush at the same time. He was crying because he sensed the grief around him. And then, Sarah, who was fifteen had been his nurse and he would respond to her mood, whatever it was. We were all grubby bales of misery, huddled about lamps.

I have often wished I had been old enough at the time to look into Papa's heart that night. If I could know what that

67

moment meant to him, I could have set my compass towards
him and been sure. I know that I did love him in a way, and
that I admired many things about him. He had a poetry about
him that I loved. That had made him a successful preacher. He
could hit ninety-seven out of a hundred with a gun. He could
swim Lake Maitland from Maitland to Winter Park, and no
man in the village could put my father's shoulders to the
ground. We were so certain of Papa's invincibility in combat
that when a village woman scolded Everett for some misde-
meanor, and told him that God would punish him, Everett,
just two years old, reared back and told her, "He better not
bother me. Papa will shoot Him down." He found out better
later on, but that goes to show you how big our Papa looked
to us. We had seen him bring down bears and panthers with
his gun, and chin the bar more times than any man in compet-
ing distance. He had to our knowledge licked two men who
Mama told him had to be licked. All that part was just fine with
me. But I was Mama's child. I knew that she had not always
been happy, and I wanted to know just how sad he was that
night.

I have repeatedly called up that picture and questioned it.
Papa cried some too, as he moved in his awkward way about
the place. From the kitchen to the front porch and back again.
He kept saying, "Poor thing! She suffered so much." I do not
know what he meant by that. It could have been love and pity
for her suffering ending at last. It could have been remorse
mixed with relief. The hard-driving force was no longer op-
posed to his easy-going pace. He could put his potentialities
to sleep and be happy in the laugh of the day. He could do
next year or never, what Mama would have insisted must be
done today. Rome, the eternal city, meant two different things
to my parents. To Mama, it meant, you must build it today so
it could last through eternity. To Papa, it meant that you could
plan to lay some bricks today and you have the rest of eternity
to finish it. With all that time, why hurry? God had made more
time than anything else, anyway. Why act so stingy about it?

Then too, I used to notice how Mama used to snatch Papa.

That is, he would start to put up an argument that would have been terrific on the store porch, but Mama would pitch in with a single word or a sentence and mess it all up. You could tell he was mad as fire with no words to blow it out with. He would sit over in the corner and cut his eyes at her real hard. He was used to being a hero on the store porch and in church affairs, and I can see how he must have felt to be always outdone around home. I know now that that is a griping thing to a man—not to be able to whip his woman mentally. Some women know how to give their man that conquesting feeling. My mother took her over-the-creek man and bare-knuckled him from brogans to broadcloth, and I am certain that he was proud of the change, in public. But in the house, he might have always felt over-the-creek, and because that was not the statue he had made for himself to look at, he resented it. But then, you cannot blame my mother too much if she did not see him as his entranced congregations did. The one who makes the idols never worships them, however tenderly he might have molded the clay. You cannot have knowledge and worship at the same time. Mystery is the essence of divinity. Gods must keep their distances from men.

Anyway, the next day, Sam Moseley's span of fine horses, hitched to our wagon, carried my mother to Macedonia Baptist Church for the last time. The finality of the thing came to me fully when the earth began to thud on the coffin.

That night, all of Mama's children were assembled together for the last time on earth. The next day, Bob and Sarah went back to Jacksonville to school. Papa was away from home a great deal, so two weeks later, I was on my way to Jacksonville, too. I was under age, but the school had agreed to take me in under the circumstances. My sister was to look after me, in a way.

The midnight train had to be waved down at Maitland for me. That would put me into Jacksonville in the daytime.

As my brother Dick drove the mile with me that night, we approached the curve in the road that skirts Lake Catherine, and suddenly I saw the first picture of my visions. I had seen

69

myself upon that curve at night leaving the village home, bowed down with grief that was more than common. As it all flashed back to me, I started violently for a minute, then I moved closer beside Dick as if he could shield me from those others that were to come. He asked me what was the matter, and I said I thought I heard something moving down by the lake. He laughed at that, and we rode on, the lantern showing the roadway, and me keeping as close to Dick as I could. A little, humped-up, shabby-backed trunk was behind us in the buckboard. I was on my way from the village, never to return to it as a real part of the town.

Jacksonville made me know that I was a little colored girl. Things were all about the town to point this out to me. Street cars and stores and then talk I heard around the school. I was no longer among the white people whose homes I could barge into with a sure sense of welcome. These white people had funny ways. I could tell that even from a distance. I didn't get a piece of candy or a bag of crackers just for going into a store in Jacksonville as I did when I went into Galloway's or Hill's at Maitland, or Joe Clarke's in Eatonville.

Around the school I was an awful bother. The girls complained that they couldn't get a chance to talk without me turning up somewhere to be in the way. I broke up many good "He said" conferences just by showing up. It was not my intention to do so. What I wanted was for it to go full steam ahead and let me listen. But that didn't seem to please. I was not in the "he said" class, and they wished I would kindly please stay out of the way. My underskirt was hanging, for instance. Why didn't I go some place and fix it? My head looked like a hoo-raw's nest. Why didn't I go comb it? If I took time enough to match my stockings, I wouldn't have time to be trying to listen in on grown folk's business. These venerable old ladies were anywhere from fifteen to eighteen.

In the classroom I got along splendidly. The only difficulty was that I was rated as sassy. I just had to talk back at established authority and that established authority hated back talk worse than barbed-wire pie. My brother was asked to speak

to me in addition to a licking or two. But on the whole, things went along all right. My immediate teachers were enthusiastic about me. It was the guardians of study-hour and prayer meetings who felt that their burden was extra hard to bear.

School in Jacksonville was one of those twilight things. It was not dark, but it lacked the bold sunlight that I craved. I worshipped two of my teachers and loved gingersnaps with cheese, and sour pickles. But I was deprived of the loving pine, the lakes, the wild violets in the woods and the animals I used to know. No more holding down first base on the team with my brothers and their friends. Just a jagged hole where my home used to be.

At times, the girls of the school were lined up two and two and taken for a walk. On one of these occasions, I had an experience that set my heart to fluttering. I saw a woman sitting on a porch who looked at a distance like Mama. Maybe it *was* Mama! Maybe she was not dead at all. They had made some mistake. Mama had gone off to Jacksonville and they thought that she was dead. The woman was sitting in a rocking chair just like Mama always did. It must be Mama! But before I came abreast of the porch in my rigid place in line, the woman got up and went inside. I wanted to stop and go in. But I didn't even breathe my hope to anyone. I made up my mind to run away someday and find the house and let Mama know where I was. But before I did, the hope that the woman really was my mother passed. I accepted my bereavement.

CHAPTER 7

JACKSONVILLE AND AFTER

My sister moped a great deal. She was Papa's favorite
child, and I am certain that she loved him more than
anything on earth, my baby brother Everett being
next in her love. So two months after I came to school, Sarah
said that she was sick and wanted to go home. Papa arranged
for her to leave school.

That had very tragic results for Sarah. In a week or two after
she left me in Jacksonville, she wrote back that Papa had
married again. That hurt us all, somehow. But it was worse for
Sarah, for my step-mother must have resented Papa's tender
indulgence for his older daughter. It was not long before the
news came back that she had insisted that Papa put Sarah out
of the house. That was terrible enough, but it was not satisfac-
tory to Papa's new wife. Papa must go over and beat Sarah
with a buggy whip for commenting on the marriage happen-
ing so soon after Mama's death. Sarah must be driven out of
town. So Sarah just married and went down on the Manatee
River to live. She took Everett with her. She probably left
more behind her than she took away.

What Papa and Sarah felt during these times, I have never

heard from either of them. I know that it must have ploughed very deep with both of them.

God, how I longed to lay my hands upon my stepmother's short, pudgy hulk! No gun, no blade, no club would do. Just flesh against flesh and leave the end of the struggle to the hidden Old Women who sit and spin.

Papa had honored his first-born daughter from the day of her birth. If she was not fore-told, she was certainly fore-wished. Three sons had come, and he was glad of their robust health, but after the first one, he wanted a little girl child around the house. For several years then, it had been a wish deferred. So that when she did arrive, small, under-sized, but a girl, his joy was boundless. He changed and washed her diapers. She was not allowed to cry as an infant, and when she grew old enough to let on, her wishes did not go unregarded. What was it Papa's girl-baby wanted to eat? She wanted two dolls instead of one? Bless her little heart! A cheeky little rascal! Papa would bring it when he came. The two oldest boys had to get out of their beds late one night and stay outdoors for an hour or more because little three-year-old Sarah woke up and looked out of the window and decided that she wanted to see the stars outdoors. It was no use for the boys to point out that she could see stars aplenty through the window. Papa thundered, "Get up and take dat young'un out doors! Let her look at de stars just as long as she wants to. And don't let me hear a mutter out of you. If I hear one *grumble,* I'll drop your britches below your hocks and bust de hide on you!"

Sarah was diminutive. Even when she was small, you could tell that she never would grow much. She would be short like Papa's mother, and her own mother. She had something of both of them in her face. Papa delighted in putting the finest and the softest shoes on her dainty feet; the fluffiest white organdy dresses with the stiffest ribbon sashes. "Dat's a switching little gal!" he used to gloat.

She had music lessons on the piano. It did not matter that she was not interested in music, it was part of his pride. The parlor organ was bought in Jacksonville and shipped down as

a surprise for Sarah on her tenth birthday. She had a gold ring for her finger, and gold earrings. When I begged for music lessons, I was told to dry up before he bust the hide on my back.

If the rest of us wanted to sneak jelly or preserves and get off without a licking, the thing to do was to get Sarah in on it. Papa might ignore the whipping-purge that Mama was organizing until he found that Sarah was mixed up in it. Then he would lay aside the county newspaper which he was given to reading, and shout at Mama, "Dat'll do! Dat'll do, Lulu! I can't stand all dat racket around de place." Of course, if Mama was really in the mood, Papa's protest would change no plans, but at times it would, and we would all escape because of Sarah. I have seen Papa actually snatch the switch out of Mama's hand when she got to Sarah. But if Mama thought that the chastisement was really in order, she would send out to the peach tree for another one and the whipping would go right on. Papa knew better than to stick his bill in when Mama was really determined. Under such circumstances, Sarah was certain to get some sort of a present on Monday when Papa came back from Sanford.

He had never struck her in his life. She never got but one from him, and that was this cruel thing at the instigation of our stepmother. Neither Papa nor Sarah ever looked at each other in the same way again, nor at the world. Nor did they look like the same people to the world who knew them. Their heads hung down and they studied the ground under their feet too much.

As for me, looking on, it made a tiger out of me. It did not matter so much to me that Sarah was Papa's favorite. I got my joys in other ways, and so, did not miss his petting. I do not think that I ever really wanted it. It made me miserable to see Sarah look like that. And six years later I paid the score off in a small way. It was on a Monday morning, six years after Sarah's heartbreak, that my stepmother threatened to beat me for my impudence, after vainly trying to get Papa to undertake the job. I guess that the memory of the time that he had struck

75

Sarah at his wife's demand, influenced Papa and saved me. I do not think that she considered that a changed man might be in front of her. I do not think that she thought that I would resist in the presence of my father after all that had happened and shown his lack of will. I do not think that she even thought that she could whip me if I resisted. She did think, if she thought at all, that all she had to do was to start on me, and Papa would be forced to jump in and finish up the job to her satisfaction in order to stay in her good graces. Old memories of her power over him told her to assert herself, and she pitched in. She called me a sassy, impudent heifer, announced that she was going to take me down a buttonhole lower, and threw a bottle at my head. The bottle came sailing slowly through the air and missed me easily. She never should have missed.

The primeval in me leaped to life. Ha! This was the very corn I wanted to grind. Fight! Not having to put up with what she did to us through Papa! Direct action and everything up to me. I looked at her hard. And like everybody else's enemy, her looks, her smells, her sounds were all mixed up with her doings, and she deserved punishment for them as well as her acts. The feelings of all those six years were pressing inside me like steam under a valve. I didn't have any thoughts to speak of. Just the fierce instinct of flesh on flesh—me kicking and beating on her pudgy self—those two ugly false teeth in front—her dead on the floor—grinning like a dead dog in the sun. Consequences be damned! If I died, let me die with my hands soaked in her blood. I wanted her blood, and plenty of it. That is the way I went into the fight, and that is the way I fought it.

She had the advantage of me in weight, that was all. It did not seem to do her a bit of good. Maybe she did not have the guts, and certainly she underestimated mine. She gave way before my first rush and found herself pinned against the wall, with my fists pounding at her face without pity. She scratched and clawed at me, but I felt nothing at all. In a few seconds, she gave up. I could see her face when she realized that I

76

meant to kill her. She spat on my dress, then, and did what she could to cover up from my renewed fury. She had given up fighting except for trying to spit in my face, and I did not intend for her to get away.

She yelled for Papa, but that was no good. Papa was disturbed, no doubt of it, but he wept and fiddled in the door and asked me to stop, while her head was traveling between my fist and the wall, and I wished that my fist had weighed a ton. She tried to do something. She pulled my hair and scratched at me. But I had come up fighting with boys. Hair-pulling didn't worry me.

She screamed that she was going to get Papa's pistol and kill me. She tried to get across the room to the dresser drawer, but I knew I couldn't let that happen. So the fight got hotter. A friend of hers who weighed over two hundred pounds lived across the street. She heard the rumpus and came running. I visualized that she would try to grab me, and I realized that my stepmother would get her chance. So I grabbed my stepmother by the collar and dragged her to a hatchet against the wall and managed to get hold of it. As Mrs. G. waddled through the living room door, I hollered to her to get back, and let fly with that hatchet with all that my right arm would do. It struck the wall too close to her head to make her happy. She reeled around and rolled down those front steps yelling that I had gone crazy. But she never came back and the fight went on. I was so mad when I saw my adversary sagging to the floor I didn't know what to do. I began to scream with rage. I had not beaten more than two years out of her yet. I made up my mind to stomp her, but at last, Papa came to, and pulled me away.

I had a scratch on my neck and two or three on my arms, but that was all. I was not at all pacified. She owed me four more years. Besides there was her spit on the front of my dress. I promised myself to pay her for the old and the new too, the first chance I got. Years later, after I had graduated from Barnard and I was doing research, I found out where she was. I drove twenty miles to finish the job, only to find out that

77

she was a chronic invalid. She had an incurable sore on her neck. I couldn't tackle her under such circumstances, so I turned back, all frustrated inside. All I could do was to wish that she had a lot more neck to rot.

That fight brought things to a head between Papa and his wife. She said Papa had to have me arrested, but Papa said he didn't have to do but two things—die and stay black. And then, he would never let me sleep in jail a night. She took the matter to the church and the people laughed. Most of them had been praying for something like that to happen. They were annoyed because she didn't get her head stomped. The thing rocked on for a few months. She demanded that Papa "handle" some of the sisters of the church who kept cracking her about it, but he explained that there was nothing he could do. They were old friends of my mother's and it was natural for them to feel as they did. There were two or three hot word battles on the church grounds, and then she left Papa with the understanding that he could get her back when he had made "them good-for-nothing nigger wimmens know dat she was Mrs. Reverend." So she went on off with her lip hung down lower than a mason's apron.

Papa went to see a lawyer and he said to send her clothes to her if she had not come back after three weeks. And that is just what Papa did. She "lawed" for a divorce and he let it slide. The black Anne Boleyn had come at last to the morning and the axe. The simile ends there. The King really had an axe. It has always seemed to me under the provocation a sad lack that preachers could not go armed like that. Perhaps it is just as well that it has been arranged so that the state has taken over the business of execution. Not every skunk in the world rates a first-class killing. Hanging is too good for some folks. They just need their behinds kicked. And that is all that woman rated. But, you understand, this was six years after I went up to Jacksonville. I put it in right here because I was thinking so hard.

But back to Jacksonville and the school. I had gotten used to the grits and gravy for breakfast, had found out how not to

be bored at prayer-meeting—you could always write notes if you didn't go to sleep—and how to poke fun at acidulated disciplinarians, and how to slip through a crack in the fence and cross the street to the grocery store for ginger snaps and pickles which were forbidden between meals. I had generally made a sort of adjustment. Lessons had never worried me, though arithmetic still seemed an unnecessary evil.

Then, one day, the Second in Command sent for me to tell me that my room and board had not been paid. What was I going to do about it? I certainly didn't know. Then she gave me a free hand opinion of the Reverend John Hurston that Chief Justice Taney could not have surpassed. Every few days after that I was called in and asked what was I going to do. After a while she did not call me in, she would just yell out of the window to where I might be playing in the yard. That used to keep me shrunk up inside. I got so I wouldn't play too hard. The call might come at any time. My spirits would not have quite so far to fall.

But I stayed out the year, but not because my bills were paid. I was put to scrubbing down the stair steps every Saturday, and sent to help clean up the pantry and do what I could in the kitchen after school. Then too, the city of Jacksonville had a spelling bee in all the Negro schools and I won it for my school. I received an atlas of the world and a Bible as prizes, besides so much lemonade and cake that I told President Collier that I could feel it coming through my skin. He had such a big laugh that I made up my mind to hurry up and get grown and marry him. For his part, he didn't seem to know that he had been picked out. In fact, he seemed to be quite patient about it. Never tried to hurry my growth at all, and never mentioned the matter. He acted like he was satisfied with some stale, old, decrepit woman of twenty-five or so. It used to drive me mad. I comforted myself with the thought that he would cry his eyes out when I would suddenly appear before him, tall and beautiful and disdainful and make him beg me for a whole week before I would give in and marry him, and of course fire all of those old half-dead teachers who

79

were hanging around him. Maybe they would drown themselves in the St. John's River. Oh, I might stop them just before they jumped in. I never did decide what to do with all my disgruntled rivals after I dragged them away from the river. They could rake up the yard, but a yard somewhere a long way from where *he* was. That would be better for everybody. A yard in Africa would be just dandy. They would naturally die of old age in a week or so.

I wrote some letters from him to me and read his tender words with tears in my eyes. I made us a secret post office behind the laundry. One day his letters to me would get written and buried, and the next day I would dig them up and read them. Then I would answer them and assure him he did not have to worry. I meant to marry him as soon as they let me put on long dresses, which I hoped would not be too far off. A month or two more ought to age me quite a bit.

This torrid love affair was conducted from a hole in the ground behind the laundry and came to an abrupt end. One of those same hateful teachers who was mean enough to get grown before I did, reported to my husband-in-reserve that it was I who had put a wet brick in her bed while she was presiding over study hour in the chapel. So much fuss over nothing! Just a brick that had been soaked overnight in a rain-barrel placed between the sheets near the foot of the bed, and they made as much fuss about it as if ice cream had been abolished.

It was true that it was a coldish spell of weather in February and all that. But what fun would a cold brick be in June? I ask you!

Oh, the perfidy, the deceit of the man to whom I had given my love and all my lovely letters in the hole behind the laundry! He listened to this unholy female and took me into his office and closed the door. He did not fold me lovingly in his arms and say, "Darling! I understand. You did it all for me." No! The blind fool lifted up my skirt in the rear and spanked a prospective tall, beautiful lady's pants. So improper, to say the least! I made up my mind to get even. I *wouldn't* marry him

now, no matter how hard he begged me. Insult me, would he? Turning up *my* dress just like I was some child! Ah, he would pine for my love and never get it. In addition to letting him starve for my love, I was going off and die in a pitiful way. Very lonely and dramatic at the same time, however.

The whole thing was so unjust. She did *not* see me put that brick in her bed. And if the duty-girl did look back over her shoulder and see me coming down the hall with the brick in my hand, what kind of a decent person is that? Going around and looking backwards at people! When I would be grown and sit up in my fine palace eating beef stew and fried chicken, that duty-girl was going to be out in my backyard gnawing door-knobs.

Time passed. Spring came up the St. John's River from down the Everglades way, and school closed in a blaze of programs, cantatas and speeches, and trunks went bumping down stairs. My brother hurried off to take a job. I was to stay there and Papa would send for me.

I kept looking out of the window so that I could see Papa when he came up the walk to the office. But nobody came for me. Weeks passed, and then a letter came. Papa said that the school could adopt me. The Second in Command sent for me and told me about it. She said that she had no place for a girl so young, and besides she was too busy to bring up any children.

It was crumbling news for me. It impressed every detail of the office and her person on my mind. I noted more clearly than ever the thick gray-black ropes of her half-Negro, half-White hair, her thin lips, and white-folks-looking nose. All in all, her yellow skin browned down by age looked like it had been dried between the leaves of a book. I had always been afraid of her sharp tongue and quick hand, but this day she seemed to speak a little softer than usual, and in half-finished sentences, as if she had her tender parts to hide. She took out her purse and handed me some money. She was going to pay my way home by the boat, and I must tell my father to send her her dollar and a half.

81

The boat trip was thrilling on the side-wheeler *City of Jacksonville*. The water life, the smothering foliage that draped the river banks, the miles of purple hyacinths, all thrilled me anew. The wild thing was back in the jungle.

The curtain of trees along the river shut out the world so that it seemed that the river and the chugging boat was all that there was, and that pleased me a lot. Inside, the boat was glittering with shiny brass.

White-clad waiters dashed about with trays for the first class upstairs. There was an almost ceaseless rattle of dishes. Red carpet underfoot. Big, shiny lights overhead. White men in greasy overalls popping up from down below now and then to lean on the deck rail for a breath of air. A mulatto waiter with a patch over one eye who kept bringing me slabs of pie and cake and chicken and steak sandwiches, and sent me astern to eat them. Things clattered up the gang plank, and then more things rumbled down into the hold. People on the flimsy docks waving goodbye to anybody who wanted to wave back. Wild hogs appearing now and then along the shore. 'Gators, disturbed by the wash, slipping off of palm logs into the stream. Schools of mullet breaking water now and then. Flocks of water fowl disturbed at the approach of the steamer, then settling back again to feed. Catfish as long as a man pacing the boat like porpoises for kitchen scraps. A group of turpentine hands with queer haircuts, in blue overalls with red handkerchiefs around their necks, who huddled around a tall, black man with a guitar round his neck. They ate out of shoe boxes and sang between drinks out of a common bottle. A stocking-foot woman was with them with a dirk in her garter. Her new shoes were in a basket beside her. She dipped snuff and kept missing the spittoon. The glitter of brass and the red carpet made her nervous. The captain kept passing through and pulling my hair gently and asking me to spell something, and kept being surprised when I did. He called out "separate" when I was getting off at Sanford, and I spelled it back at him as I went down the gang plank. I left him leaning on the rail and looking like he had some more words he wanted spelled. Then he

threw a half dollar that fell just ahead of me and smiled good-bye.

The day after I started from Jacksonville, the boat docked at Sanford, with the town of Enterprise a shadowy suspicion across the five miles of Lake Monroe. I had to go to the railroad station to take the train for the fifteen miles to Maitland.

The conductor and the whole crew knew me from seeing me with my father so often. They remembered me for another reason, too, which embarrassed me a lot. This very train and crew had been my first experience with railroads. I had seen trains often, but never up so close as that day about four years before when Papa had decided to take me up to Sanford with him. Then I was at the station with Papa and my two oldest brothers. We heard the train blow, leaving Winter Park, three miles south. So we picked up our things and moved down from the platform to a spot beside the track. The train came thundering around Lake Lily, and snorted up to the station. I was there looking the thing dead in the face, and it was fixing its one big, mean-looking eye on me. It looked fit to gnaw me right up. It was truly a most fearsome thing!

The porter swung down and dropped his stool. The conductor in his eyeglasses stood down, changing greetings with Papa, Mr. Wescott, the station-agent, and all of the others whom he knew from long association.

"All aboard!" The train only hesitated at Maitland. It didn't really stop.

This thing was bad, but I saw a chance to save myself yet and still. It did not just have to get me if I moved fast enough.

My father swung up to the platform, and turned around. My brother Bob had me by the hand and prepared to hand me up. This was the last safe moment I had. I tore loose from Bob and dashed under the train and out again. I was going home.

Everybody yelled. The conductor louder than anybody else. "Catch her! Head her off over there!" The engineer held down his whistle. The fireman jumped off and took after me. Everybody was after me. It looked as if the whole world had

turned into my enemies. I didn't have a friend to my name.

"There she goes! Hem her up! Head her off from that barbed-wire fence!" My own big brother was chasing me as hard as anybody else. My legs were getting tired and I was winded, but I was running for my life. Brother Bob headed me off from home, so I doubled back into Galloway's store and ran behind the counter. Old Harry, Galloway's son, about Bob's age, grabbed me and pulled me out. I was hauled on board kicking and screaming to the huge amusement of everybody but me. As soon as I saw the glamor of the plush and metal of the inside of that coach, I calmed down. The conductor gave the engineer the high ball and the train rolled. It didn't hurt a bit. Papa laughed and laughed. The porter passed through holding his sides. The conductor came to take Papa's ticket and kept on teasing me about hurting the train's feelings. In a little while he was back with a glass pistol filled with candy. By the time I got to Sanford, I was crazy about the train. I just wished they would quit laughing at me. The inside of that train was too pretty for words. It took years for me to get over loving it.

So when I climbed on board that morning—some four years later, I had that look of "Get away from me, porter! Don't you see I'm too big to be helped on trains"—they all smiled in memory of our first meeting, and let it go at that. The porter was a member of Papa's church in Sanford, and sat beside me when he was not busy.

So I came back to my father's house which was no longer home. The very walls were gummy with gloom. Too much went on to take the task of telling it. Papa's children were in his way, because they were too much trouble to his wife. Ragged, dirty clothes and hit-and-miss meals. The four older children were definitely gone for good. One by one, we four younger ones were shifted to the homes of Mama's friends.

Perhaps it could be no other way. Certainly no other way was open to a man who loved peace and ease the way my father did.

My stepmother was sleeping in Mama's feather bed. The one thing which Mama had brought from her father's house. She had said it must be mine. To see this interloper piled up in my mother's bed was too much for me to bear. I had to do something. The others had been miserable about it all along. I rallied my brother Joel to my aid and we took the mattress off of the bed.

Papa had told her that it was his, so he was faced with the dilemma. I stood my ground, and the other children present backed me. She thought a good beating for me ought to settle the ownership once and for all. John took my part, he was always doing that, dear John, and physical violence, yes actual bloodshed seemed inevitable for a moment. John and Papa stood face to face, and Papa had an open knife in his hand.

Then he looked his defiant son in the eyes and dropped his hand. He just told John to leave home. However, my step-mother had lost her point. She never was pleasured to rack her bones on Mama's feather bed again. Though there were plenty of beds for her to sleep in, she hated to take any dictation at all from us, especially me.

But Papa's shoulders began to get tired. He didn't rear back and strut like he used to. His well-cut broadcloth, Stetson hats, hand-made alligator-skin shoes and walking stick had earned him the title of Big Nigger with his children. Behind his back, of course. He didn't put and take with his cane any more. He just walked along. It didn't take him near so long to put on his hat.

So my second vision picture came to be. I had seen myself homeless and uncared for. There was a chill about that picture which used to wake me up shivering. I had always thought I would be in some lone, arctic wasteland with no one under the sound of my voice. I found the cold, the desolate solitude, and earless silences, but I discovered that all that geography was within me. It only needed time to reveal it.

My vagrancy had begun in reality. I knew that. There was

an end to my journey and it had happiness in it for me. It was certain and sure. But the way! Its agony was equally certain. It was before me, and no one could spare me my pilgrimage. The rod of compelment was laid to my back. I must go the way.

CHAPTER 8

BACK STAGE AND THE RAILROAD

There is something about poverty that smells like death. Dead dreams dropping off the heart like leaves in a dry season and rotting around the feet; impulses smothered too long in the fetid air of underground caves. The soul lives in a sickly air. People can be slave-ships in shoes.

This wordless feeling went with me from the time I was ten years old until I achieved a sort of competence around twenty. Naturally, the first five years were the worst. Things and circumstances gave life a most depressing odor.

The five years following my leaving the school at Jacksonville were haunted. I was shifted from house to house of relatives and friends and found comfort nowhere. I was without books to read most of the time, except where I could get hold of them by mere chance. That left no room for selection. I was miserable, and no doubt made others miserable around me, because they could not see what was the matter with me, and I had no part in what interested them.

I was in school off and on, which gave me vagrant peeps into the light, but these intervals lacked peace because I had no guarantee that they would last. I was growing and the general

thought was that I could bring in something. This book-reading business was a hold-back and an unrelieved evil. I could not do very much, but look at so-and-so. She was nursing for some good white people. A dollar a week and most of her clothes. People who had no parents could not afford to sit around on school benches wearing out what clothes they had.

One of the most serious objections to me was that having nothing, I still did not know how to be humble. A child in my place ought to realize I was lucky to have a roof over my head and anything to eat at all. And from their point of view, they were right. From mine, my stomach pains were the least of my sufferings. I wanted what they could not conceive of. I could not reveal myself for lack of expression, and then for lack of hope of understanding, even if I could have found the words. I was not comfortable to have around. Strange things must have looked out of my eyes like Lazarus after his resurrection.

So I was forever shifting. I walked by my corpse. I smelt it and felt it. I smelt the corpses of those among whom I must live, though they did not. They were as much at home with theirs as death in a tomb.

Gradually, I came to the point of attempting self-support. It was a glorious feeling when it came to me. But the actual working out of the thing was not so simple as the concept. I was about fourteen then.

For one thing, I really was young for the try. Then my growth was retarded somewhat so that I looked younger than I really was. Housewives would open the door at my ring and look me over. No, they wanted some one old enough to be responsible. No, they wanted some one strong enough to do the work, and so on like that. Did my mother know I was out looking for work? Sometimes in bed at night I would ask myself that very question and wonder.

But now and then some one would like my looks and give me a try. I did very badly because I was interested in the front of the house, not the back. No matter how I resolved, I'd get tangled up with their reading matter, and lose my job. It was not that I was lazy, I just was not interested in dusting and

dishwashing. But I always made friends with the children if there were any. That was not intentional. We just got together somehow. That would be fun, but going out to play did not help much on jobs.

One woman liked me for it. She had two little girls, seven and five. I was hired as an upstairs maid. For two or three days things went on very well. The president of the kitchen was a fat, black old woman who had nursed the master of the house and was a fixture. Nobody is so powerful in a southern family as one of these family fixtures. No matter who hires you, the fixture can fire you. They roam all over the house bossing everybody from the boss on down. Nobody must upset Cynthia or Rhoda or Beckey. If you can't get along with the house president you can't keep the job.

And Miz Cally was President in Full in this house. She looked at me cut-eye first thing because the madam had hired me without asking her about it. She went into her grumble just as soon as I stuck my head in the kitchen door. She looked at me for a moment with her hands on her hips and burst out, "Lawd a'mercy! Miz Alice must done took you to raise! She don't need no more young'uns round de place. Dis house needs a woman to give aid and assistance."

She showed her further disapproval by vetoing every move I made. She was to show me where to find the aprons, and she did. Just as soon as I pulled open the drawer, she bustled me right away from it with her hips.

"Don't you go pulling and hauling through *my* drawers! I keeps things in they place. You take de apron I give you and git on up dem stairs."

I didn't get mad with her. I took the apron and put it on with quite a bit of editing by Sister Cally, and went on up the back stairs. As I emerged on the upper floor, two pairs of gray-blue eyes were ranged on me.

"Hello!" said the two little girls in chorus.

"Hello!" I answered back.

"You going to work for us?" the taller one asked, and fell in beside me.

89

"Yeah." Maybe I cracked a smile or something, for both of them took a hand on either side and we went on into the room where Mrs. Alice was waiting for me to show me what to do and how to do it.

She was a very beautiful woman in her middle twenties, and she was combing out her magnificent hair. She looked at me through the looking glass, and we both started to grinning for some reason or another.

She showed me how to make beds and clean up. There were three rooms up there, but she told me not to try to do too much at a time. Just keep things looking sort of neat. Then she dressed and left the house. I got things straightened out with Helen and Genevieve acting as convoy at every step. Things went all right till I got to the bathroom, then somehow or other we three found ourselves in a tussle. Screaming, laughing, splashing water and tussling, when a dark shadow filled up the door. Heinz could have wrung enough vinegar out of Cally's look to run his pickle works.

"You going 'way from here!" she prophesied, and shook her head so vigorously that her head rag wagged. She was going to get me gone from there!

"No!" screamed Helen, the littlest girl, and held on to me.

"No! No! No!" Genevieve shrieked.

"Humph! You just wait till yo' daddy come home!" Cally gloomed. "I ain't never seen no sich caper like dis since I been borned in dis world." Then she stumped on back downstairs.

"Don't you go," Genevieve begged. "I like you."

"Me too, I like you too," Helen chorused. "If you go home, we'll go with you."

I had to wait on the table at dinner that night, with my apron too long for me. Mrs. Alice and the children were giving a glowing account of me. The boss glanced at me tolerantly a time or two. Helen would grab hold of my clothes every time I passed her chair, and play in the vegetable dishes when I offered them to her, until her father threatened to spank her hands, but he looked up at me and smiled a little. He looked to me like an aged old soul of thirty-five or so.

Cally kept on cracking the kitchen door to see how I was getting along in there, and I suspect to give the boss a view of her disapproving face.

Things rocked on for a week or two. Mrs. Alice went out more and more to bridge clubs and things like that. She didn't care whether I made up the rooms or not so long as the children were entertained. She would come in late in the afternoon and tell Cally to run upstairs and straighten up a bit.

"What's dat gal been doing?" Cally would growl. Dat gal she was talking about had been off to the park with the children, or stretched out on the floor telling stories or reading aloud from some of their story books. Their mother had been free to go about her business, and a good time was had by all—except Cally.

Before a month passed, things came to a head: Cally burst into the dining room one night and flew all over the place. The boss had to get somebody to do his cooking. She was tired of doing all the work. She just wasn't going to cook and look after things downstairs and then troop upstairs and do the work somebody else was getting paid for. She was old. Her joints hurt her so bad till she couldn't rest of nights. They really needed to get somebody to help.

Mrs. Alice sat there stark, still and quiet. The boss looked at her, then at old Cally, and then at me.

Finally, he said, "I never meant for you to work yourself down like that, Aunt Cally. You've done more than your share."

" 'Deed, Gawd knows I is!" Cally agreed belligerently, rolling her white eyeballs in my direction.

"Isn't Zora taking care of the upstairs? I thought that was what she was hired for," the boss asked, and looked at his wife.

"Taking care of what?" Cally snorted. " 'Deed, I ain't lying, Mr. Ed. I wouldn't tell a lie on nobody—"

"I know you wouldn't, Auntie," he soothed.

"Dat gal don't do a living thing round dis house but play all day long wid these young 'uns. Den I has to scuffle up dem stairs and do round, cause effen I didn't, dis here place would

be like a hawg-pen. Dat's what it would. I *has* to go and do it, Mr. Ed, else it wouldn't never git done. And I'm sick and *tired*. I'm gwine 'way from here!''

"Naw, Cally, you can't do it. You been with me all my life, and I don't aim to let you go. Zora will have to go. These children are too big now to need a nurse.''

What did he say that for? My public went into sound and action. Mrs. Alice was letting a tear or two slip. Otherwise she was as still as stone. But Helen scrambled out of her chair with her jaws latched back to the last notch. She stumbled up against me and swung on. Genevieve screamed "No!" in a regular chant like a cheer leader, and ran to me, too. Their mother never raised her head. The boss turned to her.

"Darling, why don't you quiet these children?" he asked gently.

"No! No! No! Zora can't go!" my cheering squad yelled, slinging tears right and left.

"Shut up!" the boss grated at the children and put his hand on the table and scuffled his feet as if he meant to rush off for the hair brush. "I'll be on you in one more minute! Hush!"

It was easy to see that his heart was not in any spanking. His frown was not right for it. The yelling kept right on. Cally flounced on back to the kitchen, and he got up and hauled the children upstairs. In a minute he called his wife and shut the bedroom door.

I cleared off the table, and when I sat down in the kitchen to eat, Cally slammed a plate in front of me with some dried-up fried eggs left from breakfast. She put the steak away in the ice-box ostentatiously, just daring me with her eyes to cheep about it. I kept good and quiet.

In about a half hour the boss came down and talked to Cally. I was to stay on and look after the children. His wife was going to look around for a woman to take care of the upstairs and the front of the house, too. Cally would have less to do. He sort of apologized when he said the children were so attached to me that he hated to get rid of me on their account. Not once did he say a word to me. So Cally was mollified to an extent.

92

If she had not gotten rid of me, her rank had been recognized at any rate. That was what she was fighting for anyway. He told her to go down to a certain shoe store the next day and tell them to let her have some more comfortable shoes and send the bill to him. Then he went back upstairs very quietly. Cally talked to me then, and gave me a piece of pie.

But that was not the end. I could sense that my being there was doing something to that house. There were looks between husband and wife at times. He was not satisfied, and it was not the two dollars a week I was getting. He was not mean to me, he just acted funny. His wife was as good as gold. She made me a white dress herself and bought me a Sunday hat. She would go out to her bridge clubs and things like that, but she was usually home before he got there. Sometimes she would be home before the children and I got home from our prowls. And how we did prowl! Then the boss took to coming home at odd hours and going in the kitchen and talking to Cally for a long time.

One evening he just fired me suddenly after the children had been put to bed. I hated it, because I was having all the fun in the world. He had followed me down to the foot of the stairs. While he was paying me off, Mrs. Alice came out of her room and stood at the top of the stairs.

"Ed," she began.

"Now, you go on back in your room, Alice; I'm handling this. Go on! You don't need Zora to take care of those children. She is not going to be here another day. I mean that."

He saw me out of the door, and I went off feeling sad. I didn't know what he was firing me for. The children were more than satisfied with my company. His wife seemed very glad to have me around. I couldn't see what was wrong.

Years later when I had seen more, I concluded that he was jealous of his wife. He was not one of those pretty men, and she was a beautiful thing, much younger than he was. I do not think that she ever did anything wrong, but he felt insecure. If she had to be around to keep up with the children, she had her hands full. There was much less danger of her wandering

93

off. Cally was in his confidence. I am certain that he got full reports on his wife's goings and comings. He loved his wife dearly, and he was afraid his miracle might fade. She had told me herself that she had married at seventeen. She was certainly a lovely, soft-looking thing. She never wore the things people didn't want to look at, and she did wear things you always wanted to see, and she had an easy kind of sweet smell. A lot of men would have taken over the job of worrying with her at the drop of a hat.

Well, then, I didn't have a job any more. I didn't have money either, but I had bought a pair of shoes.

But I was lucky in a way. Somebody told the woman I was staying with about another job, so I went to see about it, and the lady took me. She was sick in the bed, and she had a little girl three years old, but this child did not shine like Helen and Genevieve. She was sort of old-looking in the face.

I didn't like that house. It frowned at me just as soon as I crossed the door-sill. It was a big house with plenty of things in it but the rooms just sat across the hall from each other and made gloomy faces back and forth.

The sick lady was named Mrs. Moncrief, and she had two older sisters who had never been married, and they gloomed. The cook was an old family relic on the female side and she was out of the habit of smiling, too.

Mr. Moncrief used to laugh, but not around the house, and it was no good laugh when he did it. The reason I knew was, about a week after I joined up, he took to waylaying me down the street a piece and walking with me. It made me feel very uncomfortable for him to do that. I didn't see what he wanted to do it for anyway. It was not long before he told me he was sick and tired of that house full of sour-looking women. He was sick of the town and everything in it. He was selling out his business and going away. He would take me to Canada with him if I wanted to go, and if I had any sense I would jump at the chance.

I kept telling him I didn't want to go. I did want to go some place else, but not with him. It sounded grand if he would just

pay my way up there and he go some place else. His belly laid all over his belt, and he was so chuckle-headed that you couldn't see his collar. But he didn't seem to have but one ear, and it couldn't hear a thing but 'yes'.

So every morning, I hated to go back to that house, but I hated more to go home at night.

Finally, I got over being timid of his being the boss and just told him not to bother me. He laughed at that. Then I said that I would tell his wife, and he laughed again. The very next night he was waiting for me.

So I went in and told his wife to make him stop waylaying me. I did not tell her about Canada. I needn't worry about that. I just wanted him to stop making me feel shame by walking along with me. People might talk.

Right then I learned a lesson to carry with me through life. I'll never tell another wife. She laid there a long time and said nothing, then she tried to smile as if it were a joke that was mildly funny. Then she began to cry without moving anything in her face. It was terrible to look at, and I wanted to run out of there and hide and never let anybody see me again. But it was hard to move my feet. So I began to cry, too. She shook her head and said, "You have nothing to cry about, Zora. You haven't been lying here for three years with somebody hoping to find you dead every morning. You don't know what it means for every girl who comes in hailing distance to be mixed up in your life. You don't know what it means to give birth to a child for your husband and find that your health is gone the day the baby is born and for him not to care what becomes of the baby or you either. God! Why couldn't he leave *you* alone?"

I saw her fumbling for the glass of water on the bed-table, so I handed it to her and ran out of the house. I felt lower than sea-bottom. I ran off so that I could cry alone. I never meant to foot that house again, nor to see anybody who lived in it.

But the next day around nine o'clock he drove up to where I lived.

"So you told on me, did you?" He opened right up and I

95

thought that he was going to kill me then and there.

"I told you if you didn't leave me alone I was going to tell," I quavered.

"Oh, that is all right, girlie. She's not my boss. She hasn't a thing to do with our business. It's you and me going to Canada, not that old maid I married by mistake. When can you be ready?"

That was too much. He was not even listening to what I had to say. I gave up and told him I could be ready on Saturday.

"That's three days off," he objected. "You can't have all that getting-ready to do. How about tomorrow night?"

"Well, all right, tomorrow night," I lied.

"Meet me at the station. You don't need your clothes. I'll buy you something decent to wear on the way. Just be there. Nope, you better stay here. I'll come get you. Don't you fool me, now. Just be there. I'm not the kind of a man that stands for no fooling. I'm not the kind of man to be worried with so much responsibilities. Never should have let myself get married in the first place. All I need is a young, full-of-feelings girl to sleep with and enjoy life. I always did keep me a colored girl. My last one moved off to Chicago and sort of left me without. I want a colored girl and I'm giving you the preference."

He went on down the steps and I ran inside to pack up my few things. In an hour I had moved. He came for me the next night, I was told, and tried to search the house to see if the landlady had tried to block him by telling a lie. He could not conceive of my not wanting to go with him.

Two weeks later it was in the papers that he had taken all of his own money that he could get his hands on and some other people's money, and had vanished. Nobody seemed to know which way he went. The Black Dispatch (Negro grapevine) reported that the colored office girl of a well-known white doctor had gone with him.

I never tried to give any information. I felt that my big mouth had worked overtime as it was. I never even went back to get my pay.

I was out of a job again. I got out of many more. Sometimes I didn't suit the people. Sometimes the people didn't suit me. Sometimes my insides tortured me so that I was restless and unstable. I just was not the type. I was doing none of the things I wanted to do. I had to do numerous uninteresting things I did not want to do, and it was tearing me to pieces.

I wanted family love and peace and a resting place. I wanted books and school. When I saw more fortunate people of my own age on their way to and from school, I would cry inside and be depressed for days, until I learned how to mash down on my feelings and numb them for a spell. I felt crowded in on, and hope was beginning to waver.

The third vision of aimless wandering was on me as I had seen it. My brother Dick had married and sent for me to come to Sanford and stay with him. I got hopeful for school again. He sent me a ticket, and I went. I didn't want to go, though. As soon as I got back to Sanford, my father ordered me to stay at his house.

It was no more than a month after I got there before my stepmother and I had our fight.

I found my father a changed person. The bounce was gone from the man. The wreck of his home and the public reaction to it was telling on him. In spite of all, I was sorry for him and that added to my resentment towards his wife.

In all fairness to her, she probably did the best she could, according to her lights. It was just tragic that her light was so poor. A little more sense would have told her that the time and manner of her marriage to my father had killed any hope of success from the start. No warning bell inside of her caused her to question the wisdom of an arrangement made over so many fundamental stumbling stones. My father certainly could not see the consequences, for he had never had to consider them too seriously. Mama had always been there to do that. Suddenly he must have realized with inward terror that Lucy was not there any more. This was not just another escapade which Mama would maul his knit for in private and smooth out publicly. It had rushed him along to where he did not want

97

to go already and the end was not in sight. This new wife had wormed her way out of her little crack in the world to become what looked to her like a great lady, and the big river was too much for her craft. Instead of the world dipping the knee to the new-made Mrs. Reverend, they were spitting on her intentions and calling her a storm-buzzard. Certainly if my father had not built up a strong following years before, he could not have lasted three months. As it was, his foundations rotted from under him, and seven years saw him wrecked. He did not defend her and establish her. It might have been because he was not the kind of a man who could live without his friends, and his old friends, male and female, were the very ones who were leading the attack to disestablish her. Then, too, a certain amount of the prestige every wife enjoys arises out of where the man got her from and how. She lacked the comfort of these bulwarks too. She must have decided that if she could destroy his children she would be safe, but the opposite course would have been the only extenuating circumstance in the eyes of the public. The failure of the project would have been obvious in a few months or even weeks if Papa had been the kind of man to meet the conflict with courage. As it was, the misery of the situation continued for years. He was dragging around like a stepped-on worm. My brief appearance on the scene acted like a catalyzer. A few more months and the thing fell to pieces for good.

I could not bear the air for miles around. It was too personal and pressing, and humid with memories of what used to be.

So I went off to another town to find work. It was the same as at home so far as the dreariness and lack of hope and blunted impulses were concerned. But one thing did happen that lifted me up. In a pile of rubbish I found a copy of Milton's complete works. The back was gone and the book was yellowed. But it was all there. So I read *Paradise Lost* and luxuriated in Milton's syllables and rhythms without ever having heard that Milton was one of the greatest poets of the world. I read it because I liked it.

I worked through the whole volume and then I put it among

my things. When I was supposed to be looking for work, I would be stretched out somewhere in the woods reading slowly so that I could understand the words. Some of them I did not. But I had read so many books that my reading vocabulary at least was not too meager.

A young woman who wanted to go off on a trip asked me to hold down her job for two months. She worked in a doctor's office and all I had to do was to answer the telephone and do around a little.

The doctor thought that I would not be suitable at first, but he had to have somebody right away so he took a deep breath and said he'd try me. We got along just very well indeed after the first day. I became so interested and useful that he said if his old girl did not come back when she promised, he was going to see to it that I was trained for a practical nurse when I was a bit older.

But just at that time I received a letter from Bob, my oldest brother. He had just graduated from Medicine and said that he wanted to help me to go to school. He was sending for me to come to him right away. His wife sent love. He knew that I was going to love his children. He had married in his Freshman year in college and had three of them.

Nothing can describe my joy. I was going to have a home again. I was going to school. I was going to be with my brother! He had remembered me at last. My five haunted years were over!

I shall never forget the exaltation of my hurried packing. When I got on the train, I said goodbye—not to anybody in particular, but to the town, to loneliness, to defeat and frustration, to shabby living, to sterile houses and numbed pangs, to the kind of people I had no wish to know; to an era. I waved it goodbye and sank back into the cushions of the seat.

It was near night. I shall never forget how the red ball of the sun hung on the horizon and raced along with the train for a short space, and then plunged below the belly-band of the earth. There have been other suns that set in significance for me, but *that* sun! It was a book-mark in the pages of a life. I

remember the long, strung-out cloud that measured it for the fall.

But I was due for more frustration. There was to be no school for me right away. I was needed around the house. My brother took me for a walk and explained to me that it would cause trouble if he put me in school at once. His wife would feel that he was pampering me. Just work along and be useful around the house and he would work things out in time.

This did not make me happy at all. I wanted to get through high school. I had a way of life inside me and I wanted it with a want that was twisting me. And now, it seemed I was just as far off as before. I was not even going to get paid for working this time, and no time off. But on the other hand, I was with my beloved brother, and the children were adorable! I was soon wrapped up in them head over heels.

It was get up early in the morning and make a fire in the kitchen range. Don't make too much noise and wake up my sister-in-law. I must remember that she was a mother and needed the rest. She had borne my brother's children and deserved the best that he could do for her, and so on. It didn't sound just right. I was not the father of those children, and several months later I found out what was wrong. It came to me in a flash. She had never borne a child for me, so I did not owe her a thing. Maybe somebody did, but it certainly wasn't I. My brother was acting as if I were the father of those children, instead of himself. There was much more, but my brother is dead and I do not wish to even risk being unjust to his memory, or unkind to the living. My sister-in-law is one of the most devoted mothers in the world. She was brave and loyal to my brother when it took courage to be that way. After all she was married to him, not I.

But I made an unexpected friend. She was a white woman and poor. She had children of my own age. Her husband was an electrician. She began to take an interest in me and to put ideas in my head. I will not go so far as to say that I was poorly dressed, for that would be bragging. The best I can say is that I could not be arrested for indecent exposure. I remember

100

wanting gloves. I had never had a pair, and one of my friends told me that I ought to have on gloves when I went anywhere. I could not have them and I was most unhappy. But then, I was not in a position to buy a handkerchief.

This friend slipped me a message one day to come to her house. We had a code. Her son would pass and whistle until I showed myself to let him know I heard. Then he would go on and as soon as I could I would follow. This particular day, she told me that she had a job for me. I was delighted beyond words.

"It's a swell job if you can get it, Zora. I think you can. I told my husband to do all he can, and he thinks he's got it hemmed up for you."

"Oooh! What is it?"

"It is a lady's maid job. She is a singer down at the theater where he is electrician. She brought a maid with her from up north, but the maid met up with a lot of colored people and looks like she's going to get married right off. She don't want the job no more. The lady asked the men around the theater to get her somebody, and my husband thought about you and I told him to tell the rest of the men he had just the right girl for a maid. It seems like she is a mighty nice person."

I was too excited to sit still. I was frightened too, because I did not know the first thing about being a lady's maid. All I hoped was that the lady would overlook that part and give me a chance to catch on.

"You got to look nice for that. So I sent Valena down to buy you a little dress." Valena was her daughter. "It's cheap, but it's neat and stylish. Go inside Valena's room and try it on."

The dress was of navy blue poplin with a box-pleated skirt and a little round, white collar. To my own self, I never did look so pretty before. I put on the dress, and Valena's dark blue felt hat with a rolled brim. She saw to it that I shined my shoes, and then gave me car-fare and sent me off with every bit of advice she could think of.

My feet mounted up the golden stairs as I entered the stage

door of that theater. The sounds, the smells, the back-stage jumble of things were all things to bear me up into a sweeter atmosphere. I felt like dancing towards the dressing room when it was pointed out to me. But my friend was walking with me, coaching me how to act, and I had to be as quiet and sober as could be.

The matinee performance of *H.M.S. Pinafore* was on, so I was told to wait. In a little while a tenor and a soprano voice quit singing a duet and a beautiful blonde girl of about twenty-two came hurrying into the dressing room. I waited until she went inside and closed the door, then I knocked and was told to come in.

She looked at me and smiled so hard till she almost laughed.

"Hello, little girl," she chanted. "Where did you come from?"

"Home. I come to see you."

"Oh, you did? That's fine. What did you come to see me about?"

"I come to work for you."

"Work for me?" She threw back her head and laughed. That frightened me a great deal. Maybe it was all a joke and there was no job after all. "Doing what?" she carolled on.

"Be your lady's maid."

"You? Why, how old are you?"

"Twenty," I said, and tried to look serious as I had been told. But she laughed so hard at that, till I forgot and laughed too.

"Oh, no, you are not twenty." She laughed some more, but it was not scornful laughter. Just bubbling fun.

"Well, eighteen, then," I compromised.

"No, not eighteen, either."

"Well, then, how about sixteen?"

She laughed at that. Instead of frowning in a sedate way as I had been told, here I was laughing like a fool myself.

"I don't believe you are sixteen, but I'll let it go at that," she said.

"Next birthday. Honest."

"It's all right; you're hired. But let's don't bring this age business up again. I think I'm going to like you. What is your name?"

I told her, fearing all the time she was going to ask questions about my family; but she didn't.

"Well, Zora, I pay ten dollars a week and expenses. You think that will do?"

I almost fell over. Ten dollars each and every week! Was there that much money in the world sure enough? Com-press-ti-bility!! It wouldn't take long for me to own a bank at that rate.

"Yes, ma'am!" I shouted.

"Well, change my shoes for me."

She stuck out her foot, and pointed at the pair she wanted to put on. I got them on with her tickling me in the back. She showed me a white dress she wanted to change into and I jumped to get it and hook it up. She touched up her face laughing at me in the mirror and dashed out. I was crazy about her right then. I washed out her shoelaces from a pair of white shoes and her stockings, which were on the back of a chair and wrung them out in a bath towel for quick drying, and sat down before the mirror to look at myself. It was truly wonderful!

So I had to examine all the curious cosmetics on the table. I was sort of trying them out when she came in.

That night, she let me stand in the wings and hear her sing her duet with the tenor, "Farewell, my own! Light of my life, farewell!" It was so beautiful to me that she seemed more than human. Everything was pleasing and exciting. If there was any more to Heaven than this, I didn't want to see it.

I did not go back home, that is to my brother's house, at all. I was afraid he would try to keep me. I slept on a cot in the room with Valena. She was almost as excited as I was, had come down to see me every night and had met the cast. We were important people, she and I. Her mother had to make us shut up talking and go to sleep every night.

The end of the enchanted week came and the company was to move on. Miss M—— whom I was serving asked me about

my clothes and luggage. She told me not to come down to the train with an old dilapidated suitcase for that would make her ashamed. So the upshot of it was that she advanced me the money to buy one, and then paid me for the week. I paid my friend the six dollars which she had spent for my new dress. Valena gave me the hat, an extra pair of panties and stockings. I bought a comb and brush and tooth brush, paste, and two handkerchiefs. Miss M—— did not know when I came down to the station that morning that my new suitcase was stuffed with newspapers to keep my things from rattling.

The company, a Gilbert and Sullivan repertoire, had its own coach. That was another glory to dazzle my eyes. The leading man had a valet, and the contralto had an English maid, both white. I was the only Negro around. But that did not worry me in the least. I had no chance to be lonesome, because the company welcomed me like, or as, a new play-pretty. It did not strike me as curious then. I never even thought about it. Now, I can see the reason for it.

In the first place, I was a Southerner, and had the map of Dixie on my tongue. They were all northerners except the orchestra leader, who came from Pensacola. It was not that my grammar was bad, it was the idioms. They did not know of the way an average southern child, white and black, is raised on simile and invective. They know how to call names. It is an every day affair to hear somebody called a mullet-headed, mule-eared, wall-eyed, hog-nosed, gator-faced, shad-mouthed, screw-necked, goat-bellied, puzzle-gutted, camel-backed, butt-sprung, battle-hammed, knock-kneed, razor-legged, box-ankled, shovel-footed, unmated so and so! Eyes looking like skint-ginny nuts, and mouth looking like a dishpan full of broke-up crockery! They can tell you in simile exactly how you walk and smell. They can furnish a picture gallery of your ancestors, and a notion of what your children will be like. What ought to happen to you is full of images and flavor. Since that stratum of the southern population is not given to book-reading, they take their comparisons right out of the barn yard and

the woods. When they get through with you, you and your whole family look like an acre of totem-poles.

First thing, I was young and green, so the baritone started out teasing me the first day. He waylaid me down the coach aisle away from Miss M—— and told me I looked like a nice girl and he wanted to help me out. He was going to tell me just how to get along. I was very glad and thanked him. He told me to sit down by him and let him give me a few pointers. I did and he asked me a few very ordinary questions about where I was born and so on. Very sober-faced. All of a sudden he yelled so the whole coach could hear him. "Porter! A flock of hand towels and a seven o'clock call!"

Nearly everybody burst out laughing. I couldn't see what for. I knew the joke was on me somehow, but I didn't know what it was. I sat there blank-faced and that made them laugh more. Miss M—— did not laugh. She called me and told me to sit down by her and not to listen to dirty cracks. Finally she let me know what the joke was. Then I jumped up and told that man to stop trying to run the hog over me! That set everybody off again. They teased me all the time just to hear me talk. But there was no malice in it. If I got mad and spoke my piece, they liked it even better. I was stuffed with ice cream sodas and coca-cola.

Another reason was that it was fun to them to get hold of somebody whom they could shock. I was hurt to my heart because the company manager called me into his dressing room and asked me how I liked my job. After I got through telling him how pleased I was, he rushed out with his face half-made up screaming, "Stop, oh, Zora! Please stop! Shame on you! Telling me a dirty story like that. Oh! I have never been so shocked in all my life!"

Heads popped out of dressing-rooms all over. Groans, sad head-shakings and murmurs of outrage. Sad! Sad! They were glad I had not told them such a thing. Too bad! Too bad! Not a smile in the crowd. The more I tried to explain the worse it got. Some locked their doors to shield their ears from such contamination. Finally Miss M—— broke down and laughed

105

and told me what the gag was. For a long while nobody could get me inside a dressing room outside of Miss M——'s. But that didn't stop the teasing. They would think up more, like having one of the men contrive to walk down the aisle with me and then everybody lift shocked eyebrows, pretend to blush and wink at each other, and sigh, "Zora! Zora! What would your mother say?" I would be so upset that I wouldn't know what to do. Maybe they really believed I wasn't nice!

Another sly trick they played on my ignorance was that some of the men would call me and with a very serious face send me to some of the girls to ask about the welfare and condition of cherries and spangles. They would give me a tip and tell me to hurry back with the answer. Some of the girls would send back word that the men need not worry their heads at all. They would never know the first thing about the condition of their cherries and spangles. Some of the girls sent answers full of double talk which went over my head. The soubrette spoke her mind to the men about that practice and it stopped.

But none of this had malice in it. Just their idea of good backstage gags. By the time they stopped, it seemed that I was necessary to everybody. I was continually stuffed with sweets, nut meats, and soft-drinks. I was welcome in everybody's coach seat and the girls used to pitch pennies to see who carried me off to their hotel rooms. We played games and told stories. They often ordered beer and pretzels, but nobody offered me a drink. I heard all about their love affairs and troubles. They were all looking forward to playing or singing leads some day. Some great personage had raved about all of their performances. The dirty producers and casting directors just hadn't given them their chance. Miss M—— finally put a stop to my going off with the others as soon as she was ready for bed. I had to stay wherever she stayed after that. She had her own affairs to talk about.

She paid for a course for me in manicuring and I practiced on everybody until I became very efficient at it. That course came in handy to me later on.

With all this petting, I became as cocky as a sparrow on Fifth Avenue. I got a scrap book, and everybody gave me a picture to put in it. I pasted each one on a separate page and wrote comments under each picture. This created a great deal of interest, because some of the comments were quite pert. They egged me on to elaborate. Then I got another idea. I would comment on daily doings and post the sheets on the call-board. This took on right away. The result stayed strictly mine less than a week because members of the cast began to call me aside and tell me things to put in about others. It got to be so general that everybody was writing it. It was just my handwriting, mostly. Then it got beyond that. Most of the cast ceased to wait for me. They would take a pencil to the board and set down their own item. Answers to the wisecracks would appear promptly, and often cause uproarious laughter. They always started off with either "Zora says" or "The observant reporter of the call-board asserts"—Lord, Zora said more *things!* I was continually astonished, but always amused. There were, of course, some sly digs at supposedly secret love affairs at times, but no vicious thrusts. Everybody enjoyed it, even the victims. This hilarious game came to a sudden end. The company manager had been a member of the cast. One day he received a telegram offering him a fat part in a Broadway show, and of course, he left us. So a new manager was sent on from New York.

Somehow, he struck everybody wrong from the start. The baritone who was always quick on the draw said he looked like he had been soaked in greasy dish-water and had not been wiped off. Even Miss M—— who seldom "cracked"—said he reminded her of the left-overs from the stock yards. His trousers sagged at the knees, so I named him Old Bustle-Knees. His name was Smith, but he became known on the quiet as "B.K."

He was on the make, you could see that the moment he landed, and you had to give him credit for ambition. He gave Miss M—— the first chance to be his love life for the duration. She snooted him as if he were actually a slaughter-house by-

product. He kept on down the line until he did actually land a lady of the ensemble who had visions of becoming a lead if not actually a star. It hurt everybody, Helen's defection, for she had been very popular. It must have hurt her too, because she used to come in and leave the theater at his heels with her eyes away from everybody, usually leading "B.K.'s" fox terrier on a leash. That was her symbol of office.

But having gained a heart interest did not seem to satisfy him. He took a bitter hatred of Miss M—— to his heart to nurse. He pulled every nasty, annoying trick on her that he could think of to humiliate her.

Therefore, it was decided to give him an entire issue of the call-board. The name of Smith was not in the publication but Bustle-Knees was, and no punches were pulled. It took nearly all night and half of the next day to rub it up until it glittered. Everybody had a hand in it except our lost Helen, the fox terrier and Smith. Some stage hands even put in their nickel's worth. By the time we got through, he looked like a forest full of primitive demon masks with a pacing gait.

When he read it, he was as hot as seven hells with West Hell and Ginny Gall thrown in. It was all in my handwriting, so he couldn't fire anybody. But he could and did forbid any papers to appear on the call-board again. Nothing but official notices. He told Miss M—— that I had to be fired, but she refused him flat even after he said he knew I had named him Bustle-Knees. So we knew that Helen had told him that. He had that name before she had gone over to him.

But our suffering did not last more than six weeks. He had the temerity to juggle the box-office reports to his own profit and got fired. The last I saw of him was one night after the stage was struck. There was a single bare bulb as if for rehearsal on stage and he was standing by it, his hands shoved far down in his overcoat pockets looking like first one soggy thing and then another. Helen was off side standing very still in the shadows, shifting the dog's leash from hand to hand. The next day, we were enjoying his space more than we ever had his company. Helen went to bed with a sick stomach.

Not long after that, the run came to an end. Miss M—— had a part in another show all set, but rehearsals would not start for two weeks, so she took me to her home in Boston and I found out some things which I did not want to know, particularly.

At times she had been as playful as a kitten. At others, she would be solemn and moody. She loved her mother excessively, but when she received those long, wordy letters from her, she read them with a still face, and tore them up carefully. Then she would be gloomy, and keep me beside her every minute. Sometimes she would become excessively playful. It was puzzling to see a person cry a while and then commence to romp like a puppy and keep it up for hours. Sometimes she had to have sherry before she went to bed after a hard romp with me. She invented a game for us to play in our hotel room. It was known as "Jake." She would take rouge and paint her face all over a most startling red. Then I must take eye-shadow and paint myself blue. Blue Jake and Red Jake would then chase each other into closets, across beds, into bath rooms, with our sheet-robes trailing around us and tripping us up at odd moments. We crouched and growled and ambushed each other and laughed and yelled until we were exhausted.

Then maybe next day she hardly said a word.

Of course, the members of her family had been described to me often. Her mother had been married three times. There had been four children, by the first very early marriage, but only the oldest one, John, was alive. He was a man around forty now, and never had been married. He didn't work regularly, but was very jolly and obliging. Another brother, Charlie, about twelve years younger than Johnnie, was a city fireman in Boston. He had two children. He was a son of the second marriage. Miss M—— was eight years younger than Charlie, and had a different father.

When I got to their home in the outskirts of Boston, I saw that the old lady had made improvements as she went along. Johnnie, her first born, was homely. One thing struck me forcibly; his teeth had either not come out of his gums very

far, or they had been sawed off. Charlie was a big, robust Irishman who was not very handsome, but not bad at all. He would do nicely. Miss M—— was a startling blonde beauty, no less. She was doing rather well as a singer, Charlie was getting on in the Fire Department, and their older brother was just named Johnnie.

This Johnnie started in to tease me right away. His niece, Mary, Charlie's daughter, was staying with her grandmother when we arrived, and Johnnie took more pleasure in teasing Mary and me than in anything else. He just could not leave us alone. Whenever he got me separated from Mary, Miss M—— or her mother would soon show up and call me away— in a subtle way, of course, but it always happened. He could tell such funny Irish jokes that I liked to be around him.

One day he played a terrible joke on me. I washed all of my clothes and hung them out to dry, and went on back upstairs to play checkers with Mary. The house stood on a corner with a generous yard all around it. The corner was very noisy because two main street-car lines crossed there and it was a transfer point. About two hours after I had hung up my clothes, Mary and I became conscious of an unusual rumble of voices outside. We thought there had been an accident, so we rushed to the window to see.

I was petrified with horror and shame. I had three pairs of panties out on the line, and now, there was a little bunch of dandelions stuck in the clothes pins holding each pair of my panties. Men and women, but men particularly were hanging over the fence and laughing and joking. I knew right off that that was Johnnie's work. Miss M—— was gone into town on a shopping trip, so I ran downstairs crying to tell her mother about it. Being Irish, she told me not to mind Johnnie; to go out there and take them down. Unconscious of the trap, I rushed out of the kitchen door towards the line. Then the full horror struck me. In addition to the dandelions in the clothes-pins there was a jaunty little nosegay of them pinned on one leg of a pair! Seeing me approach the line, the crowd snickered louder. I was covered with confusion and ran back inside

followed by guffaws. I told Mrs. M—— that I was not going to take down those clothes. Johnnie was sitting by the kitchen table at the window, and where he could take it all in. When I said I wouldn't take the clothes down, he got up and said, "Stop crying, Zora. I'll go take them down for you." That pacified me. He went outside and the noise turned into a riot. I looked out of the window, and Johnnie had the pair with the bouquet on it, holding it up in his hands and examining it from all angles, turning it slowly for the benefit of his audience. He felt it all over, as if somebody had them on, and kept on fooling like that until traffic was nearly tied up. I was inside throwing conniptions until his mother reminded me through her chuckles that nobody would know my panties from anybody else's. Those people out there did not know I was living. That was a good point, so I went on back upstairs, but I was mad with Johnnie for hours.

But he was so nice and jolly the next morning that I got over it. He led me into the deep corner of the yard to show me the lilacs in bloom. He talked on awhile and asked me to loan him two dollars. He had to go and see about a job for the next day, he said. He would make six dollars at it, and pay me back the next night. I ran upstairs and got the money for him. He thanked me, but told me not to tell. I promised and went back inside.

Johnnie fooled around the house for perhaps an hour and went off. Noontime came and he was not back. Miss M—— and her mother looked worried at each other but did not say too much about it. We had supper about six o'clock and he still was not back. Neither of them ate anything this time. They looked at each other and looked more than worried. They were scared. They hustled Mary and me upstairs as soon as possible. They stayed down in the kitchen and mumbled and mumbled. After another hour or so, Miss M—— called me down and asked me, with her hands trembling, if I had loaned Johnnie any money. I hesitated. I had promised not to tell. She pressed me, and seeing that there was something important about it, I told her about the two dollars. She called her

mother weakly and collapsed in a chair. When her mother found out she crumpled up and had to be put to bed. The outwardly gay house had turned into a spectral place because I had loaned Johnnie two dollars. I couldn't see why. A message was hurriedly sent to Charlie and around ten o'clock, he arrived and the mumbling went on downstairs. Finally he decided to spend the night and stretched out on the couch in the living room.

About midnight, I heard a terrible scream from Mrs. M——'s room. She slept on the first floor on account of her knee. She said it was rheumatism from scrubbing too many floors.

Mary, Miss M—— and I all bolted for the head of the stairs at the same time. Another scream, "Ooh, Johnnie!" from an old, anguished throat.

Scuffling, bustling, short, angry sounds from Charlie. Running steps across the wide porch that all but surrounded the house. Down the walk to the street and away.

We rushed into Mrs. M——'s room. She was lying in bed, her face contorted in pain, and holding one shoulder with her hand. Tears were seeping from her eyes. The window onto the porch was open and Charlie was not present in the house.

"Mama! Mama!" Miss M—— screamed. "What happened?"

The old woman kept her eyes closed, and kept her hand on her shoulder. We waited, but she sobbed on with her lips pursed together.

Miss M—— began to fuss around the head of the bed to make her mother more comfortable. Finally she lifted the hand clutching the shoulder and revealed a great bluish-red bruise on the point of the shoulder, and began to cry herself.

"Oh, Mama! How did you get hurt like that? Zora, you and Mary get me some hot water and witch hazel! Oh, Mama!"

There was a trudgy scuffling on the porch, and Charlie came in the door dragging Johnnie. Charlie had a length of iron pipe in his hand and his face was something terrible to look at. Miss M—— took it all in for a long moment and without

raising her voice, she asked, "Why did you do it, Johnnie? Why?"

"Why do you waste your time asking this unfortunate brute such a question?" Charlie asked Miss M——. "His crazy brain told him to do it. He's had liquor, and he went where it sent him. I have begged and begged Mama to put him back where he can't do any harm, but she won't listen to me. You heard me tonight begging her to let me call the police when he didn't come back. You begged her, but she wouldn't listen to either of us. I kept waiting for the phone to ring and say he had done something like this somewhere, but, but here—"

Johnnie stood there and never lifted his head. I felt terrible for having given him the money. But I realized too, that at that time I didn't have the faintest notion what could happen. Instead of trying to watch him so closely that it couldn't happen, they should have warned me. Charlie said as much a minute later, but his sister explained that her mother would not let her do it. Her mother had said that she would keep an eye on him.

Charlie took the clothes line and tied the passive Johnnie hand and foot in the kitchen, then came back and forced his mother to talk.

She said that she had not gone to sleep, really, lying there and worrying about her first born, when she heard the window near her bed being pushed up gently. At first, she was not sure, but as she turned over in bed, she could see the form of a man. She could see him stepping into the room. She was speechless with fright as the figure crept up to the head of the bed with the bludgeon half lifted. As the blow was about to descend, she knew from his breathing it was Johnnie. She tried to duck but the blow fell, luckily missing her head but landing on her shoulder. She screamed and Johnnie, seeing that he was not only recognized, but that the house was aroused, ran to the table at the foot of the bed and tried to pick up something there. But hearing the bustle overhead, and Charlie bursting in from the living room, he ran to the window and fled, with Charlie at his heels.

113

Charlie said that he had cornered him in a hedge at the other end of the block, still with the length of iron pipe in his hand. He had given up without a struggle and let himself be brought back.

It turned out that Johnnie had been after some very valuable art objects grouped on the table at the foot of the bed. They belonged to a rich Bostonian who was in Europe at the time. Mrs. M—— had once worked for her, and when she went abroad, she had left the priceless things there rather than at her house which might be burglarized. She did not dream that anyone would be tempted to burglarize the M—— home, so she had entrusted them to her former and trusted servant. No one except the family knew that they were there, and so Mrs. M—— had covered them over on the table and felt safe.

I learned that Johnnie had helped to kill a man in a robbery attempt when he was seventeen. He and his pal had done the thing but had been caught before the robbery was completed. The older boy was executed, but Johnnie's sentence was commuted to life because of his youth. He had remained in Charlestown prison for eighteen years. And no matter what the weather or the circumstances might be, his mother had never missed a visiting day, nor ever failed to take him something.

She was a widow a second time when he committed the murder. She was out in domestic service, but her love never flagged. Sometimes money was so scarce that she could not afford to pay transportation to Charlestown and take him something, too. When it got like that, she took him something and walked. Her passion was to free her son. She renewed her promise to him every time she saw him. This went on for seventeen years.

Then the man whose cook she had been for fifteen years, became governor of Massachusetts. He knew his cook's heart. So a few months after he was inaugurated, he opened the prison doors for Johnnie M——. He could not grant him a pardon because the crime had been too heinous. The best that he could do was to parole him in care of his faithful mother.

Her second son had finished high school and finally worked himself into the Fire Department; her daughter's beauty and her voice had gotten her a scholarship at the New England Conservatory of Music. They were on their way, and now, her eldest son was free again. All she had to do was to watch him and see to it that he got hold of no whiskey. Johnnie was good-natured and easy to manage as long as he was sober. But he became a savage, lusting to kill as soon as whiskey touched his brain. Kill to get more money to buy more whiskey to drive him to kill again. Those art objects represented not beauty to him, but money for whiskey and around the circle again. The fact that it was the woman who had borne him who was standing between him and the money which the treasure would bring meant nothing after he had taken a drink.

I went back upstairs that night while she still whimpered and begged Charles, "Don't call the police to take the poor, unfortunate thing back to prison. He told me time and time again that he would die if ever he was taken back, Charlie. It would be murder, Charlie. Charlie, please don't do a thing like that."

Charles pointed out that while Johnnie *was* a poor unfortunate, he was too dangerous to be at large. Even if he did not later kill his own mother, the family would be responsible if the animal killed somebody else. It was too awful to think about. Perhaps it would be the kindest thing to let him die in prison. His mother had to give up her job just to sit around and watch Johnnie. He, Charlie, had to deny his wife and children things to take care of his mother and brother. His sister, with her lovely voice had to cut her training short to make money to help support them. His mother was willing to risk the lives of innocent people and the futures of her two younger children for the sake of that inhuman wretch. And so on.

But the morning found her just as stubborn, and Charles went on back home. That afternoon a telegram came for Miss M—— to report for rehearsal in Reading, Pa., and we left that night.

I never saw the house or Johnnie again, and Miss M——

never mentioned him to me again. But from then on I knew what was haunting her face; why she had been putting off marriage with her sweetheart.

About four months later, she met a wealthy business man of Newark, and I could tell that she was sunk. It all happened very suddenly, but gloriously. She told me that now that she was going to be married and leave the stage, she did not want me to work for any one else in the business. In fact, she thought that I should not be working at all. I ought to be in school. She said she thought I had a mind, and that it would be a shame for me not to have any further training. She wished that she herself could go abroad to study, but that was definitely out of the question, now. The deep reservoir of things inside her gave off a sigh.

We were in northern Virginia then, and moving towards Baltimore. When we got there, she inquired about schools, gave me a big bearful hug, and what little money she could spare and told me to keep in touch with her. She would do whatever she could to help me out.

That was the way we parted. I had been with her for eighteen months and though neither of us realized it, I had been in school all that time. I had loosened up in every joint and expanded in every direction.

I had done some reading. Not as much as before, but more discriminate reading. The tenor was a Harvard man who had travelled on the Continent. He always had books along with him, and offered them to me more and more. The first time I asked to borrow one, he looked at me in a way that said "What for?" But when he found that I really read it and enjoyed it, he relaxed and began to hand them to me gruffly. He never acted as if he liked it, but I knew better. That was just the Harvard in him.

Then there was the music side. They broke me in to good music, that is, the classics, if you want to put it that way. There was no conscious attempt to do this. Just from being around, I became familiar with Gilbert and Sullivan, and the best parts of the light opera field. Grand opera too, for all of the leads

116

had backgrounds of private classical instruction as well as conservatory training. Even the bit performers and the chorus had some kind of formal training in voice, and most of them played the piano. It was not unusual for some of the principals to drop down at the piano after a matinee performance and begin to sing arias from grand opera. Sing them with a wistfulness. The arias which they would sing at the Metropolitan or La Scala as they had once hoped actively, and still hoped passively even as the hair got thinner and the hips got heavier. Others, dressed for the street, would drift over and ease into the singing. Thus I would hear solos, duets, quartets and sextets from the best known operas. They would eagerly explain to me what they were when I asked. They would go on to say how Caruso, Farrar, Mary Garden, Trentini, Schumann-Heink, Matzenauer and so forth had interpreted this or that piece, and demonstrate it by singing. Perhaps that was their trouble. They were not originators, but followers of originators. Anyway, it was perfectly glorious for me, though I am sure nobody thought of it that way. I just happened to be there while they released their inside dreams.

I can see now how capable these people were, who were taking light opera to the sticks. For instance, the opening night in Lancaster, Pa., was so riotous that the house manager came backstage and said it was certain to be held over. The company decided on the off-chance to prepare *The Chocolate Soldier* for the new week. When the curtain went up the next Monday night, a very smooth performance of the "Soldier" was unveiled to the public. They did the same thing with *The Firefly* in Bridgeport, Connecticut, later on. It was very beautiful, but tough on me. I got so sick of holding "sides" and feeding cues that I was ready to throw an acre of fits. But it did teach me the lesson that you can do what you have to do. Like that tree-climbing rabbit of Uncle Remus, who was "just 'bluged to clam dat tree." A hound was on his tail and he had to do the impossible and he did it.

More than that, I saw thirty-odd people made up of all classes and races living a communal life. There were little

touches of professional jealously and a catty crack now and then, but let sickness or trouble touch any member and the whole cast rallied around to help out. It was a marvelous thing to see. There were a few there from good families and well-to-do homes who slept in shabby hotels and made meals on sandwiches without a murmur. From what they said and did, you would think they were as poor as the rest.

With all branches of Anglo-Saxon, Irish, three Jews and one Negro together in a huddle, and all friendly, there were a lot of racial gags. Everybody was so sure that nobody hesitated to pull them. It was all taken in good part. Naturally, all of the Negro gags were pulled on me. There were enough of the others to divide things up. For instance, one night, Miss M—— cut her eyes in my direction slyly, began to talk about blondes, brunettes and burnt-ettes. They gagged me so much before overture was called that it made Miss M—— go out there and cut a hog. In her long recitative in the first act of *Pinafore* where the heroine mulls over what she is leaving in her father's house and what she is going to in marrying the poor hero, she mentions dirty children crying and dingy clothes a "drying." That night she frightened herself nearly to death by chanting in full rich tones about "dingy children crying." The audience, no doubt, began to wonder what kind of a marriage it was she was contemplating. But the whole experience on that job gave me an approach to racial understanding. It was easy to keep on feeling that way. Furthermore, it discouraged any sensitiveness on my part, so that I am still not conscious of my race no matter where I may go. I found out too that you are bound to be jostled in the "crowded street of life." That in itself need not be dangerous unless you have the open razors of personal vanity in your pants pocket. The passers-by don't hurt you, but if you go around like that, they make you hurt yourself.

The experience had matured me in other ways. I had seen, I had been privileged to see folks substituting love for failure of career. I would listen to one and another pour out their feelings sitting on a stool back stage between acts and scenes.

Then too, I had seen careers filling up the empty holes left by love, and covering up the wreck of things internal. Those experiences, though vicarious, made me see things and think.

And now, at last it was all over. It was not at all clear to me how I was going to do it, but I was going back to school.

One minute I felt brave and fine about it all. The wish to be back in school had never left me. But alone by myself and feeling it over, I was scared. Before this job I had been lonely; I had been bare and bony of comfort and love. Working with these people I had been sitting by a warm fire for a year and a half and gotten used to the feel of peace. Now, I was to take up my pilgrim's stick and go outside again. Maybe it would be different now. Seven of my unhappy visions had passed me and bowed. The seventh one, the house that needed paint, that had threatened me with so much suffering that I used to sit up in bed sodden with agony, had passed. I had fled from it to put on the blue poplin dress. At least that was not before me any more. I took a firm grip on the only weapon I had— hope, and set my feet. Maybe everything would be all right from now on. Maybe. Well, I put on my shoes and I started.

CHAPTER 9

SCHOOL AGAIN

Back, out walking on fly-paper again. Money was what I needed to get back in school. I could have saved a lot of money if I had received it. But theatrical salaries being so uncertain, I did not get mine half the time. I had it when I had it, but when it was not paid I never worried. But now I needed it. Miss M—— was having her troubles, trying to help her folks she informed me by mail, so I never directly asked her for anything more. I had no resentment, either. It had all been very pleasant.

I tried waiting on table, and made a good waitress when my mind was on it, which was not often. I resented being patronized, more than the monotony of the job; those presumptuous cut-eye looks and supposed-to-be accidental touches on the thigh to see how I took to things. Men at the old game of "stealing a feel." People who paid for a quarter meal, left me a nickel tip, and then stood outside the door and nodded their heads for me to follow on and hear the rest of the story. But I was lacking in curiosity. I was not worrying so much about virtue. The thing just did not call me. There was neither the beauty of love, nor material advantage in it for me. After all,

what is the use in having swine without pearls? Some educated men sat and talked about the things I was interested in, but if I seemed to listen, looked at me as much to say, "What would that mean to you?"

Then in the midst of other difficulties, I had to get sick. Not a sensible sickness for poor folks to have. No, I must get down with appendicitis and have to have an operation right away. So it was the free ward of the Maryland General Hospital for me.

When I was taken up to the amphitheatre for the operation I went up there placing a bet with God. I did not fear death. Nobody would miss me very much, and I had no treasures to leave behind me, so I would not go out of life looking backwards on that account. But I bet God that if I lived, I would try to find out the vague directions whispered in my ears and find the road it seemed that I must follow. How? When? Why? What? All those answers were hidden from me.

So two o'clock that day when they dressed me for surgery and took me up there in that room with the northern light and many windows, I stepped out of the chair before the nurse could interfere, walked to a window and took a good look out over Baltimore and the world as far as I could see, resigned myself to fate and unaided, climbed upon the table, and breathed deeply when the ether cone was placed over my nose.

I scared the doctor and the nurses by not waking up until nine o'clock that night, but otherwise I was all right. I was alive, so I had to win my bet with God.

Soon, I had another waitress's job, trying to save money again, but I was only jumping up and down in my own foottracks.

I tried several other things but always I had that feeling that you have in a dream of trying to run, and sinking to your knees at every step in soft sticky mud. And this mud not only felt obscene to my feet, it smelled filthy to my nose. How to pull out?

How then did I get back to school? I just went. I got tired

of trying to get the money to go. My clothes were practically gone. Nickeling and dimering along was not getting me anywhere. So I went to the night high school in Baltimore and that did something for my soul.

There I met the man who was to give me the key to certain things. In English, I was under Dwight O. W. Holmes. There is no more dynamic teacher anywhere under any skin. He radiates newness and nerve and says to your mind, "There is something wonderful to behold just ahead. Let's go see what it is." He is a pilgrim to the horizon. Anyway, that is the way he struck me. He made the way clear. Something about his face killed the drabness and discouragement in me. I felt that the thing could be done.

I turned in written work and answered questions like everybody else, but he took no notice of me particularly until one night in the study of English poets he read *Kubla Khan* by Samuel Taylor Coleridge. You must get him to read it for you sometime. He is not a pretty man, but he has the face of a scholar, not dry and set like, but fire flashes from his deep-set eyes. His high-bridged, but sort of bent nose over his thin-lipped mouth—well the whole thing reminds you of some old Roman like Cicero, Caesar or Virgil in tan skin.

That night, he liquefied the immortal grains of Coleridge, and let the fountain flow. I do not know whether something in my attitude attracted his attention, or whether what I had done previously made him direct the stream at me. Certainly every time he lifted his eyes from the page, he looked right into my eyes. It did not make me see him particularly, but it made me see the poem. That night seemed queer, but I am so visual-minded that all the other senses induce pictures in me. Listening to Samuel Taylor Coleridge's *Kubla Khan* for the first time, I saw all that the poet had meant for me to see with him, and infinite cosmic things besides. I was not of the work-a-day world for days after Mr. Holmes's voice had ceased.

This was my world, I said to myself, and I shall be in it, and surrounded by it, if it is the last thing I do on God's green dirt-ball.

123

But he did something more positive than that. He stopped me after class and complimented me on my work. He did something else. He never asked me anything about myself, but he looked at me and toned his voice in such a way that I felt he knew all about me. His whole manner said, "No matter about the difficulties past and present, step on it!"

I went back to class only twice after that. I did not say a word to him about my resolve. But the next week, I went out to Morgan College to register in the high school department.

William Pickens, a negro, was the Dean there, and he fooled me too. I was prepared to be all scared of him and his kind. I had no money and no family to refer to. I just went and he talked to me. He gave me a brief examination and gave me credit for two years' work in high school and assigned me to class. He was just as understanding as Dwight Holmes in a way.

Knowing that I had no money, he evidently spoke to his wife, because she sent for me a few days later and told me enthusiastically that she had a job for me that would enable me to stay in school. Dr. Baldwin, a white clergyman, and one of the trustees of Morgan, had a wife with a broken hip. He wanted a girl to stay at the house, help her dress in the morning, undress at night and generally look after her. There was no need for anyone except in the morning and at night. He would give me a home and two dollars a week. The way Mrs. Pickens described the work to me, I could tell she knew I would be glad to accept the job and I was.

So I went to live with the Baldwins. The family consisted of the Minister, his wife and his daughter, Miss Maria, who seemed to be in her thirties and unmarried.

They had a great library, and I waded in. I acted as if the books would run away. I remember committing to memory, Gray's *Elegy in a Country Churchyard* over night, lest I never get a chance to read it again. Next I learned the *Ballad of Reading Gaol* and started on the *Rubaiyat*.

It would be dramatic in a Cinderella way if I were to say that the well-dressed students at school snubbed me and shoved

124

me around, but that I studied hard and triumphed over them. I did study hard because I realized that I was three years behind schedule, and then again study has never been hard to me. Then too, I had hundreds of books under my skin already. Not selected reading, all of it. Some of it could be called trashy. I had been through Nick Carter, Horatio Alger, Bertha M. Clay and the whole slew of dime novelists in addition to some really constructive reading. I do not regret the trash. It has harmed me in no way. It was a help, because acquiring the reading habit early is the important thing. Taste and natural development will take care of the rest later on.

Nobody shoved me around. There were eighteen people in my class. Six of them were boys. Good-looking, well-dressed girls from Baltimore's best Negro families were class-mates of mine. Ethel Cummings, the daughter of a very successful lawyer, Bernice Naylor, whose father was a big preacher, the Hughes girls, Bernice and Gwendolyn, who were not only beautiful, but whose family is distinguished in the professions all over America. Mary Jane Watkins of New York, now a dentist, and considered the most sex-appealing thing, with her lush figure and big eyes and soft skin, and all of the girls in my class passed for pretty. It was said to be, not only the best-looking class on the campus, college or prep, but the best-looking ever to happen together. You see, Rosa Brown, who was easily the most luscious piece of gal meat in all colored Baltimore was in that class too. She had not only lovely eyes set in a cameo-like face, but shining, beautiful black curls that fell easily to her waist. She has done well by herself, too. She is now married to Tanner Moore, a prosperous lawyer of Philadelphia. Town house, cars and country place, and things like that.

Well, here was this class of pretty girls and snappy boys. The girls were in the majority, but what we had of boys were in demand in town and on campus. The class knew it caused a lot of trouble too, as the college girls were always growling about "that prep class" grabbing off the college men. They passed a rule about it, but it did not help matters. They, the

125

college girls, just got left out of things, themselves, while the prep girls romped on.

And here I was, with my face looking like it had been chopped out of a knot of pine wood with a hatchet on somebody's off day, sitting up in the middle of all this pretty. To make things worse, I had only one dress, a change of underwear and one pair of tan oxfords.

Therefore, I did not rush up to make friends, but neither did I shrink away. My second day at school, I had to blow my nose and I had no handkerchief with me. Mary Jane Watkins was sitting next to me, so she quickly shoved her handkerchief in my hand without saying a word. We were in chapel and Dr. Spencer was up speaking. So she kept her eyes front. I nodded my thanks and so began a friendship.

Bernice Hughes, whose father, Dr. W.A.C. Hughes, was somebody really important in the Methodist Episcopal Church, and a trustee of the College, sat watching me after about a week in school. Her grey eyes were fixed on me, and her red lips were puckered in a frown. I did not know what to think. But it was in English History which I liked very much and I was not doing badly in recitation. When the period was over and the class passed on to the next room, she fell in beside me and said, "If you ain't one knowing fool! I'm naming you old Knowledge Bug." Then she laughed that kind of a laugh she has to cover up her feelings and I laughed too. Bernice can register something that makes you look at her and like her no matter what she does.

"I'm sitting by you tomorrow, fool, and from now on. You hear me?" She went on with her catching laugh. "No use in both of us studying like a fool. You can just study for both of us."

So from then on, I was knee deep in the Hughes family. There is more looks and native ability in the Hughes clan to the square child than any I can think of off hand. If they do not always make a brilliant showing, it is not because they can't do it. Their looks and charm interfere with their brainwork, that is all. And you are not going to forget them either. If a

126

Hughes is in town, you are going to know it in one way or another.

It soon became apparent that my lack of clothes was no drawback to my getting along. Sometimes somebody would ask me, "Zora, what do you think you'll wear to school tomorrow?" I'd humor the joke and describe what I was going to wear. But let a program or a get-together come along, and all the girls in the class would be backing me off in a corner, or writing me notes offering to lend me something to wear. I would have to take it in rotation to keep from causing hard feelings.

I got on with the boys, too. In no time I made Stanley James, a varsity football man. Then it was Douglas Camper, a senior college man. His brother was a football star at Howard University in Washington. Our class had cornered all of the college seniors so that not one college girl was escorted to the senior prom. We just couldn't see how functions like that could go on without our gang. Mary Jane had cornered Ed Wilson, the Clark Gable of the campus, for the occasion, so the marines had landed.

Whenever Miss Clarke, our English teacher, was absent, I was put in charge of the class. This happened time and time again, sometimes for a whole week at a time. With history it was the same. Once I had the history classes for nearly a month and had to be excused from my other classes. At times like that, my classmates were perfectly respectful to me until the bell rang. Then how they would poke fun at my serious face while I was teaching!

With Dean Pickens to coach me, I placed second in the school oratorical contest. Rosa Brown placed first and Bernice Hughes third, indicating that our class was determined to be head muck-de-muck in everything that went on.

My first publication was on the blackboard in the assembly hall at Morgan. I decided to write an allegory using the faculty members as characters. Most of my classmates were in the know.

I went to school extra early that morning and when the bell

127

rang for assembly, the big board was covered with the story. Dr. Spencer, the President of Morgan, had a great shock of curly white hair. He was the kindly "Great Gray Bear" of the story. Dean Pickens was the "Ferocious Pick." Practically every faculty member was up there, to the great entertainment of the student body. Furthermore, we could see the various members of the faculty sneaking peeps at the board over their shoulders from time to time as the service went on.

When Dr. Spencer rose to read from the Bible, his face was as red as a beet under all that white hair. He ran his fingers through his hair two or three times as he kept looking back at the board.

After the short service was over, he commented on it and actually burst out laughing. Then, of course, everybody else could laugh. All except one man who was there to succeed Dean Pickens, who was going to New York to work for the N.A.A.C.P. This man clouded up and tried to rain. He was up there in the character of "Pocket Tooth" and he didn't like it. He had earned that name because his two canine teeth were extra long, but sort of square at the ends. My class decided that they looked like the pockets on my dress. So far as we were concerned, he was Pocket Tooth, and he stayed Pocket Tooth for the duration. He led devotions next morning and dared everybody to write anything like that on that board again. Dean Pickens, for all his ferocious official frown and hot temper, was full of boy. Down in his apartment, Mrs. Pickens ran things, and he played with his three children. Ruby, the youngest, seemed to have the inside track with him. I was in and out of the Pickens home every day. I actually heard him discussing with Ruby her chances of licking Harriet, her older sister. She had tried it, and failed. Dean Pickens was full of sympathy, but he told her he was afraid Harriet was too tough for her. She had better get even with Harriet some other way. If she felt she must fight, hit Harriet one quick lick and run. That was the best advice he could give her. Mrs. Pickens put down her book and looked at her husband just as she would have at Bill, her son.

My two years at Morgan went off very happily indeed. The atmosphere made me feel right. I was at last doing the things I wanted to do. Every new thing I learned in school made me happy. The science courses were tremendously interesting to me. Perhaps it was because Professor Calloway was such an earnest teacher. I did not do well in mathematics. Why should A minus B? Who the devil was X anyway? I could not even imagine. I still do not know. I passed the courses because Professor Johnson, knowing that I did well in everything else, just made it a rule to give me a C. He probably understood that I am one of those people who have no number sense. I have been told that you can never factor A − B to the place where it comes out even. I wouldn't know because I never tried to find out.

When it came time to consider college, I planned to stay on at Morgan. But that was changed by chance. Mae Miller, daughter of the well-known Dr. Kelly Miller of Howard University, came over to Morgan to spend the weekend with her first cousins, Bernice and Gwendolyn Hughes. So we were thrown together. After a few hours of fun and capers, she said, "Zora, you are Howard material. Why don't you come to Howard?"

Now as everyone knows, Howard University is the capstone of Negro education in the world. There gather Negro money, beauty, and prestige. It is to the Negro what Harvard is to the whites. They say the same thing about a Howard man that they do about Harvard—you can tell a Howard man as far as you can see him, but you can't tell him much. He listens to the doings of other Negro schools and their graduates with bored tolerance. Not only is the scholastic rating at Howard high, but tea is poured in the manner!

I had heard all about the swank fraternities and sororities and the clothes and everything, and I knew I could never make it. I told Mae that.

"You can come and live at our house, Zora," Bernice offered. At the time, her parents were living in Washington, and Bernice and Gwendolyn were in the boarding department at

Morgan. "I'll ask Mama the next time she comes over. Then you won't have any room and board to pay. We'll all get together and rustle you up a job to make your tuition."

So that summer I moved on to Washington and got a job. First, as a waitress in the exclusive Cosmos Club downtown, and later as a manicurist in the G Street shop of Mr. George Robinson. He is a Negro who has a chain of white barber shops in downtown Washington. I managed to scrape together money for my first quarter's tuition, and went up to register.

Lo and behold, there was Dwight Holmes sitting up there at Howard! He saved my spirits again. I was short of money, and Morgan did not have the class A rating that it now has. There was trouble for me and I was just about to give up and call it a day when I had a talk with Dwight Holmes. He encouraged me all he could, and so I stuck and made up all of those hours I needed.

I shall never forget my first college assembly, sitting there in the chapel of that great University. I was so exalted that I said to the spirit of Howard, "You have taken me in. I am a tiny bit of your greatness. I swear to you that I shall never make you ashamed of me."

It did not wear off. Every time I sat there as part and parcel of things, looking up there at the platform crowded with faculty members, the music, the hundreds of students about me, it would come down on me again. When on Mondays we ended the service by singing Alma Mater, I felt just as if it were the Star Spangled Banner:

> "Reared against the eastern sky
> Proudly there on hill-top high
> Up above the lake so blue
> Stands Old Howard brave and true.
> There she stands for truth and right,
> Sending forth her rays of light,
> Clad in robes of majesty
> Old Howard! We sing of thee."

My soul stood on tiptoe and stretched up to take in all that it meant. So I was careful to do my class work and be worthy to stand there under the shadow of the hovering spirit of Howard. I felt the ladder under my feet.

Mr. Robinson arranged for me to come to work at three-thirty every afternoon and work until eight-thirty. In that way, I was able to support myself. Soon, most of the customers knew I was a student, and tipped me accordingly. I averaged twelve to fifteen dollars a week.

Mr. Robinson's 1410 G Street shop was frequented by bankers, Senators, Cabinet Members, Congressmen, and Gentlemen of the Press. The National Press Club was one block down the same street, the Treasury Building was one block up the street and the Capitol not far away.

I learned things from holding the hands of men like that. The talk was of world affairs, national happenings, personalities, the latest quips from the cloak rooms of Congress and such things. I heard many things from the White House and the Senate before they appeared in print. They probably were bursting to talk to somebody, and I was safe. If I told, nobody would have believed me anyway. Besides, I was much flattered by being told and warned not to repeat what I had heard. Sometimes a Senator, a banker, a newspaper correspondent attached to the White House would all be sitting around my table at one time. While I worked on one, the others waited, and they all talked. Sometimes they concentrated on teasing me. At other times they talked about what had happened, or what they reasoned was bound to happen. Intimate stories about personalities, their secret love affairs, cloak room retorts, and the like. Soon they took me for granted and would say, "Zora knows how to keep a secret. She's all right." Now, I know that my discretion really didn't matter. They were relieving their pent-up feelings where it could do no harm.

Some of them meant more to me than others because they paid me more attention. Frederick William Wile, White House Correspondent, used to talk to me at times quite seri-

ously about life and opportunities and things like that. He had seen three presidents come and go. He had traveled with them, to say nothing of his other traveling to and from upon the earth. He had read extensively. Sometimes he would be full of stories and cracks, such as commenting on the wife of an ex-president who had been quite the grand dame when she was First Lady. "Why, she was so glad when that man proposed to her that she fell out of bed!"

But at other times he would talk to me quite seriously about attitudes, points of view, why one man was great and another a mere facile politician, and so on.

There were other prominent members of the press who would sit and talk longer than it took me to do their hands. One of them, knowing that certain others sat around and talked, wrote out questions two or three times for me to ask and tell him what was said. Each time the questions were answered, but I was told to keep that under my hat, and so I had to turn around and lie and say the man didn't tell me. I never realized how serious it was until he offered me twenty-five dollars to ask a certain southern Congressman something and let him know as quickly as possible. He sent out and bought me a quart of French ice cream to bind the bargain. The man came in on his regular time, which was next day, and in his soft voice, began to tell me how important it was to be honorable at all times and to be trustworthy. How could I ask him then? Besides, he was an excellent Greek scholar and translated my entire lesson for me, which was from Xenophon's *Cyropædeia,* and talked at length on the ancient Greeks and Persians. The news man was all right. He had to get his information the best way he could, but for me, it would have been terrible to do that nice man like that. I told the reporter how it was and he understood and never asked me again.

Mr. Johns, a pressman, big, slow, with his eternal walking stick, was always looking for a laugh. Logan, our head-porter, was his regular meat. Logan had a long head, so flat on each side that it looked like it had been pressed between two planks. His toes turned in and his answers were funny.

One day, while shining Mr. John's shoes, he told him what a fighter he was. He really was tough when he got mad, according to himself. According to Logan, Logan was mean! Just couldn't help it. He had Indian blood in him. Just mean and strong. When he straightened out his African soup-bone (arm), something was just bound to fall. If a man didn't fall when *he* hit him, he went around behind him to see what was propping him up. Yassuh! Mr. Johns listened at Logan and smiled. He egged him on to tell more of his powers. The very next day Mr. Johns came in and announced that they had a bear up at Keith's theater, and they needed somebody to wrestle with him. There was good money in it for the man who would come right forward and wrestle with that bear, and knowing that Logan needed money and that he was fearless, he had put Logan's name down. He liked Logan too well to let him get cheated out of such a swell chance to get rich and famous. All Logan needed to do was to go to the theater and tell them that Mr. Johns sent him.

"Naw sir, Mr. Johns," Logan said, "I ain't wrestling no bear. Naw sir!"

"But Logan, you told me—everybody in here heard you—that when you get mad, you go bear-hunting with your fist. You don't even have to hunt this bear. He's right up there on the corner waiting for you. You can't let me down like this. I've already told the man you would be glad to wrestle his old bear!"

"How big is dat bear, Mister Johns?"

"Oh, he is just a full grown bear, Logan. Nothing to worry about at all. He wouldn't weigh more than two hundred pounds at the outside. Soft snap for a man like you, and you weigh about that yourself, Logan."

"Naw Sir! Not no big bear like that. Naw Sir!"

"Well, Logan, what kind of a bear would you consider? You just tell me, and I'll fix it up with the man."

"Git me a little bitty baby bear, Mr. Johns, 'bout three months old. Dats de kind of bear I wants to wrestle wid. Yassuh!"

133

The mental picture of a big, long-armed, awkward six-footer like Logan wrestling with a tiny cub was too much for the shop. Dignity of every sort went out of the window. The bear cycle took on. Every day, important men, high in life, came in with suggestions on the wrestle. It kept up until Logan furnished them with another laugh by getting into jail over the weekend for beating his wife about a hog-head. He thought she had given a pimp the "ears offen dat head" and found out after he was in jail that it had no ears when he bought it. Mr. Johns went down and persuaded the judge to let Logan go, and then Logan in a burst of good will offered to give the judge the hog-head—still uncooked. The judge chased Logan out of the court, and that hog-head became a classic around the shop.

An incident happened that made me realize how theories go by the board when a person's livelihood is threatened. A man, a Negro, came into the shop one afternoon and sat down in Banks's chair. Banks was the manager and had the first chair by the door. It was so surprising that for a minute Banks just looked at him and never said a word. Finally, he found his tongue and asked, "What do you want?"

"Hair-cut and shave," the man said belligerently.

"But you can't get no hair-cut and shave here. Mr. Robinson has a fine shop for Negroes on U Street near Fifteenth," Banks told him.

"I know it, but I want one here. The Constitution of the United States—"

But by that time, Banks had him by the arm. Not roughly, but he was helping him out of his chair, nevertheless.

"I don't know how to cut your hair," Banks objected. "I was trained on straight hair. Nobody in here knows how."

"Oh, don't hand me that stuff!" the crusader snarled. "Don't be such an Uncle Tom."

"Run on, fellow. You can't get waited on in here."

"I'll stay right here until I do. I know my rights. Things like this have got to be broken up. I'll get waited on all right, or sue the place."

134

"Go ahead and sue," Banks retorted. "Go on uptown, and get your hair cut, man. Don't be so hard headed for nothing."

"I'm getting waited on right here!"

"You're next, Mr. Powell," Banks said to a waiting customer. "Sorry mister, but you better go on uptown."

"But I have a right to be waited on wherever I please," the Negro said and started towards Updyke's chair which was being emptied. Updyke whirled his chair around so that he could not sit down and stepped in front of it. "Don't you touch *my* chair!" Updyke glared. "Go on about your business."

But instead of going, he made to get into the chair by force.

"Don't argue with him! Throw him out of here!" somebody in the back cried. And in a minute, barbers, customers all lathered and with hair half cut, and porters, were all helping to throw the Negro out.

The rush carried him way out into the middle of G Street and flung him down. He tried to lie there and be a martyr, but the roar of oncoming cars made him jump up and scurry off. We never heard any more about it. I did not participate in the melee, but I wanted him thrown out, too. My business was threatened.

It was only that night in bed that I analyzed the whole thing and realized that I was giving sanction to Jim Crow, which theoretically, I was supposed to resist. But here were ten Negro barbers, three porters and two manicurists all stirred up at the threat of our living through loss of patronage. Nobody thought it out at the moment. It was an instinctive thing. That was the first time it was called to my attention that self-interest rides over all sorts of lives. I have seen the same thing happen hundreds of times since, and now I understand it. One sees it breaking over racial, national, religious and class lines. Anglo-Saxon against Anglo-Saxon, Jew against Jew, Negro against Negro, and all sorts of combinations of the three against other combinations of the three. Off-hand, you might say that we fifteen Negroes should have felt the racial thing and served him. He was one of us. Perhaps it would have been a beautiful thing if Banks had turned to the shop crowded with

135

customers and announced that this man was going to be served like everybody else even at the risk of losing their patronage, with all of the other employees lined up in the center of the floor shouting, "So say we all!" It would have been a stirring gesture, and made the headlines for a day. Then we could all have gone home to our unpaid rents and bills and things like that. I could leave school and begin my wanderings again. The "militant" Negro who would have been the cause of it all, would have perched on the smuddled-up wreck of things and crowed. Nobody ever found out who or what he was. Perhaps he did what he did on the spur of the moment, not realizing that serving him would have ruined Mr. Robinson, another Negro who had got what he had the hard way. For not only would the G Street shop have been forced to close, but the F Street shop and all of his other six downtown shops. Wrecking George Robinson like that on a "race" angle would have been ironic tragedy. He always helped out any Negro who was trying to do anything progressive as far as he was able. He had no education himself, but he was for it. He would give any Howard University student a job in his shops if they could qualify, even if it was only a few hours a week.

So I do not know what was the ultimate right in this case. I do know how I felt at the time. There is always something fiendish and loathsome about a person who threatens to deprive you of your way of making a living. That is just human-like, I reckon.

At the University, I got on well both in class work and the matter of making friends. I could not take in but so many social affairs because I had to work, and then I had to study my lessons after work hours at night, and I was carrying a heavy program.

The teacher who most influenced me was Dr. Lorenzo Dow Turner, head of the English department. He was tall, lean, with a head of wavy black hair above his thin, aesthetic, tan-colored face. He was a Harvard man and knew his subject. His delivery was soft and restrained. The fact that he looked to be in his late twenties or early thirties at most made the girls

136

conscious of shiny noses before they entered his classroom.

Listening to him, I decided that I must be an English teacher and lean over my desk and discourse on the 18th-Century poets, and explain the roots of the modern novel. Children just getting born were going to hear about Addison, Poe, De Quincey, Steele, Coleridge, Keats and Shelley from me, leaning nonchalantly over my desk. Defoe, Burns, Swift, Milton and Scott were going to be sympathetically, but adequately explained, with just that suspicion of a smile now and then before I returned to my notes.

The man who seemed to me to be most overpowering was E. C. Williams, Librarian and head of the Romance Language department. He was cosmopolitan and world-traveled. His wit was instant and subtle. He was so inaccessible in a way, too. He told me once that a flirtation with a co-ed was to him like playing with a teething-ring. He liked smart, sophisticated women. He used to lunch every day with E. D. Davis, head of the Greek and German department. Davis was just the antithesis of Williams, so shy, in the Charles S. Johnson manner, in spite of his erudition. They would invite me to come along and would pay for my milk and pie. Williams did most of the talking. I put in something now and then. Davis sat and smiled. Professor Williams egged me on to kiss him. He said that Davis would throw a fit, and he wanted to be present to see it. He whispered that Davis liked to have me around, but from what he ever said, I couldn't notice. When I was sick, Professor Davis came to see me and brought me an arm load of roses, but he sat there half an hour and scarcely said a word. He just sat there and smiled now and then.

One day a pretty Washington girl visited me on the campus and joined us at lunch. She laid down a heavy barrage around E. C. Williams. He leaned back in his chair in the midst of her too obvious play and said suddenly, "Girlie, you would flirt with the Pope."

She was taken aback and turned a melting smile upon Davis and colored. "You wouldn't say that about me, would you, Professor Davis?"

"No, I'd say the only reason you wouldn't flirt with the Pope is that he is so hard to get to."

That floored us. Davis talking up like that! Then he shut up in his shell again.

All in all, I did a year and a half of work at Howard University. I would have done the two full years, but I was out on account of illness, and by the time that was over, I did not have the money for my tuition.

I joined the Zeta Phi Beta Sorority, took part in all the literary activities on the campus, and made The Stylus, the small literary society on the hill. I named the student paper *The Hill Top.* The Stylus was limited to 19 members, two of them being faculty members. Dr. Alain Leroy Locke was the presiding genius and we had very interesting meetings.

My joining The Stylus influenced my later moves. On account of a short story which I wrote for The Stylus, Charles S. Johnson, who was just then founding *Opportunity Magazine,* wrote to me for material. He explained that he was writing to all of the Negro colleges with the idea of introducing new writers and new material to the public. I sent on "Drenched in Light" and he published it. Later, he published my second story "Spunk." He wrote me a kind letter and said something about New York. So, beginning to feel the urge to write, I wanted to be in New York.

This move on the part of Dr. Johnson was the root of the so-called Negro Renaissance. It was his work, and only his hush-mouth nature has caused it to be attributed to many others. The success of *Opportunity* Award dinners was news. Later on, the best of this material was collected in a book called *The New Negro* and edited by Dr. Alain Locke, but it was the same material, for the most part, gathered and published by Dr. Charles Spurgeon Johnson, now of the Department of Social Sciences, Fisk University, Nashville, Tennessee.

Being out of school for lack of funds, and wanting to be in New York, I decided to go there and try to get back in school in that city. So the first week of January, 1925, found me in New York with $1.50, no job, no friends, and a lot of hope.

138

The Charles Johnsons befriended me as best they could. I could always find something to eat out at their house. Mrs. Johnson would give me carfare and encouragement. I came to worship them really, and when we had a misunderstanding, it grew out of my intense loyalty to them. A certain woman knew how I felt and persuaded me to do something to "protect" them, which she knew would hurt. Then she doubled right back and prepared them for my "perfidy." She had her own plans all worked out what to do about the schism. I saw that they believed her so I just let it go, as much as it hurt me inside. I have never ceased to regret it, nor had the sense to tell them just what happened.

So I came to New York through *Opportunity,* and through *Opportunity* to Barnard. I won a prize for a short story at the first Award dinner, May 1, 1925, and Fannie Hurst offered me a job as her secretary, and Annie Nathan Meyer offered to get me a scholarship to Barnard. My record was good enough, and I entered Barnard in the fall, graduating in 1928.

I have no lurid tales to tell of race discrimination at Barnard. I made a few friends in the first few days. Eleanor Beer, who lived on the next chair to me in Economics, was the first. She was a New York girl with a sumptuous home down in W. 71st Street, near the Hudson. She invited me down often, and her mother set out to brush me up on good manners. I learned a lot of things from them. They were well traveled and cosmopolitan. I found out about forks, who entered a room first, sat down first, and who offered to shake hands. A great deal more of material like that. These people are still lying very close to my heart. I was invited to Eleanor's wedding when she married Enzo de Chetalat, a Swiss mining engineer, but I was down in Florida at the time. So I sent her a hat-box full of orange blossoms for the occasion, so she could know how I felt.

The Social Register crowd at Barnard soon took me up, and I became Barnard's sacred black cow. If you had not had lunch with me, you had not shot from taw. I was secretary to Fannie

139

Hurst and living at her 67th Street duplex apartment, so things were going very well with me.

Because my work was top-heavy with English, Political Science, History and Geology, my advisor at Barnard recommended Fine Arts, Economics, and Anthropology for cultural reasons. I started in under Dr. Gladys Reichard, had a term paper called to the attention of Dr. Franz Boas and thereby gave up my dream of leaning over a desk and explaining Addison and Steele to the sprouting generations.

I began to treasure up the words of Dr. Reichard, Dr. Ruth Benedict, and Dr. Boas, the King of Kings.

That man can make people work the hardest with just a look or a word, of anybody else in creation. He is idolized by everybody who takes his orders. We all call him Papa, too. One day, I burst into his office and asked for "Papa Franz" and his secretary gave me a look and told me I had better not let him hear me say that. Of course, I knew better, but at a social gathering of the Department of Anthropology at his house a few nights later, I brought it up.

"Of course, Zora is my daughter. Certainly!" he said with a smile. "Just one of my missteps, that's all." The sabre cut on his cheek, which it is said he got in a duel at Heidelberg, lifted in a smile.

Away from his office, Dr. Boas is full of youth and fun, and abhors dull, stodgy arguments. Get to the point is his idea. Don't raise a point which you cannot defend. He wants facts, not guesses, and he can pin you down so expertly that you soon lose the habit of talking all over your face. Either that, or you leave off Anthropology.

I had the same feeling at Barnard that I did at Howard, only more so. I felt that I was highly privileged and determined to make the most of it. I did not resolve to be a grind, however, to show the white folks that I had brains. I took it for granted that they knew that. Else, why was I at Barnard? Not everyone who cries, "Lord! Lord!" can enter those sacred iron gates. In her high scholastic standards, equipment, the quality of her student-body and graduates, Barnard has a right to the first

line of Alma Mater. "Beside the waters of the Hudson, Our Alma Mater stands serene!" Dean Gildersleeve has that certain touch. We know there are women's colleges that are older, but not better ones.

So I set out to maintain a good average, take part in whatever went on, and just be a part of the college like everybody else. I graduated with a *B* record, and I am entirely satisfied.

Mrs. Meyer, who was the moving spirit in founding the college and who is still a trustee, did nobly by me in getting me in. No matter what I might do for her, I would still be in her debt.

Two weeks before I graduated from Barnard, Dr. Boas sent for me and told me that he had arranged a fellowship for me. I was to go south and collect Negro folk-lore. Shortly before that, I had been admitted to the American Folk-Lore Society. Later, while I was in the field, I was invited to become a member of the American Ethnological Society, and shortly after the American Anthropological Society.

Booker T. Washington said once that you must not judge a man by the heights to which he has risen, but by the depths from which he came. So to me these honors meant something, insignificant as they might appear to the world. It was a long step for the waif of Eatonville. From the depth of my inner heart I appreciated the fact that the world had not been altogether unkind to Mama's child.

While in the field, I drove to Memphis, Tennessee, and had a beautiful reconciliation with Bob, my oldest brother, and his family. We had not seen each other since I ran off to be a lady's maid. He said that it had taken him a long time to realize what I was getting at. He regretted deeply that he had not been of more service to me on the way. My father had been killed in an automobile accident during my first year at Morgan, and Bob talked to me about his last days. In reality, my father was the baby of the family. With my mother gone and nobody to guide him, life had not hurt him, but it had turned him loose to hurt himself. He had been miserable over the dispersion of his children when he came to realize that it was so. We were

141

all so sorry for him, instead of feeling bitter as might have been expected. Old Maker had left out the steering gear when He gave Papa his talents.

In Memphis, my brother Ben was doing well as a pharmacist and owner of the East Memphis Drug Store. Between his dogs, his wife, his store, and his car, he was quite the laughing, witty person and I was glad that he was. We talked about Clifford Joel who had become, and still is, principal of the Negro High School in Decatur, Alabama, and I told him about seeing John in Jacksonville, Florida, where he was doing well with his market. I had the latest news for them on Everett, Mama's baby child, in the Post Office in Brooklyn, New York. Dick, the lovable, the irresponsible, was having a high-heel time up and down the east coast of the United States. He had never cared about school, but he had developed into a chef cook and could always take care of himself. Sarah was struggling along with a husband for whom we all wished a short sickness and a quick funeral.

It was a most happy interval for me. I drove back to New Orleans to my work in a glowing aura. I felt the warm embrace of kin and kind for the first time since the night after my mother's funeral, when we had huddled about the organ all sodden and bewildered, with the walls of our home suddenly blown down. On September 18, that house had been a hovering home. September 19, it had turned into a bleak place of desolation with unknown dangers creeping upon us from unseen quarters that made of us a whimpering huddle, though then we could not see why. But now, that was all over. We could touch each other in the spirit if not in the flesh.

CHAPTER 10

RESEARCH

R esearch is formalized curiosity. It is poking and prying
with a purpose. It is a seeking that he who wishes may
know the cosmic secrets of the world and they that dwell
therein.

Two weeks before I graduated from Barnard College, Dr.
Boas had arranged a fellowship for me. I was to go south and
do research in folk-lore.

I was extremely proud that Papa Franz felt like sending me.
As is well known, Dr. Franz Boas of the Department of An-
thropology of Columbia University, is the greatest An-
thropologist alive for two reasons. The first is his insatiable
hunger for knowledge and then more knowledge; and the
second is his genius for pure objectivity. He has no pet wishes
to prove. His instructions are to go out and find what is there.
He outlines his theory, but if the facts do not agree with it, he
would not warp a jot or dot of the findings to save his theory.
So knowing all this, I was proud that he trusted me. I went off
in a vehicle made out of Corona stuff.

My first six months were disappointing. I found out later
that it was not because I had no talents for research, but
because I did not have the right approach. The glamor of

Barnard College was still upon me. I dwelt in marble halls. I knew where the material was all right. But, I went about asking, in carefully accented Barnardese, "Pardon me, but do you know any folk tales or folk songs?" The men and women who had whole treasuries of material just seeping through their pores, looked at me and shook their heads. No, they had never heard of anything like that around there. Maybe it was over in the next county. Why didn't I try over there? I did, and got the self-same answer. Oh, I got a few little items. But compared with what I did later, not enough to make a flea a waltzing jacket. Considering the mood of my going south, I went back to New York with my heart beneath my knees and my knees in some lonesome valley.

I stood before Papa Franz and cried salty tears. He gave me a good going over, but later I found that he was not as disappointed as he let me think. He knew I was green and feeling my oats, and that only bitter disappointment was going to purge me. It did.

What I learned from him then and later, stood me in good stead when Godmother, Mrs. R. Osgood Mason, set aside two hundred dollars a month for a two-year period for me to work.

My relations with Godmother were curious. Laugh if you will, but there was and is a psychic bond between us. She could read my mind, not only when I was in her presence, but thousands of miles away. Both Max Eastman and Richmond Barthe have told me that she could do the same with them. But, the thing that delighted her was the fact that I was her only Godchild who could read her thoughts at a distance. Her old fingers were cramped and she could not write, but in her friend Cornelia Chapin's exact script, a letter would find me in Alabama, or Florida, or in the Bahama Islands and lay me by the heels for what I was *thinking.* "You have broken the law," it would accuse sternly. "You are dissipating your powers in things that have no real meaning," and go on to lacerate me. "Keep silent. Does a child in the womb speak?"

She was just as pagan as I. She had lived for years among the Plains Indians and had collected a beautiful book of Indian

lore. Often when she wished to impress upon me my garrulity, she would take this book from the shelf and read me something of Indian beauty and restraint. Sometimes, I would feel like a rabbit at a dog convention. She would invite me to dinner at her apartment, 399 Park Avenue, and then she, Cornelia Chapin, and Miss Chapin's sister, Mrs. Katherine Garrison Biddle, would all hem me up and give me what for. When they had given me a proper straightening, and they felt that I saw the light, all the sternness would vanish, and I would be wrapped in love. A present of money from Godmother, a coat from Miss Chapin, a dress from Mrs. Biddle. We had a great deal to talk about because Cornelia Chapin was a sculptor, Katherine Biddle, a poet, and Godmother, an earnest patron of the arts.

Then too, she was Godmother to Miguel Covarrubias and Langston Hughes. Sometimes all of us were there. She has several paintings by Covarrubias on her walls. She summoned us when one or the other of us returned from our labors. Miguel and I would exhibit our movies, and Godmother and the Chapin family, including brother Paul Chapin, would praise us and pan us, according as we had done. Godmother could be as tender as Mother love when she felt that you had been right spiritually. But anything, however clever, in you that felt like insincerity to her, called forth her well known "That is nothing! It has no soul in it. You have broken the law!" Her tongue was a knout, cutting off your outer pretenses, and bleeding your vanity like a rusty nail. She was merciless to a lie, spoken, acted or insinuated.

She was extremely human. There she was sitting up there at the table over capon, caviar and gleaming silver, eager to hear every word on every phase of life on a saw-mill "job." I must tell the tales, sing the songs, do the dances, and repeat the raucous sayings and doings of the Negro farthest down. She is altogether in sympathy with them, because she says truthfully, they are utterly sincere in living.

* * *

145

My search for knowledge of things took me into many strange places and adventures. My life was in danger several times. If I had not learned how to take care of myself in these circumstances, I could have been maimed or killed on most any day of the several years of my research work. Primitive minds are quick to sunshine and quick to anger. Some little word, look or gesture can move them either to love or to sticking a knife between your ribs. You just have to sense the delicate balance and maintain it.

In some instances, there is nothing personal in the killing. The killer wishes to establish a reputation as a killer, and you'll do as a sample. Some of them go around, making their announcements in singing:

> I'm going to make me a graveyard of my own,
> I'm going to make me a graveyard of my own,
> Oh, carried me down on de smoky road,
> Brought me back on de coolin' board,
> But I'm going to make me a graveyard of my own.

And since the law is lax on these big saw-mill, turpentine and railroad "jobs," there is a good chance that they never will be jailed for it. All of these places have plenty of men and women who are fugitives from justice. The management asks no questions. They need help and they can't be bothered looking for a bug under every chip. In some places, the "law" is forbidden to come on the premises to hunt for malefactors who did their malefacting elsewhere. The wheels of industry must move, and if these men don't do the work, who is there to do it?

So if a man, or a woman, has been on the gang for petty-thieving and mere mayhem, and is green with jealousy of the others who did the same amount of time for a killing and had something to brag about, why not look around for an easy victim and become a hero, too? I was nominated like that once in Polk County, Florida, and the only reason that I was not

elected, was because a friend got in there and staved off old club-footed Death.

> Polk County! Ah!
> Where the water tastes like cherry wine.
> Where they fell great trees with axe and muscle.

These poets of the swinging blade! The brief, but infinitely graceful, dance of body and axe-head as it lifts over the head in a fluid arc, dances in air and rushes down to bite into the tree, all in beauty. Where the logs march into the mill with its smokestacks disputing with the elements, its boiler room reddening the sky, and its great circular saw screaming arrogantly as it attacks the tree like a lion making its kill. The log on the carriage coming to the saw. A growling grumble. Then contact! Yeelld-u-u-ow! And a board is laid shining and new on a pile. All day, all night. Rumble, thunder and grumble. Yee-ee-ow! Sweating black bodies, muscled like gods, working to feed the hunger of the great tooth. Polk County!

Polk County. Black men laughing and singing. They go down in the phosphate mines and bring up the wet dust of the bones of pre-historic monsters, to make rich land in far places, so that people can eat. But, all of it is not dust. Huge ribs, twenty feet from belly to back bone. Some old-time sea monster caught in the shallows in that morning when God said, "Let's make some more dry land. Stay there, great Leviathan! Stay there as a memory and a monument to Time." Shark-teeth as wide as the hand of a working man. Joints of backbone three feet high, bearing witness to the mighty monster of the deep when the Painted Land rose up and did her first dance with the morning sun. Gazing on these relics, forty thousand years old and more, one visualizes the great surrender to chance and change when these creatures were rocked to sleep and slumber by the birth of land.

Polk County. Black men from tree to tree among the lordly

147

pines, a swift, slanting stroke to bleed the trees for gum. Paint, explosives, marine stores, flavors, perfumes, tone for a violin bow, and many other things which the black men who bleed the trees never heard about.

Polk County. The clang of nine-pound hammers on railroad steel. The world must ride.

Hah! A rhythmic swing of the body, hammer falls, and another spike driven to the head in the tie.

> Oh, Mobile! Hank!
> Oh, Alabama! Hank!
> Oh, Fort Myers! Hank!
> Oh, in Florida! Hank!
> Oh, let's shake it! Hank!
> Oh, let's break it! Hank!
> Oh, let's shake it! Hank!
> Oh, just a hair! Hank!

The singing-liner cuts short his chant. The straw-boss relaxes with a gesture of his hand. Another rail spiked down. Another offering to the soul of civilization whose other name is travel.

> Evalina! Make your dress a little longer, hark!
> Oh Evalina! Make your dress a little longer, hark!
> I see your thighs—
> Lawd, Lawd, I see your thighs!
>
> Oh, Angeline! Oh Angeline!
> Oh, Angeline dat great, great gal of mine
> And when she walks
> And when she walks
> And when she walks, she rocks and rolls behind!
>
> You feel her legs
> You feel her legs
> You feel her legs
> Then you want to feel her thighs.

148

Polk County. Black men scrambling up ladders into orange trees. Singing, laughing, cursing, boasting of last night's love, and looking forward to the darkness again. They do not say embrace when they mean that they slept with a woman. A behind is a behind and not a form. Nobody says anything about incompatability when they mean it does not suit. No bones are made about being fed up.

I got up this morning, and I knowed I didn't want it,
'Cause I slept last night with my hand all on it.
Yea! Polk County!
You don't know Polk County like I do
Anybody been there, tell you the same thing, too.
Eh, rider, rider!
Polk County, where the water tastes like cherry wine.

Polk County. After dark, the jooks. Songs are born out of feelings with an old beat-up piano, or a guitar for a mid-wife. Love made and unmade. Who put out dat lie, it was supposed to last forever? Love is when it is. No more here? Plenty more down the road. Take you where I'm going, woman? Hell no! Let every town furnish its own. Yeah, I'm going. Who care anything about no train fare? The railroad track is there, ain't it? I can count tires just like I been doing. I can ride de blind, can't I?

Got on de train didn't have no fare
But I rode some
Yes I rode some
Got on de train didn't have no fare
Conductor ast me what I'm doing there
But I rode some
Yes I rode some.

Well, he grabbed me by de collar and he led me to de door
But I rode some
Yes I rode some.

Well, he grabbed me by de collar and he led me to de door
He rapped me over de head with a forty-four
But I rode some
Yes I rode some.

Polk County in the jooks. Dancing the square dance. Dancing the scroush. Dancing the belly-rub. Knocking the right hat off the wrong head, and backing it up with a switch-blade.

"Fan-foot, what you doing with my man's hat cocked on *your* nappy head? I know you want to see your Jesus. Who's a whore? Yeah I sleeps with my mens, but they pays me. I wouldn't be a fan-foot like you—just on de road somewhere. Runs up and down de road from job to job making pay-days and don't git a thing for but wet drawers. You kiss my black, independent, money-making ass! Fool wid me and I'll cut all your holes into one. Don't nobody hold her! Let her jump on me! She pay her way on me, and I'll pay it off. Make time in old Bartow jail for her."

Maybe somebody stops the fight before the two switch-blades go together. Maybe nobody can. A short, swift dash in. A lucky jab by one opponent and the other one is dead. Maybe one gets a chill in the feet and leaps out of the door. Maybe both get cut badly and back off. Anyhow, the fun of the place goes on. More dancing and singing and buying of drinks, parched peanuts, fried rabbit. Full drummy bass from the piano with weepy, intricate right hand stuff. Singing the memories of Ella Wall, the Queen of love in the jooks of Polk County. Ella Wall, Plauchita, nothin' Liza.

Honey, let your draws hang low

It is a sad, parting song. Each verse ends up with "It's de last time, shaking in de bed with you."

More dancing, drinks, peanuts, singing
Roll me with your stomach, baby.
Feed me with your tongue

150

Do it a long time, baby
Till you make me——
Quarters Boss! High Sheriff? Lemme git gone from here!
Cold, rainy day, some old cold, rainy day
I'll be back, some old cold, rainy day.

Oh de rocks may be my pillow, Lawd!
De sand may be my bed
I'll be back some old cold, rainy day.

"Who run? What you running from the man for, nigger?
Me, I don't aim to run a step. I ain't going to run unless they
run me. Dat white man come messing with me and I'll cut him
a brand new butt-hole. I'm going to live anyhow until I die.
Play me some music so I can dance! Aw, spank dat box, man!!
Them white folks don't care nothing bout no nigger getting
cut and kilt, nohow. They ain't coming in here. I done kilt me
four and they ain't hung me yet. Beat dat box!"

"Yeah, but you ain't kilt no women, yet. They's mighty
particular 'bout you killing up women."

"And I ain't killing none neither. I ain't crazy in de head.
Nigger woman can kill all us men she wants to and they don't
care. Leave us kill a woman and they'll run you just as long
as you can find something to step on. I got good sense. I know
I ain't got no show. De white mens and de nigger women is
running this thing. Sing about old Georgy Buck and let's
dance off of it. Hit dat box!"

Old Georgy Buck is dead
Last word he said
I don't want no shortening in my bread.
Rabbit on de log
Ain't got no dog
Shoot him wid my rifle, bam! bam!

And the night, the pay night rocks on with music and gam-
bling and laughter and dancing and fights. The big pile of
cross-ties burning out in front simmers down to low ashes

151

before sun-up, so then it is time to throw up all the likker you can't keep down and go somewhere and sleep the rest off, whether your knife has blood on it or not. That is, unless some strange, low member of your own race has gone and pumped to the white folks about something getting hurt. Very few of those kind are to be found.

That is the primeval flavor of the place, and as I said before, out of this primitive approach to things, I all but lost my life.

It was in a saw-mill jook in Polk County that I almost got cut to death.

Lucy really wanted to kill me. I didn't mean any harm. All I was doing was collecting songs from Slim, who used to be her man back up in West Florida before he ran off from her. It is true that she found out where he was after nearly a year, and followed him to Polk County and he paid her some slight attention. He was knocking the pad with women, all around, and he seemed to want to sort of free-lance at it. But what he seemed to care most about was picking his guitar, and singing.

He was a valuable source of material to me, so I built him up a bit by buying him drinks and letting him ride in my car.

I figure that Lucy took a pick at me for three reasons. The first one was, her vanity was rubbed sore at not being able to hold her man. That was hard to own up to in a community where so much stress was laid on suiting. Nobody else had offered to shack up with her either. She was getting a very limited retail trade and Slim was ignoring the whole business. I had store-bought clothes, a lighter skin, and a shiny car, so she saw wherein she could use me for an alibi. So in spite of public knowledge of the situation for a year or more before I came, she was telling it around that I came and broke them up. She was going to cut everything off of me but "quit it."

Her second reason was, because of my research methods I had dug in with the male community. Most of the women liked me, too. Especially her sworn enemy, Big Sweet. She was scared of Big Sweet, but she probably reasoned that if she cut Big Sweet's protégée it would be a slam on Big Sweet and

152

build up her own reputation. She was fighting Big Sweet through me.

Her third reason was, she had been in little scraps and been to jail off and on, but she could not swear that she had ever killed anybody. She was small potatoes and nobody was paying her any mind. I was easy. I had no gun, knife or any sort of weapon. I did not even know how to do that kind of fighting.

Lucky for me, I had friended with Big Sweet. She came to my notice within the first week that I arrived on location. I heard somebody, a woman's voice "specifying" up this line of houses from where I lived and asked who it was.

"Dat's Big Sweet," my landlady told me. "She got her foot up on somebody. Ain't she specifying?"

She was really giving the particulars. She was giving a "reading," a word borrowed from the fortune-tellers. She was giving her opponent lurid data and bringing him up to date on his ancestry, his looks, smell, gait, clothes, and his route through Hell in the hereafter. My landlady went outside where nearly everybody else of the four or five hundred people on the "job" were to listen to the reading. Big Sweet broke the news to him, in one of her mildest bulletins that his pa was a double-humpted camel and his ma was a grass-gut cow, but even so, he tore her wide open in the act of getting born, and so on and so forth. He was a bitch's baby out of a buzzard egg.

My landlady explained to me what was meant by "putting your foot up" on a person. If you are sufficiently armed—enough to stand off a panzer division—and know what to do with your weapons after you get 'em, it is all right to go to the house of your enemy, put one foot up on his steps, rest one elbow on your knee and play in the family. That is another way of saying play the dozens, which is a way of saying low-rate your enemy's ancestors and him, down to the present moment for reference, and then go into his future as far as your imagination leads you. But if you have no faith in your personal courage and confidence in your arsenal, don't try it. It is a risky

153

pleasure. So then I had a measure of this Big Sweet.

"Hurt who?" Mrs. Bertha snorted at my fears. "Big Sweet? Humb! Tain't a man, woman nor child on this job going to tackle Big Sweet. If God send her a pistol she'll send him a man. She can handle a knife with anybody. She'll join hands and cut a duel. Dat Cracker Quarters Boss wears two pistols round his waist and goes for bad, but he won't break a breath with Big Sweet lessen he got his pistol in his hand. Cause if he start anything with her, he won't never get a chance to draw it. She done kilt two mens on this job and they said she kilt some before she ever come here. She ain't mean. She don't bother nobody. She just don't stand for no foolishness, dat's all."

Right away, I decided that Big Sweet was going to be my friend. From what I had seen and heard in the short time I had been there, I felt as timid as an egg without a shell. So the next afternoon when she was pointed out to me, I waited until she was well up the sawdust road to the Commissary, then I got in my car and went that way as if by accident. When I pulled up beside her and offered her a ride, she frowned at me first, then looked puzzled, but finally broke into a smile and got in.

By the time we got to the Commissary post office we were getting along fine. She told everybody I was her friend. We did not go back to the Quarters at once. She carried me around to several places and showed me off. We made a date to go down to Lakeland come Saturday, which we did. By the time we sighted the Quarters on the way back from Lakeland, she had told me, "You sho is crazy!" Which is a way of saying I was witty. "I loves to friend with somebody like you. I aims to look out for you, too. Do your fighting for you. Nobody better not start nothing with you, do I'll get my switch-blade and go round de ham-bone looking for meat."

We shook hands and I gave her one of my bracelets. After that everything went well for me. Big Sweet helped me to collect material in a big way. She had no idea what I wanted with it, but if I wanted it, she meant to see to it that I got it. She pointed out people who knew songs and stories. She

wouldn't stand for balkiness on their part. We held two lying contests, story-telling contests to you, and Big Sweet passed on who rated the prizes. In that way, there was no arguments about it.

So when the word came to Big Sweet that Lucy was threatening me, she put her foot up on Lucy in a most particular manner and warned her against the try. I suggested buying a knife for defense, but she said I would certainly be killed that way.

"You don't know how to handle no knife. You ain't got dat kind of a sense. You wouldn't even know how to hold it to de best advantage. You would draw your arm way back to stop her, and whilst you was doing all dat, Lucy would run in under your arm and be done cut you to death before you could touch her. And then again, when you sure 'nough fighting, it ain't enough to just stick 'em wid your knife. You got to ram it in to de hilt, then you pull *down*. They ain't no more trouble after dat. They's *dead*. But don't you bother 'bout no fighting. You ain't like me. You don't even sleep with no mens. I wanted to be a virgin one time, but I couldn't keep it up. I needed the money too bad. But I think it's nice for you to be like that. You just keep on writing down them lies. I'll take care of all de fighting. Dat'll make it more better, since we done made friends."

She warned me that Lucy might try to "steal" me. That is, ambush me, or otherwise attack me without warning. So I was careful. I went nowhere on foot without Big Sweet.

Several weeks went by, then I ventured to the jook alone. Big Sweet let it be known that she was not going. But later she came in and went over to the coon-can game in the corner. Thinking I was alone, Lucy waited until things were in full swing and then came in with the very man to whom Big Sweet had given the "reading." There was only one door. I was far from it. I saw no escape for me when Lucy strode in, knife in hand. I saw sudden death very near that moment. I was paralyzed with fear. Big Sweet was in a crowd over in the corner, and did not see Lucy come in. But the sudden quiet of the

place made her look around as Lucy charged. My friend was large and portly, but extremely light on her feet. She sprang like a lioness and I think the very surprise of Big Sweet being there when Lucy thought she was over to another party at the Pine Mill unnerved Lucy. She stopped abruptly as Big Sweet charged. The next moment, it was too late for Lucy to start again. The man who came in with Lucy tried to help her out, but two other men joined Big Sweet in the battle. It took on amazingly. It seemed that anybody who had any fighting to do, decided to settle-up then and there. Switch-blades, ice-picks and old-fashioned razors were out. One or two razors had already been bent back and thrown across the room, but our fight was the main attraction. Big Sweet yelled to me to run. I really ran, too. I ran out of the place, ran to my room, threw my things in the car and left the place. When the sun came up I was a hundred miles up the road, headed for New Orleans.

In New Orleans, I delved into Hoodoo, or sympathetic magic. I studied with the Frizzly Rooster, and all of the other noted "doctors." I learned the routines for making and breaking marriages; driving off and punishing enemies; influencing the minds of judges and juries in favor of clients; killing by remote control and other things. In order to work with these "two-headed" doctors, I had to go through an initiation with each. The routine varied with each doctor.

In one case it was not only elaborate, it was impressive. I lay naked for three days and nights on a couch, with my navel to a rattlesnake skin which had been dressed and dedicated to the ceremony. I ate no food in all that time. Only a pitcher of water was on a little table at the head of the couch so that my soul would not wander off in search of water and be attacked by evil influences and not return to me. On the second day, I began to dream strange exalted dreams. On the third night, I had dreams that seemed real for weeks. In one, I strode across the heavens with lightning flashing from under my feet, and grumbling thunder following in my wake.

In this particular ceremony, my finger was cut and I became

156

blood brother to the rattlesnake. We were to aid each other forever. I was to walk with the storm and hold my power, and get my answers to life and things in storms. The symbol of lightning was painted on my back. This was to be mine forever.

In another ceremony, I had to sit at the crossroads at midnight in complete darkness and meet the Devil, and make a compact. That was a long, long hour as I sat flat on the ground there alone and invited the King of Hell.

The most terrifying was going to a lonely glade in the swamp to get the black cat bone. The magic circle was made and all of the participants were inside. I was told that anything outside that circle was in deadly peril. The fire was built inside, the pot prepared and the black cat was thrown in with the proper ceremony and boiled until his bones fell apart. Strange and terrible monsters seemed to thunder up to that ring while this was going on. It took months for me to doubt it afterwards.

When I left Louisiana, I went to South Florida again, and from what I heard around Miami, I decided to go to the Bahamas. I had heard some Bahaman music and seen a Jumping Dance out in Liberty City and I was entranced.

This music of the Bahaman Negroes was more original, dynamic and African, than American Negro songs. I just had to know more. So without giving Godmother a chance to object, I sailed for Nassau.

I loved the place the moment I landed. Then, that first night as I lay in bed, listening to the rustle of a cocoanut palm just outside my window, a song accompanied by string and drum, broke out in full harmony. I got up and peeped out and saw four young men and they were singing "Bellamina," led by Ned Isaacs. I did not know him then, but I met him the next day. The song has a beautiful air, and the oddest rhythm.

> Bellamina, Bellamina!
> She come back in the harbor
> Bellamina, Bellamina

She come back in the harbor
Put Bellamina on the dock
And paint Bellamina black! Black!
Oh, put the Bellamina on the dock
And paint Bellamina, black! Black!

I found out later that it was a song about a rum-running boat that had been gleaming white, but after it had been captured by the United States Coast Guard and released, it was painted black for obvious reasons.

That was my welcome to Nassau, and it was a beautiful one. The next day I got an idea of what prolific song-makers the Bahamans are. With that West African accent grafted on English of the uneducated Bahaman, I was told, "you do anything, we put you in sing." I walked carefully to keep out of "sing."

This visit to Nassau was to have far-reaching effects. I stayed on, ran to every Jumping Dance that I heard of, learned to "jump," collected more than a hundred tunes and resolved to make them known to the world.

On my return to New York in 1932, after trying vainly to interest others, I introduced Bahaman songs and dances to a New York audience at the John Golden Theater, and both the songs and the dances took on. The concert achieved its purpose. I aimed to show what beauty and appeal there was in genuine Negro material, as against the Broadway concept, and it went over.

Since then, there has been a sharp trend towards genuine Negro material. The dances aroused a tremendous interest in primitive Negro dancing. Hall Johnson took my group to appear with his singers at the Lewisohn Stadium that summer and built his "Run Lil' Chillun" around them and the religious scene from my concert, "From Sun To Sun." That was not all, the dramatized presentation of Negro work songs in that same concert aroused interest in them and they have been exploited by singers ever since.

I had no intention of making concert my field. I wanted to

show the wealth and beauty of the material to those who were in the field and therefore I felt that my job was well done when it took on.

My group was invited to perform at the New School of Social Research; in the folk-dance carnival at the Vanderbilt Hotel in New York; at Nyack; at St. Louis; Chicago; Rollins College in Winter Park, Florida; Lake Wales; Sanford; Orlando; Constitution Hall, Washington, D.C.; and Daytona Beach, Florida.

Besides the finding of the dances and the music, two other important things happened to me in Nassau. One was, I lived through that terrible five-day hurricane of 1929. It was horrible in its intensity and duration. I saw dead people washing around on the streets when it was over. You could smell the stench from dead animals as well. More than three hundred houses were blown down in the city of Nassau alone.

Then I saw something else out there. I met Leon Walton Young. He is a grizzly, stocky black man, who is a legislator in the House. He represented the first district in the Bahamas and had done so for more than twenty years when I met him.

Leon Walton Young was either a great hero, or a black bounder, according to who was doing the talking. He was a great champion and a hero in the mouths of the lowly blacks of the islands and to a somewhat lesser degree to the native-born whites. He was a Bahaman for the Bahaman man and a stout fellow along those lines. To the English, who had been sent out to take the jobs of the natives, white and black, he was a cheeky dastard of a black colonial who needed to be put in his place. He was also too much for the mixed blood negroes of education and property, who were as prejudiced against his color as the English. What was more, Leon Walton Young had no formal education, though I found him like George Schuyler of New York to be better read than most people with college degrees. But did he, because of his lack of schooling, defer to the Negroes who had journeyed to London and Edinburgh? He most certainly did not, and what was more, he more than held his own in the hustings.

159

There was a much felt need for him to be put down, but those who put on the white armor of St. George to go out and slay the dragon always came back—not honorably dead on their shields—but splattered all over with mud and the seat of their pants torn and missing. A peasant mounted on a mule had unhorsed a cavalier and took his pants. The dance drums of Grantstown and Baintown would throb and his humbled opponents would be "put in sing."

He so humbled a governor, who tried to overawe Young by reminding him that he was "His Majesty's representative in these Islands" that the Governor was recalled and sent to some peaceful spot in West Africa. Young had replied to that pompous statement with, "Yes, but if you continue your tactics out here you will make me forget it."

That was one of his gentlest thumps on the Governor's pride and prestige. His Majesty's Representative accused Young of having said publicly that he, the Governor, was a bum out of the streets of London, and to his eternal rage, Young more than admitted the statement. The English appointees and the high yellows shuddered at such temerity, but the local whites and the working blacks gloried in his spunk.

A most dramatic incident came out of this struggle of the local Bahamans against the policy of the British Government of taking care of the surplus of unemployed at the expense of the Islands.

When I returned to Nassau for the fourth time in 1935, the elections for the House were on.

A Negro barrister, who is not yellow, but who liked to think he was, had thrown down the gauntlet to Young. He had informed the English that he would rid them of the troublesome Leon Walton Young. The young man whom I shall call Botts because that is not his name, got a pat on the back, and was told to go ahead.

As I said before, Young represented the First District which was the richest in the Islands. It is that end of the island of New Providence where the hotels, the homes of the wealthy foreigners and the business and Government houses are located.

160

He had been reelected for three terms of seven years each.

A local white business man came to Young in secret and told him what was happening under cover. Young, on hearing the boasts of Botts, got busy in secret on his own. He took under his wing a young white barrister, only a year out of Lincoln's Inn and primed him for a candidate. Botts was up for reelection, and the young white stripling was dressed to "stand" for Botts's district, which was in the outer Islands. Secret messages went to the district in the outer Islands, the political fence was looked over and put in order, and then Young launched his attack.

He stood out in the middle of Bay Street, flung wide his arms like a cross and cried out: "Send me a man to stand for First District! I am going out to Aleuthera to stand, so that this Botts, this betrayer of his country and his people, can be driven out of office. Send me a man!"

Nobody sent him a man, as he well knew they would not. His reelection was taken for granted. But he stirred the Bahamas from end to end by his gesture. People remembered things about Barrister Botts they otherwise would have forgotten. Poor people down on the waterfront remembered that, though he went for a great man now, his mother had stood down on the waterfront night after night, selling fried fish to send him to England to be educated. His father was living and prosperous. He was in business, and a member of the House, but long years ago he had divorced Botts's mother for a woman of lighter skin. But the mother had seen him through the Inner Temple. He had come back, not full of gratitude for the sacrifices she had made, but scornful of her black skin and all that she stood for. People said that he paid her ten shillings ($2.50) a week to stay away from his house. He was being accused of robbing his younger brother of funds and legal action was underway at the very moment of the election.

The election was to be on Sunday. On Friday, Botts went out in a chartered boat. He was dressed in the latest from London and quite the patrician. On the boat with him was the

161

same white man who had given Young all the information. The man was to report on everything that went on, though Botts thought he was there out of gratitude and admiration.

On Saturday, Leon Walton Young, his protégée and his coterie of workers boarded a big black boat to go out to Aleuthera. With them was Wilbur Botts, going out to campaign against his brother. They left the old woman, mother of both of the boys on the dock. She was ragged, not too clean, and bitter. As the boat steamed out, she was muttering, "God! I wish I could go! I want to campaign against him, too!" And she shook her clenched fists in the general direction of her barrister-son's district. "God! I wish I could go!"

Before dawn on that Sunday morning, a big black boat with Leon Walton Young and his barrister protégée dropped anchor in a harbor at Aleuthera. About eight o'clock, Botts came on deck on his boat, dressed in faultless doe-skin trousers to take the air. Seeing the big black boat which had not been there the night before, he lifted his glasses and studied the boat and the people on her deck. Suddenly, he lowered his glasses and turned to the white man Leon Young had placed at his elbow, and asked, "Isn't that Young on that boat?"

The man took the glasses and pretended to find out what he already knew. "Yes, that is Walton Young."

Botts dropped heavily into a deck chair without regards to his creases. He was a sodden mess from then on through the election.

They all landed and the fight was on. The protégée of Young won without making a single speech. It was Young who dashed from place to place talking and rallying the people. By noon, Botts conceded the election to his opponent and returned to Nassau.

I was down at the wharf when the boats returned. I wanted to see the behavior of the old woman who had been divorced by her husband for being too black after he gained a certain amount of success. The same woman who had been barred from her son's home for the same reason, after she had felt no labor was too humble for her to do to put him through law

162

school in London to come home to her a barrister. She was not there. I wondered if she was off somewhere trying to rustle up a tuppence or two, or merely that she did not want to look on his dear face when his pretentions had met his realities. She had her bitter moments, but after all, she was his mother.

Monday night the election was "in sing." Young's election came up a few days later and as he well knew, he was returned to his seat, but not before he had engineered the defeat of Botts, Sr., in another district. Then the drums of Baintown really thundered.

> Young—Dun, dun, dun, dun!
> Him a great dentist—dun, dun!
> Him pull Botts out the House!

And the common folk danced off of the feat and were very glad. To them, life was not hopeless as long as their champion was in the fight.

The humble Negroes of America are great song-makers, but the Bahaman is greater. He is more prolific and his tunes are better. Nothing is too big, or little, to be "put in sing." They only need discovery. They are much more original than the Calypso singers of Trinidad as will be found the moment you put it to the proof.

I hear that now the Duke of Windsor is their great hero. To them, he is "Our King." I would love to hear how he and his Duchess have been put in sing.

I enjoyed collecting the folk-tales and I believe the people from whom I collected them enjoyed the telling of them, just as much as I did the hearing. Once they got started, the "lies" just rolled and story-tellers fought for a chance to talk. It was the same with the songs. The one thing to be guarded against, in the interest of truth, was over-enthusiasm. For instance, if a song was going good, and the material ran out, the singer was apt to interpolate pieces of other songs into it. The only way you can know when that happens, is to know your mate-

rial so well that you can sense the violation. Even if you do not know the song that is being used for padding, you can tell the change in rhythm and tempo. The words do not count. The subject matter in Negro folk songs can be anything and go from love to work, to travel, to food, to weather, to fight, to demanding the return of a wig by a woman who has turned unfaithful. The tune is the unity of the thing. And you have to know what you are doing when you begin to pass on that, because Negroes can fit in more words and leave out more and still keep the tune than anyone I can think of.

One bit of research I did jointly for the *Journal of Negro History* and Columbia University, was in Mobile, Alabama. There I went to talk to Cudjo Lewis. That is the American version of his name. His African name was Kossola-O-Lo-Loo-Ay.

He arrived on the last load of slaves run into the United States and was the only Negro alive that came over on a slave ship. It happened in 1859 just when the fight between the South and the Abolitionists was moving toward the Civil War. He has died since I saw him.

I found him a cheerful, poetical old gentleman in his late nineties, who could tell a good story. His interpretation of the story of Jonah is marvelous.

He was a good Christian and so he pretended to have forgotten all of his African religion. He turned me off with the statement that his Nigerian religion was the same as Christianity. "We know it a God, you unner'stand, but we don't know He got a Son."

He told me in detail of the circumstances in Africa that brought about his slavery here. How the powerful Kingdom of Dahomey, finding the slave trade so profitable, had abandoned farming, hunting and all else to capture slaves to stock the barracoons on the beach at Dmydah to sell to the slavers who came from across the ocean. How quarrels were manufactured by the King of Dahomey with more peaceful agricultural nations in striking distance of Dahomey in Nigeria and Gold Coast; how they were assaulted, completely wiped off

the map, their names never to appear again, except when they were named in boastful chant before the King at one of his "customs" when his glory was being sung. The able-bodied who were captured were marched to Abomey, the capital city of Dahomey and displayed to the King, then put into the barracoons to await a buyer. The too old, the too young, the injured in battle were instantly beheaded and their heads smoked and carried back to the King. He paid off on heads, dead or alive. The skulls of the slaughtered were not wasted either. The King had his famous Palace of Skulls. The Palace grounds had a massive gate of skull-heads. The wall surrounding the grounds were built of skulls. You see, the Kings of Dahomey were truly great and mighty and a lot of skulls were bound to come out of their ambitions. While it looked awesome and splendid to him and his warriors, the sight must have been most grewsome and crude to western eyes. Imagine a Palace of Hindu or Zulu skulls in London! Or Javanese skulls in The Hague!

One thing impressed me strongly from this three months of association with Cudjo Lewis. The white people had held my people in slavery here in America. They had bought us, it is true and exploited us. But the inescapable fact that stuck in my craw, was: my people had *sold* me and the white people had bought me. That did away with the folklore I had been brought up on—that the white people had gone to Africa, waved a red handkerchief at the Africans and lured them aboard ship and sailed away. I know that civilized money stirred up African greed. That wars between tribes were often stirred up by white traders to provide more slaves in the barracoons and all that. But, if the African princes had been as pure and as innocent as I would like to think, it could not have happened. No, my own people had butchered and killed, exterminated whole nations and torn families apart, for a profit before the strangers got their chance at a cut. It was a sobering thought. What is more, all that this Cudjo told me was verified from other historical sources. It impressed upon me the universal nature of greed and glory. Lack of power and

165

opportunity passes off too often for virtue. If I were King, let us say, over the Western Hemisphere tomorrow, instead of who I am, what would I consider right and just? Would I put the cloak of Justice on my ambition and send her out a-whoring after conquests? It is something to ponder over with fear.

Cudjo's eyes were full of tears and memory of fear when he told me of the assault on his city and its capture. He said that his nation, the Takkoi, lived "three sleeps" from Dahomey. The attack came at dawn as the Takkoi were getting out of bed to go to their fields outside the city. A whooping horde of the famed Dahoman women warriors burst through the main gate, seized people as they fled from their houses and beheaded victims with one stroke of their big swords.

"Oh, oh! I runnee this way to that gate, but they there. I runnee to another one, but they there, too. All eight gates they there. Them women, they very strong. I nineteen years old, but they too strong for me. They take me and tie me. I don't know where my people at. I never see them no more."

He described the awful slaughter as the Amazons sacked the city. The clusters of human heads at their belts. The plight of those who fled through the gates to fall into the hands of the male warriors outside. How his King was finally captured and carried before the King of Dahomey, who had broken his rule and come on this expedition in person because of a grudge against the King of Takkoi, and how the vanquished monarch was led before him, bound.

"Now, that you have dared to send impudent words to me," the King of Dahomey said, "your country is conquered and you are before me in chains. I shall take you to Abomey."

"No," the King of Takkoi answered. "I am King in Takkoi. I will not go to Dahomey." He knew that he would be killed for a spectacle in Dahomey. He chose to die at home.

So two Dahoman warriors held each of his hands and an Amazon struck off his head.

Later, two representatives of a European power attended the Customs of the King at Abomey, and tell of seeing the highly polished skull of the King of Takkoi mounted in a

166

beautiful ship-model. His name and his nation were mentioned in the chant to the glory of Dahomey. The skull was treated with the utmost respect, as the King of Dahomey would expect his to be treated in case he fell in battle. That was the custom in West Africa. For the same reason, no one of royal blood was sold into slavery. They were killed. There are no descendants of royal African blood among American Negroes for that reason. The Negroes who claim that they are descendants of royal African blood have taken a leaf out of the book of the white ancestor-hounds in America, whose folks went to England with William the Conqueror, got restless and caught the *Mayflower* for Boston, then feeling a romantic lack, rushed down the coast and descended from Pocahontas. From the number of her children, one is forced to the conclusion that that Pocahontas wasn't so poky, after all.

Kossola told me of the March to Abomey after the fall of Takkoi. How they were yoked by forked sticks and tied in a chain. How the Dahomans halted the march the second day in order to smoke the heads of the victims because they were spoiling. The prisoners had to watch the heads of their friends and relatives turning on long poles in the smoke. Abomey and the palace of the King and then the march to the coast and the barracoons. They were there sometime before a ship came to trade. Many, many tribes were there, each in a separate barracoon, lest they war among themselves. The traders could choose which tribe they wanted. When the tribe was decided upon, he was carried into the barracoon where that tribe was confined, the women were lined up on one side and the men on the other. He walked down between the lines and selected the individuals he wanted. They usually took an equal number.

He described the embarcation and the trip across the ocean in the *Chlotilde,* a fast sailing vessel built by the Maher brothers of Maine, who had moved to Alabama. They were chased by a British man-of-war on the lookout for slavers, but the *Chlotilde* showed him her heels. Finally the cargo arrived in Mobile. They were unloaded up the river, the boat sunk, and the

167

hundred-odd Africans began a four-year life of slavery.

"We so surprised to see mule and plow. We so surprised to see man pushee and mule pullee."

After the war, these Africans made a settlement of their own at Plateau, Alabama, three miles up the river from Mobile. They farmed and worked in the lumber mills and bought property. The descendants are still there.

Kossola's great sorrow in America was the death of his favorite son, David, killed by a train. He refused to believe it was his David when he saw the body. He refused to let the bell be tolled for him.

"If dat my boy, where his head? No, dat not my David. Dat not my boy. My boy gone to Mobile. No. No! Don't ringee de bell for David. Dat not him."

But, finally his wife persuaded him that the headless body on the window blind was their son. He cried hard for several minutes and then said, "Ringee de bell."

His other great sorrow was that he had lost track of his folks in Africa.

"They don't know what become of Kossola. When you go there, you tellee where I at." He begged me. He did not know that his tribe was no more upon this earth, except for those who reached the barracoon at Dmydah. None of his family was in the barracoon. He had missed seeing their heads in the smoke, no doubt. It is easy to see how few would have looked on that sight too closely.

"I lonely for my folks. They don't know. Maybe they ask everybody go there where Kossola. I know they hunt for me." There was a tragic catch in his voice like the whimper of a lost dog.

After seventy-five years, he still had that tragic sense of loss. That yearning for blood and cultural ties. That sense of mutilation. It gave me something to feel about.

Of my research in the British West Indies and Haiti, my greatest thrill was coming face to face with a Zombie and photographing her. This act had never happened before in the

history of man. I mean the taking of the picture. I have said all that I know on the subject in the book *Tell My Horse,* which has been published also in England under the title *Voodoo Gods.* I have spoken over the air on "We the People" on the subject, and the matter has been so publicized that I will not go into details here. But, it was a tremendous thrill, though utterly macabre.

I went Canzo in Voodoo ceremonies in Haiti and the ceremonies were both beautiful and terrifying.

I did not find them any more invalid than any other religion. Rather, I hold that any religion that satisfies the individual urge is valid for that person. It does satisfy millions, so it is true for its believers. The Sect Rouge, also known as the Cochon Gris (gray pig) and Ving Bra-Drig (from the sound of the small drum), a cannibalistic society there, has taken cover under the name of Voodoo, but the two things are in no wise the same. What is more, if science ever gets to the bottom of Voodoo in Haiti and Africa, it will be found that some important medical secrets, still unknown to medical science, give it its power, rather than the gestures of ceremony.

CHAPTER 11

BOOKS AND THINGS

While I was in the research field in 1929, the idea of *Jonah's Gourd Vine* came to me. I had written a few short stories, but the idea of attempting a book seemed so big, that I gazed at it in the quiet of the night, but hid it away from even myself in daylight.

For one thing, it seemed off-key. What I wanted to tell was a story about a man, and from what I had read and heard, Negroes were supposed to write about the Race Problem. I was and am thoroughly sick of the subject. My interest lies in what makes a man or a woman do such-and-so, regardless of his color. It seemed to me that the human beings I met reacted pretty much the same to the same stimuli. Different idioms, yes. Circumstances and conditions having power to influence, yes. Inherent difference, no. But I said to myself that that was not what was expected of me, so I was afraid to tell a story the way I wanted, or rather the way the story told itself to me. So I went on that way for three years.

Something else held my attention for a while. As I told you before, I had been pitched head-foremost into the Baptist Church when I was born. I had heard the singing, the preach-

171

ing and the prayers. They were a part of me. But on the concert stage, I always heard songs called spirituals sung and applauded as Negro music, and I wondered what would happen if a white audience ever heard a real spiritual. To me, what the Negroes did in Macedonia Baptist Church was finer than anything that any trained composer had done to the folk songs.

I had collected a mass of work songs, blues and spirituals in the course of my years of research. After offering them to two Negro composers and having them refused on the ground that white audiences would not listen to anything but highly arranged spirituals, I decided to see if that was true. I doubted it because I had seen groups of white people in my father's church as early as I could remember. They had come to hear the singing, and certainly there was no distinguished composer in Zion Hope Baptist Church. The congregation just got hold of the tune and arranged as they went along as the spirit moved them. And any musician, I don't care if he stayed at a conservatory until his teeth were gone and he smelled like old-folks, could never even approach what those untrained singers could do. LET THE PEOPLE SING, was and is my motto, and finally I resolved to see what would happen.

So on money I had borrowed, I put on a show at the John Golden Theater on January 10, 1932, and tried out my theory. The performance was well received by both the audience and the critics. Because I know that music without motion is not natural with my people, I did not have the singers stand in a stiff group and reach for the high note. I told them to just imagine that they were in Macedonia and go ahead. One critic said that he did not believe that the concert was rehearsed, it looked so natural. I had dramatized a working day on a railroad camp, from the shack-rouser waking up the camp at dawn until the primitive dance in the deep woods at night.

While I did not lose any money, I did not make much. But I am satisfied that I proved my point. I have seen the effects of that concert in all the Negro singing groups since then. Primitive Negro dancing has been given tremendous impetus.

172

Work songs have taken on. In that performance I introduced West Indian songs and dances and they have come to take an important place in America. I am not upset by the fact that others have made something out of the things I pointed out. Rather I am glad if I have called any beauty to the attention of those who can use it.

In May, 1932, the depression did away with money for research so far as I was concerned. So I took my nerve in my hand and decided to try to write the story I had been carrying around in me. Back in my native village, I wrote first *Mules and Men.* That is, I edited the huge mass of material I had, arranged it in some sequence and laid it aside. It was published after my first novel. Mr. Robert Wunsch and Dr. John Rice were both on the faculty at Rollins College, at Winter Park, which is three miles from Eatonville. Dr. Edwin Osgood Grover, Dr. Hamilton Holt, President of Rollins, together with Rice and Wunsch, were interested in me. I gave three folk concerts at the college under their urging.

Then I wrote a short story, "The Gilded Six-Bits," which Bob Wunsch read to his class in creative writing before he sent it off to *Story Magazine.* Thus I came to know Martha Foley and her husband, Whit Burnett, the editors of *Story.* They bought the story and it was published in the August issue, 1933. They never told me, but it is my belief that they did some missionary work among publishers in my behalf, because four publishers wrote me and asked if I had anything of book-length. Mr. Bertram Lippincott, of the J. B. Lippincott Company, was among these. He wrote a gentle-like letter and so I was not afraid of him. Exposing my efforts did not seem so rash to me after reading his letter. I wrote him and said that I was writing a book. Mind you, not the first word was on paper when I wrote him that letter. But the very next week I moved up to Sanford where I was not so much at home as at Eatonville, and could concentrate more and sat down to write *Jonah's Gourd Vine.*

I rented a house with a bed and stove in it for $1.50 a week. I paid two weeks and then my money ran out. My cousin,

Willie Lee Hurston, was working and making $3.50 per week, and she always gave me the fifty cents to buy groceries with. In about three months, I finished the book. The problem of getting it typed was then upon me. Municipal Judge S.A.B. Wilkinson asked his secretary, Mildred Knight, if she would not do it for me and wait on the money. I explained to her that the book might not even be taken by Lippincott. I had been working on a hope. She took the manuscript home with her and read it. Then she offered to type it for me. She said, "It is going to be accepted, all right. I'll type it. Even if the first publisher does not take it, somebody will." So between them, they bought the paper and carbon and the book was typed.

I took it down to the American Express office to mail it and found that it cost $1.83 cents to mail, and I did not have it. So I went to see Mrs. John Leonardi, a most capable woman lawyer, and wife of the County Prosecutor. She did not have the money at the moment, but she was the treasurer of the local Daughter Elks. She "borrowed" $2.00 from the treasury and gave it to me to mail my book. That was on October 3, 1933. On October 16, I had an acceptance by wire.

But it did not come so simply as that. I had been hired by the Seminole County Chamber of Commerce to entertain the business district of Sanford with my concert group for that day. I was very glad to get the work, because my landlord was pressing me for the back rent. I now owed $18. I was to receive $25 for the day, so I saw my way clear to pay up my rent, and have a little over. It was not to be that way, however. At eight o'clock of October 16, my landlord came and told me to get out. I told her that I could pay her that day, but she said she didn't believe that I would ever have that much money. No, she preferred the house. So I took my card table and my clothes up to my Uncle Isaiah's house and went off to entertain the city at eleven o'clock. The sound truck went up and down the streets and my boys sang. That afternoon while I was still on the sound truck, a Western Union messenger handed me a wire. Naturally I did not open it there. We were through at three o'clock. The Chamber of Commerce not only paid us,

we were all given an order which we could take to any store we wanted and get what we chose. I needed shoes, so I took mine to a shoe store. My heart was weighing as much as cord-wood, and so I forgot the wire until I was having the shoes fitted. When I opened it and read that *Jonah's Gourd Vine* was accepted and that Lippincott was offering me $200 advance, I tore out of that place with one old shoe and one new one on and ran to the Western Union office. Lippincott had asked for an answer by wire and they got it! Terms accepted. I never expect to have a greater thrill than that wire gave me. You know the feeling when you found your first pubic hair. Greater than that. When Producer Arthur Hornblow took me to lunch at Lucey's and hired me at Paramount, it was nice— very nice. I was most elated. But I had had five books accepted then, been a Guggenheim fellow twice, spoken at three book fairs with all the literary greats of America and some from abroad, and so I was a little more used to things. So you see why Bertram Lippincott is *Colonel* Bert to me. When the Negroes in the south name a white man a colonel, it means CLASS. Something like a monarch, only bigger and better. And when the colored population in the south confer a title, the white people recognize it because the Negroes are never wrong. They may flatter an ordinary bossman by calling him "Cap'n" but when they say "Colonel," "General" and "Governor" they are recognizing something internal. It is there, and it is accepted because it can be seen.

I wrote *Their Eyes Were Watching God* in Haiti. It was dammed up in me, and I wrote it under internal pressure in seven weeks. I wish that I could write it again. In fact, I regret all of my books. It is one of the tragedies of life that one cannot have all the wisdom one is ever to possess in the beginning. Perhaps, it is just as well to be rash and foolish for a while. If writers were too wise, perhaps no books would get written at all. It might be better to ask yourself "Why?" afterwards than before. Anyway, the force from somewhere in Space which commands you to write in the first place, gives you no choice. You take up the pen when you are told, and write what is

commanded. There is no agony like bearing an untold story inside you. You have all heard of the Spartan youth with the fox under his cloak.

Dust Tracks on a Road is being written in California where I did not expect to be at this time.

I did not come out here to California to write about the state. I did not come to get into the movies. I came because my good friend, Katharane Edson Mershon, invited me out here to rest and have a good time. However, I have written a book here, and gone to work in the movies. This surprises me because I did not think that I would live long enough to do anything out here but die. Friend Katharane Mershon is a mountain goat while I am a lowland turtle. I want to rock along on level ground. She can't look at a mountain without leaping on it. I think she is ashamed if she ever catches both of her feet on the same level. She cries "Excelsior!" in her sleep. Jack, her husband, told me that the reason he has that sort of smoothed-off look was because she dragged him up a mountain the next day after they got married and he has never been able to get his right shape back again. Well, 1941 was a hard year for me, too. She showed me California. Before it was over, I felt like I had spent two months walking a cross-cut saw. The minute I get to be governor of California, I mean to get me an over-sized plane and a spirit-level and fix this state so it can be looked at without rearing back. EPIC nothing! LEVEL! Level California! And I do mean LEVEL!!!!

CHAPTER 12

MY PEOPLE! MY PEOPLE!

My people! My people!" From the earliest rocking of my cradle days, I have heard this cry go up from Negro lips. It is forced outward by pity, scorn and hopeless resignation. It is called forth by the observations of one class of Negro on the doings of another branch of the brother in black. For instance, well-mannered Negroes groan out like that when they board a train or a bus and find other Negroes on there with their shoes off, stuffing themselves with fried fish, bananas and peanuts, and throwing the garbage on the floor. Maybe they are not only eating and drinking. The offenders may be "loud-talking" the place, and holding back nothing of their private lives, in a voice that embraces the entire coach. The well-dressed Negro shrinks back in his seat at that, shakes his head and sighs, "My people! My people!"

Now, the well-mannered Negro is embarrassed by the crude behavior of the others. They are not friends, and have never seen each other before. So why should he or she be embarrassed? It is like this: The well-bred Negro has looked around and seen America with his eyes. He or she has set himself to measure up to what he thinks of as the white stan-

177

dard of living. He is conscious of the fact that the Negro in America needs more respect if he expects to get any acceptance at all. Therefore, after straining every nerve to get an education, maintain an attractive home, dress decently, and otherwise conform, he is dismayed at the sight of other Negroes tearing down what he is trying to build up. It is said every day, "And that good-for-nothing, trashy Negro is the one the white people judge us all by. They think we're all just alike. My people! My people!"

What that educated Negro knows further is that he can do very little towards imposing his own viewpoint on the lowlier members of his race. Class and culture stand between. The humble Negro has a built-up antagonism to the "Big Nigger." It is a curious thing that he does not resent a white man looking down on him. But he resents any lines between himself and the wealthy and educated of his own race. "He's a nigger just like us," is the sullen rejoinder. The only answer to this is "My people! My people!"

So the quiet-spoken Negro man or woman who finds himself in the midst of one of these "broadcasts" as on the train, cannot go over and say "Don't act like that, brother. You're giving us all a black eye." He or she would know better than to try that. The performance would not only go on, it would get better with the "dickty" Negro as the butt of all the quips. The educated Negro may know all about the differential calculus and the theory of evolution, but he is fighting entirely out of his class when he tries to quip with the underprivileged. The bookless may have difficulty in reading a paragraph in a newspaper, but when they get down to "playing the dozens" they have no equal in America, and, I'd risk a sizeable bet, in the whole world. Starting off in first by calling you a seven-sided son-of-a-bitch, and pausing to name the sides, they proceed to "specify" until the tip-top branch of your family tree has been "given a reading." No profit in that to the upper class Negro, so he minds his own business and groans, "My people! My people!"

It being a traditional cry, I was bound to hear it often and

under many circumstances. But it is not the only folk label that I heard. "Race Pride"—"Race Prejudice"—"Race Man"—"Race Solidarity"—"Race Consciousness"—"Race."

"Race Prejudice" I was instructed was something bad that white people used on us. It seemed that white people felt superior to black ones and would not give Negroes justice for that reason. "Race Pride" was something that, if we had it, we would feel ourselves superior to the whites. A black skin was the greatest honor that could be blessed on any man. A "Race Man" was somebody who always kept the glory and honor of his race before him. Must stand ever ready to defend the Negro race from all hurt, harm and danger. Especially if a white person said "Nigger," "You people," "Negress" or "Darkies." It was a mark of shame if somebody accused: "Why, you are not a Race Man (or woman)." People made whole careers of being "Race" men and women. They were champions of the race. "Race Consciousness" is a plea to Negroes to bear their color in mind at all times. It was just a phrase to me when I was a child. I knew it was supposed to mean something deep. By the time I got grown I saw that it was only an imposing line of syllables, for no Negro in America is apt to forget his race. "Race Solidarity" looked like something solid in my childhood, but like all other mirages, it faded as I came close enough to look. As soon as I could think, I saw that there is no such thing as Race Solidarity in America with any group. It is freely admitted that it does not exist among Negroes. Our so-called Race Leaders cry over it. Others accept it as a natural thing that Negroes should not remain an unmelting black knot in the body politic. Our interests are too varied. Personal benefits run counter to race lines too often for it to hold. If it did, we could never fit into the national pattern. Since the race line has never held any other group in America, why expect it to be effective with us? The upper class Negroes admit it in their own phrases. The lower class Negroes say it with a tale.

It seems that a Negro was asked to lead the congregation in prayer. He got down on his knees and began, "Oh, Lawd,

I got something to ask You, but I know You can't do it."

"Go on, Brother Isham and ask Him."

"Lawd," Brother Isham began again, "I really want to ask You something but I just know You can't do it."

"Aw, Brother Isham, go on and tell the Lawd what you want. He's the Lawd! Ain't nothing He can't do! He can even lead a butt-headed cow by the horns. You're killing up time. Go 'head on, Brother Isham, and let the church roll on."

"Well then, Lawd, I ask You to get these Negroes together, but I know You can't do it." Then there is laughter and "My people! My people!"

Hearing things like this from my childhood, sooner or later I was bound to have some curiosity about my race of people.

What fell into my ears from time to time tended more to confuse than to clarify. One thing made a liar out of the one that went before and the thing that came after. At different times I heard opposite viewpoints expressed by the same person or persons.

For instance, come school-closing time and like formal occasions, I heard speeches which brought thunderous applause. I did not know the word for it at the time, but it did not take me long to know the material was traditional. Just as folk as the songs in church. I knew that because so many people got up and used the same, identical phrases: (a) The Negro had made the greatest progress in fifty years of any race on the face of the globe. (b) Negroes composed the most *beautiful* race on earth, being just like a flower garden with every color and kind. (c) Negroes were the bravest men on earth, facing every danger like lions, and fighting with demons. We must remember with pride that the first blood spilled for American Independence was that of the brave and daring Crispus Attucks, a Negro who had bared his black breast to the bullets of the British tyrants at Boston, and thus struck the first blow for American liberty. They had marched with Colonel Shaw during the Civil War and hurled back the forces of the iniquitous South, who sought to hold black men in bondage. It was a Negro named Simon who had been the only one with enough

pity and compassion in his heart to help the Savior bear His cross upon Calvary. It was the Negro troops under Teddy Roosevelt who won the battle of San Juan Hill.

It was the genius of the Negro which had invented the steam engine, the cotton gin, the air brake, and numerous other things—but conniving white men had seen the Negro's inventions and run off and put them into practice before the Negro had a chance to do anything about it. Thus the white man got credit for what the genius of the Negro brain had produced. Were it not for the envy and greed of the white man, the Negro would hold his rightful place—the noblest and the greatest man on earth.

The people listening would cheer themselves hoarse and go home feeling good. Over the fences next day it would be agreed that it was a wonderful speech, and nothing but the God's truth. What a great people we would be if we only had our rights!

But my own pinnacle would be made to reel and rock anyway by other things I heard from the very people who always applauded "the great speech," when it was shouted to them from the school-house rostrum. For instance, let some member of the community do or say something which was considered either dumb or venial and the verdict would be "Dat's just like a nigger!" or "Nigger from nigger leave nigger"—("Nothing from nothing leave nothing"). It was not said in either admiration or pity. Utter scorn was in the saying. "Old Cuffy just got to cut de fool, you know. Monkey see, monkey do. Nigger see de white man do something, he jump in and try to do like de white man, and make a great big old mess." "My people! My people!"

"Yeah, youse mighty right. Another monkey on de line. De white man, you understand, he was a railroad engineer, so he had a pet monkey he used to take along wid him all de time. De monkey, he set up there in de cab wid de engineer and see what he do to run de train. Way after while, figger he can run de train just as good as de engineer his own self. He was just itching to git at dat throttle and bust dat main line wide open.

Well, one day de engineer jumped down at de station to git his orders and old monkey seen his chance. He just jumped up in de engineer's seat, grabbed a holt of dat throttle, and dat engine was splitting de wind down de track. So de engineer sent a message on ahead, say 'Clear de track. Monkey on de line!' Well, Brer Monk he was holding de throttle wide open and jumping up and down and laughing fit to kill. Course, he didn't know nothing about no side tracks and no switches and no schedules, so he was making a mile a minute when he hit a open switch and a string of box cars was standing on de siding. Ker-blam-er-lam-er-lam! And dat was de last of Brer Engine-driving Monk. Lovely monkey he was, but a damned poor engineer." "My people! My people!"

Everybody would laugh at that, and the laughter puzzled me some. Weren't Negroes the smartest people on earth, or something like that? Somebody ought to remind the people of what we had heard at the schoolhouse. Instead of that, there would be more monkey stories.

There was the one about the white doctor who had a pet monkey who wanted to be a doctor. Kept worrying his master to show him how, and the doctor had other troubles, too. Another man had a bulldog who used to pass the doctor's gate every day and pick a fight with the monkey. Finally, the doctor saw a way to stop the monkey from worrying him about showing him how to be a doctor. "Whip that bulldog until he evacuates, then bring me some of it, monkey. I'll take it and show you how to be a doctor, and then I'll treat it in a way so as to ruin that bulldog for life. He won't be no more trouble to you."

"Oh, I'll git it, boss. Don't you worry. I sho' wants to be a doctor, and then again, dat old bulldog sho' is worry-some."

No sooner did the bulldog reach the gate that day, than the monkey, which could not wait for the bulldog to start the fight as usual, jumped on the dog. The monkey was all over him like gravy over rice. He put all he had into it and it went on until the doctor came out and drove the dog off and gave the

monkey a chance to bolt into the office with what he had been fighting for.

"Here it tis, boss. It was a tight fight, but I got it."

"Fine! Fine!" the doctor told him. "Now, gimme that bottle over there. I'll fix that bulldog so he'll never be able to sit down again. When I get through with this, he'll be ruined for life."

"Hold on there, boss! Hold on there a minute! I wish you wouldn't do dat, boss."

"How come? You want to get rid of that old bulldog, don't you?"

"Dat's right, I sho' do."

"Well, why don't you want me to fix him, then?"

"Well, boss, you see it's like dis. Dat was a tight fight, a mighty tight fight. I could have been mistaken about dat bulldog, boss, we was all tangled up together so bad. You better leave dat fixing business alone, boss. De wrong man might git hurt."

There were many other tales, equally ludicrous, in which the Negro, sometimes symbolized by the monkey, and sometimes named outright, ran off with the wrong understanding of what he had seen and heard. Several white and Negro proposals of marriage were compared, and the like. The white suitor had said his love had dove's eyes. His valet had hurried to compliment his girl by saying she had dog's eyes, and so on.

There was a general acceptance of the monkey as kinfolks. Perhaps it was some distant memory of tribal monkey reverence from Africa which had been forgotten in the main, but remembered in some vague way. Perhaps it was an acknowledgment of our talent for mimicry with the monkey as a symbol.

The classic monkey parable, which is very much alive wherever the Negroes congregate in America, is the one about "My people!"

It seems that a monkey squatted down in the middle of a highway to play. A Cadillac full of white people came along, saw the monkey at play and carefully drove around him. Then

183

came a Buick full of more white people and did the same. The monkey kept right on playing. Way after a while a T-model Ford came along full of Negroes. But instead of driving around the monkey, the car headed straight for him. He only saved his life by a quick leap to the shoulder of the road. He sat there and watched the car rattle off in the distance and sighed "My people! My people!"

A new addition to the tale is that the monkey has quit saying "My people!" He is now saying, "Those people! Those people!"

I found the Negro, and always the blackest Negro, being made the butt of all jokes, particularly black women.

They brought bad luck for a week if they came to your house of a Monday morning. They were evil. They slept with their fists balled up ready to fight and squabble even while they were asleep. They even had evil dreams. White, yellow and brown girls dreamed about roses and perfume and kisses. Black gals dreamed about guns, razors, ice-picks, hatchets and hot lye. I heard men swear they had seen women dreaming and knew these things to be true.

"Oh, gwan!" somebody would chide, laughing. "You know dat ain't so."

"Oh, now, he ain't lying," somebody else would take up the theme. "I know for my own self. I done slept wid yaller women and I done slept wid black ones. They *is* evil. You marry a yaller or a brown woman and wake her up in de night and she will sort of stretch herself and say, "I know what I was dreaming when you woke me up. I was dreaming I had done baked you a chicken and cooked you a great big old cake, and we was at de table eating our dinner out of de same plate, and I was sitting on your lap and we was just enjoying ourselves to death!" Then she will kiss you more times than you ask her to, and go on back to sleep. But you take and wake up a black gal, now! First thing she been sleeping wid her fists balled up, and you shake her, she'll lam you five or six times before you can get her awake. Then when she do git wake she'll have off and ast you, "Nigger, what you wake me up for? Know what

184

I was dreaming when you woke me up? I dreamt dat you shook your old rusty black fist under my nose and I split your head open wid a axe.' Then she'll kick your feets away from hers, snatch de covers all over on her side, ball up her fists agin, and gwan back to sleep. You can't tell me nothing. I know." "My people!"

This always was, and is still, good for a raucous burst of laughter. I listened to this talk and became more and more confused. If it was so honorable and glorious to be black, why was it the yellow-skinned people among us had so much prestige? Even a child in the first grade could see that this was so from what happened in the classroom and on school programs. The light-skinned children were always the angels, fairies and queens of school plays. The lighter the girl, the more money and prestige she was apt to marry. So on into high school years, I was asking myself questions. Were Negroes the great heroes I heard about from the platform, or were they the ridiculous monkeys of every-day talk? Was it really honorable to be black? There was even talk that it was no use for Negro boys and girls to rub all the hair off of their heads against college walls. There was no place for them to go with it after they got all this education. Some of the older heads held that it was too much for Negroes to handle. Better leave such things for the white folks, who knew what to do with it. But there were others who were all for pushing ahead. I saw the conflict in my own home between my parents. My mother was the one to dare all. My father was satisfied.

This Negro business came home to me in incidents and ways. There was the time when Old Man Bronner was taken out and beaten. Mr. Bronner was a white man of the poor class who had settled in aristocratic Maitland. One night just after dark, we heard terrible cries back in the woods behind Park Lake. Sam Mosely, his brother Elijah, and Ike Clarke, hurried up to our gate and they were armed. The howls of pain kept up. Old fears and memories must have stirred inside of the grown folks. Many people closed and barred their doors. Papa

and the men around our gate were sullen and restless as the cries churned over the woods and lake.

"Who do you reckon it is?" Sam Mosely asked.

"I don't know for sure, but some thinks it's Jim Watson. Anyhow, he ain't home yet," Clarke said, and all of them looked at each other in an asking way.

Finally Papa said, "Well, hold on a minute till I go get my rifle."

"Tain't no ifs and buts about it," Elijah Mosely said gravely. "We can't leave Jim Watson be beat to death like that."

Papa had sensed that these armed men had not come to merely stand around and talk. They had come to see if he would go with the rest. When he came out shoving the sixteen bullets into his rifle, and dropping more into his pocket, Mama made no move to stop him. "Well, we all got families," he said with an attempt at lightness. "Shoot off your gun, somebody, so de rest will know we ready."

Papa himself pointed his Winchester rifle at the sky and fired a shot. Another shot answered him from around the store and a huddle of figures came hurrying up the road in the dark.

"It's Jim Watson. Us got to go git him!" and the dozen or more men armed with double-barreled shotguns, breech-loaders, pistols and Papa's repeating Winchester hurried off on their grim mission. Perhaps not a single one of them expected to return alive. No doubt they hoped. But they went.

Mama gasped a short sentence of some sort and herded us all into the house and barred the door. Lights went out all over the village and doors were barred. Axes had been dragged in from wood piles, grass-hooks, pitch-forks and scythes were ranked up in corners behind those barred doors. If the men did not come back, or if they only came back in part, the women and children were ready to do the best they could. Mama spoke only to say she wished Hezekiah and John, the two biggest boys, had not gone to Maitland late in the afternoon. They were not back and she feared they might start home and— But she did not cry. Our seven hounds with big, ferocious Ned in the lead, barked around the house. We

huddled around Mama in her room and kept quiet. There was not a human sound in all the village. Nothing had ever happened before in our vicinity to create such tension. But people had memories and told tales of what happened back there in Georgia, and Alabama and West Florida that made the skin of the young crawl with transmitted memory, and reminded the old heads that they were still flinchy.

The dark silence of the village kept up for an hour or more. The once loud cries fell and fell until our straining ears could no longer find them. Strangest of all, not a shot was fired. We huddled in the dark and waited, and died a little, and waited. The silence was ten times more punishing than the cries.

At long last, a bubble of laughing voices approached our barn from the rear. It got louder and took on other dimensions between the barn and the house. Mama hissed at us to shut up when, in fact, nobody was saying a thing.

"Hey, there Little-Bits," Papa bellowed. "Open up!"

"Strike a light, Daught," Mama told my sister, feeling around in the dark to find Sarah's hand to give her the matches which I had seen clutched in her fingers before she had put out the light. Mama had said very little, and I could not see her face in the dark; somehow she could not scratch a match now that Papa was home again.

All of the men came in behind Papa, laughing and joking, perhaps more from relief than anything else.

"Don't stand there grinning like a chessy cat, Mr. Hurston," Mama scolded. "You ain't told me a thing."

"Oh, it wasn't Jim Watson at all, Lulu. You remember 'bout a week ago Old Man Bronner wrote something in de Orlando paper about H.'s daughter and W.B.J.'s son being seen sitting around the lakes an awful lot?"

"Yeah, I heard something about it."

"Well, you know those rich white folks wasn't going to 'low nothing like dat. So some of 'em waylaid him this evening. They pulled him down off of a load of hay he was hauling and drug him off back there in de woods and tanned his hide for him."

"Did y'all see any of it?"

"Nope, we could hear him hollering for a while, though. We never got no further than the lake. A white man, one of the J—— boys was standing in the bushes at de road. When we got ready to turn off round de lake he stepped out and spoke to us and told us it didn't concern us. They had Bronner down there tied down on his all-fours, and de men was taking turns wid dat bull whip. They must have been standing on tip-toes to do it. You could hear them licks clear out to de road."

The men all laughed. Somebody mocked Bronner's cries and moans a time or two and the crowd laughed immoderately. They had gone out to rescue a neighbor or die in the attempt, and they were back with their families. So they let loose their insides and laughed. They resurrected a joke or two and worried it like a bone and laughed some more. Then they just laughed. The men who spoke of members of their race as monkeys had gone out to die for one. The men who were always saying, "My skin-folks, but not kinfolks; my race but not my taste," had rushed forth to die for one of these same contemptibles. They shoved each other around and laughed. So I could see that what looked like ridicule was really the Negro poking a little fun at himself. At the same time, just like other people, hoping and wishing he was what the orators said he was.

My mother eased back in her chair and took a dip of snuff. Maybe she did not feel so well, for she didn't get tickled at all. After a while, she ordered us off to bed in a rough voice. Time was, and the men scattered. Mama sat right where she was until Hezekiah and John came home around ten o'clock. She gave them an awful going over with her tongue for staying out late, and then she eased to bed.

I was dredged up inside that night, so I did not think about the incident's general connection with race. Besides I had to go to sleep. But days later, it was called to my recollection again. There was a program at the Methodist Church, and Mrs. Mattie Moseley, it was announced, was to have a paper.

She was also going to have a fine new dress to read it in. We all wanted to see the dress.

The time came and she had the dress on. The subject of her paper was, "What will the Negroes do with the Whites?" I do not know what she decided was to be done. It seemed equally unimportant to the rest of the town. I remember that everybody said it was a fine subject. But the next week, the women talked about nothing else but the new wrist watch she had on. It was the first one ever seen in our town.

But in me, the affair stirred up more confusion. Why bring the subject up? Something was moving around me which I had no hooks to grasp. What was this about white and black people that was being talked about?

Certainly nothing changed in the village. The townspeople who were in domestic service over in Maitland or Winter Park went to work as usual. The white people interested in Eatonville came and went as before. Mr. Irving Batchellor, the author, who had a show place in Winter Park, petted up Willie Sewell, who was his head gardener, in the same old way. Bishop Whipple petted Elijah Mosely, and Mrs. Mars, who was his sister, did lots of things for Lulu Mosely, Elijah's wife. What was all the talk about? It certainly was puzzling to me.

As time went on, the confusion grew. By the time that I got to high school, I was conscious of a group that was neither the top nor the bottom of Negrodom. I met the type which designates itself as "the better-thinking Negro." I was thrown off my stride by finding that while they considered themselves Race Champions, they wanted nothing to do with anything frankly Negroid. They drew color lines within the race. The Spirituals, the Blues, *any* definitely Negroid thing was just not done. They went to the trouble at times to protest the use of them by Negro artists. Booker T. Washington was absolutely vile for advocating industrial education. There was no analysis, no seeking for merits. If it was old Cuffy, down with it! "My People! My People!"

This irritated me until I got to the place where I could analyze. The thing they were trying to do went wrong because

it lacked reason. It lacked reason because they were attempting to stand equal with the best in America without having the tools to work with. They were attempting a flight away from Negro-dom because they felt that there was so much scorn for black skin in the nation that their only security was in flight. They lacked the happy carelessness of a class beneath them and the understanding of the top-flight Negro above them. Once, when they used to set their mouths in what they thought was the Boston Crimp, and ask me about the great differences between the ordinary Negro and "the better-thinking Negro," I used to show my irritation by saying I did not know who the better-thinking Negro was. I knew who the think-they-are-better Negroes were, but who were the better-thinkers was another matter. But when I came to understand what made them make their useless motions, and saw them pacing a cage that wasn't there, I felt more sympathy than irritation. If they want to establish a sort of fur-coat peerage, let 'em! Since they can find no comfort where they happened to be born, no especial talents to lift them, and other doors are closed to them, they have to find some pleasure somewhere in life. They have to use whatever their mentality provides. "My People! My People!"

So I sensed early, that the Negro race was not one band of heavenly love. There was stress and strain inside as well as out. Being black was not enough. It took more than a community of skin color to make your love come down on you. That was the beginning of my peace.

But one thing and another kept the conflict going on inside me, off and on for years. Sometimes I was sure that the Negro race was all that the platform speakers said. Then I would hear so much self-deprecation that I would be deflated. Over and over I heard people shake their heads and explain us by the supposed prayer of a humble Negro, who got down on his knees and said: "Lawd, you know I ain't nothing. My wife, she ain't nothing. My chillun ain't nothing, and if you fool 'round us, Lawd, you won't be nothing neither."

Light came to me when I realized that I did not have to

190

consider any racial group as a whole. God made them duck by duck and that was the only way I could see them. I learned that skins were no measure of what was inside people. So none of the Race clichés meant anything anymore. I began to laugh at both white and black who claimed special blessings on the basis of race. Therefore I saw no curse in being black, nor no extra flavor by being white. I saw no benefit in excusing my looks by claiming to be half Indian. In fact, I boast that I am the only Negro in the United States whose grandfather on the mother's side was *not* an Indian chief. Neither did I descend from George Washington, Thomas Jefferson, nor any Governor of a Southern state. I see no need to manufacture me a legend to beat the facts. I do not coyly admit to a touch of the tarbrush to my Indian and white ancestry. You can consider me Old Tar-Brush in person if you want to. I am a mixed-blood, it is true, but I differ from the party line in that I neither consider it an honor nor a shame. I neither claim Jefferson as my grandpa, nor exclaim, "Just look how that white man took advantage of my grandma!" It does not matter in the first place, and then in the next place, I do not know how it came about. Since nobody ever told me, I give my ancestress the benefit of the doubt. She probably ran away from him just as fast as she could. But if that white man could run faster than my grandma, that was no fault of hers. Anyway, you must remember, he didn't have a thing to do but to keep on running forward. She, being the pursued, had to look back over her shoulder every now and then to see how she was doing. And you know your ownself, how looking backwards slows people up.

In this same connection, I have been told that God meant for all the so-called races of the world to stay just as they are, and the people who say that may be right. But it is a well known fact that no matter where two sets of people come together, there are bound to be some in-betweens. It looks like the command was given to people's heads, because the other parts don't seem to have heard tell. When the next batch is made up, maybe Old Maker will straighten all that out.

Maybe the men will be more tangle-footed and the women a whole lot more faster around the feet. That will bring about a great deal more of racial and other kinds of purity, but a somewhat less exciting world. It might work, but I doubt it. There will have to be something harder to get across than an ocean to keep East and West from meeting. But maybe Old Maker will have a remedy. Maybe even He has given up. Perhaps in a moment of discouragement He turned the job over to Adolf Hitler and went on about His business of making more beetles.

I do not share the gloomy thought that Negroes in America are doomed to be stomped out bodaciously, nor even shackled to the bottom of things. Of course some of them will be tromped out, and some will always be at the bottom, keeping company with other bottom-folks. It would be against all nature for all the Negroes to be either at the bottom, top, or in between. It has never happened with anybody else, so why with us? No, we will go where the internal drive carries us like everybody else. It is up to the individual. If you haven't got it, you can't show it. If you have got it, you can't hide it. That is one of the strongest laws God ever made.

I maintain that I have been a Negro three times—a Negro baby, a Negro girl and a Negro woman. Still, if you have received no clear cut impression of what the Negro in America is like, then you are in the same place with me. There is no *The Negro* here. Our lives are so diversified, internal attitudes so varied, appearances and capabilities so different, that there is no possible classification so catholic that it will cover us all, except My people! My people!

CHAPTER 13

TWO WOMEN IN PARTICULAR

Two women, among the number whom I have known intimately force me to keep them well in mind. Both of them have rare talents, are drenched in human gravy, and both of them have meant a great deal to me in friendship and inward experience. One, Fanny Hurst because she is so young for her years, and Ethel Waters because she is both so old and so young for hers.

Understand me, their ages have nothing to do with their birthdays. Ethel Waters is still a young woman. Fanny Hurst is far from old.

In my undergraduate days I was secretary to Fanny Hurst. From day to day she amazed me with her moods. Immediately before and after a very serious moment you could just see her playing with her dolls. You never knew where her impishness would break out again.

One day, for instance, I caught her playing at keeping house with company coming to see her. She told me not to leave the office. If the doorbell rang, Clara, her cook, was to answer it. Then she went downstairs and told Clara that I was to answer the doorbell. Then she went on to another part of the house.

Presently I heard the bell, and it just happened that I was on my way downstairs to get a drink of water. I wondered why Clara did not go to the door. What was my amazement to see Miss Hurst herself open the door and come in, greet herself graciously and invite herself to have some tea. Which she did. She went into that huge duplex studio and had toasted English muffins and played she had company with her for an hour or more. Then she came on back up to her office and went to work.

I knew that she was an only child. She did not even have cousins to play with. She was born to wealth. With the help of images, I could see that lonely child in a big house making up her own games. Being of artistic bent, I could see her making up characters to play with. Naturally she had to talk for her characters, or they would not say what she wanted them to. Most children play at that at times. I had done that extensively so I knew what she was doing when I saw her with the door half open, ringing her own doorbell and inviting herself to have some tea and muffins. When she was tired of her game, she just quit and was a grown woman again.

On another occasion, she called me up from the outside. She had been out for about two hours when she called me and told me to meet her at 67th Street and Columbus Avenue with her goloshes. She was not coming home immediately. She had to go somewhere else and she needed her goloshes. It was a gloomy day with snow and slush underfoot.

So, I grabbed up her goloshes and hurried down to the corner to wait for her to come along in a cab, as she had said. She warned me that she was at Columbus Circle and I would have to hurry, or she would be there before I was. I ran part of the way and was happy that I was there before her. I looked this a way and I looked that a way, but no Fanny Hurst peeping out of a cab. I waited from one foot to the other. The wind was searching me like the police. After a long wait I decided that something had detained her or changed her plans. Perhaps, she was trying to reach me on the phone. I hurried on back to Number 27 and went inside. Who was stretched out

on the divan, all draped in a gorgeous American Beauty rose housecoat, but Fanny Hurst! Been home such a long time that she was all draped and eating candy. It was not April, but she was playing April Fool on me. She never let on to me about that trick one way or another. She was grown again by then, and looking just as solemn as if she never played.

She likes for me to drive her, and we have made several tours. Her impishness broke out once on the road. She told me to have the car all serviced and ready for next morning. We were going up to Belgrade Lakes in Maine to pay Elizabeth Marbury a visit.

So soon next day we were on the road. She was Fanny Hurst, the famous author as far as Saratoga Springs. As we drove into the heart of town, she turned to me and said, "Zora, the water here at Saratoga is marvelous. Have you ever had any of it?"

"No, Miss Hurst, I never did."

"Then we must stop and let you have a drink. It would never do for you to miss having a drink of Saratoga water."

We parked near the famous United States Hotel and got out.

"It would be nice to stop over here for the night," she said. "I'll go see about the hotel. There is a fountain over there in the park. Be sure and get yourself a drink! You can take Lummox for a run while you get your water."

I took Lummox out of the car. To say I took Lummox for a run would be merely making a speech-figure. Lummox weighed about three pounds, and with his short legs, when he thought that he was running he was just jumping up and down in the same place. But anyway, I took him along to get the water. It was so-so as far as the taste went.

When I got back to the car, she was waiting for me. It was too early in the season for the hotel to be open. Too bad! She knew I would have enjoyed it so much. Well, I really ought to have some pleasure. Had I ever seen Niagara Falls?

"No, Miss Hurst. I always wanted to see it, but I never had a chance."

195

"Zora! You mean to tell me that you have never seen Niagara Falls?"

"No." I felt right sheepish about it when she put it that way.

"Oh, you must see the Falls. Get in the car and let's go. You must see those Falls right now." The way she sounded, my whole life was bare up to then and wrecked for the future unless I saw Niagara Falls.

The next afternoon around five o'clock, we were at Niagara Falls. It had been a lovely trip across Northern New York State.

"Here we are, now, Zora. Hurry up and take a good look at the Falls. I brought you all the way over here so that you could see them."

She didn't need to urge me. I leaned on the rail and looked and looked. It was worth the trip, all right. It was just like watching the Atlantic Ocean jump off of Pike's Peak.

In ten minutes or so, Miss Hurst touched me and I turned around.

"Zora, have you ever been across the International Bridge? I think you ought to see the Falls from the Canadian side. Come on, so you can see it from over there. It would be too bad for you to come all the way over here to see it and not see it from the Bridge."

So we drove across the Bridge. A Canadian Customs Official tackled us immediately. The car had to be registered. How long did we intend to stay?

"You'd better register it for two weeks," Miss Hurst answered and it was done. The sun was almost down.

"Look, Zora, Hamilton is only a short distance. I know you want to see it. Come on, let's drive on, and spend the night at Hamilton."

We drove on. I was surprised to see that everything in Canada looked so much like everything in the United States. It was deep twilight when we got into Hamilton.

"They tell me Kitchener is a most interesting little place, Zora. I know it would be fun to go on there and spend the night." So on to Kitchener we went.

196

Here was Fanny Hurst, a great artist and globe famous, behaving like a little girl, teasing her nurse to take her to the zoo, and having a fine time at it.

Well, we spent an exciting two weeks motoring over Ontario, seeing the country-side and eating at quaint but well-appointed inns. She was like a child at a circus. She was a run-away, with no responsibilities. A man in upper New York State dangled his old cherry trees at us as we drove homeward. He didn't have any business to do it. We parked and crept over into his old orchard and ate all we could, filled up our hats and drove on. Maybe he never missed them, but if he did, Miss Hurst said that it served him right for planting trees like that to dangle at people. Teach him a lesson. We came rolling south by east laughing, eating Royal Anne cherries and spitting seeds. It was glorious! Who has not eaten stolen fruit?

Fanny Hurst, the author, and the wife of Jacques Danielson, was not with us again until we hit Westchester on the way home. Then she replaced Mrs. Hurst's little Fanny and began to discuss her next book with me and got very serious in her manner.

While Fanny Hurst brings a very level head to her dressing, she exults in her new things like any debutante. She knows exactly what goes with her very white skin, black hair and sloe eyes, and she wears it. I doubt if any woman on earth has gotten better effects than she has with black, white and red. Not only that, she knows how to parade it when she gets it on. She will never be jailed for uglying up a town.

THIS ETHEL WATERS

I am due to have this friendship with Ethel Waters, because I worked for it.

She came to me across the footlights. Not the artist alone, but the person, and I wanted to know her very much. I was too timid to go backstage and haunt her, so I wrote her letters and she just plain ignored me. But I kept right on. I sensed

a great humanness and depth about her soul and I wanted to know someone like that.

Then Carl Van Vechten gave a dinner for me. A great many celebrities were there, including Sinclair Lewis, Dwight Fiske, Anna Mae Wong, Blanche Knopf, an Italian soprano, and my old friend, Jane Belo. Carl whispered to me that Ethel Waters was coming in later. He was fond of her himself and he knew I wanted to know her better, so he had persuaded her to come. Carl is given to doing nice things like that.

We got to talking, Ethel and I, and got on very well. Then I found that what I suspected, was true. Ethel Waters is a very shy person. It had not been her intention to ignore me. She had felt that I belonged to another world and had no need of her. She thought that I had been merely curious. She laughed at her error and said, "And here you were just like me all the time." She got warm and friendly, and we went on from there. When she was implored to sing, she asked me first what I wanted to hear. It was "Stormy Weather," of course, and she did it beautifully.

Then I did something for her. She told us that she was going to appear with Hall Johnson's Choir at Carnegie Hall, and planned to do some spirituals. Immediately, the Italian soprano and others present advised her not to do it. The argument was that Marian Anderson, Roland Hayes and Paul Robeson had sung them so successfully that her audience would make comparisons and Ethel would suffer by it. I saw the hurt in Ethel's face and jumped in. I objected that Ethel was not going to do any concertized versions of spirituals. She had never rubbed any hair off of her head against any college walls and she was not going to sing that way. She was going to sing those spirituals just the way her humble mother had sung them to her.

She turned to me with a warm, grateful smile on her face, and said, "Thank you."

When she got ready to leave, she got her wraps and said, "Come on, Zora. Let's go on uptown." I went along with her, her husband, and faithful Lashley, a young woman spiritual

singer from somewhere in Mississippi, whom Ethel has taken under her wing.

We kept up with each other after that, and I got to know her very well. We exchanged confidences that really mean something to both of us. I am her friend, and her tongue is in my mouth. I can speak her sentiments for her, though Ethel Waters can do very well indeed in speaking for herself. She has a homely philosophy that reaches all corners of Life, and she has words to fit when she speaks.

She is one of the strangest bundles of people that I have ever met. You can just see the different folks wrapped up in her if you associate with her long. Just like watching an open fire— the color and shape of her personality is never the same twice. She has extraordinary talents which her lack of formal education prevents her from displaying. She never had a chance to go beyond the third grade in school. A terrible fear is in me that the world will never really know her. You have seen her and heard her on the stage, but so little of her capabilities gets seen. Her struggle for adequate expression throws her into moods at times. She said to me Christmas Day of 1941, "You have the advantage of me, Zora. I can only show what is on the stage. You can write a different kind of book each time."

She is a Catholic, and deeply religious. She plays a good game of bridge, but no card-playing at her house on Sundays. No more than her mother would have had in her house. Nobody is going to dance and cut capers around her on the Sabbath, either. What she sings about and acts out on the stage, has nothing to do with her private life.

Her background is most humble. She does not mind saying that she was born in the slums of Philadelphia in an atmosphere that smacked of the rural South. She neither drinks nor smokes and is always chasing me into a far corner of the room when I light a cigarette. She thanks God that I don't drink.

Her religious bent shows in unexpected ways. For instance, we were discussing her work in "Cabins in the Sky." She said, "When we started to rehearse the spirituals, some of those no-manners people started to swinging 'em, and get smart. I

told 'em they better not play with God's music like that. I told 'em if I caught any of 'em at it, I'd knock 'em clean over into that orchestra pit." Her eyes flashed fire as she told me about it. Then she calmed down and laughed. "Of course, you know, Zora, God didn't want me to knock 'em over. That was an idea of mine."

And this fact of her background has a great deal to do with her approach to people. She is shy and you must convince her that she is really wanted before she will open up her tender parts and show you. Even in her career, I am persuaded that Ethel Waters does not know that she has arrived. For that reason, she is grateful for any show of love or appreciation. People to whom she has given her love and trust have exploited it heartlessly, like hogs under an acorn tree—guzzling and grabbing with their ears hanging over their eyes, and never looking up to see the high tree that the acorns fell off of.

She has been married twice, unhappily each time because I am certain that neither man could perceive her.

"I was thirteen when I married the first time," she confided to me. "And I was a virgin when I got married."

Now, she is in love with Archie Savage, who is a talented dancer, and formerly of the Dunham group. They met during the rehearsals for "Cabins in the Sky" and the affair is on! It looks as if they will make a wed, because they are eternally together. He has given her a taste for things outside the theater like art museums and the opera. He has sold her on the pictures, statues and paintings, but she says that this opera business sticks in her craw. She says she can't see why people fool with a thing like that that just isn't natural.

"Singing is music, Zora, but this Grand Opera is a game. The opera singers lay so much down that they can make that high note, and the audiences fades 'em the price of admission that they can't do it. Of course, all those high class folks that lay bets on high notes are good sports. If the singers haul off and win the bet, they give 'em a great big hand, and go outside for a smoke. And the only reason that opera houses don't

make no more money than they do, is because so many more folks would rather bet on race horses. I don't bet on nothing because I don't think it's right. But if I did, my money would be on the horse."

Still if Sonny (our intimate name for Archie) wants to take her to the opera, she will go to please him. "He is fire and fuel to my life," she told me and played with her handkerchief like a teen-age girl.

She went on the stage at thirteen and says that she got eight dollars a week for her first salary. She was so frightened that she had to be pushed on to sing her song, and then another member of the cast had to come on with her until she could get started. Then too, they had to place a chair for her to lean on to overcome her nervousness.

At fifteen, she introduced the St. Louis Blues to the world. She saw a sheet of the music, had it played for her, then wrote to W. C. Handy for permission to use it. Handy answered on a postal card and told her to go as far as she liked, or words to that effect. If W. C. Handy had only known at that time the importance of his act!

She is gay and sombre by turns. I have listened to her telling a story and noticed her change of mood in mid-story. I have asked her to repeat something particularly pungent that she has said, and had her tell me, "I couldn't say it now. My thoughts are different. Sometime when I am thinking that same way, I'll tell it to you again."

The similes and metaphors just drip off of her lips. One day I sat in her living room on Hobart Street in Los Angeles, deep in thought. I had really forgotten that others were present. She nudged Archie Savage and pointed at me. "Salvation looking at the temple forlorn," she commented and laughed. "What you doing, Zora? Pasturing in your mind?"

"It's nice to be talking things over with you, Zora," she told me another time. "Conversation is the ceremony of companionship."

Speaking of a man we both know, she said, "The bigger lie he tells, the more guts he tells it with."

201

"That man's jaws are loaded with big words, but he never says a thing," she said speaking of a mutual friend. "He got his words out of a book. I got mine out of life."

"She shot him lightly and he died politely," she commented after reading in the *Los Angeles Examiner* about a woman killing her lover.

Commenting on a man who had used coarse language, she said, "I'd rather him to talk differently, but you can't hold him responsible, Zora, they are all the words he's got."

Ethel Waters has known great success and terrible personal tragedy, so she knows that no one can have everything.

"Don't care how good the music is, Zora, you can't dance on every set."

I am grateful for the friendship of Fanny Hurst and Ethel Waters. But how does one speak of honest gratitude? Who can know the outer ranges of friendship? I am tempted to say that no one can live without it. It seems to me that trying to live without friends, is like milking a bear to get cream for your morning coffee. It is a whole lot of trouble, and then not worth much after you get it.

CHAPTER 14

LOVE

What do I really know about love? I have had some experiences and feel fluent enough for my own satisfaction. Love, I find is like singing. Everybody can do enough to satisfy themselves, though it may not impress the neighbors as being very much. That is the way it is with me, but whether I know anything unusual, I couldn't say. Don't look for me to call a string of names and point out chapter and verse. Ladies do not kiss and tell any more than gentlemen do.

I have read many books where the heroine was in love for a long time without knowing it. I have talked with people and they have told me the same thing. So maybe that is the way it ought to be. That is not the way it is with me at all. I have been *out* of love with people for a long time, perhaps without finding it out. But when I fall *in,* I can feel the bump. That is a fact and I would not try to fool you. Love may be a sleepy, creeping thing with some others, but it is a mighty wakening thing with me. I feel the jar, and I know it from my head on down.

Though I started falling in love before I was seven years old, I never had a fellow until I was nearly grown. I was such a poor

picker. I would have had better luck if I had stuck to boys around my own age, but that wouldn't do me. I wanted somebody with long pants on, and they acted as if they didn't know I was even born. The heartless wretches would walk right past my gate with grown women and pay me no attention at all, other than to say hello or something like that. Then I would have to look around for another future husband, only to have the same thing happen all over again.

Of course, in high school I received mushy notes and wrote them. A day or two, a week or month at most would see the end of the affair. Gone without a trace. I was in my freshman year in college when I first got excited, really.

He could stomp a piano out of this world, sing a fair baritone and dance beautifully. He noticed me, too, and I was carried away. For the first time since my mother's death, there was someone who felt really close and warm to me.

This affair went on all through my college life, with the exception of two fallings-out. We got married immediately after I finished my work at Barnard College, which should have been the happiest day of my life. St. Augustine, Florida, is a beautiful setting for such a thing.

But, it was not my happiest day. I was assailed by doubts. For the first time since I met him, I asked myself if I really were in love, or if this had been a habit. I had an uncomfortable feeling of unreality. The day and the occasion did not underscore any features of nature nor circumstance, and I wondered why. Who had cancelled the well-advertised tour of the moon? Somebody had turned a hose on the sun. What I had taken for eternity turned out to be a moment walking in its sleep.

After our last falling-out, he asked me please to forgive him, and I said that I did. But now, had I really? A wind full of memories blew out of the past and brought a chilling fog. This was not the expected bright dawn. Rather, some vagrant ray had played a trick on the night. I could not bring myself to tell him my thoughts. I just couldn't, no matter how hard I tried, but there they were crowding me from pillar to post.

Back in New York, I met Mrs. Mason and she offered me the chance to return to my research work, and I accepted it. It seemed a way out without saying anything very much. Let nature take its course. I did not tell him about the arrangement. Rather, I urged him to return to Chicago to continue his medical work. Then I stretched my shivering insides out and went back to work. I have seen him only once since then. He has married again, and I hope that he is happy.

Having made such a mess, I did not rush at any serious affair right away. I set to work and really worked in earnest. Work was to be all of me, so I said. Three years went by. I had finished that phase of research and was considering writing my first book, when I met the man who was really to lay me by the heels. I met P.M.P.

He was tall, dark brown, magnificently built, with a beautifully modelled back head. His profile was strong and good. The nose and lip were especially good front and side. But his looks only drew my eyes in the beginning. I did not fall in love with him just for that. He had a fine mind and that intrigued me. When a man keeps beating me to the draw mentally, he begins to get glamorous.

I did not just fall in love. I made a parachute jump. No matter which way I probed him, I found something more to admire. We fitted each other like a glove. His intellect got me first for I am the kind of a woman that likes to move on mentally from point to point, and I like for my man to be there way ahead of me. Then if he is strong and honest, it goes on from there. Good looks are not essential, just extra added attraction. He had all of those things and more. It seems to me that God must have put in extra time making him up. He stood on his own feet so firmly that he reared back.

To illustrate the point, I got into trouble with him for trying to loan him a quarter. It came about this way.

I lived in the Graham Court at 116th Street and Seventh Avenue. He lived down in 64th Street, Columbus Hill. He came to call one night and everything went off sweetly until he got ready to leave. At the door he told me to let him go

205

because he was going to walk home. He had spent the only nickel he had that night to come to see me. That upset me, and I ran to get a quarter to loan him until his pay day. What did I do that for? He flew hot. In fact he was the hottest man in the five boroughs. Why did I insult him like that? The responsibility was all his. He had known that he did not have his return fare when he left home, but he had wanted to come, and so he had come. Let him take the consequences for his own acts. What kind of a coward did I take him for? How could he deserve my respect if he behaved like a cream puff? He was a *man*! No woman on earth could either lend him nor give him a cent. If a man could not do for a woman, what good was he on earth? His great desire was to do for me. *Please* let him be a *man*!

For a minute I was hurt and then I saw his point. He had done a beautiful thing and I was killing it off in my blindness. If it pleased him to walk all of that distance for my sake, it pleased him as evidence of his devotion. Then too, he wanted to do all the doing, and keep me on the receiving end. He soared in my respect from that moment on. Nor did he ever change. He meant to be the head, *so help him over the fence!*

That very manliness, sweet as it was, made us both suffer. My career balked the completeness of his ideal. I really wanted to conform, but it was impossible. To me there was no conflict. My work was one thing, and he was all of the rest. But, I could not make him see that. Nothing must be in my life but himself.

But, I am ahead of my story. I was interested in him for nearly two years before he knew it. A great deal happened between the time we met and the time we had any serious talk.

As I said, I loved, but I did not say so, because nobody asked me. I made up my mind to keep my feelings to myself since they did not seem to matter to anyone else but me.

I went South, did some more concert work and wrote *Jonah's Gourd Vine* and *Mules and Men,* then came back to New York.

He began to make shy overtures to me. I pretended not to notice for a while so that I could be sure and not be hurt. Then

he gave me the extreme pleasure of telling me right out loud about it. It seems that he had been in love with me just as long as I had been with him, but he was afraid that I didn't mean him any good, as the saying goes. He had been trying to make me tell him something. He began by complimenting me on my clothes. Then one night when we had attended the Alpha Phi Alpha fraternity dance—yes, he is an Alpha man—he told me that the white dress I was wearing was beautiful, but I did not have on an evening wrap rich enough to suit him. He had in mind just the kind he wanted to see me in, and when he made the kind of money he expected to, the first thing he meant to do was to buy me a gorgeous evening wrap and everything to go with it. He wanted *his* wife to look swell. He looked at me from under his eyelashes to see how I was taking it. I smiled and so he went on.

"You know, Zora, you've got a real man on your hands. You've got somebody to do for you. I'm tired of seeing you work so hard. I wouldn't want *my* wife to do anything but look after me. Be home looking like Skookums when I got there."

He always said I reminded him of the Indian on the Skookum Apples, so I knew he meant me to understand that he wanted to be coming home to me, and with those words he endowed me with Radio City, the General Motors Corporation, the United States, Europe, Asia and some outlying continents. I had everything!

So actively began the real love affair of my life. He was then a graduate of City College, and was working for his Master's degree at Columbia. He had no money. He was born of West Indian parents in the Columbus Hill district of New York City, and had nothing to offer but what it takes—a bright soul, a fine mind in a fine body, and courage. He is so modest that I do not think that he yet knows his assets. That was to make trouble for us later on.

It was a curious situation. He was so extraordinary that I lived in terrible fear lest women camp on his doorstep in droves and take him away from me. I found out later on that he could not believe that I wanted just him. So there began

207

an agonizing tug of war. Looking at a very serious photograph of me that Carl Van Vechten had made, he told me one night in a voice full of feeling that that was the way he wanted me to look all the time unless I was with him. I almost laughed out loud. That was just the way I felt. I hated to think of him smiling unless he was smiling at me. His grins were too precious to be wasted on ordinary mortals, especially women.

If he could only have realized what a lot he had to offer, he need not have suffered so much through doubting that he could hold me. I was hog-tied and branded, but he didn't realize it. He could make me fetch and carry, but he wouldn't believe it. So when I had to meet people on business, or went to literary parties and things like that, it would drive him into a sulk, and then he would make me unhappy. I too, failed to see how deeply he felt. I would interpret his moods as indifference and die, and die, and die.

He begged me to give up my career, marry him and live outside of New York City. I really wanted to do anything he wanted me to do, but that one thing I could not do. It was not just my contract with my publishers, it was that I had things clawing inside of me that must be said. I could not see that my work should make any difference in marriage. He was all and everything else to me but that. One did not conflict with the other in my mind. But it was different with him. He felt that he did not matter to me enough. He was the master kind. All, or nothing, for him.

The terrible thing was that we could neither leave each other alone, nor compromise. Let me seem too cordial with any male and something was going to happen. Just let him smile too broad at any woman, and no sooner did we get inside my door than the war was on! One night (I didn't decide this) something primitive inside me tore past the barriers and before I realized it, I had slapped his face. That was a mistake. He was still smoldering from an incident a week old. A fellow had met us on Seventh Avenue and kissed me on my cheek. Just one of those casual things, but it had burned up P.M.P. So I had unknowingly given him an opening he had

208

been praying for. He paid me off then and there with interest. No broken bones, you understand, and no black eyes. I realized afterwards that my hot head could tell me to beat him, but it would cost me something. I would have to bring head to get head. I couldn't get his and leave mine locked up in the dresser-drawer.

Then I knew I was too deeply in love to be my old self. For always a blow to my body had infuriated me beyond measure. Even with my parents, that was true. But somehow, I didn't hate him at all. We sat down on the floor and each one of us tried to take all the blame. He went out and bought some pie and I made a pot of hot chocolate and we were more affectionate than ever. The next day he made me a book case that I needed and you couldn't get a pin between us.

But fate was watching us and laughing. About a month later when he was with me, the telephone rang. Would I please come down to an apartment in the Fifties and meet an out-of-town celebrity? He was in town for only two days and he wanted to meet me before he left. When I turned from the phone, P.M.P. was changed. He begged me not to go. I reminded him that I had promised, and begged him to come along. He refused and walked out. I went, but I was most unhappy.

This sort of thing kept up time after time. He would not be reconciled to the thing. We were alternately the happiest people in the world, and the most miserable. I suddenly decided to go away to see if I could live without him. I did not even tell him that I was going. But I wired him from some town in Virginia.

Miss Barnicle of New York University asked me to join her and Alan Lomax on a short bit of research. I was to select the area and contact the subjects. Alan Lomax was joining us with a recording machine. So because I was delirious with joy and pain, I suddenly decided to leave New York and see if I could come to some decision. I knew no more at the end than I did when I went South. Six weeks later I was back in New York and just as much his slave as ever.

Really, I never had occasion to doubt his sincerity, but I used to drag my heart over hot coals by supposing. I did not know that I could suffer so. Then all of my careless words came to haunt me. For theatrical effect, I had uttered sacred words and oaths to others before him. How I hated myself for the sacrilege now! It would have seemed so wonderful never to have uttered them before.

But no matter how soaked we were in ecstasy, the telephone or the door bell would ring, and there would be my career again. A charge had been laid upon me and I must follow the call. He said once with pathos in his voice, that at times he could not feel my presence. My real self had escaped him. I could tell from both his face and his voice that it hurt him terribly. It hurt me just as much to see him hurt. He really had nothing to worry about, but I could not make him see it. So there we were. Caught in a fiendish trap. We could not leave each other alone, and we could not shield each other from hurt. Our bitterest enemies could not have contrived more exquisite torture for us.

Another phase troubled me. As soon as he took his second degree, he was in line for bigger and better jobs. I began to feel that our love was slowing down his efforts. He had brains and character. He ought to go a long way. I grew terribly afraid that later on he would feel that I had thwarted him in a way and come to resent me. That was a scorching thought. Even if I married him, what about five years from now, the way we were going?

In the midst of this, I received my Guggenheim fellowship. This was my chance to release him, and fight myself free from my obsession. He would get over me in a few months and go on to be a very big man. So I sailed off to Jamaica. But I freely admit that everywhere I set my feet down, there were tracks of blood. Blood from the very middle of my heart. I did not write because if I had written and he answered my letter, everything would have broken down.

So I pitched in to work hard on my research to smother my feelings. But the thing would not down. The plot was far from

the circumstances, but I tried to embalm all the tenderness of my passion for him in *Their Eyes Were Watching God*.

When I returned to America after nearly two years in the Caribbean, I found that he had left his telephone number with my publishers. For some time, I did not use it. Not because I did not want to, but because the moment when I should hear his voice something would be in wait for me. It might be warm and eager. It might be cool and impersonal, just with overtones from the grave of things. So I went south and stayed several months before I ventured to use it. Even when I returned to New York it took me nearly two months to get up my courage. When I did make the call, I cursed myself for the delay. Here was the shy, warm man I had left.

Then we met and talked. We both were stunned by the revelation that all along we had both thought and acted desperately in exile, and all to no purpose. We were still in the toils and after all my agony, I found out that he was a sucker for me, and he found out that I was in his bag. And I had a triumph that only a woman could understand. He had not turned into a tramp in my absence, but neither had he flamed like a newborn star in his profession. He confessed that he needed my aggravating presence to push him. He had settled down to a plodding desk job and reconciled himself. He had let his waistline go a bit and that bespoke his inside feeling. That made me happy no end. No woman wants a man all finished and perfect. You have to have something to work on and prod. That waistline went down in a jiffy and he began to discuss work-plans with enthusiasm. He could see something ahead of him besides time. I was happy. If he had been crippled in both legs, it would have suited me even better.

What will be the end? That is not for me to know. Life poses questions and that two-headed spirit that rules the beginning and end of things called Death, has all the answers. And even if I did know all, I am supposed to have some private business to myself. What I do know, I have no intention of putting but so much in the public ears.

Perhaps the oath of Hercules shall always defeat me in love.

Once when I was small and first coming upon the story of "The Choice of Hercules," I was so impressed that I swore an oath to leave all pleasure and take the hard road of labor. Perhaps God heard me and wrote down my words in His book. I have thought so at times. Be that as it may, I have the satisfaction of knowing that I have loved and been loved by the perfect man. If I never hear of love again, I have known the real thing.

So much for what I know about the major courses in love. However, there are some minor courses which I have not grasped so well, and would be thankful for some coaching and advice.

First is the number of men who pant in my ear on short acquaintance, "You passionate thing! I can see you are just *burning* up! Most men would be disappointing to you. It takes a man like me for you. Ahhh! I know that you will just wreck me! Your eyes and your lips tell me a lot. You are a walking furnace!" This amazes me sometimes. Often when this is whispered gustily into my ear, I am feeling no more amorous than a charter member of the Union League Club. I may be thinking of turnip greens with dumplings, or more royalty checks, and here is a man who visualizes me on a divan sending the world up in smoke. It has happened so often that I have come to expect it. There must be something about me that looks sort of couchy. Maybe it is a birth-mark. My mother could have been frightened by a bed. There is nothing to be done about it, I suppose. But, I must say about these mirages that seem to rise around me, that the timing is way off on occasion.

Number two is, a man may lose interest in me and go where his fancy leads him, and we can still meet as friends. But if I get tired and let on about it, he is certain to become an enemy of mine. That forces me to lie like the cross-ties from New York to Key West. I have learned to frame it so that I can claim to be deserted and devastated by him. Then he goes off with a sort of twilight tenderness for me, wondering what it is that he's got that brings so many women down! I do not even have to show real tears. All I need to do is show my

stricken face and dash away from him to hide my supposed heartbreak and renunciation. He understands that I am fleeing before his allure so that I can be firm in my resolution to save the pieces. He knew all along that he was a hard man to resist, so he visualized my dampened pillow. It is a good thing that some of them have sent roses as a poultice and stayed away. Otherwise, they might have found the poor, heartbroken wreck of a thing all dressed to kill and gone out for a high-heel time with the new interest, who has the new interesting things to say and do. Now, how to break off without acting deceitful and still keep a friend?

Number three is kin to Number two, in a way. Under the spell of moonlight, music, flowers or the cut and smell of good tweeds, I sometimes feel the divine urge for an hour, a day or maybe a week. Then it is gone and my interest returns to corn pone and mustard greens, or rubbing a paragraph with a soft cloth. Then my ex-sharer of a mood calls up in a fevered voice and reminds me of every silly thing I said, and eggs me on to say them all over again. It is the third presentation of turkey hash after Christmas. It is asking me to be a seven-sided liar. Accuses me of being faithless and inconsistent if I don't. There is no inconsistency there. I was sincere for the moment in which I said the things. It is strictly a matter of time. It was true for the moment, but the next day or the next week, is not that moment. No two moments are any more alike than two snow-flakes. Like snowflakes, they get that same look from being so plentiful and falling so close together. But examine them closely and see the multiple differences between them. Each moment has its own task and capacity, and doesn't melt down like snow and form again. It keeps its character forever. So the great difficulty lies in trying to transpose last night's moment to a day which has no knowledge of it. That look, that tender touch, was issued by the mint of the richest of all kingdoms. That same expression of today is utter counterfeit, or at best the wildest of inflation. What could be more zestless than passing out cancelled checks? It is wrong to be called faithless under circumstances like that. What to do?

I have a strong suspicion, but I can't be sure that much that passes for constant love is a golded-up moment walking in its sleep. Some people know that it is the walk of the dead, but in desperation and desolation, they have staked everything on life after death and the resurrection, so they haunt the grave-yard. They build an altar on the tomb and wait there like faithful Mary for the stone to roll away. So the moment has authority over all of their lives. They pray constantly for the miracle of the moment to burst its bonds and spread out over time.

But pay no attention to what I say about love, for as I said before, it may not mean a thing. It is my own bath-tub singing. Just because my mouth opens up like a prayer book, it does not just have to flap like a Bible. And then again, anybody whose mouth is cut cross-ways is given to lying, unconsciously as well as knowingly. So pay my few scattering remarks no mind as to love in general. I only know my part.

Anyway, it seems to be the unknown country from which no traveler ever returns. What seems to be a returning pilgrim is another person born in the strange country with the same-looking ears and hands. He is a stranger to the person who fared forth, and a stranger to family and old friends. He is clothed in mystery henceforth and forever. So, perhaps no-body knows, or can tell, any more than I. Maybe the old Negro folk-rhyme tells all there is to know:

> Love is a funny thing; Love is a blossom;
> If you want your finger bit, poke it at a possum.

CHAPTER 15

RELIGION

You wouldn't think that a person who was born with
God in the house would ever have any questions to ask
on the subject.

But as early as I can remember, I was questing and seeking.
It was not that I did not hear. I tumbled right into the Mission-
ary Baptist Church when I was born. I saw the preachers and
the pulpits, the people and the pews. Both at home and from
the pulpit, I heard my father, known to thousands as "Rever-
end Jno" (an abbreviation for John) explain all about God's
habits, His heaven, His ways, and Means. Everything was
known and settled.

From the pews I heard a ready acceptance of all that Papa
said. Feet beneath the pews beat out a rhythm as he pictured
the scenery of heaven. Heads nodded with conviction in time
to Papa's words. Tense snatches of tune broke out and some
shouted until they fell into a trance at the recognition of what
they heard from the pulpit. Come "love feast"* some of the

*The "Love Feast" or "Experience Meeting" is a meeting held either the Friday
night or the Sunday morning before Communion. Since no one is supposed to take
Communion unless he or she is in harmony with all other members, there are great

congregation told of getting close enough to peep into God's sitting room windows. Some went further. They had been inside the place and looked all around. They spoke of sights and scenes around God's throne.

That should have been enough for me. But somehow it left a lack in my mind. They should have looked and acted differently from other people after experiences like that. But these people looked and acted like everybody else—or so it seemed to me. They ploughed, chopped wood, went possum-hunting, washed clothes, raked up back-yards and cooked collard greens like anybody else. No more ornaments and nothing. It mystified me. There were so many things they neglected to look after while they were right there in the presence of All-Power. I made up my mind to do better than that if ever I made the trip.

I wanted to know, for instance, why didn't God make grown babies instead of those little measly things that messed up didies and cried all the time? What was the sense in making babies with no teeth? He knew that they had to have teeth, didn't He? So why not give babies their teeth in the beginning instead of hiding the toothless things in hollow stumps and logs for grannies and doctors to find and give to people? He could see all the trouble people had with babies, rubbing their gums and putting wood-lice around their necks to get them to cut teeth. Why did God hate for children to play on Sundays? If Christ, God's son, hated to die, and God hated for Him to die and have everybody grieving over it ever since, why did He have to do it? Why did people die anyway?

It was explained to me that Christ died to save the world from sin and then too, so that folks did not have to die anymore. That was a simple, clear-cut explanation. But then I heard my father and other preachers accusing people of sin. They went so far as to say that people were so prone to sin, that they sinned with every breath they drew. You couldn't

protestations of love and friendship. It is an opportunity to re-affirm faith plus anything the imagination might dictate.

even breathe without sinning! How could that happen if we had already been saved from it? So far as the dying part was concerned, I saw enough funerals to know that somebody was dying. It seemed to me that somebody had been fooled and I so stated to my father and two of his colleagues. When they got through with me, I knew better than to say that out loud again, but their shocked and angry tirades did nothing for my bewilderment. My head was full of misty fumes of doubt.

Neither could I understand the passionate declarations of love for a being that nobody could see. Your family, your puppy and the new bull-calf, yes. But a spirit away off who found fault with everybody all the time, that was more than I could fathom. When I was asked if I loved God, I always said yes because I knew that that was the thing I was supposed to say. It was a guilty secret with me for a long time. I did not dare ask even my chums if they meant it when they said they loved God with all their souls and minds and hearts, and would be glad to die if He wanted them to. Maybe they had found out how to do it, and I was afraid of what they might say if they found out I hadn't. Maybe they wouldn't even play with me anymore.

As I grew, the questions went to sleep in me. I just said the words, made the motions and went on. My father being a preacher, and my mother superintendent of the Sunday School, I naturally was always having to do with religious ceremonies. I even enjoyed participation at times; I was moved, not by the spirit, but by action, more or less dramatic.

I liked revival meetings particularly. During these meetings the preacher let himself go. God was called by all of His praise-giving names. The scenery of heaven was described in detail. Hallelujah Avenue and Amen Street were paved with gold so fine that you couldn't drop a pea on them but what they rang like chimes. Hallelujah Avenue ran north and south across heaven, and was tuned to sound alto and bass. Amen Street ran east and west and was tuned to "treble" and tenor. These streets crossed each other right in front of the throne and made harmony all the time. Yes, and right there on that

217

corner was where all the loved ones who had gone on before would be waiting for those left behind.

Oh yes! They were all there in their white robes with the glittering crowns on their heads, golden girdles clasped about their waists and shoes of jewelled gold on their feet, singing the hallelujah song and waiting. And as they walked up and down the golden streets, their shoes would sing, "sol me, sol do" at every step.

Hell was described in dramatic fury. Flames of fire leaped up a thousand miles from the furnaces of Hell, and raised blisters on a sinning man's back before he hardly got started downward. Hell-hounds pursued their ever-dying souls. Everybody under the sound of the preacher's voice was warned, while yet they were on pleading terms with mercy, to take steps to be sure that they would not be a brand in that eternal burning.

Sinners lined the mourner's bench from the opening night of the revival. Before the week was over, several or all of them would be "under conviction." People, solemn of face, crept off to the woods to "praying ground" to seek religion. Every church member worked on them hard, and there was great clamor and rejoicing when any of them "come through" religion.

The pressure on the unconverted was stepped up by music and high drama. For instance I have seen my father stop preaching suddenly and walk down to the front edge of the pulpit and breathe into a whispered song. One of his most effective ones was:

> Run! Run! Run to the City of Refuge, children!
> Run! Oh, run! Or else you'll be consumed.

The congregation working like a Greek chorus behind him, would take up the song and the mood and hold it over for a while even after he had gone back into the sermon at high altitude:

Are you ready-ee? Hah!
For that great day, hah!
When the moon shall drape her face in mourning, hah!
And the sun drip down in blood, hah!
When the stars, hah!
Shall burst forth from their diamond sockets, hah!
And the mountains shall skip like lambs, hah!
Havoc will be there, my friends, hah!
With her jaws wide open, hah!
And the sinner-man, hah!
He will run to the rocks, hah!
And cry, Oh rocks! Hah!
Hide me! Hah!
Hide me from the face of an angry God, hah!
Hide me, Ohhhhhh!
But the rocks shall cry, hah!
Git away! Sinner man git away, hah!

(Tense harmonic chant seeps over the audience.)

> You run to de rocks,
CHORUS: You can't hide
SOLOIST: Oh, you run to de rocks
CHORUS: Can't hide
SOLOIST: Oh, run to de mountain, you can't hide
ALL: Can't hide sinner, you can't hide.
> Rocks cry, I'm burning too, hah!
> In the eternal burning, hah!
> Sinner man! Hah!
> Where will you stand? Hah!
> In that great gittin'-up morning? Hah!

The congregation would be right in there at the right mo-
ment bearing Papa up and heightening the effect of the fear-
some picture a hundred-fold. The more susceptible would be
swept away on the tide and "come through" shouting, and the
most reluctant would begin to waver. Seldom would there be
anybody left at the mourners' bench when the revival meeting
was over. I have seen my father "bring through" as many as

219

seventy-five in one two-week period of revival. Then a day would be set to begin the induction into the regular congregation. The first thing was to hear their testimony or Christian experience, and thus the congregation could judge whether they had really "got religion" or whether they were faking and needed to be sent back to "lick de calf over" again.

It was exciting to hear them tell their "visions." This was known as admitting people to the church on "Christian experience." This was an exciting time.

These visions are traditional. I knew them by heart as did the rest of the congregation, but still it was exciting to see how the converts would handle them. Some of them made up new details. Some of them would forget a part and improvise clumsily or fill up the gap with shouting. The audience knew, but everybody acted as if every word of it was new.

First they told of suddenly becoming conscious that they had to die. They became conscious of their sins. They were Godly sorry. But somehow, they could not believe. They started to pray. They prayed and they prayed to have their sins forgiven and their souls converted. While they laid under conviction, the hell-hounds pursued them as they ran for salvation. They hung over Hell by one strand of hair. Outside of the meeting, any of the listeners would have laughed at the idea of anybody with hair as close to their heads as ninety-nine is to a hundred hanging over Hell or anywhere else by a strand of that hair. But it was part of the vision and the congregation shuddered and groaned at the picture in a fervent manner. The vision must go on. While the seeker hung there, flames of fire leaped up and all but destroyed their ever-dying souls. But they called on the name of Jesus and immediately that dilemma was over. They then found themselves walking over Hell on a foot-log so narrow that they had to put one foot right in front of the other while the howling hell-hounds pursued them relentlessly. Lord! They saw no way of rescue. But they looked on the other side and saw a little white man and he called to them to come there. So they called the name of Jesus and suddenly they were on the other side. He poured the oil

220

of salvation into their souls and, hallelujah! They never expect to turn back. But still they wouldn't believe. So they asked God, if he had saved their souls, to give them a sign. If their sins were forgiven and their souls set free, please move that big star in the west over to the east. The star moved over. But still they wouldn't believe. If they were really saved, please move that big oak tree across the road. The tree skipped across the road and kept on growing just like it had always been there. Still they didn't believe. So they asked God for one more sign. Would He please make the sun shout so they could be sure. At that God got mad and said He had shown them all the signs He intended to. If they still didn't believe, He would send their bodies to the grave, where the worm never dies, and their souls to Hell, where the fire is never quenched. So then they cried out "I believe! I believe!" Then the dungeon shook and their chains fell off. "Glory! I know I got religion! I know I been converted and my soul set free! I never will forget that day when the morning star bust in my soul. I never expect to turn back!"

The convert shouted. Ecstatic cries, snatches of chants, old converts shouting in frenzy with the new. When the tumult finally died down, the pastor asks if the candidate is acceptable and there is unanimous consent. He or she is given the right hand of fellowship, and the next candidate takes the floor. And so on to the end.

I know now that I liked that part because it was high drama. I liked the baptisms in the lake too, and the funerals for the same reason. But of the inner thing, I was right where I was when I first began to seek answers.

Away from the church after the emotional fire had died down, there were little jokes about some of the testimony. For instance a deacon said in my hearing, "Sister Seeny ought to know better than to be worrying God about moving the sun for her. She asked Him to move de tree to convince her, and He done it. Then she took and asked Him to move a star for her and He done it. But when she kept on worrying Him about moving the sun, He took and told her, says, 'I don't

221

mind moving that tree for you, and I don't mind moving a star just to pacify your mind, because I got plenty of *them.* I ain't got but one sun, Seeny, and I ain't going to be shoving it around to please you and nobody else. I'd like mighty much for you to believe, but if you can't believe without me moving my sun for you, you can just go right on to Hell.' "

The thing slept on in me until my college years without any real decision. I made the necessary motions and forgot to think. But when I studied both history and philosophy, the struggle began again.

When I studied the history of the great religions of the world, I saw that even in his religion, man carried himself along. His worship of strength was there. God was made to look that way too. We see the Emperor Constantine, as pagan as he could lay in his hide, having his famous vision of the cross with the injunction: *"In Hoc Signo Vinces,"* and arising next day not only to win a great battle, but to start out on his missionary journey with his sword. He could not sing like Peter, and he could not preach like Paul. He probably did not even have a good straining voice like my father to win converts and influence people. But he had his good points—one of them being a sword—and a seasoned army. And the way he brought sinners to repentance was nothing short of miraculous. Whole tribes and nations fell under conviction just as soon as they heard he was on the way. They did not wait for any stars to move, nor trees to jump the road. By the time he crossed the border, they knew they had been converted. Their testimony was in on Christian experience and they were all ready for the right hand of fellowship and baptism. It seems that Reverend Brother Emperor Constantine carried the gospel up and down Europe with his revival meetings to such an extent that Christianity really took on. In Rome where Christians had been looked upon as rather indifferent lion-bait at best, and as keepers of virgins in their homes for no real good to the virgins among other things at their worst, Christianity mounted. Where before, Emperors could scarcely find enough of them to keep the spectacles going, now they were everywhere, in

places high and low. The arrow had left the bow. Christianity was on its way to world power that would last. That was only the beginning. Military power was to be called in time and time again to carry forward the gospel of peace. There is not apt to be any difference of opinion between you and a dead man.

It was obvious that two men, both outsiders, had given my religion its chances of success. First the apostle Paul, who had been Saul, the erudite Pharisee, had arisen with a vision when he fell off of his horse on the way to Damascus. He not only formulated the religion, but exerted his brilliant mind to carry it to the most civilized nations of his time. Then Constantine took up with force where Paul left off with persuasion.

I saw the same thing with different details, happen in all the other great religions, and seeing these things, I went to thinking and questing again. I have achieved a certain peace within myself, but perhaps the seeking after the inner heart of truth will never cease in me. All sorts of interesting speculations arise.

Will military might determine the dominant religion of tomorrow? Who knows? Maybe Franklin Delano Roosevelt will fall on his head tomorrow and arise with a vision of Father Divine in the sky and the motto, "Peace! It's wonderful!" glowing like a rainbow above it.

Maybe our President would not even have to fall off of a horse, or a battleship, as the case might be. If Father Divine should come to control thirty million votes, the President could just skip the fall; that is, off of the horse.

Then, we might hear the former Franklin D. Roosevelt addressed as Sincere Determination. Eleanor would be Divine Eternal Commutation. Celestial Bountiful Tribulations would be Sister Frances Perkins. Harry Hopkins, Angelic Saintly Shadow. His Vocal Honor, La Guardia, would be known as Always Sounding Trumpet, and on his evident good works in his nursery, Harold Ickes would be bound to win the title of Fruitful Love Abounding.

Things getting into a fix like that, Sincere Determination,

being Arch Angel in the first degree, could have the honor of handing Father Divine his first bite at every meal. Celestial B. Tribulations would be in the kitchen dividing the opinion of the cooks. Eleanor, Divine Commutation, would be a Tidings-Angel, spreading the new gospel far and wide.

The Senate Chamber would be something to see. All of the seats in the center taken out and a long table loaded down with baked hams, turkeys, cakes and pies all ready for the legislative session to begin. With Father Divine at the head and Sincere Determination at the foot, slicing ham and turkey for the saints, there might not be much peace, but the laws would be truly wonderful. The saints would not overeat, either; what with being forced to raise their hands and cry "Peace!" every time Father Divine spoke and "it's truly wonderful" every time Sincere Determination uttered a sound, their eating would be negligible.

It would be a most holy conclave around that table. Sincere Determination would naturally be Senate president, seated under a huge picture of Father Divine. There would be no more disturbing debates and wrangling. The Lord would pass the law to Sincere Determination and he would pass it on to the Senate. The Senate would pass their plates for more ham and salad.

Father Divine would confine himself to pontifical audiences and meditation. He might even get himself a shoe embroidered with a quart or two of jewels for the dowagers of Park Avenue, Beacon Street and Sutton Place to have the extreme pleasure of kissing. His foot would be in it, of course. He wouldn't belittle a lady by sending out a cold shoe for impressively devout lady-angels to kiss like that.

Naturally, Sincere Determination would be able to read the Divine mind and then pass on which ones rated crowns of empire and which didn't. It would be the privilege of our Angelic Admirals and generals, "Puissant Defenders of the Faith," to demote all infidels and correct all typographical errors, emperor to impotent, and vice versa; according as a man worships, so is he, as the saying goes.

Naturally, there would be no more private money. Father would hold it all for everybody. No more just homes. Every house a "heaven." Peace!

Our holy fighting men would have high arching wings that covered up their mouths but left their ears wide open—a splendid type of fighting saints.

Don't think this impossible because of certain natural difficulties. Father Divine's looks need not be any drawback, nor a stumbling stone to our religious faith. Just let him collect enough votes and he will be a sure-enough pretty man in this world. Men with no more personal looks than he have founded all of our great religions. After all, the cradle of a creed is no Hollywood casting office.

So, having looked at the subject from many sides, studied beliefs by word of mouth and then as they fit into great rigid forms, I find I know a great deal about form, but little or nothing about the mysteries I sought as a child. As the ancient tent-maker said, I have come out of the same door wherein I went.

But certain things have seemed to me to be true as I heard the tongues of those who had speech, and listened at the lips of books. It seems to me to be true that heavens are placed in the sky because it is the unreachable. The unreachable and therefore the unknowable always seem divine—hence, religion. People need religion because the great masses fear life and its consequences. Its responsibilities weigh heavy. Feeling a weakness in the face of great forces, men seek an alliance with omnipotence to bolster up their feeling of weakness, even though the omnipotence they rely upon is a creature of their own minds. It gives them a feeling of security. Strong, self-determining men are notorious for their lack of reverence. Constantine, having converted millions to Christianity by the sword, himself refused the consolation of Christ until his last hour. Some say not even then.

As for me, I do not pretend to read God's mind. If He has a plan of the Universe worked out to the smallest detail, it would be folly for me to presume to get down on my knees

and attempt to revise it. That, to me, seems the highest form of sacrilege. So I do not pray. I accept the means at my disposal for working out my destiny. It seems to me that I have been given a mind and will-power for that very purpose. I do not expect God to single me out and grant me advantages over my fellow men. Prayer is for those who need it. Prayer seems to me a cry of weakness, and an attempt to avoid, by trickery, the rules of the game as laid down. I do not choose to admit weakness. I accept the challenge of responsibility. Life, as it is, does not frighten me, since I have made my peace with the universe as I find it, and bow to its laws. The ever-sleepless sea in its bed, crying out "how long?" to Time; million-formed and never motionless flame; the contemplation of these two aspects alone, affords me sufficient food for ten spans of my expected lifetime. It seems to me that organized creeds are collections of words around a wish. I feel no need for such. However, I would not, by word or deed, attempt to deprive another of the consolation it affords. It is simply not for me. Somebody else may have my rapturous glance at the archangels. The springing of the yellow line of morning out of the misty deep of dawn, is glory enough for me. I know that nothing is destructible; things merely change forms. When the consciousness we know as life ceases, I know that I shall still be part and parcel of the world. I was a part before the sun rolled into shape and burst forth in the glory of change. I was, when the earth was hurled out from its fiery rim. I shall return with the earth to Father Sun, and still exist in substance when the sun has lost its fire, and disintegrated in infinity to perhaps become a part of the whirling rubble in space. Why fear? The stuff of my being is matter, ever changing, ever moving, but never lost; so what need of denominations and creeds to deny myself the comfort of all my fellow men? The wide belt of the universe has no need for finger-rings. I am one with the infinite and need no other assurance.

CHAPTER 16

LOOKING THINGS OVER

Well, that is the way things stand up to now. I can look back and see sharp shadows, high lights, and smudgy inbetweens. I have been in Sorrow's kitchen and licked out all the pots. Then I have stood on the peaky mountain wrappen in rainbows, with a harp and a sword in my hands.

What I had to swallow in the kitchen has not made me less glad to have lived, nor made me want to low-rate the human race, nor any whole sections of it. I take no refuge from myself in bitterness. To me, bitterness is the under-arm odor of wishful weakness. It is the graceless acknowledgment of defeat. I have no urge to make any concessions like that to the world as yet. I might be like that some day, but I doubt it. I am in the struggle with the sword in my hands, and I don't intend to run until you run me. So why give off the smell of something dead under the house while I am still in there tussling with my sword in my hand?

If tough breaks have not soured me, neither have my glory-moments caused me to build any altars to myself where I can burn incense before God's best job of work. My sense of

humor will always stand in the way of my seeing myself, my family, my race or my nation as the whole intent of the universe. When I see what we really are like, I know that God is too great an artist for we folks on my side of the creek to be all of His best works. Some of His finest touches are among us, without doubt, but some more of His masterpieces are among those folks who live over the creek.

I see too, that while we all talk about justice more than any other quality on earth, there is no such thing as justice in the absolute in the world. We are too human to conceive of it. We all want the breaks, and what seems just to us is something that favors our wishes. If we did not feel that way, there would be no monuments to conquerors in our high places. It is obvious that the successful warrior is great to us because he went and took things from somebody else that we could use, and made the vanquished pay dearly for keeping it from us so long. To us, our man-of-arms is almost divine in that he seized good things from folks who could not appreciate them (well, not like we could, anyway) and brought them where they belonged. Nobody wants to hear anything about the side of the conquered. Any remarks from him is rebellion. This attitude does not arise out of studied cruelty, but out of the human bent that makes us feel that the man who wants the same thing we want, must be a crook and needs a good killing. "Look at the miserable creature!" we shout in justification. "Too weak to hold what we want!"

So looking back and forth in history and around the temporary scene, I do not visualize the moon dripping down in blood, nor the sun batting his fiery eyes and laying down in the cradle of eternity to rock himself into sleep and slumber at instances of human self-bias. I know that the sun and the moon must be used to sights like that by now. I too yearn for universal justice, but how to bring it about is another thing. It is such a complicated thing, for justice, like beauty is in the eye of the beholder. There is universal agreement of the principle, but the application brings on the fight. Oh, for some disinterested party to pass on things! Somebody will hurry to

tell me that we voted God to the bench for that. But the lawyers who interpret His opinions, make His decisions sound just like they made them up themselves. Being an idealist, I too wish that the world was better than I am. Like all the rest of my fellow men, I don't want to live around people with no more principles than I have. My inner fineness is continually outraged at finding that the world is a whole family of Hurstons.

Seeing these things, I have come to the point by trying to make the day at hand a positive thing, and realizing the uselessness of gloominess.

Therefore, I see nothing but futility in looking back over my shoulder in rebuke at the grave of some white man who has been dead too long to talk about. That is just what I would be doing in trying to fix the blame for the dark days of slavery and the Reconstruction. From what I can learn, it was sad. Certainly. But my ancestors who lived and died in it are dead. The white men who profited by their labor and lives are dead also. I have no personal memory of those times, nor no responsibility for them. Neither has the grandson of the man who held my folks. So I see no need in button-holing that grandson like the Ancient Mariner did the wedding guest and calling for the High Sheriff to put him under arrest.

I am not so stupid as to think that I would be bringing this descendant of a slave-owner any news. He has heard just as much about the thing as I have. I am not so humorless as to visualize this grandson falling out on the sidewalk before me, and throwing an acre of fits in remorse because his old folks held slaves. No, indeed! If it happened to be a fine day and he had had a nice breakfast, he might stop and answer me like this:

"In the first place, I was not able to get any better view of social conditions from my grandmother's womb than you could from your grandmother's. Let us say for the sake of argument that I detest the institution of slavery and all that it implied, just as much as you do. You must admit that I was no more powerful to do anything about it in my unborn state than

229

you were in yours. Why fix your eyes on me? I respectfully refer you to my ancestors, and bid you a good day."

If I still lingered before him, he might answer me further by asking questions like this:

"Are you so simple as to assume that the Big Surrender (Note: The South, both black and white speak of Lee's surrender to Grant as the Big Surrender) banished the concept of human slavery from the earth? What is the principle of slavery? Only the literal buying and selling of human flesh on the block? That was only an outside symbol. Real slavery is couched in the desire and the efforts of any man or community to live and advance their interests at the expense of the lives and interests of others. All of the outward signs come out of that. Do you not realize that the power, prestige and prosperity of the greatest nations on earth rests on colonies and sources of raw materials? Why else are great wars waged? If you have not thought, then why waste up time with your vapid accusations? If you have, then why single *me* out?" And like Pilate, he will light a cigar, and stroll on off without waiting for an answer.

Anticipating such an answer, I have no intention of wasting my time beating on old graves with a club. I know that I cannot pry aloose the clutching hand of Time, so I will turn all my thoughts and energies on the present. I will settle for from now on.

And why not? For me to pretend that I am Old Black Joe and waste my time on his problems, would be just as ridiculous as for the government of Winston Churchill to bill the Duke of Normandy the first of every month, or for the Jews to hang around the pyramids trying to picket Old Pharaoh. While I have a handkerchief over my eyes crying over the landing of the first slaves in 1619, I might miss something swell that is going on in 1942. Furthermore, if somebody were to consider my grandmother's ungranted wishes, and give *me* what *she* wanted, I would be too put out for words.

What do I want, then? I will tell you in a parable. A Negro deacon was down on his knees praying at a wake held for a

230

sister who had died that day. He had his eyes closed and was going great guns, when he noticed that he was not getting anymore "amens" from the rest. He opened his eyes and saw that everybody else was gone except himself and the dead woman. Then he saw the reason. The supposedly dead woman was trying to sit up. He bolted for the door himself, but it slammed shut so quickly that it caught his flying coat-tails and held him sort of static. "Oh, no, Gabriel!" the deacon shouted, "dat ain't no way for you to do. I can do my own running, but you got to 'low me the same chance as the rest."

I don't know any more about the future than you do. I hope that it will be full of work, because I have come to know by experience that work is the nearest thing to happiness that I can find. No matter what else I have among the things that humans want, I go to pieces in a short while if I do not work. What all my work shall be, I don't know that either, every hour being a stranger to you until you live it. I want a busy life, a just mind and a timely death.

But if I should live to be very old, I have laid plans for that so that it will not be too tiresome. So far, I have never used coffee, liquor, nor any form of stimulant. When I get old, and my joints and bones tell me about it, I can sit around and write for myself, if for nobody else, and read slowly and carefully the mysticism of the East, and re-read Spinoza with love and care. All the while my days can be a succession of coffee cups. Then when the sleeplessness of old age attacks me, I can have a likker bottle snug in my pantry and sip away and sleep. Get mellow and think kindly of the world. I think I can be like that because I have known the joy and pain of deep friendship. I have served and been served. I have made some good enemies for which I am not a bit sorry. I have loved unselfishly, and I have fondled hatred with the red-hot tongs of Hell. That's living.

I have no race prejudice of any kind. My kinfolks, and my "skinfolks" are dearly loved. My own circumference of every-day life is there. But I see their same virtues and vices everywhere I look. So I give you all my right hand of fellowship and

231

love, and hope for the same from you. In my eyesight, you lose nothing by not looking just like me. I will remember you all in my good thoughts, and I ask you kindly to do the same for me. Not only just me. You who play the zig-zag lightning of power over the world, with the grumbling thunder in your wake, think kindly of those who walk in the dust. And you who walk in humble places, think kindly too, of others. There has been no proof in the world so far that you would be less arrogant if you held the lever of power in your hands. Let us all be kissing-friends. Consider that with tolerance and patience, we godly demons may breed a noble world in a few hundred generations or so. Maybe all of us who do not have the good fortune to meet or meet again, in this world, will meet at a barbecue.

APPENDIX
TO
DUST TRACKS ON A ROAD

"MY PEOPLE, MY PEOPLE!"

My People, My People!" This very minute, nations of people are moaning it and shaking their heads with a sigh. Thousands and millions of people are uttering it in different parts of the globe. Differences of geography and language make differences in sound, that's all. The sentiment is the same. Yet and still it is a private wail, sacred to my people.

Not that the expression is hard to hear. It is being thrown around with freedom. It is the interpretation that is difficult. No doubt hundreds of outsiders standing around have heard it often enough, but only those who have friended with us like Carl Van Vechten know what it means.

Which ever way you go to describe it—the cry, the sigh, the wail, the groaning grin or grinning groan of "My People, My People!" bursts from us when we see sights that bring on despair.

Say that a brown young woman, fresh from the classic halls of Barnard College and escorted by a black boy from Yale, enters the subway at 50th street. They are well-dressed, well-mannered and good to look at. The eyes of the entire coach agree on that. They are returning from a concert by Marian Anderson and are still vibrating from her glowing tones. They are saying happy things about the tribute the huge white audi-

235

ence paid her genius and her arts. Oh yes, they say, "the Race is going to amount to something after all. Definitely! Look at George W. Carver and Ernest Just and Abram Harris, and Barthe is getting on right well with his sculpture and E. Simms Campbell is holding his own on *Esquire* and oh yes, Charles S. Johnson isn't doing so badly either. Paul Robeson, E. Franklin Frazier, Roland Hayes, well you just take them for granted. There is hope indeed for the Race."

By that time the train pulls into 72nd street. Two scabby-looking Negroes come scrambling into the coach. The coach is not full. There are plenty of seats, but no matter how many vacant seats there are, no other place will do, except side by side with the Yale-Barnard couple. No, indeed! Being dirty and smelly, do they keep quiet otherwise? A thousand times, No! They woof, bookoo, broadcast and otherwise distriminate from one end of the coach to the other. They consider it a golden opportunity to put on a show. Everybody in the coach being new to them, they naturally have not heard about the way one of the pair beat his woman on Lenox Avenue. Therefore they must be told in great detail what led up to the fracas, how many teeth he knocked out during the fight, and what happened after. His partner is right there, isn't he? Well, all right now. He's in the conversation too, so he must talk out of his mouth and let the coach know just how he fixed *his* woman up when she tried that same on *him.*

Barnard and Yale sit there and dwindle and dwindle. They do not look around the coach to see what is in the faces of the white passengers. They know too well what is there. Some are grinning from the heel up and some are stonily quiet. But both kinds are thinking "That's just like a Negro." Not just like *some* Negroes, mind you, No, like all. Only difference is some Negroes are better dressed. Feeling all of this like rock-salt under the skin, Yale and Barnard shake their heads and moan "My People, My People!"

Maybe at the other end of the coach another couple are saying the same thing but with a different emotion. They say it with a chuckle. They have enjoyed the show, and they are

236

saying in the same tone of voice that a proud father uses when he boasts to others about that bad little boy of his at home. "Mischievous, into everything, beats up all the kids in the neighborhood. Don't know what I'm going to do with the little rascal." That's the way some folks say the thing.

Certain of My People have come to dread railway day coaches for this same reason. They dread such scenes more than they do the dirty upholstery and other inconveniences of a Jim Crow coach. They detest the forced grouping. The railroad company feels "you are all colored aren't you? So why not all together? If you are not all alike, *that's your own fault.* Once upon a time you were all alike. You had no business to change. If you are not that way, then it's just too bad. You're supposed to be like that." So when sensitive souls are forced to travel that way they sit there numb and when some free soul takes off his shoes and socks, they mutter "My race but not My taste." When somebody else eats fried fish, bananas and a mess of peanuts and throws all the leavings on the floor, they gasp "My skinfolks but not my kinfolks." And sadly over all, they keep sighing "My People, My People!"

Who are My People? I would say all those hosts spoken of as Negroes, Colored folks, Aunt Hagar's chillum, the brother in black, Race men and women, and My People. They range in color from Walter White, white through high yaller, yaller, Punkin color, high brown, vaseline brown, seal brown, black, smooth black, dusty black, rusty black, coal black, lam black and damn black. My people there in the south of the world, the east of the world, in the west and even some few in the north. Still and all, you can't just point out my people by skin color.

White people have come running to me with a deep wrinkle between the eyes asking me things. They have heard talk going around about this passing, so they are trying to get some information so they can know. So since I have been asked, that gives me leave to talk right out of my mouth.

In the first place, this passing business works both ways. All the passing is not passing for white. We have white folks

237

among us passing for colored. They just happened to be born with a tinge of brown in the skin and took up being colored as a profession. Take James Weldon Johnson for instance.

There's a man white enough to suit Hitler and he's been passing for colored for years.

Now, don't get the idea that he is not welcome among us. He certainly is. He has more than paid his way. But he just is not a Negro. You take a look at him and ask why I talk like that. But you know, I told you back there not to depend too much on skin. You'll certainly get mis-put on your road if you put too much weight on that. Look at James Weldon Johnson from head to foot, but don't let that skin color and that osko-bolic hair fool you. Watch him! Does he parade when he walks? No, James Weldon Johnson proceeds. Did anybody ever, *ever* see him grin? No, he smiles. He couldn't give a grin if he tried. He can't even Uncle Tom. Not that I complain of "Tomming" if it's done right.

"Tomming" is not an aggressive act, it is true, but it has its uses like feinting in the prize ring. But James Weldon Johnson can't Tom. He has been seen trying it, but it was sad. Let him look around at some of the other large Negroes and hand over the dice.

No, I never expect to see James Weldon Johnson a success in the strictly Negro Arts, but I would not be at all surprised to see him crowned. The man is just full of that old monarch material. If some day I looked out of my window on Seventh Avenue and saw him in an ermine robe and a great procession going to the Cathedral of St. John the Divine to be crowned I wouldn't be a bit surprised. Maybe he'd make a mighty fine king at that. He's tried all he knew how to pass for colored, but he just hasn't made it. His own brother is scared in his presence. He bows and scrapes and calls him The Duke.

So now you say "Well, if you can't tell who My People are by skin color, how are you going to know?" There's more ways than one of telling, and I'm going to point them out right now.

Wait until you see a congregation of more than two dark complected people. If they can't agree on a single, solitary thing, then you can go off satisfied. Those are My People. It's just against nature for us to agree with each other. We not only refuse to agree, we'll get mad and fight about it. *But only each other!* Anybody else can cool us off right now. We fly hot quick, but we are easily cooled when we find out the person who made us mad is not another Negro.

There is the folk-tale of the white man who hired five men to take hold of a rope to pull up a cement block. They caught hold and gave a yank and the little stone flew way up to the pulley the first time. The men looked at one 'nother in surprise and so one of them said to the bossman: "Boss, how come you hire all of us to pull up that one little piece of rock? One man could do that by hisself." "Yeah, I know it," the bossman told him, "but I just wanted to see five Negroes pulling together once."

Then there is the story of the man who was called on to pray. He got down and he said "Oh Lord, I want to ask something, but I know you can't do it. I just *know* you can't do it." Then he took a long pause.

Somebody got restless and said "Go ahead and ask Him. That's God you talking to. He can do anything."

The man who was praying said "I know He is supposed to do all things, but this what I wants to ask. . . ."

"Aw go on and ask Him. God A'Mighty can do anything. Go on, brother, and ask Him and finish up your prayer."

"Well, alright, I'll ask Him. O Lord, I'm asking you because they tell me to go ahead. I'm asking you something, but I just know you can't do it. I just *know* you can't do it but I'll just ask you. Lord, I'm asking you to bring my people together, but I *know* you can't do it, Lord. Amen."

Maybe the Lord *can* do it, but he hasn't done it yet.

It do say in the Bible that the Lord started the disturbance himself. It was the sons of Ham who built the first big city and

239

started the tower of Babel. They were singing and building their way to heaven when the Lord came down and confused their tongues. We haven't built no more towers and things like that but we still got the confusion. The other part about the building and what not may be just a folk-tale, but we've got proof about the tongue power.

So when you find a set of folks who won't agree on a thing, those are My People.

B

If you have your doubts, go and listen to the man. If he hunts for six big words where one little one would do, that's My People. If he can't find that big word he's feeling for, he is going to make a new one. But somehow or other that new-made word fits the thing it was made for. Sounds good, too. Take for instance the time when the man needed the word *slander* and he didn't know it. He just made the word distrimi-nate and anybody that heard the word would know what he meant. "Don't distriminate de woman." Somebody didn't know the word total nor entire so they made bodacious. Then there's asterperious, and so on. When you find a man chewing up the dictionary and spitting out language, that's My People.

C

If you still have doubts, study the man and watch his ways. See if all of him fits into today. If he has no memory of yesterday, nor no concept of tomorrow, then he is My People. There is no tomorrow in the man. He mentions the word plentiful and often. But there is no real belief in a day that is not here and present. For him to believe in a tomorrow would mean an obligation to consequences. There is no sense of conse-quences. Else he is not My People.

240

D

If you are still not satisfied, put down two piles of money. Do not leave less than a thousand dollars in one pile and do not leave more than a dollar and a quarter in the other. Expose these two sums where they are equally easy to take. If he takes the thousand dollars he is not My People. That is settled. My People never steal more than a dollar and a quarter. This test is one of the strongest.

E

But the proof positive is the recognition of the monkey as our brother. No matter where you find the brother in black he is telling a story about his brother the monkey. Different languages and geography, but that same tenderness. There is recognition everywhere of the monkey as a brother. Whenever we want to poke a little fun at ourselves, we throw the cloak of our short-comings over the monkey. This is the American classic:

The monkey was playing in the road one day and a big new Cadillac come down the road full of white people. The driver saw the monkey and drove sort of to one side and went on. Several more cars came by and never troubled the monkey at all. Way after while here come long a Ford car full of Colored folks. The driver was showing off, washing his foot in the gas tank. The car could do 60 and he was doing 70 (he had the accelerator down to the floor). Instead of slowing up when he saw the monkey, he got faster and tried to run over him. The monkey just barely escaped by jumping way to one side. The Negro hollered at him and said, "Why de hell don't you git out of de way? You see me washing my feet in the gas tank! I ought to kill you." By that time they went on down the road. The monkey sat there and shook his head and said "My People, My People!" However, Georgette Harvey, that superb actress, said that she had spoken with our brother the monkey recently and he does not say "My People" any more. She says

the last monkey she talked with was saying "Those People, Those People!" Maybe he done quit the Race. Walked out cold on the family.

<center>F</center>

If you look at a man and mistrust your eyes, do something and see if he will imitate you right away. If he does, that's My People. We love to imitate. We would rather do a good imitation than any amount of something original. Nothing is half so good as something that is just like something else. And no title is so coveted as the "black this or that." Roland Hayes is right white folksy that way. He has pointedly refused the title of "The Black Caruso." It's got to be Roland Hayes or nothing. But he is exceptional that way. We have Black Patti, Black Yankees, Black Giants. Rose McClendon was referred to time and again as the Black Barrymore. Why we even had a Black Dillinger! He was the Negro that Dillinger carried out of Crown Point when he made his famous wooden gun escape. Of course he didn't last but a day or two after he got back to Detroit or Buffalo, or where ever he was before the police gave him a black-out. He could have kept quiet and lived a long time perhaps, but he would rather risk dying than to miss wearing his title. As far as he was able, he was old Dillinger himself. Julian, the parachute jumper, risked his life by falling in the East River pretending he knew how to run an aeroplane like Lindbergh to gain his title of Black Eagle. Lindbergh landed in Paris and Julian landed in New-York harbor, but, anyhow, he flew some.

What did Haiti ever do to make the world glad it happened? Well, they held a black revolution right behind the white one in France. And now their Senators and Deputies go around looking like cartoons of French Ministers and Senators in spade whiskers and other goatee forms. They wave their hands and arms and explain about their latin temperaments, but it is not impressive. If you didn't hear them talk, in a bunch, they

<center>242</center>

could be Adam Powell's Abbysinia Baptist Church turning out and nobody would know the difference.

In Jamaica, the various degrees of Negroes put on some outward show to impress you that no matter what your eyes tell you, that they are really white folks—*white* English folks inside. The moment you meet a mulatto there he makes an opportunity to tell you who his father was. You are bound to hear a lot about that Englishman or that Scot. But never a word about the black mama. It is as if she didn't exist. Had never existed at all. You get the impression that Jamaica is the place where roosters lay eggs. That these Englishmen come there and without benefit of females they just scratch out a nest and lay an egg that hatches out a Jamaican.

As badly as the Ethiopians hated to part with Haile Selassie and freedom, it must be some comfort to have Mussolini for a model. By now, all the Rasses and other big shots are tootching out their lips ferociously, gritting their teeth and otherwise making faces like Il Duce. And I'll bet you a fat man against sweet back that all the little boy Ethiopians are doing a mean pouter pigeon strut around Addis Ababa.

And right here in these United States, we don't miss doing a thing that the white folks do, possible or impossible. Education, Sports, keeping up with the Joneses and the whole shebang. The unanswerable retort to criticism is "The white folks do it, don't they?" In Mobile, Alabama, I saw the Millionaires' ball. A man who roomed in the same house with me got me a ticket and carried me to a seat in the balcony. He warned me not to come down on the dance floor until the first dance was over. The Millionaires and their lady friends would want the floor all to themselves for that dance. It was very special. I was duly impressed, I tell you.

The ball opened with music. A fairly good dance orchestra was on the job. That first dance, exclusively for the Millionaires, was announced and each Millionaire and his lady friend were announced by name as they took the floor.

"John D. Rockefeller, dancing with Miss Selma Jones!" I looked down and out walked Mr. Rockefeller in a pair of

white wool pants with a black pin stripe, pink silk shirt without a coat because it was summer time. Ordinarily, Mr. Rockefeller delivered hats for a millinery shop, but not tonight.

Commodore Vanderbilt was announced and took the floor. The Commodore was so thin in his ice-cream pants that he just had no behind at all. Mr. Ford pranced out with his lady doing a hot cut-out. J. P. Morgan entered doing a mean black-bottom, and so on. Also each Millionaire presented his lady friend with a five-dollar gold piece after the dance. It was reasoned the Millionaires would have done the same for the same pleasure.

G

Last but not least, My People love a show. We love to act more than we love to see acting done. We love to look at them and we love to put them on, and we love audiences when we get to specifying. That's why some of us take advantage of trains and other public places like dance halls and picnics. We just love to dramatize.

Now you've been told, so you ought to know. But maybe, after all the Negro doesn't really exist. What we think is a race is detached moods and phases of other people walking around. What we have been talking about might not exist at all. Could be the shade patterns of something else thrown on the ground—other folks, seen in shadow. And even if we do exist it's all an accident anyway. God made everybody else's color. We took ours by mistake. The way the old folks tell it, it was like this, you see.

God didn't make people all of a sudden. He made folks by degrees. First he stomped out the clay and then he cut out the patterns and propped 'em against the fence to dry. Then after they was dry, He took and blowed the breath of life into 'em and sent 'em on off. Next day He told everybody to come up and get toe-nails. So everybody come and got their toe-nails and finger-nails and went on off. Another time He said for everybody to come get their Nose and Mouth because He

244

was giving 'em out that day. So everybody come got noses and mouths and went on off. Kept on like that till folks had everything but their color. So one day God called everybody up and said, "Now I want everybody around the throne at seven o'clock sharp tomorrow morning. I'm going to give out color tomorrow morning and I want everybody here on time. I got a lot more creating to do and I want to give out this color and be through with that."

Seven o'clock next morning God was sitting on His throne with His great crown on His head. He looked North, He looked East, He looked West and He looked Australia and blazing worlds was falling off of His teeth. After a while He looked down from His high towers of elevation and considered the Multitudes in front of Him. He looked to His left and said, "Youse red people!" so they all turned red and said "Thank you, God" and they went on off. He looked at the next host and said, "Youse yellow people!" and they got yellow and said "Thank you, God" and they went on off. Then He looked at the next multitude and said, "Youse white people" and they got white and told Him, "Thank you, God" and they went on off. God looked on His other hand and said, "Gabriel, look like I miss some hosts." Gabriel looked all around and said, "Yes, sir, several multitudes ain't here." "Well," God told him, "you go hunt 'em up and tell 'em I say they better come quick if they want any color. Fool with me and I won't give out no more." So Gabriel went round everywhere hunting till way after while he found the lost multitudes down by the Sea of Life asleep under a tree. So he told them they better hurry if they wanted any color. God wasn't going to wait on them much longer. So everybody jumped up and went running up to the throne. When the first ones got there they couldn't stop because the ones behind kept on pushing and shoving. They kept on until the throne was careening way over to one side. So God hollered at 'em "Get back! Get back!!" But they thought He said "Git black!" So they got black and just kept the thing agoing.

245

So according to that, we are no race. We are just a collection
of people who overslept our time and got caught in the draft.

ZORA NEALE HURSTON
July 2, 1937
Port-au-Prince, Haiti.

SEEING THE WORLD
AS IT IS

Thing lies forever in her birthing-bed and glories. But hungry Time squats beside her couch and waits. His frame was made out of emptiness, and his mouth set wide for prey. Mystery is his oldest son, and power is his portion.

That brings me before the unlived hour, that first mystery of the Universe with its unknown face and reflecting back. For it was said on the day of first sayings that Time should speak backward over his shoulder, and none should see his face, so scornful is he of the creatures of Thing.

What the faceless years will do to me, I do not know. I see Time's footprints, and I gaze into his reflections. My knees have dragged the basement of Hell and I have been in Sorrow's Kitchen, and it has seemed to me that I have licked out all the pots. The winters have been and my soul-stuff has lain mute like a plain while the herds of happenings thundered across my breast. In these times there were deep chasms in me which had forgotten their memory of the sun.

But time has his beneficent moods. He has commanded some servant-moments to transport me to high towers of elevation so that I might look out on the breadth of things. This is a privilege granted to a servant of many hours, but a master

of few, from the master of a trillion billion hours and the servant of none.

In those moments I have seen that it is futile for me to seek the face of, and fear, an accusing God withdrawn somewhere beyond the stars in space. I myself live upon a star, and I can be satisfied with the millions of assurances of deity about me. If I have not felt the divinity of man in his cults, I have found it in his works. When I lift my eyes to the towering structures of Manhattan, and look upon the mighty tunnels and bridges of the world, I know that my search is over, and that I can depart in peace. For my soul tells me, "Truly this is the son of God. The rocks and the winds, the tides and the hills are his servants. If he talks in finger-rings, he works in horizons which dwarf the equator. His works are as noble as his words are foolish."

I found that I had no need of either class or race prejudice, those scourges of humanity. The solace of easy generalization was taken from me, but I received the richer gift of individualism. When I have been made to suffer or when I have been made happy by others, I have known that individuals were responsible for that, and not races. All clumps of people turn out to be individuals on close inspection.

This has called for a huge cutting of dead wood on my part. From my earliest remembrance, I heard the phrases, "Race Problem," "Race Pride," "Race Man or Woman," "Race Solidarity," "Race Consciousness," "Race Leader," and the like. It was a point of pride to be pointed out as a "Race Man." And to say to one, "Why, you are not a race man," was low-rating a person. Of course these phrases were merely sounding syllables to me as a child. Then the time came when I thought they meant something. I cannot say that they ever really came clear in my mind, but they probably were as clear to me as they were to the great multitude who uttered them. Now, they mean nothing to me again. At least nothing that I want to feel.

There could be something wrong with me because I see Negroes neither better nor worse than any other race. Race

248

pride is a luxury I cannot afford. There are too many implications behind the term. Now, suppose a Negro does something really magnificent, and I glory, not in the benefit to mankind, but in the fact that the doer was a Negro. Must I not also go hang my head in shame when a member of my race does something execrable? If I glory, then the obligation is laid upon me to blush also. I *do* glory when a Negro does something fine, I gloat because he or she has done a fine thing, but not because he was a Negro. That is incidental and accidental. It is the human achievement which I honor. I execrate a foul act of a Negro but again not on the grounds that the doer was a Negro, but because it was foul. A member of my race just happened to be the fouler of humanity. In other words, I know that I cannot accept responsibility for thirteen million people. Every tub must sit on its own bottom regardless. So "Race Pride" in me had to go. And anyway, why should I be proud to be a Negro? Why should anybody be proud to be white? Or yellow? Or red? After all, the word "race" is a loose classification of physical characteristics. It tells nothing about the insides of people. Pointing at achievements tells nothing either. Races have never done anything. What seems race achievement is the work of individuals. The white race did not go into a laboratory and invent incandescent light. That was Edison. The Jews did not work out Relativity. That was Einstein. The Negroes did not find out the inner secrets of peanuts and sweet potatoes, nor the secret of the development of the egg. That was Carver and Just. If you are under the impression that every white man is an Edison, just look around a bit. If you have the idea that every Negro is a Carver, you had better take off plenty of time to do your searching.

No, instead of Race Pride being a virtue, it is a sapping vice. It has caused more suffering in the world than religious opinion, and that is saying a lot.

"Race Conscious" is about the same as Race Pride in meaning. But, granting the shade of difference, all you say for it is, "Be continually conscious of what race you belong to so you can be proud." That is the effect of the thing. But what use

is that? I don't care which race you belong to. If you are only one quarter honest in your judgment, you can seldom be proud. Why waste time keeping conscious of your physical aspects? What the world is crying and dying for at this moment is less race consciousness. The human race would blot itself out entirely if it had any more. It is a deadly explosive on the tongues of men. I choose to forget it.

This Race Problem business, now. I have asked many well-educated people of both races to tell me what the problem is. They look startled at first. Then I can see them scratching around inside themselves hunting for the meaning of the words which they have used with so much glibness and unc-tion. I have never had an answer that was an answer, so I have had to make up my own. Since there is no fundamental con-flict, since there is no solid reason why the blacks and the whites cannot live in one nation in perfect harmony, the only thing in the way of it is Race Pride and Race Consciousness on both sides. A bear has been grabbed by the tail. The captor and the captured are walking around a tree snarling at each other. The man is scared to turn the bear loose, and his hand-hold is slipping. The bear wants to go on about his business, but he feels that something must be done about that tail-hold. So they just keep on following each other around the tree.

So Race Pride and Race Consciousness seem to me to be not only fallacious, but a thing to be abhorred. It is the root of misunderstanding and hence misery and injustice. I cannot, with logic cry against it in others and wallow in it myself. The only satisfaction to be gained from it anyway is, "I ain't noth-ing, my folks ain't nothing, but that makes no difference at all. I belong to such-and-such a race." Poor nourishment accord-ing to my notion. Mighty little to chew on. You have to season it awfully high with egotism to make it tasty.

Priding yourself on your physical make up, something over which you have no control, is just another sign that the human cuss is determined not to be grateful. He gives himself a big hand on the way he looks and lets on that he arranged it all himself. God got suspicious that he was going to be like that

250

before He made him, and that is why Old Maker caught up on all of His creating before He made Man. He knew that if Man had seen how He did it, just as soon as a woman came along to listen to him, Man would have been saying, "See that old striped tiger over there? *I* made him. Turned him out one morning before breakfast." And so on until there would not have been a thing in Heaven or earth that he didn't take credit for. So God did the only thing he could to narrow down the field for boasting. He made him late and kept him dumb.

And how can Race Solidarity be possible in a nation made up of as many elements as these United States? It could result in nothing short of chaos. The fate of each and every group is bound up with the others. Individual ability in any group must function for all the rest. National disaster touches us all. There is no escape in grouping. And in practice there can be no sharp lines drawn, because the interest of every individual in any racial group is not identical with the others. Section, locality, self-interest, special fitness, and the like set one group of Anglo-Saxons, Jews, and Negroes against another set of Anglo-Saxons, Jews, and Negroes. We are influenced by a pain in the pocket just like everybody else. During the Civil War Negroes fought in the Confederate Army because many Negroes were themselves slave-owners, and were just as mad at Lincoln as anybody else in the South. Anybody who goes before a body and purports to plead for what "The Negro" wants, is a liar and knows it. Negroes want a variety of things and many of them diametrically opposed. There is no single Negro nor no single organization which can carry the thirteen million in any direction. Even Joe Louis can't do it, but he comes nearer to it than anyone else at present.

And why should Negroes be united? Nobody else in America is. If it were true, then one of two other things would be true. One, that they were united on what the white people are united on, and it would take a God to tell what that is; and be moving towards complete and immediate assimilation. Or we would be united on something specially Negroid, and that would lead towards a hard black knot in the body politic which

would be impossible of place in the nation. All of the upper class Negroes certainly want political and economic equality. That is the most universal thing I can pin down.

Negroes are just like anybody else. Some soar. Some plod ahead. Some just make a mess and step back in it—like the rest of America and the world. So Racial Solidarity is a fiction and always will be. Therefore, I have lifted the word out of my mouth.

A Race Man is somebody, not necessarily able, who places his race before all else. He says he will buy everything from a Negro merchant as far as possible, support all "race" institutions and movements and so on. The only thing that keeps this from working is that it is impossible to form a nation within a nation. He makes spurts and jerks at it, but every day he is forced away from it by necessity. He finds that he can neither make money nor spend money in a restricted orbit. He is part of the national economy. But he can give the idea plenty of talk. He springs to arms over such things as the title of Carl Van Vechten's book, *Nigger Heaven,* or Will Rogers saying over the radio that most of the cowboy songs were nothing more than adaptations of "nigger tunes." He does this because he feels that he is defending his race. Sometimes the causes are just, and sometimes they are ridiculous. His zeal is honest enough; it is merely a lack of analysis that leads him into error.

As I said before, the Race Leader is a fiction that is good only at the political trough. But it is not nearly so good as it used to be. The white political leaders have found out more or less that they cannot deliver wholesale. Many of them are successful in a way, but not in any great, big, plushy way. The politician may try ever so hard, but, if people won't follow, he just can't lead. Being an American, I am just like the rest of the Yankees, the Westerners, the Southerners, the Negroes, the Irish, the Indians, and the Jews. I don't lead well either. Don't just tell me what to do. Tell me what is being contemplated and let me help figure on the bill. That is my idea, and I am going to stick to it. Negroes are so much like the rest of

America that they not only question what is put before them, but they have got so they order something else besides gin at the bars, which is certainly a sign of something. So I have thrown over the idea of Race Leadership, too.

I know that there is race prejudice, not only in America, but also wherever two races meet together in numbers. I have met it in the flesh, and I have found out that it is never all on one side, either. I do not give it heart room because it seems to me to be the last refuge of the weak. From what little I have been able to learn, I know that goodness, ability, vice, and dumbness know nothing about race lives or geography. I do not wish to close the frontiers of life upon my own self. I do not wish to deny myself the expansion of seeking into individual capabilities and depths by living in a space whose boundaries are race and nation. Lord, give my poor stammering tongue at least one taste of the whole round world, if you please, Sir.

And then I know so well that the people who make a boast of racial, class, or national prejudices do so out of a sense of incapability to which they refuse to give a voice. Instead they try to be ingenious by limiting competition. They are racial card-sharks trying to rig the game so that they cannot lose. Trying to stack the deck. If I choose to call these card-palmers poor sports, then the burden of proof is on them. I give the matter the corner of my eye and smile at the back-hand compliment, for I know that if I had been born where *they* were born, and they had been born where *I* was born, it is hardly likely that we ever would have met. So I smile and not bitterly, either. For I know that Equality is as you do it and not as you talk it. If you are better than I, you can tell me about it if you want to, but then again, show me so I can know. It is always good to be learning something. But if you never make me know it, I'll keep on questioning. I love to be in the presence of my superiors. If I don't catch on right away, crumble it up fine so I can handle it. And then again, if you can't *show* me your superiority, don't bother to bring the mess up, lest I merely rate you as a bully.

Since I wash myself of race pride and repudiate race solidar-

253

ity, by the same token I turn my back upon the past. I see no reason to keep my eyes fixed on the dark years of slavery and the Reconstruction. I am three generations removed from it, and therefore have no experience of the thing. From what I can learn, it was sad. No doubt America would have been better off if it never had been. But it was and there is no use in beating around the bush. Still, there seems to me to be nothing but futility in gazing backward over my shoulder and buking the grave of some white man who has been dead too long to talk about. Neither do I see any use in button-holing his grandson about it. The old man probably did cut some capers back there, and I'll bet you anything my old folks didn't like it. But the old man is dead. My old folks are dead. Let them wrestle all over Hell about it if they want to. That is their business. The present is upon me and that white man's grand-children as well. I have business with the grandson as of today. I want to get on with the business in hand. Since I cannot pry loose the clutching hand of time, I will settle for some influence on the present. It is ridiculous for me to make out that I'm Old Black Joe and waste my time rehashing his problems. That would be just as ridiculous as it would be for the Jews to hang around the pyramids trying to get a word with Old Cheops. Or for the English to be billing the Duke of Normandy the first of every month.

I am all for starting something brand new in co-operation with the present incumbent. If I don't get any co-operation, I am going to start something anyway. The world is not just going to stand still looking like a fool at a funeral if I can help it. Let's bring up right now and lay a hearing on it.

Standing on the watch-wall and looking, I no longer expect the millennium. It would be wishful thinking to be searching for justice in the absolute. People are not made so it will happen, because from all I can see, the world is a whole family of Hurstons. It has always been a family of Hurstons, so it is foolish to expect any justice untwisted by the selfish hand. Look into the Book of Books and it is not even there. The Old Testament is devoted to what was right and just from the

254

viewpoint of the Ancient Hebrews. All of their enemies were twenty-two carat evil. They, the Hebrews, were never aggressors. The Lord wanted His children to have a country full of big grapes and tall corn. Incidentally while they were getting it, they might as well get rid of some trashy tribes that He never did think much of, anyway. With all of its figs and things, Canaan was their destiny. God sent somebody especially to tell them about it. If the conquest looked like bloody rape to the Canaanites, that was because their evil ways would not let them see a point which was right under their nose. So you had to drive it in under the ribs. King David, who invented the "protection" racket in those days before he was saved by being made king, was a great hero. He only killed and pillaged to help out his own folks. He was a man after God's own heart, and was quite serviceable in helping God get rid of no-count rascals who were cluttering up the place.

The New Testament is not quite so frank but it is equally biased. Paul and the disciples set up a New Order in Palestine after the death of Jesus, but the Jews gave it nothing but their shoulder-blades. So now, the Orthodox Jew became a manifest enemy of right. To this day, the names of Pharisee and Sadducee are synonymous with hypocrite and crook to ninety-nine and a half percent of the Christian world. While in fact, the Pharisee was an order small in number, highly educated, well born, and clean living men whose mission was to guard the purity of the creed. The Sadducees were almost as lofty. Naturally in the turmoil of the times, they got embroiled in politics in the very nature of the form of their government, but so have both branches of Christianity.

Then there is the slaughter of the innocents by Herod. One thing strikes me curious about that slaughter. The unconverted Jews never seemed to have missed their babies. So Herod must have carefully selected babies from families who forty years later were going to turn Christian. He probably did not realize what a bad example he was setting for the new religionists. He could not have known that centuries later

Christians would themselves slaughter more innocents in one night than his soldiers ever saw.

Those Jews who would not accept Christianity look very bad in the New Testament. And two thousand years have gone by and all the Western World uses the sign of the Cross, but it is evident that the Jews are not the only ones who do not accept it. The Occident has never been christianized and never will be. It is an oriental concept which the sons of hammer-throwing Thor have no enzymes to digest. It calls for meekness, and the West is just not made meek. Instead of being proud to turn the other cheek, our boast is beating the other fellow to the punch.

We have even turned the Gospel of peace into a wrestle, we club each other over the head to prove who is the best missionary. Nature asserts itself. We can neither give up our platitudes nor our profits. The platitudes sound beautiful, but the profits feel like silk.

Popes and Prelates, Bishops and Elders have halted sermons on peace at the sound of battle and rushed out of their pulpits brandishing swords and screaming for blood in Jesus' name. The pews followed the pulpit in glee. So it is obvious that the Prince of Peace is nothing more than a symbol. He has been drafted into every army in the Occident. He must have a delegate behind every cannon. We have tangled with the soft and yielding thing for twenty long centuries without any more progress than letting the words take up around the house. We are moral enough, just not Christians. If we love meekness as we say, then Napoleon should be pictured in a nun's robe, Bismarck in a cassock and George Washington in a Gandhi diaper. The pedestals should read "These stones do honor to our meekest men. Their piety laid millions low. Praise the Lord!" The actual representation would reveal the confusion in our minds. According to our worship, Joe Louis rates a Cardinal's hat.

But back to Mahatma Gandhi. His application of Christian principles is causing us great distress. We want the people to hear about it from Greenland's icy mountains, to India's coral

strand, but we do wish that they would not lose their heads and carry the thing too far, like Gandhi does for instance. It is a bad thing for business.

No, actual justice is somewhere away off. We only see its flickering image here. Everybody has it on his tongue and nobody has it at heart. Take, for instance, the matter of conquest.

The Kings of Dahomey once marched up and down West Africa, butchering the aged and the helpless of the surrounding tribes and nations, and selling the able off into Western slavery. The Dahomans would have been outraged if anybody had said they were unjust. What could be more just? The profits were enormous. But they did feel that there was no more justice in the world when the French came in and conquered them. The French would have shrugged down the Pyramids if they had been told that they were not just. What could be fairer? The Germans have now conquered the French and the French wonder how those Germans can be so lacking in soul. But the Germans open their blue eyes in amazement. Why, nothing could be more reasonable and just. If the world cannot find pure justice among the Germans, they will never find it anywhere. If the French want to be unfair enough to begrudge them their little profit on the deal, it shows how narrow and mean-minded a Frenchman really can be.

There is no diffused light on anything international so that a comparatively whole scene may be observed. Light is sharply directed on one spot, leaving not only the greater part in darkness but also denying by implication that the great unlighted field exists. It is no longer profitable, with few exceptions, to ask people what they think, for you will be told what they wish, instead. Perhaps at no other period in the history of the world have people lived in such a dreamy state. People even waste time denouncing their enemies in open warfare for shooting back too hard, or too accurately. There is no attempt to be accurate as to truth, however. The whole idea is to be complimentary to one's self and keep alive the dream. The

257

other man's side commits gross butcheries. One's own side wins smashing victories.

Being human and a part of humanity, I like to think that my own nation is more just than any other in spite of the facts on hand. It makes me feel prouder and bigger to think that way. But now and then the embroidered hangings blow aside, and I am less exalted. I see that the high principles enunciated so throatedly are like the flowers in spring—they have nothing to do with the case. If my conclusions are in error, then the orators and copy-books were wrong to start off with. I should have been told in the very beginning that those were words to copy, but not to go by. But they didn't tell me that. They swore by jeepers and by joe that there were certain unshakable truths that no man nor nation could make out without.

There was the dignity of man. His inalienable rights were sacred. Man, noble man, had risen in his might and glory and had stamped out the vile institution of slavery. That is just what they said. But I know that the principle of human bondage has not yet vanished from the earth. I know that great nations are standing on it. I would not go so far as to deny that there has been no progress toward the concept of liberty. Already it has been agreed that the name of slavery is very bad. No civilized nation will use such a term anymore. Neither will they keep the business around the home. Life will be on a loftier level by operating at a distance and calling it acquiring sources of raw material, and keeping the market open. It has been decided also, that it is not cricket to enslave one's own kind. That is unspeakable tyranny.

But must a nation suffer from lack of prosperity and expansion by lofty concepts? Not at all! If a ruler can find a place way off where the people do not look like him, kill enough of them to convince the rest that they ought to support him with their lives and labor, that ruler is hailed as a great conqueror, and people build monuments to him. The very weapons he used are also honored. They picture him in unforgetting stone with the sacred tool of his conquest in his hand.

258

Democracy, like religion, never was designed to make our profits less.

Now, for instance, if the English people were to quarter troops in France, and force the French to work for them for forty-eight cents a week while they took more than a billion dollars a year out of France, the English would be Occidentally execrated. But actually, the British Government does just that in India, to the glory of the democratic way. They are hailed as not only great Empire builders, the English are extolled as leaders of civilization. And the very people who claim that it is a noble thing to die for freedom and democracy cry out in horror when they hear tell of a "revolt" in India. They even wax frothy if anyone points out the inconsistency of their morals. So this life as we know it is a great thing. It would have to be, to justify certain things.

I do not mean to single England out as something strange and different in the world. We, too, have our Marines in China. We, too, consider machine gun bullets good laxatives for heathens who get constipated with toxic ideas about a country of their own. If the patient dies from the treatment, it was not because the medicine was not good. We are positive of that. We have seen it work on other patients twice before it killed them and three times after. Then, too, no matter what the outcome, you have to give the doctor credit for trying.

The United States being the giant of the Western World, we have our responsibilities. The little Latin brother south of the border has been a trifle trying at times. Nobody doubts that he means to be a good neighbor. We know that his intentions are the best. It is only that he is so gay and fiesta-minded that he is liable to make arrangements that benefit nobody but himself. Not a selfish bone in his body, you know. Just too full of rumba. So it is our big brotherly duty to teach him right from wrong. He must be taught to share with big brother before big brother comes down and kicks his teeth in. A big *good* neighbor is a lovely thing to have. We are far too moral a people to allow poor Latin judgment to hinder good works.

But there is a geographical boundary to our principles.

They are not to leave the United States unless we take them ourselves. Japan's application of our principles to Asia is never to be sufficiently deplored. We are like the southern planter's bride when he kissed her the first time.

"Darling," she fretted, "do niggers hug and kiss like this?"

"Why, I reckon they do, honey. Fact is, I'm sure of it. Why do you ask?"

"You go right out and kill the last one of 'em tomorrow morning. Things like this is much too good for niggers."

Our indignation is more than justified. We Westerners composed that piece about trading in China with gunboats and cannons long decades ago. Japan is now plagiarizing in the most flagrant manner. We also wrote that song about keeping a whole hemisphere under your wing. Now the Nipponese are singing our song all over Asia. They are full of stuff and need a good working out. The only holdback to the thing is that they have copied our medicine chest. They are stocked up with the same steel pills and cannon plasters that Doctor Occident prescribes.

Mexico, the dear little papoose, has been on the sick list, too. Gangrene had set in in the upper limbs, so to speak, and amputation was the only thing which could save the patient. Even so, the patient malingered for a long time, and internal dosage had to be resorted to on occasion. The doctor is not sure that all of the germs have been eradicated from the system as yet, but, when the patient breaks out of the hospital, what can the doctor do?

In great and far-sighted magnanimity, no cases have been overlooked. The African tribesmen were saved from the stuffiness of overweening pride and property just in the nick of time.

Looking at all these things, I am driven to the conclusion that democracy is a wonderful thing, but too powerful to be trusted in any but purely occidental hands. Asia and Africa should know about it. They should die for it in defense of its originators, but they must not use it themselves.

All around me, bitter tears are being shed over the fate of

Holland, Belgium, France, and England. I must confess to being a little dry around the eyes. I hear people shaking with shudders at the thought of Germany collecting taxes in Holland. I have not heard a word against Holland collecting one twelfth of poor people's wages in Asia. That makes the ruling families in Holland very rich, as they should be. What happens to the poor Javanese and Balinese is unimportant; Hitler's crime is that he is actually doing a thing like that to his own kind. That is international cannibalism and should be stopped. He is a bandit. That is true, but that is not what is held against him. He is muscling in on well-established mobs. Give him credit. He cased some joints away off in Africa and Asia, but the big mobs already had them paying protection money and warned him to stay away. The only way he can climb out of the punk class is to high-jack the load and that is just what he is doing. President Roosevelt could extend his four freedoms to some people right here in America before he takes it all aboard, and, no doubt, he would do it too, if it would bring in the same amount of glory. I am not bitter, but I see what I see. He can call names across an ocean, but he evidently has not the courage to speak even softly at home. Take away the ocean and he simmers right down. I wish that I could say differently, but I cannot. I will fight for my country, but I will not lie for her. Our country is so busy playing "fence" to the mobsters that the cost in human suffering cannot be considered yet. We can take that up in the next depression.

As I see it, the doctrines of democracy deal with the aspirations of men's souls, but the application deals with things. One hand in somebody else's pocket and one on your gun, and you are highly civilized. Your heart is where it belongs—in your pocket-book. Put it in your bosom and you are backward. Desire enough for your own use only, and you are a heathen. Civilized people have things to show to the neighbors.

This is not to say, however, that the darker races are visiting angels, just touristing around here below. They have acted the same way when they had a chance and will act that way again, comes the break. I just think it would be a good thing for the

261

Anglo-Saxon to get the idea out of his head that everybody else owes him something just for being blonde. I am forced to the conclusion that two-thirds of them do hold that view. The idea of human slavery is so deeply ground in that the pink-toes can't get it out of their system. It has just been decided to move the slave quarters farther away from the house. It would be a fine thing if on leaving office, the blond brother could point with pride to the fact that his administration had done away with group-profit at the expense of others. I know well that it has never happened before, but it could happen, couldn't it?

To mention the hundred years of the Anglo-Saxon in China alone is proof enough of the evils of this view point. The millions of Chinese who have died for our prestige and profit! They are still dying for it. Justify it with all the proud and pretty phrases you please, but if we think our policy is right, you just let the Chinese move a gunboat in the Hudson to drum up trade with us. The scream of outrage would wake up saints in the backrooms of Heaven. And what is worse, we go on as if the so-called inferior people are not thinking; or if they do, it does not matter. As if no day could ever come when that which went over the Devil's back will buckle under his belly. People may not be well-armed at present, but you can't stop them from thinking.

I do not brood, however, over the wide gaps between ideals and practices. The world is too full of inconsistencies for that. I recognize that men are given to handling words long before those words have any internal meaning for them. It is as if we were children playing in a field and found something round and hard to play with. It may be full of beauty and pleasure, and then again it may be full of death.

And now to another matter. Many people have pointed out to me that I am a Negro, and that I am poor. Why then have I not joined a party of protest? I will tell you why. I see many good points in, let us say, the Communist Party. Anyone would be a liar and a fool to claim that there was no good in it. But I am so put together that I do not have much of a herd

instinct. Or if I must be connected with the flock, let *me* be the shepherd my ownself. That is just the way I am made.

You cannot arouse any enthusiasm in me to join in a protest for the boss to provide me with a better hoe to chop his cotton with. Why must I chop cotton at all? Why fix a class of cotton-choppers? I will join in no protests for the boss to put a little more stuffing in my bunk. I don't even want the bunk. I want the boss's bed. It seems to me that the people who are enunciating these principles are so saturated with European ideas that they miss the whole point of America. The people who founded this country, and the immigrants who came later, came here to get away from class distinctions and to keep their unborn children from knowing about them. I am all for the idea of free vertical movement, nothing horizontal. Let him who can, go up, and him who cannot stay there, mount down to the level his capabilities rate. It works out that way anyhow, hence the saying from shirt-sleeves to shirt-sleeves in three generations. The able at the bottom always snatch the ladder from under the weak on the top rung. That is the way it should be. A dead grandfather's back has proven to be a poor prop time and time again. If they have gone up there and stayed, they had something more than a lucky ancestor. So I can get no lift out of nominating myself to be a peasant and celebrating any feasts back stairs. I want the front of the house and I am going to keep on trying even if I never satisfy my plan.

Then, too, it seems to me that if I say a whole system must be upset for me to win, I am saying that I cannot sit in the game, and that safer rules must be made to give me a chance. I repudiate that. If others are in there, deal me a hand and let me see what I can make of it, even though I know some in there are dealing from the bottom and cheating like hell in other ways. If I can win anything in a game like that, I know I'll end up with the pot if the sharks can be eliminated. As the Negroes say down south, "You can't beat me and my prayers," and they are not talking about supplications either when they talk like that. I don't want to bother with any boring from within. If the leaders on the left feel that only violence can

right things, I see no need of finger-nail warfare. Why not take a stronger position? Shoot in the hearse, don't care how sad the funeral is. Get the feeling of the bantam hen jumping on the mule. Kill dead and go to jail. I am not bloodthirsty and have no yearning for strife, but if what they say is true, that there must be this upset, why not make it cosmic? A lot of people would join in for the drama of it, who would not be moved by guile.

I do not say that my conclusions about anything are true for the Universe, but I have lived in many ways, sweet and bitter, and they feel right for me. I have seen and heard. I have sat in judgment upon the ways of others, and in the voiceless quiet of the night I have also called myself to judgment. I cannot have the joy of knowing that I found always a shining reflection of honor and wisdom in the mirror of my soul on those occasions. I have given myself more harrowing pain than anyone else has ever been capable of giving me. No one else can inflict the hurt of faith unkept. I have had the corroding insight at times of recognizing that I am a bundle of sham and tinsel, honest metal and sincerity that cannot be untangled. My dross has given my other parts great sorrow.

But, on the other hand, I have given myself the pleasure of sunrises blooming out of oceans, and sunsets drenching heaped-up clouds. I have walked in storms with a crown of clouds about my head and the zig zag lightning playing through my fingers. The gods of the upper air have uncovered their faces to my eyes. I have made friends with trees and vales. I have found out that my real home is in the water, that the earth is only my step-mother. My old man, the Sun, sired me out of the sea.

Like all mortals, I have been shaped by the chisel in the hand of Chance—bulged out here by a sense of victory, shrunken there by the press of failure and the knowledge of unworthiness. But it has been given to me to strive with life, and to conquer the fear of death. I have been correlated to the world so that I know the indifference of the sun to human emotions. I know that destruction and construction are but two faces of

Dame Nature, and that it is nothing to her if I choose to make personal tragedy out of her unbreakable laws.

So I ask of her few things. May I never do good consciously, nor evil unconsciously. Let my evil be known to me in advance of my acts, and my good when Nature wills. May I be granted a just mind and a timely death.

While I am still far below the allotted span of time, and notwithstanding, I feel that I have lived. I have the joy and pain of strong friendships. I have served and been served. I have made enemies of which I am not ashamed. I have been faithless, and then I have been faithful and steadfast until the blood ran down into my shoes. I have loved unselfishly with all the ardor of a strong heart, and I have hated with all the power of my soul. What waits for me in the future? I do not know. I cannot even imagine, and I am glad for that. But already, I have touched the four corners of the horizon, for from hard searching it seems to me that tears and laughter, love and hate, make up the sum of life.

THE INSIDE LIGHT—BEING
A SALUTE TO FRIENDSHIP

✢

Now take friendship for instance. It is a wonderful trade, a noble thing for anyone to work at. God made the world out of tough things, so it could last, and then He made some juice out of the most interior and best things that He had and poured it around for flavor.

You see lonesome-looking old red hills who do not even have clothes to cover their backs just lying there looking useless. Looking just like Old Maker had a junk pile like everybody else. But go back and look at them late in the day and see the herd of friendly shadows browsing happily around the feet of those hills. Then gaze up at the top and surprise the departing sun, all colored-up with its feelings, saying a sweet good night to those lonesome hills, and making them a promise that he will never forget them. So much tender beauty in a parting must mean a friendship. "I will visit you with my love," says the sun. That is why the hills endure.

Personally, I know what it means. I have never been as good a friend as I meant to be. I keep seeing new heights and depths of possibilities which ought to be reached, only to be frustrated by the press of life which is no friend to grace. I have my loyalties and my unselfish acts to my credit, but I feel the lack of perfection in them, and it leaves a hunger in me.

But I have received unaccountable friendship that is satisfy-

ing. Such as I am, I am a precious gift, as the unlettered Negro would say it. Stripped to my skin, that is just what I am. Without the juice of friendship, I would not be even what I seem to be. So many people have stretched out their hands and helped me along my wander. With the eye of faith, some have beheld me at Hell's dark door, with no rudder in my hand, and no light in my heart, and steered me to a peace within. Some others have flown into that awful place west and south of old original Hell and, with great compassion, lifted me off of the blistering coals and showed me trees and flowers. All these are the powers and privileges of friendship.

So many evidences of friendship have been revealed to me, that time and paper would not bear the load. Friendships of a moment, an hour or a day, that were nevertheless important, by humble folk whose names have become dusted over, while the feeling of the touch remained, friendly expression having ways like musk. It can throw light back on a day that was so dark, that even the sun refused to take responsibility for it.

It was decreed in the beginning of things that I should meet Mrs. R. Osgood Mason. She had been in the last of my prophetic visions from the first coming of them. I could not know that until I met her. But the moment I walked into the room, I knew that this was the end. There were the two women just as I had always seen them, but always in my dream the faces were misty. Miss Cornelia Chapin was arranging a huge bowl of Calla lilies as I entered the room. There were the strange flowers I had always seen. Her posture was as I had seen it hundreds of times. Mrs. Mason was seated in a chair and everything about her was as I knew it. Only now I could see her face. Born so widely apart in every way, the key to certain phases of my life had been placed in her hand. I had been sent to her to get it. I owe her and owe her and owe her! Not only for material help, but for spiritual guidance.

With the exception of Godmother, Carl Van Vechten has bawled me out more times than anyone else I know. He has not been one of those white "friends of the Negro" who seeks to earn it cheaply by being eternally complimentary. If he is

your friend, he will point out your failings as well as your good points in the most direct manner. Take it or leave it. If you can't stand him that way, you need not bother. If he is not interested in you one way or another, he will tell you that, too, in the most off-hand manner, but he is as true as the equator if he is for you. I offer him and his wife Fania Marinoff my humble and sincere thanks.

Both as her secretary and as a friend, Fanny Hurst has picked on me to my profit. She is a curious mixture of little girl and very sophisticated woman. You have to stop and look at her closely to tell which she is from moment to moment. Her transitions are quick as lightning and just as mysterious. I have watched her under all kinds of conditions, and she never ceases to amaze me. Behold her phoning to a swanky hotel for reservations for herself and the Princess Zora, *and* parading me in there all dressed up as an Asiatic person of royal blood and keeping a straight face while the attendants goggled at me and bowed low! Like a little girl, I have known her in the joy of a compelling new gown to take me to tea in some exclusive spot in New York. I would be the press agent for her dress, for everybody was sure to look if *they* saw somebody like me strolling into the Astor or the Biltmore. She can wear clothes and who knows it is her? On the spur of the moment she has taken me galloping over thousands of miles of this North American continent in my Chevrolet for a lark, and then just as suddenly decided to return and go to work. In one moment after figuratively playing with her dolls, she is deep in some social problem. She has been my good friend for many years, and I love her.

To the James Huberts, of Urban League fame, I offer something precious from the best of my treasures. If ever I came to feel that they no longer cared, I would be truly miserable. They elected me to be a Hubert and I mean to hold them to it.

To the Beers, Eleanor Beer de Chetelat, and her mother, Mrs. George W. Beer, twenty-one guns!

I am indebted to Amy Spingarn in a most profound manner. She knows what I mean by that.

Harry T. Burleigh, composer of "Deep River" and other great tunes, worked on me while I was a student to give me perspective and poise. He kept on saying that Negroes did not aim high enough as a rule. They mistook talent for art. One must work. Art was more than inspiration. Besides, he used to take me out to eat in good places to get me used to things. He looks like Otto Kahn in brownskin *and* behaves like a maharajah, with which I do not quarrel.

Of the people who have served me, Bob Wunsch is a man who has no superiors and few equals. Where the man gets all of his soul meat from, I really would like to know. All the greed and grime of the world passes him and never touches him, somehow. I wish that I could make him into a powder and season up the human dough so something could be made out of it. He has enough flavoring in him to do it.

The way I can say how I feel about Dr. Henry Allen Moe is to say that he is twin brother to Bob Wunsch. You cannot talk to the man without feeling that you could have done better in the past and rushing out to improve up from where you are. He has something glinty inside of him that he can't hide. If you have seen him, you have been helped.

I have said that I am grateful to the Charles S. Johnsons and I mean it. Not one iota of their kindness to me has been forgotten.

I fell in love with Jane Belo because she is not what she is supposed to be. She has brains and talent and uses them when she was born rich and pretty, and could have gotten along without any sense. She spent years in Bali studying native custom. She returned to America and went down into the deep South to make comparative studies, with me along. Often as we rode down lonesome roads in South Carolina, I wondered about her tremendous mental energy, and my admiration grew and grew. I also wondered at times why she liked me so much. Certainly it was not from want of friends. Being born of a rich Texas family, familiar with the drawing

rooms of America and the continent, she certainly is not starved for company. Yet she thinks that I am a desirable friend to have, and acts like it. Now, she is married to Dr. Frank Tannenbaum, Department of History, Columbia University, and they have a farm up the state and actually milk cows. She draws and paints well enough to make a living at it if she had to, has written things in Anthropology that Dr. Margaret Mead approves of, milks cows and sets her little hat over her nose. How can you place a person like that? I give up. She can just keep on being my friend, and I'll let somebody else explain her.

I value Miguel and Rose Covarrubias for old time's sake. Long before they were married, we polished off many a fried chicken together. Along with Harry Block, we fried "hand chicken" (jointed fried chicken to be eaten with the hand) and settled the affairs of the world over the bones. We did many amusing but senseless things, and kept up our brain power by eating more chicken. Maybe that is why Miguel is such a fine artist. He has hewed to the line, and never let his success induce him to take to trashy foods on fancy plates.

James Weldon Johnson and his wife Grace did much to make my early years in New York pleasant and profitable. I have never seen any other two people who could be right so often, and charming about it at the same time.

Walter White and his glamorous Gladys used to have me over and feed me on good fried chicken in my student days for no other reason than that they just wanted to. They have lent me some pleasant hours. I mean to pay them back sometime.

There are so many others, Colonel and Mrs. Bert Lippincott, Frank Frazier, Paul and Eslanda Robeson, Lawrence Brown, Calvin J. Ferguson, Dr. Edwin Osgood Grover, Dr. Hamilton Holt, H. P. Davis, J. P. McEvoy, Edna St. Vincent Millay, Dr. and Mrs. Simeon L. Carson of Washington, D.C., along with Betram Barker. As I said in the beginning of this, that I was a precious gift, what there is of me. I could not find space for all of the donors on paper, though there is plenty of

room in my heart. I am just sort of assembled up together out of friendship and put together by time.

Josephine Van Doltzen Pease, that sprout of an old Philadelphia family who writes such charming stories for children, and our mutual friend, Edith Darling Thompson, are right inside the most inside part of my heart. They are both sacred figures on my altar when I deck it to offer something to love.

How could I ever think I could make out without that remarkable couple Whit Burnett and Martha Foley? I just happened to put his name down first. Either way you take that family, it's got a head to it. One head with whiskers to it, and one plain, but both real heads. Even little David, their son, has got his mind made up. Being little, he gets over-ruled at times, but he knows what he wants to do and puts a lot of vim into the thing. It is not his fault if Whit and Martha have ideas of censorship. I have no idea what he will pick out to do by the time he gets grown, but, whatever it is, you won't find any bewildered David Foley-Burnett wandering around. I'll bet you a fat man on that. Two fat men to your skinny one.

Another California crowd that got me liking them and grateful too, is that Herbert Childs, with his cherub-looking wife.

Katharane Edson Mershon has been a good friend to me. She is a person of immense understanding. It makes me sit and ponder. I do not know whether her ready sympathy grows out of her own experiences, or whether it was always there and only expanded by having struggled herself. I suppose it is both.

She was born of Katherine Philips Edson, the woman who put the minimum wage law for women on the statute books of California. It was no fault of hers that dirty politics later rubbed it out. She did many other things for the good of California, like fighting for the preservation of the Redwood forests. She sat, a lone woman, in the Washington Disarmament Conference, and, after forty, sent her two sons through good colleges by the sweat of her brow.

So Katharane Edson Mershon probably inherited some feel-

272

ings. Anyway, she took life in her hands and hied herself away from home at sixteen and went forth to dance for inside expression. She did important things in the now famous Play House of Pasadena, conducted a school of dance and was a director for the famous school of Ruth St. Denis. After she married, she spent nine years in Bali, conducting a clinic at her own expense. More than that, she did not do it by proxy. She was there every day, giving medicine for fever, washing sores and sitting by the dying. Dancing was her way of doing things but she was impelled by mercy into this other field. Her husband was with her in this. His main passion is making gardens, but he threw himself into the clinic with enthusiasm.

For me, she gave me back my health and my hope, and I have her to thank for the sparing of my unprofitable life.

Jack Mershon, husband of Katharane's heart, is the son of William B. Mershon of Saginaw, Michigan. This William B. went into the Michigan forests and hacked him out a fortune. Tough as whit leather, with a passion for hunting and fishing, he nevertheless is one of the best informed men in the world on Americana, with especial emphasis on the Northwest. He has endowed parks, settlements, replanted whole forests of millions of trees in Michigan, and done things to make Saginaw a fine city, which the younger generation knows little about, because he himself says nothing.

Jack like his wife ran off from home and supported himself on the stage. He is soft in manner, but now and then you can see some of the gruff old stuff of William B. Mershon oozing through his hide. That same kind of mule-headedness on one side and generosity on the other. He will probably never be a hard-cussing, hard-driving empire builder like his old man, but what he aims to do, he does.

Mrs. Mershon invited me out to California, and a story starts from that. Being trustful and full of faith, I hurried out there. She fed me well, called in the doctors and cleared the malaria out of my marrow, took me to I. Magnin's and dressed me up. I was just burning up with gratitude and still did not suspect a thing.

273

Then I began to notice a leer in her eye! This woman had designs on me. I could tell that from her look, but I could not tell what it was. I should have known! I should have been suspicious, but I was dumb to the fact and did not suspect a thing until I was ambushed.

One day she said to me off-hand, "You ought to see a bit of California while you are out here."

"Oh, that would be fine!" I crackled and gleamed at the idea. So I saw California! At first, I thought it was just to give *me* some pleasure, but I soon found out it was the gleeful malice of a Californiac taking revenge upon a poor defenseless Florida Fiend.

She fried me in the deserts, looking at poppies, succulents (cactus, to you and everybody else except Californiacs), Joshua trees, kiln dried lizards and lupin bushes. Just look at those wild lilacs! Observe that chaparrel! Don't miss that juniper. Don't say you haven't seen our cottonwood. Regard those nobles (California oaks).

Next thing I know, we would be loping up some roughback mountain and every hump and hollow would be pointed out to me. No need for me to murmur that I had to watch the road while driving. Just look at that peak! Now! You can look down over that rim. When I took refuge in watching the road, she switched technique on me. Her husband, Jack Mershon, was pressed into service, so all I had to do was to sit in the back seat of the Buick while Katharane twisted my head from side to side and pointed out the sights.

From San Diego up, we looked at every wave on the Pacific, lizards, bushes, prune and orange groves, date palms, eucalyptus, gullies with and without water that these Californiacs call rivers, asphalt pits where the remains of prehistoric animals had been found, the prehistoric bones in person, saber-tooth tigers, short-faced bears (bears, before bears saw Californiacs and pulled long faces), old fashioned elephants that ran mostly to teeth, saurians and what not. Then there was barracuda and shark meat, abalones, beaches full of people in dark sun glasses, Hollywood, and slacks with hips in them all swearing

274

to God and other responsible characters that they sure look pretty, and most of them lying and unrepentant. Man! I saw Southern California, and thought I had done something. Me, being from Florida, I had held my peace, and only murmured now and then a hint or two about our own climate and trees and things like that. Nothing offensive, you understand. I wouldn't really say how good it was, because I wanted to be polite. So I drew a long breath when we had prospected over Southern California, and I had kept from exploding.

"Now, I shall take you to see Northern California—the best part of the state," my fiendish friend gloated. "Ah, the mountains!"

"But, I don't care too much about mountains," I murmured through the alkali in my mouth.

"You are going to see it just the same. You are not going back east and pretend you saw none of the beauty of my state. You are going to see California, and like it—you Florida Fiend. Just because your Florida mud-turtles have been used to bogging down in swamps and those Everglades, whatever they are—and they don't sound like much to me, is no reason for you to ignore the beauties of California mountains. Let's go!"

So we went north. We drove over rocky ridges and stopped on ledges miles up in the air and gazed upon the Pacific. Redwood forests, Golden Gates, cable cars, missions, gaps, gullies, San Simeon-with-William Randolph Hearst, Monterey-with-history, Carmel-with-artists and atmosphere, Big Sur and Santa Barbara, Bay Bridges and Giant Sequoia, Alcatraz, wharves, Capitol buildings, mountains that didn't have sense enough to know it was summer and time to take off their winter clothes, seals, sealrocks, and then seals on seal-rocks, pelicans and pelican rocks and then that [] Pacific!

Finally, back at Carmel, I struck. A person has just so many places to bump falling down rocky cliffs. But did I escape? No, indeed! I was standing on a big pile of bony rocks on Point Lobos, when I announced that I thought I (sort of) had the idea of California and knew what it was about.

"Oh, no!" Katharane grated maliciously. "Seen California! Why, this is the second largest state in the Union! You haven't half seen it, but you are going to. I've got you out here and I mean to rub your nose in California. You are going to see it, I'm here to tell you." So on we went. I saw, and I saw and I *saw*! Man! I tell you that I saw California. For instance, I saw the hats in San Francisco! Finally, I came to the conclusion that in Los Angeles the women get hats imposed upon them. In San Francisco, they go out in the woods and shoot 'em.

Then after I had galloped from one end of the state to the other and from edge to ocean and back again, Katharane Mershon up and tells me, "All I wanted you to see was the redwoods!"

I mean to write to the Florida Chamber of Commerce and get them to trick a gang of Californiacs to Florida and let me be the guide. It is going to be good, and I wouldn't fool you. From Key West to the Perdido river they are going to see every orange tree, rattlesnake, gopher, coudar, palm tree, sand pile, beach mango tree, sapodilla, kumquat, alligator, tourist trap, celery patch, bean field, strawberry, lake, jook, gulf, ocean and river in between, and if their constitutions sort of wear away, it will be unfortunate, but one of the hazards of war.

But California is nice. *Buen* nice! Of course they lie about the California climate a little more than we do about ours, but you don't hold that against them. They have to, to rank up with us. But at that this California is a swell state, especially from Santa Barbara on north. Of course, coming from Florida, I feel like the man when he saw a hunch back for the first time—it seems that California does wear its hips a bit high. I mean all those mountains. Too much of the state is standing up on edge. To my notion, land is supposed to lie down and be walked on—not rearing up, staring you in the face. It is too biggity and imposing. But on the whole, California will do for a lovely state until God can make up something better. So I forgive Katharane Mershon for showing me the place. Another score for friendship.

Therefore, I can say that I have had friends. Friendship is a mysterious and ocean-bottom thing. Who can know the outer ranges of it? Perhaps no human being has ever explored its limits. Anyway, God must have thought well of it when He made it. Make the attempt if you want to, but you will find that trying to go through life without friendship, is like milking a bear to get cream for your morning coffee. It is a whole lot of trouble, and then not worth much after you get it.

11:00 A.M. July 20, 1941
1392 Hull Lane
Altadena, California

CONCERT

A nd now, I must mention something, not because it means so much to me, but because it did mean something to others.

On January 10, 1932, I presented a Negro Folk Concert at the John Golden Theater in New York.

I am not a singer, a dancer, nor even a musician. I was, therefore, seeking no reputation in either field. I did the concert because I knew that nowhere had the general public ever heard Negro music as done by Negroes. There had been numerous concerts of Negro spirituals by famous Negro singers, but none as it was done by, let us say, Macedonia Baptist Church. They had been tampered with by musicians, and had their faces lifted to the degree that when real Negroes heard them, they sat back and listened just like white audiences did. It was just as strange to them as to the Swedes, for example. Beautiful songs and arrangements but going under the wrong titles.

Here was the difference. When I was coming up, I had heard songs and singing. People made the tunes and sang them because they were pretty and satisfied something. Then I got away from home and learned about "holler singing." Holler singing or classic, if you want to call it that, is not done for the sake of agreeable sound. It is a sporting proposition. The singer, after years of training, puts out a brag that he or

she can perform certain tricks with the voice, and the audience comes and bets him the admission price that he can't do it. They lean back in the seats and wait eagerly for the shake, the high jump or the low dive. If the performer makes it, he rakes in the pot. If not, he can go back and yell "Whoa! Har! Gee!" to some mule.

I saw that Negro music and musicians were getting lost in the betting ring. I did not hope to stop the ones who were ambitious to qualify as holler experts. That was all right in its place. I just wanted people to know what real Negro music sounded like. There were the two things.

Of course, I had known this all along, but my years of research accented this situation inside of me and troubled me. Was the real voice of my people never to be heard? This ersatz Negro music was getting on. It was like the story from Hans Christian Andersen where the shadow became the man. That would not have been important if the arrangements had been better music than the originals, but they were not. They conformed more to Conservatory rules of music but that is not saying much. They were highly flavored with Bach and Brahms, and Gregorian chants, but why drag them in? It seemed to me a determined effort to squeeze all of the rich black juice out of the songs and present a sort of musical octoroon to the public. Like some more "passing for white."

Now in collecting tales and hoodoo rituals, I had taken time out to collect a mass of Negro songs of all descriptions. I was not supposed to do that, but I could not resist it. Sitting around in saw-mill quarters, turpentine camps, prison camps, railroad camps and jooks, I soaked them in as I went. My people are not going to do but so much of anything before they sing something. I always encouraged it because I loved it and could not be different. I brought this mass home, seeing all the possibilities for some Negro musicians to do something fine with it.

Being a friend of Hall Johnson's, I turned it over to him to use as he wished with his concert group. He kept it for nearly a year. I called him up about it two or three times and finally

he told me that he saw no use for it. The public only wanted to hear spirituals, and spirituals that had been well arranged. I knew that he was mistaken, for white people used to crowd Zion Hope Baptist Church, where my father was pastor to hear the singing, and there certainly were no trained musicians around there. I had seen it in various Negro churches where the congregations just grabbed hold of a tune and everybody worked on it in his or her own way to magnificent harmonic effect. I knew that they liked the work songs, for I had seen them park their cars by a gang of workers just to listen to what happened. So in spite of what he said, I kept to my own convictions.

When he gave me back the songs, I talked about a real Negro concert for a while, to anybody who would listen, and then decided to do it. But I felt that I did not know enough to do it alone.

Not only did I want the singing very natural, I wanted to display West Indian folk dancing. I had been out in the Bahama Islands collecting material and had witnessed the dynamic Fire Dance which had three parts; the Jumping Dance, The Ring Play and the Congo. It was so stirring and magnificent that I had to admit to myself that we had nothing in America to equal it. I went to the dancing every chance I got, and took pains to learn them. I could just see an American audience being thrilled.

So the first step I took was to assemble a troup of sixteen Bahamans who could dance. Then I went back to Hall Johnson with the proposition that we combine his singers and my dancers for a dramatic concert. I had the script all written. It was a dramatization of a working day on a Florida railroad camp with the Fire Dance for a climax. Hall Johnson looked it over and agreed to the thing.

But his mind must have changed, because I took my dancers up to his studio four times, but the rehearsals never came off. Twice he was not even there. Once he said he had a rehearsal of his own group which could not be put off, and once there was no explanation. Besides, something unfortunate hap-

281

pened. While my dancers sat around me and waited, two or three of the singers talked in stage whispers about "monkey chasers dancing." They ridiculed the whole idea. Who wanted to be mixed up with anything like that?

The American Negroes have the unfortunate habit of speaking of West Indians as "monkey-chasers," pretending to believe that the West Indians catch monkeys and stew them with rice.

I heard what was being said very distinctly, but I hoped that my group did not. But they did and began to show hurt in their faces. I could not let them feel that I shared the foolish prejudice, which I do not, so I had to make a move. I showed my resentment, gathered my folks, and we all went down to my place in 66th Street. It looked as if I were licked. I had spoken to a man in Judson's Bureau in Steinway Hall about booking us, and now it all looked hopeless. So I went down next day to call it all off.

He said I ought to go ahead. It sounded fine to him. But go ahead on my own. He happened to know that Gaston, Hall Johnson's manager, wanted me headed off. He saw in my idea a threat to Hall Johnson's group. "You are being strung along on this rehearsal gag to throw you off. Go ahead on your own."

So I went ahead. We rehearsed at my house, here and there, and anywhere. The secretary to John Golden liked the idea after seeing a rehearsal and got me the theater. She undertook to handle the press for me, so I just turned over the money to her and she did well by me.

I had talked Godmother, Mrs. R. Osgood Mason, into helping me. Dr. Locke, her main Negro confidant, had opposed it at first, but he was finally won over. You see, he had been born in Philadelphia, educated at Harvard and Oxford and had never known the common run of Negroes. He was not at all sympathetic to our expression. To his credit, he has changed his viewpoint.

Then came that Sunday night of the tenth. We had a good house, mostly white shirt fronts and ermine. Godmother was

out there sitting close enough for me to see her and encourage me. Locke was there, too, in faultless tails. He came back stage to give me a pat of encouragement and went back out front. I needed it. I was as nervous as I could be, and if I had known then as much as I know now, I would have been even more nervous. Fools rush in where angels fear to tread.

From the lifting of the curtain on the dawn scene where the shack rouser awakens the camp to the end of the first half, it was evident that the audience was with us. The male chorus "lined track" and "spiked" to tremendous applause. The curtain had to be lifted and lowered and then again. I was standing there in the wings still shivering, when Lee Whipper, who had played the part of the itinerant preacher in a beautiful manner, gave me a shove and I found myself out on the stage. A tremendous burst of applause met me, and so I had to say something.

I explained why I had done it. That music without motion was unnatural with Negroes, and what I had tried to do was to present Negro singing in a natural way—with action. I don't know what else I said, but the audience was kind and I walked off to an applauding house.

Right here, let me set something straight. Godmother had meant for me to call Dr. Locke to the stage to make any explanations, but she had not told me. Neither had Locke told me. I was stupid. When he told me where he would be sitting, he evidently thought that would be enough. But I had not thought of any speech in all my troubles of rehearsals, making costumes and keeping things going. It just had not occurred to me. I would not have been out there myself if Lee Whipper had not shoved me. I found out later that I had seemed to ignore Dr. Locke, for which I am very sorry. I would have much rather had him make a thought-out speech than my improvising. It just did not occur to me in all my excitement. It may be too late, but I ask him please to pardon me. He had been helpful and I meant him good.

The second half of the program went off even better than the first. As soon as the curtain went up on the Fire Dancers,

their costuming got a hand. It broke out time and again during the dancing and thundered as Caroline Rich and Strawn executed the last movement with the group as a back-ground. It was good it was the last thing, for nothing could have followed it.

Hall Johnson did a generous thing. I had sent tickets and he and his manager came back stage and Hall said, "You proved your point all right. When you talked to me about it, it sounded like a crazy mess. I really came to see you do a flop, but it was swell!" I thought that was fine of Hall.

The New School of Social Research presented us six weeks later and we danced at the Vanderbilt, Nyack, and various places. But I was worn out with back stage arguments, eternal demands for money, a disturbance in my dance group because one of the men, who was incidentally the poorest dancer of all, preached that I was an American exploiting them and they ought to go ahead under his guidance. Stew-Beef, Lias Strawn and Motor-Boat pointed out to him that they had never dreamed of dancing in public until I had picked them up. I had rehearsed them for months, fed them and routined them into something. Why had *he* never thought of it before I did. He had discouraged the others from joining me until it began to look successful. So they meant to stick with me, American or no American. But two of the women joined the trouble maker and I fired all three of them. The whole thing was beginning to wear me down. When some other things began to annoy me, I decided to go home to Florida and try to write the book I had in mind, which was *Jonah's Gourd Vine*. Before it was hardly started, I heard that Hall Johnson had raided my group and was using it in his "Run Little Chillun." I never saw the production, but I was told that the religious scene was the spitting image of the one from my concert also. As I said, I never saw it so I wouldn't know.

But this I do know, that people became very much alive to West Indian dancing and work songs. I have heard myself over the air dozens of times and felt the influence of that concert running through what has been done since. My name

is never mentioned, of course, because that is not the way theater people do things, but that concert and the rave notices I got from the critics shoved the viewpoint over towards the natural Negro.

Theater Arts Magazine photographed us and presented us in its April issue following the concert at the John Golden. The Folk Dance Society presented us at the Vanderbilt. We appeared at the first National Folk Festival in St. Louis in 1934, at Chicago in 1934, and at Constitution Hall in Washington, D.C. In Chicago, I had only ten days to try to prepare a full length program and it was not smooth considering that I had only very raw material to work with in so short a time, but at that the dancers and a dramatic bit went over splendidly and got good notices. Katherine Dunham loaned us her studio for rehearsal twice, which was kind of her. Anyway, West Indian dancing had gone west and created interest just as it had done in the east. When I got to Jamaica on my first Guggenheim fellowship in 1936, I found that Katherine Dunham had been there a few months before collecting dances, and had gone on to Haiti.

I made no real money out of my concert work. I might have done so if I had taken it up as a life work. But I am satisfied in knowing that I established a trend and pointed Negro expression back towards the saner ground of our own unbelievable originality.

AFTERWORD

ZORA NEALE HURSTON:
"A NEGRO WAY OF SAYING"

I.

The Reverend Harry Middleton Hyatt, an Episcopal priest whose five-volume classic collection, *Hoodoo, Conjuration, Witchcraft, and Rootwork,* more than amply returned an investment of forty years' research, once asked me during an interview in 1977 what had become of another eccentric collector whom he admired. "I met her in the field in the thirties. I think," he reflected for a few seconds, "that her first name was Zora." It was an innocent question, made reasonable by the body of confused and often contradictory rumors that make Zora Neale Hurston's own legend as richly curious and as dense as are the black myths she did so much to preserve in her classic anthropological works, *Mules and Men* and *Tell My Horse,* and in her fiction.

A graduate of Barnard, where she studied under Franz Boas, Zora Neale Hurston published seven books—four novels, two books of folklore, and an autobiography—and more than fifty shorter works between the middle of the Harlem Renaissance and the end of the Korean War, when she was the

287

dominant black woman writer in the United States. The dark obscurity into which her career then lapsed reflects her staunchly independent political stances rather than any deficiency of craft or vision. Virtually ignored after the early fifties, even by the Black Arts movement in the sixties, an otherwise noisy and intense spell of black image- and myth-making that rescued so many black writers from remaindered oblivion, Hurston embodied a more or less harmonious but nevertheless problematic unity of opposites. It is this complexity that refuses to lend itself to the glib categories of "radical" or "conservative," "black" or "Negro," "revolutionary" or "Uncle Tom"—categories of little use in literary criticism. It is this same complexity, embodied in her fiction, that, until Alice Walker published her important essay ("In Search of Zora Neale Hurston") in *Ms.* magazine in 1975, had made Hurston's place in black literary history an ambiguous one at best.

The rediscovery of Afro-American writers has usually turned on larger political criteria, of which the writer's work is supposedly a mere reflection. The deeply satisfying aspect of the rediscovery of Zora Neale Hurston is that black women generated it primarily to establish a maternal literary ancestry. Alice Walker's moving essay recounts her attempts to find Hurston's unmarked grave in the Garden of the Heavenly Rest, a segregated cemetery in Fort Pierce, Florida. Hurston became a metaphor for the black woman writer's search for tradition. The craft of Alice Walker, Gayl Jones, Gloria Naylor, and Toni Cade Bambara bears, in markedly different ways, strong affinities with Hurston's. Their attention to Hurston signifies a novel sophistication in black literature: they read Hurston not only for the spiritual kinship inherent in such relations but because she used black vernacular speech and rituals, in ways subtle and various, to chart the coming to consciousness of black women, so glaringly absent in other black fiction. This use of the vernacular became the fundamental framework for all but one of her novels and is particularly effective in her classic work *Their Eyes Were Watching God,*

published in 1937, which is more closely related to Henry James's *The Portrait of a Lady* and Jean Toomer's *Cane* than to Langston Hughes's and Richard Wright's proletarian literature, so popular in the Depression.

The charting of Janie Crawford's fulfillment as an autonomous imagination, *Their Eyes* is a lyrical novel that correlates the need of her first two husbands for ownership of progressively larger physical space (and the gaudy accoutrements of upward mobility) with the suppression of self-awareness in their wife. Only with her third and last lover, a roustabout called Tea Cake whose unstructured frolics center around and about the Florida swamps, does Janie at last bloom, as does the large pear tree that stands beside her grandmother's tiny log cabin.

> She saw a dust bearing bee sink into the sanctum of a bloom; the thousand sister calyxes arch to meet the love embrace and the ecstatic shiver of the tree from root to tiniest branch creaming in every blossom and frothing with delight. So this was a marriage!

To plot Janie's journey from object to subject, the narrative of the novel shifts from third to a blend of first and third person (known as "free indirect discourse"), signifying this awareness of self in Janie. *Their Eyes* is a bold feminist novel, the first to be explicitly so in the Afro-American tradition. Yet in its concern with the project of finding a voice, with language as an instrument of injury and salvation, of selfhood and empowerment, it suggests many of the themes that inspirit Hurston's oeuvre as a whole.

II.

One of the most moving passages in American literature is Zora Neale Hurston's account of her last encounter with her dying mother, found in a chapter entitled "Wandering" in her autobiography, *Dust Tracks on a Road* (1942):

As I crowded in, they lifted up the bed and turned it around so that Mama's eyes would face east. I thought that she looked to me as the head of the bed reversed. Her mouth was slightly open, but her breathing took up so much of her strength that she could not talk. But she looked at me, or so I felt, to speak for her. She depended on me for a voice.

We can begin to understand the rhetorical distance that separated Hurston from her contemporaries if we compare this passage with a similar scene published just three years later in *Black Boy* by Richard Wright, Hurston's dominant black male contemporary and rival: "Once, in the night, my mother called me to her bed and told me that she could not endure the pain, and she wanted to die. I held her hand and begged her to be quiet. That night I ceased to react to my mother; my feelings were frozen." If Hurston represents her final moments with her mother in terms of the search for voice, then Wright attributes to a similar experience a certain "somberness of spirit that I was never to lose," which "grew into a symbol in my mind, gathering to itself . . . the poverty, the ignorance, the helplessness. . . ." Few authors in the black tradition have less in common than Zora Neale Hurston and Richard Wright. And whereas Wright would reign through the forties as our predominant author, Hurston's fame reached its zenith in 1943 with a *Saturday Review* cover story honoring the success of *Dust Tracks.* Seven years later, she would be serving as a maid in Rivo Alto, Florida; ten years after that she would die in the County Welfare Home in Fort Pierce, Florida.

How could the recipient of two Guggenheims and the author of four novels, a dozen short stories, two musicals, two books on black mythology, dozens of essays, and a prizewinning autobiography virtually "disappear" from her readership for three full decades? There are no easy answers to this quandary, despite the concerted attempts of scholars to resolve it. It is clear, however, that the loving, diverse, and

enthusiastic responses that Hurston's work engenders today were not shared by several of her influential black male contemporaries. The reasons for this are complex and stem largely from what we might think of as their "racial ideologies."

Part of Hurston's received heritage—and perhaps the paramount received notion that links the novel of manners in the Harlem Renaissance, the social realism of the thirties, and the cultural nationalism of the Black Arts movement—was the idea that racism had reduced black people to mere ciphers, to beings who only react to an omnipresent racial oppression, whose culture is "deprived" where different, and whose psyches are in the main "pathological." Albert Murray, the writer and social critic, calls this "the Social Science Fiction Monster." Socialists, separatists, and civil rights advocates alike have been devoured by this beast.

Hurston thought this idea degrading, its propagation a trap, and railed against it. It was, she said, upheld by "the sobbing school of Negrohood who hold that nature somehow has given them a dirty deal." Unlike Hughes and Wright, Hurston chose deliberately to ignore this "false picture that distorted...." Freedom, she wrote in *Moses, Man of the Mountain,* "was something internal.... The man himself must make his own emancipation." And she declared her first novel a manifesto against the "arrogance" of whites assuming that "black lives are only defensive reactions to white actions." Her strategy was not calculated to please.

What we might think of as Hurston's mythic realism, lush and dense within a lyrical black idiom, seemed politically retrograde to the proponents of a social or critical realism. If Wright, Ellison, Brown, and Hurston were engaged in a battle over ideal fictional modes with which to represent the Negro, clearly Hurston lost the battle.

But not the war.

After Hurston and her choice of style for the black novel were silenced for nearly three decades, what we have witnessed since is clearly a marvelous instance of the return of the repressed. For Zora Neale Hurston has been "rediscovered"

in a manner unprecedented in the black tradition: several black women writers, among whom are some of the most accomplished writers in America today, have openly turned to her works as sources of narrative strategies, to be repeated, imitated, and revised, in acts of textual bonding. Responding to Wright's critique, Hurston claimed that she had wanted at long last to write a black novel, and "not a treatise on sociology." It is this urge that resonates in Toni Morrison's *Song of Solomon* and *Beloved,* and in Walker's depiction of Hurston as our prime symbol of "racial health—a sense of black people as complete, complex, *undiminished* human beings, a sense that is lacking in so much black writing and literature." In a tradition in which male authors have ardently denied black literary paternity, this is a major development, one that heralds the refinement of our notion of tradition: Zora and her daughters are a tradition-within-the-tradition, a black woman's voice.

The resurgence of popular and academic readerships of Hurston's works signifies her multiple canonization in the black, the American, and the feminist traditions. Within the critical establishment, scholars of every stripe have found in Hurston texts for all seasons. More people have read Hurston's works since 1975 than did between that date and the publication of her first novel, in 1934.

III.

Rereading Hurston, I am always struck by the density of intimate experiences she cloaked in richly elaborated imagery. It is this concern for the figurative capacity of black language, for what a character in *Mules and Men* calls "a hidden meaning, jus' like de Bible . . . de inside meanin' of words," that unites Hurston's anthropological studies with her fiction. For the folklore Hurston collected so meticulously as Franz Boas's student at Barnard became metaphors, allegories, and performances in her novels, the traditional recurring canonical metaphors of black culture. Always more of a novelist than a social scientist, even Hurston's academic collections center on

the quality of imagination that makes these lives whole and splendid. But it is in the novel that Hurston's use of the black idiom realizes its fullest effect. In *Jonah's Gourd Vine,* her first novel, for instance, the errant preacher, John, as described by Robert Hemenway "is a poet who graces his world with language but cannot find the words to secure his own personal grace." This concern for language and for the "natural" poets who "bring barbaric splendor of word and song into the very camp of the mockers" not only connects her two disciplines but also makes of "the suspended linguistic moment" a thing to behold indeed. Invariably, Hurston's writing depends for its strength on the text, not the context, as does John's climactic sermon, a *tour de force* of black image and metaphor. Image and metaphor define John's world; his failure to interpret himself leads finally to his self-destruction. As Robert Hemenway, Hurston's biographer, concludes, "Such passages eventually add up to a theory of language and behavior."

Using "the spy-glass of Anthropology," her work celebrates rather than moralizes; it shows rather than tells, such that "both behavior and art become self-evident as the tale texts and hoodoo rituals accrete during the reading." As author, she functions as "a midwife participating in the birth of a body of folklore, . . . the first wondering contacts with natural law." The myths she describes so accurately are in fact "alternative modes for perceiving reality," and never just condescending depictions of the quaint. Hurston sees "the Dozens," for example, that age-old black ritual of graceful insult, as, among other things, a verbal defense of the sanctity of the family, conjured through ingenious plays on words. Though attacked by Wright and virtually ignored by his literary heirs, Hurston's ideas about language and craft undergird many of the most successful contributions to Afro-American literature that followed.

IV.

We can understand Hurston's complex and contradictory legacy more fully if we examine *Dust Tracks on a Road,* her own controversial account of her life. Hurston did make significant parts of herself up, like a masquerader putting on a disguise for the ball, like a character in her fictions. In this way, Hurston *wrote* herself, and sought in her works to rewrite the "self" of "the race," in its several private and public guises, largely for ideological reasons. That which she chooses to reveal is the life of her imagination, as it sought to mold and interpret her environment. That which she silences or deletes, similarly, is all that her readership would draw upon to delimit or pigeonhole her life as a synecdoche of "the race problem," an exceptional part standing for the debased whole.

Hurston's achievement in *Dust Tracks* is twofold. First, she gives us a *writer's* life, rather than an account, as she says, of "the Negro problem." So many events in this text are figured in terms of Hurston's growing awareness and mastery of books and language, language and linguistic rituals as spoken and written both by masters of the Western tradition and by ordinary members of the black community. These two "speech communities," as it were, are Hurston's great sources of inspiration not only in her novels but also in her autobiography.

The representation of her sources of language seems to be her principal concern, as she constantly shifts back and forth between her "literate" narrator's voice and a highly idiomatic black voice found in wonderful passages of free indirect discourse. Hurston moves in and out of these distinct voices effortlessly, seamlessly, just as she does in *Their Eyes* to chart Janie's coming to consciousness. It is this usage of a *divided* voice, a double voice unreconciled, that strikes me as her great achievement, a verbal analogue of her double experiences as a woman in a male-dominated world and as a black person in a nonblack world, a woman writer's revision of W. E. B.

294

Du Bois's metaphor of "double-consciousness" for the hyphenated African-American.

Her language, variegated by the twin voices that intertwine throughout the text, retains the power to unsettle.

> There is something about poverty that smells like death.
> Dead dreams dropping off the heart like leaves in a dry
> season and rotting around the feet; impulses smothered too
> long in the fetid air of underground caves. The soul lives
> in a sickly air. People can be slave-ships in shoes.

Elsewhere she analyzes black "idioms" used by a culture "raised on simile and invective. They know how to call names," she concludes, then lists some, such as 'gator-mouthed, box-ankled, puzzle-gutted, shovel-footed: "Eyes looking like skint-ginny nuts, and mouth looking like a dishpan full of broke-up crockery!"

Immediately following the passage about her mother's death, she writes:

> The Master-Maker in His making had made Old Death.
> Made him with big, soft feet and square toes. Made him
> with a face that reflects the face of all things, but neither
> changes itself, nor is mirrored anywhere. Made the body of
> death out of infinite hunger. Made a weapon of his hand to
> satisfy his needs. This was the morning of the day of the
> beginning of things.

Language, in these passages, is not merely "adornment," as Hurston described a key black linguistic practice; rather, manner and meaning are perfectly in tune: she says the thing in the most meaningful manner. Nor is she being "cute," or pandering to a condescending white readership. She is "naming" emotions, as she says, in a language both deeply personal and culturally specific.

The second reason that *Dust Tracks* succeeds as literature arises from the first: Hurston's unresolved tension between

her double voices signifies her full understanding of modernism. Hurston uses the two voices in her text to celebrate the psychological fragmentation both of modernity and of the black American. As Barbara Johnson has written, hers is a rhetoric of division, rather than a fiction of psychological or cultural unity. Zora Neale Hurston, the "real" Zora Neale Hurston that we long to locate in this text, dwells in the silence that separates these two voices: she is both, and neither; bilingual, and mute. This strategy helps to explain her attraction to so many contemporary critics and writers, who can turn to her works again and again only to be startled at her remarkable artistry.

But the life that Hurston could write was not the life she could live. In fact, Hurston's life, so much more readily than does the standard sociological rendering, reveals how economic limits determine our choices even more than does violence or love. Put simply, Hurston wrote well when she was comfortable, wrote poorly when she was not. Financial problems—book sales, grants and fellowships too few and too paltry, ignorant editors and a smothering patron—produced the sort of dependence that affects, if not determines, her style, a relation she explored somewhat ironically in "What White Publishers Won't Print." We cannot oversimplify the relation between Hurston's art and her life; nor can we reduce the complexity of her postwar politics, which, rooted in her distaste for the pathological image of blacks, were markedly conservative and Republican.

Nor can we sentimentalize her disastrous final decade, when she found herself working as a maid on the very day the *Saturday Evening Post* published her short story "Conscience of the Court" and often found herself without money, surviving after 1957 on unemployment benefits, substitute teaching, and welfare checks. "In her last days," Hemenway concludes dispassionately, "Zora lived a difficult life—alone, proud, ill, obsessed with a book she could not finish."

The excavation of her buried life helped a new generation read Hurston again. But ultimately we must find Hurston's

legacy in her art, where she "ploughed up some literacy and laid by some alphabets." Her importance rests with the legacy of fiction and lore she constructed so cannily. As Hurston herself noted, "Roll your eyes in ecstasy and ape his every move, but until we have placed something upon his street corner that is our own, we are right back where we were when they filed our iron collar off." If, as a friend eulogized, "She didn't come to you empty," then she does not leave black literature empty. If her earlier obscurity and neglect today seem inconceivable, perhaps now, as she wrote of Moses, she has "crossed over."

HENRY LOUIS GATES, JR.

SELECTED BIBLIOGRAPHY

WORKS BY ZORA NEALE HURSTON

Jonah's Gourd Vine. Philadelphia: J. B. Lippincott, 1934.

Mules and Men. Philadelphia: J. B. Lippincott, 1935.

Their Eyes Were Watching God. Philadelphia: J. B. Lippincott, 1937.

Tell My Horse. Philadelphia: J. B. Lippincott, 1938.

Moses, Man of the Mountain. Philadelphia: J. B. Lippincott, 1939.

Dust Tracks on a Road. Philadelphia: J. B. Lippincott, 1942.

Seraph on the Suwanee. New York: Charles Scribner's Sons, 1948.

I Love Myself When I Am Laughing . . . & Then Again When I Am Looking Mean and Impressive: A Zora Neale Hurston Reader. Edited by Alice Walker. Old Westbury, N.Y.: The Feminist Press, 1979.

The Sanctified Church. Edited by Toni Cade Bambara. Berkeley: Turtle Island, 1981.

Spunk: The Selected Short Stories of Zora Neale Hurston. Berkeley: Turtle Island, 1985.

WORKS ABOUT ZORA NEALE HURSTON

Baker, Houston A., Jr. *Blues, Ideology, and Afro-American Literature: A Vernacular Theory,* pp. 15–63. Chicago: University of Chicago Press, 1984.

Bloom, Harold, ed. *Zora Neale Hurston.* New York: Chelsea House, 1986.

———, ed. *Zora Neale Hurston's "Their Eyes Were Watching God."* New York: Chelsea House, 1987.

Byrd, James W. "Zora Neale Hurston: A Novel Folklorist." *Tennessee Folklore Society Bulletin* 21 (1955): 37–41.

Cooke, Michael G. "Solitude: The Beginnings of Self-Realization in Zora Neale Hurston, Richard Wright, and Ralph Ellison." In Michael G. Cooke, *Afro-American Literature in the Twentieth Century,* pp. 71–110. New Haven: Yale University Press, 1984.

Dance, Daryl C. "Zora Neale Hurston." In *American Women Writers: Bibliographical Essays,* edited by Maurice Duke, et al. Westport, Conn.: Greenwood Press, 1983.

Gates, Henry Louis, Jr. "The Speakerly Text." In Henry Louis Gates, Jr., *The Signifying Monkey,* pp. 170–217. New York: Oxford University Press, 1988.

Giles, James R. "The Significance of Time in Zora Neale Hurston's *Their Eyes Were Watching God.*" *Negro American Literature Forum* 6 (Summer 1972): 52–53, 60.

Hemenway, Robert E. *Zora Neale Hurston: A Literary Biography.* Chicago: University of Illinois Press, 1977.

Holloway, Karla. *The Character of the Word: The Texts of Zora Neale Hurston.* Westport, Conn.: Greenwood Press, 1987.

Holt, Elvin. "Zora Neale Hurston." In *Fifty Southern Writers After 1900,* edited by Joseph M. Flura and Robert Bain, pp. 259–69. Westport, Conn.: Greenwood Press, 1987.

Howard, Lillie Pearl. *Zora Neale Hurston.* Boston: Twayne, 1980.

———. "Zora Neale Hurston." In *Dictionary of Literary Biography,* vol. 51, edited by Trudier Harris, pp. 133–45. Detroit: Gale, 1987.

Jackson, Blyden. "Some Negroes in the Land of Goshen." *Tennessee Folklore Society Bulletin* 19 (4) (December 1953): 103–7.

Johnson, Barbara. "Metaphor, Metonymy, and Voice in *Their Eyes.*" In *Black Literature and Literary Theory,* edited by Henry Louis Gates, Jr., pp. 205–21. New York: Methuen, 1984.

————. "Thresholds of Difference: Structures of Address in Zora Neale Hurston." In *"Race," Writing and Difference,* edited by Henry Lewis Gates, Jr. Chicago: University of Chicago Press, 1986.

Jordan, June. "On Richard Wright and Zora Neale Hurston." *Black World* 23 (10) (August 1974): 4–8.

Kubitschek, Missy Dehn. " 'Tuh de Horizon and Back': The Female Quest in *Their Eyes." Black American Literature Forum* 17 (3) (Fall 1983): 109–15.

Lionnet, Françoise. "Autoethnography: The Anarchic Style of *Dust Tracks on a Road."* In Françoise Lionnet, *Autobiographical Voices: Race, Gender, Self-Portraiture,* pp. 97–130. Ithaca: Cornell University Press, 1989.

Lupton, Mary Jane. "Zora Neale Hurston and the Survival of the Female." *Southern Literary Journal* 15 (Fall 1982): 45–54.

Meese, Elizabeth. "Orality and Textuality in Zora Neale Hurston's *Their Eyes."* In Elizabeth Meese, *Crossing the Double Cross: The Practice of Feminist Criticism,* pp. 39–55. Chapel Hill: University of North Carolina Press, 1986.

Newson, Adele S. *Zora Neale Hurston: A Reference Guide.* Boston: G. K. Hall, 1987.

Rayson, Ann. *"Dust Tracks on a Road:* Zora Neale Hurston and the Form of Black Autobiography." *Negro American Literature Forum* 7 (Summer 1973): 42–44.

Sheffey, Ruthe T., ed. *A Rainbow Round Her Shoulder: The Zora Neale Hurston Symposium Papers.* Baltimore: Morgan State University Press, 1982.

Smith, Barbara. "Sexual Politics and the Fiction of Zora Neale Hurston." *Radical Teacher* 8 (May 1978): 26–30.

Stepto, Robert B. *From Behind the Veil.* Urbana: University of Illinois Press, 1979.

Walker, Alice. "In Search of Zora Neale Hurston." *Ms.,* March 1975, pp. 74–79, 85–89.

Wall, Cheryl A. "Zora Neale Hurston: Changing Her Own Words." In *American Novelists Revisited: Essays in Feminist Criticism,* edited by Fritz Fleischmann, pp. 370–93. Boston: G. K. Hall, 1982.

Washington, Mary Helen. "Zora Neale Hurston: A Woman Half in Shadow." Introduction to *I Love Myself When I Am Laughing,* edited by Alice Walker. Old Westbury, N.Y.: Feminist Press, 1979.

————. " 'I Love the Way Janie Crawford Left Her Husbands': Zora Neale Hurston's Emergent Female Hero." In Mary Helen Washington, *Invented*

Lives: Narratives of Black Women, 1860–1960. New York: Anchor Press, 1987.

Willis, Miriam. "Folklore and the Creative Artist: Lydia Cabrera and Zora Neale Hurston." *CLA Journal* 27 (September 1983): 81–90.

Wolff, Maria Tai. "Listening and Living: Reading and Experience in *Their Eyes.*" *BALF* 16 (1) (Spring 1982): 29–33.

CHRONOLOGY

January 7, 1891 Born in Notasulga, Alabama, the fifth of eight children, to John Hurston, a carpenter and Baptist preacher, and Lucy Potts Hurston, a former schoolteacher.

September 1917–
June 1918 Attends Morgan Academy in Baltimore, completing the high school requirements.

Summer 1918 Works as a waitress in a nightclub and a manicurist in a black-owned barbershop that serves only whites.

1918–19 Attends Howard Prep School, Washington, D.C.

1919–24 Attends Howard University; receives an associate degree in 1920.

1921 Publishes her first story, "John Redding Goes to Sea," in the *Stylus,* the campus literary society's magazine.

December 1924 Publishes "Drenched in Light," a short story, in *Opportunity.*

1925 Submits a story, "Spunk," and a play, *Color Struck,* to *Opportunity*'s literary contest. Both win second-place awards; publishes "Spunk" in the June number.

1925–27 Attends Barnard College, studying anthropology with Franz Boas.

1926 Begins field work for Boas in Harlem.

January 1926	Publishes "John Redding Goes to Sea" in *Opportunity.*
Summer 1926	Organizes *Fire!* with Langston Hughes and Wallace Thurman; they publish only one issue, in November 1926. The issue includes Hurston's "Sweat."
August 1926	Publishes "Muttsy" in *Opportunity.*
September 1926	Publishes "Possum or Pig" in the *Forum.*
September–November 1926	Publishes "The Eatonville Anthology" in the *Messenger.*
1927	Publishes *The First One,* a play, in Charles S. Johnson's *Ebony and Topaz.*
February 1927	Goes to Florida to collect folklore.
May 19, 1927	Marries Herbert Sheen.
September 1927	First visits Mrs. Rufus Osgood Mason, seeking patronage.
October 1927	Publishes an account of the black settlement at St. Augustine, Florida, in the *Journal of Negro History;* also in this issue: "Cudjo's Own Story of the Last African Slaver."
December 1927	Signs a contract with Mason, enabling her to return to the South to collect folklore.
1928	Satirized as "Sweetie Mae Carr" in Wallace Thurman's novel about the Harlem Renaissance *Infants of the Spring;* receives a bachelor of arts degree from Barnard.
January 1928	Relations with Sheen break off.
May 1928	Publishes "How It Feels to Be Colored Me" in the *World Tomorrow.*
1930–32	Organizes the field notes that become *Mules and Men.*
May–June 1930	Works on the play *Mule Bone* with Langston Hughes.
1931	Publishes "Hoodoo in America" in the *Journal of American Folklore.*
February 1931	Breaks with Langston Hughes over the authorship of *Mule Bone.*
July 7, 1931	Divorces Sheen.

September 1931	Writes for a theatrical revue called *Fast and Furious.*
January 1932	Writes and stages a theatrical revue called *The Great Day,* first performed on January 10 on Broadway at the John Golden Theatre; works with the creative literature department of Rollins College, Winter Park, Florida, to produce a concert program of Negro music.
1933	Writes "The Fiery Chariot."
January 1933	Stages *From Sun to Sun* (a version of *Great Day*) at Rollins College.
August 1933	Publishes "The Gilded Six-Bits" in *Story.*
1934	Publishes six essays in Nancy Cunard's anthology, *Negro.*
January 1934	Goes to Bethune-Cookman College to establish a school of dramatic arts "based on pure Negro expression."
May 1934	Publishes *Jonah's Gourd Vine,* originally titled *Big Nigger;* it is a Book-of-the-Month Club selection.
September 1934	Publishes "The Fire and the Cloud" in the *Challenge.*
November 1934	*Singing Steel* (a version of *Great Day*) performed in Chicago.
January 1935	Makes an abortive attempt to study for a Ph.D. in anthropology at Columbia University on a fellowship from the Rosenwald Foundation. In fact, she seldom attends classes.
August 1935	Joins the WPA Federal Theatre Project as a "dramatic coach."
October 1935	*Mules and Men* published.
March 1936	Awarded a Guggenheim Fellowship to study West Indian Obeah practices.
April–September 1936	In Jamaica.
September–March 1937	In Haiti; writes *Their Eyes Were Watching God* in seven weeks.
May 1937	Returns to Haiti on a renewed Guggenheim.
September 1937	Returns to the United States; *Their Eyes Were Watching God* published, September 18.

February–March 1938.	Writes *Tell My Horse;* it is published the same year.
April 1938	Joins the Federal Writers Project in Florida to work on *The Florida Negro.*
1939	Publishes "Now Take Noses" in *Cordially Yours.*
June 1939	Receives an honorary Doctor of Letters degree from Morgan State College.
June 27, 1939	Marries Albert Price III in Florida.
Summer 1939	Hired as a drama instructor by North Carolina College for Negroes at Durham; meets Paul Green, professor of drama, at the University of North Carolina.
November 1939	*Moses, Man of the Mountain* published.
February 1940	Files for divorce from Price, though the two are reconciled briefly.
Summer 1940	Makes a folklore-collecting trip to South Carolina.
Spring–July 1941	Writes *Dust Tracks on a Road.*
July 1941	Publishes "Cock Robin, Beale Street" in the *Southern Literary Messenger.*
October 1941–January 1942	Works as a story consultant at Paramount Pictures.
July 1942	Publishes "Story in Harlem Slang" in the *American Mercury.*
September 5, 1942	Publishes a profile of Lawrence Silas in the *Saturday Evening Post.*
November 1942	*Dust Tracks on a Road* published.
February 1943	Awarded the Anisfield-Wolf Book Award in Race Relations for *Dust Tracks;* on the cover of the *Saturday Review.*
March 1943	Receives Howard University's Distinguished Alumni Award.
May 1943	Publishes "The 'Pet Negro' Syndrome" in the *American Mercury.*
November 1943	Divorce from Price granted.
June 1944	Publishes "My Most Humiliating Jim Crow Experience" in the *Negro Digest.*
1945	Writes *Mrs. Doctor;* it is rejected by Lippincott.

March 1945	Publishes "The Rise of the Begging Joints" in the *American Mercury.*
December 1945	Publishes "Crazy for This Democracy" in the *Negro Digest.*
1947	Publishes a review of Robert Tallant's *Voodoo in New Orleans* in the *Journal of American Folklore.*
May 1947	Goes to British Honduras to research black communities in Central America; writes *Seraph on the Suwanee;* stays in Honduras until March 1948.
September 1948	Falsely accused of molesting a ten-year-old boy and arrested; case finally dismissed in March 1949.
October 1948	*Seraph on the Suwanee* published.
March 1950	Publishes "Conscience of the Court" in the *Saturday Evening Post,* while working as a maid in Rivo Island, Florida.
April 1950	Publishes "What White Publishers Won't Print" in the *Saturday Evening Post.*
November 1950	Publishes "I Saw Negro Votes Peddled" in the *American Legion* magazine.
Winter 1950–51	Moves to Belle Glade, Florida.
June 1951	Publishes "Why the Negro Won't Buy Communism" in the *American Legion* magazine.
December 8, 1951	Publishes "A Negro Voter Sizes Up Taft" in the *Saturday Evening Post.*
1952	Hired by the *Pittsburgh Courier* to cover the Ruby McCollum case.
May 1956	Receives an award for "education and human relations" at Bethune-Cookman College.
June 1956	Works as a librarian at Patrick Air Force Base in Florida; fired in 1957.
1957–59	Writes a column on "Hoodoo and Black Magic" for the *Fort Pierce Chronicle.*
1958	Works as a substitute teacher at Lincoln Park Academy, Fort Pierce.
Early 1959	Suffers a stroke.
October 1959	Forced to enter the St. Lucie County Welfare Home.

January 28, 1960	Dies in the St. Lucie County Welfare Home of "hypertensive heart disease"; buried in an unmarked grave in the Garden of Heavenly Rest, Fort Pierce.
August 1973	Alice Walker discovers and marks Hurston's grave.
March 1975	Walker publishes "In Search of Zora Neale Hurston," in *Ms.*, launching a Hurston revival.

About the author

About the book

Read on

Insights,
Interviews
& More...

"She *Was* the Party"

by Valerie Boyd

ZORA NEALE HURSTON knew how to make an entrance. On May 1, 1925, at a literary awards dinner sponsored by *Opportunity* magazine, the earthy Harlem newcomer turned heads and raised eyebrows as she claimed four awards: a second-place fiction prize for her short story "Spunk," a second-place award in drama for her play *Color Struck,* and two honorable mentions.

The names of the writers who beat out Hurston for first place that night would soon be forgotten. But the name of the second-place winner buzzed on tongues all night, and for days and years to come.

Lest anyone forget her, Hurston made a wholly memorable entrance at a party following the awards dinner. She strode into the room—jammed with writers and arts patrons, black and white—and flung a long, richly colored scarf around her neck with dramatic flourish as she bellowed a reminder of the title of her winning play: *"Coloooooor Struuckkkk!"* Her exultant entrance literally stopped the party for a moment, just as she had intended. In this way, Hurston made it known that a bright and powerful presence had arrived.

By all accounts, Zora Neale Hurston could walk into a roomful of strangers and, a few minutes and a few stories later, leave them so completely charmed that they often found themselves offering to help her in any way they could.

Gamely accepting such offers—and employing her own talent and scrappiness—

Courtesy of the Estate of Carl Van Vechten, Joseph Solomon, executor

Hurston became the most successful and most significant black woman writer of the first half of the twentieth century. Over a career that spanned more than thirty years, she published four novels, two books of folklore, an autobiography, numerous short stories, and several essays, articles, and plays.

Born on January 7, 1891, in Notasulga, Alabama, Hurston moved with her family to Eatonville, Florida, when she was still a toddler. Her writings reveal no recollection of her Alabama beginnings. For Hurston, Eatonville was always home.

Established in 1887, the rural community near Orlando was the nation's first incorporated black township. It was, as Hurston described it, "a city of five lakes, three croquet courts, three hundred brown skins, three hundred good swimmers, plenty guavas, two schools, and no jailhouse."

In Eatonville, Zora was never indoctrinated in inferiority, and she could see the evidence of black achievement all around her. She could look to town hall and see black men, including her father, John Hurston, formulating the laws that governed Eatonville. She could look to the Sunday schools of the town's two churches and see black women, including her mother, Lucy Potts Hurston, directing the Christian curricula. She could look to the porch of the village store and see black men and women passing worlds through their mouths in the form of colorful, engaging stories.

Growing up in this culturally affirming setting in an eight-room house on five acres of land, Zora had a relatively happy childhood, despite frequent clashes with her preacher-father, who sometimes sought to "squinch" her rambunctious spirit, she recalled. Her mother, on the other hand, urged young Zora

> " In Eatonville, Zora was never indoctrinated in inferiority, and she could see the evidence of black achievement all around her. "

and her seven siblings to "jump at de sun." Hurston explained, "We might not land on the sun, but at least we would get off the ground."

Hurston's idyllic childhood came to an abrupt end, though, when her mother died in 1904. Zora was only thirteen years old. "That hour began my wanderings," she later wrote. "Not so much in geography, but in time. Then not so much in time as in spirit."

After Lucy Hurston's death, Zora's father remarried quickly—to a young woman whom the hotheaded Zora almost killed in a fistfight—and seemed to have little time or money for his children. "Bare and bony of comfort and love," Zora worked a series of menial jobs over the ensuing years, struggled to finish her schooling, and eventually joined a Gilbert & Sullivan traveling troupe as a maid to the lead singer. In 1917, she turned up in Baltimore; by then, she was twenty-six years old and still hadn't finished high school. Needing to present herself as a teenager to qualify for free public schooling, she lopped ten years off her life—giving her year of birth as 1901. Once gone, those years were never restored: From that moment forward, Hurston would always present herself as at least ten years younger than she actually was.

Apparently, she had the looks to pull it off. Photographs reveal that she was a handsome, big-boned woman with playful yet penetrating eyes, high cheekbones, and a full, graceful mouth that was never without expression.

Zora also had a fiery intellect, an infectious sense of humor, and "the gift," as one friend put it, "of walking into hearts." Zora used

> 66 Zora had a relatively happy childhood, despite frequent clashes with her preacher-father, who sometimes sought to 'squinch' her rambunctious spirit. 99

these talents—and dozens more—to elbow her way into the Harlem Renaissance of the 1920s, befriending such luminaries as poet Langston Hughes and popular singer-actress Ethel Waters.

Though Hurston rarely drank, fellow writer Sterling Brown recalled, "When Zora was there, she *was* the party." Another friend remembered Hurston's apartment—furnished by donations she solicited from friends—as a spirited "open house" for artists. All this socializing didn't keep Hurston from her work, though. She would sometimes write in her bedroom while the party went on in the living room.

By 1935, Hurston—who'd graduated from Barnard College in 1928—had published several short stories and articles, as well as a novel, *Jonah's Gourd Vine,* and a well-received collection of black Southern folklore, *Mules and Men.* But the late thirties and early forties marked the real zenith of her career. She published her masterwork, *Their Eyes Were Watching God,* in 1937; *Tell My Horse,* her study of Haitian Vodou practices and Caribbean culture, in 1938; and another masterful novel, *Moses, Man of the Mountain,* in 1939. When her autobiography, *Dust Tracks on a Road,* was published in 1942, Hurston finally received the well-earned acclaim that had long eluded her. That year, she was profiled in *Who's Who in America, Current Biography,* and *Twentieth Century Authors.* She went on to publish another novel, *Seraph on the Suwanee,* in 1948.

Still, Hurston never received the financial rewards she deserved. (The largest royalty she ever earned from any of her books was ▶

66 'When Zora was there, she *was* the party.' 99

"She *Was* the Party" *(continued)*

$943.75.) So when she died on January 28, 1960—at age sixty-nine, after suffering a stroke—her neighbors in Fort Pierce, Florida, had to take up a collection for her February 7 funeral. The collection didn't yield enough to pay for a headstone, however, so Hurston was buried in a grave that remained unmarked until 1973.

That summer a young writer named Alice Walker traveled to Fort Pierce to place a marker on the grave of the author who had so inspired her own work. Walker found the Garden of Heavenly Rest, a segregated cemetery at the dead end of North Seventeenth Street, abandoned and overgrown with yellow-flowered weeds.

Back in 1945, Hurston had foreseen the possibility of dying without money—and she'd proposed a solution that would have benefited her and countless others. Writing to W. E. B. Du Bois, whom she called the "Dean of American Negro Artists," Hurston suggested "a cemetery for the illustrious Negro dead" on one hundred acres of land in Florida. "Let no Negro celebrity, no matter what financial condition they might be in at death, lie in inconspicuous forgetfulness," she urged. "We must assume the responsibility of their graves being known and honored." Du Bois, citing practical complications, wrote a curt reply discounting her argument.

As if impelled by Hurston's words, Walker bravely entered the snake-infested cemetery where the writer's remains had been laid to rest. Wading through waist-high weeds, she soon stumbled upon a sunken rectangular patch of ground that she determined to be Hurston's grave. Unable to afford the marker

> ❝ Hurston was buried in a grave that remained unmarked until 1973. ❞

6

she wanted—a tall, majestic black stone called "Ebony Mist"—Walker chose a plain gray headstone instead. Borrowing from a Jean Toomer poem, she dressed the marker up with a fitting epitaph: "Zora Neale Hurston: A Genius of the South." 〜

66 Wading through waist-high weeds, Alice Walker stumbled upon a sunken rectangular patch of ground that she determined to be Hurston's grave. 99

Valerie Boyd is the author of the award-winning Wrapped in Rainbows: The Life of Zora Neale Hurston. *Formerly the arts editor at the* Atlanta Journal-Constitution, *she is a professor at the University of Georgia's Grady College of Journalism and Mass Communication.* ▶

Snapshots of Zora Neale Hurston

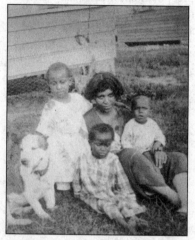

Zora surrounded by her nieces Wilhelmina (standing) and Winifred, her nephew Edgar (in Zora's lap), and Uncle Ben's dog, Prince.

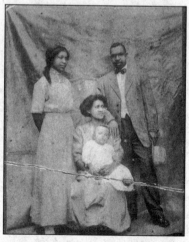

Zora (standing), with her eldest brother, Robert Hurston, sister-in-law, and nephew.

Zora with two young children.

Zora drumming on her trip to Haiti, where she penned *Their Eyes Were Watching God* and collected information on Vodou for her nonfiction work *Tell My Horse*.

The Contemporary Response to *Dust Tracks on a Road*

"Zora Sums Up"
Reprinted from *The Saturday Review*,
November 28, 1942
by Phil Strong

ZORA NEALE HURSTON'S FATHER was the preacher and chief factotum of Eatonville, Florida, one of the few villages of, for, and by Negroes in the United States. The old man was a powerful preacher and also a powerful man and husband; as a slave, says Zora, with the charming practicality which marks the manner of the whole book, he would have fetched a high price for stud stock. He could flatten people to the floor either with his big fists or his hellfire eloquence.

Zora had a good deal of her father's violence and more of her tiny mother's sensitivity, intelligence, and determination. These got her through school, after a bitter struggle, then through Howard University and Barnard, and finally made her what she is, an outstanding anthropologist in the field of Negro folklore and other Negro cultures. She has surveyed everything from Afro-American songs to Vodou and left a mark on modern American music and reasonable accounts of the over-romanticized magic of the Haitians.

This book is more of a summary than the autobiography it advertises itself as being. It is a delightful one and a wise one, full of humor, color, and good sense. It is told in exactly the right manner, simply and with candor, with a seasoning—not overdone—of the marvelous

> **As a slave, says Zora, with the charming practicality which marks the manner of the whole book, [her father] would have fetched a high price for stud stock.**

locutions of the imaginative field nigger. Miss Hurston explains that there are white niggers and black niggers; being a nigger is a matter of character rather than color among the Negroes.

After Zora's mother died her father married a fat shrew who wanted to make the social jump of being the preacher's wife. The stepmother was jealous of the children and drove them from home, one by one, including Zora, who was still in her earliest teens. The girl held "maiding" jobs but very briefly because of her fondness for books and children. These tastes conflicted with her allotted labors virtually to the exclusion of the latter; and Zora moved on and on. Finally, she caught on as a maid to the lead singer in a touring comic opera company, learned manicuring, and manicured her way through Howard.

She had learned that if one wanted to go to school the thing to do was to go to school, so she went on to Barnard, became Fanny Hurst's secretary and a favorite of Franz Boas, and thereafter made her way in research on fellowships and the five books which precede this one. She might have taken either of two attitudes from these experiences; either an arrogant, self-made Negro attitude, or the conventional bitter and downtrodden one. She takes neither because she does not see that she was under any special disadvantage, and in the end she has no reason for bitterness. This text indicates that anyone that tries to downtread Zora Neale Hurston had better wear thick-soled boots.

The race consciousness that spoils so much Negro literature is completely absent here. Miss Hurston is less impressed by her own color than most Aryan redheads. She gives ▶

66 The girl held 'maiding' jobs but very briefly because of her fondness for books and children. 99

11

one chapter to "My People"—perhaps the most sensible passage on the subject that has ever been written. She agrees with Booker T. Washington that if the stuff is in you it is likely to come out and that if it isn't it doesn't make any difference whether you are white, black, green, or cerise. Some people, she says, have made a whole career out of moaning, "My people! My people!" She thinks they would have been better engaged in some useful labor. The only thing she claims for the Negro is perhaps a little more capacity for fancy and enthusiasm than the average white man possesses.

The most amusing chapter is Miss Hurston's delightfully frank treatise on love. It makes sense, but few people have had the reckless heroism to come out with it. She has had one "great" love and still has it; she doesn't know yet how it is going to come out, since the chosen gentleman is jealous of her work, as well as of all other gentlemen discovered in even remote proximity to Zora. Miss Hurston, with a prescience of trouble, has tried to break herself of the man several times without success. Occasionally she feels like being in love with someone else, incidentally—and is, briefly. When these unfortunate swains remind her of tender passages she is all too often feeling like "a character member of the Union League Club" (this may be a slander) and the recalled endearments are "the third day of Thanksgiving turkey hash."

The conclusion is: Love is a funny thing; love is a blossom—if you want your finger bit, poke it at a possum.

It may be judged that the book is rich in humor and this is true; it is real humor—and

> **The most amusing chapter is Miss Hurston's delightfully frank treatise on love. It makes sense, but few people have had the reckless heroism to come out with it.**

humor of character, from the old deacon who prays, "Oh, Lawd, I got something to ask You, but I know You can't do it," to Zora's own feud, nourished through the years and beyond all scholarship and honors, with her gross stepmother. The old lady, at last reports, was in the hospital with some malignant growth on her neck—Miss Hurston says, quite frankly and honestly, that she wishes the woman had two necks.

She has, too, a philosophic feeling for the statement of her friend, Ethyl Waters, "Don't care how good the music is, Zora, you can't dance on every set."

It is a fine, rich, autobiography, and heartening to anyone, white, black, or tan.

> " [*Dust Tracks on a Road*] is real humor—and humor of character. "

..

"Zora Hurston's Story"
Excerpted from the *New York Times Book Review,* November 29, 1942
by Beatrice Sherman

HERE IS A THUMPING STORY, though it has none of the horrid earmarks of the Alger-type climb. Zora Neale Hurston has a considerable reputation as anthropologist and writer. When her autobiography begins, she is one of eight children in a Negro family with small prospects of making a name for herself. Yet her story is forthright and without frills. Its emphasis lies on her fighting spirit in the struggle to achieve the education she felt she had to have. The uses to which it was put— good uses too—were the fruit of things that cropped up spontaneously, demanding to be done. ▶

> " [Hurston's] story is forthright and without frills. "

The Contemporary Response to *Dust Tracks on a Road* (*continued*)

Hard work and natural talent were her mainstays. Bad luck and good came in mixed portions. But always Zora Neale Hurston felt that she was a special, a different sort of person—not in any unpleasantly cocky way, but as almost anyone does who has energy and ability and wants to use them. . . .

Her whole story is live and vivid. Told in gutsy language, it is full of the graphic metaphors and similes that color Negro speech at its richest, sometimes in direct quotations from folk stories—those lying sessions at the village store—and sometimes woven in with her own warm style. There is no "hush-mouth modesty" about the book, for Zora Neale Hurston would not "low-rate the human race" by undue expurgation of her story. . . .

Further along there are philosophical chapters on books (the Hurston books), love, "My People!" and religion. Then impression simmers down to a feeling that the author regards the Negro race much as she regards any other race—as made up of some good, some bad, and a lot of medium. The problems they face are those of any other race, with the disadvantage of being a younger lot. Anyway, her story is an encouraging and enjoyable one for any member of the human race. Any race might well be proud to have more members of the caliber and stamina of Zora Neale Hurston. ∾

> ❝ There is no 'hush-mouth modesty' about the book. ❞

Have You Read?
More by
Zora Neale Hurston

JONAH'S GOURD VINE

Zora Neale Hurston's first novel tells the story of John Buddy Pearson, a young minister who loves too many women for his own good even though he is married to Lucy, his one true love. In this sympathetic portrait of a man and his community, Hurston shows that faith and tolerance and good intentions cannot resolve the tension between the spiritual and the physical.

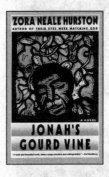

MULES AND MEN

The fruit of Hurston's labors as a folklorist and anthropologist, this celebrated treasury of black American folklore includes stories, "big old lies," songs, Vodou customs, superstitions—all the humor and wisdom that is the matchless heritage of American blacks.

THEIR EYES WERE WATCHING GOD

The epic tale of Janie Crawford, whose quest for identity takes her on a journey during which she learns what love is, experiences life's joys and sorrows, and comes home to herself in peace. Her passionate story prompted Alice Walker to say, "There is no book more important to me than this one."

15

Have You Read? *(continued)*

TELL MY HORSE

This firsthand account of the mysteries of Vodou is based on Hurston's personal experiences in Haiti and Jamaica, where she participated as an initiate and not just an observer of Vodou practices in the 1930s. Of great cultural interest, her travelogue paints a vividly authentic picture of ceremonies, customs, and superstitions.

MOSES, MAN OF THE MOUNTAIN

Based on the familiar story of the Exodus, Hurston blends the Moses of the Old Testament with the Moses of black folklore and song to create a compelling allegory of power, redemption, and faith.

SERAPH ON THE SUWANEE

Hurston's novel of turn-of-the-century white Florida "crackers" marks a daring departure for the author famous for her complex accounts of black culture and heritage. Hurston explores the evolution of a marriage full of love but very little communication and the desires of a young woman in search of herself and her place in the world.

Don't miss the next book by your favorite author. Sign up now for AuthorTracker by visiting www.AuthorTracker.com.

An Excerpt from *Barracoon: The Story of the Last "Black Cargo"*
by Zora Neale Hurston

Chapter I

It was summer when I went to talk with Cudjo so his door was standing wide open. But I knew he was somewhere about the house before I entered the yard, because I had found the gate unlocked. When Cudjo goes down into his back-field or away from home he locks his gate with an ingenious wooden peg of African invention.

I hailed him by his African name as I walked up the steps to his porch, and he looked up into my face as I stood in the door in surprise. He was eating his breakfast from a round enameled pan with his hands, in the fashion of his fatherland.

The surprise of seeing me halted his hand between pan and face. Then tears of joy welled up.

"Oh Lor', I know it *you* call my name. Nobody don't callee me my name from cross de water but you. You always callee me Kossula, jus' lak I in de Affica soil!"

I noted that another man sat eating with him and I wondered why. So I said, "I see you have company, Kossula."

"Yeah, I got to have somebody stay wid me. I been sick in de bed de five month. I needa somebody hand me some water. So I take dis man and he sleep here and take keer Cudjo. But I gittee well now."

In spite of the recent illness and the fact that his well had fallen in, I found Cudjo Lewis full of gleaming, good will. His garden was planted. There was deep shade under his China-berry tree and all was well.

He wanted to know a few things about New York and when I had answered him, he sat silently smoking. Finally, I told him I had come to talk with him. He removed his pipe from his mouth and smiled.

"I doan keer," he said, "I lakee have comp'ny come see me." Then the smile faded into a wretched weeping mask. "I so lonely. My wife she left me since de 1908. Cudjo all by hisself."

After a minute or two he remembered me and said contritely, "Excuse me. You didn't do nothin' to me. Cudjo feel so lonely, he can't help he cry sometime. Whut you want wid me?"

"First, I want to ask you how you feel today?"

Another muted silence. Then he said, "I thank God I on prayin' groun' and in a Bible country."

"But didn't you have a God back in Africa?" I asked him.

His head dropped between his hands and the tears sprung fresh. Seeing the anguish in his face, I regretted that I had come to worry this captive in a strange land. He read my face and said, "Excusee me I cry. I can't help it when I hear de name call. Oh, Lor'. I no see Afficky soil no mo'!"

Another long silence. Then, "How come you astee me ain we had no God back dere in Afficky?"

"Because you said 'thank God you were on praying ground and in a Bible country.'"

"Yeah, in Afficky we always know dere was a God; he name Alahua, but po' Affickans we cain readee de Bible, so we doan know God got a Son. We ain ignant—we jes doan know. Nobody doan tell us 'bout Adam eatee de apple, we didn't know de seven seals was sealee 'gainst us. Our parents doan tell us dat. Dey didn't tell us bout de first days. No, dass a right. We jes doan know. So dat whut you come astee me?"

I temporized. "Well, yes. I wanted to ask that, but I want to ask you many things. I want to know who you are and how you came to be a slave; and to what part of Africa do you belong, and how you fared as a slave, and how you have managed as a free man?"

Again his head was bowed for a time. When he lifted his wet face again he murmured, "Thankee Jesus! Somebody come ast about Cudjo! I want tellee somebody who I is, so maybe dey go in de Afficky soil some day and callee my name and somebody dere say, "Yeah, I know Kossula." I want you everywhere you go to tell everybody whut Cudjo say, and how come I in Americky soil since de 1859 and never see my people no mo'. I can't talkee plain, you unnerstand me, but I calls it word by word for you so it won't be too crooked for you.

"My name, is not Cudjo Lewis. It Kossula. When I gittee in Americky soil, Mr. Jim Meaher he try callee my name, but it too long, you unnerstand me, so I say, 'Well, I yo' property?' He say, 'Yeah.' Den I say, 'You callee me Cudjo. Dat do.' But in Afficky soil my mama she name me Kossula.*

* Editor's note: In *Dust Tracks on a Road*, Hurston writes that she "went to talk to Cudjo Lewis. That is the American version of his name. His African name was Kossola-O-Lo-Loo-Ay" (198). Hurston also transcribed Kossola's name as "Kossula" and "Kazoola." In my introduction and references elsewhere, I have used "Kossola," as it is consistent with Sylviane Diouf's research in *Dreams of Africa in Alabama* where she establishes "Kossola" as the likely spelling: it is a name "immediately decipherable" to the Isha Yoruba who "have a town named Kossola" (Diouf 40).

"My people, you unnerstand me, dey ain got no ivory by de door. When it ivory from de elephant stand by de door, den dat a king, a ruler, you unnerstand me. My father neither his father don't rule nobody. De ole folks dat live two hund'ed year befo' I born don't tell me de father (remote ancestor) rule nobody.

"My people in Afficky, you unnerstand me, dey not rich. Dass de truth, now. I not goin' tellee you my folks dey rich and come from high blood. Den when you go in de Afficky soil an' astee de people, dey say, 'Why Kossula over dere in Americky soil tellee de folks he rich?' I tellee you lak it tis. Now, dass right, ain it?

"My father's father, you unnerstand me, he a officer of de king. He don't live in de compound wid us. Wherever de king go, he go, you unnerstand me. De king give him plenty land, and got plenty cows and goats and sheep. Now, dass right. Maybe after while he be a little chief, I doan know. But he die when I a lil boy. Whut he gointer be later on, dat doan reechee me.

"My grandpa, he a great man. I tellee you how he go."

I was afraid that Cudjo might go off on a tangent, so I cut in with, "But Kossula, I want to hear about *you* and how *you* lived in Africa."

He gave me a look full of scornful pity and asked, "Where is de house where de mouse is de leader? In de Affica soil I cain tellee you 'bout de son before I tellee you bout de father; and derefore, you unnerstand me, I cain talk about de man who is father (*et te*) till I tellee you bout de man who he father to him, (*et, te, te*, grandfather) now, dass right ain it?

"My grandpa, you unnerstand me, he got de great big compound. He got plenty wives and chillun. His house, it is in de center de compound. In Affica soil de house of de husband it always in de center and de houses of de wives, dein in a circle round de house dey husband live in.

"He don't think hisself to marry wid so many women. No. In de Affica soil it de wife dat go findee him another wife.

"S'pose I in de Affica soil. Cudjo he been married for seven year for example. His wife say, 'Cudjo, I am growin' old. I tired. I will bring you another wife.

"Before she speakee dat, she got de girl who he doan know in her mind. She a girl she think very nice. Maybe her husband never see her. Well, she go out in de market place, maybe in de public square. She see disa girl and astee de girl, 'You know Cudjo?' De girl tellee her, 'I have heard of him.' De wife say, 'Cudjo is good. He is kind. I like you to be his wife.' De girl say 'Come with me to my papa and mama.'

"Dey go, you unnerstand me to do girl's parents together. Dey astee her questions and she answere for her husband. She astee dem questions too and if both sides satisfy wid one nother de girl's parents say, 'We give our daughter into yo' care. She ain ours no mo'. You be good to her.'

"De wife she come back to Cudjo and makee de 'rangements. Cudjo got to pay de father for de girl. If she be a rich girl dat been in de fat-house long time, you unnerstand me, he got to pay two of everything for her. Two cow, two sheep, two goat, chickens, yam, maybe gold. De rich man, keepee his daughter in de fat house long time. Sometime two year. She gittee de dinner in dere eight times a day and dey don't leavee her git in and out of bed by herself. De one whut keep de fat-house he lift dem in and out, so dey don't lose de fat.

"De man not so rich, he cain keep his girl dere long so she not so fat. So po' man don't send his daughter.

"Derefore you unnerstand me, de man pay different price for different girl. If she de daughter of a po' family, or she been married before or somthin', he don't pay much for her.

"When de new wife come first to her husband compound she live in de house wid de old wife. She teach her what to do and how to take keer de husband. When she learn all dat, den she have a house by herself.

"When dey gittee ready to buildee de new house, de man takee de machete and chop de palm tree to mark de place where de house goin' be build. Den he throw down a cow and have plenty palm wine. Den all de people come and eatee de meat and drink de wine and stomp de place smooth and buildee de house.

"My grandpa, he buildee wife house many time.

"Some men in de Affica soil don't gittee no wife cause dey cain buy none. Dey ain got nothing to give so a wife kin come to dem. Some got too many. When you hungry it is painful but when de belly too full it painful too.

"All de wives make food (*udia*) for de husband. All de men dey likee de fufu. He eatee de big calabash full to de top wid fufu, den my grandpa he lay down to sleep.

"De young wives (before they are old enough to take up the actual duties of wifehood) help put de husband to sleep. One makee wind for him wid de fan. Another one rub de head. Maybe one clean de hands and somebody look after de toe-nails. Den he sleepee and snore.

"Somebody stand guard before de door so nobody make noise and wakee him. Sometime de son of a slave in de compound makee too much noise. De man what stand guard ketchee him and takee him to my

grandpa. He sit up and lookee at de boy so. Den he astee him, "Whoever tellee you dat de mouse kin walk 'cross de roof of de mighty? Where is dat Portugee man? I swap you for tobacco! In de olden days, I walk on yo' skin!' (That is, I would kill you and make shoes from your hide) 'I drink water from yo' skull.' (I would have killed you and used your head for a drinking cup.)

"My grandpa say dat, but he don't never astee de chief to sellee nobody to de Portugee. Some chief dey gittee mad when de slave talkee so sassy and don't do work lakee dey tell 'em. Den dey sell him to de Portugee. De chief throw orange under de table. Den he call the slave boy he goin' sell and say to de boy, 'Pick me de orange under de table.' De boy stoop under de table. De chief got a man standin dere. Maybe two. When de boy go under the table to gittee de orange, de chief say, 'Ketchee de bushman!' De men grabee de boy and sellee him.

"De chief he ain always glad. One day de wife die. She still in de old wife's house and ain never been no wife to the chief yet. She too young. Why she die, Cudjo doan know.

"When dey come to tell de chief his young wife dead, he go look. He slap his hand on his wrist. Den he scream in his fist and cry. He say, 'Yea! yea! yea! my wife dead. All my goods wasted. I pay big price for her. I fatten her and now she dead and I never sleep wid her once. Yea! yea! I lose so much! She dead and still a virgin! Yea! yea, tu yea! I have a great loss.' "

Cudjo looked out over his patch of pole-beans towards the house of his daughter-in-law. I waited for him to resume, but he just sat there not seeing me. I waited but not a sound. Presently he turned to the man sitting inside the house and said, "go fetchee me some cool water."

The man took the pail and went down the path between the rows of pole-beans to the well in the daughter-in-law's yard. He returned and Kossula gulped down a healthy cup-full from a home-made tin cup.

Then he sat and smoked his pipe in silence. Finally he seemed to discover that I was still there. Then he said brusquely, "Go leave me 'lone. Cudjo tired. Come back tomorrow. Doan come in de mornin' cause den I be in de garden. Come when it hot, den Cudjo sit in de house."

So I left Cudjo sitting in his door with his bare feet exposed to the cloud of mosquitoes that swarmed in the shade of the inside of his house.

ALSO BY
ZORA NEALE HURSTON

BARRACOON
The Story of the Last "Black Cargo"
Available in Hardcover, eBook, Digital Audio, and Large Print

A major literary event: a newly published work from the author of the American classic *Their Eyes Were Watching God* that brilliantly illuminates the horror and injustices of slavery as it tells the true story of one of the last-known survivors of the Atlantic slave trade—abducted from Africa on the last "Black Cargo" ship to arrive in the United States. Offering insight into the pernicious legacy that continues to haunt us all, this poignant and powerful work is an invaluable contribution to our shared history and culture.

MULES AND MEN

Courtesy of Jane Belo estate and Margaret Mead

Zora Neale Hurston collecting folklore in the late 1930s.

MULES AND MEN

ZORA NEALE HURSTON

WITH A PREFACE BY FRANZ BOAS,
A FOREWORD BY ARNOLD RAMPERSAD,
AN AFTERWORD BY HENRY LOUIS GATES, JR.,
AND ILLUSTRATIONS BY MIGUEL COVARRUBIAS

AMISTAD
An Imprint of HarperCollins*Publishers*

First Perennial Library edition published 1990.
First Harper Perennial Modern Classics edition published 2008.

Designed by Cassandra J. Pappas

Library of Congress Cataloging-in-Publication Data is available upon request.

ISBN: 978-0-06-135017-7 (pbk.)

21 LSC 20 19 18 17

To
my dear friend
Mrs. Annie Nathan Meyer
who hauled the mud to make me
but loves me just the same

CONTENTS

Part II
HOODOO

PREFACE

Ever since the time of Uncle Remus, Negro folklore has exerted a strong attraction upon the imagination of the American public. Negro tales, songs and sayings without end, as well as descriptions of Negro magic and voodoo, have appeared; but in all of them the intimate setting in the social life of the Negro has been given very inadequately.

It is the great merit of Miss Hurston's work that she entered into the homely life of the southern Negro as one of them and was fully accepted as such by the companions of her childhood. Thus she has been able to penetrate through that affected demeanor by which the Negro excludes the White observer effectively from participating in his true inner life. Miss Hurston has been equally successful in gaining the confidence of the voodoo doctors and she gives us much that throws a new light upon the much discussed voodoo beliefs and practices. Added to all this is the charm of a loveable personality and of a revealing style which makes Miss Hurston's work an unusual contribution to our knowledge of the true inner life of the Negro.

To the student of cultural history the material presented is valuable not only by giving the Negro's reaction to everyday events, to his emotional life, his humor and passions, but it throws into relief also the peculiar amalgamation of African

and European tradition which is so important for understanding historically the character of American Negro life, with its strong African background in the West Indies, the importance of which diminishes with increasing distance from the south.

FRANZ BOAS

FOREWORD

On December 14, 1927, according to her biographer
Robert Hemenway, Zora Neale Hurston boarded a
midafternoon train at Pennsylvania Station in New
York City, bound for Mobile, Alabama. From Mobile she
would travel on to Florida and then to Louisiana, in a major
effort to gather material on African-American folklore and
other folk practices, including voodoo.

Hurston did not begin her project with the utmost confi-
dence. After all, her first significant venture as a collector of
folklore in the South had ended earlier that year with a frank
admission on her part of failure. That professional setback was
particularly galling for two reasons. First, Hurston was no
stranger to the South, having been born and reared in Eaton-
ville, Florida; as she later boasted in her autobiography *Dust
Tracks on a Road* (1942), she had "the map of Dixie on my
tongue." Secondly, she had carried out this first project col-
lecting folklore in the South with the solid backing and en-
couragement of Franz Boas, unquestionably the dominant
figure in American anthropology and Hurston's most influen-
tial professor at Barnard College, which she had entered as a
student in 1925.

Still, Hurston had been unable to make the most of these
advantages and had returned to New York with raw material

in her notebooks rather than with a mature, complex grasp of the implications of that material that would have enabled her to move from being simply a transcriber to becoming a profound interpreter of Southern folklore's place in the culture of black America. She had returned to Boas with little to show for her efforts. However, her second expedition into the South as a gatherer of folklore would end differently, even though several years passed before its success was crowned with the publication in 1935 of *Mules and Men*. Filtered through a matured consciousness, and organized according to effective journalistic and literary strategies, the material she gathered mainly between 1927 and 1928 (with additional work up to 1931 and 1932) resulted in one of the outstanding books of its kind ever published in the United States. In 1960, the year Hurston died, the celebrated American collector Alan Lomax appraised *Mules and Men* as "the most engaging, genuine, and skillfully written book in the field of folklore."

Although Hurston is far better known for the publication of her feminist novel *Their Eyes Were Watching God* (1937), no understanding of her mind and her art, or of her contribution to African-American culture or to the study of folklore, can ignore the achievement of *Mules and Men*. Almost certainly, there would have been no *Their Eyes Were Watching God* without the process of growth and maturation that resulted first from *Mules and Men*. In this book, Hurston first effected a genuine reconciliation between herself and her past, which is to say between herself as a growing individual with literary ambitions on the one hand and the evolving African-American culture and history on the other. Here, in an extended literary act—her most ambitious to date—she found at last the proper form for depicting herself in relationship to the broad range of forces within the African-American culture that had produced her, as well as for portraying the people of which she was but one member. Here she came to terms at last with the full range of black folk traditions, practices, expressions, and types of behavior, and began to trust her understanding of their multiple meanings as an index to the African-American

world. "From the earliest rocking of my cradle," she wrote in *Mules and Men,* "I had known about the capers Brer Rabbit is apt to cut and what the Squinch Owl says from the house top. But it was fitting me like a tight chemise. I couldn't see it for wearing it. It was only when I was off in college, away from my native surroundings, that I could see myself like somebody else and stand off and look at my garment. Then I had to have the spy-glass of Anthropology to look through at that."

In the case of Zora Neale Hurston, one speaks of this "coming to terms" with black folk culture carefully or not at all. Struggling to find a lofty place for herself in the world, she nevertheless arrived in New York in 1925 displaying from the start little ambivalence about traditional black culture. She was one of W.E.B. Du Bois's talented tenth—the gifted and educated leadership of the race on whom Du Bois based his hopes for African-American ascendance—without seeing herself, as members of the tenth often saw themselves, as victim caught tragically between two worlds, black and white. Instead, she draped black folk culture about herself like a fabulous robe, creating an inimitable and unforgettable personality, according to virtually everyone who recalled her, based on her mastery of jokes and stories, insights and attitudes, that derived almost directly from the black folk experience. As a fledgling writer, too, her earliest stories depended proudly—and shrewdly—on the black voices she had heard as a child growing up in Florida, the people who had taught her how to speak. She moved ambitiously among whites, often with guile and not infrequently in a servile manner; but consistently she offered herself as a child of the black South who had little desire ever to forget, much less repudiate, her folk and country roots.

This degree of identification set her apart from virtually all other writers, black and white. In his landmark study *The Souls of Black Folk* (1903), Du Bois had delved into folk culture to illustrate his thesis of black dignity and historicity. However, he had concentrated almost exclusively, in the area of psychology and philosophy, on approaches by blacks to Christianity;

in the area of art, he clung almost entirely to the noble and transcendent music of the spirituals. Other black writers, such as William Wells Brown and Charles Chesnutt, had drawn on black folkways, including both in music and in religion, in certain areas of their work, but none approached Hurston's knowledge of and commitment to folk culture. By far the best-known explorer of the black folk tradition among writers was Joel Chandler Harris, whose Uncle Remus stories, in tying animal tales to the plantation tradition, severely limited their applicability to black culture as a whole. Within what passed in those days for folklore science (as Hemenway points out, not one American university then boasted a department of folklore), efforts by white collectors to gather black material were often stymied by preconceptions about black character and by the reticence of blacks to lower their guard before such strangers. Notable among such work available in Hurston's days as a student were Guy Johnson and Howard Odum's *The Negro and His Sons* (1925) and *Negro Workaday Songs* (1926), as well as the white Mississippi folklorist Newbell Niles Puckett's *Folk Beliefs of the Southern Negro* (1927), in which Puckett had masqueraded as a voodoo priest himself in order to gain information.

As her letters to her academic mentor Franz Boas attest, Hurston had little regard for the work of these writers, especially Odum and Johnson, whom she saw as presumptuous in their confidence that they understood fully the black folk material. "Folklore is not as easy to collect as it sounds," she warned. "The best source is where there are the least outside influences and these people, being usually under-privileged, are the shyest." She was fortunate in that Boas, although a white man himself, was perhaps the outstanding champion of the notion of cultural relativism. He urged that cultures be seen on their own terms and not according to a scale that held European civilization to be the supreme standard. For all her advantages, however, Hurston still found it difficult to effect a breakthrough. In part, this was owing to the complexity of the task of understanding the material; in part, it derived from

Hurston's personal life experience, and especially from the fact that she was living at least one major lie as a student at Barnard. The two elements—the scholarly or intellectual, on the one hand, and the "purely" personal, on the other—were perhaps finally inseparable.

Hurston was born in the black town of Eatonville, Florida, on January 7, 1891—but so willfully misrepresented herself later that even her diligent biographer believed that her year of birth was 1901. This lost decade is perhaps only the major mystery of her life. What happened to Hurston between 1891 and 1917, when she started high school at Morgan Academy (later Morgan State University) in Baltimore, Maryland, is barely illuminated either by independent research or by her autobiography *Dust Tracks on a Road* (1942). Both, however, tell of a loving mother who urged her to "jump at de sun" and a dominating father, an Eatonville preacher and carpenter, whose remarriage following his wife's death began a long season of sorrow for Hurston. Apparently unable to find common ground with her new stepmother, Zora was passed around among relatives before she struck out on her own. She worked variously as a maid and a waitress, and may even have been married for a while, before she entered Morgan Academy in 1917. After being graduated from Morgan, she briefly attended Howard University in Washington, D.C., before going to New York in 1925 to study at Barnard College. *Mules and Men* is dedicated to Annie Nathan Meyer ("who hauled the mud to make me but loves me just the same"), the founder and a trustee of the college and the person directly responsible for Hurston's presence there.

As Hurston wrote, "the spy-glass of Anthropology" offered at Barnard and Columbia, especially in the persons of Boas and his associates Melville Herskovits and Ruth Benedict, enabled her to begin to see her Southern black culture accurately and comprehensively. And yet her deliberate obscuring of a decade of her life suggests that she could have approached her past, which is to say the wellspring of her folkloric knowledge, only with a certain amount of caution, perhaps even

distaste. In dropping a decade from her life, she was almost certainly denying the existence of experiences and involvements that, however unpalatable to her later on as she strove for success, had been a major part of her knowledge of her world. However, one other person was at least as important as these academics in pushing Hurston not only back into the arms of her past, as exemplified by her literal reentry into Eatonville to gather the material for the first part of *Mules and Men,* but also toward the radical belief in parapsychology and occultism, in voodoo and other forms of African religion, that generated the second, even more extraordinary part of the volume. That person was her patron Mrs. R. Osgood Mason, as Hurston reveals in *Mules and Men,* who "backed my falling in a hearty way, in a spiritual way, and in addition, financed the whole expedition in the manner of the Great Soul that she is. The world's most gallant woman."

This tribute appears at the end of Hurston's introduction, which places her in a motorcar (paid for by Mrs. Mason) precisely on the border of Eatonville—home. The wealthy septuagenarian widow of a doctor who had been himself an expert in parapsychology, Mrs. Mason was already "Godmother" to various Harlem Renaissance figures, including Alain Locke and Langston Hughes, when she took up Zora Neale Hurston and bankrolled her second folklore expedition into the South. As with Langston Hughes, whose novel *Not Without Laughter* (1930) Mrs. Mason virtually commissioned and edited, she did much more than provide Hurston with money. Volatile in personality, contemptuous of European rationalism and radically devoted to the idea of extrasensory communication, and a champion of the notion of the artistic and spiritual superiority of the darker races, Mrs. Mason, more than any of Hurston's academic advisers, paved the way for Hurston's plunging not simply into the Eatonville community of her childhood but, far more radically, into voodoo and black magic in Louisiana.

Although the voodoo section (a slightly edited version of her 1931 article "Hoodoo in America" in the *Journal of Ameri-*

can Folklore) was added at the last minute to the book in 1934 to please its publisher, Lippincott, the two sections are intimately related. The world of Eatonville and Florida in general—the world of tales spun by black men and women—is linked directly in this book to the world of New Orleans and Louisiana, where "two-headed doctors" preside over a community that believes devoutly in spells and conjures, hexes and divinations. Linking Eatonville and New Orleans is the communality and adaptability, the indomitable resilience of the imagination of Africans terrorized in the New World by objective reality in the form of slavery, segregation, and poverty. And both elements, I believe, were linked integrally to Hurston's interior world, to the fantastic personality and the altered personal history she had created for herself. "I thought about the tales I had heard as a child," Hurston recalled fancifully but pointedly during her approach by car to Eatonville. "How even the Bible was made over to suit our vivid imagination. How the devil always outsmarted God and how that over-noble hero Jack or John—not *John Henry,* who occupies the same place in Negro folklore that Casey Jones does in white lore and if anything is more recent—outsmarted the devil."

She who had been living to some extent by her wits, by her imagination, by the "lies" she created for her empowerment and salvation, as well as by her more structured, conventionally disciplined intelligence as a college student, now had begun to see her personal predicament and her imaginative response to it in a broader historical and cultural sense. To her black sources, their marvelous tales were—"lies." (" 'Zora,' George Thomas informed me, 'you come to de right place if lies is what you want. Ah'm gointer lie up a nation.' ") In one sense, it is possible to say that Hurston had become more of an African-American cultural nationalist, seeing more of the world and herself in terms of race and her own blackness. This would be true only to a limited degree, as Hurston's later involvement with reactionary political forces and personalities suggests. The power she gained from seeing her life in coher-

ence with the storytelling imagination of country blacks and with the world of conjure and black magic represented by voodoo was placed largely in a different service—self-empoweringly, to facilitate her emergence as a writer of fiction. Even before *Mules and Men* appeared in 1935, she published her first novel, *Jonah's Gourd Vine* (1934), which drew on her parents' history for inspiration. Two years after *Mules and Men* came *Their Eyes Were Watching God,* in which she effected her most harmonious blending of the themes of folklore and individualism, in a story now recognized as one of the main foundations of African-American literature.

In both main sections of *Mules and Men*—the seventy stories that make up "Folk Tales" and her encounters with five doctors in "Hoodoo"—the most fertile single device is the portrait of the narrator, Hurston herself. In both cases, she is both familiar with the culture into which she is moving and also an initiate. She is known in Eatonville, but everywhere else she must ingratiate herself into the confidence of the people, her great source. ("I stood there awkwardly, knowing that the too-ready laughter and aimless talk was a window-dressing for my benefit. The brother in black puts a laugh in every vacant place in his mind. His laugh has a hundred meanings.") So, too, with the world of hoodoo, which she approaches not as a scientific scholar, taking notes, or fraudulently, as Newbell Niles Puckett had done for his own book in representing himself as a conjure man. "None may wear the crown of power," she writes of her initiation, "without preparation. *It must be earned.*" Instead, she would be a true believer. "Belief in magic is older than writing," she declared tellingly. In the end, her teacher Luke Turner (called elsewhere Samuel Thompson by Hurston), who offered himself as the grandnephew of Marie Leveau, the most fabled figure in New Orleans hoodoo lore, invites Hurston to devote her life to the field. "He wanted me to stay with him to the end," she soberly reveals. "It has been a great sorrow to me that I could not say yes."

Much has been made about Hurston's scholarly shortcom-

ings in compiling *Mules and Men.* It seems certain that not all the stories and anecdotes in the book originated in the course of her research. Some of them, picked up elsewhere, may have been substantially ornamented by Hurston, and perhaps she invented a few. Rival versions of certain passages, published elsewhere by her, raise questions about her scholarly integrity. For the sake of symmetry, she appears to have telescoped certain periods of time into more convenient arrangements. "I had spent a year in gathering and culling over folk-tales," she wrote, when in fact she had spent a much longer period. Above all, some readers find Hurston insufficiently analytical and too much a part of her text, without that text revealing her definitively. Her shifts from the third person to the first are sometimes disconcerting. Scientific purists may find her language at times too colloquial and even racy, her sense of humor often reckless, her poetic license too frequently invoked. Her approach, some would say, was journalistic rather than scientific, self-indulgent rather than profound.

I would respond that the key to *Mules and Men* is precisely Hurston's finding of herself in the black folk world she described, and finding that black folk world, approached first by her as a student of anthropology, finally to be an unmistakable, ineradicable part of herself, her intimate psychology and history, and her desires, especially her desire to be an artist.

ARNOLD RAMPERSAD

MULES AND MEN

INTRODUCTION

I was glad when somebody told me, "You may go and collect Negro folklore."

In a way it would not be a new experience for me. When I pitched headforemost into the world I landed in the crib of negroism. From the earliest rocking of my cradle, I had known about the capers Brer Rabbit is apt to cut and what the Squinch Owl says from the house top. But it was fitting me like a tight chemise. I couldn't see it for wearing it. It was only when I was off in college, away from my native surroundings, that I could see myself like somebody else and stand off and look at my garment. Then I had to have the spy-glass of Anthropology to look through at that.

Dr. Boas asked me where I wanted to work and I said, "Florida," and gave, as my big reason, that "Florida is a place that draws people—white people from all over the world, and Negroes from every Southern state surely and some from the North and West." So I knew that it was possible for me to get a cross section of the Negro South in the one state. And then I realized that I was new myself, so it looked sensible for me to choose familiar ground.

First place I aimed to stop to collect material was Eatonville, Florida.

And now, I'm going to tell you why I decided to go to my

1

native village first. I didn't go back there so that the home folks could make admiration over me because I had been up North to college and come back with a diploma and a Chevrolet. I knew they were not going to pay either one of these items too much mind. I was just Lucy Hurston's daughter, Zora, and even if I had—to use one of our down-home expressions—had a Kaiser baby,[1] and that's something that hasn't been done in this Country yet, I'd still be just Zora to the neighbors. If I had exalted myself to impress the town, somebody would have sent me word in a match-box that I had been up North there and had rubbed the hair off of my head against some college wall, and then come back there with a lot of form and fashion and outside show to the world. But they'd stand flat-footed and tell me that they didn't have me, neither my sham-polish, to study 'bout. And that would have been that.

I hurried back to Eatonville because I knew that the town was full of material and that I could get it without hurt, harm or danger. As early as I could remember it was the habit of the men folks particularly to gather on the store porch of evenings and swap stories. Even the women folks would stop and break a breath with them at times. As a child when I was sent down to Joe Clarke's store, I'd drag out my leaving as long as possible in order to hear more.

Folklore is not as easy to collect as it sounds. The best source is where there are the least outside influences and these people, being usually under-privileged, are the shyest. They are most reluctant at times to reveal that which the soul lives by. And the Negro, in spite of his open-faced laughter, his seeming acquiescence, is particularly evasive. You see we are a polite people and we do not say to our questioner, "Get out of here!" We smile and tell him or her something that satisfies the white person because, knowing so little about us, he doesn't know what he is missing. The Indian resists curiosity by a stony silence. The Negro offers a feather-bed resistance. That is, we let the probe enter, but it never comes out. It gets

[1]Have a child by the Kaiser.

2

smothered under a lot of laughter and pleasantries.

The theory behind our tactics: "The white man is always trying to know into somebody else's business. All right, I'll set something outside the door of my mind for him to play with and handle. He can read my writing but he sho' can't read my mind. I'll put this play toy in his hand, and he will seize it and go away. Then I'll say my say and sing my song."

I knew that even *I* was going to have some hindrance among strangers. But here in Eatonville I knew everybody was going to help me. So below Palatka I began to feel eager to be there and I kicked the little Chevrolet right along.

I thought about the tales I had heard as a child. How even the Bible was made over to suit our vivid imagination. How the devil always outsmarted God and how that over-noble hero Jack or John—not *John Henry,* who occupies the same place in Negro folk-lore that Casey Jones does in white lore and if anything is more recent—outsmarted the devil. Brer Fox, Brer Deer, Brer 'Gator, Brer Dawg, Brer Rabbit, Ole Massa and his wife were walking the earth like natural men way back in the days when God himself was on the ground and men could talk with him. Way back there before God weighed up the dirt to make the mountains. When I was rounding Lily Lake I was remembering how God had made the world and the elements and people. He made souls for people, but he didn't give them out because he said:

"Folks ain't ready for souls yet. De clay ain't dry. It's de strongest thing Ah ever made. Don't aim to waste none thru loose cracks. And then men got to grow strong enough to stand it. De way things is now, if Ah give it out it would tear them shackly bodies to pieces. Bimeby, Ah give it out."

So folks went round thousands of years without no souls. All de time de soul-piece, it was setting 'round covered up wid God's loose raiment. Every now and then de wind would blow and hist up de cover and then de elements would be full of lightning and de winds would talk. So

3

people told one 'nother that God was talking in de mountains.

De white man passed by it way off and he looked but he wouldn't go close enough to touch. De Indian and de Negro, they tipped by cautious too, and all of 'em seen de light of diamonds when de winds shook de cover, and de wind dat passed over it sung songs. De Jew come past and heard de song from de soul-piece then he kept on passin' and all of a sudden he grabbed up de soul-piece and hid it under his clothes, and run off down de road. It burnt him and tore him and throwed him down and lifted him up and toted him across de mountain and he tried to break loose but he couldn't do it. He kept on hollerin' for help but de rest of 'em run hid 'way from him. Way after while they come out of holes and corners and picked up little chips and pieces that fell back on de ground. So God mixed it up wid feelings and give it out to 'em. 'Way after while when He ketch dat Jew, He's goin' to 'vide things up more ekal'.

So I rounded Park Lake and came speeding down the straight stretch into Eatonville, the city of five lakes, three croquet courts, three hundred brown skins, three hundred good swimmers, plenty guavas, two schools, and no jail-house.

Before I enter the township, I wish to make acknowledgments to Mrs. R. Osgood Mason of New York City. She backed my falling in a hearty way, in a spiritual way, and in addition, financed the whole expedition in the manner of the Great Soul that she is. The world's most gallant woman.

PART I

✜

FOLK TALES

ONE

As I crossed the Maitland-Eatonville township line I could see a group on the store porch. I was delighted. The town had not changed. Same love of talk and song. So I drove on down there before I stopped. Yes, there was George Thomas, Calvin Daniels, Jack and Charlie Jones, Gene Brazzle, B. Moseley and "Seaboard." Deep in a game of Florida-flip. All of those who were not actually playing were giving advice—"bet straightening" they call it.

"Hello, boys," I hailed them as I went into neutral.

They looked up from the game and for a moment it looked as if they had forgotten me. Then B. Moseley said, "Well, if it ain't Zora Hurston!" Then everybody crowded around the car to help greet me.

"You gointer stay awhile, Zora?"

"Yep. Several months."

"Where you gointer stay, Zora?"

"With Mett and Ellis, I reckon."

"Mett" was Mrs. Armetta Jones, an intimate friend of mine since childhood and Ellis was her husband. Their house stands under the huge camphor tree on the front street.

"Hello, heart-string," Mayor Hiram Lester yelled as he hurried up the street. "We heard all about you up North. You back home for good, I hope."

"Nope, Ah come to collect some old stories and tales and Ah know y'all know a plenty of 'em and that's why Ah headed straight for home."

"What you mean, Zora, them big old lies we tell when we're jus' sittin' around here on the store porch doin' nothin'?" asked B. Moseley.

"Yeah, those same ones about Ole Massa, and colored folks in heaven, and—oh, y'all know the kind I mean."

"Aw shucks," exclaimed George Thomas doubtfully. "Zora, don't you come here and tell de biggest lie first thing. Who you reckon want to read all them old-time tales about Brer Rabbit and Brer Bear?"

"Plenty of people, George. They are a lot more valuable than you might think. We want to set them down before it's too late."

"Too late for what?"

"Before everybody forgets all of 'em."

"No danger of that. That's all some people is good for—set 'round and lie and murder groceries."

"Ah know one right now," Calvin Daniels announced cheerfully. "It's a tale 'bout John and de frog."

"Wait till she get out her car, Calvin. Let her get settled at 'Met's' and cook a pan of ginger bread then we'll all go down and tell lies and eat ginger bread. Dat's de way to do. She's tired now from all dat drivin'."

"All right, boys," I agreed. "But Ah'll be rested by night. Be lookin' for everybody."

So I unloaded the car and crowded it into Ellis' garage and got settled. Armetta made me lie down and rest while she cooked a big pan of ginger bread for the company we expected.

Calvin Daniels and James Moseley were the first to show up.

"Calvin, Ah sure am glad that you got here. Ah'm crazy to hear about John and dat frog," I said.

"That's why Ah come so early so Ah could tell it to you and go. Ah got to go over to Wood Bridge a little later on."

"Ah'm glad you remembered me first, Calvin."

8

"Ah always like to be good as my word, and Ah just heard about a toe-party over to Wood Bridge tonight and Ah decided to make it."

"A toe-party! What on earth is that?"

"Come go with me and James and you'll see!"

"But, everybody will be here lookin' for me. They'll think Ah'm crazy—tellin' them to come and then gettin' out and goin' to Wood Bridge myself. But Ah certainly would like to go to that toe-party."

"Aw, come on. They kin come back another night. You gointer like this party."

"Well, you tell me the story first, and by that time, Ah'll know what to do."

"Ah, come on, Zora," James urged. "Git de car out. Calvin kin tell you dat one while we're on de way. Come on, let's go to de toe-party."

"No, let 'im tell me this one first, then, if Ah go he can tell me some more on de way over."

James motioned to his friend. "Hurry up and tell it, Calvin, so we kin go before somebody else come."

"Aw, most of 'em ain't comin' nohow. They all 'bout goin' to Wood Bridge, too. Lemme tell you 'bout John and dis frog:

It was night and Ole Massa sent John,[1] his favorite slave, down to the spring to get him a cool drink of water. He called John to him.

"John!"

"What you want, Massa?"

"John, I'm thirsty. Ah wants a cool drink of water, and Ah wants you to go down to de spring and dip me up a nice cool pitcher of water."

John didn't like to be sent nowhere at night, but he always tried to do everything Ole Massa told him to do, so he said, "Yessuh, Massa, Ah'll go git you some!"

Ole Massa said: "Hurry up, John. Ah'm mighty thirsty."

John took de pitcher and went on down to de spring.

[1]Negro story-hero name. See glossary.

9

There was a great big ole bull frog settin' right on de edge of de spring, and when John dipped up de water de noise skeered de frog and he hollered and jumped over in de spring.

John dropped de water pitcher and tore out for de big house, hollerin' "Massa! Massa! A big ole booger[2] done got after me!"

Ole Massa told him, "Why, John, there's no such thing as a booger."

"Oh, yes it is, Massa. He down at dat Spring."

"Don't tell me, John. Youse just excited. Furthermore, you go git me dat water Ah sent you after."

"No, indeed, Massa, you and nobody else can't send me back there so dat booger kin git me."

Ole Massa begin to figger dat John musta seen somethin' sho nuff because John never had disobeyed him before, so he ast: "John, you say you seen a booger. What did it look like?"

John tole him, "Massa, he had two great big eyes lak balls of fire, and when he was standin' up he was sittin' down and when he moved, he moved by jerks, and he had most no tail."

Long before Calvin had ended his story James had lost his air of impatience.

"Now, Ah'll tell one," he said. "That is, if you so desire."

"Sure, Ah want to hear you tell 'em till daybreak if you will," I said eagerly.

"But where's the ginger bread?" James stopped to ask.

"It's out in the kitchen," I said. "Ah'm waiting for de others to come."

"Aw, naw, give us ours now. Them others may not get here before forty o'clock and Ah'll be done et mine and be in Wood Bridge. Anyhow Ah want a corner piece and some of them others will beat me to it."

So I served them with ginger bread and buttermilk.

[2]A bogey man.

"You sure going to Wood Bridge with us after Ah git thru tellin' this one?" James asked.

"Yeah, if the others don't show up by then," I conceded.

So James told the story about the man who went to Heaven from Johnstown.

You know, when it lightnings, de angels is peepin' in de lookin' glass; when it thunders, they's rollin' out de rain-barrels; and when it rains, somebody done dropped a barrel or two and bust it.

One time, you know, there was going to be big doin's in Glory and all de angels had brand new clothes to wear and so they was all peepin' in the lookin' glasses, and therefore it got to lightning all over de sky. God tole some of de angels to roll in all de full rain barrels and they was in such a hurry that it was thunderin' from the east to the west and the zig-zag lightning went to join the mutterin' thunder and, next thing you know, some of them angels got careless and dropped a whole heap of them rain barrels, and didn't it rain!

In one place they call Johnstown they had a great flood. And so many folks got drownded that it looked jus' like Judgment day.

So some of de folks that got drownded in that flood went one place and some went another. You know, everything that happen, they got to be a nigger in it—and so one of de brothers in black went up to Heben from de flood.

When he got to the gate, Ole Peter let 'im in and made 'im welcome. De colored man was named John, so John ast Peter, says, "Is it dry in dere?"

Ole Peter tole 'im, "Why, yes it's dry in here. How come you ast that?"

"Well, you know Ah jus' come out of one flood, and Ah don't want to run into no mo'. Ooh, man! You ain't *seen* no water. You just oughter seen dat flood we had at Johnstown."

Peter says, "Yeah, we know all about it. Jus' go wid Gabriel and let him give you some new clothes."

So John went on off wid Gabriel and come back all dressed up in brand new clothes and all de time he was changin' his clothes he was tellin' Ole Gabriel all about dat flood, jus' like he didn't know already.

So when he come back from changin' his clothes, they give him a brand new gold harp and handed him to a gold bench and made him welcome. They was so tired of hearing about dat flood they was glad to see him wid his harp 'cause they figgered he'd get to playin' and forget all about it. So Peter tole him, "Now you jus' make yo'self at home and play all de music you please."

John went and took a seat on de bench and commenced to tune up his harp. By dat time, two angels come walkin' by where John was settin' so he throwed down his harp and tackled 'em.

"Say," he hollered, "Y'all want to hear 'bout de big flood Ah was in down on earth? Lawd, Lawd! It sho rained, and talkin' 'bout water!"

Dem two angels hurried on off from 'im jus' as quick as they could. He started to tellin' another one and he took to flyin'. Gab'ull went over to 'im and tried to get 'im to take it easy, but John kept right on stoppin' every angel dat he could find to tell 'im about dat flood of water.

Way after while he went over to Ole Peter and said: "Thought you said everybody would be nice and polite?"

Peter said, "Yeah, Ah said it. Ain't everybody treatin' you right?"

John said, "Naw. Ah jus' walked up to a man as nice and friendly as Ah could be and started to tell 'im 'bout all dat water Ah left back there in Johnstown and instead of him turnin' me a friendly answer he said, 'Shucks! You ain't seen no water!' and walked off and left me standin' by myself."

"Was he a *ole* man wid a crooked walkin' stick?" Peter ast John.

"Yeah."

"Did he have whiskers down to here?" Peter measured down to his waist.

12

"He sho did," John tol' 'im.

"Aw shucks," Peter tol' 'im. "Dat was Ole Nora.[3] You can't tell *him* nothin' 'bout no flood."

There was a lot of horn-honking outside and I went to the door. The crowd drew up under the mothering camphor tree in four old cars. Everybody in boisterous spirits.

"Come on, Zora! Le's go to Wood Bridge. Great toe-party goin' on. All kinds of 'freshments. We kin tell you some lies most any ole time. We never run outer lies and lovin'. Tell 'em tomorrow night. Come on if you comin'—le's go if you gwine."

So I loaded up my car with neighbors and we all went to Wood Bridge. It is a Negro community joining Maitland on the north as Eatonville does on the west, but no enterprising souls have ever organized it. They have no schoolhouse, no post office, no mayor. It is lacking in Eatonville's feeling of unity. In fact, a white woman lives there.

While we rolled along Florida No. 3, I asked Armetta where was the shindig going to be in Wood Bridge. "At Edna Pitts' house," she told me. "But she ain't givin' it by herself; it's for the lodge."

"Think it's gointer be lively?"

"Oh, yeah. Ah heard that a lot of folks from Altamonte and Longwood is comin'. Maybe from Winter Park too."

We were the tail end of the line and as we turned off the highway we could hear the boys in the first car doing what Ellis Jones called bookooing[4] before they even hit the ground. Charlie Jones was woofing[5] louder than anybody else. "Don't y'all sell off all dem pretty li'l pink toes befo' Ah git dere."

Peter Stagg: "Save me de best one!"

Soddy Sewell: "Hey, you mullet heads! Get out de way

[3]Noah.

[4]Loud talking, bullying, woofing. From French *beaucoup*.

[5]Aimless talking. See glossary.

there and let a real man smoke them toes over."

Gene Brazzle: "Come to my pick, gimme a vaseline brown!"

Big Willie Sewell: "Gimme any kind so long as you gimme more'n one."

Babe Brown, riding a running-board, guitar in hand, said, "Ah want a toe, but if it ain't got a good looking face on to it, don't bring de mess up."

When we got there the party was young. The house was swept and garnished, the refreshments on display, several people sitting around; but the spot needed some social juices to mix the ingredients. In other words, they had the carcass of a party lying around up until the minute Eatonville burst in on it. Then it woke up.

"Y'all done sold off any toes yet?" George Brown wanted to know.

Willie Mae Clarke gave him a certain look and asked him, "What's dat got to do with you, George Brown?" And he shut up. Everybody knows that Willie Mae's got the business with George Brown.

"Nope. We ain't had enough crowd, but I reckon we kin start now," Edna said. Edna and a sort of committee went inside and hung up a sheet across one end of the room. Then she came outside and called all of the young women inside. She had to coax and drag some of the girls.

"Oh, Ah'm shame-face-ted!" some of them said.

"Nobody don't want to buy *mah* ole rusty toe." Others fished around for denials from the male side.

I went on in with the rest and was herded behind the curtain.

"Say, what *is* this toe-party business?" I asked one of the girls.

"Good gracious, Zora! Ain't you never been to a toe-party before?"

"Nope. They don't have 'em up North where Ah been and Ah just got back today."

"Well, they hides all de girls behind a curtain and you stick

14

out yo' toe. Some places you take off yo' shoes and some places you keep 'em on, but most all de time you keep 'em on. When all de toes is in a line, sticking out from behind de sheet they let de men folks in and they looks over all de toes and buys de ones they want for a dime. Then they got to treat de lady dat owns dat toe to everything she want. Sometime they play it so's you keep de same partner for de whole thing and sometime they fix it so they put de girls back every hour or so and sell de toes agin.''

Well, my toe went on the line with the rest and it was sold five times during the party. Everytime a toe was sold there was a great flurry before the curtain. Each man eager to see what he had got, and whether the other men would envy him or ridicule him. One or two fellows ungallantly ran out of the door rather than treat the girls whose toe they had bought sight unseen.

Babe Brown got off on his guitar and the dancing was hilarious. There was plenty of chicken perleau and baked chicken and fried chicken and rabbit. Pig feet and chitterlings[6] and hot peanuts and drinkables. Everybody was treating wildly.

"Come on, Zora, and have a treat on me!" Charlie Jones insisted. "You done et chicken-ham and chicken-bosom wid every shag-leg in Orange County *but* me. Come on and spend some of *my* money."

"Thanks, Charlie, but Ah got five helpin's of chicken inside already. Ah either got to get another stomach or quit eatin'.''

"Quit eatin' then and go to thinking. Quit thinkin' and start to drinkin'. What you want?"

"Coca-Cola right off de ice, Charlie, and put some salt in it. Ah got a slight headache."

"Aw naw, my money don't buy no sweet slop. Choose some coon dick."

"What is coon dick?"

"Aw, Zora, jus' somethin' to make de drunk come. Made

[6]Hog intestines.

out uh grape fruit juice, corn meal mash, beef bones and a few mo' things. Come on le's git some together. It might make our love come down."

As soon as we started over into the next yard where coon dick was to be had, Charlie yelled to the barkeep, "Hey, Seymore! fix up another quart of dat low wine—here come de boom!"

It was handed to us in a quart fruit jar and we went outside to try it.

The raw likker known locally as coon dick was too much. The minute it touched my lips, the top of my head flew off. I spat it out and "choosed" some peanuts. Big Willie Sewell said, "Come on, heart-string, and have some gospel-bird[7] on me. My money spends too." His Honor, Hiram Lester, the Mayor, heard him and said, "There's no mo' chicken left, Willie. Why don't you offer her something she can get?"

"Well there *was* some chicken there when Ah passed the table a little while ago."

"Oh, so you offerin' her some chicken *was*. She can't eat that. What she want is some chicken *is*."

"Aw shut up, Hiram. Come on, Zora, le's go inside and make out we dancin'." We went on inside but it wasn't a party any more. Just some people herded together. The high spirits were simmering down and nobody had a dime left to cry so the toe-business suffered a slump. The heaped-up tables of refreshments had become shambles of chicken bones and empty platters anyway so that there was no longer any point in getting your toe sold, so when Columbus Montgomery said, "Le's go to Eatonville," Soddy Sewell jumped up and grabbed his hat and said, "I heard you, buddy."

Eatonville began to move back home right then. Nearly everybody was packed in one of the five cars when the delegation from Altamonte arrived. Johnny Barton and Georgia Burke. Everybody piled out again.

"Got yo' guitar wid you, Johnnie?"

[7]Chicken. Preachers are supposed to be fond of them.

"Man, you know Ah don't go nowhere unless Ah take my box wid me," said Johnnie in his starched blue shirt, collar pin with heart bangles hanging on each end and his cream pants with the black stripe. "And what make it so cool, Ah don't go nowhere unless I play it."

"And when you git to strowin' yo' mess and Georgy gits to singin' her alto, man it's hot as seven hells. Man, play dat 'Palm Beach.'"

Babe Brown took the guitar and Johnnie Barton grabbed the piano stool. He sung. Georgia Burke and George Thomas singing about Polk County where the water taste like wine.

My heart struck sorrow, tears come running down.

At about the thirty-seventh verse, something about:

Ah'd ruther be in Tampa with the Whip-poor-will,
Ruther be in Tampa with the Whip-poor-will
Than to be 'round here—
Honey with a hundred dollar bill,

I staggered sleepily forth to the little Chevrolet for Eatonville. The car was overflowing with passengers but I was so dull from lack of sleep that I didn't know who they were. All I knew is they belonged in Eatonville.

Somebody was woofing in my car about love and I asked him about his buddy—I don't know why now. He said, "Ah ain't got no buddy. They kilt my buddy so they could raise me. Jus' so Ah be yo' man Ah don't want no damn buddy. Ah hope they kill every man dat ever cried, 'titty-mamma' but me. Lemme be yo' kid."

Some voice from somewhere else in the car commented, "You sho' Lawd is gointer have a lot of hindrance."

Then somehow I got home and to bed and Armetta had Georgia syrup and waffles for breakfast.

TWO

The very next afternoon, as usual, the gregarious part of the town's population gathered on the store porch. All the Florida-flip players, all the eleven-card layers.[1] But they yelled over to me they'd be over that night in full. And they were.

"Zora," George Thomas informed me, "you come to de right place if lies is what you want. Ah'm gointer lie up a nation."

Charlie Jones said, "Yeah, man. Me and my sworn buddy Gene Brazzle is here. Big Moose done come down from de mountain."[2]

"Now, you gointer hear lies above suspicion," Gene added.

It was a hilarious night with a pinch of everything social mixed with the story-telling. Everybody ate ginger bread; some drank the buttermilk provided and some provided coon dick for themselves. Nobody guzzled it—just took it in social sips.

But they told stories enough for a volume by itself. Some of the stories were the familiar drummer-type of tale about two Irishmen, Pat and Mike, or two Jews as the case might be.

[1]Coon-can players. A two-handed card game popular among Southern Negroes.
[2]Important things are about to happen.

Some were the European folk-tales undiluted, like Jack and the Beanstalk. Others had slight local variations, but Negro imagination is so facile that there was little need for outside help. A'nt Hagar's son, like Joseph, put on his many-colored coat an paraded before his brethren and every man there was a Joseph.

Steve Nixon was holding class meeting across the way at St. Lawrence Church and we could hear the testimony and the songs.[3] So we began to talk about church and preachers.

"Aw, Ah don't pay all dese ole preachers no rabbit-foot,"[4] said Ellis Jones. "Some of 'em is all right but everybody dats up in de pulpit whoopin' and hollerin' ain't called to preach."

"They ain't no different from nobody else," added B. Moseley. "They mouth is cut cross ways, ain't it? Well, long as you don't see no man wid they mouth cut up and down, you know they'll all lie jus' like de rest of us."

"Yeah; and hard work in de hot sun done called a many a man to preach," said a woman called Gold, for no evident reason. "Ah heard about one man out clearin' off some new ground. De sun was so hot till a grindstone melted and run off in de shade to cool off. De man was so tired till he went and sit down on a log. 'Work, work, work! Everywhere Ah go de boss say hurry, de cap' say run. Ah got a durn good notion not to do nary one. Wisht Ah was one of dese preachers wid a whole lot of folks makin' my support for me.' He looked back over his shoulder and seen a narrer li'l strip of shade along side of de log, so he got over dere and laid down right close up to de log in de shade and said, 'Now, Lawd, if you don't pick me up and chunk me on de other side of dis log, Ah know you done called me to preach.'

"You know God never picked 'im up, so he went off and tol' everybody dat he was called to preach."

"There's many a one been called just lak dat," Ellis corroborated. "Ah knowed a man dat was called by a mule."

[3]See glossary.
[4]I ignore these preachers.

20

"A mule, Ellis? All dem b'lieve dat, stand on they head," said Little Ida.

"Yeah, a mule did call a man to preach. Ah'll show you how it was done, if you'll stand a straightenin'."

"Now, Ellis, don't mislay de truth. Sense us into dis mule-callin' business."

Ellis: These was two brothers and one of 'em was a big preacher and had good collections every Sunday. He didn't pastor nothin' but big charges. De other brother decided he wanted to preach so he went way down in de swamp behind a big plantation to de place they call de prayin' ground, and got down on his knees.

"O Lawd, Ah wants to preach. Ah feel lak Ah got a message. If you done called me to preach, gimme a sign."

Just 'bout dat time he heard a voice, "Wanh, uh wanh! Go preach, go preach, go preach!"

He went and tol' everybody, but look lak he never could git no big charge. All he ever got called was on some saw-mill, half-pint church or some turpentine still. He knocked around lak dat for ten years and then he seen his brother. De big preacher says, "Brother, you don't look like you gittin' holt of much."

"You tellin' dat right, brother. Groceries is scarce. Ah ain't dirtied a plate today."

"Whut's de matter? Don't you git no support from your church?"

"Yeah, Ah gits it such as it is, but Ah ain't never pastored no big church. Ah don't git called to nothin' but saw-mill camps and turpentine stills."

De big preacher reared back and thought a while, then he ast de other one, "Is you sure you was called to preach? Maybe you ain't cut out for no preacher."

"Oh, yeah," he told him. "Ah *know* Ah been called to de ministry. A voice spoke and tol' me so."

"Well, seem lak if God called you He is mighty slow in puttin' yo' foot on de ladder. If Ah was you Ah'd go back and ast 'im agin."

21

So de po' man went on back to de prayin' ground agin and got down on his knees. But there wasn't no big woods like it used to be. It has been all cleared off. He prayed and said, "Oh, Lawd, right here on dis spot ten years ago Ah ast you if Ah was called to preach and a voice tole me to go preach. Since dat time Ah been strugglin' in Yo' moral vineyard, but Ah ain't gathered no grapes. Now, if you really called me to preach Christ and Him crucified, please gimme another sign."

Sho nuff, jus' as soon as he said dat, de voice said "Wanh-uh! Go preach! Go preach! Go preach!"

De man jumped up and says, "Ah knowed Ah been called. Dat's de same voice. Dis time Ah'm goin ter ast Him where *must* Ah go preach."

By dat time de voice come agin and he looked 'way off and seen a mule in de plantation lot wid his head all stuck out to bray agin, and he said, "Unh hunh, youse de very son of a gun dat called me to preach befo'."

So he went on off and got a job plowin'. Dat's whut he was called to do in de first place.

Armetta said, "A many one been called to de plough and they run off and got up in de pulpit. Ah wish dese mules knowed how to take a pair of plow-lines and go to de church and ketch some of 'em like they go to de lot with a bridle and ketch mules."

Ellis: Ah knowed one preacher dat was called to preach at one of dese split-off churches. De members had done split off from a big church because they was all mean and couldn't git along wid nobody.

Dis preacher was a good man, but de congregation was so tough he couldn't make a convert in a whole year. So he sent and invited another preacher to come and conduct a revival meeting for him. De man he ast to come was a powerful hard preacher wid a good strainin' voice. He was known to get converts.

Well, he come and preached at dis split-off for two whole weeks. De people would all turn out to church and jus' set

22

dere and look at de man up dere strainin' his lungs out and
nobody would give de man no encouragement by sayin'
"Amen," and not a soul bowed down.

It was a narrer church wid one winder and dat was in de
pulpit and de door was in de front end. Dey had a mean
ole sexton wid a wooden leg. So de last night of de pro-
tracted meetin' de preacher come to church wid his grip-
sack in his hand and went on up in de pulpit. When he got
up to preach he says, "Brother Sexton, dis bein' de last
night of de meetin' Ah wants you to lock de do' and bring
me de key. Ah want everybody to stay and hear whut Ah
got to say."

De sexton brought him de key and he took his tex and
went to preachin'. He preached and he reared and pitched,
but nobody said "Amen" and nobody bowed down. So
'way after while he stooped down and opened his suit-
satchel and out wid his .44 Special. "Now," he said, "you
rounders and brick-bats—yeah, you women, Ah'm talkin' to
you. If you ain't a whole brick, den you must be a bat—
and gamblers and 'leven-card layers. Ah done preached to
you for two whole weeks and not one of you has said
'Amen,' and nobody has bowed down."

He thowed de gun on 'em. "And now Ah say bow
down!" And they beginned to bow all over dat church.

De sexton looked at his wooden leg and figgered he
couldn't bow because his leg was cut off above de knee. So
he ast, "Me too, Elder?"

"Yeah, you too, you peg-leg son of a gun. You bow
down too."

Therefo' dat sexton bent dat wooden leg and bowed
down. De preacher fired a couple of shots over they heads
and stepped out de window and went on 'bout his business.
But he skeered dem people so bad till they all rushed to
one side of de church tryin' to git out and carried dat
church buildin' twenty-eight miles befo' they thought to
turn it loose.

"Now Ellis," chided Gold when she was thru her laughter,
"You know dat's a lie. Folks over there in St. Lawrence hol-

23

din' class meetin' and you over here lyin' like de crossties from Jacksonville to Key West."

"Naw, dat ain't no lie!" Ellis contended, still laughing himself.

"Aw, yes it 'tis," Gold said. "Dat's all you men is good for—settin' 'round and lyin'. Some of you done quit lyin' and gone to flyin'."

Gene Brazzle said, "Get off of us mens now. We *is* some good. Plenty good too if you git de right one. De trouble is you women ain't good for nothin' exceptin' readin' Sears and Roebuck's bible and hollerin' 'bout, 'gimme dis and gimme dat' as soon as we draw our pay."

Shug[5] said, "Well, we don't git it by astin' you mens for it. If we work for it we kin git it. You mens don't draw no pay. You don't do nothin' but stand around and draw lightnin'."

"Ah don't say Ah'm detrimental," Gene said dryly, "but if Gold and Shug don't stop crackin' us, Ah'm gointer get 'em to go."

Gold: "Man, if you want me any, some or none, do whut you gointer do and stop cryin'."

Gene: "You ain't seen me cryin'. See me cryin', it's sign of a funeral. If Ah even look cross somebody gointer bleed."

Gold: "Aw, shut up, Gene, you ain't no big hen's biddy if you do lay gobbler eggs. You tryin' to talk like big wood when you ain't nothin' but brush."

Armetta sensed a hard anger creepin' into the teasing so she laughed to make Gene and Gold laugh and asked, "Did y'all have any words before you fell out?"

"We ain't mad wid one 'nother," Gene defended. "We jus' jokin'."

"Well, stop blowin' it and let de lyin' go on," said Charlie Jones. "Zora's gittin' restless. She think she ain't gointer hear no more."

"Oh, no Ah ain't," I lied. After a short spell of quiet, good

[5]Short for sugar.

humor was restored to the porch. In the pause we could hear
Pa Henry over in the church house sending up a prayer:

. . . You have been with me from the earliest rocking of my
 cradle up until this present moment.
You know our hearts, our Father,
And all de range of our deceitful minds,
And if you find anything like sin lurking
In and around our hearts,
Ah ast you, My Father, and my Wonder-workin' God
To pluck it out
And cast it into de sea of Fuhgitfulness
Where it will never rise to harm us in dis world
Nor condemn us in de judgment.
You heard me when Ah laid at hell's dark door
With no weapon in my hand
And no God in my heart,
And cried for three long days and nights.
You heard me, Lawd,
And stooped so low
And snatched me from the hell
Of eternal death and damnation.
You cut loose my stammerin' tongue;

You established my feet on de rock of Salvation
And yo' voice was heard in rumblin' judgment.
I thank Thee that my last night's sleepin' couch
Was not my coolin' board
And my cover
Was not my windin' sheet.
Speak to de sinner-man and bless 'im.
Touch all those
Who have been down to de doors of degradation.
Ketch de man dat's layin' in danger of consumin' fire;
And Lawd,
When Ah kin pray no mo';
When Ah done drunk down de last cup of sorrow
Look on me, yo' weak servant who feels de least of all;
'Point my soul a restin' place
Where Ah kin set down and praise yo' name forever
Is my prayer for Jesus sake
Amen and thank God.

As the prayer ended the bell of Macedonia, the Baptist
church, began to ring.

"Prayer meetin' night at Macedony," George Thomas said.

"It's too bad that it must be two churches in Eatonville," I
commented. "De town's too little. Everybody ought to go to
one."

"Dey wouldn't do dat, Zora, and you know better. Fack is,
de Christian churches nowhere don't stick together," this
from Charlie.

Everybody agreed that this was true. So Charlie went on.
"Look at all de kind of denominations we got. But de people
can't help dat 'cause de church wasn't built on no solid founda-
tion to start wid."

"Oh yes, it 'twas!" Johnnie Mae disputed him. "It was built
on solid rock. Didn't Jesus say 'On dis rock Ah build my
church?' "

"Yeah," chimed in Antie Hoyt. "And de songs says, 'On
Christ de solid rock I stand' and 'Rock of Ages.' "

Charlie was calm and patient. "Yeah, he built it on a rock,

26

but it wasn't solid. It was a pieced-up rock and that's how come de church split up now. Here's de very way it was:

Christ was walkin' long one day wid all his disciples and he said, "We're goin' for a walk today. Everybody pick up a rock and come along." So everybody got their selves a nice big rock 'ceptin' Peter. He was lazy so he picked up a li'l bit of a pebble and dropped it in his side pocket and come along.

Well, they walked all day long and de other 'leven disciples changed them rocks from one arm to de other but they kept on totin' 'em. Long towards sundown they come 'long by de Sea of Galilee and Jesus tole 'em, "Well, le's fish awhile. Cast in yo' nets right here." They done like he tole 'em and caught a great big mess of fish. Then they cooked 'em and Christ said, "Now, all y'all bring up yo' rocks." So they all brought they rocks and Christ turned 'em into bread and they all had a plenty to eat wid they fish exceptin' Peter. He couldn't hardly make a moufful offa de li'l bread he had and he didn't like dat a bit.

Two or three days after dat Christ went out doors and looked up at de sky and says, "Well, we're goin' for another walk today. Everybody git yo'self a rock and come along."

They all picked up a rock apiece and was ready to go. All but Peter. He went and tore down half a mountain. It was so big he couldn't move it wid his hands. He had to take a pinch-bar to move it. All day long Christ walked and talked to his disciples and Peter sweated and strained wid dat rock of his'n.

Way long in de evenin' Christ went up under a great big ole tree and set down and called all of his disciples around 'im and said, "Now everybody bring up yo' rocks."

So everybody brought theirs but Peter. Peter was about a mile down de road punchin' dat half a mountain he was bringin'. So Christ waited till he got dere. He looked at de rocks dat de other 'leven disciples had, den he seen dis great big mountain dat Peter had and so he got up and walked over to it and put one foot up on it and said, "Why

27

Peter, dis is a fine rock you got here! It's a noble rock! And Peter, on dis rock Ah'm gointer build my church."

Peter says, "Naw you ain't neither. You won't build no church house on *dis* rock. You gointer turn dis rock into bread."

Christ knowed dat Peter meant dat thing so he turnt de hillside into bread and dat mountain is de bread he fed de 5,000 wid. Den he took dem 'leven other rocks and glued 'em together and built his church on it.

And that's how come de Christian churches is split up into so many different kinds—cause it's built on pieced-up rock.

There was a storm of laughter following Charlie's tale. "Zora, you come talkin' bout puttin' de two churches together and not havin' but one in dis town," Armetta said chidingly. "You know better'n dat. Baptis' and Methdis' always got a pick out at one 'nother. One time two preachers—one Methdis' an de other one Baptis' wuz on uh train and de engine blowed up and bein' in de colored coach right back of de engine they got blowed up too. When they saw theyself startin' up in de air de Baptis' preacher hollered, 'Ah bet Ah go higher than you!' "

Then Gold spoke up and said, "Now, lemme tell one. Ah know one about a man as black as Gene."

"Whut you always crackin' me for?" Gene wanted to know. "Ah ain't a bit blacker than you."

"Oh, yes you is, Gene. Youse a whole heap blacker than Ah is."

"Aw, go head on, Gold. Youse blacker than me. You jus' look my color cause youse fat. If you wasn't no fatter than me you'd be so black till lightnin' bugs would follow you at twelve o'clock in de day, thinkin' it's midnight."

"Dat's a lie, youse blacker than Ah ever dared to be. Youse lam' black. Youse so black till they have to throw a sheet over yo' head so de sun kin rise every mornin'. Ah know yo' ma cried when she seen *you.*"

28

"Well, anyhow, Gold, youse blacker than me. If Ah was as fat as you Ah'd be a yaller man."

"Youse a liar. Youse as yaller as you ever gointer git. When a person is poor he look bright and de fatter you git de darker you look."

"Is dat yo' excuse for being so black, Gold?"

Armetta soothed Gold's feelings and stopped the war. When the air cleared Gold asked, "Do y'all know how come we are black?"

"Yeah," said Ellis. "It's because two black niggers got together."

"Aw, naw," Gold disputed petulantly. "Well, since you so smart, tell me where dem two black niggers come from in de first beginnin'."

"They musta come from Zar, and dat's on de other side of far."

"Uh, hunh!" Gold gloated. "Ah knowed you didn't know whut you was talkin' about. Now Ah'm goin' ter tell you how come we so black:

Long before they got thru makin' de Atlantic Ocean and haulin' de rocks for de mountains, God was makin' up de people.[6] But He didn't finish 'em all at one time. Ah'm compelled to say dat some folks is walkin' 'round dis town right now ain't finished yet and never will be.

Well, He give out eyes one day. All de nations come up and got they eyes. Then He give out teeth and so on. Then He set a day to give out color. So seven o'clock dat mornin' everybody was due to git they color except de niggers. So God give everybody they color and they went on off. Then He set there for three hours and one-half and no niggers. It was gettin' hot and God wanted to git His work done and go set in de cool. So He sent de angels. Rayfield and Gab'ull[7] to go git 'em so He could 'tend some mo' business.

[6]See glossary.

[7]The angels Raphael and Gabriel.

29

They hunted all over Heben till dey found de colored folks. All stretched out sleep on de grass under de tree of life. So Rayfield woke 'em up and tole 'em God wanted 'em.

They all jumped up and run on up to de th'one and they was so skeered they might miss sumpin' they begin to push and shove one 'nother, bumpin' against all de angels and turnin' over foot-stools. They even had de th'one all pushed one-sided.

So God hollered "Git back! Git back!" And they misunderstood Him and thought He said, "Git black," and they been black ever since.

Gene rolled his eyeballs into one corner of his head.

"Now Gold call herself gettin' even wid me—tellin' dat lie. 'Tain't no such a story nowhere. She jus' made dat one up herself."

"Naw, she didn't," Armetta defended. "Ah *been* knowin' dat ole tale."

"Me too," said Shoo-pie.

"Don't you know you can't git de best of no woman in de talkin' game? Her tongue is all de weapon a woman got," George Thomas chided Gene. "She could have had mo' sense, but she told God no, she'd ruther take it out in hips. So God give her her ruthers. She got plenty hips, plenty mouf and no brains."

"Oh, yes, womens is got sense too," Mathilda Moseley jumped in. "But they got too much sense to go 'round braggin' about it like y'all do. De lady people always got de advantage of mens because God fixed it dat way."

"Whut ole black advantage is y'all got?" B. Moseley asked indignantly. "We got all de strength and all de law and all de money and you can't git a thing but whut we jes' take pity on you and give you."

"And dat's jus' de point," said Mathilda triumphantly. "You *do* give it to us, but how come you do it?" And without

30

waiting for an answer Mathilda began to tell why women
always take advantage of men.

You see in de very first days, God made a man and a
woman and put 'em in a house together to live. 'Way back
in them days de woman was just as strong as de man and
both of 'em did de same things. They useter get to fussin'
'bout who gointer do this and that and sometime they'd
fight, but they was even balanced and neither one could
whip de other one.

One day de man said to hisself, "B'lieve Ah'm gointer
go see God and ast Him for a li'l mo' strength so Ah kin
whip dis 'oman and make her mind. Ah'm tired of de way
things is." So he went on up to God.

"Good mawnin', Ole Father."

"Howdy man. Whut you doin' 'round my throne so soon
dis mawnin'?"

"Ah'm troubled in mind, and nobody can't ease mah
spirit 'ceptin' you."

God said: "Put yo' plea in de right form and Ah'll hear
and answer."

"Ole Maker, wid de mawnin' stars glitterin' in yo' shinin'
crown, wid de dust from yo' footsteps makin' worlds upon
worlds, wid de blazin' bird we call de sun flyin' out of yo'
right hand in de mawnin' and consumin' all day de flesh
and blood of stump-black darkness, and comes flyin' home
every evenin' to rest on yo' left hand, and never once in all
yo' eternal years, mistood de left hand for de right, Ah ast
you *please* to give me mo' strength than dat woman you
give me, so Ah kin make her mind. Ah know you don't
want to be always comin' down way past de moon and stars
to be straightenin' her out and its got to be done. So give
me a li'l mo' strength, Ole Maker and Ah'll do it."

"All right, Man, you got mo' strength than woman."

So de man run all de way down de stairs from Heben till
he got home. He was so anxious to try his strength on de
woman dat he couldn't take his time. Soon's he got in de
house he hollered "Woman! Here's yo' boss. God done

31

tole me to handle you in which ever way Ah please. Ah'm
yo' boss."

De woman flew to fightin' 'im right off. She fought 'im
frightenin' but he beat her. She got her wind and tried 'im
agin but he whipped her agin. She got herself together and
made de third try on him vigorous but he beat her every
time. He was so proud he could whip 'er at last, dat he just
crowed over her and made her do a lot of things she didn't
like. He told her, "Long as you obey me, Ah'll be good to
yuh, but every time yuh rear up Ah'm gointer put plenty
wood on yo' back and plenty water in yo' eyes."

De woman was so mad she went straight up to Heben
and stood befo' de Lawd. She didn't waste no words. She
said, "Lawd, Ah come befo' you mighty mad t'day. Ah
want back my strength and power Ah useter have."

"Woman, you got de same power you had since de be-
ginnin'."

"Why is it then, dat de man kin beat me now and he
useter couldn't do it?"

"He got mo' strength than he useter have. He come and
ast me for it and Ah give it to 'im. Ah gives to them that
ast, and you ain't never ast me for no mo' power."

"Please suh, God, Ah'm astin' you for it now. Jus'
gimme de same as you give him."

God shook his head. "It's too late now, woman. Whut
Ah give, Ah never take back. Ah give him mo' strength
than you and no matter how much Ah give you, he'll have
mo'."

De woman was so mad she wheeled around and went on
off. She went straight to de devil and told him what had
happened.

He said, "Don't be dis-incouraged, woman. You listen to
me and you'll come out mo' than conqueror. Take dem
frowns out yo' face and turn round and go right on back to
Heben and ast God to give you dat bunch of keys hangin'
by de mantel-piece. Then you bring 'em to me and Ah'll
show you what to do wid 'em."

So de woman climbed back up to Heben agin. She was
mighty tired but she was more out-done that she was tired
so she climbed all night long and got back up to Heben

agin. When she got befo' de throne, butter wouldn't melt in her mouf.

"O Lawd and Master of de rainbow, Ah know yo' power. You never make two mountains without you put a valley in between. Ah know you kin hit a straight lick wid a crooked stick."

"Ast for whut you want, woman."

"God, gimme dat bunch of keys hangin' by yo' mantel-piece."

"Take 'em."

So de woman took de keys and hurried on back to de devil wid 'em. There was three keys on de bunch. Devil say, "See dese three keys? They got mo' power in 'em than all de strength de man kin ever git if you handle 'em right. Now dis first big key is to de do' of de kitchen, and you know a man always favors his stomach. Dis second one is de key to de bedroom and he don't like to be shut out from dat neither and dis last key is de key to de cradle and he don't want to be cut off from his generations at all. So now you take dese keys and go lock up everything and wait till he come to you. Then don't you unlock nothin' until he use his strength for yo' benefit and yo' desires."

De woman thanked 'im and tole 'im, "If it wasn't for you, Lawd knows whut us po' women folks would do."

She started off but de devil halted her. "Jus' one mo' thing: don't go home braggin' 'bout yo' keys. Jus' lock up everything and say nothin' until you git asked. And then don't talk too much."

De woman went on home and did like de devil tole her. When de man come home from work she was settin' on de porch singin' some song 'bout "Peck on de wood make de bed go good."

When de man found de three doors fastened what useter stand wide open he swelled up like pine lumber after a rain. First thing he tried to break in cause he figgered his strength would overcome all obstacles. When he saw he couldn't do it, he ast de woman, "Who locked dis do'?"

She tole 'im, "Me."

"Where did you git de key from?"

"God give it to me."

33

He run up to God and said, "God, woman got me locked 'way from my vittles, my bed and my generations, and she say you give her the keys."

God said, "I did, Man, Ah give her de keys, but de devil showed her how to use 'em!"

"Well, Ole Maker, please gimme some keys jus' lak 'em so she can't git de full control."

"No, Man, what Ah give Ah give. Woman got de key."

"How kin Ah know 'bout my generations?"

"Ast de woman."

So de man come on back and submitted hisself to de woman and she opened de doors.

He wasn't satisfied but he had to give in. 'Way after while he said to de woman, "Le's us divide up. Ah'll give you half of my strength if you lemme hold de keys in my hands."

De woman thought dat over so de devil popped and tol her, "Tell 'im, naw. Let 'im keep his strength and you keep yo' keys."

So de woman wouldn't trade wid 'im and de man had to mortgage his strength to her to live. And dat's why de man makes and de woman takes. You men is still braggin' 'bout yo' strength and de women is sittin' on de keys and lettin' you blow off till she git ready to put de bridle on you.

B. Moseley looked over at Mathilda and said, "You just like a hen in de barnyard. You cackle so much you give de rooster de blues."

Mathilda looked over at him archly and quoted:

> Stepped on a pin, de pin bent
> And dat's de way de story went.

"Y'all lady people ain't smarter *than* all men folks. You got plow lines on some of us, but some of us is too smart for you. We go past you jus' like lightnin' thru de trees," Willie Sewell boasted. "And what make it so cool, we close enough to you to have a scronchous time, but never no halter on our necks.

Ah know they won't git none on dis last neck of mine."

"Oh, you kin be had," Gold retorted. "Ah mean dat ab-stifically."

"Yeah? But not wid de trace chains. Never no shack up. Ah want dis tip-in love and tip yo' hat and walk out. Ah don't want nobody to have dis dyin' love for me."

Richard Jones said: "Yeah, man. Love is a funny thing; love is a blossom. If you want yo' finger bit poke it at a pos-sum."

Jack Oscar Jones, who had been quiet for some time, slumped way down in his chair, straightened up and said, "Ah know a speech about love."

Ruth Marshall laughed doubtfully. "Now, Jack, you can't make me b'lieve you know de first thing about no love."

"Yeah he do, too," Clara, Jack's wife defended.

"Whut do he know, then?" Ruth persisted.

"Aw, Lawd," Clara wagged her head knowingly. "You ain't got no business knowing dat. Dat's *us* business. But he know jus' as much about love as de nex' man."

"You don't say!" Johnnie Mae twitted her sister-in-law. "Blow it out, then, Jack, and tell a blind man somethin'."

"Ah'm gointer say it, then me and Zora's goin' out to Montgomery and git up a cool watermelon, ain't we, Zora?"

"If you got de price," I came back. "Ah got de car so all we need is a strong determination and we'll have melon."

"No, Zora ain't goin' nowhere wid my husband," Clara announced. "If he got anything to tell her—it's gointer be right here in front of me."

Jack laughed at Clara's feigned jealousy and recited:

SONG POEM

When the clock struck one I had just begun. Begun with Sue, begun with Sal, begun with that pretty Johnson gal.

When the clock struck two, I was through, I was through with Sue, through with Sal, through with that pretty Johnson gal.

When the clock struck three I was free, free with Sue, free with Sal, free with that pretty Johnson gal.

When the clock struck four I was at the door, at the door with Sue, at the door with Sal, at the door with that pretty Johnson gal.

When the clock struck five I was alive, alive with Sue, alive with Sal, alive with that pretty Johnson gal.

When the clock struck six I was fixed, fixed with Sue, fixed with Sal, fixed with that pretty Johnson gal.

When the clock struck seven I was even, even with Sue, even with Sal, even with that pretty Johnson gal.

When the clock struck eight I was at your gate, gate with Sue, gate with Sal, gate with that pretty Johnson gal.

When the clock struck nine I was behind, behind with Sue, behind with Sal, behind with that pretty Johnson gal.

When the clock struck ten I was in the bin, in the bin with Sue, in the bin with Sal, in the bin with that pretty Johnson gal.

When the clock struck eleven, I was in heaven, in heaven with Sue, in heaven with Sal, in heaven with that pretty Johnson gal.

When the clock struck twelve I was in hell, in hell with Sue, in hell with Sal, in hell with that pretty Johnson gal.

"Who was all dis Sue and dis Sal and dat pretty Johnson gal?" Clara demanded of Jack.

"Dat ain't for you to know. My name is West, and Ah'm so different from de rest."

"You sound like one man courtin' three gals, but Ah know a story 'bout three mens courtin' one gal," Shug commented.

"Dat's bogish,"[8] cried Bennie Lee thickly.

"Whut's bogish?" Shug demanded. She and Bennie were step-brother and sister and they had had a lawsuit over the property of his late father and her late mother, so a very little of Bennie's sugar would sweeten Shug's tea and vice versa.

"Ah don't want to lissen to no ole talk 'bout three mens

[8]Bogus.

36

after no one 'oman. It's always more'n three womens after every man."

"Well, de way Ah know de story, there was three mens after de same girl," Shug insisted. "You drunk, Bennie Lee. You done drunk so much of dis ole coon dick till you full of monkies."

"Whut you gointer do?" Bennie demanded. "Whut you gointer do?" No answer was expected to this question. It was just Bennie Lee's favorite retort. "De monkies got me, now whut you gointer do?"

"Ah ain't got you to study about, Bennie Lee. If God ain't payin' you no mo' mind than Ah is, youse in hell right now. Ah ain't talkin' to you nohow. Zora, you wanter hear dis story?"

"Sure, Shug. That's what Ah'm here for."

"Somebody's gointer bleed," Bennie Lee threatened. Nobody paid him any mind.

"God knows Ah don't wanter hear Shug tell nothin'," Bennie Lee complained.

"Ah wish yo' monkies would tell you to go hide in de hammock and forgit to tell you de way home." Shug was getting peeved.

"You better shut up befo' Ah whip yo' head to de red. Ah wish Ah was God. Ah'd turn you into a blamed hawg, and then Ah'd concrete de whole world over so you wouldn't have not one nary place to root."

"Dat's dat two-bits in change you got in yo' pocket now dat's talkin' for you. But befo' de summer's over *you'll* be rootin' lak a hawg. You already lookin' over-plus lak one now. Don't you worry 'bout me."

Bennie Lee tried to ask his well-known question but the coon dick was too strong. He mumbled down into his shirt bosom and went to sleep.

THREE

Youse in de majority, now Shug," B. Moseley said, seeing Bennie asleep. "Le's hear 'bout dat man wid three women."
Shug said:

Naw, it was three mens went to court a girl, Ah told you. Dis was a real pretty girl wid shiny black hair and coal black eyes. And all dese men wanted to marry her, so they all went and ast her pa if they could have her. He looked 'em all over, but he couldn't decide which one of 'em would make de best husband and de girl, she couldn't make up her mind, so one Sunday night when he walked into de parlor where they was all sittin' and said to 'em, "Well, all y'all want to marry my daughter and youse all good men and Ah can't decide which one will make her de best husband. So y'all be here tomorrow mornin' at daybreak and we'll have a contest and de one dat can do de quickest trick kin have de girl."

Nex' mornin' de first one got up seen it wasn't no water in de bucket to cook breakfas' wid. So he tole de girl's mama to give him de water bucket and he would go to the spring and git her some.

He took de bucket in his hand and then he found out dat de spring was ten miles off. But he said he didn't mind

39

dat. He went on and dipped up de water and hurried on back wid it. When he got to de five-mile post he looked down into de bucket and seen dat de bottom had done dropped out. Then he recollected dat he heard somethin' fall when he dipped up de water so he turned round and run back to de spring and clapped in dat bottom before de water had time to spill.

De ole man thought dat was a pretty quick trick, but de second man says, "Wait a minute. Ah want a grubbin' hoe and a axe and a plow and a harrow." So he got everything he ast for. There was ten acres of wood lot right nex' to de house. He went out dere and chopped down all de trees, grubbed up de roots, ploughed de field, harrowed it, planted it in cow-peas, and had green peas for dinner.

De ole man says "Dat's de quickest trick. Can't nobody beat dat. No use in tryin'. He done won de girl."

De last man said, "You ain't even givin' me a chance to win de girl."

So he took his high-powered rifle and went out into de woods about seben or eight miles until he spied a deer. He took aim and fired. Then he run home, run round behind de house and set his gun down and then run back out in de woods and caught de deer and held 'im till de bullet hit 'im.

So he won de girl.

Robert Williams said:
Ah know another man wid a daughter.

The man sent his daughter off to school for seben years, den she come home all finished up. So he said to her, "Daughter, git yo' things and write me a letter to my brother!" So she did.

He says, "Head it up," and she done so.

"Now tell 'im, 'Dear Brother, our chile is done come home from school and all finished up and we is very proud of her.' "

Then he ast de girl "Is you got dat?"

She tole 'im "yeah."

40

"Now tell him some mo'. 'Our mule is dead but Ah got another mule and when Ah say (clucking sound of tongue and teeth) he moved from de word.' "

"Is you got dat?" he ast de girl.

"Naw suh," she tole 'im.

He waited a while and he ast her again, "You got dat down yet?"

"Naw suh, Ah ain't got it yet."

"How come you ain't got it?"

"Cause Ah can't spell (clucking sound)."

"You mean to tell me you been off to school seben years and can't spell (clucking sound)? Why Ah could spell dat myself and Ah ain't been to school a day in mah life. Well jes' say (clucking sound) he'll know what yo' mean and go on wid de letter."

Henry "Nigger" Byrd said:
I know one about a letter too.

My father owned a fas' horse—I mean a *fast* horse. We was livin' in Ocala then. Mah mother took sick and mah father come and said, "Skeet,"—he uster call me Skeet— "You oughter wire yo' sister in St. Petersburg."

"I jus' wired her," I tole him.

"Whut did you put in it?"

I tole 'im.

He says, "Dat ain't right. I'm goin' ketch it." He went out in de pasture and caught de horse and shod 'im and curried 'im and brushed 'im off good, put de saddle on 'im and got on 'im, and caught dat telegram and read it and took it on to mah sister.

Soon as he left de house, mama said, "You chillun make a fire in de stove and fix somethin' for de ole man to eat."

Befo' she could git de word out her mouf, him and mah sister rode up to de do' and said "Whoa!"

By dat time a flea ast me for a shoe-shine so I left.

Armetta said: "Nigger, I didn't know you could lie like that."

41

"I ain't lyin', Armetta. We had dat horse. We had a cow too and she was so sway-backed that she could use de bushy part of her tail for a umbrella over her head."

"Shet up, Nig!" "Seaboard" Hamilton pretended to be outraged. "Ah knowed you could sing barytone but Ah wouldn't a b'lieved de lyin' was in you if Ah didn't hear you myself. Whut makes you bore wid such a great big augur?"

Little Julius Henry, who should have been home in bed spoke up. "Mah brother John had a horse 'way back dere in slavery time."

"Let de dollars hush whilst de nickel speak," Charlies Jones derided Julius' youth. "Julius, whut make you wanta jump in a hogshead when a kag[1] will hold yuh? You hear dese hard ole coons lyin' up a nation and you stick in yo' bill."

"If his mouf is cut cross ways and he's two years ole, he kin lie good as anybody else," John French defended. "Blow it, Julius."

Julius spat out into the yard, trying to give the impression that he was skeeting tobacco juice like a man.[2]

De rooster chew t'backer, de hen dip snuff.
De biddy can't do it, but he struts his stuff.
Ole John, he was workin' for Massa and Massa had two hawses and he lakted John, so he give John one of his hawses.
When John git to workin' 'em he'd haul off and beat Massa's hawse, but he never would hit his'n. So then some white folks tole ole Massa 'bout John beatin' his hawse and never beatin' his own. So Massa tole John if he ever heard tell of him layin' a whip on his hawse agin he was gointer take and kill John's hawse dead as a nit.
John tole 'im, "Massa, if you kill my hawse, Ah'll beatcher makin' money."
One day John hit ole Massa's hawse agin. Dey went and tole Massa' bout it. He come down dere where John was

[1]Keg.

[2]This story is of European origin, but has been colored by the negro mouth.

haulin' trash, wid a great big ole knife and cut John's
hawse's th'oat and he fell dead.

John jumped down off de wagon and skint his hawse,
and tied de hide up on a stick and throwed it cross his
shoulder, and went on down town.

Ole John was a fortune teller hisself but nobody 'round
dere didn't know it. He met a man and de man ast John,
"Whut's dat you got over yo' shoulder dere, John?"

"It's a fortune teller, boss."

"Make it talk some, John, and I'll give you a sack of
money and a hawse and saddle, and five head of cattle."

John put de hide on de ground and pulled out de stick
and hit 'cross de hawse hide and hold his head down dere
to lissen.

"Dere's a man in yo' bed-room behind de bed talkin' to
yo' wife."

De man went inside his house to see. When he come
back out he said, "Yeah, John, you sho tellin' de truth.
Make him talk some mo'."

John went to puttin' de stick back in de hide. "Naw,
Massa, he's tired now."

De white man says, "Ah'll give you six head of sheeps
and fo' hawses and fo' sacks of money."

John pulled out de stick and hit down on de hide and
hold down his head to lissen.

"It's a man in yo' kitchen openin' yo' stove." De man
went back into his house and come out agin and tole John,
"Yo, fortune-teller sho is right. Here's de things Ah prom-
ised you."

John rode on past Ole Massa's house wid all his sacks of
money and drivin' his sheeps and cattle, whoopin' and crac-
kin' his whip. "Yee, whoo-pee, yee!" Crack!

Massa said, "John, where did you git all dat?"

John said, "Ah tole you if you kilt mah hawse Ah'd
beatcher makin' money."

Massa said to 'im, "Reckon if Ah kilt mah hawse Ah'd
make dat much money?"

"Yeah, Massa, Ah reckon so."

So ole Massa went out and kilt his hawse and went to
town hollerin', "Hawse hide for sale! Hawse hide for sale!"

43

One man said, "Hold on dere. Ah'll give you two-bits for it to bottom some chears."

Ole Massa tole 'im, "Youse crazy!" and went on hollerin' "Hawse hide for sale!"

"Ah'll gi' you twenty cents for it to cover some chears," another man said.

"You must be stone crazy! Why, dis hide is worth five thousand dollars."

De people all laughed at 'im so he took his hawse hide and throwed it away and went and bought hisself another hawse.

Ole John, he already rich, he didn't have to work but he jus' love to fool 'round hawses so he went to drivin' hawse and buggy for Massa. And when nobody wasn't wid him, John would let his grandma ride in Massa's buggy. Dey tole ole Massa 'bout it and he said, "John, Ah hear you been had yo' grandma ridin' in mah buggy. De first time Ah ketch her in it, Ah'm gointer kill 'er."

John tole 'im, "If you kill my grandma, Ah'll beatcher makin' money."

Pretty soon some white folks tole Massa dat John was takin' his gran'ma to town in his buggy and was hittin' his hawse and showin' off. So ole Massa come out dere and cut John's gran'ma's th'oat.

So John buried his gran'ma in secret and went and got his same ole hawse hide and keered it up town agin and went 'round talkin' 'bout, "Fortune-teller, fortune-teller!"

One man tole 'im, "Why, John, make it talk some for me. Ah'll give you six head of goats, six sheeps, and a hawse and a saddle to ride 'im wid."

So John made it talk and de man was pleased so he give John more'n he promised 'im, and John went on back past Massa's house wid his stuff so ole Massa could see 'im.

Ole Massa run out and ast, "Oh, John, where did you git all dat?"

John said, "Ah tole you if you kill mah gran'ma Ah'd beatcher makin' money."

Massa said, "You reckon if Ah kill mine, Ah'll make all dat?"

"Yeah, Ah reckon so."

So Massa runned and cut his gran'ma's th'oat and went up town hollerin' "gran'ma for sale! gran'ma for sale!"

Wouldn't nobody break a breath wid him. Dey thought he was crazy. He went on back home and grabbed John and tole 'im, "You made me kill my gran'ma and my good hawse and Ah'm gointer throw you in de river."

John tole 'im, "If you throw me in de river, Ah'll beatcher makin' money."

"Naw you won't neither," Massa tole 'im. "You done made yo' last money and done yo' las' do."

He got ole John in de sack and keered 'im down to de river, but he done forgot his weights, so he went back home to git some.

While he was gone after de weights a toad frog come by dere and John seen 'im. So he hollered and said, "Mr. Hoptoad, if you open dis sack and let me out Ah'll give you a dollar."

Toad frog let 'im out, so he got a soft-shell turtle and put it in de sack wid two big ole bricks. Then ole Massa got his weights and come tied 'em on de sack and throwed it in de river.

Whilst Massa was down to de water foolin' wid dat sack, John had done got out his hawse hide and went on up town agin hollerin', "Fortune-teller! fortune-teller!"

One rich man said "Make it talk for me, John."

John pulled out de stick and hit on de hide, and put his ear down. "Uh man is in yo' smoke-house stealin' meat and another one is in yo' money-safe."

De man went inside to see and when he come back he said, "You sho kin tell de truth."

So John went by Massa's house on a new hawse, wid a sack of money tied on each side of de saddle. Ole Massa seen 'im and ast, "Oh, John, where'd you git all dat?"

"Ah tole you if you throw me in de river Ah'd beatcher makin' money."

Massa ast, "Reckon if Ah let you throw me in de river, Ah'd make all dat?"

"Yeah, Massa, Ah *know* so."

John got ole Massa in de sack and keered 'im down to de river. John didn't forgit *his* weights. He put de weights

on ole Massa and jus' befo' he throwed 'im out he said,
"Goodbye, Massa, Ah hope you find all you lookin' for."
And dat wuz de las' of ole Massa.

"Dat wuz a long tale for a li'l boy lak you," George Thomas
praised Julius.
"Ah knows a heap uh tales," Julius retorted.

Whut is de workinest pill you ever seen? Lemme tell you
whut kind of a pill it was and how much it worked.
It wuz a ole man one time and he had de rheumatism so
bad he didn't know what to do. Ah tole 'im to go to town
and git some of dem conthartic pills.[3]
He went and got de pills lak Ah tole 'im, but on his way
back he opened de box and went to lookin' at de pills. He
wuz comin' cross some new ground where dey hadn't even
started to clear up de land. He drop one of de pills but he
didn't bother to pick it up—skeered he might hurt his back
stoopin' over.
He got to de house and say, "Ole lady, look down yon-
der whut a big smoke! Whut is dat, nohow?"
She say, "Ah don't know."
"Well," he say. "Guess Ah better walk down dere and
see whut dat big smoke *is* down dere."
He come back. "Guess whut it is, ole lady? One of dem
conthartic pills done worked all dem roots out de ground
and got 'em burning!"

"Julius, you little but you loud. Dat's a over average lie you
tole," Shug laughed. "Lak de wind Ah seen on de East Coast.
It blowed a crooked road straight and blowed a well up out
de ground and blowed and blowed until it scattered de days
of de week so bad till Sunday didn't come till late Tuesday
evenin'."
"Shug, Whuss yuh gonna do?" Bennie Lee tried to rise to
the surface but failed and slumped back into slumber.
"A good boy, but a po' boy," somebody commented as

[3]Compound cathartic.

John French made his mind up.

"Zora, Ah'm gointer tell one, but you be sho and tell de folks Ah tole it. Don't say Seymore said it because he took you on de all-day fishin' trip to Titusville. Don't say Seaboard Hamilton tole it 'cause he always give you a big hunk of barbecue when you go for a sandwich. Give ole John French whut's comin' to 'im."

"You gointer tell it or you gointer spend de night tellin' us you gointer tell it?" I asked.

Ah got to say a piece of litery (literary) fust to git mah wind on.
Well Ah went up on dat meat-skin
And Ah come down on dat bone
And Ah grabbed dat piece of corn-bread
And Ah made dat biscuit moan.
Once a man had two sons. One was name Jim and de other one dey call him Jack for short. Dey papa was a most rich man, so he called de boys to 'im one night and tole 'em, "Ah don't want y'all settin' 'round waitin' for me tuh die tuh git whut Ah'm gointer give yuh. Here's five hundred dollars apiece. Dat's yo' sheer of de proppity. Go put yo'selves on de ladder. Take and make men out of yourselves."
Jim took his and bought a big farm and a pair of mules and settled down.
Jack took his money and went on down de road skinnin' and winnin'. He won from so many mens till he had threbbled his money. Den he met a man says, "Come on, le's skin some." De man says "Money on de wood" and he laid down a hundred dollars.
Jack looked at de hund'ud dollars and put down five hund'ud and says, "Man, Ah ain't for no spuddin'.[4] You playin' wid yo' stuff out de winder.[5] You fat 'round de heart.[6] Bet some money."

[4]Playing for small change.

[5]Risking nothing, i.e. hat, coat and shoes out the window so that the owner can run if he loses.

[6]Scared.

De man covered Jack's money and dey went to skinnin'. Jack was dealin' and he thought he seen de other man on de turn so he said, "Five hund'ud mo' my ten spot is de bes'."

De other man covered 'im and Jack slapped down another five hund'ud and said, "Five hund'ud mo' you fall dis time."

De other man never said a word. He put down five hund'ud mo'.

Jack got to singin':

"When yo' card git-uh lucky, oh pardner
You oughter be in a rollin' game."

He flipped de card and bless God it wuz de ten spot! Jack had done fell hisself instead of de other man. He was all put out.

Says, "Well, Ah done los' all mah money so de game is through."

De other man say, "We kin still play on. Ah'll bet you all de money on de table against yo' life."

Jack agreed to play 'cause he figgered he could out-shoot and out-cut any man on de road and if de man tried to kill *him* he'd git kilt hisself. So dey shuffled agin and Jack pulled a card and it fell third in hand.

Den de man got up and he was twelve foot tall and Jack was so skeered he didn't know whut to do. De man looked down on 'im and tole 'im says, "De Devil[7] is mah name and Ah live across de deep blue sea. Ah could kill you right now, but Ah'll give yuh another chance. If you git to my house befo' de sun sets and rise agin Ah won't kill yuh, but if you don't Ah'll be compelled to take yo' life."

Den he vanished.

Jack went on down de road jus' a cryin' till he met uh ole man.

Says, "Whuss de matter, Jack?"

"Ah played skin wid de Devil for mah life and he winned and tole me if Ah ain't to his house by de time de sun sets and rise agin he's gointer take mah life, and he live way across de ocean."

[7]See glossary.

48

De ole man says, "You sho is in a bad fix, Jack. Dere ain't but one thing dat kin cross de ocean in dat time."

"Whut is dat?"

"It's uh bald eagle. She come down to de edge of de ocean every mornin' and dip herself in de sea and pick off all de dead feathers. When she dip herself de third time and pick herself she rocks herself and spread her wings and mount de sky and go straight across de deep blue sea. And every time she holler, you give her piece uh dat yearlin' or she'll eat you.

"Now if you could be dere wid a yearlin' bull and when she git thru dippin' and pick herself and rock to mount de sky and jump straddle of her back wid dat bull yearlin' you could make it."

Jack wuz dere wid de yearlin' waitin' for dat eagle to come. He wuz watchin' her from behind de bushes and seen her when she come out de water and picked off de dead feather and rocked to go on high.

He jumped on de eagle's back wid his yearlin' and de eagle was out flyin' de sun. After while she turned her head from side to side and her blazin' eyes lit up first de north den de south and she hollered, "Ah-h-h, Ah, ah! One quarter cross de ocean! Don't see nothin' but blue water, uh!"

Jack was so skeered dat instead of him givin' de eagle uh quarter of de meat, he give her de whole bull. After while she say, "Ah-h-h, ah, ah! One half way cross de ocean! Don't see nothin' but blue water!"

Jack didn't have no mo' meat so he tore off one leg and give it to her. She swallowed dat and flew on. She hollered agin, "Ah-h-h. Ah, ha! Mighty nigh cross de ocean! Don't see nothin' but blue water! Uh!"

Jack tore off one arm and give it to her and she et dat and pretty soon she lit on land and Jack jumped off and de eagle flew on off to her nest.

Jack didn't know which way de Devil lived so he ast. "Dat first big white house 'round de bend in de road," dey tole 'im.

Jack walked to de Devil's house and knocked on de do'.

"Who's dat?"

"One of de Devil's friends. One widout uh arm and widout uh leg."

Devil tole his wife, says: "Look behind de do' and hand dat man uh arm and leg." She give Jack de arm and leg and Jack put 'em on.

Devil says, "See you got here in time for breakfas'. But Ah got uh job for yuh befo' you eat. Ah got uh hund'ud acres uh new ground ain't never had uh brush cut on it. Ah want you to go out dere and cut down all de trees and brushes, grub up all de roots and pile 'em and burn 'em befo' dinner time. If you don't, Ah'll hafta take yo' life."

Jus' 'bout dat time de Devil's chillen come out to look at Jack and he seen he had one real pretty daughter, but Jack wuz too worried to think 'bout no girls. So he took de tools and went on out to de wood lot and went to work.

By de time he chopped down one tree he wuz tired and he knowed it would take 'im ten years to clear dat ground right, so Jack set down and went to cryin'. 'Bout dat time de Devil's pretty daughter come wid his breakfas'. "Whuss de matter, Jack?"

"Yo papa done gimme uh job he know Ah can't git through wid, and he's gonna take mah life and Ah don't wanna die."

"Eat yo' breakfas' Jack, and put yo' head in mah lap and go to sleep."

Jack done lak she tole 'im and went to sleep and when he woke up every tree was down, every bush—and de roots grubbed up and burnt. Look lak never had been a blade uh grass dere.

De Devil come out to see how Jack wuz makin' out and seen dat hundred acres cleaned off so nice and said, "Uh, huh, Ah see youse uh wise man, 'most wise as me. Now Ah got another job for yuh. Ah got uh well, uh hundred feet deep and Ah want yuh to dip it dry. Ah mean dry, Ah want it so dry till Ah kin see dust from it and den Ah want you to bring me whut you find at de bottom."

Jack took de bucket and went to de well and went to work but he seen dat de water wuz comin' in faster dan he could draw it out. So he sat down and begin to cry.

De Devil's daughter come praipsin long wid Jack's din-

ner and seen Jack settin' down cryin'. "Whuss de matter, Jack? Don't cry lak dat lessen you wanta make me cry too."

"Yo' pa done put me to doin' somethin' he know Ah can't never finish and if Ah don't git thru he is gonna take mah life."

"Eat yo' dinner, Jack and put yo' head in mah lap and go to sleep."

Jack done lak she tole 'im and when he woke up de well wuz so dry till red dust wuz boilin' out of it lak smoke. De girl handed 'im a ring and tole 'im "Give papa dis ring. Dat's whut he wanted. It's mama's ring and she lost it in de well de other day."

When de Devil come to see whut Jack wuz doin', Jack give 'im de ring and de Devil looked and seen all dat dust pourin' out de well. He say, "Ah see youse uh very smart man. Almos' as wise as me. All right, Ah got just one mo' job for you and if you do dat Ah'll spare yo' life and let you marry mah daughter to boot. You take dese two geeses and go up dat cocoanut palm tree and pick 'em, and bring me de geeses when you git 'em picked and bring me every feather dat come off 'em. If you lose one Ah'll have to take yo' life."

Jack took de two geeses and clammed up de cocoanut palm tree and tried to pick dem geeses. But he was more'n uh hundred feet off de ground and every time he'd pull uh feather often one of dem birds, de wind would blow it away. So Jack began to cry agin. By dat time Beatrice Devil come up wid his supper. "Whuss de matter, Jack?"

"Yo' papa is bound tuh kill me. He know Ah can't pick no geeses up no palm tree, and save de feathers."

"Eat yo' supper Jack and lay down in mah lap."

When Jack woke up all both de geeses wuz picked and de girl had all de feathers even; she had done caught dem out de air dat got away from Jack. De Devil said, "Well, now you done everything Ah tole you, you kin have mah daughter. Y'all take dat ole house down de road apiece. Dat's where me and her ma got our start."

So Jack and de Devil's daughter got married and went to keepin' house.

Way in de night, Beatrice woke up and shook Jack.

51

"Jack! Jack! Wake up! Papa's comin' here to kill you. Git up and go to de barn. He got two horses dat kin jump a thousand miles at every jump. One is named Hallowed-be-thy-name and de other, Thy-kingdom-come. Go hitch 'em to dat buck board and head 'em dis way and le's go."

Jack run to de barn and harnessed de hawses and headed towards de house where his wife wuz at. When he got to de do' she jumped in and hollered, "Le's go, Jack. Papa's comin' after us!"

When de Devil got to de house to kill Jack and found out Jack wuz gone, he run to de barn to hitch up his fas' hawses. When he seen dat dey wuz gone, he hitched up his jumpin' bull dat could jump five hundred miles at every jump, and down de road, baby!

De Devil wuz drivin' dat bull! Wid every jump he'd holler, "Oh! Hallowed-be-thy-name! Thy-kingdom-come!" And every time de hawses would hear 'im call 'em they'd fall to they knees and de bull would gain on 'em.

De girl say, "Jack, he's 'bout to ketch us! Git out and drag yo' feet backwards nine steps, throw some sand over yo' shoulders and le's go!"

Jack done dat and de hawses got up and off they went, but every time they hear they master's voice they'd stop till de girl told Jack to drag his foot three times nine times and he did it and they gained so fast on de Devil dat de hawses couldn't hear 'im no mo', and dey got away.

De Devil passed uh man and he say, "Is you seen uh man in uh buck board wid uh pretty girl wid coal black hair and red eyes behind two fas' hawses?"

De man said, "No, Ah speck dey done made it to de mountain and if dey gone to de mountain you can't over-take 'em."

"Jack and his wife wuz right dere den listenin' to de Devil. When de daughter saw her pa comin' she turned herself and de hawses into goats and they wuz croppin' grass. Jack wuz so tough she couldn't turn him into nothin' so she saw a holler log and she tole 'im to go hide in it, which he did. De Devil looked all around and he seen dat log and his mind jus' tole 'im to go look in it and he went

and picked de log up and said, "Ah, ha! Ah gotcher!"

Jack wuz so skeered inside dat log he begin to call on de Lawd and he said, "O Lawd, have mercy."

You know de Devil don't lak tuh hear de name uh de Lawd so he throwed down dat log and said, "Damn it! If Ah had of knowed dat God wuz in dat log Ah never would a picked it up."

So he got back in and picked up de reins and hollered to de bull, "Turn, bull, turn! Turn clean roh-hound. Turn bull tu-urn, turn clee-ean round!"

De jumpin' bull turnt so fast till he fell and broke his own neck and throwed de Devil out on his head and kilt 'im. So dat's why dey say Jack beat de Devil.

"Boy, how kin you hold all dat in yo' head?" Jack Jones asked John. "Bet if dat lie was somethin' to do yuh some good yuh couldn't remember it."

Johnnie Mae yawned wide open and Ernest seeing her called out, "Hey, there, Johnnie Mae, throw mah trunk out befo' you shet up dat place!"

This reflection upon the size of her mouth peeved Johnnie Mae no end and she and Ernest left in a red hot family argument. Then everybody else found out that they were sleepy. So in the local term everybody went to the "pad."

Lee Robinson over in the church was leading an ole spiritual, "When I come to Die," to which I listened with one ear, while I heard the parting quips of the story-tellers with the other.

Though it was after ten the street lights were still on. B. Moseley had not put out the lights because the service in the church was not over yet, so I sat on the porch for a while looking towards the heaven-rasping oaks on the back street, towards the glassy silver of Lake Sabelia. Over in the church I could hear Mrs. Laura Henderson finishing her testimony . . . "to make Heben mah home when Ah come to die. Oh, Ah'll never forget dat day when de mornin' star bust in mah heart! Ah'll never turn back! O evenin' sun, when you git on

de other side, tell mah Lawd Ah'm here prayin'."

The next afternoon I sat on the porch again. The young'uns had the grassy lane that ran past the left side of the house playing the same games that I had played in the same lane years before. With the camphor tree as a base, they played "Going 'Round de Mountain." Little Hubert Alexander was in the ring. The others danced rhythmically 'round him and sang:

> Going around de mountain two by two
> Going around de mountain two by two
> Tell me who love sugar and candy.
>
> Now, show me your motion, two by two
> Show me your motion two by two
> Tell me who love sugar and candy.

I tried to write a letter but the games were too exciting. "Little Sally Walker," "Draw a bucket of water," "Sissy in de barn," and at last that most raucous, popular and most African of games, "Chirck, mah Chick, mah Craney crow." Little Harriet Staggers, the smallest girl in the game, was contending for the place of the mama hen. She fought hard, but the larger girls promptly overruled her and she had to take her place in line behind the other little biddies, two-year-old Donnie Brown, being a year younger than Harriet, was the hindmost chick.

During the hilarious uproar of the game, Charlie Jones and Bubber Mimms came up and sat on the porch with me.

"Good Lawd, Zora! How kin you stand all dat racket? Why don't you run dem chaps 'way from here?" Seeing his nieces, Laura and Melinda and his nephew, Judson, he started to chase them off home but I made him see that it was a happy accident that they had chosen the lane as a playground. That I was enjoying it more than the chaps.

That settled, Charlie asked, "Well, Zora, did we lie enough for you las' night?"

54

"You lied good but not enough," I answered.

"Course, Zora, you ain't at de right place to git de bes' lies. Why don't you go down 'round Bartow and Lakeland and 'round in dere—Polk County? Dat's where they really lies up a mess and dats where dey makes up all de songs and things lak dat. Ain't you never hea'd dat in Polk County de water drink lak cherry wine?"

"Seems like when Ah was a child 'round here Ah heard de folks pickin' de guitar and singin' songs to dat effect."

"Dat's right. If Ah was you, Ah'd drop down dere and see. It's liable to do you a lot uh good."

"If Ah wuz in power[8] Ah'd go 'long wid you, Zora," Bubber added wistfully. "Ah learnt all Ah know 'bout pickin' de box[9] in Polk County. But Ah ain't even got money essence. 'Tain't no mo' hawgs 'round here. Ah cain't buy no chickens. Guess Ah have tuh eat gopher."[10]

"Where you gointer git yo' gophers, Bubber?" Charlie asked. "Doc Biddy and his pa done 'bout cleaned out dis part of de State."

"Oh, Ah got a new improvement dat's gointer be a lot of help to me and Doc Biddy and all of us po' folks."

"What is it, Bubber?"

"Ah'm gointer prune a gang of soft-shells (turtles) and grow me some gophers."

The sun slid lower and lower and at last lost its grip on the western slant of the sky and dipped three times into the bloody sea—sending up crimson spray with each plunge. At last it sunk and night roosted on the tree-tops and houses.

Bubber picked the box and Charlie sang me songs of the railroad camps. Among others, he taught me verses of JOHN HENRY, the king of railroad track-laying songs which runs as follows:[11]

[8]Funds.

[9]Playing the guitar.

[10]Dry land tortoise.

[11]See glossary.

John Henry driving on the right hand side,
Steam drill driving on the left,
Says, 'fore I'll let your steam drill beat me down
I'll hammer my fool self to death,
Hammer my fool self to death.

John Henry told his Captain,
When you go to town
Please bring me back a nine pound hammer
And I'll drive your steel on down,
And I'll drive your steel on down.

John Henry told his Captain,
Man ain't nothing but a man,
And 'fore I'll let that steam drill beat me down
I'll die with this hammer in my hand,
Die with this hammer in my hand.

Captain ast John Henry,
What is that storm I hear?
He says Cap'n that ain't no storm,
'Tain't nothing but my hammer in the air,
Nothing but my hammer in the air.

John Henry told his Captain,
Bury me under the sills of the floor,
So when they get to playing good old Georgy skin,
Bet 'em fifty to a dollar more,
Fifty to a dollar more.

John Henry had a little woman,
The dress she wore was red,
Says I'm going down the track,
And she never looked back.
I'm going where John Henry fell dead,
Going where John Henry fell dead.

Who's going to shoe your pretty lil feet?
And who's going to glove your hand?
Who's going to kiss your dimpled cheek?
And who's going to be your man?
Who's going to be your man?

My father's going to shoe my pretty lil feet;
My brother's going to glove my hand;
My sister's going to kiss my dimpled cheek;
John Henry's going to be my man,
John Henry's going to be my man.

Where did you get your pretty lil dress?
The shoes you wear so fine?
I got my shoes from a railroad man,
My dress from a man in the mine,
My dress from a man in the mine.

They talked and told strong stories of Ella, Wall, East Coast Mary, Planchita and lesser jook[12] lights around whom the glory of Polk County surged. Saw-mill and turpentine bosses and prison camp "cap'ns" set to music passed over the guitar strings and Charlie's mouth and I knew I had to visit Polk County right now.

A hasty good-bye to Eatonville's oaks and oleanders and the wheels of the Chevvie split Orlando wide open—headed south-west for corn (likker) and song.

[12]A fun house. Where they sing, dance, gamble, love, and compose "blues" songs incidentally.

FOUR

Twelve miles below Kissimmee I passed under an arch that marked the Polk County line. I was in the famed Polk County.

How often had I heard "Polk County Blues."
"You don't know Polk County lak Ah do.
Anybody been dere, tell you de same thing too."

The asphalt curved deeply and when it straightened out we saw a huge smoke-stack blowing smut against the sky. A big sign said, "Everglades Cypress Lumber Company, Loughman, Florida."

We had meant to keep on to Bartow or Lakeland and we debated the subject between us until we reached the opening, then I won. We went in. The little Chevrolet was all against it. The thirty odd miles that we had come, it argued, was nothing but an appetizer. Lakeland was still thirty miles away and no telling what the road held. But it sauntered on down the bark-covered road and into the quarters just as if it had really wanted to come.

We halted beside two women walking to the commissary and asked where we could get a place to stay, despite the signs all over that this was private property and that no one could

enter without the consent of the company.

One of the women was named "Babe" Hill and she sent me to her mother's house to get a room. I learned later that Mrs. Allen ran the boarding-house under patronage of the company. So we put up at Mrs. Allen's.

That night the place was full of men—come to look over the new addition to the quarters. Very little was said directly to me and when I tried to be friendly there was a noticeable disposition to *fend* me off. This worried me because I saw at once that this group of several hundred Negroes from all over the South was a rich field for folk-lore, but here was I figuratively starving to death in the midst of plenty.

Babe had a son who lived at the house with his grandmother and we soon made friends. Later the sullen Babe and I got on cordial terms. I found out afterwards that during the Christmas holidays of 1926 she had shot her husband to death, had fled to Tampa where she had bobbed her hair and eluded capture for several months but had been traced thru letters to her mother and had been arrested and lodged in Bartow jail. After a few months she had been allowed to come home and the case was forgotten. Negro women *are* punished in these parts for killing men, but only if they exceed the quota. I don't remember what the quota is. Perhaps I did hear but I forgot. One woman had killed five when I left that turpentine still where she lived. The sheriff was thinking of calling on her and scolding her severely.

James Presley used to come every night and play his guitar. Mrs. Allen's temporary brother-in-law could play a good second but he didn't have a box so I used to lend him mine. They would play. The men would crowd in and buy soft drinks and woof at me, the stranger, but I knew I wasn't getting on. The ole feather-bed tactics.

Then one day after Cliffert Ulmer, Babe's son, and I had driven down to Lakeland together he felt close enough to tell me what was the trouble. They all thought I must be a revenue officer or a detective of some kind. They were accustomed to strange women dropping into the quarters, but not in shiny

gray Chevrolets. They usually came plodding down the big road or counting railroad ties. The car made me look too prosperous. So they set me aside as different. And since most of them were fugitives from justice or had done plenty time, a detective was just the last thing they felt they needed on that "job."

I took occasion that night to impress the job with the fact that I was also a fugitive from justice, "bootlegging." They were hot behind me in Jacksonville and they wanted me in Miami. So I was hiding out. That sounded reasonable. Bootleggers always have cars. I was taken in.

The following Saturday was pay-day. They paid off twice a month and pay night is big doings. At least one dance at the section of the quarters known as the Pine Mill and two or three in the big Cypress Side. The company works with two kinds of lumber.

You can tell where the dances are to be held by the fires. Huge bonfires of faulty logs and slabs are lit outside the house in which the dances are held. The refreshments are parched[1] peanuts, fried rabbit, fish, chicken and chitterlings.

The only music is guitar music and the only dance is the ole square dance. James Presley is especially invited to every party to play. His pay is plenty of coon dick, and he *plays*.

Joe Willard is in great demand to call figures. He rebels occasionally because he likes to dance too.

But all of the fun isn't inside the house. A group can always be found outside about the fire, standing around and woofing and occasionally telling stories.

The biggest dance on this particular pay-night was over to the Pine Mill. James Presley and Slim assured me that they would be over there, so Cliffert Ulmer took me there. Being the reigning curiosity of the "job" lots of folks came to see what I'd do. So it was a great dance.

The guitars cried out "Polk County," "Red River" and just instrumental hits with no name, that still are played by all good

[1] Roasted.

box pickers. The dancing was hilarious to put it mildly. Babe, Lucy, Big Sweet, East Coast Mary and many other of the well-known women were there. The men swung them lustily, but nobody asked me to dance. I was just crazy to get into the dance, too. I had heard my mother speak of it and praise square dancing to the skies, but it looked as if I was doomed to be a wallflower and that was a new role for me. Even Cliffert didn't ask me to dance. It was so jolly, too. At the end of every set Joe Willard would trick the men. Instead of calling the next figure as expected he'd bawl out, "Grab yo' partners and march up to de table and treat." Some of the men did, but some would bolt for the door and stand about the fire and woof until the next set was called.

I went outside to join the woofers, since I seemed to have no standing among the dancers. Not exactly a hush fell about the fire, but a lull came. I stood there awkwardly, knowing that the too-ready laughter and aimless talk was a window-dressing for my benefit. The brother in black puts a laugh in every vacant place in his mind. His laugh has a hundred meanings. It may mean amusement, anger, grief, bewilderment, chagrin, curiosity, simple pleasure or any other of the known or unde- fined emotions. Clardia Thornton of Magazine Point, Ala-

bama, was telling me about another woman taking her husband away from her. When the show-down came and he told Clardia in the presence of the other woman that he didn't want her—could never use her again, she tole me "Den, Zora, Ah wuz so outdone, Ah just opened mah mouf and laffed."

The folks around the fire laughed and boisterously shoved each other about, but I knew they were not tickled. But I soon had the answer. A pencil-shaped fellow with a big Adam's apple gave me the key.

"Ma'am, whut might be yo' entrimmins?" he asked with what was supposed to be a killing bow.

"My whut?"

"Yo entrimmins? Yo entitlum?"

The "entitlum" gave me the cue, "Oh, my name is Zora Hurston. And whut may be yours?"

More people came closer quickly.

"Mah name is Pitts and Ah'm sho glad to meet yuh. Ah asted Cliffert tuh knock me down tuh yuh but he wouldn't make me 'quainted. So Ah'm makin' mahseff 'quainted."

"Ah'm glad you did, Mr. Pitts."

"Sho nuff?" archly.

"Yeah. Ah wouldn't be sayin' it if Ah didn't mean it."

He looked me over shrewdly. "Ah see dat las' crap you shot, Miss, and Ah fade yuh."

I laughed heartily. The whole fire laughed at his quick comeback and more people came out to listen.

"Miss, you know uh heap uh dese hard heads wants to woof at you but dey skeered."

"How come, Mr. Pitts? Do I look like a bear or panther?"

"Naw, but dey say youse rich and dey ain't got de nerve to open dey mouf."

I mentally cursed the $12.74 dress from Macy's that I had on among all the $1.98 mail-order dresses. I looked about and noted the number of bungalow aprons and even the rolled down paper bags on the heads of several women. I did look different and resolved to fix all that no later than the next morning.

"Oh, Ah ain't got doodley squat,"[2] I countered. "Mah man brought me dis dress de las' time he went to Jacksonville. We wuz sellin' plenty stuff den and makin' good money. Wisht Ah had dat money now."

Then Pitts began woofing at me and the others stood around to see how I took it.

"Say, Miss, you know nearly all dese niggers is after you. Dat's all dey talk about out in de swamp."

"You don't say. Tell 'em to make me know it."

"Ah ain't tellin' nobody nothin'. Ah ain't puttin' out nothin' to no ole hard head but ole folks eyes and Ah ain't doin' dat till they dead. Ah talks for Number One. Second stanza: Some of 'em talkin' 'bout marryin' you and dey wouldn't know whut to do wid you if they had you. Now, dat's a fack."

"You reckon?"

"Ah know dey wouldn't. Dey'd 'spect you tuh git out de bed and fix dem some breakfus' and a bucket. Dat's 'cause dey don't know no better. Dey's thin-brainded. Now me, Ah wouldn't let you fix me no breakfus'. Ah git up and fix mah own and den, whut make it so cool, Ah'd fix *you* some and set it on de back of de cook-stove so you could git it when you wake up. Dese mens don't even know how to talk to nobody lak you. If you wuz tuh ast dese niggers somethin' dey'd answer you 'yeah' and 'naw.' Now, if you wuz some ole gator-back 'oman dey'd be tellin' you jus' right. But dat ain't de way tuh talk tuh nobody lak *you.* Now you ast *me* somethin' and see how Ah'll answer yuh."

"Mr. Pitts, are you havin' a good time?"

(In a prim falsetto) "Yes, Ma'am. See, dat's de way tuh talk tuh *you.*"

I laughed and the crowd laughed and Pitts laughed. Very successful woofing. Pitts treated me and we got on. Soon a boy came to me from Cliffert Ulmer asking me to dance. I found out that that was the social custom. The fellow that wants to broach a young woman doesn't come himself to ask. He sends

[2]Nothing.

his friend. Somebody came to me for Joe Willard and soon I was swamped with bids to dance. They were afraid of me before. My laughing acceptance of Pitts' woofing had put everybody at his ease.

James Presley and Slim spied noble at the orchestra. I had the chance to learn more about "John Henry" maybe. So I strolled over to James Presley and asked him if he knew how to play it.

"Ah'll play it if you sing it," he countered. So he played and I started to sing the verses I knew. They put me on the table and everybody urged me to spread my jenk,[3] so I did the best I could. Joe Willard knew two verses and sang them. Eugene Oliver knew one; Big Sweet knew one. And how James Presley can make his box cry out the accompaniment!

By the time that the song was over, before Joe Willard lifted me down from the table I knew that I was in the inner circle. I had first to convince the "job" that I was not an enemy in the person of the law; and, second, I had to prove that I was their kind. "John Henry" got me over my second hurdle.

After that my car was everybody's car. James Presley, Slim and I teamed up and we had to do "John Henry" wherever we appeared. We soon had a reputation that way. We went to Mulberry, Pierce and Lakeland.

After that I got confidential and told them all what I wanted. At first they couldn't conceive of anybody wanting to put down "lies." But when I got the idea over we held a lying contest and posted the notices at the Post Office and the commissary. I gave four prizes and some tall lying was done. The men and women enjoyed themselves and the contest broke up in a square dance with Joe Willard calling figures.

The contest was a huge success in every way. I not only collected a great deal of material but it started individuals coming to me privately to tell me stories they had no chance to tell during the contest.

Cliffert Ulmer told me that I'd get a great deal more by

[3]Have a good time.

going out with the swamp-gang. He said they lied a plenty while they worked. I spoke to the quarters boss and the swamp boss and both agreed that it was all right, so I strowed it all over the quarters that I was going out to the swamp with the boys next day. My own particular crowd, Cliffert, James, Joe Willard, Jim Allen and Eugene Oliver were to look out for me and see to it that I didn't get snake-bit nor 'gator-swallowed. The watchman, who sleeps out in the swamps and gets up steam in the skitter every morning before the men get to the cypress swamp, had been killed by a panther two weeks before, but they assured me that nothing like that could happen to me; not with the help I had.

Having watched some members of that swamp crew handle axes, I didn't doubt for a moment that they could do all that they said. Not only do they chop rhythmically, but they do a beautiful double twirl above their heads with the ascending axe before it begins that accurate and bird-like descent. They can hurl their axes great distances and behead moccasins or sink the blade into an alligator's skull. In fact, they seem to be able to do everything with their instrument that a blade can do. It is a magnificent sight to watch the marvelous co-ordination between the handsome black torsos and the twirling axes.

So next morning we were to be off to the woods.

It wasn't midnight dark and it wasn't day yet. When I awoke the saw-mill camp was a dawn gray. You could see the big saw-mill but you couldn't see the smoke from the chimney. You could see the congregation of shacks and the dim outlines of the scrub oaks among the houses, but you couldn't see the grey quilts of Spanish Moss that hung from the trees.

Dick Willie was the only man abroad. It was his business to be the first one out. He was the shack-rouser. Men are not supposed to over-sleep and Dick Willie gets paid to see to it that they don't. Listen to him singing as he goes down the line.

Wake up, bullies, and git on de rock. 'Tain't quite daylight but it's four o'clock.

66

Coming up the next line, he's got another song.

Wake up, Jacob, day's a breakin'. Git yo' hoe-cake a bakin' and
yo' shirt tail shakin'.

What does he say when he gets to the jook and the long-
house?⁴ I'm fixing to tell you right now what he says. He raps
on the floor of the porch with a stick and says:

"Ah ha! What make de rooster crow every morning at
sun-up?

"Dat's to let de pimps and rounders know de workin' man
is on his way."

About that time you see a light in every shack. Every kitchen
is scorching up fat-back and hoe-cake. Nearly every skillet is
full of corn-bread. But some like biscuit-bread better. Break
your hoe-cake half in two. Half on the plate, half in the dinner-
bucket. Throw in your black-eyed peas and fat meat left from
supper and your bucket is fixed. Pour meat grease in your
plate with plenty of cane syrup. Mix it and sop it with your
bread. A big bowl of coffee, a drink of water from the tin
dipper in the pail. Grab your dinner-bucket and hit the grit.
Don't keep the straw-boss⁵ waiting.

This morning when we got to the meeting place, the fore-
man wasn't there. So the men squatted along the railroad track
and waited.

Joe Willard was sitting with me on the end of a cross-tie
when he saw Jim Presley coming in a run with his bucket and
jumper-jacket.

"Hey, Jim, where the swamp boss? He ain't got here yet."

"He's ill—sick in the bed Ah hope, but Ah bet he'll git here
yet."

"Aw, he ain't sick. Ah bet you a fat man he ain't," Joe said.

"How come?" somebody asked him and Joe answered:

⁴See glossary.

⁵The low-paid poor white section boss on a railroad; similar to swamp boss who
works the gang that gets the timber to the sawmill.

"Man, he's too ugly. If a spell of sickness ever tried to slip up on him, he'd skeer it into a three weeks' spasm."

Blue Baby[6] stuck in his oar and said: "He ain't so ugly. Ye all jus' ain't seen no real ugly man. Ah seen a man so ugly till he could get behind a jimpson weed and hatch monkies."

Everybody laughed and moved closer together. Then Officer Richardson said: "Ah seen a man so ugly till they had to spread a sheet over his head at night so sleep could slip up on him."

They laughed some more, then Cliffert Ulmer said:

"Ah'm goin' to talk with my mouth wide open. Those men y'all been talkin' 'bout wasn't ugly at all. Those was pretty men. Ah knowed one so ugly till you could throw him in the Mississippi river and skim ugly for six months."

"Give Cliff de little dog," Jim Allen said. "He done tole the biggest lie."

"He ain't lyin'," Joe Martin tole them. "Ah knowed dat same man. He didn't die—he jus' uglied away."

They laughed a great big old kah kah laugh and got closer together.

"Looka here, folkses," Jim Presley exclaimed. "Wese a half hour behind schedule and no swamp boss and no log train here yet. What yo' all reckon is the matter sho' 'nough?"

"Must be something terrible when white folks get slow about putting us to work."

"Yeah," says Good Black. "You know back in slavery Ole Massa was out in de field sort of lookin' things over, when a shower of rain come up. The field hands was glad it rained so they could knock off for a while. So one slave named John says:

"More rain, more rest."

"Ole Massa says, 'What's dat you say?'

"John says, 'More rain, more grass.' "

"There goes de big whistle. We ought to be out in the woods almost."

[6]See glossary.

68

The big whistle at the saw-mill boomed and shrilled and pretty soon the log-train came racking along. No flats for logs behind the little engine. The foreman dropped off the tender as the train stopped.

"No loggin' today, boys. Got to send the train to the Everglades to fetch up the track gang and their tools."

"Lawd, Lawd, we got a day off," Joe Willard said, trying to make it sound like he was all put out about it. "Let's go back, boys. Sorry you won't git to de swamp, Zora."

"Aw, naw," the Foreman said. "Y'all had better g'wan over to the mill and see if they need you over there."

And he walked on off, chewing his tobacco and spitting his juice.

The men began to shoulder jumper-jackets and grab hold of buckets.

Allen asked: "Ain't dat a mean man? No work in the swamp and still he won't let us knock off."

"He's mean all right, but Ah done seen meaner men than him," said Handy Pitts.

"Where?"

"Oh, up in Middle Georgy. They had a straw boss and he was so mean dat when the boiler burst and blowed some of the men up in the air, he docked 'em for de time they was off de job."

Tush Hawg up and said: "Over on de East Coast Ah used to have a road boss and he was so mean and times was so hard till he laid off de hands of his watch."

Wiley said: "He's almost as bad as Joe Brown. Ah used to work in his mine and he was so mean till he wouldn't give God an honest prayer without snatching back 'Amen.'"

Ulmer says: "Joe Wiley, youse as big a liar as you is a man! Whoo-wee. Boy, you molds 'em. But lemme tell y'all a sho nuff tale 'bout Ole Massa."

"Go 'head and tell it, Cliff," shouted Eugene Oliver. "Ah love to hear tales about Ole Massa and John. John sho was one smart nigger."

So Cliff Ulmer went on.

You know befo' surrender Ole Massa had a nigger name
John and John always prayed every night befo' he went to
bed and his prayer was for God to come git him and take
him to Heaven right away. He didn't even want to take
time to die. He wanted de Lawd to come git him just like
he was—boot, sock and all. He'd git down on his knees
and say: "O Lawd, it's once more and again yo' humble
servant is knee-bent and body-bowed—my heart beneath
my knees and my knees in some lonesome valley, crying
for mercy while mercy kin be found. O Lawd, Ah'm astin'
you in de humblest way I know how to be *so* pleased as to
come in yo' fiery chariot and take me to yo' Heben and its
immortal glory. Come Lawd, you know Ah have such a
hard time. Old Massa works me *so* hard, and don't gimme
no time to rest. So come, Lawd, wid peace in one hand and
pardon in de other and take me away from this sin-
sorrowing world. Ah'm tired and Ah want to go home."

So one night Ole Massa passed by John's shack and heard
him beggin' de Lawd to come git him in his fiery chariot
and take him away; so he made up his mind to find out if
John meant dat thing. So he goes on up to de big house
and got hisself a bed sheet and come on back. He throwed
de sheet over his head and knocked on de door.

John quit prayin' and ast: "Who dat?"

Ole Massa say: "It's me, John, de Lawd, done come wid
my fiery chariot to take you away from this sin-sick world."

Right under de bed John had business. He told his wife:
"Tell Him Ah ain't here, Liza."

At first Liza didn't say nothin' at all, but de Lawd kept
right on callin' John: "Come on, John, and go to Heben
wid me where you won't have to plough no mo' furrows
and hoe no mo' corn. Come on, John."

Liza says: "John ain't here, Lawd, you hafta come back
another time."

Lawd says: "Well, then Liza, you'll do."

Liza whispers and says: "John, come out from underneath
dat bed and g'wan wid de Lawd. You been beggin' him to
come git you. Now g'wan wid him."

John back under de bed not saying a mumblin' word. De
Lawd out on de door step kept on callin'.

70

Liza says: "John, Ah thought you was so anxious to get to Heben. Come out and go on wid God."

John says: "Don't you hear him say 'You'll do'? Why don't you go wid him?"

"Ah ain't a goin' nowhere. Youse de one been whoopin' and hollerin' for him to come git you and if you don't come out from under dat bed Ah'm gointer tell God youse here."

Ole Massa makin' out he's God, says: "Come on, Liza, you'll do."

Liza says: "O, Lawd, John is right here underneath de bed."

"Come on John, and go to Heben wid me and its immortal glory."

John crept out from under de bed and went to de door and cracked it and when he seen all dat white standin' on de doorsteps he jumped back. He says: "O, Lawd, Ah can't go to Heben wid you in yo' fiery chariot in dese ole dirty britches; gimme time to put on my Sunday pants."

"All right, John, put on yo' Sunday pants."

John fooled around just as long as he could, changing them pants, but when he went back to de door, de big white glory was still standin' there. So he says agin: "O, Lawd, de Good Book says in Heben no filth is found and I got on his dirty sweaty shirt. Ah can't go wid you in dis old nasty shirt. Gimme time to put on my Sunday shirt!"

"All right, John, go put on yo' Sunday shirt."

John took and fumbled around a long time changing his shirt, and den he went back to de door, but Ole Massa was still on de door step. John didn't had nothin' else to change so he opened de door a little piece and says:

"O, Lawd, Ah'm ready to go to Heben wid you in yo' fiery chariot, but de radiance of yo' countenance is *so* bright, Ah can't come out by you. Stand back jus' a li'l way please."

Ole Massa stepped back a li'l bit.

John looked out agin and says: "O, Lawd, you know dat po' humble me is less than de dust beneath yo' shoe soles. And de radiance of yo' countenance is so bright Ah can't come out by you. Please, please, Lawd, in yo' tender

mercy, stand back a li'l bit further."

Ole Massa stepped back a li'l bit mo'.

John looked out agin and he says: "O, Lawd, Heben is
so high and wese so low; youse so great and Ah'm so weak
and yo' strength is too much for us poor sufferin' sinners.
So once mo' and agin yo' humber servant is knee-bent and
body-bowed askin' you one mo' favor befo' Ah step into
yo' fiery chariot to go to Heben wid you and wash in yo'
glory—be so pleased in yo' tender mercy as to stand back
jus' a li'l bit further."

Ole Massa stepped back a step or two mo' and out dat
door John come like a streak of lightning. All across de
punkin patch, thru de cotton over de pasture—John wid
Ole Massa right behind him. By de time dey hit de corn-
field John was way ahead of Ole Massa.

Back in de shack one of de children was cryin' and she
ast Liza: "Mama, you reckon God's gointer ketch papa and
carry him to Heben wid him?"

"Shet yo' mouf, talkin' foolishness!" Liza clashed at de
chile. "You know de Lawd can't outrun yo' pappy—
specially when he's barefooted at dat."

Kah, Kah, Kah! Everybody laughing with their mouths
wide open. If the foreman had come along right then he
would have been good and mad because he could tell their
minds were not on work.

Joe Willard says: "Wait a minute, fellows, wese walkin' too
fast. At dis rate we'll be there befo' we have time to talk some
mo' about Ole Massa and John. Tell another one, Cliffert."

"Aw, naw," Eugene Oliver hollered out.

Let *me* talk some chat. Dis is de real truth 'bout Ole
Massa 'cause my grandma told it to my mama and she told
it to me.

During slavery time, you know, Ole Massa had a nigger
named John and he was a faithful nigger and Ole Massa
lakted John a lot too.

One day Ole Massa sent for John and tole him, says:

72

"John, somebody is stealin' my corn out de field. Every mornin' when I go out I see where they done carried off some mo' of my roastin' ears. I want you to set in de corn patch tonight and ketch whoever it is."

So John said all right and he went and hid in de field.

Pretty soon he heard somethin' breakin' corn. So John sneaked up behind him wid a short stick in his hand and hollered: "Now, break another ear of Ole Massa's corn and see what *Ah'll* do to you."

John thought it was a man all dis time, but it was a bear wid his arms full of roastin' ears. He throwed down de corn and grabbed John. And him and dat bear!

John, after while got loose and got de bear by the tail wid de bear tryin' to git to him all de time. So they run around in a circle all night long. John was so tired. But he couldn't let go of de bear's tail, do de bear would grab him in de back.

After a stretch they quit runnin' and walked. John swingin' on to de bear's tail and de bear's nose 'bout to touch him in de back.

Daybreak, Ole Massa come out to see 'bout John and he seen John and de bear walkin' 'round in de ring. So he run up and says: "Lemme take holt of 'im, John, whilst you run git help!"

John says: "All right, Massa. Now you run in quick and grab 'im just so."

Ole Massa run and grabbed holt of de bear's tail and said: "Now, John you make haste to git somebody to help us."

John staggered off and set down on de grass and went to fanning hisself wid his hat.

Ole Massa was havin' plenty trouble wid dat bear and he looked over and seen John settin' on de grass and he hollered:

"John, you better g'wan git help or else I'm gwinter turn dis bear aloose!"

John says: "Turn 'im loose, then. Dat's whut Ah tried to do all night long but Ah couldn't."

Jim Allen laughed just as loud as anybody else and then he said: "We better hurry on to work befo' de buckra[7] get in behind us."

"Don't never worry about work," says Jim Presley. "There's more work in de world than there is anything else. God made de world and de white folks made work."

"Yeah, dey made work but they didn't make us do it," Joe Willard put in. "We brought dat on ourselves."

"Oh, yes, de white folks did put us to work too," said Jim Allen.

Know how it happened? After God got thru makin' de world and de varmints and de folks, he made up a great big bundle and let it down in de middle of de road. It laid dere for thousands of years, then Ole Missus said to Ole Massa: "Go pick up dat box, Ah want to see whut's in it." Ole Massa look at de box and it look so heavy dat he says to de nigger, "Go fetch me dat big ole box out dere in de road." De nigger been stumblin' over de box a long time so he tell his wife:

"'Oman, go git dat box." So de nigger 'oman she runned to git de box. She says:

"Ah always lak to open up a big box 'cause there's nearly always something good in great big boxes." So she run and grabbed a-hold of de box and opened it up and it was full of hard work.

Dat's de reason de sister in black works harder than anybody else in de world. De white man tells de nigger to work and he takes and tells his wife.

"Aw, now, dat ain't de reason niggers is working so hard," Jim Presley objected.

Dis is de way *dat* was.

God let down two bundles 'bout five miles down de road. So de white man and de nigger raced to see who

[7]West African word meaning white people.

would git there first. Well, de nigger out-run de white man
and grabbed de biggest bundle. He was so skeered de
white man would git it away from him he fell on top of de
bundle and hollered back: "Oh, Ah got here first and dis
biggest bundle is mine." De white man says: "All right,
Ah'll take yo' leavings," and picked up de li'l tee-ninchy
bundle layin' in de road. When de nigger opened up his
bundle he found a pick and shovel and a hoe and a plow
and chop-axe and then de white man opened up his bundle
and found a writin'-pen and ink. So ever since then de nig-
ger been out in de hot sun, usin' his tools and de white
man been sittin' up figgerin', ought's a ought, figger's a
figger; all for de white man, none for de nigger.

"Oh lemme spread my mess. Dis is Will Richardson doin'
dis lyin'."

You know Ole Massa took a nigger deer huntin' and
posted him in his place and told him, says: "Now you wait
right here and keep yo' gun reformed and ready. Ah'm
goin' 'round de hill and skeer up de deer and head him dis
way. When he come past, you shoot."
De nigger says: "Yessuh, Ah sho' will, Massa."
He set there and waited wid de gun all cocked and after
a while de deer come tearin' past him. He didn't make a
move to shoot de deer so he went on 'bout his business.
After while de white man come on 'round de hill and ast
de nigger: "Did you kill de deer?"
De nigger says: "Ah ain't seen no deer pass here yet."
Massa says: "Yes, you did. You couldn't help but see
him. He come right dis way."
Nigger says: "Well Ah sho' ain't seen none. All Ah seen
was a white man come along here wid a pack of chairs on
his head and Ah tipped my hat to him and waited for de
deer."

"Some colored folks ain't got no sense, and when Ah see
'em like dat," Ah say, "My race but not my taste."

FIVE

Y'all ever hear dat lie 'bout big talk?" cut in Joe Wiley. "Yeah we done heard it, Joe, but Ah kin hear it some 'gin. Tell it, Joe," pleaded Gene Oliver.

During slavery time two ole niggers wuz talkin' an' one said tuh de other one, "Ole Massa made me so mad yistiddy till Ah give 'im uh good cussin' out. Man, Ah called 'im everything wid uh handle on it."

De other one says, "You didn't cuss *Ole Massa*, didja? Good God! Whut did he do tuh you?"

"He didn't do *nothin'*, an' man, Ah laid one cussin' on 'im! Ah'm uh man lak dis, Ah won't stan' no hunchin'. Ah betcha he won't bother *me* no mo'."

"Well, if you cussed 'im an' he didn't do nothin' tuh you, de nex' time he make me mad Ah'm goin' tuh lay uh hearin' on him."

Nex' day de nigger did somethin'. Ole Massa got in behind 'im and he turnt 'round an' give Ole Massa one good cussin' an Ole Massa had 'im took down and whipped nearly tuh death. Nex' time he saw dat other nigger he says tuh 'im. "Thought you tole me, you cussed Ole Massa out and he never opened his mouf."

"Ah did."

"Well, how come he never did nothin' tuh yuh? Ah did

77

it an' he come nigh uh killin' *me.*"

"Man, you didn't go cuss 'im tuh his face, didja?"

"Sho Ah did. Ain't dat whut you tole me you done?"

"Naw, Ah didn't say Ah cussed 'im tuh his face. You sho is crazy. Ah thought you had mo' sense than dat. When Ah cussed Ole Massa he wuz settin' on de front porch an' Ah wuz down at de big gate."

De other nigger wuz mad but he didn't let on. Way after while he 'proached de nigger dat got 'im de beatin' an' tole 'im, "Know whut Ah done tuhday?"

"Naw, whut you done? Give Ole Massa 'nother cussin'?"

"Naw, Ah ain't never goin' do dat no mo'. Ah peeped up under Ole Miss's drawers."

"Man, hush yo' mouf! You knows you ain't looked up under ole Miss's clothes!"

"Yes, Ah did too. Ah looked right up her very drawers."

"You better hush dat talk! Somebody goin' hear you and Ole Massa'll have you kilt."

"Well, Ah sho done it an' she never done nothin' neither."

"Well, whut did she say?"

"Not uh mumblin' word, an' Ah stopped and looked jus' as long as Ah wanted tuh an' went on 'bout mah business."

"Well, de nex' time Ah see her settin' out on de porch Ah'm goin' tuh look too."

"Help yo'self."

Dat very day Ole Miss wuz settin' out on de porch in de cool uh de evenin' all dressed up in her starchy white clothes. She had her legs all crossed up and de nigger walked up tuh de edge uh de porch and peeped up under Ole Miss's clothes. She took and hollered an' Ole Massa come out an' had dat nigger almost kilt alive.

When he wuz able tuh be 'bout agin he said tuh de other nigger, "Thought you tole me you peeped up under Ole Miss's drawers?"

"Ah sho did."

"Well, how come she never done nothin' tuh *you?* She got me nearly kilt."

"Man, when Ah looked under Ole Miss's drawers they

wuz hangin' out on de clothes line. You didn't go look up
in 'em while she had 'em on, didja? You sho is uh fool! Ah
thought you had mo' sense than dat, Ah claire Ah did. It's
uh wonder he didn't kill yuh dead. Umph, umph, umph.
You sho ain't got no sense atall."

"Yeah," said Black Baby, "But dat wasn't John de white
folks was foolin' wid. John was too smart for Ole Massa. He
never got no beatin'!"

De first colored man what was brought to dis country
was name John. He didn't know nothin' mo' than you told
him and he never forgot nothin' you told him either. So he
was sold to a white man.
 Things he didn't know he would ask about. They went to
a house and John never seen a house so he asked what it
was. Ole Massa tole him it was his kingdom. So dey goes
on into de house and dere was the fireplace. He asked what
was that. Ole Massa told him it was his flame 'vaperator.
 The cat was settin' dere. He asked what it was. Ole
Massa told him it was his round head.
 So dey went upstairs. When he got on de stair steps he
asked what dey was. Ole Massa told him it was his jacob
ladder. So when they got up stairs he had a roller foot bed.
John asked what was dat. Ole Massa told him it was his
flowery-bed-of-ease. So dey came down and went out to de
lot. He had a barn. John asked what was dat. Ole Massa
told him, dat was his mound. So he had a Jack in the sta-
ble, too. John asked, "What in de world is dat?" Ole Massa
said: "Dat's July, de God dam."
 So de next day Ole Massa was up stairs sleep and John
was smokin'. It flamed de 'vaperator and de cat was settin'
dere and it got set afire. The cat goes to de barn where
Ole Massa had lots of hay and fodder in de barn. So de cat
set it on fire. John watched de Jack kicking up hay and fod-
der. He would see de hay and fodder go up and come
down but he thought de Jack was eatin' de hay and fodder.
 So he goes upstairs and called Ole Massa and told him to

get up off'n his flowery-bed-of-ease and come down on his jacob ladder. He said: "I done flamed the 'vaperator and it caught de round head and set him on fire. He's gone to de mound and set it on fire, and July the God dam is eatin' up everything he kin git his mouf on."

Massa turned over in de bed and ast, "Whut dat you say, John?"

John tole 'im agin. Massa was still sleepy so he ast John agin whut he say. John was gittin' tired so he say, "Aw, you better git up out dat bed and come on down stairs. Ah done set dat ole cat afire and he run out to de barn and set it afire and dat ole Jackass is eatin' up everything he git his mouf on."

Gene Oliver said: "Y'all hush and lemme tell this one befo' we git to de mill. This ain't no slavery time talk."

Once they tried a colored man in Mobile for stealing a goat. He was so poorly dressed, and dirty—that de judge told him, "Six months on de country road, you stink so."

A white man was standing dere and he said, "Judge, he don't stink, Ah got a nigger who smells worser than a billy goat." De judge told de man to bring him on over so he could smell him. De next day de man took de billy goat and de nigger and went to de court and sent de judge word dat de nigger and de billy goat wuz out dere and which one did he want fust.

The judge told him to bring in de goat. When he carried de goat he smelled so bad dat de judge fainted. Dey got ice water and throwed it in de Judge's face 'til he come to. He told 'em to bring in de nigger and when dey brung in de nigger de goat fainted.

Joe Wiley said: "Ah jus' got to tell this one, do Ah can't rest."

In slavery time dere was a colored man what was named John. He went along wid Ole Massa everywhere he went. He used to make out he could tell fortunes. One day him

80

and his Old Massa was goin' along and John said, "Ole Massa, Ah kin tell fortunes." Ole Massa made out he didn't pay him no attention. But when they got to de next man's plantation Old Massa told de landlord, "I have a nigger dat kin tell fortunes." So de other man said, "Dat nigger can't tell no fortunes. I bet my plantation and all my niggers against yours dat he can't tell no fortunes."

Ole Massa says: "I'll take yo' bet. I bet everything in de world I got on John 'cause he don't lie. If he say he can tell fortunes, he can tell 'em. Bet you my plantation and all my niggers against yours and throw in de wood lot extry."

So they called Notary Public and signed up de bet. Ole Massa straddled his horse and John got on his mule and they went on home.

John was in de misery all that night for he knowed he was gointer be de cause of Ole Massa losin' all he had.

Every mornin' John useter be up and have Old Massa's saddle horse curried and saddled at de door when Ole Massa woke up. But *this* mornin' Old Massa had to git John out of de bed.

John useter always ride side by side with Massa, but on de way over to de plantation where de bet was on, he rode way behind.

So de man on de plantation had went out and caught a coon and had a big old iron wash-pot turned down over it.

There was many person there to hear John tell what was under de wash-pot.

Ole Massa brought John out and tole him, say: "John, if you tell what's under dat wash pot Ah'll make you independent, rich. If you don't, Ah'm goin' to kill you because you'll make me lose my plantation and everything I got."

John walked 'round and 'round dat pot but he couldn't git de least inklin' of what was underneath it. Drops of sweat as big as yo' fist was rollin' off of John. At last he give up and said: "Well, you got de ole coon at last."

When John said that, Ole Massa jumped in de air and cracked his heels twice befo' he hit de ground. De man that was bettin' against Ole Massa fell to his knees wid de cold sweat pourin' off him. Ole Massa said: "John, you

done won another plantation fo' me. That's a coon under that pot sho 'nuff."

So he give John a new suit of clothes and a saddle horse. And John quit tellin' fortunes after that.

Going back home Ole Massa said: "Well, John, you done made me vast rich so I goin' to Philly-Me-York and won't be back in three weeks. I leave everything in yo' charge."

So Ole Massa and his wife got on de train and John went to de depot with 'em and seen 'em off on de train bid 'em goodbye. Then he hurried on back to de plantation. Ole Massa and Ole Miss got off at de first station and made it on back to see whut John was doin'.

John went back and told de niggers, "Massa's gone to Philly-Me-York and left everything in my charge. Ah want one of you niggers to git on a mule and ride three miles north, and another one three miles west and another one three miles south and another one three miles east. Tell everybody to come here—there's gointer be a ball here tonight. The rest of you go into the lot and kill hogs until you can walk on 'em."

So they did. John goes in and dressed up in Ole Massa's swaller-tail clothes, put on his collar and tie; got a box of cigars and put under his arm, and one cigar in his mouth.

When the crowd come John said: "Y'all kin dance and Ah'm goin' to call figgers."

So he got Massa's biggest rockin' chair and put it up in Massa's bed and then he got up in the bed in the chair and begin to call figgers:

"Hands up!" "Four circle right." "Half back." "Two ladies change." He was puffing his cigar all de time.

'Bout this time John seen a white couple come in but they looked so trashy he figgered they was piney woods crackers, so he told 'em to g'wan out in de kitchen and git some barbecue and likker and to stay out there where they belong. So he went to callin' figgers agin. De git Fiddles[1] was raisin' cain over in de corner and John was callin' for de new set:

[1]Guitars.

"Choose yo' partners." "Couples to yo' places like horses to de traces." "Sashay all." "Sixteen hands up." "Swing Miss Sally 'round and 'round and bring her back to me!"

Just as he went to say "Four hands up," he seen Ole Massa comin' out the kitchen wipin' the dirt off his face.

Ole Massa said: "John, just look whut you done done! I'm gointer take you to that persimmon tree and break yo' neck for this—killing up all my hogs and havin' all these niggers in my house."

John ast, "Ole Massa, Ah know you gointer kill me, but can Ah have a word with my friend Jack before you kill me?"

"Yes, John, but have it quick."

So John called Jack and told him; says: "Ole Massa is gointer hang me under that persimmon tree. Now you get three matches and get in the top of the tree. Ah'm gointer pray and when you hear me ast God to let it lightning Ah want you to strike matches."

Jack went on out to the tree. Ole Massa brought John on out with the rope around his neck and put it over a limb.

"Now, John," said Massa, "have you got any last words to say?"

"Yes sir, Ah want to pray."

"Pray and pray damn quick. I'm clean out of patience with you, John."

So John knelt down. "O Lord, here Ah am at de foot of de persimmon tree. If you're gointer destroy Old Massa tonight, with his wife and chillun and everything he got, lemme see it lightnin'."

Jack up the tree, struck a match. Ole Massa caught hold of John and said: "John, don't pray no more."

John said: "Oh yes, turn me loose so Ah can pray. O Lord, here Ah am tonight callin' on Thee and Thee alone. If you are gointer destroy Ole Massa tonight, his wife and chillun and all he got, Ah want to see it lightnin' again."

Jack struck another match and Ole Massa started to run. He give John his freedom and a heap of land and stock. He run so fast that it took a express train running at the rate of ninety miles an hour and six months to bring him back, and that's how come niggers got they freedom today.

83

Well, we were at the mill at last, as slow as we had walked. Old Hannah[2] was climbing the road of the sky, heating up sand beds and sweating peoples. No wonder nobody wanted to work. Three fried men are not equal to one good cool one. The men stood around the door for a minute or two, then dropped down on the shady side of the building. Work was too discouraging to think about. Phew! Sun and sawdust, sweat and sand. Nobody called a meeting and voted to sit in the shade. It just happened naturally.

Jim Allen said, "Reckon we better go inside and see if they want us?"

"Oh hell, naw!" shouted Lennie Barnes. "We ain't no mill-hands nohow. Let's stay right where we is till they find us. We got plenty to do—lyin' on Ole Massa and slavery days. Lemme handle a li'l language long here wid de rest. Y'all ever hear 'bout dat nigger dat found a gold watch?"

"Yeah, Ah done heard it," said Cliff, "but go on and tell it, Lonnie, so yo' egg bag kin rest easy."[3]

"Well, once upon a time was a good ole time.
Monkey chew tobacco and spit white lime."
A colored man was walking down de road one day and he found a gold watch and chain. He didn't know what it was, so the first thing he met was a white man, so he showed the white man de watch and ast him what it was. White man said, "Lemme see it in my hand."

De colored man give it to him and de white man said, "Why this is a gold watch, and de next time you find anything kickin' in de road put in yo' pocket and sell it."

With that he put the watch in his pocket and left de colored man standing there.

So de colored man walked on down de road a piece further and walked up on a little turtle. He tied a string to it

[2]The Sun.

[3]So you can be at ease. A hen is supposed to suffer when she has a fully developed egg in her.

and put de turtle in his pocket and let de string hang out.

So he met another colored fellow and the fellow ast him says: "Cap, what time you got?"

He pulled out de turtle and told de man, "It's a quarter past leben and kickin' lak hell for twelve."

Larkins White says: "Y'all been wearin' Ole Massa's southern can[4] out dis mornin'. Pass him over here to me and lemme handle some grammar wid him."

"You got him, Ah just hope dat straw boss don't come sidlin' 'round here," somebody said.

"Ah got to tell you 'bout Old Massa down in de piney woods."

During slavery uh nigger name Jack run off from his marster and took and hid hisself down in de piney woods.

Ole Massa hunted and hunted but he never could ketch dat nigger.

But Jack had uh good friend on de plantation dat useter slip 'im somethin' t' eat and fetch de banjo down and play 'im somethin' every day so's he could dance some. Jack wuz tryin' to make it on off de mountain where Old Massa couldn't fetch 'im back. So Ole Massa got on to dis other nigger slippin' out to Jack but he couldn't ketch 'im so he tole 'im if he lead 'im to where Jack wuz he'd give 'im a new suit uh clothes. So he said, "All right."

So he tole Old Massa to follow him and do whutever he sing. So Ole Massa said, "All right."

So dat day de nigger took Jack some dinner and de Banjo. So Jack et. Den he tole him, say: "Jack I got uh new song fuh yuh today."

"Play it and lemme dance some."

"It's about Ole Massa."

Jack said, "I don't give uh damn 'bout Ole Massa. Ah don't b'long tuh him no mo'. Play it and lemme dance."

So he started to playin'.

[4]His hips.

"From pine to pine, Mister Pinkney.
From pine to pine, Mister Pinkney."

Jack was justa dancin' fallin' off de log and cuttin' de pigeon wing—(diddle dip, diddle dip—diddle dip) "from pine to pine Mr. Pinkney."

White man coming closer all de time.
"Now take yo' time Mister Pinkney.
Now take yo' time Mister Pinkney."
(Diddle dip, diddle dip, diddle dip, diddle dip)
"Now grab 'im now Mister Pinkney
Now grab 'im now Mister Pinkney."
(Diddle dip, diddle dip, diddle dip, diddle dip)
"Now grab 'im now Mister Pinkney."

So they caught Jack and put uh hundred lashes on his back and put him back to work.

"Now Ah tole dat one for myself, now Ah got to tell one for my wife."

"Aw, g'wan tell de lie, Larkins, if you want to. You know you ain't tellin' no lie for yo' wife. No mo' than de rest of us. You lyin' cause you like it." James Presley put in. "Hurry up so somebody else kin plough up some literary and lay-by some alphabets."

Two mens dat didn't know how tuh count good had been haulin' up cawn and they stopped at de cemetery wid de last load 'cause it wuz gittin' kinda dark. They thought they'd git thru instead uh goin' 'way tuh one of 'em's barn. When they wuz goin' in de gate two ear uh cawn dropped off de waggin, but they didn't stop tuh bother wid 'em, just then. They wuz in uh big hurry tuh git home. They wuz justa vidin' it up. "You take dis'n an Ah'll take dat'un, you take dat'un and Ah'll take dis'un."

An ole nigger heard 'em while he wuz passin' de cemetery an' run home tuh tell ole Massa 'bout it.

"Massa, de Lawd and de devil is down in de cemetery 'vidin' up souls. Ah heard 'em. One say, 'you take that 'un an' Ah'll take dis'un'."

Ole Massa wuz sick in de easy chear, he couldn't git about by hisself, but he said, "Jack, Ah don't know whut dis foolishness is, but Ah know you lyin'."

"Naw Ah ain't neither, Ah swear it's so."

"Can't be, Jack, youse crazy."

"Naw, Ah ain't neither; if you don' believe me, come see for yo'self."

"Guess Ah better go see whut you talkin' 'bout; if you fool me, Ah'm gointer have a hundred lashes put on yo' back in de mawnin' suh."

They went on down tuh de cemetery wid Jack pushin' Massa in his rollin' chear, an' it wuz sho dark down dere too. So they couldn't see de two ears uh cawn layin' in de gate.

Sho nuff Ole Massa heard 'em sayin' "Ah'll take dis'un," and de other say, "An' Ah'll take dis'un." Ole Massa got skeered hisself but he wuzn't lettin' on, an' Jack whispered tuh 'im, "Unh hunh, didn't Ah tell you de Lawd an' de devil wuz down here 'vidin' up souls?"

They waited awhile there in de gate listenin' den they heard 'em say, "Now, we'll go git dem two at de gate."

Jack says, "Ah knows de Lawd gwine take you, and Ah ain't gwine let de devil get me—Ah'm gwine home." An' he did an' lef' Ole Massa settin' dere at de cemetery gate in his rollin' chear, but when he got home, Ole Massa had done beat 'im home and wuz settin' by de fire smokin' uh seegar."

Jim Allen began to fidget. "Don't y'all reckon we better g'wan inside? They might need us."

Lonnie Barnes shouted, "Aw naw—you sho is worrysome. You bad as white folks. You know they say a white man git in some kind of trouble, he'll fret and fret until he kill hisself. A nigger git into trouble, he'll fret a while, then g'wan to sleep."

"Yeah, dat's right, too," Eugene Oliver agreed. "Didja ever hear de white man's prayer?"

"Who in Polk County ain't heard dat?" cut in Officer Richardson.

"Well, if you know it so good, lemme hear *you* say it," Eugene snapped back.

"Oh, Ah don't know it well enough to say it. Ah jus' know it well enough to know it."

"Well, all right then, when Ah'm changing my dollars, you keep yo' pennies out."

"Ah don't know it, Eugene, say it for me," begged Peter Noble. "Don't pay Office no mind."

Well, it come a famine and all de crops was dried up and Brother John was ast to pray. He had prayed for rain last year and it had rained, so all de white folks 'sembled at they church and called on Brother John to pray agin, so he got down and prayed:

"Lord, first thing, I want you to understand that this ain't no nigger talking to you. This is a white man and I want you to hear me. Pay some attention to me. I don't worry and bother you all the time like these niggers—asking you

88

for a whole heap of things that they don't know what to do with after they git 'em—so when I do ask a favor, I want it granted. Now, Lord, we want some rain. Our crops is all burning up and we'd like a little rain. But I don't mean for you to come in a hell of a storm like you did last year— kicking up racket like niggers at a barbecue. I want you to come calm and easy. Now, another thing, Lord, I want to speak about. Don't let these niggers be as sassy as they have been in the past. Keep 'em in their places, Lord, Amen."

Larkins White burst out:

And dat put me in de mind of a nigger dat useter do a lot of prayin' up under 'simmon tree, durin' slavery time. He'd go up dere and pray to God and beg Him to kill all de white folks. Ole Massa heard about it and so de next day he got hisself a armload of sizeable rocks and went up de 'simmon tree, before de nigger got dere, and when he begin to pray and beg de Lawd to kill all de white folks, Ole Massa let one of dese rocks fall on Ole Nigger's head. It was a heavy rock and knocked de nigger over. So when he got up he looked up and said: "Lawd, I ast you to kill all de white folks, can't you tell a white man from a nigger?"

Joe Wiley says: "Y'all might as well make up yo' mind to bear wid me, 'cause Ah feel Ah got to tell a lie on Ole Massa for my mamma. Ah done lied on him enough for myself. So Ah'm gointer tell it if I bust my gall tryin'."

Ole John was a slave, you know. And there was Ole Massa and Ole Missy and de two li' children—a girl and a boy.

Well, John was workin' in de field and he seen de children out on de lake in a boat, just a hollerin'. They had done lost they oars and was 'bout to turn over. So then he went and tole Ole Massa and Ole Missy.

Well, Ole Missy, she hollered and said: "It's so sad to lose these 'cause Ah ain't never goin' to have no more chil-

89

dren." Ole Massa made her hush and they went down to de water and follered de shore on 'round till they found 'em. John pulled off his shoes and hopped in and swum out and got in de boat wid de children and brought 'em to shore.

Well, Massa and John take 'em to de house. So they was all so glad 'cause de children got saved. So Massa told 'im to make a good crop dat year and fill up de barn, and den when he lay by de crops nex' year, he was going to set him free.

So John raised so much crop dat year he filled de barn and had to put some of it in de house.

So Friday come, and Massa said, "Well, de day done come that I said I'd set you free. I hate to do it, but I don't like to make myself out a lie. I hate to git rid of a good nigger lak you."

So he went in de house and give John one of his old suits of clothes to put on. So John put it on and come in to shake hands and tell 'em goodbye. De children they cry, and Ole Missy she cry. Didn't want to see John go. So John took his bundle and put it on his stick and hung it crost his shoulder.

Well, Ole John started on down de road. Well, Ole Massa said, "John, de children love yuh."

"Yassuh."

"John, I love yuh."

"Yassuh."

"And Missy *like* yuh!"

"Yassuh."

"But 'member, John, youse a nigger."

"Yassuh."

Fur as John could hear 'im down de road he wuz hollerin', "John, Oh John! De children loves you. And I love you. De Missy *like* you."

John would holler back, "Yassuh."

"But 'member youse a nigger, tho!"

Ole Massa kept callin' 'im and his voice was pitiful. But John kept right on steppin' to Canada. He answered Ole Massa every time he called 'im, but he consumed on wid his bag.

90

SIX

Tookie Allen passed by the mill all dressed up in a tight shake-baby.[1] She must have thought she looked good because she was walking that way. All the men stopped talking for a while. Joe Willard hollered at her.

"Hey, Tookie, how do you like your new dress?"

Tookie made out she didn't hear, but anybody could tell that she had. That was why she had put on her new dress, and come past the mill a wringing and twisting—so she could hear the men talking about her in the dress.

"Lawd, look at Tookie switchin' it and lookin' back at it! She's done gone crazy thru de hips." Joe Willard just couldn't take his eyes off of Tookie.

"Aw, man, you done seen Tookie and her walk too much to be makin' all dat miration over it. If you can't show me nothin' better than dat, don't bring de mess up," Cliff Ulmer hooted. "Less tell some more lies on Ole Massa and John."

"John sho was a smart nigger now. He useter git de best of Ole Massa all de time," gloated Sack Daddy.

"Yeah, but some white folks is smarter than you think," put in Eugene Oliver.

[1] A dress very tight across the hips but with a full short skirt; very popular on the "jobs."

For instance now, take a man I know up in West Florida. He hired a colored man to clear off some new ground, but dat skillet blonde[2] was too lazy to work. De white man would show him what to do then he's g'wan back to de house and keep his books. Soon as he turned his back de nigger would flop down and go to sleep. When he hear somebody comin' he'd hit de log a few licks with de flat of de ax and say, "Klunk, klunk, you think Ah'm workin' but Ah ain't."

De white man heard him but he didn't say a word. Sat'-day night come and Ole Cuffee went up to de white man to git his pay. De white man stacked up his great big ole silver dollars and shook 'em in his hand and says, "Clink, clink, you think I'm gointer pay you, but I ain't."

By that time somebody saw the straw boss coming so every-body made it on into the mill. The mill boss said, "What are y'all comin' in here for? Ah ain't got enough work for my own men. Git for home."

The swamp gang shuffled on out of the mill. "Umph, umph, umph," said Black Baby. "We coulda *done* been gone if we had a knowed dat."

"Ah told y'all to come an' go inside but you wouldn't take a listen. Y'all think Ah'm an ole Fogey. Young Coon for running but old coon for cunning."

We went on back to the quarters.

When Mrs. Bertha Allen saw us coming from the mill she began to hunt up the hoe and the rake. She looked under the porch and behind the house until she got them both and placed them handy. As soon as Jim Allen hit the steps she said:

"Ah'm mighty proud y'all got a day off. Maybe Ah kin git dis yard all clean today. Jus' look at de trash and dirt! And it's so many weeds in dis yard, Ah'm liable to git snake bit at my own door."

"Tain't no use in you gittin' yo' mouf all primped up for no hoein' and rakin' out of me, Bertha. Call yo' grandson and let

[2]Very black person.

92

him do it. Ah'm too old for dat," said Jim testily.

"Ah'm standin' in my tracks and steppin' back on my abstract[3]—Ah ain't gointer rake up no yard. Ah'm goin' fishin'," Cliffert Ulmer snapped back. "Grandma, you worries mo' 'bout dis place than de man dat owns it. You ain't de Everglades Cypress Lumber Comp'ny sho nuff. Youse just shacking in one of their shanties. Leave de weeds go. Somebody'll come chop 'em some day."

"Naw, Ah ain't gointer leave 'em go! You and Jim would wallow in dirt right up to yo' necks if it wasn't for me."

Jim threw down his jumper and his dinner bucket. "Now, *Ah'm* goin' fishin' too. When Bertha starts her jawin' Ah can't stay on de place. Her tongue is hung in de middle and works both ways. Come on Cliff, less git de poles!"

"Speck Ah'm gointer have to make a new line for my trout pole," Cliff said. "Dat great big ole fish Ah hooked las' time carried my other line off in his mouth, 'member?"

"Aw, dat wasn't no trout got yo' line; dat's whut you tell us, but dat was a log bit yo' hook dat time." Larkins White twitted.

"Yes dat was a trout, too now. Ah'm a real fisherman. Ah ain't like y'all. Ah kin ketch fish anywhere. All Ah want to know, is there any water. Man, Ah kin ketch fish out a water bucket. Don't b'lieve me, just come on down to de lake. Ah'll bet, Ah'll pull 'em all de fish out de lake befo' y'all git yo' bait dug."

"Dat's a go," shouted Larkins. "Less go! Come on de rest of y'all to see dis thing out. Dis boy 'bout to burst his britches since he been chawin' tobacco reg'lar and workin' in de swamp wid us mens."

Cliff picked up the hoe and went 'round behind the house to dig some bait. Old Jim went inside and got the spool of No. 8 cotton and a piece of beeswax and went to twisting a trout line. He baptized the hook in asafetida and put his hunting knife in his pocket, met Cliffert at the gate and they were off

[3] I am standing my ground.

93

to join the others down by the jook. Big Sweet and Lucy got out their poles and joined us. It was almost like a log-rolling[4] or a barbecue. The quarters were high. The men didn't get off from work every day like this.

We proaged on thru the woods that was full of magnolia, pine, cedar, oak, cypress, hickory and many kinds of trees whose names I do not know. It is hard to know all the trees in Florida. But everywhere they were twined with climbing vines and veiled in moss.

"What's de matter, Ah don't hear no birds?" complained Eugene Oliver. "It don't seem natural."

Everybody looked up at one time like cows in a pasture.

"Oh you know how come we don't hear no birds. It's Friday and de mocking bird ain't here," said Big Sweet after a period of observation.

"What's Friday got to do with the mockin' bird?" Eugene challenged.

"Dat's exactly what Ah want to know," said Joe Wiley.

"Well," said Big Sweet. "Nobody never sees no mockin' bird on Friday. They ain't on earth dat day."

"Well, if they ain't on earth, where is they?"

"They's all gone to hell on Friday with a grain of sand in they mouth to help out they friend." She continued:

Once there was a man and he was very wicked. He useter rob and steal and he was always in a fight and killin' up people. But he was awful good to birds and mockin' birds was his favorite. This was a long time ago before de man first started to buildin' de Rocky Mountains. Well, 'way after while somebody kilt him, and being he had done lived so bad, when he died he went straight to hell.

De birds all hated it mighty bad when they seen him in hell, so they tried to git him out. But the fire was too hot so they give up—all but de mockin' birds. They come to-gether and decided to tote sand until they squenched de

4When people used to get out logs to build a house they would get the neighbors to help. Plenty of food and drink served. Very gay time.

fire in hell. So they set a day and they all agreed on it. Every Friday they totes sand to hell. And that's how come nobody don't never see no mockin' bird[5] on Friday.

Joe Wiley chuckled. "If them mockin' birds ever speck to do dat man any good they better git some box-cars to haul dat sand. Dat one li'l grain they totin' in their bill ain't helpin' none. But anyhow it goes to show you dat animals got sense as well as peoples." Joe went on—

Now take cat-fish for instances. Ah knows a man dat useter go fishin' every Sunday. His wife begged him not to do it and his pastor strained wid him for years but it didn't do no good. He just would go ketch him a fish every Sabbath. One Sunday he went and just as soon as he got to de water he seen a great big ole cat-fish up under some water lilies pickin' his teeth with his fins. So de man baited his pole and dropped de hook right down in front of de big fish. Dat cat grabbed de hook and took out for deep water. De man held on and pretty soon dat fish pulled him in. He couldn't git out. Some folks on de way to church seen him and run down to de water but he was in too deep. So he went down de first time and when he come up he hollered—"Tell my wife." By dat time de fish pulled him under again. When he come up he hollered, "Tell my wife—" and went down again. When he come up de third time he said: "Tell my wife to fear God and cat-fish," and went down for de last time and he never come up no mo'.

"Aw, you b'lieve dat old lie?" Joe Willard growled. "Ah don't."

"Well, Ah do. Nobody ain't gointer git me to fishin' on Sunday," said Big Sweet fervently.

"How come nothin' don't happen to all dese white folks dat go fishin' on Sunday? Niggers got all de signs and white folks got all de money," retorted Joe Willard.

[5]Some say it is a jay bird.

95

"Yeah, but all cat-fish ain't so sensible." Joe Wiley cut in with a sly grin on his face. "One time when Ah was livin' in Plateau, Alabama—dat's right on de Alabama river you know—Ah put out some fish lines one night and went on home. Durin' de night de river fell and dat left de hooks up out de water and when Ah went there next morning a cat-fish had done jumped up after dat bait till he was washed down in sweat."

Jim Presley said, "I know you tellin' de truth, Joe, 'cause Ah saw a coach whip after a race runner one day. And de race runner was running so fast to git away from dat coach whip dat his tail got so hot it set de world on fire, and dat coach whip was running so hard to ketch him till he put de fire out wid his sweat."

Jim Allen said, "Y'all sho must not b'long to no church de way y'all tells lies. Y'all done quit tellin' 'em. Y'all done gone to moldin' 'em. But y'all want to know how come snakes got poison in they mouth and nothin' else ain't got it?"

"Yeah, tell it, Jim," urged Arthur Hopkins.

Old man Allen turned angrily upon Arthur.

"Don't you be callin' me by my first name. Ah'm old enough for yo' grand paw! You respect my gray hairs. Ah don't play wid chillun. Play wid a puppy and he'll lick yo' mouf."

"Ah didn't mean no harm."

"Dat's all right, Arthur. Ah ain't mad. Ah jus' don't play wid chillun. You go play wid Cliff and Sam and Eugene. They's yo' equal. Ah was a man when yo' daddy was born."

"Well, anyhow, Mr. Jim, please tell us how come de snakes got poison."

Well, when God made de snake he put him in de bushes to ornament de ground. But things didn't suit de snake so one day he got on de ladder and went up to see God.

"Good mawnin', God."

"How do you do, Snake?"

"Ah ain't so many, God, you put me down there on my

96

belly in de dust and everything trods upon me and kills off my generations. Ah ain't got no kind of protection at all."

God looked off towards immensity and thought about de subject for awhile, then he said, "Ah didn't mean for nothin' to be stompin' you snakes lak dat. You got to have some kind of a protection. Here, take dis poison and put it in yo' mouf and when they tromps on you, protect yo' self."

So de snake took de poison in his mouf and went on back.

So after awhile all de other varmints went up to God.

"Good evenin', God."

"How you makin' it, varmints?"

"God, please do somethin' 'bout dat snake. He' layin' in de bushes there wid poison in his mouf and he's strikin' everything dat shakes de bush. He's killin' up our generations. Wese skeered to walk de earth."

So God sent for de snake and tole him:

"Snake, when Ah give you dat poison, Ah didn't mean for you to be hittin' and killin' everything dat shake de bush. I give you dat poison and tole you to protect yo'self when they tromples on you. But you killin' everything dat moves. Ah didn't mean for you to do dat."

De snake say, "Lawd, you know Ah'm down here in de dust. Ah ain't got no claws to fight wid, and Ah ain't got no feets to git me out de way. All Ah kin see is feets comin' to tromple me. Ah can't tell who my enemy is and who is my friend. You gimme dis protection in my mouf and Ah uses it."

God thought it over for a while then he says:

"Well, snake, I don't want yo' generations all stomped out and I don't want you killin' everything else dat moves. Here take dis bell and tie it to yo' tail. When you hear feets comin' you ring yo' bell and if it's yo' friend, he'll be keerful. If it's yo' enemy, it's you and him."

So dat's how de snake got his poison and dat's how come he got rattles.

Biddy, biddy, bend my story is end.

Turn loose de rooster and hold de hen.

"Don't tell no mo' 'bout no snakes—specially when we walkin' in all dis tall grass," pleaded Presley. "Ah speck Ah'm gointer be seein' 'em in my sleep tonight. Lawd, Ah'm skeered of snakes."

"Who ain't?" cut in Cliff Ulmer. "It sho is gittin' hot. Ah'll be glad when we git to de lake so Ah kin find myself some shade."

"Man, youse two miles from dat lake yet, and otherwise it ain't hot today," said Joe Wiley. "He ain't seen it hot, is he Will House?"

"Naw, Joe, when me and you was hoboing down in Texas it was so hot till we saw old stumps and logs crawlin' off in de shade."

Eugene Oliver said, "Aw dat wasn't hot. Ah seen it so hot till two cakes of ice left the ice house and went down the street and fainted."

Arthur Hopkins put in: "Ah knowed two men who went to Tampa all dressed up in new blue serge suits, and it was so hot dat when de train pulled into Tampa two blue suits got off de train. De men had done melted out of 'em."

Will House said, "Dat wasn't hot. Dat was chilly weather. Me and Joe Wiley went fishin' and it was so hot dat before we got to de water, we met de fish, coming swimming up de road in dust."

"Dat's a fact, too," added Joe Wiley. "Ah remember dat day well. It was so hot dat Ah struck a match to light my pipe and set de lake afire. Burnt half of it, den took de water dat was left and put out de fire."

Joe Willard said "Hush! Don't Ah hear a noise?"

Eugene and Cliffert shouted together, "Yeah—went down to de river—

> Heard a mighty racket
> Nothing but de bull frog
> Pullin' off his jacket!"

98

"Dat ain't what Ah hea'd," said Joe.

"Well, whut did you hear?"

"Ah see a chigger[6] over in de fence corner wid a splinter in his foot and a seed tick is pickin' it out wid a fence rail and de chigger is hollerin', 'Lawd, have mercy.' "

"Dat brings me to de boll-weevil," said Larkins White. "A boll-weevil flew onto de steerin' wheel of a white man's car and says, 'Mister, lemme drive yo' car.'

"De white man says, 'You can't drive no car.'

"Boll-weevil says: 'Oh yeah, Ah kin. Ah drove in five thousand cars last year and Ah'm going to drive in ten thousand dis year.'

"A man told a tale on de boll-weevil agin. Says he heard a terrible racket and noise down in de field, went down to see whut it was and whut you reckon? It was Ole Man Boll-Weevil whippin' li' Willie Boll-Weevil 'cause he couldn't carry two rows at a time."

Will House said, "Ah know a lie on a black gnat. Me and my buddy Joe Wiley was ramshackin' Georgy over when we come to a loggin' camp. So bein' out of work we ast for a job. So de man puts us on and give us some oxes to drive. Ah had a six-yoke team and Joe was drivin' a twelve-yoke team. As we was comin' thru de woods we heard somethin' hummin' and we didn't know what it was. So we got hungry and went in a place to eat and when we come out a gnat had done et up de six-yoke team and de twelve-yoke team, and was sittin' up on de wagon pickin' his teeth wid a ox-horn and cryin' for somethin' to eat."

"Yeah," put in Joe Wiley, "we seen a man tie his cow and calf out to pasture and a mosquito come along and et up de cow and was ringin' de bell for de calf."

"Dat wasn't no full-grown mosquito at dat," said Eugene Oliver, "Ah was travellin' in Texas and laid down and went to sleep. De skeeters bit me so hard till Ah seen a ole iron

[6]A young flea.

99

wash-pot, so Ah crawled under it and turned it down over me good so de skeeters couldn't git to me. But you know dem skeeters bored right thru dat iron pot. So I up wid a hatchet and bradded their bills into de pot. So they flew on off 'cross Galveston bay wid de wash pot on their bills."

"Look," said Black Baby, "on de Indian River we went to bed and heard de mosquitoes singin' like bull alligators. So we got under four blankets. Shucks! dat wasn't nothin'. Dem mosquitoes just screwed off dem short bills, reached back in they hip-pocket and took out they long bills and screwed 'em on and come right on through dem blankets and got us."

"Is dat de biggest mosquito you all ever seen? Shucks! Dey was li'l baby mosquitoes! One day my ole man took some men and went out into de woods to cut some fence posts. And a big rain come up so they went up under a great big ole tree. It was so big it would take six men to meet around it. De other men set down on de roots but my ole man stood up and leaned against de tree. Well, sir, a big old skeeter come up on de other side of dat tree and bored right thru it and got blood out of my ole man's back. Dat made him so mad till he up wid his ax and bradded dat mosquito's bill into dat tree. By dat time de rain stopped and they all went home.

"Next day when they come out, dat mosquito had done cleaned up ten acres dying. And two or three weeks after dat my ole man got enough bones from dat skeeter to fence in dat ten acres."

Everybody liked to hear about the mosquito. They laughed all over themselves.

"Yeah," said Sack Daddy, "you sho is tellin' de truth 'bout dat big old mosquito 'cause my ole man bought dat same piece of land and raised a crop of pumpkins on it and lemme tell y'all right now—mosquito dust is de finest fertilizer in de world. Dat land was so rich and we raised pumpkins so big dat we et five miles up in one of 'em and five miles down and ten miles acrost one and we ain't never found out how far it went. But my ole man was buildin' a scaffold inside so we could cut de pumpkin meat without so much trouble, when he dropped his

hammer. He tole me, he says, 'Son, Ah done dropped my hammer. Go git it for me.' Well, Ah went down in de pumpkin and begin to hunt dat hammer. Ah was foolin' 'round in there all day, when I met a man and he ast me what Ah was lookin' for. Ah tole him my ole man had done dropped his hammer and sent me to find it for him. De man tole me Ah might as well give it up for a lost cause, he had been lookin' for a double mule-team and a wagon that had got lost in there for three weeks and he hadn't found no trace of 'em yet. So Ah stepped on a pin, de pin bent and dat's de way de story went.''

"Dat was rich land but my ole man had some rich land too,'' put in Will House. "My ole man planted cucumbers and he went along droppin' de seeds and befo' he could git out de way he'd have ripe cucumbers in his pockets. What is the richest land you ever seen?''

"Well,'' replied Joe Wiley, "my ole man had some land dat was so rich dat our mule died and we buried him down in our bottom-land and de next mornin' he had done sprouted li'l jackasses.''

"Aw, dat land wasn't so rich,'' objected Ulmer. "My ole man had some land and it was so rich dat he drove a stob[7] in de ground at de end of a corn-row for a landmark and next morning there was ten ears of corn on de corn stalk and four ears growin' on de stob.''

"Dat lan' y'all talkin' 'bout might do, if you give it plenty commercial-nal[8] but my ole man wouldn't farm no po' land like dat,'' said Joe Wiley. "Now, one year we was kinda late puttin' in our crops. Everybody else had corn a foot high when papa said, 'Well, chillun, Ah reckon we better plant some corn.' So Ah was droppin' and my brother was hillin' up behind me. We had done planted 'bout a dozen rows when Ah looked back and seen de corn comin' up. Ah didn't want it to grow too fast 'cause it would make all fodder and no

[7]Stake.

[8]Commercial fertilizer.

101

roastin' ears so Ah hollered to my brother to sit down on some of it to stunt de growth. So he did, and de next day he dropped me back a note—says: "passed thru Heben yesterday at twelve o'clock sellin' roastin' ears to de angels."

"Yeah," says Larkins White, "dat was some pretty rich ground, but whut is de poorest ground you ever seen?"

Arthur Hopkins spoke right up and said:

"Ah seen some land so poor dat it took nine partridges to holler 'Bob White.' "

"Dat was rich land, boy," declared Larkins. "Ah seen land so poor dat de people come together and 'cided dat it was too poor to raise anything on, so they give it to de church, so de congregation built de church and called a pastor and held de meetin'. But de land was so poor they had to wire up to Jacksonville for ten sacks of commercial-nal before dey could raise a tune on dat land."

The laughter was halted by the sound of a woodpecker against a cypress. Lonnie Barnes up with his gun to kill it, but Lucy stopped him.

"What you want to kill dat ole thing for? He ain't fitten to eat. Save dat shot and powder to kill me a rabbit. Ah sho would love a nice tender cotton-tail. Slim Ellis brought me a great big ole fat ham off a rabbit last night, and Ah lakted dat."

"Ah kin shoot you a rabbit just as good as Slim kin," Lonnie protested. "Ah wasn't gointer kill no ole tough peckerwood for you to eat, baby. Ah was goin' to shoot dat red-head for his meanness. You know de peckerwood come pretty nigh drownin' de whole world once."

"How was dat?"

Well, you know when de Flood was and dey had two of everything in de ark—well, Ole Nora[9] didn't take on no trees, so de woodpecker set 'round and set 'round for a week or so then he felt like he just had to peck himself some wood. So he begin to peck on de Ark. Ole Nora

[9]Noah.

come to him and tole him, "Don't peck on de Ark. If you peck a hole in it, we'll all drown."

Woodpecker says: "But Ah'm hungry for some wood to peck."

Ole Nora says, "Ah don't keer how hongry you gits don't you peck on dis ark no mo. You want to drown everybody and everything?"

So de woodpecker would sneak 'round behind Ole Nora's back and peck every chance he got. He'd hide hisself way down in de hold where he thought nobody could find him and peck and peck. So one day Ole Nora come caught him at it. He never opened his mouth to dat woodpecker. He just hauled off and give dat peckerwood a cold head-whipping wid a sledge hammer, and dat's why a peckerwood got a red head today—'cause Ole Nora bloodied it wid dat hammer. Dat's how come Ah feel like shootin' every one of 'em Ah see. Tryin' to drown *me* before Ah was born.

"A whole lot went on on dat ole Ark," Larkins White commented. "Dat's where de possum lost de hair off his tail."

"Now don't you tell me no possum ever had no hair on dat slick tail of his'n," said Black Baby, " 'cause Ah know better."

Yes, he did have hair on his tail one time. Yes, indeed. De possum had a bushy tail wid long silk hair on it. Why, it useter be one of de prettiest sights you ever seen. De possum struttin' 'round wid his great big ole plumey tail. Dat was 'way back in de olden times before de big flood.

But de possum was lazy—jus' like he is today. He sleep too much. You see Ole Nora had a son name Ham and he loved to be playin' music all de time. He had a banjo and a fiddle and maybe a guitar too. But de rain come up so sudden he didn't have time to put 'em on de ark. So when rain kept comin' down he fretted a lot 'cause he didn't have nothin' to play. So he found a ole cigar box and made hisself a banjo, but he didn't have no strings for it. So he seen de possum stretched out sleeping wid his tail all

spread 'round. So Ham slipped up and shaved de possum's tail and made de strings for his banjo out de hairs. When dat possum woke up from his nap, Ham was playin' his tail hairs down to de bricks and dat's why de possum ain't got no hair on his tail today. Losin' his pretty tail sorta broke de possum's spirit too. He ain't never been de same since. Dat's how come he always actin' shame-faced. He know his tail ain't whut it useter be; and de possum feel mighty bad about it.

"A lot of things ain't whut they useter be," observed Jim Presley. "Now take de 'gator for instance. He been changed 'round powerful since he been made."

"Yeah," cut in Eugene Oliver, "He useter have a nice tongue so he could talk like a nat'chal man, but Brer Dog caused de 'gator to lose his tongue, and dat's how come he hate de dog today."

"Brer 'Gator didn't fall out wid Brer Dog 'bout no tongue," retorted Presley.

Brer Dog done de 'gator a dirty trick 'bout his mouth. You know God made de dog and the 'gator without no mouth. So they seen everybody else had a mouth so they made it up to git theirselves a mouth like de other var-mints. So they agreed to cut one 'nothers' mouth, and each one said dat when de other one tole 'em to stop cuttin' they would. So Brer Dog got his mouth first. Brer 'Gator took de razor and cut. Brer Dog tole him, "Stop," which he did. Den Brer Dog took de razor and begin to cut Brer 'Gator a mouth. When his mouth was big as he wanted it, Brer 'Gator says, "Stop, Brer Dog. Dat'll do, I thank you, please." But Brer Dog kept right on cuttin' till he ruint Brer 'Gator's face. Brer 'Gator was a very handsome gent'-man befo' Brer Dog done him that a way, and everytime he look in de lookin' glass he cry like a baby over de dis-figgerment of his face. And dat's how come de 'gator hate de dog.

"My people, my people," lamented Oliver. "They just will talk whut they don't know."

"Go on Oliver."

De 'gator didn't fall out wid de dog 'bout no mouth cuttin' scrape. You know all de animals was havin' a ball down in de pine woods, and so they all chipped in for refreshments and then they didn't have no music for de dance. So all de animals what could 'greed to furnish music. So de dog said he'd be de trumpet in de band, and de horse and de frog and de mockin' bird and all said they'd be there and help out all they could. But they didn't have no bass drum, till somebody said, "Whut's de matter wid Brer 'Gator, why he don't play de bass drum for us?" Dey called Brer 'Gator but he wasn't at de meetin' so de varmints depitized Brer Dog to go call on Brer 'Gator and see if he wouldn't furnish de drum music for de dance. Which he did.

"Good evenin', Brer 'Gator."

"My compliments, Brer Dog, how you makin' out? Ah'm always glad when folks visit me. Whut you want?"

"Well Brer 'Gator, de varmints is holdin' a big convention tonight in de piney woods and we want you to furnish us a little bit of yo' drum music."

"It's like this, Brer Dog, tell de other animals dat Ah'm mighty proud they wants me and de compliments run all over me, but my wife is po'ly and my chillun is down sick. But Ah'll lend you my drum if you know anybody kin play it, and know how to take keer of it too!"

"Oh, Ah'll do *dat,* Brer 'Gator. You just put it in my keer. You don't have to worry 'bout dat atall."

So de dog took Brer 'Gator's tongue to de ball dat night and they beat it for a drum. De varmints lakted de bass drum so well till they didn't play nothin' else hardly. So by daybreak it was wore clean out. Brer Dog didn't want to go tell Brer 'Gator they had done wore his tongue out so he hid from Brer 'Gator. Course de 'gator don't like it 'bout his tongue so he's de sworn enemy of de dog.

105

Big Sweet says, "Dat's de first time Ah ever heard 'bout de dawg wearin' out de 'gator's tongue, but Ah do know he useter be a pretty varmint. He was pure white all over wid red and yeller stripes around his neck. He was pretty like dat 'till he met up wid Brer Rabbit. Kah, kah, kah! Ah have to laugh everytime Ah think how sharp dat ole rabbit rascal is."

"Yeah," said Sam Hopkins. "At night time, at de right time; Ah've always understood it's de habit of de rabbit to dance in de wood."

"When Ah'm shellin' my corn; you keep out yo' nubbins, Sam," Big Sweet snapped as she spat her snuff.

Ah'm tellin' dis lie on de 'gator. Well, de 'gator was a pretty white varmint wid coal black eyes. He useter swim in de water, but he never did bog up in de mud lak he do now. When he come out de water he useter lay up on de clean grass so he wouldn't dirty hisself all up.

So one day he was layin' up on de grass in a marsh sunnin' hisself and sleepin' when Brer Rabbit come bustin' cross de marsh and run right over Brer 'Gator before he stopped. Brer 'Gator woke up and seen who it was trompin' all over him and trackin' up his pretty white hide. So he seen Brer Rabbit, so he ast him, "Brer Rabbit, what you mean by runnin' all cross me and messin' up my clothes lak dis?"

Brer Rabbit was up behind a clump of bushes peerin' out to see what was after him. So he tole de 'gator, says: "Ah

106

ain't got time to see what Ah'm runnin' over nor under. Ah got trouble behind me."

'Gator ast, "Whut is trouble? Ah ain't never heard tell of dat befo'."

Brer Rabbit says, "You ain't never heard tell of trouble?"

Brer 'Gator tole him, "No."

Rabbit says: "All right, you jus' stay right where you at and Ah'll show you whut trouble is."

He peered 'round to see if de coast was clear and loped off, and Brer 'Gator washed Brer Rabbit's foot tracks off his hide and went on back to sleep agin.

Brer Rabbit went on off and lit him a li'dard knot[10] and come on back. He sat dat marsh afire on every side. All around Brer 'Gator de fire was burnin' in flames of fire. De 'gator woke up and pitched out to run, but every which a way he run de fire met him.

He seen Brer Rabbit sittin' up on de high ground jus' killin' hisself laughin'. So he hollered and ast him:

"Brer Rabbit, whut's all dis goin' on?"

"Dat's trouble, Brer 'Gator, dat's trouble youse in."

De 'gator run from side to side, round and round. Way after while he broke thru and hit de water "ker ploogum!" He got all cooled off but he had done got smoked all up befo' he got to de water, and his eyes is all red from de smoke. And dat's how come a 'gator is black today—cause de rabbit took advantage of him lak dat.

[10]Lightwood, fat pine. So called because it is frequently used as a torch.

SEVEN

J oe Wiley said, " 'Tain't nothin' cute as a rabbit. When they come cuter than him, they got to have 'cute indiges- tion." He cleared his throat and continued:

Dat's de reason de dog is mad wid de rabbit[1] now—'cause he fooled de dog.

You know they useter call on de same girl. De rabbit useter g'wan up to de house and cross his legs on de porch and court de girl. Brer Dog, he'd come in de gate wid his banjo under his arm.

"Good evenin', Miss Saphronie."

"My compliments, Brer Dog, come have a chair on de pe-azza."

"No thank you ma'am, Miss Saphronie. B'lieve Ah'll set out here under de Chinaberry tree."

So he'd set out dere and pick de banjo and sing all 'bout:

If Miss Fronie was a gal of mine
She wouldn't do nothin' but starch and iron.

So de girl wouldn't pay no mind to Brer Rabbit at all. She'd be listenin' to Brer Dog sing. Every time he'd stop

[1]See glossary.

she'd holler out dere to him, "Wont you favor us wid another piece, Brer Dog? Ah sho do love singin' especially when they got a good voice and picks de banjo at de same time."

Brer Rabbit saw he wasn't makin' no time wid Miss Saphronie so he waylaid Brer Dog down in de piney woods one day and says:

"Brer Dog, you sho is got a mellow voice. You can sing. Wisht Ah could sing like dat, den maybe Miss Fronie would pay me some mind."

"Gawan, Brer Rabbit, you makin' great 'miration at nothin'. Ah can whoop a little, but Ah really do wish Ah could sing enough to suit Miss Fronie."

"Well, dat's de very point Ah'm comin' out on. Ah know a way to make yo' voice sweeter."

"How? Brer Rabbit, how?"

"Ah knows a way."

"Hurry up and tell me, Brer Rabbit. Don't keep me waitin' like dis. Make haste."

"Ah got to see inside yo' throat first. Lemme see dat and Ah can tell you exactly what to do so you can sing more better."

Brer Dog stretched his mouth wide open and the rabbit peered way down inside. Brer Dog had his mouth latched back to de last notch and his eyes shut. So Brer Rabbit pulled out his razor and split Brer Dog's tongue and tore out across de mountain wid de dog right in behind him. Him and him! Brer Rabbit had done ruint Brer Dog's voice, but he ain't had time to stop at Miss Fronie's nor nowhere else 'cause dat dog is so mad he won't give him time.

"Yeah," said Cliff.

De dog is sho hot after him. Run dem doggone rabbits so that they sent word to de dogs dat they want peace. So they had a convention. De rabbit took de floor and said they was tired of runnin', and dodgin' all de time, and they asted de dogs to please leave rabbits alone and run some-

thin' else. So de dogs put it to a vote and 'greed to leave off runnin' rabbits.

So after de big meetin' Brer Dog invites de rabbit over to his house to have dinner wid him.

He started on thru de woods wid Brer Dog but every now and then he'd stop and scratch his ear and listen. He stop right in his tracks. Dog say:

"Aw, come on Brer Rabbit, you too suscautious. Come on."

Kept dat up till they come to de branch just 'fore they got to Brer Dog's house. Just as Brer Rabbit started to step out on de foot-log, he heard some dogs barkin' way down de creek. He heard de old hound say, "How o-l-d is he?" and the young dogs answer him: "Twenty-one or two, twenty-one or two!" So Brer Rabbit say, "Excuse me, but Ah don't reckon Ah better go home wid you today, Brer Dog."

"Aw, come on, Brer Rabbit, you always gitten scared for nothin'. Come on."

"Ah hear dogs barkin', Brer Dog."

"Naw, you don't, Brer Rabbit."

"Yes, Ah do. Ah know, dat's dogs barkin'."

"S'posin' it is, it don't make no difference. Ain't we done held a convention and passed a law dogs run no mo' rabbits? Don't pay no 'tention to every li'l bit of barkin' you hear."

Rabbit scratch his ear and say,

"Yeah, but all de dogs ain't been to no convention, and anyhow some of dese fool dogs ain't got no better sense than to run all over dat law and break it up. De rabbits didn't go to school much and he didn't learn but three letter, and that's trust no mistake. Run every time de bush shake."

So he raced on home without breakin' another breath wid de dog.

"Dat's right," cut in Larkins White. "De Rabbits run from everything. They held a meetin' and decided. They say, 'Le's all go drown ourselves 'cause ain't nothin' skeered of us.' So it was agreed.

111

"They all started to de water in a body fast as time could wheel and roll. When they was crossin' de marsh jus' befo' they got to de sea, a frog hollered, 'Quit it, quit it!' So they say, 'Somethin' is 'fraid of us, so we won't drown ourselves.' So they all turnt 'round and went home."

"Dat's as bad as dat goat Ah seen back in South Carolina. We was on de tobacco truck goin' after plants when we passed a goat long side de road. He was jus' chewin' and he looked up and ast, 'Whose truck is dat?' Nobody answered him. When we come on back Ah said, 'Mr. Rush Pinkney's, why?' De goat says, 'Oh nothin',' and kept right on chewin'."

"Ow, Big Sweet! gimme dat lyin' goat! You know damn well dat goat ain't broke a breath wid you and nobody else," scolded Jim Allen.

"But a goat's got plenty sense, ugly as he is," said Arthur Hopkins.

Ah know my ole man had a goat and one Sunday mornin' he got mama to wash his shirt so't would be clean for him to wear to church. It was a pretty red silk shirt and my ole man was crazy about it.

So my ole lady washed it and hung it out to dry so she could iron it befo' church time. Our goat spied pa's shirt hangin' on de line and et it up tiddy umpty.

My ole man was so mad wid dat goat 'bout his shirt till he grabbed him and tied him on de railroad track so de train could run over him and kill him.

But dat old goat was smart. When he seen dat train bearin' down on him, he coughed up dat red shirt and waved de train down.

Dad Boykin said: "No ef and ands about it. A goat is a smart varmint, but my feets sho is tired."

"Dat *was* a long two miles," Jim Allen added. "Ah see de lake now, and Ah sho am glad."

"Doggone it!" said Lonnie Barnes, "here we is almost at de lake and Ah ain't got myself no game yet. But maybe Ah'll

have mo' luck on de way back."

"Yeah," Lucy remarked dryly, "dat gun you totin' ain't doin' you much good! Might just as well left it home."

"He act just like dat nigger did in slavery time wid Ole Massa's gun," laughed Willie Roberts.

"How as dat?"

Well, you know John was Ole Massa's pet nigger. He give John de best of everything and John thought Ole Massa was made outa gold. So one day Massa decided he wanted a piece of deer meat to eat so he called John and some more of his niggers together and told 'em:

"Now Ah want y'all to go git me a deer today. Ah'm goin' to give John my new gun and Ah want de rest of y'all go 'round and skeer up de deer and head him towards John, and he will shoot him wid de gun." When de others got there they said, "Did you git him, John?"

He said, "Naw, Ah didn't."

They said, "Well how come you didn't? He come right dead down de hill towards you."

"Y'all crazy! You think Ah'm gointer sprain Massa's brand new gun shootin' up hill wid it?"

"Dat's put me in de mind of a gun my ole man had," said Gene Oliver. "He shot a man wid it one time and de bullet worked him twice befo' it kilt him and three times after. If you hold it high, it would sweep de sky; if you hold it level, it'd kill de devil."

"Oh Gene, stop yo' lyin'! You don't stop lyin' and gone to flyin'."

"Dat ain't no lie, dat's a fact. One night I fired it myself," said Pitts.

"It's a wonder you didn't shoot it off dat time when de quarters boss was hot behind you."

"Let dat ride! Ah didn't want to kill dat ole cracker. But one night Ah heard somethin' stumblin' 'round our woodpile, so Ah grabbed de gun, stepped to de back door and fired it at de woodpile, and went on back to bed. All night long Ah

113

heard somethin' goin' 'round and 'round de house hummin' like a nest of hornets. When daybreak come Ah found out what it was. What you reckon? It was dat bullet. De night was so dark it was runnin' 'round de house waitin' for daylight so it could find out which was the way to go!''

"Dat was a mighty gun yo' pa had," agreed Larkins, "but Ah had a gun dat would lay dat one in the shade. It could shoot so far till Ah had to put salt down de barrel so de game Ah kilt wid it would keep till Ah got to it.''

"Larkins—'' Jim Allen started to protest.

"Mr. Allen, dat ain't no lie. Dat's a fack. Dat gun was so bad dat all Ah need to do was walk out in de woods wid it to skeer all de varmints. Ah went huntin' one day and saw three thousand ducks in a pond. Jus' as Ah levelled dis gun to fire, de weather turned cold and de water in de lake froze solid and them ducks flew off wid de lake froze to their feets.''

"Larkins, s'posin' you was to die right now, where would you land?—jus' as straight to hell as a martin to his gourd. Whew! you sho kin lie. You'd pass slap thru hell proper. Jus' a bouncin' and a jumpin' and go clear to Ginny Gall, and dat's four miles south of West Hell; you better stop yo' lyin', man.''

"Dat ain't no lie, man. You jus' ain't seen no real guns and no good shootin'.''

"Ah don't want to see none. Less fish. Here we is at de lake. You can't talk and ketch fish too. You'll skeer all de fish away.''

"Aw, nobody ain't even got a hook baited yet. Leave Larkins lie till we git set!'' suggested Joe Wiley. "You gittin' old, Jim, when you can't stand good lyin'. It's jus' like sound doctrine. Everybody can't stand it.''

"Who gittin' old? Not me! Ah laks de lies. All I said is yo' talkin' skeers off all de trouts and sheepheads. Ah can't eat no lies.''

"Aw, gran'pa, don't be so astorperious! We all wants to hear Larkins' tale. I'm goin' ketch you some fish. We ain't off

114

lak dis often. Tomorrow we'll be back in de swamp 'mong de cypress knees, de 'gators, and de moccasins, and strainin' wid de swamp boss," pleaded Cliff. "Go head on, and talk, Larkins, God ain't gonna bother you."

"Well," says Larkins:

A man had a wife and a whole passle of young 'uns, and they didn't have nothin' to eat.

He told his ole lady, "Well, Ah got a load of ammunition in my gun, so Ah'm gointer go out in de woods and see what Ah kin bring back for us to eat."

His wife said: "That's right, go see can't you kill us somethin'—if 'tain't nothin' but a squirrel."

He went on huntin' wid his gun. It was one of dese muzzle-loads. He knowed he didn't have but one load of ammunition so he was very careful not to stumble and let his gun go off by accident.

He had done walked more'n three miles from home and he ain't saw anything to shoot at. He got worried. Then all of a sudden he spied some wild turkeys settin' up in a tree on a limb. He started to shoot at 'em, when he looked over in de pond and seen a passle of wild ducks; and down at de edge of de pond he saw a great big deer. He heard some noise behind him and he looked 'round and seen some partiges.

He wanted all of 'em and he didn't know how he could get 'em. So he stood and he thought and he thought. Then he decided what to do.

He took aim, but he didn't shoot at de turkeys. He shot de limb de turkeys was settin' on and de ball split dat limb and let all dem turkeys' feets dropped right down thru de crack and de split limb shet up on 'em and helt 'em right dere. De ball went on over and fell into de pond and kilt all dem ducks. De gun had too heavy a charge in her, so it bust and de barrel flew over and kilt dat deer. De stock kicked de man in de breast and he fell backwards and smothered all dem partiges.

Well, he drug his deer up under de tree and got his

ducks out de pond and piled them up wid de turkeys and so forth. He seen he couldn't tote all dat game so he went on home to git his mule and wagon.

Soon as he come in de gate his wife said:

"Where is de game you was gointer bring back? you musta lost yo' gun, you ain't got it."

He told his wife, "Ah wears de longest pants in dis house. You leave me tend to my business and you mind yours. Jus' you put on de pot and be ready. Plenty rations is comin'."

He took his team on back in de woods wid him and loaded up de wagon. He wouldn't git up on de wagon hisself because he figgered his mule had enough to pull without him.

Just as he got his game all loaded on de wagon, it commenced to rain but he walked on beside of the mule pattin' him and tellin' him to "come up," till they got home.

When he got home his wife says: "De pot is boilin'. Where is de game you tole me about?"

He looked back and seen his wagon wasn't behind de mule where it ought to have been. Far as he could see— nothin' but them leather traces, but no wagon.

Then he knowed de rain had done made dem traces stretch, and de wagon hadn't moved from where he loaded it.

So he told his wife, "De game will be here. Don't you worry."

So he just took de mule out and stabled him and wrapped dem traces 'round de gate post and went on in de house.

De next day it was dry and de sun was hot and it shrunk up dem traces, and about twelve o'clock they brought dat wagon home, "Cluck-cluck, cluck-cluck," right on up to de gate.

In spite of the laughter and talk, Cliff had landed two perch already, so Jim Allen laughed with the rest.

"Now," he said, beaming upon the fish his grandson had hooked, "I'm goin' to tell y'all about de hawk and de buzzard.

116

You know de hawk and de buzzard was settin' up in a pine tree one day, so de hawk says: "How you get yo' livin', Brer Buzzard?"

"Oh Ah'm makin' out pretty good, Brer Hawk. Ah waits on de salvation of de Lawd."

Hawk says, "Humph, Ah don't wait on de mercy of nobody. Ah takes mine."

"Ah bet, Ah'll live to pick yo' bones, Brer Hawk."

"Aw naw, you won't, Brer Buzzard. Watch me git my livin'."

He seen a sparrer sittin' on a dead limb of a tree and he sailed off and dived down at dat sparrer. De end of de limb was stickin' out and he run his breast right up on de sharp point and hung dere. De sparrer flew on off.

After while he got so weak he knowed he was gointer die. So de buzzard flew past just so—flyin' slow you know, and said, "Un hunh, Brer Hawk, Ah told you Ah was gointer live to pick yo' bones. Ah waits on de salvation of de Lawd." And dat's de way it is wid some of you young colts."

"Heh, heh, heh! Y'all talkin' 'bout me being old. Ah betcher Ah'll be here when a many of y'all is gone."

Joe Wiley said: "Less table discussion 'bout dyin' and open up de house for new business.

Y'all want to know how come they always use raw-hide on mule, so Ah'm gointer tell you. Whenever they make a whip they gointer have raw-hide on it, if it ain't nothin' but de tip.

A man had a mule you know and he had a ox too. So he used to work 'em together.

Both of 'em used to get real tired befo' knockin' off time but dat ole ox had mo' sense than de mule, so he played off sick.

Every day de mule would go out and work by hisself and de ox stayed in de stable. Every night when de mule come in, he'd ast, "Whut did Massa say 'bout me today?"

De mule would say, "Oh nothin'," or maybe he'd say,

117

"Ah heard him say how sorry he was you was sick and couldn't work."

De ox would laugh and go on to sleep.

One day de mule got tired, so he said, "Massa dat ox ain't sick. 'Tain't a thing de matter wid him. He's jus' playin' off sick. Ah'm tired of doin' all dis work by myself."

So dat night when he got in de stable, de ox ast him. "What did Ole Massa say 'bout me today?"

Mule told him, "Ah didn't hear him say a thing, but Ah saw him talkin' to de butcher man."

So de ox jumped up and said, "Ah'm well. Tell Ole Massa Ah'll be to work tomorrow."

But de next mornin' bright and soon de butcher come led him off.

So he said to de mule, "If you hadn't of told Massa on me, Ah wouldn't be goin' where Ah am. They're gointer kill me, but Ah'll always be war on yo' back."

And that's why they use raw-hide on mule's back—on account of dat mule and dat ox."

"Oh, well, if we gointer go way back there and tell how everything started," said Ulmer, "Ah might just as well tell how come we got gophers."

"Pay 'tention to yo' pole, Cliff," Jim Allen scolded. "You gittin' a bite. You got 'im! A trout too! If dat fool ain't lucky wid fish!"

Old Man Jim strung the trout expertly. "Now, Cliff, you kin do all de talkin' you want, just as long as you ketch me some fish Ah don't keer."

"Well," began Cliff:

God was sittin' down by de sea makin' sea fishes. He made de whale and throwed dat in and it swum off. He made a shark and throwed it in and then he made mullets and shad-fish and cats and trouts and they all swum on off.

De Devil was standin' behind him lookin' over his shoulder.

Way after while, God made a turtle and throwed it in de

118

water and it swum on off. Devil says, "Ah kin make one of
those things."

God said, "No, you can't neither."

Devil told him, "Aw, Ah kin so make one of those
things. 'Tain't nothin' to make nohow. Who couldn't do
dat? Ah jus' can't blow de breath of life into it, but Ah sho
kin make a turtle."

God said: "Devil, Ah know you can't make none, but if
you think you kin make one go 'head and make it and
Ah'll blow de breath of life into it for you."

You see, God was sittin' down by de sea, makin' de fish
outa sea-mud. But de Devil went on up de hill so God
couldn't watch him workin', and made his outa high land
dirt. God waited nearly all day befo' de Devil come back
wid his turtle.

As soon as God seen it, He said, "Devil, dat ain't no tur-
tle you done made."

Devil flew hot right off. "Dat ain't no turtle? Who say
dat ain't no turtle? Sho it's a turtle."

God shook his head, says, "Dat sho *ain't* no turtle, but
Ah'll blow de breath of life into it like Ah promised."

Devil stood Him down dat dat was a turtle.

So God blowed de breath of life into what de Devil had
done made, and throwed him into de water. He swum out.
God throwed him in again. He come on out. Throwed him
in de third time and he come out de third time.

God says: "See, Ah told you dat wasn't no turtle."

"Yes, suh, dat *is* a turtle."

"Devil, don't you know dat all turtles loves de water?
Don't you see whut you done made won't stay in there?"

Devil said, "Ah don't keer, dat's a turtle, Ah keep a 'tel-
lin' you."

God disputed him down dat it wasn't no turtle. Devil
looked it over and scratched his head. Then he says, "Well,
anyhow it will go for one." And that's why we have go-
phers!

"Dat gopher had good sense. He know he was a dry-land
turtle so he didn't try to mix wid de rest. Take for instance de

time they had de gopher up in court.

"De gopher come in and looked all around de place. De judge was a turtle, de lawyers was turtles, de witnesses was turtles and they had turtles for jurymen.

"So de gopher ast de judge to excuse his case and let him come back some other time. De judge ast him how come he wanted to put off his case and de gopher looked all around de room and said, 'Blood is thicker than water,' and escused hisself from de place.

"Yeah," said Floyd Thomas, "but even God ain't satisfied wid some of de things He makes and changes 'em Hisself."

Jim Presley wanted to know what God ever changed, to Floyd's knowledge.

Well, He made butterflies after de world wuz all finished and thru. You know de Lawd seen so much bare ground till He got sick and tired lookin' at it. So God tole 'em to fetch 'im his prunin' shears and trimmed up de trees and made grass and flowers and throwed 'em all over de clearin's and dey growed dere from memorial days.

Way after while de flowers said, "Wese put heah to keep de world comp'ny but wese lonesome ourselves." So God said, "A world is somethin' ain't never finished. Soon's you make one thing you got to make somethin' else to go wid it. Gimme dem li'l tee-ninchy shears."

So he went 'round clippin' li'l pieces offa everything—de sky, de trees, de flowers, de earth, de varmints and every one of dem li'l clippin's flew off. When folks seen all them li'l scraps fallin' from God's scissors and flutterin' they called 'em flutter-bys. But you know how it is wid de brother in black. He got a big mouf and a stambling tongue. So he got it all mixed up and said, "butter-fly" and folks been calling 'em dat ever since. Dat's how come we got butterflies of every color and kind and dat's why dey hangs 'round de flowers. Dey wuz made to keep de flowers company.

"Watch out, Cliffert!" yelled Jim Allen. "A 'gator must be on yo' hook! Look at it! It's dived like a duck."

"Aw, 'tain't nothin' but a gar fish on it. Ah kin tell by his bite!" said Cliff.

"You pull him up and see!" Jim commanded.

Cliff hauled away and landed a large gar on the grass.

"See, Ah told you, Gran'pa. Don't you worry. Ah'm gointer ketch you mo' fish than you kin eat. Plenty for Mama and Gran'ma too. Less take dis gar-fish home to de cat."

"Yeah," said Jim Presley. "Y' take de cat a fish, too. They love it better than God loves Gabriel—and dat's His best angel."

"He sho do and dat's how cats got into a mess of trouble—'bout eatin' fish," added Jim Presley.

"How was dat? I done forgot if Ah ever knowed."

"If, if, if," mocked Jim Allen. "Office Richardson, youse always iffin'! If a frog had wings he wouldn't bump his rump so much."

"Gran'pa is right in wid de cats," Cliff teased. "He's so skeered he ain't gointer git all de fish he kin eat, he's just like a watch-dog when de folks is at de table. He'll bite anybody then. Think they cheatin' 'im outa his vittles."

Jim Presley spat in the lake and began:

Once upon a time was a good ole time—monkey chew tobacco and spit white lime.

Well, this was a man dat had a wife and five chillun, and a dog and a cat.

Well, de hongry times caught 'em. Hard times everywhere. Nobody didn't have no mo' then jus' enough to keep 'em alive. First they had a long dry spell dat parched up de crops, then de river rose and drowned out everything. You could count anybody's ribs. De white folks all got faces look lak blue-John[2] and de niggers had de white mouf.[3]

So dis man laid in de bed one night and consulted wid his piller. Dat means he talked it over wid his wife. And he

[2]Skimmed milk.

[3]A very hungry person is supposed to look ashy-gray around the mouth.

told her, "Tomorrow less git our pole and go to de lake and see kin we ketch a mess of fish. Dat's our last chance. De fish done got so skeerce and educated they's hard to ketch, but we kin try."

They was at de lake bright and soon de next day. De man took de fishin' pole hisself 'cause he was skeered to trust his wife er de chillun wid it. It was they last chance to git some grub.

So de man fished all day long till he caught seven fishes. Not no great big trouts nor mud-cats but li'l perches and brims. So he tole 'em, "Now, Ah got a fish apiece for all of us, but Ah'm gointer keep on till Ah ketch one apiece for our dog and our cat."

So he fished on till sundown and caught a fish for the dog and de cat, and then they went on home and cooked de fish.

After de fish was all cooked and ready de woman said: "We got to have some drinkin' water. Less go down to de spring to git some. You better come help me tote it 'cause Ah feel too weak to bring it by myself."

So de husband got de water bucket off de shelf and went to de spring wid his wife. But 'fore he went, he told de chillun, "Now, y'all watch out and keep de cat off de fish. She'll steal it sho if she kin."

De chillun tole him, "Yessuh," but they got to foolin' 'round and playin' and forgot all about de cat, and she jumped up on de table and et all de fish but one. She was so full she jus' couldn't hold another mouthful without bustin' wide open.

When de old folks come back and seen what de cat had done they bust out cryin'. They knowed dat one li'l fish divided up wouldn't save they lives. They knowed they had to starve to death. De man looked at de cat and he knowed dat one mo' fish would kill her so he said, "Ah'm gointer make her greedy gut kill her." So he made de cat eat dat other fish and de man and his wife and chillun and de dog and cat all died.

De cat died first so's he was already in Heben when de rest of de family got there. So when God put de man's soul on de scales to weigh it, de cat come up and was lookin' at

de man, and de man was lookin' at de cat.

God seen how they eye-balled one 'nother so He ast de man, "Man, what is it between you and dis cat?"

So de man said, "God, dat cat's got all our nine lives in her belly." And he told God all about de fish.

God looked hard at dat cat for a hundred years, but it seem lak a minute.

Then he said: "Gabriel, Peter, Rayfield, John and Michael, all y'all ketch dat cat, and throw him outa Heben."

So they did and he was fallin' for nine days, and there ain't been no cats in Heben since. But he still got dem nine lives in his belly and you got to kill him nine times befo' he'll stay dead.

> Stepped on a pin, de pin bent
> And dat's de way de story went.

"Dat may be so, Presley," commented Jim Allen, "but if Ah ketch one messin' 'round *my* fish, Ah bet Ah kin knock dat man and woman and dem five chillun, de dog *and* de cat outa any cat Ah ever seen wid one lick."

"Dat's one something, Ah ain't never gointer kill," announced Willard forcefully. "It's dead bad luck."

"Me neither," assented Sack Daddy. "Everybody know it's nine years hard luck. Ah shot a man once up in West Florida, killed him dead for bull-dozin' me in a skin game, and got clean away. Ah got down in de phosphate mines around Mulberry and was doin' fine till Ah shacked up wid a woman dat had a great big ole black cat wid a white star in his bosom. He had a habit of jumpin' up on de bed all durin' de night time. One night Ah woke up and he was on my chest wid his nose right to mine, suckin' my breath.

"Ah got so mad Ah grabbed dat sucker by de tail and bust his brains out aginst a stanchion. My woman cried and carried on 'bout de cat and she tole me Ah was gointer have bad luck. Man, you know it wasn't two weeks befo' Sheriff Joe Brown laid his hand on my shoulder and tole me, 'Le's go.' Ah made five years for dat at Raiford. Killin' cats is bad luck."

123

"Talkin' 'bout dogs," put in Gene Oliver, "they got plenty sense. Nobody can't fool dogs much."

"And speakin' 'bout hams," cut in Big Sweet meaningly, "if Joe Willard don't stay out of dat bunk he was in last night, Ah'm gointer sprinkle some salt down his back and sugar-cure *his* hams."

Joe snatched his pole out of the water with a jerk and glared at Big Sweet, who stood sidewise looking at him most pointedly.

"Aw, woman, quit tryin' to signify."[4]

"Ah kin signify all Ah please, Mr. Nappy-chin, so long as Ah know what Ah'm talkin' about."

"See dat?" Joe appealed to the other men. "We git a day off and figger we kin ketch some fish and enjoy ourselves, but naw, some wimmins got to drag behind us, even to de lake."

"You didn't figger Ah was draggin' behind you when you was bringin' dat Sears and Roebuck catalogue over to my house and beggin' me to choose my ruthers.[5] Lemme tell *you* something, *any* time Ah shack up wid any man Ah gives myself de privilege to go wherever he might be, night or day. Ah got de law in my mouth."

"Lawd, ain't she specifyin'!" sniggered Wiley.

"Oh, Big Sweet does dat," agreed Richardson. "Ah knowed she had somethin' up her sleeve when she got Lucy and come along."

"Lawd," Willard said bitterly. "My people, my people," as de monkey said. "You fool wid Aunt Hagar's[6] chillun and they'll sho distriminate you and put yo' name in de streets."

Jim Allen commented: "Well, you know what they say—a man can cackerlate his life till he git mixed up wid a woman or git straddle of a cow."

Big Sweet turned viciously upon the old man. "Who you

[4]To show off.

[5]Make a choice.

[6]Negroes are in similie children of Hagar; white folks, of Sarah.

callin' a cow, fool? Ah know you ain't namin' *my* mama's daughter no cow."

"Now all y'all heard what Ah said. Ah ain't called nobody no cow," Jim defended himself. "Dat's just an old time by-word 'bout no man kin tell what's gointer happen when he gits mixed up wid a woman or set straddle of a cow."

"I done heard my gran'paw say dem very words many and many a time," chimed in Larkins. "There's a whole heap of them kinda by-words. Like for instance:

" 'Ole coon for cunnin', young coon for runnin',' and 'Ah can't dance, but Ah know good moves.' They all got a hidden meanin', jus' like de Bible. Everybody can't understand what they mean. Most people is thin-brained. They's born wid they feet under de moon. Some folks is born wid they feet on de sun and they kin seek out de inside meanin' of words."

"Fack is, it's a story 'bout a man sittin' straddle of a cow," Jim Allen went on.

A man and his wife had a boy and they thought so much of him that they sent him off to college. At de end of seven years, he schooled out and come home and de old man and his ma was real proud to have de only boy 'round there dat was book-learnt.

So de next mornin' after he come home, de ma was milkin' de cows and had one young cow dat had never been to de pail befo' and she used to kick every time anybody milked her.

She was actin' extry bad dat mornin' so de woman called her husband and ast him to come help her wid de cow. So he went out and tried to hold her, but she kept on rearin' and pitchin' and kickin' over de milk pail, so he said to his wife: "We don't need to strain wid dis cow. We got a son inside that's been to school for seben years and done learnt everything. He'll know jus' what to do wid a kickin' cow. Ah'll go call him."

So he called de boy and told him.

De boy come on out to de cow-lot and looked every-

thing over. Den he said, "Mama, cow-kickin' is all a matter of scientific principle. You see before a cow can kick she has to hump herself up in the back. So all we need to do is to take the hump out the cow's back."

His paw said, "Son, Ah don't see how you gointer do dat. But 'course you been off to college and you know a heap mo' than me and yo' ma ever will know. Go 'head and take de hump outa de heifer. We'd be mighty much obliged."

De son put on his gold eye glasses and studied de cow from head to foot. Then he said, "All we need to keep this animal from humping is a weight on her back."

"What kinda weight do she need, son?"

"Oh, any kind of a weight, jus' so it's heavy enough, papa," de son told him. "It's all in mathematics."

"Where we gointer git any weight lak dat, son?"

"Why don't you get up there, papa? You're just about the weight we need."

"Son, you been off to school a long time, and maybe you done forgot how hard it is for anybody to sit on a cow, and Ah'm gittin' old, you know."

"But, papa, I can fix that part, too. I'll tie your feet together under her belly so she can't throw you. You just get on up there."

"All right, son, if you say so, Ah'll git straddle of dis cow. You know more'n Ah do, Ah reckon."

So they tied de cow up short to a tree and de ole man got on by de hardest,[7] and de boy passed a rope under her belly and tied his papa on. De old lady tried to milk de cow but she was buckin' and rearin' so till de ole man felt he couldn't stand it no mo'. So he hollered to de boy, "Cut de rope, son, cut de rope! Ah want to git down."

Instead of de boy cuttin' loose his papa's feet he cut de rope dat had de cow tied to de tree and she lit out 'cross de wood wid de ole man's feet tied under de cow. Wasn't no way for him to git off.

De cow went bustin' on down de back-road wid de ole man till they met a sister he knowed. She was surprised to

[7]With great difficulty.

126

see de man on de cow, so she ast: "My lawd, Brother So-
and-so, where you goin'?"

He tole her, "Only God and dis cow knows."

"Wonder what de swamp boss is studyin' 'bout whilst we
out here fishin'?" Oliver wondered.

"Nobody don't know and here's one dat don't keer," Cliff
Ulmer volunteered. "Ah done caught me a nice mess of fish
and Ah'm gointer bust dat jook wide open tonight.

"Ah was over there last night and maybe de boys didn't get
off lyin'! Somebody tole one on de snail.

"You know de snail's wife took sick and sent him for de
doctor.

"She was real low ill-sick and rolled from one side of de bed
to de other. She was groanin', 'Lawd knows Ah got so much
misery Ah hope de Doctor'll soon git here to me.'

"After seben years she heard a scufflin' at de door. She was
real happy so she ast, 'Is dat you baby, done come back wid
de doctor? Ah'm so glad!'

"He says, 'Don't try to rush me—Ah ain't gone yet.' He
had been seben years gettin' to de door."

"Yeah, Ah was over there too," said Larkins White, "and
somebody else tole a lie on de snail. A snail was crossin' de
road for seben years. Just as he got across a tree fell and barely
missed him 'bout a inch or two. If he had a been where he was
six months before it would er kilt him. De snail looked back
at de tree and tole de people, 'See, it pays to be fast.' "

"Look at de wind risin'!" Willard exclaimed.

"We ain't no hogs, Joe, we can't see no wind."

"You kin see it, if you squirt some sow milk in yo' eyes. Ah
seen it one time," Jim Allen announced.

"How did it look, gran'pa? Dat's a sight Ah sho would love
to see," cried Cliff.

"Naw, you wouldn't, son. De wind is blood red and when
you see it comin' it look lak a bloody ocean rushin' down on
you from every side. It ain't got no sides and no top. Youse
jus' drownin' in blood and can't help yo'self. When Ah was

127

a li'l chap dey tole me if Ah put hawg milk in mah eyes Ah could see de wind, and—"

"Why they say 'hawg milk'? Can't you try some cow milk?" Cliffert asked.

"De hawg is de onliest thing God ever made whut kin see de wind. Ain't you never seen uh sow take a good look in one direction and go tuh makin' up a good warm nest? She see great winds a comin' a whole day off."

"Well, how didja quit seein' de wind, gran'pa?"

"De sow milk wore outa mah eyes gradual lak, but Ah seen dat wind fo' more'n a week. Dey had to blindfold me tuh keep me from runnin' wild."

Cliff Ulmer said:

De wind is a woman, and de water is a woman too. They useter talk together a whole heap. Mrs. Wind useter go set down by de ocean and talk and patch and crochet.

They was jus' like all lady people. They loved to talk about their chillun, and brag on 'em.

Mrs. Water useter say, "Look at *my* chillun! Ah got de biggest and de littlest in de world. All kinds of chillun. Every color in de world, and every shape!"

De wind lady bragged louder than de water woman: "Oh, but Ah got mo' different chilluns than anybody in de world. They flies, they walks, they swims, they sings, they talks, they cries. They got all de colors from de sun. Lawd, my chillun sho is a pleasure. 'Tain't nobody got no babies like mine."

Mrs. Water got tired of hearin' 'bout Mrs. Wind's chillun so she got so she hated 'em.

One day a whole passle of her chillun come to Mrs. Wind and says: "Mama, wese thirsty. Kin we go git us a cool drink of water?"

She says, "Yeah chillun. Run on over to Mrs. Water and hurry right back soon."

When them chillun went to squinch they thirst Mrs. Water grabbed 'em all and drowned 'em.

When her chillun didn't come home, de wind woman got

worried. So she went on down to de water and ast for her babies.

"Good evenin' Mis' Water, you see my chillun today?"

De water woman tole her, "No-oo-oo."

Mrs. Wind knew her chillun had come down to Mrs. Water's house, so she passed over de ocean callin' her chillun, and every time she call de white feathers would come up on top of de water. And dat's how come we got white caps on waves. It's de feathers comin' up when de wind woman calls her lost babies.

When you see a storm on de water, it's de wind and de water fightin' over dem chillun.

" 'Bout dat time a flea wanted to get a hair cut, so Ah left."

129

EIGHT

Y'all been tellin' and lyin' 'bout all dese varmints but you ain't yet spoke about de high chief boss of all de world which is de lion," Sack Daddy commented.

"He's de King of de Beasts, but he ain't no King of de World, now Sack," Dad Boykin spoke up. "He *thought* he was de King till John give him a straightenin'."

"Don't put dat lie out!" Sack Daddy contended. "De lion won't stand no straightenin'."

"Course I 'gree wid you dat everybody can't show de lion no deep point, but John showed it to him. Oh, yeah, John not only straightened him out, he showed dat ole lion where in."

"When did he do all of dis, Dad? Ah ain't never heard tell of it." Dad spoke up:

Oh, dis was way befo' yo' time. Ah don't recolleck myself. De old folks told me about John and de lion. Well, John was ridin' long one day straddle of his horse when de grizzly bear come pranchin' out in de middle of de road and hollered: "Hold on a minute! They tell me you goin' 'round strowin' it dat youse de King of de World."

John stopped his horse: "Whoa! Yeah, Ah'm de King of

de World, don't you b'lieve it?" John told him.

"Naw, you ain't no King. Ah'm de King of de World. You can't be no King till you whip me. Git down and fight."

John hit de ground and de fight started. First, John grabbed him a rough-dried brick and started to work de fat offa de bear's head. De bear just fumbled 'round till he got a good holt, then he begin to squeeze and squeeze. John knowed he couldn't stand dat much longer, do he'd be jus' another man wid his breath done give out. So he reached into his pocket and got out his razor and slipped it between dat bear's ribs. De bear turnt loose and reeled on over in de bushes to lay down. He had enough of dat fight.

John got back on his horse and rode on off.

De lion smelt de bear's blood and come runnin' to where de grizzly was layin' and started to lappin' his blood.

De bear was skeered de lion was gointer eat him while he was all cut and bleedin' nearly to death, so he hollered and said: *"Please* don't touch me, Brer Lion. Ah done met de King of de World and he done cut me all up."

De lion got his bristles all up and clashed down at de bear: "Don't you lay there and tell me you done met de King of de World and not be talkin' 'bout me! Ah'll tear you to pieces!"

"Oh, don't tetch me, Brer Lion! Please lemme alone so Ah kin git well."

"Well, don't you call nobody no King of de World but me."

"But Brer Lion, Ah done *met* de King sho' nuff. Wait till you see him and you'll say Ah'm right."

"Naw, Ah won't, neither. Show him to me and Ah'll show you how much King he is."

"All right, Brer Lion, you jus' have a seat right behind dese bushes. He'll be by here befo' long."

Lion squatted down by de bear and waited. Fust person he saw goin' up de road was a old man. Lion jumped up and ast de bear, "Is dat him?"

132

Bear say, "Naw, dat's Uncle Yistiddy, he's a useter-be!"

After while a li'l boy passed down de road. De lion seen him and jumped up agin. "Is dat him?" he ast de bear.

Bear told him, "Naw, dat's li'l tomorrow, he's a gointer-be, you jus' lay quiet. Ah'll let you know when he gits here."

Sho nuff after while here come John on his horse but he had done got his gun. Lion jumped up agin and ast, "Is dat him?"

Bear say: "Yeah, dat's him! Dat's de King of de World."

Lion reared up and cracked his tail back and forwards like a bull-whip. He 'lowed, "You wait till Ah git thru wid him and you won't be callin' him no King no mo'."

He took and galloped out in de middle of de road right in front of John's horse and laid his years back. His tail was crackin' like torpedoes.

"Stop!" de lion hollered at John. "They tell me you goes for de King of de World!"

John looked him dead in de ball of his eye and told him, "Yeah, Ah'm de King. Don't you like it, don't you take it. Here's mah collar, come and shake it!"

De lion and John eye-balled one another for a minute or two, den de lion sprung on John.

Talk about fightin'! Man, you ain't seen no sich fightin' and wrasslin' since de mornin' stars sung together. De lion clawed and bit John and John bit him right back.

Way after while John got to his rifle and he up wid de muzzle right in ole lion's face and pulled de trigger. Long, slim black feller, snatch 'er back and hear 'er beller! Dog damn! Dat was too much for de lion. He turnt go of John and wheeled to run to de woods. John levelled down on him agin and let him have another load, right in his hind-quarters.

Dat ole lion give John de book; de bookity book.[1] He hauled de fast mail back into de woods where de bear was laid up.

"Move over," he told de bear. "Ah wanta lay down too."

[1] Sound word meaning running.

"How come?" de bear ast him.

"Ah done met de King of de World, and he done ruint me."

"Brer Lion, how you know you done met de King?"

" 'Cause he made lightnin' in my face and thunder in my hips. Ah know Ah done met de King, move over."

"Dad, dat lie of your'n done brought up a high wind," said Jim Allen, measuring the weather with his eye. "Look a li'l bit like rain."

"Tain't gonna rain, but de wind's too high for fish to bite. Le's go back," suggested Presley. "All them that caught fish got fish. All them that didn't got another chance."

Everybody began to gather up things. The bait cans were kicked over so that the worms could find homes. The strings of fish were tied to pole ends. When Joe Wiley went to pull up his string of fish, he found a water moccasin stealin' them and the men made a great ceremony of killin' it. Then they started away from the water. Cliff had a long string of fish.

"Look, Gran'pa" he said, "Ah reckon you satisfied, ain't you?"

"Sho Ah'm satisfied, Ah must *is* got cat blood in me 'cause Ah never gits tired of fish. Ah knows how to eat 'em too, and dat's somethin' everybody don't know."

"Oh, anybody can eat fish," said Joe Willard.

"Yeah," Jim conceded grudgingly, "they kin eat it, but they can't git de real refreshment out de meat like they oughter."

"If you kin git any mo' refreshment off a fish bone than me, you must be got two necks and a gang of bellies," said Larkins.

"You see," went on Jim, "y'all ain't got into de techincal apex of de business. When y'all see a great big platter of fried fish y'all jus' grab hold of a fish and bite him any which way, and dat's wrong."

"Dat's good enough for me!" declared Willard emphati-

134

cally. "Anywhere and any place Ah ketch a fish Ah'm ready to bite him 'ceptin' he's raw."

"Me too."

"See dat?" Jim cried, exasperated. "You young folks is just like a passle of crows in a corn patch. Everybody talkin' at one time. Ain't nary one of you tried to learn how to eat a fish right."

"How you eat 'em, Mr. Allen?" Gene Oliver asked to pacify him.

"Well, after yo' hands is washed and de blessin' is said, you look at de fried fish, but you don't grab it. First thing you chooses a piece of corn-bread for yo' plate whilst youse lookin' de platter over for a nice fat perch or maybe it's trout. Nobody wid any manners or home-raisin' don't take de fork and turn over every fish in de dish in order to pick de best one. You does dat wid yo' eye whilst youse choosin' yo' pone bread. Now, then, take yo' fork and stick straight at de fish you done choosed, and if somebody ast you to take two, you say 'No ma'am, Ah thank you. This un will do for right now.'

"You see if you got too many fishes on yo' plate at once, folkses, you can't lay 'em out proper. So you take one fish at de time. Then you turn him over and take yo' fork and start at de tail, liff de meat all off de bone clear up to de head, 'thout misplacin' a bone. You eats dat wid some bread. Not a whole heap of bread—just enough to keep you from swallerin' de fish befo' you enjoy de consequences. When you thru on dat side of de fish turn him over and do de same on de other side. Don't eat de heads. Shove 'em to one side till you thru wid all de fish from de platter, den when there ain't no mo' fish wid sides to 'em, you reach back and pull dem heads befo' you and start at de back of de fish neck and eat right on thru to his jaw-bones.

"Now then, if it's summer time, go set on de porch and rest yo'self in de cool. If it's winter time, go git in front of de fireplace and warm yo'self—now Ah done tole you right. A

whole heap of people talks about fish-eatin' but Ah done tole you real."

"He's tellin' you right," agreed Dad Boykin. "Ah'm older than he is, 'cause Ah was eighty-one las' November, and Ah was eatin' fish befo' Jim was born, but Ah never did get de gennywine schoolin' till Jim showed me. But Ah teached him somethin' too, didn't Ah, Jim?"

"Yeah, Dad, yo' showed me how to warm myself."

There was a great burst of laughter from the young men, but the two old men scowled upon them.

"You see," Dad said bitingly. "You young poots won't lissen to nothin'! Not a one of you knows how to warm hisself right and youse so hard-headed you don't want to be teached. Any fool kin lam hisself up in a chimbley corner and cook his shins, but when it comes right down to de entrimmins, youse as ig'nant as a hog up under a acorn tree— he eats and grunts and never look up to see where de acorns is comin' from."

"Dad, *please* such, teach us how to warm ourselves," begged Cliff. "We all wants to know."

"Oh, y'all done wasted too much time, almost back in de quarters now, and de crowd will be scatterin'."

"Dat's all right, Dad," urged Joe Willard soothingly. "We ain't goin' nowhere till we been teached by you."

"Well, then, Ah'll tell y'all somethin'. De real way to git warm is first to git a good rockin' chear and draw it up to de fire. Don't flop yo'self down in it lak a cow in de pasture. Draw it right up in de center of de fireplace 'cause dat's de best. Some folks love to pile into de chimbley corner 'cause they's lazy and feared somebody gointer step on they foots. They don't want to have no trouble shiftin' 'em back and forth. But de center is de best place, so take dat. You even might have to push and shove a li'l bit to git dere, but dat's all right, go' head.

"When you git yo' chear all set where you wants it, then you walk up to de mantel piece and turn yo' back to de fire—dat's

136

to knock de breezes offen yo' back. You know, all de time youse outside in de weather, li'l breezes and winds is jumpin' on yo' back and crawlin' down yo' neck, to hide. They'll stay right there if you don't do somethin' to git shet of 'em. They don't lak fires, so when you turn yo' back to de fire, de inflamed atmosphere goes up under yo' coat-tails and runs dem winds and breezes out from up dere. Sometimes, lessen you drive 'em off, they goes to bed wid you. Ain't y'all never been so you couldn't git warm don't keer how much kivver you put on?"

"Many's de time I been lak dat."

"Well," went on Dad, "Dat because some stray breezes had done rode you to bed. Now dat brings up to de second claw of de subjick. You done got rid of de back breezes, so you git in yo' chear and pull off yo' shoes and set in yo' sock feet. Now, don't set there all spraddle-legged and let de heat just hit you any which way, put yo' feet right close together so dat both yo' big toes is side by side. Then you shove 'em up close to de fire and let 'em git good and hot. Ah know it don't look lak it but dem toes'll warm you all over. You see when Ah was studyin' doctor Ah found out dat you got a leader dat runs from yo' big toe straight to yo' heart, and when you git dem toes hot youse hot all over."

"Yeah, Ah b'lieve youse right, Dad, 'bout dat warmin' business, but Ah wisht somebody'd tell us how to git cool right now."

The party was back in the camp. Everybody began to head for his own shack.

"See you tonight at de jook," Jim Presley called to Willard. "Don't you and Big Sweet put on no roll now. Ah hate to see men and wimmin folks fightin'."

"Me too," said Wiley emphatically. "If a man kin whip his woman and whip her good; all right, but when they don't do nothin' but fight, it makes my stomach turn."

"Well," said Big Sweet crisply. "If Joe Willard try to take dese few fishes he done caught where he shacked up last night,

137

Ah'm gointer take my Tampa switch-blade knife, and Ah'm goin' 'round de hambone lookin' for meat."

"Aw, is *dat* so?" Joe challenged her.

"Ah been baptized, papa, and Ah wouldn't mislead you," Big Sweet told him to his teeth.

"Hey, hey!" Gene Oliver exclaimed. "Big Moose done come down from de mountain. Ah'm gointer be at dat jook tonight to see what Big Sweet and Ella Wall gointer talk about."

"Me too. De time is done come where big britches gointer fit li'l Willie,"[2] Joe Wiley declared significantly.

"Oh, wese all gointer be there," Larkins said. "Say, Big Sweet, don't let de 'gator beat you to de pond,[3] do he'll give you mo' trouble than de day is long."

So everybody got for home.

Back in the quarters the sun was setting. Plenty women over the cook-pot scorching up supper. Lots of them were already thru cooking, with the pots shoved to the back of the stove while they put on fresh things and went out in front of the house to see and be seen.

The fishermen began scraping fish and hot grease began to pop in happy houses. All but the Allen's. Mrs. Allen wouldn't have a thing to do with our fish because Mr. Allen and Cliffert had made her mad about the yard. So I fried the fish. She wouldn't touch a bite, but Mr. Allen, Cliffert and I pitched into it. Mr. Allen might have eaten by the rules but Cliffert and I went at it rough-and-tumble with no holds barred.

But we did sit down on the front porch to rest after the fish was eaten.

The men were still coming into the quarters from various parts of the "job." The children played "Shoo-round," and "Chick-mah-Chick" until Mrs. Williams called her four year

[2]Things have come to critical pass.

[3]Don't be out-done; or don't be too slow.

old Frankie and put her to sleep by rocking her and singing "Mister Frog."

It wasn't black dark, but night was peeping around the corner. The quarters were getting alive. Woofing, threats and brags up and down the line.

Three figures in the dusk-dark detached themselves from the railroad track and came walking into the quarters. A tall black grim-faced man with a rusty black reticule, followed by two women.

Everybody thought he was a bootlegger and yelled orders to him to that effect. He paid no attention, but set down his bag slowly, opened it still slower and took out a dog-eared Bible and opened it. The crowd quieted down. They knew he was a travelling preacher, a "stump-knocker" in the language of the "job."

Some fell silent to listen. Others sucked their teeth and either went back into their houses or went on to the jook.

When he had a reasonable amount of attention he nodded to the woman at his left and she raised "Death comes a Creepin'" and the crowd helped out. At the end the preacher began:[4]

You all done been over in Pentecost (got to feeling
spiritual by singing) and now we going to talk about de
woman that was taken from man. I take my text from
Genesis two and twenty-one (Gen. 2:21)

Behold de Rib!
Now, my beloved,
Behold means to look and see.
Look at dis woman God done made,
But first thing, ah hah!
Ah wants you to gaze upon God's previous works.
Almighty and arisen God, hah!
Peace-giving and prayer-hearing God,

[4]See glossary.

139

High-riding and strong armded God
Walking acrost his globe creation, hah!

Wid de blue elements for a helmet
And a wall of fire round his feet
He wakes de sun every morning from his fiery bed
Wid de breath of his smile
And commands de moon wid his eyes.
And Oh—
Wid de eye of Faith
I can see him
Standing out on de eaves of ether
Breathing clouds from out his nostrils,
Blowing storms from 'tween his lips
I can see!
Him seize de mighty axe of his proving power
And smite the stubborn-standing space,
And laid it wide open in a mighty gash—
Making a place to hold de world
I can see him—
Molding de world out of thought and power
And whirling it out on its eternal track,

Ah hah, my strong armded God!
He set de blood red eye of de sun in de sky
And told it,
Wait, wait! Wait there till Shiloh come
I can see!
Him mold de mighty mountains
And melting de skies into seas.
Oh, Behold, and look and see! hah
We see in de beginning
He made de bestes every one after its kind,
De birds that fly de trackless air,
De fishes dat swim de mighty deep—
Male and fee-male, hah!
Then he took of de dust of de earth
And made man in his own image.
And man was alone,
Even de lion had a mate
So God shook his head
And a thousand million diamonds
Flew out from his glittering crown
And studded de evening sky and made de stars.
So God put Adam into a deep sleep
And took out a bone, ah hah!
And it is said that it was a rib.
Behold de rib!
A bone out of a man's side.
He put de man to sleep and made wo-man,
And men and women been sleeping together ever since.
Behold de rib!
Brothers, if God
Had taken dat bone out of man's head
He would have meant for woman to rule, hah
If he had taken a bone out of his foot,
He would have meant for us to dominize and rule.
He could have made her out of back-bone
And then she would have been behind us.
But, no, God Amighty, he took de bone out of his side
So dat places de woman beside us;
Hah! God knowed his own mind.
Behold de rib!

And now I leave dis thought wid you,
Let us all go marchin' up to de gates of Glory.
Tramp! tramp! tramp!
In step wid de host dat John saw.
Male and female like God made us
Side by side.
Oh, behold de rib!
And less all set down in Glory together
Right round his glorified throne
And praise his name forever.
 Amen.

At the end of the sermon the woman on the preacher's left raised, "Been a Listenin' All de Night Long," and the preacher descended from his fiery cloud and lifted the collection in his hat. The singers switched to, "You Can't Hide, Sinners, You Can't Hide." The sparse contribution taken, the trio drifted back into the darkness of the railroad, walking towards Kissimmee.

NINE

The little drama of religion over, the "job" reverted to the business of amusing itself. Everybody making it to the jook hurriedly or slowly as the spirit moved.

Big Sweet came by and we went over together. I didn't go with Cliffert because it would mean that I'd be considered his property more or less and the other men would keep away from me, and being let alone is no way to collect folk-lore.

The jook was in full play when we walked in. The piano was throbbing like a stringed drum and the couples slow-dragging about the floor were urging the player on to new lows. "Jook, Johnnie, Ah know you kin spank dat ole pe-anner." "Jook it Johnnie!"[1] "Throw it in de alley!"[2]

The Florida-flip game was roaring away at the left. Four men playing skin game with small piles of loose change.[3]

"High, Jack, game," one side called.

"Low and not ashamed," from the other.

Another deal.

Dealer: (to play at left) "Whut yuh say?"

Player: "Beggin'."

[1] Play the piano in the manner of the jook or "blues."
[2] Get low down.
[3] See glossary.

Dealer: "Git up off yo' knees. Go 'head and tell 'em Ah sent you." (I give you one point.)

Dealer: "Pull off, partner."

A frenzied slapping of cards on the table. "Ha! we caught little britches!" (low) "Pull off again!"

"Can't. Ain't seen de deck but one time."

"Aw shucks. Ah got de wrong sign from you. Ah thought you had de king."

"Nope, Ah can't ketch a thing. Ah can't even ketch nobody lookin' at me."

The opponents grin knowingly and one of them sticks the Jack up on his forehead and gloats, "De Jack's a gentleman." It is now the highest card out.

A furious play to the end of the hand and the dealer cries: "Gone from three. Jus' like Jeff Crowder's eye" (out).

"Out!" cries the outraged opponents. "Out yo' head! Out wid whut!"

"We played high, low, game!"

"Take dat game right out yo' mouf. We got twenty by tens."

"Le's go to school." (Let's count game.)

One player slyly picks up the deck and tries to mix it with his cards.

"Aw naw, put down dat deck! You can't count it on me."

"Aw, you tryin' to bully de game, but if you ain't prepared to back yo' crap wid hot lead, don't bring de mess up."

Joe Wiley was on the floor in the crap game. He called me to come stand by him and give him luck. Big Sweet left me there and went on over to the skin game.

Somebody had squeezed the alcohol out of several cans of Sterno and added sugar, water and boiled-off spirits of nitre and called it wine. It was dealt out with the utmost secrecy. The quarters boss had a way of standing around in the dark and listening and he didn't allow a drop of likker on the job. Paynights used to mean two or three killings but this boss had ended the murders abruptly. And one caught with likker was sent down to Bartow to the jail and bound over to the Big

Court. So it had come to the place where "low" wine was about all the quarters could get and the drinker was taking two terrible risks at that—arrest and death.

But there was enough spirits about for things to keep lively. The crap game was frothy. Office had the dice when I walked up. He was shivering the dice and sliding them out expertly.

"Hah! good dice is findin' de money! Six is mah point."

"Whut's yo' come bet?" Blue asked.

"Two bits."

"Two bits you don't six."

Office picked up the dice stealthily, shook them, or rather failed to shake them craftily and slid them out. Blue stopped them. Office threw three times and three times Blue stopped them. Office took out his switch-blade knife and glared at Blue.

"Nigger, don't you stop mah dice befo' dey point."

"You chokin' dem dice. Shake and lemme hear de music."

I wanted to get into the game in a small way but Big Sweet was high balling[4] me to come over to the skin game. I went over to see what she wanted and was given her purse to hold. She wanted to play and she wanted a free hand. It was the liveliest and most intense game in the place. I got all worked up myself watching the falling cards.

A saddle-colored fellow called "Texas Red" was fighting the wine inside him by trying to tenor "Ol' Pal, Why Don't You Answer Me," while he hung over the game watching it. His nasal tones offended Big Sweet, who turned and asked him, "Did somebody hit yuh tuh start yuh? 'Cause if dey did Ah'm goin' ter hit yuh to stop yuh." Texas and Big Sweet did what is locally known as "eye-balling" each other. His eyes fell lower. Her knife was already open, so he strolled on off.

There had been a new deal. Everybody was getting a fresh card.

Dealer: "You want a card, Big Sweet?"

Big Sweet: "Yeah, Ah wanta scoop one in de rough."

4Waving ahead. A railroad term.

Dealer: "Aw right, yo' card is gointer cost you a dollar. Put yo' money on de wood and make de bet go good and then agin, put yo' money in sight and save a fight."

She drew a card from the deck and put it face up beside her, with a dollar bill.

Dealer: "Heah, Hardy, heah's a good card—a queen." He tossed the card to Hardy.

Hardy: "Aw naw, Ah don't play dem gals till way late in de night."

Dealer: "Well take de ace and go to wee-shoppy-tony and dat means East Hell. Ah'm gointer ketch you anyhow."

Hardy: "When you ketch me, you damn sho will ketch a man dat's caught a many one. Ah'm playin' up a nation."

Dealer: "Put down! You all owe de bet a dime. Damn sitters rob St. Peter, rob St. Paul."

Larkins: "Dat nigger is gointer top somebody. He's got a cub.[5] Ah ain't goin' in dat damn steel trap."

Dealer: "Aw naw, Ah ain't! You sap-sucker!" (To Hardy) "You owe de bet a dime if you never pay it."

The dealer starts down the deck, and the singing goes with it. Christopher Jenkins' deep baritone is something to remember.

> "Let de deal go down, boys.[6]
> Let de deal go down.
> When yo' card gits lucky, oh padner;
> You ought to be in a rollin' game."

Each line punctuated by "hah!" and a falling card.

Larkins: "Ah'm dead on de turn."

Dealer: "Ah heard you buddy."

"Ain't had no money, oh padner!"

(To Larkins) "You head-pecked shorty, drive up to de cryin'

[5] He has arranged the cards so he can deal winning cards to himself and losing cards to others.

[6] See appendix.

146

post and hitch up. You want another card?"

Larkins: "Shuffle and deal and ain't stop fallin' yet." (He means he stays in the game so he takes another hand.)

Dealer: "Put down dat chicken-change quarter you got in yo' hand."

The singing goes on—

> "Ah'm goin' back to de Bama,
> Won't be worried wid you."

(To Hardy) "De nine" (card dealer holds) "is de best. Is you got air nickel to cry?"

> "Let de deal go down, boys;
> Let de deal go down."

Big Sweet: "De four" (card she holds) "says a dollar mo'."

Dealer: "Oh hell and brothers! Ah'm strictly a two-bit man."

Big Sweet (arrogantly): "You full of dat ole ism blood. Fat covered yo' heart. Youse skeered to bet. Gamblin' wid yo' stuff out de window."[7]

Dealer: "Dollar mo'."

Hardy: "Hell broke loose in Georgy!"

Big Sweet: "Ah mean to carry y'all to Palatka and bring yuh back by de way of Winter Park."

Hardy: "Big Sweet, Ah don't b'lieve Ah'll see yo' raise."

Big Sweet: "Oh g'wan and bet. You got mo' sense than me. Look at dem damn kidneys all over yo' head."

> "Ain't had no trouble, Lawd padner
> Till Ah stop by here."

Dealer: "Take it and cry, children." (His card falls.) "Dey sent me out by de way of Sandusky. Lemme see kin Ah find me a clean card."

[7] Risking nothing. Ready to run.

147

Big Sweet: "Ah caught you guilty lyin'! Make a bet and tell a lie about it."

Hardy: "He done cocked a face card. Look out we don't ketch *you* guilty."

Big Sweet: "He got de cards in his hand."

"Let de deal go down, boys,
Let de deal go down."

Hardy: "Dat's me. Ah thought dat card was in Bee-luther-hatchee!"[8]

Dealer: "Tell de truth and stay in de church! Ah'm from down in Ginny-Gall where they eat cow-belly, skin and all. Big Sweet, everybody done fell but you. You must be setting on roots."

Big Sweet: "Nope, Ah got my Joe Moore in my hair."[9]

Dealer: "Well, Ah got de cards. I can cheat if I want to and beat you anyway."

Big Sweet: "You mess wid dem cards and see if Ah don't fill you full of looky-deres."

Hardy: "Whut a looky-dere?"

Big Sweet: "A knot on yo' head so big till when you go down de street everybody will point at it and say 'Looky-dere.' "

Dealer: (His card falls.) "Ah'm hot as seven hells."

Big Sweet: "Ah played de last card. Ah don't tell lies all de time. Now, you rich son of a bitch, pay off."

Larkins: "God! She must be sittin' on roots! Luck is a fortune."

Big Sweet raked in the money and passed it to me. She was about to place another bet when we heard a lot of noise outside. Everybody looked at the door at one time.

"Dat *must* be de Mulberry crowd. Nobody else wouldn't keep dat much noise. Ella Wall strowin' it."

[8] A mythical place, like "ginny gall."

[9] A piece of gamblers lucky hoodoo.

"She's plenty propaganda, all right."

Ella Wall flung a loud laugh back over her shoulder as she flourished in. Everybody looked at her, then they looked at Big Sweet. Big Sweet looked at Ella, but she seemed not to mind. The air was as tight as a fiddle string.

Ella wrung her hips to the Florida-flip game. Big Sweet stayed on at the skin game but didn't play. Joe Willard, knowing the imminence of forthright action, suddenly got deep into the crap game.

Lucy came in the door with a bright gloat in her eyes and went straight to Ella. So far as speaking was concerned she didn't see Big Sweet, but she did flirt past the skin game once, overcome with merriment.

"Dat li'l narrer contracted piece uh meatskin gointer make me stomp her right now!" Big Sweet exploded. "De two-faced heifer! Been hangin' 'round me so she kin tote news to Ella. If she don't look out she'll have on her last clean dress befo' de crack of day."

"Ah'm surprised at Lucy," I agreed. "Ah thought you all were de *best* of friends."

"She mad 'cause Ah dared her to jump *you*. She don't lak Slim always playing JOHN HENRY for you. She would have done cut you to death if Ah hadn't of took and told her."

"Ah can see she doesn't like it, but—"

"Neb' mind 'bout ole Lucy. She know Ah backs yo' fallin'. She know if she scratch yo' skin Ah'll kill her so dead till she can't fall. They'll have to push her over. Ella Wall look lak she tryin' to make me kill her too, flourishin' dat ole knife 'round. But she oughter know de man dat made one, made two. She better not vary, do Ah'll be all over her jus' lak gravy over rice."

Lucy and Ella were alternately shoo-shooing[10] to each other and guffawing. Then Ella would say something to the whole table and laugh.

Over at the Florida-flip game somebody began to sing that

[10]Whispering.

jook tribute to Ella Wall which has been sung in every jook and on every "job" in South Florida:

> Go to Ella Wall
> Oh, go to Ella Wall
> If you want good boody[11]
> Oh, go to Ella Wall
>
> Oh, she's long and tall
> Oh, she's long and tall
> And she rocks her rider
> From uh wall to wall
>
> Oh, go to Ella Wall
> Take yo' trunk and all—

"Tell 'em 'bout me!" Ella Wall snapped her fingers and revolved her hips with her hands.

"I'm raggedy, but right; patchey but tight; stringy, but I *will* hang on."

"Look at her puttin' out her brags." Big Sweet nudged me. "Loud-talkin' de place. But countin' from yo' little finger back to the thumb; if she start anything Ah got her some."

I knew that Big Sweet didn't mind fighting; didn't mind killing and didn't too much mind dying. I began to worry a bit. Ella kept on hurling slurs. So I said, "Come on, Big Sweet, we got to go to home."

"Nope, Ah ain't got to do nothin' but die and stay black. Ah stays right here till de jook close if anybody else stay. You look and see how much in dat pocket book."

I looked. "Forty-one dollars and sixty-three cents."

"Just you hold on to it. Ah don't want a thing in mah hands but dis knife."

Big Sweet turned to scoop a card in the rough. Just at that moment Ella chose to yell over, "Hey, bigger-than-me!" at Big Sweet. She whirled around angrily and asked me, "Didn't dat storm-buzzard throw a slam at me?"

[11]Sex.

150

"Naw, she was hollerin' at somebody else," I lied to keep the peace.

Nothing happening, Ella shouted, " 'Tain't nothin' to her. She ain't hit me yet."

Big Sweet heard that and threw in her cards and faced about. "If anything start, Little-Bit, you run out de door like a streak uh lightning and get in yo' car. They gointer try to hurt you too."

I thought of all I had to live for and turned cold at the thought of dying in a violent manner in a sordid saw-mill camp. But for my very life I knew I couldn't leave Big Sweet even if the fight came. She had been too faithful to me. So I assured her that I wasn't going unless she did. My only weapons were my teeth and toe-nails.

Ella crowded her luck. She yelled out, "Lucy, go tell Mr. Lots-of-Papa Joe Willard Ah say come here. Jus' tell 'im his weakness want 'im. He know who dat is."

Lucy started across. Ella stood up akimbo, but everybody knew she was prepared to back her brag with cold steel in some form, or she wouldn't have been there talking like she was.

A click beside me and I knew that the spring blade knife that Big Sweet carried was open.

"Stop right where you is, Lucy," Big Sweet ordered, "lessen you want to see yo' Jesus."

"Gwan Lucy," Ella Wall called out, " 'tain't nothin' stoppin' yuh. See nothin', say nothin'."

Big Sweet turned to Ella. "Maybe Ah ain't nothin'. But Ah say Lucy ain't gointer tell Joe Willard nothin'. What you sendin' *her* for? Why don't you go yo'self? Dere he is."

"Well, Ah kin go, now," Ella countered.

Big Sweet took a step forward that would put her right in Ella's path in case she tried to cross the room. "Ah can't hear what you say for yo' damn teeth rattlin'. Come on!"

Then the only thing that could have stopped the killing happened. The Quarters Boss stepped in the door with a .45

in his hand and another on his hip. Expect he had been eaves-dropping as usual.

"What's the matter here, y'all? Big Sweet, what you mean tuh do wid that knife?"

"Ahm jus' 'bout tuh send God two niggers. Come in here bull-dozin' me."

The Quarters Boss looked all around and pointed at Ella. "What tha hell *you* doin' in here wid weapons? You don't belong on this job nohow. Git the hell outa here and that quick. This place is for people that works on this job. Git! Somebody'll be in Barton jail in twenty minutes."

"You don't need tuh run her off, Cap'n," Big Sweet said. "Ah can git her tuh go. Jus' you stand back and gimme lief. She done stepped on mah starter and Ahm rearin' tuh go. If God'll send me uh pistol Ah'll send 'im uh man!"

"You ain't gonna kill nobody right under mah nose," the Quarters Boss snorted. "Gimme that knife you got dere, Big Sweet."

"Naw suh! Nobody gits *mah* knife. Ah bought it for dat storm-buzzard over dere and Ah means tuh use it on her, too. As long as uh mule go bareheaded she better not part her lips tuh me. Do Ah'll kill her, law or no law. Don't you touch me, white folks!"

"Aw she ain't so bad!" Ella sneered as she wrung her hips towards the door. "She didn't kill Jesse James."

"Git on 'way from here!" the Boss yelled behind her. "Lessen yuh wanna make time in Barton jail. Git off these premises and that quick! Gimme that knife!" He took the knife and gave Ella a shove. She moved sullenly behind her crowd away from the door, mumbling threats. He followed and stayed outside until the car pulled off. Then he stuck his head back inside and said, "Now you behave yo'self, Big Sweet. Ah don't wanna hafta jail yuh."

Soon as he was gone the mob got around Big Sweet. "You wuz noble!" Joe Willard told her, "You wuz uh whole woman and half uh man. You made dat cracker stand off a *you*."

"Who wouldn't?" said Presley. "She got loaded muscles.

152

You notice he don't tackle Big Sweet lak he do de rest round here. Dats cause she ain't got uh bit better sense then tuh make 'im kill her."

"Dats right," Big Sweet admitted, "and de nex' time Joe tell his Mulberry woman tuh come here bulldozin' *me*, Ahm gointer beat 'im to death grabbin' at 'im."

Joe Willard affected supreme innocence. "Will you lissen at dis 'oman? Ah ain't sent fuh nobody. Y'all see Ah didn't never go where she wuz, didn't yuh? Come on Big Sweet, less go home. How 'bout uh li'l keerless love? Ahm all ravalled out from de strain."

Joe and Big Sweet went home together and that was that.

When the quarters boss had gone, I saw Box-Car Daddy creeping back in the door. I didn't see him leave the place so I asked him where he had been.

"Had to step off a li'l piece," he told me with an effort at nonchalance.

"He always steps off whenever he see dat Quarters Boss, and he doing right, too," someone said.

"How come?" I asked. "Nobody else don't run."

Everybody laughed but nobody told me a thing. But after a while Box-Car began to sing a new song and I liked the swing of it.

"What's dat you singing, Box-Car?" I asked.

" 'Ah'm Gointer Loose dis Right-hand Shackle from 'Round my Leg.' Dat's a chain-gang song. Thought everybody knowed dat."

"Nope, never heard it. Ain't never been to de gang. How did you learn it?"

"Working on de gang."

"Whut you doin' on de gang, Box-Car? You look like a good boy, but a poor boy."

"Oh, dey put me under arrest one day for vacancy in Bartow. When de judge found out Ah had a job of work. He took and searched me and when he found out Ah had a deck of cards on me, he charged me wid totin' concealed cards, and attempt to gamble, and gimme three months. Then dey made

out another charge 'ginst me. 'Cused me of highway shufflin', and attempt to gamble. You know dese white folks sho hates tuh turn a nigger loose, if every dey git dey hands on 'im. And dis very quarters boss was Cap'n on de gang where Ah wuz. Me and him ain't never gointer set hawses."[12] So he went on singing:

All day long, you heard me moan
Don't you tell my Cap'n which way I gone
Ah'm gointer lose dis right hand shackle from 'round my leg.

You work me late, you work me soon
Some time you work me by de light of de moon
Ah'm gointer lose dis right hand shackle from 'round my leg.

I learned several other songs. Thanks to James Presley and Slim; and Gene Oliver and his sister brought me many additional tales.

But the very next pay-night when I went to a dance at the Pine Mill, Lucy tried to steal me. That is the local term for an attack by stealth. Big Sweet saved me and urged me to stay on, assuring me that she could always defend me, but I shivered at the thought of dying with a knife in my back, or having my face mutilated. At any rate, I had made a very fine and full collection on the Saw-Mill Camp, so I felt no regrets at shoving off.

The last night at Loughman was very merry. We had a party at Mrs. Allen's. James Presley and Slim with their boxes; Joe Willard calling figures in his best mood. Because it was a special occasion and because I was urged, I actually took a sip of low-wine and found out how very low it was. The dancing stopped and I was hilariously toted off to bed and the party moved to my bedroom. We had had a rain flood early in the afternoon and a medium size rattlesnake had come in out of the wet. I had thrown away a pile of worn out stockings and he was asleep upon them there in the corner by the washstand.

[12]Never going to get along. As two horses pull together.

154

The boys wanted to kill it, but I begged them not to hurt my lowly brother. He rattled away for a while, but when everybody got around the bed on the far end of the room and got quiet, he moved in the manner of an hour-hand to a crack where the floor and wall had separated, and popped out of sight.

Cliffert told me the last Loughman story around midnight.

"Zora, did yuh ever hear 'bout Jack and de Devil buckin' 'ginst one 'nother to see which one was de strongest?"

"Naw. Ah done heard a lot about de Devil and dat Jack, but not dat tale *you* know. Tell it."

Jack and de Devil wuz settin' down under a tree one day arguin' 'bout who was de strongest. De Devil got tired of talkin' and went and picked up a mule. Jack went and picked up de same mule. De Devil run to a great big old oak tree and pulled it up by de roots. Jack grabbed holt of one jus' as big and pulled it up. De Devil broke a anchor cable. Jack took it and broke it agin.

So de Devil says, "Shucks! Dis ain't no sho nuff trial. Dis is chillun foolishness. Meet me out in dat hund'ed acre clearin' tomorrow mornin' at nine o'clock and we'll see who kin throw mah hammer de furtherest. De one do dat is de strongest."

Jack says, "Dat suits me."

So nex' mawnin' de Devil wuz dere on time wid his hammer. It wuz bigger'n de white folks church house in Winter Park. A whole heap uh folks had done come out tuh see which one would win.

Jack wuz late. He come gallopin' up on hawseback and reined in de hawse so short till he reared up his hind legs.

Jack jumped off and says: "Wese all heah, le's go. Who goin' first?"

De Devil tole 'im, "Me. Everybody stand back and gimme room."

So he throwed de hammer and it went so high till it went clean outa sight. Devil tole 'em, "Iss Tuesday now. Y'all go home and come back Thursday mornin' at nine. It won't fall till then."

155

Sho 'nuff de hammer fell on Thursday mornin' at nine o'clock and knocked out a hole big as Polk County.

Dey lifted de hammer out de hole and levelled it and it wuz Jack's time to throw.

Jack took his time and walked 'round de hammer to de handle and took holt of it and throwed his head back and looked up at de sky.

"Look out, Rayfield! Move over, Gabriel! You better stand 'way back, Jesus! Ah'm fixin' to throw." He meant Heaven.

Devil run up to 'im, says, "Hold on dere a minute! Don't you throw mah damn hammer up dere! Ah left a whole lot uh mah tools up dere when dey put me out and Ah ain't got 'em back yet. Don't you *throw* mah hammer up dere!"

TEN

So I left most of my things at Loughman and ran down in the phosphate country around Mulberry. Around Mulberry, Pierce and Lakeland, I collected a mass of children's tales and games. The company operating the mines at Pierce maintains very excellent living conditions in their quarters. The cottages are on clean, tree-lined streets. There is a good hospital and a nine-months school. They will not employ a boy under seventeen so that the parents are not tempted to put minors to work. There is a cheerful community center with a large green-covered table for crap games under a shady oak.

We held a lying contest out under the trees in the night time, some sitting, some standing, everybody in a jolly mood. Mack C. Ford proved to be a mighty story teller before the Lord.

I found out about creation from him. The tail of the porpoise is on crosswise and he explains the mystery of that.

"Zora, did you ever see a porpoise?"

"Yep. Many times."

"Didja ever notice his tail?"

"Don't b'lieve Ah did. He moves so fast till Ah don't re-member much except seeing him turning somersault and

shootin' up and down de Indian River like lightnin' thru de trees."

Well, it's on crossways. Every other fish got his tail on straight but de porpoise. His is on crossways and bent down lak dis. (He bent down the fingers of his left hand sharply from the knuckles.)

De reason for dat is, God made de world and de sky and de birds and animals and de fishes. He finished off de stars and de trees.

Den He made a gold track clear 'round de world and greased it, and called de sun to Him and says, "Now Sun, Ah done made everything but Time and Ah want you to make dat. Ah made dat gold track for you to run on and Ah want you to git on it and go 'round de world jus' as fas' as you kin stave it and de time it take you to go and come Ah'm gointer call it 'day' and 'night.' "

De porpoise was standin' 'round and heard God when He spoke to de sun. So he says, "B'lieve Ah'll take dat trip around de world myself."

So de sun lit out and de porpoise took out. Him and him! 'Round de world—lickety split!

So de porpoise beat de sun 'round de world by a hour and three minutes.

When God seen dat He shook His head and says, "Unh, unh! Dis ain't gointer do. Ah never meant for nothin' to be faster than de sun."

So He took out behind dat porpoise and run him for three days and nights befo' He overtook him. But when he *did* ketch dat ole porpoise He grabbed him by de tail and snatched it off and set it back on crossways to slow him up. He can't beat de sun no mo' but he's de next fastest thing in de world.

Everybody laughed one of those blow-out laughs, so Mack Ford said, "Mah lyin' done got good tuh me, so Ahm gointer tell yuh how come de dawg hates de cat."

De dog and de cat used to live next door to one 'nother and both of 'em loved ham. Every time they git a chance they'd buy a slice of ham.

One time both of 'em got holt of a li'l extry change so de dog said to de cat, "Sis Cat, we both got a li'l money, and it would be fine if bofe of us could buy a ham apiece. But neither one of us ain't got enough money to buy a whole ham by ourselves. Why don't we put our money together and buy us a ham together?"

"Aw right, Brer Dawg. T'morrer begin' Sat'day, le's we go to town and git ourselves a ham."

So de next day they went to town and bought de ham. They didn't have no convenience so they had to walk and tote it. De dawg toted it first and he said as he walked up de road wid de ham over his shoulder, "Ours! Ours! Ours! Our ham!"

After while it was de cat's time to tote de meat. She said, "My ham, my ham, my ham." Dawg heard her but he didn't say nothin'.

When de dawg took it agin he says, "Ours, ours, our ham!" Cat toted it and says, "My ham, my ham."

Dawg says, "Sis Cat, how come you keep on sayin' 'My ham' when you totes our meat. Ah always say, 'Our ham.' "

De Cat didn't turn him no answer, but every time she toted de ham she'd say "My ham" and every time de dawg toted it he'd say "Ours."

When they was almost home, de cat was carryin' de ham and all of a sudden she sprung up a tree and set up there eatin' up de ham. De dawg did all he could to stop her, but he couldn't clim' and so he couldn't do nothin' but bark. But he tole de cat, "You up dat tree eatin' all de ham, and Ah can't git to you. But when you come down ahm gointer make you take dis Indian River for uh dusty road."

"Didja ever pass off much time round de railroad camps, Zora?" asked Mr. Ford.

159

"Ah been round dere some."

"Ah wuz jus' fixin' tuh tell yuh if you ain't been there you missed some good singin', well ez some good lyin'. Ever hear dat song bout 'Gointer See my Long-haired Babe'?"[1]

"Naw, but ah sho wisht ah had. Can you sing it?"

"Sho can and then ahm gointer do it too, and that one bout 'Oh Lulu, oh Gal.'"

"Ah know you want to hear some more stories, don't you? Ah know ah feels lak tellin' some."

"Unh hunh," I agreed.

"Don't you know dat's one word de Devil made up?"

"Nope, Ah had never heard about it. It's a mighty useful word Ah know for lazy folks like me."

"Yes, everybody says 'unh hunh' and Ah'll tell you why." He cleared his throat and continued:

Ole Devil looked around hell one day and seen his place was short of help so he thought he'd run up to Heben and kidnap some angels to keep things runnin' tell he got reinforcements from Miami.

Well, he slipped up on a great crowd of angels on de outskirts of Heben and stuffed a couple of thousand in his mouth, a few hundred under each arm and wrapped his tail 'round another thousand and darted off towards hell.

When he was flyin' low over de earth lookin' for a place to land, a man looked up and seen de Devil and ast 'im, "Ole Devil, Ah see you got a load of angels. Is you goin' back for mo'?"

Devil opened his mouth and tole 'im, "Yeah," and all de li'l angels flew out of his mouf and went on back to Heben. While he was tryin' to ketch 'em he lost all de others. So he went back after another load.

He was flyin' low agin and de same man seen him and says, "Ole Devil, Ah see you got another load uh angels."

[1]See appendix.

Devil nodded his head and said "unh hunh," and dat's why we say it today.

"Dat's a fine story. Tell me some more."

"Ah'm gointer tell you all about Big Sixteen and High Walker and Bloody Bones but first Ah want to ask you a question."

"All right, go ahead and ask me."

"Zora, why do you think dese li'l slim women was put on earth?"

"Couldn't tell you to save my life."

"Well, dese slim ones was put here to beautify de world."

"De big ones musta been put here for de same reason."

"Ah, naw, Zora. Ah don't agree wid you there."

"Well then, what *was* they put here for?"

"To show dese slim girls how far they kin stretch without bustin'."

Everybody out under the trees laughed except Good Bread. She took in a whole lot of breath and added to herself. Then she rolled her eyes and said, "Mack Ford, Ah don't come in yo' conversation atall. You jus' leave me out yo' mouf. And furthermo' Ah don't crack."

"Nobody ain't called yo name, Good Bread, Ah wuz jus' passin' uh joke."

"Oh yes you wuz hintin' at me."

"Aw, nobody ain't studyin' bout yuh. Jus' cause you done set round and growed ruffles round yo' hips nobody can't mention fat 'thout you makin' out they talkin' bout you. Ah wuzn't personatin' yuh, but if de cap fit yuh, wear it."

"G'wan Mack, you knows dat a very little uh yo' sugar sweetens mah tea. Don't git *me* started."

"G'wan start something if dats de way yuh feel. You kin be stopped. Now you tryin' to make somebody believe you so bad till you have tuh tote uh pistol tah bed tuh keep from gettin' in uh fight wid yo' self! You got mo' poison in yuh than dat snake dat wuz so poison tell he bit de railroad track and killed de train, hunh?"

"Don't y'all break dis lyin' contest up in no fight," Christopher Jenkins said.

Mah Honey laughed scornfully. "Aw, tain't gointer be no fight. Good Bread jus' feel lak bull woofin' uh little t'night. Her likker told her tuh pick uh fight but let Mack make uh break at her now, and there'll hafta be some good runnin' done befo' dat fight come off. Tain't nothin' tuh her. She know she ugly. She look lak de devil ground up in pieces."

Good Bread jumped up with her pocket knife out. "Who y'all tryin tuh double teen? Trying tuh run de hawg over de wrong one now."

"Aw set down Good Bread, and put dat froe back in yo' pocket. Somebody's liable tuh take dat ole piece uh knife you got and wear it out round yo' own neck."

"Dats what Ah say," Christopher put in. "She always tryin' tuh loud talk somebody. Ah hates women wid men's overalls on anyhow."

"Let her holler all she wants tuh," Ford added off-hand. "Dis is uh holler day. She kin whoop lak de Seaboard and squall lak de A.C.L. Nobody don't keer, long as she don't put her hand on me. Sho as she do dat Ahm gointer light her shuck for her."

Good Bread got to her feet importantly as if she was going to do something. For a fraction of a second I held my breath in fear. Nobody else paid it the least bit of mind. Good Bread flounced on off.

"Ahm glad she gone," said Mah Honey. "She always pickin' fights and gittin beat. Dat 'oman hates peace and agreement." He looked after her a moment then yelled after her. "Hey, lady, you got all you' bust in de back!" Everybody laughed and Mah Honey went on. "She so mad now she'll stay way and let Mack tell Zora some lies. Gwan, Mack, you got de business."

"Aw, Ah feel lak singin'," Mack Ford said.

"Well nobody don't feel lak hearin' yuh, so g'wan tell dat lie on Big Sixteen. Ah never gits tired uh dat one."

"You ruther hear uh story, Zora?"

162

"Yeah, g'wan tell it. Dats jus' what Ah'm here for."
"Well alright then:

It was slavery time, Zora, when Big Sixteen was a man.
They called 'im Sixteen 'cause dat was de number of de
shoe he wore. He was big and strong and Ole Massa
looked to him to do everything.

One day Ole Massa said, "Big Sixteen, Ah b'lieve Ah
want you to move dem sills Ah had hewed out down in de
swamp."

"I yassuh, Massa."

Big Sixteen went down in de swamp and picked up dem
12×12's and brought 'em on up to de house and stack
'em. No one man ain't never toted a 12×12 befo' nor
since.

So Ole Massa said one day, "Go fetch in de mules. Ah
want to look 'em over."

Big Sixteen went on down to de pasture and caught dem
mules by de bridle but they was contrary and balky and he
tore de bridles to pieces pullin' on 'em, so he picked one
of 'em up under each arm and brought 'em up to Old
Massa.

He says, "Big Sixteen, if you kin tote a pair of balky
mules, you kin do anything. You kin ketch de Devil."

"Yassuh, Ah kin, if you git me a nine-pound hammer
and a pick and shovel!"

Ole Massa got Sixteen de things he ast for and tole 'im
to go ahead and bring him de Devil.

Big Sixteen went out in front of de house and went to
diggin'. He was diggin' nearly a month befo' he got where
he wanted. Then he took his hammer and went and
knocked on de Devil's door. Devil answered de door his-
self.

"Who dat out dere?"

"It's Big Sixteen."

"What you want?"

"Wanta have a word wid you for a minute."

Soon as de Devil poked his head out de door, Sixteen
lammed him over de head wid dat hammer and picked 'im

163

up and carried 'im back to Old Massa.

Ole Massa looked at de dead Devil and hollered, "Take dat ugly thing 'way from here, quick! Ah didn't think you'd ketch de Devil sho 'nuff."

So Sixteen picked up de Devil and throwed 'im back down de hole.

Way after while, Big Sixteen died and went up to Heben. But Peter looked at him and tole 'im to g'wan 'way from dere. He was too powerful. He might git outa order and there wouldn't be nobody to handle 'im. But he had to go somewhere so he went on to hell.

Soon as he got to de gate de Devil's children was playin' in de yard and they seen 'im and run to de house, says, "Mama, mama! Dat man's out dere dat kilt papa!"

So she called 'im in de house and shet de door. When Sixteen got dere she handed 'im a li'l piece of fire and said, "You ain't comin' in here. Here, take dis hot coal and g'wan off and start you a hell uh yo' own."

So when you see a Jack O'Lantern in de woods at night you know it's Big Sixteen wid his piece of fire lookin' for a place to go.

"Give us somethin' to wet our goozles wid, and you kin git some lies, Zora," Jenkins prompted. I stood treats.

"Now g'wan, Mack, and lie some more," I said, and he remarked:

"De mosquitoes mighty bad right now, but down there on de East Coast they used to 'em. Know why we got so many skeeters heah and why we have so many storms?"

"Naw, but Ah'd love to know," I answered eagerly.

Well, one Christmas time, God was goin' to Palatka. De Devil was in de neighborhood too and seen God goin' long de big road, so he jumped behind a stump and hid. Not dat he was skeered uh God, but he wanted to git a Christmas present outa God but he didn't wanta give God nothin'.

So he squatted down behind dis stump till God come along and then he jumped up and said, "Christmas gift!"

God just looked back over his shoulder and said, "Take de East Coast," and kept on walkin'. And dat's why we got storms and skeeters—it's de Devil's property.

I should mention it is a custom in the deep South for the children to go out Christmas morning "catching" people by saying "Christmas gift." The one who says it first gets a present from the other. The adults usually prepare for this by providing plenty of hard candy, nuts, coconuts, fruits and the like. They never try to catch the neighbors' children but let themselves be caught.

"Ah know one mo' story on de devil. Reckon Ah'll tell it now.

"One day de Devil was walkin' along when he met Raw Head."

"Who is Raw Head?" I interrupted to ask. "Ah been hearin' his name called all my life, but never did find out who he was."

"Why, Zora! Ah thought everybody knowed who Raw Head was. Why he was a man dat was more'n a man. He was big and strong like Big Sixteen and he was two-headed. He knowed all de words dat Moses used to make. God give 'im de power to bring de ten plagues and part de Red Sea. He had done seen de Smokey Mountain and de Burnin' Bush. And his head didn't have no hair on it, and it sweated blood all de time. Dat's why he was named Raw Head."[2] Then Mr. Ford told the following story:

As Ah started to say, de Devil met Raw Head and they passed de time of day. Neither one wasn't skeered of de other, so they talked about de work they been doin'.
Raw Head said he had done turnt a man into a ground puppy. Devil said he been havin' a good time breakin' up couples. All over de world de Devil had husbands and wives fightin' and partin'.

[2]He was a conjure doctor. They are always referred to as "two-headed doctors," i.e. twice as much sense.

165

Tol 'im says, "Devil, youse my cousin and Ah know you got mo' power than me, but Ah know one couple you can't part. They lives cross de big creek in my district, and Ah done everything Ah could but nothin' can't come between 'em."

Devil says, "Dat's because de right one ain't tried yet. Ah kin part any two people. Jus' like Ah kin throw 'em together. You show 'em to me and Ah betcha half of hell Ah'll have 'em fightin' and partin' befo' Sunday."

So de Devil went to where dis couple lived and took up 'round de house.

He done everything he could but they wouldn't fight and they wouldn't part. Devil was real outdone. He had never had such a tussle since they throwed him outer Heben, and it was Friday. He seen he was 'bout to lose half of his kingdom and have to go back on his brag.

He was 'bout to give up and go somewhere else dat night when he met a woman as barefooted as a yard-dog. They spoke and she says, "You don't look so good. You been down sick?"

Devil told her, "Naw, but Ah been tryin' to break up dat lovin' couple up de road a piece there, but Ah can't do it."

De woman says, "Aw shucks, is dat all? Tell you whut: Ah ain't never had a pair of shoes in my life and if you promise to give me a pair of shoes tonight Ah'll part 'em for you."

"If you part 'em you get de shoes, and good ones at dat. But you got to do it first."

"Don't you worry 'bout dat, you jus' meet me at dat sweet-gum tree on de edge of de swamp tomorrer evenin' and bring de shoes."

Next mornin' she got up soon and went past de place to see where de man was workin' at. He was plowin' way off from de house. So she spoke to 'im nice and polite and went on up to de house where de wife was.

De wife asted her in and give her a chair. She took her seat and begin to praise everything on de place. It was de prettiest house she ever seen. It was de bes' lookin' yard in dat part of the state. Dat was de finest dawg she ever laid

166

eyes on. *Nobody* never had no cat as good as dat one was.

De wife thanked her for all her compliments and give her a pound of butter.

De woman told her, "Everything you got is pretty, but youse de prettiest of all."

De wife is crazy 'bout her husband and she can't stand to see him left out so she say, "My husband is prettier than Ah ever dared to be."

"Oh, yeah, he's pretty too. Almost as pretty as you. De only thing dat spoil his looks is dat long flesh-mole on his neck. Now if dat was off he'd be de prettiest man in de world."

De wife says, "Ah thinks he's already de prettiest man in de world, but if anything will make 'im *mo'* prettier still, Ah will too gladly do it."

"Well, then, you better cut dat big ole mole offa his neck."

"How kin Ah do dat? He skeered to cut it off. Say he might bleed to death."

"Aw naw, he won't neither. He won't lose more'n a drop of blood if you cut it off right quick wid a sharp razor and then wipe cob-web on de place. It's a pity he won't let you do it 'cause it sho do spoil his looks."

"If Ah knowed jus' how to do it, Ah sho would, 'cause Ah love him so and he is too pretty a man to be spoilt by a mole."

"Why don't you take de razor to bed wid you tonight. Then when he gets to sleep, you chop it off right quick and fix it lak Ah told you. He'll thank you for it next day."

De wife thanked de woman and give her a settin' of eggs and de woman told her good-bye and went on down to de field where de husband was plowin', and sidled up to him. "Good mornin' suh, you sho is a hard-workin' man."

"Yes ma'am, Ah works hard but Ah loves to work so Ah kin do for my wife. She's all Ah got."

"Yeah, and she sho got a man when she got you. 'Tain't many mens dat will hit from sun to sun for a woman."

The man said, "Sho ain't. But ain't no man got no wife as good as mine."

De woman spit on de ground and said, "It's good for a

person's mind to be satisfied. But lovin' a person don't make them love you. And youse a pitiful case."

"Why you say dat? Ain't I got de prettiest wife in de world. And what make it so cool, she's de sweetest wife God ever made."

"All Ah got to say is 'Watch out.' "

"Watch out for what? My wife don't need no watchin'. She's pretty, it's true, but Ah don't have to watch her."

"Somebody else done found out she pretty too and she's gointer gid rid of *you*. You better keep a close watch on her and when you go to bed tonight, make out you sleep and see if she don't try to cut yo' throat wid a razor!"

"Git off dis place—lyin' on my wife?"

De woman hid in de bushes outside de fence row and watched. Sho nuff, pretty soon he knocked off and went on towards de house. When he got dere he searched all over de place to see if anybody was there besides his wife. He didn't find nothin' but he watched everybody dat passed de gate, and he didn't say nothin' to his wife.

Dat night he got in bed right after supper and laid there wid his eyes shut. De wife went and got his razor and slipped it to bed wid her. When she thought he was good and sleep she got de cob-web in one hand and de razor in de other and leaned over him to cut his mole off. He had de cover up 'round his neck and soon as she started to ease it back he opened his eyes and grabbed her and took de razor.

"Unh, hunh! Ah was told you was goin' to cut my throat, but Ah didn't b'lieve it. From now on, we ain't no mo' husband and wife."

He dressed and left her cryin' in de bed.

De woman run on down to de sweet-gum tree to git her shoes. De Devil come brought 'em but he took and cut a long sapling and tied de shoe to de end of it and held 'em out to de woman and told her, "You parted 'em all right. Here's de shoes I promised you. But anybody dat kin create mo' disturbance than me is too dangerous. Ah don't want 'em round me. Here, take yo' shoes." And soon as she took 'em he vanished.

168

Horace Sharp said, "You lemme tell one now, Mack; you been talkin' all night. Tell yuh bout de farmer courtin' a girl.

Well, the startin' of it is, a farmer was courtin' a girl and after he decided to marry her, they married and started home. So when he passed a nice farm he said to the girl: "You see dat nice farm over yonder?" She said, "Yes." He said: "Well, all of these are mine." (Strokes his whiskers.)

Well, they traveled on further and they saw a herd of cattle and he said, "See dat nice herd of cattle?" She said. "Yes." "Well, all of these are mine." He smoothed his whiskers again.

So he traveled on a piece further and come to a big plantation with a big nice house on it, and he said: "All of these are mine."

So he traveled on further. He said, "See dat nice bunch of sheep?" She said, "Yes." "Well, all of these are mine."

Traveled on further. Come across a nice bunch of hogs and he said: "See dat nice bunch of hogs?" "Yes." "Well, all of these are mine."

So the last go 'round he got home and drove up to a dirty li'l shack and told her to get out and come in.

She says, "You got all those nice houses and want me to come in there? I couldn't afford to come in here. *Why you told me a story.* I'm going back home."

He says, "Why no, I didn't tell you a story. Everytime I showed you those things I said 'all of these were mine' and Ah wuz talkin' bout my whiskers." So the girl jumped out of the wagon and out for home she went.

Goat fell down and skint his chin
Great God A'mighty how de goat did grin.

"You do pretty good, Horace," Mah Honey drawled, "but how come you want to stick in yo' bill when Mack is talkin'? Dat story you told ain't doodly squat."

"Less see *you* tell one better'n dat one, then," Horace slashed back.

"Oh Ah can't tell none worth listenin' tuh and you can't neither. Only difference in us is Ah know Ah can't and you

don't. Dat lie you told is po' ez owl harkey. Gwan tell some mo' Mack. Maybe somebody'll come long and help yuh out after while."

"Ah thought Horace's story wuz jus' alright," Lessie Lee Hudson said. "Can't eve'ybody talk de same."

"Course it wuz!" Horace yelled, "it wuz alright wid everybody 'ceptin Mah Honey. He's a nigger wid white folks' head—let *him* tell it. He make out he know every chink in China."

"What you gointer do?" Mah Honey asked. "Ah kin tell yuh fo' yuh part yo' lips. You ain't gointer do nothin' but mildew."

Somebody came along singing, "You Won't Do," and everybody looked round at one time like cows in a pasture. "Here come A.D. He kin lie good too. Hurry up, A.D. and help Mack out!"

"What Mack doin'?"

"Lyin' up a breeze."

"Awright, lemme git in dis shag-lag. Who lied last?"

"Mack. Youse next."

"Who all know what uh squinch owl[3] is?" Frazier lit out.

"Man, who you reckon it is, *don't* know what dat bad luck thing is?" Christopher Jenkins asked. "Sign uh death every time you hear one hollerin round yo' house. Ah shoots every one Ah kin find."

"You kin stop 'em without shootin' 'em. Jus' tie uh loose knot in uh string and every time he holler you pull de knot uh lil bit tighter. Dat chokes 'im. Keep on you choke 'im tuh death. Go out doors nex' mawnin and look ahround you'll find uh dead owl round dere somewhere." Said Mah Honey.

"All you need tuh do is turn somethin' wrong side outuds, pull off yo' coat and turn it or else you kin turn uh pocket," Carrie Jones added. "Me, Ah always pull off uh stockin' and turn it. Dat always drives 'im off."

"Throw some salt on de lamp or stick uh rusty fork in de

[3]Screech owl, sometimes known as a shivering owl.

170

floor will do de same thing. In fact its de best of all; Ah mean de salt in de lamp. Nothin' evil can't stand salt, let alone burnin' salt.''

"Lemme tell y'all how come we got squinch owls and then y'all kin talk all yuh please bout how tuh kill 'em and drive 'em off de house top in de night time," said A.D.

Yuh know Ole Marster had uh ole maid sister that never been married. You know how stringy white folks necks gits when dey gits ole. Well hers had done got that-a-way and more special cause she never been married.

Her name wuz Miss Pheenie and Ole Marster had uh daughter so there wuz young mens round de parlor and de porch. All in de sittin' chairs and in de hammock under de trees. So Miss Pheenie useter stand round and peer at 'em and grin lak uh possum—wishin' she could git courted and married.

So one devilish young buck, he seen de feelin' in her so he 'gin tuh make manners wid her and last thing he done, he told her says, "If you go set up on de roof uh de house all night Ah'll marry yuh in de mawnin'."

It wuz uh bitter cold night. De wind searchin' lak de police. So she clambed up dere and set straddle of de highest part cause she couldn't stick nowhere's else. And she couldn't help but shake and shiver. And everytime de clock would strike de hour she'd say, "C-o-o-o-l-d on de housetop, but uh young man in de mawnin.'" She kept dat up till de clock struck four, when she tumbled down, froze tuh death. But de very next night after they buried her, she took de shape of uh owl and wuz back dere shivverin' and cryin'. And dats how come us got squinch owls.

"Dat sho waz uh true lie, A.D.," Carrie said. "Ah sho is wished many de time dat Miss Pheenie had uh stayed off de top uh dat house."

"Ah knows one 'bout uh witch woman," A.D. went on. "Ah'll tell dat one too, whilst Ah got mah wind."

"Naw, Ah don't wanta hear bout no witches ridin' no-

body," Baby-face Turl objected. "Ah been near rode tuh death in mah time. Can't bear tuh hear tell of it."

"Well then Ah kin tell yuh bout dat talkin' mule.

Ole feller one time had uh mule. His name wuz Bill. Every mornin' de man go tuh ketch 'im he say, "Come 'round, Bill!"

So one mornin' he slept late, so he decided while he wuz drinkin' some coffee he'd send his son tuh ketch Ole Bill.

Told 'im say, "Go down dere, boy, and bring me dat mule up here."

Boy, he sich a fast Aleck, he grabbed de bridle and went on down tuh de lot tuh ketch ole Bill.

He say, "Come round, Bill!"

De mule looked round at 'im. He told de mule, "Tain't no use you rollin' yo' eyes at *me*. Pa want yuh dis mawnin'. Come on round and stick yo' head in dis bridle."

Mule kept on lookin' at 'im and said, "Every mornin' it's 'Come round, Bill! Come round, Bill!' Don't hardly git no night rest befo' it's 'Come round, Bill!' "

De boy throwed down dat bridle and flew back tuh de house and told his Pa, "Dat mule is talkin'."

"Ah g'wan, boy, tellin' yo' lies! G'wan ketch dat mule."

"Naw suh, Pa, dat mule's done gone tuh talkin'. You hatta ketch dat mule yo' ownself. Ah ain't gwine."

Ole man looked at ole lady and say, "See whut uh lie dat boy is tellin'?"

So he gits out and goes on down after de mule hisself. When he got down dere he hollered, "Come round, Bill!"

Ole mule looked round and says, "Every mornin' it's come round, Bill!"

De old man had uh little fice dog useter foller 'im everywhere he go, so he lit out wid de lil fice right behind 'im. So he told de ole lady, "De boy ain't told much of uh lie. Dat mule *is* talkin'. Ah never heered uh mule talk befo'."

172

Lil fice say, "Me neither."

De ole man got skeered agin. Right through de woods
he went wid de fice right behind 'im. He nearly run hisself
tuh death. He stopped and commenced blowin' and says,
"Ahm so tired Ah don't know whut tuh do."

Lil dog run and set down in front of 'im and went to
hasslin'[4] and says, "Me too."

Dat man is runnin' yet.

Everybody agreed that the old man did right by running,
only some thought they could have bettered his record both
for speed and distance.

"What make you love tuh tell dem skeery lies, A.D.?"
Clarence Beale asked.

Lessie Lee snuggled up to Clarence with the eyes of Eve
and said, "He skeers me too, Clarence. Less me and you hug
up together." Clarence grabbed her and wrapped her up
tight.

"Youse jus' all right, A.D. If you know another one
skeerier than dat one, Ah'll give yuh five dollars tuh tell it.
And then Ah'm gointer git de job uh keepin' de boogers offa
Lessie Lee tuhnight. G'wan tell it."

"Yeah man!" Christopher Jenkins chimed in. "All dese frail
eels gittin' skittish. Tell some mo' A.D. Skeer Carrie right up
on me!"

So A.D. told another one.

This wuz uh man. His name was High Walker. He
walked into a boneyard with skull-heads and other bones.
So he would call them, "Rise up bloody bones and shake
yo'self." And de bones would rise up and come together,
and shake theirselves and part and lay back down. Then he
would say to hisself, "High Walker," and de bones would
say, "Be walkin'."

When he'd git off a little way he'd look back over his

[4]Panting.

shoulder and shake hisself and say, "High Walker and bloody bones," and de bones would shake theirselves. Therefore he knowed he had power.

So uh man sold hisself to de high chief devil. He give 'im his whole soul and body tuh do ez he pleased wid it. He went out in uh drift uh woods[5] and laid down flat on his back beyond all dese skull heads and bloody bones and said, "Go 'way Lawd, and come here Devil and do as you please wid me. Cause Ah want tuh do everything in de world dats wrong and never do nothing right."

And he dried up and died away on doin' wrong. His meat all left his bones and de bones all wuz separated.

And at dat time High Walker walked upon his skull head and kicked and kicked it on ahead of him a many and a many times and said tuh it, "Rise up and shake yo'self. High Walker is here."

Ole skull head wouldn't say nothin'. He looked back over his shoulder cause he heard some noises behind him and said, "Bloody bones you won't say nothin' yet. Rise tuh de power in de flesh."

Den de skull head said, "My mouf brought me here and if you don't mind, you'n will bring you here."

High Walker went on back to his white folks and told de white man dat a dry skull head wuz talkin' in de drift today. White man say he didn't believe it.

"Well, if you don't believe it, come go wid me and Ah'll prove it. And if it don't speak, you kin chop mah head off right where it at."

So de white man and High Walker went back in de drift tuh find dis ole skull head. So when he walked up tuh it, he begin tuh kick and kick de ole skull head, but it wouldn't say nothin'. High Walker looked at de white man and seen 'im whettin' his knife. Whettin' it hard and de sound of it said rick-de-rick, rick-de-rick, rick-de-rick! So High Walker kicked and kicked dat ole skull head and called it many and many uh time, but it never said nothin'. So de white man cut off High Walker's head.

[5] 10,000 "faces" in the turpentine woods, i.e. tree trunks that have been cut on one side to make the sap run from which turpentine is made.

And de ole dry skull head said, "See dat now! Ah told you dat mouf brought me here and if you didn't mind out it'd bring you here."

So de bloody bones riz up and shook they selves seben times and de white man got skeered and said, "What you mean by dis?"

De bloody bones say, "We got High Walker and we all bloody bones now in de drift together."

The next day was Thursday and I got a letter from Big Sweet saying I must be back at Loughman by Saturday because that was pay night and Thelma and Cliffert were getting married and big doings would be going on.

Friday I arrived in Loughman. Thelma and Cliffert got married on Saturday and everybody that wasn't mad put out to give them a big time.

The biggest crowd was over at the Pine Mill where Jim Presley was playing so I wanted to go there. Big Sweet didn't want to go there much. At least that is what she told everybody, but she told me to go on. She might be over later. She gave me some advice about looking out for myself.

"Don't let nobody bring yuh nothin' tuh eat and drink, and don't let 'em send it neither. They liable tuh put uh spider in yo' dumplin'. Don't let nobody git yuh intuh no fuss, cause you can't do dis kind uh fightin'. You don't know no better'n tuh go face tuh face tuh fight. Lucy and dem ain't gointer fight nobody lak dat. They think it make 'em look big tuh cut yuh. Ah done went tuh her and put mah foot up on her door step and told her dat if she tetch yuh Ah'll gently chain-gang fuh her, but she don't aim tuh lemme ketch her. She mean tuh slip up on yuh sometime and hit yuh uh back hand lick wid her knife and turn her hand over right quick and hit yuh forward wid it and pull it down. Then she aims tuh run cross back yards and jump fences so fast till me and de law neither can't find her."

"Well, Big Sweet, if it's like dat, Ah speck Ah better not go

175

out unless you be wid me," I told her.

"Oh yeah, you go on. You come here tuh see and lissen and Ah means fuh yuh tuh do it. Jus' watch out. Ah could give yuh uh knife tuh tote but dat wouldn't do you no good. You don't know how tuh handle it. Ah got two round here. One real good one Ah got down in Tampa, and one ole froe.[6] But you jus' gwan over dere and mind what Ah tell yuh. Ahm liable tuh be dere tuhreckly mahself. And don't git biggity wid nobody and let yuh head start more than yo' rump kin stand."

I promised sincerely and took Cliffert and Thelma in the car with me to the Pine Mill.

A new man had come from Groveland, where another big sawmill was located, and he was standing behind Jim Presley and Slim, singing new songs, and I was so glad that I had come. It didn't take me long to learn some new ones and I forgot all about Lucy.

Way after midnight Big Sweet came in. The place was hot by then. Everything was done got loud. The music, the dancing, the laughing, and nobody could say a thing even over the card games unless they made it sound something like singing. Heard one woman playing Coon Can sing out:

> Give mah man mah money, tuh play Coon Can
> He lost all mah money but he played his hand.

In a little while I heard her again:

> Befo' Ah'll lose mah rider's change
> Ah'll spread short deuces and tab de game.

Big Sweet nodded me over in a corner and said, "Ah done strowed it over on de other side dat Ahm gone home tuh bed. Jus' wanta see whut might come off."

"Lucy ain't been here atall," I told her. "Believe she skeered you might kill her sho 'nuff."

[6] A damaged pocket knife.

176

"She know Ah will lessen she kill me first. Ah hates uh two-facedted heifer lak her. And Ah ain't skeered tuh see Mah Jesus neither cause de Bible say God loves uh plain sinner and he's married tuh de backslider. Ah got jus' as good uh chance at Heben as anybody else. So have yo' correct amount uh fun. Ahm settin' right over dere in dat skin game."

Heard somebody at the Florida Flip game say, "Ahm gone—jus' lak uh turkey through de corn. Deal!"

Heard somebody else in the game say, "Beggin'" and the dealer told him, "Eat acorns."[7]

Heard Blue Baby ask Box-Car, "Who is dat new nigger over dere by de refreshments? God Amighty, ugly got de mug on him wid four wheel brakes."

"He's de new skitter man.[8] He sho' ain't nobody's pretty baby. Bet he have tuh slip up on de dipper tuh git uh drink uh water. B'lieve Ah'll holler at 'im. 'Hey Ugly, who made you? Don't start tuh lyin' on God now.'"

A general laugh followed this. Box-Car, a little proud of his crack, grabbed Blue Baby. "Come on less go over dere and marry Cliff and Thelma all over agin. Hey Cliff, you and Thelma git up on de floor and raise yo' right hand. Y'all ain't been hitched right till Box-Car git thew widja." The couple bashfully stood up.

"Join hands. Alright Cliff, Ahm de preacher—

> Here's yo' woman, here's de ring,
> Here's de banana, here's de skin
> Now you married, go—

A huge burst of laughter drowned out Box Car's voice and when the laugh died out, I could hear Nunkie, "reading the deck" where the flip game used to be. Calling the names of the cards and laying them down rhythmically and dramatically as he read:

[7] I give you one point.

[8] A panther had killed the other one a week earlier.

177

Ace means the first time that Ah met you, Deuce means there was nobody there but us two, Trey means the third party, Charlie was his name, Four spot means the fourth time you tried dat same ole game, Five spot is five years you played me for a clown, Six spot, six feet of earth when de deal goes down, Now, Ahm holdin' de seben spot for each day in de week, Eight spot, eight hours you sheba-ed wid yo' sheik, Nine spot means nine hours Ah work hard every day, Ten spot de tenth of every month Ah brought you home mah pay, De Jack is Three Card Charlie who played me for a goat, De Queen, dat's you, pretty mama, also tryin' tuh cut mah throat, De King, dat hot papa Nunkie, and he's gointer wear de crown, So be keerful y'all ain't broke when de deal goes down.

Nunkie looked around belligerently on the last sentence and Joe Willard jumped up and pulled at Big Sweet.

"Play some music, Jim, y'all over dere, and less dance some mo'. Nunkie wants tuh pick uh fight wid Who Flung. Play us uh slow drag. Come on Big Sweet, less me and you have uh schronchuns dance."

"Dance wid Zora, honey, Ah don't choose tuh move from where Ahm at. Ah ain't mad wid nobody, baby, jus' wanta set and look on uh while yet."

Heard the new singing man climbing up on

> Tell me, tell me where de blood red river ru-u-un
> Oh tell me where de blood red river run
> From mah back door, straight to de risin' sun.

Heard Slim's bass strings under the singing throbbing like all Africa and Jim Presley's melody crying like repentance as four or five couples took the floor. Doing the slow drag, doing the schronch. Joe Willard doing a traveling buck and wing towards where I stood against the wall facing the open door.

Just about that time Lucy hopped up in the doorway with an open knife in her hands. She saw me first thing. Maybe she had been outside peeping a long time and there I was leaning

against the wall right close to Slim. One door in the place and Lucy standing in it.

"Stop dat music," she yelled without moving. "Don't vip another vop till Ah say so! Ah means tuh turn dis place out right now. Ah got de law in mah mouf."

So she started walking hippily straight at me. She knew I couldn't get out easily because she had me barred and she knew not many people will risk running into a knife blade to stop a fight. So she didn't have to run. I didn't move but I was running in my skin. I could hear the blade already crying in my flesh. I was sick and weak. But a flash from the corner about ten feet off and Lucy had something else to think about besides me. Big Sweet was flying at her with an open blade and now it was Lucy's time to try to make it to the door. Big Sweet kicked her somewhere about the knees and she fell. A doubled back razor flew thru the air very close to Big Sweet's head. Crip, the new skitter man, had hurled it. It whizzed past Big Sweet and stuck in the wall; then Joe Willard went for Crip. Jim Presley punched me violently and said, "Run you chile! Run and ride! Dis is gointer be uh nasty ditch. Lucy been feedin' Crip under rations tuh git him tuh help her. Run clean off dis job! Some uh dese folks goin' tuh judgment and some goin' tuh jail. Come on, less run!"

Slim stuck out the guitar to keep two struggling men from blocking my way. Lucy was screaming. Crip had hold of Big Sweet's clothes in the back and Joe was slugging him loose. Curses, oaths, cries and the whole place was in motion. Blood was on the floor. I fell out of the door over a man lying on the steps, who either fell himself trying to run or got knocked down. I don't know. I was in the car in a second and in high just too quick. Jim and Slim helped me throw my bags into the car and I saw the sun rising as I approached Crescent City.

179

PART II

⁖

HOODOO

ONE

Winter passed and caterpillars began to cross the road
again. I had spent a year in gathering and culling
over folk-tales. I loved it, but I had to bear in mind
that there was a limit to the money to be spent on the project,
and as yet, I had done nothing about hoodoo.

So I slept a night, and the next morning I headed my toe-
nails toward Louisiana and New Orleans in particular.

New Orleans is now and has ever been the hoodoo capital
of America. Great names in rites that vie with those of Hayti
in deeds that keep alive the powers of Africa.

Hoodoo, or Voodoo, as pronounced by the whites, is burn-
ing with a flame in America, with all the intensity of a sup-
pressed religion. It has its thousands of secret adherents. It
adapts itself like Christianity to its locale, reclaiming some of
its borrowed characteristics to itself, such as fire-worship as
signified in the Christian church by the altar and the candles
and the belief in the power of water to sanctify as in baptism.

Belief in magic is older than writing. So nobody knows how
it started.

The way we tell it, hoodoo started way back there before
everything. Six days of magic spells and mighty words and the
world with its elements above and below was made. And now,
God is leaning back taking a seventh day rest. When the

eighth day comes around, He'll start to making new again.

Man wasn't made until around half-past five on the sixth day, so he can't know how anything was done. Kingdoms crushed and crumbled whilst man went gazing up into the sky and down into the hollows of the earth trying to catch God working with His hands so he could find out His secrets and learn how to accomplish and do. But no man yet has seen God's hand, nor yet His finger-nails. All they could know was that God made everything to pass and perish except stones. God made stones for memory. He builds a mountain Himself when He wants things not forgot. Then His voice is heard in rumbling judgment.

Moses was the first man who ever learned God's power-compelling words and it took him forty years to learn ten words. So he made ten plagues and ten commandments. But God gave him His rod for a present, and showed him the back part of His glory. Then too, Moses could walk out of the sight of man. But Moses never would have stood before the Burning Bush, if he had not married Jethro's daughter. Jethro was a great hoodoo man. Jethro could tell Moses could carry power as soon as he saw him. In fact he felt him coming. Therefore, he took Moses and crowned him and taught him. So Moses passed on beyond Jethro with his rod. He lifted it up and tore a nation out of Pharaoh's side, and Pharaoh couldn't help himself. Moses talked with the snake that lives in a hole right under God's foot-rest. Moses had fire in his head and a cloud in his mouth. The snake had told him God's making words. The words of doing and the words of obedience. Many a man thinks he is making something when he's only changing things around. But God let Moses make. And then Moses had so much power he made the eight winged angels split open a mountain to bury him in, and shut up the hole behind them.

And ever since the days of Moses, kings have been toting rods for a sign of power. But it's mostly sham-polish because no king has ever had the power of even one of Moses' ten words. Because Moses made a nation and a book, a thousand

million leaves of ordinary men's writing couldn't tell what Moses said.

Then when the moon had dragged a thousand tides behind her, Solomon was a man. So Sheba, from her country where she was, felt him carrying power and therefore she came to talk with Solomon and hear him.

The Queen of Sheba was an Ethiopian just like Jethro, with power unequal to man. She didn't have to deny herself to give gold to Solomon. She had gold-making words. But she was thirsty, and the country where she lived was dry to her mouth. So she listened to her talking ring and went to see Solomon, and the fountain in his garden quenched her thirst.

So she made Solomon wise and gave him her talking ring. And Solomon built a room with a secret door and everyday he shut himself inside and listened to his ring. So he wrote down the ring-talk in books.

That's what the old ones said in ancient times and we talk it again.

It was way back there—the old folks told it—that Raw-Head-And-Bloody-Bones had reached down and laid hold of the taproot that points to the center of the world. And they talked about High Walker too. But they talked in people's language and nobody knew them but the old folks.

Nobody knows for sure how many thousands in America are warmed by the fire of hoodoo, because the worship is bound in secrecy. It is not the accepted theology of the Nation and so believers conceal their faith. Brother from sister, husband from wife. Nobody can say where it begins or ends. Mouths don't empty themselves unless the ears are sympathetic and knowing.

That is why these voodoo ritualistic orgies of Broadway and popular fiction are so laughable. The profound silence of the initiated remains what it is. Hoodoo is not drum beating and dancing. There are no moon-worshippers among the Negroes in America.

I was once talking to Mrs. Rachel Silas of Sanford, Florida,

so I asked her where I could find a good hoodoo doctor.

"Do you believe in dat ole fogeyism, chile? Ah don't see how nobody could do none of dat work, do you?" She laughed unnecessarily. "Ah been hearin' 'bout dat mess ever since Ah been big enough tuh know mahself, but shucks! Ah don't believe nobody kin do me no harm lessen they git somethin' in mah mouth."

"Don't fool yourself," I answered with assurance. "People can do things to you. I done seen things happen."

"Sho nuff? Well, well, well! Maybe things *kin* be done tuh harm yuh, cause Ah done heard *good* folks—folks dat ought to know—say dat it sho is a fact. Anyhow Ah figger it pays tuh be keerful."

"Oh yeah, Mrs. Rachel, Ah've seen a woman full of scorpions."

"Oh it kin be done, honey, no effs and ands 'bout de thing. There's things that kin be done. Ah seen uh' 'oman wid uh gopher in her belly. You could see 'm movin' 'round in her. And once every day he'd turn hisself clear over and then you could hear her hollerin' for more'n a mile. Dat hard shell would be cuttin' her insides. Way after 'while she took down ill sick from it and died. Ah knowed de man dat done dat trick. Dat wuz done in uh dish of hoppin-john."[1]

Mrs. Viney White, a neighbor, was sitting there so she spoke. "Ah knowed into dat mahself. It wuz done over her breaking de leg of one of his hens dat wuz scratchin' up her garden. When she took down sick Ah went to see her and Ah told her folks right then dat somebody had done throwed at her, but they didn't b'lieve in nothin'. Went and got a Medical doctor, and they can't do them kind of cases no good at all. Fact is it makes it worser." She stopped short and nodded her head apprehensively towards the window. Rachel nodded her head knowingly. "She out dere now, tryin' tuh eavesdrop."

"Who you talkin' 'bout?" I asked.

[1]Peas and rice cooked together.

186

"De one dat does all de underhand work 'round here. She even throwed at *me* once, but she can't do nothin'. Ah totes mah Big John de Conquerer[2] wid me. And Ah sprinkles mustard seed 'round my door every night before Ah goes tuh bed."

"Yeah, and another thing," Mrs. Rachel said, "Ah keeps her offa me too. She tries tuh come in dis yard so she kin put something down for me too, but air Lawd, Ah got something buried at dat gate dat she can't cross. She done been dere several times, but she can't cross."

"Ah'd git her tuh go if ah wuz you, Rachel," Mrs. Viney said.

"Wisht ah knowed how. Ah'd sho do it."

"You throw salt behind her, everytime she go out of her gate. Do dat nine times and Ah bet she'll move so fast she won't even know where she's going. Somebody salted a woman over in Georgetown and she done moved so much she done wore out her furniture on de movin' wagon. But looka here, Zora, whut you want wid a two-headed doctor? Is somebody done throwed a old shoe at *you?*"

"Not exactly neither one, Mrs. Viney. Just want to learn how to do things myself."

"Oh, honey, Ah wouldn't mess with it if Ah wuz you. Dat's a thing dat's got to be handled just so, do it'll kill you. Me and Rachel both knows somebody that could teach you if they will. Dis woman ain't lak some of these hoodoo doctors. She don't do nothin' but good. You couldn't pay her to be rottin' people's teeths out, and fillin' folks wid snakes and lizards and spiders and things like dat."

So I went to study with Eulalia, who specialized in Man-and-woman cases. Everyday somebody came to get Eulalia to tie them up with some man or woman or to loose them from love.

Eulalia was average sized with very dark skin and bushy eyebrows. Her house was squatting among the palmettoes and

[2]A root, extensively used in conjure.

the mossy scrub oaks. Nothing pretty in the house nor outside. No paint and no flowers. So one day a woman came to get tied to a man.

"Who is dis man?" Eulalia wanted to know.

"Jerry Moore," the woman told her. "He want me and Ah know it, but dat 'oman he got she got roots buried and he can't git shet of her—do we would of done been married."

Eulalia sat still and thought awhile. Then she said: "Course Ah'm uh Christian woman and don't believe in partin' no husband and wife but since she done worked roots on him, to hold him where he don't want to be, it tain't no sin for me to loose him. Where they live at?"

"Down Young's Quarters. De third house from dis end."

"Do she ever go off from home and stays a good while durin' de time he ain't there neither?"

"Yas Ma'am! She all de time way from dat house—off fan-footin' whilst he workin' lak a dog! It's a shame!"

"Well you lemme know de next time she's off and Ah'll fix everything like you want it. Put that money back in yo' purse, Ah don't want a thing till de work is done."

Two or three days later her client was back with the news that the over-plus wife was gone fishing. Eulalia sent her away and put on her shoes.

"Git dat salt-bowl and a lemon," she said to me. "Now write Jerry's name and his wife's nine times on a piece of paper and cut a little hole in the stem end of that lemon and pour some of that gun-powder in de hole and roll that paper tight and shove it inside the lemon. Wrap de lemon and de bowl of salt up and less go."

In Jerry Moore's yard, Eulalia looked all around and looked up at the sun a great deal, then pointed out a spot.

"Dig a little hole right here and bury dat lemon. It's got to be buried with the bloom-end down and it's got to be where de settin' sun will shine on it."

So I buried the lemon and Eulalia walked around to the kitchen door. By the time I had the lemon buried the door was

open and we went inside. She looked all about and found some red pepper.

"Lift dat stove-lid for me," she ordered, and I did. She threw some of the pepper into the stove and we went on into the other room which was the bedroom and living-room all in one. Then Eulalia took the bowl and went from corner to corner "salting" the room. She'd toss a sprinkling into a corner and say, "Just fuss and fuss till you part and go away." Under the bed was sprinkled also. It was all over in a minute or two. Then we went out and shut the kitchen door and hurried away. And Saturday night Eulalia got her pay and the next day she set the ceremony to bring about the marriage.

TWO

Now I was in New Orleans and I asked. They told me Algiers, the part of New Orleans that is across the river to the west. I went there and lived for four months and asked. I found women reading cards and doing mail order business in names and insinuations of well known factors in conjure. Nothing worth putting on paper. But they all claimed some knowledge and link with Marie Leveau. From so much of hearing the name I asked everywhere for this Leveau and everybody told me differently. But from what they said I was eager to know to the end of the talk. It carried me back across the river into the Vieux Carré. All agreed that she had lived and died in the French quarter of New Orleans. So I went there to ask.

I found an oil painting of the queen of conjure on the walls of the Cabildo, and mention of her in the guide books of New Orleans, but I did a lot of stumbling and asking before I heard of Luke Turner, himself a hoodoo doctor, who says that he is her nephew.

When I found out about Turner, I had already studied under five two-headed doctors and had gone thru an initiation ceremony with each. So I asked Turner to take me as a pupil. He was very cold. In fact he showed no eagerness even to talk with me. He feels sure of his powers and seeks no one. He

refused to take me as a pupil and in addition to his habitual indifference I could see he had no faith in my sincerity. I could see him searching my face for whatever was behind what I said. The City of New Orleans has a law against fortune tellers, hoodoo doctors and the like, and Turner did not know me. He asked me to excuse him as he was waiting upon someone in the inner room. I let him go but I sat right there and waited. When he returned, he tried to shoo me away by being rude. I stayed on. Finally he named an impossible price for tuition. I stayed and dickered. He all but threw me out, but I stayed and urged him.

I made three more trips before he would talk to me in any way that I could feel encouraged. He talked about Marie Leveau because I asked. I wanted to know if she was really as great as they told me. So he enlightened my ignorance and taught me. We sat before the soft coal fire in his grate.

"Time went around pointing out what God had already made. Moses had seen the Burning Bush. Solomon by magic knowed all wisdom. And Marie Leveau was a woman in New Orleans.

"She was born February 2, 1827. Anybody don't believe I tell the truth can go look at the book in St. Louis Cathedral. Her mama and her papa, they wasn't married and his name was Christophe Glapion.

"She was very pretty, one of the Creole Quadroons and many people said she would never be a hoodoo doctor like her mama and her grandma before her. She liked to go to the balls very much where all the young men fell in love with her. But Alexander, the great two-headed doctor felt the power in her and so he tell her she must come to study with him. Marie, she rather dance and make love, but one day a rattlesnake come to her in her bedroom and spoke to her. So she went to Alexander and studied. But soon she could teach her teacher and the snake stayed with her always.

"She has her house on St. Anne Street and people come from the ends of America to get help from her. Even Queen

Victoria ask her help and send her a cashmere shawl with money also.

"Now, some white people say she hold hoodoo dance on Congo Square every week. But Marie Leveau never hold no hoodoo dance. That was a pleasure dance. They beat the drum with the shin bone of a donkey and everybody dance like they do in Hayti. Hoodoo is private. She give the dance the first Friday night in each month and they have crab gumbo and rice to eat and the people dance. The white people come look on, and think they see all, when they only see a dance.

"The police hear so much about Marie Leveau that they come to her house in St. Anne Street to put her in jail. First one come, she stretch out her left hand and he turn round and round and never stop until some one come lead him away. Then two come together—she put them to running and barking like dogs. Four come and she put them to beating each other with night sticks. The whole station force come. They knock at her door. She know who they are before she ever look. She did work at her altar and they all went to sleep on her steps.

"Out on Lake Pontchartrain at Bayou St. John she hold a great feast every year on the Eve of St. John's, June 24th. It is Midsummer Eve, and the Sun give special benefits then and need great honor. The special drum be played then. It is a cowhide stretched over a half-barrel. Beat with a jaw-bone. Some say a man but I think they do not know. I think the jawbone of an ass or a cow. She hold the feast of St. John's partly because she is a Catholic and partly because of hoodoo.

"The ones around her altar fix everything for the feast. Nobody see Marie Leveau for nine days before the feast. But when the great crowd of people at the feast call upon her, she would rise out of the waters of the lake with a great communion candle burning upon her head and another in each one of her hands. She walked upon the waters to the shore. As a little boy I saw her myself. When the feast was over, she went back into the lake, and nobody saw her for nine days again.

"On the feast that I saw her open the waters, she looked

hard at me and nodded her head so that her tignon shook. Then I knew I was called to take up her work. She was very old and I was a lad of seventeen. Soon I went to wait upon her Altar, both on St. Anne Street and her house on Bayou St. John's.

"The rattlesnake that had come to her a little one when she was also young was very huge. He piled great upon his altar and took nothing from the food set before him. One night he sang and Marie Leveau called me from my sleep to look at him and see. 'Look well, Turner,' she told me. 'No one shall hear and see such as this for many centuries.'

"She went to her Great Altar and made great ceremony. The snake finished his song and seemed to sleep. She drove me back to my bed and went again to her Altar.

"The next morning, the great snake was not at his altar. His hide was before the Great Altar stuffed with spices and things of power. Never did I know what become of his flesh. It is said that the snake went off to the woods alone after the death of Marie Leveau, but they don't know. This is his skin that I wear about my shoulders whenever I reach for power.

"Three days Marie, she set at the Altar with the great sun candle burning and shining in her face. She set the water upon the Altar and turned to the window, and looked upon the lake. The sky grew dark. The lightning raced to the seventeen quarters of the heavens and the lake heaved like a mighty herd of cattle rolling in a pasture. The house shook with the earth.

"She told me, 'You are afraid. That is right, you should fear. Go to your own house and build an altar. Power will come.' So I hurried to my mother's house and told them.

"Some who loved her hurried out to Bayou St. John and tried to enter the house but she try hard to send them off. They beat upon the door, but she will not open. The terrible strong wind at last tore the house away and set it in the lake. The thunder and lightning grow greater. Then the loving ones find a boat and went out to where her house floats on one side and break a window to bring her out, but she begs, 'NO! Please, no,' she tell them. 'I want to die here in the lake,' but they

194

would not permit her. She did not wish their destruction, so she let herself be drawn away from her altar in the lake. And the wind, the thunder and lightning, and the water all ceased the moment she set foot on dry land.

"That night she also sing a song and is dead, yes. So I have the snake skin and do works with the power she leave me."

"How did Marie Leveau do her work?" I asked feeling that I had gotten a little closer to him.

"She go to her great Altar and seek until she become the same as the spirit, then she come out into the room where she listens to them that come to ask. When they finish she answer them as a god. If a lady have a bad enemy and come to her she go into her altar room and when she come out and take her seat, the lady will say to her:

" 'Oh, Good Mother. I come to you with my heart bowed down and my shoulders drooping, and my spirits broken; for an enemy has sorely tried me; has caused my loved ones to leave me; has taken from me my worldly goods and my gold; has spoken meanly of me and caused my friends to lose faith in me. On my knees I pray to you, Good Mother, that you will cause confusion to reign in the house of my enemy and that you will take their power from them and cause them to be unsuccessful.'

"Marie Leveau is not a woman when she answer the one who ask. No. She is a god, yes. Whatever she say, it will come so. She say:

" 'Oh, my daughter, I have heard your woes and your pains and tribulations, and in the depth of the wisdom of the gods I will help you find peace and happiness.

" 'It is written that you will take of the Vinagredes Four Volle[1] for him, and you will dip into it a sheet of pure parchment paper, and on this sheet you will write the names of your enemies and send it to the house of your enemies, tightly sealed with the wax of the porcupine plant.

" 'Then when the sun shall have risen and gone down three

[1]Four Thieves Vinegar. For paraphernalia of conjure, see appendix.

195

times, you will take of the water of Mars, called War Water, and in front of the house of your enemy you will sprinkle it. This you will do as you pass by. If it be a woman, you will take the egg of a guinea fowl, and put it into the powder of the fruit of cayenne and the dust of Goofer,[2] and you will set it on the fire in your own house and in clear water from the skies you will boil it until it shall be hard. This you will do so that there shall be no fruit from her womb.

" 'And you shall take of the Damnation Powders, two drachmas, and of the water powders, two drachmas and make a package of it and send it to the home of the one who has spoken badly of you and has treated you mean, so that damnation and trouble shall be on the head of your enemy and not on you.

" 'You will do this so that you will undo your enemies and you will take the power to harm you away from your enemies.

" 'Oh daughter, go you in peace and do the works required of you, so that you will have rest and comfort from your enemies and that they will have not the power to harm you and lower you in the sight of your people and belittle you in the sight of your friends. So be it.' "

By the time that Turner had finished his recitation he wasn't too conscious of me. In fact he gave me the feeling that he was just speaking, but not for my benefit. He was away off somewhere. He made a final dramatic gesture with open hands and hushed for a minute. Then he sank deeper into himself and went on:

"But when she put the last curse on a person, it would be better if that man was dead, yes."

With an impatient gesture he signalled me not to interrupt him.

"She set the altar for the curse with black candles that have been dressed in vinegar. She would write the name of the person to be cursed on the candle with a needle. Then she place fifteen cents in the lap of Death upon the altar to pay the

[2]Dirt taken out of a grave.

spirit to obey her orders. Then she place her hands flat upon the table and say the curse-prayer.

" 'To The Man God: O great One, I have been sorely tried by my enemies and have been blasphemed and lied against. My good thoughts and my honest actions have been turned to bad actions and dishonest ideas. My home has been disrespected, my children have been cursed and ill-treated. My dear ones have been backbitten and their virtue questioned. O Man God, I beg that this that I ask for my enemies shall come to pass:

" 'That the South wind shall scorch their bodies and make them wither and shall not be tempered to them. That the North wind shall freeze their blood and numb their muscles and that it shall not be tempered to them. That the West wind shall blow away their life's breath and will not leave their hair grow, and that their finger nails shall fall off and their bones shall crumble. That the East wind shall make their minds grow dark, their sight shall fail and their seed dry up so that they shall not multiply.

" 'I ask that their fathers and mothers from their furtherest generation will not intercede for them before the great throne, and the wombs of their women shall not bear fruit except for strangers, and that they shall become extinct. I pray that the children who may come shall be weak of mind and paralyzed of limb and that they themselves shall curse them in their turn for ever turning the breath of life into their bodies. I pray that disease and death shall be forever with them and that their worldly goods shall not prosper, and that their crops shall not multiply and that their cows, their sheep, and their hogs and all their living beasts shall die of starvation and thirst. I pray that their house shall be unroofed and that the rain, the thunder and lightning shall find the innermost recesses of their home and that the foundation shall crumble and the floods tear it asunder. I pray that the sun shall not shed its rays on them in benevolence, but instead it shall beat down on them and burn them and destroy them. I pray that the moon shall not give them peace, but instead shall deride them and decry them

and cause their minds to shrivel. I pray that their friends shall betray them and cause them loss of power, of gold and of silver, and that their enemies shall smite them until they beg for mercy which shall not be given them. I pray that their tongues shall forget how to speak in sweet words, and that it shall be paralyzed and that all about them will be desolation, pestilence and death. O Man God, I ask you for all these things because they have dragged me in the dust and destroyed my good name; broken my heart and caused me to curse the day that I was born. So be it.' "

Turner again made that gesture with his hands that meant the end. Then he sat in a dazed silence. My own spirits had been falling all during the terrible curse and he did not have to tell me to be quiet this time. After a long period of waiting I rose to go. "The Spirit say you come back tomorrow," he breathed as I passed his knees. I nodded that I had heard and went out. The next day he began to prepare me for my initiation ceremony, for rest assured that no one may approach the Altar without the crown, and none may wear the crown of power without preparation. *It must be earned.*

And what is this crown of power? Nothing definite in material. Turner crowned me with a consecrated snake skin. I have been crowned in other places with flowers, with ornamental paper, with cloth, with sycamore bark, with egg-shells. It is the meaning, not the material that counts. The crown without the preparation means no more than a college diploma without the four years' work.

This preparation period is akin to that of all mystics. Clean living, even to clean thoughts. A sort of going to the wilderness in the spirit. The details do not matter. My nine days being up, and possessed of the three snake skins and the new underwear required, I entered Turner's house as an inmate to finish the last three days of my novitiate. Turner had become so sure of my fitness as a hoodoo doctor that he would accept no money from me except what was necessary to defray the actual cost of the ceremony.

So I ate my final meal before six o'clock of the evening

before and went to bed for the last time with my right stocking on and my left leg bare.

I entered the old pink stucco house in the Vieux Carré at nine o'clock in the morning with the parcel of needed things. Turner placed the new underwear on the big Altar; prepared the couch with the snake-skin cover upon which I was to lie for three days. With the help of other members of the college of hoodoo doctors called together to initiate me, the snake skins I had brought were made into garments for me to wear. One was coiled into a high headpiece—the crown. One had loops attached to slip on my arms so that it could be worn as a shawl, and the other was made into a girdle for my loins. All places have significance. These garments were placed on the small altar in the corner. The throne of the snake. The Great One[3] was called upon to enter the garments and dwell there.

I was made ready and at three o'clock in the afternoon, naked as I came into the world, I was stretched, face downwards, my navel to the snake skin cover, and began my three day search for the spirit that he might accept me or reject me according to his will. Three days my body must lie silent and fasting while my spirit went wherever spirits must go that seek answers never given to men as men.

I could have no food, but a pitcher of water was placed on a small table at the head of the couch, that my spirit might not waste time in search of water which should be spent in search of the Power-Giver. The spirit must have water, and if none had been provided it would wander in search of it. And evil spirits might attack it as it wandered about dangerous places. If it should be seriously injured, it might never return to me.

For sixty-nine hours I lay there. I had five psychic experiences and awoke at last with no feeling of hunger, only one of exaltation.

I opened my eyes because Turner called me. He stood before the Great Altar dressed ceremoniously. Five others were with him.

[3] The Spirit.

199

"Seeker, come," Turner called.

I made to rise and go to him. Another laid his hand upon me lightly, restraining me from rising.

"How must I come?" he asked in my behalf.

"You must come to the spirit across running water," Turner answered in a sort of chant.

So a tub was placed beside the bed. I was assisted to my feet and led to the tub. Two men poured water into the tub while I stepped into it and out again on the other side.

"She has crossed the dangerous stream in search of the spirit," the one who spoke for me chanted.

"The spirit does not know her name. What is she called?"

"She has no name but what the spirit gives."

"I see her conquering and accomplishing with the lightning and making her road with thunder. She shall be called the Rain-Bringer."

I was stretched again upon the couch. Turner approached me with two brothers, one on either side of him. One held a small paint brush dipped in yellow, the other bore one dipped in red. With ceremony Turner painted the lightning symbol down my back from my right shoulder to my left hip. This was to be my sign forever. The Great One was to speak to me in storms.

I was now dressed in the new underwear and a white veil was placed over my head, covering my face, and I was seated in a chair.

After I was dressed, a pair of eyes was painted on my cheeks as a sign that I could see in more ways than one. The sun was painted on my forehead. Many came into the room and performed ceremonial acts, but none spoke to me. Nor could I speak to them while the veil covered my face. Turner cut the little finger of my right hand and caught the gushing blood in a wine cup. He added wine and mixed it with the blood. Then he and all the other five leaders let blood from themselves also and mixed it with wine in another glass. I was led to drink from the cup containing their mingled bloods, and each of them in turn beginning with Turner drank mine. At high noon

200

I was seated at the splendid altar. It was dressed in the center with a huge communion candle with my name upon it set in sand, five large iced cakes in different colors, a plate of honeyed St. Joseph's bread, a plate of serpent-shaped breads, spinach and egg cakes fried in olive oil, breaded Chinese okra fried in olive oil, roast veal and wine, two huge yellow bouquets, two red bouquets and two white bouquets and thirty-six yellow tapers and a bottle of holy water.

Turner seated me and stood behind me with his ceremonial hat upon his head, and the crown of power in his hand. "Spirit! I ask you to take her. Do you hear me, Spirit? Will you take her? Spirit, I want you to take her, she is worthy!" He held the crown poised above my head for a full minute. A profound silence held the room. Then he lifted the veil from my face and let it fall behind my head and crowned me with power. He lit my candle for me. But from then on I might be a candle-lighter myself. All the candles were reverently lit. We all sat down and ate the feast. First a glass of blessed oil was handed me by Turner. "Drink this without tasting it." I gulped it down and he took the glass from my hand, took a sip of the little that remained. Then he handed it to the brother at his right who did the same, until it went around the table.

"Eat first the spinach cakes," Turner exhorted, and we did. Then the meal began. It was full of joy and laughter, even though we knew that the final ceremony waited only for the good hour of twelve midnight.

About ten o'clock we all piled into an old Studebaker sedan—all but Turner who led us on a truck. Out Road No. 61 we rattled until a certain spot was reached. The truck was unloaded beside the road and sent back to town. It was a little after eleven. The swamp was dismal and damp, but after some stumbly walking we came to a little glade deep in the wood, near the lake. A candle was burning at each of the four corners of the clearing, representing the four corners of the world and the four winds. I could hear the occasional slap-slap of the water. With a whispered chant some twigs were gathered and tied into a broom. Some pine straw was collected. The sheets

of typing paper I had been urged to bring were brought out and nine sheets were blessed and my petition written nine times on each sheet by the light from a shaded lantern. The crate containing the black sheep was opened and the sheep led forward into the center of the circle. He stood there dazedly while the chant of strange syllables rose. I asked Turner the words, but he replied that in good time I would know what to say. It was not to be taught. If nothing came, to be silent. The head and withers of the sheep were stroked as the chanting went on. Turner became more and more voluble. At last he seized the straw and stuffed some into the sheep's nostrils. The animal struggled. A knife flashed and the sheep dropped to its knees, then fell prone with its mouth open in a weak cry. My petition was thrust into its throat that he might cry it to the Great One. The broom was seized and dipped in the blood from the slit throat and the ground swept vigorously—back and forth, back and forth—the length of the dying sheep. It was swept from the four winds toward the center. The sweeping went on as long as the blood gushed. Earth, the mother of the Great One and us all, has been appeased. With a sharp stick Turner traced the outline of the sheep and the digging commenced. The sheep was never touched. The ground was dug from under him so that his body dropped down into the hole. He was covered with nine sheets of paper bearing the petition and the earth heaped upon him. A white candle was set upon the grave and we straggled back to the road and the Studebaker.

I studied under Turner five months and learned all of the Leveau routines; but in this book all of the works of any doctor cannot be given. However, we performed several of Turner's own routines.

Once a woman, an excited, angry woman wanted something done to keep her husband true. So she came and paid Turner gladly for his services.

Turner took a piece of string that had been "treated" at the altar and gave it to the woman.

"Measure the man where I tell you. But he must never know. Measure him in his sleep then fetch back the string to me."

The next day the woman came at ten o'clock instead of nine as Turner had told her, so he made her wait until twelve o'clock, that being a good hour. Twelve is one of the benign hours of the day while ten is a malignant hour. Then Turner took the string and tied nine knots in it and tied it to a larger piece of string which he tied about her waist. She was completely undressed for the ceremony and Turner cut some hair from under her left armpit and some from the right side of the groin and put it together. Then he cut some from the right arm-pit and a tuft from the left groin and it was all placed on the altar, and burned in a votive light with the wish for her husband to love her and forget all others. She went away quite happy. She was so satisfied with the work that she returned with a friend a few days later.

Turner, with his toothless mouth, his Berber-looking face, said to the new caller:

"I can see you got trouble." He shivered. "It is all in the room. I feel the pain of it; Anger, Malice. Tell me who is this man you so fight with?"

"My husband's brother. He hate me and make all the trouble he can," the woman said in a tone so even and dull that it was hard to believe she meant what she said. "He must leave this town or die. Yes, it is much better if he is dead." Then she burst out, "Yeah, he should be dead long time ago. Long before he spy upon me, before he tell lies, lies, lies. I should be very happy for his funeral."

"Oh I can feel the great hate around you," Turner said. "It follow you everywhere, but I kill nobody, I send him away if you want so he never come back. I put guards along the road in the spirit world, and these he cannot pass, no. When he go, never will he come back to New Orleans. You see him no more. He will be forgotten and all his works."

"Then I am satisfied, yes," the woman said. "When will you send him off?"

"I ask the spirit, you will know."

She paid him and he sent her off and Turner went to his snake altar and sat in silence for a long time. When he arose, he sent me out to buy nine black chickens, and some Four Thieves Vinegar.[4] He himself went out and got nine small sticks upon which he had me write the troublesome brother-in-law's name—one time on each stick. At ten that night we went out into the small interior court so prevalent in New Orleans and drove nine stakes into the ground. The left leg of a chicken was tied to each stake. Then a fire was built with the nine sticks on which the name had been written. The ground was sprinkled all over with the Four Thieves Vinegar and Turner began his dance. From the fire to the circle of fluttering chickens and back again to the fire. The feathers were picked from the heads of the chickens in the frenzy of the dance and scattered to the four winds. He called the victim's name each time as he whirled three times with the chicken's head-feathers in his hand, then he flung them far.

The terrified chickens flopped and fluttered frantically in the dim firelight. I had been told to keep up the chant of the victim's name in rhythm and to beat the ground with a stick. This I did with fervor and Turner danced on. One by one the chickens were seized and killed by having their heads pulled off. But Turner was in such a condition with his whirling and dancing that he seemed in a hypnotic state. When the last fowl was dead, Turner drank a great draught of wine and sank before the altar. When he arose, we gathered some ashes from the fire and sprinkled the bodies of the dead chickens and I was told to get out the car. We drove out one of the main highways for a mile and threw one of the chickens away. Then another mile and another chicken until the nine dead chickens had been disposed of. The spirits of the dead chickens had been instructed never to let the trouble-maker pass inward to New Orleans again after he had passed them going out.

[4] A conjure mixture. See Paraphernalia of Conjure.

* * *

One day Turner told me that he had taught me all that he could and he was quite satisfied with me. He wanted me to stay and work with him as a partner. He said that soon I would be in possession of the entire business, for the spirit had spoken to him and told him that I was the last doctor that he would make; that one year and seventy-nine days from then he would die. He wanted me to stay with him to the end. It has been a great sorrow to me that I could not say yes.

THREE

Anatol Pierre, of New Orleans, was a middle-aged octoroon. He is a Catholic and lays some feeble claim to kinship with Marie Leveau.

He had the most elaborate temple of any of the practitioners. His altar room was off by itself and absolutely sacrosanct.

He made little difficulty about taking me after I showed him that I had worked with others.

Pierre was very emotional and sometimes he would be sharp with his clients, indifferent as to whether they hired him or not. But he quickly adjusted himself to my being around him and at the end of the first week began to prepare me for the crown.

The ceremony was as follows:

On Saturday I was told to have the materials for my initiation bath ready for the following Tuesday at eleven o'clock. I must have a bottle of lavender toilet water, Jap honeysuckle perfume, and orange blossom water. I must get a full bunch of parsley and brew a pint of strong parsley water. I must have at hand sugar, salt and Vacher Balm. Two long pink candles must be provided, one to be burned at the initiation, one to be lit on the altar for me in Pierre's secret room.

He came to my house in Belville Court at a quarter to eleven to see if all was right. The tub was half-filled with warm

water and Pierre put in all of the ingredients, along with a handful of salt and three tablespoons of sugar.

The candles had been dressed on Saturday and one was already burning on the secret altar for me. The other long pink candle was rolled around the tub three times, "In nomina patria, et filia, et spiritu sanctus, Amen." Then it was marked for a four day burning and lit. The spirit was called three times. "Kind spirit, whose name is Moccasin, answer me." This I was told to repeat three times, snapping my fingers.

Then I, already prepared, stepped into the tub and was bathed by the teacher. Particular attention was paid to my head and back and chest since there the "controls" lie. While in the tub, my left little finger was cut a little and his finger was cut and the blood bond made. "Now you are of my flesh and of the spirit, and neither one of us will ever deny you."

He dried me and I put on new underwear bought for the occasion and dressed with oil of geranium, and was told to stretch upon the couch and read the third chapter of Job night and morning for nine days. I was given a little Bible that had been "visited" by the spirit and told the names of the spirits to call for any kind of work I might want to perform. I am to call on Great Moccasin for all kinds of power and also to have him stir up the particular spirit I may need for a specific task. I must call on Kangaroo to stop worrying; call on Jenipee spirit for marriages; call on Death spirit for killing, and the seventeen "quarters"[1] of spirit to aid me if one spirit seems insufficient.

I was told to burn the marked candle every day for two hours—from eleven till one, in the northeast corner of the room. While it is burning I must go into the silence and talk to the spirit through the candle.

On the fifth day Pierre called again and I resumed my studies, but now as an advanced pupil. In the four months that followed these are some of the things I learned from him:

A man called Muttsy Ivins came running to Pierre soon after

[1] See appendix.

208

my initiation was over. Pierre looked him over with some instinctive antipathy. So he wouldn't help him out by asking questions. He just let Mr. Muttsy tell him the best way he could. So he began by saying, "A lot of hurting things have been done to me, Pierre, and now its done got to de place Ah'm skeered for mah life."

"That's a lie, yes," Pierre snapped.

"Naw it 'tain't!" Muttsy insisted. "Ah done found things 'round mah door step and in mah yard and Ah know who's doin' it too."

"Yes, you find things in your yard because you continue to sleep with the wife of another man and you are afraid because he has said that he will kill you if you don't leave her alone. You are crazy to think that you can lie to me. Tell me the truth and then tell me what you want me to do."

"Ah want him out de way—kilt, cause he swear he's gointer kill me. And since one of us got to die, Ah'd ruther it to be him than me."

"I knew you wanted a death the minute you got in here. I don't like to work for death."

"Please, Pierre, Ah'm skeered to walk de streets after dark, and me and de woman done gone too far to turn back. And he got de consumption nohow. But Ah don't wanter die before he do. Ah'm a well man."

"That's enough about that. How much money have you got?"

"Two hundred dollars."

"Two fifty is my terms, and I ain't a bit anxious for the job at that."

Pierre turned to me and began to give me a list of things to get for my own use and seemed to forget the man behind him.

"Maybe Ah kin git dat other fifty dollars and maybe not. These ain't no easy times. Money is tight."

"Well, goodbye, we're busy folks here. You don't have to do this thing anyway. You can leave town."

"And leave mah good trucking business? Dat'll never hap-

pen. Ah kin git yo' money. When yo' goin' ter do de work?''

"You pay the money and go home. It is not for you to know how and when the work is done. Go home with faith.''

The next morning soon, Pierre sent me out to get a beef brain, a beef tongue, a beef heart and a live black chicken. When I returned he had prepared a jar of bad vinegar. He wrote Muttsy's enemy's name nine times on a slip of paper. He split open the heart, placed the paper in it, pinned up the opening with eighteen steel needles, and dropped it into the jar of vinegar, point downward.

The main altar was draped in black and the crudely carved figure of Death was placed upon it to shield us from the power of death.

Black candles were lit on the altar. A black crown was made and placed on the head of Death. The name of the man to die was written on paper nine times and placed on the altar one degree below Death, and the jar containing the heart was set on this paper. The candles burned for twelve hours.

Then Pierre made a coffin six inches long. I was sent out to buy a small doll. It was dressed in black to represent the man and placed in the coffin with his name under the doll. The coffin was left open upon the altar. Then we went far out to a lonely spot and dug a grave which was much longer and wider than the coffin. A black cat was placed in the grave and the whole covered with a cloth that we fastened down so that the cat could not get out. The black chicken was then taken from its confinement and fed a half glass of whiskey in which a paper had been soaked that bore the name of the man who was to die. The chicken was put in with the cat, and left there for a full month.

The night after the entombment of the cat and the chicken, we began to burn the black candles. Nine candles were set to burn in a barrel and every night at twelve o'clock we would go to the barrel and call upon the spirit of Death to follow the man. The candles were dressed by biting off the bottoms, as Pierre called for vengeance. Then the bottom was lighted instead of the top.

At the end of the month, the coffin containing the doll was carried out to the grave of the cat and chicken and buried upon their remains. A white bouquet was placed at the head and foot of the grave.

The beef brain was placed on a plate with nine hot peppers around it to cause insanity and brain hemorrhages, and placed on the altar. The tongue was slit, the name of the victim inserted, the slit was closed with a pack of pins and buried in the tomb.

"The black candles must burn for ninety days," Pierre told me. "He cannot live. No one can stand that."

Every night for ninety days Pierre slept in his holy place in a black draped coffin. And the man died.

Another conjure doctor solicited trade among Pierre's clients and his boasts of power, and his belittling comments of Pierre's power vexed him. So he said to me one day: "That fellow boasts too much, yes. Maybe if I send him a swelling he won't be out on the banquette bragging so much."

So Pierre took me with him to steal a new brick. We took the brick home and dressed nine black candles by writing the offensive doctor's name on each. His name was written nine times on a piece of paper and placed face down on the brick. It was tied there securely with twine. We put the black candles to burn, one each day for nine days, and then Pierre dug a well to the water table and slipped the brick slowly to the bottom. "Just like the brick soaks up the water, so that man will swell."

FOUR

I heard of Father Watson the "Frizzly Rooster" from afar, from people for whom he had "worked" and their friends, and from people who attended his meetings held twice a week in Myrtle Wreath Hall in New Orleans. His name is "Father" Watson, which in itself attests his Catholic leanings, though he is formally a Protestant.

On a given night I had a front seat in his hall. There were the usual camp-followers sitting upon the platform and bustling around performing chores. Two or three songs and a prayer were the preliminaries.

At last Father Watson appeared in a satin garment of royal purple, belted by a gold cord. He had the figure for wearing that sort of thing and he probably knew it. Between prayers and songs he talked, setting forth his powers. He could curse anybody he wished—and make the curse stick. He could remove curses, no matter who had laid them on whom. Hence his title The Frizzly Rooster. Many persons keep a frizzled chicken in the yard to locate and scratch up any hoodoo that may be buried for them. These chickens have, no doubt, earned this reputation by their ugly appearance—with all of their feathers set in backwards. He could "read" anybody at sight. He could "read" anyone who remained out of his sight if they but stuck two fingers inside the door. He could "read"

anyone, no matter how far away, if he were given their height and color. He begged to be challenged.

He predicted the hour and the minute, nineteen years hence, when he should die—without even having been ill a moment in his whole life. God had told him.

He sold some small packets of love powders before whose powers all opposition must break down. He announced some new keys that were guaranteed to unlock every door and remove every obstacle in the way of success that the world knew. These keys had been sent to him by God through a small Jew boy. The old keys had been sent through a Jew man. They were powerful as long as they did not touch the floor—but if you ever dropped them, they lost their power. These new keys at five dollars each were not affected by being dropped, and were otherwise much more powerful.

I lingered after the meeting and made an appointment with him for the next day at his home.

Before my first interview with the Frizzly Rooster was fairly begun, I could understand his great following. He had the physique of Paul Robeson with the sex appeal and hypnotic what-ever-you-might-call-it of Rasputin. I could see that women would rise to flee from him but in mid-flight would whirl and end shivering at his feet. It was that way in fact.

His wife Mary knew how slight her hold was and continually planned to leave him.

"Only thing that's holding me here is this." She pointed to a large piece of brain-coral that was forever in a holy spot on the altar. "That's where his power is. If I could get me a piece, I could go start up a business all by myself. If I could only find a piece."

"It's very plentiful down in South Florida," I told her. "But if that piece is so precious, and you're his wife, I'd take it and let *him* get another piece."

214

"Oh my God! Naw! That would be my end. He's too powerful. I'm leaving him," she whispered this stealthily. "You get me a piece of that—you know."

The Frizzly Rooster entered and Mary was a different person at once. But every time that she was alone with me it was "That on the altar, you know. When you back in Florida, get me a piece. I'm leaving this man to his women." Then a quick hush and forced laughter at her husband's approach.

So I became the pupil of Reverend Father Joe Watson, "The Frizzly Rooster" and his wife, Mary, who assisted him in all things. She was "round the altar"; that is while he talked with the clients, and usually decided on whatever "work" was to be done, she "set" the things on the altar and in the jars. There was one jar in the kitchen filled with honey and sugar. All the "sweet" works were set in this jar. That is, the names and the thing desired were written on paper and thrust into this jar to stay. Already four or five hundred slips of paper had accumulated in the jar. There was another jar called the "break up" jar. It held vinegar with some unsweetened coffee added. Papers were left in this one also.

When finally it was agreed that I should come to study with them, I was put to running errands such as "dusting" houses, throwing pecans, rolling apples, as the case might be; but I was not told why the thing was being done. After two weeks of this I was taken off this phase and initiated. This was the first step towards the door of the mysteries.

My initiation consisted of the Pea Vine Candle Drill. I was told to remain five days without sexual intercourse. I must remain indoors all day the day before the initiation and fast. I might wet my throat when necessary, but I was not to swallow water.

When I arrived at the house the next morning a little before nine, as per instructions, six other persons were there,

so that there were nine of us—all in white except Father Watson who was in his purple robe. There was no talking. We went at once to the altar room. The altar was blazing. There were three candles around the vessel of holy water, three around the sacred sand pail, and one large cream candle burning in it. A picture of St. George and a large piece of brain coral were in the center. Father Watson dressed eight long blue candles and one black one, while the rest of us sat in the chairs around the wall. Then he lit the eight blue candles one by one from the altar and set them in the pattern of a moving serpent. Then I was called to the altar and both Father Watson and his wife laid hands on me. The black candle was placed in my hand; I was told to light it from all the other candles. I lit it at number one and pinched out the flame, and re-lit it at number two and so on till it had been lit by the eighth candle. Then I held the candle in my left hand, and by my right was conducted back to the altar by Father Watson. I was led through the maze of candles beginning at number eight. We circled numbers seven, five and three. When we reached the altar he lifted me upon the step. As I stood there, he called aloud, "Spirit! She's standing here without no home and no friends. She wants you to take her in." Then we began at number one and threaded back to number eight, circling three, five and seven. Then back to the altar again. Again he lifted me and placed me upon the step of the altar. Again the spirit was addressed as before. Then he lifted me down by placing his hands in my arm-pits. This time I did not walk at all. I was carried through the maze and I was to knock down each candle as I passed it with my foot. If I missed one, I was not to try again, but to knock it down on my way back to the altar. Arrived there the third time, I was lifted up and told to pinch out my black candle. "Now," Father told me, "you are made Boss of Candles. You have the power to light candles and put out candles, and to work with the spirits anywhere on earth."

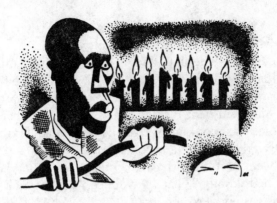

Then all of the candles on the floor were collected and one of them handed to each of the persons present. Father took the black candle himself and we formed a ring. Everybody was given two matches each. The candles were held in our left hands, matches in the right; at a signal everybody stooped at the same moment, the matches scratched in perfect time and our candles lighted in concert. Then Father Watson walked rhythmically around the person at his right. Exchanged candles with her and went back to his place. Then that person did the same to the next so that the black candle went all around the circle and back to Father. I was then seated on a stool before the altar, sprinkled lightly with holy sand and water and confirmed as a Boss of Candles.

Then conversation broke out. We went into the next room and had a breakfast that was mostly fruit and smothered chicken. Afterwards the nine candles used in the ceremony were wrapped up and given to me to keep. They were to be used for lighting other candles only, not to be just burned in the ordinary sense.

In a few days I was allowed to hold consultations on my own. I felt insecure and said so to Father Watson.

"Of course you do now," he answered me, "but you have to learn and grow. I'm right here behind you. Talk to your people first, then come see me."

Within the hour a woman came to me. A man had shot and seriously wounded her husband and was in jail.

"But, honey," she all but wept, "they say ain't a thing going to be done with him. They say he got good white folks back of him and he's going to be let loose soon as the case is tried. I want him punished. Picking a fuss with my husband just to get chance to shoot him. We needs help. Somebody that can hit a straight lick with a crooked stick."

So I went in to the Frizzly Rooster to find out what I must do and he told me, "That a low fence." He meant a difficulty that was easily overcome.

"Go back and get five dollars from her and tell her to go home and rest easy. That man will be punished. When we get through with him, white folks or no white folks, he'll find a tough jury sitting on his case." The woman paid me and left in perfect confidence of Father Watson.

So he and I went into the workroom.

"Now," he said, "when you want a person punished who is already indicted, write his name on a slip of paper and put it in a sugar bowl or some other deep something like that. Now get your paper and pencil and write the name; alright now, you got it in the bowl. Now put in some red pepper, some black pepper—don't be skeered to put it in, it needs a lot. Put in one eightpenny nail, fifteen cents worth of ammonia and two door keys. You drop one key down in the bowl and you leave the other one against the side of the bowl. Now you got your bowl set. Go to your bowl every day at twelve o'clock and turn the key that is standing against the side of the bowl. That is to keep the man locked in jail. And every time you turn the key, add a little vinegar. Now I know this will do the job. All it needs is for you to do it in faith. I'm trusting this job to you entirely. Less see what you going to do. That can wait another minute. Come sit with me in the outside room and hear this woman out here that's waiting."

So we went outside and found a weakish woman in her early thirties that looked like somebody had dropped a sack of something soft on a chair.

The Frizzly Rooster put on his manner, looking like a brown, purple and gold throne-angel in a house.

"Good morning, sister er, er——"

"Murchison," she helped out.

"Tell us how you want to be helped, Sister Murchison."

She looked at me as if I was in the way and he read her eyes.

"She's alright, dear one. She's one of us. I brought her in with me to assist and help."

I thought still I was in her way but she told her business just the same.

"Too many women in my house. My husband's mother is there and she hates me and always puttin' my husband up to fight me. Look like I can't get her out of my house no ways I try. So I done come to you."

"We can fix that up in no time, dear one. Now go take a flat onion. If it was a man, I'd say a sharp pointed onion. Core the onion out, and write her name five times on paper and stuff it into the hole in the onion and close it back with the cut-out piece of onion. Now you watch when she leaves the house and then you roll the onion behind her before anybody else crosses the door-sill. And you make a wish at the same time for her to leave your house. She won't be there two weeks more." The woman paid and left.

That night we held a ceremony in the altar room on the case. We took a red candle and burnt it just enough to consume the tip. Then it was cut into three parts and the short lengths of candle were put into a glass of holy water. Then we took the glass and went at midnight to the door of the woman's house and the Frizzly Rooster held the glass in his hands and said, "In the name of the Father, in the name of the Son, in the name of the Holy Ghost." He shook the glass three times violently up and down, and the last time he threw the glass to the ground and broke it, and said, "Dismiss this woman from this place." We scarcely paused as this was said and done and we kept going and went home by another way because that was part of the ceremony.

Somebody came against a very popular preacher. "He's

getting too rich and big. I want something done to keep him down. They tell me he's 'bout to get to be a bishop. I sho' would hate for that to happen. I got forty dollars in my pocket right now for the work."

So that night the altar blazed with the blue light. We wrote the preacher's name on a slip of paper with black ink. We took a small doll and ripped open its back and put in the paper with the name along with some bitter aloes and cayenne pepper and sewed the rip up again with the black thread. The hands of the doll were tied behind it and a black veil tied over the face and knotted behind it so that the man it represented would be blind and always do the things to keep himself from progressing. The doll was then placed in a kneeling position in a dark corner where it would not be disturbed. He would be frustrated as long as the doll was not disturbed.

When several of my jobs had turned out satisfactorily to Father Watson, he said to me, "You will do well, but you need the Black Cat Bone. Sometimes you have to be able to walk invisible. Some things must be done in deep secret, so you have to walk out of the sight of man."

First I had to get ready even to try this most terrible of experiences—getting the Black Cat Bone.

First we had to wait on the weather. When a big rain started, a new receptacle was set out in the yard. It could not be put out until the rain actually started for fear the sun might shine in it. The water must be brought inside before the weather faired off for the same reason. If lightning shone on it, it was ruined.

We finally got the water for the bath and I had to fast and "seek," shut in a room that had been purged by smoke. Twenty-four hours without food except a special wine that was fed to me every four hours. It did not make me drunk in the accepted sense of the word. I merely seemed to lose my body, my mind seemed very clear.

When dark came, we went out to catch a black cat. I must catch him with my own hands. Finding and catching black cats is hard work, unless one has been released for you to find.

Then we repaired to a prepared place in the woods and a circle drawn and "protected" with nine horseshoes. Then the fire and the pot were made ready. A roomy iron pot with a lid. When the water boiled I was to toss in the terrified, trembling cat.

When he screamed, I was told to curse him. He screamed three times, the last time weak and resigned. The lid was clamped down, the fire kept vigorously alive. At midnight the lid was lifted. Here was the moment! The bones of the cat must be passed through my mouth until one tasted bitter.

Suddenly, the Rooster and Mary rushed in close to the pot and he cried, "Look out! This is liable to kill you. Hold your nerve!" They both looked fearfully around the circle. They communicated some unearthly terror to me. Maybe I went off in a trance. Great beast-like creatures thundered up to the circle from all sides. Indescribable noises, sights, feelings. Death was at hand! Seemed unavoidable! I don't know. Many times I have thought and felt, but I always have to say the same thing. I don't know. I don't know.

Before day I was home, with a small white bone for me to carry.

FIVE

Dr. Duke is a member of a disappearing school of folk
magic. He spends days and nights out in the woods and
swamps and is therefore known as a "swamper." A
swamper is a root-and-conjure doctor who goes to the swamps
and gathers his or her own herbs and roots. Most of the
doctors buy their materials from regular supply houses.

He took me to the woods with him many times in order that
I might learn the herbs by sight and scent. Not only is it
important to be able to identify the plant, but the swamper
must know when and how to gather it. For instance, the most
widely used root known as John de Conqueror must be gath-
ered before September 21st. Wonder of the World Root must
be spoken to with ceremony before it is disturbed, or forces
will be released that will harm whoever handles it. Snakes
guard other herbs and roots and must not be killed.

He is a man past fifty but very active. He believes his power
is unlimited and that nothing can stand against his medicine.

His specialty is law cases. People come to him from a great
distance, and I know that he received a fee of one hundred and
eighty five dollars from James Beasley, who was in the Parish
prison accused of assault with attempt to murder.

For that particular case we went first to the cemetery. With
his right hand he took dirt from the graves of nine children.

I was not permitted to do any of this because I was only a beginner with him and had not the power to approach spirits directly. They might kill me for my audacity.

The dirt was put in a new white bowl and carried back to the altar room and placed among the burning candles, facing the east. Then I was sent for sugar and sulphur. Three teaspoons each of sugar and sulphur were added to the graveyard dirt. Then he prayed over it, while I knelt opposite him. The spirits were asked to come with power more than equal to a man. Afterwards, I was sent out to buy a cheap suit of men's underclothes. This we turned wrong side out and dressed with the prepared graveyard dust. I had been told to buy a new pair of tan socks also, and these were dressed in the same way.

As soon as Dr. Duke had been retained, I had been sent to the prison with a "dressed" Bible and Beasley was instructed to read the Thirty-fifth Psalm every day until his case should be called.

On the day he came up for trial, Dr. Duke took the new underclothes to the jail and put them on his client just before he started to march to the court room. The left sock was put on wrongside out.

Dr. Duke, like all of the conjure masters, has more than one way of doing every job. People are different and what will win with one person has no effect upon another. We had occasion to use all of the other ways of winning law suits in the course of practice.

In one hard case the prisoner had his shoes "dressed with the court." That was to keep the court under his control.

We wrote the judge's name three times, the prisoner's name three times, the district attorney's name three times, and folded the paper small, and the prisoner was told to wear it in his shoe.

Then we got some oil of rose geranium, lavender oil, verbena oil. Put three drops of oil of geranium in one-half ounce Jockey Club. Shook it and gave it to the client. He must use seven to nine drops on his person in court, but we had to dress his clothes, also. We went before court set to dress the court

room and jury box and judge's stand, and have our client take perfume and rub it on his hand and rub from his face down his whole front.

To silence opposing witnesses, we took a beef tongue, nine pins, nine needles, and split the beef tongue. We wrote the names of those against our man and cut the names out and crossed them up in slit of tongue with red pepper and beef gall, and pinned the slit up with crossed needles and pins. We hung the tongue up in a chimney, tip up, and smoked the tongue for thirty-six hours. Then we took it down and put it in ice and lit on it from three to four black candles stuck in ice. Our client read the Twenty-second Psalm and Thirty-fifth also, because it was for murder. Then we asked the spirits for power more than equal to man.

So many people came to Dr. Duke to be uncrossed that he took great pains to teach me that routine. He never let me perform it, but allowed me to watch him do it many times.

Take seven lumps of incense. Take three matches to light the incense. Wave the incense before the candles on the altar. Make client bow over the incense three times. Then circle him with a glass of water three times, and repeat this three times. Fan him with the incense smoke three times— each time he bows his head. Then sprinkle him seven times with water, then lead him to and from the door and turn him around three times over incense that has been placed at the door. Then seat the client and sprinkle every corner of the room with water, three times, and also three times down the middle of the room, then go to another room and do the same. Smoke his underclothes and dress them. Don't turn the client's hand loose as he steps over the incense. Smoke him once at the door and three times at each corner. The room must be thoroughly smoked—even under the furniture—before the client leaves the room. After the evil has been driven out of him, it must also be driven from the room so it cannot return to him.

*　　*　　*

So much has been said and written about hoodoo doctors driving people away from a place that we cannot omit mentioning it. This was also one of Dr. Duke's specialties.

A woman was tired of a no-good husband; she told us about it.

"He won't work and make support for me, and he won't git on out the way and leave somebody else do it. He spend up all my money playing coon-can and kotch and then expect me to buy him a suit of clothes, and then he all the time fighting me about my wages."

"You sure you don't want him no more?" Dr. Duke asked her. "You know women get mad and say things they takes back over night."

"Lawd knows I means this. I don't want to meet him riding nor walking."

So. Dr. Duke told her what to do. She must take the right foot track of her hateful husband and parch it in an old tin frying pan. When she picks it up she must have a dark bottle with her to put the track in. Then she must get a dirt dauber nest, some cayenne pepper and parch that together and add it to the track. Put all of this into a dirty sock and tie it up. She must turn the bundle from her always as she ties it. She must carry it to the river at twelve noon. When she gets within forty feet of the river, she must run fast to the edge of the water, whirl suddenly and hurl the sock over her left shoulder into the water and never look back, and say, "Go, and go quick in the name of the Lord."

So she went off and I never saw her again.

Dr. Samuel Jenkins lives across the river in Marrero, Louisiana. He does some work, but his great specialty is reading the cards. I have seen him glance at people without being asked or without using his cards and making the most startling statements that all turned out to be true.

A young matron went out with me to Dr. Jenkins's one day just for the sake of the ride. He glanced at her and told her that she was deceiving her husband with a very worthless fellow. That she must stop at once or she would be found out. Her husband was most devoted, but once he mistrusted her he would accept no explanations. This was late in October, and her downfall came in December.

Dr. Charles S. Johnson, the well-known Negro sociologist, came to New Orleans on business while I was there and since I had to see Dr. Jenkins, he went with me. Without being asked, Dr. Jenkins told him that he would receive a sudden notice to go on a long trip. The next day, Dr. Johnson received a wire sending him to West Africa.

Once Dr. Jenkins put a light on a wish of mine that a certain influential white woman would help me, and assured me that she would never lose interest in me as long as she lived. The next morning at ten o'clock I received a wire from her stating that she would stand by me as long as she lived. He did this sort of thing day after day, and the faith in him is huge. Let me state here that most of his clients are white and upper-class people at that.

In appearance he is a handsome robust dark-skinned man around forty.

There are many superstitions concerning the dead.

All over the South and in the Bahamas the spirits of the dead have great power which is used chiefly to harm. It will be noted how frequently graveyard dust is required in the practice of hoodoo, goofer dust as it is often called.

It is to be noted that in nearly all of the killing ceremonies the cemetery is used.

The Ewe-speaking peoples[1] of the west coast of Africa all make offerings of food and drink—particularly libations of palm wine and banana beer upon the graves of the ancestor.

[1] A West African nation from which many slaves came to America.

It is to be noted in America that the spirit is always given a pint of good whiskey. He is frequently also paid for his labor in cash.

It is well known that church members are buried with their feet to the east so that they will arise on that last day facing the rising sun. Sinners are buried facing the opposite direction. The theory is that sunlight will do them harm rather than good, as they will no doubt wish to hide their faces from an angry God.

Ghosts cannot cross water—so that if a hoodoo doctor wishes to sic a dead spirit upon a man who lives across water, he must first hold the mirror ceremony to fetch the victim from across the water.

People who die from the sick bed may walk any night, but Friday night is the night of the people who died in the dark— who were executed. These people have never been in the light. They died with the black cap over the face. Thus, they are blind. On Friday nights they visit the folks who died from sick beds and they lead the blind ones wherever they wish to visit.

Ghosts feel hot and smell faintish. According to testimony all except those who died in the dark may visit their former homes every night at twelve o'clock. But they must be back in the cemetery at two o'clock sharp or they will be shut out by the watchman and must wander about for the rest of the night. That is why the living are frightened by seeing ghosts at times. Some spirit has lingered too long with the living person it still loves and has been shut out from home.

Pop Drummond of Fernandina, Fla., says they are not asleep at all. They "Sings and has church and has a happy time, but some are spiteful and show themselves to scare folks." Their voices are high and thin. Some ghosts grow very fat if they get plenty to eat. They are very fond of honey. Some who have been to the holy place wear seven-starred crowns and are very "suscautious" and sensible.

Dirt from sinners' graves is supposed to be very powerful, but some hoodoo doctors will use only that from the graves

of infants. They say that the sinner's grave is powerful to kill, but his spirit is likely to get unruly and kill others for the pleasure of killing. It is too dangerous to commission.

The spirit newly released from the body is likely to be destructive. This is why a cloth is thrown over the face of a clock in the death chamber and the looking glass is covered over. The clock will never run again, nor will the mirror ever cast any more reflections if they are not covered so that the spirit cannot see them.

When it rains at a funeral it is said that God wishes to wash their tracks off the face of the earth, they were so displeasing to him.

If a murder victim is buried in a sitting position, the murderer will be speedily brought to justice. The victim sitting before the throne is able to demand that justice be done. If he is lying prone he cannot do this.

A fresh egg in the hand of a murder victim will prevent the murderer's going far from the scene. The egg represents life, and so the dead victim is holding the life of the murderer in his hand.

Sometimes the dead are offended by acts of the living and slap the face of the living. When this happens, the head is slapped one-sided and the victim can never straighten his neck. Speak gently to ghosts, and do not abuse the children of the dead.

It is not good to answer the first time that your name is called. It may be a spirit and if you answer it, you will die shortly. They never call more than once at a time, so by waiting you will miss probable death.[2]

[2]See Appendix for superstitions concerning sudden death.

SIX

Before telling of my experiences with Kitty Brown I want to relate the following conjure stories which illustrate the attitude of Negroes of the Deep South toward this subject.

Old Lady Celestine went next door one day and asked her neighbor to lend her a quarter.

"I want it all in nickels, please, yes."

"Ah don't have five nickels, Tante Celestine, but Ah'll send a boy to get them for you," the obliging neighbor told her. So she did and Celestine took the money with a cold smile and went home.

Soon after another neighbor came in and the talk came around to Celestine.

"Celestine is not mad any more about the word we had last week. She was just in to pay me a visit."

"Humph!" snorted the neighbor, "maybe she come in to dust yo' door step. You shouldn't let people in that hate you. They come to do you harm."

"Oh no, she was very nice. She borrowed a quarter from me."

"Did she ask for small change?"

"Yes."

"Then she is still mad and means to harm you. They always

231

try to get small change from the ones they wish to harm. Celestine always trying to hurt somebody."

"You think so? You make me very skeered."

"Go send your son to see what she is doing. Ah'll bet she has a candle on yo' money now."

The boy was sent and came running back in terror. "Oh Mamma, come look at what Tante Celestine is doin'."

The two women crept to the crack in old Celestine's door. There in midsummer was the chimney ablaze with black candles. A cup in front of each candle, holding the money. The old woman was stretched out on her belly with her head in the fire-place twirling a huge sieve with a pair of shears stuck in the mesh, whirling and twirling the sieve and muttering the name of the woman who had loaned her the five nickels.

"She is cutting my heart with the shears!" the woman gasped; "the murderer should die." She burst into the house without ceremony and all the Treme[1] heard about the fight that followed.

Mrs. Grant lived down below Canal Street and was a faithful disciple of Dr. Strong, a popular hoodoo doctor who lived on Urquhart Street near St. Claude.

One hot summer night Mr. Grant couldn't sleep, so he sat on the upper balcony in his underwear chewing tobacco. Mrs. Grant was in bed.

A tall black woman lived two blocks down the street. She and Mrs. Grant had had some words a few days past and the black woman had been to a hoodoo doctor and bought a powder to throw at Mrs. Grant's door. She had waited till the hour of two in the morning to do it. Just as she was "dusting" the door, Mr. Grant on the balcony spit and some of the tobacco juice struck the woman.

She had no business at the Grant house at all, let alone at two o'clock in the morning throwing War Powder against the door. But even so, she stepped back and gave Mr. Grant a piece of her mind that was highly seasoned. It was a splendid

[1]The old French quarter of New Orleans.

232

bit of Creole invective art. He was very apologetic, but Mrs. Grant came to the door to see what was the trouble.

Her enemy had retreated, but as soon as she opened the door she saw the white powder against the door and on the steps. Moreover, there was an egg shell on each step.

Mrs. Grant shrieked in terror and slammed the door shut. She grabbed the chamber pot and ran out of the back door. Next door were three boys. She climbed into their back yard and woke up the family. She must have some urine from the boys. This she carried through the neighbor's front gate to her own door and dashed it over the door and steps. One of the boys was paid to take the egg shells away. She could not enter her front door until the conjure was removed. The neighborhood was aroused—she must have a can of lye. She must have some river water in which to dissolve the lye. All this was dashed against the door and steps.

Early next morning she was at the door of Dr. Strong. He congratulated her on the steps she had already taken, but told her that to be sure she had counteracted all the bad work, she must draw the enemy's "wine." That is, she must injure her enemy enough to draw blood.

So Mrs. Grant hurried home and half-filled three quart bottles with water. She put these in a basket, and the basket on her arm, and set out for the restaurant where the night-sprinkler-of-powders was a cook.

She asked to speak to her, and as soon as she appeared— bam! bam! bam! went the bottles over her head and the "wine" flowed. But she fought back and in the fracas she bit Mrs. Grant's thumb severely, drawing *her* "wine."

This complicated affairs again. Something must be done to neutralize this loss of blood. She hurried home and called one of the boys next door and said: "Son, here's five dollars. Go get me a black chicken—not a white feather on him—and keep the change for your trouble."

The chicken was brought. She seized her husband's razor and split the live bird down the breast and thrust her fist inside. As the hot blood and entrails enveloped her hand, she

went into a sort of frenzy, shouting: "I got her, I got her, I got her now!"

A wealthy planter in Middle Georgia was very arrogant in his demeanor towards his Negro servants. He boasted of being "unreconstructed" and that he didn't allow no niggers to sass him.

A Negro family lived on his place and worked for him. The father, it seems, was the yard man, the mother, the cook. The boys worked in the field and a daughter worked in the house and waited on the table.

There was a huge rib-roast of beef one night for dinner. The white man spoke very sharply for some reason to the girl and she sassed right back. He jumped to his feet and seized the half-eaten roast by the naked ribs and struck her with the vertebrate end. The blow landed squarely on her temple and she dropped dead.

The cook was attracted to the dining-room door by the tumult. The white man resumed his seat and was replenishing his plate. He coolly told the mother of the dead girl to "Call Dave and you all take that sow up off the floor."

Dave came and the parents bore away the body of their daughter, the mother weeping.

Now Dave was known to dabble in hoodoo. The Negroes around both depended upon him and feared him.

He came back to clear away the blood of the murdered girl. He came with a pail and scrubbing brush. But first he sopped his handkerchief in the blood and put it into his pocket. Then he washed up the floor.

That night the Negro family moved away. They knew better than to expect any justice. They knew better than to make too much fuss about what had happened.

But less than two weeks later, the planter looked out of his window one night and thought he saw Dave running across the lawn away from the house. He put up the window and called to demand what he was doing on his place, but the figure disappeared in the trees. He shut the window and went to his wife's room to tell her about it and found her in laughing

hysteria. She laughed for three days despite all that the doctors did to quiet her. On the fourth day she became maniacal and attacked her husband. Shortly it was realized that she was hopelessly insane and she had to be put in an institution. She made no attempt to hurt anyone except her husband. She was gentleness itself with her two children.

The plantation became intolerable to the planter, so he decided to move to more cheerful surroundings with his children. He had some friends in South Carolina, so he withdrew his large account at the bank and transferred it to South Carolina and set up a good home with the help of a housekeeper.

Two years passed and he became more cheerful. Then one night he heard steps outside his window and looked out. He saw a man—a Negro. He was sure it was Old Dave. The man ran away as before. He called and ran from the house in pursuit. He was determined to kill him if he caught him, for he began to fear ambush from the family of the girl he had murdered. He ran back to get his son, his gun and the dogs to trail the Negro.

As he burst into the front door he was knocked down by a blow on the head, but was not unconscious. His twenty year old son was raving and screaming above him with a poker in his hand. He struck blow after blow, his father dodging and covering himself as best he could. The housekeeper rushed up and caught the poker from behind and saved the man on the floor. The boy was led away weeping by the woman, but renewed his attack upon his father later in the night. This kept up for more than a month before the devoted parent would consent to his confinement in an institution for the criminally insane.

This was a crushing blow to the proud and wealthy ex-planter. He once more gathered up his goods and moved away. But a year later the visitation returned. He saw Dave. He was sure of it. This time he locked himself in his room and asked the housekeeper through the door about his daughter. She reported the girl missing. He decided at once that his black enemies had carried off his daughter Abbie. He made

ready to pursue. He unlocked his door and stepped into the hall to put on his overcoat. When he opened the closet his daughter pointed a gun in his face and pulled the trigger. The gun snapped. It happened to be unloaded. She had hidden in the closet to shoot him whenever he emerged from his room. Her disordered brain had overlooked the cartridges.

So he moved to Baltimore—out in a fashionable neighborhood. The nurse who came to look after his deranged daughter had become his mistress. He skulked about, fearful of every Negro man he saw. At no time must any Negro man come upon his premises. He kept guns loaded and handy, but hidden from his giggling, simpering daughter, Abbie, who now and then attacked him with her fists. His love for his children was tremendous. He even contrived to have his son released in his charge. But two weeks later, as he drove the family out, the young man sitting in the rear seat attacked him from behind and would have killed him but for the paramour and a traffic officer.

"When I was a boy[2] about ten years old there was a man named Levi Conway whom I knew well. He operated a ferry and had money and was highly respected by all. He was very careful about what he wore. He was tall and brown and wore a pompadour. He usually wore a broad-brimmed Stetson.

"He began to change. People thought he was going crazy. He owned lots of residential property but he quickly lost everything in some way that nobody seemed to understand. He grew careless in his dress and became positively untidy. He even got to the point where he'd buy ten cents worth of whiskey and drink it right out of the bottle.

"He began to pick up junk—old boilers, stones, wheels, pieces of harness, etc., and drag it around for miles every day. Then he'd bring it home and pile it in his backyard. This kept up for ten years or more.

"Finally he got sick in bed and couldn't get up.

[2]Told by Pierre Landeau of New Orleans.

"Tante Lida kept house for him. She was worried over his sickness, so she decided to get a woman from the Treme to find out what was wrong. The woman came. She was about fifty with a sore on her nose.

"She looked at Levi in the bed. Then she came out to Tante Lida. 'Sure, something has been done. I don't believe I can do anything to save him now, but I can tell you who did the work. You fix a place for me to stay here tonight and in the morning I will tell you.'

"Early next morning she sent for a heart of sheep or beef. She had them get her a package of needles and a new kettle. She lit a wood fire in the yard and filled the kettle one-third full of water and stood over the pot with the heart. She stuck the needles in one by one, muttering and murmuring as she stuck them in. When the water was boiling hard she dropped the heart in. It was about eleven o'clock in the morning.

" 'Now we shall know who has done this thing to Levi. In a few minutes the one who did it will come and ask for two things. Don't let him have either.'

"In a few minutes in came Pere Voltaire, a man whom all of us knew. He asked how Levi was. They told him pretty bad! He asked would they let him have two eggs and they said they had none. Then he asked would they lend him the wheelbarrow, and they said it wasn't there. The old woman winked and said, 'That is he.'

"He went on off. Then she told them to look into the pot, and they did. The heart was gone.

"A week later Levi died.

"This is the funny part. Some time after that my older brother, my cousin and I rowed over to the west bank of the river. Just knocking about as boys will, we found an old leaky boat turned upside down on the bank just out of reach of the water. I wondered who owned the piece of trash. My brother told me it belonged to Pere Voltaire. I said: 'Why doesn't he get a decent boat? This is too rotten to float.'

"I turned it over and found a great deal of junk under it—bundles tied up in rags, old bottles and cans and the like.

237

So I started to throwing the stuff into the water and my cousin helped me. We pushed the boat in, too. My brother tried to stop us.

"I forget now how it was that Pere Voltaire knew we did that. But two days later I began to shake as if I had an ague. Nothing the doctors could do stopped me. Two days later my cousin began to shake and two days after that my brother started to shake. It was three or four months before we could be stopped. But my brother stopped first. Then my cousin, then at last I stopped."

SEVEN

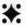

Kitty Brown is a well-known hoodoo doctor of New Orleans, and a Catholic. She liked to make marriages and put lovers together. She is squat, black and benign. Often when we had leisure, she told funny stories. Her herb garden was pretty full and we often supplied other doctors with plants. Very few raise things since the supply houses carry about everything that is needed. But sometimes a thing is wanted fresh from the ground. That's where Kitty's garden came in.

When the matter of my initiation came up she said, "In order for you to reach the spirit somebody has got to suffer. I'll suffer for you because I'm strong. It might be the death of you."

It was in October 1928, when I was a pupil of hers, that I shared in a hoodoo dance. This was not a pleasure dance, but ceremonial. In another generation African dances were held in Congo Square, now Beauregard Square. Those were held for social purposes and were of the same type as the fire dances and jumping dances of the present in the Bahamas. But the hoodoo dance is done for a specific purpose. It is always a case of death-to-the-enemy that calls forth a dance. They are very rare even in New Orleans now, even within the most inner circle, and no layman ever participates, nor has ever been

239

allowed to witness such a ceremony.

This is how the dance came to be held. I sat with my teacher in her front room as the various cases were disposed of. It was my business to assist wherever possible, such as running errands for materials or verifying addresses, locating materials in the various drawers and cabinets, undressing and handling patients, writing out formulas as they were dictated, and finally making "hands."[1] At last, of course, I could do all of the work while she looked on and made corrections where necessary.

This particular day, a little before noon, came Rachael Roe. She was dry with anger, hate, outraged confidence and desire for revenge. John Doe had made violent love to her; had lain in her bed and bosom for the last three years; had received of Rachael everything material and emotional a woman can give. They had both worked and saved and had contributed to a joint savings account. Now, only the day before yesterday, he had married another. He had lured a young and pretty girl to his bed with Rachael's earnings; yes. Had set up housekeeping with Rachael's sweat and blood. She had gone to him and he had laughed at his former sweetheart, yes. The police could do nothing, no. The bank was sorry, but they could do nothing, no. So Rachael had come to Kitty.

Did she still love her John Doe? Perhaps; she didn't know. If he would return to her she should strive to forget, but she was certain he'd not return. How could he? But if he were dead she could smile again, yes—could go back to her work and save some more money, yes. Perhaps she might even meet a man who could restore her confidence in menfolk.

Kitty appraised her quickly. "A dance could be held for him that would carry him away right now, but they cost something."

"How much?"

"A whole lot. How much kin you bring me?"

"I got thirty-seven dollars."

"Dat ain't enough. Got to pay de dancers and set de table."

[1] Manufacturing certain luck charms.

One hundred dollars was agreed upon. It was paid by seven o'clock that same night. We were kept very busy, for the dance was set from ten to one the next day, those being bad hours. I ran to certain addresses to assemble a sort of college of bishops to be present and participate. The table was set with cake, wine, roast duck and barbecued goat.

By nine-thirty the next morning the other five participants were there and had dressed for the dance. A dispute arose about me. Some felt I had not gone far enough to dance. I could wait upon the altar, but not take the floor. Finally I was allowed to dance, as a delegate for my master who had a troublesome case of neuritis. The food was being finished off in the kitchen.

Promptly on the stroke of ten Death mounted his black draped throne and assumed his regal crown, Death being represented by a rudely carved wooden statue, bust length. A box was draped in black sateen and Kitty placed him upon it and set his red crown on. She hobbled back to her seat. I had the petition and the name of the man written on seven slips of paper—one for each participant. I was told to stick them in Death's grinning mouth. I did so, so that the end of each slip protruded. At the command I up-ended nine black tapers that had been dressed by a bath in whiskey and bad vinegar, and bit off the butt end to light, calling upon Death to take notice. As I had been instructed, I said: "Spirit of Death, take notice I am fixing your candles for you. I want you to hear me." I said this three times and the assembly gave three snaps with the thumb and middle finger.

The candles were set upside down and lighted on the altar, three to the left of Death, three to the right, and three before him.

I resumed my seat, and everyone was silent until Kitty was possessed. The exaltation caught like fire. Then B. arose drunkenly and danced a few steps. The clapping began lightly. He circled the room, then prostrated himself before the altar, and, getting to his hands and knees, with his teeth pulled one of the slips from the jaws of Death. He turned a violent

somersault and began the dance, not intricate, but violent and muscle-twitching.

We were to dance three hours, and the time was divided equally, so that the more participants the less time each was called upon to dance. There were six of us, since Kitty could not actively participate, so that we each had forty minutes to dance. Plenty of liquor was provided so that when one appeared exhausted the bottle was pressed to his lips and he danced on. But the fury of the rhythm more than the stimulant kept the dancers going. The heel-patting was a perfect drum rhythm, and the hand clapping had various stimulating breaks. At any rate no one fell from exhaustion, though I know that even I, the youngest, could not have danced continuously on an ordinary dance floor unsupported by a partner for that length of time.

Nearly all ended on the moment in a twitchy collapse, and the next most inspired prostrated himself and began his dance with the characteristic somersault. Death was being continuously besought to follow the footsteps of John Doe. There was no regular formula. They all "talked to him" in their own way, the others calling out to the dancer to "talk to him." Some of the postures were obscene in the extreme. Some were grotesque, limping steps of old men and women. Some were mere agile leapings. But the faces! That is where the dedication lay.

When the fourth dancer had finished and lay upon the floor retching in every muscle, Kitty was taken. The call had come for her. I could not get upon the floor quickly enough for the others and was hurled before the altar. It got me there and I danced, I don't know how, but at any rate, when we sat about the table later, all agreed that Mother Kitty had done well to take me.

I have neglected to say that one or two of the dancers remained upon the floor "in the spirit" after their dance and had to be lifted up and revived at the end.

Death had some of all the food placed before him. An uncorked pint of good whiskey was right under his nose. He was paid fifteen cents and remained on his throne until one

o'clock that night. Then all of the food before him was taken up with the tablecloth on which it rested and was thrown into the Mississippi River.

The person danced upon is not supposed to live more than nine days after the dance. I was very eager to see what would happen in this case. But five days after the dance John Doe deserted his bride for the comforting arms of Rachael and she hurried to Mother Kitty to have the spell removed. She said he complained of breast pains and she was fearfully afraid for him. So I was sent to get the beef heart out of the cemetery (which had been put there as of the routine), and John and Rachael made use of the new furniture bought for his bride. I think he feared that Rachael might have him fixed, so he probably fled to her as soon as the zest for a new wife had abated.

Kitty began by teaching me various ways of bringing back a man or woman who had left his or her mate. She had plenty to work on, too. In love cases the client is often told what to do at home. Minnie Foster was the best customer Kitty had. She wanted something for every little failing in her lover. Kitty said to her one day, "You must be skeered of yourself with that man of yours."

"No, Ma'am, I ain't. But I love him and I just want to make sure. Just you give me something to make his love more stronger."

"Alright, Minnie, I'll do it, but you ain't got no reason to be so unsettled with me behind you. Do like I say and you'll be alright.

"Use six red candles. Stick sixty pins in each candle—thirty on each side. Write the name of your sweetheart three times on a small square of paper and stick it underneath the candle. Burn one of these prepared candles each night for six nights. Make six slips of paper and write the name of the loved one once on each slip. Then put a pin in the paper on all four sides of the name. Each morning take up the sixty pins left from the burning of the candles, and save them. Then smoke the slip of paper with the four pins in it in incense smoke and bury it

with the pins under your door step. The piece of paper with the name written on it three times, upon which each candle stands while burning, must be kept each day until the last candle is burned. Then bury it in the same hole with the rest. When you are sticking the pins in the candles, keep repeating: 'Tumba Walla, Bumba Walla, bring Gabe Staggers back to me.' "

Minnie paid her five dollars, thanked her loudly and hurried off to tighten the love-shackles on her Gabriel. But the following week she was back again.

"Ain't you got dat man to you wishes, yet, Minnie?" Kitty asked, half in fun and half in impatience.

"He love me, I b'lieve, but he gone off to Mobile with a construction gang and I got skeered he might not come back. Something might delay him on his trip."

"Oh, alright Minnie, go do like I say and he'll sure be back. Write the name of the absent party six times on paper. Put the paper in a water glass with two tablespoons full of quicksilver on it. Write his or her name three times each on six candles and burn one on a window sill in the daytime for six days."

Minnie paid and went home, but a week later she was back, washed down in tears. So Kitty gave her a stronger help.

"This is bound to bring him. Can't help it, Minnie. Now go home and stop fretting and do this:

"Write his name three times. Dig a hole in the ground. Get a left-foot soiled-sock from him secretly. His hatband may be used also. Put the paper with the name in the hole first. Then the sock or hatband. Then light a red candle on top of it all and burn it. Put a spray of Sweet Basil in a glass of water beside the candle. Light the candle at noon and burn until one. Light it again at six P.M. and burn till seven. (Always pinch out a candle—never blow it.) After the candle is lit, turn a barrel over the hole. When you get it in place, knock on it three times to call the spirit and say: 'Tumba Walla, Bumba Walla, bring Gabriel Staggers home to me.' "

We saw nothing of Minnie for six weeks, then she came in another storm of tears.

"Miss Kitty, Gabriel done got to de place I can't tell him his eye is black. What can I do to rule de man I love?"

"Do like I say, honey, and you can rule. Get his sock. Take one silver dime, some hair from his head or his hatband. Lay the sock out on a table, bottom up. Write his name three times and put it on the sock. Place the dime on the name and the hair or hatband on the dime. Put a piece of 'he' Lodestone[2] on top of the hair and sprinkle it with steel dust. As you do this, say, 'Feed the he, feed the she.' That is what you call feeding the Lodestone. Then fold the sock heel on the toe and roll it all up together, tight. Pin the bundle by crossing two needles. Then wet it with whiskey and set it up over a door. And don't 'low him to go off no more, do you going to lose all control.

"Now listen, honey, this is the way to change a man's mind about going away: Take the left shoe, set it up straight, then roll it one-half over first to the right, then to the left. Roll it to a coming-in door and point it straight in the door, and he can't leave. Hatband or sock can be made into a ball and rolled the same way: but it must be put under the sill or over the door."

Once Sis Cat got hongry and caught herself a rat and set herself down to eat 'im. Rat tried and tried to git loose but Sis Cat was too fast and strong. So jus' as de cat started to eat 'im he says, "Hol' on dere, Sis Cat! Ain't you got no manners atall? You going set up to de table and eat 'thout washing yo' face and hands?"

Sis Cat was mighty hongry but she hate for de rat to think she ain't got no manners, so she went to de water and washed her face and hands and when she got back de rat was gone.

So de cat caught herself a rat again and set down to eat. So de Rat said, "Where's yo' manners at, Sis Cat? You going to eat 'thout washing yo' face and hands?"

"Oh, Ah got plenty manners," de cat told 'im. "But Ah eats

[2]Magnetic iron ore.

245

mah dinner and washes mah face and uses mah manners afterwards.'' So she et right on 'im and washed her face and hands. And cat's been washin' after eatin' ever since.

I'm sitting here like Sis Cat, washing my face and usin' my manners.

GLOSSARY

Jack or John (not John Henry) is the great human culture hero in Negro folklore. He is like Daniel in Jewish folklore, the wish-fulfillment hero of the race. The one who, nevertheless, or in spite of laughter, usually defeats Ole Massa, God and the Devil. Even when Massa seems to have him in a hopeless dilemma he wins out by a trick. Brer Rabbit, Jack (or John) and the Devil are continuations of the same thing. p. 9

Woofing is a sort of aimless talking. A man half seriously flirts with a girl, half seriously threatens to fight or brags of his prowess in love, battle or in financial matters. The term comes from the purposeless barking of dogs at night. p. 13

Testimony. There is a meeting called a "love-feast" in the Methodist Church and an "experience meeting" with the Baptists. It is held once a month, either on a week-night or a Sunday morning preceding the Communion service. It is a Protestant confessional. No one is supposed to take communion unless he is on good terms with all of the other church members and is free from sin otherwise. The love-feast gives opportunity for public expression of good-will to the world. There are three set forms with variations. (1) The person who expects to testify raises a hymn. After a verse or two he or she speaks expressing (a) love for everybody, (b) joy at being present, (c) tells of the determination to stay in the field to the end. (2) Singing of a "hot" spiritual, giving the right hand of fellowship to

the entire church, a shouting, tearful finish. (3) (a) Expresses joy at being present, (b) recites incident of conversion, telling in detail the visions seen and voices heard, (c) expresses determination to hold out to the end. p. 20

It is singular that God never finds fault, never censures the Negro. He sees faults but expects nothing different. He is lacking in bitterness as is the Negro story-teller himself in circumstances that ordinarily would call for pity. p. 29

The devil is not the terror that he is in European folk-lore. He is a powerful trickster who often competes successfully with God. There is a strong suspicion that the devil is an extension of the story-makers while God is the supposedly impregnable white masters, who are nevertheless defeated by the Negroes. p. 48

John Henry. This is a song of the railroad camps and is suited to the spiking rhythm, though it is, like all the other work songs, sung in the jooks and other social places. It is not a very old song, being younger by far than Casey Jones and like that song being the celebration of an incidence of bravery. John Henry is not as widely distributed as "Mule on de Mount," "Uncle Bud" or several of the older songs, though it has a better air than most of the work songs. *John Henry has no place in Negro folk-lore except in this one circumstance.* The story told in the ballad is of John Henry, who is a great steel-driver, growing jealous when the company installs a steam drill. He boasts that he can beat the steam drill hammering home spikes, and asks his boss for a 9-pound hammer saying that if he has a good hammer he can beat the steam drill driving. The hammer is provided and he attempts to beat the drill. He does so for nearly an hour, then his heart fails him and he drops dead from exhaustion. It is told in direct dialogue for the greater part. The last three verses show internal evidence of being interpolated from English ballads. Judge the comparative newness of the song by the fact that he is competing with something as recent as a steam drill. For music for "John Henry" see Appendix. p. 55

Long House. Another name for jook. Sometimes means a mere bawdy house. A long low building cut into rooms that all open on a common porch. A woman lives in each of the rooms. p. 67

Blue Baby. Nicknames such as this one given from appearances or acts, i.e. "Blue Baby" was so black he looked blue. "Tush Hawg," a rough man; full of fight like a wild boar. p. 68

One notes that among the animals the rabbit is the trickster hero. Lacking in size, strength and natural weapons such as teeth and claws, he continues to overcome by cunning. There are other minor characters that are heroic, but Brer Rabbit is first. In Florida, Brer Gopher, the dry-land tortoise, is also a hero and perhaps nearly equal to the rabbit. p. 109

The colored preacher, in his cooler passages, strives for grammatical correctness, but goes natural when he warms up. The "hah" is a breathing device, done rhythmically to punctuate the lines. The congregation wants to hear the preacher breathing or "straining." p. 139

Georgia Skin Game. Any number of "Pikers" can play at a time, but there are two "principals" who do the dealing. Both of them are not dealing at the same time, however. But when the first one who deals "falls" the other principal takes the deal. If he in turn falls it goes back to the first dealer. The principals draw the first two cards. The pikers draw from the third card on. Unless a player or players want to "scoop one in the rough," he can choose his own card which can be any card in the deck except the card on top of the deck and that one goes to the dealer. The dealer charges anything he pleases for the privilege of "scooping," the money being put in sight. It is the player's bet. After the ones who wish to have scooped, then the dealer begins to "turn" the cards. That is, flipping them off the deck face upwards and the pikers choose a card each from among those turned off to bet on. Sometimes several pikers are on the same card. When all have selected their cards and have their bets down, they begin to chant "Turn 'em" to the dealer. He turns them until a player falls. That is, a card like the one he is holding falls. For instance one holds the 10 of hearts. When another 10 falls he loses. Then the players cry "hold 'em" until the player selects another clean card, one that has not fallen. The fresh side bets are down and the chant "turn 'em" and the singing "Let de deal go Down" until the deck is run out. p. 143

APPENDIX

I

NEGRO SONGS WITH MUSIC

JOHN HENRY

1 John Henry driving on the right hand side,
Steam drill driving on the left,
Says, 'fore I'll let your steam drill beat me down
I'll hammer my fool self to death,
Hammer my fool self to death.

2 John Henry told his Captain,
When you go to town
Please bring me back a nine pound hammer
And I'll drive your steel on down.
And I'll drive your steel on down.

3 John Henry told his Captain,
Man ain't nothing but a man,
And 'fore I'll let that steam drill beat me down
I'll die with this hammer in my hand,
Die with this hammer in my hand.

4 Captain ast John Henry,
What is that storm I hear?
He says Cap'n that ain't no storm,
'Tain't nothing but my hammer in the air,
Nothing but my hammer in the air.

5 John Henry told his Captain,
Bury me under the sills of the floor,
So when they get to playing good old Georgy skin,
Bet 'em fifty to a dollar more,
Fifty to a dollar more.

6 John Henry had a little woman,
The dress she wore was red,
. Says I'm going down the track,
And she never looked back.
I'm going where John Henry fell dead,
Going where John Henry fell dead.

7 Who's going to shoe your pretty li'l' feet?
And who's going to glove your hand?
Who's going to kiss your dimpled cheek?
And who's going to be your man?
Who's going to be your man?

8 My father's going to shoe my pretty li'l' feet;
My brother's going to glove my hand;
My sister's going to kiss my dimpled cheek;
John Henry's going to be my man,
John Henry's going to be my man.

9 Where did you get your pretty li'l' dress?
The shoes you wear so fine?
I got my shoes from a railroad man,
My dress from a man in the mine,
My dress from a man in the mine.

JOHN HENRY

(Work Song Series)

From the Zora Neale Hurston
Collection of Negro Folklore

Arranged by C. Spencer Tocus

1. John Hen-ry driv-ing on the right hand side,

Steam drill driv-ing on the left, Says, 'fore I'll let your steam drill

beat me down I'll ham-mer my fool self to

death, Ham-mer my fool self to death.

Hm Hm hah!

254

Hm......................... Hm.. 2. John Hm.... Hah
3. The
4. John

EAST COAST BLUES

1 Don't you hear that East Coast when she blows,
 Oh, don't you hear that East Coast when she blows,
 Ah, don't you hear that East Coast when she blows.

2 I'm going down that long lonesome road,
 Oh, I'm going down that long lonesome road,
 Ah, I'm going down that long lonesome road.

3 I'm going where the chilly winds don't blow,
 Oh, I'm going where the chilly winds don't blow,
 Ah, I'm going where the chilly winds don't blow.

4 You treat me mean you sho going see it again,
 Oh, you treat me mean you sho going see it again,
 Ah, you treat me mean you sho going see it again.

5 I love you honey but your woman got me barred,
 Oh, I love you honey but your woman got me barred,
 Ah, I love you honey but your woman got me barred.

6 Love ain't nothing but the easy going heart disease,
 Oh, love ain't nothing but the easy going heart disease,
 Ah, love ain't nothing but the easy going heart disease.

EAST COAST BLUES

(Social Song Series)

From the Zora Neale Hurston Collection of Negro Folklore

PLEASE DON'T DRIVE ME

(Convict Song)

From the Zora Neale Hurston
Collection of Negro Folklore

Arranged by Porter Grainger

Please don't drive me be - cause I'm blind.

B'lieve I can make it if I take my time.

1 Please don't drive me because I'm blind,
 B'lieve I kin make it if I take my time.

2 Lift up de hammer and let it fall down,
 It's a hard rocky bottom and it must be found.

3 De cap'n say hurry, de boss say run,
 I got a damn good notion not to do nary one.

COLD RAINY DAY

Cold rain-y day. Some old cold rain-y day I'll be back some old cold rain-y day. Old Smok-ey Joe Lawd, he died on the road Say-ing I'll be back some day.

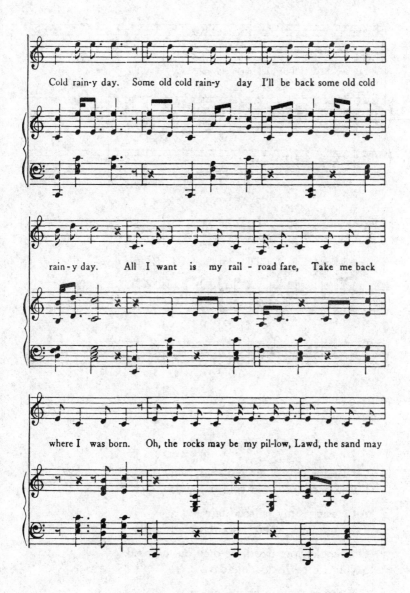

Cold rain-y day. Some old cold rain-y day I'll be back some old cold

rain-y day. All I want is my rail - road fare, Take me back

where I was born. Oh, the rocks may be my pil-low, Lawd, the sand may

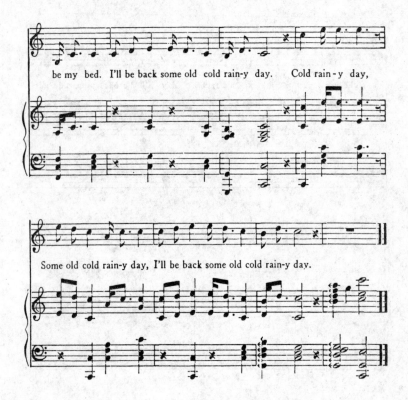

be my bed. I'll be back some old cold rain-y day. Cold rain-y day,

Some old cold rain-y day, I'll be back some old cold rain-y day.

1 Cold rainy day, some old cold, rainy day,
 I'll be back some old cold, rainy day.

2 All I want is my railroad fare,
 Take me back where I was born.

3 Ole Smoky Joe, Lawd, he died on the road
 Saying I'll be back some day.

4 Oh, the rocks may be my pillow
 Lawd, the sand may be my bed,
 I'll be back some old cold, rainy day.

GOING TO SEE MY LONG-HAIRED BABE

SOLOIST:

Oh Lulu! Oh Gal!
Want to see you, so bad.

CHORUS:

Going to see my long-haired babe;
Going to see my long-haired babe,
Oh Lawd I'm going 'cross the water
See my long-haired babe.

SOLOIST:

What you reckon Mr. Treadwell
Said to Mr. Goff,
Lawd I b'lieve I'll go South,
Pay them poor boys off.

CHORUS:

SOLOIST:

Lawd I ast that woman
Lemme be her kid,
And she looked at me
And began to smile.

CHORUS:

SOLOIST:

Oh Lulu! Oh Gal!

ALL:

Want to see you, so bad.

GOING TO SEE MY LONG-HAIRED BABE

(Spiking Rhythm)

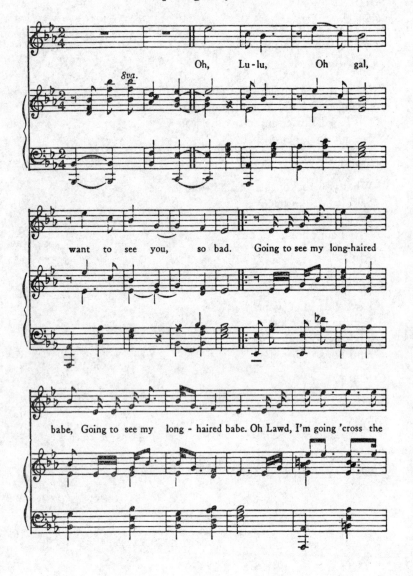

Oh, Lu-lu, Oh gal,

want to see you, so bad. Going to see my long-haired

babe, Going to see my long-haired babe. Oh Lawd, I'm going 'cross the

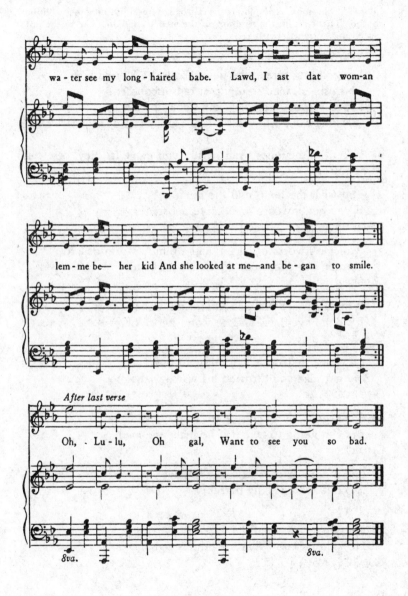

wa-ter see my long-haired babe. Lawd, I ast dat wom-an

lem-me be— her kid And she looked at me—and be-gan to smile.

After last verse

Oh, Lu-lu, Oh gal, Want to see you so bad.

8va. *8va.*

263

CAN'T YOU LINE IT?

NOTE: This song is common to the railroad camps. It is suited to the "lining" rhythm. That is, it fits the straining of the men at the lining bars as the rail is placed in position to be spiked down.

1 When I get in Illinois
I'm going to spread the news about the Florida boys.
Chorus: (All men straining at rail in concert.)
Shove it over! Hey, hey, can't you line it?
(Shaking rail.) Ah, shack-a-lack-a-lack-a-lack-a-lack-a-lack-a-lack.

 (Grunt as they move rail.) Can't you move it? Hey, hey, can't
 you try.

2 Tell what the hobo told the bum,
If you get any corn-bread save me some.
CHORUS:

3 A nickle's worth of bacon, and a dime's worth of lard,
I would buy more but the time's too hard.
CHORUS:

4 Wonder what's the matter with the walking boss,
It's done five-thirty and he won't knock off.
CHORUS:

5 I ast my Cap'n what's the time of day,
He got mad and throwed his watch away.
CHORUS:

6 Cap'n got a pistol and he try to play bad,
But I'm going to take it if he make me mad.
CHORUS:

7 Cap'n got a burner* I'd like to have,
A 32:20 with a shiny barrel.
CHORUS:

8 De Cap'n can't read, de Cap'n can't write,
How do he know that the time is right?
CHORUS:

*Gun.

9 Me and my buddy and two three more,
 Going to ramshack Georgy everywhere we go.
CHORUS:

10 Here come a woman walking 'cross the field,
 Her mouth exhausting like an automobile.

CAN'T YOU LINE IT?

(Work Song Series)

From the Zora Neale Hurston *Arranged by Portia D. Duhart*
Collection of Negro Folklore

265

266

THERE STANDS A BLUE BIRD (CHILDREN)

Another version: Going around de mountain, two by two (actions suit words).

1 There stands a blue-bird, tra, la, la, la.
There stands a blue-bird tra, la, la, la.
Gimme sugar, coffee and tea.

2 Now trip around the ocean, tra, la, la, la.
Now trip around the ocean, tra, la, la, la.
Gimme sugar, coffee and tea (one in ring dances around ring).

3 Show me your motion, tra, la, la, la (does solo dance).
Show me your motion, tra, la, la, la.
Gimme sugar, coffee and tea.

4 Show me a better one, tra, la, la, la (second solo step).
Show me a better one, tra, la, la, la.

5 Choose your partner, tra, la, la, la.
Choose your partner, tra, la, la, la.
Gimme sugar, coffee and tea.

(One in ring chooses partner and the new chosen partner takes his place in the ring and the other comes out.)

THERE STANDS A BLUE BIRD

(Children's Game)

From the Zora Neale Hurston
Collection of Negro Folklore

Arranged by C. Spencer Tocus

tra la la la, Gim-me su-gar cof-fee and tea. Now

skip a-round the o-cean, tra la la la—, Skip a-round the o-cean.

tra la la la—, Gim-me su-gar, cof-fee and tea.

MULE ON DE MOUNT

NOTE: The most widely distributed and best known of all Negro work songs. Since folk songs grow by incremental repetition the diversified subject matter that it accumulates as it ages is one of the evidences of its distribution and usage. This has everything in folk life in it. Several stories to say nothing of just lyric matter. It is something like the Odyssey, or the Iliad.

1 Cap'n got a mule, mule on the Mount called Jerry
 Cap'n got a mule, mule on the Mount called Jerry
 I can ride, Lawd, Lawd, I can ride.
 (He won't come down, Lawd; Lawd, he won't come down, in
 another version.)

2 I don't want no cold corn bread and molasses,
 I don't want no cold corn bread and molasses,
 Gimme beans, Lawd, Lawd, gimme beans.

3 I don't want no coal-black woman for my regular,
 I don't want no coal-black woman for my regular,
 She's too low-down, Lawd, Lawd, she's too low-down.

4 I got a woman, she's got money 'cumulated,
 I got a woman, she's got money 'cumulated,
 In de bank, Lawd, Lawd, in de bank.

5 I got a woman she's pretty but she's too bulldozing,
 I got a woman she's pretty but she's too bulldozing,
 She won't live long, Lawd, Lawd, she won't live long.

6 Every pay day, pay day I gits a letter,
 Every pay day, pay day I gits a letter,
 Son come home, Lawd, Lawd, son come home.

7 If I can just make June, July and August,
 If I can just make June, July and August,
 I'm going home, Lawd, Lawd, I'm going home.

8 Don't you hear them, coo-coo birds keep a'hollering,
 Don't you hear them, coo-coo birds keep a'hollering,
 It's sign of rain, Lawd, Lawd, it's sign of rain.

9 I got a rain-bow wrapped and tied around my shoulder,
 I got a rain-bow wrapped and tied around my shoulder,
 It ain't goin' rain, Lawd, Lawd, it ain't goin' rain.

269

MULE ON DE MOUNT

(Work Song Series)

From the Zora Neale Hurston
Collection of Negro Folklore

Arranged by C. Spencer Tocus

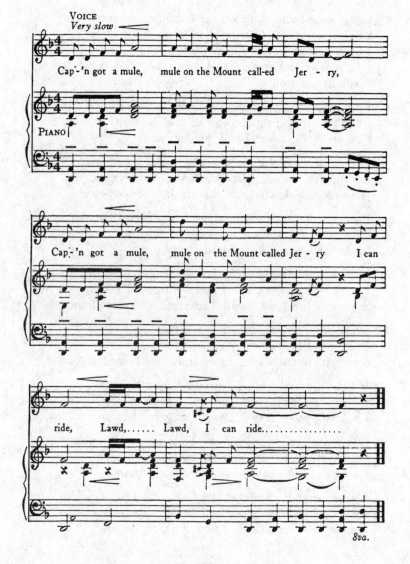

LET THE DEAL GO DOWN

(Gaming song suited to the action of Georgia Skin Game.)

SOLOIST:

1 When your card gits lucky, oh partner,
 You ought to be in a rolling game.

CHORUS:

 Let the deal go down, boys,
 Let the deal go down.

SOLOIST:

2 I ain't had no money, Lawd, partner,
 I ain't had no change.

CHORUS:

SOLOIST:

3 I ain't had no trouble, Lawd, partner,
 Till I stop by here.

CHORUS:

SOLOIST:

4 I'm going back to de 'Bama, Lawd, partner,
 Won't be worried with you.

Slowly

When your card gits luck-y, oh, part-ner,

LET THE DEAL GO DOWN

You ought to be in a roll - ing game.

Let the deal go down, boys, Let the deal go down.

II

FORMULAE OF HOODOO DOCTORS[1]

CONCERNING SUDDEN DEATH

1. Put an egg in a murdered man's hand and the murderer can't get away. He will wander right around the scene.
2. If a murder victim falls on his face, the murderer can't escape punishment. He will usually be executed.
3. If the blood of the victim is put in a jug and buried at the north corner of his house, the murderer will be caught and convicted.
4. Bury the victim with his hat on and the murderer will never get away.
5. If you kill and step backwards over the body, they will never catch you.
6. If you are murdered or commit suicide, you are dead before your times comes. God is not ready for you, and so your soul must prowl about until your time comes.
7. If you suspect that a person has been killed by hoodoo, put a cassava stick in the hand and he will punish the murderer. If he is killed by violence, put the stick in one hand and a knife and fork in the other. The spirit of the murdered one will first drive the slayer insane, and then kill him with great violence.
8. If people die wishing to see someone, they will stay limp and warm for days. They are waiting.
9. If a person dies who has not had his fling in this world, he will turn on his face in the grave.
10. If a person dies without speaking his mind about matters, he will purge (foam at the mouth after death). Hence the expression: "I ain't goin' to purge when I die (I shall speak my mind)."

[1]The formulae, paraphernalia and prescriptions of conjure are reprinted through the courtesy of the *Journal of American Folklore*.

TO RENT A HOUSE

Tie up some rice and sycamore bark in a small piece of goods. Tie six fig leaves and a piece of John de Conquer root in another piece. Cheesecloth is good. Boil both bundles in a quart of water at the same time. Strain it out. Now sprinkle the rice and sycamore bark mixed together in front of the house. Put the fig leaves and John de Conquer root in a corner of the house and scrub the house with the water they were boiled in. Mix it with a pail of scrub water.

FOR BAD WORK—(DEATH)

Take a coconut that has three eyes. Take the name of the person you want to get rid of and write it on the paper like a coffin. (Put the name all over the coffin.) Put this down in the nut. (Pour out water.) Put beef gall and vinegar in the nut and the person's name all around the coconut. Stand nut up in sand and set one black candle on top of it. Number the days from one to fifteen days. Every day mark that coconut at twelve o'clock A.M. or P.M., and by the fifteenth day they will be gone. Never let the candle go out. You must light the new candle and set it on top of the old stub which has burnt down to a wafer.

COURT SCRAPES

a. Take the names of all the *good* witnesses (for your client), the judge and your client's lawyer. Put the names in a dish and pour sweet oil on them and burn a white candle each morning beside it for one hour, from nine to ten. The day of the trial when you put it upon the altar, don't take it down until the trial is over.

b. Take the names of the opponent of your client, his witnesses and his lawyer. Take all of their names on one piece of paper. Put it between two whole bricks. Put the top brick crossways. On the day of the trial set a bucket or dishpan on top of the bricks with ice in it. That's to freeze them out so they can't talk.

c. Take the names of your client's lawyer, witnesses and lawyer on paper. Buy a beef tongue and split it from the base towards the tip, thus separating top from bottom. Put the

paper with names in the split tongue along with eighteen pods of hot pepper and pin it through and through with pins and needles. Put it in a tin pail with plenty of vinegar and keep it on ice until the day of court. That day, pour kerosene in the bucket and burn it, and they will destroy themselves in court.

d. Put the names of the judge and all those *for* your client on paper. Take the names of the twelve apostles after Judas hung himself and write each apostle's name on a sage leaf. Take six candles and burn them standing in holy water. Have your client wear six of the sage leaves in each shoe and the jury will be made for him.

e. Write all the enemies' names on paper. Put them in a can. Then take soot and ashes from the chimney of your client and mix it with salt. Stick pins crosswise in the candles and burn them at a good hour. Put some ice in a bucket and set the can in it. Let your client recite the One Hundred Twentieth Psalm before Court and in Court.

f. To let John the conqueror win your case; take one-half pint whiskey, nine pieces of John the Conqueror Root one inch long. Let it soak thirty-eight hours till all the strength is out. (Gather all roots before September 21.) Shake up good and drain off roots in another bottle. Get one ounce of white rose or Jockey Club perfume and pour into the mixture. Dress your client with this before going to Court.

TO KILL AND HARM

Get bad vinegar, beef gall, filet gumbo with red pepper, and put names written across each other in bottles. Shake the bottle for nine mornings and talk and tell it what you want it to do. To kill the victim, turn it upside down and bury it breast deep, and he will die.

RUNNING FEET

To give anyone the running feet: Take sand out of one of his tracks and mix the sand with red pepper; throw some into a running stream of water and this will cause the person to run from place to place, until finally he runs himself to death.

TO MAKE A MAN COME HOME

Take nine deep red or pink candles. Write his name three times on each candle. Wash the candles with Van-Van. Put the name three times on paper and place under the candles, and call the name of the party three times as the candle is placed at the hours of seven, nine or eleven.

TO MAKE PEOPLE LOVE YOU

Take nine lumps of starch, nine of sugar, nine teaspoons of steel dust. Wet it all with Jockey Club cologne. Take nine pieces of ribbon, blue, red or yellow. Take a dessertspoonful and put it on a piece of ribbon and tie it in a bag. As each fold is gathered together call his name. As you wrap it with yellow thread call his name till you finish. Make nine bags and place them under a rug, behind an armoire, under a step or over a door. They will love you and give you everything they can get. Distance makes no difference. Your mind is talking to his mind and nothing beats that.

TO BREAK UP A LOVE AFFAIR

Take nine needles, break each needle in three pieces. Write each person's name three times on paper. Write one name backwards and one forwards and lay the broken needles on the paper. Take five black candles, four red and three green.

Tie a string across the door from it, suspend a large candle upside down. It will hang low on the door; burn one each day for one hour. If you burn your first in the daytime, keep on in the day; if at night, continue at night. A tin plate with paper and needles in it must be placed to catch wax in.

When the ninth day is finished, go out into the street and get some white or black dog dung. A dog only drops his dung in the street when he is running and barking, and whoever you curse will run and bark likewise. Put it in a bag with the paper and carry it to running water, and one of the parties will leave town.

III

PARAPHERNALIA OF CONJURE

It would be impossible for anyone to find out all the things that are being used in conjure in America. Anything may be conjure and nothing may be conjure, according to the doctor, the time and the use of the article.

What is set down here are the things most commonly used.

1. Fast Luck: Aqueous solution of oil of Citronella. It is put in scrub water to scrub the house. It brings luck in business by pulling customers into a store.
2. Red Fast Luck: Oil of Cinnamon and Oil of Vanilla, with wintergreen. Used as above to bring luck.
3. Essence of Van Van: Ten percent. Oil of Lemon Grass in alcohol. (Different doctors specify either grain, mentholated, or wood alcohol), used for luck and power of all kinds. It is the most popular conjure drug in Louisiana.
4. Fast Scrubbing Essence: A mixture of thirteen oils. It is burned with incense for fish-fry luck, i.e., business success. It includes:
 Essence Cinnamon
 Essence Wintergreen
 Essence Geranium
 Essence Bergamot
 Essence Orange Flowers, used also in initiation baths
 Essence Lavender, used also in initiation baths
 Essence Anice
 Essence St. Michael
 Essence Rosemary.
5. Water Notre Dame: Oil of White Rose and water. Sprinkle it about the home to make peace.
6. War Water: Oil of Tar in water (filtered). Break a glass of it on the steps wherever you wish to create strife. (It is sometimes made of creolin in water.)
7. Four Thieves Vinegar. It is used for breaking up homes,

277

for making a person run crazy, for driving off. It is sometimes put with a name in a bottle and the bottle thrown into moving water. It is used also to "dress" cocoanuts to kill and drive crazy.

8. Egyptian Paradise Seed (Amonium Melegreta). This is used in seeking success. Take a picture of St. Peter and put it at the front door and a picture of St. Michael at the back door. Put the Paradise seeds in little bags and put one behind each saint. It is known as "feeding the saint."

9. Guinea Paradise seed. Use as above.

10. Guinea pepper. This may also be used for feeding saints; also for breaking up homes or protecting one from conjure.

11. White Mustard seed. For protection against harm.

12. Black Mustard seed. For causing disturbance and strife.

13. Has-no-harra: Jasmine lotion. Brings luck to gamblers.

14. Carnation, a perfume. As above.

15. Three Jacks and a King. A perfume. As above.

16. Narcisse. As above but mild.

17. Nutmegs, bored and stuffed with quicksilver and sealed with wax, and rolled in Argentorium are very lucky for gamblers.

18. Lucky Dog is best of all for gamblers' use.

19. Essence of Bend-over. Used to rule and have your way.

20. Cleo-May, a perfume. To compel men to love you.

21. Jockey Club, a perfume. To make love and get work.

22. Jasmine Perfume. For luck in general.

23. White Rose. To make peace.

24. French Lilac. Best for vampires.

25. Taper Oil: perfumed olive oil. To burn candles in.

26. St. Joseph's Mixture:
 Buds from the Garden of Gilead
 Berries of the Fish
 Wishing Beans
 Juniper Berries
 Japanese scented Lucky Beans
 Large Star Anice

27. Steel dust is sprinkled over black load stone in certain

ceremonies. It is called "feeding the he, feeding the she."

28. Steel dust is attracted by a horse-shoe magnet to draw people to you. Used to get love, trade, etc.

29. Gold and silver magnetic sand. Powdered silver gilt used with a magnet to draw people to you.

30. *Saltpetre* is dissolved in water and sprinkled about to ward off conjure.

31. Scrub waters other than the Fast Lucks (see above, 1 and 2) are colored and perfumed and used as follows: red, for luck and protection; yellow, for money; blue (always colored with copperas), for protection and friends.

32. Roots and Herbs are used freely under widespread names:

 Big John the Conqueror.

 Little John the Conqueror. It is also put in Notre Dame Water or Waterloo in order to win.

 World-wonder Root. It is used in treasure-hunts. Bury a piece in the four corners of the field; also hide it in the four corners of your house to keep things in your favor.

 Ruler's Root. Used as above.

 Rattlesnake Root.

 Dragon's Blood (red root fibres). Crushed. Used for many purposes.

 Valerian Root. Put a piece in your pillow to quiet nerves.

 Adam and Eve Roots (paid). Sew together in bag and carry on person for protection.

 Five-fingered grass. Used to uncross. Make tea, strain it and bathe in it nine times.

 Waste Away Tea. Same as above.

33. Pictures of Saints, etc., are used also.

 St. Michael, the Archangel. To Conquer.

 St. Expedite. For quick work.

 St. Mary. For cure in sickness.

 St. Joseph with infant Jesus. To get job.

 St. Peter without the key. For success.

 St. Peter with the key. For great and speedy success.

St. Anthony de Padua. For luck.

St. Mary Magdalene. For luck in love (for women).

Sacred Heart of Jesus. For organic diseases.

34. Crosses. For luck.

35. Scapular. For protection.

36. Medals. For success.

37. Candles are used with set meanings for the different colors. They are often very large, one candle costing as much as six dollars.

White. For peace and to uncross and for weddings.

Red. For victory.

Pink. For love (some say for drawing success).

Green. To drive off (some say for success).

Blue. For success and protection (for causing death also).

Yellow. For money.

Brown. For drawing money and people.

Lavender. To cause harm (to induce triumph also).

Black. Always for evil or death.

Valive candles. For making Novenas.

38. The Bible. All hold that the Bible is the great conjure book in the world. Moses is honored as the greatest conjurer. "The names he knowed to call God by was what give him the power to conquer Pharaoh and divide the Red Sea."

IV

PRESCRIPTIONS OF ROOT DOCTORS

Folk medicine is practiced by a great number of persons. On the "jobs," that is, in the sawmill camps, the turpentine stills, mining camps and among the lowly generally, doctors are not generally called to prescribe for illnesses, certainly, nor for the social diseases. Nearly all of the conjure doctors practice "roots," but some of the root doctors are not hoodoo doctors. One of these latter at Bogaloosa, Louisiana, and one at Bartow, Florida, enjoy a huge patronage. They make medicine only, and white and colored swarm about them claiming cures.

The following are some prescriptions gathered here and there in Florida, Alabama and Louisiana:

GONORRHEA

a. Fifty cents of iodide potash in two quarts of water. Boil down to one quart. Add two teaspoons of Epsom salts. Take a big swallow three times a day.

b. Fifty cents iodide potash to one quart sarsaparilla. Take three teaspoons three times a day in water.

c. A good handful of May pop roots; one pint ribbon cane syrup; one-half plug of Brown's Mule tobacco cut up. Add fifty cents iodide potash. Take this three times a day as a tonic.

d. Parch egg shells and drink the tea.

e. For Running Range (Claps): Take blackberry root, sheep weed, boil together. Put a little blueing in (a pinch) and a pinch of laundry soap. Put all this in a quart of water. Take one-half glass three times a day and drink one-half glass of water behind it.

f. One quart water, one handful of blackberry root, one pinch of alum, one pinch of yellow soap. Boil together. Put in last nine drops of turpentine. Drink it for water until it goes through the bladder.

281

SYPHILIS

a. Ashes of one good cigar, fifteen cents worth of blue ointment. Mix and put on the sores.
b. Get the heart of a rotten log and powder it fine. Tie it up in a muslin cloth. Wash the sores with good castile soap and powder them with the wood dust.
c. When there are blue-balls (buboes), smear the swellings with mashed up granddaddies (daddy-long-legs) and it will bring them to a head.
d. Take a gum ball, cigar, soda and rice. Burn the gum ball and cigar and parch the rice. Powder it and sift and mix with vaseline. It is ready for use.
e. Boil red oak bark, palmetto root, fig root, two pinches of alum, nine drops of turpentine, two quarts of water together to one quart. Take one-half cup at a time. (Use no other water.)

FOR BLADDER TROUBLE

One pint of boiling water, two tablespoons of flaxseed, two tablespoons of cream of tartar. Drink one-half glass in the morning and one-half at night.

FISTULA

Sweet gum bark and mullen cooked down with lard. Make a salve.

RHEUMATISM

Take mullen leaves (five or six) and steep in one quart of water. Drink three to four wine glasses a day.

SWELLING

Oil of white rose (fifteen cents), oil of lavender (fifteen cents), Jockey Club (fifteen cents), Japanese honeysuckle (fifteen cents). Rub.

FOR BLINDNESS

a. Slate dust and pulverized sugar. Blow it in the eyes. (It must be finely pulverized to remove film.)

b. Get somebody to catch a catfish. Get the gall and put it in a bottle. Drop one drop in each eye. Cut the skin off. It gives the sight a free look.

LOCK-JAW

a. Draw out the nail. Beat the wound and squeeze out all the blood possible. Then take a piece of fat bacon, some tobacco and a penny and tie it on the wound.

b. Draw out the nail and drive it in a green tree on the sun-rise side, and the place will heal.

FLOODING[1]

One grated nutmeg, pinch of alum in a quart of water (cooked). Take one-half glass three times daily.

SICK AT STOMACH

Make a tea of parched rice and bay leaves (six). Give a cup at a time. Drink no other water.

LIVE THINGS IN STOMACH (FITS)

Take a silver quarter with a woman's head on it. Stand her on her head and file it in one-half cup of sweet milk. Add nine parts of garlic. Boil and give to drink after straining.

MEDICINE TO PURGE

Jack of War tea, one tablespoon to a cup of water with a pinch of soda after it is ready to drink.

[1]Menstruation.

283

Sheep weed leaves, bay leaf, sarsaparilla root. Take the bark and cut it all up fine. Make a tea. Take one tablespoon and put in two cups of water and strain and sweeten. You drink some and give some to patient.

Put a fig leaf and poison oak in shoe. (Get fig leaves off a tree that hasn't borne fruit. Stem them so that nobody will know.)

TO MAKE A TONIC

One quart of wine, three pinches of raw rice, three dusts of cinnamon (about one heaping teaspoon), five small pieces of the hull of pomegranate about the size of a fingernail, five tablespoons of sugar. Let it come to a boil, set one-half hour and strain. Dose: one tablespoon.

(When the pomegranate is in season, gather all the hulls you can for use at other times in the year.)

POISONS

There are few instances of actual poisoning. When a conjure doctor tells one of his patients, "Youse poisoned nearly to death," he does not necessarily mean that poison has been swallowed. He might mean that, but the instances are rare. He names that something has been put down for the patient. He may be: (1) "buried in the graveyard"; (2) "throwed in de river"; (3) "nailed up in a tree"; (4) put into a snake, rabbit, frog or chicken; (5) just buried in his own yard; (6) or hung up and punished. Juice of the nightshade, extract of polk root, and juice of the milkweed have been used as vegetable poisons, and poisonous spiders and powdered worms and insects are used as animal poisons. I have heard of one case of the poison sac of the rattlesnake being placed in the water pail of an enemy. But this sort of poisoning is rare.

It is firmly held in such cases that doctor's medicine can do the patient no good. What he needs is a "two-headed" doctor, that is, the conjure man. In some cases the hoodoo man does effect a cure where the physician fails because he has faith working with him. Often the patient is organically sound. He is afraid that he has been "fixed," and there is nothing that a medical doctor can do to remove

284

that fear. Besides, some poisons of a low order, like decomposed reptiles and the like, are not listed in the American pharmacopoeia. The doctor would never suspect their presence and would not be prepared to treat the patient if he did.

AFTERWORD

✵

ZORA NEALE HURSTON:
"A NEGRO WAY OF SAYING"

I.

The Reverend Harry Middleton Hyatt, an Episcopal priest whose five-volume classic collection, *Hoodoo, Conjuration, Witchcraft, and Rootwork,* more than amply returned an investment of forty years' research, once asked me during an interview in 1977 what had become of another eccentric collector whom he admired. "I met her in the field in the thirties, I think," he reflected for a few seconds, "that her first name was Zora." It was an innocent question, made reasonable by the body of confused and often contradictory rumors that make Zora Neale Hurston's own legend as richly curious and as dense as are the black myths she did so much to preserve in her classic anthropological works, *Mules and Men* and *Tell My Horse,* and in her fiction.

A graduate of Barnard, where she studied under Franz Boas, Zora Neale Hurston published seven books—four novels, two books of folklore, and an autobiography—and more than fifty shorter works between the middle of the Harlem Renaissance and the end of the Korean War, when she was

the dominant black woman writer in the United States. The dark obscurity into which her career then lapsed reflects her staunchly independent political stances rather than any deficiency of craft or vision. Virtually ignored after the early fifties, even by the Black Arts movement in the sixties, an otherwise noisy and intense spell of black image- and myth-making that rescued so many black writers from remaindered oblivion, Hurston embodied a more or less harmonious but nevertheless problematic unity of opposites. It is this complexity that refuses to lend itself to the glib categories of "radical" or "conservative," "black" or "Negro," "revolutionary" or "Uncle Tom"—categories of little use in literary criticism. It is this same complexity, embodied in her fiction, that, until Alice Walker published her important essay ("In Search of Zora Neale Hurston") in *Ms.* magazine in 1975, had made Hurston's place in black literary history an ambiguous one at best.

The rediscovery of Afro-American writers has usually turned on larger political criteria, of which the writer's work is supposedly a mere reflection. The deeply satisfying aspect of the rediscovery of Zora Neale Hurston is that black women generated it primarily to establish a maternal literary ancestry. Alice Walker's moving essay recounts her attempts to find Hurston's unmarked grave in the Garden of the Heavenly Rest, a segregated cemetery in Fort Pierce, Florida. Hurston became a metaphor for the black woman writer's search for tradition. The craft of Alice Walker, Gayl Jones, Gloria Naylor, and Toni Cade Bambara bears, in markedly different ways, strong affinities with Hurston's. Their attention to Hurston signifies a novel sophistication in black literature: they read Hurston not only for the spiritual kinship inherent in such relations but because she used black vernacular speech and rituals, in ways subtle and various, to chart the coming to consciousness of black women, so glaringly absent in other black fiction. This use of the vernacular became the fundamental framework for all but one of her novels and is particularly

effective in her classic work *Their Eyes Were Watching God,*
published in 1937, which is more closely related to Henry
James's *The Portrait of a Lady* and Jean Toomer's *Cane* than to
Langston Hughes's and Richard Wright's proletarian litera-
ture, so popular in the Depression.

The charting of Janie Crawford's fulfillment as an autono-
mous imagination, *Their Eyes* is a lyrical novel that correlates
the need of her first two husbands for ownership of progres-
sively larger physical space (and the gaudy accoutrements of
upward mobility) with the suppression of self-awareness in
their wife. Only with her third and last lover, a roustabout
called Tea Cake whose unstructured frolics center around and
about the Florida swamps, does Janie at last bloom, as does the
large pear tree that stands beside her grandmother's tiny log
cabin.

> She saw a dust bearing bee sink into the sanctum of a
> bloom; the thousand sister calyxes arch to meet the love
> embrace and the ecstatic shiver of the tree from root to
> tiniest branch creaming in every blossom and frothing with
> delight. So this was a marriage!

To plot Janie's journey from object to subject, the narrative
of the novel shifts from third to a blend of first and third
person (known as "free indirect discourse"), signifying this
awareness of self in Janie. *Their Eyes* is a bold feminist novel,
the first to be explicitly so in the Afro-American tradition. Yet
in its concern with the project of finding a voice, with lan-
guage as an instrument of injury and salvation, of selfhood and
empowerment, it suggests many of the themes that inspirit
Hurston's oeuvre as a whole.

II.

One of the most moving passages in American literature is
Zora Neale Hurston's account of her last encounter with her

dying mother, found in a chapter entitled "Wandering" in her autobiography, *Dust Tracks on a Road* (1942):

> As I crowded in, they lifted up the bed and turned it around so that Mama's eyes would face east. I thought that she looked to me as the head of the bed reversed. Her mouth was slightly open, but her breathing took up so much of her strength that she could not talk. But she looked at me, or so I felt, to speak for her. She depended on me for a voice.

We can begin to understand the rhetorical distance that separated Hurston from her contemporaries if we compare this passage with a similar scene published just three years later in *Black Boy* by Richard Wright. Hurston's dominant black male contemporary and rival: "Once, in the night, my mother called me to her bed and told me that she could not endure the pain, and she wanted to die. I held her hand and begged her to be quiet. That night I ceased to react to my mother; my feelings were frozen." If Hurston represents her final moments with her mother in terms of the search for voice, then Wright attributes to a similar experience a certain "somberness of spirit that I was never to lose," which "grew into a symbol in my mind, gathering to itself . . . the poverty, the ignorance, the helplessness. . . ." Few authors in the black tradition have less in common than Zora Neale Hurston and Richard Wright. And whereas Wright would reign through the forties as our predominant author, Hurston's fame reached its zenith in 1943 with a *Saturday Review* cover story honoring the success of *Dust Tracks*. Seven years later, she would be serving as a maid in Rivo Alto, Florida; ten years after that she would die in the County Welfare Home in Fort Pierce, Florida.

How could the recipient of two Guggenheims and the author of four novels, a dozen short stories, two musicals, two books on black mythology, dozens of essays, and a prizewinning autobiography virtually "disappear" from her readership

for three full decades? There are no easy answers to this quandary, despite the concerted attempts of scholars to resolve it. It is clear, however, that the loving, diverse, and enthusiastic responses that Hurston's work engenders today were not shared by several of her influential black male contemporaries. The reasons for this are complex and stem largely from what we might think of as their "racial ideologies."

Part of Hurston's received heritage—and perhaps the paramount received notion that links the novel of manners in the Harlem Renaissance, the social realism of the thirties, and the cultural nationalism of the Black Arts movement—was the idea that racism had reduced black people to mere ciphers, to beings who only react to an omnipresent racial oppression, whose culture is "deprived" where different, and whose psyches are in the main "pathological." Albert Murray, the writer and social critic, calls this "the Social Science Fiction Monster." Socialists, separatists, and civil rights advocates alike have been devoured by this beast.

Hurston thought this idea degrading, its propagation a trap, and railed against it. It was, she said, upheld by "the sobbing school of Negrohood who hold that nature somehow has given them a dirty deal." Unlike Hughes and Wright, Hurston chose deliberately to ignore this "false picture that distorted. . . ." Freedom, she wrote in *Moses, Man of the Mountain*, "was something internal. . . . The man himself must make his own emancipation." And she declared her first novel a manifesto against the "arrogance" of whites assuming that "black lives are only defensive reactions to white actions." Her strategy was not calculated to please.

What we might think of as Hurston's mythic realism, lush and dense within a lyrical black idiom, seemed politically retrograde to the proponents of a social or critical realism. If Wright, Ellison, Brown, and Hurston were engaged in a battle over ideal fictional modes with which to represent the Negro, clearly Hurston lost the battle.

But not the war.

After Hurston and her choice of style for the black novel

were silenced for nearly three decades, what we have witnessed since is clearly a marvelous instance of the return of the repressed. For Zora Neale Hurston has been "rediscovered" in a manner unprecedented in the black tradition: several black women writers, among whom are some of the most accomplished writers in America today, have openly turned to her works as sources of narrative strategies, to be repeated, imitated, and revised, in acts of textual bonding. Responding to Wright's critique, Hurston claimed that she had wanted at long last to write a black novel, and "not a treatise on sociology." It is this urge that resonates in Toni Morrison's *Song of Solomon* and *Beloved,* and in Walker's depiction of Hurston as our prime symbol of "racial health—a sense of black people as complete, complex, *undiminished* human beings, a sense that is lacking in so much black writing and literature." In a tradition in which male authors have ardently denied black literary paternity, this is a major development, one that heralds the refinement of our notion of tradition: Zora and her daughters are a tradition-within-the-tradition, a black woman's voice.

The resurgence of popular and academic readerships of Hurston's works signifies her multiple canonization in the black, the American, and the feminist traditions. Within the critical establishment, scholars of every stripe have found in Hurston texts for all seasons. More people have read Hurston's works since 1975 than did between that date and the publication of her first novel, in 1934.

III.

Rereading Hurston, I am always struck by the density of intimate experiences she cloaked in richly elaborated imagery. It is this concern for the figurative capacity of black language, for what a character in *Mules and Men* calls "a hidden meaning, jus' like de Bible . . . de inside meanin' of words," that unites Hurston's anthropological studies with her fiction. For the folklore Hurston collected so meticulously as Franz Boas's

student at Barnard became metaphors, allegories, and performances in her novels, the traditional recurring canonical metaphors of black culture. Always more of a novelist than a social scientist, even Hurston's academic collections center on the quality of imagination that makes these lives whole and splendid. But it is in the novel that Hurston's use of the black idiom realizes its fullest effect. In *Jonah's Gourd Vine,* her first novel, for instance, the errant preacher, John, as described by Robert Hemenwoh "is a poet who graces his world with language but cannot find the words to secure his own personal grace." This concern for language and for the "natural" poets who "bring barbaric splendor of word and song into the very camp of the mockers" not only connects her two disciplines but also makes of "the suspended linguistic moment" a thing to behold indeed. Invariably, Hurston's writing depends for its strength on the text, not the context, as does John's climactic sermon, a *tour de force* of black image and metaphor. Image and metaphor define John's world; his failure to interpret himself leads finally to his self-destruction. As Robert Hemenway, Hurston's biographer, concludes, "Such passages eventually add up to a theory of language and behavior."

Using "the spy-glass of Anthropology," her work celebrates rather than moralizes; it shows rather than tells, such that "both behavior and art become self-evident as the tale texts and hoodoo rituals accrete during the reading." As author, she functions as "a midwife participating in the birth of a body of folklore, . . . the first wondering contacts with natural law." The myths she describes so accurately are in fact "alternative modes for perceiving reality," and never just condescending depictions of the quaint. Hurston sees "the Dozens," for example, that age-old black ritual of graceful insult, as, among other things, a verbal defense of the sanctity of the family, conjured through ingenious plays on words. Though attacked by Wright and virtually ignored by his literary heirs, Hurston's ideas about language and craft undergird many of the most successful contributions to Afro-American literature that followed.

IV.

We can understand Hurston's complex and contradictory legacy more fully if we examine *Dust Tracks on a Road,* her own controversial account of her life. Hurston did make significant parts of herself up, like a masquerader putting on a disguise for the ball, like a character in her fictions. In this way, Hurston *wrote* herself, and sought in her works to rewrite the "self" of "the race," in its several private and public guises, largely for ideological reasons. That which she chooses to reveal is the life of her imagination, as it sought to mold and interpret her environment. That which she silences or deletes, similarly, is all that her readership would draw upon to delimit or pigeonhole her life as a synecdoche of "the race problem," an exceptional part standing for the debased whole.

Hurston's achievement in *Dust Tracks* is twofold. First, she gives us a *writer's* life, rather than an account, as she says, of "the Negro problem." So many events in this text are figured in terms of Hurston's growing awareness and mastery of books and language, language and linguistic rituals as spoken and written both by masters of the Western tradition and by ordinary members of the black community. These two "speech communities," as it were, are Hurston's great sources of inspiration not only in her novels but also in her autobiography.

The representation of her sources of language seems to be her principal concern, as she constantly shifts back and forth between her "literate" narrator's voice and a highly idiomatic black voice found in wonderful passages of free indirect discourse. Hurston moves in and out of these distinct voices effortlessly, seamlessly, just as she does in *Their Eyes* to chart Janie's coming to consciousness. It is this usage of a *divided* voice, a double voice unreconciled, that strikes me as her great achievement, a verbal analogue of her double experiences as a woman in a male-dominated world and as a black person in a nonblack world, a woman writer's revision of W. E. B. Du

Bois's metaphor of "double consciousness" for the hyphenated African-American.

Her language, variegated by the twin voices that intertwine throughout the text, retains the power to unsettle:

> There is something about poverty that smells like death.
> Dead dreams dropping off the heart like leaves in a dry
> season and rotting around the feet; impulses smothered too
> long in the fetid air of underground caves. The soul lives
> in a sickly air. People can be slave-ships in shoes.

Elsewhere she analyzes black "idioms" used by a culture "raised on simile and invective. They know how to call names," she concludes, then lists some, such as 'gator-mouthed, box-ankled, puzzle-gutted, shovel-footed: "Eyes looking like skint-ginny nuts, and mouth looking like a dishpan full of broke-up crockery!"

Immediately following the passage about her mother's death, she writes:

> The Master-Maker in His making had made Old Death.
> Made him with big, soft feet and square toes. Made him
> with a face that reflects the face of all things, but neither
> changes itself, nor is mirrored anywhere. Made the body of
> death out of infinite hunger. Made a weapon of his hand to
> satisfy his needs. This was the morning of the day of the
> beginning of things.

Language, in these passages, is not merely "adornment," as Hurston described a key black linguistic practice; rather, manner and meaning are perfectly in tune: she says the thing in the most meaningful manner. Nor is she being "cute," or pandering to a condescending white readership. She is "naming" emotions, as she says, in a language both deeply personal and culturally specific.

The second reason that *Dust Tracks* succeeds as literature arises from the first: Hurston's unresolved tension between

her double voices signifies her full understanding of modernism. Hurston uses the two voices in her text to celebrate the psychological fragmentation both of modernity and of the black American. As Barbara Johnson has written, hers is a rhetoric of division, rather than a fiction of psychological or cultural unity. Zora Neale Hurston, the "real" Zora Neale Hurston that we long to locate in this text, dwells in the silence that separates these two voices: she is both, and neither; bilingual, and mute. This strategy helps to explain her attraction to so many contemporary critics and writers, who can turn to her works again and again only to be startled at her remarkable artistry.

But the life that Hurston could write was not the life she could live. In fact, Hurston's life, so much more readily than does the standard sociological rendering, reveals how economic limits determine our choices even more than does violence or love. Put simply, Hurston wrote well when she was comfortable, wrote poorly when she was not. Financial problems—book sales, grants and fellowships too few and too paltry, ignorant editors and a smothering patron—produced the sort of dependence that affects, if not determines, her style, a relation she explored somewhat ironically in "What White Publishers Won't Print." We cannot oversimplify the relation between Hurston's art and her life; nor can we reduce the complexity of her postwar politics, which, rooted in her distaste for the pathological image of blacks, were markedly conservative and Republican.

Nor can we sentimentalize her disastrous final decade, when she found herself working as a maid on the very day the *Saturday Evening Post* published her short story "Conscience of the Court" and often found herself without money, surviving after 1957 on unemployment benefits, substitute teaching, and welfare checks. "In her last days," Hemenway concludes dispassionately, "Zora lived a difficult life—alone, proud, ill, obsessed with a book she could not finish."

The excavation of her buried life helped a new generation read Hurston again. But ultimately we must find Hurston's

296

legacy in her art, where she "ploughed up some literacy and laid by some alphabets." Her importance rests with the legacy of fiction and lore she constructed so cannily. As Hurston herself noted, "Roll your eyes in ecstasy and ape his every move, but until we have placed something upon his street corner that is our own, we are right back where we were when they filed our iron collar off." If, as a friend eulogized, "She didn't come to you empty," then she does not leave black literature empty. If her earlier obscurity and neglect today seem inconceivable, perhaps now, as she wrote of Moses, she has "crossed over."

HENRY LOUIS GATES, JR.

SELECTED BIBLIOGRAPHY

WORKS BY ZORA NEALE HURSTON

Jonah's Gourd Vine. Philadelphia: J. B. Lippincott, 1934.

Mules and Men. Philadelphia: J. B. Lippincott, 1935.

Their Eyes Were Watching God. Philadelphia: J. B. Lippincott, 1937.

Tell My Horse. Philadelphia: J. B. Lippincott, 1938.

Moses, Man of the Mountain. Philadelphia: J. B. Lippincott, 1939.

Dust Tracks on a Road. Philadelphia: J. B. Lippincott, 1942.

Seraph on the Suwanee. New York: Charles Scribner's Sons, 1948.

I Love Myself When I Am Laughing . . . & Then Again When I Am Looking Mean and Impressive: A Zora Neale Hurston Reader. Edited by Alice Walker. Old Westbury, N.Y.: The Feminist Press, 1979.

The Sanctified Church. Edited by Toni Cade Bambara. Berkeley: Turtle Island, 1981.

Spunk: The Selected Short Stories of Zora Neale Hurston. Berkeley: Turtle Island, 1985.

WORKS ABOUT ZORA NEALE HURSTON

Baker, Houston A., Jr. *Blues, Ideology, and Afro-American Literature: A Vernacular Theory,* pp. 15–63. Chicago: University of Chicago Press, 1984.

Bloom, Harold, ed. *Zora Neale Hurston.* New York: Chelsea House, 1986.

———, ed. *Zora Neale Hurston's "Their Eyes Were Watching God."* New York: Chelsea House, 1987.

Byrd, James W. "Zora Neale Hurston: A Novel Folklorist." *Tennessee Folklore Society Bulletin* 21 (1955): 37–41.

Cooke, Michael G. "Solitude: The Beginnings of Self-Realization in Zora Neale Hurston, Richard Wright, and Ralph Ellison." In Michael G. Cooke, *Afro-American Literature in the Twentieth Century,* pp. 71–110. New Haven: Yale University Press, 1984.

Dance, Daryl C. "Zora Neale Hurston." In *American Women Writers: Bibliographical Essays,* edited by Maurice Duke, et al. Westport, Conn.: Greenwood Press, 1983.

Gates, Henry Louis, Jr. "The Speakerly Text." In Henry Louis Gates, Jr., *The Signifying Monkey,* pp. 170–217. New York: Oxford University Press, 1988.

Giles, James R. "The Significance of Time in Zora Neale Hurston's *Their Eyes Were Watching God." Negro American Literature Forum* 6 (Summer 1972): 52–53, 60.

Hemenway, Robert E. *Zora Neale Hurston: A Literary Biography.* Chicago: University of Illinois Press, 1977.

Holloway, Karla. *The Character of the Word: The Texts of Zora Neale Hurston.* Westport, Conn.: Greenwood Press, 1987.

Holt, Elvin. "Zora Neale Hurston." In *Fifty Southern Writers After 1900,* edited by Joseph M. Flura and Robert Bain, pp. 259–69. Westport, Conn.: Greenwood Press, 1987.

Howard, Lillie Pearl. *Zora Neale Hurston.* Boston: Twayne, 1980.

———. "Zora Neale Hurston." In *Dictionary of Literary Biography,* vol. 51, edited by Trudier Harris, pp. 133–45. Detroit: Gale, 1987.

Jackson, Blyden. "Some Negroes in the Land of Goshen." *Tennessee Folklore Society Bulletin* 19 (4) (December 1953): 103–7.

Johnson, Barbara. "Metaphor, Metonymy, and Voice in *Their Eyes.*" In *Black Literature and Literary Theory,* edited by Henry Louis Gates, Jr., pp. 205–21. New York: Methuen, 1984.

————. "Thresholds of Difference: Structures of Address in Zora Neale Hurston." In *"Race," Writing and Difference,* edited by Henry Lewis Gates, Jr. Chicago: University of Chicago Press, 1986.

Jordan, June. "On Richard Wright and Zora Neale Hurston." *Black World* 23 (10) (August 1974): 4–8.

Kubitschek, Missy Dehn. " 'Tuh de Horizon and Back': The Female Quest in *Their Eyes.*" *Black American Literature Forum* 17 (3) (Fall 1983): 109–15.

Lionnet, Françoise. "Autoethnography: The Anarchic Style of *Dust Tracks on a Road.*" In Françoise Lionnet, *Autobiographical Voices: Race, Gender, Self-Portraiture,* pp. 97–130. Ithaca: Cornell University Press, 1989.

Lupton, Mary Jane. "Zora Neale Hurston and the Survival of the Female." *Southern Literary Journal* 15 (Fall 1982): 45–54.

Meese, Elizabeth. "Orality and Textuality in Zora Neale Hurston's *Their Eyes.*" In Elizabeth Meese, *Crossing the Double Cross: The Practice of Feminist Criticism,* pp. 39–55. Chapel Hill: University of North Carolina Press, 1986.

Newson, Adele S. *Zora Neale Hurston: A Reference Guide.* Boston: G. K. Hall, 1987.

Rayson, Ann. "*Dust Tracks on a Road:* Zora Neale Hurston and the Form of Black Autobiography." *Negro American Literature Forum* 7 (Summer 1973): 42–44.

Sheffey, Ruthe T., ed. *A Rainbow Round Her Shoulder: The Zora Neale Hurston Symposium Papers.* Baltimore: Morgan State University Press, 1982.

Smith, Barbara. "Sexual Politics and the Fiction of Zora Neale Hurston." *Radical Teacher* 8 (May 1978): 26–30.

Stepto, Robert B. *From Behind the Veil.* Urbana: University of Illinois Press, 1979.

Walker, Alice. "In Search of Zora Neale Hurston." *Ms.,* March 1975, pp. 74–79, 85–89.

Wall, Cheryl A. "Zora Neale Hurston: Changing Her Own Words." In *American Novelists Revisited: Essays in Feminist Criticism,* edited by Fritz Fleischmann, pp. 370–93. Boston: G. K. Hall, 1982.

Washington, Mary Helen. "Zora Neale Hurston: A Woman Half in Shadow." Introduction to *I Love Myself When I Am Laughing,* edited by Alice Walker. Old Westbury, N.Y.: Feminist Press, 1979.

———. " 'I Love the Way Janie Crawford Left Her Husbands': Zora Neale Hurston's Emergent Female Hero." In Mary Helen Washington, *Invented Lives: Narratives of Black Women, 1860–1960.* New York: Anchor Press, 1987.

Willis, Miriam. "Folklore and the Creative Artist: Lydia Cabrera and Zora Neale Hurston." *CLA Journal* 27 (September 1983): 81–90.

Wolff, Maria Tai. "Listening and Living: Reading and Experience in *Their Eyes.*" *BALF* 16 (1) (Spring 1982): 29–33.

CHRONOLOGY

January 7, 1891 Born in Eatonville, Florida, the fifth of eight children, to John Hurston, a carpenter and Baptist preacher, and Lucy Potts Hurston, a former schoolteacher.

September 1917– June 1918 Attends Morgan Academy in Baltimore, completing the high school requirements.

Summer 1918 Works as a waitress in a nightclub and a manicurist in a black-owned barbershop that serves only whites.

1918–19 Attends Howard Prep School, Washington, D.C.

1919–24 Attends Howard University; receives an associate degree in 1920.

1921 Publishes her first story, "John Redding Goes to Sea," in the *Stylus*, the campus literary society's magazine.

December 1924 Publishes "Drenched in Light," a short story, in *Opportunity*.

1925 Submits a story, "Spunk," and a play, *Color Struck*, to *Opportunity*'s literary contest. Both

	win second-place awards; publishes "Spunk" in the June number.
1925–27	Attends Barnard College, studying anthropology with Franz Boas.
1926	Begins field work for Boas in Harlem.
January 1926	Publishes "John Redding Goes to Sea" in *Opportunity.*
Summer 1926	Organizes *Fire!* with Langston Hughes and Wallace Thurman; they publish only one issue, in November 1926. The issue includes Hurston's "Sweat."
August 1926	Publishes "Muttsy" in *Opportunity.*
September 1926	Publishes "Possum or Pig" in the *Forum.*
September–November 1926	Publishes "The Eatonville Anthology" in the *Messenger.*
1927	Publishes *The First One,* a play, in Charles S. Johnson's *Ebony and Topaz.*
February 1927	Goes to Florida to collect folklore.
May 19, 1927	Marries Herbert Sheen.
September 1927	First visits Mrs. Rufus Osgood Mason, seeking patronage.
October 1927	Publishes an account of the black settlement at St. Augustine, Florida, in the *Journal of Negro History;* also in this issue: "Cudjo's Own Story of the Last African Slaver."
December 1927	Signs a contract with Mason, enabling her to return to the South to collect folklore.
1928	Satirized as "Sweetie Mae Carr" in Wallace Thurman's novel about the Harlem Renaissance *Infants of the Spring;* receives a bachelor of arts degree from Barnard.
January 1928	Relations with Sheen break off.

May 1928	Publishes "How It Feels to Be Colored Me" in the *World Tomorrow*.
1930–32	Organizes the field notes that become *Mules and Men*.
May–June 1930	Works on the play *Mule Bone* with Langston Hughes.
1931	Publishes "Hoodoo in America" in the *Journal of American Folklore*.
February 1931	Breaks with Langston Hughes over the authorship of *Mule Bone*.
July 7, 1931	Divorces Sheen.
September 1931	Writes for a theatrical revue called *Fast and Furious*.
January 1932	Writes and stages a theatrical revue called *The Great Day,* first performed on January 10 on Broadway at the John Golden Theatre; works with the creative literature department of Rollins College, Winter Park, Florida, to produce a concert program of Negro music.
1933	Writes "The Fiery Chariot."
January 1933	Stages *From Sun to Sun* (a version of *Great Day*) at Rollins College.
August 1933	Publishes "The Gilded Six-Bits" in *Story*.
1934	Publishes six essays in Nancy Cunard's anthology, *Negro*.
January 1934	Goes to Bethune-Cookman College to establish a school of dramatic arts "based on pure Negro expression."
May 1934	Publishes *Jonah's Gourd Vine,* originally titled *Big Nigger;* it is a Book-of-the-Month Club selection.

September 1934	Publishes "The Fire and the Cloud" in the *Challenge*.
November 1934	*Singing Steel* (a version of *Great Day*) performed in Chicago.
January 1935	Makes an abortive attempt to study for a Ph.D in anthropology at Columbia University on a fellowship from the Rosenwald Foundation. In fact, she seldom attends classes.
August 1935	Joins the WPA Federal Theatre Project as a "dramatic coach."
October 1935	*Mules and Men* published.
March 1936	Awarded a Guggenheim Fellowship to study West Indian Obeah practices.
April–September 1936	In Jamaica.
September–March 1937	In Haiti; writes *Their Eyes Were Watching God* in seven weeks.
May 1937	Returns to Haiti on a renewed Guggenheim.
September 1937	Returns to the United States; *Their Eyes Were Watching God* published, September 18.
February–March 1938	Writes *Tell My Horse;* it is published the same year.
April 1938	Joins the Federal Writers Project in Florida to work on *The Florida Negro*.
1939	Publishes "Now Take Noses" in *Cordially Yours*.
June 1939	Receives an honorary Doctor of Letters degree from Morgan State College.
June 27, 1939	Marries Albert Price III in Florida.

Summer 1939	Hired as a drama instructor by North Carolina College for Negroes at Durham; meets Paul Green, professor of drama, at the University of North Carolina.
November 1939	*Moses, Man of the Mountain* published.
February 1940	Files for divorce from Price, though the two are reconciled briefly.
Summer 1940	Makes a folklore-collecting trip to South Carolina.
Spring–July 1941	Writes *Dust Tracks on a Road.*
July 1941	Publishes "Cock Robin, Beale Street" in the *Southern Literary Messenger.*
October 1941–January 1942	Works as a story consultant at Paramount Pictures.
July 1942	Publishes "Story in Harlem Slang" in the *American Mercury.*
September 5, 1942	Publishes a profile of Lawrence Silas in the *Saturday Evening Post.*
November 1942	*Dust Tracks on a Road* published.
February 1943	Awarded the Anisfield-Wolf Book Award in Race Relations for *Dust Tracks;* on the cover of the *Saturday Review.*
March 1943	Receives Howard University's Distinguished Alumni Award.
May 1943	Publishes "The 'Pet Negro' Syndrome" in the *American Mercury.*
November 1943	Divorce from Price granted.
June 1944	Publishes "My Most Humiliating Jim Crow Experience" in the *Negro Digest.*
1945	Writes *Mrs. Doctor;* it is rejected by Lippincott.

March 1945	Publishes "The Rise of the Begging Joints" in the *American Mercury.*
December 1945	Publishes "Crazy for This Democracy" in the *Negro Digest.*
1947	Publishes a review of Robert Tallant's *Voodoo in New Orleans* in the *Journal of American Folklore.*
May 1947	Goes to British Honduras to research black communities in Central America; writes *Seraph on the Suwanee;* stays in Honduras until March 1948.
September 1948	Falsely accused of molesting a ten-year-old boy and arrested; case finally dismissed in March 1949.
October 1948	*Seraph on the Suwanee* published.
March 1950	Publishes "Conscience of the Court" in the *Saturday Evening Post,* while working as a maid in Rivo Island, Florida.
April 1950	Publishes "What White Publishers Won't Print" in the *Saturday Evening Post.*
November 1950	Publishes "I Saw Negro Votes Peddled" in the *American Legion* magazine.
Winter 1950–51	Moves to Belle Glade, Florida.
June 1951	Publishes "Why the Negro Won't Buy Communism" in the *American Legion* magazine.
December 8, 1951	Publishes "A Negro Voter Sizes Up Taft" in the *Saturday Evening Post.*
1952	Hired by the *Pittsburgh Courier* to cover the Ruby McCollum case.
May 1956	Receives an award for "education and human relations" at Bethune-Cookman College.

June 1956	Works as a librarian at Patrick Air Force Base in Florida; fired in 1957.
1957–59	Writes a column on "Hoodoo and Black Magic" for the *Fort Pierce Chronicle.*
1958	Works as a substitute teacher at Lincoln Park Academy, Fort Pierce.
Early 1959	Suffers a stroke.
October 1959	Forced to enter the St. Lucie County Welfare Home.
January 28, 1960	Dies in the St. Lucie County Welfare Home of "hypertensive heart disease"; buried in an unmarked grave in the Garden of Heavenly Rest, Fort Pierce.
August 1973	Alice Walker discovers and marks Hurston's grave.
March 1975	Walker publishes "In Search of Zora Neale Hurston," in *Ms.,* launching a Hurston revival.

About the author

About the book

Read on

Insights,
Interviews
& More . . .

"In Search of Zora Neale Hurston"

by Alice Walker

The work of Zora Neale Hurston was relatively unknown in 1975, when Alice Walker, beloved author of The Color Purple, *wrote her groundbreaking essay "In Search of Zora Neale Hurston" (Ms. magazine, March 1975). In this seminal piece, reprinted here in its entirety, Walker illuminates her idol's life and work.*

"On January 16, 1959, Zora Neale Hurston, suffering from the effects of a stroke and writing painfully in longhand, composed a letter to the 'editorial department' of Harper & Brothers inquiring if they would be interested in seeing 'the book I am laboring upon at the present—a life of Herod the Great.' One year and twelve days later, Zora Neale Hurston died without funds to provide for her burial, a resident of the St. Lucie County, Florida, Welfare Home. She lies today in an unmarked grave in a segregated cemetery in Fort Pierce, Florida, a resting place generally symbolic of the black writer's fate in America.

"Zora Neale Hurston is one of the most significant unread authors in America, the author of two minor classics and four other major books."

—*Robert Hemenway, "Zora Hurston and the Eatonville Anthropology," from* The Harlem Renaissance Remembered, *edited by Arna Bontemps (Dodd, 1972)*

Courtesy of the Estate of Carl Van Vechten, Joseph Solomon, Executor

ON AUGUST 15, 1973, I wake up just as the plane is lowering over Sanford, Florida, which

means I am also looking down on Eatonville, Zora Neale Hurston's birthplace. I recognize it from Zora's description in *Mules and Men*: "the city of five lakes, three croquet courts, three hundred brown skins, three hundred good swimmers, plenty guavas, two schools, and no jailhouse." Of course I cannot see the guavas, but the five lakes are still there, and it is the lakes I count as the plane prepares to land in Orlando.

From the air, Florida looks completely flat, and as we near the ground this impression does not change. This is the first time I have seen the interior of the state, which Zora wrote about so well, but there are the acres of orange groves, the sand, mangrove trees, and scrub pine that I know from her books. Getting off the plane I walk through the hot moist air of midday into the tacky but air-conditioned airport. I search for Charlotte Hunt, my companion on the Zora Hurston expedition. She lives in Winter Park, Florida, very near Eatonville, and is writing her graduate dissertation on Zora. I see her waving—a large pleasant-faced white woman in dark glasses. We have written to each other for several weeks, swapping our latest finds (mostly hers) on Zora, and trying to make sense out of the mass of information obtained (often erroneous or simply confusing) from Zora herself—through her stories and autobiography—and from people who wrote about her.

Eatonville has lived for such a long time in my imagination that I can hardly believe it will be found existing in its own right. But after twenty minutes on the expressway, Charlotte turns off and I see a small settlement of houses and stores set with ▶

no particular pattern in the sandy soil off the road. We stop in front of a neat gray building that has two fascinating signs: EATONVILLE POST OFFICE and EATONVILLE CITY HALL.

Inside the Eatonville City Hall half of the building, a slender, dark, brown-skin woman sits looking through letters on a desk. When she hears we are searching for anyone who might have known Zora Neale Hurston, she leans back in thought. Because I don't wish to inspire foot-dragging in people who might know something about Zora they're not sure they should tell, I have decided on a simple, but I feel profoundly *useful*, lie.

"I am Miss Hurston's niece," I prompt the young woman, who brings her head down with a smile.

"I think Mrs. Moseley is about the only one still living who might remember her," she says.

"Do you mean *Mathilda* Moseley, the woman who tells those 'woman-is-smarter-than-man' lies in Zora's book?"

"Yes," says the young woman. "Mrs. Moseley is real old now, of course. But this time of day, she should be at home."

I stand at the counter looking down on her, the first Eatonville resident I have spoken to. Because of Zora's books, I feel I know something about her; at least I know what the town she grew up in was like years before she was born.

"Tell me something," I say, "do the schools teach Zora's books here?"

"No," she says, "they don't. I don't think most people know anything about Zora Neale Hurston, or knew about any of the great things she did. She was a fine lady. I've read all of her books myself, but I don't think many other folks in Eatonville have."

"Many of the church people around here, as I understand it," says Charlotte in a murmured aside, "thought Zora was pretty loose. I don't think they appreciated her writing about them."

"Well," I say to the young woman, "thank you for your help." She clarifies her directions to Mrs. Moseley's house and smiles as Charlotte and I turn to go.

"The letter to Harper's does not expose a publisher's rejection of an unknown masterpiece, but it does reveal how the bright promise of the Harlem Renaissance deteriorated for many of the writers who shared in its exuberance. It also indicates the personal tragedy of Zora Neale Hurston: Barnard graduate, author of four novels, two books of folklore, one volume

of autobiography, the most important collector of Afro-American folklore in America, reduced by poverty and circumstance to seek a publisher by unsolicited mail."

—*Robert Hemenway*

"Zora Neale Hurston was born in 1901, 1902, or 1903—depending on how old she felt herself to be at the time someone asked."

—*Librarian, Beinecke Library, Yale University*

THE MOSELEY HOUSE is small and white and snug, its tiny yard nearly swallowed up by oleanders and hibiscus bushes. Charlotte and I knock on the door. I call out. But there is no answer. This strikes us as peculiar. We have had time to figure out an age for Mrs. Moseley—not dates or a number, just old. I am thinking of a quivery, bedridden invalid when we hear the car. We look behind us to see an old black-and-white Buick— paint peeling and grillwork rusty—pulling into the drive. A neat old lady in a purple dress and white hair is straining at the wheel. She is frowning because Charlotte's car is in the way.

Mrs. Moseley looks at us suspiciously. "Yes, I knew Zora Neale," she says, unsmilingly and with a rather cold stare at Charlotte (who I imagine feels very *white* at that moment), "but that was a long time ago, and I don't want to talk about it."

"Yes ma'am," I murmur, bringing all my sympathy to bear on the situation.

"Not only that," Mrs. Moseley continues, "I've been sick. Been in the hospital for an operation. Ruptured artery. The doctors didn't believe I was going to live, but you see me alive, don't you?"

"Looking well, too," I comment.

Mrs. Moseley is out of her car. A thin, sprightly woman with nice gold-studded false teeth, uppers and lowers. I like her because she stands there *straight* beside her car, with a hand on her hip and her straw pocketbook on her arm. She wears white T-strap shoes with heels that show off her well-shaped legs.

"I'm eighty-two years old, you know," she says. "And I just can't remember things the way I used to. Anyhow, Zora Neale left here to go to school and she never really came back to live. She'd come here for material for her books, but that was all. She spent most of her time down in South Florida." ▶

"You know, Mrs. Moseley, I saw your name in one of Zora's books."

"You did?" She looks at me with only slightly more interest. "I read some of her books a long time ago, but then people got to borrowing and borrowing and they borrowed them all away."

"I could send you a copy of everything that's been reprinted." I offer. "Would you like me to do that?"

"No," says Mrs. Moseley promptly. "I don't read much any more. Besides, all of that was *so* long ago. . . ."

Charlotte and I settle back against the car in the sun. Mrs. Moseley tells us at length and with exact recall every step in her recent operation, ending with: "What those doctors didn't know—when they were expecting me to die (and they didn't even think I'd live long enough for them to have to take out my stitches!)—is that Jesus is the best doctor, and if *He* says for you to get well, that's all that counts."

With this philosophy, Charlotte and I murmur quick assent: being Southerners and church bred, we have heard that belief before. But what we learn from Mrs. Moseley is that she does not remember much beyond the year 1938. She shows us a picture of her father and mother and says that her father was Joe Clarke's brother. Joe Clarke, as every Zora Hurston reader knows, was the first mayor of Eatonville; his fictional counterpart is Jody Starks of *Their Eyes Were Watching God*. We also get directions to where Joe Clarke's store *was*—where Club Eaton is now. Club Eaton, a long orange-beige nightspot we had seen on the main road, is apparently famous for the

good times in it regularly had by all. It is, perhaps, the modern equivalent of the store porch, where all the men of Zora's childhood came to tell "lies," that is, black folktales, that were "made and used on the spot," to take a line from Zora. As for Zora's exact birthplace, Mrs. Moseley has no idea.

After I have commented on the healthy growth of her hibiscus bushes, she becomes more talkative. She mentions how much she *loved* to dance, when she was a young woman, and talks about how good her husband was. When he was alive, she says, she was completely happy because he allowed her to be completely free. "I was so free I had to pinch myself sometimes to tell if I was a married woman."

Relaxed now, she tells us about going to school with Zora. "Zora and I went to the same school. It's called Hungerford High now. It *was* only to the eighth-grade. But our teachers were so good that by the time you left you knew college subjects. When I went to Morris Brown in Atlanta, the teachers there were just teaching me the same things I had already learned right in Eatonville. I wrote Mama and told her I was going to come home and help her with her babies. I wasn't learning anything new."

"Tell me something, Mrs. Moseley," I ask, "why do you suppose Zora was against integration? I read somewhere that she was against school desegregation because she felt it was an insult to black teachers."

"Oh, one of them [white people] came around asking me about integration. One day I was doing my shopping. I heard 'em over there talking about it in the store, about the schools. And I got on out of the way because I knew ▶

"In Search of Zora Neale Hurston" *(continued)*

if they asked me, they wouldn't like what I was going to tell 'em. But they came up and asked me anyhow. 'What do you think about this integration?' one of them said. I acted like I thought I had heard wrong. 'You're asking *me* what *I* think about integration?' I said. 'Well, as you can see I'm just an old colored woman'—I was seventy-five or seventy-six then—'and this is the first time anybody ever asked me about integration. And nobody asked my grandmother what she thought, either, but her daddy was one of you all.'" Mrs. Moseley seems satisfied with this memory of her rejoinder. She looks at Charlotte. "I have the blood of three races in my veins," she says belligerently, "white, black, and Indian, and nobody asked me *anything* before."

"Do you think living in Eatonville made integration less appealing to you?"

"Well, I can tell you this: I have lived in Eatonville all my life and I've been in the governing of this town. I've been everything but Mayor and I've been *assistant* Mayor. Eatonville was and is an all-black town. We have our own police department, post office, and town hall. Our own school and good teachers. Do I need integration?

"They took over Goldsboro, because the black people who lived there never incorporated like we did. And now I don't even know if any black folks live there. They built big houses up there around the lakes. But we didn't let that happen in Eatonville, and we don't sell land to just anybody. And you see, we're still here."

When we leave, Mrs. Moseley is standing by her car, waving. I think of the letter Roy Wilkins wrote to a black newspaper blasting Zora Neale for her lack of enthusiasm about the integration of schools. I wonder if he knew the experience of Eatonville she was coming from. Not many black people in America have come from a self-contained, all-black community where loyalty and unity are taken for granted. A place where black pride is nothing new.

There is, however, one thing Mrs. Moseley said that bothered me.

"Tell me, Mrs. Moseley," I had asked, "Why is it that thirteen years after Zora's death, no marker has been put on her grave?"

And Mrs. Moseley answered: "The reason she doesn't have a stone is because she wasn't buried here. She was buried down in South Florida somewhere. I don't think anybody really knew where she was."

"Only to reach a wider audience, need she ever write books—because she is a perfect book of entertainment in herself. In her youth she was always

getting scholarships and things from wealthy white people, some of whom simply paid her just to sit around and represent the Negro race for them, she did it in such a racy fashion. She was full of sidesplitting anecdotes, humorous tales, and tragicomic stories, remembered out of her life in the South as a daughter of a traveling minister of God. She could make you laugh one minute and cry the next. To many of her white friends, no doubt, she was a perfect 'darkie,' in the nice meaning they give the term—that is, a naïve, childlike, sweet, humorous, and highly colored Negro.

"But Miss Hurston was clever, too—a student who didn't let college give her a broad 'a' and who had great scorn for all pretentions, academic or otherwise. That is why she was such a fine folklore collector, able to go among the people and never act as if she had been to school at all. Almost nobody else could stop the average Harlemite on Lenox Avenue and measure his head with a strange-looking, anthropological device and not get bawled out for the attempt, except Zora, who used to stop anyone whose head looked interesting, and measure it."

—*Langston Hughes,* The Big Sea *(Knopf)*

"What does it matter what white folks must have thought about her?"
—*Student, Black Women Writers Class, Wellesley College*

MRS. SARAH PEEK PATTERSON is a handsome, red-haired woman in her late forties, wearing orange slacks and gold earrings. She is the director of Lee-Peek Mortuary in Fort Pierce, the establishment that handled Zora's burial. Unlike most black funeral homes in Southern towns that sit like palaces among the general poverty, Lee-Peek has a run-down, *small* look. Perhaps this is because it is painted purple and white, as are its Cadillac chariots. These colors do not age well. The rooms are cluttered and grimy, and the bathroom is a tiny, stale-smelling prison, with a bottle of black hair dye (apparently used to touch up the hair of the corpses) dripping into the face bowl. Two pine burial boxes are resting in the bathtub.

Mrs. Patterson herself is pleasant and helpful.

"As I told you over the phone, Mrs. Patterson," I begin, shaking her hand and looking into her penny-brown eyes, "I am Zora Neale Hurston's niece, and I would like to have a marker put on her grave. You said, when I called you last week, that you could tell me where the grave is." ▶

"In Search of Zora Neale Hurston" *(continued)*

By this time I am, of course, completely into being Zora's niece, and the lie comes with perfect naturalness to my lips. Besides, as far as I'm concerned, she *is* my aunt—and that of all black people as well.

"She was buried in 1960," exclaims Mrs. Patterson. "That was when my father was running this funeral home. He's sick now or I'd let you talk to him. But I know where she's buried. She's in the old cemetery, the Garden of the Heavenly Rest, on Seventeenth Street. Just when you go in the gate there's a circle, and she's buried right in the middle of it. Hers is the only grave in that circle— because people don't bury in that cemetery any more."

She turns to a stocky, black-skinned woman in her thirties, wearing a green polo shirt and white jeans cut off at the knee. "This lady will show you where it is," she says.

"I can't tell you how much I appreciate this," I say to Mrs. Patterson, as I rise to go. "And could you tell me something else? You see, I never met my aunt. When she died I was still a junior in high school. But could you tell me what she died of, and what kind of funeral she had?"

"I don't know exactly what she died of," Mrs. Patterson says, "I know she didn't have any money. Folks took up a collection to bury her. . . . I believe she died of malnutrition."

"Malnutrition?"

Outside, in the blistering sun, I lean my head against Charlotte's even more blistering cartop. The sting of the hot metal only intensifies my anger. *"Malnutrition?"* I manage to mutter. "Hell, our condition hasn't

changed *any* since Phillis Wheatley's time. *She* died of malnutrition!"

"Really?" says Charlotte, "I didn't know that."

"One cannot overemphasize the extent of her commitment. It was so great that her marriage in the spring of 1927 to Herbert Sheen was short-lived. Although divorce did not come officially until 1931, the two separated amicably after only a few months, Hurston to continue her collecting, Sheen to attend Medical School. Hurston never married again."

—*Robert Hemenway*

"WHAT IS YOUR NAME?" I ask the woman who has climbed into the back seat.

"Rosalee," she says. She has a rough, pleasant voice, as if she is a singer who also smokes a lot. She is homely, and has an air of ready indifference.

"Another woman came by here wanting to see the grave," she says, lighting up a cigarette. "She was a little short, dumpty white lady from one of these Florida schools. Orlando or Daytona. But let me tell you something before we get started. All I know is where the cemetery is. I don't know one thing about that grave. You better go back in and ask her to draw you a map."

A few moments later, with Mrs. Patterson's diagram of where the grave is, we head for the cemetery.

We drive past blocks of small, pastel-colored houses and turn right onto Seventeenth Street. At the very end, we ▶

"In Search of Zora Neale Hurston" *(continued)*

reach a tall curving gate, with the words "Garden of Heavenly Rest" fading into the stone. I expected, from Mrs. Patterson's small drawing, to find a small circle—which would have placed Zora's grave five or ten paces from the road. But the "circle" is over an acre large and looks more like an abandoned field. Tall weeds choke the dirt road and scrape against the sides of the car. It doesn't help either that I step out into an active anthill.

"I don't know about y'all," I say, "but I don't even believe this." I am used to the haphazard cemetery-keeping that is traditional in most Southern black communities, but this neglect is staggering. As far as I can see there is nothing but bushes and weeds, some as tall as my waist. One grave is near the road, and Charlotte elects to investigate it. It is fairly clean, and belongs to someone who died in 1963.

Rosalee and I plunge into the weeds; I pull my long dress up to my hips. The weeds scratch my knees, and the insects have a feast. Looking back, I see Charlotte standing resolutely near the road.

"Aren't you coming?" I call.

"No," she calls back. "I'm from these parts and I know what's out there." She means snakes.

"Shit," I say, my whole life and the people I love flashing melodramatically before my eyes. Rosalee is a few yards to my right.

"How're you going to find anything out here?" she asks. And I stand still a few seconds, looking at the weeds. Some of them are quite pretty, with tiny yellow flowers. They are thick and healthy, but dead weeds under them have formed a thick gray carpet on the ground. A snake could be lying six inches from my big toe and I wouldn't see it. We move slowly, very slowly, our eyes alert, our legs trembly. It is hard to tell where the center of the circle is since the circle is not really round, but more like half of something round. There are things crackling and hissing in the grass. Sandspurs are sticking to the inside of my skirt. Sand and ants cover my feet. I look toward the road and notice that there are, indeed, *two* large curving stones, making an entrance and exit to the cemetery. I take my bearings from them and try to navigate to exact center. But the center of anything can be very large, and a grave is not a pinpoint. Finding the grave seems positively hopeless. There is only one thing to do:

"Zora!" I yell as loud as I can (causing Rosalee to jump), "are you out here?"

"If she is, I sho hope she don't answer you. If she do, I'm gone."

"Zora!" I call again, "I'm here. Are you?"

"If she is," grumbles Rosalee, "I hope she'll keep it to herself."

"Zora!" Then I start fussing with her. "I hope you don't think I'm going to stand out here all day, with these snakes watching me and these ants having a field day. In fact, I'm going to call you just one or two more times." On a clump of dried grass, near a small busy tree, my eye falls on one of the largest bugs I have ever seen. It is on its back, and is as large as three of my fingers. I walk toward it, and yell "Zo-ra!" and my foot sinks into a hole. I look down. I am standing in a sunken rectangle that is about six feet long and about three or four feet wide. I look up to see where the two gates are.

"Well," I say, "this is the center, or approximately anyhow. It's also the only sunken spot we've found. Doesn't this look like a grave to you?"

"For the sake of not going no farther through these bushes," Rosalee growls, "yes, it do."

"Wait a minute," I say, "I have to look around some more to be sure this is the only spot that resembles a grave. But you don't have to come."

Rosalee smiles—a grin, really—beautiful and tough.

"Naw," she says, "I feels sorry for you. If one of these snakes got a hold of you out here by yourself I'd feel *real* bad." She laughs. "I done come this far, I'll go on with you."

"Thank you, Rosalee," I say. "Zora thanks you too."

"Just as long as she don't try to tell me in person," she says, and together we walk down the field.

"The gusto and flavor of Zora Neal[e] Hurston's storytelling, for example, long before the yarns were published in *Mules and Men* and other books, became a local legend which might . . . have spread further under different conditions. A tiny shift in the center of gravity could have made them bestsellers."

—*Arna Bontemps,* Personals *(Paul Bremen, Ltd., London; 1963)*

"Bitter over the rejection of her folklore's value, especially in the black community, frustrated by what she felt was her failure to convert the Afro-American world view into the forms of prose fiction, Hurston finally gave up."

—*Robert Hemenway* ▶

"In Search of Zora Neale Hurston" *(continued)*

WHEN CHARLOTTE AND I drive up to the Merritt Monument Company, I immediately see the headstone I want.

"How much is this one?" I ask the young woman in charge, pointing to a tall black stone. It looks as majestic as Zora herself must have been when she was learning voodoo from those root doctors down in New Orleans.

"Oh, *that* one," she says, "that's our finest. That's Ebony Mist."

"Well, how much is it?"

"I don't know. But wait," she says, looking around in relief, "here comes somebody who'll know."

A small, sunburned man with squinty green eyes come sup. He must be the engraver, I think, because his eyes are contracted into slits as if he has been keeping stone dust out of them for years.

"That's Ebony Mist," he says. "That's our best."

"How much is it?" I ask, beginning to realize I probably *can't* afford it.

He gives me a price that would feed a dozen Sahelian drought victims for three years. I realize I must honor the dead, but between the dead great and the living starving, there is no choice.

"I have a lot of letters to be engraved," I say, standing by the plain gray marker I have chosen. It is pale and ordinary, not at all like Zora, and makes me momentarily angry that I am not rich.

We got into his office and I hand him a sheet of paper that has:

ZORA NEALE HURSTON
"A GENIUS OF THE SOUTH"

"A genius of the South" is from one of Jean
Toomer's poems.

"Where is this grave?" the monument man
asks. "If it's in a new cemetery, the stone has to
be flat."

"Well, it's not a new cemetery and Zora—
my aunt—doesn't need anything flat because
with the weeds out there, you'd never be able
to see it. You'll have to go out there with me."

He grunts.

"And take a long pole and 'sound' the
spot," I add. "Because there's no way of telling
it's a grave, except that it's sunken."

"Well," he says, after taking my money and
writing up a receipt, in the full awareness that
he's the only monument dealer for miles, "you
take this flag" (he hands me a four-foot-long
pole with a red-metal marker on top) "and
take it out to the cemetery and put it where
you think the grave is. It'll take us about three
weeks to get the stone out there."

I wonder if he knows he is sending me to
another confrontation with the snakes. He
probably does. Charlotte has told me she will
cut my leg and suck out the blood, if I am bit.

"At least send me a photograph when it's
done, won't you?"

He says he will.

"Hurston's return to her folklore-collecting
in December of 1927 was made possible by
Mrs. R. Osgood Mason, an elderly white
patron of the arts, who at various times also
helped Langston Hughes, Alain Locke, ▶

"In Search of Zora Neale Hurston" *(continued)*

Richmond Barthe, and Miguel Covarrubias. Hurston apparently came
to her attention through the intercession of Locke, who frequently
served as a kind of liaison between the young black talent and Mrs.
Mason. The entire relationship between this woman and the Harlem
Renaissance deserves extended study, for it represents much of the
ambiguity involved in white patronage of black artists. All her artists
were instructed to call her 'Godmother'; there was a decided emphasis
on the 'primitive' aspects of black culture, apparently a holdover from
Mrs. Mason's interest in the Plains Indians. In Hurston's case there
were special restrictions imposed by her patron: although she was to
be paid a handsome salary for her folklore collecting, she was to limit
her correspondence and publish nothing of her research without prior
approval."

—*Robert Hemenway*

"You have to read the chapters Zora *left out* of her autobiography."
—*Student, Special Collections Room*
Beinecke Library, Yale University

DR. BENTON, a friend of Zora's and a practicing M.D. in Fort Pierce, is one
of those old, good-looking men whom I always have trouble not liking. (It
no longer bothers me that I may be constantly searching for father figures;
by this time, I have found several and dearly enjoyed knowing them all.)
He is shrewd, with steady brown eyes under hair that is almost white. He is
probably in his seventies, but doesn't look it. He carries himself with
dignity, and has cause to be proud of the new clinic where he now practices
medicine. His nurse looks at us with suspicion, but Dr. Benton's eyes have
the penetration of a scalpel cutting through skin. I guess right away that if
he knows anything at all about Zora Hurston, he will not believe I am her
niece. "Eatonville?" Dr. Benton says, leaning forward in his chair, looking
first at me, then at Charlotte. "Yes, I know Eatonville, I grew up not far
from there. I knew the whole bunch of Zora's family." (He looks at the
shape of my cheekbones, the size of my eyes, and the nappiness of my
hair.) "I knew her daddy. The old man. He was a hardworking, Christian
man. Did the best he could for his family. He was the mayor of Eatonville
for a while, you know.

"My father was the mayor of Goldsboro. You probably never heard of

it. It never incorporated like Eatonville did, and has just about disappeared. But Eatonville is still all-black."

He pauses and looks at me. "And you're Zora's niece," he says wonderingly.

"Well," I say with shy dignity, yet with some tinge, I hope, of a nineteenth-century blush, "I'm illegitimate. That's why I never knew Aunt Zora."

I love him for the way he comes to my rescue. "You're *not* illegitimate!" he cries, his eyes resting on me fondly. "All of us are God's children! Don't you even *think* such a thing!"

And I hate myself for lying to him. Still I ask myself, would I have gotten this far toward getting the headstone and finding out about Zora Hurston's last days without telling my lie? Actually I probably would have. But I don't like taking chances that could get me stranded in Central Florida.

"Zora didn't get along with her family. I don't know why. Did you read her autobiography, *Dust Tracks on a Road*?"

"Yes, I did," I say. "It pained me to see Zora pretending to be naïve and grateful about the old white 'Godmother' who helped finance her research, but I loved the part where she ran off from home after falling out with her brother's wife."

Dr. Benton nodded. "When she got sick, I tried to get her to go back to her family, but she refused. There wasn't any real hatred; they just never had gotten along and Zora wouldn't go to them. She didn't want to go to the country home, either, but she had to, because she couldn't do a thing for herself."

"I was surprised to learn she died of malnutrition."

Dr. Benton seems startled. "Zora *didn't* die of malnutrition," he says indignantly. "Where did you get that story from? She had a stroke and she died in the welfare home." He seems particularly upset, distressed, but sits back reflectively in his chair: "She was an incredible woman," he muses. "Sometimes when I closed my office, I'd go by her house and just talk to her for an hour or two. She was a well-read, well-traveled woman and always had her own ideas about what was going on . . ."

"I never knew her, you know. Only some of Carl Van Vechten's photographs and some newspaper photographs. . . . What did she look like?"

"When I knew her, in the fifties, she was a big woman, *erect*. Not ▶

17

"In Search of Zora Neale Hurston" *(continued)*

quite as light as I am [Dr. Benton is dark beige], and about five foot, seven inches, and she weighed about two hundred pounds. Probably more. She . . . "

"What! Zora was *fat!* She wasn't in Van Vechten's pictures!"

"Zora loved to eat," Dr. Benton says complacently. "She could sit down with a mound of ice cream and just eat and talk till it was all gone."

While Dr. Benton is talking, I recall that the Van Vechten pictures were taken when Zora was still a young woman. In them she appears tall, tan, and healthy. In later newspaper photographs—when she was in her forties—I remembered that she seemed heavier and several shades lighter. I reasoned that the earlier photographs were taken while she was busy collecting folklore materials in the hot Florida sun.

"She had high blood pressure. Her health wasn't good. . . . She used to live in one of my houses—on School Court Street. It's a block house . . . I don't recall the number. But my wife and I used to invite her over to the house for dinner. *She always ate well,*" he says emphatically.

"That's comforting to know," I say, wondering where Zora ate when she wasn't with the Bentons.

"Sometimes she would run out of groceries—after she got sick—and she'd call me. 'Come over here and see 'bout me,' she'd say. And I'd take her shopping and buy her groceries.

"She was always studying. Her mind—before the stroke—just worked all the time. She was always going somewhere, too. She

once went to Honduras to study something. And when she died, she was working on that book about Herod the Great. She was so intelligent! And really had perfect expressions. Her English was beautiful." (I suspect that is a clever way to let me know Zora herself didn't speak in the "black English" her characters used.)

"I used to read all of her books," Dr. Benton continues, "but it was a long time ago. I remember one about . . . it was called, I think, 'The Children of God' [*Their Eyes Were Watching God*], and I remember Janie and Teapot [Teacake] and the mad dog riding on the cow in that hurricane and bit old Teapot on the cheek. . . ."

I am delighted that he remembers even this much of the story, even if the names are wrong, but seeing his affection for Zora I feel I must ask him about her burial. "Did she *really* have a pauper's funeral?"

"She *didn't* have a pauper's funeral!" he says with great heat. "Everybody around here *loved* Zora."

"We just came back from ordering a headstone," I say quietly, because he *is* an old man and the color is coming and going on his face, "but to tell the truth, I can't be positive what I found is the grave. All I know is the spot I found was the only grave-size hole in the area."

"I remember it wasn't near the road," says Dr. Benton, more calmly. "Some other lady came by here and we went out looking for the grave and I took a long iron stick and poked all over that part of the cemetery but we didn't find anything. She took some pictures of the general area. Do the weeds still come up to your knees?" ▶

"And beyond," I murmur. This time there isn't any doubt. Dr. Benton feels ashamed.

As he walks us to our car, he continues to talk about Zora. "She couldn't really write much near the end. She had the stroke and it left her weak; her mind was affected. She couldn't think about anything for long.

"She came here from Daytona, I think. She owned a houseboat over there. When she came here, she sold it. She lived on that money, then she worked as a maid—for an article on maids she was writing—and she worked for the *Chronicle* writing the horoscope column.

"I think black people here in Florida got mad at her because she was for some politician they were against. She said this politician *built* schools for blacks while the one they wanted just talked about it. And although Zora wasn't egotistical, what she thought, she thought; and generally what she thought, she said."

When we leave Dr. Benton's office, I realize I have missed my plane back home to Jackson, Mississippi. That being so, Charlotte and I decide to find the house Zora lived in before she was taken to the country welfare home to die. From among her many notes, Charlotte locates a letter of Zora's she has copied that carries the address: 1734 School Court Street. We ask several people for directions. Finally, two old gentlemen in a dusty gray Plymouth offer to lead us there. School Court Street is not paved, and the road is full of mud puddles. It is dismal and squalid, redeemed only by the brightness of the late afternoon sun. Now I can understand what a "block" house is. It is a house shaped like a block, for one thing, surrounded by others just like it. Some houses are blue and some are green or yellow. Zora's is light green. They are tiny—about fifty by fifty feet, squatty with flat roofs. The house Zora lived in looks worse than the others, but that is its only distinction. It also has three ragged and dirty children sitting on the steps.

"Is this where y'all live?" I ask, aiming my camera.

"No, ma'am" they say in unison, looking at me earnestly. "We live over yonder. This Miss So-and-So's house; but she in the hospital."

We chatter inconsequentially while I take more pictures. A car drives up with a young black couple in it. They scowl fiercely at Charlotte and don't look at me with friendliness, either. They get out and stand in their doorway across the street. I go up to them to explain. "Did you know Zora Hurston used to live right across from you?" I ask.

"Who?" They stare at me blankly, then become curiously attentive, as

if they think I made the name up. They are both Afro-ed and he is somberly dashiki-ed.

I suddenly feel frail and exhausted. "It's too long a story," I say, "but tell me something, is there anybody on this street who's lived here for more than thirteen years?"

"That old man down there," the young man says, pointing. Sure enough, there is a man sitting on his steps three houses down. He has graying hair and is very neat, but there is a weakness about him. He reminds me of Mrs. Turner's husband in *Their Eyes Were Watching God*. He's rather "vanishing"-looking, as if his features have been sanded down. In the old days, before black was beautiful, he was probably considered attractive, because he has wavy hair and light-brown skin; but now, well, light skin has ceased to be its own reward.

After the preliminaries, there is only one thing I want to know: "Tell me something," I begin, looking down at Zora's house, "did Zora like flowers?"

He looks at me queerly. "As a matter of fact," he says, looking regretfully at the bare, rough yard that surrounds her former house, "she was crazy about them. And she was a great gardener. She loved azaleas, and that running and blooming vine [morning glories], and she really loved that night-smelling flower [gardenia]. She kept a vegetable garden year-round, too. She raised collards and tomatoes and things like that.

"Everyone in this community thought well of Miss Hurston. When she died, people all up and down this street took up a collection for her burial. We put her away nice."

"Why didn't somebody put up a headstone?"

"Well, you know, one was never requested. Her and her family didn't get along. They didn't even come to the funeral."

"And did she live there by herself?"

"Yes, until they took her away. She lived with—just her and her companion, Sport."

My ears perk up. "Who?"

"Sport, you know, her dog. He was her only companion. He was a big brown-and-white dog."

When I walk back to the car, Charlotte is talking to the young couple on their porch. They are relaxed and smiling.

"I told them about the famous lady who used to live across the street from them," says Charlotte as we drive off. "Of course they had ▶

21

About the author

no idea Zora ever lived, let alone that she lived across the street. I think I'll send some of her books to them."

"That's real kind of you," I say.

"I am not tragically colored. There is no great sorrow dammed up in my soul, nor lurking behind my eyes. I do not mind at all. I do not belong to the sobbing school of Negrohood who hold that nature somehow has given them a lowdown dirty deal and whose feelings are all hurt about it. . . . No, I do not weep at the world—I am too busy sharpening my oyster knife."

—*Zora Neale Hurston, "How It Feels to Be Colored Me,"* World Tomorrow, *1928*

Alice Walker is the author of Revolutionary Petunias and Other Poems *(Harcourt), which was nominated for a National Book Award, and* In Love & Trouble: Stories of Black Women *(Harcourt), which received the Rosenthal Foundation Award from the National Institute of Arts and Letters.*

THERE ARE TIMES—and finding Zora Hurston's grave was one of them—when normal responses of grief, horror, and so on, do not make sense because they bear no real relation to the depth of the emotion one feels. It was impossible for me to cry when I saw the field full of weeds where Zora is. Partly this is because I have come to know Zora through her books and she was not a teary sort of person herself; but partly, too, it is because there is a point at which even grief feels absurd. And at this point laughter gushes up to retrieve sanity.

It is only later, when the pain is not so direct a threat to one's own existence that what was learned in that moment of comical lunacy is understood. Such moments rob us of both youth and vanity. But perhaps they are also times when greater disciplines are born.

∾

Wrestling with *Mules and Men*
The Story Behind the Book

The following is excerpted from Robert E. Hemenway's Zora Neale Hurston: A Literary Biography *(The University of Illinois Press, 1977) and is reprinted by permission of The University of Illinois Press.*

FOLKLORE, HURSTON SAID, is the art people create before they find out there is such a thing as art; it comes from a folk's "first wondering contact with natural law"—that is, laws of human nature as well as laws of natural process, the truths of a group's experience as well as the principles of physics. These interpretations of nature, called "unscientific" or "crude," often turn out to be wise and poetic explanations for the ways of the world. The parable of the hog under the oak tree—he eats and grunts but never looks up to see where the acorns are coming from—teaches less about the laws of gravity than about the importance of looking for the sources of good fortune; "Ah means tuh prop you up on ev'y leanin' side" is a more graceful explanation of peer support than the jargon of the behavioral psychologist. The folklorist learns to respect these wondering beliefs as artistic expressions which teach one how to live, and Hurston had learned a good deal about both art and life by the time she returned to New York in March, 1930.

She was faced, however, with a scholarly problem: What was her responsibility in

Wrestling with *Mules and Men* *(continued)*

explaining the lore? What stance should she take in relation to the folk? How could she make others see this great cultural wealth? The final answers to these questions came in *Mules and Men*. Not published until 1935, the book was largely completed between March, 1930, when Mrs. Mason first paid her rent for the room in Westfield, and September of 1932, when Zora received her last payments from her patron. By the time readers shared in her discoveries, some of her ideas were six years old, and Hurston had gone on to a career as a novelist and dramatist. As she organized her field notes during 1930–32, she conceptualized black folklore, exploring the ways black history affected folk narratives, hypothesizing about racial characteristics in traditional communication. This mature conception of folklore changed only slightly over the years, and it antedates her best work as an artist. Even though her first novel was published prior to *Mules and Men*, it was written after she had completed the folklore research. In a sense, her career as a folklorist ended when she finished with her field notes, and after the fall of 1932 she usually conceived of herself as a creative writer—even when writing about folklore.

The struggle to shape a book, or, more accurately, a series of books, from her mass of folklore texts became increasingly difficult. She worked fiercely for the remainder of 1930, producing a number of different drafts; by the end of the year she was still confident, but much more tentative than when she had returned from her travels. She told Mrs. Mason, "I shall wrassle me up a future, or die trying." Publishers had various ideas for revision, but no one was ready to publish. Mrs. Mason's support could not go on forever, and the white woman was growing less patient with each rejection. Zora told her, "I am trying to get some bone in my legs so that you can see me standing so that I shall cease to worry you." Publishers had been telling her that she was too impatient, that "large sums are not invested without due thought." In the childlike imagery that Mrs. Mason enjoyed and Hurston knew would charm, she told her Godmother that she would be more aggressive: "So watch your sunburnt child do some shuffling. That is the thing that I have lacked—the urge to push hard and insist on a hearing."

Early in 1931 Hurston decided to forget about her folktale manuscript and write up the story of Cudjo Lewis. A second manuscript, on conjure, was making the rounds after extensive editing by Locke, but the initial reports were not promising. Soon she had a hundred-page manuscript

about Lewis entitled "Barracoon," but her old friend, the editor Harry Block, said it was not ready. Her strength was being stolen by infected tonsils, and she felt "only half of me at least a third of the time." Block also read the conjure manuscript and urged her to make it less a mere collection, more a "geographical and chronological narrative." It all added up to rejection—a failure symbolized by Mrs. Mason's formal severance of their contract on March 31. Zora could continue to work her manuscripts, but she would do so without regular subsidy.

In June the city of New York began to tear up the street outside her apartment on West Sixty-sixth, and the noise "disorganized" her; she fled upstate to a friend's house in Pleasantville, struggling again with *Mules and Men*, the folktales that seemed to have the best chance of publication. Mrs. Mason gave her $100 for the month, but it was not enough. She asked for more, and assured Godmother that "by July first I can make some arrangements that will help tide me over." Zora was troubled at being suddenly thrust out from under the Mason umbrella, and the peace of mind she needed to work was frequently missing. She searched for employment, even proposing to Godmother that she be provided capital so that she could "set up as a chicken specialist" who would "be ready to supply hot fried chicken at a moment's notice to the carriage trade." She explained, "Why do I think of this? I firmly believe that I shall succeed as a writer, but the time element is important."

One of the Great Depression's unemployed, Zora still wrestled with *Mules and Men* during the summer of 1931; she felt that she was beginning to find herself: "It has been a most intense summer, not a moment of relaxation, but I like working hard." In the fall the hard work began to pay off. George Antheil, the French composer, contacted her on behalf of Nancy Cunard, to ask if she had any folklore essays that Cunard might use in an anthology she was putting together. Zora was waiting for a chance to demonstrate the richness of her material, and after getting Godmother's approval, she met with Antheil. He went away with six essays, charmed and dazzled by this dynamic woman who he believed "would be the most stolen-from Negro in the world for the next ten years at least."

The daughter of British nobility, Nancy Cunard was a flamboyant personality who made frequent trips to Harlem in the late twenties and early thirties, much to the delight of the journalists who luridly reported her every move. Despite her family's opposition, she had fallen in love with a black ▸

Wrestling with *Mules and Men* *(continued)*

musician, and a major reason for assembling the anthology was to dedicate it to him. She solicited contributions world wide, ending up with a massive volume entitled *Negro* that took years to prepare for publication.

Hurston's essays in *Negro* probably were written in 1930, since there are a number of favorable references to Hughes that would not have been likely after "Mule Bone." The most analytical part of her series, "Characteristics of Negro Expression," represents her first attempt to summarize her field work. The article is disorganized, indicating that the task proved difficult. Its thesis, however, is clearly stated: creativity is the distinguishing characteristic of black American culture. In an assimilationist era, when black intellectuals stressed the similarities between the races, Hurston proudly affirmed the cultural differences. She believed that an esthetically oriented black subculture provided a striking contrast to the imaginative wasteland of white society. Although she did not use the phrase, she was really saying that whites were culturally deprived because they lacked soul.

Hurston's emphasis throughout *Negro* is on communicative forms as distinctive black art. She identifies one of the key characteristics of Negro expression as the "will to adorn." Hurston speaks of black people's taking what white civilization offered and ornamenting it for their own use. She cites how the "American Negro has done wonders to the English language" by introducing unusual metaphors and similes ("one at a time, like lawyers going to heaven") double descriptive adjectives (*low-down,*

kill-dead), and verbal nouns (*funeralize*). Her explanation for this behavior is that "the stark, trimmed phrases of the Occident seem too bare for the voluptuous child of the sun, hence the adornment. It arises out of the same impulse as ... the making of sculpture."

However interesting, Hurston's *Negro* essays were not a comprehensive account of black American folklore, and *Mules and Men* remains her primary expression of the extensive research of 1927–32. It sought a publisher in several versions between 1929 and 1934, although the book's core—seventy folktale texts—remained the same. Zora left New York for Eatonville in the spring of 1932, and the change in scenery became a major factor in enabling her to complete the book. She told friends that she was happier in Eatonville than she had been for years: "The air is sweet, literally sweet." She planted a garden with black-eyed peas, watermelons, pole beans, and okra, then got to work again on the book, revising all day and sitting on her porch at night to listen to the mockingbirds and smell the honeysuckle. By July the garden had been victimized by dry weather, but *Mules and Men* was finished and being typed.

By September the manuscript was looking again for a publisher. The tales that in 1929 were "going to press" became, in 1932, "folk tales with background so that they are in atmosphere and not just stuck out into cold space. I want the reader to see why Negroes tell such glorious tales. He [the Negro] has more images within his skull than any other human in circulation. That is why it makes me furious when some ham like [Octavus Roy] ▶

Cohen or Roark Bradford gets off a nothing else but and calls it a high spot of Negro humor and imagery." She told another correspondent that she was leaving out all the theory and restricting the book to the folktales themselves and how they were collected. The manuscript made the rounds, for the next two years; not until her first novel, *Jonah's Gourd Vine*, had been accepted by Lippincott's did it find a publisher. Even then, her editor, Bertram Lippincott, asked her to revise the manuscript, "so that it would not be too technical for the average reader." Since the publisher wanted a "$3.50 book," she also selected and condensed from her earlier hoodoo article to add to the volume, the hoodoo section forming the last third of the book. This material (discussed earlier) was changed only slightly from the 1931 version in the *Journal of American Folklore*.

With *Mules and Men* scheduled for publication February, 1935, she became afraid that Papa Franz might not endorse such an unscientific work:

Longwood, Fla.
Aug. 20, 1934
Dear Dr. Boas,

I am full of tremors, lest you decide that you do not want to write the introduction to my *Mules and Men*. I want you to do it so very much. Also I want Dr. [Ruth] Benedict to read the ms. and offer suggestions. Sort of edit it you know.

Mr. Lippincott likes the book very much and he will push it. His firm, as you know, probably publishes more text-books than any other in America and he is conservative. He wants a very readable book that the average reader can understand, at the same time one that will have value as a reference book. I have inserted the between-story conversation and business because when I offered it without it, every publisher said it was too monotonous. Now three houses want to publish it. So I hope that the unscientific matter that must be there for the sake of the average reader will not keep you from writing the introduction. It so happens that the conversations and incidents are true. But of course I never would have set them down for scientists to read. I know that the learned societies are interested in the story in many ways that would never interest the average mind. He needs no stimulation. But the man in the street is different.

So *please* consider all this and do not refuse Mr. Lippincott's request to write the introduction to *Mules and Men*. And then in addition, I feel that the persons who have the most information on a subject should teach the public. Who knows more about folk-lore than you and Dr. Benedict? Therefore the stuff published

in America should pass under your eye. *You* see some of the preposterous stuff put out by various persons on various folk-subjects. This is not said merely to get you to write the introduction to my book. No. But an enormous amount of loose writing is being done.

My best to Drs. [Otto] Klineberg and [Gladys] Reichard.

Most Sincerely,
Zora Hurston

Boas granted his approval after checking the manuscript for authenticity. He stressed in his preface that it offered "the intimate setting in the social life of the Negro" absent from previous folklore books. ∾

Have You Read?
More by
Zora Neale Hurston

JONAH'S GOURD VINE

Zora Neale Hurston's first novel tells the story of John Buddy Pearson, a young minister who loves too many women for his own good even though he is married to Lucy, his one true love. In this sympathetic portrait of a man and his community, Hurston shows that faith and tolerance and good intentions cannot resolve the tension between the spiritual and the physical.

THEIR EYES WERE WATCHING GOD

The epic tale of Janie Crawford, whose quest for identity takes her on a journey during which she learns what love is, experiences life's joys and sorrows, and comes home to herself in peace. Her passionate story prompted Alice Walker to say, "There is no book more important to me than this one."

THE COMPLETE STORIES

This landmark gathering of Zora Neale Hurston's short fiction—most of which appeared only in literary magazines during her lifetime and some of which has never before been published—reveals the evolution of one of the most important African American writers. Spanning her career from 1921 to 1955, these stories attest to Hurston's tremendous range and establish themes that recur in her longer

fiction. The stories in this collection map, in rich language and imagery, Hurston's development and concerns as a writer and provide an invaluable reflection of the mind and imagination of the author of the acclaimed novel *Their Eyes Were Watching God*.

TELL MY HORSE

This firsthand account of the mysteries of Vodou is based on Hurston's personal experiences in Haiti and Jamaica, where she participated as an initiate and not just an observer of Vodou practices in the 1930s. Of great cultural interest, her travelogue paints a vividly authentic picture of ceremonies, customs, and superstitions.

MOSES, MAN OF THE MOUNTAIN

Based on the familiar story of the Exodus, Hurston blends the Moses of the Old Testament with the Moses of black folklore and song to create a compelling allegory of power, redemption, and faith.

DUST TRACKS ON A ROAD

First published in 1942 at the crest of her popularity as a writer, this is Hurston's imaginative and exuberant account of her rise from childhood poverty in the rural South to a prominent place among the leading artists and intellectuals of the Harlem Renaissance. It is a book full of the wit and wisdom of a proud and spirited woman who started off low and climbed high.

Have You Read? *(continued)*

SERAPH ON THE SUWANEE

Hurston's novel of turn-of-the-century white Florida "crackers" marks a daring departure for the author famous for her complex accounts of black culture and heritage. Hurston explores the evolution of a marriage full of love but very little communication and the desires of a young woman in search of herself and her place in the world.

EVERY TONGUE GOT TO CONFESS

African American folklore was Zora Neale Hurston's first love. Collected in the late 1920s, these hilarious, bittersweet, often saucy folktales—some of which date back to the Civil War—provide a fascinating, verdant slice of African American life in the rural South at the turn of the twentieth century. Arranged according to subject—from God Tales, Preacher Tales, and Devil Tales to Heaven Tales, White-Folk Tales, and Mistaken Identity Tales—they reveal attitudes about slavery, faith, race relations, family, and romance that have been passed on for generations. They capture the heart and soul of the vital, independent, and creative community that so inspired Zora Neale Hurston.

Don't miss the next book by your favorite author. Sign up now for AuthorTracker by visiting www.AuthorTracker.com.

TELL MY HORSE

Ascending the sacred waterfalls at Saut d'Eau

TELL MY HORSE

VOODOO AND LIFE

IN HAITI AND

JAMAICA

ZORA NEALE HURSTON

WITH A NEW FOREWORD BY ISHMAEL REED
SERIES EDITOR: HENRY LOUIS GATES, JR.

AMISTAD

An Imprint of HarperCollinsPublishers

To
Carl Van Vechten
God's image of a friend

AMISTAD

"More Than a Voodoo" copyright © 1990 by Ishmael Reed.

A hardcover edition of this book was originally published by J. B. Lippincott, Inc.

P.S.™ is a trademark of HarperCollins Publishers.

FIRST PERENNIAL LIBRARY EDITION PUBLISHED 1990.
FIRST HARPER PERENNIAL MODERN CLASSICS EDITION PUBLISHED 2009.

Designed by Cassandra J. Pappas

Library of Congress Cataloging-in-Publication Data is available upon request.

ISBN 978-0-06-169513-1

21 22 23 LSC 20 19 18 17 16

CONTENTS

Part III
VOODOO IN HAITI

ILLUSTRATIONS

PART I

❖

JAMAICA

CHAPTER 1

THE ROOSTER'S NEST

Jamaica, British West Indies, has something else besides its mountains of majesty and its quick, green valleys. Jamaica has its moments when the land, as in St. Mary's, thrusts out its sensuous bosom to the sea. Jamaica has its "bush." That is, the island has more usable plants for medicinal and edible purposes than any other spot on earth. Jamaica has its Norman W. Manley, that brilliant young barrister who looks like the younger Pitt in yellow skin, and who can do as much with a jury as Darrow or Liebowitz ever did. The island has its craze among the peasants known as Pocomania, which looks as if it might be translated into "a little crazy." But Brother Levi says it means "something out of nothing." It is important to a great number of people in Jamaica, so perhaps we ought to peep in on it a while.

The two greatest leaders of the cult in Jamaica are Mother Saul, who is the most regal woman since Sheba went to see Solomon, and Brother Levi, who is a scrontous-looking man himself.

Brother Levi said that this cult all started in a joke but worked on into something important. It was "dry" Pocomania

3

when it began. Then it got "spirit" in it and "wet." What with the music and the barbaric rituals, I became interested and took up around the place. I witnessed a wonderful ceremony with candles. I asked Brother Levi why this ceremony and he said, "We hold candle march after Joseph. Joseph came from cave where Christ was born in the manger with a candle. He was walking before Mary and her baby. You know Christ was not born in the manger. Mary and Joseph were too afraid for that. He was born in a cave and He never came out until He was six months old. The three wise men see the star but they can't find Him because He is hid in cave. When they can't find Him after six months, they make a magic ceremony and the angel come tell Joseph the men wanted to see Him. That day was called 'Christ must day' because it means 'Christ must find today,' so we have Christmas day, but the majority of people are ignorant. They think Him born that day."

I went to the various "tables" set in Pocomania, which boils down to a mixture of African obeah and Christianity enlivened by very beautiful singing. I went to a "Sun Dial"—that is a ceremony around the clock (24 hours long). The place was decorated from the gate in, with braided palm fronds and quacca bush. Inside the temple, the wall behind the altar was papered with newspapers.

There, the ceremony was in the open air. A long table covered with white. Under this table, on the ground, lighted candles to attract the spirits. There was a mysterious bottle which guaranteed "the spirit come." The Shepherd entered followed by the Sword Boy, carrying a wooden sword. After him came the Symbol Boy with a cross, chanting. Then came the Unter Boy with a supple jack, a switch very much like a rattan cane in his hand. During the ceremony he flogged those who were "not in spirit" that is, those who sat still. They are said to "cramp" the others who are in spirit. The Governess followed the Unter Boy. She has charge of all the women, but otherwise she functions something like the Mambo of Haiti. She aids the Shepherd and generally fires the meeting by leading the songs and whipping up the crowd. There followed

4

then the Shepherd Boy who is the "armor-bearer" to the Shepherd.

Their ceremony is exciting at times with singing, marching, baptisms at sacred pools in the yard. Miraculous "cures" (Mother Saul actually sat down upon a screaming Chinese boy to cure him of insanity); and the dancing about the tables with that tremendous exhalation of the breath to set the rhythm. That is the most characteristic thing of the whole ceremony. That dancing about the lighted candle pattern on the ground and that way of making a rhythmic instrument and of the breathing apparatus—such is Pocomania, but what I have discussed certainly is not all of it.

These "Balm yards" are deep in the lives of the Jamaican peasants. A Balm Yard is a place where they give baths, and the people who operate these yards are to their followers both doctor and priest. Sometimes he or she diagnoses a case as a natural ailment, and a bath or series of baths in infusions of secret plants is prescribed. More often the diagnosis is that the patient has been "hurt" by a duppy, and the bath is given to drive the spirit off. The Balm Yard with a reputation is never lacking for business. These anonymous rulers of the common people have decreed certain rules and regulations for events in life that are rigidly adhered to. For instance the customs about birth and death. The childbed and the person of the newborn baby must be protected from the dead by marks made with bluing. When it is moved from this room, the open Bible must precede it to keep off the duppies, and so on.

Tables are usually set because something for which a ceremony has been performed is accomplished. The grateful recipient of favor from the gods then sets a table of thanksgiving. No one except the heads of the Balm Yard and the supplicants are told what it is for. Most of the country products are served with plenty of raw rum. The first and most important thing is a small piece of bread in a small glass of water as a symbol of plenty.

And then Jamaica has its social viewpoints and stratifications which influence so seriously its economic direction.

Jamaica is the land where the rooster lays an egg. Jamaica is two per cent white and the other ninety-eight per cent all degrees of mixture between white and black, and that is where the rooster's nest comes in. Being an English colony, it is very British. Colonies always do imitate the mother country more or less. For instance some Americans are still aping the English as best they can even though they have had one hundred and fifty years in which to recover.

So in Jamaica it is the aim of everybody to talk English, act English and *look* English. And that last specification is where the greatest difficulties arise. It is not so difficult to put a coat of European culture over African culture, but it is next to impossible to lay a European face over an African face in the same generation. So everybody who has any hope at all is looking out for the next generation and so on. The color line in Jamaica between the white Englishman and the blacks is not as sharply drawn as between the mulattoes and the blacks. To avoid the consequences of posterity the mulattoes give the blacks a first class letting alone. There is a frantic stampede white-ward to escape from Jamaica's black mass. Under ordinary circumstances the trend would be towards the majority group, of course. But one must remember that Jamaica has slavery in her past and it takes many generations for the slave derivatives to get over their awe for the master-kind. Then there is the colonial attitude. Add to that the negro's natural aptitude for imitation and you have Jamaica.

In some cases the parents of these mulattoes have been properly married, but most often that is not the case. The mixed-blood bears the name with the bar sinister. However, the mulatto has prestige, no matter how he happened to come by his light skin. And the system of honoring or esteeming his approach to the Caucasian state is so elaborate that first, second, third and fourth degrees of illegitimacy are honored in order of their nearness to the source of whiteness. Sometimes it is so far fetched, that one is reminded of that line from "Of Thee I Sing," where the French Ambassador boasts, "She is the illegitimate daughter of the illegitimate son of the illegiti-

6

mate nephew of the great Napoleon." In Jamaica just substitute the word Englishman for Napoleon and you have the situation.

Perhaps the Jamaican mixed bloods are logical and right, perhaps the only answer to the question of what is to become of the negro in the Western world is that he must be absorbed by the whites. Frederick Douglass thought so. If he was right, then the strategy of the American Negro is all wrong, that is, the attempt to achieve a position equal to the white population in every way but each race to maintain its separate identity. Perhaps we should strike our camps and make use of the cover of night and execute a masterly retreat under white skins. If that is what must be, then any way at all of getting more whiteness among us is a step in the right direction. I do not pretend to know what is wise and best. The situation presents a curious spectacle to the eyes of an American Negro. It is as if one stepped back to the days of slavery or the generation immediately after surrender when negroes had little else to boast of except a left-hand kinship with the master, and the privileges that usually went with it of being house servants instead of field hands. Then, as in Jamaica at present, no shame was attached to a child born "in a carriage with no top." But the pendulum has swung away over to the other side of our American clock. Even in His Majesty's colony it may work out to everybody's satisfaction in a few hundred years, if the majority of the population, which is black, can be persuaded to cease reproduction. That is the weak place in the scheme. The blacks keep on being black and reminding folk where mulattoes come from, thus conjuring up tragi-comic dramas that bedevil security of the Jamaican mixed bloods.

Everywhere else a person is white or black by birth, but it is so arranged in Jamaica that a person may be black by birth but white by proclamation. That is, he gets himself declared legally white. When I used the word black I mean in the American sense where anyone who has any colored blood at all, no matter how white the appearance, speaks of himself as black. I was told that the late John Hope, late President of

Atlanta University, precipitated a panic in Kingston on his visit there in 1935, a few months before his death. He was quite white in appearance and when he landed and visited the Rockefeller Institute in Kingston and was so honored by them, the "census white" Jamaicans assumed that he was of pure white blood. A great banquet was given him at the Myrtle Bank Hotel, which is the last word in swank in Jamaica. All went well until John Hope was called upon to respond to a toast. He began his reply with, "We negroes—." Several people all but collapsed. John Hope was whiter than any of the mulattoes there who had had themselves ruled white. So that if a man as white as that called himself a negro, what about them? Consternation struck the banquet like a blight. Of course, there were real white English and American people there too, and I would have loved to have read their minds at that moment. I certainly would.

The joke about being white on the census records and colored otherwise has its curious angles. The English seem to feel that "If it makes a few of you happy and better colonials to be officially white, very well. You are white on the census rolls." The Englishman keeps on being very polite and cordial to the legal whites in public, but ignores them utterly in private and social life. And the darker negroes do not forget how they came to be white. So I wonder what really is gained by it. George Bernard Shaw on his recent tour observed this class of Jamaicans and called them "those pink people" of Jamaica.

That brings us to the matter of the rooster's nest again. When a Jamaican is born of a black woman and some English or Scotsman, the black mother is literally and figuratively kept out of sight as far as possible, but no one is allowed to forget that white father, however questionable the circumstances of birth. You hear about "My father this and my father that, and my father who was English, you know," until you get the impression that he or she *had* no mother. Black skin is so utterly condemned that the black mother is not going to be mentioned nor exhibited. You get the impression that these virile Englishmen do not require women to reproduce. They

just come out to Jamaica, scratch out a nest and lay eggs that hatch out into "pink" Jamaicans.

But a new day is in sight for Jamaica. The black people of Jamaica are beginning to respect themselves. They are beginning to love their own things like their songs, their Anansi stories and proverbs and dances. Jamaican proverbs are particularly rich in philosophy, irony and humor. The following are a few in common use:

1. Rockatone at ribber bottom no know sun hot. (The person in easy circumstances cannot appreciate the sufferings of the poor.)
2. Seven year no 'nough to wash speckle off guinea hen back. (Human nature never changes.)
3. Sharp spur mek maugre horse cut caper. (The pinch of circumstances forces people to do what they thought impossible.)
4. Sickness ride horse come, take foot go away. (It is easier to get sick than it is to get well.)
5. Table napkin want to turn table cloth. (Referring to social climbing.)
6. Bull horn nebber too heavy for him head. (We always see ourselves in a favorable light.)
7. Cock roach nebber in de right befo' fowl. (The oppressor always justifies his oppression of the weak.)
8. If you want fo' lick old woman pot, you scratch him back. (The masculine pronoun is always used for female. Use flattery and you will succeed.)
9. Do fe do make guinea nigger come a' Jamaica. (Fighting among themselves in Africa caused the negroes to be sold into slavery in America.)
10. Dog run for him character; hog run for him life. (It means nothing to you, but everything to me.)
11. Finger nebber say, "look here," him say "look dere." (People always point out the shortcomings of others but never their own.)
12. Cutacoo on man back no yerry what kim massa yerry. (The basket on a man's back does not hear what he hears.)

9

Up until three years ago these proverbs and everything else Jamaican have been lumped with black skins and utterly condemned.

There is Mrs. Norman W. Manley, a real Englishwoman who is capturing Jamaican form in her sculpture. Her work has strength of conception and a delicate skill in execution. Because she used native models, she has been cried down by the "census whites" who know nothing about art but know that they do not like anything dark, however great the art may be. Mrs. Manley's work belongs in New York and London and Paris. It is wasted on Kingston for the most part, but the *West Indian Review,* which is the voice of thinking Jamaica, has found her. That is a very hopeful sign. And there is the yeast of the Bailey Sisters and the Meikle Brothers and their leagues, and influences like the Quill and Ink Club which is actively inviting Jamaica's soul to come out from its hiding place. The Rooster's Nest is bound to be less glamorous in the future.

CHAPTER 2

CURRY GOAT

The very best place to be in all the world is St. Mary's parish, Jamaica. And the best spot in St. Mary's is Port Maria, though all of St. Mary's is fine. Old Maker put himself to a lot of trouble to make that part of the island of Jamaica, for everything there is perfect. The sea is the one true celestial blue, and the shore, the promontories, the rocks and the grass are the models for the rest of the world to take pattern after. If Jamaica is the first island of the West Indies in culture, then St. Mary's is the first parish of Jamaica. The people there are alert, keen, well-read and hospitable.

They did something for me there that has never been done for another woman. They gave me a curry goat feed. That is something utterly masculine in every detail. Even a man takes the part of a woman in the "shay shay" singing and dancing that goes on after the feed.

It was held on a Wednesday night at the house of C. I. Magnus. His bachelor quarters sat upon a hill that overlooked his large banana plantation. I heard that Dr. Leslie, Claude Bell, Rupert Meikle and his two big, handsome brothers and Larry Coke and some others bought up all those goats that

were curried for the feed. I have no way of knowing who all chipped in to buy things, but the affair was lavish.

We set out from Port Maria in Claude Bell's car, containing Claude, Dr. Leslie and I. Then Larry Coke overtook us and we ambled along until we ran into something exciting. Just around a bend in the road we came to an arch woven of palm fronds before a gate. There were other arches of the same leading back to a booth constructed in the same manner. It was not quite finished. Men were seated in the yard braiding more palm fronds. A great many people were in the yard, under the palm booth and in the house. Three women with elaborate cakes upon their heads were dancing under the arch at the gate. The cakes were of many layers and one of the cakes was decorated with a veil. The cake-bearers danced and turned under the arch, and turned and danced and sang with the others something about "Let the stranger in." This kept up until an elderly woman touched one of the dancers. Then the one who was touched whirled around gently, went inside the yard and on into the house. Another was touched and turned and she went in and then the third.

"What is going on here?" I asked Claude Bell, and he told me that this was a country wedding. That is, it was the preparation for one. Claude Bell is the Superintendent of Public Works in St. Mary's, so that everybody knows him. He went over and said that we wished to come in and the groom-to-be made us welcome. I asked how was it that they all knew at once who the groom was and they said that he would always be found out front being very proud and expansive and doing all the greeting and accepting all the compliments.

We went inside the house and saw the cakes arranged to keep their vigil for the night. A lighted candle was placed beside the main cake, and it was kept burning all that night. It did add something to the weight of the occasion to drape that bride's cake in a white lace veil and surround it with lights for a night. It made one spectator at least feel solemn about marriage. After being introduced to the shy little bride and shaking hands with the proud groom we went off after promis-

12

ing to come back to the wedding next day.

So on to the Magnus plantation and the curry goat feed. It was after sundown when we arrived. Already some of the others were there before us. Around a fire under a clump of mango trees, two or three Hindoos were preparing the food. Magnus was setting out several dozen quarts of the famous T. T. L. rum, considered the best in Jamaica. They told me that a feed without T. T. L. was just nothing at all. It must be served or it is no proper curry goat feed. The moon rose full and tropical white and under it I could see the musicians huddled under another clump of trees waiting until they should be told to perform.

Finally there were about thirty guests in all including some very pretty half-Chinese girls. The cooks announced and we went inside to eat. Before that everybody had found congenial companions and had wandered around the grounds warming themselves by the moonlight.

It appeared that there must be a presiding officer at a curry goat. Some wanted the very popular Larry Coke, but it seemed that more wanted the more popular Dr. Leslie, so it went that way. He sat at the head of the table and directed the fun. There was a story-telling contest, bits of song, reminiscences that were side splitting and humorous pokes and jibes at each other. All of this came along with the cock soup. This feast is so masculine that chicken soup would not be allowed. It must be soup from roosters. After the cock soup comes ram goat and rice. No nanny goat in this meal either. It is ram goat or nothing. The third spread was banana dumpling with dip-and-flash. That is, you dip your boiled banana in the suruwa sauce, flash off the surplus and take a bite. By that time the place was on fire with life. Every course was being washed down with T. T. L. Wits were marvelously sharpened; that very pretty Lucille Woung was eating out of the same spoon with J. T. Robertson; Reginald Beckford kept on trying to introduce somebody and the others always howled him down because he always got wound up and couldn't find his way out. Finally Dr. Leslie asked him why he never finished and he said "Being a

13

banana man, I have to go around the corner before I get my target." The award for the best story-teller went to Rupert Meikle, but his brother H. O. S. Meikle ran him a close second.

The band began playing outside there in the moonlight and we ran away from the table to see it. You have to see those native Jamaica bands to hear them. They are doing almost as much dancing with the playing as they are playing. As I said before no woman appears with the players, though there is a woman's part in the dancing. That part is taken by a man especially trained for that. The whole thing is strong meat, but compelling. There is some barbaric dancing to magnificent rhythms. They played that famous Jamaican air "Ten Pound Ten," "Donkey Want Water," "Salaam," and "Sally Brown." All strong and raw, but magnificent music and dancing. It is to be remembered that curry goat is a strong feed, so they could not have femalish music around there.

We got home in time to sleep a little before going on to the wedding the next afternoon.

The wedding was at the church and the guests all finally got there by sending one car back and forth several times. The bride came in the last load. There were many, many delays, but finally the couple were married and everybody went back to the house for the reception.

At the house it came to me what a lot of trouble these country people were taking to create the atmosphere of romance and mystery. Here was a couple who were in late middle life, who had lived together so long that they had grown children and were just getting married. Seemingly it all should have been rather drab and matter of fact. Surely there could be no mystery and glamor left for them to find in each other. But the couple and all the district were making believe that there was. It was like sewing ruffles on fence rails. The will to make life beautiful was strong. It happens this way frequently in Jamaica. That is, many couples live together as husband and wife for a generation and then marry. They explain that they always intended to marry, but never had the

14

money. They do not mean by that that they did not have the price of the marriage license. They mean that they did not have the money for the big wedding and all that it means. So they go on raising their children on the understanding that if and when they can afford it they will have the wedding. Sometimes, as in this case, the couple is along in years and with grown children before the money can be spared. In the meanwhile, they live and work together like any two people who have been married by the preacher.

Back at the house everything was very gay with cake and wine and banter. There was a master of ceremonies. The bride's face was covered with her veil. In fact it had never been uncovered. She was made to stand like that and the master of ceremonies received bids on who was to lift her veil first. The highest bidder got the first peep. The first man to peep had bid six shillings. I thought that that was very high for a poor man until I found that on such occasions it was agreed that the word shilling is substituted for pence. It would sound too poor to say pence. He paid his sixpence amid great applause and lifted the bride's veil and peeped and put it back in place. Then the bidding began again and kept up until the master of ceremonies put a stop to it. The bidding had gone on for some time and everyone pretended a curiosity about the youth and glamor they imagined to be hidden under the veil.

After the unveiling of the bride we left. The groom made us promise that we would be present at the "turn thanks." That is a ceremony held at the church on the Sunday after the eighth day after the wedding. Again everybody goes to the church to see the bride again in her finery. The pastor and the Justice of the Peace are there and give the happy couple a lecture on how to live together. But the bride does not wear her veil this time, she is resplendent in her "turn-thanks" hat. The couple are turning thanks for the blessing of getting married.

But we did not go to the turn-thanks. Something happened

15

in Claude Bell's summer house that rushed me off in another direction.

The next morning after the wedding I was lounging in the summer house and looking at the sea when a young man of St. Mary's dropped in. I do not remember how we got around to it, but the subject of love came up somehow. He let it be known that he thought that women who went in for careers were just so much wasted material. American women, he contended, were destroyed by their brains. But they were only a step or two worse off than the rest of the women of the Western world. He felt it was a great tragedy to look at American women, whom he thought the most beautiful and vivacious women on earth, and then to think what little use they were as women. I had been reclining on my shoulder-blades in a deck chair, but this statement brought me up straight. I assured him that he was talking about what he didn't know.

"Oh, yes, I do," he countered, "I was not born yesterday and my light has not been kept under a bushel, whatever that is."

"You are blaspheming, of course, but go ahead and let me see what you are driving at."

"Oh, these wisdom-wise Western women, afraid of their function in life, are so tiresomely useless! We men do not need your puny brains to settle the affairs of the world. The truth is, it is yet to be proved that you have any. But some of you are clever enough to run mental pawnshops, that is you loan out a certain amount of entertainment and hospitality on some masculine tricks and phrases and later pass them off as your own. Being a woman is the only thing that you can do with any real genius and you refuse to do that."

I tried to name some women of genius but I was cut short. The man was vehement.

"You self-blinded women are like the hen who lived by a sea-wall. She could hear the roar of the breakers but she never flew to the top of the wall to see what it was that made the sound. She said to herself and to all who would listen to her,

16

'The world is something that makes a big noise.' Having arrived at that conclusion, she thought that she had found a great truth and was satisfied for the rest of her life. She died without ever hopping upon the sea-wall to look and see if there was anything to the world besides noise. She had lived beside the biggest thing in the world and never saw it."

"So you really feel that all women are dumb, I see."

"No, not all women. Just those who think that they are the most intelligent, as a rule. And the Occidental men are stupid for letting you ruin yourselves and the men along with you."

Of course I did not agree with him and so I gave him my most aggravating grunt. I succeeded in snorting a bit of scorn into it. I went on to remark that Western men, especially American men, probably knew as much about love as the next one.

Then *he* snorted scornfully. He went on to say that the men of the West and American men particularly knew nothing about the function of love in the scheme of life. I cut in to mention Bernarr McFadden. He snorted again and went on. Even if a few did have some inkling, they did not know how to go about it. He was very vehement about it. He said we insulted God's intentions so grossly that it was a wonder that western women had not given up the idea of mating and marriage altogether. But many men, and consequently women, in Jamaica were better informed. I wanted to know how it was that these Jamaicans had been blessed beyond all others on this side of the big waters, and he replied that there were oriental influences in Jamaica that had been at work for generations, so that Jamaica was prepared to teach continental America something about love. Saying this, he left the summer house and strode towards his car which was parked in the drive. But he could not say all that to me and then walk off like that. I caught him on the running board of his car and carried him back. When I showed a disposition to listen instead of scoffing, we had a very long talk. That is, he talked and I listened most respectfully.

Before he drove away he had told me about the specialists

who prepare young girls for love. This practise is not universal in Jamaica, but it is common enough to speak of here. I asked to be shown, and he promised to use his influence in certain quarters that I might study the matter at close range. It was arranged for me to spend two weeks with one of the practitioners and learn what I could in that time. There are several of these advisors scattered about that section of Jamaica, but people not inside the circle know nothing about what is going on.

These specialists are always women. They are old women who have lived with a great deal of subtlety themselves. Having passed through the active period and become widows, or otherwise removed from active service, they are re-inducted in an advisory capacity.

The young girl who is to be married shortly or about to become the mistress of an influential man is turned over to the old woman for preparation. The wish is to bring complete innocence and complete competence together in the same girl. She is being educated for her life work under experts.

For a few days the old woman does not touch her. She is taking her pupil through the lecture stages of instruction. Among other things she is told that the consummation of love cannot properly take place in bed. Soft beds are not for love. They are comforts for the old and lack-a-daisical. Also she is told that her very position must be an invitation. When her lord and master enters the chamber she must be on the floor with only her shoulders and the soles of her feet touching the floor. It is *so* that he must find her. Not lying sluggishly in bed like an old cow, and hiding under the covers like a thief who has snatched a bit of beef from the market stall. The exact posture is demonstrated over and over again. The girl must keep on trying until she can assume it easily. In addition she is instructed at length on muscular control inside her body and out, and this also was rehearsed again and again, until it was certain that the young candidate had grasped all that was meant.

The last day has arrived. This is the day of the wedding. The

old woman gives her first a "balm bath," that is, a hot herb bath. Only these old women know the secret of which herbs to use to steep a virgin for marriage. It is intended, this bath is, to remove everything mental, spiritual and physical that might work against a happy mating. No soap is used at this point. It is a medicinal sweating tub to open the pores and stimulate the candidate generally. Immediately that the virgin leaves the bath she is covered and sweated for a long time. Then she is bathed again in soapy water.

Now the subtleties begin. Jamaica has a grass called khus khus. The sweet scent from its roots is the very odor of seduction. Days before the old woman has prepared an extract from these roots in oil and it is at hand in a bowl. She begins and massages the girl from head to foot with this fragrant unction. The toes, the fingers, the thighs, and there is a special motional treatment for every part of the body. It seemed to me that the breasts alone were ignored. But when the body massage is over, she returns to the breasts. These are bathed several times in warm water in which something special had been steeped. After that they are massaged ever so lightly with the very tips of the fingers dipped in khus khus. This fingertip motion is circular and moves ever towards the nipple. Arriving there, it begins over and over again. Finally the breasts are cupped and the nipples flicked with a warm feather back and forth, back and forth until there was a reaction to stimulation. The breasts stiffened and pouted, while the rest of the body relaxed.

But the old woman is not through. She carries this same light-fingered manipulation down the body and the girl swoons. She is revived by a mere sip of rum in which a single leaf of ganga has been steeped. Ganga is that "wisdom weed" which has been brought from the banks of the sacred Ganges to Jamaica. The girl revives and the massage continues. She swoons again and is revived. But she is not aware of the work-a-day world. She is in a twilight state of awareness, cushioned on a cloud of love thoughts.

Now the old woman talks to her again. It is a brief summation of all that has been said and done for the past week.

"You feel that you are sick now but that is because the reason for which you were made has not been fulfilled. You cannot be happy nor complete until that has happened. But the success of everything is with you. You have the happiest duty of any creature on earth and you must perform it well. The whole duty of a woman is love and comfort. You were never intended for anything else. You are made for love and comfort. Think of yourself in that way and no other. If you do as I teach you, heaven is with you and the man who is taking you to his house to love and comfort him. He is taking you there for that reason and for no other. That is all that men ever want women for, love and softness and peace, and you must not fail him."

The old instructor ran over physical points briefly again. She stressed the point that there must be no fear. If the girl experienced any pain, then she had failed to learn what she had been taught with so much comfort and repetition. *There was nothing to fear.* Love killed no one. Rather it made them beautiful and happy. She said this over and over again.

Still stressing relaxed muscles, the old woman took a broad white band of cloth and wound it tightly about the loins of the girl well below the navel. She circled the body with the band perhaps four times and then secured it with safety pins. It was wound very tightly and seemed useless at first. All the time that this was being done the girl was crying to be taken to her future husband. The old woman seemingly ignored her and massaged her here and there briefly.

They began to put her wedding clothes upon the girl. The old woman was almost whispering to her that she was the most important part of all creation, and that she must accept her role gladly. She must not make war on her destiny and creation. The impatient girl was finally robed for her wedding and she was led out of the room to face the public and her man. But here went no frightened, shaking figure under a veil. No nerve-racked female behaving as if she approached her doom. This young, young thing went forth with the assurance of infinity. And she had such eagerness in her as she went!

20

CHAPTER 3

HUNTING THE WILD HOG

If you go to Jamaica you are going to want to visit the Maroons at Accompong. They are under the present rule of Colonel Rowe, who is an intelligent, cheerful man. But I warn you in advance not to ride his wall-eyed, pot-bellied mule. He sent her to meet me at the end of the railroad line so that I would not have to climb that last high peak on foot. That was very kind of Colonel Rowe, and I appreciate his hospitality, but that mule of his just did not fall in with the scheme somehow. The only thing that kept her from throwing me, was the fact that I fell off first. And the only thing that kept her from kicking me, biting me and trampling me under foot after I fell off was the speed with which I got out of the way after the fall. I think she meant to chase me straight up that mountain afterwards, but one of Colonel Rowe's boys grabbed her bridle and held her while I withdrew. She was so provoked when she saw me escaping, that she reared and pitched till the saddle and everything else fell off except the halter. Maybe it was that snappy orange-colored four-in-hand tie that I was wearing that put her against me. I hate to think it was my face. Whatever it was, she started to rolling her

21

pop-eyes at me as soon as I approached her. One thing I will say for her, she was not deceitful. She never pretended to like me. I got upon her back without the least bit of co-operation from her. She was against it from the start and let me know. I was the one who felt we might be sisters under the skin. She corrected all of that about a half mile down the trail and so I had to climb that mountain into Accompong on my own two legs.

The thing that struck me forcefully was the feeling of great age about the place. Standing on that old parade ground, which is now a cricket field, I could feel the dead generations crowding me. Here was the oldest settlement of freedmen in the Western world, no doubt. Men who had thrown off the bands of slavery by their own courage and ingenuity. The courage and daring of the Maroons strike like a purple beam across the history of Jamaica. And yet as I stood there looking into the sea beyond Black river from the mountains of St. Catherine, and looking at the thatched huts close at hand, I could not help remembering that a whole civilization and the mightiest nation on earth had grown up on the mainland since the first runaway slave had taken refuge in these mountains. They were here before the Pilgrims landed on the bleak shores of Massachusetts. Now, Massachusetts had stretched from the Atlantic to the Pacific and Accompong had remained itself.

I settled down at the house of Colonel Rowe to stay a while. I knew that he wondered about me—why I had come there and what I wanted. I never told him. He told me how Dr. Herskovits had been there and passed a night with him; how some one else had spent three weeks to study their dances and how much money they had spent in doing this. I kept on day by day saying nothing as to why I had come. He offered to stage a dance for me also. I thanked him, but declined. I did not tell him that I was too old a hand at collecting to fall for staged-dance affairs. If I do not see a dance or a ceremony in its natural setting and sequence, I do not bother. Self-experience has taught me that those staged affairs are never the same

22

as the real thing. I had been told by some of the Maroons that their big dance, and only real one, came on January 6th. That was when they went out to the wooded peaks the day before and came back with individual masques and costumes upon them. They are summoned from their night long retreat by the Abeng, or Conk-shell. Then there is a day of Afro-Karamante' dancing and singing, and feasting on jerked pork.

What I was actually doing was making general observations. I wanted to see what the Maroons were like, really. Since they are a self-governing body, I wanted to see how they felt about education, transportation, public health and democracy. I wanted to see their culture and art expressions and knew that if I asked for anything especially, I would get something out of context. I had heard a great deal about their primitive medicines and wanted to know about that. I was interested in vegetable poisons and their antidote. So I just sat around and waited.

There are other Maroon settlements besides Accompong, but England made treaty with Accompong only. There are now about a thousand people there and Colonel Rowe governs the town according to Maroon law and custom. The whole thing is very primitive, but he told me he wished to bring things up to date. There is a great deal of lethargy, however, and utter unconsciousness of what is going on in the world outside.

For instance, there was not a stove in all Accompong. The cooking, ironing and whatever else is done, is done over an open fire with the women squatting on their haunches inhaling the smoke. I told Rowe that he ought to buy a stove himself to show the others what to do. He said he could not afford one. Stoves are not customary in Jamaica outside of good homes in the cities anyway. They are imported luxuries. I recognized that and took another tack. We would build one! I designed an affair to be made of rock and cement and Colonel Rowe and some men he gathered undertook to make it. We sent out to the city and bought some sheet tin for the stove pipe and the pot-holes. I measured the bottoms of the pots and

23

designed a hole to fit each of the three. The center hole was for the great iron pot, and then there were two other holes of different sizes. Colonel Rowe had some lime there, and he sent his son and grandchildren out to collect more rocks. His son-in-law-to-be mixed the clay and lime and in a day the furnace-like stove was built. The kitchen house lacking a floor anyway, the stove was built clear across one side of the room so that there was room on top of it for pots and pans not in use. The pot-holes were lined with tin so that the pots would not break the mortar. Then we left it a day to dry. We were really joyful when we fired it the next day and found out that it worked. Many of the Maroons came down to look at the miracle. There were pots boiling on the fire; no smoke in the room, but a great column of black smoke shooting out of the stove pipe which stuck out of the side of the house.

In the building of the stove I came to know little Tom, the Colonel's grandson. He is a most lovable and pathetic little figure. He is built very sturdy and is over strong for his age. He lives at the house of his grandfather because he has no mother and his father will not work for himself, let alone for his son. He is not only lazy and shiftless, he is disloyal to Colonel Rowe who has wasted a great deal of money on him. Little Tom is there among more favored grandchildren and his life is wretched. The others may strike him, kick him, I even saw one of them burn him without being punished for it. He is fed last and least and is punished severely for showing any resentment towards the treatment he gets from his cousins. They are the children of the Colonel's favorite child, his youngest daughter, and she is there to watch and see that her three darlings are not in any way annoyed by Tom. He was so warmed by the little comfort he got out of me that I wished very much to adopt him. He is just full of love and goodwill and nowhere to use it. It was most pointedly scorned when he offered it. When I asked why all this cruelty to such a small child, they answered with that excuse of all cruel people, "He is a very bad child. He has criminal tendencies. If we do not treat him harshly he will grow up to be nothing but a brute."

24

So they abuse him and beat him and scorn him for his future good.

It was not long before I noticed people who were not Maroons climbing the mountain road past the Colonel's gate. I found that they were coming to Accompong for treatment. Colonel Rowe began to tell me about it and soon after that I met the chief medicine man. Colonel Rowe told me he was a liar and over ambitious politically, but that he really knew his business as a primitive doctor. Later I found that to be true. He was a wonderful doctor, but he wanted to be the chief. At one time he had seized the treaty that was signed long ago between England and the Maroons and attempted to make himself the chief. This had failed and he was still not too sincere in his dealings with Colonel Rowe, but their outward relations were friendly enough. So he took to coming around to talk with me.

First we talked about things that are generally talked about in Jamaica. Brother Anansi, the Spider, that great cultural hero of West Africa who is personated in Haiti by Ti Malice and in the United States by Brer Rabbit. About duppies and how and where they existed, and how to detect them. I learned that they lived mostly in silk-cotton trees and in almond trees. One should never plant either of those trees too close to the house because the duppies will live in them and "throw heat" on the people as they come and go about the house. One can tell when a duppy is near by the feeling of heat and the swelling of the head. A duppy can swell one's head to a huge thing just by being near. But if one drinks tea from that branch of the snake weed family known as Spirit Weed, duppies can't touch you. You can walk into a room where all kinds of evil and duppies are and be perfectly safe.

The Whooping Boy came up. Some say that the Whooping Boy is the great ghost of a "penner" (a cow-herd). He can be seen and heard only in August. Then he can be heard at a great distance whooping, cracking his whip and "penning" his ghost cows. He frightens real cows when he "pauses" (cracks) his whip.

25

The Three-leg-Horse manifests himself just before Christmas, a woman said that "him drag hearse when him was alive" (he was used to pull a hearse when he was alive) and that he did not appear until one in the morning. From then until four o'clock he ranged the highways and might attack a wayfarer if he chanced to meet one. If he chases you, you can only escape by running under a fence. If you climb over it, he will jump the fence after you.

But the men all looked at each other and laughed. They denied that the Three-leg-Horse ever hurt any one. Girls, they said, were afraid of it, but it was not dangerous. He appeared around Christmas time to enjoy himself. When the country people masque with the horse head and cow head for the parades, the three-legged-Horse wrapped himself up in a sheet and went along with them in disguise. But if one looked close he could be distinguished from the people in masques, because he was two legs in front and one behind. His gait is a jump and a leap that sounds "Te-coom-tum! Te-coom-tum!" In some parts of Jamaica he is called "The Three-legged Aurelia," and they, the people, dance in the road with the expectation that the spirit horse will come before seven o'clock at night, and pass the night revelling in masquerade. Two main singers and dancers lead the rest in this outdoor ceremony and it is all quite happy.

All in all from what I heard, I have the strong belief that the Three-legged-Horse is a sex symbol and that the celebration of it is a fragment of some West African puberty ceremony for boys. All the women feared it. They had all been told to fear it. But none of the men were afraid at all. Perhaps under those masques and robes of the male revellers is some culture secret worth knowing. But it was quite certain that my sex barred me from getting anything more than the other women knew. (I found the "Société Trois-jambe" in Haiti also but could learn nothing definite of its inner meaning.)

But the Rolling-Calf is the most celebrated of all the apparitions in Jamaica. His two great eyes are balls of fire, he moves like lightning and "he has no abiding city." He wanders all

over Jamaica. The Rolling-Calf is a plague put upon the earth to trouble people, and he will always be here. He keeps chiefly to the country parts and comes whirling down hills to the terror of the wayfarer. But the biggest harm that he does is to spoil the shape of the female dog. He harms the dog; she squeals and the owner goes into the yard and sees nothing but a flame of fire vanishing in the distance. The dog's shape is ruined, and she will never have puppies again. Rolling-Calf can be seen most any moonlight night roving the lanes of the countryside.

After a night or two of talk, the medicine man began to talk about his profession and soon I was a spectator while he practised his arts. I learned of the terrors and benefits of Cow-itch and of that potent plant known as Madame Fate. "It is a cruel weed," he told me, and I found he had understated its powers. I saw him working with the Cassada bean, the Sleep-and-Wake, Horse Bath and Marjo Bitters. Boil five leaves of Horse Bath and drink it with a pinch of salt and your kidneys are cleaned out magnificently. Boil six leaves and drink it and you will die. Marjo Bitter is a vine that grows on rocks. Take a length from your elbow to your wrist and make a tea and it is a most excellent medicine. Boil a length to the palm of your hand and you are violently poisoned. He used the bark of a tree called Jessamy, well boiled for a purgative. Twelve minutes after drinking the wine glass of medicine the purge begins and keeps up for five days without weakening the patient or griping.

I went with him to visit the "God wood" tree (Birch Gum). It is called "God Wood" because it is the first tree that ever was made. It is the original tree of good and evil. He had a covenant with that tree on the sunny side. We went there more than once. One day we went there to prevent the enemies of the medicine man from harming him. He took a strong nail and a hammer with him and drove the nail into the tree up to the head with three strokes; dropped the hammer and walked away rapidly without looking back. Later on, he sent me back to fetch the hammer to him.

He proved to me that all you need to do to poison a person and leave them horribly swollen was to touch a chip of this tree to their skin while they were sweating. It was uncanny.

We went to see a girl sick in bed. The medicine man was not in high favor with the mother; but Accompong is self-sufficient. They keep to their primitive medicine particularly. He went in and looked down on the sick girl and said that it was a desperate case, but he could cure her. But first the mother must chop down the papaya tree that was growing just outside of the bed-room window. The mother objected. That was the only tree that she had and she needed the fruit for food. The medicine man said that she *must* cut it down. It was too close to the house to begin with. It sapped the strength of the inmates. And it was a tall tree, taller than the house and she ought to know that if a paw paw or papaya tree were allowed to grow taller than the house, that somebody would die. The mother hooted that off. That tree had nothing to do with the sickness of her daughter. If he did not know what to do for her, let him say so and go on about his business and she would call in someone else. If he knew what to do, get busy and stop wasting time on the paw paw tree.

Day by day the young woman grew weaker in spite of all that was done for her. Finally she called her mother to the bed and said, "Mama, cut the tree for me, please."

"I will do anything to make you well again, daughter, but cutting that tree is so unnecessary. It is nothing but a belief of ignorant people. Why must I cut down the tree that gives us so much food?"

Several times a day, now the girl begged her mother to cut the tree. She said if she were strong enough she would find the machete and chop it down herself. She cried all the time and followed her mother with her eyes pleading.

"Mama, I am weaker today than I was yesterday. Mama, please chop down the tree. Since I was a baby I have heard that the paw paw was an unlucky tree."

"And ever since you were a baby you have been eating the fruit," the mother retorted. "I spend every ha' penny I can

28

find to make you well, and now you want me to do a foolish thing like killing my tree. No!''

"Mama, if it is cut I will live. If you don't cut it I will die."

The girl grew weaker and finally died. The grief stricken mother rushed outside with the machete and chopped down the tree. It was lying in the yard full of withered leaves and fruit when the girl was buried. But even then the woman was not completely convinced. She thinks often that it might have been coincidence. I passed her house on my way to visit the daughter of Esau Rowe, who is the brother of the Colonel. The mourning mother was looking down at the great mass of withered fruit when I spoke to her. She did not exactly ask me for a little money, but she opened the way for me to offer it. I gave her three shillings with the utmost joy because I knew she needed it.

"Thank you," she said half choked with tears. "My girl is dead. I—I don't know—" she looked down at the tree, "I don't know if it was I who could have saved her. I wish I could know. Have you noticed how hungry a person can be the next day after a funeral? But I don't suppose you could know about such things at all.''

One night Colonel Rowe, Medicine Man and I sat on what is going to be a porch when the Colonel finds enough money to finish it, looking down on the world and talking. The tree frogs on the mountainside opposite were keeping up a fearful din. Colonel Rowe said it was a sign of rain. I said I hoped not, for then all Accompong would become a sea of sticky mud. I expressed the wish that the frogs shut up. Colonel Rowe said that Medicine Man could make them hush but that would have no effect upon the weather.

"He can stop those frogs over on that other peak?" I asked.

"Yes, he can stop them at will. I have seen him do it, many times."

"Can you, really?" I turned to Medicine Man.

"That is very easy to do."

"Do it for me, then. I'd like to see that done."

He stood up and turned his face toward the mountain peak

opposite and made a quick motion with one hand and seemed to inhale deeply from his waist up. He held this pose stiffly for a moment, then relaxed. The millions of frogs in the trees on that uninhabited peak opposite us ceased chirping as suddenly as a lightning flash. Medicine Man sat back down and would have gone on telling me the terrible things that the milk from the stalk of the paw paw tree does to male virility, but I stopped him. I had to listen to this sudden silence for a while.

"Oh, they will not sing again until I permit them," Medicine Man assured me. "They will not sing again until I pass the house of Esau on my way home. When I get there I will whistle so that you will know that I am there. Then they will commence again."

We talked on awhile about the poisonous effect of Dumb Cane and of bissy (Kola nut) as an antidote, and how to kill with horse hair and bamboo dust. I was glad, however, when Medicine Man rose to go.

"Oh, you need not worry," Colonel Rowe told me, "he can do what he says."

He walked out of Colonel's tumbledown gate and began to climb the mountain in that easy way that Maroons have from a life time of mountain climbing, and grew dim in the darkness. After a few minutes we heard the whistle way up the path and like an orchestra under the conductor's baton, the frog symphony broke out. And it was certainly going on when I finally dropped off to sleep.

I kept on worrying the Colonel about jerked pig. I wanted to eat some of it. The jerked pig of the Maroons is famous beyond the seas. He explained to me that the Maroons did not jerk domestic pork. It was the flesh of the wild hog that they dressed that way. Why not kill a wild hog then, and jerk it, I wanted to know.

"Mama! That is much harder than you think. Wild hog is very sensible creature. He does not let you kill him so easily. Besides, he lives in the Cock-Pit country and that is hard travelling even for us here who are accustomed to rocks and mountains."

30

"And there are not so many now as there use to be. We have killed many and then the mongoose also kill some," Medicine Man added.

"A mongoose kill a wild hog? I cannot believe it!" I exclaimed.

"Oh, that mongoose, he a terrible insect," Medicine Man said. "He is very destroyfull, Mama! If the pig is on her feet she will tear that mongoose to pieces, Mama! But when she is giving birth the mongoose run there and seize the little pig as it is born and eat it. So we do not have so many wild pig now."

But I kept on talking and begging and coaxing until a hunting party was organized. A hunting party usually consists of four hunters, the dogs and the baggage boy, but this one was augmented because few of the men had much work to do at the moment, and then I was going, and women do go on hog hunts in Accompong. If I had had more sense I would not have gone either, but you live and learn. The party was made up of Colonel Rowe, his brother Esau, Tom Colly, his two sons-in-law, his prospective son-in-law, his son who acted as baggage boy and your humble servant.

The day before, old machetes were filed down to spear heads and made razor sharp. Then they were attached to long handles and thus became spears. All of this *had* to be done the day before, especially the sharpening of all blades. If you sharpen your cutting weapons on the day of the hunt, your dogs will be killed by the hog.

We were up before dawn the day of the hunt, and with all equipment, food for several days, cooking utensils, weapons, and the like, we found our way by stealth to the graveyard. Medicine Man was to meet us there and he was true to his word. There the ancestors of all the hunters were invoked to strengthen their arms. The graves are never marked in Accompong for certain reasons, and thus if a person does not himself know the graves of his relatives there is no way of finding out. One of the men had been away in Cuba for several years and could not find his father's grave. That was consid-

ered not so good, but not too bad either. No attempt was made to guess at it for fear of waking up the wrong duppy, who might do him harm. So the ceremony over, it was necessary for us to be out and gone before anyone in Accompong should speak to us. That would be the worst of luck. In fact, we were all prepared to turn back in case it happened to us. Some of us would be expected to be killed before we returned.

The baggage-boy was carrying our food which was not very heavy for the Maroons are splendid human engines. Not a fat person in all Maroon town. That comes, I suppose, from climbing mountains and a simple diet. They are lean, tough and durable. They can march, fight or work for hours on a small amount of food. The food on the hunt was corn pone, Cassada-by-me (Cassava bread), green plantain, salt, pimento and other spices to cure the hog when and if we caught him, *and* coffee. The baggage boy carried the iron skillet and the coffee pot also. The hunters carried their own guns and blades. I stumbled along with my camera and note book and a few little womanish things like comb and tooth brush and a towel.

We struck out back of the cemetery and by full sun-up we were in the Cock-Pit country. There is no need for me to try to describe the Cock-Pits. They are great gaping funnel-shaped holes in the earth that cover miles and miles of territory in this part of Jamaica. They are monstrous things that have never been explored. The rock formations are hardly believable. Mr. Astly Clerk is all for exploiting them as a tourist lure. But very few tourists have the stamina necessary to visit even one of them let alone descend into these curious, deep openings. They are monstrous.

By the time we reached the first of the Cock-Pits I was tired but I did not let on to the men. I thought that they would soon be tired too and I could get a rest without complaining. But they marched on and on. The dogs ran here and there but no hog sign. As the country became more rocky and full of holes and jags and points and loose looking boulders, I

32

thought more and more how nice it would be to be back in Accompong.

Around noon, we halted briefly, ate and marched on. I suggested to Colonel Rowe that perhaps all the hogs had been killed already and we might be wasting our time. I let him know that I would not hold the party responsible if they killed no hogs. We had tried and now we could return with colors flying. He just looked at me and laughed. "Why," he said, "this is too soon to expect to find hog sign. Sometimes we are out four days before we even pick up the sign. If we pick up the hog sign tomorrow before night, we will have a luck."

And four more hours till sun-down!

We picked up no hog sign that day, but the men found a nest of wild bees in a tree growing out of the wall down inside a Cock-Pit. Everybody was delighted over the find. I asked them how would they get it. They tried several times to climb down to it but the wall was too sheer and the tree leaned too far out to climb into it. So Colly let himself be swung head foremost over the precipice by his heels and he was pulled up with the dripping honey combs. I had to look away. It was too much for my nerves, but no one else seemed to think anything of the feat.

While they were eating the honey, I sprawled out on a big hot rock to rest and the Colonel noticed it and ordered the men to build a hut for the night. It was near sun-down anyway.

The men took their machetes and chopped down enough branches to make a small shack and inside of an hour it was ready for use.

We found no hog sign the second day and I lost my Kodak somewhere. Maybe I threw it away. My riding boots were chafing my heels and I was sore all over. But those Maroons were fresh as daisies and swinging along singing their Karamante' songs. The favorite one means "We we are coming, oh." It says in Karamanti, "Blue Yerry, ai! Blue Yerry Gallo, Blue Yerry!"

It was near dark on the third day the dogs picked up the hog sign. No sight of him, you understand. They struck a scent and

33

began to dash about like ferrets hungry for blood. But it was too late for even a Maroon to do anything about it. The men built the hut dead on the trail and we settled down for the night. Esau explained that they built the hut on the trail for a purpose. He said that the wild hog is an enchanted beast. He has his habits and does not change them. He has several hiding places along one trail and works from one to the other. When he reaches the limit of his range, he is bound to double back on his trail, seeking one of his other hideaways. He can go a long time without food but he must have water. And so if the dogs keep after him he has no time to hunt water. When there is little rain and the waterholes are dried up, he will climb the rocks and drink the water from Wild Pines (a species of orchid). But it takes time for him to find these plants. He cannot do it with dogs at his heels. The hunters must not sleep too soundly during the night as the hog will repass and they will not know it. He is very shrewd. When he gets near the camp and smells the smoke he will climb higher and pass the camp higher up the mountain and be lost before morning.

We did not sleep much that night. And I suppose it was mostly my fault that we didn't. I was inside the hut by myself for one thing and I was a little scared because the men had told me scary things about hogs. They had said that when a wild boar, harassed by the dogs and hunter, turns back down the trail, you must be prepared to give him the trail or kill him. His hide was tough and unless the bullet struck squarely and in a vital spot, it might be deflected. Then the men had to go in with their knives and spears and kill or be killed. I was afraid that the men would go to sleep and the boar be upon us before we knew it. So I kept awake and kept the others awake by talking and asking questions. We could hear the dogs at a distance, barking and charging and parrying. So the night passed.

The next day the chase was really hot. About noon the party divided. Colonel Rowe with three men went ahead to catch up with the dogs and see if the hog had made a stand. Esau, Colly and Tom stayed with me. That is, they stayed back to

tackle the brute in case he doubled back on his track. We heard a great deal of noise far ahead, but no sound of shots nor anything conclusive. By three o'clock, however, the sounds were coming nearer, and the men looked after their guns. Then we heard a terrific and prolonged battle and the barking of the dogs ceased.

"Sounds like he has killed the dogs," said Esau.

"Killed five dogs?" I asked.

"If he is a big one, that would not be hard for him to do," Esau said. "When he gets desperate he will kill anything that stands in his way. But he will not kill the dogs if he can get at the hunter. He knows that the hunter is his real enemy. Sometimes he will charge the dogs, and swerve so fast that the hunter is caught off guard, and attack. A man is in real danger there."

It was not long after that, that we heard deep panting. It was a long way off but it seemed upon us. There was a huge boulder over to the right and I moved nearer to it so that I might hide behind it if necessary after seeing the wild boar approach and pass. The panting came nearer. Now we could hear him trotting and dislodging small stones. The men got ready to meet the charge. The boar with his huge, curving tusks dripping with dogs' blood came charging down upon us. I had never pictured anything so huge, so fierce nor so fast. Everybody cleared the way. He had come too fast for Esau to get good aim on a vital spot.

Just around a huge rock he whirled about. He made two complete circles faster than thought and backed into a small opening in the rock. He had made his stand and resolved to fight. Only his snout was visible from where we were. The men crept closer and Esau chanced a shot. The bullet nicked his nose and the shocking power of it knocked the hog to his knees. We rushed forward, the men expecting to finish him off with the knives. At that moment he leaped up and charged the crowd. I raced back to the big rock and scrambled up. What was going on behind my back I did not know until I got on top of the rock and looked back. Tom had scurried to safety

also. Colly had not quite made it. The hog had cut the muscle in the calf of his leg and he was down. But Esau rushed in and almost pressed the muzzle of his rifle against the head of the boar and fired. The hog made a half turn and fell. Esau shot him again to make sure and he scarcely twitched after that.

While we were doing the best we could for Colly, the others came. They had heard the shooting. As soon as Colly was made as comfortable as possible, the men supported him and all made a circle around the fallen boar. They shook each other's hand most solemnly across the body of the hog and kissed each other for dangers past. All this was done with the utmost gravity. Finally Colonel Rowe said, "Well, we got him. We have a luck."

Then all of the men began to cut dry wood for a big fire. When the fire began to be lively, they cut green bush of a certain kind. They put the pig into the fire on his side and covered him with green bush to sweat him so that they could scrape off the hair. When one side was thoroughly cleaned, they scraped the other side and then washed the whole to a snowy white and gutted the hog. Everything was now done in high good humor. No effort was made to save the chitterlings and hasslets, which were referred to as "the fifth quarter," because there was no way to handle it on the march. All of the bones were removed, seasoned and dried over the fire so that they could be taken home. The meat was then seasoned with salt, pepper and spices and put over the fire to cook. It was such a big hog that it took nearly all night to finish cooking. It required two men to turn it over when necessary. While it was being cooked and giving off delicious odors, the men talked and told stories and sang songs. One told the story of Paul Bogle, the Jamaican hero of the war of 1797 who made such a noble fight against the British. Unable to stop the fighting until they could capture the leader, they finally appealed to their new allies, the Maroons, who some say betrayed Bogle into the hands of the English. Paul Bogle never knew how it was that he was surprised by the English in a cave

and taken. He was hanged with his whole family and the war stopped.

Towards morning we ate our fill of jerked pork. It is more delicious than our barbecue. It is hard to imagine anything better than pork the way the Maroons jerk it. When we had eaten all that we could hold, the rest was packed up with the bones and we started the long trek back to Accompong. My blistered feet told me time and time again that we would never get there, but we finally did. What was left of the wild pig was given to the families and friends of the hunters. They never sell it because they say they hunt for fun. We came marching in singing the Karamante' songs.

> Blue yerry, ai
> Blue yerry
> Blue yerry, gallo
> Blue yerry!

CHAPTER 4

NIGHT SONG AFTER DEATH

The most universal ceremony in Jamaica is an African survival called "The Nine Night." Minor details vary according to parish and district, but in the main it is identical all over the island. In reality it is old African ancestor worship in fragmentary form. The West African tradition of appeasing the spirit of the dead lest they do the living a mischief.

Among the upper classes it has degenerated into something that approximates the American wake, with this one difference: when the people who attend wakes leave the house of mourning they always call out a cheerful goodbye to the family. In Jamaica any form of goodbye is taboo. Even the family and housemates, after everyone else is gone, go to their separate rooms without taking leave of each other. Then one by one the windows and doors are slowly closed in silence. The lights in the various rooms go out in the same way so that the house is gradually darkened. The dead is dismissed.

But the barefoot people, the dwellers in wattled huts, the donkey riders, are at great pains to observe every part of the ancient ceremony as it has been handed down to them. Let me

speak of one that I saw in St. Thomas.

This man had died in the hospital some distance from home. He was as poor in death as he had been in life. He had walked barefooted all his days so now there would be no hearse, no car, no cart—not even a donkey to move this wretched clay. Well then, a rude stretcher was made out of a sheet and two bamboo poles and men set out on foot to bring the body home. There are always more men than donkeys.

According to custom, several people from the district went along with the body-bearers to sing along the road with the body. The rest of the district were to meet them halfway. It is a rigid rule that the whole district must participate in case of death. All kinds of bad feelings are suspended for the time being so that they sing together with the dead.

The news of his death had come to his woman near sundown so that many things had to be done at night that are usually done in daylight. That is, make coffee, mix butterdough, provide rum and bread for the "set up." Some folks had to stay behind to look after this.

The bearers and these folks had been gone a long time when we others set out to meet them half way. Two or three naked lights or flambeaux were among us but nobody felt the need of them. A little cement bridge had been agreed upon as the halfway mark, so we halted there to wait. Perhaps it seemed longer than it really was because people saved up the entertainment inside them for the time when the body would arrive. So we were a sort of sightless, soundless, shapeless, stillness there in the dark, wishing for life.

At last a way-off whisper began to put on flesh. In the space of a dozen breaths the keening harmony was lapping at our ears. Somebody among us struck matches and our naked lights flared. The shapeless crowd-mass became individuals. A hum seemed to rise from the ground around us and became singing in answer to the coming singers and in welcome to the dead.

The corpse might have been an African monarch on safari, the way he came borne in his hammock. The two crowds became one. Fresh shoulders eagerly took up the burden and

all voices agreed on one song. Then there was a jumbled motion that finally straightened out into some sort of a marching order with singing. Harmony rained down on sea and shore. The mountains of St. Thomas heaved up in the moonlessness; the smoking flambeaux splashed the walking herd; bare feet trod the road in soundless rhythm and the dead man rode like a Pharaoh—his rags and his wretchedness gilded in glory.

The less fortunate of the district who for one reason or another could not help with the singing on the road were waiting for us at the house. The widow stood in the inner door and cried in a ceremonial way. Her head was draped in a bath towel in such a way that at a short distance it looked like a shaggy white wig.

Everything that could be done was already done because the Nanas, or old nurses of the district, had charge. There was a strong flavor of matriarchal rule about the place. Unconscious or not, an acknowledgment of the priestess ran through it all. There was one who seemed especially to have authority over the rest. She conferred with the wife in a whisper for a moment and then ordered several women to make a shirt for the dead man out of cloth that she produced from nowhere it seemed. She turned from that to other things. But even in the midst of the much-do she had time to observe that only one woman was working on the shirt. To be sure the lone worker was most skillful with her needle, but the Nana stopped her and glared all about her at the other women.

"One woman no make shirt for dead." She accused the others with a look. "What for do?" (What can I do about it?) asked the efficient seamstress. "Them don't help me."

Everybody knew it was bad luck for only one woman to sew a garment for the dead. It exposed her to spite-work from the ghost of the departed. They were being a little lazy, that was all. But they did go to work with a will when the Nana got in behind them. "I tell you to make shirt, and you *make* shirt!" she scolded. "My word must stand for dominate." (My word must rule.)

41

The other nanas were washing the body. The Nana-Superior stopped them while the body was being dried with a towel. They did nothing right unless she watched them every minute, she complained. Where were the lime and the nutmeg, she demanded to know? Could a person be called ready for burial when his nose, mouth, under his arms and between his legs had not been rubbed with slices of lime and a nutmeg? Of course not! The women explained to her that lime and nutmeg had not been provided by the wife of the deceased. What could they do about it? Nana ran somebody out to pick some off of anybody's tree. The messenger was not to come back without it. The body must be prepared in the ceremonial way, and no other, Must do!

The burial was to take place in the yard as is usual among the common people of Jamaica, but the grave could not be opened until morning. So Nana sent men out to gather lumber for the coffin. Boards were bought until there was no more money. Then the rest were gifts from backyards, or just scraped up from here and there until the coffin was ready for the body.

When it came time to place the body in the coffin there was a great deal of talk back and forth. Some few said that he had been a fairly good man and that they were sure that once buried, he would not return. All the trouble of keeping the ghost, or duppy, in the grave was unnecessary. But the majority were for taking no chances. Every precaution for keeping duppies in graves must be taken. So as soon as the body was placed in the coffin, the pillow with the parched peas, corn and coffee beans sewed inside it was placed under his head. Then they took stronger methods. They took four short nails and drove one in each cuff of the shirt as close to the hand as possible to hold the hands firmly in place. The heel of each sock was nailed down in the same way. Now the duppy was "nailed hand and foot."

The brother of the corpse was summoned and he spoke to the dead and said, "We nail you down hand and foot. You must stay there till judgment. If we want you we come wake

you." Some salt mixed with "compellance" powder was sprinkled in the coffin and it was finally closed.

Followed activities of the set-up. The leader tracked out sankeys. (Methodist hymns.) Then he looked about him and asked, "Who is the treble?" That is, who is raising the hymns? A willing volunteer obliged and the rest of us sang. There were periods of short prayers, a little story-telling, a period of eating and the like until the last cock-crow (5 A.M.).

Several bottles of rum were handed over to the gravediggers early that morning and after sprinkling the ground with rum they all drank some and began digging with a will. After that, every bottle that was opened, the first drink out of it was poured into the grave for the dead. Soon the grave was opened, the parched corn and peas thrown in and the coffin lowered with proper rituals and patted to rest in the earth. The trail of salt and ground coffee was laid from the grave to the house door to prevent the return of the duppy and people went on home.

A sort of wake is held every night after this until the ninth night after death, but it is understood that practically no one except the family and old friends will bother to come again until the "nine night." But all being new to me, I decided to miss nothing. So each night I came bringing some white rum for folks to talk by, I made bold to ask the reason for the nine night. With everybody helping out with detail they told me.

It all stems from the firm belief in survival after death. Or rather that there *is no death.* Activities are merely changed from one condition to the other. One old man smoking jackass rope tobacco said to me in explanation: "One day you see a man walking the road, the next day you come to his yard and find him dead. Him don't walk, him don't talk again. He is still and silent and does none of the things that he used to do. But you look upon him and you see that he has all the parts that the living have. Why is it that he cannot do what the living do? It is because the thing that gave power to these parts is no longer there. That is the duppy, and that is the most powerful part of any man. Everybody has evil in them, and when a man

43

is alive, the heart and the brain controls him and he will not abandon himself to many evil things. But when the duppy leaves the body, it no longer has anything to restrain it and it will do more terrible things than any man ever dreamed of. It is not good for a duppy to stay among living folk. The duppy is much too powerful and is apt to hurt people all the time. So we make nine night to force the duppy to stay in his grave."

"Where is the duppy until nine night?" I asked. "Doesn't it stay in its grave at all until then?"

"Oh, yes. The duppy goes into the grave with the body and it stays in there the first day and the next. But the third day at midnight it rises from the grave."

The eyes of a youngish matron flew wide open. "Eh, eh!" she exclaimed, "True, sah?" (Is that true?)

"Sure, I see it myself," said the narrator.

"Eh, eh," the matron said sliding forward in her seat, "Tell, make see." (Explain it to us.)

"It was when I was a pickney (small child) my uncle died and was buried in the yard. I had heard tell that the duppy rises on the third night at cock-crow, so I got up out of my bed and went into the yard on the third night after his death and climbed a big mango tree where I could see the grave. I heard the cock-crow and felt the midnight breeze. Then I saw some thick mist come from the grave and make a huge white ball that lifted itself free from the earth for a moment, then sat down on top of the grave. I was just a pickney, so I got frightened and I climbed down from the mango tree and ran into the house. The duppy, him go dream to mama (appeared to her in a dream) and tell her and she told me not to do that again. One must never spy on a duppy, because it vexes him. The duppy told mama that if I had not been a part of the family he would have hurt me."

This narrative excited everybody. They all began to tell what they knew about duppies.

"A pickney duppy is stronger than the duppy of a man," one said.

"Oh, no. A coolie duppy is stronger than all other duppies."

"No, man, a Chinee duppy is strongest of all."

"Well," the man who started it all summed up, "all duppies got power to hurt you. He can breathe on you and make you sick. If he touches you, you will have fits."

"But," somebody defended the duppies, "duppies will never come inside your yard to hurt you unless somebody send him. It is a rude [wicked] person who set duppies on folks."

"Oh, many people are cruel, man. Some goes to the cemetery with rum and threepence and a calabash stick. They throw the rum and the money on the grave for the duppy and then they beat the grave with the calabash stick. Then they throw themselves down upon the grave and they roll on the grave and they beat it and call the duppy and tell him, 'You see what advantage so-and-so takes of me! You see how I punish [how I suffer]. I want you to follow so-and-so. I want you to lick him! I want you to lick him so!' [The grave is beaten violently with the stick.] And the duppy comes out of the grave and does what he is paid to do. Otherwise he would stay in his grave."

"But some duppy is rude, man. Some duppy will come even if nobody don't send call him. If he is not tied down he will come. Some duppy take a big strong chain to hold him down. I see a grave chained like that up in Manchester. They have to send to England to get a chain strong enough to tie him.

"Duppy is strong, but no matter how strong he is, he can't come in the house if you put tobacco seed over the door. He can't come in until he count all the seed, and duppy can't count more than nine. If you put more than ten, duppy will never come inside. The duppy counts with a jerk and when he gets to nine he wails, 'Lord, I miss!' And then he have to start all over again. He will keep that up until last cock-crow and then duppy *must* go back to his grave."

Somebody contends that duppies *can* count and do anything else if they have salt. Salt, they said, makes sense. That is why nobody gives salt to duppies because with salt, they are too strong for mortals. Somebody else shouts that that is not the reason at all. Duppies, he says, do not like salt. Salt gives

"temper" to mortal food and duppies are not mortal any longer so they do not need salt. When he leaves off being mortal, the duppy does not need anything to temper his vittles. Another says that salt is *not* given because salt is heavy. It holds duppies to the ground. He cannot fly and depart if he has salt. Once Africans could all fly because they never ate salt. Many of them were brought to Jamaica to be slaves, but they never were slaves. They flew back to Africa. Those who ate salt had to stay in Jamaica and be slaves, because they were too heavy to fly. A woman was positive that duppies do not like salt. She said that salt vexed duppies. If a duppy sees salt around a place he will keep away. He will run right back to his grave.

The Nana said that was true and moreover, a duppy was in bad danger if he did not get back to his grave. He positively must be there by last cock-crow. And that is how a duppy can be punished for leaving the grave to hurt people. She said that if you meet a duppy in the road and you are wearing a felt hat, take off the hat and fold it four times and sit on it and the duppy cannot come close enough to you to hurt you, and neither can he run back to his grave. He is tied until you let him go. So you can hold him from his grave until after cock-crow and make him a homeless duppy forever.

"I never heard of sitting on a hat to hold a duppy," an old man said, "so I would not trust a hat. A river stone is what will tie a duppy." There was a great groan of agreement to this. "You take two river stones. You must have one stone from the bed of the river to sit on, and one little flat river stone to place on top of your head and the duppy cannot come up to you and he cannot go back to his grave."

"True, true, that is very true," the room agreed. So the man went on.

"One worthless woman died and soon after her duppy came to harm the family in the next yard to where she use to live. The family had a daughter, and she being a very young girl, they sent her always for water. One night they sent her for water after dark. Soon she run back in the house and fell in

46

a fit. She had many fits and foamed at the mouth."

"If they foam at the mouth, that is a sign of duppy."

"Eh, eh, that sure is duppy."

"So the father gave her salt to eat and made a cross on her forehead with chalk. Then he rubbed under her arms with garlic and she got better and was able to talk. She said that she saw the old woman who had died and the duppy came up to her and laughed in her face and threw heat on her and touched her. Then she had fits and knew nothing until she was revived. The father grew very mad when he heard this. He went outside and got two river stones to trap the duppy. He sat very still with the river-stones on his head and under him. The duppy came and saw him and tried to run back to the grave, but she could not go. Then the duppy tried to rush upon him and hurt him, but she could not do that either. So the duppy advanced, and the duppy backed up. This went on for quite a while. Then she began to plead, 'Do, Bucky Massa, let me go! Let me go back to the grave. I won't do it again! Do, Bucky Massa, please let me go!' But the man said, 'No, you worthless duppy, I'll keep you until day.' He meant to do so, but he fell asleep after awhile and the top rock fell off of his head. The duppy saw it and quick as lightning, it ran back to the grave and never came out again. Nobody ever saw that duppy again."

"But some duppies wish to stay in their graves," Nana said, "and it is a most cruel thing to wake them after they are gone. Let them rest. They don't need to come back for nothing after they are gone. God gives the duppy nine days after death to do and take with him what he wants. After that let him rest."

Then I wanted to ask a question. "You tell me that the duppy rises on the third night after death and that he does not depart until the ninth night. But where is he all this time?" I asked.

"Oh, the duppy goes back and forth from the grave to his house where he use to live. He is in the yard and he visits all the places where he use to go. On the ninth night he goes back to the apartment [room] where he lived last and where he

breathed his last breath and takes with him the shadow of everything he wants. We know that he is there, so we prepare everything for him in that dead room that he wants so that he will go away happy and not come back and harm us. We know that he likes singing and to see his family and friends for the last time. The whole district comes to make him happy so that he will rest well and not come back again."

The talk went on and on all about duppies caught in bottles; duppies caught in pimento sticks to make a terrible weapon; duppies sitting on beds of the sick and "throwing heat" on them; duppies paid to throw the sick out of bed; duppies raining showers of stones in the houses; duppies forcing men to turn around and walk with them from town to town. So the nights ran together and made nine.

On that ninth night Joe Forsythe and I came to the familiar yard. People stood about in small collections talking. A great table at the far left was loaded with foodstuffs. Fried fish, rice, rum, bread, coffee, wet sugar for the coffee, fowl, and what not. A sizable tarpaulin had been stretched on tall poles from one house wall. Chairs and boxes were spaced around the edge of the covered area and boards were laid between these to make plenty of seats. A small deal table was in the center and a four-spouted naked light hung directly over the table. There was a chair for the leader when the time should arrive for him to "track out" the hymn for the rest to sing. The beginning of everything was there, but nothing had shaped up yet. I went inside to pay my respects to the widow.

Most of the patriarchs had already arrived and were in the dead room. The feast for the duppy was spread. There was white rum and white rice without salt and white fowl also saltless. The wooden bath bowl was full of water and placed in the center of the floor. A glass of drinking water was on the white draped table with the food which was not in plates at all, but spread on banana leaves. The bed was snowy white in its cleanliness.

The intimates sat and talked casually. Now and then one of the old women looked out of the door and bawled at some girl

whom she considered too free with the boys. But mostly they had the air of just waiting around for something. I could hear a great hub-bub of talking from the outside and looked out to find that the yard was full of people.

Suddenly one Nana removed her clay pipe from her lips and stared pointedly at the door for a moment, then nudged her neighbor to look. She looked in the same direction and in turn nudged her neighbor. Calling-attention gestures swept the room in the silence. Everything was conveyed by gesture. The first Nana led the "seeing." Her eyes went from door to bed, from bed to bath bowl, from bath bowl to table, and all eyes followed hers. Little nods of gratification as the duppy was observed to eat or drink, or bathe, or take the shadow of his bed and meal. Finally he was seen to take a seat to enjoy the evening. Then the leader arose and spoke to him.

"We know you come," he said with gracious courtesy. "We glad you come. Myself two times."

All others nod and murmur in agreement. The duppy is assured of a welcome in every way. "We do the best we can."

The leader went outside and took his place under the four-pronged naked light and began tracking out the songs. The "treble" raised the song. He had a dramatic falsetto with uncanny qualifications. It could not be called a good voice, but it did things to those who could sing. It seemed to search out the hidden roads to harmony so the others could find them. The night song had begun. It kept up hour after hour. The monotony varied only by the new inventions in melody and harmony on the same song.

Way late the leader cried "Sola!" That was an invitation for those who had special or favorite songs to track the verses out for the others to sing the chorus. Ten or more people were instantly tracking out. The leader gave precedence to a girl. She was a penny brown girl with high lights in her eyes. She acted out the verses of a song and raised the singing to a frenzied pitch.

Inside the room the old ones kept the duppy entertained with Anansi stories. Now and then they sang a little. A short

49

squirt of song and then another story would come. Its syllables would behave like tambour tones under the obligato of the singing outside. It fitted together beautifully because Anansi stories are partly sung anyway. So rhythmic and musical is the Jamaican dialect that the tale drifts naturally from words to chant and from chant to song unconsciously. There was Brer Anansi and Brer Grassquit; Brer Anansi and the Chatting Pot; Brer Frog's dissatisfaction with his flat behind and Anansi's effort to teach him how to make stiffening for it. And how all the labor was lost on account of Brer Frog's boasting and ingratitude. "So Frog don't learn how to make him behind stick out like other animals. Him still have round behind with no shape because him don't know how to make the stiffening." A great burst of laughter. This is the best liked tale and it is told more than once.

Eleven o'clock arrives and "tea" is served. When this is over it is still a half hour till midnight. Plaintive tunes, mournful songs are sung now. A new and most doleful arrangement of "Lead Kindly Light" fairly drips tears. Then "Good Night" sung over and over. Finally the leader signals a halt. He then solemnly invites all the family and close friends together in the dead room to help discharge the dead.

I was signalled to come too so I went. Inside the tiny room it was very crowded and solemn. The brother of the dead man was selected to preside. He tracked out, "There is rest for the Weary," and after that he prayed:

"Lord, we come to send off the spirit of our dear one to thee. We know him is with thee for him is thy child and not Satan child. So him is not with Satan in Hell but with thee in Heaven. Accept him there, Lord. Don't drive him out of thy Kingdom. And whether him is gone to thee or to Satan, help we to discharge him from this house forever. The living has no right with the dead. Amen." He tracked out a sankey and then addressed the duppy directly.

"We know you come and we make you welcome. We give you white fowl; we give you rice and leave your bed for you. We leave you water and we do *everything* for you. Done!!! Go

50

on to your rest now and no do we no harm. We no want to see you again. You must left and you not to come again. *No come back!* Mind now, you come again we plant you!"

Now this closest male relative of the dead man seizes the sheet from the bed and casts it to the floor. The mattress follows. Eager hands help gather up the slats and take the bed down completely. The slats are thrown to the floor with a great clatter. The brother takes one of the slats and beats the pile of bedding on the floor before it is taken outdoors. The women seize the banana leaves with the food heaped on them and throw them out of the window. The water follows. A Nana looks at the door and nudges. They all "see" the duppy depart. The duppy that was once a man can have no more friendly relationship with mortals.

Instantly outside the tempo changes. They grow jubilant. A "village lawyer" holds up his hand in restraint. "It no finish yet! It no finish yet!"

"Yes, man, it finish. Him gone. Bed is outside."

"Then what about the chalk marks? Make I see." (Show them to me.)

In their eagerness to begin play, some have overlooked or forgotten this last necessity. The know-it-all takes a piece of white chalk and with an air of importance makes a cross mark on all the windows and doors. The recent activities inside have driven the duppy out. The cross marks are meant to keep him out. It is finished.

A play spirit seized the yard. Men hunted up rocks with which to play "Dollyman." A game where fingers get crushed and fights commence. Temporary love affairs were developing right and left. In spite of the older women who tried to keep an eye on the girls, there were numerous love-lit excursions into the outer darkness. Two men with cow-cords under their arms swaggered about very conscious of the weapon they carried. But a "bad stick" under the arm of a stocky, grim looking fellow was regarded with awe.

This was one of the far-famed "Ebolite" sticks. They are made from pimento wood, which becomes "prementa" on the

51

lips of the peasant. A stick of pimento about a yard long is cut. It is roasted in a fire with great skill so that the bark sheds completely without injuring the wood beneath. A little more roasting and the stick becomes a beautiful, dark, glistening thing. The stick is buried in a grave, a coolie grave is the preference, and allowed to remain there for two or three weeks. In this time, the duppy of the person buried there has come to live in the stick. After it is dug up it is polished and the two ends and sometimes the middle of the stick is wound with brass wire. The stick is ready for its baptism after the wire and it is given a name. This name is always feminine. It is named for some mule or horse or obeah woman. Soon everyone in the district knows this stick just as well as if it were justice of the peace. People whisper its name as if it were a person. "Me see Alice in the yard," and no man however full of rum would jostle the owner of Alice in the yard. But rum was talking thru several men there. "Red men licking a black man," is the way one woman spoke of it.

I was standing in the swirl of all this when Joe touched my arm. "Let's go," he said.

"No, I don't want to go. Look, one man has got his fingers mashed over there at the dollyman game. I think it's going to be a fight. I want to see it."

"Plenty fight, man. But I take you to see Koo-min-ah. That's the best kind of nine night. It don't happen often. It's a nine night but it don't happen until the person been dead a year and a half. The Africans do this with the Maroons. I take great trouble to fix it so you can come see. Come on. They make two 'house' tonight."

When we reached the yard where the Koo-min-ah was being held we found that we were early for the Koo-min-ah but late for a magnificent Congo. Both the drumming and the muscular subtleties were extraordinary.

Zachariah, "The Power," came forward and received me and later explained that they built the house for the duppy after he was gone eighteen months because it was not certain that the spirit had definitely settled down in his new home

before then. If the house which in reality is a cement tomb were built earlier than that, it might be closed while the duppy happened to be out, and then he would become a wandering spirit.

Back of us was an elaborate palm booth. Off to one side the Maroons were jerking a pig. Close by the Africans were preparing a goat with all fragrant herbs. Four or five persons in full ceremonials appeared out of a house there in the back. The Power hurriedly left us and went into the house. The intriguing monotony of the Congo died down and people began to collect around the great booth. There is a bustle inside there but the flambeau hanging from a palm stem is not yet lighted.

The Power appears for a moment at the door and the light flares. Four men who look like African nabobs I find are the drummers, and the four less panoplied men with them are the "rackling" men. That is the men who play the triple rhythm on the back of the drum with little sticks. There are two "shuckers," the men who play the cha cha.

There under the booth are two "houses" for the dead. Between them is a wooden bath bowl which contains a large calabash full of water. That is all. I wonder about the bowl and the calabash but the time is past for asking questions, because the drummers are pounding the drumheads with hammers and turning pegs in tuning their instruments.

There is the thunder of drums subtly rubbed with bare heels, and the ferocious attack of the rackling men. The thing has begun. They are "making house for duppy." The hands of the drummers weave their magic and the drums speak of old times and old things.

A few warming-up steps by some dancers. Then a woman breaks through the dancers with a leap like a lioness emerging from cover. Just like that. She sings with gestures as she challenges the drummers, a lioness defying the tribesmen.

"Ah minnie wah oh, Ah minnie wah oh!"

And the men at the instruments reply:

"Saykay ah brah ay."

She makes some liquid movements of her upper body and cries again:

"Yekko tekko, yekko tekko, Yahm pahn sah ay!"

The men:

"Ah yah yee-ai, Ah yah yee-ai, ah say oh!"

She danced thru one furious movement and cried again:

"Yekko tekko, ah pah ahah ai!"

This whole thing was repeated many times with more singers and dancers entering into it each time. Now the scores of dancers circled the tombs. It was asymmetric dancing that yet had balance and beauty. It was certainly most compelling. There was a big movement and a little movement. The big movement was like a sunset in its scope and color. The little movement had the almost imperceptible ripple of a serpent's back. It was a cameo in dancing.

One male dancer suddenly ceases and demands rum. All the others join him. Zachariah hesitates and fools around a bit, but they insist and he produces a bottle. The oldest man among the Africans is summoned. It is the law that he must have the first drink that is poured. It is handed to him with deference. Zachariah takes the next drink himself, then the woman singer-dancer who I learn is called "The Governess." Then the drummers, then the rackling men and the shuckers, then the dancers. Lastly, these who just stand and sing. They don't really belong, so if nothing is left for them no harm is done.

The dancing begins in earnest now. The Governess is like an intoxicating spirit that whips up the crowd. Those rackling men become fiends from hell. The shuckers do a magnificent muscle dance which they tell me is African. The drums and the movements of the dancers draw so close together that the drums become people and the people become drums. The pulse of the drum is their shoulders and belly. Truly the drum is inside their bodies. More rum, more fire.

"Hand a' bowl, Knife a' throat
Rope a' tie me, Hand a' bowl

54

"Hand a' bowl, Day a' light
Wango doe, doe, Knife a' throat

"Hand a' bowl, Knife a' throat
Want ingwalla, Fum dees ah"

Now Zachariah proved the magnificent dancer that he was. He dominated the group with his skill. The whole performance rose to a pitch. They all followed him in spirit and ferocity if not in skill. It was the goat song that was being sung. The Governess was speaking for the sacrificial one, and Zachariah was dancing the priest. Women began to "cramp." They flung themselves about and fell quivering. It is law that they be not allowed to lie on the ground and they were instantly seized up by men and the tempo increased. Clothes were torn away unconsciously. Two or three hot, wet bodies collided with me. I saw women picked up by their buttocks, their bodies bent backwards so limply that their heads and heels trailed the ground. Their faces were bathed in rum to revive them. If it took too long, they were carried outside of the lighted circle somewhere to be revived. The drummers, the shuckers, the rackling men had played their faces into ferocious masks. Ecstatic body movements went with every throb.

Zachariah leaped over both graves, over the seated drummers, whirled his body in mid-air, fell on his back, arched his back until only his head and toes touched the ground, held the pose in trembling ecstasy for a long moment, then hurled his lower body up and seized a cramping woman with his thighs and brought her down. Somebody rushed in and broke his scissors hold and the dance went on.

Too late I saw the goat dragged up between the tombs and the knife in Zachariah's hand. In a flash he was catching the blood from its throat in a glass. There was a great pressing forward for a drop of his wonder-working blood, but the crowd was driven back. Still in motion, Zachariah took a deep drink from the glass, then allowed each drummer a little sip. "The Power" then danced with the glass and finally with a

leap and a cry, hurled it as far from him as he could. Some of the crowd motioned to follow the glass and take it up, but "The Power" shook his head in warning and chanted without ceasing to dance, "Who want to take it up, take it up, but it is trouble to do so." That halted the rush instantly. Not a soul ventured to go.

After a magnificent flourish that coincided with sounds of the drums, "The Power" went into a cramp himself and sank to the ground. Nobody touched him. Then I saw the rising calabash. There before my eyes the calabash full of water rose from the bath bowl and slowly mounted to the top of the palm booth and as slowly sank again. The drums went on and on. They sang on and on.

Hand a' bowl. . . . Cocks crowing raucously. . . . Day a' light. . . . Night took on a deathly look. . . . Want ingwalla. . . . The spirit went out of the drums. . . . Fum dee ah. . . . The sun came up walking sideways.

CHAPTER 5

WOMEN IN THE CARIBBEAN

I t is a curious thing to be a woman in the Caribbean after you have been a woman in these United States. It has been said that the United States is a large collection of little nations, each having its own ways, and that is right. But the thing that binds them all together is the way they look at women, and that is right, too. The majority of men in all the states are pretty much agreed that just for being born a girl-baby you ought to have laws and privileges and pay and per-quisites. And so far as being allowed to voice opinions is concerned, why, they consider that you are born with the law in your mouth, and that is not a bad arrangement either. The majority of the solid citizens strain their ears trying to find out what it is that their womenfolk want so they can strain around and try to get it for them, and that is a *very* good idea and the right way to look at things.

But now Miss America, World's champion woman, you take your promenading self down into the cobalt blue waters of the Caribbean and see what happens. You meet a lot of darkish men who make vociferous love to you, but otherwise pay you no mind. If you try to talk sense, they look at you right pitifully

as if to say, "What a pity! That mouth that was made to supply some man (and why not me) with kisses, is spoiling itself asking stupidities about banana production and wages!" It is not that they try to put you in your place, no. They consider that you never had any. If they think about it at all, they think that they are removing you from MAN's place and then granting you the privilege of receiving his caresses and otherwise ministering to his comfort when he has time to give you for such matters. Otherwise they flout your God-given right to be the most important item in the universe and assume your prerogatives themselves. The usurpers! Naturally women do not receive the same educational advantages as the men.

This sex superiority is further complicated by class and color ratings. Of course all women are inferior to all men by God and law down there. But if a woman is wealthy, of good family and mulatto, she can overcome some of her drawbacks. But if she is of no particular family, poor and black, she is in a bad way indeed in that man's world. She had better pray to the Lord to turn her into a donkey and be done with the thing. It is assumed that God made poor black females for beasts of burden, and nobody is going to interfere with providence. Most assuredly no upper class man is going to demean himself by assisting one of them with a heavy load. If he were caught in such an act he probably would become an outcast among his kind. It is just considered down there that God made two kinds of donkeys, one kind that can talk. The black women of Jamaica load banana boats now, and the black women used to coal ships when they burned coal.

The old African custom of polygamy is rampant down there. The finer touches of keeping mistresses come from Europe, however. The privileges those men have of several families at the same time! And their wives don't like it a bit better than we do, but the whole national set-up favors him and crushes her. If one woman is protected in breaking into her husband's arrangements and regulating his pleasures, what is to hinder the others? The thing might become general and that would

58

be a sad state of affairs! No, selfish, jealous wives must be discouraged.

Women get no bonus just for being female down there. She can do the same labors as a man or a mule and nobody thinks anything about it. In Jamaica it is a common sight to see skinny-looking but muscular black women sitting on top of a pile of rocks with a hammer making little ones out of big ones. They look so wretched with their bare black feet all gnarled and distorted from walking barefooted over rocks. The nails on their big toes thickened like a hoof from a life time of knocking against stones. All covered over with the gray dust of the road, those feet look almost saurian and repellent. Of course their clothing is meager, cheap and ugly. But they sit by the roadside on their enormous pile of rocks and crack down all day long. Often they build a slight shelter of palm leaves to protect them from the sun. The government buys the crushed rock to use in road-building and maintenance. It is said that a woman who sticks to her business with the help of a child or two can average about one dollar and a half per week. It is very hard, but women in Jamaica must eat like everywhere else. And everywhere in the Caribbean women carry a donkey's load on their heads and walk up and down mountains with it.

But the upper class women in the Caribbean have an assurance that no woman in the United States possesses. The men of her class are going to marry inside their class. They will have their love affairs and their families wherever they will or may. But seldom does one contract a marriage outside of his class. Here in the United States a man is liable to marry whenever he falls in love. The two things are tied together in his mind. But in the Caribbean it is different. Love and marriage need not be related at all. What is shocking to an American mind is that the man has no obligation to a girl outside of his class. She has no rights which he is bound to respect. What is worse, the community would be shocked if he did respect them. Fatherhood gives no upper class man the license to trample down conventions and crash lines, nor shades-of-color

lines, by marrying outside his class.

Here is an example of this from Jamaica. A pretty girl, but definitely brown, boarded a train to come down to Kingston to work for the United Fruit Company as a typist. A young man, a mulatto, was already on the train travelling in the same class as the girl. He was immediately attracted to the girl's lush appeal and laid siege. This went on for months after she was established in Kingston and her mother had come to join her. The girl was thrilled at his attentions even though he never took her out to meet his friends. She began to dream the impossible, that this mulatto of good family had honorable intentions towards her mama's daughter. Now then, her girl friend in whom she confided her great hope and greater love, began to tell her that rumors were about that he was engaged to a girl of his own set. The lovelorn little country bird charged him but he denied it in the most positive manner. She believed him and kept up the female game of advance and retreat to lure him into the golden circle of matrimony.

Then one Sunday night he did not call to take her for a country ride as usual. He did not come until Tuesday night. He did not come into the house then. He stayed in the car and called her to come and go for a ride. As soon as she was in the car she said, "George, my friend says that you are going to be married. She says that the girl's mother came to borrow cake pans from my friend's mother early Monday morning, saying that you were going to marry her daughter tomorrow. Is it true?" "No, it is not true, darling, I love no one but you. Do you think I would be taking you for a drive tonight if I expected to marry someone else tomorrow?" He drove faster up into the wooded heights and away from Kingston.

Up in a safe little spot he induced her to leave the car after a struggle and possessed her. Afterwards, standing above her he said humbly, "I lied to you, dear. I *am* getting married tomorrow as they told you. But I just had to have you. I could have no peace of mind for thinking of you. I had to do it tonight because tomorrow I will be married and I can not continue calling on you. Come on, get into the car. I've got

to get on back to town and attend to several things for to-morrow."

And he drove like the wind to her door and never even alighted to help her, but rushed her out of the car. In the struggle before getting out of the car before her seduction she had lost one of her pumps. Evidently not wishing to leave any clues for his bride to find, he discovered the shoe a short distance from the house of the ravished girl and threw it in the road where it was found later by her friend and returned to her.

His wedding, next day, was considered one of the great social events of the year. But that is not the end. A year or two later this same man heard that the girl he had ravished was about to marry. He told the other man of his own experience with her and asked in a scornful tone, "You don't want second-hand goods, do you?" The other man did not. She is still around Kingston drinking too much and generally being careless of herself. But what becomes of her is unimportant. The honor of two men has been saved, and men's honor is important in the Caribbean.

In Haiti the law says that a woman may accuse no man of being the father of her child unless she is married to him. Thus unattached men who have been out for a few nights of pleasure need fear no embarrassment from girls who come to complain of consequences. Furthermore several intelligent Haitian women have told me that a man may marry a girl but if he wishes to do so, he can return her to her parents by saying simply, "I was not the first." Then he can vindicate his honor by getting a divorce and marry the woman he prefers. So far as the discarded bride is concerned, she has no redress. She cannot refute his statement. What could she offer as proof? The marriage would have to be consummated before the husband could have grounds for his complaint. And after that the bride is in a difficult position to make out a case for her virginity before marriage. It is barely possible that some girls, not really wanted as wives, but unattainable otherwise, have been traduced out of their good names and their husband's

61

homes at the same time after satiation. Who knows?

Take the case of Mr. A. He was a widower in his late forties. A spinster in her early thirties worked in a store very near his place of business. They fell in love and he proposed marriage. They married quietly and went to Leogane to spend their honeymoon. Leogane is a small town about twelve miles south of Port-au-Prince. During the night he accused her of having lost her virgin status and not only drove her from the bed, but he also drove her from the house. She, in this great distress of mind, started out to walk back to Port-au-Prince because she had no other way of getting there, turned out penniless and barehanded the way she was. But her virtuous husband considered that she was getting off too light. He went outside himself and gathered up a band of rowdies and paid them to follow her all the way to Port-au-Prince beating drums, and dish pans and five-gallon cans, while they made announcements about the state of affairs to everyone they met. This outraged man whose honor had nearly been tampered with secured a divorce and married a sister of a well known physician in Port-au-Prince. The allegedly unvirtuous wife hid around a year or two and died. Perhaps she suffered some but then he was a man and therefore sacred and his honor must be protected even if it takes forty women to do it.

PART II

❖

POLITICS AND
PERSONALITIES
OF HAITI

CHAPTER 6

REBIRTH OF A NATION

For four hundred years the blacks of Haiti had yearned for peace. For three hundred years the island was spoken of as a paradise of riches and pleasures, but that was in reference to the whites to whom the spirit of the land gave welcome. Haiti has meant spilt blood and tears for blacks. So the Haitians got no answer to their prayers. Even when they had fought and driven out the white oppressors, oppression did not cease. They sought peace under kingdoms and other ruling names. They sought it in the high, cold, beautiful mountains of the island and in the sudden small alluvial plains, but it eluded them and vanished from their hands.

A prophet could have foretold it was to come to them from another land and another people utterly unlike the Haitian people in any respect. The prophet might have said, "Your freedom from strife and your peace shall come when these symbols shall appear. There shall come a voice in the night. A new and bloody river shall pour from a man-made rock in your chief city. Then shall be a cry from the heart of Haiti—a great cry, a crescendo cry. There shall be survivors, and they shall have a look and a message. There shall be a Day and the

Day shall mother a Howl, and the Howl shall be remembered in Haiti forever and nations beyond the borders shall hear it and stir. Then shall appear a Plume against the sky. It shall be a black plume against the sky which shall give fright to many at its coming, but it shall bring peace to Haiti. You who have hopes, watch for these signs. Many false prophets shall arrive who will promise you peace and faith, but they are lacking in the device of peace. Wait for the plume in the sky."

THE VOICE IN THE NIGHT

A whisper ran along the edge of the dawn. A young girl heard rifle shots spattering the darkness of a night that was holding its breath. The girl stirred in fright and went to waken her father and her family where they were, but there was no need. All Haiti was awake and listening for shots. The father ordered the family to dress in haste and questioned the girl nervously. "Your ears are younger than mine. Did it seem to you that those shots came from the direction of the palace? For if they came from the palace or *near* the palace, the people in the prison—go see if the door is secure."

The girl went to the door but instead of seeing to the fastening, she eased the door open and crept outside. A band of Cacos passed swinging machetes. There were signs on many gates announcing that foreigners occupied those houses.

"But this is a street of foreigners," said one of the Cacos to his fellows. "Let us go into a street of Haitians so that we may kill some people." The girl drew her Haitian face back into the shadows and the little band of knife-men went on the business of hunting work.

The girl crept out onto the sidewalk again straining to translate the whisper of the night. Outside the ominous pulsation of the city was more definite. The voice of the night rose higher to say what it would. This night *must* say something, the political situation was too tense to pass another day undefined, and every house in Haiti had an ear strained with fear or with hope. Behind her, Fannie heard her father find the

unlatched door by his gasp of terror. Across the street she saw someone all but crawling along the sidewalk as close to the wall as possible. She found that it was the son of a neighbor around her own age. She hailed him in a whisper, and he beckoned her to cross the street to where he was. He seemed to be afraid for her.

"What are you doing outside, Fannie?"

"I heard shots, Etienne. Why are you outside tonight? It is very dangerous. I saw Cacos walking."

The boy crept close to her in the dark to give tongue to the speechless something that was reeking in the air.

"Sh-sh-Fannie. The people in the prison are dead!"

"How do you know that, Etienne?"

"A whisper came to our door. A Voice—nobody saw who spoke. But it is certain. The people in the prison are dead."

THE BLOODY RIVER

The people and the women of Port-au-Prince came to the prison that dawn morning. Winged tongues had whispered at every door, "The people in the prison are dead! Our people in the prison are dead!" A very few worried the bone of whether Jean Vilbrun Guillaume Sam was still President in the palace or a fugitive in the French Legation. But nobody listened to them talk. The collected mass said, "The people in the prison are dead." Or some said it like a question, "Are our people dead in the prison?"

Some blamed the political foes who had harried President Sam to the point where he had seized nearly two hundred men, all members of good families, and imprisoned them more as hostages for the good behavior of the leaders than as politicians suspected of plotting the overthrow of the Sam administration. Some denounced the machinations of Sam and his adherents. President Sam, they said, was a cheat and a fraud. He was a man of no honor. He had not the politesse. He had no regard for established rules of occupying the palace. He did not respect the conventions. He was a greedy and

67

detestable criminal. He had been in the palace for five months, or nearly so. That was sufficient time for him to "assure his future," if he had been alert and intelligent about the national funds. Why then must the monster resist the efforts of other desiring men to improve their fortunes? When Sam had captured the principal cities, had not Theodore sailed away like a gentleman? Now that General Bobo had marched from the north and invested the capitol, why did Sam ignore the conventions governing the situation? Clearly the man was a greedy, stupid pig lacking in good manners. A man like that deserved no loyalty and allegiance from cultured folk. He must expect revolution. The men in the prison were heroes for having resisted him. This was the opinion of the majority. A few still felt that Sam having gained the presidency should not be deposed by violence, and that his resistance was justified. Moreover, the nation wanted peace. The people were weary of the "generals" and their endless revolutions and counterrevolution. Their greed and ambition were destroying the nation. They breathed a great prayer for Peace! But where in Haiti?

They had heard shots and the President had issued orders to kill the political prisoners in the prison at the first shots of the opposing forces. And now it was generally agreed that the shots had come from the Champ de Mars and that the President's Caco army on which he had depended, had answered weakly before it deserted the President's cause. So now the families of the prisoners were there and they must go into the jail. Screams and groans had been reported with muffled shots. The families must know if the unhappy sounds pertained to their own. Someone said that fifteen bloody men with bloody blades had just left the jail. But Charles Oscar Etienne, Chief military officer of the government, could not be found to be questioned. Chocotte and Paul Herard were inside, rumor said, but no one could enter to question them. But dawn discovered a drain from the inside of the prison flowing with gouts and clots of blood. The doors crashed open before the

68

fury of families and friends of families and they surged to the cells of their relatives to be reassured of their safety.

THE CRESCENDO CRY

There in the cells in huddled stillness were shot bodies and cut bodies. Skulls crushed in by machetes' blows and bowels ripped away by blades. Men with machetes had been ordered to follow the rifle men. The finished youth of the three sons of Polynice in their helplessness called out to pity and retribution. The hunks of human flesh screamed of outrage. The blood screamed. The women screamed. The great cry went up from the bloody cells and hung over Haiti like smoke over a ruin. And the sun rushed up from his slot in the horizon to listen.

THE SURVIVORS

They lifted the heaps of the dead and found a man. He screamed and muttered and screamed. He was mad. Another one could talk, "I heard them when they said, 'Fifteen men, forward march!' " Then he whispered, "I heard Chocotte, the adjutant, say, 'Fire close to the ground. A bullet in the head for each man. Every one of the political prisoners must die. The arrondissement's orders are that not one be left standing. They don't know the kind of man that General Vilbrun is.' But I am still alive, am I not? The slaughter of July twenty-seventh is past and I am still alive." They led out Stephen Alexis; they led out a mad man and they led out another. These three had survived the massacre. "But where is the body of Charles Oscar Etienne?" Polynice cried. "He cannot be alive or this butchery could not have happened. He is the Chief military officer of Haiti with the care and protection of these unarmed and helpless people."

"He is the friend of Guillaume Sam," someone answered him.

"But honor lays a greater obligation than friendship; and if

69

friendship made such a monster of a man, then it is a thing vile indeed. No, Oscar Etienne is dead. Only over his dead body could such a thing have happened. Show me the body of Etienne. Look near the bodies of my three young sons. It must be there. He could not have betrayed them out of their young lives in so wretched a manner. Look well and find the body of this honorable man who died in defense of his own honor and the helplessness of his prisoners. We must bury him with honor like our great ones. Like L'Ouverture he died defending Haiti from brutality and butchery."

So Polynice went about among the dismembered parts of bodies to which no one could give a name, searching for one small piece of the protector of the helpless that he might do it honor and thus wash his own grief, which was a terrible thing. After a while someone told him, "But Oscar Etienne is not dead. He was seen to leave the prison before five o'clock. It was he who ordered the massacre. He has taken refuge in the Dominican legation. He will not come out for any reason at all."

"Then I must go and bring him out. It will be a great kindness to him after this terrible end of my sons. He will not wish to live and remember his defeat in the carrying out of his duty. I must hurry to relieve him of his memories."

Polynice rushed to the Dominican legation and dragged out the cringing Etienne who went limp with terror when he saw the awful face of the father of the Polynices. He mumbled "mistakes" and "misunderstanding" and placed the blame upon President Vilbrun Sam. But it is doubtful if Polynice heard a word. He dragged him to the sidewalk and gave him three calming bullets, one for each of his murdered sons and stepped over the dead body where it lay and strode off. The crowd followed him to the home of Etienne where they stripped it first and then levelled it to its foundation. In their rage they left nothing standing that one might say "Here is the remains of the house of Etienne who betrayed and slaughtered defenseless men under his protection for the crime of difference of politics." His heart retched terribly as he went through

70

the city that was weeping and washing the dead as he made his way to the French legation to see if he might not speak with General Sam. The weepers and Polynice were the survivors with the mad man and Stephen Alexis and that other one who did not die.

THE DAY AND THE HOWL

All that day of the massacre the families washed bodies and wept and hung over human fragments asking of the bloody lumps, "Is it you, my love, that I touch and hold?" And in that desperate affection every lump was carried away from the prison to somebody's heart and a loving burial. They knew that Vilbrun Guillaume Sam hid in the French legation after fighting his way out of the palace with something of the courage of Christophe and the ferocity of Dessalines. But this day was the day of the dead. It was not the day of thinking of Vilbrun Sam. This was the day of feeling. The next day the one hundred and sixty-seven martyrs would be buried. With their bodies out of sight, perhaps they could think again. So another night of whispers and sleeplessness and the funeral processions streamed to the churches from all directions. People fell into the processions as they passed grim and solemn. Men called out encouragement from houses along the way. Women wept at windows. Body after body climbed toward the great church of the Sacred Heart. Funeral met funeral at the door. Peasant women with their weeping handkerchiefs tied tight about their loins wailed all about the doors along the routes. The people who had not been able to get into the church stopped the processions of bodies as they were carried from the church and wept over them.

One black peasant woman fell upon her knees with her arms outstretched like a crucifix and cried, "They say that the white man is coming to rule Haiti again. The black man is so cruel to his own, *let the white man come!*"

With the bodies in the earth, with the expectation of American intervention, with the prong of such cries in their hearts,

the people moved toward the French legation. They were not to be balked. For this day and this act amenities national and inter-national were suspended. The outraged voice of Haiti had changed from a sob to a howl. They dragged General Jean Vilbrun Guillaume Sam, until the dawn of the day of the massacre, president of the Republic, from his hiding place. They chopped his hand that tried in its last desperation to save him from the massed frenzy outside the legation gates. They dragged him through the door into the court and there a woman whose dainty hands had never even held a broom, struck him a vicious blow with a machete at the root of his neck, and he was hurled over the gate to the people who chopped off his parts and dragged his torso in the streets.

THE PLUME AGAINST THE SKY

They were like that when the black plume of the American battleship smoke lifted itself against the sky. They were like that when Admiral Caperton from afar off gazed at Port-au-Prince through his marine glasses. They were so engaged when the U.S.S. *Washington* arrived in the harbor with Caperton in command. When he landed, he found the head of Guillaume Sam hoisted on a pole on the Champ de Mars and his torso being dragged about and worried by the mob. This dead and mutilated corpse seemingly useless to all on earth except those who might have loved it while it was living. But it should be entombed in marble for it was the deliverer of Haiti. L'Ouverture had beaten back the outside enemies of Haiti, but the bloody stump of Sam's body was to quell Haiti's internal foes, who had become more dangerous to Haiti than anyone else. The smoke from the funnels of the U.S.S. *Washington* was a black plume with a white hope. This was the last hour of the last day of the last year that ambitious and greedy demagogues could substitute bought Caco blades for voting power. It was the end of the revolution and the beginning of peace.

THE NEXT
HUNDRED YEARS

Peeps at personalities in the Black Republic.

Haiti has always been two places. First it was the Haiti of the masters and slaves. Now it is Haiti of the wealthy and educated mulattoes and the Haiti of the blacks. Haiti of the Champ de Mars and Haiti of the Bolosse. Turgeau against the Salines. Under this present administration, the two Haitis are nearer one than at any time in the history of the country. The mulattoes began their contention for equality with the whites at least a generation before freedom for the blacks was even thought of. In 1789 it was estimated that the mulattoes owned at least ten per cent of the productive land and held among them over 50,000 black slaves. Therefore when they sent representatives to France to fight for their rights and privileges, they would have been injuring themselves to have asked the same thing for the blacks. So they fought only for themselves.

In 1791 under Boukmann, Biasson and Jean-François, the blacks began their savage lunge for freedom and in 1804 they were free. Their bid for freedom had to have lunge and it had to be savage, for every man's hand was against them. Certainly

their kinfolks, the mulattoes, could see no good for themselves in freedom for the blacks. Thus the very stream of Haitian liberty had two sources. It was only the white Frenchman's scorn of the mulattoes and his cruelty that forced Pétion and his followers into the camp of the blacks.

Since the struggle began, L'Ouverture died in a damp, cold prison in France, Dessalines was assassinated by the people whom he helped to free, Christophe was driven to suicide, three more presidents have been assassinated, there have been fourteen revolutions, three out-and-out kingdoms established and abolished, a military occupation by a foreign white power which lasted for nineteen years. The occupation is ended and Haiti is left with a stable currency, the beginnings of a system of transportation, a modern capitol, the nucleus of a modern army.

So Haiti, the black republic, and where does she go from here? That all depends. It depends mostly upon the action of a group of intelligent young Haitians grouped around Dividnaud, the brilliant young Minister of the Interior. These young men who hold the hope of a new Haiti because they are vigorous thinkers who have abandoned the traditional political tricks.

In the past, as now, Haiti's curse has been her politicians. There are still too many men of influence in the country who believe that a national election is a mandate from the people to build themselves a big new house in Pétionville and Kenscoff and a trip to Paris.

It is not that Haiti has had no able men in the presidential chair in the past. Several able and high minded men have been elected to office at various times. But their good intentions have been stultified by self-seekers and treasury-raiders who surrounded them. So far there has been little recognition of compromise, which is the greatest invention of civilization and its corollary, recognition of the rule of the majority which is civilization's most useful tool of government. Of course, it is more difficult to discover the will of the majority in a nation where less than ten per cent of the population can read and

write. Still there is a remarkable lack of agreement among those few who do read and write.

Of course Haiti is not now and never has been a democracy according to the American concept. It is an elected monarchy. The President of Haiti is really a king with a palace, with a reign limited to a term of years. The term republic is used very loosely in this case. There is no concept of the rule of the majority in Haiti. The majority, being unable to read and to write, have not the least idea of what is being done in their name. Haitian class consciousness and the universal acceptance of the divine right of the crust of the upper crust is a direct denial of the concept of democracy. Neither is the Haitian chambers of Senate and deputies the same sort of thing as our Senate and House. No man may seek either of those offices in Haiti unless he has the approval of the Palace.

In addition to the self seekers who continually resorted to violence to improve their condition—they always called themselves patriots—Haiti has suffered from another internal enemy. Another brand of patriot. Out of office, he continually did everything possible to chock the wheels of government. In office himself, he spent his time waving the flag and orating on Haiti's past glory. The bones of L'Ouverture, Christophe and Dessalines were rattled for the poor peasants' breakfast, dinner and supper, never mentioning the fact that the constructive efforts of these three great men were blocked by just such "patriots" as the present day patriots. No one mentioned that all three died miserably because of their genuine love of country. Less worthy men have lived to rob, oppress, and sail off to Jamaica on their way to Paris and the boulevards. These talking patriots, who have tried to move the wheels of Haiti on wind from their lungs, are blood brothers to the empty wind bags who have done so much to nullify opportunity among the American Negroes. The Negroes of the United States have passed through a tongue-and-lung era that is three generations long. These "Race Men's" claim to greatness being the ability to mount any platform at short notice and rattle the bones of Crispus Attucks; tell what great folks the

Rex Hardy, Jr.

The American Minister and President Stenio Vincent (right)

thirteenth and fourteenth amendments to the constitution had made out of us; and *never* fail to quote, "We have made the greatest progress in sixty years of any people on the face of the globe." That always brought the house down. Even the white politicians found out what a sure-fire hit that line was and used it always when addressing a Negro audience. It made us feel so good that the office seeker did not need to give out any jobs. In fact I am told that some white man way back there around the period of the Reconstruction invented the line. It has only been changed by bringing it up to date with the number of years mentioned. Perhaps the original demagogue reared back with one hand in his bosom and the other one fumbling in his coat tails for a handkerchief and said, "You have made the greatest progress in ten years, etc." But America has produced a generation of Negroes who are impatient of the orators. They want to hear about more jobs and houses and meat on the table. They are resentful of opportunities lost while their parents sat satisfied and happy listening to crummy orators. Our heroes are no longer talkers but doers. This leaves some of our "race" men and women of yesterday puzzled and hurt. "Race leaders" are simply obsolete. The man and woman of today in America is the one who makes us believe he can make our side-meat taste like ham.

These same sentiments are mounting in Haiti. But they have not spread as rapidly as in the United States because so few of the Haitian population can read and write. But it is there and growing. There is a group of brilliant young men who have come together to form a scientific society under the leadership of Dr. Camille Lherisson, who is a great grandson of a Lowell of Massachusetts. He is a graduate of Magill University in Canada and Harvard, and head of the Department of Biology in the Medical School at Port-au-Prince, and on the staff of the hospital. Dr. Dorsainville, Dr. Louis Mars, and several other men of high calibre meet in the paved court of Dr. Lherisson's home once every week to listen to foreign scientists who happen to be visiting Haiti at the time, or to provoke discussion among themselves. These men with Divid-

77

naud, who is the most politically conscious of them all, are the realists of Haiti. Dr. Rulx Léon, Director General of the Public Health Department, is definitely of these thinking men who hold the future of Haiti in their hands. One has only to look through the Service d' Hygiene and visit the hospitals to realize what a great man is Dr. Léon. The finest medical men in Haiti are on his staff. He does not even permit his own feelings toward the men to influence him. Every one in Port-au-Prince knows that he is the personal enemy of the most brilliant man of his staff and yet he retains him. "The man is a genius. Haiti needs his talents," Dr. Léon explained. "It is not for me to thrust my personal disagreements before the welfare of the country. I am trying to keep this department up to the standard set by the American doctors of the Occupation. Unfortunately there is so little money with which to work." And the man in question is just as big as Dr. Léon. He gives everything in him to his work. Everywhere in the National Medical Service there is evidence of great talent and high character.

It is touching to go through the hospital and visit the maternity ward. Young Dr. Sam has charge there. He is the son of the President Guillaume Sam, whose horrible death brought on the Occupation in 1915. Nowhere is there a more earnest physician than Dr. Sam. How he loves those babies that are delivered under his care! This is real devotion. His face is so fine and intelligent, and he is so careful with the very poorest of the peasant mothers who come to his out-patient clinic! Nothing is finer in all Haiti than Dr. Sam at work. The same thing, but not so obvious, is felt about Dr. Seide. The Service d'Hygiene is full of character and talent and that is another way of saying that Dr. Leon is a big man. Any little-souled man would be too petty to hire such men. The man evidently has no fear of being dwarfed by his subordinates.

Among these men, and Elie Lescot, Haitian minister at Washington, is of them, one sees the real tragedy of Haiti. Here are clear headed, honest men of ability who see what is to be done for the salvation of Haiti, but there are "so many

Rex Hardy, Jr.

Dr. Rulx Léon and family

ways that wind and wind" and there is so much red tape, so many bad political habits that must be forgotten before they can be at all effective. People are beginning to say that the most promising man in Haiti to untangle this snarl-upon-snarl in government is the dynamic young Dividnaud. He is not only intelligent, he has force in his makeup and a world of courage. He conducts the affairs of his department with a brisk celerity. He is no dreamer, no rattler-of-bones, no demagogue. The Minister of the Interior is a man of action if ever one lived. And he is continually spoken of as the most audacious man in all Haiti. It has been proven conclusively that he cannot be bluffed and bullied. The President knows that and the people know that the President knows it. There is a spirit in him and others that is opposed to the old-style Haitian who has his eyes closed to fact and keeps chanting to himself that Haiti has a glorious past and that everything is just lovely. They know that everything is *not* lovely; that what happened in 1804 was all to Haiti's glory, but this is another century and another age. The patriots of 1804 did what was necessary then. It is now another time that calls for patriotism. They feel that they must do those things which will prove that they deserve their freedom. It is said over and over that they are weary of the type of politician who does everything to benefit himself and nothing to benefit his country but who is the first to rush to press to "defend" Haiti from criticism. These "defenses" are the only returns that Haiti receives for the money the "defender" is allowed to squander and the opportunities for national advancement that he ignores or prostitutes to his own advantage. The honest and earnest of Haiti do not want Haiti apologized for. They want to make these apologies unnecessary. So they are now laying the groundwork for greater unity and progress in the future.

They realize that internal matters are not so glory-getting as foreign wars, but they are even more necessary. They see that all is *not* well, that public education, transportation and economics need more attention, much more than do the bones of Dessalines. The peasants of Haiti are so hungry, and relief

would not be difficult with some planning. They are refusing to see the glorified Haiti of the demagogue's tongue. These few intellectuals must struggle against the blind political pirates and the inert mass of illiterates.

That brings us to the most striking phenomenon in Haiti to a visiting American. That habit of lying! It is safe to say that this art, pastime, expedient or whatever one wishes to call it, is more than any other factor responsible for Haiti's tragic history. Certain people in the early days of the Republic took to deceiving first themselves and then others to keep from looking at the dismal picture before them. For it was dismal, make no mistake about that, if it is looked at from the viewpoint of the educated mulatto and the thinking blacks. This freedom from slavery only looked like a big watermelon cutting and fish-fry to the irresponsible blacks, those people who have no memory of yesterday and no suspicion of tomorrow. L'Ouverture, Christophe, Pétion and Dessalines saw it as the grave problem it was. No country has ever had more difficult tasks. In the first place Haiti had never been a country. It had always been a colony so that there had never been any real government there. So that the victors were not taking over an established government. They were trying to make a government of the wreck of a colony. And not out of the people who had at least been in the habit of thinking of government as something real and tangible. They were trying to make a nation out of very diffident material. These few intelligent blacks and mulattoes set out to make a nation out of slaves to whom the very word government sounded like something vague and distant. Government was something, they felt, for masters and employers to worry over while one rested from the ardors of slavery. It has not yet come to be the concern of the great mass of Haitians.

It must have been a terrible hour for each of the three actual liberators of Haiti, when having driven the last of the Frenchmen from their shores, they came at last face to face with the people for whom they had fought so ferociously and so long. Christophe, Dessalines and Pétion were realists. Every plan

81

they laid out attests this. They tried to deal with things as they were. But Dessalines was murdered; Christophe killed himself mercifully to prevent the people for whom he had fought so valiantly from doing it in a more brutal manner. Pétion saw his co-leaders fall and abandoned his great plans for restoration of the coffee and sugar estates and other developments that had once brought such great wealth to the colony of Saint Dominique.

Perhaps it was in this way that Haitians began to deceive themselves about actualities and to throw a gloss over facts. Certainly at the present time the art of saying what one would like to be believed instead of the glaring fact is highly developed in Haiti. And when an unpleasant truth must be acknowledged a childish and fantastic explanation is ready at hand. More often it is an explanation that nobody but an idiot could accept but it is told to intelligent people with an air of gravity. This lying habit goes from the thatched hut to the mansion, the only differences being in the things that are lied about. The upper class lie about the things for the most part that touch their pride. The peasant lies about things that affect his well-being like work, and food, and small change. The Haitian peasant is a warm and gentle person, really. But he often fancies himself to be Ti Malice, the sharp trickster of Haitian folk-lore.

The Haitian people are gentle and lovable except for their enormous and unconscious cruelty. It is the peasants who tie the feet of chickens and turkeys together and sling the bundle over their shoulders with the heads of the fowls hanging down and walk for miles down mountains to the market. The sun grows hot and the creatures all but perish of thirst and they do faint from their unnatural and unhappy position. I have bought chickens from women who came into my yard and found them unconscious. Sometimes the skin would be rubbed from their thighs from being tied too tight. They bore holes in the rumps of the donkeys by prodding them with sharp sticks to make them hurry when they have been driving donkeys for centuries and should know by now that the little

animals are not inclined to speed. I have seen great pieces of hide scraped off the rumps and thighs of these patient little beasts, yet they were still being driven. There are thousands of donkeys in Haiti whose ears have been beaten off in an effort to hurry them. I have seen horses raw from their withers to their rumps, scalded by saddles and still being worked.

I say Haitian people are unconsciously cruel instead of merely the peasants. I know that the upper classes do not sell chickens nor drive donkeys, but they do rule the country and make the laws. If they were conscious of the cruelty of the thing, they would forbid it. I spoke of this one day to Jules Faine when I visited him and found him chasing some boys away who were trying to kill birds with stones. I said that he was the first Haitian whom I had noticed who seemed to care about such things.

"Why should these peasants be tender with animals?" he asked gently. "No one has been tender with them."

"Why do you Americans always speak of our cruelty to animals?" The editor of the *Le Matin* asked me. "You are cruel also. You boil live lobsters."

"Yes," I said, "but the people who sell them would not be permitted to drag them by the legs from Massachusetts to Virginia, nor to half-skin them on the way."

"It is all the same." He shied away from actuality and went on.

Then again under the very sound of the drums, the upper class Haitian will tell you that there is no such thing as Voodoo in Haiti, and that all that has been written about it is nothing but the malicious lies of foreigners. He knows that is not so and should know that you know that it is not true. Down in his heart he does not hate Voodoo worship. Even if he is not an adept himself he sees it about him every day and takes it for a matter of course, but he lies to save his own and the national pride. He has read the fantastic things that have been written about Haitian Voodoo by people who know nothing at all about it. Consequently, there are the stereotyped tales of virgin worship, human sacrifice and other elements bor-

rowed from European origins. All this paints the Haitian as a savage and he does not like to be spoken of like that. So he takes refuge in flight. He denies the knowledge and the existence of the whole thing. But a peasant who has been kindly treated will answer frankly if he is not intimidated by the presence of a Gros Negre or a policeman. That is, if the policeman is strange to him or is known to be self-conscious about Voodoo. But that same peasant who answered you so freely and so frankly about Voodoo, if you paid him in advance for the simplest service would not return with your change. The employer class in Haiti continually warn their foreign friends not to pay for any service in advance nor to send anyone off with change. The peasant does not consider this as stealing. He prides himself on having put over a smart business deal. What he might lose by it in future business never occurs to him. And while this applies particularly to the servant class, it is just as well not to pay any money in advance to *anyone* in Haiti unless you know them very well indeed.

This self-deception on the upper levels takes another turn. It sounds a good deal like wishful thinking out loud. They would like to say that Haiti is a happy and well-ordered country and so they just say it, obvious facts to the contrary. There is the marked tendency to refuse responsibility for anything that is unfavorable. Some outside influence, they say, usually the United States or Santo Domingo, is responsible for all the ills of Haiti. For example in June and July I learned that thousands of Haitian laborers were being expelled from Cuba and returned to Haiti. Knowing that work was scarce and hunger plentiful already I asked what was going to be done about providing jobs for these additional hands. Among answers I got was "What can we do? We are a poor country that has been made poorer by an Occupation forced upon us by the United States. So now we have no money to provide work for our laborers." "But," I countered, "you and many others have told me that the Occupation brought a great deal of money here which you were sorry to lose." "Oh, perhaps they did make jobs for a few hundred people, but what is that when

84

they robbed the country so completely? You *see* that we have nothing left, and besides they are still holding our customs and so we cannot sell our coffee to any advantage. France will always buy our coffee if only they would make decent terms with France. Then there would be work for all our people."

"But I have just heard that France has attempted to collect more for her debt than your country actually owed her and the American fiscal agents would not permit it. Is that not true?"

"We know nothing, Mademoiselle. All we know is that the Marines saw that our country was rich and so they came and robbed us until we grew tired of it and drove them away."

"You evidently were very slow to wrath because they stayed here nineteen years, I believe," I said.

"Yes, and we would have let them stay here longer but the Americans have no politeness so we drove them out. They knew that they had no right to come here in the beginning."

"But, didn't you have some sort of disturbance here, and were you not in embarrassing debt to some European nations? It seems that I heard something of the sort."

"We never owed any debts. We had plenty of gold in our bank which the Americans took away and never returned to us. They claimed that we owed debts so that they could have an excuse to rob us. When they had impoverished the country they left, and now our streets are full of beggars and the whole country is very poor. But what can a weak country like Haiti do when a powerful nation like your own forces its military upon us, kills our citizens and steals our money?"

"No doubt you are correct in what you say. However, an official of your own government told me that Haiti borrowed $40,000,000 to pay off these same foreign debts which you tell never existed at all."

"Mlle., I swear on the head of my mother that we had no debts. The Americans did force us to borrow the money so that they could steal it from us. That is the truth. Poor Haiti has suffered much."

All this was spoken with the utmost gravity. There was a dash of self pity in it. He was patently sorry for himself and

all of the citizens who had suffered so much for love of country. If I did not know that every word of it was a lie, I would have been bound to believe him, his lies were that bold and brazen. His statements presupposed that I could not read and even if I could that there were no historical documents in existence that dealt with Haiti. I soon learned to accept these insults to my intelligence without protest because they happened so often.

With all the grave problems in Haiti to be dealt with, President Stenio Vincent, himself, finds time to indulge in the national pastime of blowing up a hurricane with his tongue. He has fabricated a conqueror's role for himself and struts as the second deliverer of Haiti, thus ranking himself with L'Ouverture, Dessalines and Christophe. He goes about it by having himself photographed with the frowning mien of a conqueror and looking for all the world like a ferocious rabbit. Without cracking a smile he announces himself as the Second Deliverer of Haiti. He bases his claim on the fact that President Roosevelt, in keeping with his good-neighbor policy, withdrew the Marines from Haiti during Vincent's administration. He knows that the N.A.A.C.P., The Nation and certain other organizations had a great deal more to do with the withdrawal of the Marines than Vincent did and much more than they are given credit for. In fact they are never mentioned when Vincent orates about Second Independence and honors himself as the Second Liberator. The story of how he drove out the Marines all by himself is a great one, the way he tells it. He even holds a celebration about it every year on August 21st. For the 1937 celebration he is supposed to have spent 80,000 gourds (about $16,000) to illumine the city of Port-au-Prince in celebration of an event that never took place.

But in spite of the great cost, something seemed lacking. Not a great number of people turned out and those who did come did not effervesce. It went off with more spirit in 1936 when the people were not so hungry as they had become a year later. The Haitian people naturally love fetes, and under

normal circumstances they are happy to join in celebrating anything at all. No one in Haiti actually believes that President Vincent drove out the Marines, because even the humblest peasant knows that there was no fighting on the occasion of their departure and from past experience they know if there had been any fighting the Marines would have been on top as usual. But if the President wished to celebrate something, why not? After all the imagination is a beautiful thing.

Now in 1937 hunger and want were stalking the land. There were people who did not have a garment of any kind to cover their nakedness so that they could not come out of doors at all. As far back as November 1936 there were scared whispers about prisoners starving to death in the prison in Port-au-Prince. The jobless peasant still felt hungry after his meal of sour oranges. They had nothing really against a celebration for any reason whatsoever, but some "pois rouge et dee wee" (red beans and rice) would have suited their mood better than the electric lights, especially in celebration of a fiction. A great many expressed resentment toward the whole thing. Why celebrate the leaving of the Marine Corps when nobody wanted the Marines to go anyway? Their era of prosperity had left with the Marines. If President Vincent had arranged for them to go, then he was no friend to the people. The man they wanted to honor was the one who could bring them back. A great many of them had their doubts as to whether the $16,000 stated actually was spent. "They don't spend all of this money as they tell us. The Gros Negre only find more excuse to take money for themselves." The Champ de Mars was full of suspicion and doubt that night.

It is a well known fact, and freely acknowledged in Haiti, that before the withdrawal of the American Marines, Colonel Little and the officers of the Occupation prepared a Haitian fighting force of three thousand men under Colonel Calixe. With so many trained men, and with the equipment left by the Americans plus that bought by the Haitian government, it would seem that some effective resistance could be made to an invasion from Santo Domingo if necessary. Therefore it is

astonishing to read the recent statements of President Vincent that Haiti is defenseless before the onslaughts of Santo Domingo. That statement is far from true and very puzzling until one considers the reports of starvation among the Haitian peasants and the rumors of uprisings. One revolt was reported definitely under way at Cayes in the south when the massacre took place on the border. That whole department was said to be seething with revolt at the results of hunger. Does President Vincent think it better to allow the Dominicans to kill a few thousand Haitian peasants than to arm the peasants and risk being killed himself? Does he fear that if the stores of ammunition in the basement of the palace were issued to the army that his own days in the palace would be numbered? From actual conditions in Haiti these questions are not too far fetched. President Vincent practically acknowledged it himself in his statement to Quentin Reynolds in which he said that the Garde d'Haiti was only large enough to police Haiti. Are his own people more to be feared than Trujillo? Does he reason that after all those few thousand of peasants are dead and gone and he is still President in the palace? But if the arms and the ammunition in the basement of the palace ever got out of his control in his attempt to avenge their massacre, he might find himself "sailing for Jamaica" like many other Haitian ex-presidents have done?

Another significant figure in Haitian life is Colonel Calixe, chief of the Garde d'Haiti, which means that he is the number one man in the military forces of Haiti. He is a tall, slender black man around forty with the most beautiful hands and feet that I have ever beheld on a man. He is truly loved and honored by the three thousand men under him. His officers are well-trained professional men—doctors, engineers, lawyers and the like. There is no doubt that the military love their chief. But it is apparent that others fear his influence. Perhaps they think he might be moved to seize executive power, for he is bound by a curious oath. Not only must he refrain from moving against the Palace, he is further under threat of punishment of death if anything should happen to the President

in any way at all. More than that, the ammunition is kept in the basement of the Palace under the special eye of Col. Armand, mulatto choice of the President for military chief. But the Garde d'Haiti was trained and established under the American military officers of the Occupation, and it is said that Colonel Little selected Calixe as the most able of all the Haitian officers available and had insisted on him as chief. Someone told me that the American officers had preferred Calixe, but also that President Vincent had felt that the appointment was wise because Colonel Calixe was a hero among the blacks and also because he is from the North. He is a native of Fort Liberty, a small town near Cape Haitian, and the North has always played an important part in the history of Haiti. This was then an attempt to soften the differences between the blacks and the mulattoes and recognize the importance of the North. Otherwise the administration would have preferred the mulatto Colonel André or La Fontant if Armand was not appointed. To his great credit it must be said that in the face of great opposition, the President has taken many steps to destroy this antagonism between the mulattoes and the blacks which has been the cause of so much bloodshed in Haiti's past and has been one of the major obstacles to national unity. But the end is not yet in sight. Anyway, there is Colonel Calixe with his long tapering fingers and his beautiful slender feet, very honest and conscientious and doing a beautiful job of keeping order in Haiti. If he is conscious of the jitters he inspires in other office holders and men of ambitions, he does not show it. He has told me that he is a man of arms and wishes no other job than the one he has. In fact we have a standing joke between us that when I become President of Haiti, he is going to be my chief of the army and I am going to allow him to establish state farms in all of the departments of Haiti, a thing which he has long wanted to do in order to eliminate the beggars from the streets of Port-au-Prince, and provide food for the hospitals, jails and other state institutions, since there is not enough tax money to do these things well. He is pathetically eager to clear the streets of Haiti of beggars and petty

thieves and to make his department shine generally. If he has ambitions outside of his office, he dissembles well. And what a beautifully polished Sam Brown belt on his perfect figure and what lovely, gold-looking buckles on his belt!

There is somebody else in Haiti that the people cannot forget. He is not there in person, but his shadow walks around like a man. That is the shadow of Trujillo, President of neighboring Santo Domingo. Trujillo is not in Haiti; he is not even a Haitian but he has connections that reach all around. He has relatives there and numerous friends and admirers. All day long, Haitians are pointing to the Man of Santo Domingo. Some of them with fear, the rest with admiration. Some Haitians even speak of him with hope. They reason that if he can bring peace and advancement to Santo Domingo, he can contrive something of the kind in Haiti. They remember his resplendent visit to Haiti in 1936 and afterwards his gift of food and provisions to the Haitian peasants. Trujillo is *really* among those present in Haiti. Moreover, the Haitian who cannot find work in his own country, immediately thinks of migrating to Santo Domingo. Before the recent border trouble, there were thousands of Haitians in Santo Domingo because of better working and living conditions. With this condition in mind, Trujillo is supposed to have made a speech in which he threatened in a veiled manner to clean up the Haitian end of the island. His contention being, perhaps, that his own country always had to share the burden of Haiti's poor economic arrangement. So that Santo Domingo's own strides toward advancement were being shortened by having to absorb great numbers of the unemployed of her practically static neighbor. So the poor people of Haiti see more in Trujillo than just the President of a neighboring country.

Among the whispered angles of the notorious case of Joseph Jolibois, Fils, is the one that Jolibois, Fils, was the friend of Trujillo, and that when the President of Santo Domingo learned of his mysterious death in jail, he burst into a rage and expelled the Haitian Minister from his country. He is said to have accused someone very high in Haitian national life of

murdering his friend Jolibois, Fils, to get him out of the way because he was becoming too popular with the people and too open in his opposition to the Administration. That was in 1936. Since then people whisper: "They say that Jolibois was poisoned in that prison. Jolibois was accused of shooting Elie Elius to death but there was no proof. They say that both men were troublesome and were liquidated for that reason. They say that Trujillo is in a great rage over the death of his friend and means to avenge him. Soon now, perhaps, he will come with his great army to punish the Haitian government for the death of Jolibois. Who knows?"

These new and vigorous young Haitian intellectuals feel that Santo Domingo's great advancement should spur Haiti out of her fog of self-deception, internal strife and general backwardness. They are advocating universal free grammar schools as in the United States and a common language. As things stand, the upper class Haitians speak French and the peasants speak Creole. M. Sejourne' rightfully contends that the barrier of language is a serious thing in a nation. It makes for division and distrust through lack of understanding. He thinks that either French must speedily be taught to all, or that Haiti must adopt Creole as its official language and commission some of its scholars like Jules Faine to reduce the patois to writing. Then there is the matter of religion. Nominally Haiti is a Catholic country, but in reality it is deeply pagan. Some of the young men are ceasing to apologize for this. They feel that the foreign Catholic priests do the country much more harm than Voodoo does. They are eager for the day when they shall expel the French and Belgian priests whom they say foster and propagate "war between the skins." They mean by that, that they encourage differences among the mulattoes and the blacks, besides impoverishing the country by the great sums that they collect and send to Rome and France. Also they say that the priests, in order to crush a powerful rival, place all the evils of politics and what not upon the shoulders of Voodoo.

The politicians, to cover up their mistakes, have also seized

upon this device. As someone in America said of whiskey, Voodoo has more enemies in public and more friends in private than anything else in Haiti. None of the sons of Voodoo who sit in high places have yet had the courage to defend it publicly, though they know quite well and acknowledge privately that Voodoo is a harmless pagan cult that sacrifices domestic animals at its worst. The very same animals that are killed and eaten every day in most of the civilized countries of the world. So since Voodoo is openly acknowledged by the humble only, it is safe to blame all the ill of Haiti on Voodoo. I predict that this state of affairs will not last forever. A feeling of nationalism is growing in Haiti among the young. They admire France less and less, and their own native patterns more. They are contending that Voodoo is not what is wrong with Haiti. The thing fettering the country is its politics and those foreign priests.

Well, anyway, there is Haiti as it is, and there is this class of new and thinking young Haitians who are on the side lines for the most part at the moment, becoming more and more world-and-progress conscious all the time. And always there is the dynamic and forceful Trujillo, the Ever-Ready, gazing across the frontier with a steely eye. Whither Haiti?

CHAPTER 8

THE BLACK JOAN OF ARC

Haiti, the black daughter of France, also has its Joan of Arc. Celestina Simon stands over against The Maid of Orleans. Both of these young women sprung alike from the soil. Both led armies and came to unbelievable power by no other right than communion with mysterious voices and spirits. Both of these women stood behind weak ruling chairs, and both departed their glory for ignominy. The Duke of Burgundy burned Joan at the stake. The conquering hordes of Michel Cincinnatus Leconte drove Celestina Simon from the Haitian palace and doomed her to a dark and dishonored old age. But if Celestina and her father were driven out of power and public life, they have not lost their places in the minds of the people. More legends surround the name of Simon than any other character in the history of Haiti.

History says that General François Antoine Simon became President of Haiti in 1908, but practically the whole country agrees that he never should have been. There are countless tales of this crude soldier peasant's stumbling and blunders in the palace where he had no right to be. His not knowing what to do in matters of state; what to say to foreign diplomats; and

how to behave amid the luxuries of the palace, all are told and told again. But these possibilities have never been considered by the men who made him president in a desperate effort to cut short the reforms instituted by the noble Nord Alexis. It was near the end of the presidential term of Nord Alexis and he was full of years. He did not wish to run for office again, but he was favoring a man who was pledged to continue his policies of honesty in government and the development of Haiti. This seemed a waste of money and opportunity to certain politicians. They had enough of the stringent honesty of President Alexis and wanted no more of the like. So they engineered General Simon into the palace. They knew he was too ignorant and boorish to make much of a president. But they did not shove him into the palace to do any governing. He was put there as a device. His "advisors" knew perfectly well what to do about matters of state. At least they knew what they *wanted* to do about such things. And the great benefits to be derived from having the perfect tool in office as a facade were too great to be lost on account of the tool's bad social form. What the "advisors" had not reckoned with was Celestina Simon and Simalo, the goat.

It was not that no one had ever heard of Celestina's powers as a Mambo. That was no secret. Everybody around Aux Cayes and the Department of the South generally knew that General François Antoine Simon was a great follower of the loa, and that his daughter Celestina was his trusted priestess. No one was surprised at this, for while Simon was the military governor of the Department of the South, it was well known that he had come up the military ladder from the most humble beginnings. Also, practically everyone had heard of his pet goat Simalo. It was claimed by the soldiers of Simon's army that they were invincible because of the presence of the priestess Celestina and her consort, Simalo, in the front ranks of the force. Their combined powers utterly routed the government forces at Ansa-à-veau, so they said.

General Simon, it is recalled, had taken the field because he had been removed from office by Nord Alexis. He had been

removed because he let it be known that he had presidential ambitions and President Alexis had his own ideas as to who should follow him in office. So he determined to squelch Simon by demoting him. But as Nord Alexis well knew, Simon was being prompted by others with more intelligence but less courage. And Simon won the battle of Ansa-à-veau and won his way into the national palace only because the government was betrayed and because others had uses for a man like Simon. But Simon brought along with his usefulness, himself, his daughter Celestina, and Simalo, the goat. There are tales and tales of the services to the loa on that march from Aux Cayes to Port-au-Prince, especially the services that Celestina made to Ogoun Feraille, the god of war, to make the men of her army impervious to bullet and blade. The army came marching into the capital carrying their coco macaque sticks to which had been tied a red handkerchief. This was a sign that Ogoun was protecting them. The stories of Celestina's part in the battles, of her marching in advance of the men and firing them by her own ferocious attack upon the enemy had all preceded the army to the capital. The populace therefore made a great clamor as she entered the city at the head of the men of arms and called her the black Joan of Arc.

When her father became president, her prestige increased, and the flattery about her became almost hysterical when it was discovered that President Simon did and granted whatever Celestina approved. She was not only loved as a daughter, she was revered and respected as a great houngan. Nevertheless there was a great deal of laughter behind sophisticated hands in Port-au-Prince at the antics of the attachments of the president to his daughter and his goat.

But the laughter died very quickly. In the first place Simon was not as manageable as anticipated. He took flattery seriously and it bloated him. It was impossible to ignore the fact that the saying of Celestina and the behavior of Simalo were of greater importance to him than any other national affairs, for indeed, the woman and the goat had come to be affairs of the nation.

The disgust and the fear of the upper class Haitians grew with their astonishment. For instance, when it was common knowledge that Voodoo services and the ceremonies were being held in the national palace, many of them decided to keep as far away as possible and to have nothing at all to do with such persons, but President Simon thought differently. He gave great dinners and other state functions and the aristocrats dared not refuse his invitations. They knew the temper of the man too well for that. So they came at his thinly veiled command, ate, drank, and danced. Before his face they laughed loudly at all of his jokes and made the appearance of happiness. The moment his back was turned they looked at each other fearfully. They also looked with dread suspicion at the food and the wine. "Are we drinking wine or dirty *blood* and wine?" they asked each other in quick whispers. Dare they leave the potage untasted? Is this roast really beef or is it————? But just then the face of the president was turned toward them and they chewed and swallowed with fear and made out somehow to smile and flatter. Often it was said that a Voodoo ceremony was going on in the basement chambers while the state function was glittering its farcical way in the salon.

The Mountain House, the summer palace of President Simon, was the scene of the greatest ceremonies, however. It was rumored that there took place the celebrations of the dread Secte Rouge and that years later the blood stains on the walls and floor of one room were so ghastly that they were difficult to cover with paint. There Simon, and all those in the high places who believed with him, gathered for these services under the priestess Celestina and Simalo.

The most dramatic story of all tells about the breaking of Simalo's heart. Rumor had it that years before there had been a "marriage" between Celestina and Simalo. A houngan had mysteriously tied them together for many causes and the power of each depended upon the other. All had gone happily until they were elevated to the palace. Then the flattery of many men gave Simon hope that his black daughter might

capture a man of position and wealth. His and her ears heard only the flattery. They heard none of the fear and loathing that was increasing about them. Simon and Celestina saw nothing to prevent an advantageous marriage, so they began to plan for it. So far as they could see, the only barrier was the previous betrothal to Simalo. So they set about getting a divorce.

A powerful houngan whom Simon had brought from the South with him was said to have officiated at this ceremony. At the same time an elaborate function was going on in the salon of the palace. It was to be a celebration of the freeing of Celestina from her vows to the goat so that she might marry a man. Celestina herself was kept in her own bedroom until the ceremony was over. It was said to be a terrible wrench to her and she supported the sorrow with difficulty. It was only the prospect of a brilliant marriage, now that she was the daughter of the president, that sustained her in grief.

President Simon himself went from salon to basement several times watching the progress in his impatience to report the "liberation" of Celestina, feeling of course that several men of wealth and education were ready to prostrate themselves before his daughter. And each time that he left the room, the uneasy crowd above stairs exchanged hurried looks and whispers about the ceremony going on beneath them. It was one of those secrets that everyone had gotten hold of.

Finally, as he started below again, an attendant met him in the corridor and whispered that the ceremony was over and "Celestina est libre." The President sought his daughter and led her into the great salon, announcing, "Celestina is free. She may marry anyone she chooses now."

The news was received in great embarrassment. There was a polite show of joy, but no man rushed forward to take the widow of Simalo. One young deputy who escorted her on several occasions was fired on from ambush and killed; it was never made clear just why. At any rate, she has never married a man.

As for Simalo, it is said that his grief over the divorce was so great that he did not linger long after that. Some say, of

course, that he was killed by the houngan that same day. A few days later there were as many whispers about the manner of his death as there would have been about the archbishop. It was certain that he was dead and both Simon and Celestina were sodden with grief. It is said that they could not bear the thought of Simalo being dumped in a hole and buried like any other dead animal. He must be buried like a man who had obligations to a god and hopes of eternity. So a priest and the Catholic church were tricked into giving him a Christian burial. The body of Simalo in a closed coffin was borne to the Cathedral in great pomp and glory. It was represented to the priest that a close relative of the president had passed away. There were great bouquets of flowers, smoking censora, the chanted mass for the dead and great weeping. A most impressive funeral, all in all. It was only when the services were completely over that the priest became suspicious and discovered that all this holy service had been performed over a goat. He was furious and the scandal spread over all Haiti. Some contend that the ill luck that attended Simon after was because of his treatment of Simalo. Perhaps this elaborate funeral was an act of atonement. Perhaps Simon was hiding his heartbreak in the rites. It might have been the first flinching from the price of ambition. After all these years educated folk of Port-au-Prince are still laughing at the clown who occupied their palace for two years. But there is pathos too in the story.

It is the story of a peasant who gained the palace but lost his goat. He sacrificed his best friend to ambition which turned upon him and mocked his happiness to death. In the fog of flattery, he lost sight of the fact that goats and peasants are seldom the helms of empire.

Of this triumvirate, Celestina, Simon and Simalo who had come up from the south to the capitol of Haiti, perhaps Simalo, by his early death, came off best. There was President Simon in the palace, there by the grace of corrupt politicians who planned to use him to their own advantage, believing that he was there by the magic powers of his daughter and his goat.

Here he was making every social, diplomatic and political

blunder conceivable, and thinking that he was cutting a great figure. And all the while, his make-believe paradise was dissolving before harsh reality. His simple faith like the priests of Baal was in his daughter and in his gods and they failed him.

It must have been disheartening to the peasant-General-Governor-President Simon when, confident of victory on account of the powers of Ogoun, he took the field against Leconte, to find that the most numerous and best directed bullets always win battles in spite of the gods. But it is said that he never lost faith in the powers of Celestina and the loa. He firmly believed, but for her he never would have become governor of the South.

There are many to agree with him in this. It is said that Celestina was possessed of the greatest courage and urged her father to fight at every challenge. It was because of this prompt and strong action that he pulled himself up by his boot straps. Of course, they say his way of explanation that Celestina had this great courage was because she had such power from the loa. They never failed her until she broke her vows. But, anyway, it is a matter of history that she not only had great personal bravery, she was able to inspire others with the same, her father and his soldiers being the first to feel her personality.

The people laugh and laugh at the capers of President Simon in the palace. They do not laugh at Celestina. She is today an elderly woman living in poverty in the South and she is still to the thinking Haitian a sinister figure. The glory of the days when she had a special military attaché of her own (General André Chevalier) and wielded power absolute from the palace are gone. She is a surly figure of the past. Some say that she pronounced a terrible curse against the man whose victorious army drove Simon from power. So that when the palace was blown up and Leconte killed, they said it was the power of Celestina still at work.

There are numerous accounts of Simon's grief at the loss of his goat. He used to weary his listeners with his memories of the feats of Simalo in military campaigns. It was plain that he

considered the goat more than beast, more than man, more than just a friend. There was something of worship there.

It is said that one Sunday after the death of Simalo, Simon had the cabinet members and several other persons of importance assembled at the palace. He delivered one of the orations that he delighted to make and having embarrassed himself by making a faux pas, dismissed them. But a few intimates were allowed to remain and wander about informally. The President was moving towards his private apartments when he ran into the Minister of War, General Septimus Marius. He stopped suddenly as if he had seen a ghost and then broke into tears and said, "My dear Marius, as soon as I see your long beard, I think of my dear Simalo." And he wept so hard that the other guests felt that they had better weep with him.

There seems to be no doubt that Celestina and Simon enjoyed their places of power in the palace. Also that the young Amazon stirred something heroic in the hearts of Haiti for a time. She brought a whiff of the battle field with her as she came and made virile men think again of Christophe and Dessalines.

But soon the tales of the "services" in the palace, the sacrifices at Mountain House, the cruelty of Celestina and the affairs of the goat filled Haiti's cup of disgust to the brim. Insurrections began. Simon and Celestina confident in their loa marched out to conquer as before. Simon beat down one uprising only to be met by others. He was living over the life of Macbeth and his lady, both betrayed by their mysteries. After many harried months, he bowed before that which he could no longer oppose with conviction. So Simon like many other presidents of Haiti sailed for Jamaica.

In his exile the peasant who had become a soldier, then a general, then a governor, then a president must have thought about his march from himself into the capital, into other men's hopes and schemes. In a foreign land there he had no army, no importance, no daughter, no goat. He had nothing but time for weapons and friends and the chances are he had never learned how to use time in bulk. Probably he used what he

100

could of it in remembering, and no doubt he remembered the days when he was governor of Aux Cayes, when he, his priestess daughter and his goat were happy rulers, before ambition tricked them into the palace.

"Oh, well," they conclude, "what can you expect? One cannot expect to prosper who breaks his vows to the loa. If President Simon had not killed Simalo—"

Ah Bo Bo!

CHAPTER 9

DEATH OF LECONTE

This is the story of the death of President Leconte the way the people tell it. The history books all say Cincinnatus Leconte died in the explosion that destroyed the palace, but the people do not tell it that way. Not one person, high or low, ever told me that Leconte was killed by the explosion. It is generally accepted that the destruction of the palace was to cover up the fact that the President was already dead by violence.

There are many reasons given for the alleged assassination, and each one of these motives has its own cast of characters in the tragedy. But the main actors always remain the same. These men were ambitious and stood to gain political power and what goes with it in Haiti by the death of President Leconte.

For example, some tell a story of the little son of Leconte who was said to be a love child. He loved the boy with a great love, but that seemed not to be reason enough to cause him to marry the mother of his child. She belonged to a high caste family and there was said to be a great deal of hard feeling between the family of the young woman and the President.

Those who contend that this friction was behind the assassination point out that the child was not in the palace when the explosion took place. He was at the home of his mother's people.

All the other reasons given for his alleged assassination were political. The only differences in the accounts were, whose political aspirations were being choked off by Leconte's actions.

It is not to be inferred from this that Leconte was a tyrant. On the contrary he is credited with beginning numerous reforms and generally taking progressive steps. He was merely in the way of other men's ambition by virtue of the office he held.

The first person who told me about it said that he was not even killed in the executive mansion. He said that a message came to the president to visit his little son who was with his mother at the time. He disguised himself and entered the bus driven by the aged coachman of the palace called Edmond, whose loyalty to Leconte was doubtful. Rumor says that they left the palace by the gate called Port Salnave, and that Leconte left the conveyance at the house of the father of his child's mother, whose father was one of his Ministers, and never came out again. That is, he never came out alive. The family whose honor had been outraged by the refusal of Leconte to marry the daughter of the house had secretly joined forces with the president's political enemies. Some of them were in the house when Leconte arrived. The arrangements for the body to be carried out on the Plain-Cul-de-Sac to be buried had already been made. It is said that he was killed after a short altercation. The body was wrapped up, placed in the bus and driven out to the estate of one of the conspirators to be buried. The old coachman was rewarded and the palace blown up. The very next person that I told this version to, agreed that Leconte did get into the bus and he did leave the palace by the gate Salnave. But they maintained that he was lured out by the coachman whom he trusted. This Edmond came to the President with a tale of his cabinet gathered at a

certain place on the Plain-Cul-de-Sac and plotting the downfall of the president at that very moment. President Leconte must come and see this infamy with his own eyes. The President slightly disguised entered the bus and was driven off. Out on the Plain, the bus was surrounded and he was killed and buried out there on the estate of a powerful man who himself had presidential ambitions.

But I kept on talking to people and asking questions about Leconte and they kept on telling me things. So I came to hear from many people a story that was the same in all the essential points. Minor details differed of course. But the happenings that follow were repeated to me by numerous persons.

Sansarique, Leconte's Minister of the Interior, was most faithful to his chief and loved him like a brother. He got wind of a conspiracy against the life of Leconte and warned him time and again to be careful. But the President was not inclined to take these warnings too seriously. He knew that he was very popular with the people and went to work building Casernes and planning other improvements. But the conspirators grew bold by seeming immunity. They began to move with more assurance. Rumors of plots and conspiracies increased. Definite plans seemed to have been made and the Minister of the Interior began to be really alarmed and rushed to the President and mentioned names. He accused Tancred Auguste, Volcius Nerette, Chef de Sûreté, and La Roche, Minister of Agriculture, of plotting to overthrow the regime of Leconte and to make Auguste president in his stead. He urged the President to lose no time in arresting Auguste and Nerette. But such was the confidence of Leconte in his wellbeing that he refused to believe this advice. He put it down to over anxiety on the part of a friend. This was the state of affairs for some time before the night of the explosion.

One man told me what he saw on the night of August 7, 1912. It was the habit of many men of the upper class to gather at Thibeaut's Café on the Champ-de-Mars to eat, sip drinks, and play dice, practically every night. This night of August 7th, the crowd who loved a game of chance for moderate

stakes gathered as usual. Because, he explained "when the tambour sounds, the hounsi come." Meaning those who love a thing will follow it.

But this particular evening, there was to be no dice. Thibeaut served the many social and political lights their coffee and some one called for the dice. Thibeaut's face went very stern. "Gentlemen, no dice tonight. You will please leave early as I wish to close the Café and get to bed at a good hour. Good evening, gentlemen."

The men were naturally surprised at this unusual announcement. They left the Café reluctantly in little groups and went elsewhere. My informant says that from the Champ-de-Mars, he and three associates looked towards the palace and saw the President standing alone on the balcony of the Palace. "Look at Conte Conte," somebody said, using the familiar name of affection that the people had made for him. The President was just standing there outlined by the Palace lights as if in deep thought. Across from the Palace and watching it closely was Tancred Auguste mounted on his grey horse.

The young men balked of their dice game and social evening soon left the Champ-de-Mars and the pensive President behind and went on their way seeking other amusements.

This is what they say was going on inside the Palace. Some time during the night the Chef de Sûreté came to the Palace accompanied by several men. He sent word to Leconte that he must see him on a matter of vital importance and thus persuaded the President to receive him at such an unusual hour. He said it was a matter which necessitated the greatest secrecy and Leconte hearing this took the party to the telegraph room where Nerette knew he always went when he wished to receive secret reports. This room was not only built sound proof, but it was detached from the Palace building proper for greater secrecy.

Inside the locked room Nerette began a recital of having discovered a plot against the President's regime. He began a rambling narrative that not only lacked any evidence of a plot, but the jumble of words was lacking in sense. Leconte asked

the Chef to tell him what he meant by these disconnected statements and began to pace up and down, no doubt trying to figure out for himself why he had been disturbed to listen to such a senseless tale. He knew there was something behind it. There were several minutes of silence while Leconte paced up and down, puzzled and annoyed. Nerette and his men huddled at one end of the room, the president pacing up and down. One time when Leconte had reached the end farthest away from Nerette, that plotter whispered to the men, "Qu'est ce que vous attendez?" (What are you waiting for?) The frightened men still huddled where they were and Nerette grew angry, "Eh, bien, Messieurs, Ca n ap'tan?" The armed butchers were lashed into action so that when the President's back was again turned to them they drew their knives and did what they had come there to do. They did in desperation that which they were afraid not to do. They butchered Leconte.

When the hacking and slashing was over, the body was removed through the Salnave door and carried to the house of one of the assassins. The work was done. Leconte was dead and his body actually removed from the palace without the faithful guard suspecting that he was not safely in bed. The conspirators most concerned were sent for and came hurriedly to the house to verify the information. The body was carefully examined. There was no mistake. The late President of Haiti was there at the feet of the men who toasted the success of the coup in rum. Then plans for the coming "elections" were rehearsed again. That settled, the final details that would dispose of the body and cover the evidence of the assassination were gone over for the last time. The body was left in the care and in the house of the same man where it now was. He was loyal to the conspirators and they had his assurance that the body would be disposed of as planned. The higher ups might go on and look to the matter of "elections." He knew they would remember him when making the new appointments. They could rest assured the body would never be seen again. Most certainly it would not be seen by anyone who favored

Leconte in his life time. So some of the conspirators hurried away to attend to matters of state while others remained there in the house with the body of Leconte, waiting. It was kept there until a man was found to take it away on a donkey. At first the body was wrapped and thrown across the donkey's back. But it was too bloody—too apt to attract attention in that way. So the peasant cut it up with his machete and loaded it in a sac paille (straw bag with two huge pockets. A sort of pannier for carrying loads on a donkey) and he was then ordered to dispose of it on an estate on the Plain-Cul-de-Sac. This peasant was paid, sworn to secrecy and dismissed. But soon he was bragging about his part in the crime. He would display his machete and explain proudly, "This is the knife that cut up the body of Leconte." During the administration that followed Leconte, it is said that he was ordered killed by a strychnine injection. But the President himself died of poisoning before it happened.

The conspirator to whose house the body of Leconte was taken before it was finally disposed of, from a nothing and a nobody, was given a government position immediately after the next administration came to power. Even his grandmother was given a pension. Indeed, the man is said to hold a government position at this moment. He seems to have fared better than anyone else who figured in the murder plot. For the candidate alleged to be at the bottom of the whole matter was himself assassinated by poisoning less than a year after taking office. Volcius Nerette was one of the 167 who were butchered in the prison by Sam and Etienne in 1915. The eight men with knives who did the actual killing of Leconte were arrested on a trumped-up charge and taken out side of the harbor in a boat and killed and their bodies thrown overboard. The man who cut up the body and hauled it away became an idiot. He still goes about the city laughing his laugh and showing the machete and gloating. But nobody listens.

When the word came back to the conspirators waiting in the house that the body had been disposed of, the brains of the plot hurried forth to find the man to carry out the final detail

to cover up the murder of Leconte. He called on a young electrician named Faine (no relation to the well-known writer Jules Faine) and dragged him from his bed. Faine was told nothing about what had gone on before. He was ordered to blow up the palace at once or die. It is to be remembered that great stores of ammunition were hoarded in the palace. He was forced to rig up a device to set off this immense hoard of explosives. It is said that only fear of certain death persuaded the young man to do the work.

Thus early in the morning of August 8, 1912, the city of Port-au-Prince was rocked by an explosion that completely wrecked the palace. Other buildings near by were also injured. People were thrown out of their beds in Belair and even in Pétionville, approximately six miles away. Nearly three hundred soldiers, the palace guard, were belched out of the eruption, headless, legless, armless, eyes burnt out by the powder and just bodies and parts of bodies, mangled and mingled.

The people of Port-au-Prince awakened like that out of their sleep all rushed out doors because everybody thought it was an earthquake. When they got outside they saw it was the palace and came running, putting their cries of surprise and terror with the hurt and harmed who were crawling off from the wreckage. Sansarique rushed into the ruins seeking his friend Leconte, who was not there and would not have been able to answer him if he had been. Nobody could stop the Minister of the Interior. He tore off the hands that held him. He rushed about through the smoking ruins calling Leconte, hoping he could save him. He kept crying out that he had warned him against his enemies. Finding no way to help Leconte, finding nothing in the likeness of his friend, he wept for him bitterly. He was like old David at the gates when they brought home Absalom. They say that the friendship between Sansarique and Leconte was a beautiful thing. Here was another Damon and Pythias, another David and Jonathan. He alone of all those near to Leconte was not concerned with his political future. He had rushed into the ruins to do those

things which become a man and a friend. No matter who tells the story and how, they dwell on the nobility of Sansarique. And indeed, it is a thing to make songs about.

When the daylight came they picked up something that nobody could say with any certainty was President Leconte and held a funeral. But then the way things were nobody could say the formless matter was not the late president either. So they held a state funeral and buried it.

All that being settled, right away, Tancred Auguste, with the help of his friends, was elected President of Haiti. Perhaps he could feel that divinity had pointed him to power. One day there had been Leconte occupying the palace, popular with the people, and going on about building things like Solomon. Seemingly this man was to occupy the national palace for many years to come. The people willed it to be that way. They had elected him and turned their thoughts towards peace.

But evidently God did not agree with the Haitian people, for behold God repudiated their candidate by belching him out of the palace. The poor taste of the people was corrected, and Tancred Auguste became their ruler. The sight of the explosion must have affected him deeply if rumor is true that he took to talking to himself. Also, they say he disliked to pass the ruins and avoided doing so until one day he attended a wedding and the carriages were passing the ruins before he realized it. The sight of the tragic spot must have touched his compassion too deeply, for he began to mutter aloud and almost left the carriage. At any rate, the palace food proved too rich for him, for less than a year after he had taken office he died of a digestive disturbance that his enemies called poison. So God must have changed His mind about him also. And while he was being buried, even before his body left the Cathedral for the cemetery, the mourners heard shots being fired from different parts of the City of Port-au-Prince. The successor to Tancred Auguste was being "elected."

This is what they say in Port-au-Prince about the death of President Leconte, who built the great Casernes.

Ah Bo Bo!

PART III

✧

VOODOO
IN HAITI

CHAPTER 10

VOODOO AND VOODOO GODS

D r. Holly says that in the beginning God and His woman went into the bedroom together to commence creation. That was the beginning of everything and Voodoo is just as old as that. It is the old, old mysticism of the world in African terms. Voodoo is a religion of creation and life. It is the worship of the sun, the water and other natural forces, but the symbolism is no better understood than that of other religions and consequently is taken too literally.

Thus the uplifted forefinger in greeting in Voodoo is really phallic and that means the male attributes of the Creator. The handclasp that ends in the fingers of one hand encircling the thumb of the other signifies the vulva encircling the penis, denoting the female aspect of deity. "What is the truth?" Dr. Holly asked me, and knowing that I could not answer him he answered himself through a Voodoo ceremony in which the Mambo, that is the priestess, richly dressed is asked this question ritualistically. She replies by throwing back her veil and revealing her sex organs. The ceremony means that this is the infinite, the ultimate truth. There is no mystery beyond the mysterious source of life. The ceremony continues on another

phase after this. It is a dance analogous to the nuptial flight of the queen bee. The Mambo discards six veils in this dance and falls at last naked, and spiritually intoxicated, to the ground. It is considered the highest honor for all males participating to kiss her organ of creation, for Damballa, the god of gods, has permitted them to come face to face with truth.

Some of the other men of education in Haiti who have given time to the study of Voodoo esoterics do not see such deep meanings in Voodoo practices. They see only a pagan religion with an African pantheon. And right here, let it be said that the Haitian gods, mysteres, or loa are not the Catholic calendar of saints done over in black as has been stated by casual observers. This has been said over and over in print because the adepts have been seen buying the lithographs of saints, but this is done because they wish some visual representation of the invisible ones, and as yet no Haitian artist has given them an interpretation or concept of the loa. But even the most illiterate peasant knows that the picture of the saint is only an approximation of the loa. In proof of this, most of the houngans require those who place themselves under their tutelage in order to become hounci to bring a composition book for notes, and in this they must copy the houngan's concept of the loa. I have seen several of these books with the drawings, and none of them even pretend to look like the catholic saints. Neither are their attributes the same.

Who are the loa, then? I would not pretend to call the name of every mystere in Haiti. *No one* knows the name of every loa because every major section of Haiti has its own local variation. It has gods and goddesses of places and forces that are unknown fifty miles away. The heads of "families" of gods are known all over the country, but there are endless variations of the demigods even in the same localities. It is easy to see the unlettered meeting some unknown natural phenomenon and not knowing how to explain it, and a new local demigod is named. It is always added to the "family," to which it seems, by the circumstances, to belong. Hence, the long list of Ogouns, Erzulies, Cimbys, Legbas, and the like. All over

Rex Hardy, Jr.

The Voodoo altar, piled with sacred objects and food

Haiti, however, it is agreed that there are two *classes* of deities, the Rada or Arada and the Petro. The Rada gods are the "good" gods and are said to have originated in Dahomey. The Petro gods are the ones who do evil work and are said to have been brought over from the Congo, some say Guinea and the Congo have provided the two sets of gods but place names of Dahomey are included in the names of the Rada deities. Perhaps there is a mingling of several African localities and spirits under the one head in Haiti. Damballah or Dambala Ouedo Freda Tocan Dahomey, to give him his full name, heads the Rada gods. Baron Samedi (Lord of Saturday) Baron Cimeterre (Lord of the Cemetery) and Baron Crois (Lord of the cross), one spirit with three names is the head of the Petro loa. Let us first meet the Rada designations.

DAMBALA, OF DAMBALLAH OUEDO
(PRONOUNCED WAY-DOE)

Damballah Ouedo is the supreme Mystere and his signature is the serpent. Though the picture that is bought of him is that of St. Patrick, he in no way resembles that Irish saint. The picture of St. Patrick is used because it has the snakes in it which no other saint has. All over Haiti it is well established that Damballah is identified as Moses, whose symbol was the serpent. This worship of Moses recalls the hard-to-explain fact that wherever the Negro is found, there are traditional tales of Moses and his supernatural powers that are not in the Bible, nor can they be found in any written life of Moses. The rod of Moses is said to have been a subtle serpent and hence came his great powers. All over the Southern United States, the British West Indies and Haiti there are reverent tales of Moses and his magic. It is hardly possible that all of them sprang up spontaneously in these widely separated areas on the blacks coming in contact with Christianity after coming to the Americas. It is more probable that there is a tradition of Moses as the great father of magic scattered over Africa and Asia. Perhaps some of his feats recorded in the Pentateuch are the folk

116

Door of the room to Erzulie

beliefs of such a character grouped about a man for it is well established that if a memory is great enough, other memories will cluster about it, and those in turn will bring their suites of memories to gather about this focal point, because perhaps, they are all scattered parts of the one thing like Plato's concept of the perfect thing. At any rate, concerning Moses' rod and the serpent, they say that many witch doctors in Africa can so hypnotize a snake that it can be made rigid and seemingly lifeless and carried as a cane and brought to life again at the will of the witch doctor. They contend that that was why the rod of Aaron, which was none other than the rod of Moses, was such a cane thrust into the hand of Aaron at the right moment. Such were the "rods" of the magicians of the Pharaoh. But Moses knew that his "rod" fed on the variety that the king's men of magic used, so he knew what would happen the moment that the magicians turned their "rods" into snakes.

This serpent signature of Damballah, also spelt Damballa and Dambala, is responsible for the belief by the casual observer that the snake is worshipped in Haiti. This is not accurate. There is no actual worship of the snake as such in Haiti. It is treated with reverence because it is considered the servant of Damballah. Everywhere I found an altar to Damballah, I found either an iron representation of the snake beside the pool, or an actual green snake which lived in a special place upon the altar. And in each instance I asked about the divinity of the snake and they told me that the snake was not a god but the "bonne" (maid servant) of Damballah and was therefore protected and honored.

Damballah is the highest and most powerful of all the gods, but never is he referred to as the father of the gods as was Jupiter, Odin and great Zeus, and while he is not spoken of as the father of the gods, whenever any of the other gods meet him they bow themselves and sing, "Ohe', Ohe'! Ce Papa nous qui pe' passe'!" (It is our papa who passes.) He is the father of all that is powerful and good. The others are under him in power, that is all. He never does "bad" work. If you make a ceremony to any of the other gods and ask favors, they

118

must come to Damballah to get the permission and the power to do it. Papa Damballah is the *great source*.

Around Damballah is grouped the worship of the beautiful in nature. One must offer him flowers, the best perfumes, a pair of white chickens; his "mange" sec (dry food) consisting of corn meal and an egg which must be placed on the altar on a white plate. He is offered cakes, french melons, watermelons, pineapples, rice, bananas, grapes, oranges, apples and the like. There must be a porcelain pot with a cover on the altar, desserts and sweet liquors, and olive oil. There must be a representation of Damballah within the oratory, a small crucifix, a bouquet, a bottle of liquor, a glass of oil to keep his lamps burning on his day. He brings good luck to those who make offerings to him regularly and faithfully. "It is possible for you to have a grand situation and it is even possible to become a minister or the president if you serve Papa Damballah faithfully. But yes!" His day is Wednesday in the afternoon of every week and his sacrifice is a pair of white chickens, hen and cock. The average houngan says that he is given the white cock and hen because he guards domestic happiness. Dr. Holly says it is another acknowledgment of the bi-sexual concept of the Creator, and that Damballah with the subtle wisdom and powers represented by the snake is to the Africans something of a creator, if not actively, certainly The Source. His color is white. His woman is Aida Ouedo. His signature is the ascending snakes on a rod or a crucifix. He is the fourth in the order of the service, being preceded by (1) Papa Legba, opener of gates (opportunities), (2) Loco Attison, Mystere of work and knowledge, (3) Mah-lah-sah, the guardian of the doorsill. None of these are so important as Damballah. But the order has been established to have things ready when he arrives through possession of some of the persons taking part in the ceremony. There is a definite behavior for the possession of each of the gods. The houngan (Voodoo priest) or the mambo or priestess can say at once what god possesses a person present. Perhaps the wrong impression is conveyed by the expression that the other gods precede Damballah in the services.

Actually, they are his suite and surround him and go before or after him in order to more quickly serve his commands. In the Voodoo temple or peristyle, the place of Damballah, there must also be the places of Legba, Ogoun, Loco, the cross of Guedé who is the messenger of the gods, of Erzulie, Mademoiselle Brigitte and brave Guedé. Damballah resides within the snake on the altar in the midst of all these objects. The construction must face the rising sun and there must be a door which looks toward the west.

SONGS TO DAMBALLAH

NO. 1

Me roi *e'* Damballah Ouedo, ou ce gran moun, ho, ho, ho, me roi *e'*.
Damballah Ouedo ou ce' gran moun la k'lle ou.
(My king is Damballah Ouedo. You are a great man, ho, ho, ho, my king is.)

NO. 2

Ah Damballah, bon jour, bon jour, bon jour, Damballah Ouedo!
Apres Manday, Damballah ou mah ou yeah, oh, oh, oh oui may lah, Damballah,
Ouido, moin, ah may Vinant lauh yo.

There is in Voodoo worship a reverent remoteness where Damballah is concerned. There are not the numerous personal anecdotes about him as about some of the lesser and more familiar gods. I asked why they did not ask more things of him, and I was told that when they make "services" to the other gods they are making them to Damballah indirectly for none of the others can do anything unless he gives them the power. There is the feeling of awe. One approaches the lesser gods and they in turn approach the great one. The others must listen and take sides in the neighborhood disputes, jealousies and feuds. One comes to Damballah for advancement and he is approached through beauty. Give Damballah his sweet wine and feed his wisdom with white pigeons.

Nobody in Haiti ever really told me who Erzulie Freida was, but they told me what she was like and what she did. From all of that it is plain that she is the pagan goddess of love. In Greece and Rome the goddesses of love had husbands and bore children, Erzulie has no children and her husband is all the men of Haiti. That is, anyone of them that she chooses for herself. But so far, no one in Haiti has formulated her. As the perfect female she must be loved and obeyed. She whose love is so strong and binding that it cannot tolerate a rival. She is the female counterpart of Damballah. But high and low they serve her, dream of her, have visions of her as of the Holy Grail. Every Thursday and every Saturday millions of candles are lighted in her honor. Thousands of beds, pure in their snowy whiteness and perfumed are spread for her. Desserts, sweet drinks, perfumes and flowers are offered to her and hundreds of thousands of men of all ages and classes enter those pagan bowers to devote themselves to this spirit. On that day, no mortal woman may lay possessive hands upon these men claimed by Erzulie. They will not permit themselves to be caressed or fondled even in the slightest manner, even if they are married. No woman may enter the chamber set aside for her worship except to clean it and prepare it for the "service." For Erzulie Freida is a most jealous female spirit. Hundreds of wives have been forced to step aside entirely by her demands.

She has been identified as the Blessed Virgin, but this is far from true. Here again the use of the pictures of the Catholic saints have confused observers who do not listen long enough. Erzulie is not the passive queen of heaven and mother of anybody. She is the ideal of the love bed. She is so perfect that all other women are a distortion as compared to her. The Virgin Mary and all of the female saints of the Church have been elevated, and celebrated for their abstinence. Erzulie is worshipped for her perfection in giving herself to mortal man. To be chosen by a goddess is an exaltation for men to live for.

The most popular Voodoo song in all Haiti, outside of the invocation to Legba, is the love song to Erzulie.

Erzulie is said to be a beautiful young woman of lush appearance. She is a mulatto and so when she is impersonated by the blacks, they powder their faces with talcum. She is represented as having firm, full breasts and other perfect female attributes. She is a rich young woman and wears a gold ring on her finger with a stone in it. She also wears a gold chain about her neck, attires herself in beautiful, expensive raiment and sheds intoxicating odors from her person. To men she is gorgeous, gracious and beneficent. She promotes the advancement of her devotees and looks after their welfare generally. She comes to them in radiant ecstasy every Thursday and Saturday night and claims them.

Toward womankind, Erzulie is implacable. It is said that no girl will gain a husband if an altar to Erzulie is in the house. Her jealousy delights in frustrating all the plans and hopes of the young woman in love. Women do not "give her food" unless they tend toward the hermaphrodite or are elderly women who are widows or have already abandoned the hope of mating. To women and their desires, she is all but maliciously cruel, for not only does she choose and set aside for herself young and handsome men and thus bar them from marriage, she frequently chooses married men and thrusts herself between the woman and her happiness. From the time that the man concludes that he has been called by her, there is a room in her house that the wife may not enter except to prepare it for her spiritual rival. There is a bed that she must make spotless, but may never rest upon. It is said that the most terrible consequences would follow such an act of sacrilege and no woman could escape the vengeance of the enraged Erzulie should she be bold enough to do it. But it is almost certain that no male devotee of the goddess would allow it to occur.

How does a man know that he has been called? It usually begins in troubled dreams. At first his dreams are vague. He is visited by a strange being which he cannot identify. He

122

cannot make out at first what is wanted of him. He touches rich fabrics momentarily but they flit away from his grasp. Strange perfumes wisp across his face, but he cannot know where they came from nor find a name out of his memory for them. The dream visitations become more frequent and definite and sometimes Erzulie identifies herself definitely. But more often, the matter is more elusive. He falls ill, other unhappy things befall him. Finally his friends urge him to visit a houngan for a consultation. Quickly then, the visitor is identified as the goddess of love and the young man is told that he has been having bad luck because the goddess is angry at his neglect. She behaves like any other female when she is spurned. A baptism is advised and a "service" is instituted for the offended loa and she is placated and the young man's ill fortune ceases.

But things are not always so simply arranged. Sometimes the man chosen is in love with a mortal woman and it is a terrible renunciation he is called upon to make. There are tales of men who have fought against it valiantly as long as they could. They fought until ill luck and ill health finally broke their wills before they bowed to the inexorable goddess. Death would have ensued had they not finally given in, and terrible misfortune for his earthly inamorata also. However, numerous men in Haiti do not wait to be called. They attach themselves to the cult voluntarily. It is more or less a vow of chastity certainly binding for specified times, and if the man is not married then he can never do so. If he is married his life with his wife will become so difficult that separation and divorce follows. So there are two ways of becoming an adept of Erzulie Freida—as a "réclamé" meaning, one called by her, and the other way of voluntary attachment through inclination. Besides this merely amorous goddess, there is another Erzulie, or perhaps another aspect of the same deity. She is the terrible Erzulie, ge-rouge (Erzulie, the red-eyed) but she does not belong to the Rada. She belongs to the dreaded Petro phalanx. She is described as an older woman and terrible to look upon. Her name has been mentioned in connection with

123

the demon worship of the Bocors and the Secte Rouge.

The "baptism" or initiation into the cult of Erzulie is perhaps the most simple of all the voodoo rites. All gods and goddesses must be fed, of course, and so the first thing that the supplicant must do it to "give food" to Erzulie. There must be prepared a special bread and Madeira wine, rice-flour, eggs, a liqueur, a pair of white pigeons, a pair of chickens. There must be a white pot with a cover to it. This food is needed at the ceremony, during which the applicant's head is "washed."

This washing of the head is necessary in most of their ceremonies. In this case the candidate must have made a natte (mat made of banana leaf-stems) or a couch made of fragrant branches of trees. He must dress himself in a long white night shirt. The houngan places him upon the leafy couch and recites three Ave Marias, three Credos and the Confiteor three times. Then he sprinkles the couch with flour and a little syrup. The houngan then takes some leafy branches and dips them in the water in the white pot which has been provided for washing the head of the candidate. While the priest is sprinkling the head with this, the houngi and the Canzos are singing:

"Erzulie Tocan Freida Dahomey, Ce ou qui faut ce' ou
 qui bon
Erzulie Freida Tocan Maitresse m'ap mouter
Ce'ou min qui Maitresse."

The houngi and the adepts continue to sing all during the consecration of the candidate unassisted by the drums. The drums play *after* a ceremony to Erzulie, *never during* the service. While the attendants are chanting, the houngan very carefully parts the hair of the candidate, who is stretched upon the couch. After the parted hair is perfumed, an egg is broken on the head, some Madeira wine, cooked rice placed thereon, and then the head is wrapped in a white handkerchief large enough to hold everything that has been heaped upon the head. The singing keeps up all the while. A chicken is then

killed on the candidate's head and some of the blood is allowed to mingle with the other symbols already there. The candidate is now commanded to rise. This is the last act of the initiation. Sometimes a spirit enters the head of the new-made adept immediately. He is "mounted" by the spirit of Erzulie, who sometimes talks at great length, giving advice and making recommendations. While this is going on a quantity of plain white rice is cooked—a portion sufficient for one person only—and he eats some of it. What he does not eat is buried before the door of his house.

The candidate now produces the ring of silver, because silver is a metal that has wisdom in it, and hands it to the houngan, who takes it and blesses it and places it upon the young man's finger as in a marriage ceremony. Now, for the first time since the beginning of the ceremony, the priest makes the libation. The five wines are elevated and offered to the spirits at the four cardinal points and finally poured in three places on the earth for the dead, for in this as in everything else in Haiti, the thirst of the dead must be relieved. The financial condition of the applicant gauges the amount and the variety of the wines served on this occasion. It is the wish of all concerned to make it a resplendent occasion and there is no limit to the amount of money spent if it can be obtained by the applicant. Enormous sums have been spent on these initiations into the cult of Erzulie Freida. It is such a moment in the life of a man! More care and talent have gone into the songs for this occasion than any other music in Haiti. Haiti's greatest musician, Ludovic Lamotte, has worked upon these folk songs. From the evidence, the services to Erzulie are the most idealistic occasions in Haiti. It is a beautiful thing. Visualize a large group of upper class Haitians all in white, their singing voices muted by exaltation doing service to man's eternal quest, a pure life, the perfect woman, and all in a setting as beautiful and idyllic as money and imagination available can make it. "Erzulie, Nin Nin, Oh!" is Haiti's favorite folk song.

Rex Hardy, Jr.

Drums and drummers

1.

"Erzulie ninnin, oh! hey! Erzulie ninnim oh, hey!
Moin senti ma pe' monte', ce moin minn yagaza.

2.

"General Jean—Baptiste, oh ti parrain
Ou t'entre' lan caille la, oui parrain
Toutes mesdames yo a genoux, chapelette you
Lan main yo, yo pe' roule' mise' yo
Ti mouns yo a' genoux, chapelette you
Erzulie ninninm oh, Hey gran Erzulie Freida
Dague, Tocan, Mirorize, nan nan ninnin oh, hey
Movin senti ma pe' monte' ce' moin minn yagaza."

3.

(Spoken in "Langage" recitative)
"Oh Aziblo, qui dit qui dit ce' bo yo
Ba houn bloco ita ona yo, Damballah Ouedo
Tocan, Syhrinise o Agoue', Ouedo, Pap Ogoun oh,
Dambala, O Legba Hypolite, Oh
Ah Brozacaine, Azaca, Neque, nago, nago pique cocur yo
Oh Loco, co loco, bel loco Ouedo, Loco guinea
Ta Manibo, Docu, Doca, D agoue' moinminn
Negue, candilica calicassague, ata, couine des
Oh mogue', Clemezie, Clemeille, papa mare' yo.

4.

"Erzulie, Ninninm oh, hey grann' Erzulie
Freida dague, Tocan Miroize, maman, ninninm oh, hey!
Moun senti ma pe' mouti', ce moin mimm yagaza, Hey!"

More upper class Haitians "make food" for Erzulie Freida
than for any other loa in Haiti. Forever after the consecration,
they wear a gold chain about their necks under their shirts and
a ring on the finger with the initials E. F. cut inside of it. I have
examined several of these rings. I know one man who has
combined the two things. He has a ring made of a bit of gold
chain. And there is a whole library of tales of how this man

and that was "réclamé" by the goddess Erzulie, or how that one came to attach himself to the Cult. I have stood in one of the bedrooms, decorated and furnished for a visit from the invisible perfection. I looked at the little government employee standing there amid the cut flowers, the cakes, the perfumes and the lace covered bed and with the spur of imagination, saw his common clay glow with some borrowed light and his earthiness transfigured as he mated with a goddess that night—with Erzulie, the lady upon the rock whose toes are pretty and flowery.

PAPA LEGBA ATTIBON

Legba Attibon is the god of the gate. He rules the gate of the hounfort, the entrance to the cemetery and he is also Baron Carrefour, Lord of the crossroads. The way to all things is in his hands. Therefore he is the first god in all Haiti in point of service. Every service to whatever loa for whatever purpose must be preceded by a service to Legba. The peasants say he is an old man that moves about with a sac paille (large pouch woven of straw) and therefore the houngan must take everything to be used in his service in the Sac paille called Macout. They say he has a brother, however, who eats his food from a kwee, which is a bowl made from half a calabash.

The picture of John the Baptist is used to represent Papa Legba. The rooster offered to him must be Zinga, what we would call a speckled black and white rooster. All of his food must be roasted. He eats roasted corn, peanuts, bananas, sweet potatoes, chicken, a tobacco pipe for smoking, some tobacco, some soft drinks. All these things must be put in the Macoute and tied to the limb of a tree that has been baptized in the name of Papa Legba.

Of all the Haitian gods, Legba is probably best known to the foreigners for no one can exist in Haiti very long without hearing the drums and the chanting to Papa Legba asking him to open the gate.

"Papa Legba, ouvirier barriere pour moi agoe
Papa Legba, ouvirier barriere pour moi
Attibon Legba, ouvirier barriere pour moi passer
Passer Vrai, loa moi passer m' a remerci loa moin."

There are several variations of this prayer-chant. In fact at every different place that I heard the ceremony I heard another version, but always it is that prayer song to the god of the gates to permit them and the loa to pass. The other loa cannot enter to serve them unless Legba permits them to do so. Hence the fervent invocation to him. Another often sung invocation is:

"Legba cli-yan, cli-yan Zandor, Zandor, Attibon Legba, Zander immole'
Legba cli-yan, cli-yan Zand-Zandor Attibon Legba Zander immole'."

Legba's altar is a tree near the hounfort, preferably with the branches touching the hounfort. His offering is made in the branches and his repository is at the foot of the tree. Legba is a spirit of the fields, the woods and the general outdoors. There is one important distinction between offering a chicken to Legba and offering it to the other loa. With the others his head is bent back and his throat is cut, but for Legba his neck *must be wrung.*

Papa Legba has no special day. All of the days are his, since he must go before all of the ceremonies. Loco Atisou follows Legba in the service, and is in fact "saluted" in the Legba ceremony. This is absolutely necessary. If it is not done Loco will be offended and the gods called in the invocation will not come.

Loco Atisou gives knowledge and wisdom to the houngan and indicates to them what should be done. In case clients come to them Loco shows the houngan what leaves and medicaments to use for treating the ailments. Either in the hounfort or anywhere else, the houngan can take his Ascon and call

Rex Hardy, Jr.

The signature of a god, Agoue'ta Royo, Master of Waters

Papa Loco and he will indicate the malady of the patient if the sickness is natural. If it is unnatural, he will advise the houngan.

Loco is the god of medicine and wisdom, but at the same time a great drinker of rum. Sacrifice to him a gray cock. His day is Wednesday. The image of St. Joseph is used for Loco Atisou.

SONG OF LOCO ATISOU

Va, Loco, Loco Valadi', Va, Loco, Loco Valadi
Va, Loco, Loco Valadi', Va, Loco, Loco Valadi
Man, Jean Valou Loco, Loco Valadi.

Most of the other gods of national importance will be briefly explained as they occur in ceremonies. This work does not pretend to give a full account of either Voodoo or Voodoo gods. It would require several volumes to attempt to cover completely the gods and Voodoo practices of one vicinity alone. Voodoo in Haiti has gathered about itself more detail of gods and rites than the Catholic church has in Rome.

A study of the Marassas and the Dossou or Dossa, the twin gods represented by the little joined plates, is worthy of a volume in itself. The same could be said of the Ogouns, the Cimbys, and the ramifications of Agoue'ta-Royo, the Master of Waters, the Erzulies, the Damballas and the Locos. I am merely attempting to give an effect of the whole in the round. It is unfortunate for the social sciences that an intelligent man like Dr. Dorsainville has not seen fit to do something with Haitian mysticism comparable to Frazer's *The Golden Bough.* The history of the Ascon would be a most interesting thing in itself. The layman as well as the scientist would like to know how this gourd sheathed in beads and snake vertebrae, and sometimes containing a human bone, came to be the fixed and honored object that it is. It has its commandments as the voice of the gods and certainly it is hallowed. How did it get that way? Who began it? Where exactly?

CHAPTER 11

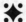

ISLE DE LA GONAVE

Everybody knows that La Gonave is a whale that lingered so long in Haitian waters that he became an island. He bears a sleeping woman on his back. Any late afternoon anyone in Port-au-Prince who looks out to sea can see her lying there on her back with her hands folded across her middle sleeping peacefully. It is said that the Haitians prayed to Damballa for peace and prosperity. Damballa was away on a journey accompanied by his suite, including two wives, Aida and Cilla. When the invocations reached Damballa where he was travelling in the sky, he sent his woman Cilla with a message to his beloved Haitians. He commanded Agoue'ta-Royo to provide a boat for his wife and to transport her safely to Port-au-Prince so that she could give the people the formula for peace. Papa Agoue' sent a great whale to bear Cilla and instructed him to transport the woman of Damballa with safety and speed and comfort. The whale performed everything that the Master of Waters commanded him. He rode Madame Cilla so quickly and so gently that she fell asleep, and did not know that she arrived at her destination. The whale dared not wake her to tell her that she was in Haiti. So every day he swims far

out to sea and visits with his friends. But at sundown he creeps back into the harbor so that Madame Cilla may land if she should awake. She has the formula of peace in her sleeping hand. When she wakes up, she will give it to the people.

From the house of George de Lespinasse high in Pacot I watched the island of La Gonave float out of the harbor with the sun each day and return at sundown. And I wanted to go out there where it was. William Seabrook in his *Magic Island* had fired my imagination with his account of The White King of La Gonave. I wanted to see the Kingdom of Faustin Wirkus. Then two weeks before Christmas of 1936 a friend of mine, Frank Crumbie, Jr., of Nyack, New York, suggested that we go over together and do some investigation. He knew people and Creole and I knew methods. So we made preparations to go.

Frank Crumbie, or Junior, as he was known among his intimates, knew where to find a boat. He engaged a small sailing boat known as a shallop to take us across the eighteen miles of bay water to La Gonave. The captain told us to be ready to sail between eight and nine at night because the wind would be right then. Then is the only time a sailing vessel can put out from Port-au-Prince for La Gonave. Mr. and Mrs. Scott drove us down to the waterfront with our army cots and other paraphernalia and saw us off. The captain and his crew of one other man poled the boat out into deep water and we began our all night voyage to the island of the sleeping woman.

The wind did not catch the sails at once. The men rowed and rowed. I looked at the big stars blazing so near overhead sunk in a sky that was itself luminous. Junior was already getting sea sick and trying to get comfortable. The men began a song and I asked Junior what it was they were singing so earnestly. He said, "A song to Papa Agoue', the Master of the Waters. They are asking him for a wind." The wind rose and soon we swept past the Bissotone Navy Yard and on our way. The stars soon lost themselves in clouds and down came a heavy shower of rain. I put on my rain coat and big straw hat.

134

Junior took refuge in his sleeping bag, but we got dampish just the same. The men took no notice of the downpour. The lights of Port-au-Prince had faded when the sky cleared. Then we saw the luminous sea! It glowed like one vast jewel. It glittered like bushels and bushels of gems poured into the casket that God keeps right behind His throne for beauty. The moving fish put on their gilding. It was a privilege to move upon this liquid radiance. Junior was sick by this time but the men who were used to Haitian night seas did not pay attention. I had the feeling of being adrift in a boat alone.

All night the captain and the crew talked, smoked cigarettes we gave them and sailed and talked so that daylight found us off the coast of La Gonave. We saw two or three little thatched houses. The captain told the crew to announce our arrival. He took a conk shell and stood up on the prow and blew several mingled rhythms and tones, "Tell them two ti blancs (unimportant whites or mulattoes) are coming." The crew blew again and sat down as the sun was rising. At 11:00 o'clock we landed at Ansa-a-galets.

La Gonave's well advertised mosquitoes met us at the landing. That same landing that Faustin Wirkus had built during his reign. But away from the mangrove swamps the town rose high and dry and the mosquitoes ceased to be important.

The days went by and we made acquaintances. The chief of police there and his subordinates were very kind and entertaining. I saw Haitian folk games played and began to hear the folk tales about Ti Malice and Bouke'. For the first time I heard about the sacred stones of Voodoo. I found on this remote island a peace I have never known anywhere else on earth. La Gonave is the mother of peace. Its outlines which from Port-au-Prince look like a sleeping woman are prophetic. And the moonlight tasted like wine.

One of the Lieutenants of the Garde d'Haiti was collecting sacred stones for Faustin Wirkus. He was telling Junior about it in my presence so I asked questions. The Haitian peasants come upon the stone implements of the dead and gone aborigines and think that they are stones inhabited by the loa. In

Africa they have a god of thunder called Shango or Shangor. He hurls his bolts and makes stones that are full of power. They think that these stones in Haiti were made by their god Shango and that the various gods of Voodoo reside in them. The moment that they see a stone of a certain shape and color they say that it belongs to a certain god because they have come to be associated that way. This one is Damballa. That one is Agoue'. Another is Ogoun. And so on. When one finds one of these stones it is considered very lucky. It is said, "You have found a loa." When the finder acquires enough money to pay for the ceremony, the stone is baptized in the rites of the god to whom it is dedicated and placed upon the little shrine in the home upon a white plate and treated with the greatest respect. At stated times it is bathed in oil and little things are offered to it. Some of these stones have been in certain families for generations. No amount of money could buy them. The way to tell whether a stone has a loa or not is to cup it in the hand and breathe upon it. If it sweats then it has a spirit in it. If not, then it is useless.

We heard about one famous stone that had so much power that it urinated. It was identified as Papa Guedé, who had ordered it to be clothed, so it wore a dress. It attracted so many people and caused so much disturbance indoors that the owner had it chained outside the door. One of the American officers of the Occupation named Whitney saw it and finally got it for himself. It was a curious idol and he wanted it for his desk. The Haitian guard attached to Whitney's station told him that it would urinate and not to put it on his desk but he did so in spite of warning and on several occasions he found his desk wet and then he removed it to the outdoors again. They said he took it away to the United States with him when he left.

At Ansa-a-galets I met the black marine. A sergeant of the Garde d'Haiti lived in the house beside mine and I kept hearing "Jesus Christ!" and "God Damn!" mixed up with whatever he was saying in Creole. When we became friendly enough to converse, I told him that I had heard him and said

that it was remarkable to hear the ejaculations from him.

"Oh," he said, "I served with the Marines when they were here."

"I see," I replied facetiously, "then you are a black Marine."

"But yes," he replied proudly, "I am a black Marine. I speak like one always. Perhaps you would like me to kill something for you. I kill that dog for you." It was a half-starved dog that had taken to hanging around me.

"No, no, don't kill it. Poor thing!" He put his pistol back into its holster. "Jesus Christ! God Damn! I kill something," he swaggered. I learned afterwards that he had told all his friends and associates that he must be just like an American Marine because the femme American had recognized the likeness at once. Perhaps by this time he has promoted himself to Colonel Little.

I met Madame Lamissier Mille from Archahaie, that rich alluvial plain going north from Port-au-Prince which is called the granary of Haiti. There are so many wealthy and productive plantations of bananas, coconuts and garden produce that the whole place is swathed in rich green foliage. From this Lamissier I heard the name Vixama, which is hard to hear even in Haiti. You hear much about the mythical man in the mountain near St. Marc, but few know and breathe the name Vixama. What was more important than the secret name of a legendary figure, was the invitation to visit a real Bocor who has his hounfort at Archahaie whom she said was a "parent" of hers which means in Creole that they were related. This was the opening I had wished for, so I eagerly accepted. We passed Christmas day in Ansa-a-galets, and I had stewed goat with the Chief of Police. The next night our party of five marched single file down the stony path to the sea in the white light of a gross old moon and embarked for Port-au-Prince. When the sun arose the next morning it was pleasant to stretch myself along the gunwale and look far down into the water and see the animal life down there. I saw a huge shark point his nose up and lazily follow it to the surface; I saw a great ray swim-

137

ming about and numerous parrot fish. It rained on us twice, but that night around nine o'clock, we landed in Port-au-Prince, and the next day Lamissier went off to Archahaie to find out when her cousin, the Bocor, would receive me. I was very eager for him to admit me, because Archahaie is the greatest place known in Haiti for Voodoo.

CHAPTER 12

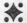

ARCHAHAIE AND
WHAT IT MEANS

Early in January I went to Archahaie to the hounfort of Dieu Donnez St. Leger. He has a large following and owns large plantations himself. He lives in a compound like an African chief with the various family connections in smaller houses within the enclosure. About one hundred people are under him as head of the family or clan. He is very intelligent, reads and writes well and sees to it that all of the children in his compound go to school. The arch above the door to the hounfort and peristyle were both painted in stripes alternating green, white, blue and orange. The walls were green and red.

He was extremely kind in allowing me to attend all of their ceremonies and in making explanations. He had his Mambo, Madame Isabel Etienne, take great pains with me to conduct me through the rites step by step and to teach me the songs of the services. I was in a fortunate position, for his place has such a large following that there were ceremonies nearly every day. Sometimes two or three in the same day. Red cocks were tied before the door of the mysteries awaiting the hour of sacrifice. I was learning many things and

139

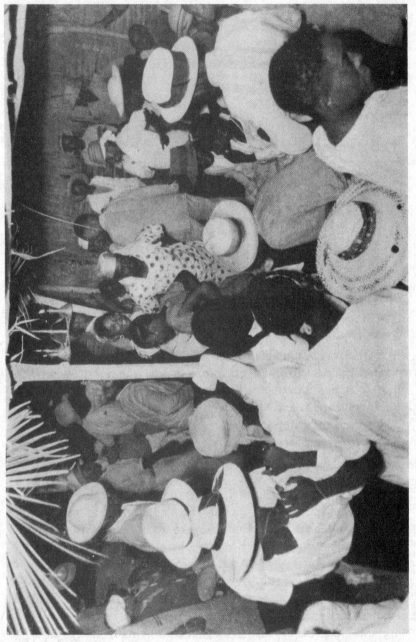

Rex Hardy, Jr.

being astonished at the elaborate rituals that Voodoo has developed in Haiti. After the ceremonies the drums played for Congo dances and men and women helped to teach me the steps. First, of course, was the Jean Valou, the Congo and then the Mascaron. Other steps were introduced as the occasion demanded until I could follow whatever they did in the dance and singing.

One night something very interesting and very terrifying came to pass. A houngan had died and Dieu Donnez was to officiate at the Wete' loa non tete yum mort (Taking the spirit from the head of the dead). This ceremony is also called the Manger des morts (The food or feast of the dead) or the Courir Zinc (To run the Zinc fish hook of the dead). This ceremony is not always in honor of a houngan. It is also celebrated for a dead hounci or canzo.

That day a pair of white pigeons were obtained, some olive oil, flour, more than thirty pieces of fat pine wood, a pair of chickens, some coarse corn meal, and a saddle blanket, and a large white plate. Two chairs were placed under the peristyle and the dead body of the houngan was placed on them and covered with the saddle blanket.

The chickens and the pigeons were killed and cooked without seasoning. They were very careful that no salt whatever should touch anything. This reminded me of my experiences in Jamaica and how it was felt that salt was offensive to the dead. The coarse corn meal was put in a pan and parched or roasted as one would roast peanuts or coffee. Every minute or two the assistant would pick up the pan and shake it to make it roast evenly. When it was finished, it was placed in the white plate. Then slivers of pine wood were lighted and placed for illumination instead of candles.

Dieu Donnez himself made a sparkling fire under the peristyle and when it burned hot and fierce, he took the white plate with the corn meal in one hand and the white pot with the chickens in the other and approached the fire chanting:

141

"Har'au Va Erique Dan, Sobo Dis Vou qui nan
Ce'bon Die qui maitre, Afrique Guinin, tous les morts
Hai' 'an Va erique dan."

The body of the dead man sat up with its staring eyes,
bowed its head and fell back again and then a stone fell at the
feet of Dieu Donnez, and it was so unexpected that I could not
discover how it was done. There it was, and its presence
excited the hounci, the canzo and the visitors tremendously.
But its presence meant that the loa or mystere which had lived
in the dead man and controlled him was separated from him.
He could go peacefully to rest and the loa would be employed
by someone else. If the spirit were not taken away from the
head of the dead, then it would have to go and dwell at the
bottom of the water until this ceremony is performed. Some
say that the spirit of the houngan must pass one year at the
bottom of the water anyway. When the ceremony is finished,
after the man has been buried, the two chairs are dressed with
the saddle cover, but are otherwise unoccupied except in a
spiritual way, if you want to look at it like that.

Dieu Donnez then addressed the dead spirit in the African
jargon called "langage." That is a private matter with each
houngan and it varies with each time he employs it because
different loa dictate different things to him. So that is always
new. But the opening prayer which is taken from the Catholic
church remains fixed. No one knows what was said to the dead
man to get him to relinquish the mystere but he had sat up,
bowed his head with its unchanging eyes and laid back down
and the stone had fallen at the feet of Dieu Donnez St. Leger.
Now he produced a fish hook made of zinc and passed it
through the flames three times. This is the "Zinc" of the dead
that is his no longer. The power it held will pass on to his
successor, which in this case was his son.

Then all of the assistants began to march around the two
dressed-up chairs, each with a flaming pine torch in his or her
hands, and it was a most impressive sight. Mambo Etienne
rattled her ascon and began the singing. The whole crowd

Mambo Etienne, Archahaie

sang lustily and well. The two Petro drums began their rhythmic march from Guinea across the seas and the three Rada drums answered them in exultation.

The chickens cooked in olive oil without salt were placed on a white plate and Dieu Donnez offered them to the dead with tremendous earnestness and dignity. After that the plates were paraded around the two chairs and buried with the food on them.

It was then the thing of terror happened. There were some odd noises from a human throat somewhere in the crowd behind me. Instantly the triumphant feeling left the place and was succeeded by one of fear. A man was possessed, it seemed, and began crashing things and people as he cavorted toward the center of things. There was a whisper that an evil spirit had materialized, and from appearances, this might well have been true, for the face of the man had lost itself in a horrible mask. It was unbelievable in its frightfulness. But that was not all. A feeling had entered the place. It was a feeling of unspeakable evil. A menace that could not be recognized by ordinary human fears, and the remarkable thing was that everybody seemed to feel it simultaneously and recoiled from the bearer of it like a wheat field before a wind.

Instantly Dieu Donnez faced this one with his ascon and other signs of office to drive it away from there, but it did not submit at once. He uttered many prayers and the terror of the crowd grew as the struggle dragged out. The fear was so humid you could smell it and feel it on your tongue. But the amazing thing was that the people did not take refuge in flight. They pressed nearer Dieu Donnez and at last he prevailed. The man fell. His body relaxed and his features untangled themselves and became a face again. They wiped his face and head with a red handkerchief and put him on a natte where he went to sleep soundly and woke up after a long while with a weary look in his eyes.

They poured libations for the dead and the ceremony ended.

It was explained to me later that the Courir Zinc is not a

difficult ceremony to perform, but that it is dangerous for any except a full fledged and experienced houngan to try it for fear that evil spirits may appear and do great harm before the good loa can be summoned to drive them off. The happening confirmed the belief of the people that Dieu Donnez St. Leger is a great and a powerful houngan. It is said that he is also a powerful Bocor when he serves in that capacity.

Life had plenty of flip for me at Archahaie. I could put my army cot under the peristyle during the day and lie there in the cool and rest and watch the people come to Dieu Donnez for various things. Several sick persons were there at all times. The sick men sat around under the trees or laid on their nattes in long shirts without any trousers. Sometimes I visited among them and practised up on Creole. But usually I was wherever Madame Etienne was. Not because she was next to Dieu Donnez himself in importance but because she is a kindly person, very entertaining and an amazing dancer for all of her bulk. She has charge of running the establishment and no one dares disobey her. All of the food for the hundred or more people in the compound is prepared at a common point. The work is divided up by Madame Etienne and supervised by her. She works as hard as anybody.

Leaving the professional aspect of the place aside it is one of those patriarchal communities so numerous in Haiti. It is the African compound where the male head of the family rules over all of the ramifications of the family and looks after them. It is a clan. Dieu Donnez has a little house all to himself where he can retire and rest after tiresome and strenuous work. He would send for me to come there so that he could instruct me. There is nothing primitive about the man away from his profession. He is gentle but intelligent and business-like. All of his lectures had to be written. He took ashes and drew the signatures of the loa on the ground and I had to copy them until he was satisfied. Sometimes abruptly he would leave the hounfort and go on a tour of inspection of his extensive banana and coconut plantations. I have a suspicion that he is a person who likes solitude and that it was a way he had of

escaping from the nig-nagging of crowds. He inherited his office of priest from his father, who many say was a greater houngan than Dieu Donnez is. Anyway, Dieu Donnez is a hereditary houngan and that is considered the real and the true way in Haiti. One day I said that I must go to Port-au-Prince to see about my mail and he let me go, saying that nothing important was in prospect for the time being anyway. So I rode one of those bone-racking, liver-shaking camions back to the capitol and Lucille, who was always so anxious about my safety whenever I was out of her sight.

But I was not in Port-au-Prince many days before the Master sent for me by a young man who is part of the clan and is also of the palace guard. Dieu Donnez said for me to be there within three days to bring a bottle of toilet water, a fountain pen for him and a bottle of ink. I went with portable stove, army cot and the things that Dieu Donnez wanted. And I am very glad that I went. He was going to set up a hounfort and make a houngan and these things would call for many ceremonies. I was very glad about it all. My Creole was getting pretty good by now.

The next day after my arrival at Archahaie, we set out for the place where the new hounfort was to be established. Dieu Donnez said that I could wait until next morning and come by camion but I said I'd rather walk with the rest. We set out gaily near sundown with great quantities of everything including the spirit of laughter. We sang as the dusk closed in on us plodding down the dusty road. We joked and frolicked. Madame De Grasse Celestin was riding her donkey amid two great sacs paille full of good things for the trip. After a while I rode some too and Mambo Etienne's son walked alongside and joked and sang and kept the little animal moving. So we went on like this for hours into the night. It was a dark night but nobody cared. We were like a happy army stealing a march.

We came to a point of huge mango trees where a man was standing beside the road. It was the place to leave the highway and go down a twining path across running water that chuck-

led among the greenery. Now and then houses hid behind the trees. We walked two miles perhaps and the straggling army halted again. We had reached our destination, the compound of Annee' La Cour, who is a cousin of Dieu Donnez and for whom the Master was going to set up the hounfort. We had halted because there were formalities that required it.

A canzo came out with a torch light and brought corn meal and water and a houngan made the signature of a loa upon the ground, and threw the water three times upon the ground for the dead. Mambo Etienne did the same. They went through a ritual proper to the occasion, but brief. The other canzo came after and threw water ceremonially. Then the hounci. After that we all went inside.

We found great piles of palm fronds piled under the peri-style and a quantity of gay colored paper. The women were waiting to be told what to do and Mambo Etienne put us all to work stripping the palm fronds into strips so fine that when it was done, it looked like a great, cream and green ostrich plume. Mambo Etienne and Annee' La Cour cut the fringe away from the central stalks and draped the "plumes" over the back of a chair. These were going to be cut into smaller pieces and used to decorate the peristyle and the various repositories of the gods. More work was going on out under the great elm tree that was to be dedicated to Loco and late in the night I went out there and spread up my bed to sleep. The next morning Dieu Donnez himself arrived with the rest of the clan in tow, and there was a great ceremony at the entrance for him. We were given some delicious hot tea called channelle before breakfast and it was a most refreshing and surprising thing. Channelle tea is a lovely habit for anybody to have. I was put to work cutting up the colored paper to be strung across the peristyle to decorate it and spent the entire morning at it. By that time a crowd was beginning to collect. When the peristyle was all decorated, I went out to the cooking place where the women were cooking great quantities of food. I noticed that Madame Etienne found the rocks herself to sup-port the large cooking pots, and that she marked each rock

with a cross mark in charcoal. She answered me that this was done to keep them from breaking when they were heated.

Soon Dieu Donnez sent for me to come to him under the peristyle. He was breaking up the Ascon. That must be done to remake it for a new Canzo or a houngan. He wanted me to see how it was done. I was allowed to help him restring the beads and snake-bones that surround the gourd that becomes the most sacred object in Haiti outside of the stones which contain loa. Each important god has a bead of a different color dedicated to him or her and these are represented in the arrangement of the beads on the Ascon and in the grand necklace that is worn by all the grades from a hounci to a houngan. The Collier hounci is neither as long nor as elaborate as the Collier Canzo or houngan. The necklace of the houngan is a splendid affair that is looped about his shoulders in a specific manner. It must be very long for that.

That afternoon the ceremonies began. The drums and the hounfort were dedicated. But of course, the very first ceremony was to Papa Legba. I ought to explain that while the people always say and sing "legba," the scholars tell me that the African word is Lecbah or Letbah. Perhaps the people are in error. All I know is they sing "Papa Legba, ouvrier barriere por moi passer." Anyway out in the courtyard of the hounfort of Annee' La Cour, the great preparation was going on. The drapeaux done in blue and white with the symbols in blue and red on it was flying from a pole high on the hounfort with its roasted ear of corn for the god who loves it. I saw the red rooster tied out in front of the house of ceremony. I saw the great tree well decorated with lacified palm fronds. Pieces of this stripped palm fronds were everywhere. In the hounfort were niches for the different gods. The pole with an iron serpent beside it for Damballa, "Li qui retti en ciel" (He who lives in the sky) and whose symbol on earth is the serpent. In the second room were the things dedicated to the congos with their resplendent colors. The congo and the Rada should not occupy the same room but they should be under the same roof.

Soon now, we were summoned to the hounfort to begin,

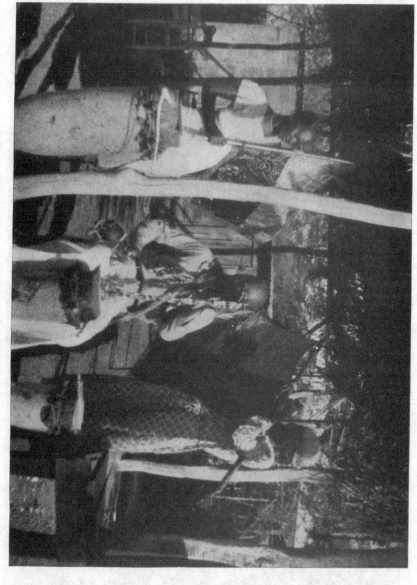

Houngan in full ceremonials with drapeaux (flags)

Rex Hardy, Jr.

and Mambo Etienne tied my red and yellow handkerchief on my head in the proper loose knot at the back of my head. We removed our shoes and went into the hounfort, where Dieu Donnez, Annee' La Cour were already. The altar was set. Dieu Donnez was seated in a very low chair facing the altar. When we were all in that the place could hold, he covered his head with his ceremonial handkerchief and began the monotonous Litany:

> Dieu Donnez: Ela Grand-Pere Eternel,
> Us: Ela Grand-Pere, Eternal, sin dior e'
> Ela Grand-Pere Eternel, Sin dior docor Ague'
> Ela Grand-Pere Eternal Sime nan-min bon O
> sain'en.
> Dieu Donnez: Ela Saint Michel.
> Us: Ela Saint Michel, sin dior e' . . .''

and so on as before.

This continued until Saint Gabriel Raphael, Nicolas, Joseph, John the Baptist, Saint Peter, Paul, Andre', Jacques, Jean, Phillipe', Come et Damien, Luc, Marc, Louis, Augustine, Vincent, Thomas, Laurent, Sainte Marie, Mere De Dieu, Saint Vierge Marie (A distinction between Virgin Mary and the mother of God), Sainte Catherine, Saintes Lucie, Cecile, Agnes and Agatha. These were all on the Christian side and the same response was sung for each name. Now the houngan began to chant the names of the Voodoo gods, and we responded as before, including the pagan deities in our chants.

"Ela Lecba Atibon, Sin Dior e', Ela Lecba Atibon, Sin dior docor Ague', Ela Lecba Atibon si' m nan min bon Dieu O Sain 'en."

We were led on to chant to Loco Atisson, Ela Aizan Velequiete, Ela Sobo, Ela Badere, Ela Agassou, Ela Ague' Ta-Royo, Ela Bosou, Ela Agaron, Ela Azacca, Ela Erzulie, Freda, Ela Ogoun Bodagris, Ela Ogoun Feraille, Ela Ogoun Shango, Ela Ogoun Taus Sam, Ela Ogoun Achade', Ela Ogoun Palama, Ela Ossage, Ela Baron Carrefour, Ela Baron La Croix, Ela

Baron Cimeterre, Ela Guede' Nibo, Ela Papa Cimby, Ela Nanchon Congo, Ela Nanchon Sine'gal, Ela Nanchon Ibo, Ela Nanchon Caplarou, Ela Nanchon Annine, Ela Papa Brise', Ela Contes Loas Petros, Ela Contes Boccos, Ela Contes Houngeni-cons, Ela Contes Laplaces, Ela Contes Port-Drapeaux, Ela Contes Ounci Canzos, Ela Ounci Des-sounins, Ela Contes Ounci Bossales, Ela Contes Hounfort, Ela Contes Oganiers.

Now inside a room of the hounfort, decorated for the occasion, we found a large table on which was placed food and drinks of all the gods to be honored along with the food of Legba, for Legba is never honored alone. He opens the gate so that the other gods come to their worshippers. All over the table there were plates, couis (pronounced Kwee) bottles and flacons. Under the table were the terrines, that is the baked clay containers like crude plates, cruches (little baked clay water-jugs), the chickens dedicated to the different gods, the perfumes and aromatics and leaves which would be used in the ceremonies. All of these were grouped about a watch light whose fuel is olive oil.

Here there was an interruption. Three women entered all dressed in black. They looked like a mother and her two daughters. The service was promptly stopped and the Mambo sent them away almost harshly. The older woman tried to argue, but they were hustled on out. I asked in a whisper why this was done and they said, "They have on black for mourning and so they cannot come in here. This is for the living. Baron Samedi must not be present."

I asked, "But suppose he manifests himself in some of the adepts? There must be some here consecrated to him."

"In that case, we would make a ceremony to drive him away. This is not the day of the dead. This is for the living. All the work would go wrong if he were here."

Dieu Donnez sprinkled the water in the direction of the four quarters of the world. The Canzos and the houncis followed his example. They all faced the door which looks toward the north and chanted, "Afrique-Guinin Atibon Legba, ouvrir barriere pour nous." Dieu Donnez then took the coui

of corn meal and drew a design on the ground in the center of which he poured a little of each of the drinks dedicated to Legba. He took a piece of the baked banana, herring, a few grains of corn, a bit of watermelon, a bit of cake and placed them all in a single little heap within the design. Until then Dieu Donnez had done all these things seated in a very low chair. Now he arose and took two "poule Zinga" (speckled chickens), one in each hand. These he elevated to the east, the west, the north and the south in turn, saying: "Au nom du Grand Maitre, Tocan Frieda Dahomey, Marassas, Dossou, Dossa, toute l'Esprits, Atibon, Ogoun, Locos, Negue, fait, Negue Defait." The assistants knelt down. The houngan passed the two chickens over the heads of the kneeling Canzos and houncis. Then he turned to a niche dedicated to Legba and saluted it. Returning then to that north-facing door, he took the two chickens in one hand and a firebrand in the other, and set fire to the three heaps of gunpowder placed around the design or signature of Legba while the adepts were chanting:

"Ce Letbah, qui ap vini, ce papa Legba laissez barriere l'our."

The moment had come to consecrate the chickens to Legba. Dieu Donnez knelt and kissed the earth. He kissed three times the signature of Legba. The whole crowd followed his example. The drums woke up. First the tenor boulatier, then the sirgonh and last the thundering hountah, which controls the mood and the movement of the dancers. Some of the hounci began the Jean Valou. Dieu Donnez broke the wings of one of the chickens, then its legs, holding the throat of the fowl in such a way that it did not cry out as the sickening sound of cracking bones broke through the singing. Then he wrung its neck. In every other ceremony the throat is cut. The supposedly dead bird was placed upon the signature, but after what seemed like a full minute, even with its broken thighs, it leaped in its death agony and crashed into me. My heart flinched and my flesh drew up like tripe. With averted eyes I heard the next song begin with the rattle of the Ascon:

The drums woke up

Jean Valey dance, voodoo ceremony

Rex Hardy, Jr. *In full ritual the Houngan kisses the sword*

"Ouanga te' papa Legba, Legba Touton, Legba Atibon—"
they began with a list and ended, "Toute hounci fait Croix."

The order of the ceremonies to the gods continued according to the rhythm of the offerings. The next god honored was Aisan who walks with the Marassas, Yumeaux ad Trumeaux and the child who follows the twins which is called the Dossou. They are the gods of the little joined plates that one finds displayed all over Haiti. The full name is Marassas Cinigal (black twins) Dahomey.

Mambo Etienne shook her Ascon and sang:

"Aisan, hey! Onape' laisse' coule'
Aisan, hey! Oua te' Corone' Gis."

We were now in full ceremony. Dieu Donnez bowed himself twice toward the altar. He took a white pigeon and lifted it to the four quarters of the earth before he killed it. Then all of the good angels and twins were supposed to enter the hounfort. This ceremony to the twins is observed by all who have or have had twins in the family. It is believed that twins have some special power to harm if they are not appeased. It seems that everyone in Haiti has been involved with twins in one way or another, so that the ceremony is universal. The food was all on white plates and divided into two parts. One part for the Marassas and the other for the adepts.

Mambo Mabo Aizan, who walks with the Marassas, the twins, is the wife of Papa Loco, whose full name is Loco Atison Goue' Azambloguide', Loa Atinoque', and he is always accompanied by a Nanchon-Aan-Hizo-Yan-go. In the ceremonies of the days of Grand Fete, when all of the mysteries are honored and saluted, the ceremony to Loco comes immediately after the Marassas. So Dieu Donnez took a grayish cock in his two hands and lifted it toward the altar at the same time that he bowed himself. Then he turned toward the east, toward the south and toward the west. He poured the libation of rum and clairin on the ground and chanted:

"Loco Anbe'! Ce Loco Azambloguidi
Loca Anhe'! Loco Atinogue' Apoyoci
Loco, Loco Atinis do guidi, Loco
Azamblonguidi Atinogue', Loco he'!''

The houngan saluted the white pot on the altar that was dedicated to Loco. The Mambo and several servitors became possessed and the crowd became excited because they were glad that the god was manifesting himself so freely. In this exalted condition these "horses" of Loco dressed an altar to him. They placed a table and placed on it the sacred stone dedicated to Loco, his white pot, chapilets, images of St. Joseph and his drinks. A visiting houngan became possessed and the cry went up that "Papa Loco 'Amarre les points' ''—that is, he was "tying the points." That means that the loa was personally taking a hand in execution of the things asked of him by his followers. For instance, a man came to Dieu Donnez to make good in a business venture. He had come to the houngan to find out what he must do to insure success. He wanted the houngan to invoke the "Master of his head," to give him the information and assistance needed. The houngan summoned his loa and he came and it was Papa Loco. He demanded certain articles and indicated to Dieu Donnez which ceremony to observe and how to conduct it. The loa then left the houngan and he informed the man who had asked the favor what the loa had demanded. The man gave the houngan the money to buy the things and to celebrate the ceremony. The supplicant, of course, would not be present at this. But when Dieu Donnez went to perform the rites, Loco took possession of the body of the houngan and performed the ceremony himself. Then he was "tying the points." The reason it was known that Loco was there himself, was because he said with the lips of the houngan, "Vivant yo pas rainmin loa, yo rabi voodoo ce' ouanga yo rainmin."

But Loco can be terrible sometimes. He refuses to answer when he pleases. He refused to answer the very next applicant. The man was very eager for an answer but the houngan

Rex Hardy, Jr.

The loa "mounts" the houngan

told him to wait until another time. But for two women who had asked health favors of Loco Papa Loco indicated a ceremony out under the tree that was his repository. So we took our chairs and went out under the tree. We marched three times around the tree carrying the chairs and singing. The little baskets with the offerings were hanging from the limbs. The houngans intoned the ceremony and we answered. Two live chickens were passed all about the heads and the shoulders of the two kneeling women. Dieu Donnez made a cross on top of the heads of both women with the corn meal. Both women were made to stand and were faced both ways as they danced around the tree. When they had danced so far, the priest faced them the other way. Finally the chicken of each woman was surrendered to the priest and killed with a knife—their heads bent far back to expose their throats. More singing with four women marching around the tree picking the chickens as they went. The loose feathers in the lamp light made a pattern of a loose tumbling circle in the air like playful little clouds or like suntracks in the sky. Some of the cooked chicken was returned and the two women executed a wild dance about the tree and the signature of Loco on the ground. Then some of the food was put in the hollow of the tree for the god.

There was a new note on the Rada drums. We went into the hounfort to the altar of Ogoun. There are many Ogouns. Ogoun Badagris, Ogoun Ferraille, Ogoun Shango or Chango, Ogoun Balingio. But this ceremony was to Ogoun Badagris. Before his altar there were eggs and corn meal, the signs of fertility. There were sweets, and parched corn and peanuts. Of course, the water dedicated to the dead and the liqueurs, cognac, red wine, rum clairin and a red cock. The same one that I had seen tied all day by one leg before the bath house of ceremony. I felt I knew that rooster because another had attacked him while he was tethered there and while he showed plenty of courage, being tied by the leg hindered his movements, and I had driven off his assailant. I looked into his round brown eye in the hounfort and looked away. A sword was stuck into the earth at the central pole and a round black

Altar to Ogoun Feraille, God of War (old iron and other metals are offered to him)

hat something like a Turkish fez was hung on the handle of it. Joswee, the sabreur (sword-bearer) who belonged to the compound of Dieu Donnez, engaged Pierre Charles the sabreur of Annee' La Cour in mock combat. It was a very lively encounter and brought wild cheering. As Pierre Charles was forced to give away before Joswee, a figure leaped into the door. It was all in blazing red from head to foot. The skirts of the robes were very full and trimmed in white lace. This figure rushed forward, put on the fez, seized the sword and challenged Joswee fiercely. The crowd went mad as the clever dance went on. Neither really conquered the other. It was not done to prove strength and courage. It was done as a symbol of Ogoun's power to help warriors and for the magnificent and spirited grotesque.

The Man in red dress was Ogoun. At a point, both lowered their blades and Ogoun planted a ceremonial kiss on the brow of Joswee. The drums commenced to walk with the songs and Dieu Donnez took the red rooster from Joswee. He surprised the fowl by setting off a little heap of gunpowder near him and the rooster leaped high. The crowd called that "foula poule." The servitors following Mambo Etienne knelt and kissed the earth. One female hounci, when she knelt before Madame Etienne received a good kick in the behind for not behaving properly. The second prayer was chanted and the tongue of the red rooster is torn out before it is killed with a sharp knife. Some of its blood is smeared on the wall with a cluster of feathers from the throat. The body of the rooster was placed before the altar. The drums changed their tempo and Dieu Donnez left the hounfort and crossed the peristyle followed by everybody because he was going to salute all the repositories in the place. Several servitors became possessed during this part of the ceremony. There was a great deal of spirited dancing under the peristyle after the repositories had been honored. The figure of Ogoun dominated the movement. Dieu Donnez was beating the hountah, the greatest Rada drum, women wishing children prostrated themselves before Ogoun and when he danced with them in a way to symbolize

Rex Hardy, Jr.

The sabreur before the gods

sex and procreation there was joy and even ecstasy in their faces. He did not always approach them from the front. He sometimes approached them from the rear as they danced face to face with someone else and made his motions of promise.

We then honored Damballa, the great and the pure. He was given the sweet soft drinks and white chickens. He it is who looks after peace and love in the home so that a pair of white chickens, a hen and a rooster, are offered him. They must be bought a month in advance and dedicated to his intention. When they have been sacrificed, they are laid side by side before the altar.

The last deity to be honored was Brave Guedé, who is a sort of messenger of all the gods. Then we danced for the rest of the night. We knew that the next day a Petro ceremony, "A day of promise," was in store for us but we danced the sun out of bed just the same. After daylight, the nattes or sleeping mats were full of people that looked like dead bodies getting some sleep before the ceremonies of the day should begin. Lamissier woke me up to hand me a cup of chanelle tea and to tell me that Dieu Donnez wanted me.

I had about two hours of instruction in the nature of the gods and something about their origins. I had some practise in drawing with corn meal the verver or signatures of various loa. Then he let me see him work on the Paquettes de Congo. They are those figures which must be present at a baptism and the new drapeaux (flags) and the new sabre were to be baptized on Sunday.

Before we go into the description of the outdoor altar to Petro, let me give you some idea of the differences between a Rada god and a Petro divinity.

As has been said before, Damballa and his suite are high and pure. They do only good things for people, but they are slow and lacking in power. The Petro gods on the other hand are terrible and wicked, but they are more powerful and quick. They can be made to do good things, however, as well as evil. They give big doses of medicine and effect quick cures. So these Petro gods are resorted to by a vast number of people

The mambo offers to Damballa

"Horse" mounted by Papa Guedé

who wish to gain something but fear them at the same time. The Rada spirits demand nothing more than chickens and pigeons, and there are no consequences or hereafter to what they do for you, while the Petros demand hogs, goats, sheep, cows, dogs and in some instances they have been known to take dead bodies from the tombs. The Petros work for you only if you make a promise of service to them. You can promise a service to be fulfilled as far away as thirty years, but at the end of that time, the promise *must* be kept or the spirits begin to take revenge. It seems that they actually do collect on the debt owed to them, for first the domestic animals of the family begin to die and when all these are gone, the children fall ill and die if the service is still not done and finally the head of the house. If you make a promise to the Petros *it is going to be kept.*

The Petros and the Congos, who sometimes unite, are the cults who make use of charms, ouangas (pronounced wanga). The Petro Quita Sec have the power to take human life. There is a long list of these spirits who have the same names as the Rada gods except that the second name distinguishes them from the rada. "Ge-rouge" after a name places that god in the Petros or the Congos. For instance we find Damballa Ge-rouge, which means "red-eyed," Erzulle, ge-rouge, Ogoun ge-rouge, Damballa-la-flambeau. The list included the Congos Savanne, that is, Congos of the open field or woods, such as Congo Mazambi, Congo Zandor, Marinette-pied-seche (dry foot), Erzulie Mapiangue, Bacca loup-gerow, Petit Jean Petro. They are recognized as evil, but one must feed them to have better luck than others. Louis Romin says, "All these mysteres make big cures and do heavy work. When you have a big sickness case about which Rada mysteres are too helpless to bring recovery Petro will undertake the treatment and *cure* the party. They give you luck to find a job or to start any kind of trading. They lend you big support or give you something to protect you in order that nothing will happen to you and that no one will cause you to be sick, and the demons or the devil will be unable to do you anything at night."

Offering to Congo Savanne

Therefore, since these evil mysteres are so useful, it is necessary for the houngan to have them under his control. Many, many families have their day of promise to the Petros for health, wealth or advancement in life.

The Petros make great use of fire. When a Petro ceremony is going on, there is always a big fire close by the hounfort with a bar of iron stuck into the middle of the flames.

Every Christmas, the Petros fix baths for all of those for whom they have worked during the year. They also give them "guards." Sometimes they dose their followers with machettas. Sometimes they cut a piece out of your body and put something in the hole and close it up. Two minutes afterwards, you feel nothing and know nothing about the wound. Neither can anyone see it again.

No Petro ceremony is held in the hounfort where the niche or repository of Damballa is. Even the door to the hounfort must be kept closed while the Petro service is going on. Neither can the two services be held in the same day.

The Petro *ceremony of promise* or of service to Petro is held in the open air.

Two large draperies or curtains are joined together at one end by a large hoop or circle of some kind and suspended from a limb of a tree. Beside this is a partition built to that end formed by the two sides of the niche. The loose ends opposite fall about a table which is covered by the curtains. A picture representing Maitresse Erzulie, St. Joseph and Loco is hung at the bottom of the niche which is decorated by a knot of red ribbon. A white plate is on the table with a knife, fork and spoon. As many different kinds of perfume as the supplicant can afford are on the table also with bouquets of flowers. At a little distance from the draped niche is the tonnelle, a palm thatched shed open on all sides which contains the two Petro drums. It must be ten metres from the niche. That distance is fixed.

The animals consecrated to Petro Quita Moudong are the pig, the goat, male and female; and the dog.

During the afternoon we saw the niche, the tonnelle being

Rex Hardy, Jr.

built and three holes being dug not far from the niche. Everything was ready by night time. The houngan went into the court to see that everything was ready and it was. The fire, the niche, the tonnelle, the animals, the family who wished to make the promise to Petro and the Canzos and houncis. Seeing all this, he had the animals led up to the holes and began the services.

First came the Litany to Saint Joseph, then the Pater-Noster. These being intoned and finished, he demanded to know as a matter of form if the animals had been bought for the ceremony. A Canzo answered that they had been bought and they were now present. He then asked if they had been bathed. He was told that they had been bathed. He next asked if they had been perfumed. He was told that all of the animals present had been perfumed also. Since these things had been attended to, he said that they must be dressed. Then a sort of cape, or tunic was thrown over the back of each animal and tied with a ribbon about the neck and another under its tail. The heads of the animals were wrapped in a white cloth.

The officiating houngan gave the word after the Voodoo prayers had been said, and the procession with the animals began. It circled the niche, the tonnelle, the three holes and a house of ceremony. The three holes were illuminated by a dozen white candles. Here before the holes Dieu Donnez drew his sabre from its scabbard and cut off the testicles of the pig, which he first elevated for the edification of the crowd, then placed on a white plate prepared to receive this sacred burden. The houngan turned again to the groaning animal and stuck him in the throat and caught the blood, or part of it in the white soup plate. Then he drank some blood from the wound himself. Then the family who was making the promise was brought forward and placed money, gold money, in the plate with the blood. It could not be less than five dollars, somebody told me.

The family drank some of the blood from the plate and crossing themselves dipped their fingers in the blood and drew a cross on their foreheads and on napes of their necks

in the hot blood of the pig. They put a cruche with wine in it in one of the end holes and a cruche with liquor in the other. The middle hole received the blood and the testicles of the hog. At that moment an adept knelt, kissed the earth three times and stated the demands of the family upon the gods.

The pig is always sacrificed the first day of the ceremony. The next day was the day of Quita, and in a ceremony essentially the same, the male and female goat were sacrificed. The male goat was brought under the tonnelle in its little flowered cape, but he was most unwilling. We chanted, we sang, and effort was made to lead the goat gaily about the center pole but he balked and had to be pushed every step of the way in the procession. The red-clad Ogoun bestrode him and the crowd yelled and pushed and pulled but the goat was emphatic in his desire to have nothing to do with the affair. The crowd sang and shouted exultantly but I could hear the pathetic, frightened bleat of the goat beneath it all, as he was buffeted and dragged to make a grand spectacle of his death.

The next day was spent in the chants and dances to Petro Quita and on which day a bull was sacrificed. Dressed in the ruffled cape tied upon its back, it was led about and the world ran behind it chanting:

> "Wah, wah, wah, wah, wah O bay
> Wah, wah, wah, wah, wah O bay
> Wah, wah, wah, wah, wah O bay
> Pas Tombé."

During the procession with the bull I heard the most beautiful song that I heard in all Haiti. The air was exquisite and I promised myself to keep it in mind. The sound of the words stayed with me long enough to write them down, but to my great regret the tune that I intended to bring home in my mouth to Harry T. Burleigh escaped me like the angels out of the Devil's mouth. The words they chanted as they followed the bull, which was unwilling, like the goat, to go, were:

172

Bah day, bah day, oh man jah ee!
Bah day, bah day, oh man jah ee!
Bah day, bah day, oh man jah ee!
Oh bah day, oh way, oh man jah ee.

The thing that the adepts seemed to enjoy most was the drink of Petro. That is a mixture of pig blood, fresh from the wound, white wine, red wine, a pinch of flour, cannelle and nutmeg. All of this is put in a bowl and whipped well. It was most agreeable to the participants, and eagerly quaffed. In fact it seemed extremely good and even a small sip was jealously sought.

The next morning, I received a message from my good friend Louis Romain to come to Port-au-Prince to witness a Canzo ceremony, so I got the first camion and did not see the end of the Petro at Archahaie. However I did see a Petro Moudong ceremony in which they sacrificed a dog.

That ceremony was the same except that the dog was not killed so soon in this instance. Only part of one of his ears was cut off by the priest. Then an assistant pulled the teeth of the dog and finally he was buried alive. The god had indicated that he desired his food thus.

I was under the wing of Louis Romain and his wife, who is herself a Mambo and they were extremely kind and considerate of me. Louis has the gift of making you understand in one sentence more than most people can with a page. I found every word he ever told me to be true. Never once did he attempt to mislead me. He saw to it that I went places and saw things. He was preparing me to "go Canzo" myself. That is the second degree of initiation in the department of the West. It is the second step towards the priesthood.

The usual routine is this:

The spirit enters the head of a person. He is possessed of this spirit and sometimes he or she is troubled by it because the possession comes at times and places that are, perhaps, embarrassing. On advice, he goes to a houngan and the spirit is identified and the "horse" is advised to make food for the

173

Mme. Romain, a mambo

loa who is the master of his head. As soon as the person is financially able, he or she goes through the ceremony of baptism known as "getting the head washed." Three days before the reception of the degree, the candidate presents himself to the houngan, who receives him and makes certain libations to the spirit who has claimed the candidate. The libation varies according to the god. It is a sweet liquor if it is Damballa, rum for Ogoun, Loco or Legba. The candidate is dressed in a long white shirt with sleeves to the wrists. The head of the applicant is wrapped in a large white handkerchief and he is put to bed on a natte where he must remain for seventy-two hours. The last day, which is the day of consecration, his head is washed, and he is given something to eat and drink. He usually rises possessed of his loa, who continues the service in place of the houngan. Then he is a hounci bossal, the first step of the way to the priesthood. This does not mean that all houncis become houngans. Far from it. Only a small proportion ever take the second step, which is the Canzo.

The Canzo is a hounci who "brule son zinc" (burns his zinc fish hook). The second degree renders the hounci invulnerable to fire. Like the candidate for the first degree, the hounci who wishes to be Canzo presents himself at the hounfort of the houngan seven days before the service is to be finished. He carries with him a long white night gown, He is put to bed in the first room of the hounfort on a bed of mimbon leaves. But an odd number of candidates cannot take the degree at the same time. It must be an even number, or one must wait, because the hounci are put to bed in pairs. The two men who sleep together thus are called brothers-in-law. If it is a pair of women, they are sisters-in-law. They are given nothing to eat except fresh fruits, milk and the like. The Mambo or the priest lies down occasionally to instruct the candidates, and they are cautioned to relax and to permit the spirit to dominate them.

When the seventh day, which is the day of consecration arrives, a great fire is built and a large kettle of water put on it and allowed to boil. A small stone or a piece of money is thrown in the pot by the houngan. The houngan, after saluting

the gods of the candidates, sounds the Ascon and pronounces the sacred words: "Ce grand Maitre qui passe avant nous, tous les saints, les morts, Marassas, Afrique Guinin, Ce yo qui fait, quit defait." (This Grand Master, that is Lord of Lords, who passes before us, all the saints, the dead, the twins, African gods, that which they do, they are able to undo.) The adepts, the houncis, the Canzos already consecrated salute with the drums the newly elected.

The houngan pours the libations, some into the flames. He places a small amount of gunpowder near the small kettle; he approaches it with a fire brand in his hand, and sets it off. He sets off a small amount of gunpowder in the hand of each candidate. Then he himself, to the great astonishment of the crowd, puts both hands into the boiling pot and takes out the stone or the money there without burning himself.

Then the brule zinc begins. The four little clay pots are put on three iron pegs for each pot. The pine wood is set and a blazing fire under each pot is kept up. Two small chickens are torn to death and some of the features dipped in their blood are stuck to each pot. The drums are beating and the Canzo who has been assigned to each candidate conducts him or her in line. A huge sheet or cloth is spread over the Canzos and candidates. They dance around the blazing pots from one to the other. The boiling chickens have been removed from the water and cornmeal added. One servitor takes the boiling corn meal from a pot, rolls it into balls with his hands and passes them quickly to a candidate, who passes it along. They are instructed to anoint their hands from the white plate of olive oil so that they will not burn themselves from the hot corn meal mush. They proceed from pot to pot. The left foot and the left hand of each candidate is thrust into the fire, but they are not burned. It is to prove to them that they are impervious to fire that the food and the hand are exposed to flame. All this time the drums are beating furiously and the crowd of servitors and hounci are dancing round in the circle behind the Canzos with their candidates. When the fiery ordeal is over, the corn meal balls, the knife, fork and white plate, with a

piece of white calico, the iron bars called "pieds-zin," are all tied up together with the calico and some leaves, and they are buried in a large hole. Pieces of the pine wood (bois pins) and some of all the food, a glass, one of the ounzin, some money, rum and clairin all are buried. The houngan orders the houncis to cover the hole. They toss in the dirt and stamp it down with the left foot. The next day, the houngan invests the new Canzo, who are all dressed in new white things, with grand colliers (necklaces) and the Ascons. Now they may hold consultations and serve the houngans most directly. It is a very joyful time for everybody. The peristyle of the hounfort fairly glitters with the crowds all dressed in new white for the final details.

The next step is to become a priest, but that is for the few. The way most acceptable to become a priest is by inheritance. But many are "claimed" by the gods. There are still others who just take up the trade.

The most famous houngans in Haiti are:

Do-See-Mah (sound spelling) of Cotes De Fer, a horse back ride up in the hills from the Sea. Port-de-Paix is the nearest large town. Do-See-Mah is the houngan of the upper classes. He is said to be so independent that he will not see anyone about his profession on Sunday no matter how urgent the case.

Ti Cousin (Little Cousin) of Leogane. Said to be the richest houngan in all Haiti. He has applied business methods to his profession and certainly has prospered. He is overlord of great stretches of land and many people. Some say that he is more often a Bocor than a houngan.

Dieu Donnez St. Leger of Archahaie. He is not a rich man, but he is not a poor one either. Every young person under his care must attend school.

Di Di, a little beyond Archahaie on the north.

Archahaie is the most famous and the most dreaded spot in all Haiti for Voodoo work. It is supposed to be the great center of the Zombie trade. But Kenscoff and many other localities have their names in the mouths of the people.

Ah Bo Bo!

CHAPTER 13

ZOMBIES

What is the whole truth and nothing else but the truth about Zombies? I do not know, but I know that I saw the broken remnant, relic, or refuse of Felicia Felix-Mentor in a hospital yard.

Here in the shadow of the Empire State Building, death and the graveyard are final. It is such a positive end that we use it as a measure of nothingness and eternity. We have the quick and the dead. But in Haiti there is the quick, the dead, and then there are Zombies.

This is the way Zombies are spoken of: They are the bodies without souls. The living dead. Once they were dead, and after that they were called back to life again.

No one can stay in Haiti long without hearing Zombies mentioned in one way or another, and the fear of this thing and all that it means seeps over the country like a ground current of cold air. This fear is real and deep. It is more like a group of fears. For there is the outspoken fear among the peasants of the work of Zombies. Sit in the market place and pass a day with the market woman and notice how often some vendeuse cries out that a Zombie with its invisible hand has

Felicia Felix-Mentor, the Zombie

filched her money, or her goods. Or the accusation is made that a Zombie has been set upon her or some one of her family to work a piece of evil. Big Zombies who come in the night to do malice are talked about. Also the little girl Zombies who are sent out by their owners in the dark dawn to sell little packets of roasted coffee. Before sun up their cries of "Cafe grille" can be heard from dark places in the streets and one can only see them if one calls out for the seller to come with her goods. Then the little dead one makes herself visible and mounts the steps.

The upper class Haitians fear too, but they do not talk about it so openly as do the poor. But to them also it is a horrible possibility. Think of the fiendishness of the thing. It is not good for a person who has lived all his life surrounded by a degree of fastidious culture, loved to his last breath by family and friends, to contemplate the probability of his resurrected body being dragged from the vault—the best that love and means could provide, and set to toiling ceaselessly in the banana fields, working like a beast, unclothed like a beast, and like a brute crouching in some foul den in the few hours allowed for rest and food. From an educated, intelligent being to an unthinking, unknowing beast. Then there is the helplessness of the situation. Family and friends cannot rescue the victim because they do not know. They think the loved one is sleeping peacefully in his grave. They may motor past the plantation where the Zombie who was once dear to them is held captive often and again and its soulless eyes may have fallen upon them without thought or recognition. It is not to be wondered at that now and then when the rumor spreads that a Zombie has been found and recognized, that angry crowds gather and threaten violence to the persons alleged to be responsible for the crime.

Yet in spite of this obvious fear and the preparations that I found being made to safeguard the bodies of the dead against this possibility, I was told by numerous upper class Haitians that the whole thing was a myth. They pointed out that the common people were superstitious, and that the talk of Zom-

bies had no more basis in fact than the European belief in the Werewolf.

But I had the good fortune to learn of several celebrated cases in the past and then in addition, I had the rare opportunity to see and touch an authentic case. I listened to the broken noises in its throat, and then, I did what no one else had ever done, I photographed it. If I had not experienced all of this in the strong sunlight of a hospital yard, I might have come away from Haiti interested but doubtful. But I saw this case of Felicia Felix-Mentor, which was vouched for by the highest authority. So I know that there are Zombies in Haiti. People have been called back from the dead.

Now, why have these dead folk not been allowed to remain in their graves? There are several answers to this question, according to the case.

A was awakened because somebody required his body as a beast of burden. In his natural state he could never have been hired to work with his hands, so he was made into a Zombie because they wanted his services as a laborer. B was summoned to labor also but he is reduced to the level of a beast as an act of revenge. C was the culmination of "ba' Moun" ceremony and pledge. That is, he was given as a sacrifice to pay off a debt to a spirit for benefits received.

I asked how the victims were chosen and many told me that any corpse not too old to work would do. The Bocor watched the cemetery and went back and took suitable bodies. Others said no, that the Bocor and his associates knew exactly who was going to be resurrected even before they died. They knew this because they themselves brought about the "death."

Maybe a plantation owner has come to the Bocor to "buy" some laborers, or perhaps an enemy wants the utmost in revenge. He makes an agreement with the Bocor to do the work. After the proper ceremony, the Bocor in his most powerful and dreaded aspect mounts a horse with his face toward the horse's tail and rides after dark to the house of the victim. There he places his lips to the crack of the door and sucks out the soul of the victim and rides off in all speed. Soon the victim

182

falls ill, usually beginning with a headache, and in a few hours is dead. The Bocor, not being a member of the family, is naturally not invited to the funeral. But he is there in the cemetery. He has spied on everything from a distance. He is in the cemetery but does not approach the party. He never even faces it directly, but takes in everything out of the corner of his eye. At midnight he will return for his victim.

Everybody agrees that the Bocor is there at the tomb at midnight with the soul of the dead one. But some contend that he has it in a bottle all labelled. Others say no, that he has it in his bare hand. That is the only disagreement. The tomb is opened by the associates and the Bocor enters the tomb, calls the name of the victim. He *must* answer because the Bocor has the soul there in his hand. The dead man answers by lifting his head and the moment he does this, the Bocor passes the soul under his nose for a brief second and chains his wrists. Then he beats the victim on the head to awaken him further. Then he leads him forth and the tomb is closed again as if it never had been disturbed.

The victim is surrounded by the associates and the march to the hounfort (Voodoo temple and its surroundings) begins. He is hustled along in the middle of the crowd. Thus he is screened from prying eyes to a great degree and also in his half-waking state he is unable to orientate himself. But the victim is not carried directly to the hounfort. First he is carried past the house where he lived. *This* is always done. *Must* be. If the victim were not taken past his former house, later on he would recognize it and return. But once he is taken past, it is gone from his consciousness forever. It is as if it never existed for him. He is then taken to the hounfort and given a drop of a liquid, the formula for which is most secret. After that the victim is a Zombie. He will work ferociously and tirelessly without consciousness of his surroundings and conditions and without memory of his former state. He can never speak again, unless he is given salt. "We have examples of a man who gave salt to a demon by mistake and he come man again and can write the name of the man who gave him to the loa,"

Jean Nichols told me and added that of course the family of the victim went straight to a Bocor and "gave" the man who had "given" their son.

Now this "Ba Moun" (give man) ceremony is a thing much talked about in Haiti. It is the old European belief in selling one's self to the devil but with Haitian variations. In Europe the man gives himself at the end of a certain period. Over in Haiti he gives others and only gives himself when no more acceptable victims can be found. But he cannot give strangers. It must be a real sacrifice. He must give members of his own family or most intimate friends. Each year the sacrifice must be renewed and there is no avoiding the payments. There are tales of men giving every member of the family, even his wife after nieces, nephews, sons and daughters were gone. Then at last he must go himself. There are lurid tales of the last days of men who have gained wealth and power thru "give man."

The wife of one man found him sitting apart from the family weeping. When she demanded to know the trouble, he told her that he had been called to go, but she was not to worry because he had put everything in order. He was crying because he had loved her very much and it was hard to leave her. She pointed out that he was not sick and of course it was ridiculous for him to talk of death. Then with his head in her lap he told her about the "services" he had made to obtain the advantages he had had in order to surround her with increasing comforts. Finally she was the only person left that he could offer but he would gladly die himself rather than offer her as a sacrifice. He told her of watching the day of the vow come and go while his heart grew heavier with every passing hour. The second night of the contract lapsed and he heard the beasts stirring in their little box. The third night which was the one just past, a huge and a terrible beast had emerged in the room. If he could go to the Bocor that same day with a victim, he still could go another year at least. But he had no one to offer except his wife and he had no desire to live without her. He took an affectionate farewell of her, shut

184

himself in his own room and continued to weep. Two days later he was dead.

Another man received the summons late one night. Bosu Tricorne, the terrible three-horned god, had appeared in his room and made him know that he must go. Bosu Tricorne bore a summons from Baron Cimiterre, the lord of the cemetery. He sprang from his bed in terror and woke up his family by his fear noises. He had to be restrained from hurling himself out of the window. And all the time he was shouting of the things he had done to gain success. Naming the people he had given. The family in great embarrassment dragged him away from the window and tried to confine him in a room where his shouts could not be heard by the neighbors. That failing, they sent him off to a private room in a hospital where he spent two days confessing before he died. There are many, many tales like that in the mouths of the people.

There is the story of one man of great courage who, coming to the end of his sacrifices, feeling that he had received what he bargained for, went two days ahead and gave himself up to the spirit to die. But the spirit so admired his courage that he gave him back all of the years he had bargained to take.

Why do men allegedly make such bargains with the spirits who have such terrible power to reward and punish?

When a man is ambitious and sees no way to get there, he becomes desperate. When he has nothing and wants prosperity he goes to a houngan and says, "I have nothing and I am disposed to do anything to have money."

The houngan replies, "He who does not search, does not find."

"I have come to you because I wish to search," the man replies.

"Well, then," the houngan says, "we are going to make a ceremony, and the loa are going to talk with you."

The houngan and the man go into the hounfort. He goes to a small altar and makes the symbol with ashes and gunpowder (indicating that it is a Petro invocation), pours the libation and begins to sing with the Ascon and then asks the seeker,

185

Altar to Baron Cimeterre

"What loa you want me to call for you?"

The man makes his choice. Then the houngan begins in earnest to summon the loa wanted. No one knows what he says because he is talking "langage" that is, language, a way of denoting the African patter used by all houngans for special occasions. The syllables are his very own, that is, something that cannot be taught. It must come to the priest from the loa. He calls many gods. Then the big jars under the table that contain spirits of houngans long dead begin to groan. These spirits in jars have been at the bottom of the water for a long time. The loa was not taken from their heads at death and so they did not go away from the earth but went to the bottom of the water to stay until they got tired and demanded to be taken out. All houngans have one more of these spirit jars in the hounfort. Some have many. The groaning of the jars gets louder as the houngan keeps calling. Finally one jar speaks distinctly, "Pourquoi ou derange' moi?" (Why do you disturb me?) The houngan signals the man to answer the loa. So he states his case.

"Papa, loa, ou mem, qui connais toute baggage ou mem qui chef te de l'eau, moi duange' on pour mande' ou servir moi." (Papa, loa, yourself, who knows all things, you yourself who is master of waters, I disturb you to ask you to serve me.)

The Voice: Ma connasis ca on besoin. Mais, on dispose pour servir moi aussi? (I know what you want, but are you disposed to serve me also?)

The Man: Yes, command me what you want.

Voice: I am going to give you all that you want, but you must make all things that I want. Write your name in your own blood and put the paper in the jar.

The houngan, still chanting, pricks the man's finger so sharply that he cries out. The blood flows and the supplicant dips a pen in it and writes his name and puts the paper in the jar. The houngan opens a bottle of rum and pours some in the jar. There is the gurgling sound of drinking.

The Voice: And now I am good (I do good) for you. Now I tell you what you must do. You must give me someone that

you love. Today you are going into your house and stay until tomorrow. On the eighth day you are returning here with something of the man that you are going to give me. Come also with some money in gold. The voice ceases. The houngan finishes presently, after repeating everything that the Voice from the jar has said, and dismisses the man. He goes away and returns on the day appointed and the houngan calls up the loa again.

The Voice: Are you prepared for me?

The Man: Yes.

The Voice: Have you done all that I told you?

The Man: Yes.

The Voice (to houngan): Go out. (to man) Give me the gold money.

(The man gives it.)

The Voice: Now, you belong to me and I can do with you as I wish. If I want you in the cemetery I can put you there.

The Man: Yes, I know you have all power with me. I put myself in your care because I want prosperity.

The Voice: That I will give you. Look under the table. You will find a little box. In this box there are little beasts. Take this little box and put it in your pocket. Every eighth day you must put in it five hosts (Communion wafers). *Never forget to give the hosts.* Now, go to your house and put the little box in a big box. Treat it as if it were your son. It is now your son. Every midnight open the box and let the beasts out. At four o'clock he will return and cry to come in and you will open for him and close the box again. And every time you give the beasts the communion, immediately after, you will receive large sums of money. Each year on this date you will come to me with another man that you wish to give me. Also you must bring the box with the beasts. If you do not come, the third night after the date, the beasts in the box will become great huge animals and execute my will upon you for your failure to keep your vow. If you are very sick on that day that the offering falls due say to your best friend that he must bring the offering box for you. Also you must send the name of the

188

person you intend to give me as pay for working for you and he must sign a new contract with me for you.

All is finished between the Voice and the man. The houngan re-enters and sends the man away with assurance that he will commence the work at once. Alone he makes ceremony to call the soul of the person who is to be sacrificed. No one would be permitted to see that. When the work in the hounfort is finished, then speeds the rider on the horse. The rider who faces backwards on the horse, who will soon place his lips to the crack of the victim's door and draw his soul away. Then will follow the funeral and after that the midnight awakening. And the march to the hounfort for the drop of liquid that will make him a Zombie, one of the living dead.

Some maintain that a real and true priest of Voodoo, the houngan, has nothing to do with such practices. That it is the bocor and priests of the devil—worshipping cults—who do these things. But it is not always easy to tell just who is a houngan and who is a bocor. Often the two offices occupy the same man at different times. There is no doubt that some houngans hold secret ceremonies which their usual following know nothing of. It would be necessary to investigate every houngan and bocor in Haiti rigidly over a period of years to determine who was purely houngan and who was purely bocor. There is certainly some overlapping in certain cases. A well known houngan of Leogane, who has become a very wealthy man by his profession is spoken of as a bocor more often than as a houngan. There are others in the same category that I could name. Soon after I arrived in Haiti a young woman who was on friendly terms with me said, "You know, you should not go around alone picking acquaintances with these houngans. You are liable to get involved in something that is not good. You must have someone to guide you." I laughed it off at the time, but months later I began to see what she was hinting at.

What is involved in the "give man" and making of Zombies is a question that cannot be answered anywhere with legal proof. Many names are called. Most frequently mentioned in

this respect is the Man of Trou Forban. That legendary charac-
ter who lives in the hole in the mountain near St. Marc. He
who has enchanted caves full of coffee and sugar plantations.
The entrance to this cave or this series of caves is said to be
closed by a huge rock that is lifted by a glance from the master.
The Marines are said to have blown up this great rock with
dynamite at one time, but the next morning it was there whole
and in place again. When the master of Trou Forban walks,
the whole earth trembles. There are tales of the master and his
wife, who is reputed to be a greater bocor than he. She does
not live with him at Trou Forban. She is said to have a great
hounfort of her own on the mountain called Tapion near Petit
Gouave. She is such a great houngan that she is honored by
Agoue' te Royo, Maitre l'eau, and walks the waters with the
same ease that others walk the earth. But she rides in boats
whenever it suits her fancy. One time she took a sailboat to
go up the coast near St. Marc to visit her husband, Vixama.
She appeared to be an ordinary peasant woman and the cap-
tain paid her no especial attention until they arrived on the
coast below Trou Forban. Then she revealed herself and ex-
pressed her great satisfaction with the voyage. She felt that the
captain had been extremely kind and courteous, so she went
to call her husband to come down to the sea to meet him.
Realizing now who she was, the captain was afraid and made
ready to sail away before she could return from the long trip
up the mountain. But she had mounted to the trou very
quickly and returned with Vixama to find the captain and his
crew poling the boat away from the shore in the wildest terror.
The wind was against them and they could not sail away. Mme.
Vixama smiled at their fright and hurled two grains of corn
which she held in her hand on to the deck of the boat and they
immediately turned into golden coin. The captain was more
afraid and hastily brushed them into the sea. They sailed south
all during the night, much relieved that they had broken all
connections with Vixama and his wife. But at first light the
next morning he found four gold coins of the same denomina-
tion as the two that he had refused the day before. Then he

190

knew that the woman of Vixama had passed the night on board and had given them a good voyage as well—the four gold coins were worth twenty dollars each.

There are endless tales of the feats of the occupant of this hole high up on this inaccessible mountain. But in fact it has yet to be proved that anyone has ever laid eyes on him. He is like the goddess in the volcano of Hawaii, and Vulcan in Mt. Vesuvius. It is true that men, taking advantage of the legend and the credulous nature of the people, have set up business in the mountain to their profit. The name of this Man of Trou Forban is known by few and rarely spoken by those who know it. This whispered name is Vixama, which in itself means invisible spirit. He who sits with a hive of honey-bees in his long flowing beard. It is he who is reputed to be the greatest buyer of souls. His contact man is reputed to be Mardi Progres. But we hear too much about the practice around Archahaie and other places to credit Trou Forban as the headquarters. Some much more accessible places than the mountain top is the answer. And some much more substantial being than the invisible Vixama.

If embalming were customary, it would remove the possibility of Zombies from the minds of the people. But since it is not done, many families take precautions against the body being disturbed.

Some set up a watch in the cemetery for thirty-six hours after the burial. There could be no revival after that. Some families have the bodies cut open, insuring real death. Many peasants put a knife in the right hand of the corpse and flex the arm in such a way that it will deal a blow with the knife to whoever disturbs it for the first day or so. But the most popular defense is to poison the body. Many of the doctors have especially long hypodermic needles for injecting a dose of poison into the heart, and sometimes into other parts of the body as well.

A case reported from Port du Paix proves the necessity of this. In Haiti if a person dies whose parents are still alive, the mother does not follow the body to the grave unless it is an

only child. Neither does she wear mourning in the regular sense. She wears that coarse material known as "gris-blanc." The next day after the burial, however, she goes to the grave to say her private farewell.

In the following case everything had seemed irregular. The girl's sudden illness and quick death. Then, too, her body stayed warm. So the family was persuaded that her death was unnatural and that some further use was to be made of her body after burial. They were urged to have it secretly poisoned before it was interred. This was done and the funeral went off in routine manner.

The next day, like Mary going to the tomb of Jesus, the mother made her way to the cemetery to breathe those last syllables that mothers do over their dead, and like Mary she found the stones rolled away. The tomb was open and the body lifted out of the coffin. It had not been moved because it was so obviously poisoned. But the ghouls had not troubled themselves to rearrange things as they were.

Testimony regarding Zombies with names and dates come from all parts of Haiti. I shall cite a few without using actual names to avoid embarrassing the families of the victims.

In the year 1898 at Cap Haitian a woman had one son who was well educated but rather petted and spoiled. There was some trouble about a girl. He refused to accept responsibility and when his mother was approached by a member of the girl's family she refused to give any sort of satisfaction. Two weeks later the boy died rather suddenly and was buried. Several Sundays later the mother went to church and after she went wandering around the town—just walking aimlessly in her grief, she found herself walking along Bord Mer. She saw some laborers loading ox carts with bags of coffee and was astonished to see her son among these silent workers who were being driven to work with ever increasing speed by the foreman. She saw her son see her without any sign of recognition. She rushed up to him screaming out his name. He regarded her without recognition and without sound. By this time the foreman tore her loose from the boy and drove her

away. She went to get help, but it was a long time and when she returned she could not find him. The foreman denied that there had ever been anyone of that description around. She never saw him again, though she haunted the water front and coffee warehouses until she died.

A white Protestant missionary minister told me that he had a young man convert to his flock who was a highly intelligent fellow and a clever musician. He went to a dance and fell dead on the floor. The missionary conducted the funeral and saw the young man placed in the tomb and the tomb closed. A few weeks later another white minister of another Protestant denomination came to him and said, "I had occasion to visit the jail and who do you suppose I saw there? It was C. R."

"But it is not possible. C. R. is dead. I saw him buried with my own eyes."

"Well, you just go down to the prison and see for yourself. He is there, for nobody knows I saw him. After I had talked with a prisoner I went there to see, I passed along the line of cells and saw him crouching like some wild beast in one of the cells. I hurried here to tell you about it."

The former pastor of C. R. hurried to the prison and made some excuse to visit in the cell block. And there was his late convert, just as he had been told. This happened in Port-au-Prince.

Then there was the case of P., also a young man. He died and was buried. The day of the funeral passed and the mother being so stricken some friends remained overnight in the house with her and her daughter. It seems that the sister of the dead boy was more wakeful than the rest. Late in the night she heard subdued chanting, the sound of blows in the street approaching the house and looked out of the window. At the moment she did so, she heard the voice of her brother crying out: "Mama! Mama! Sauvez moi!" (Save me!) She screamed and aroused the house and others of the inside looked out and saw the procession and heard the cry. But such is the terror inspired by these ghouls, that no one, not even the mother or sister, dared go out to attempt a rescue. The procession moved

on out of sight. And in the morning the young girl was found to be insane.

But the most famous Zombie case of all Haiti is the case of Marie M. It was back in October 1909 that this beautiful young daughter of a prominent family died and was buried. Everything appeared normal and people generally forgot about the beautiful girl who had died in the very bloom of her youth. Five years passed.

Then one day a group of girls from the same school which Marie had attended went for a walk with one of the Sisters who conducted the school. As they passed a house one of the girls screamed and said that she had seen Marie M. The Sister tried to convince her she was mistaken. But others had seen her too. The news swept over Port-au-Prince like wild fire. The house was surrounded, but the owner refused to let anyone enter without the proper legal steps. The father of the supposedly dead girl was urged to take out a warrant and have the house searched. This he refused to do at once. Finally he was forced to do so by the pressure of public opinion. By that time the owner had left secretly. There was no one nor nothing in the house. The sullen action of the father caused many to accuse him of complicity in the case. Some accused her uncle and others her god father. And some accused all three. The public clamored for her grave to be opened for inspection. Finally this was done. A skeleton was in the coffin but it was too long for the box. Also the clothes that the girl had been buried in were not upon the corpse. They were neatly folded beside the skeleton that had strangely outgrown its coffin.

It is said that the reason she was in the house where she was seen was that the houngan who had held her had died. His wife wanted to be rid of the Zombies that he had collected. She went to a priest about it and he told her these people must be liberated. Restitution must be made as far as possible. So the widow of the houngan had turned over Marie M. among others to this officer of the church and it was while they were wondering what steps to take in the matter that she was seen

by her school mates. Later dressed in the habit of a nun she was smuggled off to France where she was seen later in a convent by her brother. It was the most notorious case in all Haiti and people still talk about it whenever Zombies are mentioned.

In the course of a conversation on November 8, 1936, Dr. Rulx Léon, Director-General of the Service d' Hygiene, told me that a Zombie had been found on the road and was now at the hospital at Gonaives. I had his permission to make an investigation of the matter. He gave me letters to the officers of the hospital. On the following Sunday I went up to Gonaives and spent the day. The chief of staff of the hospital was very kind and helped me in every way that he could. We found the Zombie in the hospital yard. They had just set her dinner before her but she was not eating. She hovered against the fence in a sort of defensive position. The moment that she sensed our approach, she broke off a limb of a shrub and began to use it to dust and clean the ground and the fence and the table which bore her food. She huddled the cloth about her head more closely and showed every sign of fear and expectation of abuse and violence. The two doctors with me made kindly noises and tried to reassure her. She seemed to hear nothing. Just kept on trying to hide herself. The doctor uncovered her head for a moment but she promptly clapped her arms and hands over it to shut out the things she dreaded.

I said to the doctor that I had permission of Dr. Léon to take some pictures and he helped me to go about it. I took her first in the position that she assumed herself whenever left alone. That is, cringing against the wall with the cloth hiding her face and head. Then in other positions. Finally the doctor forcibly uncovered her and held her so that I could take her face. And the sight was dreadful. That blank face with the dead eyes. The eyelids were white all around the eyes as if they had been burned with acid. It was pronounced enough to come out in the picture. There was nothing that you could say to her or get from her except by looking at her, and the sight of this wreckage was too much to endure for long. We went to a more

cheerful part of the hospital and sat down to talk. We discussed at great length the theories of how Zombies come to be. It was concluded that it is not a case of awakening the dead, but a matter of the semblance of death induced by some drug known to a few. Some secret probably brought from Africa and handed down from generation to generation. These men know the effect of the drug and the antidote. It is evident that it destroys that part of the brain which governs speech and will power. The victims can move and act but cannot formulate thought. The two doctors expressed their desire to gain this secret, but they realize the impossibility of doing so. These secret societies are secret. They will die before they will tell. They cited instances. I said I was willing to try. Dr. Legros said that perhaps I would find myself involved in something so terrible, something from which I could not extricate myself alive, and that I would curse the day that I had entered upon my search. Then we came back to the case in hand, and Dr. Legros and Dr. Belfong told me her story.

Her name is Felicia Felix-Mentor. She was a native of Ennery and she and her husband kept a little grocery. She had one child, a boy. In 1907 she took suddenly ill and died and was buried. There were the records to show. The years passed. The husband married again and advanced himself in life. The little boy became a man. People had forgotten all about the wife and mother who had died so long ago.

Then one day in October 1936 someone saw a naked woman on the road and reported it to the Garde d'Haiti. Then this same woman turned up on a farm and said, "This is the farm of my father. I used to live here." The tenants tried to drive her away. Finally the boss was sent for and he came and recognized her as his sister who had died and been buried twenty-nine years before. She was in such wretched condition that the authorities were called in and she was sent to the hospital. Her husband was sent for to confirm the identification, but he refused. He was embarrassed by the matter as he was now a minor official and wanted nothing to do with the affair at all. But President Vincent and Dr. Leon were in the

neighborhood at the time and he was forced to come. He did so and reluctantly made the identification of this woman as his former wife.

How did this woman, supposedly dead for twenty-nine years, come to be wandering naked on a road? Nobody will tell who knows. The secret is with some bocor dead or alive. Sometimes a missionary converts one of these bocors and he gives up all his paraphernalia to the church and frees his captives if he has any. They are not freed publicly, you understand, as that would bring down the vengeance of the community upon his head. These creatures, unable to tell anything —for almost always they have lost the power of speech forever—are found wandering about. Sometimes the bocor dies and his widow refuses their responsibility for various reasons. Then again they are set free. Neither of these happenings is common.

But Zombies are wanted for more uses besides field work. They are reputedly used as sneak thieves. The market women cry out continually that little Zombies are stealing their change and goods. Their invisible hands are believed to provide well for their owners. But I have heard of still another service performed by Zombies. It is in the story that follows:

A certain matron of Port-au-Prince had five daughters and her niece also living with her. Suddenly she began to marry them off one after the other in rapid succession. They were attractive girls but there were numerous girls who were more attractive whose parents could not find desirable husbands for. People began to marvel at the miracle. When madame was asked directly how she did it, she always answered by saying, "Filles ce'marchandies peressables" (Girls are perishable goods, it is necessary to get them off hand quickly). That told nobody anything, but they kept on wondering just the same.

Then one morning a woman well acquainted with the madame of the marrying daughters got up to go to the lazy people's mass. This is celebrated at 4:00 A.M. and is called the lazy people's mass because it is not necessary to dress properly to attend it. It is held mostly for the servants anyway. So

197

people who want to go to mass and want no bother, get up and go and come back home and go to sleep again.

This woman's clock had stopped so she guessed at the hour and got up at 2:00 A.M. instead of 3:00 A.M. and hurried to St. Anne's to the mass. She hurried up the high steps expecting to find the service about to begin. Instead she found an empty church except for the vestibule. In the vestibule she found two little girls dressed for first communion and with lighted candles in their hands kneeling on the floor. The whole thing was too out of place and distorted and for a while the woman just stared. Then she found her tongue and asked, "What are you two little girls doing here at such an hour and why are you dressed for first communion?"

She got no answer as she asked again, "Who are you anyway? You must go home. You cannot remain here like this."

Then one of the little figures in white turned its dead eyes on her and said, "We are here at the orders of Madame M. P., and we shall not be able to depart until all of her daughters are married."

At this the woman screamed and fled.

It is told that before the year was out all of the girls in the family had married. But already four of them had been divorced. For it is said that nothing gotten through "give man" is permanent.

Ah Bo Bo!

CHAPTER 14

SECTE ROUGE

I f you stay in Haiti long enough and really mingle with the people, the time will come when you hear secret societies mentioned. Nobody, of course, sits down and gives lectures on these dread gatherings. It is not in any open way that you come to know. You hear a little thing here and see a little thing there that seem to have no connection at first. It takes a long time and a mass of incidents before it all links up and gains significance. To bring it down to a personal thing, I came at it backwards. I did not move from cause to effect. I saw the effect and it aroused my curiosity to go seek the cause.

For instance, I kept meeting up with an unreasoning fear. Repeated incidents thrust upon my notice a fear out of all proportion to the danger. That is, to what seemed to be the danger. Some of the things I heard and saw seemed crazy until I realized that it was all too simple to be nothing more than it showed from the outside. The first of these incidents came after I had been in Haiti less than a month.

I had taken my little house in the suburbs of Port-au-Prince with the excellent maid that Mme. Jules Faine had found for me. One night I heard drums throbbing at a distance. They

came from the mountain that rose as a sort of backdrop behind the village. Immediately the sounds caught my attention, not just because they were drum tones. I had heard plenty drum music since I had been there. You cannot avoid hearing the drums in Haiti. Besides M. Clement Magliore, publisher of *Le Matin* and other friends had taken me to Saturday night bomboches and I had heard the rada drums. But the drum that I was hearing this night did not have the deep singing quality of the rada. This was a keen, high-pitched sound that was highly repetitious. I resolved to go and see this new kind of dance, or whatever it was.

I began to dress and woke up Lucille, the maid. I told her what I planned to do and told her to get dressed. She got up and dressed readily enough, but she refused to go. She refused to go outside the door. Lucille went even further than that. She went and stood guard and would not let me go outside of the door either. And all the explanation she would give was, "It is very bad to go there, Mademoiselle. Do not search for the drums. Anyway the drum is not near. It is far away. But such things are very bad."

Since I could not do anything to make her go with me, I had to stay home. This incident struck me as strange, the more I thought about it. It was not usual for Lucille not to want to do anything I wanted done because she loved to please. Already I was beginning to love her and to depend upon her. Later on I put her on the roster of my few earthly friends and gave her all my faith. Lucille with her great heart, her willingness to help, her sympathy under varying conditions and her great honesty. The treasury of the United States could be left in her hands with absolute safety. In addition she is extremely kind. Thinking the incident of the drum over for several days I asked Lucille what she meant. Why was it bad for me to go to the music-makers? She knew that I had been to other native gatherings. Why not this one also? She gave some sort of a general answer. I have asked her many times since, but to this day, she has never said anything more definite than "Some things are very dangerous to see, Mademoiselle. There are

many good things for you to learn. I am well content if you do not run to every drum that you hear." That was the first instance.

The second incident came shortly afterwards and was more pointed. After two months I grew tired of my landlord swindling me and moved to Pacot. There Joseph bestowed himself upon me as a yard-boy. Two days after I agreed to keep him, he moved his wife and infant child into his room that was in a sort of basement. All went well for a week or two. One night I was propped up in bed writing as usual, when I smelled an odor of something burning. It smelled awful. Like rubber and several other things equally disagreeable smouldering. I stood it as long as I could in bed, and then I got up and called Lucille, who slept in the room next to mine. We went about looking for the source. When we got to the salon which was directly over Joseph's room the smell was overwhelming, so I concluded he was responsible for it.

I called down to Joseph and demanded to know what on earth was going on. He told me he was burning something to drive off bad things. What bad things, I wanted to know. I was good and angry about the thing. He said not to be angry, please. But cochon gris (gray pigs) qui mange' moun (who eat people) were after his baby and he "was make a little ceremony to drive them away." I told him to come into the house and tell me about it, but he refused. He was not going to open his room door until daylight. The house was so arranged that he must come into the yard, round the corner of the house and mount a high flight of steps before he could enter the house. This he refused to do. He begged me not to be angry, but he could not come out until daylight.

When I came down to breakfast the next morning and looked down at the yard and saw Joseph's wife sitting there in the sunlight calmly nursing her child, Joseph's explanations of the night before seemed so ridiculous that I grew very peevish and I made myself a promise to give him a highly seasoned piece of my mind. But he did not wait for me to summon him. As soon as he saw me at the table he came of

201

his own accord. He told me that he had seen figures in white robes and hoods, no, some of them had red gowns and hoods, lurking in the paraseuse (hedge) the night before. He thought the cochons gris knew that he had a very young baby and they wanted to take it and eat it.

"Now Joseph," I objected, "you are trying to excuse yourself for disturbing me by telling a fantastic lie. In the first place I have never seen a grey pig and do not believe they exist. In the second place, hogs do not go about in robes of any sort and neither do they go about eating babies. Pas capab'."

"But yes, Mademoiselle, there are very bad thing that go about at night. I have great fear from what I see last night. I want you to take my baby in the house with you. Then nobody can steal him."

"No, Joseph, your baby is too young. He would cry all of the time and disturb me. I must have quiet to write a book."

"But he is very little, Mademoiselle. He cannot cry much. Take him to sleep at night, please, Mademoiselle. If you don't want baby in the house, then please give me seven gourds and I put my wife and baby on the boat and send them to Petit Gouave. My family will take care of them. Then I come back and I work for you very good because then I will not worry about my baby die. First they make him die, then they take him from the grave."

The discussion was broken off there because an upper class Haitian came at that moment for a morning visit. The Haitian peasant is very humble before his betters, so Joseph shut up quickly and went on back to cleaning up the yard. The gentleman and I went on the front gallery that commands such a magnificent view of Port-au-Prince and the sea, and sat down. I laughed and told him the fantastic explanation that Joseph had made. He laughed briefly, then he said he was thirsty. He would neither permit me to go for a glass of water for him, nor call Lucille to bring it. He would just go out to the kitchen and let Lucille give it to him there. After he went to the rear, I thought I'd join him and offer him a drink of rum. When I reached the end of the salon I saw that he was not asking

Lucille for water at all. He was on the back gallery speaking to Joseph in the yard. He was speaking in Creole and calling Joseph every kind of a stupid miscreant. He ended his tirade by saying that since Joseph had been so foolish as to tell a foreigner, who might go off and say bad things about Haiti, such things, he was going to see that the Garde d'Haiti gave him a good beating with a coco-macaque. Knowing that I would embarrass my friend by letting him know that I had heard, I went back to the porch as quietly as I could and waited until he returned before I mentioned the rum.

When he came back to where I sat he accepted the rum and then explained to me with all the charm that an upper class Haitian is so full of, that the peasants of Haiti were a poetical group. They loved the metaphor and the simile. They had various figures of speech that could easily be misunderstood by those who did not know their ways. For example: It was the habit of the peasant to say "mange' moun" (eat a man) when he really meant to kill. Had I never heard the Haitian threat "map mange' ou sans cel" (I'll eat you without salt)? It is of course the same exaggerated threat that is commonly used in the United States by white and black. "I'll eat you up! I'll eat you alive; I'll chew you up!"

I acknowledged that I had heard the expression in the market several times. I added that we Negroes of America also employed the figures of speech continuously. Very well then, he replied, I would understand, and not take the mode of speech of the peasants literally. He never referred directly to Joseph and neither did I. He sipped his rum, and I drank coconut water and we studied the magnificent panorama before us and spent a pleasant morning. But the thing left me quivering with curiosity and I wanted to call Joseph and ask questions. I did not do this because I knew that the time had passed for him to answer me truthfully. He was visibly cowed by that Gros Negre. I would have given most anything to know what it was Joseph had started to explain.

A little later I told a very intelligent young Haitian woman that I was going to the mountains shortly to study Voodoo

practices. We had come to be very close to each other. We had gotten to the place where neither of us lied to each other about our respective countries. I freely admitted gangsters, corrupt political machines, race prejudice and lynchings. She as frankly deplored bad politics, overemphasized class distinctions, lack of public schools and transportation. We neither of us apologized for Voodoo. We both acknowledged it among us, but both of us saw it as a religion no more venal, no more impractical than any other.

So when I told her that I was going to Archahaie to live in the compound of a bocor in order to learn all I could about Voodoo, I did not expect her to take the attitude of the majority of the Haitian elite, who have become sensitive about any reference to Voodoo in Haiti. In a way they are justified in this because the people who have written about it, with one exception, that of Dr. Melville Herskovits, have not known the first thing about it. After I had spoken she sat very still for a while, and then she asked me if I knew the man well that I was going to study with. I said no, not very well, but I had reports from many directions that he was powerful. She was very slow about talking, but she said that I was not to go about trusting myself to people that I knew nothing about. Furthermore it was not possible for me to know whom to trust without advice. All was not gold that glittered. There were different kinds of priests. Some of them worked with two hands. Some things were good to know and some things were not. I must make no contacts nor must I go anywhere to stay unless I let my friends advise me. She was as solemn and specific about the warning as she was vague about what I was to fear. But she showed herself a friend in that she introduced me to an excellent mambo (priestess) whom I found sincere in all her dealings with me.

A physician of very high calibre said the same thing to me at Gonaives the day that I visited the Zombie there at the hospital and photographed her, or it. Over the coffee cups we discussed the possibility of a drug being used to produce this semblance of death. That is his theory of the matter. He said that he would give much to know the secret of it. It was his

belief that many scientific truths were hidden in some of these primitive practices that have been brought from Africa. But the knowledge of the plants and formulae are secret. They are usually kept in certain families, and nothing will induce the guardians of these ancient mysteries to divulge them. He had met up with some startling things in primitive chemistry by reason of his position at the hospital, but never had he been able to break down the resistance of the holders of those secrets. One man was placed in prison and threatened with a long term unless he told. The prisoner produced a fever temperature much higher than any mortal man is supposed to be able to stand to force the prison authorities to release him. But this they refused to do. Then he sent another prisoner to get a little pouch of powdered leaves which he had hidden in his clothes. He refused to let either the doctors or the gendarmes get it for him. When he had it, he mixed a pinch of it with water, allowed it to stand for a few minutes and drank the mixture. In three hours his temperature was perfectly normal. Soon they released him without being able to gain one word of information out of him. He merely stated that what they asked was a family secret brought over from Guinea. He could not reveal it. That was final. He left the prison and the hospital as he had come.

Hearing this, I determined to get at the secret of Zombies. The doctor said that I would not only render a great service to Haiti, but to medicine in general if I could discover this secret. But it might cost me a great deal to learn. I said I was devoted to the project and willing to try no matter how difficult. He hesitated long and then said, "Perhaps it will cost you more than you are willing to pay, perhaps things will be required of you that you cannot stand. Suppose you were forced to—could you endure to see a human being killed? Perhaps nothing like that will ever happen, but no one on the outside could know what might be required. Perhaps one's humanity and decency might prevent one from penetrating very far. Many Haitian intellectuals have curiosity but they know if they go to dabble in such matters, they may disappear permanently.

But leaving possible danger aside, they have scruples."

Things like this kept on happening. Like Arius and Lucille having one of those quarrels over jurisdiction that all Haitian servants seem to be having eternally, and during which Arius saying that she had better be careful how she insulted him. She must know whom she was dealing with before she went too far. On hearing this, Lucille was as terrified as if he had pointed a gun at her heart. She came to me and wanted to leave. I persuaded her against it and chided Arius a little. But the next day when an old man entered the yard with his black head covered with a red handkerchief, Lucille fled the place and went down to the nearest police station for protection. Then at La Gonave I heard references to things done by some society in a village across the Morne from Ansa-a'-galets which the Garde d'Haiti was going to suppress. Then on one of those little sailboats that matches itself against wind and tide for eighteen miles between Ansa-a'-galets and Port-au-Prince, I heard some more puzzling talk. Things mentioned, not by name, but by insinuation, and only briefly at that. Then that quick hush of uneasiness. But in all this time, not one single individual had ever mentioned directly the existence of secret societies let alone put a name to one. What had been conveyed was a feeling of fear of something that nobody wanted to discuss.

Then one afternoon in the Tourist Bar, a man who is a Haitian and also not a Haitian said something that suddenly connected all of these happenings and gave them a meaning beside. So I began to see a great deal of him. From time to time he told me many things and, without knowing it, put me on the trail of what to look for. One N'gan (houngan) with whom I was particularly friendly answered my questions quite frankly and took me to a house in the Belair district where the cobblestones of the floor were polished like marble from the passage of so many feet and so many generations that they inspired awe in themselves. There first I saw and examined a paper, yellow with age, that bore the "mot de passage" (pass-

word) and discovered that Cochon Gris was a name of a society.

On the way back home I remarked that I had seen no altar and hounfort as I was accustomed to in Voodoo worship. There were a few things about, but I knew what to expect and the regular set-up was not there. There were a dozen bottles on a table, some crunches, or clay water jugs. The place of honor was given to an immense black stone that was attached to a heavy chain, which was itself held by an iron bar whose two ends were buried in the masonry of the wall. A well used cuvette was before the stone that had the same look of age and memory as an ancient gibbet. When we first entered, the bocor had touched the stone proudly and said, "This is for Petro. It has the power to do all things—the good and the evil." Certainly neither of us disputed the statement. But when we were clear of the place, I said I knew that the bocor had lied to us. The houngan was proud of me, then, as a pupil because I had noticed the difference. He said that it really was not a place of Voodoo. That the Cochon Gris was a secret society and a thing forbidden by law and detested by all except the members. That they used the name of Voodoo to cloak their gatherings and evade arrest and extinction.

Later on I introduced the subject in a conversation with a well-known physician of Port-au-Prince and he discussed the matter most intelligently.

"Our history has been unfortunate. First we were brought here to Haiti and enslaved. We suffered great cruelties under the French and even when they had been driven out, they left here certain traits of government that have been unfortunate for us. Thus having been a nation continually disturbed by revolution and other features not helpful to advancement we have not been able to develop economically and culturally as many of us have wished. These things being true, we have not been able to control certain bad elements because of a lack of a sufficient police force."

"But," I broke in, "with all the wealth of the United States and all the policing, we still have gangsters and the Ku Klux

207

Klan. Older European nations still have their problems of crime."

"Thank you for your understanding. We have a society that is detestable to all the people of Haiti. It is known as the Cochon Gris, Secte Rouge and the Vinbrindingue and all of these names mean one and the same thing. It is outside of, and has nothing to do with Voodoo worship. They are banded together to eat human flesh. Perhaps they are descended from the Mondongues and other cannibals who were brought to this Island in the Colonial days. These terrible people were kept under control during the French period by the very strictures of slavery. But in the disturbances of the Haitian period, they began their secret meetings and were well organized before they came to public notice. It is generally believed that the society spread widely during the administration of President Fabre Geffrard (1858–1867). Perhaps it began much earlier, we are not sure. But their evil practices had made them thoroughly hated and feared before the end of this administration. It is not difficult to understand why Haiti has not even yet thoroughly rid herself of these detestable creatures. It is because of their great secrecy of movement on the one hand and the fear that they inspire on the other. It is like your American gangsters. They intimidate the common people so that even when they could give the police actual proof of their depredations, they are afraid to appear in court against them.

"The cemeteries are the places where they display the most horrible aspects of their inclinations. Someone dies after a short illness, or a sudden indisposition. The night of the burial, the Vinbrindingues go to the cemetery, the chain around the tomb is broken and the grave profaned. The coffin is pulled out and opened and the body spirited away. And now, if you are friendly to Haiti as you say you are, you must speak the truth to the world. Many white writers who have passed a short time here have heard these things mentioned, and knowing nothing of the Voodoo religion except the Congo dances, they conclude that the two things are the same. That gives a

208

wrong impression to the world and makes Haiti a subject for slander."

Dr. Melville Herskovits heard this society mentioned at Mirablais as the "Bissage," and "Cochon sans poils" (*Life in a Haitian Valley,* page 243). He quotes Dr. Elsie Clewes Parsons as saying that the peasants around Jacmel told her "people *do* eat people at Aux Cayes. I *know* it." Her informant went on to tell of human finger nails being found on what had been sold as pigs' feet (pages 246, 247).

"But how can I say these things until I am very sure?" I asked him. I had participated in many ceremonies, and had never seen anything that even bordered on human sacrifice, but I knew that I did not know every Voodoo ceremony in Haiti. How could I say unless I eliminated the possibility of an occasional sacrifice? Later I found what he said to be true.

Then I found out about another secret society. It is composed of educated, upper class Haitians who are sworn to destroy the Red Sect in Haiti. They are now taking the first step of the program. That is, to drive the adepts of the organization out from under the cloak of Voodooism so that they may be recognized and crushed by the government. Naturally, there are laws against murder in Haiti, however committed. In addition the penal code contains provisions against magic practices which can be invoked when evil traits are discovered. Official Haiti knows of the Secte Rouge and frowns upon it, but one must have legal proof to gain a conviction. A high official of the Garde d'Haiti told me that he has every known member in the neighborhood of Port-au-Prince under surveillance. "But one cannot arrest a man for what he believes," he said, "one must have proof that the suspect has put his belief to action. And when we have that, ah, you shall see something." My attention was called to the trial and conviction of the sorceress in the affair of Jeanne Nelie, "That affair which gave place to a trial which echoed around the world." The effect of this conviction was to cause the adepts of Secte Rouge to take refuge under the greatest secrecy which has since been axiomatic. Now they give themselves names of

the Petros, the Erzulies and the Locos, and perhaps many other Voodoo loas.

I witnessed one such fraudulent ceremony myself one night on the Plain Cul-de-Sac. In company with a man who knew all about Voodoo in that part of Haiti, I was returning from a Congo dance when we approached a small cluster of houses where a ceremony was in progress. I asked to stop and see it and we did. I got a very disagreeable surprise, because they sacrificed a dog. This must be some new cult of Voodoo, I concluded, so I asked. They told me it was a service to Mondongue, who always made his appearance in the form of a great dog, and when one beheld such a manifestation, it was certainly a time for fear. My friend and I soon left. When we were far away, he said to me, "They do not make a Voodoo service at all. Mondongue is not a loa of Voodoo. They do not always content themselves with dog, I am afraid." He showed the strongest feeling of revulsion to the whole matter and I was glad because then I did not need to hide my own distaste. I had not read St. Mery at that time and had never heard the name Mondongue pronounced in all Haiti:

"Never has there been a character more hideous than that of these last (The Mondongues), whose depravities have reached the execrable of excesses, that of to eat their fellows. There were brought to Saint Dominique (Haiti) some of these butchers of human flesh (for at the houses of these butchers the flesh of humans has been sold as veal) and here (in Haiti) they caused, as in Africa, the horror of the other Negroes.— One is convinced that these people have kept up their odious inclinations. Notably in 1786 a Negress was confined in a hospital on a plantation in the vicinity of Jeremy. The proprietor having remarked that the greater part of the Negro babies perished in the first eight days after their birth, spied upon the midwife whom he surprised eating one of these infants who had recently been buried. She confessed that she caused them to die for this purpose."*

*Tome Premier, page 39, L. E. Moreau de St. Mery.

The most celebrated meeting place in the Department of the West used to be the bridge across the lake at Miragoane. An awful sight to the late traveller! The bridge covered with candles, the brilliantly costumed figures, themselves bearing multiple candles and the little coffin that is their object of worship, in the center of the floor of the bridge, the sharp piercing voice of the little drum and the wildly dancing horde.

This is how a meeting was held.

The two marked stones were struck together, the whispered word was sent secretly, but swiftly by word of mouth to all of the adepts. A full meeting was to be held in a town some miles south of Port-au-Prince. This distance is a bit tiresome even by automobile, considering the condition of the roads. But one of the remarkable things concerning the members of the Red Sect is their great mobility. They cover great distances with incredible speed.

The meeting is in a sort of court surrounded by several small cailles (thatched houses). There is a huge silk cotton tree in the open space, and behind the houses, fields and fields of cane.

The night was very dark but starry. Only a homemade lamp made simply and crudely from a condensed milk can fought against the blackness. Members came in like shadows from all directions. One came down a narrow path from the main road. Two more came into the opening from cane fields, parting the rustling leaves so skillfully that there was no sound. They kept coming like this and every member carried his sac paille which held his trappings. There was subdued talk but no whispers. The time had not come for expression, that was all. They kept coming until perhaps a hundred persons were gathered there. Looking around the court, they were just ordinary looking people. Might be anybody at all getting ready for a prayer meeting or a country dance.

All of the officers came at last and the word went around for everyone to robe themselves. This was quickly done and the drab crowd became a shining assembly in red and white with bared heads. Some began to leap and dance, imitating the

motions of various animals. The singing and dancing became general and the head coverings were put on. The adepts were now all transformed into demons with tails and horns, cows, hogs, dogs and goats. Some even became cocks, and all of a most terrifying aspect. Standing silently in that dimlit court-yard they were enough to strike terror into the breast of the most courageous. But now they began to dance and sing. The little, high pitched drum resounded and the Emperor, a most fearful sight, took the center of the group and began to sing and the President, the Minister, the Queen, the cuisineres, the officers, the servants, bourresouse, and all the grades joined in and the sound and the movement was like hell boiling over. Over and anew they sang to the drums.

> Carrefour tingindingue, mi haut, mi bas-e'
> Carrefour tingindingue, mi haut, mi bas-e'
> Oun prali' tingindingue, mi haut, mi bas, tingindingue
> Oun prali' tingindingue, mi haut, mi bas, tingindingue
> Oun prali' tingindingue, mi haut, mi bas, tingindingue

Now the whole body prepared to depart. Every member lighted a candle and, chanting to the drums, they struck a rhythmic half dance, half trot and marched forth to a certain cross-road not more than a mile away. The Secte Rouge was going to the cross-roads to do honor to the loa who rules there. What they wished for tonight would be in his realm. They were going there to give food and drink and money to Maitre Carrefour (Lord of the Cross Roads) and after that they were going to ask favors of him.

As the fearsome procession pranced on down the highway, it halted before several doors and danced furiously. The doors opened and other figures leaped out, red-robed like the rest. They had candles blazing on top of their heads, on the backs of their hands and planted on their feet. They joined the dancing and marched off with the band. These turned out to be honorary members, who partake in the dancing only until a further degree is conferred upon them. The honorary mem-

bers are those who are in sympathy with the society, but for one reason or another are not yet fully initiated. The group moves on with the little coffin being carried in the very middle of the procession. It is brilliant with candles. This was the soul about which everything moved.

At the cross-roads, Maitre Carrefour was given food and drink and money. But only the copper one cent pieces of Haitian money known as "cob." The coffin was set down in the very center of the cross roads and the ceremony performed. After Maitre Carrefour had been well fed and his thirst slaked, he was asked for powers. He was asked to grant powers to find victims on the road and he was asked for powers to overtake and overpower these victims. Finally the Master of the Cross-roads gave a sign of assent by entering the head of one of the female adepts. She became possessed. The entire body of the society became jubilant of success and concluded the service and marched off to a cemetery not too far away.

They were going there to do honor to Baron Maitre Cimiterre and to ask him for powers similar to those already granted by Maitre Carrefour, that is, success in their maneuvers, fortune to find victims, and power to catch and to eat them.

They were singing again, but the song had changed. Now they were singing and whirling as they went.

"Sortie Nan Cimiterre, toute corps moin senti malingue'
Sortie Nan Cimiterre, toute corps moin senti malingue'
Sortie Nan Cimiterre, toute corps moin senti malingue,'
Sortie Nan Cimiterre, toute corps moin senti malingue' "

And so singing and dancing they arrived at the gate of the cemetery. The main body halted at the gate while the queen entered and went to a grave that had evidently been selected in advance and began to dance about it. This she did five times, but stopped at the head of the tomb to sing each time that she arrived there. After the fifth turn she took a bottle of clairin

and with it outlined a large cross upon the stone and placed a candle at the head and a kwee (bowl made by cutting a calabash in half lengthwise) with blood seasoned with condiments in it at the foot of the cross. The cross is the emblem of Baron Cimiterre, who is also called Baron Samedi, and Baron Croix. She danced some more and sang a song that began with

"Cote' toute moun" (where are all men, or everybody).

Then everybody entered the cemetery in single file, each person with his or her hand on the hip of the person before and with a lighted candle in the other. The youngest adept is selected and stretched upon the tomb and all the lighted candles are placed around him. The kwee, a bowl made of half a calabash, is set upon his navel. Everybody around the tomb place the palms of their hands together and sing, moving around the tomb until each person returns again to stand before their own candle. The invocation was made and when it was felt Baron Samedi had granted the request, the queen announced, "The powers are joined with the degrees!" All others bowed and covered their eyes so that nobody knew the exact moment that she left the cemetery. Nor which way she went. Then the youngest adept arose and went and none saw him go either. Then all the rest ran out in every direction as fast as they could because all feared that Baron Cimiterre would select him or her as a victim. But soon the whole convoy was joined together again not far from the cemetery. The last two men came out of the gate walking backwards, brandishing well sharpened machetes, defending the rear from an attack by the Lord of the Dead.

Now it was decided that the convoy should proceed to a certain bridge over a stream that crossed the highway near a sedgy lake. This it seems, had long been a favorite rendezvous. At the bridge, more candles were brought forth and every part of the structure was brilliantly illuminated, even to the rails at the sides. The little coffin was set down in the center of the

floor of the bridge. It was an awful sight. This bridge lighted up by hundreds of flickering candles, peopled by a horde of fantastic creatures with the coffin, the symbol of their strange appetites and endeavors, in the midst.

A strong guard for defense was stationed along the road on either side of the bridge to prevent attacks from enemies. There had been trouble on other occasions. The Brave Guedé, servants of Baron Samedi, who are particularly numerous in that neighborhood, and who consider this bridge their particular place of worship, had fallen upon the Secte Rouge in the midst of their celebration in times past and inflicted serious injuries. So these guards, armed with machetes, were thrown out along the road to deal with these people without mercy in case they attempted to dislodge the Red Sect this night.

Now the members of the society went running and dancing along the routes hunting for victims. They had been granted all powers and everything else was arranged. The higher officers remained on the bridge relatively inactive. They would intercept any luckless person who tried to pass that point. Woe be to the wayfarer who had no "mot de passage" who approached that bridge that night.

The bourresouse, the advance guard, ran fast and hunted farther afield than all the rest. The success of the whole matter rests upon the courage, discretion, and efficiency of this advance guard. They are beautifully trained stealthy scouts. They faded off into the darkness swiftly like so many leopards with their cords in their hands. These cords are made from the dried and well cured intestines of human beings who have been the victims of other raids. They are light and have the tensile strength of cello strings. The gut of one victim drags to his death his successor. Except in special cases no particular person is hunted. The advance guard, cord in hand ready for instant use, stalks the quarry. And the amount of territory that these guards can cover in a short time is unbelievable. When a victim is located, he is surrounded and the cord is whipped

215

about his throat to silence him first. Then he is bound and led before the main convoy.

The main convoy waited there on the bridge relatively inactive until the word came that someone was approaching from the west on horse back. At any moment the rider might have been dragged from his horse without giving him an opportunity for resistance, but knowing that he must cross that bridge the guards and the other servants allowed him to proceed. Just before he reached the brilliantly lighted bridge, he dismounted and hesitated a long time, evidently considering turning back. But finally he, a well dressed young man, approached with the utmost diffidence and was challenged. Dripping with terror, he first made the sign of the cross, before he thought to answer, "Si lili te' houmba, min dia, mi haut." It was a glorious thing that that handsome, well dressed young man knew that fantastic sentence. The Emperor was favorably impressed by him also. He was almost paternal in his manner as he bade the boy proceed.

Soon after, one detail of the bourresouse returned with game from the chase and led their victim before the Emperor, the Queen, the President, the minister and all of the other officers. Finally all of the guards returned, but that took hours. When all were in, the whole convoy moved back to the original meeting place. Then the ceremony began to change the three victims into beef. That is, one was "turned" into a "cow" and two into "pigs." And under these terms they were killed, and divided. Everyone received their share of the game except the honorary members. They serve without being allowed a taste.

By that time dawn is nigh. The animals and demons are "transformed" again into human beings who may walk anywhere without attracting the least attention. After the happenings of the night one might expect the sun to rise on Judgment Day. But no, it was just a common day outside in the court.

The identities of the Secte Rouge, Cochon Gris, Vinbrindingue are really secret, hence the difficulty for the Garde d'Haiti to cope with it. Like the American gangster and racket-

216

eer, their deeds are well-known. But the difficulty is to prove it in court. And like the American racketeer, the Secte Rouge takes care that its members do not talk. It is a thing most secret and it stays that way. The very lives of the members depend upon it. There is swift punishment for the adept who talks. When suspicion of being garrulous falls upon a member, he or she is thoroughly investigated, but with the utmost secrecy, without the suspect knowing that he is suspect. But he is followed and watched until he is either accounted innocent or found guilty. If he is found guilty, the executioners are sent to wait upon him. By hook or crook, he is gotten into a boat and carried out beyond aid and interference from the shore. After being told the why of the thing, if indeed that is necessary, his hands are seized by one man and held behind him, while another grips his head under his arm. A violent blow with a rock behind the ear stuns him and at the same time serves to abraise the skin. A deadly and quick-acting poison is then rubbed into the wound. There is no antidote for this poison and the victim knows it. However well he might know how to swim, when he is thrown overboard, he knows it would be useless. He would never be alive long enough to reach the shore. When his body strikes the water, the incident is closed.

Ah Bo Bo!

CHAPTER 15

PARLAY CHEVAL OU
(TELL MY HORSE)

Gods always behave like the people who make them.
One can see the hand of the Haitian peasant in that
boisterous god, Guedé, because he does and says the
things that the peasants would like to do and say. You can see
him in the market women, in the domestic servant who now
and then appears before her employer "mounted" by this god
who takes occasion to say many stinging things to the boss.
You can see him in the field hand, and certainly in the group
of women about a public well or spring, chattering, gossiping
and dragging out the shortcomings of their employers and the
people like him. Nothing in Haiti is quite so obvious as that
this loa is the deification of the common people of Haiti. The
mulattoes give this spirit no food and pay it no attention at all.
He belongs to the blacks and the uneducated blacks at that.
He is a hilarious divinity and full of the stuff of burlesque. This
manifestation comes as near a social criticism of the classes by
the masses as anything in all Haiti. Guedé has another distinc-
tion. It is the one loa which is entirely Haitian. There is neither
European nor African background for it. It sprang up or was

219

called up by some local need and now is firmly established among the blacks.

This god of the common people has no hounfort. A cross at the head of a tomb inside the yard of the hounfort is his niche. If there is none there it is enough for the houngan to plant a cross dedicated to him.

The apparel of this god is in keeping with his people. He likes to dress himself in an old black overcoat, a torn old black hat with a high crown and worn-out black pants. He loves to smoke a cigar. He cavorts about, making coarse gestures, executing steps like the prancing of a horse, drinking and talking.

His drink is very special. This god likes clairin well seasoned with hot peppers, to which powdered nutmeg is added at times. The grated nutmeg should always be in this strong, raw rum infusion, but when it is not to be had, Guedé will content himself with the pepper in alcohol. He also drinks pure clairin, that raw white rum of Haiti. He eats roasted peanuts, and parched corn which is placed at the foot of the cross on a plate. No white cloth is used in this offering as in others.

There is no real service or ritual for Guedé. One places a circle of twenty white candles about the cross dedicated to him. Some adepts offer him an old redingote or an old pair of pants, but roasted peanuts and parched corn are customary. The people who created Guedé needed a god of derision. They needed a spirit which could burlesque the society that crushed him, so Guedé eats roasted peanuts and parched corn like his devotees. He delights in an old coat and pants and a torn old hat. So dressed and fed, he bites with sarcasm and slashes with ridicule the class that despises him.

But for all his simple requirements, Guedé is a powerful loa. He has charge of everyone within the regions of the dead, and he presides over all that is done there. He is a grave-digger and opens the tombs and when he wishes to do so he takes out the souls and uses them in his service.

Guedé is never visible. He manifests himself by "mounting" a subject as a rider mounts a horse, then he speaks and

acts through his mount. The person mounted does nothing of his own accord. He is the horse of the loa until the spirit departs. Under the whip and guidance of the spirit-rider, the "horse" does and says many things that he or she would never have uttered un-ridden.

"Parlay Cheval Ou" (Tell My Horse), the loa begins to dictate through the lips of his mount and goes on and on. Sometimes Guedé dictates the most caustic and belittling statements concerning some pompous person who is present. A prominent official is made ridiculous before a crowd of peasants. It is useless to try to answer Guedé because the spirit merely becomes angry and may reprove the important person by speaking of some compromising event in the past in the coarsest language or predicting something of the sort in the near future to the great interest of the listening peasants who accept every word from the lips of the horse of Guedé as gospel truth. On several occasions, it was observed that Guedé seemed to enjoy humbling his betters. On one occasion Guedé reviled a well-dressed couple in a car that passed. Their names were called and the comments were truly devastating to say the least.

With such behavior one is forced to believe that some of the valuable commentators are "mounted" by the spirit and that others are feigning possession in order to express their resentment general and particular. That phrase "Parlay cheval ou" is in daily, hourly use in Haiti and no doubt it is used as a blind for self-expression. There are often many drunken people in the cemeteries who claim to be "mounted." The way to differentiate between the persons really "mounted" and the frauds is to require them to swallow some of the drink of Guedé and to wash their whole face in it. The faker will always draw back because he fears to get that raw rum and hot pepper in his eyes, while the subject really mounted will do it. They do it without being told and it never seems to injure them. So one is forced to the conclusion that a great deal of the Guedé "mounts" have something to say and lack the courage to say it except under the cover of Brave Guedé.

Down in the neighborhood of Port-au-Prince behind St. Joseph's I witnessed one of these simulated possessions. A man was crying, "Tell my horse," again and again and defaming many persons. A girl approached. He called her Erzulie and shouted, "Erzulie, don't you remember I have connections with you for a cake?" The girl was chagrined no end and looked pathetic. One of the men took a hand and cried, "Shoo!" as if he were shooing chickens. Immediately the faker started to run. He stopped after a step or two and looked about him and asked, "Who did that to me?" Everybody laughed. I asked why he seemed afraid. They explained that the majority of such characters are chicken thieves and they live in fear of the police. They knew the nasty accusation against the girl was inspired by malice at being refused, so they knew the way to stop it and did. The "mount" moved on away looking like a wet chicken.

A tragic case of a Guedé mount happened near Pont Beudet. A woman known to be a Lesbian was "mounted" one afternoon. The spirit announced through her mouth, "Tell my horse I have told this woman repeatedly to stop making love to women. It is a vile thing and I object to it. Tell my horse that this woman promised me twice that she would never do such a thing again, but each time she has broken her word to me as soon as she could find a woman suitable for her purpose. But she has made love to women for the last time. She has lied to Guedé for the last time. Tell my horse to tell that woman I am going to kill her today. She will not lie again." The woman pranced and galloped like a horse to a great mango tree, climbed it far up among the top limbs and dived off and broke her neck.

But the peasants believe that the things that "mounts" claim to see in the past and future are absolutely accurate. There are thousands of claims of great revelations. They are identical for the most part, however, with the claims that the believers in fortune-tellers make in the United States.

The spirit Guedé (pronounced geeday) originated at Miragoane and its originator's especial meeting place was the

bridge across the lake at Miragoane, where the Departments of the South and the West meet. These people who originated this cult were Bossals who were once huddled on the waterfront in Port-au-Prince in the neighborhood of the place where all of the slaves were disembarked from the ships. There came to be a great huddle of these people living on a very low social and economic level in the stretch flanking the bay. For some cause, these folk had gained the despisement of the city, and the contempt in which they were held caused a great body of them to migrate to the vicinity of Miragoane, and there the cult arose. It is too close to the cult of Baron Cimeterre not to be related. It is obvious that it is another twist given to the functions of that loa. The spirit of Guedé is Baron Cimeterre with social consciousness, plus a touch of burlesque and slapstick.

It is interesting to note that this cult does not exist in the North nor in the Artibonite. He belongs to the South and the West, and the people in the West and South who do not make food for Guedé are careful not to anger him or to offend in any way. It is dangerous to make his spirit angry. When a "mount" of this spirit is making devastating revelations the common comment is "Guedé pas drah." (Guedé is not a sheet), that is, Guedé covers up nothing. It seems to be his mission to expose and reveal. At any rate, Guedé is a whimsical deity, and his revelations are often most startlingly accurate and very cruel. Papa Guedé is almost identical with Baron Cimeterre, Baron Samedi and Baron Croix, who is one god with three epithets, and all of them mean the Lord of the dead. Perhaps that is natural for the god of the poor to be akin to the god of the dead, for there is something about poverty that smells of death.

One man stood out against all the rest and insisted that Baron Cimeterre and Baron Samedi were separate deities. Maybe so, but I do not blame the others who think that they are the same. The general belief is that both, if one could consider them separately, live in the cemetery. This physician, who says that he is an authority, maintains that Baron Cimeterre has his abode in an elm tree, lives always in the forest, and may be worshipped anywhere in the woods. Baron

Samedi lives in the cemetery or anywhere else he chooses. Baron Cimeterre speaks with authority like a great lord while Baron Samedi always announces his presence with "Ca ou vley?" (What do you want of me?) Both of them, like Guedé, can open tombs and command the dead to do their bidding. Baron Cimeterre is absolute ruler of the cemetery and Baron Samedi is also. This authority says that both of these gods are doctors and point out roots and herbs to be used, and that they give specific directions as to how they must be used. Sometimes he prescribes leaves and states that they must be powdered; at other times he might use those same leaves as a tea; at other times he might use the same leaves as a poultice. But Louis Romain, who is a great houngan, says that this god is not a doctor. Papa Loco is the god of medicine and knowledge.

Some say that you must talk to Baron Samedi or Cimeterre with a cow foot. That is necessary because you must place your hand in his while you make your request of him. When he leaves, he will take away with him whatever he is holding. So you get the foreleg of a cow with a foot attached and offer that as your hand. He holds to the foot and when he leaves you, merely let go of the other end and all is well. You do not lose your hand and arm as you would have done had you not taken care.

Baron Samedi delights in dressing his "horses" in shabby and fantastic clothes like Papa Guedé. Women dressed like men and men like women. Often the men, in addition to wearing female clothes, thrust a calabash up under their skirts to simulate pregnancy. Women put on men's coats and prance about with a stick between their legs to imitate the male sex organs. Baron Samedi is a very facetious god like Guedé. He is simple in his tastes also. Since he craves neither hounfort nor altar, when the houngan wishes to summon him to ask a service, he goes into the court and to the tree which is the repository of Baron Samedi and sprinkles the ground with clairin or rum and lights either three or thirteen white candles.

The people love Samedi because he knows the herbs and roots to make them well and because he is a loquacious god

and gives them plenty of detail along with the medicine. Sometimes he sends the dead on a mission. Sometimes he will not permit a soul to leave the cemetery because he will not permit them to be used to do a mischief to a person he has chosen, nor to one who has placed himself under his protection. Baron Samedi has no especial offering. When the houngan wishes to summon him outside of the hounfort, as in the woods or the plains, a shot fired in the air will summon him and he will appear and ask, "Ca ou vley?" In certain parts of Haiti, however, they offer Baron Samedi a black goat or a black chicken. It is placed on a plate and placed beneath the tree for him. Beside the plate they place an ear of corn, a bottle of clairin and three bottles of Kola.

Baron Cimeterre is also very popular all over Haiti. He is also a doctor of medicine and prescribes a great number of healing baths for the sick people under his care. He is very powerful but also temperamental and full of whimsy.

The houngan who wishes to summon him goes to the elm tree consecrated to him and raps three times with the baguette of a Rada drum and recites the prayer common in all voodoo ceremonies. He then demands of Damballah the authority or permission to enter into communication with Baron Cimeterre. He says to Baron Cimeterre, "Ce ou minn, Baron moi vley. Chretiens besoin concones ou." (It is you that I call for or want. Living people need you.) Then he sings a song to Baron Cimeterre. Baron becomes incarnate in the houngan or in a canzo. Sometimes he employs the dead. It is Baron Cimeterre that one invokes to draw a dead man from his tomb. Without this formality, one could not leave the cemetery with the souls one had invoked.

One offers Baron Cimeterre a black goat or a black chicken, which is prepared and placed at the roots of the tree. At the moment of invocation one pours rum or clairin on the roots of the tree.

November first and second are great days of obligation to these spirits. The houngan and the Mambo go to the cemetery on the night of the first to begin the invocation for All Saints

Day which follows. The graveyard is blazing with lighted candles for this important celebration. It must have been a joyful thing to the Africans newly arrived in Saint Dominique to find their worship of the dead confirmed in the European All Saints Day, but the services to Baron Samedi or Cimeterre are more than just an expansion of Halloween. The Christian Church has merely given the cult an annual feast day. The rest of it has come out of Africa with adaptations on Haitian soil. This cult of the dead has so many ramifications that it touches in some way the majority of the Voodoo cults and services.

CEREMONY OF THE TETE L'EAU

In Haiti spirits inhabit the heads of streams, known as sources, the cascades, and the grottoes. Sometimes the spot has a master, or a mistress, and sometimes it has both. The loa most commonly found in possession of these nooks and grottoes are Papa Badere, Cimby Apaca, Papa Sobo, Papa Pierre, and the white woman, Mademoiselle Charlotte.

Spirits occupy all of the sources, cascades and grottoes, but certain places in Haiti are ruled by spirits who are known to reside there by everyone in the country. For instance, the grotto at Leogane is inhabited by Madam Anacaona. Papa Sobo rules the grotto at Turgean and Cimby-Apaca-endeux-eaux.

The ceremony Tete l'eau (Head of the water) is a thing to induce the belief in gods and spirits. It is held on a night when the moon is shining full and white—and in Haiti the moonlight is a white that the temperate zones never could believe possible. The ceremony is held from nine to ten o'clock at night; that is, the ceremony does not begin until that hour. About that time the adepts and the invited guests begin to arrive at the source. There is a large white table cloth and sometimes two. Dishes and silver sufficient to serve all of the company is provided.

The houngan opens the ceremony by invoking the Master of the source. As always he salutes first the superior spirits. He invokes The Master of All Things, then Jesus, Mary, Joseph

and John the Baptist. He recites the Ava Maria, the credo, the Pater Noster. The adepts respond with the prayers. Then the houngan sprinkles the source, the cascade or the grotto, as the case might be, with flour, breaks three to thirteen eggs in the source or cascade. He turns himself towards the four cardinal points successively, and taking in his hands the sealed bottles of fine wines, he offers them with an air of majesty to the spirit. Opening then the bottles, he pours some from each on the ground all around the source. The different wines are poured separately and in turn. At this moment of making the libation the houngan approaches the source, strikes three blows upon the Rada drums, and the resonance rolls over the moonlit water and the towering rocks sheathed in verdure. He strikes three other notes from the Petro drums, which sing so humanly, and the rhythmic sound departs in pursuit of the other music fleeing over the hills. A gun is fired and all of the assistants bow themselves toward the source and remain with the head bowed while the houngan intones the liturgic song:

> "Faitre, Maitre, L'Afrique Guinin ce' protection
> Nous Ap Maide', ce d'lo qui poti mortel, protection
> Maitre d'lo pour-toute petites li"

(Master, African Master of Guinea, we ask your protection. The water, which is able to hear mortals, we ask protection for all of us children.)

At this exhortation the crowd responds. Then the houngan commands the houncis and the canzos present to prepare a plate for the spirit who protects the place. They immediately spread the table cloth beside the source and lay the plates for all, but they are careful to reserve a particular plate for the god or goddess. This plate that the houngan carries himself to the source before anyone touches anything to eat, is thrown into the water with all that it contains. It must contain a piece of everything served at the feast for the main course and a piece of each of the cakes for the dessert. Only after this is done may the adepts and the guests approach the table to eat. And there

227

is plenty to eat and to drink! There is roast turkey, chicken, beef, goat and white rice. Great plates of different kinds of bread and several kinds of cakes. To drink there is champagne, red wine, white wine, beer, clairin, tafia and various liqueurs. Nearly always, the spirit becomes embodied in the houngan and thus takes part in all of the eating and drinking. There is music and happiness. The feast usually continues until three or four o'clock in the morning.

This ceremony is a lovely and impressive affair when conducted by a member of the upper class. Like the ceremony to Erzulie, it loses in beauty and purpose when it is celebrated by people too poor to make the proper provisions. Many wealthy people who do not wish to make a public announcement that they make food for Voodoo gods, merely announce to their friends that "A repast is offered on the banks of such and such a river *very* near the source," or often the servants of the family organize the service if not too many outsiders are asked. In this case the food is merely served on a plate at the source and the drinks poured. This ceremony is so beautiful in setting and spirit that it is necessary to participate in it to fully appreciate it.

The most famous cascade in all Haiti is at Saut d'Eau, a triple waterfall just above Ville Bonheur. Every year, people make a pilgrimage from all over the country to this beautiful waterfall which translates into "leap of the water." Up until about three years ago there were two divisions of the falls, but since the flood in Haiti of 1933 there are now three beautiful torrents tumbling down from their great heights that men might see and worship.

My sister-in-law, Emma Williams, wife of Dr. Leonard Williams of Brooklyn, was visiting me in Haiti when the day in July came for everybody to go up to Haiti's holy place of miracles. Hermann Pape had offered to drive us in his car, and we so gladly accepted. It was a lively party in Hermann's sedan with plenty of food and things to drink. We bumped along the rocky road and passed people walking briskly with youth. Old people padded along and stepped aside to let us pass. Women and men rode bourriques and horses. They went any way they could, but

they went. It is the great annual "going up" in Haiti. When it came time to ford a river with the car, we paused. The men went in for a swim and the women spread the table beside the stream and we ate, ascended spiritually a little on the beauty of the scenery and drove on to Ville Bonheur.

We got to Ville Bonheur after dark and found a great number of little booths selling candy, Kola and the things that people usually buy when they go off gala. There was music of different kinds. Hermann got into one of the many dice games that were going on. It was very strange to me because they played it with three dice in a cup instead of two in the hand the way I had been taught. We were all tired but the great crowds, the flambeaux and candle-lighted places kept us moving from one excitement to another. It was like a fair only less hard and brittle. There is a softness and gentleness of manner about the Haitian peasant that makes itself felt whenever and wherever you get near him. The ground was practically paved with mango seeds and everybody was looking for a place to sleep. The insides of the few houses of the town had already been taken, for many people had come the day before. The women who were selling candles were doing a great business. Many of them were pushing about through the crowd selling the new prayers to the miraculous virgin and the two others. These printed prayers to the three women of miracles were printed partly in Spanish and partly in French to accommodate both the Haitians and the Dominicans. We bought both prayers and candles.

Finally Hermann found us a place to sleep. It was under the porch of a little caille. The car was moved over there and we got out our folding cots. Hermann slept on the natte beside us. The other young man who had come along to help Hermann with the driving as well as to enjoy the trip finally wandered off and we simmered off to sleep at last.

We woke and found several peasants standing around us in utter silence and gazing down on us in our riding breeches and boots. As soon as we stirred, they were happy to help us find water to wash our faces and get ourselves fixed up. We were

going up to the spot where the miraculous virgin lit in a palm tree. At daylight throngs were pouring into the enclosure where the church stood and slowly trickling out again.

We had that small cup of coffee that all Haitians take in the morning. But first we must get all six of the persons in our party together. We found the two ladies easily but that other young man remained invisible until Hermann met Ti Jean and he told him that our missing companion had found a lady friend to sleep with and was late abed. Hermann led us all to the house and was all for us peeping in but we declined and waited until he came out of his own accord.

We had coffee and waded through the sellers of candles and amulets. These amulets were little heart-shaped affairs made of printed cotton with a string to wear about the neck. Some were selling colored cords to hang as an offering upon the sacred tree at the falls. We bought things and went into the enclosure where an unfinished church was standing. This is where the sacred palm tree once stood. On either side of the path were blackened stones, and each one of these stones was surrounded by an ecstastic crowd anointing themselves with the candle grease that sobbed down over the stones from the votive candles. They anointed their faces and their arms and their bare breasts. Some had ailing feet and legs and they anointed them. Several women were rubbing their buttocks and thighs without any self-consciousness at all. And thousands upon thousands poured into the place and up to the church and back again. The mass was celebrated at an early hour and when we entered the enclosure the people were pouring out of the church. There was Ti Cousin, the great houngan of Leogane, striding past all in snowy white linen; Dieu Donnez St. Leger, the great one of famed Archahaie, going toward the church. The scene was like a great place of flame in that no part of it was still at any time and it had so many different movements making up the whole. And it had its changing colors like fire too and one could feel the inner heat from the people.

This great shrine of Haiti got its first breath of life in 1884, they say. In that year a beautiful, luminous virgin lit in the

fronds of a palm tree there and waved her gorgeous wings and blessed the people. She paused there a long time and the whole countryside saw her. Seeing the adoration of the people, the Catholic Priest of the parish came out to drive off the apparition. Finally she sang a beautiful song and left of her own volition. She had not been disturbed at all by the priest. People came to the palm tree and were miraculously cured and others were helped in various ways. The people began to worship the tree. The news spread all over Haiti and more and more people came. The Catholic Church was neglected. So the priest became so incensed that he ordered the palm tree to be chopped down, but he could find no one who would chop it. Finally he became so incensed at the adoration of the people for the tree that he seized a machete and ran to the tree to cut it down himself. But the first blow of the blade against the tree caused the machete to bounce back and strike the priest on the head and wound him so seriously that he was taken to the hospital in Port-au-Prince, where he soon died of his wound. Later on the tree was destroyed by the church and a church was built on the spot to take the place of the palm tree, but it is reported that several churches have burned on that site. One was destroyed by lightning. That is the story of the Virgin of Ville Bonheur.

The cascade at Saut d'Eau attracts as many people as the palm tree. From Ville Bonheur they mount on horseback to the falls. There the people drape their offerings of colored cotton cords on the sacred tree, undress and climb the misted rocks so that the sacred water may wet their bodies. Immediately many of them become possessed. The spirit Agoue' ta-Royo enters their heads and they stagger about as if they are drunk. Some of them talk in the unknown tongues. Louis Romain, the houngan of the Bolosse who was preparing me for initiation at the time begged me not to enter the water. He said, and others agreed with him that Agoue' ta-Royo, the Maitre L'Eau (Master of Waters) might enter my head and since I was not baptized he might just stay in my head for years and worry me.

The belief is widespread in Haiti that Agoue' ta-Royo carries off people whom he chooses to a land beneath the waters.

Saut d'Eau. Disrobing to ascend the falls

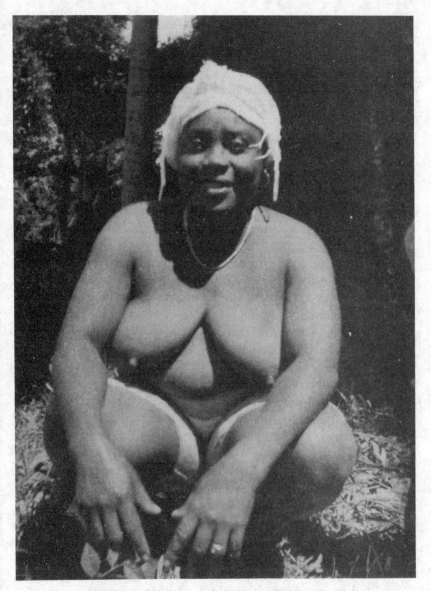

Saut d'Eau. After the touch of the sacred stream

One woman told me that she had lived there for seven years. There are thousands who say that they have been there. They say they have no memory of how they got there nor how they left. There is a great belief in a land beneath the waters. Some say it is not beneath the waters, but one must pass through the waters to get there. One man told me that there is a place in Haiti where a great cave has been hollowed out by a waterfall and that if one knows the way they may pass under the fall and enter this great cave. He says that there is an opening from the cave like a chimney that permits one to emerge again and that this is where people have been taken who speak of having been under the water for years. He promised several times to show me this place, but he never got around to it. Some day when I have a great deal of leisure, I shall visit Haiti for the express purpose of visiting the kingdom of Agoue' ta-Royo and see things for myself.

There was a fly in the ointment that day. The local priest who is a Haitian had used his influence to station a gendarme at the falls. Therefore there were few cases of possession. There was a lavish denunciation of the priest though. High and low were there and all felt that a police at the waterfall at Saut d'Eau was a desecration, but expressions of fervor were not to be suppressed entirely and the hundreds of people entering the eternal mists from the spray and ascending the sacred stones and assuming all possible postures of adoration made a picture that might have been painted by Doré. It was very beautiful and fitting. Whether they had the words to fit their feelings or not, it was a moving sight to see these people turning from sordid things once each year to go into an ecstasy of worship of the beautiful in water-forms. Perhaps the priest has some good reason for attempting to break up this annual celebration at the waterfalls. I only heard that the Church does not approve and so it must be stopped if possible.

I fail to see where it would have been more uplifting for them to have been inside a church listening to a man urging them to "contemplate the sufferings of our Lord," which is just another way of punishing one's self for nothing. It is very

much better for them to climb the rocks in their bare clean feet and meet Him face to face in their search for the eternal in beauty.

MANGER YIAMM (FEAST OF THE YAMS)

Another simple and lovely ceremony that I had the pleasure of witnessing is the Feast of the Yams. It is celebrated in all parts of Haiti and is compulsory with all the cults of Voodoo. The Rada cult, the Congo, the Petro, the Ibo and Congo Petro, all must do honor to the Yam once each year. It is not an expensive feast, fortunately, so that everybody can look forward to it with pleasure. It falls on the day before the day of the great animal sacrifices.

We had to buy the yams for the feast on the last day in October. We must also buy a piece of salt fish to go along with the yams. Plenty of olive oil and white candles too. The olive oil to cook the yams and the fish with. The candles for illumination and because they are required in the rites.

The Feast of the Yams is a ceremony that must be done annually. If one is an adept of any Voodoo cult at all, then he must observe Manger Yiamm. I was glad that it had to be done while I was there.

The ceremony was celebrated this way. We gathered under the peristyle. The houngan invoked the mysteries beginning with that long formula in which a long list of the Christian saints are called first, and then a long list of the more important loa of Voodoo, the adepts responding behind each name. Each was saluted and the favorite drink of each loa was poured on the ground around the center post for the dead. Then the hounci gathered around and the houngan approached the repositories of all of the loa in the hounfort, whom he saluted with equal reverence. The houncis now gathered up all the yams that had been brought by the crowd and prepared to cook them. The service went on with prayers and the whole assembly chanting the Pater Noster, the Credo and the Confiteor. Then they began to sing the airs dedicated to the vari-

ous loa. They sang songs to Papa Legba, Papa Loco, Papa Cimby, to some Congos, to Maitre Grand Bois, Papa Badere, Manchon Ibo, but the most beautiful ones it seemed to me were dedicated to Grand Erzulie.

All this time the yams and fish were being prepared. Some adepts were sent out to cut a great quantity of banana leaves. These were arranged into a sort of bed and the whole thing surrounded by candles. Then everybody assembled upon this couch of leaves to wait for the yams to be served. The candles were lighted and it was very agreeable to lie on the fresh cool leaves surrounded by light.

When the word came that the yams were ready, the houngan sprinkled flour all around the couch. Then he went into the hounfort and the food was carried in to him and he offered some of it to the loa. Then everyone was served and we passed the rest of the night singing and amusing ourselves. Several people were possessed during the singing and dancing. Three or four loa presented themselves at the same time through different people. A great many prophetic statements were made and some of those present were profoundly moved by the revelations. One spirit identified as Grande Libido entered one of his servants and forced him to chase away a guest whom he had especially invited. The loa said that the guest was a stranger to true Voodoo worship, but he was given to demon-worship. This revelation was most embarrassing to the guest, who tried to deny it. But his friend, possessed of his loa, began to announce dates, places and incidents of his practices and he ran out of the place in the greatest haste and confusion. Soon after, the loa left the friend who had driven him out and as soon as he came to himself, he asked for his friend and was much distressed at what had taken place. He left us singing and dancing and went off to seek him.

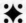

GRAVEYARD DIRT
AND OTHER POISONS

They take dirt from a graveyard to maim and kill. And the principle behind this practice is more subtle than the surface shows. It is hardly probable that more than one per cent of the people who dig into an old grave to get a handful of dirt to destroy an enemy, or the enemy of a client, know what they do. To most of them it is a superstition connected in their minds with the idea of ghosts and the belief in their power to harm. But soil from deep in an old grave has prestige wherever the negro exists in the Western world. In the United States it is called goofer dust and there is a great deal of laughter among educated people over it. The idea of some old witch doctor going to a cemetery at dead of night to dig arm-length deep in a grave for dirt with which to harm and kill does seem ridiculous. Now, wait just a moment before you laugh too hard at this old hoodoo man or woman of magic. Listen to some men of science on the same subject.

Sir Spencer Wells ("The Disposal of the Dead"), "Shane found germs of scarlatina in the soil surrounding a grave after thirty years."

Dr. Domingo Foriero of Rio de Janeiro, "If each corpse is

the bearer of millions of organisms specific of ill, imagine what a cemetery must be in which new foci are forming around each body! More than twenty years after the death of a body, Shane found the germs of yellow fever, scarlatina, typhoid and other infectious diseases."

Pasteur: "What outlooks are opened to the mind in regard to the possible influence of soil with the etiology of disease and the probable danger of the earth of cemeteries!"

So it appears that instead of being a harmless superstition of the ignorant, the African men of magic found out the deadly qualities of graveyard dirt. In some way they discovered that the earth surrounding a corpse that had sufficient time to thoroughly decay was impregnated with deadly power. It happened ages before the idea gained ground in the civilized areas. It might, in some accidental way, come out of the ancestor worship of West Africa. That is a mere shot in the dark, but what it illuminates is the great interest in subtle ways of providing death, and this brings up the whole matter of poisons and poisonings, not only in Haiti, but wherever the negro exists in the Western world.

Naturally, this cult of poisoning that has come in fragmentary form from Africa has built up an alertness and caution that is extreme in certain quarters. Naturally the accusations far out-number the actual cases. But who knows what the actual cases are? Even in countries with the most efficient crime detection agencies and with medical science, many, many cases of poisoning escape detection as has been proven by police records. There have been many instances where poisoners were detected only because they killed too many in the same way. In the United States great masses of young negro children are taught to eat and drink nowhere except at home. There is the gravest suspicion of unsolicited foods. In Jamaica, British West Indies, people carry bissy (Kola Nut) as an antidote. In Haiti there is extreme wariness and precaution. One educated man told me that he never orders the same drink at the same saloon on consecutive visits so that it is impossible to anticipate his order and prepare a bottle for him.

What is most interesting is that the use of poisons follows the African pattern rather than the European. It is rare that the poison is bought at a drug store. In most cases it is a vegetable poison, which makes them harder to detect than the mineral poisons so often used by the Europeans. And when the European poison is used it is seldom employed in the same fashion. Who has made all of these experiments and not only found out the poisonous plants in the New World, but found the most efficient use of them? It is a clear case of an African survival distorted by circumstances.

For example, let us look at death by hair. Kussula (Cudjoe Lewis), who was brought over from Africa in 1859 to be a slave, and who died in Mobile, Alabama, in 1934, told me that his King in Africa was a good man and did not like wicked things. So he allowed no man to keep the head of a leopard. I asked him what was wicked about possessing the head of a leopard. He said that men made bad medicine and killed people with it. Just how, he could not say, because, he explained, he was only a boy when he was brought away and he had not learned. But it was very bad for a man to keep the head of a leopard. If one killed a leopard and did not bring the head to the King, then everybody knew that he was a wicked man who meant to do evil, and so he was executed at once before he had a chance to do it. I met Chief Justice Johnson of Liberia and asked him for a leopard skin. He said that he would send me one, but that it was certain that he could not get me one with the head, because the native chiefs always kept the heads of all leopards killed in their territory. Duke, an African dancer in New York, told me that the head was important because of the whiskers. Duke is a Fanti from the Gold Coast and he said that there, also, it was a capital crime to keep the head of a leopard. And when the head was brought to the king, before the hunter was allowed to leave, the leopard's whiskers were counted and not one must be missing on pain of death. The assumption, that if the hunter has kept one, then he intends to kill someone with it and so he is a murderer already by intent, so they execute him at once. The whiskers,

he stated most positively were deadly poison, not a quick violent death, but very sure. How and why, he could not, or would not tell me.

Now, there are no leopards in Jamaica or Haiti. But in both places, when I asked about poisons, I was told about *chopped hair from the tail of a horse.* Chop it up short and mix it in something like mush and give it to the one you wish to kill and their stomach and intestines will become full of sores and death is certain. The short bits of hair will penetrate the tissues like so many needles and each bit will first irritate, then puncture, the intestine. A clear adaptation of the African leopard whisker method of killing. There is a variation of this in Jamaica also. They curry a horse and clean off the curry comb in the food of the victim. He not only gets the hair, he gets all the germs from the skin and hair of the horse. A violent and fatal vomiting is said to follow this.

Kossula, who was a Takkoi, from a country in Nigeria, "three sleeps" from the Abomeh, capital city of Dahomey, Chief Justice Johnson of Liberia and Duke from the Gold Coast all report the same practise in their separate areas. And these areas are all inside the territory from which the greater part of the slaves were drawn for service in the Americas. Leopard whiskers not being available, those adept in the practise of killing by hair looked for a substitute and found the coarse, stiff hair of the horse's tail.

Duke also told me of the poison to be found in the rudimentary legs of a rock python and the gall-bladder of a crocodile. In Jamaica I heard of the poisonous qualities of the gall-bladder of the alligator. Dried and powered lizards in Africa and powered lizards in Jamaica, Haiti and Florida. And the numerous vegetable poisons that had been worked out as to application, dosage and deadliness in Africa had to find substitutes in the Western world. And the fact that so many have been found, the tremendous quantity of experimentation that has been done, again proves the inclination of the seekers.

There is no way of knowing how many other plants are used

as poisons, but the following were checked and rechecked in different areas of the West Indies!

1. Night Shade (Jamaica). Antidote—Bissy (Kola Nut).
2. Red Head (Jamaica). Antidote—Bissy (Kola Nut).
3. Bitter Cassava (Jamaica). Antidote—Mix clay and water and drink.
4. Dumb cane (Jamaica). Antidote—None known. (The juice from this plant attacks the throat first and so constricts the vocal cords that the victim cannot speak. A flood of saliva pours from the mouth and drenches the lower part of the face. Terrible skin eruptions occur wherever this poisoned saliva has touched.)
5. Rose Apple (root is black and very poisonous). Antidote—None known.
6. Dogwood root (Haiti, Jamaica, Bahamas). Antidote—None known.
7. Black sage (Haiti, Jamaica, Bahamas). Antidote—None known.
8. Dust of Bamboo (Haiti, Jamaica, Bahamas). Antidote—None known.

ANIMAL DERIVATIVES

1. Horse hair
2. Dried gallowass (a poisonous lizard).
3. Dried Mabolier (Haitian lizard).
4. Spiders, worms and insects.
5. The gleanings from a curry comb after currying a horse.

MINERAL DERIVATIVES

1. Ground bottle glass.
2. Calomel. (Applied externally. The drug is mixed with water and the under garments of the victim are soaked in the solution for an hour or two and dried without rinsing. It is absorbed through the skin when the wearer perspires and produces a dangerous swelling.)
3. Arsenic. (Dr. Rulx Léon in defending Haiti from the charge of primitive poisonings, estimated that most of the

poisoning done in Haiti is done by Arsenic. He says that during the last days of slavery a quantity of Arsenic was stolen by the slaves from some plantation owners and was later parcelled out. That was around 1793 and it is hardly probable that the original supply has lasted until the present. Anyway there is bountiful evidence of other poisons being used. In 1934, however, there was an attempt to assassinate President Stenio Vincent by Arsenic. It was established that thirty grains of Arsenic was bought in Santo Domingo for the purpose by the conspirators. It was bought outside Haiti to cover the trail, but it was traced to the purchaser nevertheless. It had been ordered in the name of a legislator who knew nothing of the matter. Names very big in the political life of Haiti were mentioned in connection with this attempt upon the life of the President. But the affair occurred just before the visit of President Roosevelt and so the matter was hushed up quickly. Eighteen grains of the thirty purchased are still unaccounted for. A grocery store on the Champ de Mars failed because it was rumored that a member of the family which owned the business had actual possession, or access to, the missing eighteen grains of Arsenic. No one but the family traded at *that* store. It goes without saying that few would be concerned very much about this particular eighteen grains if great quantities of the same thing were known to be loose in Haiti already. There is a poison which the Cacos use to treat the blades of their machetes before a battle.)

The subject of poisons and poisonings in the whole area of the Caribbean is too important to omit altogether, though a thorough study of the matter would require years of investigation. It has such an immense background and an infinite sinister future. There are the various reasons for poisoning and the accompanying temptation. There is the age-old inclination; there is the security of secrecy and the ease of gaining the weapon that exists in all countries. In addition to death by poisoning, in Haiti there is the necessity of poisoning the

bodies of the dead against the ravages of the Zombie-makers and the Société ge Rouge (Red-eyed Society, another name for the Secte Rouge).

Ah Bo Bo!

CHAPTER 17

DOCTOR RESER

A thing is mighty big when time and distance cannot shrink it. That is how vivid my memory is of the colorful Dr. Reser of Pont Beudet. I am breaking a promise by writing this, and maybe the cocks are crowing because of it, but all the cocks in creation can crow three times if they must. I am going to say something about Dr. Reser. A piece about Haiti without Dr. Reser would be lacking in flavor.

I heard many things about Dr. Reser before I met him. A great deal is said about the white man who is a houngan (Voodoo priest). All of the foreigners living in Port-au-Prince know him and like him. A great many Haitians admit that he is deep in the inner secrets of Voodoo, and startling legends have grown up about him. Some say that he belongs to the Société de Couleve (Snake Society) which is supposed to be headed by Dr. Arthur Holly. Its object is said to be the extermination of the Secte Rouge and the devil worshippers in Haiti. One young man assured me that they all wore a snake tattooed on their forearms. He had seen the snake on Dr. Reser's arm. It had life. He had seen Dr. Reser feed it eggs.

After I met Reser I asked to see this symbol. It turned out to be a dragon which he had had tattooed on his arm when he was in the navy. But to many Haitians it is a sacred snake that eats eggs and performs miracles of magic.

Therefore it was not long before I went out to Pont Beudet and found this much-talked-of man. But then everybody finds Dr. Reser as soon as they land in Port-au-Prince. He is one of the showpieces of Haiti, like the Citadel. This white American is better known than any other living character in Haiti.

As officer in charge of the state insane asylum at Pont Beudet, Dr. Reser has a comfortable house with a large well screened veranda. He has three sets of bed springs suspended by chains with comfortable mattresses on this screened porch. And these contraptions make good swings in the daytime and good beds at night. He is a gracious host and serves good native food at his table and tall, cool fruit drinks on his porch. He is a facile conversationalist on an amazing number of subjects. Philosophy, esoterics, erotica, travel, physics, psychology, chemistry, geology, religions, folk lore and many subjects I have heard him discuss in a single afternoon.

So I took to spending time on his porch when I was not busy otherwise. We would play cards and talk and swap tales and listen to the harmless lunatics who wandered about the grounds and occasionally came up to the screened porch to beg a cigarette or say something that seemed important to their crippled minds. It was very nice to lie sprawled on my back on one of those swing-beds and pass the day. His house boy, Telemarque, was sure to appear with lemonade or orange juice about once every hour. The insane patients would be depended upon to yell something startling ever so often, and then Dr. Reser talks well. He has been in Haiti eleven years by the calendar but in soul he came from Africa with the rest of the people.

Seeing how the Haitian people, high and low, far and near, love and trust him, I tackled him one day on the business of being a white king of Haiti.

"Doctor Reser," I called over from one swing-bed to the other.

"I am not a doctor, you know. I am a pharmacist's mate, first class, retired U.S.N. They began to call me doctor while I was in the Public Health service at Port-de-Paix and they have just kept it up."

"I stand corrected, but getting back to what I started to say, Doctor, the people all seem to love you so much. Now in all the adventure tales I have ever read, the natives, finding a white man among them, always assume that he is a god, and at *least* make him a king. Here you have been in Haiti for eleven years according to your own story. You are on the most friendly terms with the Haitians of any white man in Haiti and still no kingly crown. How is that?"

"Well, I tell you, Zora, if you show yourself sincere, the Haitians will make a good friend of a white man, but hardly a king. They just don't run to royalty."

"Not even a *white* man?"

"Not even a white man, and the Haitians who made themselves kings did not fare so well, either, if you will recall."

I sat bolt upright at that. He had his mouth open and he was making broad statements.

"But on the island of La Gonave they made a king out of a sergeant of Marines."

"Oh, no, they didn't."

"But King Faustin Wirkus—"

"All I have to say about Wirkus and that white king business is that he had a good collaborator. Let's have another round of orange juice."

"You mean to say he was no king at all?"

"I mean just that."

"May I quote you as saying that?"

"Certainly. Now, how about that orange juice?"

"With pleasure, Doctor. Can I change the subject and talk about you instead?"

"I suppose so."

"Why is it then that the Haitians and the Haitian peasants

247

particularly love *you* so much?"

"They are infinitely kind and gentle and all that I have ever done to earn their love is to return their unfailing courtesy."

One tall lanky patient of the asylum hung around the porch and kept reciting the tales of Fontaine. It was a steady monotonous flow of syllables with his eyes fixed on us. It was a curious thing to see his mouth so active and the upper part of his face so still. It was plain that the upper part of his face did not know what the lower part was doing. One Syrian, formerly a merchant in Port-au-Prince, kept standing with his face against the porch wishing Dr. Reser well.

"Doctor Reser! Doctor Reser!" he kept calling. "I like for you to eat a very good eating. The very best eating in the United States."

"Thank you very much," Dr. Reser answered each time.

"Dr. Reser, I was driving very fast to Port-au-Prince—about sixty meters an hour—and I make three times around a pork [pig]. I tell the man, 'You pay five dollars duty to American government every time you leave pork in the street.' "

"Yes, yes," Dr. Reser answered with feigned interest. "Perhaps you want to go and look after the chickens for me."

The man hurried off very happy in the thought of performing a service for Dr. Reser and the conversation took up again on the porch.

I was speaking of returning to Port-au-Prince but Dr. Reser would not hear of it. They were expecting Joseph White, the American Vice-Consul, and his little new wife; M. C. Love, of the West India Oil Company; Frank Crumbie, Jr., of Nyack, New York; Mr. and Mrs. Scott and John Lassiter, American fiscal agents to the Haitian government; all were coming out that night with some newly arrived officials of the Pan American Airways.

Dr. Reser was giving a Voodoo dance for them and he was asking me to stay. I was on very friendly terms with all of them and so I was grateful to Dr. Reser for asking me. Cicerone, the greatest drummer in all Haiti, performed upon the *Houn-*

tah, the great thundering rada drum, that night. Everyone who cannot go to Africa should go to Pont Beudet, Haiti, to hear Cicerone play. He is not much to look at. He is past middle life, and is small and black and sort of shaggy. The magic of him is in those hands. The sun-stuff that places him among the geniuses of the timpani is found in those fingers that have actually been modified by their association with the taut heads of drums. Ah, yes, one must hear Cicerone of Pont-Beudet!

It was all very glinty and strong, what went on that night. The white visitors, whether they would have had it different or not, were a sort of audience around the walls. Strong action in the center. Many of Dr. Reser's Haitian friends came in. Some were upper class, educated men who received the introduction with poise and charm. Some were the peasants who were going to participate in the dance. They were all so glad to see Dr. Reser and made extravagant expressions of pleasure. One dark brown man with aquiline feature told him, "It is *such* a pleasure to see you again. I would have been hump-backed if I had not met you!" All of this was spoken in Creole, of course.

The evening got under way. Cicerone and the other drummers paid many of the guests the compliment of playing a special salute for each, after which the guest paid the drummers the compliment of a round of drinks or the cash for the purpose. The evening rose in spirit—the drumming, the singing, the dancers and the dancing. I was taught the Jean Valou. Midnight dashed past us on the run. Finally the others left and I was put to bed in Dr. Reser's bedroom while he and the others who lived there slept in the swing-beds on the porch.

The crowing of roosters, the small waking noises of the world, and the little dawn wind, all acknowledging the receipt of the new day, got me up. It took shape out of a ropy white mist, but there it was, the very last day that God had made, and it went about the business of changing people the way days always do. I got up to go home at once.

But I did not go as I had planned. A young woman came

to bring a message to Dr. Reser. It was from Aux Cayes in the south. It had been passed along by word of mouth of market women until it came to the young woman in Port-au-Prince, and it was an invitation to attend a ceremony in the south. What kind of ceremony was it going to be? It was to be a ceremony where the food was to be cooked without fire. Real food? Yes, a great pot of real food—enough to feed all of the people attending the ceremony—would be cooked without fire. Was such a thing *possible?* The young woman asked for a cup and saucer, a piece of laundry blue, a cup of cold water and a fresh egg. No, she did not wish to acquire the egg herself for fear that we might believe that she had one prepared. Dr. Reser went out and got one himself and gave it to her. She placed it in the cup at once. Poured some of the cold water on it and covered the cup with the saucer and made a cross mark on the saucer with the bluing. Then she bowed her head and mumbled a prayer for a few minutes. None of us could catch the exact words of what she said in that prayer. When it was over, she lifted the saucer and offered the egg to Dr. Reser with a diffident smile and told him to break it. He refused on the grounds that he had on his best gray suit and did not wish to have it spattered with egg. She assured him time and time again that the egg would not spatter over his clothes. At last he broke the egg very carefully and found it done. That was startling enough. But the realest surprise came when the egg was found to be harder in the center than anywhere else. The young woman now begged him to eat the egg. He was so reluctant to do so that it was necessary for her to coax him a great deal, but she prevailed at last and he ate the egg. Then she assured him that he would never die of poisoning. He would always be warned in time to avoid eating poisoned food or touching poisoned surfaces. Would he now accept the invitation to the ceremony? He would with great unction and avidity. I asked to come along and so it was arranged. A few days later we jolted over the rocky road south to Aux Cayes. It was night when our party arrived. A guard stood beside the main highway to guide us to the hounfort.

After the proper little ceremonies of greeting an important guest and the one of entering was over we were assigned sleeping space and went to bed, on our nattes under a great mimbon tree.

Their ceremony was held in the court of a great hounfort and the members of the society all came bearing foodstuffs. There were great heaps of peas, carrots, cabbage, string beans, onions, corn meal, rice and egg-plant.

The next morning the women were up preparing the little cups of coffee that everyone drinks in Haiti before breakfast. Then there was breakfast. After that the women went about dressing the food for the ceremony while the men amused themselves with a game of dice that is played with three "bones" instead of the two that we used in the United States.

Many, many things came to pass in a ceremonial way and then the "cooking" of the food without fire began. All that I could see, and afterwards when I talked it over with Dr. Reser, he confirmed my impression, was that the people formed a circle about the big iron pot that contained the mingled food. The Mambo began to sing, with the Ascon of course, and then the drums began to sound. At the first note of the boulatier, the smallest of the Rada drums, the men took off their hats and the women the colored handkerchiefs that every woman wears to a ceremony and began to dance, circling the pot. As they went they chanted and waved their hats and handkerchiefs at the pot as if fanning an invisible flame. This went on and on. When the houngan and the Mambo concluded the ritual, the food was dipped up with a wooden spoon and served to all. Everybody ate with their fingers for it is an unbreakable law of this ceremony that no metal except the pot must touch this food, so knives, forks and spoons are forbidden.

How was the food cooked? I do not know. Dr. Reser and I tried bribery and everything else in our power to learn the secret, but it belongs to that small group and nothing we could devise would do any good. Dr. Reser knew the girl who had boiled the egg in cold water very well indeed. I would say that they are very intimate friends. He concentrated upon her

251

finally, but all she would say was that it was a family secret brought from Africa which could not be divulged. He kept at her and she yielded enough to say that she could not tell him until he had been baptised in a certain ceremony. He went to the trouble and expense to have the baptism. After that was over, she returned to her original position that it was an inherited secret which she could not divulge under pain of death. So that is as far as we got on the food-without-fire ceremony. This is an annual affair and some day I shall try again.

I visited Dr. Reser many more times and polished my shoulder in his bed-swings and listened and ate. But one thing I never did. I never went to him for the information that I had come to Haiti to seek. One reason for this was that everyone who goes to Haiti to find out something makes a bee line for Dr. Reser and tries to pump out of him all that they can in a few weeks and then they sail off and write as if they had seen something. Be it said right here that Dr. Reser tells no more than he wants to, so what they get is bound to be limited first by Dr. Reser's own information, which is bound to be limited by the nature of Haiti's vastly complicated and varigated lore, and second by what he chooses to give out to the lazy mind-pickers who descend upon him. Since he has plans of his own for the future, he gives out nothing of any great importance. Thus they waste their time in Haiti on him. But the most important reason why I never tried to get my information second-hand out of Dr. Reser was because I consider myself amply equipped to go out in the field and get it myself. So my association with him was fifty per cent social and fifty per cent a study of the man himself. I wanted to know all I could about this educated, widely travelled man, this ex-navy man who could so completely find his soul and his peace in the African rituals of Haiti. I have seen him in the grip of the African loa (spirits) known as possession: that is, the spirits have entered his head and driven his own consciousness out. I have seen him reeling as if he were drunk under the spirit possession like any Haitian peasant and I was trying to reconcile the well-read man of science with the credulous man of emotions. A man

who could break off a discussion of Aristotle to show me with child-like eagerness, a stone that he had found which contained a loa. So I spent as much time as I could spare from other things on his porch sprawled upon one of his bed-swings. Besides he is a very fine and generous person; and then again, so many things happened around his place.

He is very kind and tender with the unfortunate people in the asylum. Though many have applied for his job, he is still considered by the Chief of the Service d'Hygiène the best man for the place. Of course, the criminally insane and the violent ones are strictly confined, but the harmless have a measure of liberty. And some days they hang around Dr. Reser's porch and say things and say things. He never drives them away nor speaks to one of them harshly.

One afternoon on the porch I fell to wondering what part of the United States Dr. Reser came from. I had tried to place him by his accent but I was not sure. So I asked, "Where are you from, Dr. Reser."

"I am from Lapland, Zora."

"Why, Dr. Reser, I thought you said you were an American."

"I am, but I am from Lapland just the same."

I fell to wondering if Lapland had become an American colony while my back was turned. He saw my bewilderment and chuckled.

"Yes, I am from Lapland—where Missouri laps over on Arkansas."

Naturally I laughed at that and he went on in the brogue of the hill-billy reciting about folk-heroes: "Yes, I'm the guy that chewed the wad the goat eat that butted the bull off the bridge!"

Just then the Syrian hurried up to the porch and called:

"Dr. Reser! Dr. *Reser!* The soldiers of Monte Carlo killed the Dead Sea, then they built the Casino!"

"Thanks for the information," Dr. Reser replied.

The patient who spent all of his waking hours quoting Fontaine's fables came to the porch too. I had laughed heartily at

253

Dr. Reser's quotations from the folk lore of the Ozarks, and perhaps our merriment attracted them. Another patient came up and began to babble the Haitian folk tales about Brother Bouki and Ti Malice.

Dr. Reser went on: "Raised on six shooters till I got big enough to eat growed shotguns. I warm up the Gulf of Mexico and bathe therein. I mount the wild ass and hop from crag to crag. I swim the Mississippi River from end to end with five hundred pound shot in my teeth! Airy dad gummed man that don't believe it, I'll hold him by the neck and leave him wiggle his fool self to death."

"Dr. Reser! Dr. *Reser!*" The Syrian attracts attention to himself. "They have horse racing in Palestine. The horses have contracts in Jewish and Arabic and English and the Jewish horse *must* be second. It's political."

The man who recited Fontaine pointed his stagnant eyes on the porch and babbled on as if he raced with the man who was talking about Ti Malice and Bouki, but he had a weaker voice. So we heard very distinctly:

"Of course, Bouki was very angry with Ti Malice for what he had done and Ti Malice was afraid, so he ran away very fast until he came to a fence. The fence had a hole in it, but the hole was not very big, but Malice tried to go through—"

"Dr. Reser! Dr. *Reser!* Never speak to person with tired physinomic! I drive car five years without license and the United States Government was very content."

"Are they annoying you?" Dr. Reser asked me. "They never worry *me* at all."

"Oh, no," I answered. "It is very interesting. Let them go on."

"All right, then. It will soon be time for them to go to bed anyway."

The Syrian was very close to the screen now. "When you write to the president, every amigo here remember you," he was advising us. "Dr. Reser, what is love?"

"I really don't know," Reser replied. "What is it?"

254

"Love is the heart. And what is the heart? It is the communication of the body."

The sun was setting and I lifted my eyes as the father of worlds dropped towards the horizon. In the near distance a royal palm flaunted itself above the other foliage with its stiff rod of a new leaf making assignation with life.

"Dr. Reser, I know love what it is," the Syrian went on. "I go in Cuba once and they have a house there. The bell ring 'ting!!' and you go in and they shake you like this and in the morning you come out and you know about life."

The Syrian turned suddenly and walked over to the shrubbery and began to gather hibiscus blooms. Dr. Reser sent the man who always quoted Fontaine to stop him from denuding the plants. Then we could hear the other one still telling his story of Malice and Bouki. "—Malice was stuck in the hole in the fence and he could not go forward neither could he back out. His behind was too big to pass through. So Bouki found him there but he did not know it. He saw this great behind stuck in the fence but he was impatient to overtake Malice so he slapped it and said:

" 'Behind, have you seen Malice?'

"The behind said, 'Push me and I'll tell you.'

"So Brother Bouki gave a great shove and bushed Ti Malice through the hole and he ran away. It was only after he was gone that Bouki knew it was Malice, so—"

He received the signal that supper was being served so he abruptly left us. In a short while we saw a file of men being conducted through the grounds to their sleeping quarters. Several women stood about within their enclosure, which was fenced in by heavy chicken wire. As the line of men came abreast of the space where the women were standing, one of the women walked up to the fence, suddenly lifted her skirts up around her waist and presented herself. Instantly one of the men broke from the line and ran to her. It was all unplanned, simple and instinctive. Presently the guard who was marching in front heard the commotion and looked around. He rushed back and dragged the man away with the help of two others.

The woman stumbled back to a stool and drooped down in a sort of apathy. The man was forced to his cell and could be heard cursing and howling all night long.

As for us, we waited outside until the black curtain ran all the way around the hoop of the horizon. Then Telemarque announced and we went inside and ate the delicious bits of lean cured pork that Telemarque knows how to cook. We ate jean-jean and rice, which is Haiti's most delicious native dish. Jean-jean is a little wild mushroom that grows there and Mme. Jules Faine prepares jean-jean and rice better than anyone else in Haiti.

Dr. Reser was discussing tides and the movement of ocean current for a while. Then somehow we got off on determining the sex of children before birth. He stated positively that it could be done by means of a gold ring suspended on a chain. From there he went precipitately into the occult and the occult in Haiti. He offered as justification for his firm belief in the power of the Voodoo gods several instances of miraculous cures, warnings, foretelling of events and prophecies. Some of them were striking. He told of visions of Prepti. He promised to introduce me to Prepti but we never did arrange it. Prepti was secretary to Charlemagne Peralt, one of the leaders of the Caco rebellion. Prepti was an educated and cultivated man and had no desire to perform any such service for Charlemagne Peralt, but he was kidnapped by Peralt and tortured and forced to serve him for three years as his secretary. He was forced to accompany Peralt during all of the fighting in the rebellion. Running away from an engagement with the Marines, Prepti fell over a cliff into a crevice from which he could not extricate himself. The sides were too sheer and steep. He struggled until he realized that escape was impossible. Then he cried out but there was no one to hear him. He grew hungry and thirsty and after the second day resigned himself to die. But during the night as he lay against the rocks in his extremity, came a vision of Ogoun with his red robes and long white beard. He assured Prepti that he would not die there, and that he would be found and rescued. Then came a vision

of Erzulie, the goddess of love, who comforted him and also promised him that he would be rescued. Prepti stayed there several days. He was dried up and starved when they found him, but so much alive he completely recovered from his exposure and starvation. He had another vision also in which God sent two angels with needles and thread to make dolls and the movement of these figures showed him what would happen. And it all happened that way.

Dr. Reser began to tell of his experiences while in the psychological state known as possession. Incident piled on incident. A new personality burned up the one that had eaten supper with us. His blue-gray eyes glowed, but at the same time they drew far back into his head as if they went inside to gaze on things kept in a secret place. After awhile he began to speak. He told of marvelous revelations of the Brave Guedé cult. And as he spoke, he moved farther and farther from known land and into the territory of myths and mists. Before our very eyes, he walked out of his Nordic body and changed. Whatever the stuff of which the soul of Haiti is made, he was that. You could see the snake god of Dahomey hovering about him. Africa was in his tones. He throbbed and glowed. He used English words but he talked to me from another continent. He was dancing before his gods and the fire of Shango played about him. Then I knew how Moses felt when he beheld the burning bush. Moses had seen fires and he had seen bushes, but he had never seen a bush with a fiery ego and I had never seen a man who dwelt in flame, who was coldly afire in the pores. Perhaps some day I shall visit his roomy porch again and drink his orangeade and listen to him discourse on Aristotle, but even in the midst of it, I shall remember his hour of fire.

Ah Bo Bo!!

GOD AND THE PINTARDS

With all of their ineptitude for certain concepts that the Anglo-Saxon holds sacred, the Haitian people have a tremendous talent for getting themselves loved. They are drenched in kindliness and beaming out with charm. They are like the pintards of God that Dr. Reser told me about. That is a Haitian folk tale that somebody told to him. A pintard is a guinea-fowl.

God planted a rice field one year. It was a rice field that was equal to His station and circumstances. It began to ripen and God began to look forward to the day of reaping.

One day a message came to God saying, "God, the pintards are eating up all of your rice. If you don't do something about it, there won't be any rice to reap."

So God called the Angel Michael and told him, "Here, Michael, you take this gun and go down to my rice fields and kill those pintards. They are eating up all of my rice and I did not plant rice for them. Go and shoot enough of them to scare off the rest. I meant to have a great crop this year."

The Angel Michael took the gun and went on down to God's rice fields to shoot the pintards as he had been told.

When he was about there the pintards saw him coming with God's gun and they all flew up into a huge mimbon tree and began to sing and clap their wings together in rhythm. Michael came up to the tree and pointed the shot-gun at the great mass of pintards crowded into the tree singing and making rhythm. But the song and the rhythm were so compelling that he forgot to pull the trigger. With the gun still pointing he began to keep time with the wing clapping. Then he went to dancing and finally he laid the gun down and danced until he was exhausted. Then he took up the gun and went away and told God saying, "God, I could not shoot those pintards. They were too happy and made too beautiful a dance-song for me to kill them." With a shamed face, because he had not done what God sent him to do, Michael put the gun down and went away.

God called Gabriel and said, "Gabriel, I don't aim to have all of my rice eaten up by those pintards. You take this gun and go down there and shoot them, and otherwise drive them away from my rice fields. I sent Michael and he never did a thing. Now you go and hurry up. I want some rice this year."

So Gabriel took the gun and went on down to God's rice field to shoot the pintards, but they saw him coming too and flew up into the mimbon tree and began to clap wings and sing, and Gabriel began to dance and forgot all about God's rice field for a whole day. When he saw the sun going down he remembered why he had been sent and he was so ashamed of himself that he couldn't bear to face God. So he met Peter and handed him the gun and said, "Please take God His gun for me. I am ashamed to go back."

Peter took the gun and told God what Gabriel had said. So God sent Peter and told him, "You go and *kill* those pintards! I do not plant rice for pintards and don't intend to have my crop all ruined by them, either. Go and clear them out." Peter took the gun and went down in a hurry to do God's will. But he got all charmed by the song and the dance and when he went back with the gun he was too ashamed to talk.

So God took the gun and went down to His rice fields

Himself. The pintards saw Him coming and left the rice and flew up into the tree again. They saw it was God Himself, so they sang a new song and put on a double rhythm and then they doubled it again. God aimed the gun but before He knew it He was dancing and because of the song He didn't care whether He saved any rice or not. So He said, "I can't kill these pintards—they are too happy and joyful to be killed. But I do want my rice fields so I know what I will do. There is the world that I have made and so far it is sad and nobody is happy there and nothing goes right. I'll send these pintards down there to take music and laughter so the world can forget its troubles."

And that is what He did. He called Shango, the god of thunder and lightning, and he made a shaft of lightning and the pintards slid down it and landed in Guinea. So that is why music and dancing came from Guinea—God sent it there first.

APPENDIX

❖

MAITRESSE ERSULIE

Ersulie nain nain oh! Ersulie nain nain oh!
Ersulie ya gaga gaaza, La roseé fait bro-
dè tou temps soleil par lévé La ro seé fait bro-
dè tou temps soleil par lévé Ersulie nain nain oh!
Ersu lie nain nain oh! Ersulie ya gaza.

dè tou temps so-leil par lé-´ vé, La ro seé fait bro-

de tou temps so-leil par lé-vé Er-su-lie nain nain oh!....

Er-su lie nain nain oh!.... Er su-lie ya ga-za..........

265

FÉRAILLE

Féraille oh! nan main qui moun ma quité baquiya
laquain moin ré tem songéogoun Fé raille ma conso
lé ma prendconrail oh! relé nan qui
temps ron sima lade oh cor wa non yé nan qui
temps nan qui temps oh! Cor wa nonyé ma con so
lé ma prend con rail oh! so bé guim as sura.

No. 2

Fé - raille oh!....nan main qui moun ma qui - té.... ba - qui - ya

la - quan moin ré tem songé - - o - goun Fé raille... ma con-so

lé ma prend - con - rail oh!...... re - lé nan qui

temps ron si - - ma lade oh cor wa non yé nan qui

temps nan qui temps.... oh! Cor wa non - yé ma con so

le' ma prend... con rail oh!..... so bé guim as su - ra.

266

RADA

Coté ma prend Coté ma prend Médi
oh! Aanago Coté ma prend Coté ma
prend Médi oh! Ana go Cotéma go.

RADA

Bonjour papa Legba bonjour timoun moin yo Bon-
jour papa Legba bonjour ti moun moin yoma pé man dé
ou con man non yéma pé man dé on con man non
yé bonjour pa pa Legba bonjour ti moun moin yo Bon.

JANVALO (JEAN VALDO)

Adia ban moin zui potó tou félé
Adia ban moin zui poté tou félé Adia ban moin
zui zui ya ma qué félé Adia ban moin zui zui
ya ma qué félé Adia ban moin zui poté tout félé.

A - dia ban moin zui po - tó..... tou fé - lé

A - dia ban moin zui po - té.... tou fé - lé A - dia ban moin

zui zui ya ma qué fé - lé A - dia ban moin zui zui

ya ma qué fé - lé A - dia ban moin zui po - té..... tout fé - lé.

JANVALO

Adi bon ça ma dit si ma dènié oh! ga-
dé mi sè ya cé pon do moins adi bon ça ma
dit sit ma dénié oh! gade mi sè ya cé pon do moins.

A - di bon ça ma dit si ma dè - nié oh! ga-

dé mi sè ya cé pon do moins.. a - di bon ça ma

dit si ma dé - nié oh! ga - de mi sè ya cé pon do moins...

268

SAINT JACQUES

St. Jacques pas là St. Jacques pas là St. Jacques pas là
cé moin qui là St. Jacques pas là oh! chien ya modé moin.

PETRO

Nous vley wè Dan Pétro Nous vley wé oh!
Nous vley wè si ya qui té caille la tom bé
Nous vley wè Dan Petro Nous vley wè oh! Nous vley wè
oh! Si ya quité caille là tom bé elan oh!

PETRO

Salut moin oh! Sa lut moin oh! Salut moins
Nous sé vi lan rent nan caille là oh! Salut moins.
oh a diĕ salut moins oh Salut moins oh Salut moins
nous sè vi lan rent nan caille la oh! Salut moins Salut.

No. 9

Sa - lut moin oh! Sa lut moin.... oh! Sa - lut moins

Nous sé vi lan rent nan caille là oh! Sa - lut moins.....

oh.... a diĕ sa-lut moins.... oh Sa-lut moins.. oh Sa-lut moins

nous sè vi lan rent nan caille la oh! Sa - lut moins... Sa-lut.

270

IBO

Ibo Lélé Ibo Lélé Iyanman
ça ou gain yen çonça I bo Lélé cé con
ça moin danté Ibo Iyanman oh! Anan Iyanman
Con çam danté I bo Iyanman oh! An an Iyan man.

IBO

Ibo moin youn oh! Ibo moin youn oh! I—
bo moin youn oh! m'pa gan guin man man gindémoin Grand
Ibo moin youn oh! m'pa gan guin man man gindé moins.

271

DAMBALLA

Fiolé por Dambalá Dambala wè do Fio-
lé oh! Dambala Wè do Fiolĕ por Dambala
Dambala Wédo Fiolé por Dam ba la.

Fi - o - lé por Dam-ba-lá.... Dam-ba - la wè do Fi - o -

lé oh!.... Dam-ba - la Wè do Fi - o - lé por Dam-ba-la

.... Dam-ba - la Wé do Fi - o - lé por Dam ba la.....

OGOUN

Ogoun tra vail oh! Ogoun por mangé Ogoun tra-
vail oh! Ogoun por mangé Ogoun tra vail tout nan nuit por O-
goun por mangé yiĕre soi Ogoun dor mi sans sou per.

O - goun tra vail oh! O-goun por man - gé...... O - goun tra -

vail oh! O-goun por man - gé O - goun tra vail tout nan nuit por O-

goun por man - gé yiĕ - re soi O - goun dor mi sans sou per.

SALONGO

Zin zin zin zin zin zin Ba yan min oh! Saya Pim ba
zin zin zin zin zin zin Ba yan min oh! Saya Pimba

SALONGO

Tousa Tousa rè lè Tou Salonggo Tou
sa Tou sa rè lè Tou Sa longgo Tousa Tou sa rè lè Tou Sa
longgo.

LOCO

Loco Mabia Ebon Azacan Loco Ma-
bia Ello oh! Loco Mabia Ello Azagan
Loco Mabia Ello oh! Jean valou Moin Jean valou
Moin Loco Loco Mabia Ello Loco Ma Lo.

274

MAMBO ISAN

Mambo Isan ma pralé Oh! Ma pralé quéléfré
m'pralé chaché fammil moin yo Mam bo Isan ma pralé
Oh! Ma pra lé quáléfré m'pra lé chaché fammil moin
yo Mam bo Isan oh! cé ron qui maré moin Mambo I san
oh! céron qui ma ré moin cé ron qua laqué'm oh!

No. 2

Mam-bo I - san ma pra - lé.... Oh!... Ma pra-lé qué-lé-fré

.... m'pra-lé cha-ché fammil - moin yo... Mam bo I - san ma pra - lé..

..... Oh!.... Ma pra lé qué- lé- fré... m'pra lé cha - ché fammil moin

yo... Mam bo I - sanoh! cé ron... qui ma - ré moin... Mam-bo I san

oh! cé - ron qui ma ré moin cé ron qua la - qué'm oh!.....

DAMBALA

Filé na filé fem Dambala Wèdo
Filé na filé Dambala Wèdo cá conclèv oh! lèv oh!

Fi - lé na fi - lé fem Dam - ba - la.... Wè - do

Fi - lé na fi - lé Dam - ba - la Wè - do cé con - lèv oh!.. lèv oh!..

276

AGOË (AGOUÉ TE ROYO)

Aroquè si ou gain yen chanson nivo pon ou chan-
té wa chan té l'nan hounfort oud ronan hounfort ou Pi-
ga on mon tre criole than son ni vo Pi Vo on criole
va ga té mo yen ou Agoë ta royo neg bas sin bleu neg dlo salé
 neg
coqui doré Si ou gain yen chanson ni vo pon ou chan-
té Wa chan télnan houn for ou Pi ga ou mon tré creole chan son
 nivo.

277

SOBO

Gué Manyan man yanga dé hounfort wa
ga dé houn for wa Sobo gué ma yan
be! Gué Man hé O gui Manyan Man yanga dé houn
for wa Sobo Ga dé houn for wa So bo Gué Man yan bé!

Gué Man - yan man yan - - ga dé houn fort wa

ga dé houn for wa So - bo...... gué ma yan

be!.... Gué Man hé O gui Man - yan Man yan - ga dé houn

for wa So - bo.... Ga dé houn for wa So bo... Gué Man yan bé!

OGOUN

Alou man dia hé! Ogoun oh! ohsans yo oh!
aho! Alou man O sange ba conle qui man de dra-
po o Sane ba conlé qui man dé dra po lila O goun bare I baba.

A - lou man dia hé!.... O - goun oh! oh - sans yo oh!..

........ a - ho!..... A - lou man... O sange ba con - le qui man de dra-po

o Sane ba con - lé qui man dé dra po li - la O goun ba r-e I ba - ba.

278

SECTE ROUGE

Carrefour, tingindingue, mi haut, mi bas-é
Carrefour, tingindingue, mi haut, mi bas-é
Oun pralé, tingindingue, mi haut, mi bas, tingindingue
Oun pralé, tingindingue, mi haut, mi bas, tingindingue
Oun pralé, tingindingue, mi haut, mi bas,
tingindingue.

SECTE ROUGE

Sortie nan cimiterre, toute corps moin sentie malingue
Sortie nan cimiterre, toute corps moin sentie malingue
Sortie nan cimiterre, toute corps moin sentie malingue
Sortie nan cimiterre, toute corps moin sentie malingue.

279

CHANT BEGINNING ALL RADA CEREMONIES

Héla grand pere étérnel sin joé Heé-
la grand pere étérnel sin jozé do co agué Hé-
la grand pere étérnel sin'nam min bon Diĕ o
Saint yen.

No. 3

Hé - la grand pere é - tér - nel sin jo - é Hé-

la grand pere é - tér - nel sin joz - é do co a - gué Hé-

la grand pere é - ter - nel sin' nam min bon Diĕ o Saint yen.

TUNE TO CALL THE "LOA"

LA MYSTÉRIEUSE, MÉRINGUE

A. L. Duroseau

ÉTONNEMENT, MÉRINGUE CARACTÉRISTIQUE

A. Herandez

—BONNE HUMEUR—
MÉRINGUE HAITÏENNE

à Miss Zora Neale Hurston

Arthur L. Duroseau

OLGA, MÉRINGUE PAR

Arthur Lyncíe Duroseau

Arthur Lyncie Duroseau

No. 5

CHANSON DE CALICOT

LA DOUCEUR

Méringue Haïtienne par Arthur L. Duroseau

—PETRO—

1st drum
or
Tambour maman

2nd drum
or
Rallé

—IBO—

1st drum

2nd drum

RADA

1st drum

2nd drum

3rd drum

286

—JANVALHO—

287

AFTERWORD

❖

ZORA NEALE HURSTON: "A NEGRO WAY OF SAYING"

I.

The Reverend Harry Middleton Hyatt, an Episcopal priest whose five-volume classic collection, *Hoodoo, Conjuration, Witchcraft, and Rootwork,* more than amply returned an investment of forty years' research, once asked me during an interview in 1977 what had become of another eccentric collector whom he admired. "I met her in the field in the thirties. I think," he reflected for a few seconds, "that her first name was Zora." It was an innocent question, made reasonable by the body of confused and often contradictory rumors that make Zora Neale Hurston's own legend as richly curious and as dense as are the black myths she did so much to preserve in her classic anthropological works, *Mules and Men* and *Tell My Horse,* and in her fiction.

A graduate of Barnard, where she studied under Franz Boas, Zora Neale Hurston published seven books—four novels, two books of folklore, and an autobiography—and more than fifty shorter works between the middle of the Harlem Renaissance and the end of the Korean War, when she was

the dominant black woman writer in the United States. The dark obscurity into which her career then lapsed reflects her staunchly independent political stances rather than any deficiency of craft or vision. Virtually ignored after the early fifties, even by the Black Arts movement in the sixties, an otherwise noisy and intense spell of black image- and myth-making that rescued so many black writers from remaindered oblivion, Hurston embodied a more or less harmonious but nevertheless problematic unity of opposites. It is this complexity that refuses to lend itself to the glib categories of "radical" or "conservative," "black" or "Negro," "revolutionary" or "Uncle Tom"—categories of little use in literary criticism. It is this same complexity, embodied in her fiction, that, until Alice Walker published her important essay ("In Search of Zora Neale Hurston") in *Ms.* magazine in 1975, had made Hurston's place in black literary history an ambiguous one at best.

The rediscovery of Afro-American writers has usually turned on larger political criteria, of which the writer's work is supposedly a mere reflection. The deeply satisfying aspect of the rediscovery of Zora Neale Hurston is that black women generated it primarily to establish a maternal literary ancestry. Alice Walker's moving essay recounts her attempts to find Hurston's unmarked grave in the Garden of the Heavenly Rest, a segregated cemetery in Fort Pierce, Florida. Hurston became a metaphor for the black woman writer's search for tradition. The craft of Alice Walker, Gayl Jones, Gloria Naylor, and Toni Cade Bambara bears, in markedly different ways, strong affinities with Hurston's. Their attention to Hurston signifies a novel sophistication in black literature: they read Hurston not only for the spiritual kinship inherent in such relations but because she used black vernacular speech and rituals, in ways subtle and various, to chart the coming to consciousness of black women, so glaringly absent in other black fiction. This use of the vernacular became the fundamental framework for all but one of her novels and is particularly

effective in her classic work *Their Eyes Were Watching God,* published in 1937, which is more closely related to Henry James's *The Portrait of a Lady* and Jean Toomer's *Cane* than to Langston Hughes's and Richard Wright's proletarian literature, so popular in the Depression.

The charting of Janie Crawford's fulfillment as an autonomous imagination, *Their Eyes* is a lyrical novel that correlates the need of her first two husbands for ownership of progressively larger physical space (and the gaudy accoutrements of upward mobility) with the suppression of self-awareness in their wife. Only with her third and last lover, a roustabout called Tea Cake whose unstructured frolics center around and about the Florida swamps, does Janie at last bloom, as does the large pear tree that stands beside her grandmother's tiny log cabin.

> She saw a dust bearing bee sink into the sanctum of a
> bloom; the thousand sister calyxes arch to meet the love
> embrace and the ecstatic shiver of the tree from root to
> tiniest branch creaming in every blossom and frothing with
> delight. So this was a marriage!

To plot Janie's journey from object to subject, the narrative of the novel shifts from third to a blend of first and third person (known as "free indirect discourse"), signifying this awareness of self in Janie. *Their Eyes* is a bold feminist novel, the first to be explicitly so in the Afro-American tradition. Yet in its concern with the project of finding a voice, with language as an instrument of injury and salvation, of selfhood and empowerment, it suggests many of the themes that inspirit Hurston's oeuvre as a whole.

II.

One of the most moving passages in American literature is Zora Neale Hurston's account of her last encounter with her

dying mother, found in a chapter entitled "Wandering" in her autobiography, *Dust Tracks on a Road* (1942):

> As I crowded in, they lifted up the bed and turned it around so that Mama's eyes would face east. I thought that she looked to me as the head of the bed reversed. Her mouth was slightly open, but her breathing took up so much of her strength that she could not talk. But she looked at me, or so I felt, to speak for her. She depended on me for a voice.

We can begin to understand the rhetorical distance that separated Hurston from her contemporaries if we compare this passage with a similar scene published just three years later in *Black Boy* by Richard Wright, Hurston's dominant black male contemporary and rival: "Once, in the night, my mother called me to her bed and told me that she could not endure the pain, and she wanted to die. I held her hand and begged her to be quiet. That night I ceased to react to my mother; my feelings were frozen." If Hurston represents her final moments with her mother in terms of the search for voice, then Wright attributes to a similar experience a certain "somberness of spirit that I was never to lose," which "grew into a symbol in my mind, gathering to itself . . . the poverty, the ignorance, the helplessness. . . ." Few authors in the black tradition have less in common than Zora Neale Hurston and Richard Wright. And whereas Wright would reign through the forties as our predominant author, Hurston's fame reached its zenith in 1943 with a *Saturday Review* cover story honoring the success of *Dust Tracks.* Seven years later, she would be serving as a maid in Rivo Alto, Florida; ten years after that she would die in the County Welfare Home in Fort Pierce, Florida.

How could the recipient of two Guggenheims and the author of four novels, a dozen short stories, two musicals, two books on black mythology, dozens of essays, and a prizewinning autobiography virtually "disappear" from her readership

for three full decades? There are no easy answers to this quandary, despite the concerted attempts of scholars to resolve it. It is clear, however, that the loving, diverse, and enthusiastic responses that Hurston's work engenders today were not shared by several of her influential black male contemporaries. The reasons for this are complex and stem largely from what we might think of as their "racial ideologies."

Part of Hurston's received heritage—and perhaps the paramount received notion that links the novel of manners in the Harlem Renaissance, the social realism of the thirties, and the cultural nationalism of the Black Arts movement—was the idea that racism had reduced black people to mere ciphers, to beings who only react to an omnipresent racial oppression, whose culture is "deprived" where different, and whose psyches are in the main "pathological." Albert Murray, the writer and social critic, calls this "the Social Science Fiction Monster." Socialists, separatists, and civil rights advocates alike have been devoured by this beast.

Hurston thought this idea degrading, its propagation a trap, and railed against it. It was, she said, upheld by "the sobbing school of Negrohood who hold that nature somehow has given them a dirty deal." Unlike Hughes and Wright, Hurston chose deliberately to ignore this "false picture that distorted. . . ." Freedom, she wrote in *Moses, Man of the Mountain,* "was something internal. . . . The man himself must make his own emancipation." And she declared her first novel a manifesto against the "arrogance" of whites assuming that "black lives are only defensive reactions to white actions." Her strategy was not calculated to please.

What we might think of as Hurston's mythic realism, lush and dense within a lyrical black idiom, seemed politically retrograde to the proponents of a social or critical realism. If Wright, Ellison, Brown, and Hurston were engaged in a battle over ideal fictional modes with which to represent the Negro, clearly Hurston lost the battle.

But not the war.

After Hurston and her choice of style for the black novel

were silenced for nearly three decades, what we have witnessed since is clearly a marvelous instance of the return of the repressed. For Zora Neale Hurston has been "rediscovered" in a manner unprecedented in the black tradition: several black women writers, among whom are some of the most accomplished writers in America today, have openly turned to her works as sources of narrative strategies, to be repeated, imitated, and revised, in acts of textual bonding. Responding to Wright's critique, Hurston claimed that she had wanted at long last to write a black novel, and "not a treatise on sociology." It is this urge that resonates in Toni Morrison's *Song of Solomon* and *Beloved,* and in Walker's depiction of Hurston as our prime symbol of "racial health—a sense of black people as complete, complex, *undiminished* human beings, a sense that is lacking in so much black writing and literature." In a tradition in which male authors have ardently denied black literary paternity, this is a major development, one that heralds the refinement of our notion of tradition: Zora and her daughters are a tradition-within-the-tradition, a black woman's voice.

The resurgence of popular and academic readerships of Hurston's works signifies her multiple canonization in the black, the American, and the feminist traditions. Within the critical establishment, scholars of every stripe have found in Hurston texts for all seasons. More people have read Hurston's works since 1975 than did between that date and the publication of her first novel, in 1934.

III.

Rereading Hurston, I am always struck by the density of intimate experiences she cloaked in richly elaborated imagery. It is this concern for the figurative capacity of black language, for what a character in *Mules and Men* calls "a hidden meaning, jus' like de Bible . . . de inside meanin' of words," that unites Hurston's anthropological studies with her fiction. For the folklore Hurston collected so meticulously as Franz Boas's

student at Barnard became metaphors, allegories, and performances in her novels, the traditional recurring canonical metaphors of black culture. Always more of a novelist than a social scientist, even Hurston's academic collections center on the quality of imagination that makes these lives whole and splendid. But it is in the novel that Hurston's use of the black idiom realizes its fullest effect. In *Jonah's Gourd Vine,* her first novel, for instance, the errant preacher, John, as described by Robert Hemenway "is a poet who graces his world with language but cannot find the words to secure his own personal grace." This concern for language and for the "natural" poets who "bring barbaric splendor of word and song into the very camp of the mockers" not only connects her two disciplines but also makes of "the suspended linguistic moment" a thing to behold indeed. Invariably, Hurston's writing depends for its strength on the text, not the context, as does John's climactic sermon, a *tour de force* of black image and metaphor. Image and metaphor define John's world; his failure to interpret himself leads finally to his self-destruction. As Robert Hemenway, Hurston's biographer, concludes, "Such passages eventually add up to a theory of language and behavior."

Using "the spy-glass of Anthropology," her work celebrates rather than moralizes; it shows rather than tells, such that "both behavior and art become self-evident as the tale texts and hoodoo rituals accrete during the reading." As author, she functions as "a midwife participating in the birth of a body of folklore, . . . the first wondering contacts with natural law." The myths she describes so accurately are in fact "alternative modes for perceiving reality," and never just condescending depictions of the quaint. Hurston sees "the Dozens," for example, that age-old black ritual of graceful insult, as, among other things, a verbal defense of the sanctity of the family, conjured through ingenious plays on words. Though attacked by Wright and virtually ignored by his literary heirs, Hurston's ideas about language and craft undergird many of the most successful contributions to Afro-American literature that followed.

IV.

We can understand Hurston's complex and contradictory legacy more fully if we examine *Dust Tracks on a Road,* her own controversial account of her life. Hurston did make significant parts of herself up, like a masquerader putting on a disguise for the ball, like a character in her fictions. In this way, Hurston *wrote* herself, and sought in her works to rewrite the "self" of "the race," in its several private and public guises, largely for ideological reasons. That which she chooses to reveal is the life of her imagination, as it sought to mold and interpret her environment. That which she silences or deletes, similarly, is all that her readership would draw upon to delimit or pigeonhole her life as a synecdoche of "the race problem," an exceptional part standing for the debased whole.

Hurston's achievement in *Dust Tracks* is twofold. First, she gives us a *writer's* life, rather than an account, as she says, of "the Negro problem." So many events in this text are figured in terms of Hurston's growing awareness and mastery of books and language, language and linguistic rituals as spoken and written both by masters of the Western tradition and by ordinary members of the black community. These two "speech communities," as it were, are Hurston's great sources of inspiration not only in her novels but also in her autobiography.

The representation of her sources of language seems to be her principal concern, as she constantly shifts back and forth between her "literate" narrator's voice and a highly idiomatic black voice found in wonderful passages of free indirect discourse. Hurston moves in and out of these distinct voices effortlessly, seamlessly, just as she does in *Their Eyes* to chart Janie's coming to consciousness. It is this usage of a *divided* voice, a double voice unreconciled, that strikes me as her great achievement, a verbal analogue of her double experiences as a woman in a male-dominated world and as a black person in a nonblack world, a woman writer's revision of W. E. B. Du

Bois's metaphor of "double consciousness" for the hyphenated African-American.

Her language, variegated by the twin voices that intertwine throughout the text, retains the power to unsettle:

> There is something about poverty that smells like death.
> Dead dreams dropping off the heart like leaves in a dry
> season and rotting around the feet; impulses smothered too
> long in the fetid air of underground caves. The soul lives
> in a sickly air. People can be slave-ships in shoes.

Elsewhere she analyzes black "idioms" used by a culture "raised on simile and invective. They know how to call names," she concludes, then lists some, such as 'gatormouthed, box-ankled, puzzle-gutted, shovel-footed: "Eyes looking like skint-ginny nuts, and mouth looking like a dishpan full of broke-up crockery!"

Immediately following the passage about her mother's death, she writes:

> The Master-Maker in His making had made Old Death.
> Made him with big, soft feet and square toes. Made him
> with a face that reflects the face of all things, but neither
> changes itself, nor is mirrored anywhere. Made the body of
> death out of infinite hunger. Made a weapon of his hand to
> satisfy his needs. This was the morning of the day of the
> beginning of things.

Language, in these passages, is not merely "adornment," as Hurston described a key black linguistic practice; rather, manner and meaning are perfectly in tune: she says the thing in the most meaningful manner. Nor is she being "cute," or pandering to a condescending white readership. She is "naming" emotions, as she says, in a language both deeply personal and culturally specific.

The second reason that *Dust Tracks* succeeds as literature arises from the first: Hurston's unresolved tension between

her double voices signifies her full understanding of modernism. Hurston uses the two voices in her text to celebrate the psychological fragmentation both of modernity and of the black American. As Barbara Johnson has written, hers is a rhetoric of division, rather than a fiction of psychological or cultural unity. Zora Neale Hurston, the "real" Zora Neale Hurston that we long to locate in this text, dwells in the silence that separates these two voices: she is both, and neither; bilingual, and mute. This strategy helps to explain her attraction to so many contemporary critics and writers, who can turn to her works again and again only to be startled at her remarkable artistry.

But the life that Hurston could write was not the life she could live. In fact, Hurston's life, so much more readily than does the standard sociological rendering, reveals how economic limits determine our choices even more than does violence or love. Put simply, Hurston wrote well when she was comfortable, wrote poorly when she was not. Financial problems—book sales, grants and fellowships too few and too paltry, ignorant editors and a smothering patron—produced the sort of dependence that affects, if not determines, her style, a relation she explored somewhat ironically in "What White Publishers Won't Print." We cannot oversimplify the relation between Hurston's art and her life; nor can we reduce the complexity of her postwar politics, which, rooted in her distaste for the pathological image of blacks, were markedly conservative and Republican.

Nor can we sentimentalize her disastrous final decade, when she found herself working as a maid on the very day the *Saturday Evening Post* published her short story "Conscience of the Court" and often found herself without money, surviving after 1957 on unemployment benefits, substitute teaching, and welfare checks. "In her last days," Hemenway concludes dispassionately, "Zora lived a difficult life—alone, proud, ill, obsessed with a book she could not finish."

The excavation of her buried life helped a new generation read Hurston again. But ultimately we must find Hurston's

legacy in her art, where she "ploughed up some literacy and laid by some alphabets." Her importance rests with the legacy of fiction and lore she constructed so cannily. As Hurston herself noted, "Roll your eyes in ecstasy and ape his every move, but until we have placed something upon his street corner that is our own, we are right back where we were when they filed our iron collar off." If, as a friend eulogized, "She didn't come to you empty," then she does not leave black literature empty. If her earlier obscurity and neglect today seem inconceivable, perhaps now, as she wrote of Moses, she has "crossed over."

HENRY LOUIS GATES, JR.

SELECTED BIBLIOGRAPHY

WORKS BY ZORA NEALE HURSTON

Jonah's Gourd Vine. Philadelphia: J. B. Lippincott, 1934.

Mules and Men. Philadelphia: J. B. Lippincott, 1935.

Their Eyes Were Watching God. Philadelphia: J. B. Lippincott, 1937.

Tell My Horse. Philadelphia: J. B. Lippincott, 1938.

Moses, Man of the Mountain. Philadelphia: J. B. Lippincott, 1939.

Dust Tracks on a Road. Philadelphia: J. B. Lippincott, 1942.

Seraph on the Suwanee. New York: Charles Scribner's Sons, 1948.

I Love Myself When I Am Laughing . . . & Then Again When I Am Looking Mean and Impressive: A Zora Neale Hurston Reader. Edited by Alice Walker. Old Westbury, N.Y.: The Feminist Press, 1979.

The Sanctified Church. Edited by Toni Cade Bambara. Berkeley: Turtle Island, 1981.

Spunk: The Selected Short Stories of Zora Neale Hurston. Berkeley: Turtle Island, 1985.

WORKS ABOUT ZORA NEALE HURSTON

Baker, Houston A., Jr. *Blues, Ideology, and Afro-American Literature: A Vernacular Theory,* pp. 15–63. Chicago: University of Chicago Press, 1984.

Bloom, Harold, ed. *Zora Neale Hurston.* New York: Chelsea House, 1986.

———, ed. *Zora Neale Hurston's "Their Eyes Were Watching God."* New York: Chelsea House, 1987.

Byrd, James W. "Zora Neale Hurston: A Novel Folklorist." *Tennessee Folklore Society Bulletin* 21 (1955): 37–41.

Cooke, Michael G. "Solitude: The Beginnings of Self-Realization in Zora Neale Hurston, Richard Wright, and Ralph Ellison." In Michael G. Cooke, *Afro-American Literature in the Twentieth Century,* pp. 71–110. New Haven: Yale University Press, 1984.

Dance, Daryl C. "Zora Neale Hurston." In *American Women Writers: Bibliographical Essays,* edited by Maurice Duke, et al. Westport, Conn.: Greenwood Press, 1983.

Gates, Henry Louis, Jr. "The Speakerly Text." In Henry Louis Gates, Jr., *The Signifying Monkey,* pp. 170–217. New York: Oxford University Press, 1988.

Giles, James R. "The Significance of Time in Zora Neale Hurston's *Their Eyes Were Watching God." Negro American Literature Forum* 6 (Summer 1972): 52–53, 60.

Hemenway, Robert E. *Zora Neale Hurston: A Literary Biography.* Chicago: University of Illinois Press, 1977.

Holloway, Karla. *The Character of the Word: The Texts of Zora Neale Hurston.* Westport, Conn.: Greenwood Press, 1987.

Holt, Elvin. "Zora Neale Hurston." In *Fifty Southern Writers After 1900,* edited by Joseph M. Flura and Robert Bain, pp. 259–69. Westport, Conn.: Greenwood Press, 1987.

Howard, Lillie Pearl. *Zora Neale Hurston.* Boston: Twayne, 1980.

———. "Zora Neale Hurston." In *Dictionary of Literary Biography,* vol. 51, edited by Trudier Harris, pp. 133–45. Detroit: Gale, 1987.

Jackson, Blyden. "Some Negroes in the Land of Goshen." *Tennessee Folklore Society Bulletin* 19 (4) (December 1953): 103–7.

Johnson, Barbara. "Metaphor, Metonymy, and Voice in *Their Eyes.*" In *Black Literature and Literary Theory,* edited by Henry Louis Gates, Jr., pp. 205–21. New York: Methuen, 1984.

————. "Thresholds of Difference: Structures of Address in Zora Neale Hurston." In *"Race," Writing and Difference,* edited by Henry Lewis Gates, Jr. Chicago: University of Chicago Press, 1986.

Jordan, June. "On Richard Wright and Zora Neale Hurston." *Black World* 23 (10) (August 1974): 4–8.

Kubitschek, Missy Dehn. " 'Tuh de Horizon and Back': The Female Quest in *Their Eyes.*" *Black American Literature Forum* 17 (3) (Fall 1983): 109–15.

Lionnet, Françoise. "Autoethnography: The Anarchic Style of *Dust Tracks on a Road.*" In Françoise Lionnet, *Autobiographical Voices: Race, Gender, Self-Portraiture,* pp. 97–130. Ithaca: Cornell University Press, 1989.

Lupton, Mary Jane. "Zora Neale Hurston and the Survival of the Female." *Southern Literary Journal* 15 (Fall 1982): 45–54.

Meese, Elizabeth. "Orality and Textuality in Zora Neale Hurston's *Their Eyes.*" In Elizabeth Meese, *Crossing the Double Cross: The Practice of Feminist Criticism,* pp. 39–55. Chapel Hill: University of North Carolina Press, 1986.

Newson, Adele S. *Zora Neale Hurston: A Reference Guide.* Boston: G. K. Hall, 1987.

Rayson, Ann. *"Dust Tracks on a Road:* Zora Neale Hurston and the Form of Black Autobiography." *Negro American Literature Forum* 7 (Summer 1973): 42–44.

Sheffey, Ruthe T., ed. *A Rainbow Round Her Shoulder: The Zora Neale Hurston Symposium Papers.* Baltimore: Morgan State University Press, 1982.

Smith, Barbara. "Sexual Politics and the Fiction of Zora Neale Hurston." *Radical Teacher* 8 (May 1978): 26–30.

Stepto, Robert B. *From Behind the Veil.* Urbana: University of Illinois Press, 1979.

Walker, Alice. "In Search of Zora Neale Hurston." *Ms.,* March 1975, pp. 74–79, 85–89.

Wall, Cheryl A. "Zora Neale Hurston: Changing Her Own Words." In *American Novelists Revisited: Essays in Feminist Criticism,* edited by Fritz Fleischmann, pp. 370–93. Boston: G. K. Hall, 1982.

Washington, Mary Helen. "Zora Neale Hurston: A Woman Half in Shadow." Introduction to *I Love Myself When I Am Laughing,* edited by Alice Walker. Old Westbury, N.Y.: Feminist Press, 1979.

———. " 'I Love the Way Janie Crawford Left Her Husbands': Zora Neale Hurston's Emergent Female Hero." In Mary Helen Washington, *Invented Lives: Narratives of Black Women, 1860–1960.* New York: Anchor Press, 1987.

Willis, Miriam. "Folklore and the Creative Artist: Lydia Cabrera and Zora Neale Hurston." *CLA Journal* 27 (September 1983): 81–90.

Wolff, Maria Tai. "Listening and Living: Reading and Experience in *Their Eyes.*" *BALF* 16 (1) (Spring 1982): 29–33.

CHRONOLOGY

January 7, 1891	Born in Eatonville, Florida, the fifth of eight children, to John Hurston, a carpenter and Baptist preacher, and Lucy Potts Hurston, a former schoolteacher.
September 1917–June 1918	Attends Morgan Academy in Baltimore, completing the high school requirements.
Summer 1918	Works as a waitress in a nightclub and a manicurist in a black-owned barbershop that serves only whites.
1918–19	Attends Howard Prep School, Washington, D.C.
1919–24	Attends Howard University; receives an associate degree in 1920.
1921	Publishes her first story, "John Redding Goes to Sea," in the *Stylus,* the campus literary society's magazine.
December 1924	Publishes "Drenched in Light," a short story, in *Opportunity.*
1925	Submits a story, "Spunk," and a play, *Color Struck,* to *Opportunity*'s literary contest. Both

	win second-place awards; publishes "Spunk" in the June number.
1925–27	Attends Barnard College, studying anthropology with Franz Boas.
1926	Begins field work for Boas in Harlem.
January 1926	Publishes "John Redding Goes to Sea" in *Opportunity*.
Summer 1926	Organizes *Fire!* with Langston Hughes and Wallace Thurman; they publish only one issue, in November 1926. The issue includes Hurston's "Sweat."
August 1926	Publishes "Muttsy" in *Opportunity*.
September 1926	Publishes "Possum or Pig" in the *Forum*.
September–November 1926	Publishes "The Eatonville Anthology" in the *Messenger*.
1927	Publishes *The First One*, a play, in Charles S. Johnson's *Ebony and Topaz*.
February 1927	Goes to Florida to collect folklore.
May 19, 1927	Marries Herbert Sheen.
September 1927	First visits Mrs. Rufus Osgood Mason, seeking patronage.
October 1927	Publishes an account of the black settlement at St. Augustine, Florida, in the *Journal of Negro History;* also in this issue: "Cudjo's Own Story of the Last African Slaver."
December 1927	Signs a contract with Mason, enabling her to return to the South to collect folklore.
1928	Satirized as "Sweetie Mae Carr" in Wallace Thurman's novel about the Harlem Renaissance *Infants of the Spring;* receives a bachelor of arts degree from Barnard.
January 1928	Relations with Sheen break off.

May 1928	Publishes "How It Feels to Be Colored Me" in the *World Tomorrow*.
1930–32	Organizes the field notes that become *Mules and Men*.
May–June 1930	Works on the play *Mule Bone* with Langston Hughes.
1931	Publishes "Hoodoo in America" in the *Journal of American Folklore*.
February 1931	Breaks with Langston Hughes over the authorship of *Mule Bone*.
July 7, 1931	Divorces Sheen.
September 1931	Writes for a theatrical revue called *Fast and Furious*.
January 1932	Writes and stages a theatrical revue called *The Great Day*, first performed on January 10 on Broadway at the John Golden Theatre; works with the creative literature department of Rollins College, Winter Park, Florida, to produce a concert program of Negro music.
1933	Writes "The Fiery Chariot."
January 1933	Stages *From Sun to Sun* (a version of *Great Day*) at Rollins College.
August 1933	Publishes "The Gilded Six-Bits" in *Story*.
1934	Publishes six essays in Nancy Cunard's anthology, *Negro*.
January 1934	Goes to Bethune-Cookman College to establish a school of dramatic arts "based on pure Negro expression."
May 1934	Publishes *Jonah's Gourd Vine*, originally titled *Big Nigger*; it is a Book-of-the-Month Club selection.

September 1934	Publishes "The Fire and the Cloud" in the *Challenge*.
November 1934	*Singing Steel* (a version of *Great Day*) performed in Chicago.
January 1935	Makes an abortive attempt to study for a Ph.D in anthropology at Columbia University on a fellowship from the Rosenwald Foundation. In fact, she seldom attends classes.
August 1935	Joins the WPA Federal Theatre Project as a "dramatic coach."
October 1935	*Mules and Men* published.
March 1936	Awarded a Guggenheim Fellowship to study West Indian Obeah practices.
April–September 1936	In Jamaica.
September–March 1937	In Haiti; writes *Their Eyes Were Watching God* in seven weeks.
May 1937	Returns to Haiti on a renewed Guggenheim.
September 1937	Returns to the United States; *Their Eyes Were Watching God* published, September 18.
February–March 1938	Writes *Tell My Horse;* it is published the same year.
April 1938	Joins the Federal Writers Project in Florida to work on *The Florida Negro*.
1939	Publishes "Now Take Noses" in *Cordially Yours*.
June 1939	Receives an honorary Doctor of Letters degree from Morgan State College.
June 27, 1939	Marries Albert Price III in Florida.

Summer 1939	Hired as a drama instructor by North Carolina College for Negroes at Durham; meets Paul Green, professor of drama, at the University of North Carolina.
November 1939	*Moses, Man of the Mountain* published.
February 1940	Files for divorce from Price, though the two are reconciled briefly.
Summer 1940	Makes a folklore-collecting trip to South Carolina.
Spring–July 1941	Writes *Dust Tracks on a Road.*
July 1941	Publishes "Cock Robin, Beale Street" in the *Southern Literary Messenger.*
October 1941–January 1942	Works as a story consultant at Paramount Pictures.
July 1942	Publishes "Story in Harlem Slang" in the *American Mercury.*
September 5, 1942	Publishes a profile of Lawrence Silas in the *Saturday Evening Post.*
November 1942	*Dust Tracks on a Road* published.
February 1943	Awarded the Anisfield-Wolf Book Award in Race Relations for *Dust Tracks;* on the cover of the *Saturday Review.*
March 1943	Receives Howard University's Distinguished Alumni Award.
May 1943	Publishes "The 'Pet Negro' Syndrome" in the *American Mercury.*
November 1943	Divorce from Price granted.
June 1944	Publishes "My Most Humiliating Jim Crow Experience" in the *Negro Digest.*
1945	Writes *Mrs. Doctor;* it is rejected by Lippincott.

March 1945	Publishes "The Rise of the Begging Joints" in the *American Mercury.*
December 1945	Publishes "Crazy for This Democracy" in the *Negro Digest.*
1947	Publishes a review of Robert Tallant's *Voodoo in New Orleans* in the *Journal of American Folklore.*
May 1947	Goes to British Honduras to research black communities in Central America; writes *Seraph on the Suwanee;* stays in Honduras until March 1948.
September 1948	Falsely accused of molesting a ten-year-old boy and arrested; case finally dismissed in March 1949.
October 1948	*Seraph on the Suwanee* published.
March 1950	Publishes "Conscience of the Court" in the *Saturday Evening Post,* while working as a maid in Rivo Island, Florida.
April 1950	Publishes "What White Publishers Won't Print" in the *Saturday Evening Post.*
November 1950	Publishes "I Saw Negro Votes Peddled" in the *American Legion* magazine.
Winter 1950–51	Moves to Belle Glade, Florida.
June 1951	Publishes "Why the Negro Won't Buy Communism" in the *American Legion* magazine.
December 8, 1951	Publishes "A Negro Voter Sizes Up Taft" in the *Saturday Evening Post.*
1952	Hired by the *Pittsburgh Courier* to cover the Ruby McCollum case.
May 1956	Receives an award for "education and human relations" at Bethune-Cookman College.

June 1956	Works as a librarian at Patrick Air Force Base in Florida; fired in 1957.
1957–59	Writes a column on "Hoodoo and Black Magic" for the *Fort Pierce Chronicle.*
1958	Works as a substitute teacher at Lincoln Park Academy, Fort Pierce.
Early 1959	Suffers a stroke.
October 1959	Forced to enter the St. Lucie County Welfare Home.
January 28, 1960	Dies in the St. Lucie County Welfare Home of "hypertensive heart disease"; buried in an unmarked grave in the Garden of Heavenly Rest, Fort Pierce.
August 1973	Alice Walker discovers and marks Hurston's grave.
March 1975	Walker publishes "In Search of Zora Neale Hurston," in *Ms.,* launching a Hurston revival.

About the author

About the book

Insights,
Interviews
& More . . .

Read on

She *Was* the Party

by Valerie Boyd

ZORA NEALE HURSTON knew how to make an entrance. On May 1, 1925, at a literary awards dinner sponsored by *Opportunity* magazine, the earthy Harlem newcomer turned heads and raised eyebrows as she claimed four awards: a second-place fiction prize for her short story "Spunk," a second-place award in drama for her play *Color Struck*, and two honorable mentions.

The names of the writers who beat out Hurston for first place that night would soon be forgotten. But the name of the second-place winner buzzed on tongues all night, and for days and years to come.

Lest anyone forget her, Hurston made a wholly memorable entrance at a party following the awards dinner. She strode into the room—jammed with writers and arts patrons, black and white—and flung a long, richly colored scarf around her neck with dramatic flourish as she bellowed a reminder of the title of her winning play: "*Coloooooor Struuckkkk!*" Her exultant entrance literally stopped the party for a moment, just as she had intended. In this way, Hurston made it known that a bright and powerful presence had arrived.

By all accounts, Zora Neale Hurston could walk into a roomful of strangers and, a few minutes and a few stories later, leave them so completely charmed that they often found themselves offering to help her in any way they could.

Gamely accepting such offers—and employing her own talent and scrappiness—Hurston became the most successful and most significant black woman writer of the first half of the twentieth century. Over a career that spanned more than thirty years,

Author photograph by Carl Van Vechten, courtesy of the Van Vechten Trust

she published four novels, two books of folklore, an autobiography, numerous short stories, and several essays, articles, and plays.

Born on January 7, 1891, in Notasulga, Alabama, Hurston moved with her family to Eatonville, Florida, when she was still a toddler. Her writings reveal no recollection of her Alabama beginnings. For Hurston, Eatonville was always home.

Established in 1887, the rural community near Orlando was the nation's first incorporated black township. It was, as Hurston described it, "a city of five lakes, three croquet courts, three hundred brown skins, three hundred good swimmers, plenty guavas, two schools, and no jailhouse."

In Eatonville, Zora was never indoctrinated in inferiority, and she could see the evidence of black achievement all around her. She could look to town hall and see black men, including her father, John Hurston, formulating the laws that governed Eatonville. She could look to the Sunday schools of the town's two churches and see black women, including her mother, Lucy Potts Hurston, directing the Christian curricula. She could look to the porch of the village store and see black men and women passing worlds through their mouths in the form of colorful, engaging stories.

Growing up in this culturally affirming setting in an eight-room house on five acres of land, Zora had a relatively happy childhood, despite frequent clashes with her preacher-father, who sometimes sought to "squinch" her rambunctious spirit, she recalled. Her mother, on the other hand, urged young Zora and her seven siblings to "jump at de sun." Hurston explained, "We might not land on the sun, but at least we would get off the ground."

Hurston's idyllic childhood came to an abrupt end, though, when her mother died ▶

> **"** In Eatonville, Zora was never indoctrinated in inferiority, and she could see the evidence of black achievement all around her. **"**

She *Was* the Party *(continued)*

in 1904. Zora was only thirteen years old. "That hour began my wanderings," she later wrote. "Not so much in geography, but in time. Then not so much in time as in spirit."

After Lucy Hurston's death, Zora's father remarried quickly—to a young woman whom the hotheaded Zora almost killed in a fistfight—and seemed to have little time or money for his children. "Bare and bony of comfort and love," Zora worked a series of menial jobs over the ensuing years, struggled to finish her schooling, and eventually joined a Gilbert & Sullivan traveling troupe as a maid to the lead singer. In 1917, she turned up in Baltimore; by then, she was twenty-six years old and still hadn't finished high school. Needing to present herself as a teenager to qualify for free public schooling, she lopped ten years off her life—giving her year of birth as 1901. Once gone, those years were never restored: from that moment forward, Hurston would always present herself as at least ten years younger than she actually was.

Apparently, she had the looks to pull it off. Photographs reveal that she was a handsome, big-boned woman with playful yet penetrating eyes, high cheekbones, and a full, graceful mouth that was never without expression.

Zora also had a fiery intellect, an infectious sense of humor, and "the gift," as one friend put it, "of walking into hearts." Zora used these talents—and dozens more—to elbow her way into the Harlem Renaissance of the 1920s, befriending such luminaries as poet Langston Hughes and popular singer-actress Ethel Waters.

Though Hurston rarely drank, fellow writer Sterling Brown recalled, "When Zora was there, she *was* the party." Another friend remembered Hurston's apartment—

> 'When Zora was there, she *was* the party.'

4

furnished by donations she solicited from friends—as a spirited "open house" for artists. All this socializing didn't keep Hurston from her work, though. She would sometimes write in her bedroom while the party went on in the living room.

By 1935, Hurston—who'd graduated from Barnard College in 1928—had published several short stories and articles, as well as a novel, *Jonah's Gourd Vine*, and a well-received collection of black Southern folklore, *Mules and Men*. But the late thirties and early forties marked the real zenith of her career. She published her masterwork, *Their Eyes Were Watching God*, in 1937; *Tell My Horse*, her study of Haitian Voodoo practices and Caribbean culture, in 1938; and another masterful novel, *Moses, Man of the Mountain*, in 1939. When her autobiography, *Dust Tracks on a Road*, was published in 1942, Hurston finally received the well-earned acclaim that had long eluded her. That year, she was profiled in *Who's Who in America*, *Current Biography*, and *Twentieth Century Authors*. She went on to publish another novel, *Seraph on the Suwanee*, in 1948.

Still, Hurston never received the financial rewards she deserved. (The largest royalty she ever earned from any of her books was $943.75.) So, when she died on January 28, 1960—at age sixty-nine, after suffering a stroke—her neighbors in Fort Pierce, Florida, had to take up a collection for her February 7 funeral. The collection didn't yield enough to pay for a headstone, however, and Hurston was buried in a grave that remained unmarked until 1973.

That summer, a young writer named Alice Walker traveled to Fort Pierce to place a marker on the grave of the author who had so inspired her own work. Walker found ▶

> "Hurston was buried in a grave that remained unmarked until 1973."

She *Was* the Party *(continued)*

the Garden of Heavenly Rest, a segregated cemetery at the dead end of North Seventeenth Street, abandoned and overgrown with yellow-flowered weeds.

Back in 1945, Hurston had foreseen the possibility of dying without money—and she'd proposed a solution that would have benefited her and countless others. Writing to W. E. B. Du Bois, whom she called the "Dean of American Negro Artists," Hurston suggested "a cemetery for the illustrious Negro dead" on one hundred acres of land in Florida. "Let no Negro celebrity, no matter what financial condition they might be in at death, lie in inconspicuous forgetfulness," she urged. "We must assume the responsibility of their graves being known and honored." Du Bois, citing practical complications, wrote a curt reply discounting her argument.

As if impelled by Hurston's words, Walker bravely entered the snake-infested cemetery where the writer's remains had been laid to rest. Wading through waist-high weeds, she soon stumbled upon a sunken rectangular patch of ground that she determined to be Hurston's grave. Unable to afford the marker she wanted—a tall, majestic black stone called "Ebony Mist"—Walker chose a plain gray headstone instead. Borrowing from a Jean Toomer poem, she dressed the marker up with a fitting epitaph: "Zora Neale Hurston: A Genius of the South."

> " Wading through waist-high weeds, Alice Walker stumbled upon a sunken rectangular patch of ground that she determined to be Hurston's grave. "

Valerie Boyd is the author of the award-winning Wrapped in Rainbows: The Life of Zora Neale Hurston. *Formerly the arts editor at the* Atlanta Journal-Constitution, *she is a professor at the University of Georgia's Grady College of Journalism and Mass Communication.*

More Than a
Voodoo Work

by Ishmael Reed

A LINE FROM Countee Cullen's famous
poem "Heritage" typifies the attitudes
of many "educated" white and black
Americans for whom African and Neo-
African religions are exotic faiths whose
gods, "quaint . . . outlandish . . . ," and
"heathen," are "naught" to them. It took
the restless intellect of Zora Neale Hurston
to make Neo-African religion, and its gods,
more than "naught." The result was *Tell
My Horse*, a major work of the Voodoo
bibliography, which includes books written
in Spanish, French, Portuguese, and Creole
as well as English. The majority of these
works have yet to be translated, which
makes Hurston's work a treasure for the
English reader who is curious about the
subject. Though Voodoo had been driven
underground by the time *Tell My Horse*
was published, there has been a resurgence,
due to the arrival in the United States of
many of its followers from South and
Central America and the Caribbean.
Since white American readers are suspicious
of the scholarship of those they deem to be
aliens—they seem to need one of their own
to translate—the efforts of such scholars
as Robert Thompson, Robert Gover, and
Michael Ventura and musicians like Kip
Hanrahan and David Byrne have been
invaluable in defusing some of the
hysteria with which Neo-African religion
has been regarded in the United States,
a Protestant country. The contemporary
misunderstanding of Voodoo was shown
by the harsh criticism that African priests
and Americans like Rev. George A. ▶

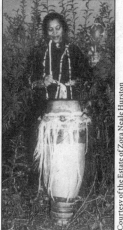

Courtesy of the Estate of Zora Neale Hurston

*Zora drumming on
her trip to Haiti,
where she penned*
Their Eyes Were
Watching God *and
collected information
on Voodoo for her
nonfiction work*
Tell My Horse.

More Than a Voodoo Work *(continued)*

Stallings, Jr., received from the Catholic hierarchy as a result of their incorporation of the African style into Western Catholic rites—even though such blending of styles has been long established in the Caribbean, Central and South America, and Haiti, where it is said that the people are ninety-five percent Catholic and one hundred percent Voodoo. It is against this background that Zora Neale Hurston's pioneer work can be appreciated, though one can understand why a writer tackling such a taboo subject would have appeared odd to the intellectually slothful of her time.

But *Tell My Horse*, the result of Hurston's travels to Jamaica and Haiti, is more than a Voodoo work. She writes intelligently about the botany, sociology, anthropology, geology, and politics of these nations in a style that is devoid of pompous jargon and accessible to the general reader. It is an entertaining book.

Hurston's gift for storytelling is immense, whether writing about the hunting of a wild boar by the Maroons at Accompong ("Men who had thrown off the bands of slavery by their . . . courage and ingenuity") or about the extraordinary steps that Jamaicans take to appease a "duppy," lest it return from the grave and do harm to the living. In one of the book's very good interviews an informant tells Hurston that "the duppy . . . is the most powerful part of any man. Everybody has evil in them, and when a man is alive, the heart and brain controls him and he will not abandon himself to many evil things. But when the duppy leaves the body, it no longer has anything to restrain it and it will do more terrible things than any man ever dreamed of. It is not good for a duppy to stay among living folk."

Part travelogue, *Tell My Horse* invokes the

beauty of Jamaica and Haiti and the sacred zones where African gods continue to dwell—the "good" ones, the Rada group, and the "bad" ones, the Petros. The enemies of Voodoo have exploited rumors associating the Secte Rouge, a Petro sect, with human sacrifice in order to defame Voodoo, less a religion than the common language of slaves from different African tribes thrown together in the Americas for commercial reasons. This common language was feared because it not only united the Africans but also made it easier for them to forge alliances with those Native Americans whose customs were similar. Voodoo has been the inspiration for the major slave revolts in this hemisphere, including the one that ousted the French from Haiti, but just as Christianity has been used by tyrants as a means for persecuting their opponents, Voodoo has been similarly abused.

Hurston's account of the Neo-African religion practiced in Haiti is fascinating. She gives a thorough description of the main loas (gods), their needs, their desires, and their powers. The details about art and dance are informative, though she describes the dance as "barbaric." But the most interesting discussion in *Tell My Horse* concerns possession, that strange phenomenon during which a mortal is taken over by a god. (One wonders what would happen if "possession," this amazing phenomenon, were as available to the millions of anxiety-ridden Americans as are the billions of toxic stress-reducing pills that are shoveled across drugstore counters and the illegal substances consumed by Americans that make ours a nation of junkies.)

It is interesting to note that a growing number of psychiatrists and physicians are beginning to trace the mental and physical health problems of many blacks—in ▶

More Than a Voodoo Work *(continued)*

particular the lack of self-esteem—to the symbolic annihilation to which their culture is subjected by the white-pride school curricula and media. Perhaps another cause of this depression is the severance of any link to the images of their ancient religion. One wonders how the millions of Catholics and Protestants who came to these shores or the followers of Buddhism and Confucianism would have fared had their faiths been driven underground, depriving them of spiritual nourishment, or if their religions had been exposed to the kind of pillorying that Neo-African religion receives in the media and from the motion picture industry. Typical of the treatment accorded Voodoo was NBC anchorman Tom Brokaw's sensational announcement that the drug murders occurring in Mexico in 1988 were the result of Voodoo rites; it was revealed later that the so-called drug cult had been inspired by a Hollywood "Voodoo" film titled *The Believers.*

Contemporary myths about black literature proliferate, but the fate of the average black writer, male or female, is the same: the nonavailability of their books; reviews that are often influenced by racist ideology or that exhibit a double standard; the difficulty in getting their views aired—these are just some of the problems that hamper their careers. Most would agree with Countee Cullen's assessment that a black writer in a country in which they are treated as aliens is "a curious thing."

For Hurston, though, the human family has room for a President Jean Vilbrun Guillaume Sam, a "greedy detestable criminal," as well as his son, known by the peasants of his time as "fine" and "intelligent." In her novel *Their Eyes*

Were Watching God, despite their flaws, the men are productive and talented. In *Tell My Horse*, Hurston describes, without sermonizing, the Jamaican practice of cultivating geishas for the delight of prospective grooms and comments in passing on the practice of polygamy. When commenting about the status of women in the United States, she sounds more like Phyllis Schlafly than Bell Hooks or Michelle Wallace: "The majority of men in all the states are pretty much agreed that just for being born a girl-baby you ought to have laws and privileges and pay and perquisites. And so far as being allowed to voice opinions is concerned, why, they consider that you are born with the law in your mouth, and that is not a bad arrangement either. The majority of the solid citizens strain their ears trying to find out what it is that their womenfolk want so they can strain around and try to get it for them, and that is a *very* good idea and the right way to look at things." Ironically, many of today's feminists would consider such thinking to be "retrograde." Zora Neale Hurston has also gained the reputation of a racial chauvinist. She reserves some of her harshest opinions for black nationalists (Race Men), whom she dismisses as "windbags" and "demagogues."

The Zora Neale Hurston of *Tell My Horse* is skeptical, cynical, funny, ironic, brilliant, and innovative. With its mixture of techniques and genres, this book, originally published in 1938, is bound to be the postmodernist book of the nineties. But her greatest accomplishment is in revealing the profound beauty and appeal of a faith older than Christianity, Buddhism, and Islam, a faith that has survived in spite of its horrendously bad reputation and the persecution of its followers. ∽

Have You Read?
More by Zora Neale Hurston

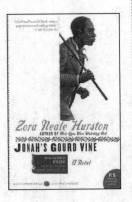

JONAH'S GOURD VINE

Zora Neale Hurston's first novel tells the story of John Buddy Pearson, a young minister who loves too many women for his own good even though he is married to Lucy, his one true love. In this sympathetic portrait of a man and his community, Hurston shows that faith, tolerance, and good intentions cannot resolve the tension between the spiritual and the physical.

THEIR EYES WERE WATCHING GOD

The epic tale of Janie Crawford, whose quest for identity takes her on a journey during which she learns what love is, experiences life's joys and sorrows, and comes home to herself in peace. Her passionate story prompted Alice Walker to say, "There is no book more important to me than this one."

MULES AND MEN

The fruit of Hurston's labors as a folklorist and anthropologist, this celebrated treasury of black American folklore includes stories, "big old lies," songs, Voodoo customs, superstitions—all the humor and wisdom that is the matchless heritage of American blacks.

THE COMPLETE STORIES

This landmark gathering of Zora Neale Hurston's short fiction—most of which appeared only in literary magazines during her lifetime and some of which has never before been published—reveals the evolution of one of the most important African American writers. Spanning her career from 1921 to 1955, these stories attest to Hurston's tremendous range and establish themes that recur in her longer fiction. The stories in this collection map, in rich language and imagery, Hurston's development and concerns as a writer and provide an invaluable reflection of the mind and imagination of the author of the acclaimed novel *Their Eyes Were Watching God*.

Have You Read? *(continued)*

MOSES, MAN OF THE MOUNTAIN

Based on the familiar story of the Exodus, Hurston blends the Moses of the Old Testament with the Moses of black folklore and song to create a compelling allegory of power, redemption, and faith.

DUST TRACKS ON THE ROAD

First published in 1942 at the crest of her popularity as a writer, this is Hurston's imaginative and exuberant account of her rise from childhood poverty in the rural South to a prominent place among the leading artists and intellectuals of the Harlem Renaissance. It is a book full of the wit and wisdom of a proud and spirited woman who started off low and climbed high.

SERAPH ON THE SUWANEE

Set among the community of "Florida Crackers" at the turn of the twentieth century, Hurston's novel marks a daring departure for the author famous for her complex accounts of black culture and heritage. Hurston explores the evolution of a marriage full of love but very little communication and the desires of a young woman in search of herself and her place in the world.

MULE BONE

Mule Bone is the only collaboration between Zora Neale Hurston and Langston Hughes, two stars of the Harlem Renaissance, and it holds an unparalleled place in the annals of African American theater. Set in Eatonville, Florida—Hurston's hometown and the inspiration for much of her fiction—this energetic and often farcical play centers on Jim and Dave, a two-man song-and-dance team, and Daisy, the woman who comes between them. Overcome by jealousy, Jim hits Dave with a mule bone and hilarity follows chaos as the town splits into two factions: the Methodists, who want to pardon Jim; and the Baptists, who wish to banish him for his crime.

EVERY TONGUE GOT TO CONFESS

African American folklore was Zora Neale
Hurston's first love. Collected in the late
1920s, these hilarious, bittersweet, often saucy
folktales—some of which date back to the
Civil War—provide a fascinating, verdant
slice of African American life in the rural
South at the turn of the twentieth century.
Arranged according to subject—from God
Tales, Preacher Tales, and Devil Tales to
Heaven Tales, White-Folk Tales, and
Mistaken Identity Tales—they reveal
attitudes about slavery, faith, race relations,
family, and romance that have been passed
on for generations. They capture the heart
and soul of the vital, independent, and
creative community that so inspired
Zora Neale Hurston.

Discover great authors,
exclusive offers, and
more at hc.com.

MOSES, MAN OF THE MOUNTAIN

MOSES, MAN OF THE MOUNTAIN

ZORA NEALE HURSTON

WITH A FOREWORD BY
DEBORAH E. MCDOWELL
SERIES EDITOR: HENRY LOUIS GATES, JR.

AMISTAD

An Imprint of HarperCollinsPublishers

To
Edwin Osgood Grover

AUTHOR'S INTRODUCTION

Moses was an old man with a beard. He was the great law-giver. He had some trouble with Pharaoh about some plagues and led the Children of Israel out of Egypt and on to the Promised Land. He died on Mount Nebo and the angels buried him there. That is the common concept of Moses in the Christian world.

But there are other concepts of Moses abroad in the world. Asia and all the Near East are sown with legends of this character. They are so numerous and so varied that some students have come to doubt if the Moses of the Christian concept is real. Then Africa has her mouth on Moses. All across the continent there are the legends of the greatness of Moses, but not because of his beard nor because he brought the laws down from Sinai. No, he is revered because he had the power to go up the mountain and to bring them down. Many men could climb mountains. Anyone could bring down laws that had been handed to them. But who can talk with God face to face? Who had the power to command God to go to a peak of a mountain and there demand of Him laws with which to govern a nation? What other man has ever seen with his eyes even the back part of God's glory? Who else has ever commanded the wind and the hail? The light and darkness?

That calls for power, and that is what Africa sees in Moses to worship. For he is worshipped as a god.

In Haiti, the highest god in the Haitian pantheon is Damballa Ouedo Ouedo Tocan Freda Dahomey and he is identified as Moses, the serpent god. But this deity did not originate in Haiti. His home is in Dahomey and is worshipped there extensively. Moses had his rod of power, which was a living serpent. So that in every temple of Damballa there is a living snake, or the symbol.

And this worship of Moses as the greatest one of magic is not confined to Africa. Wherever the children of Africa have been scattered by slavery, there is the acceptance of Moses as the fountain of mystic powers. This is not confined to Negroes. In America there are countless people of other races depending upon mystic symbols and seals and syllables said to have been used by Moses to work his wonders. There are millions of copies of a certain book, *The Sixth and Seventh Books of Moses,* being read and consulted in secret because the readers believe in Moses. Some even maintain that the stories of the miracles of Jesus are but Mosaic legends told again. Nobody can tell how many tales and legends of Moses are alive in the world nor how far they have travelled, so many have collected around his name.

So all across Africa, America, the West Indies, there are tales of the powers of Moses and great worship of him and his powers. But it does not flow from the Ten Commandments. It is his rod of power, the terror he showed before all Israel and to Pharaoh, and THAT MIGHTY HAND.

THE AUTHOR.

MOSES, MAN OF THE MOUNTAIN

In all the signs and wonders which the Lord sent him to do in the land of Egypt to Pharaoh, and to all his servants and to all his lands, and in all that mighty hand *and in* all the great terror *which Moses showed in the sight of all Israel!*
Deuteronomy 34:11–12

CHAPTER 1

Have mercy! Lord, have mercy on my poor soul!"
Women gave birth and whispered cries like this in
caves and out-of-the-way places that humans didn't usu-
ally use for birthplaces. Moses hadn't come yet, and these
were the years when Israel first made tears. Pharaoh had en-
tered the bedrooms of Israel. The birthing beds of Hebrews
were matters of state. The Hebrew womb had fallen under the
heel of Pharaoh. A ruler great in his newness and new in his
greatness had arisen in Egypt and he had said, "This is law.
Hebrew boys shall not be born. All offenders against this law
shall suffer death by drowning."

So women in the pains of labor hid in caves and rocks. They
must cry, but they could not cry out loud. They pressed their
teeth together. A night might force upon them a thousand
years of feelings. Men learned to beat upon their breasts with
clenched fists and breathe out their agony without sound. A
great force of suffering accumulated between the basement of
heaven and the roof of hell. The shadow of Pharaoh squatted
in the dark corners of every birthing place in Goshen. Hebrew
women shuddered with terror at the indifference of their
wombs to the Egyptian law.

The province of Goshen was living under the New Egypt
and the New Egyptian and they were made to know it in many

ways. The sign of the new order towered over places of preference. It shadowed over work, and fear was given body and wings.

The Hebrews had already been driven out of their well-built homes and shoved further back in Goshen. Then came more decrees:

1. Israel, you are slaves from now on. Pharaoh assumes no responsibility for the fact that some of you got old before he came to power. Old as well as young must work in his brickyards and road camps.
 a. No sleeping after dawn. Fifty lashes for being late to work.
 b. Fifty lashes for working slow.
 c. One hundred lashes for being absent.
 d. One hundred lashes for sassing the bossman.
 e. Death for hitting a foreman.
2. Babies take notice: Positively no more boy babies allowed among Hebrews. Infants defying this law shall be drowned in the Nile.

Hebrews were disarmed and prevented from becoming citizens of Egypt, they found out that they were aliens, and from one new decree to the next they sank lower and lower. So they had no comfort left but to beat their breasts to crush the agony inside. Israel had learned to weep.

CHAPTER 2

The sun was setting. Under the brilliant, cloudless Egyptian sun thousands of Hebrew workers were struggling with building stones. Some of their backs were bloody from the lash; many of them were stoopy from age and all of them were sweaty and bent and tired from work. The Egyptian foreman gazed at the drooping sun in awe and breathed with reverence: "Ah, Horus, golden god! Lord of both horizons. The weaver of the beginning of things!"

Amram, struggling with the help of another man to move a heavy stone into place in the foundation, heard him and looked up.

"Horus may be all those good things to the Egyptians, brother, but that sun-god is just something to fry our backs."

"I heard him what he said," the other worker whispered back. "If Horus is the weaver of the beginning of things, he's done put some mighty strange threads in his loom."

"And still and all I used to admire him too, before this new government come in, didn't you?"

"Uhuh. I used to admire everything in Egypt. But the palms and the plains ain't scenery to me no more. They just look like suffering to me now."

3

"They look that way to me too, now," Amram whispered back, "and the worst part about it is, my wife is going to have another baby."

"I heard about it, Amram. What you going to do? Take her off in the wilderness like I did mine?"

"Don't know exactly, Caleb. One man was telling me he hid his wife out in a boat until it was all over. Turned out to be a girl so it was all right."

"How soon you expecting?"

"Of course you can't never be sure exactly, but we figure in two or three days more. I'm planning on hunting up some good cave or some place like that the secret police don't know about yet. Thought I'd take tonight to locate a place. Will you go along with me?"

"Sure I will. You got the midwife engaged?"

"Yes, that's all fixed up. Going to send my boy Aaron and my girl Miriam along to help around generally. They can do little things around and watch out for spies. Old Puah, the midwife, knows her business all right and she's just as loyal as she can be, but she's getting kind of old, you know."

"That's right. It's good you got a sizeable boy and girl to run errands and to stand watch. It's liable to happen while we are at work, you know."

"Oh, yes, and that's how come I want to find a place and get it sort of fixed up with a quilt or two for my wife to rest on and some water and things like that so when the time comes I won't need to worry. It's a sin and a shame our wives can't even have a baby in peace."

"And that's just the reason I want to go with that delegation to see old Pharaoh tonight. You know a bunch of us are going tonight to see him to protest these new decrees, don't you?"

"Sure, but I don't believe it'll do a bit of good. Still and all I want to go just to see what he's going to say this time. But it makes me fighting mad to see him sit up there, him and his so-called advisors, and laugh right in our faces. Reckon we'll

4

get back from our little cave hunt in time to go along with the rest?"

"Hope so. I just don't see how he can keep on putting out all these decrees and making 'em meaner all the time. He's got to give us some kind of a justice sooner or later."

"You think so, Caleb? I don't. I saw his eyes last time. That man loves to see us suffer. He loves to see us hurt and ache. That's how come he lets us come—to be sure he's griping us good. I've about made up my mind that these protests ain't doing us no good at all."

"You reckon, Amram?"

"Sure. You all talk like somebody else made these laws and Pharaoh don't know nothing about 'em. He makes 'em his own self and he's glad when we come tell him they hurt. Why, that's a whole lot of pleasure to him, to be making up laws all the time and to have a crowd like us around handy to pass all his mean ones on. Why, he's got a law about everything under the sun! Next thing you know he'll be saying cats can't have kittens. He figures that it makes a big man out of him to be passing and passing laws and rules. He thinks that makes him look more like a king. Long time ago he done passed all the laws that could do anybody good. So now he sits up and studies up laws to do hurt and harm, and we're the only folks in Egypt he got the nerve to put 'em on. He aims to keep us down so he'll always have somebody to wipe his feet on. He brags that him and the Egyptian nation is eating high on the hog now."

"Well, it's his time now, be mine after while, maybe."

"Maybe is right. He's got us in the go-long and I just don't see no way out unless he was to die and a better man come along."

"It certainly is hard, Amram, getting use to being a slave."

"And look what he done done! Passed a law we can't go in the temples no more. He says their gods ain't our gods."

"Like what other gods do we know anything about. It gives you a real empty feeling not to have no gods anymore. If we

5

can't go to the temples in Thebes and Memphis and Luxor, we could build us one in Goshen and sacrifice, Amram. Maybe if we do that they might help us to get our rights back again."

"Caleb, those temples were built by Egyptians and those gods were made by Egyptians. Gods always love the people who make 'em. We can't put no faith in them."

"Don't say that, Amram. That don't leave me no way to turn at all. Makes me feel like my insides been ripped out."

"Well, Caleb, I'm giving it out just like I figured it out. We just ain't got no out that I can see. Anybody depending on somebody else's gods is depending on a fox not to eat chickens. I don't see no way out but death and, Caleb, you are up against a hard game when you got to die to beat it."

The foreman was coming so they quit whispering and speeded up their work for a while. It was about dark and they knew they couldn't work much longer anyway. The foreman glanced at them in passing and went on. They began to whisper again right away, under pretense of adjusting a rope for lifting a stone.

"Caleb?"

"I hear you, Amram."

"Wouldn't it be swell if some of us hid knives in our clothes when we went to see Pharaoh?"

"It sure would. But they always search us, don't they, before they let us in."

"I know, but it is something nice to think about, ain't it?"

"Sure is."

"Right now, everybody's nerve is gone, but someday, maybe not in our time, but, he's bound to meet his match first and last."

"That's a long time to wait, Amram, but I reckon it is the best we can do. I hate myself for not trying it even if they all kill me for it."

"That's what I hate 'em for too, making me scared to die. It's a funny thing, the less people have to live for, the less nerve they have to risk losing—nothing."

6

"Where'd you get that good word from, Amram? It sure is the truth. I know it by myself."

"Oh, you learn things as you go along. I hope I don't have another boy, Caleb. Even if the soldiers don't find him and kill him, I don't want him feeling like I feel. I want him to be a man."

CHAPTER 3

Amram and Caleb got off and plodded on home. Amram was full of feelings about his wife's condition and Caleb talked about the protest meeting. He wanted Amram to go if he could.

"I guess you're right about it not doing no good and I reckon we all know it. But I guess the reason we go is it makes us feel like we still got some say-so over our life. In that way we don't feel quite so much like mules."

Amram said, "Eat your supper just as quick as you can if you going with me and let's go locate a hiding place for my wife."

They said goodbye at the door of Amram's hut and Caleb went on home. Amram stepped inside to fate. Jochebed's water had broken and she was in labor. Old Puah was in the back room squatting down by the straw pallet of Jochebed whispering to her to "bear down!" in her harsh old voice.

Amram knelt by his wife and kissed her. She lifted her arms about his neck and hung there.

"Amram," she whispered, "You won't have no time to move me at all. But you mustn't let me scream, hear? No matter how hard the pain gets you mustn't let me scream. Pharaoh's secret police don't never stop prowling."

"I know that. Oh, honey, I hate for our child to come like this. I don't feel like no man at all."

"You can't help it, honey. You done the best you could. Just don't let me scream out when I get so bad I don't know what I'm doing. Hold my mouth good, Amram. Don't let me expose our child to murder, in case it's a boy."

"I promise, Jochebed, but this is a mean moment in life."

She hugged him faintly and smiled up. "The pains took me hard once or twice. I was afraid it was going to come before you got here," she said with a sort of happiness in her voice because her husband was there at her time.

In a little while Amram started to eat his supper. But no sooner did he begin than Jochebed uttered a cry. He flew back to her side and lifted her head in his arms and put one hand over her mouth. She tried hard to scream, but Amram was there.

The back of Amram's hard hand filled her mouth. His rough hand clamped down fiercely over her lower face. Jochebed fought for her breath and for the boon of shrieking out her agony and suffering.

"Shhh! The Egyptians will hear you!"

The woman may have heard, but she struggled harder to release the agony of her loins through cries. Her lungs almost exploded with the pent-in air. She clawed at her husband's hands which so relentlessly smothered her gasping cries. She drew up her knees violently and arched her back.

Now old Puah, the midwife, knelt over Jochebed and laid helping hands upon her belly. "Bear down!" the midwife commanded sternly. "Bear down, Jochebed, and have done with this birthing. It is taking much too long. Bear down, I tell you!" The command was stern but whispered. It was muted by fear like every other sound in the house. Old Puah put her lips to the other's ear and beseeched, "Ah, Jochebed, will you not hurry up with this child before the soldiers pass again?"

"Shut up, woman," Amram began, but had to turn all of his attention and strength to muffling the agony of his wife. She was flinging her head from side to side to wrench free of the hands that gripped her lower face like a vice. Finally the pain wave passed and she subsided on the straw limp and white.

9

"Ah, it is awful when a woman cannot even cry out in childbirth," Puah said. "When will these Egyptians be punished for their crimes?"

"Hush! Mouth almighty!" Amram said. "The very air in Goshen has ears. Have you got the medicine fixed for her and ready?"

"Certainly, Amram. I didn't start to delivering babies just yesterday. As soon as I know a woman's time is near, I boil the herbs for her."

"Where is it, then?" Amram whispered anxiously.

"In that pot over against the wall. But do you think it is safe to give it now? It will speed up her labor but—" She looked fearfully over her shoulder towards the dark door of the outer room.

Jochebed set her teeth and hissed a groan. Instantly her husband's hands flew to her mouth. From his kneeling position he looked over his shoulder into the outer room and whispered "Aaron."

A young voice charged with fear whispered back from the dark outer room. "Yessir, papa."

"Don't stand there yelling back and forth with me! Come and hear what I have to say."

Aaron the boy entered the back room lit dimly by the crude oil lamp on the floor and stood timidly back of the squatting Puah. The lamp shone between the pale face of his mother on the straw pallet and the tortured features of his father kneeling over her. He didn't feel so much like a coward as he had out there in the dark front room for he saw the fear on the faces of the three grown folks in the room.

"Yessir, papa, what you want with me?"

"Where is your sister?"

"Miriam is out there—" indicating the outer room.

"Tell her to come here."

Aaron tiptoed back into the other room without a sound and came back shoving Miriam before him. They knelt before Amram and presented their ears.

"Miriam, you go and squat just inside the front door and

watch. If anyone approaches come quickly. Do not call out."

"Yessir, papa."

"Aaron, you go outside."

"Not outside, papa. Please don't make me go outside," Aaron gasped in terror. "The secret police!"

"Yes, outside!" Amram answered sternly. "These Egyptian scoundrel-beasts must be overcome somehow. There ain't but a few of us Hebrews. We ain't got nothing to fight with. Do as I tell you. Go out to the main street and watch. When you see a band of the plug-uglies coming, run back and whisper to Miriam. She will give us the sign."

"But I ain't but twelve years old. All them Egyptian soldiers—"

"Go on! It's done got so that Israelite boys can't wait to get grown to be men. You will have to be a man right now." Amram gestured towards the pallet, the midwife and the room and Aaron stumbled out into the Egyptian darkness to watch. Miriam took her post by the house door and Puah gave Jochebed the drink she called the "friend of women" while Amram knelt in love and fear beside her head. He looked down on the thick red hair of his wife, her white face with the eyes closed in weariness, the hollows in her neck and her breasts. He saw the tracks of time over all and thought, "Of course, Jochebed ain't a girl no more. We got a son twelve years old and a daughter who is nine. Girl-wives must turn into women some time or other."

The oil in the lamp was getting low and Amram moved to replenish it. Old Puah measured and folded swaddling clothes and the night kept its silence outside the house.

Suddenly screams full of terror, sounds of strife and things overthrown came from another quarter of the village. Screams, gagging cries, metal on metal, metal on softer substances.

Amram rushed to the middle door. "Where is that, Miriam?"

"Beyond the house of Hur," the girl sobbed. "Oh, please

11

let me call in Aaron and let's bar the door, papa. The soldiers will kill us!"

A great scream of pain burst from the throat of Jochebed and Amram flew to her bedside and silenced her as before. The struggle was brief and fierce. Then it all ended with a little sigh of relief at the momentary cessation of pain. Amram smoothed back her hair and put his palm soothingly upon his wife's head.

"You, you let me scream," Jochebed accused Amram weakly between subsiding gasps.

Amram thought to quiet her fears with soothing words, but just then Aaron plunged through the front door, stumbling over Miriam's knees and flung his ghastly face into the back room.

"Papa! Mama! Puah! They had a baby at Jacob's house and the soldiers took it and killed it! It was a boy baby, papa, so the Egyptians took it and killed it. Jacob tried to save his baby so they killed him too. I saw it all from the darkness outside."

"How did they know the child was there?" Amram asked.

"They have been skulking around the neighborhood since yesterday, someone told me. Maybe they heard it cry. Perhaps somebody told on them."

Three pairs of eyes sought the midwife at once.

"We know your loyalty, Puah," Amram said, "but some of the midwives have been known to go from the confinement to the Egyptians."

"And, papa," Aaron went on, "the soldiers also killed Jacob's wife. Was it because she cried so loud?"

For a space they all swam in the silence in the room. All their bodies leaned forward as if in flight. The midwife, the husband and the woman on the straw, these were crumbling bags of fear. The naked flame of the rush light on the floor even tried to flee before the tiny breeze from the door. Then suddenly Jochebed clenched her fists and groaned like the earth birthing mountains, and the body and feel of the sound threatened them like a sword until the cry of the newborn baby ended it all.

12

Old Puah was squatted on her haunches to receive the child. The man heard the cry but did not look behind him. He looked at the pain-struck face of his wife and she begged him with her looks. Puah busied herself around behind him for a minute and then she spoke.

"Amram, your wife has borne you a son."

CHAPTER 4

Amram bowed his head for a space, then straightened tensely as if he listened to every sound in Egypt, however distant. As if he gazed and saw every sight and scene in the Kingdom from end to end. As if he felt every throb and tasted every draught.

"A son?" he gasped at last.

"A son," Puah answered him, "and a beautiful child."

"It must not live to cry again. Give it to me."

Jochebed roused herself upon her elbows.

"No."

"Give me the child, Puah," Amram said with a fearful calm in his voice. "It is a whole lot better for it to stop breathing in my hands than for those—"

Jochebed had struggled to her knees. "No! My son is going to live. If the Egyptians come to kill it, then they got to kill me before they do him. If Pharaoh done scared all the love out of its papa, then let all Egypt come against me. I can't die but one time nohow, and it might as well be now. Puah, hand me my son!"

Amram turned his stricken face upon his wife. "Jochebed, there are different kinds of courage. Sometimes ordinary love and courage ain't enough for the occasion. But a woman wouldn't recognize a time like that when it come."

"Is my son got a Hebrew for a father or a Pharaoh?"

"But you heard what Aaron said."

"What of it? Pharaoh may be dead tomorrow. Who knows? Let's take a chance."

Amram looked about him wearily. "Well, if we must fool the crocodiles, let us begin and do it right. Aaron, go and watch up and down the road while I dig out a cave under the inside wall of the house. It must be large enough to hold the child."

Aaron arose sullenly. "But, papa, the soldiers may come along and kill me. They'll ask me what I'm doing out there."

"Go on! As soon as I have finished I will come and stand guard myself and you can go to bed. The sound of my battle with the soldiers will warn you all to hide the child."

Jochebed, clutching her new son to her breast, threw her husband a look so full of love and happiness that Amram felt for the moment that the sacrifice of his own body was a little thing.

The police, the secret police. That was what worried the people of Goshen. Just to look around, they were nowhere, but from the effects they were everywhere. Were ears pressed to their walls at night? It seemed so. A casual conversation might bring a public whipping and extra hours of work. How did Pharaoh find out so much? Hebrew began to suspect Hebrew. Men were accused of treason and revolt for saying Pharaoh was not kind. Everything was treason and subject to labor fines and lashings. No one except women were sent to jail. Pharaoh said it was a waste of man power and groceries to fasten up able-bodied Hebrews in jail. Every crime not punishable by death could be worked out in the brickyards, the stone quarries or on buildings. A beautiful new city bore his name and more were being planned. The Hebrews did not know all this about new plans. They talked together and said that when the new city of Rameses was finished, that Pharaoh would be satisfied. Some of them even thought that they might get back their houses and lands.

But Pharaoh took counsel with his servants. Week after

week he called them to listen to his newest ideas that he was going to work into plans. The servants told Pharaoh that all of his thoughts had genius and after ten meetings they told him his plans were perfect. So he called the Hebrew elders together to listen. He was going to speak to them in the public place. His messengers went all through Goshen and they went on all the public works telling them to come to the meeting. Pharaoh was going to be good and kind enough to appear before them in person and speak to them of his own free will. Three days after the announcement he was going to speak on the Hebrew future.

The people in Goshen were excited. Hope burst its binding string and gushed over the province.

Jochebed held her baby on her lap and smiled at her husband. "Maybe we won't have to hide our baby no more, Amram. Maybe we can circumcise it and hold a christening."

"Maybe."

"I could make some little honey cakes and have palm wine and beer. That would be just like old times, wouldn't it?"

"Yes, it would. Like when Aaron and Miriam come."

"Only this baby is so much prettier than either one of them ever was, ain't he?"

"I think so. He's awful fine looking. Too bad we can't show him around some. Finest looking baby in Egypt."

"You know, Amram, I just felt all along that Pharaoh couldn't keep up his meanness. It was too awful to last."

"What makes you think he's changed his mind? Him sending for us got everybody to hoping and wishing, but it don't have to be what we hope at all."

"Oh, there you go again! Amram, what makes you always looking for the dark side of everything? I declare to my rest you just like an old sorehead bear. Naturally, Pharaoh is fixing to free us and leave our boy babies alone. He couldn't do nothing else."

"Oh, yes, he could, too. Everybody to their own nature. He don't have to smell through our nose at all, and I don't believe nothing until I see it."

16

"Aw, Amram, you wrong this time. I done talked to a heap of people and they all think like I do."

"You all ain't thinking, you wishing. Anyhow, keep our baby in the hole just like we been doing for the last three months. Keep him hid till we hear further. 'Tain't no use in taking chances."

"He's getting so strong! Look at him trying to sit alone! Look at him! He's mad now cause he can't quite make it. Listen at the voice he's got on him!"

"That's just the thing I'm scared of. I can't half work for worrying. Some of them secret spies is bound to hear him before long. Then what we going to do, honey? I thought they had us last night."

"Oh, a couple of days more and we won't have to worry."

"I hope you know what you hoping about, but old Pharaoh is mighty hard, honey, mighty hard."

"You just wait till the meeting and you going to see I'm right. God wouldn't let this thing we're under keep on like it's going. It's bound to come a change."

"What god you talking about, Jochebed? These gods was here in Egypt long before we ever thought of coming here. Don't look to them for too much, honey. Then you won't be disappointed."

Jochebed made to lay the child down on the pallet and it burst into lusty crying. Instantly the woman and her husband became hunted beasts. She grabbed the baby up and pressed its face into her soft bosom and glared towards the window and the door like something at bay. Amram crept to the door and looked around outside. When he returned the child had vanished into the dark hole under the wall, and the hole covered with a mat, but its voice could be heard nevertheless.

"See what I told you?" Amram gasped. "First and last we're all going to be butchered without mercy. Oh, Lord! why didn't I die before I cried? Why did I have to live for this?"

Jochebed seized the child again and pacified him quickly.

"Well, we got by again," she sighed with relief.

17

"But for how long?" Amram demanded. "Tomorrow, maybe, or in the next half an hour."

"You didn't see no spies around outside, did you?"

"Jochebed, you don't have to see spies for them to see you. Maybe the soldiers are on the way already."

Jochebed started to say something, but her husband shut her off with a gesture. His head hung down and for several minutes the thud-thud-thudding of his fists against his breast were like a funeral march in drum tones; a tearless sorrow throbbing over death; a muted wail without words. Finally he could bear his feelings and he stopped.

"You oughtn't to carry on like that, Amram, when Pharaoh done sent for you. Maybe things will be all right after you all talk with him and explain things."

"Listen, woman, Pharaoh is a flesh and blood man just like you and me, strange as it may seem. This won't be the first of his hearing how bad off we is here in Goshen. We ain't in the fix we're in by no accident, neither. He knows the feelings of a husband and a father. It is a terrible thing to strip a man of his meaning to his wife and children. Pharaoh knows all that. He means to do all that he is doing and maybe more. He had hunted around in his own heart for something to measure one's feelings by and the things that would hurt us the most. Then when he found them, he has done those things with calculated spite. You're just dumb to the fact. And another thing, he ain't sending for us to better our condition. He hates the very sight of us. The only reason he consents to look at us at all is because he wants to destroy us some more and enjoy seeing it gripe us."

The woman bent like a willow and cried softly over the child like a thin soprano sob song. Amram carried the bass part with his fists against his chest. Finally they crept to bed without eating. But all night the woman soothed herself by thinking "maybe." Amram dreamed dreams of smiting out with a bloody sword. Then it was time for him to get up and go to work again.

Everybody at work was whispering about the meeting with

18

Pharaoh and everybody had made up their minds what would happen there, each one according to his courage. Some rolled over and over in a wallow of hope and scratched their backs with wishes. These men were afraid to think. Some stared in the face of probabilities and braced themselves for the shock.

So the meeting came. The Hebrew Elders went and stood in the public place that was full of soldiers fully armed. Then Pharaoh came in surrounded by his high-born servants and took his place. After his chief scribe got through telling the Hebrews what a blessing it was for Pharaoh to not only let them see his sacred body, he was actually going to let them listen to his voice. He was going to speak to them, using his own sacred voice and lips. They had done nothing to deserve such a great blessing. It just went to show how very kind and gentle and gracious great Pharaoh was. Always considering others before he did himself, and so on and so forth. Then Pharaoh himself rose to speak.

He said that his goodness and mercies were too well known to waste time talking about. The only reason he mentioned it at all was because he could see all over Goshen that it was not appreciated as he had hoped and expected. Here they were, Hebrews, who had come down into Egypt as the allies and aides of those oppressors of the Egyptian people, and as such had trampled on the proud breast of Egyptian liberty for more than three hundred years. But the gods had used the magnificent courage of the real Egyptians to finally conquer and expel those sheep-herding interlopers whom the Hebrews had aided in every way they could to deprive the real Egyptians of their homes and their liberties. And now that they, the Hebrews, were conquered and beaten, he might have killed them all. That would have been right and just, seeing the great injury his beloved country had suffered at their hands. But did he do that? No! He was gentle and he spared them and allowed them to continue to live in the country. All he had required of them was that they work and build him a few cities here and there to pay back in a small way for all the great benefits they had received in their long residence in Egypt and also to give

19

back some of the wealth they had so ruthlessly raped from the helpless body of Egypt when she was in no position to defend herself.

And now, what does he discover? He finds that these same Hebrews, instead of setting to work with glad hearts, happy that they have been given a chance, even in a small way, to make some sort of pay back on their huge debt to Egypt, and to redeem themselves in the eyes of the world, were congregating in Goshen and planning protests against his mild and beneficent decrees! It was hard to believe, but he happened to have the facts. So what did it prove? It was too plain for even the most merciful to ignore that these Hebrews whom he had saved from the fury of his people and against the advice of his wise counsellors, did not want to pay their debt to Egypt and decency. They were doing all they could to evade it. This show of ingratitude and hardness of heart was bound to arouse the mild but courageous Egyptian nation to fury unless something was done to show the loyal nation, who had suffered so much already, that its ruler would not further encourage such iniquities. His piercing eyes and all-hearing ears had discovered a well-organized plot to swindle Egypt out of her just amount of work out of them, by slowing up their work—a most reprehensible and low-down trick worthy only of Hyksos and Hebrews! But he had a remedy for this. The overseers had been instructed to use the lash more freely to speed up work and to rub salt in the welts raised by the whip. But still that did not repay poor suffering Egypt for the work they had lost in the past. So he now decreed that Hebrews must begin work one hour earlier in the morning and work one hour more in the evening.

Furthermore, the dishonesty and general wickedness of the Hebrews had reached the gods in their remote retreats and the gods had cried out for cleansing. The gods had announced emphatically that they would visit no altars which Hebrews were allowed to approach. Hebrews must not approach a single temple in Egypt. Neither must they build temples to

20

Egyptian gods in Goshen. The gods were forbidden the boundaries of Goshen.

Just in passing he wanted to acknowledge a petition with many signatures that had reached him. In it the Hebrews had again raised that question of leaving Egypt. He just wanted to say neither in this generation nor yet in the generations of their great grandchildren would they be allowed to escape their just punishments. Did the Egyptians run away when they were being robbed and oppressed by these same malefactors and their friends? No!

Then he went on to say that even greater wickedness had been uncovered. His laws and most royal decrees were being flouted. He, after taking counsel with his wise advisors, had decreed that all boy babies born to the Hebrews must be destroyed. But he found that certain people were plotting together to make his laws come to nothing. And something was going to be done about it. The strong arm of Pharaoh had never failed against his enemies, in spite of his merciful nature.

Pharaoh paused and looked at the faces of the Hebrew Elders grouped below and before him. He saw the uncomfortable stir that moved them almost imperceptibly. The slight shifting of feet; the nervous movements of hands, the gaping, stricken faces of the less wary among them, and he smiled.

"I see that I got you by the short hair when I told you I know what is going on about those boy babies. That is not the worst yet. My police have captured several of those midwives who have been waiting on your womenfolks in secret. They claimed that they wouldn't talk, but when my men got through with them they talked and talked aplenty, from old Puah on down."

Amram started violently and then hated himself for his weakness, but he couldn't help himself. It looked like Pharaoh was looking straight at him. He could see the gleam in Pharaoh's eyes as he went on. "So now I know all about those births behind rocks and in caves and such as that. And I know all about those babies hidden out in the woods and in holes dug under house walls. My soldiers will be around to call on

you, and when they come to call, they won't miss nobody. I done told you."

The Elders looked at one another and finally Hur spoke up. "Give us a chance, Great Pharaoh. We proved ourselves builders and generally constructive under the last regime. We love Egypt. It is the only home we know. Trust us and see if we are good citizens or not."

"Why should I trust people without monuments and memories? It looks bad to me—a people who honor nobody. It is a sign that you forget your benefactors as soon as possible after the need is past."

"We don't build monuments, but we do have memories."

"How is anyone to know that? Take for instance your great man Joseph. As long as you have been in Egypt you have not raised one stone to his memory."

"Look at it another way. Perhaps we do not need stones to remind us. It could be that some folks need stones to remind them. It could be that memorial stones are signs of bad memories. We just don't trust our memories to stones."

Pharoah's face darkened at this. He laughed in a harsh way.

"Well, anyway, you won't need no stones to remind your children and your great-great-grandchildren of the punishment that Rameses put on you. You are going to work and work and work. You are going to weep and you are going to bleed and bleed until you have paid in a measure for your crimes against Egypt. I done told you now. Don't give me no trouble unless you want to make me mad."

The Elders shuffled out of the place somehow and started on home. "No rest, no property, no babies, no gods," Amram gasped. "Why would anybody want to live? Why don't we kill ourselves and be done with the thing?"

"Maybe we hope we'll beat the game somehow without dying. That's human, ain't it?" somebody said and so they dragged themselves on home to tell what was said. They ground their souls between their teeth as they went but there was nothing to spit out. It was just a grinding and an aching.

Jochebed was asleep when Amram got home, so he

wouldn't wake her to hear what he had to say. Tomorrow was time enough to start the weeping. So he stepped over the straw bed of his two older children and stretched out beside his wife till daylight. Then he told her.

She didn't say anything and she didn't stand up. She took the sleeping baby in her arms and sat there on the straw pallet staring down in its face. Amram squatted down before her and stared down at the baby too. Its little hands and feet and the helpless soft body was between the man and the woman and they huddled over it in silence for a long time. Then Amram said huskily, "Shall we grant it merciful escape, Jochebed?" and felt in her lap for her hand and pressed it. He could not bear to look at her eyes.

"No, Amram."

"Those brutal soldiers, Jochebed, grin with pleasure when they hunt down one of our children like hounds after rabbits."

"I don't care, honey. If my child is murdered, old Pharaoh has got to do the murdering his own self. I ain't going to allow him to make me do his murdering for him. If the gods want the life of my innocent boy, then they got to make a move and show me. I mean to hold out till they do. Let's hide it on the river like some others I know."

"All right, honey. I sure do want him to live and do well." Impulsively he caught the child up in his arms.

"To think that we have not had the joy of giving it a name, nor fondling it, nor circumcising it lest it cry out and be found."

"It sure is sad. But you hurry on to work, Amram, before the soldiers come to hunt you up. It sure would hurt me to my heart to have to see 'em lay that salted lash on your back."

"But what will you do about this big, fat son of ours?"

"Go on to work, Amram, and I will find some way. One of the children is always on guard."

Amram hurried off and Jochebed called the children to her. "Go and cut me rushes from the marshes," she told them. "Go and hurry back fast. I got to make a good basket. Get me the best rushes you can."

23

The basket was scarcely started when Amram reached home after dark. Jochebed had given way to her despair more than once and crumpled on the straw beside her growing child. Twice he had cried so loud that Jochebed knew he could be heard all over the neighborhood and prayed that no prowling Egyptians were near.

So four people forgot hunger that night and sleep was not present in them. Four pairs of ears strained towards the night outside the house and four hearts fainted at every creeping sound as four pairs of fingers toiled over the basket until it was woven strong and tight and daubed and calked with pitch and mud.

"You think, Amram, if I took the baby before Pharaoh and begged him, he might get sorry for me and let me keep my child?"

"Get sorry for you? No. He plans harsher measures for us. The horn that is hooking us gets stiffer day by day. If you could only run away with him or hide him for a while!"

"There ain't no other way then, but the river. All the roads is full of spies. Goshen is ringed with steel. Amram, do you think this basket will be safe?"

"I hope so, Jochebed. It is a real good basket, even if we was in a hurry. I don't believe the water will get into it. Hand me the baby and let us see how he fits in it."

Jochebed lined the basket lovingly with one of her garments and then with goose feathers before she laid the child inside. Then she knew the basket was ready, so it was the time for tears. There was nothing any more with which to busy her hands and brace her spirits. She beat her breasts and wept without restraint for several minutes. Amram bowed his head in silence. Aaron and Miriam sat in dumb terror watching their parents and occasionally smiting their breasts to show their sympathy of grief.

"We must put him on the river, Amram," Jochebed said at last. "That is why I made the boat—the basket for him."

"But why upon the river?"

"We ain't never been nowhere, Amram, so we don't know.

24

It could be other people besides those we know that live along the Nile. It may even run outside of Egypt. Maybe someone among them may find him and love him. Maybe even in Egypt there might be somebody with a heart." She broke down into sobbing again. "Anyway, there ain't nothing left for us to do. One thing I know Pharaoh can't make out of me. He can't take my son away from me and make me a murderer at the same time. That's one thing I don't aim to let him do."

Amram looked at his wife's face and was fed inwardly by her look. So the night of the morning found them with the basket moving stealthily down to the Nile. At the river, Amram withdrew with Aaron and Miriam to watch. Jochebed fed the child copiously from her breasts and put him back into the basket. Then the thought assailed her that perhaps her basket was not seaworthy after all. She took him out again and held him across her knees as she tried her woven boat upon the water. It floated dry and lightly upon the stream. She drew it back to her and placed her baby in it for the last time and covered it with the lid. The little bark was propelled out from the shore among the tall bulrushes and rested there with the Nile lapping it gently and lulling the child to sleep.

Jochebed squatted there watching until her husband sent Miriam to call her lest she be found there by some Egyptians. She rose stiffly after a while and closed her bosom slowly. She spoke to Miriam and told the girl to station herself beneath the clump of palms not too far away to see what happened to the child. She must go home and sprawl on the earthen floor with her fears. Then she spoke to the morning, and the Nile: "Nile, youse such a great big river and he is such a little bitty thing. Show him some mercy, please."

CHAPTER 5

All the little stars crept back into heaven and the sun rose. Miriam, standing on the watch wall among the palms, calmed herself and sat down. Her eyes wandered from the particular spot among the bulrushes to bulrushes in general. Then she regarded the river and the activities on the river. Far up-stream, several fishing boats were out. A group was drawing water with oxen for the fields. Water birds swooping and diving, and occasionally feeding-fishes, flinging their bodies out of the water in the exultation of the kill. Then Miriam went to sleep.

She woke up with a guilty start and looked for the little ark on the river which contained her baby brother. It was not there. She looked all around her to see if anyone was watching her and feeling sure on that score, she crept down to the spot where the basket had been and parted the bulrushes. The child and his basket were gone, that was all. And she had not the least idea of where he had gone, nor how. What should she tell her parents? She began to cry.

But her tears did not flow long. Down-stream at some distance she saw a glorious sight. A large party of young women dressed in rich clothing was clustered on the bank. The morning sun struck against shining metal ornaments and drew Miriam away from her search for her brother and from her tired

and frightened self. She crept downstream, keeping as close to the shrubbery growing along the river as best she could.

Ten young women stood out in the stream holding up a long piece of cloth that shielded another young woman from public view, or almost shielded her. Two others washed and massaged her for several minutes while Miriam watched from her hiding place. It was a marvelous scene to her and she felt uplifted from gazing on it. This could be nobody else but the Princess Royal—only daughter of Pharaoh, newly widowed by the death of the Assyrian crown prince and returned to Egypt. Miriam noted her person, her trappings and her attendants and said to herself: "Royalty is a wonderful thing. It sure is a fine happening. It ought to be so that everybody that wanted to could be a queen. I wish I could get close enough to touch that princess. I wish I was one of those girls waiting on her, even."

The Princess came up out of the river. The girls holding the screening cloth moved up with her on dry land and kept shielding her until she was rubbed down, oiled and dressed. There was chatting and laughter. The lift of a thin, sweet tone came to where she crouched in the bushes and the child Miriam stood up and craned her neck to see where it came from. And now she saw two black eunuchs squatting on their heels at a distance from the bathing party playing, one on a flute and the other on a stringed instrument. Some of the girls took positions and began to dance. The others went on folding garments, packing caskets with toilet articles and generally preparing to leave the bathing place. The dance ended and then the music. The Princess rose from the stool placed for her and was instantly surrounded by her party. One eunuch carried a sunshade over her head. Two girls waved ornate fans on long handles. Miriam's heart beat fast as she realized that they were coming in her direction. Now she would be able to see them at close range.

But the party did not move off at once. Something in the water had attracted the attention of the Princess. She was directing someone in the party to it. One of the girls removed

27

her sandals and went down into the stream and came out with a dark, oval object. "Aha!" thought Miriam, "They had forgotten the casket in which is kept the things for washing the Princess. They will get a good scolding for that. But I wish they had left it so I could have seen what was in it. That would have been wonderful! I could have run after her and returned it to her and maybe she might have made me one of her ladies in waiting. Oh, a lady in waiting to the Princess! Nothing could be greater than that."

The party moved off leisurely and came abreast of Miriam. They were not more than thirty feet from where she hid. She was so entranced that she stood up, the better to see, and one of the ladies saw her.

"It is a Hebrew!" she all but screamed. "What is she doing here? Catch her!"

"She is only a child," the Princess said lightly. "She can do nothing harmful."

"But she might be a spy," one of the ladies pointed out.

"Yes, these Hebrews may be planning to assassinate you."

The eunuchs drew their swords at this and looked threateningly at Miriam.

"Nonsense!" the Princess rejoined. "No one knew we were coming here today and no one—not even I—knows where we go tomorrow."

"Still she should be questioned. Never can tell what these Hebrews might do to overthrow the government."

"Governments are not overthrown by little girls," the Princess retorted, and the party swept on its way towards the palace of Pharaoh.

Miriam stood blinking for a long time. She was completely beside herself with ecstasy. She had seen the daughter of Pharaoh. The daughter of Pharaoh had spoken to her. Well, anyhow she had spoken of her. All her life she was going to remember the gait of the Princess when she walked. She wondered if that movement was a special gift to royalty or if people like her could copy it. She certainly meant to try it before her playmates. "This is the way the Princess walks," she would tell

them. "I know, because I saw her and she spoke to me." She flew home as fast as her legs could move to tell what she had seen.

She burst into the house and found her mother stretched upon the floor facing the little cave where she had hidden the baby so often, and her mother was holding one of his little garments and weeping bitterly. Then Miriam remembered, not just that she had seen the Princess and heard her speak, but why she had been posted at that lonely place on the bank of the Nile at all. She recoiled from her mother's face in panic.

"What happened to my child, Miriam?"

"Oh—er—" Miriam came back to herself from her dreams of the palace. "I—I don't know, mama."

"You don't know?" Jochebed sprang to her feet in fury. "You don't know when you were left there to find out? You stupid dunce! Why *don't* you know? Didn't you stay where I put you?"

"Yes. Yes, mama, but I—I went to sleep. I was so tired from last night that I couldn't help it. I went to sleep after sun-up."

Seeing her frenzied mother searching for something with which to strike her made Miriam come alive inside more thoroughly than she ever had done before in her life and suddenly an explanation flashed across her brain.

"You see, mama, while I was asleep, the basket with your baby in it floated down-stream and the Princess saw it and took him home to the palace with her."

"The Princess? You mean Pharaoh's daughter?"

"Yes, mama, she's the very one. She was bathing herself in the river down below me and the basket with the baby in it floated down to where she was after she had finished her bath and was perfumed and anointed and dressed with a whole heap of pretty things in her hair. Then when she was ready to go she saw the baby and sent and took it with her. I met the party on the road and tried to ask 'em what they was doing with your child, but they took and drawed a sword on me and made like they was going to kill me."

Jochebed wept bitterly. She felt her heart crowding her

29

throat. She felt like the whole of Egypt was crowded into her middle and still she felt empty of joy.

"Now I know my poor little baby will be killed," she wailed and bowed herself again upon the floor. "The sea-buzzards will kill it just for fun."

"No, mama, she was real nice. She walked like this and smiled at me. And when some of her servants threatened me she told them to leave me alone. She had music played when she found the child and took it to the palace like she was proud. I love the Princess, mama. I wish she would take me to the palace too."

"Miriam, I ain't to be fooled with today: is you telling me the truth, or is you trying to dodge a whipping for not minding the baby?"

"But, mama, I *did* see her send for the casket and take it home with her. One of her ladies in waiting carried it herself."

"Oh, I am so sorry that I did not stay myself to watch! Maybe I won't never know what become of my baby. Miriam, are you sure it was the same basket which we made to hold the baby?"

"Yes, ma'am. I could see them get it even from a distance. And the Princess had on red sandals and her toenails was red."

"And how did she treat the baby?"

"She made them play music and they danced for her because she was so glad because she had found the child. I could see everything they did, mama. I wasn't far from the Princess. She told 'em she loved the child a lot already."

Jochebed stiffened her back and stood up suddenly. "I ain't a bit surprised to hear the Princess loved him. He is a mighty pretty child, and smart as a whip for his age." A glow began to gleam through her seamed face. "So my child is in the palace! I'll go let the neighbors know." She tied her best shawl over her head and got as far as the door and stopped. "No, I reckon I ought to tell my husband about our son getting to be a Prince of the house of Pharaoh before I tell the others." She took off her shawl and turned back. "Get busy, Miriam, folks will be coming in to see us when they hear. The house

30

must look better than it's looking now for big doings like this. We is kinfolks to the Pharaohs now." She thrust the broom into Miriam's hands and herself began to make up a batch of honey cookies.

Jochebed began to mix the dough. She took great care with it and all the time laboring Miriam for more detail.

"Miriam."

"Yes, mama."

"Come here to me. You didn't tell me whether the baby cried or not when the Princess opened the basket."

"No, ma'am. I did not hear him cry at all. And, mama, the Princess had a headdress of blue feathers that fell down over her shoulders in a real pretty way like this." Miriam grabbed a shawl and draped it over her head and strutted about.

"What did she *say*, Miriam, when she saw him? Tell me her exact words."

"She said, 'What a beautiful child!' "

"Did she say that? She must be a real fine Princess sure enough."

"Oh, she is. Maybe if I was to go and ask her, she might take me for a nurse to the baby."

"Hush up talking foolish! Youse too young. She would need a woman with breast milk. I will go myself tomorrow to the palace and find out if they need anybody."

Jochebed kneaded dough vigorously and bustled about. "Blow up the fire, Miriam. I want a bed of coals to bake these hot cakes." She patted out the little honey cakes and put them on the fire. "Think I *will* run over to Rachel's, Hur's wife, and tell her about it. We have always been the best of friends and she would feel hurt if I kept anything secret from her like this. I'll tell her it's a secret and she won't tell a soul. Mind you now, Miriam, don't let them cakes burn."

When Amram entered the door that night, very tired and sore from work, he greeted his wife with "What is this I hear about the daughter of Pharaoh adopting our son?"

"Oh, you done heard it already?" Jochebed asked with a pleased air.

"Who in Goshen ain't heard? That is all the folks are talking about. Well, is it so?"

"Certainly, it is so."

"How do you know? Did the palace say anything to you?"

"Why, no. Reckon they didn't count us enough to tell us, us being Hebrews. But Miriam saw her bathing party at the river and saw them take the child."

"Humph! Pharaoh's killing every Hebrew boy child he can get his hands on and his daughter taking one home for a son. Ridiculous!"

"Oh, the Egyptians may not be as cruel as you make them out to be. Come here, Miriam, and tell your pa what you saw and what you heard."

Miriam told again what she had told her mother and added, "And she wanted me to come to the palace to take care of the child for her."

"See, Mr. Smarty!" Jochebed cried triumphantly. "Always hunting for something mean and low. You don't even believe butter is greasy."

"Oh, I'm willing enough to believe if you give me something to go on. I still want to ask Miriam some questions. For instance, if Miriam was *not* close enough to make out any special marks on the casket, how can she know it was the same one? Millions like that been made in Egypt. If Miriam didn't hear the baby cry how could she tell *what* was in the basket? It might have been the toilet articles of the Princess or a hundred other things. And then again even if she had heard a baby cry unless she was close enough to see the baby, how does she know it was the same one? Couldn't the party have brought a baby with them from the palace?"

Jochebed lost her good nature at that. Possibly he touched upon fears already hidden in her heart so she flew hot and turned upon Amram.

"Oh, you make me sick with your doubts and your suspicions! Always looking for a bug under every chip! Throwing cold water on everything! As if your own daughter couldn't tell the truth! I suppose you would rather believe that a croco-

dile come along while Miriam closed her eyes for a minute and et up our poor child."

"It could have happened, you know."

"Shut up!" Jochebed screamed. "You ain't human! You ain't got no feelings! First you wanted to kill the child yourself and—"

"No, Jochebed, I didn't want to kill my boy. Pharaoh passed that law, not me. I just wanted to keep the soldiers from having the satisfaction of murdering it, that was all."

"And when I wouldn't let you, you, its papa, I stopped you from killing it, you want to believe now that the crocodiles et it up or either the soldiers found it after all and drowned it. Amram, youse as hard as a flint inside. I hate you."

"Jochebed," Amram said patiently, "I don't want to rob you out of your hope. I dread to think myself. But don't let us not raise up our hope to the throne of truth. Let us go ask at the palace tomorrow. Anyway, you had no business telling this thing all around until you had talked with me."

They had to stop quarreling because people began dropping in. Soon the house was full of people gloating inwardly and chuckling out loud. "Ho, ho! Pharaoh hates Hebrews, does he? He passes a law to destroy all our sons and he gets a Hebrew child for a grandson. Ain't that rich?"

And Amram hated it all. It made him feel flimsy and artificial. He felt worse because he could hear Miriam outside, the center of a large crowd, telling and retelling her story. "The child was crying and that is how she found him. So Pharaoh's daughter asked me to bring mama to the palace to be a nurse for the child."

"And why not?" one elder asked. "There is plenty of Hebrew blood in that family already. That is why that Pharaoh wants to kill us all off. He is scared somebody will come along and tell who his real folks are. The country can't get along without us. Take Joseph for example now: Did Egypt ever amount to anything until he took hold of things? I ask you, did it now? Tell me! We are going to have another great man in

33

the palace when this boy they just took in grows up. This country can't make out without us."

"You said something just now, but you didn't know it," another added. "The higher-ups who got Hebrew blood in 'em is always the ones to persecute us. I got it from somebody that ought to know, that the grandmother of Pharaoh was a Hebrew woman."

"Why, they tell me that the new commissioner of finance is an out-and-out Hebrew who renounced his race. He won't even be seen speaking to one of us."

"That would be just like him to do a trick like that. Afraid of being recognized, that's why."

"For my part," one of the women said, "I think the Princess is a very fine woman. It is time we quit straining against the new order and took a active part in it." There was hearty agreement from many women with this viewpoint.

"Oh, you women!" Amram snorted. "You are always ready to go with the conqueror. You recognize nothing but power. If it is a woman, a cow, a ewe, a dog or whatever female it is—let the male fight and die for her, and the moment that he is thoroughly beaten or killed, she gives herself to his conqueror. Talk about men being hard! We are the sentimental fools and you are the realists. Phooey!"

The little cakes were finally all gone and the crowd talked far into the night of the Hebrew victory over Pharaoh and went home. They did not question too closely for proof. They wanted to believe, and they did. It kept them from feeling utterly vanquished by Pharaoh. They had something to cherish and chew on, if they could say they had a Hebrew in the palace.

So the next day, Jochebed washed herself and walked the long and dusty way to the palace gate to offer herself as nurse to the baby, but they would not let her in. There was no new baby to be nursed, they told her. The Princess had been summoned home from Assyria on the death of her husband and had brought her infant son with her several months ago. But what is that to you, Hebrew woman? Anyway, no Hebrew

34

servants were being used in the palace. Begone with you!

Still and all, Goshen never gave up their belief in the Hebrew in the palace. It was something for men to dream about. Jochebed became a figure of importance—the mother of our Prince in the palace. Miriam told her story again and again to more believing ears. It grew with being handled until it was a history of the Hebrew in the palace, no less. Men claimed to have seen signs at the birth of the child, and Miriam came to believe every detail of it as she added them and retold them time and time again. Others conceived and added details at their pleasure and the legends grew like grass.

CHAPTER 6

nside the royal palace affairs went on unconscious of the legends of Goshen. The Pharaoh had his programs, national and international. At home he worked to reorganize the county into a unit intensely loyal to the new regime. Externally he strove to bulwark the country against outside attack. Force was his juices and force was his meat. It was his boast that his reign should make it so that outsiders trembled when they breathed the mighty name of Egypt. The very rims of the earth should bear the spread wings of the Hawk-god Horus, who signified the sun in Egypt and should bear its light to all the world.

Inside the palace was Pharaoh's son and daughter. The son Ta-Phar had all the self-assurance of the actual ruler without his father's ability. He was impatient of the day when he should take hold of the rod of state. Ah, then Egypt and the world would see a Pharaoh! Crowns, state and personal robes would take on new glory. Finer chariots and horses and many more dinners of state. His tomb should outdo every pyramid that had been built or ever would be built. The stumbling stones in the path of doing these things had never occurred to him. What was the use of being a Pharaoh if one could not be lavish? Why should the wishes of a Pharaoh be opposed? So none about the court dared oppose him. In the chase and other

tests of strength and skill, the courtiers learned to be a poor second to his poorer first. The arrow of the Suten-Rech, Ta-Phar, was somehow found in a vital spot in every dead lion or antelope.

Inside the palace also was the Pharaoh's widowed daughter who was not expected to do any more than she did. She must lend her support to the female robes of state. She must lend her ears to the sounds of mighty words boiling out of futile men. She must bear something in male form, for after all that is what she was born for—a passageway for boy children. If she seemed too attentive to her son and a little blank while her brother, the heir apparent, poured out his boasts, he attributed it to her jealousy that she would not be sharing the throne with him when the time came to share or not to share. She had been mated with a foreign prince and since she had the misfortune to become a widow, she must not be allowed the notion that living in the palace meant advancing the position of that misfit son of hers. Ta-Phar did not intend to break his neck in the chase nor expose himself too much in battle. Just to make way for that Moses, that little smart-aleck who was always nosing among the papyrus rolls in the library.

Inside the palace walls was Moses, son of the Princess and second in line for the throne of Egypt. To his mother he was the most beautiful child in all Egypt. He was considered a handsome child by all. And everyone who came inside the royal enclosures was conscious of him. At first he followed the household servants about asking what and how and why until they tried to devise means of directing his attention elsewhere.

Then it was the gardeners and the grooms who caught his imagination. He was always wanting to know about plants. Was a frog a plant? Well, if a frog was not a plant, why was it in the garden? Who put it there? Why did frogs want to come in the garden? Why was the sky blue? Who bent it up like that? Did it ever fall down? If the sun could come up by itself and could roost on the high perch of noon, why did it fall down in the evening? Where did it go at night? Where was the river going and what were the sounds it said? Who made

the first day? When? Why? Some of these questions went unanswered, but not all. There was one old man who tended the horses. He had answers in the form of stories for nearly every question that Moses asked and he told stories unasked because they just came to him to tell. They were unexpected visitors, those stories were, he explained to the eager little boy, and they stood outside his door until they were asked to come in. He did not know why they called upon him and did not call on many others. They tortured him at times, these people and events who came unasked and walked about in his mind. They always seemed to want to get out where people could see them. That had puzzled the old stableman a great deal because they were not always beautiful nor their behavior pleasant. Nevertheless one and all wanted to get out as soon as ever they could to show themselves. They always departed about their own business once they had been given outside life by his lips—for he could not write at all. So they had no home in the papyrus rolls like others who spring from the minds of scribes. These, his images and happenings of the mind, scrambled from his lips and entertained the listeners for a day, then went to join the thousands of other dreams where they dwelt. Where did they hide? He did not know. But he believed that they did not die. They were stronger and more enduring than men.

So Moses learned how God made that first day. He had ordered the covering robe stripped from the sun. Why had He done so? Well, you see, He had made the world and the firmaments. He had hammered out the great bowl of investing firmament and starred it with rivets. Then the company of heaven had asked to see the work of His hands and He had said, "Let there be light" and flung back the blanket from the sun and the world stood revealed.

"Then why do we have nights between days?" Moses asked.

"Well, He is still working on the world and He must hide His hand from us humans. That is why things grow at night. Most things are born in the mothering darkness and most things die. Darkness is the womb of creation, my boy. But the

sun with his seven horns of flame is the father of life."

Hours and hours they sat, the old hostler and the little boy behind the royal stables, in the shade of the structure. And the images arose in the brain chamber of Mentu, the stableman, and stumbled off his lips and became real creatures to Moses— to live in his memory forever.

"You see, male man was made with five strong senses to gather the truth of things and his mind is a threshing floor to clean his truth in. This is often an unhappy thing, for man sees himself as he really is. Thus he is made very miserable. But he does not destroy himself because the female man was made with squint eyes so that she sees only those things which please her. And her threshing floor is cramped and cluttered. She cannot separate the wheat from the chaff. But she achieves a harvest that makes her happy. When she sees man fleeing from his bowl in horror of himself, she feeds him from her own dish and he is blindly and divinely happy. Ah, yes, the female companion of man has the gift of the soothing-balm of lies."

From old Mentu Moses learned much about the ways of animals. The old man interpreted their noises and told Moses what they said. It was very amusing to the boy to hear the comments of all the birds and the beasts on human conduct and appearances. In fact, they were human by Mentu's interpretations. Tara the monkey, for example, was he not the smart-aleck person of no importance always trying to imitate his betters and making a mess of things? Why, certainly! Some folks said that monkeys were old folks and that all old folks turned to monkeys, when they got old. Possibly they did, but Mentu was not old enough yet to find out for sure. But he thought it just as well when Moses should be old enough to hunt seriously, that he refrain from shooting those monkeys with his arrows. "You might kill an old friend or two among those monkeys, Moses. And I know you don't want to do a thing like that."

"I certainly don't," Moses said emphatically. "Least of all would I want to kill *you*, Mentu. But how would I know?"

"If, when age comes upon me to the stage when I find myself a monkey, I would let you know."

"But how could you, Mentu? You couldn't talk to me like you do now, you know."

"That's right, too."

Both the little boy and the old man fell into a gloomy mood for a moment.

"I have it!" Mentu finally shouted. "You know how I always tease you by running my hand down your collar?"

"Yes."

"Well, if ever you come upon a company of monkeys and one should spring upon your shoulder and thrust its paw down your neck, you can be sure it's me."

They were both very happy at finding a solution. Moses leaned his head on the bosom of the old man and said. "Then I would take you into the palace as my pet and you would have a fine gold collar for your neck and plenty of fruits and nuts to eat, and sleep right on the bed with me."

"It would be lovely if I were a monkey now, to enjoy all of that."

"Wouldn't it, though? I wish you were a monkey right now so I could take you inside with me and give you things."

Mentu sighed heavily. So they decided to hunt the little birds that live in the tall grass by the river. They took a number of throw-sticks and set out. On the way Moses led the old man to the spot where he was trying to build a playhouse of bits of stone. A lizard peeped out from behind a rock nearby and looked at them with a long, earnest stare.

"That same lizard is there every day when I play here," Moses told Mentu.

"He thinks you are acting crazy," Mentu told him.

"Why? Why is it crazy for me to build a playhouse like the cities of Rameses and Pithom that the Hebrews are building for Pharaoh?"

"The lizard does not understand it that way. He thinks all structures are made for nesting. He thinks you have been building a nest for your mate to lay eggs in. He says you take

40

too long about it so that your mate must be ready to bust from holding her eggs so long. He asks why do men build such high nests for their mates? Are they afraid that their eggs will be stolen?"

Moses laughed heartily at that, and he suspected that the grimace on the face of the old man was more of a laugh than a sign of serious thought.

"Did he say all of that, Mentu? How do you know?"

"You are too young to understand now, but when you are older I will tell you how it is that men can understand the language of the birds and the animals and the plants."

"You are not teasing me, Mentu? The lizard really said that?"

"Why, certainly he did. I explained to him that humans do many things in their nests besides lay eggs. He says he cannot understand such doings but perhaps it is just as well. He asks if you will be good enough to stun a few flies for him so that he can catch them."

"But, Mentu," Moses objected, "you told me once that lizards like to catch their flies alive and vigorous. You said it was a point of pride with him to use his speed and cunning."

"So I did, little Suten-Rech. So I did, and they do when they are young and virile. But this lizard complains that he is old like me and a little hungry like me. He says that he has been driven out of the company of the females by younger males. He has lost the power that once resided in his mighty hind legs so that he cannot spring so far nor so quickly as before. So he cannot catch enough flies to support himself. And what is worse, he cannot catch the females any longer. He is much too slow. A sad, sad situation. He fears he will father no more families."

"Why doesn't he ask some of them to wait for him?" Moses asked full of sympathy.

"It is sad but true that females seeking love do not wait for the weak and the aged. When the power to spring is gone— when you are older you will understand such things. A very trying period in a male thing's life."

41

"He could lie in wait and seize him a wife as she passed. Then he wouldn't have to run after her and he would not need so much strength to overcome her struggles," Moses offered.

"He says he had a fight about that yesterday. He ambushed a female, a handsome young thing, but a young buck heard the struggle and attacked him in his weak moments, and drove him off. He is quite lame from the mauling he took. So it would be nice if you crippled some flies so that he might eat a dinner. When one is too old for love, one finds great comfort in good dinners."

Moses obliged the lizard with some flies and said to Mentu, "Maybe you would like something to eat, too. I think I could get you something from the palace kitchen without too much trouble."

"Of course I would, Prince Moses. You have a big heart in that young body of yours. Of course, I would like something to eat. It would be ridiculous for the stableman to pretend that the food of Pharaoh was not good enough for his belly. Food makes people what they are. If the palace food makes a god out of high-born Pharaoh, it ought at least to make a man out of me."

"Then I will go and get you something from the cook."

"Thanks, Prince Moses, but be very careful that nobody finds out the food is for the stableman. The scraps from Pharaoh's table are set aside and dedicated to the stomachs of Pharaoh's dogs. Don't be caught in the misuse of the dogs' dishes. Sacrilege is a terrible crime."

Moses hurried to embrace the old man.

"Why do you embrace me, Prince Moses?" Mentu asked.

"Because I love you better than anyone, except my mother," Moses answered with his face pressed against the cheek of Mentu.

"Why do you love me? It is natural for the stableman to love a prince, but why should a prince love a stableman?"

"I love you because you know all about the beginnings of things and you tell me about them. You tell me such nice lizard-talk."

42

"Well, all love is tempered with something, so it might as well be lizard-talk as plenty and power. Run along now and fetch me some meat. The food of Pharaoh has a lovely after-taste."

Moses hurried off towards the kitchen and brought back a filling snack for his friend. Day after day he kept this up until old Mentu ceased to struggle with the older yard servants for bits of the hog head when roast pork was on the palace table. This was always an occasion with yard help. Roast pork at Pharaoh's table meant boiled hog head for the help. And old Mentu used to struggle mightily for such bits as he could get. But now he loftily stood aside from the struggle and explained to the others mysteriously, "I am eating further back on the hog now."

And Mentu continued to charge the imagination of the boy with his tales of creation. Those first days of the world, which he called the "Kingdom Age," when people lived as long as trees.

"In the beginning," Mentu would say, "there was neither nothing nor anything. Darkness hid in darkness—shrouded in nothingness." Or he would talk at length on the seven rays of time; on fire, the father of the sacrifice who was the triple-formed messenger of men to the gods—as fire on earth, as lightning in the air and as the sun in heaven.

It was the talk of Mentu which stirred the inquisitive Moses to stealing into the enclosure of the priests. After that first time, he would slip away from his tutors and attendants and go softly into the temples and into the forbidden precincts behind the temples where the priests lived and worked. And always he came out with more details of the home life of the gods when they were not attending their altars and being the inexpressible to men. In vain did the priests try to discourage him. They set magic tricks to awe and frighten him, but he would not stay away. He learned to feed the sacred snakes and handle the altar fires without hurt to himself. He begged to be taught the mysteries of signs and omens and the power of sayings and seals until the priests despaired. "What power will

43

we have over the Suten-Rech if they are going to know as much as we do?" they asked themselves and put him off on account of his age. "Come back to us after you have had your manhood ceremony and we will teach you," they told him. When he was gone they said, "Oh, he will be far too interested in war and women to bother with temple magic by that time. Who would bother with being a priest if he could be a prince anyway? All young boys have silly notions. Five years from now he will laugh at the idea. Our Pharaoh, when he was a boy, begged to be allowed to be a charioteer."

"So it goes," a priest devoted to Rah concluded. "But the contributions at the altars are getting thin. Let us make a new sun-god to renew the devotions of the people. I have just invented a new incense that shall be known as his breath and indication of his presence at the altar."

CHAPTER 7

The seven red mares rushed the sun across the sky, the infinite expanse and the dawns made companies and formed years and the years brought Moses to young manhood and gave him bone and muscle. Mentu had taught Moses about horses. He showed him what made a fine horse and he showed him how to ride and sit.

"Further up towards his shoulders, Prince Moses, and bring up those knees. You can't lead an army until you can ride a horse."

"But my uncle, Pharaoh's son, leads his men with his chariot."

"A war chariot is a splendid vehicle, Prince Moses, but there is more action on the back of a horse. You fight down on the enemy then, and not among them. There are too many sides to a war chariot anyway. Men can surround it and trap you. They can break off wheels from the clumsy thing. But on horseback now, your chariot is a living thing and quick to answer your impulses. Speed is vital in war."

"My mother says she will order a splendid chariot for me."

"Keep it for parades, but fight on horseback and win your wars. Your uncle is Pharaoh's son and eighteen years older than you. He will be head of state and the nominal head of the army. But you shall be the first man of Egypt in war."

The men of war also loved the avid attention that Moses gave to their advice. They need not fear to differ with him nor scold him. He was a born trooper, they all agreed, as they watched his quick grasp of intricate problems and his tendency to experiment with troop placement and maneuvers. There was something about him, outside of being the grandson of Pharaoh, that made men listen to him with respect. There was something about him that assured them he was a companion to be relied on in times of danger. They wanted to follow him into whatever escapade he thought up. He was the young men's choice for a leader. To the old officers he was an upstart who tried to think and every statesman knew that thinking was not for soldiers.

For a long time his activities made no impression upon his young uncle, the Pharaoh apparent, because he was busy with affairs of his own. There was palace etiquette to struggle with; robes of state to be fitted and worn properly. Royal visits from other countries, hunts and ceremonies. Then there were the intrigues inside the palace and council to make sure that the woman who was his sister and the mother of Moses should not herself encroach upon her brother's future power and prestige, and that she should not persuade their father to harbor any such foolish notions about Moses. Ta-Phar jealously guarded his prerogative and that took time and energy. He felt that he was already something of a statesman and gave time now and then to thinking up new strictures for the Hebrews. It was his definite impression that the nation as a whole was softening towards these people and tending towards their attitude of before the revolution. Such laxness might give the Hebrews their opportunity to invite foreign allies to come in and send his family packing again and he had no taste for foreign travel under such circumstances. He wanted to rule and be King. The palace, to him, was not so much a residence as it was the seat of authority. He was more relieved than worried at the zest of Moses for the outdoor life. If he got any pleasure out of excelling with the bow and arrow and hurling spears at marks, let him do it. There were plenty of spears in

46

Egypt to be hurled by others for the heir of Pharaoh. In the hunt, the game was always prepared for his final thrust so why spend hours in practice? Moses was merely lacking in appreciation of his position of a prince, the more fool, he.

Then came the day of the bi-annual military maneuvers. This was a happy day for the Crown Prince. This was the day he would appear in his new chariot and armor with the Egyptian force behind him. The last maneuver had been led by his father and he and Moses had played minor roles in the pageant. But this time his father was suffering from an injury to his hip and had decided to watch the action from a reviewing stand, in company with a visiting king and his retinue. The Prince would be King for the day.

All day there had been the rumble of war chariots past the palace and out to the great field that bordered the Nile. Drums shouted and rumbled; bands blared, a thousand decorated floats were moored on the Nile opposite the parade ground to await the wives and daughters of nobles and officers out on the field in mock battle. Two sets of tents faced each other at opposite ends of the field and at right angles to the river so that the action would be visible to the reviewing stand and the flower-decked barges on the Nile.

The hawk of Horus, the sun-god, mounted to his noon perch and flew down the western sky for two hours, his blazing eyes fixed on the horizon of night. The men had been ordered to their tents since dawn. The princes and nobles now repaired to their decorated pavilions to dress. The barges with their ornate and brilliant-colored awnings filled and Pharaoh took his seat upon his open-air throne. The six royal trumpeters took their places before Pharaoh and at a sign they began the salute to Pharaoh in his incarnation of the sun-god.

Then from their rich pavilions issued the princes and nobles of Egypt and mounted their chariots. Martial music played and the parade of the nobles before the throne of Pharaoh began. Shouts and cheers came from the barges and the standing people as each beautifully caparisoned war chariot with its three steeds passed in review and saluted the throne as they

47

passed. First came the empty chariot of Pharaoh, the horses led by grooms in the livery of the palace. Then came the chariot of Egypt's Crown Prince with Ta-Phar the son of Pharaoh at the reins. He was followed by Moses in a chariot less richly worked and draped. Then all the other chariots filed past four abreast, wheeled about the field and returned to their tents to get ready for the maneuvers in earnest.

While they made ready, a company of dancers from the royal ballet leaped out from behind the reviewing stand and danced for the entertainment of the throne and the barges. The activities of the gods was the theme of the ballet and it was well received.

The trumpeters again. This time they announced the maneuvers and the order. His Majesty's forces were divided into the blues and the reds. The reds would be led by that embodiment of all that was pure and noble, the image of Pharaoh himself, Suten-Rech Ta-Phar. The blues were nobly led by the slightly lesser sun of the world and grandson of Pharaoh, Suten-Rech Moses, son of the daughter of Pharaoh. They saluted in every direction and retired.

Out upon the field they rode the ranks of red charioteers with the Prince at the head. They came out in perfect formation, massed close together and chanting, "Who is so great as Pharaoh, and who can meet his glance?"

"A truly magnificent force!" a visiting dignitary said to Pharaoh. "Magnificent?" Pharaoh retorted. "Why, man alive! You are looking at the finest chariot force in the world. It's stupendous! There never was such a fighting machine in the history of warfare. And it will be a long time before its equal will be seen again. It was our highly developed war chariots which swept out the Hyksos. They are unbeatable."

The red force had reached the center of the field and all eyes looked towards the blue camp for the defending force, but not a single chariot emerged. There was a thick brush back of the camp. Suddenly a hundred soldiers mounted on camels trotted from the camp and rode, none too hastily, towards the chariot force with lifted spears. The Prince and his men were too

startled for a moment to move. People did not know what to think. Some of them laughed.

"What kind of a stupid joke is this?" the Prince sneered. "Bear down on them, my men, surround them and capture them."

The chariots got into furious motion. But as the horses got wind of the camels they began to rear and snort. At that precise moment a thousand horsemen burst from the wood and raced through the camp like lightning. As they cleared the tents a blood-chilling war whoop burst from the riders. They brandished their spears and bore down upon the chariots like so many fiends from hell. But they did not make a direct charge as their frenzied speed indicated. When almost near enough for hand-to-hand conflict, the horsemen split into two parties and executed a lightning-swift flanking movement and attacked the chariots from the side and rear. With quick jabs and thrusts, the charioteers were hurled from their machines. Bridles were seized. A wave of foot soldiers followed the cavalry and the charioteers struggling on the ground with their heavy armor and weapons, and often tangled in the reins of their chariots were overcome and taken prisoner. It was a rout. The throne and barges were on their feet first in surprise, then in alarm. Some asked, "Are those horsemen Egyptians or are they Hebrews and their allies, the hated Hyksos? Only men of the desert ride like that!"

And on the field the action went on furiously. Two thirds of the chariots were empty. The field was full of plunging horses, tangled harness and shouting men. It looked as if God were stirring up hell with a pitchfork. But in a little while it was evident that order was emerging out of the tangle. Prisoners were tied to the tails of chariots and the foot soldiers were springing into the chariots and taking the reins to quiet the horses. Out in front of the struggling mass a horseman with his knees almost under his chin was brandishing his spear and riding around the chariot of Ta-Phar the Crown Prince, feinting at him from all sides as he circled the chariot with the confidence and speed of a hawk. The horseman circled the

chariot six times, keeping the Prince in the chariot constantly off-balance trying to defend himself with his shield and spear from all sides before the horseman sent in the thrust that toppled the Prince out of the chariot. He did not dismount to secure the prisoner. Ta-Phar's personal attendants rushed forward to lift him up. Moses seized the bridle of the three horses hitched to the chariot and led them away from the fallen Prince, helpless on the ground. Then only did a cry go up from the blue forces. "Moses! Moses!" The grandstands and barges took it up and shouted with delight. "It is Moses. What a soldier!"

An elderly Egyptian statesman sitting directly behind Pharaoh leaned forward and whispered, "Did you see what I saw? I believe we have a great military leader on our hands."

"Don't I know it? I intend to keep working on that boy until I make a great soldier out of him. My mind never sleeps," Pharaoh said in a manner to give the impression that he had planned the whole thing, himself. "It won't be long now before we punish those Ethiopians for inviting refugee Hyksos and Hebrews into their country to plot against Egypt. We have a military genius in Moses. I shall instruct him further."

Solemnly walking his horse, Moses led the parade of the victors around the field and up to the dais of Pharaoh to receive the trophy of the victor. He leaped off his horse, bowed himself to the ground and said, "As you have seen today, so will we do to the enemies of Pharaoh." Pharaoh acknowledged the salute and presented the trophy. Receiving it, Moses whirled his horse and gave a magnificent display of horsemanship before he led his lightly clad troops back to their tents.

The visiting dignitary leaned towards Pharaoh again and said: "I thought you said your chariot force was the finest in the world."

"I did and it is," Pharaoh said with some heat.

"What inspired rabble was it that defeated them out there, then?" the dignitary asked with a trace of malice in his voice.

"Rabble? You must be crazy in the head. That was strategy.

50

Why, man alive, you were privileged to look on the world's finest cavalry and infantry forces. I have merely been keeping it under cover. It's something new in tactics. The newest development in warfare will always arise in Egypt. Rabble indeed! Don't get silly in your old age."

Back in his pavilion Prince Ta-Phar, unaware of his father's sentiments, was beating his attendants and swearing. "Treason! Treachery! and all of you knew of this heathenish trick that was to be played on the army of Egypt and kept a vile silence."

"But the blues are part of the army, too. It was just one side against the other," one young officer tried to explain while dodging cuffs and blows. "Everybody knew the riding practices were going on. You said—"

"Shut up! You bitch's baby you! When I reveal to Pharaoh the intrigue and treachery in his own army, everyone even suspected of guilty knowledge shall be whipped like slaves. Camels! Half-naked soldiers on horseback! What kind of an army is this? That Moses! When the time comes he is going to feel the weight of my hand. Nothing different! But what can you expect of a Suten-Rech who takes sides with Hebrews and hangs around the stables with grooms?"

As Moses entered his pavilion he saw a figure squatting in the far corner with a court wig lopsided over one eye and a hit-or-miss collection of garments on. A general's tunic, a shenti of a priest, the headdress of a high state official. It was not until Moses' eyes traveled to the worn-out sandals that he received a clue to the puzzle. Then he looked up at the face in the midst of this costume mixture and burst out laughing.

"Mentu!"

"I—I know I have no business on the parade grounds. I am little better than a Hebrew or a swineherd in Pharaoh's eyes, but—"

"Shut up! You old monkey you! Where on earth did you get those clothes?"

"Oh, a piece here and a piece there. Everybody, even the servants, were gone to the maneuvers and so it was easy."

51

They fell upon each other laughing. Moses straightened up the wig and the headdress and held the old man off at arm's length to survey him.

"Not so bad," he laughed. "If they don't get too close. It got you inside anyway. Why didn't you ask me for a pass?"

"It seemed too much for a stableman to ask. And I wanted to see you ride."

"Did I do all right?"

"It could not have been better. Your seat, your knees, your hands, all perfect. You were a horse and the horse was a prince. Did Pharaoh approve?"

"I don't know yet. I'll find that out tomorrow at breakfast. Tonight is the great banquet. No personal matters taken up then."

"Well, anyhow, the Prince and those old-time army men have found out that they over-sported themselves with their war chariots just like I told you."

"My Mentu, if ever I become King you shall be Grand Advisor to the throne with eating privileges at my table."

"May you soon be Pharaoh! But long before that time I will have gone to join the monkeys or the snakes, if I learn more than I do now."

"Snakes?"

"Didn't you know that wise men do not die? When they have attained a certain stage of wisdom they enter the serpents."

"I did not know that. The priests never told me."

"They tell nothing that doesn't pay. Their business is like the cemetery. They take in but they never put out."

"Some day I shall look into their business and find out why they control rulers."

"Oh, they bite the rulers and everybody else with the tiny teeth of fear. Then rub ointment on the sore. Now, I had better go before I am seen."

"Take my own horse and ride him to the stables, Mentu, and may the forty-two gods in the hall of the double Maati find you just."

52

"May the deathless serpent that guards the book of Thoth whisper in your ears, my Suten-Rech. You are a man conferring with destiny."

Moses rushed to the door of the tent and seized Mentu by the shoulders and dragged him back.

"Come back here, Mentu."

"Why, Suten-Rech! In a few minutes your tent will be full of admirers and—er—some of them might recognize their clothes."

"Never mind that. I'll slip you out the back way if it comes to that. What about this deathless snake guarding the book of Thoth?"

"To tell you the truth, I don't know anything about it. All I know is what I have heard. It was told by the father of the father of my father to the father of my father and the father of my father has told it to my father."

"It is a really old story then."

"Sure. And the cry of it is that there is a book which Thoth himself wrote with his own hand which, if you read it, will bring you to the gods. When you read only two pages in this book you will enchant the heavens, the earth, the abyss, the mountain, and the sea. You will know what the birds of the air and the creeping things are saying. You will know the secrets of the deep because the power is there to bring them to you. And when you read the second page, you can go into the world of ghosts and come back to the shape you were on earth. You will see the sun shining in the sky, with all the gods, and the full moon."

"Where is this book, Mentu? Do the priests know it?"

"The priests have heard of it, of course, and now and then some one of them will pretend that he has read a page. But if they had read from that book, Suten-Rech, they would never remain a priest in Pharaoh's temples. They would be too powerful for the place."

"The priests are men of learning, Mentu. They must be wise."

"They don't just have to be. Certainly they know what is in

53

the books. That is learning, not wisdom. Learning without wisdom is a load of books on a donkey's back. I want *you* to understand."

"Where is this book, I ask you, Mentu? I mean to read it."

"The cry of it is that it is in the middle of the river at Koptos, in an iron box; in the iron box is a bronze box; in the bronze box is a sycamore box; in the sycamore box is an ivory and ebony box and in the ebony box is a silver box; in the silver box is a golden box and in that is the book. And there is a deathless snake by the box to guard it. That is all that they told me so I don't know any more."

"If it were not for the feasts and the entertainments, and the announcements of the promotions in the army, I would start out for Koptos tomorrow, Mentu. It may be only an old tale, what you have told me, but I mean to search the river at Koptos for that snake and that book. Even if they are not there and never were there, it will be an interesting trip. When I go, you are going along. I will ask Pharaoh for you as my special attendant tomorrow. And if the box is there, Mentu, if it is only there!"

"If it is there and the snake is overcome, you will be the greatest priest the world will ever know. So far as I am concerned, if you take me with you, I won't be nothing but your shadow, and you'll be my boss. But I bet you I'll be the top pauper in all Egypt. I'll bet you that."

The old man went out full of joy. Moses stood in the door of his tent and the sun went down in an Egyptian way—without a memory in the sky.

CHAPTER 8

The announcements were made. The very next day after the maneuvers, they were made before all the big men of the army in their uniforms and armor. The men who sat in big chairs around the throne were there with the officers, for they were the ones who made the wars for the generals to fight. Pharaoh told the announcements to the scribe and he wrote them down, and a man with a loud voice for speaking read them out to the people. The Suten-Rech, Moses, was Commander-in-Chief of the armies of Egypt by reason of what had happened the day before. He was the chief commander for life or until Pharaoh could see further, that is, until somebody could show a better way to win battles than Moses had. In reply, Moses begged that the honor be given to somebody else, somebody more worthy than he was. He gave as a reason, in addition to his unworthiness, that he wanted to go traveling into foreign countries and see how they lived and made war there. But Pharaoh was not interested in the ways of other peoples. He was not interested in their wars and warfare unless they were the enemies of Egypt or Egypt's allies. All that could wait. He was interested in winning wars at home and abroad. It would be time enough to consider how the people in those far-off countries lived after he had conquered them. Moses felt twisted and torn by his elevation. He had worked

hard for more than three years to earn it, and now he didn't want it. He couldn't say to Pharaoh, "You are breaking into my arrangements with your old decorations." He had to pretend he liked it.

His Uncle Ta-Phar hated it too, but his personal feelings could not stand in the face of the enthusiasm of the military bloc and the intensified nationalism which had been whipped up for a generation by his father. Egypt was spreading by conquest and alliances based on force. If they didn't keep on getting more they would begin to look weak. So Ta-Phar had to swallow the elevation of Moses and make out he liked it. But after all, he was the heir to the throne and when the armies went out, he could always ride in front, if he wanted to. And then again, the time would come when he would be Pharaoh himself and then other arrangements could be made. The old folks had a saying that the belt that went over the devil's back had to buckle under his belly. He could wait old Moses out and when his time came, that upstart was going to catch it. "Your hands must knead everybody's dough, and every shirt is too tight for you," he said to Moses time and again when they quarreled. "You are my father's first grandson, and so he dotes on you; and you are my sister's only child and so she spoils you. Just wait until they are gone and see what *I* do for you. I mean to make you catch me a natural hurry, and don't you forget it."

So this was the way he spoke to Moses in the corridor of the palace after the announcements were over, and Moses laughed in his face.

"I wouldn't let on if I were you, Ta-Phar. Somebody might hear you and laugh at you. Then you will have to get a law passed that people can't laugh at Princes."

"Another bit of impudence out of you and I'll whip you."

"No, you won't whip me, Uncle Ta-Phar, but there might be a fight. But there would have to be some good running done before that fight comes off."

"And why?"

"Because in the language of the soldiers' camps, I'd have to

56

run you down and hem you up before I could get a fight out of you. You don't want no parts of me, and I know it; and you know it, and you know that I know you know it."

Moses strolled on off and joined his military escort and left Ta-Phar standing where he was. So Moses forgot all about him in a few minutes because his heart in all its height was far from the palace and armies and honors and hopes of honors. He was in his private suite with Mentu who was in the new clothes of his new job as personal attendant to the new commander of the Egyptian armies. But, they were not talking about troops and munitions and strategy. They were deep in the mysteries of life and magic. Moses had decided to go to Koptos at the first opportunity.

But years and wars and years of wars stood between him and his journey. The might of Egypt was stretching across the world. Ethiopia was conquered; Assyria kept in fear, Babylonia was terrorized. All tributes flowed towards Rameses and Memphis. No one knew how the Egyptian armies would strike nor when. The men were permanently in barracks. Once war was decided upon, Moses was on the march and they did not know whom they marched against until they were past the boundaries of Egypt. Against some nations they fought in formal battle formation and crushed them by sheer weight and numbers; another time, they lured out the main army of the enemy by sending an inferior force before the gates. When the attacking Egyptian forces retreated before the defenders, the swift-striking horsemen and foot soldiers of Moses fell upon them from ambush and cut off their retreat, and hewed them down like saplings. The returning armies of Egypt staggered home under the weight of booty and led slaves in hordes. The streets of the cities teemed with strange nationalities and tongues. From the Sudan, all Asia and Greece.

So always Moses was asking himself, "When will there be enough of conquests? When will I follow my own mind and read the pages of Thoth?"

He came to feel, somehow, that he would never die until he had read that book hidden in the river at Koptos. So he was

reckless in his daring. The huge hope of audacity spurred him and he took chances to win that no other leader would have dared, and won because his men had come to believe that he could not fail, so they fought like fiends from hell.

He knew what sorrow meant because old Mentu died. "Please give me the funeral and tomb of a priest," he begged Moses at the last. "That is what I wanted to be. But I wanted to be a great one—not just another one to light fires and burn incense. I couldn't make it from where I started. You have the power to insist—bury me as a priest."

"Don't you worry, Mentu. It is going to be done just like you want it. You have been my best friend. I am very sorry you will not be going to Koptos with me as we had planned, for I shall go."

"Maybe I will, who knows? And, Suten-Rech, don't forget what I told you about the monkeys and the snakes. It might be true, you know. The old folks often know things you can't find in a book."

"Oh, I won't forget. I won't forget anything that you have ever taught me, the sayings, and the proverbs and all. They have helped me a lot."

"You are right to listen to proverbs. They are short sayings made out of long experience. Goodbye, son. I wanted a long life, but I didn't mean to get old. Look out for the snakes and monkeys and find out what they say."

Moses astonished the court by the elaborate burial of his servant Mentu. Everything needful was inside the tomb for the Ka of Mentu, even to the picture of a Prince and his groom on a river journey to a place where a serpent lived in the water. And no one knew why it was there but Moses. The tomb was surrounded on the outside by a fenced-in garden, and Moses ordered that no creature that entered that enclosure was to be killed at any time, especially if it were a monkey or a snake.

Sitting alone in his quarters he would picture Mentu in the Hall of the double Maati, justifying his life before the forty-two gods and crying:

"Hail, thou who eatest shades, who cometh forth from the place where the Nile riseth, I have not committed theft.

"Hail, Leg of Fire, who comest forth from Akhekky, I have not eaten my heart [harbored malice]."

And so on to the forty-two deities, and Moses felt that if he could only be as pure as old Mentu when it came his time to enter the court of Osiris Nu, he would be satisfied.

So these thoughts reminded Moses keenly of his days among the priests and he took to visiting them again. Now, he was the great soldier and a powerful Prince, and the priests behaved accordingly. By his own inclination he was better educated than any scribe in Egypt. He had read all of the books in the library, and all of the priests knew that he had read them. They were proud and happy to have him come among them. It gave new prestige to the priesthood which had declined considerably under the war party now in power.

"Tell me, and then again show me, so I can know," was what Moses said to them about every bit of magic in the temples. "Never mind the ceremonies. They are not important. I can learn them from the other side of the altar. They are nothing anyway, but the dressing for what goes on behind the scenes. Make me know."

Some of them thought that Moses took seriously the things that meant so much to them, but he didn't. He learned all of their tricks as he went along, but only to sift them through his mind to see if any of them led towards real knowledge, or the book in the river. At last he knew all that there was to be known and still he found no doors that either hinged on hell nor heaven. He called the names a thousand times, but saw no faces of gods. But he learned many things to distract the minds of unthinking people from their real troubles, and to taint men with the fear of life. In this he saw a certain mastery over people if one cared to use it or needed to use it.

Then his mother died and he missed her very much. The Ethiopian Princess who had been brought to the palace as his wife as a sign of peace between Egypt and Ethiopia, meant nothing to him. Perhaps that was because he meant nothing

to her other than what had been arranged for in the treaty. He looked at her face that seemed to come to a point at her nose like a fox and wondered if he would have loved her if he had been allowed to win her as lesser men won their wives. But it wasn't worth thinking about too much, and so he didn't think.

But he knew it was not because he did not feel. Long ago before he was twenty, he had found out that he was two beings. In short, he was everybody boiled down to a drop. Everybody is two beings: one lives and flourishes in the daylight and stands guard. The other being walks and howls at night. He could be a lot of things to some woman when he found the right one. But the eye-looks of this treaty-wife in the palace was as impersonal as his own. She did not awaken the urge in him to give her the pain and tenderness that make up a marriage. He was always polite and kind. Whatever secrets her body held were no concern of his. And she was happy at being part of the court life. Some day, sometime, he would find a woman and crush from her body that essence that made men live. He would rouse her tears and her tenderness and he would give her something that she could not live without, of which his property and position was only a sign of his inward giving.

In the meanwhile, he had a great struggle on his hands. As the actual chief of the army he was demanding that Hebrews be included in the forces of Egypt. But he was being strenuously opposed by most of the court and a large part of the officers. They argued that they were not citizens of Egypt, but enemy-prisoners, and as such, it would be rash to put arms into their hands again. Who knew when they might rise up against their conquerors and turn the tables? Moses argued that they were enemies certainly, because they were treated as such. More than a generation of years had passed since the revolution and it was time that these people either be restored to citizenship or sent out of Egypt. It was a weak spot in any nation to have a large body of disaffected people within its confines. And then again, civilization and decency demanded

60

less harsh treatment for human beings. If they could not vote and bear arms at once, then shorten their hours of work and repeal the law that said their boy babies must be killed. It was not being obeyed anyway, and since it put Egypt in a bad light before other nations, why not strike it from the books? The anti-Hebrew party led by Ta-Phar shouted "No" to all of these proposals. If the Hebrews were sent out, wouldn't they go and join themselves with some enemies of Egypt and return as invaders? They knew all of the back roads and the weak spots of the country. They would know when and where to strike. No, not one Hebrew was going to escape from Egypt. Pharaoh receded from his former position a little. He took off two hours from their working day and rescinded the order on boy babies. Moses took this as a hopeful sign and waited for a chance to demand other changes in the status of Goshen.

The Hebrews heard of his efforts in their behalf and sent little presents to him in secret to return him some thanks. He took occasion to slip down into Goshen once or twice to see their actual conditions and to talk with some of the leaders. What he saw touched him so that he resolved in his heart to do whatever was in his power to better their condition. He went directly to Pharaoh for a talk, and told him what was in his mind.

"To outside nations, Pharaoh, we seem better than we are. My idea is, if we wish to be really great is to be better than we seem."

"Don't be too brash, Moses. I have been thinking too. But it is hard to go against public opinion. The Hebrews are thoroughly hated in Egypt. I don't say that I did not intensify the feeling to a degree when I came to the throne. But I only played on the instrument I found already. Be patient and some further changes might be decreed on my death."

"Let us hope that might be a long time off. In the meantime their misery is awful. It is too terrible to look at. Go see for yourself."

"I am old and sick and a trip like that would have me flat on my back for months. I don't believe the country in general

would want my days shortened for the sake of those people. They brought it all on themselves anyway. Now, let's table that subject and get back to these Persians. Do you think we got a chance against them if we invade them? Or do you think we ought to work them up to attack us?"

"I'll think it over and let you know. It's a ticklish question whichever way you take it. If we go there we've got to figure out how to carry enough supplies for a long journey and a long stay. This living off of the countries we pass through calls for a lot of extra fighting and we lose men and animals. If they invade us, even if we win, they destroy too much property and lives. Can't we rest from wars and turn to home problems for a while?"

"Egypt has no home problems that I can see," Pharaoh said coldly and turned over in bed. "What internal problems we had, got settled before you were born. Send in my nurse as you go out, and report on the Persian campaign tomorrow."

CHAPTER 9

Moses didn't have any more notion of killing that Egyptian overseer than he did of flying. It just happened. The whole thing started in the chambers of his wife. He had made his report to Pharaoh on the conduct of the Persian war and went on to his own house to tell the Princess that he was going away on a campaign. When he entered her bedroom she had shrunk away from him as if he had been a crocodile. She ran across the room to the farthest wall and covered her face. Moses stopped dead in his tracks and looked at her.

"What is the matter with you, woman? Are you crazy?"

"You kissed me."

"I kissed *you?*"

"Yes, you did!"

"When?"

"Don't stand there and make out you don't know what you did. You kissed me when we—when you received me as your wife two years ago."

"Oh, I had to do it then. What is wrong with that?"

"You Hebrew! putting your hands on *me!*"

"Hebrew? I a Hebrew? What ever put that notion in your head?"

"Get out of my room. The very idea of me being married

to a Hebrew makes me sick at the stomach. Don't you dare to come near me. That gang of rapists and slaves."

"I am not a Hebrew. I am not a slave. And so far as that treaty-kiss is concerned, if you can call that rape you have plenty of imagination. If my indifference to you in the past isn't enough, you can take my word for it, you are absolutely safe from me."

"It is rape for you to even look at me. Get out of my bedroom. This is no place for Hebrew slaves. Get back to your place in Goshen."

"Do you realize what you are saying? As Mentu would have said, you must be blind in one eye and can't see out of the other one. This is Prince Moses, Commander-in-Chief of the Egyptian armies, standing before you. You are here in my palace because I beat your father in Ethiopia, remember? Not because *I* sought you as a wife."

"I don't care how many wars and battles you have won. Bragging of your conquests does not excuse you from being a Hebrew."

"Why do you call me a Hebrew all of a sudden?"

"Because everybody connected with the court is calling you a Hebrew. Your Uncle Ta-Phar says so himself."

"But everybody around here, and Ta-Phar especially, knows who I am—my mother, my father and my grandfather. So if I am a Hebrew they are Hebrews, and that goes for Ta-Phar too."

"Oh, no, they are not your relations. Your mother did have a son by the Prince of Assyria, but he died and your mother wanted to guarantee an inheritance with Pharaoh, so she took a Hebrew child and passed it off as her own. Nobody ever would have known why you are always hanging around in Goshen and upholding those Hebrews and trying to put weapons in their hands so they can slaughter the rest of us. But now we know why. You are one of them."

"I can prove that these are all lies whispered around by my enemies out of jealousy, no doubt."

"How? How can you prove it? Your so-called mother is

dead. A Hebrew woman came to the palace gates yesterday and demanded an audience with Prince Moses, stating emphatically that she was your sister."

"*My* sister?"

"Yes, your sister. She came to the palace gates and asked to see you. Of course, they wouldn't let her in. They asked her what she, a Hebrew, wanted with a Prince of the royal house and she said that she wanted to let you know that her father had been killed by the soldiers in some sort of an uprising. She thought you would do something about it—you being her brother."

"My sister in Goshen? Ridiculous!"

"Yes, your sister. What a filthy trick has been played on me and my country! She says she remembers when you were born and how you were put on the river in an ark and that is how the Princess got hold of you in the first place."

"If you and Ta-Phar despise Hebrews so much, how is it you are so willing to take the unsupported word of one of them as gospel truth? My word ought at least to be as good as hers."

"Just about. One Hebrew's word against another."

Moses strode out of the room. He was angry. He never remembered being so angry before in his life. This was the work of Ta-Phar. This was the answer of the court to his plea for justice against oppression. This was mob malice. He made up his mind to go straight to Pharaoh and say that since they claimed that he was a Hebrew, they did not need his despised services in the Egyptian army. Let Ta-Phar or some of the other silly, useless nobles do for Egypt what he had done. But a second thought came to him. Perhaps he ought to wait until he was calm before he went to his grandfather. One thing was certain—that Persian war could wait until he came to himself again. It would never do to take the field in his present state of mind. He decided to take a walk and think things over. Then he would ask for an audience with Pharaoh and explain his situation and his feelings. Him a Hebrew? "That is the way with people. I am finding out," he was saying aloud to himself

and the Infinite Expanse. "If they do you wrong, they invent a bad name for you, a good name for their acts and then destroy you in the name of virtue." He kept on walking and thinking. The idea of calling him, Prince Moses, a Hebrew! If Ta-Phar thought so, why had he been so hush-mouth about it all these years? For it was no secret that Ta-Phar had never loved him. He had openly resented both his mother and him. So why did he bring the mess up now? Had some Hebrew really made such a claim? He didn't believe it. It was too much to believe. More likely Ta-Phar had thought it up himself since his mother's death, realizing the difficulty of proof, and the harm it would do before the proof could be had. So! The court was really angry with him for asking justice for Hebrews. "They have decided to destroy me out of hand," Moses reflected. "They are ready to do anything to confirm them in their position, and to do that, they have to prostitute the language. They must blow out the sun and switch on a spotlight."

He walked and thought and felt and walked. He was outside the new city of the King, the towered city of Rameses, named for his grandfather, before he realized where he was. He was upon the new public works, a causeway, splendidly conceived, which was being built with forced Hebrew labor. He saw the men straining and striving and the Egyptian bossman striding among them and striking out with his bull whip without regards to whom he hit nor why. Moses stopped in his tracks and looked on. He looked at the straining backs of the workmen and then at the face of the foreman, and suddenly he saw all Egypt in that face. The newness come to power, the cruelty and greed. And he thought, "I have risked my life and exposed myself to a thousand dangers for such as him. Only some of them strut around the capitol in robes of state. But the same faces. And their faces got that way from keeping company with their souls."

The foreman saw Moses and knew him. Who was it in Egypt that did not know that face and figure? It was Moses, the Suten-Rech, the mighty man of arms. The singers said that he

66

was the savior of Egypt, the conqueror of the world. Both oceans knew him, the ocean of the sea and the ocean of the air. His name and fame were great, his clothes were fine. It was not often that a prince looked on a foreman nor the foreman on a prince. So the foreman wanted a smile of notice and a nod of approval from so rich and just a man. He must do something to attract his eye. Aha! there was a weasly Hebrew straining with a rock that was too heavy for him. Look at him, now! His knee joints were sprung and his back was humped. His neck was stringy from straining. The lash spat derisively in the air and wrapped around the Hebrew's shoulders, and bit into his short ribs. The sudden pain made him drop the stone he was lifting and it crushed his foot.

"Pick it up!" snarled the foreman and hit him again. By this time the foreman felt as mighty as the reputation of Moses. He fought a hundred battles on the Hebrew's back and the Hebrew grovelled on his all-fours begging for mercy. But that did not save him. The whip kept singing. He crawled between the knees of the overseer to protect his head and face. He was too close in for the lash to strike him but still he could not save himself. He begged for mercy, and it made a whining obbligato to go with the rhythm of the blows because the foreman turned the stock of the whip in his hand and beat him about his head and shoulders. Other workmen cowered in fear and wailed in sympathy and terror.

Moses heard the wails and woke out of his nausea at what he was seeing. He leaped upon the foreman and snatched the whip away. With his right arm, so famous in Asia and Africa, he swung and struck the foreman between the eyes and staggered him. A terrible surprise crept to the eyes of the man and peeped out at Moses. Twice again he struck the creature of Pharaoh's hatred and intolerance and the man lay on the sand without a quiver. Moses stooped down and saw the man was dead.

Moses straightened up and thought came back. "I didn't mean to kill him," he said softly.

"You didn't kill him, Suten-Rech." The Hebrews all

crowded about the Prince and wept for joy. "You didn't kill him. You just hurt him and he died from being hurt."

"Anyway, he is dead," Moses said with more calm than he felt. "Bury him well in the sand and keep your mouths shut about it. Pharaoh would be angry if he knew."

Moses stayed until the overseer was buried and the place smoothed over. "Go on about your work as if nothing had happened. If anybody asks you what became of your foreman say that a dignitary passed and called him away, and he has not returned. That is all you know."

The physical exertion had given Moses a sort of release from his turmoil of spirit. He turned back feeling better. He went to see his grandfather and arranged to have the war put off for another week. He was not sorry the foreman was dead; he was only sorry that he had had to get mixed up in it at such a time and under such circumstances. If Ta-Phar and some others heard about it, they would use it to bolster up the stories they were circulating about him. He felt reasonably safe that the Hebrew workmen would not expose him. He had jeopardized his future for their sake. It would be both graceless and foolish for them to spread the report around.

He felt lonely in the palace and he felt lonely in the camp. So he went to visit the tomb of Mentu the second day after the killing of the foreman. "Am I a Hebrew?" he asked himself there, but found nothing to convince him that he was. But one thing had come out of it—he found a new sympathy for the oppressed of all mankind. He lost his taste for war. Warfare, under the fanfare and flattery of the court, had been his outlet. And now it had lost its glamor. He was saying to the glory of struggle and victory, "Go away, honey, you have lost your sweetness." He was denying what he had held to be the truth. Well, he thought, he was twenty-five. His youth was behind him. Henceforth he was a man of thought.

A week later he was drawn to pass the palace where he had killed the foreman. He was surprised to find that a Hebrew foreman had been appointed to take the dead man's place. But things were going little better than before. Two of the work-

men were having a fist-fight and paying no attention to the foreman.

"What is the trouble?" Moses asked. "What's the matter with you men?"

The foreman approached Moses respectfully and shook his head sadly as he explained, "Some of them want to knock off work early to hold a protest meeting, and the others agree with me that it just wouldn't do. It would look very bad to my over-boss that just as soon as a Hebrew got to be foreman, the men left work whenever they got ready to hold meetings."

"Your foreman is right," Moses agreed, speaking to the men. "This sort of thing is what I am working for. Hebrew foremen first and keeping on up the line until you have Hebrew state officials. But if you start leaving work and creating disturbances, you will find yourselves worse off than you were, instead of better."

"That is what I tell them," the foreman said, "but being one of them, my people despise me so much that they won't pay me no mind."

"They had better if they know what is good for them." Moses spoke firmly. "You must be united among yourselves and you must obey your foreman. You must respect yourselves if you want others to respect you. Now you get back to work, all of you, and do what your foreman tells you." Moses spoke in a military tone of voice.

"And why do we have to be taking orders from him?" one of the men asked scornfully, pointing at the Hebrew foreman. "I don't intend to let no Hebrew boss me around."

"And why not?" Moses asked in surprise.

"He ain't no better than I am. I don't mean to take nothing off of him at all."

"Oh, but you are wrong there, all of you. You ought to be glad to have one of your own over you."

One of the men who had been fighting turned to Moses with a sneer on his lips. "We thought that this was Prince Moses, chief of the Egyptian army. We did not know that you was straw-boss of public works. In fact we didn't know that

you was our bossman at all. Nobody ain't told us you was suppose to come round here acting like a overseer."

"I am not your bossman at all. I am your friend. I want you to act in such a way that I can help you," Moses replied patiently.

"And how come you want to help *us?* How much are you getting out of it? Perhaps it is just like the people say. A cousin of mine who talks with a man who has a friend who talks with a palace guard says that all the people of the court say that youse jealous of Suten-Rech Ta-Phar and that you go around stirring up trouble to make yourself a King. You want to be everybody's boss."

Moses shrunk up inside like darkness at dawn. Such misunderstanding of motives! Such a will to see evil where only good was meant. Such a trampling on his sacrifices, for he had all but decided to resign from the army and to devote his time to bettering the condition of the Hebrews.

"I don't want to be anybody's boss. In fact, that is the very thing I want to do away with," he said quietly.

"Don't look like it," one of the men retorted. "If what you are doing ain't bossing then there isn't a crocodile in the Nile! Calling yourself our friend, and liable to get anybody in Goshen killed if ever they find—"

"Sh-sh-sh!"

Everybody looked scared and glanced about them fearfully.

"Don't you people see that I am trying to help you? Being a bossman is the last thing on earth I want to do. I want you—"

"Oh, yeah! We're mighty proud to hear all of them sentiments out of you. Cause some of us was scared you was trying to get to be our boss. And since we ain't heard tell of nobody putting you over us, so far as I'm concerned I'd rather have a enemy overseer that just beat me and sent me on home with a sore back than one of them friends that might kill me and bury me in the sand."

For a moment Moses stood hurt at the lack of appreciation of his behavior and of the motives that prompted him. Then he was afraid of what might happen if such talk reached Phar-

aoh. Then he saw the gloating look on the face of the one who was talking, and a brother gloat on the face of several others. So! The will to humble a man more powerful than themselves was stronger than the emotion of gratitude. It was stronger than the wish for the common brotherhood of man. It was the cruelty of chickens—fleeing with great clamor before superior force but merciless towards the helpless. It made him feel cruel himself for a moment. Then his anger passed and he felt sad again. Well, anyway, the Hebrew who had been made overseer understood. Moses could tell by his face. The whole thing was too big and sudden for quick words from him. He turned abruptly and walked away.

"Did I tell that Prince something?" he heard the voice of a man behind him. "I told his head a mess!"

"You sure did. I'll bet you he won't come messing around here no more. Ha! Many dogs are the death of the lion."

"So they think I could not have answered them, or that I was afraid," Moses mused as he strode on off. "They don't realize that it all would have been too easy for me."

Thinking and walking and feeling, he was at home before he knew it. He did not follow his usual pattern by stopping in the big reception hall and sending word by one of his servants to the Princess that he had arrived. He went straight to his private suite and sat down to think. But this was not the place. Observing that the door between his apartment and that of the Princess was firmly closed for the first time, it brought back all of his unpleasant happenings of the week. So he summoned his steward and commanded him to follow to his quarters in the barracks.

"You are to bring several changes of clothes to me here," Moses told the steward, "and a well-filled purse and the most necessary ornaments. I am going to live with my men for a long while. Hurry and do as I tell you."

"I have something to tell you, Suten-Rech, if you will listen."

"First go and get me what I told you and then tell me whatever you want to."

71

The steward hurried off in the new darkness and Moses sat and thought, and grew by inches as he thought. "The time has come for a decision in my life. I'm going to sit right here until my whiskers touch the ground, if I don't come to some decision as to which way my life is going and why." He sat motionless with his hands joined behind his head until the steward returned with his things.

"Suten-Rech, there are some who say that you are an enemy of Egypt."

"They do?"

"Yessir, they say that you are stirring up the Hebrews to rise against the country."

"They wish to destroy me, and so they have quit using sense and taken to using phrases. Slogans can be worse than swords if they are only put in the right mouths."

"Yessir. And they say that you are going about secretly killing off the oveseers who had charge of large groups of Hebrews to give them a chance to kill us."

"They said I killed overseers? Who said that? When?"

"I think the word was sent secretly to Pharaoh today telling him when and how you killed this particular man and where his body can be found."

"Oh."

"It is said that Pharaoh is very angry with you and plans to have you seized tomorrow morning when you go to that conference about troop movement. Suten-Rech, I love you and I love to serve you. It would have been better if you had not declared yourself a Hebrew."

"I never did."

"There are several people who swear that you told them that you were a Hebrew and would do anything at all to serve them."

"Just one lie after another one. Somebody wants me out of the way and they are not missing a trick to get rid of me. But it does not distress me as much as it would have done a month ago, now that I have made up my mind to leave Memphis and perhaps leave Egypt."

"But why?"

"For one thing, I suppose it is the easiest thing for me to do right now. Property always rewards its defenders and the property owners now believe that I am plotting with the Hebrew slaves against their possessions. So the people who are lying against me are in high favor now according to the signs. So I am going away."

"When?"

"Before the old man becomes a child again." When Moses said that, he was telling his thoughts by pictures. The people said that Horus, the sun-god, the god of the two horizons, became a baby each morning at sunrise and grew older all day long. By sundown he was an old man with a beard. But during the night his youth returned and he rose the next morning in his red glory and with his watchful eye drove away all darkness.

"Oh, Suten-Rech, please take me with you."

"No, I am going alone. I want to leave all that I was behind me for a while—perhaps forever."

"Oh, Prince Moses! Egypt could not spare you. You are part of the King himself and he is descended from Ra. You must not think of leaving the country. Justice will win."

"That may be so, and then again you may be right. But I'm going just the same. You must tell my wife, the Princess, first of all. Get the news to her tomorrow after breakfast, will you?"

"Oh, yes, sir, I will."

"I trust you to do exactly as I tell you. She must be told first of all. Announce to her ladies in waiting that you have come with a message from me. Then wait until you deliver the news to her in person."

"Where will you go?"

"To the desert, I reckon, to think. I feel something I have never been conscious of before, and I must find out from within myself what to do about it."

"What is that?"

"I feel the cursing thought of the law and power. I had

always felt the beneficence of law and power and never stopped to consider that it had any other side. It is a sword with two edges. Never mind whether it is directed against me honestly or not. That has nothing to do with its power to injure me."

Moses kept his steward with him until he was ready to go. His signet, his state ring, his other rings and necklaces he hid about his person with his money and went out into the darkness. He knew the steward would do as he was told to because he was afraid not to. He knew that the steward would wait a long time before the Princess would receive that message from him in the morning, and so it would be very late before anyone else knew that he was running away. He would be beyond the borders before they suspected that he was not in his quarters, or somewhere around the palace.

CHAPTER 10

All night he traveled and thought. He found his un-
formed wishes taking shape. He was wishing for a
country he had never seen. He was seeing visions of
a nation he had never heard of where there would be more
equality of opportunity and less difference between top and
bottom.

Out under the late moonlight he could see chickens roost-
ing along the ridgepoles of barns with the arrogant tail feath-
ers of roosters sticking out against the sky, and that brought
his thoughts around to the hundreds of questions he wanted
to ask of Nature. It gave him a freshening hope, as he fled for
his life from Rameses. "The man who interprets Nature is
always held in great honor. I am going to live and talk with
Nature and know her secrets. Then I will be powerful, no
matter where I may be. And now that I am free from wars and
warfare, I shall go to Koptos. Not at this very moment, for if
I am found in Egypt they will kill me sure. Wait a little while
and grow whiskers and they won't know me from the next
one, especially if I stay away from certain vicinities. I am going
to answer the questions that Mentu raised in me. Is there a box
in the middle of the river at Koptos? Does it contain a book?
Was the book written by the god Thoth, whose messenger is
the Ibis? Is it guarded by a snake? Is the snake really deathless?

These were the questions that hurt him to hold inside him because the saw-teeth of his curiosity and impatience gave him no peace. From now on his sword should cease to think for him. He would spend the rest of his life asking Nature the why of her moods and measures. As he sailed swiftly down the river Nile, he saw many things in the water and along the banks which he would like to investigate and which he now regretted to leave. He realized now how Mentu had aroused his thought, and that once you wake up thought in a man, you can never put it to sleep again. He saw that he had merely been suppressing himself during his military period. That was over and gone. Everybody has some special road of thought along which they travel when they are alone to themselves. And his road of thought is what makes every man what he is.

Bright and soon three mornings later, Moses was standing beside the Red Sea. What he wanted was a large boat to cross over into Asia. He talked to first one man and another about renting a boat, but with no success. It was early for the rest of the world, but late so far as the fishermen were concerned. Three hours before every available boat had gone out to catch fish. So Moses finally sat down to wait until a seaworthy craft should come in with its load, or without one as the luck might be. So that is how he got to talking with the old man who said he was too old to go out with his boy any longer.

While he waited he noticed what he had not noticed before—that whoever was about the water front had left off what they were doing and were collected about him. They were respectful, even reverential to a degree, but everybody's thoughts and actions were influenced by his presence. Under the circumstances it began to worry him a little. Several of the men withdrew into a knot down the beach a little way. Then the old man crept up to him.

"Suten-Rech," he said in a low tone, "them men is figuring out how to make some money out of you."

"They do? And how do they plan to do it?"

The old man scratched his head and regarded Moses shrewdly. "We don't see a Prince in a hurry often."

"How do they know that I am a Prince? And why do they think I am in a hurry?"

"All anybody needs to do is to look at you and they would know you was a Prince. The way you act proves that you're in a big hurry to cross over on the other side. So them men—yonder, Suten-Rech—done agreed not to find you a boat until you are ready to pay a large price for it. None of us ain't got nothing, you know."

"I wish they would hurry and make up their minds on the price."

The old man crept closer and murmured in the ear of Moses.

"Some folks got minds already made up that could help you."

"Why don't they let me know, then? I am really in a big hurry to cross over."

"Take me for instance—I am poor and old too, so that the money would do me more good than anybody else around here."

"Have you a boat?"

"No, my Prince. But I have something to tell you which you don't need a boat to do if you will give me the money whilst the others are too far off to hear what we are saying."

Moses reached for his purse and gave generously. The man kissed the money in a sort of ecstasy and hid it in his clothes.

"I never expected to be so rich!" he said in an exalted tone. "Now, I can have a funeral of the second class with a tomb. Oh, yes, my Prince, it is all a matter of the hour and the tide and you can wade across the sea."

"The Red Sea is a mighty place of waters. You are joking with me and I am in no mood for jokes."

"Don't kill me, Suten-Rech, I wouldn't dare to joke with such a big man as you. Look, you walk down the beach about two miles north and you come to a narrow neck of water, where the Red Sea joins the outer sea. It ain't never very deep there at no time, and at certain times at low tide, the strait is just about dry. If a man started at the hour when the tide is

lowest, before it rushes back he could be on the other side—if the man was right peart in his walking. A sort of light trot would put you across there in no time."

Moses hurried away and broke into a run as soon as he was out of sight. The tide was receding, but he did not stand and wait for it. He pulled off his shoes and his shenti, the short skirt worn by the military men and began to wade across. All the time the water was shrinking away before him. So Moses felt himself moving Godward with an understanding of force and time. So he walked out with clean feet on the other side.

Moses had crossed over. He was not in Egypt. He had crossed over and now he was not an Egyptian. He had crossed over. The short sword at his thigh had a jewelled hilt but he had crossed over and so it was no longer the sign of high birth and power. He had crossed over, so he sat down on a rock near the seashore to rest himself. He had crossed over so he was not of the house of Pharaoh. He did not own a palace because he had crossed over. He did not have an Ethiopian Princess for a wife. He had crossed over. He did not have friends to sustain him. He had crossed over. He did not have enemies to strain against his strength and power. He had crossed over. He was subject to no law except the laws of tooth and talon. He had crossed over. The sun who was his friend and ancestor in Egypt was arrogant and bitter in Asia. He had crossed over. He felt as empty as a post hole for he was none of the things he once had been. He was a man sitting on a rock. He had crossed over.

CHAPTER 11

Which way he was going when he got rested, Moses didn't know. He knew where he had come from and what it meant, but where he was going was something else again. Oh, well, he had the rest of his life to strain with that subject. So he sat on a rock in the morning sun on the far side of the Red Sea and conferred with the Never Untrue, which in a common way of speaking people call Experience. In this way he walked backwards over his road from the palace to the seat on the rock in a strange nation. He looked back and the glance changed him like Lot's wife.

"How was a young man to know these things?" he thought out loud. "You have to go to life to know life. God! It costs you something to do good! You learn that by experience, too. If you want that good feeling that comes from doing things for other folks then you have to pay for it in abuse and misunderstanding. It seems like the first law of Nature is that everybody likes to receive things, but nobody likes to feel grateful. And the very next law is that people talk about tenderness and mercy, but they love force. If you feed a thousand people you are a nice man with suspicious motives. If you kill a thousand you are a hero. Continue to get them killed by the thousands and you are a great conqueror, than which nothing on earth is greater. Oppress them and you are a great ruler. Rob them

by law and they are proud and happy if you let them glimpse you occasionally surrounded by the riches that you have trampled out of their hides. You are truly divine if you meet their weakness with the sword to slay and the dogs to tear. The only time you run a great risk is when you serve them. The most repulsive thing to all men is gratitude. Men give up property, freedom and even life before they will have the obligation laid on them. Yet they make offerings at every altar and pray fervently to every god they have ever made to make them thankful. But no god has ever twisted Nature to that extent. So they often rush out of temples to destroy those who have served them too well.

Two hours passed by Moses and gave him eye-looks. Then the strange sun drove him from his rock to find some shelter and some food. And since everything moves ever west, Moses buckled on his shoes and his shenti and went on across the world with the sun.

That night he came to a place where caravans rested for the night. There was a squat stone and mud house and several tents. Men from the four directions gathered around a fire outside and let their night selves live. They laughed a lot and drank to bring on feelings and talked. Many races and tongues like the streets of Memphis and Rameses. One woman particularly was conscious of the approval of men. She had fine eyes and she rocked her upper body in the saddle of her hips as she walked about the fire from group to group, feinting at men with her eyes and attacking them with her body. One man played upon a stringed instrument and finally the woman danced in a way that Moses liked. The man played again and another man sang a song with sad words but funny gestures and intonations. "I had a good woman but the fool laid down and died—" and the audience made him sing the details over and over and over.

Late in the night two camel drivers got into a quarrel over their beasts. They drew knives but did not use them. They grabbed up rocks and made all the motions of throwing but didn't throw. Their threats were terrible. They had everything

for a good fight except the courage. They imitated a frenzy to rush upon each other so successfully that they actually did. The shock of actually having to do what they had threatened to do was too much. They sprang apart and ran several yards in opposite directions before they went back into character.

"Ha!" one screamed back, "it is a good thing you didn't catch me. If you had they would have toted you across three yards—this yard, the church yard and the graveyard."

"I don't beat up bums like you. I pass you up and call you lucky. I'm bad! and if you hit me they'll give you four names— Nubby, Peggy, Bad-eyed and Shorty, cause you'll look like all of them."

"Humph! Nobody is scared of you. They tell me you stick pegs in tigers' hips, but I'll make you pull this peg out."

"Oh, you're not so bad! If I jumped on you I might not beat you but scarce as people is around here, we'll draw a crowd."

They kept this up at a safe distance from each other until they both ran out of threats. Then they returned to the circle about the fire and drank together as if not a word had passed between them. When they turned in to sleep they rolled themselves in their separate blankets and slept side by side.

Moses took no active part in anything that went on though he was interested and entertained by all that he could understand. After the passage of threats between the camel drivers Moses thought: "Here it is just like it is in Egypt—the scared people do all of the biggest talk."

A party of travelers from the Sudan played their drums and danced. One man with a dirk in his hand danced a marvelous pantomime of a hunter going through a jungle. He trod the jungle path. He was on the lookout for sudden death from the brush and the trees. He thought he heard sounds and stopped to listen. He suddenly hid himself behind a tree. False alarm. He proceeded swiftly and leaped over impediments in his path. He carefully parted shrubbery and looked for danger before he ventured further. He whirled about when he sensed danger behind him. A leopard! It attacked and he fought it off and killed it after a terrible struggle and ended the dance with

81

a triumphant flinging of his shiny black body about. It was so realistic that Moses felt he could hear the snarl of the beast as it fought.

Late that night when most of the travelers were asleep the chief of an Arab caravan of traders called across the fire to Moses.

"Well, how do you do, soldier?" he asked.

Moses listened to his mode of speech and decided the man had been educated by books or travels, probably both. He was well-dressed in a manner and bore himself with an air that proved he was accustomed to commanding others. Moses noted all this quickly, in the space of time it took to form an answer.

"Why do you call me a soldier?" Moses countered.

"Because you look like one. But like an officer soldier more than the common kind."

"Well, I have seen some service."

"Egyptian soldiers are very good fighters. I know from experience."

"Not the worst in the world."

"Well, what is on your mind?"

"Oh, nothing much. This place and the next one I suppose. I am just on the loose for a while."

"That is fine. I have a job for you."

"What kind of a job is it?"

"Right in your line—fighting."

"Where is the war?"

"Anywhere that we find booty that is takeable. Can you ride?"

"Anything with four legs under it."

"Better come along then. A lot of stuff could be picked up along the route, by fighting men."

"Thanks, but I've just made up my mind to never fight again except in self-defense. It seems that fighting is a game where everybody is the loser. I have simply abandoned the idea of force. I want to sit and think."

"That is a crying shame with the build you got on you.

Great big frame, fine legs, beautiful muscles—perfect fighting machine."

"Thanks. I've been told that before and I have led many a battle and chopped down my share of men. But I doubt that any life I have ever taken benefited anybody. The property I took from conquered countries didn't make anybody rich. It just whetted their appetites for more. No, no more soldiering for me."

"Where are you headed for now? It is odd to see a high-born Egyptian around here. That outfit you got on cost aplenty, too."

"Just walking away, and following my toes."

"You can ride in my caravan tomorrow morning. Ride as far as you like and leave us whenever you want to. Of course, I'm hoping you will stay. We need a man like you for both offensive and defensive fighting. But you can have your way."

"Thanks. Believe I will ride with you for a while. No telling what I might think by tomorrow this time."

All day the next day Moses rode in the caravan of the desert Nomads. He sat a fine stallion and rode with pleasure. Everybody in the band seemed eager to win him over. As they went on, however, he became a little ill at ease. Too many of the men wanted to feel the texture of his fine linen with their rough hands. Too many of them wanted to heft the fine steel of his jewelled sword, which he never presented by its hilt. Always he held it by the hilt and let them pass their hands along its beautiful blade. Then again there was too much curiosity about the jewels on his hands and neck. He felt the bite of the tiny fear known as suspicion. If he did not join the robber-traders, they but waited until night to take him. He could picture his stripped corpse being casually left behind at the next encampment. The prospect did not worry him too much because he knew that he didn't have to make that en-campment. So long as they were on the march, he had a distinct advantage, mounted the way he was. The chief thought that he was at his mercy. All right, let him think it. But when he got ready to leave the caravan, nothing could be

done about it. The first large settlement that they passed he would rein in and announce off-hand that he was stopping there.

But early in the afternoon he saw his first mountain. It made him feel as if he had been lacking in something vital to life all along. He saw the great mountain at a distance lifting its rocky crown above the world and he was dumbstruck with awe. To him it had its being in grandeur, so it was right and proper to draw itself apart from the surrounding country and hide its mysteries in its heart. It was near; it was far. It called. It forbade. It was all things to his inner consciousness. He must believe in gods again, for here was the tomb of a god a thousand greater than the pyramids. No, it was not a negative and vain thing like a pyramid, whose builders were puny pigmies about the toes of this mountain. This was not a mere pile of stone. It had an aura of clouds upon its brow. This sublime earth form was the living place of a god, certainly. It had peace and fury in its face. Moses slowed his mount to gaze on the eminence.

"What is the name of that mountain?" he asked the man nearest him.

"It's according to where you live. The people on one side of it call it Horeb. On the other side they call it Sinai."

For more than an hour the train of men and animals wound close to the mountain and it changed its aspect every few minutes as it drew near, but gaining in glory and never losing. Then the way veered off to the right and the distance.

So Moses got down off his horse suddenly and walked away by himself and the riders nearest him were too surprised to act until he had gained ground in rocky territory. So Moses walked towards the mountain for some time. When he found water he quenched his thirst and sat down by the well.

CHAPTER 12

Moses sat there by the spring of water. He saw well-trod paths leading away in several directions. So people lived hereabouts—people with cattle. He began to wonder where he would sleep that night and how. Tomorrow he would visit the mountain. That was settled in his mind. But he was tired now and he wanted a good night's rest. He wondered if the people who made those paths were neighborly folks or would he have to fight for his life before he found a resting place. The cool of the trees surrounding the spring was homey enough to suit him.

Here came sheep and cattle down one path driven by young voices. All of the animals crowded around the watering trough in eager thirst, stamping and looking for someone to draw the water for them. Down the path came a troop of seven girls who looked to Moses to range in years from about six to seventeen or so. They could not see him so easily from where he sat on the ground at the foot of a sycamore tree. So the girls came with their water jars and filled them first. He watched their happy ways as they spilled little splashes of water on each other in fun. One girl about twelve splashed water from a pot into the face of an older girl and turned to run away. The other one chased her and both of them came tearing towards the spot where Moses sat on the roots of the tree. They both saw

him at the same time and halted dead in their tracks with little screams of alarm. They whirled as quickly as they could and ran back to the well. He could see them telling the rest of them about finding him. They pointed the place out to the tallest of the girls. They all looked worried for a moment and seemed about to go away without watering the stock at all. At this Moses stood up and made a gesture of friendliness and sat down again. They set down their water jugs and began to draw water for the cattle and to laugh and talk again.

Then from another direction came bursting three young men who were, Moses estimated, between seventeen and twenty-one years old. They rushed down upon the little party about the well, whooping, driving off the cattle and scattering them all about. The girls ran in fright and began to hide wherever they could—all except the tallest one. She stood her ground at the well where she was pulling up a bucket of water and looked at what was going on with a great hatred in her eyes. She stood there until she saw one of the boys deliberately trip up one of her sisters as she ran from him in terror. She heard his big ugly laugh as the girl fell sprawling on her face. Then she set down the bucket and flew at him with her little fists. The other two boys were scattering stock and little girls in every direction.

Moses forgot the resolve he had made in Egypt to mind his own business and leave other folks' affairs alone. He leaped from his place and rushed to the aid of the girl who was being shaken violently by the man whom she had tried to chastise for hurting her little sister. Moses sent in a smashing blow to the head that sent him to his knees. As he was rising, Moses slapped his face with the flat of his sword and sent him down again. This time he did not try to get up. He looked at the sword first and then Moses and saw him all over. He stayed on his knees and raised his hands for mercy. Moses' scorn of the bully mounted at his cowardice so he snatched him to his feet and knocked him down again. Pick on little girls, would he, then just as soon as he faced a man, beg for mercy! He left

86

the man on the ground and went after the others and chased them completely away.

The girls crowded around him, all talking at once and acting out their gratitude. He could not understand a word they said but he read their gestures. So he helped them to round up their cattle again and to water them. Then they waved shy little goodbye gestures and followed their stock back up the way they had come.

Moses sat back down under the sycamore tree. He still didn't know where he was going to sleep that night and the sun was setting. It went down and down and at last it hung like a big gold dishpan against the wall of God. Just then the tallest of the girls came back down the path and motioned him to follow her home. He got up and walked behind her at a respectful distance for fear that she might not feel safe with him. In less than half a mile of walking they came out in a big clearing, with a huge tent under shade trees and cattle pens and all the things that make up the household of a patriarch.

The master of the place met him at the gate and made him welcome. He was an oldish man with a gray beard. But his eyes were large and dark and they had power in them. Moses felt his personality before he spoke. To the surprise of Moses he could speak Egyptian well.

"Come right in, Moses, and make yourself at home."

"How did you know my name was Moses?"

"I don't know it. But that is what you were thinking when you came up."

"That certainly is the truth. I was wondering whether to tell you my real name or not. You have the advantage of me now, because you know my name, but I don't know yours."

"Jethro is the name my father named me. As chief of my clan I am chief Jethro. Otherwise, I am Ruel. Among the Kenites a priest has a ceremonial name, too. Pretty general habit all over the land of Midian. But I guess you already know that."

"Well, I tell you, it's like this. Over there where I come

from, news from this side of the Red Sea don't get around very fast."

"Let's table that discussion and take up one more important. I certainly am mighty much obliged to you for looking out for my girls down at the well this evening—but wait, don't say a word till I get you inside on a couch so you can slip out of those shoes and rest your feet. The womenfolks are out there around the cook pots stirring up something to eat."

Moses sat down on a low couch and took off his shoes. A servant brought a basin of water to wash his feet. So he took off his sword and headdress and made himself comfortable.

"Now to go back to this business of my daughters at the well."

"That was no more than decency demanded. No man would stand and let a gang of ruffians mistreat girls."

Moses looked at Jethro and saw a man dignified and graying. He looked as if he was supposed to be listened to, but there was no insistence on his face. He looked capable of guiding people, but he didn't look as if he were determined to do it. Wisdom and a kind of strength were gathered together in the man, but his self-confidence had not driven off simplicity. He knew little sorrow[s] and joys as well as big ones. He looked as if he could understand and talk with shepherds as well as kings. So Moses was not surprised when he spoke to hear him dropping into idiom of the simple people. It took nothing from his majestic hearing, and somehow it fitted him. Moses was constrained to meet him on his level as they talked.

"But, Moses, it didn't just happen today. Nearly every day those same rough varmints annoy my children. Law and order is in a terrible state in Midian."

"If what I saw today is a sample, it sure is," Moses agreed.

"Oh, you don't know the half of it. I am getting along in years, you know. Not the man I once was at all. It hurts me to see my girls shoved around every time they go to water the cows."

"It's none of my business, but why do you send the girls?

88

Why not send your sons and your menservants?" Moses asked.

"It is a shameful situation, Moses. I hate to talk about it, but my wife don't have nothing but girls. Seven children and not a boy! Why, I can't hold up my head around here. They say I am too weak to father boys."

"Nothing to be ashamed about at all, Jethro. Why don't you send your menservants to water the cows? Send somebody that can strain with those hoodlums."

"They have run away, my menservants, all but one and he is old. Those wretches would kill him sure if he went down to the well."

"But, Jethro, why do they run off your cattle and bother your girls?"

"Well, I tell you, Moses, my house has always been powerful. From generation to generation it was that way. Right and justice prevailed in all Midian. But for the last few years a weak King has been on the throne and the robbers and things are just about to take us. Nobody is afraid of the King so people do not respect their chiefs and the country is gone to the dogs. Nobody can have any more than he has the might to protect. It all started with the downfall of the Hyksos in Egypt many years ago. Bands of them retreating before the Egyptians' army overran this country and got things so upset we just haven't been able to get straight since. No real unity any more. If a chief hasn't got an army of his own, he's in a mighty poor fix. Our menservants ran off and joined up with gangs who live in caves and what not. They drive off cattle and raid encampments. My own herds have been raided until I am a poor man. The three men you whipped yesterday are runaway servants turned bandits. Because I am a priest they are afraid to come up here. But they hang around the well, terrify my girls and stampede the cattle. Each day or so we lose another beast which I reckon they have killed to eat." There was a sad resignation in the voice of Jethro. "So I reckon the day will come when we won't have any stock to water."

"Not necessarily so. They could be stopped," Moses said belligerently.

Jethro shook his head slowly. "No, I am afraid it's too late. We have no man power to fight and that is what it takes."

The tallest girl came into the tent and began to put the food before her father and Moses. She arranged lamps to the best advantage and this time Moses happened to look up and see her squarely in the face. To him her eyes looked so large and brilliant that the rest of her face was a suburb. Her whole body was extremely pleasant to look at and something about her made every cell in his body thrust out its head.

Moses turned to Jethro after the girl went out of the tent and said, "If they come around stealing cattle while I am here they better bring their good luck charm along because they are going to need it."

"Oh, you mustn't let my talk drag you into something that may get you hurt. By the way, that oldest girl of mine is named Zipporah. You must excuse me for running my mouth so much that I haven't introduced you to the family."

"That is the second time that you have read my mind, Jethro. You must teach me how to do that."

"It is a gift and not a learning, Moses. But to get back to this cattle business, I can't thank you enough for what you did down at the well. The girls came home and told me about the high-class Egyptian sitting by the well who fought the boys with the strength of ten men."

"How did they know I was a high-born Egyptian? I might have been anybody at all from anywhere."

"Moses, I never saw anybody who looked more like what he was than you do. You are the quality, and no mistake about it. I asked the girls why they had left a stranger who had protected them so unselfishly, sitting by a well. Zipporah said that in her excitement she forgot her manners. So you must excuse her, Moses. She is very young."

"That is natural and neither of you need to apologize for your manners nor your hospitality."

The two men ate alone with the three oldest girls serving them. There was some music and laughter after supper and Moses forgot that he ever had been tired or unhappy in his

life. He went to bed and slept soundly and was up with the sun and walking over the place. He hoped that Zipporah would be around early too. He felt strongly the need of the sight of her. There was no thought of the adventures of the open road in his head that morning.

And there was the mountain to see and to feel. No, he did not desire to go away from here. His cells had the memory of this locality. It was easy for Moses to conceive that the dust that he was made from came off of that mountain there. This was the place that had called him in his unfinished dreams since childhood. He had been here often, by some mysterious forecast of dreams. Nobody here seemed strange and everything seemed familiar. He even found it natural and easy to drop into the dialect of the people with Jethro and the others whom he met. He talked it deliberately to put everybody at their ease. It was only in moments of stress in the times that were to come that he instinctively reverted to the language of the court. But here he blended into the background. This was his resting place, his eternal niche in infinity. The mountain hovered over him and called him as a mother would. He must go up and embrace his mother. He told Jethro how he felt while Jethro showed him over the place after breakfast.

"I know it," Jethro said, "and I beg you to stay here with me. In fact, I felt you coming somehow. I was not a bit surprised when the girls got back with the cows and told me about you. I feel a great power in you that you don't know anything about as yet. I really hope that you will make up your mind to stay here."

"Oh, I like it here," said Moses.

"I'm glad to hear that, Moses. I hope you won't find things too uncomfortable around here. Of course I'm a chief and a Prince in Midian, but I realize that's not like being a Prince in Egypt. We don't have any court life and no formality. A Prince in Midian can herd his own sheep if he has a mind to and nothing said about it."

"That sounds just fine. Formality can get too burdensome."

"Well, you see in Egypt the rulers don't have to go near the

91

people, but here a chief is looked on as the sort of father of his tribe. He can go without sandals and most of us just talk the language of the people. I have traveled some and that is how I learned Egyptian, but I don't get a chance to use it much around here."

"I want to talk the dialect of your people. Its no use of talking unless people understand what you say."

"That's right, Moses. Well, we'll get in a lot of practice on it if you stay around here. We won't have a chance to talk our high Egyptian except when we're off by ourselves. And then it's always a great advantage when you're managing people to be able to speak their kind of language. Stiff words frighten poor folks. I hope you stay here, Moses. You will make a fine friend for a man."

"I thank you for your compliments, Jethro. When you don't know anything about me or nothing. I ought to tell you about myself before I accept your home as my own."

"Plenty of time for the little details of your life. I know that you are brave and honest. Everything else about a person is garnishment."

"Thanks for your confidence. Look here, Jethro, where do those thugs hang out around here?"

"Oh, in a big cave about two miles off. There are around a dozen or so in the bunch from what I can learn."

"Is that all?" Moses asked.

"That's about right from what I can learn. But that's too many for us to strain with in the fix we're in. It's awful, the way they go around bulldozing and running over helpless people. And what makes me so mad is, some of those same men were under my shelter all their lives until they got this notion of living by grabbing."

Jethro looked sad and frustrated and the face of Moses hardened when he saw it. The older man tried to look away quickly, but Moses saw it and stiffened himself a little.

"Do you reckon they have destroyed all the cattle that they have driven off your place?" Moses asked.

"Couldn't possibly have eaten up all those cows and things.

Why, they have a big herd grazing around there that they have taken from different people. I have suffered the most since they knew that we can't put up a fight."

"Oh, yes, we can and we will. Got any weapons around here?"

"Yes, I have some good blades—spears and swords—but nobody to use them. It's a sin and a shame too, the way those thugs take advantage of our helplessness. Why, as I said, some of those same robbers used to work for me."

"No later than tomorrow we are going to get back some of your stuff. We are going to attack their hide-out."

"We?" Jethro exclaimed in alarm. "Who do you mean by we?"

"Me and you and that one manservant you have left and Zipporah. We will dress her up like a man."

"But, Moses, she is nothing but a woman. She wouldn't be a bit of service in a fight."

"Yes, she will, too. All I want her to do when the fight gets hot is to stand at my back with an extra spear and sword in her hands. Then they can't surprise me from the rear and I will have plenty tools to fight with. You and the servant must drive off the herds while I fight and keep them from stopping you. Once we get them back they would not dare to come here to start anything. They must be badly armed else they would have attacked your camp before now. As you said, they are a bunch of run-off servants who have neither the guts nor the steel to make a bold strike. Besides, they don't know how to fight. Let's see after our weapons today and take the brigands an hour before dawn tomorrow. They won't be able to see us too clearly and they will think that we are a big fighting force. Are you for it?"

"I'll have to be. I can't let you be more willing to fight for my stuff than I am myself. But it's mighty risky, Moses."

"Oh, not so risky as you think. We will have the advantage of surprise and the half darkness. Besides we have right on our side. If I don't teach those cur dogs something about shoving girls around and stealing their cows, I hope I don't sleep

93

another night. Tomorrow before dawn then?"

"You are the soldier man so you must know what you are talking about. We are going to do like you say, that is on condition that you promise to stay here with us."

"I promise since you ask me the third time as I know you mean it. You are my father from now on."

"Thank you. It's grand to have a son even though my wife didn't bear you. Now let's go get out those fighting tools and clean 'em up. I am beginning to get sort of bloodthirsty myself. Those skunks have run me ragged in the last six months. I am good to my servants, too, and that is what makes it so bad, what they have done to us. And that puts me in mind of my manservant. He is a dead shot with a bow and arrow."

"That's fine then. So then we can take your wife and that second biggest girl along."

"What for? My wife can't fight and she makes a poor out running. She's fat right where a cow is—under her tail."

"She'll do for what I want," Moses said, confidently; "You just tell her to mind me. We are going to carry some firewood up there and sneak up near the mouth of the cave and light a fire of fat pine wood that will burn fast and bright."

"What for?"

"When the noise of the cattle being driven off wakes up those in the cave they will rush out to protect what they have stolen. Then you and I and your man will drive them back with a shower of arrows. If any of them break out anywhere we will fight it out with spears first and if that does not stop them, it will have to be swords."

"So you mean for the women to drive off the cattle ahead of the fight?"

"That's it. They must wait until they see the fire start before they stampede the herd. But they must not walk those cows off. They must run them off in a hurry or else they will get mixed up in the fight and we will have to leave our posts and rescue them. This is one time your wife has got to keep up with those who *can* run."

"But, Moses, the question that is sticking in my craw is, who is going to make that fire?"

"I'm going to do it myself. Your shooting man is going to cover me while I get it done. Now, get it straight. The whole idea is to bottle those skunks up in that cave. Put the fear of force into them so that all we don't kill and maim will be glad to leave the neighborhood."

"Moses, you got leader-blood in you. Just full of that old monarch stuff. You got me so I'm ready to tackle a den of lions. Let me go stir my wife and children up."

That night Moses took the servant and scouted the vicinity of the cave. They found vantage points in absolute silence and watched the camp in the cave put out their fire and go into the black hole of the cave to sleep. Then the two wrapped themselves in their blankets and went to sleep also. Moses woke first and saw the light of the false dawn in the sky and made ready. He knew that Jethro and the women would be there soon. Presently he saw them moving towards him like shadows, so silently they moved. So Moses sent everybody to their posts and crept up to start his fire. He soon had the kindling crackling. Then he fled back to his vantage point and the cattle began to jump up from where they were lying and thunder off before the women's blows and cries.

A face with a questioning voice appeared at the door of the cave and got an arrow in his chest. Another and another arrow sped into the mouth of the cave from the bows of the three men. Several men approached the door of the cave with various weapons in their hands. A shower of arrows drove them back with loud shouts and screams and excited jibbering talk. Nobody ventured to show themselves for a long while.

"This is the time for us to make our get-away," Moses counselled. "The firelight makes them a good target and hides us where we are. But daylight will change it around. And that is what they are waiting for. We got somebody in there. Maybe two or three. Let's go while the going is good."

They melted into the grayness and went on home. As they entered the compound, some tired gray clouds were resting

on the ground but the sun came up and drove them off. The household all went to work penning up the big new herd before they thought about breakfast.

"Honey," Jethro's wife said as they looked over the herd, "looks like we've got a few cows here that we didn't have before. Them speckled cows, for instance. I disremember us having any cows like that."

"Well, I am not going to tote a casket in my pocket about it," Jethro said with a cheerful tone of voice. "I don't expect to take to bed sick over it for even one day. It just makes me and my son Moses hungry for our breakfast. You women get to doing around."

CHAPTER 13

That evening it was Moses and Jethro, armed to the teeth, who drove the cattle to water. No troublesome ruffians appeared, however. The next morning Moses, instead of the girls, took over the task of herding the cattle to grazing ground, but he was not challenged. They heard nothing at all from the cave of the robbers. But the second morning, two dirty ragged men came shuffling up to the tent of Jethro and asked to see him.

"Oh, so you come back to steal more cattle, do you?" Jethro snarled at them when he saw them. "Look, Moses, these men are two of my servants who ran off and turned bandit. Now they say they want to come back to work. What must we do with them?"

"Oh, no, we didn't run off, boss. We was carried off by them robbers and we couldn't get loose from them until the leader and three more got shot the other night in a raid. Them others that didn't get killed that was holding us run off and so we had our chance to come on home and that's what we did."

Jethro looked at the raggedy men before him and over his shoulder at Moses. "What must we do with 'em, son? I know they are lying about being carried off by force, but they might behave decently if we gave them another chance. What do you say?"

97

"Give them the old army discipline and put them to work. I'll be seeing them if they start any more cattle stealing around here."

So every morning Moses drove out the flocks to graze and brought them home in the evening. There was no more trouble at the well nor anywhere else. The women went to work on suitable clothes for Moses, and he put his jewelry away until the family should need it. He and Jethro spent hours together talking over symbols and meanings and Jethro was the teacher. Moses told him about what he had learned among the priests in Egypt. He had met the bull of the sacred marks and the unknown history* and Jethro was eager to hear all he had to say. But in nearly every case he had knowledge and methods far beyond anything that Moses had seen in Egypt. He forbade Moses to go up on the mountain until he gave him permission, and that made Moses a little unhappy. But he reasoned that the time would come when Jethro would take him to the mountain and so he was patient. In the meanwhile he was mastering the language of the Midianites as if he had been born to it. After all, he found it was close to the Egyptian so it made few difficulties for him.

He was glad one day when Jethro told him, "Moses, tomorrow night there is going to be a big clothes-putting-on and eating down the road a piece here and these two biggest girls have been harassing me and their mama to go. Reckon you better come go along. I'm not so much at these shindigs these days."

"I'd love to go," Moses said and looked across at Zipporah.

"That's mighty nice because you can go along with my wife and the girls. I'll stay home with the little children. I don't like to leave them by themselves."

"I'll do the best I can to look after them."

"Oh, I have every faith in you. Let's eat. Herding sheep and cattle is a mighty hungry job to my experience."

*The priests in selecting the young bull for worship always pretended that it had appeared in their midst mysteriously, by divine guidance. No one was supposed to know anything about its origin. Divine origin was claimed for it.

Moses went to bed rather surprised at how often he was thinking about Zipporah. He felt rather inadequate in dealing with her. She was no woman to be ordered into his tent at his pleasure and ordered out again at his will. He was not a military officer on a campaign to acquire his women by a nod. He had affairs around the court, of course, but not love affairs. He did not want any more treaty wives by arrangement. He wanted to win a woman and hold her by love. The matter was smooth and round like a ball. There was his heart's desire inside the sphere but the outside presented no place of entry, and Moses yearned for some progress in the matter with all his heart.

The next night, mounted on camels, they set out for the celebration. The two girls rode on the same camel. Their mother said she would feel better with Moses driving her than one of the girls. Her bones were too old to be falling off of camels. So they set out in the dark. The girls began a repetitious little folk tune and after a while Moses could join in the refrain. It was too early for the moon and the darkness seemed to snuggle them all together in a sweet world all to themselves until they rode into the light of the celebration.

Moses was never to forget that party as long as he lived. There was feasting, music and games where everybody took part. But Moses felt lonesome and out of things. People treated him like he was some great lord. They were too deferential and impressed. Nobody ran up and grabbed him and pulled him into a game. They served him before anyone else was given a mouthful. And a barrel-shaped man kept choosing Zipporah for a partner in the games. Moses never realized that fat-faced men looked so much like fiends before. He caught himself feeling for his sword before he realized what he was doing. He was almost sorry that he had ceased to wear it with his new clothes. And Zipporah, the little devil, looked him right in the eye and kept on laughing happily and encouraging that fat-faced fool. He was glum all the way home, but the girls kept up their chatter and singing. He felt like slapping their faces, especially Zipporah's and he wanted to scold the moon

for shining and somehow adding to his misery.

When they rode into the yard a servant came out with a light to help them dismount. As Moses walked towards the other camel to help the girls to dismount Zipporah feinted at him with her eyes and jumped down and started off. Her sister romped after her and her mother waddled behind them towards the big tent. Moses stood for a moment like a blazing tree on the plains, burning fiercely with the pitch from his own heart. Then for some reason Zipporah turned back from the door of the tent and came back in the moonlight towards the grunting camels.

"Come here, Zipporah!" Moses said tensely but in a low voice.

She looked up as if she was surprised to find him there. "What do you want with me?" she asked casually.

"Come here to me, woman. I know exactly what to do with you."

"Oh, you do, do you?"

"I certainly do. Come here."

"No."

"Yes! I want you."

"I don't come running like that. Even a hen must be sought after, Mister Moses, and I won't be less than a chicken."

"Oh, you are going to be run after, young lady. Don't be so hard to get. Come farther away from that door before I come after you."

He didn't wait. He rushed over and seized her girdle and snatched her towards him. And now that he had his hands on her, all the words that he had been preparing to say to her vanished from his tongue. He crushed her body against his and kissed her with as much energy as he needed for a cavalry charge. These were his words for her. When he finally let her go she ran into the big tent a few steps ahead of him and sat down by her mother.

Moses followed her more slowly and went to where Jethro was lying on a couch.

"Have a good time, Moses?" Jethro asked with his eyes

100

closed. Moses was frightened inside but he answered calmly. "Oh, yes, it was a rather nice party."

"I thought you might like it, though it was not one of the really big local affairs. But when you and Zipporah get married you are going to see a real celebration."

Moses was dumbfounded. "Then I can really have her, sir?" he stammered like a schoolboy.

"I took you for my son, didn't I? And now if my daughter wants to take you for a husband, why should I object?"

"She told you that, Jethro? She said she wanted me?"

"She didn't need to tell me. She has been thinking it for weeks and somehow other people's thoughts are like glass to me, especially those who are close to me. When she came in the door just now she was determined to have you for a husband before another week was over. You are of the same mind and I know it, so there is no need of beating around the bush. I was never more pleased about anything in my life. Now I know you will stay here with me."

Zipporah was clinging to her mother and weeping the tears all girls weep when they have captured the man of their choice. Jethro's wife was hugging her daughter and weeping in sympathy with her. She too had recollections of a night and an hour. She too had won the one man in all the world for her. She had had her ecstasy. So she rocked herself back and forth and cried tears.

Moses crossed and knelt before Jethro who placed his hand on Moses' head.

"My son, I hope."

"I will never fail her, father. I will hunt up new roads to heaven for her to go by. I mean to share every pleasure. And then again I will stand by her to the seventh sorrow. I love her."

He rose and went out of the tent door without speaking another word. And Zipporah rose from beside her mother and followed him to his sleeping tent.

101

CHAPTER 14

Zipporah of the tawny skin. Zipporah of the flowing body. Zipporah of the night-black eyes. Zipporah of the luxuriant, crinkly hair that covered her shoulders like a great ruff of feathers. Zipporah of the full, dark red lips. Zipporah of the warm, brown arms. These were the pictures that went with Moses all day long as he herded Jethro's sheep. Night and the time to go home was always too long coming. He loved her little songs, her childish delight in the Egyptian ornaments he had given her and others he bought for her from traders. She was beautiful when she was weaving. She was irresistible when she danced and played. She was always doing something that kept him enthralled. He spent no more evenings in the big tent with Jethro any more.

One morning Jethro was standing at the gate of the corral when Moses came there to let out the sheep.

"Just thought I'd go along with you today, Moses."

"That's fine. In fact, it's a high honor."

"No, just a lonely old man wanting a chance to talk, I reckon. I don't see very much of you these days, you know."

Moses blushed from the guilty feeling inside that he had been neglecting his friend of late. He herded the sheep before them for a long time before they found a good grassy spot. Then they sat down on the slope side by side.

"Moses," Jethro began a little sadly, "when you came here you were a man with a mission. I felt it in you strong."

"Did you? I sort of had the feeling that I had given up all missions. The life of a missionary seemed hard."

"Oh, you were out of dreams for the moment, but the great dreamer, the great leader was there. You have a great soul and something down in Egypt had waked it up. And you can't wake up thoughts in men and put them back to sleep again."

"I have a wife now and I have you and the mountain for a friend and that seems to be all that I need."

"Moses, what about the book in the box in the river at Koptos?"

"That is only a myth, perhaps."

"I notice you say perhaps, Moses. Look in front of you, son. That is a sacred mountain before you, Moses, and once you felt it, but no more. Once we had long talks in the evening that I meant should lead to something important later on, but you don't inquire of me any more."

"Jethro, you are still my best friend. But I have a woman now."

"Have you never had a woman before?"

"No. Not like this one. I have been as most soldiers among women, but not one was ever able to make me lose an hour from a campaign. But with Zipporah it seems that a whole lifetime would be too short to search out all her wonders. Why, her feet and supple toes are worth hours of watching. I have a consuming greed to absorb her inside of me so that I can possess her completely, but she seems to escape away from me all the time. Maybe my whole life will be necessary for the pursuit."

Jethro gave a grunt and fell back on his homely philosophy.

"You have more greatness about you than any man I ever heard of, Moses. Don't over-pull your belly on this love business and destroy it. Love some and think some."

Moses thought to himself, "If he only knew what a mess I have made of my life so far, he wouldn't think I am so great." Out loud he said, "Jethro, you see all that in me because you

love me. I'm nothing but a happy man having the wisest man and the finest man on earth for my friend, and having my home with my wife. You probably look down on that as nothing but desire."

"No, I don't, Moses. I don't fault you for that. Everybody has to be young a while before they get old. It's too bad, but it's so. What you're feeling now has got its place in life. Desire is the germ of the mind. There is no creation without it. Desire is a woman who is little understood and much slandered when her back is turned. She is a woman with a beautiful face and an ugly back. She drives a strong-legged crowd before her, gilded with the light from her face, and pushing the world before it. Behind her is a limping horde with the cawing black bird of age sitting on its shoulders, screaming imprecations at her back. They are renegades who do not deserve their past. Those who say desire is ugly have poor memories."

"Then you approve of my love?"

"Yes, I do, Moses, and then again I don't."

"Why?"

"You are an over-average man, Moses, and I hate to see you wasted on a woman. What goes for the everyday men does not apply to you. You have something that spoke to me from a distance. It can't die and it can't be hidden. You can't run away from it and you can't do away with it. It is a glory and a tragedy. You are sentenced by fate to lead."

"Lead who and what?"

"Men. In some way or another, whatever men you are thrown in with, you will lead. I am sorry for you, but that is true."

"There is no comfort in that. All I ever want to do is to herd your sheep, talk with you and take comfort in the arms of my wife, and bring up the sons, which I hope for in abundance, to be good and gentle. I want to sit on the side of Mount Horeb and ask Nature some questions."

"No use talking to you right away, I see. But you have a great call and some day you will have to answer. You can

wring and twist all you want to, but when the hour comes you will have no choice but to go."

A long, thoughtful silence fell between them. After a while Jethro said, "I had thought to take you to the mountain soon, but—"

"That is where I want to go. Why do you forbid me to go?"

"Because you are not ready to go, Moses. That mountain is holy ground. Our people have worshipped on that mountain for many generations. So many that I don't know my own self. But God and the mountain can wait. You are still a young man."

"Why do you say that mountain is holy, Jethro? Why did the Kenites start to worshipping there in the beginning?"

"Why did you feel something about it, Moses? Perhaps they felt just as you did."

"Yes, Jethro, I have a feeling, but perhaps it's only a feeling because the mountain has the size and shape of majesty. That might be all. I don't know."

"No, there is a god up there, Moses. I have heard voices."

"Voices, Jethro?"

"Yes, Moses. But I am not so sure I make out exactly what they say. Perhaps it calls for more power than I have to really understand. But I *feel* the command to bring other people besides the Kenites to know this god and worship him. Besides, I am too old for missionary work now. But over and above all that, I feel that the call was never meant for me. I know now that the God of the mountain has been waiting for you."

"For me? Why, Jethro, I am nothing but your sheepherder who has the honor to be married to your daughter. If this god found you not strong enough with all your great knowledge and power, then I—why, you are the greatest man who ever lived."

"No, Moses. You are a hundred times my superior. The great I AM took the soul of the world and wrapped some flesh around it and that made you. You are the one being waited for on this mountain. You have the eyes to see and the ears

to hear. You are the son of the mountain. The mountain has waited for the man."

Moses frowned a little and sat quiet for a long while. Jethro studied his face and said nothing more while he watched the movements of the flocks. Finally Jethro said, "There are lots of plants and things that you ought to study so you can know their habits."

Jethro picked up his staff and walked off a short distance and came back to where Moses sat with a plant and began to teach him its properties. Moses was so interested that they spent the rest of the day that way. The older man went home feeling close to his pupil again and warm inside.

Mrs. Jethro had supper ready. She never asked Jethro where he had been after long absences. She was used to it and besides she knew she would get no answer. But Zipporah questioned Moses, and Jethro answered for him by telling her to work harder on the weaving of the new tent of camel's hair and not to be so talkative. She pouted at this and said, "I just wanted to tell you a message came for you today. We are going to have company tomorrow."

"Who is it that's coming?"

"Oh, that rascal from the other side of the mountain that comes over here with his gang every time they run out of rations and eat us out of house and home," Mrs. Jethro broke in with resentment. "But you just *will* feed him every time."

"Oh, you mean Chief Zeppo," Jethro said, laughing.

"I don't mean nobody else," Mrs. Jethro went on. "Some day he is going to over-pull that belly of his and die with the colic and I sure won't care. Killing up our beef and mutton to fill that desert that he calls a stomach!"

"Well," Jethro temporized, "we have to be neighborly. And then again I am a chief and we just have to set a table accordingly."

"And, Moses, dear," Zipporah said, "you must let the servants look after the sheep tomorrow. You must stay home and put on your fine Egyptian linen and ornaments."

"But I gave you all that jewelry except my belt and sword,

dear. You put it on. I like to see you all dressed up."

"No, you put it on, darling. I want them all to see you in it, all looking like a King or something like that."

"Why, darling? I'm just your father's herdsman."

"Because she wants all the rest of the women to envy her, that's why," her father snapped.

"Now, papa."

"Pay her no mind, Moses," Jethro said, dropping into the vernacular. "She is just like all the rest of the women. She wants to make out to the rest that you were some big high muck-de-muck back there in Egypt so she can put on side as Mrs. Muck-de-Muck, and earn some envy out of the rest of the women around here. She wants to make a Prince out of you so all the other women can suffer envy of the Princess Zippo-rah. Don't blame her for it. She's a woman, isn't she?"

Moses thought that Jethro had come close to doing what he had avoided doing before, that is, asking him who he really was. And now Moses felt that he must tell him everything. So he set the very next night for his time. He needed the day to bring himself to open the door that he had closed on his feelings. Since he had been with Jethro he had achieved a certain calm by forcing an internal silence on his soul. Suddenly it came to him that his new happiness had washed him out. He no longer cared. Tonight was as good as any other time. So he sat down and told his family everything that mattered.

"You are not to be blamed for anything, Moses. Your youth couldn't tell you that you couldn't make big men out of bigots. Urging compassion on your grandfather was useless because he did not have any place inside of him to put it. In my experience I have found out it is no more use to give advice to an old man than to give a tonic to a corpse."

"But his own grandfather ought to have had more feeling for him," Jethro's wife objected. "Don't those people in Egypt have no heart at all?"

"Oh, yes, there are plenty of fine, generous people in Egypt," Moses told her. "But Pharaoh is a man of great ambi-

tion. He does not have sons and grandsons in his heart. He has only connections who win honors and wars in his name."

"He is not by himself in that, I am sorry to say," Jethro said. "His feeling is very common on thrones."

"Well, all that is behind me and I have found a real father and a real home at last. I don't say anything about my beautiful wife. But if you all would rather not have me here after what I told you—"

"Don't even say what you started to say," Jethro said earnestly. "We all love you, each one of us in the way that is right and proper. And look what you have done for us. You came and found us in a pretty low state. Me a chief that had next to no power and now you have built me up around here. You found our cattle gone and got us more than we had. Why, we are eating high on the hog now, and all because you are here with us. No, Moses, you are never to consider leaving us. The bonds you have here are never to be broken as long as any of us are alive. Tomorrow we take the blood oath together and then I am going to open things to you that I have kept closed up to now."

"Thank you, Jethro. You are truly a generous man and I love you like my own self."

"More than me?" Zipporah pouted.

"No, silly. You are myself and the best-loved part of me, too."

"How can I believe that, Moses, when here you are a Prince and never told me a word about it."

"How did I know that a wonderful girl like you would stoop to marry a mere Prince? Especially a Prince without power and wealth. A miserable exile."

Zipporah was very pleased at this but she pretended to pout. "Don't try to flatter me, Moses. Here I am married to a Prince of the blood royal and the neighbors don't know a thing about it. Is that nice?"

"Very nice, being married to you."

"Moses, you must take me to Egypt."

"Why, dear?"

"Don't you want to show me our palace and all those places and people that you told us about?"

"Yes, I do, but I wouldn't want you to feel as I felt in those palaces and places. It might not be so wonderful as you think."

"Oh, I think you are mean! I don't believe you want that—that Ethiopian, that other Princess to know about me."

"Oh, don't be silly. I never even kissed her, really. That wasn't love, that was a treaty we were carrying out. I think she liked being a part of the court more than she did your husband. Several times I had the feeling that she was disappointed because she was not married to my Uncle Ta-Phar instead of me. She would have been a step nearer the throne as his wife. But he was already married at the time."

"I want to go and lay my eyes on that female," Zipporah said from the fountain of assurance of being desired, "and let her see *me*."

"But it would be worth my life to be caught in Egypt," Moses said. "As long as my grandfather lives it would be certain death. He believes that I am trying to undo his conquest and so he hates me. Ta-Phar took care of that. He figures Pharaoh is about to die and he is afraid the army might substitute me for him on the throne."

"You ought to let them do it, too," Zipporah said with shining eyes. "You were born to be a King, like papa says. I'll be very happy when we can go home."

"This is my home now, darling. Positively. I am through with palaces and Kings and wars of Kings. Such things don't seem to be worth all they cost. Give me the black tent of Jethro with his wisdom and faith and the sheltering mountain and you and I can't imagine anything more worth having. They can have the palaces."

"Moses, darling, you can't talk like that. You have a wife to look after now. If you don't want such things for yourself, you ought to claim them for—for others."

"Oh, leave the man alone!" Jethro snapped. "You are just like all the rest of the women—ready to upset the whole world to make an opportunity to dress yourself up in ornaments.

109

That is all women around Kings are good for. Put on more ornaments than anybody else and make more chances to wear 'em. Fix it so you won't have no competition, then parade your swag in front of the others and let 'em look on and envy you. You make property-grabbers out of otherwise good men. Leave Moses alone. There is something bigger in store for him than being a mere king."

Then Moses asked a bold question.

"One thing, Jethro, I ask you as my father and my friend. Will you go down into Egypt for me and renew the offerings at the tomb of my mother and my friend, Mentu? I will give you all directions."

"I will go," Jethro said simply.

"She might not be my actual mother as they say. She might have adopted me from Assyria, or found me on the Nile or borne me. It doesn't matter to me for she was a real mother, loving and kind. I prefer to think that she bore me, and I do not want her tomb neglected. Mentu was a servant who became a friend. Renew the offerings at his tomb."

"I will do all of that."

"Some day, you shall go with me to Koptos. Further than that I am not concerned with Egypt. Your house is mine. Your gods are my gods and your ways are mine. My life, so far as it is any use to you, is yours."

CHAPTER 15

The years went by with a loping gait and left tracks all over the place. A profound calm took up in the face of Moses. It grew rugged like the mountain but held its power inside. He loved his wife and their two sons, but there was no more ecstasy. He spent his days with Jethro's flocks and Nature. He learned the secrets of plants and animals, and the living and the giving earth. Long years had passed since he embraced the religion of Jethro. He had learned to build the altars of uncut stone or earth and make the offerings, and the tribesmen had come to accept him, both as a chief second only to Jethro and as a priest. He practically lived on the mountain, in the desert, beside streams, feeding his mind on Nature. Sometimes he would be absent for days and sometimes weeks in seeking answers to questions that Nature put to him. Jethro now sat at his feet in all things except one. Jethro was still his master in magic but Moses steadily closed the gap between them and that delighted old Jethro more than his grandsons.

Time put tracks on Zipporah. She came to know that she still had a certain power over Moses, but that she could not follow him past the door of the tent. He loved her and the children and was gentle with them, but Jethro was his company. Her flowing body had taken to bulging here and there so she quit putting accent on her body and took pride in her

two growing sons. Now and then she recalled her dreams of the palaces of Egypt and was a little petulant with Moses. But he had made her feel that tears and pleas were no good. She had gone down into Egypt with her father each year when he went to renew the offerings of light and incense and each time she had had a fit of despondency on her return. The glory of her husband's feats of arms were not forgotten in Egypt and she would hear of it while she was there, and it made her regret what might have been. If Moses only had the proper ambition, she might be mistress of the palace someone had pointed out to her. And her sons might be Princes near the throne.

Time left its footprints all over Jethro, too. He had shrunk up in his skin considerably, so that it no longer fitted his frame. But a hopeful light had come in his eyes. He was making of Moses what he himself had wanted to be—a great priest. Moses had the genius for leadership which he lacked. Moses had comparative youth and he had fire. Moses had education and breeding and Moses had soul in soul. All he needed to do was to point the direction and Moses passed him in accomplishment with a leap. Here was the man of science such as the world had never seen. But his beloved son-in-law had a serious failing. He had no mission in life except to study. Jethro with the help of Moses had become the wealthiest man in Midian. With his wealth and backing and Moses' own popularity, Moses could become King over all the local chiefs, but he made no move in that direction even when he was urged. He just had no wish to govern his fellow men.

The quick grasp of things that Moses had and his talent for developing what he found always amazed Jethro as well as delighted him. He had shown Moses how to effect a sending of flies upon an enemy and the next month Moses had produced such a swarm that the whole household had to work furiously for days to get rid of them. But he had not stopped at that. Moses went out into the wilderness alone and stayed for weeks without letting him know what he was about. When he returned he produced swarms of every insect and reptile

112

at will. He drove off a wandering band of vagrants with a plague of snakes. Once when Zeppo sent word that he would accept Jethro's invitation to come over and eat meat with him for a few days, Moses laughed. Zeppo came with his huge family and lit down off his donkey and made straight for the cook tent to get "a little something to give him an appetite." Moses stood and watched him until he flopped down on a seat by the cook tent door. Then Moses lifted his right hand and extended it before him and frogs literally rained about Zeppo. His mouth was crawling with them and they were everywhere. Frogs swarmed over the family and they swarmed over beasts. Zeppo and his family screamed and fled in every direction till they were safely off the place. His womenfolks kept up with him as best they could. He did not desert his youngest granddaughter because she could keep up with him. Next day he sent back for his donkeys. He also sent back a note which obviously had taxed Zeppo's small education a lot to write. It read like this:

"DEAR COUSIN JETHRO:
 I take my seat and take my pen in hand to write you a letter. I want to know where is your raising that you ain't got no more manners than to let frogs be hopping all over people when they come to visit you? I have been a good and faithful cousin to you. I have always been kind enough to drop whatever I was doing and accept your invitation to bring my family and pass a few days with you and eat meat. But I know when I been insulted and I'll never accept another invitation to pass a week with you, not even if you ask me. But if you insist I will not refuse the meat you offer me. You can send it by my messenger when he comes.
 Your loving cousin,
 ZEPPO.

P.S. I'll bound you all them frogs was the work of that son-in-law of yours, Moses. Nobody else could have done it."

113

So Jethro wrote back a letter like this:

"DEAR COUSIN ZEPPO:

All the manners I ever had you done et it up long ago. So I reckon there just ain't no more. You will have to refuse my offer of beef because I am not slaughtering today. All my cows have a bone in their legs. All of my beds are full of folks so you can't snore in my ears no more.

<div align="center">

Your loving cousin,

JETHRO.

</div>

P.S. Yes, my son Moses is the finest hoodoo man in the world and my wife says that stopping you from eating somebody else's groceries is his greatest piece of work. But she may be wrong.

Have you ever seen his sendings of snakes and lice?"

Time left his signs in Egypt, too. Death came and startled old Pharaoh. So Moses heard about it in Midian and came to Jethro one day ready to travel. He and Jethro dropped into the dialect of the people as they often did at times.

"My grandfather is dead and I am going down into Egypt."

"You going to the funeral?"

"No. I am going to Koptos at last."

"So you didn't forget, did you?"

"No."

Jethro thought a while then he said, "It's funny how long wishes will last, isn't it?"

"Sure is. Come to think of it, I've been with you twenty years."

"Did it seem very long to you, Moses?"

"No, Jethro, that is, in general it didn't. I have been happy about everything. And I have tried to deserve my memories. It was just my wish that worried me. Sometimes it looked like time was going to mock it to death. Twenty years is a long time to wait."

"Yes, I know by myself, Moses. I got a wish that's forty years old. Ever notice how long wishes can last?"

"It all depends on what sort of stuff they are made out of. You know about me, but I didn't know you had one living with you, too. What is it?"

"Oh, I've always meant to tell you about it first and last. Fact of the matter is I tried to tell you once or twice. But I figured you wasn't ready for it yet, because I could see you straining against understanding. Maybe I'll broach it when you get back from Koptos. By the way, while you are down in Egypt, why don't you look in on them Hebrews and see how they are making out? Things might be different with them now that they got a new King."

"All right, I will, though I have no way of helping them at all, now. I don't know as I rightly understand them and I feel sure they don't understand me. I'm sure they didn't twenty years ago. It wouldn't be a bit of use for me to go among them, I'm afraid."

"Oh, I don't know, now. Do you reckon your uncle, the new Pharaoh, will try to put you under arrest?"

"I am not going near the palace. Anyway, few people would know me, now. I am going straight to Koptos and when I return I will come with a forked stick in my hand and a fire pan on my head."

"The symbols of the hundred-bolt lightning and the sun, eh?"

"That's right."

"Let me go with you, Moses. Maybe I ain't too old for the journey."

"It will be a hard journey. Maybe Mentu's story is only a myth. Even if it is true, we might lose our lives in the attempt."

"I guess you're right, Moses. You go down and come back with the power, if it is to be had. It might come in handy some time. I used to teach you but now you can tell me and then again you show me about the God of our mountain. Your brain leaps past my stumbling mind to the inside meaning of things. But I don't lose a thing by it. Through you, I just got better eyes and ears and legs than I used to have. And that right hand of yours!"

115

So Moses went on down into Egypt and left Jethro sitting on the side of the mountain, back-thinking on his twenty years with Moses. And the more he thought the bigger Moses got in his sight.

Moses had lifted his right hand in Midian and the people feared it. The first few times that he made the gesture before a miracle nobody noticed it particularly. But when it kept on happening, that right hand became a symbol of terror and wonders. Then it quit being a sign of power to the people; it became to them power in itself. He lifted it and they experienced the miracle of water turned to blood. It had been done in a small way by the Cushite priests for a long time. But Moses lifted his hand and extended it imperiously and the rivulets and springs and wells and streams ran blood all that day. Moses lifted his hand and a malicious gossip was struck with leprosy. It was Moses who learned the secret power to command the power of flame. It was Moses who could bring on or drive off the cattle disease.

It was Moses, too, who saw in the little puff of white smoke that rose from the incense on the altar the symbol of the Presence behind the clouds on the crest of the holy mountain and he developed the smoke into a thick white mass that hung stationary and huge above the altar for as long as the ceremony lasted. It rested there in volume and mystery like the Presence it symbolized. It made the voice of the unseen Moses speaking behind the altar seem like the voice of God. It seemed to the people that Moses but lifted his right hand and the cloud from Mount Horeb appeared upon the altar. From so many signs and wonders that they had witnessed when Moses extended that right hand before him, they came to believe that the hand of Moses held all of the powers of the supernatural in its grasp. It had a separate existence from the rest of his body. So when Moses lifted his hand the smoke of the incense ceased to be smoke. It became the Presence. If it was not the actual Presence, then it enclosed and clothed the Presence. Finally the smoke itself was deified. It was not understood so it became divine.

116

Now Moses found out how to make the excrescence that he called Manna appear on a certain plant. So Jethro himself began to be in awe of him. "No use talking," Jethro said to his wife. "Moses done found out something we others don't know about. Looks like he done found them secret words that's the keys to God that we all been looking for. I figure he's about ready to go to work."

CHAPTER 16

Oone day Moses came walking up and looking tired and
lean for his height.

"Well, I see you got back," Jethro said off-hand.

"Yes, back after a whole long year," Moses said, dropping
his walking stick and taking off his shoes.

"It seemed like it too, Moses. You was mighty missed
around here."

"I'm glad to hear it. I missed being here with all of you
too."

"Once in a while I would get to fretting about you. I didn't
know whether you would make it back or not."

"I wondered the same thing my own self a heap of times."

"Well, if I ain't too previous, Moses, did you get your
wish?"

"I sure did. That's why I'm so wore out like I am."

"Do you care if I ask you how it was?"

"No, I don't. In fact, I don't intend to eat nor sleep until
I tell you. I have been needing your ear and your advice for
so long."

So Moses stretched himself upon the couch and told Jethro
how he had passed through lower Egypt like a shadow of a
cloud and hurried on to the Thebiad, where Koptos is.

He had gone into the temple of Isis at Koptos and brought

an ox and a goose and some wine and made a burnt offering and a drink offering before Isis of Koptos. He spent four days with the priests of the temple.

On the morning of the fifth day he had called a priest to him and with his powers had commanded the priest to make a magic cabin that was full of men and diving tackle. Moses himself put the spell on it and put life in it and gave the men breath and said to them, "Workmen, go to the place in the river where the book is, and work for me." Then he had sunk the cabin in the water. In three days they had come to the place in the river where the box was and made a shoal out of sand to make the water shallow. They worked night and day.

Then he found the box all wrapped around with scorpions and snakes and different other kinds of reptiles. But he knew what to do for them so that they all laid sleeping as if they were dead. Then he met the deathless snake. So the snake got ready for a hard fight and Moses fought him all the next day. Moses did not win over the deathless snake but then the snake did not beat him, so they met and fought again the next day. At sundown Moses felt that he had the advantage of the snake to a certain degree, so he called up all of his power of mind as well as his body, for if he won he would have more power than any man on earth and also the deathless snake would come under his command. And he wanted the obedience of the snake. So late in the third day, he beat the snake and commanded the snake to meet him anywhere in the world that he might call. So the snake did not appear to resist him any more.

Then Moses took the book out of the golden box that was closed in all the other boxes. And when he went with the book Light went before him and Darkness after. He knew the ways and the meaning of Light and he heard the voice of Darkness and knew its thoughts.

So Moses read the book and then he was able to command the heavens and the earth, the abyss and the mountain, and the sea. He knew the language of the birds of the air, the creatures that people the deep and what the beasts of the wilds all said. He saw the sun and the moon and the stars of the sky as no

119

man had ever seen them before, for a divine power was with him.

When he had read the book, he took a new piece of papyrus and copied the words of the book on it. Then he washed off the writing with beer and drank the beer for then he knew he would never forget what he had read. So he put the book back in the golden box and put the golden box back inside the other boxes at the bottom of the river and commanded the snake to guard it until he should come again. And if he never returned, no man was ever to see the book until the end of Time. And the deathless snake took up his watch beside the box.

So then Moses broke a seal and read a spell over the workmen that he had made and told them, "Work for me back to the place from which you brought me." They toiled night and day and that is how Moses came back to the harbor in Koptos. From one thing and another he found out that he had been nearly a year about the business of the book. The priests of Ra, suspecting his success, tried to stop him, but he proved himself top-superior to all that they did, and came out of Egypt with a high hand. So then there was nothing for him to do but to come on home and be with his folks.

"Then you are ready for the big job," Jethro said with an inside force that just barely grazed his face.

"What big job are you talking about, Jethro?"

"That big job I been saving up to get done for over forty years. I knowed all along I couldn't do it myself."

"What kind of a job is it, Jethro? Maybe I can do it if it ain't too big for me."

"There ain't no jobs too big for you, now, Moses. Not with the help you got."

"Tell me then, Jethro, so I can know what it is."

"It's my wish, Moses. You got yours now and you know how a wish is with you. It will keep on plaguing you till you get it. Ain't that right?"

"It sure is."

Jethro fumbled with his clothes a minute or so. Then he

asked, "Oh, er—Moses, did you ask about them Hebrews while you was knocking around in Egypt?"

"Sure did, Jethro. I thought they was in a bad fix when I used to live down there. But they are in a sure enough bad fix now. Ta-Phar is bearing down on them in a big way."

"You don't tell me!"

"That's right. He claims they didn't do no work under his father. They were just fooling around with tools. So the first thing he did was to put them on double shift, working night and day. Why, he's got more government projects going on than you can shake a stick at. Those poor devils are building a brand-new Egypt under the lash."

Jethro smoothed his beard down for a while and thought.

"You know, Moses, I been thinking we're kind of selfish. Here we done found out about the one true God. The others been grabbing hold of little parts of Him and calling all of them parts a god by itself. It's like calling each limb of a person a man. I been sort of thinking we ought to let more people know about what we done found."

"They all know by now, don't they? That is, everybody round here already knows about Jehovah, don't they?"

"That's just the point I'm coming out on. Not enough folks know about him. We ought to spread it around. And that's the wish I been nursing for forty-odd years."

"But, Jethro, everywhere you go, the people got gods already. They won't hear about no more. In my travels I been way past the Jordan into the land of the Amorites, and the Canaanites and the Philistines and they all got gods that suit them. Who would listen to us? Where would you get the people to make converts out of?"

"How about them Israelites? They're down there in Egypt without no god of their own and no more protection than a bareheaded mule. How come you can't go down there and lead them out?"

"Who, me? I tried some missionary work down there twenty-odd years ago and that is just how come I got to be an exile. No, I'm satisfied with things the way they are going."

121

"You still letting love run you after all these years?"

"No, it ain't that, Jethro. I think the world of my wife. But it ain't love I feel for her no more. It's the recollection of love that comforts me and makes me want her to be happy."

"Well, what is it then, Moses, that you don't want to go?"

"I'm just satisfied with my life right here. I got everything that a man could want. I've been to Koptos. I just want to sit on the mountain and ask God some questions about life."

"You won't go?"

"Not to turn you a short answer, Jethro, but I'm through messing in other folks' business. I can't go, no."

Jethro's feelings took his features and formed a face that was wretched. "I sort of counted on you, Moses. In fact, all my dependence was in you."

"I just couldn't do it, nohow. I'm not cut out for that. I love silence and quiet places. I want to enquire. I don't want to be enquired of. With a mob of people around me like that I couldn't hear my ears."

"Those people, I mean those Hebrews, need help, Moses. And besides, we could convert 'em, maybe. That really would be something—a big crowd like that coming through religion, all at one time."

"I don't say it wouldn't. But I don't want to be the preacher. I'm through trying to regulate other folks' business. There ain't no future to it at all—just a whole lot of past. If you find a cow stuck in the mire, and pull her out, she'll hook you sure. I just want to practice up on all this new stuff I done learned."

"Get them folks out of Egypt and use them to practice on, why don't you?"

"How am I going to do that, Jethro? Pharaoh is getting too much benefit out of those Hebrews. He wouldn't let them leave. And another thing, why should they trust me? They don't know anything about me. They wouldn't believe I meant them any good. They wouldn't follow me."

"You could try. It would make a mighty big man out of you, Moses, if you did. You could even be King if you wanted to."

"I don't want other folks' property enough for that."

122

"You wouldn't have to call yourself a King. You could just sort of rule along without taking on the title."

"Jethro, it's not the title I am afraid of, it's the thing itself. It makes no difference what he calls himself, king or ruler, who sends the young men out to be killed and takes the people's cattle away from them. Titles ain't nothing but nicknames."

So Moses went back to herding sheep on Mount Horeb and went on asking Nature her secrets. He was at peace with himself, but not for long. The spirit of Jethro's tongue was docile, but he never let up on the subject. Moses kept on refusing but it got harder and harder to do so. Jethro had a feather touch but he crowded Moses farther and farther into a corner until Moses went around with a harried look. To make it worse the whole family was of the same mind. It followed him around the place and went to bed with him. One night he felt that he couldn't bear it any longer so he gave Jethro and his wife a flat refusal, and went off to bed.

Jethro and the full-bloomed Zipporah sat looking after him until he was out of hearing.

"Well, that's the end, I reckon," Zipporah sighed. "If he won't, he won't. But I can't see to my soul how come he don't want to be a King. I don't ask for much. I don't bother him when he stays off on that mountain days at a time. I don't part my lips when he prowls all over Asia and Africa from one nation to another fooling with bugs and worms. All I ever asked for myself was to be Queen and he won't do it. Me with my two boys getting grown—it's hard on me."

"And a better piece of ruling material ain't never been born on earth," Jethro agreed. "It's a sin and a shame. He is a great priest. Jehovah went out of His way to make him. His kind may never be seen no more on earth. He could call sinners to repentance, he could preach the socks off of sin if he only would. If he don't want to be a King, that's all right. But he sure ought to go get that passel of Hebrew people and convert 'em to Jehovah. He could do it easy, with the power he's got. The man is just running over with spirit."

123

"Just a fine King going to waste," Zipporah said bitterly. "Look at the shape the man's got on him! Portly and strong and everything. He sure would look noble in a crown. So far as the Queen is concerned, I would do just as well as the next one with the right clothes on. It's a shame that Moses is that stubborn."

"Well, he might think I'm through with the thing, but first and last he's going to find out different. I ain't been to Koptos, it is true, and had no fight with no never-dying snake, but maybe there is still something about snakes that he can learn. The backside of that mountain may get too hot to hold him yet."

CHAPTER 17

Moses sat up on the mountain passing nations through his mind. Way late in the day he climbed up to a place where he had been resting every afternoon for a long time. He was watching the development of a family of reptiles under a rock beneath a bushy growth. So he went on up putting words into the mouths of the various little creatures that he saw on the way. What these creatures had to say about people had plenty of seasoning.

Moses rounded a large boulder in sight of the spot where he was going and went on easily. There was the bush, and there was the rock under it. He was within a few feet of it when the bush burst into furious flame. Moses could not believe his eyes, but neither could he shut them on the sight. Because the bush was burning brightly but its leaves did not twist and crumple in the heat and they did not fall as ashes beneath charred limbs as they should have done. It just burned and Moses, awed though he was, could no more help coming closer to try and see the why of the burning bush than he could quit growing old. Both things were bound up in his birth. Moses drew near the bush.

"Moses," spoke a great voice which Moses did not know, "take off your shoes."

"How come, Lord? I know no voice like that can't be like mine."

"This ground you are walking on is holy ground. Take off those shoes."

"Yes, sir, Lord." Moses loosened his shoes and took them off without once taking his eyes off of the burning bush that did not wither. Moses stood barefooted and bareheaded and trembled with awe.

"Moses!"

"Yes, sir!"

"Come closer, Moses. There is something that you must hear."

"I'm coming." Moses faltered nearer the flame and stood. For the first time in all his life he felt naked, meek and void.

"Moses, look on the ground in front of you."

Moses looked down, and started back in terror.

"What is it you see, Moses?"

"It's a snake! It's a deadly poison snake," Moses said in fear, and started to run away down the mountain.

"Moses!"

"Yes, sir, Lord."

"Come back here." Moses came because the mysterious voice commanded, but he came in fear. "Moses," the voice ordered, "pick up that snake." Moses shrivelled and shrank from the order. "Pick it up by the tail."

Moses gathered his strength and stooped. He seized the snake by the tail expecting to be bitten immediately. But except for a curious tremor of life that somehow communicated itself to the hand of Moses and from his hand to his arm and from his arm throughout his body, it might have been the wooden image of a snake. It was heavy for its length in wood, but it was stiff and motionless like stone. Moses was amazed that the writhing serpent on the ground could have become so quickly the lifeless thing in his hands. It was a walking stick carved in imitation of a snake.

"Moses, put it down." Moses dropped the rod and it became a living snake again. Suddenly his fear left him. He

126

picked up the snake in that certain way again and it became again a rod to his right hand. It was his, he knew by the feel of it. It was the rest of him. But the voice came again.

"Moses, I want you to go down into Egypt."

"Into Egypt? How come, Lord? Egypt is no place for me to go."

"I said Egypt, Moses. I heard my people, the Hebrews, when they cried, when they kept on groaning to me for help. I want you to go down and tell that Pharaoh I say to let my people go."

"He won't pay me no attention, Lord. I know he won't."

"Go ahead, like I told you, Moses. I am tired of hearing the groaning in my ear. I mean to overcome Pharaoh this time. Go on down there and I'll go with you."

"And those people, Lord, they won't believe in me. I don't talk their kind of talk in the first place and then again, I got a stammering tongue. I never could make a speech. Send somebody else, Lord."

"You go on; I'll go with you. Open your mouth and I'll speak for you."

"Well, Lord, if I go, tell me what to say; they won't believe in me," Moses said with hopeless resignation. "I don't even know your name. Who must I tell them sent me?"

"Tell them I AM WHAT I AM."

"Yes, sir, I'll go tell them, but I know it won't do any good."

"Somebody with a speaking mouth will be provided to talk for you. Go down into Egypt, Moses, and lead my people to the place I have provided for them. I AM WHAT I AM."

The Voice was hushed. The bush no longer burned. In fact, it looked just like it had yesterday and the day before and the day before that. The mountain was just as usual with the wind yelling "Whoo-youuu" against its rocky knots. There was nothing to speak to the senses of Moses and verify what he had heard and to hold him to what he had so unwillingly promised. That is, nothing but the rod he held in his hand. Therefore it was not a vision and neither was it a dream. This bush had

127

blazed with fire before his eyes, but it had not burned as was natural. A serpent had become a rod to his hand and a rod had become a serpent and back again. Life could never be again what it once was. He had promised a god to go down into hated Egypt and command a man whom he hated and who hated him to permit a people whom Pharaoh hated to leave his servitude and go free. Moses dropped to a shady rock and sat with his face covered until the sun got low and red. Then he dragged himself home behind his mumbling sheep.

CHAPTER 18

Jethro was very helpful when Moses told him about it. In fact he seemed to Moses to glow and to swell with pleasure. "No need in you taking the thing so serious, Moses. It might not be as hard to do as you think."

"No, it's just ten times as hard. I can't do it, and that I AM WHAT I AM ought to know it. It's going to be just about as hard to talk to them Hebrews as it is to Pharaoh. But the promise done been made, so—"

"Oh, I don't know, Moses. It stands to reason that anybody in slavery would be glad to be free."

"Humph!"

"And when you look at it again, a nation of folks with no particular god would naturally be glad for a god to choose them for his own and then pick out a land to give them."

"When they can get loose from slavery in Egypt and fight the folks that already got the land and lick 'em, they got it. It don't seem such a much to me—that land part don't."

"Oh, I don't know, now. With a good military leader, they might make out top-superior to everything they meet."

"Did you ever lead an army? It takes more than promise of some land to make a fighting army out of folks that just got free. Men fight with more than their hands."

"Well, anyhow, Moses, I can help you out some."

"How?"

"On one of those trips down into Egypt I met up with some of those Hebrews and I think I could maybe find a sort of headman among them who could help you out some."

"That would be mighty convenient if you could. Why, I don't talk their language. I don't talk with their thoughts. I don't know the first thing about them and they know next to nothing about me. I just can't go."

"How about your promise on the mountain?"

"It wasn't so much my promising as it was a command. I got to go, but I feel like the job don't belong to me. I never could talk to crowds, and least of all these people that is so strange to me."

"I'll go down into Egypt, Moses, and bring out a man to help you handle the people until you feel you can manage. His name is Aaron."

"And what am I going to say to him, Jethro, to get him to work with me?"

"Why can't I tell him the Voice mentioned him by name?"

"Tell him whatever you want to, Jethro," Moses said and walked away with his head hung down. "I'm going off to the wilderness to think. I am a man that has been called."

CHAPTER 19

Moses talked with Aaron and got more aggravated and put out every time they sat down together to plan. This Aaron was a short, squatty man who wanted things. First he wanted clothes like an Egyptian noble with ornaments. Then he wanted titles. Then Moses must recognize him as a brother. Moses refused at first to even listen, but Jethro persuaded him that the connection might be useful down in Egypt. He could make the old legend serve him. So Moses consented by a freezing silence. Then he wanted things for his family, and then he wanted things for his tribe. He was a Levite and the Levites must lead in all things or he could not consider a thing.

"This sounds like the very kind of thing I hate," Moses said with some heat, "and before I'll be bogged down in a lot of politics, I'll call the whole thing off."

"But the Voice," Jethro reminded him quickly.

"Oh, I'll go back and ask that Voice again. I'll find out if I have to go through all this to save people that think more of personal preference than they do of rescuing a whole people and making up a nation."

So Jethro convinced Aaron that he really must give up some of his demands, or he would find himself back in Egypt and in the same fix he was before he, Jethro, had smuggled him

out. This frightened Aaron and no more was said about his offices and prerogatives for a while. He did mutter something about people who wanted to make kings out of themselves, but didn't want anybody else to advance themselves the least bit. But Moses ignored all this and finished his plan of campaign.

It wasn't long after that he was saying goodbye to Midian and to his family. Jethro and the family mounted camels and went with Moses and Aaron for a day's march.

"It may be a month and it may be a year, but I won't be back until I march out with the children of Israel. We have no army to face Pharaoh with. I got to fight all Egypt with my right hand."

Jethro had dismounted and stood by Moses, showing all the old affection he felt.

"Be sure and come back, son. I hope you don't come by yourself, but come back home." He leaned his old head on Moses' broad chest like a child. "I wish I was in your shoes, Moses. Going on missions is a great privilege."

"I thought you was over-anxious for me to go, Jethro. That feeling helped me to consent to the Voice. I could feel how much it meant to you."

"I'm anxious for you to go, but I'm more anxious for you to come back. I realize it now when you are going. Don't let old Pharaoh kill you. You got power. Use it. Nothing can stand against your hand when you lift it up. All my love and all my powers go with you, son. And don't hold my impatience against me. You will know what it is to get tired of waiting on visions when you get old like me."

Moses looked past the outline of Aaron mounted on a camel toward the Red Sea, and for a moment he wavered. Then he looked back at the shape of Mount Sinai with its shoulder-wrapping of clouds and heard the mutter of thunder from its throat. He embraced Jethro affectionately and turned his feet resolutely towards Egypt. Jethro stood watching him for a long time, but Moses was on his way. He never looked back.

CHAPTER 20

Moses was. back in Egypt and the people of Goshen knew it. The leaders in Israel had known that Aaron had slipped out of Egypt to meet him, and they had been listening and looking for his return. Aaron had sent the tremor along the grapevine immediately after he returned—"our man of god is in Egypt."

Tremendous excitement rippled down the secret ways of Goshen.

"They say he owns a god" was whispered in hopeful emotion.

"Sure enough?" others questioned. "Wonder how do folks get hold of gods?"

"That's more than I can tell you because it's more than I know. But that ain't the point. The point I'm coming out on is, this god wants to work in our behalf. He aims to put us in power with the Egyptians."

"Hush your mouth! You don't mean to tell me that!"

"That's what he claims."

"It sure is something if it's so."

"They say he can really do what he says."

"What you say his name is?"

"The new god or the man—which one you talking about?"

"The man, fool."

133

"They call him Moses, because they say he came out of the water in some way or other. So they call his name Moses."

The other man paused and scratched his head and thought. "Look like to me I heard that name before somewhere a long time ago. Wasn't there a Prince of Egypt named Moses?"

"This is the same one."

"Well, what is he doing with a strange god and how come he wants to help us out? I ain't never seen no Egyptian with that sort of a notion."

"It seems like that's how come he had to leave Egypt a long time ago—because he had sympathy for us. He took and killed an Egyptian overseer for beating on Hebrews, so old Pharaoh, I don't mean this Pharaoh we got now, I mean the old gentleman, got in behind him to kill him, so he had to run on off."

"Well, if he did that he's a friend of the race, and that's something we ain't got too much of. When can I meet him and see him? I wants to shake his hand."

"He was at the house of Aaron, they tell me, but he's hard to locate. Don't stay in one spot too long. That's to keep them secret police all fuddled up in case they try to grab him. But they tell me everybody is going to have a chance to meet him, first and last."

Other whisperers were asking, "Now this god that Aaron says Moses has got, where do he come from and what is his sign?"

"Nobody ain't seen no sign yet. Ain't even made no motion to build him a temple yet. It seems funny a god without a place to stay or anything."

And as for Moses himself, now that he had accepted the call and was down in Egypt, a sort of grim and stony peace came to him. He set himself to his task with determination.

Immediately after his arrival in Goshen he told Aaron to summon the Elders of the tribes to meet him, and anyone else of influence. When they came, Moses was surprised to find a woman among them.

"Who is this woman, Aaron?" Moses asked.

"That's Miriam, my sister."

"But what is she doing here? I have called the Elders to me on serious business."

Aaron showed irritation, pointed up by a certain arrogance.

"My sister Miriam is a great prophetess, Moses. Talking about influence, she's got plenty. We couldn't make out without her, that's all. Everybody comes to her to get things straightened out. She's a two-headed woman with power." He looked at Moses and challenged him with his eyes.

"She can hit a straight lick with a crooked stick, just the same as you can do."

Moses closed his eyes for a moment so that Aaron could not look through them into his mind and said simply, "In that case we need her. Tell her to stay. She would be useful in handling the women."

"Oh, she can handle the women, all right. In fact she can handle anybody. We ought to call a meeting of all the people right away and let her speak before everybody for you."

"No, Aaron," Moses said positively, "this is not the time I have appointed for speech-making. It is too soon. First we have to organize the Elders, then let the Elders prepare the people for us." He saw the petulant look on the goatlike face of Aaron and asked, "When did Miriam address the whole congregation of Israel last?"

"Oh, she ain't never done it yet," Aaron stammered.

"Did she ever speak to your whole tribe of Levi?"

"No, she ain't, not yet. She ain't never needed to, that's all. But she could really do it if she wanted to."

"Then what makes you so sure she could do all this speaking and influencing if you never have seen her do it?"

"Because her house is full every night of the people who come to her house to get help. Miriam got a certain little bundle that she makes, that ain't no bigger than a man's thumb. You put that around your neck and wear it, and nothing can't do you no harm."

"Hmm! It's a wonder every Hebrew in Egypt wouldn't have one of them. Pharaoh and his overseers wouldn't be a bit

135

of trouble then. Why haven't you and Miriam done that on a large plan and freed Israel long ago?"

"We haven't considered like that and if we did, we might say that we, that is, Miriam, was called to prophesy to the people and not to save 'em."

"Oh, I see," Moses said significantly. "It's nothing for us to get angry about anyway."

"Who said I was mad?"

"I wouldn't say you were mad exactly, but we do seem to argue a lot about everything, Aaron, and none of it is necessary. The point I want to get clear in your mind is that if you, I mean Miriam, is called to prophesy to Israel and I am called to save Israel, our paths don't conflict at all."

Aaron was caught off guard by this statement and he didn't like it, and Moses saw it. Finally he said sullenly, "That ain't the point at all."

"What is the point?" Moses persisted.

"Well, er—the point is, I don't see how come she, that is, both of us, can't get credit for what we got to do in saving Israel. And that is mighty important."

"Oh, you will be of great help in gathering the people and explaining my plans and you will get proper recognition for it, too. But we don't need to worry about recognition right now. What we need to worry about is the success of the plan. It's a mighty big project we got on our hands, Aaron. Let's bury ourselves in it, Aaron, and give it our whole devotion. It's too big for us to be mere people. We've got to give up being people and feel like the tools of destiny, that's a big honor in itself, Aaron. I want you to think it over."

A certain good humor was restored and Moses went on working out his plans and passing them out through Aaron, until finally the meeting of the Elders of Israel took place. When Moses spoke to them he said nothing about his whole plan. He merely said to them, "I come to bring you a message from a god who has chosen you as his people to love and protect."

"How did this god hear about us?" the Elders wanted to

know. "You say he spoke to you in a far-away mountain. How did he hear about us here in Egypt?"

"You cried out for deliverance in your great sufferings, didn't you?" Moses asked.

"We sure did. We been crying a long, long time, but no gods, least of all the very ones we worship, didn't hear us at all," the Elders told Moses with suffering in their eyes and hopelessness in their voices.

"But this god of the mountain has ears," Moses said with conviction. "He heard your cries and sent me to tell you that he has chosen you and that he has the power to save you, even in spite of Pharaoh."

There was great excitement at this.

"What is the sign of this god?" they wanted to know.

"His sign is power," Moses answered with assurance.

"What we want to know is, What is his messenger?"

"I am his messenger," Moses answered with equal assurance.

"We want to know how we can recognize his signs when we meet 'em. What animal does he live in? Is he a bull like Apis, a cow like Isis, a cat like—"

"This god never shows himself through any animal. He has no representation on earth in any form. He speaks in fire and smoke, but the fire and the smoke are not god. He has no images and wants none made in his name."

"What is the name of this god, Moses? Maybe he is a god of Egypt who has left Egypt and sends to us from some place away off."

"No, he is no Egyptian god. He has not uttered his name as yet."

"You must not know a whole heap about this god your own self, Moses, if you don't even know his name. Didn't you even find out that much about him?"

"I asked him his name."

"And what did he tell you?" the Elders asked.

" 'I am what I am,' is all he said, but that is a great answer. It takes in the whole world and the firmaments of heaven."

That was a great mouthful for the people and they went off muttering to themselves in their unlettered tongues "I am what I am" over and over and blowing in the ashes of their hopelessness to kindle hope. They had intended to ask many more questions about this strange god who had sent to them— about his wife, and his food and his children, and what especial sin he punished, but all these questions had been smothered. So the Elders went off from the meeting to begin to spread the word to the people to meet Moses in a secret grove for a ceremony.

There, deep in the forest and amid the silences, Moses built the altar of rough stone as Jethro had taught him and performed the sacrifice as he had come to do for so long on the mountain with Jethro. And the people began to catch fire and worship.

Moses instituted the ceremonies to the god of the mountain and established altars and more and more the people came to them and began the new practices.

"The god of the mountain detests the flesh of hogs," Moses told them. "No worshipper of I AM WHAT I AM may eat pork," Moses commanded, and people began to give it up. He taught them many other laws. His god loved justice, he taught them justice and right among peoples, more than obligations to altars.

"When do we bear down on Pharaoh and this freedom?" Aaron asked impatiently.

"One thing at a time," Moses told him. "We have to lay a foundation before we try to build."

After several weeks had passed the Elders asked Moses, "When will we be free?"

"You will be free when you hear the thunder," Moses told them. "Pharaoh will issue a decree and you will think that you are free. You will march out and you will think that you are free. But one day, after you have suffered many things, when the thunder is heard from the mountain, you will be free, if you have courage."

"You can see further with your eyes closed than we can with

138

ours wide open," some of the people clung about Moses and told him. "You're our rod of salvation, Moses. Lie down and sleep and dream for us."

And the Hebrews, working and suffering, and wondering about the nature of thunder, went through their days holding their hearts still against the present, prayed for the day of thunder.

CHAPTER 21

Therefore Moses took his rod in his hand and went to see
Pharaoh. He took Aaron along for his dressing. It
looked better to the people anyway for Aaron to go.
Suspicion was too easy to arouse if Moses went alone. Some
would think he had only stirred them up in order to betray
them to Pharaoh. He had heard hints and whispers that maybe
he was buying his way back in with Pharaoh by stirring them
up to show what was in them so Pharaoh could have an excuse
to butcher them all. Pharaoh had done everything else that
could be done. Nothing else for him to do but kill them and
they didn't put that past him for a minute. Anyway, Moses had
reason to believe that few if any accepted the story of his
kinship with Miriam and Aaron. He was still an Egyptian
noble to them. If he wanted to cast in his lot with them, well
and good. But blood was thicker than missionary zeal and he
would bear watching. Why should he serve them anyway? It
looked mighty funny when you come to think of it, at that.

Now Moses was at the palace with Aaron.

Pharaoh took his seat and had his Queen with him so that
Moses could see that she was the Ethiopian Princess who had
once been his wife away back there when he was a Prince in
Egypt and wore a jewelled sword at his side. Moses could see
that it was supposed to hurt him and he was sorry for them a

140

little. She had been all these years living off of more treaty kisses and Pharaoh had been living off the power, when he had gotten hold of it at last. Moses could picture just how fretful Ta-Phar and his wife had been while they waited for Rameses the Great to die. Moses could see Ta-Phar's old face slipping down into his neck. His Queen's hips looked like they had moved round in front of her, or more like they had abdicated in favor of her stomach. No, he still didn't care, no matter how much he saw that they wished he would. He stood with his rod in his hand and measured them. He stood before Pharaoh and felt as if he stood in the presence of the evil dead. And he was glad that he stood facing them at last. The past and the future were pouring out of time.

Pharaoh let Aaron stand before him and say what Moses had told him to say. He listened to the end, but he paid little attention to the ex-slave who he saw was quaking inside while he tried to put on a show of arrogance. At the same time Pharaoh kept looking to Moses for confirmation and assurance. So he listened casually to the voice of Aaron. But he paid strict attention to Moses. When Aaron had finished he ignored him and acted just as if Moses had spoken directly.

"Well, Moses, so you are back again doing your best to destroy the country."

"No, I leave that job to you. I am here by divine command to save a people, not to destroy."

"Oh, yes, I know. You are bent on being King of something, even if it is nothing but the Hebrews."

"No, Pharaoh, my call is higher than that. I am commanded to lead them out of their suffering to something better. And I'm going to carry them off."

Pharaoh laughed without moving his features. But Moses could see the formal set of his expression change to scornful banter. "And how do you aim to do that, Moses? Those Hebrews are mighty poor fighting material, and you ought to know what my army is."

"You have your army and I have my powers. I mean to attack you with what I have. Our side is stronger than yours."

141

"Since when?"

"Since a new and a stronger god has called them through me to his service. Your gods never were anything more than a dedication of the forty-two judges of the forty-two Names of Egypt, and they are still servants to be ordered. The god I represent is one who commands. We shall win."

"With what?"

"With my uplifted right hand. If you can stand that, you can stand the flood."

Pharaoh indulged in a broad sneer. "Oh, you are still messing around with hoodoo, eh? You ought to know better than to come back here depending on that."

"And why not, Pharaoh?"

"You forget, Moses, that the priests of Pharaoh are the greatest priests on earth."

"I don't forget any such a thing, because I never knew it. I do remember though that I could surpass any priest in Egypt long before I left here."

"That's rich! First you come here pretending that you can't talk—bringing a slave to do your talking. Then you open your mouth in the wrong place. I'm going to call your bluff so these Hebrews can see what a friend they are trusting. And then I'm going to show you up for the pleasure of the thing."

"You mean we are going to show each other up. You fear me more than I do you and with good reason, too."

"Moses, I could call the palace guard and have you dead in a few minutes. I am going to do something worse. I am going to expose you first and then leave you to the people." He turned to a guard. "Call the priests from the temple. I want them here right now."

While they waited Ta-Phar smiled at Moses with utter cruelty in his face.

"You see, Moses, I know why you have come back to Egypt and it is not to rescue these miserable Hebrews. You are merely trying to use them to frighten Egypt into making you a King. I'm glad that you have come in the way you did. I intend to keep you at your activities so that Egypt can see you

142

as the country's worst enemy—trying to arouse the slaves against the people."

"To me, Ta-Phar, the Hebrews are people."

"To me, Moses, slaves are slaves."

Moses could see Aaron wilting and he could see Pharaoh gloating at the sight. The priests came in, never missing a convention sacred nor civil until Pharaoh told them to rise and listen to what he had to say.

"This fraud and hypocrite was run out of Egypt around thirty years ago, after trying to be a priest, a soldier and a Prince, and first one thing and another. Now he's back trying to tote off our slaves on some religious cock and bull story. He claims he has enough magic in his right hand to outdo all my army and all my priests and the Hebrews are stupid enough to believe him, it seems. Go ahead with your skill and make a fool of him so the people can go on back to work and he can go on back wherever he has been hiding out all these years."

The chief priest bowed and announced the marvelous feat of turning their rods into snakes and back again.

Moses said, "Excuse me, Pharaoh, but I don't believe I want to be bothered with such children's foolishness. I won't work on that trick at all. Let Aaron do it. I'll wait till they do something worth noticing."

"Oh, you won't get out of it that easy," Pharaoh sneered. "Go ahead, men, and make him show you. We'll give him something to do besides brag on himself."

So the priests manipulated their rods and danced and finally threw them down on the floor before Pharaoh and they began to writhe and crawl. Pharaoh looked triumphantly at Moses. But Moses was looking all around the throne room in unconcern. So Pharaoh sent him a challenging snort. Moses merely handed his rod to Aaron and said, "Throw the rod down, Aaron, if that is the only thing that will pacify Pharaoh. Throw it down and get back out of the way."

Aaron dropped the rod of Moses to the floor with a "plop" and stepped back. The rod of Moses came alive. Its head darted out and seized the snake nearest it and swallowed it.

143

The next one and the next one was run down and disappeared head first down the throat of Moses' living rod.

"Is that all you got to show me?" Moses asked casually.

"Show him something else!" Pharaoh ordered angrily.

"Er—er—Pharaoh, we didn't prepare anything more for right now, but if you have him back here later on we'll guarantee to show him."

"Oh, I'll have him back here and you are going to show him," Pharaoh retorted.

"Well, let me know when you get ready," Moses said. "And if that is all for right now, Aaron, go pick up that rod and show it to Pharaoh."

Aaron picked up the rod and found it a budding stick. So he showed it to Pharaoh and the priests and the sight of it made their eyes pop.

"You see what power I got behind me, Pharaoh. Will you let my people go?" Moses asked earnestly.

"No! I got work for those Hebrews to do, and they are going to do it, too."

"But the god of the mountain told me to tell you to let them go regardless."

"Moses, do you think you can come back here and scare me with a jumped-up tale about a mountain god and a few tricks and make me change my plans?"

"Pharaoh, do you think you can holler loud enough to break into a god's arrangements? *Will you let those Hebrews go?*"

"No! I won't."

"I see you call yourself a hooking-bull at the landing. You don't aim to let nothing pass."

"That's right, Moses. And certainly I won't let those Hebrews go."

"You're right sure about that, I take it?"

"Just as sure as you snore."

"One of us is bound to be wrong because I am just as sure that you will."

"The will of a Pharaoh and the might of Egypt says I won't."

144

"Somebody is lying and I know it's not me. I bid you a pleasant evening."

Moses left the palace but the news of what had happened in the palace was spreading over the city of ear. Egyptians collected in little knots and talked. The story of the rod that was a snake, and a budding bough became a legend overnight. People recalled the glory of Moses as a soldier and waited to catch glimpses of him on the streets.

But the court and the people of wealth sneered at his ambitions.

"So he is going to carry off our slaves by hoodoo, is he? Well, well, well! Pharaoh knows what to do with men like him. He is playing with that Moses like a cat with a mouse. When he is tired of the game he'll clamp down on him like a trap."

"I don't believe that snake story, but it is funny, isn't it? What would slaves want to be free for anyway? They are being fed and taken care of. What more could they want? I am off for a little trip down the Nile; let me know when Pharaoh closes in on Moses. I want to be in at the death."

Moses was satisfied so long as the people talked. For what he had to do concerned all Egypt and not just Pharaoh alone.

CHAPTER 22

Goshen was a land of moving feet. Feet, torchlights and whispers. The news of what went on that day in the palace was traveling. Shadowy figures spoke out of darkened doors. Messages were sent by smoke and fire.

That was the work of Moses' helpers. Moses himself sat in his house and planned with Aaron and others.

"You got Pharaoh on a wonder, all right," Aaron gloated. "Reckon he won't switch around by tomorrow and let us go?"

"I hope not," Moses answered earnestly. "That would ruin us."

"How come, Moses? I thought that was what we was working after."

"It is, but I hope he don't give in right away."

"Why? It would save us a heap of work and worry."

"No, it wouldn't either. That would be the best way to beat us. You see, Aaron, we have come and demanded the people in the name of a god that neither Pharaoh nor the Hebrews ever heard about before. He has got to prove himself before them all to make folks believe. They have heard of God by ear but they don't know. If they went out from Egypt before I showed them signs and wonders it wouldn't be a week before they would be building altars to Egyptian gods. So what would be a better chance to show his powers than for Pharaoh to

146

refuse and for me to beat him down with powers? That's what I aim to do. I don't want his consent, really. It would spoil everything I planned. I mean to whip his head to the ground and then lead out with a high hand."

"So that's why you talked to him so biggity like you did, eh?"

"That's just why I did. I know I got the power to bring him low. So the more he rears and pitches the more the people will believe when I whip him down. It ain't just to get you all out of Egypt, it's to make something out of you afterwards. That's the main idea. If Pharaoh lets the Hebrews go peaceably it won't be six months before they will be back here ready to serve him again. If I'm to make a nation of you, you've got to be cut loose forever."

"I guess you know your business, Moses, but it seems like if we was to present a petition to Pharaoh, now that we got him worried—"

"I see you don't know people, Aaron. Pharaoh is not worried at all. He's not taking this serious yet, but he will when he has to. Now let's get back to our next visit to Pharaoh. One week from today we're going to call on him again. By that time his priests will have something ready that they think I can't do. He'll be glad to see me about that time."

"What we going to do next time?"

"Oh, that is all according to how I feel that day. Nothing too important. I'm saving the best for the last. Aaron, that's about all for now."

Aaron went on out with the other heads of the tribes and Moses was glad to be alone. He went and sat in the door and studied the night. Timid crowds collected at a little distance and watched him. He paid no attention to them really for his heart was in Midian, and his thoughts were walking the road in that direction. Jethro his father and friend. Zipporah and the numerous comforts and pleasures that flowed from her. His sons that were young men now and just as puzzling to him as young men have always been to their parents. The whispering crowds studying him from dark doorways were not on his

mind nor heart. Nothing in Egypt was close to him. They could keep their distance forever.

But one person was bold enough to break in on his reverie. A curly headed boy in his mid-teens came up and stood smiling timidly at Moses.

"Hello," Moses said. "And what do they call you around the house?"

"Joshua. I live down the road there a piece. I expect you know who my papa is. He's always at the meetings. His name is Nun. Sort of bushy black beard and all."

"Oh, yes, so you are the son of Nun."

"Yep. I want to work for you."

"Oh, you do, do you? And why do you want to work for me?"

"Because you are great—greatest man that ever lived, I think, and then besides that I like you."

"Why, Joshua?"

"Oh, just 'cause, I reckon. I wish I was big and strong like you and I wish I was brave and great and I just like to be around you, that's all."

"That is a searching speech you made, Joshua, and I think we ought to clinch it in some way. We ought to do something so folks will know we are friends. What would you suggest?"

"I reckon I'm sort of big for it, but I think a neck-hug would be just fine."

"That was just what I was going to say. Come on!"

Joshua jumped forward and flung himself on Moses' neck and the leader of men clasped the boy to him until it hurt. Moses thought of his own sons back home and he thought of this welcome bit of warmth in Egypt.

"Joshua, you are the first person to come to me since I started out on this mission that didn't want something for himself."

"Oh, yes, I do. I want something too." Moses' arms relaxed and his face fell.

"Well, what is it that you want, Joshua—a high office for your papa if we succeed?"

148

"No, I want to be the one to wait on you right now."

Moses' arm tightened about him again. "You are the first to offer me your services, and I am going to remember it. Go get your things and come sleep in this house right away."

"Oh, I couldn't do that. Miss Miriam might not like it. She don't like many things that go on, you know."

"You leave Miss Miriam to me, Joshua. Go get your things and move in on us. I can use you."

Joshua bolted off like a roebuck and Moses sighed happily, "God even found me in Egypt. If I make no mistake, there's a real man in that boy."

149

CHAPTER 23

Moses walked up the high steps of the palace next Wednesday with Aaron right behind him, and they told him Pharaoh was in the parlor waiting on him to come. The whole temple of priests were standing around just as Moses expected. He saw the expression of the face of Pharaoh and knew that Ta-Phar was treating the whole thing as a farce.

"Well, Moses, what you got to say today?" Pharaoh asked sort of offhand like he already knew the answer.

"The Lord says, 'Pharaoh, let my people go.'"

"And I say they won't."

"We beg to differ with you, Pharaoh, and that's why we are here."

"Don't make a bit of difference to me and that's why I am here."

"You know, Pharaoh, I figgered you was going to say that, because you and your servants and friends are trying to take us for a joke, so I better give you a sign and something to wonder about."

"Go right ahead, Moses. But I'm telling you in advance that anything you do, I, that is, my priests, are prepared to turn it right back on you."

"Well, that is your privilege. Anyhow the Lord told me to lift my right hand against you."

Moses walked to the center of the room and turned his face to the east and lifted his hand. He turned to the north and lifted his hand again. He turned to the west and last to the south and did the same. Then he stood perfectly motionless facing Pharaoh and lifted his right hand stiffly with his rod extended and held the position solemn and motionless for a space. Then he lowered it and said, "The Lord has spoken."

"Is that all?" Pharaoh sneered.

"Just ask for a drink of water and you will find out."

Pharaoh immediately ordered a glass of water. The attendant came in, bowed and hurried out after the drink of water. But in a minute he was back followed by the steward and the whole palace staff. They knelt in terror and told Pharaoh that all the water around the palace had turned to blood.

"Well, get off the palace grounds and find me some that isn't blood. I don't want no foolishness about my drinking water."

In a short space of time they were back saying that every well and spring in the city was flowing blood. Through the windows came the sounds of terror and dismay. People were running to the palace and to the temples. They wanted water. Their beasts wanted water. Carriers were sent to the river and came back screaming that the Nile was running blood. Fish were dying and floating on the bloody stream. Pharaoh commanded men to dig wells lest all Egypt perish for want of water. Pharaoh went outside himself to witness this thing of Egypt running down in blood as if it had been wounded like a beast.

He saw and he heard the dismay of the people. Quickly he assembled the court and sat in council.

"What is it?" everybody wanted to know.

"Oh, some trick of Moses'," Pharaoh answered. "He's trying to scare us into elevating him to power. What else could he want?"

"Arrest him!"

"No, that wouldn't do."

"Why?"

"If I do that," Pharaoh explained, "the people will hear about it and believe in him."

"That would be terrible. Why, the man is a radical. He would have the common people talking about equality."

"Yes, and he would free the Hebrews."

"And what would we do without slaves?"

"Oh, that would never do. We must not let that happen."

"Don't you worry about that," Pharaoh assured them. "I'll see to that; we must beat him at his own game."

"But how? And we've got to have water to drink. Blood won't do."

"Yes, indeed we must have water."

"How are we going to get it?"

"Let Pharaoh go out and command the river to run water. It can't fail to obey."

Everybody looked towards Pharaoh and an embarrassing pause fell on the room as he hesitated. Finally he spoke.

"That will hardly be necessary. I have a better plan."

"What is it?"

"I shall trick Moses into turning this blood into water again. I'll promise to do what he wants—that is, let the Hebrews leave Egypt."

"No! No! we need our slaves."

"But I don't intend to deprive ourselves. When he has done his work, we'll change our minds and laugh at him."

Everybody beamed and grew calm.

"That is a splendid idea, Pharaoh. Meet trickery with tricks. Serve that radical just right, too."

"But what about the people? Won't they go over to him when they find out we had to go to him and make him promises?"

"They need never know. Listen, each of you must go out and spread reports that I, Pharaoh, turned the waters of Egypt into blood to prove my powers, and turned it back into water

152

to prove my will. The priests will never deny it. They feel ashamed as it is."

"Sounds reasonable. Where is this Moses?"

"In Goshen, but we must pretend to ignore his existence. This is a strictly Egyptian affair. Don't mention his name at all."

"We'll all go out and calm the people."

"Fine, and I'll send secretly for Moses and trick him. By tomorrow night everything will be as it was."

"Perhaps we had better give him some sort of office to keep him quiet."

"No!" Pharaoh said with fury in his voice. "Never! and those priests had better do something to take the edge off of this thing or they are going to hear from me."

The priests went to the temple in a body. The next morning they sent word to Pharaoh that they could also cause streams to bleed like a wound. Pharaoh sent for Moses and Aaron and they and the priests assembled about a well that had been sunk in the palace grounds. The priests huddled about it and performed a ceremony. Finally they announced that they had produced blood by magic and Moses and Aaron looked down and saw it was red.

"So you admit my priests have turned your trick back on you," Pharaoh asked scornfully.

"Yes, they really did," Moses said meekly.

"So your god can't be very original, Moses, and I can't see any reason for letting him change my plans. Bring me a better trick than that one before you come back here wasting my time."

"Well, one bellyful won't fatten you. How about next Wednesday at the same time?"

"Good. My priests will be ready and waiting. You amateurs need a good straightening out and we might as well give it to you. Guards, see that these men get off the place."

Pharaoh flouted his skirt contemptuously as he mounted the steps and went inside. Moses walked away without breaking

another breath with him, and Aaron brushed past him and passed out of the palace gates before him.

He let Moses overtake him down the road a piece and fell in beside him. "Moses," he said, "it looks like your project got a back-set today."

"You think so?"

"I couldn't help it from what happened. Looks like those priests know just as much as you do."

"You reckon?"

"Seems so, don't it? You think it's any use in us going back to see Pharaoh any more?"

"He'll be looking for us next Wednesday for sure. We couldn't hardly back out of it now, do you think?"

"Oh, I don't know. Well, this is your movement and if you want to go back it's up to you."

"I'll be going back all right. Don't you worry about that."

So next Wednesday Moses and Aaron went up the steps to the palace again.

"Well, what did your Lord say today, Moses?" Pharaoh asked.

"He said to tell you, 'Let my people go.' "

"And what do you aim to do about it?"

"What He told me to do. Just a little sign to let you know that He means business."

"Well, my priests are here to teach you some more."

"I can't learn no younger, so I might as well begin. Let's all go outside for my lesson this time."

Pharaoh got right up and went outside where his flower garden was and Moses and the priests went out behind him.

Moses didn't lose any time. He walked to the made pond in the garden and lifted up his rod in his right hand and frogs swarmed out of the pond all over the garden. They filled the garden and the grounds and still they poured out of the fish pond. Hundreds and thousands and millions struggled over each other in the shallow water, clambered to the stone wall about the pond and leaped off in all directions. Moses still stood with his right hand lifted and the frogs kept on coming.

154

Little frogs, big frogs, green frogs, toad frogs, rain frogs, bull frogs, every kind of frog that ever leaped or hopped. The foundation of the world seemed made of frogs and they came pouring out of that pond. The world croaked and leaped. The party fled inside but the palace was full of frogs. The streets and the cisterns were full. They leaped all over everywhere. They poured their millions out of the Nile, and every other stream and spring and still Moses held up his hand. The frogs kept coming till sundown. By that time the palace was besieged by citizens crying for relief from frogs. So Pharaoh commanded his priests to dispel them. They begged for time, so Pharaoh asked Moses to do away with the things.

"I'll be back tomorrow and talk it over," Moses said and went home.

The next morning streets, yards, fields and gardens held mounds of dead and stinking frogs. Moses saw piles and furrows of dead frogs as he made his way to the palace through a terrified populace.

"What! Your priests haven't done anything about this plague of frogs yet?" Moses demanded of Pharaoh.

"The worthless creatures who live in wealth off my bounty have done nothing yet," Pharaoh admitted as he hurled a cup of water full of tadpoles out of the window.

"Then I reckon the Lord with my poor help will have to do it," Moses said. He lifted up his rod and went outside and the millions of frogs began their march to the Nile. From all over the city and the province they hopped solemnly riverward and leaped in till only the dead and rotting heaps and furrows were left in streets and fields. Moses ordered these to be buried. Men, women and children worked all day and all night and by mid-afternoon the third day of the plague of frogs, Egypt was free of the sending. So Moses went home again.

But the next day a messenger came hurriedly for him and Aaron.

"We fixed him that time," Aaron gloated on the way. "I'll bet he wants to tell us he's glad to let us Hebrews go."

"That may be so, Aaron, but I doubt it."

155

"Why?"

"Because, if Pharaoh lets me lead off the Hebrews, he will be driven from his throne by the nobles. They think they can't exist without slaves and Pharaoh wouldn't dare to go against them, not that he wants to anyway."

"He sent us a mighty nice message to come."

"Yes, to come and be assassinated in secret, but by now he knows that won't do."

"Why?"

"Because my death wouldn't do him any good if the common people knew why, and I have taken pains to let them know how all those frogs happened in Egypt and Pharaoh knows that they know."

"Moses, I hope this time he means to set us free. I don't want to believe nothing else."

"You are going to find out you are wrong."

"What else could he want with us? We beat him and he wants to give up, that's all."

"I hope not. I want to show that man a thing or two."

When they got to the palace, fresh and clean again, Pharaoh and the priests were assembled.

"Did you want to see me about something?" Moses asked.

"Yes, I want to see you about that frog trick you pulled," the King said shortly. "My priests want to teach you their version of the same thing. In fact, one of the priests says he remembered teaching you that stunt some years back when you used to hang around the temple so much."

"He never did," Moses retorted. "But I am here to be taught."

They went outside and the frogs poured again. When they began to be plentiful in the garden, Pharaoh held up his hand and said, "That's aplenty—a gracious plenty. Now send them on off like Moses did."

The officiating priest stopped in his tracks and looked right sheepish at Pharaoh. The frogs kept on coming.

"I said stop," Pharaoh said coldly. The frogs kept on coming.

"You heard me!" Pharaoh roared. "I said stop those frogs and I mean stop. That's too many frogs already. Enough is enough and more than that is nothing but a nuisance."

The frogs kept right on coming.

"You chuckle-headed fool! Head those frogs for the river!" The chief priest made motions, he waved his wand, he chanted something and the whole college of priests began to whirl. But the frogs kept right on coming and filling up the grounds. The priest pointed his rod towards the river but the frogs hopped in every other direction. They had to bring something for Pharaoh to stand on.

Finally Moses lifted his hand and the frogs in solemn procession and in a sort of rhythm moved on to the river as the others had done.

"I'll have another message for you next Wednesday this time," Moses said with a bow and walked off with Aaron at his heels.

Pharaoh didn't send for the court and the nobles, and this time they sent to him asking for an audience.

"The people are holding meetings and protesting against frogs," they told Pharaoh.

"But the frogs are all gone. Not a frog, well, no more than the usual amount to be found anywhere."

"They think you sent them."

"But why would I want to plague my people with frogs?"

"Oh, they remember about the bloody streams and they think you sent frogs to show your power again."

"Oh."

"I don't see why the army couldn't be called out to put a stop to things like that."

"How?"

"Well, er—"

"It's getting around that a great man is doing these things and the people want to know him."

"I think it would be a good thing to order that Moses to leave Egypt before sundown. Get rid of him!"

"No!" Pharaoh said forcefully. "He'll go off as he did

before and come back to make more trouble. I want to beat him at his own tricks and ruin him forever. Finish him! That's my will and intention. Besides, he might have an army some-where outside the country. Humble him and then destroy him. That's my plan and I mean to go through with it if it is the last thing I do."

"No more frogs, I hope," said one courtier wearily.

"What must we tell the people?"

"Tell them that we are forever striving for their good. We will pass a law: frogs must stay out of the houses of the peo-ple."

The people thought that Pharaoh was very thoughtful of their comfort and needs when they heard about the law.

The very next week on Wednesday, Moses went to the sitting room of the palace and Pharaoh was waiting.

"I have a little sign from the Lord to let you know He says, 'Let my people go,' Moses stated as soon as they had gotten through with the manners necessary around the court.

"I'm not letting them go, so you better show me your sign. But I'm telling you right now, no more frogs, Moses."

"This sign is also for your counsellors and judges. So you better call them in, too."

Pharaoh pointed out that he made a habit of making up his own mind, but if Moses wanted to entertain some more people with his tricks he would have them called. Moses had to wait for a long time before they all got there.

When the chairs were all full of nobles with their shaved heads and shoulders wrapped in cloaks, Moses lifted his right hand with his rod and all the others in the room began first to twitch, then to squirm and then to scratch and claw madly at their persons. One aged noble picked something off the edge of his cloak and gasped in disgusted surprise. "A louse! No, I mean lice!" But he could have saved his breath, for everyone present from Pharaoh down to the palace cat had made the same discovery.

"I pronounce on all Egypt, except Goshen, the plague of lice," Moses said solemnly and turned to go.

Pharaoh screamed at his college of priests. "Do something about this plague of lice and do it quick. And another thing, don't you dare scratch yourselves in front of me. Do something!"

The itching, twitching college of priests stood before Pharaoh as solemn as they could and the chief priest said, "Pharaoh, this plague is the finger of God. We don't know how it is done at all." But as they hurried out as fast as the priestly gait would allow, the chief priest said to his associates, "I mean to know this trick by next planting season."

"Moses!" Pharaoh called after him down the long corridor. "Moses!"

"Don't know just when I'll be back," Moses said over his shoulder, "but I'm coming."

A little further down the hall he called back, "I'd let them children of Israel go if I were you, but don't let *me* over-persuade you." Then he went on home to think.

And behind Pharaoh's outward show of indifference, he was beginning to worry a little. The thought came to him that if he issued a public order expelling the Hebrews from Egypt it would save his face and rid him of the harassment of Moses. He hinted as much to his courtiers, but they refused to listen. They had no intention of depriving themselves of their slaves like that. So Pharaoh issued a statement that the people themselves had brought on the plague of lice. The gods of Egypt had noticed their vice and loose living and had punished them. The people were silenced by the surprise of the thing.

"I haven't slept with more women than usual," one farmer asserted. "The gods are getting very strict these days."

CHAPTER 24

Moses made no move to see Pharaoh for a whole month. Aaron and the council of the Elders of Israel were jubilant and urged Moses to press the issue but he would not be hurried. All Egypt was whispering and he pointed out that the Egyptian people would be begging Pharaoh to send them out before long. So let things rock on as they were for a while.

But he was not sleeping. He was coaching Joshua who was learning to read and write. Moses had placed him at the head of the boys' military society, and nearly every night there were drills and marchings. Caleb, a few years older than Joshua, was heading the young men's battalions, and Hur headed the older men. Moses was impressing upon them the necessity of military training and what he was doing with them was intensive. Their drill grounds were secret places and their hours of gathering changed often enough to be confusing to spies. Moses was particularly pleased with Joshua. Here was a person of action. No great talent for thinking, but a wizard in action. And his loyalty was so great that Moses would catch him studying his face trying to anticipate the wishes of Moses so he could hurry to do them. Moses was absolutely satisfied with him. Here was the perfect instrument to his hand. Give him time and growth, that was all. Israel, if it escaped Egypt, was

160

going to have to do some fighting on its way to becoming a nation and here was hope. His eyes and ears served Moses well.

"Chief," Joshua whispered to Moses one morning, "a lot of the old heads are complaining because you make 'em drill."

"What do they say about it, Joshua?"

"They say they was under the impression that you had found some god who was going to save us. They didn't know they had to join the army."

"Don't they know, Joshua, that God Himself can't save people who won't try to save themselves?"

"They say that Pharaoh's army is too terrible for them to face. They'd rather stay in slavery if they got to stand up before those soldiers and get killed."

"I know just how they feel, Joshua. I've been noticing things. And they don't need to worry about Pharaoh and his army. I'll take care of that part. But what is to become of them when we get out of Egypt? Do they think the world will be full of angels when they get out of here?"

"I reckon so. That's the way they talk anyhow. A lot of them are real discouraged."

"Pay 'em no mind and keep right on drilling and practicing with your spears and arrows. Somebody got to have some sense. I'm depending on you and Caleb to pull this thing off right."

"Oh, we will keep our part moving along. I got six thousand boys fifteen to seventeen years old and all of them want to fight just as quick as they can. Caleb's young men are all right too. It's just them old folks that's grumbling. We ought to march off and leave 'em here."

"No, Joshua, we can't do that, nice as it would be. They just don't think. They are trying to go on what they know and that ain't enough. So many more people know things than think things. One thought can put thousands to knowing, but knowing one thing don't put many to thinking. You see how it is?"

"Yes, sir. They know so much already they don't do no more thinking."

"That's just the point. What them old folks know is a stumbling stone to their thinking. But just for that we can't leave 'em behind. Joshua, when you find a man who has lost the way, you don't make fun of him and scorn him and leave him there. You show him the way. If you don't do that you just prove that you're sort of lost yourself. Remember that, son, if you ever get in the lead of people."

"Yes, sir. I mean I won't forget."

"Good for you. Now, Joshua, I think we're about ready to go see old Pharaoh again. He thinks we done forgot him, I reckon. But we ain't. Tomorrow is Wednesday. The Lord got a few more suggestions to make to that man by now. I better go see him tomorrow afternoon."

"I wish I could go with you sometimes. Oh, yes, Miss Miriam says I am in her way around here. She told me to stay away and quit talking so much out of my mouth."

"Don't let Miss Miriam worry you. Just agree with her and go on like I told you. Let her head work for the present. You won't lose nothing in the long run. I don't forget a thing."

CHAPTER 25

Next day at the palace Moses told Pharaoh, "The Lord told me to tell you He said, 'Let my people go.'"

Pharaoh said, "We here in Egypt have known gods for thousands of years. I can't see why I should pay this new voice you talk about any mind at all. Who is He anyhow?"

"Why should I lose time talking to deaf ears?" Moses retorted. "The question before the house is will you let the Israelites go?"

"No."

"Well, it's mighty bad news for you, because if you don't, you're going to be plagued with flies."

With no more talk than that Moses lifted his rod with his right hand and flies seemed to pour out of the sleeves of his garments. The hum from their wings filled the room. The number of them darkened the rooms and Pharaoh and priests fought to flee the place. But it was no better outside. The city of the Pharaohs was smothered with flies. Moses changed his rod to his left hand and walked on out of the palace. All around him and Aaron was a space free from flies. So they went on back to Goshen and the people heard about it and hoped.

There was no mistaking the public panic this time. The

public besieged the nobles and the nobles waited on Pharaoh. Their faces were long and haggard. Some retched with nausea as they waited.

"We realize that we have held you back too long, Pharaoh. We stopped you when you would have done something to put an end to these calamities. You must not let us interfere with you any further."

"It is good to feel your confidence and co-operation, but what can be done?"

"Find out what office that Moses is after and give it to him. Do something. We couldn't live through another plague of flies. We just couldn't!"

"I'll find out, but he claims he doesn't want anything in Egypt except the freedom of the slaves."

"That is not to be even discussed. Our work must go on. We can't let ourselves be robbed like that. I don't believe that Moses wants a thing like that himself. He's a Prince! He is one of us. He is being clever to get back his titles and his property. Let him have them. It would be cheap at that."

"Yes, tell him he need not carry those Hebrews off in order to have somebody to rule over. Make him governor of a province. The Nome of the Thebiad has no ruler at present. Give him that."

"Something must be done, Pharaoh. Our Hebrews are getting impudent and restless. Why, only this morning my steward was knocked down by one of my slaves because he tried to chastise the Hebrew for impertinence. It's awful! They are beginning to be bold and important. I heard of several instances of resistance to discipline. The idea of Egyptians having to fight with Hebrews!"

"Why not bribe him to go back where he came from?"

"He is despicable," Pharaoh said. "But I don't believe that he could be bribed. Remember he walked off and left wealth and position before. It is something else he wants. I don't see what he wants with our Hebrews, but if that is not his real aim, I don't know yet what it is he wants."

"Anything but our slaves. That is, anything in reason."

164

"Well, I'll send for him and put a stop to his nuisances."

"Do! This thing is not as funny as it was."

The next day Pharaoh sent for Moses and asked, "Moses, what is it you want for these Israelites anyway?"

"We want to go out of Egypt where we can worship in our own way."

"All of the Hebrews at one time?"

"Every last one of them from gray beard to battle heights. Every sheep and cow, even. That's what we want."

"Well, do away with these blasted flies and I'll let them go. That is provided you don't take them very far."

"How far do you mean?"

"Oh, not out of Egypt. A couple of hours' march ought to do."

"No, that is not enough, Pharaoh."

"It will have to do. I can't let my work be neglected while my slaves go too far away. No, indeed."

"The flies stay, then."

"Oh, no, Moses, do away with these flies and I'll let them go."

Moses said, "I'll go home and at five o'clock sharp, the flies shall vanish from Egypt."

"All right, Moses, you do away with this plague of flies and go on home. I'll send word tomorrow what day you can lead the people off to serve their god in the wilderness."

Moses changed his rod from his left hand to his right and lifted it and went on home and at five o'clock sharp the plague of flies disappeared from Egypt as they had come. The people of Goshen had a torchlight parade that night to celebrate the end of slavery.

But Moses waited a week and no messenger came to tell them. So the next Wednesday Moses went to the palace and Pharaoh laughed at him.

"Pharaoh, you made a fool out of me before all the people in Goshen."

"That's a fact, Moses, I sure did," Pharaoh said, laughing

fit to kill himself, "but you have to admit I couldn't have done it if you hadn't furnished the material."

"Well, the Lord says that you are going to have a cattle murrain all over Egypt, except in Goshen. All your cattle are going to die. See if you can laugh that off. Why don't you kill me? I'll tell you why. Your will is paralyzed by power and your fear."

Moses changed hands on his rod and lifted it and turned to go. "One thing only can save you—when you come to know that justice is greater than pride. You know where I live when you get ready to talk sense."

And Moses walked away.

Moses walked out of the palace of Pharaoh knowing that he carried Pharaoh's peace and security in his hand.

If Pharaoh relented and let the Hebrews go, he would rid himself of the worry and humiliation he was suffering. But on the other hand he would have to face a danger more sure and certain right away. The nobles would never permit him to save his face at their expense. Even the servants who served about him personally belonged to that ruling class and so he could not even hope to escape with his life. If the house of Pharaoh had not preached and practiced hatred and vengeance for generations, he could save himself by a show of generosity and dismiss the slaves. But the intolerance of Pharaoh and his fathers was fighting against him. Pharaoh was locked up in his own palace and inside himself. Moses walked out of the palace with a sense of power.

And in the privacy of his retiring room, Pharaoh was thinking the same thing, but in a different mood. After hours of seclusion and thought he still did not have the answer. So he set his face in stiff, proud lines and went among his courtiers expressing indifference and scorn. He wanted Moses dead, but he wanted it done by his own hand. And the people harassed Pharaoh with their fears and apprehensions, and the Princes worried him, so he had to make a gesture, but he did it with a growing feeling of desperation and frustration.

"Moses had courage," he thought grimly. "He walked away from it all."

Pharaoh had dreamed of making his name and fame greater than that of his father. How could he do it and abandon the public works? And how could he carry on the public works without the Hebrews? Even his military strength rested on these slaves. For, without them men would have to be taken from other things to fill their places. He had too often boasted of this advantage of holding the Hebrews for the army to forget it. They would resist him too. Nothing to do but wait until the gods favored his cause.

The third day Pharaoh sent for Moses and begged him to take off the plague and he would let the people go. Moses stopped what few cattle that were left from dying, but Pharaoh went back on his word again. Moses knew why he did it, and Pharaoh suspected that Moses knew, but neither of them gave a sign that they knew. When Moses went to see him he said, "Moses, these people must not have much to do if they got time to be planning camp meetings and barbecues. I just gave orders to all my foremen to double their tasks. The old folks always said that an idle mind is the devil's workshop and this just goes to prove it."

"That's very serious talk you are doing, Pharaoh," Moses said. "The Lord don't love ugliness and He usually does something to let you know. Now, you done promised and took back your word so much till I reckon I'll have to send you another plague. You have got to learn that there is something in the world bigger than your pride and vengeance."

The chief priest stood up and said, "It's hard on the people, all these plagues and things. Why not let those Israelites go, Pharaoh? This Moses is threatening us with another plague."

"Oh, nothing but tricks," Pharaoh sneered. "He's bound to run out of tricks after a while."

Moses looked behind the mask of Pharaoh and was almost sorry for him. Then he remembered what he had to do. He handed Aaron his rod and walked to the fireplace and took up a handful of ashes and in the presence of Pharaoh, his court

167

and the priests he said, "I am sending you a plague of boils on everybody in Egypt except Goshen." He threw the handful of ashes toward heaven and kept his hand lifted until the light air had scattered the ashes to the four winds. And all over Egypt from Pharaoh to the swineherds, people broke out in boils. Pharaoh called on his priests for help, but they were too sore to move from their beds. And nobody was well enough to wait upon the others. The whole nation, except Goshen, groaned and suffered until Pharaoh sent for Moses and promised solemnly this time to let the Hebrews go. Egypt had suffered ten awful days and a great number of people muttered that the labor of the Israelites wasn't worth it. Why not let them go? But again Pharaoh changed his mind. The majority of the ruling class saw ruin in social change. So Moses went to him and said:

"I see that you think you are smarter than God. You have promised after each plague to let the Israelites depart to worship their God in their own way and in places of their own choosing, and each time you have double talked as soon as the trouble was taken off you. All right, tomorrow at this same time, I promise you a deadly storm of hail that shall kill people in the streets and in the fields; it shall strike down animals; it shall destroy crops and ruin houses."

"Hail?" asked Pharaoh of his court. "What is this man talking about? I never heard of such a thing."

So Moses told him what it was. And Pharaoh laughed out loud at that. "Hail!" he laughed. "Hail in a country where we don't even have rain? You are not trying to amuse me now after all your other tricks?"

Pharaoh laughed some more and everybody helped him. They knew Moses had power because they had seen his signs and wonders but hail in Egypt was too much to believe. What! Water so cold that it turned to stone? This was really too much. And falling from the sky? How would Moses get the water up there in the first place? and even if he could, how would he get the coldness up to it to turn the water to stones and make it fall? Now, Moses has really overstepped his

bounds. This must be a joke. They were relieved that he threatened hail instead of something that really could happen like a flood. Maybe it was like Pharaoh had said, Moses was bound to run out of tricks after a while and this looked like the end. The menace of Moses was gone for good. Pharaoh had worn him out.

"Meet me out on the battalion grounds outside of town tomorrow at this same time and see who is right and who is wrong," Moses challenged. "I may be lying. You better try me and see."

Everybody was coming to see this plague of hailstorms for hardly anybody in Egypt had even seen ice. A few who had traveled tried to tell what it was like, but even they had not seen ice showers. All over the city people were making jokes about it. Such a nonsense. Ice out of the sky where everybody knew the hot sun lived.

This public interest was new. At first the battle of enchantments was between Moses, Pharaoh and the priests, but by now, from what they had seen and suffered, all Egypt was interested in that man who sent plagues. And a plague like hail that really couldn't happen was something to go to see. The people turned out by the thousands.

Pharaoh rolled in a little late with all of his priests behind him. As soon as he saw Moses he called, "Moses, are you ready to make ice fall out of the sky on us yet?"

Moses looked at the sky closely before he answered. "Not quite ready yet. I'll let you know in a little while."

"I'll bet you're not ready." So he told his priests to make some magic to entertain the people while Moses got ready, which they did for more than an hour.

All of a sudden Moses looked at the sky and walked out in the middle of the parade ground and took his stand. He lifted both hands high and spread them abroad and the hundred-prong lightning began to play across the sky, and thunder rolled behind it from east to west. Zig-zag fire darted from the sky to the earth and ran along the ground. Then while Moses still held up his hands, the hail began to fall. It fell and it fell

169

and everybody fled the place but Moses. He stood as if he were cast in stone with the lightning playing about him and the hailstones falling like shot from heaven. The people fled with Pharaoh, but they did not escape the hail. It devastated Egypt as Moses had promised.

The chief scribe lifted himself from the ground where he had fallen when some younger man tripped him in flight and said, "There has been nothing like it since Egypt became a nation," and everybody else was saying the same thing.

They came with the east wind and went with the west wind. That is how the locust came into Egypt at the call of Moses. The hail storm had frightened Pharaoh while it lasted and he had said the people of Goshen could go. But as soon as it was over, he sent soldiers to guard the borders of Goshen so that not a soul could depart. He aggravated the matter by refusing the brickmakers straw, which had always been furnished to them. Now, he said, they must find straw for themselves and at the same time they must turn out just as many bricks. He was going hard.

So Moses lifted his right hand and the east wind woke up from where it was sleeping and romped across the narrow valley of Egypt all day and all night. And on the wind came the locusts in such hosts that daylight became dark. Their wings clashed out a din and their voices muttered of hunger. They came and muttered and trembled upon the wheat fields and muttered and ate and grumbled in their jaws until not a leaf was left standing in Egypt. Then when Egypt was eaten bare they attached themselves to a west wind that blew and went with the wind into the Red Sea.

The servants of Pharaoh gathered around him and asked him, "Pharaoh, how long is this man going to be set like a trap in Egypt to catch us? The nation can't stand this kind of a thing much longer. We're just about ruined already. Aren't you ever going to do anything to stop it?"

"Then you will support me if I send these Hebrews out of my sight?"

"Do we have to go that far? Can't we compromise somehow?"

"We can see," Pharaoh said wearily.

"Give them a light vacation—a day or two ought not to ruin us."

"Call out the army, and send it down into Goshen."

"For what? Killing our slaves won't get our work done."

"Oh, let's leave it to Pharaoh. He is responsible for the country. He is conducting this on his own responsibility. Let's leave it to his intelligence."

Pharaoh wilted under this back-handed thrust and dismissed the council.

So Pharaoh sent for Moses and Aaron.

"Moses," he said, "I've about decided to let those people go out to worship like you asked me. But I can't let everybody go. You understand. If I did that my work would be at a standstill. Now if you all could let me know exactly who is going out to worship and just where they plan to go and how long they aim to be gone, I might give you some consideration."

"Pharaoh, if I told you any of those things you asked me, I would be telling you what I don't know myself. The Lord of Israel has ordered all the people to go out to a place which He will point out after we get on the way. That's all he told me, and I'm selling it just like I bought it."

"Before I let you go I will have to know when you are going, where you are going and how long you plan to stay."

"I can't tell you that, Pharaoh," Moses said stubbornly.

"Then nobody is going to step. Think I'm going to have all the help off the place at one time and I don't even know where they are at?"

"The time will come, Pharaoh, when they will go, and that soon, I'll bound you that."

"You say they will and I say they won't and I happen to be King of Egypt. And all Egypt will support me in my position."

"We'll see about that, King or no King. The god I represent is stronger than thrones."

171

The next Wednesday Moses got up early in the morning and sent word around all over Goshen for the people to get hold of every lamp they could get their hands on and lay in a-plenty of oil. Gather up a-plenty lightwood and kindling because they were going to need it mighty bad. Then he went on over to the palace to talk with Pharaoh.

Moses noted that Pharaoh looked sunken and worn. His haggard face was a grim, ashen mask. But his eyes glittered like an asp at bay. Moses noted too that his right hand rested on the hilt of his sword.

"Pharaoh," Moses began with a deceptive gentleness, "I come this time to save you from yourself."

Pharaoh started at the sound of Moses' voice as if he had been stabbed.

"Say what you have to say and leave here. I don't want to see you. I don't want to hear your voice. I don't want to hear your wretched name called again."

"I see that you are afraid, Pharaoh."

"A Pharaoh afraid?"

"That crown and that throne make you a Pharaoh, but inside of that frame you are a man. And you are afraid. And I know you do not know what you are afraid of. Your fear is so vast that it has crumbled you up inside. But for that you would have killed me weeks ago."

"Liar!"

"Pharaoh," Moses went on calmly, "as I came along I saw long trains of people fleeing Egypt—to the mountains, up the river, anywhere so long as they got out of Egypt. Not Hebrews, mind you, but your own people. They were afraid. Whole villages and towns were empty. It seems that Egypt has learned my name."

"Egypt knew your name before and nobody left but you."

"That was because I was not warring against Egypt then. They had never suffered plagues. But now they flee away. You can calm Egypt and restore your country to peace."

"If you have come to tell me to let those Hebrews go, I tell you right now, No! I will not let them go."

"You mean you can't let them go. You wish you could. You know and I know what it would cost you. You can't undo in a few weeks what you took generations to do. So you don't dare to do what would ease your position."

"Never mind about the affairs of Egypt. They do not concern you. You came here to ask me to let the Hebrews go. I tell you, No. So you have nothing to keep you here."

"But, Pharaoh, I can't go. My conscience wouldn't let me until I warn you that my God says you must let His people go."

"Moses, I know nothing about this God. Nobody seems to know anything about Him but you. I can't allow the welfare of Egypt to be destroyed by your superstitions. You see that your tricks have not moved me."

"Oh, yes, they have. You and Egypt will never be the same after I am gone. And I warn you that I have other tricks, as you call them in scorn, more terrible than those that you have experienced. Don't make me use them to scourge you. Let the Israelites go."

"You can't scare me, Moses. Out of the consciousness of my might, I have been indulgent with you. Don't provoke me any further."

"No, you have temporized with me because you are weak."

"Weak? Why, I have a million men under arms."

"And in your panic you contemplate sending a million men against one man. I thought you said you were brave."

Pharaoh half rose from his seat in his anger. "You are getting beyond your depth, Moses. I might forget my patience in a moment."

"Oh, you will have your hour with me, when the time that is set for it comes. In the meanwhile I am to tell you to let the Hebrews go."

"And I tell you that I will not let them go. Nothing on earth can make me change my mind."

"Nothing, Pharaoh?"

"Nothing, on my sacred oath, nothing. My very soul revolts at the thought."

"Then you have forgotten your past terrors."

"I never had any to forget."

"Perhaps not, but, Pharaoh, when you come to wind up that last ball of sorrow, don't forget that I reasoned with you."

"Fear is no part of me, say what you will."

"Pharaoh, have you ever seen darkness?"

"Of course I have! A night has followed every day I ever saw."

"But did a day always follow every night you ever saw, Pharaoh?"

"It never failed yet."

"It is just possible that a Pharaoh even is about to learn something new. You are going to have darkness in the broad open daylight. I am turning my back on you and the great invisible darkness that stands behind me shall make itself known. I am loosing the plague of darkness on Egypt."

Moses went out of the palace and lifted his right hand and the light began to thicken. There were no clouds in the sky. The world just began to grow dim. By the time Moses got home it was dusk in mid-afternoon. Then it went on from there. Egypt knew darkness, living crawling darkness that had a life of its own. It had body like the wind and it heaved in motion like the sea.

In Goshen, lamps burned in every house and at the doors. But in other Egypt the darkness smothered down upon the earth. Its pall silenced cries and choked back laughter. Even the beasts ceased groaning after the first hour. Egypt was soundless and motionless for three whole days. And outside of Goshen, nobody saw anybody else for the space of three days. It was a soundless vacuum like in heaven when the orchestra before the throne strikes silence for the space of half an hour once in every thousand years. When the three full days were over the darkness began to lift and to withdraw itself across the Red Sea into the land of Midian, into a certain mountain from which it had come.

In the druggy gray shadow of the departing darkness, children and parents groped toward each other and huddled to-

gether in silence a long while before they spoke. The lion that had fought off its own cubs in the terror of sightlessness hovered them again, and the asp had faith once more in its fangs.

"Horus is dead beneath the sundown horizon. His light will never come again," one priest whispered to the others. These were the first words spoken in Egypt since the reign of nights without days.

"Egypt will die in this coldness that has leaked out of the darkness," his brother whimpered. "How can we strain against a man who has killed our gods? Darkness strips everybody of everything. We can't live."

And everywhere in Egypt tongues began to move and say, "The pride and stubbornness of Pharaoh has destroyed us all."

And what they saw with their eyes was terrible. Old ones, sick and poor; children, women trampled to death during the darkness when the nation was stampeded by fear. Bodies on steps and in doorways.

The moment that he could see his hand before his face Pharaoh began to call out to his attendants to come closer to him. "I am King of a dead nation," he moaned. "Go beg Moses to come. The children of Israel can go. Find lamps and lanterns and go get me Moses."

But by the time that his messengers could grope their way to Goshen the light of a natural night had lightened Egypt. There was no moon, but the stars could be plainly seen. So Pharaoh haughtily refused to talk to Moses when he came, and put him off until morning and went off to bed.

"Moses," he said next morning, "as bad as I hate to see you in any form or fashion, I am a reasonable man. So I am prepared to let you go and take the children of Israel to go serve your God, but your flocks and your herds stay right here. You understand me, don't you?"

"I heard you, Pharaoh, but when we go out to worship, not a hoof will be left in Egypt."

"If you are only going out to worship your God as you say, what do you need livestock for?"

175

"We don't know what we might need to serve the Lord with until we get there. The flocks and the herds go with us or we don't go."

"Well, you don't go then. Egypt will not be robbed like that."

"Ta-Phar, I'm just as wore out with you as you are with me. I been just fooling along with you because I remember you're mean and stubborn, so I took advantage of it to let you make a fool out of yourself before Egypt. But I'm through playing with you now. I came back into Egypt to lead out the children of Israel. I am showing you my ugly laugh now."

"Don't you stand up here in my palace and talk to me like that, Moses. I am King in Egypt. Get out! And look out for yourself too. Don't look in my face again, for the day you do is the day you die. Get out!"

Moses laughed a laugh that he had been saving up for more than thirty years. "You told the truth then, Ta-Phar. I will certainly not see your face again—not that I ever got any pleasure out of it anyway. But you will hear from me again, and you sure won't like it when you do."

"It is my will not to see you again. Be warned."

"But I tell you, Pharaoh, that you will. I am talking for Israel now and you are talking for Egypt. But a time will come when you will seek me out so that Ta-Phar and Moses may stand face to face. You will seek me out to fight me. And I'll be there, Ta-Phar, and I'll be exulting like a stallion."

"And if that time ever comes, you be there like a stallion. I shall be there, a lion in his strength."

"Let us hope for the meeting," Moses said with restrained feeling. And he was gone.

176

CHAPTER 26

Night came walking through Egypt swishing her black dress. The palace and the peasant slept. Pharaoh and the servants of Pharaoh had assured the Egyptians that the terrors of Moses were ended. He had said that Moses must cease and the word of a Pharaoh was enough. So the nation slept its sleep untroubled.

In Goshen the blind-eyed goddess of night huddled close, and families stayed inside their houses and waited. A bloody bunch of hyssop had swished against every door in Goshen three times—once on the lintel overhead and once on the door facing at either side. Then the people had gone inside and sat behind the blood and waited as Moses had ordered. Their new god, who had chosen them through Moses, was going to fight Pharaoh for their sake. He had asked the sign of the three bloody marks on the door and the people had done their part. The rest was for Moses and God to do. So the dark stillness in Goshen was not sleeping darkness. It meant waiting. The lamb had been sacrificed and eaten in every house in the land and his signal blood guarded the doors. The night went on its way.

Darkness balanced up on midnight looking both ways for day. Then the great cry arose in Egypt. They cried and died in Egypt. It was the great cry that had issued first from the

throat of Israel years before and spread to the rim bones of the world and come back again. And now it poured out through the mouth of the Egyptian nation. It was such a cry that there was none like it since the morning stars sang together, and never shall be another like it as long as heaven is happy. Egypt cried out at the death of the first-born. Every house in Egypt was bloody. Blood outside the door in Goshen, blood inside every other house in Egypt.

Pharaoh looked upon his first-born and wept. His son was dead and the son of his son was dead in his own blood. There were snorts and bellows from his stables from the smell of animal blood. So Pharaoh cried for his dead with all of his voice. Every house in Egypt strained its voice trying to express its bereavement. The noise of it struck the sky and came back to the Nile and ran with it to the sea, the Egyptian chorus of sorrow indoors.

Outside, the paths and pavements were full of soft, swift feet fleeing into Goshen with its listening ears. These were the sounds of the night, sounds without words.

With the sunrise, Princes and people said, "This is the hand, the right hand of Moses." They lifted their dead from beds and said in awe, "Moses and the God of the Israelites." They rolled their dead from straw mats and pallets and said, "Moses and his right hand." They crowded in and around the palace and shouted, "Get Moses and the Hebrews out of Egypt. If you don't, everybody in Egypt will be dead."

So Pharaoh sent for Moses to dismiss him, his God and his people from Egypt. He was no longer proud Pharaoh with the mask-like face. He was a man whose son was dead. But Moses refused to go see Pharaoh all that day. Burials went on and burials went out from houses all day in long lines and solemn weeping, and all Egypt was in tears. Pharaoh sent messengers to Moses again telling him not that the Hebrews might go, but that they must go.

Moses heard the message sitting in his house but he didn't

178

say a word right then. The news was too big to speak at once. He had to sit with his feelings for a while. Afterwards he called his leaders to him and told them, "Your slavery is over. Pharaoh is broken at last. We march out of Egypt with a free people. We march out with a high hand."

The people cried when Moses told them. He had expected wild clamor; the sound of cymbals and exultant singing and dancing. But the people wept out of their eyes. Goshen was very still. No songs and shouts.

"Free at last! Free at last! Thank God Almighty I'm free at last! No more toting sand and mixing mortar! No more taking rocks and building things for Pharaoh! No more whipping and bloody backs! No more slaving from can't see in the morning to can't see at night! Free! Free! So free till I'm foolish!" They just sat with centuries in their eyes and cried. A few could express themselves like that. But the majority just sat in the doors of their dwellings staring out at life.

But Moses put a stop to all of that. "You won't be free for long if you keep that up. Stop that shouting, and stop that sitting, people! Get everything you got together and let's go, and that quick."

"Why, Moses?" some of them asked. "We're free now and we can take our own time about everything."

"You people been around Pharaoh all this time and don't know him no better than that? He is scared today and so he says you can go. Tomorrow or next day he will realize what he's losing and send his army into Goshen to put you back to

work. Grab up your things right now. Tonight we leave Egypt forever."

"Good gracious!" somebody grumbled, "I was figuring on going fishing tomorrow morning. I don't want to be bothered with no packing up today. It's too much like work and I just got free this morning."

"That's the heaven's truth, too," plenty of others chimed in. "Looks like we done swapped one bossman for another one. I don't want nobody giving me no orders no more."

"But it was Moses that got us free," Joshua told them. "If it hadn't been for him we would be hauling rocks right this minute."

"Oh, I don't know about that. This God that done chose us would have got us free anyhow. I never did much care for this Moses like some of you all."

"What's the matter with Moses? He got us free all right."

"Oh, I have every confidence in the man, I just don't trust him."

But Moses himself moved from place to place urging hurry and everybody, unwilling or not, did what he said. The women told Miriam's committee that they just couldn't get ready because it was baking day. "We got dough set to rise and we can't disturb it or it won't be light." Miriam went back and told Moses what they said and he went to see about it himself. "Mix your dough," Moses told them, "but don't put your seasoning in it so it won't spoil, and while you are at it, mix enough for a week. And that is just part of what I want done. Everybody roast a lamb so that everybody in Goshen can eat a full meal with some greens to settle the stomach. We got a long, hard march in front of us—tonight!"

Finally Moses got them ready in the spirit so everywhere in Goshen the people were saying, "Tonight!"

Everybody said it according to their thought and their feelings. Some talked it with the edge of their lips. Some rolled it deep in their throats. Some throbbed it inside their hearts and let their bodies move with the rhythm. Some said it with

their eyes, with a gleam, with future-searching gazes. Some said it with a question, "Tonight?"

They fixed and they did around and got ready. Nothing was still. Children hunted the bitter herbs. Men slaughtered beasts and tied bundles. Women mixed dough and cooked. And all the time everybody thought back over the years and every now and then they breathed, "Tonight!" Moses had inspired them for the journey and they were going.

The God of the two horizons took flight beyond the western line and the frenzied hurry of the day took shape. Flocks and herds gathered and ready. Bundles tied. Every group had met its leader and been told.

"Now," Moses said to a group of men under Nun, "go quickly to the tomb of Joseph and bring me the casket with his bones. He brought Israel into Egypt and Israel must take him out of a land that is no longer fit for his dust. Hurry!"

The gorgeous carved and painted casket of Joseph rested on a pedestal before the house of Moses, and its bearers were appointed. So Moses told everybody to eat in haste, leaving nothing to eat behind them when they were ready to go.

They sang a song. Now that they were ready to go and going, it was triumphant but it was sad. It was a long time since Israel had done any singing much and they had forgotten how to shout. Moses noticed that their glad notes broke on wails. Israel was used to wailing now. They had forgotten how to laud. His heart hurt for them. So he said to himself that they should see glory mountains and shiny valleys and they should learn to sing.

He led them out of Goshen with a high hand. Out and out the tread of the tribes behind him. A great horde of mixed-blooded people grabbed up their things and joined the hosts of Israel. "Let us be free too," they begged and Moses said yes to them. His fighting men in front and behind with Joshua's volunteer boys in the center to give aid and assistance to women and children. Out and out he led. People cried and died and stayed where they fell. Aged ones hobbled and were partly carried, old ones, crippled by the generations behind

182

them and blinded by the look ahead, grasped and clutched at young shoulders and gasped, "Don't leave me behind." Babies borned themselves and joined the procession out. Out was such a big word in Egypt to the Hebrews.

"Which way, Moses?" Aaron asked.

"By the wilderness of the Red Sea."

"It's a whole heap shorter through the land of the Philistines."

"I know, Aaron. But our people are leaving slavery. It takes free men for fighting. The Philistines might let us through without fighting but it's too much of a risk. If these people see an army right now they would turn right around and run back into Goshen. So let's head them for the Red Sea."

The soft murmur of sandals and bare feet kept up in the night without a moon as Moses and his hosts moved on.

"On our way at last," Aaron said happily to Nun.

"After four hundred and thirty years to the day. It still seems like it ain't so to me, Aaron. Ain't but one thing I'm sorry about."

"What is that, Nun? I can't imagine any sorrows connected with the thing."

"I sure hate to miss seeing those Egyptians doing our work in all that hot sun."

"I hadn't thought of that, Nun, but it sure would be a lovely sight. I never want to even see a brick again—not even a brick house to live in."

"Me neither. Where we going now?"

"Out, Nun, out!"

"I don't mean that. I mean just exactly where we're going to live permanent when we get out?"

"Moses may know, but if he does he ain't told nobody yet."

"You reckon it's all right to ask him?"

"I guess so. You can ask him if you want to."

"Where is he now?"

"He was just ahead of us a few minutes ago."

The two men looked up and became conscious of a changed rhythm in the multitudes around them and behind them. It

was a sort of spontaneous mass halt and they saw the reason right away. Ahead of them at a short distance was a column of fire. What it consumed was hard to understand for it towered up steady and solid as no flame they had ever seen. It was like an illumination that glowed but never flamed. It brightened the countryside, but never grew more nor less.

"What is that?" Nun asked in fear.

"It must be where Moses is. You think it is his right hand shining like that?"

"It could be. Is nothing impossible to Moses?"

"It don't look like it. Let's go ahead to see what it is."

The two leaders marching ahead of the host hurried nearer the fiery column and stopped. It was moving ahead as if it was borne but nothing was holding it up. Its many colored lights just moved along ahead of Moses like a vertical beam.

"Moses! Moses!" Aaron gasped. "What is that?"

"The pillar of fire that will always go in front of us at night. It is the sign of the Presence. In the daytime it will be a cloud. Go tell the people not to be afraid."

With the fiery sign the people marched all night and camped next day far from the city of Rameses at Pihahiroth on the shore of the sea to rest and eat. Moses gazed across the water and exulted.

CHAPTER 28

Next morning Pharaoh woke up and looked out of the window on the city, new and fine, its towers, its parks and streets, which the Hebrews had built for his father and him. He had a strange feeling of newness as if he had not seen these sights for a long time. As if he had awakened among familiar surroundings after a long, horrid dream. Then he noticed something. No work was going on around the half-finished public building near the palace grounds. He called a servant right away and asked about it. The servant didn't know.

"Well, go find out," Pharaoh snapped and ordered his breakfast. After a while the servant came back and said that no Hebrews had been seen that morning by anybody except a very sick old Hebrew found by the road by some fishermen. No work had been done for two whole days.

"Two days! You must be wrong."

"Send to Goshen and find out what's the matter. Some more foolishness out of that Moses, I reckon. If it is, I'm through playing with that man. He dies today, him and all his magic. I don't see why I stood him as long as I did."

The word came back, "A great song was heard, then the whole host of the Israelites were seen marching out, driving

185

their flocks and herds, two days ago. Nobody has heard from them since."

"Oh, that worship they were talking about. I did say that they could go. I was too worried about the funeral of the first-born to notice things. It is a terrible thing to lose a son." Then Pharaoh became alarmed. "Do you suppose those Hebrews have run away?"

"A lot of people are saying the same thing, and they want their work done and they aren't getting a bit done today."

Pharaoh thought a minute and his blood jumped salty. He was angry with himself. He could have killed Moses and saved himself this trouble. But he had yearned to humble the man first. To outwit him and shame him. Then would have come death for Moses. But the man had made a fool of him instead before the whole nation, and now he was gone with the Hebrews as he had threatened. Pharaoh was resolved on his death if he could lay hands on him now. He rose up with a great scowl on his face. "That's my trouble," he said, "I'm too good-natured."

"That's right, you certainly are," all the servants and courtiers agreed.

"I must have been out of my head to let those people go off and now we have nobody to work for us. That is, I mean that just because I was grieved down at the death of my son and my grandson and the first-born of all the other people and said things, this man Moses takes advantage of my good nature and runs off with our Hebrews."

"And why should we let them stop working for us and go off like that?" one of the courtiers asked. "It's a sin and a shame when you come to think about it. Them Hebrews off doing nothing and our work going undone."

"It's worse than that," one of the others agreed. "And they could be stopped, you know. They couldn't be very far by now, and them on foot, too."

"Get me my war chariots!" Pharaoh shouted. "Six hundred fighting chariots and men to fill them and have them ready in half an hour. I'm going after those Hebrews and I'm going to

bring 'em back. And so far as that Moses is concerned I mean to kill him with my own hands. That rascal has been imposing on me for thirty-odd years. Always some trick up his sleeve. Get me my fighting chariots and do it now!"

People scurried in every direction and Pharaoh began to dress himself for war.

"My finest sword and javelin! I am a man of war today and it is the happiest day of my life. I have been tricked and tricked and made a fool of by that Moses ever since he was weaned from his nurse. He is facing me today for the last time. Where are my chariots and men?"

With a kill-mad cry, the six hundred chariots with Pharaoh in the lead thundered out of the city before a cloud of road dust, and raced down the road to way off.

CHAPTER 29

I t was late afternoon of the second day when Moses came down to the sea. He ordered rest overnight and plenty cooking and eating to keep up the strength of the hosts. Some people grumbled about sore feet and some missed their beds and houses. Moses let the Elders take care of that. He went down to look at the sea and beyond.

That was the way things were when Joshua came running and shouting, "Pharaoh! The Egyptians! They are coming down behind us. Chariots!"

Moses hurried back to the Israelites. By now the thunder of hoofs and the growl of chariot wheels were easy to hear.

Women screamed in open-mouthed terror and whimpered in fear. Men cursed, cried out and milled about in great whorls. Some tried to run away to the woods to hide, others just stood or squatted on the ground in dumb fear. When they saw Moses come among them they crowded about him. Some clung to him while others screamed at him. He shook them off roughly and kept marching towards the rear.

"I always told my husband not to bother with this mess," one woman sobbed. "I tried to tell him we was getting along all right under the Egyptians. But he was so hard-headed he had to go and get mixed up in it."

Voices broke out everywhere and all were sprung with fear.

The war chariots of Pharaoh were in plain view now though distant on the plain. Moses could hear many things as he shoved through the camp.

"Couldn't that man find graves enough in Egypt to bury us all without dragging us out here in the wilderness to die?"

"Didn't I say all along that this Moses was some fake prophet? That god he made up out of his own head—"

"Didn't I always tell you all that them Egyptians was nice people to work for? You couldn't find better bossmen nowhere."

"The idea of coming and fooling people off from home and leaving 'em with no protection. I mean to tell Pharaoh just how it was."

"Didn't I always say we was better off in slavery than we would be wandering all over the wilderness following after some stray man that nobody don't know nothing about? Tell the truth, didn't I always say that?"

"I told you all a long time ago that we had enough gods in Egypt without messing with some fool religion that nobody don't know nothing about but Moses. You all just let him make a fool out of you. I always knowed it was some trick in it. That man is a pure Egyptian and Pharaoh is his brother. He just toled us off so his brother could butcher us in the wilderness. I told you all so."

"You heard me at the meeting distinctly tell that man to leave us alone and let us serve our Egyptian masters in peace, didn't you? We was getting along fine—plenty to eat and a place to sleep and everything. We wouldn't be in the fix we're in right now if that Moses had of let us alone."

"Who asked him to butt in nohow? Our business didn't concern him, did it? It was our backs they was beating. It wasn't none of his and if we was satisfied he ought to been tickled to death. Now Pharaoh is going to kill us all."

"Great Ra! Great Horus! Great Thoth! Great Isis and the forty-two gods of the double justice! Save us."

Slowed down by the weight of the chariots over the rough ground, the horses were coming in a walk. Moses reached the

189

rear of his great huddle of trembling humanity and took his stand, between danger and his charges. Again, he was one against all Egypt. Listening and thinking back, it was hard to keep his feelings from flying to his head. He had but to step aside and leave them to Pharaoh and his servants. But Pharaoh himself was driving the first chariot as the cavalcade approached, and he wanted to face him and beat him one last time. He laughed to himself as he thought, "Pharaoh thinks he's pursuing me, but it's the other way around. I been on his trail for thirty years, and now I got the old coon at last, as Jethro would say. Let me fuddle him all up for a night and then I will raise my hand. First and last, I'm showing him my ugly laugh."

As the chariots drew near the panic grew in Israel. They committed every kind of folly and showed their inside weakness. Then Moses showed his power again. He turned his back on the Egyptian horde and spoke to his people. Spoke to them in their own dialect as one of them.

"Stand still!" he commanded in a sterner voice than they had ever heard before. "Stand still, every last one of you and stop that screaming and yelling. You haven't got a thing to be scared of. That ain't nobody but Pharaoh and his army and we done beat them too many times before. Don't get so excited about nothing! The Lord is going to fight for you just as He's been doing all along. Stand still and see the salvation of the Lord which He is going to show you today. See those Egyptians there? Take a good look at 'em, because those Egyptians that you are looking at today, you're never going to see *them* no more as long as you live. And nobody else won't be seeing them either. Stand still and keep quiet is all I ask you to do."

Moses didn't lift his hand while he talked but the command in his voice was calming. Suddenly everybody felt secure and brave.

Moses just stood and looked and the pillar of cloud that went before the host moved around from the sea and spread itself like a great plumey curtain between the Israelites and Pharaoh and hid each camp from the other. The Israelites felt

shut in and safe. The Egyptians felt shut out and puzzled. They were afraid to attack until they could know what went on behind that cloud screen, so Pharaoh ordered his forces to camp until next day and then to attack with vigor.

"They can't get away from us so we might as well get some sleep. Our horses need freshening too," Pharaoh ordered. "We got them in a trap—between us and the sea. We'll close the trap in the morning." So they turned in and rested so they could have plenty of vim to butcher Hebrews in the morning.

But Moses never slept. The signal pillar of fire glowed behind the cloud screen and lighted the camp of Israel. Moses himself went back to the sea and stood. When the hour came he called up the east wind and stretched out his hand. They broke the head of the eastern drum and marched out on the sea. The retreating tidal waters did not creep on as was their habit; they fell back from the strait on either side like two mighty armies in retreat. Both sides shrank away from the uplifted hand like lambs before a lion. The waters fled back and back and back and stood in a solid wall on either side and waited on the powers to close them up again.

Then Moses ordered the march. In the same order in which they had come down to the sea, Moses told his hosts to cross over. Flocks first, then women and children followed by the six hundred thousand men of fighting age armed with whatever Moses could find in Egypt to put in their hands—clubs, spears, javelins, old swords, sticks and anything that could wound and tear.

The bones of Joseph crossed over after the women and children. Then Moses challenged Pharaoh. The smoky cloud screen lifted. The fiery pillar again went before the hosts and the sentries of the Egyptian army saw that the children of Israel were escaping across the sea and ran to wake up the camp. "Wake up! The Hebrews have broke camp and are gone."

The camp woke up by degrees. Nobody could believe the sentry at first. They had to get to their feet and get their heads clear of dreams first, and then the peeping dawn did the rest.

It was hard to believe, but the sea was really divided and the Hebrews were tramping across on dry land.

"Well, I'll be—" Pharaoh began, then sprang to action. "Get up and harness the horses! Don't let 'em get away! A palace and high houses to the man who overtakes Moses and hands him over to me alive! Get up and get after our slaves."

In a few minutes the camp was furiously alive. Leaping into chariots, shouts, cries, plunging and neighing of horses, clash of arms on shields, posing Pharaoh's chariot with its three Arabian horses in front of the forces and the furious charge to the sea crossing while the last ranks of the Hebrews were still in sight.

Moses heard the commotion in the Egyptian camp and knew that his movements had been seen as he intended them to be. He hurried across after the last man and waited. He saw the mad charge down the beach. He saw them hesitate there to debate the wisdom of trying the unusual crossing. Then he deliberately showed himself to Pharaoh and the frenzied pursuit was on. The six hundred chariots dashed down into the sea ten and twenty abreast. The Egyptians shouted in triumph as they viewed the cowering Israelites on the opposite shore.

Then when the Egyptians had thoroughly committed themselves to the sea bed and wagered their lives and their vengeance on it, Moses stood on the opposite shore and looked hard at his pursuers. He could distinguish the royal chariot with its fiery Arabians well in the lead. Those were fine horses, Moses recognized, and a splendid chariot. But Ta-Phar had always thought too well of chariots. He could not see his uncle's face at that distance and read its expression, but he could feel it, the hatred, the bafflement and the lust for vengeance. Behind him the Israelites were already over their joy at the miraculous crossing and were beginning to cry out in fear.

"Moses! The Egyptians are coming after us! Ain't no more seas for us to cross."

"I see them. Don't worry."

What he knew must come, happened. Away from the smooth sand of the shore, the horses and the heavy chariots struck rough going. Horses began to flounder and fall as they stepped into holes and soft clay. Chariots swerved, over-turned, and control was lost. Chariots coming after plunged into the tangle and were themselves overturned. Then Moses lifted his hand.

The gripping east wind loosed its mighty fingers and the sea water came rushing back to its bed. It was a moving time. There was the outspoken voice of the wind going east; the mad grumble and shout of the waves as they raced back to embrace each other over the clamor of men in fright, the scream of drowning horses, the last mad struggle of the chari-ots. That all made a boiling place in the sea for a space. Then there was just the heaving Red Sea with its two shores. Egypt on one side and Moses and his mission on the other. Moses stood and looked on the sea. It was a long time before he thought to change his rod from his right hand to his left and let the wind and the sea subside.

Behind him he heard the people exulting. "Didn't we outdo old Pharaoh, though?" Miriam was asking everybody. "It was a great victory for our God," Aaron was saying. "The Lord is a man of war. The Lord is His name." "Old Pharaoh thought he knew who to fool with and who to let alone." "We showed him something. Yeah, he's dead out there in the ocean and there ain't no help for it. That's one old Pharaoh won't have no great big old tombstone over him."

"Well, he's got the great big sea over him, and I reckon that's big enough to suit anybody."

They made a song on that and danced it off. A man with a good voice got out in the center of the ring and sang.

"Old Pharaoh's dead!"

And the chorus answered, "How did he die?"

And the solo man went to dancing and said: "Well, he died like this!" and he danced that off. Then he sang another part and everybody went on dancing and shouting.

"Oh, he died in his chariot and he died in the sea
And he wouldn't have died at all if he let us be."

They sang that over and over and danced on it until they got tired. Then Miriam took the cymbal and some more women went behind her and they went all over the camp singing:

"Oh, Miriam played the cymbal over the Red Sea
Miriam played the cymbal over the Red Sea
Miriam played the cymbal over the Red Sea.
Oh, Miriam played the cymbal right over."

And they clapped time on that with their hands and danced and double clapped it off like they did the other song because everybody was happy and felt like clapping and dancing. Then Moses told them to make camp for the night.

Moses strolled down the beach a little way and sat down on the same boulder that he had sat down on after the first crossing so many years ago. It was another morning and another crossing and so he thought thoughts again. This time he had crossed over safely with a nation behind him and no weapon worth talking about but his right hand. Well, the present was an egg laid by the past that had the future inside its shell. So Moses sat on the rock and said, "You, Voice, you told me to lead out, and by the hardest, I did it. So I'm down here by the Red Sea with these people. You know more about 'em than I do, Lord. What must I do with them now?"

A little tee-nincy voice raised up in the back of his mind and said: "Old Rameses is dead. Ta-Phar is dead. The set who bucked against you and hated you are dead. You know one time you were the idol of Egypt. The army still thinks you are the biggest man they ever made. Moses, you can go back to Egypt and be King. You can do even better than that. You can control the army which controls the King. The Voice told you to lead out and you have led out with a high hand. You have done your duty. The Israelites are out of Egypt and they are free. If they fall into slavery again somewhere else that's none

of your business. You set them free. Moses, there is Egypt right over there and the King is dead in the sea."

Moses sat on the rock and thought back. He had sat on this rock when he fled from Pharaoh the first time and something had shown him clearly the futility of a life of war. Right on this rock he had forsworn the sword and glory. He got to his feet and looked earnestly at the camp for a while, then he said, "Which way, Lord, which way must I lead Your people?"

CHAPTER 30

The next morning everybody was around Moses' tent soon after sunrise. Joshua couldn't hold them back. "We just want to tell him what a great big man he is—bringing us off like that with his outstretched hand."

Another one said, "Joshua, go on, call him out so we can tell him how we feel. It just came to us in the night that nobody ain't thanked him yet. We was so excited yesterday on getting free and getting across the sea, that nobody ain't bowed down and nobody ain't turned him no thanks. Go wake him up, Joshua, so we can tell him."

"Mighty sorry," Joshua told them, "but I just can't do it. Fact of the matter is, he ain't asleep. He's been up a long time talking with God."

"With God?"

"Unhunh."

"Tell me how he sounds when he's talking with God."

"I didn't hear him. He goes off by himself to do that."

"Well, well, well! Is Aaron off talking with God, too?"

"Nope, nobody can do that but Moses. God don't talk to everybody that comes slew-footing down the road. You know, there ain't but one Moses in the world. Never was one before and never will be one again."

"Well, well, well. Reckon we'll rock on down the road to the camp."

"Ain't you going to wait for him and tell him yourself?"

"Oh, no, you can just tell him for us. He ain't in the notion of putting out no plagues or nothing, is he?"

"Oh, no, he wouldn't be lifting his hand and stretching it out against us. He saves that for our enemies."

"Oh, much obliged to you, Joshua. Some of us was kind of worried. We didn't know if he might get us off and lift up that right hand and destroy us all."

"Nothing like that at all. Nothing he likes better than to see us prosper. That's what he led us out for, to better our condition from what it was."

"And he sure Lord is done it, too. He's a fine man, a noble man! He's just like a lion. Look, Joshua, how about that thing he calls a cloud that moves in front of us in the daytime and that fiery thing at night—you reckon it's harmful?"

"No harm in it at all. It wouldn't harm a living soul. It's just there for our guide and leader, so we can know our Lord is with us. Of course, I wouldn't advise nobody to rush up to it and try to touch it. Stay your distance and it's just all right."

"I 'clare to my rest, Joshua, you sure is one smart young one. You done been round Moses so much till you talk just like him. Well, we'll be getting on back to camp. Where we headed to from here?"

"Moses will tell you when he gets ready."

The committee made their manners and went on back to their tents. They had found out what they came for—the intention of Moses towards Israel. Some feared him, and many doubted him. Thoughts had troubled many all night. They wanted some assurances.

But Moses was not talking with God as Joshua had said. Moses was down beside the sea gazing on the work of the waves.

The tide had strewn the beach with bodies. The dead bodies

of the Egyptian soldiers were flung up along the shore in scores, flung helter-skelter like dolls.

Moses walked among them until he found the body of Ta-Phar, once Pharaoh of Egypt. As he looked down on the dead face, frozen in a gasp, he thought, "So powerful on one side of the Red Sea, so helpless on the other."

Standing there, Moses was torn by the pitiful sight of all the sudden dead, for a moment, and then he reflected that he had saved them from a fate much worse. They could not have overcome his strategy and carried the Hebrews back, and to return without them would have ruined them all politically and cost them their lives in a much more painful manner. As it was they would be heroes. They had tried to recapture Egypt's slaves and had lost their lives in the attempt.

Moses stooped and removed the great ring of state from Pharaoh's drowned hand and studied it in his own palm. It brought all his thoughts of peace and power and he weighed it in his hand for a long time. Then it was no longer the key to the Egyptian palace to him. It was just so much gold, and so many gems. He thought of saving it for Jethro, then he smiled. Jethro wouldn't give a fig for it for his own use. He thought how proud and happy Zipporah would be to own the royal ring of Egypt, and it grew to be a sinister thing.

"Only something to stir up ambition and create unhappiness," Moses said out loud as he hurled it as far into the sea as he could. Then he hurried back to the camp and ordered the people to march.

And this was the way they formed to march: The stiff white billowy cloud first. Then Moses on his horse, then the tribe of Levi and the whole host of nearly two million people behind him. So Moses led and he led and he led in the general direction of Mount Sinai for three days and nights. Straight into the wilderness of Shur where there was next to no water and nothing to eat. It took him three days' march to make a full camp so everybody could rest. Moses remembered the numerous wells, and springs he had seen in this vicinity when he passed through one time on a journey.

Soon as the people saw the water everybody went running to get a drink and to water their stock. Then they went to fussing and came running to Moses and crying:

"Moses, what you reckon we're going to drink for water?"

"There's plenty water round here, ain't it? Why you come running to me?"

"Call it water if you want to. If it ain't the nastiest and the bitterest stuff! Even my camel won't drink it. What you mean by tolling us off from all that good water for, to drag us out here to die wanting water?"

The words and the ferocity with which they were spoken caused Moses to inhale deeply before he tried to speak.

"Do you really think I want anybody to die out here?"

"Well, if you didn't, what did you bring us to any such of a God-forsaken place as this? Nobody don't know what you got up your sleeve."

"Let's don't talk about it any more. I'll go out and sample the water. Maybe we can do something about it. Come on, Joshua, and go with me."

Moses, with Joshua at his heels, went to the nearest stream to drink some of the water. People and beasts were lined up around every piece of water there was and every eye either accused Moses or pleaded with him to do something. Moses could feel the hostility in their eyes attacking his skin as he walked through the multitudes to the water. They watched him while he tasted it and spat it out. Some people laughed when he did it. Others began to wail, " 'Tain't no use! We're bound to all die in this desert, with our tongues all parched out of our mouths. We just can't make it to where good drinking water is. Maybe this is the way it was intended to be."

A great clamor went on all the time that Moses stood with the dipper in his hand, taking a sip of water, wallowing it around in his mouth and spitting it out. Where had he tasted water like that before and what had been done about it? All of a sudden he remembered a scene in a distant waste where he had found nothing but bitter water to drink and then he remembered the traveler who looked like an Arab who had

gone to a certain tree, broken off a branch and thrust it into the spring, and instantly the composition of the water was changed. It was not marvelous drinking water after that but it was very drinkable. If only he could find a tree like that around here now!

So he told the people to make themselves comfortable for a few minutes. He had to go and question God. The people muttered and grumbled but there was nothing to do but wait. Moses walked off with Joshua and Aaron behind him and went walking in the woods. No more than a half an hour in the woods and Moses found a whole grove of the trees he was looking for. So he sent and had some tree-chopping done and sweetened the water. The people all drank and watered their stock and went to bed that night telling each other what a great man Moses was. He could even sweeten water that God had left bitter. There was no doubt about it, they had a great leader in front of them. Moses sat thinking, "Supposing I had not met that desert traveler way back yonder? Why was I chosen to lead these people instead of somebody else? They have revolted against me twice before we are fairly started on the journey. Why should I lead people whose ways are strange to me and who neither understand me nor trust me? How come, Voice?"

CHAPTER 31

The next day bright and early Moses was on the march. He led on to Elim because he knew there were a dozen huge springs of water in a grove of seventy palms. Moses decided to camp three nights so that the stock could be well watered and eat the grass growing around there.

He was pleased to see everybody in good humor again. But inside he was lonesome for Jethro and his family and all day his thoughts were in Midian. He took one of the mixed people who had come out of Egypt with him and sent him off on a camel to find the land of the Kenites and tell Jethro what had happened.* Joshua felt hurt that he was not given such a confidential mission, but when Moses told him, "Son, there's liable to be some fighting before long and young as you are, you are my man of war. I couldn't do without you that long."

Soon one morning, over the muttered protests of many who wanted to just stay on where they were, Moses struck camp and went. His road was roughly towards Mount Sinai and he meant to be there as soon as possible. When the people saw the holy mountain they were bound to believe in its God. They were bound to understand Him better. Maybe there, they would realize that they were really free people at last.

*A multitude of mixed-blood people marched out of Egypt with the Hebrews.

Now they acted like they knew they were free by ear but they couldn't conceive of it. They did not believe they could take on any responsibility for themselves at all. They kept clamoring for somebody to act for them. But Moses had made up his mind to be patient until they should learn something. He was looking forward to Sinai and all it meant to him and them.

They struck out across the wilderness of Sin, and Moses marched them as hard as they could go to shorten both his time and his journey. To Moses, the quickest way to show the people to God and God to the hosts, was the best. Besides he hoped that his messenger had reached Jethro and that his friend and father would soon be meeting them somewhere along the way. So he led on across the barren waste called the Wilderness of Sin.

Joshua, mounted on a horse, rode up and down the line and passed out the orders as Moses gave them to him. While he was passing up and down and back and forth he would hear all that the people had to say and he let Moses know how they felt. So one night when the hosts were deep in the wilderness, he rode back and looked up Moses.

"The people are grumbling again," he told Moses gloomily.

"What's the matter this time?"

"They say they're hungry. They talk about splitting off. Some of them done formed a committee."

"Oh, they have, eh? Go tell 'em I say come here."

When Joshua went and told the committee what Moses said, they got mad with him and told all about his big mouth and his slew feet before they got through. "You up there running your mouth to that man Moses, and get us all killed with some kind of a plague. You ain't no good and you better quit lying on us, too."

"But you said all I told him and more besides. If you are dissatisfied how come you don't tell the man instead of doing all this talking and backbiting? He's here to help us and that's what he's trying to do."

"Listen at that long, tall young one that ain't quit wetting

202

his diapers yet, trying to tell us what to do with our own mouths. Here we was talking before he was born and now he's going to come along and tell us how to talk. Course, we did mention that we ain't had nothing decent to eat since we been in this wilderness and that looks like this Moses ought to do better than he's doing if he makes out he knows all about God and can get anything he wants, more specially since he went and drug us off from our good homes in Egypt. But that ain't talking about nobody. That's just saying."

"Well, Moses is just saying that you come on up front and talk your big talk to him instead of to me and the rest of the people. And he's sitting in his tent and he's looking for you right now. Come on."

"We're going and see what he want with us, but don't you be running up there putting out no lies on us no more, and we don't mean no Joe more, we mean no blamed more."

"I am the servant of Moses and his adopted son too, so don't let me hear nothing you don't want him to know. Anyhow, you all done talked this thing so much and so loud, till it's funny for you to make out it's any secret. I bet the folks way back in Egypt could hear your whooping and hollering for rations that you ain't bought."

"We ain't supposed to buy nothing. Moses is supposed to look out for us and take care of us. We left our good homes in Egypt for his sake, didn't we?"

"No. He wasn't the one in slavery. His back wasn't subject to no lash, you know. He was a Prince of the house of Pharaoh. He didn't have to pay us no mind if he didn't want to."

"Humph! I ain't saying nothing but there's a bug under that chip."

"Aw, don't change so many words with me. Bug under that chip! Why you so suspicious? Don't jaw at me. I ain't the boss. Come on and tell Moses about it."

Moses called Aaron to him. "Come on, Aaron, we got to sit on a case. The people are all hungry and mad."

"I done heard all about it. They been griping me since yesterday."

"You didn't say nothing to me about it, Aaron."

"Oh, it was just something that didn't need much attention. I figgered I could handle it myself. I'd naturally understand 'em better than you."

Moses didn't say anything for a minute. He looked at Aaron's face and he noticed the way he walked. His face looked like Ta-Phar's. There was the look of weak brains and strong pride. And he walked like he was conscious of the envy of men. "A beggar on horseback," Moses said to himself. "And first and last, something will have to be done about him." Out loud he said, "Well, Aaron, whatever it was you did and said to 'em, it don't seem to pacify 'em. Let's take our seats under that big tree over there, so all them that wants to can come before us."

So the committee of two hundred, selected from all of the tribes, came up to Moses and Aaron under the tree. "It's no use for me to try to talk any high court language to these people. I might as well get right down with them, and you don't need to talk for me anymore, Aaron. I'll just talk to the people myself." So when the people crowded up before the two men, Moses spoke to them as a Hebrew.

"Eh, eh!" one old crone exclaimed with pleasure. "Moses is getting so he talks our language just like we talk it ourselves."

"Yeah, and the more Moses gets natural with us, the stiffer Aaron gets. He tries to sound like some high-toned Egyptian talking proper—when he don't forget to do it."

"And that's what makes it funny—he forgets."

"Yes, and Moses forgets too and goes back to talking his proper talk when he gets excited, too. I done took notice of that."

Nobody answered right away because everybody waited for somebody else to talk first. Then all of a sudden somebody started to beat his breast and wail and the whole crowd took it up and wailed. They cried out, "I wish to God we had of died whilst we was back in Egypt. There we was sitting down every day to a big pot of meat and bread. If this God you done

204

got us mixed with just had to kill us, we sure wish He had of killed us down in Egypt on a full stomach. We don't care if they did work us some. We would much rather die tired than to die hungry."

"What makes you think you got to holler and cry about it?" Moses asked. "We're assembled and gathered here to find out what you all are grumbling and mumbling about and do what we can about it. We didn't come here to fuss and fight. Now what's the matter?"

"Not to be so much trouble, but we're hungry, boss."

"I'm mighty sorry to hear that, folkses. I realize myself that rations are none too plentiful around here."

"What we want to know is why you bring us off here where there ain't a thing to eat."

This put Moses on a deep thought and before he realized it he was thinking the thoughts and speaking the language of a cultivated man.

"I had the idea all along that you came out here hunting freedom. I didn't know you were hunting a barbecue. Freedom looks like the biggest thing that God ever made to me, and being a little hungry for the sake of it ought not to stop you. Your wives and your children are your own now. I lift your eyes to the hills. I have been hungry a lot of times in places just like this, but I felt that getting what I went after was worth it, so I made myself satisfied. I found out want won't kill you half as quick as worry will."

"Where you get that good word from?" Aaron asked Moses in quick admiration.

"Oh, I don't know exactly. Just from living, I reckon, Aaron." Moses began to relax again. "Now you committeemen that's standing before me, where do you all figure I was going to find enough groceries to feed all of you all?"

"That we don't know and we figure it ain't none of our business. You brought us out there, didn't you? We want to know if this powerful God you talk about is here amongst us or if He ain't."

Moses was irritated but he tried not to show it. He took a long breath before he spoke.

"Well, if going a little hungry for your own sake is such a worry to you I'll have to do something about it. Go tell the people they are going to get bread and it's going to be bread from heaven. This evening the Lord is going to send you meat and meat a-plenty. Tomorrow morning, go look on the ground anywhere around here and pick up the bread to go with it. You are bound to hear some more qualifications about that bread later on. I'll send it out by my helpers. Now all of you go on about your business and let me think awhile."

So that's how the people had the great feast of quail that night and manna in the morning. Ten million quail came and lit all over the camp and the people caught them and quail meat was boiling so that they could smell it clear back to the Red Sea. Then the next morning they went out soon and early to pick up bread. They never had seen any bread like that. It wasn't a loaf and it wasn't rolls and it wasn't pone bread and it wasn't hoe-cake. It was in grains like seeds. So the people looked at it and called it manna because they didn't know what else to call it. Manna was a word that didn't mean anything in particular anyhow, so they called the grains of bread by that name. They ate aplenty of quail and manna and in the cool of the evening they sat around and said that they knew that was a mighty good God that took up with them, and Moses was a fine man to come tell them about it.

When they praised Moses to his face, he merely said to Aaron, "Gather up a peck of that manna and put it on the altar for a souvenir to remember by. Nobody ever saw this kind of bread before, and nobody is going to see any more after this journey is over. Save some so your great-grandchildren will know what happened out here. They ought to know what dangers threatened us and how they were met."

Moses himself felt lonely and yearned for Jethro and his family. He felt more like an alien than he ever had felt in his life. But the mountain spoke to him from afar, and he answered it in his heart. And his worries and troubles shed off

without really touching him because there was Sinai ahead. Here the people would find peace, God and a perfect understanding. These people were blind. It wouldn't do to mock them and leave them. He must put them on the right road. That was his difficult mission.

When they camped at Rephidim, several days' march closer to Sinai, and found that there was no water there, the committee did not wait on Moses respectfully. They rushed up to him with threatening gestures and told him, "Give us some water to drink, man. We ain't for no foolishness today. One time it's nasty water that not even a hog could drink. Then we ain't got nothing to eat. Now we ain't got no water at all. What kind of a leader is you anyhow?"

Moses said calmly, "You ain't talking to me, you know. It wasn't my idea to bring you out of Egypt. Your God commanded me to bring you. Go talk to Him. But I'm telling you now your attitude is a temptation to God to punish you, and punish you to death."

Nevertheless Moses went on off and talked with God. He said to Him, "Do you see these people of yours would just as soon stone me as not? What must I do about it?"

Then Moses saw an inner vision of a strong stream of clear water surging inside the cliff on the hillside. So he called the committee to him and touched the cliffside with his rod and the fountain of water gushed forth. While the people and the cattle drank, Moses called Joshua to him and told him, "Get me a stone and mark it with a new name for this place. We done had such a big fuss here that the name of the place got to be something that fits the case. From now on, the name of this place is Massah, which means a big fuss."

Joshua told Moses, "I sure will attend to that first thing in the morning, but I got a message for you."

"What is it, Joshua? It must be serious from the look on your face."

"It is, Moses. The Amalekites, those folks who live on the other side of the ridge, aim to jump on us for a fight."

"I was afraid of that. When do they aim to strike?"

"Oh, in a day or so. They are sending out for their kinfolks and friends to come and help fight. As soon as they get here they mean to beat us and to take our stuff."

"Joshua, we are going to fight 'em tomorrow morning from sun-up on. Go get out all the fighting men we got right now."

"You don't think I'm too young for the men to follow me?"

"No. That makes no difference. Young or old men will follow you if you got that something to make 'em willing. You are going to be one of the great men of arms, watch my word. This will be good practice for you and it will be good for the people. Once they win a battle it will tend to lift up their heads. Now they are scared of everything and they think nothing is scared of them. They need to win something.

"Right now these Israelites are just like a passel of rabbits. You know, Joshua, one time the rabbits all met together in a convention and decided to kill themselves because nothing looked up to them and nothing was scared of them. So they all headed for the river to drown themselves. They hopped like an army down to the river bank. But just before they got to the river there was a marsh that the rabbits had to cross and while they were crossing it they ran over some frogs and the frogs hopped up crying, 'Quit it! Quit it!' So the rabbits said to one another, 'Those frogs are scared of us. We don't need to kill ourselves no more because something in the world is scared of us. Let's go on back home.' So they went on home happy again. Now that is just what the Israelites need—a victory. They just come out of slavery where they've been stomped down and trampled on. So we got to fight them Amalekites, and, Joshua, we got to win. If we don't these people will go to pieces and all our hard work will be undone. We got to win tomorrow, Joshua, for them."

"We would have a better chance, Moses, if you led us. You're a great fighting man of experience."

"Joshua, I done laid down the sword altogether. It wouldn't do for me to be seen with a sword in my hand. I am the man of God. But I'm going to fight them just the same, and I don't aim to touch a sword. You'll get help from me."

"How you going to do it, then?"

"I'm going to mount that hill yonder with my rod in my hand and fight 'em with powers. I'm going to be there with the rod of God in my right hand and, Joshua, they can't win. Otherwise they would whip our raw fighting men before noontime. I got to be there with my rod."

The next morning Moses took Aaron and Hur with him and climbed the hill before dawn. The Israelites and the Amalekites were on opposite sides of another hill close by. The Amalekites hustled around getting ready to attack the Hebrews as soon as the former got enough men, not dreaming that the desperate Hebrews were ready to fight. Moses had instructed Joshua to have his men drawn up and ready before daylight. When he reached the top of the hill with Aaron and Hur, he would wave a torch of fire just once. Then Joshua must rush down the hillside and fall upon the enemy with fury. At that moment, Moses would lift his hands against the Amalekites and Israel must win that day or be Israel no more.

Joshua went among his six hundred thousand poorly armed fighting men and encouraged them as he woke up the camp. Then all was ready. He looked to his sword, balanced his heavy-handled spear and stood poised on the hilltop above the sleeping Amalekites and waited. The fiery signal came and Joshua charged down the hillside and began to crowd the enemy camp. The Amalekites were pushed back and back. And Moses stood with outstretched arms, fighting for Israel with his powers. He was calling on the invisible powers from Mount Sinai to fight and they fought for him. The untrained ex-slaves fought like old veterans and drove the hard-pressed Amalekites from point to point.

Then Moses began to feel the weight of his arms. Against his will they began to sink a little.

"Aaron," he said tensely, "my arms are falling. Our men will lose and they just can't lose now."

"Don't let 'em fall, Moses!" Hur and Aaron begged.

"You think I want 'em to fall?" Moses asked. "Trouble is they done got too heavy for me." With dismay, they saw his

arms slowly sinking to his sides. But they saw something more. They saw the tide of battle turn. The Amalekites suddenly made a stand. They took the impact of the on-rushing Hebrews and hurled them back. Messengers came running to Moses from Joshua to ask him what to do. Moses sent back word what to do. Then his strength came back in his arms and he lifted and pointed his rod and strength flowed back into Israel again. The old men and women crowded hilltops and looked down on the battlefield and chanted. When the arms of Moses were up a high bragging chant filled the valley of strife. Then Moses' arms sank again and Israel was pressed hard, the nation of Israel muttered like sleeping thunder in the dark. And that was the way the fighting went all day. And Moses' strength was almost gone. He sat on the ground too tired to lift his head.

"Look and tell me, Aaron, how is Israel making out down there?"

"Pretty poorly, Moses. As far as I can make out from here, it looks like it's a big retreat."

"We can't lose, Aaron. We just can't lose. I keep on telling you. It'll be the breaking up of everything. We got to win. You all help me to my feet. I got to get my hands up as high as my head if it kills me. Help me up, you all!"

They got Moses up. The nation round about the fight was moaning low. Moses got up and his hands went high above his head and the Hebrews went to winning again, but they had lost a lot of blood. Then Moses felt his arms settling down and he looked through a dark cloud and saw the future of Israel. Beaten, dishanded and what was left of it, slaves again. The star of Israel sank with his hands. Suddenly he cried out to Aaron and said, "Come here, Aaron! Come here you two! Here, shove that big high rock under me so I can sit down. I just can't stand up no more. Now, Aaron, you stand here at my right hand and Hur you come stand at my left. Hold up my hands and I'll send the powers to fight our battle."

Moses managed to stay on his tired feet until Hur and Aaron rolled the rock up behind him for a seat. "Now you all,

prop me up on every leaning side. Don't let my hands fall. Aaron, you and Hur. We're holding up the world with these hands."

So the almost beaten and discouraged Israel staged a desperate rally to gain ground they had lost time and time again. Joshua stormed positions that seemed too strong to take and took them. He was thinking to himself, "I got to win for us else we won't be nobody. What's left of us will be less than we was in Egypt. There won't be no new God and no new nation if I don't win. I got to win for Moses. He done give all his life and his powers to us. Him and me got to win." So he led desperately and furiously and at darkfall stood master of a truly bloody battleground. And the surrounding chant of Israel was high and hoarse. Joshua surveyed the field and called his weary men to him and complimented them. "Rest yourselves the best way you can right where you are while I go up the hill and hear what else Moses wants us to do." So he climbed the hill to where Moses stood with his tired arms and shining eyes. Joshua took off his blood-soaked shoes when he stood before Moses and bowed his head.

"Nothing for you to hang your head about, Joshua," Moses told him. "You had a fight today that was a fight. Egypt's best general could not have beaten you today, not the way you fought and led."

"Thank you for your compliments, Moses. But if you hadn't of lifted up your arms—you whipped them Amalekites, Moses. All I did was to carry your sword for you." The two men stood face to face and embraced each other with eye-looks. Then they shook hands with a tight grip. "We brought them out from under Pharaoh with a high hand, Joshua. We crossed the sea on dry land. We have fought and conquered a nation today. So now we are ready for the mountain of God. Let's march to Sinai."

CHAPTER 32

Moses spent the whole next day counting up and dividing the spoils taken from the Amalekites. Horses, cows, mules, camels, women, wine and jewelry, and household vessels of gold and silver. So Moses was tired when night fell and went to bed early. He sent word for everybody to get plenty of rest in the next three days because in that time the sick and wounded from the battle ought to be up and around again. Then they would once more be on the march. The next camp would be the wilderness of Sinai, at the foot of the shiny mountain, whose mists veiled the presence of God.

Soon one morning they broke camp and set out on the road to Sinai. Miriam and Aaron came knocking at Moses' door just before he stepped out to see about the line of march. They stood still and waited for him to say something first.

"Good morning, folks, you're around sort of early this morning."

"It's time we was around some place," Miriam said and flung her head and gave a sort of wink to her hips. "The way things is going round here we ought to done been round your tent door."

Moses looked at both of them very hard and let them talk. Aaron saw Miriam looking at him right hard so he tightened

212

his face up and said, "We ain't being treated right, Miriam and me. Ain't no ifs and ands about it. We just done had the hog run over us, that's all."

"I'm not surprised at either one of you talking like you do, but I wish *you* would tell me why you do."

"Don't try to make out you're dumb now, Moses. You ain't nobody's fool. And we ain't neither. Here we done whipped old Pharaoh down and took this nation of people away from him and brought 'em safe across the Red Sea and done I don't know what all in these three months, let alone whipping them Amalekites and here you don't give us no credit at all. You and Joshua is everything and me and Aaron ain't nothing. And we're the very ones that got this thing together and kept it together all down the line."

"You done just fine down in Egypt, both of you."

"We're mighty glad to hear you own up to it," Aaron said in an ugly tone of voice. "Well, all right now, if we been all that help to you how come you don't show by giving us more offices and honors? Looks like we could have a badge of some kind and some regalia to wear in front of the people so they could know we're the three head bosses of Israel."

"And another thing, Aaron forgot to mention, is this Joshua who got his mouth stuck in everything. You got to put that young rooster in his place and make him stay in it. He's getting too biggity and sassy for any good use. Him giving orders to men with whiskers just like he was some priest and prophet."

"Don't worry," Moses said calmly, "that Joshua is going to be put in his place and I'll see to it myself that he stays in it. Now down in Egypt I promised both of you places of preference and you are going to get just what I promised as soon as things can be organized. That will be after we get to Mount Sinai. Now what else you got to say, say it quick so we can go."

"Well," Aaron said, "you know back in Egypt, Miriam was a big prophet and people come to find out things from her. But since we been out here, she don't get no recognition no more."

"You can't hold me responsible for that, can you?"

213

"Looks like you could stand her up before the people and tell 'em that you back her up as a prophet and look on her as a great one on—er—on equality with the best. It would mean a whole lot to her."

"Well, I tell you all, it's like this. You will get all I promised you back in Egypt. I recognize that you need rich regalia to dress in to keep you from feeling like slaves again, and I will see to it in a lavish way. But don't look for too much else. The Lord usually gives a man what he is worth. The question before the house is, how much are you going to be worth to the people on this journey, not how much the people are going to be worth to you. And leaders have to be people who give up things. They ain't made out of people who grab things. Well, goodbye, see you after Sinai."

Three days later Israel was camped at the foot of Mount Sinai. And Moses pitched his tent exactly at the foot of the eminence with all of Israel behind him. They looked towards Moses and Moses looked towards the mountain.

Joshua asked Moses, "Will you go up this evening, Moses?"

"No, Joshua. The shiny mountain is there in front of me and there are the people behind me that the Voice from the mountain told me to bring. But I can't go up there till I get a sign."

So Israel camped in the wilderness before Sinai and waited for the Lord to speak. Way into the night as Moses sat in the door of his tent watching the top of the mountain, he said out loud, "Well, Lord, here is Israel." But the mountain was dark and silent. It seemed as if the first man had never been on earth, so far as the mountain knew.

The next day there was great excitement. The people saw a retinue coming mounted on camels, donkeys and horses. There were outriders and glimpses of glittering metal as the sun touched here and there on the caravan as it came in sight around the mountain. The people, fresh from one battle, wanted to know who the travelers were and what they wanted. Some rushed back after swords and spears when they saw the armed outriders and the splendor of the equipment. Joshua, lounging outside the tent, saw them and called Moses to come

and look. "Must I choose out some fighting men and go challenge 'em before they get here and challenge us?" he wanted to know.

As soon as Moses could make out the white stallion at the head of the procession he knew who it was. Jethro had gotten his message and was coming to meet him. He could tell that was old Jethro on the racing camel right behind the white horse. He climbed up on a high rock and waved his hand in a certain way and Jethro broke out of the procession and came galloping up to Moses at top speed. Jethro put on a fierce scowl and came up looking every inch the stern patriarch, which was what he intended to do. He really wanted to grin from ear to ear when he caught sight of Moses but he thought that wouldn't do under the circumstances. And Moses had his company manners on, too. He jumped down off the rock and ran forward to the door of his tent. He had Joshua to help Jethro to dismount, then he himself ran and knelt down so low before Jethro that his head touched the ground. That made Jethro feel big for Moses to kneel before him like that before all the people. But in a second he touched Moses on the shoulder and whispered, "Get up out of that dirt, Moses. I know that I'm your father-in-law and all that, but me and you don't have to put on all these airs with one another, do we? Not after all these years, do we?" The formality of it made Jethro feel cold and distant from his friend.

Moses got on up. "Of course we don't need no airs for each other, Jethro. I just didn't want these folks to think I didn't give my father-in-law the right respect."

"Oh, is that the way it was?" Jethro asked and laughed with relief. "Both of us putting on outside show to the world. Now let's be ourselves."

"Well, Jethro, I see you got my message and come. That makes me as happy as two men. How's my wife and children?"

"Just as fine as silk. I brought 'em all along because they wouldn't let me leave 'em behind."

"I'm mighty glad of that. I'm just dying to see my wife."

"Oh, she'll be glad to see you again, too. She all dressed up

215

so till it would take a doctor to tell her how near she is dressed to death."

Moses laughed heartily, and Jethro went on. "Zipporah always was sort of queeny-like in her ways. Just give her the least excuse and she'll put her trunk on her back and the lid on her head."

"I brought her some more jewelry out of Egypt and a few Amalekite pieces I saved for her from the stuff after the battle."

"I don't know where she's going to put it. She ain't got a finger nor a toe left uncovered. If all them necklaces she got on don't choke her to death I'd sure like to know the reason why. All her life, my daughter's been going around looking for a throne to sit on."

"Let me go greet her and make her welcome and get you all camped and everything. Then you and me can sit and talk like we used to, only I got plenty to tell you this time."

"Well, don't let Zipporah tie you up the way she always does. This is the greatest day we ever spent together and we got to talk."

Moses hurried off to where Zipporah and her attendants were gathered. The male attendants had dismounted and were standing by their mounts as rigid as ramrods. But Zipporah still sat her racing camel with its splendid accoutrements. Moses made a low bow before her and helped her to dismount.

"You look very beautiful, Zipporah," he told her.

"Still?" she asked him with great happiness in her voice.

"Still and always, Zipporah. Come on into my tent while your own is being set up."

He took her hand and they started towards his tent.

"But where did you get all the retainers and guards and what not?" he asked with a sly smile. "You are as elegant as Pharaoh."

"Oh, you know those are papa's servants with a few extra Kenites for show. But I wasn't coming here before all these

people looking cheap. I'm the wife of Moses and Jethro's daughter."

She saw his face looking solemn and asked timidly, "You aren't mad with me, are you?"

"Oh, no, Zipporah, not at all."

"Well, what are you so frowned up about then?"

"You have come upon me in a solemn moment in my life. It's solemn for me, and for Jethro and for the people, and in a way for you too, Zipporah."

"Why? Oh, are you going to be King?"

"Oh, no, nothing like that. But you see, personally, my carefree days are over for a long, long time. I'm a leader now. It is a great hour for Jethro because his wish of a lifetime is fulfilled in part at least. For the people, an unsettled new life, and now they are here to meet a new God, and for the God to see them and pass on them. I don't suppose this ever happened before in the world and it might never happen again. And so far as you are concerned, you have lost the husband you used to have. I'm a leader now, and you'll have to suffer for it along with me."

"I'm still loving you, Moses. You see that I'm marching into your tent behind you just like that night—the night we got married, don't you? It's not all pride that keeps my bosom thrust out. There's some love there, too, Moses."

"That makes me real happy, Zipporah. We can talk about other things now. You can tell me about the children, and how Jethro is feeling about the great undertaking and everything tonight. Are these some of the clothes you bought recently? You wear your clothes better than Pharaoh's daughter. The womenfolks are admiring you too. Look all around you."

"I see them. Isn't that Miriam—that bitter-looking old woman over there?"

"That's right. She looks as if her face had fallen into disuse years ago."

"Oh, she just has the look of never having been loved. She has that terrible look of never having been nuded by a man.

217

I don't want her near me if I can help it. What on earth is all that she's got on?"

"Don't take it too seriously. It's her idea of what a leading woman ought to look like. She's the leader of the women of Israel, you know."

"Oh, is she?"

"And she feels she should be Leader-in-Chief. She has more brains and more courage, too, than Aaron, but no talent for leadership. Too spiteful and bitter. Life has been cruel to her. Don't judge her."

"She looks as if she's already judging *me*. She's the one you ought to speak to, not me. Go tell her to take that look off of her face. She doesn't look like she's expecting to meet God at all." She laughed and pinched Moses to make him laugh too. But he was solemn.

"Well, here we are at my tent. I'm sorry it can't be the jovial informal place that our tent is back home. This is the tent of the leader, with messengers and others running in and out all the time. But your own tent will be private."

At the door of the tent Zipporah looked back and saw that a great crowd, mostly women and children, were following them at a respectful distance. They had seen her come and watched her in growing numbers as she sat on her camel waiting for Moses to welcome her. More had seen her dismount, and that was when Miriam elbowed her way through the crowd to glare at her.

When Miriam showed herself through the growing crowd of awe-struck women, it was her intention herself to welcome Zipporah and as the leader of Israel's womanhood, impress herself and her office upon the wife of Moses. But the glitter and glamour of Zipporah's entourage and the poise and elegance of Zipporah herself had balked Miriam. She burst through the crowd and just stood there staring and glaring. The sight of the daughter of Jethro in her finery carried Miriam back to that morning long ago when she had seen the daughter of Pharaoh bathing in the Nile.

Miriam was very unhappy at sight of Zipporah. She knew

that all the feminine eyes of Israel saw the wife of Moses just as she did. They were bound to be impressed and to fall in behind her if she but beckoned. Miriam looked at her own rough clothing which was hung with jewelry that had been taken in battle, then turned her eyes away from the fine raiment of the woman on the camel. She looked again and saw well-cared-for hands and feet of Zipporah, and looked at her own gnarled fists and her square feet all twisted and coarsened by slavery, and almost snarled out loud. She, Miriam, had had so little in her life and now this place she had won by hard work and chance was being taken from her by the looks of a Prince's daughter who hadn't done anything but deck herself to come here and bewitch the eyes of foolish women! Miriam boiled with anger and a sense of injustice. So she snarled and said things to the women about her.

"Look at the hussy! Look what is getting down off that camel, will you! Somebody to come queen it over us poor people and rob us. Look at her trying to look like Mrs. Pharaoh! That Moses and his tricks. Fooling me and Aaron to do all the hard work for him down in Egypt and telling us all he meant to do for us as soon as he got to Sinai. Then soon as he got here, before he can talk to God, he got to send for that woman to put her over me! I'll show him. I'll show her too. I don't aim to be robbed out of my labor like that. Just look at her—the way she walks."

"I see her!" a woman at Miriam's elbow breathed in ecstasy. "Oooh, ain't she elegant! Ain't she pretty, though? I'd give anything to look like that. She looks like Mrs. Leader."

Miriam turned and spat at the woman, but unwilling as her eyes were, she saw the admiration of Zipporah in thousands of faces and she felt utterly helpless in the presence of it. She was carried forward against her will by the slow wave of women that crept behind Moses and Zipporah as they walked. She could see women already trying to set down their broad bare feet in the same way that Zipporah set down her dainty sandals. Her walk and her gestures were catching. They were more than willing to take the wife of Moses for a pattern. So

219

Miriam gave vent to her feelings in another way.

"Look at you!" she screamed. "Look at you! Running and gaping behind a woman and what she got on when we come here to this mountain to meet our God. Is that any way to act? You ought to be so glad that we got a God that made us free and now He is picking out a home for us and here you go running after somebody because they got on gold anklets and neck-rings and forget all about our new God in the mountain. Look at old Aunt Judy! Awringing and atwisting herself and grinning like she was some young gal! And she look like somebody slapped her in the face with a buzzard gut! All of you look like you done gone crazy! Get on back to your tents! Somebody in Israel got to have some sense."

Miriam changed the direction of their feet, but she did not change the direction of their thoughts. She went off to talk to Aaron about it.

Meanwhile Moses reached his tent door and ushered Zipporah inside. Then he stepped back outside to give final orders before he excluded himself from the public for the night. He told Joshua what to do and then saw Jethro approaching.

"You don't tell me you are turning in already, Moses," Jethro said with objection in his voice.

"Yes, I am. Got to talk with my wife."

"We got to talk some, too, Moses. Very important matters we got to talk over together."

"All right, you and I will talk all day tomorrow."

"But it's still daylight, Moses, we could go over a lot of things before dark if you would consider."

"Oh, well, it's so near sundown it's not worth bothering. See you tomorrow."

Jethro looked at Moses searchingly and said, "Moses, you are hurrying the sun across the sky to sleep with a woman."

"I believe I'm guilty, Jethro. It's your daughter's fault. It's a shame the way this woman keeps me running after her, but it looks like there ain't no help for it. I reckon I'll have to keep it up until I die."

"Don't forget you are called, Moses. You got a work to do

220

that's going to take up about all of your time."

"Did the Voice say give up my wife too? I hope not."

"But, Moses, you have to consecrate yourself for work that you got to do. Women pull men aside, you know."

"You're right, I reckon, Jethro. In fact, I know you are right and maybe the day will come when I can go by your rule, but I will have to get a lot older than I am. Right now it's too hard for me. How come I can't have my wife with me to enjoy?"

"Moses, I reckon each one of us is talking from his own standpoint. Maybe you're right and I'm wrong. People put a whole lot of things on altars that they can't put inside of themselves, so there's a pile of things on altars that ain't in people, and then again, there's a lot of things in people that ain't on altars. So I reckon it was meant to be like that."

"Yes, Jethro, I have found all that out for myself. Everything in its time and place. Zipporah is waiting for me. See you tomorrow morning."

Next morning when Jethro came to the tent of Moses to look for him he was out and gone. Zipporah was being moved to a tent of her own with her several attendants, and thousands of women were crowded around staring at Zipporah and her trappings. Mrs. Moses was the greatest sensation the women had ever had.

Miriam came up to look and see because the whole nation of women was talking about nothing else, and she couldn't stay away. They had no more interest in prophecy and politics. They were still interested in the earrings of Mrs. Moses and her sandals, and the way she walked and her fine-twined colored linens. What she was doing was the way they all wanted to do. Anyhow they could all dream about it and talk, even if they couldn't be like that. Miriam stood off at a short distance from the elaborate tent being put up for the exclusive use of Mrs. Moses and her saliva turned to venom in her mouth. She went up closer to finger the royal linen that Moses had brought out of Egypt for his wife. Then, as before, she looked down at her rough clothing and work-twisted feet and hands and she became aware of class. This woman of Moses'

had been oiled with something from birth that she lacked and the futility of wishing for it made her more angry than ever. She whirled to find Aaron and Moses so she could empty herself out somehow.

She found Aaron and had another talk with him, but Moses was holding big court out under a shade tree. People by the thousands stood around for him to pass on their cases. They had been waiting for several weeks for Moses to set court, and law cases had accumulated. Moses listened to evidence and passed out judgment until his mouth was tired. Then Jethro called him to one side and spoke to him.

"Moses, what you got all these folks hanging around you like this for?"

"Big court has set, Jethro. I'm handling cases."

"Is that what you call yourself doing? I thought it was a dog-fight or something like that going on. If you're handling cases why don't you handle 'em right, Moses? You can't make out the way you are going."

"How you mean, Jethro?"

"Look at all these thousands of people standing around waiting for their cases to come up. You can't handle that many cases in one day."

"Well, you see, Jethro, we've been so busy with other things that I just haven't had time to sit on no cases. Naturally everybody comes to me when they have words over things and I have to lay a hearing on each case."

"Well, I'm telling you that you just can't do it, Moses. You got more than two million souls under you and you ain't but one lone man. You can't listen to every little jumped-up fuss that people get up. It will wear you out and kill you dead. And then again it ain't fair to the people to come stand round you all day like this without knowing whether you're going to find time to see 'em or not."

"What am I going to do then, Jethro? The folks just will law one another. Somebody's got to sit on the case."

"You sure are right there and I don't mind telling you so. But you can't listen to every case. It's much too much. Tell you

222

what to do. You appoint good men to sit on all these small cases and get rid of 'em. You listen to the great big ones that nobody can settle but you. Then everything will work along smooth for everybody."

"All right, Jethro. That's a good idea you give me and I mean to carry it out just like you told me. You being a chief over people nearly all your life, you have learned something about how to handle 'em. I have been more of a military man."

"That is not your job in this case. You got to be something to these people that looks like God. That's a mighty big thing by itself. You appoint men to fight and men to judge, and men to wear the robes of priests and servants around the gathering place of the spirit. You have to be the something bigger and better than the robes and the outward signs. You have to stand between the people and God."

"That's a mighty big mouthful you said, Jethro. It's big like the womb of Time."

"I know it, Moses. But you can fill the bill. It's just one step higher up the shiny mountain for you, and you been climbing all the time. Be something pointing toward God to the folks, Moses. That's what you was born to be."

When Jethro's words went into the little door in Moses' ear, something else went inside besides. He felt that he had been embraced by Time itself. He was never to be the same man again.

"And if you don't mind, Moses, let me get on back home again."

"Oh, no, Jethro, I want you to stay with me all the time. I need you real bad to see this thing out to the end."

"You did need me, but now you don't. Let me go on home again. You got your wife and children now, and I done you all the good I could already. You know where home is any time you want to talk anything over. In fact it will be a help to you to come home and talk things over with me now and then. You know these woods and roads better than anybody else on earth. Much as you done traveled 'em. Come home for

a few days when you can. Sun-up tomorrow I reckon I'll hit the grit for home. Mighty lonesome there now without you and the children. Everybody married off and out of the house. It ain't much for me to do now but sit and think."

"I'll be there with you as often as I can get away. You know my heart is there, don't you?"

"Yes, Moses, I do. But this work done waited so long to get done, son. I hope you fulfill your birth-mission and do it right. Me and God neither one can't make out without you. We both realize you got an awful load to carry, but there wasn't no other way to get it done. Don't forget that when things get awful bad with you, me and God will both be sorry, but the mission, Moses, the mission." Jethro lifted his old hands up on the shoulders of Moses, gave him a powerful eye-look that lasted a long time; leaned his head on Moses' strong chest and hugged Moses very hard. In effect he had departed for home in spirit and at the same time pleaded for understanding. He was gone when Moses woke up in the morning.

CHAPTER 33

Next day at a good hour, Moses went up on the mountain as if he had been called. The shining mountain. The mountain with a Voice. The mountain that cloaked the Presence. The mountain that had given Moses and Israel a God. The mountain that had given him his rod of God. The mountain that was the altar of the world. That was the way Moses was thinking when he climbed up its woody slopes with Joshua following behind him at a distance.

And from the cloud-ringed summit the Lord called out to Moses and told him who He was. To make Moses remember, the Lord called to mind the victories over Pharaoh in Egypt and the miracles since Israel had crossed the Red Sea. So Moses told Him right away that he remembered well.

"Moses, I see the people you brought here before me and I think well of them. Now, if they will listen to me when I speak, and keep the laws I'm going to hand down, I'm going to make a peculiar treasure out of those same people."

"Thank you, Lord," Moses said.

"Now, Moses, you go back to the people and see to it that they wash themselves all over today and tomorrow and wash their clothes, too, and generally clean up and then you sanctify them for two days and get them all ready for the third day. And I am coming down in the plain sight of everybody on

Mount Sinai. And, Moses, I'm going to have a trumpet sound one long pull. And when you hear that, tell everybody to gather around the foot of the mountain. I'm coming."

Moses went on down and got all the people cleaned up and made all the arrangements. Then he told the people, "I know how forward and brash some of you people are, so I'm going to tell you right now that Mount Sinai is holy ground. Don't a one of you set foot on it, nor even put your hands on it. When the Lord appears to you on the top of the mountain, you stand still and listen because it is sure death to the one that touches that mountain. You hear me? Even your animals better not be caught grazing on it. And now don't nobody sleep with your husbands and wives until God done been here and gone."

It was the third day and it was morning. Moses got up soon and put on the special new robe that Zipporah had had made for him. Everybody was clean and dressed. A low rumble of thunder from the mountain brought everybody out of their tents to gaze at the mountain and to listen. They saw the huge white cloud drop down and rest on the crest of the mountain like a Pharaoh assuming his throne. Something like lightning played in fiery figures, over and above the cloud-like visitor and great flashes darted from the interior of the mass and went back inside again. And the trumpet on the mountain sounded so long and so loud that everybody trembled.

"Come on, people!" Moses called out and told everybody. "Come on out. God wants to see you and talk to you. Everybody come stand right where I put you on this low part of the mountain and don't nobody try to go up. You are here to meet God and listen."

Dense white and black columns of smoke rose from the entire upper half of the mountain, and the great mass shook and quivered like a forest. The voice of the trumpet got louder and louder. Then Moses spoke to God and God answered him.

Moses said, "Here's Your people, Lord. Where are You?"

"I'm coming down on top of the mountain to meet you.

Don't let nobody set foot on the mountain but you. But I want you to come on up to the top of the mountain. I want to talk with you."

Moses started on up the mountain and all of the people were scared for him. Some of them cried and begged him not to go. But most of them left their mouths just like the Lord found them. If they were open, they stayed open. If they were shut, they might just as well have had the lockjaw for all the use they made of their mouths. But right in front of everybody, Moses went on up into the smoke and flames and disappeared from sight.

And when Moses got up on the mountain top and vanished from the sight of the people, only one man had nerve enough to put his feet in the tracks of Moses. Joshua dashed from the multitude and began to run up the mountain the same way that Moses had gone. People hollered to him to stop. Some of them began to wail for his death, but he kept right on.

"You going to drop dead, Joshua!" some of them hollered. "Don't go up there, Joshua!"

"My bossman and leader went up there, didn't he?" Joshua called back.

"He got that right hand of his and that rod, Joshua. He can walk out of the sight of men. He got the black cat bone and snake wisdom. He's a two-headed man. He ain't like nobody else on earth. Better come on back, Joshua, before that snake gets to you. We don't see no more of Moses. Maybe he's dead up there himself."

"Well, if he's dead up there with God, lemme go up and die too." So Joshua entered the smoke and fire and disappeared from the people like Moses did. But when he got near the top of the mountain, glory awed him to his knees. He saw Moses standing higher up and seven suns circling around him and the moon was under his feet. Moses held his rod in his left hand and elevated it towards the center of a whorl of light. His right hand was lifted and glowed like the firmament at sunrise. Therefore he knew Moses had more power than man because a voice spoke out of the equator of the moving light and Moses

answered it back again. So that is how the people got laws and commandments from heaven, because Moses had power enough to take them out of the mouth of God and give them to the people. So Moses stayed up on the mountain and kept company with God for forty nights and days, and he didn't eat and he didn't get hungry. But he fed Joshua every day by a miracle. Therefore Joshua slept down below where Moses sat talking with God and saw Moses in a way that nobody else had ever seen him.

CHAPTER 34

Moses stayed up on the mountain so long because it takes a long time to learn God's secret words that have the power in them to make and to do. Moses learned ten words from God. So he took the ten words of power and he made ten commandments out of them. On the back side of the words there were seals and these seals had the power of all destructions. So Moses came down the mountain with plagues of death in his hands, besides more power to create and to do. And Joshua walked behind him in adoration and awe. Moses walked with the two tables of testimony in his hands and Joshua walked with worship.

But Moses had stayed within the aureate cloud for forty days and the people below had just about given him up. Most of them thought that Joshua and Moses were dead up there in the smoke. But some said, "Oh, he ain't dead. He just bit off more than he can chew so he done run off across the mountain and left us. We better begin to shift for ourselves."

They didn't say anything to Mrs. Moses because she seemed too much like a stranger to them to visit with her up close. Not that she tried to make them feel that way. But she looked like a ruler's wife to them and they kept off and looked at her tent and her servants and her clothes.

Aaron didn't give out any information at all. He kept on

saying, "How would I know what that man is doing up there? He never tells me nothing. The Lord told me and him and Miriam to run this thing, but you see how he carries on. He goes up on the mountain to talk to God by himself and that leaves me and Miriam in the dark. I am beginning to think like a whole lot of people in Israel. You can't put no dependence at all in no Egyptian, don't care who it is."

Miriam said, "Yes, that no-count Egyptian come with his mealy mouth and talked me and Aaron into bringing you all off. We was the ones that done all the work because he ain't one of us sure enough. He couldn't have got nobody to follow him. Here I was a big prophetess in Israel and Aaron was a leader, so the people followed us on and off and now he done took full charge and full credit for everything. We ain't even good enough to go up with him and speak with the Lord. And look at that dark complected woman he done brought and put up to be a Queen over the rest of us women. Why, it's awful. I never seen such a caper cut in all my born days."

"Well, that being the case, let's we back the deal. We don't know nothing about where we headed for and nothing, and nobody don't know nothing about this new Lord in the mountain but Moses and Jethro." A bosom friend of Aaron's said this and looked to Aaron for the approval that he knew he would get.

"But we do know something about our gods back in Egypt," Miriam went on. "Maybe that's how come we having such a hard time, because we done give up our gods. Isis will sure help you if you pray to her and pray right. Did the Bull God Apis ever go back on us? No!"

"Well, then now, how come we can't have an altar to our real gods and maybe they will help us. It wouldn't be a bad idea, seeing the fix we're in. Aaron, you been used to working gold. How come you can't make us a golden calf for our altar?"

"I ain't telling you all to do nothing behind Moses' back that he wouldn't like. But if everybody will go and break off them dangles off your earrings and build me the right kind of a fire,

230

I believe I could make a right good calf of gold for the altar. Then you can worship like you did in Egypt. Some of you go east and some go north and west and south and collect up all the ornaments you can get hold of. No telling what I might turn out if you all just will insist on me doing it. And while the image is being cast you all might just as well get ready to celebrate the service, you know what to do just as well as I do. Now everybody do around right smart and we might find something to consolate us out here in this wilderness where we been dragged for nothing."

The thing shook Israel like a wind. Suddenly the camp came alive. People stripped themselves and their children of ornaments and threw the things in the collection baskets with a smile. "A real old down home Egyptian ceremony getting ready to come off with Aaron at the altar. Just like old times back home. And they tell me a breakdown and stomp is going to follow." People began to rush around and collect wines and drinkables and stuff to eat. Everybody oiled their whole bodies before they put on their Sunday clothes. For the first part of the ceremony they put on their best clothes. For the last part they were prepared to take them off. So they oiled themselves all over. The oil would do for a dress in the after dance.

"When you reckon it's going to be ready to worship, Aaron?" the people asked him about the golden calf he was making with engraving tools.

"Tonight some time. Be ready tomorrow for worship, since you all are forcing me to do this thing."

That night when the image was cooling, Aaron looked at his work and admired it exceedingly. "That sure is one fine piece of work, if I do say so myself. Believe I'll make an altar for it while it is cooling." And that's exactly what Aaron did. And the next morning when the finger of the eastern sun pointed in the face of the calf and set it to shining and shimmering, Aaron got behind the altar and the people worshipped.

"These be thy gods, O Israel, which brought thee up out of the land of Egypt. We don't know anything about no Lord in

231

no mountain at all. Moses made Him up so let Moses keep Him."

Then they finished the altar part of it and got up to play. They cast off clothes and they cast off care. Drums and cymbals and harps and voices singing loud and happy. Shining bodies moved and turned and collided joyfully. Maidens danced in ecstasy with closed eyes and nobody looked too closely at faces. Joy was the feeling, joy!

CHAPTER 35

Moses lifted the freshly chiseled tablets of stone in his hands and gazed down the mountain to where Israel waited in the valley. He knew a great exultation. Now men could be free because they could govern themselves. They had something of the essence of divinity expressed in order. They had the chart and compass of behavior. They need not stumble into blind ways and injure themselves. This was bigger than Israel itself. It comprehended the world. Israel could be a heaven for all men forever, by these sacred stones.

With flakes of light still clinging to his face, Moses turned down the mountain with the tablets of testimony in his hands. He heard nothing earthly nor sensed anything about him until he descended to where Joshua waited for him. With his eyes turned inward, he sat down on a stone opposite Joshua to rest.

"Joshua, I have laws. Israel is going to know peace and justice."

Moses indicated the sacred stones on his lap.

Then from far off a sound, a noise made up of many sounds came up to Moses and he listened. And his ears accepted what his soul refused. It was a wild and savage shout of voices and drums that Moses heard, but his spirit rejected it, because it injured his vision of destiny for Israel. It clashed with his

exalted forty days. It soiled what had passed between him and God. So for a long time Moses sat silent and listened, hoping that he dreamed. Finally he asked Joshua, "Do I hear shouting and singing, Joshua, or is it just a ringing in my ears?"

"It's shouting and singing, Moses."

Moses sat sodden and sad for a long while and then a new hope crept into his voice.

"Do *you* hear anything that sounds like singing and cymbals, Joshua, or does it just sound like that to me because I'm tired and sort of frazzled out?"

Joshua looked at the face of Moses and pitied him.

"I hear a mighty loud noise down below," Joshua evaded.

Moses looked down at the stones in his lap and passed his hand over the carved figures reverently and then he looked back up the mountain as if he would retreat up there. Then he brought his attention back to the tumult below.

"Does it sound like the voice of the people shouting for victory, Joshua? Maybe the Amalekites have come up against Israel while we've been up here with God."

"No, Moses, it's not the voice of mastery that I hear. It's the voice of Israel, but they are not shouting for conquering anybody."

Moses sat and listened for a while longer, shutting his heart against what he feared.

"Well, Joshua," he said haltingly, "do they sound to you like they are crying out for help? They could be overcome, you know, by some nation that might attack, with both of us away."

Joshua listened carefully for a moment. "No, it's not the voice of them that cry for being overcome."

"What do you reckon could have happened to Israel, Joshua?" Moses tried to persevere in his hopes.

"Oh, that's singing and dancing that I hear. Sounds like the dance songs to Apis, the Bull-god to me. Listen at those drums!"

Moses snatched his face away from Joshua and the last glimmer of light that had clung to his face from God, died to ashes.

"Oh, no, Joshua, they couldn't do a thing like that. Not after all we have been through from Egypt on! Not after they cried to God to deliver them from Egypt and its sorrows! Not after the God of the mountain sent me to save them from all harm and danger, and brought them here to the mountain to give them laws and pledges! No, Joshua, they wouldn't be back in unforgetfulness and ingratitude here at the foot of Sinai. They couldn't be howling in idolatry in the very ears of God."

"It certainly is the sound of drumming and chanting to Apis that I hear."

Moses stood up and closed his eyes with the tablets clasped tightly to his breast. Then he started slowly up the mountainside again. "I better go back and talk to God again about Israel. He'd know better what to do than I would." He left Joshua behind him and struggled on back toward God.

But he didn't get far. At first he thought it was the wind scuffling around in the brush. Then he knew it was the Voice that spoke and halted him.

"Moses," it said like a strong breeze in the pine tops, "don't come up here to me. Hurry down!"

"Lord," Moses sobbed, "have they betrayed you?"

"They have betrayed me. They have betrayed you, and most of all they have dirtied their souls by betraying themselves. Go down, Moses, and halt them in their headlong flight. The people that you have brought out of Egypt have soiled themselves and tempted me to destroy them. They are worshipping a calf of gold and giving it the credit for bringing them out of the land of Egypt, and out of the house of bondage. Go stop them before I get too tired of their ingratitude and kill them."

The Voice was gone and the light was gone and Moses turned cold and heavy and went down the mountain like God descending into Eden. First it was the mountain top and then the high shoulder and then the heavy hips of the mountain and then the crumbling ankles of the mountain and then the plain where Israel waited for a sign from God.

So Moses stood before the altar of the golden calf with the tablets of stone in his hands. Drunken shouts filled his ears; bodies drunk on the liquor of feeling rocked and reeled and contorted about him with eyes glazed and covered. Aaron with his bearded chin stuck out in front of him was presiding at the altar. His two oldest sons, Abihu and Nadab, chief acolytes in the dance and revel were shouting and leaping, and thumping their naked bodies and urging the people on.

"Aaron!" Moses cried at him with a stern voice. "Aaron, do you hear me?" Moses had to call three times before Aaron really saw him standing before the altar with the law from Sinai in his hands. Aaron took one long comprehending look and sunk behind the altar on his knees. The eyes of Moses had gutted him. Aaron hid himself behind the pagan altar while Moses towered tall and grim before it with the tablets of God in his hands. All around the spot the tumult boiled, for few had seen with their eyes or heard.

The calf and all its meaning and all the thoughts it collected glimmered and winked at Moses from its altar and suddenly Moses raised one of the tablets with its fine writings and hurled it at the graven image and saw the golden calf topple over on its side. The force of the impact shattered the sacred stone and crumbled it in pieces. Moses lifted the other stone and hurled it, and the calf broke in pieces and the pieces scattered around the altar. But in breaking the calf, the tablets of testimony had been broken to crumbling stone. Moses stood in his wrath and considered. The law from Sinai had broken the idol of Egypt, but the sacred tablets had themselves been destroyed in the clash. Egypt against Sinai. It was going to be a hard struggle.

The crash of stone on metal had attracted attention. Drums faltered and stopped. Dancers paused and looked and saw Moses destroying Apis and froze to sculpture in poses, which broke into flight. Some ran heedless. Some crept off slowly with dazed faces to hiding places. Before Apis and Aaron they were clothed in joy and license. Before Moses and Sinai they were naked to their souls. They slunk into places of conceal-

ment as best they could. Moses strode over the huge vacant square of celebration with Joshua at his heels, looking, looking and seeing. Looking inside of people by their outward appearance and sickening at what he saw. He circled and circled and came back to the naked altar and stopped.

Moses found Aaron squatting down behind the altar trying to hide himself. Moses kicked over the altar and snatched Aaron to his feet and looked him dead in the eye. He looked at the man and saw him as he was, stripped of the imitation of dignity that he affected lately; saw him naked of the imitation of himself that he wore as best he might.

"Aaron," he said, "what on earth did these people do to you to make you bring such a sin on everybody like you did?"

Aaron tried to back off but Moses had him by his whiskers and he wouldn't let him go. So Aaron cringed and fawned and said, "Lord, Moses, you're my bossman, and I know it. I wouldn't think of putting myself on an equal with you. You're a great big high cockadoo and I ain't nothing. So you oughtn't to be wasting your time getting mad with me. You done been round these people long enough to know 'em. You know they ain't nothing and if you and God fool with 'em you won't be nothing neither."

"Aaron, you haven't said a thing yet to excuse yourself for what you have done. Tell me and tell me quick why you have betrayed God and the people in the way you have done."

Aaron lifted his hand as if to break Moses' grip on his beard, but the eye of Moses forbade him. He winced and said, "You oughtn't to hold my whiskers like that, Moses, the people are looking at us, and me being a leader—"

"The people are looking at you naked and capering around like an old goat, too. Let's forget about that while you answer me."

Moses did not miss the look of hatred born of hurt vanity in Aaron's eyes as he sought to placate Moses by dissembling.

"Now, Moses, you know these people is always up for something that ain't no good. They don't mean nobody no good including theirselves. Know what they did? When you

didn't come back right away they was going round behind your back running you down and scandalizing your name and making out you was dead or done run on off and they took and brought me all them ornaments, just because they knowed I used to work in gold, and they told me, we don't know what become of that man Moses. Make us some gods to march in front of us instead of that cloud. And they shoved all them earrings and things in my hands and naturally I didn't want to be bothered with the things, so just to get 'em out of my hands I took and threw 'em in the fire and what you reckon, boss? All I did was to fling them earrings into the fire, and out come that calf."

"Aaron, you haven't said a thing yet and that is because you haven't thought a thing yet, nor felt anything except your own importance. Your whole body is nothing but a big bag to toe your littleness in."

Moses thrust Aaron from him so roughly that he all but fell. Then Moses strode away, noting as he went how many people who had taken no part in the ceremony to the bull. There was open disgust on the faces of many and that made Moses think. Some were here because of Sinai and all that it meant and some were just here. A divided people, and that would never do, not at this point in their history. So Moses made a decision. He straightened his shoulders and marched to the gate of the camp and lifted both hands in the air.

People saw Moses standing like a crucifix and came. Moses still stood and they kept coming and questioning each other and coming. When a great multitude stood before him, Moses began to speak and cried out, "Who is on the Lord's side? Who is on the Lord's side?" Moses kept crying until the words became a chant. "Who is on the Lord's side?" Israel's ears were wrung. "Who is on the Lord's side?" It woke up fear in the guilty. Israel was stung. "Who is on the Lord's side?" It freshened hope in the hearts of the just. Israel was called. "Who is on the Lord's side?" And some young Levites were the first to come closer and say, "We are, Moses, we are for the Lord of Sinai." Then others joined until thousands upon

thousands stood by Moses. Then he said, "You who are on the Lord's side, take your swords in your hands and come to me." The surging multitudes of young men gathered around Moses with ready swords. So Aaron saw one of his sons, Eleazar, and all the other Levites go to Moses with swords and he was afraid to stay away. He came to Moses also with his sword and his censor in his hand and stood.

Moses said, "You all know what a foul thing has happened in Israel today. You know better than I do who the leaders and the agitators were. If this is to be a great nation, it must be purged of such evil-doers, or all Israel must perish. You have your eager weapons, men. Spare not a soul who is guilty." Their swords leaped out of their scabbards like day out of dawn.

The struggle began. Drunken people in hidden places roused from a stupor with their eyes wide open in judgment. Aaron saw two of his sons dragged forth and cut down before his eyes. He dropped his sword and swung his censor in wide arcs to call to the minds of the avengers that he was a priest. He stood between the living and the dead with his censor in his hand, weeping and quaking and cursing. He was afraid to fight, afraid to run and ashamed to cry out loud.

For hours there was fleeing and screaming and hiding and bloody swords. Then there was quiet again in the camp. It only remained to bury the dead. Aaron came creeping and looked down into the faces of Nadab and Abihu, his two dead sons, and wept. The men buried his sons with the other thousand leaders of the revolt slain by the sons of Levi. Aaron started a little song in his heart that went like this: "It's your time now, be mine after while. Oh, it's your time now, but be mine after while, oh, it's your time now, but it'll be mine after while." And from that minute on till the hour he died Aaron kept his eyes on Moses in secret and waited his chance. All he needed was the strength to seize his hour for vengeance. His hate was strong but his heart was weak. From then on for forty years the underhand struggle went on. Sometimes he made an open attack upon Moses when Aaron thought he could succeed, but

always the secret struggle went on to destroy him and have Aaron in the saddle. And always the strength of Moses trampled down the weak cunning of Aaron.

Moses was hard on Israel, after that. He felt that only discipline would save what he had begun and so he chastened the people severely. They suffered epidemics of ailments and many discomforts. It was then that he established the House of God. It was called the Tabernacle of the Congregation and Moses set it apart from all other tents, even his own. He pitched it far outside the camp. And when Moses went out to the tabernacle everybody saw him go and everybody was afraid. Would he lift his rod against them? Would he raise that right hand? As Moses went the people stood in their tent doors and watched him pass. And every eye in Israel followed him in fear.

They watched him go inside the door of the new tabernacle and they saw the shimmering cloudy pillar descend and they saw it stand at the door of the tabernacle and in awe they rose as one man and worshipped the God who had chosen to live among them. They heard the Lord talking to Moses from the cloud like two friends talking face to face. They heard Moses tell the Lord, "If you don't go with us, don't send me by myself, Lord. Other people will make a fool out of us."

So the Lord told him, "I'll always be there, Moses, because I love you and I know you by your name."

"Thank you, Lord. One favor more I want to ask you while I am still on pleading terms with mercy."

"What is it, Moses?"

"Lord, I done seen your pillar of fire and your pillar of cloud and heard your voice in rumbling thunder. I done seen the cloudy cloak that hides your glory, but I ain't never seen your glory itself. Lord, be so pleased in your tender mercy as to show me your glory."

The Lord answered Moses and told him, "Moses, I will make all My goodness pass before you. And I will proclaim the name of the Lord before you and I will be gracious to whom I will be gracious, and show mercy unto whom I will

show mercy, but, Moses, you just can't see My face, for no man can see My face and live. But, Moses, since it is you that ask me, look, see there is a place by Me and you go and stand upon that certain rock and when My Glory passes by, I'll take you and put you in a crack in the rock, and I will cover you with My hand while I pass by, then I will move My hand and you shall see the back parts of My Glory, but My face you shall never see."

So Moses thanked the Lord for letting him see that much and God told him, "Moses, get you two more nice smooth pieces of stone and bring it up to the top of the mountain so I can put those same laws that you broke upon that golden calf down again. These people need laws and rules to go by."

Moses got up early next morning and took the stones and went up to the top of the mountain and kept company with God again. And when he came down with the law in his hands, the skin of his face was iridescent and shining, but Moses didn't know it himself, that is, until the people gazed at him in awe and talked about his shining face. So they knew that God had covered Moses with His hand in the cleft of the rock and passed His Glory by Moses.

And Moses took the tablets of testimony into the tabernacle and the pillar of cloud went in behind Moses and rested on the altar. So that was the first time that God had come inside the house to live with people.

CHAPTER 36

And how is the black Mrs. Pharaoh making out this morning?"

"Who are you talking about, Miss Miriam?"

"Oh, you know I'm talking about that dark-complected woman that Moses done brought here trying to make out she's a lordgod sitting on a bygod. All dressed up every day like King Pharaoh's horse. She needn't think because her papa is some kind of a chief in Midian and she's married to Moses that she can come dictating to me."

"Is she done took to dictating, Miss Miriam? I didn't never hear of her saying nothing to nobody."

"She don't have to. But you seen her flourishing herself all over the place trying to get the influence of people's minds."

"You reckon?"

"No! I know it. She come here with the idea of getting control of the womenfolks and to root me out as a leader—after I done worked like a fool to get us free. Her idea is to get you all back into slavery again. You just swapped one Pharaoh for another one, to my notion. You don't want to go back into slavery, do you?"

"I sure don't. I used to get so tired of kneading dough for them rich Egyptians to eat. My knees was all wore out from kneeling down all day and half the night over them bread

troughs. No, sir! I sure don't want no more slavery. Though I sure would love a loaf of that good old Egyptian bread."

"Well, you women better get together and do something or you will find that Ethiopian woman and that Moses will have us all out here in the woods using us for slaves."

"What can we do to head it off?"

"Get together as many women as you can and go stand around the tent of Moses and holler for him to get rid of that Ethiopian wife of his."

"Thought you said she was a Midianite?"

"Oh, don't try to take me up on every little point. Even if she was born and raised in Midian her folks could still come from Ethiopia, couldn't they? Tell me! Look how dark her skin is. We don't want people like that among us mixing up our blood and all. That woman has got to go. Go get up some people to protest. When enough of you all get around this tent, my brother Aaron and me will go see Moses and demand him to get her off the place. Got us round here looking like her servants."

Miriam walked and talked all day so that by three o'clock that afternoon two or three thousand women were milling around the tent of Moses and muttering. Finally Moses sent Joshua out to demand what was wrong out there. Aaron and Miriam stepped out of the crowd and answered him. "It's no wonder the people is dissatisfied," they told Moses. "You got that strange woman around here—"

"What strange woman you talking about?" Moses asked shortly.

"That one in your tent," Miriam said perversely.

"She might be strange to you, but she sure ain't no stranger to me. She's been my wife more than twenty years. I hope you don't aim to tell me that I can't have my wife with me. I hope you ain't messing in my business to that extent."

"I mind my own business and I let other folks' business alone. Anybody that knows me can tell you that." Miriam evaded for the moment.

"Well, what do you think you got to do with my wife being here?" Moses insisted.

"Tell him, Aaron."

"That's right, Aaron, you tell me. I know you two ain't using up my time to try to break into my arrangements. Go on, Aaron, and tell me what you got to say about my wife."

"It ain't so much her being your wife as it is who she is."

"Jethro's daughter is good enough for anybody and any place. In fact, it is hard to find a place good enough for her. I could draw some harsh comparisons between you, but I won't do you that bad."

"It's her color, Moses. She's too dark to be around here."

"Why?"

"Well, you see the people, that is, the ladyfolks, don't want her ruling over them, dark as she is."

"In the first place she ain't ruling over nobody and in the second place she's my wife and nobody ain't got nothing to do with how dark or how white she is but me."

"Oh, yes, we have. That's the very thing we don't like. You act like you're the boss of everything. God didn't call you, and you only, you know."

"Who else did He call, then?"

"He called me and Miriam too. All three of us is supposed to be on a equal balance."

"He didn't call you and you can't balance equal with me, but even if you could how come you think you got leave to stick your bill into my private business?"

"It's not us, it's the people. We don't care if she was black as tar. But the people come crying in our ears and we have to look out for what they want."

"That's a lie, Aaron. Nobody didn't come to neither one of you to complain about my wife's color. I got eyes in my head and ears on other people's heads. You two been proaging this camp over all day long working this thing up. Nobody here don't care anything about my wife's color. Haven't we had the mixed multitudes with us ever since we started from Egypt? Didn't they march out with us and not one soul in Israel has

ever mentioned the subject. I know exactly what's the matter with you two. You want to stand in my shoes which they are much too big for your feet. The women all are making admiration over my wife and now Miriam is jealous and spiteful. I've given up everything else I wanted in life for the sake of this mission I have, but I mean to protect her against your littleness and malice."

"You wrong there, Moses. We ain't got no feeling against your wife. But we can't afford to look over the wants of the people, Moses. We got to consider the people."

"Aaron, you got ambition to be a leader without having anything else to go with it. I been noticing you tipping around and plotting and conniving. But you'll never be a leader. You are much too sensitive to the wishes of the people but you are too unconscious of their needs. And then again, you got a big idea of your own importance. I wish I could buy you for what you are really worth and sell you for what you think you're worth. I sure would make money on the deal."

"Don't let him holler you down, Aaron," Miriam jumped in. "The Lord did call us just as much as He did Moses and it's about time we took our stand in front of the people. I was a prophetess in Israel while he was herding sheep in Midian. And that woman he done brought here to lord it over us, that black Mrs. Pharaoh got to leave here right now. She ain't going to lord it over me, after I done done all the hard part of it."

"Miss Miriam, your case is pitiful. The trouble with you is that nobody ever married you. And when a woman ain't got no man to look after, she takes on the world in place of the man she missed. You are one of those people who learn nothing in the long turnings and twistings of experience. But you better keep my wife's name out of your mouth. That's all I got to say."

Miriam lifted up her voice so all the women on the outside could hear what she said.

"Who you talking to, Moses? I know you ain't trying to tell me to shut up. The Lord don't speak through your mouth

alone. He speaks through my mouth and Aaron's mouth just as much as He speaks through yours."

Moses rose in fury. "Come on over to the tabernacle, both of you, and we'll see who the Lord called and who He didn't. We might as well settle this thing in front of everybody once and for all."

So they three went to the Tent of Testimony with a great crowd following behind them and set the ceremony. And the Voice spoke out of the cloud and was angry with Miriam and Aaron. Then the cloud lifted and everybody saw that Miriam was a leper. Aaron fell on his knees and called Moses by all the praise-giving names, and begged for both of them. God! Miriam was a horrible sight in her leprous whiteness! Everybody shrank away from her in terror and disgust. So Moses put her outside of the camp as unclean for seven days. The camp remained stationary until she was healed again. All the rest of her days, Miriam was very silent. Whole days passed by at times in which she never uttered a word. Those seven days outside the camp seemed to put a veil between her and the world which never lifted. Now and then she would whisper to whoever happened to be close around. "He lifted his right hand. I saw him do it. He lifted his right hand and the thing come upon me. I felt it when it come. His right hand was clothed in light."

CHAPTER 37

The months and years went by. Moses had long ago sent his wife back home to Jethro, not because he no longer cared, but because this great thing that had grabbed hold of his life was doing things to their life together. Both of them changed under it. Moses became even less talkative than he had always been, and he had never had too many words to say. He lived in deep thought and reflection. He spent whole nights in the mountains alone except when Joshua followed him without his consent. Several times he crossed the mountain and spent a day or two with Jethro to talk things over and he always found help and comfort in the old man. The visits never failed to benefit both Moses and Israel.

Zipporah changed too. She was born the daughter of a powerful chief and though the fortunes of her father's house had gone down for a while, this was changed with the coming of Moses, and the wealth and prestige of Jethro's house was as great as any in all Midian. So she was used to ruling and seeing ruling done. To her, the most natural thing in the world would have been for Moses to assume the crown of Israel. She felt that the people expected it. And in fact they would have preferred it. They were used to Kings and rulers and felt lonesome and defenseless under this light pressure of leadership that Moses exerted. But Moses was stubborn on that

point. He had no wish to impose his will on others and he said so every time the subject arose. So she looked towards what had been in men's relations to each other, and he faced towards what was to be, and a whole world stood between their two horizons. So after a while she was glad to leave the meager, hard fare of the camp and return to Jethro's tent. She understood herself there and felt that she knew the Moses who snatched a few days from Israel now and then to spend with her and Jethro. She took her younger son back with her to be company for her and to help Jethro, now that he was getting feeble with age. The oldest boy, Gershom, had stayed in the camp with Moses, and had become a Prince of Israel in the new order which Moses had set up, as a sop to certain Elders in Israel. The hosts of the Hebrews were growing rich as they moved on by war and plunder, and the heads of families wanted some excuse to show their wealth. So titles and ranks had come to be, with the Levites outranking every other tribe. And Zipporah's son had become a Prince even though she never became a Queen. On the whole, however, Zipporah's mood lacked light.

But still Moses led the people. He thought and led. He prayed and led. He wrote and had his moments of philosophy and led, even when he knew that he would have been better loved as a King and more popular as a politician. But he chose to be a leader and he was. He stood in his high, lonely place and led. Jethro and Joshua glimpsed through the clouds that hid the peak where he stood from the common herd, but that was all. Joshua was so attached to him that he continued to serve about his person as often as he could despite his own leadership in the army. That pleased Moses and helped Joshua, for Moses spent hours at times teaching the younger man strategy and discipline of men.

This was not just sentiment on the part of Moses. Israel was going to have to fight and fight hard many times before the sons of Jacob should find and possess the place that was to be their home. So they needed military men to lead. Jethro had warned Moses that he must not take the risk of getting killed.

Military officers could be made at any time, but the genius of Moses could never be replaced. So Moses taught Joshua and let him lead the army. It was easy to teach him, for Joshua had those things in him that make a great man of war.

There was something else about Joshua that encouraged Moses besides his unfailing loyalty to his chief and the cause. He had all those big virtues that command respect, and all those commonplace vices that make men understood. Men congregated about him. They respected his virtues and admired his vices. So he became the left hand of Moses, and Moses confided in him freely about his plans and afterthoughts. Joshua knew all of his hopes and disillusionments. All Israel had heard of the Promised Land, but only Joshua had heard the name of Canaan coupled with it.

"It's a mighty fine place for a homeland, Joshua," Moses confided to him, "but I don't know yet whether the people have got back enough of what Pharaoh took out of them to go take it. We got the outside stuff to take it, but I ain't positively sure we got the insides yet."

"The way I see it, Moses, we ought to have it now. I'm ready if you're ready to tell me."

"No, we got to feel our way along, son. We got to go slow," Moses said, sliding into the mood and the expressions of the people as he liked to do at times. "You done seen how they blow up for nothing at all and fight against their own selves and all. I done found out from this that people can do an awful lot of feeling without doing a lick of thinking. And you and I know that we have some folks around here that loves to stir up feelings for their own benefit. I ain't naming no names. I'm letting things ride for a while longer till I see further."

"Well, Moses, I'll tell you like you told me once. Silence is all the genius a fool has and it is one of the things a smart man knows how to use when he needs it. You know what to do and how to do it better than anybody else but God."

"Thank you, Joshua, for your words and what I know is behind 'em. But, Joshua, with that other ear that I don't use for everyday listening, I hear a crowd coming here to talk. Go

round the bend of the road there and meet whoever it is and see can't you straighten out the business they coming after. That will give me a chance to go on with my writing. I'm a week behind on my journal right now."

Joshua hurried on out and disappeared around the bend in the road and came face to face with the committee of seventy Elders on the way to confer with Moses. As soon as they saw Joshua, they hurried up to him and asked, "Is that man Moses in his quarters now or is he off hiding out in the mountain like he always does when we got something important to take up with him?"

"Don't waste up your time lying up some nerve to say what you ain't got guts enough to say otherwise. Tell me what you want and maybe I can get it for you."

"We didn't come to talk with Little Moses, we got business with the real thing. If we wanted to talk with substitutes we got Aaron right along here with us, and we wouldn't need you with him along."

"I ain't no Little Moses, even if you all done give me that nickname for spite. But just the same you better tell me what you want with the chief or else you won't see him at all. There's a few things I can do to save him some work and worry. Maybe if you'll tell me I can do you some good."

"All right, little leader, you go get us something to eat. We want plenty of everything and we want it right now. We want fresh meat and vegetables and fish and fruit and if we don't get it, we can get another leader that can take us back to Egypt. We ain't the helpless people we used to be."

"This talk is too serious for me to listen to."

"We thought so in the first place, but you just would dip in."

Joshua singled out Aaron and talked to him. "Aaron," he told him, "You know that Moses ain't got no provisions stored away nowhere. He eats the same as all the rest of us. Why don't you explain to these people so they can be satisfied and not worry Moses for nothing?"

Aaron stroked his long beard with a smug hand gesture and

generally settled his priestly robes before he spoke.

"Oh, I can't say I know that much about the way Moses is running things. He don't count me enough to tell me nothing. How am I going to tell people something I don't know my own self?"

Joshua stood there for a minute feeling them stoning him with evil thoughts. Then he turned to go.

"Well, I'll go tell Moses that you are coming. But you all got the wrong idea about things."

Joshua re-entered the tent of Moses and stood and waited for Moses to recognize him, the way he always did. Moses looked up from his writing. "What's the matter, Joshua?" he asked.

"My people! My people!"

"What's wrong this time, Joshua?"

"I reckon you're going to have to take your rod and do something for 'em or something to 'em, one. My people just won't do. That complaint committee is outside to see you. The people are grumbling again."

"Over what?" Moses asked with a touch of impatience.

"Excuse me, chief, for talking with my mouth wide open. The people is mumbling and grumbling about something to eat."

"Tell them seventy Elders to come on in, Joshua. Maybe I can make 'em understand why we are out here, but sometimes I doubt it."

The committee of seventy filed into the tent and stood gloomily behind Moses. He turned his chair to face them.

"All right, get it told. What's the matter now?"

"Moses, we're hungry."

"There's plenty manna. I see to that every day."

"But we're tired of manna. We want something else to eat."

"Why don't you find it then? Nobody is stopping you, are they?"

"We can't find nothing around here."

"If you can't find anything except the manna which I provide for you, how do you expect me to find anything?"

251

The committee began to boil like a pot. The spokesman whirled and made gestures with his hands. They acted out desperation, despair and futility. "Lawd, listen at that man! Here he done took and brought us out of Egypt where we was getting along just fine. We remember the nice fresh fish we used to get back there in Egypt every day. Nice sweet-tasting little pan-fish and a person could get all they could eat for five cents. Unhunh! and didn't we used to eat 'em, too. And the nice fresh cucumbers, and the watermelons, and the leeks and the onions and plenty garlic for seasoning! You could get a decent meal most anywhere before you could turn around. And now look where we're at—out here in this hungry wilderness with our souls all dried up and nothing but this manna before our eyes. Oh, we wish we had of died down there in Egypt instead of coming off like a pack of fools."

Moses listened until the end and then he said, "I'm sure sorry for you all, but not because you are crying after the fleshpots of Egypt. I'm sorry for you because you don't feel hungry nowhere else except in your bellies. You have lost sight of your high destiny in your scramble after food. You hate me at times for not being more interested in your stomachs than in your hearts. You are looking at this thing from one viewpoint and I'm looking at it from another. Here I am struggling to make a great nation out of you and you are worrying about fried fish and cucumbers! Do you see me eating anything like that?"

"We don't know what you eat while you shut yourself up inside this great big old tent."

"Where do you reckon I would get it from?"

"Oh, you got that right hand of yours and that rod, ain't you? You got quails and this manna and water and a whole heap of other things with it. You could give us anything we wanted if you would."

"I see. You trust my ability, but you don't trust my judgment."

"We don't mean it that way exactly. But it's hard to love freedom if it keeps you hungry."

252

Moses saw a certain pleasure in Aaron's eye so he said, "Aaron, you could help out the people in a case like this."

"Oh, they know that if I had the power you got they wouldn't want for a thing. I been all through what they been through and I got some sympathy for 'em. They all know that."

"I see, Aaron. I see just what you mean, and it ain't what they think you mean, but we'll come to that part later on. Now, you Elders of the people, somebody done got you in the notion that I can get anything you want to eat and drink at a moment's notice. Supposing I could. But that ain't the question. I don't want to spend all my time and strength pulling miracles for the sake of your bellies. I'm here to make a nation out of you all, if you will work with me."

"Lord, the man come talking about making us a nation when we ain't even got garlic to season with! We want something besides this manna to eat."

Moses stood up and looked down on the committee and said, "It's a good thing your cattle can't talk or they would slur you as you do me, for your lack of interest in fodder. Well, go on home and I'll stop planning the future for you for the moment to satisfy your lusts. But it is getting a little tiresome, this always assailing me about trifles. You committeemen never come to help me, you come to complain."

They started on out and Moses let them go, all but Aaron. When they were alone Moses said to him, "Aaron, you ain't as helpful as you might be. I been noticing it right along. Here I made you the high priest, and gave you all the pomp and regalia that I could but you still don't seem to feel your responsibility the way I would like."

Aaron fingered the jewelled girdle about his loins and stroked his beard. "Oh, well," he said, walking to the door, "maybe there's a lot of things you don't understand. Maybe sometime you'll find out you can't dog people around and dominate 'em as you see fit. That you can't use other folks for your stepping stones and then throw 'em away." Aaron flourished on out and around the bend of the road and left Moses

in deep thought. Moses made two decisions and called Joshua.

"Joshua, get ready. I am going to send a representative from each tribe to spy out the Promised Land and you are going. Call a meeting of the Elders and find out who the other eleven men are by tomorrow night. I want this pilgrimage to end before long."

CHAPTER 38

T he other decision Moses kept to himself. But with his plan all formed he felt better. The spies would come back with a favorable report. They were bound to. It was late August and all of the fruit trees would be loaded down. He had been in Canaan at this time of the year and knew what it looked like. They were bound to be favorably impressed. Then a swift, hard military thrust and the journey would be over. The Israelites would have a home, a God and a name. He would miss the mountains of Midian with Jethro's sheep trotting before him. The long exchange of thoughts with Jethro and the little comforts and delights with Zipporah. Jethro was getting mighty old. Maybe Moses would get back in time to spend a year or two with him. He hoped so very much. That night while the people feasted on quail which Moses had brought in to them on a big wind, Moses sat on the side of the mountain and fought with himself. He asked himself, "Why not go on home and leave these people to do whatever they want to? Aaron is stupid and full of conceit like all little men suddenly elevated to places of power. But if he wants to lead, why not go on and lead your life and let him lead? You brought them out of Egypt with the might of your right hand and you have done this thing up to now. Here they are in striking distance of Canaan with an army and with laws

and statutes. Why not quietly go on home?" It was a tough battle, but Moses came down the mountain in the morning and went on with his plans for taking Canaan. For a period during the night he had had a vision of freedom but morning found him back in harness. He was a man who had been called.

Forty days passed and the spies came back. They came back with a bunch of grapes that it took two men to carry and they brought melons and cucumbers and various fruits and vegetables and the people were fired to go where things like that were growing.

Then they heard about the people they had to fight before they could own the land and another wind swept the camp. It made no difference that two of the spies sent out said that they had a good chance to win. Not even the word of Joshua, the military leader of Israel, could talk down the fear inspired by the other ten.

"The land is rich," Joshua and Caleb told them. Caleb said, "All we got to do is to go take it. It's right there for us, ain't that right, Joshua?"

"It certainly is. We could lay down a hard campaign of two weeks and own every inch of Canaan from end to end. All it needs is some good hard fighting before they get time to double-teen us."

Another spy said, "Don't you all listen to Joshua and Caleb. Them two is crazy in the head. Just listen at them now and all of us will be dead. Them people live in stone houses and even the town's got walls around 'em. We couldn't never take 'em. And just look how many nations we got to fight! There's the Amalekites, and they live in the southern part there and they are stronger than they was when we fought 'em a few years back."

"But we are stronger too," Joshua cut in. "Don't forget that. And then another thing, we was just as green as grass when we whipped 'em last time. We ought to mop up for 'em this time. Shucks! They ain't no trouble."

"Don't tell me they ain't no trouble. And then there's some

256

mountains all around and they just full of fighting folks. There's the Hittites and the Amorites and the Jebusites and, man, those folks can fight. And then over along the seacoast those Canaanites, and there sure is plenty of 'em to fight too."

Caleb said, "Aw, let's go on up and take the place. We can beat all those little nations one by one. Half a day to a nation and take that place. It sure is pretty country. Then we will have a place of our own that we can rule over and do as we please."

"Folks, don't you let Joshua and Caleb fool nobody. You ain't heard the worst yet. Do you know we passed through one place where everybody was giants? Yesirree, those men of Anak are sure enough big men. Why, they are so big we look like grasshoppers to ourselves beside them and that ain't the worst of it, we looked like grasshoppers to them, too. Don't you let Caleb and Joshua fool you to run up against those people. Wouldn't nothing be left of Israel but a grease spot."

A few men wanted to follow Moses, Caleb and Joshua, but the big majority got scared and pulled back. They got so scared that they got mad.

"From one thing to another, that Moses keeps us in a strut. If it ain't one thing it's another. Now he wants us to go get ourselves killed just to make him a King and we just ain't going to do it. That man don't mean us no good at all. Let's go on back to Egypt where we belong, but first thing let's kill him for bringing us off."

Moses heard the mad clamor of the multitudes and knew the danger that he faced. Men circled him where he stood, snarling like animals. All they needed was a leader with courage enough to cross that small bare circle of ground that separated them from Moses. "Now is your time, Aaron," Moses thought to himself. "Now is your time if you only had the courage to seize it. But you are a snarling hyena, waiting for some lion to make your kill for you." But never for a moment did Moses forget that some unknown might find the spark that would destroy him, and more than that, destroy his mission. But in spite of it all he was cool enough to note the shuffle of the grass in the wind and the little dance of dust in a whirlwind. He

257

realized that he was in great danger of being taken for a mere man where he stood. While in the Tabernacle of the Congregation they could scarcely think of him apart from the mysteries. So he turned suddenly and walked in that direction, wondering if he would live long enough to make it. And the clamoring mob, led by their Prince, followed him.

He invited the Princes and the Elders to enter and told the people to wait outside. He entered last and faced the angry Princes and Elders for a full minute in silence then fell on his face in the door.

A great gasp went up from the Princes and the people outside crowded back from the door in some nameless fear. The figure of Moses on the ground did not look helpless somehow. It inspired more terror than it would have even with the uplifted hand. Everybody shrunk away as far as they could.

Old Miriam outside crept forward a little in front of the others and then backed away as fast as she could. Then she broke a silence of several months.

"Something awful will happen from this," she whispered from a throat so dry that it rattled. "It is a bad sign. He will lift that right hand and Israel will suffer terribly. It is better to do as he says."

The people and the Princes stood back and gazed on Moses. Not a man in Israel would have touched him. Their weapons were frozen to their hands, though the wish for his death was in the minds of many Princes and Elders. Moses sensed his victory and slowly stood erect.

Moses stood up and swept the nation with his eyes and they were scared.

"Lord," Moses said, "what kind of cowards are these You sent me to lead? You bring them out of slavery in Egypt with a high hand. You take care of them in the wilderness. You speak to them from Sinai and point out a beautiful rich country which You tell them is theirs. All they need to do is to show fight to a bunch of scrub nations and take the country and cease their wanderings in the wilderness. But will they do it,

Lord? No! They are cowards. And none of these slave-minded cowards shall enter the land You promised them. They shall wander in this wilderness until they are all dead. That is, all those who are grown enough to know what they are talking about. Their carcasses shall rot in this wilderness. I am not talking about Joshua and Caleb, Lord. I am talking about these others. I can make something out of their children, but not out of them. They have the essence of greatness in them and I shall fight them and fight myself and the world and even God for them. They shall not refuse their destiny. In this wilderness shall they be consumed, and here they shall die."

When the people thought overnight about what Moses had said, they were more scared of him than they were of the fighting nations. So they got up soon in the morning and went up on the mountain and told Moses that they were ready to fight now, and they were willing to acknowledge to the fact that they talked too much the day before. But Moses told them, "It won't do you no good to come around talking about fighting today, because that ain't in my plans. You're just breaking into my arrangements to be starting any war today. Go on home, all of you. The Lord ain't helping you do no fighting today. You go beyond that mountain and tackle those Amalekites and Canaanites and you'll get your whipping because I'm not going and the Ark of the Covenant is not going and Joshua is not going, so if you want to be hardheaded and go jump on those people, go right ahead."

But some of the Princes told the people to come on and fight, because, they argued, if they won't it would prove that they didn't need Moses as much as they thought they did. In fact, if they won they could cut loose from him and God and everything else and be so free till they were foolish. So they went on to fight and the battle went against them from the beginning and they had to run it out for the most part, those who were able to run.

Therefore next day Moses turned the hosts of Israel back into the wilderness to serve their forty years and grow men and women in places of slaves. To wander and to fall down

and to die in strange places where nobody lived and where nobody would live again for thousands of years. The Voice had said to take a nation across the Jordan, and the generation which he had brought out of Egypt had failed him. "The third generation will feel free and noble. Then I can mold a nation. Forty years is a long, long time, Joshua, but the Voice commanded me to lead." And Moses was very sad.

CHAPTER 39

They wandered in the wilderness and wandered and sickened and died and gave birth and revolted again and again. So they came in their wanderings to Kadesh which is in the desert of Zin.

Moses was sitting in his tent writing when he looked up and saw Miriam standing over him. Everything about her was asserting itself that day. Her rusty gray hair that used to be a dry-looking red; her pale eye-lashes that had always been that way and her drooping jowls and shrunken-up figure.

"Well, Miss Miriam," Moses said, making a place for her to sit down, "this sure is a surprise, you coming to pay me a visit."

"Naw, it ain't," Miriam said without taking her eyes off of Moses' face nor changing a muscle in her own. "Nothing don't ever surprise you. You know everything beforehand. You know, but you let things happen for reasons."

Moses looked at the mask of her face. It looked like nothing had moved in it for years. Nothing had gone in its portals and nothing had come out. It seemed to have finished with everything and just to have been waiting on time.

"Moses, I come here this evening to ask you to let me die."

"Why, Miss Miriam!"

"I ask you kindly, please, Moses, to let me die."

"What makes you think you got to get *my* consent to die?"

"Cause I know I can't die without it. That right hand of yours—it's got light in front of it and darkness behind. Moses, I come in the humblest way I know how to let you know I done quit straining against you. I done quit putting my poor little strength up against yours. I'm just a beat old woman and I want to die."

"But, Miss Miriam, you ain't had time to enjoy your freedom yet. You ought to want to live to enjoy it and to see Israel a nation."

"This freedom is more than a notion, Moses. It's a good thing. It's bound to be a good thing 'cause everybody wants it. But maybe I didn't know what to do with it, 'cause I ain't been so happy. That ain't what I come to talk about, Moses. I come here to ask you to please let me die."

"That's something nobody ain't never asked me before. That ain't something that I can pass on like the vessels before the altar, Miriam. God got to tell you that and he is seldom known to even do that."

"I want to go on back home and lay down, Moses. Is you going to let me die or not?"

"Miss Miriam, you sure your mind is all right and everything?"

"Yes, I'm real sure, and I know I want to die. I reckon I done tackled something too big for me and it done throwed me like a bucking horse. I been through living for years. I just ain't dead yet."

"How long do you figure you been through living, Miss Miriam?"

"Ever since I spent that week outside the camp when, er—when I was a leper. When I was unclean and had the leprosy and looked at myself all over and I was shut out from everything and from the living. That was when I got to thinking with only certain places in my head and I got to fleeing all over with fear. And you showed me your hand, that shiny right hand of yours, every night while I was outside the camp there in the dark. You kept it held up over my head and I'd run all

night long but I couldn't get away from it. You see, I was a prophetess back in Egypt and I had power, that is what the people told me, anyhow. So when you didn't do to suit me, I made up my mind to fight your power with mine. But I found out I was no more against you than a grain of sand against a mountain, because you beat me and then you bottled me up inside of my own body and you been keeping me in jail inside myself ever since. Turn me loose, Moses, so I can go on and die."

"I can't stop you from dying, Miss Miriam. This notion you got must come from a long way off because it is so strange."

"Moses, I'm going home to lay down to die. Don't let me see your hand over me like it's been every night for years. I don't need to drag my bones to Canaan to lay 'em down. This wilderness will do if you are through with me."

"Just what did you want me to do about your case, Miss Miriam?"

"You know just as well as I do, Moses. Just let your right hand fall from over me. You still punishing me about that wife of yours, Moses? Don't hold me here no more. Open your fingers, Moses, just a little bit and let the husks of a weak old woman escape out past 'em."

"Do you think that I am God, Miriam?"

"Indeed, I don't know, Moses. That's what I been trying to figure out for years. Sometimes I think you're just that Egyptian Prince that took up with us for some reason or other. Then again I would agree with some of them others that you was an Ethiopian. Once or twice I thought you was the sacred bull of Egypt with the known markings but the unknown history. Sometimes I thought God's voice in the tabernacle sounded mighty much like yours. But ever since you punished me with leprosy, I knew you had power uncommon to man. I been knowing ever since you healed me and took me back into the congregation that you wasn't through with me. You love that woman and we hurt her. You meant for us to punish and to punish well, didn't you? So you locked me up inside

263

myself and left me to wait on your hour. Moses, ain't I done punished enough?"

"How do you know all of this?" Moses asked and studied her while she answered him.

"Oh, I don't know how I know, but I do. When I found out I couldn't do no more in Israel than you let me, I made up my mind to go on off and die, but I found out I couldn't even do that unless you let me. I saw all them people dead in the wilderness from snake-bites and disease and one thing and another and I looked at their bones and wished it was me. I waited and I waited, but death always avoided me. Aaron was waiting for the crown in Canaan, but I just been waiting to die. Now, I ask you please to leave me go. I done tried to be as stiff as you was stout, but I found out I got to come ask you to die. You knew it all along and you been waiting for me to come."

"I certainly didn't expect you to come here to say what you did."

"No, Moses, don't put me off like that. Talk to me straight. I come here to you for something and I don't mean to go till you tell me yes or no. I don't mean to leave here until I get what I come after."

The repulsive old woman was tragic. She had been sent on a mission as he had been sent, and the burden had torn and twisted her. She had been petty, envious and mean, but she had served. But then fate had provided no compensations for making her a bearer. Miriam had lived on hopes where other women lived on memories. And that was bound to do something to her. She was not sent to be what she wanted to be, so she had wasted herself procuring pangs for people who had. Moses looked at her and through her with pity. She seemed to hold everything about herself very still until he got through looking. Then she got up and moved to the door.

"Much obliged, Moses. Now I can go."

"Much obliged for what, Miriam?"

"I felt your right hand fall from over me. I'm going on back to my tent now and rest. It's no sense in something like me

264

being alive. I am going to die now, Moses. Keep that right hand of yours down."

Moses didn't say anything more. He just looked at her and watched her go. She went off a little brisk. Her face almost moved. She seemed to see something with her eyes. She made deep prints with her feet.

Miriam went back and laid down just like she said she would, and the next morning they found her dead with a bitter twist on her mask of a face.

Moses called a halt and told the people what it meant to lose a patriot like Miriam. The young ones were told what the old ones had forgotten—all about those days back in Egypt when the house of the prophetess Miriam was the meeting place of all those who were willing to work for freedom. How she had gathered folks together by two and threes and changed weakness into resolution. Her dust weighed as much as all Israel. The people all listened and thought it was a great speech. They even mourned when Moses ordered them to mourn for thirty days. They held a great crying for Miriam. So Moses buried her with a big ceremony and ordered a great tomb of rocks to be piled up over her grave.

On the way back from the funeral Moses considered the life and death of Miriam. She was a woman, but he never had been able to quite think of her as such. What with her lack of female beauty and female attractions, and her loveless life with one end sunk in slavery and the other twisted and snarled in freedom. He wondered which had hurt her most. He thought how the threads of his life had gotten tangled with the threads of this homely slave woman. He wondered if she had not been born if he would have been standing there in the desert of Zin. In fact, he wondered if the Exodus would have taken place at all. How? If she had not come to the palace gates to ask for him and to claim him as a brother, would he have left Egypt as he did? He doubted it. He never would have known Jethro, nor loved Zipporah, nor known the shiny mountain, nor led out a nation with a high hand, nor suffered as he had done and was doomed to keep on doing. A mighty thing had happened

in the world through the stumblings of a woman who couldn't see where she was going. She needed a big tomb so the generations that come after would know her and remember.

Well, Miriam was gone. There was Aaron left and himself. And there was the desert and the wilderness and the forty years and the people. This was the second going-out. He had led out Pharaoh's slaves. Now he must lead out a free and singing people from inside the cringing slaves. He turned from burying Miriam and set his face grimly for the task.

Then a running messenger came from Jethro telling Moses that he must come. Jethro was sick and wanted Moses' company. He mounted his white stallion in the night and rode hard back towards Midian, and was there on the third day.

The old chieftain was lying on his couch. On his face was a great stare that had not changed for days. But he saw Moses standing before him and smiled.

"Lift up his bed and carry him outdoors," Moses ordered at once.

They bore him out and Moses ordered them to place him under a tree with his face to the mountain and then he sat down beside him and touched his feeble hand. Life seemed to come back into the sunken face at once.

"That was right, Moses. That was right and good."

"Lying shut-in was no place for you, Jethro. You are a man without bounds."

"My eyes and my mind keep taking me where my old legs can't keep up. My old age is burdensome for that reason, now."

He rested awhile then he said, "I knew you were worked to death, and I wouldn't have sent for you except that I had to ask you a question, and I was afraid I couldn't wait for you to come."

"You know I would have been miserable if you hadn't sent for me—if you hadn't let me know in some way."

"Well, Moses, you never said so in too many words, but your love for me had something to do with your going back into Egypt to lead the Israelites, didn't it?"

"Perhaps it did, Jethro, but perhaps it was my destiny anyway."

The old man reached out and caught hold of Moses' hand and drew him closer. He lifted himself up and held the face of Moses between his hands and searched his face with his eyes.

"You don't hold it against me, Moses, do you?"

"Hold it against you? No, Jethro."

"I worried you so about my wish. You might have refused the call and been much happier here. Often and again I have blamed myself for urging you."

"You shouldn't have felt that way. You said yourself it was my destiny."

"Your friendship didn't shrink away from me in the least?"

"Not in the least, Jethro. Your friendship would have been worth ten times more."

Jethro embraced Moses with his skinny old arms and lay back smiling.

"I knew better all the time but I had to ask. If I had another night and day, you could tell me about the Israelites and the work. But as it is, about all you can do is to cover up my face for me. I didn't want anybody to do it but you."

That night the family and the tribe mourned around Jethro's body and the next day Moses buried him in the path that led up the side of the mountain and planted a grove of trees to honor him. On the seventh day he set out for the camp of Israel again, sadder and more bereaved than he had ever been in his life before, or was ever to be again.

He wished that he could order a great crying in Israel for Jethro. He wished that the nation could know how much Jethro had meant to it. But he knew misunderstanding would come out of his act and so he mourned alone. He must keep on doing them good on the sly.

The years went on doing their slow drag over Israel and left it fat and strong. When Joshua marched out against a people he won. There was no longer famine and thirst among his

267

army and always, now, the hosts moved nearer the Jordan, and Israel grew conscious of its might.

So at Jeshurun, the people offered Moses a kingly crown. "You brought our old folks out of slavery and you have led us from one degree of grace to another until now we are folks wherever our feet fall on dry land. We want to turn you some humble thanks so it ain't nothing but right for you to be our King and live rich. You done worked forty years for us for nothing. Therefore we took all the crowns that we beat off of the heads of Kings that we conquered and melted them all down and made them into one crown, something that's fitten for your conquering head. It ain't much, Moses, but it will give you some idea of how we feel."

Moses stood up and thanked everybody very kindly. But he went on to say that he wasn't sure that people ought to have Kings at all. It's pretty hard to find a man who wouldn't weaken under the strain of power and get biggity and over-bearing. He himself might not be any better than nobody else if he had the chance. So they better let this King business rest for a while. "This freedom is a funny thing," he told them. "It ain't something permanent like rocks and hills. It's like manna; you just got to keep on gathering it fresh every day. If you don't, one day you're going to find you ain't got none no more. I'm getting kind of old and I been with you like you say since back in Egypt. It's been kind of tough sometimes, and maybe I neglected a lot of things I could have done off by myself. But if you just keep free and be a fine nation of folks I'll feel like I bought something with my life. You done got free of Pharaoh and the Egyptian oppressors, be careful you don't raise up none among yourselves." Moses left with drooping heart.

The people had missed the whole point of his forty-odd years of work. He loved freedom and justice with a fierce love and he wanted Israel to be free and just. All that he had done to them and for them was intended to bring them to his viewpoint. And here they were wanting to be like other halted people that they touched along the way. They despised their

high destiny. They misunderstood him so far that they even offered him a crown! As if he could not have had that from the very first. He could have led them to Midian and with Jethro to help him, set up a kingdom within a few weeks after leaving Egypt. He need not have experienced a wilderness, and deserts and hunger and thirst and misunderstanding and sacrifice to wear a crown. The hem of the sky ran in close around him and oppressed him. It took a long time to thrust it out again. Well, anyway, he could hope. He had produced the physical base for greatness.

These young Hebrews were something. They were bound to get somewhere if only they fell into the right hands after he was gone. And that put him to thinking back. The mood stayed on him for several days. Then the cloud of fire lifted from above the tabernacle and moved the Israelites to the plain at the foot of Mount Hor. And it rested there so Israel camped awhile.

As soon as they had gotten settled down, Aaron sent a delegation of Levites to Moses to protest a decision Moses had made about the services. Moses listened until they were through and then he said, "The words you have brought here in your mouths are not your own. Somebody else made them and loaded your mouth up with 'em. Go back and tell Aaron to come and tell me what he's got to say his own self."

Aaron came, but he took his own time about it. He explained to Moses that his beard-boy was looking after his beard so he could not come right away.

"Your beard-boy?" Moses exclaimed.

"Now, Moses, you know the Lord has given me as a sign of special favor the longest and the finest whiskers in all Israel. And me being who I am I don't really have time to do for it like I should. So I had to sign up one of the young men around the altar to wait on my beard and tend to it. I give him the responsibility and if it gets out of shape and careless looking he'll have to suffer for it. The Lord don't want His gifts to be despised."

It all sank into the mind of Moses and he thought it over well before he spoke.

"Aaron, do you think that if you had of stayed back there in Egypt that the Lord would have bothered about whether your whiskers was greased or not?"

"We don't need to waste time over that because I ain't back there in Egypt. A smart man like me couldn't be kept down like that nohow. I got too much brains for people. You don't meet my kind every day. I let folks think they are using me for a tool when all the time I'm using them for a step-ladder."

Moses felt an acid wind from Aaron's words blowing across his face. He didn't need to look at the man to read him. He had been reading him for forty years or so. He didn't need to look for interpretation. He knew the meaning before he heard the words. So he went on to conclusions.

"Aaron, we're here at Mount Hor—not too far from the Jordan, but still a little distance off. I'm going up in the mountain to ask the Lord what He wants me to do next. Would you like to go up with me this time?"

"That's all goodness been begging righteous to do all these forty years. I should have been up there to meet God at Sinai. It made me look like a fool before Israel. The high priest his own self can't go to see God!"

"Well, you can go with me this time, Aaron. We won't have no hard words about all those other times you didn't go. But if God had of asked for you, Aaron, I would have come straight back and told you."

"I hope you would have, Moses."

"All right, come on and let's go. But let's take your oldest boy Eleazar along with us. God might want to see him and talk with him, too. No telling, he might make a fine priest when he gets a little older."

"I ain't got the least doubt about that, Moses. I done my best to bring him up right. He'd look noble in the robes, too—after I am gone."

The three men went up the mountainside together. Aaron and Moses walked a little ahead and Eleazar followed respect-

fully behind. Moses wore a short robe belted in at the waist with his traditional short sword at his side. He walked with his rod in his left hand, and now and then he helped Aaron over rough places with his right. They went up and round the mountain and then up. The huge camp of Israel below them began to take on a pattern. Moses saw that Aaron had stopped stroking his beard and was panting hard. So he paused and turned to Eleazar and told him, "Eleazar, you wait here until I call you. Your father is going higher up. He's got to listen to God."

Moses could see the tired old shoulders of Aaron stiffen with pride at that. He almost stood erect. They traveled on up the mountain for some time yet. Nobody tried to talk because both of them realized it was useless then. At last Moses stopped before a cool grotto in the mountainside with a rude stone seat inside. Aaron practically dragged himself to the seat and panted a long time before he could measure out his breath.

"Do you always have to climb this high to talk with God?" Aaron asked when he got his breath back.

"Higher than this, Aaron. Sometimes men have to push through the sky to reach Him. We stopped here to rest a minute, that's all."

Aaron groaned out loud.

"Supposing we talk awhile then, Aaron. I'm the leader of Israel and you're the high priest and we ain't had our heads together since way back there, Aaron, before Sinai."

"That's right, but it ain't no fault of mine. I been kept back in the background and I been kept in the dark about things. You don't never tell me nothing. Joshua is the only one that gets any information around here."

"Well, Canaan is right close now and we ain't got too much time to talk and plan. You know things won't be the same over there that it is out here in the wilderness."

"Don't I know it? I been waiting for it for forty years. I'm getting pretty old, but I think I can make it. It won't be so hard

over there as it is in the wilderness nohow. Then Israel can reward me for my labors."

"But the Lord said, Aaron, that all the old folks who came out of Egypt had to die in the wilderness, all except Joshua and Caleb."

"Oh, I never took much stock in that, Moses. I'm not the people, you know. I believe I'm going to make it and when I do, I mean to be folks over there. The thought of it has kept me living or else I would have gone like Miriam. She fretted herself to death about who was going to get us there. That was foolish. I let who can get us there, then we can see about things after that. I know how to handle people."

"You think so, Aaron?"

"I sure do, unless I'm mighty mistaken." Aaron sat stroking his beard with a little gesture that was smug and flourishing at the same time. He knew he was important and he knew his clothes were fine. He looked just as satisfied as the snake that lives under God's foot-stool.

"Yet and still, Aaron, you have never done anything that I could not have prevented if I had wanted to and you never done a thing that I didn't undo."

"It's not too late, Moses. We're born but we ain't dead yet."

Moses stood up suddenly and looked Aaron straight in the eye. Aaron unveiled his eyes for the first time in front of Moses since the law was given at Sinai. There was neither love nor mercy in his look.

"You got your power and your brains, Moses, but you ain't never made the people happy like you said."

"I never said I'd make them happy people. I promised to make them great. Anyway, happiness is not something you can catch and lock up in a vault like wealth. Happiness is nothing but everyday living seen through a veil."

"Well, I can give 'em what they want better than you ever did, and I'll show you when we get over there. You can't scare people away from what they want over there. We won't need you any more. My time is coming just like I always knowed it would."

272

He gave Moses a look full of triumph and old hatred.

"Take off those robes, Aaron," Moses said shortly.

Aaron acted as if he didn't hear Moses right away. Then he gave Moses a scornful look. Then he chuckled slightly and crossed his legs and smoothed the skirts of his priestly robe.

"Aaron, take off those robes."

"I ain't going to do it, Moses. God put these robes on me and He'll have to be the one to take 'em off. I know you been begrudging 'em to me for a powerful long time. I just wouldn't step down for you."

"God didn't put no robes on you, Aaron. I put 'em on you and I'm taking them off, because they don't fit you."

"You mean God never called me down there in Egypt at all?"

"No, Aaron."

"You told me He did."

"Yes, I did, Aaron. I thought I needed you for the big job I had to do because you were of the Hebrews. I did need you too, but you didn't do the job I picked out for you."

"You always held me back. You—"

"No, you got the wrong idea altogether. You held yourself back. You didn't think about service half as much as you did about getting served, Aaron. Your tiny horizon never did get no bigger, so you mistook a spotlight for the sun."

Aaron began to crumble. He didn't look at Moses any more. He began to finger his garments in different places all over himself and to dwindle and shrink.

"Those robes don't belong to you, Aaron. I planned them for a bigger man. Take 'em on off."

"What would I do without my robes?" Aaron wailed in anguish. "They're mine! They belong to the high priest. How do I know that God didn't call me? You said so yourself."

Moses snatched Aaron to his feet and Aaron looked into the eyes of Moses and lifted off his high headpiece and set it down on a stone in a soft, regretful way. Then piece by piece he shed his robes to his last undergarment and stood with his old corded arms and legs protruding from the short garment.

Moses stooped and collected all of the rich regalia and laid them carefully on a rock. Aaron watched him without daring to move his feet out of his tracks until Moses turned back to him again.

"Aaron."

"Yes, Moses," Aaron whimpered.

"Aaron, you can't go over yonder with the people."

"Why, Moses? You know I always done the best I could."

"No. Not for the people, Aaron. You are blind. You didn't see Miriam and her face. You didn't see the graveyards in the wilderness. You didn't see the significance of the Ark of the Covenant nor the Tent of Testimony. All you saw was the gold and silver vessels and the robes and the power that goes with it. No, Aaron, you can't go over there and make a fool out of Israel's graves."

"What am I going to do then, Moses? You can't leave me looking like this. "How can I go back before Israel?"

"You can't go back before Israel, Aaron."

Aaron looked hard in Moses' face and fell to his knees.

"Moses! Moses, please. I'll be a lot of help to you from now on. Moses, spare me, if you please."

Moses looked way off across the plain where the tents of Israel stretched for miles and held his eyes for a long pause. Then he said, "I haven't spared myself, Aaron. I had to quit being a person a long time ago, and I had to become a thing, a tool, an instrument for a cause. I wasn't spared, Aaron. No."

"No, and you didn't spare my two sons at Sinai—just for dancing and making a little ceremony before a god of Egypt which we had always known. My poor boys—you killed them!"

"I didn't kill your boys at Sinai, Aaron, though I know that you have always accused me of it, and hated me. But you know just as well as I do why they died. What they signified had to die if Israel was to be great."

"Let me be high priest over there, Moses, in the big new tabernacle with—"

"No, Aaron."

Aaron crawled to the knees of Moses and clasped them. "Moses, looks like pity and mercy would—"

"Aaron, the future of Israel is higher than pity and mercy. And why should I spare you? I did not spare the first-born. I did not spare Pharaoh. I did not spare myself. I did not spare my wife and my friend. Jethro is dead and I might have spent several more happy years with him instead of out in the wilderness leading a people and being reviled for doing what was best instead of what was popular. No, Aaron, nothing and nobody has been spared to make this nation great. And since you wouldn't give yourself in any other way, Aaron, you will have to do something for Israel by denial."

"Moses, you don't need to take me along. Just let me go up here in the mountain and let me shift for myself. Please, Moses, don't kill me."

"You don't mean that, Aaron. You mean to double back and appeal to the people to back you up on account of your age and place. No, Aaron, fifty years of work can't be destroyed to give you a tomb in Canaan. God called you on Mount Hor. The tomb of Aaron the first high priest of Israel will be huge and fine, high up in this noble mountain. God has built you a pyramid greater than Pharaoh, and generations of Israelites will make pilgrimages to the grave of Aaron, the patriot. God will remember your sacrifice and guard your memories."

The knife descended and Aaron's old limbs crumpled in the dust of the mountain. Moses looked down on him and wept. He remembered so much from way back. "Is this my brother? Is this pitiful old carcass blood of my blood? Maybe this is me myself in other moods. Who am I to judge him?" Moses looked down the mountain at tented Israel and shook his head. "I have made a nation, but at a price." Then he buried Aaron and marked the place. "Poor Aaron, he died so hard for God!" Then he picked up the robes and walked firmly down the mountain to where Eleazar waited.

"Put on these robes, Eleazar. You are high priest now." The young man seized the robes eagerly. Then he halted for

a moment and looked back up the mountain the way Moses had come down. He looked back the second time and then he looked into the face of Moses and began to undress himself. He dressed himself in the priestly scarlet and purple and set the breastplate of twelve stones upon his bosom. After that he never looked back again. He straightened his figure to set his garments well and fell in beside Moses and they started down the mountain side by side.

They descended to the camp and the people looked at Eleazar in the robes of Aaron, so Moses told them all, "God called Aaron in the mountain. You must build a big high tomb over him, and you must mourn him for thirty days. He was denied many pleasures for your sake."

CHAPTER 40

Israel met nations and fought and conquered and moved on towards Canaan. Moses lifted his rod and made a way out of no way when it was needed and they moved on. They fought the giants of Bashan and conquered and moved on till one day they camped again on the River Jordan where their forefathers had been before.

"When are we crossing over?" That is what everybody wanted to know. "We are here! When do we cross over?"

Moses ordered Israel to camp and rest for two weeks. The battle against Bashan had been hard. Everybody needed a rest. So he sat in his tent day by day and wrote in his journal. The wanderings of Israel were there set down by his hand.

Joshua kept running in and out for first one thing and then another, so Moses told him to have a seat.

"Joshua, we been here at the river around two weeks, ain't that right?"

"Yes, sir, it sure is."

"How is the sick and the afflicted coming on?"

"If you talking about the soldiers, all them that was going to die are already dead. The rest of 'em will get well. Everything is in good shape, considering. Anyhow, chief, we ain't the same folks we was when we viewed the Jordan last time. We're a people now."

"It looks that way, Joshua. But when you was down at the Jordan last time you was such a lad of a boy that your moustache did not show. Your hair is all mixed with gray this time."

"Yeah, that's so, but I still don't feel no strain in a campaign. I'm able."

"That's good, because you are going to need everything you got in you on the other side. And that brings me to a subject I been wanting to take up with you a long time."

"What is it, Moses? You know I'm always ready to listen when you talk."

"Joshua, I'm old. I ain't getting old. I'm already old. Supposing the Lord was to call me. What would become of Israel?"

"I'd do the very best I could in the same way that you would do it if you were there. But I don't want to be no secondhand ruler because I'm a first class fighting man. You must live and cross over and govern us till the rod just naturally falls out of your hand. Everybody in Israel is expecting you to be there."

"But sooner or later I'll have to go and you will have to govern in every way, Joshua, because there won't be nobody else to do it. Eleazar is a good and obedient servant, but that's all.

"Anyway, we done passed a lot of mileposts and we done come to the place where we need a fighting leader more than anything else. Israel has got her laws and her God. All she needs now is land and it takes fighting to get that."

"You know I'll fight, don't you?"

"Oh, yes, you're a general among generals. But now when Israel ain't fighting, you got to do something about governing the people. Now one thing I want you to get in your head: You can't have a state of individuals. Everybody just can't be allowed to do as they please. I love liberty and I love freedom so I started off giving everybody a loose rein. But I soon found out that it wouldn't do. A great state is a well-blended mash of something of all of the people and all of none of the people. You understand. The liquor of statecraft is distilled from the mash you got. How can a nation speak with one voice if they

278

are not one? Don't forget, now. If you do, you encourage all the stupid but greedy and ambitious to sprout like toadstools and that's the end of right and reason in the state. Coddling and wheedling is not going to stop these destroyers. To a haughty belly, kindness is hard to swallow and harder to digest."

"I won't forget. I saw what you went through with some in Israel."

"And don't let the people take up too many habits from the nations they come in contact with and throw away what they got from God. They are blessed. Nobody else ever got a straight talk from God like we have. Don't let 'em throw it away. You know, Joshua, it ain't everybody who can go right up and talk with God. And then, too, it's less than that who can talk with God and then bring back the right word from the talk. It is so easy to mix up what you are wishing with what God is saying. You might not get another good interpreter. You better hold on to what you got."

"Yes, sir, I'll do just like you tell me, as far as I am able."

"I got every faith in your good intentions, son. Just do the best you can. And, Joshua, patience and understanding helps out a whole lot. What we been trying to do all these forty-odd years was to channel the intentions of men. We got to fix their intentions. I'm wondering if the doings of the best of us will ever be good, but we can give 'em intentions to fumble their way back to God."

They talked on for some time. Then Joshua observed, "Moses, we been through thick and thin since we pulled out of Egypt that night. You seen plenty hard times, but did you ever have any pleasure since you been with us? It didn't look like it to me, except for the little time your wife was with us."

"The highest point of my feelings, Joshua, was when I spent the forty days on Mount Sinai talking with God and making plans for the people. And the highest feeling of that was when I had the laws in my hand ready to come down. The lowest feeling for me in these forty-odd years was when I came down and saw my Israel around that golden calf. I felt mighty sad,

Joshua, when Jethro died. He meant more to me than anybody else in my whole life. Sometimes I feel he meant more to Israel than I do. He was a big man. A mighty big man if you look at him right. The worst time I ever had was when we fought those Amalekites. Oh! I was in plenty of trouble that time. We were out on a limb, Joshua, and we come pretty nigh getting sawed off. That fight showed me you were strong, Joshua, so it was worth it all right."

"Yes, that was a tight fight. Something like the monkey and the bulldog. The monkey told his bossman that he whipped the bulldog all right until it came time for him to sit down. Then he told his bossman he might have got the best of that bulldog, but the more he sit down, the more he doubted it."

"That puts me in mind of that tussle I had with Balaam and that mule of his. That was the best time I had on the whole trip up to now."

"Oh, I remember that time. He was that big hoodoo man from Pethor. He was coming down to put a curse on us and his mule turned around and sassed him good."

"Yes, that's the one. I fixed that old mule up for Balaam and made him say what he did. And when I fixed old Balaam up just like I did his mule and made him talk for our side."

"Seems like it was a donkey he was riding."

"That point don't seem important to me, Joshua, not from this distance. The point is, the fun I had with him. Here was old King Balak sicking Balaam on us to curse us and making big sacrifices of bulls and goats and things on seven altars at a time. Then when Balaam opens his mouth to curse us, out comes a blessing on Israel. Old Balak got right in behind him for saying a blessing instead of a curse so Balaam moved the altars to another place and sacrificed seven times and got his mouth all full of curses again. But when he opened it, out come another blessing, and by that time Balaam was scratching his head and thinking sure enough. Well, the third time he tried it and got fooled, he made out he intended to do that all the time. But that was fun for me, outdoing Balaam like that. It was the first time since we left Egypt that I had a chance to

strain against anybody that was trying to do something. It's good to sort of stretch yourself sometime. Power loves to meet power and strength loves strength."

"King Balak didn't know who he was sending Balaam up against. But the rest of us were scared, because we had heard all about how much power he had."

"He did have power, Joshua. He certainly did, but not enough."

"It's bad to have some power, but not enough."

"It certainly is, Joshua. It's a good thing for anybody to know just how much they have and when to stop."

Both men fell silent and thought on that awhile. Then Moses stood up.

"Joshua, I'm going up."

"Onto that mountain there—Mount Nebo?"

"Yes, Joshua. I love mountains. And then, too, I want to talk with God."

"Can I go up with you this time?"

"No, Joshua. I got to ask God some questions. You stay with the people. But you can go as far as the foot of the mountain with me and we can talk."

Moses took his rod and set out and the people saw him. And many feelings followed him as he went. Some thought ambitious thoughts and all of them thought awe. He halted at the very beginning of the climb and turned to Joshua.

"I know you want to follow me, Joshua, but not this time. If I don't come down in thirty days, you must come to search for me. God might call me up there, you know."

Moses put his arm around Joshua's shoulder briefly and began to climb.

Moses sat on the peak of Pisgah, looking both ways in time. He looked down first and saw the tents of Israel spread out like the pattern of a giant rug that moved and shimmered in the sunlight.

It was a sight such as the world had never seen before. A whole nation assembled together and under tents. Prominent in the front was the Tabernacle, the Tent of the Testimony that

sheltered the Ark of the Covenant and the sacred mysteries that had made Israel a nation and set it apart from other nations. Inside were the gold and silver vessels, and candlesticks and basins. The rich and jewelled vestments of the priests and attendants and the instruments of worship. Outside, the cloudy pillar of the Guiding Presence hung serenely above the entrance as a sign and a promise to Israel. The Tabernacle sat brooding in the plain and hovering its mysteries like the sphinx.

There, eastward before the Tabernacle was his own roomy tent and the tents of the families of Aaron. The tents of Reuben were a large city to the south of the main tent as always. Ephraim's section in its allotted place to the west; the hosts of Dan to the north and Judah pitched to the rising sun. All good fighting men who would die for the glory of the tabernacle and Israel. A splendid and orderly sight—a magnificent spectacle. Moses lingered over it a long time with his eyes.

The sounds of Israel's existence came up to him. The lowing of herds, hammering of metal, sounds of strife, of crying and dying and sounds of song. Moses felt happy over that. His dreams had in no way been completely fulfilled. He had meant to make a perfect people, free and just, noble and strong, that should be a light for all the world and for time and eternity. And he wasn't sure he had succeeded. He had found out that no man may make another free. Freedom was something internal. The outside signs were just signs and symbols of the man inside. All you could do was to give the opportunity for freedom and the man himself must make his own emancipation. He remembered how often he had had to fight Israel to halt a return to Egypt and slavery. Responsibility had seemed too awful to them time and time again. They had wanted to kill him several times for forcing them to be men. Only their awe and terror of his powers had saved his life. No man among the revolters had courage enough to touch his body or he would have died long ago. The few men, like Joshua who had courage, believed in his dream. So he had lived on and fought on through the wilderness and back again to the Jordan. And now

he sat on Nebo's highest peak called Pisgah and gazed down on Israel and across at the Promised Land.

That carried him back in his mind to the earliest rocking of his cradle that he could remember, up until the present moment. Things thought and felt. Things done and undone. Joy, sorrow, defeat and triumph. What was and what might have been. Everything ended in riddles. He, Moses, who had never wanted to rule anyone had been thrust into the position of absolute rule- and law-giver. No man on earth had ever wielded so much power. He visited over Egypt and his various travels and studies and work, and the sun moved on and big pregnant-looking clouds wallowed past and eyed the solitary figure on the peak and moved on. Moses was fighting again all his wars, agonizing in wilderness and deserts, facing revolts of Princes of Israel who had been slaves or the sons of slaves before he lifted his rod in Egypt. Ambitious men and women, stiff-necked with new pride. Wars, plagues of snakes and fevers and famine, misunderstanding and hatred. Only the short secret visits across mountains and plains to Jethro's house to light up his life. Something had made him endure it all, but he did not know what it was. Once or twice he had felt that Jethro could have told him, but he never did. He did hover over him occasionally as if he felt for him, but he always stopped short of speech.

But here Israel was at the Jordan. If he had failed in his highest dreams he had succeeded in others. Perhaps he had not failed so miserably as he sometimes felt. Israel was at the Jordan inside as well as out. Perhaps he had done as much as it was possible for one man to do for another. He had put the future in their hands to do with it according to their hearts and their talents. Over the river they would till fields that they had not cleared and dwell in cities that they had not built.

He had given Israel back the notes to songs. The words would be according to their own dreams, but they would sing. They had songs and singers.

They might not be absolutely free inside, but anyway he had taken from them the sorrow of serving without will, and had

given them the strife of freedom. He had called to their memories the forgotten words of love and family. They had the blessing of being responsible for their own.

Moses lifted his eyes over Canaan. It was a good country and just as he had remembered it from his travels in his youth. He had known what the twelve spies would find before they got there. He merely wanted their interpretations for the people. If their representatives saw the benefits and not the difficulties, then Israel was ready for Canaan. If they saw the difficulties bigger than the benefits, they were unfit for citizenship and he would have to draw back and try again in another generation. The report of the twelve spies showed him somehow he had failed to stir the people to the full courage of responsibility in their first approach to the Jordan forty years before. They were still a horde of slaves, then. To his dying day he would always feel bad about this first great failure of his. But, well, anyway, this time Israel had her songs and her singers. Israel had a fine army of fighters. Israel had laws on tables of stone and Israel had a God. He had lifted their eyes to the mountain. Out of a rotting mass of creeds he had made a religion that had height and depth. Of course, he had made his mistakes and had his regrets. But every heart has its graveyard. But some things had been well done. Now God had a voice and glory.

So Israel was at the Jordan in every way. He had learned from his first failure and so looking on the nation beneath him, the gall of the numerous and senseless revolts grew less. You do not mock a man for being blind. You lead him.

The dimming sunlight gave him inside vision. He looked through time far and near. He saw the twelve priests, with Eleazar leading, descend into the shallow ford of the Jordan, bearing the sacred Ark of the Convenant on its staves. They must pick up twelve stones from the bed of the river as a sign forever. A strong front guard of fighting men would come down to the water's edge eight abreast and divide in midstream and pour four deep on either side of the Ark and mount up on the other bank. They would go before to beat

back any challenge to the crossing. Then the people and the herds would come down into the water the same way. Night and day, day and night, they would come down into the river and flow past the Ark and up into Canaan. Last would come the strong rear guard and last of all the priests would bear the Ark up the bank and the feet of Israel would be in Canaan. The high-lifted rod could be lowered.

And what would he, Moses, do over there? What could he do for Israel that he had not already done? Nothing but live in a palace and wear a crown. A deep frown settled on the face of Moses. He had known palaces and the shadows of crowns had fallen athwart his head. He recoiled inwardly and felt cold.

No, he didn't want to rule that way. He wanted freedom. He wanted to ask God and Nature questions. He wanted to revel in mountains. He wanted to sit on the slopes of Sinai and remember God's glory that he had glimpsed from the cleft in the rock. An altar high on Sinai where he had heard the Voice and seen the burning bush and had the rod thrust into his hands. Surely the Voice wouldn't trouble him again. He had answered and served his fifty years. Israel was at the Jordan and free. The Voice should welcome him and speak of other things like mysteries of sea and sky and air. There was his youngest son ruling the tribe in Jethro's place. He had seen next to nothing of his children and grandchildren. It would be nice to be among them. They wouldn't understand him any more than the Hebrews had, but at least he wouldn't have to lead them. Zipporah was old and reconciled. They could talk about simple things together like asking about who was still living and who was dead and things like that.

What about Israel? What would people think of him for leaving them like that? Well, if he were dead they would make out some way without him. He was still hale and strong. None of his natural powers had failed him yet. He had ten good active years ahead of him, barring accidents. Maybe twenty years. He could go over the Jordan and spend them straining against things that he had strained against for fifty years. He

could wear crowns and robes. But one day he must die as other men died. And they looked upon him as different from other men and followed him only through fear and awe. When he was sickened and crumbled like ordinary men, what would become of his laws and statutes? No, Moses must not die among the Hebrews. They must not see him die.

So Moses set to work to build a tomb on Nebo for himself. The leader of Israel would be buried there. He would end in mystery as he had come. Then his laws would stand and he could spend those last years away from conniving politicians, stupid, but stubborn pushers and suspicions and avarice. He could dwell forever in the mountains without having to descend and struggle with the sordid. He worked furiously for hours piling stones over his relinquished power.

Under one stone he found an ancient lizard and asked him, "What are you doing under there, old lizard?"

"Oh, just resting from living and thinking about the time when my ancestors ruled the world. That was a glorious time."

"How do you know your ancestors ruled the world? Your life span isn't very long, you know," Moses said, sitting down on a rock to listen and rest.

"Oh, we lizards don't try to keep our memories in our bodies. We have a keeper of memories and when we want to know what used to be, we go to him to find out."

"Do all lizards go to ask?"

"No, Moses, you don't have to know much to enjoy a fresh batch of flies and worms or to have children. No, some lizards never ask."

"Did you ever inquire?" Moses asked as he produced a small swarm of flies by lifting his right hand slightly. The lizard looked at him in surprise and pleasure and ate down a few flies before he answered.

"Oh, yes, I have been to ask. There was some dispute on this mountain about the month of the flood. So I traveled out to ask."

"Where did you have to go?"

"No need to wear myself out talking so much. I am an old lizard as you see and it's hard to be talking so much on a full stomach, though I'm much obliged to you for the favor of the flies. But if I told you where to go, it wouldn't do you any good. The keeper of our memories is hard to reach and hard to talk to. I'm getting sleepy now."

"Maybe I could reach him and could talk with him. You never can tell."

But the lizard was fast asleep. Moses got up and moved more rock upon the mound. Just then the lizard woke up and said, "You could try anyway. One who can produce fly-swarms might find a way. Listen: you must go east to a great mountain called Sinai and climb to the very top. There is a great flat stone on the very top and on that stone is another stone that is the very peak. And under that peak stone, and resting on the flat stone, is a bearded lizard who knows all the things that used to be."

"Would he know how the world was made, and the heavens?"

"Oh, yes, that is one of our important memories."

"I must go and talk with him. My work is finished but it is dark. I think I'll sleep on the mountain and start out soon in the morning. It is a long, long walk to Sinai. I have seen that mountain before."

But Moses did not sleep on the mountain. He sat on the mountain top for a while gazing at the dim shapes of things over Jordan in the night. He looked down at Israel's smoking, flaming stretch and turned away from his memories of fire-spitting mountains and night-vigils with God. "Lord, Your people are here." He took his rod in his right hand and lifted it and Nebo trembled. The moon in its reddest mood became to him a standing place for his feet and the sky ran down so close to gaze on Moses that the seven great suns of the Universe went wheeling around his head. He stood in the bosom of thunder and the zig-zag lightning above him joined the

287

muttering thunder. Fire and flame played all over the peak where the people could see. The voice of the thunder leaped from peak to plain and Moses stood in the midst of it and said "Farewell." Then he turned with a firm tread and descended the other side of the mountain and headed back over the years.

AFTERWORD

✜

ZORA NEALE HURSTON: "A NEGRO WAY OF SAYING"

I.

The Reverend Harry Middleton Hyatt, an Episcopal priest whose five-volume classic collection, *Hoodoo, Conjuration, Witchcraft, and Rootwork,* more than amply returned an investment of forty years' research, once asked me during an interview in 1977 what had become of another eccentric collector whom he admired. "I met her in the field in the thirties. I think," he reflected for a few seconds, "that her first name was Zora." It was an innocent question, made reasonable by the body of confused and often contradictory rumors that make Zora Neale Hurston's own legend as richly curious and as dense as are the black myths she did so much to preserve in her classic anthropological works, *Mules and Men* and *Tell My Horse,* and in her fiction.

A graduate of Barnard, where she studied under Franz Boas, Zora Neale Hurston published seven books—four novels, two books of folklore, and an autobiography—and more than fifty shorter works between the middle of the Harlem Renaissance and the end of the Korean War, when she was the dominant black woman writer in the United States. The dark obscurity into which her career then lapsed reflects her staunchly independent political stances rather than any defi-

ciency of craft or vision. Virtually ignored after the early fifties, even by the Black Arts movement in the sixties, an otherwise noisy and intense spell of black image- and myth-making that rescued so many black writers from remaindered oblivion, Hurston embodied a more or less harmonious but nevertheless problematic unity of opposites. It is this complexity that refuses to lend itself to the glib categories of "radical" or "conservative," " black" or "Negro," " revolutionary" or "Uncle Tom"—categories of little use in literary criticism. It is this same complexity, embodied in her fiction, that, until Alice Walker published her important essay ("In Search of Zora Neale Hurston") in *Ms.* magazine in 1975, had made Hurston's place in black literary history an ambiguous one at best.

The rediscovery of Afro-American writers has usually turned on larger political criteria, of which the writer's work is supposedly a mere reflection. The deeply satisfying aspect of the rediscovery of Zora Neale Hurston is that black women generated it primarily to establish a maternal literary ancestry. Alice Walker's moving essay recounts her attempts to find Hurston's unmarked grave in the Garden of the Heavenly Rest, a segregated cemetery in Fort Pierce, Florida. Hurston became a metaphor for the black woman writer's search for tradition. The craft of Alice Walker, Gayl Jones, Gloria Naylor, and Toni Cade Bambara bears, in markedly different ways, strong affinities with Hurston's. Their attention to Hurston signifies a novel sophistication in black literature: they read Hurston not only for the spiritual kinship inherent in such relations but because she used black vernacular speech and rituals, in ways subtle and various, to chart the coming to consciousness of black women, so glaringly absent in other black fiction. This use of the vernacular became the fundamental framework for all but one of her novels and is particularly effective in her classic work *Their Eyes Were Watching God*, published in 1937, which is more closely related to Henry

James's *The Portrait of a Lady* and Jean Toomer's *Cane* than to Langston Hughes's and Richard Wright's proletarian literature, so popular in the Depression.

The charting of Janie Crawford's fulfillment as an autonomous imagination, *Their Eyes* is a lyrical novel that correlates the need of her first two husbands for ownership of progressively larger physical space (and the gaudy accoutrements of upward mobility) with the suppression of self-awareness in their wife. Only with her third and last lover, a roustabout called Tea Cake whose unstructured frolics center around and about the Florida swamps, does Janie at last bloom, as does the large pear tree that stands beside her grandmother's tiny log cabin.

> She saw a dust bearing bee sink into the sanctum of a bloom; the thousand sister calyxes arch to meet the love embrace and the ecstatic shiver of the tree from root to tiniest branch creaming in every blossom and frothing with delight. So this was a marriage!

To plot Janie's journey from object to subject, the narrative of the novel shifts from third to a blend of first and third person (known as "free indirect discourse"), signifying this awareness of self in Janie. *Their Eyes* is a bold feminist novel, the first to be explicitly so in the Afro-American tradition. Yet in its concern with the project of finding a voice, with language as an instrument of injury and salvation, of selfhood and empowerment, it suggests many of the themes that inspirit Hurston's oeuvre as a whole.

II.

One of the most moving passages in American literature is Zora Neale Hurston's account of her last encounter with her dying mother, found in a chapter entitled "Wandering" in her autobiography, *Dust Tracks on a Road* (1942):

As I crowded in, they lifted up the bed and turned it around so that Mama's eyes would face east. I thought that she looked to me as the head of the bed reversed. Her mouth was slightly open, but her breathing took up so much of her strength that she could not talk. But she looked at me, or so I felt, to speak for her. She depended on me for a voice.

We can begin to understand the rhetorical distance that separated Hurston from her contemporaries if we compare this passage with a similar scene published just three years later in *Black Boy* by Richard Wright, Hurston's dominant black male contemporary and rival: "Once, in the night, my mother called me to her bed and told me that she could not endure the pain, and she wanted to die. I held her hand and begged her to be quiet. That night I ceased to react to my mother; my feelings were frozen." If Hurston represents her final moments with her mother in terms of the search for voice, then Wright attributes to a similar experience a certain "somberness of spirit that I was never to lose," which "grew into a symbol in my mind, gathering to itself . . . the poverty, the ignorance, the helplessness. . . ." Few authors in the black tradition have less in common than Zora Neale Hurston and Richard Wright. And whereas Wright would reign through the forties as our predominant author, Hurston's fame reached its zenith in 1943 with a *Saturday Review* cover story honoring the success of *Dust Tracks*. Seven years later, she would be serving as a maid in Rivo Alto, Florida; ten years after that she would die in the County Welfare Home in Fort Pierce, Florida.

How could the recipient of two Guggenheims and the author of four novels, a dozen short stories, two musicals, two books on black mythology, dozens of essays, and a prizewinning autobiography virtually "disappear" from her readership for three full decades? There are no easy answers to this quandary, despite the concerted attempts of scholars to resolve it. It is clear, however, that the loving, diverse, and

enthusiastic responses that Hurston's work engenders today were not shared by several of her influential black male contemporaries. The reasons for this are complex and stem largely from what we might think of as their "racial ideologies."

Part of Hurston's received heritage—and perhaps the paramount received notion that links the novel of manners in the Harlem Renaissance, the social realism of the thirties, and the cultural nationalism of the Black Arts movement—was the idea that racism had reduced black people to mere ciphers, to beings who only react to an omnipresent racial oppression, whose culture is "deprived" where different, and whose psyches are in the main "pathological." Albert Murray, the writer and social critic, calls this "the Social Science Fiction Monster." Socialists, separatists, and civil rights advocates alike have been devoured by this beast.

Hurston thought this idea degrading, its propagation a trap, and railed against it. It was, she said, upheld by "the sobbing school of Negrohood who hold that nature somehow has given them a dirty deal." Unlike Hughes and Wright, Hurston chose deliberately to ignore this "false picture that distorted. . . ." Freedom, she wrote in *Moses, Man of the Mountain*, "was something internal. . . . The man himself must make his own emancipation." And she declared her first novel a manifesto against the "arrogance" of whites assuming that "black lives are only defensive reactions to white actions." Her strategy was not calculated to please.

What we might think of as Hurston's mythic realism, lush and dense within a lyrical black idiom, seemed politically retrograde to the proponents of a social or critical realism. If Wright, Ellison, Brown, and Hurston were engaged in a battle over ideal fictional modes with which to represent the Negro, clearly Hurston lost the battle.

But not the war.

After Hurston and her choice of style for the black novel were silenced for nearly three decades, what we have witnessed since is clearly a marvelous instance of the return of the repressed. For Zora Neale Hurston has been "rediscovered"

in a manner unprecedented in the black tradition: several black women writers, among whom are some of the most accomplished writers in America today, have openly turned to her works as sources of narrative strategies, to be repeated, imitated, and revised, in acts of textual bonding. Responding to Wright's critique, Hurston claimed that she had wanted at long last to write a black novel, and "not a treatise on sociology." It is this urge that resonates in Toni Morrison's *Song of Solomon* and *Beloved,* and in Walker's depiction of Hurston as our prime symbol of "racial health"—a sense of black people as complete, complex, *undiminished* human beings, a sense that is lacking in so much black writing and literature." In a tradition in which male authors have ardently denied black literary paternity, this is a major development, one that heralds the refinement of our notion of tradition: Zora and her daughters are a tradition-within-the-tradition, a black woman's voice.

The resurgence of popular and academic readerships of Hurston's works signifies her multiple canonization in the black, the American, and the feminist traditions. Within the critical establishment, scholars of every stripe have found in Hurston texts for all seasons. More people have read Hurston's works since 1975 than did between that date and the publication of her first novel, in 1934.

III.

Rereading Hurston, I am always struck by the density of intimate experiences she cloaked in richly elaborated imagery. It is this concern for the figurative capacity of black language, for what a character in *Mules and Men* calls "a hidden meaning, jus' like de Bible . . . de inside meanin' of words," that unites Hurston's anthropological studies with her fiction. For the folklore Hurston collected so meticulously as Franz Boas's student at Barnard became metaphors, allegories, and performances in her novels, the traditional recurring canonical metaphors of black culture. Always more of a novelist than a social scientist, even Hurston's academic collections center on

294

the quality of imagination that makes these lives whole and splendid. But it is in the novel that Hurston's use of the black idiom realized its fullest effect. In *Johan's Gourd Vine,* her first novel, for instance, the errant preacher, John, as described by Robert Hemenway, "is a poet who graces his world with language but cannot find the words to secure his own personal grace." This concern for language and for the "natural" poets who "bring barbaric splendor of word and song into the very camp of the mockers" not only connects her two disciplines but also makes of "the suspended linguistic moment" a thing to behold indeed. Invariably, Hurston's writing depends for its strength on the text, not the context, as does John's climactic sermon, a *tour de force* of black image and metaphor. Image and metaphor define John's world; his failure to interpret himself leads finally to his self-destruction. As Robert Hemenway, Hurston's biographer, concludes, "Such passages eventually add up to a theory of language and behavior."

Using "the spy-glass of Anthropology," her work celebrates rather than moralizes; it shows rather than tells, such that "both behavior and art become self-evident as the tale texts and hoodoo rituals accrete during the reading." As author, she functions as "a midwife participating in the birth of a body of folklore, . . . the first wondering contacts with natural law." The myths she describes so accurately are in fact "alternative modes for perceiving reality," and never just condescending depictions of the quaint. Hurston sees "the Dozens," for example, that age-old black ritual of graceful insult, as, among other things, a verbal defense of the sanctity of the family, conjured through ingenious plays on words. Though attacked by Wright and virtually ignored by his literary heirs, Hurston's ideas about language and craft undergird many of the most successful contributions to Afro-American literature that followed.

IV.

We can understand Hurston's complex and contradictory legacy more fully if we examine *Dust Tracks on a Road,* her own controversial account of her life. Hurston did make significant parts of herself up, like a masquerader putting on a disguise for the ball, like a character in her fictions. In this way, Hurston *wrote* herself, and sought in her works to rewrite the "self" of "the race," in its several private and public guises, largely for ideological reasons. That which she chooses to reveal is the life of her imagination, as it sought to mold and interpret her environment. That which she silences or deletes, similarly, is all that her readership would draw upon to delimit or pigeonhole her life as a synecdoche of "the race problem," an exceptional part standing for the debased whole.

Hurston's achievement in *Dust Tracks* is twofold. First, she gives us a *writer's* life, rather than an account, as she says, of "the Negro problem." So many events in this text are figured in terms of Hurston's growing awareness and mastery of books and language, language and linguistic rituals as spoken and written both by masters of the Western tradition and by ordinary members of the black community. These two "speech communities," as it were, are Hurston's great sources of inspiration not only in her novels but also in her autobiography.

The representation of her sources of language seems to be her principal concern, as she constantly shifts back and forth between her "literate" narrator's voice and a highly idiomatic black voice found in wonderful passages of free indirect discourse. Hurston moves in and out of these distinct voices effortlessly, seamlessly, just as she does in *Their Eyes* to chart Janie's coming to consciousness. It is this usage of a *divided* voice, a double voice unreconciled, that strikes me as her great achievement, a verbal analogue of her double experiences as a woman in a male-dominated world and as a black person in a nonblack world, a woman writer's revision of W. E. B. Du

Bois's metaphor of "double-consciousness" for the hyphenated African-American.

Her language, variegated by the twin voices that intertwine throughout the text, retains the power to unsettle.

> There is something about poverty that smells like death.
> Dead dreams dropping off the heart like leaves in a dry
> season and rotting around the feet; impulses smothered too
> long in the fetid air of underground caves. The soul lives
> in a sickly air. People can be slave-ships in shoes.

Elsewhere she analyzes black "idioms" used by a culture "raised on smile and invective. They know how to call names," she concludes, then lists some, such as 'gator-mouthed, box-ankled, puzzle-gutted, shovel-footed: "Eyes looking like skint-ginny nuts, and mouth looking like a dish-pan full of broke-up crockery!"

Immediately following the passage about her mother's death, she writes:

> The Master-Maker in His making had made Old Death.
> Made him with big, soft feet and square toes. Made him
> with a face that reflects the face of all things, but neither
> changes itself, nor is mirrored anywhere. Made the body of
> death out of infinite hunger. Made a weapon of his hand to
> satisfy his needs. This was the morning of the day of the
> beginning of things.

Language, in these passages, is not merely "adornment," as Hurston described a key black linguistic practice; rather, manner and meaning are perfectly in tune: she says the thing in the most meaningful manner. Nor is she being "cute," or pandering to a condescending white readership. She is "naming" emotions, as she says, in a language both deeply personal and culturally specific.

The second reason that *Dust Tracks* succeeds as literature arises from the first: Hurston's unresolved tension between

her double voices signifies her full understanding of modernism. Hurston uses the two voices in her text to celebrate the psychological fragmentation both of modernity and of the black American. As Barbara Johnson has written, hers is a rhetoric of division, rather than a fiction of psychological or cultural unity. Zora Neale Hurston, the "real" Zora Neale Hurston that we long to locate in this text, dwells in the silence that separates these two voices: she is both, and neither; bilingual, and mute. This strategy helps to explain her attraction to so many contemporary critics and writers, who can turn to her works again and again only to be startled at her remarkable artistry.

But the life that Hurston could write was not the life she could live. In fact, Hurston's life, so much more readily than does the standard sociological rendering, reveals how economic limits determine our choices even more than does violence or love. Put simply, Hurston wrote well when she was comfortable, wrote poorly when she was not. Financial problems—book sales, grants and fellowships too few and too paltry, ignorant editors and a smothering patron—produced the sort of dependence that affects, if not determines, her style, a relation she explored somewhat ironically in "What White Publishers Won't Print." We cannot oversimplify the relation between Hurston's art and her life; nor can we reduce the complexity of her postwar politics, which, rooted in her distaste for the pathological image of blacks, were markedly conservative and Republican.

Nor can we sentimentalize her disastrous final decade, when she found herself working as a maid on the very day the *Saturday Evening Post* published her short story "Conscience of the Court" and often found herself without money, surviving after 1957 on unemployment benefits, substitute teaching, and welfare checks. "In her last days," Hemenway concludes dispassionately, "Zora lived a difficult life—alone, proud, ill, obsessed with a book she could not finish."

The excavation of her buried life helped a new generation read Hurston again. But ultimately we must find Hurston's

legacy in her art, where she "ploughed up some literacy and laid by some alphabets." Her importance rests with the legacy of fiction and lore she constructed so cannily. As Hurston herself noted, "Roll your eyes in ecstasy and ape his every move, but until we have placed something upon his street corner that is our own, we are right back where we were when they filed our iron collar off." If, as a friend eulogized, "She didn't come to you empty," then she does not leave black literature empty. If her earlier obscurity and neglect today seem inconceivable, perhaps now, as she wrote of Moses, she has "crossed over."

HENRY LOUIS GATES, JR.

SELECTED BIBLIOGRAPHY

WORKS BY ZORA NEALE HURSTON

Jonah's Gourd Vine. Philadelphia: J. B. Lippincott, 1934.

Mules and Men. Philadelphia: J. B. Lippincott, 1935.

Their Eyes Were Watching God. Philadelphia: J. B. Lippincott, 1937.

Tell My Horse. Philadelphia: J. B. Lippincott, 1938.

Moses, Man of the Mountain. Philadelphia: J. B. Lippincott, 1939.

Dust Tracks on a Road. Philadelphia: J. B. Lippincott, 1942.

Seraph on the Suwanee. New York: Charles Scribner's Sons, 1948.

I Love Myself When I Am Laughing . . . & Then Again When I Am Looking Mean and Impressive: A Zora Neale Hurston Reader. Edited by Alice Walker. Old Westbury, N.Y.: The Feminist Press, 1979.

The Sanctified Church. Edited by Toni Cade Bambara. Berkeley: Turtle Island, 1981.

Spunk: The Selected Short Stories of Zora Neale Hurston. Berkeley: Turtle Island, 1985.

WORKS ABOUT ZORA NEALE HURSTON

Baker, Houston, A., Jr. *Blues, Ideology, and Afro-American Literature: A Vernacular Theory,* pp. 15–63. Chicago: University of Chicago Press, 1984.

Bloom, Harold, ed. *Zora Neale Hurston.* New York: Chelsea House, 1986.

————, ed. *Zora Neale Hurston's "Their Eyes Were Watching God."* New York: Chelsea House, 1987.

Byrd, James W. "Zora Neale Hurston: A Novel Folklorist." *Tennessee Folklore Society Bulletin* 21 (1955): 37–41.

Cooke, Michael G. "Solitude: The Beginnings of Self-Realization in Zora Neale Hurston, Richard Wright, and Ralph Ellison." In Michael G. Cooke, *Afro-American Literature in the Twentieth Century,* pp. 71–110. New Haven: Yale University Press, 1984.

Dance, Daryl C. "Zora Neale Hurston." In *American Women Writers: Bibliographical Essays,* edited by Maurice Duke, et al. Westport, Conn.: Greenwood Press, 1983.

Gates, Henry Louis, Jr. "The Speakerly Text." In Henry Louis Gates, Jr., *The Signifying Monkey,* pp. 170–217. New York: Oxford University Press, 1988.

Giles, James R. "The Significance of Time in Zora Neale Hurston's *Their Eyes Were Watching God." Negro American Literature Forum* 6 (Summer 1972): 52–53, 60.

Hemenway, Robert E. *Zora Neale Hurston: A Literary Biography.* Chicago: University of Illinois Press, 1977.

Holloway, Karla. *The Character of the Word: The Texts of Zora Neale Hurston.* Westport, Conn.: Greenwood Press, 1987.

Holt, Elvin. "Zora Neale Hurston." In *Fifty Southern Writers After 1900,* edited by Joseph M. Flura and Robert Bain, pp. 259–69. Westport, Conn.: Greenwood Press, 1987.

Howard, Lillie Pearl. *Zora Neale Hurston.* Boston: Twayne, 1980.

————. "Zora Neale Hurston." In *Dictionary of Literary Biography,* vol. 51, edited by Trudier Harris, pp. 133–45. Detroit: Gale, 1987.

Jackson, Blyden. "Some Negroes in the Land of Goshen." *Tennessee Folklore Society Bulletin* 19 (4) (December 1953): 103–7.

Johnson, Barbara. "Metaphor, Metonymy, and Voice in *Their Eyes."* In *Black Literature and Literary Theory,* edited by Henry Louis Gates, Jr., pp. 205–21. New York: Methuen, 1984.

————. "Thresholds of Difference: Structures of Address in Zora Neale Hurston." In *"Race," Writing and Difference,* edited by Henry Lewis Gates, Jr. Chicago: University of Chicago Press, 1986.

Jordan, June. "On Richard Wright and Zora Neale Hurston." *Black World* 23 (10) (August 1974): 4–8.

Kubitschek, Missy Dehn. " 'Tuh de Horizon and Back': The Female Quest in *Their Eyes." Black American Literature Forum* 17 (3) (Fall 1983): 109–15.

Lionnet, Françoise. "Autoethnography: The Anarchic Style of *Dust Tracks on a Road.*" In Françoise Lionnet, *Autobiographical Voices: Race, Gender, Self-Portraiture,* pp. 97–130. Ithaca: Cornell University Press, 1989.

Lupton, Mary Jane. "Zora Neale Hurston and the Survival of the Female." *Southern Literary Journal* 15 (Fall 1982): 45–54.

Meese, Elizabeth. "Orality and Textuality in Zora Neale Hurston's *Their Eyes.*" In Elizabeth Meese, *Crossing the Double Cross: The Practice of Feminist Criticism,* pp. 39–55. Chapel Hill: University of North Carolina Press, 1986.

Newson, Adele S. *Zora Neale Hurston: A Reference Guide.* Boston: G. K. Hall, 1987.

Rayson, Ann. "*Dust Tracks on a Road:* Zora Neale Hurston and the Form of Black Autobiography." *Negro American Literature Forum* 7 (Summer 1973): 42–44.

Sheffey, Ruthe T., ed. *A Rainbow Round Her Shoulder: The Zora Neale Hurston Symposium Papers.* Baltimore: Morgan State University Press, 1982.

Smith, Barbara. "Sexual Politics and the Fiction of Zora Neale Hurston." *Radical Teacher* 8 (May 1978): 26–30.

Stepto, Robert B. *From Behind the Veil.* Urbana: University of Illinois Press, 1979.

Walker, Alice. "In Search of Zora Neale Hurston." *Ms.,* March 1975, pp. 74–79, 85–89.

Wall, Cheryl A. "Zora Neale Hurston: Changing Her Own Words." In *American Novelists Revisited: Essays in Feminist Criticism,* edited by Fritz Fleischmann, pp. 370–93. Boston: G. K. Hall, 1982.

Washington, Mary Helen. "Zora Neale Hurston: A Woman Half in Shadow." Introduction to *I Love Myself When I Am Laughing,* edited by Alice Walker. Old Westbury, N.Y.: Feminist Press, 1979.

———. " 'I Love the Way Janie Crawford Left Her Husbands': Zora Neale Hurston's Emergent Female Hero." In Mary Helen Washington, *Invented Lives: Narratives of Black Women, 1860–1960.* New York: Anchor Press, 1987.

Willis, Miriam. "Folklore and the Creative Artist: Lydia Cabrera and Zora Neale Hurston." *CLA Journal* 27 (September 1983): 81–90.

Wolff, Maria Tai. "Listening and Living: Reading and Experiencing in *Their Eyes.*" *BALF* 16 (1) (Spring 1982): 29–33.

CHRONOLOGY

January 7, 1891	Born in Eatonville, Florida, the fifth of eight children, to John Hurston, a carpenter and Baptist preacher, and Lucy Potts Hurston, a former schoolteacher.
September 1917– June 1918	Attends Morgan Academy in Baltimore, completing the high school requirements.
Summer 1918	Works as a waitress in a nightclub and a manicurist in a black-owned barbershop that serves only whites.
1918–19	Attends Howard Prep School, Washington, D.C.
1919–24	Attends Howard University; receives an associate degree in 1920.
1921	Publishes her first story, "John Redding Goes to Sea," in the *Stylus,* the campus literary society's magazine.
December 1924	Publishes "Drenched in Light," a short story, in *Opportunity.*
1925	Submits a story, "Spunk," and a play, *Color Struck,* to *Opportunity's* literary contest. Both win second-place awards; publishes "Spunk" in the June number.
1925–27	Attends Barnard College, studying anthropology with Franz Boas.
1926	Begins field work for Boas in Harlem.

January 1926	Publishes "John Redding Goes to Sea" in *Opportunity*.
Summer 1926	Organizes *Fire!* with Langston Hughes and Wallace Thurman; they publish only one issue, in November 1926. The issue includes Hurston's "Sweat."
August 1926	Publishes "Muttsy" in *Opportunity*.
September 1926	Publishes "Possum or Pig" in the *Forum*.
September–November 1926	Publishes "The Eatonville Anthology" in the *Messenger*.
1927	Publishes *The First One*, a play, in Charles S. Johnson's *Ebony and Topaz*.
February 1927	Goes to Florida to collect folklore.
May 19, 1927	Marries Herbert Sheen.
September 1927	First visits Mrs. Rufus Osgood Mason, seeking patronage.
October 1927	Publishes an account of the black settlement at St. Augustine, Florida, in the *Journal of Negro History;* also in this issue: "Cudjo's Own Story of the Last African Slaver."
December 1927	Signs a contract with Mason, enabling her to return to the South to collect folklore.
1928	Satirized as "Sweetie Mae Carr" in Wallace Thurman's novel about the Harlem Renaissance *Infants of the Spring;* receives a bachelor of arts degree from Barnard.
January 1928	Relations with Sheen break off.
May 1928	Publishes "How It Feels to Be Colored Me" in the *World Tomorrow*.
1930–32	Organizes the field notes that become *Mules and Men*.
May–June 1930	Works on the play *Mule Bone* with Langston Hughes.
1931	Publishes "Hoodoo in America" in the *Journal of American Folklore*.
February 1931	Breaks with Langston Hughes over the authorship of *Mule Bone*.
July 7, 1931	Divorces Sheen.

September 1931	Writes for a theatrical revue called *Fast and Furious.*
January 1932	Writes and stages a theatrical revue called *The Great Day,* first performed on January 10 on Broadway at the John Golden Theatre; works with the creative literature department of Rollins College, Winter Park, Florida, to produce a concert program of Negro music.
1933	Writes "The Fiery Chariot."
January 1933	Stages *From Sun to Sun* (a version of *Great Day*) at Rollins College.
August 1933	Publishes "The Gilded Six-Bits" in *Story.*
1934	Publishes six essays in Nancy Cunard's anthology, *Negro.*
January 1934	Goes to Bethune-Cookman College to establish a school of dramatic arts "based on pure Negro expression."
May 1934	Publishes *Jonah's Gourd Vine,* originally titled *Big Nigger;* it is a Book-of-the-Month Club selection.
September 1934	Publishes "The Fire and the Cloud" in the *Challenge.*
November 1934	*Singing Steel* (a version of *Great Day*) performed in Chicago.
January 1935	Makes an abortive attempt to study for a Ph.D in anthropology at Columbia University on a fellowship from the Rosenwald Foundation. In fact, she seldom attends classes.
August 1935	Joins the WPA Federal Theatre Project as a "dramatic coach."
October 1935	*Mules and Men* published.
March 1936	Awarded a Guggenheim Fellowship to study West Indian Obeah practices.
April– September 1936	In Jamaica.
September– March 1937	In Haiti; writes *Their Eyes Were Watching God* in seven weeks.
May 1937	Returns to Haiti on a renewed Guggenheim.
September 1937	Returns to the United States; *Their Eyes Were Watching God* published, September 18.

February–March 1938.	Writes *Tell My Horse;* it is published the same year.
April 1938	Joins the Federal Writers Project in Florida to work on *The Florida Negro.*
1939	Publishes "Now Take Noses" in *Cordially Yours.*
June 1939	Receives an honorary Doctor of Letters degree from Morgan State College.
June 27, 1939	Marries Albert Price III in Florida.
Summer 1939	Hired as a drama instructor by North Carolina College for Negroes at Durham; meets Paul Green, professor of drama, at the University of North Carolina.
November 1939	*Moses, Man of the Mountain* published.
February 1940	Files for divorce from Price, though the two are reconciled briefly.
Summer 1940	Makes a folklore-collecting trip to South Carolina.
Spring–July 1941	Writes *Dust Tracks on a Road.*
July 1941	Publishes "Cock Robin, Beale Street" in the *Southern Literary Messenger.*
October 1941–January 1942	Works as a story consultant at Paramount Pictures.
July 1942	Publishes "Story in Harlem Slang" in the *American Mercury.*
September 5, 1942	Publishes a profile of Lawrence Silas in the *Saturday Evening Post.*
November 1942	*Dust Tracks on a Road* published.
February 1943	Awarded the Anisfield-Wolf Book Award in Race Relations for *Dust Tracks;* on the cover of the *Saturday Review.*
March 1943	Receives Howard University's Distinguished Alumni Award.
May 1943	Publishes "The 'Pet Negro' Syndrome" in the *American Mercury.*
November 1943	Divorce from Price granted.
June 1944	Publishes "My Most Humiliating Jim Crow Experience" in the *Negro Digest.*
1945	Writes *Mrs. Doctor;* it is rejected by Lippincott.

March 1945	Publishes "The Rise of the Begging Joints" in the *American Mercury*.
December 1945	Publishes "Crazy for This Democracy" in the *Negro Digest*.
1947	Publishes a review of Robert Tallant's *Voodoo in New Orleans* in the *Journal of American Folklore*.
May 1947	Goes to British Honduras to research black communities in Central America; writes *Seraph on the Suwanee;* stays in Honduras until March 1948.
September 1948	Falsely accused of molesting a ten-year-old boy and arrested; case finally dismissed in March 1949.
October 1948	*Seraph on the Suwanee* published.
March 1950	Publishes "Conscience of the Court" in the *Saturday Evening Post,* while working as a maid in Rivo Island, Florida.
April 1950	Publishes "What White Publishers Won't Print" in the *Saturday Evening Post.*
November 1950	Publishes "I Saw Negro Votes Peddled" in the *American Legion* magazine.
Winter 1950–51	Moves to Belle Glade, Florida.
June 1951	Publishes "Why the Negro Won't Buy Communism" in the *American Legion* magazine.
December 8, 1951	Publishes "A Negro Voter Sizes Up Taft" in the *Saturday Evening Post.*
1952	Hired by the *Pittsburgh Courier* to cover the Ruby McCollum case.
May 1956	Receives an award for "education and human relations" at Bethune-Cookman College.
June 1956	Works as a librarian at Patrick Air Force Base in Florida; fired in 1957.
1957–59	Writes a column on "Hoodoo and Black Magic" for the *Fort Pierce Chronicle.*
1958	Works as a substitute teacher at Lincoln Park Academy, Fort Pierce.
Early 1959	Suffers a stroke.
October 1959	Forced to enter the St. Lucie County Welfare Home.

January 28, 1960	Dies in the St. Lucie County Welfare Home of "hypertensive heart disease"; buried in an unmarked grave in the Garden of Heavenly Rest, Fort Pierce.
August 1973	Alice Walker discovers and marks Hurston's grave.
March 1975	Walker publishes "In Search of Zora Neale Hurston," in *Ms.*, launching a Hurston revival.

About the author

About the book

Insights,
Interviews
& More...

Read on

She *Was* the Party

by Valerie Boyd

ZORA NEALE HURSTON knew how to make an entrance. On May 1, 1925, at a literary awards dinner sponsored by *Opportunity* magazine, the earthy Harlem newcomer turned heads and raised eyebrows as she claimed four awards: a second-place fiction prize for her short story "Spunk,"a second-place award in drama for her play *Color Struck*, and two honorable mentions.

The names of the writers who beat out Hurston for first place that night would soon be forgotten. But the name of the second-place winner buzzed on tongues all night, and for days and years to come.

Lest anyone forget her, Hurston made a wholly memorable entrance at a party following the awards dinner. She strode into the room—jammed with writers and arts patrons, black and white—and flung a long, richly colored scarf around her neck with dramatic flourish as she bellowed a reminder of the title of her winning play: *"Coloooooor Struuckkkk!"* Her exultant entrance literally stopped the party for a moment, just as she had intended. In this way, Hurston made it known that a bright and powerful presence had arrived.

By all accounts, Zora Neale Hurston could walk into a roomful of strangers and, a few minutes and a few stories later, leave them so completely charmed that they often found themselves offering to help her in any way they could.

Gamely accepting such offers—and employing her own talent and scrappiness—Hurston became the most successful and most significant black woman writer of the first half of the twentieth century. Over a

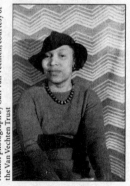

career that spanned more than thirty years, she published four novels, two books of folklore, an autobiography, numerous short stories, and several essays, articles, and plays.

Born on January 7, 1891, in Notasulga, Alabama, Hurston moved with her family to Eatonville, Florida, when she was still a toddler. Her writings reveal no recollection of her Alabama beginnings. For Hurston, Eatonville was always home.

Established in 1887, the rural community near Orlando was the nation's first incorporated black township. It was, as Hurston described it, "a city of five lakes, three croquet courts, three hundred brown skins, three hundred good swimmers, plenty guavas, two schools, and no jailhouse."

In Eatonville, Zora was never indoctrinated in inferiority, and she could see the evidence of black achievement all around her. She could look to town hall and see black men, including her father, John Hurston, formulating the laws that governed Eatonville. She could look to the Sunday schools of the town's two churches and see black women, including her mother, Lucy Potts Hurston, directing the Christian curricula. She could look to the porch of the village store and see black men and women passing worlds through their mouths in the form of colorful, engaging stories.

Growing up in this culturally affirming setting in an eight-room house on five acres of land, Zora had a relatively happy childhood, despite frequent clashes with her preacher-father, who sometimes sought to "squinch" her rambunctious spirit, she recalled. Her mother, on the other hand, urged young Zora and her seven siblings to "jump at de sun." Hurston explained, "We might not land on the sun, but at least we would get off the ground." ▶

> ❝ In Eatonville, Zora was never indoctrinated in inferiority, and she could see the evidence of black achievement all around her. ❞

Hurston's idyllic childhood came to an abrupt end, though, when her mother died in 1904. Zora was only thirteen years old. "That hour began my wanderings," she later wrote. "Not so much in geography, but in time. Then not so much in time as in spirit."

After Lucy Hurston's death, Zora's father remarried quickly—to a young woman whom the hotheaded Zora almost killed in a fistfight—and seemed to have little time or money for his children. "Bare and bony of comfort and love," Zora worked a series of menial jobs over the ensuing years, struggled to finish her schooling, and eventually joined a Gilbert & Sullivan traveling troupe as a maid to the lead singer. In 1917, she turned up in Baltimore; by then, she was twenty-six years old and still hadn't finished high school. Needing to present herself as a teenager to qualify for free public schooling, she lopped ten years off her life—giving her year of birth as 1901. Once gone, those years were never restored: from that moment forward, Hurston would always present herself as at least ten years younger than she actually was.

Apparently, she had the looks to pull it off. Photographs reveal that she was a handsome, big-boned woman with playful yet penetrating eyes, high cheekbones, and a full, graceful mouth that was never without expression.

Zora also had a fiery intellect, an infectious sense of humor, and "the gift," as one friend put it, "of walking into hearts." Zora used these talents—and dozens more—to elbow her way into the Harlem Renaissance of the 1920s, befriending such luminaries as poet Langston Hughes and popular singer-actress Ethel Waters.

Though Hurston rarely drank, fellow writer Sterling Brown recalled, "When Zora was there, she *was* the party." Another friend remembered Hurston's apartment—furnished by donations she solicited from friends—as a spirited "open house" for artists. All this socializing didn't keep Hurston from her work, though. She would sometimes write in her bedroom while the party went on in the living room.

By 1935, Hurston—who'd graduated from Barnard College in 1928—had published several short stories and articles, as well as a novel, *Jonah's Gourd Vine*, and a well-received collection of black Southern folklore, *Mules and Men*. But the late thirties and early forties marked the real zenith of her career. She published her masterwork, *Their Eyes Were Watching God*, in 1937; *Tell My Horse*, her study of Haitian Voodoo practices and Caribbean culture, in 1938; and another masterful novel, *Moses, Man of the Mountain*, in 1939. When her autobiography, *Dust Tracks on a Road*, was published in 1942, Hurston finally received the well-earned acclaim that had long eluded her. That year, she was profiled in *Who's Who in America*, *Current Biography*, and *Twentieth Century Authors*. She went on to publish another novel, *Seraph on the Suwanee*, in 1948.

Still, Hurston never received the financial rewards she deserved. (The largest royalty she ever earned from any of her books was $943.75.) So, when she died on January 28, 1960—at age sixty-nine, after suffering a stroke—her neighbors in Fort Pierce, Florida, had to take up a collection for her February 7 funeral. The collection didn't yield enough to pay for a headstone, ▶

66 'When Zora was there, she *was* the party.' 99

however, and Hurston was buried in a grave that remained unmarked until 1973.

That summer, a young writer named Alice Walker traveled to Fort Pierce to place a marker on the grave of the author who had so inspired her own work. Walker found the Garden of Heavenly Rest, a segregated cemetery at the dead end of North Seventeenth Street, abandoned and overgrown with yellow-flowered weeds.

Back in 1945, Hurston had foreseen the possibility of dying without money—and she'd proposed a solution that would have benefited her and countless others. Writing to W. E. B. Du Bois, whom she called the "Dean of American Negro Artists," Hurston suggested "a cemetery for the illustrious Negro dead" on one hundred acres of land in Florida. "Let no Negro celebrity, no matter what financial condition they might be in at death, lie in inconspicuous forgetfulness," she urged. "We must assume the responsibility of their graves being known and honored." Du Bois, citing practical complications, wrote a curt reply discounting her argument.

As if impelled by Hurston's words, Walker bravely entered the snake-infested cemetery where the writer's remains had been laid to rest. Wading through waist-high weeds, she soon stumbled upon a sunken rectangular patch of ground that she determined to be Hurston's grave. Unable to afford the marker she wanted—a tall, majestic black stone called "Ebony Mist"—Walker chose a plain gray headstone instead. Borrowing from a Jean Toomer poem, she dressed the marker up with a fitting epitaph: "Zora Neale Hurston: A Genius of the South."

> " Hurston was buried in a grave that remained unmarked until 1973 ... [when,] wading through waist-high weeds, Alice Walker stumbled upon a sunken rectangular patch of ground that she determined to be Hurston's grave. "

Valerie Boyd is the author of the award-winning Wrapped in Rainbows: The Life of Zora Neale Hurston. *Formerly the arts editor at the* Atlanta Journal-Constitution, *she is a professor at the University of Georgia's Grady College of Journalism and Mass Communication.*

Lines of Descent/ Dissenting Lines

by Deborah E. McDowell

IF A PEOPLE'S MYTHS are the fullest expression of its spirit and culture, nowhere is this more evident than in African Americans' appropriation of the story of Moses, the myth of the Israelites' exodus from Egyptian bondage. As Albert Raboteau writes in *Slave Religion*, "the symbols, myths and values of Judeo-Christian tradition helped form the slave community's image of itself." White colonists also identified with this tradition, seeing "the journey across the Atlantic to the New World as the exodus of a new Israel from the bondage of Europe into the promised land of milk and honey." But the colonists' Promised Land was the slaves' Egypt, a reversal made palpable and immortal in such spirituals as "Go Down Moses," "Oh Mary, Don't You Weep," and in the countless refigurations of the Mosaic myth throughout African American literature, oral and written.

A selective list would include Frances E. W. Harper's "Moses: A Story of the Nile," Paul Laurence Dunbar's "Ante-Bellum Sermon," James Weldon Johnson's "Let My People Go," Robert Hayden's "Runagate, Runagate," Margaret Walker's "Prophets for a New Day," and Martin Luther King's famous last sermon, "I See the Promised Land," delivered on the eve of his assassination. Punctuated with references to Pharaoh and Egypt, the sermon builds to its now famous crescendo: "I've been to the mountaintop," "I've seen the promised land," and the resounding prophecy: "We as a people will get to the promised land."

Thus, when Zora Neale Hurston turned

to retelling the Exodus story in *Moses, Man of the Mountain*, she was building on a mountain of a tradition and anticipating its perpetuation. Very early in her literary career, Hurston established her fascination with rewriting the sacred myths of the Judeo-Christian tradition in African American terms and idioms. She saw and manipulated the possibilities that Old Testament stories held for chronicling the movements in the sluggish odyssey of black Americans toward emancipation in the United States. Her play, *The First One*, submitted to the *Opportunity* magazine contest in 1926, mocked the myth of Ham, seized by proslavery advocates as the biblical justification of chattel slavery in the United States. In 1934, she published "The Fire and the Cloud" in the September issue of *Challenge* magazine, edited by Dorothy West. A two-page story in the form of an exchange between a world-weary Moses and an inquisitive lizard, "The Fire and the Cloud" is a synopsis of the trials and triumphs of Moses's leadership, which is at its end. His newly dug grave on Mount Nebo is ready to receive him.

Appearing in that same issue of *Challenge* was a letter to the editor from Arna Bontemps in which he dismissed the doomsayers who had dug an early grave for the Harlem Renaissance "younger writers." The Exodus myth ready at hand, Bontemps denied that the writers were "washed up" and "old before our time. . . . We left Egypt in the late twenties and presently crossed the Red Sea. Naturally the wandering in the wilderness followed. The promised land is ahead." *Moses, Man of the Mountain* might well be seen as Zora Neale Hurston's "promised land," if we take that to mean a realization of her artistic and intellectual ▶

powers. It is certainly proof that she was far from "washed up" as a writer.

To claim that this badly flawed novel is a realization of Hurston's artistic power would be, to many, to claim a bit too much. Her contemporaries thought little of it and few scholars now attend to it, choosing, instead, to focus almost all their attention on *Their Eyes Were Watching God*. In his omnibus review in the January 1940 issue of *Opportunity*, Alain Locke offered faint praise for the novel's sustained "characterization and dialogue" but decided that it lacked "vital dramatization," "genuine folk portraiture," substituting "caricature" instead. In the August 5, 1941, issue of *New Masses*, Ralph Ellison surveyed "Recent Negro Fiction," concluding that only Richard Wright and Langston Hughes had taken Negro fiction beyond the narrow confines that bound it in the 1920s. He commended Richard Wright's *Native Son* and *Uncle Tom's Children* for "overcoming the social and cultural isolation of Negro life and moving into a world of unlimited intellectual and imaginative possibilities." He praised Hughes's fiction for its "awareness of the working class and socially dispossessed Negro and his connection with the international scheme of things." Turning to *Moses, Man of the Mountain*, Ellison noted that, although it "possess[ed] technical competence, [it] retain[ed] the blight of calculated burlesque." He offered his ultimate assessment: "For Negro fiction [*Moses, Man of the Mountain*] did nothing."

By this point in Hurston's career, the orthodoxies such as those Locke and Ellison imposed on black writers had come to be

expected. Locke tended to reserve especially harsh judgments for the women writers of the Harlem Renaissance. Jessie Fauset was a favorite target. Locke described her novel *Comedy, American Style* (1933) as "too mid-Victorian for moving power today." He also criticized Hurston's *Their Eyes Were Watching God* for "failing to come to grips with the motive and social document fiction." Even if we grant Locke's assumption that "social documentation" constitutes the *sine qua non* of black fiction in the thirties, we would have to conclude that he works with a narrow definition of the "social" in judging Hurston's fiction to be lacking in this regard. That in *Moses* Hurston casts her own social concerns in the terms of antiquity and eschews the urban realism that Wright perfected doesn't mean that she shows no concern for contemporary social issues and how they might be addressed in fiction. She simply offers no easy pieties and tidy solutions. She astutely saw in Wright's work, to which her own was often invidiously compared, pat and unexamined solutions to complex and monumental social ills. For example, in her review of Wright's *Uncle Tom's Children* (1938), she criticized the solution he offered throughout the thirties and forties: "the PARTY–state responsibility for everything and individual responsibility for nothing, not even feeding oneself." In writing this, she doubtless had Wright's novella *Fire and Cloud* in mind. In this piece, Wright tries to reconcile his religious heritage with the teachings of Marxism by fashioning a solution for a community suffering from famine and the grip of Jim Crow. The novella centers on Dan Taylor, the ▶

spiritual leader of his community, also described as "Moses, leading his people out of the wilderness and into the Promised Land." Taylor comes to see the futility of old-time religion against the repressive white power structure and, at the story's end, leads the community in a mass interracial march to City Hall.

Hurston's own story, "The Fire and the Cloud," might be read as a short answer to Wright's version, as well as a preface to *Moses, Man of the Mountain.* The novel goes on to question whether liberation is ever achieved through a single charismatic leader. In *Moses,* Hurston explores and at times critiques the idea of a religious leader who mediates between an oppressed people and God, the state, or any other Presence. She also liberates her pen from what Harold Cruse refers to, in a different context, as the "literary religion of socialist realism." Without doubting that fiction has real power in the world, Hurston seems loath, as Wright does not, to use her fiction to "lead" her readers toward any pat solution to the continuing problem of racism and oppression.

Throughout, Hurston's novel dramatizes and critiques the terms and problematics of liberation. After Moses has led the Israelites to Canaan, he seems to question the wisdom of any people's dependence on a single leader, or deliverer, concluding that "No man may make another free. Freedom was something internal. . . . All you could do was to give the opportunity for freedom and the man himself must make his own emancipation." However, in passing the mantle to Joshua, he explains, "You can't have a state of individuals. Everybody just

can't be allowed to do as they please."
The chosen people must not "take up too
many habits from the nations they come in
contact with." Thus, he preserves the idea
of one leader even while asking, "How can
a nation speak with one voice if they are not
one?" Finally, though, it is precisely Moses's
"one voice" that does speak for the people.

Hurston transfers her critique of the "Big
Voice" from *Their Eyes Were Watching God*
to *Moses*. And from her first novel, *Jonah's
Gourd Vine*, she transfers her dramatization
of the complex relationship between religion
and gender. In all three novels, the "Big
Voice" is synonymous with the male voice.
While the opening of *Moses* is promising
in its attempt to establish a triadic parallel
between ancient Hebrew slavery, Negro
slavery, and female oppression, that parallel
is not sustained throughout the novel. In
the opening scene, the persecution of the
Hebrew male babies is connected (as if
through the umbilical cord) to the suffering
of their mothers. The one cannot be
considered apart from the other, as the
public world of male power intrudes into
and controls the fruit of women's bodies.
And while Moses's mother, Jochebed, fights
the law of the state by not permitting her
husband to kill her son, in the end that
disobedience is not sustained.
 The "place" of women in this narrative
of patriarchy's origins is to be followers, and
the places in which they figure in the novel
are perhaps its most troubling. While one
is simply tempted to write these passages
off, or to read them as throwbacks to "the
Gilded Six Bits" and harbingers of *Seraph
on the Suwanee* (in both of which works ▶

Hurston's feminist bite seems toothless), here, in *Moses*, these passages seem to coincide not so much with any feminist ambivalences on Hurston's part but rather with the very substance of one of the most sacred and revered narratives Hurston attempts to tell. In retelling the Pentateuch—said to have been written by Moses under divine inspiration—Hurston positions herself in a narrative in which women are marginalized and oppressed. The various feminist critiques of biblical authorship and authority inscribing the law of the father are by now familiar, and it is not simply reading Hurston backward to suggest that she found much about this tradition to decry. We remember Janie's comment to Jodie in *Their Eyes Were Watching God*, "sometimes God gits familiar wid us womenfolks too and talks his inside business," but in *Moses*, it is only the great liberator who talks to God face to face. Implied in that image of talking face to face with God is a logic of equality, of the horizontal, a transgressive logic that runs throughout Hurston's work. However, that same face-to-face conversation is man to man. Although a woman's voice opens the text, speaking the anguish of childbirth, women's voices and desires are hushed and trivialized throughout, subordinated to the greatness of the male.

Moses is advised by a series of men in decreasing hierarchical order. Mentu, the stableman, whom Moses makes his servant, advises him on the strategies of warfare that lead Moses to celebrated success as a conqueror. But it is Jethro, Moses's father-in-law, who is, next to God, the Voice, the man to whose authority Moses most often

defers. He advises Moses to "consecrate [himself] for the work" to which God has called him and to remember that "women pull men aside." For almost the duration of his marriage to Jethro's daughter, Zipporah, Moses is away from his family fulfilling his divine mission. Finally, leadership in the novel is reducible to the practice and process of male bonding and filiation. Moses is called by a male God, advised by a revered patriarch, and then passes the mantle of leadership to another man, Joshua.

That leadership is seen as synonymous with an anointed male is made especially clear in Moses's treatment of his alleged sister, Miriam. He is disturbed to find her among the group of Elders he has summoned on "serious business," but Aaron explains that Miriam is a prophet. Because Moses never speaks to Miriam directly, Aaron must mediate between the two. To Aaron's suggestion that Miriam make a speech before a general meeting, Moses responds, "This is not the time I have appointed for speech making." He does instruct Aaron to "tell her to stay," though, only because "she would be useful in handling the women." Women are thus secondary and peripheral to the strategies and demands of nation building, forming at best a caste within a nation.

In her long allegorical poem, *Moses: A Story of the Nile*, Frances E. W. Harper tells the story of Moses incorporating the suppressed perspectives of two women (one Hebrew, the other, Egyptian), both represented as Moses's mother. While Hurston does not restore the status of the mother(s) in her telling of the tale, one could say that in putting her mouth ▶

on the Mosaic myth, she exposes the structures of gender at its base. In other words, in telling the story of a people's deliverance into a new nation state—a Fatherland, if you will—Hurston says much about the relations between nationalism and masculinity and how, for both, the presence of the feminine is a problem. The place of "race" and the idea of a "people" and its origins are at the heart of that story, which Hurston represents as a war story. The novel identifies concerns with racial origins—and perhaps origins more generally—as the genesis of many of the world's evils. Hurston could not have chosen a more timely year in which to launch these concerns.

1939 was the year in which both Hurston's novel and Freud's *Moses and Monotheism* were published. More uncanny than the fact that both books were published in the same year and reentered this sacred text was that both ventured boldly to call Moses's racial origins into question. Referring to his book as "The Man Moses; A Historical Novel," Freud sought to establish Moses's Egyptian heritage definitively, arguing on the root of his name, *Mose*—the Egyptian word for child. But, as many biblical scholars have noted, the book rests mainly on hypotheses and conjectures that establish nothing if not Freud's ambivalence toward his own Jewish origins. Conversely, in her *Moses*, Hurston is not so much intent on establishing the patriarch's origins beyond dispute but rather on casting doubts about Moses's "pure" origins and, by extension, on the very idea of "racial purity."

Hurston's training in anthropology

would logically bring her to this place. As a student of Franz Boas, she understood racial divisions as idealized abstractions, albeit with undeniably concrete functions and consequences in the real world. Her concerns with the consequences of racial classification link Hurston with other Harlem Renaissance writers who, through thematizing racial passing, explored race as a cultural construct rather than a biological fact: James Weldon Johnson in *The Autobiography of an Ex-Colored Man* (1912), Walter White in *Flight* (1926), Jessie Fauset in *Plum Bun* (1929), and Nella Larsen in *Passing* (1929). Hurston's *Moses*, like all of these works, can be read as an intervention in the discourses about race raging throughout the 1920s and 1930s, discourses used to justify not only socio-economic stratification of blacks in the United States but also the utter extinction of Jews under Nazi Germany.

That Hurston was concerned with questions of racial purity in a novel published in 1939 gains significance when we consider that this was the year Hitler ordered the attack on Poland and led Germany into a world war, although his borrowed theories of eugenics—based on the idea of racial improvement through selective breeding—were popular long before Hitler came to power and were influential in various countries throughout the twenties and thirties. In the United States, the eugenics movement was linked to racist campaigns against blacks and anti-immigration campaigns against European "undesirables." Alfred Wiggam's *The Fruit of the Family Tree* (1924) was just one of a number of works devoted to the ▶

proposition that "a mixed population with differing racial inheritances, different minds and blood make for the stability or instability of a nation." Wiggam sought to strengthen his case by posing the question, "Have not all past civilizations gone to pieces when they mixed their breeds?" Eugenics was thus essential to "the production of a great race . . . the sum and meaning of all politics, the one living purpose of the state." Wiggam's propaganda rhymed clearly with Hitler's more belligerent version expounded in but not restricted to his autobiography, *Mein Kampf*, which is by now well known. The Germans were to his mind the "highest species of humanity on earth," chosen by Providence to be the Master Race. But they would remain so only if they guarded and controlled the "purity of their own blood." Hitler's goal was a united Aryan nation, a "folkish state" that "must set race in the center of all life" and "take care to keep it pure." That meant exterminating Jews and Slavs.

The shadow of Nazism is cast from the beginning of *Moses, Man of the Mountain*, which opens on the process of marking Hebrew male babies for extinction. Parents search for places in which to hide their children, "some good cave . . . that the secret police don't know about yet." The Hebrews speculate that there is "Plenty of Hebrew blood [in Pharaoh's] family already. That is why [he] wants to kill us off. He is scared somebody will come along and tell who his real folks are." "The higher-ups who got Hebrew blood in 'em is always the ones to know that the grandmother of Pharaoh was a Hebrew woman." Coincident with the

mass annihilation of Hebrew boys, the Pharaoh passes laws that condemn Hebrews to slavery and prevent them from becoming citizens of Egypt. With a double edge on passing as it refers to law and passing as it refers to racial disguise, the slaves interpret the Pharaoh's actions: he "figures that it makes a big man out of him to be passing and passing laws and rules."

But the novel spins the greatest mystery around the origins of Moses. From the moment Miriam loses sight of him and then weaves a tale of his disappearance into the Egyptian palace with the Pharaoh's daughter, his origins are open to conjecture and dispute. Moses's first wife, a war bride, shrinks from him, because she suspects he is a Hebrew. Jethro's daughters identify him as a "high-born Egyptian." The Hebrews suspect Moses of being an Egyptian, and when Pharaoh and his army come after them soon after their escape, they declare Moses a "pure Egyptian and Pharaoh his brother. He just toled us off so his brother could butcher us in the wilderness."

Most of Moses's problems as the leader of the Hebrews stem from the Hebrews' lack of trust, which is often linked to their doubts about Moses's ancestry. Despite his identification of himself as a Hebrew, the narrative keeps those doubts as to his racial origins alive and unresolved. In sustaining the ambiguities of race throughout the text, Hurston effectively argues against a system of racial classification whose validity she disputes. This tactic squarely positions the novel against the Nazi blood myths and for those Jews who lost their lives to this mythology. But the alliances in the novel are not always so clear-cut. ▶

At first glance, the coordinates of the novel's typology seem clearly drawn: Jewish oppression in Egypt prefigures black oppression in America, which parallels Jewish oppression under Hitler. The fulfillment of democracy equals liberation from oppression, but there the parallel lines of typology crisscross and become as confused and confusing as the lines of genealogy, a confusion perfectly matched to the novel's satiric mode. Satire, which literally means "a dish filled with mixed fruits," envelops and defines *Moses, Man of the Mountain*, a mode perhaps appropriate to a novel that insists that the fruits of everyone's loins are "mixed." The reader is occasionally bewildered and frustrated by this mix in that every attempt to penetrate to some essential, extractable political position or source is concealed behind the mélange of humor, conjure stories, folktales, and braided historical narratives, and is ultimately thwarted. The novel's elusiveness, though, is partly explained by the repressive climate in which it was published.

In writing this political allegory analogizing Hebrew oppression in biblical antiquity, black oppression in the contemporary United States, and Jewish oppression in Nazi Germany, Hurston probably remembered the fact that the U.S. government made aggressive efforts during World War I to stifle any publications that did not lend their full support to the war effort. The black press was the target of heavy surveillance, during that time when the *Messenger* had its second-class mailing permit revoked and *The Crisis* was removed from soldiers'

reading rooms abroad because of its "seditious" contents. W. E. B. DuBois answered with his famous "Close Ranks" editorial, encouraging blacks to "forget our special grievances and close our ranks shoulder to shoulder with our own white fellow citizens and the allied nations that are fighting for democracy."

During World War II, surveillance of the black press intensified, though no steps were actually taken against specific publications. According to Patrick Washburn in *A Question of Sedition: The Federal Government's Investigation of the Black Press During World War II*, no less than seven government agencies—the Justice Department, the FBI, the Post Office, the Office of Facts and Figures, the Office of War Information, the Office of Censorship, and the War Production Board—exerted various forms of pressure on the black press to curb its outspoken attacks on the government. The government was obstinate in its beliefs that black publications were "subversive sheets," which were actively pro-Axis. The black press was expected to postpone its agitation for full black citizenship until the end of the war, lest the Axis powers exploit the fact that America preached democracy abroad but practiced Jim Crow at home.

That the events surrounding World Wars I and II have not been seen as logical contexts for reading *Moses, Man of the Mountain* derives partly from a tendency many have to compartmentalize history into neat chronological time segments. While critics have certainly discussed Hurston's World War II journalism, few have looked to *Moses* as the precursor of ▶

these later, more controversial writings. That Hurston was concerned with war is evident throughout the novel. In Chapter VIII, which could accurately be titled "Chiefly About War Matters," the war opinions are especially explicit. In fact, drama and dialogue are virtually sacrificed to the narration of Moses's role as commander-in-chief of the Egyptian armies during the period of intensified nationalism and widespread conquest that expanded the Egyptian empire. Whole passages seem to be direct commentaries on aspects and controversies of war, most notably the relations between race and war. One of Moses's first initiatives as commander is to demand that Hebrews be included in the Egyptian army, but he is strenuously opposed by members of the courts and officers of the army.

> They argue that [the Hebrews] were not citizens of Egypt, but enemy-prisoners, and as such, it would be rash to put arms into their hands again. Who knew when they might rise up against their conquerors and turn the tables?

After Egypt has conquered Ethiopia, kept Assyria in fear, and terrorized Babylonia, Moses wants to cease imperialist conquest, "to rest from wars and turn to home problems for a while." But Pharaoh responds that "Egypt has no home problems."

Of course, all of these passages recall arguments about the position of blacks in practically every war in which the United States has fought. More often than not,

blacks were excluded from combat because to include them then made it difficult to deny them the rights of full, first-class citizenship. And arming blacks, certainly in the War for Independence, aroused fears that they would retaliate against their true enslavers.

Hurston settles on a clever strategy not only in this chapter but also in the overall design of the novel. She turns the power of historical memory to her advantage, and the U.S. government's sinister hypocrisy against itself. She manipulates the government's expressed concern for preserving democracy and uses it on behalf of blacks persecuted by the forces of Jim Crow in the United States.

Casting contemporary issues of racial oppression in the perspective of antiquity could be seen to represent a distortion of the biblical text and a flagrant disregard for the historical record, however fragmentary and contested they both are. To be sure, in the Old Testament epoch the social category of race had not acquired the meaning it has in modern Western societies, but that does not mean that either racial categories or racism are purely latter-day constructions. Hurston makes and capitalizes on this very point in *Moses, Man of the Mountain*, without any pretenses toward scholarly authority or discipline. She blurs the distinctions of history just as she blurs the distinctions of race to intriguing effect.

Interestingly, she continued to grapple with the power of the Mosaic myth on her imagination throughout her career. It figures prominently in her efforts to understand the evils of racism. In "Seeing the World as It Is," deleted from the first edition of *Dust Tracks on a Road*, she asserted: ▶

> The Old Testament is devoted to what was right and just from the viewpoint of the Ancient Hebrews. All of their enemies were twenty-two carat evil. They, the Hebrews, were never aggressors. The Lord wanted His Children to have a country full of big grapes and tall corn. Incidentally, while they were getting it, they might as well get rid of some trashy tribes that He never did think much of anyway.

Her editor at Lippincott suggested that she eliminate "international opinions" from the book as they were "irrelevant to autobiography." She complied.

As Robert Hemenway points out in his biography of Hurston, the Japanese attack on Pearl Harbor forced Hurston to delete such commentary and to revise other controversial passages in *Dust Tracks on a Road*. It was only after the war that she unleashed her most direct and venomous attacks on American social institutions, now stripped of the wrap of biblical legend and the American flag. Significantly, these less oblique attacks appeared in black publications such as *Negro Digest*, in which she published "Crazy for This Democracy" (1945). There she referred to Roosevelt's famous phrase "the arsenal of democracy" as the "arse-and-all of democracy," and went on to argue that:

> Jim Crow laws have been put on the books for a purpose and that purpose is . . . to promote in the mind of the smallest white child the conviction of First by Birth, eternal and irrevocable

like the place assigned to the Levites
by Moses over the other tribes of the
Hebrews.

Simply excerpted from their contexts,
these passages are disturbing, but when
recontextualized they show a writer
working back to her cultural origins
and all the complications attached to
considering them. The complication of
race is paramount. The reader cannot stop
at the above excerpt from "Seeing the World
as It Is," for it is followed by reference to "the
kings of Dahomey [who] once marched
up and down West Africa, butchering the
aged and the helpless of the surrounding
tribes and nations and selling the able off
into Western slavery" and to Anglo-Saxon
greed, rape, and pillaging, all for the
"idea . . . that everybody else owes [them]
something for being blonde." The entire
essay is a diffuse discourse on the history
and problematics of "race consciousness,"
which Hurston had come to see as a
"deadly explosive on the tongues of men."
No "race" is omitted from her catalogue
of "international cannibalism" that implies
some disturbing parallels between "nation,"
"race," "Volk" and "folk."
 That World War II and Hitler seemed
to stimulate these essays that logically
follow *Moses* is clear, but here, Hitler
might best be seen not simply as a political
figure but also as a metaphor for slavery,
racism, anti-Semitism, antifeminism,
Jim Crow, and the general repression on
which Hurston had declared war. She had
left behind the lyricism and pastoralism of
Their Eyes Were Watching God with its
imagery of pear trees and bees dusting ▶

pollen, though she retained the justly celebrated language of the "folk."

Hurston's use of folklore has been the convenient "evidence" her detractors have summoned to argue against her fiction's "serious intent." Those critics, like Alain Locke and Richard Wright, mainly saw her work as "folklore fiction" and thus read it as the antithesis of "socially motivated" fiction. *Moses, Man of the Mountain* annuls that false opposition. Even some of those sympathetic readers of Hurston's work have seen it as only folklore and, hence, to many, it is mere entertainment. For instance, Benjamin Brawley defended Hurston's folklore, noting that she, "like some others who have dealt in folklore . . . [had] not escaped criticism at the hands of those who frowned upon her broad humor and the lowly nature of her material." Ending on a patronizing note, he described Hurston as "taking a bright story wherever it may be found, she passes it on, leaving to others the duty and the pleasure of philosophizing."

Such commentary—by supporters and detractors alike—has overlooked the extent to which the majority of Hurston's writings combine a gift for storytelling with the "pleasure of philosophizing" about "the international scheme of things," Ellison notwithstanding. Judgments like Ellison's are at least partly explained by the prominence of Hurston's hometown of Eatonville in her writing, a prominence which has led scholars to give it supreme explanatory power in estimations of her work. All too often Hurston's readers have consigned her to Eatonville and left her there on the porch. Adding other

dimensions to the characterizations of Hurston's birthplace as an idyllic and sheltered all-black town, and the porch, to quote Blyden Jackson, as "the recurring site of a comedic and animated village forum" is difficult to do, for this characterization is the backbone of Hurston's legendary status. Even when readers stretch her province to New Orleans and the Caribbean, the sites of her fieldwork, they often read these migrations as extensions of Eatonville, seen as the repository of black folk culture on which all Hurston's work is dependent.

But reducing Eatonville and its symbolic geographic coordinates to the repositories of black "folk" expression that Hurston mined so well "regionalizes" her work and ensures her removal from a more global context of cultural production and exchange. In other words, however important Eatonville is as the site that birthed and nurtured Hurston's creative genius, much is lost in so circumscribing her work and her world. In *Moses, Man of the Mountain* she has clearly traveled far from Eatonville and far from her own earlier "race-conscious" positions. Of course she had lived in America and experienced the humiliations of Jim Crow long enough to know that the discursive problematization of "race" and racialist thinking did not lead to the social elimination of racism. The race wars that she fictionalizes in *Moses, Man of the Mountain* are only one testament to that awareness and sign that she had grown weary of what Marthe Roberts calls the "fatality of filiation," which both enriches and burdens us with origins, with race. The consequences of Hurston's shifting positions on race have yet to alter in any ▶

significant way the single most persistent image of her as the folklorist of Eatonville. That is regarded as the single most persistent criterion of her literary value. With this new edition of *Moses* we might begin to enlarge her province, to really see her as one of the characters she described in her fiction—one of the "big picture talkers," who "use[d] a side of the world for a canvas." ∾

Have You Read?
More by Zora Neale Hurston

JONAH'S GOURD VINE

Zora Neale Hurston's first novel tells the story of John Buddy Pearson, a young minister who loves too many women for his own good even though he is married to Lucy, his one true love. In this sympathetic portrait of a man and his community, Hurston shows that faith, tolerance, and good intentions cannot resolve the tension between the spiritual and the physical.

THEIR EYES WERE WATCHING GOD

The epic tale of Janie Crawford, whose quest for identity takes her on a journey during which she learns what love is, experiences life's joys and sorrows, and comes home to herself in peace. Her passionate story prompted Alice Walker to say, "There is no book more important to me than this one."

MULES AND MEN

The fruit of Hurston's labors as a folklorist and anthropologist, this celebrated treasury of black American folklore includes stories, "big old lies," songs, Voodoo customs, superstitions—all the humor and wisdom that is the matchless heritage of American blacks.

THE COMPLETE STORIES

This landmark gathering of Zora Neale Hurston's short fiction—most of which appeared only in literary magazines during her lifetime and some of which has never before been published—reveals the evolution of one of the most important African American writers. Spanning her career from 1921 to 1955, these stories attest to Hurston's tremendous range and establish themes that recur in her longer fiction. The stories in this collection map, in rich language and imagery, Hurston's development and concerns as a writer and provide an invaluable reflection of the mind and imagination of the author of the acclaimed novel *Their Eyes Were Watching God*.

TELL MY HORSE

This firsthand account of the mysteries of Voodoo is based on Hurston's personal experiences in Haiti and Jamaica, where she participated as an initiate and not just an observer of Voodoo practices in the 1930s. Of great cultural interest, her travelogue paints a vividly authentic picture of ceremonies, customs, and superstitions.

DUST TRACKS ON THE ROAD

First published in 1942 at the crest of her popularity as a writer, this is Hurston's imaginative and exuberant account of her rise from childhood poverty in the rural South to a prominent place among the leading artists and intellectuals of the Harlem Renaissance. It is a book full of the wit and wisdom of a proud and spirited woman who started off low and climbed high.

SERAPH ON THE SUWANEE

Set among the community of "Florida Crackers" at the turn of the twentieth century, Hurston's novel marks a daring departure for the author famous for her complex accounts of black culture and heritage. Hurston explores the evolution of a marriage full of love but very little communication and the desires of a young woman in search of herself and her place in the world.

MULE BONE

Mule Bone is the only collaboration between Zora Neale Hurston and Langston Hughes, two stars of the Harlem Renaissance, and it holds an unparalleled place in the annals of African American theater. Set in Eatonville, Florida—Hurston's hometown and the inspiration for much of her fiction—this energetic and often farcical play centers on Jim and Dave, a two-man song-and-dance team, and Daisy, the woman who comes between them. Overcome by jealousy, Jim hits Dave with a mule bone and hilarity follows chaos as the town splits into two factions: the Methodists, who want to pardon Jim; and the Baptists, who wish to banish him for his crime.

EVERY TONGUE GOT TO CONFESS

ZORA NEALE
HURSTON
AUTHOR OF
Their Eyes Were Watching God

Every Tongue
Got to Confess
Negro Folk-tales from the Gulf States

African American folklore was Zora Neale Hurston's first love. Collected in the late 1920s, these hilarious, bittersweet, often saucy folktales—some of which date back to the Civil War—provide a fascinating, verdant slice of African American life in the rural South at the turn of the twentieth century. Arranged according to subject—from God Tales, Preacher Tales, and Devil Tales to Heaven Tales, White-Folk Tales, and Mistaken Identity Tales—they reveal attitudes about slavery, faith, race relations, family, and romance that have been passed on for generations. They capture the heart and soul of the vital, independent, and creative community that so inspired Zora Neale Hurston.

Their Eyes Were Watching God

BOOKS BY ZORA NEALE HURSTON

Jonah's Gourd Vine

Mules and Men

Their Eyes Were Watching God

Tell My Horse

Moses, Man of the Mountain

Dust Tracks on a Road

Seraph on the Suwanee

The Sanctified Church

Spunk: The Selected Short Stories of Zora Neale Hurston

Mule Bone: A Comedy of Negro Life

(a play written with Langston Hughes)

The Complete Stories

Every Tongue Got to Confess

CHILDREN'S BOOKS BY ZORA NEALE HURSTON

What's the Hurry Fox?

The Skull Talks Back

The Six Fools

Lies and Other Tall Tales

Zora Neale Hurston

Their Eyes Were Watching God

With a Foreword by
Edwidge Danticat
and an Afterword by
Henry Louis Gates, Jr.

AMISTAD

An Imprint of HarperCollinsPublishers

NEW YORK ● LONDON ● TORONTO ● SYDNEY

AMISTAD

First Perennial Library edition published 1990.

First Perennial Classics edition published 1998.

First Harper Perennial Modern Classics edition published 2006. Reissued 2013.

The Library of Congress has catalogued the previous Perennial Classics edition as follows:

Hurston, Zora Neale.
 Their eyes were watching God : a novel / Zora Neale Hurston ; with an afterword by Henry Louis Gates, Jr.—1st Perennial Classics ed.
 p. cm.
ISBN 0-06-093141-8
Includes bibliographical references.
 1. Afro-American women—psychology—Fiction. 2. Self-realization—Fiction. 3. Psychological fiction. I. Title.
PS3515.U789T5 1999
813'.52-dc21 98-45543

ISBN 978-0-06-083867-6 (pbk.)

21 22 23 ❖/LSC 40 39 38

To Henry Allen Moe

Contents

Foreword

I

"Ships at a distance have every man's wish on board." So begins Zora Neale Hurston's brilliant novel about a woman's search for her authentic self and for real love. At first it might seem contradictory that a work whose central character is the remarkably resolute and resilient Janie Crawford should start with a dictum about "the life of men." However, that is one of the many shrewd manifestations of Zora Neale Hurston's enormous talents: her ability to render a world complete with its codes and disciplines within a few sentences, and then placing in that world her vision of how her people—the women and men of her own creation, her characters—function, triumph, and survive. So off that metaphorically distant ship comes our heroine Janie Crawford, and suddenly we realize that she had been on her own singular journey all along, her dreams "mocked to death by Time," but never totally defeated. And since women "remember everything they don't want to forget," Janie Crawford recalls all the crucial moments of her life, from the time she first discovers that she is a "colored" little girl by searching for her face in a group photograph, to the moment she returns to Eatonville, Florida, from the Everglades, not swindled and deceived, as had been expected, but heartbroken, yet boldly defiant, after

having toiled in the bean fields, survived a hurricane, and lost the man she loved.

Janie Crawford is able to retrace her steps, disembark from her own ship, come home, and remember, because she has been close to death but has lived a very full life. So in spite of the judgmental voices that greet her upon her return, in spite of the "mass cruelty" invoked by her prodigal status, Janie has earned the right to be the griot of her own tale, the heroine of her own quest, the "member" of her own remembering.

In the loose call-and-response structure that frames the novel—Janie's friend Pheoby asks her to tell her where she has been, and Janie responds with the story that constitutes the book—Janie's is an intimate audience of one. She entrusts her adventures to Pheoby to retell to others only if Pheoby chooses. ("You can tell 'em what Ah say if you wants to. Dat's just de same as me 'cause mah tongue is in mah friend's mouf.") Janie is recounting her story as much to Pheoby as to herself. Her response to Pheoby's call is at the same time an echo, much like the nymph Echo who retains only her voice after having literally been torn apart. Hurston herself also becomes Janie's echo by picking up the narrative thread in intervals, places where in real life, or in real time, Janie might have simply grown tired of talking. Much like the porch sitters at the beginning of the book who are the first to see Janie arrive, Janie, Pheoby, and Zora Neale Hurston form their own storytelling chain, and it is through their linking of voices that we are taken on this intimate yet communal journey that is *Their Eyes Were Watching God*.

II

I have always been extremely proud to remind all who would listen that Zora Neale Hurston's masterpiece, *Their Eyes Were Watching God*, was written, by her own account, in seven

weeks, in my homeland, Haiti. I once made a complete fool of myself in front of a group of young women writers who had just created a book club and had gracefully invited me to their first meeting. Soon after the book club's newly elected president announced that the first book they'd be reading would be *Their Eyes Were Watching God*, I intervened to declare, "Did you know that Zora wrote it in seven weeks in Haiti?"

I was hastily rebuffed by a curt "So?" from one of the members.

"So?" I replied, embarrassed. "Could *you* write a book like that in seven weeks?"

Of course Hurston's own account of how long it took to compose the novel has been debated and contested. However, I am awed by her ability to have found the time during her anthropological travels and constant research in Haiti to produce a novel—at all. As a writer, I am amazed by the way she often managed to use the places and circumstances she found herself in to create a room, a world, of her own. Even with the menace of pennilessness always looming, she somehow unearthed the solace, or perhaps the desperation, to write.

Many of my contemporaries, including myself, often complain—sometimes with book contracts in tow—about not having enough time, money, and space to write. Yet Zora battled to write and she did, knowing, as Janie Crawford must have also known, that "there is no agony like bearing an untold story inside you." Thus, no matter how many times I have read this book, when Janie begins telling that untold story inside her, I am always doubly elated, both with the story itself and with the way in which it came to be. And so when I blurt out my favorite piece of Hurston trivia, I do it partially out of pride for her association with Haiti but I also do it heeding Alice Walker's extremely wise advice in her

foreword to Robert E. Hemenway's literary biography of Hurston: *"We are a People."* (And I include all the international peoples of the African diaspora in this category.) *"A People do not throw their geniuses away."*

Fortunately, over the years, I have met very few active readers of my generation (born after 1960), writers and non-writers alike, who would even consider throwing Zora away. Many of us can remember vividly our first encounter with her work, particularly *Their Eyes Were Watching God*. Because of the efforts of Ms. Walker and others, who valiantly reclaimed Zora for themselves and for all of us, we read Zora either in high school or in college classes, where her work is enthusiastically taught by men and women—most of whom were much older than we were when they first read her—and still had the exuberance of a recent discovery, much as in the early days of a love affair, or a reunion with a friend long thought dead.

I first read *Their Eyes Were Watching God* in an elective black history class at Clara Barton High School in Brooklyn, New York. The class was taught by a young teacher who conducted it during his lunch hour. There was not much reading for young adults about Zora and her work, so we struggled with the plot and the language with a lot of coaching from our teacher. Most of us were new immigrants to the United States and read Janie, Pheoby, and Tea Cake's dialogue out loud with our heavy Creole accents, and managed to come away with only a glimmer of the brilliance of what we had read.

At times, feeling as if my lack of English had robbed me of precious narrative information, I would raise questions that went beyond the scope of the novel, and my teacher would become very excited, applauding the fact that I was stretching my imagination way beyond the words in front of me, which is what all good readers are supposed to do.

"Where was Tea Cake's family?" I would ask. "And what did Janie's friend Pheoby do while Janie was gone?"

I would later explore more purposefully deliberate questions about the book in a freshman English class at Barnard College, where Zora had also been a student in the 1920s. Hers were among the books in a glass case in the Barnard library that also highlighted other famous alumnae authors, including the poet, playwright, and novelist Ntozake Shange. Each time I walked by that glass case, I felt my dream of becoming an author growing more and more attainable, partly because Zora and Ntozake were black women, like me.

"Zora has lived in my country," I happily told one of my classmates, "and now I am living in hers." I liked to think that Zora was drawn to Haiti partly because of the many similarities between Haitian and Southern African-American culture. Zora was from an all-black town, run and governed by black people, and I was from a black republic, where Frederick Douglass had resided and where Katherine Dunham had studied and danced. In *Tell My Horse*, Zora finds an equivalent for the cunning Brer Rabbit of the Uncle Remus stories in Haiti's sly Ti Malis of popular lore. And in the rural belief that our dead will one day return to Ginen, Africa, she uncovered echoes of the strong convictions of many of those who were forced on board slave ships for points of no return.

There were so many things that I found familiar in *Their Eyes Were Watching God:* the dead-on orality in both the narration and dialogue; the communal gatherings on open porches at dusk; the intimate storytelling *(krik? krak!);* the communal tall-tale sessions, both about real people who have erred *(zen)* and fictional folks who have hilariously blundered *(blag)*. Her description of the elaborate burial of Janie's pet mule reminded me of an incident that she detailed in *Tell My Horse* in which Haitian president Antoine Simon ordered an elaborate Catholic funeral at the national cathedral for his pet

goat Simalo, something many Haitians would laugh about for years.

In class at Barnard, we gladly raised structural questions about *Their Eyes Were Watching God*. Was it a love story or an adventure story? We decided it could be both, as many other complex novels are. Besides, don't adventures often include romance? And aren't all exciting romances adventures?

We brought up issues that concerned us as young feminists and womanists. Was Janie Crawford a good female role model or was she solely defined by the men in her life? Many of us argued that Janie did not have to be a role model at all. She simply had to be a fully realized and complex character, which she was. She certainly manifested a will of her own in spite of the efforts of her grandmother and her two first husbands to dominate her, leaving her first husband when life with him grew unbearable, and taking off with Tea Cake against public opinion after the second husband died.

Why did Janie allow Tea Cake to beat her? Some of us thought that Hurston tried to envision characters who are neither too holy nor too evil. Her men and women are extremely nuanced, reflecting human strengths as well as frailties. If Tea Cake were too cruel, then Janie would not love him at all. If he were too uniformly pious, then rather than being her equal, as he was at work in the fields, he would be worshipped by her, and "all gods who receive homage are cruel. All gods dispense suffering without reasons . . . half gods are worshipped in wine and flowers. Real gods require blood." In the end, Janie receives from Tea Cake the equivalent of all three—wine, flowers, and blood—and she becomes like a treasured relative whose love affair we could never wholeheartedly condone, but the source of which we could certainly understand. Tea Cake gives his life for Janie, and this, if nothing else, serves as some atonement for many of his sins.

In spite of Janie's choices concerning Tea Cake, or perhaps because of them, she experiences more freedom than most women (certainly most poor women) of her time. And as much as she loves Tea Cake, she ultimately chooses to live and not to die with him, and her final act is not to follow him to the grave, but to bury him and return alone to a community that will not embrace and welcome her without first being given an explanation as to where she has been and what she has been through.

III

For many decades and, hopefully, centuries to come, *Their Eyes Were Watching God* will probably be at the center of Zora Neale Hurston's legacy as a novelist. Perhaps because it was written in such a short and, reportedly, emotionally charged period, this is a novel with an overpowering sense of exigency and urgency in its layered plot, swift pace, intricate narration, and in the raw anguish evoked by the conflicting paths laid out for Janie Crawford as she attempts to survive her grandmother's restricted vision of a black woman's life and realize her own self-conceived liberation. Like all individual thinkers, Janie Crawford pays the price of exclusion for nonconformity, much like Hurston herself, who was accused of stereotyping the people she loved when she perhaps simply listened to them much more closely than others, and sought to reclaim and reclassify their voices.

The novel not only offers a penetrating view of Janie's evolving thinking process but we are also given plenty of insight into the mindsets of those who would wish to condemn her. Janie, however, is never overly critical of her neighbors' faultfinding reactions to her. She either ignores them entirely or pities them for never having left the safety of their town and never having lived and loved as deeply as she has.

Having survived all she has, Janie now has a deeper understanding of her own actions as well as a greater comprehension of human behavior in general.

"It's uh known fact, Pheoby, you got tuh go there tuh know there," she explains to her friend. "Two things everybody's got tuh do fuh theyselves . . . They got tuh go tuh God and they got tuh find out about livin' fuh theyselves."

Along with the classic conflict between an individual's wishes and a community's censure, there are many contemporary motifs in this novel, events that could have been easily plucked out of early-twenty-first-century headlines: loveless marriages; verbal and physical abuse; mercy killing, or a killing in self-defense, depending on how you interpret it; forbidden love; a public and passionate affair between a younger man and an older woman from different stations in life. Many of the minor characters in the novel are vibrantly multicultural, from African Americans to Native Americans to the Caribbeans who live and work in the Everglades. (To this day, migrant labor and hurricanes remain very concrete elements of life in Florida.)

The influence of Zora's work, particularly *Their Eyes Were Watching God,* will continue to be felt for years in the works of many generations of writers. For example, Janie Crawford shares a literary kinship with Celie of Alice Walker's *The Color Purple,* whose eyes not only watch God, but whose words and letters, whose voice, speak directly to God.

Part of the reason Janie's grandmother Nanny pushes her into a loveless marriage to Logan Killicks, her first husband, is that Nanny was born into slavery and had little choice over her own destiny. Nanny has craved small comforts, like sitting idly on a porch, and wants her granddaughter to have them, along with money and status, no matter what the emotional cost. What Nanny may not have considered is that Janie

would have her own ideas of freedom. However, Nanny is also pained by a deferred dream of her own.

Nanny confesses to young Janie, "Ah wanted to preach a great sermon about colored women sittin' on high, but they wasn't no pulpit for me."

In Toni Morrison's *Beloved,* Beloved's grandmother Baby Suggs preaches the sermon Nanny never got to preach. Baby Suggs "became an unchurched preacher, one who visited pulpits." However, her most-used pulpit was one that Baby Suggs created for herself, outdoors, in a clearing: "After situating herself on a huge flat-sided rock, Baby Suggs bowed her head and prayed silently. . . . Finally she called the women to her. 'Cry,' she told them. 'For the living and for the dead. Just cry.' And without covering their eyes the women let loose."

What a difference it might have made to young Janie to have heard her grandmother preach that sermon, to have heard her Nanny say, as Baby Suggs did, "More than your life-holding womb and your life-giving private parts . . . love your heart. For this is the prize."

IV

In the circular narration of *Their Eyes Were Watching God,* at the end of the book, a whole new life lies ahead, uncharted for a still relatively young Janie Crawford. She has told her story and has satisfied "that oldest human longing—self-revelation." And now she must go on.

We know that Janie will never forget Tea Cake. Not only did she love him very deeply, but her life and travels with him have opened up her world and her heart in irreversible ways. However, we get hints that Janie will continue to live on her own uncompromising terms, for even as she has lost her beloved, she has also discovered many deeper layers of herself.

"Now, dat's how everything wuz, Pheoby, jus' lak Ah told yuh," she says to her friend as she prepares to wrap up

her story. "So Ah'm back home agin and Ah'm satisfied tuh be heah. Ah done been to de horizon and back and now Ah kin set heah in mah house and live by comparisons."

Janie's life, by comparison, might seem more turbulent than most. However, both her past and her future can best be characterized by the way she describes her love for Tea Cake at the end of the book. Not like a "grindstone" that is the same everywhere and has the same effect on everything it touches, but like the sea, the sea of distant ships with every man's wish on board, the powerful moving sea that "takes its shape from de shore it meets," and is "different with every shore."

EDWIDGE DANTICAT

1

Ships at a distance have every man's wish on board. For some they come in with the tide. For others they sail forever on the horizon, never out of sight, never landing until the Watcher turns his eyes away in resignation, his dreams mocked to death by Time. That is the life of men.

Now, women forget all those things they don't want to remember, and remember everything they don't want to forget. The dream is the truth. Then they act and do things accordingly.

So the beginning of this was a woman and she had come back from burying the dead. Not the dead of sick and ailing with friends at the pillow and the feet. She had come back from the sodden and the bloated; the sudden dead, their eyes flung wide open in judgment.

The people all saw her come because it was sundown. The sun was gone, but he had left his footprints in the sky. It was the time for sitting on porches beside the road. It was the time to hear things and talk. These sitters had been tongueless, earless, eyeless conveniences all day long. Mules and other brutes had occupied their skins. But now, the sun and the bossman were gone, so the skins felt powerful and human. They became lords of sounds and lesser things. They passed nations through their mouths. They sat in judgment.

Seeing the woman as she was made them remember the envy they had stored up from other times. So they chewed up the back parts of their minds and swallowed with relish. They made burning statements with questions, and killing tools out of laughs. It was mass cruelty. A mood come alive. Words walking without masters; walking altogether like harmony in a song.

"What she doin coming back here in dem overhalls? Can't she find no dress to put on?—Where's dat blue satin dress she left here in?—Where all dat money her husband took and died and left her?—What dat ole forty year ole 'oman doin' wid her hair swingin' down her back lak some young gal?—Where she left dat young lad of a boy she went off here wid?—Thought she was going to marry?—Where he left *her*?—What he done wid all her money?—Betcha he off wid some gal so young she ain't even got no hairs—why she don't stay in her class?—"

When she got to where they were she turned her face on the bander log and spoke. They scrambled a noisy "good evenin'" and left their mouths setting open and their ears full of hope. Her speech was pleasant enough, but she kept walking straight on to her gate. The porch couldn't talk for looking.

The men noticed her firm buttocks like she had grape fruits in her hip pockets; the great rope of black hair swinging to her waist and unraveling in the wind like a plume; then her pugnacious breasts trying to bore holes in her shirt. They, the men, were saving with the mind what they lost with the eye. The women took the faded shirt and muddy overalls and laid them away for remembrance. It was a weapon against her strength and if it turned out of no significance, still it was a hope that she might fall to their level some day.

But nobody moved, nobody spoke, nobody even thought to swallow spit until after her gate slammed behind her.

Pearl Stone opened her mouth and laughed real hard because she

didn't know what else to do. She fell all over Mrs. Sumpkins while she laughed. Mrs. Sumpkins snorted violently and sucked her teeth.

"Humph! Y'all let her worry yuh. You ain't like me. Ah ain't got her to study 'bout. If she ain't got manners enough to stop and let folks know how she been makin' out, let her g'wan!"

"She ain't even worth talkin' after," Lulu Moss drawled through her nose. "She sits high, but she looks low. Dat's what Ah say 'bout dese ole women runnin' after young boys."

Pheoby Watson hitched her rocking chair forward before she spoke. "Well, nobody don't know if it's anything to tell or not. Me, Ah'm her best friend, and *Ah* don't know."

"Maybe us don't know into things lak you do, but we all know how she went 'way from here and us sho seen her come back. 'Tain't no use in your tryin' to cloak no ole woman lak Janie Starks, Pheoby, friend or no friend."

"At dat she ain't so ole as some of y'all dat's talking."

"She's way past forty to my knowledge, Pheoby."

"No more'n forty at de outside."

"She's 'way too old for a boy like Tea Cake."

"Tea Cake ain't been no boy for some time. He's round thirty his ownself."

"Don't keer what it was, she could stop and say a few words with us. She act like we done done something to her," Pearl Stone complained. "She de one been doin' wrong."

"You mean, you mad 'cause she didn't stop and tell us all her business. Anyhow, what you ever know her to do so bad as y'all make out? The worst thing Ah ever knowed her to do was taking a few years offa her age and dat ain't never harmed nobody. Y'all makes me tired. De way you talkin' you'd think de folks in dis town didn't do nothin' in de bed 'cept praise de Lawd. You have to 'scuse me, 'cause Ah'm bound to go take her some supper." Pheoby stood up sharply.

"Don't mind us," Lulu smiled, "just go right ahead, us can mind yo' house for you till you git back. Mah supper is done. You bettah go see how she feel. You kin let de rest of us know."

"Lawd," Pearl agreed, "Ah done scorched-up dat lil meat and bread too long to talk about. Ah kin stay 'way from home long as Ah please. Mah husband ain't fussy."

"Oh, er, Pheoby, if youse ready to go, Ah could walk over dere wid you," Mrs. Sumpkins volunteered. "It's sort of duskin' down dark. De booger man might ketch yuh."

"Naw, Ah thank yuh. Nothin' couldn't ketch me dese few steps Ah'm goin'. Anyhow mah husband tell me say no first class booger would have me. If she got anything to tell yuh, you'll hear it."

Pheoby hurried on off with a covered bowl in her hands. She left the porch pelting her back with unasked questions. They hoped the answers were cruel and strange. When she arrived at the place, Pheoby Watson didn't go in by the front gate and down the palm walk to the front door. She walked around the fence corner and went in the intimate gate with her heaping plate of mulatto rice. Janie must be round that side.

She found her sitting on the steps of the back porch with the lamps all filled and the chimneys cleaned.

"Hello, Janie, how you comin'?"

"Aw, pretty good, Ah'm tryin' to soak some uh de tiredness and de dirt outa mah feet." She laughed a little.

"Ah see you is. Gal, you sho looks *good*. You looks like youse yo' own daughter." They both laughed. "Even wid dem overhalls on, you shows yo' womanhood."

"G'wan! G'wan! You must think Ah brought yuh somethin'. When Ah ain't brought home a thing but mahself."

"Dat's a gracious plenty. Yo' friends wouldn't want nothin' better."

"Ah takes dat flattery offa you, Pheoby, 'cause Ah know it's

from de heart." Janie extended her hand. "Good Lawd, Pheoby! ain't you never goin' tuh gimme dat lil rations you brought me? Ah ain't had a thing on mah stomach today exceptin' mah hand." They both laughed easily. "Give it here and have a seat."

"Ah knowed you'd be hongry. No time to be huntin' stove wood after dark. Mah mulatto rice ain't so good dis time. Not enough bacon grease, but Ah reckon it'll kill hongry."

"Ah'll tell you in a minute," Janie said, lifting the cover. "Gal, it's *too* good! you switches a mean fanny round in a kitchen."

"Aw, dat ain't much to eat, Janie. But Ah'm liable to have something sho nuff good tomorrow, 'cause you done come."

Janie ate heartily and said nothing. The varicolored cloud dust that the sun had stirred up in the sky was settling by slow degrees.

"Here, Pheoby, take yo' ole plate. Ah ain't got a bit of use for a empty dish. Dat grub sho come in handy."

Pheoby laughed at her friend's rough joke. "Youse just as crazy as you ever was."

"Hand me dat wash-rag on dat chair by you, honey. Lemme scrub mah feet." She took the cloth and rubbed vigorously. Laughter came to her from the big road.

"Well, Ah see Mouth-Almighty is still sittin' in de same place. And Ah reckon they got *me* up in they mouth now."

"Yes indeed. You know if you pass some people and don't speak tuh suit 'em dey got tuh go way back in yo' life and see whut you ever done. They know mo' 'bout yuh than you do yo' self. An envious heart makes a treacherous ear. They done 'heard' 'bout you just what they hope done happened."

"If God don't think no mo' 'bout 'em then Ah do, they's a lost ball in de high grass."

"Ah hears what they say 'cause they just will collect round mah porch 'cause it's on de big road. Mah husband git so sick of 'em sometime he makes 'em all git for home."

"Sam is right too. They just wearin' out yo' sittin' chairs."

"Yeah, Sam say most of 'em goes to church so they'll be sure to rise in Judgment. Dat's de day dat every secret is s'posed to be made known. They wants to be there and hear it *all*."

"Sam is *too* crazy! You can't stop laughin' when youse round him."

"Uuh hunh. He says he aims to be there hisself so he can find out who stole his corn-cob pipe."

"Pheoby, dat Sam of your'n just won't quit! Crazy thing!"

"Most of dese zigaboos is so het up over yo' business till they liable to hurry theyself to Judgment to find out about you if they don't soon know. You better make haste and tell 'em 'bout you and Tea Cake gittin' married, and if he taken all yo' money and went off wid some young gal, and where at he is now and where at is all yo' clothes dat you got to come back here in overhalls."

"Ah don't mean to bother wid tellin' 'em nothin', Pheoby. 'Tain't worth de trouble. You can tell 'em what Ah say if you wants to. Dat's just de same as me 'cause mah tongue is in mah friend's mouf."

"If you so desire Ah'll tell 'em what you tell me to tell 'em."

"To start off wid, people like dem wastes up too much time puttin' they mouf on things they don't know nothin' about. Now they got to look into me loving Tea Cake and see whether it was done right or not! They don't know if life is a mess of corn-meal dumplings, and if love is a bed-quilt!"

"So long as they get a name to gnaw on they don't care whose it is, and what about, 'specially if they can make it sound like evil."

"If they wants to see and know, why they don't come kiss and be kissed? Ah could then sit down and tell 'em things. Ah been a delegate to de big 'ssociation of life. Yessuh! De Grand Lodge, de big convention of livin' is just where Ah been dis year and a half y'all ain't seen me."

They sat there in the fresh young darkness close together. Pheoby eager to feel and do through Janie, but hating to show her zest for fear it might be thought mere curiosity. Janie full of that oldest human longing—self revelation. Pheoby held her tongue for a long time, but she couldn't help moving her feet. So Janie spoke.

"They don't need to worry about me and my overhalls long as Ah still got nine hundred dollars in de bank. Tea Cake got me into wearing 'em—following behind him. Tea Cake ain't wasted up no money of mine, and he ain't left me for no young gal, neither. He give me every consolation in de world. He'd tell 'em so too, if he was here. If he wasn't gone."

Pheoby dilated all over with eagerness, "Tea Cake gone?"

"Yeah, Pheoby, Tea Cake is gone. And dat's de only reason you see me back here—cause Ah ain't got nothing to make me happy no more where Ah was at. Down in the Everglades there, down on the muck."

"It's hard for me to understand what you mean, de way you tell it. And then again Ah'm hard of understandin' at times."

"Naw, 'tain't nothin' lak you might think. So 'tain't no use in me telling you somethin' unless Ah give you de understandin' to go 'long wid it. Unless you see de fur, a mink skin ain't no different from a coon hide. Looka heah, Pheoby, is Sam waitin' on you for his supper?"

"It's all ready and waitin'. If he ain't got sense enough to eat it, dat's his hard luck."

"Well then, we can set right where we is and talk. Ah got the house all opened up to let dis breeze get a little catchin'.

"Pheoby, we been kissin'-friends for twenty years, so Ah depend on you for a good thought. And Ah'm talking to you from dat standpoint."

Time makes everything old so the kissing, young darkness became a monstropolous old thing while Janie talked.

2

Janie saw her life like a great tree in leaf with the things suffered, things enjoyed, things done and undone. Dawn and doom was in the branches.

"Ah know exactly what Ah got to tell yuh, but it's hard to know where to start at.

"Ah ain't never seen mah papa. And Ah didn't know 'im if Ah did. Mah mama neither. She was gone from round dere long before Ah wuz big enough tuh know. Mah grandma raised me. Mah grandma and de white folks she worked wid. She had a house out in de back-yard and dat's where Ah wuz born. They was quality white folks up dere in West Florida. Named Washburn. She had four gran'chillun on de place and all of us played together and dat's how come Ah never called mah Grandma nothin' but Nanny, 'cause dat's what everybody on de place called her. Nanny used to ketch us in our devilment and lick every youngun on de place and Mis' Washburn did de same. Ah reckon dey never hit us ah lick amiss 'cause dem three boys and us two girls wuz pretty aggravatin', Ah speck.

"Ah was wid dem white chillun so much till Ah didn't know Ah wuzn't white till Ah was round six years old. Wouldn't have found it out then, but a man come long takin' pictures and with-

out askin' anybody, Shelby, dat was de oldest boy, he told him to take us. Round a week later de man brought de picture for Mis' Washburn to see and pay him which she did, then give us all a good lickin'.

"So when we looked at de picture and everybody got pointed out there wasn't nobody left except a real dark little girl with long hair standing by Eleanor. Dat's where Ah wuz s'posed to be, but Ah couldn't recognize dat dark chile as me. So Ah ast, 'where is me? Ah don't see me.'

"Everybody laughed, even Mr. Washburn. Miss Nellie, de Mama of de chillun who come back home after her husband dead, she pointed to de dark one and said, 'Dat's you, Alphabet, don't you know yo' ownself?'

"Dey all useter call me Alphabet 'cause so many people had done named me different names. Ah looked at de picture a long time and seen it was mah dress and mah hair so Ah said:

"'Aw, aw! Ah'm colored!'

"Den dey all laughed real hard. But before Ah seen de picture Ah thought Ah wuz just like de rest.

"Us lived dere havin' fun till de chillun at school got to teasin' me 'bout livin' in de white folks' back-yard. Dere wuz uh knotty head gal name Mayrella dat useter git mad every time she look at me. Mis' Washburn useter dress me up in all de clothes her gran'chillun didn't need no mo' which still wuz better'n whut de rest uh de colored chillun had. And then she useter put hair ribbon on mah head fuh me tuh wear. Dat useter rile Mayrella uh lot. So she would pick at me all de time and put some others up tuh do de same. They'd push me 'way from de ring plays and make out they couldn't play wid nobody dat lived on premises. Den they'd tell me not to be takin' on over mah looks 'cause they mama told 'em 'bout de hound dawgs huntin' mah papa all night long. 'Bout Mr. Washburn and de sheriff puttin' de

bloodhounds on de trail tuh ketch mah papa for whut he done tuh mah mama. Dey didn't tell about how he wuz seen tryin' tuh git in touch wid mah mama later on so he could marry her. Naw, dey didn't talk dat part of it atall. Dey made it sound real bad so as tuh crumple mah feathers. None of 'em didn't even remember whut his name wuz, but dey all knowed de bloodhound part by heart. Nanny didn't love tuh see me wid mah head hung down, so she figgered it would be mo' better fuh me if us had uh house. She got de land and everything and then Mis' Washburn helped out uh whole heap wid things."

Pheoby's hungry listening helped Janie to tell her story. So she went on thinking back to her young years and explaining them to her friend in soft, easy phrases while all around the house, the night time put on flesh and blackness.

She thought awhile and decided that her conscious life had commenced at Nanny's gate. On a late afternoon Nanny had called her to come inside the house because she had spied Janie letting Johnny Taylor kiss her over the gatepost.

It was a spring afternoon in West Florida. Janie had spent most of the day under a blossoming pear tree in the back-yard. She had been spending every minute that she could steal from her chores under that tree for the last three days. That was to say, ever since the first tiny bloom had opened. It had called her to come and gaze on a mystery. From barren brown stems to glistening leaf-buds; from the leaf-buds to snowy virginity of bloom. It stirred her tremendously. How? Why? It was like a flute song forgotten in another existence and remembered again. What? How? Why? This singing she heard that had nothing to do with her ears. The rose of the world was breathing out smell. It followed her through all her waking moments and caressed her in her sleep. It connected itself with other vaguely felt matters that had struck her outside observation and buried

themselves in her flesh. Now they emerged and quested about her consciousness.

She was stretched on her back beneath the pear tree soaking in the alto chant of the visiting bees, the gold of the sun and the panting breath of the breeze when the inaudible voice of it all came to her. She saw a dust-bearing bee sink into the sanctum of a bloom; the thousand sister-calyxes arch to meet the love embrace and the ecstatic shiver of the tree from root to tiniest branch creaming in every blossom and frothing with delight. So this was a marriage! She had been summoned to behold a revelation. Then Janie felt a pain remorseless sweet that left her limp and languid.

After a while she got up from where she was and went over the little garden field entire. She was seeking confirmation of the voice and vision, and everywhere she found and acknowledged answers. A personal answer for all other creations except herself. She felt an answer seeking her, but where? When? How? She found herself at the kitchen door and stumbled inside. In the air of the room were flies tumbling and singing, marrying and giving in marriage. When she reached the narrow hallway she was reminded that her grandmother was home with a sick headache. She was lying across the bed asleep so Janie tipped on out of the front door. Oh to be a pear tree—*any* tree in bloom! With kissing bees singing of the beginning of the world! She was sixteen. She had glossy leaves and bursting buds and she wanted to struggle with life but it seemed to elude her. Where were the singing bees for her? Nothing on the place nor in her grandma's house answered her. She searched as much of the world as she could from the top of the front steps and then went on down to the front gate and leaned over to gaze up and down the road. Looking, waiting, breathing short with impatience. Waiting for the world to be made.

Through pollinated air she saw a glorious being coming up the road. In her former blindness she had known him as shiftless

Johnny Taylor, tall and lean. That was before the golden dust of pollen had beglamored his rags and her eyes.

In the last stages of Nanny's sleep, she dreamed of voices. Voices far-off but persistent, and gradually coming nearer. Janie's voice. Janie talking in whispery snatches with a male voice she couldn't quite place. That brought her wide awake. She bolted upright and peered out of the window and saw Johnny Taylor lacerating her Janie with a kiss.

"Janie!"

The old woman's voice was so lacking in command and reproof, so full of crumbling dissolution,—that Janie half believed that Nanny had not seen her. So she extended herself outside of her dream and went inside of the house. That was the end of her childhood.

Nanny's head and face looked like the standing roots of some old tree that had been torn away by storm. Foundation of ancient power that no longer mattered. The cooling palma christi leaves that Janie had bound about her grandma's head with a white rag had wilted down and become part and parcel of the woman. Her eyes didn't bore and pierce. They diffused and melted Janie, the room and the world into one comprehension.

"Janie, youse uh 'oman, now, so—"

"Naw, Nanny, naw Ah ain't no real 'oman yet."

The thought was too new and heavy for Janie. She fought it away.

Nanny closed her eyes and nodded a slow, weary affirmation many times before she gave it voice.

"Yeah, Janie, youse got yo' womanhood on yuh. So Ah mout ez well tell yuh whut Ah been savin' up for uh spell. Ah wants to see you married right away."

"Me, married? Naw, Nanny, no ma'am! Whut Ah know 'bout uh husband?"

"Whut Ah seen just now is plenty for me, honey, Ah don't want no trashy nigger, no breath-and-britches, lak Johnny Taylor usin' yo' body to wipe his foots on."

Nanny's words made Janie's kiss across the gatepost seem like a manure pile after a rain.

"Look at me, Janie. Don't set dere wid yo' head hung down. Look at yo' ole grandma!" Her voice began snagging on the prongs of her feelings. "Ah don't want to be talkin' to you lak dis. Fact is Ah done been on mah knees to mah Maker many's de time askin' *please*—for Him not to make de burden too heavy for me to bear."

"Nanny, Ah just—Ah didn't mean nothin' bad."

"Dat's what makes me skeered. You don't mean no harm. You don't even know where harm is at. Ah'm ole now. Ah can't be always guidin' yo' feet from harm and danger. Ah wants to see you married right away."

"Who Ah'm goin' tuh marry off-hand lak dat? Ah don't know nobody."

"De Lawd will provide. He know Ah done bore de burden in de heat uh de day. Somebody done spoke to me 'bout you long time ago. Ah ain't said nothin' 'cause dat wasn't de way Ah placed you. Ah wanted yuh to school out and pick from a higher bush and a sweeter berry. But dat ain't yo' idea, Ah see."

"Nanny, who—who dat been askin' you for me?"

"Brother Logan Killicks. He's a good man, too."

"Naw, Nanny, no ma'am! Is dat whut he been hangin' round here for? He look like some ole skullhead in de grave yard."

The older woman sat bolt upright and put her feet to the floor, and thrust back the leaves from her face.

"So you don't want to marry off decent like, do yuh? You just wants to hug and kiss and feel around with first one man and then another, huh? You wants to make me suck de same sorrow yo'

mama did, eh? Mah ole head ain't gray enough. Mah back ain't bowed enough to suit yuh!"

The vision of Logan Killicks was desecrating the pear tree, but Janie didn't know how to tell Nanny that. She merely hunched over and pouted at the floor.

"Janie."

"Yes, ma'am."

"You answer me when Ah speak. Don't you set dere poutin' wid me after all Ah done went through for you!"

She slapped the girl's face violently, and forced her head back so that their eyes met in struggle. With her hand uplifted for the second blow she saw the huge tear that welled up from Janie's heart and stood in each eye. She saw the terrible agony and the lips tightened down to hold back the cry and desisted. Instead she brushed back the heavy hair from Janie's face and stood there suffering and loving and weeping internally for both of them.

"Come to yo' Grandma, honey. Set in her lap lak yo' use tuh. Yo' Nanny wouldn't harm a hair uh yo' head. She don't want nobody else to do it neither if she kin help it. Honey, de white man is de ruler of everything as fur as Ah been able tuh find out. Maybe it's some place way off in de ocean where de black man is in power, but we don't know nothin' but what we see. So de white man throw down de load and tell de nigger man tuh pick it up. He pick it up because he have to, but he don't tote it. He hand it to his womenfolks. De nigger woman is de mule uh de world so fur as Ah can see. Ah been prayin' fuh it tuh be different wid you. Lawd, Lawd, Lawd!"

For a long time she sat rocking with the girl held tightly to her sunken breast. Janie's long legs dangled over one arm of the chair and the long braids of her hair swung low on the other side. Nanny half sung, half sobbed a running chantprayer over the head of the weeping girl.

"Lawd have mercy! It was a long time on de way but Ah reckon it had to come. Oh Jesus! Do, Jesus! Ah done de best Ah could."

Finally, they both grew calm.

"Janie, how long you been 'lowin' Johnny Taylor to kiss you?"

"Only dis one time, Nanny. Ah don't love him at all. Whut made me do it is—oh, Ah don't know."

"Thank yuh, Massa Jesus."

"Ah ain't gointuh do it no mo', Nanny. Please don't make me marry Mr. Killicks."

"'Tain't Logan Killicks Ah wants you to have, baby, it's protection. Ah ain't gittin' ole, honey. Ah'm *done* ole. One mornin' soon, now, de angel wid de sword is gointuh stop by here. De day and de hour is hid from me, but it won't be long. Ah ast de Lawd when you was uh infant in mah arms to let me stay here till you got grown. He done spared me to see de day. Mah daily prayer now is tuh let dese golden moments rolls on a few days longer till Ah see you safe in life."

"Lemme wait, Nanny, please, jus' a lil bit mo'."

"Don't think Ah don't feel wid you, Janie, 'cause Ah do. Ah couldn't love yuh no more if Ah had uh felt yo' birth pains mah-self. Fact uh de matter, Ah loves yuh a whole heap more'n Ah do yo' mama, de one Ah did birth. But you got to take in consideration you ain't no everyday chile like most of 'em. You ain't got no papa, you might jus' as well say no mama, for de good she do yuh. You ain't got nobody but me. And mah head is ole and tilted towards de grave. Neither can you stand alone by yo'self. De thought uh you bein' kicked around from pillar tuh post is uh hurtin' thing. Every tear you drop squeezes a cup uh blood outa mah heart. Ah got tuh try and do for you befo' mah head is cold."

A sobbing sigh burst out of Janie. The old woman answered her with little soothing pats of the hand.

"You know, honey, us colored folks is branches without roots and that makes things come round in queer ways. You in particular. Ah was born back due in slavery so it wasn't for me to fulfill my dreams of whut a woman oughta be and to do. Dat's one of de hold-backs of slavery. But nothing can't stop you from wishin'. You can't beat nobody down so low till you can rob 'em of they will. Ah didn't want to be used for a work-ox and a brood-sow and Ah didn't want mah daughter used dat way neither. It sho wasn't mah will for things to happen lak they did. Ah even hated de way you was born. But, all de same Ah said thank God, Ah got another chance. Ah wanted to preach a great sermon about colored women sittin' on high, but they wasn't no pulpit for me. Freedom found me wid a baby daughter in mah arms, so Ah said Ah'd take a broom and a cook-pot and throw up a highway through de wilderness for her. She would expound what Ah felt. But somehow she got lost offa de highway and next thing Ah knowed here you was in de world. So whilst Ah was tendin' you of nights Ah said Ah'd save de text for you. Ah been waitin' a long time, Janie, but nothin' Ah been through ain't too much if you just take a stand on high ground lak Ah dreamed."

Old Nanny sat there rocking Janie like an infant and thinking back and back. Mind-pictures brought feelings, and feelings dragged out dramas from the hollows of her heart.

"Dat mornin' on de big plantation close to Savannah, a rider come in a gallop tellin' 'bout Sherman takin' Atlanta. Marse Robert's son had done been kilt at Chickamauga. So he grabbed his gun and straddled his best horse and went off wid de rest of de gray-headed men and young boys to drive de Yankees back into Tennessee.

"They was all cheerin' and cryin' and shoutin' for de men dat was ridin' off. Ah couldn't see nothin' cause yo' mama wasn't but a week old, and Ah was flat uh mah back. But pretty soon he let

on he forgot somethin' and run into mah cabin and made me let down mah hair for de last time. He sorta wropped his hand in it, pulled mah big toe, lak he always done, and was gone after de rest lak lightnin'. Ah heard 'em give one last whoop for him. Then de big house and de quarters got sober and silent.

"It was de cool of de evenin' when Mistis come walkin' in mah door. She throwed de door wide open and stood dere lookin' at me outa her eyes and her face. Look lak she been livin' through uh hundred years in January without one day of spring. She come stood over me in de bed.

"'Nanny, Ah come to see that baby uh yourn.'

"Ah tried not to feel de breeze off her face, but it got so cold in dere dat Ah was freezin' to death under the kivvers. So Ah couldn't move right away lak Ah aimed to. But Ah knowed Ah had to make haste and do it.

"'You better git dat kivver offa dat youngun and dat quick!' she clashed at me. 'Look lak you don't know who is Mistis on dis plantation, Madam. But Ah aims to show you.'

"By dat time I had done managed tuh unkivver mah baby enough for her to see de head and face.

"'Nigger, whut's yo' baby doin' wid gray eyes and yaller hair?' She begin tuh slap mah jaws ever which a'way. Ah never felt the fust ones 'cause Ah wuz too busy gittin' de kivver back over mah chile. But dem last lick burnt me lak fire. Ah had too many feelin's tuh tell which one tuh follow so Ah didn't cry and Ah didn't do nothin' else. But then she kept on astin me how come mah baby look white. She asted me dat maybe twenty-five or thirty times, lak she got tuh sayin' dat and couldn't help herself. So Ah told her, 'Ah don't know nothin' but what Ah'm told tuh do, 'cause Ah ain't nothin' but uh nigger and uh slave.'

"Instead of pacifyin' her lak Ah thought, look lak she got madder. But Ah reckon she was tired and wore out 'cause she

didn't hit me no more. She went to de foot of de bed and wiped her hands on her handksher. 'Ah wouldn't dirty mah hands on yuh. But first thing in de mornin' de overseer will take you to de whippin' post and tie you down on yo' knees and cut de hide offa yo' yaller back. One hundred lashes wid a raw-hide on yo' bare back. Ah'll have you whipped till de blood run down to yo' heels! Ah mean to count de licks mahself. And if it kills you Ah'll stand de loss. Anyhow, as soon as dat brat is a month old Ah'm going to sell it offa dis place.'

"She flounced on off and let her wintertime wid me. Ah knowed mah body wasn't healed, but Ah couldn't consider dat. In de black dark Ah wrapped mah baby de best Ah knowed how and made it to de swamp by de river. Ah knowed de place was full uh moccasins and other bitin' snakes, but Ah was more skeered uh whut was behind me. Ah hide in dere day and night and suckled de baby every time she start to cry, for fear somebody might hear her and Ah'd git found. Ah ain't sayin' uh friend or two didn't feel mah care. And den de Good Lawd seen to it dat Ah wasn't taken. Ah don't see how come mah milk didn't kill mah chile, wid me so skeered and worried all de time. De noise uh de owls skeered me; de limbs of dem cypress trees took to crawlin' and movin' round after dark, and two three times Ah heered panthers prowlin' round. But nothin' never hurt me 'cause de Lawd knowed how it was.

"Den, one night Ah heard de big guns boomin' lak thunder. It kept up all night long. And de next mornin' Ah could see uh big ship at a distance and a great stirrin' round. So Ah wrapped Leafy up in moss and fixed her good in a tree and picked mah way on down to de landin'. The men was all in blue, and Ah heard people say Sherman was comin' to meet de boats in Savannah, and all of us slaves was free. So Ah run got mah baby and got in quotation wid people and found a place Ah could stay.

"But it was a long time after dat befo' de Big Surrender at Richmond. Den de big bell ring in Atlanta and all de men in gray uniforms had to go to Moultrie, and bury their swords in de ground to show they was never to fight about slavery no mo'. So den we knowed we was free.

"Ah wouldn't marry nobody, though Ah could have uh heap uh times, cause Ah didn't want nobody mistreating mah baby. So Ah got with some good white people and come down here in West Florida to work and make de sun shine on both sides of de street for Leafy.

"Mah Madam help me wid her just lak she been doin' wid you. Ah put her in school when it got so it was a school to put her in. Ah was 'spectin' to make a school teacher outa her.

"But one day she didn't come home at de usual time and Ah waited and waited, but she never come all dat night. Ah took a lantern and went round askin' everybody but nobody ain't seen her. De next mornin' she come crawlin' in on her hands and knees. A sight to see. Dat school teacher had done hid her in de woods all night long, and he had done raped mah baby and run on off just before day.

"She was only seventeen, and somethin' lak dat to happen! Lawd a'mussy! Look lak Ah kin see it all over again. It was a long time before she was well, and by dat time we knowed you was on de way. And after you was born she took to drinkin' likker and stayin' out nights. Couldn't git her to stay here and nowhere else. Lawd knows where she is right now. She ain't dead, 'cause Ah'd know it by mah feelings, but sometimes Ah wish she was at rest.

"And, Janie, maybe it wasn't much, but Ah done de best Ah kin by you. Ah raked and scraped and bought dis lil piece uh land so you wouldn't have to stay in de white folks' yard and tuck yo' head befo' other chillun at school. Dat was all right when you was little. But when you got big enough to understand things, Ah

wanted you to look upon yo'self. Ah don't want yo' feathers always crumpled by folks throwin' up things in yo' face. And Ah can't die easy thinkin' maybe de menfolks white or black is makin' a spit cup outa you: Have some sympathy fuh me. Put me down easy, Janie, Ah'm a cracked plate."

3

There are years that ask questions and years that answer. Janie *had*
had no chance to know things, so she had to ask. Did marriage end
the cosmic loneliness of the unmated? Did marriage compel love
like the sun the day?

In the few days to live before she went to Logan Killicks and
his often-mentioned sixty acres, Janie asked inside of herself and
out. She was back and forth to the pear tree continuously wonder-
ing and thinking. Finally out of Nanny's talk and her own conjec-
tures she made a sort of comfort for herself. Yes, she would love
Logan after they were married. She could see no way for it to come
about, but Nanny and the old folks had said it, so it must be so.
Husbands and wives always loved each other, and that was what
marriage meant. It was just so. Janie felt glad of the thought, for
then it wouldn't seem so destructive and mouldy. She wouldn't be
lonely anymore.

Janie and Logan got married in Nanny's parlor of a Saturday
evening with three cakes and big platters of fried rabbit and
chicken. Everything to eat in abundance. Nanny and Mrs. Wash-
burn had seen to that. But nobody put anything on the seat of
Logan's wagon to make it ride glorious on the way to his house.
It was a lonesome place like a stump in the middle of the woods

where nobody had ever been. The house was absent of flavor, too. But anyhow Janie went on inside to wait for love to begin. The new moon had been up and down three times before she got worried in mind. Then she went to see Nanny in Mrs. Washburn's kitchen on the day for beaten biscuits.

Nanny beamed all out with gladness and made her come up to the bread board so she could kiss her.

"Lawd a'mussy, honey, Ah sho is glad tuh see mah chile! G'wan inside and let Mis' Washburn know youse heah. Umph! Umph! Umph! How is dat husband uh yourn?"

Janie didn't go in where Mrs. Washburn was. She didn't say anything to match up with Nanny's gladness either. She just fell on a chair with her hips and sat there. Between the biscuits and her beaming pride Nanny didn't notice for a minute. But after a while she found the conversation getting lonesome so she looked up at Janie.

"Whut's de matter, sugar? You ain't none too spry dis mornin'."

"Oh, nothin' much, Ah reckon. Ah come to get a lil information from you."

The old woman looked amazed, then gave a big clatter of laughter. "Don't tell me you done got knocked up already, less see—dis Saturday it's two month and two weeks."

"No'm, Ah don't think so anyhow." Janie blushed a little.

"You ain't got nothin' to be shamed of, honey, youse uh married 'oman. You got yo' lawful husband same as Mis' Washburn or anybody else!"

"Ah'm all right dat way. Ah *know* 'tain't nothin' dere."

"You and Logan been fussin'? Lawd, Ah know dat grassgut, liver-lipted nigger ain't done took and beat mah baby already! Ah'll take a stick and salivate 'im!"

"No'm, he ain't even talked 'bout hittin' me. He says he never mean to lay de weight uh his hand on me in malice. He

chops all de wood he think Ah wants and den he totes it inside de kitchen for me. Keeps both water buckets full."

"Humph! don't 'spect all dat tuh keep up. He ain't kissin' yo' mouf when he carry on over yuh lak dat. He's kissin' yo' foot and 'tain't in uh man tuh kiss foot long. Mouf kissin' is on uh equal and dat's natural but when dey got to bow down tuh love, dey soon straightens up."

"Yes'm."

"Well, if he do all dat whut you come in heah wid uh face long as mah arm for?"

"'Cause you told me Ah mus gointer love him, and, and Ah don't. Maybe if somebody was to tell me how, Ah could do it."

"You come heah wid yo' mouf full uh foolishness on uh busy day. Heah you got uh prop tuh lean on all yo' bawn days, and big protection, and everybody got tuh tip dey hat tuh you and call you Mis' Killicks, and you come worryin' me 'bout love."

"But Nanny, Ah wants to want him sometimes. Ah don't want him to do all de wantin'."

"If you don't want him, you sho oughta. Heah you is wid de onliest organ in town, amongst colored folks, in yo' parlor. Got a house bought and paid for and sixty acres uh land right on de big road and . . . Lawd have mussy! Dat's de very prong all us black women gits hung on. Dis love! Dat's just whut's got us uh pullin' and uh haulin' and sweatin' and doin' from can't see in de mornin' till can't see at night. Dat's how come de ole folks say dat bein' uh fool don't kill nobody. It jus' makes you sweat. Ah betcha you wants some dressed up dude dat got to look at de sole of his shoe everytime he cross de street tuh see whether he got enough leather dere tuh make it across. You can buy and sell such as dem wid what you got. In fact you can buy 'em and give 'em away."

"Ah ain't studyin' 'bout none of 'em. At de same time Ah ain't takin' dat ole land tuh heart neither. Ah could throw ten acres of it

over de fence every day and never look back to see where it fell. Ah feel de same way 'bout Mr. Killicks too. Some folks never was meant to be loved and he's one of 'em."

"How come?"

"'Cause Ah hates de way his head is so long one way and so flat on de sides and dat pone uh fat back uh his neck."

"He never made his own head. You talk so silly."

"Ah don't keer who made it, Ah don't like de job. His belly is too big too, now, and his toe-nails look lak mule foots. And 'tain't nothin' in de way of him washin' his feet every evenin' before he comes tuh bed. 'Tain't nothin' tuh hinder him 'cause Ah places de water for him. Ah'd ruther be shot wid tacks than tuh turn over in de bed and stir up de air whilst he is in dere. He don't even never mention nothin' pretty."

She began to cry.

"Ah wants things sweet wid mah marriage lak when you sit under a pear tree and think. Ah . . . "

"'Tain't no use in you cryin', Janie. Grandma done been long uh few roads herself. But folks is meant to cry 'bout somethin' or other. Better leave things de way dey is. Youse young yet. No tellin' whut mout happen befo' you die. Wait awhile, baby. Yo' mind will change."

Nanny sent Janie along with a stern mien, but she dwindled all the rest of the day as she worked. And when she gained the privacy of her own little shack she stayed on her knees so long she forgot she was there herself. There is a basin in the mind where words float around on thought and thought on sound and sight. Then there is a depth of thought untouched by words, and deeper still a gulf of formless feelings untouched by thought. Nanny entered this infinity of conscious pain again on her old knees. Towards morning she muttered, "Lawd, you know mah heart. Ah done de best Ah could do. De rest is left to you." She scuffled up from her knees and fell heavily across the bed. A month later she was dead.

So Janie waited a bloom time, and a green time and an orange time. But when the pollen again gilded the sun and sifted down on the world she began to stand around the gate and expect things. What things? She didn't know exactly. Her breath was gusty and short. She knew things that nobody had ever told her. For instance, the words of the trees and the wind. She often spoke to falling seeds and said, "Ah hope you fall on soft ground," because she had heard seeds saying that to each other as they passed. She knew the world was a stallion rolling in the blue pasture of ether. She knew that God tore down the old world every evening and built a new one by sun-up. It was wonderful to see it take form with the sun and emerge from the gray dust of its making. The familiar people and things had failed her so she hung over the gate and looked up the road towards way off. She knew now that marriage did not make love. Janie's first dream was dead, so she became a woman.

4

Long before the year was up, Janie noticed that her husband had stopped talking in rhymes to her. He had ceased to wonder at her long black hair and finger it. Six months back he had told her, "If Ah kin haul de wood heah and chop it fuh yuh, look lak you oughta be able tuh tote it inside. Mah fust wife never bothered me 'bout choppin' no wood nohow. She'd grab dat ax and sling chips lak uh man. You done been spoilt rotten."

So Janie had told him, "Ah'm just as stiff as you is stout. If you can stand not to chop and tote wood Ah reckon you can stand not to git no dinner. 'Scuse mah freezolity, Mist' Killicks, but Ah don't mean to chop de first chip."

"Aw you know Ah'm gwine chop de wood fuh yuh. Even if you is stingy as you can be wid me. Yo' Grandma and me myself done spoilt yuh now, and Ah reckon Ah have tuh keep on wid it."

One morning soon he called her out of the kitchen to the barn. He had the mule all saddled at the gate.

"Looka heah, LilBit, help me out some. Cut up dese seed taters fuh me. Ah got tuh go step off a piece."

"Where you goin'?"

"Over tuh Lake City tuh see uh man about uh mule."

"Whut you need two mules fuh? Lessen you aims to swap off dis one."

"Naw, Ah needs two mules dis yeah. Taters is goin' tuh be taters in de fall. Bringin' big prices. Ah aims tuh run two plows, and dis man Ah'm talkin' 'bout is got uh mule all gentled up so even uh woman kin handle 'im."

Logan held his wad of tobacco real still in his jaw like a thermometer of his feelings while he studied Janie's face and waited for her to say something.

"So Ah thought Ah mout as well go see." He tagged on and swallowed to kill time but Janie said nothing except, "Ah'll cut de p'taters fuh yuh. When yuh comin' back?"

"Don't know exactly. Round dust dark Ah reckon. It's uh sorta long trip—specially if Ah hafter lead one on de way back."

When Janie had finished indoors she sat down in the barn with the potatoes. But springtime reached her in there so she moved everything to a place in the yard where she could see the road. The noon sun filtered through the leaves of the fine oak tree where she sat and made lacy patterns on the ground. She had been there a long time when she heard whistling coming down the road.

It was a cityfied, stylish dressed man with his hat set at an angle that didn't belong in these parts. His coat was over his arm, but he didn't need it to represent his clothes. The shirt with the silk sleeveholders was dazzling enough for the world. He whistled, mopped his face and walked like he knew where he was going. He was a seal-brown color but he acted like Mr. Washburn or somebody like that to Janie. Where would such a man be coming from and where was he going? He didn't look her way nor no other way except straight ahead, so Janie ran to the pump and jerked the handle hard while she pumped. It made a loud noise and also made her heavy hair fall down. So he stopped and looked hard, and then he asked her for a cool drink of water.

Janie pumped it off until she got a good look at the man. He talked friendly while he drank.

Joe Starks was the name, yeah Joe Starks from in and through Georgy. Been workin' for white folks all his life. Saved up some money—round three hundred dollars, yes indeed, right here in his pocket. Kept hearin' 'bout them buildin' a new state down heah in Floridy and sort of wanted to come. But he was makin' money where he was. But when he heard all about 'em makin' a town all outa colored folks, he knowed dat was de place he wanted to be. He had always wanted to be a big voice, but de white folks had all de sayso where he come from and everywhere else, exceptin' dis place dat colored folks was buildin' theirselves. Dat was right too. De man dat built things oughta boss it. Let colored folks build things too if dey wants to crow over somethin'. He was glad he had his money all saved up. He meant to git dere whilst de town wuz yet a baby. He meant to buy in big. It had always been his wish and desire to be a big voice and he had to live nearly thirty years to find a chance. Where was Janie's papa and mama?

"Dey dead, Ah reckon. Ah wouldn't know 'bout 'em 'cause mah Grandma raised me. She dead too."

"She dead too! Well, who's lookin' after a lil girl-chile lak you?"

"Ah'm married."

"You married? You ain't hardly old enough to be weaned. Ah betcha you still craves sugar-tits, doncher?"

"Yeah, and Ah makes and sucks 'em when de notion strikes me. Drinks sweeten' water too."

"Ah loves dat mahself. Never specks to get too old to enjoy syrup sweeten' water when it's cools and nice."

"Us got plenty syrup in de barn. Ribbon-cane syrup. If you so desires—"

"Where yo' husband at, Mis' er-er."

"Mah name is Janie Mae Killicks since Ah got married. Useter be name Janie Mae Crawford. Mah husband is gone tuh buy a mule fuh me tuh plow. He left me cuttin' up seed p'taters."

"You behind a plow! You ain't got no mo' business wid uh plow than uh hog is got wid uh holiday! You ain't got no business cuttin' up no seed p'taters neither. A pretty doll-baby lak you is made to sit on de front porch and rock and fan yo'self and eat p'taters dat other folks plant just special for you."

Janie laughed and drew two quarts of syrup from the barrel and Joe Starks pumped the water bucket full of cool water. They sat under the tree and talked. He was going on down to the new part of Florida, but no harm to stop and chat. He later decided he needed a rest anyway. It would do him good to rest a week or two.

Every day after that they managed to meet in the scrub oaks across the road and talk about when he would be a big ruler of things with her reaping the benefits. Janie pulled back a long time because he did not represent sun-up and pollen and blooming trees, but he spoke for far horizon. He spoke for change and chance. Still she hung back. The memory of Nanny was still powerful and strong.

"Janie, if you think Ah aims to tole you off and make a dog outa you, youse wrong. Ah wants to make a wife outa you."

"You mean dat, Joe?"

"De day you puts yo' hand in mine, Ah wouldn't let de sun go down on us single. Ah'm uh man wid principles. You ain't never knowed what it was to be treated lak a lady and Ah wants to be de one tuh show yuh. Call me Jody lak you do sometime."

"Jody," she smiled up at him, "but s'posin'—"

"Leave de s'posin' and everything else to me. Ah'll be down dis road uh little after sunup tomorrow mornin' to wait for you. You come go wid me. Den all de rest of yo' natural life you kin live

lak you oughta. Kiss me and shake yo' head. When you do dat, yo' plentiful hair breaks lak day."

Janie debated the matter that night in bed.

"Logan, you 'sleep?"

"If Ah wuz, you'd be done woke me up callin' me."

"Ah wuz thinkin' real hard about us; about you and me."

"It's about time. Youse powerful independent around here sometime considerin'."

"Considerin' whut for instance?"

"Considerin' youse born in a carriage 'thout no top to it, and yo' mama and you bein' born and raised in de white folks back-yard."

"You didn't say all dat when you wuz begging Nanny for me to marry you."

"Ah thought you would 'preciate good treatment. Thought Ah'd take and make somethin' outa yuh. You think youse white folks by de way you act."

"S'posin' Ah wuz to run off and leave yuh sometime."

There! Janie had put words in his held-in fears. She might run off sure enough. The thought put a terrible ache in Logan's body, but he thought it best to put on scorn.

"Ah'm gettin' sleepy, Janie. Let's don't talk no mo'. 'Tain't too many mens would trust yuh, knowin' yo' folks lak dey do."

"Ah might take and find somebody dat did trust me and leave yuh."

"Shucks! 'Tain't no mo' fools lak me. A whole lot of mens will grin in yo' face, but dey ain't gwine tuh work and feed yuh. You won't git far and you won't be long, when dat big gut reach over and grab dat little one, you'll be too glad to come back here."

"You don't take nothin' to count but sow-belly and cornbread."

"Ah'm sleepy. Ah don't aim to worry mah gut into a fiddle-

string wid no s'posin'." He flopped over resentful in his agony and pretended sleep. He hoped that he had hurt her as she had hurt him.

Janie got up with him the next morning and had the breakfast halfway done when he bellowed from the barn.

"Janie!" Logan called harshly. "Come help me move dis manure pile befo' de sun gits hot. You don't take a bit of interest in dis place. 'Tain't no use in foolin' round in dat kitchen all day long."

Janie walked to the door with the pan in her hand still stirring the cornmeal dough and looked towards the barn. The sun from ambush was threatening the world with red daggers, but the shadows were gray and solid-looking around the barn. Logan with his shovel looked like a black bear doing some clumsy dance on his hind legs.

"You don't need mah help out dere, Logan. Youse in yo' place and Ah'm in mine."

"You ain't got no particular place. It's wherever Ah need yuh. Git uh move on yuh, and dat quick."

"Mah mamma didn't tell me Ah wuz born in no hurry. So whut business Ah got rushin' now? Anyhow dat ain't whut youse mad about. Youse mad 'cause Ah don't fall down and wash-up dese sixty acres uh ground yuh got. You ain't done me no favor by marryin' me. And if dat's what you call yo'self doin', Ah don't thank yuh for it. Youse mad 'cause Ah'm tellin' yuh whut you already knowed."

Logan dropped his shovel and made two or three clumsy steps towards the house, then stopped abruptly.

"Don't you change too many words wid me dis mawnin', Janie, do Ah'll take and change ends wid yuh! Heah, Ah just as good as take you out de white folks' kitchen and set you down on yo' royal diasticutis and you take and low-rate me! Ah'll take holt uh dat ax and come in dere and kill yuh! You better

dry up in dere! Ah'm too honest and hard-workin' for anybody in yo' family, dat's de reason you don't want me!" The last sentence was half a sob and half a cry. "Ah guess some low-lifed nigger is grinnin' in yo' face and lyin' tuh yuh. God damn yo' hide!"

Janie turned from the door without answering, and stood still in the middle of the floor without knowing it. She turned wrongside out just standing there and feeling. When the throbbing calmed a little she gave Logan's speech a hard thought and placed it beside other things she had seen and heard. When she had finished with that she dumped the dough on the skillet and smoothed it over with her hand. She wasn't even angry. Logan was accusing her of her mamma, her grandmama and her feelings, and she couldn't do a thing about any of it. The sow-belly in the pan needed turning. She flipped it over and shoved it back. A little cold water in the coffee pot to settle it. Turned the hoe-cake with a plate and then made a little laugh. What was she losing so much time for? A feeling of sudden newness and change came over her. Janie hurried out of the front gate and turned south. Even if Joe was not there waiting for her, the change was bound to do her good.

The morning road air was like a new dress. That made her feel the apron tied around her waist. She untied it and flung it on a low bush beside the road and walked on, picking flowers and making a bouquet. After that she came to where Joe Starks was waiting for her with a hired rig. He was very solemn and helped her to the seat beside him. With him on it, it sat like some high, ruling chair. From now on until death she was going to have flower dust and springtime sprinkled over everything. A bee for her bloom. Her old thoughts were going to come in handy now, but new words would have to be made and said to fit them.

"Green Cove Springs," he told the driver. So they were married there before sundown, just like Joe had said. With new clothes of silk and wool.

They sat on the boarding house porch and saw the sun plunge into the same crack in the earth from which the night emerged.

5

On the train the next day, Joe didn't make many speeches with rhymes to her, but he bought her the best things the butcher had, like apples and a glass lantern full of candies. Mostly he talked about plans for the town when he got there. They were bound to need somebody like him. Janie took a lot of looks at him and she was proud of what she saw. Kind of portly like rich white folks. Strange trains, and people and places didn't scare him neither. Where they got off the train at Maitland he found a buggy to carry them over to the colored town right away.

It was early in the afternoon when they got there, so Joe said they must walk over the place and look around. They locked arms and strolled from end to end of the town. Joe noted the scant dozen of shame-faced houses scattered in the sand and palmetto roots and said, "God, they call this a town? Why, 'tain't nothing but a raw place in de woods."

"It is a whole heap littler than Ah thought." Janie admitted her disappointment.

"Just like Ah thought," Joe said. "A whole heap uh talk and nobody doin' nothin'. I god, where's de Mayor?" he asked some- body. "Ah want tuh speak wid de Mayor."

Two men who were sitting on their shoulderblades under a

huge live oak tree almost sat upright at the tone of his voice. They stared at Joe's face, his clothes and his wife.

"Where y'all come from in sich uh big haste?" Lee Coker asked.

"Middle Georgy," Starks answered briskly. "Joe Starks is mah name, from in and through Georgy."

"You and yo' daughter goin' tuh join wid us in fellowship?" the other reclining figure asked. "Mighty glad tuh have yuh. Hicks is the name. Guv'nor Amos Hicks from Buford, South Carolina. Free, single, disengaged."

"I god, Ah ain't nowhere near old enough to have no grown daughter. This here is mah wife."

Hicks sank back and lost interest at once.

"Where is de Mayor?" Starks persisted. "Ah wants tuh talk wid *him*."

"Youse uh mite too previous for dat," Coker told him. "Us ain't got none yit."

"Ain't got no Mayor! Well, who tells y'all what to do?"

"Nobody. Everybody's grown. And then agin, Ah reckon us just ain't thought about it. Ah know Ah ain't."

"Ah did think about it one day," Hicks said dreamily, "but then Ah forgot it and ain't thought about it since then."

"No wonder things ain't no better," Joe commented. "Ah'm buyin' in here, and buyin' in big. Soon's we find some place to sleep tonight us menfolks got to call people together and form a committee. Then we can get things movin' round here."

"Ah kin point yuh where yuh kin sleep," Hicks offered. "Man got his house done built and his wife ain't come yet."

Starks and Janie moved on off in the direction indicated with Hicks and Coker boring into their backs with looks.

"Dat man talks like a section foreman," Coker commented. "He's mighty compellment."

"Shucks!" said Hicks. "Mah britches is just as long as his. But

dat wife uh hisn! Ah'm uh son of uh Combunction if Ah don't go tuh Georgy and git me one just like her."

"Whut wid?"

"Wid mah talk, man."

"It takes money tuh feed pretty women. Dey gits uh lavish uh talk."

"Not lak mine. Dey loves to hear me talk because dey can't understand it. Mah co-talkin' is too deep. Too much co to it."

"Umph!"

"You don't believe me, do yuh? You don't know de women Ah kin git to mah command."

"Umph!"

"You ain't never seen me when Ah'm out pleasurin' and givin' pleasure."

"Umph!"

"It's uh good thing he married her befo' she seen me. Ah kin be some trouble when Ah take uh notion."

"Umph!"

"Ah'm uh bitch's baby round lady people."

"Ah's much ruther see all dat than to hear 'bout it. Come on less go see whut he gointuh do 'bout dis town."

They got up and sauntered over to where Starks was living for the present. Already the town had found the strangers. Joe was on the porch talking to a small group of men. Janie could be seen through the bedroom window getting settled. Joe had rented the house for a month. The men were all around him, and he was talking to them by asking questions.

"Whut is de real name of de place?"

"Some say West Maitland and some say Eatonville. Dat's 'cause Cap'n Eaton give us some land along wid Mr. Laurence. But Cap'n Eaton give de first piece."

"How much did they give?"

"Oh 'bout fifty acres."

"How much is y'all got now?"

"Oh 'bout de same."

"Dat ain't near enough. Who owns de land joining on to whut yuh got?"

"Cap'n Eaton."

"Where *is* dis Cap'n Eaton?"

"Over dere in Maitland, 'ceptin' when he go visitin' or somethin'."

"Lemme speak to mah wife a minute and Ah'm goin' see de man. You cannot have no town without some land to build it on. Y'all ain't got enough here to cuss a cat on without gittin' yo' mouf full of hair."

"He ain't got no mo' land tuh give away. Yuh needs plenty money if yuh wants any mo'."

"Ah specks to pay him."

The idea was funny to them and they wanted to laugh. They tried hard to hold it in, but enough incredulous laughter burst out of their eyes and leaked from the corners of their mouths to inform anyone of their thoughts. So Joe walked off abruptly. Most of them went along to show him the way and to be there when his bluff was called.

Hicks didn't go far. He turned back to the house as soon as he felt he wouldn't be missed from the crowd and mounted the porch.

"Evenin', Miz Starks."

"Good evenin'."

"You reckon you gointuh like round here?"

"Ah reckon so."

"Anything *Ah* kin do tuh help out, why you kin call on me."

"Much obliged."

There was a long dead pause. Janie was not jumping at her

chance like she ought to. Look like she didn't hardly know he was there. She needed waking up.

"Folks must be mighty close-mouthed where you come from."

"Dat's right. But it must be different at yo' home."

He was a long time thinking but finally he saw and stumbled down the steps with a surly "'Bye."

"Good bye."

That night Coker asked him about it.

"Ah saw yuh when yuh ducked back tuh Starks' house. Well, how didju make out?"

"Who, me? Ah ain't been near de place, man. Ah been down tuh de lake tryin' tuh ketch me uh fish."

"Umph!"

"Dat 'oman ain't so awfully pretty no how when yuh take de second look at her. Ah had to sorta pass by de house on de way back and seen her good. 'Tain't nothin' to her 'ceptin' dat long hair."

"Umph!"

"And anyhow, Ah done took uhlikin' tuh de man. Ah wouldn't harm him at all. She ain't half ez pretty ez uh gal Ah run off and left up in South Cal'lina."

"Hicks, Ah'd git mad and say you wuz lyin' if Ah didn't know yuh so good. You just talkin' to consolate yo'self by word of mouth. You got uh willin' mind, but youse too light behind. A whole heap uh men seen de same thing you seen but they got better sense than you. You oughta know you can't take no 'oman lak dat from no man lak him. A man dat ups and buys two hundred acres uh land at one whack and pays cash for it."

"Naw! He didn't buy it sho nuff?"

"He sho did. Come off wid de papers in his pocket. He done called a meetin' on his porch tomorrow. Ain't never seen no sich uh colored man befo' in all mah bawn days. He's gointuh put up uh store and git uh post office from de Goven'ment."

That irritated Hicks and he didn't know why. He was the average mortal. It troubled him to get used to the world one way and then suddenly have it turn different. He wasn't ready to think of colored people in post offices yet. He laughed boisterously.

"Y'all let dat stray darky tell y'all any ole lie! Uh colored man sittin' up in uh post office!" He made an obscene sound.

"He's liable tuh do it too, Hicks. Ah hope so anyhow. Us colored folks is too envious of one 'nother. Dat's how come us don't git no further than us do. Us talks about de white man keepin' us down! Shucks! He don't have tuh. Us keeps our own selves down."

"Now who said Ah didn't want de man tuh git us uh post office? He kin be de king uh Jerusalem fuh all Ah keer. Still and all, 'tain't no use in telling lies just 'cause uh heap uh folks don't know no better. Yo' common sense oughta tell yuh de white folks ain't goin' tuh 'low him tuh run no post office."

"Dat we don't know, Hicks. He say he kin and Ah b'lieve he know whut he's talkin' 'bout. Ah reckon if colored folks got they own town they kin have post offices and whatsoever they please, regardless. And then agin, Ah don't speck de white folks way off yonder give uh damn. Less us wait and see."

"Oh, Ah'm waitin' all right. Specks tuh keep on waitin' till hell freeze over."

"Aw, git reconciled! Dat woman don't want you. You got tuh learn dat all de women in de world ain't been brought up on no teppentine still, and no saw-mill camp. There's some women dat jus' ain't for you tuh broach. You can't git *her* wid no fish sandwich."

They argued a bit more then went on to the house where Joe was and found him in his shirt-sleeves, standing with his legs wide apart, asking questions and smoking a cigar.

"Where's de closest saw-mill?" He was asking Tony Taylor.

"'Bout seben miles goin' t'wards Apopka," Tony told him. "Thinkin' 'bout buildin' right away?"

"I god, yeah. But not de house Ah specks tuh live in. Dat kin wait till Ah make up mah mind where Ah wants it located. Ah figgers we all needs uh store in uh big hurry."

"Uh store?" Tony shouted in surprise.

"Yeah, uh store right heah in town wid everything in it you needs. 'Tain't uh bit uh use in everybody proagin' way over tuh Maitland tuh buy uh little meal and flour when they could git it right heah."

"Dat would be kinda nice, Brother Starks, since you mention it."

"I god, course it would! And then agin uh store is good in other ways. Ah got tuh have a place tuh be at when folks comes tuh buy land. And furthermo' everything is got tuh have uh center and uh heart tuh it, and uh town ain't no different from nowhere else. It would be natural fuh de store tuh be meetin' place fuh de town."

"Dat sho is de truth, now."

"Oh, we'll have dis town all fixed up tereckly. Don't miss bein' at de meetin' tuhmorrow."

Just about time for the committee meeting called to meet on his porch next day, the first wagon load of lumber drove up and Jody went to show them where to put it. Told Janie to hold the committee there until he got back, he didn't want to miss them, but he meant to count every foot of that lumber before it touched the ground. He could have saved his breath and Janie could have kept right on with what she was doing. In the first place everybody was late in coming; then the next thing as soon as they heard where Jody was, they kept right on up there where the new lumber was rattling off the wagon and being piled under the big live oak tree. So that's where the meeting was held with Tony Taylor acting as chairman and Jody doing all the talking. A day was named for roads and they

all agreed to bring axes and things like that and chop out two roads running each way. That applied to everybody except Tony and Coker. They could carpenter, so Jody hired them to go to work on his store bright and soon the next morning. Jody himself would be busy driving around from town to town telling people about Eatonville and drumming up citizens to move there.

Janie was astonished to see the money Jody had spent for the land come back to him so fast. Ten new families bought lots and moved to town in six weeks. It all looked too big and rushing for her to keep track of. Before the store had a complete roof, Jody had canned goods piled on the floor and was selling so much he didn't have time to go off on his talking tours. She had her first taste of presiding over it the day it was complete and finished. Jody told her to dress up and stand in the store all that evening. Everybody was coming sort of fixed up, and he didn't mean for nobody else's wife to rank with her. She must look on herself as the bell-cow, the other women were the gang. So the put on one of her bought dresses and went up the new-cut road all dressed in wine-colored red. Her silken ruffles rustled and muttered about her. The other women had on percale and calico with here and there a headrag among the older ones.

Nobody was buying anything that night. They didn't come there for that. They had come to make a welcome. So Joe knocked in the head of a barrel of soda crackers and cut some cheese.

"Everybody come right forward and make merry. I god, it's mah treat." Jody gave one of his big heh heh laughs and stood back. Janie dipped up the lemonade like he told her. A big tin cup full for everybody. Tony Taylor felt so good when it was all gone that he felt to make a speech.

"Ladies and gent'men, we'se come tuhgether and gethered heah tuh welcome tuh our midst one who has seen fit tuh cast in his lot amongst us. He didn't just come hisself neither. He have

seen fit tuh bring his, er, er, de light uh his home, dat is his wife amongst us also. She couldn't look no mo' better and no nobler if she wuz de queen uh England. It's uh pledger fuh her tuh be heah amongst us. Brother Starks, we welcomes you and all dat you have seen fit tuh bring amongst us—yo' belov-ed wife, yo' store, yo' land—"

A big-mouthed burst of laughter cut him short.

"Dat'll do, Tony," Lige Moss yelled out. "Mist' Starks is uh smart man, we'se all willin' tuh acknowledge tuh dat, but de day he comes waggin' down de road wid two hund'ed acres uf land over his shoulder, Ah wants tuh be dere tuh see it."

Another big blow-out of a laugh. Tony was a little peeved at having the one speech of his lifetime ruined like that.

"All y'all know whut wuz meant. Ah don't see how come—"

"'Cause you jump up tuh make speeches and don't know how," Lige said.

"Ah wuz speakin' jus' all right befo' you stuck yo' bill in."

"Naw, you wuzn't, Tony. Youse way outa jurisdiction. You can't welcome uh man and his wife 'thout you make comparison about Isaac and Rebecca at de well, else it don't show de love between 'em if you don't."

Everybody agreed that that was right. It was sort of pitiful for Tony not to know he couldn't make a speech without saying that. Some tittered at his ignorance. So Tony said testily, "If all them dat's goin-tuh cut de monkey is done cut it and through wid, we'll thank Brother Starks fuh a respond."

So Joe Starks and his cigar took the center of the floor.

"Ah thanks you all for yo' kind welcome and for extendin' tuh me de right hand uh fellowship. Ah kin see dat dis town is full uh union and love. Ah means tuh put mah hands tuh de plow heah, and strain every nerve tuh make dis our town de metropolis uh de state. So maybe Ah better tell yuh in case you don't know dat if we expect

tuh move on, us got tuh incorporate lak every other town. Us got tuh incorporate, and us got tuh have uh mayor, if things is tuh be done and done right. Ah welcome you all on behalf uh me and mah wife tuh dis store and tuh de other things tuh come. Amen."

Tony led the loud hand-clapping and was out in the center of the floor when it stopped.

"Brothers and sisters, since us can't never expect tuh better our choice, Ah move dat we make Brother Starks our Mayor until we kin see further."

"Second dat motion!!!" It was everybody talking at once, so it was no need of putting it to a vote.

"And now we'll listen tuh uh few words uh encouragement from Mrs. Mayor Starks."

The burst of applause was cut short by Joe taking the floor himself.

"Thank yuh fuh yo' compliments, but mah wife don't know nothin' 'bout no speech-makin'. Ah never married her for nothin' lak dat. She's uh woman and her place is in de home."

Janie made her face laugh after a short pause, but it wasn't too easy. She had never thought of making a speech, and didn't know if she cared to make one at all. It must have been the way Joe spoke out without giving her a chance to say anything one way or another that took the bloom off of things. But anyway, she went down the road behind him that night feeling cold. He strode along invested with his new dignity, thought and planned out loud, unconscious of her thoughts.

"De mayor of uh town lak dis can't lay round home too much. De place needs buildin' up. Janie, Ah'll git hold uh some-body tuh help out in de store and you kin look after things whilst Ah drum up things otherwise."

"Oh Jody, Ah can't do nothin' wid no store lessen youse there. Ah could maybe come in and help you when things git rushed, but—"

"I god, Ah don't see how come yuh can't. 'Tain't nothin' atall tuh hinder yuh if yuh got uh thimble full uh sense. You got tuh. Ah got too much else on mah hands as Mayor. Dis town needs some light right now."

"Unh hunh, it *is* uh little dark right long heah."

"'Course it is. 'Tain't no use in scufflin' over all dese stumps and roots in de dark. Ah'll call uh meetin' bout de dark and de roots right away. Ah'll sit on dis case first thing."

The very next day with money out of his own pocket he sent off to Sears, Roebuck and Company for the street lamp and told the town to meet the following Thursday night to vote on it. Nobody had ever thought of street lamps and some of them said it was a useless notion. They went so far as to vote against it, but the majority ruled.

But the whole town got vain over it after it came. That was because the Mayor didn't just take it out of the crate and stick it up on a post. He unwrapped it and had it wiped off carefully and put it up on a showcase for a week for everybody to see. Then he set a time for the lighting and sent word all around Orange County for one and all to come to the lamplighting. He sent men out to the swamp to cut the finest and the straightest cypress post they could find, and kept on sending them back to hunt another one until they found one that pleased him. He had talked to the people already about the hospitality of the occasion.

"Y'all know we can't invite people to our town just dry long so. I god, naw. We got tuh feed 'em something, and 'tain't nothin' people laks better'n barbecue. Ah'll give one whole hawg mah ownself. Seem lak all de rest uh y'all put tuhgether oughta be able tuh scrape up two mo'. Tell yo' womenfolks tuh do 'round 'bout some pies and cakes and sweet p'tater pone."

That's the way it went, too. The women got together the

sweets and the men looked after the meats. The day before the lighting, they dug a big hole in back of the store and filled it full of oak wood and burned it down to a glowing bed of coals. It took them the whole night to barbecue the three hogs. Hambo and Pearson had full charge while the others helped out with turning the meat now and then while Hambo swabbed it all over with the sauce. In between times they told stories, laughed and told more stories and sung songs. They cut all sorts of capers and whiffed the meat as it slowly came to perfection with the seasoning penetrating to the bone. The younger boys had to rig up the saw-horses with boards for the women to use as tables. Then it was after sun-up and everybody not needed went home to rest up for the feast.

By five o'clock the town was full of every kind of a vehicle and swarming with people. They wanted to see that lamp lit at dusk. Near the time, Joe assembled everybody in the street before the store and made a speech.

"Folkses, de sun is goin' down. De Sun-maker brings it up in de mornin', and de Sun-maker sends it tuh bed at night. Us poor weak humans can't do nothin' tuh hurry it up nor to slow it down. All we can do, if we want any light after de settin' or befo' de risin', is tuh make some light ourselves. So dat's how come lamps was made. Dis evenin' we'se all assembled heah tuh light uh lamp. Dis occasion is something for us all tuh remember tuh our dyin' day. De first street lamp in uh colored town. Lift yo' eyes and gaze on it. And when Ah touch de match tuh dat lamp-wick let de light penetrate inside of yuh, and let it shine, let it shine, let it shine. Brother Davis, lead us in a word uh prayer. Ask uh blessin' on dis town in uh most particular manner."

While Davis chanted a traditional prayer-poem with his own variations, Joe mounted the box that had been placed for the purpose and opened the brazen door of the lamp. As the word

Amen was said, he touched the lighted match to the wick, and Mrs. Bogle's alto burst out in:

> *We'll walk in de light, de beautiful light*
> *Come where the dew drops of mercy shine bright*
> *Shine all around us by day and by night*
> *Jesus, the light of the world.*

They, all of them, all of the people took it up and sung it over and over until it was wrung dry, and no further innovations of tone and tempo were conceivable. Then they hushed and ate barbecue.

When it was all over that night in bed Jody asked Janie, "Well, honey, how yuh lak bein' Mrs. Mayor?"

"It's all right Ah reckon, but don't yuh think it keeps us in uh kinda strain?"

"Strain? You mean de cookin' and waitin' on folks?"

"Naw, Jody, it jus' looks lak it keeps us in some way we ain't natural wid one 'nother. You'se always off talkin' and fixin' things, and Ah feels lak Ah'm jus' markin' time. Hope it soon gits over."

"Over, Janie? I god, Ah ain't even started good. Ah told you in de very first beginnin' dat Ah aimed tuh be uh big voice. You oughta be glad, 'cause dat makes uh big woman outa you."

A feeling of coldness and fear took hold of her. She felt far away from things and lonely.

Janie soon began to feel the impact of awe and envy against her sensibilities. The wife of the Mayor was not just another woman as she had supposed. She slept with authority and so she was part of it in the town mind. She couldn't get but so close to most of them in spirit. It was especially noticeable after Joe had forced through a town ditch to drain the street in front of the

store. They had murmured hotly about slavery being over, but every man filled his assignment.

There was something about Joe Starks that cowed the town. It was not because of physical fear. He was no fist fighter. His bulk was not even imposing as men go. Neither was it because he was more literate than the rest. Something else made men give way before him. He had a bow-down command in his face, and every step he took made the thing more tangible.

Take for instance that new house of his. It had two stories with porches, with bannisters and such things. The rest of the town looked like servants' quarters surrounding the "big house." And different from everybody else in the town he put off moving in until it had been painted, in and out. And look at the way he painted it—a gloaty, sparkly white. The kind of promenading white that the houses of Bishop Whipple, W. B. Jackson and the Vanderpool's wore. It made the village feel funny talking to him— just like he was anybody else. Then there was the matter of the spittoons. No sooner was he all set as the Mayor—post master— landlord—storekeeper, than he bought a desk like Mr. Hill or Mr. Galloway over in Maitland with one of those swing-around chairs to it. What with him biting down on cigars and saving his breath on talk and swinging round in that chair, it weakened people. And then he spit in that gold-looking vase that anybody else would have been glad to put on their front-room table. Said it was a spit- toon just like his used-to-be bossman used to have in his bank up there in Atlanta. Didn't have to get up and go to the door every time he had to spit. Didn't spit on his floor neither. Had that golded-up spitting pot right handy. But he went further than that. He bought a little lady-size spitting pot for Janie to spit in. Had it right in the parlor with little sprigs of flowers painted all around the sides. It took people by surprise because most of the women dipped snuff and of course had a spit-cup in the house. But how

could they know up-to-date folks was spitting in flowery little things like that? It sort of made the rest of them feel that they had been taken advantage of. Like things had been kept from them. Maybe more things in the world besides spitting pots had been hid from them, when they wasn't told no better than to spit in tomato cans. It was bad enough for white people, but when one of your own color could be so different it put you on a wonder. It was like seeing your sister turn into a 'gator. A familiar strangeness. You keep seeing your sister in the 'gator and the 'gator in your sister, and you'd rather not. There was no doubt that the town respected him and even admired him in a way. But any man who walks in the way of power and property is bound to meet hate. So when speakers stood up when the occasion demanded and said "Our beloved Mayor," it was one of those statements that everybody says but nobody actually believes like "God is everywhere." It was just a handle to wind up the tongue with. As time went on and the benefits he had conferred upon the town receded in time they sat on his store porch while he was busy inside and discussed him. Like one day after he caught Henry Pitts with a wagon load of his ribbon cane and took the cane away from Pitts and made him leave town. Some of them thought Starks ought not to have done that. He had so much cane and everything else. But they didn't say that while Joe Starks was on the porch. When the mail came from Maitland and he went inside to sort it out everybody had their say.

Sim Jones started off as soon as he was sure that Starks couldn't hear him.

"It's uh sin and uh shame runnin' dat po' man way from here lak dat. Colored folks oughtn't tuh be so hard on one 'nother."

"Ah don't see it dat way atall," Sam Watson said shortly. "Let colored folks learn to work for what dey git lak everybody else. Nobody ain't stopped Pitts from plantin' de cane he wanted tuh. Starks give him uh job, what mo' do he want?"

"Ah know dat too," Jones said, "but, Sam, Joe Starks is too exact wid folks. All he got he done made it offa de rest of us. He didn't have all dat when he come here."

"Yeah, but none uh all dis you see and you'se settin' on wasn't here neither, when he come. Give de devil his due."

"But now, Sam, you know dat all he do is big-belly round and tell other folks what tuh do. He loves obedience out of everybody under de sound of his voice."

"You kin feel a switch in his hand when he's talkin' to yuh," Oscar Scott complained. "Dat chastisin' feelin' he totes sorter gives yuh de protolapsis uh de cutinary linin'."

"He's uh whirlwind among breezes," Jeff Bruce threw in.

"Speakin' of winds, he's de wind and we'se de grass. We bend which ever way he blows," Sam Watson agreed, "but at dat us needs him. De town wouldn't be nothin' if it wasn't for him. He can't help bein' sorta bossy. Some folks needs thrones, and ruling-chairs and crowns tuh make they influence felt. He don't. He's got uh throne in de seat of his pants."

"Whut Ah don't lak 'bout de man is, he talks tuh unlettered folks wid books in his jaws," Hicks complained. "Showin' off his learnin'. To look at me you wouldn't think it, but Ah got uh brother pastorin' up round Ocala dat got good learnin'. If he wuz here, Joe Starks wouldn't make no fool outa him lak he do de rest uh y'all."

"Ah often wonder how dat lil wife uh hisn makes out wid him, 'cause he's uh man dat changes everything, but nothin' don't change him."

"You know many's de time Ah done thought about dat mah-self. He gits on her ever now and then when she make little mistakes round de store."

"Whut make her keep her head tied up lak some ole 'oman round de store? Nobody couldn't *git* me tuh tie no rag on mah head if Ah had hair lak dat."

"Maybe he make her do it. Maybe he skeered some de rest of us mens might touch it round dat store. It sho is uh hidden mystery tuh me."

"She sho don't talk much. De way he rears and pitches in de store sometimes when she make uh mistake is sort of ungodly, but she don't seem to mind at all. Reckon dey understand one 'nother."

The town had a basketful of feelings good and bad about Joe's positions and possessions, but none had the temerity to challenge him. They bowed down to him rather, because he was all of these things, and then again he was all of these things because the town bowed down.

6

Every morning the world flung itself over and exposed the town to the sun. So Janie had another day. And every day had a store in it, except Sundays. The store itself was a pleasant place if only she didn't have to sell things. When the people sat around on the porch and passed around the pictures of their thoughts for the others to look at and see, it was nice. The fact that the thought pictures were always crayon enlargements of life made it even nicer to listen to.

Take for instance the case of Matt Bonner's yellow mule. They had him up for conversation every day the Lord sent. Most especial if Matt was there himself to listen. Sam and Lige and Walter were the ringleaders of the mule-talkers. The others threw in whatever they could chance upon, but it seemed as if Sam and Lige and Walter could hear and see more about that mule than the whole county put together. All they needed was to see Matt's long spare shape coming down the street and by the time he got to the porch they were ready for him.

"Hello, Matt."

"Evenin', Sam."

"Mighty glad you come 'long right now, Matt. Me and some others wuz jus' about tuh come hunt yuh."

"Whut fuh, Sam?"

"Mighty serious matter, man. Serious!!"

"Yeah man," Lige would cut in, dolefully. "It needs yo' strict attention. You ought not tuh lose no time."

"Whut is it then? You oughta hurry up and tell me."

"Reckon we better not tell yuh heah at de store. It's too fur off tuh do any good. We better all walk on down by Lake Sabelia."

"Whut's wrong, man? Ah ain't after none uh y'alls foolishness now."

"Dat mule uh yourn, Matt. You better go see 'bout him. He's bad off."

"Where 'bouts? Did he wade in de lake and uh alligator ketch him?"

"Worser'n dat. De womenfolks got yo' mule. When Ah come round de lake 'bout noontime mah wife and some others had 'im flat on de ground usin' his sides fuh uh wash board."

The great clap of laughter that they have been holding in, bursts out. Sam never cracks a smile. "Yeah, Matt, dat mule so skinny till de women is usin' his rib bones fuh uh rub-board, and hangin' things out on his hock-bones tuh dry."

Matt realizes that they have tricked him again and the laughter makes him mad and when he gets mad he stammers.

"You'se uh stinkin' lie, Sam, and yo' feet ain't mates. Y-y-y-you!"

"Aw, man, 'tain't no use in you gittin' mad. Yuh know yuh don't feed de mule. How he gointuh git fat?"

"Ah-ah-ah d-d-does feed 'im! Ah g-g-gived 'im uh full cup uh cawn every feedin'."

"Lige knows all about dat cup uh cawn. He hid round yo' barn and watched yuh. 'Tain't no feed cup you measures dat cawn outa. It's uh tea cup."

"Ah does feed 'im. He's jus' too mean tuh git fat. He stay poor and rawbony jus' fuh spite. Skeered he'll hafta work some."

"Yeah, you feeds 'im. Feeds 'im offa 'come up' and seasons it wid raw-hide."

"Does feed de ornery varmint! Don't keer whut Ah do Ah can't git long wid 'im. He fights every inch in front uh de plow, and even lay back his ears tuh kick and bite when Ah go in de stall tuh feed 'im."

"Git reconciled, Matt," Lige soothed. "Us all knows he's mean. Ah seen 'im when he took after one uh dem Roberts chillun in de street and woulda caught 'im and maybe trompled 'im tuh death if de wind hadn't of changed all of a sudden. Yuh see de youngun wuz tryin' tuh make it tuh de fence uh Starks' onion patch and de mule wuz dead in behind 'im and gainin' on 'im every jump, when all of a sudden de wind changed and blowed de mule way off his course, him bein' so poor and everything, and before de ornery varmint could tack, de youngun had done got over de fence." The porch laughed and Matt got mad again.

"Maybe de mule takes out after everybody," Sam said, "'cause he thinks everybody he hear comin' is Matt Bonner comin' tuh work 'im on uh empty stomach."

"Aw, naw, aw, naw. You stop dat right now," Walter objected. "Dat mule don't think Ah look lak no Matt Bonner. He ain't dat dumb. If Ah thought he didn't know no better Ah'd have mah picture took and give it tuh dat mule so's he could learn better. Ah ain't gointuh 'low 'im tuh hold nothin' lak dat against me."

Matt struggled to say something but his tongue failed him so he jumped down off the porch and walked away as mad as he could be. But that never halted the mule talk. There would be more stories about how poor the brute was; his age; his evil disposition and his latest caper. Everybody indulged in mule talk. He was next to the Mayor in prominence, and made better talking.

Janie loved the conversation and sometimes she thought up good stories on the mule, but Joe had forbidden her to indulge.

He didn't want her talking after such trashy people. "You'se Mrs. Mayor Starks, Janie. I god, Ah can't see what uh woman uh yo' stability would want tuh be treasurin' all dat gum-grease from folks dat don't even own de house dey sleep in. 'Tain't no earthly use. They's jus' some puny humans playin' round de toes uh Time."

Janie noted that while he didn't talk the mule himself, he sat and laughed at it. Laughed his big heh, heh laugh too. But then when Lige or Sam or Walter or some of the other big picture talkers were using a side of the world for a canvas, Joe would hustle her off inside the store to sell something. Look like he took pleasure in doing it. Why couldn't he go himself sometimes? She had come to hate the inside of that store anyway. That Post Office too. People always coming and asking for mail at the wrong time. Just when she was trying to count up something or write in an account book. Get her so hackled she'd make the wrong change for stamps. Then too, she couldn't read everybody's writing. Some folks wrote so funny and spelt things different from what she knew about. As a rule, Joe put up the mail himself, but sometimes when he was off she had to do it herself and it always ended up in a fuss.

The store itself kept her with a sick headache. The labor of getting things down off of a shelf or out of a barrel was nothing. And so long as people wanted only a can of tomatoes or a pound of rice it was all right. But supposing they went on and said a pound and a half of bacon and a half pound of lard? The whole thing changed from a little walking and stretching to a mathematical dilemma. Or maybe cheese was thirty-seven cents a pound and somebody came and asked for a dime's worth. She went through many silent rebellions over things like that. Such a waste of life and time. But Joe kept saying that she could do it if she wanted to and he wanted her to use her privileges. That was the rock she was battered against.

This business of the head-rag irked her endlessly. But Jody was set on it. Her hair was NOT going to show in the store. It didn't seem sensible at all. That was because Joe never told Janie how jealous he was. He never told her how often he had seen the other men figuratively wallowing in it as she went about things in the store. And one night he had caught Walter standing behind Janie and brushing the back of his hand back and forth across the loose end of her braid ever so lightly so as to enjoy the feel of it without Janie knowing what he was doing. Joe was at the back of the store and Walter didn't see him. He felt like rushing forth with the meat knife and chopping off the offending hand. That night he ordered Janie to tie up her hair around the store. That was all. She was there in the store for *him* to look at, not those others. But he never said things like that. It just wasn't in him. Take the matter of the yellow mule, for instance.

Late one afternoon Matt came from the west with a halter in his hand. "Been huntin' fuh mah mule. Anybody seen 'im?" he asked.

"Seen 'im soon dis mornin' over behind de schoolhouse," Lum said. "'Bout ten o'clock or so. He musta been out all night tuh be way over dere dat early."

"He wuz," Matt answered. "Seen 'im last night but Ah couldn't ketch 'im. Ah'm 'bliged tuh git 'im in tuhnight 'cause Ah got some plowin' fuh tuhmorrow. Done promised tuh plow Thompson's grove."

"Reckon you'll ever git through de job wid dat mule-frame?" Lige asked.

"Aw dat mule is plenty strong. Jus' evil and don't want tuh be led."

"Dat's right. Dey tell me he brought you heah tuh dis town. Say you started tuh Miccanopy but de mule had better sense and brung yuh on heah."

"It's uh l-l-lie! Ah set out fuh dis town when Ah left West Floridy."

"You mean tuh tell me you rode dat mule all de way from West Floridy down heah?"

"Sho he did, Lige. But he didn't mean tuh. He wuz satisfied up dere, but de mule wuzn't. So one mornin' he got straddle uh de mule and he took and brought 'im on off. Mule had sense. Folks up dat way don't eat biscuit bread but once uh week."

There was always a little seriousness behind the teasing of Matt, so when he got huffed and walked on off nobody minded. He was known to buy side-meat by the slice. Carried home little bags of meal and flour in his hand. He didn't seem to mind too much so long as it didn't cost him anything.

About half an hour after he left they heard the braying of the mule at the edge of the woods. He was coming past the store very soon.

"Less ketch Matt's mule fuh 'im and have some fun."

"Now, Lum, you know dat mule ain't aimin' tuh let hisself be caught. Less watch *you* do it."

When the mule was in front of the store, Lum went out and tackled him. The brute jerked up his head, laid back his ears and rushed to the attack. Lum had to run for safety. Five or six more men left the porch and surrounded the fractious beast, goosing him in the sides and making him show his temper. But he had more spirit left than body. He was soon panting and heaving from the effort of spinning his old carcass about. Everybody was having fun at the mule-baiting. All but Janie.

She snatched her head away from the spectacle and began muttering to herself. "They oughta be shamed uh theyselves! Teasin' dat poor brute beast lak they is! Done been worked tuh death; done had his disposition ruint wid mistreatment, and now they got tuh finish devilin' 'im tuh death. Wisht Ah had mah way wid 'em all."

She walked away from the porch and found something to busy herself with in the back of the store so she did not hear Jody when he stopped laughing. She didn't know that he had heard her, but she did hear him yell out, "Lum, I god, dat's enough! Y'all done had yo' fun now. Stop yo' foolishness and go tell Matt Bonner Ah wants tuh have uh talk wid him right away."

Janie came back out front and sat down. She didn't say anything and neither did Joe. But after a while he looked down at his feet and said, "Janie, Ah reckon you better go fetch me dem old black gaiters. Dese tan shoes sets mah feet on fire. Plenty room in 'em, but they hurts regardless."

She got up without a word and went off for the shoes. A little war of defense for helpless things was going on inside her. People ought to have some regard for helpless things. She wanted to fight about it. "But Ah hates disagreement and confusion, so Ah better not talk. It makes it hard tuh git along." She didn't hurry back. She fumbled around long enough to get her face straight. When she got back, Joe was talking with Matt.

"Fifteen dollars? I god you'se as crazy as uh betsy bug! Five dollars."

"L-l-less we strack uh compermise, Brother Mayor. Less m-make it ten."

"Five dollars." Joe rolled his cigar in his mouth and rolled his eyes away indifferently.

"If dat mule is wuth somethin' tuh *you*, Brother Mayor, he's wuth mo' tuh me. More special when Ah got uh job uh work tuhmorrow."

"Five dollars."

"All right, Brother Mayor. If you wants tuh rob uh poor man lak me uh everything he got tuh make uh livin' wid, Ah'll take de five dollars. Dat mule been wid me twenty-three years. It's mighty hard."

Mayor Starks deliberately changed his shoes before he reached into his pocket for the money. By that time Matt was wringing and twisting like a hen on a hot brick. But as soon as his hand closed on the money his face broke into a grin.

"Beatyuh tradin' dat time, Starks! Dat mule is liable tuh be dead befo' de week is out. You won't git no work outa him."

"Didn't buy 'im fuh no work. I god, Ah bought dat varmint tuh let 'im rest. You didn't have gumption enough tuh do it."

A respectful silence fell on the place. Sam looked at Joe and said, "Dat's uh new idea 'bout varmints, Mayor Starks. But Ah laks it mah ownself. It's uh noble thing you done." Everybody agreed with that.

Janie stood still while they all made comments. When it was all done she stood in front of Joe and said, "Jody, dat wuz uh mighty fine thing fuh you tuh do. 'Tain't everybody would have thought of it, 'cause it ain't no everyday thought. Freein' dat mule makes uh mighty big man outa you. Something like George Washington and Lincoln. Abraham Lincoln, he had de whole United States tuh rule so he freed de Negroes. You got uh town so you freed uh mule. You have tuh have power tuh free things and dat makes you lak uh king uh something."

Hambo said, "Yo' wife is uh born orator, Starks. Us never knowed dat befo'. She put jus' de right words tuh our thoughts."

Joe bit down hard on his cigar and beamed all around, but he never said a word. The town talked it for three days and said that's just what they would have done if they had been rich men like Joe Starks. Anyhow a free mule in town was something new to talk about. Starks piled fodder under the big tree near the porch and the mule was usually around the store like the other citizens. Nearly everybody took the habit of fetching along a handful of fodder to throw on the pile. He almost got fat and they took a great pride in him. New lies sprung up about his free-

mule doings. How he pushed open Lindsay's kitchen door and slept in the place one night and fought until they made coffee for his breakfast; how he stuck his head in the Pearsons' window while the family was at the table and Mrs. Pearson mistook him for Rev. Pearson and handed him a plate; he ran Mrs. Tully off of the croquet ground for having such an ugly shape; he ran and caught up with Becky Anderson on the way to Maitland so as to keep his head out of the sun under her umbrella; he got tired of listening to Redmond's long-winded prayer, and went inside the Baptist church and broke up the meeting. He did everything but let himself be bridled and visit Matt Bonner.

But way after a while he died. Lum found him under the big tree on his rawbony back with all four feet up in the air. That wasn't natural and it didn't look right, but Sam said it would have been more unnatural for him to have laid down on his side and died like any other beast. He had seen Death coming and had stood his ground and fought it like a natural man. He had fought it to the last breath. Naturally he didn't have time to straighten himself out. Death had to take him like it found him.

When the news got around, it was like the end of a war or something like that. Everybody that could knocked off from work to stand around and talk. But finally there was nothing to do but drag him out like all other dead brutes. Drag him out to the edge of the hammock which was far enough off to satisfy sanitary conditions in the town. The rest was up to the buzzards. Everybody was going to the dragging-out. The news had got Mayor Starks out of bed before time. His pair of gray horses was out under the tree and the men were fooling with the gear when Janie arrived at the store with Joe's breakfast.

"I god, Lum, you fasten up dis store good befo' you leave, you hear me?" He was eating fast and talking with one eye out of the door on the operations.

"Whut you tellin' 'im tuh fasten up for, Jody?" Janie asked, surprised.

"'Cause it won't be nobody heah tuh look after de store. Ah'm goin' tuh de draggin'-out mahself."

"'Tain't nothin' so important Ah got tuh do tuhday, Jody. How come Ah can't go long wid you tuh de draggin'-out?"

Joe was struck speechless for a minute. "Why, Janie! You wouldn't be seen at uh draggin'-out, wouldja? Wid any and everybody in uh passle pushin' and shovin' wid they no-manners selves? Naw, naw!"

"You would be dere wid me, wouldn't yuh?"

"Dat's right, but Ah'm uh man even if Ah is de Mayor. But de mayor's wife is somethin' different again. Anyhow they's liable tuh need me tuh say uh few words over de carcass, dis bein' uh special case. But *you* ain't goin' off in all dat mess uh commonness. Ah'm surprised at yuh fuh askin'."

He wiped his lips of ham gravy and put on his hat. "Shet de door behind yuh, Janie. Lum is too busy wid de hawses."

After more shouting of advice and orders and useless comments, the town escorted the carcass off. No, the carcass moved off with the town, and left Janie standing in the doorway.

Out in the swamp they made great ceremony over the mule. They mocked everything human in death. Starks led off with a great eulogy on our departed citizen, our most distinguished citizen and the grief he left behind him, and the people loved the speech. It made him more solid than building the schoolhouse had done. He stood on the distended belly of the mule for a platform and made gestures. When he stepped down, they hoisted Sam up and he talked about the mule as a school teacher first. Then he set his hat like John Pearson and imitated his preaching. He spoke of the joys of mule-heaven to which the dear brother had departed this valley of sorrow; the mule-angels flying

around; the miles of green corn and cool water, a pasture of pure bran with a river of molasses running through it; and most glorious of all, *No* Matt Bonner with plow lines and halters to come in and corrupt. Up there, mule-angels would have people to ride on and from his place beside the glittering throne, the dear departed brother would look down into hell and see the devil plowing Matt Bonner all day long in a hell-hot sun and laying the rawhide to his back.

With that the sisters got mock-happy and shouted and had to be held up by the menfolks. Everybody enjoyed themselves to the highest and then finally the mule was left to the already impatient buzzards. They were holding a great flying-meet way up over the heads of the mourners and some of the nearby trees were already peopled with the stoop-shouldered forms.

As soon as the crowd was out of sight they closed in circles. The near ones got nearer and the far ones got near. A circle, a swoop and a hop with spread-out wings. Close in, close in till some of the more hungry or daring perched on the carcass. They wanted to begin, but the Parson wasn't there, so a messenger was sent to the ruler in a tree where he sat.

The flock had to wait the white-headed leader, but it was hard. They jostled each other and pecked at heads in hungry irritation. Some walked up and down the beast from head to tail, tail to head. The Parson sat motionless in a dead pine tree about two miles off. He had scented the matter as quickly as any of the rest, but decorum demanded that he sit oblivious until he was notified. Then he took off with ponderous flight and circled and lowered, circled and lowered until the others danced in joy and hunger at his approach.

He finally lit on the ground and walked around the body to see if it were really dead. Peered into its nose and mouth. Examined it well from end to end and leaped upon it and

bowed, and the others danced a response. That being over, he balanced and asked:

"What killed this man?"

The chorus answered, "Bare, bare fat."

"What killed this man?"

"Bare, bare fat."

"What killed this man?"

"Bare, bare fat."

"Who'll stand his funeral?"

"We!!!!!"

"Well, all right now."

So he picked out the eyes in the ceremonial way and the feast went on. The yaller mule was gone from the town except for the porch talk, and for the children visiting his bleaching bones now and then in the spirit of adventure.

Joe returned to the store full of pleasure and good humor but he didn't want Janie to notice it because he saw that she was sullen and he resented that. She had no right to be, the way he thought things out. She wasn't even appreciative of his efforts and she had plenty cause to be. Here he was just pouring honor all over her; building a high chair for her to sit in and overlook the world and she here pouting over it! Not that he wanted anybody else, but just too many women would be glad to be in her place. He ought to box her jaws! But he didn't feel like fighting today, so he made an attack upon her position backhand.

"Ah had tuh laugh at de people out dere in de woods dis mornin', Janie. You can't help but laugh at de capers they cuts. But all the same, Ah wish mah people would git mo' business in 'em and not spend so much time on foolishness."

"Everybody can't be lak you, Jody. Somebody is bound tuh want tuh laugh and play."

"Who don't love tuh laugh and play?"

"You make out like you don't, anyhow."

"I god, Ah don't make out no such uh lie! But it's uh time fuh all things. But it's awful tuh see so many people don't want nothin' but uh full belly and uh place tuh lay down and sleep afterwards. It makes me sad sometimes and then agin it makes me mad. They say things sometimes that tickles me nearly tuh death, but Ah won't laugh jus' tuh dis-incourage 'em." Janie took the easy way away from a fuss. She didn't change her mind but she agreed with her mouth. Her heart said, "Even so, but you don't have to cry about it."

But sometimes Sam Watson and Lige Moss forced a belly laugh out of Joe himself with their eternal arguments. It never ended because there was no end to reach. It was a contest in hyperbole and carried on for no other reason.

Maybe Sam would be sitting on the porch when Lige walked up. If nobody was there to speak of, nothing happened. But if the town was there like on Saturday night, Lige would come up with a very grave air. Couldn't even pass the time of day, for being so busy thinking. Then when he was asked what was the matter in order to start him off, he'd say, "Dis question done 'bout drove me crazy. And Sam, he know so much into things, Ah wants some information on de subject."

Walter Thomas was due to speak up and egg the matter on. "Yeah, Sam always got more information than he know what to do wid. He's bound to tell yuh whatever it is you wants tuh know."

Sam begins an elaborate show of avoiding the struggle. That draws everybody on the porch into it.

"How come you want me *tuh* tell yuh? You always claim God done met you round de corner and talked His inside business wid yuh. 'Tain't no use in you askin' *me* nothin'. Ah'm questionizin' *you*."

"How you gointuh do dat, Sam, when Ah arrived dis conversation mahself? Ah'm askin' *you*."

"Askin' me what? You ain't told me de subjick yit."

"Don't aim tuh tell yuh! Ah aims tuh keep yuh in de dark all de time. If you'se smart lak you let on you is, you kin find out."

"Yuh skeered to lemme know whut it is, 'cause yuh know Ah'll tear it tuh pieces. You got to have a subjick tuh talk from, do yuh can't talk. If uh man ain't got no bounds, he ain't got no place tuh stop."

By this time, they are the center of the world.

"Well all right then. Since you own up you ain't smart enough tuh find out whut Ah'm talkin' 'bout, Ah'll tell you. Whut is it dat keeps uh man from gettin' burnt on uh red-hot stove—caution or nature?"

"Shucks! Ah thought you had somethin' hard tuh ast me. Walter kin tell yuh dat."

"If de conversation is too deep for yuh, how come yuh don't tell me so, and hush up? Walter can't tell me nothin' uh de kind. Ah'm uh educated man, Ah keeps mah arrangements in mah hands, and if it kept me up all night long studyin' 'bout it, Walter ain't liable tuh be no help to me. Ah needs uh man lak you."

"And then agin, Lige, Ah'm gointuh tell yuh. Ah'm gointuh run dis conversation from uh gnat heel to uh lice. It's nature dat keeps uh man off of uh red-hot stove."

"Uuh huuh! Ah knowed you would going tuh crawl up in dat holler! But Ah aims tuh smoke yuh right out. 'Tain't no nature at all, it's caution, Sam."

"'Tain't no sich uh thing! Nature tells yuh not tuh fool wid no red-hot stove, and you don't do it neither."

"Listen, Sam, if it was nature, nobody wouldn't have tuh look out for babies touchin' stoves, would they? 'Cause dey just naturally wouldn't touch it. But dey sho will. So it's caution."

"Naw it ain't, it's nature, cause nature makes caution. It's de strongest thing dat God ever made, now. Fact is it's de onliest thing God ever made. He made nature and nature made everything else."

"Naw nature didn't neither. A whole heap of things ain't even been made yit."

"Tell me somethin' you know of dat nature ain't made."

"She ain't made it so you kin ride uh butt-headed cow and hold on tuh de horns."

"Yeah, but dat ain't yo' point."

"Yeah it is too."

"Naw it ain't neither."

"Well what *is* mah point?"

"You ain't got none, so far."

"Yeah he is too," Walter cut in. "De red-hot stove is his point."

"He know mighty much, but he ain't proved it yit."

"Sam, Ah say it's caution, not nature dat keeps folks off uh red-hot stove."

"How is de son gointuh be before his paw? Nature is de first of everything. Ever since self was self, nature been keepin' folks off of red-hot stoves. Dat caution you talkin' 'bout ain't nothin' but uh humbug. He's uh inseck dat nothin' he got belongs to him. He got eyes, lak somethin' else; wings lak somethin' else—everything! Even his hum is de sound of somebody else."

"Man, whut you talkin' 'bout? Caution is de greatest thing in de world. If it wasn't for caution—"

"Show me somethin' dat caution ever made! Look whut nature took and done. Nature got so high in uh black hen she got tuh lay uh white egg. Now you tell me, how come, whut got intuh man dat he got tuh have hair round his mouth? Nature!"

"Dat ain't—"

The porch was boiling now. Starks left the store to Hezekiah Potts, the delivery boy, and come took a seat in his high chair.

"Look at dat great big ole scoundrel-beast up dere at Hall's fillin' station—uh great big old scoundrel. He eats up all de folks outa de house and den eat de house."

"Aw 'tain't no sich a varmint nowhere dat kin eat no house! Dat's uh lie. Ah wuz dere yiste'ddy and Ah ain't seen nothin' lak dat. Where is he?"

"Ah didn't see him but Ah reckon he is in de back-yard some place. But dey got his picture out front dere. They was nailin' it up when Ah come pass dere dis evenin'."

"Well all right now, if he eats up houses how come he don't eat up de fillin' station?"

"Dat's 'cause dey got him tied up so he can't. Dey got uh great big picture tellin' how many gallons of dat Sinclair high-compression gas he drink at one time and how he's more'n uh million years old."

"'Tain't *nothin'* no million years old!"

"De picture is right up dere where anybody kin see it. Dey can't make de picture till dey see de thing, kin dey?"

"How dey goin' to tell he's uh million years old? Nobody wasn't born dat fur back."

"By de rings on his tail Ah reckon. Man, dese white folks got ways for tellin' anything dey wants tuh know."

"Well, where he been at all dis time, then?"

"Dey caught him over dere in Egypt. Seem lak he used tuh hang round dere and eat up dem Pharaohs' tombstones. Dey got de picture of him doin' it. Nature is high in uh varmint lak dat. Nature and salt. Dat's whut makes up strong man lak Big John de Conquer. He was uh man wid salt in him. He could give uh flavor to *anything*."

"Yeah, but he was uh man dat wuz more'n man. 'Tain't no

mo' lak him. He wouldn't dig potatoes, and he wouldn't rake hay: He wouldn't take a whipping, and he wouldn't run away."

"Oh yeah, somebody else could if dey tried hard enough. Me mahself, Ah got salt in *me*. If Ah like man flesh, Ah could eat some man every day, some of 'em is so trashy they'd let me eat 'em."

"Lawd, Ah loves to talk about Big John. Less we tell lies on Ole John."

But here come Bootsie, and Teadi and Big 'oman down the street making out they are pretty by the way they walk. They have got that fresh, new taste about them like young mustard greens in the spring, and the young men on the porch are just bound to tell them about it and buy them some treats.

"Heah come mah order right now," Charlie Jones announces and scrambles off the porch to meet them. But he has plenty of competition. A pushing, shoving show of gallantry. They all beg the girls to just buy anything they can think of. Please let them pay for it. Joe is begged to wrap up all the candy in the store and order more. All the peanuts and soda water—everything!

"Gal, Ah'm crazy 'bout you," Charlie goes on to the entertainment of everybody. "Ah'll do anything in the world except work for you and give you mah money."

The girls and everybody else help laugh. They know it's not courtship. It's acting-out courtship and everybody is in the play. The three girls hold the center of the stage till Daisy Blunt comes walking down the street in the moonlight.

Daisy is walking a drum tune. You can almost hear it by looking at the way she walks. She is black and she knows that white clothes look good on her, so she wears them for dress up. She's got those big black eyes with plenty shiny white in them that makes them shine like brand new money and she knows what God gave women eyelashes for, too. Her hair is not what you might call straight. It's negro hair, but it's got a kind of white fla-

vor. Like the piece of string out of a ham. It's not ham at all, but it's been around ham and got the flavor. It was spread down thick and heavy over her shoulders and looked just right under a big white hat.

"Lawd, Lawd, Lawd," that same Charlie Jones exclaims rushing over to Daisy. "It must be uh recess in heben if St. Peter is lettin' his angels out lak dis. You got three men already layin' at de point uh death 'bout yuh, and heah's uhnother fool dat's willin' tuh make time on yo' gang."

All the rest of the single men have crowded around Daisy by this time. She is parading and blushing at the same time.

"If you know anybody dat's 'bout tub die 'bout me, yuh know more'n Ah do," Daisy bridled. "Wisht Ah knowed who it is."

"Now, Daisy, *you* know Jim, and Dave and Lum is 'bout tuh kill one 'nother 'bout you. Don't stand up here and tell dat big ole got-dat-wrong."

"Dey a mighty hush-mouf about it if dey is. Dey ain't never told me nothin'."

"Unhunh, you talked too fast. Heah, Jim and Dave is right upon de porch and Lum is inside de store."

A big burst of laughter at Daisy's discomfiture. The boys had to act out their rivalry too. Only this time, everybody knew they meant some of it. But all the same the porch enjoyed the play and helped out whenever extras were needed.

David said, "Jim don't love Daisy. He don't love yuh lak Ah do."

Jim bellowed indignantly, "Who don't love Daisy? Ah know you ain't talkin' 'bout me."

Dave: "Well all right, less prove dis thing right now. We'll prove right now who love dis gal de best. How much time is you willin' tuh make fuh Daisy?"

Jim: "Twenty yeahs!"

Dave: "See? Ah told yuh dat nigger didn't love yuh. Me,

Ah'll beg de Judge tuh hang me, and wouldn't take nothin' less than life."

There was a big long laugh from the porch. Then Jim had to demand a test.

"Dave, how much would you be willin' tuh do for Daisy if she was to turn fool enough tuh marry yuh?"

"Me and Daisy done talked dat over, but if you just got tuh know, Ah'd buy Daisy uh passenger train and give it tuh her."

"Humph! Is dat all? Ah'd buy her uh steamship and then Ah'd hire some mens tuh run it fur her."

"Daisy, don't let Jim fool you wid his talk. He don't aim tuh do nothin' fuh yuh. Uh lil ole steamship! Daisy, Ah'll take uh job cleanin' out de Atlantic Ocean fuh you any time you say you so desire." There was a great laugh and then they hushed to listen.

"Daisy," Jim began, "you know mah heart and all de ranges uh mah mind. And you know if Ah wuz ridin' up in uh earoplane way up in de sky and Ah looked down and seen you walkin' and knowed you'd have tuh walk ten miles tuh git home, Ah'd step backward offa dat earoplane just to walk home wid you."

There was one of those big blow-out laughs and Janie was wallowing in it. Then Jody ruined it all for her.

Mrs. Bogle came walking down the street towards the porch. Mrs. Bogle who was many times a grandmother, but had a blushing air of coquetry about her that cloaked her sunken cheeks. You saw a fluttering fan before her face and magnolia blooms and sleepy lakes under the moonlight when she walked. There was no obvious reason for it, it was just so. Her first husband had been a coachman but "studied jury" to win her. He had finally become a preacher to hold her till his death. Her second husband worked in Fohnes orange grove—but tried to preach when he caught her eye. He never got any further than a class leader, but that was something to offer her. It proved his

love and pride. She was a wind on the ocean. She moved men, but the helm determined the port. Now, this night she mounted the steps and the men noticed her until she passed inside the door.

"I god, Janie," Starks said impatiently, "why don't you go on and see whut Mrs. Bogle want? Whut you waitin' on?"

Janie wanted to hear the rest of the play-acting and how it ended, but she got up sullenly and went inside. She came back to the porch with her bristles sticking out all over her and with dis-satisfaction written all over her face. Joe saw it and lifted his own hackles a bit.

Jim Weston had secretly borrowed a dime and soon he was loudly beseeching Daisy to have a treat on him. Finally she con-sented to take a pickled pig foot on him. Janie was getting up a large order when they came in, so Lum waited on them. That is, he went back to the keg but came back without the pig foot.

"Mist' Starks, de pig feets is all gone!" he called out.

"Aw naw dey ain't, Lum. Ah bought uh whole new kag of 'em wid dat last order from Jacksonville. It come in yistiddy."

Joe came and helped Lum look but he couldn't find the new keg either, so he went to the nail over his desk that he used for a file to search for the order.

"Janie, where's dat last bill uh ladin'?"

"It's right dere on de nail, ain't it?"

"Naw it ain't neither. You ain't put it where Ah told yuh tuh. If you'd git yo' mind out de streets and keep it on yo' business maybe you could git somethin' straight sometimes."

"Aw, look around dere, Jody. Dat bill ain't apt tuh be gone off nowheres. If it ain't hangin' on de nail, it's on yo' desk. You bound tuh find it if you look."

"Wid you heah, Ah oughtn't tuh hafta do all dat lookin' and searchin'. Ah done told you time and time agin tuh stick all dem

papers on dat nail! All you got tuh do is mind me. How come you can't do lak Ah tell yuh?"

"You sho loves to tell me whut to do, but Ah can't tell you nothin' Ah see!"

"Dat's 'cause you need tellin'," he rejoined hotly. "It would be pitiful if Ah didn't. Somebody got to think for women and chillun and chickens and cows. I god, they sho don't think none theirselves."

"Ah knows uh few things, and womenfolks thinks sometimes too!"

"Aw naw they don't. They just think they's thinkin'. When Ah see one thing Ah understands ten. You see ten things and don't understand one."

Times and scenes like that put Janie to thinking about the inside state of her marriage. Time came when she fought back with her tongue as best she could, but it didn't do her any good. It just made Joe do more. He wanted her submission and he'd keep on fighting until he felt he had it.

So gradually, she pressed her teeth together and learned to hush. The spirit of the marriage left the bedroom and took to living in the parlor. It was there to shake hands whenever company came to visit, but it never went back inside the bedroom again. So she put something in there to represent the spirit like a Virgin Mary image in a church. The bed was no longer a daisy-field for her and Joe to play in. It was a place where she went and laid down when she was sleepy and tired.

She wasn't petal-open anymore with him. She was twenty-four and seven years married when she knew. She found that out one day when he slapped her face in the kitchen. It happened over one of those dinners that chasten all women sometimes. They plan and they fix and they do, and then some kitchen-dwelling fiend slips a scorchy, soggy, tasteless mess into their

pots and pans. Janie was a good cook, and Joe had looked forward to his dinner as a refuge from other things. So when the bread didn't rise, and the fish wasn't quite done at the bone, and the rice was scorched, he slapped Janie until she had a ringing sound in her ears and told her about her brains before he stalked on back to the store.

Janie stood where he left her for unmeasured time and thought. She stood there until something fell off the shelf inside her. Then she went inside there to see what it was. It was her image of Jody tumbled down and shattered. But looking at it she saw that it never was the flesh and blood figure of her dreams. Just something she had grabbed up to drape her dreams over. In a way she turned her back upon the image where it lay and looked further. She had no more blossomy openings dusting pollen over her man, neither any glistening young fruit where the petals used to be. She found that she had a host of thoughts she had never expressed to him, and numerous emotions she had never let Jody know about. Things packed up and put away in parts of her heart where he could never find them. She was saving up feelings for some man she had never seen. She had an inside and an outside now and suddenly she knew how not to mix them.

She bathed and put on a fresh dress and head kerchief and went on to the store before Jody had time to send for her. That was a bow to the outside of things.

Jody was on the porch and the porch was full of Eatonville as usual at this time of the day. He was baiting Mrs. Tony Robbins as he always did when she came to the store. Janie could see Jody watching her out of the corner of his eye while he joked roughly with Mrs. Robbins. He wanted to be friendly with her again. His big, big laugh was as much for her as for the baiting. He was longing for peace but on his own terms.

"I god, Mrs. Robbins, whut make you come heah and worry

me when you see Ah'm readin' mah newspaper?" Mayor Starks lowered the paper in pretended annoyance.

Mrs. Robbins struck her pity-pose and assumed the voice.

"'Cause Ah'm hongry, Mist' Starks. 'Deed Ah is. Me and mah chillun is hongry. Tony don't fee-eed me!"

This was what the porch was waiting for. They burst into a laugh.

"Mrs. Robbins, how can you make out you'se hongry when Tony comes in here every Satitday and buys groceries lak a man? Three weeks' shame on yuh!"

"If he buy all dat you talkin' 'bout, Mist' Starks, God knows whut he do wid it. He sho don't bring it home, and me and mah po' chillun is *so* hongry! Mist' Starks, please gimme uh lil piece uh meat fur me and mah chillun."

"Ah know you don't need it, but come on inside. You ain't goin' tuh lemme read till Ah give it to yuh."

Mrs. Tony's ecstasy was divine. "Thank you, Mist' Starks. You'se noble! You'se du most gentlemanfied man Ah ever did see. You'se uh king!"

The salt pork box was in the back of the store and during the walk Mrs. Tony was so eager she sometimes stepped on Joe's heels, sometimes she was a little before him. Something like a hungry cat when somebody approaches her pan with meat. Running a little, caressing a little and all the time making little urging-on cries.

"Yes, indeedy, Mist' Starks, you'se noble. You got sympathy for me and mah po' chillun. Tony don't give us nothin' tuh eat and we'se *so* hongry. Tony don't fee-eed me!"

This brought them to the meat box. Joe took up the big meat knife and selected a piece of side meat to cut. Mrs. Tony was all but dancing around him.

"Dat's right, Mist' Starks! Gimme uh lil piece 'bout dis

wide." She indicated as wide as her wrist and hand. "Me and mah chillun is *so* hongry!"

Starks hardly looked at her measurements. He had seen them too often. He marked off a piece much smaller and sunk the blade in. Mrs. Tony all but fell to the floor in her agony.

"Lawd a'mussy! Mist' Starks, you ain't gointuh gimme dat lil tee-ninchy piece fuh me and all mah chillun, is yuh? Lawd, we'se *so* hongry!"

Starks cut right on and reached for a piece of wrapping paper. Mrs. Tony leaped away from the proffered cut of meat as if it were a rattlesnake.

"Ah wouldn't tetch it! Dat lil eyeful uh bacon for me and all mah chillun! Lawd, some folks is got everything and they's so gripin' and so mean!"

Starks made as if to throw the meat back in the box and close it. Mrs. Tony swooped like lightning and seized it, and started towards the door.

"Some folks ain't got no heart in dey bosom. They's willin' tuh see uh po' woman and her helpless chillun starve tuh death. God's gointuh put 'em under arrest, some uh dese days, wid dey stingy gripin' ways."

She stepped from the store porch and marched off in high dudgeon! Some laughed and some got mad.

"If dat wuz *mah* wife," said Walter Thomas, "Ah'd kill her cemetery dead."

"More special after Ah done bought her everything mah wages kin stand, lak Tony do," Coker said. "In de fust place Ah never would spend on *no* woman whut Tony spend on *her.*"

Starks came back and took his seat. He had to stop and add the meat to Tony's account.

"Well, Tony tells me tuh humor her along. He moved here from up de State hopin' tuh change her, but it ain't. He say he

can't bear tuh leave her and he hate to kill her, so 'tain't nothin' tuh do but put up wid her."

"Dat's 'cause Tony love her too good," said Coker. "Ah could break her if she wuz mine. Ah'd break her or kill her. Makin' uh fool outa me in front of everybody."

"Tony won't never hit her. He says beatin' women is just like steppin' on baby chickens. He claims 'tain't no place on uh woman tuh hit," Joe Lindsay said with scornful disapproval, "but Ah'd kill uh baby just born dis mawnin' fuh uh thing lak dat. 'Tain't nothin' but low-down spitefulness 'ginst her husband make her do it."

"Dat's de God's truth," Jim Stone agreed. "Dat's de very reason."

Janie did what she had never done before, that is, thrust herself into the conversation.

"Sometimes God gits familiar wid us womenfolks too and talks His inside business. He told me how surprised He was 'bout y'all turning out so smart after Him makin' yuh different; and how surprised y'all is goin' tuh be if you ever find out you don't know half as much 'bout us as you think you do. It's so easy to make yo'-self out God Almighty when you ain't got nothin' tuh strain against but women and chickens."

"You gettin' too moufy, Janie," Starks told her. "Go fetch me de checker-board *and* de checkers. Sam Watson, you'se mah fish."

7

The years took all the fight out of Janie's face. For a while she thought it was gone from her soul. No matter what Jody did, she said nothing. She had learned how to talk some and leave some. She was a rut in the road. Plenty of life beneath the surface but it was kept beaten down by the wheels. Sometimes she stuck out into the future, imagining her life different from what it was. But mostly she lived between her hat and her heels, with her emotional disturbances like shade patterns in the woods—come and gone with the sun. She got nothing from Jody except what money could buy, and she was giving away what she didn't value.

Now and again she thought of a country road at sun-up and considered flight. To where? To what? Then too she considered thirty-five is twice seventeen and nothing was the same at all.

"Maybe he ain't nothin'," she cautioned herself, "but he is something in my mouth. He's got tuh be else Ah ain't got nothin' tuh live for. Ah'll lie and say he is. If Ah don't, life won't be nothin' but uh store and uh house."

She didn't read books so she didn't know that she was the world and the heavens boiled down to a drop. Man attempting to climb to painless heights from his dung hill.

Then one day she sat and watched the shadow of herself going about tending store and prostrating itself before Jody, while all the time she herself sat under a shady tree with the wind blowing through her hair and her clothes. Somebody near about making summertime out of lonesomeness.

This was the first time it happened, but after a while it got so common she ceased to be surprised. It was like a drug. In a way it was good because it reconciled her to things. She got so she received all things with the stolidness of the earth which soaks up urine and perfume with the same indifference.

One day she noticed that Joe didn't sit down. He just stood in front of a chair and fell in it. That made her look at him all over. Joe wasn't so young as he used to be. There was already something dead about him. He didn't rear back in his knees any longer. He squatted over his ankles when he walked. That stillness at the back of his neck. His prosperous-looking belly that used to thrust out so pugnaciously and intimidate folks, sagged like a load suspended from his loins. It didn't seem to be a part of him anymore. Eyes a little absent too.

Jody must have noticed it too. Maybe, he had seen it long before Janie did, and had been fearing for her to see. Because he began to talk about her age all the time, as if he didn't want her to stay young while he grew old. It was always "You oughta throw somethin' over yo' shoulders befo' you go outside. You ain't no young pullet no mo'. You'se uh ole hen now." One day he called her off the croquet grounds. "Dat's somethin' for de young folks, Janie, you out dere jumpin' round and won't be able tuh git out de bed tuhmorrer." If he thought to deceive her, he was wrong. For the first time she could see a man's head naked of its skull. Saw the cunning thoughts race in and out through the caves and promontories of his mind long before they darted out of the tunnel of his mouth. She saw he was

hurting inside so she let it pass without talking. She just measured out a little time for him and set it aside to wait.

It got to be terrible in the store. The more his back ached and his muscle dissolved into fat and the fat melted off his bones, the more fractious he became with Janie. Especially in the store. The more people in there the more ridicule he poured over her body to point attention away from his own. So one day Steve Mixon wanted some chewing tobacco and Janie cut it wrong. She hated that tobacco knife anyway. It worked very stiff. She fumbled with the thing and cut way away from the mark. Mixon didn't mind. He held it up for a joke to tease Janie a little.

"Looka heah, Brother Mayor, whut yo' wife done took and done." It was cut comical, so everybody laughed at it. "Uh woman and uh knife—no kind of uh knife, don't b'long tuhgether." There was some more good-natured laughter at the expense of women.

Jody didn't laugh. He hurried across from the post office side and took the plug of tobacco away from Mixon and cut it again. Cut it exactly on the mark and glared at Janie.

"I god amighty! A woman stay round uh store till she get old as Methusalem and still can't cut a little thing like a plug of tobacco! Don't stand dere rollin' yo' pop eyes at me wid yo' rump hangin' nearly to yo' knees!"

A big laugh started off in the store but people got to thinking and stopped. It was funny if you looked at it right quick, but it got pitiful if you thought about it awhile. It was like somebody snatched off part of a woman's clothes while she wasn't looking and the streets were crowded. Then too, Janie took the middle of the floor to talk right into Jody's face, and that was something that hadn't been done before.

"Stop mixin' up mah doings wid mah looks, Jody. When you git through tellin' me how tuh cut uh plug uh tobacco, then you kin tell me whether mah behind is on straight or not."

"Wha—whut's dat you say, Janie? You must be out yo' head."

"Naw, Ah ain't outa mah head neither."

"You must be. Talkin' any such language as dat."

"You de one started talkin' under people's clothes. Not me."

"Whut's de matter wid you, nohow? You ain't no young girl to be gettin' all insulted 'bout yo' looks. You ain't no young courtin' gal. You'se uh ole woman, nearly forty."

"Yeah, Ah'm nearly forty and you'se already fifty. How come you can't talk about dat sometimes instead of always pointin' at me?"

"T'ain't no use in gettin' all mad, Janie, 'cause Ah mention you ain't no young gal no mo'. Nobody in heah ain't lookin' for no wife outa yuh. Old as you is."

"Naw, Ah ain't no young gal no mo' but den Ah ain't no old woman neither. Ah reckon Ah looks mah age too. But Ah'm uh woman every inch of me, and Ah know it. Dat's uh whole lot more'n *you* kin say. You big-bellies round here and put out a lot of brag, but 'tain't nothin' to it but yo' big voice. Humph! Talkin' 'bout *me* lookin' old! When you pull down yo' britches, you look lak de change uh life."

"Great God from Zion!" Sam Watson gasped. "Y'all really playin' de dozens tuhnight."

"Wha—whut's dat you said?" Joe challenged, hoping his ears had fooled him.

"You heard her, you ain't blind," Walter taunted.

"Ah ruther be shot with tacks than tuh hear dat 'bout mah-self," Lige Moss commiserated.

Then Joe Starks realized all the meanings and his vanity bled like a flood. Janie had robbed him of his illusion of irresistible maleness that all men cherish, which was terrible. The thing that Saul's daughter had done to David. But Janie had done worse, she had cast down his empty armor before men and they had laughed,

would keep on laughing. When he paraded his possessions here-after, they would not consider the two together. They'd look with envy at the things and pity the man that owned them. When he sat in judgment it would be the same. Good-for-nothing's like Dave and Lum and Jim wouldn't change place with him. For what can excuse a man in the eyes of other men for lack of strength? Raggedy-behind squirts of sixteen and seventeen would be giving him their merciless pity out of their eyes while their mouths said something humble. There was nothing to do in life anymore. Ambition was useless. And the cruel deceit of Janie! Making all that show of humbleness and scorning him all the time! Laughing at him, and now putting the town up to do the same. Joe Starks didn't know the words for all this, but he knew the feeling. So he struck Janie with all his might and drove her from the store.

8

After that night Jody moved his things and slept in a room downstairs.
He didn't really hate Janie, but he wanted her to think so. He had
crawled off to lick his wounds. They didn't talk too much around
the store either. Anybody that didn't know would have thought
that things had blown over, it looked so quiet and peaceful
around. But the stillness was the sleep of swords. So new thoughts
had to be thought and new words said. She didn't want to live like
that. Why must Joe be so mad with her for making him look small
when he did it to her all the time? Had been doing it for years.
Well, if she must eat out of a long-handled spoon, she must. Jody
might get over his mad spell any time at all and begin to act like
somebody towards her.

Then too she noticed how baggy Joe was getting all over.
Like bags hanging from an ironing board. A little sack hung from
the corners of his eyes and rested on his cheek-bones; a loose-
filled bag of feathers hung from his ears and rested on his neck
beneath his chin. A sack of flabby something hung from his loins
and rested on his thighs when he sat down. But even these things
were running down like candle grease as time moved on.

He made new alliances too. People he never bothered with
one way or another now seemed to have his ear. He had always

been scornful of root-doctors and all their kind, but now she saw a
faker from over around Altamonte Springs, hanging around the
place almost daily. Always talking in low tones when she came near,
or hushed altogether. She didn't know that he was driven by a des-
perate hope to appear the old-time body in her sight. She was sorry
about the root-doctor because she feared that Joe was depending
on the scoundrel to make him well when what he needed was a
doctor, and a good one. She was worried about his not eating his
meals, till she found out he was having old lady Davis to cook for
him. She knew that she was a much better cook than the old
woman, and cleaner about the kitchen. So she bought a beef-bone
and made him some soup.

"Naw, thank you," he told her shortly. "Ah'm havin' uh hard
enough time tuh try and git well as it is."

She was stunned at first and hurt afterwards. So she went
straight to her bosom friend, Pheoby Watson, and told her about it.

"Ah'd ruther be dead than for Jody tuh think Ah'd hurt
him," she sobbed to Pheoby. "It ain't always been too pleasant,
'cause you know how Joe worships de works of his own hands,
but God in heben knows Ah wouldn't do one thing tuh hurt
nobody. It's too underhand and mean."

"Janie, Ah though maybe de thing would die down and you
never would know nothin' 'bout it, but it's been singin' round
here ever since de big fuss in de store dat Joe was 'fixed' and you
wuz de one dat did it."

"Pheoby, for de longest time, Ah been feelin' dat somethin'
set for still-bait, but dis is—is—oh Pheoby! Whut *kin* I do?"

"You can't do nothin' but make out you don't know it. It's
too late fuh y'all tuh be splittin' up and gittin' divorce. Just g'wan
back home and set down on yo' royal diasticutis and say nothin'.
Nobody don't b'lieve it nohow."

"Tuh think Ah been wid Jody twenty yeahs and Ah just now

got tuh bear de name uh poisonin' him! It's 'bout to kill me, Pheoby. Sorrow dogged by sorrow is in mah heart."

"Dat's lie dat trashy nigger dat calls hisself uh two-headed doctor brought tuh 'im in order tuh git in wid Jody. He seen he wuz sick—everybody been knowin' dat for de last longest, and den Ah reckon he heard y'all wuz kind of at variance, so dat wuz his chance. Last summer dat multiplied cockroach wuz round heah tryin' tuh sell gophers!"

"Pheoby, Ah don't even b'lieve Jody b'lieve dat lie. He ain't never took no stock in de mess. He just make out he b'lieve it tuh hurt me. Ah'm stone dead from standin' still and tryin' tuh smile."

She cried often in the weeks that followed. Joe got too weak to look after things and took to his bed. But he relentlessly refused to admit her to his sick room. People came and went in the house. This one and that one came into her house with covered plates of broth and other sick-room dishes without taking the least notice of her as Joe's wife. People who never had known what it was to enter the gate of the Mayor's yard unless it were to do some menial job now paraded in and out as his confidants. They came to the store and ostentatiously looked over whatever she was doing and went back to report to him at the house. Said things like "Mr. Starks need *somebody* tuh sorta look out for 'im till he kin git on his feet again and look for hisself."

But Jody was never to get on his feet again. Janie had Sam Watson to bring her the news from the sick room, and when he told her how things were, she had him bring a doctor from Orlando without giving Joe a chance to refuse, and without saying she sent for him.

"Just a matter of time," the doctor told her. "When a man's kidneys stop working altogether, there is no way for him to live. He needed medical attention two years ago. Too late now."

So Janie began to think of Death. Death, that strange being with the huge square toes who lived way in the West. The great one who lived in the straight house like a platform without sides to it, and without a roof. What need has Death for a cover, and what winds can blow against him? He stands in his high house that overlooks the world. Stands watchful and motionless all day with his sword drawn back, waiting for the messenger to bid him come. Been standing there before there was a where or a when or a then. She was liable to find a feather from his wings lying in her yard any day now. She was sad and afraid too. Poor Jody! He ought not to have to wrassle in there by himself. She sent Sam in to suggest a visit, but Jody said No. These medical doctors wuz all right with the Godly sick, but they didn't know a thing about a case like his. He'd be all right just as soon as the two-headed man found what had been buried against him. He wasn't going to die at all. That was what he thought. But Sam told her different, so she knew. And then if he hadn't, the next morning she was bound to know, for people began to gather in the big yard under the palm and china-berry trees. People who would not have dared to foot the place before crept in and did not come to the house. Just squatted under the trees and waited. Rumor, that wingless bird, had shadowed over the town.

She got up that morning with the firm determination to go on in there and have a good talk with Jody. But she sat a long time with the walls creeping in on her. Four walls squeezing her breath out. Fear lest he depart while she sat trembling upstairs nerved her and she was inside the room before she caught her breath. She didn't make the cheerful, casual start that she had thought out. Something stood like an oxen's foot on her tongue, and then too, Jody, no Joe, gave her a ferocious look. A look with all the unthinkable coldness of outer space. She must talk to a man who was ten immensities away.

He was lying on his side facing the door like he was expecting somebody or something. A sort of changing look on his face. Weak-looking but sharp-pointed about the eyes. Through the thin counterpane she could see what was left of his belly huddled before him on the bed like some helpless thing seeking shelter.

The half-washed bedclothes hurt her pride for Jody. He had always been so clean.

"Whut you doin' in heah, Janie?"

"Come tuh see 'bout you and how you wuz makin' out."

He gave a deep-growling sound like a hog dying down in the swamp and trying to drive off disturbance. "Ah come in heah tuh git shet uh you but look lak 'tain't doin' me no good. G'wan out. Ah needs tuh rest."

"Naw, Jody, Ah come in heah tuh talk widja and Ah'm goin- tuh do it too. It's for both of our sakes Ah'm talkin'."

He gave another ground grumble and eased over on his back.

"Jody, maybe Ah ain't been sich uh good wife tuh you, but Jody—"

"Dat's 'cause you ain't got de right feelin' for nobody. You oughter have some sympathy 'bout yo'self. You ain't no hog."

"But, Jody, Ah meant tuh be awful nice."

"Much as Ah done fuh yuh. Holdin' me up tuh scorn. No sympathy!"

"Naw, Jody, it wasn't because Ah didn't have no sympathy. Ah had uh lavish uh dat. Ah just didn't never git no chance tuh use none of it. You wouldn't let me."

"Dat's right, blame everything on me. Ah wouldn't let you show no feelin'! When, Janie, dat's all Ah ever wanted or desired. Now you come blamin' me!"

"'Tain't dat, Jody. Ah ain't here tuh blame nobody. Ah'm just tryin' tuh make you know what kinda person Ah is befo' it's too late."

"Too late?" he whispered.

His eyes buckled in a vacant-mouthed terror and she saw the awful surprise in his face and answered it.

"Yeah, Jody, don't keer whut dat multiplied cockroach told yuh tuh git yo' money, you got tuh die, and yuh can't live."

A deep sob came out of Jody's weak frame. It was like beating a bass drum in a hen-house. Then it rose high like pulling in a trombone.

"Janie! Janie! don't tell me Ah got tuh die, and Ah ain't used tuh thinkin' 'bout it."

"'Tain't really no need of you dying, Jody, if you had of—de doctor—but it don't do no good bringin' dat up now. Dat's just whut Ah wants tuh say, Jody. You wouldn't listen. You done lived wid me for twenty years and you don't half know me atall. And you could have but you was so busy worshippin' de works of yo' own hands, and cuffin' folks around in their minds till you didn't see uh whole heap uh things yuh could have."

"Leave heah, Janie. Don't come heah—"

"Ah knowed you wasn't gointuh lissen tuh me. You changes everything but nothin' don't change you—not even death. But Ah ain't goin' outa here and Ah ain't gointuh hush. Naw, you gointuh listen tuh me one time befo' you die. Have yo' way all yo' life, trample and mash down and then die ruther than tuh let yo'self heah 'bout it. Listen, Jody, you ain't de Jody ah run off down de road wid. You'se whut's left after he died. Ah run off tuh keep house wid you in uh wonderful way. But you wasn't satisfied wid me de way Ah was. Naw! Mah own mind had tuh be squeezed and crowded out tuh make room for yours in me."

"Shut up! Ah wish thunder and lightnin' would kill yuh!"

"Ah know it. And now you got tuh die tuh find out dat you got tuh pacify somebody besides yo'self if you wants any love and

any sympathy in dis world. You ain't tried tuh pacify *nobody* but yo'self. Too busy listening tuh yo' own big voice."

"All dis tearin' down talk!" Jody whispered with sweat globules forming all over his face and arms. "Git outa heah!"

"All dis bowin' down, all dis obedience under yo' voice—dat ain't whut Ah rushed off down de road tuh find out about you."

A sound of strife in Jody's throat, but his eyes stared unwillingly into a corner of the room so Janie knew the futile fight was not with her. The icy sword of the square-toed one had cut off his breath and left his hands in a pose of agonizing protest. Janie gave them peace on his breast, then she studied his dead face for a long time.

"Dis sittin' in de rulin' chair is been hard on Jody," she muttered out loud. She was full of pity for the first time in years. Jody had been hard on her and others, but life had mishandled him too. Poor Joe! Maybe if she had known some other way to try, she might have made his face different. But what that other way could be, she had no idea. She thought back and forth about what had happened in the making of a voice out of a man. Then thought about herself. Years ago, she had told her girl self to wait for her in the looking glass. It had been a long time since she had remembered. Perhaps she'd better look. She went over to the dresser and looked hard at her skin and features. The young girl was gone, but a handsome woman had taken her place. She tore off the kerchief from her head and let down her plentiful hair. The weight, the length, the glory was there. She took careful stock of herself, then combed her hair and tied it back up again. Then she starched and ironed her face, forming it into just what people wanted to see, and opened up the window and cried, "Come heah people! Jody is dead. Mah husband is gone from me."

9

Joe's funeral was the finest thing Orange County had ever seen with
Negro eyes. The motor hearse, the Cadillac and Buick carriages;
Dr. Henderson there in his Lincoln; the hosts from far and wide.
Then again the gold and red and purple, the gloat and glamor of
the secret orders, each with its insinuations of power and glory
undreamed of by the uninitiated. People on farm horses and
mules; babies riding astride of brothers' and sisters' backs. The
Elks band ranked at the church door and playing "Safe in the
Arms of Jesus" with such a dominant drum rhythm that it could
be stepped off smartly by the long line as it filed inside. The Lit-
tle Emperor of the cross-roads was leaving Orange County as he
had come—with the out-stretched hand of power.

Janie starched and ironed her face and came set in the funeral
behind her veil. It was like a wall of stone and steel. The funeral
was going on outside. All things concerning death and burial
were said and done. Finish. End. Nevermore. Darkness. Deep
hole. Dissolution. Eternity. Weeping and wailing outside. Inside
the expensive black folds were resurrection and life. She did not
reach outside for anything, nor did the things of death reach
inside to disturb her calm. She sent her face to Joe's funeral, and
herself went rollicking with the springtime across the world.

After a while the people finished their celebration and Janie went on home.

Before she slept that night she burnt up every one of her head rags and went about the house next morning with her hair in one thick braid swinging well below her waist. That was the only change people saw in her. She kept the store in the same way except of evenings she sat on the porch and listened and sent Hezekiah in to wait on late custom. She saw no reason to rush at changing things around. She would have the rest of her life to do as she pleased.

Most of the day she was at the store, but at night she was there in the big house and sometimes it creaked and cried all night under the weight of lonesomeness. Then she'd lie awake in bed asking lonesomeness some questions. She asked if she wanted to leave and go back where she had come from and try to find her mother. Maybe tend her grandmother's grave. Sort of look over the old stamping ground generally. Digging around inside of herself like that she found that she had no interest in that seldom-seen mother at all. She hated her grandmother and had hidden it from herself all these years under a cloak of pity. She had been getting ready for her great journey to the horizons in search of *people;* it was important to all the world that she should find them and they find her. But she had been whipped like a cur dog, and run off down a back road after *things.* It was all according to the way you see things. Some people could look at a mud-puddle and see an ocean with ships. But Nanny belonged to that other kind that loved to deal in scraps. Here Nanny had taken the biggest thing God ever made, the horizon—for no matter how far a person can go the horizon is still way beyond you—and pinched it in to such a little bit of a thing that she could tie it about her granddaughter's neck tight enough to choke her. She hated the old woman who had twisted her so in the name of love.

Most humans didn't love one another nohow, and this mislove was so strong that even common blood couldn't overcome it all the time. She had found a jewel down inside herself and she had wanted to walk where people could see her and gleam it around. But she had been set in the market-place to sell. Been set for still-bait. When God had made The Man, he made him out of stuff that sung all the time and glittered all over. Then after that some angels got jealous and chopped him into millions of pieces, but still he glittered and hummed. So they beat him down to nothing but sparks but each little spark had a shine and a song. So they covered each one over with mud. And the lonesomeness in the sparks make them hunt for one another, but the mud is deaf and dumb. Like all the other tumbling mud-balls, Janie had tried to show her shine.

Janie found out very soon that her widowhood and property was a great challenge in South Florida. Before Jody had been dead a month, she noticed how often men who had never been intimates of Joe, drove considerable distances to ask after her welfare and offer their services as advisor.

"Uh woman by herself is uh pitiful thing," she was told over and again. "Dey needs aid and assistance. God never meant 'em tuh try tuh stand by theirselves. You ain't been used tuh knockin' round and doin' fuh yo'self, Mis' Starks. You been well taken keer of, you needs uh man."

Janie laughed at all these well-wishers because she knew that they knew plenty of women alone; that she was not the first one they had ever seen. But most of the others were poor. Besides she liked being lonesome for a change. This freedom feeling was fine. These men didn't represent a thing she wanted to know about. She had already experienced them through Logan and Joe. She felt like slapping some of them for sitting around grinning at her like a pack of chessy cats, trying to make out they looked like love.

Ike Green sat on her case seriously one evening on the store porch when he was lucky enough to catch her alone.

"You wants be keerful 'bout who you marry, Mis' Starks. Dese strange men runnin' heah tryin' tuh take advantage of yo' condition."

"Marry!" Janie almost screamed. "Joe ain't had time tuh git cold yet. Ah ain't even give marryin' de first thought."

"But you will. You'se too young uh 'oman tuh stay single, and you'se too pretty for de mens tuh leave yuh alone. You'se bound tuh marry."

"Ah hope not. Ah mean, at dis present time it don't come befo' me. Joe ain't been dead two months. Ain't got settled down in his grave."

"Dat's whut you say now, but two months mo' and you'll sing another tune. Den you want tuh be keerful. Womenfolks is easy taken advantage of. You know what tuh let none uh dese stray niggers dat's settin' round heah git de inside track on yuh. They's jes lak uh pack uh hawgs, when dey see uh full trough. Whut yuh needs is uh man dat yuh done lived uhround and know all about tuh sort of manage yo' things fuh yuh and ginerally do round."

Janie jumped upon her feet. "Lawd, Ike Green, you'se uh case! Dis subjick you bringin' up ain't fit tuh be talked about at all. Lemme go inside and help Hezekiah weigh up dat barrel uh sugar dat just come in." She rushed on inside the store and whispered to Hezekiah, "Ah'm gone tuh de house. Lemme know when dat ole pee-de-bed is gone and Ah'll be right back."

Six months of wearing black passed and not one suitor had ever gained the house porch. Janie talked and laughed in the store at times, but never seemed to want to go further. She was happy except for the store. She knew by her head that she was absolute owner, but it always seemed to her that she was still clerking for

Joe and that soon he would come in and find something wrong that she had done. She almost apologized to the tenants the first time she collected the rents. Felt like a usurper. But she hid that feeling by sending Hezekiah who was the best imitation of Joe that his seventeen years could make. He had even taken to smoking, and smoking cigars, since Joe's death and tried to bite 'em tight in one side of his mouth like Joe. Every chance he got he was reared back in Joe's swivel chair trying to thrust out his lean belly into a paunch. She'd laugh quietly at his no-harm posing and pretend she didn't see it. One day as she came in the back door of the store she heard him bawling at Tripp Crawford, "Naw indeed, we can't do nothin' uh de kind! I god, you ain't paid for dem last rations you done et up. I god, you won't git no mo' outa dis store than you got money tuh pay for. I god, dis ain't Gimme, Florida, dis is Eatonville." Another time she overheard him using Joe's favorite expression for pointing out the differences between himself and the careless-living, mouthy town. "Ah'm an educated man, Ah keep mah arrangements in mah hands." She laughed outright at that. His acting didn't hurt nobody and she wouldn't know what to do without him. He sensed that and came to treat her like baby-sister, as if to say "You poor little thing, give it to big brother. He'll fix it for you." His sense of ownership made him honest too, except for an occasional jaw-breaker, or a packet of sen-sen. The sen-sen was to let on to the other boys and the pullet-size girls that he had a liquor breath to cover. This business of managing stores and women store-owners was trying on a man's nerves. He needed a drink of liquor now and then to keep up.

When Janie emerged into her mourning white, she had hosts of admirers in and out of town. Everything open and frank. Men of property too among the crowd, but nobody seemed to get any further than the store. She was always too busy to take them to the house to entertain. They were all so respectful and stiff with

her, that she might have been the Empress of Japan. They felt that it was not fitting to mention desire to the widow of Joseph Starks. You spoke of honor and respect. And all that they said and did was refracted by her inattention and shot off towards the rim-bones of nothing. She and Pheoby Watson visited back and forth and once in awhile sat around the lakes and fished. She was just basking in freedom for the most part without the need for thought. A Sanford undertaker was pressing his cause through Pheoby, and Janie was listening pleasantly but undisturbed. It might be nice to marry him, at that. No hurry. Such things take time to think about, or rather she pretended to Pheoby that that was what she was doing.

"'Tain't dat Ah worries over Joe's death, Pheoby. Ah jus' loves dis freedom."

"Sh-sh-sh! Don't let nobody hear you say dat, Janie. Folks will say you ain't sorry he's gone."

"Let 'em say whut dey wants tuh, Pheoby. To my thinkin' mourning oughtn't tuh last no longer'n grief."

10

One day Hezekiah asked off from work to go off with the ball team.
Janie told him not to hurry back. She could close up the store
herself this once. He cautioned her about the catches on the win-
dows and doors and swaggered off to Winter Park.

Business was dull all day, because numbers of people had
gone to the game. She decided to close early, because it was
hardly worth the trouble of keeping open on an afternoon like
this. She had set six o'clock as her limit.

At five-thirty a tall man came into the place. Janie was lean-
ing on the counter making aimless pencil marks on a piece of
wrapping paper. She knew she didn't know his name, but he
looked familiar.

"Good evenin', Mis' Starks," he said with a sly grin as if they
had a good joke together. She was in favor of the story that was
making him laugh before she even heard it.

"Good evenin'," she answered pleasantly. "You got all de
advantage 'cause Ah don't know yo' name."

"People wouldn't know me lak dey would *you*."

"Ah guess standin' in uh store do make uh person git tuh be
known in de vicinity. Look lak Ah seen you somewhere."

"Oh, Ah don't live no further than Orlandah. Ah'm easy

tuh see on Church Street most any day or night. You got any smokin' tobacco?"

She opened the glass case. "What kind?"

"Camels."

She handed over the cigarettes and took the money. He broke the pack and thrust one between his full, purple lips.

"You got a lil piece uh fire over dere, lady?"

They both laughed and she handed him two kitchen matches out of a box for that purpose. It was time for him to go but he didn't. He leaned on the counter with one elbow and cold-cocked her a look.

"Why ain't *you* at de ball game, too? Everybody else is dere."

"Well, Ah see somebody else besides me ain't dere. Ah just sold some cigarettes." They laughed again.

"Dat's 'cause Ah'm dumb. Ah got de thing all mixed up. Ah thought de game was gointuh be out at Hungerford. So Ah got uh ride tuh where dis road turns off from de Dixie Highway and walked over here and then Ah find out de game is in Winter Park."

That was funny to both of them too.

"So what you gointuh do now? All de cars in Eatonville is gone."

"How about playin' *you* some checkers? You looks hard tuh beat."

"Ah is, 'cause Ah can't play uh lick."

"You don't cherish de game, then?"

"Yes, Ah do, and then agin Ah don't know whether Ah do or not, 'cause nobody ain't never showed me how."

"Dis is de last day for *dat* excuse. You got uh board round heah?"

"Yes indeed. De men folks treasures de game round heah. Ah just ain't never learnt how."

He set it up and began to show her and she found herself

glowing inside. Somebody wanted her to play. Somebody thought it natural for her to play. That was even nice. She looked him over and got little thrills from every one of his good points. Those full, lazy eyes with the lashes curling sharply away like drawn scimitars. The lean, over-padded shoulders and narrow waist. Even nice!

He was jumping her king! She screamed in protest against losing the king she had had such a hard time acquiring. Before she knew it she had grabbed his hand to stop him. He struggled gallantly to free himself. That is he struggled, but not hard enough to wrench a lady's fingers.

"Ah got uh right tuh take it. You left it right in mah way."

"Yeah, but Ah wuz lookin' off when you went and stuck yo' men right up next tuh mine. No fair!"

"You ain't supposed tuh look off, Mis' Starks. It's de biggest part uh de game tuh watch out! Leave go mah hand."

"No suh! Not mah king. You kin take another one, but not dat one."

They scrambled and upset the board and laughed at that.

"Anyhow it's time for uh Coca-Cola," he said. "Ah'll come teach yuh some mo' another time."

"It's all right tuh come teach me, but don't come tuh cheat me."

"Yuh can't beat uh woman. Dey jes won't stand fuh it. But Ah'll come teach yuh agin. You gointuh be uh good player too, after while."

"You reckon so? Jody useter tell me Ah never would learn. It wuz too heavy fuh mah brains."

"Folks is playin' it wid sense and folks is playin' it without. But you got good meat on yo' head. You'll learn. Have uh cool drink on me."

"Oh all right, thank yuh. Got plenty cold ones tuhday. Nobody ain't been heah tuh buy none. All gone off tuh de game."

"You oughta be at de next game. 'Tain't no use in *you* stayin' heah if everybody else is gone. You don't buy from yo'self, do yuh?"

"You crazy thing! 'Course Ah don't. But Ah'm worried 'bout you uh little."

"How come? 'Fraid Ah ain't gointuh pay fuh dese drinks?"

"Aw naw! How you gointuh git back home?"

"Wait round heah fuh a car. If none don't come, Ah got good shoe leather. 'Tain't but seben miles no how. Ah could walk dat in no time. Easy."

"If it wuz me, Ah'd wait on uh train. Seben miles is uh kinda long walk."

"It would be for you, 'cause you ain't used to it. But Ah'm seen women walk further'n dat. You could too, if yuh had it tuh do."

"Maybe so, but Ah'll ride de train long as Ah got railroad fare."

"Ah don't need no pocket-full uh money to ride de train lak uh woman. When Ah takes uh notion Ah rides anyhow—money or no money."

"Now ain't you somethin'! Mr. er—er—You never did tell me whut yo' name wuz."

"Ah sho didn't. Wuzn't expectin' fuh it to be needed. De name mah mama gimme is Vergible Woods. Dey calls me Tea Cake for short."

"Tea Cake! So you sweet as all dat?" She laughed and he gave her a little cut-eye look to get her meaning.

"Ah may be guilty. You better try me and see."

She did something halfway between a laugh and a frown and he set his hat on straight.

"B'lieve Ah done cut uh hawg, so Ah guess Ah better ketch air." He made an elaborate act of tipping to the door stealthily. Then looked back at her with an irresistible grin on his face. Janie burst out laughing in spite of herself. "You crazy thing!"

He turned and threw his hat at her feet. "If she don't throw it at me, Ah'll take a chance on comin' back," he announced, making gestures to indicate he was hidden behind a post. She picked up the hat and threw it after him with a laugh. "Even if she had uh brick she couldn't hurt yuh wid it," he said to an invisible companion. "De lady can't throw." He gestured to his companion, stepped out from behind the imaginary lamp post, set his coat and hat and strolled back to where Janie was as if he had just come in the store.

"Evenin', Mis' Starks. Could yuh lemme have uh pound uh knuckle puddin'* till Saturday? Ah'm sho tuh pay yuh then."

"You needs ten pounds, Mr. Tea Cake. Ah'll let yuh have all Ah got and you needn't bother 'bout payin' it back."

They joked and went on till the people began to come in. Then he took a seat and made talk and laughter with the rest until closing time. When everyone else had left he said, "Ah reckon Ah done over-layed mah leavin' time, but Ah figgured you needed somebody tuh help yuh shut up de place. Since nobody else ain't round heah, maybe Ah kin git de job."

"Thankyuh, Mr. Tea Cake. It is kinda strainin' fuh me."

"Who ever heard of uh teacake bein' called Mister! If you wanta be real hightoned and call me Mr. Woods, dat's de way you feel about it. If yuh wants tuh be uh lil friendly and call me Tea Cake, dat would be real nice." He was closing and bolting windows all the time he talked.

"All right, then. Thank yuh, Tea Cake. How's dat?"

"Jes lak uh lil girl wid her Easter dress on. Even nice!" He locked the door and shook it to be sure and handed her the key. "Come on now, Ah'll see yuh inside yo' door and git on down de Dixie."

*A beating with the fist.

Janie was halfway down the palm-lined walk before she had a thought for her safety. Maybe this strange man was up to something! But it was no place to show her fear there in the darkness between the house and the store. He had hold of her arm too. Then in a moment it was gone. Tea Cake wasn't strange. Seemed as if she had known him all her life. Look how she had been able to talk with him right off! He tipped his hat at the door and was off with the briefest good night.

So she sat on the porch and watched the moon rise. Soon its amber fluid was drenching the earth, and quenching the thirst of the day.

11

Janie wanted to ask Hezekiah about Tea Cake, but she was afraid he might misunderstand her and think she was interested. In the first place he looked too young for her. Must be around twenty-five and here *she* was around forty. Then again he didn't look like he had too much. Maybe he was hanging around to get in with her and strip her of all that she had. Just as well if she never saw him again. He was probably the kind of man who lived with various women but never married. Fact is, she decided to treat him so cold if he ever did foot the place that he'd be sure not to come hanging around there again.

He waited a week exactly to come back for Janie's snub. It was early in the afternoon and she and Hezekiah were alone. She heard somebody humming like they were feeling for pitch and looked towards the door. Tea Cake stood there mimicking the tuning of a guitar. He frowned and struggled with the pegs of his imaginary instrument watching her out of the corner of his eye with that secret joke playing over his face. Finally she smiled and he sung middle C, put his guitar under his arm and walked on back to where she was.

"Evenin', folks. Thought y'all might lak uh lil music this evenin' so Ah brought long mah box."

"Crazy thing!" Janie commented, beaming out with light.

He acknowledged the compliment with a smile and sat down on a box. "Anybody have uh Coca-Cola wid me?"

"Ah just had one," Janie temporized with her conscience.

"It'll hafter be done all over agin, Mis' Starks."

"How come?"

"'Cause it wasn't done right dat time. 'Kiah bring us two bottles from de bottom uh de box."

"How you been makin' out since Ah seen yuh last, Tea Cake?"

"Can't kick. Could be worse. Made four days dis week and got de pay in mah pocket."

"We got a rich man round here, then. Buyin' passenger trains uh battleships this week?"

"Which one do *you* want? It all depends on you."

"Oh, if you'se treatin' me tuh it, Ah b'lieve Ah'll take de passenger train. If it blow up Ah'll still be on land."

"Choose de battleship if dat's whut you really want. Ah know where one is right now. Seen one round Key West de other day."

"How you gointuh git it?"

"Ah shucks, dem Admirals is always ole folks. Can't no ole man stop me from gittin' no ship for yuh if dat's whut you want. Ah'd git dat ship out from under him so slick till he'd be walkin' de water lak ole Peter befo' he knowed it."

They played away the evening again. Everybody was surprised at Janie playing checkers but they liked it. Three or four stood behind her and coached her moves and generally made merry with her in a restrained way. Finally everybody went home but Tea Cake.

"You kin close up, 'Kiah," Janie said. "Think Ah'll g'wan home."

Tea Cake fell in beside her and mounted the porch this time. So she offered him a seat and they made a lot of laughter out of

nothing. Near eleven o'clock she remembered a piece of pound cake she had put away. Tea Cake went out to the lemon tree at the corner of the kitchen and picked some lemons and squeezed them for her. So they had lemonade too.

"Moon's too pretty fuh anybody tuh be sleepin' it away," Tea Cake said after they had washed up the plates and glasses. "Less us go fishin'."

"Fishin'? Dis time uh night?"

"Unhhunh, fishin'. Ah know where de bream is beddin'. Seen 'em when Ah come round de lake dis evenin'. Where's yo' fishin' poles? Less go set on de lake."

It was so crazy digging worms by lamp light and setting out for Lake Sabelia after midnight that she felt like a child breaking rules. That's what made Janie like it. They caught two or three and got home just before day. Then she had to smuggle Tea Cake out by the back gate and that made it seem like some great secret she was keeping from the town.

"Mis' Janie," Hezekiah began sullenly next day, "you oughtn't 'low dat Tea Cake tuh be walkin' tuh de house wid yuh. Ah'll go wid yuh mahself after dis, if you'se skeered."

"What's de matter wid Tea Cake, 'Kiah? Is he uh thief uh somethin'?"

"Ah ain't never heard nobody say he stole nothin'."

"Is he bad 'bout totin' pistols and knives tuh hurt people wid?"

"Dey don't say he ever cut nobody or shot nobody neither."

"Well, is he—he—is he got uh wife or something lak dat? Not dat it's any uh mah business." She held her breath for the answer.

"No'm. And nobody wouldn't marry Tea Cake tuh starve tuh death lessen it's somebody jes lak him—ain't used to nothin'. 'Course he always keep hisself in changin' clothes. Dat long-

legged Tea Cake ain't got doodly squat. He ain't got no business makin' hissef familiar wid nobody lak you. Ah said Ah wuz goin' to tell yuh so yuh could know."

"Oh dat's all right, Hezekiah. Thank yuh mighty much."

The next night when she mounted her steps Tea Cake was there before her, sitting on the porch in the dark. He had a string of fresh-caught trout for a present.

"Ah'll clean 'em, you fry 'em and let's eat," he said with the assurance of not being refused. They went out into the kitchen and fixed up the hot fish and corn muffins and ate. Then Tea Cake went to the piano without so much as asking and began playing blues and singing, and throwing grins over his shoulder. The sounds lulled Janie to soft slumber and she woke up with Tea Cake combing her hair and scratching the dandruff from her scalp. It made her more comfortable and drowsy.

"Tea Cake, where you git uh comb from tuh be combin' mah hair wid?"

"Ah brought it wid me. Come prepared tuh lay mah hands on it tuhnight."

"Why, Tea Cake? Whut good do combin' mah hair do *you*? It's *mah* comfortable, not yourn."

"It's mine too. Ah ain't been sleepin' so good for more'n uh week cause Ah been wishin' so bad tuh git mah hands in yo' hair. It's so pretty. It feels jus' lak underneath uh dove's wing next to mah face."

"Umph! You'se mighty easy satisfied. Ah been had dis same hair next tuh mah face ever since Ah cried de fust time, and 'tain't never gimme me no thrill."

"Ah tell you lak you told me—you'se mighty hard tuh satisfy. Ah betcha dem lips don't satisfy yuh neither."

"Dat's right, Tea Cake. They's dere and Ah make use of 'em whenever it's necessary, but nothin' special tuh me."

"Umph! umph! umph! Ah betcha you don't never go tuh de lookin' glass and enjoy yo' eyes yo'self. You lets other folks git all de enjoyment out of 'em 'thout takin' in any of it yo'self."

"Naw, Ah never gazes at 'em in de lookin' glass. If anybody else gits any pleasure out of 'em Ah ain't been told about it."

"See dat? You'se got de world in uh jug and make out you don't know it. But Ah'm glad tuh be de one tuh tell yuh."

"Ah guess you done told plenty women all about it."

"Ah'm de Apostle Paul tuh de Gentiles. Ah tells 'em and then agin Ah shows 'em."

"Ah thought so." She yawned and made to get up from the sofa. "You done got me so sleepy wid yo' head-scratchin' Ah kin hardly make it tuh de bed." She stood up at once, collecting her hair. He sat still.

"Naw, you ain't sleepy, Mis' Janie. You jus' want me tuh go. You figger Ah'm uh rounder and uh pimp and you done wasted too much time talkin' wid me."

"Why, Tea Cake! Whut ever put dat notion in yo' head?"

"De way you looked at me when Ah said whut Ah did. Yo' face skeered me so bad till mah whiskers drawed up."

"Ah ain't got no business bein' mad at nothin' you do and say. You got it all wrong. Ah ain't mad atall."

"Ah know it and dat's what puts de shamery on me. You'se jus' disgusted wid me. Yo' face jus' left here and went off somewhere else. Naw, you ain't mad wid me. Ah be glad if you was, 'cause then Ah might do somethin' tuh please yuh. But lak it is—"

"Mah likes and dislikes ought not tuh make no difference wid you, Tea Cake. Dat's fuh yo' lady friend. Ah'm jus' uh some-time friend uh yourn."

Janie walked towards the stairway slowly, and Tea Cake sat where he was, as if he had frozen to his seat, in fear that once he

got up, he'd never get back in it again. He swallowed hard and looked at her walk away.

"Ah didn't aim tuh let on tuh yuh 'bout it, leastways not right away, but Ah ruther be shot wid tacks than fuh you tuh act wid me lak you is right now. You got me in de go-long."

At the newel post Janie whirled around and for the space of a thought she was lit up like a transfiguration. Her next thought brought her crashing down. He's just saying anything for the time being, feeling he's got me so I'll b'lieve him. The next thought buried her under tons of cold futility. He's trading on being younger than me. Getting ready to laugh at me for an old fool. But oh, what wouldn't I give to be twelve years younger so I could b'lieve him!

"Aw, Tea Cake, you just say dat tuhnight because de fish and corn bread tasted sort of good. Tomorrow yo' mind would change."

"Naw, it wouldn't neither. Ah know better."

"Anyhow from what you told me when we wuz back dere in de kitchen Ah'm nearly twelve years older than you."

"Ah done thought all about dat and tried tuh struggle aginst it, but it don't do me no good. De thought uh mah youngness don't satisfy me lak yo' presence do."

"It makes uh whole heap uh difference wid most folks, Tea Cake."

"Things lak dat got uh whole lot tuh do wid convenience, but it ain't got nothin' tuh do wid love."

"Well, Ah love tuh find out whut you think after sun-up tomorrow. Dis is jus' yo' night thought."

"You got yo' ideas and Ah got mine. Ah got uh dollar dat says you'se wrong. But Ah reckon you don't bet money, neither."

"Ah never have done it so fur. But as de old folks always say,

Ah'm born but Ah ain't dead. No tellin' whut Ah'm liable tuh do yet."

He got up suddenly and took his hat. "Good night, Mis' Janie. Look lak we done run our conversation from grass roots tuh pine trees. G'bye." He almost ran out of the door.

Janie hung over the newel post thinking so long that she all but went to sleep there. However, before she went to bed she took a good look at her mouth, eyes and hair.

All next day in the house and store she thought resisting thoughts about Tea Cake. She even ridiculed him in her mind and was a little ashamed of the association. But every hour or two the battle had to be fought all over again. She couldn't make him look just like any other man to her. He looked like the love thoughts of women. He could be a bee to a blossom—a pear tree blossom in the spring. He seemed to be crushing scent out of the world with his footsteps. Crushing aromatic herbs with every step he took. Spices hung about him. He was a glance from God.

So he didn't come that night and she laid in bed and pretended to think scornfully of him. "Bet he's hangin' round some jook or 'nother. Glad Ah treated him cold. Whut do Ah want wid some trashy nigger out de streets? Bet he's livin' wid some woman or 'nother and takin' me for uh fool. Glad Ah caught mahself in time." She tried to console herself that way.

The next morning she awoke hearing a knocking on the front door and found Tea Cake there.

"Hello, Mis' Janie, Ah hope Ah woke you up."

"You sho did, Tea Cake. Come in and rest yo' hat. Whut you doin' out so soon dis mornin'?"

"Thought Ah'd try tuh git heah soon enough tuh tell yuh mah daytime thoughts. Ah see yuh needs tuh know mah daytime feelings. Ah can't sense yuh intuh it at night."

"You crazy thing! Is dat whut you come here for at day-break?"

"Sho is. You needs tellin' and showin', and dat's whut Ah'm doin'. Ah picked some strawberries too, Ah figgered you might like."

"Tea Cake, Ah 'clare Ah don't know whut tuh make outa you. You'se so crazy. You better lemme fix you some breakfast."

"Ain't got time. Ah got uh job uh work. Gottuh be back in Orlandah at eight o'clock. See yuh later, tell you straighter."

He bolted down the walk and was gone. But that night when she left the store, he was stretched out in the hammock on the porch with his hat over his face pretending to sleep. She called him. He pretended not to hear. He snored louder. She went to the hammock to shake him and he seized and pulled her in with him. After a little, she let him adjust her in his arms and laid there for a while.

"Tea Cake, Ah don't know 'bout you, but Ah'm hongry, come on let's eat some supper."

They went inside and their laughter rang out first from the kitchen and all over the house.

Janie awoke next morning by feeling Tea Cake almost kissing her breath away. Holding her and caressing her as if he feared she might escape his grasp and fly away. Then he must dress hurriedly and get to his job on time. He wouldn't let her get him any breakfast at all. He wanted her to get her rest. He made her stay where she was. In her heart she wanted to get his breakfast for him. But she stayed in bed long after he was gone.

So much had been breathed out by the pores that Tea Cake still was there. She could feel him and almost see him bucking around the room in the upper air. After a long time of passive happiness, she got up and opened the window and let Tea Cake leap forth and mount to the sky on a wind. That was the beginning of things.

In the cool of the afternoon the fiend from hell specially sent
to lovers arrived at Janie's ear. Doubt. All the fears that circum-
stance could provide and the heart feel, attacked her on every
side. This was a new sensation for her, but no less excruciating. If
only Tea Cake would make her certain! He did not return that
night nor the next and so she plunged into the abyss and
descended to the ninth darkness where light has never been.

But the fourth day after he came in the afternoon driving a
battered car. Jumped out like a deer and made the gesture of
tying it to a post on the store porch. Ready with his grin! She
adored him and hated him at the same time. How could he make
her suffer so and then come grinning like that with that darling
way he had? He pinched her arm as he walked inside the door.

"Brought me somethin' tuh haul you off in," he told her
with that secret chuckle. "Git yo' hat if you gointuh wear one.
We got tuh go buy groceries."

"Ah sells groceries right here in dis store, Tea Cake, if you
don't happen tuh know." She tried to look cold but she was smil-
ing in spite of herself.

"Not de kind we want fuh de occasion. You sells groceries for
ordinary people. We'se gointuh buy for *you*. De big Sunday
School picnic is tomorrow—bet you done forget it—and we got
tuh be dere wid uh swell basket and ourselves."

"Ah don't know 'bout dat, Tea Cake. Tell yuh whut you do.
G'wan down tuh de house and wait for me. Be dere in uh
minute."

As soon as she thought it looked right she slipped out of the
back and joined Tea Cake. No need of fooling herself. Maybe he
was just being polite.

"Tea Cake, you sure you want me tuh go tuh dis picnic wid
yuh?"

"Me scramble 'round tuh git de money tuh take yuh—been

workin' lak uh dawg for two whole weeks—and she come astin' me if Ah want her tuh go! Puttin' mahself tuh uh whole heap uh trouble tuh git dis car so you kin go over tuh Winter Park or Orlandah tuh buy de things you might need and dis woman set dere and ast me if Ah want her tuh go!"

"Don't git mad, Tea Cake, Ah just didn't want you doin' nothin' outa politeness. If dere's somebody else you'd ruther take, it's all right wid me."

"Naw, it ain't all right wid you. If it was you wouldn't be sayin' dat. Have de nerve tuh say whut you mean."

"Well, all right, Tea Cake, Ah wants tuh go wid you real bad, but,—oh, Tea Cake, don't make no false pretense wid me!"

"Janie, Ah hope God may kill me, if Ah'm lyin'. Nobody else on earth kin hold uh candle tuh you, baby. You got de keys to de kingdom."

12

It was after the picnic that the town began to notice things and got mad. Tea Cake and Mrs. Mayor Starks! All the men that she could get, and fooling with somebody like Tea Cake! Another thing, Joe Starks hadn't been dead but nine months and here she goes sashaying off to a picnic in pink linen. Done quit attending church, like she used to. Gone off to Sanford in a car with Tea Cake and her all dressed in blue! It was a shame. Done took to high heel slippers and a ten dollar hat! Looking like some young girl, always in blue because Tea Cake told her to wear it. Poor Joe Starks. Bet he turns over in his grave every day. Tea Cake and Janie gone hunting. Tea Cake and Janie gone fishing. Tea Cake and Janie gone to Orlando to the movies. Tea Cake and Janie gone to a dance. Tea Cake making flower beds in Janie's yard and seeding the garden for her. Chopping down that tree she never did like by the dining room window. All those signs of possession. Tea Cake in a borrowed car teaching Janie to drive. Tea Cake and Janie playing checkers; playing coon-can; playing Florida flip on the store porch all afternoon as if nobody else was there. Day after day and week after week.

"Pheoby," Sam Watson said one night as he got in the bed, "Ah b'lieve yo' buddy is all tied up with dat Tea Cake shonough. Didn't b'lieve it at first."

"Aw she don't mean nothin' by it. Ah think she's sort of stuck on dat undertaker up at Sanford."

"It's somebody 'cause she looks might good dese days. New dresses and her hair combed a different way nearly every day. You got to have something to comb hair over. When you see uh woman doin' so much rakin' in her head, she's combin' at some man or 'nother."

"'Course she kin do as she please, but dat's uh good chance she got up at Sanford. De man's wife died and he got uh lovely place tuh take her to—already furnished. Better'n her house Joe left her."

"You better sense her intuh things then 'cause Tea Cake can't do nothin' but help her spend whut she got. Ah reckon dat's whut he's after. Throwin' away whut Joe Starks worked hard tuh git tuhgether."

"Dat's de way it looks. Still and all, she's her own woman. She oughta know by now whut she wants tuh do."

"De men wuz talkin' 'bout it in de grove tuhday and givin' her and Tea Cake both de devil. Dey figger he's spendin' on her now in order tuh make her spend on him later."

"Umph! Umph! Umph!"

"Oh dey got it all figgered out. Maybe it ain't as bad as they say, but they talk it and make it sound real bad on her part."

"Dat's jealousy and malice. Some uh dem very mens wants tuh do whut dey claim deys skeered Tea Cake is doin'."

"De Pastor claim Tea Cake don't 'low her tuh come tuh church only once in awhile 'cause he want dat change tuh buy gas wid. Just draggin' de woman away from church. But anyhow, she's yo' bosom friend, so you better go see 'bout her. Drop uh lil hint here and dere and if Tea Cake is tryin' tuh rob her she kin see and know. Ah laks de woman and Ah sho would hate tuh see her come up lak Mis' Tyler."

"Aw mah God, naw! Reckon Ah better step over dere tomorrow and have some chat wid Janie. She jus' ain't thinkin' whut she doin', dat's all."

The next morning Pheoby picked her way over to Janie's house like a hen to a neighbor's garden. Stopped and talked a little with everyone she met, turned aside momentarily to pause at a porch or two—going straight by walking crooked. So her firm intention looked like an accident and she didn't have to give her opinion to folks along the way.

Janie acted glad to see her and after a while Pheoby broached her with, "Janie, everybody's talkin' 'bout how dat Tea Cake is draggin' you round tuh places you ain't used tuh. Baseball games and huntin' and fishin'. He don't know you'se useter uh more high time crowd than dat. You always did class off."

"Jody classed me off. Ah didn't. Naw, Pheoby, Tea Cake ain't draggin' me off nowhere Ah don't want tuh go. Ah always did want tuh git round uh whole heap, but Jody wouldn't 'low me tuh. When Ah wasn't in de store he wanted me tuh jes sit wid folded hands and sit dere. And Ah'd sit dere wid de walls creepin' up on me and squeezin' all de life outa me. Pheoby, dese educated women got uh heap of things to sit down and consider. Somebody done tole 'em what to set down for. Nobody ain't told poor me, so sittin' still worries me. Ah wants tuh utilize mahself all over."

"But, Janie, Tea Cake, whilst he ain't no jail-bird, he ain't got uh dime tuh cry. Ain't you skeered he's jes after yo' money—him bein' younger than you?"

"He ain't never ast de first penny from me yet, and if he love property he ain't no different from all de rest of us. All dese ole men dat's settin' round me is after de same thing. They's three mo' widder women in town, how come dey don't break dey neck after dem? 'Cause dey ain't got nothin', dat's why."

"Folks seen you out in colors and dey thinks you ain't payin' de right amount uh respect tuh yo' dead husband."

"Ah ain't grievin' so why do Ah hafta mourn? Tea Cake love me in blue, so Ah wears it. Jody ain't never in his life picked out no color for me. De world picked out black and white for mournin', Joe didn't. So Ah wasn't wearin' it for him. Ah was wearin' it for de rest of y'all."

"But anyhow, watch yo'self, Janie, and don't be took advantage of. You know how dese young men is wid older women. Most of de time dey's after whut dey kin git, then dey's gone lak uh turkey through de corn."

"Tea Cake don't talk dat way. He's aimin' tuh make hisself permanent wid me. We done made up our mind tuh marry."

"Janie, you'se yo' own woman, and Ah hope you know whut you doin'. Ah sho hope you ain't lak uh possum—de older you gits, de less sense yuh got. Ah'd feel uh whole heap better 'bout yuh if you wuz marryin' dat man up dere in Sanford. He got somethin' tuh put long side uh whut you got and dat make it more better. He's endurable."

"Still and all Ah'd ruther be wid Tea Cake."

"Well, if yo' mind is already made up, 'tain't nothin' nobody kin do. But you'se takin' uh awful chance."

"No mo' than Ah took befo' and no mo' than anybody else takes when dey gits married. It always changes folks, and sometimes it brings out dirt and meanness dat even de person didn't know they had in 'em theyselves. You know dat. Maybe Tea Cake might turn out lak dat. Maybe not. Anyhow Ah'm ready and willin' tuh try 'im."

"Well, when you aim tuh step off?"

"Dat we don't know. De store is got tuh be sold and then we'se goin' off somewhere tuh git married."

"How come you sellin' out de store?"

"'Cause Tea Cake ain't no Jody Starks, and if he tried tuh be, it would be uh complete flommuck. But de minute Ah marries 'im everybody is gointuh be makin' comparisons. So us is goin' off somewhere and start all over in Tea Cake's way. Dis ain't no business proposition, and no race after property and titles. Dis is uh love game. Ah done lived Grandma's way, now Ah means tuh live mine."

"What you mean by dat, Janie?"

"She was borned in slavery time when folks, dat is black folks, didn't sit down anytime dey felt lak it. So sittin' on porches lak de white madam looked lak uh mighty fine thing tuh her. Dat's whut she wanted for me—don't keer whut it cost. Git up on uh high chair and sit dere. She didn't have time tuh think whut tuh do after you got up on de stool uh do nothin'. De object wuz tuh git dere. So Ah got up on de high stool lak she told me, but Pheoby, Ah done nearly languished tuh death up dere. Ah felt like de world wuz cryin' extry and Ah ain't read de common news yet."

"Maybe so, Janie. Still and all Ah'd love tuh experience it for just one year. It look lak heben tuh me from where Ah'm at."

"Ah reckon so."

"But anyhow, Janie, you be keerful 'bout dis sellin' out and goin' off wid strange men. Look whut happened tuh Annie Tyler. Took whut little she had and went off tuh Tampa wid dat boy dey call Who Flung. It's somethin' tuh think about."

"It sho is. Still Ah ain't Mis' Tyler and Tea Cake ain't no Who Flung, and he ain't no stranger tuh me. We'se just as good as married already. But Ah ain't puttin' it in de street. Ah'm tellin' *you*."

"Ah jus lak uh chicken. Chicken drink water, but he don't pee-pee."

"Oh, Ah know you don't talk. We ain't shame faced. We jus' ain't ready tuh make no big kerflommuck as yet."

"You doin' right not tuh talk it, but Janie, you'se takin' uh mighty big chance."

"'Tain't so big uh chance as it seem lak, Pheoby. Ah'm older than Tea Cake, yes. But he done showed me where it's de thought dat makes de difference in ages. If people thinks de same they can make it all right. So in the beginnin' new thoughts had tuh be thought and new words said. After Ah got used tuh dat, we gits 'long jus' fine. He done taught me de maiden language all over. Wait till you see de new blue satin Tea Cake done picked out for me tuh stand up wid him in. High heel slippers, necklace, earrings, *everything* he wants tuh see me in. Some of dese mornin's and it won't be long, you gointuh wake up callin' me and Ah'll be gone."

13

Jacksonville. Tea Cake's letter had said Jacksonville. He had worked in the railroad shops up there before and his old boss had promised him a job come next pay day. No need for Janie to wait any longer. Wear the new blue dress because he meant to marry her right from the train. Hurry up and come because he was about to turn into pure sugar thinking about her. Come on, baby, papa Tea Cake never could be mad with you!

Janie's train left too early in the day for the town to witness much, but the few who saw her leave bore plenty witness. They had to give it to her, she sho looked good, but she had no business to do it. It was hard to love a woman that always made you feel so wishful.

The train beat on itself and danced on the shiny steel rails mile after mile. Every now and then the engineer would play on his whistle for the people in the towns he passed by. And the train shuffled on to Jacksonville, and to a whole lot of things she wanted to see and to know.

And there was Tea Cake in the big old station in a new blue suit and straw hat, hauling her off to a preacher's house first thing. Then right on to the room he had been sleeping in for two weeks all by himself waiting for her to come. And such another

hugging and kissing and carrying on you never saw. It made her so glad she was scared of herself. They stayed at home and rested that night, but the next night they went to a show and after that they rode around on the trolley cars and sort of looked things over for themselves. Tea Cake was spending and doing out of his own pocket, so Janie never told him about the two hundred dollars she had pinned inside her shirt next to her skin. Pheoby had insisted that she bring it along and keep it secret just to be on the safe side. She had ten dollars over her fare in her pocket book. Let Tea Cake think that was all she had. Things might not turn out like she thought. Every minute since she had stepped off the train she had been laughing at Pheoby's advice. She meant to tell Tea Cake the joke some time when she was sure she wouldn't hurt his feelings. So it came around that she had been married a week and sent Pheoby a card with a picture on it.

That morning Tea Cake got up earlier than Janie did. She felt sleepy and told him to go get some fish to fry for breakfast. By the time he had gone and come back she would have finished her nap out. He told her he would and she turned over and went back to sleep. She woke up and Tea Cake still wasn't there and the clock said it was getting late, so she got up and washed her face and hands. Perhaps he was down in the kitchen fixing around to let her sleep. Janie went down and the landlady made her drink some coffee with her because she said her husband was dead and it was bad to be having your morning coffee by yourself.

"Yo' husband gone tuh work dis mornin', Mis' Woods? Ah seen him go out uh good while uh go. Me and you kin be comp'ny for one 'nother, can't us?"

"Oh yes, indeed, Mis' Samuels. You puts me in de mind uh mah friend back in Eatonville. Yeah, you'se nice and friendly jus' lak her."

Therefore Janie drank her coffee and sankled on back to her

room without asking her landlady anything. Tea Cake must be hunting all over the city for that fish. She kept that thought in front of her in order not to think too much. When she heard the twelve o'clock whistle she decided to get up and dress. That was when she found out her two hundred dollars was gone. There was the little cloth purse with the safety pin on the chair beneath her clothes and the money just wasn't nowhere in the room. She knew from the beginning that the money wasn't any place she knew of if it wasn't in that little pocket book pinned to her pink silk vest. But the exercise of searching the room kept her busy and that was good for her to keep moving, even though she wasn't doing anything but turning around in her tracks.

But, don't care how firm your determination is, you can't keep turning round in one place like a horse grinding sugar cane. So Janie took to sitting over the room. Sit and look. The room inside looked like the mouth of an alligator—gaped wide open to swallow something down. Outside the window Jacksonville looked like it needed a fence around it to keep it from running out on ether's bosom. It was too big to be warm, let alone to need somebody like her. All day and night she worried time like a bone.

Way late in the morning the thought of Annie Tyler and Who Flung came to pay her a visit. Annie Tyler who at fifty-two had been left a widow with a good home and insurance money.

Mrs. Tyler with her dyed hair, newly straightened and her uncomfortable new false teeth, her leathery skin, blotchy with powder and her giggle. Her love affairs, affairs with boys in their late teens or early twenties for all of whom she spent her money on suits of clothes, shoes, watches and things like that and how they all left her as soon as their wants were satisfied. Then when her ready cash was gone, had come Who Flung to denounce his predecessor as a scoundrel and took up around the house himself. It was he who persuaded her to sell her house and come to

Tampa with him. The town had seen her limp off. The under-sized high-heel slippers were punishing her tired feet that looked like bunions all over. Her body squeezed and crowded into a tight corset that shoved her middle up under her chin. But she had gone off laughing and sure. As sure as Janie had been.

Then two weeks later the porter and conductor of the north bound local had helped her off the train at Maitland. Hair all gray and black and bluish and reddish in streaks. All the capers that cheap dye could cut was showing in her hair. Those slippers bent and griped just like her work-worn feet. The corset gone and the shaking old woman hanging all over herself. Everything that you could see was hanging. Her chin hung from her ears and rippled down her neck like drapes. Her hanging bosom and stomach and buttocks and legs that draped down over her ankles. She groaned but never giggled.

She was broken and her pride was gone, so she told those who asked what had happened. Who Flung had taken her to a shabby room in a shabby house in a shabby street and promised to marry her next day. They stayed in the room two whole days then she woke up to find Who Flung and her money gone. She got up to stir around and see if she could find him, and found herself too worn out to do much. All she found out was that she was too old a vessel for new wine. The next day hunger had driven her out to shift. She had stood on the streets and smiled and smiled, and then smiled and begged and then just begged. After a week of world-bruising a young man from home had come along and seen her. She couldn't tell him how it was. She just told him she got off the train and somebody had stolen her purse. Naturally, he had believed her and taken her home with him to give her time to rest up a day or two, then he had bought her a ticket for home.

They put her to bed and sent for her married daughter from

up around Ocala to come see about her. The daughter came as soon as she could and took Annie Tyler away to die in peace. She had waited all her life for something, and it had killed her when it found her.

The thing made itself into pictures and hung around Janie's bedside all night long. Anyhow, she wasn't going back to Eatonville to be laughed at and pitied. She had ten dollars in her pocket and twelve hundred in the bank. But oh God, don't let Tea Cake be off somewhere hurt and Ah not know nothing about it. And God, please suh, don't let him love nobody else but me. Maybe Ah'm is uh fool, Lawd, lak dey say, but Lawd, Ah been so lonesome, and Ah been waitin', Jesus. Ah done waited uh long time.

Janie dozed off to sleep but she woke up in time to see the sun sending up spies ahead of him to mark out the road through the dark. He peeped up over the door sill of the world and made a little foolishness with red. But pretty soon, he laid all that aside and went about his business dressed all in white. But it was always going to be dark to Janie if Tea Cake didn't soon come back. She got out of the bed but a chair couldn't hold her. She dwindled down on the floor with her head in a rocking chair.

After a while there was somebody playing a guitar outside her door. Played right smart while. It sounded lovely too. But it was sad to hear it feeling blue like Janie was. Then whoever it was started to singing "Ring de bells of mercy. Call de sinner man home." Her heart all but smothered her.

"Tea Cake, is dat you?"

"You know so well it's me, Janie. How come you don't open de door?"

But he never waited. He walked on in with a guitar and a grin. Guitar hanging round his neck with a red silk cord and a grin hanging from his ears.

"Don't need tuh ast me where Ah been all dis time, 'cause it's mah all day job tuh tell yuh."

"Tea Cake, Ah—"

"Good Lawd, Janie, whut you doin' settin' on de floor?"

He took her head in his hands and eased himself into the chair. She still didn't say anything. He sat stroking her head and looking down into her face.

"Ah see whut it is. You doubted me 'bout de money. Thought Ah had done took it and gone. Ah don't blame yuh but it wasn't lak you think. De girl baby ain't born and her mama is dead, dat can git me tuh spend our money on her. Ah told yo' before dat you got de keys tuh de kingdom. You can depend on dat."

"Still and all you went off and left me all day and all night."

"'Twasn't 'cause Ah wanted tuh stay off lak dat, and it sho Lawd, wuzn't no woman. If you didn't have de power tuh hold me and hold me tight, Ah wouldn't be callin' yuh Mis' Woods. Ah met plenty women before Ah knowed you tuh talk tuh. You'se de onliest woman in de world Ah ever even mentioned gittin' married tuh. You bein' older don't make no difference. Don't never consider dat no mo'. If Ah ever gits tuh messin' round another woman it won't be on account of her age. It'll be because she got me in de same way you got me—so Ah can't help mahself."

He sat down on the floor beside her and kissed and playfully turned up the corner of her mouth until she smiled.

"Looka here, folks," he announced to an imaginary audience, "Sister Woods is 'bout tuh quit her husband!"

Janie laughed at that and let herself lean on him. Then she announced to the same audience, "Mis' Woods got herself uh new lil boy rooster, but he been off somewhere and won't tell her."

"First thing, though, us got tuh eat together, Janie. Then we can talk."

"One thing, Ah won't send you out after no fish."

He pinched her in the side and ignored what she said.

"'Tain't no need of neither one of us workin' dis mornin'. Call Mis' Samuels and let her fix whatever you want."

"Tea Cake, if you don't hurry up and tell me, Ah'll take and beat yo' head flat as uh dime."

Tea Cake stuck out till he had some breakfast, then he talked and acted out the story.

He spied the money while he was tying his tie. He took it up and looked at it out of curiosity and put it in his pocket to count it while he was out to find some fish to fry. When he found out how much it was, he was excited and felt like letting folks know who he was. Before he found the fish market he met a fellow he used to work with at the round house. One word brought on another one and pretty soon he made up his mind to spend some of it. He never had had his hand on so much money before in his life, so he made up his mind to see how it felt to be a millionaire. They went on out to Callahan round the railroad shops and he decided to give a big chicken and macaroni supper that night, free to all.

He bought up the stuff and they found somebody to pick the guitar so they could all dance some. So they sent the message all around for people to come. And come they did. A big table loaded down with fried chicken and biscuits and a wash-tub full of macaroni with plenty cheese in it. When the fellow began to pick the box the people begin to come from east, west, north and Australia. And he stood in the door and paid all the ugly women two dollars *not* to come in. One big meriny colored woman was so ugly till it was worth five dollars for her not to come in, so he gave it to her.

They had a big time till one man come in who thought he was bad. He tried to pull and haul over all the chickens and pick

out the livers and gizzards to eat. Nobody else couldn't pacify him so they called Tea Cake to come see if he could stop him. So Tea Cake walked up and asked him, "Say, whut's de matter wid you, nohow?"

"Ah don't want nobody handin' me nothin'. Specially don't issue me out no rations. Ah always chooses mah rations." He kept right on plowing through the pile uh chicken. So Tea Cake got mad.

"You got mo' nerve than uh brass monkey. Tell me, what post office did *you* ever pee in? Ah craves tuh know."

"Whut you mean by dat now?" the fellow asked.

"Ah means dis—it takes jus' as much nerve tuh cut caper lak dat in uh United States Government Post Office as it do tuh comes pullin' and haulin' over any chicken Ah pay for. Hit de ground. Damned if Ah ain't gointuh try you dis night."

So they all went outside to see if Tea Cake could handle the boogerboo. Tea Cake knocked out two of his teeth, so that man went on off from there. Then two men tried to pick a fight with one another, so Tea Cake said they had to kiss and make up. They didn't want to do it. They'd rather go to jail, but everybody else liked the idea, so they made 'em do it. Afterwards, both of them spit and gagged and wiped their mouths with the back of their hands. One went outside and chewed a little grass like a sick dog, he said to keep it from killing him.

Then everybody began to holler at the music because the man couldn't play but three pieces. So Tea Cake took the guitar and played himself. He was glad of the chance because he hadn't had his hand on a box since he put his in the pawn shop to get some money to hire a car for Janie soon after he met her. He missed his music. So that put him in the notion he ought to have one. He bought the guitar on the spot and paid fifteen dollars cash. It was really worth sixty-five any day.

Just before day the party wore out. So Tea Cake hurried on back to his new wife. He had done found out how rich people feel and he had a fine guitar and twelve dollars left in his pocket and all he needed now was a great big old hug and kiss from Janie.

"You musta thought yo' wife was powerful ugly. Dem ugly women dat you paid two dollars not to come in, could git tuh de door. You never even 'lowed me tuh git dat close." She pouted.

"Janie, Ah would have give Jacksonville wid Tampa for a jump-back for you to be dere wid me. Ah started to come git yuh two three times."

"Well, how come yuh didn't come git me?"

"Janie, would you have come if Ah did?"

"Sho Ah would. Ah laks fun just as good as you do."

"Janie, Ah wanted tuh, mighty much, but Ah was skeered. Too skeered Ah might lose yuh."

"Why?"

"Dem wuzn't no high muckty mucks. Dem wuz railroad hands and dey womenfolks. You ain't usetuh folks lak dat and Ah wuz skeered you might git all mad and quit me for takin' you 'mongst 'em. But Ah wanted yuh wid me jus' de same. Befo' us got married Ah made up mah mind not tuh let you see no commonness in me. When Ah git mad habits on, Ah'd go off and keep it out yo' sight. 'Tain't mah notion tuh drag *you* down wid me."

"Looka heah, Tea Cake, if you ever go off from me and have a good time lak dat and then come back heah tellin' me how nice Ah is, Ah specks tuh kill yuh dead. You heah me?"

"So you aims tuh partake wid everything, hunh?"

"Yeah, Tea Cake, don't keer what it is."

"Dat's all Ah wants tuh know. From now on you'se mah wife and mah woman and everything else in de world Ah needs."

"Ah hope so."

"And honey, don't you worry 'bout yo' lil ole two hundred dollars. It's big pay day dis comin' Saturday at de railroad yards. Ah'm gointuh take dis twelve dollars in mah pocket and win it all back and mo'."

"How?"

"Honey, since you loose me and gimme privilege tuh tell yuh all about mahself, Ah'll tell yuh. You done married one uh de best gamblers God ever made. Cards or dice either one. Ah can take uh shoe string and win uh tan-yard. Wish yuh could see me rollin'. But dis time it's gointuh be nothin' but tough men's talkin' all kinds uh talk so it ain't no place for you tuh be, but 'twon't be long befo' you see me."

All the rest of the week Tea Cake was busy practising up on his dice. He would flip them on the bare floor, on the rug and on the bed. He'd squat and throw, sit in a chair and throw and stand and throw. It was very exciting to Janie who had never touched dice in her life. Then he'd take his deck of cards and shuffle and cut, shuffle and cut and deal out then examine each hand carefully, and do it again. So Saturday came. He went out and bought a new switch-blade knife and two decks of star-back playing cards that morning and left Janie around noon.

"They'll start to paying off, pretty soon now. Ah wants tuh git in de game whilst de big money is in it. Ah ain't fuh no spuddin' tuhday. Ah'll come home wid de money or Ah'll come back on uh stretcher." He cut nine hairs out of the mole of her head for luck and went off happy.

Janie waited till midnight without worrying, but after that she began to be afraid. So she got up and sat around scared and miserable. Thinking and fearing all sorts of dangers. Wondering at herself as she had many times this week that she was not shocked at Tea Cake's gambling. It was part of him, so it was all right. She rather found herself angry at imaginary people who might try to

criticize. Let the old hypocrites learn to mind their own business, and leave other folks alone. Tea Cake wasn't doing a bit more harm trying to win hisself a little money than they was always doing with their lying tongues. Tea Cake had more good nature under his toe-nails than they had in their so-called Christian hearts. She better not hear none of them old backbiters talking about *her* husband! Please, Jesus, don't let them nasty niggers hurt her boy. If they do, Master Jesus, grant her a good gun and a chance to shoot 'em. Tea Cake had a knife it was true, but that was only to protect hisself. God knows, Tea Cake wouldn't harm a fly.

Daylight was creeping around the cracks of the world when Janie heard a feeble rap on the door. She sprung to the door and flung it wide. Tea Cake was out there looking like he was asleep standing up. In some strange way it was frightening. Janie caught his arm to arouse him and he stumbled into the room and fell.

"Tea Cake! You chile! What's de matter, honey?"

"Dey cut me, dat's all. Don't cry. Git me out dis coat quick as yuh can."

He told her he wasn't cut but twice but she had to have him naked so she could look him all over and fix him up to a certain extent. He told her not to call a doctor unless he got much worse. It was mostly loss of blood anyhow.

"Ah won the money jus' lak ah told yuh. Round midnight Ah had yo' two hundred dollars and wuz ready tuh quit even though it wuz uh heap mo' money in de game. But dey wanted uh chance tuh win it back so Ah set back down tuh play some mo'. Ah knowed ole Double-Ugly wuz 'bout broke and wanted tuh fight 'bout it, so Ah set down tuh give 'im his chance tuh git back his money and then to give 'im uh quick trip tuh hell if he tried tuh pull dat razor Ah glimpsed in his pocket. Honey, no up-to-date man don't fool wid no razor. De man wid his switch-blade will be done cut yuh tuh death while you foolin' wid uh razor.

But Double-Ugly brags he's too fast wid it tuh git hurt, but Ah knowed better.

"So round four o'clock Ah had done cleaned 'em out complete—all except two men dat got up and left while dey had money for groceries, and one man dat wuz lucky. Then Ah rose tuh bid 'em good bye agin. None of 'em didn't lak it, but dey all realized it wuz fair. Ah had done give 'em a fair chance. All but Double-Ugly. He claimed Ah switched de dice. Ah shoved de money down deep in mah pocket and picked up mah hat and coat wid mah left hand and kept mah right hand on mah knife. Ah didn't keer what he *said* long as he didn't try tuh *do* nothin'. Ah got mah hat on and one arm in mah coat as Ah got to de door. Right dere he jumped at me as Ah turned to see de doorstep outside and cut me twice in de back.

"Baby, Ah run mah other arm in mah coat-sleeve and grabbed dat nigger by his necktie befo' he could bat his eye and then Ah wuz all over 'im jus' lak gravy over rice. He lost his razor tryin' tuh git loose from me. He wuz hollerin' for me tuh turn him loose, but baby, Ah turnt him every way *but* loose. Ah left him on the doorstep and got here to yuh de quickest way Ah could. Ah know Ah ain't cut too deep 'cause he was too skeered tuh run up on me close enough. Sorta pull de flesh together with stickin' plaster. Ah'll be all right in uh day or so."

Janie was painting on iodine and crying.

"You ain't de one to be cryin', Janie. It's his ole lady oughta do dat. You done gimme luck. Look in mah left hand pants pocket and see whut yo' daddy brought yuh. When Ah tell yuh Ah'm gointuh bring it, Ah don't lie."

They counted it together—three hundred and twenty-two dollars. It was almost like Tea Cake had held up the Paymaster. He made her take the two hundred and put it back in the secret place. Then Janie told him about the other money she had in the bank.

"Put dat two hundred back wid de rest, Janie. Mah dice. Ah no need no assistance tuh help me feed mah woman. From now on, you gointuh eat whutever mah money can buy yuh and wear de same. When Ah ain't got nothin' you don't git nothin'."

"Dat's all right wid me."

He was getting drowsy, but he pinched her leg playfully because he was glad she took things the way he wanted her to. "Listen, mama, soon as Ah git over dis lil cuttin' scrape, we gointuh do somethin' crazy."

"Whut's dat?"

"We goin' on de muck."

"Whut's de muck, and where is it at?"

"Oh down in de Everglades round Clewiston and Belle Glade where dey raise all dat cane and string-beans and tomatuhs. Folks don't do nothin' down dere but make money and fun and foolishness. We must go dere."

He drifted off into sleep and Janie looked down on him and felt a self-crushing love. So her soul crawled out from its hiding place.

14

To Janie's strange eyes, everything in the Everglades was big and new. Big Lake Okechobee, big beans, big cane, big weeds, big everything. Weeds that did well to grow waist high up the state were eight and often ten feet tall down there. Ground so rich that everything went wild. Volunteer cane just taking the place. Dirt roads so rich and black that a half mile of it would have fertilized a Kansas wheat field. Wild cane on either side of the road hiding the rest of the world. People wild too.

"Season don't open up till last of September, but we had tuh git heah ahead uh time tuh git us uh room," Tea Cake explained. "Two weeks from now, it'll be so many folks heah dey won't be lookin' fuh rooms, dey'll be jus' looking fuh somewhere tuh sleep. Now we got uh chance tuh git uh room at de hotel, where dey got uh bath tub. Yuh can't live on de muck 'thout yuh take uh bath every day. Do dat muck'll itch yuh lak ants. 'Tain't but one place round heah wid uh bath tub. 'Tain't nowhere near enough rooms."

"Whut we gointuh do round heah?"

"All day Ah'm pickin' beans. All night Ah'm pickin' mah box and rollin' dice. Between de beans and de dice Ah can't lose. Ah'm gone right now tuh pick me uh job uh work wid de best man on de muck. Before de rest of 'em gits heah. You can

always git jobs round heah in de season, but not wid de right folks."

"When do de job open up, Tea Cake? Everybody round here look lak dey waitin' too."

"Dat's right. De big men haves uh certain time tuh open de season jus' lak in everything else. Mah boss-man didn't get sufficient seed. He's out huntin' up uh few mo' bushels. Den we'se gointuh plantin'."

"Bushels?"

"Yeah, bushels. Dis ain't no game fuh pennies. Po' man ain't got no business at de show."

The very next day he burst into the room in high excitement. "Boss done bought out another man and want me down on de lake. He got houses fuh de first ones dat git dere. Less go!"

They rattled nine miles in a borrowed car to the quarters that squatted so close that only the dyke separated them from great, sprawling Okechobee. Janie fussed around the shack making a home while Tea Cake planted beans. After hours they fished. Every now and then they'd run across a party of Indians in their long, narrow dug-outs calmly winning their living in the trackless ways of the 'Glades. Finally the beans were in. Nothing much to do but wait to pick them. Tea Cake picked his box a great deal for Janie, but he still didn't have enough to do. No need of gambling yet. The people who were pouring in were broke. They didn't come bringing money, they were coming to make some.

"Tell yuh whut, Janie, less buy us some shootin' tools and go huntin' round heah."

"Dat would be fine, Tea Cake, exceptin' you know Ah can't shoot. But Ah'd love tuh go wid *you*."

"Oh, you needs tuh learn how. 'Tain't no need uh you not knowin' how tuh handle shootin' tools. Even if you didn't never find no game, it's always some trashy rascal dat needs uh good

killin'," he laughed. "Less go intuh Palm Beach and spend some of our money."

Every day they were practising. Tea Cake made her shoot at little things just to give her good aim. Pistol and shot gun and rifle. It got so the others stood around and watched them. Some of the men would beg for a shot at the target themselves. It was the most exciting thing on the muck. Better than the jook and the pool-room unless some special band was playing for a dance. And the thing that got everybody was the way Janie caught on. She got to the place she could shoot a hawk out of a pine tree and not tear him up. Shoot his head off. She got to be a better shot than Tea Cake. They'd go out any late afternoon and come back loaded down with game. One night they got a boat and went out hunting alligators. Shining their phosphorescent eyes and shooting them in the dark. They could sell the hides and teeth in Palm Beach besides having fun together till work got pressing.

Day by day now, the hordes of workers poured in. Some came limping in with their shoes and sore feet from walking. It's hard trying to follow your shoe instead of your shoe following you. They came in wagons from way up in Georgia and they came in truck loads from east, west, north and south. Permanent transients with no attachments and tired looking men with their families and dogs in flivvers. All night, all day, hurrying in to pick beans. Skillets, beds, patched up spare inner tubes all hanging and dangling from the ancient cars on the outside and hopeful humanity, herded and hovered on the inside, chugging on to the muck. People ugly from ignorance and broken from being poor.

All night now the jooks clanged and clamored. Pianos living three lifetimes in one. Blues made and used right on the spot. Dancing, fighting, singing, crying, laughing, winning and losing love every hour. Work all day for money, fight all night for love. The rich black earth clinging to bodies and biting the skin like ants.

Finally no more sleeping places. Men made big fires and fifty or sixty men slept around each fire. But they had to pay the man whose land they slept on. He ran the fire just like his boarding place—for pay. But nobody cared. They made good money, even to the children. So they spent good money. Next month and next year were other times. No need to mix them up with the present.

Tea Cake's house was a magnet, the unauthorized center of the "job." The way he would sit in the doorway and play his guitar made people stop and listen and maybe disappoint the jook for that night. He was always laughing and full of fun too. He kept everybody laughing in the bean field.

Janie stayed home and boiled big pots of blackeyed peas and rice. Sometimes baked big pans of navy beans with plenty of sugar and hunks of bacon laying on top. That was something Tea Cake loved so no matter if Janie had fixed beans two or three times during the week, they had baked beans again on Sunday. She always had some kind of dessert too, as Tea Cake said it give a man something to taper off on. Sometimes she'd straighten out the two-room house and take the rifle and have fried rabbit for supper when Tea Cake got home. She didn't leave him itching and scratching in his work clothes, either. The kettle of hot water was already waiting when he got in.

Then Tea Cake took to popping in at the kitchen door at odd hours. Between breakfast and dinner, sometimes. Then often around two o'clock he'd come home and tease and wrestle with her for a half hour and slip on back to work. So one day she asked him about it.

"Tea Cake, whut you doin' back in de quarters when everybody else is still workin'?"

"Come tuh see 'bout you. De boogerman liable tuh tote yuh off whilst Ah'm gone."

"'Tain't no boogerman got me tuh study 'bout. Maybe you think Ah ain't treatin' yuh right and you watchin' me."

"Naw, naw, Janie. Ah *know* better'n dat. But since you got dat in yo' head, Ah'll have tuh tell yuh de real truth, so yuh can know. Janie, Ah gits lonesome out dere all day 'thout yuh. After dis, you betta come git uh job uh work out dere lak de rest uh de women—so Ah won't be losin' time comin' home."

"Tea Cake, you'se uh mess! Can't do 'thout me dat lil time."

"'Tain't no lil time. It's near 'bout all day."

So the very next morning Janie got ready to pick beans along with Tea Cake. There was a suppressed murmur when she picked up a basket and went to work. She was already getting to be a special case on the muck. It was generally assumed that she thought herself too good to work like the rest of the women and that Tea Cake "pomped her up tuh dat." But all day long the romping and playing they carried on behind the boss's back made her popular right away. It got the whole field to playing off and on. Then Tea Cake would help get supper afterwards.

"You don't think Ah'm tryin' tuh git outa takin' keer uh yuh, do yuh, Janie, 'cause Ah ast yuh tuh work long side uh me?" Tea Cake asked her at the end of her first week in the field.

"Ah naw, honey. Ah laks it. It's mo' nicer than settin' round dese quarters all day. Clerkin' in dat store wuz hard, but heah, we ain't got nothin' tuh do but do our work and come home and love."

The house was full of people every night. That is, all around the doorstep was full. Some were there to hear Tea Cake pick the box; some came to talk and tell stories, but most of them came to get into whatever game was going on or might go on. Sometimes Tea Cake lost heavily, for there were several good gamblers on the lake. Sometimes he won and made Janie proud of his skill. But outside of the two jooks, everything on that job went on around those two.

Sometimes Janie would think of the old days in the big white house and the store and laugh to herself. What if Eatonville could see her now in her blue denim overalls and heavy shoes? The crowd of people around her and a dice game on her floor! She was sorry for her friends back there and scornful of the others. The men held big arguments here like they used to do on the store porch. Only here, she could listen and laugh and even talk some herself if she wanted to. She got so she could tell big stories herself from listening to the rest. Because she loved to hear it, and the men loved to hear themselves, they would "woof" and "booger-boo" around the games to the limit. No matter how rough it was, people seldom got mad, because everything was done for a laugh. Everybody loved to hear Ed Dockery, Bootyny, and Sop-de-Bottom in a skin game. Ed Dockery was dealing one night and he looked over at Sop-de-Bottom's card and he could tell Sop thought he was going to win. He hollered, "Ah'll break up *dat* settin' uh eggs." Sop looked and said, "Root de peg." Bootyny asked, "What are you goin' tuh do? Do do!" Everybody was watching that next card fall. Ed got ready to turn. "Ah'm gointuh sweep out hell and burn up de broom." He slammed down another dollar. "Don't oversport yourself, Ed," Bootyny challenged. "You gittin' too yaller." Ed caught hold of the corner of the card. Sop dropped a dollar. "Ah'm gointuh shoot in de hearse, don't keer how sad de funeral be." Ed said, "You see how this man is teasin' hell?" Tea Cake nudged Sop not to bet. "You gointuh git caught in uh bullet storm if you don't watch out." Sop said, "Aw 'tain't nothin' tuh dat bear but his curly hair. Ah can look through muddy water and see dry land." Ed turned off the card and hollered, "Zachariah, Ah says come down out dat sycamore tree. You can't do no business." Nobody fell on that card. Everybody was scared of the next one. Ed looked around and saw Gabe standing behind his chair and hollered, "Move, from over me, Gabe! You too black. You draw

heat! Sop, you wanta pick up dat bet whilst you got uh chance?"
"Naw, man, Ah wish Ah had uh thousand-leg tuh put on it." "So
yuh won't lissen, huh? Dumb niggers and free schools. Ah'm goin-
tuh take and teach yuh. Ah'll main-line but Ah won't side-track."
Ed flipped the next card and Sop fell and lost. Everybody hollered
and laughed. Ed laughed and said, "Git off de muck! You ain't
nothin'. Dat's all! Hot boilin' water won't help yuh none." Ed
kept on laughing because he had been so scared before. "Sop,
Bootyny, all y'all dat lemme win yo' money: Ah'm sending it
straight off to Sears and Roebuck and buy me some clothes, and
when Ah turn out Christmas day, it would take a doctor to tell me
how near Ah is dressed tuh death."

15

Janie learned what it felt like to be jealous. A little chunky girl took to picking a play out of Tea Cake in the fields and in the quarters. If he said anything at all, she'd take the opposite side and hit him or shove him and run away to make him chase her. Janie knew what she was up to—luring him away from the crowd. It kept up for two or three weeks with Nunkie getting bolder all the time. She'd hit Tea Cake playfully and the minute he so much as tapped her with his finger she'd fall against him or fall on the ground and have to be picked up. She'd be almost helpless. It took a good deal of handling to set her on her feet again. And another thing, Tea Cake didn't seem to be able to fend her off as promptly as Janie thought he ought to. She began to be snappish a little. A little seed of fear was growing into a tree. Maybe some day Tea Cake would weaken. Maybe he had already given secret encouragement and this was Nunkie's way of bragging about it. Other people began to notice too, and that put Janie more on a wonder.

One day they were working near where the beans ended and the sugar cane began. Janie had marched off a little from Tea Cake's side with another woman for a chat. When she glanced around Tea Cake was gone. Nunkie too. She knew because she looked.

"Where's Tea Cake?" she asked Sop-de-Bottom.

He waved his hand towards the cane field and hurried away. Janie never thought at all. She just acted on feelings. She rushed into the cane and about the fifth row down she found Tea Cake and Nunkie struggling. She was on them before either knew.

"Whut's de matter heah?" Janie asked in a cold rage. They sprang apart.

"Nothin'," Tea Cake told her, standing shame-faced.

"Well, whut you doin' in heah? How come you ain't out dere wid de rest?"

"She grabbed mah workin' tickets outa mah shirt pocket and Ah run tuh git 'em back," Tea Cake explained, showing the tickets, considerably mauled about in the struggle.

Janie made a move to seize Nunkie but the girl fled. So she took out behind her over the humped-up cane rows. But Nunkie did not mean to be caught. So Janie went on home. The sight of the fields and the other happy people was too much for her that day. She walked slowly and thoughtfully to the quarters. It wasn't long before Tea Cake found her there and tried to talk. She cut him short with a blow and they fought from one room to the other, Janie trying to beat him, and Tea Cake kept holding her wrists and wherever he could to keep her from going too far.

"Ah b'lieve you been messin' round her!" she panted furiously.

"No sich uh thing!" Tea Cake retorted.

"Ah b'lieve yuh did."

"Don't keer how big uh lie get told, somebody kin b'lieve it!"

They fought on. "You done hurt mah heart, now you come wid uh lie tuh bruise mah ears! Turn go mah hands!" Janie seethed. But Tea Cake never let go. They wrestled on until they were doped with their own fumes and emanations; till their clothes had been torn away; till he hurled her to the floor and held her there melting her resistance with the heat of his body, doing things with their bodies to express the inexpressible; kissed

her until she arched her body to meet him and they fell asleep in sweet exhaustion.

The next morning Janie asked like a woman, "You still love ole Nunkie?"

"Naw, never did, and you know it too. Ah didn't want her."

"Yeah, you did." She didn't say this because she believed it. She wanted to hear his denial. She had to crow over the fallen Nunkie.

"Whut would Ah do wid dat lil chunk of a woman wid you around? She ain't good for nothin' exceptin' tuh set up in uh corner by de kitchen stove and break wood over her head. You'se something tuh make uh man forgit tuh git old and forgit tuh die."

16

The season closed and people went away like they had come—in droves. Tea Cake and Janie decided to stay since they wanted to make another season on the muck. There was nothing to do, after they had gathered several bushels of dried beans to save over and sell to the planters in the fall. So Janie began to look around and see people and things she hadn't noticed during the season.

For instance during the summer when she heard the subtle but compelling rhythms of the Bahaman drummers, she'd walk over and watch the dances. She did not laugh the "Saws" to scorn as she had heard the people doing in the season. She got to like it a lot and she and Tea Cake were on hand every night till the others teased them about it.

Janie came to know Mrs. Turner now. She had seen her several times during the season, but neither ever spoke. Now they got to be visiting friends.

Mrs. Turner was a milky sort of a woman that belonged to child-bed. Her shoulders rounded a little, and she must have been conscious of her pelvis because she kept it stuck out in front of her so she could always see it. Tea Cake made a lot of fun about Mrs. Turner's shape behind her back. He claimed that she had been shaped up by a cow kicking her from behind. She was an

ironing board with things throwed at it. Then that same cow took and stepped in her mouth when she was a baby and left it wide and flat with her chin and nose almost meeting.

But Mrs. Turner's shape and features were entirely approved by Mrs. Turner. Her nose was slightly pointed and she was proud. Her thin lips were an ever delight to her eyes. Even her buttocks in bas-relief were a source of pride. To her way of thinking all these things set her aside from Negroes. That was why she sought out Janie to friend with. Janie's coffee-and-cream complexion and her luxurious hair made Mrs. Turner forgive her for wearing overalls like the other women who worked in the fields. She didn't forgive her for marrying a man as dark as Tea Cake, but she felt that she could remedy that. That was what her brother was born for. She seldom stayed long when she found Tea Cake at home, but when she happened to drop in and catch Janie alone, she'd spend hours chatting away. Her disfavorite subject was Negroes.

"Mis' Woods, Ah have often said to mah husband, Ah don't see how uh lady like Mis' Woods can stand all them common niggers round her place all de time."

"They don't worry me atall, Mis' Turner. Fact about de thing is, they tickles me wid they talk."

"You got mo' nerve than me. When somebody talked mah husband intuh comin' down heah tuh open up uh eatin' place Ah never dreamt so many different kins uh black folks could colleck in one place. Did Ah never woulda come. Ah ain't useter 'ssociatin' wid black folks. Mah son claims dey draws lightnin'." They laughed a little and after many of these talks Mrs. Turner said, "Yo' husband musta had plenty money when y'all got married."

"Whut make you think dat, Mis' Turner?"

"Tuh git hold of uh woman lak you. You got mo' nerve than me. Ah jus' couldn't see mahself married to no black man. It's too many black folks already. We oughta lighten up de race."

"Naw, mah husband didn't had nothin' but hisself. He's easy tuh love if you mess round 'im. Ah loves 'im."

"Why you, Mis' Woods! Ah don't b'lieve it. You'se jus' sorter hypnotized, dat's all."

"Naw, it's real. Ah couldn't stand it if he wuz tuh quit me. Don't know whut Ah'd do. He kin take most any lil thing and make summertime out of it when times is dull. Then we lives offa dat happiness he made till some mo' happiness come along."

"You'se different from me. Ah can't stand black niggers. Ah don't blame de white folks from hatin' 'em 'cause Ah can't stand 'em mahself. 'Nother thing, Ah hates tuh see folks lak me and you mixed up wid 'em. Us oughta class off."

"Us can't *do* it. We'se uh mingled people and all of us got black kinfolks as well as yaller kinfolks. How come you so against black?"

"And dey makes me tired. Always laughin'! Dey laughs too much and dey laughs too loud. Always singin' ol' nigger songs! Always cuttin' de monkey for white folks. If it wuzn't for so many black folks it wouldn't be no race problem. De white folks would take us in wid dem. De black ones is holdin' us back."

"You reckon? 'course Ah ain't never thought about it too much. But Ah don't figger dey even gointuh want us for comp'ny. We'se too poor."

"'Tain't de poorness, it's de color and de features. Who want any lil ole black baby layin' up in de baby buggy lookin' lak uh fly in buttermilk? Who wants to be mixed up wid uh rusty black man, and uh black woman goin' down de street in all dem loud colors, and whoopin' and hollerin' and laughin' over nothin'? Ah don't know. Don't bring me no nigger doctor tuh hang over mah sick-bed. Ah done had six chillun—wuzn't lucky enough tuh raise but dat one— and ain't never had uh nigger tuh even feel mah pulse. White doctors always gits mah money. Ah don't go in no nigger store tuh buy

nothin' neither. Colored folks don't know nothin' 'bout no business. Deliver me!"

Mrs. Turner was almost screaming in fanatical earnestness by now. Janie was dumb and bewildered before and she clucked sympathetically and wished she knew what to say. It was so evident that Mrs. Turner took black folk as a personal affront to herself.

"Look at me! Ah ain't got no flat nose and liver lips. Ah'm uh featured woman. Ah got white folks' features in mah face. Still and all Ah got tuh be lumped in wid all de rest. It ain't fair. Even if dey don't take us in wid de whites, dey oughta make us uh class tuh ourselves."

"It don't worry me atall, but Ah reckon Ah ain't got no real head fur thinkin'."

"You oughta meet mah brother. He's real smart. Got dead straight hair. Dey made him uh delegate tuh de Sunday School Convention and he read uh paper on Booker T. Washington and tore him tuh pieces!"

"Booker T.? He wuz a great big man, wusn't he?"

"'Sposed tuh be. All he ever done was cut de monkey for white folks. So dey pomped him up. But you know whut de ole folks say 'de higher de monkey climbs de mo' he show his behind' so dat's de way it wuz wid Booker T. Mah brother hit 'im every time dey give 'im chance tuh speak."

"Ah was raised on de notion dat he wuz uh great big man," was all that Janie knew to say.

"He didn't do nothin' but hold us back—talkin' 'bout work when de race ain't never done nothin' else. He wuz uh enemy tuh us, dat's whut. He wuz uh white folks' nigger."

According to all Janie had been taught this was sacrilege so she sat without speaking at all. But Mrs. Turner went on.

"Ah done sent fuh mah brother tuh come down and spend uh while wid us. He's sorter outa work now. Ah wants yuh tuh

meet him mo' special. You and him would make up uh swell cou-
ple if you wuzn't already married. He's uh fine carpenter, when
he kin git anything tuh do."

"Yeah, maybe so. But Ah *is* married now, so 'tain't no use in
considerin'."

Mrs. Turner finally rose to go after being very firm about sev-
eral other viewpoints of either herself, her son or her brother. She
begged Janie to drop in on her anytime, but never once men-
tioning Tea Cake. Finally she was gone and Janie hurried to her
kitchen to put on supper and found Tea Cake sitting in there with
his head between his hands.

"Tea Cake! Ah didn't know you wuz home."

"Ah know yuh didn't. Ah been heah uh long time listenin' to
dat heifer run me down tuh de dawgs uh try tuh tole you off
from me."

"So dat whut she wuz up to? Ah didn't know."

"'Course she is. She got some no-count brother she wants
yuh tuh hook up wid and take keer of Ah reckon."

"Shucks! If dat's her notion she's barkin' up de wrong tree.
Mah hands is full already."

"Thanky Ma'am. Ah hates dat woman lak poison. Keep her
from round dis house. Her look lak uh white woman! Wid dat
meriny skin and hair jus' as close tuh her head as ninety-nine is
tuh uh hundred! Since she hate black folks so, she don't need our
money in her ol' eatin' place. Ah'll pass de word along. We kin go
tuh dat white man's place and git good treatment. Her and dat
whittled-down husband uh hers! And dat son! He's jus' uh dirty
trick her womb played on her. Ah'm telling her husband tuh keep
her home. Ah don't want her round dis house."

One day Tea Cake met Turner and his son on the street. He
was a vanishing-looking kind of a man as if there used to be parts
about him that stuck out individually but now he hadn't a thing

about him that wasn't dwindled and blurred. Just like he had been sand-papered down to a long oval mass. Tea Cake felt sorry for him without knowing why. So he didn't blurt out the insults he had intended. But he couldn't hold in everything. They talked about the prospects for the coming season for a moment, then Tea Cake said, "Yo' wife don't seem tuh have nothin' much tuh do, so she kin visit uh lot. Mine got too much tuh do tuh go visitin' and too much tuh spend time talkin' tuh folks dat visit her."

"Mah wife takes time fuh whatever she wants tuh do. Real strong headed dat way. Yes indeed." He laughed a high lungless laugh. "De chillun don't keep her in no mo' so she visits when she chooses."

"De chillun?" Tea Cake asked him in surprise. "You got any smaller than him?" He indicated the son who seemed around twenty or so. "Ah ain't seen yo' others."

"Ah reckon you ain't 'cause dey all passed on befo' dis one wuz born. We ain't had no luck atall wid our chillun. We lucky to raise him. He's de last stroke of exhausted nature."

He gave his powerless laugh again and Tea Cake and the boy joined in with him. Then Tea Cake walked on off and went home to Janie.

"Her husband can't do nothin' wid dat butt-headed woman. All you can do is treat her cold whenever she come round here."

Janie tried that, but short of telling Mrs. Turner bluntly, there was nothing she could do to discourage her completely. She felt honored by Janie's acquaintance and she quickly forgave and forgot snubs in order to keep it. Anyone who looked more white folkish than herself was better than she was in her criteria, therefore it was right that they should be cruel to her at times, just as she was cruel to those more negroid than herself in direct ratio to their negroness. Like the pecking-order in a chicken yard. Insensate cruelty to those you can whip, and groveling submission to those you

can't. Once having set up her idols and built altars to them it was inevitable that she would worship there. It was inevitable that she should accept any inconsistency and cruelty from her deity as all good worshippers do from theirs. All gods who receive homage are cruel. All gods dispense suffering without reason. Otherwise they would not be worshipped. Through indiscriminate suffering men know fear and fear is the most divine emotion. It is the stones for altars and the beginning of wisdom. Half gods are worshipped in wine and flowers. Real gods require blood.

Mrs. Turner, like all other believers had built an altar to the unattainable—Caucasian characteristics for all. Her god would smite her, would hurl her from pinnacles and lose her in deserts, but she would not forsake his altars. Behind her crude words was a belief that somehow she and others through worship could attain her paradise—a heaven of straighthaired, thin-lipped, high-nose boned white seraphs. The physical impossibilities in no way injured faith. That was the mystery and mysteries are the chores of gods. Beyond her faith was a fanaticism to defend the altars of her god. It was distressing to emerge from her inner temple and find these black desecrators howling with laughter before the door. Oh, for an army, terrible with banners *and swords!*

So she didn't cling to Janie Woods the woman. She paid homage to Janie's Caucasian characteristics as such. And when she was with Janie she had a feeling of transmutation, as if she herself had become whiter and with straighter hair and she hated Tea Cake first for his defilement of divinity and next for his telling mockery of her. If she only knew something she could do about it! But she didn't. Once she was complaining about the carry-ings-on at the jook and Tea Cake snapped, "Aw, don't make God look so foolish—findin' fault wid everything He made."

So Mrs. Turner frowned most of the time. She had so much to disapprove of. It didn't affect Tea Cake and Janie too much. It

just gave them something to talk about in the summertime when everything was dull on the muck. Otherwise they made little trips to Palm Beach, Fort Myers and Fort Lauderdale for their fun. Before they realized it the sun was cooler and the crowds came pouring onto the muck again.

17

A great deal of the old crowd were back. But there were lots of new ones too. Some of these men made passes at Janie, and women who didn't know took out after Tea Cake. Didn't take them long to be put right, however. Still and all, jealousies arose now and then on both sides. When Mrs. Turner's brother came and she brought him over to be introduced, Tea Cake had a brainstorm. Before the week was over he had whipped Janie. Not because her behavior justified his jealousy, but it relieved that awful fear inside him. Being able to whip her reassured him in possession. No brutal beating at all. He just slapped her around a bit to show he was boss. Everybody talked about it next day in the fields. It aroused a sort of envy in both men and women. The way he petted and pampered her as if those two or three face slaps had nearly killed her made the women see visions and the helpless way she hung on him made men dream dreams.

"Tea Cake, you sho is a lucky man," Sop-de-Bottom told him. "Uh person can see every place you hit her. Ah bet she never raised her hand tuh hit yuh back, neither. Take some uh dese ol' rusty black women and dey would fight yuh all night long and next day nobody couldn't tell you ever hit 'em. Dat's de reason Ah done quit beatin' mah woman. You can't make no

mark on 'em at all. Lawd! wouldn't Ah love tuh whip uh tender woman lak Janie! Ah bet she don't even holler. She jus' cries, eh Tea Cake?"

"Dat's right."

"See dat! Mah woman would spread her lungs all over Palm Beach County, let alone knock out mah jaw teeth. You don't know dat woman uh mine. She got ninety-nine rows uh jaw teeth and git her good and mad, she'll wade through solid rock up to her hip pockets."

"Mah Janie is uh high time woman and useter things. Ah didn't git her outa de middle uh de road. Ah got her outa uh big fine house. Right now she got money enough in de bank tuh buy up dese ziggaboos and give 'em away."

"Hush yo' mouf! And she down heah on de muck lak anybody else!"

"Janie is wherever *Ah* wants tuh be. Dat's de kind uh wife she is and Ah love her for it. Ah wouldn't be knockin' her around. Ah didn't wants whup her last night, but ol' Mis' Turner done sent for her brother tuh come tuh bait Janie in and take her way from me. Ah didn't whup Janie 'cause *she* done nothin'. Ah beat her tuh show dem Turners who is boss. Ah set in de kitchen one day and heard dat woman tell mah wife Ah'm too black fuh her. She don't see how Janie can stand me."

"Tell her husband on her."

"Shucks! Ah b'lieve he's skeered of her."

"Knock her teeth down her throat."

"Dat would look like she had some influence when she ain't. Ah jus' let her see dat Ah got control."

"So she live offa our money and don't lak black folks, huh? O.K. we'll have her gone from here befo' two weeks is up. Ah'm goin' right off tuh all de men and drop rocks aginst her."

"Ah ain't mad wid her for whut she done, 'cause she ain't

done me nothin' yet. Ah'm mad at her for thinkin'. Her and her gang got tuh go."

"Us is wid yuh, Tea Cake. You know dat already. Dat Turner woman is real smart, accordin' tuh her notions. Reckon she done heard 'bout dat money yo' wife got in de bank and she's bound tuh rope her in tuh her family one way or another."

"Sop, Ah don't think it's half de money as it is de looks. She's color-struck. She ain't got de kind of uh mind you meet every day. She ain't a fact and neither do she make a good story when you tell about her."

"Ah yeah, she's too smart tuh stay round heah. She figgers we'se jus' uh bunch uh dumb niggers so she think she'll grow horns. But dat's uh lie. She'll die butt-headed."

Saturday afternoon when the work tickets were turned into cash everybody began to buy coon-dick and get drunk. By dusk dark Belle Glade was full of loud-talking, staggering men. Plenty women had gotten their knots charged too. The police chief in his speedy Ford was rushing from jook to jook and eating house trying to keep order, but making few arrests. Not enough jail-space for all the drunks so why bother with a few? All he could do to keep down fights and get the white men out of colored town by nine o'clock. Dick Sterrett and Coodemay seemed to be the worst off. Their likker told them to go from place to place pushing and shoving and loud-talking and they were doing it.

Way after a while they arrived at Mrs. Turner's eating house and found the place full to the limit. Tea Cake, Stew Beef, Sop-de-Bottom, Bootyny, Motor Boat and all the familiar crowd was there. Coodemay straightened up as if in surprise and asked, "Say, whut y'all doin' in heah?"

"Eatin'," Stew Beef told him. "Dey got beef stew, so you *know* Ah'd be heah."

"We all laks tuh take uh rest from our women folks' cookin'

once in uh while, so us all eatin' way from home tuhnight. Anyhow Mis' Turner got de best ole grub in town."

Mrs. Turner back and forth in the dining room heard Sop when he said this and beamed.

"Ah speck you two last ones tuh come in is gointuh have tuh wait for uh seat. Ah'm all full up now."

"Dat's all right," Sterrett objected. "You fry me some fish. Ah kin eat dat standin' up. Cuppa coffee on de side."

"Sling me up uh plate uh dat stew beef wid some coffee too, please ma'am. Sterrett is jus' ez drunk ez Ah is; and if he kin eat standin' up, Ah kin do de same." Coodemay leaned drunkenly against the wall and everybody laughed.

Pretty soon the girl that was waiting table for Mrs. Turner brought in the order and Sterrett took his fish and coffee in his hands and stood there. Coodemay wouldn't take his off the tray like he should have.

"Naw, you hold it fuh me, baby, and lemme eat," he told the waitress. He took the fork and started to eat off the tray.

"Nobody ain't got no time tuh hold yo' grub up in front uh yo' face," she told Coodemay. "Heah, take it yo'self."

"You'se right," Coodemay told her. "Gimme it heah. Sop kin gimme his chear."

"You'se uh lie," Sop retorted. "Ah ain't through and Ah ain't ready tuh git up."

Coodemay tried to shove Sop out of the chair and Sop resisted. That brought on a whole lot of shoving and scrambling and coffee got spilt on Sop. So he aimed at Coodemay with a saucer and hit Bootyny. Bootyny threw his thick coffee cup at Coodemay and just missed Stew Beef. So it got to be a big fight. Mrs. Turner came running in out of the kitchen. Then Tea Cake got up and caught hold of Coodemay by the collar.

"Looka heah, y'all, don't come in heah and raise no disturbance

in de place. Mis' Turner is too nice uh woman fuh dat. In fact, she's more nicer than anybody else on de muck." Mrs. Turner beamed on Tea Cake.

"Ah knows dat. All of us knows it. But Ah don't give uh damn how nice she is, Ah got tuh have some place tuh set down and eat. Sop ain't gointuh bluff me, neither. Let 'im fight lak a man. Take yo' hands off me, Tea Cake."

"Naw, Ah won't neither. You comin' on outa de place."

"Who gointuh make me come out?"

"Me, dat's who. Ah'm in heah, ain't Ah? If you don't want tuh respect nice people lak Mrs. Turner, God knows you gointuh respect me! Come on outa heah, Coodemay."

"Turn him loose, Tea Cake!" Sterrett shouted. "Dat's *mah* buddy. Us come in heah together and he ain't goin' nowhere until Ah go mahself."

"Well, both of yuh is goin'!" Tea Cake shouted and fastened down on Coodemay. Dockery grabbed Sterrett and they wrassled all over the place. Some more joined in and dishes and tables began to crash.

Mrs. Turner saw with dismay that Tea Cake's taking them out was worse than letting them stay in. She ran out in the back somewhere and got her husband to put a stop to things. He came in, took a look and squinched down into a chair in an off corner and didn't open his mouth. So Mrs. Turner struggled into the mass and caught Tea Cake by the arm.

"Dat's all right, Tea Cake, Ah 'preciate yo' help, but leave 'em alone."

"Naw suh, Mis' Turner, Ah'm gointuh show 'em dey can't come runnin' over nice people and loud-talk no place whilst Ah'm around. Dey goin' outa heah!"

By that time everybody in and around the place was taking sides. Somehow or other Mrs. Turner fell down and nobody

knew she was down there under all the fighting, and broken dishes and crippled up tables and broken-off chair legs and window panes and such things. It got so that the floor was knee-deep with something no matter where you put your foot down. But Tea Cake kept right on until Coodemay told him, "Ah'm wrong. Ah'm wrong! Y'all tried tuh tell me right and Ah wouldn't lissen. Ah ain't mad wid nobody. Just tuh show y'all Ah ain't mad, me and Sterrett gointuh buy everybody somethin' tuh drink. Ole man Vickers got some good coondick over round Pahokee. Come on everybody. Let's go git our knots charged." Everybody got in a good humor and left.

Mrs. Turner got up off the floor hollering for the police. Look at her place! How come nobody didn't call the police? Then she found out that one of her hands was all stepped on and her fingers were bleeding pretty peart. Two or three people who were not there during the fracas poked their heads in at the door to sympathize but that made Mrs. Turner madder. She told them where to go in a hurry. Then she saw her husband sitting over there in the corner with his long bony legs all crossed up smoking his pipe.

"What kinda man is *you*, Turner? You see dese no count niggers come in heah and break up mah place! How kin you set and see yo' wife all trompled on? You ain't no kinda man at all. You seen dat Tea Cake shove me down! Yes you did! You ain't raised yo' hand tuh do nothin' about it."

Turner removed his pipe and answered: "Yeah, and you see how Ah did swell up too, didn't yuh? You tell Tea Cake he better be keerful Ah don't swell up again." At that Turner crossed his legs the other way and kept right on smoking his pipe.

Mrs. Turner hit at him the best she could with her hurt hand and then spoke her mind for half an hour.

"It's a good thing mah brother wuzn't round heah when it happened do he would uh kilt somebody. Mah son too. Dey got

some manhood about 'em. We'se goin' back tuh Miami where folks is civilized."

Nobody told her right away that her son and brother were already on their way after pointed warnings outside the café. No time for fooling around. They were hurrying into Palm Beach. She'd find out about that later on.

Monday morning Coodemay and Sterrett stopped by and begged her pardon profusely and gave her five dollars apiece. Then Coodemay said, "Dey tell me Ah wuz drunk Sat'day night and clownin' down. Ah don't 'member uh thing 'bout it. But when Ah git tuh peepin' through mah likker, dey tell me Ah'm uh mess."

18

Since Tea Cake and Janie had friended with the Bahaman workers in the 'Glades, they, the "Saws," had been gradually drawn into the American crowd. They quit hiding out to hold their dances when they found that their American friends didn't laugh at them as they feared. Many of the Americans learned to jump and liked it as much as the "Saws." So they began to hold dances night after night in the quarters, usually behind Tea Cake's house. Often now, Tea Cake and Janie stayed up so late at the fire dances that Tea Cake would not let her go with him to the field. He wanted her to get her rest.

So she was home by herself one afternoon when she saw a band of Seminoles passing by. The men walking in front and the laden, stolid women following them like burros. She had seen Indians several times in the 'Glades, in twos and threes, but this was a large party. They were headed towards the Palm Beach road and kept moving steadily. About an hour later another party appeared and went the same way. Then another just before sundown. This time she asked where they were all going and at last one of the men answered her.

"Going to high ground. Saw-grass bloom. Hurricane coming."

Everybody was talking about it that night. But nobody was

worried. The fire dance kept up till nearly dawn. The next day, more Indians moved east, unhurried but steady. Still a blue sky and fair weather. Beans running fine and prices good, so the Indians could be, *must* be, wrong. You couldn't have a hurricane when you're making seven and eight dollars a day picking beans. Indians are dumb anyhow, always were. Another night of Stew Beef making dynamic subtleties with his drum and living, sculptural, grotesques in the dance. Next day, no Indians passed at all. It was hot and sultry and Janie left the field and went home.

Morning came without motion. The winds, to the tiniest, lisping baby breath had left the earth. Even before the sun gave light, dead day was creeping from bush to bush watching man.

Some rabbits scurried through the quarters going east. Some possums slunk by and their route was definite. One or two at a time, then more. By the time the people left the fields the procession was constant. Snakes, rattlesnakes began to cross the quarters. The men killed a few, but they could not be missed from the crawling horde. People stayed indoors until daylight. Several times during the night Janie heard the snort of big animals like deer. Once the muted voice of a panther. Going east and east. That night the palm and banana trees began that long distance talk with rain. Several people took fright and picked up and went in to Palm Beach anyway. A thousand buzzards held a flying meet and then went above the clouds and stayed.

One of the Bahaman boys stopped by Tea Cake's house in a car and hollered. Tea Cake came out throwin' laughter over his shoulder into the house.

"Hello Tea Cake."

"Hello 'Lias. You leavin', Ah see."

"Yeah man. You and Janie wanta go? Ah wouldn't give nobody else uh chawnce at uh seat till Ah found out if you all had anyway tuh go."

"Thank yuh ever so much, Lias. But we 'bout decided tuh stay."

"De crow gahn up, man."

"Dat ain't nothin'. You ain't seen de bossman go up, is yuh? Well all right now. Man, de money's too good on the muck. It's liable tuh fair off by tuhmorrer. Ah wouldn't leave if Ah wuz you."

"Mah uncle come for me. He say hurricane warning out in Palm Beach. Not so bad dere, but man, dis muck is too low and dat big lake is liable tuh bust."

"Ah naw, man. Some boys in dere now talkin' 'bout it. Some of 'em been in de 'Glades fuh years. 'Tain't nothin' but uh lil blow. You'll lose de whole day tuhmorrer tryin' tuh git back out heah."

"De Indians gahn east, man. It's dangerous."

"Dey don't always know. Indians don't know much uh nothin', tuh tell de truth. Else dey'd own dis country still. De white folks ain't gone nowhere. Dey oughta know if it's danger-ous. You better stay heah, man. Big jumpin' dance tuhnight right heah, when it fair off."

Lias hesitated and started to climb out, but his uncle wouldn't let him. "Dis time tuhmorrer you gointuh wish you follow crow," he snorted and drove off. Lias waved back to them gaily.

"If Ah never see you no mo' on earth, Ah'll meet you in Africa."

Others hurried east like the Indians and rabbits and snakes and coons. But the majority sat around laughing and waiting for the sun to get friendly again.

Several men collected at Tea Cake's house and sat around stuffing courage into each other's ears. Janie baked a big pan of beans and something she called sweet biscuits and they all man-aged to be happy enough.

Most of the great flame-throwers were there and naturally,

handling Big John de Conquer and his works. How he had done everything big on earth, then went up tuh heben without dying atall. Went up there picking a guitar and got all de angels doing the ring-shout round and round de throne. Then everybody but God and Old Peter flew off on a flying race to Jericho and back and John de Conquer won the race; went on down to hell, beat the old devil and passed out ice water to everybody down there. Somebody tried to say that it was a mouth organ harp that John was playing, but the rest of them would not hear that. Don't care how good anybody could play a harp, God would rather to hear a guitar. That brought them back to Tea Cake. How come he couldn't hit that box a lick or two? Well, all right now, make us know it.

When it got good to everybody, Muck-Boy woke up and began to chant with the rhythm and everybody bore down on the last word of the line:

> Yo' mama don't wear no *Draws*
> Ah seen her when she took 'em *Off*
> She soaked 'em in alco*Hol*
> She sold 'em tuh de Santy *Claus*
> He told her 'twas aginst de *Law*
> To wear dem dirty *Draws*

Then Muck-Boy went crazy through the feet and danced himself and everybody else crazy. When he finished he sat back down on the floor and went to sleep again. Then they got to playing Florida flip and coon-can. Then it was dice. Not for money. This was a show-off game. Everybody posing his fancy shots. As always it broiled down to Tea Cake and Motor Boat. Tea Cake with his shy grin and Motor Boat with his face like a little black cherubim just from a church tower doing amazing things with anybody's dice. The others forgot the work and the

weather watching them throw. It was art. A thousand dollars a throw in Madison Square Garden wouldn't have gotten any more breathless suspense. It would have just been more people holding in.

After a while somebody looked out and said, "It ain't gitting no fairer out dere. B'lieve Ah'll git on over tuh mah shack." Motor Boat and Tea Cake were still playing so everybody left them at it.

Sometime that night the winds came back. Everything in the world had a strong rattle, sharp and short like Stew Beef vibrating the drum head near the edge with his fingers. By morning Gabriel was playing the deep tones in the center of the drum. So when Janie looked out of her door she saw the drifting mists gathered in the west—that cloud field of the sky—to arm themselves with thunders and march forth against the world. Louder and higher and lower and wider the sound and motion spread, mounting, sinking, darking.

It woke up old Okechobee and the monster began to roll in his bed. Began to roll and complain like a peevish world on a grumble. The folks in the quarters and the people in the big houses further around the shore heard the big lake and wondered. The people felt uncomfortable but safe because there were the seawalls to chain the senseless monster in his bed. The folks let the people do the thinking. If the castles thought themselves secure, the cabins needn't worry. Their decision was already made as always. Chink up your cracks, shiver in your wet beds and wait on the mercy of the Lord. The bossman might have the thing stopped before morning anyway. It is so easy to be hopeful in the day time when you can see the things you wish on. But it was night, it stayed night. Night was striding across nothingness with the whole round world in his hands.

A big burst of thunder and lightning that trampled over the

roof of the house. So Tea Cake and Motor stopped playing. Motor looked up in his angel-looking way and said, "Big Massa draw him chair upstairs."

"Ah'm glad y'all stop dat crap-shootin' even if it wasn't for money," Janie said. "Ole Massa is doin' *His* work now. Us oughta keep quiet."

They huddled closer and stared at the door. They just didn't use another part of their bodies, and they didn't look at anything but the door. The time was past for asking the white folks what to look for through that door. Six eyes were questioning *God*.

Through the screaming wind they heard things crashing and things hurtling and dashing with unbelievable velocity. A baby rabbit, terror ridden, squirmed through a hole in the floor and squatted off there in the shadows against the wall, seeming to know that nobody wanted its flesh at such a time. And the lake got madder and madder with only its dikes between them and him.

In a little wind-lull, Tea Cake touched Janie and said, "Ah reckon you wish now you had of stayed in yo' big house 'way from such as dis, don't yuh?"

"Naw."

"Naw?"

"Yeah, naw. People don't die till dey time come nohow, don't keer where you at. Ah'm wid mah husband in uh storm, dat's all."

"Thanky, Ma'am. But 'sposing you wuz tuh die, now. You wouldn't git mad at me for draggin' yuh heah?"

"Naw. We been tuhgether round two years. If you kin see de light at daybreak, you don't keer if you die at dusk. It's so many people never seen de light at all. Ah wuz fumblin' round and God opened de door."

He dropped to the floor and put his head in her lap. "Well then,

Janie, you meant whut you didn't say, 'cause Ah never *knowed* you wuz so satisfied wid me lak dat. Ah kinda thought—"

The wind came back with triple fury, and put out the light for the last time. They sat in company with the others in other shanties, their eyes straining against crude walls and their souls asking if He meant to measure their puny might against His. They seemed to be staring at the dark, but their eyes were watching God.

As soon as Tea Cake went out pushing wind in front of him, he saw that the wind and water had given life to lots of things that folks think of as dead and given death to so much that had been living things. Water everywhere. Stray fish swimming in the yard. Three inches more and the water would be in the house. Already in some. He decided to try to find a car to take them out of the 'Glades before worse things happened. He turned back to tell Janie about it so she could be ready to go.

"Git our insurance papers tuhgether, Janie. Ah'll tote mah box mahself and things lak dat."

"You got all de money out de dresser drawer, already?"

"Naw, git it quick and cut up piece off de table-cloth tuh wrap it up in. Us liable tuh git wet tuh our necks. Cut uh piece uh dat oilcloth quick fuh our papers. We got tuh go, if it ain't too late. De dish can't bear it out no longer."

He snatched the oilcloth off the table and took out his knife. Janie held it straight while he slashed off a strip.

"But Tea Cake, it's too awful out dere. Maybe it's better tuh stay heah in de wet than it is tuh try tuh—"

He stunned the argument with half a word. "Fix," he said and fought his way outside. He had seen more than Janie had.

Janie took a big needle and ran up a longish sack. Found some newspaper and wrapped up the paper money and papers and thrust them in and whipped over the open end with her needle. Before

she could get it thoroughly hidden in the pocket of her overalls, Tea Cake burst in again.

"'Tain't no cars, Janie."

"Ah thought not! Whut we gointuh do now?"

"We got tuh walk."

"In all dis weather, Tea Cake? Ah don't b'lieve Ah could make it out de quarters."

"Oh yeah you kin. Me and you and Motor Boat kin all lock arms and hold one 'nother down. Eh, Motor?"

"He's sleep on de bed in yonder," Janie said. Tea Cake called without moving.

"Motor Boat! You better git up from dere! Hell done broke loose in Georgy. Dis minute! How kin you sleep at uh time lak dis? Water knee deep in de yard."

They stepped out in water almost to their buttocks and managed to turn east. Tea Cake had to throw his box away, and Janie saw how it hurt him. Dodging flying missiles, floating dangers, avoiding stepping in holes and warmed on the wind now at their backs until they gained comparatively dry land. They had to fight to keep from being pushed the wrong way and to hold together. They saw other people like themselves struggling along. A house down, here and there, frightened cattle. But above all the drive of the wind and the water. And the lake. Under its multiplied roar could be heard a mighty sound of grinding rock and timber and a wail. They looked back. Saw people trying to run in raging waters and screaming when they found they couldn't. A huge barrier of the makings of the dike to which the cabins had been added was rolling and tumbling forward. Ten feet higher and as far as they could see the muttering wall advanced before the braced-up waters like a road crusher on a cosmic scale. The monstropolous beast had left his bed. The two hundred miles an hour wind had loosed his chains. He seized hold of his dikes and ran

forward until he met the quarters; uprooted them like grass and rushed on after his supposed-to-be conquerors, rolling the dikes, rolling the houses, rolling the people in the houses along with other timbers. The sea was walking the earth with a heavy heel.

"De lake is comin'!" Tea Cake gasped.

"De lake!" In amazed horror from Motor Boat, "De lake!"

"It's comin' behind us!" Janie shuddered. "Us can't fly."

"But we still kin run," Tea Cake shouted and they ran. The gushing water ran faster. The great body was held back, but rivers spouted through fissures in the rolling wall and broke like day. The three fugitives ran past another line of shanties that topped a slight rise and gained a little. They cried out as best they could, "De lake is comin'!" and barred doors flew open and others joined them in flight crying the same as they went. "De lake is comin'!" and the pursuing waters growled and shouted ahead, "Yes, Ah'm comin'!", and those who could fled on.

They made it to a tall house on a hump of ground and Janie said, "Less stop heah. Ah can't make it no further. Ah'm done give out."

"All of us is done give out," Tea Cake corrected. "We'se goin' inside out dis weather, kill or cure." He knocked with the handle of his knife, while they leaned their faces and shoulders against the wall. He knocked once more then he and Motor Boat went round to the back and forced a door. Nobody there.

"Dese people had mo' sense than Ah did," Tea Cake said as they dropped to the floor and lay there panting. "Us oughta went on wid 'Lias lak he ast me."

"You didn't know," Janie contended. "And when yuh don't know, yuh just don't know. De storms might not of come sho nuff."

They went to sleep promptly but Janie woke up first. She heard the sound of rushing water and sat up.

"Tea Cake! Motor Boat! De lake is comin'!"

The lake *was* coming on. Slower and wider, but coming. It had trampled on most of its supporting wall and lowered its front by spreading. But it came muttering and grumbling onward like a tired mammoth just the same.

"Dis is uh high tall house. Maybe it won't reach heah at all," Janie counseled. "And if it do, maybe it won't reach tuh de upstairs part."

"Janie, Lake Okechobee is forty miles wide and sixty miles long. Dat's uh whole heap uh water. If dis wind is shovin' dat whole lake disa way, dis house ain't nothin' tuh swaller. Us better go. Motor Boat!"

"Whut you want, man?"

"De lake is comin'!"

"Aw, naw it 'tain't."

"Yes, it is *so* comin'! Listen! You kin hear it way off."

"It kin jus' come on. Ah'll wait right here."

"Aw, get up, Motor Boat! Less make it tuh de Palm Beach road. Dat's on uh fill. We'se pretty safe dere."

"Ah'm safe here, man. Go ahead if yuh wants to. Ah'm sleepy."

"Whut you gointuh do if de lake reach heah?"

"Go upstairs."

"S'posing it come up dere?"

"Swim, man. Dat's all."

"Well, uh, Good bye, Motor Boat. Everything is pretty bad, yuh know. Us might git missed of one 'nother. You sho is a grand friend fuh uh man tuh have."

"Good bye, Tea Cake. Y'all oughta stay here and sleep, man. No use in goin' off and leavin' me lak dis."

"We don't wanta. Come on wid us. It might be night time when de water hem you up in heah. Dat's how come Ah won't stay. Come on, man."

"Tea Cake, Ah got tuh have mah sleep. Definitely."

"Good bye, then, Motor. Ah wish you all de luck. Goin' over tuh Nassau fuh dat visit widja when all dis is over."

"Definitely, Tea Cake. Mah mama's house is yours."

Tea Cake and Janie were some distance from the house before they struck serious water. Then they had to swim a distance, and Janie could not hold up more than a few strokes at a time, so Tea Cake bore her up till finally they hit a ridge that led on towards the fill. It seemed to him the wind was weakening a little so he kept looking for a place to rest and catch his breath. His wind was gone. Janie was tired and limping, but she had not had to do that hard swimming in the turbulent waters, so Tea Cake was much worse off. But they couldn't stop. Gaining the fill was something but it was no guarantee. The lake was coming. They had to reach the six-mile bridge. It was high and safe perhaps.

Everybody was walking the fill. Hurrying, dragging, falling, crying, calling out names hopefully and hopelessly. Wind and rain beating on old folks and beating on babies. Tea Cake stumbled once or twice in his weariness and Janie held him up. So they reached the bridge at Six Mile Bend and thought to rest.

But it was crowded. White people had preempted that point of elevation and there was no more room. They could climb up one of its high sides and down the other, that was all. Miles further on, still no rest.

They passed a dead man in a sitting position on a hummock, entirely surrounded by wild animals and snakes. Common danger made common friends. Nothing sought a conquest over the other.

Another man clung to a cypress tree on a tiny island. A tin roof of a building hung from the branches by electric wires and the wind swung it back and forth like a mighty ax. The man dared

not move a step to his right lest this crushing blade split him open. He dared not step left for a large rattlesnake was stretched full length with his head in the wind. There was a strip of water between the island and the fill, and the man clung to the tree and cried for help.

"De snake won't bite yuh," Tea Cake yelled to him. "He skeered tuh go intuh uh coil. Skeered he'll be blowed away. Step round dat side and swim off!"

Soon after that Tea Cake felt he couldn't walk anymore. Not right away. So he stretched long side of the road to rest. Janie spread herself between him and the wind and he closed his eyes and let the tiredness seep out of his limbs. On each side of the fill was a great expanse of water like lakes—water full of things living and dead. Things that didn't belong in water. As far as the eye could reach, water and wind playing upon it in fury. A large piece of tar-paper roofing sailed through the air and scudded along the fill until it hung against a tree. Janie saw it with joy. That was the very thing to cover Tea Cake with. She could lean against it and hold it down. The wind wasn't quite so bad as it was anyway. The very thing. Poor Tea Cake!

She crept on hands and knees to the piece of roofing and caught hold of it by either side. Immediately the wind lifted both of them and she saw herself sailing off the fill to the right, out and out over the lashing water. She screamed terribly and released the roofing which sailed away as she plunged downward into the water.

"Tea Cake!" He heard her and sprang up. Janie was trying to swim but fighting water too hard. He saw a cow swimming slowly towards the fill in an oblique line. A massive built dog was sitting on her shoulders and shivering and growling. The cow was approaching Janie. A few strokes would bring her there.

"Make it tuh de cow and grab hold of her tail! Don't use yo' feet. Jus' yo' hands is enough. Dat's right, come on!"

Janie achieved the tail of the cow and lifted her head up along the cow's rump, as far as she could above water. The cow sunk a little with the added load and thrashed a moment in terror. Thought she was being pulled down by a gator. Then she continued on. The dog stood up and growled like a lion, stiff-standing hackles, stiff muscles, teeth uncovered as he lashed up his fury for the charge. Tea Cake split the water like an otter, opening his knife as he dived. The dog raced down the backbone of the cow to the attack and Janie screamed and slipped far back on the tail of the cow, just out of reach of the dog's angry jaws. He wanted to plunge in after her but dreaded the water, somehow. Tea Cake rose out of the water at the cow's rump and seized the dog by the neck. But he was a powerful dog and Tea Cake was over-tired. So he didn't kill the dog with one stroke as he had intended. But the dog couldn't free himself either. They fought and somehow he managed to bite Tea Cake high up on his cheek-bone once. Then Tea Cake finished him and sent him to the bottom to stay there. The cow relieved of a great weight was landing on the fill with Janie before Tea Cake stroked in and crawled weakly upon the fill again.

Janie began to fuss around his face where the dog had bitten him but he said it didn't amount to anything. "He'd uh raised hell though if he had uh grabbed me uh inch higher and bit me in mah eye. Yuh can't buy eyes in de store, yuh know." He flopped to the edge of the fill as if the storm wasn't going on at all. "Lemme rest awhile, then us got tuh make it on intuh town somehow."

It was next day by the sun and the clock when they reached Palm Beach. It was years later by their bodies. Winters and winters of hardship and suffering. The wheel kept turning round and round. Hope, hopelessness and despair. But the storm blew itself out as they approached the city of refuge.

Havoc was there with her mouth wide open. Back in the Everglades the wind had romped among lakes and trees. In the city it had raged among houses and men. Tea Cake and Janie stood on the edge of things and looked over the desolation.

"How kin Ah find uh doctor fuh yo' face in all dis mess?" Janie wailed.

"Ain't got de damn doctor tuh study 'bout. Us needs uh place tuh rest."

A great deal of their money and perseverance and they found a place to sleep. It was just that. No place to live at all. Just sleep. Tea Cake looked all around and sat heavily on the side of the bed.

"Well," he said humbly, "reckon you never 'spected tuh come tuh dis when you took up wid me, didja?"

"Once upon uh time, Ah never 'spected nothin', Tea Cake, but bein' dead from the standin' still and tryin' tuh laugh. But you come 'long and made somethin' outa me. So Ah'm thankful fuh anything we come through together."

"Thanky, Ma'am."

"You was twice noble tuh save me from dat dawg. Tea Cake, Ah don't speck you seen his eyes lak Ah did. He didn't aim tuh jus' bite me, Tea Cake. He aimed tuh kill me stone dead. Ah'm never tuh fuhgit dem eyes. He wuzn't nothin' all over but pure hate. Wonder where he come from?"

"Yeah, Ah did see 'im too. It wuz frightenin'. Ah didn't mean tuh take his hate neither. He had tuh die uh me one. Mah switch blade said it wuz him."

"Po' me, he'd tore me tuh pieces, if it wuzn't fuh you, honey."

"You don't have tuh say, if it wuzn't fuh me, baby, cause Ah'm *heah,* and then Ah want yuh tuh know it's uh man heah."

19

And then again Him-with-the-square-toes had gone back to his house. He stood once more and again in his high flat house without sides to it and without a roof with his soulless sword standing upright in his hand. His pale white horse had galloped over waters, and thundered over land. The time of dying was over. It was time to bury the dead.

"Janie, us been in dis dirty, slouchy place two days now, and dat's too much. Us got tuh git outa dis house and outa dis man's town. Ah never did lak round heah."

"Where we goin', Tea Cake? Dat we don't know."

"Maybe, we could go back up de state, if yuh want tuh go."

"Ah didn't say dat, but if dat is whut you—"

"Naw, Ah ain't said nothin' uh de kind. Ah wuz tryin' not tuh keep you outa yo' comfortable no longer'n you wanted tuh stay."

"If Ah'm in yo' way—"

"Will you lissen at dis woman? Me 'bout tuh bust mah britches tryin' tuh stay wid her and she heah—she oughta be shot wid tacks!"

"All right then, you name somethin' and we'll do it. We kin give it uh poor man's trial anyhow."

"Anyhow Ah done got rested up and de bed bugs is done got

too bold round heah. Ah didn't notice when mah rest wuz broke. Ah'm goin' out and look around and see whut we kin do. Ah'll give *any*thing uh common trial."

"You better stay inside dis house and git some rest. 'Tain't nothin' tuh find out dere nohow."

"But Ah wants tuh look and see, Janie. Maybe it's some kinda work fuh me tuh help do."

"Whut dey want you tuh help do, you ain't gointuh like it. Dey's grabbin' all de menfolks dey kin git dey hands on and makin' 'em help bury de dead. Dey claims dey's after de unemployed, but dey ain't bein' too particular about whether you'se employed or not. You stay in dis house. De Red Cross is doin' all dat kin be done otherwise fuh de sick and de 'fflicted."

"Ah got money on me, Janie. Dey can't bother me. Anyhow Ah wants tuh go see how things is sho nuff. Ah wants tuh see if Ah kin hear anything 'bout de boys from de 'Glades. Maybe dey all come through all right. Maybe not."

Tea Cake went out and wandered around. Saw the hand of horror on everything. Houses without roofs, and roofs without houses. Steel and stone all crushed and crumbled like wood. The mother of malice had trifled with men.

While Tea Cake was standing and looking he saw two men coming towards him with rifles on their shoulders. Two white men, so he thought about what Janie had told him and flexed his knees to run. But in a moment he saw that wouldn't do him any good. They had already seen him and they were too close to miss him if they shot. Maybe they would pass on by. Maybe when they saw he had money they would realize he was not a tramp.

"Hello, there, Jim," the tallest one called out. "We been lookin' fuh you."

"Mah name ain't no Jim," Tea Cake said watchfully. "Whut you been lookin' fuh *me* fuh? Ah ain't done nothin'."

"Dat's whut we want yuh fuh—not doin' nothin'. Come on less go bury some uh dese heah dead folks. Dey ain't gittin' buried fast enough."

Tea Cake hung back defensively. "Whut Ah got tuh do wid dat? Ah'm uh workin' man wid money in mah pocket. Jus' got blowed outa de 'Glades by de storm."

The short man made a quick move with his rifle. "Git on down de road dere, suh! Don't look out somebody'll be buryin' *you!* G'wan in front uh me, suh!"

Tea Cake found that he was part of a small army that had been pressed into service to clear the wreckage in public places and bury the dead. Bodies had to be searched out, carried to certain gathering places and buried. Corpses were not just found in wrecked houses. They were under houses, tangled in shrubbery, floating in water, hanging in trees, drifting under wreckage.

Trucks lined with drag kept rolling in from the 'Glades and other outlying parts, each with its load of twenty-five bodies. Some bodies fully dressed, some naked and some in all degrees of dishevelment. Some bodies with calm faces and satisfied hands. Some dead with fighting faces and eyes flung wide open in wonder. Death had found them watching, trying to see beyond seeing.

Miserable, sullen men, black and white under guard had to keep on searching for bodies and digging graves. A huge ditch was dug across the white cemetery and a big ditch was opened across the black graveyard. Plenty quick-lime on hand to throw over the bodies as soon as they were received. They had already been unburied too long. The men were making every effort to get them covered up as quickly as possible. But the guards stopped them. They had received orders to be carried out.

"Hey, dere, y'all! Don't dump dem bodies in de hole lak dat! Examine every last one of 'em and find out if they's white or black."

"Us got tuh handle 'em slow lak dat? God have mussy! In de

condition they's in got tuh examine 'em? Whut difference do it make 'bout de color? Dey all needs buryin' in uh hurry."

"Got orders from headquarters. They makin' coffins fuh all de white folks. 'Tain't nothin' but cheap pine, but dat's better'n nothin'. Don't dump no white folks in de hole jus' so."

"Whut tuh do 'bout de colored folks? Got boxes fuh dem too?"

"Nope. They cain't find enough of 'em tuh go 'round. Jus' sprinkle plenty quick-lime over 'em and cover 'em up."

"Shucks! Nobody can't tell nothin' 'bout some uh dese bodies, de shape dey's in. Can't tell whether dey's white or black."

The guards had a long conference over that. After a while they came back and told the men, "Look at they hair, when you cain't tell no other way. And don't lemme ketch none uh y'all dumpin' white folks, and don't be wastin' no boxes on colored. They's too hard tuh git holt of right now."

"They's mighty particular how dese dead folks goes tuh judgment," Tea Cake observed to the man working next to him. "Look lak dey think God don't know nothin' 'bout de Jim Crow law."

Tea Cake had been working several hours when the thought of Janie worrying about him made him desperate. So when a truck drove up to be unloaded he bolted and ran. He was ordered to halt on pain of being shot at, but he kept right on and got away. He found Janie sad and crying just as he had thought. They calmed each other about his absence then Tea Cake brought up another matter.

"Janie, us got tuh git outa dis house and outa dis man's town. Ah don't mean tuh work lak dat no mo'."

"Naw, naw, Tea Cake. Less stay right in heah until it's all over. If dey can't see yuh, dey can't bother yuh."

"Aw naw. S'posin' dey come round searchin'? Less git outa heah tuhnight."

"Where us goin', Tea Cake?"

"De quickest place is de 'Glades. Less make it on back down dere. Dis town is full uh trouble and compellment."

"But, Tea Cake, de hurricane wuz down in de 'Glades too. It'll be dead folks tuh be buried down dere too."

"Yeah, Ah know, Janie, but it couldn't never be lak it 'tis heah. In de first place dey been bringin' bodies outa dere all day so it can't be but so many mo' tuh find. And then again it never wuz as many dere as it wuz heah. And then too, Janie, de white folks down dere knows us. It's bad bein' strange niggers wid white folks. Everybody is aginst yuh."

"Dat sho is de truth. De ones de white man know is nice colored folks. De ones he don't know is bad niggers." Janie said this and laughed and Tea Cake laughed with her.

"Janie, Ah done watched it time and time again; each and every white man think he know all de GOOD darkies already. He don't need tuh know no mo'. So far as he's concerned, all dem he don't know oughta be tried and sentenced tuh six months behind de United States privy house at hard smellin'."

"How come de United States privy house, Tea Cake?"

"Well, you know Old Uncle Sam always do have de biggest and de best uh everything. So de white man figger dat anything less than de Uncle Sam's consolidated water closet would be too easy. So Ah means tuh go where de white folks know me. Ah feels lak uh motherless chile round heah."

They got things together and stole out of the house and away. The next morning they were back on the muck. They worked hard all day fixing up a house to live in so that Tea Cake could go out looking for something to do the next day. He got out soon next morning more out of curiosity than eagerness to work. Stayed off all day. That night he came in beaming out with light.

"Who you reckon Ah seen, Janie? Bet you can't guess."

"Ah'll betcha uh fat man you seen Sop-de-Bottom."

"Yeah Ah seen him and Stew Beef and Dockery and 'Lias, and Coodemay and Bootyny. Guess who else!"

"Lawd knows. Is it Sterrett?"

"Naw, he got caught in the rush. 'Lias help bury him in Palm Beach. Guess who else?"

"Ah g'wan tell me, Tea Cake. Ah don't know. It can't be Motor Boat."

"Dat's jus' who it is. Ole Motor! De son of a gun laid up in dat house and slept and de lake come moved de house way off somewhere and Motor didn't know nothin' 'bout it till de storm wuz 'bout over."

"Naw!"

"Yeah man. Heah we nelly kill our fool selves runnin' way from danger and him lay up dere and sleep and float on off!"

"Well, you know dey say luck is uh fortune."

"Dat's right too. Look, Ah got uh job uh work. Help clearin' up things in general, and then dey goin' build dat dike sho nuff. Dat ground got to be cleared off too. Plenty work. Dey needs mo' men even."

So Tea Cake made three hearty weeks. He bought another rifle and a pistol and he and Janie bucked each other as to who was the best shot with Janie ranking him always with the rifle. She could knock the head off of a chicken-hawk sitting up a pine tree. Tea Cake was a little jealous, but proud of his pupil.

About the middle of the fourth week Tea Cake came home early one afternoon complaining of his head. Sick headache that made him lie down for a while. He woke up hungry. Janie had his supper ready but by the time he walked from the bedroom to the table, he said he didn't b'lieve he wanted a thing.

"Thought you tole me you wuz hongry!" Janie wailed.

"Ah thought so too," Tea Cake said very quietly and dropped his head in his hands.

"But Ah done baked yuh uh pan uh beans."

"Ah knows dey's good all right but Ah don't choose nothin' now, Ah thank yuh, Janie."

He went back to bed. Way in the midnight he woke Janie up in his nightmarish struggle with an enemy that was at his throat. Janie struck a light and quieted him.

"Whut's de matter, honey?" She soothed and soothed. "You got tuh tell me so Ah kin feel widja. Lemme bear de pain 'long widja, baby. Where hurt yuh, sugar?"

"Somethin' got after me in mah sleep, Janie." He all but cried, "Tried tuh choke me tuh death. Hadn't been fuh *you* Ah'd be dead."

"You sho wuz strainin' wid it. But you'se all right, honey. Ah'm heah."

He went on back to sleep, but there was no getting around it. He was sick in the morning. He tried to make it but Janie wouldn't hear of his going out at all.

"If Ah kin jus' make out de week," Tea Cake said.

"Folks wuz makin' weeks befo' you wuz born and they goin-tuh be makin' 'em after you'se gone. Lay back down, Tea Cake. Ah'm goin' git de doctor tuh come see 'bout yuh."

"Aw ain't dat bad, Janie. Looka heah! Ah kin walk all over de place."

"But you'se too sick tuh play wid. Plenty fever round heah since de storm."

"Gimme uh drink uh water befo' you leave, then."

Janie dipped up a glass of water and brought it to the bed. Tea Cake took it and filled his mouth then gagged horribly, disgorged that which was in his mouth and threw the glass upon the floor. Janie was frantic with alarm.

"Whut make you ack lak dat wid yo' drinkin' water, Tea Cake? You ast me tuh give it tuh yuh."

"Dat water is somethin' wrong wid it. It nelly choke me tuh death. Ah tole yuh somethin' jumped on me heah last night and choked me. You come makin' out ah wuz dreamin'."

"Maybe it wuz uh witch ridin' yuh, honey. Ah'll see can't Ah find some mustard seed whilst Ah's out. But Ah'm sho tuh fetch de doctor when Ah'm come."

Tea Cake didn't say anything against it and Janie herself hurried off. This sickness to her was worse than the storm. As soon as she was well out of sight, Tea Cake got up and dumped the water bucket and washed it clean. Then he struggled to the irrigation pump and filled it again. He was not accusing Janie of malice and design. He was accusing her of carelessness. She ought to realize that water buckets needed washing like everything else. He'd tell her about it good and proper when she got back. What was she thinking about nohow? He found himself very angry about it. He eased the bucket on the table and sat down to rest before taking a drink.

Finally he dipped up a drink. It was so good and cool! Come to think about it, he hadn't had a drink since yesterday. That was what he needed to give him an appetite for his beans. He found himself wanting it very much, so he threw back his head as he rushed the glass to his lips. But the demon was there before him, strangling, killing him quickly. It was a great relief to expel the water from his mouth. He sprawled on the bed again and lay there shivering until Janie and the doctor arrived. The white doctor who had been around so long that he was part of the muck. Who told the workmen stories with brawny sweaty words in them. He came into the house quickly, hat sitting on the left back corner of his head.

"Hi there, Tea Cake. What de hell's de matter with *you?*"

"Wisht Ah knowed, Doctah Simmons. But Ah sho is sick."

"Ah, naw Tea Cake. 'Tain't a thing wrong that a quart of coon-dick wouldn't cure. You haven't been gettin' yo' right likker lately, eh?" He slapped Tea Cake lustily across his back and Tea Cake tried to smile as he was expected to do. But it was hard. The doctor opened up his bag and went to work.

"You do look a little peaked, Tea Cake. You got a temperature and yo' pulse is kinda off. What you been doin' here lately?"

"Nothin' 'cept workin' and gamin' uh little, doctah. But look lak water done turn't aginst me."

"Water? How do you mean?"

"Can't keep it on mah stomach, at all."

"What else?"

Janie came around the bed full of concern.

"Doctah, Tea Cake ain't tellin' yuh everything lak he oughta. We wuz caught in dat hurricane out heah, and Tea Cake overstrained hisself swimmin' such uh long time and holdin' me up too, and walkin' all dem miles in de storm and then befo' he could git his rest he had tuh come git me out de water agin and fightin' wid dat big ole dawg and de dawg bitin' 'im in de face and everything. Ah been spectin' him tuh be sick befo' now."

"Dawg bit 'im, did you say?"

"Aw twudn't nothin' much, doctah. It wuz all healed over in two three days," Tea Cake said impatiently. "Dat been over uh month ago, nohow. Dis is somethin' new, doctah. Ah figgers de water is yet bad. It's bound tuh be. Too many dead folks been in it fuh it tuh be good tuh drink fuh uh long time. Dat's de way Ah figgers it anyhow."

"All right, Tea Cake. Ah'll send you some medicine and tell Janie how tuh take care of you. Anyhow, I want you in a bed by yo'self until you hear from me. Just you keep Janie out of yo' bed for awhile, hear? Come on out to the car with me, Janie. I want to send Tea Cake some pills to take right away."

Outside he fumbled in his bag and gave Janie a tiny bottle with a few pellets inside.

"Give him one of these every hour to keep him quiet, Janie, and stay out of his way when he gets in one of his fits of gagging and choking."

"How you know he's havin' 'em, doctah? Dat's jus' what Ah come out heah tuh tell yuh."

"Janie, I'm pretty sure that was a mad dawg bit yo' husband. It's too late to get hold of de dawg's head. But de symptoms is all there. It's mighty bad dat it's gone on so long. Some shots right after it happened would have fixed him right up."

"You mean he's liable tuh die, doctah?"

"Sho is. But de worst thing is he's liable tuh suffer somethin' awful befo' he goes."

"Doctor, Ah loves him fit tuh kill. Tell me anything tuh do and Ah'll do it."

"'Bout de only thing you can do, Janie, is to put him in the County Hospital where they can tie him down and look after him."

"But he don't like no hospital at all. He'd think Ah wuz tired uh doin' fuh 'im, when God knows Ah ain't. Ah can't stand de idea us tyin' Tea Cake lak he wuz uh mad dawg."

"It almost amounts to dat, Janie. He's got almost no chance to pull through and he's liable to bite somebody else, specially you, and then you'll be in the same fix he's in. It's mighty bad."

"Can't nothin' be done fuh his case, doctah? Us got plenty money in de bank in Orlandah, doctah. See can't yuh do some-thin' special tuh save him. Anything it cost, doctah, Ah don't keer, but please, doctah."

"Do what I can. Ah'll phone into Palm Beach right away for the serum which he should have had three weeks ago. I'll do all I can to save him, Janie. But it looks too late. People in

his condition can't swallow water, you know, and in other ways it's terrible."

Janie fooled around outside awhile to try and think it wasn't so. If she didn't see the sickness in his face she could imagine it wasn't really happening. Well, she thought, that big old dawg with the hatred in his eyes had killed her after all. She wished she had slipped off that cow-tail and drowned then and there and been done. But to kill her through Tea Cake was too much to bear. Tea Cake, the son of Evening Sun, had to die for loving her. She looked hard at the sky for a long time. Somewhere up there beyond blue ether's bosom sat He. Was He noticing what was going on around here? He must be because He knew everything. Did He *mean* to do this thing to Tea Cake and her? It wasn't anything she could fight. She could only ache and wait. Maybe it was some big tease and when He saw it had gone far enough He'd give her a sign. She looked hard for something up there to move for a sign. A star in the daytime, maybe, or the sun to shout, or even a mutter of thunder. Her arms went up in a desperate supplication for a minute. It wasn't exactly pleading, it was asking questions. The sky stayed hard looking and quiet so she went inside the house. God would do less than He had in His heart.

Tea Cake was lying with his eyes closed and Janie hoped he was asleep. He wasn't. A great fear had took hold of him. What was this thing that set his brains afire and grabbed at his throat with iron fingers? Where did it come from and why did it hang around him? He hoped it would stop before Janie noticed anything. He wanted to try to drink water again but he didn't want her to see him fail. As soon as she got out of the kitchen he meant to go to the bucket and drink right quick before anything had time to stop him. No need to worry Janie, until he couldn't help it. He heard her cleaning out the stove and saw her go out back to empty the ashes. He leaped at the bucket at once. But this time

the sight of the water was enough. He was on the kitchen floor in great agony when she returned. She petted him, soothed him, and got him back to bed. She made up her mind to go see about that medicine from Palm Beach. Maybe she could find somebody to drive over there for it.

"Feel better now, Tea Cake, baby chile?"

"Uh huh, uh little."

"Well, b'lieve Ah'll rake up de front yard. De mens is got cane chewin's and peanut hulls all over de place. Don't want de doctah tuh come back heah and find it still de same."

"Don't take too long, Janie. Don't lak tuh be by mahself when Ah'm sick."

She ran down the road just as fast as she could. Halfway to town she met Sop-de-Bottom and Dockery coming towards her.

"Hello, Janie, how's Tea Cake?"

"Pretty bad off. Ah'm gointuh see 'bout medicine fuh 'im right now."

"Doctor told somebody he wuz sick so us come tuh see. Thought somethin' he never come tuh work."

"Y'all set wid 'im till Ah git back. He need de company right long in heah."

She fanned on down the road to town and found Dr. Simmons. Yes, he had had an answer. They didn't have any serum but they had wired Miami to send it. She needn't worry. It would be there early the next morning if not before. People didn't fool around in a case like that. No, it wouldn't do for her to hire no car to go after it. Just go home and wait. That was all. When she reached home the visitors rose to go.

When they were alone Tea Cake wanted to put his head in Janie's lap and tell her how he felt and let her mama him in her sweet way. But something Sop had told him made his tongue lie cold and heavy like a dead lizard between his jaws. Mrs. Turner's

brother was back on the muck and now he had this mysterious sickness. People didn't just take sick like this for nothing.

"Janie, whut is dat Turner woman's brother doin' back on de muck?"

"Ah don't know, Tea Cake. Didn't even knowed he wuz back."

"Accordin' tuh mah notion, you did. Whut you slip off from me just now for?"

"Tea Cake, Ah don't lak you astin' me no sich question. Dat shows how sick you is sho nuff. You'se jealous 'thout me givin' you cause."

"Well, whut didja slip off from de house 'thout tellin' me you wuz goin'. You ain't never done dat befo'."

"Dat wuz cause Ah wuz tryin' not tuh let yuh worry 'bout yo' condition. De doctah sent after some mo' medicine and Ah went tuh see if it come."

Tea Cake began to cry and Janie hovered him in her arms like a child. She sat on the side of the bed and sort of rocked him back to peace.

"Tea Cake, 'tain't no use in you bein' jealous uh me. In de first place Ah couldn't love nobody but yuh. And in de second place, Ah jus' uh ole woman dat nobody don't want but you."

"Naw, you ain't neither. You only sound ole when you tell folks when you wuz born, but wid de eye you'se young enough tuh suit most any man. Dat ain't no lie. Ah knows plenty mo' men would take yuh and work hard fuh de privilege. Ah done heard 'em talk."

"Maybe so, Tea Cake, Ah ain't never tried tuh find out. Ah jus' know dat God snatched me out de fire through you. And Ah loves yuh and feel glad."

"Thank yuh, ma'am, but don't say you'se ole. You'se uh lil girl baby all de time. God made it so you spent yo' ole age first

wid somebody else, and saved up yo' young girl days to spend wid me."

"Ah feel dat uh way too, Tea Cake, and Ah thank yuh fuh sayin' it."

"'Tain't no trouble tuh say whut's already so. You'se uh pretty woman outside uh bein' nice."

"Aw, Tea Cake."

"Yeah you is too. Everytime Ah see uh patch uh roses uh somethin' over sportin' they selves makin' out they pretty, Ah tell 'em 'Ah want yuh tuh see mah Janie sometime.' You must let de flowers see yuh sometimes, heah, Janie?"

"You keep dat up, Tea Cake, Ah'll b'lieve yuh after while," Janie said archly and fixed him back in bed. It was then she felt the pistol under the pillow. It gave her a quick ugly throb, but she didn't ask him about it since he didn't say. Never had Tea Cake slept with a pistol under his head before. "Neb' mind 'bout all dat cleanin' round de front yard," he told her as she straightened up from fixing the bed. "You stay where Ah kin see yuh."

"All right, Tea Cake, jus' as you say."

"And if Mis' Turner's lap-legged brother come prowlin' by heah you kin tell 'im Ah got him stopped wid four wheel brakes. 'Tain't no need of him standin' 'round watchin' de job."

"Ah won't be tellin' 'im nothin' 'cause Ah don't expect tuh see 'im."

Tea Cake had two bad attacks that night. Janie saw a changing look come in his face. Tea Cake was gone. Something else was looking out of his face. She made up her mind to be off after the doctor with the first glow of day. So she was up and dressed when Tea Cake awoke from the fitful sleep that had come to him just before day. He almost snarled when he saw her dressed to go.

"Where are you goin', Janie?"

"After de doctor, Tea Cake. You'se too sick tuh be heah in dis

house 'thout de doctah. Maybe we oughta git yuh tuh de hospital."

"Ah ain't goin' tuh no hospital no where. Put dat in yo' pipe and smoke it. Guess you tired uh waitin' on me and doing fuh me. Dat ain't de way Ah been wid *you*. Ah never is been able tuh do enough fuh yuh."

"Tea Cake, you'se sick. You'se takin' everything in de way Ah don't mean it. Ah couldn't never be tired uh waitin' on you. Ah'm just skeered you'se too sick fuh me tuh handle. Ah wants yuh tuh git well, honey. Dat's all."

He gave her a look full of blank ferocity and gurgled in his throat. She saw him sitting up in bed and moving about so that he could watch her every move. And she was beginning to feel fear of this strange thing in Tea Cake's body. So when he went out to the outhouse she rushed to see if the pistol was loaded. It was a six shooter and three of the chambers were full. She started to unload it but she feared he might break it and find out she knew. That might urge his disordered mind to action. If that medicine would only come! She whirled the cylinder so that if he even did draw the gun on her it would snap three times before it would fire. She would at least have warning. She could either run or try to take it away before it was too late. Anyway Tea Cake wouldn't hurt *her*. He was jealous and wanted to scare her. She'd just be in the kitchen as usual and never let on. They'd laugh over it when he got well. She found the box of cartridges, however, and emptied it. Just as well to take the rifle from back of the head of the bed. She broke it and put the shell in her apron pocket and put it in a corner in the kitchen almost behind the stove where it was hard to see. She could outrun his knife if it came to that. Of course she was too fussy, but it did no harm to play safe. She ought not to let poor sick Tea Cake do something that would run him crazy when he found out what he had done.

She saw him coming from the outhouse with a queer loping

gait, swinging his head from side to side and his jaws clenched in a funny way. This was too awful! Where was Dr. Simmons with that medicine? She was glad she was here to look after him. Folks would do such mean things to her Tea Cake if they saw him in such a fix. Treat Tea Cake like he was some mad dog when nobody in the world had more kindness about them. All he needed was for the doctor to come on with that medicine. He came back into the house without speaking, in fact, he did not seem to notice she was there and fell heavily into the bed and slept. Janie was standing by the stove washing up the dishes when he spoke to her in a queer cold voice.

"Janie, how come you can't sleep in de same bed wid me no mo'?"

"De doctah told you tuh sleep by yo'self, Tea Cake. Don't yuh remember him tellin' you dat yistiddy?"

"How come you ruther sleep on uh pallet than tuh sleep in de bed wid me?" Janie saw then that he had the gun in his hand that was hanging to his side. "Answer me when Ah speak."

"Tea Cake, Tea Cake, honey! Go lay down! Ah'll be too glad tuh be in dere wid yuh de minute de doctor say so. Go lay back down. He'll be heah wid some new medicine right away."

"Janie, Ah done went through everything tuh be good tuh you and it hurt me tuh mah heart tuh be ill treated lak Ah is."

The gun came up unsteadily but quickly and leveled at Janie's breast. She noted that even in his delirium he took good aim. Maybe he would point to scare her, that was all.

The pistol snapped once. Instinctively Janie's hand flew behind her on the rifle and brought it around. Most likely this would scare him off. If only the doctor would come! If anybody at all would come! She broke the rifle deftly and shoved in the shell as the second click told her that Tea Cake's suffering brain was urging him on to kill.

"Tea Cake, put down dat gun and go back tuh bed!" Janie yelled at him as the gun wavered weakly in his hand.

He steadied himself against the jamb of the door and Janie thought to run into him and grab his arm, but she saw the quick motion of taking aim and heard the click. Saw the ferocious look in his eyes and went mad with fear as she had done in the water that time. She threw up the barrel of the rifle in frenzied hope and fear. Hope that he'd see it and run, desperate fear for her life. But if Tea Cake could have counted costs he would not have been there with the pistol in his hands. No knowledge of fear nor rifles nor anything else was there. He paid no more attention to the pointing gun than if it were Janie's dog finger. She saw him stiffen himself all over as he leveled and took aim. The fiend in him must kill and Janie was the only thing living he saw.

The pistol and the rifle rang out almost together. The pistol just enough after the rifle to seem its echo. Tea Cake crumpled as his bullet buried itself in the joist over Janie's head. Janie saw the look on his face and leaped forward as he crashed forward in her arms. She was trying to hover him as he closed his teeth in the flesh of her forearm. They came down heavily like that. Janie struggled to a sitting position and pried the dead Tea Cake's teeth from her arm.

It was the meanest moment of eternity. A minute before she was just a scared human being fighting for its life. Now she was her sacrificing self with Tea Cake's head in her lap. She had wanted him to live so much and he was dead. No hour is ever eternity, but it has its right to weep. Janie held his head tightly to her breast and wept and thanked him wordlessly for giving her the chance for loving service. She had to hug him tight for soon he would be gone, and she had to tell him for the last time. Then the grief of outer darkness descended.

So that same day of Janie's great sorrow she was in jail. And

when the doctor told the sheriff and the judge how it was, they all said she must be tried that same day. No need to punish her in jail by waiting. Three hours in jail and then they set the court for her case. The time was short and everything, but sufficient people were there. Plenty of white people came to look on this strangeness. And all the Negroes for miles around. Who was it didn't know about the love between Tea Cake and Janie?

The court set and Janie saw the judge who had put on a great robe to listen about her and Tea Cake. And twelve more white men had stopped whatever they were doing to listen and pass on what happened between Janie and Tea Cake Woods, and as to whether things were done right or not. That was funny too. Twelve strange men who didn't know a thing about people like Tea Cake and her were going to sit on the thing. Eight or ten white women had come to look at her too. They wore good clothes and had the pinky color that comes of good food. They were nobody's poor white folks. What need had *they* to leave their richness to come look on Janie in her overalls? But they didn't seem too mad, Janie thought. It would be nice if she could make *them* know how it was instead of those menfolks. Oh, and she hoped that undertaker was fixing Tea Cake up fine. They ought to let her go see about it. Yes, and there was Mr. Prescott that she knew right well and he was going to tell the twelve men to kill her for shooting Tea Cake. And a strange man from Palm Beach who was going to ask them not to kill her, and none of them knew.

Then she saw all of the colored people standing up in the back of the courtroom. Packed tight like a case of celery, only much darker than that. They were all against her, she could see. So many were there against her that a light slap from each one of them would have beat her to death. She felt them pelting her with dirty thoughts. They were there with their tongues cocked

and loaded, the only real weapon left to weak folks. The only killing tool they are allowed to use in the presence of white folks.

So it was all ready after a while and they wanted people to talk so that they could know what was right to do about Janie Woods, the relic of Tea Cake's Janie. The white part of the room got calmer the more serious it got, but a tongue storm struck the Negroes like wind among palm trees. They talked all of a sudden and all together like a choir and the top parts of their bodies moved on the rhythm of it. They sent word by the bailiff to Mr. Prescott they wanted to testify in the case. Tea Cake was a good boy. He had been good to that woman. No nigger woman ain't never been treated no better. Naw suh! He worked like a dog for her and nearly killed himself saving her in the storm, then soon as he got a little fever from the water, she had took up with another man. Sent for him to come there from way off. Hanging was too good. All they wanted was a chance to testify. The bailiff went up and the sheriff and the judge, and the police chief, and the lawyers all came together to listen for a few minutes, then they parted again and the sheriff took the stand and told how Janie had come to his house with the doctor and how he found things when he drove out to hers.

Then they called Dr. Simmons and he told about Tea Cake's sickness and how dangerous it was to Janie and the whole town, and how he was scared for her and thought to have Tea Cake locked up in the jail, but seeing Janie's care he neglected to do it. And how he found Janie all bit in the arm, sitting on the floor and petting Tea Cake's head when he got there. And the pistol right by his hand on the floor. Then he stepped down.

"Any further evidence to present, Mr. Prescott?" the judge asked.

"No, Your Honor. The State rests."

The palm tree dance began again among the Negroes in the back. They had come to talk. The State couldn't rest until it heard.

"Mistah Prescott, Ah got somethin' tuh say," Sop-de-Bottom spoke out anonymously from the anonymous herd.

The courtroom swung round on itself to look.

"If you know what's good for you, you better shut your mouth up until somebody calls you," Mr. Prescott told him coldly.

"Yassuh, Mr. Prescott."

"We are handling this case. Another word out of *you*, out of any of you niggers back there, and I'll bind you over to the big court."

"Yassuh."

The white women made a little applause and Mr. Prescott glared at the back of the house and stepped down. Then the strange white man that was going to talk for her got up there. He whispered a little with the clerk and then called on Janie to take the stand and talk. After a few little questions he told her to tell just how it happened and to speak the truth, the whole truth and nothing but the truth. So help her God.

They all leaned over to listen while she talked. First thing she had to remember was she was not at home. She was in the courthouse fighting something and it wasn't death. It was worse than that. It was lying thoughts. She had to go way back to let them know how she and Tea Cake had been with one another so they could see she could never shoot Tea Cake out of malice.

She tried to make them see how terrible it was that things were fixed so that Tea Cake couldn't come back to himself until he had got rid of that mad dog that was in him and he couldn't get rid of the dog and live. He had to die to get rid of the dog. But she hadn't wanted to kill him. A man is up against a hard game when he must die to beat it. She made them see how she couldn't ever want to be rid of him. She didn't plead to anybody. She just sat there and told and when she was through she hushed. She had been through for some time before the judge and the

lawyer and the rest seemed to know it. But she sat on in that trial chair until the lawyer told her she could come down.

"The defense rests," her lawyer said. Then he and Prescott whispered together and both of them talked to the judge in secret up high there where he sat. Then they both sat down.

"Gentlemen of the jury, it is for you to decide whether the defendant has committed a cold blooded murder or whether she is a poor broken creature, a devoted wife trapped by unfortunate circumstances who really in firing a rifle bullet into the heart of her late husband did a great act of mercy. If you find her a wanton killer you must bring in a verdict of first degree murder. If the evidence does not justify that then you must set her free. There is no middle course."

The jury filed out and the courtroom began to drone with talk, a few people got up and moved about. And Janie sat like a lump and waited. It was not death she feared. It was misunderstanding. If they made a verdict that she didn't want Tea Cake and wanted him dead, then that was a real sin and a shame. It was worse than murder. Then the jury was back again. Out five minutes by the courthouse clock.

"We find the death of Vergible Woods to be entirely accidental and justifiable, and that no blame should rest upon the defendant Janie Woods."

So she was free and the judge and everybody up there smiled with her and shook her hand. And the white women cried and stood around her like a protecting wall and the Negroes, with heads hung down, shuffled out and away. The sun was almost down and Janie had seen the sun rise on her troubled love and then she had shot Tea Cake and had been in jail and had been tried for her life and now she was free. Nothing to do with the little that was left of the day but to visit the kind white friends who had realized her feelings and thank them. So the sun went down.

She took a room at the boarding house for the night and heard the men talking around the front.

"Aw you know dem white mens wuzn't gointuh do nothin' tuh no woman dat look lak her."

"She didn't kill no white man, did she? Well, long as she don't shoot no white man she kin kill jus' as many niggers as she please."

"Yeah, de nigger women kin kill up all de mens dey wants tuh, but you bet' not kill one uh dem. De white folks will sho hang yuh if yuh do."

"Well, you know whut dey say 'uh white man and uh nigger woman is de freest thing on earth.' Dey do as dey please."

Janie buried Tea Cake in Palm Beach. She knew he loved the 'Glades but it was too low for him to lie with water maybe washing over him with every heavy rain. Anyway, the 'Glades and its waters had killed him. She wanted him out of the way of storms, so she had a strong vault built in the cemetery at West Palm Beach. Janie had wired to Orlando for money to put him away. Tea Cake was the son of Evening Sun, and nothing was too good. The Undertaker did a handsome job and Tea Cake slept royally on his white silken couch among the roses she had bought. He looked almost ready to grin. Janie bought him a brand new guitar and put it in his hands. He would be thinking up new songs to play to her when she got there.

Sop and his friends had tried to hurt her but she knew it was because they loved Tea Cake and didn't understand. So she sent Sop word and to all the others through him. So the day of the funeral they came with shame and apology in their faces. They wanted her quick forgetfulness. So they filled up and overflowed the ten sedans that Janie had hired and added others to the line. Then the band played, and Tea Cake rode like a Pharaoh to his tomb. No expensive veils and robes for Janie this time. She went on in her overalls. She was too busy feeling grief to dress like grief.

20

Because they really loved Janie just a little less than they had loved Tea Cake, and because they wanted to think well of themselves, they wanted their hostile attitude forgotten. So they blamed it all on Mrs. Turner's brother and ran him off the muck again. They'd show him about coming back there posing like he was good looking and putting himself where men's wives could look at him. Even if they didn't look it wasn't his fault, he had put himself in the way.

"Naw, Ah ain't mad wid Janie," Sop went around explaining. "Tea Cake had done gone crazy. You can't blame her for puhtectin' herself. She wuz crazy 'bout 'im. Look at de way she put him away. Ah ain't got anything in mah heart aginst her. And Ah never woulda thought uh thing, but de very first day dat laplegged nigger come back heah makin' out he wuz lookin' fuh work, he come astin' me 'bout how wuz Mr. and Mrs. Woods makin' out. Dat goes tuh show yuh he wuz up tuh somethin'."

"So when Stew Beef and Bootyny and some of de rest of 'em got behind 'im he come runnin' tuh me tuh save 'im. Ah told 'im, don't come tuh *me* wid yo' hair blowin' back, 'cause, Ah'm goin-tuh send yuh, and Ah sho did. De bitches' baby!" That was enough, they eased their feelings by beating him and running him

off. Anyway, their anger against Janie had lasted two whole days and that was too long to keep remembering anything. Too much of a strain.

They had begged Janie to stay on with them and she had stayed a few weeks to keep them from feeling bad. But the muck meant Tea Cake and Tea Cake wasn't there. So it was just a great expanse of black mud. She had given away everything in their little house except a package of garden seed that Tea Cake had bought to plant. The planting never got done because he had been waiting for the right time of the moon when his sickness overtook him. The seeds reminded Janie of Tea Cake more than anything else because he was always planting things. She had noticed them on the kitchen shelf when she came home from the funeral and had put them in her breast pocket. Now that she was home, she meant to plant them for remembrance.

Janie stirred her strong feet in the pan of water. The tiredness was gone so she dried them off on the towel.

"Now, dat's how everything wuz, Pheoby, jus' lak Ah told yuh. So Ah'm back home agin and Ah'm satisfied tuh be heah. Ah done been tuh de horizon and back and now Ah kin set heah in mah house and live by comparisons. Dis house ain't so absent of things lak it used tuh be befo' Tea Cake come along. It's full uh thoughts, 'specially dat bedroom.

"Ah know all dem sitters-and-talkers gointuh worry they guts into fiddle strings till dey find out whut we been talkin' 'bout. Dat's all right, Pheoby, tell 'em. Dey gointuh make 'miration 'cause mah love didn't work lak they love, if dey ever had any. Then you must tell 'em dat love ain't somethin' lak uh grindstone dat's de same thing everywhere and do de same thing tuh everything it touch. Love is lak de sea. It's uh movin' thing, but still and all, it takes its shape from de shore it meets, and it's different with every shore."

"Lawd!" Pheoby breathed out heavily, "Ah done growed ten feet higher from jus' listenin' tuh you, Janie. Ah ain't satisfied wid mahself no mo'. Ah means tuh make Sam take me fishin' wid him after this. Nobody better not criticize yuh in mah hearin'."

"Now, Pheoby, don't feel too mean wid de rest of 'em 'cause dey's parched up from not knowin' things. Dem meatskins is *got* tuh rattle tuh make out they's alive. Let 'em consolate theyselves wid talk. 'Course, talkin' don't amount tuh uh hill uh beans when yuh can't do nothin' else. And listenin' tuh dat kind uh talk is jus' lak openin' yo' mouth and lettin' de moon shine down yo' throat. It's uh known fact, Pheoby, you got tuh *go* there tuh *know* there. Yo' papa and yo' mama and nobody else can't tell yuh and show yuh. Two things everybody's got tuh do fuh theyselves. They got tuh go tuh God, and they got tuh find out about livin' fuh theyselves."

There was a finished silence after that so that for the first time they could hear the wind picking at the pine trees. It made Pheoby think of Sam waiting for her and getting fretful. It made Janie think about that room upstairs—her bedroom. Pheoby hugged Janie real hard and cut the darkness in flight.

Soon everything around downstairs was shut and fastened. Janie mounted the stairs with her lamp. The light in her hand was like a spark of sun-stuff washing her face in fire. Her shadow behind fell black and headlong down the stairs. Now, in her room, the place tasted fresh again. The wind through the open windows had broomed out all the fetid feeling of absence and nothingness. She closed in and sat down. Combing road-dust out of her hair. Thinking.

The day of the gun, and the bloody body, and the court-house came and commenced to sing a sobbing sigh out of every corner in the room; out of each and every chair and thing. Commenced to sing, commenced to sob and sigh, singing and sob-

bing. Then Tea Cake came prancing around her where she was and the song of the sigh flew out of the window and lit in the top of the pine trees. Tea Cake, with the sun for a shawl. Of course he wasn't dead. He could never be dead until she herself had finished feeling and thinking. The kiss of his memory made pictures of love and light against the wall. Here was peace. She pulled in her horizon like a great fish-net. Pulled it from around the waist of the world and draped it over her shoulder. So much of life in its meshes! She called in her soul to come and see.

Afterword

Zora Neale Hurston:
"A Negro Way of Saying"

I.

The Reverend Harry Middleton Hyatt, an Episcopal priest whose five-volume classic collection, *Hoodoo, Conjuration, Witchcraft, and Rootwork,* more than amply returned an investment of forty years' research, once asked me during an interview in 1977 what had become of another eccentric collector whom he admired. "I met her in the field in the thirties. I think," he reflected for a few seconds, "that her first name was Zora." It was an innocent question, made reasonable by the body of confused and often contradictory rumors that make Zora Neale Hurston's own legend as richly curious and as dense as are the black myths she did so much to preserve in her classic anthropological works, *Mules and Men* and *Tell My Horse,* and in her fiction.

A graduate of Barnard, where she studied under Franz Boas, Zora Neale Hurston published seven books—four novels, two books of folklore, and an autobiography—and more than fifty shorter works between the middle of the Harlem Renaissance and

the end of the Korean War, when she was the dominant black woman writer in the United States. The dark obscurity into which her career then lapsed reflects her staunchly independent political stances rather than any deficiency of craft or vision. Virtually ignored after the early fifties, even by the Black Arts movement in the sixties, an otherwise noisy and intense spell of black image- and myth-making that rescued so many black writers from remaindered oblivion, Hurston embodied a more or less harmonious but nevertheless problematic unity of opposites. It is this complexity that refuses to lend itself to the glib categories of "radical" or "conservative," "black" or "Negro," "revolutionary" or "Uncle Tom"—categories of little use in literary criticism. It is this same complexity, embodied in her fiction, that, until Alice Walker published her important essay ("In Search of Zora Neale Hurston") in *Ms.* magazine in 1975, had made Hurston's place in black literary history an ambiguous one at best.

The rediscovery of Afro-American writers has usually turned on larger political criteria, of which the writer's work is supposedly a mere reflection. The deeply satisfying aspect of the rediscovery of Zora Neale Hurston is that black women generated it primarily to establish a maternal literary ancestry. Alice Walker's moving essay recounts her attempts to find Hurston's unmarked grave in the Garden of the Heavenly Rest, a segregated cemetery in Fort Pierce, Florida. Hurston became a metaphor for the black woman writer's search for tradition. The craft of Alice Walker, Gayl Jones, Gloria Naylor, and Toni Cade Bambara bears, in markedly different ways, strong affinities with Hurston's. Their attention to Hurston signifies a novel sophistication in black literature: they read Hurston not only for the spiritual kinship inherent in such relations but because she used black vernacular speech and rituals, in ways subtle and various, to chart the coming to consciousness of black women, so glaringly absent in other

black fiction. This use of the vernacular became the fundamental framework for all but one of her novels and is particularly effective in her classic work *Their Eyes Were Watching God*, published in 1937, which is more closely related to Henry James's *The Portrait of a Lady* and Jean Toomer's *Cane* than to Langston Hughes's and Richard Wright's proletarian literature, so popular in the Depression.

The charting of Janie Crawford's fulfillment as an autonomous imagination, *Their Eyes* is a lyrical novel that correlates the need of her first two husbands for ownership of progressively larger physical space (and the gaudy accoutrements of upward mobility) with the suppression of self-awareness in their wife. Only with her third and last lover, a roustabout called Tea Cake whose unstructured frolics center around and about the Florida swamps, does Janie at last bloom, as does the large pear tree that stands beside her grandmother's tiny log cabin.

> She saw a dust bearing bee sink into the sanctum of a bloom;
> the thousand sister calyxes arch to meet the love embrace and
> the ecstatic shiver of the tree from root to tiniest branch cream-
> ing in every blossom and frothing with delight. So this was a
> marriage!

To plot Janie's journey from object to subject, the narrative of the novel shifts from third to a blend of first and third person (known as "free indirect discourse"), signifying this awareness of self in Janie. *Their Eyes* is a bold feminist novel, the first to be explicitly so in the Afro-American tradition. Yet in its concern with the project of finding a voice, with language as an instrument of injury and salvation, of selfhood and empowerment, it suggests many of the themes that inspirit Hurston's oeuvre as a whole.

II.

One of the most moving passages in American literature is Zora Neale Hurston's account of her last encounter with her dying mother, found in a chapter entitled "Wandering" in her autobiography, *Dust Tracks on a Road* (1942):

> As I crowded in, they lifted up the bed and turned it around so that Mama's eyes would face east. I thought that she looked to me as the head of the bed reversed. Her mouth was slightly open, but her breathing took up so much of her strength that she could not talk. But she looked at me, or so I felt, to speak for her. She depended on me for a voice.

We can begin to understand the rhetorical distance that separated Hurston from her contemporaries if we compare this passage with a similar scene published just three years later in *Black Boy* by Richard Wright, Hurston's dominant black male contemporary and rival: "Once, in the night, my mother called me to her bed and told me that she could not endure the pain, and she wanted to die. I held her hand and begged her to be quiet. That night I ceased to react to my mother; my feelings were frozen." If Hurston represents her final moments with her mother in terms of the search for voice, then Wright attributes to a similar experience a certain "somberness of spirit that I was never to lose," which "grew into a symbol in my mind, gathering to itself . . . the poverty, the ignorance, the helplessness. . . ." Few authors in the black tradition have less in common than Zora Neale Hurston and Richard Wright. And whereas Wright would reign through the forties as our predominant author, Hurston's fame reached its zenith in 1943 with a *Saturday Review* cover story honoring the success of *Dust Tracks*. Seven years later, she would be serving as a maid in Rivo Alto, Florida; ten years after that she would die in the County Welfare Home in Fort Pierce, Florida.

How could the recipient of two Guggenheims and the author of four novels, a dozen short stories, two musicals, two books on black mythology, dozens of essays, and a prizewinning autobiography virtually "disappear" from her readership for three full decades? There are no easy answers to this quandary, despite the concerted attempts of scholars to resolve it. It is clear, however, that the loving, diverse, and enthusiastic responses that Hurston's work engenders today were not shared by several of her influential black male contemporaries. The reasons for this are complex and stem largely from what we might think of as their "racial ideologies."

Part of Hurston's received heritage—and perhaps the paramount received notion that links the novel of manners in the Harlem Renaissance, the social realism of the thirties, and the cultural nationalism of the Black Arts movement—was the idea that racism had reduced black people to mere ciphers, to beings who only react to an omnipresent racial oppression, whose culture is "deprived" where different, and whose psyches are in the main "pathological." Albert Murray, the writer and social critic, calls this "the Social Science Fiction Monster." Socialists, separatists, and civil rights advocates alike have been devoured by this beast.

Hurston thought this idea degrading, its propagation a trap, and railed against it. It was, she said, upheld by "the sobbing school of Negrohood who hold that nature somehow has given them a dirty deal." Unlike Hughes and Wright, Hurston chose deliberately to ignore this "false picture that distorted. . . ." Freedom, she wrote in *Moses, Man of the Mountain,* "was something internal. . . . The man himself must make his own emancipation." And she declared her first novel a manifesto against the "arrogance" of whites assuming that "black lives are only defensive reactions to white actions." Her strategy was not calculated to please.

What we might think of as Hurston's mythic realism, lush and dense within a lyrical black idiom, seemed politically retrograde to the proponents of a social or critical realism. If Wright, Ellison, Brown, and Hurston were engaged in a battle over ideal fictional modes with which to represent the Negro, clearly Hurston lost the battle.

But not the war.

After Hurston and her choice of style for the black novel were silenced for nearly three decades, what we have witnessed since is clearly a marvelous instance of the return of the repressed. For Zora Neale Hurston has been "rediscovered" in a manner unprecedented in the black tradition: several black women writers, among whom are some of the most accomplished writers in America today, have openly turned to her works as sources of narrative strategies, to be repeated, imitated, and revised, in acts of textual bonding. Responding to Wright's critique, Hurston claimed that she had wanted at long last to write a black novel, and "not a treatise on sociology." It is this urge that resonates in Toni Morrison's *Song of Solomon* and *Beloved,* and in Walker's depiction of Hurston as our prime symbol of "racial health—a sense of black people as complete, complex, *undiminished* human beings, a sense that is lacking in so much black writing and literature." In a tradition in which male authors have ardently denied black literary paternity, this is a major development, one that heralds the refinement of our notion of tradition: Zora and her daughters are a tradition-within-the-tradition, a black woman's voice.

The resurgence of popular and academic readerships of Hurston's works signifies her multiple canonization in the black, the American, and the feminist traditions. Within the critical establishment, scholars of every stripe have found in Hurston texts for all seasons. More people have read Hurston's works since 1975 than did between that date and the publication of her first novel, in 1934.

III.

Rereading Hurston, I am always struck by the density of intimate experiences she cloaked in richly elaborated imagery. It is this concern for the figurative capacity of black language, for what a character in *Mules and Men* calls "a hidden meaning, jus' like de Bible . . . de inside meanin' of words," that unites Hurston's anthropological studies with her fiction. For the folklore Hurston collected so meticulously as Franz Boas's student at Barnard became metaphors, allegories, and performances in her novels, the traditional recurring canonical metaphors of black culture. Always more of a novelist than a social scientist, even Hurston's academic collections center on the quality of imagination that makes these lives whole and splendid. But it is in the novel that Hurston's use of the black idiom realizes its fullest effect. In *Jonah's Gourd Vine*, her first novel, for instance, the errant preacher, John, as described by Robert Hemenway "is a poet who graces his world with language but cannot find the words to secure his own personal grace." This concern for language and for the "natural" poets who "bring barbaric splendor of word and song into the very camp of the mockers" not only connects her two disciplines but also makes of "the suspended linguistic moment" a thing to behold indeed. Invariably, Hurston's writing depends for its strength on the text, not the context, as does John's climactic sermon, a *tour de force* of black image and metaphor. Image and metaphor define John's world; his failure to interpret himself leads finally to his self-destruction. As Robert Hemenway, Hurston's biographer, concludes, "Such passages eventually add up to a theory of language and behavior."

Using "the spy-glass of Anthropology," her work celebrates rather than moralizes; it shows rather than tells, such that "both behavior and art become self-evident as the tale texts and

hoodoo rituals accrete during the reading." As author, she func-
tions as "a midwife participating in the birth of a body of folk-
lore, . . . the first wondering contacts with natural law." The
myths she describes so accurately are in fact "alternative modes
for perceiving reality," and never just condescending depictions
of the quaint. Hurston sees "the Dozens," for example, that
age-old black ritual of graceful insult, as, among other things, a
verbal defense of the sanctity of the family, conjured through
ingenious plays on words. Though attacked by Wright and vir-
tually ignored by his literary heirs, Hurston's ideas about lan-
guage and craft undergird many of the most successful contribu-
tions to Afro-American literature that followed.

IV.

We can understand Hurston's complex and contradictory legacy
more fully if we examine *Dust Tracks on a Road,* her own con-
troversial account of her life. Hurston did make significant parts
of herself up, like a masquerader putting on a disguise for the
ball, like a character in her fictions. In this way, Hurston *wrote*
herself, and sought in her works to rewrite the "self" of "the
race," in its several private and public guises, largely for ideolog-
ical reasons. That which she chooses to reveal is the life of her
imagination, as it sought to mold and interpret her environ-
ment. That which she silences or deletes, similarly, is all that her
readership would draw upon to delimit or pigeonhole her life as
a synecdoche of "the race problem," an exceptional part stand-
ing for the debased whole.

Hurston's achievement in *Dust Tracks* is twofold. First, she
gives us a *writer's* life, rather than an account, as she says, of
"the Negro problem." So many events in this text are figured in
terms of Hurston's growing awareness and mastery of books

and language, language and linguistic rituals as spoken and written both by masters of the Western tradition and by ordinary members of the black community. These two "speech communities," as it were, are Hurston's great sources of inspiration not only in her novels but also in her autobiography.

The representation of her sources of language seems to be her principal concern, as she constantly shifts back and forth between her "literate" narrator's voice and a highly idiomatic black voice found in wonderful passages of free indirect discourse. Hurston moves in and out of these distinct voices effortlessly, seamlessly, just as she does in *Their Eyes* to chart Janie's coming to consciousness. It is this usage of a *divided* voice, a double voice unreconciled, that strikes me as her great achievement, a verbal analogue of her double experiences as a woman in a male-dominated world and as a black person in a nonblack world, a woman writer's revision of W. E. B. Du Bois's metaphor of "double-consciousness" for the hyphenated African-American.

Her language, variegated by the twin voices that intertwine throughout the text, retains the power to unsettle.

> There is something about poverty that smells like death. Dead dreams dropping off the heart like leaves in a dry season and rotting around the feet; impulses smothered too long in the fetid air of underground caves. The soul lives in a sickly air. People can be slave-ships in shoes.

Elsewhere she analyzes black "idioms" used by a culture "raised on simile and invective. They know how to call names," she concludes, then lists some, such as 'gator-mouthed, box-ankled, puzzle-gutted, shovel-footed: "Eyes looking like skint-ginny nuts, and mouth looking like a dishpan full of broke-up crockery!"

Immediately following the passage about her mother's death, she writes:

> The Master-Maker in His making had made Old Death. Made him with big, soft feet and square toes. Made him with a face that reflects the face of all things, but neither changes itself, nor is mirrored anywhere. Made the body of death out of infinite hunger. Made a weapon of his hand to satisfy his needs. This was the morning of the day of the beginning of things.

Language, in these passages, is not merely "adornment," as Hurston described a key black linguistic practice; rather, manner and meaning are perfectly in tune: she says the thing in the most meaningful manner. Nor is she being "cute," or pandering to a condescending white readership. She is "naming" emotions, as she says, in a language both deeply personal and culturally specific.

The second reason that *Dust Tracks* succeeds as literature arises from the first: Hurston's unresolved tension between her double voices signifies her full understanding of modernism. Hurston uses the two voices in her text to celebrate the psychological fragmentation both of modernity and of the black American. As Barbara Johnson has written, hers is a rhetoric of division, rather than a fiction of psychological or cultural unity. Zora Neale Hurston, the "real" Zora Neale Hurston that we long to locate in this text, dwells in the silence that separates these two voices: she is both, and neither; bilingual, and mute. This strategy helps to explain her attraction to so many contemporary critics and writers, who can turn to her works again and again only to be startled at her remarkable artistry.

But the life that Hurston could write was not the life she could live. In fact, Hurston's life, so much more readily than does the standard sociological rendering, reveals how economic limits determine

our choices even more than does violence or love. Put simply, Hurston wrote well when she was comfortable, wrote poorly when she was not. Financial problems—book sales, grants and fellowships too few and too paltry, ignorant editors and a smothering patron—produced the sort of dependence that affects, if not determines, her style, a relation she explored somewhat ironically in "What White Publishers Won't Print." We cannot oversimplify the relation between Hurston's art and her life; nor can we reduce the complexity of her postwar politics, which, rooted in her distaste for the pathological image of blacks, were markedly conservative and Republican.

Nor can we sentimentalize her disastrous final decade, when she found herself working as a maid on the very day the *Saturday Evening Post* published her short story "Conscience of the Court" and often found herself without money, surviving after 1957 on unemployment benefits, substitute teaching, and welfare checks. "In her last days," Hemenway concludes dispassionately, "Zora lived a difficult life—alone, proud, ill, obsessed with a book she could not finish."

The excavation of her buried life helped a new generation read Hurston again. But ultimately we must find Hurston's legacy in her art, where she "ploughed up some literacy and laid by some alphabets." Her importance rests with the legacy of fiction and lore she constructed so cannily. As Hurston herself noted, "Roll your eyes in ecstasy and ape his every move, but until we have placed something upon his street corner that is our own, we are right back where we were when they filed our iron collar off." If, as a friend eulogized, "She didn't come to you empty," then she does not leave black literature empty. If her earlier obscurity and neglect today seem inconceivable, perhaps now, as she wrote of Moses, she has "crossed over."

HENRY LOUIS GATES, JR.

Selected Bibliography

<section_heading>WORKS BY ZORA NEALE HURSTON</section_heading>

Jonah's Gourd Vine. Philadelphia: J. B. Lippincott, 1934.

Mules and Men. Philadelphia: J. B. Lippincott, 1935.

Their Eyes Were Watching God. Philadelphia: J. B. Lippincott, 1937.

Tell My Horse. Philadelphia: J. B. Lippincott, 1938.

Moses, Man of the Mountain. Philadelphia: J. B. Lippincott, 1939.

Dust Tracks on a Road. Philadelphia: J. B. Lippincott, 1942.

Seraph on the Suwanee. New York: Charles Scribner's Sons, 1948.

I Love Myself When I Am Laughing . . . & Then Again When I Am Looking Mean and Impressive: A Zora Neale Hurston Reader. Edited by Alice Walker. Old Westbury, N.Y.: The Feminist Press, 1979.

The Sanctified Church. Edited by Toni Cade Bambara. Berkeley: Turtle Island, 1981.

Spunk: The Selected Short Stories of Zora Neale Hurston. Berkeley: Turtle Island, 1985.

WORKS ABOUT ZORA NEALE HURSTON

Baker, Houston A., Jr. *Blues, Ideology, and Afro-American Literature: A Vernacular Theory,* pp. 15–63. Chicago: University of Chicago Press, 1984.

Bloom, Harold, ed. *Zora Neale Hurston.* New York: Chelsea House, 1986.

—, ed. *Zora Neale Hurston's "Their Eyes Were Watching God."* New York: Chelsea House, 1987.

Byrd, James W. "Zora Neale Hurston: A Novel Folklorist." *Tennessee Folklore Society Bulletin* 21 (1955): 37–41.

Cooke, Michael G. "Solitude: The Beginnings of Self-Realization in Zora Neale Hurston, Richard Wright, and Ralph Ellison." In Michael G. Cooke, *Afro-American Literature in the Twentieth Century,* pp. 71–110. New Haven: Yale University Press, 1984.

Dance, Daryl C. "Zora Neale Hurston." In *American Women Writers: Bibliographical Essays,* edited by Maurice Duke, et al. Westport, Conn.: Greenwood Press, 1983.

Gates, Henry Louis, Jr. "The Speakerly Text." In Henry Louis Gates, Jr., *The Signifying Monkey,* pp. 170–217. New York: Oxford University Press, 1988.

Giles, James R. "The Significance of Time in Zora Neale Hurston's *Their Eyes Were Watching God.*" *Negro American Literature Forum* 6 (Summer 1972): 52–53, 60.

Hemenway, Robert E. *Zora Neale Hurston: A Literary Biography.* Chicago: University of Illinois Press, 1977.

Holloway, Karla. *The Character of the Word: The Texts of Zora Neale Hurston.* Westport, Conn.: Greenwood Press, 1987.

Holt, Elvin. "Zora Neale Hurston." In *Fifty Southern Writers After 1900,* edited by Joseph M. Flura and Robert Bain, pp. 259–69. Westport, Conn.: Greenwood Press, 1987.

Howard, Lillie Pearl. *Zora Neale Hurston*. Boston: Twayne, 1980.

—. "Zora Neale Hurston." In *Dictionary of Literary Biography*, vol. 51, edited by Trudier Harris, pp. 133–45. Detroit: Gale, 1987.

Jackson, Blyden. "Some Negroes in the Land of Goshen." *Tennessee Folklore Society Bulletin* 19 (4) (December 1953): 103–7.

Johnson, Barbara. "Metaphor, Metonymy, and Voice in *Their Eyes*." In *Black Literature and Literary Theory*, edited by Henry Louis Gates, Jr., pp. 205–21. New York: Methuen, 1984.

—. "Thresholds of Difference: Structures of Address in Zora Neale Hurston." In *"Race," Writing and Difference*, edited by Henry Lewis Gates, Jr. Chicago: University of Chicago Press, 1986.

Jordan, June. "On Richard Wright and Zora Neale Hurston." *Black World* 23 (10) (August 1974): 4–8.

Kubitschek, Missy Dehn. " 'Tuh de Horizon and Back': The Female Quest in *Their Eyes*." *Black American Literature Forum* 17 (3) (Fall 1983): 109–15.

Lionnet, Françoise. "Autoethnography: The Anarchic Style of *Dust Tracks on a Road*." In Françoise Lionnet, *Autobiographical Voices: Race, Gender, Self-Portraiture*, pp. 97–130. Ithaca: Cornell University Press, 1989.

Lupton, Mary Jane. "Zora Neale Hurston and the Survival of the Female." *Southern Literary Journal* 15 (Fall 1982): 45–54.

Meese, Elizabeth. "Orality and Textuality in Zora Neale Hurston's *Their Eyes*." In Elizabeth Meese, *Crossing the Double Cross: The Practice of Feminist Criticism*, pp. 39–55. Chapel Hill: University of North Carolina Press, 1986.

Newson, Adele S. *Zora Neale Hurston: A Reference Guide*. Boston: G. K. Hall, 1987.

Rayson, Ann. "*Dust Tracks on a Road:* Zora Neale Hurston and the Form of Black Autobiography." *Negro American Literature Forum* 7 (Summer 1973): 42–44.

Sheffey, Ruthe T., ed. *A Rainbow Round Her Shoulder: The Zora Neale Hurston Symposium Papers.* Baltimore: Morgan State University Press, 1982.

Smith, Barbara. "Sexual Politics and the Fiction of Zora Neale Hurston." *Radical Teacher* 8 (May 1978): 26–30.

Stepto, Robert B. *From Behind the Veil.* Urbana: University of Illinois Press, 1979.

Walker, Alice. "In Search of Zora Neale Hurston." *Ms.,* March 1975, pp. 74–79, 85–89.

Wall, Cheryl A. "Zora Neale Hurston: Changing Her Own Words." In *American Novelists Revisited: Essays in Feminist Criticism,* edited by Fritz Fleischmann, pp. 370–93. Boston: G. K. Hall, 1982.

Washington, Mary Helen. "Zora Neale Hurston: A Woman Half in Shadow." Introduction to *I Love Myself When I Am Laughing,* edited by Alice Walker. Old Westbury, N.Y.: Feminist Press, 1979.

—. " 'I Love the Way Janie Crawford Left Her Husbands': Zora Neale Hurston's Emergent Female Hero." In Mary Helen Washington, *Invented Lives: Narratives of Black Women, 1860–1960.* New York: Anchor Press, 1987.

Willis, Miriam. "Folklore and the Creative Artist: Lydia Cabrera and Zora Neale Hurston." *CLA Journal 27* (September 1983): 81–90.

Wolff, Maria Tai. "Listening and Living: Reading and Experience in *Their Eyes.*" *BALF* 16 (1) (Spring 1982): 29–33.

Chronology

January 7, 1891 Born in Notasulga, Alabama, the fifth of eight children, to John Hurston, a carpenter and Baptist preacher, and Lucy Potts Hurston, a former schoolteacher.

September 1917–
June 1918 Attends Morgan Academy in Baltimore, completing the high school requirements.

Summer 1918 Works as a waitress in a nightclub and a manicurist in a black-owned barbershop that serves only whites.

1918–19 Attends Howard Prep School, Washington, D.C.

1919–24 Attends Howard University; receives an associate degree in 1920.

1921 Publishes her first story, "John Redding Goes to Sea," in the *Stylus,* the campus literary society's magazine.

December 1924	Publishes "Drenched in Light," a short story, in *Opportunity*.
1925	Submits a story, "Spunk," and a play, *Color Struck*, to *Opportunity*'s literary contest. Both win second-place awards; publishes "Spunk" in the June number.
1925–27	Attends Barnard College, studying anthropology with Franz Boas.
1926	Begins field work for Boas in Harlem.
January 1926	Publishes "John Redding Goes to Sea" in *Opportunity*.
Summer 1926	Organizes *Fire!* with Langston Hughes and Wallace Thurman; they publish only one issue, in November 1926. The issue includes Hurston's "Sweat."
August 1926	Publishes "Muttsy" in *Opportunity*.
September 1926	Publishes "Possum or Pig" in the *Forum*.
September–November 1926	Publishes "The Eatonville Anthology" in the *Messenger*.
1927	Publishes *The First One*, a play, in Charles S. Johnson's *Ebony and Topaz*.
February 1927	Goes to Florida to collect folklore.

May 19, 1927 Marries Herbert Sheen.

September 1927 First visits Mrs. Rufus Osgood Mason, seeking patronage.

October 1927 Publishes an account of the black settlement at St. Augustine, Florida, in the *Journal of Negro History;* also in this issue: "Cudjo's Own Story of the Last African Slaver."

December 1927 Signs a contract with Mason, enabling her to return to the South to collect folklore.

1928 Satirized as "Sweetie Mae Carr" in Wallace Thurman's novel about the Harlem Renaissance *Infants of the Spring;* receives a bachelor of arts degree from Barnard.

January 1928 Relations with Sheen break off.

May 1928 Publishes "How It Feels to Be Colored Me" in the *World Tomorrow.*

1930–32 Organizes the field notes that become *Mules and Men.*

May–June 1930 Works on the play *Mule Bone* with Langston Hughes.

1931 Publishes "Hoodoo in America" in the *Journal of American Folklore.*

February 1931	Breaks with Langston Hughes over the authorship of *Mule Bone*.
July 7, 1931	Divorces Sheen.
September 1931	Writes for a theatrical revue called *Fast and Furious*.
January 1932	Writes and stages a theatrical revue called *The Great Day*, first performed on January 10 on Broadway at the John Golden Theatre; works with the creative literature department of Rollins College, Winter Park, Florida, to produce a concert program of Negro music.
1933	Writes "The Fiery Chariot."
January 1933	Stages *From Sun to Sun* (a version of *Great Day*) at Rollins College.
August 1933	Publishes "The Gilded Six-Bits" in *Story*.
1934	Publishes six essays in Nancy Cunard's anthology, *Negro*.
January 1934	Goes to Bethune-Cookman College to establish a school of dramatic arts "based on pure Negro expression."
May 1934	Publishes *Jonah's Gourd Vine*, originally titled *Big Nigger;* it is a Book-of-the-Month Club selection.

September 1934 Publishes "The Fire and the Cloud" in the *Challenge*.

November 1934 *Singing Steel* (a version of *Great Day*) performed in Chicago.

January 1935 Makes an abortive attempt to study for a Ph.D in anthropology at Columbia University on a fellowship from the Rosenwald Foundation. In fact, she seldom attends classes.

August 1935 Joins the WPA Federal Theatre Project as a "dramatic coach."

October 1935 *Mules and Men* published.

March 1936 Awarded a Guggenheim Fellowship to study West Indian Obeah practices.

April–
September 1936 In Jamaica.

September–
March 1937 In Haiti; writes *Their Eyes Were Watching God* in seven weeks.

May 1937 Returns to Haiti on a renewed Guggenheim.

September 1937 Returns to the United States; *Their Eyes Were Watching God* published, September 18.

February–
March 1938 Writes *Tell My Horse;* it is published the same year.

April 1938	Joins the Federal Writers Project in Florida to work on *The Florida Negro*.
1939	Publishes "Now Take Noses" in *Cordially Yours*.
June 1939	Receives an honorary Doctor of Letters degree from Morgan State College.
June 27, 1939	Marries Albert Price III in Florida.
Summer 1939	Hired as a drama instructor by North Carolina College for Negroes at Durham; meets Paul Green, professor of drama, at the University of North Carolina.
November 1939	*Moses, Man of the Mountain* published.
February 1940	Files for divorce from Price, though the two are reconciled briefly.
Summer 1940	Makes a folklore-collecting trip to South Carolina.
Spring–July 1941	Writes *Dust Tracks on a Road*.
July 1941	Publishes "Cock Robin, Beale Street" in the *Southern Literary Messenger*.
October 1941– January 1942	Works as a story consultant at Paramount Pictures.

July 1942 Publishes "Story in Harlem Slang" in the *American Mercury*.

September 5, 1942 Publishes a profile of Lawrence Silas in the *Saturday Evening Post*.

November 1942 *Dust Tracks on a Road* published.

February 1943 Awarded the Anisfield-Wolf Book Award in Race Relations for *Dust Tracks;* on the cover of the *Saturday Review*.

March 1943 Receives Howard University's Distinguished Alumni Award.

May 1943 Publishes "The 'Pet Negro' Syndrome" in the *American Mercury*.

November 1943 Divorce from Price granted.

June 1944 Publishes "My Most Humiliating Jim Crow Experience" in the *Negro Digest*.

1945 Writes *Mrs. Doctor;* it is rejected by Lippincott.

March 1945 Publishes "The Rise of the Begging Joints" in the *American Mercury*.

December 1945 Publishes "Crazy for This Democracy" in the *Negro Digest*.

1947	Publishes a review of Robert Tallant's *Voodoo in New Orleans* in the *Journal of American Folklore*.
May 1947	Goes to British Honduras to research black communities in Central America; writes *Seraph on the Suwanee;* stays in Honduras until March 1948.
September 1948	Falsely accused of molesting a ten-year-old boy and arrested; case finally dismissed in March 1949.
October 1948	*Seraph on the Suwanee* published.
March 1950	Publishes "Conscience of the Court" in the *Saturday Evening Post,* while working as a maid in Rivo Island, Florida.
April 1950	Publishes "What White Publishers Won't Print" in the *Saturday Evening Post.*
November 1950	Publishes "I Saw Negro Votes Peddled" in the *American Legion* magazine.
Winter 1950–51	Moves to Belle Glade, Florida.
June 1951	Publishes "Why the Negro Won't Buy Communism" in the *American Legion* magazine.
December 8, 1951	Publishes "A Negro Voter Sizes Up Taft" in the *Saturday Evening Post.*

1952 Hired by the *Pittsburgh Courier* to cover the Ruby McCollum case.

May 1956 Receives an award for "education and human relations" at Bethune-Cookman College.

June 1956 Works as a librarian at Patrick Air Force Base in Florida; fired in 1957.

1957–59 Writes a column on "Hoodoo and Black Magic" for the *Fort Pierce Chronicle*.

1958 Works as a substitute teacher at Lincoln Park Academy, Fort Pierce.

Early 1959 Suffers a stroke.

October 1959 Forced to enter the St. Lucie County Welfare Home.

January 28, 1960 Dies in the St. Lucie County Welfare Home of "hypertensive heart disease"; buried in an unmarked grave in the Garden of Heavenly Rest, Fort Pierce.

August 1973 Alice Walker discovers and marks Hurston's grave.

March 1975 Walker publishes "In Search of Zora Neale Hurston," in *Ms.*, launching a Hurston revival.

Acknowledgments

Their Eyes
Were Watching God

The trustees for the Zora Neale Hurston Trust gratefully acknowledge the contributions made by so many people who worked hard to produce this outstanding new hardcover edition of Zora Neale Hurston's groundbreaking novel, *Their Eyes Were Watching God*. The success of this endeavor can be attributed to all of those who worked to bring this novel out of its lost period, to those who dedicated themselves to reintroducing Zora's priceless novel to the world, and to those who have pledged to keep this novel before the eyes of the world.

We are deeply indebted to Alice Walker for loving this novel. It was her search for Zora's works and her embrace of the complete Zora that led to a reintroduction of *Their Eyes Were Watching God*. We are also grateful for the contribution of the late Dr. Robert Hemenway, who, following public recognition of Alice Walker's discoveries, published the first biography of Zora Neale Hurston and helped to initiate a resurgent publication of *Their Eyes Were Watching God*. We are grateful to others who discovered and carried the word: Dr. Deborah Plant, who found enlightenment in *Their Eyes Were Watching God*, and Valerie Boyd and the late Cheryl Wall—part of the throng of torchbearers for Zora's classic work. We are also grateful to Oprah Winfrey for giving this novel a life in film.

Because so many have loved *Their Eyes Were Watching God*, it has endured and passed the test of time.

This latest edition of *Their Eyes Were Watching God* has only been possible because of the dedicated efforts of our editorial director, publishers, and our agent. We want to acknowledge Tracy Sherrod, vice president and editorial director of Amistad at Harper-Collins, and her staff, whose dedication to this new edition is found throughout the novel and is particularly evident in the stunning artwork of the dust jacket overseen by art director Stephen Brayda. In addition, we wish to acknowledge Tara Parsons, associate publisher of Amistad, and her staff for their contributions to the success of this outstanding edition of *Their Eyes Were Watching God*; and we want to thank Judith Curr, president of HarperOne, for her continuing advocacy of Zora's works. We especially want to acknowledge our agent, Joy Harris, and those in her agency who work tirelessly to assure the success of Hurston projects. We thank Adam Reed, and we thank all other members of Joy's team who labor on our behalf. Joy's efforts to lift up the Trust have always kept us moving true north.

We extend our heartfelt appreciation to Zora's family of authors, journalists, teachers, academicians, scholars, and many legions of fans and readers whose continuing appreciation of *Their Eyes Were Watching God* has brought it to its well-deserved place in the literary canon of the twentieth and twenty-first centuries.

About the author

About the book

Read on

Insights,
Interviews
& More . . .

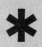

"She *Was* the Party"

by Valerie Boyd

ZORA NEALE HURSTON knew how to make an entrance. On May 1, 1925, at a literary awards dinner sponsored by *Opportunity* magazine, the earthy Harlem newcomer turned heads and raised eyebrows as she claimed four awards: a second-place fiction prize for her short story "Spunk," a second-place award in drama for her play *Color Struck,* and two honorable mentions.

The names of the writers who beat out Hurston for first place that night would soon be forgotten. But the name of the second-place winner buzzed on tongues all night, and for days and years to come.

Lest anyone forget her, Hurston made a wholly memorable entrance at a party following the awards dinner. She strode into the room—jammed with writers and arts patrons, black and white—and flung a long, richly colored scarf around her neck with dramatic flourish as she bellowed a reminder of the title of her winning play: *"Coloooooor Struuckkkk!"* Her exultant entrance literally stopped the party for a moment, just as she had intended. In this way, Hurston made it known that a bright and powerful presence had arrived.

By all accounts, Zora Neale Hurston could walk into a roomful of strangers and, a few minutes and a few stories later, leave them so completely charmed that they often found themselves offering to help her in any way they could.

Gamely accepting such offers—and employing her own talent and scrappiness—

Courtesy of the Estate of Carl Van Vechten, Joseph Solomon, Executor

Hurston became the most successful and most significant black woman writer of the first half of the twentieth century. Over a career that spanned more than thirty years, she published four novels, two books of folklore, an autobiography, numerous short stories, and several essays, articles, and plays.

Born on January 7, 1891, in Notasulga, Alabama, Hurston moved with her family to Eatonville, Florida, when she was still a toddler. Her writings reveal no recollection of her Alabama beginnings. For Hurston, Eatonville was always home.

Established in 1887, the rural community near Orlando was the nation's first incorporated black township. It was, as Hurston described it, "a city of five lakes, three croquet courts, three hundred brown skins, three hundred good swimmers, plenty guavas, two schools, and no jailhouse."

In Eatonville, Zora was never indoctrinated in inferiority, and she could see the evidence of black achievement all around her. She could look to town hall and see black men, including her father, John Hurston, formulating the laws that governed Eatonville. She could look to the Sunday schools of the town's two churches and see black women, including her mother, Lucy Potts Hurston, directing the Christian curricula. She could look to the porch of the village store and see black men and women passing worlds through their mouths in the form of colorful, engaging stories.

Growing up in this culturally affirming setting in an eight-room house on five acres of land, Zora had a relatively happy childhood, despite frequent clashes with her preacher-father, who sometimes sought to "squinch" her rambunctious spirit, she recalled. Her mother, on the other hand, ▶

> 66 In Eatonville, Zora was never indoctrinated in inferiority, and she could see the evidence of black achievement all around her. 99

urged young Zora and her seven siblings to "jump at de sun." Hurston explained, "We might not land on the sun, but at least we would get off the ground."

Hurston's idyllic childhood came to an abrupt end, though, when her mother died in 1904. Zora was only thirteen years old. "That hour began my wanderings," she later wrote. "Not so much in geography, but in time. Then not so much in time as in spirit."

After Lucy Hurston's death, Zora's father remarried quickly—to a young woman whom the hotheaded Zora almost killed in a fistfight—and seemed to have little time or money for his children. "Bare and bony of comfort and love," Zora worked a series of menial jobs over the ensuing years, struggled to finish her schooling, and eventually joined a Gilbert & Sullivan traveling troupe as a maid to the lead singer. In 1917, she turned up in Baltimore; by then, she was twenty-six years old and still hadn't finished high school. Needing to present herself as a teenager to qualify for free public schooling, she lopped ten years off her life—giving her year of birth as 1901. Once gone, those years were never restored: From that moment forward, Hurston would always present herself as at least ten years younger than she actually was.

Apparently, she had the looks to pull it off. Photographs reveal that she was a handsome, big-boned woman with playful yet penetrating eyes, high cheekbones, and a full, graceful mouth that was never without expression.

Zora also had a fiery intellect, an infectious sense of humor, and "the gift," as one friend put it, "of walking into hearts." Zora used

66 Zora had a relatively happy childhood, despite frequent clashes with her preacher-father, who sometimes sought to 'squinch' her rambunctious spirit. 99

4

these talents—and dozens more—to elbow her way into the Harlem Renaissance of the 1920s, befriending such luminaries as poet Langston Hughes and popular singer-actress Ethel Waters.

Though Hurston rarely drank, fellow writer Sterling Brown recalled, "When Zora was there, she *was* the party." Another friend remembered Hurston's apartment—furnished by donations she solicited from friends—as a spirited "open house" for artists. All this socializing didn't keep Hurston from her work, though. She would sometimes write in her bedroom while the party went on in the living room.

By 1935, Hurston—who'd graduated from Barnard College in 1928—had published several short stories and articles, as well as a novel, *Jonah's Gourd Vine,* and a well-received collection of black Southern folklore, *Mules and Men.* But the late thirties and early forties marked the real zenith of her career. She published her masterwork, *Their Eyes Were Watching God,* in 1937; *Tell My Horse,* her study of Haitian Vodou practices and Caribbean culture, in 1938; and another masterful novel, *Moses, Man of the Mountain,* in 1939. When her autobiography, *Dust Tracks on a Road,* was published in 1942, Hurston finally received the well-earned acclaim that had long eluded her. That year, she was profiled in *Who's Who in America, Current Biography,* and *Twentieth Century Authors.* She went on to publish another novel, *Seraph on the Suwanee,* in 1948.

Still, Hurston never received the financial rewards she deserved. (The largest royalty she ever earned from any of her books was ▶

66 'When Zora was there, she *was* the party.' 99

5

$943.75.) So when she died on January 28, 1960—at age sixty-nine, after suffering a stroke—her neighbors in Fort Pierce, Florida, had to take up a collection for her February 7 funeral. The collection didn't yield enough to pay for a headstone, however, and Hurston was buried in a grave that remained unmarked until 1973.

That summer, a young writer named Alice Walker traveled to Fort Pierce to place a marker on the grave of the author who had so inspired her own work. Walker found the Garden of Heavenly Rest, a segregated cemetery at the dead end of North Seventeenth Street, abandoned and overgrown with yellow-flowered weeds.

Back in 1945, Hurston had foreseen the possibility of dying without money—and she'd proposed a solution that would have benefited her and countless others. Writing to W. E. B. Du Bois, whom she called the "Dean of American Negro Artists," Hurston suggested "a cemetery for the illustrious Negro dead" on one hundred acres of land in Florida. "Let no Negro celebrity, no matter what financial condition they might be in at death, lie in inconspicuous forgetfulness," she urged. "We must assume the responsibility of their graves being known and honored." Du Bois, citing practical complications, wrote a curt reply discounting her argument.

As if impelled by Hurston's words, Walker bravely entered the snake-infested cemetery where the writer's remains had been laid to rest. Wading through waist-high weeds, she soon stumbled upon a sunken rectangular patch of ground that she determined to be Hurston's grave. Unable to afford the marker

" Hurston was buried in a grave that remained unmarked until 1973. "

she wanted—a tall, majestic black stone called "Ebony Mist"—Walker chose a plain gray headstone instead. Borrowing from a Jean Toomer poem, she dressed the marker up with a fitting epitaph: "Zora Neale Hurston: A Genius of the South." ❧

> 66 Wading through waist-high weeds, Alice Walker stumbled upon a sunken rectangular patch of ground that she determined to be Hurston's grave. 99

Valerie Boyd is the author of the award-winning Wrapped in Rainbows: The Life of Zora Neale Hurston. *Formerly the arts editor at the* Atlanta Journal-Constitution, *she is a professor at the University of Georgia's Grady College of Journalism and Mass Communication.*

A Protofeminist Postcard from Haiti

by Valerie Boyd

ZORA NEALE HURSTON wrote *Their Eyes Were Watching God* under emotional duress. She'd kept the novel "dammed up" inside for months, she would recall, and she wrote it under "internal pressure."

By the fall of 1936, when Hurston began working on her transcendent tale of a black woman's journey of self-discovery, she had already made a name for herself as a promising novelist and anthropologist. In 1934, Hurston had published her first novel, *Jonah's Gourd Vine*—partly a fictionalized account of her parents' marriage—to critical acclaim. "*Jonah's Gourd Vine* can be called without fear of exaggeration the most vital and original novel about the American Negro that has yet been written," the *New York Times* declared. A year later, Hurston published *Mules and Men*, a book of folklore that grew out of her experience as a daughter of the black South.

Though Hurston left Eatonville, Florida, as a teenager, she returned to her hometown again and again in her fiction. She also made frequent visits to the village—and to many other places in the South—to study black folk culture under the tutelage of famed anthropologist Franz Boas, her professor at New York's Barnard College. After earning a bachelor's degree from Barnard, becoming a bright light of the Harlem Renaissance, and dropping out of a Ph.D. program at Columbia University, Hurston won a Guggenheim

66 She wrote *Their Eyes Were Watching God* under 'internal pressure.' 99

8

fellowship to study indigenous religious practices in Jamaica and Haiti. The fellowship also gave the famously independent author a way out of a problematic love affair.

For more than a year, Hurston, a divorcée in her mid-forties, had been dating a man twenty years her junior. A graduate student at Columbia University, his name was Percival McGuire Punter. Though she would later identify him only by his initials in her autobiography, *Dust Tracks on a Road*, Hurston noted that he "was tall, dark brown" and "magnificently built." But, she hastened to add: "His looks only drew my eyes in the beginning. I did not fall in love with him just for that. He had a fine mind and that intrigued me. When a man keeps beating me to the draw mentally, he begins to get glamorous."

In short order, Hurston and Punter were immersed in an intensely passionate, mutually satisfying romance—a relationship that the thrice-married Hurston called "the real love affair of my life."

Eventually, Punter asked her to give up her career, marry him, and leave New York. The idea of giving up her career was chilling. "I really wanted to do anything he wanted me to do," Hurston wrote, "but that one thing I could not do."

Punter did not seem to understand that Hurston's work was her sustenance. "I'm tired of seeing you work so hard," he told her. "I wouldn't want my wife to do anything but look after me." But Zora needed to do more with her life than look after a man, no matter how wonderful he might be. "I had things clawing inside of me that must be said," she tried to explain. "I could not see that my work should make any difference in marriage. He ▶

'When a man keeps beating me to the draw mentally, he begins to get glamorous.'

A Protofeminist Postcard from Haiti
(continued)

was all and everything else to me but that. One did not conflict with the other in my mind. But it was different with him. He felt that he did not matter to me enough. He was the master kind. All or nothing, for him."

Hurston and Punter continued to see each other, despite this fundamental conflict, and mutual jealousies erupted and escalated. If Punter smiled too broadly at a woman on Seventh Avenue, Zora fumed. If she accepted a kiss on the cheek from a male acquaintance, Punter smoldered. Their love became blissful misery. "We were alternately the happiest people in the world," Zora recognized, "and the most miserable."

One night, an argument turned particularly ugly. "Something primitive inside me tore past the barriers and before I realized it, I had slapped his face," Hurston remembered. Angry over some week-old hurt, Punter struck back. To Hurston's horror, she and Punter were soon trading slaps and shoves. "No broken bones," she recalled, "and no black eyes," but combat nonetheless. Stunned by the wrong turn their passion had taken, the two ended up on the floor together, entwined in mutual apologies.

But something had changed for Hurston. "Then I knew I was too deeply in love to be my old self," she admitted. "For always a blow to my body had infuriated me beyond measure. . . . But somehow, I didn't hate him at all." Hurston—"delirious with joy and pain"— had lost hold of herself. And this frightened her.

The Guggenheim fellowship, as she saw it, was "my chance to release him, and fight

myself free from my obsession." With this justification, Hurston said a hasty farewell to her beloved and sailed off to Jamaica, where she threw herself into her research in an attempt to smother her feelings for Punter.

A few months later, she moved on to Haiti, which released a flood of emotions that forced her to sit down and write—sometimes late at night after a strenuous day of research for her forthcoming book on Haitian Vodou and Caribbean culture. Commanded by a "force somewhere in Space," as she dramatically put it, Hurston started writing a novel, working urgently for days on end. All the while, her love for Punter stayed on her mind. "The plot was far from the circumstances," she noted, "but I tried to embalm all the tenderness of my passion for him in *Their Eyes Were Watching God*." In just seven weeks, right before Christmas 1936, Hurston finished her second novel.

Published in September 1937, *Their Eyes Were Watching God* is the story of Janie Crawford, a deep-thinking, deep-feeling black woman who embarks on a search for her own self. Janie's journey begins at sixteen, when her dying grandmother marries her off to Logan Killicks, an older man with sixty acres, a mule, and a lump of fatback on his neck that Janie despises. Rebelling against Logan's attempts to turn her into a workhorse, Janie runs off with Joe Starks, a citified fellow with big dreams and a big voice. Joe marries Janie and takes her to Eatonville, where he soon becomes mayor, postmaster, and primary landowner. The kind of man with "uh throne in de seat of his pants," as one character puts it, Joe Starks ▶

> **She moved on to Haiti, which released a flood of emotions that forced her to sit down and write.**

A Protofeminist Postcard from Haiti
(*continued*)

is clearly modeled on Joe Clarke, the mayor of Eatonville during much of Hurston's childhood there. Cowed by Joe's chauvinism, Janie becomes "a rut in the road," as Hurston writes. But after Joe's death, the forty-year-old Janie falls in love with Tea Cake, a free-spirited laborer much younger than herself. Obviously cut from the same cloth as Hurston's own younger man, Tea Cake is Janie's true love—or, in the author's words, he is "sun-up and pollen and blooming trees." With Tea Cake, Janie is free to become herself.

Among the challenges that Janie and Tea Cake face together is a devastating hurricane, patterned after the 1928 Lake Okeechobee hurricane that killed nearly two thousand people in the Florida Everglades. Though Hurston was not in Florida during that storm, she later interviewed many of its survivors; she also was able to re-create the hurricane in vivid detail because she herself had survived a 1929 hurricane in the Bahamas.

Hurston freely used such incidents from her own life to inform *Their Eyes Were Watching God,* which is, at heart, a love story inspired by her relationship with Punter. But Tea Cake is not Punter, and Janie is not Zora Neale Hurston. To be sure, Hurston imbued Janie with some of the questing quality that characterized her own life. But Janie is more conventional than Hurston ever was; consequently, she seeks her identity in the eyes and arms of men. Hurston, on the other hand, sought her identity in her own self, in her work, in speaking—and writing—her own mind.

In *Their Eyes Were Watching God,* Hurston

> " Hurston imbued Janie with some of the questing quality that characterized her own life. "

ransacked the language—the King's English as well as Eatonville's Ebonics—to achieve a precision of expression that was stunning. For more than fifteen years, through her previous books as well as numerous short stories and plays, the author had been working to capture in words the beauty and the complexity of her Eatonville experience—and of the rural, self-educated black folks who'd been her neighbors there. In *Their Eyes Were Watching God*, she finally achieved this elusive goal. Significantly, she did so by making a crucial revision to her memories of the village: In all her previous attempts to depict Eatonville in fiction, the storytellers had been mostly men. In this novel, however, Hurston put her story in the mouth and the mind of a woman—and the result is a book of extraordinary appeal.

Because Hurston placed Janie on the road to self-realization and independence, *Their Eyes Were Watching God* has been hailed as a feminist novel. Whether Hurston saw it that way or not, she certainly used it to convey her view that women were the equals of men in every way—and that their inner lives were infinitely rich and worthy of exploration.

Given these protofeminist themes, the book was not well received by some male critics. Richard Wright, soon to become the bestselling author of *Native Son*, categorically dismissed Hurston's book: "The sensory sweep of her novel carries no theme, no message, no thought," he wrote.

Over the years, of course, most critics have emphatically disagreed with Wright's dim assessment of Hurston's novel, which is now required reading in high schools and ▶

> **❝ Given these protofeminist themes, the book was not well received by some male critics. ❞**

A Protofeminist Postcard from Haiti
(*continued*)

colleges throughout the country. "There is no book more important to me than this one," Alice Walker has said. And Oprah Winfrey has called *Their Eyes Were Watching God* her "favorite love story of all time." Winfrey's admiration for the novel inspired her to produce a television adaptation of it, which aired for the first time on March 6, 2005. Starring Academy Award winner Halle Berry as Janie, the TV movie was watched by an estimated 24.6 million viewers, further entrenching the novel in the public consciousness and in the American literary canon.

Today, *Their Eyes Were Watching God* is widely regarded as a masterpiece. In 1937, though, the jury was still out, but certainly leaning in Hurston's favor. The book earned rave reviews; Hurston was featured in several newspaper profiles; and Pulitzer Prize-winning poet Edna St. Vincent Millay sent Hurston a telegram congratulating her on her new novel. "God *does* love black people, doesn't He?" Hurston joked with a friend. "Or am *I* just out on parole?" ᔪ

> " Today, *Their Eyes Were Watching God* is widely regarded as a masterpiece. In 1937, though, the jury was still out, but certainly leaning in Hurston's favor. "

Have You Read?
More by
Zora Neale Hurston

JONAH'S GOURD VINE

Zora Neale Hurston's first novel tells the story of John Buddy Pearson, a young minister who loves too many women for his own good even though he is married to Lucy, his one true love. In this sympathetic portrait of a man and his community, Hurston shows that faith and tolerance and good intentions cannot resolve the tension between the spiritual and the physical.

MULES AND MEN

The fruit of Hurston's labors as a folklorist and anthropologist, this celebrated treasury of black American folklore includes stories, "big old lies," songs, Vodou customs, superstitions—all the humor and wisdom that is the matchless heritage of American blacks.

TELL MY HORSE

This first-hand account of the mysteries of Vodou is based on Hurston's personal experiences in Haiti and Jamaica, where she participated as an initiate and not just an observer of Voudou practices in the 1930s. Of great cultural interest, her travelogue paints a vividly authentic picture of ceremonies, customs, and superstitions.

Have You Read? *(continued)*

MOSES, MAN OF THE MOUNTAIN

Based on the familiar story of the Exodus, this novel blends the Moses of the Old Testament with the Moses of black folklore and song to create a compelling allegory of power, redemption, and faith.

DUST TRACKS ON A ROAD

First published in 1942 at the crest of her popularity as a writer, this is Hurston's imaginative and exuberant account of her rise from childhood poverty in the rural South to a prominent place among the leading artists and intellectuals of the Harlem Renaissance. It is a book full of the wit and wisdom of a proud and spirited woman who started off low and climbed high.

SERAPH ON THE SUWANEE

Hurston's novel of turn-of-the-century white Florida "crackers" marks a daring departure for the author famous for her complex accounts of black culture and heritage. Hurston explores the evolution of a marriage full of love but very little communication and the desires of a young woman in search of herself and her place in the world.

Discover great authors, exclusive offers, and more at hc.com.

An Excerpt from *Barracoon: The Story of the Last "Black Cargo"*

by Zora Neale Hurston

Chapter I

It was summer when I went to talk with Cudjo so his door was standing wide open. But I knew he was somewhere about the house before I entered the yard, because I had found the gate unlocked. When Cudjo goes down into his back-field or away from home he locks his gate with an ingenious wooden peg of African invention.

I hailed him by his African name as I walked up the steps to his porch, and he looked up into my face as I stood in the door in surprise. He was eating his breakfast from a round enameled pan with his hands, in the fashion of his fatherland.

The surprise of seeing me halted his hand between pan and face. Then tears of joy welled up.

"Oh Lor', I know it *you* call my name. Nobody don't callee me my name from cross de water but you. You always callee me Kossula, jus' lak I in de Affica soil!"

I noted that another man sat eating with him and I wondered why. So I said, "I see you have company, Kossula."

"Yeah, I got to have somebody stay wid me. I been sick in de bed de five month. I needa somebody hand me some water. So I take dis man and he sleep here and take keer Cudjo. But I gittee well now."

In spite of the recent illness and the fact that his well had fallen in, I found Cudjo Lewis full of gleaming, good will. His garden was planted. There was deep shade under his China-berry tree and all was well.

He wanted to know a few things about New York and when I had answered him, he sat silently smoking. Finally, I told him I had come to talk with him. He removed his pipe from his mouth and smiled.

"I doan keer," he said, "I lakee have comp'ny come see me." Then the smile faded into a wretched weeping mask. "I so lonely. My wife she left me since de 1908. Cudjo all by hisself."

After a minute or two he remembered me and said contritely, "Excuse me. You didn't do nothin' to me. Cudjo feel so lonely, he can't help he cry sometime. Whut you want wid me?"

"First, I want to ask you how you feel today?"

Another muted silence. Then he said, "I thank God I on prayin' groun' and in a Bible country."

"But didn't you have a God back in Africa?" I asked him.

His head dropped between his hands and the tears sprung fresh. Seeing the anguish in his face, I regretted that I had come to worry this captive in a strange land. He read my face and said, "Excusee me I cry. I can't help it when I hear de name call. Oh, Lor'. I no see Afficky soil no mo'!"

Another long silence. Then, "How come you astee me ain we had no God back dere in Afficky?"

"Because you said 'thank God you were on praying ground and in a Bible country.' "

"Yeah, in Afficky we always know dere was a God; he name Alahua, but po' Affickans we cain readee de Bible, so we doan know God got a Son. We ain ignant—we jes doan know. Nobody doan tell us 'bout Adam eatee de apple, we didn't know de seven seals was sealee 'gainst us. Our parents doan tell us dat. Dey didn't tell us bout de first days. No, dass a right. We jes doan know. So dat whut you come astee me?"

I temporized. "Well, yes. I wanted to ask that, but I want to ask you many things. I want to know who you are and how you came to be a slave; and to what part of Africa do you belong, and how you fared as a slave, and how you have managed as a free man?"

Again his head was bowed for a time. When he lifted his wet face again he murmured, "Thankee Jesus! Somebody come ast about Cudjo! I want tellee somebody who I is, so maybe dey go in de Afficky soil some day and callee my name and somebody dere say, "Yeah, I know Kossula." I want you everywhere you go to tell everybody whut Cudjo say, and how come I in Americky soil since de 1859 and never see my people no mo'. I can't talkee plain, you unnerstand me, but I calls it word by word for you so it won't be too crooked for you.

"My name, is not Cudjo Lewis. It Kossula. When I gittee in Americky soil, Mr. Jim Meaher he try callee my name, but it too long, you unnerstand me, so I say, 'Well, I yo' property?' He say, 'Yeah.' Den I say, 'You callee me Cudjo. Dat do.' But in Afficky soil my mama she name me Kossula.*

* [Editor's note: *In Dust Tracks on a Road*, Hurston writes that she "went to talk to Cudjo Lewis. That is the American version of his name. His African name was Kossola-O-Lo-Loo-Ay" (198). Hurston also transcribed Kossola's name as "Kossula" and "Kazoola." In my introduction and references elsewhere, I have used "Kossola," as it is consistent with Sylviane Diouf's research in *Dreams of Africa in Alabama* where she establishes "Kossola" as the likely spelling: it is a name "immediately decipherable" to the Isha Yoruba who "have a town named Kossola" (Diouf 40).]

"My people, you unnerstand me, dey ain got no ivory by de door. When it ivory from de elephant stand by de door, den dat a king, a ruler, you unnerstand me. My father neither his father don't rule nobody. De ole folks dat live two hund'ed year befo' I born don't tell me de father (remote ancestor) rule nobody.

"My people in Afficky, you unnerstand me, dey not rich. Dass de truth, now. I not goin' tellee you my folks dey rich and come from high blood. Den when you go in de Afficky soil an' astee de people, dey say, 'Why Kossula over dere in Americky soil tellee de folks he rich?' I tellee you lak it tis. Now, dass right, ain it?

"My father's father, you unnerstand me, he a officer of de king. He don't live in de compound wid us. Wherever de king go, he go, you unnerstand me. De king give him plenty land, and got plenty cows and goats and sheep. Now, dass right. Maybe after while he be a little chief, I doan know. But he die when I a lil boy. Whut he gointer be later on, dat doan reechee me.

"My grandpa, he a great man. I tellee you how he go."

I was afraid that Cudjo might go off on a tangent, so I cut in with, "But Kossula, I want to hear about *you* and how *you* lived in Africa."

He gave me a look full of scornful pity and asked, "Where is de house where de mouse is de leader? In de Affica soil I cain tellee you 'bout de son before I tellee you bout de father; and derefore, you unnerstand me, I cain talk about de man who is father (*et te*) till I tellee you bout de man who he father to him (*et, te, te*, grandfather), now, dass right ain it?

"My grandpa, you unnerstand me, he got de great big compound. He got plenty wives and chillun. His house, it is in de center de compound. In Affica soil de house of de husband it always in de center and de houses of de wives, dein in a circle round de house dey husband live in.

"He don't think hisself to marry wid so many women. No. In de Affica soil it de wife dat go findee him another wife.

"S'pose I in de Affica soil. Cudjo he been married for seven year for example. His wife say, 'Cudjo, I am growin' old. I tired. I will bring you another wife.'

"Before she speakee dat, she got de girl who he doan know in her mind. She a girl she think very nice. Maybe her husband never see her. Well, she go out in de market place, maybe in de public square. She see disa girl and astee de girl, 'You know Cudjo?' De girl tellee her, 'I have heard of him.' De wife say, 'Cudjo is good. He is kind. I like you to be his wife.' De girl say 'Come with me to my papa and mama.'

"Dey go, you unnerstand me to de girl's parents together. Dey astee her questions and she answere for her husband. She astee dem questions too and if both sides satisfy wid one nother de girl's parents say, 'We give our daughter into yo' care. She ain ours no mo'. You be good to her.'

"De wife she come back to Cudjo and makee de 'rangements. Cudjo got to pay de father for de girl. If she be a rich girl dat been in de fat-house long time, you unnerstand me, he got to pay two of everything for her. Two cow, two sheep, two goat, chickens, yam, maybe gold. De rich man, keepee his daughter in de fat house long time. Sometime two year. She gittee de dinner in dere eight times a day and dey don't leavee her git in and out de bed by herself. De one whut keep de fat-house he lift dem in and out, so dey don't lose de fat.

"De man not so rich, he cain keep his girl dere long so she not so fat. So po' man don't send his daughter.

"Derefore you unnerstand me, de man pay different price for different girl. If she de daughter of a po' family, or she been married before or somthin', he don't pay much for her.

"When de new wife come first to her husband compound she live in de house wid de old wife. She teach her what to do and how to take keer de husband. When she learn all dat, den she have a house by herself.

"When dey gittee ready to buildee de new house, de man takee de machete and chop de palm tree to mark de place where de house goin' be build. Den he throw down a cow and have plenty palm wine. Den all de people come and eatee de meat and drink de wine and stomp de place smooth and buildee de house.

"My grandpa, he buildee wife house many time.

"Some men in de Affica soil don't gittee no wife cause dey cain buy none. Dey ain got nothing to give so a wife kin come to dem. Some got too many. When you hungry it is painful but when de belly too full it painful too.

"All de wives make food (*udia*) for de husband. All de men dey likee de fufu. He eatee de big calabash full to de top wid fufu, den my grandpa he lay down to sleep.

"De young wives (before they are old enough to take up the actual duties of wifehood) help put de husband to sleep. One makee wind for him wid de fan. Another one rub de head. Maybe one clean de hands and somebody look after de toe-nails. Den he sleepee and snore.

"Somebody stand guard before de door so nobody make noise and wakee him. Sometime de son of a slave in de compound makee too much

noise. De man what stand guard ketchee him and takee him to my grandpa. He sit up and lookee at de boy so. Den he astee him,

'Whoever tellee you dat de mouse kin walk 'cross de roof of de mighty? Where is dat Portugee man? I swap you for tobacco! In de olden days, I walk on yo' skin!' (That is, I would kill you and make shoes from your hide.) 'I drink water from yo' skull.' (I would have killed you and used your head for a drinking cup.)

"My grandpa say dat, but he don't never astee de chief to sellee nobody to de Portugee. Some chief dey gittee mad when de slave talkee so sassy and don't do work lakee dey tell 'em. Den dey sell him to de Portugee. De chief throw orange under de table. Den he call the slave boy he goin' sell and say to de boy, 'Pick me de orange under de table.' De boy stoop under de table. De chief got a man standin dere. Maybe two. When de boy go under the table to gittee de orange, de chief say, 'Ketchee de bushman!' De men grabee de boy and sellee him.

"De chief he ain always glad. One day de wife die. She still in de old wife's house and ain never been no wife to the chief yet. She too young. Why she die, Cudjo doan know.

"When dey come to tell de chief his young wife dead, he go look. He slap his hand on his wrist. Den he scream in his fist and cry. He say, 'Yea! yea! yea! my wife dead. All my goods wasted. I pay big price for her. I fatten her and now she dead and I never sleep wid her once. Yea! yea! I lose so much! She dead and still a virgin! Yea! yea, tu yea! I have a great loss.' "

Cudjo looked out over his patch of pole-beans towards the house of his daughter-in-law. I waited for him to resume, but he just sat there not seeing me. I waited but not a sound. Presently he turned to the man sitting inside the house and said, "go fetchee me some cool water."

The man took the pail and went down the path between the rows of pole-beans to the well in the daughter-in-law's yard. He returned and Kossula gulped down a healthy cup-full from a home-made tin cup.

Then he sat and smoked his pipe in silence. Finally he seemed to discover that I was still there. Then he said brusquely, "Go leave me 'lone. Cudjo tired. Come back tomorrow. Doan come in de mornin' cause den I be in de garden. Come when it hot, den Cudjo sit in de house."

So I left Cudjo sitting in his door with his bare feet exposed to the cloud of mosquitoes that swarmed in the shade of the inside of his house.

ALSO BY
ZORA NEALE HURSTON

BARRACOON
The Story of the Last "Black Cargo"
Available in Hardcover, eBook, Digital Audio, and Large Print

A major literary event: a newly published work from the author of the American classic *Their Eyes Were Watching God* that brilliantly illuminates the horror and injustices of slavery as it tells the true story of one of the last-known survivors of the Atlantic slave trade—abducted from Africa on the last "Black Cargo" ship to arrive in the United States. Offering insight into the pernicious legacy that continues to haunt us all, this poignant and powerful work is an invaluable contribution to our shared history and culture.

ZORA NEALE HURSTON

(1891–1960) was a novelist, folklorist, dramatist, ethnographer, and cultural anthropologist. Her many celebrated books include *Dust Tracks on a Road*; *Jonah's Gourd Vine*; *Mules and Men*; *Seraph on the Suwanee*; *Moses, Man of the Mountain*; *Every Tongue Got to Confess*; *Barracoon*; and *Hitting a Straight Lick with a Crooked Stick*.

WWW.ZORANEALEHURSTON.COM

COVER ARTIST'S NOTE

PATRICK DOUGHER

"So much of my work is about representing people of color in ways that highlight our beauty, nobility, and divinity. Zora Neale Hurston certainly exemplifies all of these virtues and more. Creating the art for this reissue of *Their Eyes Were Watching God* was both a great honor and a great challenge. Ms. Hurston is one of my favorite authors and this book is my favorite of her works. I wanted to create art that paid homage to her greatness and importance. I wanted to create art that would bring a smile to her face were she still with us. Looking at images of Ms. Hurston for reference and inspiration I was struck by how beautiful, stylish, and dignified she was, yes and how colorful, bold, and powerful. I tried to reflect all these things in the art I produced. I hope Zora is somewhere watching and smiling…"

FOREWORD BY
EDWIDGE DANTICAT

AFTERWORD BY
HENRY LOUIS GATES JR.

"A deeply soulful novel. Hurston is a lyrical writer . . . [who] believes in the transformative power of storytelling, and takes risks with sentiment that few contemporary writers are prepared to make."
—ZADIE SMITH

Cover art by Patrick Dougher | Cover design by Stephen Brayda
Cover photograph © OSTILL is Franck Camhi/Shutterstock

Available from HarperAudio and HarperCollins e-books

Discover great authors, exclusive offers, and more at hc.com.

AMISTAD
An Imprint of HarperCollins*Publishers*

FICTION 0220
ISBN 978-0-06-083867-6

9 780060 838676 5 1 7 9 9

USA $17.99 CAN $21.99

SERAPH ON THE SUWANEE

SERAPH ON THE SUWANEE

A NOVEL

ZORA NEALE HURSTON

WITH A NEW FOREWORD BY HAZEL V. CARBY
SERIES EDITOR: HENRY LOUIS GATES, JR.

AMISTAD

An Imprint of HarperCollinsPublishers

FIRST HARPER PERENNIAL EDITION PUBLISHED 1991.
FIRST HARPER PERENNIAL MODERN CLASSICS EDITION PUBLISHED 2008.

Designed by Cassandra J. Pappas

The Library of Congress has catalogued the previous edition as follows:

Hurston, Zora Neale.
 Seraph on the Suwanee / by Zora Neale Hurston.—1st Harper
Perennial ed.
 p. cm.
 Reprint. Originally published : New York : Scribner's Sons, 1948.
Includes bibliographical references.

 ISBN 0-06-097359-5 (paper)
 I. Title.
PS3515.U789S47 1991 90-55503
813'.52—dc20

ISBN 978-0-06-165111-3 (pbk.)

21 22 LSC(H) 20 19 18 17 16 15 14 13 12 11 10 9 8

To
Marjorie Kinnan Rawlings
and
Mrs. Spessard L. Holland
With Loving Admiration

CHAPTER 1

Sawley, the town, is in west Florida, on the famous Suwanee River. It is flanked on the south by the curving course of the river which Stephen Foster made famous without ever having looked upon its waters, running swift and deep through the primitive forests, and reddened by the chemicals leeched out of drinking roots. On the north, the town is flanked by cultivated fields planted to corn, cane potatoes, tobacco and small patches of cotton.

However, few of these fields were intensively cultivated. For the most part they were scratchy plantings, the people being mostly occupied in the production of turpentine and lumber. The life of Sawley streamed out from the sawmill and the "teppentime 'still." Then too, there was ignorance and poverty, and the ever-present hookworm. The farms and the scanty flowers in front yards and in tin cans and buckets looked like the people. Trees and plants always look like the people they live with, somehow.

This was in the first decade of the new century, when the automobile was known as the horseless carriage, and had not exerted its tremendous influence on the roads of the nation. There was then no U.S. 90, the legendary Old Spanish Trail, stretching straight broad concrete from Jacksonville on the Atlantic to San Diego on the Pacific. There was the sandy pike,

1

deeply rutted by wagon wheels over which the folks of Sawley hauled their tobacco to market at Live Oak, or fresh-killed hogmeat, corn and peanuts to Madison or Monticello on the west. Few ever dreamed of venturing any farther east nor west.

Few were concerned with the past. They had heard that the stubbornly resisting Indians had been there where they now lived, but they were dead and gone. Osceola, Miccanope, Billy Bow-Legs were nothing more than names that had even lost their bitter flavor. The conquering Spaniards had done their murdering, robbing, and raping and had long ago withdrawn from the Floridas. Few knew and nobody cared that the Hidalgos under De Sota had moved westward along this very route. The people thought no more of them than they did the magnolias and bay and other ornamental trees which grew so plentifully in the swamps along the river, nor the fame of the stream. They knew that there were plenty of black bass, locally known as trout, in the Suwanee, and bream and perch and cat-fish. There were soft-shell turtles that made a mighty nice dish when stewed down to a low gravy, or the "chicken meat" of those same turtles fried crisp and brown. Fresh water turtles were a mighty fine article of food anyway you looked at it. It was commonly said that a turtle had every kind of meat on him. The white "chicken meat," the dark "beef" and the in-between "pork." You could stew, boil and fry, and none of it cost you a cent. All you needed was a strip of white side-meat on the hook, and you had you some turtle meat.

But the people also knew that while the Suwanee furnished free meat, it furnished plenty of mosquitoes and malaria too. If you wanted to stay on your feet, you bought your quinine every Saturday along with your groceries. Work was hard, pleasures few, and malaria and hookworm plentiful. However, the live oaks set along the streets and in many yards grew splendidly and gave good shade. The Spanish moss hung down everywhere and seemed to interest travellers from the North, though these were few and far between. Nobody gave these Yankees any particular encouragement to settle around

Sawley. The Reconstruction was little more than a generation behind. Men still living had moved into west Florida after Sherman had burned Atlanta and made his triumphant march to the sea. A dozen or more men who had worn the gray of the confederacy were local residents. Damn Yankees were suspect of foraging around still looking for loot; and if not that, gloating over the downfall of The Cause.

This was a Sunday and the sawmill and the 'still were silent. No Yankees passing through. The Negroes were about their own doings in their own part of town, and white Sawley was either in church or on the way. Less than a thousand persons inhabited the town, and more than half the white population belonged to Day Spring Baptist Church. The menfolks, as everywhere, were not too good on attendance, but they paid their dues more or less, and the women and children went.

On this particular Sunday, though, there was a large turn-out. Not that there was any revival meeting going on, which always brought everybody out, nor were they hurrying to the church because it was believed that the pastor, Reverend Carl Middleton, had anything new to say, or any new way of saying what he always said.

Sawley was boiling like a big red ants' nest that had been ploughed up. It was rumored that Arvay, the younger of the two Henson girls was a'courting at last. To be exact, Arvay was not a'courting so much as she was being courted, and what with Arvay's past record and everything, this was something that people had to see.

In the first place, Arvay was all of twenty-one, and according to local custom, should have been married at least five years ago. But at sixteen, shortly after the marriage of her older sister Larraine, commonly known as "'Raine," to the Reverend Carl Middleton, Arvay had turned from the world. Such religious fervor was not unknown among white people, but it certainly was uncommon. During "protracted meeting," another name for the two weeks of revival that came around every summertime, most anybody was liable to get full of the spirit and shout in church and sing and pray. Back-sliders and

3

"sinner-folks" crowded the mourner's-bench and got religion over and over again. But it seldom lasted more than a month after the meetings closed. Nobody heard any more about it until the next time. A local wit put it this way: Sawley wore out the knees of its britches crawling to the Cross and wore out the seat of its pants back-sliding. Excessive ceremonies were things that the Negroes went in for. White folks just didn't go on like that.

So it was something when Arvay Henson, now, took her stand. Arvay could have done so different. In the first place, Arvay was still mighty young to take on self-denying. And then again, Arvay was pretty if you liked delicate-made girls. Her shape was not exactly in style in those parts, but that could easily be overlooked. She had breasts to her bosom, but elsewhere Arvay was lean-made in every way. No heavy-hipped girl below that extremely small waist, and her legs were long and slim-made instead of the much-admired "whiskey-keg" look to her legs that was common. She had plenty of long light yellow hair with a low wave to it with Gulf-blue eyes. Arvay had a fine-made kind of a nose and mouth and a face shaped like an egg laid by a Leghorn pullet, with a faint spread of pink around her upper cheeks. True, she was said to be so slim that a man would have to shake the sheets to find her in bed, but there were many around Sawley who were willing to put themselves to the trouble of making a thorough search of the bed every night. Many a man felt that given the chance, he could put plenty of meat on Arvay's bones. So there was a feeling of shock and loss when Arvay gave up the world. It brought on plenty of talk.

Arvay, young and white, and teasing to the fancy of many men, had got up in church on First Sunday, Communion Day, and announced that she was through with the world and its sinful and deceitful ways. She solemnly said that she had given her whole heart and her life to the work of God. She planned to be a missionary and craved to be sent away off somewhere to take the Word to the heathens. Tell them of Christ and Him crucified, and warn them of the dangers in which they stood

in their ignorance, of a burning and everlasting Hell. Also make them know that they had to die, and of the horrors of dying in their ignorance and sin.

Arvay's tearful speech followed the usual pattern, and everybody said it was just fine. There had been nothing about the heathens of China, India and Africa wallowing around on the heavenly chairs, nor ankling up and down the golden streets. None of her hearers could have imagined such a thing. Fancy meeting a Hindu, with his middle tied up in a dhoti and with white head-rag on, around the Throne, or singing in the Choir! It was too much, and nobody tried to imagine any such thing. He ought to consider himself pretty lucky to get saved from Hell. What became of him after that was [just not] talked about. The job of the missionaries was to save. So all of the women and a few of the older men cried tears of joy at the renunciation of the girl. She had to be full of The Spirit to talk that way, and so young, and therefore apt to be deviled and pestered by the flesh. It would be a mighty fine thing, the harried older women thought, if more girls felt as Arvay did. Therefore, on that day of Arvay's renunciation, when the girl had finished off by asking the prayers of the congregation, their earnest prayers that she might hold out and never, never turn back but go on and on to greater grace, "Amens" burst out all over the church. The pastor himself had gotten to his feet and paid his young sister-in-law a great tribute.

"This young girl's devotion to the cause of Christ makes me feel ashamed," Reverend Middleton had said. "Here she is, too young to be sent into the field as yet, but ready and willing to go. Ready to go wherever the Spirit might send her. Her stand ought to make me and all of us grown folks feel ashamed. And if you, my flock feel that you can spare me, I will declare myself ready and willing to go."

The flock had cried some more at the thought of the pastor's offer to sacrifice himself, but it was felt that he could not be spared. Anyway, it would take a lot of money to send him. To compensate for this denial, the parsonage was re-painted, and

5

five dollars a month was added to his salary, bringing the total to an even seventy dollars a month.

Five years had passed since Arvay had turned her back on the world and all its sins and snares. Arvay still played the organ for the Sunday School, and she took an active part in church work. Otherwise, she kept strictly to herself. It was not too difficult for her, because the community soon put Arvay Henson down as queer, if not a little "tetched." Nothing like her sister 'Raine at all, who was robust, not to say a trifle lusty, and pretty in the ways that the rural community favored. 'Raine had a full head of curly reddish hair, big legs and a busty chest. 'Raine was lively and full of chat. 'Raine took after her father's side of the family, while Arvay looked like her mother's folks, and even had her mother's ways to an extent. Maria Henson was overly religious, not given to laughter, and was considered meek and mild. The old heads recalled that Maria Henson had been given to fits and spasms in her girlhood the same way that Arvay was right now. No one thought too much about the seizures. Fits were things that happened to some young girls, but they grew out of them sooner or later. It was usually taken as a sign of a girl being "highstrung." Marriage would straighten her out.

For the last three years, Arvay had been having hysterical seizures, classified in the local language as "having fits." Sometimes they came upon her in church right after the sermon, but more often she was took down right after she got home from the service, and usually when some extra brash young gallant had forced himself upon her to the extent of seeing her home. It called for lots of persistence and a thick hide to "scorch" Arvay Henson home, but her looks and her unattainability nerved various young bucks to try it now and then. After the long walk in almost complete silence on Arvay's part, the venture invariably ended in an hysterical display as soon as the young man got inside the Henson parlor. Hardly did she get her hat off before she was sprawled out on the horse-hair sofa clenching hands and teeth and bobbling around and up and down, and with her mother running in with a small vial

6

of spirits of turpentine and the sugar dish with a teaspoon in it to administer the dose of three "draps" of "teppentime on sugar" forced between the teeth of Arvay to bring her to. The embarrassed would-be suitor stumbled out, and that was the end of his hopes. One by one the more brash were discouraged, and the timid never tried.

But now, the rumor had flashed around that Arvay Henson had met her match. Arvay Henson was being courted in spite of all she could do and say and so the town and outlying country and districts, all were good and stirred up. And the news was so exciting that nobody wanted to be told about it. Everybody wanted to go to church and to be there and see for themselves.

And there were three prongs to stir up interest. The first was that Arvay was taking company at all. The second was who it was who was sparking Arvay; but the most hooking horn of all was the way it was being done.

The man was Jim Meserve, whose ancestors had held plantations upon the Alabama River before the War. In that respect, Jim Meserve differed from the rest of the inhabitants of Sawley, who had always been of the poor whites who had scratched out some kind of an existence in the scrub oaks and pines, far removed from the ease of the big estates.

Not that Jim Meserve had come among the people of Sawley with anything. He had brought little more than the suit he had on, the high laced boots, and the broad-brimmed felt hat, which he wore so rakishly on his curly head. The fortunes of the War had wiped Jim's grand-father clean. His own father had had no chance to even inherit. Jim had come to town three months ago with only a small bundle, containing his changing clothes. But Jim had a flavor about him. He was like a hamstring. He was not meat any longer, but he smelled of what he had once been associated with.

Jim Meserve was very handsome too, and had stirred the hearts of practically every single girl in town. Caps were set to catch the laughing stranger. He was obviously Black Irish in his ancestry somewhere. He had the thick head of curly

7

black hair, deep blue eyes with long black lashes, so that they were what the Irish called "set in with a sooty finger," dimples in his lean cheeks, white strong teeth set in a chaffing mouth.

Jim had the gift of gab, no doubt about it. Within a week of his arrival in Sawley, he had talked himself into a job as woodsman on a turpentine camp. That was a miracle in itself, for "teppentime" folks are born, not made, and certainly not over-night. They are born in teppentime, live all their lives in it, and die and go to their graves smelling of teppentime. And Brock Henson, Arvay's father, who was an over-rider for the firm, and known to be a hard man to handle, had interceded for Jim and got him the job. A man had to go some to out-talk Brock Henson on anything. Brock Henson was a Cracker from way back. Life had not been easy for him, and he had cutting edges on his spirit, in spite of his love of jokes. Working that job out of the squat-shouldered, tobacco-chewing, rusty-haired Brock was a feather in Jim's cap, and gave him a standing.

Jim had the nerve of a brass monkey, everybody agreed. But then, he made no bones about the fact that he was really stuck on Arvay Henson. She just suited him, he said, and was worth the trouble of breaking in. Too, Jim laughed off the notion that Arvay was through with the world and had no use for love. So it looked like the brash devil was a'courting Arvay anyhow in spite of the well-known obstacles.

The Sunday before, Jim Meserve had rushed up to the Henson home and had escorted Arvay to *and* from church and people nearly split their sides at Jim walking along the road holding Arvay's arm with every kind of politeness in spite of all she could do and say. What would come off next? That was what they all wanted to see and to know. The doings were something like a well-trained hound dog tackling a bob-cat, and everybody wanted to be in on the fun. So they were all on the way to church that Sunday morning, walking, in buggies, riding horse-back and some even straddling grass-gut mules or in double wagons pulled by mules.

8

Brock Henson had never made as much as a hundred dollars in any month in his life. The family lived in a clapboard house more than two miles east of the heart of Sawley, and nearly a mile from the Baptist church. The house had been a dark ugly red when Brock Henson, promoted to over-rider, had moved in ten years before. It had not been repainted since, and was now a rusty, splotchy gray-brown. Only one room in the house, the parlor, was ceilinged overhead. In the two bedrooms and the kitchen, the rafters were bare and skinny. Water for the household came from a well out back, and the privyhouse leaned a little to one side less than fifty feet from the kitchen door. A fig tree, two pear trees which bore pears that were only good for preserving, were scattered far apart in the field back of the house. There was a huge mulberry tree that redeemed the very back of the unkempt garden space.

The Sawley people, eager to be amused at Arvay's expense, had no idea who or what Arvay Henson was. They had no way of knowing that Arvay was timid from feeling unsafe inside. Nor had anyone, not even her parents, the answer to Arvay's reactions to people. They did not suspect that the general preference for Larraine, Arvay's more robust and aggressive sister, had done something to Arvay's soul across the years. They could not know, because Arvay had never told anyone how she felt and why.

Arvay had one comforting advantage over Larraine. Arvay could play music and Larraine just couldn't learn it. Arvay had been asked to spend a summer with her mother's sister in Madison one time, and this aunt could play on the organ some. Arvay had shown great interest and a quick ability and had surprised the family on her return to Sawley in the fall, by being able to pick out melodies, and to play a few songs with full harmony all the way through. The Henson parlor organ, which had been bought years ago for style and had seldom been sounded, began to be used. Arvay was in there nearly every day practicing and practicing. She showed herself very apt with music.

9

But even this talent and comfort had laid a'road to ambush the timid Arvay. It had brought down upon her her most crushing blow so far, and this hurt had convinced Arvay Henson that happiness, love and normal relationships were not meant for her. Somehow, God had denied her the fate of sharing in the common happiness and joys of the world. Only she knew that her renunciation had been an acknowledgement of this conviction.

It had come about this way. Arvay was not quite sixteen when Carl Middleton, twenty-six, and newly ordained to the ministry, was called to Sawley to pastor Day Spring Baptist church. Middleton was five-feet-ten, deep-chested and husky, so that the godless Brock Henson snurled behind his back that Middleton ought to be mortally ashamed of himself to be dodging honest work like he was doing. Carl Middleton up in a pulpit beating on a Bible and hollering was nothing but a first class teppentime-still hand going to waste.

The female Hensons disagreed with Brock. Maria and Larraine shouted and hollered Brock down that the new pastor was just wonderful. Brock laughed it off by saying that they would naturally say that because the new preacher was a bachelor and 'Raine and her mother were up to baiting a hook for the puzzle-gutted slob. Arvay said nothing in Middleton's favor or against him because she considered him too wonderful for her to ever have a chance with him. She listened to Larraine and the older girls rave over the way one lock of his brown hair dangled over his forehead when he got really active in the pulpit. How his gray eyes blazed and his face got all tied up with rage when he was giving general sin and sinners in general the very devil.

Arvay was secretly glorified then when the new pastor seemed to single her out. He made two or three attempts to talk with the shy and almost wordless girl. Then happening to hear that she could play the organ, he made her organist for the Sunday School out of hand. Then he suggested that he call at the Henson home on Friday afternoons to go over the songs with her for the following Sunday. There was not much talk

in the countrified parlor, but Arvay shone inside at Middleton's very presence. She fell in love, and began to live a sweet and secret life inside herself. The pastor leaning over her shoulder while she sat at the organ, little touches of his hand seemingly by accident, softness in his voice, and telling her that she was an exceptional young girl.

This went on for months, with Middleton paying Larraine and none of the older girls any attention. Then, all of a sudden, Larraine developed great interest in church affairs and in the program for the Children's Day exercises in particular. She was always on hand in the parlor or at the church. And Larraine was seventeen and had on long dresses and could take company. The Sunday after Children's Day, Middleton scorched Larraine home from the night service and the next day Larraine announced to Arvay that she and the pastor were engaged to be married.

Even with 'Raine married to Middleton, Arvay could not bring herself to feel that her instincts had deceived her. Ah, no! There had been a mistake somewhere. Maybe even at the bottom of Carl's sudden marriage with Larraine.

It was twice as hard for Arvay because she had no one to whom she could open her feelings. Not to her parents who were bragging over 'Raine catching the new pastor. And certainly not to her only sister whom Arvay felt had somehow toled her true love away from her.

Believing in her heart that she was secretly loved by Carl, it gradually came to Arvay that the next move was up to her. The best plan would be to get herself sent far off to some foreign land. Some day, and without doubt pretty soon, Carl would follow her there. She would be standing in a flower yard, and she would see Carl coming a long way off, tired and worn out and sad. He would kneel down on his knees, kiss the hem of her garment, tell her how it all happened and beg her to forgive and to forget. Larraine would be dead—of a broken heart because Carl had found her out and told her to her face that she had parted him from his true love by her double-tongued lies and deceitfulness.

11

Outside of her dreams Arvay could detect no weakening in Carl except for a kind of a look he gave her sometimes from the pulpit. Otherwise, Larraine seemed to have her husband fetching and toting at her commands. But Arvay comforted herself that right was bound to win some old day, and dreamed and waited. The waiting was mighty hard, for Arvay found that it caused her to dream dreams that made her body plague her in miserable strange ways. For instance, what got the matter with her every time that Larraine got pregnant? It was something beyond Arvay's understanding. Some imp of Satan seemed to grab hold of her and drag her right into the darkened bedroom where Carl and 'Raine were, and made her look and see and hear from beginning to the end. It was after 'Raine's second announcement that Arvay felt her spasms coming on.

Not a soul in Sawley suspected this secret life of Arvay's. Most of them would have laughed at her if they had known about it. Carl Middleton had soon shot his bolt in Sawley. The new wore off him mighty quick. He never did say anything that had not been already said, and his repetitions were not very dramatic. His church members allowed that he would do, and that was the best that they could give him. He stayed home with his wife and had no loud kind of vices. Some complained that he couldn't lead a song worth talking about. Some wag went so far as to say that Reverend Middleton couldn't even raise a tune if you put a wagon-load of good compost under him and ten sacks of commercial fertilizer. They would have thought that a pretty young girl like Arvay was clean out of her head to be making so much out of nothing. But Arvay had felt wanted and warm and secure and important to someone for awhile, and it was hard for her to forget.

CHAPTER 2

That Sunday morning Arvay had no idea of the extent of interest in her affairs, but she did know how she felt. She fooled around and lingered over the breakfast table.

"Don't you reckon that you ought to be getting yourself fixed for Sunday School, Arvay?" Brock Henson asked sharply. "It's nearly nine o'clock."

Arvay jumped visibly and quivered. "That is, if I was going. I don't reckon I'll be going this morning."

"How come?" Brock demanded. "Before now, look like you couldn't get there soon enough. Why ain't you going this morning?"

"Oh, I just don't feel to be bothered, I reckon. Somebody else can preside at the organ one time, I reckon. I won't be so much missed."

"Call yourself trying to cold-shoulder Jim Meserve, I take it. If you had the sense that God give a june bug you'd feel glad that he feels to scorch you to and from. Ain't you never going to have sense enough to get yourself a husband? You intend to lay round here on me for the rest of your days and moan and pray?"

"I help you to say," Maria Henson agreed. "Arvay ain't acting with no sense at all. Here all these gals around here 'bout to bust they guts trying to git to him, and Arvay, that

seems like she got the preference with him, trying to cut the tom fool.''

"You all talk like I ain't got no feelings at all. You reckon I feel like pulling off down the road with him so he can make a fool out of me in front of everybody? Naw! I just ain't a'going.''

But in the end she was driven from kitchen to her own room to dress. In sullen anger, she took as long as she could. She was no more than half dressed when she heard her father greeting Jim Meserve out on the porch. She became so nervous that she was useless to herself. It was a good thing that Maria ran in and helped her into the pink lawn dress at last, and put her accessories in her trembling hands. "Aw, good gracious, Arvie! You ain't ready as yet? What in the nation you been doing all this time?'' Maria made quick and anxious movements as she grumbled and rushed the dressing of her daughter along. "Got Mister Meserve out there waiting all this time. You don't even act with the sense you do have. Move! I'll button your frock for you. Make haste, Arvie! Don't comb and pull at that hair all day. Mister Meserve sure looks noble in his Sunday clothes. Make haste before he gits tired of waiting on you and leave you.''

Arvay in the deeply flounced pink lawn dress, and with her flaxen hair swept up in front into a high pompadour, stood grim and panting before the looking-glass, her eyes stretched wide in fear like a colt that has been saddled for the first time; stood jerking at the body of her dress across her bust.

"You're all ready, now. I'll go tell him that you'll be right out. Naw, no need for you to grab up that Quarterly. Sunday School must be mighty nigh over by now. Here's a clean handkerchief for you pocketbook. Hurry on out to greet the young man.''

Arvay heard her mother taking extra spry steps down the hallway and out on the front porch.

She halted with cold trembling hands in the doorway to brace herself. While she was doing this, she glanced around. Just as Arvay had accused him to herself beforehand, Jim

14

Meserve had a face full of grin. He was doing the talking, and her parents were seconding every word with nods and smiles of agreement. Currying favor, Arvay mentally scorned them, and acting two glad dogs in a meat-house!

She stepped out on the porch with a long fast step, made the briefest manners of her lifetime without halting, and was almost loping by the time her feet hit the ground. By not turning her head in the slightest, she could pretend to know nothing about the dismay in the faces of her parents, and to have no notion at all about what Jim Meserve was thinking. She had offered the grand insult, and now maybe she would be left in peace.

Halfway to the gate she felt her elbow being caught by a man's long and strong fingers, and the tall shape of Jim Meserve was walking along beside her.

"Why, Miss Arvay," Jim said in great concern, "you wouldn't run off and leave me, would you?" They came to the shabby gate and he swung it outwards with one hand, while clinging to her arm with the other. "And I already know your answer to that 'Not if you can keep up,' is what you mean to tell me, ain't it, Miss Arvay?"

As they turned towards Sawley, Arvay heard a suppressed guffaw from her father and her face flamed. She looked up angrily into the young man's face and said nothing for several steps. Then she could hold in no longer and said from between clenched teeth, "What you grinning all over yourself like a chessy-cat for? You act like you found a mare's nest and can't count the eggs."

Jim Meserve seemed to take enjoyment out of her burst of rage and laughed some more.

"Grinning just like the Devil's doll-baby!" Arvay added as a further insult.

"Wouldn't hurt your face to grin a little, would it, Miss Arvay? You got yours all tied up in a winter-knot, or like you been feasting off of green persimmons."

"That wouldn't be necessary at all, Mister Meserve. You'se doing enough grinning and skinning back your gums for the

15

two of us. I'd give a good whoop and a holler, though, if you was to go on about your business and leave me be."

"Why, Miss Arvay?"

"Why? Well, just because."

"That don't tell me nothing, Miss Arvay. I know that is a woman's reason for most anything, but not being a woman, it don't spell out a thing to me. Go ahead and tell me something that I can understand. I might be sort of chuckle-headed, so don't chunk the whole pan of bread at me; crumble it up fine so I can handle it."

Arvay stopped in her tracks and tried to release her arm by a gentle jerk, but it did not work.

"Why do you want to come a'pestering and a'picking at me for? You know that you just want to make game of me!" There were tears in her voice if not in her eyes. "I never done nothin' to you for you to come taking me for a figure of fun, and making a laughing-stock out of me for folks to poke fun at."

The laughter died off out of Jim Meserve's face, and he stopped and stood looking down into her tortured eyes for a full minute.

"So you got notions like that about me, Miss Arvay?" Jim asked very soberly and kept studying the girl's face.

"You and everybody else," Arvay replied defiantly, but with something child-like and pathetic in her voice.

"But why, Miss Arvay? Why would anybody want to poke fun at you?"

"Because, because you don't, you couldn't mean what you say, that's how come."

"And why wouldn't I mean what I say? Why wouldn't I or most any man want you for your sweet little self?"

"Because you just wouldn't, that's all," Arvay stuttered out, and her face flushed red and she worked her eyelids rapidly to hold back the tears. At the point of failure, she shut her eyes tightly for a second and made a quick quarter turn to hide her face.

Instantly Jim seized her by her shoulders and whirled the

16

slim girl back to face him, and Arvay's hand flew up and slapped Jim's face with all her might and main. "You leave me be!" Arvay tried to release herself and run away, but Jim held her too firmly. "I told you to quit bothering me!"

"No, Miss Arvay, that I can't do at all. You need my help and my protection too bad for that, I see." With a solemn kind of soberness, Jim drew the shrinking Arvay to him. "You have made me see into something that I don't reckon you understand your ownself. I have to stay with you and stand by you and give my good protection to keep you from hurting your ownself too much. No, I can't leave you be, not until you and me both can see further."

"Oh, you don't have to take it on yourself to worry about me, Mister Meserve," Arvay protested weakly.

"Oh, but I do! I have to because you don't understand your ownself, Miss Arvay, and somebody stronger than you, and that can see further than you, and somebody that feels your care, will have to be on hand to look after you. Now we got things all straightened out like. Come on." And Jim let go of Arvay's shoulders and took her companionably by her hand and faced up the road. "You'll get more used to me before long and see into things."

"See into what?" Arvay questioned shortly as she followed Jim along the road.

"Oh, a lot of things, Miss Arvay, that you ain't got the right ideas about as yet. It's bound to come to you in time. I'll be around to look out for you and point out things."

Arvay refused to comment further, and with eyes straight ahead of her, she walked determinedly on the sandy road. After a few paces, Jim shucked off his solemn manner, and returned to his laughing good humor in a marvellous way. He chuckled and squeezed Arvay's arm lightly.

"Didn't take me long to learn just how you're made, Miss Arvay, and now I know how to handle you. You and me are going to have a mighty high old time together."

The straight road waved along over the slight rises. On either side yellow and blue flowers were ornamenting the

17

spring. They passed groves of live oak, scrub oak, scattering pines, and over towards the river, bay and magnolia in exotic white bloom. Deep curtains of gray moss hung from the trees and waved ever so slightly in the breeze. Budding wild grapevines and briars tangled up trees and peeped out from upper branches. Possum persimmons spread their limbs among the rest.

But Arvay took these in through a gray veil of apprehension. Folks would be coming along this road and see her in the company of Jim, and she pictured them grinning slyly and making jokes about her. Her mind imaged up the picture of the future. After Jim had made a public show of her, he would naturally get himself a regular girl, and they would all laugh at her, Arvay, and say how Jim Meserve and whoever his wife might be had made her look like a fool at a funeral. If only nobody came along! Oh, but she was not born for luck. Somebody would be sure and certain to come along. Arvay walked in dread of that moment.

All of Arvay's fears were confirmed, as a shabby old buckboard came abreast of them, with the deep sand pouring from the rim of every wheel. There was no mistaking that one and all were extremely interested in her in company with Jim. Their necks craned out, and their eyes snapped in curiosity. Old Lady Minnie Brawley was so scared that her wrinkled-around old eyes might miss something that she reached up a freckled old claw and flung back the bib part of her floppy calico bonnet the better to gaze and to peer. Grins and giggles broke out among the younger members of the clan. Her oldest son, who was at the reins, had to pull to a halt and scrape up some talk the best way that he could.

"Mawning, Miss Arvie, and Mister Jim. Hit's mighty hot and dusty walking for you all," he said. "You better hop in here with us and ride on to the church."

That grass-gut horse had more on him right then than he ought to have had, but Arvay suddenly saw a way out of her embarrassment.

"Yessuh, I thank you," Arvay said eagerly and made a

18

motion to approach the buckboard. As crowded as it was, it would be almost a miracle if she was able to get in. There would certainly be no room for Jim.

"Mighty much obliged to you all for your kindness." Jim smiled his most charming, and swept off his hat to the Brawley females, while with his other hand, he held Arvay's arm so that she could not advance. "But I can't see room for the two of us, and knowing Miss Arvay as I do, I know that she would disfavor to part with my company, and so as not to disappoint her so much, I think that we'd better just walk."

Arvay could have screamed and fought, especially as she saw how Brawley whipped up his horse and wheeled off. Making haste to get to the church-grounds so they could talk and tell. She tried to disengage her arm, but just then she heard another rig coming up behind them and looked back in unhappy defeat.

"Let go of me!" she hissed. "Making a fool out of me right out here on the Big Road. Acting just like the Devil!"

"Don't know who told you, honey, but you sure got it right. Those who know me well call me by my right name, Peter Rip-Saw, the Devil's high sheriff and son-in-law."

Arvay looked over her shoulder and dwindled down in helpless misery. What could she do? She would die before she let folks see her out there on a public road tussling and scuffling with a man. It would cause all kinds of talk, say she was letting a man get common with her. There was nothing for her to do but to pass the time of day and swap manners with the loaded down carriage and the two double-team wagons that passed them in rapid succession.

But the unusual activity along the Big Road did not sufficiently prepare Arvay for the spectacle when she came in sight of the church-grounds. The place was thronged as she had seldom seen it before. Horses, mules, buggies, wagons, buckboards and carriages were crowded together out under the oak grove where the congregation usually collected and ate from baskets on Big Meeting Day. Many bicycles leaned against the trunks of trees. People were mingling and moving

about. It was the social time between the letting out of Sunday School and the taking in of morning service. Arvay looked, and unconsciously clung to Jim's arm.

"Where in the world did all these folks come from?" Jim asked in surprise. "Everybody seems to be present from Joe Cry to Jimmy Giggle."

"Indeed, I sure don't know," Arvay mumbled.

As Jim boldly led her around and talked and joked with folks, Arvay had her ego nourished by the envious looks from single women and courting girls. Her vanity put on a little flesh, and she began to say a word or two herself to people. And besides, right in front of all those jealous girls, Jim was treating her like she was some precious play-pretty that might break in two. Bradford Cary III's wife could not have been handled more up to time than she was being handled. She was being helped over every little stick and root, and he fended so that she was not bumped into and jostled around. It was a soul-satisfying mock-up. If only it could be so!

Arvay saw three girls in a bunch trying to look amused at her, but even Arvay could see that it was hardly big enough to reach across their thin-lipped mouths. It didn't taste near as good as they were trying to make out. They were the three ringleaders in the social set of the poor. The most popular at all the square dances, barbecues and things like that. To make sure and crumple Arvay's feathers, they got themselves in the way so that she could overhear their comments as if by accident.

"That don't mean a thing. Mister Meserve is much too lively and used to things to waste up much time on missionaries."

"And what would he want with a skinny thing like that? He being tall and spare-built hisself, he would naturally want somebody with some meat on they bones. Folks don't go to the butcher-shop to buy bones unless they aim to make lye-soap."

There was a blow of mirthless laughter at this piece of wit, and the chunky girl, giving a switch to her full hips, was

encouraged to go on. "Can you imagine them married and in the bed together? I bet they would sound like a big dish-pan of crockery rattling together."

The three tickled themselves out loud at this and looked at Arvay.

"Oh, it won't never come to that," the third announced with assurance. "I got enough meat on my bones to straighten him out and put a stop to this. Don't you worry."

If Jim heard, he gave no notice. He accepted an invitation to a square dance for himself, and his especial company, Miss Henson, ten days later.

"Is that all right with you, Miss Arvay?" Jim asked with great solicitude.

"Most certainly!" Arvay replied and looked the three leaders of the sawmill set dead in the eyes.

But Arvay was sunk again when she and Jim went inside and beheld most of the young folks, married and single, packing into the center aisle pews behind them to comment and to be witnesses to what went on. She sank down into her seat, three rows from the front. Jim did not seem to notice a thing. He came parading like a king down the aisle behind her, stood until she had entered the pew, came in after her, stood and looked out over the fast filling church, hitched up his pants and sat down.

Suddenly Arvay became conscious of Carl's inspection from the back of the pulpit. It was funny, but she had forgotten all about the man she had thought that she had loved so hard and so hopelessly for six long years. But there was no mistaking. Every time that she looked off, when she brought her eyes back to the pulpit, she caught him watching her in a curious way from under the awning of his hand resting on his brows. It made Arvay nervous, and she squirmed.

And there was Jim Meserve brazenly leaning against her, shoulder to shoulder. It gave Arvay some kind of feeling of being caught acting unfaithful by Carl Middleton. Why? Never had a word of love passed between them. Even so, his look seemed now to say that he had seized upon her secret,

21

and he was sadly accusing her of defection. She inched away from Jim as far as she could, which was only a few inches, but Jim promptly closed the gap again. A loud whisper somewhere behind her applauded Jim.

"Go, gator, and muddy the water!"

"I'd give a spot cash one hundred dollars if Jim would up and buss her."

"Oh, he'll do it all right."

"Aw, aw! That Arvay would throw a acre of fits."

Along about the end of the uninspiring sermon, Arvay was startled by a quick but tender pressure on her arm by Jim. She turned her head in surprise and their eyes met head on. He was looking at her in some intense and hungry way. Some common pulse began to pump something from Jim to her. Arvay noticed for the first time that Jim was made out of flesh. It was too intense, and Arvay, flushing deeply, snatched her eyes away. She flung her eyes up to the choir stand, and in doing so, caught her sister's eyes upon her. Larraine must have been looking at her for some time, because the look was set, and it was as plain as day that Larraine was not pleased at what she was looking at. Her face was as naked as a jay-bird in whistling time. Her eyes went from Arvay to Jim and back again.

Arvay knew that look only too well. Just let Arvay get hold of something that gave her particular pleasure, and that look came over Larraine. Only today, there was an out-done look mixed up in Larraine's face, and Arvay knew why. There was no way in the world for 'Raine to handle Jim first and then fling him at Arvay when she was tired or he was damaged and scarred. She had Carl Middleton, and she had three children to boot. Let her pout and crave! Here was something that she could do nothing about. Something that Brock Henson could not snatch away from Arvay and hand over to Larraine. Jim Meserve, placed beside Carl Middleton, was like a slick race-horse beside a grass-gut mule. Was Larraine sitting up there being sorry that she had been in such a haste to grab Carl?

"Excuse me, Miss Arvay," Jim was murmuring as he got up

22

from his seat. Jim was following the local custom. The collection was lifted right after the sermon. It was the habit of the young courting men to go outside immediately after the sermon, stretch their legs for a few minutes, and then just as the collection began, to swagger back in, and ostentatiously hand their lady-love a coin to put in the collection. It was a sure sign of who belonged to whom.

After the young men had bestowed their gifts, the girls arose proudly, and with their fellows swaggering after them, paraded up to the table, and dropped their coin with a ring. One young couple right after the other parading up, and returning simpering to their seats. It was hard on the girl or the fellow whose time had been beaten, but it was a triumph for the winners. Arvay cast her eyes up briefly at Larraine, and trembled as she realized what was about to happen. Never had she marched in the parade before.

The deacons took their places, the pastor made his appeal for money, the organ struck up *Pass Me Not O Gentle Saviour* at a lively pace, and the choir rose and lead the singing. The young men waited until the old fogies had thinned out, then they came back in looking like conquerors, and began to rejoin their ladies, giving the money out before they took their seats. Jim pressed a quarter into Arvay's palm, hitched up his britches arrogantly and sat down. It only waited now until some couple began the parade.

"Come on, honey," Jim whispered to Arvay. "We might as well lead off."

Arvay got to her feet, feeling every eye upon her. They had hardly made the aisle, though, before fifteen to twenty other couples were struggling into the aisles. Arvay went back to her seat feeling an exhilaration that she had never known before. She belonged to something. They nodded and grinned at each other, these couples, as they met and passed going up and down the aisle. She looked up to see how Larraine was taking it. She could hardly sing along with the rest for watching Arvay, and she was not smiling either. Arvay looked and felt glad.

Surrounded by her new associations, Arvay lingered in front of the church with Jim, feeling like she had fed on kings. Out of this feeling came a tremulous desire to take refuge in this man. To be forever warm and included in the atmosphere that he stirred up around him. The feel of his long-fingered hand on her arm, and the look from his eyes tingled her in a way that she had never felt before.

But with the intensity of desire stirred up in her came despair. This was the prettiest man that she had ever laid eyes on. He didn't have any great vast money, but this was no common Cracker boy whatsoever. Why, even the Carys had heard mention of his folks. What in the world did she have to win him with?

Ah, no, this pretty, laughing fellow was too far out of her reach. Things as wonderful as this were never meant for nobody like her. This was first-class, and she was born to take other people's leavings.

He had scorched her to church and back today to make good his bet. It had turned out very nice and happy for her in a way, but then again, it had given her something to wish for which she could never have. Nothing to do but submit herself to her fate.

But submission tazzled you all up inside. To cover up her feelings, Arvay began to try to be quick and care-free with answers, and began to talk at random. She hardly knew what she was saying and doing before she arrived at her gate.

"Oh, no indeed, Mister Meserve, you don't think my hair is the prettiest in the world, no such a thing." And Arvay affected a hollow laugh to show that she was not as simple as he might think. "I know that you just say things [like] that to pass the time. You think country folks like us ain't got no sense, I reckon."

"Why, Miss Arvay! You don't mean to tell me that you disbelieve me what I say?"

Arvay hung her head and refused to meet his eyes, even when he shook her elbow and tried to make her look.

"You do wish to get rid of me, don't you?"

Arvay still stumbled along and said nothing.

"Silence gives consent, Miss Arvay. Look like I hit the nail right on the head."

They were at the gate, and Arvay wanted to rush inside and away, but Jim detained her by holding her arm.

"But you might as well save yourself a whole heap of trouble in that line, Miss Arvay, because I'm going to marry you first and last."

Arvay was half in the gate. In spite of Jim's smiling way, there was something serious-sounding in his voice, and Arvay looked up into his face to see what his words really meant. Something in his eyes sent the blood rushing to her face, and involuntarily Arvay bowed her head and concealed her face on the top of the shaky gate-post.

"Oh, you know that you don't mean that, Mister Meserve." Arvay mumbled and lifted her face the slightest.

"Oh, but I do, Miss Arvay." Jim chuckled a little.

"You act like I, that is, somebody been just waiting around for you to ask 'em that. Supposing that I don't love you, or no other man, enough to marry 'em."

"That would mean that you didn't have all that belongs to you. I'd make a girl like *you* a damned fine husband." And Jim laughed at his own brashness.

"I been laying off to give my life to missionary work, Mr. Meserve. Even if you mean what you say, I'd have to take time to make up my mind."

"Oh, I mean it sure as you're born, and so far as making up your mind is concerned, that matters a difference. Women folks don't have no mind to make up nohow. They wasn't made for that. Lady folks were just made to laugh and act loving and kind and have a good man to do for them all he's able, and have him as many boy-children as he figgers he'd like to have, and make him so happy that he's willing to work and fetch in every dad-blamed thing that his wife thinks she would like to have. That's what women are made for."

"You reckon?"

"No, I know it. Since I been here in Sawley, I done got in

25

the notion that I'd like to get hold of one of the useless things to keep for a play-pretty. I'm going on twenty-five, been knocking around the country for seven years now, seen a lot of women and places, and seen a lot of things. It's about time I settled down, get me a real pretty wife, and start to raise me a house full of young 'uns."

"Well, you don't have to worry." Arvay smiled with a corner of her mouth. "From all I can learn, plenty of these girls around here would be only too glad to have you. It looks like you can just about take your pick."

Jim grinned. "That being the case, I'm picking you. I'm marrying you because I'm too tough for you to get shed of like you seem to be trying to do."

There it was, straight and simple. But this was like coming through religion, Arvay considered. Like your thoughts while you were out at the praying-ground in the depths of the woods, or being down at the mourners' bench during protracted meeting with the preacher, deacons and all the folks from the Amen corner standing around and over you begging and pleading with you to turn loose your doubting and only believe. Put your whole faith in the mercy of God and believe. Eternal life, Heaven and its immortal glory were yours if you only would believe. The hold-back was that it was not all that easy to believe. That was just the trouble. Bad luck, yes. That was easy to believe in from human experience, but a whole heap of happiness and good luck just didn't come to folks like that. Certainly, things had never turned out that way for her. Now, was she to believe that this very pretty man clothed in all the joys of Heaven and earth was for *her,* and all that she had to do was to part her lips and say "yes" to have him all for herself for life? Oh, no, this was just another hurting joke being played on her.

"You figger that you'se all that tough, Mister Meserve?" Arvay imagined that Jim's hand on her elbow trembled some as he assisted her through the gate. Naturally, she was mistaken. How could this brash man, with everything in the world at his command, be nervous about anything? Knowing

26

his power, he was just funning with her to show to the world that he could do what other boys hadn't been able to do. She glanced up at his face briefly and saw a deep grin beginning to spread out over his face.

"Sure do, Miss Arvay. What I'm about to tell you will give you some kind of idea. One time I was bossing a gang of lumberjacks and we was felling a big stand of cypress when a terrible thunderstorm come up all of a sudden. It was a mighty bad storm, Miss Arvay. Big wind a'blowing, heavy drops of rain, both chain and ball lightning forking from tree-top to tree-top and zig-zagging around something awful. Well, a great big bolt of that lightning, red-hot and gritting its teeth, took off and headed straight at me. It's a habit of mine, Miss Arvay, when I catch a streak of lightning aiming at me, to stand in my tracks and slap it right back where it come from."

Arvay with the front of her skirts lifted slightly was mounting the steps side by side with Jim. She looked up at his face in buck-eyed astonishment.

"Slap lightning, Mister Meserve?"

"Yep, because I don't aim to be imposed on like that by nothing nor nobody. But this here streak of lightning must of been even faster than it's supposed to be, because the next thing I knowed, it had done got past my hand and struck me."

"Struck you, and you ain't dead?"

"That's right, Miss Arvay. I'm shamed to admit it, but it hit me, *kerwhammmmm!* and right in the head at that. All I could do to stay on my feet from that lick the lightning hit me. Man! But was I mad! Just as hot as Tucker when the mule kicked his Mammy. All them colored men that was working under me come running to see if I was killed. Outside of a slight headache, there was nothing wrong with me at all. Told 'em they might as well go on back to work. I wasn't hurt at all, but that sneaking bolt of lightning was done up pretty bad. Yes, Ma'am! Last I seen of it, it was going off through the woods a'limping."

Jim's face brimmed over with laughter like an orange being squeezed, and he stood with one hand resting on the jamb of

the door holding back the explosion until Arvay joined him in it.

"Why, Mister Meserve!" Arvay flashed angry eyes up at him. "Telling that big old something-ain't-so, and on the Sabbath Day at that!"

Jim stood in utter amazement as she made to push past him and go inside. "Poking fun at people and taking 'em for dumb fools!" Arvay went on. "Nobody with any sense would put a bit of dependence in anything that you say. Always trying to make light of folks."

With that Arvay flounced angrily inside the house. Jim hesitated outside the door for a second. If he had not been specifically invited to partake of dinner by Brock Henson, warmly seconded by Maria, and had not gladly accepted, he would have turned and left the place. But he followed Arvay. She was flinging her hat on the home-made hat-rack against the wall in the hall, and as Jim came up to her, was about to walk away without even offering to rest his hat. As he removed it, she snatched it out of his hand and hung it on one of the cow-horns without a word.

Maria, with an apron over her Sunday clothes, poked her head in the back door of the hall and beamed.

"Oh, so you all got back from church, did you? Walk right in the parlor, Mister Jim, and make yourself comfortable. Dinner'll be on the table tuhreckly."

"I thank you, Mrs. Henson." Jim replied as cheerfully as he could and walked on into the parlor ahead of Arvay. He sat down on one of the old parlor-rockers near the organ, and Arvay sank down on the horse-hair sofa on the other side of the room. She reached for a palm-leaf fan from the lower shelf of the table and began to fan herself nervously.

"You mean that you didn't see the joke in that tale, Miss Arvay?" Jim asked.

"Oh, so that was supposed to be a joke? I don't favor so many jokes, Mister Meserve. I don't like to be took for a fool. I admire for folks to talk plain and say just what they mean."

Arvay stole a look across the room and saw that something

seemed to be troubling the man in his face, and she interpreted it from what she had inside her. Fear flew to her heart. Maybe Larraine knew her old feelings about Carl, and had maliciously said something to Jim about it. She remembered that Larraine had been talking to Jim for a few minutes on the church-grounds while she had been tied up elsewhere. It would be just like 'Raine to do a trick like that.

Jim, for his part, balked and puzzled, was trying to find an easier way with Arvay. While he sought, he entertained himself by taking stock of the room. There was the what-not in one corner loaded down with the usual things: sea-shells, a mustache cup and saucer with a motto on it in gilt letters, a cheap Japanese fan spread open, numerous other bits of cheap crockery with fanciful shapes and colors. There was the inevitable center table with the big family Bible on the under shelf. On top of the table was the parlor kerosene lamp, with a decorated globe, and a strip of red flannel in the oil compartment for decoration. A cheap family album was on one corner of the table under the lamp, and a stereoptican lantern with pictures on the corner cater-cornered across. The remaining corners held fancy cups and saucers.

The four walls were crowded with ill-assorted pictures. All those in frames had nails beneath them so that the frame rested on those nails and leaned out from the wall at the top. The place of honor, over the mantlepiece was held by some artist's concept of General Robert E. Lee at Manassas. In that era, battle scenes were in high favor, and in these scenes, the generals all sat on rearing, fat-rumped horses. Though the enemy was always right up under the feet of the general's horse, he assumed that the men he led could not see them. Generals always pointed either their swords or their fingers to show [their] men the enemy. Lee, astride his famous Traveller, was pointing at the blue-clad Union soldiers and looking furious.

There were lithographs, unframed, depicting Bible scenes tacked plentifully around the walls. Peter was there in his unfortunate attempt to walk the waters like Christ. Acknowl-

edging his lack of faith and his failure, he was pictured as squatting on the surface of the water, looking up guiltily into the face of his Master, who stood there calmly on the waves. It struck Jim that if Peter could squat like that without sinking, he could walk, and he started to comment on it, but remembered and held his peace. The other pictures, with the exception of a gaudy calendar advertising feed, seed, and fertilizers, were family pictures done in the prevalent crayon enlargements in showy frames. Brock Henson in a fierce mustache was on a bamboo easel in the corner by the sofa. There was one, obviously the wedding picture, in which Brock sat cross-legged in a chair with a stiff derby hat on his knees, and a young and pretty Maria standing beside the chair with one hand resting on his shoulder. Maria the mother, was in another frame, seated with a fat blob that must be Arvay on her lap, while another disfigurement that had to mean Larraine in a highly ruffled dress, leaned against her knee. This picture gave him an opening for conversation.

"That's you and your mother and your sister, ain't it?"

"Yes." Arvay answered, and ceased waving her fan for a moment. "That was took in Monticello one time when I wasn't nothing but a baby. A man come long two or three years back making enlargements, so Ma give it to him to get enlarged."

"Oh, I see." Jim pretended an interest that he did not feel, and now that he had an opening, he carried on. "Larraine looks so jolly in the picture, and even when you talk to her, that I'm surprised that she took up with that sorry preacher. How come that to come about, you reckon?"

"Why?" And Arvay's eyes flung wide open in a fright that Jim could not understand. "Why, how come you to ask a thing like that?"

"Oh, it's nothing to take so serious as all that, Miss Arvay. I just had the notion that your sister wasn't so full of religion as all that, and neither your pastor, so far as that is concerned. He looks like nothing but a big old humbug to me, and I

wondered how she happened to get took in by something like that."

"Oh," Arvay sort of gasped, and the next thing Jim knew she was sprawled out on the sofa in the grip of a spasm.

"Good God, she's took with that again!" Jim jumped to his feet. "Mrs. Henson! Mrs. Henson!" He called out. "Come quick! Miss Arvay is having another spasm!"

Mrs. Henson came running, and she had the sugar dish with a teaspoon in it in one hand and a small flat bottle of spirits of turpentine in the other. The harshness of spirits of turpentine had earned it a high place as a cure-all.

"Oh, do, Jesus!" Maria Henson panted. "Look like she's took worse than usual. Help me with her, will you, Mister Jim?"

"Be only too glad to, if you'll show me what to do."

All the time, Jim was studying the behavior of the girl very closely.

"Hold her down, will you, whilst I drop three drops of this here teppentime on a spoonful of sugar. That always fetches her around."

Jim obligingly took hold of Arvay's shoulders, while Maria, with shaking hands, fixed the preparation.

"Got to git it to her mighty quick," Maria trembled out. "Git this spoon betwixt her teeth [or] she's liable to bite her tongue off." She stooped and tried to force the spoon between the clenched teeth. Just then, Arvay flailed out with both arms, and the loaded spoon went flying across the room. "Oh, my Gawd, Mister Jim! She's liable to be done bit her tongue in two before I can git anymore fixed for her. Hold her for me tight as you can, please."

"Here, you're nervous your ownself, Mrs. Henson. You better take hold of her shoulders and lemme try to fix the medicine and get it in her mouth."

Jim's tone of authority gave Maria confidence, and she grabbed hold of the struggling girl, while Jim retrieved the spoon, dipped up fresh sugar, and standing directly over

31

Arvay's head, took the little bottle and began to drop the turpentine. He was very deliberate.

"Make haste!" Maria screamed. "Git that spoon in her mouth before she bites her tongue! Do, my Maker!"

"She ever bit it as yet?" Jim asked calmly as he waited for the second drop to fall.

"Naw, but she's liable to. Hurry up!"

But Jim, standing there tall and composed over Arvay, would not be hurried. There were seconds, it seemed to Maria between each drop. Two of the drops were finally deposited on the sugar in the spoon. The mother looked anxiously, tracing the course of each drop. Jim looked from the bottle to the spoon, to Arvay's face and back again to the poised bottle and the spoon. Now for that last third drop. Suddenly his hand gave a nervous twitch, and the third, or maybe third and fourth drop together, missed the spoon entirely, and landed right in the outside corner of Arvay's right eye.

Then a hurricane struck the over-crowded parlor. Arvay gave a yell from the very bottom of her lungs and catapulted her body from that sofa. She was all over the room at one time, seemingly, knocking over and upsetting things. Jim thought that she was going to climb the wall like a cat, and all the time she was gasping out yells. Jim heard Brock's footsteps hurrying up the hall just as Arvay got her directions and split out of the door. She collided with her father, rushed on past the temporary obstruction, and vanished down the hall in a cloud of flying yellow hair and pink skirts. Nothing but scream and screech in her wake as she made it to the back porch.

There was a frantic rattle of metal from the back porch.

"Poor, poor, thing!" Maria moaned. "Trying to git to some water to wash out her eye. I better go help her."

"We can all go help her with her eye," Jim offered as Brock Henson appeared in the parlor door. "Looks like she's sort of over her spasm by now." Jim and Brock Henson stood face to face and looked each other dead in the eye for a long moment. "We'll give what aid we can in washing out her

32

pretty eye." With a dry grin smothering in his face, Jim led the way to the back porch.

Arvay was splashing cold water in her face frantically. Brock went and ranged himself against the wall. Jim took the half empty water pail and went out to the well and drew it full. Maria fluttered around like a hen with ducks for children at the edge of a pond and made little noises of sympathy.

"What took place in there, Arvay?" Brock asked unnecessarily, as Jim mounted the porch with the full bucket of fresh water.

"That varmint! Ooooooooh! He poured teppentime right in my eye! He done it a purpose, too." Arvay splashed and sobbed.

"Oh, I don't reckon he meant it to hurt you," Brock said casually. "Your eye ain't hurt none to mention. That being the case, you sure ought to thank him. Quickest cure for spasm-fits I ever did see. Yessiree!"

Arvay turned on Jim. "You long-legged scoundrel-beast, you! You and your no-count jokes. I got a good notion to take me a gun and kill you!"

"Aw, now, Miss Arvay," Jim drawled in good-humored unconcern. "You wouldn't take and kill you best-goodest would you?"

"Git away from me, sir! Git on away from me! Pouring teppentime in my eye for a joke. Git! Light a shuck often this place!"

"Damn!" Brock breathed deeply impressed. "Jim, you sure done worked a miracle. I never knowed that Arvay had that much life in her."

"It's all right, Mr. Henson, I'll be able to handle all that. A woman knows who her master is all right, and she answers to his commands. We'll make out good enough."

Arvay, egged on to greater rage, ran to the shelf and seized the bucket of water.

"Git from here, Jim Meserve! If you don't hurry up and git from here, I aim to dash this bucket of water on you. Git! And don't you dast to foot this place again."

33

Arvay was further maddened by the evidence that Jim was not sorry for what he had done. Not godly sorry anyway. He put on a sorry look on his face, but his eyes were grinning.

"Go ahead and fling that water on me, if you will and want to, Miss Arvay, but you ought to know that I wouldn't want to do a single thing to hurt *you*, not on purpose, anyhow. I beg your humble pardon for letting that little tetch of teppentime git into your eye. I wouldn't harm a hair on your pretty head. Fact is, I'd rather all the rest of the women in the world to be dead than for you to even have the toothache. That's the way I feel towards you."

Arvay had no more wish to throw water on Jim at all, but she stood there with the bucket in her hand, and not knowing how to get rid of it with dignity, just stood there. Jim helped her out. He stepped up, took the pail and put it back up on the shelf, then turned with an undisguised grin on his face this time.

"It was a good thing, Miss Arvay and you know it. Saved you a lot of spells of sickness, and me a whole lot of doctors bills."

Arvay got that, and right in front of her parents too. It gave her a stirring feeling inside, though she still held her mouth in an angry line.

"Anyhow," Jim went on and actually laughing now, "it got you to your feet long enough for me to talk to you and to tell you how I feel."

Arvay began to believe a little in Jim's sincerity, him talking like that right in the presence of her folks, and all. Then a terrible feeling of guilt came over her. Even if Jim meant it, she was not fitten. Here was the most wonderful man in all the world pomping her all up, and she had been living in mental adultery with her sister's husband for all of those wasted years. She was not fitten for a fine man like Jim. He was worth more than she was able to give him. The Bible said plainly that you could sin inwardly just as much as if you had actually done the thing, and she had sinned. Nothing to do but to turn her back on her happiness and never let on that she had ever wanted

34

Jim. But now that meant turning from the noonday of joy back into the dark mole holes that she had been living in so long. It was a terrible choice. But to be honest with Jim, there was nothing else for her to do. She acted on the conviction immediately. She brushed past him towards the door into the hall to retire to her room until Jim was gone.

"Where do you think you're going?" Jim demanded and grabbed her by her arm and jerked her backwards. "You can't leave here unlessen you say that I'm forgiven for what I did."

"I, I better go comb my hair, I reckon," Arvay said.

"Yeah, do," Maria urged. "It looks like a whoo-raw's nest. Dinner is all fixed, so don't be all day in there."

"And come ready to say the right thing soon as you get back," Jim ordered. "Shake a leg! The foundations of my patience gives way mighty easy."

Arvay went off meekly enough. She wanted to be by herself to think awhile anyway. She was falling into step with hope and she wanted to pick herself over inside just in case. As she combed out her hair and put it up again, she thought and asked questions of herself. If Jim really wanted her, what about herself?

Now, in the first place, was she really in love? She was beginning to feel that she was, or could be anyway. She might recede from this high point in the future, and retreat to the one of ruthlessness where only those things that count with the neighbors would seem worth fighting for, but right now she was smoking with illusions.

And the way Jim had talked coming along the road made things seem too easy. He had just as good as excused the woman he married from all worry and bother. In so many words he had said, "Love and marry me and sleep with me. That is all I need you for. Your brains are not sufficient to help me with my work; you can't think with me. Let's get this thing straight in the beginning. Putting your head on the same pillow with mine is not the same thing as mingling your brains with mine anymore than crying when I cry is giving you the power to feel my sorrow. You can feel my sympathy but not

35

my sorrow." All in all, that meant that if she married Jim Meserve, her whole duty as a wife was to just love him good, be nice and kind around the house and have children for him. She could do that and be more than happy and satisfied, but it looked too simple. There must be a catch in it somewhere. Being of high family, and having more book learning than she had, and being all that handsome, he could be as choosey as he pleased, and he was bound to be looking for something else. There was bound to come a time when he was going to feel outdone in not finding those other things in her.

Arvay took a long, tremulous breath. Her heart was leading her into the arms of Jim Meserve. The fearful future lying in ambush for her. Well, maybe God would have mercy and help her when it came. She might be able to hold onto Jim, and keep him from quitting her some way or another. Holding her breath in a fearful tenseness, she changed into a fresh dress, pinched her cheeks to make them pink, and slowly went out to join Jim and her father on the back porch.

Jim looked at her with admiration and came and stood in front of her and looked down earnestly into her face.

"All right now," he jollied, "what you got to say?"

"I got to forgive you, I reckon, Mister Meserve."

"You had better. I'm liable to take and frail you good."

Arvay smiled and cast her eyes to the floor. Then she reached out timidly and took his hand. "Come on. I got something pretty to show you before Maw can get dinner on the table. 'Tain't nothing but a mulberry tree, but I think it's fine."

Arvay pulled and they jumped off the porch into the yard. Just then Maria stuck her head out of the kitchen door.

"No time for that now, Arvie. I'm just putting dinner on the table."

"Won't take but a minute, Maw. I want to show him where I used to play doll-house."

"What in the nation for, Arvie? 'Tain't a thing out there for nobody to see at all. You ain't had no play-things out there for the last longest, and Mister Meserve done seen a many mul-

berry tree before now, I 'speck. I wants to git out of this hot kitchen over this cook-stove."

Arvay didn't talk back, but she led Jim on off determinedly. She held on to Jim's hand and hurried him along. Her mother had no idea about her at all, she was beginning to believe. Before anything more could be said, she wanted a cleansing of her sacred place. She wanted Carl and all her thoughts about him to be gone from under that mulberry tree. She wanted to feel that the temple was cleansed, and that she herself was clean and worthy of what she was about to receive. Only the strength that Jim radiated could drive out the old things. Jim just had to come here and broom out before she risked sitting down to the table with him and having him say that he cared for her and ask her to marry him. Arvay all but ran across the field, dragging Jim along with her.

They entered the place under the tree and stood there hand in hand, almost hidden from the outside by the low-hanging, supple limbs. It was a cool green temple of peace.

"Oh, but this is nice and pleasant," Jim exclaimed. "I don't fault you for liking it here. Feels like we got the world all to ourselves under here. Just you and me."

Arvay held tight to Jim's hand and said nothing. She led him around the tree in a solemn walk till they came back to the same spot again. She stood looking up through the new green leaves, punctuated by tiny fuzzy things that looked like green, stubby worms. Those were the young mulberries coming on. She was just standing there clinging to Jim's hand and feeling that everything little had been swept away by bigness when she heard her mother bawling for them, sharply and impatiently.

The feeling around the table was tense for a while. Everybody thinking about the same thing and trying to act like they were not. It was obvious that the tale Brock felt impelled to tell about marriage customs in the backwoods of Arkansaw was prompted by his thoughts.

"Girls marry off soon back in Arkansaw where I come from," Brock began by way of ringing in his story, and both

Arvay and Maria jumped at the crudeness of the way Brock was bringing out what they were all thinking about.

"You didn't come from no Arkansaw," Maria snapped by way of heading off what she knew was coming. "You was borned back there in middle Georgia."

"Matters a difference about where I was borned, Maria. I'm talking about what I learned when I was visiting over there in the backwoods of Arkansaw. Now."

"You ain't even been nowhere near there, Brock, so you might as well squat that rabbit right now and jump another one. Anyhow, nobody don't want to hear that old-time lie. You done told it so many times that everybody is sick and tired of hearing it."

That was a way that Brock had for the last year or so. Everything that happened was in Arkansaw, influenced by a paper-backed book that had the rural South by the ears for the last few years and had become a sort of laughing Bible among them, called *A Slow Train Through Arkansas.*

"But I want to hear him tell it," Jim said. "Never been in them parts myself, and I'd favor to get some information on the marrying subject just as quick as I can. I needs any assistance I can get hold of along in here."

Arvay as well as her mother suffered. Act too anxious, and it might drive the man away. And just as things looked kind of hopeful, Brock had to flap his big mouth. Arvay sat stiff with misery. Maria suddenly remembered that she had not brought in the bowl of gravy and the pitcher of lemonade, and mentioning it, gave herself opportunity to not be present when the disaster struck her child.

But Brock, full of his purpose, was not hurried. He wallowed the thing around and waited for Maria to go and come. He watched Maria settle miserably into her seat again and then began:

"Oh, 'tain't much of a story, Jim, it's just the habit they got back there in them Arkansaw mountains. When a fellow sees a girl he figgers he'd love to marry, he goes to her Paw and asks for her. So the girl's Paw, if the fellow is agreeable to him,

calls the girl to him, and they stand her up in a barrel. If her head sticks out, they figger that she's old enough to git married, and he turns her over to her new husband."

"Unhunh!" Jim chuckled. "That's a good system, but how about it if she ain't tall enough for her head to stick out the barrel? Do the fellow have to wait till she grows some more?"

"Not in Arkansaw." Brock laughed. "Naw, indeed. If her head don't stick out, they saws the barrel off some."

Both of the men burst out laughing loud at that, but Arvay felt stiff around her lips, and the fork fell from her fingers. Jim was going to think that she was much too old to marry from that. But she saw Jim with a serious face look at her as if he had caught her in some crime.

"Then they don't have no chance to do no missionarying around out there, eh?"

"Not a tap." Brock assured him positively, "And it's a damned good thing too, I figger."

"You got a barrel handy, Mr. Henson?" Jim asked with a serious face.

"Sure have."

Jim pretended to scramble to his feet. "Well, maybe it can wait till after dinner is over. Into the barrel Miss Arvay goes, and if her head sticks out, I'm marrying her just as sure as gun's iron."

"You sound like you got serious notions about courting, Jim."

"Look like none of you all don't understand me quite as yet," Jim replied very seriously. "I talk just like I spit. When I spit, it hits the ground, it never comes back to my mouth, does it?"

"Don't recollect that I ever knowed a thing like that to happen," Brock considered.

"Well then, when my word goes forth, I never rue back on it either. And I mean to say right here that I mean to marry Miss Arvay if she will have me. That's been my whole intention ever since the first time that I laid eyes on her. That's what I stayed here in Sawley for. If she can see her way clear to

marry me, I mean to do all within my power to do to make her life comfortable and happy."

"Spoke like a natural man," Brock said quickly. "Nobody couldn't say no more than that. So far as I'm concerned, you have my consent. I couldn't wish her to be in better hands. Now, what you got to say on the subject, baby?"

Arvay took good notice. Her father was not in the habit of using pet names to her. Calling her "baby" now was his way of pleading with her to consent. She had known for a long time that her father wanted her to be married and off his hands, so that was all right with her in a way. It was something different from that that made her fumble and twist the fringe of the tablecloth and drop her eyes while they all waited so anxiously for her answer.

"I thank you for your compliments, Mr. Meserve, and I'll accept if you feel that you really want me. That is, providing you make me a promise not to drop no more teppentime in my eye."

40

CHAPTER 3

"A rvay, what in the world is got the matter with you?"

"How, Ma?"

"Out and gone nearly every blessed night. We ain't had but a month from the start off to get you ready for your wedding, and you ain't got no time to waste traipsing around with Jim from place to place. If it ain't a cane-grinding, it's a candy-pulling. If it ain't that, it's a peanut-biling. If it ain't a peanut-biling, it's a square dance, and you never used to dance. And you need all that time to get your sewing done. You got no time for all that."

"Jim, Ma. Look like he wants me with him."

Arvay did not choose to elaborate. It was true that Jim liked to attend all those social doings, but Arvay knew that she was not forced to go along with Jim. Her fear would not let her trust Jim off too much alone. Nobody was going to whisper anything to Jim while she was present. Being a preacher's wife, Larraine no longer danced, but she did attend many of the other doings. Arvay felt the need of getting her things ready even more than her mother did, but her unease would not permit her to risk letting Jim run into Larraine when she was not there.

Larraine had been rather nice, though. She had made Arvay a wedding nightgown trimmed with lace, and had bought the

41

white kid slippers to go with the white dotted swiss that Arvay was to stand up in. Brock Henson had provided the money for the goods for the wedding dress and the Alice blue mull dress that Arvay was just finishing off this minute. She was to put it on for the reception. It was cut low in the neck with short puff sleeves.

Arvay was always with Jim in public, but she held away from him when they were alone. She did not feel fitten for him, never realizing how her contradictory behavior worried the man. Jim supposed that she would not go back on her promise, but that was not enough for Jim to marry on. He wanted things complete. His worries on that score followed him everywhere. To bed, at the table, and at his work. It was like a sandspur sticking in his skin. Particularly, he thought about it a great deal as he rode or walked through the "drifts" inspecting faces on the trees and checking generally on the work.

Two weeks of his marriage, Jim was down in the woods checking up for the pay-roll at the end of the week. Jim loved the silent chasms of the drifts. The growths, the birds and the sounds of the wind in the pines. A man could think down in there, and feel.

Jim Meserve was what was known as a woodsman in the turpentine plan of things. That meant that he was the resident head of a camp. He ran the commissary and kept the accounts of the workers and made out the time. It was his job to "ride the woods" before the semi-monthly pay-day and evaluate the work of the chippers and dippers. Their pay depended upon the number of trees streaked or dipped. The number of trees could be reduced by the number improperly worked. The limit of a "drift," a territory of one chipper, is known as the "butting-line or block," so as Jim rode his horse from drift to drift, he could enjoy both the beauty and the solitude of the pine woods. Free from the press of details around the camp, Jim came alive and stretched out his soul. Usually then, he could work out his problems. This day, he felt that he had something to bother over.

Jim was not so sure that that was what he wanted, but he

42

found that he could not help himself. What was the matter with his engagement? He felt as if he had grabbed hold of a running man by the coat, and the man had run off, leaving Jim holding the empty jacket.

"Hands full of nothing, mouth full of 'much obliged.' " Jim heard somebody singing blues at a distance.

"Nobody but Joe Kelsey," Jim laughed. He ought to know that was Joe. He was in Joe's drift. Only two men working it, the chipper and the dipper, and he knew Joe's voice from Charlie's. He ought to know it anywhere, as he said. He had made a friend out of the Negro, or the Negro had made a friend out of him, one or the other.

"Good time to run up on Joe, too. Maybe Joe might know something that could help me just in here." He hurried back to his horse and mounted. He had spotted a few cups that Joe had not cleaned out well, but he didn't care too much. That was not so good for the company, but he was not going to kick up a fuss with Joe Kelsey about it at all, because somehow, he liked the man tremendously. Joe Kelsey was a reddy brown Negro, ugly as sin, but with the best-looking smile that Jim had ever seen on a man. It always lit him right up. It always made Jim feel like playing and joking. Just seeing Joe put him into a playful mood and he decided at once to slip up on Joe and play some practical joke.

Now Joe had switched to that teppentime song:

"Oh, don't you see dat rider coming?"

The song went on to point out to dippers, chippers, woodcutters and teamsters the perils of being caught fooling around on the job by the over-rider.

Jim got up close to Joe's back and made a sudden howl like an angry bob-cat on the kill. At the same time, he clawed his fingers and stuck them into Joe's broad back.

Joe jumped around, pretending great fright, and for a minute both men went into the act of pretending. Then they both broke into loud laughter.

43

"You *ought* to be skeered, Joe, even if you ain't. You ain't doing a goddamn thing down here in this drift but shamming."

"Why, you, Mister Jim! Why, I'm almost to the butting-line."

"And leaving nigh on to a barrel of gum behind you that you ain't dipped clean, you scoundrel-beast, you."

Joe did not defend himself by claiming perfection. He pointed out his family worries, the slick and tricky way that moonshine likker had a way of slipping up on him, and so on and so forth.

"I know, I know," Jim retorted in mock sternness. "It's Saturday nights that's your trouble, Joe. Saturday pay-night, you spend all you got on likker and women. Before draw-day, you're pestering my life out of me for more money. Pretty nearly every man on the camp is the same way. Saturday night! Saturday night! Look like that's all you colored folks live for on this camp, Saturday night!"

Joe looked very serious while Jim was preaching. When the woodsman had finished, Joe kept on looking serious. Finally he scratched his head and seemed to reach a conclusion.

"I speck youse right about that Saturday night business, Mister Jim. Fact of the matter is, I knows youse dead right. But if you ever was to be a Negro just *one* Saturday night, you'd never want to be white no more."

Jim looked at Joe in astonishment for a moment, then he burst out laughing and turned away.

"You're just all right, Joe. Maybe I could learn something from that."

Jim went on to where his horse was tied and mounted. Nearly a mile farther to the west he came upon another man chipping and dismounted. This was not Joe, so Jim was critical. He got into an argument with the chipper.

"Sink 'em in, there Charlie, sink 'em in! You ain't doing a

thing but scratching that tree. Keep on scratching, and you'll be done scraped up kin. Sink 'em in!''

Charlie let his streaking iron rest on the ground for a minute as he turned a surly look on Jim. The known best chipper on the camp to be spoken to like that!

"I'm sinking 'em. What you want me to do, cut the tree down?"

"And looky there." Jim jumped from the depth of the streaks to something else. "You're drawing that face in. Keep on, it'll tossle afterwhile. And I noticed some trees back there where you put on some streaks too deep. You must be figgering on laying by timber instead of making gum. Work like that can kill off trees."

After more fault-finding, and leaving a surly Charlie behind him, Jim rode on off. He knew that he was too finicky with the man, and he knew that it was because he was not just satisfied with Arvay in a way. There seemed to be a hold-back to her love. Did she love some other man whom she could not get, and was just marrying him so as to be able to say that she had a husband of her own? Or was it that damn missionary business? Whichever one it was, it could be a lot of trouble later on. But what to do? He loved the girl too much by now to give her up! So what in hell to do? Whom could he turn to for advice? He could think of no one but Joe Kelsey, and possibly his wife, Dessie, who cooked and did for him around his bachelor quarters on the camp. Joe had plenty experience with women, certainly. Maybe he could help.

But what Joe said that night on the commissary porch, after he had listened intently to Jim about his coming marriage, worried Jim even more.

"If it's like that, Boss, you got something to think about. Because if a woman don't get hold of the man she really wants, God help the man she do get. And if she don't get hold on none at all, God help the surrounding country!"

However, Joe did leave one shine of hope out of the things he said.

"Most women folks will love you plenty if you take and see to it that they do. Make 'em knuckle under. From the very first jump, get the bridle in they mouth and ride 'em hard and stop 'em short. They's all alike, Boss. Take 'em and break 'em."

Jim Meserve went to bed thinking hard.

CHAPTER 4

Arvay and her mother were in the girl's bedroom sewing in a rush the next afternoon when Arvay heard somebody hail at the gate. It was Joe Kelsey astride a sweating horse. Recognizing him as one of Jim's men, Arvay told him to come on in.

He had a note from Jim, and Arvay tore it open and read it while he stood on the steps and waited.

It was a short note. All it said was that Jim would be there the next day right after dinnertime to take Arvay for a buggyride. She had better have on her good clothes, for they were going somewhere. Arvay told Joe to wait and took the note inside and handed it to her mother.

"That pesky Jim! Look like he don't intend to give you no chance to get your things ready at all. Might as well sent him word to come ahead. You young folks ain't nothing like we was in my day. You ain't at all responsible. If it wasn't for me doing most of the work, you'd be in a pretty fix, I'm telling you."

Arvay turned on her heels and went on back to the porch and gave Joe the message for Jim.

Over her mother's outraged protests, Arvay put on the blue mull dress the next day. She thought that it was very becoming to her looks. She was ready away ahead of time, but ate no

47

dinner. She was excited and curious about this buggy ride, and besides her corset was laced very tight. She put on the new leghorn-intention hat with the big pink rose on the floppy brim and waited. She could not help from wondering, and even worrying some. Maybe Jim had found out. She looked down at her high-buttoned white shoes and wondered. Two more weeks and she would be safely married. She wished that the time would hurry up and come.

Jim drove up just after one. He was dressed up in his suit of clothes, a new hard felt hat with a wide brim, and he had attempted to lay his thick black curls with water. Arvay watched him through the parlor window as he hitched the rig under the chinaberry tree near the gate.

"There's that Jim of your'n out there at the gate," Mrs. Henson observed unnecessarily. "And dressed up so it 'ud take ten doctors to tell how near he's dressed to death." Mrs. Henson grumbled it out, but there was pride in her manner. "Reckon you better hurry on out and meet him. Don't bring him inside this tore-up house."

"No, you go, Ma. If I bust right on out there it would look like I was dressed and waiting on him. Look like I was too anxious to get him." Arvay was reluctant to find out news if it should happen to be bad.

So Mrs. Henson went to the door, noting as Jim came down the walk that was lined on either side with quart bottles stuck neck-downwards in the ground that Jim Meserve was a well-built man. He made her wish that she was young again. Jim had it all over the square-built, stocky man with the red face that she had married. He had it over Carl Middleton too, so far as that was concerned. They called Arvay slow and poky, but she was doing mighty well for herself.

"Come right in, Jim, and have a chair."

"No, Ma'am, I thank you. Ain't got much time for setting. Got to hurry right along. Where's Arvay, Ma'am?"

"Putting on her last fixings. You know how these young gals is." She turned her head inside the door and called out to her daughter, then turned back to the young man standing

48

impatiently on the porch and gave the opinion that Arvay would be along "tuhreckly." He knew how these courting gals was, she reckoned.

In another minute or so, Arvay stood in the door and smiled at Jim.

"Well, I guess I'm ready. Where you taking me today?"

"Oh, you find out in plenty time. You ready?"

"Much as I ever will be, I reckon."

"Then the two of us is ready and rearing to go. But before we drive off, I favor to see that playhouse you used to play in under that mulberry tree. Oh, hello, there, Mr. Henson! Didn't expect to find you around home this time of day."

"Bear got me and I knocked off. Got my pay-roll all fixed up and ready anyhow." Brock Henson explained as he came to the door and made a place beside his wife where he could see the young couple on the porch.

"The bear is out there all right. Mighty hot for this time of the year. Persimmons won't never get ripe if this kind of weather keeps on."

"Where you and Arvay headed for dressed up like that?" Mrs. Henson asked, but her husband nudged her into silence.

"Oh, just round and about, Ma'am," Jim answered and took Arvay by the arm and headed her off the porch. "First thing, I want Arvay to show me her playhouse. Just favor to see the place today."

Arvay led Jim around the house towards the back, and trembled as she went. Jim held the girl's arm all the way as they went along unevenly over clods that had grass grown over them, through patches of broom-straw and down to the back and bottom of the place where the huge mulberry tree stood in swaying majesty. There was a breeze, and the big leafy growth rolled in the arms of the wind.

"Well, here it is," Arvay said as they stooped under the low-hanging willowy limbs and straightened up in the wide shady area under the tree. It was like a green cave under there, or like being inside a big green tent. Arvay wanted to hear what she would hear.

"Mighty nice place to play house in. You must have had a high old time with your playthings under here."

"Reckon so. But I growed out of things like that long time ago. Don't even know what become of the last ones I used to have."

Jim went and leaned against the great trunk of the tree and fixed his eyes on the girl in blue. He studied her so long that she became embarrassed.

"That would be natural," Jim conceded at last. "But anyhow, you just go along acting like you was playing house again anyhow. I figger that you would look awful pretty at it. Go ahead."

After some embarrassment, Arvay tried to re-live the thing for Jim, wondering what on earth he wanted her to do it for.

"Pa made me and Larraine a playhouse, and it used to be right here. Over there by the tree we had some sea-shells and things. Oh, we about fetched anything under here that we felt to keep to play with. Bottles and jars, and oh, you know things like that."

"Yeah, I know. Something like in a boy's pockets."

"I reckon so. I never even had no brother. What I liked to do when I was under here playing by myself was to catch hold of two low limbs like this and play like I was in a swing, and lean way back and gaze way up into the top of the tree. It looks so cool-like and tender green away up there. And when the wind shakes the leaves some, you can see through to the sky." And Arvay caught hold of two limbs and bracing her heels against the ground, play-acted the thing out for Jim. Her body was stretched out so that she was almost reclining as she trusted her weight to the limbs above her. "And that's when I found out that Heaven was so far off."

"How, Arvay?"

"Well, I looked and I looked as hard as I could through the top of the tree, and I never could make out a thing. No angels moving around or nothing. I never could see a thing, so I knowed that Heaven was further away than folks made out it was."

Arvay pulled herself erect, took off her heavy hat, and deposited it on the roots of the tree. Then she returned to her reclining position and peered earnestly up to the very top of the tree. Her skirt slid up slightly, revealing the tops of her shoes, and a glimpse of the ruffled top petticoat beneath.

Looking upwards so intently, Arvay did not see Jim when he sprang away from the trunk of the tree. She only knew that he had moved when she felt his arms suddenly thrust beneath her, and his hands digging into her side.

"Let go!" Jim commanded shortly.

Arvay brought her head up shortly, and for a brief moment their eyes met and held. Arvay's eyes questioned fearfully. Instinct told Arvay something, and she held on to the limbs desperately.

It was no use. Jim took one hand from under her and tore her grip from the swinging limbs. In a fraction of the second she was snatched from the sky to the ground. Her skirts were being roughly jerked upwards, and Jim was fumbling wildly at her thighs.

"Jim! You—"

Jim was gritting his teeth fiercely on encountering the barrier of her tight-legged drawers, seeking an opening. Finding none, Arvay felt one hand reach up and grasp the waistband. There was a "plop" and the girl knew that the button was gone. A tearing sound of starched fabric, and the garment was being dragged ruthlessly down her legs. Arvay opened her mouth to scream, but no sound emerged. Her mouth was closed by Jim's passionate kisses, and in a moment more, despite her struggles, Arvay knew a pain remorseless sweet.

Not until Jim lay limp and motionless upon her body, did Arvay return to herself and begin to think, and with thinking, all her old feelings of defeat and inadequacy came back on her. She was terribly afraid. She had been taken for a fool, and now her condition was worse than before. It was more than she could bear, to have been so lifted up for a few weeks only to be cast down like this. What was to become of her now? Where would she turn for refuge? Not to her folks, certainly.

She would get no sympathy there. Larraine would put on airs, and pity her all the more.

Jim moved slowly and dreamily and began to kiss her on her mouth and all over her face.

"I love you a million times more, darling," Jim whispered and took his hand to brush back the fallen strands of her hair from her forehead, and to kiss her there too.

He got to his feet, modestly bringing her with him so that they both stood erect and covered at the same time. He held her at arms length for a long minute, and tried to look into her downcast eyes. When he released her, he turned his back for a minute, and rearranged his clothes.

"We got to, we better be going now, honey. Come on and let's make haste."

So he had all he wanted of her, and he was ready to go.

Arvay's eyes crept over to her torn garment lying far over to the right where Jim had flung it.

"If you would be so kind as to excuse me for a few minutes, I—"

Jim understood and walked to the edge of the green wall and turned his back.

Arvay went swiftly to her drawers and picked them up. She shook off the little dust and a dry leaf and looked them over. The starchy little ruffle around the legs still stood bravely, but Arvay realized that she could not put them on. The button was gone, and the plaquette was ripped all the way down one leg to the ruffle. But if she did not put them on somehow, what was she to do? Not roll them up and take them into the house under her arm. Her mother's sharp eyes would never miss a thing like that. Come walking into the house after being off with a man with your drawers under your arm would never do with Maria Henson. The drawers would have to stay there under the tree until Arvay got a chance to sneak them into the house and sew them up again. Anyway no one ever came to the mulberry tree nowadays. Not wishing to leave such an intimate and revealing garment lying on the ground, Arvay looked around for a better place, and spied a dead snag of a

52

limb at the level of her head, and she hung her drawers on that. Then she walked over in deep embarrassment and stood beside Jim.

Jim turned and looked her over carefully. He smiled as he picked a dead leaf and bits of trash out of the back of her head. He smiled because he realized that the poor innocent thing knew nothing about secret trysts. She had no idea about leaving tell-tale signs.

"I better get you your hat so we can hurry on," and strode to the trunk of the tree and picked up the hat.

"I had sort of forgot it," Arvay admitted, and Jim smiled again.

"Lemme place it back on your pretty head," Jim murmured, and set it too far back on her head, and studied the effect for a minute. He changed it two or three times, while Arvay stood passively with a faint smile of embarrassment on her face.

"Look like I ain't so good on placing hats," Jim admitted at last with a laugh. "You better hook it on your ownself, I reckon. But hold on a minute, I got to take another kiss before you move."

With that, Jim caught hold of either side of the wide brim and pulled Arvay's face close to his. He kissed her lightly once or twice, then let go of the hat and began to kiss her passionately and hold her tightly in his arms. Unconsciously, Arvay's own arms went up and were locked around Jim's neck.

"That's right, sugar." Jim murmured. "Hug my neck for me. Hug me tight."

Jim's urging was altogether unnecessary. Some unknown power took hold of Arvay. She pressed her body tightly against his, fitting herself into him as closely as possible. A terrible fear came over her that he might somehow vanish away from her arms, and she sought to hold him by the tightness of her embrace and her flood of kisses. It seemed a great act of mercy when she found herself stretched on the ground again with Jim's body weighing down upon her. Even then she was not satisfied. Somehow, she seemed not to be able to get close enough to him. Never, never, close enough. She must

53

eat him up, and absorb him within herself. Then he could never leave her again.

When she was on her feet again, Arvay kissed Jim voluntarily and without words. Jim returned the kiss then grabbed her hand.

"Now I know we got to go, and we better hurry."

He grabbed her hat off the ground, and seized her hand and together they stooped and came out from under the mulberry tree. Over her shoulder as she stooped, Arvay glanced back at her drawers swinging ever so gently in the breeze. She took it as a kind of sign and symbol. Where this man was hurrying her off to, she had no idea, but she was going, and leaving her old life behind her. Left behind, but not forgotten, to be picked up another time, perhaps.

When they reached the house, Arvay turned her head to the left so that she could not see the back door. Her mother might be standing there and would read her like a book. Arvay held on to Jim's hand and went on around the house. Her parents had evidently seen them when they came out from under the tree, and were following their progress, for as they came abreast of the room where her parents slept, she spied them peeping through the sugar-sack half curtains at the window. Arvay started, and Jim, looking in the same direction to see the reason, saw them too. They were doing their best to see all they could and interpret. They snatched heads back guiltily, but the young couple had caught on to what was going on. Then Brock, to cover up, shoved the curtain aside to hail them through the window.

Jim looked, grabbed Arvay by the hand and began to run towards the gate and the buggy tied there. Their progress was not fast enough for Jim evidently, for he stopped, grabbed up Arvay who was slightly behind him, and ran staggering for the gate. He was growling like a tiger which had just made a kill and was being challenged. With the weight of the girl in his arms, he kicked open the gate, made it to the side of the buggy and thrust Arvay in as Brock Henson reached the front door. He untied the reins in a frenzy and leaped in himself while

Brock walked the width of the porch to the steps, with Mrs. Henson stooped shouldered in the door and her caved-in mouth wide open. Jim grabbed the reins, slapped them smartly on the rump of the horse and yelled, "Git up! Git up, there!" And Arvay found herself flying down the sandy road.

She could not hear Brock exclaim, "Well, I'll be god-damned!" as he gazed down the road after the flying buggy. "What the hell do you reckon is going on?"

Nor could Arvay hear her mother complain, "Something that don't mean us no good, I'll bound you. Could be dragging our girl off somewhere to rape her and then leave her here on our hands. A young 'un without no name for us to look after and to feed and raise. All that money, nigh on to forty dollars that we done spent already on things to marry her off in, too. Brock Henson, youse the biggest fool I ever did see in all my born days! If you was any man at all, you'd take that shot-gun and get on your horse and overtake 'em. Make him marry her before the sun go down."

"Aw, I wouldn't be in such a hurry, if I was you, Maria. Arvay wasn't hollering or nothing. We couldn't swear to a thing."

"Arvay not hollering!" Mrs. Henson snorted as she went to the steps and shaded her hands and looked down the road. "Nothing like Larraine. That Arvay ain't got the sense she was born with. According to my notion, you had better go get your gun."

"Better let well enough do," Brock admonished and reached for the back of a rocker turned to the wall, whirled it around and sat down. "Far as I can see, things is coming along just fine as it is. Don't reckon Jim Meserve is the kind to back out now, with the wedding day all set and all. It would take a mighty heap of gall."

"Gall! That Jim ain't nothing else but gall. Tell me!"

Brock sat down, scrooged the chair around so that he did not have to look at his wife, cut himself another chaw, chawed his tobacco and spit his juice. He could send it expertly clear over the bannister and into the yard.

55

Speeding down the road towards Sawley, Arvay was tugging with the same emotions as her mother. Jim was silent there beside her as if nothing much had happened. He kept the horse at a fast trot and paid attention to the road. Arvay kept a fearful silence because she did not know how to begin what she wanted to say in order to find out what she wanted so much to know.

They were passing the last open field before the straggling houses of Sawley began when Jim turned his face upon Arvay and grinned.

"Arvay Henson!" Jim hailed oratorically, "The apostle to the heathens!" Then he chuckled some more.

Arvay looked at him with quickly troubled eyes. Look like Jim was making fun of her. Something closed up inside of her.

Jim laughed again. "No need for you to go proaging clean around the world no more looking for no heathens to save, though."

"Why, Jim? Is they all done saved or died off?"

"Naw, indeed. That is, I reckon there's plenty of 'em still left to save. But their case don't come up in your court no more."

So after what went on under the mulberry tree, Jim figgers that I ain't fitten no more to tote the Word, Arvay thought. No getting away from what had happened. Her drawers hung on the mulberry tree, waving with the wind. Who was she now, to be telling folks how to live?

"Don't be looking so sick over it, and putting on a long face, Arvay. Missionary work is for old maids and preachers. Youse a married woman now. You ain't got no time for that."

"Married?" Jim was cruel to be making game of her at a time like this.

"Why, sure you're married, Arvay. Under that mulberry tree."

"All I know is that I been raped."

"You sure was, and the job was done up brown."

"I could have hollered for Pa."

"And it would not have done you a damn bit of good. Just

56

a trashy waste of good time and breath. Sure you was raped, and that ain't all. You're going to keep on getting raped. You couldn't be hollering for your Pa every day for the rest of your life, could you?"

"Every day?" Arvay looked across and up at Jim in startled bewilderment. "You sure got plenty nerve."

"So I been told. But that's the way the cloth's been cut, and that's the way it's made. No more missionarying around for you. You done caught your heathen, baby. You got one all by yourself. And I'm here to tell you that you done brought him through religion and absolutely converted his soul. He been hanging around the mourner's bench for quite some time, but you done brought him through religion, and saved him from a burning shell. You are a wonderful woman, Arvay."

The elements opened above Arvay and she arose inside of herself. This must mean that she had been forgiven on high. Her secret sin was forgiven and her soul set free! Else why would Jim be talking like she thought he was? She had paid under that mulberry tree.

"You talking about me and you, ain't you, Jim?"

"You know so well that I ain't talking about nobody else."

"But, but, you just got through saying that you meant to keep on raping me. That . . ."

"You got that right, and I mean to tell you, rape in the first degree. We're headed for the courthouse now, just as fast as we can wheel and roll. And the minute we get there, we're going to take out some papers on it."

"Jim!"

"You didn't realize? Good Lord Almighty! Where else would we be headed for? Arvay, I got a letter from love today, and I'll go to Hell but what I answer it. Git up there, you good-for-nothing nag, you! Git along!"

Arvay was back at her father's house before sundown, a married woman. The news of the elopement had spread over town quickly, and by seven o'clock, people began to arrive to wish them well. Her mother, balked of the wedding excitement,

was all put out at first, but of necessity made the best of things as they were. Both parents joined in pleading with Jim to stay the night and give people chance to come and make merry. Jim compromised. They were around until nine o'clock, then he drove the six miles out to the camp with his bride.

Jim carried Arvay over the doorsill and kissed her as he set her feet down in the turpentine shack.

"Well, honey, you're home, for two months anyhow."

"Two months?"

"Yep. You know that I ain't no teppentime man when it comes right down to the thing, and then it don't bring in enough now that I got me a wife. Two months is enough I figger to fix us so we can go away from here and hunt up a better-paying job."

Teppentime shacks are not built for beauty. They are temporary shelters. In a few years usually the woods are worked out, and the camp is moved. The houses are torn down and put up again at the new location. But this house with its four crude rooms looked beautiful to Arvay. The rooms were immaculately clean, but the most important thing to her was that it was her own home. "This is ours," Arvay murmured as she went about touching furniture and walls.

"Yep. Your dice, baby, to do just as you damn please. Gimme a kiss now and hug my neck for me. We better go on to bed. Pay-day tomorrow and I'll have a lot to do."

Jim himself began to get ready for bed immediately, and Arvay timidly followed him. She found out the reason for Jim's haste very soon. Less than ten minutes after the lamp had been blown out, there was a gentle rustling outside the bedroom window, and then the full tones of a guitar broke out, playing in the way that only Negroes play that instrument. Clear melody, full-bodied harmony, and added bass that imitated drums.

Arvay leaped out of bed and stood at the window. She could not be seen because of the darkness within aided by the curtains at the window. She stood in her bare feet and wedding nightgown and lived through the serenade. Instrumental

pieces, blues sung by men and some by women; spirituals, not sad and forlorn, but sung with a drummy rhythm to them; work songs and ballads.

The music outside did something strange and new to Arvay. The strains induced pictures before her eyes. They conjured up odors and tastes. Streams of colors played across the sky for her, and she tasted exotic fruits. Looking out into the white moonlight of the night, she saw the trees and the woods for the first time from inside. The sky-scraping pines became feeling beings, standing there forever watching, and watching, and whispering with their branches in a rumbling song. They were the tree-men with the many toes probing into the earth. The giants who stood forever on one foot and waited.

The concert came to an end on an old ballad that Arvay had heard often, but had never really learned. It was being led by a female voice, a deep alto, backed up by the other mingled voices and the guitar. Arvay resolved that she would learn that song the very next day. The song was an old, old ballad and it haunted you. Sweet and bitter mixed up in just the right amounts.

> Love, Oh, love, Oh careless love
> Goes right to the head like wine
> Broken the heart of many a poor girl
> But you'll never break this heart of mine.
>
> Love, Oh, love, Oh careless love
> Love, Oh, love, Oh careless love
> You cause me to weep, you cause me to moan
> You cause me to leave my happy home.

The ballad went on for many more verses, and Arvay was all but moved to tears. After a few minutes, she noticed that the serenade was over.

"Oh, that was just too sweet and too wonderful, Jim. Don't expect to ever forget this night, the longest day I live."

"This is some of that damn Joe Kelsey's doings," Jim grum-

bled to hide his own emotion. "It would be just like that bastard to cut a caper like that."

He stooped over quickly and fetched a five gallon jug from under the bed and hurried to the window.

"Thank you, folks. Me and my wife both thank you for the music of welcome home."

There was great applause at this, and Jim had to wait a long time for it to die down. Then Arvay saw a male figure step nearer the window, strike a pose and begin to deliver an elaborate ramble of welcome to the newly wed couple. After a few sentences, the speaker got lost and scrambled in the jungle of florid syllables, and the crowd outside began to jeer and scream with laughter.

"That'll do, Joe Kelsey," Jim yelled out with mock serious-ness. "You done lied enough for one time. Here, take this jug of moonshine and see that everybody gets some. Now, don't go on off and drink it all up your ownself, you buzzard, you! You know I know you, Joe."

There was loud laughter at this back-handed caress, and the crowd hurried off to the Jook to have themselves a time.

"You oughtn't to have spoke to the poor man like that, especially after he got up the serenade for us, Jim."

"Pay that no mind, honey. Joe knows where he stands with me. I would trust Joe Kelsey quicker than any man on earth I know of, and Joe knows it."

"Is he the same one that you been sending in messages by?"

"That's right. He's my right-hand man around this camp. Dessie, the woman who's been doing for me here, is his wife. Two nicest folks it has ever been my pleasure to meet. I made arrangements for Dessie to help you around some. Hope you find her all right too. She's evermore easy to get along with."

Arvay was a daughter of the South. She knew exactly what to think from that.

"Joe is your pet, I'll bound you."

"Kee-reck! Different from every other Negro I ever did see. He's remarkable. Honest as the day is long. Just mighty damn fine, that's all."

60

Arvay sympathized and understood. Every Southern white man has his pet Negro. His Negro is always fine, honest, faithful to him unto death, and most remarkable. Indeed, no other Negro on earth is fitten to hold him a light, and few white people. He never lies, and in fact can do no wrong. If he happens to do what other people might consider wrong, it is never his Negro's fault. He was pushed and shoved into it by some unworthy varmint. If he kills somebody else, the dead varmint took and run into the pet's knife or bullet and practically committed suicide just to put the pet in wrong, the low-life-ted scoundrel-beast! If the white patron has his way, the pet will never serve a day in jail for it. The utmost of his influence will be invoked to balk the law. Turn go *his* Negro from that jail!

Arvay had asked, and Jim had consented for her to help him out around the commissary. He conceded that it would be a help to him and the women on the camp for the store to be open all day.

So from time to time, Arvay could have been seen, if anybody watched her closely enough, weighing up a pound or so extra for Dessie and Joe on everything. She balanced this off by either cutting somebody else light weight, or waiting until she was alone in the store and adding a pound or so to some other account. Side-meat added to one, sugar and coffee to another, snuff and tobacco to still other people, and growing very haughty and mad if anybody complained. She came to be very fond of Dessie, and Joe was her husband's man.

Her married life moved on smoothly and happily for Arvay except for one thing. Larraine and Carl drove out two or three times every week. Larraine came even when Carl did not, and Arvay wished so much that she wouldn't. She couldn't say a thing against it, and that made it very hard. Jim would think it funny if she ordered her own sister off the camp, but that was just what Arvay felt like doing.

Larraine was too bossy, Arvay felt. Dashing in and bossing around, and taking things in charge. It looked as if she could

not bear for Arvay to be the head of a single thing.

Arvay objected to Carl, not because he dipped in her business at all, but because he stirred up memories, and kept her feeling of guilt alive and active. She wanted to forget the whole thing. To cast it in the sea of forgetfulness, where it would never rise to shame her in this world, or condemn her in the Judgment.

In this same connection, Larraine gave her a lot of worry. She was always calling Jim aside and giving him advice on how to manage things. Arvay, fearing that Larraine knew of her secret passion of the past, feared that 'Raine might by accident or intention let her tongue slip. Jim would lose his faith in her, and then where would she be? She would be miserable every time that her sister managed to get Jim off to one side. She searched his face for signs after every session. So far, she had seen nothing, but she wished that Larraine would stay off the place. Oh, well, the two months would soon be up, and she and Jim would be off somewhere too far for Larraine to be around. Arvay shook and trembled, and saved her complete happiness for that day.

Then the blow fell. She had been married for only six weeks when she was almost knocked off her feet by Dessie.

They were in the kitchen together. Dessie often helped her out in more ways than she was being paid for. Dessie looked at her very hard and began to chuckle.

"What's wrong, Dessie?"

"I declare! That husband you done married is all parts of a man."

"What do you mean by that, Dessie?"

"Youse knocked up, that's what."

"Knocked up?" Arvay had heard the term too many times to misunderstand what was meant by it. Arvay just did not want to hear it.

"Going to have a young 'un, just as sure as youse born to die."

"No, Dessie. I'm sure that you're mistaken. I, I ain't noticed a thing."

"That's because it's a little early for signs just as yet. You ain't hardly more'n a month gone up right now. But you will. I can see that th'obbing in your neck. Youse up the creek, honey, and they ain't no iffs and ands about it."

"Dessie!" Arvay moaned.

"Oh, 'tain't nothing to be scared about. I done had five, and 'tain't nothing to the thing. You has birth-pains, naturally, but lemme tell you, them is the easiest forgotten pains they is in all the world. Oh, you remembers enough about it later on to tell about it, but that's about all you can do. Don't you worry none."

Arvay had every intention to keep the secret to herself until after Jim had notified the owner that he was leaving, but she had no chance. Larraine drove up that very afternoon behind her little bay mare, and Dessie, not realizing what she did, hurried to tell "Miz' Middleton" the news. Jim came home to get a new hame to take out to the barns and Larraine had to up and blab her mouth to Jim.

Jim was glad and proud enough, but the upshot of it was that Jim said what Arvay had feared. It meant that they could not go away until the child was born. He wouldn't think of dragging his wife around from pillar to post in her condition.

In her nervous turmoil, brought on by disappointment and memories of other frustrations, somehow Arvay found her eyes fixed on Larraine's throat. That night Arvay had a strange dream. She saw 'Raine's white neck. It was huge like the standpipe at the water works, and down its long length blood was running and running from a huge gash near the top. Somehow she was impelled to look at her own hands, and in her right was a long sharp knife. Arvay woke up with a start, and scrouged up just as close to Jim as she could. She was almost afraid to go to sleep again.

Another night Arvay dreamed that she was in a beautiful forest of trees and very happy. Music and singing were coming to her from unseen voices. Suddenly the instruments and voices hushed as if in terrible fear. In the silence, Larraine came walking through the woods. A tiger leaped upon Lar-

raine and tore her throat away. Great streams of blood ran down and some of it clotted between Larraine's breasts. Somehow Avary was not afraid of the tiger. She looked on indifferently as the beast lapped Larraine's blood fiercely, and when he was sated and moved away the music began again. Waking, Arvay shuddered with remorse. She knew then that she had been hating her own sister for years.

Jim himself began to notice how nervous Arvay was getting to be. He thought that the store was too much worry for her, and told her not to bother with it anymore. He would make out all right. But Arvay said no, it was just that she was tired of teppentiming, she guessed, and wanted to make a change.

"Jim, please! Take me on off. I won't care if we don't have much spending change for a while. I just crave to go away from here."

"Can't see my way clear to do that, Little-Bit. It wouldn't be the right thing for me to do. You're nervous on account of your condition. I wouldn't be no kind of a husband at all if I didn't look out for you no better than that. And then, Dessie is an A-number-one mid-wife. I'd ruther for you to be where she could see after you."

"Couldn't we go and take Joe and Dessie with us?"

"That would be a hot come-off when we don't even know where we are going to be our ownselves. You just wait. The minute that you get able to move with the baby, I'll make a move."

"Six more months, maybe, Jim."

"Can't be helped, Arvie. It ought not to seem so long. And then too, you got your folks close around to do for you. Your Mama and Larraine both. Naw, I can't see no sense in pulling out now, and running you into danger."

Arvay developed strange moods and appetites. A great craving for meat, and for clay. Arvay had seen many people in Sawley eat clay, but she had never touched it herself. Now she had a taste for clay, that fine, cream-colored clay which she had seen her mother eating all her life. There was not much clay in Florida, but there was a deposit not too far from Saw-

64

ley, to the north of town. Many a time Arvay had gone with her mother and seen her eat it hungrily after a rain. She had even seen her mother bake it into little cakes and sigh with satisfaction afterwards. It had tasted so smooth and good!

But Jim exploded with disgust when Arvay asked him to get her some clay from the bank to eat. He pitched into Dessie hot and heavy when he found that Dessie had sent her twelve-year-old son for clay and smuggled it in to Arvay. He had better not find any more of the goddamned filthy, dirty stuff around the place. If he did, he was going around the ham-bone looking for meat! That was the word with the bark on it. Nothing but a notion anyway. No nourishment in the thing.

Arvay hungered and retreated inside of her self with her fears. She came to the place where she wished that Larraine would tell and have it over with. But, no, Larraine was acting cruel. Holding the thing back to keep Arvay in suspense. There was nothing for Arvay to do but huddle with her eternal fear and wait.

The first quarrel arose over something which Jim contended later was trashy, and had nothing to do with them.

Arvay had gone back to reading a chapter in the Bible every night. Like many others, she had the habit of letting the Bible fall open and reading the chapter where it opened as a sort of message.

The night of the quarrel, the Book fell open in Genesis, and at the story of the killing of Abel by Cain. She read for quite a while; then Jim, beside her in the bed, asked her what she was reading, not because he was interested, but so as not to feel lonesome and excluded. Arvay told him.

"And it was an awful crime for Cain to do," Arvay commented. "It wasn't Abel's fault if God didn't accept Cain's sacrifice."

"And I don't blame God neither. I'd turn against a man that didn't have no better sense than to burn a stinking cabbage right under my nose."

"But what else could he have done, Jim? He tilled the fields, didn't he?"

"That's what I been told, Arvay. Cain's first crime was not killing his brother Abel, but in not having no sense of humor. The man was so chuckle-headed that he couldn't even take a joke."

"Joke?" Arvay was so outraged that she hurriedly propped herself up on one elbow and frowned down into Jim's face. "You must be crazy or [an] awful wicked one, to be looking for jokes in the Bible."

"Well, if it's about the doings of people, it must be plenty jokes in there."

"Well, I never!" Arvay sighed and sank back on her pillow. "Jokes in the Word of God."

"Sure, Arvie, if you can see 'em like they is. Now, take this same man, Cain, that you been reading about. He never would have got into all that trouble if he could have seen a joke. He never would have up and scorched a stinking, rotten cabbage under God's nose for no sacrifice. Common sense ought to have told him God wouldn't stand for him stinking up Heaven and all like that. How come he couldn't have made God a nice cool salad and took it to Him? That would have been something out of his garden too, wouldn't it? Tell me!"

The battle raged and roiled. The sacred quality of the Bible, sinner-people who could make mock of holy things. Folks given to jokes and the dumbness of those who couldn't see a joke, and on and on. Jim was not really annoyed at first, he just enjoyed teasing Arvay, but Arvay went further than Jim thought necessary, and he stung her somewhat with ridicule. For the first time, Arvay refused Jim's goodnight hug, turned her back on him and got as far away from him as she could.

It was three whole days before the house got warm and intimate again. But fights leave scars on people, no matter how slight, and both had revealed things inside them that they usually concealed. Jim found out that Arvay considered him a sinner and a scoffer. Arvay found out that Jim thought her a trifle dumb.

CHAPTER 5

t was in the heat of summer when Arvay's baby came. With Dessie there giving expert aid, commanding Arvay to "Bear down! Bear down, I tell you!" making the girl get out of bed and kneel at the foot and strain against a sheet twisted into a rope and tied to the bed-post, Arvay came through easily.

After a while, Dessie brought Arvay's baby to her, all attended to and dressed. It had cried briefly when Dessie smacked the breath of life into it, then Arvay had heard no more. It was very quiet when Dessie put it in her arms, and Dessie was quiet too. Arvay was afraid that it might be dead.

Something must be wrong. She could tell from Dessie's kind eyes trying to lie to her and look enthusiastic. "It's a boy, and I know that his daddy will be glad."

Arvay looked at her baby, and then she understood. It was nothing like Jim at all. The hair and eyelashes were perfectly white. It would be a blond. That was disappointing but not serious. What else she saw made Arvay cry out in horror.

"Dessie! Dessie! What is the matter with my child's hands?"

"It would take a God to tell, Miz' Arvay. Them don't look much like fingers, do they?"

"Good gracious! They look more like strings. And his hands, Dessie. Why they look too little for his body."

Arvay passed her hand over the quiet baby's head as if to

comfort it and then gave another cry. There was practically no forehead nor backhead on her child. The head narrowed like an egg on top. Arvay began to cry. Then when she had cried a while, she looked her baby all over and cried some more. The feet were long, and the toes well formed, but they looked too long for a new-born baby to have. And there was no arch to the tiny feet. They were perfectly flat, with a little lump of flesh huddled under what should have been the in-step. Arvay studied the little red bundle of flesh in her arms.

It certainly did not favor Jim. Who did it remind her of? Finally she knew. He looked like her Uncle Chester, her mother's youngest brother. The one that they seldom talked about. The one who was sort of queer in his head. Oh, Jesus! How could she show this child to Jim? In what words could she explain? She handed the bundle off to one side, so as to be sure not to overlay it, and turned away and cried.

When Jim came, he acted like Dessie. He tried to say something nice. Arvay kept up with his face with her eyes. Jim was kind and asked her how she felt over and over again, but he did not enthuse at all. He kissed her and petted her much too much.

"What must we name him?" Arvay asked and prayed.

"Oh, no rush about that at all," Jim said casually. "We got plenty time to figger that out, Little-Bit. You just rest your self up good so we can move off from here."

Arvay was left alone with her child. Jim mentioned details of work. Too bad, but he was in a sort of a slow hurry. Had to look after things. He was a family man now, and had to make support for three.

Arvay could not keep from continually searching over the child. She was made conscious of the mouth at last. It was exceptionally small, and what there was of it was concentrated in the bottom lip. It was a tiny pink pug thrust out at the world. It did not hang loosely at all. Just a tiny half moon no bigger than Arvay's finger nail.

But the size of the mouth was no measure of the appetite of the child. He attacked ferociously when put to the breast.

Arvay had to laugh at his eagerness. It was strange that the child seldom cried out demanding to be fed. Occasionally he made a low whimpering sound and moved his limbs in complaint. But always he seized upon the breast; he did not simply accept it as most children did. Jim, watching one afternoon, looked on with astonishment.

"It's a damn lucky thing that you got plenty of milk, honey. If you didn't have it, I'm mighty scared that young 'un would eat you clean up. Look at him go to it!"

The baby's defects only increased Arvay's love for it. She mooned over it, caressed it with pity added to her love. She spent a long time morning and night bathing it, rubbing it over with sweet oil and massaging and manipulating the narrow head. She was doing her best to shape it into a more agreeable form. Whether it was on account of her labors, or just nature, she was surprised every morning to note a little change. The head gradually ceased to be different enough to attract particular notice, and Arvay rejoiced with tears. Still, the bones of the string-like fingers did not appear to be gaining in size and strength. For a long time, the finger bones felt like limber cartilage to the touch. Arvay wondered if her son would ever be able to use his tiny hands. Nor was there any change in the shape of the baby's feet. It took on weight and grew decidedly better-looking if you did not examine the hands and the feet.

Arvay shut herself in the bedroom with her baby where she could talk aloud to herself for a while every day after Jim had been gotten off to work.

"Poor little thing, you! Mam is going to love you, don't care who else don't care. You couldn't help it. You ain't the blame at all. This is the punishment for the way I used to be. I thought that I had done paid off, but I reckon not. I never thought it would come like this, but it must be the chastisement I been looking for. You're Mama's precious honey, and don't you cry."

This was an unnecessary admonition, for the baby seldom cried. Even when he was several months old and a husky body,

the child made few demands. It lay in the crude crib that Joe Kelsey had knocked together, calling on no one until he was picked and fed or attended to. Neither did the child show any recognition or eagerness at the sight of anyone at all. He seized upon his food almost angrily, and when he was full, he could be put down again without a murmur. One thing only Arvay began to notice about him very early. The child seemed to be very much afraid. Any sudden movement, any strange object introduced into his presence brought screams of terror. Otherwise, Arvay's son was a world within himself.

When a week, ten days, and then two weeks went by and Jim had made no mention of a name for the child, Arvay gritted her teeth and put on a brave show of outwitting her husband. She included Dessie.

"Let's we bake a cake, Dessie, for the baby."

"Baby? He ain't near old enough to be eating no cake, Miss Arvie."

"I know, Dessie, but I want you to help me out with a cake for giving him a name."

Then Arvay smiled in a sly way. "I mean to get ahead of Jim and name the baby my ownself. It's natural for a man to want the first boy named after him, but I always loved the name of Earl David, and said that if I ever had a boy-child I was going to name him that. While Jim is laying low to fix up some big preparation to name the baby after him, I mean to get ahead and say it first. Supper tonight, I'll place the cake on the table with the name all wrote on top. You know how men folks are, and we women have to take advantage of 'em now and then."

Dessie agreed and the cake was made. Arvay was by no means sure that Dessie had been taken in, but that part did not matter. It was a case of saving face.

Jim made no objections to the choice of a name at all. Said it was very pretty, and a whole lot better than plain Jim Meserve. He didn't know as he wanted a child named after himself anyway. Let every man have a name all to himself.

That was a nice way of putting it, Arvay reflected at the other end of the table. Jim was putting on to keep from hurt-

ing her feelings. Before she went to bed that night, she opened the new family Bible, and on the lined page at the back, wrote *Earl David Meserve, born July 26, 1906.*

Jim was off somewhere in the quarters. Probably at Joe's house, where Arvay suspected Jim found the occasional drink that he took, and was taking more and more often here of late. He probably would not be home for some time.

So Arvay felt free to get on her knees and pray. First, she asked God for the health and welfare of her child, and please, let Earl David never be taken away from her. Then she prayed for Jim. Prayed for the saving of his soul; that he be moved to hurry up and take her away from the vicinity of Sawley and keep on loving her.

Two months after Earl was born, Jim gave notice to the turpentine firm that he was leaving, and that announcement gave Arvay great satisfaction. Where they were going, how and why did not concern her. It did not matter so long as she was going away from Sawley. When they sat in the day coach, with the round-topped metal-bound trunk in the baggage car, and the telescope bag and the shabby old satchel in the rack over their heads, they had all their worldly possessions with them. Jim had around a hundred dollars in his pockets, mostly from the sale of their household goods, and his last paycheck. Her husband was beside her on the seat, and her baby was in her lap. They were headed east and south away from what she used to know and feel and Arvay was asking for nothing more.

They landed in Citrabelle, a bright-looking flowery town on the Florida ridge south of Polk County. By ways that Arvay knew nothing of, Jim had come to a decision to settle there, and had a job as foreman of a crew of fruit-pickers. She knew that she was settled in a light and airy cottage painted a bright yellow and trimmed with white. She did observe that folks down in these parts did seem to be powerful fond of painting houses and planting flowers. It was a very pretty habit, though, and Arvay put out to have herself a flower yard too. Outside

of the miles and miles of orange groves, the people raised nothing but vegetables to eat. Not a speck of cotton or tobacco, or the things she was used to seeing growing. Things had a picnicky, pleasury look that, while it was pretty, made Arvay wonder if folks were not taking things too easy down in here. Heaven wasn't going to be any refreshment to folks if they got along with no more trouble than this. As far as she could see, the place was plumb given over to pleasure. Flower-yards looked as if folks had spent as much time fixing and attending them as they did back in west Florida to raise a crop of corn, peanuts, cotton or tobacco. It was the duty of man to suffer in this world, and these people round down here in south Florida were plainly shirking their duty. They were living entirely too easy. There just didn't seem to Arvay to be any kind of honest work that kept folks bowed down from can't-see-in-the-morning till can't-see-at-night. Then too they could get hold of all the oranges, grapefruit and tangerines that they could lay under without spending a cent. What treat would a whole orange or tangerine in a Christmas stocking be to a person down in here? It just didn't seem right for folks to live as loose and as careless as all this. And look at the wages that were paid down in this vicinity! It was hard for her to believe. It worried Arvay so that finally she had to seek some information from Jim.

"When do these folks around here get down to work sure enough, Jim?" Arvay asked one day.

"Get to work, Arvay? Why, that's what they're doing all the time."

"You mean folks round here don't do no more'n this, and make all that money?"

"That's right. Fruit is the main thing, then truck-gardening. Ninety-day crops down in here. Three crops a year. Sell it to the commission houses, put your money in your pocket and put in another crop."

"Well suh! Nothing much to do but just wallow around. I don't know what's to become of folks. They'll be too lazy to draw they breath after while."

"Feel like you're being carried to the skies on flowery beds of ease, eh?" Jim laughed. "You married yourself a man, honey. I told you, like that old hymn says, marriage with me never was designed to make your pleasures less. Rest easy, you ain't seen nothing as yet. I aim to have you living so fine some day that this will look like a teppentime camp beside it. You're such a baby-child, Arvay. Maybe that's why I love you so hard." He kissed the back of her neck. "You don't have to worry about a thing. You got a man who can bring it when he come."

Therefore, Arvay knew nothing about the desperate struggle Jim was going through for their very existence. She did not know about those terrible three weeks when Jim, knowing nothing about citrus-fruit production, had stood around with his hands in his pockets feeling and turning over the little money he had, and casting about for some way to get into the work. How he had finally decided that since the colored men did all of the manual work, they were the ones who actually knew how things were done, and how he had taken up around the jooks and gathering places in Colored Town, and swapped stories, and stood treats, and eased in questions in desperate hope, wondering if his money would hold out until he could get a footing, and how he had finally gotten information which landed him his job.

She did not know that fruit-cutters seldom worked at all from the end of the season early in June until it opened again around the middle of September when they began to cut grapefruit, however short of money they might be. But Jim had made an arrangement to look after the company groves during the summer months, seeing to the pruning, ploughing of the groves, fertilizing and hoeing. His pay envelope would be less, but it would be enough to keep them going, to save them from living on credit and having a big grocery bill facing him when the season opened. He had persuaded at least half of his crew to go along with him, and they worked all summer and opened up in the fall with money ahead.

During those summer months, Jim used his head too. Gain-

74

ing a greater intimacy with his men, he subtly worked up the spirit of rivalry in fruit-cutting. Who was the best, sure enough? There got to be arguments and contests about it. The men took to bringing their bags and clippers along and any left-over fruit in the groves they were tending got cut in a fury of competition. There is always some fruit that gets over-looked and always sour-orange trees in every grove. They make a particularly fine-flavored lemonade. The men never left one with fruit on it now, and when the season opened up, they were rearing to go. They told him of the best cutters in other crews and for other companies, and Jim shifted around until he had nothing but experts under him, and augmented his crew by three men. By Christmas, they were "raising a fog" in any grove that they were thrown in, and the amount of fruit they cut had been duly taken note of at the packing-house. The manager stopped Jim and had a talk with him. He was particularly grateful because Jim had served during the off months when it was so hard to get work done, and his record since the season opened was impressive. It was now arranged for Jim to get the same money all the year round and a bonus for exceeding a certain number of boxes a week. His men got their added money in the number of boxes they cut. They were the highest-paid men in that part of the state and getting known. To foster the spirit, the manager lined Jim and his men up on the loading-platform the day before Christmas, praised them to the highest in front of everybody, and presented each man with a Christmas turkey.

Arvay had the big turkey that Jim had received. She baked it and they ate it, but she never asked for the story behind it, and since the eager Jim, feeling no curiosity in her about his achievement, was that kind of a man, he did not offer her the information. He ate his dinner, and went off somewhere and came home drunk. Arvay was displeased about it and acted sullen, but she never sought the why of that either.

That did not mean that there were no high places in her existence. In spite of her silent resentment over Earl, and in spite of her lack of expression, there were times when they

grabbed hands and mounted to Heaven together. They played music on the instrument of life. It was merely that two or three of the keys were out of fix, and there was a break in the tune when they were touched. There was no other child besides Earl, and neither of them dared mention it. Both were torn between longing and fear. A normal child would cancel out to an extent the disappointment over Earl, but then, supposing it came here another Earl? Arvay knew nothing of contraceptives, nor did Jim mention anything like that. She just noted that at certain times Jim found it convenient to stay out late, and come home tired. And he drank more than he used to. Arvay took what happiness she could in looking after Earl. She avenged herself on Jim by spending hours in his absence in teaching the slow-moving Earl to walk and to talk. It was slow and hard work, but by the time he was a year-and-a-half old, he could stay on his feet and take a few steps. A few months later, she was overjoyed to hear him lisp out a word. It was either "eat" or "meat," Arvay could not tell which, but it was a word and she was proud and glad.

She had worked on those feeble hands and feet so hard they had to respond some to the continual manipulations and oilings. Earl didn't look so odd now, and she was proud of her work. He was still scary and showed no particular attachments. Secretly, it hurt Arvay to see that he did not show more preference for her, who gave all her time and energy to him, than he did for Jim, who bought him little toys and candies, but never played with him at all. So Arvay used to make up little fibs to tell Jim when he came home about the cute and loving things Earl said and did when they were there alone. Jim never believed a word of it, she could tell, but he never put himself to the trouble to make her out a liar. He took it for just what it was, her consolation, and let it go at that.

Who shall ascend into the hill of the Lord? And who shall stand in His holy place? Arvay thought that it would be herself when and if she could birth Jim a perfect child and by this means tie him forever to her. Jim felt that he would stand on the mount of transfiguration when Arvay showed some appre-

ciation of his love as expressed by what he was striving to do for her. Thus they fumbled and searched for each other in silent darkness.

Therefore, she was both exalted and torn with anxious fears when she passed her time and knew that she was pregnant. She looked at Earl, and day by day sloped around and could not find tongue to mention her condition to Jim. She had seen his terrible agony at the birth of Earl; he could not bear that again. He might just slip on his travelling-shoes, and she would never know where he made his last tracks. Well, Earl was two years old, and able to get around some, and if push came to the shove, she could go back up home to her parents and get some kind of a work while her mother looked after Earl for her.

While she was bumbling around in this miasma of fear, Jim literally jumped into the house one afternoon, grinning proudly.

"Well, sugar, your husband's done got you a home."

"A home?"

"Yep. I done beat a man out of five acres of good land."

"Naw!"

"Yep. It's not right up in town, though. Out to the west of here, close to the Big Swamp. It's even been cleared, but not having no attention paid to it in seven years, it's growed up some. Don't take long in a climate like this. Better throw on something, and let's go take a look at our land."

Arvay knew the general direction. The Big Swamp was a growth that ran north and south for eight or nine miles, and formed the western barrier of the town. They strolled on out there hand in hand in happiness. Jim led her to the place, and told her that they were now on the east line of their property.

"Why, Jim, this just fine! I bet you had to pay a plenty for all this land."

"Nope. I told you that I beat the fool out of the place. He ain't paid no taxes on it since he's had it, and he was about to lose it for taxes anyhow. So he said if I would give him two hundred cash, he'd make me out a clear deed to the place, then I paid up the taxes and it was mine. Of course he don't have

nothing to do with that part no more. That's between me, the State, and County. But it's something less than a hundred all told."

"Naw, Jim!"

"That Cracker could have kept up his taxes, and made a good living out of this land besides, but he was too damn lazy and trifling. One crop of anything one time a year would have taken care of everything, but it was too much work for him. Come telling me that he had been trying to get money enough together to hire a nigger or two to put it in shape for him, but seemed as if he never could make it. When he got it, it was all fresh cleared. I don't know what more he wanted. Well, maybe that was the way it was meant to be so we could get hold of it. I'll bet you anything it'll be clean as a whistle a month from now, and I'll be planting me a grove."

"Oh, Jim! It do place us way up yonder, don't it?"

"Well, it gives us a toe-hold anyhow. My next young 'un is going to be born on his Daddy's place. I never did like the idea of no child of mine being born on borrowed land."

Arvay's heart began to beat very fast. My goodness! You couldn't never fool Jim about a thing. She might as well own up to it.

"You sure got the sharpest eyes, Jim. Here I ain't no more'n two months gone. How did you know it already?"

"Is that so, honey? You're mistaken, and I didn't know it, but I'm ever so glad to get the news. Come on here and hug my neck."

"I'm so glad that you're glad, Jim. I"

"Just give me something more to scuffle for. This one is bound to look like me. That means I'm in the ham-scram and got to hustle like hell to get a house up for him to be born in. I ain't been half doing, but I got to stretch out now and be a man."

They walked over the place hand in hand, Jim pointing out and stepping off and talking. Those two or three scattered palmetto palms, he was going to leave standing. They looked pretty scattered around in a grove. This east end of the place

78

was good and sandy. Just the right kind of ground for a grove. The sandier the land, the thinner the skin and the juicier the orange. He was putting all but a half acre in grove. When it got to bearing good, it would more than take care of the place. The house site with the flower yard, the vegetable garden and barnyard would be that other half an acre. That would face towards the west, and the land began to slide off into muck up that way, which would make it more suitable for vegetables and flowers.

They wandered on up that way to give Arvay a chance to pick out where she wanted the house to be placed. There was a good-sized camphor tree about seventy feet back from the west line, and maybe fifty feet from the north line and Arvay decided that she wanted the house placed so that the tree would shade her kitchen door.

"A woman spends so much time around the back that it would be nice to have it cool and shady."

"You're right, Arvay. In fact, all the family passes more time out back than they do anywhere else, and it don't seem sensible to place everything out front for other folks to look at, and don't have nothing for comfort. We can say, then, ten feet from this tree is your kitchen door."

Everything was nice and agreeable until they faced towards the west, then Arvay stood still in her tracks and gasped.

"Jim! Looka there!" and she pointed dramatically at the swamp.

The swamp was so obvious, that Jim thought she must be pointing at something else.

"What is it, honey?"

"That Big Swamp."

"Ain't it noble? I just wish that I was in shape to take in right up to the edge of it. That's the finest stretch of muck outside the Everglades. And look at that stand of timber! If I just had the cash that five acres of that timber would bring, we wouldn't have to worry about a thing. Don't you fret, honey, some day I'm going to get it for you."

"Get it?" And Arvay's eyes flew open in terror. "I don't

79

want no parts of that awful place. It's dark and haunted-looking and too big and strong to overcome. It's frightening! Like some big old varmint or something to eat you up."

"Why, honey, that ain't nothing but a lot of big trees and stuff growing together. Nothing to hurt you at all. They grows so thick and big and plentiful because the land is wet and rich. Some underground water breaking to the surface in spots along in there. Ain't never been disturbed and been growing like that for maybe thousands of years. That's what makes that land so rich. Plenty stuff done rotted into it, and none of it been used up for cropping. I sure would love to own it."

"Jim, it don't look safe to even be around. I know it's just full and running over with varmints, bears and pant'ers, and wild-cats and gators and rattlesnakes. . . ."

"Not hardly no rattlesnakes, Arvay. They likes clear high, dry ground. We run upon quite a few around in groves. Of course, there would be plenty of moccasins in a place like that, but since you don't have to go in there for nothing, you don't have to worry about that."

"But my child, Jim. Earl is too little to know how to look out for hisself, and he's liable to stray off in there, like young 'uns will, and get snake-bit, or tore to pieces by some varmint or other."

"Earl?" And Jim laughed harshly. "That scary thing ain't apt to stray nowhere at all. If that's all you got to worry about, you can put your mind at rest. He's scared to death of even a baby chicken, and then he ain't all that active."

"You can laugh, Jim, but that place is frightening and awful. I wish that you wouldn't buy the place."

"You mean you want me to give up a lifetime start for a notion like that? Naw, Arvay, it wouldn't be fair to you and my children to give in to a thing like that. Besides, I done passed my word to the man, and the deal is closed."

"Well, I reckon 'tain't nothing more to be said, Jim, but that swamp is a frightening thing."

"Oh, you'll get used to it after a while and pay no attention to it. Any varmint out of there that I catch trespassing on my

property will wish that he had stayed at home. Don't you worry. It's a good half a mile off anyhow, and wild animals are more scared of men than we are of them. They ain't apt to bother around."

Jim went right to work clearing and planting his land, and laying the plans for his new home. He would have loved to tell Arvay how he managed on so little money, and let her laugh with him, but Arvay seemed very listless about it, and kept dwelling on the matter of the swamp every time he brought the matter up.

The cleaning up of the five acres had really cost him only ten gallons of moon-shine at a dollar and a half a gallon, ten pounds of sugar, two ten cent bags of salt, a quart of vinegar and some red pepper. There was a foot-note of a half a box of shotgun shells. All he did was to mention his purchase among his crew and the necessity of getting the thing done, to be called aside by two of the men an hour later and be told that if the above mentioned supplies were furnished, the job could be taken care of the first slack Saturday that came along.

Jim furnished what was suggested, and was extra careful not to ask what would become of the shot-gun shells. Too many Crackers saved hog-feed by letting their hogs run wild in the woods until just before time to butcher for Jim to want to know too much. If a big barbecue was going to be held on his place to get it cleaned up, he knew nothing about where all that meat came from. Having provided what was suggested, he showed no further interest until late Sunday afternoon when he was urged to go take a look at the place.

No less than two hundred grown people could have gotten all that work done over the week-end. From fence-line to fence-line the place was thoroughly cleaned and even the brush piled and burnt. As a gauge to the size of the gathering, Jim found a barrel under some trees that had been full of lemonade, but was empty now. Monday, downtown, the markets which usually got the colored trade were wondering what on earth had become of the colored folks. They had more than

four hundred pounds of unsold meat on hand. His crew brought him many compliments and assured him that anytime he needed any further help, why all he needed to do was to let them know. He was a perfect gentleman, and they were only too glad to oblige him. It was the same every way he turned. Negroes whom he had never seen before were saying the same thing. Jim was laughing up his sleeve and wanted to take Arvay into the joke, then decided against it.

Once he was on the inside, he found that he got help in other ways. It seemed to be a sort of underground system in Colored Town that the whites did not know about. Two brothers who were good carpenters and did a good deal of work for the best real estate firm in town sought him out and made him a very reasonable figure to build his house, furnishing all the materials. They had, it seemed, connections with a big lumber company, and they could buy cheaper than he could himself. Jim decided to chance it and was more than satisfied with the results. Never did Jim go out to see how the work was coming along but what he took a jug along with him, and never did he go but what some others were around helping the carpenters work.

When the house and barn were declared finished, he took Arvay out to see her new home, and found all the trash cleaned up and hauled away.

"Jim," Arvay objected after the house was inspected, "it's nice and all, but they done toted off all that scrap lumber. It would of helped us out quite considerable for stove-wood. You ought to go make 'em put the last piece of it right back on this place."

"Then I wouldn't be no gentleman no more, Arvay, and that would cost me something. That's like broken food from the table. The help don't look for ladies and gentlemen to trace up a thing like that. If I act like I don't notice it, I got a lot of willing friends, and nobody will ever steal a thing off this place. I got this house built way under the regular figure anyhow. All of 'em would feel hard towards me if I went around asking about those scraps of wood. Leave it be."

82

Arvay felt a comparison in this, and it hurt. Jim just as good as said that she wasn't used to things, and he had to teach her and tell her. But she had a child on the way, and only the Lord knew whether it would come right or not. If it was deformed, she would need all the good-will that she could get hold of to stay with Jim. So she pressed her teeth together and said no more.

Arvay just had no idea. She had no understanding to what extent she was benefiting from the good will that Jim had been building up ever since he had come to town. She knew nothing of his twisting and turning and conniving to make life pleasant for her sake. Neither had she any knowledge of the little arrangements he had made with the butcher-boys on the through trains to handle small lots of fancy fruit to bring in a little something extra. She never asked anything, and so Jim never volunteered to tell her.

She saw the young trees being set out in the grove, but she did not know that a friend of one of the men on his crew worked at a nursery, and had fixed it so that Jim was getting the benefit of every doubt, and the doubts were numerous. His grove was planted to the very finest and the most money-making trees. Only the oranges like Parson Browns, Pineapples, Temples, Navels and Valencias went into the Meserve grove. The very early and the very late fruits when the prices would be high. The early fruit to one side and the late to the other with a broad band of grapefruit down the middle. The tangerine were set like a border trimming the grove on all sides towards the house. All budded stock so that Jim could look for a crop on the third year. Since he had the usual contract of six years to pay for his trees, he never actually paid a cent out of his own pocket. Before the time was up, the grove had paid for itself over and over.

CHAPTER 7

Arvay had planned the roomy bedroom in the north-
west corner of the house for herself and Jim. It was
across the hall from the front room, or parlor. In the
old-fashioned double bed in this room her second child was
born.

To the physical pain of her labor was added her secret worry
as to whether the child would be normal or not. She gave birth
to the squalling infant in an agony of uncertainty.

She kept her eyes closed as long as possible while the doctor
and a woman friend attended to it, pretending to be in a
swoon. But she opened her eyes as soon as she heard the
doctor exclaim, "What a fine baby! Good set of lungs too. Just
listen at her squall!"

"Do lemme see my baby, Doctor." Arvay struggled to one
elbow with her eyes fixed on the fat child that the doctor was
hefting. "I know it's got to be tended to, but lemme see it first,
please."

It was a fine-looking infant, and active. Arvay looked at the
reddy-brown down on its head and sighed. It reminded her of
Larraine. Why couldn't it look more like Jim and been a boy?
She let them take the child from her and sank back on her
pillow. Where was Jim? He had been there before her last

terrible pains. What would he say and do when he saw the little girl?

The bed had been changed, and she had been bathed and changed into a fresh nightgown when she heard Jim's voice outside the room door. Then he came in with the baby in his arms.

"A damn fine baby you had for me, honey."

"She looks a little like Larraine, don't you think?" And Arvay twisted her mouth in an apologetic kind of a way. She hoped that Jim could see his way to forgive her.

"Lorraine!" Jim snorted in scorn. "In the pig's eye! My child don't look like Larraine, nothing of the kind. She takes right after my mother, as you would know if you had ever seen her. She's got that same auburn hair and her mouth and eyes. They're light blue now, but them eyes will be a kind of blue-gray in a little while. Larraine! I'm naming her Angeline, after my mother, too."

Arvay closed her eyes in happiness. She could have asked no more of God than this happiness and enthusiasm out of Jim. She hoped that Jim was right about who the child took after. She didn't want any child of hers taking after Larraine. Jim came and sat down on the side of the bed with the little bundle in one arm. With the other hand, he caught hold of hers and stroked up and down her arm tenderly.

"You better let me have the baby then while you go write in the Bible."

Jim reluctantly placed the bundle in her arms and crossed the hall to the living room and wrote: *"Angeline Meserve, Sunday morning, January 7, 1909, at 4:45. A pretty and healthy daughter."*

While Jim was writing, and in his enthusiasm wondering if he ought to add something more, Arvay was examining her new daughter from head to foot. The child was perfect. Not even a birthmark to mar the tender white skin. When Jim returned, she had the child at her breast.

From that hour on, Arvay found out what Jim was like as

a father. He was hanging over the baby's crib practically all the time that he was in the house. He had to look at the child and touch it before he could leave for work in the morning. He came bolting in from work and made for wherever the baby was. It made her laugh to see him changing the baby's diapers, if the child happened to wet herself while Arvay was busy. He was afraid that her skin would get chafed if she had to wait a minute. Arvay kept to her bed a week, and the last day of her confinement, she had to smile at Jim's childishness. He came in with a little white box and hurried to the crib. Propping herself up on one elbow, Arvay could see him trying to put a little gold finger-ring on Angeline's finger. His disappointment was great when he found that the finger was too small as yet, and the ring kept slipping off.

"You ain't supposed to place that on until the child is older, Jim. What is that else you got?"

It was a little gold locket with Angeline's name carved on it. A tiny gold heart hung from a fine gold chain. Jim was dangling it in front of the baby's eyes and trying to delight it.

"Look like I got three babies on my hands," Arvay smiled. "It would be better if you laid it away, Jim, until she gets about three months old. That'll be time enough to start to ornamenting her up."

Then Arvay turned her face away. There had been no little ring nor anything for poor Earl. Already, she could see the pattern opening out. Her own childhood all over again, with Angeline favored like 'Raine always had been, and she made ready to resist. The lines were drawn, and she had become a partisan.

She was hardly up and around before she detected a new drive of energy in Jim. He began to make new plans. He turned and twisted every way to bring in more money, and to place it so it would grow. He bought a Jersey cow so that there could be plenty of milk and butter around the house. He came home one evening with two hundred strawberry plants and set them.

"By the time that big woman of mine gets so she can eat,

86

I want her to have strawberries with cream all over 'em. The little rascal!''

Jim bragged on Angeline excessively, but even Arvay could see that the child was quick to catch on to things, and further, that the baby had a decided preference for her father. By the time that Angie was three months old, she could distinguish Jim by sight, and knew the sound of his voice, which puffed Jim up enormously. Arvay could be nursing her, with Jim across the room. The moment he spoke, Angeline would release the breast long enough to turn her little head quickly and show her toothless gums in a smile at Jim. She would go to him at any time from Arvay's arms. One afternoon, Arvay was changing Angie into clean things so that she would be nice and fresh when Jim got there. She had bathed and powdered the baby, and was folding a diaper to pin on her, when Jim arrived and began to call out. Immediately the little thing began to move her limbs about eagerly, and even tried to pull herself up to go to him. As Arvay kept on with the dressing and Jim did not appear, Angie first began to fret and then to scream in angry impatience.

"Shut up!" Arvay scolded as she jerked the baby into her clothes. "I'm the one that's doing for you, and you squalling after Jim. Hush!"

Jim overheard her and flew into the room and snatched Angeline up in his arms. The little devil immediately behaved as if she had just been rescued from mortal danger. She snuggled her head up under Jim's chin and looked out at her mother in a most accusing way.

"You need that little rump of yourn blistered good for you, that's all," Arvay commented. "Give her back here, Jim, and lemme fling her dress over her head. That ain't nothing but a petticoat."

But the instant Arvay reached up her hands, Angeline scrambled and clung to Jim and pretended utter terror. Jim fended Arvay off and ran out of the backdoor laughing.

"You may think that's funny, Jim, but I sure don't. That child has got to be taught to mind. That very young'un is

going to cause you to suck sorrow some of these days."

"Aw, naw she won't, because she loves her Daddy, and she's always going to do what her Daddy tells her to do." Then he laughed. "If she don't do like I tell her, then I'll do like she tells me and we'll be bound to get along. You ain't to hit her, well no more'n to slap her little hands. Please don't have me to come in and find no whelps on this child, Arvay. If I ever do, it's going to make a lot of difference between us. I mean that from my heart."

"Well, people!" Arvay gasped in amazement as she saw the serious look on Jim's face. "This is my first time to see a man cut the crazy over a child to that extent. Look like I done borned somebody to be over me in my own house. I don't count for nothing no more around here, I see. Angeline is the boss."

"Naw, honey, naw. You got the wrong understanding. Yes, I love the child with all that I'm able, but don't you see it's because she's yours that I love her so? I'm loving you through her and her through you."

Arvay was mollified to an extent, but still she wondered. She hated to be low enough to feel jealous of her own child.

Then Jim took to going off from home nearly every night. Once the baby was asleep, he found some excuse to go out nearly every night, and he usually came in with liquor on his breath. That gave Arvay to wonder if the bonds between them were not slackening off.

What was more disturbing, Jim, usually so good-natured, began to get into fights. Arvay wondered what had got into the man. It was more puzzling because the fights were never serious. No pistol-whippings, no cutting-scrapes nor things like that. Just fist-fights that even left no marks on Jim worth mentioning. Furthermore, they always ended up in complete making-up with his opponent. Jim and his opponents were thicker after the battles than before. What was it all about? Oh, Arvay just knew that one of these nights, some desperado was going to kill her husband dead. She fretted and worried and

begged Jim to desist. Jim took her solicitude for him with a pleased smiled.

They had kept up a correspondence with Joe and Dessie Kelsey. Three or four letters a year each way, and now in her worry, Arvay called them to mind. Jim always liked having Joe around, and maybe if Joe was here, Jim could be broken of these new habits. She knew that Joe wanted to come, but had never been able to get enough money together to bring his family. Without giving her reason, Arvay broached the matter to Jim one evening.

"Damn, Arvay! I'm sure glad you mentioned Joe. Wonder why I didn't think of him before now? He's the very man I need. I can easily throw up a house back there in the grove for him, and have him right here. I'm going to send for him. You drop him a line and tell him to be ready to leave from there in a week. I'm sending his train-fare Monday week."

Arvay was very pleased at the way Jim had taken her suggestion. She felt that she could look forward and see her happiness ahead. It was as if she had been walking in the dark and come to a house where a light leaned out of the window and smiled.

But before Joe and his family could get there, Jim got into another fight that was a fight. It was to go down in local history as the Battle of the Horse's Behind.

Jim left home early that night, telling Arvay that he was going over into Colored Town to see about getting the house put up in the grove. She never did know if he reached his destination. She forgot to ask in the excitement afterwards.

The fight was with Hawley Pitts. The two men were not enemies, but certainly they were not exactly friends.

Hawley Pitts had the reputation of being the ugliest white man in the county, and probably that had something to do with his social outlook. He was tall on a broad-built frame, with a very red neck and ears. But it was Hawley's mouth that had made him his great reputation. His lips were unusually thick—thick at the corners of the mouth. He must have felt shy about his looks, for he had taken occasion to throw off on Jim

Meserve's "pretty looks" more than once around the barrooms when he was sure that Jim could hear him.

Jim, seeing several of his cronies in the bar as he passed, hailed and decided to halt for a few minutes for a drink and an exchange of pleasantries. A score or more were lined up along the bar, and Jim made a place for himself and ordered.

Hawley Pitts had the floor. He was bearing down on Pearly Snead this time. Pearly was a harmless fellow, something under middle height, and slight of build. His wife had run off from him the week before with another man, and was said to be over to Lakeland living with him as man and wife. Some friend had seen her, and told Pearly where she was, and Pearly was so much in love that he had taken out over there and humbled himself enough to beg her to come back to him regardless. What made it bad, Pearly's wife had not only refused with scorn, but meeting someone from Citrabelle on the street in Lakeland, she had laughed and repeated Pearly's tearful plea and her answer. It was soon all over Citrabelle, and now Hawley was having himself a time ragging Pearly about it.

Hawley was too big for Pearly to fight to any advantage, and so he tried to make a laugh and leave the place, like he was humoring the joke.

"Where you trying to sneak off to?" Hawley demanded, and grabbing Pearly by the back of his shirt, hauled him back again. "I ain't had my proper amount of fun out of you yet. You stay right here till I tell you that you can go."

Pearly wanted to fight. Anybody could see that. His fists balled up and he eyed Hawley's face in a hungry way. But he decided that it would not pay, and tried to turn it off in a grin. Hawley saw the same thing that Jim and the others did, and he laughed, and jerked Pearly's shirt out of his pants all the way around.

"You got a willing mind, Pearly, but too light behind. You're just as hot as little sister but scared to fight, eh?"

Jim moved in next to Pearly, and looked Hawley hard in the

eye across Pearly's head. He looked so hard and so long that everybody got quiet.

"Hawley," Jim said finally, and with great deliberation, "I could object to a big, over-built man like you picking on a runt like Pearly. I could get mad because you was born a fool and tell you about it. But I pass all that up, and just take exception to your face." Jim spoke in a nasty quiet way that made his voice carry all over the place.

"What the hell you mean?" Hawley asked. "Taking exception to my face?"

"Yeah, your damn ugly face! I'm bound to take exception, Hawley Pitts. No scoundrel-beast can disrespect *my* wife without giving a strict account to me."

This was certainly exciting, and everybody drew in close.

"Your wife, Jim Meserve? What the hell *is* you talking about sure enough? Why, I ain't hardly ever even broke a breath with her on the streets. Accusing me of insulting your wife!"

"Naw, you ain't been talking to her, Hawley, and I give you full credit for having *that* much sense. But you been committing something worse than that."

"All right! All right! Now what can you claim that I ever done to your wife?"

"You been offering Mrs. Meserve the dirtiest kind of a disrespect. You been proaging out here in the public streets where she could come along and see you with a face like that."

"My face?" Hawley felt his face suspiciously. "I must say that I can't catch on to what you mean." Hawley kept looking from one man to another.

"Yeah, your natural goddamned face! Why, I'd just as soon for her to see you without your pants on as that face. It's a damn lie. It ain't no face at all. I can't consider that thing no face. And that mouth of yours just won't do at all. It's a horse's behind, and a female horse at that."

Spontaneous and raucous laughter broke out instantly. Even Pearly could take a part.

"You, you, say a thing like that to *me?* That's fighting talk."

"I mean it that way, Hawley. No man can insult my wife without giving me some satisfaction. If I allow you to get away with exposing a face like that on the public streets, next thing I know, you'll be out in broad daylight without your damn pants on. The only way you can get out of fighting me here and now is for you to hurry on home and ask your wife for a pair of her drawers and put 'em on that face of yours before you brazen out in public anymore. Git for home!"

The two men went together like lightning. The infuriated Pitts charged, and Jim met him halfway and straightened his head up with a powerful drive to his neck. Men scattered in every direction to be out of the way but at the same time be where they could take in all the battle.

There was no under-dog in this fight. The men were about the same height. Hawley had several pounds of advantage, but Jim was five years younger. It was hard blow for hard blow and neither man dodging away. Fists drumming against chests, and heads and teeth bared back in the frenzy of the battle. Take a blow and give as many as possible in return. So good a man, so good a man! Knock down and drag out, with the men on the side lines jumping up and down and cheering action. Up and down the room in rough and tumble; from the off wall to the bar and back again, panting, gasping, scuffling and smiting and being smitten. It was a close fight, and if Jim got more applause, it was due to his more nimble foot-work, and greater popularity around town. Hawley went down at last and stayed down, but Jim Meserve knew that he had been in a battle and that he had fought a man.

"Got enough?" Jim panted standing over Hawley. "You going to quit being so brazen and put some drawers on that face?"

Hawley did not have to answer, for just then the town marshal, who had been at the door for the greater part of the fight, ran in officially as if he had just arrived.

"What the hell is going on in here?" the law demanded and glared all around him.

"Jim Meserve picked a fight with me and jumped me," Hawley mumbled, getting slowly to his feet.

"He did?" The marshal glowered at Jim then looked around at everybody in the place. "Who saw what went on?" the officer evaded.

Nobody had seen a thing, it developed. Pitts appealed to first one and the other but not a soul would go as far as to witness to a thing. Oh, some kind of a scuffling had gone on, but not a man there could rightly swear to a thing. Who had started it, who had hit who was more than they could say.

"Hell! It was a fair fight wasn't it?" one irritated citizen blurted out at last. "What more can a man ask for than that? If Pitts had of won he would of felt that Jim was a sorry sport to have swore out a warrant against him, wouldn't he? I wouldn't go a step to testify for nothing."

Feeling mistreated and imposed upon, Hawley, with slumped-down shoulders, turned and started to leave the place. It was Jim who hurried forward and caught him and brought him back. Hawley jerked away angrily at first, then Jim charmed him with his eyes, and took his arm and drew him back to the bar.

"Set 'em up," Jim said to the bartender. "Me and my friend Hawley are having a drink together. What's yours, Hawley? It's on me. Come on all you jar-heads! This is to Hawley Pitts, a fair fighter and a true friend."

There was a moment of bewilderment, then every man in the place crowded up to the bar and began to lay down money and order and yell for Jim and Hawley to wait until they got theirs. Pearly tucked in his shirt-tail and joined the rest. A half hour later, no one who was not present would have known that there had been a fight. Jim led them to make over Hawley and to feed his ego. Jim slipped in something about Hawley's swell build and his loaded muscles, and Hawley swelled like a pouter pigeon. He swelled so that he had room inside for a big gesture. So he reached and got Pearly and placed his big arm around the little man's shoulder.

"Say, Pearly, you being luckier than the rest of us, not

having no old hen to bother with, how about us all going over to your house and finishing off this thing?"

Pearly was so tickled that he almost split wide open, so they all went over there and caroused for a couple of hours. Jim could see that they had done a good thing, for after an hour or so of the kind of stories men tell when they are off to themselves and a few more drinks, Pearly stood up and announced, "What the heck am I worrying about *his* hard luck for? What business I got feeling any sympathy for *him?* He got her on his hands, let him keep her."

Having secured himself some more partisans, Jim went on home in high fettle, but Arvay all but fainted when she saw his face and knuckles. She made a great demonstration of her sentiments, and Jim felt highly paid. He kept on being brusque and telling her not to fuss over him, but all the time he was leaning right into it. But Arvay did not understand.

"Jim, you got ways that I don't believe that I'm ever to understand. What you want to get into a fight for is more than I can see."

"Just put it down to me being a man and part Irish and let it go at that. You get so at times that you got to give vent to your muscles. Don't bother too much about understanding right now. Just hug my neck for me and call it square."

CHAPTER 8

The arrival of the Kelseys made life exactly right for Arvay. For some time Jim was kept close around the place getting Joe and them settled down and the work laid out. Joe and his three big boys were to look after the grove and the place. Dessie was to take care of the family washing. Arvay did not know enough about groves right then to realize that the grove would need no particular care for a year or more. She did not notice that because Jim had Joe and his boys broadcast black-eye peas over the entire grove. That crop served a three-fold purpose. It provided an enormous amount of additional food for the added mouths. The cows could eat the pea-vines for hay. It was a cover crop that added nitrate to the soil. That was all for the grove, and Arvay did not notice that Jim and Joe were off in a huddle a great deal, and that more often than not, Joe was not even on the place. His big boys did the milking, looked after the barn, the chicken-yard and the garden.

Arvay was not to pay too much attention because Dessie was up around the house most of the time. It was just as good as a visit to west Florida to hear Dessie talk. Arvay was brought up to date on everything that had happened since she left. Whose babies Dessie had caught, and who were supposed to be the fathers, but who they really favored, and so on and on

as they set hens, being careful to put all the eggs but two of a setting in with the right hand to hatch out pullets and only two roosters to a batch. They took hens off the nests with their broods, housed them in coops and kept going over Sawley, Jim and Joe.

Dessie caught on to the signs right away, and Arvay saw them confirmed in her body. She was going to have another child. But thinking things over, she waited nearly a month more to speak of her condition to Jim.

The day, or to be more exact the night, that Arvay chose for the revelation was unfortunate for her.

Jim, eager to accumulate and prosper as well as to help Joe out, had set Joe up in a whiskey still. It was located about three miles to the south in the very edge of the hammock. Joe could pay back the money that Jim had put out as he went along. All over a certain profit was to go to Jim after that. Both men considered that fair as Jim was to furnish the customers while Joe ran the still.

Joe had made his first run that night, with Jim and most of the important men of the community present. Everything had gone off swell, and a very good time had been had by all. They could look forward to good likker, because Joe really knew how to make it, charred barrels and all. There was no need for him to get rid of it in a hurry, so it could age. No law was going to touch that still. The law was present at the run. Moonshine likker was an old southern custom. Nothing wrong with it at all. So Jim had come home feeling fine.

As soon as Jim began to undress, Arvay stirred in bed and told Jim of her condition.

Jim was in a mood for wit and laughter, and Arvay's solemn eyes provoked him more. And when her eyes and her tone of voice plead with Jim to excuse her for what had happened, Jim just could not resist pulling Arvay's leg a bit. So he stood straddled legged, put on a stern face and pontificated.

"Now, as to that matter you just mentioned, Arvay, I'm agreeable, providing you promise me one thing."

"What is it, Jim?"

"You can have that baby, providing that you swear and promise me to bring it here a boy."

"Why, Jim! What a thing for you to make me swear to! How on earth can I tell what the child will be?"

"Easy enough. Just make up your mind to do as I tell you, and have that child a boy. I never did want no girls around the house."

Arvay stretched her eyes, and looked at Jim a long time before she could say a word.

"That's a mighty funny thing for you to say, Jim. The way you makes over Angie nobody would think you didn't want no girl."

"Oh, I'm just putting on when I carry on like that, Arvay. I don't really want no girl, and don't you dare to have me no other one."

"Jim." Arvay gulped and swallowed. "That's no way to talk to me at all, and me in my condition too. It's cruel and mean, that's what it is. Cruel."

"Cruel? Why, what do you mean? If I got a cruel bone in me, this is my first of hearing about it. Why, I'm a mighty good-natured man, according to all that I can hear. Look how nice I acted when you up and had Angie on me. If I had of been cruel, I could of made you tie her up in a sack and chunk her into the lake, but I didn't do it. Or made you take her out in the swamp and lose her, but I never done that neither. I seen you was fond of the little thing, so I let you keep her for a pet. I'm a mighty good-natured man. Tell me!"

The stricken Arvay turned her face to the wall and said no more. Jim got into bed and blew out the light. After probably half an hour, Arvay murmured, "Jim."

"What is it, Arvay?"

"Supposing, supposing the child was to be born a girl."

"No use in supposing, Arvay. I know that you wouldn't have no girl after I done told you specifically to bring it here a boy." Then Jim went on off to sleep.

Arvay did not get to sleep until nearly morning, lying awake and supposing what could happen if the child happened to be

97

a girl. And as she conjectured, she trembled.

Jim had evidently forgotten the teasing that he had given Arvay the night before, for he kissed her tenderly on waking and fondled her hair.

"You ain't to take no chances and run no risks, Arvay, in your condition. No lifting and stretching at all. Earl is big and old enough to keep you in wood and water. See to it that he keeps that bucket full in the kitchen, and keeps plenty of stove wood in the box."

"He ain't but seven, Jim."

"I could tote in wood and water long before that, Arvay. You let that boy do something and get manly. Naw, I don't want none of Dessie's young'uns doing it for Earl. I'll fill up the bucket and the box every morning before I go. Earl is to look after it for the rest of the day, you hear?"

"Yeah, Jim. He can't . . ."

"It's all cut and stacked, ain't it? More'n two strands of good dry oak and pine out there for you to burn. All he got to do is tote in two or three pieces at a time and fill up that box before you start to cook supper. You understand?"

"Yes, Jim."

"In your condition, I want you to have every care. You ain't to worry about a thing. And don't look so sad and solemn, Arvie. You never got with this young'un out in no palmetto scrubs. You got it right here in the bed with Jim Meserve. You got full protection."

Arvay almost spoke and reminded Jim of what he had said the night before. But she could not bring herself to do so.

Jim went to work planning to make things better for Arvay in every way. With any luck at all with the still, by the time the child was born, he would have that carpet for the parlor and hall that Arvay wanted, and he would surprise her with a piano. Arvay played much better than she did when he married her, but that old second-hand organ was no help. He was going to deck her out with a brand new piano if things turned out as he hoped.

In her fear and desperation, Arvay fled back to her old time

98

religion. Again and again she considered calling to Jim's mind his promise to love and protect her, but each time she failed of the courage to take her fate into her own hands and bring the matter to a head. Arvay could feel no faith in her own power over Jim, so she began again to take great stock in miracles. Arvay crept into the Bible and pulled down the lid. She made herself into parables and identified herself with Hannah before the conception of Samuel, and with Hagar, driven out into the desert by Abraham, and other sorrowful women. All day long during the hours that Jim was absent, Arvay went around muttering prayers for deliverance from her fancied danger.

Along with the habit of talking to herself, Arvay acquired the subconscious habit of keeping one hand on her abdomen. Any hand that was not busy at any time that she was awake went to her body. Round and round went the hand, round and round and round and round, as if she caressed the child inside her, and sought to placate it and persuade it to be a boy. In fact, she besought it aloud when she was sure that she would not be overheard.

"Be nice, honey. Be nice, now, and come here a boy-child for your Mama. You see the fix I'm in. Jim is liable to leave me if you ain't a boy. Me with three little hungry mouths to feed and to do for. I wouldn't have nowhere at all to go. Except to go pile up on Larraine, and I'd rather be dead and in my grave than to have to do a thing like that."

Arvay mentioned the same thing to the Lord several times a day.

Then, when she was seven months gone in pregnancy, Arvay discovered that Jim's demand had been only a joke. The day she found that out had been a trying one for her.

Angie was a great favorite with Bubber, Dessie's oldest boy, who was twenty, and working as yard man on the estate of a wealthy Yankee. Thoughtlessly, Bubber had brought home a mango for Angie and none for Earl, the night before. Arvay had put it away until morning. In mid-morning, Arvay had given it to Angie, and told her to divide with Earl. The chil-

dren were out in the yard, and Arvay went on with her sewing.

Soon there were inhuman screams from the frontyard. Arvay's instant thought was that some wild beast had crept in from the swamp and was attacking Earl. The terrible snarly howls kept up as Arvay raced through the house to the front, grabbing the breech-loader from the head of the bed as she ran. She knew little about handling guns, but this did not occur to her as she ran.

The sight that met her eyes was far worse than if she had found a wild beast attacking her son.

Earl had the mango clutched in one hand as he lay drawn up in a knot on the ground. Angie was standing over him, hitting at the boy with a tiny branch of verbena, with the flowers still on it. Angie was striking at Earl with the spike of verbena, and Earl was on the ground clutching the mango and emitting those animal howls.

What had happened was obvious to Arvay on the porch. Earl had snatched the mango and attempted to flee to some safe place and eat it. He had run towards the corner of the yard and come up against a tangle of alaman bushes overrun by a Cherokee rose growing along the fence. There the little girl had overtaken him, and he had dropped to the ground. The verbena bed was at hand, and Angie had broken off a branch no more than a foot long and was menacing her brother with it.

The scene told Arvay more than she wanted to know. The twig could not have hurt very much even in the hands of a grown man, and certainly three-year-old Angie could do him no harm with the thing. And the sounds! There was nothing human in them. She would never forget them the longest day that she lived. Earl had never made sounds like that before. Not in her hearing anyway.

Arvay leaned the gun against the porch with a shaking hand. A terrible anger took hold of her. For a confused minute, she did not know whether she was angry with Earl for his cowardice, or with Angie for teasing the poor child. Then she knew who was to blame. Bubber had no business to bring that

100

mango on the place. She got off the porch and bent over the howling Earl and wrenched it from his hand and flung it over the fence.

"Hush up! Hush up, I tell you!" she cried as she hauled her son to his feet and shook him violently. She felt that if those sounds kept up another minute that she would lose her mind.

But while Arvay sought to cut off the sounds, Angie ran out of the gate and recovered her fruit, and was eating it. Earl saw her, and began to howl again. He kept it up until Arvay had dragged him clear around the house. Arvay had no time to take the mango from Angie again. She was too occupied with Earl. Those sounds had to cease at any cost. No doubt Dessie had heard them already. She must never learn that they had come from Earl's throat.

Arvay was shaken as she had never been before in all her life. Even the sight of the child at birth had not been as shocking as this.

"Oh, God, is my child going to be marked from this?"

After the noon dinner, the children were out in the yard, each amusing him and herself in their own way. Earl wandered on down to Dessie's and Arvay was glad. After a while, Angie lay down on the front porch and went to sleep.

It was time for Arvay to start the supper finally. She went out in the kitchen and put on the stew, washed some yams and put them in the oven, and a pot of snap-peas and okra. While they were cooking, Arvay suffered as she washed the rice the regulation five waters and left it to soak. It would cook very quickly when she got to it.

There was no more wood in the box. She had no wish to call Earl to get the wood for her. If only some of Dessie's children would happen up.

Then a great anger and revolt seized upon her.

"I'm a'going out there and get me a turn of wood! Let Jim Meserve just try to help himself. If I overstrain and this child come here too soon, I don't care. It could be a blessing. I won't have to worry anymore. It's got to come here a boy, is

it? I'll fix him! Let him worry like I been worried all this time."

Arvay went out into the yard, but she did not reach the wood-pile. Halfway there, she got to the pump and halted. No reason to it, her mind just wandered, and she halted. There was no water bucket on the broad shelf that Jim had built around the pump for Arvay's convenience, but Arvay took hold of the handle of the pump and started to pump. The pump had a strong suction, and the round handle went up in the air at the first stroke. Arvay let it stay there with her hand attached. She stood there for several minutes, her right hand hanging to the up-tilted pump handle, and her left hand going round and round over her abdomen. She hung there like a rag-doll and mumbled and suffered.

Then her eyes saw the sun in the west. It was just over the tops of the swamp trees. Some atavistic impulse arose in her, and suddenly the sun took on divine significance. She looked at it for several minutes, then slowly left the pump and advanced to a clear space facing the west and lifted her arms to pray.

"O, evening sun! You go where God is every night. Please take Him a message from me. Tell Him to take this child from me right now, or let me know that it's coming here a boy. Give me a sign by you. And, O evening sun, when you get on the other side, tell my Lord that I'm here praying. Tell Him . . ."

Arvay started violently, for just at that moment a shadow came between her and the sun. After a second she got it straight and knew what it was. Jim had come around the corner of the house from the front.

"Oh!" Arvay let her arms come slowly to her sides.

"What's the matter, Little-Bits? Sending up a prayer for rain? I hope you get an answer, because the grove could certainly stand it along in here."

Arvay retreated before Jim for several steps. Backing back towards the pump but keeping her eyes fixed on Jim who had been smiling at first but was standing looking at her now with a worried look on his face.

102

"Naw! Naw, Jim Meserve, I wasn't praying for no rain. Know what I was praying for?" And now Arvay began to come forward again. "I was praying for God to take this child from me right now."

"My God, Arvay! What for? You know what that would mean, don't you?"

"I sure do. And that's exactly what I was praying for."

Jim was able to calm Arvay down after awhile, and find out what was the trouble. But not for long. When with difficulty Jim recalled the incident and told Arvay that it was a joke, she was not comforted at all.

"A joke! A joke and here I been suffering all this time! Jim, I'm never going to forget you for this thing."

Jim did not laugh it off as he had been inclined to do at first. He was quite serious, and apologized to Arvay most humbly. But when the only response he got was an indicting stare then a shamefaced hanging of her head, Jim dug deeper.

"But, Arvay, I thought that anybody at all would see through a joke like that. Anybody with even a teaspoonful of sense knows that you can't tell what a child'll turn out to be until it gets born. And furthermore, you know so well that I'd go to Hell for my daughter, and wade through solid rock up to my hips to do it. And then again, I'd be bound to love any child that you had for me."

Somehow, one of Arvay's braids had worked aloose, and Jim looked at her standing there with her head bowed and the yellow braid dangling over her shoulder and she looked pitiful and helpless to him. He did not want to talk about the thing any longer, nor to remember anything at all against her.

"You didn't act like it, Jim," Arvay accused sullenly. Then the corners of her mouth went down and her voice trembled. "Looked to me like you just aimed to quit me, and was just fixing up any old kind of a shabby, sorry excuse to do it on." Arvay choked back a sob. "And me with three little bitty chillun on my hands to look after and do for. I was hurt-ed, Jim. Hurt-ed to my very heart, and felt like I was throwed clean away."

"Goddammit, why?" The sight of Arvay's drooping figure, the piteous tone of her voice made Jim see the months of pain and fear that Arvay had lived through in silence and so needlessly, and it was almost more than he could bear. It made him angry that Arvay should have suffered so uselessly, and through her belated revelation, make him agonize so. "What cause have you ever had to doubt me, Arvay? Have I ever mistreated you in any way whatsoever? Have I ever neglected to do my utmost for you and for my children?"

"Can't say as you have," Arvay murmured with her eyes still lowered.

"Then why would you put such an utmost application upon a silly thing like that? Where is your common, ordinary sense? Why did you want to twist a joke around like that?"

Jim whirled and loped off without waiting for an answer. He fled down into the peace and green calm of the grove to be alone in his anguish of feelings.

There was not sufficient understanding in his marriage, Jim said inside himself. It could not keep on like this. He was panging and paining far too much. What help for it except by parting from Arvay?

Minutes and possibly an hour passed with Jim controversing inside his mind. His thoughts and feelings made living pictures thrown against the white sand of the grove and the dark glossy foliage of the orange trees. He wouldn't be coming home anymore from work of evenings and finding Arvay doing around in the kitchen fixing him the kind of a supper that she figured he might choose and fancy. He wouldn't be grabbing up that sassy, impudent little piece of girl called Angeline. That bossy little chunk of prettiness that had the spunk to tussle and squall for what she wanted until she got it. And even poor helpless Earl. Who on earth would look after and protect him if his father was not around? And this place, who would love it as he did and push it on to the beauty and helpfulness that he saw in it? What would poor helpless Arvay do with a place like this on her hands and nobody to tell her and show her what to do about it? And Arvay herself,

what would become of the poor weak thing without the proper person to give her the right care? She needed and required the best that the world could afford. No one understood that but himself. Some other dumb fool might come along, find her forlorn and take the advantage and brutalize her in some way or other.

With that thought, Jim leaped up from where he was seated under a grapefruit tree as if he had found himself in striking distance of a rattler, and headed back towards the house. My God! What had got into him? Had he really been wallowing around under that tree thinking about quitting his wife? Arvay had acted dumb, but what more could you expect? She was a woman and women folks were not given to thinking nohow. It was not in their make-up to do much thinking. That was what men were made for. Women were made to hover and to feel. He had gotten used to the comforts of a home through Arvay, and her tender and loving care. He could not do without a woman now after that, and what other woman on earth was he willing to suffer with and do for? Why, she wasn't even born yet and her mama was already dead. Arvay was his woman, and it was his privilege to do for her. It was his part to put in the thinking. He had no business pushing off nothing like that on her. He had played the fool, not Arvay. As Jim neared the house the thing came to him that had been dodging around in his mind for years. There was something about Arvay that put him in mind of his mother. They didn't favor each other in the face, but there was something there that was the same. Maybe that was what had caught his attention the first time that he had laid eyes on Arvay. Maybe that was why he had never missed his family since he had married her. All the agony of his lost mother was gone when he could rest his head on Arvay's bosom and go to sleep of nights.

That was just part of it, Jim went on, as he strode on through the thriving young grove. There was something about Arvay besides her good looks. Something like a vapor, which reached to him and delivered him into her hands tied and bound. Now, supposing some other man should find out what

he knew about Arvay, and be soothing his trashy head on Arvay's soft and comforting bosom, and breathing his breath in her face? Oh, but Jim would kill him dead wherever found.

In the kitchen Jim found Arvay switching around as fast as she could to finish his supper. And right away he became the loving and protecting husband, the ardent lover. He seized Arvay midway in a passage from the table to the stove and held her tight and kissed her and murmured sweet soothing things until that mysterious green light appeared in Arvay's blue eyes. Arvay's eyes had some strange power to change like that when she was stirred for him. Each time that she succumbed to his love making, Arvay's eyes gradually changed from that placid blue to a misty greenish-blue like the waters of the sea at times and at places. It warmed him, it burned him and bound him. But Jim did not consider himself weak in being overcome like that. He placed Arvay as having powers that few women on earth had. The strange thing was that she did not know her own strength. Maybe it was just as well. Knowing more, she might not have been so contented where she was. Twenty to twenty-five years later on, he could afford to let her know. No sense in crowding his luck.

Gradually, as the days went by, Arvay regained her composure, but she retained a residue of resentment. She felt like a fool for having suffered all those months so needlessly, and she stubbornly blamed Jim for making a fool of her.

And to add to that, the child was a boy, and as Dessie exclaimed, the spitting image of Jim. Couldn't have been anymore like Jim if Jim had spit him out of his mouth. Jim promptly named him James Kenneth Meserve, and he came to be called Kenny.

When Arvay was able to be up and around, she found a new carpet in the parlor and the hall, and there was a piano sitting where the old wheezy organ used to be. Next thing to be done, Jim said, was to have running water in the house. He aimed to put in electric lights some of these days.

The still that Arvay knew nothing about was doing well

indeed. Jim added another room to Joe's house and sunk a pump down that end of the grove. Dessie was going to have another baby herself, so Arvay thought that Jim was very good-hearted to get another woman to come in and take care of the washing so Dessie wouldn't have to strain. Arvay had to smile when Jim began to talk about buying an automobile. That back-gap was going to be widened into a driveway.

"Jim sure has got big notions," Arvay confided to Dessie. "It's nice to have all them big notions, but getting hold of the money is another thing."

"Oh, he's born lucky, you might say," Dessie answered mysteriously. "He's liable to stumble up on it. You never can tell."

Arvay had no idea about anything. But all the new improvements around the place lifted her up. From what she heard from west Florida, she was far and ahead of Larraine. Carl was still pastoring small charges. He had shifted twice since Arvay and Jim had married, and the changes were always for the worse. His youth was no longer a selling point.

What in the world had been the matter with her, Arvay wondered, wanting a man like Carl? Well, she had been young and ignorant then. Maybe she should tell Jim all about it now. But no, that would give him a stick to crack her over the head with. Better let sleeping dogs lie. Anyway, she'd never be able to feel resentment toward Larraine from now on.

CHAPTER 9

Kenny Meserve was a very lively child; everybody made over him. Arvay noticed that he would hang around the piano just as soon as he could walk. He was bold, and even more self-assured than Angie, but he had a cute smile to go with it.

Kenny got no public notice, and deserved none, until he was eight years old.

His favorite playmate and faithful follower was Belinda, three months younger than he was. Belinda was Dessie's baby.

Kenny was bossy like his father, and he preferred Belinda to all the other children he knew because Belinda was persuaded that he was very smart and showered admiration in various ways upon him. Then too, Belinda was right there on the place and handy. But Belinda's greatest charm for Kenny was her artistry. Belinda could stand on her head. Stand on her head with a better balance than Kenny had ever seen in any one. It was perfection, and Kenny admired her no end for it. He would even have been jealous, but he had taught it to her. Even though the pupil now surpassed her master, Kenneth was not jealous. She was a product of his skill.

Belinda contended that Kenny turned the best cart-wheels of anybody in the world. Kenny could always think up some

scrape for them to get into, too. She could always help carry things through. It was a solid friendship.

It was through this friendship that Kenny came to public notice, and Arvay came to tears.

Kenny had led his expedition into town and wound up at the railroad station. The train came in, and Kenny particularly liked trains. It was the rhythm of movement and sound that entranced him, but he did not know that then. All he knew was that he loved trains. He got to see them seldom too, living out of town like that.

The train was a crack Pullman and parlor car affair—New York to Palm Beach and the Florida east coast in general. As the train blew for Citrabelle, Kenny with Belinda beside him, lined up beside the track to enjoy the sight. Kenny was so overcome that he felt to worship. He wanted to do something in worship of the train. But what? A portly looking tourist came out on the platform between the coaches as the train slowed to a stop. He looked at the children and smiled. It was a nice smile, and that decided Kenny.

"Mister! Mister!" And as he finished shouting Kenny threw a perfect cartwheel. As he came up, he had another idea. He would offer the most perfect thing on earth to this train and the man who smiled on the platform. "Want to see Linda stand on her head?"

The smile got broader. The man misunderstood. He thought that Kenny was after making himself a little change. He tossed Kenny a quarter with an indulgent smile and said, "Sure thing. Let Belinda stand on her head."

Belinda needed no more than a flourish of the hand from Kenny. She made the proper approach, and in an instant, was standing on her head. Kenny looked raptly first at Belinda, and then at the man on the step.

"Ain't she wonderful? Nobody can't stand on their head that good. Nobody but Belinda. I showed her how myself."

Belinda's performance was attracting enormous interest among the passengers on the train. Kenny was about to burst

109

his shirt with pride at the excitement Belinda created. He did not understand the reason. Belinda was innocent of underwear. She was there on her head, with her short percale skirt hanging over her face, with her shining little black behind glinting in the sun. Kenny was innocent, and besides he had seen it so often as he put his pupil through her paces that he paid no attention. As yet the two had no idea of nakedness.

Therefore, Kenny was outraged when he was heckled by a gray-haired chesty woman from the car ahead.

"Boy! You! You shameless little rascal, you! Turn that child down!"

Kenny was surprised and evermore hurt at such lack of appreciation of art. Here was the greatest artist of her time, and some fool hollering to turn her down. Kenny gave the outraged matron a snurling look, and ignored her after that. The excitement on the train was increased rather than diminished by the protest. Passengers from the off side of the cars crowded over to see the show. There were smothered chuckles, and some unsmothered, running the whole length of the train.

"Turn her down, I say!" the woman screamed again.

Kenny had not thought of gaining money by the show. It was intended as a tribute. But the nice man had given him a quarter to turn Belinda up. Two-bits was a heap of money when you came right down to it. If it was worth all that much to see Belinda stand on her head, it was worth double the money to stop seeing it.

"Fifty cents to turn her down!" Kenny shouted, clothed in innocence and arrogance.

The audience roared with laughter at this turn of affairs. The heckler became more furious at being opposed, and then made the butt of laughter by the dirty-faced little imp on the ground with his frayed palmetto hat shoved far back on his head.

"Fifty cents indeed!" The woman screamed. "You turn that child down, I say!"

Kenny turned to Belinda like an impresario and directed:

110

"Wiggle your toes, Belinda!"

Belinda knew what was meant. She was to show that she could move her lower extremities and still keep her balance. That was the most technical part of the thing. Few could accomplish that. So the wrongside-up child proudly waved her fat legs and wiggled her toes. Kenny flung his eyes up at his audience. "What did I tell you? You have seen the most wonderfullest thing on earth."

The train was about to pull off, but the woman, who was evidently accustomed to being obeyed, gave another angry and impatient command to turn Belinda down.

"You heard what I said. Fifty cents." And Kenny braced his legs far apart and eye-balled his heckler belligerently.

The audience howled.

"Attaboy!" The smiling man who had donated the quarter tossed another at Belinda. Somebody else flipped a coin, a big round silver dollar.

"Hooray for Belinda!"

Silver money began to spout from every window and platform.

The train began to move, and Kenny signified that Belinda could end the performance. She came down gracefully as the train pulled out of the station to more cheers. The last the passengers saw of the two children, they were standing and smiling and waving after the train.

When it had rounded the long curve to the south, and was no longer visible, the children searched around and collected the coins in Belinda's skirt. It was too much for them to count exactly, so they went across the street to the general store and Carl Galloway, the son of the proprietor, who waited on the people, counted it for them. Nine dollars and some odd cents.

"Whoo-eee! Belinda, we're rich as we can be!" Kenny gloated and bought a dozen bananas for them to eat on as they walked homeward in clouds of triumph. Neither of them could make out what was wrong with that crazy woman.

"Tetched in the head," Kenny diagnosed.

"Tetched in her head," Belinda repeated as always.

The two children sankled on home eating bananas and feeling happy, never dreaming that the story of the performance was being told and laughed at all over town. That Kenny Meserve! He took after his Pappy all right. Nobody but a Meserve would have thought up such a thing.

Jim heard about it as he came through town after work. He was joshed and teased, and he laughed and replied in kind. He was rather proud of Kenny. A chip off the old block, all right.

So Jim was put out when he got home and found Arvay all upset over the incident. Kenny and Belinda had been whipped and were in deep disgrace. Jim took exception right away.

"What is it to be lawing and jawing about, Arvie? It was nothing but children's doings. They ain't got the least idea about nothing unless you done put [it] into their heads. Let it be."

"I won't let it be, Jim! The way the twig is bent, the tree is bound to be inclined. I try to raise my children clean and right. I don't intend to have nobody around here toling a young'un of mine off and leading him astray. I don't intend to put up with it at all."

"Ha! Belinda leading Kenny! That's a joke. Nobody ain't apt to do no leading around Kenny Meserve. He's too much like his old man for that. I take it as a grand insult for you to even say such a thing. That was Kenny's own idea from stem to stern. Anyhow, what can be done about it now? It's done and over with."

Arvay looked up into Jim's positive eyes and gave a pained gasp. She slumped in silence for awhile before she spoke.

"Belinda being that no-count Joe's young'un, I reckon any caper that she might up and cut just have to be put up with. Look like Joe is the boss on this place."

"Now just what do you mean by that, Honey?" Jim asked in surprise and irritation. He made an impatient gesture, then comprehension came to him. He gave a big, clapping laugh and picked Arvay up and sat down with her in his lap.

"This baby-wife I got can't stand for her husband to think well of nobody but her." Jim caressed Arvay under her chin

and cajoled her along. "Look, Little-Bits, I think as much of you as God does of Gabriel, and you know that's His pet angel. But . . ."

"But what?" Arvay pouted.

"But Joe is my helper. Sort of standing at my right hand. You don't know what a lot of help Joe has been to me, off and on. You're my wife, the most precious thing that I got, and nobody don't compare with you. What's between me and Joe is something different altogether and I wouldn't want you to take a pick at him. Just try to feel and believe that every move I make is in your interest, baby. Will you try to feel that without me always having to tell you so?"

Arvay nodded, then under Jim's kisses slipped one arm about his neck.

"Long as Joe ain't got more influence over you than I have, Jim, I ain't got a thing against him. I don't aim to make out that I like the notion of them young'uns being up around the depot naked and all, though. It ain't Christian. It's more like little heathens that ain't got nobody to teach 'em right from wrong. And Kenny . . ."

Jim realized what was before him. No amount of reasoning was going to do any good. Arvay lived by her feelings and not by conscious reasoning, so he fondled her and cajoled and teased her and thus got her mind off the subject and left her feeling assured.

The lifeless scare-crow that Arvay had set up herself had been knocked down and trampled under foot, and Arvay had a great feeling of power and victory. As much as Jim thought of Joe, she had more power of her husband than Joe had. It made her feel very good. So uplifted that she was extra nice to Dessie and her children next day. She so far forgave Belinda's little bare body that right after breakfast she dug out all of Angeline's clothes that her daughter had outgrown and gave them to Dessie for Belinda. The feeling of guilt drove her to town to buy enough white lawn to make Belinda a dress for Sunday School and a ribbon bow for her hair.

Something more than remorse was moving inside Arvay.

113

She found that it was a kind of gratitude for the happening. Out of it had come her first glimmering of really being Jim Meserve's wife, and while it was not anything like a full realization, a hope, a possibility that it could be so. She might come to win this great and perfect man some day. That being the case, it was worth all the world to be right there in the house with Jim and to have the privilege to do for him the best that she knew how. It was a good thing having Joe and his family on the place. They had brought her luck.

So reconciled was Arvay, that she surprised herself by the way she reacted to a small incident that happened a few days later.

Jim had ordered some cement for the front walk, and the white man who delivered it drove up with it under the camphor tree in the back yard. Kenny and Belinda were playing out around there, and came running up to see what was arriving. The driver saw the children as he jumped down from his seat, and to make talk with them, pretended that he did not know who they were. His face was all ready to smile at his own teasing as he looked at Kenny first and asked, "Whose little boy are you?"

Kenny gave him a look from under his long lashes that called the man a dumb fool and retorted, "You know so well that I'm Kenny, Jim Meserve's son."

The man looked at Arvay, who had come to the door and winked his eye and chuckled. "And mighty proud about it, I see."

"Sure." Kenny braced himself and challenged the man with his eyes. "My Daddy can lick any man in the world."

"You don't tell me!" The truck-driver affected to be mightily impressed, and making no fun out of Kenny, turned to Belinda and asked her, "And whose little girl are you?"

Belinda wanted to come off as well as Kenny had, and was obviously stumped for an answer for a moment. She shuffled her bare feet in the sand, then flung up her head and said, "I'm Miss Arvay's little girl, that's who."

Both the truck-driver and Arvay had their mouths wide

114

open for a minute and couldn't close them. Then the driver gave a great guffaw. He had gotten his laugh at last.

"Aw, gwan! Miss Arvay ain't your mother, nothing of the kind!" He rocked and rolled with laughter. He slapped his thigh, and looked to Arvay to join him in the joke.

"Yes I is Miss Arvay's little girl too," contended Belinda about to cry. "Yes I is, too. She gave me a pretty white dress for Sunday School," and Belinda spread her skirts to illustrate, "and a *pretty* pink ribbon for my head. Yes I is her little girl so!"

Arvay saw Belinda about to cry and understood. Belinda valued her and counted on her care and wanted to be loved by her. Arvay knew that feeling.

"Yes indeed, Belinda is my little girl," Arvay said with conviction as she came slowly down the steps to direct the delivery of the cement. "Born right here on the place, and I wouldn't take a play-pretty for her either, I'm a'telling you!"

It was worth something to Arvay to see Belinda's happy and triumphant look. With her head away up, Belinda marched around in a small circle with her soiled little skirt spread out on both sides.

"That *is* right," the driver agreed and fell in with the play. "Excuse me, Belinda. I just forgot." With that, Arvay pointed him to the wash-shed, and he began unloading the sacks of cement under there, while the two children looked on importantly.

Arvay felt very light-hearted for the rest of the afternoon, and told Jim about it as soon as they were alone in the bedroom.

"Knew from the very first time that I saw you, Little-Bits, that you was all heart," Jim remarked feelingly.

"You reckon?" Arvay blushed under Jim's approval.

"Naw, I know, honey, and that makes up for a lot of things. I can read your writing. Know you a lot better than you know your ownself, Arvay, and always have."

"I try to do what's right, Jim. Always did, to the best that I know how."

"And I believe you," Jim remarked after a pause. "You do the very best that you know how." Jim kissed her then and let it go at that. He went to bed feeling very encouraged. It looked as if Arvay was finding her way. The only snag was, could he make her understand that there was a way and that it was necessary for her to find it? How was he to bring a thing like that about? He had tried every way that he knew how and had only temporary results. Maybe it would just come all of a sudden some day. Then life would be perfect indeed.

Things went on very comfortably, Arvay thought, for two whole years. Many improvements of living took place around the house. Jim sank a deep well with a motor pump and there was running water in the house and a bathroom. The house was thoroughly screened and had a fresh coat of paint. Then came electric lights. Everything on the place reflected a greater degree of prosperity, and Arvay felt fine, but that was because she had no idea of the major source of Jim's income. Whenever she thanked Jim for some new comfort and inquired about possible raises in his salary, Jim always answered her in a parable, using a gambler's phrase, "Good dice are bringing the money!" As Arvay did little visiting around and encouraged few visitors, she knew nothing about the still.

Time and again when Jim made a big sale, he longed to run to Arvay and show her his pockets loaded down with money, but he knew his wife too well for that. Having anything to do with alcohol in any way whatsoever would outrage her religious principles. Jim was down in the grove talking over the work with Joe, or off somewhere on business, was all that she ever knew.

Then one day a dash of gossip fell in her ear while she was downtown on the streets, and Jim found a crying, outraged woman when he got home. Arvay was still too unsure of herself to lay down any ultimatums to her husband, so she took it out on Joe. He was leading her husband astray, and on top of that, she had a half-grown son, and he too was in danger of being ruined by Joe and his likkery ways.

Jim gritted his teeth and told Arvay that it was not Joe at all. He was the one who was responsible for the whole thing, and that she was not to tackle Joe on the subject at all. It was his still, and Joe was just running it for him. Let Joe right alone. Furthermore, it all had been done for her furtherance; she had and was enjoying the benefits from it. He had not meant for her to know, but now that she did, she was not to say a word to Joe about it. Joe had been careful to protect Jim, capable and ever so honest and faithful. Joe had run the risk of the chain-gang being faithful to him. It would be a very shabby return to place the blame on Joe.

With her hands tied like that, Arvay could not blaze out on Joe as she burned to do, but she showed her feelings by short-talking Joe everytime that she had occasion to speak to him. There were no more of those pleasant little exchanges of talk. It was a short "yes" or "no" or "what" and no more.

Arvay was throwing the rabbit in the briar patch without knowing it, and she would not have cared if she did. Under Jim's pressure, Joe had put some of his likker money into two lots in Colored Town. He had never admired working the grove, and now he felt that he had a sufficient accumulation of money to knock off. Only his feeling of loyalty had held Joe on the job for years. So now, under Arvay's short-talking, Joe claimed that his feelings were hurt-ed. He never liked to be around where he wasn't wanted. Miz' Arvay seemed like she would rather have his space than his company. It would be much more better if he took his family and got off the place. Which he did in a kind of a slow hurry. He had the shell of a six-room house thrown up on his lots and moved into the unfinished structure. That was as far as the house ever got. Joe bought himself a car and announced that he had got to be people in Citrabelle. Doing things on a high-toned scale. Heavy-set Daddy. If a woman asked him for a nickel, he gave her a ten-dollar bill. Ask him for a drink of likker, and he bought her a whiskey-still. Joe Kelsey was really some trouble. Money coming in from the still and not too much work to do, Joe said that he was getting more like the rich folks every day.

117

Living on premises and tending to groves was in the past.

Arvay was secretly joyful when Joe moved, but not for long. When the little house in the grove was empty, Arvay found that its silence left a vacancy in her days. Joe and Dessie and their children were a part of the pattern of her life. She was too proud to own it to Jim, but Arvay missed them, and wanted them back very much. It was denied her the simple way of just going to Dessie and telling her to move on back. Jim could do a thing like that, and would have done so but he believed that it would be against his wife's wishes. Therefore both of them glummed around and snapped at each other for other reasons.

Keeping her remorse to herself, Arvay could not know how Dessie wanted to return. With Joe cutting the tom-fool like he was, Dessie had small pleasure in being the mistress of her own home. A word of welcome from Arvay would have brought her and her children back. Joe would have been along in time.

The house in the grove was empty and Arvay was sorry and Jim was glum about it.

CHAPTER 10

Arvay could see Jim walking over the place and looking around, his thoughts reflected in his face. Things were getting to look shabby. Barn and chicken-yard not looked after, and fence-rows growing up in weeds. Arvay used to sit out under the camphor tree of afternoons and sympathize with the scenery, but now she avoided being caught out there. It might give Jim a chance to comment on the state of things, and the very thought of that put a squinge in her. She could see that Jim was aggravated and fretted about the way things were looking, because he was different from her father. Everything had to be neat and well-cared for around Jim.

He took to going off on fishing trips with men friends of Saturdays, coming back late of Sunday afternoons. Some of his men friends had cars, and he went off with them.

After months of days, Jim came back off of one of these trips and said to Arvay, "I've got somebody for the house in the grove."

"I'm mighty proud and glad about that, Jim. Who is it?"

"A white family."

"Would I know who they is?"

"Not hardly. He's a fisherman from over on the coast. That is, he was till he got a bad case of fish-poisoning and had to

119

quit it for a while. He needs something to do to take care of his family till he can get well enough to go back to fishing."

"How many young'uns is he got?"

"Two. Girls. One is a little chap around seven or eight years old. The other one is almost a grown young lady. Around Earl's age, I reckon."

"Mighty far apart, I would say. How come that?"

"I ain't responsible, so I really wouldn't know. Didn't even feel that it was my business to ask."

A few days later the new family drove up in a truck. It was homemade from an old Ford car.

Arvay was annoyed because she felt that Jim had held things back from her. Jim had said that they were white folks, but the man turned out to be a Portuguese, and his name was Corregio. That made them foreigners, and no foreigners were ever quite white to Arvay. Real white people talked English and without any funny sounds to it. The fact that his wife was a Georgia-born girl that he had married up around Savannah did not help the case one bit, so far as Arvay could see. The woman had gone back on her kind and fallen from grace.

But the sins of the parents certainly had not fallen [on] the children's looks. The older girl had dark brown hair and eyes, and the hair was lit up with golden glints. That would come from her mother's light brown hair. She was more American looking like her mother, but there was a sort of Latin overlay that made her exotic. She was already ripe-looking, and all in all, a very pretty girl. It seemed strange to Arvay for her to be named plain Lucy Ann with those looks. The younger girl was named Felicia, and her name fitted her. Great, soft mellow eyes with lashes so long that Arvay said that you could almost plait them. High arching eyebrows in a shiny black curve, that almost met over the bridge of her nose. Her hair was so thick and rich that Arvay thought with wonder that she must have ten hairs to every one of Angeline's and she had always considered that Angie had an extra thick head of hair. Young as she was, already it went curling to her waist. Her lips were red, red, and rosy.

Jim could have told her all these things at the start, but he had not done so, and Arvay couldn't say that she liked it at all. It was as if he called himself slipping something over on her. Come to think of it, what did this Gee know about tending a grove? And this Georgia Cracker woman who had lowered herself to marrying a foreigner, was not going to be one bit of service to her around the house. This was no laughing, obliging Dessie. There were two separate families now on the place.

Angeline and Kenny stood and gazed as the Corregios unloaded their things and toted them in the house. They too were disappointed. Lucy Ann was too old to interest them, and Angeline scorned Felicia off as much too young for her company. Kenny sidled around to Felicia to see if she was any use to him. When he found that she could neither skin the cat, throw cartwheels, stand on her head, walk on her hands, nor use a pop-gun, he was through. Anyway, he had arrived at the stage where he was scornful of girls. The weakly things couldn't play ball, run or fight worth a cent. Just a waste of good material.

Earl was not at home when the new tenants arrived. Optimistically, and because she had no one else to send, Arvay had sent him after the clothes. He had been gone for two hours, and she did not expect him back for some time as yet. The distance to Colored Town was not great, but Earl always took a long time to go any place and return. His movements were so undecided and slow. It was around sundown when Earl came stumbling through the gate. The clothes were beginning to hang out of the bundle. Arvay was on the watch for him, and ran out to catch the dangling clean things. No use in scolding him. He couldn't do any better than that. She simply took the basket from him, and let him stumble on after her into the house. Arvay told him that he must be all tired out, and sent him on into his room, that he shared with Kenny, to lie down for a while before supper.

Arvay had the supper nearly ready, and hurried back to the kitchen to finish off things. In that way, she forgot to mention

to Earl that they had folks down in the small house now. It didn't make any difference she thought, as she went about preparing the supper. He would know it soon anyway. She was making out a pan of biscuits when her attention was gradually caught by a peculiar kind of noise. A whimpering, whining, that broke into a kind of a yelp now and then as it grew more insistent. Something like a dog penned up in a strange place, or when a hunting dog sees its master take down the gun and is impatient to be off on the chase.

It seemed to Arvay to come from the vicinity of the boys' room. The thing was so puzzling that Arvay tipped through the hall to the door and listened.

It was coming from in there all right. She wondered if that devilish Kenny had toled somebody's dog off and got it shut up in there. Arvay was vexed with Kenny. He knew how scared Earl was of animals. So scared that he would not even go near a live chicken. Kenny was always pestering her for a dog, but no pets had ever been allowed on the place on account of Earl. Now, look like that Kenny had stolen a march on her, and slipped a puppy in there to frighten poor Earl to death. She wanted to turn the door-knob and see, but her hands were in the biscuit dough and she couldn't. Then the sounds ceased, and Arvay turned away with relief.

"Maybe I was mistaken. Somebody could of passed along by the place with a dog."

She was shoving the big pan of biscuits into the bake-oven when she heard the sounds again. She could not be mistaken this time. She ran to the door of the boys' room and listened. Along with the whimpering yelps, there was a sound of running feet around inside the room. That would be poor Earl, too frightened of that puppy to even scream. Kenny was going to catch it, and catch it good for this. She took hold, and flung the door wide open.

Her eyes flung around angrily, but there was no dog in the room. Earl, with unseeing eyes, was doing the trampling and running around. She stood and he couldn't help seeing her there, but there was no recognition in his eyes. She became

frightened and called his name, but it made no difference at all. He was bent over with his head and nose thrust forward and running and turning back on his course and running like a hound dog hunting for the scent. He found it, lost it again, and turned fast and hunted to pick it up again. Whining and whimpering and making growly noises in his throat from time to time. At last, he seemed to fix on it as coming through the window, and with a sound of triumph he flung himself against the screen. It was nailed around the window and didn't give, and the horrified Arvay saw him fling himself against it time and time again, and then begin to scratch and claw at it furiously. Arvay screamed at him to bring him to his senses. The only way she knew that her cries were heard was that he looked, and thereby his attention was directed to the open door. He didn't see his mother. He only saw the opening, and dashed and sprung for it, knocking Arvay down as he leaped past and over her, and by the time she could look, he was leaping out through the kitchen door.

Arvay jumped to her feet and ran after him calling him to halt. By the time she reached the kitchen door, though, she could spy him running down through the grove like a hunting dog on the trail. He turned and twisted frantically, but finally headed dead for the house in the grove. Arvay sprang from the door and raced after him.

"Oh, my God! He'll go there in that condition, and I can't bear for them folks to see my boy that a'ways."

Arvay was in a good way to lose the race, but she was saved by seeing Jim, who she did not know had come home, coming from the direction of the house in the grove. He saw that something was wrong with Earl right away, and planted himself in the path of Earl's loping advance. When the boy was in reach, Jim tackled the slender frame and bore it easily to the ground. When he had subdued the thrashing and struggling to an extent, he slung Earl over his shoulder and hurried with him to the house, carried him back into the room and locked the door on him.

"What in the world's come over the boy, you reckon, Jim?"

Arvay panted out, when Jim returned to the kitchen.

Jim dropped down into a chair at the table, and rested his forehead in his hands.

"It would take a God to tell, Arvay. Anyhow, now we know that we got to keep a sharp eye on him after this. No telling what might happen. Don't leave him out of your sight when I'm not on the place."

Arvay could see that Jim was mightily shaken. He had a grayish film over the skin of his face, and his eyes looked scared. His shoulders sagged and sagged, and he didn't feel to talk anymore, not even when they all sat down to eat.

Arvay was stirred up too, and agreed with Jim that he was right. But as the days passed by, she decided that she couldn't keep up with Earl all the time and get her housework attended to. Two weeks later, when Jim went off right after supper, she missed Earl around dusk-dark, and went all over the place in frantic search of him. She found him at last with his eyes glued to the kitchen window of the little house, hungrily watching the Corregio family gathered around the supper table. They were eating and laughing and talking mightily, and perhaps that was why none of them as yet had noticed the face pressed against the window. Arvay approached as quietly as she could, collared Earl, and clapped her hand over his mouth to prevent any betraying sounds, and dragged him away. The only way Earl resisted her was to bite the hand that she had placed over his mouth. Otherwise, he let her lead him away.

Jim demanded to know how Arvay's hand got hurt like that, and she had to tell him. Two of her fingers were bitten too badly for her to hide.

Jim sat on the side of their bed and thought some time before he spoke. Then, taking Arvay's bloody hand in his own, he said, "Arvay, this can't go on. Earl has got to be put away."

Arvay's eyes flew wide open in terror.

"Why, why, what do you mean by that, Jim?"

"Just what I said. Chattahoochee, Arvay. Earl ain't in no condition to be aloose."

"Why you say a thing like that, Jim?"

"Now, don't ask me no dumb questions like that, honey. He's liable to hurt himself." And he stroked the wrist of her injured hand. "He'll do harm to other folks. We ought not to risk it. No later than sunrise in the morning, we ought to take steps to put the boy away."

"You set there and think that I'm a'going to agree to a thing like that?" And Arvay took her hand away angrily. "Putting my child in some crazy house? Nothing much wrong with Earl. He was all right, and you know it, until you fetched them furriners here on the place. They must have some different scent from regular folks and it maked Earl sick in some way or another. All you got to do is to get rid of 'em; and Earl will be all right."

"No, Arvay, you're ever so wrong about that. Something about one or the other of those girls has woke up something in the boy. They didn't put it there, though. It's been there all along. You see the boy can't control himself, and we had better take things in time."

"Jim, as I have said time and time again, there's things about you that I'm never to understand. Would you rather to place your own son in a crazy house than to do away with them people?"

"Those folks ain't got a thing to do with it, Arvay, I keep on trying to tell you and to show you," Jim snapped angrily. "Why can't we look at this thing in a sensible way and take steps to head off trouble? Why do we have to duck and dodge and whip the Devil around the stump and lay ourselves open to sorrow and trouble? Why can't we just quietly put the boy away and provide for him, and let it go at that? I don't hold *you* responsible for his condition. It come through your father's folks, but you didn't have nothing to do with that. I'm trying to be fair about it all I know how, but look like you won't try to meet me at all."

"That's right, throw it up in my face!" Arvay blazed. "I know that you been had it in you to say all the time. I been looking for you to puke it up long time ago. What you stay

125

with me for, I don't know, because I know so well that you don't think I got no sense, and my folks don't amount to a hill of beans in your sight. You come from some big high muck-de-mucks, and we ain't nothing but piney-woods Crackers and poor white trash. Even niggers is better than we is, according to your kind. Joe Kelsey's word stands higher than mine any old day. You can say it don't, but actions speak louder than words. You give him more credit for sense than you do me. All I'm good for is to lay up in the bed with you and satisfy your feelings and do around here for you. Naw, I'll never give my consent for Earl to be put away. Never so long as my head is warm. Earl is always wrong because he's like my folks. 'Tain't never nothing wrong with Angeline and Kenny because they take after your side. But I'm here to tell you that I'll wade in blood to my knees for him. He's not going to be put away."

"Well," Jim said quietly after a wait, "you've had your say, and I know a whole lot more than I used to. I reckon it wouldn't be no use for me to call to your attention that there was no compellment about us getting married, Arvay. I didn't have it to do. I knew what your folks were like before we got married, so I must have wanted to marry you."

"So you decided to put up with [it] even so, eh? But you can't stand nothing that looks like my folks around the house. Since you hate the sight of Earl so bad, why don't you just quit me and lemme go on back where you got me from?"

"Because you're my wife, and I put in to spend the rest of my days with you. All right, Arvay, I won't be the one to break up our home. Henceforward, I got no more to say on the subject of Earl. I submit to your determination. One thing you got to understand, and that thoroughly. I'm not telling Alfredo Corregio to move out. I have a reason for wanting him around, and here he stays till I see further. Suit your ownself about Earl. But bear in mind that anything bad that happens will be laid at your door."

"Satisfaction to me," Arvay snapped. "I know so well that Earl wouldn't hurt a living soul."

Jim looked at Arvay's injured hand significantly, then began to take off his shoes.

"I only wish that I was as sure about that as you seem to be, Arvay. I love Earl too, but I'm a man that's given to facts. And what makes it worse, I know, and you know too, that Earl's got some great craving after guns. Only thing I ever noticed that he wanted to play with. Goes hog wild just at the very sight of one. You know so well that I've had to keep my shot-gun, rifle and pistol hid away for the last three years, and daresent leave 'em loaded, just in case he might run upon one of 'em."

"Oh, I know what you're hinting at, Jim. Earl did aim that rifle at Kenny one time, but he was just playing, and you know it."

"Naw, I don't, Arvay. I do know that he pulled the trigger several times, but the gun just wasn't loaded. Kenny might have been blown to pieces. Naw, I don't know no such a god-damn thing that Earl was joking. I wouldn't swear to no lie like that, and I don't aim to take no chances."

"Things *is* come to a pretty place when you done got so you call me a liar to my face." Arvay began to cry. "And all because I try to take up for my child. The poor, pitiful thing ain't got nobody to care for him but me."

Jim sank wearily into bed and kept his mouth.

127

CHAPTER 11

Mrs. Corregio was a handsome woman, a year or so older than Arvay. Bright-eyed, a trifle full-bodied and full of laughs and jokes. And hardly was she settled on the place than she took to a habit that offended Arvay mortally. Finding that Jim was fond of sea-food, she was forever—or so it seemed to Arvay—cooking up batches of fried shrimp, devilled crabs, fish in Savannah kinds of ways, and sending one of her family up to invite the Meserves down to eat with them. Arvay stood steadfast in her tracks and refused to go or even to touch a mouthful of what she called "Geechy messes," but Jim accepted with pleasure and came back telling how good it was. Jim even offered the grand insult of urging Arvay to get the recipes from Alfredo's wife and fixing some of those dishes her ownself. Jim had had no experience in being a woman and he didn't understand. It kept Arvay worried and hurt. She put the worst interpretation on it; that Corregio woman was "fly" and doing her level best to bait Jim Meserve in.

And if it was not the mother, then it could be that Lucy Ann. Unfortunate as it was, you had to admit that the girl was really pretty and ever so young and fresh, and Jim was too much around that house in the grove. He claimed to be making some kind of plans and talking things over with Alfredo, but

you never could tell. Arvay wanted to be fair about the thing, and often and again she reminded herself that Jim was old enough to be Lucy Ann's father. She called to mind the girl's instant popularity on coming to Citrabelle. All the grass was worn down on that little back road from the cars and the feet of eager young local fellows. Jim laughed over it, so he couldn't be thinking of the girl for himself. Jim was not that kind of a man to take a back seat or ring a backing-bell for any man. So she ought to feel satisfied, only she wasn't. No matter how you twisted things around, Jim was spending too much time down in there. Arvay felt double-teened and over-powered by those Gees. So she contended about Earl. Her aim was to hit a straight lick with a crooked stick. Jim, however, was acting mighty stubborn about it. He reminded her that the Corregios never would have been there if she had let Joe alone.

Instead of getting rid of them as she wished, Arvay was truly alarmed when Jim announced that he was closing down his still. He was selling out right away to a couple of men who had been trying to buy in with him for some time. Arvay's interpretation of the sale went like this: The Corregios had gotten such a hold over Jim that he had turned against Joe Kelsey. Any day now they might turn him against his own wife. If they could run off Joe Kelsey, God from glory! Anything was apt to come off next. They could run the hog over anything.

The truth of the matter was that Jim was getting out because an election was coming up and the man most likely to win the nomination for sheriff was doing a lot of speaking before women's clubs and church groups and swearing that he would enforce Prohibition even if he had to ring the entire county with deputies as close together as pickets on a fence. No use in playing the hog, Jim concluded. He had done mighty well. Better be satisfied with his profits and knock off. He had, in addition, put away enough to give him a start in another business. He sold out. The last run was celebrated hilariously by most of the prominent men in the county, and Jim gave Joe a lump sum, and the still went into the hands of its new

owners. That last run had been the rooster, the boar, the bull, the stud and stallion of all stag parties. Jim had abdicated like a king.

Some time back, Jim had bought a strongbox and kept it in the closet. Arvay noted now that he was careful to keep it locked and the key on his ring. She had no idea how much was in there. That made her feel shut out. She accused the Corregios of being behind that too. Jim was so careful for fear that Earl would prowl upon it and get hold of weapons. The tension over Earl kept them from talking things out, and neither knew too much about what the other had in mind. The very air of the home was charged with opposition.

Arvay did a lot of communing with herself. Now, she thought, Jim's real feelings were exposed. He had never taken her for his equal. He was that same James Kenneth Meserve of the great plantations, and looked down on her as the backwoods Cracker, the piney-woods rooter, and thought that he could just run the hog over her in anyway that he pleased. He could tell her to her face that those Gees were there to stay and she couldn't help herself. He could snatch her son from her, to accommodate those Gees, and stick her child in a crazyhouse. Well, she might not come from no high muck-de-mucks, but she would show him a thing or two. She was Little David to his mighty Goliath. He might go for a big cigar, but she would smoke him!

Jim went around feeling down-hearted. He could not understand why Arvay was acting so bull-headed and contrary about Earl. She had seen the signs just as plain as day. Why did she want to chance what could happen most any hour. What the hell was the matter with her nohow? Here he had got hold of Alfredo and was doing his level best to get into shrimping, a legal and profitable business to bring her more comforts and pleasures and she looked like she was pulling against him. She had reared and pitched against the still, yet she acted like it made her mad when he sold it. He didn't make her out at all. Didn't she want him anymore? He couldn't make heads nor tails out of that part either. She came to his

embraces eagerly enough, but the very next day she was pouting around as usual. As much as it would hurt him, if she wanted to get shed of him, he would grant it. But she fended off any hint along that line too. What on earth was he to do? It all fumed up from Earl somehow, and Jim began to resent the boy. Then he would catch himself and reason over it. Earl was a pitiful thing and not responsible. If he could only make Arvay see things in the right way about the boy, they could be happy again.

All unconsciously, Jim was giving Arvay more cause for worry every day. Jim was fond of children and petted and played with Felicia too when he came upon her playing with Angeline and Kenny in the grove. Arvay noted with displeasure that within a week of the coming of the Corregios, her two younger children had made friends with Felicia and included her in everything, even begging her to eat with them when they were called to supper if she happened to be up around the house at the time. Arvay looked and listened, and felt that she was losing ground all up and down the line. She blamed Jim for it all. He just would insist on having that family around. So everytime that she saw Felicia romping with her children; everytime that she heard blow-outs of laughter from the house in the grove of nights, and knew that Jim was down there taking part, and thought about Earl being in that room under watch-care, she boiled. She felt that she and Earl were shut off in loneliness by themselves. So from one thing to another, Arvay began to entertain a strange thought. She began to consider quitting Jim. She could not hold up her end against what she had to contend with. The great river plantations were too powerful for the piney woods, but never would she bow and buckle herself down and acknowledge it. She would march away from Jim and go back with her own kind.

First, she wrote a letter to her mother saying that she was coming to pay her a visit. She was bringing Earl along so her mother could see how he had grown. Two years before she had paid a short visit and carried all of her children, but this time, she was only bringing Earl.

As for support, Arvay figured that she could give music lessons, take in some plain sewing, and make enough to feed and clothe them anyway. She would be satisfied, for she would be where nobody looked down on her, and nobody would be talking about putting poor Earl away.

Still, Arvay wavered back and forth until she told Jim that she wanted to go see her mother, and take Earl along, and he handed her two hundred dollars, and did not question her about when she would be back. That decided her. In a cold fury she packed all of her best clothes and those of Earl's and went off to Sawley.

Arvay's ardent championship of her background and her family got a set-back as soon as she stepped off the train. Sawley looked poor and shabby and mean. Nothing like the bright flourishing look of Citrabelle. Things dragged around and houses looked like shacks and had no paint on them. Even the bank seemed narrow-contracted and silly. Beside the winter homes of the Yankees around Citrabelle, Bradford Cary's home no longer appeared so rich. Everything seemed to have shrunk up since she moved away.

Beside her own home and carefully tended grove, the Henson house and place looked just too awful for words. Inside and out, the place galled her. Before she was in the house two hours she found herself criticizing things.

"Mama, why don't you put on one of those housedresses that I sent you? Why you want to go around in them old raggedy things?"

She had not eaten out of cracked dishes in so long that her gorge rose at doing so now, and she hated to put the bent and rusty old cheap forks to her mouth.

But she braced herself to glory in her folks and keep up the fight. She spent the next day cleaning piles of old junk and mess out of the house and burning it over her mother's protest. It was no use at all that Arvay could see. Just junk for junk's sake. She had fallen over an old horse-collar as she came in the front door the first time. Then too, Arvay wanted things nice and clean for Earl. Rats, roaches and flies were simply

taking the place. He could get hold of any kind of sickness at all from things like that. Why, her barn at home was better than this. Jim had bins lined with tin to keep out the rats and had screen wire on the doors and windows to keep biting flies away from his horse and cows. It had been so long that she had clean forgotten that some folks had flies and roaches and bed-bugs in their houses.

In her second day of dragging out junk and burning and scalding and scrubbing, Carl and Larraine and their five children jolted up in an old Ford and lit down. Arvay could not see that they were any improvement on the scenery at all. Some changes had been made. Either they had changed or she had.

"What awful gang of Crackers is that?" she asked herself as the car pulled up in the yard, and before she recognized who they were. True, Carl had been turned off from Day Spring for some years now, but they didn't have to look as poor and as common as all that. Common in the flesh and common in what they had on. It was all right seeing them here in Sawley, but Arvay was not sure that she would have liked to own them in Citrabelle. They were too poor for anybody to like them too much, and to have many friends. So common-cladded, and their poor-looking skins, and unbred feet and legs, and the whole make of them. She was indeed glad that Jim was not standing beside her now and seeing her folks as she saw them. She wouldn't have a thing to rear back on. They made Arvay angry, letting her down like that. It made her feel to be cruel, and she let Larraine see all of her things. It did her good to see Larraine letting her eyes get narrow at the style and cut of her clothes, and see her fingering the materials on the sly. Off-hand-like, she handed Earl five dollars to go into town with his cousins and treat them to ice cream and things. It did her good to see the look of gloating pride on her mother's face. Maria gave Larraine a cut-eye look as much as to say, "Now, how do [you] like that come stepping up to you?" Arvay was not bringing up the tail end of things any more.

Arvay could not make the house very comfortable or pretty,

but she did get it fairly clean and orderly. She went into town and got some stuff for curtains, and fixed up what had been her and Larraine's old room for Earl, and settled him down in there. She herself slept in with her mother. She laid in a good supply of staple groceries, and began to consider ways and means.

If she was to give music lessons, she would need a piano. Where was the money coming from for that? Then it was a considerable distance for children to walk to take lessons. She would need a new sewing machine to take in sewing, but the same thing was in the way. How many folks would walk that far to fit and try on a cheap dress? Ready-made things were getting to be the style in Sawley like everywhere else. Arvay decided to go out under the mulberry tree and think things over.

The problems of making a living were immediately swamped by her emotions when she got under the tree. There was an old wooden box under there, probably left by some children picking mulberries. Arvay sat down on it, dazed by the feelings that swept over her. A memory inexpressibly sweet. No injury that she could conjure up could stand up beside the ecstasy that she had felt here. God, please have mercy on her poor soul, but she was a slave to that man! How? Why? Those were answers that were hidden away from her poor knowledge. All that she knew was that it was so.

Far, far up in the leafy haven of the tree, she spied a small gray body nestling close to the trunk of the tree. It was a screech owl sleeping during the daylight hours.

The screech owl was a lonesome creature, crying and shivering from housetops and nearby trees during the darkness for something or someone to come and drive away the lonesome feeling from its heart. Nobody that she ever knew of liked to hear that cry. They said that it meant the approach of death. Maybe they thought about death when they heard it because death was such a lonesome thing.

Sitting there, Arvay asked herself, would she have ever escaped from this ugly and lonesome place if Jim had not come

along and just seized upon her and carried her off to the light? She doubted it. She could have spent all her days in that awful old house, her heart sleeping in the daylight of men, and crying lonesome in the night. Crying pitiful and lonesome like the screech owl.

Then what had got into her? Was she fighting Jim to get back to this?

Arvay went back to the house and wrote Jim a letter. It was the first one that she had written in the five days since she had been in Sawley. She would not, however, let on that she was backing water. What she wrote was that her father being dead now, and her mother getting old, would he mind if she left Earl up there with her mother for a while to keep her company? Maria really ought not to be there in the house all by herself. Please answer right away and let her know what he thought about it. His ever-loving wife, Arvay Meserve.

Jim answered by Special Delivery. He too thought that her mother was too old to be there alone. If she felt that she could spare Earl, why not let him stay there with his grandmother for a while? He could send five dollars a week for Earl's support as long as he stayed there, and anyway, he thought that they ought to look after Maria, now that Brock Henson was dead. He planned to send Maria ten dollars every month to take care of her groceries as long as she lived. Arvay was to find out about the taxes on the place and let him know. That was to make sure that Maria had some place to stay and take any worry off her mind. Let her last days be her best ones. He wanted Arvay to know that he missed her presence, and hoped that she would not be away from him too long. Her ever devoted husband, Jim.

Out of the money she had on hand, Arvay paid up the taxes, and left word at the office that the tax bills from now on were to be sent to her husband in Citrabelle. Carl said that he didn't have the time, so Arvay paid a man to plough and harrow the place and put in a vegetable garden, so Earl could have plenty of fresh things to eat. Like he was used to at home.

The sacrifice of parting from Earl was almost more than she

could bear, but the call of Jim could no more be resisted than the sun-flower can help turning its face to the sun. Her heart, her body, everything about her cried for the presence of that man. How in the world had she ever thought that she could stay away?

CHAPTER 12

Arvay's hackles got up just as soon as she reached home. She had been compelled and overpersuaded by her attachment to Jim to the compromise on Earl, and she resented her enslavement.

She observed that nobody bowed down, and not one soul repented because Earl was away from there. There was an air of triumph, and a sort of freedom-feeling that gave a big Amen to Earl's absence. Moving around in this atmosphere, Arvay got fiery mad.

"Earl's got just as much right to be here as anybody else, and a heap more than some that's flourishing around here so much," she told herself.

But Arvay was able to hold her feelings in for two whole weeks. After that, she began to wonder out loud if poor Earl was getting a sufficient to eat.

"Of course he is, honey. I sent the money ahead, and on top of that I sent a crate of fruit, and made arrangements to keep a good supply on hand up there. You know that your mother wouldn't neglect and mistreat Earl. From the way she wrote me, she's ever so glad to have him with her."

"Yeah, but I know, Jim. I feel and believe that Mama do love the boy, but she's getting old and apt to be careless about fixing regular meals."

137

Jim blunted that off and put the conversation to death by motioning to Angeline to pass him the dish of lima beans. From Arvay's point of view, he acted hateful that way every time she brought the subject up.

"Earl is liable to get to proaging around down there in the field and get hisself snake-bit," Arvay began to worry a week later.

"Didn't I understand you to say that you had the place ploughed up and put under cultivation?" Jim asked in an off-hand way.

"Yeah, but a snake could happen to be crossing the place to get to the woods and Earl could get bit and die like a dog up there with nobody to see after him right."

Jim let that lay right where Arvay had flung it and went on about something else. He encouraged Kenny to tell him all about a new tune that he had just learned from Joe, and how he had got it down perfect how to tune the box from the key of C into *Sebastopol,* called "Vasterpool" by Joe, and back again. Kenny asked for a quart whiskey bottle so he could break off the neck and keep it. Joe was going to start teaching him how to bottle-neck.

Arvay came to the breakfast table one morning relating a dream that she had had. That Suwanee river was no distance from the house at all. It was ever so deep and treacherous. In her dream she had seen poor Earl following some boys down to the river and being over-persuaded to go in swimming, and getting drowned. Arvay told how she saw his poor body go down and get hung on a snag way under the water and wasn't even found until it was much too late.

"That comes from that big mess of pig-tails that you had yesterday," Jim chuckled. "I tell you about eating all that heavy kind of stuff. You're liable to dream anything with something like that laying heavy on your stomach."

Nor, as weeks went by, could Jim be persuaded to sit down and worry over a dozen more gruesome possibilities. Every week, as Jim had requested, Maria dropped them a card saying how well Earl was getting along. Pretty occasionally, a boy

who lived down the road a piece stopped by, and took Earl into Sawley with him to see the movies. Earl had a good appetite and was doing well. Didn't act homesick at all.

It was going into the sixth month since Arvay had left Earl up at Sawley that she decided she had been baffled around enough about her son. Without even bothering to pack a bag, she just caught the eleven o'clock train and went to Sawley, took the indifferent Earl from her protesting mother and brought him on back home. She had not even bothered to tell Jim that she was going. The next afternoon she was back and slamming things around in the kitchen defiantly.

Angie, beginning to pout out under her blouses and getting boy-conscious, merely said, "Oh, hello, Earl. I see you got back" and wetting her finger, tried to lay a fish-hook curl just in front of her ear. Kenny poured out on the indifferent Earl all about how he was learning to make that weeping sound on the guitar with his bottle-neck. Gosh, but he was getting good! He had frammed *John Henry* behind Joe all the way. With Joe bottle-necking and carrying the tune, and him framming out a mean bass, it was something.

Jim got home an hour or so later, and without even giving him the time of day, Arvay whirled on him with, "You see that Earl is back home I reckon. I know you don't like it, but you can't help yourself."

"Why, good evening, Arvay. Did you hear me say a word against it? You come home with your behind stuck up your back like a black ant."

"Well, I just want to let you know in front that Earl is home, and he's here to stay. If he have to be drove away from his home, I'll go along with him."

"Aw, what the hell!" Jim exploded and went out and took pains to slam the door as he went.

Out on the front porch Jim halted and began to reason more than to feel.

"Now why the goddamn hell Arvay want to act so contrary for?" He walked out to the top step and took a stand. "But Arvay is a true mother, bless her heart! I can't fault her too

much for what she's done, crazy as it is. Mother-meat never gives over, I reckon. They'll die and go to hell for their young."

With that conclusion, Jim simmered down. He was not blind, and shuddered at what might be ahead of him. Then his manhood and the obligation of it took hold of him.

"I'll have to throw my strong arm of protection around her the best that I can. Nothing else left for me to do."

CHAPTER 13

Arvay looked at the clock. It was just before nine o'clock in the evening. She looked because she hoped that it was late enough to tell Kenny to leave that piano alone and go to bed. Kenny had somehow transferred what he learned on the guitar to the piano and could drum out quite a few pieces. But it was all what Arvay called rag-time stuff and reels. Now he was in there, stomping and drumming out that tune on the piano called *Charleston!* and he and Angie were chanting it and dancing it off. "Hey, hey! Charles-ton! Charles-ton!" How Arvay had come to hate that tune. No matter which way she turned, she couldn't hear nothing else, unless it was *Shake That Thing.* Some Ethel Waters, who Kenny and Angeline thought was great. So Arvay was watching the clock. At nine-thirty, she was going to make them stop that racket.

It was on a Thursday night. Arvay had a little low rocking chair in her room and she took up two shirts of Jim's and began to sew the buttons back on. This wash-woman she had didn't care how she wrung the buttons off of things. The wash came home with buttons missing, and rips and tears in clothes. Dessie wouldn't have let things like that happen. She would give a play-pretty to have Dessie back right now. Jim was off somewhere. Could be down there in the grove running off his

mouth with Alfredo as usual for all she knew. Earl was in his room by his lonesome self. He had gone in soon after supper to go to bed. He had been home for over a month now, and went off by himself a lot. Just vanished off. Arvay always took for granted that he was around the place somewhere to himself, and never bothered. He seemed to have forgotten all about the house down in the grove since his return, and Arvay felt vindicated and glad.

"Now, just look at this shirt, will you?" Arvay broke out in anger. "That trifling woman's done shoved all the buttons off this shirt with the smoothening-iron. Dessie always took more care than that. Dessie is a good woman, don't care which way you take her. Wonder if I was to—"

A short shriek, full of terror, ripped the air. Then a long, long cry, and then more short screams as if somebody was suffering awful and mortal pains of danger. Arvay sprang to her feet and stood with her eyes flaring and the shirt dangling from her hand.

More shrieks, then a short howl kind of a sound and yelps mixed in with the screams. It sounded from the grove, and Arvay ran head-long towards the back door. From there she heard mingled voices yelling in excitement from down at the bottom of the grove. There were no more shrieks of pain, and no more yelps and growls.

"Gee whizz!" Kenny breathed back of Arvay's shoulder. "Sounds like Earl."

"Couldn't be," Arvay said shortly. "Earl's been gone to bed too long to talk about."

"It sounded like him to me too," Angeline insisted, and the three of them pitched out of the door into the darkness and went hurrying towards the source of excitement. The children ran faster than Arvay could.

Arvay was going fast, though, when she suddenly whirled and ran back to the house. She ran to the boys' room and flung open the door. Her fingers flew to the switch and drenched the room in light so as to make sure. Earl's bed was empty. He had never been in it at all.

142

"Do, my Jesus! Something has done hurt my boy!"

Arvay fled the room and the house and headed down through the grove. She was panting with fear and crying. That swamp! She had always known that some beast bred in there was going to hurt her child.

She turned back once again to grab the axe from the woodpile, slung it over her shoulder and ran again. Be it a hundred panthers and bears, she would slay them all this night.

There was a small group gathered tight together, and somebody was holding a lantern and shedding light down on the ground, and they stood still and looked. She could make out Mrs. Corregio, Felicia, her own two children, and a man. She could hear more voices close at hand and running towards them.

"Where is he at?" Arvay screamed out of her fear as she rushed up.

Mrs. Corregio pointed in the general direction of south with her arm and hand, but never lifted her face from weeping to see who it was that asked.

Arvay was close enough now to see what they were looking at. It was Lucy Ann Corregio lying on the ground. Her heavy, glinty hair was spread out far beyond her head, and tangled like. Her eyes were closed and her mouth was open loosely. Blood was running down from a mangly spot on the side of her neck. The fingers of the white hand that lay limply across her body were chewed and bloody. The tubular maroon-colored skirt that she had on was up almost around her waist and there was a bleeding wound on one thigh. She was lying so quietly that for a long minute Arvay could not tell whether she was alive or dead.

Three men, seeing the light, came scrambling over the fence in their haste and joined the group.

"What's the matter? We heard screaming. Who's hurt?" Then they shoved their way into the circle and looked down, and the veins began to swell out in their necks. Arvay could hear running and shouting off to the south and the west in the grove.

"Help!" A shout came to her ears. "Head him off. He's gone thataway. Help!"

Arvay burned and turned to dry ashes inside as she heard a short series of triumphant yelps from the distance.

"That's Earl!" Kenny shouted. Arvay wheeled to the side and struck him hard on the side of his head.

"Shut up! Get on back to that house, the two of you. Git!" Arvay turned with the axe still over her shoulder and headed her children before her. They were cowed by her manner and ran ahead after a few steps homeward in the dark. They bolted inside ahead of her and disappeared. Arvay leaned the axe against the steps and went on in to seclude herself and think what steps to take. Then she realized how her coming off like that would look in case they were trying to make out that it was Earl, and went slowly but deliberately back down into the grove.

By that time many men had gathered. Lucy Ann was not there on the ground any more. She had been lifted and carried inside the house and her mother and sister were in there with her. From the babble of talk Arvay learned that the girl was not dead. Somebody had gone to fetch a doctor. Somebody else had gone to notify the police.

"Aw, to hell with that!" Arvay heard one man say. "We know who did it. What we need is a posse to run the so-and-so down and string him up. Can't a clean-living, pretty white girl like Lucy Ann get no more protection than that? Don't need no damn Sheriff. Let's go, men!"

There was a muttering and a motion of a head, and the men quieted down to a grumble. They saw then that Arvay was present. They shifted around and said nothing to her at all. But their eyes and their ways made Arvay's flesh crawl all over her. She melted out and went on back to her house.

She found that she could walk the distance, but her feet were on the drag. The horizon to the south flashed intermittently with lightning, playing for some distant rainstorm that way. The faint echo of rumbling thunder sank way down in the west.

As she approached the steps, she found something for her mind to handle, to drive off the madness of fear. She must be sure to put the axe back at the wood-pile. Jim was extra particular about everything being where it was supposed to be. When he went to split kindling-wood in the morning, he would be mighty mad if that axe was not to his hand.

But the axe was not leaning against the steps as she had left it. Naturally. Jim had come along, and put it back where it belonged. That meant that he was back from town, and she was glad. Just to use up time, Arvay walked over to the wood-pile and looked. The axe was not stuck up in the chopping-block as Jim invariably left it. It was not leaning against the block as Kenny sometimes left it. Arvay looked all around the wood-pile, but the axe was nowhere around. That was very funny. Then the weak trembles ran all over Arvay. Maybe some man, thirsting for her son's blood, had passed there and picked it up. She rushed fearfully into the kitchen, and closed and bolted the door behind her. She was very glad that the children had neglected to turn off the light as they went through. Darkness held unspeakable terror for her this night.

She headed on across the room to get to her bedroom and wait there for Jim. She was almost at the door leading into the hall-way, when she felt, more than heard, some movement under the table. The table cover that hung down on all sides made it shadowy under there. She flung her hands up to her breast, and gapped out a sound from her throat. Her eyes were compelled to the floor, and she saw the head of the axe being snatched under the table farther, and she heard a kind of a snarl.

Something rose up so suddenly under the table that it tilted and sent the salt celler, pepper sauce bottle and vinegar crashing to the floor. A form began to spring away from the over-turned table as Arvay leaped for the door, grabbed desperately for the light switch, and plunged the room in darkness so that she could not be so easily seen and make her escape.

The tall slight form of Earl fell on her back and tried to grab at her throat. Arvay fought the weak hands off after a short

struggle and held them powerless to harm her there in the dark. Holding to the limp fingers for dear life, she shoved his head back violently twice to keep him from biting her hands.

"Don't lose no time, son, like this. Run! They aim to kill you just as quick as they can lay hands on you. Run! I don't aim to hurt you. Run, and run fast and get somewhere and hide. Now, run!"

She released the hands, and heard Earl's steps breaking for the back door, and his fumbling with the lock. Arvay flew over there and drew it back for him quickly.

"You ain't got no time to lose. Run just as fast as you can."

"Yes, Ma'am," Earl muttered. In a moment more, the form faded from the door, and Arvay heard fast steps padding around the south side of the house and away through the front. Arvay bolted the door again and hurried to her room at the front.

She had hardly reached it when men surged all around the house and grim and angry voices sounded outside of every window.

They wanted Earl. They wanted him, and they meant to have him. He might as well come on out peaceable, because if he didn't, they'd get him even if they had to burn the house down on him to get him.

Arvay tipped across the hall to peep out of the parlor windows, but found her two children in there, their faces charged with terror. So Arvay, seeing her young, found the strength to stiffen herself and walk to the side window and speak to the men outside.

"Earl is not here," she told them. "I don't know no more where he's at than you do."

There was a sullen silence, then a muttered conference. Arvay knew that there could be few strangers out there. Most of them had to be men that she knew. They hated to face her and break right into the house. After a long while, the same voice spoke, a voice that was unknown to her.

"We'd like to talk to Jim if he is there."

146

"Jim ain't here neither. He went off right after supper. Said that he was going to step downtown."

There was another period of low mumbles. Then Arvay heard somebody say, "I saw him passing some time ago. I think I know where to find him."

But just at that minute, Jim came urgently through the front gate. Arvay saw the dark mass move to meet him, and close in around him near the gate. There was talk and talk, though Arvay could not distinguish a word. Both Kenny and Angeline wanted to run out there where Jim was, but Arvay made them keep quiet where they were. Finally, Jim walked down the path alone and mounted the steps.

"I'm going along with the men, honey," Jim said quietly, and took pains to place his arms around her waist and keep them there while he talked. "We're going to try to locate Earl. That is, if he's not hid around the house somewhere."

"No, he ain't here, Jim, and I don't know where he went to."

"Well, I certainly am sorry to my heart that he up and ran off. It makes things look mighty bad, and harder for me to handle. I hate worse than anything in the world that he did what he did."

"Oh, they done already persuaded you that Earl is guilty, eh?"

"Aw, honey, please don't. Them others don't need to know, but you and I know how he acted before he was took off to west Florida. Then tonight, there can't be a shadow of a doubt about the thing."

"Why can't there be, Jim?"

"Because, honey, the girl has come to now, and she says that she started out to the outhouse with a lighted lantern in her hand. She saw Earl when he jumped out from behind the corner of the house after her. She tried to run, but he was on her before she could get a start. She saw him, honey. Alfredo and them heard her hollering, and Alfredo leaped out of the door. Lucy Ann had dropped the lantern, but it's one of them ship lanterns, and it didn't go out. Alfredo could see Earl and

recognize him. He had the girl down by then, and was biting at her legs. He never let go until Alfredo was almost on him, then he sprung up and took off through the grove with Alfredo after him, but he lost him. No, honey, no doubt about the thing. Alfredo and all of 'em realize that the boy is not just right in his head, and with me taking care of all doctors' bills and everything, Alfredo won't press the charges if Earl can just be found and give himself up."

"What good will that do, Jim?"

"What good will it do? Arvay, practically every man out there has got a wife, a sister or a daughter, and some all three. You ought to be able to see how they wouldn't want nobody like Earl loose on the community. You got a daughter. You know just how you would feel if it was somebody else, now don't you?"

"Yeah, but if I just thought that Earl was guilty."

"Aw, honey, please don't hurt me no more by giving me the idea that you feel I want to be unjust to my own son. Did you know that the screen wire is all tore loose from his window except at the top? That means that when he made out that he was so sleepy right after supper, he was being cunning enough to fool us and give himself time to tear loose that screen so he could get out without anybody missing him. For all we know, it might have been done before dark. Before I go off, I got to go and see that it's nailed down again good and tight. I don't want him doubling back and sneaking in through that window and maybe hurting you or Angeline or Kenny, or maybe all of you."

Arvay let him go without saying another word. She remembered that scene in the kitchen no more than an hour ago. The weak fingers feeling for her throat and the axe. The intent was here, only the strength was lacking. But then, Arvay comforted herself quickly, poor Earl thought that she was somebody else.

Arvay heard men's voices and the pounding of the hammer as the screen wire was firmly nailed back in place. Two men whom she knew well came shamefaced through the house

with Jim and spoke softly to her as they tramped around helping secure all the windows and doors. Jim cautioned Arvay and the children not to open them on any account until he returned. Then he went outside, placed himself in the midst of the posse of around a hundred men and they tramped off to search for her son.

As the hours stumbled past on rusty ankles and she heard nothing, Arvay began to hope that Earl had gotten clean away. Towards daylight, what was left of the mob came back to the house with Jim. They had a new lead. Jim thought that Earl might have taken refuge at Joe Kelsey's house, and they had been there just a short while ago. Earl was not there, and had not been there, Joe swore. But the Sheriff and some others thought that Joe was acting funny and guilty. Joe was holding back something that he knew, the Sheriff charged.

Joe was naturally terrified, and looked and looked at Jim with pleading eyes. Jim knew that Joe was hiding something, so he told Joe that it was all right. He must tell them anything that he might know.

"I don't know for sure, Mister Jim, but Earl could be down in the Big Swamp somewhere."

"Naw, Joe. You must be mistaken. Not Earl. Scary as he was, I can't see him rashing around in that swamp."

"But I have seen him going in there, Mister Jim, often and on." Joe looked at the Sheriff with a sly grin and continued. "When I used to have business down in there, I have seen him ducking and dodging down in there. I never hailed him because he never acted like he was slipping and I thought he called hisself playing sort of hide and seek and I would just ruin up the play by letting on that I seen him. Oh, yeah, I have seen him going in and coming out too many times."

They got the general directions from Joe of where Earl had been seen. Bloodhounds had been sent for. They were back at the house to get something of Earl's for the hounds to take his scent from. Then they veered to the south and streamed off towards the swamp. The bell-toned dogs sang out on the trail before long, and the men marched forward to that.

149

The search went on and on. Now and then, Arvay could hear the distant baying. The day died behind the deep dark swamp, and still Jim did not come home. Hawley Pitts brought word about three o'clock the next afternoon that Earl had been located. They had trailed him to a place deep in the swamp that was almost opposite this house. Jim wanted her to know. He was staying to try and handle things. He wanted some hot coffee and something that he could eat.

Arvay rose up right away. She made Hawley eat, then she packed up a big mess of meat and bread and a dinner-bucket full of hot coffee all sweetened and with cream in it, and sent it back by Hawley.

"Tell Earl I say to come on home with you all, Hawley. Tell him I say so, please."

"Oh, I tell him, Mrs. Meserve, and don't you fret nor worry. Nobody don't want to hurt the boy."

Two hours later, Jim sent word by somebody else that Earl was surrounded and he would be home just as soon as he could persuade Earl to give himself up to the Sheriff. They were close enough to the boy to make themselves heard, but Earl, so far, acted as if he didn't hear them. He was in a spot that was hard for them to get to. They could see him as plain as day, but he was hard to rush, and they found out that he had a gun. A Winchester rifle, and just as soon as anybody tried to get near him, he levelled the gun and dared them to come on.

No sooner had the second messenger left than Arvay went to the parlor and peeped behind the piano. Yes, Jim's rifle was really gone.

Now when and how had Earl got that rifle out of the house? He certainly did not have it when he fled the house that night—and Arvay trembled as she remembered—or he would not have seized that axe. Arvay went back in her mind and recalled that Earl had often disappeared from around the house for long periods since his return from Sawley. He could have sneaked that gun out on any of those days. Well, it certainly was a lucky thing that the gun was not loaded. Then

150

a frightening thought came to Arvay. If he had searched around until he found the gun, maybe he had found the ammunition too. Arvay whirled and ran across the hall into the bedroom and to the pair of old boots in the back of the closet. Jim had had two boxes of long cartridges for that repeating rifle. Squatting on her heels, Arvay searched deep in the boots and found that both boxes were missing. With her face white and hands trembling, she was able to find comfort for a moment in the assumption that even if Earl did have the gun and the ammunition, he still did not know how to handle any kind of a gun, let alone that repeating rifle. But how could she swear to a thing like that? Off from her mother up there in Sawley, Earl might have asked and been taught something about handling guns by the boy who had been chumming around with him. All country boys knew something about guns. One hand fluttered to her breast, and still squatting on her heels, Arvay collapsed against the closet wall.

"My God, my God! It's a wonder somebody ain't been killed!"

Jim did not return to Arvay all that night. The word came that the posse were in a tight fix because the men dared not show themselves too plainly for fear of getting shot. Every time anybody showed himself, Earl upped with that rifle and levelled down. Coming at him from the rear meant cutting a way through two miles of dense swamp.

Jim staggered in home with a haggard face and told Arvay how it was. He saw the suffering in her own eyes and was very gentle with her.

"I know how you feel, Little-Bits, and I'm doing all I can to make things come off peaceable and right."

"Oh Jim, Jim! Why can't you holler out to Earl and let him know that you're there to help him and . . ."

"I haven't been doing a thing but begging and pleading with him, honey. I have told him and told him that nobody wanted to hurt him, and nobody was going to harm him if he would only come on out and give himself up. But, Arvay, Earl

acts like he don't know me from nobody else." Jim hushed and bowed his head on his arms for a minute.

"He draws that gun on me every time I try to get near him, and the men are all getting wore out from fooling with him. Nobody's said so in my hearing, but I know so well that if it wasn't for my presence, they would have killed Earl long time ago."

Arvay looked at the drooping figure of the man there at the table and a tender feeling went over her. But for too many years Arvay had thought of her husband as a being stronger than all others on earth. What God neglected, Jim Meserve took care of. Between the two, God and Jim, all things came to pass. They had charge of things. She had been praying ever since she had found out that Earl was surrounded in that swamp. So far, God had not made a move so it was up to Jim. So now, Arvay went to her husband and hung by her arms around his neck as she sank to her knees beside his chair.

"Jim! Jim! Don't let them men kill my boy. Just get him back safe one more time, please, Jim, so we can put him away." Arvay pressed her wet face tight against Jim's chest and whispered, "Please, Jim."

Jim hugged Arvay tenderly and tried to make her see the difficulties of the situation. To get to where Earl was, you had to watch your step mighty careful. Big roots humped up, and a slip of the foot, and over you would go into that deep spring that was running swiftly underground. Even a good swimmer would have all that he could do to keep from being carried away underground by that water. And there was no doubt that Earl would shoot while the man was struggling in the water. You had to creep along slow, and expose yourself to be shot at. The men were getting pretty tired, but he would do the best he could.

Jim went on back and joined the men. He had a promise that nothing would be done until he returned. He thanked them on his return for being so considerate of his feelings. He realized that this thing could not keep on forever.

So, calling soothingly to Earl, Jim started from the south

border of the sink hole and began to pick along to where Earl stood braced between two great cypress trees. Earl's face was cold and unrecognizing. Jim caught hold to vines and shrubs to keep from slipping off the precarious footing into the water, and said nice things to Earl and kept going. He was a good half way along the dangerous route when Earl stepped forth and levelled the rifle and took aim.

Jim's Stetson leaped in the air and fell into the pool. A tiny trickle of blood started down his forehead as he fell on his face and tried to shield himself behind the bole of a tree. Earl, seeing his father where he had no chance of escape, advanced to get Jim exactly under his gun-sight again. Jim was helpless before him.

There was a shout of fury from the watching men. One gun, two guns, then two or three more blazed. The slight body jumped and fell forward with the rifle under it.

CHAPTER 14

rvay saw some men coming late that Saturday afternoon—just a few men, with Jim, his hat in his hand, walking slowly in the lead. The rest of them followed Jim, and leaned together, carrying something between them. Arvay fled into the bedroom and slammed the door.

The men stopped out there in the yard at the foot of the steps, and stood there with their heads uncovered. Jim came into the bedroom and found Arvay leaning against the wall near the foot of the bed. The pain was showing in his face so that Arvay almost overlooked the little spot of dried blood above his right forehead. His broad shoulders hung down like a cape. He placed his arm about Arvay's waist and without speaking, led her to the front door.

The silent bareheaded men looked at Arvay, then looked down at what was at their feet.

"I'll go and have the bell tolled," Hawley Pitts offered, and all the others nodded solemn agreement. It was a relief that they could do something kind for Arvay and Jim.

"I'll thank you kindly, Hawley," Jim said. This was indeed a great kindness. The body of his son was not going to be handled like a criminal. Friends were going to accord it the ritual of a good Christian who had died in his sick-bed, with

the pastor and the family and friends standing around the bedside. Jim tucked his head a brief moment on Arvay's shoulder, then lifted it. "Yes, I'll thank you to toll the bell."

Hawley nodded, and turned his big frame towards the gate.

"Stop!" Arvay screamed, and tried to tear herself from Jim's embrace. "No you don't. Don't go tolling no bell for my boy. Earl ain't dead."

Hawley stopped dead in his tracks, and all the men looked from one to the other, then down at what was lying at the bottom of the steps.

"You needn't to look, and try to make out that's my boy dead there on the ground. It's somebody else. Oh, please don't toll the bell."

Jim took Arvay in his arms, and putting one hand firmly under her chin, lifted her face and made her eyes meet his.

"Look at me, darling. Look your Jim in the face. Our Earl is dead, honey. The poor thing was not sufficient for the world he was forced to live in. He has come to his peace at last. But the world ain't finished for you, honey. You've got me beside you. We got our two children and a world of loving friends. Our child, born out of our deep sweet love, is dead, honey, and laying out there on the ground. He's out there waiting for you to bid him in. You have always give him your love, haven't you? Well, out of that, go, darling, and give him the look of peace."

Arvay felt the power of Jim coming over her. She rested her head on his shoulders for a moment, then left the shelter of his arms and moved forward. She went down the five steps and stood over the body. She saw the many wounds in the chest. Slowly, she lifted the veil of Spanish moss that covered the face and gazed. Somehow, none of the bullets had struck Earl above his shoulders. The weak but handsome face was unmarred and was inhabited at last by a peace and a calm. Arvay passed her hand over it slowly as if to probe

155

the mystery of the vanished life as well as to caress. Slowly now she stood erect and looked at Jim. She felt his arm beneath her shoulder just as plain as if he had been standing beside her. Arvay bowed her head and said softly, "Yes, now you can toll the bell. Toll the bell for my boy, somebody, please."

CHAPTER 15

Hug my neck for me, honey," Jim drew near in the bed and pulled Arvay closer to him. "You haven't been sweet with me for a whole month now."

"Jim! And poor Earl dead and covered up in a four-sided grave!"

"But I'm still here, honey-pie, and still your husband."

"But I'm grieving so, Jim. I . . ."

"Naw, Arvay, you ain't grieving as much as you let on. You're mourning all right, but that ain't grief."

Arvay tensed herself to return a shocked and outraged answer, but just then Jim began to rub her shoulder as he talked, and then to slide his hand gently down towards her breasts in little circular motions.

"You just hate to own to yourself that a great burden done fell off your shoulders."

"Naw, Jim, I'm never to get over losing my boy, and losing him the way I did."

And at that moment, Arvay hated herself, because for the life of her, she could not move away from Jim, nor could she fling his hand away. She found herself softening, relaxing, and then throbbing under Jim's hand. She hated the man violently, and she hated him because he had so much power over her.

"Don't, Jim," Arvay murmured drowsily. "How in the

world can I mourn for my boy with you feeling and hauling over me like that? Stop!''

But Jim did not stop, and Arvay did not resist him. Her body got warm and she seemed to be sinking, sinking, down through the mattress, through the floor and through the world on some soft cloudy material, and drifting off through the rim-bones of space. Passive, passive, receptive and dream-like, until she felt Jim's first kiss on her lips. It came as a great mercy and a blessing, and Arvay departed from herself and knew nothing until she came to earth again and found herself in the familiar bed.

Jim turned on his side, laid his head on her breast and went right off to sleep with Arvay's fingers running through his hair, and she went to sleep herself with her hands tangled in his curls.

When morning came, Arvay knew that she must come back to her family somehow. She would have died rather than admit that Jim was telling the truth, but she knew it for herself. She acknowledged to herself that she had put on the greatest show of grief when she caught herself feeling relieved. A great, great burden *had* been wrenched off her shoulders, something that stood between her and Jim, and she hated to admit that anything that did that was worrisome. She had worn a shield and buckler for eighteen long years, and it had been very hard on her heart at times, but she had taken her stand, and stubbornly held it, because she had seen no way to retreat. Something must be wrong with her, for she knew that she could part with anything, even principles, before she could give up this man.

It was a Saturday, and the children were around the house and they worried her. She wanted to be alone to herself to feel and to think. They were so alive, and romped and played so noisily. Even at their Saturday tasks of helping out with a thorough cleaning, they found the energy and the occasion to chase each other back and forth through the house and around in the yard and yell and scream.

''What kind of a Devil am I?'' Arvay asked herself, as with

158

her head tied up in a towel, she swept down the cob-webs over the house. "I ain't got time to put up with my own young'uns while I think about Jim. Here I want 'em out of my way so I can give all my attention to what went on last night. That man's got me so that I'm just about as near nothing as anybody could be. Well, I just got to fight against it. I'll show him. When he comes home, I'm going to be mourning harder than I ever was, that's what I am."

Dinner was the mid-day meal. Jim got off early on Saturdays, but he was never home that early. By the time he knocked his men off and they got back to the packing-house and got paid off and all, it was always mid-afternoon. The whole house was clean, and her own room was just a little bit garnished. That vase full of pink oleander blooms on the small table by the head of the bed was not put there to tempt Jim of course. It just made the room look more cheerful like. They had been through a lot of grief, and a few flowers made things look more brighter.

"Mama, we're through with the dinner dishes, and please can I go over to Joe's and practice some?" Kenny asked, and gave a pleading look up in her face. "You ought to let me go this time, Mama. I haven't been for a long time now. Maybe I'll be done forgot all I used to know on the box."

"Gwan, then, and stop bothering me, Kenny. But you better be back in this house before dark, else I'll attend to you, suh." Then an inspiration came to Arvay. "Angie better go 'long with you to see to it that you come home on time."

The two children screamed in joy and tore out. They went running and tussling out of the gate and away. Arvay took a long breath of relief and went about her thinking.

It led her to the boys' room. She went inside and looked around. In spite of her dedicated air, she knew exactly what she meant to do. She gathered up all of Earl's clothes and folded things one by one on the bed. She was going to put them somewhere out of sight. She was through going in there and sitting when the children were not at home and fingering Earl's things. Yes, Earl was dead. Nothing she could do would

bring him back. She would store his things away out in the barn for a keep-sake. She could creep out there at times unbeknowings to Jim and handle them when she felt to. Arvay bundled everything up and tied the large package up neatly. She placed it on the floor by the door, then took time to place everything so that the room belonged to Kenny in full. It had taken her quite some time because she would not move hurriedly. It did not seem right to move like that. She looked at the package as she left the room. It could stay there until Jim or the children came home, and took it upstairs in the barn for her.

"I ain't giving in to Jim at all," Arvay told herself. "But it'll make a little more room for Kenny, him being so active and all."

Arvay came out and walked into the kitchen. She wanted to look over what she had to fix for supper. She might decide on something that took a long time. She felt for a good nice meal.

There was food in the house, but nothing that her taste called for in particular. Jim and the children might not care for what she had either. A nice bait of stew beef, browned down low with good gravy and rice and string beans out of the garden with that ham hock, with new potatoes dropped on top of the beans to steam, and maybe stir up a pan of ginger bread to eat with the buttermilk afterwards. That ought to be kind of nice for Saturday night. A baked chicken and sweet potatoes could be the main things for Sunday dinner. She would slip on something and go pick out the meat herself, instead of using the telephone, which Jim had fixed to save her steps. It was Saturday anyhow, and quite a few things had to be bought for the coming week. Jim favored his stomach.

Therefore Arvay was not at home when Jim arrived. She took the shortcut across the back of the place on her return, but saw nothing of her husband. So she went in by the back door, laid the package of meat on the table, and went on to the front of the house to take off her things before starting to cook the supper. Arvay halted long enough, though, to chunk up the dying fire with a piece of fat pine and two pieces of

good dry oak. Then she decided that it might be better to get the stew on to simmer while she changed and rested awhile.

Jim bragged on Arvay's beef stews. He said that he had never liked beef stew before he had married. It was really something wonderful the way his wife fixed it. So Arvay browned the chunks of red meat carefully, added salt and whole pepper corns with a little flour, added her water, then clamped down the pot lid and went on up front to change.

No sooner did she enter the bedroom than she heard Jim's voice out around the front gate. With her hands uplifted to take off her hat, Arvay went to the front window to look and see who it was that Jim was talking with.

She gave a great gasp. It was Fast Mary, a young woman whom folks made lots of jokes about.

Fast Mary had been crying, Arvay could see from the way her shoulders moved when she snuffled, and the way she wiped her eyes with her sleeve. The window was open, so Arvay stood in the shadow of the curtains and listened.

"You say that Kenny insulted you, Mary?"

"He sure did, and hurt me to my very heart, too, now." Some more sniffles. "I wasn't bothering him at all. I was sitting on the steps at the Long House, that's where I live, and he and his sister come along, and looked at me and begin to giggle and poke fun at me."

"That Kenny is a little limb of Satan. You musn't pay no attention to him. But just what did he do and say?"

"Stopped and looked up under my clothes and pointed, Mister Jim. It's kind of hot today, and I was kind of thin-cladded like, and . . ."

Arvay saw Jim pass his hand over his mouth for a moment, and she knew exactly why. According to the folklore of the town, the weather had nothing to do with the way Fast Mary dressed. She was well known, without having a real friend in the town. She had the misfortune to be too good-looking and too available for women to take to her, but not pretty enough for any man to excuse her generosity and want to protect her. Nor had she the avarice nor the hardness to turn her position

to profit. Mary had an accumulation of poverties that worked against her. So Fast Mary had a room at what was known as "The Long House" because it was a one-story structure of about fifteen rooms, side by side, all facing on a common porch. A cheap homely unpainted building inhabited by such as Mary.

"So while I was setting up there on the top step of my house, trying to catch myself a sort of cool breeze off the gutter and looking around, your two children come along, and Kenny, he had to stop and point. He said that it looked like a mulberry pie. I wasn't bothering him nor nobody else."

Arvay saw Jim choking down a laugh while Mary buried her head in the crook of her arm and cried. Jim got his face fixed for sympathy and a serious consideration of the case just as Mary raised her eyes.

What do Jim mean by listening to all that rigmarole from that fan-foot, that street-walker, that brick-bat for? Arvay thought from her hiding place behind the curtain. They say any man can have her for a fish sandwich and a drink of gin. They claims that she takes men right up on the court-house lawn on dark nights, asks 'em for a dime apiece, lays down, grabs hold of the grass and tells 'em, "Let's go!"

"Well, Mary," Jim was saying with a half-hidden grin on his face, "you realize that Kenny ain't hardly twelve years old as yet. He couldn't be expected to know what he was talking about. It would take a man with experience to give you a sound opinion."

Mary's head and eyes came up quickly, and even from where Arvay stood she could see a different look in Mary's face.

"That's right, Mister Jim. Take for instance a man like you. You wouldn't say a thing like that about me, would you?"

"I couldn't say nothing one way or another, Mary, not unless I got hold of more information than I have. You could maybe give me a full description, and then I would know whether Kenny was lying or not."

Arvay almost forgot herself and hollered out through the

window on hearing that and watching Jim's sly grin and Mary beginning to wring and twist herself. For a second, Arvay felt to burst right out there and jump on her. But Jim would say that she had lowered herself. But she had to let it be known that she was home somehow and get that woman away from her gate and that soon. Suddenly she knew what she was going to do. She flew back to the kitchen, grabbed her scrubbing-bucket, got some hot water, dumped some Gold Dust in it, grabbed her scrub-rag and brush and broke for the front porch. She remembered to halt at the door, and come out on the porch just as if she had no idea that anybody was around.

Mary, facing towards the house, saw her first, and Arvay could see the bad surprise in her face. Then that made Jim look around.

"Why, hello there, honey!" Jim looked and sounded as if he didn't care. "I didn't know that you had got back home as yet."

"Well, I'm here." Arvay stated most positively.

There was a bodied silence, then Jim said, "Mary here's been telling me that Kenny's been up to devilling her some way. Poking fun at her, and she come out to let us know about it."

"Kenny and Angie left here to go to Joe's house. Where would they come in contact with Mary?"

"She says that it was at her house, that is The Long House."

"What in the world would Kenny be doing at The Long House?" Arvay asked in a bruising way.

"Oh, they wasn't there, exactly, Miz' Arvay," Mary hurried to say, as ingratiatingly as possible. "They was just passing by and Kenny had to stop and meddle at me."

"Don't you worry, Mary, I'll really tend to him for meddling with *you.*" Arvay snatched a rocking chair viciously and began to look it over for dust. "I'll mighty nigh beat him to death."

Mary didn't go for no weather prophet at all, but she knew when the climate got too cold for her clothes. Mary turned and went away, and went away so hurriedly that she took the

163

wrong direction. Instead of turning north towards town, she turned south where there was nowhere to go except along the Meserve fence line. Jim decided not to use the front door just then, but went clear around the house, and Arvay heard him come in the back door and fool around for a minute or so before he came up the hall. Arvay was too mad to look right then. And now that she had come out there with that outfit under false pretense, she had to do something with it to fool Jim.

"That Kenny!" Arvay exclaimed out loud. "He won't do a single thing like you tell him to do. Sent him out here to scrub this porch, and these steps ain't seen a drop of water. Then had to sankle around that Long House. I aim to take me a bunch of peach hickories and use him up."

From back in the house, Jim chuckled amiably. "No more than to be expected, honey. You know how boys are about doing anything useful around a house. You just have to stand right over 'em to get anything done at all. Kenny had business to clean that porch and them steps for you," Jim hurried to be agreeable. "You ought to tan his hide for him when he gets back."

"Without a doubt," Arvay declared, though she knew very well she had no such intention. She was wondering about Jim, and as mad as fire with Mary. Jim was going to have to sense her into something about Mary and that quick. Maybe all this month past while she had been mourning, Jim had been fooling around that Mary. She was just wondering how to tackle the subject when she saw Mary retracing her steps. Arvay had no intention of speaking to Mary, so she attacked the top step with a great flourish of soap-suds and scrubbing brush. To be sure not to look around she put plenty of muscle into the job.

"Humph!" Arvay heard behind her from the region of the gate. "Some of these old nice-nasty folks make me sick of my stomach. Putting on all them holy airs, and trying to slur at me."

Arvay raised up and look over her shoulder at Mary, who was not passing the gate, but standing there, face all broken

up with anger, and her arms akimbo. Arvay stood and looked with the brush in one hand and the cloth in the other and scorned the cheaply clad young woman with her eyes. She washed the face, the thin body, the cheap dress and the run-over high-heeled shoes with a look that was as good as hurling a bucket of solid sewage over the girl. Mary took it all in and reacted accordingly.

"Don't you be looking at me with your scorn like that!" Mary bellowed. "Making out I ain't nothing. With your cold-acting ways, nobody in town can't tell whether you're a man or a woman."

Jim had retreated somewhere inside. Arvay favored Mary with another scornful look, dropped the brush in the bucket, dipped her cloth, wrung it out with great deliberation, then said coolly, "That ain't *your* trouble, honey. They all know about *you* . . . exactly."

Arvay heard a smothered chuckle from Jim. He was in the bedroom.

"You, you!" Mary, in wild rage, floundered for an answer to that. "I, I, well, never mind. That's all right for you, Madam. I won't do nothing to you. I'll place you in the hands of the Lord. I'll pray for you, Miss Arvay. I'll get down on my knees for you! And when I get down on *my* knees and talk to God . . ."

Fast Mary kimboed herself again, wagged her head positively and angrily, and left the rest to Arvay's imagination. Anything was liable to happen from that. Arvay could even look for another Flood.

Arvay stroked her with her eyes again and slimed her over like a million snails. She dried the top steps with the big rag, then dropped it in the bucket and took the brush in her hands.

"*You* praying to God against anybody? Humph! That's a pretty come off. I'll bet you when you get down on them rusty knees and get to worrying God, He goes in His privy-house and slams the door. That's what He thinks about *you* and *your* prayers."

Maybe it was not what Arvay said and the way she said it

that hurt Mary so much. It could have been that loud cackle that came out through the bedroom window. Jim was in there roaring with laughter. So Mary flirted her skirts and began to move off.

"That's all right for you, picking at me when I ain't done nothing to you." Mary halted for a moment and called back: "Just because I ain't got no whole heap of money like you, you think that you got a call to take and hurt my feelings. Treat me just like I was some old dog. I got feelings just like anybody else."

"You keep 'em away from my husband then, and you'll get along all right," Arvay yelled back. "Just let me catch you a'wringing and a'twisting your narrow self and grinning up in his face one more time if you dare, and I'll take me something and do my level best to salivate you! Rack on away from here!"

In her rage, Arvay did not bother to fake at the steps anymore. She dashed the bucket of water in the yard and went storming back through the house.

"You sure did give poor Mary a reading, honey." Jim was still chuckling as Arvay passed the bedroom door. "Come here."

"What do you want?" Arvay asked as she stood stiffly before him.

"You, as usual, but right now I want to know if you feel mad at me?"

"What I got to feel mad with you about, Jim? I don't reckon you told that heifer to come racking up here to grin up in your face. I don't believe that Kenny and Angie said or done a living thing to that fan-foot. Anyhow, it shows how low she is to be setting in public with her no-count, trashy legs gapped open, knowing that she wasn't dressed for that. If they did even look at the slouchy wretch, she grabbed at the occasion to run to you hoping to get a trade out of the thing before it was over, the hungry-gut sow!"

"You reckon that was her idea?" Jim shied off.

"What else? But you wouldn't stoop to nothing like that,

166

that is I don't reckon you would." And Arvay questioned Jim with her eyes.

"Well, I'd have to be pretty hard up and starved out to come to it, I reckon, Arvay. It would be tough titty at that."

"I help you to say!" Arvay encouraged the idea. "Now I reckon I better go fix you some supper." She looked at Jim hard, lying there across the bed, then slowly turned to go.

Arvay went into her kitchen. She took good pains about everything and fixed things well. The ginger bread was full of raisins and spices, and the crust glittered from plenty of butter, eggs and milk when she drew it out of the oven. Around the supper table neither Arvay nor Jim mentioned a thing about passing The Long House to the children. Let them keep their little secret, while their parents kept theirs.

Arvay took the supper things off the table, went to the big earthenware churn and filled first all the glasses, then an earthenware pitcher of fresh buttermilk and set it convenient to Jim's hand. He was very fond of fresh-churned buttermilk. She made generous squares of the thick hot ginger bread and piled up a plate of it on the table. Then she sat back down, accepted Jim's compliments on it and the children's cries of delight and arranged herself inside.

"You going to town I reckon after supper, Jim."

"Bound to. Saturday night, you know. You want to come along?"

"Not in particular, Jim."

"Something you forgot to get while you were downtown this evening and want me to bring it for you?"

"No, I reckon I about got everything. I just wanted to ask you if you run into Joe to mention to him to step here. I got a little few things that Dessie could make use of with that houseful of young'uns she's got. Tell Joe to step by here and get 'em."

"Saturday night, and Joe is bound to be downtown somewhere, and I'll tell him sure. But if it ain't too heavy, I could just as easy take it along and hand it to him. What is it you plan on sending Dessie?"

"Earl's things. I got 'em all fixed up into a bundle and tied." Arvay bit into her ginger bread, chewed, swallowed, then fumbled with her fork before she lifted her eyes. "They wouldn't be fitten for nothing by the time Kenny growed up big enough to wear 'em. They's bound to fit somebody in Dessie's house. No need in letting 'em lay round here and rot when somebody could be getting some good out of 'em. They ain't a bit of use around here."

Arvay saw Jim's head come up and felt his searching gaze. The blood of her body began to climb to her head. She felt her ears getting hot and knew that her face was flushed. She lowered her face and began to poke at the tiny fragment of ginger bread on her plate like a maiden. Passionate pictures formed on her eyelids and faded and were instantly replaced by others. Earl lying dead there at the front steps. That first time that she had seen Jim Meserve, his broad felt hat shoved back from his tumbling curls and his white teeth flashing in a laugh as he talked with two other young men in Sawley. Their first visit to the mulberry tree. Earl as a new-born infant and her pangs of pain at the sight of him. Coming down the courthouse steps the day of her marriage. The moment that she knew that she was pregnant for her Jim. Wrapped in a glory cloud, she had walked to the window and looked out at the tall pines around the camp and heard them singing in the wind. The joyous moment when Jim had come running into the room with the newborn Kenny in his arms. Earl in his coffin. The pictures stopped and a bell was tolling, and tolling and tolling.

She looked up suddenly at Jim for help and he was there at the head of the table and the tolling ceased in her head. The same way that her agony had been bearable that day when she had looked from the dead face of Earl to Jim up on the porch by the door. Yes, Jim Meserve in his ffesh was really there at the table with her. This was a miracle right out of the Bible. For some reason, still and as yet not revealed to Arvay, this miracle of a man had married her. She had been blessed beyond all other women of this world. How on earth had she

ever risked losing his presence? Jim was there, but at any moment he might vanish from her sight, never to be seen again.

"You, you won't let them men keep you off from home too late tonight, will you please, Jim?" Arvay murmured without looking at Jim directly.

"No chance of that," Jim answered heartily. "I can attend to what little I got to do in no time, then I'll rattle my hocks on home."

Jim got up at once and hurried off. Arvay sat wrapped in a glory cloud of feeling while the children chattered on without her paying them the least attention. Arvay was off in a far country until she was recalled by Angie and Kenny contesting over the ginger bread. Both claimed the right to the still uncut other end of the dessert. Arvay came to herself with a jolt.

"Don't you!" she shouted as she sprang to her feet and snatched the pan from both of them. "I just dare you to touch that other end. You know that your Papa likes them corner pieces! Touch 'em if you dare and I'll salivate you!"

CHAPTER 16

A ngeline Meserve was in her bedroom all by herself. It was a comfortable room, and fixed up with the oddities and little fripperies that a girl of seventeen would be apt to think attractive. Pennants of different high schools, souvenirs of school parties and dances.

The warm May sunshine came in through the two windows that faced the south this Sunday morning. Angeline had shoved back the curtains so that the room was brightly lighted. She herself was utterly without clothing, planted before the long mirror in her dresser, admiring herself. Her thick, curly hair was loose and fell well below her shoulders and in the light looked like a flood of ribbon-cane syrup in a clear glass bottle with the sun shining through it. Angeline had the comb in her hand and was combing it with slow movements, and posing her hair first one way, then another: over her right shoulder, straight back from her face and down her back, then over her left shoulder, as she posed and smiled at herself.

"Wonder how Hatton would like to see me like this?" And Angeline smiled and smiled. "Or maybe he would rather see me like this," and she changed her hair and her position. She stood with both arms flung out languidly, her head far back, and her hair tumbling away from the back of her head as if it had been poured. Her feet were close together and her pubic

170

hairs reflected back from the mirror like a triangle of bronzy gold pointed downward in the heart-shaped area of her pelvis. "But maybe he don't care about seeing me in no way at all." The smile fled away from her face. "Some of those older girls can beat my time with him." The girl looked sad and solemn. She stared at the creamy perfection of her body through smoky eyes. The stiff, out-thrust breasts with the old-rose nipples, the perfection of line down to her bare toes.

"Why? Why will Hatton turn me down for them? My shape is all right, and I'm not ugly in my face neither." Angeline's lips began to tremble. "It's just because I'm too young for him, and they won't let me take company."

Angeline went and flung her despised perfection across the bed and began to cry.

"What chance have *I* got against all those old grown girls that's after Hatton? I wish that I was dead."

Angeline had been crying and glooming for some time when she heard her mother calling her.

"Ma'am," she muttered through her pillow finally.

"With Jim and Kenny out the way, even though it's Sunday, I can work some on your graduating things. I can fit and try on this dress anyhow, and be ready to run it up and whip on the ruffles tomorrow. Get into that new white slip and I'll be right in there to try on this dress."

"Yessum." And Angeline got up sullenly, took the new slip out of the dresser drawer and snatched it angrily over her head.

Arvay crossed the hall and came into Angie's room with her arms full of billowy white, and her pin-cushion pinned to her bosom. Businesslike, she flung the unfinished dress over Angie's head and began to size up and pin here and there.

"My, goodness, Angie! This dress come near being too tight across in here." Arvay was too nice to mention breasts. It was just across in here. Her eyes popped, and she looked hard in her daughter's face. It was startling and shocking too. While she wasn't looking, her girl had taken on the shape of a woman. As she fitted on down, she took note that Angie had

171

shaped out round her hips too. She worked on in silence, turning Angeline this way and that. Things went on very well until she got to the hem.

"Better step up on that chair, Angie. My knees gets too tired squatting down so long. Get up there so I can level this hem."

Angie got up on a wooden-bottomed chair. Now she could see only the lower half of herself in the glass. She could see her mother pinning a deep hem in the dress that let it hang just below her knees.

"Mama! Stop putting all that hem in my dress, making me look like I was some little old girl! No, Mama, no!"

The pitch and intensity of Angie's voice made Arvay jump.

"Why, Angie!" Arvay looked her surprise. "What in the world is done got into you?"

Angie was jumping up and down on the chair in a frenzy like she used to do when she was a little girl and determined to have her way. She was jumping, stomping her feet and screaming "No!" over and over like a chant.

"I'm not going to wear no short dress! I'm seventeen, and I'm not no little girl, and I'm not going to wear no short dress. I'm not going out there on that platform in no short dress like I was some little girl. I'm not going to . . ."

"Why, Angie, you act like you done gone clean crazy through your head. Look like you would feel proud for folks to think that you was schooling out so young. Plenty time for you to look like some full-grown woman. When you school out of college up there in Tallahassee later on, then you can be fixed up more like a woman. I . . ."

"I don't care if I don't never get to no Tallahassee!" Angeline grabbed her hands full of the dress and started to rip and tear. Arvay was just in time to prevent any damage being done by grabbing Angie's hands. "I don't care if I don't never go to no college at all. I'm not going out there to that exercise where folks can see me looking like no little child of a girl. I'm old enough to take company like other girls do, and I'm not going to be made out to be no child. Beat me if you want to,

you can't kill me, and if you kill me, you sure Lord can't eat me. I'm not going to wear no short dress."

Arvay stood back and looked at the raging girl up on the chair for a long time before she could bring out what was in her mind.

"Oh, so you looks upon yourself as a grown woman now, I see." She said it very quietly and tightened her lips.

"Well, I am, ain't I?" Angeline retorted defiantly. "Some folks my age are married, and even got children."

"Call yourself hitting a straight lick with a crooked stick, I take it." Arvay murmured this equally quietly, while she looked up at the stranger standing on the chair. "The main idea you want understood is that you smell yourself and wants to take company. Boys and books don't mix, Angie, and I ever hoped that you would school out before you got a notion like that in your head."

"Think I aim to be some old maid sitting around teaching school or something?"

"Well, you said a while back, around Thanksgiving, that you wanted to go off to that college for girls up there in Tallahassee and school out, didn't you? Nobody didn't ask you for that. You said it your ownself. I ain't never had much schooling; never had the chance to rub the hair off of my head against no college walls, and I thought that it would be mighty nice for you to get hold of the advantage that I missed. All I know is my a b c's. Read some and figger a little. I thought that it would be nice, after you mentioned it, to have my girl come home with papers to hang on the wall."

"It would be nice too, Mama." Angeline spoke without heat in her voice now. "But, but, if I got to stay little for four more long years for that, Mama, I'd rather not. Fact is, I don't think I could live that long."

"Just what would rush you to a four-sided grave so soon, Angie? I wish that you would let me know."

"Because I want to take company, and . . ."

"Is it somebody particular that you so anxious to be with?" Arvay asked and trembled down her limbs.

"Yes, Ma'am. It's Hatton Howland, Mama."

"Hatton Howland? Ain't that that Yankee boy that drives that blue Chivvylay and works at the filling station?"

"That's right."

"But he's a Yankee, Angie, and you're born and raised up in the South, and to mingle up like that ain't—"

"I don't care!" Angie shouted passionately. "I don't care if he even come from Diddy-Wah-Diddy! I don't care nothing at all about no old Civil War. I don't care nothing about Jeff Davis nor Abraham Lincoln nor Lee nor nobody else if it's got to come between me and Hatton Howland. Compared with him, it comes before me just like a gnat in a whirlwind."

"You and this Hatton must of been seeing mighty much of one another to be feeling that a'way," Arvay remarked. "Though to my rest, I can't see when it could of been."

Angeline jumped down from the chair and sat on the bed.

"Mama, I been loving Hatton since way before Christmas, but he never noticed me at all. Treated me just like I was some little bitty girl. Flourishing around with all those twenty and so on years old women, and wouldn't do no more than pass the time of day with me." Then an intense glow came from behind Angie's eyes. "But, Mama, all the boys around school are crazy about Hatton, and so they asked him to the Easter dance. And what you reckon? I asked him to dance with me, and he did, Mama! Hatton Howland danced with *me!* Then while we were dancing sort over in a corner around the potted palms, I kissed him, Mama, and then he asked me to dance with him next time. And ever since then, he's been noticing me a lot."

"I see," Arvay mumbled off. "But I never thought a girl of mine would put herself in the way of a man like that. I thought that she would look upon herself more than that. I'm hurt to my heart to hear it."

"But, Mama! You just don't catch on so good. You see, I knew that poor Hatton would love me if he only knew me, so I had to let the poor thing know, so he could come to be happy some day."

174

Then Angie was not a grown girl anymore. She rushed to her mother and began to cry with sobs.

"But you wouldn't let me take company when I asked you to, and you keep me looking like some little old twelve-year-old girl, and all them grown old girls are taking the advantage of me. Riding around in Hatton's car, and going to the show and to parties with him, and I can't go nowhere and can't do a thing, and they're going to take him away from me."

Arvay held the sobbing girl a long time and let her cry. She had felt so warm and surrounded these last three years. Now the thing she had feared but refused to look at openly had come upon her. Her children were growing up. The little family circle could be broken up. A tall, loose-jointed, rusty-headed boy with gray eyes could make her daughter carry on like this. Angeline didn't need her. She was willing to give up all the care that she had given her, all the plans that she had made and had been made for her for that freckled boy from somewhere up in Michigan, who worked at a filling station to help support his widowed mother. Trying to keep Angie a child had done her no good. It was as if a crack had opened in the wall of her home and a cold damp draft was blowing through.

"Move, Angie. I got to get what I'm going to do on your dress for today off my hands and see about fixing dinner. Get back up on the chair one more time."

Angeline got back up on the chair with swollen eyes. With dead-feeling fingers, Arvay dropped the hem of the stiff organdy dress to Angie's ankles and pinned it all the way around.

175

CHAPTER 17

"S o I reckon we better leave her take company, you think, Jim?" Arvay asked in the privacy of their bedroom late that Sunday afternoon when she and Jim were both lying down, sluggish from the heavy meal.

"You know that I don't mind, honey. You was the one that was against it. I thought that it would have been all right the day she turned sixteen."

"Well, then, I can tell her that if she gets her di-plooma all right, we can let her have company a couple of nights a week. Maybe after the new wears off, she won't be so hog-wild over that Hatton Howland and all. You reckon?"

"How do I know, honey? It could be Angie just thinks she loves him because he's older than she is. Young girls are apt to feel that way. Or because she wants to have it that she took him away from those older girls. And then again, she might really care, for a while anyhow. Love is a funny thing, Little-Bits. Seems like that one person gets next to your heart, and you can't shake 'em loose no matter which way you twist and turn. You just got to go on serving 'em all your born days."

For a space, Arvay traveled the road that she had come for the last twenty years. Her love had mounted her to the tops of peaky mountains. It had dragged her in the dust. She had been in Hell's kitchen and licked out all the pots. She had

176

stood for moments on the right hand side of God.

"I hope my child don't fall such a slave to nobody that they can just handle her anyway they will or may, and she be so under the influence that she can't help herself. I don't never want her to know the feeling of that."

Jim looked at Arvay very hard for a minute, then he let his head sink back down on the pillow and smiled a secret smile.

"I differ from you on that, Arvay. I want her to feel just like that. That is the only way to be in love. It ain't really love when you gamble with your stuff out the window. Leave all your best things outside and come in and get in the game, and soon as you win a little something, jump and run."

"But it's so compellment, Jim. When you'se so that anything a person puts on you, you'se willing to take and swallow just so you can still be there."

"Love ain't nothing else *but* compellment, honey. 'Tain't love when you can help yourself. When you can chew but you can't swallow, you're just filling out an arrangement. I don't say that I'm rearing for my girl to jump in love so soon like this, and with Hatton neither, but when it do hit her, I want it to be the real thing."

Now, just what was real love? Arvay asked herself and sat in silence searching experience for the answer. She could find no one word to express what she felt was love. Maybe these high-bred, book-learnt kind of folks had been taught and told what it was, but nobody had taught her things like that. Arvay did come to a kernel of what she felt that love ought to be and to do. Love to her meant to possess as she was possessed. To be wrapped around and held in an embrace so warm and so tight that the Booger Man, the raw-head-and-bloody-bones of lonesomeness, could never come nigh her. An eternal refuge and everlasting welcome of heart to rest and rely on. Never had she been sure that she possessed anyone, though Jim had told her time and again that she owned him through and through. It was too wonderful to be so for her, but she hoped for that miracle for her daughter, and she was not too ready to believe that Angeline had found it in Hatton. How could

it come to pass between a Yankee and her daughter? It might be, but Arvay felt to wait a long, long time and see.

Arvay was determined, and held onto to her own construction of things even after she saw that the moment the permission was given for Angeline to take company, Hatton Howland seemed to fairly infest the house. The Friday and Sunday nights arrangements didn't hold water, because other times he was there supposedly to talk about music with Kenny. Hatton just took up around the place, that was all. He came with a saxophone and pretended to practice with Kenny at the piano. But the graduating exercises the last Friday night in May, and getting ready and all, kept Arvay so busy that she could take comfort in that. Kenny was conducting the school band for the exercises, and what with seeing to a new suit for him and Angie's clothes, and rehearsals, things were not too obvious for her.

But Angie's infatuation was as plain as day after that. She laid her diploma on top of the piano and seemed to forget that she had it, but she took the bouquet that Hatton sent her for graduation into the bedroom clasped in her arms and gave those flowers every care. They were the new Talisman roses, and the way she found new things to exclaim about them every hour or so hurt Arvay to her heart.

The tocsin sounded for Arvay the Sunday night following Angie's graduation. Jim had climbed into his Buick sedan that morning with Alfredo and gone over to the coast. He had not returned at nine o'clock that night, and Arvay was in her bedroom with the door stretched wide open so she could hear what went on in the parlor across the hall. She had quietly worked her little rocker as near to the door as possible, and sat there pretending to devote herself to a Wine of Cardui almanac. She glanced at all the pictures of the women who wrote that it had done them so much good. Women who had yearned for children for years, but none came to bless their homes. This one had taken only ten bottles when a lovely child came to gladden her home. She recommended [it] to all women in her same fix.

178

Arvay's ears caught a long silence, then some sort of quick and sudden movement, then Hatton's voice, husky and drugged like.

"Angie! Do that again, and so help me, I'll rape you!"

"So rape me, and I'll help you!" came just as fervently from her daughter's lips.

Arvay was on her feet in an instant, with the intention of rushing across the hall, denouncing Hatton as a low-down scamp and a scoundrel-beast, and no gentleman whatsoever, and driving him off the place. Hatton being gutted and shot with tacks, Angeline would be attended to for lowering herself to that extent. But with her feet at the bedroom door, she became confused as to just what to say when she got into the parlor.

"I don't mean to say a mumbling word! I'll kill him dead and then stomp his head, the Yankee scamp, the dirty Carpet-bagger! Done burnt out and robbed and murdered all over the South, and now come back to take the under-currents of my child! I'll get me a gun and go in there and shoot him dead."

Arvay ran on tip-toes to the closet, flung it open and laid her hand on the Winchester repeating rifle, and instantly, its association with Earl made it burn her hand. She snatched her hand away, fled to the dresser and fumbled desperately under Jim's handkerchiefs, ties and collars until she laid her hand on the revolver. Her fingers trembled so that she had trouble breaking the gun and shoving in the cartridges. She loaded it fully, then whirled and walked to the door.

At that moment the front door flew open and Jim came stalking in. Arvay was surprised. Her agitation was so great that she had not noticed the sound of the car entering the yard. Jim, with a good-natured look on his face, stood in the hall between the two doors and looked first into the parlor and then at Arvay with the gun gripped in her hand in the bedroom door. He started, then wordlessly shoved her back before him as he entered the bedroom and closed the door.

In hot, jerky phrases, Arvay told him the story. To her surprise, Jim chuckled.

"Nothing to laugh over, Jim Meserve. While you set here sniggling and giggling, that scamp is liable to be over there raping our child."

"You mean our child is liable to be over there raping Hatton, don't you?" He laughed some more. "If I know my daughter, this is one battle that the Yankees will never win."

Then Jim got very sober in the face. Fiddling with the revolver in his hand, he sat on the side of the bed and considered.

"I think I had better spend some time tomorrow looking up Hatton and finding out all I can about him. So far, I don't know nothing excepting that his Papa and Mama come down here from somewhere in Michigan eight or nine years back and settled. Since his old man died, his Mama's been renting rooms to tourists in the winter time. I reckon what little Hatton brings in since he got out of school helps along. I don't know a thing against his character, so far as I have heard. He does seem to be mighty popular with the young folks. Could be because he's got that nice-looking car. But anyhow, I'll look into things without delay."

"Look into things, Jim? What for? 'Tain't nothing to be looked into as I can see. His case don't need to come up in our court at all. Just run him off the place and double-dog dare him to foot this place again. That's all that you need to do. Shoot him down like a mangy dog if he dast to shove his toe-nails across this doorway another time."

"Don't look like you're taking Angie into account. Her feelings have got to be considered. Unless I'm mighty mistaken, Angie's got her mind set on having the poor boy, and I'm mighty afraid that he's going to be had. If he don't want her, and is determined not to have her, if he got good sense he better grab the first thing smoking and make his left-here now. If he don't, and that mighty quick, he's a gone ginny."

"Well! If this don't take the rag clean off the bush! You

180

mean to set there on your honkers and don't do nothing at all?"

"Nothing for me to do till I see more into things, Arvay. You know so well that Angie is my heart-string. I can't bring myself to take no steps that might hurt her feelings. Lemme search up this Hatton Howland and see if he will in any way do. If he won't, I'll have to try and seek some way to make her see that he won't do for her. Now, come on and let's go cross there and act nice with 'em and see can't we get some idea how the land is laying."

Arvay's experiences of love and passion told her things the moment that she stood in the parlor door. Angie and Hatton, being warned of their approach, were seated on either end of the sofa. Arvay stood and took in the situation with her experienced eye. Indeed, things had come to a critical fix. Angeline, drooping in her corner of the sofa looked to be under a heavy dose of laudanum. The long lashes of her eyes drooped to almost closing. Hatton, flushed in the face, was fidgeting like he had a hot stove lid in the seat of his pants. To Arvay's knowing eye, Hatton further betrayed his condition by throwing one arm about a pillow and patting and petting it with the fingers of his long, strong hand. Arvay smiled inwardly with a feeling of morbid triumph, and crossed the room slowly and took a seat opposite. This romance was unwelcome to her at this time, but it was not all one-sided, anyhow. Angeline was giving this long tall boy just as good as he sent. Angie had put Hatton on the linger, all right. Yes indeed!

Arvay was seated in a big chair close to the piano. She was so interested in watching and learning that she just sat and had nothing to say. Through her preoccupation she heard Jim, with the aid of a lot of jokes and sayings, skillfully lead Hatton to talk about himself and his plans.

Hatton made eighteen dollars a week at the filling-station regularly. Of course he picked up some tips, eight to ten dollars in the run of a week on an average. The Chevrolet, a little over a year old now, was paid for. The Howland home place was clean and clear. It had been about half paid for when

his father died, and since then, he had managed to pay the debt off and the place was clear. His mother had nothing at all to worry her mind. She picked up a good deal on her rooms and meals during the season, and he could carry things over the summer months with ease.

"You Yankees can really find a dollar," Jim laughed. "I have to hand it to you. You really know how to hustle."

Hatton laughed with Jim. "Well, you know what they say about us Damnyankees down here. Come down with a dirty shirt and five dollars and never change either one and still manage to end up rich."

"So you intend to follow that example too, do you?"

"Well, I'll give in to the extent of changing my shirt, but I really am determined to get hold of something."

Neither Arvay nor Jim missed the sly glance at Angeline as Hatton talked. It was a prod for the girl to take notice.

"I want a wife and a home some day, and I don't want it to be too long off, either. A man ought to have something to give a wife after he takes her away from her home. If it costs me every drop of blood I own, I mean for *my* wife to have something."

"That's a nice thing to say, you child," Arvay stepped in, "but have you got anything besides yourself?"

Hatton, instead of being crushed, gave a mysterious smile. He cut one quick look at Angie, then at Jim and then put on a casual look.

"Oh, I'm not in any danger of starving to death right away. I think that I can say that I can get along. But the money that I handle now is not a drop in the bucket to what I intend to have a little later on. When and if I marry, I want it so that my wife can toss a ten dollar bill in the penny collection in church, and if the usher looks surprised at her and frowns, take her finger and beckon him back and fling in a hundred and tell him to go with that. If she catches him frowning any more, she'll call him back and fling in a thousand."

When the laughter died down, Jim worked his hips out

eagerly to the edge of his chair and leaned forward towards Hatton.

"Spoken like a man, Howland. I don't favor nobody marrying for nothing but pure love, and when he comes to that, he ought to be able and willing to do the last thing on earth to look after his woman and the children they might have. That oath he took before God and man when he stood on the floor ought to come in front of everything else on earth. No excuses granted nor accepted. Come pay-day, leave your pretty wife sit on her front porch and look down the road and say with a smile, 'Well here come my husband and them.' "

"Them what?" Arvay asked.

"Them dollars, fool. Let him be man enough to bring it when he comes. It might be so that you have to make your own rules, and ignore all the ready-made ones that folks already know about, but bring it when you come."

Jim at least did not miss the quick, bright and hopeful look that Hatton flashed him for a second.

"You look at things the same way I do, Mr. Meserve. When I get a wife, I mean to bring it or die in the attempt. Being a Damnyankee, I can't let business get away. Why don't you let us have your business, Mr. Meserve? I don't remember ever having the pleasure of servicing your car."

"You goddamned hustler," Jim chuckled. "All right, Hatton. You got a right to pull in all the business you can. I need a good grease job right now. I go to work pretty early, so it will have to be after I knock off tomorrow evening."

"It doesn't have to be that way, Mr. Meserve. If you stop by the station, I could drive you to work, bring the car back and service it, and pick you up any hour and any place that you say."

"You sound like somebody who means to get ahead. That's the ticket! I'll be there at seven o'clock sharp tomorrow morning."

The two men had made a date to talk, but the inning went over Arvay's head. She wondered why Angeline gave such a rustle and began to pick over herself. With a nervous gesture,

the girl grabbed up a pillow and began pulling at the threads in the seams, and ripping them open without knowing what she was doing. Arvay reached over and took the pillow out of her hand and dropped it on the floor beside the piano.

Hatton arose abruptly. "Think that I better hit the hay. Be waiting for you at seven o'clock in the morning, sir. Goodnight, Mrs. Meserve."

Angeline stood up with determination and went with Hatton to the door. While she lingered out on the dark porch for a few minutes in low conversation with Hatton, Arvay too saw a chance to speak.

"Well, what do [you] make out of it, Jim?"

"But he sounds mighty promising, for a fellow as young as he is."

"Promising! Shucks! I like to see some of those things *done.* I'd rather *see* a promise than to hear about it any day."

Jim said nothing to that, and they sat awhile, both concerned with the unseen matter on the porch.

Arvay was on the lookout for Jim when he came home late the next afternoon, but Angeline was looking even harder. She had crept out to the front gate, and was there to run and jump on the runningboard when Jim slowed for the turn in.

"Daddy! The car's been washed and polished!"

"Yep, your Yankee put about the best servicing job on her that I've ever seen."

Angeline flung her arms around Jim's neck and practically choked him to a stop in the yard.

"Did I hear you say, *my* Yankee, Daddy?"

"Did I hear *you* say that?" Jim countered.

"Did you hear *Hatton* say that, Daddy?"

"Well, something to that effect."

Arvay, looking out of the kitchen window, heard it all, and saw her daughter fling the car door open in a frenzy, leap in Jim's lap and almost strangle him while she covered him with kisses.

"You got him for me, Daddy? You made him promise? Oh, Daddy, Daddy, Daddy, Daddy!"

"Hold on here, baby. I didn't make him promise me nothing. I thought that my girl could handle a thing like that herself."

Angeline got very quiet. Jim hugged her shoulder and laughed.

"I didn't need to, Angie. It didn't take but a minute or so for me to see that you had already laid poor Hatton under conviction. All I could do to keep him from crawling down my throat. From what I could learn, he's been holding off for fear that I wouldn't let him have you."

Angeline went into another frenzy of hugging and kissing her father and uttering senseless sounds.

"So I didn't need to bother about that end," Jim went on. "We just talked business together."

Jim shoved Angie out of the way and got out of the car and came on inside the house. Angie and Kenny had their usual tussle for the wheel to drive the car into the garage. Kenny beat Angie to the seat that time, she flirted her skirt at him, then ran on into the kitchen behind Jim.

Jim came in extra nice to Arvay. He had brought her a large bag of Japanese plums and forbade the children to touch a one unless their mother gave them permission.

"I know how you love the things, and there were three big trees on the place where we cut fruit today, so I made a couple of the men pick you some since they were so handy. I hope that our two trees will bear next year. Then you can have all that you want to eat."

They fooled around with off-hand talk and comments until they were around the supper table, then Jim got around to what he meant to say.

"That Hatton Howland is quite some hustler in this world." He cut into a baked yam and looked across at Arvay with a brightness in his face.

"I don't see where working at a filling station is nothing to brag over," Arvay said.

"And it ain't. It seems that he just holds onto that for a stall so he can't be picked up for vagrancy and have to tell where he really makes his living from."

"Well, how do he make his living?" Arvay asked wearily.

"He's no slough. He got that job as soon as he got out of school, but he seen that he would never get independent working like that. So he worked around and got in with the Boleta man, and started out to selling tickets for the Numbers. He made so good till a couple of years back, the head of the Big House up in Orlando sent for him, and put all the business in this county in Hatton's hands. He's really been making the money since then. On the quiet, naturally. No wonder he could pay for that car spot cash, pay off what was owed on his mother's house, wear the kind of clothes he wears, and to cap it all off, he's got some two to three thousand dollars stuck away. That ain't bad for a lad of twenty-two."

"Except that he's liable to be placed under arrest at any time and work it out on the chain-gang."

"Aw, naw. The Big House up in Orlando has seen to that. He's got all the protection from the law that he needs. Not only that, he don't have to run no risks in turning in his collections. They got a man with guards to come around and pick it up."

"I see, Jim. That Yankee is smarter than I give him credit for."

"Just what do you mean by that?"

"You done let him out-talk you, that's what, and you goes for smart. But he's took you right on in."

Arvay kept a close watch on the ardent courtship, but still the runaway marriage in mid-June was something that she was not prepared for. Kenny, who had gone along with Angie and Hatton called her around sundown that day and told her. Arvay turned from the telephone with slumping shoulders.

"Jim, my girl is married to Hatton." Arvay leaned against the jamb of the door and her lips trembled. "I, I just can't get it into me that my baby girl is old enough for nothing like that.

And then, and then the way it was done, Jim. I, I . . ." Arvay twisted her mouth to keep from crying. "Her shoulders ain't old enough for a responsibility as heavy as that. Oh, Jesus!"

Arvay advanced into the kitchen making fumbling motions with her hands. "They're over to Hatton's Mama's house."

"Well, why don't you call 'em up and tell 'em to come on home, honey. That's all they're waiting for."

Arvay stood for a space in heavy silence, then she seemed to come alive again. She looked to Jim hopefully and touched him on his arm.

"You go call 'em, Jim. It's better for you to talk to 'em and tell 'em to come on home. Whilst you'se doing that I can fling some egg-nog together for 'em to drink. Go ahead and make 'em come on home."

Arvay was in a feverish frenzy as she switched around getting ready to receive the young couple. Rinsing out and polishing up the cut-glass punch bowl and cups that went with it. Jim had to run out and help her along.

"Run out to the hen-nests for me, Jim, please, and fetch me all the fresh eggs you can find Oh, I hope and pray that I got enough cow-cream to go in the egg-nog. I ever vominates poor-made egg-nog Hand me that bottle of whiskey here Now where in the world did I lay that nutmeg grater? Now I had that nutmeg in my hand just a while ago. Lord, I can't tell my head from my feet. . . . Dip me up another cup of sugar, there, Jim. . . . Thing like this just would have to come off when I ain't got nothing fitten to eat in the house. . . . You reckon that Angie's room could be fixed up good enough for 'em to stay in till they can do better, Jim? Hatton would be ever so welcome if he thinks the place is good enough for him. . . . Here take this egg-beater and whisk up them whites for me whilst I get down my cake plate and slice what's left over from that white pound cake I made for last Sunday. . . . Just lift up that punch-bowl for a second whilst I slide this Sunday tablecloth on the table. Things will look nice and clean. . . ."

The table was arranged with the brimming bowl of egg-nog

so rich that it poured slowly, so yellow with egg yolks that it was a dark gold. The cake was sliced and arranged in a swirl on the fluted plate when they heard Hatton's car slowing down in the yard. Arvay put out her best napkins, and stacked her best plates to eat cake from.

Then Arvay stood trembling and with a fixed smile on her face looking towards the front door.

"Drag it on in here and get your whipping!" Jim yelled out as they heard the shuffling feet of the three on the front porch. "Come in with your britches down!"

Angeline flung open the door and led the others in with a laugh.

Jim grabbed Hatton and wrestled him around boisterously and hollered over his shoulder to Arvay. "I got this one, you grab the other one and frail her good! We'll show 'em how to run off and marry on us."

Arvay did catch hold of her daughter, hugged her first lest the fiery temper of Angeline prompt her to say the things that Arvay feared, then slapped her two or three times playfully across her buttocks.

"Now, Madam, get in that kitchen and taste that egg-nog I fixed for you. Git!"

Angeline looked at Arvay in astonishment for a minute, then ran for the kitchen pretending to cry loudly into the crook of her elbow. Arvay followed as if in pursuit.

In a minute or two everybody was around the table. Hatton pulled up a chair and sat as close as he could to Angie and placed his arm about her waist. Angie turned a look of such utter happiness upon him that a pain ripped up and down Arvay's body. She was presiding at the punch-bowl, and the hand with the ladle shook a little.

"Things sure can change in a hurry," Arvay said as cheerfully as she could as she dipped up egg-nog and filled cups. "This morning, Angie, you wasn't nothing but my little girl, and now this evening you're a married woman."

"That's right, Mama," Angie murmured with lowered eyes. "But I'm still your little girl, ain't I?"

Arvay dropped the ladle and rushed around and flung her arms about Angie's shoulders and buried her face in the back of the girl's neck. "To be sure and naturally, baby. Only I feel another gap, a kind of a vacant place in my arms. I" Arvay choked back a sob and looked pitifully at Jim.

Hatton stood up and looked pleadingly at Arvay and spoke with emotion.

"Mrs. Meserve, I know that you feel hard towards me for stealing your daughter like I did, but I love her so much, and when she said that she would have me, I was scared to wait. Scared she might change her mind, so I rushed off and got papers for her while she was still in the notion. I intend to be good to her till the day I die, and I hope that some day you can forgive me, and look upon me as a son."

Neither Jim nor any of the family was ever to know what it cost Arvay to say what she did next. She took her seat again and spoke slowly.

"Time changes folks, Hatton, as they go along the road. Some things a person one time wouldn't do for big money, they get so they'll do 'em for nothing. If you love Angie like that, and feel to be my son along with it, I'm only too proud and happy to have you."

Hatton got up without a word and completed the conquest. He bent over Arvay's chair and kissed her respectfully. Tears began to run down her cheeks.

"What makes females cry so much?" Kenny looked from his father to Hatton in genuine bewilderment. "We just left Mrs. Howland crying, and come home and find Mama doing the same."

"Because we born children, take pains to raise 'em, and then they leave us for somebody else, Kenny." Arvay was sobbing full force now.

"Look like you would be glad to get rid of 'em some day or other and take some rest," Kenny pursued. "When I get grown and marry and have children, I don't intend to let mine lay around me but so long. I'm going to run mine off by the

time they get half grown and let 'em go scuffle for themselves. I'll be sick and tired of 'em by that time."

They laughed a long time at that.

"Oh, you hush up, Kenny," Arvay chided. "Your last diapers ain't hardly dry yet, and you come telling grown folks what to do. Ain't you something?"

"But I think that's a darned good plan, Mama."

"Yeah, Kenny, but supposing they never come back to you? You would be hurting your ownself maybe more than them. A mother feels to keep in quotation with her child and don't care what it takes to do it."

"Table that!" Jim bellowed, "and let's open up the house for new business. Now that I got me a grown son, we got to make some arrangements."

"If you mean some place for Angie and Hatton to stay till they can see further, I don't see no reason why they can't stay right on in Angie's room. We could maybe get hold of a bigger bed."

Angeline and Hatton exchanged quick and embarrassed looks.

"Mother Howland is fixing us up a room over there," Angie said.

"Oh, that don't need to call for any long discussion," Hatton said. "Until we can build, which we intend to do just as soon as we can locate a lot that Angie likes, we got two homes, and we can stay at first one and then the other. We are in a shape where we don't need to be no burden on nobody, and soon as we can build, we'll get into a house of our own."

"Take your behind down off your shoulders, Hatton. You said that you wanted me to look upon you as a son, didn't you?"

"Yes sir, and I do."

"Well, you're at home here just as much as anywhere else, and if you listen to the advice I give you, you won't be building for quite some time as yet, and you won't be buying no lot right up in town. You willing for me to lead you and guide you?"

190

"In every way—Dad."

"Well then, let me place my wisdom tooth in your head, and put you on the road to something big. Don't never be afraid to try big things, Hatton. The time to get scared is when you mess with something little. That's where you get your whipping. Ready for the question?"

"Let her rip!"

"You have told me about your Number business and the money you got put away. There'll be another county election in a couple of years, and things might not be the same. Before that time, if you're as smart as I think you are, you'll put your money into something where no cheap and hungry politicians can't bleed it out of you in one way or another. Too many politicians look on their offices as a means of receiving what they call stolen goods. Let some smart man make a pile in some illegal way, then bleed him for it. You take all the risk and they take all the money. Get me?"

"I guess I do."

"Well, before the next election comes around, I want you to hide all that money you make on Numbers in land. Then you can't be touched. Land is highly legal. You will be a realtor by then."

"I'm willing, that is, if you will show me how."

"It's something mighty big and hard that I got for you to do, but if you're willing to tackle it, it will give you a lifetime start so you don't never need to be in the ham-scram again. You and Angie can go right on from there to something really big."

"Gee, that sounds like something. Lead me to it is all I ask you to do."

"Okay, if you got guts in you, this is where it'll show. I want you to clear that swamp."

"Swamp?" Some kind of sound burst out of everybody. Jim was the only calm person in the room. He reached over, laid his hand on top of Arvay's and began to stroke it in a gentle and affectionate way.

"That's what I said, son, that swamp. There's a great big

191

fortune hid in that dark old swamp. All it needs is the brains and the nerve to get it out. I been wanting to tackle it for nearly twenty years. Ever since I bought this place, but I wasn't in no position to handle it then, and anyhow the time wasn't right. The machinery necessary wasn't on hand in those days. Now it is, you're young and smart, and you can do the job that I been saving up for my sons to do. When you see daylight through that place from here, you're going to be a mighty well-off young man. Are you game?"

"You bet your bottom dollar if there's anything can be made out of it, and you show me how to go about it."

"It's so damn easy and soft that I hate to tell it. All these smart real estate operators done slept a good bet, and I don't want 'em woke up until you get things tied up so that they got to come in by you to get a smell."

"Keep on, Dad, my pockets are already crying for that money."

"Well, the truth is, that's all state land. The State of Florida and nobody else wants to be bothered with it in the fix it's in. Like Miami Beach before that guy from Indianapolis come along and filled it in and made it worth plenty millions. Then they were willing to pay a fortune for a home site on it."

"But my few thousands wouldn't be a drop in the bucket, Dad."

"That's where you're wrong. If you bite big enough, you can get a whale of a lot of cash right out of that swamp without hardly moving a muscle. If you take in two miles north to south on this side, then run a line straight through the swamp far enough to take in that lake back there in the woods about two miles from the swamp and square it all off into a rectangle, you get enough timber to bust a bank when you sell it off. Putnam, or any of those big fellows will buy a fine stand like that, and after you sign the contract, nothing more for you to do but to sit back while they go in there and take the lumber out and hand you the check. In fact, just as soon as they estimate the footage in there, you get your check in front. Then you can lay it aside until they get through, and have it

192

on hand to develop your real estate with. You got to fill in the lowest part, and then you are ready to develop a new addition to this town. That swamp has held the town from growing west long enough."

To Arvay's astonishment, and somewhat to her dismay, Hatton took the proposition under consideration. A week later, Hatton said that he was willing to try it. She could not make herself believe that the thing was really going to be tackled, until Jim and Hatton drove up to Tallahassee for two days, secured the huge tract for a few cents an acre, and she saw the surveyors at work.

"What on earth did you want to sic that poor boy on that nasty old swamp for, Jim?" Arvay asked that night as they were getting ready to go to bed. "He could of made a living some other easier way."

Jim was unbuttoning his shirt, and he paused and looked at Arvay combing out her long hair in front of the dresser.

"Don't you have no idea, Arvay?"

"Why, no I don't, Jim. You done bought that boat for fishing and all, and got Alfredo working on it for you. I don't see how come you couldn't take him in with you on that."

Jim dropped down and began to unlace his shoes. He got more quiet and took a long time before he looked up at Arvay again.

"So you really ain't got no notion why I wanted that swamp cleaned off, have you, honey?"

"Naw I told you. None at all."

Jim jerked off first one heavy shoe and then the other.

"Well, maybe it'll come to you some day."

They didn't talk about it anymore and went on to bed.

193

CHAPTER 18

The year that followed Angie's marriage was to Arvay faintly melancholy, like twilight. Many things came to make her happy and proud, but the old familiar things in her life were fading away.

Arvay was alone much more than she used to be. Jim's shrimping business was on a safe enough basis now for Alfredo to move his family over to the coast with him so that there was no one living on the place now but Jim and Arvay, and Jim drove to the coast as often as possible these days. Kenny was up at the University of Florida at Gainesville. He wrote frequent and enthusiastic letters home, mostly about his activities in the University band, but that was not like his familiar presence around the house. Angeline was sweet and dutiful, but Angie was Hatton's wife first before she was anything else.

Arvay had ceased to worry about the success of the marriage. Angie and Hatton got along beautifully together, and neither he nor his mother did or said anything that Arvay could put down as a dirty Yankee trick. In fact, Arvay admitted to herself that she was jealous of that woman. By degrees Angie was becoming a Howland, being influenced by both Hatton and his mother. Arvay could see Angie's brisk new ways. Getting vigorous and thrifty increasingly, and proud

about it. Putting up jams and jellies and running up house-dresses for herself. This in spite of Hatton's fond indulgence of Angie to everything that she wanted. And financially, Hatton was doing remarkably well. Under Jim's tutelage many wealthy and able business men had been induced to buy into the project, and things were being done on a very big scale.

With a melancholy pride in the astonishing rise of her daughter's husband, Arvay watched the progress of things from the coming of the surveyors to the completion of the sumptuous club house of the country club in the new Howland Development.

As Jim had predicted, modern machinery and methods had cleared that swamp in an amazingly short time. Arvay, from her seat on the front porch, watched the gangs of husky black roustabouts rumbling past in truck loads, singing, chanting, laughing as they went to the swamp and moved about in their high boots, and swinging shining axes to rhythm, felling the giant trees. Gnawing at the feet of the forest to make way for the setting sun.

Arvay was surprised at finding herself feeling a sympathy with the swamp. She was used to certain outlines against the sky and now it seemed a pity and a shame for those trees to be destroyed. She had hated and feared the swamp, but long association had changed her without her realizing it. She and the swamp had a generation of life together and memories to keep. She hated to see it go. But the horde of black men sang and chanted and swarmed and hacked, machinery rumbled and rattled, huge trucks grumbled and rolled until one day Arvay saw the sun setting behind the horizon of the world. The opening spread north and north before her eyes. The swamp monster retreated before the magic of man.

Arvay watched the conquest of her old enemy with the utmost fascination. It was very personal to her, though she never said so to anyone. She followed the progress of the men day by day. Now they were nearing the place of Earl's death. Who knew how many times Earl had been there before that fatal day! What had he done and felt there? Another day and

195

they were about at the place. Arvay was so excited that she could scarcely sleep that night. The next morning she was in her rocking chair on the porch very early, as soon as Jim had gotten off to work. This morning, perhaps at this minute, those men must be felling those three big trees by the pool, and those others that surrounded the glade. Oh, do, Jesus!

Did that swarm of black men see or hear anything mysterious, or feel any strange presence? Were they halting, looking puzzled over some small something that she had failed to find on her secret visit to the place? Was there another place in there that she knew nothing about? Something that might reveal the unknown inner life of the son that she had borne. Arvay burned to halt the trucks loaded down with the miry, sweaty men as they rolled past her door at sundown, but then again, how could she ask them anything? She could watch and feel and forever wonder, but she must keep such things to herself.

Where the loggers had been one day, the bulldozers followed the next, and right behind the big machines came the long train of dump-trucks pouring dry sand into the narrow, muddy gully that had been the lowest part of the swamp. Raw, dark gashes made by the bulldozers were streets stretching across the new fill and would soon be paved. Sewers, watermains and electric lines rushed across to take the comforts of civilization to those who would make their homes over there. Influence had brought prompt action on the part of the county, and no sooner had the area opposite the Meserve place been filled in than Arvay saw the engineers laying out the ornate stone causeway that was to arch the low part of the land for the main highway. Tons of cement and steel were delivered and piled not too far from Arvay's front door, and she could watch the approaches of the causeway being laid. It began no more than a hundred feet from her front gate.

As Jim had predicted, the giving of the tract for the links and the club house had been a smart move for Hatton. The right people bought sites in the new development and it bloomed. The Howland Development exerted a tremendous

effect on Citrabelle and the surrounding country. It came along and stratified the town. The original line of the swamp gave accent like a railroad track. Those who belonged moved west.

Hatton and Angie had one of the choicest sites on the big lake that was now known as Lake Charm, and Arvay felt pride in that. She saw her daughter friending with people whom she herself had never dreamed of associating with. The sons and daughters of first and second degree Yankees and wealthy southerners. Angie and Hatton played tennis and golf, went in swimming, canoed and motor-boated with the rest, and talked about getting sun-tanned.

Arvay took pride in all this, but underneath, it created a kind of lonesomeness in her. It made her wonder if she was needed anymore. She felt outside of this new life of her daughter. Kenny never seemed homesick either. What went on up there at the University seemed to fill his life. Jim was carried away with his shrimping and ran back and forth to the coast. Arvay considered that she had only her hands to offer service with, and since nothing was required of her in that way anymore, she felt unnecessary most of the time. Her house was silent now, and her arms felt empty and useless. This Howland Development seemed infinitely more threatening to her than the dark gloom of the swamp had been. It was ever so personal to her, so she kept up her vigil on the porch, keeping track of every new change out there.

Jim watched it too, and with great satisfaction. When he did not prowl around over there of a Sunday, he took his newspaper and they sat on the porch and watched.

They sat there one Sunday and watched the cars glitter south from Citrabelle, swing around the huge half circle and sweep across the causeway.

"Just look at that!" Jim beamed at Arvay. "Hatton and the company are really selling and making money, but quiet as it's kept, we haven't been hurt a tap by the deal. This place is worth a whole lot more than it used to be on account of that development."

Jim was looking at her and beaming so that Arvay sensed that Jim was looking for her to say something, but for the life of her, she could not make out what was expected of her. She thrashed around for a while in her mind, then did the best that she could.

"I'll bound you," Arvay nodded and agreed. Then an alarming thought came to her. "But you don't aim to sell our home, do you, Jim?"

"Hell, no, Arvay! Not till Kenny gets through college anyhow. This place will be worth a whale of a lot more by then. You don't seem to realize how big this development is and what a change it has made in things around here."

Again Arvay could feel that Jim expected something of her but she still had no idea what he wanted her to say.

"Yeah, it's mighty nice, all right. But from the sums and amounts of money that folks have been spending over there it sure ought to be, Jim."

"Hatton's done mighty fine," Jim persisted. "Angie married her cup off when she landed that boy. Sensible, honest and with plenty push to him. I would of hated for her to miss a chap like that."

Arvay sat up and took a long look at Jim. Certain things were stirring in her mind.

"Well, she took good pains not to miss him, I notice. And that brings me to something that I have ever wondered about."

"For instance, honey?"

"Angie was under eighteen when she run off and got married, Jim."

"That's a fact, Arvay."

"It's always puzzled me how in the world she got a license to marry in Florida under age without neither one of us being there nor giving our consent."

Jim laid his folded paper in his lap and sat silent for a while. Then he braced himself and said evenly, "She wasn't by herself that day, Arvay. I was there." Jim waited a moment and

198

spoke again. "She didn't go without consent at all. I was there."

Arvay's eyes took on that remote and unknowable look like the eyes of a python in repose. She had retreated within herself to her temple of refuge. Why, she asked herself, should she be surprised at being ignored like this? It had always been that way as long as she could remember. She had never been counted or necessary. Coming to know that she was born to be like that, she had finally found a refuge for herself from the whole round world. Not a happy, laughing place, but it was safe from all hurt, harm and danger. And who had toled and tricked her out of her refuge? That Jim Meserve who had come grinning with his teeth down the Big Road, and now to treat her like this. Making such a serious move with her own and only daughter and just as good as telling her that she couldn't help herself. All of a sudden Arvay whirled on Jim with clenched fists.

"So you can brag about you was there, eh?" Arvay accused hotly. "You, you deceiving scoundrel-beast!"

The house shook when Arvay slammed the front door behind her. She did not go into their communal bedroom. She felt then that she would never enter it again. She went into Angie's room and went to bed with her Bible. She stretched on her back and looked up at the ceiling. She tried to read again, but turned restlessly on her side. She kept on opening the Bible, but never finished a single verse. What had been done to her was too tearing-down to bear. And the reason that she construed for it all was most hurting.

She didn't belong where she was, that was it. Jim was a Meserve. Angeline was a Meserve. Kenny was a Meserve, but so far as they were concerned, she was still a Henson. Sort of a handmaiden around the house. She had married a Meserve and borned Meserves, but she was not one of them. A handmaiden like Hagar, who had found favor in the master's sight. They didn't have to count her when anything important was to be done. Just go right ahead and ignore her. Took her for dumb and ignorant, and so narrow in her mind that she

199

couldn't be expected to see that Hatton was a fine boy. Like she was ignorant and dumb enough to hold anything against the boy because he happened to be born up North! She could see as well as the next one that Yankees were like everybody else. She was as happy as the next one that Angie had married Hatton, and she would of freely give her consent if they had give her time to know the boy and get used to the idea. You couldn't find a nicer and more mannerable young man nowhere in the world, nor a better husband for her daughter. Oh, she might of said a off-hand word or two about Hatton being a Yankee, but they ought to of give her credit for being too sensible than to take it serious-like.

So now she would wash her hands of the whole mess. She would take no more pride in the development. It was Jim's ideas and Hatton's carrying 'em through. Let 'em have it! She couldn't turn her back on her children, but so far as Jim Meserve was concerned, she was through with him for good and all. This time she meant it. Never would she go back to his bed again.

Then Arvay turned over on her stomach and buried her face in the pillow. Arvay sobbed and wept. Her resolutions against Jim Meserve were just like the lightning-bugs holding a convention. They met at night and made scorning speeches against the sun and swore to do away with it and light up the world themselves. But the sun came up the next morning and they all went under the leaves and owned up that the sun was boss-man in the world. Well, she would hold out until Jim came and carried her back across that hall by main force, which he did at midnight.

CHAPTER 19

Since the fishing operations began, Jim was all new life and energy. He was back and forth to the coast sometimes twice a week.

"What you got to be running back and forth so much for?" Arvay asked petulantly. "You don't spend no time around your home at all these days. Can't that expert of yours that you place so much confidence in handle things?"

"Certainly! Alfredo don't fail to bring in the stuff if they can be found at all, and he's as honest a man as I ever expect to meet. I go up there as much just to be around boats and fishermen as I do to look after my business. Arvay, I love the sea!"

"I'm convinced that you must love something over there. You break your neck out of here every chance you get."

"We'll soon be living on the coast regular, I hope. I'm just hanging on at the packing-house till I get enough money ahead to see Kenny through the University up there in Gainesville, then I can afford to gamble just on my fishing. I don't want to draw out what I put in Hatton's firm so that the Meserve name can stay in there, and Kenny can have a share when he gets out of college. Though, from the way he talks, it might not be necessary at all. He claims that he's going to make his living with his box."

201

"I hope that you ain't paying that no mind. I been hearing the darkies picking boxes ever since I been old enough to know anything, and I got my first time to see any of 'em make a living at it. Just something for fun. It's all right to humor Kenny to an extent, but who you reckon is going to pay good money to hear anybody pick a box?"

"That's Kenny's business. Maybe he knows what he's talking about. He keeps up with that kind of a thing, and claims that white bands up North and in different places like New Orleans are taking over darky music and making more money at it than the darkies used to. Singers and musicians and all. You do hear it over the radio at times, Arvay. Kenny claims that it is just a matter of time when white artists will take it all over. Getting to it's not considered just darky music and dancing nowadays. It's American, and belongs to everybody. Just like that swamp; so far they have slept over the darky way of picking a box. He aims to be the first one to make it something for the public, and he might be right for all we know. Anyhow, just in case he might be wrong, I mean to give him a good education so he can have something to fall back on. That done, I can give my whole time and thoughts to building me up a first-class fishing fleet. That's how I aim to make your living from now on. Angeline is already well-cared for."

"Think that you'll ever make it?

"Without a doubt, Arvay. The last four trips, Alfredo has come in with big-pay hauls. The last time, he took that boat out and sunk her!" Jim's eyes glowed light with excitement like a boy at a ball-game.

"My God, Jim! You mean that Alfredo done sunk your boat?"

Jim laughed gaily. "Naw, indeed. When a shrimper says that, he means that he come in loaded to the rails. From the load on board, the stern of the boat is riding low down to the water. Fishermen got their own way of saying things. Got their own way of talking by signs too and a whole lot of crazy things. You really ought to be along with me some times. They'd make you laugh yourself to death. That's the only real life to

202

live, though my own folks would never have looked for a Meserve to take to a thing like that. As I reckon I told you, my father wanted me to take up law. If not that, the Army out of West Point. He never said where the money was coming from."

"They you broke off, took to knocking around, worked in teppentime, and married somebody like me."

"That's a fact. Seems like I had more sense [than] the rest of my crowd." Jim grabbed Arvay by both corners of her mouth and playfully stretched it across her face and kissed her in the middle of it.

"I had too much sense to follow their lead. While my old man was sitting around reading and taking notes trying to trace up who did what in the Civil War, and my two brothers were posing around waiting for the good old times that they had heard went on before the War to come back again, I shucked out to get in touch with the New South. So far, I don't think that I have made out so bad, do you?"

"Can't say as you have, Jim. Fact is, from where we started off, you've spied noble. That's why I can't see why you always want to be tackling something new. We got a mighty good home, and with what you bring in, we don't want for a thing."

Jim looked at Arvay wistfully for a moment and said, "Maybe you will see into my reasons some day, Arvay. It ain't for me to point out some things for your information. I'll sure feel fine though when you come to realize for yourself."

"Seeing that I don't catch on to what you mean, Jim, look like you would tell me," Arvay replied after a pause.

"Naw, Arvay. That way wouldn't do me no good. Just search around inside yourself and some day you will understand what I mean." Jim's eyes wandered to a pair of fishing-boots over in one corner of the room and went and picked them up and looked them over carefully. "Alfredo is doing so fine with that boat that I feel like some kind of a king, only bigger and better. I just dare him to make six more trips like the last one! Damned if I won't haul off, reach back, and take that last piece of change that I still got stuck away and buy me

another boat. That would make it the sooner for us to move to the coast for good."

"Get rid of our home?" Arvay asked in alarm.

"You ever known me to chunk money away like that?" Jim waved an arm towards the front of the house. "With the county paving a road south right in front of our door, and with all those new houses going up across the street there, that big development across the viaduct, this five acres is worth a young fortune now. It will be worth many times more a few years from now. I told you that I was saving it for Kenny. If he didn't have nothing else it would give him a good start in life. Give me one good year with my fishing and we won't need it for ourselves. We'll have the goddamn world by the tail with a down-hill pull."

"You really is set on moving to the coast, I see," Arvay murmured after a moment's thought. "How is Alfredo and all making out down there?" Arvay turned her head and looked away off as if she were not really concerned with the answer. Just asking for politeness.

"Just fine! His wife is a mighty fine cook, you know, and she's boarding some of the single men to help out, and they're coming along fine. I promised to bring you along with me sometime and have her fix us up a good sea-food dinner and generally have a grand time."

Arvay didn't say anything and Jim urged on. "When must I let 'em know?"

"I wouldn't want to put her to all that trouble, Jim."

"No trouble at all, honey. She would enjoy doing it and having you."

"I might be in your way."

"Aw, honey," Jim protested. "You never have been down there with me. Come on!"

"Naw."

"Well stay here then!" Jim shouted and slammed on out of the house and jumped into his car and drove off swiftly.

The shrimping fleet moved north for the summer and worked the Georgia and South Carolina coasts with Thunder-

bolt, Georgia, as a general base. Alfredo had gone up and Jim got regular reports, but was sorry that the distance was too great for him to make. That made him even more impatient to cut loose from his job and do nothing but fish. But when the fleet headed south in the fall, Alfredo brought him news of a good boat that he could get reasonable. The owner couldn't spare the time to fish it profitably by reason of women, whiskey and maybe too much whistling. Alfredo ran into the owner at just the right minute, and pledged Jim to buy the boat before anybody else found out that the man was willing to sell it so cheaply. It was really a bargain, and in better shape than the one Jim already had. More modern and all. Diesel powered and more icing-space.

Jim decided that this was too good a chance for him to miss, so he took the last two thousand dollars left over from his liquor venture, raked and scraped around otherwise, and laid the price of the boat on the line.

"You never got hold of such a bargain in your life, Boss, and you never will again in this world," Alfredo told him. "That damn fool sure did us a favor. He's gone crazy about some woman here in Savannah, and all he's after is some ready cash to satisfy her mind. No notion of work at all no more. Well, his loss is our gain."

"You said it, Alfredo," Jim replied. "But I owe this chance of luck to you. Once more and again you have shown yourself to be a true friend to me, and taking care of my interest. I couldn't find a better friend nowhere. Anything that I can do for you at anytime, the favor is in me."

Alfredo asked for nothing, and that made Jim feel even more obligated. Therefore, some weeks later when Jim was at Alfredo's house for a business talk and one of Mrs. Corregio's meals, he was moved to offer something that he found that they prized more than money.

The fifteen-year-old Felicia, who was, as Arvay complained, well developed for her age, was looking at a newspaper in a wishful way.

"Oh," she sighed, "look like folks enjoy themselves so

much at these football games. Gee, I wish I could go to one one time."

"Nothing to hinder you from going, is it?" Jim asked.

"You have to have different kind of clothes from what I got to go to a place like that, Mister Jim, and then, unless you belong to that college, you have to be asked to the social part, I mean. I don't have the clothes, and there's nobody to ask me to it."

Immediately Jim saw his chance. "Oh, I don't know about that, now Felicia. Kenny's up there at Gainesville, and almost like a brother to you. I don't have the least doubt that if he had any idea you wanted to go he would ask you."

"Oh, don't pay no attention to Felicia, Mister Jim," Mrs. Corregio hurried to say. "Some things is out of her reach and she might as well realize. She's been to her high school games and that ought to do her."

But Jim could see the wishfulness in the mother's eyes as well. She was merely afraid to ask anything of him.

"A person ought to do a few of the things they want to do in this world before they pass on, Felicia. You just leave it to your Uncle Jim, and he'll fix it for you."

"I was just talking, Mister Jim. Kenny wouldn't want to be bothered with nobody like me in a place like that."

"You don't know who Kenny wants to be bothered with. You let him talk his own chat."

Feeling that it was a very small thing that he could do for Alfredo, within twenty-four hours Jim had had a confidential talk with Angeline first, and then gotten off a letter to Kenny.

That was how it happened that Arvay saw Felicia at the football game. The Meserve family was bound to be there. Kenny was drum-major for the band, and they had to be there to see a thing like that at the big game on Thanksgiving Day. Kenny had reserved seats in a box for his family, and the number of friends whom Angeline specified. Prominent citizens of Citrabelle had the next box to gloat over their local boy.

They were all there early and in their places ahead of time

to watch the huge grandstand fill up and greet old friends from other towns who would be sure to be there too. Angeline and Hatton seemed to know everybody. Jim and Arvay were kept busy accepting introductions and shaking hands. Prosperous looking young folks out of families that Arvay had never expected to pull level with.

"Our children might not be the bell-cows, but if they ain't they's right up in the gang," Arvay made a proud aside to Jim. "They seem to be right in with the best they is."

"Naturally," Jim boasted. "They got good manners, they got something, and they look like something. That's the stuff that makes for friends."

Jim and his party and everybody else became conscious of a young couple who had entered at one end of the field, and were parading down the other side. Everybody was asking, "Who is that?"

"Why, that's Kenny, my boy." Jim spoke so that he could be heard for several boxes around.

"Who is that pretty girl he's got with him?"

That was what everybody wanted to know. The girl attracted a lot of attention first, because she had an unbelievable mass of curly black hair that poured and tumbled nearly to her waist, and glittered in the sun, in a company of almost universal bobbed heads. Men like hair and they looked. Then she was so fresh and tender-looking. They noted that she was really built from her neck on down. The men looked at that and the women took in her clothes. She was dressed in a white sweater suit, topped by a perky white tam over one eye, white buckskin oxfords, and a loose-fitting light-weight white coat. It was just the right thing for her dark hair and eyes. Brilliant big eyes, and a high natural pink in her cheeks. Kenny Meserve, ever the showman, was doing his stuff. He paraded along, pausing to make introductions, or when he was hailed by some yearning student who hoped for an introduction to his date. He had the eyes of the public, and he seemed to know it. It was a very eye-taking thing as he made his progress around three quarters of the grandstand, pretending to look

for someone, till he arrived before the box where his party sat.

Arvay was not expecting, so she did not recognize Felicia until the couple was almost at the entrance to the box. She had no right to look for Felicia at a place like this, and certainly not in that kind of clothes. When she did make out who that was with Kenny, she was thunder-struck by lightning.

"Hey, folks!" Kenny hailed, and handled Felicia as proudly as if he had been escorting the Princess Royal. "Feliciana's here at last to use that seat I reserved in the family box." He went on to usher the smiling girl in to her seat. "Take care of her for me, kinfolks. I got to go. The band will parade in in a few minutes. Angie, I'm trusting you to look out after my interests. Feliciana is my date for the day. All of these college back-biters have had a look at her and their mouths are fairly drooling. Stand by me, Sis. Fight off the competition the best you can."

"We'll hold that line," Hatton promised.

"Satisfaction!" Kenny smiled and turned to go with a wave of his hand. "See you later and tell you straighter."

Arvay was entirely excused from keeping Felicia's company. Angeline's crowd took care of that. They made introductions, and kept up a great clatter until the teams marched in led by their respective bands. Kenny, now dressed in a showy uniform, and carrying a decorated baton, was the star of the piece. The Gators were on the home grounds, and the grandstand went wild when Kenny came prancing down the field. He shed more glory on his folks by saluting them as he passed the box in his tour around the field.

Kenny and the band brought up the drooping spirits of the students, alumni and fans at the half, when the visiting team had the Gators at 6-0. He ran over and spent some time in the box with them as the game took up again. Then he had to join the cheer-leaders and do his stuff. Jim was about to split his britches, but Arvay had no trouble at all in keeping quiet. She had never seen a football game before, anyway, so she could be excused for not going crazy when the Gators crushed across the enemy's goal line for a touchdown and then converted. In

the last five minutes of the game, and on the third down, they did it again, and converted. It seemed to Arvay that over a million crazy people piled out onto the field and fell in behind the Gator band doing what they called the snake-dance. The bank president was a Gator grad, and he grabbed Jim and carried him out there too, and only the wives were left sitting there. The other women smiled indulgently, and Arvay acted it out as they did and chatted along, but she was going crazy in her own way.

Where and how did Felicia get those clothes that she had on? What was she doing here? Kenny had never mentioned Felicia in a single letter to her, so something underhand was going on. How much of Kenny's acting towards Felicia was put on and how much was real? Was Kenny bleeding them out of money that they could use otherwise to put clothes like that on that Felicia's back? Or was Jim crazy about something else in that Corregio home besides Alfredo's wife's cooking? Was it the mother or the daughter? Oh, that was too awful to think about. Laying around with the father and running after the son.

It turned out that Angeline and Hatton had good friends in Gainesville too. It was already arranged for Arvay and Jim to go to the home of one of these friends with them to dinner, and to rest and change their clothes.

The home was very good, and everything was done to make them comfortable, and Arvay tried to feel and act happy. She acted it out the best she could, but she couldn't feel that way. First and foremost, the presence of Felicia had her worried. She had no idea what it meant, but the rest of the family seemed to know. As in the case of Angie and Hatton, maybe Kenny would be married to this girl before she knew anything about it at all. That made her miserable. The very name of Corregio called up sorrow and suffering to her mind. Why did that girl have to show up on a day like this, and in company with her son?

In addition, Arvay felt so out of place. All that this day meant in college circles was strange to her. She felt awkward

and out of place. Listening to the people around her, she became terribly conscious of her way of speech. She hated to open her mouth for fear of making a balk, and putting her children to shame.

"Let's don't bother with the dance, Jim," Arvay suggested. "We got a long drive ahead of us, and it's getting late. Let's just say good-bye, thank the folks and go on home."

"But we can't do that, Arvay. Kenny is doing some special playing tonight at the dance, and he would feel mighty hurt if we wouldn't even wait to hear him."

Arvay found that she had to go. The family double-teened her and reluctantly she changed into a fresh dress and went to sit with Jim along the wall with a number of women who were chaperoning their daughters.

The sight that Arvay dreaded to see came before her eyes. Kenny came with his guitar around his neck and with Felicia on his arm. She created just as much excitement at the dance as she had at the game. She was dressed in a fluffy ruby-red tulle dress with a girdle of crushed cloth of gold. All of her decorations were gold. Gold kid slippers and a big gold flower in her flowing hair. She looked like the daughter of some foreign ruling-man. Almost instantly, she and Kenny were the center of things.

Angeline looked beautiful too. In a pale green something with silver-gilt touches, she and Felicia standing together had the floor. Angeline chummed up to Felicia and kept things looking like a pair of sisters.

Jim and the banker, who had stayed for the dance because his own niece was a guest, stood together near the wall chatting away when an important-looking man joined them and began to talk along. It turned out that he was the head of the Chamber of Commerce at Leesburg.

"Those are two really beautiful girls, yonder. The two standing together with that crowd of boys around them."

"Home town girls." The banker jumped in quickly and rocked back and forth on his heels. "Products of Citrabelle,

prettiest little town in Florida, and grows nothing but pretty girls. Ain't that right, Jim?"

"Correct. Why, those two are about the ugliest in town. Fact is, they were run out of Citrabelle for the day so that the folks could enjoy their Thanksgiving dinner." The three men chuckled, and Jim went one better. "Just a couple of culls off of my place."

"I'll take your culls off of your hands and take 'em to Leesburg to ugly up the place."

"Aw, naw you don't, neither!" the banker objected. "Don't try to steal our samples. Come on down to Citrabelle and pick you a pair out of stock. This is Mr. James Kenneth Meserve, one of our first citizens, and that red-head is his daughter, and that black-haired one is his son's date."

"Congratulations, Meserve. You got a good thing all the way around."

"Yeah, but you haven't seen the best as yet. Turn around here and meet my pretty wife."

There was plenty to smile over, if Arvay had been in any notion to smile. Her face got cramps for the next hour while she tried her best to carry off everything nice. The orchestra assembled and the dance began. The parents took the chairs ranged around the wall and watched the young folks dance. A waltz, a fox-trot, and then Arvay and Jim grew proud as the drums opened up on Kenny's specialty, *House That Jack Built.* The way they had heard it at home was nothing to what this band could do with it. It was really *something.* The students seemed to be familiar with the piece enough to jump in every time they got to that line, "That milked that cow with the crumpled horn"—they all shouted it out.

The hall was full of exciting activity. The young folks were doing the Lindy Hop, and it seemed to Arvay that everything that could be done with a shin-bone was being done. Hundreds of young healthy boys were hurling pretty well-dressed girls around. Arvay noted that there was not a homely girl in the place, and a high percentage ranged to real beauty, and her own daughter was right up there in the front ranks. She

211

could not enjoy anything, however, for Felicia Corregio was there flashing around the room and stopping close to the band between every dance.

Jim and the rest insisted that the Corregios were as white as they were, but it made Arvay feel haunted to see any member of that family. Over the exciting rhythm of Kenny's composition Arvay could hear the mournful tolling of a bell. Pictures came before her eyes. Earl growling and hurling himself against the screen. Lucy Ann lying still and white and bleeding on the ground. The growling rumble of human men turned into a mob. Tolling, tolling, tolling sound of the bell. The siege in the swamp. Earl's quiet face in death. Tolling. Dead-and-gone. Dead-and-gone! The bell struck out with halting tongue.

Arvay struggled and tried to shake it off. Long ago she had brought herself to admit that the Corregios were not responsible for what happened, and as Jim said, Alfredo had acted a noble friend through it all. He had shown himself a faithful helper and friend since then, too. But the name called up that which she had tried hardest to forget. What human can desert his memories? The bell kept on tolling in her head. The heavy, slow-talking clapper seemed to be beating against her very skull. She waited and suffered between strokes. As the piece came to an end, Arvay leaped to her feet.

"Well, we done heard Kenny's special, Jim. It's time for us to go."

"Aw, what's the hurry, Arvay? I'd like to watch and hear some more of this thing."

"What for? This dance ain't for us. It's for these boys and girls."

"Yeah, but I want to watch and see. Looks like Kenny knows what he's talking about. Those white boys are playing that rag-time down to the bricks, and you saw that dancing, didn't you? I want to see as much as I can of it. You could almost think those were colored folks playing that music. I want to . . ."

Arvay was on her feet and had Jim by his arm. The band was

resting for a minute or two, and Hatton, Angeline and Felicia were over there talking and laughing with Kenny. Arvay looked and wanted to go.

"I done begged you and begged you," Arvay gritted out in a low tone. "I'm going, and I'm going this minute. You can take me if you want to, Jim. Suit yourself. If you don't come on this instant, I'm going anyhow. I'll go on out of here and grab the first thing smoking and go on home. You can stay here and gap at that Felicia until you get good and tired. I'm going!"

Jim backed the Buick out with a *zoosh*, wheeled around and headed through town in a hurry.

"You going too fast, Jim, with all these hundreds of cars on the streets. You're liable to hurt somebody."

Jim paid no attention. He cut through traffic like a razor and kept on going to the highway. No sooner did he hit it than he did what Angie and Kenny's crowd called washing his foot in the tank. That Buick squatted to the road and Arvay saw the needle moving up to fifty, sixty and beyond. She was terrified. She hated fast driving, and Jim so well knew it, but she was in no mind to ask him any favors. She gritted her teeth, held onto the door with one hand and put on brakes with her feet. East by south the car raced along with not one word being spoken between them.

Arvay was ever so glad when they approached Orlando. It was too big for Jim to dash through there, and this time of the year, Orange Avenue would be fairly working with northern cars. He would be slowed to a creep by the lights and traffic, and maybe by the time they got through there, Jim would have come to his sense.

But Arvay did not know the road. It was all strange to her coming from the direction they had. They came right into highway U.S. 17, which took them south without really entering the city. Also, there was that new three-lane stretch of twenty miles to Kissimmee. Jim stuck his foot in the tank and went from there. They were out on the Kissimmee Prairie, in the Florida cow-country, and little traffic. Arvay took one look

213

and saw the needle slip past seventy, and closed her eyes. Before she knew it, they were in Kissimmee and approaching the bridge leaving town.

"Jim! Jim! Jim! Look out for that bridge! Don't kill me about that gnatty-tail gal! Jim! Oh, Lord have mercy!"

Jim took the bridge just like he did the rest of the road, and they flashed on past ranches with the trees and fence-posts whirling in a mad dance past Arvay's eyes. Jim never said a word. "Wahooo!" the horn cried when Jim overtook a night-operating truck, and the wind yelled "whooo-ooom" as the Buick flashed past. Arvay screamed again when Jim passed a truck, and found another meeting him. He slashed between the two by a slight wiggle of the wheel almost rubbing hub-caps as he went with both. His hand was steady on the wheel, his face was grim and his foot was in the tank. Arvay screamed again as they entered Lakeland. The Buick dived down the slight hill to the ornamental lake, and for a second, it seemed to her that Jim would never be able to swerve to the right around the lake. It seemed as if it would plunge straight ahead into the water. Jim made the curve smoothly and kept on going. The car consumed on its way and Arvay screamed and cried. She had been sobbing and crying constantly for the last fifty miles when Jim pulled up into their drive with a sudden stop. Without a word, he reached across her, flung open the door on her side, and Arvay stumbled out crying very hard.

Jim made no effort to assist her up the steps as he usually did. He stomped up on the porch, unlocked the door, flung it open, switched on the hall light, and wheeled to go and put the car in the garage. Arvay staggered on into the bedroom, and sank down on the side of the bed in a lump, still shaking and crying.

Arvay would have felt better if Jim had stayed outside a while and given her a chance to collect herself, but he didn't. In no time, he came walking heavy over the floor. Hard-heeling and coming fast. He flung the bedroom door wide open and came and stood spraddle-legged in the middle of the floor. Instead of coming to her and trying to soothe her feel-

ings, Jim just stood and looked down on her as if she were a chair. Arvay quit sobbing and leaped to her feet.

"Don't you stand there gapping at me, after you done done your best to kill me dead on that road! I got a good notion to take that gun and blow your infernal brains out!"

Jim went to taking off his clothes. He acted more like he had not heard what she said than anything else. Arvay stood there getting madder as he stripped and got into the pants of his pajamas.

"Oh, so you call yourself discounting me, do you?" Arvay screamed. "I think too much of myself to kill you like I ought to, but I'm through with you, Jim Meserve. I'm just as through with you as I is my baby-shirt."

She ran to the closet, snatched down her nightgown and headed for the door. Jim picked up the jacket of his pajamas, and let Arvay get as far as the door. Then he reached forward, caught her by the arm and flung her back into the room so forcibly that the back of her legs came up against the bed and she sat down without planning on it. Jim stood over her and glowered.

"Did I tell you that you could leave this room, Arvay?"

"N-n-no, Jim."

"Well, what did you start out of here for, then?"

"I-I thought that I had better go sleep—"

"You thought like Lit! Did I tell you to do any thinking?"

"No, Jim, you didn't."

"Well, don't let me hear none of your thinking unless I give you my command."

Jim stood and frowned down on the thoroughly frightened Arvay for a long time. She felt like a mouse under the paw of a cat. She looked up at him fearfully, caught his eyes on her, and then down quickly.

"Where I made my big mistake was in not starting you off with a good beating just as soon as I married you. I have never laid the weight of my hand on you in malice, and you done got beside yourself. What you mean by sitting there all drawed

215

up into a winter knot? Get up from there and get out of those clothes.''

Arvay got up timidly and Jim gave her a little shove towards the dresser, and Arvay's fighting blood got up. Besides, she was persuaded by now that Jim was not going to hit her. He never had so far. She whirled on him.

''Don't you dare to shove me, Jim Meserve! I'll wade knee deep in your blood. And I'm not a'going to take off . . . Jim! Jim! Don't hit me!''

Jim didn't hit her. He just grabbed the powder blue flat crêpe dress at the neck and ripped it off her, and flung the rags of it against the wall.

''Didn't I tell you to off with them rags? Off with 'em! Up with that petticoat and down with them pants before you make me hurt you. Move!''

Arvay, pulled at her underclothes in a desperate effort to get them off. Her slip stuck as she got it up to her shoulders, and she screamed as she felt Jim with a rough hand rip it off and hurl it away. She reached for her nightgown on the bed to cover herself, but Jim brought her up short.

''Did I command you to put on a gown, Madam? Leave it lay!''

Arvay stood with nothing on but her shoes and stockings, then remembered them and fairly clawed them off, and stood shivering with fright as naked as she had been born. She looked longingly at the closet door and took a step in that direction.

''Don't you move!'' Jim bellowed harshly. ''You're my damn property, and I want you right where you are, and I want you naked. Stand right there in your tracks until I tell you that you can move.''

Arvay, her lips trembling to keep from crying, stood there with her legs close together and waited. Jim threw back the bed covers to the foot of the bed, then sat down in the little rocker, rested his hands on his thighs and looked Arvay over in a very cool way for awhile. Then he rested his face in his hands and sat silent and motionless for minutes. He was

216

moved by love and pity, but Arvay could not know this from the way he spoke when he suddenly lifted his head.

"All right now," Jim commanded. "I reckon that you can go to bed. But move in a hurry before I change my mind."

Arvay leaped in and began to scramble the covers up over her to her very neck. With a springing jump, Jim was at the bedside and grabbing the upper corners, flung all the covers back over the foot of the bed.

"Who the hell told you to pull up any covers?" Jim demanded sternly. "You're too damned fast and previous! I'll let you know when I want you covered up, Madam."

Arvay laid there among her fears. But her fear of loss was much greater than her physical fear. Felicia and all the Corregios fell off Arvay's shoulder like a loose garment in her anxiety for reconciliation with this man who stood like a statue of authority beside the bed. No bells tolled; no memories could find a place with her then. The hours of that morning before they had set out for Gainesville had seemed ordinary then. Looking back on that time from where she was now, they seemed to form a time of untellable bliss. If she could but have them back again! The most ordinary minute of peace with Jim in the past appeared like time spent in Paradise.

After what seemed like months to Arvay, Jim took his ample time and got in the bed with her. He stretched himself full length upon her, but in the same way that he might have laid himself down on a couch. After more years of suspense, Jim elevated himself from the shoulders up and looked down into Arvay's eyes.

"Hug my neck, Arvay," Jim said in the same way that he could have been telling her to pour him another cup of coffee.

Arvay flung her arms around Jim's neck with gladness. It could be that she had made her escape out of Hell. While she hugged and kissed her husband, Arvay prayed and promised God. Ah, but let these golden moments roll on a few years longer, please, God. She made vows and promises. If God would fix it so that she got over this greasy log, she would certainly sand the next one. That is, she would keep the Cor-

217

regios out of her mouth and mind. Grant her this one favor of peace and agreement with Jim once more and again, and she would not bother God for no more favors. She would not even part her lips if the time should ever come when Kenny saw fit to court and marry Felicia, hard as the pill would be for her to swallow. By this time Arvay had hugged and hugged and kissed and kissed for what she decided was abundant and sufficient time. She lowered her arms and waited.

"Who told you to stop hugging my neck?" Jim demanded. "Get to hugging my neck and kiss me until I tell you it's time to knock off. I don't want no flabby kind of kissing neither. Go to work!"

Arvay hugged and she kissed and she kissed and she hugged.

"But Jim, you ain't acting mutual with me. That makes it hard work to do."

"You can't kiss me and talk at the same time, so hush talking."

Jim could feel Arvay's skin changing temperature, and the change in her breathing. The change became more and more pronounced. She kissed him violently and hungrily for a minute, then braced her hands against his shoulders and did all she could to shove him away from her.

"Go 'way from me, Jim, and leave me be!" Arvay began to scream and cry. "I can't stand this bondage you got me in. I can't endure no more! I can't never feel satisfied that I got you tied to me, and I can't leave you, and I can't kill you nor hurt you in no way at all. I'm tied and bound down in a burning Hell and no way out that I can see. I can't see never no peace of mind. It's a sure enough hard game when you got to die to beat it, but that's just what I aim to do—kill myself!"

Arvay ended on a high and agonizing scream of desperation.

Jim said nothing. Resting on his elbows, he took Arvay's face between his hands and looked down in her eyes which were running over with tears. Gradually, the features of her face relaxed and that calm Buddha mask that she always wore

came over her face. But Jim was concentrating on her eyes. Once again he saw that greenish infusion creep in and mingle with the sky blue of her eyes. That peculiar thing about Arvay's eyes that he had a momentary glimpse of the first time that he had encountered her on the street at Sawley. He had seen it more fully when he had kissed her for the first time that Sunday at the table when they had become engaged. It had been daringly out in the open that flaming hour under the mulberry tree. It was an eternal and a compelling mystery how Arvay's face could stay as stiff as a false-face on Halloween while that something crept up like a tiger in the jungle peeping out through shielding leaves at its prey, and looked out through the eye-holes of the mask.

"No, I can't see no way out of my binding bondage but death, Jim. I aim to kill myself, so tomorrow I'll be dead and gone. I never is sure whether you love me or not, and I just can't endure no more."

For an answer, Jim kissed Arvay with a kind of happy arrogance, then snuggled his head down on her breast in that way he had that Arvay thought was so much like a helpless child, and went off into peaceful sleep.

Arvay buried her hand in his hair as she loved to do and stayed awake for awhile with her thoughts. And she had promised to escape this man by death tomorrow.

Tomorrow? When and what was that? Who ever has believed in the reality of death in the presence of vibrant life? It is a parable sometimes told by the old. Some man in a far country, whom you never knew, went off somewhere one time, and being a fool, laid down and died. But who, in love, ever paid any attention to a made-up tale like that?

Y ou really mean to take her out, Boss?" Alfredo asked and looked for an answer in Jim's face.

"Hell, yes! Just got my pilot's license, took a week off from my job to be here, and then not go?"

"Okay. It's a little windy out there, and you not being too experienced, I didn't know whether you felt to take the risk. Quite a few boats ain't going out today. But then some are going right on. Even if you hadn't decided to go, I was going. This little wind is going to die down before night anyhow. From the northwest, and it won't blow real strong."

"Sure, Eddie Halliard and several more of the best men are going out," the Mate chimed in. "A little wind is even a help in getting the net over the side. Let's go, My Captain."

"Damn! But that sounds good!" Jim beamed. "First time in my life. Captain Meserve of the *Angeline*. Say it again, Stumpy, and lemme hear you."

"Gimme an order so I can answer you right."

"Wait, Stumpy, lemme get in the pilot-house with my hands on the wheel and look important. You and my Third Man stand there on deck and look scared. Alfredo, you get ashore and get aboard your own command, so everything'll look natural. All right now, let's go through it right."

Jim struck a pose, frowned ferociously at his crew, cleared his throat and bellowed.

"You Third Man, have you got all necessary stores on board?"

"Yes, My Captain, we are well provisioned."

"Mate!"

"Yes, My Captain!"

"Everything ship-shape below?"

"Yes, My Captain. We can cast off and head for the inlet."

"Well, why the hell don't you do it then, and let's go?"

They all broke into a laugh. The lines were cast off, and Jim moved the *Angeline* out safely from the dock and stood out in the stream. The *Arvay Henson,* Alfredo in command, waited long enough for the *Angeline* to clear sufficiently, then came out to pair with the *Angeline,* and the two moved off, gaining speed gradually towards Mosquito Inlet.

When Jim had piloted his boat through the tricky inlet, and her bow slid out into the Atlantic, Jim waved at Alfredo gaily and said to Stumpy, who stood on deck by the pilot-house door: "Stumpy, Heaven can't be no treat to me after this. I got all the Heaven I want right now."

"It ought to feel fine to be captaining your own boat, but I don't ever expect to own one. I done swore on a stack of women so high that I was going to save up and own me a boat someday, but I knowed that I was lying when I said it. Too much good likker that needs drinking up, and everytime I see a pretty woman switching along, I got to stop and drop a flag on it."

They laughed, noted that the *Arvay Henson* had headed north, and swung that way. As the bow of the *Angeline* cut the choppy water, Jim looked to starboard over the seemingly limitless sea to the horizon where it curved away from sight in waving lines. He looked to port, at the dim line of the Florida coast, and forward at the three boats ahead, and was content.

"You're not afraid with a new captain like me, Stumpy?"

"No, indeed. You're doing just all right. I watched you how you brought her through the inlet. That was where the danger was. Anyhow, a fisherman got so many good chances to lose his life that if he stops to dwell on that, he'd be scared to death all the time. I ain't scared of a thing but old Bozo."

"Who in the hell is Bozo?"

"Nobody ain't told you who Bozo is as yet? Man, you ain't no real fisherman until you meet old Bozo and fight him."

"Who is he, and where can he be found, Stumpy?"

Stumpy laughed and summoned the Third Man from the galley.

"Come on up, Charlie. The Captain wants to locate Bozo. You fought him last, didn't you? Come on up and tell My Captain where Bozo can be found!"

The Third Man, who had been putting on breakfast, came up the steps, wiping his hand on a sugar sack towel, and put on a very serious face.

"I hate like everything that nobody never mentioned it to me while we was on the hill. We're way outside now, and you have to wait until we go ashore again. Still and all, I figger that I can give you some idea where Bozo lives, and how he can be found. Then you can go and challenge him to a fight anytime you want to."

Before the Third Man got through with his fantastic directions, Jim caught on that this was some joke. With the state of Florida as flat as a flounder, he was told that he had to cross the Lick-and-Spit Mountains just back of New Smyrna. Then he turned short to port and went through the land of the Mollymoes. A Mollymoe was a peculiar kind of a bird. He never relieved himself but once a year, and when he did, why, you could smell him for a mile or more. That was how he came to have his name. Come through that country and you were right at a big plantation. That was where Bozo lived. Yes, sir! Big house and everything. Bozo seemed to have a plenty. Rich and well-to-do. All you had to do then was to go right up and knock on the door, and when Bozo opened it, challenge him

222

to a fight. The man who whipped Bozo would be the king of the world.

"Did you whip him?" Jim asked to humor the joke.

"No, can't say as I did. Fact is, I never laid eyes on Bozo. Just like everybody else, all I ever saw was Bozo's cat."

"How was that, Charlie?"

"It was bad, Cap'n. As far as I seen it was mighty bad and more than I figgered that I could handle."

"Even being a fisherman?" Jim helped the story out.

"Even for a fisherman, and they can handle more'n anybody else in the world. You see, Cap'n, that cat was as big as a yearling calf to start off with. Then as things went along, when I seen that cat drink off a skillet full of hot boiling grease for coffee, and then take up a blazing li'dard knot out the fire and use it for toilet paper, I figgered that it was time for me to go! And man, I really went. I was running so fast till I had to turn sideways to keep from flying."

They laughed that off and then Jim asked, "So you never got a chance to see Bozo himself, eh?"

"What? Wait for Bozo? If his cat was that big and tough I didn't want to meet that Bozo riding nor walking. I went there feeling fit to fight, but my Mama always told me never to let my head start more than my behind could stand. If Bozo is any tougher than his cat, I don't admire to meet him."

"Same thing happened to me," Stumpy nodded solemnly. "All the fishermen'll tell you the same. Don't care how you meet him he's the privileged vessel and you better treat him that way."

"Much obliged for the information," Jim said. "And now that I know about Bozo, I take it that I'm initiated."

"Kee-rect, My Captain," the Third Man grinned. "Reckon I'd better go finish off breakfast. Old Bozo is liable to board us any time and we ought to be in shape to tackle him."

Jim sat on his stool at the wheel and contemplated the ocean of sea around him. The colors charmed and pleased him. There was the delicate green close at hand, and flipping inward toward the faint outline of the Florida coast. To star-

board and infinity, it took on a blue-green, and where the sun rested on it, it seemed to be over-laid by a silvery veil. A line of porpoises dipped and dived in a solemn parade between ship and shore. Portuguese Men-of-War sailed in purple glory. That was another thing that fascinated Jim about the sea, the seemingly infinity of form. No matter how much you saw, the sea had still other marvels of shape and color. He would never, never tire of the sea.

Jim had his breakfast and returned to the wheel. The small fleet went on northward. Jim and his crew cracked jokes and contentedly followed until they noticed signs of slowing down of the vessels ahead.

"Alfredo's going to fish, I believe. Okay, boys, let's try along."

The Mate went to the smaller winch, Third Man took the try-net in his hands, and as the strong steel cable was played out and out the net, shaped something like a wind-sleeve at an airport, went overboard and down for sixty fathoms. Jim sent the engine ahead, and the boat made a large slow circle for half an hour.

"Let's get it!" Jim sang out, and his eyes were filled with eagerness as the net came over the port side, and was dumped on the deck. There were numerous kinds of deep sea life spilled on the deck when the net was emptied, but the men took little notice of it. The three of them were eagerly counting the shrimp.

"Nowhere near fifty there," Jim said in a flat voice when the count was over. "Not enough to be worth a drag."

The boat cruised for a half hour, then they tried again. As ever, the sea gulls appeared seeming from nowhere when a net was raised, and swarmed around, hungry for the rejected marine life that would be shovelled overboard when the shrimp was picked out. The men had not bothered to clear the deck before, but the try-net came up loaded this time. The birds were tired of waiting, and swarmed in.

"Near enough," Jim decided. "Let's go overboard."

The eager ritual was performed. Each man had a station and

hurried to it. Jim to his wheel in the pilot-house. The Mate to the big winch. The Third Man took the bag of the big net in his hand and stood at the starboard rail and waited.

The mast was amidship, immediately aft of the pilot-house. The boom, to which the big rig was attached by pulleys and strong steel cables, was drawn up at around a hundred and sixty degree angle against the mast with its loose end pointing almost skyward like a cannon at rest. Now the boom was slowly lowered by means of the winch, swung to starboard to let the big drag-net slide into the sea. First, the long, coarse-fringy chafing-gear touched the surface of the water, got wet and began to sink. Then the whole of the mesh sank down and down until the boards, used for weights, were lying flat on the ocean like two big doors afloat on either side of the net.

"Is she spreading right?" Jim asked.

"Yep, she's just all right," the Mate answered. Immediately, the Third Man dropped the big bag over, and Jim sent the boat ahead. The cable ran out and out from the big drum to the sixty fathom line and the big net with its protecting chafing-gear was sweeping the bottom of the ocean. The drag was on. The Third Man went forward, picked up the bamboo stick that had a huge round cork fixed to it about eighteen inches from the butt end. Below that it was weighted. On the other end was a small triangular pennant of dark blue. This was the flag. They dropped that overboard, and it stood up like a buoy with the little pennant flying. It was a marker so that the boat could stay over the shrimp, and drag back and forth through them.

The boat began the slow circling around that flag with the steel cable stretching out and down astern. The boat listed to port or to starboard from the weight of the big net sweeping the bottom according to the position of the boat in relation to the net. For two hours it would go on that way. Slow and easy around that flag.

As Alfredo had predicted, the wind was dying down. By the time the net was brought to the side, there was just enough sea to help lift the net over side. They had almost had bad luck.

The net was maneuvered around to port just in time to miss the stern and avoid fouling the propellers.

The bag was dumped on deck with its wealth of strange sea forms and the shrimp separated from the rest. The sea gulls miraculously appeared, as if spontaneously created out of the water and screamed to the crew to hurry.

"Not but eleven boxes," Jim said when the shrimp were measured up.

"Yeah," the Mate put in, "but that'll pay for ice and fuel. What we get after this will be gravy. We might sink her on the evening drag."

"Could be," Jim muttered. "Look, their feet are red. They're on the travel. Now if we just hit the right direction we might go in top boat."

"Let's make this a two-meal day and go over again, My Captain. I need some spending change. Anything I love is a big percentage."

"I'm more than ready, boys, if you don't mind the strain," Jim said and looked at the Third Man.

"Hell, yeah. Might be plenty nuggets at the bottom of this lake right under us. Let's go!"

They let the heading of what they had go until the drag was on again then the two men of the crew sat on the hatch cover and "cracked heads" and talked while the boat began again its slow circle.

"Wonder where do shrimp go when they disappear from the sea?" The Third asked. "Sometimes, don't care which way you go, they just can't be found."

"I believe that they get up under ledges close in shore, especially in bad weather."

"Well, we know that they travel down the coast in winter, go clean around the State of Florida and come into the Gulf. But where do they be when you can't find 'em at all?"

"You suppose that there's some underground, or undersea, passage across under Florida that connects the ocean and the Gulf and some of them know it and go that way?"

"Could be. Then, too, they travel at night sometimes. When

226

you see 'em with red feet, they been travelling at night."

The net was brought over the side again, and this time they had had better luck. Forty boxes, after being headed, went into the hold. Jim felt good. The men began to get gay and talk about what they were going to do on the hill. "The hill" meant being ashore. Fernandina, St. Augustine, New Smyrna, whichever port they went in, the ladies were going to have a very interesting time. Oh, but they were!

Jim's first trip as a captain lasted three days. They went up and down the coast, but no boat made a record catch. Eddie Halliard came in top boat with two hundred and six boxes. Jim had one hundred and eighty-six in his hold. He had beaten Alfredo by five boxes and felt very good indeed.

He was thrilled when the boats began signalling that they were leaving the fishing ground. A chance to stick his head in a crown could not have given him the pleasure that he got from receiving his first sign language and answering it.

With the *Arvay Henson* nearly a hundred feet off his star-board, he saw Alfredo leave his pilot-house and come on deck. Jim hurried to do the same and looked across. Alfredo flung both his arms to his left about waist high, left palm facing out and right palm towards his body. With his hands and fingers out straight, he made the fluttering motion of fish tails swim-ming.

"Haul hips," Jim interpreted. Leaving the fishing ground. Jim did the same to indicate that he had the message.

Alfredo made a loose fist of his right hand as if he grasped a round cylinder, threw his head back, and placed the fist to his mouth.

"And going to have plenty to drink," Jim read the flash and returned it.

With the same right hand, held this time slightly to the right of his body on a level with his chest, Alfredo made the motion of winding a clock in a strenuous way.

"Going home to sleep with my wife." Winding the clock being the last thing before going to bed. Jim replied and the three signs were in. The boats were going into port.

They turned their bows south, paired off, and were under way. It was important for each boat to have a partner to afford assistance in case of trouble, and trouble can come swiftly and disastrously on the sea.

Proudly, after a five hours' run, Jim brought the *Angeline* through the inlet, and laid her dead beside the dock. Alfredo tied the *Arvay Henson* alongside when he got in a half hour later. According to arrangement, he sold his shrimp through Toomer, a "factory" with a fleet of seven boats, paid off his two crews and everybody headed uptown.

Jim jubilated from place to place for two or three hours, then stepped into a Jook that was very popular with the fishermen. The Jook organ was blaring out popular records, some few couples danced off and on, and the bar was crowded. Jim was congratulated and treated and he stood for drinks in return. Young women who were pretty, and some who merely had pretty intentions, were being very fond of the men with plentiful percentages. Five and ten dollar bills were laid down for two-bit drinks, and the ladies were allowed to keep the change. What kind of a fisherman was that who grabbed up change?

Stumpy was in there up against the bar with a girl with a moderately good-looking face and a shape like a partridge. He was treating and she was pocketing change. When Jim sat down at a table, Stumpy saw him and came over.

"My girl has got a friend who wants to meet you."

"Well, I'm not going to run from her. Might even drop a flag on it if it suits."

Stumpy, with the two girls, joined Jim at the table and he promptly stood treats. He played the game according to the rules up to a certain point, but he was gambling with his stuff out the window. Jim fancied pretty women, the kind that gave him a tussle to get. This one was not ugly, just usual-looking, and was there to pick up change. But the girl didn't have to know what he was thinking, and she didn't.

"Who eats your white chicken?" Jim asked her. The girl bridled and looked flattered and took hope.

228

"Nobody, Captain Meserve. Haven't found nobody that I cares for."

"Then maybe there's a chance for me." His change came, and he put it in his pocket. The girl looked pained.

"Oh, you just ought to see the pretty new bed-spread that I bought yesterday. It's a dream!"

"I bet it is, too. Tell me how it looks." The girl thought that he was very dumb. She cuddled closer and began to try to put that thing on him. Jim petted and patted and looked impressed. "Go on and describe it to me. I'll bet it's got pretty flowers on it."

"Tell you what. You come on to my room and I'll let you see it."

"I'd just love to. But look at Stumpy over at the bar getting into a spending-duel with the Third Man from the *Savannah*. Let's watch him."

"Aw, yeah?" Stumpy was retorting. "We brought in plenty on the *Angeline*. I know that I can beat you spending."

"Aw, is that so? Well, make me know it. I don't believe nothing until I see it. I don't believe that the old sow had pigs. I don't even believe that lard is greasy."

Both called up their lady friends, bought rounds and let the girls pick up the change. They kept on until both of them were stony.

"Still I aim to beat you," Stumpy said. "I got my owner right here with me. Brought him along because I suspicioned some piker like you was going to get up in my face. Hell, it's plenty more shrimp out there in the ocean, and we sure know how to find 'em. Lemme have ten dollars, Boss, until the next trip."

Jim didn't grab at his pocket at all.

"Look, Stumpy, it ain't that I'm scared that you won't pay me back. But why do away with ten dollars you haven't even made yet? I paid you nearly a hundred dollars about six o'clock this evening."

"That's right, but it's all gone now."

"How about knocking off, and beginning to put something away for a rainy day?"

"Because that ain't no sensible way for a fisherman to do, Boss. I might get washed overboard crossing the bar the very next trip. A shark may get me before the next week is over. What do I need to put away money for somebody else to spend? I knowed a fisherman once who cut a caper like that and it brought him all kinds of bad luck. I knowed him mighty well. He was a good friend of mine."

Stumpy, high as a Georgia pine, made a gesture with his arm to call witnesses to his tale.

"Practically everybody in here knows who George Kemp was."

There was almost unanimous agreement. Those who did not know him personally, knew about him. One of those good fishermen who had fallen from grace. Good-hearted as he could be. A good boy, but a poor boy. Jim just had to hear George's pitiful story as a warning if nothing more.

George had been a regular fisherman, then all of a sudden something got the matter with him and he started to saving money. Stay out six, seven, ten days and never felt right unless he sunk his boat. Made a heap of money for his owner, a Portuguese factory outfit, and money for himself. Saved it all up and finally bought himself a boat of his own. Then he got to making himself some big money, but the poor fool didn't learn no better. Kept right on dodging good likker and hiding away from loving women and saving up money for hard times.

"So look what happened to the back-slider. A fly gal out to do herself some good gigged poor George on down to the courthouse and married him. And neither did she lose any time letting George know just what she married him for. I been told that love ain't nothing but the easy-going heart disease, but that she-eel made it quick. Had George working so hard till he soon come down with heart trouble. Doctor give him up for dead.

"You know, My Captain, lying is lying and joking is joking, but to stick a crooked stick like that up a straight man's behind

230

is really too provoking. Knowing that he wouldn't be here long, George got to thinking. He admired to leave that eel just like he found her, which was down and out. So he calls all of us who was his friends to his house, gives away every cent he had, drinks up all the likker that he can hold, makes the three leaving-the-fishing-ground signs, and lays down on his bed and dies."

Jim doubted the story mightily, but practically every man there swore it was so. It was added that George found that he had two thin dimes on the back of his dresser, so he tossed them in his mouth and swallowed them with a drink of water. George had won the big pot after all. You just can't beat a fisherman.

"And what lesson do we learn from that?" Stumpy parodied a Sunday school teacher to the amusement of the crowd. "What do the Bible teach and tell a fisherman to do?"

"Spend it just like you make it!" came back in a roar from the crowd. "Don't leave a thing on the hill when you go to sea! Fatten no frogs for snakes!"

"Kee-reck!" Stumpy cried out, and looked at Jim in triumph. Jim laughed, reached in his pocket and handed Stumpy the ten.

Stumpy, who had been given his name for being tall, yelled for drinkers to treat, and to cheer him in his victory over his opponent. The ten-spot vanished in a blow.

Then in honor of the triumph of his crew-man, and of his new life, Jim stood the next round of drinks. For some time Jim had been yearning to feel his own deck under him, and that was his good-bye gift. Leaving Stumpy still "specifying," Jim drove back across the bridge to the shrimping docks and stood for a long time watching the life of the river, whose surface looked oily under the light of a cloudy moon. There was the fleet of boats tied up, two and three abreast; the shrimp factories, the swift life and death circle in the water traced out by phosphorescent streaks.

If he just didn't have to ever go back and be bothered with

231

the packing-house! Kenny had two more years in college, and that seemed like an eternity to Jim now. Just thinking about the long wait got Jim so impatient that the spirit of profanity descended upon him. Leaning on the starboard rail Jim spoke in tongues and double-cussed all the way.

CHAPTER 21

Time came when Arvay had a new addition to her house. It was a spacy and pretty sleeping-porch added onto the south side of the home. What had once been the [side] window of the living-room was now a pair of glass doors opening out onto the new porch.

Arvay was stunned by the newness of the idea, but she made no objections. She had seen that kind of porches attached to houses of people, but of a class of folks whom she thought of as too high-toned for her to compare with. For the used-to-be Arvay Henson, that kind of a thing was a mighty high kick for a low cow.

So Arvay was much relieved when Angie took charge of the empty new porch, forbidding any of the old porch chairs to be moved in. No, Angie declared, there had to be brand new things, and things meant especially for a porch like that. Things built for coolness, and bright and reclining-like. Angie selected wicker furniture with cretonne cushions and covers, a chaise longue for that corner to the right of the door. A pair of daybeds with good mattresses and bright covers and pillows fitted into spaces against the house wall for lounging by day and for sleeping on hot nights, with shaded lamps handy to read by. When Angie got through Arvay thought that the porch was prettier than anything that she had ever seen in her

life. It put her in mind of an inside flower garden.

Arvay tried not to let on, but to save her soul she could not take up on that porch at first. She felt highly privileged to have it under her care, but she could not feel that she had any right to be there. She swept and dusted and petted and patted pillows and tended to the plants that Angie had spotted around in there for looks to make up for her uncomfortable feeling. A kind of outside show of ownership. She never sat down unless Jim insisted, and then she did not lean back in the deep, comfortable chairs. Arvay made excuses about the damp night air to keep from mussing up those day-beds until Jim declared that he would be damned if he was going to foot bills for a sleeping porch and good beds and then stick in the same old room on warm nights. He was going to sleep out there. Arvay followed Jim meekly and found that she managed to sleep all right. It got easier every time that she tried it. After a week of that, Arvay took her mending out there one afternoon, and after a few minutes of trial, sat all the way back in a chair. She had not been settled like that very long before Hatton's mother called her on the phone, and in well-covered pride, Arvay invited her over to sit awhile and share a pitcher of cold lemonade with her.

Mrs. Howland made much over the porch, and over the lemonade. They chatted pleasantly, and afterwards Arvay decided that she had never passed a more agreeable afternoon. The porch belonged to her after that. She had noted a difference in Mrs. Howland's manner with her, she thought. She took to inviting other women friends to drop in and they all expressed envy of her porch. It built Arvay up and made her feel more inside of things. It was a kind of throne room, and out there, Arvay felt that she could measure arms and cope. Just looking around her gave her courage. Out there, Arvay had the courage to visit the graveyard of years and dig up dates and examine them cheerfully. It was a long, long way from the turpentine woods to her sleeping-porch.

Arvay's unsureness went away when she stepped out there. She had bright ideas and thought up things to say in answer

234

to people. Arvay joked and laughed with Jim and they had a great deal of fun these days.

Every evening, as soon as supper was over, Arvay led the way out there to lounge around and wait for an event of her day. For the last year or so, she had been a little too bound for her usual good health. So her doctor had given her a routine to overcome this. He was a young new doctor that Angie had thrust upon her. He was against laxatives and the castor oil mixed with turpentine that Arvay had been raised to. Seven in the morning and eight at night had come to be Arvay's hours for her vigil. That gave her a good two hours after supper on the porch to enjoy the place with Jim.

Arvay had no fault to find with her routine. It was funny, she reflected more than once, how things could change around. Once upon a time, she would not have given what she was doing a second thought. But now she had to restrain the impulse to make a victorious announcement and put herself in the way to receive compliments.

This particular evening was soon before Easter, but otherwise it was a good deal like others that Arvay already knew about. The differences were that Arvay heard the first whip-wills-widow of the year from somewhere outside in the dark. Then a bull alligator bellowed in rumbling thunder from a lake off towards the south. Jim lowered his newspaper and gloated.

"Spring is here!" He laid the paper down and lit his pipe. "When you hear a bull gator bellow and a whip-poor-will call, spring is here for sure. The weather man can't fool a gator."

"Sure sign," Arvay agreed. "Umm Jim! Just smell that night-blooming jessamine that Hatton and Kenny set out for me last Fall! Ain't it sweet?"

"Mighty, mighty nice. Mighty nice." Jim picked up his paper again.

"You mentioning the gators and spring and all puts me in the mind that Kenny and his foolishness will come loping up here before long."

"No more'n three more months now," Jim conceded cheerfully.

"With the house rammed and crammed with his cronies a'whooping and a'hollering and banging on that pianner and everything else they can get their hands on and eating up everything just as fast as I can get it cooked for 'em," Arvay complained happily. "Wonder how they's all making out over in New Orleans right now."

"That's right." Jim said. "You remember that Kenny mentioned in that last letter that they—the Gator band, I mean—was going to New Orleans to play at some kind of music-festival at that college up there. . . ."

"Tulane University," Arvay supplied with a touch of pride. "I declare to my rest, I never knowed that there was so many of these colleges in the world until Kenny got mixed up in one. Every time I turn around he's teaching me another name."

Jim yanked the hunting-case gold watch from his fob and snapped it open.

"That final concert was from three to six today, wasn't it? Yeah, they're all through playing now and on the way to Gainesville, I reckon by now. Though the professor might let 'em stay over tonight and head back for Gainesville tomorrow sometime."

"What time is it now, Jim, near about eight?"

"Two minutes of."

"Then I reckon I better go." Arvay put her hands on the arms of the chair and got up. "I don't know what kind of a caper it is that Kenny cuts that makes folks act so crazy over his playing, but it sure is something or other."

Arvay moved leisurely towards the door into the house. As she went, the perfume from the flowers surged around her. The moon was rising, and some mocking-birds in a tangerine tree began to trill sleepily. The whip-poor-will was still sending out his lonesome call. Arvay paused in the door and looked back on the softly lighted porch. It was to her the most beautiful and perfect scene in all the world. She was as near

to complete happiness as she had ever been in her life. The porch told her that she belonged. Slowly she turned away and went on to the bath.

Just then the telephone in the hall began to yell in long pulls. She heard Jim's solid tread down the hall, and the instrument rattle.

"Hello! Hello! Yeah, that's right . . . Yes, it is . . . Speaking."

Sounds like somebody sort of strange, Arvay decided.

"Long distance? . . . Did you say New Orleans?"

"Jim!" Arvay yelled through the closed door. "Didn't they say New Orleans? Do, My Maker! What's done happened to Kenny?"

"Just a minute, honey," Jim said quickly and impatiently through the door. "Oh, hello! Hello, Kenny boy! . . . Sure, I know your voice. Glad to listen to it any old time. What you got to say?"

Arvay leaned back, but she did not relax. Kenny couldn't be too bad off if he was able to come to the phone.

"Oh, he did, eh? That's just fine. How did you make out? . . . Gee, I'm proud to hear that. . . . You don't say! Oh, I knew all along that you could do it. Sure. . . . Oh, you did? . . . Well, if you've done put your name down on it, I don't see that's anything more to be said. Naturally, me and your mother will feel sort of disappointed for you not to go ahead and finish school. Wait just a second, and I'll get her to the phone. . . ."

There was really no need for Jim to call Arvay. She had heard him through the door and was both eager and anxious to get to the phone, but found herself too seriously involved.

"Tell him to hold on for just a minute, Jim, then I'll be there."

Arvay heard Jim give her message over the wire.

"You got to catch the New York train in three minutes? Too bad. I'll tell her what you say. She says to give you her love. Wire us the minute you get there, and back it right up with a letter so that we'll know where to reach you. If you

237

need anything, don't feel bashful about letting me know. I'm with you, son. Good-bye."

Arvay tried desperately to make it, but the click of the receiver found her scrambling to a standing position with her clothes up around her waist. Jim waited in silence until she came out of the door and told her.

A famous leader of a famous New York band had been playing an engagement at a celebrated New Orleans hotel. The engagement ended the very day that the Gator band had arrived at Tulane, but the bandleader had sent his men on ahead, and waited to scout the Gator band. He was there to hear Kenny play for three sessions. He liked Kenny's piece a lot. It was a rhumba and it went over swell. As soon as the concert was over that evening, he had managed to get Kenny to one side and make him an offer. Fifty dollars a week to start with, and double that in ninety days if Kenny took with the public in New York. So much for the exclusive use of Kenny's piece besides, and when it was published, Kenny would get something from that too. Kenny thought that it was a great opportunity, and he had grabbed it. The band was going into a famous nightclub in New York in two weeks.

A coldness as from outer space crept over Arvay as she listened. It stiffened her tongue and choked her throat so that it was a long time before she could speak.

"And you stood there and let him go?" Arvay managed to say at last.

"What else could I do, honey? He had done passed his word and signed the contract. He couldn't go back on that. And then again as he said, he never has had any notion of doing nothing else but playing music for a living. It don't matter too much whether he finishes school or not. He figured on two or three years after he finished school to get to the very place that he got today. Looking at it from that standpoint, he's five or six years ahead of schedule. And if he don't make out up there in New York, he can come on back to school, can't he? I don't see no reason for you to feel so bad."

"I reckon you don't, Jim. I feel and believe that you'se

telling the truth from your very heart. But just the same, I hope that you and nobody else don't never feel like I do right now. You never is known the feeling I got right now. All the little family I done got together is gone and done left me in one way or another."

Arvay sobbed and cried and leaned her head against the wall and shook. Jim reached out and warm-armed her up tight against his chest.

"You're ever so wrong, honey baby." Jim petted and tried to soothe. "You still got your children as much as ever. And even if you didn't, you still got me, ain't you?"

Arvay freed herself and pushed past Jim and towards the front of the house. Through the width of the living-room she could see the enchantment of the porch, but she saw it as from afar and in a vision. Like John on the island of Patmos. A golden land of refuge where all would be peace, but from which she was now expelled. Her power seemed broken. She stood looking, and new tears crept out from her eyes. Tears without sound that nevertheless flowed freely.

"Just like I always thought and feared . . . they all done turned from me and gone. . . . Why couldn't I have been setting quiet-like on my porch when my baby come to me and told me that he aimed to go off and leave me? So then I could of handled my feelings."

Arvay turned into her old bedroom and fell across the bed on her face. She was conscious that she had left Jim standing very still and looking after her with a heavy expression on his face. Behind the closed door of the room, she went forth to face the demon of waste and desert places and take him for her company.

CHAPTER 22

Arvay had no idea how long it had been since she had left Jim standing open-armed in the hall. Lying on her face, she heard him enter the room and switch on the light. Out of the cracks of her eyes she saw him quietly changing into his night clothes. She began to charge him with not caring how she felt. He had loosed Kenny to leave home regardless of her feelings. Now, with her crying her heart out, he was going on out on the porch to sleep and leaving her to her misery and lonesomeness. But no, Jim came to the side of the bed and pulled her to a sitting position. Arvay did not help him, but she did nothing to resist him either. She let herself be hauled to her feet and hugged.

Without a sound Jim began to unloose her clothes and to handle her like she was a little child. Arvay was warmed and began to help out. In her nightgown, she stood looking diffidently at Jim for a while, then made the first step.

"Wouldn't you ruther us to go out on the porch to sleep, Jim? It feels kind of hot inside here to me. Come on."

Timidly, she took Jim's hand and led the way. Jim gripped her hand hard and followed her with lighter movements than he had used in the bedroom. Arvay believed in her porch again. Jim was still willing to be with her there. No sooner did

she step through the French doors than she felt strong again, and went on to bed.

In the gentle darkness with the spring perfume drifting through, and the voices of nightbirds charming her ears, Jim near at hand on the other bed, and the comfort of her body, Arvay could hunt and find her way back to light and warmth.

Of course Kenny was a good and loving son to her. He would not have gone off sudden like that unless he had a reason. Kenny meant to be loving and kind. What was his reason then? Arvay searched and searched for a sacrifice and could find none unless she put it on the Corregios. She could not risk accusing them to Jim, but she could use and handle them as she pleased if she didn't talk out loud. She was free to controverse all she wanted to in her mind. Kenny had jumped out and gone up North to be his own man.

That Felicia, no doubt put up to it and prompted by her mother, who would naturally want her to luck up on a good, nice white boy to marry to. And naturally she would go her length to tie up somebody like Kenny. Sure she would. Her Mama would make her see that she couldn't get to Kenny and handle him like she wanted to as long as he was under the influence of his Mama. So the first thing she had to do was to talk him into leaving school and going away off somewhere on his own. Handle his own money and do as he pleased. Then they could turn and twist his poor young mind any which a'way they pleased, which was to skull-drag him into marrying Felicia and letting her handle all his money. Oh, it was as plain as day!

Lying there in the dark on her day-bed, Arvay resolved to deal with Felicia and her mother and handle them anyway she pleased. In order to hate deeply and completely, one must have an image stripped of everything but that which lends itself to scorn and hate. Arvay had thought of herself since childhood as a soldier in the army of her Lord. A soldier of the Cross, and a follower of the Meek and Lowly Lamb, never once, in all these years, and hearing the expression as often as

241

she had, [noticing] the contradiction in the term. Who was the enemy to be assaulted without mercy and exterminated? Who else but the folks who did not accept the Prince of Peace and Him Crucified?

Felicia and her mother were nothing but heathen idolaters, and not to be treated white. Arvay proceeded to set up images of them among the African savages and heathen Chinee. They were not fellow-humans, nothing of the kind. She stripped them bald-naked and mocked at them. They were as stark-naked as a jay-bird in whistling time, and Christianity was the gospel of sufficient clothes.

She ought to know. She had heard the accounts of the foreign missionaries often and again, and she was one who had paid strict attention. She had sympathized with these martyrs for God who suffered themselves to be sent far, far away from a well-cladded Christian country to those heathen countries, where, for not knowing Christ in the pardon of their sins, folks went brazenly around with all kinds of things right out in the open.

The poor suffering missionaries had not come right out with certain words, but they made it plain enough for anybody to understand that their sad duty was mostly in looking conditions over, praying over conditions, and then telling the benighted heathens for Christ's sake, to cover conditions up. Every letter that the missionary society got from the missionaries had a plea in it for more covers.

And right here, in these United States, a Bible land, and a praying and gospel country, were these two naked huzzy-heathens trying to pass themselves off as folks, white folks at that, and doing their level best to tole her son off from her. They were no different from that awful Herodias and her daughter Salome who had got John the Baptist killed for nothing. They had been put in the Bible to warn folks against just such sluts as Felicia and her Mama. Babylonian females with no God in their hearts, and no weapon against evil in their hands. Just out to bring ruin and destruction on widows and orphan-children. That back-sliding Corregio woman was

no doubt right at this minute getting ready to drag her low-down self and her trashy daughter up to New York running after Kenny. Maybe the poor boy went off like that to get away from them. No telling. And go up there, like that Salome, dressed in nothing but veils to tempt the poor boy with her body. Arvay shuddered at the picture, for her interpretation of a veil was a skimpy piece of utterly transparent stuff pinned on a hat. And she wouldn't put it past Felicia to go dancing and prancing before Kenny and even chunk the scrap of veil away. A'jumping and a'wringing and a'twisting herself with her naked legs flinging every which a'way. You could be bound that they wouldn't be crossed at all. And no responsible person around to lay a halting-hand upon her. And his Mama not on hand to lead the poor boy away.

Arvay shook and shuddered at her home-made picture. It was horrifying to her, but strangely brought her comfort. She could reconcile. Her baby hadn't gone off from her of his own will and was distant from her only in the flesh. Furthermore, the wickedness of those Corregio females was too awful. God didn't like ugly, and neither did God eat okra. You could get too slick for God to stomach you. Therefore, He was bound to take her part against wicked evil. He just wouldn't put up with a thing like that. Felicia and her Maw would catch it and catch it good! No doubt about it. Kenny would soon need his mother's care again and be back home. She could see him right now lounging around on her porch with his long-legged, good-looking and joking self.

Sure of her victory, Arvay felt better right away. She did not even hate the Corregios anymore. Foreseeing their sorrowful fate, she was inclined to feel sorry for them. They didn't count as her enemies anymore. To complete the banishment, Arvay reached up and turned on the light over her head and took a pleased look all around the porch. Hearing Jim stir a little from the influence of the light, Arvay cut it off quickly and went peacefully off to sleep.

CHAPTER 23

Arvay woke up that morning in August feeling sluggish and irritated. She felt irritated because she felt empty-handed and sluggish. She had been feeling that way off and on ever since Kenny had gone up North. Arvay had no arrangements for spending idle time. She did not read things, and was not even given to fancy-work. Her life had been patterned to serve and now there was nobody for her to wait on and do for. Her impulses were balked and it made her sluggish in her mind. That called to her mind that she was not as young as she used to be.

Jim was up and out of doors a good half hour ahead of her. Even before she put her feet to the rag rug, she could hear Jim and Jeff Kelsey, Joe's third son, laughing boisterously out around the back door and it irritated her. The contrast to her own feelings this morning was painful.

What in the world did they find to skin back their gums and sniggle over to all of that, Arvay wondered, as she got into her underclothes. Giggle! Sniggle! Skin back their gums! Cackle! Must of found a mare's nest and couldn't count the eggs.

As she flung on her housedress, she made up her mind to go out in the kitchen, and by the way she acted, put a damper on all that. She hurried herself to get to it. Then she caught

244

herself and walked slow. It would be better if she let on that they themselves had got her out of humor by the foolishness they were carrying on. She would go about her business of fixing breakfast just as usual, then wait till somebody said or did something that she could take exception to, and turn their dampers down for 'em good and proper.

Jim and Jeff were outside the kitchen door under the tree just as she had thought. Instead of going to the door and passing the time of day as she ordinarily would have, she made a great clatter of putting fresh water in the kettle, lighting the stove under it, and measuring out the cup of grits to cook.

"Mawning, Miss Arvay," Jeff ventured with a hesitant smile as Arvay came near the door. "You looking fine as silk."

Arvay more grunted than spoke, and Jim looked up at her in surprise. "What's the matter, honey?" Jim asked with some concern. "Don't look like you're feeling so good this morning."

"How can I when I get woke up with a whole lot of whooping and hollering around my back door?"

"Oh, that's too bad, Little-Bits. It wasn't intended. Fact of the matter, I had the idea that you was woke before I was, and was just laying there sort of resting. Jeff ain't been here but a very few minutes. But I'm ever so sorry if we woke you up."

Jeff said nothing. He looked uneasy, and fumbled around with the pruning tools that had been brought from the shed. He began to bunch them together to go away from the door. The laughter that had lit up his face faded from the hair-line and died out finally under his chin.

"Oh, then I'm a liar!" Arvay snapped. "I reckon that I ought to know whether I was asleep or not. Tell me!"

Jeff grabbed up the tools and went on away from there. As he neared the line of the grove, he cast a look over his chunky shoulders at Jim that said, "I ain't deserting you, Boss, but you know how things is. Around that back door ain't no place for me right at present."

"Hold on there, a minute, Jeff!" Jim called after him, and

245

Jeff halted at the line of the grove and waited. "I ain't through telling you what I want done."

Jim joined the husky young Negro and after a moment of embarrassment on both sides, they began to laugh.

"Look like Ole Miss got up on the wrong side of the bed this mawning. Whew! I'm due to be scarce around your house today."

"Her feathers seem to be ruffled about something, though I ain't got the least idea what it is. But she'll be all right in a minute or so."

"Good mawning, Boss!" It came in a well-known baritone voice from behind, and Jim turned to see Joe inside the side gate and approaching in a good-humored roll.

"Come on over here, you trashy rascal, you! I got you fair and square this time, and I aim to put you to work. Haul it on over here."

The men disappeared down in the grove somewhere. Arvay placed the bucket of fresh eggs handy, but before she broke any in the skillet of hot ham grease, she went to the door and called. She had got in her lick and she felt better already. She was fixing enough so that Joe and Jeff could have something too.

In a few minutes, Jim and Joe appeared at the door. Jim came straight on in, scraping his feet on the steps before he stepped into the kitchen. He pulled her ear playfully as he passed her and fled into the bathroom from her pretended lunge at him.

"Look out for yourself, Joe, the best way you can!" He yelled back in mock alarm over his shoulder. "It's a bear-cat aloose in there."

He returned in a few minutes with his hands washed and his hair combed a little, and took his place at the table. Arvay saw Jim and Joe exchange winks, then Joe's hat came scaling into the kitchen and landed under the table.

"If it don't get throwed back at me, I know that it's safe to hang around."

"Aw, come on in here and set down, Joe, and quit your

246

foolishness!" Arvay scolded. "What become of Jeff? Don't he want nothing to eat today?"

"I'll go let him know," Joe said smilingly. "Jeff sure would feel hurted if I didn't. He ever favors his guts."

Jeff and Joe came back together after a while, and settled out under the camphor tree. Jim felt devilish and began to tease Joe again about working in the grove that day.

" 'Course I don't expect to get a lick of work out of you." Jim kept it up. "You ain't hit a lick of work since we closed down the still, and you don't want to see no work, nor even hear-smell of none."

"Well, you know, Mister Jim, I'm a business man, and keeps my arrangements in my hand."

"Naw!" Jim feigned great surprise and interest for the sake of the play. He glimpsed a faint grin running around the edges of Joe's aging face and was prepared to be amused. "Back your crap."

"Well, you recollect when we first shut down the still, always being more of a business man than anything else, I opened me up a grocery store to sell things."

"Before you start that lie, Joe," Arvay broke in, "you and Jeff come on inside and get yourselves a plate of breakfast. It'll be kind of cool there in the doorway."

The plates piled high with soft grits, fried ham and eggs, and the coffee pot on the floor by the door, and nothing more to eat in sight, Joe protested to Arvay that that was enough. Please don't offer them anything more. Jeff took his to the bench outside under the tree, but Joe sat down in the door. Taking whole fried eggs at a bite, and ramming them with chunks of grits, Joe smiled through his charge, set down his plate and went back to his narrative.

"Yeah, I remember when you opened that store," Jim pushed the tale along. "But if I remember correctly, it didn't last you very long."

"That sure is the evermore truth, you'se telling, Mist' Jim. What with folks trading in them big stores downtown, and me crediting so many that did buy from me, and my big family

247

eating out of the store, I used that place up in no time at all."

"What you didn't swap off for coon-dick," Jeff flung in from the outside. "Case of canned tomatoes or corn for a gallon of moonshine. It couldn't last long that a'way, Paw."

"Hush up! You got that talk from your Maw. That's what Dessie claims, but I know better. I never done nothing like that at all . . . not more'n eight or nine times."

"So what finally become of your grocery-store, Joe?" Jim asked with exaggerated interest.

"Oh, well, when things got pretty low on the shelves, and with Dessie 'buking and dogging me all the time, when a Crack—I mean a white man from back in the woods over towards Davenport come along one day and offered to trade me a half a dozen shoats able to crack corn for what I had in the store. I swapped him, lock stock and barrel and he had the store and I had me some hogs. So then I was out of the store business and into the hog business, and figgered that I had done beat him outa some fine hogs, and could make me a independent living out of raising hogs."

"And that's a mighty good business, Joe, if it's handled right. You make much on your meat?"

"Funny thing, though, Mister Jim. Them hogs must of been crossed with hound-dog or gator once. Man, they could eat! I mean they could do a mean piece of biting, but look like they never put on no meat. 'Course, I found out that hog-shorts was kind of high, and I couldn't see my way to laying in too much at a time with the money that I was handling along in then. Them crossed-up hogs didn't gain none, but they lost a'plenty. They got to walking kind of lap-legged and squealing so till I couldn't get my night rest. First, they reared up and squealed. Then they stood still and squealed, then they took to laying down and squealing right on. Got me sick and tired of hearing them take on like that. So when a widow-'oman cross the railroad tracks but sort of on the outskirts, come over one day and offered to swap me a dozen fat chickens for a half a dozen poor hogs, I took her right up on it. Look like she didn't mind paying out money to pour shorts into them hound

248

dogs on hog frames. So she had the hogs and I had the chickens. I was out of the hog business and right into the chicken business."

Jim threw back his head and laughed and laughed. Not a grin out of Joe though. He was acting out a drama of misfortune, and he had masked his face to fit the part. Until the curtain fell he was a modern Job, and suffering many things.

"So how did you make out with your chickens, Joe?" Jim asked it very seriously.

"Well, suh, look I must be born for bad luck. Here I was figgering on taking them twelve chickens and running 'em into a big chicken business. When them hens laid, I would set them eggs and hatch off a whole heap more and then from them hatch off still some more and really be in the business in a great big way. But first off, it seems like them devilish chickens was in a moult and wouldn't be laying no eggs for quite some time. Then somebody looked 'em over and told me that them white narrow-made chickens didn't have no habit of setting. All they did was lay eggs; that is, if they ever got around to doing some of it. They didn't had no feathers on 'em right then to amount to nothing, and they wasn't laying a frazzling egg, but they sure had they appetites along with 'em. By the time I found out how I had been beat out of my hogs, them greedy-gut devils had done et up all the feed I had on hand. They was eating up more feed than I could afford with the money I was handling just then."

Joe remembered to feed himself heartily for a minute or so, then went on. Arvay was surprised how entertained she had become in a tale that she knew was not more than half so.

"So what become of those poor chickens?" she asked eagerly.

"Them chickens et like mules, Miss Arvay, but I say this for 'em, they had mighty good manners and nice behavior. Smart and sensible in they heads, too. You could make 'em understand. Without me even mentioning it to 'em, they seen that I was doing the very best I could to help 'em out. When I come across a nice green patch of grass out in the country like, I

249

always went right home and took 'em out there and give 'em a chance to crap a nice mess of fresh grass. They could catch all the grasshoppers and worms around like some meat to go along with they greens. They seen that I was willing to divide with 'em what I had. It got so, that all I had to do was to go out in the yard, and they would lay down and cross they legs, making it convenient for me to tie 'em up and carry 'em to where I had done found something for 'em.''

"Hush, Joe, hush!" Arvay commanded in all good nature. "I done heard a gracious plenty about you and your business head. You ain't going to hit a lick of work your ownself, so shut up and let Jeff do something.''

Joe laughed and cleaned his plate, and poured himself another cup of coffee.

"No'm, I don't speck I will do much long in these dog days. I wouldn't exactly say that me and work had words, but we'se sort of at variance, you might say. Then too, I'm knocking along in years. I'm near abouts old enough for your daddy, Miss Arvay. Anyhow, I done raised Kenny and trained him to make a good living. I done done my share.''

Arvay felt the same painful twist that she had felt years ago about Joe and Kenny. Then she took hold of herself. It wasn't right to feel jealous that way. She saw now why she had been so set against the music. It gave Joe a hold over her boy that made her feel excluded.

"Between me and you, Miss Arvie, we sure pulled that boy through, didn't us?''

Arvay shook her head slowly. "You mean you did, Joe. You learnt Kenny all that your ownself. I don't know the first pick on a box.''

"That's where you'se ever so wrong, Miss Arvay. 'Tain't everybody that can learn music like that. Kenny took to it because he brought that talent in the world with him. He got that part from you. He just naturally worried and pestered me to death to teach him. I knowed that he couldn't help hisself. What's bred in the bones'll be bound to come out in the flesh. Yeah, that boy come here full of music from you.''

250

"I always thought about Kenny as taking after Jim," Arvay said as if she were talking to herself. Joe looked at Jim and gave a great guffaw.

"Mister Jim? Why, Mister Jim couldn't even tote a tune if you put it in a basket for him. Looks, yeah, but that music part he takes right after you."

Arvay thought a minute, then her face lightened. "You could be right at that, Joe. I ever loved to hear and to play music. I took to it just like Kenny did when I was a chap of a child. And just like you say, Larraine never could learn none. Only different from Kenny, I had small chance to learn much of it. I ever wanted to learn more though. I know that I could of learnt a lot more than I know if I had of had a chance." Arvay sat quietly for a minute and her face lighted timidly. "Yeah, I guess, I hope, that Kenny did take his music after me."

"Couldn't be nobody else, Miss Arvay," Joe said positively. "And it sure is a noble gift to have. I learnt what I know by the hardest, but you and Kenny is just gifted to that. It's a shame and a pity that you didn't have more chance."

"I thank you, Joe," and Arvay smiled diffidently. "And I want you to know that I'm ever so proud about the way Kenny is making out. I'm glad too that he appreciates you and what you have done for him enough to send for you to be with him up North there. Kenny would look for you to come looking nice and clean, and I would want you to go that way too, Joe. How you fixed for something to put on up North? Jim's got a shirt or two that he could spare, and I reckon we could see to it that you get a new suit of clothes."

"Thank you so much, Miss Arvie. You'se mighty kind and thoughtable like. I is sort of low on changing-clothes, since you make mention of it."

Jim snatched out his watch and brought the meeting to a close.

"Quarter to eight. You all through eating, Jeff?"

"Them few little mouthfuls *been* gone too long to talk about," Jeff laughed. "I'm ready for the question. Let's go!"

"You come on too, Joe. Come on and keep us company some. You ain't no good for nothing else."

"You gwan and leave Joe here with me. I got a few things to give him, and I got to hunt 'em up."

Arvay wasted no time. She was concerned about her son. Joe was to see to it that Kenny behaved. As she charged Joe to keep a stiff hand over Kenny, she moved around briskly searching through Jim's things and coming back with an accumulation of shirts, ties and underwear for Joe.

"You better take these, Joe. Jim's got more than he can wear out anyhow. And Joe, you being one in the family and knowing how I tried to raise my chillun, and how I want 'em to behave, maybe it would be better for Kenny if you was to stay up there with him until he takes the notion to come on home. See to it that he behaves himself and walks in the right way just like I would do, hear Joe?"

"Yes Ma'am. I'll sure hold his feet to the fire and keep him straight. Without a doubt, Miss Arvay. You know that Kenny ever would mind me. It'll be just like you was there."

Arvay made a slight dissenting movement of her body. It was not that she doubted Joe, but nobody and nothing could be the same as a mother's care.

"He's still a baby, Joe, and more particular, my baby-child. He ain't no hard grown man to be off by hisself like that. Don't care what he say, you go with him and stand by him, Joe, and prop him up on every leaning side. Don't allow him to forget his principles and his raising. And if he should mention anything about returning back home, you encourage him to it, Joe, will you please?"

"Sure will, Miss Arvay. It wouldn't do for him to be up there among strangers and out of work. Don't you worry none. We Meserves'll look after one another."

Arvay was comforted to think that "Uncle Joe" would be there with Kenny. She knew so well how much Joe loved her boy. Still and all, it was not the same as Kenny being where she could do for him herself. However comfortably Kenny might be making out up there, her arms were still empty and

her hands had nothing to do. With Earl dead, Angeline married off and needing nothing, Kenny up there doing so well and not calling on her for a thing, Jim off from home so much with his boats, there was little for her serving hands to do. She felt like a dammed-up creek. Green scum was covering her over.

Thinking like that, the lift that Joe had given her was all but dissipated even before he left the house. She felt unnecessary. To take up the slack, Arvay decided to make a big potato pone for Jim. He ever loved it, and it took up a lot of time and called for work. She got out a big baking-pan, washed off a mound of sweet potatoes and started to grate them. The food-chopper would have done it easier and in a third of the time, but she wanted the feeling of doing. She peeled and grated with great care, fighting against that sluggish and lonesome feeling.

That was what Arvay was doing when she heard Jim yelling for her around three o'clock.

"Arvay! Arvay! Run here quick! I got something to show you! Run!"

Arvay did not run, but she walked very fast. From Jim's voice, it sounded like some kind of alarm.

Following the direction of his voice, Arvay hurried south through the grove. About midway, she saw Jim standing alone with his back almost to her. He was fooling with something that she couldn't make out until she was in twenty or thirty feet of him. Then she saw and stopped dead in her tracks.

Jim had the biggest diamond-back by the neck that she had ever seen, and the snake was trying to get aloose. Jim was holding it out at arms' length from him and laughing. The snake was trying to coil itself around his arm. It was eight feet long if it was an inch, and being a rattler, thick according. Arvay had a deep-seated fear and dislike of snakes. Any kind of a snake. She shrank from worms even because they reminded her of snakes. She avoided touching the shed skin of a snake, even with her shoes.

"A snake! Jim! My God a'mighty, Jim! What you doing with that thing up in your hands?" Arvay screamed this out in

jerks. Her heart was thumping so that she felt stifled.

Jim looked at her fright and chuckled. "Going to put him in a box and . . ." Jim had to halt to struggle with the reptile to keep it from coiling about his arm. "Jeff . . . gone to the barn . . . to get me a box."

Successful for the moment, Jim turned a bragging, triumphant face on Arvay. She could tell that he was expecting her to admire what he was doing. Just like a little boy turning cartwheels in front of the house where his girl lived. But this was nothing to be fooling with. Supposing that thing got aloose. The thought of that possibility frightened Arvay so that she began to grow numb. She could see the lightning-like strike of the big head and feel in her own body the fiery pang from the long, curving fangs. And for a thing like that to happen to Jim. Oh, it was too horrifying! Then from her fear and pity, Arvay grew angry. Why would Jim do a thing like that, frightening her to death for nothing? It was all so unnecessary. If it happened, it would be her instant death. She could not bear to see it. Weak and trembling all over, she closed her eyes in dread.

But she could not refrain from looking, and she opened her eyes a moment later on a truly frightening scene. The writhing snake struck Jim's middle with the lower third of its body. Almost too quick to follow, it wrapped around and anchored. With horror Arvay saw more and more of the thick and powerful body ripple like water and crawl around Jim's waist. Two solid coils of awful beauty around Jim's middle, and Arvay, feeling faint, could see them tightening down.

With her mouth open and dry, Arvay's eyes flew to Jim's face to see what he was doing about it. Jim was no longer laughing. His lips began to slide back from his teeth. Arvay saw why. The tight coil about Jim's waist was terrible, but it was not the worst. The rattler was freeing its head, and Jim was grimly putting every ounce of the strength in his hands and arms to hold onto the neck of that snake. It was unbelievably powerful, and Arvay saw the big flat head being almost imperceptibly but surely withdrawn through Jim's two clutching

fists. The tip of the mouth slid down and disappeared within the upper hand. With a steady rhythm, the body of the snake quivered around Jim's waist as it exerted all its power back-crawling and straining to free its imprisoned head.

Jim's face was a straining, gasping horror now to Arvay. Hair falling over his forehead, big veins standing up in his face and neck, eyes dilated with fear and pain, and sweat pouring down in great drops.

Arvay never knew what happened to her then. She saw the imminent danger to her husband, her great love, the source of all the happiness that she had ever known, the excuse for her existence. And in this terrible danger, she went into a kind of coma standing there. Fear surrounded her about. She saw as through a casing of glass. She heard Jim faintly.

"Ar . . . vay! Help . . . me." It was breathed out on agonizing gasps.

In her consciousness Arvay flew to Jim and slew that snake and held Jim in her arms like a baby. Actually, Arvay never moved. She could neither run to the rescue nor flee away from the sight of what she feared would happen.

Then, after an endless time, Arvay heard the thump of running feet and heard Jeff scream, "My God, Mister Jim!" and Jim's agonized answer: "Jeff! . . . Oh, Jeff!"

Jeff was there and the covered box discarded on the ground. And Jeff, his prominent behind setting far out, had grabbed the snake by the tail. His strong white teeth, bordered by blue gums were snarled back in fear and rage as he threw his strength into pulling and unwinding the coils by stepping rapidly backwards around Jim and destroying the purchase of the reptile. Maybe two or three seconds that seemed like years to Arvay, and Jeff breathing loudly through nose and opened mouth asked, "Got a safe hold on his head now, Mister Jim?"

"Yeah . . . Jeff."

"I'm going to fling him. Get ready to leave go the same time I do."

Jim, with the pressure removed from his body, took a sec-

ond to fill his lungs with air. Then he whispered more steadily, "Ready."

A quick and violent movement of the arms and bodies of both men in concert, and the huge rattler sailed through the air and thumped to the right, a good twenty feet away. Arvay was sure that it would be killed by the fall. A stunned minute, then it went into battle position with a movement so smooth and quick that the eye could scarcely follow. The quivering tail was sending out that ominous sound.

In her relief, Arvay felt to run and fling herself upon Jim and hug and cry in relief and thanksgiving, but Jeff was ahead of her. He looked at Jim, waving on his feet, and flung a brawny arm across Jim's back and steadied him until he could well steady himself. Two or three minutes at the outside while Jim breathed deeply. Arvay found herself, too, in that time and took a step forward to satisfy her mind of the miracle. If she touched Jim, then she would know that he was really alive and saved.

But Jeff gave her a look that halted her where she was. The look forbade her to approach the person of Jim Meserve. It called her unworthy of such an honor and pleasure and privilege by reason of cowardice and treason and trashiness. The look held. Jeff wanted her to know that she had been judged. Then he turned back to hovering and fussing around Jim. Arvay saw that Jim was not even looking at her. In that moment Arvay realized what fear had done to her, and how she looked to those who knew about it.

Neither Jeff nor Jim asked for her aid or assistance in any way. Jim leaned on Jeff, and Jeff never even looked in her direction. He talked, but he did all his talking to Jim.

"I better see you to the house and covered up in the bed. You ought to lay down just as quick as you can, Mister Jim." Jeff hovered and guarded just as if Jim had been an infant child. Just the way Arvay wanted to do. "Lawd have mussy, Boss! It's a wonder you ain't dead. Sure proud I got to you in time."

Jim, supporting himself with one arm about Jeff's stout

shoulder, took a deep breath and patted Jeff feebly. "Don't believe that I could have held out another minute longer, Jeff. You're all that stood between me and Old Stony Lonesome. Never had any idea a snake was all that strong."

"Mighty deceiving thing, Boss. Strong as a mule. Lemme get you to bed in the house so I can come back and kill that snake."

Arvay saw Jim remember to be himself. He saw her standing there forlorn with Jeff spitting on her in his mind, and he went to making Jeff's ears and eyes out to be liars.

"My poor wife, Jeff, ain't it too bad that women folks makes such a poor out at running?"

Arvay felt whipped all over with thorns. Jim had not really told a lie with his mouth, but the way he said it and tried to smile it off to fool Jeff was too pitiful. But Arvay could see that Jeff was not swallowing it down. He was nice and polite with Jim, and stretched his mouth both ways towards his ears in a smileless gesture to let on that he agreed. But his prominent eyeballs with the fat top lids purposely kept away from Arvay. The men kept coming slowly to where she stood and farther away from the snake all the time. About ten feet away from her, Jim straightened himself and grinned the best he could.

"I believe that the old man can make it now, Jeff. You must be just about as wore out as I am. Don't you dare to hit another lick of work today. Don't never forget, Jeff, that I got you folded away in the hip-pocket of my heart. Gwan home and get in the bed and make things tough for your wife."

"Thank you, Boss, but first I got to go back there and kill that old snake."

"Don't bother, Jeff."

"Boss! That damn thing is ever so vi-grous! Dangerous as he can lay in his rusty hide. He come durned near taking your life. He's got to go way from this world."

"Naw, Jeff. Leave him be. It wasn't no fault of his. He didn't try to tackle me. I was the one that tackled him. He acted the perfect gentleman in every way. A gentleman, Jeff, puts up the best fight that he's got in him to defend his life and what

257

belongs to him. He spied noble in the fight. He put out the best he had, and it come mighty nigh being too damned much for me. Look back there! He ain't making the first move to run away. I tip my hat to a fighter like that and leave him be."

"But, Boss, that's a rattlesnake!"

"So I hear, Jeff." Jim laughed lightly as he came up to Arvay. "Let him alone, I tell you! He's a gentleman who never picks a fight, and never is known to run from one that anybody picks with him. And till the day he dies, he is one general that never loses a battle. I like that kind of a heart. I tried him fair, and he was the best. Let's don't take a cowardly advantage and double-teen him. I don't want him to die calling me a coward, and less a man than he is. I don't know whether you get my meaning or not, but you leave him be."

Jeff was unhappy about the snake, and it showed in his face. Jim looked at Jeff and chuckled.

"Here, Jeff, take this five dollars and gwan home and make your wife wish that you had of worked hard all day. Light a shuck out of here! See you bright and soon tomorrow."

Jeff brightened considerably at Jim, but never once turned his face towards Arvay.

"You sure you can make it on to the house from here, Mister Jim?"

"Just as sure as you snore. If I see myself giving out, my wife will help me along somehow. Bye, Jeff."

Arvay did not *hear* Jeff snort. He thought too much of Jim for that, but Arvay, happening to be looking at Jeff's barrel-like chest, saw it. She saw the print of that snort just as plain as day. The scorn and despisement in it cut Arvay so that she felt like killing him dead on the spot. She wanted to scream out to Jim and tell him, and make him kill Jeff then and there. But what could she say to Jim? Lynch this man for scorning me because I was right there when you were in danger of death, and I didn't even move my hand to come to your assistance, and now you got to make him stop scorning at me for that? No, no, that would never do.

"So long, Boss. See you in the morning."

"Bye, Jeff."

Then Arvay was alone with Jim in the strangeness of the familiar grove, and they had to get back to the house some way or another, and then when they got there, they had to go inside, and be in there together.

Jim walked along all right. He didn't walk very fast, but he was steady on his feet. Jeff was gone now, and Jim was not smiling any more. They just walked along until they got to the house and went inside. Arvay halted in the kitchen. Jim never paused. He kept on through to the front of the house. Arvay stood around in the kitchen with her arms bent at the elbows, and her hands drooping off her wrists like damp clothes hanging from a nail. She took a few steps one way, and stood, and then after a while she took a step or so in some other direction and stood again. No use in trying to fool with the potato pudding anymore. She couldn't keep her mind on a thing long enough for that. She wanted to just go out on the porch and stretch out, but Jim was up there somewhere.

"Do, Jesus!" and Arvay moved herself a little. "Oh, my Maker! Do, Father!" and Arvay shifted a little here and there about the kitchen, for she didn't know how long. She baked off the potato pone in a mist of gloom. Maybe three times, but twice for sure, Arvay heard Jim at the telephone, but could not make out who he was talking with nor what he was saying. Maybe he was telling Angie what had happened. Maybe even talking to Kenny in New York. Then Jim got very quiet up there, and Arvay decided that he must be lying down.

Towards sundown, she took the fryer out of the ice-box that Jim had killed for her the day before, and put it on the stove to fry, and mixed up a mess of soda biscuits. She couldn't think of much to do, so she took some cold boiled sweet potatoes left over from the night before and sliced them and fried them brown in some bacon grease. Everything was all ready then. She had a good excuse to break a breath with Jim. In trembling fear she passed on through the narrow hall.

Arvay found Jim at last, across the bed in Angie's room. Oh, but it couldn't be so! She stood there in the open door and

nothing was said. But Jim couldn't be asleep, because all the lights were on. For the very first time since she had known him, Jim was acting stiff and stout. She was on the point of backing off from the door when Jim sat up and looked straight at her.

"Jim," Arvay trembled out, and then she halted. That look that Jim was giving her, she couldn't make out. He wasn't mad, that she could easily see. One time it looked like he was hurt-ed deep inside, and then again it looked liked he was snurling at her. She tried for a minute, but for to save her ever-dying soul, she couldn't tell which it was. Anyhow, it was sharp. You could stab a breeze of wind with it and it would bleed. Arvay found herself breathing in those short quick breaths, that when dogs did it, the folks in west Florida said that they were "hassling." Arvay tried again. "Jim, I, maybe you . . ."

Jim cut her short. "Arvay, when folks have anything worth saying, they walks in noble and they talks bold." He had on his blue-striped pajamas, Arvay noted. He put his two hands down on the mattress on each side of him in a bracing way, and leaned forward ever so slightly and kept on eye-balling her and waiting.

"I—I just thought I better let you know that supper is on the table."

Jim looked at Arvay some more, and then he began to laugh in a slow, easy way. "All right, Arvay. You had the biggest chance in the world to make a great woman out of yourself. A Past Grand Noble chance. But you crapped out on it and lost the dice. So I reckon now that I will have to do the talking. Take a seat."

Arvay heard just what Jim said. It was not an invitation to rest her feet. It was a straight command. It was in the voice, in Jim's gray eyes, and Jim had rocks in his jaws. With her skirt wrapped tight about her legs, Arvay crooked timidly onto a chair by the wall and faced Jim. She saw that Jim's eyes, face and all over was so charged that involuntarily, she flung up her forearm to ward off a blow.

"Jim! Jim! You ought to give me a chance to say how sorry I is for what went on today. I'm sorry to my heart."

To Arvay's surprise, Jim made no move, and his voice was calm and low. But before he said anything, he gave a short laugh and rested his head in his hands.

"What happened today, Arvay?" And then he raised his head and looked at her and his eyes said that he bet she didn't know. That stung Arvay and she spoke according.

"You grabbing up that rattlesnake, and almost got snake-bit to death, and then just because I didn't know what steps to take . . ."

"See that, Arvay? That shows the difference between me and you. I see one thing and can understand ten. You see ten things and can't even understand one. A person can have very good eyesight, Arvay, and even wear glasses on top of that, but if they get in the habit of butting around with their eyes shut tight, they won't be able to see a thing."

"I was right there, Jim, and seen all that was there to see. Maybe now you aim to tell me that that wasn't no rattlesnake, and you never had him up in your hands. I maybe ain't got all the brains you carries, but I'm here to tell you that I'm not half as dumb as you all make me out to be."

"Naw, you ain't dumb, Arvay. You got plenty of sense if you would only use it. I guess you must be short on spirit in a way. Know what really took place today? No, so I'll have to tell you. Jim Meserve, the man that's been loving you so hard for twenty-odd years, thought that he saw a chance to do something big and brave and full of manhood, thinking maybe he might win admiration out of you and compliments and a big hug around his neck. He knowed all the time how dangerous it was, and that he had a chance to lose, but he was a man in love, so he took the chance. With Jeff around, Jim just barely broke even, that is, with the snake. He lost heavy otherwise. That was really what happened out there today, Arvay."

Arvay could not help from crying. "Jim, you have never

known me to make a oath, but I swear that I didn't want you to get hurt by that old snake."

"And I believe you, Arvay, but that only makes things worse. Maybe you couldn't of done one thing to help me, but you could of showed what you was made out of by trying. Even if it was only to show me that you understood my intentions towards you by saying a word or two. I would of felt better even if you had let me know that you saw what I was after, but you hated my guts and then pitched in and helped the rattlesnake out. Not understanding is the part that I don't like."

"Maybe you done got the idea that I don't love you and want you, Jim, but I declare I do. I don't know what come over me. . . ."

"I feel and believe that you do love me, Arvay, but I don't want that stand-still, hap-hazard kind of love. I'm just as hungry as a dog for a knowing and a doing love. You love like a coward. Don't take no steps at all. Just stand around and hope for things to happen out right. Unthankful and unknowing like a hog under a acorn tree. Eating and grunting with your ears hanging over your eyes, and never even looking up to see where the acorns are coming from. What satisfaction can I get out of that kind of a love, Arvay? Ain't you never stopped to consider at all?"

"A'plenty times. But all I could ever see was that the only holt I ever had on you was the way you craved after my body. Otherwise, I felt you looking down on me all the time."

"I heard that from you, Arvay, way back yonder, and it was a lie even when it was fresh. Look like you never have got over that old missionary distemper. Yes, I craved your body, and can't see a thing wrong with that. What the hell would I marry a woman for if I didn't want her like that? If it wasn't for that, I could just as well couple up with another man for a buddy."

"And you took the advantage of me that way, too. Keeping me ever feeling that way towards you, so you could handle me like you pleased. Yes you did!"

"You're a got-that-wrong, Arvay. You're a high-charged

woman and you was born that way. That was all the matter with you before I come along. But in place of looking things in the face, you took and blinded your eyes and took up with that old missionary foolishness to make believe that you was much too nice to feel natural. Like I said, you just ain't given to looking at things, and that is a pity and a shame. Fighting back and holding a grudge against me because I filled the bill in the finest part of our life. I was your man, that's all, just like you was my natural woman. It's a mighty good idea to let God run things. He ain't give nobody a thing He didn't expect 'em to use, your goddamned lap-legged missionaries to the contrary."

"Jim, you say you been loving me so, and I wouldn't understand, but now, you show me and tell me how I—"

"You want to expose yourself by asking me that, Arvay? I used to hope that it wouldn't never be necessary, but you done convinced me that it is, if you're ever to see and know."

Jim leaned forward and rested his elbows on his knees again. His forehead was in his hands, and his shock of black hair fell forward over his fingers.

"I didn't have a damn thing when I married you, did I, Arvay?"

"Well, nothing much to speak of, Jim."

"But with you to care for, and loving you like I did, I got off of that teppentime still just as quick as I could, so as to make a better life for you. I knew that that was all that you had ever been used to, Arvay, but I saw you as due a much higher place. So I got out from there and moved you up a notch by coming down here. It was hard scrambling, Arvay, and I didn't mind that so much. All I ever wanted to hear from you was that you realized that I was doing out of love, and thought of you so high, that I wanted to see you pomped away up there. I never have seen you as a teppentime Cracker like you have thrown in my face time and again. I saw you like a king's daughter out of a story-book with your long, soft golden hair. You were deserving, and noble, and all I ever wanted to do was to have the chance to do for you and protect you. But never one time

have I heard you mention that you understood all that."

"Oh, Jim! Jim! I . . ."

"Naw, Arvay. You've had your time to talk and you didn't do it. Let me finish what I got to say.

"You saw me in the ham-scram buying this place and making things as nice and as comfortable for you and our children as I could. I went in with Joe stilling likker, and run a heavy risk of going on the chain-gang to get hold of enough money to put you up closer to where I felt that *my* woman ought to be. I tried to keep it from you, knowing how you felt about things like that, so you'd think high of me and feel that you had done pretty fair in marrying me. When you did find out, you never came to me and flung your arms around me and told me you appreciated the length I was willing to go for you. Naw, you got jealous of the time I had to spend with Joe."

Arvay crumpled and fluttered one hand against her chest, but Jim went right on.

"I did my level best to throw my long arm of protection around you to keep you from getting hurt about Earl. I could see what was on the way a long time before you did, but you wouldn't hear to a thing. It would of happened, even up there in west Florida, but that wouldn't have been near so bad as right there where you had to live, and I could see that. But no, you would let that be. Then when he was surrounded, I humbled myself among men to keep things from being worse than they turned out to save your feelings. But if you ever understood that, I never have been made wise of it. You have as good as accused me of helping to get him killed."

"Jim, oh, if . . ."

"And without saying anything to you, I took pains to tie Alfredo to me, so he wouldn't kick up no stink to fret and worry you more than you already was, but you couldn't even see through that. He stood by me like a major and kept down a whole lot of hard feelings and talk that would have been if he hadn't, and you been doing your damndest ever since to break things up. Yeah, I paid for that outfit that Felicia had on at Gainesville that time, and stood all expenses besides, and

264

glad to do it. I was glad that Kenny had sense enough to ask her up there. I wouldn't have no shrimping business right now if it hadn't been for Alfredo being so faithful and pushing things ahead just like everything was his own. But it was all for your benefit that I was getting it done. You've never turned him nor his family a bit of thanks, and you never have had the feeling to even go down and see what I was doing, or trying to do, and you never have said once that you realized that I was scuffling like that to place you higher up."

"How could I, when you never let me know?"

"Some folks, Arvay, would have been awake enough to glimpse and see. And so far as that swamp is concerned, for twenty years it hung over my heart. I saw that it worried you, and I kept on working as hard as I could to get to the place where I could get it cleaned off for you. So when Hatton married Angie, and I seen how bad you felt over it, I put in to make them children pay you back. Hatton's made big money out of the deal, as I knew he was bound to do, but that wasn't my main reason for sicking him on it. That was done as a honor and a comfort to you, but you soon let me see that you hadn't the least notion why. I had just done something else to fret you. Same way with Angie getting married. Same way with Kenny stepping out on his own. I could see that your glory would be added to, but you haven't give me one bit of credit for love."

There was a shapeless silence crowding around in the room. It was smothering Arvay, and she wanted to say something, do something to push and drive it away, and let her find some way to creep closer to Jim again. Finally, she said what she had said before.

"Jim, I love you. If I don't, I hope God will kill me right now."

For answer, Jim stood erect, flung wide his bath-robe and his body was bare to the line of his pelvis. Arvay screamed. From his short-ribs to his pelvis, was a band of raw-red abraded flesh. The crawling mechanics of the snake applied with such tremendous muscular tension had scoured Jim raw.

265

Arvay saw Jim's lean belly trembling as he breathed.

"Your kind of love, Arvay, don't seem to be the right thing for me. My feelings inside is just how I look outside. Naw, Arvay. I done got my mind made up. I'm leaving you in the morning."

"Naw, Jim, naw! You know I love you, Jim. So why you got to quit me like this?"

"Because I'm sick and tired of hauling and dragging you along. I'm tired of excusing you because you don't understand. I'm tired of waiting for you to meet me on some high place and locking arms with me and going my way. I'm tired of hunting you, and trying to free your soul. I'm tired."

"You mean to turn me loose to scuffle for myself after I done had children for you, and been with you all these years, and . . ."

"I didn't say that I was tired of taking care of you, Arvay. I'm leaving, yes, but this house, just like it stands, is yours to do with as you will or may. I'll send you something to live on every single week. You don't need to worry over that. I'm pushing fifty now, Arvay, and no use in me hoping no more. I ever loved married life, but since I've missed it so far, no use in me hoping no further."

"Married life? Good gracious, Jim, ain't we been married all this time?"

"Oh, we got the proper papers all right, and without a doubt, the folks around the court-house are more than satisfied. But to come right down to the fact of the matter, you and me have never been really married. Our bonds have never been consecrated. Two people ain't never married until they come to the same point of view. That we don't seem to be able to do, so I'm moving over to the coast tomorrow for good. My arrangements are done made. You can consider that me and you are parted, Arvay."

"Well," Arvay murmured out at last, "what you been pointing out about not loving me ought not to take me by surprise. I never is believed that you really loved me, Jim, so your saying it now ought not to hurt me so, but it do."

"I never said that I didn't love you. I told you just as plain as ever I could that I'm through and done with filling in where you choose to be insufficient. I eat high on the hog or nothing. I don't have no notion of breaking into my arrangements to leave here tomorrow morning, but if I ever see any signs of you coming to be the woman I married you for, why then I'll be only too glad and willing to try it again."

"So, if I'm ever to be with you again, I got to make the first move."

"My meaning exactly, that is, providing you make it inside of one year from this day. If it takes you any longer than that, I won't be expecting you at all. I'm gone like a turkey through the corn."

Somehow, Arvay got out on the porch, where she crumpled on her bed.

CHAPTER 24

There is always room in oblivion. That is one place that is never full. Since Jim had left her, Arvay sometimes felt herself lost in the edges of the wastes. Her days had nothing in them now but hours. Hours that somebody else had gotten all the light and service out of and chunked them away. Old, worn-out, lifeless marks on time. Like raw, bony, homeless dogs, they took to hanging around her doorway. They were there when she got up in the morning, and still whimpering and whining of their emptiness when she went to bed at night.

Only one day out of her week had any significance. Every Monday she received an envelope addressed in Jim's handwriting. It held a money order for fifteen dollars folded in a sheet of blank paper. The fall and the winter had about passed over, but not one word of writing had appeared on that sheet of paper as yet. She tore open the envelope and looked eagerly, but never any writing appeared.

So Arvay began to fear that her life with Jim was over. He had made no move towards her, and for the life of her, she could not seek out and discover what Jim expected of her. There was some hidden key to re-open the door of her happiness, but where and what it was, she could not discover it in spite of her torture.

God and the Devil can relieve their melancholy by the exercise of power. Men, therefore, feel themselves more or less god-like to the extent to which they can create happiness, tears and terror among their fellowmen.

Arvay felt now that she had this vanity stripped from among the nourishments of her life. Her living children were on their own. She had no control over either now. She could neither confer nor deny. Jim had made himself absent so that no act of hers did anything to his days. The day of his departure, he had moved Jeff and his wife, Janie, on the place to look after things, but Jeff let no opportunity pass to have it understood that he was working for *Mister* Meserve and taking orders only from him. This was not the Jeff Kelsey, with the face like a cherub that had been built onto, when he was a child on this place. Since the day of the snake, Jeff seemed to have little use for her at all.

She went to sleep one afternoon out on the sleeping porch with her face turned towards the wall. When she somehow woke up suddenly and turned her face over her shoulders, there was Jeff standing with a "lazy boy" in one of his big brawny hands, the other hand on his hip, and his face pressed against the screen wire, staring at her. His face was pressed so hard against the screening that his nose was flattened, and his lips were distorted into purple blobs. His eyes were fixed on her and unmoving. Neither did he jump away when he saw her see him.

Traditionally, Arvay immediately thought of rape and murder. That look was so powerful and intense. But as she studied Jeff's face and eyes she got another shock. Jeff was not longing after her body. It was anger and dislike. If only he had his hands on her, he would tear her to little bitty pieces like a rag-doll.

When Jeff turned away it was with a savage abruptness. He walked a few steps and began to slash at the weeds viciously with the lazy boy. With her looking right at him, and Jeff knowing it, he slashed off the tops of some of her verbenas.

"Why, the impudent scoundrel-beast!" Arvay muttered

from between pressed lips and jumped up from the day-bed and hurried into the house. "I don't aim to take his sass at all. I'll march right out there and run him off this place!"

But with her hand on the knob of the front door, Arvay halted. Jeff was going to give her a whole lot of back-talk and remind her that *Mister* Jim had put him on the place, paid his wages and gave him his orders. Every Monday, just as regular as pig-tracks, Jeff got a letter from Jim. On three different occasions Jeff had knocked off on Friday and gone to the coast, and Arvay had sense enough to know that it was at Jim's commands. She couldn't fire Jeff—nothing of the kind—and Jeff knew it. In his absence, Jim wouldn't just trust any and everybody on the place. She could only move Jeff by appealing to Jim, and Jeff had the place in the best shape that it had ever been. He took such good care of the grove that Arvay would not have been surprised to catch Jeff out there with a curry comb dressing down the leaves. She had heard Jim what he told Jeff out there the day of the snake. No, no use in her flying out there. Jim was not going to get rid of Jeff at all.

"Jim's done quit me, and I don't believe that he wants me no more at all. If he did, he would tell me what it is he wants me to do so that we could go back together. That was just his way of doing things. So what am I doing hanging around here for? Just to get something to eat from a man that's done throwed me down? That don't make me out to be nothing. If I looked upon myself in the right way, I would pack my few things and go on back to west Florida where I reckon I belong."

But that was too drastic for Arvay's feelings. Any day, maybe tomorrow, Jim would come driving up and take her to the coast with him. Jim had left her in this house. She wanted to be where she would be easy to find when he came. He might not put himself to the trouble to proag all the way to west Florida. By her leaving, he might not consider it worth his while to even write a letter.

Arvay wished and wished from one point to the other every day. She would follow her pride and go back home to her

mother. No, Jim was her husband and she would stay right where he put her. Back and forth. Light and cloud, and always wondering what Jim wanted her to do.

The door bell rang hard before she could hardly take her seat again, and Arvay went back to the door. A tall, skinny, pimply-faced boy had her signing for a message.

Arvay held the yellow envelope as if she was holding a snail. She was afraid that an enemy, a bad enemy, had gotten to her in that envelope. Jim was telling her not to bother. He was in love with another woman and wanted his divorce. No, Kenny was hurt or in some kind of trouble up North. It could be that Jim was sick or hurt and wanted her to come look after him. Lord have mercy! Lord have mercy! Arvay began to open the envelope with fumbling hands. Her relief made her whimper when she read the message:

MAMA SICK IN THE BED. LARRAINE MIDDLETON.

Arvay read it over several times. It seemed a funny kind of a message to her. It told her so little. It didn't say whether her mother was just poorly or ill-sick in the bed. It didn't tell how long Maria had been ailing, nor from what. It didn't say come or nothing. Not even whether Maria was in need of more money. Arvay sat down on the porch and pondered for some time. She wondered if she should wire or write for more information from Larraine. If she wired right back, in a day or so she would know better what to do.

Then Arvay decided. God worked in mysterious ways His wonders to perform. He planted His footsteps on the seas and rode upon the storms. Or so the old hymn said, and Arvay believed what she had heard sung in a church. God was taking a hand in her troubles. He was directing her ways. The answer was plain. He meant for her to go back home. This was His way of showing her what to do. The Bible said, "Everything after its own kind," and her kind was up there in the piney woods around Sawley. Her family, and the folks she used to know before she fooled herself and linked up with a man who

271

was not her kind. Arvay tossed her head defiantly and rhymed out that she was a Cracker bred and a Cracker born, and when she was dead there'd be a Cracker gone. Jim's and even her own children's ways were not her ways. She had tried and tried but she did not fit in. Let Jim and them have their ways. She would go back and let Jim strain with his house and his impudent, biggity niggers his ownself.

Arvay was conscious at that moment that she had not really been trying to find the answer that Jim expected of her. As always, she had been trying to defend her background and justify it so that Jim could accept it and her along with it. She had been on the defensive ever since her marriage. The corroding poverty of her childhood became a glowing virtue, and a state to be desired. Arvay scorned off learning as a source of evil knowledge and thought fondly of ignorance as the foundation of good-heartedness and honesty. Peace, contentment and virtue hung like a rainbow over turpentine shacks and shanties. There love and free-giving abided and not on decorated sun-porches. Even Larraine and her family stood glorified in this distant light. Arvay felt eager to get back in the atmosphere of her humble beginnings. God was showing favor to His handmaiden.

Arvay got brisk and phoned in a telegram to Kenny. Then she called Angeline and told her, and asked her to please let Jim know. Then she went excitedly about her packing. She was going *home!* Home to the good old times and simple, honest things, where greed after money and power had no place.

Arvay had gotten so used to ease and even a certain amount of luxury, that she took things for granted. She hauled out the luggage that Kenny had sent her as a present and began to pack her things in happy anticipation. Her wardrobe bag, over-night case and combination hat- and shoe-box were of dark-blue leather with her initials on every piece in raised silver. The trade-mark in the rich linings said *Mark Cross.* It did not occur to Arvay that the people she was raised with didn't even know about things like these. At the moment it did

not enter her mind that this assembly of luggage had cost Kenny more than a turpentine worker ever handled in a year. That the people whom she was now gilding up had not the means to produce a son like Kenny. That the kind of father that they had had something to do with her children's good looks, and that beauty that everybody gave Angeline credit for was enhanced and made evident by her self-confidence which arose out of assurance brought on by means which Jim had provided. That her natural means had been pointed up by care, clothes and surroundings. Arvay was not analyzing. She was packing frantically to flee away, and to be gone from her married life for good. God was giving her another chance.

Nor did Arvay see the inconsistency in her exclamations when she got a taxi at the station. While the driver was loading her luggage, she stood on the sidewalk and admired around.

"Oh, I see several good changes since I been gone! What's that new building down the street there?"

"Our new and modern hotel, the Stephen Foster. We got two self-service grocery stores now, too, and with this national highway right through here, we even got some tourists camps. One coming into town from the east and one on the west."

"Oh, that's just fine and noble!"

"Sure is. The lumber is all cut out, and no more saw-mills here now. The teppentime woods is all worked out too, and if you ask me, it's a demned good thing. The folks, white and colored, that follows that kind of work don't have the kind of money to spend to make good business. I'm glad to see 'em gone from here."

"Oh," Arvay said on a less happier note. "How do folks make they living around here now?"

"Well, new ways of using peanuts has been found, and peanuts is a big money crop around here now. They're raising tobacco in a better way and more of it, and a lots of folks are getting well-off at it. Then this new paved highway through here brings in a lot of business for the hotels and the eating places and rooming houses and taxis. We handle much more money than we used to."

"That's nice," Arvay mumbled.

"Certainly it is!" The taxi man was almost belligerent about it. "We got a Junior Chamber of Commerce now, and it's out to bring more business and more prosperity to Sawley. Why, we even got a daily paper now, and it's doing well. Since the Old Gentleman died and Young Brad Cary took hold of things, some good changes have been made, but a lot of these old fogies and dumb peckerwoods don't like it."

Arvay took sides with the peckerwoods in a timid way.

"Still and all, in the good old days, the folks in Sawley was good and kind and neighborly. I'd hate to see all that done away with."

"Lady! You must not know this town too good. I moved in here fifteen years ago and I done summered and wintered with these folks. I hauled the mud to make some of 'em, and know 'em inside and out. I ain't seen no more goodness and kind-heartedness here than nowhere else. Such another back-biting and carrying on you never seen. They hate like sin to take a forward step. Just like they was took out their cradles, they'll be screwed down in their coffins."

The taxi got under way and proceeded eastward and out of Sawley to where used to be the gate of her old home.

The taxi stopped, and one look at the place, and Arvay began to draw back from old times right away. With her own modest but modern home as a yard-stick, the Henson place was too awful to contemplate. And people who held to old ideas shocked her most unpleasantly in the person of her own sister, whom she identified in that ton of coarse-looking flesh sitting on the dilapidated old steps in a faded cheap cotton dress and dirty white cotton stockings.

Larraine was taking a dip of snuff as the taxi drove up, a habit that Arvay abominated, and which she had not seen for years. Larraine lowered her snuff-box, looked the taxi up and down and from end to end with a kind of distaste, and did not seem to recognize the passenger. Larraine just looked with sullen eyes. Her gray hair was bobbed and untidy. Her eyes

said that there was nothing in the taxi that she wanted to see at all.

Arvay stood on the ground beside the taxi and revealed herself.

"Why, hello there, Larraine! Look like you don't know me."

Even so, Larraine did not greet Arvay directly. She turned her head off to the right and said, "Carl, Arvie done come. That's her."

A soiled, heavy-set man jerked his head out from under the hood of an unbelievably battered old Model T and flung his heavy features towards Arvay, standing beside the taxi. No! This drab creature could not be the once neat and self-assured Carl Middleton. His face marred and his body shaped by making too many humble motions. His face showed that he was not glad to see her for a moment, then was re-arranged to suit his words.

"Why, hello, little sister! So you did get here, eh?"

Arvay replied in kind, but she was thinking, "If that chuckle-head of yours was a hog head, I'd be willing to work for it for a solid year. Good God! I wonder if I have changed as bad as they have!"

"You want your things put off *here?*" the taxi-man asked and looked at the house and the people.

"Why, yes. Would you be so good and kind as to place 'em on the porch for me?"

Neither Carl nor Larraine said one word of encouragement. There was a loaded and waiting silence as their eyes watched the transfer of the luggage from the car to the dilapidated porch. Larraine did not move out of the way, except to slide a trifle to one side. The man had to scrouge past her.

Arvay had to do the same. Larraine looked upwards at her as she passed. Arvay went on into the narrow hallway, and stood looking in through the open door of the parlor when she heard shuffling steps back of her, and turned to see the shape-less mass and bulk of her sister coming heavily up the steps behind her, followed closely by Carl.

275

Arvay noted the museum-like arrangement of the parlor in the brief pause before she went on into her mother's room across the hall. She could see and recognize most of the things that she and her husband had sent Maria Henson in the last few years, arranged for display. The strange quiet made her fear that her mother was already dead, and that they hated to tell her. As she turned from the parlor door, she glimpsed two female faces peering at her from the back porch. Those would be Larraine's two daughters. They were mule-faced and ugly enough, Arvay decided as she stepped across the sill of her mother's room. Even in a croker-sack, Angeline would look like their mistress.

The room was very dim and still even in the bright light of early afternoon. Arvay could hear two things: the rattle of cook-pots in the kitchen, and the squeak and patter of rats in the walls. What was worse, she could smell the strong odor of rat-urine over everything. She flew a little angry that Larraine and all those grown children she had, had let things get into such a shape. Her mother was a yellowed picture of skull and skin sunk down in a deep feather pillow in the middle of the bed. She seemed to be asleep or dead. Arvay could detect no movement of any kind. She tipped to the head of the bed and leaned over.

"Mama!"

Instantly the old eyes flew open. One claw-like old hand came from under the cover. The face turned a little towards Arvay, and the old eyes peered.

"Arvie," came over eagerly, but unwilling to believe.

"It's me, Mama. Don't you know me?"

Just then, Larraine and Carl entered and took up positions at the foot of the bed. The old woman seemed not to see them, as she concentrated on the face bending over her. Then recognition, or rather assurance, came into her eyes. The old hand caught Arvay's lower arm, and the old head sank back on the pillow with a blissful smile.

"I winned! I winned!" Maria said weakly. "I lasted out until my baby child got to me. I begged my God to spare me, and

He did. But every occasionally, I was skeered I wouldn't make it."

"Mama, you're mighty sick," Arvay exclaimed in alarm, looking down into the face intently. One hand felt the old forehead for fever. "How long you been sick like this?"

"Going on nearly a month, now, Arvie. I was took down awful sick."

"How come you didn't let me know before now, Mama?"

The old eyes looked towards the foot of the bed and then closed.

"I thought that you knowed all the time, and just couldn't see your way clear to come. I didn't feel no ways slighted about it, Arvie. You done took care of me so good ever since your Paw died, till I knowed it wasn't that you didn't care, you just couldn't spare no time to come."

"Why, I just got the wire yesterday evening, Mama, and caught that mid-night train. I'd of been here too long to talk about if I had of known you was sick and needed me."

"Them telegraph folks must be acting mighty loose and careless these days." Carl jumped in very quickly. "I sent you word over three weeks ago. Don't see how it could of missed you like that."

"Never mind," Maria muttered and closed her eyes again. "My baby is here with me now, and you and Larraine will kindly excuse yourselves so I can be with Arvie a spell. I'll call you if I need anything."

Larraine went out slowly, and Carl let her pass him, then followed sullenly, stretching the room door back to the wall as he left.

"Close to that door!" Maria ordered in the strongest voice that she had used so far. "I hates for folks to be standing around eavesdropping me."

Arvay closed the door and came back to the bed.

"I left a paper with Bradford Cary to place in your hands, Arvie, in case I might be gone when you got here."

"A paper?"

"Yeah, a paper fixing things so you could come into this

277

place all by yourself without no trouble of any kind. Mr. Cary fixed it up for me as tight as bees-wax, and it's in his hands until it passes into yourn. He's sure been nice and kind."

"Bradford Cary?" Arvay's face and voice showed her surprise. "How on earth did he come to be helping you out so?"

"Now, 'tain't a thing stuck-up about Bradford Cary, Arvie. Just as easy to get along with as poor folks. Drove out to see me soon's he got back from New O'leans where Kenny played so good and told me all about it. His youngest boy was playing in that same band, and he went over there to hear it and come back bragging on Kenny. Set right down in my parlor and talked with me. Every time he seen anything in the paper about Kenny, he come out and read it to me, and talked with me."

"Well!" Arvay breathed out. "I never would of thought it of Bradford Cary, but I sure think it was mighty white of him to do it. I got to see him and thank him."

"Do that. And when he seen how Carl and Larraine was using me, hanging around just like turkey buzzards to get out of me any little change that I might git hold of, which was what you and Jim was sending me by the month, and then didn't do nothing for me, and I told him that I wanted you to have the place when I was gone, he took and fixed me up that paper so that they couldn't git hold of a thing. You go straight to him and git it when I'm gone."

"Thank you, Mama, that is, if I should happen to be the longest-liver. You might be the one to close my dying eyes."

"Naw, baby, I ain't here for long. All I could do to hold out till you could come. I know so well them limbs of Satan never sent you no word to come. They was laying round here waiting for me to die so they could move in here and take everything. Carl ain't made nothing worth mentioning for ever so many years. Long time ago folks let him know that they didn't want to hear him preach, and he won't do no kind of work, and so his family is terrible absent of things. Just living off of me, all they was able. Disfurnishing me of the little money you sent me, and piling in here and destroying up the groceries I

buy to carry me along from one time to the next one. That's all they's fitten for. Stuff they trashy guts and lay 'round like gators in the sun."

"I can't say that I feel good towards them for doing you like that, Mama. But if they's as hard up as all that, you can make over this place to Larraine if you want to. I can't say that I'm in any pressing need."

"Naw I ain't going to do it nothing of the kind. I wouldn't even give 'em air if they was stopped up in a jug, the no-manners way that they have treated me. Me here old and sick, and ain't able to do nothing for myself, and them with they hands out all the time to take from me. Larraine is done had more than her share. Naw."

"All right then, Mama, have your way. I sure can't feel good towards them for not letting me know."

The old woman tried to speak, hiccoughed several times instead, and nodded her head. When she was able to speak again, she beckoned Arvay to hold closer.

"Feel right here under this bed-tick, baby. Git it out and take it with you."

Arvay felt between the feather tick and the supporting shuck mattress, and drew out a large Manila envelope. She drew out first, two large, slick-printed unmounted photographs. One was of Kenny with his guitar in his hand standing beside a microphone. It was signed, *From Kenny to his darling Grandmother.* The other was a picture of Kenny with his guitar in a playing-position standing in front of the New York band. In both cases, he had that smile on his face. Dressed in a fine-fitting tuxedo and looking very rich. There was a blue rectangle of paper in there too. A money-order for twenty-five dollars made out to Maria Henson and signed by Kenny Meserve.

"This is noble of Kenny, Mama."

"Wasn't it though? Never forgot his old Grandma at all, up there with all them rich folks."

"When did you get it, Mama?"

"The day before I took down sick. No chance to do nothing

with it. And I didn't want them gluttonous varmints to git they hands on it, so I stuck it under me here in the bed. You take it and do what you see fit."

"All right, Mama."

"And he sent all that without me even asking him for a thing. All I done was to write him a loving letter. Mr. Cary wrote it off to Kenny for me, and he upped and done all that. Your chillun's got plenty soul and heart in 'em, Arvie. Look how Angie sends me things every Christmas, and fine things too. You and Jim sure is raised your chaps to be nice and kind. 'Tain't that a'way with Larraine nor none of her whelps."

The old woman gulped and hiccoughed again, and caught Arvay's arm and tried to pull herself into a sitting position, peering pleadingly into Arvay's eyes.

"Arvay, you been ever nice and good to me, but I got to beg one more favor of you whilst I'm still on pleading terms with mercy. I hope that you can see your way clear to grant it."

"If it's in my poor weak power, Mama, it's already granted. Tell me, and if I can do it, I sure will."

"Arvie, I know that I don't amount to much. Just one of them nothing kind of human things stumbling around 'mongst the toes of God. Ain't seldom had, nor neither done what I desired. It wasn't for me to have and to do. My footprints'll be erased off before my head is hardly cold. But, don't care for that, Arvay. I would dearly love to be put away nice, with a heap of flowers on my coffin and a church full of folks marching around to say me 'farewell.' I know that they won't care one way or another, baby, but I sure would love to die knowing that they'd be there just the same. To make pretend-like I'm mighty missed. And please, Arvay, baby, don't take me right from this house to the graveyard and finish with me. Take me to the church and pass me around."

"I'll do it, Mama, just like you say, that is, if I'm the longest-liver. You can put your dying dependence in me."

"Thankee, baby. It's four whole days till Sunday come next, and that's a mighty long time to hold anybody over. But

working folks don't have no time during the week days to be at leisure. . . ."

"Don't care what day of the week you might die, Mama dear, you'll be held over and put away on a Sunday. I'll have big services held over you on a Sunday so everybody that wills can come."

With Arvay perched by one hip beside the pillow and stroking her hand, Maria sank back down in the depths of her pillows with a look of utter rapture on her sunken face. Her toothless mouth had caved in so deeply that the nose and chin seemed about to meet. Arvay saw the thin lips work as if they tasted some delicious morsel as Maria closed her old eyes. There was a look of great triumph, as if the shabby old woman had vanquished life after all.

After a time the old woman stirred, and the second time she seemed to be trying to say something. Unable to understand the faint mumblings, Arvay tried to interpret for her mother.

"Want me to call Larraine for you, Mama?" And Arvay got up quickly to go, but the thin bony old hand clung to hers and held her back. Arvay sensed that it was some satisfaction at her presence that Maria was still trying to express. The muttering and gurgling went on for some minutes, then Maria belched, worked her lips for a moment and was very quiet. Stroking the old hand for a while, Arvay finally looked down and began to look for signs.

Arvay saw that the spark of life was gone, and quickly tipped to the door and called in Larraine. By the time that Larraine, Carl, and the three grown children who were with her assembled in the room of death, Arvay had solemnly folded her mother's tired arms, and was fishing two pennies out of her change purse to close the eyes. She sobbed as she leaned over and performed the rite, not for the passing of the old woman who was old and tired, but that the eyes she was closing forever had looked upon so little that had been joyful. Maria had passed a lonesome visit to this world.

Larraine joined in the crying and dropped down heavily on the foot of the bed, then got up hurriedly either from the

thought of sacrilege or fear of the dead, and sat on the big wooden box that held Maria's quilts. Belatedly, her children joined in the keening. "Poor Double-Maw! Poor Grandmaw! Dead and gone! Done left us here behind! Dead and gone! Dead and gone!"

It was a measured mourning like the slow strokes of a tolling bell for death, and without sing, like the slack head of a drum. It was the traditional chant.

Arvay began to straighten out the covers on the bed a little more and said in a kind of a whisper, "Next thing, we got to see about putting Mama away." The sobbing cut off instantly as if on signal, and they all moved slowly towards the door, as if afraid of being overheard by the shell of life on the bed with the two coppers holding down the eyelids. Arvay, being near the head of the bed, was the last to leave the room. She literally pursued the others outside in the backyard near the wash-pot where they had halted as around a family hearth.

Larraine began to cry hard and deep, and Arvay was touched to her heart. She ran towards 'Raine with open arms, and Larraine met her half way. They clung tight to each other and cried and patted each other with fondness.

"Don't cry so, 'Raine," Arvay consoled. "Mama lived out her time, and she's just gone to her rest. Don't cry after her so hard."

" 'Tain't that so much, Arvie, you child. It's the fix I'm in. I ain't got a thing to bury Maw with. Oh, Arvie, honey, you don't know what I been through! I ain't hardly got changing clothes. Not a dust of meal nor flour in the barrel. Out there in them scrub-oaks where we live ain't hardly fitten for a dog! But I didn't mean to leave Maw lay there and let the rats eat her whilst we went round begging up enough money to put her away. We might git hold of a few boards, and I could git Carl to knock together some kind of a box to bury Maw in. Make her a grave down there in the back of the place like."

"Aw, my God!" Arvay shuddered at the picture. "Don't fret about that part no more, 'Raine. I'm putting Mama away

and putting her away very nice. You don't have to bother yourself at all."

"It sure is a help-out, Arvie. Things have been mighty hard with me."

Arvay remembered the mention of groceries, and went for the bill-fold tucked away in the slot in her hand-bag. Fired with sisterly concern and pity, Arvay opened the bill-fold, riffled through until she came to some smaller bills and impulsively handed Larraine a ten. From little economies, from Jim, from Kenny, from Angeline and Hatton, Arvay had over a thousand dollars in her pocket-book. This was her stake for life when she had boarded the train in Citrabelle.

"Buy yourself some groceries with that, 'Raine. I reckon that'll be sufficient to carry you over the funeral. Then we can talk things over and figger out some better way for you."

Arvay smoothed down the pack of paper money to replace it. She paid no attention to the hungry way that Carl had stared at it, and the two or three steps that he had taken nearer her for a better look.

"Well then, Arvie, since you going to take care of all the expenses, you have the man to make you out a bill, and when Carl gets to pastoring another sizeable charge, we'll be only too glad to pay you back our part."

"We ain't got no part to pay, 'Raine. Your Mama saw fit not to leave you nothing, but to make over this whole place to your sister, so naturally it's her place to put her away. I ain't got nothing to do with the mess."

Arvay turned towards Carl "I haven't asked 'Raine nor you to spend one cent on putting Mama away. I promised her that I would do it, and I'm not a'going to back out on my word. I'd rather to give 'Raine than to take from her."

"I hope that you don't call that little piece of change that you handed 'Raine money, not with all you got to do with. The more some folks gets their hands on, the more grasping and mean they gets. Naw, I'm clean out of this burial business and I aim to stay out of it. 'Raine, you can act with no sense at all. Give your sister leave to run into town and run up a bill

283

for maybe over a hundred dollars, then look for me to pay half of it and more, when she's got vast money, and then this place on top of that. You take my name right out of it, and leave it out."

"Who asked you to go into any debt to bury Mama?" Arvay snapped. "I'm positive-certain I didn't, because I know so well that you ain't got nothing to do it with. I come prepared to do whatever was necessary to be done. I got a *husband!* He covers the ground he stands on. He ain't never let me know what a hard day means."

Arvay was halted by something that leaped up into Carl's brown eyes. Before, he had merely been peevish and surly. Now he looked insulted and fiery mad.

"As my sister's husband, all I thought of asking for you to do would be to drive in town and notify the funeral home to come and get Mama and prepare her for the burial. If you'll kindly do that, I won't ask nothing more of you."

"Then let that rich and noblefied husband of yours run into town for you. I sure ain't a'going to do it. And my wife ain't a'going and none of my children neither. We got to come under humble submission to you and take your orders I reckon. Put your foot in the road and walk if you want any messages toted."

Arvay stood wordless and amazed at the way things had turned out, and the fierce behavior of Carl. She looked from one to the other of the group to try and find the answer. Did she glimpse a quiet gloating look on Larraine's face? For a second she thought that Larraine looked ever so glad about the falling-out.

"I don't see no need for all this carrying on over nothing." Arvay spoke with calm out of her puzzlement. "I didn't come here to run the hog over nobody, and to hurt nobody's feelings. If I have, I didn't mean to, and I'm sorry to my heart."

"That's what I say," Larraine exclaimed heartily, and crossed to Carl and flung one arm about his shoulders. "With Mama laying in there on her cooling-board, you all ought not to be fussing and carrying on."

284

Arvay noted that 'Raine did not urge Carl to go to town, however. Instead, she began to drag him off towards the kitchen. Arvay felt too that her way of pacifying Carl exaggerated things. "Come on in here, sweet dumpling, and lemme fix you a cup of coffee and a little snack to eat. You know better than to let yourself get all fretted up like that! Don't care what nobody else do to you, you know that I'm always with you."

The exasperated Arvay stood and looked behind the two ungainly figures as they reached the back porch and creaked across the boards and disappeared into the kitchen.

"Well, people!" Arvay sighed as she looked around at the slyly grinning faces of her nephew and two nieces and felt her face getting hot. When she passed stomping through the back to get her hat, she saw 'Raine through the kitchen door with her arm about Carl's shoulders giving him pity. Carl was weighing down an old kitchen chair with the back gone, and just taking it. Just like an image being made over. 'Raine acted as if she did not see or hear Arvay when she passed the door. But Carl seemed unable to ignore Arvay's nearness.

"Arvay!" Carl loosed his head from Larraine's fat arm and looked towards the door.

"What is it, Carl?" Arvay halted.

"When you get so that you can speak to me like you ought to, and not like I was some old throwed-away dog, and quit trying to throw up all Jim got in my face, I'll do what you ask me to do. If not, I ain't doing nothing at all."

"You shock my modesty, Carl Middleton, carrying on so ignorant like that, and your wife's Mama laying dead in the house and needing quick attention. Don't do me no favors at all. I can walk to town, and I want you to know that I don't mind doing it, neither. And you keep my husband's name right out of your mouth. Jim ain't got *you* to study about. So far as he thinks about you, you can kiss his high-toned, independent, money-making foot!"

If the look that Carl gave her then had been a bullet, it would have worked her three times before it killed her and

five times after. Arvay whirled on off and went into the bedroom where Maria's body lay on the bed looking so peaceful in the face.

But the house was not peaceful around her. There was a mighty kind of scampering, rustling, pattering and gnawing in the walls and seeming from every direction around converging on the room. Placing on her hat, Arvay was struck with such horror that she started to run back to the kitchen and call on Larraine and them for help. Somebody to stand on the watchwall and guard until she could get back with the undertaker. But she checked herself and began to consider what she could do to protect her mother's face and hands from mutilation while she was gone. Arvay pulled up the sheets, the three heavy quilts and the counterpane over Maria's head and tucked them all around under her body tightly and snugly until the corpse looked like a mummy in its wrappings.

Arvay took up her pocket-book and went on out to the gate with the creeping, jubilant noises in the wall behind her.

A long-nosed, black Cadillac sedan made an almost silent stop at the gap just as she reached it.

"Hello there, Arvay!" A quiet cultivated voice expressed sudden pleasure. After a minute, Arvay recognized that Bradford Cary II was greeting her like that.

"Oh, oh, howdey do, Banker Cary."

"Very glad to know that you're back in town. Thought that was you I saw in the taxi coming out this way, so I asked the driver and he told me. I have been in the habit of dropping out here now and then to see your mother, and as soon as I could get away after I heard that you were here, why I thought I'd make two visits in one."

Arvay thanked him shyly, and also for his past goodness to her mother. Then she told him the news, and of her destination. She was conscious too that by now, all the Middletons were up around the front of the house where they could look and listen.

"No need for you to put yourself to all that trouble, Arvay. We have known each other all *your* life, and we are friends,

I'm sure. You just let me take all this bother off your hands. I'll make all the necessary arrangements and give you a chance to rest and settle your nerves. But for God's sake quit calling me Banker Cary like all these Crackers around here. I'm Brad to you, Arvay."

"Okay, Brad." Arvay smiled diffidently. "I leave everything in your able hands, and I thank you all I know how."

"And I know that you have no intention of spending a night in such an awful place as this, Arvay." Cary was looking her clothes and her accessories up and down. "Tell you what you do. I'm going to see the undertaker and make all other arrangements. But first thing, I'm sending that taxi out here to pick you up with your things. I'll speak for a suite at the Stephen Foster for you, and you can walk right in, have a nice hot bath and go to bed. My wife and I will get in touch with you this evening in some way or another. Now, just do as I tell you, and everything will be all right."

The Cadillac moved off smoothly but fast. It almost vanished by the time Arvay looked over her shoulder and back again. In the low voice that Brad used, it would have been next to impossible for any of them to have heard what had been said, but Arvay knew so well that all of them had been looking as hard as they could. She went lightly up the steps and into the house. She looked in on the well-wrapped body, then across to the parlor where her luggage was piled.

Arvay was sad when she looked around the room in there. Her poor mother had been so proud of the presents that she, Jim, and her children had sent from time to time, that they had never been used. They were all there on display—that blue-worked chenille spread with the peacock in the center, the set of dishes that she had asked Jim for six years ago—rowed out on the mantelpiece, table and what-not to the most showy advantage. The bath-robe and bed-room slippers from Angeline. The set of plated silverware that she had sent in Kenny's name two years before because her mother had hinted that she had never owned a piece. House-dresses, tablecloths, bath towels, and things like that. As much as her mother made

patch-work quilts, the sewing box with all its fixings had never been touched. The various photographs of the Meserves at different ages were arranged on top of the dilapidated old organ, and around the lamp on the center table.

There was only one object on display which Arvay did not recognize. It was a cheap celluloid soap dish on the lower shelf of the what-not. 'Raine or some of her family must have given Maria that.

Arvay was called from her mood of pity by the honking of the taxi at the door. She ran into the bedroom and retrieved the Manila envelope from Kenny to Maria from where she had hidden it and ran to the front door and asked the taxi-driver to take care of her luggage.

As Arvay was stepping into the taxi, the undertaker's conveyance arrived and Arvay took time to lead the two men into the bedroom and see Maria's body unwrapped and deposited in the basket. The owner of the funeral home was along himself, and most deferential.

"I won't hold you up for but just a minute, Mrs. Meserve. But if you would give us her birth date and such little information, we won't have to trouble you again. Banker and Mrs. Cary said that you were not to be put to no more disturbance than was necessary."

When Arvay had given the dates of birth, marriage and death, full name, maiden and married, the director was satisfied. He asked nothing about Maria's children at all. He acted as if he did not see the Middletons hovering around the front yard.

But suddenly Carl came forward to the edge of the yard. "I ain't ordering no caskets and no coffins neither!" he announced in a most positive and an accusing way. "Don't be sticking my name on none of your bills. Let the folks pay for 'em that's doing all the flourishing around and talking."

"That they will! And the one that's making *this* bill can evermore do his paying. I don't reckon that Banker Cary will feel it necessary to call on you for no help, Reverend Middleton."

Arvay was astonished, but the sight of all the Middletons coming out from their listening posts at one time took her attention so that she couldn't find a word before Carl burst out.

"Mr. Banker Bradford Cary? I seen him here just a while ago talking with my wife's sister, but what's he got to do with it?"

The undertaker fairly reared back. "Banker Cary is a public-spirited citizen. The late Maria Henson is one of Sawley's oldest and one of its most *respected* citizens. He feels that her passing is more than a family affair. She is an honored and public citizen. Things will be carried out that way."

Arvay waved her sister good-bye and the taxi whirled her away. She had that last look of 'Raine looking wistfully after her, with one fat hand which had been lifted suddenly and spontaneously, being sort of arrested in the air and hanging there. Standing there in the weed-grown yard in her shabby dress, starting to be warm and friendly, then withdrawing herself.

Arvay felt grateful towards her sister as she flash[ed] away. But for 'Raine's intervention, she might have been married to Carl. Been the mother of those awful-looking young men and women that he had fathered. Had to get in the bed with something like that! Do, Jesus! Arvay had no wish to go back out there and run any risk of another run-in with Carl. For some strange reason, he was very mean and bitter against her. But 'Raine had heard where she would be until after the funeral. 'Raine would find some excuse to make it to the hotel. Then they would talk about old times, put hard feelings behind them and be sweet sisters together. Now that they were the only Hensons left, they ought to draw closer together.

But it was Carl whom Arvay saw next day at the hotel.

"Send him on up to my room," Arvay told the bell-hop.

"No Ma'am, Mrs. Meserve. I wouldn't risk that if I was you."

"How come? He's just my sister's husband."

"Yes Ma'am, I know, but he come in here acting and talking so funny that the Boss sent me ahead to bring you a message in private. He says that you better come on down in the lobby so you can have some kind of protection. Mrs. Banker Cary called up lessen an hour ago and said that you was to be looked after real careful and get the best of attention. The Boss don't aim to take no chances on nothing happening to you."

Arvay freshened up and went down and took a seat not far from the desk. She saw Carl rise to his feet from over near the front door. This was a Carl, shabby, but fairly neat. His thinning hair was brushed and laid down with water. Something of the old prideful Carl of nearly thirty years ago was about him. He came towards Arvay with the suspicion of a timid smile on his face.

"Hello, Arvay, I thought that I'd better take this chance of having a talk with you."

"About what?" Arvay asked coldly, the memory of the day before sharply in her mind.

She could see Carl's face change instantly. It got hard, and he sat down abruptly in a chair close by. The manager fiddled with a pen and paid attention.

Carl took a long time to answer. His forearms rested on the chair and his head was thrust forward in deep thought. Finally Carl seemed to whip himself up to a point and said, "I come here in the spirit of good will and compromise, but since you feel to be scornful, I'll let you have it raw. I want that thousand dollars you owe me."

"For what?" Arvay asked astounded. "I hope you don't think that I aim to give you no thousand dollars to compromise on the place. It's mine to do with as I will or may, and I don't have to compromise."

"Oh, it's your place all right, and that's how come you're responsible in a case like this."

"Like what? I don't know what you're talking about."

"Me getting hurt so serious on your place last night."

"You hurt? How did it happen, Carl, and in what way can I be responsible. I wasn't even there."

"Matters a difference where you was. You're the owner just the same. I was walking across that old rottened-down back porch of yours that you neglected to fix and a board broke under me and I fell through and got crippled up pretty bad. Your own sister said that I ought to get double that, but I thought that I would come myself and make things easy on you. I'm ready and willing to compromise the thing for a thousand."

"A thousand?" Arvay sat there dumbfounded.

"A thousand hard dollars, and mighty reasonable at that. That ought not to be nothing for your high-toned rich husband to raise."

The manager cleared his throat to attract Arvay's attention, rustled some papers and shook his head for her to say nothing.

"Oh, er, Mrs. Meserve, not that I want to butt into your business, but as a hotel man I know something about liabilities. Now, for instance, is Middleton renting your place?"

"No."

"Is he a tenant, that is, working for you and living on your place?"

"No."

"Well, did he come there to visit at your invitation?"

"Naw indeed!" Arvay looked at Carl through narrow eyes. "From what I can learn, he and his family just come there and bunked on Mama."

"Then you don't have to worry about any claims that he might make at all. In fact, he's liable for trespassing on your premises. Turn the matter over to Banker Cary and let him handle things."

Arvay turned a very grateful face to the manager and smiled. "I thank you ever so much for your information." She tensed her body to rise, but the sympathy for the defeated overcame her. Then there was the memory of the neat, virile, vigorous and confident young man that Carl Middleton had been when she first knew him set against the picture of him now. Arvay was full of pity, and fumbled for some way to make him the gift of a small sum. Say fifty dollars, maybe. She

nodded her gratitude again at the desk and turned to Carl.

"You say that you're hurt powerful bad, Carl?" And Arvay began to look him over for the signs.

"I said so and I am." Carl snapped.

"I must say that you don't look it to me." Arvay became slightly tart.

"Naturally," Carl retorted sarcastically. "I been *trying* to treat you like a lady. Where I'm hurt at ain't to be exposed in public."

"Oh! I'm mighty sorry to hear that. But still you don't get around like you was hurt too bad nowhere. For me to take any steps at all I would have to know exactly."

"Well, if you'se determined for me to get common with you," Carl sneered and got to his feet, "it's my behind, and could be inside injuries besides for all I know." He took a step towards Arvay. "I guess now you want me to show it to you."

Arvay did not wilt as Carl seemed to expect of her. "Nope," she answered in a matter-of-fact voice. "My Mama always told me not to look on backlands. I'd rather you went to a doctor and let him tell me what is your condition."

"I been trying all I could to save you extra expense."

The manager snorted at that and the two bell-hops sniggered. That enraged Carl more and he glared around the lobby and announced, "I got me a good lawyer who says I don't have to go to all that rigmarole."

"Well then, Carl, you can just go back and tell that lawyer you got that I'm not giving you no thousand dollars, and he can law me for it all he wants to. I'm in no way responsible, but if you're in as bad a fix as you say, I can tell you something mighty good for a case like that. Get hold of some mutton tallow, then melt it and mix it together with some teppentime and grease yourself good back there."

The manager, the bell-hops and three male guests who were seated in the lobby sniggered.

"Teppentime and mutton-grease!" Carl exploded. "I come . . ."

"Yeah, it's mighty healing and dependable," Arvay con-

firmed earnestly and calmly. "Can't be beat in a case like that. Now, if it was a burn, you would need some baking soda and mix it good with some wet Octagon soap, and you take. . . ."

The laughter was more public this time. Nobody was pretending to hide it. Carl's anger and chagrin and Arvay's earnest manner made it twice as funny. Also it was plain that Arvay did not know that it was funny. She looked at Carl and all around her and went on.

"But I ain't joking. It really is mighty healing. Takes the soreness right out. I keep it on hand all the time. My husband and my . . ." The howls of laughter drowned her out and Carl's angry voice prevented Arvay's taking up again.

"You, you, female hypocrite you! I come here to get satisfaction for being mortal hurt on your rotten property! I didn't come here for you to teach and tell me how to grease my behind!"

"That'll do, Middleton!" the manager said sternly. A quick look passed between him and the burly porter who had been ostentatiously polishing the brass plates on the swinging doors that led into the dining-room. The porter straightened up and made ready to move forward. The bell-hops went on the alert. The manager came out from behind the desk and took a commanding stand. "I said *that will do!* You have got beside yourself, entirely. Mrs. Meserve is much too important to be handled carelessly, and anyhow, this hotel does not allow loose talk in front of ladies. You have worn out your welcome, and we'd much rather have your space than your company."

Carl glared and frowned at the manager and looked as if he felt to fight, but he went on out without another word. Arvay thought that Carl looked whipped and pitiful as he shuffled out through the big doors. She saw him walking slowly and with his head down as he passed the wide window. The manager stood like a victorious champion of protection until Carl was good and gone, then comforted Arvay.

"You don't need to fret about being sued, Mrs. Meserve. You sued by him! That's a joke. When Banker Cary got

293

through with him it would be manners and behavior. Ha!"

"I can't see what made him come here and carry on like that. To save my soul, I can't make him out," Arvay said in genuine confusion.

"Oh, the fool is stuck on you, Mrs. Meserve. Sweet on you and cutting the fool."

"Sweet on me?" Arvay looked around in astonishment. "He sure got a funny way of showing it."

"Oh, he just thought up that mention of money after you treated him so cold. Started to blabbing soon as he got in here about how he courted you when he first came to town."

"Courted *me?* Why, this is my first time even hearing of such a thing."

"Oh, nobody's paying his talk any mind, but that's what he claims. Said that you were so young that you might not understand and he tried to court you through your sister, but you sent word back and turned him down."

Arvay gave a gasp. "I sent word? Why, he's raving crazy." But the phrase said something to Arvay.

"He could be lying, or you never got the message one," the manager said off-hand. "Anyhow he claims that he lost interest in being a big man when he missed you, and lost interest in everything when you married. Makes out that he would have amounted to a whole lot if he could have married you." The manager's lips twisted in scorn and disbelief. "Oh, he ain't just started this whining about you. I've been told that he's been whispering it around for ever so many years. Must have made his poor wife feel mighty fine to hear a thing like that."

Arvay flushed to her hairline. "Never heard nothing as crazy as that in all my born days. Married to my own sister and acting like that. His feelings may be serving him all right, but his common sense must be gone astray."

"Crazy as a bed-bug," the manager agreed sympathetically. "So you see why I couldn't let him up to your suite and you be in there with him by yourself. No telling what the fool might try to do. I figure him out to be plumb crazy."

"I help you to say," Arvay chimed in with a nervous laugh and hurried off to her room.

Arvay fell on her face across the bed and laughed hysterically. It was too funny. Weak as she was, Carl believing that she could prop him up. Wanting to lean on her small strength! Larraine whom she had always looked upon as so self-satisfied feeling so frail of her chances that she needed to steal herself a husband from Arvay. Then both Carl and Larraine felt themselves less than she was. Maybe there were a lot of weak-feeling folks in the world. Weak as she herself was, it was strange to know that people had been depending on her. They must believe that she could hover them.

Still on her stomach across the bed, Arvay reached for a pillow and snuggled it under her head. So Carl claimed that he had sent her a message about marriage. Even if it was true, Arvay had no resentment nor felt any loss. Poor Larraine! No need at all for Carl to ever know the difference, but it was a pitiful thing. Now, he comes hunting her after all these years for a consolation and all she has on hand to give him is some teppentime and mutton-tallow to grease his behind. Teppentime and tallow. If Carl had loved her sure enough all these years as he said, it was a curious end to a long-time love affair. However, poor, poor Larraine! Poor Carl too. Life had funny ways.

CHAPTER 25

N othing left for me to wish for except that I wish poor
Mama could see how she's being put away."

Arvay looked at the glass-sided hearse, the lavender
casket inside that opened out like a couch and the smother of
floral pieces. And all the people that old Maria could have
wished for were there to pass around and say her a last fare-
well.

Bradford Cary had really made a big thing of putting Maria
Henson away. Arvay was touched and pleased. Her mother's
dying wish had been realized. With wet eyes, Arvay went
through the funeral with satisfaction and gratitude in her
heart. She could not fathom the kindness and goodness of it
all, but she was not probing and asking questions of herself nor
anybody else. It was so, and that was enough for her. Arvay
did not know that the urge to hold public office had been
growing in Bradford Cary for the last two years. But he had
to look like a man of the people and he was too well known
as a monied aristocrat. The association of his youngest son
with Kenny in the University band had given Cary an idea,
and he had followed it up by cultivating Maria Henson.
Months before her death it had spread around Sawley and the
county in general of Cary's kindness to her and his attachment
for her. Her grandson, Kenny, was assumed to be his product

and protégé. Poor people began to think mighty well of Bradford Cary II. He was a big man who made himself one of them. That was ever so much better than one of them trying to make a big man of himself. They began to say that a man like that ought to be in office and looking after their affairs. Cary let on that he was surprised at such a thought and lingered back. Many people began to push and shove him forward.

Maria's death gave him his opportunity and he took it. The local paper gave great publicity to her passing as an old and worthy citizen. The kind of citizen who was the foundation and backbone of our great nation. Clean-living, plain, honest and a devoted Christian. The common people saw themselves glorified in Maria and they loved it. That Bradford Cary was standing the expenses of the big funeral was spread by mouth. It went faster when it was understood that Cary had refused to let it be put in the paper. He was a good-hearted man who wanted no credit for what he had done.

But even if Arvay had known about the skillful manipulation, she would not have cared any more than Maria would have. Everything had been done in a fine and handsome way. Bradford Cary II had spread his prestige like a gold-worked coverlet over Maria Henson and sent her to rest as she had wished and more. Arvay was moved to her foundations and satisfied. If only her mother could see the hundreds of cars, the casket, the flowers, and the long, long line of people passing around her casket and looking down in her face!

Arvay felt sad at her mother's death, but she returned from the cemetery with happy satisfaction. A sacred promise had been kept. A dying plea had been granted. Maria, who had lived on scraps and crumbs all her life had been put away like a queen. It was some payment for all that she had missed. Bradford Cary, who had never noticed her when she was growing up, now chose to be her friend. The proof was all around her. Introductions to big and important people, dinners and taking all care and worry off her hands. Then putting her mother away the way he did. No, Arvay would not have

welcomed any pulling-down whispers about the Bradford Carys.

And with her the feeling lasted. Nearly a year later she read of his entry in the gubernatorial race with great pride and pleasure. When he won, she looked upon it as a personal triumph. She had no idea what a part she had played in Florida politics. She did not realize that she had helped to make a governor of the state.

One thing she did know, however. She came away from her mother's funeral changed inside. Big, book-learnt people had seemed glad to know her and had treated her very nice. They said praising things to her and made her ever so welcome. They complimented her on being a fine wife and mother and seemed to find nothing wrong with her. Maybe she was not as bad off as she had thought she was. It made her feel to hold up her head and to look upon herself.

What put her ahead of Larraine and the other girls who had come along with her? Seemed like it was Jim Meserve. She had caught the choicest man of them all. How had she managed to do it? The only thing that she could see was her face and her body, and maybe Jim liked her ways too. Then it could be that she wasn't too ugly after all, and her difference from the girls she used to envy was not a mistake as she had thought. Perhaps Jim's hankering after her was not such a burden to bear when she looked around at the lives of her old friends. Certainly the afternoon of her life was more pleasant than the morning had been.

CHAPTER 26

onday had been in town many hours when Arvay opened her eyes. She saw that it was ten o'clock by her watch. Arvay had had a good sleep and sat up in bed at peace and agreement with the world. She was full of resolution. She was willing to take the blame for any variance with Larraine and Carl and shoulder the job of straightening things out.

With a breakfast of broiled country-cured ham, fried eggs, hot soda biscuits with country butter, and coffee inside her, Arvay set out to make a move. The tasty ham put her in the mind of something. She would make 'Raine the present of a big ham along with a pile of other groceries. Enough to do the family for a whole month and then slip her sister twenty-five dollars for spending change. No sense in two sisters not being thick friends and depending on one another. Arvay considered that she would be wrong to hold anything against 'Raine and Carl. Not having, and never having things made people do things and act in ways that they wouldn't if they ever had anything that they wanted. If she could make it up with Jim, maybe it would be a good thing to talk him into sending for the family and finding Carl and his two sons something to do. Why, they could live in the house in the grove! The very thing.

Arvay felt a happy giving off as she went into the store. She bought a large ham for Larraine and pictured 'Raine's face when she drove up with the load of good groceries that Arvay was taking to her. It was on a second thought that Arvay ordered three more hams to be shipped to her at Citrabelle. She explained to the clerk that you couldn't cure country meat down where she lived. Too warm all the year round. She ordered a bag of paper shell pecans as a present for Jeff and Janie. Let them know that she appreciated them too. Maybe Jeff was not snappy for just nothing. He was not that way with Jim and the children. The fault could be in her. She would show him that she meant him well. Then she ordered one packed for 'Raine and two more shipped to her home. On top of the cases of canned goods and staples that she ordered delivered to 'Raine, Arvay bought a fat hen for chicken dumplings and a lot of fresh stuff to go along with it. She and 'Raine would fix a good dinner and they would all eat together for the first time in many years and have a good time together. Then Arvay remembered how they used to love fried round steak for Sunday morning breakfast and turned back and bought five pounds of top of the round to take with her.

A pleasant picture from her childhood came up before her. The Henson kitchen of a Sunday morning. A pot of soft grits on the back of the stove all ready and waiting. Big pan of biscuits made out and ready to shove into the bake-oven at the last minute. Quart bottle of molasses on the table and the dish of country butter. Big black iron skillet with grease in it waiting for Maria to get through pounding the steak with the hammer. The steak salted, sprinkled over heavy with black pepper and beat and beat until it was tender, then doused in flour and dropped into the hot pan to fry. Thick brown steak gravy with onions in it to go with the grits. Yes, they would have a good old-fashioned Sunday breakfast together. Then after that, she would make 'Raine come into town with her and pick out a couple of decent dresses, and a few other things to wear. 'Raine was bound to feel a lot better when she had silk stockings and got fixed up to look like something.

With the box of groceries loaded in the taxi, Arvay rode along the road happily noting the scene of things. The woods had not the lush, exotic look of south Florida, but there was a sturdy green fullness that was pleasing. Nowhere in the world, Arvay considered, did oak trees grow so fine. The dogwood that she missed in south Florida, the crêpe myrtle and rambler roses before a door. They didn't do well down south and she wished that they would.

"If you will be so kind as to set that box of groceries on the porch for me," Arvay told the driver at the gate, "you needn't never mind waiting for me." Arvay paid the man and tipped him. "I'm mighty much obliged to you."

The taxi drove off and left Arvay standing in the shabby yard and beaming towards the door.

Arvay waited for a sign of life, and seeing none decided that the place looked mighty quiet, and that everything was closed up so. Carl's wreck of a car was nowhere to be seen, and no smoke coming out of the chimney. They must have run into town for something. She might as well go on in and start the cooking.

The door was closed, but it was not locked. There had been no key to it in Arvay's memory. She turned the door-knob and went inside. The first thing that she noticed was that the old sewing machine was gone out of the hall, and the hat-rack was missing. That made Arvay jerk her head around to look inside the parlor, and she could hardly believe her eyes.

There was nothing in there except that relic of an organ, which had been nothing for years but a rat's nest. Yes, there was something else, but it hurt Arvay's heart to see it. All the pictures of the Meserves were there, mutilated, and trompled on the floor.

The scene was the same in every room. The house had been cleaned out of everything. Even the backless chair in the kitchen was gone. One old fork with the tines bent was lying against the wall, probably overlooked.

The back porch was just a framework. All the sound boards had been ripped off and hauled away. Only the three or four

rotten boards were left. The wash-pot was gone out of the backyard, and the three wooden wash-tubs from the wash-place.

In deep anguish, Arvay moved about, stumbling through the brittle dead weeds of the past summer, and suffering without words and without tears. Her soul was sunk in defeat. Her sense of accomplishment was gone. Both she and her dead mother had been robbed and defeated. All that fine funeral was in vain. Perhaps her mother had not got off in her high journey after all. Held back from her flight by such low-lifeted doings. No doubt Maria would get to creeping into 'Raine's shabby shack between midnight and day to frighten the fatal life out of the rascals. Arvay hoped that it would happen. Then no, she didn't. She didn't hope any such thing. She wanted her mother to be at rest at last. She had had enough of dirty, poverty-paralyzed places. Immortal Glory was where she ought to be, and setting down.

Arvay stumbled around, farther and farther away from the house crying, "Mama! Mama! Please don't fault me. I done the best that I know how." Then tears began to run from her eyes. She came to the pear tree that was the farthest to the west and looked down. There was trash piled up around it. She went to the other one, and the big fig tree and looked. They were all the same.

"They're gone, but they aim to come back, I see, and set these trees on fire."

Arvay was scattering the trash away from the trees when her neighbor to the east waved a hand at her and came through the fence. She was a woman about ten years younger than Arvay's mother, and had always been there next to them. She spoke to Arvay very warmly, and there was something peculiar in her eyes.

"You expecting to see your sister and her fambly, I reckon, ain't you?"

"Well, I sort of was."

"I reckon then that you didn't know that they moved out last Thursday. Sort of soon in the morning like. Got some man

302

that raises hogs across the river to come with his truck and carry the things off for 'em. Bright and soon in the morning, it was."

With her hands propping up her lean shoulders by resting on her pelvic bones, the gray eyes bored at Arvay and told her that she understood things. Arvay didn't open up so the neighbor could talk, so she dropped another feeler.

"I was in to see your Maw pretty occasionally after she took down sick in the bed, fetching along a mouthful of chicken soup, and a few soft things that I figgered her stomach could handle. Every time she would be expecting you, and wishing for you to come. I was mighty glad when I seen that you was here."

"And I would of been here long time before if I had of been notified. I got the message that she was sick, and caught the train that very night."

The woman looked at Arvay with belief and pity, then glanced down at the pear tree.

"Look like somebody was getting ready to burn you out in case that you stayed around here and moved in." She wound up the gray ball of hair at the back of her head. "But I don't reckon that it would happen if you was to go on home. They would treasure them pears and them figs after they was living on the place."

"But they'll never live here, Miss Hessie. Mama didn't want it, and she must of had her reasons, and I don't intend to allow it."

"Them was your Maw's wishes all right. I know it to be a fact. She loosed 'Raine and her fambly, long time before she took down sick. You wouldn't be doing the right thing to whip around and go against her wishes."

"Don't you worry, Miss Hessie. It'll never come to pass. I'll fix it so that even when I die they won't go over Mama's wishes like they please. I don't know just exactly how to go about it, but if any way can be found, they'll never make it."

"With the right kind of folks on this place, it could come to be real pretty, but not wishing to hurt your feelings about

303

your folk . . . Oh, I can readily see that you'se different from them all the way. Don't seem like you was ever born in the same fambly. I hope and trust that they didn't take off Sister Maria's memory-things. She wanted so for them not to come nigh 'em. I know that they wasn't brash enough to take *them* outa that house."

Arvay nodded her head miserably without speaking, and Miss Hessie's eyes flew wide open. "Naw, Arvay, naw! You don't mean to tell me! I can't believe that unlessen I go see it with my own eyes."

Without a word, Arvay turned and led the way to the house. Miss Hessie groaned when she saw the back porch. She grunted and grunted as they went around the house and entered by the front door.

"This looks like groceries you fetched along, too. Umph! Umph! Umph! All that good eatings for folks to do you like that."

Miss Hessie was utterly outraged when she stood in the empty parlor.

"If it was me, nothing would do me but to call the high Sheriff and stuff they rusty hides in jail! That's good enough for 'em, and just what I would do, too."

"Oh, Miss Hessie, I feel so outdone I don't know exactly what I aim to do. Come on back outside. I hate to look at it no more'n I can help. Poor, poor Mama! Her life-time memories being wallowed and dogged out in a hog-pen!"

"Send the high Sheriff to get 'em back. That's what I sure would do."

"But what would be the use, Miss Hessie? By now, I'll bet they ain't fitten to look at. Slums like them would just as soon scour the floor with Mama's tablecloths as not. It's just like my husband says. He says folks makes a bad mistake when they call places slums. He says folks are the slums instead of the places they live in. Places don't get nasty and dirty and low-down unlessen some folks make 'em like that. Place some folks in what is called slums and they'll soon make things look like a mansion. Place a slum in a mansion and he'll soon have it

looking just as bad as he do. It ain't right to blame it on the place. Leave land alone by itself, and it'll grow up into trees and flowers. It don't grow up into slouchy people."

"You sure is telling the truth there, Arvay. Much as 'Raine and Carl and all them big grown children was around here, just look at this place! And it looks even worse now with this big highway passing right by here. This shackly old house tore down, and a little care, and your place could be made to look mighty pretty."

They were out on the porch again, and Miss Hessie stood over the box of groceries and looked down.

"You got fresh meat in here, ain't you, Arvay? I know that you was expecting for it to be used right away, but you got disappointed in them not being here. I better take it on over home with me and fix it for you. By the time you get through messing around over here, you might have a good appetite."

"That's a fine idea, Miss Hessie. Make use of everything except that ham and them pecans. I'll take them down home with me. I'll come and eat with you all, if you don't mind."

"You know so well that we'll be only too glad to have you. My grand-boy, Orrie is home right now. I'll send him to tote that box over for me."

Arvay liked Miss Hessie fine, but right at this time, she was glad for her to go and leave her alone to herself. She tore out immediately for the mulberry tree far down over the brown grass and dead weeds in the back. It was late February, and the huge limbs and limber branches were nude of leaves. They made a pattern of dark lacings against the tepid sky. But soon now, three weeks at the most, tender green leaves would push out of those tight little brown bumps; badges that the tree put on every spring to show that it was in the service of the sun. Fuzzy little green knots would appear. These would turn out to be juicy, sweet, purple berries before the first of May. But most of all, this tree would become a great, graceful green canopy rolling its majesty against the summer sky. Here had been her dreams since early girlhood. Here, in violent ecstasy, had begun her real life.

305

Like her Mama's keep-sakes, this mulberry tree was her memory-thing. It brought back to her the happiest and most consecrated moments of her lifetime. As with other mortals, life is full of compromises and defeats with few clear victories to show. Here, Arvay, the woman, had triumphed, and with nothing more than her humble self, had won her a vivid way of life with love. This tree was a sacred symbol. She wished that she could use it like a badge and pin it like a bouquet over her heart.

Arvay flung a challenging look towards the highway. There was the world in shining cars; flying and flashing past. The nation crossing and re-crossing before her tree.

But between the tree and the world there stood that house. Now Arvay looked at it with a scrutiny, and darkened. Seeing it from the meaning of the tree it was no house at all. It was an evil, ill-deformed monstropolous accumulation of time and scum. It had soaked in so much of doing-without, of soul-starvation, of brutish vacancy of aim, of absent dreams, envy of trifles, ambitions for littleness, smothered cries and trampled love, that it was a sanctuary of tiny and sanctioned vices. Its walls were smoked over with the vapors from dead souls like smoky kerosene lamps.

By a lucky chance, she had been carried away from it at a fairly young age, but still, its fumes and vapors had stuck to her sufficiently to scar Jim and bruise her children. There was no getting away from it. It was a fact in truth. If it could still hurt and disease her at that distance and for so long a time, how then could she hold things against Larraine who had never been away? Look what it had done to her and to Carl and to their children, and here was another crop about to come off from them. The house had caught a distemper from the people who had lived in it, and had then diseased up people. No, it was no longer just a building. It had caught a soul of its own now. It caught people and twisted the limbs of their minds. What was in its craw gave off a bad breath. It stood between her sign of light and the seeing world. It had just about stifled what the tree had given her. The tree, the

servant of the sun, was being made out to be nothing by that ill-deformed brute of a thing. How much had it blinded her from seeing and feeling through the years!

Arvay got to her feet with great deliberation. She stood and looked up through the bare limbs of the tree once and then strode with purpose towards the house. Starting at the back, Arvay walked around it slowly and warily like a battler looking for an opening to charge in for the kill. She circled the place three times. Now and again she could hear frantic squealings and pattering as the dismal and disappointed denizens scurried around seeking something for their hunger. Arvay thought that the sounds just suited the place. It was the voice of the dark, the creeping, the gnawing and destroying. The old house was singing its song.

That determined and answered Arvay. She flung the back door wide with a clang and went inside. From room to room Arvay went gathering up and piling together the trash and rags that had been left behind. There was plenty everywhere. Then she went out in the yard and collected and shoved the masses under the sides of the house, particularly under Maria's old bedroom. Back in the house she started in Maria's bedroom and began to light fires. From room to room she went, and when she saw that they burned clear and swiftly, she ran out and set the piles underneath the house and watched them take on greedily with grim satisfaction. By the time that cars began to halt at a safe distance, and people collect on the highway to watch the fire, Arvay was seated under the mulberry tree. Looking at the conflagration, exultation swept over her followed by a peaceful calm. It was the first time in her life that she was conscious of feeling that way. She had always felt like an imperfect ball restlessly bumping and rolling and rolling and bumping. Now she felt that she had come to a dead and absolute rest.

The dry old house burned furiously, and as Arvay watched the roaring and ascending flames, she picked herself over inside and recognized why she felt as she did now. She was no longer divided in her mind. The tearing and ripping and

useless rending was finished and done. She had made a peace and was in harmony with her life. The physical sign of her disturbance was consuming down in flames, and she was under her tree of life. Arvay felt a piercing pain when she thought about her present terms with her husband. It could be that she had stumbled and fumbled around until it was too late to take in the slack. If that was the case, she would never be really happy in her lifetime. But even so, she knew her way now and could see things as they were. That was some consolation.

Arvay sat on and pictured images in the soaring flames. Evil, witchy-looking things formed, growling and twisting in agony, then perished in the cleansing fire and their thin remains were carried off by the smoke. The roof of their old den crashed in with a great roar and the victorious hosts of flames leaped and howled. After a while there was nothing but coals of embers lying low to the ground and panting out gusts of heat. Not a flicker of flame left at last.

Then Arvay got up and walked resolutely over to her neighbor's home. Miss Hessie looked at her for a moment and then told her in an off-hand voice, "Good you got here. Dinner's all ready and done."

"And I'm ready to eat it," Arvay answered and laid her hat and hand-bag on the bench on the back porch.

In the conspiracy of silence, Miss Hessie poured warm water in the wash-basin and handed Arvay a clean towel, then she turned away and put the dinner on the table. The grandson made a pitcher of ice water without asking a word about the fire. The three sat down to the table and helped their plates generously. Arvay shook her head with conviction after the first mouthful and accused Miss Hessie of being a fine cook. Miss Hessie challenged Arvay to try her and see if she was guilty. They all ate hungrily for a while.

"Appears like we had a fire in this vicinity," Miss Hessie remarked casually and helped herself to some water-melon pickle.

"I reckon that I can stand the loss, though," Arvay answered just as off-hand.

"Without a doubt. When you planning to re-build?"

"Re-build? Never to my knowing, Miss Hessie. I can't see that I belong here no more."

"That's right. What would you need a house for here with your husband and your family otherwise. Be much more sensible to sell."

"Don't know as I want to be bothered with that either, Miss Hessie. Take up too much of my time."

"Just leave it lay there and eat you up in taxes?"

"No'm. It sort of come to me to make of it a better use. Brad Cary's got the welfare of this community at heart. . . ."

"He is that. Things have took on and bloomed since he put his shoulder to the wheel here recent. A honest and sincere man. Always looking out for Sawley's advancement. But what did you have in mind?"

"Him and Evelyn, his wife you know, was talking it over with me and some others last night about this town needing a play and a pleasure park, mostly for the young'uns. It come to me since I been setting here that Mama would feel glad to know that the place was all given over to pretty flowers and somewhere for folks to set down and rest. Believe I'll turn it over to Brad and them for what they want to do for a park."

"That would really be a great improvement for Sawley, Arvay. I can't help from wishing, though, that my grand-boy here was old enough to buy it in and handle it. So you cutting loose from Sawley, eh? Never expect to live here again?"

Arvay sat erect and looked Miss Hessie in the eyes.

"Miss Hessie, my husband come along and took me off from that place and planned and fixed bigger things for me to enjoy. Look like I ought to have sense enough to appreciate what he's done, and still trying to do for me, and not be always pulling back here. You've known me ever since I was a baby in my mother's arms. You know all about us. What would I be hanging on to that old place for?"

"Not a blessed thing that I can see, Arvay. Nothing ever was there for a girl like you. And from what I can learn, you have really been blessed. But as I said to Maria over and again,

309

no more than I expected, and no more than you deserve. No use at all in you pulling back here for that little piece of land."

"Oh, I won't, Miss Hessie, except for a visit with friends. Don't you worry about me hanging onto nothing here, more especially since Mama's gone. My last string has done been loosed. It would be a turning back on my travels."

"Yes indeed it would."

"Brad has been noble with me as a friend, and then putting poor Mama away like he did. So I aim to give this place to help out what he's trying to do. Only thing I ask and require is for them to save that mulberry tree and give it every care. I feel sure they'll grant me that."

"Without a doubt. You know I'm along with your Ma, Arvay. If I never see you no more after you leave here this time, I'll remember you in my prayers."

"Do that, Miss Hessie, and I'll do all in my power to take care of things my ownself. No need of wearing God out."

CHAPTER 27

It was late in the afternoon when Arvay arrived home. She stood on the front porch and looked everything over with pleasure. Then she knew what she wanted to do first. Without taking off her hat or considering her luggage piled on the porch, she hurried straight down to the house in the grove. As she neared the house, she recalled the last time that she had been here. It was the night that she had seen Lucy Ann lying on the ground between the house and the privy. But it gave her no painful turn as she had always thought that it would do. Now it was just part of the life that had passed. A storm that she had weathered through. So she did not hesitate and halt. She hailed Jeff and Janie cheerfully as she ran.

They had been taking their comfort and came to the door in their bare feet and stood side by side. They looked at Arvay as she came and then at each other in puzzlement.

"Yeah it's me!" Arvay answered their looks with laughter. "Hello there, Jeff, you old rascal, you! Hi there, Janie!"

Arvay came to the steps and stood there looking up at them and smiling like a child. "You all look like new money in town to me. I sure am glad to see you."

Jeff was defrosted like lightning. He stammered from the rapid change of climate, but his face showed pleasure. "Why, Miss Arvay! We'se real glad to see you back." Jeff could hold

out no longer and went all the way. "I was just telling Janie how I wished that you would come on back home."

"Sure was," Janie backed Jeff up, but Arvay could see the lie in Janie's eyes. But she could also see that they were both sincere now in saying that they were glad to see her. To see this kind of Miss Arvay home again.

Arvay braced her hands on her hips and looked up at them. "Well, you no-manners thing! I so well know that Dessie never taught you no kind of manners like that, Jeff. I know Dessie too well for that. You haven't had manners enough about you to ask me in, and if you don't make room in that door, I ain't going to give you what I brought you."

Loving play-acting, they made a great show of making way for Arvay to enter. She stepped in, laughing, shoved Jeff, smacked Janie on her hips and sat down near the door. They were eager to know all about the burial and what all had gone on up there.

Arvay gave them an animated account of the funeral, but left out what she did not wish to remember, that was about how Larraine and Carl had behaved towards her. She dwelt more on the visits and the meals and other entertainments which the Carys had furnished. They were extremely interested, but suddenly Jeff cut her off.

"Who lifted your things inside for you, Miss Arvay?"

"Why, come to think about it, Jeff, nobody did. They're still out on the front porch."

"Oh Lawd, Miss Arvay! Maybe somebody done took 'em already."

"Do, Jesus! I sure hope not, Jeff. Kenny's present to me. You reckon anybody would bother 'em?"

"Sure would. Things ain't like they used to be around here, Miss Arvay. Never no more. Folks passing and re-passing all the time now. I have to watch this grove like a hawk now. Several attempts been made to steal fruit."

"Naw! You don't mean it, Jeff."

"Yes, Ma'am! Only day before yistiddy, three men together was in there just helping theyselves, and to my King oranges

at that. With that new settlement right here at us, and that club and all them folks across the bridge, I got my hands full these days. You better gimme the keys to the house and I'll run and see about your things. Be right back."

Arvay was so embarrassed that she had not left the keys with Jeff when she went off, that she hung her head and colored.

"I was so worried about Mama's condition that I clean forgot to hand 'em to you before I went off," Arvay dissembled.

"I thought you must of," Jeff conceded cheerfully. "I had sense enough to know that you wasn't locking up against us, because us Meserves don't mistrust one another. I made mention of it to Janie."

All of the turmoil and uncertainty that Arvay had felt before she went away visited her swiftly for a moment. Jeff hurried off through the sunset, and Arvay sat and fiddled with the edge of the tablecloth for a minute or so before she came to herself and began to describe her mother's casket and the flowers, all of which Janie was more than eager to hear about. Jeff was back very shortly, but Arvay had command of herself by then.

"Jeff, why do you want to make things hard on yourself? You could just as easy have brought the present that I fetched you while you were coming."

"It clear slipped my mind, Miss Arvay. I was too worried about your things and glad to see that they was still there. I put 'em in your bedroom for you. Then again, I didn't know what it was that you wanted us to have."

Then Arvay took an attitude that she would have died before adopting before she went away.

"My dumbness, Jeff. Common sense would of told me that you couldn't read my mind." Arvay stood up gaily. "Come on, you all. Let's all got up to the house and I'll show you what I brought you. I can finish off about the funeral up there."

Arvay watched with a glow while Jeff and Janie made great admiration over the ham and the bag of pecans. Janie was a good-looking brown girl. She turned large soft eyes on Arvay with deep emotions.

"I declare, Miss Arvay, but you sure is folks."

"Sure is," Jeff added sincerely. "Just like Mister Jim, ain't she, Janie? And everybody knows that Mister Jim is quality first-class. Knows how to carry hisself, and then how to treat everybody. Miss Arvay's done come to be just like him."

The reflection upon her past condition escaped Arvay in the shine and the gleaming of the present. Her face flushed, and tears came to her eyes.

"Jeff, Janie!" Arvay turned her eyes away to try and hide her feelings. "Why, that's just about the nicest thing that I ever heard in all my born days! It is! I thank you so much for telling me that."

"But it's the living truth," Jeff confirmed with feeling. "You felt for us and remembered us. Made us feel like we amount to something with you. We feel proud and glad to work around you. You'se quality all the way."

Arvay was touched and sat down abruptly in one of the wicker chairs. She looked all around the porch and her throat worked painfully. She was glad that she had had Jeff to bring the box out on the porch to open it. After a long wait, she spoke.

"You all, going back up there in Sawley learnt me more than I'm able to tell you about. I done seen and felt things that I don't want to never see and to feel no more. I don't want to find it in me, and I don't want to find it nowhere around me. If I got any narrow-hearted littleness in me, I hope to God to cut myself and let it run out."

Arvay did not use many words, but she told them that she had burned the house, and turned her back on what it stood for for good and all. She had found that she did not belong there after all. Without realizing, she had come to prefer Jim's way of handling things.

There was a feeling silence. Arvay took in the pleasure of her porch, and a long look southward through the grove. This was her life and she loved everything about it. Jim had said that she loved like a coward and he had been telling the truth. If ever she was to be with him again, it was her move. She

stiffened herself internally and said casually, "And Jeff, as soon as I rest up for a day or two, I'm going to the coast and spend a few days with my husband."

"That's ever so fine and nice, Miss Arvay. I'm proud and glad to hear you say it. You just say what day you aim to go, and I'll have the car here and all ready for you."

"The car, Jeff? Why, Jim's got it on the coast with him, ain't he?"

"That one, yes, Ma'am." Jeff fumbled around nervously. "But it's another one—I mean that I can get hold of one for your convenience."

"You bought yourself a car since I been gone, Jeff?"

"No'm."

"Then I can just get on the train, Jeff."

"No, Ma'am. You ain't to—no, I mean it's too much trouble for you to be fooling with the train. Have to go up to Palatka and lay over, and then take another train to get to the coast. Then you have to change at St. Augustine to get to New Smyrna. No'm, I can have the car here at the door any day you see fit to make the trip. You had much better go by car."

Arvay sat there and looked at Jeff and thought. There was a bug under this chip. Jeff was as good as giving her an order not to go by train. This was a roundabout order from Jim Meserve and nobody else. The faithful Jeff was carrying out an order. The thought gave Arvay some hope. Maybe he had not forgotten her then.

"All right, Jeff. If you think that that is the best way for me to go, then I place myself in your hands. I got a few dirty clothes on hand that need to be done up. Some of those pieces I would like to take with me. I would love to be there day after tomorrow, but getting those things done up . . ."

"Oh, that's no trouble, Miss Arvay," Janie spunked up. "Gather up all you feel you need, and I can suds 'em out first thing in the morning and they'll be dry in no time. I can have 'em all pressed off by dinner time. I can go in there with you right now, and whilst I'm helping you to unpack your things, you can pick out what you want freshened up."

"Why, Janie, I would thank you from the bottom of my heart if you was to help me out like that. I'll thank you until you're better paid."

Arvay woke up next morning with hope and determination. Nothing beats trial but a failure, Arvay decided. She might not win Jim back, but she meant to give it a poor man's trial. That is the best that she could do. If she failed, it was not going to be because she never tried.

The place felt like Dessie's best days all that day. Good will and cheerful willingness all around her. Janie was in the kitchen ironing by eleven o'clock. Arvay had volunteered to cook enough lunch for everybody.

"I'll bet that old east coast is something to see," Janie said wistfully as she shoved the iron back and forth busily. "And boats. I never is seen nothing like that myself, but Jeff claims that it's something wonderful to see."

Arvay looked quickly at Janie and understood. She had not thought about Janie going along before, but now, why not?

"Why, ain't you going along with me tomorrow? Jeff told me that it was a nice big sedan car that he was getting. I thought that it was understood that you would be going with us."

"Oh, Miss Arvay! Oh, Miss Arvay! I'm so glad and happy. 'Tain't nothing that I wouldn't do for you. You'se so nice and kind."

"You still got to use your influence on Jeff, Janie, to get him to kill and pick us some frying-size chickens to fix and take along with us. I think that it would be much nicer if we fixed us up something to eat to take along. See can't you talk Jeff into killing and cleaning four chickens for us. We got plenty turning round to do. While he's doing that, you and I can be stirring up a tater pone to take along. We got plenty here to eat, no need in us going off empty-handed and depending on eating hot dogs along the road, now is it?"

"No ma'am!"

"And then there's my husband. Jim ever favors his stomach, and he just dotes on my tater pone."

316

The two women did a lot of turning and fixing for the trip. Arvay kept herself so busy that she had no time to fear the outcome of her journey. She steeled herself and refused to anticipate. Let tomorrow speak for itself. She got out an old cheap suitcase and lined it with white paper to hold the lunch. She and Janie laughed at the amount that they were taking. There was the big potato pone, four fried chickens, buttered biscuits, two dozen hard-boiled eggs, potato salad, and the gallon thermos jug full of hot coffee with cream and sugar in it.

Jeff, bathed and soaped so till the skin of his face looked tight and stretched and dressed in his Sunday suit of blue serge, had the car at the door at six o'clock the next morning. With his change of clothes went a formal manner. Jeff stood stiffly as he held the back door for Arvay to get in. He carefully stowed the lunch and Arvay's over-night case in the back with her. Janie, looking as if she had wallowed in a rainbow, beamed and gleamed as she leaped into the front seat beside Jeff, and the car rolled off. Arvay's hands were cold and moist in the palms as the car turned into the highway, but no one could have told it from her face.

At first, Arvay kept her mind off her mission by studying Janie and Jeff. That innocent-looking face that Jeff had, with a surprising earnestness and dependability behind it. He had never failed Jim in any particular, and in spite of all the laughing and talking that he was doing with Janie up there, was never likely to do so. He seemed never to forget the slightest thing around the place, and never neglected to take care of it.

Janie now, that mixture of colors that she had on. Nothing that Angeline would have thought about picking out to wear at all. But strangely, they did not look funny on Janie. That cheap silk dress became her looks very well indeed. Her short hair was as straight as anybody's today and the way she had it fixed, it improved her looks. Janie was a pretty colored girl and good-hearted. Jeff had made a very lucky pick. If she did not move to the coast, they would be mighty comfortable to have around. How did colored people get their hair straight-

ened? There were no kinky-haired women these days.

As the car turned into U. S. Highway 1 and sped north towards Melbourne, Arvay began to look at the scenery. This was a different Florida than she had known. This Indian River was a beautiful thing. The groves of leaning palms that bordered it, the beautiful homes scattered along its western bank, the arrangements of the flower yards, and the signs of free-spending wealth impressed her. So many kinds of palms, flowers, pleasure boats out on the river with happy-looking people in them, and fish leaping up and splashing back. And cars, cars, cars, flashing past heading south, and cars behind and in front of them going north. And they all were "really trotting" as Jeff said. Many of them passed Arvay as Jeff never went over forty-five. Arvay smiled because she knew that must have come from Jim. He knew that she was nervous at fast driving.

That thought was encouraging, and then again it was not. Jim was the kind who would take care of her whether he wanted her again or not. Her great trial was still before her.

The car began to slow, and Jeff pointed out the ancient Turtle Mounds, kitchen middens of a people who had disappeared ages before the coming of the Spaniards; rusting old iron pots left over from the indigo industry of the Minorcans; foundations of an old fort left by the Spaniards. Jeff was very proud of his information, but Arvay was not paying him as much attention as she seemed. She was straining forward, drawing back from what was before her. Then before she knew it, Jeff was swinging the car across a high wooden bridge. The Halifax River was before them. This was the waterfront of New Smyrna. They were there.

A short drive down a narrow road seaward, and Jeff swung the car off, and parked in a wide, grassy space before a big shed-looking building that had its backside in the river.

"Here we is, Miss Arvay. We'se at the shrimping docks."

Arvay sat looking at the structure and the activities around it. Several cars and trucks were parked around. On the river side she saw many boats berthed single, double and triple alongside the warehouses and open docks. Her feet felt heavy

318

and cold, but Arvay decided that it was too late to run now. She had come thus far and she might as well wade on in. She lifted one hand to the handle of the door.

"Just keep your seat, Miss Arvay. I'll jump out and run in and ask if our boats is in," Jeff volunteered importantly.

"Well, all right, Jeff," Arvay murmured wearily, "but I reckon I ought to get on out and stretch my legs."

Janie jumped out behind Jeff and went with him into the dusky interior of the building marked with the name of a shrimping "factory." There were four more big dark doors with other names beside them, but Jeff headed into the one that had Toomer on it. In a very few minutes, he was out again.

"I asked for Captain Jim, Miss Arvay. Miss Mary Toomer, that takes care of all the business in the office, says that our boats is really in, and that Captain Meserve's done sold his shrimp and set led up, and drove off uptown. Want me to go hunt him up?"

"No, Jeff. He'll be back sometime or nother. Yeah, I reckon you better. No telling what time he might come. Tell him, tell him, oh, you can just tell him that I'm waiting here."

Arvay made to get out of the car. She did not want to meet Jim with Jeff or anybody else present. She would rather get out of the car and walk around by herself and wait. As she made to alight, a smiling, middle-aged white woman came out of the door and introduced herself. She was Mrs. Toomer, and said that Arvay's chauffeur had told her that Captain Meserve's madam was present. She knew that Captain Meserve would want to be told as soon as possible that his wife had come. One of the fishermen was going uptown. If Arvay wished, she would send him along with Jeff to locate Captain Jim. While they were gone, she would be pleased if Mrs. Meserve would step inside the office and have a seat.

Arvay went inside and smiled and answered something back when Miss Mary said something. Miss Mary was nice and pleasant, and Arvay was sure that she would like her fine, only she was too tense right now to say and do the right thing in

company. Fearing that she might be acting dumb and saying the wrong things, Arvay said that she would love to look around the place and excused herself. Out of the office, Arvay walked up and down the dock, looked off over the woods and around, but saw nothing at all with her eyes.

Then Arvay saw Jim coming. He was driving his usual fast but certain way as he swung expertly into the parking space. He was parked and striding towards the building before the car with Jeff and Janie came trailing in and stopped.

"Oh, hello, Jim!" Arvay tried to be brisk and off-handed, but flushed and faltered. Her eyes could not stay where she wanted them to.

"Hello, Arvay," Jim said casually, but looked her over boldly.

"Oh, I got so much to tell you about, Jim," Arvay chattered in nervous haste. "I know you'll want to hear how everything went off in Sawley." Arvay saw Jeff and Janie hovering around, obviously waiting for orders. They must be gotten rid of. If Jim turned her down, how could she ever go back to the house in Citrabelle if Jeff and Janie had witnessed her downfall? She turned to Jeff.

"I reckon that you want show Janie over the town, don't you, Jeff? It's all new to her, and she wanted to come see it so bad. Tell you what to do. We'll whack up the lunch. You and Janie take all you want, and leave some for me to eat. Then you won't have to hurry back."

"Hold on a minute, there," Jim interrupted. "Just what is in this lunch you're talking about?"

Glad for a chance for conversation, Arvay told Jim. Jim started at once for the borrowed car, and went into the lunch. He grabbed up a chicken wing and ate it with appreciation. Then he partitioned it out himself, and transferred the suitcases to his own car.

"That's enough for Jeff and Janie. They're going straight back home where there's plenty more. Give a man that needs it a chance. Me for instance. And potato pone, too. My favorite groceries."

Arvay was pleased that Jim wanted her cooking. She opened her eyes wide and asked, "Oh, you want Jeff to take the car on back?"

"He better get away from here. Who's going to look after things while he's off fooling around? Hit the grit, Jeff, and get on back home. Give that road a cold fever."

With the lunch on the seat between them, and eating as they pulled off, Jeff really tore out and left Arvay standing before Jim and feeling weak. Her easy retreat was cut off. She would have to deal with things one way or another, and she didn't know where nor how to start. They stood there in silence until the car was long out of sight, then Arvay looked up at Jim and said diffidently, "I'm just dying to see the boats."

"You haven't seen 'em yet?" Jim asked in surprise.

"Why, no, Jim. That is, I would rather for you to show 'em to me yourself."

"Oh, so that's the way it is, eh? Well, come ahead. Wait a minute till I grab that lunch box. I'm hungry as a dog for some of that tater pone."

With Jim lugging the suitcase, Arvay followed him through the shed and out on the river side of the building. Jim walked ahead a piece and stopped. Arvay could tell that he meant for her to look around and she did.

"Oh, Jim! You got three boats already! And, my goodness! You got one named after me."

"That was my very first one, Arvay. The *Angeline* was next. That trashy Kenny scraped up the money for that last one, so I named it after him. I aim for the next one to be the *Hatton Howland.* The fifth one will be named after that baby that Angeline is about to have. Next one after that will be named the *Big Jim,* meaning me."

"Oh, Jim, but you are doing well. Can we go on board now and look around? This is my first time to even see a boat as big as this."

With his pride well shuttered, Jim helped Arvay aboard the *Arvay Henson,* and they inspected the others too. He stuck to showing and explaining the boats. Nothing personal at all.

When Arvay was tired of climbing around, they went back to the *Arvay Henson* and sat down in the cabin.

"Let's eat!" was all the encouragement that Arvay got out of Jim. If there was any talking coming off, Arvay saw that she would have to do it herself. As they ate, Arvay fenced by telling Jim what had happened in Sawley. With him, however, she did not leave out the part about Larraine and Carl. She did not damn them, though. She surprised Jim by making allowances and excuses. They were really not to be blamed. But Jim's jaws got grim.

"Did Carl cut a caper like that because he had some idea that you had no kind of protection?"

"No. That is, I don't see how he could of got a notion like that."

"Oh," Jim said and waited some time before he spoke again. "I wouldn't quit my business to go hunt up that toadfish, but he'd better have sense enough not to never come in my sight. I hope that you didn't back off because you felt helpless at all."

"No, it wasn't that way, Jim. I just felt that they were so far back that I was sorry for 'em."

"Well, then that's okay. Say, it's some mighty nice boats tied up here, Arvay. I'd take you on board and let you see 'em and introduce you around, but you ain't dressed for nothing like that. Them high heels and that narrow skirt ain't suitable."

Arvay flashed out with light and leaned forward. "But I really want to do that, Jim. Where can I get something to put on so that I can go along?"

Jim looked at her for a minute, thrust his hands deep into his pockets and finally said as if he were talking to himself, "It would be a kind of waste of money to buy a outfit just for that. It wouldn't be needed any further, and—"

"But why can't I go out on the trip with you, Jim? I'm so proud and pleased with how you have done, that I want to go along with you and see you handle things if you'll let me."

"You really mean that, Arvay?" Jim asked after a pause.

"Jim, I'm so proud, I'm so pleased, that just a little bit more

and I'd bust wide open right here. All I wish is that I had of been here with you all along and helping you out like Miss Mary does for her husband. I know that I got the smartest husband in the world, so why wouldn't I feel proud?"

Jim didn't kiss her. He just took hold of her arm very firmly and led her across the deck to the rail.

"Come on then, honey, and let's go uptown and fix you up with something to put on. But mind you now, it's tough out there. Well, you can go along this time anyhow."

Jim bought a pair of the blue jeans that the fishermen wore, two blue shirts, and the tall rubber sea-boots, and Arvay changed into them in the back of the store. Jim told her that the Third Man bought the stores for the gallery, but Arvay would go into a grocery and come out with several things that a wife would naturally buy. Jams, and jellies, salad dressing, lettuce and tomatoes, in fact several dollars worth of extras for the galley which she kept on calling the kitchen and Jim kept on correcting her. Then they crossed the bridge again and pulled up in front of the shrimping docks.

That night they visited several boats and Arvay was introduced around. Alfredo was captain of the *Angeline,* and a husky Negro around twenty-five was in command of the *Kenny M.* Arvay was surprised at that, but soon learned that it was a common thing. There were as many if not more colored captains than white. It was who could go out there and come back with the shrimp. And nobody thought anything about it. White and Negro captains were friendly together and compared notes. Some boats had mixed crews. They all talked about the same things, and they all cursed out the owners. Everything that went wrong on a boat was named after the owner. Did the fuel pump on the engine go bad? It was a Toomer, Meserve or whatever the owner's name so-and-so of a bastard! It was that way about everything. Arvay found that Jim knew all about it, as did the other owners and laughed it off.

"The men got to have some outlet for their feelings. They don't mean a bit of harm. They run the risk of their lives out

there, and they got a right to some fun. Cussing the boss out behind his back is a lot of pleasure. I forget that I'm the owner and cuss my ownself out at times. I heard the captain of the *Kenny M.* cussing the winch to every kind of a Meserve so-and-so that he could lay his tongue to this morning when we were berthing. I just let on I didn't hear him."

Jim laughed and Arvay joined in with him. They made the rounds of the Jooks and it was the same way about getting their heads bad. Jim watched Arvay closely as he explained that life was mighty uncertain on a shrimping boat. So many ways that a man could go. Get swept overboard in rough weather; go overboard to cut the net loose when it got fouled in the propeller and a shark happen along; get a bad case of fish-poisoning, and other chances to lose his life. A man had to enjoy himself while he could. The very next trip might be his last. So if they bought likker and love recklessly, what of it? Arvay noted that he relaxed when she agreed that they had a point there. Even though most of them spent their money right away, and depended on going out there and getting more. If they never came back, how could they enjoy money in the bank anyway?

To point this up, they ran into Captain Dutch Smith of the *Savannah.* Last trip, he had lost a man going over the St. Augustine Bar and Dutch was very sad about it. The bar was always risky, and this time it was extra rough, and somehow the man had gone on deck without a line around his waist and had been swept overboard by a big sea.

"He must have been death-struck," somebody consoled Dutch. "I can't imagine what he was thinking about to have done like that. He sure knew better."

But Dutch just wouldn't be consoled. "I sure hate to lose a man," he kept on saying over and over.

"Well, Dutch," Jim put in, "he'll come to beach pretty soon and get a decent burial. That is, unless he met up with a shark. They all come to the beach sooner or later. We all do, I mean. Every man comes to the beach at last. Even if it's a shark, that's your beach, ain't it?"

All the fishermen agreed. Everybody comes rolling home to the beach some old day. No telling when you might come rolling in.

Arvay slept on board the *Arvay Henson* that night in Jim's narrow cabin. Jim saw her comfortable, then went below. Neither Mate nor Third Man slept on board that night. The Negro had a wife to go to, and the Mate had found love for the night.

They ate and had visitors all the morning. Fishermen dropping in to meet Jim's wife, or just dropping in to pass off time. Stripped to the waist, Jim went over his Diesel engine and got it to running the way he wanted it. That afternoon, Jim took on fuel and ice. Arvay was thrilled watching the five tons of crushed ice cascading down into the hold. There was laughing and talking as other boats drew up one by one and took on ice. The *Ramos,* with Fritz Toomer, son of the owner, in command, the *Savannah,* the *Thunderbolt,* the *Rosalie I,* which was called the *Rosalie Eye* with Sapelo, a popular Negro, as captain. They all seemed to like Sapelo, which was not his real name; he had got it from the island off the Georgia coast where he hailed from.

They were all getting set to cross the bar on the first tide which would cover the treacherous New Smyrna Bar around six o'clock the next morning. Jim was in the notion of heading for the Cape, that is Carnaveral, where he had done mighty well this last trip. But some of the captains talked north, off St. Augustine or Fernandina. The *Kenny M.* was going that way. Alfredo was undecided.

The rest of the day was spent very pleasantly, but it was a form of torture to Arvay, because she did not know whether she was merely a guest on board and still parted from her husband, or whether she was part of the thing.

She was awakened about five o'clock in the morning by the throbbing of the engine beneath her. She got up and peeped down and saw that Jim was the first man up. He was warming up his engine and seeing to everything. Then the other two men began to stir around down there. There was activity all

around her now as engines warmed up, men moved about on the decks of other vessels and there was a general bustle, and a calling back and forth from boat to boat.

Somebody came aboard cursing. The Third Man had gotten his head so bad that he had neglected to buy canned milk. A couple of cans were borrowed, and the man hurried on off.

A gray mist was sheeting the water when the lines were cast off and the *Arvay Henson* eased slowly off from the dock. She had not moved many lengths before the *Savannah* paired with her and they throbbed outwards towards the bar. Arvay hurriedly dressed and went out on deck. She saw boats pairing and falling in line behind the *Arvay Henson,* though none were very close. The Mate explained to her that there would not be enough water over the bar for nearly an hour yet. They were slowing along to cross it at its best, which was none too good at that. The *Arvay Henson* would get there ahead of time, but would anchor and wait for a while. Be in the first boat over, no doubt, but wait till it was safe.

"Want me to fix you some breakfast?" Arvay asked Jim, who was at the wheel inside the pilothouse just in front of the door to the cabin where she had slept.

"Nope. We'll wait for that until we get outside."

The boat roved on down the river gracefully enough. Arvay saw for the first time the forests of mangrove swamps that lined the water on each side. Flocks of white herons perched among them like great white blooms among the dark leaves. She pointed at the swarms of sea gulls moving overhead.

"They fly pretty, Jim, but from what I heard so far, they got mighty poor voices for singing."

Jim laughed. "Eating fish must be against good singing. None of these birds that live around the water got any voices for singing worth talking about."

"But look at them big-mouthed things, Jim!"

"Pelicans."

"Ain't they crazy, though? Look how they lights on the water! Stick out their feet and land on their heels!"

"He's putting on brakes to skid to a stop."

"And look at his head, Jim! Shaped like a pair of big sewing scissors, got a grin running all the way around that long bill from one side to the other. Oh, I like to look at 'em. They're crazy as they can be, but cute!"

Away off somewhere ahead, Arvay began to detect a thunder and a growling roar. It got plainer all the time. The Mate who was standing on deck in front of the door to the pilot-house looked at Jim a time or two, but Jim had his eyes straight ahead. Something was the matter, Arvay knew from the way the Mate kept looking at Jim. The thunder and roar kept getting closer and louder all the time.

Looking over Jim's shoulder through the glass of the housing, Arvay made out the dim shape of a boat coming to meet them. The sun was not up yet, and the boat was a dark mass against the grayness of the mist. The approaching vessel cut a white pompadour with its bow as it came ahead. When its bow was abreast of the bow of the *Arvay Henson,* the captain, a chestnut-colored Negro, stepped out of his pilot-house and stood on deck looking over at the *Arvay Henson.* Jim left his wheel at once and stepped on deck. The two boats were probably fifty feet apart. Jim made some mysterious motions with his hands, and the captain of the other boat doubled his two black fists, and struck one on top of the other rapidly several times. They smiled and waved at each other, and both went back to their wheels.

"Everything fast above and below?" Jim called out, and Mate and Third Man began looking around hastily for a check-up, on deck and below. Two low stools and a pail were brought in and carried below. Jim got up off the high stool that he had been sitting on to steer and shoved it into the cabin. There was a rope fixed to the bulkhead near the floor, and Jim secured the stool to the bulkhead by passing the line tightly around the legs of the stool and tying it securely. He closed the four windows in the cabin and looked around to see that nothing was left that could shift. Then he went back and stood at the wheel and peered straight ahead of him. The Mate was standing on deck in front of the door, and gave Jim a hard

questioning look over his shoulder, then fixed his eyes ahead. Arvay could see that he was not pleased about something.

The grumbling thunder ahead increased in power, and the Mate turned and spoke.

"He said that it was pounding on the bar."

Jim seemed not to hear. He kept his eyes straight ahead, and the boat held on her course.

"He said that he turned back to wait until there was more water over that bar."

For all the attention that Jim paid, the Mate might as well have saved his breath. Now amid the rumbling and roaring ahead, Arvay could distinguish a sound like a whale letting out its breath. *Shhhaaaaow!* It came now and then and mingled in with the tumult and the roar.

Now a misty moisture began to cloud the windows of the pilot-house. Jim spoke over his shoulder.

"You better get inside there, Arvay. Lay down in the berth so you won't get flung off your feet and maybe get hurt."

Jim acted calm, but Arvay could feel the excitement in him just the same. Standing in the cabin door, whose level was a good foot higher than the decking of the pilot-house, she looked ahead over Jim's shoulder and her eyes stared out in sudden fear. Perhaps ten boat lengths ahead was a colossal boiling and tumbling, grumbling and rumbling of the sea that sent a white spray mounting like somebody shaking a world-sized veil. Havoc was there with her mouth wide open.

The Mate came in from the deck, fastened the door securely after him, gave Jim a sullen look and stumbled on down the stairs. Arvay closed her door to shut out the sight ahead, and lay down in the bunk.

Suddenly, the *Arvay Henson* reared up and then stumbled. The shock was so violent that Arvay leaped to her feet in fright. Through the forward window she saw waves, gray-headed from their birth, leap up around the boat, and come storming over her bow. A hand, powerful enough to have formed creation, grabbed the boat and flung her halfway around to port. She listed way over, and for a second it seemed

that she would pitch-pole over. Arvay was hurled back against the berth, but scrambled up and peered out to see about Jim. His face was set and his jaw muscles bunched. With his feet braced far apart, Jim was fighting a battle with the wheel. Twisting his body halfway to the floor on the right, he brought the bow around and dead on course again.

The Mate came plunging up from below. "Captain! My Captain! You gone crazy? Turn back! This bar is too rough to cross right now. Oh, Captain!"

Jim never turned his head nor even seemed to hear the terrified shouts of his Mate. The boat shuddered and swung violently to starboard.

"Captain! Goddammit, you're going to lose the boat and kill us all! Captain! Captain!"

The frightened Mate, a stocky, butt-end of a man, noting that Jim paid no attention, fell on his knees and wrapped his arms about Jim's left leg, and begged Jim with his eyes. In this struggle where Jim was fighting for the life of his boat and all on board, he tried to shift his leg, but was held fast by the Mate. Arvay saw and acted almost instinctively. She flung the door open, leaped upon the Mate and grabbed him by his hair to pull him away from Jim's leg.

"Let go my husband's leg!" She pounded the man about the face with her fists then yanked and pulled again. "You want to make him wreck his boat? Turn loose!"

In the struggle, Jim was able to kick the hysterical man loose and brace his body and fight the elements.

The Mate, in a lump against the outside door, began to cry and pray. Jim twisted his body slightly to the left and lashed him with his tongue.

"Don't you be praying on my damn boat, you bastard you! Get up off of your damn rusty knees!"

But the Mate mumbled and prayed incoherently. Jim paid him no more attention for a minute or so. Arvay, standing behind Jim, fierce with anger at the Mate who had done such a senseless and dangerous thing, was like a she-bear in her rage. Jim seemed not to know that she was there. His body

strained, contorted, with his eyes ahead and his jaw-muscles showing. Arvay thought that the going was getting a little easier. Anyhow, with both hands gripped on the wheel, Jim whirled his body around to face the Mate.

"Pray, you goddamned white-livered bastard, you! Pray! I'm crossing this bar if I land you slap in Hell! Pray! Oh, you can pray on my damn boat, eh? Why you didn't pray last night while you were crawling that barrel of whores? Why you didn't pray while you was guzzling rotgut likker? You didn't have time to pray then, did you? All right now, pray your damn prayer now! Pray, goddamn you, pray!"

The boat shook and shuddered once more, and the Mate's voice was lifted again. Jim whirled on him again.

"Don't you pray another lick on this damn boat, you puking-drunk, seven-sided son of a so-and-so! Get below!"

The Mate looked at Jim's face and fairly tumbled down. Jim kept his furious face straight ahead, and the boat held her course. He said nothing to Arvay, and she said nothing to him. She stood just back of him and looked fearfully over his shoulder. She had never been so frightened in her life as she was now. The boat gave another shudder and then a leap, and glided out onto the calm waters of the Atlantic.

The contrast was utterly startling. No waves, just an undulating motion that made the distant horizon seem to go up and down slowly and gently. The sun was not up yet, but he had sent his messengers on ahead. A diffused pinkness lit up the sky to the east, then suddenly the rim of the great ball rushed up from the east of the ocean, and laid a red sword westward across the swaying water. Arvay was enchanted.

"Oh, Jim! I never have seen the ocean before. Oh, it's just too pretty for anything. Look how it's changing colors from gray to blue! I'm so proud you brought me with you."

"I thought you might like it, Arvay. Biggest thing that God ever made. It's pretty like you say, and then it can be ugly. It's good and it's bad. It's something of everything on earth."

"Oh, but it is!" Arvay looked and gasped in awe and admiration. The sea vastness, the unobstructed glory of the rising

sun, the delicate and forming colors on horizon and sea made new sensations for Arvay. She felt herself stretching and extending with her surroundings. Her eyesight seemed better, and her hearing more keen. The fear that she had experienced while crossing the bar was like a birth-pain. It was already forgotten and gone. In this mood a happy suspicion visited Arvay. She moved so that she could study Jim's profile and asked diffidently, "Jim, it would have been a whole lot easier for you to have crossed the bar later on, wouldn't it?"

Jim looked at Arvay and his eyes were set for battle.

"Maybe so, Arvay. What do you want to know for?"

"Well," and Arvay spoke in a soft maiden voice. "Because the notion just come to me that you took that awful chance so that I could see the sunrise out here on my first sight of the ocean. That right?"

"Yes." Jim bit it off shortly.

"Then, Jim, you're the boldest and the noblest man that ever forked a pair of pants. You'se a monny-ark, Jim, and that's something like a king, only bigger and better. I'm proud enough to die."

"If it reached from me to you, Arvay, I'm glad." He looked ahead for a long minute, then turned his head to the left and yelled down below.

"Cup-Cake!"

"Yes, my Captain!"

"Shake your rusty-dusty down there! I'm hungry as hell."

"It's on the fire and your name's done called. You don't come now you needn't to come at all."

"Copasetty! I'm rearing to go. You and the Mate hurry up and eat so he can come take the wheel for a while so my wife and I can come eat."

"I heard you, my Captain!" The Negro yelled back up.

Fifteen minutes later, the Mate, now calm but shame-faced, came up and took the wheel.

"Take it easy." Jim spoke as if nothing had happened between them. "We're headed for the Cape, but give some of the other boats a chance to catch up with us."

331

"Okay, my Captain," the Mate said cheerfully, and Jim and Arvay went below.

Cup-Cake, the Third Man, had done himself proud. Hot-cakes, bacon and eggs, syrup and butter on the table and hot coffee in plenty. He beamed and smiled as Arvay downed a heavy breakfast.

"Something about this ocean must bring on a big appetite," she excused herself for eating so heartily. "Or else it's Cup-Cake's cooking one. Look like I can't hardly get enough."

A half second later she knew that she had said just the right thing. Jim smiled and opened his eyes wide and looked at her with pleasure. Cup-Cake grinned all over himself.

"You just wait till I pitch you a dinner," he said. "I never do feel right to do when we'se tied up. But outside now, I can be myself in a galley. Ain't I telling it right, my Captain?"

"Oh, you'll do in a rush, Cup-Cake. I hope that my wife don't take and spoil you too rotten, bragging on your cooking. You got to be useful on deck, you know."

Cup-Cake laughed that off and rinsed out a big pot, dropped a ham hock in it, and put it on the fire. He brought out the big bundle of turnip greens from the ice box and began to pick them over.

"Sure glad you bought these, Mrs. Captain. Lay a good poultice of these, seasoned down with ham, against a man's ribs, and it'll just about cure him of whatever might ail him. Make a dead man set up on the cooling-board."

When they came top-side again, a dozen or more boats were in the offing, and more approaching from the west. The sun had become a light yolk yellow and was walking with red legs across the sky. Jim stood out on deck and made sign language back and forth from boat to boat. Now and then at Arvay's insistence, he translated for her. She made great admiration over their being able to talk to each other like that.

Finally, the *Arvay Henson* paired off with the *Rosalie I,* and put on power for the seven-hour run down to the Cape. Now and then they slowed and tried along. Finding nothing, they held on towards the Cape.

It was late when the fleet anchored off Cape Carnavarel, and none of the boats were disposed to begin operations that day. They would eat, have a good rest, and get set for two drags the next day, a three-meal day. A drag right after breakfast, one right after dinner and head and ice shrimp after supper.

Arvay and Jim sat out on deck on the hatch for a long time that night. The talk was too impersonal for her happiness, but she put on a happy face.

"Jim, I just can't get over the ocean. It's too big for me to even imagine. And night or day, it's something wonderful to look at. I feel like I never want to go away from it no more. Seems like I been off somewhere on a journey and just got home."

"Funny, Arvay, but I ever had that feeling. That's why I was bent and bound to go back to fishing. Once I had seen and been on the sea, it got inside me, and I ever longed for it like a drop of water."

"Like a drop of water, Jim?"

"Sure, Arvay. Don't you realize that the sea is the home of water? All water is off on a journey unlessen it's in the sea, and it's homesick, and bound to make its way home some day."

"Oh, I never thought about a thing like that, Jim."

"You ought to, though. You can't kill it. Mix it up in anything, and in anyway that you will or may, but sooner or later it separates itself out and heads back home to the sea. Falls on the ground, soaks down, gets to a tiny branch maybe, and that heads into a creek that runs into a river that maybe runs into a bigger river and all that millions-times multiplied drops of water marches like an army back to the sea. Some gets soaked way down in the ground in rivers and pools so far down in the rocks that folks walking along don't even know that it's there under 'em. Maybe it might get stopped up in a place like that for thousands and thousands of years, but the water never gives up. It gnaws and gnaws at them rocks till they finally gives way, and then the water gets loose and runs as fast as it can back home to the sea. Maybe, in an hour after it gets home, the sun and wind might draw it up again in a

cloud and the cloud travels out over the land, and that drop is on another journey, but don't worry, it will arrive back home again. The very same water that you see out there was right here when the world was formed. Changed places and forms too many thousands of times for you to imagine, been off from home and come back just that many times. It'll always be water, though, and always come back home. It's a million times stronger and more durable than anything that ever lived in it nor passed over it. I look at it and think about it, and I never get tired of looking and thinking."

"That's something to think about, Jim. It's never entered my mind before. Maybe it's like that with everything and everybody. If it's in there, it will return to its real self at last."

"That's well-spoken, Arvay. If it's there, it'll come out some old day. Like the water in the underground cave like Silver Springs. Underground for nobody knows how many hundreds of miles, and for nobody knows how many centuries of years, to break through in that crystal clear spring at last. That's the way life is, when you come to think about it. Some folks are surface water and are easily seen and known about. Others get caught underground, and have to cut and gnaw their way out if they ever get seen by human eyes."

That was as near as they came to anything personal, and right after that Jim stretched himself and stood up.

"We ain't doing nothing but rocking and rolling out tonight, but tomorrow we got to get them nuggets off the bottom and on ice. No, I wouldn't trust you to set out here after I'm gone in. Rail too low. Once you start to falling off of a boat you can't stop. Motion of the boat will pitch you on the way it's going. Come on in and stay in the cabin till you hear somebody stirring in the morning."

Soon the next morning things were astir. The engine was pulsing when she woke up. There was a great to-do with nets and winches on the after deck. Right after breakfast the fishing was to begin. The excitement invaded the galley, and the minute that it was over, the men left her below and went top-side. By the time that Arvay had washed up the dishes, and

reached the deck, they were going over with the try-net. Jim at the wheel sang out, "All right, boys, let's try along!"

The sleeve-like net, operated from the smaller winch, went over the side, and Jim sent the boat slowly ahead. A half hour later it was reeled up, and lifted over the side, and the contents dumped on the deck. A lot of curious-looking strange things were in it, but only twenty-odd shrimp. Jim tried to look casual, but Arvay could see that he was disappointed.

"Don't seem to be many, but let's go overboard anyhow."

The Mate went to the big winch. Cup-Cake got the big bag of the net in his hands and stood to the starboard rail to drop it overside after the big net went over and was spreading right.

"All right, let's go overboard!" Jim called out from his place at the wheel. Down came the boom, swung to starboard, and the big net went sinking down and down. The Mate watched closely to see if it was spreading evenly and right. When the boards disappeared under the water, the Third Man dropped the bag overboard, and Jim sent the boat ahead. It went round and round in a big circle slowly, listing to port or starboard from the pull of the heavy net sixty fathoms down on the bottom of the ocean. The steel cable attached to the mast made a straight line to the net below, and moved back and forth like a slow pendulum across the stern as the boat circled and circled. Things got quiet on board as the two-hour drag went on.

"All right, let's get it!" Jim called at last, and the Mate and the Third Man ran to take up their positions. Finally, the big net was brought to the side and lifted by the winch to the deck.

A cloud of gulls and pelicans appeared from nowhere, making their dissonant call-cries, and hovered for prey. They swooped and swirled as the bag was emptied on deck.

Turtles, numerous kinds of fish, a leopard shark, strange unimaginable-shaped things from the bottom of the sea cascaded out on the deck. Things in shells, soft-looking queer-shaped things; four octopi, about four feet across, bent their arms like swastikas and rolled about the deck trying to find their way back to the water. Jim stood with his hands on his hips looking down gloomily on the mass. Plenty of stuff, but

few shrimp in all that mass. Arvay saw several things that looked to her like living pin-cushions and thought to get one to save and take home with her. As she stooped to pick it up, everybody yelled at her at the same time to leave it alone.

"That's a damn whore's-egg!" Jim cautioned. "Ruin you if only one spine of it gets into your hand." Arvay jumped back from the sea-nettle and stood far off to the side.

The men went in killing things. First that astonishingly limber-bodied shark. It could whip its body around as if it hadn't a bone in it. With shovels and the axe, they fell upon it cursing the whole shark family as improperly born cutters of nets, and hefted it overside, where it was immediately fallen upon by other sharks and disappeared in a few minutes down their under-slung, saw-toothed mouths.

"A basket and a half of shrimp in all that mess," Jim said in deep disappointment, and the men were just as gloomy.

"If this kind of luck keeps up, no percentage for nobody worth mentioning," the Mate said in a heavy voice. Cup-Cake said nothing, but he did not smile as usual.

"All right, clean up the deck," Jim muttered, and went back in the pilot-house.

With shovels, the men scooped up the mass of strange life on deck, and tossed it back into the water. The sea birds screamed and swooped, picking up the dead, and catching the weakened creatures before they could dive out of reach. Turtles, sea-nettles and things with shells had nothing to worry about. Few soft-bodied things had a chance. Arvay watched the slaughter with pity. As Jim had said, the sea was good and it was cruel too. It was thing eat thing out here. She turned her head away until the struggle was over.

Arvay thought that Jim avoided her after that. He had little to say at the dinner table, and got busy down in the hold somewhere back of the engine. She went and stretched out in the cabin, but she could hear him below being surly and snappish with the men.

"It's me," Arvay wept up there in the cabin alone. "He don't want me here nohow, and now, he's blaming me for a

Jonah. I know that he wishes that I was dead and off his hands, and I wish so too."

There was an old coverless *Adventure* magazine on the table beside the head of the bunk, and Arvay picked it up and tried to read it some. All she did was to turn pages from front to back and then the other way. She looked out of first one window and then another, at the peaceful, waving horizon, at the distant boats circling and circling around flags. She could tell when the nets were taken on board by the swarms of birds and their hungry, unmusical cries.

Arvay felt even worse when Jim came and stood on deck just outside the pilot-house and she heard him mutter, "It certainly is funny. Everybody catching something but me."

Half an hour later, she heard him say in a lifeless way, "Supposing we try again, men." He took his place at the wheel, and finally gave the order to "get it." Arvay didn't bother to follow him on deck when the try-net came over the side. The kind of silence that prevailed out there told her enough. Only the hungry birds had anything to make noise about. The shovels scraped on the decks in a dispirited way. Then buckets of sea water sloshed over the deck and ran off chortling through the scuppers. Jim came nowhere near her to say nor to do a thing.

An hour later, though, she heard him swearing out there like anything. At the end of the long catalogue of damns and other trimmings, he shouted, "We're going over without a try. There's shrimp in this goddamned ocean and we got to get 'em."

Jim sat unsmiling at the wheel, never once turning his head to look at Arvay shrinking like a Portuguese man o' war on the beach, for the entire two hours. He kept looking at his watch towards the end, and finally yelled, "Goddamn it, let's get it!"

Before the net came over the side Arvay knew that the luck had changed. It was something like three savage warriors out there on the deck shouting, jumping, swearing and working the machinery.

337

"The stuff is here!" The Mate screamed.

"We're going to sink her!" Jim crowed.

"Going in high boat!" Cup-Cake bellowed.

"You're damn tooting!" Jim added, "or report to Hell the reason why."

There was furious action out there, and Arvay raised herself to peer out of the window over the bunk that gave on the after deck.

"The bailing-net!" Jim shouted. "We got to bail before we can bring her over the side. Look at the goddamned sharks grabbing at the fish gilled in the net and cutting my goddamned net to pieces!" Arvay had always known that Jim was a cursing man, but she had never heard him to this extent as he called the sharks every kind of low, unprincipled thing that he could lay his tongue to, and plenty seemed to be available. He played the dozens with them and went way back in their ancestry. Never had a shark's mother been married or begot a shark in a decent bed. And as for their pappies, they were thus-and-sos. "Liable to cut up this net so that all our catch gets away!"

But the furious and quick work saved the day. Very little got away. However, a huge silver-grey man-killing shark was inside the net and was dumped on the deck. With shouts of vengeful joy the three men fell upon it with the axe, shovel and gig. Its head was a bloody mess in no time, and it lay like dead. The men were stooping to pick up the carcass and dump it overboard by means of the winch and cables, when the limber thing whipped around all of a sudden and almost got Jim's right foot. The shark actually did take off the heel of his boot. Arvay, watching through the window, involuntarily let out a scream. There was more blaspheming the honor of female sharks, and the men fell upon the monster again. When it lay still again, they hacked through the tough hide and ripped open the belly. Arvay ran outside to see what they were looking at with so much interest. There were little live sharks inside inclosed in transparent sacs.

"Let's heave the whole she-bang over the side and let the little bastards drown!" Jim cursed.

The cables were hooked on and the huge sea-beast splashed bloodily overboard, but the men were put out to see the baby sharks free themselves of their envelopes and swim off. The men expressed the shame and the pity that they had gotten away, and Arvay thought, carried on like little boys.

They turned back to the huge mass of sea life piled on the deck and began to separate the shrimp out with zeal.

"Over two tons, I'd say," Jim estimated with satisfaction. "This gives us the start to sink her tomorrow and go in high boat."

"Just look at the money piled up there!" The Mate gloated. He sat down on a stool to look and admire some more. "I can see myself on the hill soon as we get in making some fool fisherman go broke trying to beat me spending money."

"Okay," Jim muttered, "we got 'em, let's fall to cracking heads."

"Yes, my Captain!" the crew answered and sat down to heading shrimp. No matter how late it might be, there would be no sleeping aboard until all the shrimp were headed and on ice. Good humor prevailed. The men remembered funny stories and told them to each other.

Arvay felt glad about the haul herself. She could not be looked upon as a Jonah, and Jim was in such good humor now. But then again, a winning Jim might easily be farther away from her grasp than a losing Jim. She turned around and leaned her back against the rail and looked at the three men working away. Jim was sitting on the hatch cover and looking as male as a coconut tree. What woman wouldn't be glad to get hold of a man like that? The tiny lines from the outside corners of his eyes, and around his mouth took nothing away from his looks and appeal in Arvay's eyes. Naturally, all the other females on earth were bound to see his wonders. They could not help themselves. Arvay sankled around and reached a spot close to Jim and stood and looked on for a few minutes.

"Could I give you all any help in any way?"

Jim looked up at Arvay sharply and the look flustered her.

"Maybe I could cook some supper for you, or . . ." Arvay added in a desperate hurry lest Jim tell her that there was nothing that she could do for him.

"Now that's a fine idea, Arvay. A most grand noble notion. Of course, I know that old Cup-Cake don't want to hear the news. Nothing would suit him better than to sneak off down there into the galley and pass an easy time ruining up groceries while me and Titty-Nipple squat up here heading shrimp, and getting our hands all stuck up on their horns. Now, with you being so cool and kind as get us some supper, we got old Cup-Cake's trashy hide dead in the works."

Arvay laughed from happiness and fluttered her eyelids up and down.

"What you all reckon you want me to fix for you to eat, boys?"

"You eat them few stone crabs that I picked out and laid aside for you," Jim helped out. "Fix them for your ownself. I want a great big mess of these shrimp fried to a turn with fried potatoes, and, oh, just anything more that you feel to fix. You ought to know how to feed me by now. You sure know how to cook, so suit yourself."

They all wanted the same. Whatever Mrs. Captain took a notion to fix. Fried shrimp, however, was the preference.

Then a great grin spread clear across Cup-Cake's face. "I'll have to leave you all heading by yourself for awhile. I got to hull them shrimp for Mrs. Captain. That's too hard a work for her to do."

Jim, in mock fury jumped up, and grabbed up a stool as if he meant to haul off and lam Cup over the head with it.

"What did I tell you, Titty?" Jim shouted triumphantly. "That sooner's too slick and slippery to handle. Naturally the shrimp ought to be cleaned first, but I'll show the hammer-head that I'm just as slick as he is greasy. We all will shuck shrimp for cooking, and rush that no-count jar-head back to heading shrimp."

Jim jumped up and filled a pail with the fresh, grey-green

340

shrimp and beckoning to the crew, headed for the galley on the lope. Cup and Titty followed him laughing. By the time that Arvay descended to the galley, they were laughing and cleaning the shrimp, and indulging in horse-play. Arvay looked on and noted how like little boys they acted. Didn't men ever get grown? Arvay asked herself indulgently. It was nice to see how they could play like that. It made her feel good and like taking care of them.

She fixed the dinner in a warm family atmosphere and was glad when they all praised her and said how good it was. They ate so Arvay could believe them, and it made her feel very good. She shooed them on back to their heading and cleaned up the galley as she would her own kitchen.

With nothing more to occupy her hands, Arvay went back to her personal probing. She could not rest easy. What she had come to do was still ahead.

Arvay could hear the three men laughing and joking over their work on the after deck as she came up from the galley. She stood in the pilot-house for several minutes listening. They sounded so happy and free of care together. It made her wonder if Jim was thinking seriously as she was. How was she to get out what she wanted to tell him? The sea was calm and nice. She decided to go out on the forward deck and feel the breeze and think.

Numerous were the eyes of the night. Clear and bright before the rise of the moon. She took a seat on a coil of anchor rope and began to [go] back over things. She went back over her life from the day she had first met Jim up until the day of the snake. Frankly and with truth she counted up and put values on things. Jim was right. She had pulled back and halted, and must have tried his patience something awful at times. And what made her halting and doubting so bad—Jim had given her no cause to doubt him. Her case was not the same as many women that she knew. So far as she knew, Jim had never messed around with another woman. She had never had to put on a play like some she knew had to do. They flashed around what their husbands had given them to cover

341

up the fact that they had fine clothes and rings and things, but couldn't lay their hands on their husbands after dark most of the time. Jim gave her too, and then he was present in her bed. Why then had she doubted herself? What more did she want than she had already received?

She had been a good mother, that she could swear to. She had taken good care of Jim in every way. What more then would he be expecting out of her? What had he demanded? Not whom she had descended from. Jim had never said a word along that line. He knew her folks, and if he was satisfied, what had she been whining over? Then in a flash it came back to Arvay what Jim had said to her that Sunday when they had got engaged to marry. He had told her exactly what he wanted in a wife. She had clean forgotten about it and had made herself touchy and miserable all this time for nothing. Love and be sweet to him. She had done that to the best of her ability. Certainly she had loved Jim all that she was able to love anybody. Her whole heart and mind was his and had always been so. Have him children. She had done that too. Look pretty. She had certainly kept herself looking the best that she knew how. Whether she was pretty or not was according to Jim's own eyes. He had told her often and again that she was pretty, so he must have been satisfied.

So much for the foundations and the past. What could she learn from that to help her out right now? Jim could have made up his mind to do without her.

Arvay thought some more and took a stand. According to Jim's own words, he had a good right to take her back and give her a chance to show that she had changed. She had been weak and cowardly in the past, never realizing what he had done for her, and making not anything of being his wife. But then on the other hand, she had suffered about everything that a woman could suffer through loving and clinging to Jim. From where she had come from, Jim could never realize what it had cost her to scramble and struggle along to keep alongside of him the way he travelled in life. The battle had been awful, but she had fought down the things that had made the differ-

ence between them. She had suffered a sad birth and a sadder death from her love. Now, after all the pressing pain of the journey and winning against herself in order to stand beside him, she certainly ought to be allowed to receive her crown of victory. Since she had rejoined Jim, she had tried to show him the change in her by signs, but so far he hadn't seemed to take a bit of notice. Maybe since they had parted that day in August, some other woman had come in between.

At that thought, more fighting blood than Arvay thought she had in her rushed to her heart. Her temples throbbed and her ears felt hot.

No, she told herself. It was not going to be that way at all if she could help herself. She did not aim to step aside and let no other woman take her place with Jim Meserve. She was going to have her husband back or die in the attempt. Whatever it took to bring it about she was going to do it. And she did not mean next year sometime either. She meant right here and now.

Arvay felt so intense that she could not keep her seat. She stood erect and her hands were clinched.

She was going to deal with things. Oh, yes she was! And she was not going to fool around with a try-net. She was going overboard with the drag and sweep the very bottom.

Arvay was eager to rush in and settle her fate, but she could hear the men still talking and laughing over their work. She would have to wait until that was over with.

The white, white, Florida moon rose up and began to gild the ocean. The calm surface rose and fell like the breast of a sleeping woman. Other boats twinkled off in the distance to right and left of her. A school of fish flashed silver sides as they broke surface and hurled themselves in the air to fall back, and flash again and again. Arvay saw what they were fleeing, when the fin of a huge shark rushed along in their wake. The shark too disappeared under when a school of porpoises came ploughing and diving and re-appearing on the route of the shark. The moonlight lit up her pale gold hair coiled in thick braids around her head.

Arvay let the scene swamp her. She felt privileged to be there. It was like being taken into a new lodge. The fellowship of beauty-seers. Jim had made all this. Well, anyhow, he had provided this ocean-sea for her to look at. Well, to bring it down a little more, she would never have known anything about such as this [except] by hearsay if it wasn't for Jim.

So was some other woman to receive such things from Jim? Would she stand on the front of Jim's boat and see and feel what she now saw and felt? The thought was not to be put up with. Maybe she would be young and ever so pretty, and of high family and learned in books and ways. Arvay crimped her mouth and accepted the challenge. Be she who and what she would or may, Arvay grimmed herself to go up against her. That woman would have to beat what she could do and be, and that was going to be a gracious plenty. If and when she got hold of Jim, it was not going to be as a gracious gift from Arvay. Not because she had backed off from her. Her scars would always keep her in mind that she had been in a battle. Win or lose, Arvay was determined to trot out the best horse she had in her stable, to never turn her back on the enemy, and if she lost, not to go off crying.

A great freedom and calm came to Arvay with her determination. Nothing ahead of her but war, and she was ready and eager for it to start. She sat down again on the coil of rope and pleasured herself with the night. She sat and fed her senses with the light, the movement of the sea and the march of the stars across the sky. This was all hers until death if only she had the courage and the strength to hold it, and that she meant to do. Finally, it came to her just how to begin with Jim. Now, there was Isaac and Rebecca at the well and smiling lovingly at each other. No, that wouldn't do. They had already done that part years ago. She and Jim were a married couple, even if at variance. What Ruth said to Naomi fitted things more better, but put into words that fitted just her and Jim.

"Jim, your loving Arvay has throwed off every hindering weight so as to follow you along in an easy way. Whither thou

goest, I will go along too. Thy kind of people shall be my kind of people, and thy God, my God."

Reciting this over and over so as not to forget it, Arvay went in the cabin and went to bed. The men were still working outside, but they were not chattering so much now. Their words were few and sounded tired to Arvay. They ought to be near about through. That being the case, her time was close at hand.

But how was she to get Jim off to himself to talk in private? The shrimp headed and put on ice down in the hold, Jim would go below with the crew as usual. He would pass close to the door of the cabin it was true, but not halt his steps.

Why not change what she had been doing since she had been on board and leave the door open? Jim would notice that. Well, she could attract his notice more easily anyway.

Arvay heard the movements of finishing off out on the after deck and she tensed herself and found that her limbs were trembling. She became conscious of how she was dressed. She had no silk female things on board to adorn herself with. Nothing to sleep in but one of the blue work shirts that Jim had bought her. It stopped half way between her hips and her knees. With the sound of the men dragging and scuffling baskets of shrimp as they carried them below, Arvay got up and brushed her hair and fixed her face. That was all that she could do for her looks. She opened the door about a third of the way and lay down again to wait in agitation. Now that the action was at hand, she found herself tense and trembling.

Arvay traced every movement outside with her ears. The men got through icing. She heard the hatch cover close finally, and the crew going below with tired steps, mumbling a little as they went. But she missed the well-known steps of Jim Meserve. All was quiet below when she heard Jim enter the pilot-house. She could hear him moving back and forth softly out there, and glimpse his form each time that he passed the open door. Jim did not turn on the light out there. He seemed to be fumbling back and forth as if he were searching for something. Arvay got so that she could not stand the suspense

345

any longer. She closed her eyes and called out softly, "Jim?"

"Yeah, Arvay," Jim answered wearily, and stood in the crack of the door.

"Come here, Jim. I got something to tell you."

Quickly, Jim pushed the opening a little wider and stuck his head inside the cabin. Lying there on top of the covers, Arvay felt shamefaced about her clothes. Jim was looking at her very hard from her head to her feet. Most particularly from where her shirt-tail stopped on down.

"What is it, Arvay?" Jim asked after a long time, Arvay thought.

Arvay gritted her teeth and plunged on.

"You can't go down below to sleep tonight, Jim, that is, not until I have a talk with you nohow. You can't go . . ."

"Who says I can't?"

"I say so, Jim. You're not going down there and crawl into no bunk, not until I get through with what I want with you."

Jim's face went very tense, and his eyes narrowed down. Boldly, he stepped inside the cabin and closed the door firmly behind him. He leaned his back against it and folded his hands behind him. Not a word was exchanged between them for a minute or so. Arvay's eye-lids had lowered while Jim just stood looking at her.

"You called me, Arvay, so here I am." He looked at Arvay for a long and a searching time with his eyes still narrowed down. Only Arvay thought that his head drooped a little bit.

Arvay realized that she had the floor, and it threw her into a vast panic. That chance that she had yearned for through long terrible months was in her hand. But her speech of explanations and review had flown out of her presence and was blowing off somewhere over the big ocean. She didn't have any ideas. She didn't even have any words. She was on the point of crying.

"You can't go below," Arvay stumbled out. "You got to . . ."

"Arvay, do you realize that you are giving orders to the captain of a ship? And on the high seas at that? That's mutiny,

346

which is a high crime punishable by death, and instant death if I feel like it. And then on top of that, it's pretty damned biggity and imposing."

"Captain or no captain, Jim, you're my husband, ain't you?"

"Even so, all that cheek and brass that you're acting with, you must think that you've found some weapon to your hand since I seen you last."

Arvay's blue eyes flew wide open at that. If she sounded biggity to Jim, then he didn't realize how scared she was. She mounted to the pulpit and took her text from that.

"Do I need any more weapon than I already got? Did I ever need any different?" Arvay shot an impudent and challenging look at Jim. "Maybe the reason you never see no bear-cat with hip-pockets is because he don't have no need to tote no pistol with him. I was born with all I ever needed to handle your case."

Jim's eyes now flew wide open. His body gave a jerk.

"There now! The mule done kicked Rucker!" Jim exploded, and Arvay caught him eye-balling her in a new way. "You're mighty plague-goned impudent and sassy these days." He gave Arvay a strong under-eye look. "Who's been pomping you up so? Who's been telling you that you're pretty?"

"Jim Meserve, that's who."

"Oh, is *that* the case? When did I tell you all that, Arvay?"

"Every since I knowed you . . . in one way or another. Aw, I ain't near so dumb as I used to be. I can read your writing. Actions speak louder than words."

Arvay had every intention to keep on talking and acting flip until she got out all that was in her to say, but her eyelids fluttered and drooped before that look that Jim was giving her. She just couldn't help herself. But a sound of movement made them fly open again. There was Jim coming towards the bunk like he was stalking a prey. Involuntarily, Arvay flinched.

"Don't you holler!" Jim growled. "Putting me on the linger like you did! I ought to take my belt to you and run your backside crazy!" All of a sudden, Jim stood over Arvay on the

347

bunk and offed with his jacket and flung it from him without looking to see which way it went. He tore at the buttons of his shirt frantically and threw it as if it had done something to him. "Holler if you dare! You had better not even cheep!"

It was a moment of great revelation for Arvay. She got a glimpse of something which she would never have believed possible before. Jim, Jim Meserve, Lord, had his doubts about holding her as she had hers about him. She was not the only one who had trembled. All these years and time, Jim had been feeling his way towards her and grasping at her as she had been towards him. This was a wonderful and powerful thing to know, but she must not let him know what she had perceived. Arvay trembled visibly and looked up innocently afraid and scared at Jim. But one time in her life, she wanted to fully express herself in words and let Jim know how she had improved and changed.

"Just lemme tell you one thing more, Jim. You—I want you to overlook how dumb I used to be. But, Jim, I just wasn't wise of things. Like Mama used to say, being dumb never kilt nobody. All it did was to make you sweat, and Jim, since I've been with you, I done sweated mightily."

"Aw, hush up!" Jim hurled his shoes, one after the other against the forward bulkhead. "No need for any long explanations. I can read your writing, Arvay." He stood up and shucked his pants. "You took long enough to stumble round the tea-cup to get to the handle." Jim dropped suddenly down on the side of the bunk and snatched off his socks. "And don't try to get cute and resist me, neither." He fairly flung himself at full length on the bunk, grabbed Arvay by her ears and shook her head fretfully. "Kiss me, Arvay!"

Arvay really kissed him. Jim took her face between his hands and looked into her eyes for some time.

"You had a damned good chance to be rid of me, Arvay. Me *and* my habits for good and all. Just live off apart from me with full support, but you didn't have sense enough to make good of it. And that's your hard luck, baby."

"Why, Jim?"

"Why? Because you'll damn sure never get a chance like that again. Never no more in this world, nor even in Georgia, will I act the goddamn fool for your benefit like that again. If being with me don't suit you, you got nobody but your own-self to blame. You brought this on yourself. You could have stayed away from me, but you didn't. So you're planted here now forever. You're going to do just what I say do, and you had better not let me hear you part your lips in a grumble. Do you hear me, Arvay?"

"Yes, Jim, I hear you."

The sweetness of the moment swept over Arvay so that she almost lost consciousness. Jim shook her roughly and growled.

"Well, hell! You don't act like it. What the hell you think I got a neck for if it ain't for you to be hugging?"

Arvay's arms went up in a languorous curve and clasped tightly around Jim's neck, and without being urged, she kissed him fondly time and again. Jim was gripping her shoulders so hard until it hurt her, and trembling all over his body like a child trying to keep from crying. Like a little boy who had fled in out of the dark to the comfort of his mother. After a while, Jim sighed deeply, and his head slid down and snuggled on her breast. From long habit, Arvay's fingers began to play through his hair in a gentle way. Almost immediately, Jim sighed and went off into a deep and peaceful sleep.

The *Arvay Henson* rode gently on the bosom of the Atlantic. It lifted and bowed in harmony with the wind and the sea. It was acting in submission to the infinite, and Arvay felt its peace. For the first time in her life, she acknowledged that that was the only way. She shifted her body sufficiently to lie on her right side, and with her arms still about the sleeping Jim, snuggled him more comfortably in the narrow bunk and held and hovered him as if he had been her little boy.

The movement of the boat was soothing and drowsy-like, but Arvay could not sleep. A great exaltation had come upon her, and her mind spoke in voices to her. She heard them as plain as day.

All that had happened to her, good or bad, was a part of her

own self and had come out of her. Within her own flesh were many mysteries. She lifted her left hand before her eyes and studied it in every detail with wonder. With wonder and deep awe like Moses before his burning bush. What all, Arvay asked of herself, was buried and hidden in human flesh? You toted it around with you all your life time, but you couldn't know. If you just could know, it would be all the religion that anybody needed. And what was in you was bound to come out and stand.

Earl was in her and had to come out some way or another. Arvay looked back and shuddered. Then a new feeling came. Yes, Earl had been bred in her before she was even born, but his birth had purged her flesh. He was born first. It was meant to be that way. Somebody had to pay off the debt so that the rest of the pages could be clean. God must have thought that she was the one who could shoulder the load and bear it. He had not trusted it to her mother, nor yet to Larraine. God had made her a mother to give peace and comfort around. Earl had served his purpose and was happily removed from his sufferings. It was pitiful that she had not seen things in the right way from his birth. She had been purged out, and the way was cleared for better things.

Then it was like the Resurrection. The good that was in her flesh had taken form. Angeline, female beauty, had come out of her, and Kenny, as handsome a boy as you would find anywhere. Kenny had come bringing the music part inside her that she had never had a chance to show herself. It had to be there or it could never have come out as it did. He represented those beautiful sounds that she used to hear from nowhere as she played around with her doll under the mulberry tree. But give credit where credit was due. Jim was the other part. Joined together, they had made these wonders. Human flesh was full of mysteries and a wonderful and unknown thing.

Arvay bent her neck and kissed Jim tenderly on top of his head. Jim Meserve was her man and her care. Naturally, children would grow up and seek for partners just as she had done. It was the thing to do. It was meant to be that way.

Arvay hoped fervently that her two children would find the same kind of fullness that she had found. Angeline seemed to have it already. She hoped and prayed that Kenny would find the same. It was not for her to worry about how and with whom they found what she had found. Jim was her business. Arvay bent and kissed his hair again. It was funny that she had never known Jim in full until this night. Jim was not the over-powering general that she had took him for. Oh, he had that way with other folks and things. No matter of doubt about it. From a teppentime shack to his own fleet on the ocean was a long, long road to travel. But that was the outside Jim. Inside he was nothing but a little boy to take care of, and he hungered for her hovering. Look at him now! Snuggled down and clutching onto her like Kenny when he wore diapers. Arvay felt such a swelling to protect and comfort Jim that tears came up in her eyes. So helpless sleeping there in her arms and trusting himself to her.

And just like she had not known Jim, she had known her own self even less. What she had considered her cross, she now saw as her glory. Her father and Larraine had taken from her because they felt that she had something to take from and to give out of her fullness. Her mother had looked to her for dependence. Her children, and Jim and all. Her job was mothering. What more could any woman want and need? No matter how much money they had or learning, or high family, they couldn't do a bit more mothering and hovering than she could. Holy Mary, who had been blessed to mother Jesus, had been no better off than she was. She had been poor and unlearnt too. Even poor Carl had felt her need and care. Maybe as he said, he would have come to more than he had if he had had her beside him.

Thinking and feeling that way, Arvay could not sleep. The few hours left of the darkness passed away with Jim held in her arms. Jim was hers and it was her privilege to serve him. To keep on like that in happiness and peace until they died together, giving Jim the hovering that he needed.

A breeze of dawn sprang up, and the boat rocked gently

with it. The slightly increased motion made Arvay look out upon the sea. She saw that the sun was rising. It seemed to her that the big globe of light leaped up from a bed fixed on the eastern horizon and mounted, trailing the red covers of his bed behind him. Arvay pictured that he looked and saw the *Arvay Henson* with her and Jim on board and laid that rosy path across the crinkling water straight to it to look and see if she was carrying out her work. The sunlight rose higher, climbed the rail and came on board. Arvay sat up as best she could without disturbing Jim and switched off the artificial light overhead, and met the look of the sun with confidence. Yes, she was doing what the big light had told her to do. She was serving and meant to serve. She made the sun welcome to come on in, then snuggled down again beside her husband.

AFTERWORD

❖

ZORA NEALE HURSTON:
"A NEGRO WAY OF SAYING"

I.

The Reverend Harry Middleton Hyatt, and Episcopal priest whose five-volume classic collection, *Hoodoo, Conjuration, Witchcraft, and Rootwork,* more than amply returned an investment of forty years' research, once asked me during an interview in 1977 what had become of another eccentric collector whom he admired. "I met her in the field in the thirties. I think," he reflected for a few seconds, "that her first name was Zora." It was an innocent question, made reasonable by the body of confused and often contradictory rumors that make Zora Neale Hurston's own legend as richly curious and as dense as are the black myths she did so much to preserve in her classic anthropological works, *Mules and Men* and *Tell My Horse,* and in her fiction.

A graduate of Barnard, where she studied under Franz Boas, Zora Neale Hurston published seven books—four novels, two books of folklore, and an autobiography—and more than fifty shorter works between the middle of the Harlem Renaissance and the end of the Korean War, when she was the

dominant black woman writer in the United States. The dark obscurity into which her career then lapsed reflects her staunchly independent political stances rather than any deficiency of craft or vision. Virtually ignored after the early fifties, even by the Black Arts movement in the sixties, an otherwise noisy and intense spell of black image- and myth-making that rescued so many black writers from remaindered oblivion, Hurston embodied a more or less harmonious but nevertheless problematic unity of opposites. It is this complexity that refuses to lend itself to the glib categories of "radical" or "conservative," "black" or "Negro," "revolutionary" or "Uncle Tom"—categories of little use in literary criticism. It is this same complexity, embodied in her fiction, that, until Alice Walker published her important essay ("In Search of Zora Neale Hurston") in *Ms.* magazine in 1975, had made Hurston's place in black literary history an ambiguous one at best.

The rediscovery of Afro-American writers has usually turned on larger political criteria, of which the writer's work is supposedly a mere reflection. The deeply satisfying aspect of the rediscovery of Zora Neale Hurston is that black women generated it primarily to establish a maternal literary ancestry. Alice Walker's moving essay recounts her attempts to find Hurston's unmarked grave in the Garden of the Heavenly Rest, a segregated cemetery in Fort Pierce, Florida. Hurston became a metaphor for the black woman writer's search for tradition. The craft of Alice Walker, Gayl Jones, Gloria Naylor, and Toni Cade Bambara bears, in markedly different ways, strong affinities with Hurston's. Their attention to Hurston signifies a novel sophistication in black literature: they read Hurston not only for the spiritual kinship inherent in such relations but because she used black vernacular speech and rituals, in ways subtle and various, to chart the coming to consciousness of black women, so glaringly absent in other black fiction. This use of the vernacular became the fundamental framework for all but one of her novels and is particularly effective in her classic work *Their Eyes Were Watching God,*

published in 1937, which is more closely related to Henry James's *The Portrait of a Lady* and Jean Toomer's *Cane* than to Langston Hughes's and Richard Wright's the proletarian literature, so popular in the Depression.

The charting of Janie Crawford's fulfillment as an autonomous imagination, *Their Eyes* is a lyrical novel that correlates the need of her first two husbands for ownership of progressively larger physical space (and the gaudy accoutrements of upward mobility) with the suppression of self-awareness in their wife. Only with her third and last lover, a roustabout called Tea Cake whose unstructured frolics center around and about the Florida swamps, does Janie at last bloom, as does the large pear tree that stands beside her grandmother's tiny log cabin.

> She saw a dust bearing bee sink into the sanctum of a bloom; the thousand sister calyxes arch to meet the love embrace and the ecstatic shiver of the tree from root to tiniest branch creaming in every blossom and frothing with delight. So this was a marriage!

To plot Janie's journey from object to subject, the narrative of the novel shifts from third to a blend of first and third person (known as "free indirect discourse"), signifying this awareness of self in Janie. *Their Eyes* is a bold feminist novel, the first to be explicitly so in the Afro-American tradition. Yet in its concern with the project of finding a voice, with language as an instrument of injury and salvation, of selfhood and empowerment, it suggests many of the themes that inspirit Hurston's oeuvre as a whole.

II.

One of the most moving passages in American literature is Zora Neale Hurston's account of her last encounter with her dying mother, found in a chapter entitled "Wandering" in her autobiography, *Dust Tracks on a Road* (1942):

355

As I crowded in, they lifted up the bed and turned it
around so that Mama's eyes would face east. I thought that
she looked at me as the head of the bed reversed. Her
mouth was slightly open, but her breathing took up so
much of her strength that she could not talk. But she
looked to me, or so I felt, to speak for her. She depended
on me for a voice.

We can begin to understand the rhetorical distance that
separated Hurston from her contemporaries if we compare
this passage with a similar scene published just three years
later in *Black Boy* by Richard Wright, Hurston's dominant
black male contemporary and rival: "Once, in the night, my
mother called me to her bed and told me that she could not
endure the pain, and she wanted to die. I held her hand and
begged her to be quiet. That night I ceased to react to my
mother; my feelings were frozen." If Hurston represents her
final moments with her mother in terms of the search for
voice, then Wright attributes to a similar experience a certain
"somberness of spirit that I was never to lose," which "grew
into a symbol in my mind, gathering to itself . . . the poverty,
the ignorance, the helplessness. . . ." Few authors in the black
tradition have less in common than Zora Neale Hurston and
Richard Wright. And whereas Wright would reign through
the forties as our predominant author, Hurston's fame
reached its zenith in 1943 with a *Saturday Review* cover story
honoring the success of *Dust Tracks*. Seven years later, she
would be serving as a maid in Rivo Alto, Florida; ten years
after that she would die in the County Welfare Home in Fort
Pierce, Florida.

How could the recipient of two Guggenheims and the au-
thor of four novels, a dozen short stories, two musicals, two
books on black mythology, dozens of essays, and a prizewin-
ning autobiography virtually "disappear" from her readership
for three full decades? There are no easy answers to this
quandary, despite the concerted attempts of scholars to re-
solve it. It is clear, however, that the loving, diverse, and

enthusiastic responses that Hurston's work engenders today were not shared by several of her influential black male contemporaries. The reasons for this are complex and stem largely from what we might think of as their "racial ideologies."

Part of Hurston's received heritage—and perhaps the paramount received notion that links the novel of manners in the Harlem Renaissance, the social realism of the thirties, and the cultural nationalism of the Black Arts movement—was the idea that racism had reduced black people to mere ciphers, to beings who only react to an omnipresent racial oppression, whose culture is "deprived" where different, and whose psyches are in the main "pathological." Albert Murray, the writer and social critic, calls this "the Social Science Fiction Monster." Socialists, separatists, and civil rights advocates alike have been devoured by this beast.

Hurston thought this idea degrading, its propagation a trap, and railed against it. It was, she said, upheld by "the sobbing school of Negrohood who hold that nature somehow has given them a dirty deal." Unlike Hughes and Wright, Hurston chose deliberately to ignore this "false picture that distorted. . . ." Freedom, she wrote in *Moses, Man of the Mountain,* "was something internal. . . . The man himself must make his own emancipation." And she declared her first novel a manifesto against the "arrogance" of whites assuming that "black lives are only defensive reactions to white actions." Her strategy was not calculated to please.

What we might think of as Hurston's mythic realism, lush and dense within a lyrical black idiom, seemed politically retrograde to the proponents of a social or critical realism. If Wright, Ellison, Brown, and Hurston were engaged in a battle over ideal fictional models with which to represent the Negro, clearly Hurston lost the battle.

But not the war.

After Hurston and her choice of style for the black novel were silenced for nearly three decades, what we have witnessed since is clearly a marvelous instance of the return of the repressed. For Zora Neale Hurston has been "rediscovered"

in a manner unprecedented in the black tradition: several black women writers, among whom are some of the most accomplished writers in America today, have openly turned to her works as sources of narrative strategies, to be repeated, imitated, and revised, in acts of textual bonding. Responding to Wright's critique, Hurston claimed that she had wanted at long last to write a black novel, and "not a treatise on sociology." It is this urge that resonates in Toni Morrison's *Song of Solomon* and *Beloved,* and in Walker's depiction of Hurston as our prime symbol of "racial health—a sense of black people as complete, complex, *undiminished* human beings, a sense that is lacking in so much black writing and literature." In a tradition in which male authors have ardently denied black literary paternity, this is a major development, one that heralds the refinement of our notion of tradition: Zora and her daughters are a tradition-within-the-tradition, a black woman's voice.

The resurgence of popular and academic readerships of Hurston's works signifies her multiple canonization in the black, the American, and the feminist traditions. Within the critical establishment, scholars of every stripe have found in Hurston texts for all seasons. More people have read Hurston's works since 1975 than did between that date and the publication of her first novel, in 1934.

III.

Rereading Hurston, I am always struck by the density of intimate experiences she cloaked in richly elaborated imagery. It is this concern for the figurative capacity of black language, for what a character in *Mules and Men* calls "a hidden meaning, jus' like de Bible . . . de inside meanin' of words," that unites Hurston's anthropological studies with her fiction. For the folklore Hurston collected so meticulously as Franz Boas's student at Barnard became metaphors, allegories, and performances in her novels, the traditional recurring canonical metaphors of black culture. Always more of a novelist than a social scientist, even Hurston's academic collections center on

the quality of imagination that makes these lives whole and splendid. But it is in the novel that Hurston's use of the black idiom realizes its fullest effect. In *Jonah's Gourd Vine,* her first novel, for instance, the errant preacher, John, as described by Robert Hemenway "is a poet who graces his world with language but cannot find the words to secure his own personal grace." This concern for language and for the "natural" poets who "bring barbaric splendor of word and song into the very camp of the mockers" not only connects her two disciplines but also makes of "the suspended linguistic moment" a thing to behold indeed. Invariably, Hurston's writing depends for its strength on the text, not the context, as does John's climactic sermon, a *tour de force* of black image and metaphor. Image and metaphor define John's world; his failure to interpret himself leads finally to his self-destruction. As Robert Hemenway, Hurston's biographer, concludes, "Such passages eventually add up to a theory of language and behavior."

Using "the spy-glass of Anthropology," her work celebrates rather than moralizes; it shows rather than tells, such that "both behavior and art become self-evident as the tale texts and hoodoo rituals accrete during the reading." As author, she functions as "a midwife participating in the birth of a body of folklore, . . . the first wondering contacts with natural law." The myths she describes so accurately are in fact "alternative modes for perceiving reality," and never just condescending depictions of the quaint. Hurston sees "the Dozens," for example, that age-old black ritual of graceful insult, as, among other things, a verbal defense of the sanctity of the family, conjured through ingenious plays on words. Though attacked by Wright and virtually ignored by his literary heirs, Hurston's ideas about language and craft undergrid many of the most successful contributions to Afro-American literature that followed.

IV.

We can understand Hurston's complex and contradictory legacy more fully if we examine *Dust Tracks on a Road,* her own controversial account of her life. Hurston did make significant parts of herself up, like a masquerader putting on a disguise for the ball, like a character in her fictions. In this way, Hurston *wrote* herself, and sought in her works to rewrite the "self" of "the race," in its several private and public guises, largely for ideological reasons. That which she chooses to reveal is the life of her imagination, as it sought to mold and interpret her environment. That which she silences or deletes, similarly, is all that her readership would draw upon to delimit or pigeonhole her life as a synecdoche of "the race problem," an exceptional part standing for the debased whole.

Hurston's achievement in *Dust Tracks* is twofold. First, she gives us a *writer's* life, rather than an account, as she says, of "the Negro problem." So many events in this text are figured in terms of Hurston's growing awareness and mastery of books and language, language and linguistic rituals as spoken and written both by masters of the Western tradition and by ordinary members of the black community. These two "speech communities," as it were, are Hurston's great sources of inspiration not only in her novels but also in her autobiography.

The representation of her sources of language seems to be her principal concern, as she constantly shifts back and forth between her "literate" narrator's voice and a highly idiomatic black voice found in wonderful passages of free indirect discourse. Hurston moves in and out of these distinct voices effortlessly, seamlessly, just as she does in *Their Eyes* to chart Janie's coming to consciousness. It is this usage of a *divided* voice, a double voice unreconciled, that strikes me as her great achievement, a verbal analogue of her double experiences as a woman in a male-dominated world and as a black person in a nonblack world, a woman writer's revision of W. E. B. Du

Bois's metaphor of "double-consciousness" for the hyphenated African-American.

Her language, variegated by the twin voices that intertwine throughout the text, retains the power to unsettle.

> There is something about poverty that smells like death.
> Dead dreams dropping off the heart like leaves in a dry
> season and rotting around the feet; impulses smothered too
> long in the fetid air of underground caves. The soul lives
> in a sickly air. People can be slave-ships in shoes.

Elsewhere she analyzes black "idioms" used by a culture "raised on simile and invective. They know how to call names," she concludes, then lists some, such as 'gator-mouthed, box-ankled, puzzle-gutted, shovel-footed: "Eyes looking like skint-ginny nuts, and mouth looking like a dishpan full of broke-up crockery!"

Immediately following the passage about her mother's death, she writes:

> The Master-Maker in His making had made Old Death.
> Made him with big, soft feet and square toes. Made him
> with a face that reflects the face of all things, but neither
> changes itself, nor is mirrored anywhere. Made the body of
> death out of infinite hunger. Made a weapon of his hand to
> satisfy his needs. This was the morning of the day of the
> beginning of things.

Language, in these passages, is not merely "adornment," as Hurston described a key black linguistic practice; rather, manner and meaning are perfectly in tune: she says the thing in the most meaningful manner. Nor is she being "cute," or pandering to a condescending white readership. She is "naming" emotions, as she says, in a language both deeply personal and culturally specific.

The second reason that *Dust Tracks* succeeds as literature arises from the first: Hurston's unresolved tension between

361

her double voices signifies her full understanding of modernism. Hurston uses the two voices in her text to celebrate the psychological fragmentation both of modernity and of the black American. As Barbara Johnson has written, hers is a rhetoric of division, rather than a fiction of psychological or cultural unity. Zora Neale Hurston, the "real" Zora Neale Hurston that we long to locate in this text, dwells in the silence that separates these two voices: she is both, and neither; bilingual, and mute. This strategy helps to explain her attraction to so many contemporary critics and writers, who can turn to her works again and again only to be startled at her remarkable artistry.

But the life that Hurston could write was not the life she could live. In fact, Hurston's life, so much more readily than does the standard sociological rendering, reveals how economic limits determine our choices even more than does violence or love. Put simply, Hurston wrote well when she was comfortable, wrote poorly when she was not. Financial problems—book sales, grants, and fellowships too few and too paltry, ignorant editors and a smothering patron—produced the sort of dependence that affects, if not determines, her style, a relation she explored somewhat ironically in "What White Publishers Won't Print." We cannot oversimplify the relation between Hurston's art and her life; nor can we reduce the complexity of her postwar politics, which, rooted in her distaste for the pathological image of blacks, were markedly conservative and Republican.

Nor can we sentimentalize her disastrous final decade, when she found herself working as a maid on the very day the *Saturday Evening Post* published her short story "Conscience of the Court" and often found herself without money, surviving after 1957 on unemployment benefits, substitute teaching, and welfare checks. "In her last days," Hemenway concludes dispassionately, "Zora lived in a difficult life—alone, proud, ill, obsessed with a book she could not finish."

The excavation of her buried life helped a new generation read Hurston again. But ultimately we must find Hurston's

362

legacy in her art, where she "ploughed up some literacy and laid by some alphabets." Her importance rests with the legacy of fiction and lore she constructed so cannily. As Hurston herself noted, "Roll your eyes in ecstasy and ape his every move, but until we have placed something upon his street corner that is our own, we are right back where we were when they filed our iron collar off." If, as a friend eulogized, "She didn't come to you empty," then she does not leave black literature empty. If her earlier obscurity and neglect today seem inconceivable, perhaps now, as she wrote of Moses, she has "crossed over."

HENRY LOUIS GATES, JR.

SELECTED BIBLIOGRAPHY

WORKS BY ZORA NEALE HURSTON

Jonah's Gourd Vine. Philadelphia: J. B. Lippincott, 1934.

Mules and Men. Philadelphia: J. B. Lippincott, 1935.

Their Eyes Were Watching God. Philadelphia: J. B. Lippincott, 1937.

Tell My Horse. Philadelphia: J. B. Lippincott, 1938.

Moses, Man of the Mountain. Philadelphia: J. B. Lippincott, 1939.

Dust Tracks on a Road. Philadelphia: J. B. Lippincott, 1942.

Seraph on the Suwanee. New York: Charles Scribner's Sons, 1948.

I Love Myself When I Am Laughing . . . & Then Again When I Am Looking Mean and Impressive: A Zora Neale Hurston Reader. Edited by Alice Walker. Old Westbury, N.Y.: The Feminist Press, 1979.

The Sanctified Church. Edited by Toni Cade Bambara. Berkeley: Turtle Island, 1981.

Spunk: The Selected Short Stories of Zora Neale Hurston. Berkeley: Turtle Island, 1985.

WORKS ABOUT ZORA NEALE HURSTON

Baker, Houston, A., Jr., *Blues, Ideology, and Afro-American Literature: A Vernacular Theory,* pp. 15–63. Chicago: University of Chicago Press, 1984.

Bloom, Harold, ed. *Zora Neale Hurston.* New York: Chelsea House, 1986.

———, ed. *Zora Neale Hurston's "Their Eyes Were Watching God."* New York: Chelsea House, 1987.

Byrd, James W. "Zora Neale Hurston: A Novel Folklorist." *Tennessee Folklore Society Bulletin* 21 (1955): 37–41.

Cooke, Michael G. "Solitude: The Beginnings of Self-Realization in Zora Neale Hurston, Richard Wright, and Ralph Ellison." In Michael G. Cooke, *Afro-American Literature in the Twentieth Century,* pp. 71–110. New Haven: Yale University Press, 1984.

Dance, Daryl C. "Zora Neale Hurston." In *American Women Writers: Bibliographical Essays,* edited by Maurice Duke, et al. Westport, Conn.: Greenwood Press, 1983.

Gates, Henry Louis, Jr. "The Speakerly Text." In Henry Louis Gates, Jr., *The Signifying Monkey,* pp. 170–217. New York: Oxford University Press, 1988.

Giles, James R. "The Significance of Time in Zora Neale Hurston's *Their Eyes Were Watching God.*" *Negro American Literature Forum* 6 (Summer 1972): 52–53, 60.

Hemenway, Robert E. *Zora Neale Hurston: A Literary Biography.* Chicago: University of Illinois Press, 1977.

Holloway, Karla. *The Character of the Word: The Texts of Zora Neale Hurston.* Westport, Conn.: Greenwood Press, 1987.

Holt, Elvin. "Zora Neale Hurston." In *Fifty Southern Writers After 1900,* edited by Joseph M. Flura and Robert Bain, pp. 259–69. Westport, Conn.: Greenwood Press, 1987.

Howard, Lillie Pearl. *Zora Neale Hurston.* Boston: Twayne, 1980.

———. "Zora Neale Hurston." In *Dictionary of Literary Biography,* vol. 51, edited by Trudier Harris, pp. 133–45. Detroit: Gale, 1987.

Jackson, Blyden. "Some Negroes in the Land of Goshen." *Tennessee Folklore Society Bulletin* 19 (4) (December 1953): 103–7.

Johnson, Barbara. "Metaphor, Metonymy, and Voice in *Their Eyes.*" In *Black Literature and Literary Theory,* edited by Henry Louis Gates, Jr., pp. 205–21. New York: Methuen, 1984.

———. "Thresholds of Difference: Structures of Address in Zora Neale Hurston." In *"Race," Writing and Difference,* edited by Henry Lewis Gates, Jr. Chicago: University of Chicago Press, 1986.

Jordan, June. "On Richard Wright and Zora Neale Hurston." *Black World* 23 (10) (August 1974): 4–8.

Kubitschek, Missy Dehn. " 'Tuh de Horizon and Back': The Female Quest in *Their Eyes.*" *Black American Literature Forum* 17 (3) (Fall 1983): 109–15.

Lionnet, Françoise. "Autoethnography: The Anarchic Style of *Dust Tracks on a Road.*" In Françoise Lionnet, *Autobiographical Voices: Race, Gender, Self-Portraiture,* pp. 97–130. Ithaca: Cornell University Press, 1989.

Lupton, Mary Jane. "Zora Neale Hurston and the Survival of the Female." *Southern Literary Journal* 15 (Fall 1982): 45–54.

Meese, Elizabeth. "Orality and Textuality in Zora Neale Hurston's *Their Eyes.*" In Elizabeth Meese, *Crossing the Double Cross: The Practice of Feminist Criticism,* pp. 39–55. Chapel Hill: University of North Carolina Press, 1986.

Newson, Adele S. *Zora Neale Hurston: A Reference Guide.* Boston: G. K. Hall, 1987.

Rayson, Ann. "*Dust Tracks on a Road:* Zora Neale Hurston and the Form of Black Autobiography." *Negro American Literature Forum* 7 (Summer 1973): 42–44.

Sheffey, Ruthe T., ed. *A Rainbow Round Her Shoulder: The Zora Neale Hurston Symposium Papers.* Baltimore: Morgan State University Press, 1982.

Smith, Barbara. "Sexual Politics and the Fiction of Zora Neale Hurston." *Radical Teacher* 8 (May 1978): 26–30.

Stepto, Robert B. *From Behind the Veil.* Urbana: University of Illinois Press, 1979.

Walker, Alice. "In Search of Zora Neale Hurston." *Ms.,* March 1975, pp. 74–79, 85–89.

Wall, Cheryl A. "Zora Neale Hurston: Changing Her Own Words." In *American Novelists Revisited: Essays in Feminist Criticism,* edited by Fritz Fleischmann, pp. 370–93. Boston: G. K. Hall, 1982.

Washington, Mary Helen. "Zora Neale Hurston: A Woman Half in Shadow." Introduction to *I Love Myself When I Am Laughing,* edited by Alice Walker. Old Westbury, N.Y.: Feminist Press. 1979.

———." 'I Love the Way Janie Crawford Left Her Husbands': Zora Neale Hurston's Emergent Female Hero." In Mary Helen Washington, *Invented Lives: Narratives of Black Women, 1860–1960.* New York: Anchor Press, 1987.

Willis, Miriam. "Folklore and the Creative Artist: Lydia Cabrera and Zora Neale Hurston." *CLA Journal 27* (September 1983): 81–90.

Wolff, Maria Tai. "Listening and Living: Reading and Experience in *Their Eyes.*" *BALF* 16 (1) (Spring 1982): 29–33.

CHRONOLOGY

January 7, 1891 Born in Eatonville, Florida, the fifth of eight children, to John Hurston, a carpenter and Baptist preacher, and Lucy Potts Hurston, a former schoolteacher.

September 1917– Attends Morgan Academy in Baltimore, completing the high school requirements.
June 1918

Summer 1918 Works as a waitress in a nightclub and a manicurist in a black-owned barbershop that serves only whites.

1918–19 Attends Howard Prep School, Washington, D.C.

1919–24 Attends Howard University; receives an associate degree in 1920.

1921 Publishes her first story, "John Redding Goes to Sea," in the *Stylus,* the campus literary society's magazine.

December 1924 Publishes "Drenched in Light," a short story, in *Opportunity.*

1925 Submits a story, "Spunk," and a play, *Color Struck,* to *Opportunity's* literary contest. Both win second-place awards; publishes "Spunk" in the June number.

1925–27 Attends Barnard College, studying anthropology with Franz Boas.

1926 Begins field work for Boas in Harlem.

January 1926	Publishes "John Redding Goes to Sea" in *Opportunity*.
Summer 1926	Organizes *Fire!* with Langston Hughes and Wallace Thurman; they publish only one issue, in November 1926. The issue includes Hurston's "Sweat."
August 1926	Publishes "Muttsy" in *Opportunity*.
September 1926	Publishes "Possum or Pig" in the *Forum*.
September–November 1926	Publishes "The Eatonville Anthology" in the *Messenger*.
1927	Publishes *The First One,* a play, in Charles S. Johnson's *Ebony and Topaz*.
February 1927	Goes to Florida to collect folklore.
May 19, 1927	Marries Herbert Sheen.
September 1927	First visits Mrs. Rufus Osgood Mason, seeking patronage.
October 1927	Publishes an account of the black settlement at St. Augustine, Florida, in the *Journal of Negro History;* also in this issue: "Cudjo's Own Story of the Last African Slaver."
December 1927	Signs a contract with Mason, enabling her to return to the South to collect folklore.
1928	Satirized as "Sweetie Mae Carr" in Wallace Thurman's novel about the Harlem Renaissance *Infants of the Spring;* receives a bachelor of arts degree from Barnard.
January 1928	Relations with Sheen break off.
May 1928	Publishes "How It Feels to Be Colored Me" in the *World Tomorrow*.
1930–32	Organizes the field notes that become *Mules and Men*.
May–June 1930	Works on the play *Mule Bone* with Langston Hughes.
1931	Publishes "Hoodoo in America" in the *Journal of American Folklore*.
February 1931	Breaks with Langston Hughes over the authorship of *Mule Bone*.
July 7, 1931	Divorces Sheen.

September 1931	Writes for a theatrical revue called *Fast and Furious*.
January 1932	Writes and stages a theatrical revue called *The Great Day*, first performed on January 10 on Broadway at the John Golden Theatre; works with the creative literature department of Rollins College, Winter Park, Florida, to produce a concert program of Negro music.
1933	Writes "The Fiery Chariot."
January 1933	Stages *From Sun to Sun* (a version of *Great Day*) at Rollins College.
August 1933	Publishes "The Gilded Six-Bits" in *Story*.
1934	Publishes six essays in Nancy Cunard's anthology, *Negro*.
January 1934	Goes to Bethune-Cookman College to establish a school of dramatic arts "based on pure Negro expression."
May 1934	Publishes *Jonah's Gourd Vine*, originally titled *Big Nigger*; it is a Book-of-the-Month Club selection.
September 1934	Publishes "The Fire and the Cloud" in the *Challenge*.
November 1934	*Singing Steel* (a version of *Great Day*) performed in Chicago.
January 1935	Makes an abortive attempt to study for a Ph.D in anthropology at Columbia University on a fellowship from the Rosenwald Foundation. In fact, she seldom attends classes.
August 1935	Joins the WPA Federal Theatre Project as a "dramatic coach."
October 1935	*Mules and Men* published.
March 1936	Awarded a Guggenheim Fellowship to study West Indian Obeah practices.
April–September 1936	In Jamaica.
September–March 1937	In Haiti; writes *Their Eyes Were Watching God* in seven weeks.
May 1937	Returns to Haiti on a renewed Guggenheim.
September 1937	Returns to the United States; *Their Eyes Were Watching God* published, September 18.

February– March 1938	Writes *Tell My Horse;* it is published the same year.
April 1938	Joins the Federal Writers Project in Florida to work on *The Florida Negro.*
1939	Publishes "Now Take Noses" in *Cordially Yours.*
June 1939	Receives an honorary Doctor of Letters degree from Morgan State College.
June 27, 1939	Marries Albert Price III in Florida.
Summer 1939	Hired as a drama instructor by North Carolina College for Negroes at Durham; meets Paul Green, professor of drama, at the University of North Carolina.
November 1939	*Moses, Man of the Mountain* published.
February 1940	Files for divorce from Price, though the two are reconciled briefly.
Summer 1940	Makes a folklore-collecting trip to South Carolina.
Spring– July 1941	Writes *Dust Tracks on a Road.*
July 1941	Publishes "Cock Robin, Beale Street" in the *Southern Literary Messenger.*
October 1941– January 1942	Works as a story consultant at Paramount Pictures.
July 1942	Publishes "Story in Harlem Slang" in the *American Mercury.*
September 5, 1942	Publishes a profile of Lawrence Silas in the *Saturday Evening Post.*
November 1942	*Dust Tracks on a Road* published.
February 1943	Awarded the Anisfield-Wolf Book Award in Race Relations for *Dust Tracks;* on the cover of the *Saturday Review.*
March 1943	Receives Howard University's Distinguished Alumni Award.
May 1943	Publishes "The 'Pet Negro' Syndrome" in the *American Mercury.*
November 1943	Divorce from Price granted.
June 1944	Publishes "My Most Humiliating Jim Crow Experience" in the *Negro Digest.*
1945	Writes *Mrs. Doctor;* it is rejected by Lippincott.

March 1945	Publishes "The Rise of the Begging Joints" in the *American Mercury.*
December 1945	Publishes "Crazy for This Democracy" in the *Negro Digest.*
1947	Publishes a review of Robert Tallant's *Voodoo in New Orleans* in the *Journal of American Folklore.*
May 1947	Goes to British Honduras to research black communities in Central America; writes *Seraph on the Suwanee;* stays in Honduras until March 1948.
September 1948	Falsely accused of molesting a ten-year-old boy and arrested; case finally dismissed in March 1949.
October 1948	*Seraph on the Suwanee* published.
March 1950	Publishes "Conscience of the Court" in the *Saturday Evening Post,* while working as a maid in Rivo Island, Florida.
April 1950	Publishes "What White Publishers Won't Print" in the *Saturday Evening Post.*
November 1950	Publishes "I Saw Negro Votes Peddled" in the *American Legion* magazine.
Winter 1950–51	Moves to Belle Glade, Florida.
June 1951	Publishes "Why the Negro Won't Buy Communism" in the *American Legion* magazine.
December 8, 1951	Publishes "A Negro Voter Sizes Up Taft" in the *Saturday Evening Post.*
1952	Hired by the *Pittsburgh Courier* to cover the Ruby McCollum case.
May 1956	Receives an award for "education and human relations" at Bethune-Cookman College.
June 1956	Works as a librarian at Patrick Air Force Base in Florida; fired in 1957.
1957–59	Writes a column on "Hoodoo and Black Magic" for the *Fort Pierce Chronicle.*
1958	Works as a substitute teacher at Lincoln Park Academy, Fort Pierce.
Early 1959	Suffers a stroke.
October 1959	Forced to enter the St. Lucie County Welfare Home.

January 28, 1960 Dies in the St. Lucie County Welfare Home of "hypertensive heart disease"; buried in an unmarked grave in the Garden of Heavenly Rest, Fort Pierce.

August 1973 Alice Walker discovers and marks Hurston's grave.

March 1975 Walker publishes "In Search of Zora Neale Hurston," in *Ms.,* launching a Hurston revival.

P.S.

Insights,
Interviews
& More...

She *Was* the Party

by Valerie Boyd

ZORA NEALE HURSTON knew how to make an entrance. On May 1, 1925, at a literary awards dinner sponsored by *Opportunity* magazine, the earthy Harlem newcomer turned heads and raised eyebrows as she claimed four awards: a second-place fiction prize for her short story "Spunk," a second-place award in drama for her play *Color Struck*, and two honorable mentions.

The names of the writers who beat out Hurston for first place that night would soon be forgotten. But the name of the second-place winner buzzed on tongues all night, and for days and years to come.

Lest anyone forget her, Hurston made a wholly memorable entrance at a party following the awards dinner. She strode into the room—jammed with writers and arts patrons, black and white—and flung a long, richly colored scarf around her neck with dramatic flourish as she bellowed a reminder of the title of her winning play: *"Coloooooooor Struuckkkk!"* Her exultant entrance literally stopped the party for a moment, just as she had intended. In this way, Hurston made it known that a bright and powerful presence had arrived.

By all accounts, Zora Neale Hurston could walk into a roomful of strangers and, a few minutes and a few stories later, leave them so completely charmed that they often found themselves offering to help her in any way they could.

Gamely accepting such offers—and employing her own talent and scrappiness—Hurston became the most successful and most significant black woman writer of the first half of the twentieth century. Over a career that spanned more than thirty years, she published four novels, two books of folklore, an autobiography, numerous short stories, and several essays, articles, and plays.

Born on January 7, 1891, in Notasulga, Alabama, Hurston moved with her family to Eatonville, Florida, when she was still a toddler. Her writings reveal no recollection of her Alabama beginnings. For Hurston, Eatonville was always home.

Established in 1887, the rural community near Orlando was the nation's first incorporated black township. It was, as Hurston described it, "a city of five lakes, three croquet courts, three hundred brown skins, three hundred good swimmers, plenty guavas, two schools, and no jailhouse."

In Eatonville, Zora was never indoctrinated in inferiority, and she could see the evidence of black ▶

66 In Eatonville, Zora was never indoctrinated in inferiority, and she could see the evidence of black achievement all around her. 99

achievement all around her. She could look to town hall and see black men, including her father, John Hurston, formulating the laws that governed Eatonville. She could look to the Sunday schools of the town's two churches and see black women, including her mother, Lucy Potts Hurston, directing the Christian curricula. She could look to the porch of the village store and see black men and women passing worlds through their mouths in the form of colorful, engaging stories.

Growing up in this culturally affirming setting in an eight-room house on five acres of land, Zora had a relatively happy childhood, despite frequent clashes with her preacher-father, who sometimes sought to "squinch" her rambunctious spirit, she recalled. Her mother, on the other hand, urged young Zora and her seven siblings to "jump at de sun." Hurston explained, "We might not land on the sun, but at least we would get off the ground."

Hurston's idyllic childhood came to an abrupt end, though, when her mother died in 1904. Zora was only thirteen years old. "That hour began my wanderings," she later wrote. "Not so much in geography, but in time. Then not so much in time as in spirit."

> ❝ Zora had a relatively happy childhood, despite frequent clashes with her preacher-father, who sometimes sought to 'squinch' her rambunctious spirit. ❞

After Lucy Hurston's death, Zora's father remarried quickly—to a young woman whom the hotheaded Zora almost killed in a fistfight—and seemed to have little time or money for his children. "Bare and bony of comfort and love," Zora worked a series of menial jobs over the ensuing years, struggled to finish her schooling, and eventually joined a Gilbert & Sullivan traveling troupe as a maid to the lead singer. In 1917, she turned up in Baltimore; by then, she was twenty-six years old and still hadn't finished high school. Needing to present herself as a teenager to qualify for free public schooling, she lopped ten years off her life—giving her year of birth as 1901. Once gone, those years were never restored: from that moment forward, Hurston would always present herself as at least ten years younger than she actually was.

Apparently, she had the looks to pull it off. Photographs reveal that she was a handsome, big-boned woman with playful yet penetrating eyes, high cheekbones, and a full, graceful mouth that was never without expression.

Zora also had a fiery intellect, an infectious sense of humor, and "the gift," as one friend put it, "of walking into hearts." Zora used these talents—and dozens more—to elbow her ▶

She *Was* the Party *(continued)*

way into the Harlem Renaissance of the 1920s, befriending such luminaries as poet Langston Hughes and popular singer-actress Ethel Waters.

Though Hurston rarely drank, fellow writer Sterling Brown recalled, "When Zora was there, she *was* the party." Another friend remembered Hurston's apartment—furnished by donations she solicited from friends—as a spirited "open house" for artists. All this socializing didn't keep Hurston from her work, though. She would sometimes write in her bedroom while the party went on in the living room.

By 1935, Hurston—who'd graduated from Barnard College in 1928—had published several short stories and articles, as well as a novel, *Jonah's Gourd Vine*, and a well-received collection of black Southern folklore, *Mules and Men*. But the late thirties and early forties marked the real zenith of her career. She published her masterwork, *Their Eyes Were Watching God*, in 1937; *Tell My Horse*, her study of Haitian Voodoo practices and Caribbean culture, in 1938; and another masterful novel, *Moses, Man of the Mountain*, in 1939. When her autobiography, *Dust Tracks on a Road*, was published in 1942, Hurston finally received the well-

" 'When Zora was there, she *was* the party.' "

earned acclaim that had long eluded her. That year, she was profiled in *Who's Who in America, Current Biography,* and *Twentieth Century Authors.* She went on to publish another novel, *Seraph on the Suwanee,* in 1948.

Still, Hurston never received the financial rewards she deserved. (The largest royalty she ever earned from any of her books was $943.75.) So, when she died on January 28, 1960—at age sixty-nine, after suffering a stroke—her neighbors in Fort Pierce, Florida, had to take up a collection for her February 7 funeral. The collection didn't yield enough to pay for a headstone, however, and Hurston was buried in a grave that remained unmarked until 1973.

That summer, a young writer named Alice Walker traveled to Fort Pierce to place a marker on the grave of the author who had so inspired her own work. Walker found the Garden of Heavenly Rest, a segregated cemetery at the dead end of North Seventeenth Street, abandoned and overgrown with yellow-flowered weeds.

Back in 1945, Hurston had foreseen the possibility of dying without money—and she'd proposed a solution that would have benefited ▶

" Hurston was buried in a grave that remained unmarked until 1973. "

She *Was* the Party *(continued)*

her and countless others. Writing to W. E. B. Du Bois, whom she called the "Dean of American Negro Artists," Hurston suggested "a cemetery for the illustrious Negro dead" on one hundred acres of land in Florida. "Let no Negro celebrity, no matter what financial condition they might be in at death, lie in inconspicuous forgetfulness," she urged. "We must assume the responsibility of their graves being known and honored." Du Bois, citing practical complications, wrote a curt reply discounting her argument.

As if impelled by Hurston's words, Walker bravely entered the snake-infested cemetery where the writer's remains had been laid to rest. Wading through waist-high weeds, she soon stumbled upon a sunken rectangular patch of ground that she determined to be Hurston's grave. Unable to afford the marker she wanted—a tall, majestic black stone called "Ebony Mist"—Walker chose a plain gray headstone instead. Borrowing from a Jean Toomer poem, she dressed the marker up with a fitting epitaph: "Zora Neale Hurston: A Genius of the South."

66 Wading through waist-high weeds, Alice Walker stumbled upon a sunken rectangular patch of ground that she determined to be Hurston's grave. 99

Valerie Boyd is the author of the award-winning Wrapped in Rainbows: The Life of Zora Neale Hurston. *Formerly the arts editor at the* Atlanta Journal-Constitution, *she is a professor at the University of Georgia's Grady College of Journalism and Mass Communication.*

A True Picture
of the South

by Hazel V. Carby

ON APRIL 15, 1947, Zora Neale
Hurston signed a contract with the
publishing house of Charles Scribner
& Sons for a novel concerned with life
in Florida and titled *The Sign of the
Sun*. She had finally decided to leave
J. B. Lippincott, the publisher of all
her previous books, because the
company had firmly dismissed
her last two projects. Hurston had
become disillusioned after Lippincott
turned down her proposal for a novel
about the black middle class, and
she was openly depressed when it
subsequently rejected a manuscript
set in Eatonville, the town in which
Hurston had grown up and which
had provided such rich source
material for the writing of *Mules
and Men* and *Their Eyes Were
Watching God*. Hurston felt that
the new contract promised a new
beginning. The obvious enthusiasm
of the Scribner editors for her new
novel about a Southern white family
renewed her confidence in herself,
and the $500 advance enabled
Hurston, at last, to finance the trip
to Honduras that she had been
planning for two years. She left
in May and settled into the Hotel

Cosenza, in Puerto Cortés on the north coast of Honduras, to write her novel and to plan an expedition into the mountains. As Hurston described this expedition to her editor at Scribner, Burroughs Mitchell, she hoped "to find a lost city . . . which travellers have heard about for two hundred years, but has not as yet been seen."[1] Hurston wanted her novel to be "good" so she could finance the journey that she felt was "burning [her] soul to attack."[2]

Between May and November, Hurston wrote and revised the novel for which, at various times, she had a number of titles, including *Sang the Suwanee in the Spring*, *The Queen of the Golden Hand*, *Angel in the Bed*, *Lady Angel with Her Man*, *Seraph with a Man on Hand*, *So Said the Sea*, *Good Morning Sun*, and *Seraph on the Suwanee River*. In January 1948, after three months of editorial hesitation, Scribner finally decided to go ahead with the book and asked Hurston to come to New York to work on more revisions. Her dreams of the lost city were left behind when she returned to a cold New York in February 1948. Worried that she had "been in the bush so many months," Hurston warned Burroughs Mitchell "you might have to run me down and catch me and sort of tie me up in the shed until I get house-broke again."[3]

Hurston aimed to make *Seraph* ▶

A True Picture of the South *(continued)*

on the Suwanee "a true picture of the South." She was delighted that Burroughs Mitchell was impressed with her use of Southern vernacular and idiom. In her previous novels and in the collection of folklore, *Mules and Men*, Hurston had established a reputation for her representation of black language and rhythms of speech. Though contemporary critics of Hurston's work have granted her a privileged position in the African American literary canon because of her sensitive delineation of black folk culture and black folk consciousness, particularly through language, Hurston's own views are more complex and controversial. In writing about *Seraph on the Suwanee*, Hurston repudiated theories of the uniqueness of black linguistic structures.

> I think that it should be pointed out that what is known as Negro dialect in the South is no such thing. Bear in mind that the South is the purest English section of the United States. . . . What is actually the truth is that the South, up until the 1930s, was a relic of England. . . . And you find the retention of old English beliefs and customs, songs and ballads and

Elizabethan figures of speech. They go for the simile and especially the metaphor. As in the bloom of Elizabethan literature, they love speech for the sake of speech. This is common to white and black. The invective is practiced as a folk art from earliest childhood. You have observed that when a southern Senator or Representative gets the floor, no Yankee can stand up to him so far as compelling language goes. . . . They did *not* get it from the Negroes. The Africans coming to America got it from them. If it were African, then why is it not in evidence among all Negroes in the western world? No, the agrarian system stabilized in the South by slavery slowed down change . . . and so the tendency to colorful language that characterized Shakespeare and his contemporaries and made possible the beautiful and poetic language of the King James Bible got left over to an extent in the rural South.[4]

Hurston's opinions of the formative influences acting on the linguistic structures of the black folk may ▸

cause some discomfort to critics who valorize Hurston for preserving and reproducing in her work cultural forms that they argue are essentially and uniquely black. In *Seraph on the Suwanee*, there are many phrases and sentences that evoke the language of Hurston's black figures in her previous work. Occasionally, the language is identical—whole phrases are lifted from the mouth of a black character in an earlier novel and inserted into the mouth of a member of the white Meserve family. The rhythm and syntax of Hurston's black folk haunt the reader throughout the novel.

Moreover, Hurston was concerned with establishing more than linguistic similarities between white and black in the South; she was actively trying to demonstrate her ideas of cultural influence and fusion in her novel. Kenny Meserve, the second son of Jim and Arvay Meserve, is trained as a musician by black Joe Kelsey. Hurston wrote a chapter, which the publisher later removed, on Kenny's success in New York, to explain this cultural exchange:

I felt I had to add a chapter on Kenny in New York to explain his success. Though no one to my knowledge has come right

out and said it yet, we have had
a revolution in national
expression in music that is
equivalent to Chaucer's use
of the native idiom in England.
Gershwin's *Porgy and Bess*
brought to a head that which
had been in the making for at
least a decade. There is no more
Negro music in the U.S. It has
been fused and merged and
become the national expression,
and displaced the worship of
European expression. In fact,
it is now denied, (and with some
truth) that it never was pure
Negro music, but an adaptation
of white music. . . . But the fact
remains that what has evolved
here is something American.[5]

As a white musician playing black
music, Kenny was intended to
represent Hurston's conviction
that black music was no longer
an expression of black culture but
had become a form of national
expression.

However, *Seraph on the Suwanee*
is not just a vehicle for Hurston's
theories of the relation between black
and white culture. The novel was also
an attempt to realize two ambitions
that she had been working toward
throughout the forties. Hurston ▶

wanted to sell a novel to Hollywood and to see her fiction transformed into film. In 1942, she felt optimistic. "I have a tiny wedge in Hollywood," she wrote with excitement in a letter to Carl Van Vechten, a patron of black art and black artists; she went on to tell him that she had joined the Paramount writing staff. But in 1947, Scribner tried and failed to interest Metro-Goldwyn-Mayer Pictures in the novel.

Hurston's second ambition involved a challenge to the literary conventions of the apartheid American society in which Hurston lived—conventions she felt dictated that black writers and artists should be concerned only with representing black subjects. In the same letter, she described how she had "hopes of breaking that old silly rule about Negroes not writing about white people."[6] In the postwar 1940s, Hurston was not the only black artist to confront the question of whether a racial art was also a segregated art, an art confined permanently within the limits of differences. For all black people, the Second World War embodied the acute contradictions in mobilizing against the ideology of fascism abroad, on the one hand, and, on the other, living with the fascist

practices of racism and segregation at home. For many it was an unresolved question of whether being an American and being a Negro were compatible or incompatible categories. For intellectuals, making a decision "whether it was better to be a 'Negro Artist' and develop a racial art or to be an American artist who was a Negro" was complex and contradictory.[7] In literature, these tensions are present in the conscious decisions made by some black writers to write for white magazines or to create white subjects in their fiction.

In the nine years between the publication of *Moses, Man of the Mountain* in 1939 and *Seraph on the Suwanee,* Hurston concentrated her energies on writing nonfiction for white audiences. Her autobiography, *Dust Tracks on a Road*, was published in 1942 and won the Ainsfield-Wolf Award, sponsored by the *Saturday Review*, for its contribution to "the field of race relations." Throughout the forties, Hurston was a regular contributor of essays and reviews to magazines with a predominantly white readership. Of course she ran the risk of being positioned by these magazines as a "representative Negro" expressing "representative opinions," and she also invited, and received, ▶

heavy criticism from other black intellectuals for ignoring serious aspects of black life in order to pander to a white readership. But despite the risks and the controversy that her articles generated, Hurston seems to have sought and enjoyed her position as a conservative black spokesperson.[8]

However, it is important to remember that Hurston was not alone in her direct engagement with a white readership. Some magazines, like the *Saturday Evening Post*, regularly published work from a variety of black writers, and a significant number of black novelists, including Hurston, eventually published postwar novels about white characters. In 1947, Ann Petry published *Country Place* and Willard Motley published *Knock on Any Door*. Between 1946 and 1950, Frank Yerby published five novels aimed at a mass-market audience: *The Foxes of Harrow*, *The Golden Hawk*, *The Vixens*, *Pride's Castle*, and *Floodtide*. In 1954, Richard Wright published his controversial novel *Savage Holiday*.[9] White reviewers and critics often condemned black novels about black subjects for being narrowly conceived, for being overly political, and for being didactic. The term *protest fiction* was frequently used to

describe novels by and about black people in order to suggest that somehow the practice of art had been compromised, if not contaminated, by the presence of political and ideological issues. The phrase *protest fiction* implied that fiction that was uncritical of the racialized structures of subordination at work in society somehow expressed universal, not partisan, values. When black authors created white characters in novels that were apparently not about racism or the suffering that resulted from a racist society, reviewers indirectly expressed their relief. A reviewer of *Country Place* in the *Atlantic Monthly* was glad that the novel "preaches no sermons, [and] waves no flags." [10] In the paperback edition of Petry's novel, the publishers inserted a page titled "About This Book" that explained that taking "the folksy, nostalgic front off 'Our Town'" was "a much more difficult task" than dealing with "the life of the Negro in our big Northern cities," the subject of Petry's first novel, *The Street*. Potential readers could safely retain their political illusions about the existence of democracy, for they were assured that Ann Petry was "a powerful American writer, unhampered by any one theme or hobby horse." [11] Writing about ▸

white people was thought by many white critics, reviewers, and publishers to require more literary skill, and more talent, than writing about black characters. In addition, being an author of a white novel could apparently resolve the contradiction of being both black and American.

Seraph on the Suwanee, a novel of a poor white family in Florida that gradually achieves upward economic and class mobility, was published in October 1948. Reviews on the whole were favorable if not overly enthusiastic, but Scribner was unable to interest any book clubs in the novel's distribution. The initial sales of *Seraph on the Suwanee* were good, about three thousand in the first few weeks of publication, and because of the favorable reviews, Scribner ordered another two thousand to be printed. But the events that created controversy around the novel and shattered Hurston's optimism had nothing to do with the fact that Hurston was black and her characters white. On September 13, Hurston had been arrested on charges rising from allegations of sexual misconduct with a ten-year-old boy. She emphatically denied all charges, using her passport as evidence that she had been in Honduras at the time the immoral

acts were supposed to have taken place. It must have absolutely astounded Hurston that *Seraph on the Suwanee* could become a tool in the publicity that was eventually generated from the allegations against her. On October 23, the national edition of the Baltimore *Afro-American* published a distorted and inaccurate version of the original allegations (allegations that were eventually proved to be totally false) under the banner headlines "Did She Want 'Knowing and Doing' Kind of Love?" and "Boys, 10, Accuse Zora." Above the article itself ran the two headlines "Novelist Arrested on Morals Charge," "Reviewer of Author's Latest Book Notes Character Is 'Hungry for Love.'" The story was salacious: It suggested that *Seraph on the Suwanee* advocated sexual aggressiveness in women and then used selected sentences from the novel as if they provided evidence of the author's immorality. Hurston's exploration of the sexual expectations and repressions of the novel's protagonists became, in the hands of the Baltimore *Afro-American*, the means for crucifying her. She was literally tried and found guilty in the widely syndicated story and in a subsequent editorial, which appeared in the November 6 *Afro-American*, ▶

in which the paper defended itself against criticism of the front-page publicity granted to the case by arguing that "a hush-hush attitude about perversion has permitted this menace to increase."[12]

Charges against Hurston were not dismissed until March 14, 1949, and by then, as Robert Hemenway has argued, "the damage had been done."[13] Hurston felt betrayed by a fellow black person, a court reporter who had originally leaked the story to the press, and by a black newspaper that she referred to as "the *Afro-American* sluice of filth." This sense of betrayal led Hurston to contemplate and threaten suicide in a letter that she wrote to Carl and Fania Van Vechten:

> All that I have ever tried to do has proved useless. All that I have believed in has failed me. I have resolved to die. It will take a few days for me to set my affairs in order, and then I will go.... No acquittal will persuade some people that I am innocent. I feel hurled down a filthy privy hole.[14]

The letter seems to have been written as much from a feeling of hope that it could generate the assurance and

support from friends that she needed as it was from a feeling of fear and despair that no one believed in her innocence. Hurston must have received the assurance that she sought, for she did not kill herself, and she gradually recovered her enthusiasm for living and for writing. But, presumably because of the negative publicity generated by the Baltimore *Afro-American*, Hurston seems to have done little to publicly promote her novel herself. In many ways, *Seraph on the Suwanee* was Hurston's most ambitious and most experimental novel to date. But while she regained her confidence and recovered her ambitions for her fiction in the manuscripts of three more novels, *Seraph on the Suwanee* was the last of her novels to be accepted for publication by any publishing house.

The relation between the themes of Petry's *Country Place* and Hurston's *Seraph on the Suwanee* are striking—both concentrate on complex questions of female sexuality and the sometimes violent conflict between men and women that arises from the existence of incompatible and gender-specific desires. Arvay Meserve grows up in a poor family in the turpentine town of Sawley at the turn of the twentieth century. As a young ▶

woman, she is convinced that she isn't important to anyone, and she develops a secret fantasy life in which she feels that she lives in mental adultery with her sister's husband. At twenty-one, Arvay turns her back on the "sins of the world," and uses religious devotion as a mask, an escape from the pressures of "spinsterhood" into a space that represents the only legitimate, autonomous existence for a woman. Arvay successfully gets rid of all unwanted suitors by throwing so-called fits until Jim Meserve arrives and refuses to be so easily dismissed. In the first part of the novel, Jim establishes his power over Arvay through two acts of violence. He "cures" her fits by dropping turpentine in her eye and subsequently rapes her under the mulberry tree, a tree that is symbolic of Arvay's innocent childhood. As the novel progresses, the successful gendering of each protagonist is dependent on the other. Arvay becomes "a slave" to her husband, Jim, while Jim measures and defines his masculinity entirely in relation to the extent to which he can take care of a woman. To Jim Meserve, all women are incapable of taking care of themselves, and, as they have no brains, a man, in order to become a

true man, has to think for all women in his care. Readers of *Their Eyes Were Watching God* will be reminded of the pompous second husband of Janie, Jody Starks, who asserted that "Somebody got to think for women and chillun and cows," because they couldn't think for themselves.[15] The difficulty for a feminist reading of *Seraph on the Suwanee* is that Jim Meserve, unlike Jody Starks, does not conveniently die so that his wife can get on with her life. In *Seraph* it is Arvay's expectations and desires that must be transformed to accommodate the demands of her husband.

Nevertheless, the sexual politics of *Seraph on the Suwanee* cannot be easily dismissed. The sexual ambiguity of Jim and Arvay's roles is, at times, intriguing. It is clear from Hurston's letters to her editor when she was writing about Arvay's doubts, fears, and lack of confidence that she was thinking about the men she had met who had been intimidated in their relationship with a woman who was a success in her own right. In response to her editor's unsympathetic response to the character of Arvay, Hurston admitted that, at times, she got sick of her herself, and then she asked: ▶

Have you ever been tied in close contact with a person who had a strong sense of inferiority? I have and it is hell. . . . I took this man I cared for down to Carl Van Vechten's one night so that he could meet some of my literary friends, since he had complained that I was always off with them, and ignoring him. . . . What happened? He sat off in a corner and gloomed and uglied away, and we were hardly out on the street before he was accusing me of having dragged him down there to show off what a big shot I was and how far I was above him.[16]

Reviewers also became confused about whether Jim or Arvay was the seraph of the title—who exactly was the guardian angel, and who was the angel looking after? Frank G. Slaughter, in the *New York Times Book Review,* was convinced that Arvay set out to be the *Webster's* definition of a seraph: "One of an order of celestial beings conceived as fiery and purifying ministers of Jehovah." Herschel Brickell, in the *Saturday Review,* argued that it was "the hero, Jim Meserve," who played "the part of a 'fiery and purifying minister of Jehovah,' with sufficient success to make him seraphic." [17]

Arvay's discovery that she needs to be a mother to her husband long after her own children have grown is a vision of female fulfillment that is very different from, and more controversial than, the vision of female autonomy that Hurston created in *Their Eyes Were Watching God*. But it is the very complexity and depth of Arvay's frustrated and unsatisfied desires that make *Seraph on the Suwanee* a very modern text, a text that speaks as eloquently to the contradictions and conflict of trying to live our lives as gendered beings in the 1990s as it did in 1948. ∽

Notes

1. Zora Neale Hurston to Burroughs Mitchell, September 3, 1947, Charles Scribner's Sons Archives, Author's File 3, Department of Rare Books and Special Collections, Princeton University Libraries. I would like to thank Princeton University Libraries for permission to quote from the unpublished correspondence in this collection and to thank the library staff for their invaluable assistance.

2. Zora Neale Hurston to Burroughs Mitchell, July 31, 1947, ibid.

3. Zora Neale Hurston to Burroughs Mitchell, February 14 [1948], ibid. ▸

4. Zora Neale Hurston to Burroughs Mitchell, October 2, 1947, ibid.

5. Zora Neale Hurston to Burroughs Mitchell, October, "Something Late," 1947, ibid.

6. Zora Neale Hurston to Carl Van Vechten, November 2, 1942, Carl Van Vechten Papers, James Weldon Johnson Memorial Collection, Beinecke Rare Book and Manuscript Library, Yale University. I would like to thank the Beinecke Library for permission to quote from personal correspondence and to acknowledge the invaluable assistance of the library staff.

7. See Ann Gibson, "Norman Lewis in the Forties," in *Norman Lewis: From the Harlem Renaissance to Abstraction*, May 10, 1989–June 25, 1989 (New York: Kenkeleba Gallery, 1989), pp. 9–23. Gibson argues, convincingly, that a number of black artists in the forties, including Romare Bearden, Harlan Jackson, Ronald Joseph, Norman Lewis, and Hale Woodruff, "decided it was better to be an American artist who was a Negro."

8. Robert E. Hemenway, "Ambiguities of Self, Politics of Race," in *Zora Neale Hurston: A Literary Biography* (Urbana: University of Illinois Press, 1977), chap. 11, particularly pp. 288–89.

9. Willard Motley, *Knock on Any Door* (New York: D. Appleton-Century Company, 1947); Ann Petry, *Country*

Place (New York: Houghton Mifflin, 1947); Frank Yerby, *The Foxes of Harrow* (New York: Dial Press, 1946), *The Golden Hawk* (New York: Dial Press, 1947), *The Vixens* (New York: Dial Press, 1948), *Pride's Castle* (New York: Dial Press, 1949), and *Floodtide* (New York: Dial Press, 1950); Richard Wright, *Savage Holiday* (New York: Avon, 1954).

10. John Caswell Smith, Jr., review of *Country Place, Atlantic Monthly*, November 1947: 178, 180.

11. "About This Book," in Ann Petry, *Country Place* (New York: New American Library, 1949).

12. Press clippings from the *Afro-American* (Baltimore), October 23 and November 6, 1948; the *Iowa Bystander* (Des Moines), dated October 21, 1948; and the *Ohio State News* (Columbus), October 23, 1948. The clippings are in the Charles Scribner's Sons Archives, Author's File 3.

13. Hemenway, *Zora Neale Hurston*, p. 320.

14. Zora Neale Hurston to Carl and Fania Van Vechten, n.d., as quoted in Hemenway, *Zora Neale Hurston*, pp. 321–22.

15. Zora Neale Hurston, *Their Eyes Were Watching God* (New York: Harper & Row, 1990), pp. 66–67.

16. Zora Neale Hurston to Burroughs Mitchell, October 2, 1947, ▶

A True Picture of the South *(continued)*

Charles Scribner's Sons Archives,
Author's File 3.
 17. Frank G. Slaughter, "Freud in
Turpentine," *New York Times Book
Review*, October 31, 1948: 48;
Herschel Brickell, "A Woman Saved,"
Saturday Review, November 6, 1948: 19.

Grateful acknowledgment is made
to Princeton University Libraries,
Charles Scribner's Sons Archives.

Have You Read?
More by Zora Neale Hurston

JONAH'S GOURD VINE

Zora Neale Hurston's first novel tells the story of John Buddy Pearson, a young minister who loves too many women for his own good even though he is married to Lucy, his one true love. In this sympathetic portrait of a man and his community, Hurston shows that faith, tolerance, and good intentions cannot resolve the tension between the spiritual and the physical.

THEIR EYES WERE WATCHING GOD

The epic tale of Janie Crawford, whose quest for identity takes her on a journey during which she learns what love is, experiences life's joys and sorrows, and comes home to herself in peace. Her passionate story prompted Alice Walker to say, "There is no book more important to me than this one."

Have You Read? *(continued)*

MULES AND MEN

The fruit of Hurston's labors as a folklorist and anthropologist, this celebrated treasury of black American folklore includes stories, "big old lies," songs, Voodoo customs, superstitions—all the humor and wisdom that is the matchless heritage of American blacks.

THE COMPLETE STORIES

This landmark gathering of Zora Neale Hurston's short fiction—most of which appeared only in literary magazines during her lifetime and some of which has never before been published—reveals the evolution of one of the most important African American writers. Spanning her career from 1921 to 1955, these stories attest to Hurston's tremendous range and establish themes that recur in her longer fiction. The stories in this collection map, in rich language and imagery, Hurston's development and concerns as a writer and provide an invaluable reflection of the mind and imagination of the author of the acclaimed novel *Their Eyes Were Watching God*.

TELL MY HORSE

This firsthand account of the
mysteries of Voodoo is based on
Hurston's personal experiences
in Haiti and Jamaica, where she
participated as an initiate and not
just an observer of Voodoo practices
in the 1930s. Of great cultural
interest, her travelogue paints a
vividly authentic picture of
ceremonies, customs, and
superstitions.

MOSES, MAN OF THE MOUNTAIN

Based on the familiar story of the
Exodus, Hurston blends the Moses
of the Old Testament with the Moses
of black folklore and song to create a
compelling allegory of power,
redemption, and faith.

DUST TRACKS ON THE ROAD

First published in 1942 at the crest of her popularity as a writer, this is Hurston's imaginative and exuberant account of her rise from childhood poverty in the rural South to a prominent place among the leading artists and intellectuals of the Harlem Renaissance. It is a book full of the wit and wisdom of a proud and spirited woman who started off low and climbed high.

MULE BONE

Mule Bone is the only collaboration between Zora Neale Hurston and Langston Hughes, two stars of the Harlem Renaissance, and it holds an unparalleled place in the annals of African American theater. Set in Eatonville, Florida—Hurston's hometown and the inspiration for much of her fiction—this energetic and often farcical play centers on Jim and Dave, a two-man song-and-dance team, and Daisy, the woman who comes between them. Overcome by jealousy, Jim hits Dave with a mule bone and hilarity follows chaos as the town splits into two factions: the Methodists, who want to pardon Jim; and the Baptists, who wish to banish him for his crime.

African American folklore was Zora Neale Hurston's first love. Collected in the late 1920s, these hilarious, bittersweet, often saucy folktales—some of which date back to the Civil War—provide a fascinating, verdant slice of African American life in the rural South at the turn of the twentieth century. Arranged according to subject—from God Tales, Preacher Tales, and Devil Tales to Heaven Tales, White-Folk Tales, and Mistaken Identity Tales—they reveal attitudes about slavery, faith, race relations, family, and romance that have been passed on for generations. They capture the heart and soul of the vital, independent, and creative community that so inspired Zora Neale Hurston.

JONAH'S GOURD VINE

JONAH'S GOURD VINE

A NOVEL

ZORA NEALE HURSTON

WITH A FOREWORD BY RITA DOVE
AND AN AFTERWORD BY HENRY LOUIS GATES, JR.

AMISTAD

An Imprint of HarperCollinsPublishers

AMISTAD

To
Bob Wunsch
Who is one of the long-wingded angels
Right round the throne
Go gator and muddy the water

FOREWORD

"You laks dat ole train Ah see," the Negro said to John, watching him as he all but fell down into the railroad cut, trying to keep sight of the tail of the train.

"Yeah, man Ah lakted dat. It say something but Ah ain't heered it 'nough tuh tell whut it say yit. You know whut it say?"

"It don't say nothin'. It jes' make uh powerful racket, dass all."

"Naw, it say some words too. Ahm comin' heah pleny mo' times and den Ah tell yuh whut it say."

When the publishing house of J. B. Lippincott inquired if the author of the short story "The Gilded Six Bits" was working on a novel, Zora Neale Hurston took paper and pencil and headed for home. She rented a room in Sanford, Florida, next door to the all-black town where she had grown up, and began to write *Jonah's Gourd Vine*. In October 1933, a scant four months later, the manuscript was accepted for publication.

Jonah's Gourd Vine takes the classic form of the *Bildungsroman:* John, an unlettered but determined young man, ventures forth to make his fortune. What he learns of the world and his own nature form the trajectory of his life and the novel.

Like those of many black Americans, John's origins are

murky. His mother Amy bears him while working on Alf Pearson's farm; she marries Ned Crittenden and moves to the other side of Big Creek. Ned, who was raised a slave, despises John for what he represents—for there is every indication that John is the illegitimate son of the white judge.

Even as a young man, John is aware of the power of utterance. His fear of the first locomotive he sees is quickly replaced by the desire to understand it. And though he never learns to speak to his own soul, he is fascinated by the infinite variety of nature's music:

> . . . John sat on the foot-log and made some words to go with the drums of the Creek. Things walked in the birch woods, creep, creep, creep. The hound dog's lyric crescendo lifted over and above the tree tops. He was on the foot-log, half way across the Big Creek where maybe people laughed and maybe people had lots of daughters. The moon came up. The hunted coon panted down to the Creek . . . [t]he tenor-singing hound dog went home. Night passed. No more Ned, no hurry. No telling how many girls might be living on the new and shiny side of the Big Creek. John almost trumpeted exultantly at the new sun. He breathed lustily. He stripped and carried his clothes across, then recrossed and plunged into the swift water and breasted strongly over.

This passage contains all the elements of John's spirit—his exuberant masculine energy, his gift for language, and his intense relationship between his interior self and the natural world, both his headstrong lustiness and his ability for provident forethought. (He carries his clothes across the river, then recrosses before swimming over.)

This scene, however, occurs right after his mother's repeated warning not to swim the Songahatchee and John's parting promise to her to stop "runnin' and uh rippin' and clambin' trees and rocks and jumpin'." The seeds of his inner conflict are evident.

In an ironic twist recalling the incestuous relationships in the South, John leaves home to find work under Alf Pearson, who remarks, "Your face looks sort of familiar but I can't place you" before giving him the cast-off clothes of his legitimate son. But when the judge's wife objects to John driving their coach, he is put to work in the barns.

John, who adopts Pearson as his surname, is an immediate success among the black workers, especially the women: they seduce him right and left. He focuses his attention on the fiery little Lucy Potts, the smartest black girl in the area. Her excellence inspires John to "eat up dat school," and he joins the church when he is told that Lucy sings in the choir. After a determined courtship, Lucy and John become man and wife.

Although John left home at the suggestion of his mother, he soon learns the temptation of flight. Whenever things get sticky, he runs away. And, just as he is able to break a promise to his mother minutes afterward without a second thought, John sees no discrepancy in enjoying a stream of women while swearing to love Lucy body and soul. Even before marriage, John must leave the Pearson place and find work at a logging camp to escape a jealous husband; and though he swears to Lucy that "Ah loves you and you alone," after marriage he still cannot stay away from other women. There is Mehaley and Big 'Oman and then Delphine, who comforts John while Lucy lies in labor with their fourth child. When Lucy's brother takes their marriage bed in partial payment of a debt, John beats him up and is consequently summoned to court. Alf Pearson gives him money along with some "fatherly" advice: "John, distance is the only cure for certain diseases."

John moves to the all-black settlement of Eatonville, Florida (Hurston's home town) and sends for Lucy. He grows in confidence and takes his place in the community as a man, while Lucy's energy is taken up by children; all her fierce intelligence is channeled into advising her husband. Together they forge John's reputation as minister of Zion Hope Church and eventually mayor in the neighboring town of Sanford.

Actually, John's "disease" is that he is too smooth a talker. He is carried away by his own words, just as he is carried away by his body. His stirring prayers convince him and everyone else at Zion Hope that he has been called to preach, although his wife warns him against confusing talent with commitment:

> "Lucy, look lak Ah jus' found out whut Ah kin do. De words dat sets de church on fire comes tuh me jus' so. Ah reckon de angels must tell 'em tuh me."
>
> "God don't call no man, John, and turn 'im loose uh fool."

Perhaps his most despicable flight occurs when his younger daughter Isis lies desperately ill; terrified that she will die, he runs into the arms of another woman until she recovers. (Ironically, later it is the nine-year-old Isis who stands by her dying mother.) John returns, shamefaced, with gifts for Lucy—a new dress and a pineapple—that seem as blasphemous as they are ludicrous.

The procession of women continues until John meets Hattie Tyson, who enjoins the aid of a conjure woman to keep him at her side. Lucy's sound advice grows wearisome to him, and her cautious inquiries into his infidelities finally enrage him. Remembering John's poor track record with promises, it is with foreboding that we hear him swear to Lucy: "Li'l Bit, Ah ain't never laid de weight uh mah hand on you in malice." When Lucy falls ill, John continues to see other women, and Lucy makes a decisive pronouncement on John's sin-now-atone-later attitude: "You can't clean yo'self wid yo' tongue lak uh cat." Stung by the truth, John slaps her. She turns her face to the wall, withdrawing her support from him, and dies.

This act of malice, which hastens Lucy's death, is the worm that cuts down the great vine:

> And the Lord God appointed a plant, and made it come up over Jonah, that it might be a shade over his head, to save him from this discomfort. So Jonah was exceedingly glad because of the plant. But when dawn came up the next day,

God appointed a worm which attacked the plant, so that it
withered.

<div align="right">Jonah 4: 6–7</div>

Indeed, John Pearson is a rapidly growing vine, and every-
thing he touches blossoms under his hand: he is a favorite with
the women, he is popular with the men, he is a good worker
and a gifted storyteller, and finally, as minister and mayor, he
becomes both a spiritual and a community leader. His philan-
dering ways do not seem to slow him down until he commits
the ghastly sin of striking his wife on her deathbed.

The worm, however, could also be Hattie, who is willing
to use magic more compelling than feminine wiles to topple
the preacher. John marries Hattie, and beats her after discov-
ering that he's been "conjured." When Hattie slyly pleads her
case before Deacon Harris (who is jealous of John's successes
with women), Harris assures her, "Ah'd cut down dat Jonah's
gourd vine in a uh minute, if Ah had all de say-so." When she
files for divorce, John does not confute her testimony.

The worm of malice burrows through the church commu-
nity. Long uneasy about the preacher's philanderings, the con-
gregation of Zion Hope plans to dethrone him. On the day
of reckoning, John preaches the sermon of his life.

John's final sermon is taken nearly verbatim from Hurston's
field notes on a country preacher. It is a meditation on martyr-
dom and heroism, reflecting John's position before the
church; after a brief rhapsodic digression on the creation of
earth, he zeroes in on Jesus, come on his "train of mercy" to
save mankind. In John's depiction of the Resurrection, the
train of mercy turns into the "damnation train," which in a
bizarre but effective conclusion is derailed when the cow-
catcher rams into Jesus's side. Final Judgment is pictured as a
convention where "de two trains of Time shall meet on de
trestle."

Surrounded by enemies who had once been friends, bitten
through at the root, John steps down from the pulpit and walks
out of the church. He decides to earn a living as a carpenter,

but his honest efforts fail in the face of the community's delight in persecuting a fallen idol.

Are we to sympathize with John as a victim of malicious ill-wishers, or condemn him for his despicable conduct toward his wife? Since Hattie has a spell put on him, is he to blame for his actions at all?

If we look at the Biblical story of Jonah and the vine, John's "case" becomes clearer: the prophet has predicted the fall of the great city of Nineveh, upon which its inhabitants repent by fasting and covering themselves in sackcloth and ashes. Moved to pity, the Lord revokes his sentence, and Jonah takes to the hills to sulk. After God has caused the vine to wither, he orders the sun to beat down until Jonah bemoans the loss of shade and exclaims that he is "angry enough to die." The Lord replies:

> "You pity the plant, for which you did not labor, nor did you make it grown, which came into being in a night, and perished in a night. And should not I pity Nineveh, that great city, in which there are more than a hundred and twenty thousand persons who do not know their right hand from their left, and also much cattle?"
>
> Jonah 4:10–11

Sudden growth—fame achieved without thought or labor—must maintain a precarious balance. Perhaps John's fatal flaw is his inability to listen to himself and consequently his reluctance to put any effort into changing his ways. Unable to accept responsibility for his actions, he either runs away or "licks himself clean" with fast talking. Even the heaped-on tribulations that follow Lucy's death fail to lead him to an understanding of his selfishness: all he can see is the hypocrisy of others. And when Lucy finally returns to him in a dream, he is oblivious to the warning:

> He killed the snake and carried Lucy across in his arms to where Alf Pearson stood at the cross roads and pointed

down a white shell road with his walking cane and said, "Distance is the only cure for certain diseases," and he and Lucy went racing down the dusty white road together. Somehow Lucy got lost from him, but there he was on the road—happy because the dead snake was behind him, but crying in his loneliness for Lucy.

Instead of seeing the dream as a condemning portrait of the pattern of his life, John believes he is meant to leave town—to run away again, and to seek his fortune elsewhere. The proper and rich widow Sally Lovelace takes him in, and John's luck begin to turn: they marry, his carpentry business picks up, and Zion Hope asks him back. His triumphant homecoming, resplendent in the new car Sally has bought him, brings with it the admiration of his former enemies as well as the irresistible blandishments of a sweet young thing named Ora. In no time at all, John succumbs to lust again; appalled at his weakness, he flees Sanford and heads back to his wife. So sunk in self-recrimination is he that he fails to see an oncoming train. He is killed instantly. A man who does not learn from his mistakes is doomed to repeat them. In many ways, John has cut himself down.

They called for the instrument that they had brought to America in their skins—the drum—and they played upon it. . . . The drum with the man skin that is dressed with human blood, that is beaten with a human shin-bone and speaks to gods as a man and to men as a God.

Does *Jonah's Gourd Vine* hold up today, apart from its unquestionable value as a portrait of Southern black life in the first decades of the twentieth century—or does a sympathetic portrait of a philandering preacher seem antiquated as a work of literature, politically retrograde? As his first name attests, John is Everyman, and Pearson is a surname with multitudinous echoes. In a bitter reference to the lost ancestry of black

slaves, he is someone's (but whose?) son; like that archetypal Son of God, he is "pierced" by those he has trusted; conversely, he is a man, pierced by Adam's rib, and his human frailty eventually causes his downfall.

Lucy, on the other hand, is almost a parody of the faithful, betrayed wife: she subordinates her dreams to his ambitions, she is rebuked and dies, the husband remarries, the children get farmed out. And yet no one can take Lucy's place. She haunts the novel, and her absence is at least as compelling as John's suffering.

For its time, Zora Neale Hurston's first novel, produced in four months when the author was forty-two, is a remarkable achievement. Written in the vicinity of her birthplace, *Jonah's Gourd Vine*, unsurprisingly, does not stray far from the autobiographical—John and Lucy are based on Hurston's father and mother, and Lucy's deathbed scene can be found in its original (with Zora as the nine-year-old daughter) in Hurston's autobiography, *Dust Tracks on a Road*. What is striking, however, is that this young woman did not make one of the major mistakes of first novelists—sticking too faithfully to the "true story"—but knew how to fashion of her parents' lives a tale of compelling pathos and majesty.

As a work of fiction, *Jonah's Gourd Vine* certainly has its flaws: transitions that jog, a little too much "local color." And though Hurston can hardly be blamed for wanting to infuse the text with the fieldwork she had done as an anthropologist, all too often her eloquent commentary stands full-blown and self-contained, interrupting the narrative flow. John's final sermon is a case in point, for even its masterful train imagery seems too heavy-handed a foreshadowing when the locomotive comes barreling out of the blue, a modern-day *deus ex machina,* to seal John's fate.

But Hurston's language is superb, rich with wordplay and proverbs—not only compelling when it comes to rendering the dialect of the Southern rural black but also as an omniscient narrator who neither indulges nor condemns the actions of her characters but offers the complexity of life in a story that

leaves judgment up to the reader. John Pearson is presented as a human being in all his individual paradoxes—troubled and gifted, dignified and lascivious, pure and selfish—and as the exemplification of the country preacher, he is both poet and philosopher. If language is the chief visible sign of human beings' pre-eminence over beasts, then poetry is the purest expression of man's spiritual quest. *Jonah's Gourd Vine* is a glorious paean to the power of the word, an attestation to the promise made in Langston Hughes's famous 1926 essay, "The Negro Artist and the Racial Mountain":

We younger Negro artists who create now intend to express our individual dark-skinned selves without fear or shame. If white people are pleased we are glad. If they are not, it doesn't matter. We know we are beautiful. And ugly too. The tom-tom cries and the tom-tom laughs. If colored people are pleased we are glad. If they are not, their displeasure doesn't matter either. We build our temples for tomorrow, strong as we know how, and we stand on top of the mountain, free within ourselves.

RITA DOVE

JONAH'S GOURD VINE

CHAPTER 1

God was grumbling his thunder and playing the zig-zag lightning thru his fingers.

Amy Crittenden came to the door of her cabin to spit out a wad of snuff. She looked up at the clouds.

"Ole Massa gwinter scrub floors tuhday," she observed to her husband who sat just outside the door, reared back in a chair. "Better call dem chaps in outa de cotton patch."

" 'Tain't gwine rain," he snorted, "you always talkin' more'n yuh know."

Just then a few heavy drops spattered the hard clay yard. He arose slowly. He was an older middle-age than his years gave him a right to be.

"And eben if hit do rain," Ned Crittenden concluded grudgingly, "ef dey ain't got sense 'nough tuh come in let 'em git wet."

"Yeah, but when us lef' de field, you told 'em not to come till you call 'em. Go 'head and call 'em 'fo' de rain ketch 'em."

Ned ignored Amy and shuffled thru the door with the chair, and somehow trod on Amy's bare foot. " 'Oman, why don't you git outa de doorway? Jes contrary tuh dat. You needs uh good head stompin', dass whut. You sho is one aggervatin' 'oman."

Amy flashed an angry look, then turned her face again to

1

the sea of wind-whipped cotton, turned hurriedly and took the cow-horn that hung on the wall and placed it to her lips.

"You John Buddy! You Zeke! You Zachariah! Come in!"

From way down in the cotton patch, "Yassum! Us comin'!"

Ned shuffled from one end of the cabin to the other, slamming to the wooden shutter of the window, growling between his gums and his throat the while.

The children came leaping in, racing and tumbling in tense, laughing competition—the three smaller ones getting under the feet of the three larger ones. The oldest boy led the rest, but once inside he stopped short and looked over the heads of the others, back over the way they had come.

"Shet dat door, John!" Ned bellowed, "you ain't got the sense you wuz borned wid."

Amy looked where her big son was looking. "Who dat comin' heah, John?" she asked.

"Some white folks passin' by, mama. Ahm jes' lookin' tuh see whar dey gwine."

"Come out dat do'way and shet it tight, fool! Stand dere gazin' dem white folks right in de face!" Ned gritted at him. "Yo' brazen ways wid dese white folks is gwinter git you lynched one uh dese days."

"Aw 'tain't," Amy differed impatiently, "who can't look at ole Beasley? He ain't no quality no-how."

"Shet dat door, John!" screamed Ned.

"Ah wuzn't de last one inside," John said sullenly.

"Don't you gimme no word for word," Ned screamed at him. "You jes' do lak Ah say do and keep yo' mouf shet or Ah'll take uh trace chain tuh yuh. Yo' mammy mought think youse uh lump uh gold 'cause you got uh li'l' white folks color in yo' face, but Ah'll stomp yo' guts out and dat quick! Shet dat door!"

He seized a lidard knot from beside the fireplace and limped threateningly towards John.

Amy rose from beside the cook pots like a black lioness.

"Ned Crittenden, you raise dat wood at mah boy, and you gointer make uh bad nigger outa me."

2

"Dat's right," Ned sneered, "Ah feeds 'im and clothes 'im but Ah ain't tuh do nothin' tuh dat li'l' yaller god cep'n wash 'im up."

"Dat's uh big ole resurrection lie, Ned. Uh slew-foot, drag-leg lie at dat, and Ah dare yuh tuh hit me too. You know Ahm uh fightin' dawg and mah hide is worth money. Hit me if you dare! Ah'll wash *yo'* tub uh 'gator guts and dat quick."

"See dat? Ah ain't fuh no fuss, but you tryin' tuh start uh great big ole ruction 'cause Ah tried tuh chesstize dat young-un."

"Naw, you ain't tried tuh chesstize 'im nothin' uh de kind. Youse tryin' tuh fight 'im on de sly. He is jes' ez obedient tuh you and jes' ez humble under yuh, ez he kin be. Yet and still you always washin' his face wid his color and tellin' 'im he's uh bastard. He works harder'n anybody on dis place. You ain't givin' 'im nothin'. He more'n makes whut he gits. Ah don't mind when he needs chesstizin' and you give it tuh 'im, but anytime you tries tuh knock any dese chillun 'bout dey head wid sticks and rocks, Ah'll be right dere tuh back dey fallin'. Ahm dey mama."

"And Ahm de pappy uh all but dat one."

"You knowed Ah had 'm 'fo' yuh married me, and if you didn't want 'im round, whut yuh marry me fuh? Dat ain't whut you said. You washed 'im up jes' lak he wuz gold den. You jes took tuh buckin' 'im since you been hangin' round sich ez Beasley and Mimms."

Ned sat down by the crude fireplace where the skillets and spiders (long-legged bread pans with iron cover) sprawled in the ashes.

"Strack uh light, dere, some uh y'all chaps. Hit's dark in heah."

John obediently thrust a piece of lightwood into the embers and the fire blazed up. He retreated as quickly as possible to the farther end of the cabin.

Ned smoked his strong home-grown tobacco twist for a few minutes. Then he thrust out his feet.

"Pour me some water in dat wash-basin, you chaps, and

3

some uh y'all git de washrag."

There was a scurry and bustle to do his bidding, but the drinking-gourd dropped hollowly in the water bucket. Ned heard it.

" 'Tain't no water in dat air water-bucket, Ah'll bound yuh!" He accused the room and glowered all about him, "House full uh younguns fuh me to feed and close, and heah 'tis dust dark and rainin' and not uh drop uh water in de house! Amy, whut kinda 'oman is you nohow?"

Amy said nothing. She sat on the other side of the fireplace and heaped fresh, red coals upon the lid of the spider in which the bread was cooking.

"John!" Ned thundered, "git yo' yaller behind up offa dat floor and go git me some water tuh wash mah foots."

"You been tuh de house longer'n he is," Amy said quietly. "You coulda done been got dat water."

"You think Ah'm gwine take uh 'nother man's youngun and feed 'im and close 'im fuh twelve years and den he too good tuh fetch me uh bucket uh water?" Ned bellowed.

"Iss rainin' out dere, an' rainin' hard," Amy said in the same level tones.

"Dass right," Ned sneered, "John is de house-nigger. Ole Marsa always kep' de yaller niggers in de house and give 'em uh job totin' silver dishes and goblets tuh de table. Us black niggers is de ones s'posed tuh ketch de wind and de weather."

"Ah don't want *none* uh mah chilluns pullin' tuh no spring in uh hard rain. Yo' foots kin wait. Come hawg-killin' time Ah been married tuh you twelve years and Ah done seen yuh let 'em wait uh powerful long spell some time. Ah don't want mah chilluns all stove-up wid uh bad cold from proagin' 'round in de rain."

"Ole Marse didn't ast *me* of hit wuz rainin' uh snowin' uh hot uh col'. When he spoke Ah had tuh move and move quick too, uh git uh hick'ry tuh mah back. Dese younguns ain't uh bit better'n me. Let 'em come lak Ah did."

"Naw, Ned, Ah don't want mine tuh come lak yuh come nor neither lak me, and Ahm uh whole heap younger'n you.

4

You growed up in slavery time. When Old Massa wuz drivin'
you in de rain and in de col'—he wasn't don' it tuh he'p you
'long. He wuz lookin' out for hisself. Course Ah wuz twelve
years old when Lee made de big surrender, and dey didn't
work me hard, but—but dese heah chillun is diffunt from us."

"How come dey's diffunt? Wese all niggers tuhgether, ain't
us? White man don't keer no mo' 'bout one dan he do de
other."

"Course dey don't, but we ain't got tuh let de white folks
love our chillun fuh us, is us? Dass jest de pint. We black folks
don't love our chillun. We couldn't do it when we wuz in
slavery. We borned 'em but dat didn't make 'em ourn. Dey
b'longed tuh old Massa. 'Twan't no use in treasurin' other
folkses property. It wuz liable tuh be took uhway any day. But
we's free folks now. De big bell done rung! Us chillun is ourn.
Ah doan know, mebbe hit'll take some of us generations, but
us got tuh 'gin tuh practise on treasurin' our younguns. Ah
loves dese heah already uh whole heap. Ah don't want 'em
knocked and 'buked."

Ned raked his stubbly fingers thru his grisly beard in silent
hostility. He spat in the fire and tamped his pipe.

"Dey say spare de rod and spile de child, and Gawd knows
Ah ain't gwine tuh spile nair one uh dese. Niggers wuz made
tuh work and all of 'em gwine work right long wid me. Is dat
air supper ready yit?"

"Naw hit ain't. How you speck me tuh work in de field right
long side uh you and den have supper ready jes' ez soon ez
Ah git tuh de house? Ah helt uh big-eye hoe in mah hand jes'
ez long ez you did, Ned."

"Don't you change so many words wid me, 'oman! Ah'll
knock yuh dead ez Hector. Shet yo' mouf!"

"Ah change jes' ez many words ez Ah durn please! Ahm
three times seben and uh button. Ah knows whut's de matter
wid *you*. Youse mad cause Beaseley done took dem two bales
uh cotton us made las' yeah."

"Youse uh lie!"

"Youse uh nother one, Ned Crittenden! Don't you lak it,

5

don't you take it, heah mah collar come and you shake it! Us wouldn't be in dis fix ef you had uh lissened tuh me. Ah tole you when dey hauled de cotton tuh de gin dat soon ez everything wuz counted up and Beasley give us share for yuh tuh take and haul it straight tuh dis barn. But naw, yuh couldn't lissen tuh me. Beasley told yuh tuh leave hit in *his* barn and being he's uh white man you done whut he told yuh. Now he say he ain't got no cotton uh ourn. Me and you and all de chillun done worked uh whole year. Us done made sixteen bales uh cotton and ain't even got uh cotton seed to show."

"Us et hit up, Major Beasley say. Come to think of it 'tis uh heap uh moufs in one meal barrel."

"No sich uh thing, Ned Crittenden. Fust place us ain't had nothing but meal and sow-belly tuh eat. You mealy-moufin' round cause you skeered tuh talk back tuh Rush Beasley. What us needs tuh do is git offa dis place. Us been heah too long. Ah b'longs on de other side de Big Creek anyhow. Never did lak it over heah. When us gather de crops dis yeah less move."

"Aw, Ah reckon we kin make it heah all right, when us don't have so many moufs in de meal barrel we kin come out ahead. 'Tain't goin' be dat many dis time when Ah goes to de gin house."

"How come?"

"Cause Ah done bound John over tuh Cap'n Mimms. Dat's uh great big ole boy, Amy, sixteen years old and look lak he twenty. He eats uh heap and den you won't let me git de worth uh mah rations out of 'im in work. He could be de finest plowhand in Alabama, but you won't lemme do nothin' wid 'im."

"He don't do nothin'? He's uh better hand wid uh wide sweep plow right now dan you is, and he kin chop mo' cotton dan you, and pick mo' dan Ah kin and you knows Ah kin beat you anytime." Then, as if she had just fully heard Ned, "Whut dat you say 'bout boundin' John Buddy over tuh Cap'n Mimms? You ain't uh gonna do no sich uh thing."

"Ah done done it."

In the frenzied silence, Amy noticed that the rain had

6

ceased; that the iron kettle was boiling; that a coon dog struck a trail way down the Creek, and was coming nearer, singing his threat and challenge.

"Ned Crittenden, you know jes' ez good ez Ah do dat Cap'n Mimms ain't nothin' but po' white trash, and he useter be de overseer on de plantation dat everybody knowed wuz de wust one in southern Alabama. He done whipped niggers nigh tuh death."

"You call him po' when he got uh thousand acres under de plow and more'n dat in wood lot? Fifty mules."

"Don't keer if he is. How did he git it? When Massa Pinckney got kilt in de war and ole Miss Pinckney didn't had nobody tuh look atter de place she took and married 'im. He wan't nothin' but uh overseer, lived offa clay and black m'lasses. His folks is so po' right now dey can't sit in dey house. Every time you pass dere dey settin' in de yard jes' ez barefooted ez uh yard dawg. You ain't gwine put no chile uh mine under no Mimms."

"Ah done done it, and you can't he'p yo'seff. He gwine come git 'im tuhmorrer. He's gwine sleep 'im and feed 'im and effen John Buddy's any account, he say he'll give uh suit uh close come Christmas time."

"Dis heah bindin' over ain't nothin' but uh 'nother way uh puttin' us folks back intuh slavery."

"Amy, you better quit talkin' 'bout de buckra. Some of 'em be outside and hear you and turn over you tuh de patter roller, and dey'll take you outa heah and put uh hun'ed lashes uh raw hide on yo' back. Ah done tole yuh but you won't hear."

The clash and frenzy in the air was almost visible. Something had to happen. Ned stood up and shuffled towards the door.

"Reckon Ahm gwine swill dat sow and feed de mules. Mah vittles better be ready when Ah git back."

He limped on out of the door and left it open.

"John Buddy," Amy said, "you and Zeke go fetch uh bucket full uh water and hurry back tuh yo' supper. De rest uh y'all git yo' plates and come git some uh dese cow-peas and

7

pone bread. Lawd, Lawd, Lawd. Je-sus!"

There was a lively clatter of tin plates and spoons. The largest two boys went after water, Zeke clinging in the darkness to his giant of a brother. Way down in the cotton Zeke gave way to his tears.

"John Buddy, Ah don't want you way from me. John Buddy,—" he grew incoherent. So John Buddy carried him under his arm like a shock of corn and made him laugh. Finally John said, "Sometime Ah jes' ez soon be under Mimms ez pappy. One 'bout ez bad as tother. 'Nother thing. Dis ain't slavery time and Ah got two good footses hung onto me." He began to sing lightly.

They returned with the water and were eating supper when Ned got back from the barn. His face was sullen and he carried the raw hide whip in his hand.

Amy stooped over the pot, giving second-helpings to the smaller children. Ned looked about and seeing no plate fixed for him uncoiled the whip and standing tiptoe to give himself more force, brought the whip down across Amy's back.

The pain and anger killed the cry within her. She wheeled to fight. The raw hide again. This time across her head. She charged in with a stick of wood and the fight was on. This had happened many times before. Amy's strength was almost as great as Ned's and she had youth and agility with her. Forced back to the wall by her tigress onslaught, Ned saw that victory for him was possible only by choking Amy. He thrust his knee into her abdomen and exerted a merciless pressure on her throat.

The children screamed in terror and sympathy.

"Help mama, John Buddy," Zeke screamed. John's fist shot out and Ned slid slowly down the wall as if both his legs and his insides were crumbling away.

Ned looked scarcely human on the floor. Almost like an alligator in jeans. His drooling blue lips and snaggled teeth were yellowed by tobacco.

"Lawd, Ah speck you done kilt yo' pappy, John. You didn't mean tuh, and he didn't had no business hittin' me wid dat raw

hide and neither chokin' me neither. Jesus, Jesus, Jesus, Jee-sus!"

"He ain't dead, mama. Ah see 'im breathin'." Zachariah said, "John Buddy sho is strong! Ah bet he kin whip ev'ry body in Notasulga."

Ned got up limpingly. He looked around and sat upon the bed.

"Amy, Ahm tellin' yuh, git dat punkin-colored bastard outa dis house. He don't b'long heah wid us nohow."

"He ain't de onliest yaller chile in de world. Wese uh mingled people."

Ned limped to the fireplace and Amy piled his plate with corn bread and peas.

"Git dat half-white youngun uh yourn outa heah, Amy. Heah Ah done took 'im since he wus three years old and done for 'im when he couldn't do for hisseff, and he done raised his hand tuh me. Dis house can't hol' bofe uh us. Yaller niggers ain't no good nohow."

"Oh yes dey is," Amy defended hotly, "yes dey is—jes' ez good ez anybody else. You jes' started tuh talk dat foolishness since you been hangin' 'round old Mimms. Monkey see, mon-key do."

"Well, iss de truth. Dese white folks orta know and dey say dese half-white niggers got de worst part uh bofe de white and de black folks."

"Dey ain't got no call tuh say dat. Is mo' yaller folks on de chain-gang dan black? Naw! Is dey harder tuh learn? Naw! Do dey work and have things lak other folks? Yas. Naw dese po' white folks says dat 'cause dey's jealous uh de yaller ones. How come? Ole Marse got de yaller nigger totin' his silver cup and eatin' Berksher hawg ham outa his kitchin when po' white trash scrabblin' 'round in de piney woods huntin' up uh razor back. Yaller nigger settin' up drivin' de carriage and de po' white folks got tuh step out de road and leave 'im pass by. And den agin de po' white man got daughters dat don't never eben smell de kitchin at the big house and all dem yaller chillun got mammas, and no black gal ain't never been up

9

tuh de big house and dragged Marse Nobody out. Humph! Talkin' after po' white trash! If Ah wuz ez least ez dey is, Ah speck Ah'd fret mahself tuh death."

"Aw naw," Ned sneered, "de brother in black don't fret tuh death. White man fret and worry and kill hisself. Colored folks fret uh li'l' while and gwan tuh sleep. 'Nother thing, Amy, Hagar's chillun don't faint neither when dey fall out, dey jes have uh hard old fit."

"Dass awright, Ned. You always runnin' yo' race down. We ain't had de same chance dat white folks had. Look lak Ah can't sense you intuh dat."

"Amy, niggers can't faint. Jes' ain't in 'em."

"Dass awright. Niggers gwine faint too. May not come in yo' time and it may not come in mine, but way after while, us people is gwine faint jes' lak white folks. You watch and see."

"Table dat talk. Dat John is gwine offa dis place effen Ah stay heah. He goes tuh Mimms uh he goes apin' on down de road way from heah. Ah done spoke."

"Naw Ned," Amy began, but John cut her off.

"It's all right, mama, lemme go. Ah don't keer. One place is good ez 'nother one. Leave him do all de plowin' after dis!"

With his mouth full of peas and corn bread, Ned gloated, "De crops is laid by."

"Yeah, but nex' year's crops ain't planted yit," John countered.

So John put on his brass-toed shoes and his clean shirt and was ready to leave. Amy dug out a crumpled and mouldy dollar and gave it to him.

"Where you goin', son?"

"Over de Big Creek, mama. Ah ever wanted tuh cross over."

"Ah'll go piece de way wid yuh tuh de Creek, John. Gimme uh li'dud knot, dere, Zeke, so's Ah kin see de way back."

"Good bye, pap," John called from the door. Ned grunted over a full mouth. The children bawled dolefully when John called to them.

Amy threw a rag over her bruised head and closed the door

10

after her. The night was black and starry.

"John, you wuz borned over de Creek."

"You wuz tellin' me dat one day, Ah 'member."

"Dey knows me well, over dere. Maybe Ah kin pint yuh whar some work is at."

"Yassum. Ah wants tuh make money, so's Ah kin come back and git yuh."

"Don't yuh take me tuh heart. Ah kin strain wid Ned. Ah jes' been worried 'bout you and him. Youse uh big boy now and you am gwine take and take offa 'im and swaller all his filth lak you been doin' here of late. Ah kin see dat in yo' face. Youse slow, but wid him keerin' on lak he do now, hit takes uh Gawd tuh tell whut gwine happen in dat house. He didn't useter 'buke yuh lak dat. But his old mammy and dat old cock-eyed sister uh his'n put 'im up tuh dat. He useter be crazy 'bout yuh. 'Member dat big gol' watch chain he bought fuh you tuh wear tuh big meetin'? Dey make lak he love you better'n he do de rest on 'count youse got color in your face. So he tryin' side wid dem and show 'em he don't. Ahm kinda glad fuh yuh tuh be 'way from 'round 'im. Massa Alf Pearson, he got uh big plantation and he's quality white folks. He know me too. Go in Notasulga and ast fuh 'im. Tell 'im whose boy you is and maybe he mought put yuh tuh work. And if he do, son, you scuffle hard so's he'll work yuh reg'lar. Ah hates tuh see yuh knucklin' under 'round heah all de time. G'wan, son, and be keerful uh dat foot-log 'cross de creek. De Songahatchee is strong water, and look out under foot so's yuh don't git snake bit."

"Ah done swum dat ole creek, mama—'thout yuh knowin'. Ah knowed you'd tell me not tuh swim it."

"Dat's how come Ah worries 'bout yuh. Youse always uh runnin' and uh rippin' and clambin' trees and rocks and jumpin', flingin' rocks in creeks and sich like. John, promise me yuh goin' quit dat."

"Yassum."

"Come tuh see me when yuh kin. G'bye."

Amy was gone back up the rocky path thru the blooming

11

cotton, across the barren hard clay yard. For a minute she had felt free and flighty down there as she stood in the open with her tall, bulky son. Now the welts on her face and body hurt her and the world was heavy.

John plunged on down to the Creek, singing a new song and stomping the beats. The Big Creek thundered among its rocks and whirled on down. So John sat on the foot-log and made some words to go with the drums of the Creek. Things walked in the birch woods, creep, creep, creep. The hound dog's lyric crescendo lifted over and above the tree tops. He was on the foot-log, half way across the Big Creek where maybe people laughed and maybe people had lots of daughters. The moon came up. The hunted coon panted down to the Creek, swam across and proceeded leisurely up the other side. The tenor-singing hound dog went home. Night passed. No more Ned, no hurry. No telling how many girls might be living on the new and shiny side of the Big Creek. John almost trumpeted exultantly at the new sun. He breathed lustily. He stripped and carried his clothes across, then recrossed and plunged into the swift water and breasted strongly over.

CHAPTER 2

There was a strange noise that John had never heard. He was sauntering along a road with his shoes in his hand. He could see houses here and there among the fields—not miles apart like where he had come from. Suddenly thirty or forty children erupted from a log building near the roadside, shouting and laughing. He had been to big meeting but this was no preaching. Not all them li'l' chaps. A chunky stern-faced man stood in the door momentarily with a bunch of hickories in his hand. So! This must be the school house that he had heard about. Negro children going to learn how to read and write like white folks. See! All this going on over there and the younguns over the creek chopping cotton! It must be very nice, but maybe it wasn't for over-the-creek-niggers. These girls all had on starchy little aprons over Sunday-go-to-meeting dresses. He stopped and leaned upon the fence and stared.

One little girl with bright black eyes came and stood before him, arms akimbo. She must have been a leader, for several more came and stood back of her. She looked him over boldly from his tousled brown head to his bare white feet. Then she said, "Well, folks! Where you reckon dis big yaller bee-stung nigger come from?"

Everybody laughed. He felt ashamed of his bare feet for the

13

first time in his life. How was he to know that there were colored folks that went around with their feet cramped up like white folks. He looked down at the feet of the black-eyed girl. Tiny little black shoes. One girl behind her had breasts, must be around fourteen. He looked at her again. Some others were growing up too. In fact all were looking a little bit like women—all but the little black-eyed one. When he looked back into her face he felt ashamed. Seemed as if she had caught him doing something nasty. He shifted his feet in embarrassment.

"Ah think he musta come from over de Big Creek. 'Tain't nothin' lak dat on dis side," the little tormenter went on. Then she looked right into his eyes and laughed. All the others laughed. John laughed too.

"Dat's whar Ah come from sho 'nuff," he admitted.

"Whut you doin' over heah, then?"

"Come tuh see iffen Ah could git uh job uh work. Kin yuh tell me whar Marse Alf Pearson live at?"

The little girl snorted, "Marse Alf! Don't y'all folkses over de creek know slavery time is over? 'Tain't no mo' Marse Alf, no Marse Charlie, nor Marse Tom neither. Folks whut wuz borned in slavery time go 'round callin' dese white folks Marse but we been born since freedom. We calls 'em Mister. Dey don't own nobody no mo'."

"Sho don't," the budding girl behind the little talker chimed in. She threw herself akimbo also and came walking out hippily from behind the other, challenging John to another appraisal of her person.

"Ah calls 'em anything Ah please," said another girl and pulled her apron a little tight across the body as she advanced towards the fence.

"Aw, naw, yuh don't, Clary," the little black-eyed girl disputed, "youse talkin' at de big gate now. You jus' want somebody tuh notice yuh."

"Well, effen you calls 'em Mista, Ah kin call 'em Mista too," John talked at the little spitfire. "Whar at is Mista Alf Pearson's place?"

"Way on down dis road, 'bout uh mile uh mo'. When yuh git long dere by de cotton-gin, ast somebody and dey'll tell yuh mo' exact."

John shifted from one foot to another a time or two, then started off with the long stride known as boaging.

"Thankee, thankee," he threw back over his shoulder and strode on.

The teacher poked his head out of the door and all the other girls ran around behind the school house lest he call them to account for talking to a boy. But the littlest girl stood motionless, not knowing that the others had fled. She stood still akimbo watching John stride away. Then suddenly her hands dropped to her sides and she raced along the inside of the fence and overtook John.

"Hello agin," John greeted her, glad at her friendliness.

"Hello yuhself, want uh piece uh cawn bread look on de shelf."

John laughed boisterously and the girl smiled and went on in another tone, "Whyn't *you* come tuh school too?"

" 'Cause dey never sont me. Dey tole me tuh go find work, but Ah wisht dey had uh tole me school. Whut Ah seen of it, Ah lakted it."

From behind her the irate voice of a man called, "Lucy! Lucy!! Come heah tuh me. Ah'll teach yuh 'bout talkin' wid boys!"

"See yuh later, and tell yuh straighter," John said and walked off.

John strode on into Notasulga, whistling; his tousled hair every which away over his head. He saw a group of people clustered near a small building and he timidly approached.

"Dis heah mus' be de cotton-gin wid all dem folks and hawses and buggies tied tuh de hitchin' postes."

Suddenly he was conscious of a great rumbling at hand and the train schickalacked up to the station and stopped.

John stared at the panting monster for a terrified moment, then prepared to bolt. But as he wheeled about he saw everybody's eyes upon him and there was laughter on every face.

He stopped and faced about. Tried to look unconcerned, but that great eye beneath the cloud-breathing smoke-stack glared and threatened. The engine's very sides seemed to expand and contract like a fiery-lunged monster. The engineer leaning out of his window saw the fright in John's face and blew a sharp blast on his whistle and John started violently in spite of himself. The crowd roared.

"Hey, dere, big-un," a Negro about the station called to John, "you ain't never seed nothin' dangerous lookin' lak dat befo', is yuh?"

"Naw suh and hit sho look frightenin'," John answered. His candor took the ridicule out of the faces of the crowd. "But hits uh pretty thing too. Whar it gwine?"

"Oh eve'y which and whar," the other Negro answered, with the intent to convey the impression to John that he knew so much about trains, their habits and destinations that it would be too tiresome to try to tell it all.

The train kicked up its heels and rattled on off. John watched after it until it had lost itself down its shiny road and the noise of its going was dead.

"You laks dat ole train Ah see," the Negro said to John, watching him as he all but fell down into the railroad cut, trying to keep sight of the tail of the train.

"Yeah, man, Ah lakted dat. It say something but Ah ain't heered it 'nough tuh tell whut it say yit. You know whut it say?"

"It don't say nothin'. It jes' make uh powerful racket, dass all."

"Naw, it say some words too. Ahm comin' heah plenty mo' times and den Ah tell yuh whut it say." He straightened up and suddenly remembered.

"Whar de cotton-gin at?"

"Hit's right over dere, but dey ain't hirin' nobody yit."

"Ain't lookin' tuh git hiahed. Lookin' fuh Mist' Alf Pearson."

"Dere he right over dere on de flat-form at de deepo', whut yuh want wid 'im?"

16

"Wants tuh git uh job."

"Reckon you kin git on. He done turned off his coachman fuh stovin' up one uh his good buggy hawses."

John stalked over to the freight platform.

"Is you Mist' Alf?" he asked the tall broad-built man, who was stooping over some goods.

"Why yes, what're you want?"

"Ah wants uh job uh work, please suh."

The white man continued to examine invoices without so much as a glance at the boy who stood on the ground looking up at him. Not seeing what he wanted, he straightened up and looked about him and saw John at last. Instead of answering the boy directly he stared at him fixedly for a moment, whistled and exclaimed, "What a fine stud! Why boy, you would have brought five thousand dollars on the block in slavery time! Your face looks sort of familiar but I can't place you. What's your name?"

"Mama, she name me Two-Eye-John from a preachin' she heered, but dey call me John Buddy for short."

"How old are you, John?"

"Sixteen, goin' on sebenteen."

"Dog damn! Boy you're almost as big as I am. Where'd you come from?"

"Over de Big Creek. Mama she sont me over here and told me tuh ast you tuh gimme uh job uh work. Ah kin do mos' anything."

"Humph, I should think you could. Boy, you could go bear-hunting with your fist. I believe I can make a lead plow-hand out of you."

"Yassuh, thankee, Mista Alf, Ah knows how."

"Er, who is your mama?"

"Amy Crittenden. She didn't useter be uh Crittenden. She wuz jes' Amy and b'longed tuh you 'fo surrender. She say Ah borned on yo' place."

"Oh yes. I remember her. G'wan get in my rig. The bay horses with the cream colored buggy. Fetch it on over here and drive me home."

John went over by the courthouse to get the rig. It was some distance. As soon as he was out of earshot, one of Alf Pearson's friends asked him, "Say, Judge, where'd you get the new house-nigger from?"

"Oh a boy born on my place since surrender. Mama married some stray darky and moved over the Big Creek. She sent him over here to hunt work and he ran into me and I'm hiring him. Did you ever see such a splendid specimen? He'll be a mighty fine plow hand. Too tall to be a good cotton-picker. Sixteen years old."

"Humph! Plow-hand! Dat's uh house-nigger. His kind don't make good field niggers. It's been tried. In his case it's a pity, because he'd be equal to two hands ordinary."

"Oh well, maybe I can do something with him. He seems willing enough. And anyway I know how to work 'em."

When John brought the horses to a satisfactory halt before the white pillars of the Pearson mansion, his new boss got down and said, "Now John, take those horses on to the stable and let Nunkie put 'em away. He'll show you where the quarters are. G'wan to 'em and tell old Pheemy I said fix you some place to sleep."

"Yassuh, thankee suh."

"And John, I might need you around the house sometimes, so keep clean."

"Yassuh."

"Where's the rest of your clothes?"

"Dese is dem."

"Well, you'll have to change sometime or other. I'll look around the house, and perhaps I can scare you up a change or two. My son Alfred is about your size, but he's several years older. And er, er, I'll fetch 'em down to the quarters in case I find anything. Go 'long."

Ole Pheemy gave John a bed in her own cabin, "Take dis bed heah if hit's good 'nough fuh yuh," she said pointing to a high feather bed in one corner.

"Yassum, thankee ma'am. Ah laks it jes' fine, and dis sho is uh pritty house."

18

He was looking at the newspapers plastered all over the walls.

Pheemy softened.

"Oh you ain't one uh dese uppity yaller niggers then?"

"Oh no ma'am. Ahm po' folks jes' lak you. On'y we ain't got no fine houses over de Creek lak dis heah one."

"Whus yo' name?"

"John, but Zeke and Zack and dem calls me John Buddy, yassum."

"Who yo' folks is over de Big Creek?"

"Mama she name Amy Crittenden—she—"

"Hush yo' mouf, you yaller rascal, you! Ah knowed, Ah seed reckerlection in yo' face." Pheemy rushed upon John, beating him affectionately and shoving him around. "Well, Lawd a'mussy boy! Ahm yo' granny! Yo' nable string is buried under dat air chanyberry tree. 'Member so well de very day you cried." (First cry at birth.) "Eat dis heah tater pone."

The field hands came in around dusk dark, eyeing John suspiciously, but his utter friendliness prevented the erection of barriers on his birth place. Amy's son was welcome. After supper the young folks played "Hide the Switch" and John overtook and whipped most of the girls soundly. They whipped him too. Perhaps his legs were longer, but anyway when he was "it" he managed to catch every girl in the quarters. The other boys were less successful, but girls were screaming under John's lash behind the cowpen and under the sweet-gum trees around the spring until the moon rose. John never forgot that night. Even the strong odor of their sweaty bodies was lovely to remember. He went in to bed when all of the girls had been called in by their folks. He could have romped till morning.

In bed he turned and twisted.

"Skeeters botherin' yuh, John Buddy?" Pheemy asked.

"No'm Ahm jes' wishin' Mist' Alf would lak mah work and lemme stay heah all de time." Then the black eyes of the little girl in the school yard burned at him from out of the darkness and he added, "Wisht Ah could go tuh school too."

19

"G'wan tuh sleep, chile. Heah 'tis way in de midnight and you ain't had no night rest. You gotta sleep effen you wanta do any work. Whut Marse Alf tell yuh tuh do?"

"He ain't tole me nothin' yit."

"Well, you stay heah tuh de house. Ontell he send fuh yuh. He ain't gwine overwork yuh. He don't break nobody down. Befo' surrender he didn't had no whippin' boss on *dis* place. Nawsuh. Come tuh 'membrance, 'tain't nothin' much tuh do now. De crops is laid by, de ground peas ain't ready, neither de cawn. But Ah don't speck he gointer put you in de fiel' nohow. Maybe you hand him his drinks uh drive de carridge fuh him and Ole Miss."

"Yassum," drifted back from John as he slid down and down into sleep and slumber.

That night he dreamed new dreams.

"John."

"Yassuh."

"I see the clothes fit you."

"Yassuh, Ahm powerful glad dey do, 'cause Ah laks 'em."

"John, I don't reckon I'll have you to drive us again. I thought to make a coachman out of you, but the mistress thinks you're too, er, er—large sitting up there in front. Can't see around you."

"Yassuh," John's face fell. He wasn't going to be hired after all.

"But I've got another job for you. You feed the chickens and gather the eggs every morning before breakfast. Have the fresh eggs in the pantry at the big house before seven o'clock so Emma can use some for our breakfast."

"Yassuh."

"And John, see to it that Ceasar and Bully and Nunkie keep the stables, pig pens and the chicken houses clean. Don't say anything to 'em, but when you find 'em dirty you let me know."

"Yassuh."

"And another thing, I want you to watch all of my brood

20

sows. As soon as a litter is born, you let me know. And you must keep up with every pig on the place. Count 'em every morning, and when you find one missing you look around and find out what's become of it. I'm missing entirely too many shoats. I'm good to my darkies but I can't let 'em eat up all my hogs. Now, I'm going to see if I can trust you."

"Yassuh."

"Can you read and write, John?"

"Nawsuh."

"Never been to school?"

"Nawsuh, yassuh, Ah passed by dat one d'other day."

"Well, John, there's nothing much to do on the place now, so you might as well go on down to the school and learn how to read and write. I don't reckon it will hurt you. Don't waste your time, now. Learn. I don't think the school runs but three months and it's got to close for cotton-picking. Don't fool around. You're almost grown. Three or four children on this place go so you go along with them. Go neat. I didn't have slouchy folks on my place in slavery time. Mister Alfred, my son, is studying abroad and he's left several suits around that will do for you. Be neat. Let's see your feet. I don't believe you can wear his shoes but I'll buy you a pair and take it out of your wages. You mind me and I'll make something out of you."

"Yassuh, Mister Alf. Thankee. Youse real good tuh me. Mama said you wuz good."

"She was a well-built-up girl and a splendid hoe hand. I never could see why she married that darky and let him drag her around share-cropping. Those backwoods white folks over the creek make their living by swindling the niggers."

John didn't go to school the next day. He had truly been delighted at the prospect of attending school. It had kept him glowing all day. But that night the young people got up a game of "Hide and Seek." It started a little late, about the time that the old heads were going to bed.

Bow-legged, pigeon-toed Minnie Turl was counting, "Ten, ten, double ten, forty-five, fifteen. All hid? All hid?"

21

From different directions, as the "hiders" sought cover,
"No!"

> "Three li'l' hawses in duh stable,
> One jumped out and skint his nable.
> All hid? All hid?"

"No!" from farther away.

John ran down hill towards the spring where the bushes
were thick. He paused at a clump. It looked like a good place.
There was a stealthy small sound behind it and he ran on.
Some one ran down the path behind him. A girl's hand caught
his. It was Phrony, the womanish fourteen-year-old who lived
in the third cabin from Pheemy's.

"Ah'll show yuh uh good place tuh hide," she whispered,
"nobody can't find yuh."

She dragged him off the path to the right and round and
about to a clump of sumac overrun with wild grape vines.

"Right under heah," she panted from running, "nobody
can't find yuh."

"Whar you goin' hide yuhself?" John asked as he crept into
the arboreal cave.

"Iss plenty room," Phrony whispered. "Us bofe kin hide in
heah."

She crept in also and leaned heavily upon John, giggling and
giggling as the counting went on.

> "Ah got up 'bout half-past fo'
> Forty fo' robbers wuz 'round mah do'
> Ah got up and let 'em in
> Hit 'em ovah de head wid uh rollin' pin.
> All hid? All hid?"

"Yeah."

"All dem ten feet round mah base is caught. Ahm comin'!"

There were screams and shouts of laughter. "Dere's Gold-
Dollar behind dat chanyberry tree. Ah got yuh."

"Whoo-ee! Ahm free, Minnie, Ah beat yuh in home."

"Less we run in whilst she gone de other way," John whispered.

"Naw, less we lay low 'til she git tired uh huntin' us and give us free base."

"Aw right, Phrony, but Ah loves tuh outrun 'em and beat 'em tuh de base. 'Tain't many folks kin run good ez me."

"Ah kin run good, too."

"Aw, 'tain't no girl chile kin run good ez me."

"Ah betcha 'tis. Lucy Potts kin outrun uh yearlin' and rope 'im."

"Humph! Where she at?"

"She live over in Pottstown. Her folks done bought de ole Cox place. She go to school. Dey's big niggers."

"She uh li'l' bitty gal wid black eyes and long hair plats?"

"Yeah, dat's her. She leben years ole, but she don't look it. Ahm fourteen. Ahm big. Maybe Ah'll git married nex' year."

"Ahm gwine race huh jes' soon ez Ah gits tuh school. Mista Alf gwine lemme go too."

"Dat's good. Ah done been dere las' yeah. Ah got good learnin'. Reckon Ah'll git uh husban' nex'."

Cry from up the hill, "John and Phrony, come on in. You get free base!"

They scrambled out. John first, then Phrony more slowly, and trudged up the hill. A boy was kneeling at the woods chopping-block base when they came into the crowd. The crowd began to disperse again. John started off in another direction. He looked back and saw Phrony coming behind him, but Mehaley cut in from behind a bush and reached him first.

"Come on wid me, John, lemme show yuh uh good place."
He started to say that he didn't want to hide out and talk as he had done with Phrony. He wanted to pit his strength and speed against the boy who was counting. He wanted to practise running, but he felt a flavor come out from Mehaley. He could almost sense it in his mouth and nostrils. He was cross with Phrony for following them. He let Mehaley take his hand

23

and they fled away up the hill and hid in the hay.

"De hair on yo' head so soft lak," Mehaley breathed against his cheek. "Lemme smoothen it down."

When John and Mehaley came in, Minnie Turl was counting. Everybody was hid except Phrony who sat bunched up on the door step.

"Y'all better go hide agin," she said.

"Somebody else count and lemme hide," Minnie wailed. "Ah been countin' most all de time." She came and stood near John.

"G'wan hide, Minnie, Ah'll count some," John said.

"Heh! Heh!" Phrony laughed maliciously at Minnie. Minnie looked all about her and went inside the house and to bed.

"Haley, where mah hair comb you borried from me las' Sunday? Ah wuz nice enough tuh len' it tuh yuh, but you ain't got manners 'nough tuh fetch it back." Phrony advanced upon Mehaley and John.

"You kin git yo' ole stink hair comb any time. Ah'll be glad tuh git it outa mah house. Mama tole me not tuh comb wid it 'cause she skeered Ah'd git boogers in mah haid."

"Youse uh lie! Ah ain't got no boogers in mah haid, and if you' mamy say so she's uh liar right long wid you! She ain't so bad ez she make out. Ah'll stand on yo' toes and tell yuh so."

"Git back outa mah face, Phrony. Ah don't play de dozens!" Mehaley shoved. Phrony struck, and John and all the hiders, who came running in at the sound of battle, had trouble stopping the rough and tumble.

"Did y'all had words befo' yuh fell out?" Charlie asked.

"We ain't had no words," said Mehaley.

"Whut y'all fightin' 'bout, if yuh ain't mad?"

"Aw, ole fish-mouf Phrony mad 'cause John wouldn't hide wid her and he took and hid wid me."

"Youse uh liar, madam! He did so hide wid me."

"He wouldn't stay, and Ah'll betcha Alabama wid uh fence 'round it he won't never hide wid yuh no mo'."

Mehaley preened herself akimbo and rotated her hips insolently.

"Sh-sh—" Charlie cautioned, "de old heads liable tuh wake up, and dey'll haul off and take and frail everybody. Less all tip in tuh bed. Iss way after midnight anyhow."

So John overslept next morning and by the time that he had gathered the eggs and counted the hogs it was too late for school. He didn't want to see Lucy anyway. Not the way he felt that day, but late in the afternoon as he wandered over the place, he found a tiny clearing hidden by trees.

"Dis is uh prayin' ground," he said to himself.

"O Lawd, heah 'tis once mo' and again yo' weak and humble servant is knee-bent and body bowed—Mah heart beneath mah knees and mah knees in some lonesome valley cryin' fuh mercy whilst mercy kinst be found. O Lawd! you know mah heart, and all de ranges uh mah deceitful mind—and if you find any sin lurkin' in and about mah heart please pluck it out and cast it intuh de sea uh fuhgitfulness whar it'll never rise tuh condemn me in de judgment."

That night John, deaf to Mehaley's blandishments, sat in the doorway and told tales. And Brer Rabbit and Brer Fox and Raw-Head-and-Bloody-Bones walked the earth like natural men.

Next morning, bright and soon he stood at the school-house door. The teacher was a stodgy middle-aged man who prided himself on his frowns. Every few moments he lifted his head and glared about the room. He yearned to hold his switches in his hand. He had little ambition to impart knowledge. He reigned. Later John found out he was Lucy's uncle.

"Come heah, you," he pointed his ruler at John. "Don't you know no better'n to come in my school and sit yo'self down without sayin' a word to me?"

"Yassuh," he approached the deal table that went by the name of desk.

"If you know better, why did you do it? I ought to put forty lashes on yo' bare back. You come to school?"

"Yassuh."

25

"Don't say 'yassuh' to me. Say 'Yes suh.' "

The room tittered.

"What's yo' name?"

"John."

"John whut? You got some other name besides John."

"Mama, she name me Two-Eye John—"

They burst into loud laughter. John colored and he stole a glance at Lucy. She wasn't laughing. Her hands and lips were tense. She must be put out with him for being a fool. She wasn't laughing like the rest.

"But mama and all of 'em at home calls me John Buddy."

"Buddy is a nickname. What's yo' papa' name?"

John scratched his head and thought a minute.

" 'Deed Ah don't know, suh."

There was another short silence.

"Where do you live?"

"On Mista Alf Pearson's place."

"Was you born there?"

"Yes suh."

"Well, Ah'll jus' put you down as John Pearson and you answer by that, you hear?"

"Yes suh."

"Ever been to school before?"

"Naw suh."

"Well, you get over there in de A B C class and don't let me ketch you talkin' in school."

John was amazed at the number of things to be learned. He liked to watch Lucy's class recite. They put so many figures on the board and called it long division. He would certainly be well learnt when he could do that. They parsed sentences. They spelt long words.

He studied hard because he caught Lucy watching him every time he recited. He wrote on the ground in the quarters and in a week he knew his alphabet and could count to a hundred.

"Whut you learnin' in school, John—A, B, Ab's?" Charlie asked him.

26

"Ah already know dat, Charlie. Ah kin spell 'baker' too."

"Don't b'lieve it. Not dis quick, yuh can't."

"B-a-k-bak-e-r-er baker."

"Boy, you sho is eatin' up dat school!"

"Ain't ez smart ez some. Take Lucy Potts for instink. She's almost uh 'fessor now. Nobody can't spell her down. Dey say she kin spell eve'y word in Lippincott's Blue-back Speller."

"Shucks! You ain't tryin' tuh buck up tuh her in book learnin', is yuh? Dey tell me she kin spell 'compresstibility,' and when yuh git dat fur 'tain't much mo' fuhther fur yuh tuh go."

"She sho kin spell it, 'cause Ah heered 'er do it. Some say she kin spell 'Constan-ti-nople' too."

"Ah b'lieve it. All dem Potts is smart. Her brother leads de choir at Macedony Baptis' Church, and she trebles right 'long wid dem grown women and kin sing all de notes—de square ones, de round ones, de triangles."

"Ah'll be dere tuh heah her do it nex' big meetin'. Charlie, Ah loves tuh heah singin'."

"Whyn't yuh join de choir? You oughter be able tuh sing lak git out wid all dat ches' you got."

"B'lieve Ah will, Charlie. Ah laks big meetin'."

It was three weeks from the time that John started to school 'til cotton-picking time. Prodded on all sides, he had learned to read a little and write a few words crudely.

He was sorry when school closed for the cotton-picking but he kept on studying. When the school re-opened for its final month he wanted to get promoted again. He found himself spelling out words on barns and wagons, almanacs, horse-medicine-bottles, wrapping-paper.

He had been to church; he hadn't enough courage to join the choir, but every meeting he was there. Lucy tossed her head and sang her treble and never missed a note.

When the cotton-picking began on his place, Alf Pearson said to John, "You better go across the Creek and let your mama know how you're getting along. If you see any good cotton pickers—anybody that can pick more than two hundred

a day—tell 'em I need some hands, and you be back by tomorrow night. I bought a brood sow over round Chehaw and I want you to go get her."

There was great rejoicing in Amy's house when John climbed the hill from the Creek.

They didn't know him in his new clothes. They made great " 'miration" over everything. Amy cried.

"Jes' tuh think, mah boy gittin' book-learnt! Ned, de rest uh dese chillun got tuh go tuh school nex' yeah. Sho is."

"Whut fur? So dey kin lay in de peni'ten'ry? Dat's all dese book-learnt niggers do—fill up de jails and chain-gangs. Dese boys is comin' 'long all right. All dey need tuh learn is how tuh swing uh hoe and turn a furrer. Ah ain't rubbed de hair offa mah haid 'gin no college walls and Ah got good sense. Day ain't goin' tuh no school effen Ah got anythin' tuh say 'bout it. Jes' be turnin' 'em fools!"

Stormy weather. John cut in.

"Mama, Mista Alf say if Ah could find some good cotton pickers tuh tell 'em he need hands. You know any? He payin' fifty cent uh hund'ed."

"Dat's more'n dey payin' over heah," Ned cut in eagerly, "Amy, whyn't you take Zeke and Zack and y'all g'wan make dat li'l' change? Ah'll take keer de li'l' chillun and pick up whut li'l' Ah kin git over heah. Cotton open dat side de Creek fust anyhow. By time y'all finish over dere hit'll jis' be gittin' in full swing over heah."

"Reckon us could make li'l' money. Tell 'im, 'Yeah,' John Buddy, we's comin'."

"Zack!" Ned called, "Take dis heah jug and run over tuh de Turk place and tell Ike tuh send me uh gallon. Pay 'im nex' week some time."

When the cotton was all picked and the last load hauled to the gin, Alf Pearson gave the hands two hogs to barbecue.

That was a night. Hogs roasting over the open pit of oak coals. Negroes from three other plantations. Some brought "likker." Some crocus sacks of yellow yam potatoes, and bushels of peanuts to roast, and the biggest syrup-kettle at Pear-

son's canemill was full of chicken perleau. Twenty hens and six water-buckets full of rice. Old Purlee Kimball was stirring it with a shovel.

Plenty of music and plenty of people to enjoy it. Three sets had been danced when Bully took the center of the hard-packed clay court upon which they were dancing. He had the whole rib of a two-hundred-pound hog in his hands and gnawed it as he talked.

"Hey, everybody! Stop de music. Don't vip another vop 'til Ah says so. Hog head, hog bosom, hog hips and every kind of hog there ever wuz is ready! Come git yourn. De chickens is cacklin' in de rice and dey say 'Come git it whilst iss fitten 'cause t'morrer it may be frost-bitten!' De yaller yams is spilin' in de ashes. It's uh shame! Eat it all up, and den we's gointer dance, 'cause we'll have somethin' tuh dance offa."

The hogs, the chickens, the yams disappeared. The old folks played "Ole Horse" with the parched peanuts. The musicians drank and tuned up. Bully was calling figures.

"Hey you, dere, us ain't no white folks! Put down dat fiddle! Us don't want no fiddles, neither no guitars, neither no banjoes. Less clap!"

So they danced. They called for the instrument that they had brought to America in their skins—the drum—and they played upon it. With their hands they played upon the little dance drums of Africa. The drums of kid-skin. With their feet they stomped it, and the voice of Kata-Kumba, the great drum, lifted itself within them and they heard it. The great drum that is made by priests and sits in majesty in the juju house. The drum with the man skin that is dressed with human blood, that is beaten with a human shin-bone and speaks to gods as a man and to men as a God. Then they beat upon the drum and danced. It was said, "He will serve us better if we bring him from Africa naked and thing-less." So the buckra reasoned. They tore away his clothes that Cuffy might bring nothing away, but Cuffy seized his drum and hid it in his skin under the skull bones. The shin-bones he bore openly, for he thought, "Who shall rob me of shin-bones when they see no

29

drum?'' So he laughed with cunning and said, "I, who am borne away to become an orphan, carry my parents with me. For Rhythm is she not my mother and Drama is her man?'' So he groaned aloud in the ships and hid his drum and laughed.

"Dis is jes' lak when Ah wuz uh girl,'' Amy told Pheemy and offered her body to the voice.

Furious music of the little drum whose body was still in Africa, but whose soul sung around a fire in Alabama. Flourish. Break.

> Ole cow died in Tennessee
> Send her jawbone back to me
> Jawbone walk, Jawbone talk
> Jawbone eat wid uh knife and fork.
> Ain't Ah right?
>
> CHORUS: Yeah!
> Ain't I right? Yeah!

Hollow-hand clapping for the bass notes. Heel and toe stomping for the little one. Ibo tune corrupted with Nango. Congo gods talking in Alabama.

> If you want to see me jabber
> Set me down to uh bowl uh clabber
> Ain't Ah right? Yeah!
> Now, ain't Ah right? Yeah!
>
> Ole Ant Dinah behind de pine
> One eye out and de other one blind
> Ain't Ah right? Yeah! Yeah!
> Now, ain't Ah right? Yeah!

"Looka dat boy uh yourn, Amy!'' Zeke Turk urged. "Didn't thought he knowed how tuh dance. He's rushin' de frog tuh de frolic! And looka 'Big 'Oman,' dat gal dancin' wid 'im. Lawd, she shakin' yonder skirt.''

Wisht Ah had uh needle
Fine ez Ah could sew
Ah'd sew mah baby to my side
And down de road Ah'd go.

Double clapping—

Down de road baby
Down de road baby
It's killing mama
Oh, it's killing mama.

Too hot for words. Fiery drum clapping.

"Less burn dat old moon down to a nub! Is dat you, Pheemy?"

"Yeah Lawd. Mah head is tilted to de grave, but Ah'll show y'all Ah ain't fuhgit how. Come on out heah, Dink, and help ole Pheemy do de Parse me lah."

"Heel and toe. Don't call no figgers."

"Aw yeah, less call figgers. Go 'head Bully, but don't call it lak you call for white folks and dey go praipsin 'cross the floor lake dey steppin on eggs. Us kin dance. Call 'em, Bully."

"Awright, choose yo' partners."

"Couples tuh yo' places lak hawse tuh de traces."

"Sixteen hands up!"

"Circle four."

"Y'all ain't clappin' right. Git dat time.

Raccoon up de 'simmon tree
Possum on de ground
Raccoon shake dem 'simmons down
Possum pass 'em round."

The fire died. The moon died. The shores of Africa receded. They went to sleep and woke up next day and looked

31

out on dead and dying cotton stalks and ripening possum persimmons.

As the final day of school closing drew near, John found life tremendously exciting. The drama of Pearson's plantation yielded to the tenseness around the school house. He had learned to spell his way thru several pages in his reader. He could add, subtract and divide and multiply. He proved his new power to communicate his thoughts by scratching Lucy's name in the clay wherever he found a convenient spot: with a sharp stick he had even scratched it on the back of Pheemy's chimney.

He saw Lucy at school every day. He saw her in church, and she was always in his consciousness, but he had never talked with her alone. When the opportunity presented itself he couldn't find words. Handling Big 'Oman, Lacey, Semmie, Bootsie and Mehaley merely called for action, but with Lucy he needed words and words that he did not have. One day during the practice for school closing he crowded near her and said, "Wisht Ah could speak pieces lak you do."

"You kin speak 'em better'n me," Lucy said evenly, "you got uh good voice for speakin'."

"But Ah can't learn no long ones lak you speaks. When do you learn 'em?"

"In de night time round home after Ah git thru wid mah lessons."

"You ain't got many mo' days tuh be studyin' of nights. Den whut you gwine do wid yo'self?"

"Mama always kin find plenty fuh folks tuh do."

"But Ah mean in de night time, Lucy. When youse thru wid yo' work. Don't you do nothin' but warm uh chair bottom?"

Lucy drew away quickly, "Oooh, John Buddy! You talkin' nasty."

John in turn was in confusion. "Whuss nasty?"

"You didn't hafta say 'bottom.'"

John shriveled up inside. He had intended to recite the rhymes to Lucy that the girls on the plantation thought so witty, but he realized that—

Some love collards, some love kale
But I loves uh gal wid uh short skirt tail

would drive Lucy from him in disgust. He could never tell her
that. He felt hopeless about her. Soon she was recalled to the
platform to recite and John's chance was gone. He kept on
thinking, however, and he kept on making imaginary speeches
to her. Speeches full of big words that would make her gasp
and do him "reverence." He was glad when he was selected
as the soldier to sing opposite Lucy in the duet, "Oh Soldier,
Will You Marry Me?" It meant something more than singing
with gestures beside a girl. Maybe she would realize that he
could learn things too, even if she could read the better. He
meant to change all that as quickly as possible. One day he
shyly overtook her on her way home.

"Dey tell me you kin run fast," he began awkwardly.

"Dey told you right," Lucy answered saucily, "whoever
tole you. Ah kin outrun most anybody 'round heah."

"Less we race tuh dat sweet-gum tree and see who kin
beat," John challenged.

They were off. Lucy's thin little legs pumping up and down.
The starchy strings of her blue sunbonnet fluttering under her
chin, and her bonnet lying back of her neck.

"Ah beat yuh!" John gloated over the foot or two that he
had gained with difficulty.

"Yeah, you beat me, but look how much mo' legs you got
to run wid," Lucy retorted. "Bet if Ah had dem legs nobody
couldn't never outrun me."

"Ah didn't mean tuh beat yuh. Gee, us done come uh good
ways! How much further you live from heah, Lucy?"

"Oh uh little ways cross de branch."

"B'lieve Ah'll go see how yo' ole branch look. Maybe it got
uh heap uh fish in it."

" 'Tain't got no fish in it worth talkin' 'bout. 'Tain't hardly
knee deep, John, but iss uh great big ole snake down dere."

"Whut kinda snake?"

"Uh great big ole cotton-mouf moccasin. He skeers me,

33

John. Everytime Ah go 'cross dat foot-log Ah think maybe Ah might fall in and den he'll bite me, or he might reah hisself up and bite me anyhow.''

"How come y'all don't take and kill 'im?''

"Who you reckon goin' down in de water tuh strain wid uh moccasin? He got uh hole back under the bank where you kin see 'im, but you can't git 'im 'thout you wuz down in de branch. He lay all 'round dere on de ground and even on de foot-log, but when he see somebody comin' he go in his hole, all ready for yuh and lay dere and dare yuh tuh bother 'im.''

"You jes' show 'im tuh me. Ah can't stand tuh be aggravated by no ole snake and then agin Ah don't want 'im slurrin' *you*.''

"Sh-sh, watch out, John! He 'round heah somewhere. Can't you smell 'im? Dere he is goin' in his hole!''

John took a good look at the snake, then looked all about him for a weapon. Finding none he sat down and began to remove his shoes.

"You ain't goin' in dat branch!'' Lucy gasped.

"Turn me go, Lucy. If you didn't want yo' ole snake kilt yuh oughta not showed 'im tuh me.'' He exulted, but pretended not to see her concern was for him.

He looked carefully to see that no other snakes were about, then stepped cautiously down into the water. The snake went on guard, slowly, insolently. Lucy was terrified. Suddenly, he snatched the foot-log from its place and, leaning far back to give it purchase, he rammed it home upon the big snake and held it there. The snake bit at the log again and again in its agony, but finally the biting and the thrashing ceased. John fished the snake out and stretched it upon the grass.

"Ooh, John, Ahm so glad you kilt dat ole devil. He been right dere skeerin' folks since befo' Ah wuz borned.''

"He won't skeer nobody else, lessen dey skeered uh dead snakes,'' John answered in the tone that boys use to girls on such occasions.

"Reckon his mate ain't gonna follow us and try tuh bite us for killin' dis one?''

34

"Lucy, he can't foller bofe us, lessen us go de same way."

"Thass right, John. Ah done forgot, you live over on de Alf Pearson place."

"Yeah, dat's right."

"Where M'haley and Big 'Oman live."

"Unh hunh, Ah speck dey do live dere. Ah seen uh lot uh pullet-size girl chillun 'bout de place. Nearly uh hund'ed head uh folks on dat plantation."

A heavy silence fell. Lucy looked across the shallow stream and said,

"You ain't put de foot-log back, John."

"Dat's right. Sho nuff Ah done fuhgot. Lemme tote you 'cross den. Ah kin place it back for de other folks."

"Doncha lemme fall, John. Maybe 'nother ole snake down dere."

"How Ahm gonna let uh li'l' bit lak you fall? Ah kin tote uh sack uh feed-meal and dat's twice big ez you. Lemme tote yuh. Ah 'clare Ah won't drop yuh."

John bore Lucy across the tiny stream and set her down slowly.

"Oh you done left yo' book-sack, Lucy. Got tuh take yuh back tuh git it."

"Naw, you hand it tuh me, John."

"Aw, naw, you come git it."

He carried Lucy back and she recrossed the stream the third time. As he set her down on her home side he said, "Little ez *you* is nobody wouldn't keer how fur he hafta tote you. You ain't even uh handful."

Lucy put herself akimbo, "Ahm uh li'l' piece uh leather, but well put t'gether, Ah thankee, Mist' John."

"Mah comperments, Miss Lucy."

Lucy was gone up the hill in a blue whirlwind. John replaced the foot-log and cut across lots for home.

"She is full uh pepper," John laughed to himself, "but ah laks dat. Anything 'thout no seasonin' in it ain't no good."

At home, Lucy rushed out back of the corn crib and tiptoed

35

to see if her head yet touched the mark she had made three weeks before.

"Ah shucks!" She raged, "Ah ain't growed none hardly. Ah ain't never gointer get grown. Ole M'haley way head uh me!"

She hid and cried until Emmeline, her mama, called her to set the table for supper.

The night of school closing came. John in tight new shoes and with a standing collar was on hand early. Saw Lucy enter followed by the Potts clan. Frowning mama, placid papa, strapping big sister, and the six grown brothers. Boys with "rear-back" hair held down by a thick coating of soap. Boys hobbling in new shoes and tight breeches. Girls whose hair smelled of fresh hog-lard and sweet william, and white dresses with lace, with pink or blue sashes, with ruffles, with mothers searching their bosoms for pins to yank up hanging petticoats. Tearful girls who had forgotten their speeches. Little girls with be-ribboned frizzed-out hair who got spanked for wetting their starchy panties. Proud parents. Sulky parents and offspring. Whispered envy.

"Dere's Lucy Potts over dere in uh fluted dress. Dey allus gives her de longest piece tuh speak."

"Dat's 'cause she kin learn more'n anybody else."

"Naw 'tain't, dey muches her up. Mah Semmie could learn jes' ez long uh piece ez anybody if de give it tuh her—in time. Ahm gwine take mah chillun outa school after dis and put 'em tuh work. Dey ain't learnin' 'em nothin' nohow. Dey makes cake outa some uh de chillun and cawn bread outa de rest."

Opening prayer. Song. Speech by white superintendent. Speeches rattled off like beans poured into a tin can.

"A speech by Miss Lucy Potts."

The shining big eyes in the tiny face. Lacy whiteness. Fierce hand-clapping. Lucy calm and self-assured.

"A chieftain to the highland bound, cried 'Boatman do not tarry' "—to the final "My daughter, oh my daughter." More applause. The idol had not failed her public.

"She kin speak de longest pieces and never miss uh word

36

and say 'em faster dan anybody Ah ever seed." It was agreed
Lucy was perfect. Time and speeches flew fast.

> Little fishes in de brook
> Willie ketch 'em wid uh hook
> Mama fry 'em in de pan
> Papa eat 'em lak uh man.

"Duet—Miss Lucy Potts, bassed by Mr. John Pearson."
They sang and their hearers applauded wildly. Nobody cared
whether the treble was treble or the bass was bass. It was the
gestures that counted and everybody agreed that John was
perfect as the philandering soldier of the piece and that Lucy
was just right as the over-eager maid. They had to sing it over
twice. John began to have a place of his own in the minds of
folks, more than he realized.

CHAPTER 3

One morning in the early spring John found Amy sitting before the fire in Pheemy's house.

"Howdy, mam."

"Howdy, son."

She rubbed her teeth and gums with the tiny snuff-brush. She had something to say and John knew it.

"How's everybody makin' it over de Big Creek, maw?"

"Right middlin', John. Us could do better but yo' pappy always piddlin' from piller tuh post and dat keep de rest uh us in hot water."

"Yessum. What's de trouble now?"

"Yuh know Beasley took and beat us out uh our cotton and we ain't hardly had nothin' tuh eat, so day 'fo' yistiddy Ned took and kilt one uh Beasley's yearlings way down dere in de hammock and fetched it home dere and us cooked and et some of it and put some of it down in salt. We thinkin' nobody'd ever know de diffunce, but Beasley heard de cows bellerin' when dey smelt de blood where it wuz kilt and went down dere and found de hide. So us had tuh pack up our things in meal sacks and when it wuz black dark us went on over tuh de Shelby place, and us goin' work dere dis year."

"Dat's uh whole heap better'n Beasley's place, but 'tain't

39

nigh good ez heah. Wisht y'all would come work fuh Mist' Alf."

"Ned, he too hard-headed tuh do dat. Ah done tried and tried but his back don't bend. De only difference 'tween him and uh mule is, de mule got four good foots, and he ain't got nairn. De minute anybody mention crossin' dat creek, he's good tuh make disturbiment and tear up peace. He been over dat creek all his life jes' ez barefooted ez uh yard dawg and know he ain't even got uh rooster tuh crow fuh day, yet and still you can't git 'im 'way from dere."

"How come you don't quit 'im? Come on, and fetch de chillun wid you!"

"You can't know intuh dat yit, John. In times and seasons, us gwine talk dat, but Ah come tuh take you back wid me, John."

"Me, mama?" John asked in agonized surprise, "you know Ah don't want no parts of over dat Creek."

"Mama know, son, but Mist' Shelby asted where wuz you de fust thing and say he don't want us 'thout you."

"Mama, Ah don't wanta go 'way back over dere in dem woods. All you kin hear 'bout over dere is work, push-hard and pone-bread, ole cawn bread wid nothin' in it but salt and water! Ah laks it over here where dey talks about biscuit-bread some time."

"Yeah, John Buddy, mama know jes' how yuh feels and her heart is beatin' right wid yourn. Mama love flour bread too. But, you know, lots uh white folks ain't gwine be bothered wid Ned, and us got tuh find some place tuh lay our heads. Mist' Shelby ain't uh mean man, but he don't b'lieve us kin make de crop 'thout you. Reckon you better git yo' things and come 'long."

Amy got up wearily, the ruffles of her faded calico skirt sweeping the floor as she moved.

"Ahm goin' and see Marse Alf 'bout takin' yuh. Be ready 'ginst Ah git back, John Buddy."

John watched her out of the door, then slowly he went out himself and wandered about; but finally he was standing back

40

of Pheemy's cabin and gazing at the rude scratching on the adobe chimney. "Lucy," "Lucy Ann," "Lucy Potts," "Lucy and John," "Lucy is John's girl," "No 'nife can cut our love into," "Lucy Pearson."

"Oh," John sobbed, "she ain't gonna want no over-de-creek-nigger."

He stood there a long time before he went inside and began to collect his things. Then he came upon the song book that Lucy's terrifying brother had given him when he joined the choir. There was a crude drawing of a railroad train on it. No, he couldn't leave Notasulga where the train came puffing into the depot twice a day. No, no! He dropped everything and tore out across the fields and came out at last at the railroad cut just below the station. He sat down upon the embankment and waited. Soon in the distance he heard the whistle, "Wah-ooom! Wahup, wahup!" And around the bend came first the smoke stack, belching smoke and flames of fire. The drivers turning over chanting "Opelika-black-and-dirty! Opelika-black-and-dirty." Then as she pulled into the station, the powerful whisper of steam. Starting off again, "Wolf coming! Wolf coming! Wolf coming! Opelika-black-and-dirty, Opelika-black-and-dirty! Auh—wah-hoooon"—into the great away that gave John's feet such a yearning for distance.

The train had been gone a long time when Alf Pearson's buggy pulled up beside John.

"What are you doing down here, John, with Amy looking all over Macon County for you?"

"Jes' come down tuh hear whut de train say one mo' time, Mist' Alf."

"Get in and drive me down to get the mail, John. How's the hogs getting on?"

"Jes' fine, Mist' Alf. S'pectin' two mo' litters dis week. Dat make five litters since New Year's. Ain't lost one since Chris'-mas, neither."

"Splendid, John, splendid."

"Mist' Alf, Ah don't treasure 'cross dat creek. Lemme stay heah wid you, please suh."

"John, I'm not sending you over there. Your mother is taking you. If you're ever in need of a job, come on back here and behave yourself and I'll look after you. No matter where you are, don't steal and don't get too biggety and you'll get along. Touch the horses up a little. I'm in a hurry."

CHAPTER 4

There was work a plenty on the Shelby place. John and Ned were plowing the rocky hillsides. As they turned the furrows John always strode several feet in advance of Ned. The older man limped behind his plow, stumbling now and then, slashing the mule and swearing incessantly.

"Gawd uhmighty! Git up heah, you hard-tailed bastard! Confound yuh, gee! John Buddy, whar you gwine?"

"Ahm goin' tuh git me uh sweat-rag tuh wipe mah face wid. Ahm tired uh sweat runnin' intuh mah eyes."

"You jes' tries tuh keep from workin', John. Out nearly all night proagin' over de Creek and now yuh don't wanta do nothin'."

"Ah done plowed uh acre and uh half tuh yo' one, and nowhere you put yo' foot down but whut 'tain't uh rock dere. Nobody can't make nothin' on dis place—look lak God jus' stood up and throwed uh handful uh rocks. If dis ain't work, 'tain' uh hound dawg in Georgy."

"Jes' you stay from over dat Creek, runnin' after all dem gals and git yo' night rest, dem rocks wouldn't be so worrysome."

"Ah do mo' of it than you right now. Dis ain't no slavery time," John flung back over his shoulder as he started towards the house.

43

"Yuh done got powerful biggity since yuh been on dat Pearson place," Ned muttered to himself, "Can't say uh word, 'thout he got tuh gimme two fuh one."

Amy stood trembling between her son and her husband. The other children were growing up and imitating everything that John did, as closely as possible. Zack and Zeke were already trying on John's hats and ties. Their whole talk was "over de Creek," and "man when us git on dat ole train." Amy had managed to keep things on an even keel by soothing John's feelings and reminding Ned that if John went over to Notasulga to choir practice and meeting, that he was now seventeen and ought to have a little freedom. So it had gone, and now the cotton was knee-high. The crops more than half made. She breathed a little easier. She was at the house putting on a pot of collard greens when John came in for the sweat-rag.

"Mama, better tell Ned tuh leave me be. Tell 'im tuh stop his bulldozia. Ah done heered 'im lyin' tuh Mist' Shelby makin' out Ah don't do nothin'—hard ez Ah works."

"He be's drunk when he keer on lak dat and his likker tell 'im tuh talk. Don't pay 'im no mind."

"But, mama, ev'ry time Ah go cross de Creek he look lak he go crazy and git tuh blasphemin' 'bout no 'count gals. Ah don't keer if he do be peepin' through his likkers he got tuh quit dat. Sho ez gun's iron, he got tuh quit dat. He don't know nothin' 'bout—'bout no gal Ah keeps comp'ny wid."

"Heah de rag yuh wanted, John. Go 'long back tuh work and Ah'll give Ned uh straightenin'. Dat is if he kin stand uh straightenin'."

Ned was sullen when John returned but he said nothing. He took part of his humor out on the mule and held the other inside him. He said to himself as he stumbled along behind his plow, "Damn biggity rascal! Wisht Ah had 'im tied down so he couldn't move! I'd put uh hund'ed lashes on his bare back. He know he got de advantage uh me. He don't even know his pappy and he ought tuh be proud Ah took and married his ma and made somethin' out of 'im. He ought to be humble,

44

but he ain't, and plenty folks right now on account uh his yaller skin will put 'im above me. Wisht Ah knowed somethin' that would crumple his feathers! But he sho' is makin' dis crop, though. Ah oughter clear more'n uh hund'ed dollars. Effen Ah do, Ahm gwine buy me uh hawse and buggy, and ain't gwine 'low nobody tuh hitch it up but me."

That evening the things unsaid laid a steamy blanket over talk. John made the long journey over the creek and Ned fumed.

"Whyn't you tell John whut yuh got tuh say, Ned?" Amy slapped back, "You *been* tellin' 'im."

" 'Cause Ah don't want tuh hafta kill 'im, dat's how come. He must smell hisself—done got so mannish. Some fast 'omanish gal is grinnin' in his face and he tries tuh git sides hisself."

Amy smoked her pipe and went on to bed. The children too. Zeke and Zack were in the woods trying out a new coon dog and came in after moon-up. John came home later.

When Amy brought dinner to the field next day John took his bucket and went off alone to eat. With a huge hickory tree between him and the others, he pulled out the three cornered note and read again and again.

Sweet Notasulga, Chocklit Alabama Date of kisses, month of love Dere John, you is my honey. I won't never love nobody else but you. I love choir practise now. Sugar is sweet, and lard is greasy, you love me, don't be uneasy.

Your darling,
LUCY ANN POTTS

Ned called several times before John heard him.

"John Buddy! You John! Come heah and take holt uh dese plow lines."

"Yes suh," John said at last.

"Don't set dere and answer me. When Ah speak, you move!"

"Ah, Ahm comin', but Ah ain't goin' tuh run fuh nobody."

"Looka heah, John, Ahm sick uh yo' sass. Ah got it in me tuh tell yuh and if Ah don't tell yuh, Ah'll purge when Ah die. Youse uh good fuh nothin' trashy yaller rascal—ain't fit tuh tote guts tuh uh bear." A sudden frenzy took Ned, "Anyhow, Ah done made up mah mind tuh beat you nelly tuh death. You jes' spilin' fuh uh good killin'! Drop dem britches below yo' hocks, and git down on yo' knees. Ah means tuh straighten you out dis day."

As he said this, Ned snatched off the trace-chain from the plow and turned upon John who was still twenty feet or more from his step-father. When Ned whirled about with the doubled trace-chain in his right fist he found not a cowering bulk of a boy but a defiant man, feet spread wide, a large rock drawn back to hurl.

"Don't you vary! Dog damn yuh!" John challenged. "Come uhnother step and Ah'll bust yuh wide open, wid dis rock. You kin cuff and kick Zeke and them around but Ah done promised Gawd and uh couple uh other men tuh stomp yo' guts out nex' time you raise yo' hand tuh me."

For a throbbing space the two stood face to face. Ned turned and hobbled off.

"Stand dere! Jes' you stand dere till Ah go git mah double-barrel britch-loader and Ahm gointer blow yo' brains out!"

Ned limped off towards the house. John held his pose until the older man dipped below the first rise. Then he let fall his arm, and walked back towards the hickory tree.

"Ahm gointer git behind dis tree and if dat ugly-rump nigger come back here wid dat gun, Ahm gointer bust 'im wide open wid uh rock 'fore he know whut hit 'im. Humph! Ah don't b'lieve he gone at no britch-loader nohow. He gone 'cause he got skeered Ah wuz goin' take dat trace-chain 'way from 'im and lay it 'cross his own back."

John waited a long time. Ned could have gone twice the distance and returned with a gun. If he could have looked over the hill he would have seen Ned "proaging" off to the Turk place to get a gallon of red-eye-for-courage. Finally John came out from behind the hickory tree and loosed the mules from

the plows and looped up the plow lines on the hames.

"Shucks! Ahm goin' 'way from heah." It came to John like a revelation. Distance was escape. He stopped before the burnt-off trunk of a tree that stood eight or ten feet high and threw the character of Ned Crittenden upon it.

"And you, you ole battle-hammed, slew-foot, box-ankled nubbin, you! You ain't nothin' and ain't got nothin' but whut God give uh billy-goat, and then round tryin' tuh hell-hack folks! Tryin' tuh kill somebody wid talk, but if you wants tuh fight,—dat's de very corn Ah wants tuh grind. You come grab me now and Ah bet yuh Ah'll stop *you* from suckin' eggs. Hit me now! G'wan hit me! Bet Ah'll break uh egg in yuh! Youse all parts of uh pig! You done got me jus' ez hot ez July jam, and Ah ain't got no mo' use fuh yuh than Ah is for mah baby shirt. Youse mah race but you sho ain't mah taste. Jus' you break uh breath wid me, and Ahm goin' tuh be jus' too chastisin'.

"Ahm jus' lak uh old shoe—soft when yuh rain on me and cool me off, and hard when yuh shine on me and git me hot. Tuh keep from killin' uh sorry somethin' like yuh, Ahm goin' way from heah. Ahm goin' tuh Zar, and dat's on de other side of far, and when you see me agin Ahm gointer be somebody. Mah li'l' finger will be bigger than yo' waist. Don't you part yo' lips tuh me no mo' jes' ez long ez heben is happy—do Ah'll put somethin' on yuh dat lye soap won't take off. You ain't nothin' but uh big ole pan of fell bread. Now dat's de word wid de bark on it."

John stepped back a few paces, balanced his rock, hurled it against the stump with all his might and started across the field to the creek.

The involuntary beauty of sunset found him once again upon the plantation of his birth exulting among the herd, and finding Pheemy's cabin good to be in.

CHAPTER 5

H ello, John."

"Hello, Bully."

"Whut you doin' back over here?"

"Come tuh git me uh job uh work again. Whuss de news?"

"Oh de white folks is still in de lead. Seen Mist' Alf yit?"

"Naw, goin' up tuh de big house now."

"Soon's yuh git back tuh de quarters Ah got uh bug tuh put in yo' ear."

"Awright, be back tuhreckly."

There were more used suits in Alf Pearson's clothes closet and John received them.

"My son, Mister Alfred's, clothes don't fit you now as well as they did last year, John. Too tight. Reckon I'll have to give you mine from now on. By the way, John, I've lost two hogs since you've been gone. Get back on your same job. Can you read and write fairly well now, John?"

"Yes suh."

"That's fine. I want you to take this note book and keep up with the groceries and fertilizer and feed that the folks in the quarters draw. It's hard for me to do it with running the bank and watching slick politicians. I had thought my son would have been home by now to help me, but it seems to take quite a long time to finish studying in Paris."

"Yes suh."

"You just take everybody's name on a separate page and put down everything they get the moment you hand it to 'em."

"Yes suh."

"And John, if you've been fooling around Duke's wife, leave her alone. He's been up here to me about it. Don't start no fight about it. There's plenty single girls around here."

"Ah ain't studyin' 'bout his Exie, Mist' Alf. He better talk tuh *her*. She de one come pullin' on me."

Alf Pearson laughed heartily and gave John a playful shove.

"Get along you rascal you! You're a walking orgasm. A living exultation."

"Whut's dat, Mist' Alf?"

"Oh never mind about that. Keep up with the pigs."

That night M'haley and Big 'Oman and Bootsie got up a game of "Hide and Seek" but John counted and let the other boys hide. The game ended fairly early. John had been around behind the house to look at his writing and the chimney and found it all defaced, so he didn't want to play. When the game was over he called Bully aside.

"Bully, Ah wrote some writin' on de back uh An' Pheemy's chimbley."

"Yeah, Ah know you did. Fack is, ev'rybody know yuh did, and dat's de very crow Ah wants tuh pick wid yuh."

"Is you heard who took and scratched it, and put smut out de chimbley all over it and mommucked it all up?"

"You ain't mad, is yuh?"

"Yeah, Ahm mad. Ahm jes' ez hot ez Tucker when de mule kicked his mammy, and any man dat tell me tuh mah face dat he done it he got tuh smell mah fist. You know who done it, Bully?"

"Don't yuh say Ah tole yuh and when you go tuh git atter her, don't you call my name, but M'haley took and done dat when she heered you wuz singin' in de choir. Some of 'em say you jes' done it so you could git a chance tuh see Lucy Potts."

"Whut M'haley got tuh do wid dat? Ah feel lak Ah could take and lam her wid lightnin'."

"Why doncher do it, John? If 'twas me felt bad lak you do, Ah'd beat her jes' ez long ez she last. Anyhow she takin' de under currents on you."

"Naw, Ah don't choose beatin' lady people. Uh man is crazy tuh do dat—when he know he got tuh submit hisself tuh 'em. Ahm gittin' sleepy. B'lieve Ah'll turn in."

Bully went away whistling, and John made to go inside to bed.

"John!" in a soft whisper from around the corner of the house. "Come heah, John."

John stepped to the corner, "Who dat callin' me?"

"Aw, you come see," the voice retreated into the shoulder-high cotton. John followed.

"Whut you want wid me, M'haley?"

"Look lak you ain't glad youse back."

"Yes Ah is, M'haley, but 'tain't lak de fust night Ah come. Ah reckon all de new done wore off de plantation."

" 'Tain't de plantation. Dat's jes' de same. Ah reckon you jes' ain't got time tuh strain wid us quarters niggers now. You sings on de choir at Macedony."

"Whut's singin' notes got tuh do wid it? It jus' 'tain't new no mo'."

"Naw, you jes' stuck on dat li'l' ole Lucy Ann, and she ain't nothin' but uh baby. She ain't but leben years ole."

"She twelve now, goin' on thirteen. She had her birth night de day befo' mines. Her'n on December 31, and mine's January 1. Ain't dat funny?"

"Ahm fifteen, so goody, goody, goody."

John said nothing. After a while M'haley said, "John, Ah thought once me and you wuz gointer make uh wed." He stood stolid and silent.

In the silence she threw her arms about John's passive neck and swung herself off the ground, then lay still against him.

"John."

"Hunh."

"Feel mah heart. Put yo' hand right heah. Ain't it beatin' hard? Dat's 'cause Ahm so glad youse back. Feel it again. My

51

heart is rearin' and pitchin' fur you lak uh mule in uh tin stable. John, Ah loves you, Ah swear Ah does. You so pretty and you ain't color-struck lak uh whole heap uh bright-skin people. John?"

"Hunh."

"John, hug me till mah dress fit tight."

The next day John whitewashed Pheemy's chimney, and wrote Lucy's name in huge letters across it, and on Sunday he was at church far ahead of anybody else, with a three-cornered note in his hymn-book.

"Hope ole big-mouf M'haley don't come pukin' her guts 'round heah," he thought aloud. This was another day and another place. Pearson's quarters and M'haley had no business here. His eye wandered out of the window and down the dusty road. A bunch of girls approached in starchy elegance. "Lawd, dat look lak M'haley now—comin' heah tuh bull-doze and dominize."

John fell to his knees and prayed for cleansing. He prayed aloud and the empty house threw back his resonant tones like a guitar box.

"Dat sho sound good," John exulted. "If mah voice sound *dat* good de first time Ah ever prayed in de church house, it sho won't be de las'." He arose from his knees and before the drove of girls had reached the steps John had forgotten all about his sins and fears, but he retreated to the choir-stand out of M'haley's reach.

As soon as Lucy took her seat before him he leaned forward and thrust his hymn-book into her hand. She coyly dropped hers, and he picked it up and pretended to search for a song. Lucy slyly did the same and read:

Dere Lucy:
 Whin you pass a mule tied to a tree,
 Ring his tail and think of me.

 Your sugger-lump,
 JOHN

John read:

> Long as the vine grow 'round the stump
> You are my dolling sugar lump.
> Mama whipped me last night, because Bud told her we
> was talking to each other.

<div style="text-align:right">

Your sweet heart,
LUCY ANN

</div>

John was so sweetly distracted by this note that he was blind
and deaf to his surroundings. Bud Potts had rapped loudly and
importantly and had gestured with his hands as if he were
pushing a wash-basket of clothes up on a high shelf for the
choir to rise. Everyone was standing but John. He never no-
ticed this until Oral Johnson nudged him.

"Get yo' pitch!" Bud ordered as if he were giving the order
to fire on Fort Sumter.

"Basses—duh-h-h-h. Y'all got it? Altos—fah-h-h—Tre-
bles—me-e-e-e—. Pay 'tension dere, Lucy!"

Satisfied in the matter of the pitch, Bud took a full breath
and broke out thru his nose—"Duh, duh, duh, duh! Dole la
fee so lah so fee." The altos were right behind the basses and
fighting in haughty jerks for sound supremacy—"fah! fah! me!
sol! fah-so-la-so-lah-so-fah!" The trebles pitched out in full,
Ory behind the pack and keened furiously to make up for lost
time, "—me, me, ray, do! Me-fah-lah-so-lah-so-fah! Oh me,
me, me,—"

It was a hard race and hotly contended at the top of the
lungs all the way. The trebles won because while altos, basses
and even other trebles forgot their notes in confusion and fell
by the wayside, Lucy never missed a note. Bud growled away
in the bass but Lucy treed him and held him growling in
discomfiture out upon a limb until the end of the piece cut him
down.

John beat the bass notes by a vigorous side-to-side motion
of his head and everybody in the audience thought they heard
him singing them.

<div style="text-align:center">53</div>

The preacher arose.

"Ah takes mah tex' and Ah takes mah time." He pursed up his wrinkled black face and glared all over the church. No one accepting the challenge he went on—"Ah takes mah tex' 'tween de lids uh de Bible," and slammed it shut. Another challenging glare about the room. Same results. "Don't you take and meddle wid *whar* Ah takes mah tex'. Long ez Ah gives yuh de word uh Gawd, 'tain't none uh yo' business whar Ah gits it from."

For two hours his voice beat about the ears of the people and the "Amen's" rocked and rolled back to the pulpit.

John heard little of it. He studied the back of Lucy's head and shoulders and the way the white rice buttons ran down her back and found plenty to entertain him the whole while.

When the cotton had been picked and ginned, Alf had John to pick out the hogs for the barbecue. The same elaborate preparations as usual. Same high laughter, but John sat passively in a doorway with Zeke who was getting tall and emitting ram odors.

"Less we dance, John Buddy. Ah wants tuh swing one dem gals."

John laughed scornfully, "Whut you know 'bout swingin' gals? You don't eben know how tuh dance."

"Dat's much ez *you* know. Ah done been tuh four, five frolics 'cross de Creek since you been gone."

Phrony came dashing up, hair wrapped with blue rag strings and reeking of lemon extract used as a perfume.

"John how come you ain't dancin'?"

"Ah got uh bone in mah leg," John bantered.

"Aw come on, John."

"Go head on, Phrony. You got plenty boys 'sides me. Ah tell yuh Ah got uh bone in mah leg."

"Sho 'nuff, John? When did you git it in dere? You wuz walkin' all righ' jes' fo' dark."

"He jes' funnin' wid yuh," Zeke cut in, " 'Course he got uh bone in his leg. How he goin' tuh walk if he ain't? Come on and lemme switch yo' coat."

Zeke grabbed Phrony by the point of her elbow and they plunged into the cauldron of sound.

John sat on, thinking of the words on the chimney back, but soon Exie found him.

"John, how come you ain't in de play party? M'haley dancin' wid Bully."

"She's uh much-right gal. Much right for Bully ez it is for me."

Exie laughed happily, "Big 'Oman huntin' you too and plenty mo'."

"Whut for?"

"Dey say de dance don't go so good 'thout you. Dey say de boys neither de gals don't do 'round when you ain't dere lak dey do when yo' is."

"Dey done 'thout me 'fo' dey seen me. Ah jes' don't feel lak no dancin' and whoopin' and hollerin' t'night."

"Me neither. Less we all jes' set and talk, John."

"Naw, Gawd! Ah don't want Duke pickin' no fight wid me over you. You his'n."

"Us ain't got no courthouse papers. Dat's commissary license us got. Ah kin quit anytime, and then agin effen Ah had courthouse license Ah got divorce in mah heels." She picked up John's hand and pulled it into her lap. Just then M'haley walked up to them.

"Oh 'scuse me," she turned away scornfully, "Ah didn't reckon you wuz so busy, John," she whirled and ran back to the dance.

"You better g'wan back tuh de play party, Exie. M'haley's goin' tuh tell Duke on you."

"Let her tell 'im, tell 'im, turn 'im up and smell 'im."

John rose. "Ah got tuh step off a li'l' piece. Ah'll be right back." He walked off and Exie started on back to the fire. Half way she met Duke, and John could hear the struggle of battle. He turned about and hurried to them.

"Whut you beatin' Exie 'bout? She ain't done nothin'."

"If she wan't doin' nothin', whut y'all doin' up heah in de

dark?" He struck her violently in the face again. John stepped between them.

"Don't lam dis 'oman no mo', Duke. She ain't did a thing wrong. You wanta beat on somebody, hop me. Mah shoulders is broad."

Besides the ones who had heard M'haley say out loud that John and Exie were up the hill in the dark too busy to dance, there were others who had heard what Duke said when he left the fire-lit circle. So the crowd had surrounded the three. Exie, bruised but exultant, John and Duke standing face to face.

"Fight, fight, you no kin. Kill on 'nother 'twon't be no sin," Nunkie shouted.

Old Pheemy stepped between and scattered the crowd.

"Neb mind," Duke threatened as he was led away, "Ah ain't through wid you, John Pearson. Ahm goin' git yuh! Ahm goin' tuh git yuh if Ah have tuh steal yuh! Youse bigger'n me, but mah Barlow knife'll even us up."

The dance went on. John danced a little with Big 'Oman and Bootsie but he wasn't flamboyant.

In the bed with Zeke later he said, "Zeke, Ahm goin' 'way from here."

"You ain't skeered uh Duke, is yuh?"

"Naw, Duke cuts and shoots too, but all de shootin' he do is shoot fuh home if somebody git behind 'im, and cut fuh de nearest way. He don't fight no men-folks. He's uh woman-jessie. Beat up women and run from mens. Ah ain't got him tuh study 'bout, but Ah feel lak Ah weighs uh thousand pounds and it's mah heart make me feel that away."

"How come?"

"Y'know dat li'l' gal dat trebles in de choir at Macedony—de one whut don't wrop her hair, de onliest one up dere dat don't wrop her hair no time wid all dat cord-string lake de rest? Well, Ah loves her, and she say she love me too, and Ah betcha old moufy M'haley uh some uh dese other niggers goin' make out Ahm goin' wid Exie, and dat's whut me and Duke lak tuh fought over, and then agin Mist' Alf done tole

56

me not tuh fool wid Exie and Duke goin' up tuh de big house and tell uh lie on me."

"If yuh go off somewhere, John Buddy, lemme go wid yuh, heah, Please?"

"You too little. Ain't but fourteen, and if Ah go 'way from heah atall, Ahm goin' tuh de tie-camp and cut cross ties. Man asted me tuh go yistiddy in Notasulga. Yuh makes good money too."

"John Buddy, please. Heah?"

"Naw, you stay 'round heah and watch out for Lucy. Git word tuh me iffen any ole mullet-head tries tuh cut me out. Ahm gointer write tuh you and you way-lay her and git her tuh read it fuh yuh."

"Aw, Ah kin read too. Ah kin read some."

"Whut kin you read?"

"In de fust reader it say, 'This is Ned. He has a dog,' Ah kin read dat lak anything. Dat's uh heap, ain't it?"

"Dat'll do, but Ah ain't goin tuh write 'bout no Ned in de fust reader, and neither no dawg. You do lak Ah tell yuh, and if she say she don't pay dese niggers' talk no mind, you git de word tuh me quick ez yuh kin, heah, Zeke?"

"Unhunh."

"Yuh see, she got de advantage uh me 'cause she knows Ah love her, but Ah don't know whether she love me or not. Lots uh folks makes 'miration at her. You stay 'round heah and back mah fallin', and then nex' time Ah'll take you 'long."

"Aw right, John Buddy."

The next morning John was gone—walked to Opelika and on to the tie-woods on the Alabama River.

CHAPTER 6

It was dusk-dark when John walked into the tie-camp. At some distance away he could see a group of men bunched on the ground beside a small fire. Gaming. They were so intent that John was right on them before they knew. When somebody saw him, there was a breathy cry, "De buckra!" Somebody grabbed up the dice and everyone made to run. John laughed and stepped up among them.

"Ha, ha! Y'all thought Ah wuz white, didn't yuh?"

Everyone laughed except Coon Tyler. He was every bit as large as John and several years older. He looked up at John out of red, angry eyes and growled, "You oughter quit goin' 'round skeering folks. You better hail fo' you tuh walk up on *me* agin."

John kept on laughing. "Lawd, y'all sho wuz snatchin' and grabbin'. Ah ought not tuh uh said nothin' and some uh y'all would uh been to Selma in five minutes."

Coon would not be amused, "You scoundrel-beast, you git from over de game!"

John stepped back a little, not in fear but in surprise.

"You ain't mad, is yuh?" he asked.

One of the men said, "Don't pay Coon no mind, he jes' funnin' wid yuh."

Seeing the passive attitude in John, Coon blazed, "Funnin'?

59

Y'all know Ah don't joke and Ah don't stand no jokin'. 'Tain't nothin' in de drug store'll kill yuh quick ez me.''

"Mah name is Ezeriah Hill, but de lady people calls me Uncle Dump," the oldest man in the group said to John, "Whuss yo' name, boy?"

"John. Where de boss at?"

"He gone intuh town. Be back tuhreckly. He goin' hiah yuh 'cause us needs help. Come on lemme show yuh uh place tuh sleep."

John followed him into the bunk house. "Heah whar you sleep at. Eve'ybody scorch up dey own grub. Be ready tuh hit de grit by daylight."

"Yes suh."

"Chaw tuhbacker uh smoke?"

"Naw suh."

"Wall you gwine learn 'cause you can't keep dis camp grub on yo' stomach lessen yuh do. Got tuh learn how tuh cuss too. Ah kin see you ain't nothin' but uh lad of uh boy. Mens on dese camps is full uh bulldocia 'til dey smell uh good size fist. Den dey dwindles down tuh nelly nothin'."

All next day John wielded a broad axe, a maul and pestle with the rest. He found that he liked the rhythmic swing, the chant "Cuttin' timber!" with the up stroke of the axe. Then the swift, sure descent, "Hanh!" Up again, "Cuttin' ties! Hanh." All day long, "Cuttin' timber! Hanh! Cuttin' ties, hanh!"

A boy called Do-dirty because of his supposed popularity with and his double-crossing of women, took John to town with him Saturday night. John was eager to go so he could buy writing paper and a pencil. He got it and then Do-dirty proudly showed him the town, and the town's women. It was late Sunday evening when they returned to camp and from one thing to another it was two weeks before John wrote to Ezekiel.

And when a month passed and he got no answer he began to feel that there would never be a word from Lucy. He went to town often. On the nights that he stayed in camp he was the

center of camp life. He could chin the bar more times than anyone there. He soon was the best shot, the fastest runner and in wrestling no man could put his shoulders to the ground. The boss began to invite his friends out to watch the fun. John won his first match by pinning Nelse Watson from another camp to the ground, but his greatest stunt was picking up an axe by the very tip end of the helve and keeping the head on a level with his shoulders in his out-stretched arm. Coon could muscle out one axe, but John could balance two. He could stand like a cross, immobile for several seconds with an axe muscled out in each hand. Next to showing muscle-power, John loved to tell stories. Sometimes the men sat about the fire and talked and John loved that. One night Do-dirty began, "Y'all wanta heah some lies?"

"Yeah," said Too-Sweet, "Ah evermore loves lies but you can't tell none. Leave John tell 'em 'cause he kin act 'em out. He take de part uh Brer Rabbit and Brer B'ar and Brer Fox jes' ez natche'l."

"Aw, 'tain't nothin' tuh 'im," Coon grumbled, "y'all make me sick."

Saturday afternoon Do-dirty looked off towards the West and cried, "Looka yonder! Who dat comin' runnin'?"

Everybody looked but John. He was inside getting ready to go to town.

"Do John Buddy work at dis heah camp?" he heard and recognized Zeke's voice.

"Come inside, Zeke!" he called out quickly.

Zeke came in and sat down on the bunk beside John. No words. Happiness radiated from one to the other.

"You seen Lucy?"

"Yeah, two times."

"Whut she say?"

Zeke tugged at a letter inside his clothes.

"She writ dis tuh yuh and tole me tuh mail it, but Ah run off and bring it tuh yuh. Yuh see Ah ain't got yo' letter till day befo' yestiddy. 'Cause pappy wouldn't leave me go tuh town

tuh de Post Office. John Buddy, you goin' tuh leave me stay wid yuh? Hunh?"

John spelled slowly thru his letter and smiled, "Yeah, you kin stay whut li'l' time Ahm goin' tuh be heah. Two mo' pay days and Ahm gone. Got tuh take uh birthday gif' tuh Lucy. Wisht Ah could give her Georgy under fence."

"John Buddy, Ahm hongry. Feel lak Ah ain't dirtied uh plate dis week."

"Wait uh minute. Ah'll stir yuh up uh Ash-cake and you kin sop it in some syrup. Maybe Ah ain't goin' tuh town nohow now."

John went outside and fixed the fire and put the bread in the hot ashes and covered it up.

"Reckon Ah better git uh bucket uh water, Zeke. You watch de bread. It's uh good li'l' piece tuh de spring."

Zeke watched the bread and took it out of the ashes when it was thoroughly brown. John had not returned. Most of the men lounged about outside. Finally Coon said to Zeke, "You better run down de hill dere and see whut's de matter wid yo' big buddy. Pant'er got 'im, maybe."

All alarm, Ezekiel leaped up and flew down the path he had seen John take. In a few minutes he saw John coming.

"Where you goin', Zeke?"

"Huntin' yuh. Skeered uh brute-beast had done kotched yuh."

When they got back to the bunk house, John gave Zeke his tin plate and set the gallon jug of syrup before him.

"He'p yo'self, Zeke, and grow hair on yo' chest."

Zeke poured a plate full of syrup and looked for the Ash-cake. "Whar at de bread is?" he asked John.

"You seen it since me," John answered. He looked about and seeing the suppressed laughter on the men's faces he asked, "Where de bread Ah took and cooked fuh mah li'l' bubber?"

General laughter. John got angry. "Ah say, who took and done 'way wid mah bread? Whoever done it mus' be skeered tuh own it."

Coon first, laughing instantly, "Ah et yo' damn bread. Don't you lak it, don't yuh take it, heah mah collar, come and shake it."

"Yeah and Ahm gointer shake it too dis day and year of our Lawd, and if Ah don't, Gawd knows, Ahm gointer give it uh common trial. My gal don't 'speck me tuh run."

They flew at each other and the others scrambled out of the way. Coon was too wise to clinch. He stayed his distance and slugged, but his wariness wore him out. Trying to hit and duck at the same time, he struck out ten or twelve times and landed one high on the enemy's head. John ran in and landed one smack in his enemy's mouth, and while Coon was spitting out his teeth, he ripped a mule-kicking right to the pit of Coon's stomach and the fight was over and done.

John felt good. His first real fight. Something burned inside him. He tasted blood in his mouth, but there was none actually. He wished somebody else would hit him. He wanted to feel himself taking and giving blows.

"You be keerful how you hit folks, Jawn," Uncle Dump cautioned, "you don't know yo' own strength. Dat man (indicating Coon) is hurt bad."

"He been pickin' on me ever since Ah been heah, and Ah been takin' and takin' 'til mah guts is full."

An hour before Lucy's letter had arrived Coon might have eaten John's Ash-cake and offered other insults safely. Now John was different. There was something about Lucy that stuck another and stiffer bone down his back.

He walked over and looked upon the fallen Coon. His surly black face was relaxed in a vacuous manner—blowing bloody foam out thru his swollen lips at every breath.

"Nex' time he fool wid me, Ah bet Ah'll try mah bes' tuh salivate 'im. He try tuh be uh tush hawg—puttin' out his brags everywhere."

He cooked Zeke more bread and soon the camp had settled down to normal. Somebody put Coon in his bunk, and he never spoke a word until after John had taken Zeke to town.

"Know whut," he lisped to the others, "dat boy slipped up

on me, but Ahm gwine git even wid him. 'Tain't too late. Seben years ain't too long fuh uh coudar tuh wear uh ruffled bosom shirt. Ahm gwine gently chain-gang fuh dat same nigger."

"Aw," Dump disparaged, "you got uh belly full uh John. You ain't wantin' no mo' uh him."

"Yeah Ah wants tuh fight 'im, but not wid no fist. Ah flies hot quick but Ahm very easy cooled when de man Ahm mad wid is bigger'n me."

64

CHAPTER 7

John and Zeke got back to Notasulga in time for the Christmas tree at Macedony, and John put a huge China doll on the tree for Lucy. She didn't know he had returned until he walked in during the singing and sat across the aisle from her.

At home, Emmeline Potts pounced upon the large package. "Dis is uh stray bundle dat didn't come from de Sunday School and it didn't come from dis house." She opened it. "Lucy Ann, read dis piece uh paper and tell me who give you dis great big play-pritty."

Lucy faltered. She turned the paper around two or three times.

"John Pearson."

"Dat big yaller boy from cross de Creek?"

"Yes ma'am."

"Whut he doin' givin' *you* uh present?"

"Ah don't know'm."

"Yes you do, madam. Dere's uh bug under dat chip. Mind yuh now, mah young lady; Ah ketch you foolin' wid boys, 'specially uh yaller bastard, Ahm uh goin' tuh put hick'ries tuh yo' back tuh set, Miss Potts. Ah done tole Artie Mimms he kin have yuh when yuh git sixteen."

CHAPTER 8

Alf Pearson welcomed John back with a bluff cursing out.

"I told you to leave Duke's woman alone. I didn't tell you to leave the place. Don't gimme excuses nor back talk. G'wan to work. I'll be glad when some good girl grabs you and makes something out of you. Stop running away. Face things out."

That Sunday Mehaley got two of her friends to go to Macedony with her, though they all belonged to Shiloh.

"Less go slur dat li'l' narrer-contracted Potts gal," she urged. "Somebody say John put uh great big doll-baby on de tree fuh her and den agin he bought her gold hoop ear-rings fuh her birthday. Course Ah don't believe he done no sich uh hot-do, but she fool wid me tuhday Ah means tuh beat her 'til she rope lak okra, and den agin Ah'll stomp her 'til she slack lak lime."

They crowded near Lucy after preaching, but old Emmeline was ever at Lucy's elbow. John had written Lucy to meet him at the spring, but Lucy was not permitted the liberty.

"Naw, you ain't goin' lolly-gaggin' down tuh no spring wid all dese loose gals. You goin' git in dis road 'head uh me and g'wan home."

Emmeline was most emphatic, but while she said her good

67

byes to her friends, John came up and tipped his hat.

"How yuh do, Mis' Potts."

"Howdy John," she glared like noon.

"Mis' Potts, kin Ah scorch Mis' Lucy home?"

"Lucy ain't takin' no comp'ny yit. She ain't but fourteen and Ah don't turn mah gals loose tuh take comp'ny 'til dey sixteen, and when Ah does Ah picks de comp'ny mahself. Ah ain't raisin' no gals tuh throw 'way on trash."

Richard Potts spoke up. "Whut make you got tuh plow so deep, Emmeline? Ack lak 'tain't nobody got feelings but you. All right, son, Ah reckon it won't hurt nothin' if yuh walk 'long wid Lucy jes' ahead uh us. But she too young tuh court."

The world turned to red and gold for Lucy. She had read the jealousy and malice in Mehaley's face, and John had asked for her company right in front of Mehaley and her crowd! He had faced her hard-to-face mama! She stretched up another inch. There was little to say on the way home, but she had made those big girls stand back. There was one moment when they reached the bend in the road a moment before Richard and Emmeline and John had squeezed her arm. The whole world took on life. Lucy gave no sign that she noticed the touch but in one flash she discovered for herself old truths.

John noted the prosperous look of the Potts place. It was different from every other Negro's place that he had ever seen. Flowers in the yard among whitewashed rocks. Tobacco hanging up to dry. Peanuts drying on white cloth in the sun. A smoke-house, a spring-house, a swing under a china-berry tree, bucket flowers on the porch.

"Stay and have dinner wid us," Richard Potts invited.

John stayed but ate little, and in his presence Lucy cut peas in two and split grains of rice, for which she was coarsely teased by her brothers until John left her, shamefaced.

Another look from his gray eyes that Lucy knew was her look and nobody else's, and John loped on off to Pearson's.

The next morning Lucy found a hair upon her body and exulted.

"Ahm uh woman now."

The following Saturday when she stripped to bathe in the wooden wash tub, she noted that tiny horizontal ridges had lifted her bust a step away from childhood.

She wrote John a long letter and granted him her special company.

The following case law abstracts are printed... in the
woodland with... she had run into some... in the map... had
later... he speaks very... was... finished.

She woke... found her limp and... that he... seemed
... happen.

CHAPTER 9

You Lucy!" Emmeline scolded as she struggled along
behind John and Lucy on the way from church, "Ain't
Ah done tole yuh and tole yuh not tuh let no boys be
puttin' dey hand all over yuh? You John! You stay arm-length
from dat gal and talk it out. You got uh tongue."

Lucy and John sniggered together slyly and walked an inch
or two farther apart.

"Good Gawd, dey could drive uh double team between us
now," John complained.

"Talk loud, Ah don't 'low no whisperin' tuh no gal uh
mine."

They talked about the preaching and the new hymn-books
and the proposed church organ. Some were for the innovation
but the majority of the congregation thought that kind of
music in a church would be sinful to the extreme. Emmeline
stayed close enough to hear every word.

At home Lucy's married sister, Dink, sympathetically invei-
gled Emmeline into the kitchen where she was dishing up
dinner. Lucy and John sat in the parlor with the crayon en-
largements on easels and the gilded moustache-cups and sau-
cers on wire props and the religious mottoes on the wall.

John cleared his throat to speak, but Emmeline popped in
at that moment and took her seat beside the center table. John

was on one side of the room behind her and Lucy was on the other side facing her.

"Ah been keepin' comp'ny wid you uh long time, ain't Ah, Lucy?"

"Yeah, mighty nigh uh year now."

"And you ain't never had manners 'nough tuh ast *me* fuh her comp'ny reg'lar," Emmeline snapped.

Conversation died. On the lower shelf of the center table John spied Lucy's double slate with the slate-pencil suspended from it by a string.

"Dis de same slate you use in school, ain't it, Lucy?"

"Unhunh."

John opened the slate and wrote a few words in it as softly as possible. Emmeline seemed neither to see nor hear the scratching of the pencil, but when John leaned forward and tried to hand the slate past Emmeline to Lucy, Emmeline's hand flew out like a cat's paw and grabbed the slate. She looked on both sides and saw no writing, then she opened it and looked hard at the message, "I got something to tell you. Less go for a walk." Emmeline couldn't read a word and she was afraid that no one would read it correctly for her, but one thing she was sure of, she could erase as well as the world's greatest professor. She spoiled out the words with a corner of her apron, and put the slate back under the table. Not a word was passed.

"Mama!" from the kitchen.

"Whut you want, Dink?"

"Come turn dis sweet bread out on uh plate. Ahm skeered Ah'll make it fall uh tear it, tryin' tuh git it out de pan."

Emmeline went grumbling to the rear.

"Less set on de piazza," John suggested, "Maybe us kin git uh word in edgeways 'fo' she git back."

"Aw right."

They went out on the porch and sat slyly side by side—Lucy in the old red rocker, and John on a cow-hided straight chair.

"Lucy, Ah loves yuh."

Emmeline burst out of the parlor.

"Lucy! Whut you doin' settin' on top uh dat boy?"

"Ah ain't settin' on top of 'im. Uh milk cow could git between us."

"Don't you back talk *me.* When Ah speak you *move.* You hear me Lucy?"

"Yessum."

"How come you ain't movin'? Mah orders is five feet apart. Dink know befo' she married Ah never 'lowed her tuh set closer dan five feet and you know it and when Ah don't 'low tuh one, Ah ain't gwine 'low tuh de other. Heifer! Move dat chear 'way from dat boy!"

Silence.

"Lucy!"

"Yessum."

"Is you deef?"

"No'm."

Richard came in from the barn at that moment and called his wife.

"Aw, Emmeline, don't plow so deep. You puts de shamery on folks. Come on inside and hep Dink fix de dinner. Ahm hongry."

"Naw, Ah see she done got hard-headed, and Ahm gwine pray fuh her. Hard-headed chillun never come tuh no good end. Mind whut Ah say! Ahm gwine tell God about *you,* madam."

She pulled back the curtain in the parlor so that she could see every move on the porch and prayed.

"O Lawd and our Gawd, You know Ah tries tuh raise mah chillun right and lead 'em in de way dat dey should go, and Lawd You know it 'tain't right fuh boys and gals tuh be settin' on top one 'nother; and Lawd You know You said You'd strike disobedient chillun dead in dey tracks, and Lawd make mine humble and obedient, and tuh serve Thee and walk in Thy ways and please tuh make 'em set five feet apart, and when Ah done sung mah last song, done prayed mah last prayer, please suh, Jesus, make up mah dyin' bed and keep mah chillun's feet p'inted tuh de starry pole in glory and make

73

'em set five feet 'part. Dese and all other blessin's Ah ast in Jesus name, Amen, and thang Gawd.''

"Aw Emmeline, dat prayer uh yourn ain't got out de house," Richard commented, "it's bumblin' 'round 'mong de rafters right now and dat's fur as it'll ever git.''

Out on the porch John said softly, "Meet me tuhmorrer 'cross de branch by dat swee' gum tree 'bout fo' o'clock.''

"Aw right. Aincha goin' tuh stay and have some dinner wid us?''

"Naw, Ah don't choose none. Dey got baked chicken at de big house and Ah eats from dere whenever Ah wants tuh. You gointer be sho' tuh be at our tree?''

"Unhunh.''

"Sho now?''

"Unhunh.''

"S'pos'n yo' mah uh some of de rest of 'em ketch yuh?''

Lucy threw herself akimbo. "Humph, dey can't do nothin' but beat me, and if dey beat me, it sho won't kill me, and if dey kill me dey sho can't eat me. Ah'll be dere jus' as sho as gun's iron.''

" 'Bye den, Lucy. Sho wisht Ah could smack yo' lips.''

"Whut's dat you say, John?''

"Oh nothin'. 'Bye. Doan let de booger man ketch yuh.''

"Don't let ole Raw-Head-and-Bloody-Bones waylay yuh neither.''

John was at the tree long before Lucy. He was sitting on the knurly-roots tying his handkerchief into a frogknot when he saw her coming diffidently down the hill on the Potts side of the branch. Presently she was standing before him.

" 'Lo, Lucy.''

"Hello, John. Ah see you fixin' tuh make soap.''

"Whut make you say dat, Lucy?''

"Ah see yuh got yo' bones piled up.''

She pointed to his crossed legs and they both laughed immoderately.

"Miss Lucy, uh Lucy, whyn't yuh have some set down?''

"Unrack yo' bones den and make room.''

74

Lucy sat down. John untied his handkerchief and Lucy plaited rope-grass. John attempted another knot but fumbled it nervously. Lucy caught hold of the handkerchief also.

"Lemme he'p yuh wid dat, John. Ah know how tuh tie dat. Heah, you take dem two corners and roll 'em whilst Ah git dese fixed."

They both held the handkerchief taut between them. But before the knot could be tied John pulled hard and made Lucy lean towards him.

"Lucy, something been goin' on inside uh me fuh uh long time."

Diffidently, "Whut, John?"

"Ah don't know, Lucy, but it boils up lak syrup in de summer time."

"Maybe you needs some sassafras root tuh thin yo' blood out."

"Naw, Lucy, Ah don't need no sassafras tea. You know whuss de matter wid me—but ack lak you dumb tuh de fack."

Lucy suddenly lost her fluency of speech. She worked furiously at the love-knot.

"Lucy, you pay much 'tention tuh birds?"

"Unhunh. De jay bird say 'Laz'ness will kill you,' and he go to hell ev'ry Friday and totes uh grain uh sand in his mouf tuh put out de fire, and den de doves say, 'Where you *been* so long?' "

John cut her short. "Ah don't mean dat way, Lucy. Whut Ah wants tuh know is, which would you ruther be, if you had yo' ruthers—uh lark uh flyin', uh uh dove uh settin'?"

"Ah don't know whut you talkin' 'bout, John. It mus' be uh new riddle."

"Naw 'tain't, Lucy. Po' me, Lucy. Ahm uh one wingded bird. Don't leave me lak dat, Lucy."

Suddenly Lucy shouted, "Look, John, de knot is tied right, ain't it pretty?"

"Yeah, Lucy iss sho pretty. We done took and tied dis knot, Miss Lucy, less tie uh 'nother one."

"You got mo' han'kerchiefs in yo' pocket?"

"Naw. Ah ain't studyin' 'bout no hankechers neither. De knot Ah wants tuh tie wid you is de kind dat won't come uh loose 'til us rises in judgment. You knows mah feelings."

"How Ah know whut you got inside yo' mind?"

"Yeah yuh do too. Y'all lady people sho do make it hard fuh us men folks. Look me in de eye Lucy. Kiss me and loose me so Ah kin talk."

There was an awkward bumping of mouths. Lucy had had her first kiss.

"Lucy, Ah looked up intuh Heben and Ah seen you among de angels right 'round de throne, and when Ah seen *you,* mah heart swole up and put wings on mah shoulders, and Ah 'gin tuh fly 'round too, but Ah never would uh knowed yo' name if ole Gab'ull hadn't uh whispered it tuh me."

He extended his hands appealingly.

"Miss Lucy, how 'bout changin' frum Potts tuh Pearson?"

"Yeah, John."

"When?"

"Whenever you ready fuh me. You know mo' 'bout dat dan Ah do."

"How 'bout on yo' birthday, Lucy? Us kin make merry fuh uh heap uh things den at de same time."

"Aw right, John."

It was coldish on the December night, as Lucy made ready to meet John at the church. She had only finished her wedding-dress the day before, and only her father had seemed to care whether she had one or not. Now the puffed and laced little dress of light gray cashmere lay across the bed with her new shoes and six starchy petticoats loaded down with lace of her own making.

"Lucy Ann!" Emmeline bawled from the kitchen.

"Whut, mama?"

"Don't you answer *me* no 'whut'! Ah'll come in dere and stomp yo' guts out. Whut you got all dis fiah goin' fuh?"

"Mama, you know Ah got tuh bath mah self 'fo' Ah put on dese clothes."

"Ah keers nothin' 'bout no bathin'. 'Nother thing, you

done kilt up fo' uh mah fryin'-size chickens, madam, and got 'em all cooked."

"No'm, Ah ain't kilt none uh yo' chickens. Dem wuz mah own Ah kilt fuh mah weddin'."

"How come dey yourn? You stinkin' li'l' heifer you!"

" 'Cause dem is some uh Lay-over's biddies dat Ah raised. Papa gimme dat hen las' year, and tole me tuh start raisin' mahself some chickens, so's Ah have uh good start when Ah git married, and you know Ah got twenty odd from her now."

"Youse uh lie, madam. Eve'y chicken on dis place is mines. Ah woulda give yuh uh few fuh seed if you wuz marryin' anybody. Here Artie Mimms is wid sixty acres under plow and two mules and done ast me fuh yuh ever since yuh wuz ten years old and Ah done tole 'im he could have yuh and here you is jumpin' up, goin' over mah head, and marryin' uh nigger dat ain't hardly got changin' clothes."

"He is got changin' clothes."

"Hush up! Maybe he got clothes, but he ain't got uh chamber pot tuh his name nor uh bed tuh push it under. Still he kin take you outa uh good home and drag yuh off tuh Pearson's quarters."

"Mama, yuh been hell-hackin' me eve' since us tole yuh us wuz gointer git married. Whut Ah keer 'bout ole Artie Mimms?"

"He ain't ole!"

"He is so ole, too. Ah looked at 'im good last big meetin'. His knees is sprung and his head is blossomin' fuh de grave. Ah don't want no ole springy-leg husband."

"You better want one dat kin feed yuh! Artie got dat farm and dem mules is paid fuh. He showed me and yo' paw de papers las' week."

"Whut Ah keer how many mules he got paid fuh? Ah ain't speckin' tuh live wid no mules. You tryin' tuh kill me wid talk. Don't keer whut yuh say, Ahm gointer marry John dis night, God bein' mah helper."

Lucy had been fixing her bath all during the talk. She now closed the room door, flung off her clothes with a savage

77

gesture and stepped into the tub.

Instantly Emmeline's angry hand pushed against the latched door. "Whose face you slammin' uh door in, madam? Ah means tuh bring you down offa yo' high horse! Whar dem peach hick'ries? Somebody done done 'way wid mah switches. Aaron! You go cut me five uh six good peach switches and don't bring me nothin' dat ain't long ez mah arm. Dis gal done provoked me. Ah been tryin' tuh keep offa her back 'til dat trashy yaller bastard git her outa dis house, but she won't lemme do it. Go git dem hick'ries so Ah kin roast 'em in dis fiah. Ah birthed her, she didn't birth me, and Ah'll show her she can't run de hawg over me."

"Yessum, mama, Ahm gwine."

"Make haste, Aaron. Go in uh speedy hurry!"

Lucy spoke from the wash-tub, "Mama, 'tain't no use in you sendin' Aaron out tuh be cuttin' and ruinin' papa's peach trees, 'cause Ahm tellin' anybody, ole uh young, grizzly or gray, Ah ain't takin' no whippin' tuhnight. All mah switches done growed tuh trees."

"Whuss dat you say in dere, madam?"

Richard drove 'round to the front and hitched the horse and buggy at that moment.

"Whut's all dis racket gwine on in heah?" he demanded.

"Dat youngest gal uh your'n done sassed me out, and dared me tuh hit uh. Ah birthed uh but now she's older'n me. She kin marry dat yaller wretch, but Ah means fuh her tuh tote uh sore back when he gits uh."

"Aw dry up, Emmeline, dry up! She done done her pickin', now leave her be. If she make her bed hard, she de one got tuh lay on it. 'Tain't you. Git yo' clothes on fuh de weddin'. Us Potts can't leave our baby gal go off tuh git married by herself."

"Me! Ah ain't gointer put mah foot in de place. Ahm gointer let folks see whar Ah stand. Ah sho ain't gwine squench mah feelin's fuh Lucy and dat John and you and nobody else—do Ah'll purge when Ah die."

Richard tucked Lucy into the buckboard and drove the

silent little bundle to the church huddled against him. His arm about her gave his blessing but he knew that she would have gone anyway. He but made the way easier for her little feet.

To Lucy, Macedony, so used to sound and fervor, seemed cold and vacant. Her family, her world that had been like a shell about her all her life was torn away and she felt cold and naked. The aisle seemed long, long! But it was like climbing up the stairs to glory. Her trembling fear she left on the climb. When she rode off beside John at last she said, "John Buddy, look lak de moon is givin' sunshine."

He toted her inside the house and held her in his arms infant-wise for a long time. "Lucy, don't you worry 'bout yo' folks, hear? Ahm gointer be uh father and uh mother tuh you. You jes' look tuh me, girl chile. Jes' you put yo' 'pendence in me. Ah means tuh prop you up on eve'y leanin' side."

CHAPTER 10

A month after he was married John had moved up into the house-servants' quarters just back of the big house. John had achieved a raise in his wages. Alf Pearson had given them among other things a walnut bed with twisted posts, as a wedding present, and Lucy loved it above all else. She made it a spread and bolster of homemade lace.

After a few months Mehaley began to waylay John at the pig pens and in devious ways to offer herself. John gradually relaxed and began to laugh with her. She grew bolder. The morning after Lucy's first son was born, when he found her at the chicken house before him, he said, "Mehaley, Ah ain't gonna say Ah ain't laked you 'cause youse soft and nice, but Ah got Lucy, and Ah don't keer how she feel uh nothin', Ah'll want her right on. Ah tastes her wid mah soul, but if Ah didn't take holt uh you Ah'd might soon fuhgit all 'bout yuh. Pomp love you—you go marry Pomp. He'll do fuh yuh lak uh man. You better take and marry 'im."

"Ah don't want no Pomp! John Buddy, you know'd me 'fo' yuh knowed Lucy. If y'all wuz ever tuh quit would yuh marry me, John Buddy?"

"Us ain't never gonna do no quittin' 'til one uh us is six feet in de ground, and if you git de notion tuh run tell her a whole mess tuh back her feelin's and tear up peace, you better take

wings and fly 'fo' Ah find it out. You hear me? Nothin' ain't gointer part us."

So when Pomp Lamar, the new hoe hand, fell beneath Mehaley's mango call—exotic, but fibrous and well-bodied—she answered "Yes" quickly with a persuasive kiss.

"But Ahm got tuh be married real, Pomp."

"And dat's whut Ah means tuh do, M'haley, come nex' pay-day."

"And less we g'wan off dis farm, Pomp. You know is too much back-bendin' and mule-smellin' on cotton plantations. Less go on some public works, lak uh sawmill uh sumpin'. Ah kin git 'long wid anybody any whar so long ez you half-way treat me right."

"M'haley, you might not know it, but youse gittin' uh do-right man. Whenever you needs somebody tuh do uh man's part Ah'll be 'round dere walkin' heavy over de floor."

Next pay-day the quarters was gathered at Mehaley's mother's cabin. Quantities of sweet biscuits had been cooked up along with the chickens. The wedding was set for eight o'clock and the crowd was there—all except Pomp. People began to ask questions that had no answers. Mehaley didn't get dressed. She was asked why she was still in her working clothes.

"Humph! Y'all think Ahm gwine put mah trunk on mah back and de tray on mah head, and dat man don't never come? Naw indeed! Ah ain't gwine tuh dress tuh marry no man 'til unless he be's in de house."

"You reckon he done run off?" Nunkie asked.

"Aw naw," Duke dissented. "He tole me he wuz crazy tuh marry Haley. He jus' keepin' colored folks time. When white folks say eight o'clock dey mean eight o'clock. When uh colored person say eight o'clock, dat jes' mean uh hour ago. He'll be heah in plenty time."

It was after nine when the bridegroom arrived. "Where you been at all dis time?" Mehaley's mother wanted to know.

"Ah couldn't stand on de flo' wid M'haley in dem ole

sweaty britches. Ah been off tuh borry me some clothes tuh git married in."

Mehaley began to dress with the interference of ten or more ladies. Finally she was ready, but a quarrel arose as to who was to perform the ceremony. Mehaley's father wanted to do it, but her mother had invited the pastor.

"Ah don't keer if you *is* her pappy," the mother stated, "you ain't nothin' but uh stump-knocker and Ah wants dis done real. Youse standin' in uh sho 'nuff preacher's light. G'wan set down and leave Elder Wheeler hitch 'em right. You can't read, no-how."

"Yes, Ah kin too."

"Naw, you can't neither. G'wan sit down. If us wuz down in de swamp whar us couldn't git tuh no preacher, you'd do, but here de pastor is. You ain't nothin' but uh jack-leg. Go set in de chimbley corner and be quiet."

"You always tryin' tuh make light uh mah preachin'," the husband defended, "but Gawd don't. Dis de fust one uh mah chillun tuh jump over de broomstick and Ah means tuh tie de knot mah own self."

Around eleven o'clock, the pastor, worn out by the stubbornness of the father, retired from the field, and the couple stood upon the floor.

"Whar yo' shoes, Pomp?" Mehaley asked. "You ain't gwine marry me barefooted, is yuh?"

"Dey over dere under de bed. Yo' paw and the preacher argued so long and dem new shoes hurted mah foots so bad, Ah took 'em off. Now Ah can't git 'em back on. Dat don't make uh bit uh diff'rence. You goin' tuh see mah bare foots uh whole heap after dis."

So Mehaley Grant stood up to marry Pomp Lamar and her father Woody Grant, who had committed the marriage ceremony to memory anyway, grabbed an almanac off the wall and held it open pompously before him as he recited the questions to give the lie to the several contentions that he could not read.

"Ah now puhnounce you man and wife."

"Bus' her, Pomp, bus' her rat in de mouf. She's yourn now, g'wan Pomp. Les see yuh kiss her!"

After many boisterous kisses, the women took Mehaley by the arm and led her off.

"Us goin' and bath M'haley fuh huh weddin'-night. Some uh y'all men folks grab Pomp, and give him uh washin' off."

Mehaley got out of bed that night after the guests had all gone home.

"Whar yuh gwine, Haley?"

"Huntin' fuh mah box uh snuff."

"Yo' box uh snuff? Gal, don't you know you jes' got done married tuh uh husband? Put out dat light and come git back under dese kivvers."

"Naw, Pomp, not 'til Ah gits uh dip uh snuff. Ah wants it real bad."

She hunted about until she found it. "Lawd," she cried, "you see some dem women done messed 'round and spilt soap suds in mah snuff!"

She sat down before the fireplace and wept, hard racking sobs. Pomp's assurance that she would have a dozen boxes from the Commissary first thing in the morning did not comfort her, and it was only when her stormy tears had exhausted her that she let her new husband lead her back to bed. In his arms, she said, "Pomp, don't fuhgit you said you wuz gwine take me 'way fuhm heah."

"Cose Ah is, Haley. Nex' pay-day, sho." He kept his word.

At sundown on the evening of their leaving, Lucy was on her knees at the praying ground, telling God all her feelings.

"And oh, Ah know youse uh prayer-hearin' God. Ah know you kin hit uh straight lick wid uh crooked stick. You heard me when Ah laid at hell's dark door and cried three long days and nights. You moved de stumblin' stone out my way, and now, Lawd, you know Ahm uh po' child, and uh long ways from home. You promised tuh be uh rock in uh weary land—uh shelter in de time uh storm. Amen."

Lucy and John raced around their house in the later after-

noons playing "Hail Over" and "Hide the Switch," and Lucy grew taller. The time came when she could no longer stand under John's outstretched arm. By the time her third son was born she weighed ninety-five pounds.

John had added weight to his inches and weighed two hundred and fifteen pounds, stripped. There was no doubt about it now. John was foreman at Pearson's. His reading and writing had improved to the degree where Alf could trust him with all the handling of supplies.

"John," Alf said to him one day, "you damn rascal! that girl you married is as smart as a whip and as pretty as a speckled pup. She's making a man of you. Don't let her git away."

"Oh good Lawd, naw! Mist' Alf, she even nice. Don't talk 'bout her never partin' from me. Dat sho would put de affliction on me."

"Well, John, you'd better keep Big 'Oman out of that Commissary after dark. Aha! You didn't think I knew, did you? Well, I know a lot of things that would surprise folks. You better clean yourself up."

The hand of John's heart reached out and clutched on fear. Alf Pearson shoved him on out of his office and returned to work, chuckling. Two days later Big 'Oman was gone. It got said that she was shacked up with somebody in a tie-camp on the Alabama River.

A month later John said, "Lucy, somebody done wrote Mist' Alf 'bout uh drove uh cows dey wants tuh sell 'im. He say fuh me tuh go look over 'em and see whut dey worth. Be back Sad'day."

"Iss been rainin' uh lot fuh you tuh be goin' uh long way, John."

"Goin' on horse-back, Lucy. De water ain't goin' bother me."

Lucy said no more. John didn't notice her silence in the haste of his departure, but a few miles on down the road he said, "Humph! Lucy ain't frailed me none wid uh tongue. Wonder how come dat?"

On Thursday John was cheerfully riding away from Lucy,

but at daybreak on Saturday he was dressed and ready to ride back.

"John, you ain't gwine leave me, is yuh?" Big 'Oman sobbed, "thought you come to stay. De big boss say you kin git uh job right heah."

"Ah got uh job, Big 'Oman. Done been off too long now."

The weeping girl clung to his stirrup. "When you comin' back tuh me, John?"

"In times and seasons, Big 'Oman. Lemme go now. All at rain yistiddy and las' night makes bad travelin'. Bad 'nough when Ah wuz comin'. De later it gits, de higher de river."

He dashed off quickly and rode hard, counting the miles as he went.

"Eighteen miles from home. 'Leben mo' miles. Heah 'tis de river—eight mo' miles."

The river was full of water and red as judgment with chewed-up clay land. The horse snorted and went mincing down to the bridge. Red water toting logs and talking about trouble, wresting with timber, pig-pens, and chicken coops as the wind hauls feathers, gouging out banks with timber and beating up bridges with logs.

"Git up, Roxy! Us got tuh cross dis river, don't keer if she run high ez uh bell-tower, us got tuh cross. Come on up dere. Let de damn bridge shake, bofe us kin swim."

Midway over, a huge log struck the far end of the bridge and tore it loose from the shore and it headed down stream. The whole structure loosened, rolled over and shot away.

John freed himself and struck out for shore. Fifty feet or more down stream Roxy landed, snorting her loss of faith in the judgment of man. John felt himself being carried with the stream in spite of his powerful stroke, but inch by inch he was surely gaining land. The neighing of Roxy had attracted the attention of a white squatter on the farther shore and John saw people looking on his fight with the Alabama.

There was a cry from the shore, a thud at the back of his head and he sank.

86

* * *

John strode across infinity where God sat upon his throne and looked off towards immensity and burning worlds dropped from his teeth. The sky beneath John's tread crackled and flashed eternal lightning and thunder rolled without ceasing in his wake.

Way off he heard crying, weeping, weeping and wailing—wailing like the last cry of Hope when she fled the earth. Where was the voice? He strained his eye to see. None walked across the rim bones of nothingness with him, but the wailing wailed on. Slowly John saw Lucy's face. Lucy wept at a far, far distance, but the breath of her weeping sent a cold wind across the world. Then her voice came close and her face hung miserably above his, weeping. She brought the world with her face and John could see without moving his head the familiar walls of their house.

Gradually things came closer. The gourd dipper, the water-bucket, the skillets and spiders, and his wife so close above him, forearm across her face, retching in tears.

"Whuss de matter, Lucy? You thought Ah wuzn't never comin' back? Don't you know nothin' couldn't keep me 'way from you?"

"John! Ah thought you wuz dead."

"Naw, Ah ain't dead. Whatever give you de idea Ah wuz dead, Lucy?"

"Dey brought yuh home fuh dead dis mawnin' and iss nelly sundown now and you ain't moved, and you ain't spoke 'til jus' now."

"Who brung me home?"

"De Bickerstaffs. Say de bridge washed uhway wid yuh and de hawse on it, and you got hit by de timber. Yo' lip is cut deep and yo' head is hurted in de back and uh bad place right dere side yo' nose."

"Umph, umph, umph! Lawd have mussy. Ah thought Ah been sleep. So dat's how come Ahm all wet up and mah face hurt me so, eh?"

87

"Yeah, and John, Ahm so glad you ain't dead 'way from me and mah li'l' chillun, and then agin Ah hated tuh think 'bout you herded tuh judgment in yo' sins."

A silent wait.

"You can't lay on dis floor all night. Ah got tuh git yuh in de bed some way uh 'nother. Lemme go call somebody tuh he'p me muscle yuh. Ah sent fuh mah folks but 'tain't been nobody from dat side yet."

The next day John called Lucy to him.

"Lucy."

"Yeah, John."

"Dey done tole you 'bout Big 'Oman and me?"

"Yeah, John, and some uh yo' moves Ah seen mahself, and if you loves her de bes', John, you gimme our chillun and you go on where yo' love lie."

"Lucy, don't tell me nothin' 'bout leavin' you, 'cause if you do dat, you'll make two winters come in one year."

There was a feeling silence.

"Lucy, Ah loves you and you alone. Ah swear Ah do. If Ah don't love you, God's gone tuh Dothan."

"Whut make yuh fool wid scrubs lak Big 'Oman and de rest of 'em?"

"Dat's de brute-beast in me, but Ah sho aim tuh live clean from dis on if you 'low me one mo' chance. Don't tongue-lash me—jes' try me and see. Here you done had three younguns fuh me and fixin' have uh 'nother. Try me Lucy."

The next big meeting John prayed in church, and when he came to his final:

You are de same God, Ah
Dat heard de sinner man cry.
Same God dat sent de zigzag lightning tuh
Join de mutterin' thunder.
Same God dat holds de elements
In uh unbroken chain of controllment.
Same God dat hung on Cavalry and died,
Dat we might have a right tuh de tree of life—

We thank Thee that our sleeping couch
Was not our cooling board,
Our cover was not our winding sheet . . .
Please tuh give us uh restin' place
Where we can praise Thy name forever,

Amen.

"Uh prayer went up tuhday," Deacon Moss exulted to Deacon Turl. "Dat boy got plenty fire in 'im and he got uh good strainin' voice. Les' make 'im pray uh lot."

Deacon Turl agreed and went on home to his chicken dumplings.

John never made a balk at a prayer. Some new figure, some new praise-giving name for God, every time he knelt in church. He rolled his African drum up to the altar, and called his Congo Gods by Christian names. One night at the altar-call he cried out his barbaric poetry to his "Wonder-workin" God so effectively that three converts came thru religion under the sound of his voice.

"He done more'n de pastor," Moss observed. "Dat boy is called tuh preach and don't know it. Ahm gwine tell him so."

But Moss never did. Lucy's time was drawing nigh and a woman named Delphine drifted into town from Opelika. John was away from both home and church almost continually in the next month.

Alf went to see Lucy.

"Lucy Ann, where's that husband of yours?"

"He's out 'round de barn somewheres, ain't he, Mist' Alf?" Lucy asked. She knew he was not there. She knew that Alf Pearson knew he was not there and that Alf Pearson knew that she knew he was not there, but he respected her reticence.

"Lucy, you oughta take a green club and flail John good. No matter what I put in his way to help him along, he flings it away on some slut. You take a plow-line and half kill him."

When Alf was gone Lucy looked drearily up the path for her husband and saw her oldest brother coming with his double team.

89

"Lawd a mussy!" she groaned and dropped into a chair. A heavy knocking at the door.

"Who dat?"

"Iss me, Bud. Lemme come in right now. Ahm in uh big hurry."

Lucy opened the door feebly and Bud's stumpy figure thrust itself inside aggressively as if it said in gestures, "Who you tryin' tuh keep out?"

"Lucy, Ah come tuh git dat three dollars you borried offa me."

"Well, Bud, tuh tell yuh de truth, Ah ain't got it right dis minute. Mah husband ain't here, but he'll be here pretty soon, then he'll pay yuh sho, Bud."

"Who don't know he ain't here? How he gointer be here, and layin' all 'round de jook behind de cotton gin wid Delphine?"

"You better come back, Bud, when he's here and tell 'im all dat tuh his face."

"And whut it takes tuh tell 'im, Ah got it! He ain't nothin' but uh stinkin' coward or he wouldn't always be dodgin' back uh yuh. Ah'll tell 'im all right. 'Tain't no fight in him."

"G'wan home, Bud. If papa wuzn't dead you wouldn't come heah lak dis—and me in mah condition."

"Ah know you done wished many's de time you had married Artie Mimms."

"Naw. Not nary time."

"Gimme mah money and lemme go 'fo' Ah git mad agin."

"Ah tole you Ah ain't got no money and won't have none till John come."

"You ain't gonna git none den—dat is if he ever come. Some folks say he done quit you fuh dat Delphine. She strowin' it herself all over Macon County and laffin' at yuh. You jes' dumb tuh de fact."

"You can't pay no 'tention tuh talk. Dey's talkin' everywhere. De folks is talkin' in Georgy and dey's talkin' in Italy. Ah don't pay dese talkers no mind."

"Gimme de money, Lucy, and lemme go."

90

"Done tole yuh Ah ain't got no money. Come back heah when John is home."

"Naw, Ah ain't gonna do nothin' lak dat. Ah come heah wid de determination tuh git mah money uh satisfaction, one."

"But, don't you see Ah ain't in no fix tuh be fretted all up this uh way? G'wan leave me uh lone."

Bud looked around him contemptuously. "Humph! Here mah sister is cooped up wid three li'l' chillun in uh place ain't big uhnough tuh cuss uh cat in 'thout gittin yo' mouf full uh hair."

"G'wan way from me, Bud. Ahm too sick tuh be worried."

"Naw, Ah means tuh have something fuh mah money. Gimme dat bed."

"Dat big one wid de knobs on it?"

"Yep. Who you reckon want de tother one dat dem chillun done wet in? Move! Don't you git in mah way. Move! If you wuz married tuh anybody you wouldn't be in no sich uh fix."

The bed was down in a twinkling, the feather mattress and bolster heaped upon the floor, while Bud dragged out the head and foot pieces. Lucy sank down upon the mattress and fought the lump in her throat. When her brother returned for the rails and slats, Lucy was crumpled in a little dark ball in the center of the deep mound of feathers.

"Bud, you ought'n tuh take dat bed. Mist' Alf give it tuh us. Dat's our weddin' bed."

"He oughta give 'im mo'. Git up offa dat air mattress!"

"Ah ain't, and if you don't git offa dis place Ah'll call Mist' Alf. Ah bet you'll leave here then."

"Aw Ah ain't skeered uh no white man. Ah been free ever since Grant took Richmond."

But in a few moments Bud was gone and Lucy was shivering and weeping upon the feather mattress.

"Hezekiah," she called to her oldest boy, "run down tuh de quarters lak uh li'l' man and tell An' Pheemy tuh come quick. Run on, son. Youse five years ole now, youse uh great big boy. Hurry up."

"Mama, Ahm hungry."

"Mama know it too. Run on now. Run fast, Hezekiah! Show mama how fas' you kin run. Oh Gawd have mussy on me! Have mussy in uh mos' puhticular manner. Have mussy on mah ever-dyin' soul!''

Before midnight Lucy in awful agony upon her pallet on the floor had given birth to her first daughter.

The odor of airless childbirth hung over the stuffy room. Pheemy with the help of Old Edy and Della performed the ancient rites.

Edy and Della sweetened the mother and put a clean meal-sack sheet beneath Lucy, but only Pheemy could handle the after-birth in the proper way, so that no harm could come to Lucy. That is she buried it shoulder deep to the east of the house beneath a tree, then she returned and attended to the navel string of the baby and adjusted the belly-band.

"Della, you and Edy kin go 'long now. Ah kin see after Lucy.''

They went reluctantly. As soon as the sound of their feet died away Pheemy asked, "How you feelin' inside, honey?''

"Lawd, An' Pheemy, Ah got somethin' in mah heart ain't got no name. Ah layin' here right now tryin' tuh find some words for feelin's. Look lak mah right heart ain't beatin' no mo'.''

"Neb mine, Lucy, 'bout de words. You needs sleep and rest and some chicken gruel. Ah gwine bring yuh some. Ahm gwine find some sheep pills so de baby kin have some sheep shadney.''

That night Pheemy fell asleep in a chair before the fire. The children full of corn pone and buttermilk had been asleep since early night. Lucy alone saw John when he crept in towards morning. She shut her eyes and pretended sleep. John stood looking down upon her for a long time. Lucy, later, thru the crack of her eye saw him examining the new-born baby, and felt him timidly tucking the covers under her feet, and heard him stretching himself on the floor beside the mattress; heard the deep breathing of his sleep. She raised herself upon her elbows and looked at him hard. She looked at the flicker-

92

ing fire, the rude dingy walls and everything in the room and knew that she'd never lose the picture as long as she lived. She stretched out her hand nearest her husband and rested the fingers on his tousled head. With her other arm she cuddled her baby close, and fell into a deep, healthful sleep.

When Lucy woke up, old Hannah was riding high. The light was strong in her face. She looked about and asked Pheemy, "Where John?"

"He at de barn—done chopped up uh tree for wood. Oughter be 'bout through wid his work by now. You better suckle dat chile."

John crept in and stood before Lucy while her fat daughter searched hungrily for the nipple.

"Lucy, whut you doin' sleepin' on de floor?"

"Dat's all Ah got tuh sleep on, John Buddy."

"Where de weddin' bed at?"

"Bud come took it fuh dat li'l' change us owe 'im fuhm las' year."

"When he come got it?"

"Yistiddy."

He hung his head a moment.

"Lucy, kin Ah see de baby?"

"She nussin' now, John. Soon's she git through."

"Dat ain't no trouble." He stooped and picked up mother and child and sat with them in his lap. "Lucy, Ahm sho proud uh dis li'l' girl chile you done had. Dat's jus' whut Ah wanted—uh girl so us could have it fuh uh doll-baby. An' Pheemy, don't Lucy have de biggest babies? Dis chile it almost big as her. She so little Ah hafta shake de sheets tuh find her in de bed."

She slapped him feebly.

"Ain't you got no better sense dan tuh set in uh man's lap and box his jaws? He's liable tuh let yuh fall thru his legs." He stopped laughing abruptly. "An' Pheemy you fed mah wife and slopped mah three li'l' pigs?"

"Look in de meal-barrel and see."

John didn't look. Pheemy's words told him. He laid Lucy

93

again upon the pallet and left. As he stepped thru the wire fence gap at Bud's place he saw Bud riding up the path behind him on his mule, his huge bull whip coiled upon his saddle-horn.

"Gid up dere, Sooky!" Bud Potts held his eyes stubbornly before him. John Pearson's hand flung out, grasped the mule's bridle close to the bit, and shoved the animal back upon its haunches.

"Gid down, Bud. You might kin beat me, but if you do, eve'ybody goin tuh know you been in uh fight. So good uh man, so good uh man."

"Whut you mean, John, comin' here pickin' uh fuss lak dat?"

"Ah ain't come tuh pick no fuss, Ahm come tuh fight. God bein' mah helper Ah means tuh teach yuh how tuh go proagin' 'round takin' folkses weddin' beds when dey ain't home and flinging dey wives on de floor. Gid down!"

"If you wuz any kind uh man, all dis wouldn't come tuh pass. De white folks and eve'ybody is sick and tiahed uh de way you keerin' on. Nohow you can't beat *me*. Ahm uh *man*."

"Maybe Ah can't, but Ahm so goin' tuh give it uh common trial. Hit de ground! If Ah don't beat yuh, you kin go and tell de word Ah give it uh po' man's trial."

Bud tried to ride off, but he was snatched scuffling to the ground and hammered to his knees time and time again. When he swore no more, when he begged for mercy no more, John picked him up and heaved him across the rump of the mule and recrossed the branch.

Almost home he remembered the empty meal-barrel and swerved off into the Weens' wood lot where droves of piney wood rooters nosed for ground nuts. John laid a shoat by the heels and stuck it expertly before it had squealed more than three or four times. Looking all about to see if he was seen, he swung the hog over his shoulder and took the back way home.

By that time the sun was washing herself in the bloody sea and splashing her bedclothes in red and purple. John built a

fire under the washpot, and dressed his meat before he came inside the house. When Lucy opened her eyes from a nap, crude slabs of pork steak were sizzling in the skillets.

"Where you git all dat fresh meat from, John?"

"Neb' mind where Ah got de meat from. You jes' eat 'til you git plenty. Ah'll get out and throw uh natural fuh you any time. You got uh *man* tuh fend fuh yuh."

"Lawd knows Ah do needs one. Me and mah po' li'l' chillun been singin' mighty low 'round here."

"Now, Lucy, don't start dat talk 'bout breakin' up and quittin' 'cause Ah ain't goin' tuh hear dat. Youse mah wife and all Ah want you tuh do is gimme uh chance tuh show mah spunk."

"Good Lawd, John, dat's all justice been beggin' righteous tuh do—be uh *man.* Cover de ground you stand on. Jump at de sun and eben if yuh miss it, yuh can't help grabbin' holt uh de moon."

"Li'l' Bit, please don't tongue lash me," there was a short pause, " 'cause Ah done beat Bud nelly tuh death, and dat's plenty tuh think uhbout—by rights Ah oughta kilt 'im." He rubbed his swollen knuckles.

"Oh mah Gawd! When?"

"Dis evenin'—jus' 'fo' Ah come home, Lucy. Ah wouldn't be no man atall tuh let yo' brother uh nobody else snatch uh bed out from under you, mo' special in yo' condition."

"John dat's goin' tuh cause trouble and double, Bud hate you and now you done hit 'im he ain't goin' tuh let his shirt-tail touch 'im till he tell it tuh de white folks. Lawd, me and mah po' chilluns. If dey ever git yuh on dat chain-gang Ah never speck tuh see you live no mo'."

"Ah ain't goin' tuh no chain-gang. If dey ever git in behind me, Ah'll tip on 'cross de good Lawd's green. Ah'll give mah case tuh Miss Bush and let Mother Green stand mah bond."

"Dey liable tuh grab yuh, 'fo' yuh know it."

"Aw les' squat dat rabbit and jump uh 'nother one. You ack lak you done cut loose."

"Naw, Ah ain't cut loose but look lak wese tied tuhgether

by uh long cord string and youse at one end and Ahm at de other. Way off."

"You kin take in some de slack."

"Don't look lak it."

"Aw, lemme see de caboose uh dat. Less eat dis hog meat and hoe-cake. Jes' 'cause women folks ain't got no big muscled arm and fistes lak jugs, folks claims they's weak vessels, but dass uh lie. Dat piece uh red flannel she got hung 'tween her jaws is equal tuh all de fistes God ever made and man ever seen. Jes' take and ruin a man wid dey tongue, and den dey kin hold it still and bruise 'im up jes' ez bad."

"Say whut yuh will or may, you tryin' tuh loud talk me, but, John, you gives mah folks too much tuh go on. Ah wants mah husband tuh be uh great big man and look over 'em all so's Ah kin make 'em eat up dey talk. Ah wants tuh uphold yuh in eve'ything, but yuh know John, nobody can't fight war wid uh brick."

CHAPTER 11

Duke came panting up to Lucy's late the next afternoon. Lucy was propped up in a rocker and Pheemy was washing baby rags.

"Hates tuh tell yuh, Lucy, but dey done got 'im."

"Do, Jesus."

"Yassum, de high sheriff put his hand on his shoulder down dere by de deepo' 'bout uh hour uh go. Bud Potts swo' out de warrant, and den Weens say he goin' have 'im bound over tuh de big cote. Sho is bad, and you in yo' condition."

"Where dey got 'im, Duke?"

"In de big jail. Cy Perkins, Jestice uh de Peace, goin' tuh bind 'im over. Den Judge Pearson'll set on de case nex' cote day."

Lucy rose abruptly, "Ahm goin', Pheemy. You take keer mah chillun."

"Lucy, yo' body ain't healed up yit. You can't go."

"Ah specks tuh be back 'fo' dark, An' Pheemy."

"Gal, you ain't but three days out uh labor. De elements is pizen tuh yuh, and effen yuh git lated 'til after sundown, de pizen night air sho will be de last uh you."

Lucy flung the plaid shawl about her head and shoulders. "And, An' Pheemy, if de baby cries tuh nuss 'fo' Ah git back, jus' give her uh sugar-tit tuh suck on and keep her pacified."

Lucy stepped out of the cabin door and was gone. In due time she stood in Cy Perkins' office where he was holding court. She saw her brother's bruised and beaten face. She saw her husband handcuffed and humble, his eyes turned away from the world.

The court had not set. She still had time if she worked fast. She held her shawl under the chin with the frail fingers of one hand as she went and stood before her brother.

"Don't come puttin' up no po' mouf tuh me, Lucy. Git out mah face," Bud shouted before she could speak. "Dis case ain't uh goin' tuh be nol prossed uh nothin' else. Ah wouldn't squash it fuh mah mammy. You made yo' bed now lay in it."

She turned away. Cy Perkins called her.

"Howdy, Lucy."

"Well, Ah thankee, Mist' Perkins. Ah come tuh see 'bout mah husband."

"Got any bail money, Lucy? That's what you need."

"Naw suh. Ah come wid jus' whut Ah stand in, 'cause Ah ain't got nothin' else, but Ah come."

Cy Perkins looked hard at the forlorn little figure. Lucy stood before him with her large bright eyes staring and not knowing she stared. Suddenly she sat down because she couldn't stand any more.

"Look like you're sick, Lucy."

"Mah troubles is inward. Mist' Perkins."

"Her new baby ain't but three days old," Duke volunteered.

Perkins fumbled with his papers, never looking at Lucy the while. John remained with head hung down and face averted except for one begging glance at Lucy. Finally the Justice of the Peace arose and beckoned Lucy into his back office.

"Don't try to stand up, Lucy. Set down before you fall down. It's too bad that you are out at a time like this. Listen, Lucy, this is serious. Your family is well thought of 'round here and lots of folks think John needs a good whipping before he goes to the gang. If he's got any friends he better call on 'em now. Tell you the truth, Lucy, if it wasn't for you,

98

and me knowing your papa so well, I wouldn't have parted my lips, but your husband is in a mess of trouble."

"Thankee, Mist' Perkins. Ah got fo' li'l' chillun 'round mah feet; if dey send John off Ah don't know whut'll 'come uh us all."

"Have you been to Judge Alf yet?"

"Naw suh. Ah hates tuh go 'cause he done cautioned John good tuh behave hisself, but Ah reckon Ah better."

"Hurry across there to his office. I won't set court until you get back."

Lucy didn't come back. She all but collapsed on the steps of Pearson's office, and he sent her home in his buggy. Alf Pearson strode across to Perkins' office and asked that the prisoner be released in his charge and it was done. Weens was paid for his hog, but John was bound over to the big court for the assault upon his brother-in-law. There was a great deal of loud whispering about night-riders and the dark of midnight, but nobody touched John as he drove Judge Pearson home.

"John, I'm not going to ask you why you've done these things, partly because I already know, and partly because I don't believe you do."

"If Ah had uh knowed 'twuz gointer raise all dis rukus."

Alf laughed sardonically, "Of course you did not know. Because God has given to all men the gift of blindness. That is to say that He has cursed but few with vision. Ever hear tell of a happy prophet? This old world wouldn't roll on the way He started it if men could see. Ha! In fact I think God Himself was looking off when you went and got yourself born."

"Yes suh, Ah speck so."

They turned into the cedar-lined drive that led up to the big, columned veranda.

"John, distance is the only cure for certain diseases. Here's fifty dollars. There are lots of other towns in the world besides Notasulga, and there's several hours before midnight. I know a man who could put lots of distance between him and this place before time, even wearing his two best suits—one over the other. He wouldn't fool with baggage because it would

hold him back. He would get to a railroad twenty-five or thirty miles off."

John assisted Alf Pearson to alight.

"Good bye, John. I know how to read and write and I believe Lucy does too."

He strode up the steps of his veranda very straight and stiff, as if he had an extra backbone in his back.

In the early black dark John was gone. Lucy feverishly peeped thru first one crack then another, watching up the big road after him.

"Lucy, whyn't you stay in dat bed?" Pheemy grumbled. "You look lak youse jes' determined tuh be down sick and Ah already got mah hands full wid dese chilluns."

"An' Pheemy, Ahm standin' on de watch wall. Reckon de patter rollers'll ketch 'im?"

"Lawd naw. He pitched out towards Chehaw and dem folks is in Notasulga waitin' fuh midnight."

The hours went past on their rusty ankles and midnight stood looking both ways for day.

"Hush!" said Lucy, "dey's comin'!"

Pheemy listened hard but couldn't hear a thing.

"Dat's all right, An' Pheemy, Ah don't zakly hear nothin' neither, but uh far uhway whisper look lak it's puttin' on flesh."

They stood peering for a quarter of an hour or more at the narrow slit of the big road visible from the cabin. Then sure enough as silently as horsemen can, rode twenty or thirty men in the cloud-muddied moonlight. Slowly, watchfully, as they passed the big gate that led to the quarters and on past the stately cedar drive.

"How come dey ain't turned in?" Lucy asked, a tremble.

"Dey ain't gwine set foot on Judge Alf Pearson's place, if dey run on 'im outside dey'd grab 'im. Dey might go in some folks' quarters, but 'tain't never no patter roller set foot on dis place. Dey know big wood from brush."

Pheemy told the truth, but she was only embolden to speak

after the last rider had passed the big gate, and faded into the distance.

"Maybe dey already got 'im."

"Aw naw, gal, g'wan tuh rest. Dey jes' bluffin' tuh skeer us black folks."

The next day Chuck Portlock met Alf Pearson and tried to say casually, "Say, Judge dey tell me dat nigger run off. You got any notion which way he went?"

"Afraid not, Chuck. I've treed many a coon in my time, but I don't believe I've got a drop of bloodhound in me."

CHAPTER 12

John's destination was purely accidental. When he came
out upon the big road to Chehaw, he overtook another
Negro. They hailed each other gladly in the early dawn.

"Where you bound fuh?" John asked.

"Tuh ketch me uh high henry."

"Whuss dat?"

"Uh railroad train, man, where you been all yo' days you
don't know de name of uh train?"

"Oh, 'bout in spots and places. Where you bound fuh when
you git on de train?"

"Tuh Florida, man. Dat's de new country openin' up. Now
git me straight, Ah don't mean West Florida, Ah means de real
place. Good times, good money, and no mules and cotton."

"B'lieve Ah'll go 'long wid yuh."

"Man, dat calls fuh more'n talk. Dat calls fuh money."

"How much?"

"Twenty odd dollars. 'Cordin' tuh where at you goin'."

"Where you goin'?"

"Tuh uh town called Sanford. Got uh sister dere. She keep-
in' uh boardin' house," he looked John over, "she's uh fine
lookin', portly 'oman; you better come 'long."

"Um already married, thankee jes' de same. Man, Ah got
uh putty 'oman. Li'l' bitsa thing. Ahm sho tuh send fuh her

103

soon ez Ah git settled some place."

"Aw shucks man, you ain't lak me. Ah don't take no women no place. Ah lets every town furnish its own."

They bought their tickets and John sat in a railway coach for the first time in his life, though he hid this fact from his traveling mate. To him nothing in the world ever quite equalled that first ride on a train. The rhythmic stroke of the engine, the shiny-buttoned porter bawling out the stations, the even more begilded conductor, who looked more imposing even than Judge Pearson, and then the red plush splendor, the gaudy ceiling hung with glinting lamps, the long mournful howl of the whistle. John forgot the misery of his parting from Lucy in the aura of it all. That is, he only remembered his misery in short snatches, while the glory lay all over him for hours at the time. He marvelled that just anybody could come along and be allowed to get on such a glorified thing. It ought to be extra special. He got off the train at every stop so that he could stand off a piece and feast his eyes on the engine. The greatest accumulation of power that he had ever seen.

CHAPTER 13

As John and his mate stepped off the train at Sanford, they were met by a burly, red-faced white man who looked them over sharply—which gave them both the fidgets. Finally he asked, "Where y'all come from?"

"Up de road uh piece in Wes' Florduh," John's partner answered, much to his relief.

"Want work?"

"Ah kinda got uh job promised tuh me already," John's mate answered again.

"How 'bout you, Big Yaller?"

"Nawsuh, Ah ain't got no job. Ah would love tuh hear tell uh one."

"Come along then. Ever done any work on uh railroad?"

"Nawsuh, but Ah wants tuh try."

"Git yo duds then. We going over to Wildwood. Dollar a day. Seaboard puttin' thru uh spur."

That night John slept in the railroad camp and at sun-up he was swinging a nine-pound hammer and grunting over a lining bar.

The next day he wrote Lucy and sent her all of his ready money.

All day long it was strain, sweat and rhythm. When they were lining track the water-boy would call out, "Mr. Dugan!"

The straining men would bear down on the lining bars and grunt, "Hanh!"

"Hanh!"

"Got de number ten!"

"Hanh!"

"Got de pay-car!"

"Hanh!"

"On de rear end."

"Hanh!"

"Whyncher pick 'em up!"

"Hanh!"

"Set it over."

"Hanh!"

And the rail was in place. Sometimes they'd sing it in place, but with the same rhythm.

> When Ah get in Illinois
> Ahm gointer spread de news about de Floriduh boys
> Sho-ove it over
> Hey, hey, can't you live it?

Then a rhythmic shaking of the nine-hundred-pound rail by bearing down on the bars thrust under it in concert.

"Ahshack-uh-lack-uh-lack-uh-lack-uh-lack-uh-lack-uh-hanh!"

Rail in place.

"Hey, hey, can't you try?"

He liked spiking. He liked to swing the big snub-nosed hammer above his head and drive the spike home at a blow. And then the men had a song that called his wife's name and he liked that.

"Oh Lulu!"

"Hanh!" A spike gone home under John's sledge.

"Oh, oh, gal!"

"Hanh!"

"Want to see you!"

"Hanh!"

106

"So bad."

"Hanh!"

And then again it was fun in the big camp. More than a hundred hammer-muscling men, singers, dancers, liars, fighters, bluffers and lovers. Plenty of fat meat and beans, women flocking to camp on pay-day.

On Sunday John and his breaster went into town to church. The preacher snatched figure after figure from the land of images, and the church loved it all. Back in camp that night, John preached the sermon himself for the entertainment of the men who had stayed in camp and he aped the gestures of the preacher so accurately that the crowd hung half-way between laughter and awe.

"You kin mark folks," said Blue. "Dass jes' lak dat preacher fuh de world. Pity you ain't preachin' yo'self."

"Look, John," said his breaster, "dey's uh colored town out 'cross de woods uh piece—maybe fifteen tuh twenty miles, and dey's uh preacher—"

"You mean uh whole town uh nothin' but colored folks? Who bosses it, den?"

"Dey bosses it deyself."

"You mean dey runnin' de town 'thout de white folks?"

"Sho is. Eben got uh mayor and corporation."

"Ah sho wants tuh see dat sight."

"Dat's jes' whar Ah wants tuh take yuh nex' Sunday. Dey got uh Meth'dis' preacher over dere Ah wants yuh tuh mark. He talk thru his nose and he preaches all his sermons de same way. Sho would love tuh hear you mark 'im."

"Ah'll sho do it. Whut's de name uh dat town?"

"Eatonville, Orange County."

The Negro mayor filled John with almost as much awe as the train had. When he was leaving town that Sunday night he told his friend, "Ahm comin' back tuh dis place. Uh man kin be sumpin' heah 'thout folks tramplin' all over yuh. Ah wants mah wife and chillun heah."

There were many weeks between John and the little Negro village. He would resolve to move there on next pay-day, but

trips to town, and visitors to camp defeated his plans.

But a letter from Lucy nerved him and he found work pruning orange trees in Maitland, the adjacent white town, and went to live in Eatonville.

He had meant to send for Lucy within the month, but one thing and another delayed him. One day, however, in a fit of remorse he went and drew down a month's wages in advance and sent the money to Judge Pearson for his wife because he was ashamed to write to her.

He was working for Sam Mosely, the second most prosperous man in Eatonville, and borrowed his team to meet Lucy at the train.

He wouldn't let her walk down the coach steps, but held wide his arms and made her jump into his bosom. He drove the one mile from the depot in Maitland to the heart of Eatonville with a wagon full of laughter and shouts of questions.

"Glad tuh see me, Lucy?" John asked as soon as he had loaded the battered tin trunk and the feather bed on the wagon and sprung into the driver's seat.

" 'Course, John."

"Is you only mouf glad or yuh sho nuff glad?"

"Sho nuff, but one time Ah thought you sho took uh long time tuh write tuh me and send fuh us."

"You looks lak new money 'round heah, honey. Ah'd send fuh you, if Ah didn't had bread tuh eat. Look how our li'l' gal done growed."

"Yeah she walkin' and talkin'. You been 'way from us might nigh uh yeah."

The children exclaimed at the fruit clustered golden among the dark glistening foilage.

"Ah got y'all plenty oranges at de house, y'all chaps. Yo' papa lookin' out fuh yuh."

"You got us uh house, John?" Lucy asked happily.

"Ah mean where Ah been stayin' at. Ah reckon us all kin git in dere."

" 'Tain't no mo' houses in town?"

"Yeah, two, three vacant, but us ain't got much money.

108

Sendin' fuh y'all and all, and den us ain't got nothin' tuh go in uh house but ourselves."

"Dat ain't nothin'. You go git us house of our own. 'Tain't nothin' lak being yo' own boss. Us kin sleep on de floor 'til we kin do better."

Lucy sniffed sweet air laden with night-blooming jasmine and wished that she had been born in this climate. She seemed to herself to be coming home. This was where she was meant to be. The warmth, the foliage, the fruits all seemed right and as God meant her to be surrounded. The smell of ripe guavas was new and alluring but somehow did not seem strange.

So that night John and his family were housekeeping again. John went to the woods at the edge of town and filled three crocus sacks with moss and each of the larger children had a sack apiece for a mattress. John and Lucy took the baby girl upon the feather mattress with them.

Next morning Lucy awoke at daylight and said to John in bed, "John, dis is uh fine place tuh bring up our chillun. Dey won't be seein' no other kind uh folks actin' top-superior over 'em and dat'll give'em spunk tuh be bell cows theyselves, and you git somethin' tuh do 'sides takin' orders offa other folks. Ah 'bominates dat."

"Whut's it goin' tuh be, Lucy?"

"You knows how tuh carpenter. Go ast who want uh house built, and den you take and do it. You kin prop up shacks jus' as good as some uh dem dat's doin' it."

And to John's surprise people wanted houses built all over Orange County. Central Florida was in the making.

"And now less don't pay Joe Clarke no mo' rent. Less buy dis place, John."

"Dat's uh bigger job than Ah wants tuh tackle, Lucy. You so big-eyed. Wese colored folks. Don't be so much-knowin'."

But the five acre plot was bought nevertheless, and John often sat on Joe Clarke's store porch and bragged about his determination to be a property owner.

"Aw, 'tain't you, Pearson," Walter Thomas corrected, "iss dat li'l' handful uh woman you got on de place."

109

"Yeah," Sam Mosely said earnestly, "Anybody could put hisself on de ladder wid her in de house. Dat's de very 'oman Ah been lookin' fuh all mah days."

"Yeah, but Ah seen uh first, Sam, so you might jus' ez well quit lookin'," John said and laughed.

"Oh Ah knows dat, John. 'Twon't do me no good tuh look, but yet and still it won't hurt me neither. You might up and die uh she might quit yuh and git uh sho nuff husband, and den she could switch uh mean Miss Johnson in dat big house on Mars Hill."

"Hold on dere uh minute, Sam," John retorted half in earnest amid the general laughter, "less squat dat rabbit and jump uhnother one. Anyhow mah house liable tuh be big ez your'n some uh dese days."

"Aw, he jes' jokin' yuh, Pearson," Joe Clarke, the mayor intervened, "I god, you takin' it serious."

When John got home that night Lucy was getting into bed. John stopped in the hallway and took his Winchester rifle down from the rack and made sure that it was loaded before he went into the bedroom, and sat on the side of the bed.

"Lucy, is you sorry you married me instid uh some big nigger wid uh whole heap uh money and titles hung on tuh him?"

"Whut make you ast me dat? If you tired uh me, jus' leave me. Another man over de fence waitin fuh yo' job."

John stood up, "Li'l' Bit, Ah ain't never laid de weight uh mah hand on you in malice. Ain't never raised mah hand tuh yuh eben when you gits mad and slaps mah jaws, but lemme tell you somethin' right now, and it ain't two, don't you never tell me no mo' whut you jus' tole me, 'cause if you do, Ahm goin' tuh kill yuh jes' ez sho ez gun is iron. Ahm de first wid you, and Ah means tuh be de last. Ain't never no man tuh breathe in yo' face but me. You hear me? Whut made you say dat nohow?"

"Aw, John, you know dat's jus' uh by-word. Ah hears all de women say dat."

"Yeah, Ah knows dat too, but *you* ain't tuh say it. Lemme

110

tell you somethin'. Don't keer whut come uh go, if you ever start out de door tuh leave me, you'll never make it tuh de gate. Ah means tuh blow yo' heart out and hang fuh it."

"You done—"

"Don't tell me 'bout dem trashy women Ah lusts after once in uh while. Dey's less dan leaves uh grass. Lucy do you still love me lak yuh useter?"

"Yeah John, and mo'. Ah got mo' tuh love yuh fuh now."

John said, "Neb mine mah crazy talk. Jus' you hug mah neck tight, Ah'd sweat in hell fuh yuh. Ah'd take uh job cleaning out de Atlantic Ocean jus' fuh yuh. Look lak Ah can't git useter de thought dat you married me, Lucy, and you got chillun by *me!*"

And he held Lucy tightly and thought pityingly of other men.

The very next Sunday he arose in Covenant Meeting and raised the song, "He's a Battle-Axe in de Time Uh Trouble," and when it was done he said, "Brothers and Sisters, Ah rise befo' yuh tuhday tuh tell yuh, God done called me tuh preach."

"Halleluyah! Praise de Lawd!"

"He called me long uhgo, but Ah wouldn't heed tuh de voice, but brothers and sisters, God done whipped me tuh it, and like Peter and Paul Ah means tuh preach Christ and Him crucified. He tole me tuh go, and He'd go with me, so Ah ast yo' prayers, Church, dat Ah may hold up de blood-stained banner of Christ and prove strong dat Ah may hold out tuh de end."

The church boiled over with approval, "Ah knowed it! Tole 'im long time uhgo dat's whut he wuz cut out fuh. Thang God. He's goin' tuh be uh battle-axe sho 'nuff—Hewin' down sinners tuh repentance."

His trial sermon had to be preached in a larger church—so many people wanted to hear him. He had a church to pastor before the hands had been laid on his head. The man who preached his ordination sermon was thrown in deep shadow by the man who was to be ordained.

The church he pastored at Ocoee did all they could to hold him, but the membership was less than a hundred. Zion Hope, of Sanford, membership three hundred, took him to her bosom, and her membership mounted every month.

John dumped a heavy pocketbook into Lucy's lap one Monday morning before he took off his hat.

Lucy praised him. "We goin' tuh finish payin' fuh dis place wid dis money. De nex' time, us buy de chillun some changin' clothes. You makin' good money now, John. Ah always knowed you wuz goin' tuh do good."

He wore the cloak of a cloud about his shoulders. He was above the earth. He preached and prayed. He sang and sinned, but men saw his cloak and felt it.

"Lucy, look lak Ah jus' found out whut Ah kin do. De words dat sets de church on fire comes tuh me jus' so. Ah reckon de angels must tell 'em tuh me."

"God don't call no man, John, and turn 'im loose uh fool. Jus' you handle yo' members right and youse goin' tuh be uh sho 'nuff big nigger."

"Ain't Ah treatin' 'em good, Lucy? Ah ain't had no complaints."

"Naw, you wouldn't hear no complaints 'cause you treatin' 'em too good. Don't pomp up dem deacons so much. Dey'll swell up and be de ruination of yuh. Much up de young folks and you got somebody tuh strain wid dem ole rams when dey git dey habits on. You lissen tuh me. Ah hauled de mud tuh make ole Cuffy. Ah know whuts in 'im.

"Don't syndicate wid none of 'em, do dey'll put yo' business in de street." Lucy went on, "Friend wid few. Everybody grin in yo' face don't love yuh. Anybody kin look and see and tell uh snake trail when dey come cross it but nobody kin tell which way he wuz goin' lessen he seen de snake. You keep outa sight, and in dat way, you won't give nobody uh stick tuh crack yo' head wid."

As he swaggered up to Joe Clarke's store porch in his new clothes, putting and taking with his yellow cane, Sam Mosely teased, "Well, John done got tuh be uh preacher."

"Yeah Ah is, and Ah ain't no stump-knocker neither. Ah kin go hard."

"Maybe so, John, but anybody kin preach. Hard work and hot sun done called uh many one. Anybody kin preach."

"Naw dey can't neither. Take you for instance."

"Don't want tuh. Ahm de mayor."

"You ain't goin' tuh be it after de 18th day of August. Watch and see."

"Who gointer be it; Joe Clarke? He said he wuzn't runnin'."

"Naw, Ahm gointer be de mayor."

"You runnin' fuh mayor?"

"Not now but Ahm goin' tuh run when de time come, and if you want tuh be mayor agin you better *run.* Don't fool wid it—run! Go hard uh go home. You and Clarke ain't had nobody tuh run against, but dis time big Moose done come down from de mountain. Ahm goin' tuh run you so hard 'til they can't tell yo' run-down shoe from yo' wore out sock."

General laughter.

"I God," Joe Clarke declared, "Ah never seen two sworn buddies dat tries tuh out do on 'nother lak y'all do. You so thick 'til one can't turn 'thout de other one, yet and still you always buckin' 'ginst each other."

" 'Tain't me," Sam Mosely defended, "Iss him, but he can't never ekal up tuh me 'cause Ah come heah from Wes' Flordah uh porpoise, but look whut Ah got now. Ahm uh self-made man."

"Ah come heah right out de tie woods in uh boot and uh shoe, but Ah got proppity too. Whut you goin' tuh call *me?*" He thrust out his chest.

"Uh wife-made man," Mosely retorted amid boisterous laughter, "if me and him wuz tuh swap wives Ah'd go past 'im so fast you'd think it wuz de A.C.L. passin' uh gopher."

"Better say joe, 'cause you don't know. Anyhow when you run for mayor next time git ready tuh take yo' whippin'. De time done come when big britches goin' tuh fit li'l Willie."

And Rev. Pearson did win. He was swept into office by the

113

overwhelming majority of seventeen to three.

"Tell yuh how yuh beat me, John," Mosely said on the store porch that night, "course 'twan't fair, but it wuz de way you and Lucy led de gran' march night 'fo' las' at de hall, but by rights uh preacher ain't got no business dancin'."

"Grand marchin' ain't dancin'. Ah never cut uh step."

"Dat's right too, y'all," Joe Lindsay put in, "you ain't dancin' 'til yuh cross yo' feet, but Rev. John, no sinner man couldn't uh led dat march no better'n you and Lucy. Dat li'l' 'oman steps it lightly, slightly and politely."

"Tuh make short talk outa long," added Walter Thomas, "Sam, youse uh good man. Ah don't know no better conditioned man in dese parts. Yo' morals is clean ez uh fish—and he been in bathin' all his life, but youse too dry fuh de mayor business. Jes' lak it 'twuz wid Saul and David."

Lucy was going to have another baby and in her condition she missed John a lot. Now that he was called here and there over the state to conduct revivals, she knew that he must go. She was glad to see him in new suits that his congregation proudly bestowed upon him without his asking. She loved to see him the center of admiring groups. She loved to hear him spoken of as "The Battle-Axe." She even loved his primitive poetry and his magnificent pulpit gestures, but, even so, a little cold feeling impinged upon her antennae. There was another woman.

Time and time over the dish-pan, she'd find herself talking aloud.

"Lawd lemme quit feedin' on heart meat lak Ah do. Dis baby goin' tuh be too fractious tuh live." And then again, "Lawd, if Ah meet dat woman in heben, you got tuh gimme time tuh fight uh while. Jus' ruin dis baby's temper 'fo' it git tuh dis world. 'Tain't mah fault, Lawd, Ahm jus' ez clean ez yo' robes."

This was her second baby since coming to Florida, and she remembered how happy he had been at the coming of the fourth boy. A new baby might change things, perhaps, and she was right. When the new little girl was a month old, he

114

took the lacy, frilly little bundle out of Lucy's arms and carried it out to the waiting horse and buggy.

"You ain't got time tuh fool wid dat youngun, John. You goin' up tuh Sanford tuh preach, ain't yuh?"

"Yeah, and de church got tuh see dis baby. Dis is sho mah work. De very spit uh me. 'Cep'n—"

" 'Cep'n what? Dem sho yo' gray eyes."

"Dey ain't whut Ah wuz fixin' tuh say. Dat's mah eye color alright but her eyes look at yuh lak she know sumpin. Anybody'd think she's grown. Wonder whut she thinkin' 'bout?"

"Take uh God tuh tell. Ah toted de rest uh de chillun in mah belly, but dat one wuz bred in mah heart. She bound tuh be diffunt."

"Git yo' things on, Lucy, and come on tuh Sanford wid me. De church ain't seen mah wife in six months. Put on dat li'l' red dress and come switchin' up de aisle and set on de front seat so you kin be seen. Ahm goin' tuh tote de baby, lessen you want me tuh tote bofe of yuh."

"Go 'way, Ah don't hafta wear dat ole red dress 'cause Ah got uh brand new princess, laced down de back wid uh silk cord wid tassels on it."

With her bangs above her shining eyes and the door-knob knot of hair at the back, Lucy sat on that front seat in church and felt a look strike her in the back and slide off helplessly. Her husband's glance fell on her like dew. Her look and nobody else's was in his gray eyes, and the coldness melted from the pit of her stomach, and at the end of the sermon John came down from the pulpit and took the baby from her arms and standing just before the pulpit proudly and devotedly called, "Come heah eve'ybody, one at de time and pass by and look on yo' pastor's baby girl chile. Ah could shout tuhday." And they came.

There came other times of cold feelings and times of triumphs. Only the coldnesses grew numerous.

Once she had sent him off to Alabama when she felt such a coldness that it laid her in a sick-bed. She knew that the glory of his broadcloth and Stetson would humble Bud, chagrin old

Ned and make Amy happy, and in his present glory the "leaf of grass" would wither. Lucy prayed often now, but sometimes God was tired and slept a little and didn't hear her. Maybe He had other Johns somewhere that needed His ear, but Lucy didn't get too tired. She didn't worry God too much. She had her husband and seven children now and her hands were kept busy. John had to be pushed and shoved and there was no one to do it but Lucy.

There came the day, with Lucy's maneuvering, when John stood up in the State Association and was called Moderator. "Wisht ole Ned and Bud could see me now," John gloated, "always makin' out Ah wuzn't goin' tuh be nothin'. Ah uh big nigger now. Ain't Ah Lucy?"

"You sho is. All you got tuh do now is tuh *ack* lak one."

"Don't you reckon Ah know how tuh ack, Lucy? You ain't out dere wid Brown and Battle and Ford and all dem big mens, lak Ah is. You always tryin' tuh tell me whut tuh do. Ah wouldn't be where Ah is, if Ah didn't know no more'n you think Ah do. You ain't mah guardzeen nohow."

John strode off in his dark blue broadcloth, his hand-made alligator shoes, and his black Stetson, and left Lucy sitting on their porch. The blue sky looked all wrinkled to Lucy thru the tears.

And soon Lucy knew who the woman was, and once or twice the thought troubled her that John knew she knew, but didn't care.

One night as she sang the sleep song to the younger children she noticed a sallow listlessness in Isis, her younger girl. The next day she knew it was typhoid. For a week she fought it alone. John was down the East Coast running a revival and didn't come at once. When he did come, the doctor said, "Well, Reverend, I'm glad you're here. If she can last 'til midnight she's got a chance to get over it, but—but I doubt if she will live 'til dark."

The restrained Lucy stood at the far side of the bed looking at her child, looking at John. The agony of the moment sweated great drops from his forehead. He would have fallen

on the bed but Lucy led him outside.

"Ah can't stand 'round and see mah baby girl die. Lucy! Lucy! God don't love me. Ah got tuh go 'way 'til it's all over. Ah jus' can't stay."

So John fled to Tampa away from God, and Lucy stayed by the bedside alone. He was gutted with grief, but when Hattie Tyson found out his whereabouts and joined him, he suffered it, and for some of his hours he forgot about the dying Isis, but when he returned a week later and found his daughter feebly recovering, he was glad. He brought Lucy a new dress and a pineapple.

CHAPTER 14

People in Sanford began to call Lucy aside. There was much under-voice mention of Hattie Tyson, Oviedo and shame, Gussie, Tillie, Della, church court, making changes in the pulpit and monthly conference.

"John," Lucy began abruptly one day, "you kin keep from fallin' in love wid *anybody,* if you start in time."

"Now whut you drivin' at?"

"You either got tuh stop lovin' Hattie Tyson uh you got tuh stop preachin'. Dat's whut de people say."

"Ah don't love no Hattie Tyson. De niggers lyin' on me."

"Maybe so, but if you don't you oughta stay from 'round her. Ah done seen de green tree ketch on fire, so you know uh dry one will burn."

"Lawd how some folks kin lie! Dey don't wait tuh find out a thing. Some of 'em so expert on mindin' folks' business dat dey kin look at de smoke comin' out yo' chimbley and tell yuh whut yuh cookin'."

"Yo' church officers is talkin' it too, John."

"Sho 'nuff, Lucy?"

"Dey talkin' 'bout settin' you down."

"Lawd have mussy! You ain't 'ginst me too, is yuh Lucy?"

"Naw, Ah'll never be 'ginst yuh, John, but Ah did thought you done strayed off and don't love me no mo'."

"You musta thought it, Lucy, 'cause nobody sho didn't tell yuh. If you don't know, ast somebody."

"John, now don't you go 'round dat church mealy-moufin 'round dem deacons and nobody else. Don't you break uh breath on de subjick. Face 'em out, and if dey wants tuh handle yuh in conference, go dere totin' uh high head and Ah'll be right dere 'long side of yuh."

Conference night came and the church was full. It was evident that the entire congregation was keyed up. The routine business was gotten out of the way quickly. Beulah Tansill flung her low look at the pastor and then at Deacon Tracy Patton. Deacon Patton cleared his throat and did a great deal of head scratching. The look on the pastor's face didn't seem to belong there. It was bold and unusual. It sort of dared him and the words he had brought there with him wouldn't slide off his tongue. He scratched his head some more. He had stirred up the side front the first time, he tried the opposite side back.

"Uh, ruh, uh ruh, any onfinished business?" prompted Deacon Harris.

Deacon Patton almost rose that time. Another look at Pearson and Lucy and he laid down his hat and scratched with both hands. Gave his entire head a thorough scratching and held his mouth open in sympathy.

"Shet yo' mouf, Tracy Patton!" Sister Berry cautioned. "De flies will blow yo' liver tuhreckly."

"Shet your'n. You tries tuh be so much-knowin'. You got tuh learn how tuh speak when you spokin to, come when youse called."

"Ah ain't got tuh do but two things—stay black and die," Sister Berry snapped.

"Less stand adjourned," Deacon Harris hurried, "us don't want no fight."

That was as far as the conference went. The Chairman realized that the Chief spokesman was not going to speak, hastily adjourned, hoping that Beulah and Tracy wouldn't implicate him if they talked it. He made it his business to walk home

120

with the pastor and drop a defensive suggestion in his ear in advance.

"Rev. Ahm diggin' mah sweet pitaters tuhmorrer. Goin' tuh bring you some too."

"Thanks, Aleck. Mah wife and chillun all loves dem good ole yeller yams, good ez Ah do."

"Dey sho gointer git some. Look heah, Elder Pearson Ah reckon you done heard dat some dese niggers is throwin' lies 'bout you and some woman over 'bout Oviedo. Ah ain't tole yuh nothin', and you be keerful uh dese folks dat totes yuh news. Uh dog dat'll bring uh bone will keep one. You know dat's de truth. Good night."

John had read the hostility in the meeting and his relief at his temporary deliverance was great. He said nothing to his wife, but he bought a dozen mangoes and thrust the bag into her hand.

As they undressed for bed Lucy asked in a matter of fact tone, "Whut tex' you goin' tuh preach on Sunday comin'?"

"Iss Communion so Ah reckon Ah'll preach de Passover Supper in de upper room."

"Don't you preach it. Dis thing ain't thru wid yit. 'Tain't never goin' tuh be finished 'til you tackle dey feelings and empty out dey hearts—do, it'll lay dere and fester and after while it would take God hisself tuh clean up de mess."

"Whut mo' kin Ah do? Ah wuz dere fuh dem tuh handle me and dey didn't do it."

"Dat wuz 'cause de folks didn't have no leader. They wuz plenty fight in dere. All dey needed wuz uh lead hound. You git yo'self out dey mouf and stay out of it, hear me?"

"Whut mus' Ah do?"

"You preach uh sermon on yo'self, and you call tuh they remembrance some uh de good things you done, so they kin put it long side de other and when you lookin' at two things at de same time neither one of 'em don't look so big, but don't tell uh lie, John. If youse guilty you don't need tuh git up dere and put yo' own name on de sign post uh scorn, but don't say

121

you didn't do it neither. Whut you say, let it be de truth. Dat what comes from de heart will sho reach de heart agin.''

"Mah chillun, Papa Pearson don't feel lak preachin' y'all tuh-day," he began on Sunday after he had sung a song, "y'all been looking at me fuh eight years now, but look lak some uh y'all been lookin' on me wid unseein' eye. When Ah speak tuh yuh from dis pulpit, dat ain't me talkin', dat's de voice uh God speakin' thru me. When de voice is thew, Ah jus' uhnother one uh God's crumblin' clods. Dere's seben younguns at mah house and Ah could line 'em all up in de courthouse and swear tuh eve'yone of 'em, Ahm uh natchel man but look lak some uh y'all is dumb tuh de fack.

"Course, mah children in Christ, Ah been here wid y'all fuh eight years and mo'. Ah done set by yo' bedside and buried de dead and joined tuhgether de hands uh de livin', but Ah ain't got no remembrance. Don't keer if Ah laugh, don't keer if Ah cry, when de sun, wid his blood red eye, go intuh his house at night, he takes all mah remembrance wid 'im, but some yuh y'all dat got remembrance wid such long tangues dat it kin talk tuh yuh at a distance, when y'all is settin' down and passin' nations thew yo' mouf, look close and see if in all mah doin's if dere wuz anything good mingled up uhmoungst de harm Ah done yuh. Ah ain't got no mind. Y'all is de one dat is so much-knowin' dat you kin set in judgment.

"Maybe y'all got yo' right hand uh fellership hid behind yuh. De Lawd's supper is heah befo' us on de table. Maybe mah hands ain't tuh break de bread fuh yuh, maybe mah hands ain't tuh tetch de cup no mo'. So Ahm comin' down from de pulpit and Ah ain't never goin' back lessen Ah go wid yo' hearts keepin' comp'ny wid mine and yo' fire piled on mah fire, heapin' up."

He closed the great Bible slowly, passed his handkerchief across his face and turned from the pulpit, but when he made to step down, strong hands were there to thrust him back. The church surged up, a weeping wave about him. Deacons Hambo and Harris were the first to lay hands upon him. His

122

weight seemed nothing in many hands while he was roughly, lovingly forced back into his throne-like seat.

After a few minutes of concerted weeping, he moved down to the Communion table and in a feeling whisper went thru the sacrifice of a God.

seemed... nothing to put a hand... while the... through rocks...

After a few minutes of conversation, he made a dash to the Champagne side and the...

CHAPTER 15

An' Dangie Dewoe's hut squatted low and peered at the road from behind a mass of Palma Christi and elderberry. The little rag-stuffed windows hindered the light and the walls were blackened with ancient smoke.

She had thrown several stalks of dried rabbit tobacco on the fire for power and sat with her wrinkled old face pursed up like a black fist, watching the flames.

Three quick sharp raps on the door.

"Who come?"

"One."

"Come on in, Hattie." As the woman entered An' Dangie threw some salt into the flame without so much as a look at her visitor. "Knowed you'd be back. Set down."

Hattie sat a moment impatiently, then she looked anxiously at An' Dangie and said, "He ain't been."

"He will. Sich things ez dat takes time. Did yuh feed 'im lak Ah tole yuh?"

"Ain't laid eyes on 'im in seben weeks. How Ahm goin' do it?"

"Hm-m-m." She struggled her fatness up from the chair and limped over to an old tin safe in the corner. She fumbled with the screw top of a fruit jar and returned with a light handful of wish-beans. "Stan' over de gate whar he sleeps and eat dese

125

beans and drop de hulls 'round yo' feet. Ah'll do de rest."

"Lawd, An' Dangie, dere' uh yard full uh houn' dawgs and chillun. Eben if none uh dem chillun see me, de dawgs gwine bark. Ah wuz past dere one day 'thout stoppin'."

"G'wan do lak Ah tell yuh. Ahm gwine hold de bitter bone in mah mouf so's you kin walk out de sight uh men. You bound tuh come out more'n conquer. Jes' you pay me whut Ah ast and 'tain't nothin' built up dat Ah can't tear down."

"Ah know you got de power."

"Humph! Ah reckon Ah is. Y' ever hear 'bout me boilin' uh wash-pot on uh sail needle?"

"Yas ma'am and mo' besides."

"Well don't come heah doubtin' lak you done jes' now. Aw right, pay me and g'wan do lak Ah tell yuh."

Hattie took the knotted handkerchief out of her stocking and paid. As she reached the door, the old woman called after her, " 'Member now, you done started dis and it's got tuh be kep' up do hit'll turn back on yuh."

"Yas'm."

The door slammed and An' Dangie crept to her altar in the back room and began to dress candles with war water. When the altar had been set, she dressed the coffin in red, lit the inverted candles on the altar, saying as she did so, "Now fight! Fight and fuss 'til you part." When all was done at the altar she rubbed her hands and forehead with war powder, put the catbone in her mouth, and laid herself down in the red coffin facing the altar and went into the spirit.

CHAPTER 16

L ucy was lying sick. The terrible enemy had so gnawed
away her lungs that her frame was hardly distinguishable
from the bed things.

"Isie?"

"Yes ma'am."

"Come give mama uh dose uh medicine."

"Yes'm."

The skinny-legged child of nine came bringing a cheap glass
pitcher of water. "Ah pumped it off so it would be cool and
nice fuh yuh."

"Thankee, Isie. Youse mah chile 'bove all de rest. Yo' pa
come yet?"

"Yes'm, he out 'round de barn somewhere."

"Tell 'im Ah say tuh step heah uh minute."

John Pearson crossed the back porch slowly and heavily and
entered the bedroom with downcast eyes.

"Whut you want wid me, Lucy?"

"Here 'tis Wednesday and you jus' gittin' home from San-
ford, and know Ahm at uh mah back too. You know dat
Hezekiah and John is uhway in school up tuh Jacksonville, and
dese other chillun got tuh make out de bes' dey kin. You
ought tuh uh come on home Monday and seen after things."

127

He looked sullenly at the floor and said nothing. Lucy used her spit cup and went on.

"Know too Ahm sick and you been home fuh de las' longest and ain't been near me tuh offer me uh cup uh cool water uh ast me how Ah feel."

"Oh you sick, sick, sick! Ah hates tuh be 'round folks always complainin', and then again you always doggin' me 'bout sumpin'. Ah gits sick and tired uh hearing it!"

"Well, John, you puts de words in mah mouf. If you'd stay home and look after yo' wife and chillun, Ah wouldn't have nothin' tuh talk uhbout."

"Aw, yes you would! Always jawin' and complainin'."

Lucy said, "If you keep ole Hattie Tyson's letters out dis house where mah chillun kin git holt of 'em and you kin stop folkses mouf by comin' on home instid uh layin' 'round wid her in Oviedo."

"Shet up! Ahm sick an' tired uh you' yowin' and jawin'. 'Tain't nothin' Ah hate lak gittin' sin throwed in mah face dat done got cold. Ah do ez Ah please. You jus' uh hold-back tuh me nohow. Always sick and complainin'. Uh man can't utilize hisself."

He came to the bed and stood glaring down upon her. She seemed not to notice and said calmly after a short pause, "Ahm glad tuh know dat, John. After all dese years and all dat done went on dat Ah ain't been nothin' but uh stumblin'-stone tuh yuh. Go 'head on, Mister, but remember—youse born but you ain't dead. 'Tain't nobody so slick but whut they kin stand uh 'nother greasin'. Ah done told yuh time and time uhgin dat ignorance is de hawse dat wisdom rides. Don't git miss-put on yo' road. God don't eat okra."

"Oh you always got uh mouf full uh opinions, but Ah don't need you no mo' nor nothing you got tuh say, Ahm uh man grown. Don't need no guardzeen atall. So shet yo' mouf wid me."

"Ah ain't going' tuh hush nothin' uh de kind. Youse livin' dirty and Ahm goin' tuh tell you 'bout it. Me and mah chillun got some rights. Big talk ain't changin' whut you doin'. You

can't clean yo'self wid yo' tongue lak uh cat.''

There was a resounding smack. Lucy covered her face with her hand, and John drew back in a sort of horror, and instantly strove to remove the brand from his soul by words, ''Ah tole yuh tuh hush.'' He found himself shaking as he backed towards the door.

''De hidden wedge will come tuh light some day, John. Mark mah words. Youse in de majority now, but God sho don't love ugly.''

John shambled out across the back porch, and stood for an unknowing time among the palmetto bushes in a sweating daze feeling like Nebuchadnezer in his exile.

Lucy turned her face to the wall and refused her supper that her older daughter Emmeline cooked and that Isis brought to her.

''But mama, you said special you wanted some batter-cakes.''

''You eat 'em, Isie. Mama don't want uh thing. Come on in when you thru wid yo' supper lak you always do and read mama something out yo' reader.''

But Isis didn't read. Lucy lay so still that she was frightened. She turned down the lamp by the head of the bed and started to leave, but Lucy stopped her.

''Thought you was sleep, mama.''

''Naw, Isie, been watchin' dat great big ole spider.''

''Where?''

''Up dere on de wall next tuh de ceilin'. Look lak he done took up uh stand.''

''Want me tuh kill 'im wid de broom?''

''Naw, Isie, let 'im be. You didn't put 'im dere. De one dat put 'im dere will move 'im in his own time.''

Isis could hear the other children playing in the back room.

''Reckon you wanta go play wid de rest, Isie, but mama wants tuh tell yuh somethin'.''

''Whut is it, mama?''

''Isie, Ah ain't goin' tuh be wid yuh much longer, and when Ahm dead Ah wants you tuh have dis bed. Iss mine. Ah sewed

fuh uh white woman over in Maitland and she gimme dis bedstead fuh mah work. Ah wants you tuh have it. Dis mah feather tick on here too.''

"Yes'm mama, Ah—"

"Stop cryin', Isie, you can't hear whut Ahm sayin', 'member tuh git all de education you kin. Dat's de onliest way you kin keep out from under people's feet. You always strain tuh be de bell cow, never be de tail uh nothin'. Do de best you kin, honey, 'cause neither yo' paw nor dese older chillun is goin' tuh be bothered too much wid yuh, but you goin' tuh git 'long. Mark mah words. You got de spunk, but mah po' li'l' sandy-haired chile goin' suffer uh lot 'fo' she git tuh de place she kin 'fend fuh herself. And Isie, honey, stop cryin' and lissen tuh me. Don't you love nobody better'n you do yo'self. Do, you'll be dying befo' yo' time is out. And, Isie, uh person kin be killed 'thout being stuck un blow. Some uh dese things Ahm tellin' yuh, you wont understand 'em fuh years tuh come, but de time will come when you'll know. And Isie, when Ahm dyin' don't you let 'em take de pillow from under mah head, and be covering up de clock and de lookin' glass and all sich ez dat. Ah don't want it done, heah? Ahm tellin' you in prefer-ence tuh de rest 'cause Ah know you'll see tuh it. Go wash yuh face and turn tuh de Twenty-Sixth Chapter of de Acts fuh me. Den you go git yo' night rest. If Ah want yuh, Ah'll call yuh.''

Way in the night Lucy heard John stealthily enter the room and stand with the lamp in his hand peering down into her face. When she opened her eyes she saw him start.

"Oh," he exclaimed sharply with rising inflection. Lucy searched his face with her eyes but said nothing.

"Er, er, Ah jus' thought Ah'd come see if you wanted anything," John said nervously, "if you want anything, Lucy, all you got tuh do is tuh ast me. De favor is in me.''

Lucy looked at her husband in a way that stepped across the ordinary boundaries of life and said, "Jus' have patience, John, uh few mo' days,'' and pulled down her lids over her eyes, and John was glad of that.

John rushed from Lucy's bedside to the road and strode up

130

and down in the white moonlight. Finally he took his stand beneath the umbrella tree before the house and watched the dim light in Lucy's room. Nothing came to him there and he awoke Emmeline at daybreak, "Go in yo' ma's room Daught' and come back and tell me how she makin' it."

"She say she ain't no better," Daught' told him.

The spider was lower on the wall and Lucy entertained herself by watching to see if she could detect it move.

She sent Isis to bed early that Thursday night but she herself lay awake regarding the spider. She thought that she had not slept a moment, but when in the morning Isis brought the wash basin and tooth brush, Lucy noted that the spider was lower and she had not seen it move.

That afternoon Mrs. Mattie Clarke sat with her and sent Isis out to play.

"Lucy, how is it 'tween you and God?"

"You know Ah ain't never been one to whoop and holler in church, Sister Clarke, but Ah done put on de whole armor uh faith. Ah ain't afraid tuh die."

"Ahm sho glad tuh hear dat, Sister Pearson. Yuh know uh person kin live uh clean life and den dey kin be so fretted on dey dyin' bed 'til dey lose holt of de kingdom."

"Don't worry 'bout me, Sister Clarke. Ah done been in sorrow's kitchen and Ah done licked out all de pots. Ah done died in grief and been buried in de bitter waters, and Ah done rose agin from de dead lak Lazarus. Nothin' kin touch mah soul no mo'. It wuz hard tuh loose de string-holt on mah li'l' chillun." Her voice sank to a whisper, "But Ah reckon Ah done dat too."

"Put whip tuh yo' hawses, honey. Whip 'em up."

Despite Lucy's all-night vigil she never saw the spider when he moved, but at first light she noted that he was at least a foot from the ceiling but as motionless as a painted spider in a picture.

The evening train brought her second son, John, from Jacksonville. Lucy brightened.

"Where's Hezekiah?" she asked eagerly.

"He's comin'. His girl is gointer sing uh solo at de church on Sunday and he wants to hear her. Then he's coming right on. He told me to wire him how you were."

"Don't do it, John. Let 'im enjoy de singin'."

John told her a great deal about the school and the city and she listened brightly but said little.

After that look in the late watches of the night John was afraid to be alone with Lucy. His fear of her kept him from his bed at night. He was afraid lest she should die while he was asleep and he should awake to find her spirit standing over him. He was equally afraid of her reproaches should she live, and he was troubled. More troubled than he had ever been in all his life. In all his struggles of sleep, the large bright eyes looked thru and beyond him and saw too much. He wished those eyes would close and was afraid again because of his wish.

Lucy watched the spider each day as it stood lower. And late Sunday night she cried out, "O Evening Sun, when you git on de other side, tell mah Lawd Ahm here waitin'."

And God awoke at last and nodded His head.

In the morning she told Emmeline to fry chicken for dinner. She sent Isis out to play. "You been denyin' yo' pleasure fuh me. G'wan out and play wid de rest. Ah'll call yuh if Ah want yuh. Tell everybody tuh leave me alone. Ah don't want no bother. Shet de door tight."

She never did call Isis. Late in the afternoon she saw people going and coming, coming and going. She was playing ball before the house, but she became alarmed and went in.

The afternoon was bright and a clear light streamed into the room from the bare windows. They had turned Lucy's bed so that her face was to the East. The way from which the sun comes walking in red and white. Great drops of sweat stood out on her forehead and trickled upon the quilt and Isis saw a pool of sweat standing in a hollow at the elbow. She was breathing hard, and Isis saw her set eyes fasten on her as she came into the room. She thought that she tried to say some-

132

thing to her as she stood over her mother's head, weeping with her heart.

"Get her head offa dat pillow!" Mattie Mosely ordered. "Let her head down so she kin die easy."

Hoyt Thomas moved to do it, but Isis objected. "No, no, don't touch her pillow! Mama don't want de pillow from under her head!"

"Hush Isie!" Emmeline chided, "and let mama die easy. You makin' her suffer."

"Naw, naw! she said *not* tuh!" As her father pulled her away from her place above Lucy's head, Isis thought her mother's eyes followed her and she strained her ears to catch her words. But none came.

John stood where he could see his wife's face, but where Lucy's fixed eyes might not rest upon him. They drew the pillow from beneath Lucy's head and she gulped hard once, and was dead. "6:40" someone said looking at a watch.

"Po' thing," John wept. "She don't have tuh hear no mo' hurtin' things." He hurried out to the wood pile and sat there between two feelings until Sam Mosely led him away.

"She's gone!" rang out thru the crowded room and they heard it on the porch and Mattie Mosely ran shouting down the street, "She's gone, she's gone at last!"

And the work of the shrouding began. Little Lucy, somewhat smaller in death than she had been even in life, lay washed and dressed in white beneath a sheet upon the cooling board when her oldest son arrived that evening to break his heart in grief.

That night a wind arose about the house and blew from the kitchen wall to the clump of oleanders that screened the chicken house, from the oleanders to the fence palings and back again to the house wall, and the pack of dogs followed it, rearing against the wall, leaping and pawing the fence, howling, barking and whining until the break of day, and John huddled beneath his bed-covers shaking and afraid.

CHAPTER 17

T hey put Lucy in a little coffin next day, the shiny coffin that held the beginning and the ending of so much. And the September woods were ravished by the village to provide tight little bouquets for the funeral. Sam Mosely, tall, black and silent, hitched his bays to his light wagon and he bore Lucy from her house and children and husband and worries to the church, while John, surrounded by his weeping family, walked after the wagon, shaking and crying. The village came behind and filled the little church with weeping and wild-flowers. People were stirred. The vital Lucy was gone. The wife of Moderator Pearson was dead.

"There is rest for the weary" rose and fell like an organ. Harmony soaked in tears.

"She don't need me no mo' nohow," John thought defensively.

"On the other side of Jordan, in the sweet fields of Eden—where the tree of life is blooming—"

And the hot blood in John's veins made him deny kinship with any rider of the pale white horse of death.

"Man born of woman has but a few days."

Clods of damp clay falling hollowly on the box. Out of sight of the world, and dead men heard her secrets.

That night they sat in the little parlor about the organ and

the older children sang songs while the smaller ones cried and whimpered on. John sat a little apart and thought. He was free. He was sad, but underneath his sorrow was an exultation like a live coal under gray ashes. There was no longer guilt. But a few days before he had shuddered at the dread of discovery and of Lucy's accusing eye. There was no more sin. Just a free man having his will of women. He was glad in his sadness.

The next day John Pearson and Sam Mosely met on Clarke's porch. Sam remarked, "Funny thing, ain't it John—Lucy come tuh town twelve years uhgo in mah wagon and mah wagon took her uhway."

"Yeah, but she b'longed tuh me, though, all de time," John said and exulted over his friend.

CHAPTER 18

Deacons Hambo, Watson, Hoffman and Harris waited on Rev. Pearson in his study at the parsonage.

"No mealy-moufin', Harris. No whippin' de Devil 'round de stump. He got tuh be told." Hambo urged.

"Ahm goin' tuh tell 'im how we feel. You too hot tuh talk. You ain't in yo' right mind."

"Oh yes, Ah is too, Ahm hot, though. Ahm hot ez July jam. Jee-esus Christ!"

John entered the room radiating cheer.

"Hello, boys. How yuh do?"

"Don't do all dey say, but Ah do mah share," said Hambo quickly, "and damned if you don't do yourn."

Pearson didn't know whether it was one of the bluff Hambo's jokes or not. He started to laugh, then looked at the men's faces and quit.

"Oh."

"Now lemme handle dis, Hambo, lak we said," begged Harris.

"Naw, lemme open mah mouf 'fo' Ah bust mah gall. John, is you married tuh dat Hattie Tyson?"

"Yeah."

"DeG—D—hell you is, man! Yo' wife ain't been dead but

three months, and you done jumped up and married befo' she got col' in her grave!"

"Ah got dese li'l' chillun and somebody got tuh see after 'em."

"Well de somebody you got sho ain't seein' after 'em. They's 'round de streets heah jes' ez raggedy ez jay-birds in whistlin' time. Dey sho ain't gittin' uh damn bit uh 'tention."

"Course Ah didn't marry her jus' tuh wait on de chillun. She got tuh have some pleasure."

"Course she is! Dat strumpet ain't never done nothin' but run up and down de road from one sawmill camp tuh de other and from de looks of her, times was hard. She ain't never had nothin'—not eben doodly-squat, and when she gits uh chance tuh git holt uh sumpin de ole buzzard is gone on uh rampage. She ain't got dis parsonage and dem po' li'l' motherless chillun tuh study 'bout."

"Hold on dere, Hambo, y'all. Dat's mah wife."

"Sh-h-ucks! Who don't know dat Hattie Tyson! Ah ain't gonna bite mah tongue uh damn bit and if you don't lak it, you kin jus' try me wid yo' fist. Ahm three times seben and uh button! And whut makes me mad 'nough tuh fight uh circle-saw is, you don't want uh yo'self. You done got trapped and you ain't got de guts tuh take uh rascal-beater and run her 'way from here. She done moved you 'way from Eatonville 'cause 'tain't 'nough mens and likker dere tuh suit her."

"Wait uh minute, Hambo."

"Ain't gonna wait nothin' uh de kind. Wait broke de wagon down. Ah jes' feel lak takin' uh green club and waitin' on dat wench's head until she acknowledge Ahm God and besides me there's no other! Gimme lief, John, and Ah'll make haste and do it. Ah feels lak stayin' wid yo' head uh week. Dey tell me you eben drawed uh knife on yo' son John, 'cause he tried tuh keep dah strumpet out his mama's feather bed dat she give tuh li'l' Isis on her death-bed, and nobody but uh lowdown woman would want you scornin' yo' name all up lak dat."

Pearson hung his head.

"If y'all come heah tuh 'buke me, g'wan do it."

Hoffman spoke up.

"We ain't come to 'buke you, Reverend, but de church sho is talkin' and gittin' onrestless 'bout yo' marriage."

"Yeah, dat's jus' whut Ah come fuh—tuh 'buke yuh. Ah ain't come tuh make yuh no play-party. Stoopin' down from where you stand, fuh whut?" Hambo broke out again, "Jus' 'cause you never seen no talcum powder and silk kimonos back dere in Alabama."

Harris and Hoffman took him by the arms and led him forth, and John went back upstairs and wept.

Hattie had heard it all, but she stayed out of sight until the rough tongued Hambo was gone. She went to John, but first she combed her hair and under-braided the piece of John-de-conquer root in her stiff back hair. "Dey can't move me—not wid de help Ah got," she gloated and went in to John where he lay weeping.

"Thought you tole me dat Hambo wuz yo' bosom friend?"

"He is, Hattie. Ah don't pay his rough talk no mind."

"Ah don't call dat no friend—comin' right in yo' house and talkin' 'bout yo' wife lak she wuz uh dog. If you wuz any kind of uh man you wouldn't 'low it."

"Uh preacher can't be fightin' and keerin' on. Mo' special uh Moderator. Hambo don't mean no harm. He jus' 'fraid de talk might hurt me."

"Him and them sho treats me lak uh show man treats uh ape. Come right in mah house and run de hawg over me and tryin' tuh put you 'ginst me. Youse over dem and you ought not tuh 'low 'em tuh cheap, but 'stid uh dat they comes right to yo' face and calls yo' wife uh barrel uh dem things. Lawd knows Ah ain't got no puhtection uh tall! If Miss Lucy had tuh swaller all Ah does, Ah know she glad she dead."

"Lucy ain't never had nobody to call her out her name. Dey better not. Whut make *you* call her name? Hambo is de backbone uh mah church. Ah don't aim to tear de place tuh pieces

fuh nobody. Put dat in yo' pipe and smoke it."

Hattie heard and trembled. The moment that John left town to conduct a revival meeting, she gathered what money she could and hurried to the hut of An' Dangie Dewoe.

CHAPTER 19

The Lord of the wheel that turns on itself slept, but the world kept spinning, and the troubled years sped on. Tales of weakness, tales of vice hung about John Pearson's graying head. Tales of wifely incontinence which Zion Hope swallowed hard. The old ones especially. Sitting coolly in the shade of after-life, they looked with an utter lack of tolerance upon the brawls of Hattie and John. They heard her complaints often and believed her and only refused action because they knew the complainant to be equally guilty, but less popular than the man against whom she cried. Besides, the younger generation winked at what their elders cried over. Lucy had counselled well, but there were those who exulted in John's ignominious fall from the Moderatorship after nine years tenure, and milled about him like a wolf pack about a tired old bull—looking for a throat-hold, but he had still enough of the former John to be formidable as an animal and enough of his Pagan poesy to thrill. The pack waited. John knew it and was tired unto death of fighting off the struggle which must surely come. The devouring force of the future leered at him at unexpected moments. Then too his daily self seemed to be wearing thin, and the past seeped thru and mastered him for increasingly longer periods. He whose pres-

ent had always been so bubbling that it crowded out past and future now found himself with a memory.

He began to remember friends who had lain back on the shelf of his mind for years. Now and then he surprised them by casual visits, but the pitying look would send him away and it would be a long time before he made such a call again.

He began to see a good deal of Zeke who had moved with his family to Florida, a year or two before Lucy died. He loved seeing Zeke because he was just as great a hero in his brother's eyes as he had been when he was the biggest Negro Baptist in the State and when Zion Hope had nine hundred members instead of the six hundred now on its roll. Zeke talked but always spared him.

Yes, John Pearson found himself possessed of a memory at a time when he least needed one.

"Funny thing," he said sitting in Zeke's kitchen with his wife, "things dat happened long time uhgo used to seem way off, but now it all seems lak it wuz yistiddy. You think it's dead but de past ain't stopped breathin' yet."

"Eat supper wid us, John Buddy, and stay de night."

"Thankee, Zeke. B'lieve Ah will fuh uh change." He went to bed at Zeke's after supper. Slept a long time. He awoke with a peculiar feeling and crept out of the house and went home.

"Hattie, whut am Ah doin' married tuh you?" John was standing in his wife's bedroom beside her bed and looking down on her, a few minutes later.

Hattie sat up abruptly, pulling up the shoulder straps of her nightgown.

"Is dat any way fuh you tuh do? Proagin' 'round half de night lak uh damn tom cat and den come heah, wakin' me up tuh ast uh damn fool question?"

"Well, you answer me den. Whut is us doin' married?"

"If you been married tuh uh person seben years and den come ast sich uh question, you mus' be crazy uh drunk one. You *is* drunk! You oughta know whut us doin' married jus' ez well ez Ah do."

142

"But Ah don't. God knows Ah sho don't. Look lak Ah been sleep. Ah ain't never meant tuh marry you. Ain't got no recollection uh even tryin' tuh marry yuh, but here us is married, Hattie, how come dat?"

"Is you crazy sho 'nuff?"

"Naw, Ah ain't crazy. Look lak de first time Ah been clothed in mah right mind fuh uh long time. Look lak uh whole heap uh things been goin' on in mah sleep. You got tuh tell me how come me and you is married."

"Us married 'cause you said you wanted me. Dat's how come."

"Ah don't have no 'membrance uh sayin' no sich uh thing. Don't b'lieve Ah said it neither."

"Well you sho said so—more'n once too. Ah married yuh jes' tuh git rid of yuh."

"Aw naw. Ah ain't begged you tuh marry me, nothin' uh de kind. Ah ain't said nothing' 'bout lovin' yuh tuh my knowin', but even if Ah did, youse uh experienced woman—had plenty experience 'fo' Ah ever seen yuh. You know better'n tuh b'lieve anything uh man tell yuh after ten o'clock at night. You know so well Ah ain't wanted tuh marry you. Dat's how come Ah know it's uh bug under dis chip."

"Well—if you didn't want me you made lak yuh did," Hattie said doggedly.

"Dat sho is funny, 'cause Ah know Ah wanted Miss Lucy and Ah kin call tuh memory eve'y li'l' thing 'bout our courtin' and 'bout us gittin' married. Couldn't fuhgit it if Ah wuz tuh try. Mo' special and particular, Ah remember jus' how Ah felt when she looked at me and when Ah looked at her and when we touched each other. Ah recollect how de moon looked de night us married, and her li'l' bare feets over de floor, but Ah don't remember nothin' 'bout *you*. Ah don't know how de moon looked and even if it rained uh no. Ah don't 'call to mind making no 'rangements tuh marry yuh. So you mus' know mo' 'bout it than Ah do."

Hattie pulled her long top lip down over the two large chalky-white false teeth in front and thought a while. She sank

143

back upon her pillow with an air of dismissal. "Youse drunk and anybody'd be uh fool tuh talk after yuh. You know durned well how come you married me."

"Naw, Ah don't neither. Heap uh things done went on Ah ain't meant tuh be. Lucy lef' seben chillun in mah keer. Dey ain't here now. Where is mah chillun, Hattie? Whut mah church doin' all tore up? Look at de whiskey bottles settin' 'round dis house. Dat didn't useter be."

"Yeah, and you sho drinks it too."

"But Ah didn't useter. Not in Lucy's time. She never drunk none herself lak you do, and she never brought none in de house tuh tempt me."

"Aw g'wan out heah! Don't keer if Ah do take uh swaller uh two. You de pastor uh Zion Hope, not me. You don't hav' to do lak me. Youse older'n me. Hoe yo' own row. De niggers fixin' tuh put yuh out dat pulpit 'bout yo' women and yo' likker and you tryin' tuh blame it all on me."

"Naw it's jus' uh hidden mystery tuh me—what you doin' in Miss Lucy's shoes."

And like a man arisen, but with sleep still in his eyes, he went out of the door and to his own bedroom.

Hattie lay tossing, wondering how she could get to An' Dangie Dewoe without arousing suspicion.

"Wonder is Ah done let things go too long, or is de roots jus' done wore out and done turn'd back on me?"

There was no sleep in either bedroom that night.

Hattie crept into John's bed at dawn and tried her blandishments but he thrust her rudely away.

"Don't you want me tuh love yuh no mo'?"

"Naw."

"How come?"

"It don't seem lak iss clean uh sumpin."

"Is you mad cause Ah learnt tuh love yuh so hard way back dere 'fo' Miss Lucy died?"

"Ah didn't mind you lovin' me, but Ah sho is mad wid yuh fuh marryin' me. Youse jus' lak uh blowfly. Spoil eve'y thing yuh touch. You sho ain't no Lucy Ann."

"Naw, Ah ain't no Miss Lucy, 'cause Ah ain't goin' tuh cloak yo' dirt fuh yuh. Ah ain't goin' tuh take offa yuh whut she took so you kin set up and be uh big nigger over mah bones."

" 'Tain't no danger uh me bein' no big nigger wid *you* uhround. Ah sure ain't de State Moderator no mo'."

"And dat ain't all. You fool wid me and Ah'll jerk de cover offa you and dat Berry woman. Ah'll throw uh brick in yo' coffin and don't keer how sad de funeral will be, and Ah dare yuh tuh hit me too. Ah ain't gonna be no ole man's fool."

"You know Ah don't beat no women folks. Ah married Lucy when she wuzn't but fifteen and us lived tuhgether twenty-two years and Ah ain't never lifted mah hand—"

Suddenly a seven-year-old picture came before him. Lucy's bright eyes in the sunken face. Helpless and defensive. The look. Above all, the look! John stared at it in fascinated horror for a moment. The sea of the soul, heaving after a calm, giving up its dead. He drove Hattie from his bed with vile imprecations.

"You, you!" he sobbed into the crook of his arm when he was alone, "you made me do it. And Ah ain't never goin' tuh git over it long ez Ah live."

During breakfast they quarreled over the weak coffee and Hattie swore at him.

"No woman ain't never cussed me yet and you ain't gonna do it neither—not and tote uh whole back," he gritted out between his teeth and beat her severely, and felt better. Felt almost as if he had not known her when Lucy was sick. He panged a little less. So after that he beat her whenever she vexed him. More interest paid on the debt of Lucy's slap. He pulled the crayon enlargement of Hattie's out of its frame and belligerently thrust it under the wash-pot while she was washing and his smoking eyes warned her not to protest.

"Rev'und," she began at breakfast one morning, "Ah needs uh pair uh shoes."

"Whyn't yuh go git 'em den?"

"Where Ahm goin' tuh git 'em from?"

145

"Speer got plenty and J. C. Penney swear he sells 'em."

"Dat ain't doin' me no good lessen Ah got de money tuh buy 'em wid."

"Ain't yuh got no money?"

"You ain't gimme none, is yuh? Not in de last longest."

"Oh you got shoes uh plenty. Ah see yuh have five uh six pairs 'round out under de dresser. Miss Lucy never had nothin' lak dat."

"Miss Lucy agin! Miss Lucy dis, Miss Lucy dat!"

"Yeah Miss Lucy, and Ahm gointer put uh headstone at her grave befo' anybody git shoes 'round heah—eben me."

"Mah shoes is nelly wore out, man. Dat headstone kin wait."

"Naw, Hattie, 'tain't gonna wait. Don't keer if youse so nelly barefooted 'til yo' toes make prints on de ground. She's gointer git her remembrance-stone first. You done wore out too many uh her shoes already. Here, take dis two bits and do anything you wanta wid it."

She threw it back viciously. "Don't come lounchin' me out no two bits when Ah ast you fuh shoes."

Hattie reported this to certain church officers and displayed her general shabbiness. Harris sympathized.

"Iss uh shame, Sister. Ah'd cut down dat Jonah's gourd vine in uh minute, if Ah had all de say-so. You know Ah would, but de majority of 'em don't keer whut he do, some uh dese people stands in wid it. De man mus' is got roots uh got piece uh dey tails buried by his door-step. Know whut some of 'em tole me? Says he ain't uh bit worse dan de rest uh y'all 'round de altar dere. Y'all gits all de women yuh kin. He jus' de bes' lookin' and kin git mo' of 'em dan de rest. Us pays him tuh preach and he kin sho do dat. De best in de State, and whut make it so cool, he's de bes' lookin'. Eben dem gray hairs becomes 'im. Nobody don't haft do lak he *do*, jus' do lak he *say* do. Yes ma'am, Sister Pearson 'twon't do fuh us tuh try tuh handle 'im. He'd beat de case. De mo' he beat you de better some of 'em laks it. Dey chunkin stones at yo' character and sayin' you ain't fit. Pot calling de kittle black. Dey points de

146

finger uh scorn at yuh and say yo' eye is black. All us kin do is tuh lay low and wait on de Lawd."

"Sho wisht Ah could he'p mahself," Hattie whimpered.

"They *is* help if you knows how tuh git it. Some folks kin hit uh straight lick wid uh crooked stick. They's sich uh thing ez two-headed men."

"You b'lieve in all dat ole stuff 'bout hoodoo and sich lak, Brer Harris?" Hattie watched Harris's face closely.

"Yeah, Ah do, Mrs. Rev'und. Ah done seen things done. Why hit's in de Bible, Sister! Look at Moses. He's de greatest hoodoo man dat God ever made. He went 'way from Pharaoh's palace and stayed in de desert nigh on to forty years and learnt how tuh call God by all his secret names and dat's how he got all dat power. He knowed he couldn't bring off all dem people lessen he had power unekal tuh man! How you reckon he brought on all dem plagues if he didn't had nothin' but human power? And then agin his wife wuz Ethiopian. Ah bet she learnt 'im whut he knowed. Ya, indeed, Sister Pearson. De Bible is de best conjure book in de world."

"Where Ahm goin' ter fin' uh two-headed doctor? Ah don't know nothin' 'bout things lak dat, but if it kin he'p mah condition—"

"An' Dangie Dewoe wuz full uh power, but she dead now, but up t'wards Palatka is uh 'nother one dat's good. He calls hisself War Pete."

The old black woman of the sky chased the red-eyed sun across the sky every evening and smothered him in her cloak at last. This had happened many times. Night usually found John at his brother's house until late or at the bluff Deacon Hambo's who kept filthy epithets upon his tongue for his pastor, but held down the church with an iron hand.

A fresh rumor spread over the nation. It said war. It talked of blood and glory—of travel, of North, of Oceans and transports, of white men and black.

And black men's feet learned roads. Some said good bye cheerfully . . . others fearfully, with terrors of unknown dangers in their mouths . . . others in their eagerness for distance

147

said nothing. The daybreak found them gone. The wind said North. Trains said North. The tides and tongues said North, and men moved like the great herds before the glaciers.

Conscription, uniforms, bands, strutting drum-majors, and the mudsills of the earth arose and skipped like the mountains of Jerusalem on The Day. Lowly minds who knew not their State Capitals were talking glibly of France. Over there. No man's land.

"Gen'l Pushin', Gen'l Punishin', Gen'l Perchin', Gen'l Pershin'. War risk, war bread, insurance, Camp dis-and-dat. Is you heard any news? Dead? Lawd a mussy! Sho hope mah boy come thew aw-right. De black man ain't got no voice but soon ez war come who de first man dey shove in front? De nigger! Ain't it de truth? Bet if Ole Teddy wuz in de chear he'd straighten out eve'ything. Wilson! Stop dat ole lie. Wilson ain't de man Teddy Roosevelt wuz. De fightin'est man and the rulin'est man dat God ever made. Ain't never been two sho 'nuff smart mens in dese United States—Teddy Roosevelt and Booger T. Washington. Nigger so smart he et at de White House. Built uh great big ole school wuth uh thousand dollars, maybe mo'. Teddy wuz allus sendin' fuh 'im tuh git 'im tuh he'p 'im run de Guv'ment. Yeah man, dat's de way it 'tis—niggers think up eve'ything good and de white folks steal it from us. Dass right. Nigger invented de train. White man seen it and run right off and made him one jes' lak it and told eve'ybody he thought it up. Same way wid 'lectwicity. Nigger thought dat up too. DuBois? Who is dat? 'Nother smart nigger? Man, he can't be smart ez Booger T.! Whut did dis DuBois ever do? He writes up books and papers, hunh? Shucks! dat ain't nothin', anybody kin put down words on uh piece of paper. Gimme da paper sack and lemme see dat pencil uh minute. Shucks! Writing! Man Ah thought you wuz talkin' 'bout uh man whut had done sumpin. Ah thought maybe he wuz de man dat could make sidemeat taste lak ham."

Armistice. Demobilized. Home in khaki. "Yeah man, parlez vous, man, don't come bookooin' 'round heah, yuh liable tuh git hurt. Ah could uh married one uh dem French

women but shucks, gimme uh brown skin eve'y time. Blacker
de berry sweeter de juice. Come tuh mah pick, gimme uh
good black gal. De wine wuz sour, and Ah says parlez vous,
hell! You gimme mah right change! Comme telly vous. Nar,
Ah ain't goin' back tuh no farm no mo'. Ah don't mean tuh
say, 'Git up' tuh nary 'nother mule lessen he's setting down
in mah lap. God made de world but he never made no hog
outa me tuh go 'round rootin' it up. Done done too much
bookoo plowing already! Woman quick gimme mah sumpin
t' eat. Toot sweet.''

World gone money mad. The pinch of war gone, people
must spend. Buy and forget. Spend and solace. Silks for sor-
rows. Jewels to bring back joy. The factories roared and cried,
''Hands!'' and in the haste and press white hands became
scarce. Scarce and dear. Hands? Who cares about the color of
hands? We need hands and muscle. The South—land of mus-
cled hands.

"George, haven't you got some relatives and friends down
South who'd like a job?"

"Yes, suh."

"Write 'em to come."

Some had railroad fare and quickly answered the call of the
North and sent back for others, but this was too slow. The
wheels and marts were hungry. So the great industries sent out
recruiting agents throughout the South to provide transporta-
tion to the willing but poor.

"Lawd, Sanford gettin' dis Nawth bound fever lak eve'y-
where else," Hambo complained one Sunday in church.
"Elder, you know we done lost two hund'ed members in three
months?"

"Co'se Ah knows it, Hambo. Mah pocketbook kin tell it, if
nothing else. Iss rainin' in mah meal barrel right uh long."

"Dat's awright. De celery farms is making good. All dese
folks gone Nawth makes high wages 'round heah. Less raise
de church dues," and it was done.

But a week later Hambo was back. "Looka heah, John, dis
thing is gittin' serious sho 'nuff. De white folks is gittin' wor-

ried too. Houses empty eve'ywhere. Not half 'nough people tuh work de farms—crops rotting in de ground. Folks plantin' and ain't eben takin' time tuh reap. Mules lef' standin' in de furrers. Some de folks gone 'thout lettin' de families know, and dey say iss de same way, only wurser, all over de South. Dey talkin' 'bout passin' laws tuh keep black folks from buying railroad tickets. Dey tell me dey stopped uh train in Georgy and made all de colored folks git off. Up dere iss awful, de pullman porters tell me. Ride half uh day and see nothin' but farms wid nobody on 'em."

"Yeah," Pearson answered, "had uh letter from mah son in Tennessee. Same way. In some parts de white folks jails all them recruitin' agents so dey hafta git de word uhround in secret. Folks hafta slip off. Drive off in cars and ketch trains further up de line."

"Tell yuh whut Ah seen down tuh Orlando. De man wuz skeered tuh git offa de train, but he seen uh colored man standin' 'round de deepo', so he took and called 'im and he says, 'Ahm uh labor agent, wanta work?' He tole him, 'Yes suh.' 'Well git some mo' men and have 'em down heah tuh meet de Nawth bound train at 2:40 o'clock. Ah'll stick mah hand out de winder and show wid mah fingers how many Ah got transportation for. Y'all watch good and count mah fingers right,' and he done it. Wanted sixteen. He beckoned one of 'em onto de train and fixed up wid him fuh de rest and dey all went wid 'im. Dat's all yuh kin heah. On de streets—in de pool-room—pickin' beans on de farm—in de cook kitchen— over de wash board—before dey go in church and soon ez dey come out, tellin' who done already went and who fixin' tuh go."

"Yeah," agreed Rev. Pearson, "we preachers is in uh tight fix. Us don't know whether tuh g'wan Nawth wid de biggest part of our churches or stay home wid de rest."

"Some of 'em done went. Know one man from Palatka done opened up uh church in Philadelphy and most of 'em is his ole congregation. Zion Hope sho done lost uh many one. Most of 'em young folks too."

"Well maybe they won't stay Nawth. Most of 'em ain't useter col' weather fuh one thing."

"Yeah, but dey'll git used tuh it. Dey up dere now makin' big money and livin' in brick houses. Iss powerful hard tuh git uh countryman outa town. He's jus' ez crazy 'bout it ez uh hog is 'bout town swill. Dey won't be back soon."

Do what they would, the State, County and City all over the South could do little to halt the stampede. The cry of "Goin' Nawth" hung over the land like the wail over Egypt at the death of the first-born. The railroad stations might be watched, but there could be no effective censorship over the mails. No one could keep track of the movements of cars and wagons and mules and men walking. Railroads, hardroads, dirt roads, side roads, roads were in the minds of the black South and all roads led North.

Whereas in Egypt the coming of the locust made desolation, in the farming South the departure of the Negro laid waste the agricultural industry—crops rotted, houses careened crazily in their utter desertion, and grass grew up in streets. On to the North! The land of promise.

CHAPTER 20

Hattie was rubbing in the first water and dropping the white things into the wash-pot when Deacon Harris hurried up to her back gate.

"Mawnin', Sister Pearson," opening the gate.

"Howdy do, Deacon?"

"Ain't got no right tuh grumble. How you?"

"Not so many, dis mawnin'. You look lak you in uh kinda slow hurry."

"Nope, jes' anxious tuh tell yuh uh thing uh two."

"If is sumpin tuh better mah condition, hurry up and tell it. God knows Ah sho needs somebody tuh give aid and assistance. Reverend and his gang sho is gripin' me. Ah feels lak uh cat in hell wid no claws."

"First thing, Ah got uh man Ah b'lieve, if de crowd ever git tuh hear 'im, dey'd lak 'im better'n de Rev'und."

"Where he come from?"

"Wes' Floriduh. Man he kin cold preach! Preached over in Goldsborough las' night and strowed fire all over de place. Younger man dan Pearson too."

"Can't you fix it fuh 'im tuh speak at Zion Hope?"

"Sho. Done 'bout got it fixed fuh de fourth Sunday night. Dat ain't Pastoral Sunday, but its de nex' bes'. De crowd'll be almos' ez big."

"Dat's fine! Some uh dem niggers don't b'lieve nobody kin preach but John Pearson. Let 'em see. Den maybe dey'll set 'im down. Ah don't keer whut dey do wid 'im. Ah do know one thing, Ah sho got mah belly full. Whus de other things you wuz goin' tuh tell me 'bout?"

"Well, in looking over de books, I saw where mos' of the folks whut would stand up for Rev'und so hard, is gone. If we wuz tuh bring de thing tuh uh vote Ah b'lieve we kin dig up de hidden wedge. Ah been sorta feelin' 'round 'mong some de members and b'lieve de time done come when we kin chop down dis Jonah's gourd vine."

"Dat sho would be all de heben Ah ever want to see. How kin we bring it uhbout? You got tuh have plenty tuh show do some uh dat crowd won't hear it."

"You git uh divorce from 'im. You kin git plenty witnesses tuh bear yuh out in dat. Ah'll be one mahself."

"Chile, he wouldn't keer nothin' 'bout dat. He'd be glad, Ah speck, so he kin run loose wid dat Gertie Burden. Dat's de one he sho 'nuff crazy 'bout."

"Who you tellin'? Ever since she wuz knee high. Us knowed it all de time, but thought yuh didn't."

"He don't try tuh keep it out mah sight. He washes mah face wid her night and day."

"You jokin'!"

"Know whut he told me las' time Ah got 'im 'bout her? Says, 'Don't be callin' dat girl all out her name, Miss Lucy didn't call *you* nothin'.' Deacon Harris, Ah wuz so mad Ah could uh lammed 'im wid lightnin', but how de divorce goin' set 'im down?"

"Yuh see de church punishes fuh things de law don't chastize fuh, and if iss so bad 'til de law'll handle it, de church is bound tuh. Don't need no mo' trial."

"But Ah can't eben start uh divorce trial jus' dry long so."

"You kin pick uh fight outa Sister Beery uh Gertie Burden, can't yuh? Dat'll th'ow de fat in de fiah, and bring eve'ything out in de day light, and when iss all over wid, he'll be uh lost ball in de high grass. Ah sick and tiahed uh all dese so-called

no-harm sins. Dis ain't no harm, and dat ain't no harm, and all dese li'l' no-harm sins is whut leads folks straight to hell."

"De one Ah wants tuh beat de worse is dat ole Beery Buzzard. Right on de church ground she ast me one Sunday, if Miss Lucy's bed wudden still hot when Ah got in it."

"Jump on her, den."

"She's rawbony, but she look real strong tuh me. Ole long, tall, black huzzy! Wisht Ah could hurt 'er."

"She don't eat iron biscuits and she don't sop cement gravy. She kin be hurt, and den agin, you kin git help—not open, yuh know, but on de sly. Somebody tuh hand yuh sumpin jes' when you need it bad."

"When mus' Ah tackle de slut?"

"De very nex' time Rev'und goes off somewhere tuh preach. If he's dere he'd git it stopped too quick. Befo' it make uhnough disturbment."

Two incidents nerved Hattie's hand. The first, that same evening Rev. Pearson came in from some carpentry work he had been doing out around Geneva, obviously crestfallen, but nothing she did succeeded in making him tell her the reason.

If she could have seen her husband at noon time of that very same day she would have seen him seated beside the luscious Gertie on a cypress log with her left hand in his and his right arm about her waist.

"John, Ah b'lieve Ahm goin' ter marry."

"Please, Gertie, don't say dat."

"You married, ain'tcha? Ahm twenty-two. Papa and mama spectin' me tuh marry some time uh other and dey think Ah oughter take dis chance. You know he got uh big orange grove wid uh house on it and seben hund'ed dollars in de bank."

"Dat's right, Gertie. Take yo' chance when it comes. Don't think—don't look at me. Ahm all spoilt now. Kiss me one mo' time. Den Ah got tuh go back tuh work. Lawd, Ah hope you be happy. Iss wonderful tuh marry somebody when you wants tuh. You don't keer whut you do tuh please 'em. Some women you wouldn't mind tearin' up de pavements uh hell tuh built

155

'em uh house, but some you don't give 'em nothin'. You jes' consolate 'em by word uh mouf and fill 'em full uh melody.''

Therefore the next morning at breakfast when John grumbled about the scorched grits and Hattie threatened to dash hot coffee in John's face, he beat her soundly. The muscular exercise burnt up a portion of his grief, but it urged Hattie on. A few days later, when she learned of Gertie's engagement, she was exultant. "Now maybe, it'll hurt 'im, if Ah quit 'im. Gittin' loose from me might gripe 'im now—anyhow it sho ain't gwine he'p 'im none wid Gertie.''

Hattie knew, as do other mortals, that half the joy of quitting any place is the loneliness we leave behind.

CHAPTER 21

The fourth Sunday came shining with the dangerous beauty of flame. Between Sunday School and the 11:00 o'clock service, Andrew Berry called Rev. Pearson aside.

"Is de deacon board tole yuh?"

" 'Bout whut?"

"De new preacher dey got here tuh try out tuhnight?"

"Naw, but Hambo did tell me tuh strow fire dis mawnin'. Reckon he wuz throwin' me uh hint right den."

"Ahm sho he wuz. De Black Herald got it dat dey got *you* on de let-loose and de onliest thing dat keeps some of 'em hangin' on is dey don't b'lieve nobody kin preach lak you, but if dis man dey got here tuhday kin surpass yuh, den dere'll be some changes made. Harris and de Black Dispatch say he kin drive all over yuh."

"Maybe he kin, Andrew. Ain't dat him over dere, talkin' tuh Sister Williams?"

"Yeah. He'll be tuh de service tuh hear *you* so he kin know how tuh do tuhnight when he gits up tuh preach."

John Pearson shook hands politely when he was introduced to Rev. Felton Cozy when he entered the church. Rev. Cozy was cordially invited to sit in the pulpit, which he did very pompously. All during the prayer service that led up to the

sermon he was putting on his Oxford glasses, glaring about the church and taking them off again.

Rev. Pearson preached his far-famed, "Dry Bones" sermon, and in the midst of it the congregation forgot all else. The church was alive from the pulpit to the door. When the horse in the valley of Jehoshaphat cried out, "Ha, ha! There never was a horse like me!" He brought his hearers to such a frenzy that it never subsided until two Deacons seized the preacher by the arms and reverently set him down. Others rushed up into the pulpit to fan him and wipe his face with their own kerchiefs.

"Dat's uh preachin' piece uh plunder, you hear me?" Sister Hall gloated. "Dat other man got tuh go some if he specks tuh top dat."

"Can't do it," Brother Jeff avowed, "can't be done."

"Aw, you don't know," contended Sister Scale. "Wait 'til you hear de tother one."

"Elder Pearson ain't preached lak dat in uh long time. Reckon he know?"

"Aw naw. Dey kep' it from 'im. When he know anything, de church'll be done done whut dey going tuh do."

When Rev. Cozy arose that night the congregation slid forward to the edge of its seat.

"Well, y'all done heard one sermon tuhday, and now Ah stand before you, handlin' de Alphabets." He looked all about him to get the effect of his statement. "Furthermo', Ah got uhnother serus job on mah hands. Ahm a race man! Ah solves the race problem. One great problem befo' us tuhday is whut is de blacks gointer do wid de whites?"

After five minutes or more Sister Boger whispered to Sister Pindar, "Ah ain't heard whut de tex' wuz."

"Me neither."

Cozy had put on and removed his glasses with the wide black ribbon eight times.

"And Ah say unto you, de Negro has got plenty tuh feel proud over. Ez fur back ez man kin go in his-to-ree, de black man wuz always in de lead. When Caesar stood on de Roman

158

forum, uccordin' tuh de best authority, uh black man stood beside him. Y'all say 'Amen.' Don't let uh man preach hisself tuh death and y'll set dere lak uh bump on uh log and won't he'p 'im out. Say 'Amen'!!

"And fiftly, Je-sus, Christ, wuz uh colored man hisself and Ah kin prove it! When he lived it wuz hot lak summer time, all de time, wid de sun beamin' down and scorchin' hot—how could he be uh white man in all dat hot sun? Say 'Amen'! Say it lak you mean it, and if yuh do mean it, tell me so! Don't set dere and say nothin'!

"Furthermo' Adam musta been uh colored man 'cause de Bible says God made 'im out de dust uh de earth, and where is anybody ever seen any white dust? Amen! Come on, church, say 'Amen'!

"And twelfth and lastly, all de smartest folks in de world got colored blood in 'em. Wese de smartest people God ever made and de prettiest. Take our race—wese uh mingled people. Jes' lak uh great bouquet uh flowers. Eve'y color and eve'y kind. Nobody don't need tuh go hankerin' after no white womens. We got womens in our own race jes' ez white ez anybody. We got 'em so black 'til lightnin' bugs would follow 'em at twelve o'clock in de day—thinkin' iss midnight and us got 'em in between.

"And nothin' can't go on nowhere but whut dere's uh nigger in it! Say 'Amen'!"

"Amen! He sho is tellin' de truth now!"

At the close of the service, many came forward and shook Cozy's hand and Harris glowed with triumph. He was dry and thirsty for praise in connection with his find so he tackled Sisters Watson and Boger on the way home.

"How y'all lak de sermon tuhnight?"

"Sermon?" Sister Boger made an indecent sound with her lips, "dat wan't no sermon. Dat wuz uh lecture."

"Dat's all whut it wuz," Sister Watson agreed and switched on off.

Harris knew that he must find some other weapon to move the man who had taken his best side-girl from him.

CHAPTER 22

Harris, Hattie and one-eyed Fred Tate went on with their plans for the complete overthrow of Rev. Pearson thru the public chastisement of Sister Berry, but things began to happen in other directions.

While she held a caucus one afternoon with supporters, Hambo sat at Zeke's house and sent one of Zeke's children to find John.

"John, youse in boilin' water and tuh you—look lak 'tain't no help fuh it. Dat damn 'oman you got b'lieves in all kinds uh roots and conjure. She been feedin' you outa her body fuh years. Go home now whilst she's off syndicatin' wid her gang—and rip open de mattress on yo' bed, de pillow ticks, de bolsters, dig 'round de door-steps in front de gate and look and see ain't some uh yo' draws and shirt-tails got pieces cut offa 'em. Hurry now, and come back and let us know whut you find out. G'wan! Don't stop tuh race yo' lip wid mine, and don't try tuh tell me whut you think. Jes' you g'wan do lak Ah tell yuh."

John Pearson went and returned with a miscellany of weird objects in bottles, in red flannel, and in toadskin.

"Lawd, Hambo, here's uh piece uh de tail uh—uh shirt Ah had 'fo' Lucy died. Umph! Umph! Umph!"

"Ha! Ah wuz spectin' dat!"

"Whut kin Ah do 'bout it, Hambo?"

"Give it here. Less take it tuh uh hoodoo doctor and turn it back on her, but whut you got tuh do is tuh beat de blood outa her. When you draw her wine dat breaks de spell—don't keer whut it is."

"Don't you fret 'bout dat. Ah 'bominates sich doings. She gointer git her wine drawed dis day, de Lawd bein' may helper. Ahm goin' on home and be settin' dere when she come."

Hattie saw the hole at the gate and the larger one at the front steps before she entered the yard. Inside, the upturned rugs, the ripped-up beds, all had fearful messages for her. Who had done this thing? Had her husband hired a two-headed doctor to checkmate her? How long had he been suspecting her? Where was he now?

"Hattie," John called from the dining-room. She would have bolted, but she saw he made ready to stop her. She stood trembling in the hallway like a bird before a reptile.

"Whut you jumpin' on me fuh?" she cried out as he flung himself upon her.

"You too smart uh woman tuh ast dat, and when Ah git th'ew wid you, you better turn on de fan, and make me some tracks Ah ain't seen befo' do Ahm gointer kill yuh. Hoodooin' me! Stand up dere, 'oman, Ah ain't hit you yet."

And when the neighbors pulled him from her weakening body he dropped into a chair and wept hard. Wept as he had not wept since his daughter's serious illness, emptying out his feelings.

Hattie fled the house, not even waiting to bathe her wounds nor change her clothes. When John's racking sobs had ceased, the stillness after the tumult soothed him. He bathed and slept fourteen hours. In the morning he wrote to each of his children a shy letter. On the third day Hattie struck. He was sued for divorce.

"Ahm sho glad," he told Zeke and Hambo, "she made me

jes' ez happy by quittin' ez Lucy did when she married me."

"Yeah, but if she prove adultery on you in de cotehouse, you sho goin' tuh lose yo' church," Hambo warned. "You got tuh fight it."

CHAPTER 23

Time is long by the courthouse clock.

John Pearson sat restlessly in his seat. Sitting alone except for Zeke's oldest son. Zeke had to work that day and his sister-in-law excused herself on the grounds that she "never had been to any courthouse and she didn't want no bother with it. Courthouses were bad luck to colored people—best not to be 'round there." Many of the people John had approached for witnesses had said the same thing. "Sho, sho," they wanted him to win, but "you know dese white folks—de laws and de cotehouses and de jail houses all b'longed tuh white folks and po' colored folks—course, Ah never done nothin' tuh be 'rested 'bout, but— Ah'll be prayin' fuh yuh, Elder. You bound tuh come out more'n conquer."

So John sat heavily in his seat and thought about that other time nearly thirty years before when he had sat handcuffed in Cy Perkins' office in Alabama. No fiery little Lucy here, thrusting her frailty between him and trouble. No sun of love to rise upon a gray world of hate and indifference. Look how they huddled and joked on the other side of the room. Hattie, the destroyer, was surrounded by cheer. Sullen looks his way. Oh yes, she had witnesses!

Mule-faced, slew-foot Emma Hales was there—rolling her cock-eye triumphantly at him. Why should she smite out at his

head? He remembered the potato pones, the baked chicken with corn-bread dressing, the marble cake, the potato pies that he had eaten in her house many times. He had eaten but never tarried. Never said a word out of the way to her in all his life. He wondered, but Emma knew. She remembered too well how often he had eaten her dinners and hurried away to the arms of the gray-eyed Ethel.

Deacon Harris now outwardly friendly, but he had been told weeks before of Harris's activity against him. Harris should not be hostile, he had taken no woman who loved Harris, for none had wanted him. His incompetence was one of the behind-hand jokes of the congregation. He was blind to human motives but Harris hated him with all the fury of the incompetent for the full-blooded loins.

The toadies were there. Armed with hammers. Ever eager to break the feet of fallen idols. Contemptuous that even the feet of idols should fall among them. No fury so hot as that of a sycophant as he stands above a god that has toppled from a shrine. Faces of gods must not be seen of him. He has worshipped beneath the feet so long that if a god but lowers his face among them, they obscene it with spit. "Ha!" they cried, "what kind of a divinity is this that levels his face with mine? Gods show feet—not faces. Feet that crush—feet that crumble—feet that have no eyes for men's suffering nor ears for agony, lest indeed it be a sweet offering at God's feet. If gods have no power for cruelty, why then worship them? Gods tolerate sunshine, but bestir themselves that men may have storms. From the desolation of our fireplaces, let us declare the glory. If he rides upon the silver-harnessed donkey, let us cry 'hosanna'. If he weeps in compassion, let us lynch him. The sky-rasping mountain-peak fills us with awe, but if it tumbles into the valley it is but boulders. It should be burst asunder. Too long it has tricked us into worship and filled our souls with envy. Crush! Crush! Crush! Lord, thou hast granted thy servant the boon of pounding upon a peak."

So the toadies were there. Vindictively setting the jaw-muscles. Taking folks for fools! But, yes they would testify.

Their injury was great. Let his silk-lined broadcloth look to itself. They meant to rip it from his back today. Think of it, folks! We rip up broadcloth and step on Stetsons. Costly walking-sticks can be made into wood for the cook stove.

Hattie was a goddess for the moment. She sat between the Cherubim on the altar of destruction. She chewed her gum and gloated. Those who held themselves above me, shall be abased. Him who pastored over a thousand shall rule over none. Even as I. His name shall be a hissing, and Hattie's shall be the hand that struck the harp. Selah. Let the world hiss with Hattie. If he but looked with longing! But no, only hurt and scorn was in his eyes. Hurt that so many of his old cronies surrounded her and scorn of herself. Let him ache! If she could but ache him more!

Court was set. The waves of pang that palpitated in the room did not reach up to the judge's bench. No. His honor took his seat as a walrus would among a bed of clams. He sat like a brooding thought with his eyes outside the room. It was just another day with the clerk and the stenographer.

"Hattie Pearson, pwop wah blah!"

John saw the smirking anticipation on the faces of the lawyers, the Court attendants, the white spectators, and felt as if he had fallen down a foul latrine.

"Now, how was it, Hattie?" The look around the room at the other whites, as if to say, "Now listen close. You're going to hear something rich. These niggers!"

"So you wanta quit yo' husband, do you, Hattie? How come? Wasn't he all right? Is *that* him? Why he looks like he oughta be okeh. Had too many women, eh? Didn't see you enough, is that it? Ha! ha! couldn't you get yo'self another man on the side? What you worrying about a divorce for? Why didn't you g'wan leave him and get yourself somebody else? You got divorce in yo' heels, ain't you? You must have the next one already picked out. Ha! ha! Bet he ain't worth the sixty dollars."

So it went on with each of the witnesses in turn. John laughed grimly to himself at the squirming of prospective

witnesses who would have fled but found it too late. One by one he saw four of his erstwhile intimates take the stand against him.

Finally the Clerk cast about for defense witnesses, "Say, Reverend, where's *yo'* witnesses?"

"Ain't got none."

"Why? Couldn't you find anybody to witness for you?"

"Yes suh, but who kin tell de truth and swear dat he know uh man ain't done nothin' lak dat?"

The Court laughed, but sobered with a certain respect.

"You want to enter a plea of denial?"

"Naw suh. Ahm goin' tuh say Ah did it all."

"You don't care, then, if Hattie has her freedom?"

"Naw suh, Ah sho don't. Matters uh difference tuh me whut she do, uh where she go."

The fun was over in the Court. Whisperings. Formalities. Papers. It was all over. He saw former friends slinking off to avoid his eye. Hattie was outside, flourishing her papers with over-relish. Loud talking and waving them as if they were a certificate of her virtue.

Hambo's short sturdy legs overtook John as he went down the marble steps, and Hambo's big hand smacked his shoulders.

"Well, you, ole mullet-headed tumble-bug, you!"

John eyed him wearily, "How come didn't but four uh y'all testify aginst me? Ah thought Ah had five friends."

"You ———!" Hambo went into a fit of most obscene swearing, "why didn't you call me fuh uh witness? Didn't Ah tell yuh to?"

"Yeah, but—"

"Take yo' but out my face. Ah wanted tuh git up dere and talk some chat so bad 'til de seat wuz burning me. Ah wanted tuh tell 'bout de mens Ah've knowed Hattie tuh have. She could make up uh 'scursion train all by herself. Ah wanted tuh tell de judge 'bout all dat conjure and all dem roots she been workin' on you. Feedin' you outa her body—."

"And dat's how come Ah didn't have 'em tuh call yuh. Ah

168

didn't want de white folks tuh hear 'bout nothin' lak dat. Dey knows too much 'bout us as it is, but dey some things dey ain't tuh know. Dey's some strings on our harp fuh us tuh play on and sing all tuh ourselves. Dey thinks wese all ignorant as it is, and dey thinks wese all alike, and dat dey knows us inside and out, but you know better. Dey wouldn't make no great 'miration if you had uh tole 'em Hattie had all dem mens. Dey spectin' dat. Dey wouldn't zarn 'tween uh woman lak Hattie and one lak Lucy, uh yo' wife befo' she died. Dey thinks all colored folks is de same dat way. De only difference dey makes is 'tween uh nigger dat works hard and don't sass 'em, and one dat don't. De hard worker is uh good nigger. De loafer is bad. Otherwise wese all de same. Dass how come Ah got up and said, 'Yeah, Ah done it,' 'cause dey b'lieved it anyhow, but dey b'lieved de same thing 'bout all de rest.''

It was late afternoon when John stumbled out of the court-house with his freedom that had been granted to Hattie.

"You tellin' de truth, John," Hambo agreed at last, "but don't you come puttin' me in wid dem other crabs. Don't you come talkin' tuh *me* lak dat! Ah knock yuh so dead dat yuh can't eben fall. Dey'll have tuh push yuh over. Pick up dem damn big foots uh your'n and come on up tuh mah house. Ah got barbecued spare-ribs and death puddin' ready cooked.''

On the way over there was a great deal of surface chatter out of Hambo. John kept silent except when he had to answer. At Hambo's gate he paused. "Ain't it funny, Hambo, you know all uhbout me. Us been friends fuh twenty years. Don't it look funny, dat all mah ole pleasures done got tuh be new sins? Maybe iss 'cause Ahm gittin' ole. Havin' women didn't useter be no sin. Jus' got sinful since Ah got ole.''

" 'Tain't de sin so much, John. You know our people is jus' lak uh passle uh crabs in uh basket. De minute dey see one climbin' up too high, de rest of 'em reach up and grab 'em and pull 'im back. Dey ain't gonna let nobody git nowhere if dey kin he'p it.''

CHAPTER 24

Second Sunday in the month came rolling around. Pastoral day. Covenant meeting. Communion service. But before all this must come Conference meeting on the Saturday night before, and John knew and everybody knew what the important business of the meeting would be. Zion Hope, after seventeen years, was going to vote on a pastor. Was John Pearson to be given a vote of confidence? Not if Hattie's faction prevailed. Would Felton Cozy receive the call? Not if Hambo and the John Pearson faction was still alive.

Everybody was there. John opened the meeting as usual, then stepped down and turned the chair over to Deacon Hoffman. "I know we all come here tuhnight tuh discuss some things. Ah'd ruther not tuh preside. Deacon Hoffman."

Hoffman took the chair. "Y'all know whut we come here for. Less get thru wid de most urgent business and den we kin take up new business."

He fumbled with the pile of hymnals on the table and waited. There was an uneasy shuffling of feet all over the room, but nobody arose to put a motion. Finally Hattie got up about the middle of the center aisle.

"Brother Cherman."

"Sister Pearson."

"Ah wants tuh lay charges 'ginst mah husband."

Hambo was on his feet.

"Brother Cherman! Brother Cherman!"

"Sister Pearson got de flo', Brer Hambo."

"She ain't got no business wid it. She's entirely out uh order."

"She ain't. She says she got charges tuh make uhginst her husband. Dat's whut uh Conference meetin' is for in uh Baptis' Church—tuh hear charges and tuh rectify, ain't it?"

"Yeah," Hambo answered, "but dis woman ain't got no husband in dis church, Brother Cherman. We ain't got no right listenin' tuh nothin' she got tuh say. G'wan back where you come from, Hattie, and try to improve up from uh turpentine still."

"Dat's right, too," shouted Sister Watson, "been divorced two weeks tuh mah knowin'."

"Better set down, Sister Pearson, 'til we kin git dis straight," Hoffman said, reluctantly.

"Iss straight already," Andrew Berry shouted, "when uh woman done gone tuh de cotehouse and divorcted uh man she done got her satisfaction. She ain't got no mo' tuh say. Let de mess drop. Ah ain't goin' tuh hear it."

"And another thing," Hambo put in. "Elder Pearson, you oughta git up and tell whut you found in yo' bed. Course he beat uh, and 'tain't uh man under de sound uh mah voice but whut wouldn't uh done de same. G'wan tell it, Rev'und."

"Naw, no use tuh sturry up de stink. Let it rest. Y'all g'wan do whut yuh want tuh."

There was a long, uncomfortable silence.

"G'wan talk, Harris, you and de rest dat's so anxious tuh ground-mole de pastor, but be sho and tell where *you* wuz yo'self when you seen him do all of dis y'all talkin' 'bout. Be sho and tell dat too. Humph! Youse jes' ez deep in de mud ez he is in de mire."

Another long silence. Finally Hoffman said, "De hour is growin' late. Less table dis discussion and open up de house fuh new business."

Soon the meeting was over. John, Hambo and Berry walked home together.

"If Harris and dem had uh called dat meetin' de nex' day after cote, it would a been uh smuttie rub, nelly eve'ybody would have been uhginst yuh, but two weeks is too long fuh colored tuh hold onto dey feeling. Most of 'em don't keer one way uh 'nother by now."

"Still plenty of 'em is 'ginst me," John spoke at last. "It made mah flesh crawl—Ah felt it so when Ah wuz in dere."

"But dey ain't got no guts. Dey wants tuh do dey work under cover. Dey got tuh fight war if dey wants tuh win dis battle, and dey needs cannon-guns. You can't fight war wid uh brick."

John said nothing. His words had been very few since his divorce. He was going about learning old truths for himself as all men must, and the knowledge he got burnt his insides like acid. All his years as pastor at Zion Hope he had felt borne up on a silken coverlet of friendship, but the trial had shown him that he reclined upon a board, thinly disguised. Hambo had tried vainly to bring him around. A few others had done their share. A few he recognized among the congregation as foes, avowedly; a few friends in the same degree. The rest he saw would fall in line and toady if he triumphed, and execrate him if he failed. He felt inside as if he had been taking calomel. The world had suddenly turned cold. It was not new and shiny and full of laughter. Mouldy, maggoty, full of suck-holes—one had to watch out for one's feet. Lucy must have had good eyes. She had seen so much and told him so much it had wearied him, but she hadn't seen all this. Maybe she had, and spared him. She would. Always spreading carpets for his feet and breaking off the points of thorns. But and oh, her likes were no more on this earth! People whom he had never injured snatched at his shoddy bits of carpet and sharpened the thorns for his flesh.

Nobody pushed him uphill, but everybody was willing to lend a hand to the downward shove. Oh for the wings, for the

173

wings of a dove! That he might see no more what men's faces held!

Sunday afternoon, the sunlight filtered thru the colored glass on the packed and hushed church. Women all in white. Three huge bouquets of red hibiscus below him and behind the covered Communion table. As he stood looking down into the open Bible and upon the snow-white table, his feelings ran riot over his body. "He that soppeth in the dish with me." He knew he could not preach that Last Supper. Not today. Not for many days to come. He turned the pages while he swallowed the lump in his throat and raised:

> Beloved, Beloved, now are we the sons of God
> And it doth not yet appear what we shall be
> But we know, but we know
> When He shall appear, when He shall appear
> We shall be like Him
> We shall see Him as He is.

The audience sang with him. They always sang with him well because group singers follow the leader.

Then he began in a clear, calm voice.

"Brothers and Sisters: De song we jus' sung, and seein' so many uh y'all out here tuh day, it reaches me in uh most particular manner. It wakes up uh whole family uh thoughts, and Ahm gointer speak tuh yuh outa de fullness uh mah heart. Ah want yuh tuh pray wid me whilst Ah break de bread uh life fuh de nourishment uh yo' souls.

"Our theme this morning is the wounds of Jesus. When the father shall ast, 'What are these wounds in thine hand?' He shall answer, 'Those are they with which I was wounded in the house of my friends.' Zach. 13:6.

"We read in the 53rd Chapter of Isaiah where He was wounded for our transgressions and bruised for our iniquities, and the apostle Peter affirms that His blood was spilt from before the foundation of the world.

"I have seen gamblers wounded. I have seen desperadoes

174

wounded; thieves and robbers and every other kind of charac-
ters, law-breakers and each one had a reason for his wounds.
Some of them was unthoughtful, and some for being over-
bearing, and some by the doctor's knife, but all wounds dis-
figure a person.

"Jesus was not unthoughtful. He was not overbearing. He
was never a bully. He was never sick. He was never a criminal
before the law and yet He was wounded. Now, a man usually
gets wounded in the midst of his enemies, but this man was
wounded, says the text, in the house of His friends. It is not
your enemies that harm you all the time. Watch that close
friend. Every believer in Christ is considered His friend, and
every sin we commit is a wound to Jesus. The blues we play
in our homes is a club to beat up Jesus, and these social card
parties.
Jesus have always loved us from the foundation of the world
When God
Stood out on the apex of His power
Before the hammers of creation
Fell upon the anvils of Time and hammered out the ribs of the
 earth
Before He made any ropes
By the breath of fire
And set the boundaries of the ocean by the gravity of His
 power
When God said, ha!
Let us make man
And the elders upon the altar cried, ha!
If you make man, ha!
He will sin
God my master, ha!
Father!! Ha-aa!
I am the teeth of time
That comprehended de dust of de earth
And weighed de hills in scales
That painted de rainbow dat marks de end of de parting storm
Measured de seas in de holler of my hand

That held de elements in a unbroken chain of controllment.
Make man, ha!
If he sin I will redeem him
I'll break de chasm of hell
Where de fire's never quenched
I'll go into de grave
Where de worm never dies, Ah!
So God A'mighty, Ha!
Got His stuff together
He dipped some water out of de mighty deep
He got Him a handful of dirt
From de foundation sills of de earth
He seized a thimble full of breath
From de drums of de wind, ha!
God, my master!
Now I'm ready to make man
Aa-aah!
Who shall I make him after? Ha!
Worlds within worlds begin to wheel and roll
De Sun, Ah!
Gethered up de fiery skirts of her garments
And wheeled around de throne, Ah!
Saying, Ah, make man after me, ha!
God gazed upon the sun
And sent her back to her blood-red socket
And shook His head, ha!
De Moon, ha!
Grabbed up de reins of de tides.
And dragged a thousand seas behind her
As she walked around de throne
Ah-h, please make man after me
But God said "NO!"
De stars bust out from their diamond sockets
And circled de glitterin' throne cryin'
A-aah! Make man after me
God said, "NO!"
I'll make man in my own image, ha!

I'll put him in de garden
And Jesus said, ha!
And if he sin,
I'll go his bond before yo' mighty throne
Ah, He was yo' friend
He made us all, ha!
Delegates to de judgment convention
Ah!
Faith hasn't got no eyes, but she' long-legged
But take de spy-glass of Faith
And look into dat upper room
When you are alone to yourself
When yo' heart is burnt with fire, ha!
When de blood is lopin' thru yo' veins
Like de iron monasters (monsters) on de rail
Look into dat upper chamber, ha!
We notice at de supper table
As He gazed upon His friends, ha!
His eyes flowin' wid tears, ha! He said
"My soul is exceedingly sorrowful unto death, ha!
For this night, ha!
One of you shall betray me, ha!
It were not a Roman officer, ha!
It were not a centurion
But one of you
Who I have chosen my bosom friend
That sops in the dish with me shall betray me."
I want to draw a parable.
I see Jesus
Leaving heben with all of His grandeur
Dis-robin' Hisself of His matchless honor
Yielding up de scepter of revolvin' worlds
Clothing Hisself in de garment of humanity
Coming into de world to rescue His friends.
Two thousand years have went by on their rusty ankles
But with the eye of faith, I can see Him
Look down from His high towers of elevation

I can hear Him when He walks about the golden streets
I can hear 'em ring under His footsteps
Sol me-e-e, Sol do
Sol me-e-e, Sol do
I can see Him step out upon the rim bones of nothing
Crying I am de way
De truth and de light
Ah!
God A'mighty!
I see Him grab de throttle
Of de well ordered train of mercy
I see kingdoms crush and crumble
Whilst de archangels held de winds in de corner chambers
I see Him arrive on dis earth
And walk de streets thirty and three years
Oh-h-hhh!
I see Him walking beside de sea of Galilee wid His disciples
This declaration gendered on His lips
"Let us go on to the other side"
God A'mighty!
Dey entered de boat
Wid their oarus (oars) stuck in de back
Sails unfurled to de evenin' breeze
And de ship was now sailin'
As she reached de center of de lake
Jesus was sleep on a pillow in de rear of de boat
And de dynamic powers of nature became disturbed
And de mad winds broke de heads of de Western drums
And fell down on de lake of Galilee
And buried themselves behind de gallopin' waves
And de white-caps marbilized themselves like an army
And walked out like soldiers goin' to battle
And de zig-zag lightning
Licked out her fiery tongue
And de flying clouds
Threw their wings in the channels of the deep
And bedded de waters like a road-plow

And faced de current of de chargin' billows
And de terrific bolts of thunder—they bust in de clouds
And de ship begin to reel and rock
God A'mighty!
And one of de disciples called Jesus
"Master!! Carest Thou not that we perish?"
And He arose
And de storm was in its pitch
And de lightnin' played on His raiments as He stood on the
 prow of the boat
And placed His foot upon the neck of the storm
And spoke to the howlin' winds
And de sea fell at His feet like a marble floor
And de thunders went back in their vault
Then He set down on de rim of de ship
And took de hooks of His power
And lifted de billows in His lap
And rocked de winds to sleep on His arm
And said, "Peace, be still."
And de Bible says there was a calm.
I can see Him wid de eye of faith.
When He went from Pilate's house
Wid the crown of seventy-two wounds upon His head
I can see Him as He mounted Calvary and hung upon de cross
 for our sins.
I can see-eee-ee
De mountains fall to their rocky knees when He cried
"My God, my God! Why hast Thou forsaken me?"
The mountains fell to their rocky knees and trembled like a
 beast
From the stroke of the master's axe
One angel took the flinches of God's eternal power
And bled the veins of the earth
One angel that stood at the gate with a flaming sword
Was so well pleased with his power
Until he pierced the moon with his sword
And she ran down in blood

And de sun
Batted her fiery eyes and put on her judgment robe
And laid down in de cradle of eternity
And rocked herself into sleep and slumber
He died until the great belt in the wheel of time
And de geological strata fell aloose
And a thousand angels rushed to de canopy of heben
With flamin' swords in their hands
And placed their feet upon blue ether's bosom, and looked
 back at de dazzlin' throne
And de arc angels had veiled their faces
And de throne was draped in mournin'
And de orchestra had struck silence for the space of half an
 hour
Angels had lifted their harps to de weepin' willows
And God had looked off to-wards immensity
And blazin' worlds fell off His teeth
And about that time Jesus groaned on de cross, and
Dropped His head in the locks of His shoulder and said, "It
 is finished, it is finished."
And then de chambers of hell exploded
And de damnable spirits
Come up from de Sodomistic world and rushed into de smoky
 camps of eternal night,
And cried, "Woe! Woe! Woe!"
And then de Centurion cried out,
"Surely this is the Son of God."
And about dat time
De angel of Justice unsheathed his flamin' sword and ripped
 de veil of de temple
And de High Priest vacated his office
And then de sacrificial energy penetrated de mighty strata
And quickened de bones of de prophets
And they arose from their graves and walked about in de
 streets of Jerusalem
I heard de whistle of de damnation train

Dat pulled out from Garden of Eden loaded wid cargo goin'
 to hell
Ran at break-neck speed all de way thru de law
All de way thru de prophetic age
All de way thru de reign of kings and judges—
Plowed her way thru de Jurdan
And on her way to Calvary, when she blew for de switch
Jesus stood out on her track like a rough-backed mountain
And she threw her cow-catcher in His side and His blood
 ditched de train
He died for our sins.
Wounded in the house of His friends.
That's where I got off de damnation train
And dat's where you must get off, ha!
For in dat mor-ornin', ha!
When we shall all be delegates, ha!
To dat Judgment Convention
When de two trains of Time shall meet on de trestle
And wreck de burning axles of de unformed ether
And de mountains shall skip like lambs
When Jesus shall place one foot on de neck of de sea, ha!
One foot on dry land, ah
When His chariot wheels shall be running hub-deep in fire
He shall take His friends thru the open bosom of an un-
 clouded sky
And place in their hands de "hosanna" fan
And they shall stand 'round and 'round his beatific throne
And praise His name forever, Amen.

There had been a mighty response to the sermon all thru its
length. The "bearing up" had been almost continuous, but as
Pearson's voice sank dramatically to the final Amen, Anderson
lifted a chant that kept the church on fire for several seconds
more. During this frenzy John Pearson descended from the
pulpit. Two deacons sprang to assist him at the Communion
table, but he never stopped there. With bowed head he
walked down the center aisle and out of the door—leaving
stupefaction in his wake. Hoffman and Nelse Watson posted

after him and stopped him as he left the grounds, but he brushed off their hands.

"No, chillun, Ah—Ah can't break—can't break de bread wid y'all no mo'," and he passed on.

"Man, ain't you goin' on back tuh yo' pulpit lak you got some sense?" Hambo asked that night. "If you don't some of 'em is sho tuh strow it uhround dat you wuz put out."

"Naw, Hambo. Ah don't want y'all fightin' and scratchin' over me. Let 'em talk all dey wanta."

"Ain't yuh never tuh preach and pastor no mo?"

"Ah won't say never 'cause— Never is uh long time. Ah don't b'lieve Ahm fitted tuh preach de gospel—unless de world is wrong. Yuh see dey's ready fuh uh preacher tuh be uh man uhmongst men, but dey ain't ready yet fuh 'im tuh be uh man uhmongst women. Reckon Ah better stay out de pulpit and carpenter fuh mah livin'. Reckon Ah kin do dat 'thout uh whole heap uh rigmarole."

But after a while John was not so certain. Several people who formerly had felt that they would rather wait for him several weeks to do a job now discovered that they didn't even have time to get him word. Some who already had work done shot angry, resentful looks after him and resolved not to pay him. It would be lacking in virtue to pay carpenter-preachers who got into trouble with congregations. Two men who had been glad of a chance to work under him on large jobs kept some of his tools that he had loaned them and muttered that it was no more than their due. He had worked them nearly to death in the damp and cold and hadn't paid them. One man grew so indignant that he pawned a spirit-level and two fine saws.

John was accused of killing one man by exposure and over-work. It was well known that he died of tuberculosis several months after he had worked a day or two for John, but nobody was going to be behind hand in accusations. Every bawdy in town wept over her gin and laid her downfall at John's door. He was the father of dozens of children by women he had never seen. Felton Cozy had stepped into his shoes at Zion

Hope and made it a point to adjust his glasses carefully each time he saw John lest too much sin hit him in his virtuous eye. John came to recognize all this eventually and quit telling people his troubles or his plans. He found that they rejoiced at the former and hurried away to do what they could to balk the latter.

As one man said, "Well, since he's down, less keep 'im down."

He saw himself growing shabby. It was hard to find food in variety.

One evening he came home most dejected.

"Whuss de matter, big foots?" Hambo asked. "You look all down in de mouf."

"Look lak lightnin' done struck de po' house. Dey got me in de go-long Ah reckon. All de lies dese folks strowing 'round 'bout me done got some folks in de notion Ah can't drive uh clean nail in they lumber. Look lak dey spectin' uh house Ah build tuh git tuh fornication befo' dey could get de paint on it. Lawd Jesus!"

"Come in and eat some dese snap peas and okra Ah got cooked. It'll give you mo' guts than uh goat."

"Naw thankee, Hambo. Ahm goin' lie down."

He went into his room and shut the door. "Oh Lucy! Lucy! Come git me. You knowed all dis—whut yuh leave me back heah tuh drink dis cup? Please, Lucy, take dis curse offa me. Ah done paid and paid. Ah done wept and Ah done prayed. If you see God where you is over dere ast Him tuh have mercy! Oh Jesus, Oh Jesus, Oh-wonder-workin' God. Take dis burden offa mah sobbin' heart or else take me 'way from dis sin-sick world!"

He sought Lucy thru all struggles of sleep, mewing and crying like a lost child, but she was not there. He was really searching for a lost self and crying like the old witch with her shed skin shrunken by red pepper and salt, "Ole skin, doncher know me?" But the skin was never to fit her again. Sometimes in the dark watches of the night he reproached Lucy bitterly

for leaving him. "You meant to do it," he would sob. "Ah saw yo' eyes."

By day he gave no sign of his night-thoughts. His search and his tears were hidden under bed quilts.

When Hambo woke him for breakfast next morning he didn't get up.

"Don't b'lieve Ahm goin' out tuhday, 'cause if Ah meet Cozy wid dat sham-polish smile uh his'n de way Ah feel tuhday, dey'll be tryin' me fuh murder nex' time."

His courage was broken. He lay there in bed and looked back over days that had had their trial and failure. They had all been glorious tomorrows once gilded with promise, but when they had arrived, they turned out to be just days with no more fulfillment—no more glad realities than those that had preceded—more betrayal, so why look forward? Why get up?

His divorce trial stayed with him. He saw that though it was over at the courthouse the judge and jury had moved to the street corners, the church, the houses. He was on trial everywhere, and unlike the courthouse he didn't have a chance to speak in his own behalf.

Sisters White and Carey came over around sundown with a gingerbread and melon-rind preserves.

"Always remembered you had uh sweet tooth," Sister Carey said.

They wanted to know if he was thinking of pastoring again. Certain people had crowded Cozy in, but the real folks had "chunked him out again. His shirttail may be long but we kin still spy his hips."

"He never could preach, nohow," Sister White complained, "and he been strainin' hisself tryin' tuh be stronger wid de women folks than you wuz. Settin' 'round de houses drinkin' and sayin' toastes 'bout, 'Luck tuh de duck dat swims de pond—' Bet if some dese men folks ketch 'im dey'll luck his duck fuh 'im. Since you won't consider, us callin' uh man from Savannah."

184

"Oh, he's more'n welcome to all de women folks," John rejoined.

"Where you keepin' yo'self dese days, anyhow, and whut you doin'?"

"Oh well, Sister White, since yuh ast me, Ah do any kind of uh job Ah kin git tuh make uh dollar, and Ah keeps mahself at home. Sometimes Ah reads de Bible and sometimes Ah don't feel tuh. Den Ah jus' knock uhround from pillar tuh post and sort of dream. Seem lak de dreams is true sho 'nuff sometime—iss so plain befo' me, but after while dey fades. But even while they be fadin', Ah have others. So it goes from day tuh day."

One night John had a dream. Lucy sat beside a stream and cried because she was afraid of a snake. He killed the snake and carried Lucy across in his arms to where Alf Pearson stood at the cross roads and pointed down a white shell road with his walking cane and said, "Distance is the only cure for certain diseases," and he and Lucy went racing down the dusty white road together. Somehow Lucy got lost from him, but there he was on the road—happy because the dead snake was behind him, but crying in his loneliness for Lucy. His sobbing awoke him and he said, "Maybe it's meant for me tuh leave Sanford. Whut Ahm hangin' 'round heah for, anyhow?"

At breakfast he said to Hambo, "Well, Hambo, Ah been thinkin' and thinkin' and Ah done decided dat Ahm goin' tuh give you dis town. You kin have it."

"You better say Joe, 'cause you don't know. Us been here batchin' tuhgether and gittin 'long fine. Ahm liable not tuh let yuh go. Me, Ahm in de 'B' class, be here when you leave and be here when you git back."

"Oh yeah, Ahm goin'. Gointer spread mah jenk in unother town."

"Where you figgerin' on goin'?"

"Don't know yet. When Ah colleck dem few pennies Ah got owing tuh me, iss good bye Katy, bar de door. Some uh dese mawnin's, and it won't be long, you goin' tuh wake up callin' me and Ah'll be gone."

And that is the way he went. It was equally haphazard that he landed in Plant City and went about looking for work.

Several times he passed the big white building that Baptist pride had erected and that he had been invited as Moderator to dedicate, but he passed it now with shuttered eyes. He avoided the people who might remember him.

A week and no work. Walking the streets with his tool kit. Hopeful, smiling ingratiatingly into faces like a dog in a meat house. Desperation nettling his rest.

"How yuh do, suh? Ain't you Rev'und Pearson?"

He looked sidewise quickly into the face of a tall black woman who smiled at him over a gate. Yard chock full of roses in no set pattern.

"Yes ma'am. Well, Ah thank yuh."

"Thought Ah knowed yuh. Heard yuh preach one time at our church."

"Pilgrim Rest Baptis' Church?"

"Dat's right. Dat wuz uh sermon! Come in."

John was tired. He sat heavily upon the step.

"Don't set on de do' step. Elder, heah's uh chear."

"Iss all right, Sister, jus' so Ahm settin' down."

"Naw, it 'tain't. If you set on de steps you'll git all de pains in de house. Ha, ha! Ah reckon you say niggers got all de signs and white folks got all de money."

He sat in the comfortable chair she placed for him and surrendered his hat.

"You got tuh eat supper wid me, lessen you got somewhere puhticklar tuh go. Mah dead husband said you wuz de best preacher ever borned since befo' dey built de Rocky Mountains."

Rev. Pearson laughed a space-filling laugh and waited on her lead.

"You goin' tuh be in our midst uh while?"

"Don't know, Sister—er—"

"Sister Lovelace. Knowed you wouldn't know me. Maybe you would eben disremember mah husband, but Ah sho is glad tuh have yuh in our midst. 'Scuse me uh minute whilst

186

Ah go skeer yuh up suppin' tuh eat."

She bustled inside but popped out a moment later with a palm-leaf fan.

"Cool yo'self off, Rev'und."

She was back in a few minutes with a pitcher clinking with ice.

"Have uh cool drink uh water, Elder—mighty hot. Ain't aimin' tuh fill yuh up on water, ha! ha! jes' keepin' yuh cool 'til it git done."

From the deep porch, smothered in bucket flowers the street looked so different. The world and all seemed so different—it seemed changed in a dream way. "Maybe nothin' ain't real sho 'nuff. Maybe 'tain't no world. No elements, no nothin'. Maybe wese jus' somewhere in God's mind," but when he wiggled his tired toes the world thudded and throbbed before him.

"Walk right intuh de dinin'-room and take uh chear, Rev'und. Right in dis big chear at de head uh de table. Maybe you kin make uh meal outa dis po' dinner Ah set befo' yuh, but yuh know Ahm uh widder woman and doin' de bes' ah kin."

"Dis po' dinner," consisted of fried chicken, hot biscuits, rice, mashed sweet potatoes, warmed over greens, rice pudding and iced tea.

"You goin' tuh set down and eat wid me, ain't yuh Sister Lovelace?"

"Naw, you go right uhead and eat. Ahm goin' tuh fan de flies. Dey right bad dese days. Ah been laying off tuh have de place screened, but jes' ain't got 'round tuh it. De wire is easy tuh git but dese carpenters 'round heah does sich shabby work 'til Ah ruther not be bothered."

"Ahm uh carpenter."

"You ain't got time tuh fool wid nothin' lak dat. Youse too big uh man."

"Oh, Ah got plenty time."

John felt warm heart-beats that night in his room. He de-

187

cided to drop a line or two to Sanford. He sent a cheerful line to Hambo first of all.

He wrote to Mamie Lester for news and comfort. She never answered. She felt injured that he should ask such a thing of her. Her indignation burst out of her. She asked many people, "Who do John Pearson think Ah am to be totin' news for him? He ain't nothin'." She said "nothin'" as if she had spat a stinking morsel out of her mouth.

After a long time, when he didn't get an answer, John Pearson understood, and laughed in his bed. The virtuous indignation of Mamie Lester! He could see her again as he had first seen her twenty years ago, as she had tramped into Sanford as barefooted as a yard dog with her skimpy, dirty calico dress and uncombed head; and her guitar hanging around her neck by a dirty red ribbon. How she had tried to pick him up and instead had gotten an invitation to his church. Respectability and marriage to a deacon. She, who had had no consciousness of degradation on the chain-gang and in the brothel, had now discovered she had no time for talk with fallen preachers.

Now that he had work to do, he wrote to George Gibson, asking him to return his tools that George had borrowed. George ignored the letter. He was really angry, "The son of a bum! Won't pay nobody and then come astin' me 'bout dem tools. Ah wish he would come to my face and ast me for 'em."

"Do Pearson owe you too?" another impostor asked.

"Do he? Humph!" he left the feeling that if he only had the money that John Pearson owed him, he need never worry any more.

George was indignant at being asked favors by the weak. His blood boiled.

It became the fashion that whoever was in hard luck, whoever was in debt—John Pearson had betrayed him. Gibson habitually wore a sorrowful look of infinite betrayal. In the meanwhile he used John's tools and came finally to feel that he deserved them.

The next day after the chance meeting John began his task of screening the house of Sally Lovelace, and when he was

thru he hesitated over taking the money agreed upon.

"You done fed me more'n de worth uh de job," he said.

"Aw shucks, man, uh woman dat's useter havin' uh man tuh do fuh got tuh wait on somebody. Take de money. You goin' tuh be tuh church dis Sunday?"

"Er—er—Ah don't jus' exactly know, tuh tell yuh truth, Sister Lovelace."

"You jokin', Ah know. Whut you goin' tuh do, if you don't go?"

"Not tuh turn yuh no short answer, Ah don't know."

"Oh come uhlong wid me. Deacon Turner and dem wuz overglad tuh know youse in town. Dey wants yuh tuh run our revival meetin' and dey did say suppin' 'bout yuh preachin' Communion Service."

John flinched, and Mrs. Lovelace saw it. He had to stay to supper then, and at eleven o'clock that night she knew everything. He had not spared himself, and lay with his head in her lap sobbing like a boy of four.

"Well, youse gointer pastor right here at Pilgrim Rest and none of 'em bet' not come 'round here tryin' tuh destroy yo' influence!" Sally blazed. "Ain't doodley squat dey self and goin' 'round tromplin' on folks dat's 'way uhbove 'em." She ran her fingers soothingly thru John's curly hair, and he fell asleep at her knee.

John escorted Sally to church on Sunday and preached.

"Man, you preached!" Sally said warmly during dinner— "only thing Ah heahed so many folks wuz shoutin' Ah couldn't half hear whut you wuz sayin'. You got tuh preach dat at home some time. Special fuh me."

"Preach it anytime you say, but sho 'nuff Ah felt lak ole times tuhday. Felt lak Samson when his hair begin tuh grow out agin."

"Dat's de way fuh yuh tuh feel, John. Oh yeah, 'fo' Ah fuhgit it, dere's uh lady got twenty-seben houses. She wants you tuh look over and patch up wherever dey needs fixin'. Ain't been nothin' done on 'em in two years. 'Bout two weeks steady work and den de Meth'dis' parsonage got tuh have new

189

shingles all over and me and de pastor's wife stands in. Oh you goin' tuh git 'long good in this town.''

John had finished the work on the houses before he found out that they belonged to Sally. The Methodist preacher had paid him. He found himself displeased when he heard of Sally's ownership. What would she with all that property, want with him?

"John, dey's fixin' tuh loose de pastor uh Pilgrim Rest and Ahm quite sho dey's 'bout tuh call you. So go git yo' things tuhgether and less git married tuhday so nobody can't start no talk.''

"Thank yuh, Sally.''

"You wuz aimin' tuh ast me anyhow, wuzn't yuh?''

"Sho wuz, jus' ez soon ez Ah could git tuh de place where Ah could make support fuh yuh.''

"Well, den eve'ything is all right between us. We ain't no chillun no mo', and we don't need tuh go thru uh whole lot uh form and fashion—uh kee-kee-in' and eatin' up pocket handkerchers. You done got de church and dat calls fuh over uh hund'ed dollars uh month and besides whut you got comin' in from carpenterin', and Ah got three hund'ed dollars eve'y month from de rent uh dem houses. Ahm gointer marry you, 'cause Ah love yuh and Ah b'lieve you love me, and 'cause you needs marryin'.''

"Ah sho do, Sally. Less go git married and den got set on de fish pond and ketch us uh mess uh speckled perches fuh supper. Iss uh heap mo' fun than buyin' 'em.''

"Less do. Ah always wanted tuh go sich places, but Oscar never would take me. He wuz uh good puhvider tho'.''

Sally went to bed as a matter of course that night, but John was as shy as a girl—as Lucy had been. His bride wondered at that. He stayed a long time on his knees and Sally never knew how fervently he prayed that Sally might never look at him out of the eyes of Lucy. How abjectly he begged his God to keep his path out of the way of snares and to bear him up lest he bruise his feet against a stumbling-stone, and he vowed

vows, if God would only keep his way clean. "Let Lucy see it too, Lawd, so she kin rest. And be so pleased as to cast certain memories in de sea of fuhgitfulness where dey will never rise tuh condemn me in de judgment. Amen and thang God."

CHAPTER 25

Sally, you never ought tuh bought me no car. Dat's too much money tuh take out de bank."

"Who else Ahm goin' tuh spend it on? Ah ain't got uh chick nor uh chile 'ceptin' you. If us ever goin' tuh enjoy ourselves, dis is de world tuh do it in."

"But uh Chevrolet would uh done me. You didn't hafta go buy no Cadillac."

"Wanted yuh tuh set up in uh Cadillac. Dat's yo' weddin' present and our first anniversary present all two together."

"Don't look lak us been married no year, Sally."

"But us is. Dat's 'cause we happy. Tuh think Ah lived tuh git forty-eight 'fo' Ah ever knowed whut love is."

"Ah love you de same way, Sally."

"Look here, John, you ain't been back tuh Sanford since yuh lef' dere."

"Don't keer if Ah never see it no mo' 'twill be too soon."

"Yeah, but honey, yo' buddy Hambo done been down here and paid you uh visit. You oughter go up and spend uh few days wid him, and let dem niggers see how well you gittin' uhlong."

"Awright; when you wanta go?"

"Me? Ah ain't goin'. Ah got mah guava jelly tuh put up. Ah don't trust ridin' so fur in dese cars, nohow. You go and tell

me all uhbout it. You been right up under me ever since us been married. Do yuh good tuh git off uh spell."

"Naw, Sally, Ah don't want tuh go 'thout you."

"Fool, how you goin' tuh git uh rest from me and take me wid yuh? You jes' lak uh li'l' boy and dass whut make Ah love yuh so, but you g'wan."

"Naw, Ah promised mahself never tuh sleep uh night 'way from you. Ah don't wanta break mah vow."

Sally exulted in her power and sipped honey from his lips, but she made him go, seeing the pain in John's face at the separation. It was worth her own suffering ten times over to see him that way for her.

The next morning he turned the long nose of his car northwards and pulled up at Hambo's gate. He was affectionately called every vile name in the language and fed on cow peas, but it seemed good to be there.

Three girls in their late teens stood about his gleaming chariot when he emerged towards sundown to visit the new pastor of Zion Hope church. They admired it loudly and crudely hinted for rides, but John coolly drove off without taking any hints. He was used to admiration of his car now and he had his vows.

Sanford was warm. From what he heard now as he sat under the wheel of his car, Sanford had had not a moment of happiness since he left. Zion Hope was desolate. The choir in heaven had struck silence for the space of half an hour. Wouldn't he consider a recall?

"Naw, it would be de same ole soup-bone—jus' warmed over—dat's all. Ah got uh church bigger'n dis one."

"You could give dem two Sundays and us two, couldn't yuh?" Trustee John Hall pled.

"Ah couldn't see de way tuh be 'way from home dat much. We got too much proppity down dere fuh me tuh look after."

"You got proppity?"

"Yep. Thirty houses tuh rent. Three of 'em brand new. Ah jus' finished 'em off las' week and dey was rented 'fo' de roof got on." He pulled out the huge roll of bills in his pocket,

194

"And Ah jus' got th'ew collectin' de month's rent 'fo' Ah come off."

"God uhmighty man, youse rich! You got bucks above suspicion! Oh shucks, Ah lak tuh fuhgit. Here's dat fo' dollars Ah owe you fuh buildin' dat shed-room 'fo' you went way from here. Ah could uh been done paid yuh, but Ah let talk keep me from it."

John pocketed the money without thanking him. He was grinning sardonically inside, thinking of the heat of the pavements and empty belly, the cold cruelty of want, how much men hit and beat at need when it pleads its gauntness.

But Hall was looking upon plenty and heard no miserable inside gnawings. He heard not John's cold lack of courtesy.

"But you got tuh preach for us dis comin' Sunday. Dat's Communion service. Nobody in de world kin preach dat lak you. Lemme go put it out right now, so's de whole church will know."

"You reckon Ah'd fine uh welcome, Hall?"

"Lawd yes, Rev. Pearson. You left a welcome at Zion Hope when you left here, and you kerried a welcome wid yuh where you went and you brought a welcome back wid you. Come preach for us one mo' time. God a'mighty man, Zion Hope couldn't hold all de folks dat would be dere. We'd lift a collection lak on big rally day."

But John was fingering the four dollars in his mind. He would buy a chicken for supper. Hambo would like that. He would still have enough left over to service the car and take him home.

"Nope, Brother Hall. Thankee for de invitation, but Ah feels to get on back home tuh mah wife. Can't be off too long."

He went on thinking how to show Sally how he could guard their money. Sure three dollars and a quarter would take him home. Maybe less. He wrote Sally about it, wrote her some kind of a letter every day.

While he and Hambo ate supper he heard voices on the porch—gay giggling. He motioned to see who it was.

"Aw, don't go," Hambo continued, " 'Tain't nobody but

dem three li'l' chippies from up de street. Dey gone crazy 'bout dat car. Dat kinda plump one is Ora Patton—jes' ez fresh ez dishwater. Always grinnin' up in some man's face. She's after yo' money right now. I seen her pass here eve'y few minutes—switchin' it and lookin' back at it. Set down and finish yo' supper man. Ah wouldn't pay her no rabbit-foot. She ain't wuth it."

"Oh, Ah ain't studyin' 'bout dem gals. Jus' don't want nobody tuh mess wid dat car. Dat radiator cap cost twenty-six dollars. Soon ez Ah git th'ew supper Ahm goin' tuh put de car up."

"You better, dey steal gas 'round here too, but dat Ora is hot after yuh. Her egg-bag ain't gonna rest easy 'til she git nex' tuh yuh. Money crazy. Don't give 'er uh damn cent. Be lak me. Ah wouldn't give uh bitch uh bone if she treed uh terrapin."

"She won't git nothin' outa me. Ahm lak de cemetery. Ahm takin' in, but never no put out. 'Ceptin' tuh Sally. She come tuh me in hell and Ah love her for it."

When John stepped to the door of his car he found Ora on the running-board.

"Hello, daddy."

"Oh, er, hello, daughter."

"Don't call me no daughter. Take me fuh uh short ride."

"Ahm jus' goin' tuh de garage. Two—three blocks, you kin ride dat fur if you wanta."

"Okay, stingy papa. You eben wear uh stingy-rim hat." As the car moved off silently, "Lawd! Ah wonder how it feels tuh be drivin' uh great big ole 'Kitty.'"

"Kin you drive?"

"Yeah. Lemme take de wheel jes' uh minute. Every body in town is talkin' 'bout dis blue and silver 'Kitty.' You mus' got money's mammy, and grandpa change."

"Nope, broke ez uh he-ha'nt in torment. All dis b'longs tuh mah wife. Here's de garage. Youse goin' on past it."

"Aw, gimme uh li'l' bit uh ride, daddy. Don't be so mean and hateful."

"Nope, Ahm goin' home tuhmorrer and Ah got tuh be in bed so Ah wont go tuh sleep drivin'. Move over."

He reached for the wheel and Ora shot down on the gas. They had nosed out on the road to Osteen before John dared to struggle for possession of the wheel. He hated to think of even a scratch on his paint. Then Ora pulled to the side of the road and parked and threw her arms about his neck and began to cry.

"Ora so bad and now, big, good-looking daddy is mad wid her! Po' Ora can't he'p who she like. Please don't be mad, you pretty, curly headed man."

John unwrapped her arms from 'round his neck gently.

"Well, Ah'll give you uh li'l' short ride, if thass all yuh want. Can't burn up too much gas."

Ora kissed him fleshily, "Dat's right sweet daddy. Let de wheels roll, Ah loves cars. Ride me 'til Ah sweat."

In twenty minutes John was back at the garage and Ora got out pouting. "You mus' figger Ah sweats mighty easy, papa. Ah ast yuh fuh uh ride, but you ain't gimme none hardly."

Friday came and John was glad. He was going home and Ora had failed of her purpose. He was convincing himself that God and Sally could trust him.

Friday night Ora waited for him outside the garage. Standing in the dark of a clump of hibiscus.

"Thought you wuz goin' home Tuesday?" she accused. "Here 'tis Friday night and you ain't gone yet. Ah know you jes' wants tuh git rid uh me."

"Naw, 'tain't dat. First place Ah got uh wife and second place Ahm goin' home sho 'nuff tuhmorrer and therefo' Ah ain't got no time tuh talk. Needs mah sleep. Ahm gittin' ole."

"Aw, naw, you ain't. Come on less take uh good bye ride. Less don't make it stingy lak de las' time. Less ride out tuh Oviedo and back."

She climbed in beside him and put her hands on top of his wheel and eye-balled him sweetly.

"Don't go in dis ole garage. Drive on."

197

CHAPTER 26

Two hours later when John found himself dressing in a dingy back room in Oviedo he was mad—mad at his weakness—mad at Ora, though she did not know it as yet. She was putting on her shoes on the other side of the bed.

"Daddy, you got twenty dollars you kin gimme? Ah needs so many things and you got plenty."

"Naw, Ah tole you befo' Ah didn't have nothin'. Anything you see on me b'longs tuh Sally." He laced his shoes and put on his vest, then he remembered the remainder of the four dollars he had collected. He pulled it out of his pocket and threw it at her, "Here! Take dat. Iss all Ah got, and Ah hope you rot in hell! Ah hope you never rise in judgment!" He seized his coat and put it on as he hurried out to the car. Ora grabbed up her dress and dashed after him, but he was under the wheel before she left the room, and the motor was humming when she reached the running-board. John viciously thrust her away from the car door without uttering a word. He shoved her so hard that she stumbled into the irrigation ditch, as the car picked up speed and in a moment was a red eye in the distance.

"Well, de ole gray-head bastard! Wonder whut got intuh him? Dis li'l' ole three dollars and some odd change is gonna do me uh lot uh good. Ah been strainin' up tuh git tuh Oviedo

199

fuh de last longest and here Ah is, but Ah wisht Ah knowed whut he flew hot over. Sho do. He done lef' me right where Ah wants tuh be, wid pay-day at de packin' house tuhmorrer. Jes' lak de rabbit in de briar patch.

"Bright and soon tuhmorrer Ah means tuh git me uh bottle uh perfume and some new garters—one red one tuh draw love and one yeller one tuh draw money. Hey, hey, Ah can't lose—not wid de help Ah got."

When Hambo awoke John was gone. Ten dollars was on the dresser beside the clock, and a couple of brand new night-shirts were on a chair.

"Well de hen-fired son-of-a-gun done slipped off and never tole me good bye again! Bet de wop-sided, holler-headed—— thought Ah wuz gointer cry, but he's uh slew-footed liar!" Whereupon Hambo cried over the stove as he fried his sow-bosom and made a flour hoe-cake. Then he found he couldn't eat. Frog in his throat or something so that even his coffee choked him.

The ground-mist lifted on a Florida sunrise as John fled homeward. The car droned, "ho-o-ome" and tortured the man. False pretender! Outside show to the world! Soon he would be in the shelter of Sally's presence. Faith and no questions asked. He had prayed for Lucy's return and God had answered with Sally. He drove on but half-seeing the railroad from looking inward.

The engine struck the car squarely and hurled it about like a toy. John was thrown out and lay perfectly still. Only his foot twitched a little.

"Damned, if I kin see how it happened," the engineer declared. "He musta been sleep or drunk. God knows I blowed for him when I saw him entering on the track. He wasn't drunk. Couldn't smell no likker on him, so he musta been asleep. Hell, now I'm on the carpet for carelessness, but I got witnesses I blowed."

Sally wept hard. "Naw, Ah don't want de seben thousand

dollars from de railroad. Ahm goin' tuh give it tuh his chillun. Naw, Ah don't want none of it. Ah loved 'im too much tuh rob his chillun. Jes' lemme be buried right side uh him when Ah die. Us two off by ourselves. Dass how come Ah bought uh new burial lot. Ah can't git over it, people. Jes' ez he wuz gittin ready tuh live, he got tuh git taken uhway, but Ah got one consolation, he sho wuz true tuh me. Jes' tuh think Ah had tuh live fifty years tuh git one sweet one and it throwed de light over all de other ones. Ah'll never regret uh thing. He wuz true tuh me." She said it over and over. It was a song for her heart and she kept singing it.

She sat shining darkly among the multitudes from all over the State who had come to do John Pearson homage. She sat among his children and made them love her, and when he was laid to rest she was invited to attend memorial services in twenty or more cities.

Sanford was draped in mourning on the second Sunday when Zion Hope held her memorial for John Pearson. The high-backed, throne-like chair was decorated. Tight little sweaty bouquets from the woods and yards were crowded beside ornate floral pieces. Hattie in deep mourning came back to town for the service.

She would have seated herself on the front seat before the flower-banked chair that represented the body of Rev. Pearson, but someone stopped her. "His wife is in de seat," they whispered and showed her to a place among the crowd.

Hambo rolled his eyes at the black-veiled Hattie and gritted his teeth, and whispered to Watson:

"Uhhunh, Ad done heered she wuz comin' back tuh ast us all tuh he'p her git his lodge insurances. Wisht Ah wuz God. Ah'd take and turn her intuh uh damn hawg and den Ah'd concrete de whole world over, so she couldn't find uh durned place tuh root."

And the preacher preached a barbaric requiem poem. On the pale white horse of Death. On the cold icy hands of Death. On the golden streets of glory. Of Amen Avenue. Of Halleluyah Street. On the delight of God when such as John

appeared among the singers about His throne. On the weeping sun and moon. On Death who gives a cloak to the man who walked naked in the world. And the hearers wailed with a feeling of terrible loss. They beat upon the O-go-doe, the ancient drum. O-go-doe, O-go-doe, O-go-doe! Their hearts turned to fire and their shinbones leaped unknowing to the drum. Not Kata-Kumba, the drum of triumph, that speaks of great ancestors and glorious wars. Not the little drum of kidskin, for that is to dance with joy and to call to mind birth and creation, but O-go-doe, the voice of Death—that promises nothing, that speaks with tears only, and of the past.

So at last the preacher wiped his mouth in the final way and said, "He wuz uh man, and nobody knowed 'im but God," and it was ended in rhythm. With the drumming of the feet, and the mournful dance of the heads, in rhythm, it was ended.

GLOSSARY

Lidard knot, fat pine wood, generally used for kindling. p. 2

Chaps, children. Old English use. p. 13

Buckra, white people. p. 7

Patter roller, "Patrollers," an organization of the late slavery days that continued through the Reconstruction period. Its main objective was the intimidation of Negroes. Similar to the KKK. p. 7

Hagar's chillun, Negroes, as against Sarah's children, the whites.
 p. 10

Apin' down de road, running away. p. 10

Talkin' at de big gate, boasting. Making pretence of bravery behind the back of a powerful person. The allusion comes from the old slavery-time story of the Negro who boasted to another that he had given Ole Massa a good cussin' out. The other one believed him and actually cussed Ole Massa out the next time that he was provoked, and was consequently given a terrible beating. When he was able to be at work again he asked the first Negro how it was that he was not whipped for cussing Ole Massa. The first Negro asked the other if he had cussed Ole Massa to his face. "Sho Ah did. Ain't dat whut you tole me you done?" "Aw naw, fool. Ah ain't tole yuh nothin' uh de kind. As said Ah give Ole Massa uh good cussin' out and Ah did. But when Ah did dat, he wuz settin' up on de verandah and Ah

wuz down at de big gate. You sho is uh big fool. It's uh wonder Ole Massa didn't kill you dead." p. 14

Shickalacked, a sound-word to express noise of a locomotive.
p. 15

Nable string, umbilical cord. p. 19

Boogers, head lice. p. 24

Make 'miration, pay flattering compliments. p. 28

Parched peanuts, roasted peanuts. p. 29

Cuffy, West African word meaning Negro. p. 29

Branch, colloquial for small stream. p. 34

Smell hisself, reaching puberty (girl or boy becoming conscious of). p. 45

Lies, stories, tales. p. 61

Tush hawg, wild boar, very vicious, hence a tough character. The tusks of the wild boar curve out and are dangerous weapons.
p. 63

Seben years ain't too long fuh uh coudar tuh wear uh ruffled bosom shirt, it's never too late for me to get even with you.
p. 64

Coudar, a striped, hard-shell fresh-water turtle. p. 64

Bucket flower, potted plant. Old buckets and tubs being used for flower pots. A delicate, well-cared-for person. p. 68

Lay-over, hen with a full drooping comb. Domestic animals and fowls often named for some striking characteristic. p. 77

Jook, the pleasure houses near industrial work. A combination of bawdy, gaming, and dance hall. Incidentally the cradle of the "blues." p. 90

Strowin', spreading abroad. p. 90

Sheep shadney, tea made from sheep droppings. It is sweetened and fed to very young babies. p. 92

Old Hannah, the sun. p. 93

204

Piney wood rooters, razor-back hogs. Wild hogs. They never get really fat. Inclined to toughness. p. 94

Justice been beggin' righteous tuh do, this is your duty so clearly that it is not debatable. p. 95

He ain't goin' tuh let his shirt-tail touch 'im, he won't sit down. p. 95

Ah'll give mah case tuh Miss Bush and let Mother Green stand mah bond, I'll hide in the woods. I won't need a lawyer because I'll be hidden and no one will have to stand my bond for I have put my person in care of the bushes. p. 95

Squat dat rabbit, let the matter drop, cease. p. 95

De caboose uh dat, the end; i.e., the caboose is the tail end of a freight train. p. 96

Loud talk me, making your side appear right by making more noise than the others. p. 96

Big Moose done come down from de mountain, "When the half-gods go, the gods arrive." He will make all that has gone before seem trivial beside his works. p. 113

Porpoise, pauper. p. 113

Gopher, land tortoise, native of Florida which is locally known as a gopher. p. 113

Better say Joe, that is doubtful. p. 113

Big britches goin' tuh fit li'l' Willie, he who was small is now grown. The underdog is now in position to fight for topdog place. p. 113

Bitter bone, the all-power black-cat bone. Some hoodoo doctors select it by boiling the cat alive with appropriate ceremonies (see "Hoodoo in America," *Journal of American Folk-Lore,* Vol. 44, No. 174, p. 387) and passing the bones thru the mouth until one arrives at the bitter bone. p. 126

Catbone, same as above, though some doctors do not seek a bone by taste (see "Hoodoo in America," *Journal of American Folk-Lore,* Vol. 44, No. 174, p. 396). p. 126

God don't eat okra, okra when cooked is slick and slimy, i.e., God does not like slickness, crooked ways. p. 128

When Ahm dying don't you let 'em take de pillow from under mah head. The pillow is removed from beneath the head of the dying because it is said to prolong the death struggle if left in place. All mirrors, and often all glass surfaces, are covered because it is believed the departing spirit will pause to look in them and if it does they will be forever clouded afterwards. p. 130

Doodly-squat, nothing more valuable than dung. Hence the person is in extreme poverty. p. 138

Cold preach, cold used as a superlative to mean unsurpassed. Very common usage. p. 153

Black Herald, Black Dispatch, Negro gossip. p. 157

In his cooler passages the colored preacher attempts to achieve what to him is grammatical correctness, but as he warms up he goes natural. The "ha" in the sermon marks a breath. The congregation likes to hear the preacher breathing or "straining." p. 157

Sow-bosom, salt pork, a very important item in the diet of both Negroes and poor whites in the South. p. 200

AFTERWORD

✦

ZORA NEALE HURSTON:
"A NEGRO WAY OF SAYING"

I.

The Reverend Harry Middleton Hyatt, an Episcopal priest whose five-volume classic collection, *Hoodoo, Conjuration, Witchcraft, and Rootwork,* more than amply returned an investment of forty years' research, once asked me during an interview in 1977 what had become of another eccentric collector whom he admired. "I met her in the field in the thirties. I think," he reflected for a few seconds, "that her first name was Zora." It was an innocent question, made reasonable by the body of confused and often contradictory rumors that make Zora Neale Hurston's own legend as richly curious and as dense as are the black myths she did so much to preserve in her classic anthropological works. *Mules and Men* and *Tell My Horse,* and in her fiction.

A graduate of Barnard, where she studied under Franz Boas, Zora Neale Hurston published seven books—four novels, two books of folklore, and an autobiography—and more than fifty shorter works between the middle of the Harlem Renaissance and the end of the Korean War, when she was

the dominant black woman writer in the United States. The dark obscurity into which her career then lapsed reflects her staunchly independent political stances rather than any deficiency of craft or vision. Virtually ignored after the early fifties, even by the Black Arts movement in the sixties, an otherwise noisy and intense spell of black image- and myth-making that rescued so many black writers from remaindered oblivion, Hurston embodied a more or less harmonious but nevertheless problematic unity of opposites. It is this complexity that refuses to lend itself to the glib categories of "radical" or "conservative," "black" or "Negro," "revolutionary" or "Uncle Tom"—categories of little use in literary criticism. It is this same complexity, embodied in her fiction, that, until Alice Walker published her important essay ("In Search of Zora Neale Hurston") in *Ms.* magazine in 1975, had made Hurston's place in black literary history an ambiguous one at best.

The rediscovery of Afro-American writers has usually turned on larger political criteria, of which the writer's work is supposedly a mere reflection. The deeply satisfying aspect of the rediscovery of Zora Neale Hurston is that black women generated it primarily to establish a maternal literary ancestry. Alice Walker's moving essay recounts her attempts to find Hurston's unmarked grave in the Garden of the Heavenly Rest, a segregated cemetery in Fort Pierce, Florida. Hurston became a metaphor for the black woman writer's search for tradition. The craft of Alice Walker, Gayl Jones, Gloria Naylor, and Toni Cade Bambara bears, in markedly different ways, strong affinities with Hurston's. Their attention to Hurston signifies a novel sophistication in black literature: they read Hurston not only for the spiritual kinship inherent in such relations but because she used black vernacular speech and rituals, in ways subtle and various, to chart the coming to consciousness of black women, so glaringly absent in other black fiction. This use of the vernacular became the fundamental framework for all but one of her novels and is particularly

effective in her classic work *Their Eyes Were Watching God,* published in 1937, which is more closely related to Henry James's *The Portrait of a Lady* and Jean Toomer's *Cane* than to Langston Hughes's and Richard Wright's proletarian literature, so popular in the Depression.

The charting of Janie Crawford's fulfillment as an autonomous imagination, *Their Eyes* is a lyrical novel that correlates the need of her first two husbands for ownership of progressively larger physical space (and the gaudy accoutrements of upward mobility) with the suppression of self-awareness in their wife. Only with her third and last lover, a roustabout called Tea Cake whose unstructured frolics center around and about the Florida swamps, does Janie at last bloom, as does the large pear tree that stands beside her grandmother's tiny log cabin.

> She saw a dust bearing bee sink into the sanctum of a bloom; the thousand sister calyxes arch to meet the love embrace and the ecstatic shiver of the tree from root to tiniest branch creaming in every blossom and frothing with delight. So this was a marriage!

To plot Janie's journey from object to subject, the narrative of the novel shifts from third to a blend of first and third person (known as "free indirect discourse"), signifying this awareness of self in Janie. *Their Eyes* is a bold feminist novel, the first to be explicitly so in the Afro-American tradition. Yet in its concern with the project of finding a voice, with language as an instrument of injury and salvation, of selfhood and empowerment, it suggests many of the themes that inspirit Hurston's oeuvre as a whole.

II.

One of the most moving passages in American literature is Zora Neale Hurston's account of her last encounter with her

dying mother, found in a chapter entitled "Wandering" in her autobiography, *Dust Tracks on a Road* (1942):

> As I crowded in, they lifted up the bed and turned it around so that Mama's eyes would face east. I thought that she looked to me as the head of the bed reversed. Her mouth was slightly open, but her breathing took up so much of her strength that she could not talk. But she looked at me, or so I felt, to speak for her. She depended on me for a voice.

We can begin to understand the rhetorical distance that separated Hurston from her contemporaries if we compare this passage with a similar scene published just three years later in *Black Boy* by Richard Wright, Hurston's dominant black male contemporary and rival: "Once, in the night, my mother called me to her bed and told me that she could not endure the pain, and she wanted to die. I held her hand and begged her to be quiet. That night I ceased to react to my mother; my feelings were frozen." If Hurston represents her final moments with her mother in terms of the search for voice, then Wright attributes to a similar experience a certain "somberness of spirit that I was never to lose," which "grew into a symbol in my mind, gathering to itself . . . the poverty, the ignorance, the helplessness. . . ." Few authors in the black tradition have less in common than Zora Neale Hurston and Richard Wright. And whereas Wright would reign through the forties as our predominant author, Hurston's fame reached its zenith in 1943 with a *Saturday Review* cover story honoring the success of *Dust Tracks.* Seven years later, she would be serving as a maid in Rivo Alto, Florida; ten years after that she would die in the County Welfare Home in Fort Pierce, Florida.

How could the recipient of two Guggenheims and the author of four novels, a dozen short stories, two musicals, two books on black mythology, dozens of essays, and a prizewinning autobiography virtually "disappear" from her readership

for three full decades? There are no easy answers to this quandary, despite the concerted attempts of scholars to resolve it. It is clear, however, that the loving, diverse, and enthusiastic responses that Hurston's work engenders today were not shared by several of her influential black male contemporaries. The reasons for this are complex and stem largely from what we might think of as their "racial ideologies."

Part of Hurston's received heritage—and perhaps the paramount received notion that links the novel of manners in the Harlem Renaissance, the social realism of the thirties, and the cultural nationalism of the Black Arts movement—was the idea that racism had reduced black people to mere ciphers, to beings who only react to an omnipresent racial oppression, whose culture is "deprived" where different, and whose psyches are in the main "pathological." Albert Murray, the writer and social critic, calls this "the Social Science Fiction Monster." Socialists, separatists, and civil rights advocates alike have been devoured by this beast.

Hurston thought this idea degrading, its propagation a trap, and railed against it. It was, she said, upheld by "the sobbing school of Negrohood who hold that nature somehow has given them a dirty deal." Unlike Hughes and Wright, Hurston chose deliberately to ignore this "false picture that distorted. . . ." Freedom, she wrote in *Moses, Man of the Mountain,* "was something internal. . . . The man himself must make his own emancipation." And she declared her first novel a manifesto against the "arrogance" of whites assuming that "black lives are only defensive reactions to white actions." Her strategy was not calculated to please.

What we might think of as Hurston's mythic realism, lush and dense within a lyrical black idiom, seemed politically retrograde to the proponents of a social or critical realism. If Wright, Ellison, Brown, and Hurston were engaged in a battle over ideal fictional modes with which to represent the Negro, clearly Hurston lost the battle.

But not the war.

After Hurston and her choice of style for the black novel

were silenced for nearly three decades, what we have witnessed since is clearly a marvelous instance of the return of the repressed. For Zora Neale Hurston has been "rediscovered" in a manner unprecedented in the black tradition: several black women writers, among whom are some of the most accomplished writers in America today, have openly turned to her works as sources of narrative strategies, to be repeated, imitated, and revised, in acts of textual bonding. Responding to Wright's critique, Hurston claimed that she had wanted at long last to write a black novel, and "not a treatise on sociology." It is this urge that resonates in Toni Morrison's *Song of Solomon* and *Beloved,* and in Walker's depiction of Hurston as our prime symbol of "racial health—a sense of black people as complete, complex, *undiminished* human beings, a sense that is lacking in so much black writing and literature." In a tradition in which male authors have ardently denied black literary paternity, this is a major development, one that heralds the refinement of our notion of tradition: Zora and her daughters are a tradition-within-the-tradition, a black woman's voice.

The resurgence of popular and academic readerships of Hurston's works signifies her multiple canonization in the black, the American, and the feminist traditions. Within the critical establishment, scholars of every stripe have found in Hurston texts for all seasons. More people have read Hurston's works since 1975 than did between that date and the publication of her first novel, in 1934.

III.

Rereading Hurston, I am always struck by the density of intimate experiences she cloaked in richly elaborated imagery. It is this concern for the figurative capacity of black language, for what a character in *Mules and Men* calls "a hidden meaning, jus' like de Bible . . . de inside meanin' of words," that unites Hurston's anthropological studies with her fiction. For the folklore Hurston collected so meticulously as Franz Boas's

student at Barnard became metaphors, allegories, and performances in her novels, the traditional recurring canonical metaphors of black culture. Always more of a novelist than a social scientist, even Hurston's academic collections center on the quality of imagination that makes these lives whole and splendid. But it is in the novel that Hurston's use of the black idiom realizes its fullest effect. In *Jonah's Gourd Vine,* her first novel, for instance, the errant preacher, John, as described by Robert Hemenway "is a poet who graces his world with language but cannot find the words to secure his own personal grace." This concern for language and for the "natural" poets who "bring barbaric splendor of word and song into the very camp of the mockers" not only connects her two disciplines but also makes of "the suspended linguistic moment" a thing to behold indeed. Invariably, Hurston's writing depends for its strength on the text, not the context, as does John's climactic sermon, a *tour de force* of black image and metaphor. Image and metaphor define John's world; his failure to interpret himself leads finally to his self-destruction. As Robert Hemenway, Hurston's biographer, concludes, "Such passages eventually add up to a theory of language and behavior."

Using "the spy-glass of Anthropology," her work celebrates rather than moralizes; it shows rather than tells, such that "both behavior and art become self-evident as the tale texts and hoodoo rituals accrete during the reading." As author, she functions as "a midwife participating in the birth of a body of folklore, . . . the first wondering contacts with natural law." The myths she describes so accurately are in fact "alternative modes for perceiving reality," and never just condescending depictions of the quaint. Hurston sees "the Dozens," for example, that age-old black ritual of graceful insult, as, among other things, a verbal defense of the sanctity of the family, conjured through ingenious plays on words. Though attacked by Wright and virtually ignored by his literary heirs, Hurston's ideas about language and craft undergird many of the most successful contributions to Afro-American literature that followed.

IV.

We can understand Hurston's complex and contradictory legacy more fully if we examine *Dust Tracks on a Road,* her own controversial account of her life. Hurston did make significant parts of herself up, like a masquerader putting on a disguise for the ball, like a character in her fictions. In this way, Hurston *wrote* herself, and sought in her works to rewrite the "self" of "the race," in its several private and public guises, largely for ideological reasons. That which she chooses to reveal is the life of her imagination, as it sought to mold and interpret her environment. That which she silences or deletes, similarly, is all that her readership would draw upon to delimit or pigeonhole her life as a synecdoche of "the race problem," an exceptional part standing for the debased whole.

Hurston's achievement in *Dust Tracks* is twofold. First, she gives us a *writer's* life, rather than an account, as she says, of "the Negro problem." So many events in this text are figured in terms of Hurston's growing awareness and mastery of books and language, language and linguistic rituals as spoken and written both by masters of the Western tradition and by ordinary members of the black community. These two "speech communities," as it were, are Hurston's great sources of inspiration not only in her novels but also in her autobiography.

The representation of her sources of language seems to be her principal concern, as she constantly shifts back and forth between her "literate" narrator's voice and a highly idiomatic black voice found in wonderful passages of free indirect discourse. Hurston moves in and out of these distinct voices effortlessly, seamlessly, just as she does in *Their Eyes* to chart Janie's coming to consciousness. It is this usage of a *divided* voice, a double voice unreconciled, that strikes me as her great achievement, a verbal analogue of her double experiences as a woman in a male-dominated world and as a black person in

214

a nonblack world, a woman writer's revision of W. E. B. Du Bois's metaphor of "double consciousness" for the hyphenated African-American.

Her language, variegated by the twin voices that intertwine throughout the text, retains the power to unsettle:

> There is something about poverty that smells like death.
> Dead dreams dropping off the heart like leaves in a dry
> season and rotting around the feet; impulses smothered too
> long in the fetid air of underground caves. The soul lives
> in a sickly air. People can be slave-ships in shoes.

Elsewhere she analyzes black "idioms" used by a culture "raised on simile and invective. They know how to call names," she concludes, then lists some, such as 'gator-mouthed, box-ankled, puzzle-gutted, shovel-footed: "Eyes looking like skint-ginny nuts, and mouth looking like a dishpan full of broke-up crockery!"

Immediately following the passage about her mother's death, she writes:

> The Master-Maker in His making had made Old Death.
> Made him with big, soft feet and square toes. Made him
> with a face that reflects the face of all things, but neither
> changes itself, nor is mirrored anywhere. Made the body of
> death out of infinite hunger. Made a weapon of his hand to
> satisfy his needs. This was the morning of the day of the
> beginning of things.

Language, in these passages, is not merely "adornment," as Hurston described a key black linguistic practice; rather, manner and meaning are perfectly in tune: she says the thing in the most meaningful manner. Nor is she being "cute," or pandering to a condescending white readership. She is "naming" emotions, as she says, in a language both deeply personal and culturally specific.

The second reason that *Dust Tracks* succeeds as literature

arises from the first: Hurston's unresolved tension between her double voices signifies her full understanding of modernism. Hurston uses the two voices in her text to celebrate the psychological fragmentation both of modernity and of the black American. As Barbara Johnson has written, hers is a rhetoric of division, rather than a fiction of psychological or cultural unity. Zora Neale Hurston, the "real" Zora Neale Hurston that we long to locate in this text, dwells in the silence that separates these two voices: she is both, and neither; bilingual, and mute. This strategy helps to explain her attraction to so many contemporary critics and writers, who can turn to her works again and again only to be startled at her remarkable artistry.

But the life that Hurston could write was not the life she could live. In fact, Hurston's life, so much more readily than does the standard sociological rendering, reveals how economic limits determine our choices even more than does violence or love. Put simply, Hurston wrote well when she was comfortable, wrote poorly when she was not. Financial problems—book sales, grants and fellowships too few and too paltry, ignorant editors and a smothering patron—produced the sort of dependence that affects, if not determines, her style, a relation she explored somewhat ironically in "What White Publishers Won't Print." We cannot oversimplify the relation between Hurston's art and her life; nor can we reduce the complexity of her postwar politics, which, rooted in her distaste for the pathological image of blacks, were markedly conservative and Republican.

Nor can we sentimentalize her disastrous final decade, when she found herself working as a maid on the very day the *Saturday Evening Post* published her short story "Conscience of the Court" and often found herself without money, surviving after 1957 on unemployment benefits, substitute teaching, and welfare checks. "In her last days," Hemenway concludes dispassionately, "Zora lived a difficult life—alone, proud, ill, obsessed with a book she could not finish."

The excavation of her buried life helped a new generation

read Hurston again. But ultimately we must find Hurston's legacy in her art, where she "ploughed up some literacy and laid by some alphabets." Her importance rests with the legacy of fiction and lore she constructed so cannily. As Hurston herself noted, "Roll your eyes in ecstasy and ape his every move, but until we have placed something upon his street corner that is our own, we are right back where we were when they filed our iron collar off." If, as a friend eulogized, "She didn't come to you empty," then she does not leave black literature empty. If her earlier obscurity and neglect today seem inconceivable, perhaps now, as she wrote of Moses, she has "crossed over."

HENRY LOUIS GATES, JR.

SELECTED BIBLIOGRAPHY

WORKS BY ZORA NEALE HURSTON

Jonah's Gourd Vine. Philadelphia: J. B. Lippincott, 1934.

Mules and Men. Philadelphia: J. B. Lippincott, 1935.

Their Eyes Were Watching God. Philadelphia: J. B. Lippincott, 1937.

Tell My Horse. Philadelphia: J. B. Lippincott, 1938.

Moses, Man of the Mountain. Philadelphia: J. B. Lippincott, 1939.

Dust Tracks on a Road. Philadelphia: J. B. Lippincott, 1942.

Seraph on the Suwanee. New York: Charles Scribner's Sons, 1948.

I Love Myself When I Am Laughing . . . & Then Again When I Am Looking Mean and Impressive: A Zora Neale Hurston Reader. Edited by Alice Walker. Old Westbury, N.Y.: The Feminist Press, 1979.

The Sanctified Church. Edited by Toni Cade Bambara. Berkeley: Turtle Island, 1981.

Spunk: The Selected Short Stories of Zora Neale Hurston. Berkeley: Turtle Island, 1985.

WORKS ABOUT ZORA NEALE HURSTON

Baker, Houston A., Jr. *Blues, Ideology, and Afro-American Literature: A Vernacular Theory,* pp. 15–63. Chicago: University of Chicago Press, 1984.

Bloom, Harold, ed. *Zora Neale Hurston.* New York: Chelsea House, 1986.

———, ed. *Zora Neale Hurston's "Their Eyes Were Watching God."* New York: Chelsea House, 1987.

Byrd, James W. "Zora Neale Hurston: A Novel Folklorist." *Tennessee Folklore Society Bulletin* 21 (1955): 37–41.

Cooke, Michael G. "Solitude: The Beginnings of Self-Realization in Zora Neale Hurston, Richard Wright, and Ralph Ellison." In Michael G. Cooke, *Afro-American Literature in the Twentieth Century,* pp. 71–110. New Haven: Yale University Press, 1984.

Dance, Daryl C. "Zora Neale Hurston." In *American Women Writers: Bibliographical Essays,* edited by Maurice Duke, et al. Westport, Conn.: Greenwood Press, 1983.

Gates, Henry Louis, Jr. "The Speakerly Text." In Henry Louis Gates, Jr., *The Signifying Monkey,* pp. 170–217. New York: Oxford University Press, 1988.

Giles, James R. "The Significance of Time in Zora Neale Hurston's *Their Eyes Were Watching God." Negro American Literature Forum* 6 (Summer 1972): 52–53, 60.

Hemenway, Robert E. *Zora Neale Hurston: A Literary Biography.* Chicago: University of Illinois Press, 1977.

Holloway, Karla. *The Character of the Word: The Texts of Zora Neale Hurston.* Westport, Conn.: Greenwood Press, 1987.

Holt, Elvin. "Zora Neale Hurston." In *Fifty Southern Writers After 1900,* edited by Joseph M. Flura and Robert Bain, pp. 259–69. Westport, Conn.: Greenwood Press, 1987.

Howard, Lillie Pearl. *Zora Neale Hurston.* Boston: Twayne, 1980.

———. "Zora Neale Hurston." In *Dictionary of Literary Biography,* vol. 51, edited by Trudier Harris, pp. 133–45. Detroit: Gale, 1987.

Jackson, Blyden. "Some Negroes in the Land of Goshen." *Tennessee Folklore Society Bulletin* 19 (4) (December 1953): 103–7.

Johnson, Barbara. "Metaphor, Metonymy, and Voice in *Their Eyes.*" In *Black Literature and Literary Theory,* edited by Henry Louis Gates, Jr., pp. 205–21. New York: Methuen, 1984.

―――. "Thresholds of Difference: Structures of Address in Zora Neale Hurston." In *"Race," Writing and Difference,* edited by Henry Lewis Gates, Jr. Chicago: University of Chicago Press, 1986.

Jordan, June. "On Richard Wright and Zora Neale Hurston." *Black World* 23 (10) (August 1974): 4–8.

Kubitschek, Missy Dehn. " 'Tuh de Horizon and Back': The Female Quest in *Their Eyes.*" *Black American Literature Forum* 17 (3) (Fall 1983): 109–15.

Lionnet, Françoise. "Autoethnography: The Anarchic Style of *Dust Tracks on a Road.*" In Françoise Lionnet, *Autobiographical Voices: Race, Gender, Self-Portraiture,* pp. 97–130. Ithaca: Cornell University Press, 1989.

Lupton, Mary Jane. "Zora Neale Hurston and the Survival of the Female." *Southern Literary Journal* 15 (Fall 1982): 45–54.

Meese, Elizabeth. "Orality and Textuality in Zora Neale Hurston's *Their Eyes.*" In Elizabeth Meese, *Crossing the Double Cross: The Practice of Feminist Criticism,* pp. 39–55. Chapel Hill: University of North Carolina Press, 1986.

Newson, Adele S. *Zora Neale Hurston: A Reference Guide.* Boston: G. K. Hall, 1987.

Rayson, Ann. *"Dust Tracks on a Road:* Zora Neale Hurston and the Form of Black Autobiography." *Negro American Literature Forum* 7 (Summer 1973): 42–44.

Sheffey, Ruthe T., ed. *A Rainbow Round Her Shoulder: The Zora Neale Hurston Symposium Papers.* Baltimore: Morgan State University Press, 1982.

Smith, Barbara. "Sexual Politics and the Fiction of Zora Neale Hurston." *Radical Teacher* 8 (May 1978): 26–30.

Stepto, Robert B. *From Behind the Veil.* Urbana: University of Illinois Press, 1979.

Walker, Alice. "In Search of Zora Neale Hurston." *Ms.,* March 1975, pp. 74–79, 85–89.

Wall, Cheryl A. "Zora Neale Hurston: Changing Her Own Words." In *American Novelists Revisited: Essays in Feminist Criticism,* edited by Fritz Fleischmann, pp. 370–93. Boston: G. K. Hall, 1982.

Washington, Mary Helen. "Zora Neale Hurston: A Woman Half in Shadow." Introduction to *I Love Myself When I Am Laughing,* edited by Alice Walker. Old Westbury, N.Y.: Feminist Press, 1979.

———. " 'I Love the Way Janie Crawford Left Her Husbands': Zora Neale Hurston's Emergent Female Hero." In Mary Helen Washington, *Invented Lives: Narratives of Black Women, 1860–1960.* New York: Anchor Press, 1987.

Willis, Miriam. "Folklore and the Creative Artist: Lydia Cabrera and Zora Neale Hurston." *CLA Journal* 27 (September 1983): 81–90.

Wolff, Maria Tai. "Listening and Living: Reading and Experience in *Their Eyes.*" *BALF* 16 (1) (Spring 1982): 29–33.

CHRONOLOGY

January 7, 1891	Born in Eatonville, Florida, the fifth of eight children, to John Hurston, a carpenter and Baptist preacher, and Lucy Potts Hurston, a former schoolteacher.
September 1917– June 1918	Attends Morgan Academy in Baltimore, completing the high school requirements.
Summer 1918	Works as a waitress in a nightclub and a manicurist in a black-owned barbershop that serves only whites.
1918–19	Attends Howard Prep School, Washington, D.C.
1919–24	Attends Howard University; receives an associate degree in 1920.
1921	Publishes her first story, "John Redding Goes to Sea," in the *Stylus,* the campus literary society's magazine.
December 1924	Publishes "Drenched in Light," a short story, in *Opportunity*.
1925	Submits a story, "Spunk," and a play, *Color Struck,* to *Opportunity*'s literary contest. Both

	win second-place awards; publishes "Spunk" in the June number.
1925–27	Attends Barnard College, studying anthropology with Franz Boas.
1926	Begins field work for Boas in Harlem.
January 1926	Publishes "John Redding Goes to Sea" in *Opportunity.*
Summer 1926	Organizes *Fire!* with Langston Hughes and Wallace Thurman; they publish only one issue, in November 1926. The issue includes Hurston's "Sweat."
August 1926	Publishes "Muttsy" in *Opportunity.*
September 1926	Publishes "Possum or Pig" in the *Forum.*
September–November 1926	Publishes "The Eatonville Anthology" in the *Messenger.*
1927	Publishes *The First One,* a play, in Charles S. Johnson's *Ebony and Topaz.*
February 1927	Goes to Florida to collect folklore.
May 19, 1927	Marries Herbert Sheen.
September 1927	First visits Mrs. Rufus Osgood Mason, seeking patronage.
October 1927	Publishes an account of the black settlement at St. Augustine, Florida, in the *Journal of Negro History;* also in this issue: "Cudjo's Own Story of the Last African Slaver."
December 1927	Signs a contract with Mason, enabling her to return to the South to collect folklore.
1928	Satirized as "Sweetie Mae Carr" in Wallace Thurman's novel about the Harlem Renaissance *Infants of the Spring;* receives a bachelor of arts degree from Barnard.
January 1928	Relations with Sheen break off.

May 1928	Publishes "How It Feels to Be Colored Me" in the *World Tomorrow*.
1930–32	Organizes the field notes that become *Mules and Men*.
May–June 1930	Works on the play *Mule Bone* with Langston Hughes.
1931	Publishes "Hoodoo in America" in the *Journal of American Folklore*.
February 1931	Breaks with Langston Hughes over the authorship of *Mule Bone*.
July 7, 1931	Divorces Sheen.
September 1931	Writes for a theatrical revue called *Fast and Furious*.
January 1932	Writes and stages a theatrical revue called *The Great Day*, first performed on January 10 on Broadway at the John Golden Theatre; works with the creative literature department of Rollins College, Winter Park, Florida, to produce a concert program of Negro music.
1933	Writes "The Fiery Chariot."
January 1933	Stages *From Sun to Sun* (a version of *Great Day*) at Rollins College.
August 1933	Publishes "The Gilded Six-Bits" in *Story*.
1934	Publishes six essays in Nancy Cunard's anthology, *Negro*.
January 1934	Goes to Bethune-Cookman College to establish a school of dramatic arts "based on pure Negro expression."
May 1934	Publishes *Jonah's Gourd Vine*, originally titled *Big Nigger;* it is a Book-of-the-Month Club selection.

225

September 1934	Publishes "The Fire and the Cloud" in the *Challenge*.
November 1934	*Singing Steel* (a version of *Great Day*) performed in Chicago.
January 1935	Makes an abortive attempt to study for a Ph.D in anthropology at Columbia University on a fellowship from the Rosenwald Foundation. In fact, she seldom attends classes.
August 1935	Joins the WPA Federal Theatre Project as a "dramatic coach."
October 1935	*Mules and Men* published.
March 1936	Awarded a Guggenheim Fellowship to study West Indian Obeah practices.
April– September 1936	In Jamaica.
September– March 1937	In Haiti; writes *Their Eyes Were Watching God* in seven weeks.
May 1937	Returns to Haiti on a renewed Guggenheim.
September 1937	Returns to the United States; *Their Eyes Were Watching God* published, September 18.
February– March 1938	Writes *Tell My Horse;* it is published the same year.
April 1938	Joins the Federal Writers Project in Florida to work on *The Florida Negro*.
1939	Publishes "Now Take Noses" in *Cordially Yours*.
June 1939	Receives an honorary Doctor of Letters degree from Morgan State College.
June 27, 1939	Marries Albert Price III in Florida.

Summer 1939	Hired as a drama instructor by North Carolina College for Negroes at Durham; meets Paul Green, professor of drama, at the University of North Carolina.
November 1939	*Moses, Man of the Mountain* published.
February 1940	Files for divorce from Price, though the two are reconciled briefly.
Summer 1940	Makes a folklore-collecting trip to South Carolina.
Spring–July 1941	Writes *Dust Tracks on a Road.*
July 1941	Publishes "Cock Robin, Beale Street" in the *Southern Literary Messenger.*
October 1941–January 1942	Works as a story consultant at Paramount Pictures.
July 1942	Publishes "Story in Harlem Slang" in the *American Mercury.*
September 5, 1942	Publishes a profile of Lawrence Silas in the *Saturday Evening Post.*
November 1942	*Dust Tracks on a Road* published.
February 1943	Awarded the Anisfield-Wolf Book Award in Race Relations for *Dust Tracks;* on the cover of the *Saturday Review.*
March 1943	Receives Howard University's Distinguished Alumni Award.
May 1943	Publishes "The 'Pet Negro' Syndrome" in the *American Mercury.*
November 1943	Divorce from Price granted.
June 1944	Publishes "My Most Humiliating Jim Crow Experience" in the *Negro Digest.*
1945	Writes *Mrs. Doctor;* it is rejected by Lippincott.

March 1945	Publishes "The Rise of the Begging Joints" in the *American Mercury.*
December 1945	Publishes "Crazy for This Democracy" in the *Negro Digest.*
1947	Publishes a review of Robert Tallant's *Voodoo in New Orleans* in the *Journal of American Folklore.*
May 1947	Goes to British Honduras to research black communities in Central America; writes *Seraph on the Suwanee;* stays in Honduras until March 1948.
September 1948	Falsely accused of molesting a ten-year-old boy and arrested; case finally dismissed in March 1949.
October 1948	*Seraph on the Suwanee* published.
March 1950	Publishes "Conscience of the Court" in the *Saturday Evening Post,* while working as a maid in Rivo Island, Florida.
April 1950	Publishes "What White Publishers Won't Print" in the *Saturday Evening Post.*
November 1950	Publishes "I Saw Negro Votes Peddled" in the *American Legion* magazine.
Winter 1950–51	Moves to Belle Glade, Florida.
June 1951	Publishes "Why the Negro Won't Buy Communism" in the *American Legion* magazine.
December 8, 1951	Publishes "A Negro Voter Sizes Up Taft" in the *Saturday Evening Post.*
1952	Hired by the *Pittsburgh Courier* to cover the Ruby McCollum case.
May 1956	Receives an award for "education and human relations" at Bethune-Cookman College.

June 1956	Works as a librarian at Patrick Air Force Base in Florida; fired in 1957.
1957–59	Writes a column on "Hoodoo and Black Magic" for the *Fort Pierce Chronicle.*
1958	Works as a substitute teacher at Lincoln Park Academy, Fort Pierce.
Early 1959	Suffers a stroke.
October 1959	Forced to enter the St. Lucie County Welfare Home.
January 28, 1960	Dies in the St. Lucie County Welfare Home of "hypertensive heart disease"; buried in an unmarked grave in the Garden of Heavenly Rest, Fort Pierce.
August 1973	Alice Walker discovers and marks Hurston's grave.
March 1975	Walker publishes "In Search of Zora Neale Hurston," in *Ms.,* launching a Hurston revival.

About the author

About the book

Read on

Insights,
Interviews
& More ...

"In Search of Zora Neale Hurston"

by Alice Walker

The work of Zora Neale Hurston was relatively unknown in 1975, when Alice Walker, beloved author of The Color Purple, *wrote her groundbreaking essay "In Search of Zora Neale Hurston" (Ms. magazine, March 1975). In this seminal piece, reprinted here in its entirety, Walker illuminates her idol's life and work.*

"ON JANUARY 16, 1959, Zora Neale Hurston, suffering from the effects of a stroke and writing painfully in longhand, composed a letter to the 'editorial department' of Harper & Brothers inquiring if they would be interested in seeing 'the book I am laboring upon at the present—a life of Herod the Great.' One year and twelve days later, Zora Neale Hurston died without funds to provide for her burial, a resident of the St. Lucie County, Florida, Welfare Home. She lies today in an unmarked grave in a segregated cemetery in Fort Pierce, Florida, a resting place generally symbolic of the black writer's fate in America.

"Zora Neale Hurston is one of the most significant unread authors in America, the author of two minor classics and four other major books."

—*Robert Hemenway, "Zora Hurston and the Eatonville Anthropology," from* The Harlem Renaissance Remembered, *edited by Arna Bontemps (Dodd, 1972)*

Courtesy of the Estate of Carl Van Vechten, Joseph Solomon, Executor

ON AUGUST 15, 1973, I wake up just as the plane is lowering over Sanford, Florida, which means I am also looking down on Eatonville, Zora Neale Hurston's birthplace. I recognize it from Zora's description in *Mules and Men*: "the city of five lakes, three croquet courts, three hundred brown skins, three hundred good swimmers, plenty guavas, two schools, and no jailhouse." Of course I cannot see the guavas, but the five lakes are still there, and it is the lakes I count as the plane prepares to land in Orlando.

From the air, Florida looks completely flat, and as we near the ground this impression does not change. This is the first time I have seen the interior of the state, which Zora wrote about so well, but there are the acres of orange groves, the sand, mangrove trees, and scrub pine that I know from her books. Getting off the plane I walk through the hot moist air of midday into the tacky but air-conditioned airport. I search for Charlotte Hunt, my companion on the Zora Hurston expedition. She lives in Winter Park, Florida, very near Eatonville, and is writing her graduate dissertation on Zora. I see her waving—a large pleasant-faced white woman in dark glasses. We have written to each other for several weeks, swapping our latest finds (mostly hers) on Zora, and trying to make sense out of the mass of information obtained (often erroneous or simply confusing) from Zora herself—through her stories and autobiography—and from people who wrote about her.

Eatonville has lived for such a long time in my imagination that I can hardly believe it will be found existing in its own right. ▶

"In Search of Zora Neale Hurston" *(continued)*

But after twenty minutes on the expressway, Charlotte turns off and I see a small settlement of houses and stores set with no particular pattern in the sandy soil off the road. We stop in front of a neat gray building that has two fascinating signs: EATONVILLE POST OFFICE and EATONVILLE CITY HALL.

Inside the Eatonville City Hall half of the building, a slender, dark, brown-skin woman sits looking through letters on a desk. When she hears we are searching for anyone who might have known Zora Neale Hurston, she leans back in thought. Because I don't wish to inspire foot-dragging in people who might know something about Zora they're not sure they should tell, I have decided on a simple, but I feel profoundly *useful*, lie.

"I am Miss Hurston's niece," I prompt the young woman, who brings her head down with a smile.

"I think Mrs. Moseley is about the only one still living who might remember her," she says.

"Do you mean *Mathilda* Moseley, the woman who tells those 'woman-is-smarter-than-man' lies in Zora's book?"

"Yes," says the young woman. "Mrs. Moseley is real old now, of course. But this time of day, she should be at home."

I stand at the counter looking down on her, the first Eatonville resident I have spoken to. Because of Zora's books, I feel I know something about her; at least I know what the town she grew up in was like years before she was born.

"Tell me something," I say, "do the schools teach Zora's books here?"

"No," she says, "they don't. I don't think most people know anything about Zora Neale Hurston, or knew about any of the great things she did. She was a fine lady. I've read all of her books myself, but I don't think many other folks in Eatonville have."

"Many of the church people around here, as I understand it," says Charlotte in a murmured aside, "thought Zora was pretty loose. I don't think they appreciated her writing about them."

"Well," I say to the young woman, "thank you for your help." She clarifies her directions to Mrs. Moseley's house and smiles as Charlotte and I turn to go.

"The letter to Harper's does not expose a publisher's rejection of an unknown masterpiece, but it does reveal how the bright promise of the

Harlem Renaissance deteriorated for many of the writers who shared in its exuberance. It also indicates the personal tragedy of Zora Neale Hurston: Barnard graduate, author of four novels, two books of folklore, one volume of autobiography, the most important collector of Afro-American folklore in America, reduced by poverty and circumstance to seek a publisher by unsolicited mail."

—*Robert Hemenway*

"Zora Neale Hurston was born in 1901, 1902, or 1903—depending on how old she felt herself to be at the time someone asked."

—*Librarian, Beinecke Library, Yale University*

THE MOSELEY HOUSE is small and white and snug, its tiny yard nearly swallowed up by oleanders and hibiscus bushes. Charlotte and I knock on the door. I call out. But there is no answer. This strikes us as peculiar. We have had time to figure out an age for Mrs. Moseley—not dates or a number, just old. I am thinking of a quivery, bedridden invalid when we hear the car. We look behind us to see an old black-and-white Buick—paint peeling and grillwork rusty—pulling into the drive. A neat old lady in a purple dress and white hair is straining at the wheel. She is frowning because Charlotte's car is in the way.

Mrs. Moseley looks at us suspiciously. "Yes, I knew Zora Neale," she says, unsmilingly and with a rather cold stare at Charlotte (who I imagine feels very *white* at that moment), "but that was a long time ago, and I don't want to talk about it."

"Yes ma'am," I murmur, bringing all my sympathy to bear on the situation.

"Not only that," Mrs. Moseley continues, "I've been sick. Been in the hospital for an operation. Ruptured artery. The doctors didn't believe I was going to live, but you see me alive, don't you?"

"Looking well, too," I comment.

Mrs. Moseley is out of her car. A thin, sprightly woman with nice gold-studded false teeth, uppers and lowers. I like her because she stands there *straight* beside her car, with a hand on her hip and her straw pocketbook on her arm. She wears white T-strap shoes with heels that show off her well-shaped legs.

"I'm eighty-two years old, you know," she says. "And I just can't remember things the way I used to. Anyhow, Zora Neale left here to go ▶

"In Search of Zora Neale Hurston" *(continued)*

to school and she never really came back to live. She'd come here for material for her books, but that was all. She spent most of her time down in South Florida."

"You know, Mrs. Moseley, I saw your name in one of Zora's books."

"You did?" She looks at me with only slightly more interest. "I read some of her books a long time ago, but then people got to borrowing and borrowing and they borrowed them all away."

"I could send you a copy of everything that's been reprinted." I offer. "Would you like me to do that?"

"No," says Mrs. Moseley promptly. "I don't read much any more. Besides, all of that was *so* long ago. . . ."

Charlotte and I settle back against the car in the sun. Mrs. Moseley tells us at length and with exact recall every step in her recent operation, ending with: "What those doctors didn't know—when they were expecting me to die (and they didn't even think I'd live long enough for them to have to take out my stitches!)—is that Jesus is the best doctor, and if *He* says for you to get well, that's all that counts."

With this philosophy, Charlotte and I murmur quick assent: being Southerners and church bred, we have heard that belief before. But what we learn from Mrs. Moseley is that she does not remember much beyond the year 1938. She shows us a picture of her father and mother and says that her father was Joe Clarke's brother. Joe Clarke, as every Zora Hurston reader knows, was the first mayor of Eatonville; his fictional counterpart is Jody Starks of *Their Eyes Were Watching God*. We

also get directions to where Joe Clarke's store *was*—where Club Eaton is now. Club Eaton, a long orange-beige nightspot we had seen on the main road, is apparently famous for the good times in it regularly had by all. It is, perhaps, the modern equivalent of the store porch, where all the men of Zora's childhood came to tell "lies," that is, black folktales, that were "made and used on the spot," to take a line from Zora. As for Zora's exact birthplace, Mrs. Moseley has no idea.

After I have commented on the healthy growth of her hibiscus bushes, she becomes more talkative. She mentions how much she *loved* to dance, when she was a young woman, and talks about how good her husband was. When he was alive, she says, she was completely happy because he allowed her to be completely free. "I was so free I had to pinch myself sometimes to tell if I was a married woman."

Relaxed now, she tells us about going to school with Zora. "Zora and I went to the same school. It's called Hungerford High now. It *was* only to the eighth-grade. But our teachers were so good that by the time you left you knew college subjects. When I went to Morris Brown in Atlanta, the teachers there were just teaching me the same things I had already learned right in Eatonville. I wrote Mama and told her I was going to come home and help her with her babies. I wasn't learning anything new."

"Tell me something, Mrs. Moseley," I ask, "why do you suppose Zora was against integration? I read somewhere that she was against school desegregation because she felt it was an insult to black teachers." ▶

"Oh, one of them [white people] came around asking me about integration. One day I was doing my shopping. I heard 'em over there talking about it in the store, about the schools. And I got on out of the way because I knew if they asked me, they wouldn't like what I was going to tell 'em. But they came up and asked me anyhow. 'What do you think about this integration?' one of them said. I acted like I thought I had heard wrong. 'You're asking *me* what *I* think about integration?' I said. 'Well, as you can see I'm just an old colored woman'—I was seventy-five or seventy-six then—'and this is the first time anybody ever asked me about integration. And nobody asked my grandmother what she thought, either, but her daddy was one of you all.'" Mrs. Moseley seems satisfied with this memory of her rejoinder. She looks at Charlotte. "I have the blood of three races in my veins," she says belligerently, "white, black, and Indian, and nobody asked me *anything* before."

"Do you think living in Eatonville made integration less appealing to you?"

"Well, I can tell you this: I have lived in Eatonville all my life and I've been in the governing of this town. I've been everything but Mayor and I've been *assistant* Mayor. Eatonville was and is an all-black town. We have our own police department, post office, and town hall. Our own school and good teachers. Do I need integration?

"They took over Goldsboro, because the black people who lived there never incorporated like we did. And now I don't even know if any black folks live there. They built big houses up there around the lakes. But we didn't let that happen in Eatonville, and we don't sell land to just anybody. And you see, we're still here."

When we leave, Mrs. Moseley is standing by her car, waving. I think of the letter Roy Wilkins wrote to a black newspaper blasting Zora Neale for her lack of enthusiasm about the integration of schools. I wonder if he knew the experience of Eatonville she was coming from. Not many black people in America have come from a self-contained, all-black community where loyalty and unity are taken for granted. A place where black pride is nothing new.

There is, however, one thing Mrs. Moseley said that bothered me.

"Tell me, Mrs. Moseley," I had asked, "Why is it that thirteen years after Zora's death, no marker has been put on her grave?"

And Mrs. Moseley answered: "The reason she doesn't have a stone is

because she wasn't buried here. She was buried down in South Florida somewhere. I don't think anybody really knew where she was."

"Only to reach a wider audience, need she ever write books—because she is a perfect book of entertainment in herself. In her youth she was always getting scholarships and things from wealthy white people, some of whom simply paid her just to sit around and represent the Negro race for them, she did it in such a racy fashion. She was full of sidesplitting anecdotes, humorous tales, and tragicomic stories, remembered out of her life in the South as a daughter of a traveling minister of God. She could make you laugh one minute and cry the next. To many of her white friends, no doubt, she was a perfect 'darkie,' in the nice meaning they give the term—that is, a naïve, childlike, sweet, humorous, and highly colored Negro.

"But Miss Hurston was clever, too—a student who didn't let college give her a broad 'a' and who had great scorn for all pretentions, academic or otherwise. That is why she was such a fine folklore collector, able to go among the people and never act as if she had been to school at all. Almost nobody else could stop the average Harlemite on Lenox Avenue and measure his head with a strange-looking, anthropological device and not get bawled out for the attempt, except Zora, who used to stop anyone whose head looked interesting, and measure it."

—*Langston Hughes,* The Big Sea *(Knopf)*

"What does it matter what white folks must have thought about her?"
—*Student, Black Women Writers Class, Wellesley College*

MRS. SARAH PEEK PATTERSON is a handsome, red-haired woman in her late forties, wearing orange slacks and gold earrings. She is the director of Lee-Peek Mortuary in Fort Pierce, the establishment that handled Zora's burial. Unlike most black funeral homes in Southern towns that sit like palaces among the general poverty, Lee-Peek has a run-down, *small* look. Perhaps this is because it is painted purple and white, as are its Cadillac chariots. These colors do not age well. The rooms are cluttered and grimy, and the bathroom is a tiny, stale-smelling prison, with a bottle of black hair dye (apparently used to touch up the hair of the corpses) dripping into the face bowl. Two pine burial boxes are resting in the bathtub. ▶

Mrs. Patterson herself is pleasant and helpful.

"As I told you over the phone, Mrs. Patterson," I begin, shaking her hand and looking into her penny-brown eyes, "I am Zora Neale Hurston's niece, and I would like to have a marker put on her grave. You said, when I called you last week, that you could tell me where the grave is."

By this time I am, of course, completely into being Zora's niece, and the lie comes with perfect naturalness to my lips. Besides, as far as I'm concerned, she *is* my aunt—and that of all black people as well.

"She was buried in 1960," exclaims Mrs. Patterson. "That was when my father was running this funeral home. He's sick now or I'd let you talk to him. But I know where she's buried. She's in the old cemetery, the Garden of the Heavenly Rest, on Seventeenth Street. Just when you go in the gate there's a circle, and she's buried right in the middle of it. Hers is the only grave in that circle—because people don't bury in that cemetery any more."

She turns to a stocky, black-skinned woman in her thirties, wearing a green polo shirt and white jeans cut off at the knee. "This lady will show you where it is," she says.

"I can't tell you how much I appreciate this," I say to Mrs. Patterson, as I rise to go. "And could you tell me something else? You see, I never met my aunt. When she died I was still a junior in high school. But could you tell me what she died of, and what kind of funeral she had?"

"I don't know exactly what she died of," Mrs. Patterson says, "I know she didn't have any money. Folks took up a collection to bury her. . . . I believe she died of malnutrition."

"*Malnutrition?*"

Outside, in the blistering sun, I lean my head against Charlotte's even more blistering cartop. The sting of the hot metal only intensifies my anger. "*Malnutrition?*" I manage to mutter. "Hell, our condition hasn't changed *any* since Phillis Wheatley's time. *She* died of malnutrition!"

"Really?" says Charlotte, "I didn't know that."

"One cannot overemphasize the extent of her commitment. It was so great that her marriage in the spring of 1927 to Herbert Sheen was short-lived. Although divorce did not come officially until 1931, the two separated amicably after only a few months, Hurston to continue her collecting, Sheen to attend Medical School. Hurston never married again."

—*Robert Hemenway*

"WHAT IS YOUR NAME?" I ask the woman who has climbed into the back seat.

"Rosalee," she says. She has a rough, pleasant voice, as if she is a singer who also smokes a lot. She is homely, and has an air of ready indifference.

"Another woman came by here wanting to see the grave," she says, lighting up a cigarette. "She was a little short, dumpty white lady from one of these Florida schools. Orlando or Daytona. But let me tell you something before we get started. All I know is where the cemetery is. I don't know one thing about that grave. You better go back in and ask her to draw you a map." ▶

"In Search of Zora Neale Hurston" *(continued)*

A few moments later, with Mrs. Patterson's diagram of where the grave is, we head for the cemetery.

We drive past blocks of small, pastel-colored houses and turn right onto Seventeenth Street. At the very end, we reach a tall curving gate, with the words "Garden of Heavenly Rest" fading into the stone. I expected, from Mrs. Patterson's small drawing, to find a small circle—which would have placed Zora's grave five or ten paces from the road. But the "circle" is over an acre large and looks more like an abandoned field. Tall weeds choke the dirt road and scrape against the sides of the car. It doesn't help either that I step out into an active anthill.

"I don't know about y'all," I say, "but I don't even believe this." I am used to the haphazard cemetery-keeping that is traditional in most Southern black communities, but this neglect is staggering. As far as I can see there is nothing but bushes and weeds, some as tall as my waist. One grave is near the road, and Charlotte elects to investigate it. It is fairly clean, and belongs to someone who died in 1963.

Rosalee and I plunge into the weeds; I pull my long dress up to my hips. The weeds scratch my knees, and the insects have a feast. Looking back, I see Charlotte standing resolutely near the road.

"Aren't you coming?" I call.

"No," she calls back. "I'm from these parts and I know what's out there." She means snakes.

"Shit," I say, my whole life and the people I love flashing melodramatically before my eyes. Rosalee is a few yards to my right.

"How're you going to find anything out here?" she asks. And I stand still a few seconds, looking at the weeds. Some of them are quite pretty, with tiny yellow flowers. They are thick and healthy, but dead weeds under them have formed a thick gray carpet on the ground. A snake could be lying six inches from my big toe and I wouldn't see it. We move slowly, very slowly, our eyes alert, our legs trembly. It is hard to tell where the center of the circle is since the circle is not really round, but more like half of something round. There are things crackling and hissing in the grass. Sandspurs are sticking to the inside of my skirt. Sand and ants cover my feet. I look toward the road and notice that there are, indeed, *two* large curving stones, making an entrance and exit to the cemetery. I take my bearings from them and try to navigate to exact center. But the center of anything can be very large, and a grave is not a

pinpoint. Finding the grave seems positively hopeless. There is only one thing to do:

"Zora!" I yell as loud as I can (causing Rosalee to jump), "are you out here?"

"If she is, I sho hope she don't answer you. If she do, I'm gone."

"Zora!" I call again, "I'm here. Are you?"

"If she is," grumbles Rosalee, "I hope she'll keep it to herself."

"Zora!" Then I start fussing with her. "I hope you don't think I'm going to stand out here all day, with these snakes watching me and these ants having a field day. In fact, I'm going to call you just one or two more times." On a clump of dried grass, near a small busy tree, my eye falls on one of the largest bugs I have ever seen. It is on its back, and is as large as three of my fingers. I walk toward it, and yell "Zo-ra!" and my foot sinks into a hole. I look down. I am standing in a sunken rectangle that is about six feet long and about three or four feet wide. I look up to see where the two gates are.

"Well," I say, "this is the center, or approximately anyhow. It's also the only sunken spot we've found. Doesn't this look like a grave to you?"

"For the sake of not going no farther through these bushes," Rosalee growls, "yes, it do."

"Wait a minute," I say, "I have to look around some more to be sure this is the only spot that resembles a grave. But you don't have to come."

Rosalee smiles—a grin, really—beautiful and tough.

"Naw," she says, "I feels sorry for you. If one of these snakes got a hold of you out here by yourself I'd feel *real* bad." She laughs. "I done come this far, I'll go on with you."

"Thank you, Rosalee," I say. "Zora thanks you too."

"Just as long as she don't try to tell me in person," she says, and together we walk down the field.

"The gusto and flavor of Zora Neal[e] Hurston's storytelling, for example, long before the yarns were published in *Mules and Men* and other books, became a local legend which might . . . have spread further under different conditions. A tiny shift in the center of gravity could have made them bestsellers."

—*Arna Bontemps,* Personals *(Paul Bremen, Ltd., London; 1963)*

"Bitter over the rejection of her folklore's value, especially in the black community, frustrated by what she felt was her failure to convert the ▶

Afro-American world view into the forms of prose fiction, Hurston finally gave up."

—*Robert Hemenway*

WHEN CHARLOTTE AND I drive up to the Merritt Monument Company, I immediately see the headstone I want.

"How much is this one?" I ask the young woman in charge, pointing to a tall black stone. It looks as majestic as Zora herself must have been when she was learning voodoo from those root doctors down in New Orleans.

"Oh, *that* one," she says, "that's our finest. That's Ebony Mist."

"Well, how much is it?"

"I don't know. But wait," she says, looking around in relief, "here comes somebody who'll know."

A small, sunburned man with squinty green eyes come sup. He must be the engraver, I think, because his eyes are contracted into slits as if he has been keeping stone dust out of them for years.

"That's Ebony Mist," he says. "That's our best."

"How much is it?" I ask, beginning to realize I probably *can't* afford it.

He gives me a price that would feed a dozen Sahelian drought victims for three years. I realize I must honor the dead, but between the dead great and the living starving, there is no choice.

"I have a lot of letters to be engraved," I say, standing by the plain gray marker I have chosen. It is pale and ordinary, not at all like Zora, and makes me momentarily angry that I am not rich.

We got into his office and I hand him a sheet of paper that has:

ZORA NEALE HURSTON
"A GENIUS OF THE SOUTH"
NOVELIST FOLKLORIST
ANTHROPOLOGIST
1960

"A genius of the South" is from one of Jean Toomer's poems.

"Where is this grave?" the monument man asks. "If it's in a new cemetery, the stone has to be flat."

"Well, it's not a new cemetery and Zora—my aunt—doesn't need anything flat because with the weeds out there, you'd never be able to see it. You'll have to go out there with me."

He grunts.

"And take a long pole and 'sound' the spot," I add. "Because there's no way of telling it's a grave, except that it's sunken."

"Well," he says, after taking my money and writing up a receipt, in the full awareness that he's the only monument dealer for miles, "you take this flag" (he hands me a four-foot-long pole with a red-metal marker on top) "and take it out to the cemetery and put it where you think the grave is. It'll take us about three weeks to get the stone out there."

I wonder if he knows he is sending me to another confrontation with the snakes. He probably does. Charlotte has told me she will cut my leg and suck out the blood, if I am bit.

"At least send me a photograph when it's done, won't you?"

He says he will. ▶

"In Search of Zora Neale Hurston" *(continued)*

"Hurston's return to her folklore-collecting in December of 1927 was made possible by Mrs. R. Osgood Mason, an elderly white patron of the arts, who at various times also helped Langston Hughes, Alain Locke, Richmond Barthe, and Miguel Covarrubias. Hurston apparently came to her attention through the intercession of Locke, who frequently served as a kind of liaison between the young black talent and Mrs. Mason. The entire relationship between this woman and the Harlem Renaissance deserves extended study, for it represents much of the ambiguity involved in white patronage of black artists. All her artists were instructed to call her 'Godmother'; there was a decided emphasis on the 'primitive' aspects of black culture, apparently a holdover from Mrs. Mason's interest in the Plains Indians. In Hurston's case there were special restrictions imposed by her patron: although she was to be paid a handsome salary for her folklore collecting, she was to limit her correspondence and publish nothing of her research without prior approval."

—*Robert Hemenway*

"You have to read the chapters Zora *left out* of her autobiography."
—*Student, Special Collections Room*
Beinecke Library, Yale University

DR. BENTON, a friend of Zora's and a practicing M.D. in Fort Pierce, is one of those old, good-looking men whom I always have trouble not liking. (It no longer bothers me that I may be constantly searching for father figures; by this time, I have found several and dearly enjoyed knowing them all.) He is shrewd, with steady brown eyes under hair that is almost white. He is probably in his seventies, but doesn't look it. He carries himself with dignity, and has cause to be proud of the new clinic where he now practices medicine. His nurse looks at us with suspicion, but Dr. Benton's eyes have the penetration of a scalpel cutting through skin. I guess right away that if he knows anything at all about Zora Hurston, he will not believe I am her niece. "Eatonville?" Dr. Benton says, leaning forward in his chair, looking first at me, then at Charlotte. "Yes, I know Eatonville, I grew up not far from there. I knew the whole bunch of Zora's family." (He looks at the shape of my cheekbones, the size of my eyes, and the nappiness of my hair.) "I knew her daddy. The old man. He was a hardworking, Christian man. Did the best he could for his family. He was the mayor of Eatonville for a while, you know.

"My father was the mayor of Goldsboro. You probably never heard of it. It never incorporated like Eatonville did, and has just about disappeared. But Eatonville is still all-black."

He pauses and looks at me. "And you're Zora's niece," he says wonderingly.

"Well," I say with shy dignity, yet with some tinge, I hope, of a nineteenth-century blush, "I'm illegitimate. That's why I never knew Aunt Zora."

I love him for the way he comes to my rescue. "You're *not* illegitimate!" he cries, his eyes resting on me fondly. "All of us are God's children! Don't you even *think* such a thing!"

And I hate myself for lying to him. Still I ask myself, would I have gotten this far toward getting the headstone and finding out about Zora Hurston's last days without telling my lie? Actually I probably would have. But I don't like taking chances that could get me stranded in Central Florida.

"Zora didn't get along with her family. I don't know why. Did you read her autobiography, *Dust Tracks on a Road*?"

"Yes, I did," I say. "It pained me to see Zora pretending to be naïve and grateful about the old white 'Godmother' who helped finance her research, but I loved the part where she ran off from home after falling out with her brother's wife.

Dr. Benton nodded. "When she got sick, I tried to get her to go back to her family, but she refused. There wasn't any real hatred; they just never had gotten along and Zora wouldn't go to them. She didn't want to go to the country home, either, but she had to, because she couldn't do a thing for herself."

"I was surprised to learn she died of malnutrition."

Dr. Benton seems startled. "Zora *didn't* die of malnutrition," he says indignantly. "Where did you get that story from? She had a stroke and she died in the welfare home." He seems particularly upset, distressed, but sits back reflectively in his chair: "She was an incredible woman," he muses. "Sometimes when I closed my office, I'd go by her house and just talk to her for an hour or two. She was a well-read, well-traveled woman and always had her own ideas about what was going on . . ."

"I never knew her, you know. Only some of Carl Van Vechten's photographs and some newspaper photographs. . . . What did she look like?"

"When I knew her, in the fifties, she was a big woman, *erect*. Not quite ▶

"In Search of Zora Neale Hurston" *(continued)*

as light as I am [Dr. Benton is dark beige], and about five foot, seven inches, and she weighed about two hundred pounds. Probably more. She ... "

"What! Zora was *fat!* She wasn't in Van Vechten's pictures!"

"Zora loved to eat," Dr. Benton says complacently. "She could sit down with a mound of ice cream and just eat and talk till it was all gone."

While Dr. Benton is talking, I recall that the Van Vechten pictures were taken when Zora was still a young woman. In them she appears tall, tan, and healthy. In later newspaper photographs—when she was in her forties—I remembered that she seemed heavier and several shades lighter. I reasoned that the earlier photographs were taken while she was busy collecting folklore materials in the hot Florida sun.

"She had high blood pressure. Her health wasn't good. ... She used to live in one of my houses—on School Court Street. It's a block house ... I don't recall the number. But my wife and I used to invite her over to the house for dinner. *She always ate well,*" he says emphatically.

"That's comforting to know," I say, wondering where Zora ate when she wasn't with the Bentons.

"Sometimes she would run out of groceries—after she got sick—and she'd call me. 'Come over here and see 'bout me,' she'd say. And I'd take her shopping and buy her groceries.

"She was always studying. Her mind— before the stroke—just worked all the time. She was always going somewhere, too. She

once went to Honduras to study something. And when she died, she was working on that book about Herod the Great. She was so intelligent! And really had perfect expressions. Her English was beautiful." (I suspect that is a clever way to let me know Zora herself didn't speak in the "black English" her characters used.)

"I used to read all of her books," Dr. Benton continues, "but it was a long time ago. I remember one about . . . it was called, I think, 'The Children of God' [*Their Eyes Were Watching God*], and I remember Janie and Teapot [Teacake] and the mad dog riding on the cow in that hurricane and bit old Teapot on the cheek. . . ."

I am delighted that he remembers even this much of the story, even if the names are wrong, but seeing his affection for Zora I feel I must ask him about her burial. "Did she *really* have a pauper's funeral?"

"She *didn't* have a pauper's funeral!" he says with great heat. "Everybody around here *loved* Zora."

"We just came back from ordering a headstone," I say quietly, because he *is* an old man and the color is coming and going on his face, "but to tell the truth, I can't be positive what I found is the grave. All I know is the spot I found was the only grave-size hole in the area."

"I remember it wasn't near the road," says Dr. Benton, more calmly. "Some other lady came by here and we went out looking for the grave and I took a long iron stick and poked all over that part of the cemetery but we didn't find anything. She took some pictures of the general area. Do the weeds still come up to your knees?" ▶

19

"In Search of Zora Neale Hurston" *(continued)*

"And beyond," I murmur. This time there isn't any doubt. Dr. Benton feels ashamed.

As he walks us to our car, he continues to talk about Zora. "She couldn't really write much near the end. She had the stroke and it left her weak; her mind was affected. She couldn't think about anything for long.

"She came here from Daytona, I think. She owned a houseboat over there. When she came here, she sold it. She lived on that money, then she worked as a maid—for an article on maids she was writing—and she worked for the *Chronicle* writing the horoscope column.

"I think black people here in Florida got mad at her because she was for some politician they were against. She said this politician *built* schools for blacks while the one they wanted just talked about it. And although Zora wasn't egotistical, what she thought, she thought; and generally what she thought, she said."

When we leave Dr. Benton's office, I realize I have missed my plane back home to Jackson, Mississippi. That being so, Charlotte and I decide to find the house Zora lived in before she was taken to the country welfare home to die. From among her many notes, Charlotte locates a letter of Zora's she has copied that carries the address: 1734 School Court Street. We ask several people for directions. Finally, two old gentlemen in a dusty gray Plymouth offer to lead us there. School Court Street is not paved, and the road is full of mud puddles. It is dismal and squalid, redeemed only by the brightness of the late afternoon sun. Now I can understand what a "block" house is. It is a house shaped like a block, for one thing, surrounded by others just like it. Some houses are blue and some are green or yellow. Zora's is light green. They are tiny—about fifty by fifty feet, squatty with flat roofs. The house Zora lived in looks worse than the others, but that is its only distinction. It also has three ragged and dirty children sitting on the steps.

"Is this where y'all live?" I ask, aiming my camera.

"No, ma'am" they say in unison, looking at me earnestly. "We live over yonder. This Miss So-and-So's house; but she in the hospital."

We chatter inconsequentially while I take more pictures. A car drives up with a young black couple in it. They scowl fiercely at Charlotte and don't look at me with friendliness, either. They get out and stand in their doorway across the street. I go up to them to explain. "Did you know Zora Hurston used to live right across from you?" I ask.

"Who?" They stare at me blankly, then become curiously attentive, as if they think I made the name up. They are both Afro-ed and he is somberly dashiki-ed.

I suddenly feel frail and exhausted. "It's too long a story," I say, "but tell me something, is there anybody on this street who's lived here for more than thirteen years?"

"That old man down there," the young man says, pointing. Sure enough, there is a man sitting on his steps three houses down. He has graying hair and is very neat, but there is a weakness about him. He reminds me of Mrs. Turner's husband in *Their Eyes Were Watching God*. He's rather "vanishing"-looking, as if his features have been sanded down. In the old days, before black was beautiful, he was probably considered attractive, because he has wavy hair and light-brown skin; but now, well, light skin has ceased to be its own reward.

After the preliminaries, there is only one thing I want to know: "Tell me something," I begin, looking down at Zora's house, "did Zora like flowers?"

He looks at me queerly. "As a matter of fact," he says, looking regretfully at the bare, rough yard that surrounds her former house, "she was crazy about them. And she was a great gardener. She loved azaleas, and that running and blooming vine [morning glories], and she really loved that night-smelling flower [gardenia]. She kept a vegetable garden year-round, too. She raised collards and tomatoes and things like that.

"Everyone in this community thought well of Miss Hurston. When she died, people all up and down this street took up a collection for her burial. We put her away nice."

"Why didn't somebody put up a headstone?"

"Well, you know, one was never requested. Her and her family didn't get along. They didn't even come to the funeral."

"And did she live there by herself?"

"Yes, until they took her away. She lived with—just her and her companion, Sport."

My ears perk up. "Who?"

"Sport, you know, her dog. He was her only companion. He was a big brown-and-white dog."

When I walk back to the car, Charlotte is talking to the young couple on their porch. They are relaxed and smiling. ▶

"In Search of Zora Neale Hurston" *(continued)*

"I told them about the famous lady who used to live across the street from them," says Charlotte as we drive off. "Of course they had no idea Zora ever lived, let alone that she lived across the street. I think I'll send some of her books to them."

"That's real kind of you," I say.

"I am not tragically colored. There is no great sorrow dammed up in my soul, nor lurking behind my eyes. I do not mind at all. I do not belong to the sobbing school of Negrohood who hold that nature somehow has given them a lowdown dirty deal and whose feelings are all hurt about it. . . . No, I do not weep at the world—I am too busy sharpening my oyster knife."

> —*Zora Neale Hurston, "How It Feels to Be Colored Me,"* World Tomorrow, *1928*

THERE ARE TIMES—and finding Zora Hurston's grave was one of them—when normal responses of grief, horror, and so on, do not make sense because they bear no real relation to the depth of the emotion one feels. It was impossible for me to cry when I saw the field full of weeds where Zora is. Partly this is because I have come to know Zora through her books and she was not a teary sort of person herself; but partly, too, it is because there is a point at which even grief feels absurd. And at this point laughter gushes up to retrieve sanity.

It is only later, when the pain is not so direct a threat to one's own existence that what was learned in that moment of comical lunacy is understood. Such moments rob us of both youth and vanity. But perhaps they

are also times when greater disciplines are
born. ∽

Alice Walker is the author of Revolutionary
Petunias and Other Poems *(Harcourt), which
was nominated for a National Book Award,
and* In Love & Trouble: Stories of Black
Women *(Harcourt), which received the
Rosenthal Foundation Award from the
National Institute of Arts and Letters.*

"A Series of Linguistic Moments"
Robert E. Hemenway on
Jonah's Gourd Vine

The following is excerpted from Robert E. Hemenway's Zora Neale Hurston: A Literary Biography *(The University of Illinois Press, 1977) and is reprinted by permission of The University of Illinois Press.*

THE WRITING OF *Jonah's Gourd Vine* is a good example of Hurston's dedication to her craft. She had no means of support while writing. She lived in a one-room house in Saford renting for $1.50 per week. She composed on a flimsy card table and survived on the fifty cents for groceries her cousin lent her each Friday. By the time the manuscript was completed, she owed eighteen dollars in rent, and on the morning of October 16 the landlord evicted her, despite the fact that she was about to earn her first money in three months by booking some folksingers for a city festival. She opened the publisher's telegram in the afternoon while purchasing shoes to replace her worn scraps of leather, and when she saw the figure $200 she "tore out of that place with one old shoe and one new one on and ran to the Western Union office." The book was published in the first week of May, 1934.

Jonah's Gourd Vine is an autobiographical novel, not a document for understanding Hurston's private life. It is usually dealt with as a fictionalization of her parents' marriage—complete with her father's philandering, her mother's steady strength,

and Zora's reaction to them both. The novel's main characters are named John and Lucy; their history is the Hurston family history. The plot takes John from life on an Alabama plantation to a ministerial position in Eatonville. Zora even uses the deathbed scene that she remembered as a major trauma of her youth, when her dying mother asked her to stop the neighbors from removing her pillow at the moment of passing. Having observed such parallels between art and life, the reader should be wary of accepting Hurston's fictional characters as autobiographical admissions. Often the novel portrays John and Lucy in ways in which she apparently never thought of her parents, and the novel's plot does not follow exactly the family story. For example, there is more than a hint that Lucy's death is caused by the workings of a hoodoo doctor, an idea with dramatic potential but apparently no basis in fact.

The novel is basically John's story. He rises from a life as an illiterate laborer to become moderator of a Baptist convention in central Florida. The seeds of his tragedy are sown early: he cannot resist women, and although he is a powerful man of God when in the pulpit, he is a man among women when his inspiration ends. Lucy, who is in many ways the strongest character in the novel, serving as both a mainstay for John and a cohesive force for her family, all but wills him the backbone necessary to rise in the world. But after she dies, his lusts predominate. Eventually his congregation rejects him, and he dies just as he has begun to understand both his success and his failure.

John is the bastard child of Amy ▶

Crittenden, a slave on the Pearson plantation before Emancipation. His father was probably the master, Alf Pearson, but John never knows it, and Amy never admits it. After the Civil War, Amy struggles to make a life with her cruel husband, Ned, and it is his rejection of John that causes the teenager to leave home for work at Pearson's. John is such a strong, handsome, striking figure that he is soon sent to school and put in a position of responsibility. He also falls in love with his schoolmate, Lucy Potts, the smartest girl in the class. Even though she is barely past puberty, they become engaged. Her parents object because John is from "over the creek," without money or status; but the lovers persevere, Lucy showing great courage in the face of the familial opposition. After their marriage, John is unfaithful, although he continues to express his love. He always returns to Lucy, and he violently defends wife and family when they are endangered. The Alabama portion of the novel ends when John savagely beats Lucy's brother for collecting a debt at the time she is having her third child. John is arrested and arraigned, but Pearson secures his release, advising him that "distance is the only cure for certain diseases." He runs away, ending up in Eatonville where "uh man kin be sumpin' . . . 'thout folks tramplin' all over yuh. Ah wants mah wife and chillum heah." After they arrive, Lucy encourages John in his preaching, and he becomes a major figure in the community. The family prospers despite John's indiscretions. Eventually Lucy grows sick, and all John can think of, despite the intensity of their love, is the release her death will bring from the guilt she instills in him.

After Lucy's death John marries his mistress, to the distress of his children and parishioners. The church begins to plot his downfall, and his enemies are eventually joined by his new wife, Hattie, who has become a woman scorned. John realizes that her attraction is only physical, and he is bewildered to even find himself married. After he beats Hattie for attempting to conjure him, she asks for a divorce. John refuses to contest because he recognizes the racism of the white court. He tells his friend: "Dey thinks wese all ignorant as it is, and dey thinks wese all alike, and dat dey knows us inside and out. . . . De only difference dey makes is 'tween uh nigger that work hard and don't sass 'em, and one dat don't." Although the church tries again to remove him, John deflects their efforts with powerful preaching. Finally, he voluntarily removes himself from the pulpit and discovers how quickly people relish the hardship of the dispossessed. One man says, "Well, since he's down, less

keep 'im down." After moving to a nearby town he meets a good woman, who becomes his third wife and helps him understand some of the forces within him. He returns to preaching, but is killed accidentally just as he approaches his great self-awareness.

The title of the novel is addressed not so much to this total story as to a specific act of cruelty caused by the "brute-beast" in John. In a crucial scene Lucy is lying sick, on a bed that will shortly be turned to the East so that she can die peaceably. John resents this illness because it makes him feel guilty about his mistress, and he tries to take out his frustrations on Lucy. He accuses her of always complaining, "always doggin' me bout 'sumptin." When she replies with references to his love affairs, he tells her to "shut up! Ahm sick an' tired uh yp' yawin and jawin'. 'Taint nothing ah hate lak gittin sin throwed in mah face dat done got cold. Ah do ez Ah please. You jus' uh hold back tuh me nohow . . . uh man can't utilize hisself." When she replies, "Big talk ain't chagin' what you doin.' You can't clean yo self wd yo tongue lak uh cat," he hits her for the first and only time of their marriage. From this moment John's descent begins. He dreams of Lucy, begs her forgiveness and tries to forget his act. He cannot do so, and it seems likely that this scene was what Hurston had in mind when she explained the novel's title to Carl Van Vechten: "Oh yes, the title you didn't understand. (Jonah 4:6–10). You see the prophet of God sat up under a gourd vine that had grown up in one night. But a cut worm came along and cut it down. Great and sudden growth. One act of malice and it is withered and gone."

This sort of conventional analysis for *Jonah's Gourd Vine* does not address what seems most important in reading the novel. There is little preparation for the horror of the scene; for all his faults, John has not been portrayed as a man likely to slap his wife on her deathbed. Although the episode is intended to haunt John, the haunting gets lost in the hypocrisy he encounters; he becomes as much the victim of others as of himself. This is a good example of why *Jonah's Gourd Vine* cannot be properly represented by a plot outline or a discussion of character development. The novel is less a narrative than a series of linguistic moments representing the folklife of the black South. A statement of one's independence is "Ahm three times seben and uh button." At parting people say, "Seeyuh later, and tell yuh straighter." At birth a child's "nable string" is buried under a chinaberry tree. A game of "Hide and Seek" is accompanied by a standard rhyme, probably adapted from jump-rope chants: ▶

"A Series of Linguistic Moments" *(continued)*

Ah got up 'bout half-past fo'
Fourty fo' robbers wuz round mah do'
Ah got up and let 'em in
Hit 'em ovah de head wid uh rollin' pin
All hid? All hid?

In the critical speeches of the novel, characters express themselves in the traditional metaphors of the culture. An enemy of Lucy's announces, "Ah means tuh beat her 'til she rope lak okra, and den again Ah'll stomp her 'til she slack lak lime." When John proposes, he asks Lucy if she pays attention to birds. She deliberately misunderstands him, referring to a folk belief about the blue jay, who goes "to hell ev'ry Friday and totes uh grain uh sand in his mouf tuh put out de fire." But what John wants to know is, "Which would you ruther be, if you had yo' ruthers—uh lark uh flyin', uh dove uh settin?" He proposes in a ritual (discussed earlier) handed down from slavery; somewhere he was taught the words and ways of courtship, the poetic ceremonies that adorned life under an oppressive system.

Hurston's purpose in the novel, as she stated in a letter to James Weldon Johnson, was to emphasize this quality in her characters' lives. John was to be "a Negro preacher who is neither funny nor an imitation Puritan ram rod in pants. Just the human being and poet that he must be to succeed in a Negro pulpit. I do not speak of those among us who have been tampered with and consequently have gone Presbyterian or Episcopal. I mean the common run of us who love magnificence, beauty, poetry and color so much that there

can never be too much of it." The preacher as a poet is the dominant theme in the novel, and it is the quality of imagination—his image-making faculty—that always redeems John's human failings. When in pulpit, John is an inspired artist who consecrates language. He can speak as God creating the world:

> I am the teeth of time
> That comprehended de dust of the de earth
> And weighed de hills in scales
> That painted de rainbow dat marks de end of de
> parting storm
> Measured de seas in de holler of my hand
> That held de elements in an unbroken chain of
> controllment

Yet this inspiration is only an elevated form of the verbal skill common to the group; he can also say, "Ahm jus' lak uh old shoe— soft when yuh rain on me and cool me off, and hard when yuh shine on me and git me hot."

As the two passages indicate, John's poetic powers operate in both spiritual and physical worlds; he is a poet who attempts to reconcile the secular and the religious, the spirit and the flesh. Hurston told James Weldon Johnson shortly after the book was published:

> I suppose that you have seen the criticism of my book in the *New York Times*. He means well, I guess, but I never saw such a lack of information about us. It just seems that he is unwilling to believe that a Negro preacher could have so much poetry in him. When you and I (who seem to be the only ones even among the Negroes who recognize the barbaric poetry in their sermons) know that there are hundreds of preachers who ▶

are equaling that sermon weekly. He does not know that merely being a good man is not enough to hold a Negro preacher in an important charge. He must also be an artist. He must be both a poet and an actor of a very high order, and then he must have the voice and figure. He does not realize or is unwilling to admit that the light that shone from GOD'S TROMBONES was handed to you, as was the sermon to me in *Jonah's Gourd Vine.*

The review was typical of the book's reception by the white press. Everyone liked it, primarily for its rich language. Most reviewers also demonstrated their cultural bias, so much so that even their praise becomes suspect. Margaret Wallace, in the *New York Times Book Review*, assumed that all her readers were white, and wrote that John and Lucy were "part and parcel of the tradition of their race, which is as different from ours as night and day." The *Times Literary Supplement* read the English edition and found that the marriage "is described with delicacy not often encountered in negro fiction." The *New Republic*'s review was entitled "Darktown Strutter." The *Boston Chronicle* said that the novel "presents openly the greatest problem of the Negro in all its universality: the utterly inescapable interrelation of sex, success, and society." What Hurston objected to in the *Times* review was criticism of John's climactic sermon "is too good, too brilliantly splashed with poetic imagery to be the product of any one Negro preacher." Presumably no single uneducated black man could be so poetic, so powerful in his language-shaping art. Only *Opportunity* and the *Crisis* reviewed the book without a racist bias, and the *Crisis* objected to her imposition of folklore on the story.

These reviews had to be disappointing, not because they were negative—in fact, all reporters praised the book—but for their ignorance of Hurston's purpose. Although she had no control over the racist misreadings, she had been very clear about what she was trying to portray in John, and somehow the message had gotten lost. She identified his ability to pronounce the Word as a culturally derived characteristic. Belligerently, she had originally titled the novel *Big Nigger*, hardly a casual decision. She was well aware of the controversy aroused by Van Vechten's *Nigger Heaven*, and her title could only have been meant to challenge readers acknowledging the ethnic heritage John Pearson brought to Christianity. Hurston was definitely stating that a "nigger," supposedly a downtrodden, inarticulate, ignorant, semi-human being,

was a Christian poet of extraordinary talent. That talent exposed the incredible irony that whites should ever call John such a name; his poetic gift also gave the label special significance when used by blacks among themselves. Her original dedication in *Jonah's Gourd Vine* stressed the courage of John, persons of Afro-American history, creators of beauty in the face of such epithets: "To the first and only real Negro poet in America—the preachers, who bring barbaric splendor of word and song into the very camp of the mockers."

John's poetic faculties are part of the esthetic matrix of black fold culture. Hurston surrounds her character with a world of metaphor and image that makes John's ability only heightened example of a native esthetic. If it is the language-making faculty that best defines him, that is what also defines his world. John is a man who seeks beauty, lives intensely each moment, and loves language as an end in itself. Moreover, he lives in this way because his culture honors an improvisational oral art. He tells his wife, "Lucy, don't you worry 'bout yo' folks, hear? Ahm goitner be uh father and uh mother tuh you. You jes' look tuh me, girl chile. Jes' you put yo' pendence in me. Ah means tuh prop you up on ev'y leanin' side." His human inability to fulfill this promise does not detract from the poetry in its expression. Similarly, John's vulnerability to the "brute-beast" in him coexists with his ability to thank his God for living through another night:

We thank thee that our sleeping couch
Was not our cooling board
Our cover was not our winding sheet

Such passages eventually add up to a theory of language and behavior: an ability to adorn with words the day-to-day ceremonies of living may indicate a life of profound wisdom despite observable human failings. Although a devout prayer coming from a lustful man might be thought hypocritical, John is never a hypocrite. He lives each moment sincerely, and his life deserves to be judged on its own terms. He is both spirit and flesh, a coexistence manifest in the image-making faculty that is John's special gift.

There is a contradiction at the center of *Jonah's Gourd Vine* that arises directly from Hurston's emphasis on the transcendent moment of language growing from this first. John creates poetry perceiving the world in striking images, but he can never really understand himself. ▶

"A Series of Linguistic Moments" *(continued)*

He is a poet who graces his world with language but cannot find the words to secure his own personal grace. A captive of the community's need for a public giver of words, after he has served his neighbors he is washed out, voided, left only with instincts which he does not understand and for which he is condemned. No passage demonstrates the book's contradiction more sharply that the long sermon that John preaches on the same communion Sunday when he will renounce his pulpit. It is a linguistic tour de force; traditional metaphors and similes well known in the black community are skillfully improvised. In fact, the language is so powerful that the reader forgets that the sermon is intended as a climax to the novel. As we become captured by John's language, his personal crisis—whether to remain as a man of God—fades into the background. John's crisis is not important to the sermon; only his language compels, and it is this separation of confused self from inspired utterance that frustrates him.

The climactic sermon begins with the test of Zechariah 13:6, taken to be about the wounds of Jesus received in the house of his friends. This text then becomes part of a traditional sermon topic: the story of God's creation of the world and his gift of Jesus as an agent of salvation. Jesus loved man since the "foundations of the world," well before "the hammers of creation / Fell upon the anvils of Time and hammered out the / ribs of the earth." Christ's long-standing love makes his betrayal by his friends all the more tragic and it causes John Pearson, at this moment the

inspired agent of God, to call upon his allegorical faculties:

> I want to draw a parable.
> I see Jesus
> Leaving heben will all of His grandeur
> Dis-robin' Hisself of His matchless honor
> Yielding up de scepter of revolvin' worlds
> Clothing Hisself in de garment of humanity
> Coming into de world to rescue His friends

It is "with the eye of faith" that John can see his saviour: "I can see Him step out upon the rim bones of nothing / Crying I am de way / De truth and de light." He can see him "grab de throttle of de well ordered train of mercy." John's sermon becomes a vision; the visionary cries out, "I can see-eee-ee," and his congregation shares in the sight. The vision is not an ethereal abstraction, but a living metaphor, created from blood, metal, and bones. John cannot only see, he can even hear:

> I heard de whistle of se damnation train
> Dat pulled out from Garden of Eden loaded wid
> cargo goin' to hell
> Ran at break-neck speed all de way thru de law
> All de way thru de prophetic age
> All de way thru de reign of kings and judges—
> Plowed her way thru de Jurdan
> And on her way to Calvary, when she blew for
> de switch
> Jesus stood out on her track like a rough-backed
> mountain
> And she threw her cow-catcher in His side and
> His blood ditched de train
> He died for our sins
> Wounded in the house of His friends

These images and themes were familiar to most black congregations in the South, and ▶

"A Series of Linguistic Moments" *(continued)*

many of them can still be heard in black churches. The train motif is well known; Bernard Bell has identified it, for example, as the source for the epic sermon from the Reverend Homer Barbee in Ralph Ellison's *Invisible Man*. But the sermon itself is the important literary event at this point in the novel—not the fact that it is John's final sermon before his congregation. One could remove the sermon, place it in another context, and the language would command virtually the same response: the power of the passage is in the text, not the context. It is instructive to note that the sermon was taken almost verbatim from Hurston's field notes; this is the reason she told Johnson that it was "handed" to her. It does not grow from the novelist's trying to create an appropriate sermon for John's crisis. It was collected from the Reverend C. C. Lovelace of Eau Gallie, Florida, on May 3, 1929, and Hurston had published it before, in her *Negro* essay. Lovelace was apparently not giving his last sermon, and presumably he had a good relationship with his congregation. The sermon's power, then, is inherent. Its effect comes primarily from the self-contained text. Although it supports the theme of the black preacher as poet and represents John's inspired powers, it gives us few insights into John's interior struggle. His language does serve to articulate his personal problems because it is directed away from the self toward the communal celebration. John, the man of words, becomes the victim of his bardic function. He is the epic poet of the community who sacrifices himself for the group vision.

This sermon scene reveals why the novel finally becomes as frustrating for the reader as for John. The book works at cross-purposes; it is a story of individual character in which language directs one away from the individual and toward the documentation of communal esthetic. While John should be in harmony with his community—and is, at the moment of inspiration—usually he is at odds, although his poetic gift expresses the communal experience in its highest form. If the separation between John and his group were meant to be his tragedy, then John's individual story would affect us deeply. But John is not finally a tragic character, because this potentially tragic theme becomes subordinated to the cultural argument that is used to explain his struggle.

Hurston suggests that this lack of control over one's destiny is the obvious product of Afro-American history. Uprooted from his homeland, thrown into alien culture, the African adapted as best he could to barbaric institutions offered him by the white man. But the

African heritage was never lost. It joined with white ideas, so that when white men's music wearied, Africa inspired, just as it did during John's sermons:

"Hey you, dere, us ain't no whote folks! Put down dat fiddle! Us don't want no fiddles, neither no guitars, neither no banjoes. Less clap!"

So they danced. They called for the instrument that they had brought to America in their skins—the drum—and they played upon it. With their hands they played upon the little dance drums of Africa. The drums of kid-skin. With their feet they stomped it, and the voice of Kata-Kumba, the great drum, lifted itself within them and they heard it. The great drum that is made by priests and sits in majesty in the juju house. The drum with the man skin that is dressed with human blood, that is beaten with a human shinbone and speaks to gods as a man and to men as a God. Then they beat upon the drum and danced. It was said, "He will serve us better if we bring him from Africa naked and thingless." So the burka reasoned. They tore away his clothes that Cuffy might bring nothing away, but Cuffy seized his drum and hid it in his skin under the skull bones. The shin-bones he bore openly, for he thought, "Who shall rob me of shim bones when they see no drum?" So he laughed with cunning and said, "I, who am borne away to become an orphan, carry my parents with me. For *Rhythm* is she not my mother and Drama is her man?" So he groaned aloud in the ships and hid his drum and laughed.

The only problem with this passage is that it serves poorly its novelistic context. There is no preparation for the intensity of feeling; yet the rhythmic ceremony is intended to symbolize John's dilemma. His concept of spirituality springs, as Larry Neal has argued, "from a formerly enslaved communal society, non-Christian in background, where there is really no clean cut dichotomy between the world of spirit and the world of flesh." The significance of the passage for John's personal troubles is unclear, however, and its implications remain unfulfilled until the penultimate paragraph of the book. There, when John's funeral sermon is preached, the Kata-Kumba comes to have a special meaning:

And the preacher preached a barbaric requiem poem. On the pale white horse of Death. On the cold icy hands of Death. On the golden streets of glory. Of Amen Avenue. Of Halleluyah Street. On the delight of God when such as John appeared among the singers about His throne. On the weeping sun and moon. On Death who gives a cloak to the man who walked naked in the world. And the hearers wailed with a feeling of terrible loss. They beat upon the O-go-doe, the ancient drum. O-go-doe, O-go-doe, O-go-doe! Their hearts turned to fire ▶

and their shin-ones leaped unknowing to the drum. Not Kata-Kumba, the drum of triumph, that speaks of great ancestors and glorious wars. Not the little drum of kid-skin, for that is to dance with joy and to call to mind birth and creation, but O-go-doe, the voice of Death—that promises nothing, that speaks with tears only, and of the past.

So at last the preacher wiped his mouth in the final way and said, "He wuz uh man, and nobody knowed 'him but God," and it was ended in rhythm. With the drumming of the feet, and mournful dance of the heads, in rhythm, it was ended.

Hurston demonstrates here John's conflicting impulses; she implies that his struggle is more than a person conflict. Neal has argued that in adopting Christianity blacks still were "able to shape out of it unique forms of expression that reflected the most retrievable, thence the most important, aspects of the pre-Christian cultural memory." By evoking this African past, the Kata-Kumba and the O-go-doe are meant to explain John's struggle. He is capable of great inspiration because he has access to a pre-Christian cultural memory. He is also capable of so-called Christian immorality, an immorality arising less from personal inadequacy, Hurston implies, than the limitations of American culture, a civilization that denies the beat of the drum, as it denies John's manhood. Yet within the action of the novel it is primarily John's function as a giver of words that denies him the self-awareness that could lead to a resolution of his problem. Hurston was writing a traditional novel of character about internalized conflict, while denying her hero the possibility of discovering the cultural dilemma that created his frustration. It is not by chance that John is killed in a deus ex machina ending, driving into the side of a train, which is throughout the novel a symbol of the white man's mechanized world. He is doomed to cultural collision rather than to self-understanding.

It is John's lack of self-awareness that has troubled so many readers, as Nick Aaron Ford realized long ago. In his *Contemporary Negro Novel* (1936), Ford objected to *Jonah's Gourd Vine* because John's "rise to religious prominence and financial ease is but a millstone around his neck. He is held back by some unseen cord which seems to be tethered to his racial heritage. Life crushes him almost to death, but he comes out of the mills with no graded insight into the deep mysteries which surround him."

Hurston had not yet worked out a way to fictionally resolve either the

bicultural trade-offs inherent in being black in America or the relationship between the individual artist and the community that artist serves. Nor had she discovered a way to structure a novel around the image-making faculty, the suspended linguistic moment, and to sustain that structure through plot, character, setting—all the ingredients of successful fiction. *Jonah's Gourd Vine* is a fascinating first novel, written in the three months, filled with the folklore Zora had been collecting, told out of the experience of her own family. Its beauty derives from its moments of traditional, poetic language. Although the sum may be less than the parts, the parts are remarkable indeed. ∽

Have You Read?
More by
Zora Neale Hurston

THEIR EYES WERE WATCHING GOD

The epic tale of Janie Crawford, whose quest for identity takes her on a journey during which she learns what love is, experiences life's joys and sorrows, and comes home to herself in peace. Her passionate story prompted Alice Walker to say, "There is no book more important to me than this one."

MULES AND MEN

The fruit of Hurston's labors as a folklorist and anthropologist, this celebrated treasury of black American folklore includes stories, "big old lies," songs, Vodou customs, superstitions—all the humor and wisdom that is the matchless heritage of American blacks.

THE COMPLETE STORIES

This landmark gathering of Zora Neale Hurston's short fiction—most of which appeared only in literary magazines during her lifetime and some of which has never before been published—reveals the evolution of one of the most important African American writers. Spanning her career from 1921 to 1955, these stories attest to Hurston's tremendous range and establish themes that recur in her longer fiction. The stories in this collection map, in rich language and

imagery, Hurston's development and concerns as a writer and provide an invaluable reflection of the mind and imagination of the author of the acclaimed novel *Their Eyes Were Watching God*.

TELL MY HORSE

This firsthand account of the mysteries of Vodou is based on Hurston's personal experiences in Haiti and Jamaica, where she participated as an initiate and not just an observer of Vodou practices in the 1930s. Of great cultural interest, her travelogue paints a vividly authentic picture of ceremonies, customs, and superstitions.

MOSES, MAN OF THE MOUNTAIN

Based on the familiar story of the Exodus, Hurston blends the Moses of the Old Testament with the Moses of black folklore and song to create a compelling allegory of power, redemption, and faith.

DUST TRACKS ON A ROAD

First published in 1942 at the crest of her popularity as a writer, this is Hurston's imaginative and exuberant account of her rise from childhood poverty in the rural South to a prominent place among the leading artists and intellectuals of the Harlem Renaissance. It is a book full of the wit and wisdom of a proud and spirited woman who started off low and climbed high.

Have You Read? *(continued)*

SERAPH ON THE SUWANEE

Hurston's novel of turn-of-the-century white Florida "crackers" marks a daring departure for the author famous for her complex accounts of black culture and heritage. Hurston explores the evolution of a marriage full of love but very little communication and the desires of a young woman in search of herself and her place in the world.

EVERY TONGUE GOT TO CONFESS

African American folklore was Zora Neale Hurston's first love. Collected in the late 1920s, these hilarious, bittersweet, often saucy folktales—some of which date back to the Civil War—provide a fascinating, verdant slice of African American life in the rural South at the turn of the twentieth century. Arranged according to subject—from God Tales, Preacher Tales, and Devil Tales to Heaven Tales, White-Folk Tales, and Mistaken Identity Tales—they reveal attitudes about slavery, faith, race relations, family, and romance that have been passed on for generations. They capture the heart and soul of the vital, independent, and creative community that so inspired Zora Neale Hurston.

Discover great authors, exclusive offers, and more at hc.com.

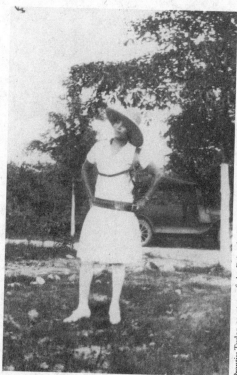

About the Author

ZORA NEALE HURSTON was born in Notasulga, Alabama, in 1891. She is the author of eight books—four novels, three books of folklore, and an autobiography—as well as some fifty shorter works. She died in 1960.

ZORA NEALE HURSTON

Every Tongue Got to Confess

Negro Folk-tales from the Gulf States

Foreword by
JOHN EDGAR WIDEMAN

Edited and with an Introduction by
CARLA KAPLAN

AMISTAD

An Imprint of HarperCollinsPublishers

A hardcover edition of this book was published in 2001 by Harper-Collins Publishers.

EVERY TONGUE GOT TO CONFESS. Copyright © 2001 by Vivian Hurston Bowden; Clifford J. Hurston, Jr.; Edgar Hurston, Sr.; Winifred Hurston Clark; Lois Hurston Gaston; Lucy Anne Hurston; and Barbara Hurston Lewis. Foreword copyright © 2001 by John Edgar Wideman. Introduction copyright © 2001 by Carla Kaplan. All rights reserved. Printed in the United States of America. No part of this book may be used or reproduced in any manner whatsoever without written permission except in the case of brief quotations embodied in critical articles and reviews. For information address HarperCollins Publishers Inc., 10 East 53rd Street, New York, NY 10022.

HarperCollins books may be purchased for educational, business, or sales promotional use. For information please write: Special Markets Department, HarperCollins Publishers Inc., 10 East 53rd Street, New York, NY 10022.

First Perennial edition published 2002.

Designed by Elliott Beard

The Library of Congress has catalogued the hardcover edition as follows:
Hurston, Zora Neale.
 Every tongue got to confess : Negro folk-tales from the Gulf states / by Zora Neale Hurston ; foreword by John Edgar Wideman ; edited and with an introduction by Carla Kaplan.— 1st ed.
 p. cm.
 Includes bibliographical references and index.
 ISBN 0-06-018893-6
 1. African Americans—Folklore. I. Kaplan, Carla. II. Title.
GR111.A47 H83 2001
398.2'089'96073—dc21 2001024521

ISBN 0-06-093454-9 (pbk.)

21 LSC 18

Acknowledgments

The estate of Zora Neale Hurston is deeply grateful for the contributions of John Edgar Wideman and Dr. Carla Kaplan to this publishing event.

We also thank our editor Julia Serebrinsky, our publisher Cathy Hemming, our agent Victoria Sanders, and our attorney Robert Youdelman who all work daily to support the literary legacy of Zora Neale Hurston.

Lastly, we thank those whose efforts past and present have been a part of Zora Neale Hurston's resurgence. Among them are: Robert Hemenway, Alice Walker, the folks at the MLA, Virginia Stanley, Jennifer Hart, Diane Burrowes and Susan Weinberg at HarperCollins Publishers, special friends of the estate Imani Wilson and Kristy Anderson, and all the teachers and librarians everywhere who introduce new readers to Zora every day.

Contents

Foreword

With the example of her vibrant, poetic style Zora Neale Hurston reminded me, instructed me that the language of fiction must never become inert, that the writer at his or her desk, page by page, line by line, word by word should animate the text, attempt to make it speak as the best storytellers speak. In her fiction, and collections of African-American narratives, Hurston provides models of good old-time tale-telling sessions. With the resources of written language, she seeks to recover, uncover, discover the techniques oral bards employed to enchant and teach their audiences. Like African-American instrumental jazz, Hurston's writing imitates the human voice. At the bottom in the gut of jazz if you listen closely you can hear—no matter how complexly, obliquely, mysteriously stylized—somebody talking, crying, growling, singing, farting, praying, stomping, voicing in all those modes through which our bodies communicate some tale about how it feels to be here on earth or leaving, or about the sweet pain of hanging on between the coming and going.

In the spring of 1968 a group of African-American students arrived at my University of Pennsylvania Department of English office and asked if I would offer a class in Black Literature. I

responded in a predictable fashion, given my education, social conditioning, and status as the only tenure-track assistant professor of color in the entire College of Arts and Sciences. No, thank you, I said, citing various reasons for declining—my already crowded academic schedule, my need to keep time free for fiction writing, family obligations, and the clincher— African-American literature was not my "field." The exchange lasted only five or ten minutes and I remember being vaguely satisfied with myself for smoothly, quickly marshaling reasonable arguments for refusing the students' request, but before the office door closed behind them, I also sensed something awful had occurred. Something much more significant than wriggling out fairly gracefully from one more demand on my already stressed time, something slightly incriminating, perhaps even shameful.

I'd watched the students' eyes watching me during my brisk, precise dismissal of their proposal. I'd seen the cloud, the almost instantaneous dulling and turning away and shrinking inward of the students' eyes speaking a painful truth: I had not simply said no to a course, I'd said no to them, to who they were, who I was in my little cubicle in Bennett Hall, to the beleaguered island of us, our collective endeavor to make sense of the treacherous currents that had brought us to an Ivy League university and also threatened daily to wipe out the small footholds and handholds we fashioned to survive there.

To cut one part of a long story short, by the next day I'd changed my mind, and I did teach a Black Literature course the following semester.

No white people in my office on that spring day in 1968. On the other hand, visualizing the presence of some sweaty, ham-fisted, Caucasian version of John Henry, the steel-driving man, hammering iron wedges between the students and me, incarcerating us behind bars as invisible as he was, clarifies the encounter. Why weren't novels and poems by Americans of African descent being taught at the university? Why were so

few of us attending and almost none of us teaching there? What rationales and agendas were served by dispensing knowledge through arbitrary, territorial "fields"? Why had the training I'd received in the so-called "best" schools alienated me from my particular cultural roots and brainwashed me into believing in some objective, universal, standard brand of culture and art—essentialist, hierarchical classifications of knowledge—that doomed people like me to marginality on the campus and worse, consigned the vast majority of us who never reach college to a stigmatized, surplus underclass.

Yes, unpacking the issues above would surely be a long story, one I've undertaken to tell in thirty years of fiction and essay. So, back to the shorter story. The class I initiated partly, I admit, to assuage my guilt, to pay dues, to erase the cloud of disappointment I've never forgotten in the students' eyes. It pains me all these years later, since the conditions brewing the cloud's ugly presence remain in place, and the scene may be replicating itself, different office, different university and victims today. But the class, let's stick to my first African-American Literature class that turned out to be a gift from the students to me rather than my offering to them, the class that leads back to Zora Neale Hurston and this folklore collection.

At the end of the first trial run of the class an appreciative student handed me *The Bluest Eye* and said, Thank you for the course, Professor Wideman. Isabel Stewart, since she was a sweet, polite, subtle young woman and didn't wish to undercut an expression of gratitude by mixing it with other, more complicated motives, didn't add, You really must teach this wonderful novel, especially since you saw fit to include only one work by a female writer in your syllabus.

The one work was *Their Eyes Were Watching God*. I had discovered it when I began teaching myself what my formal education had neglected. At the time African-American writing was dominated by males and framed intellectually by a reductive, apologetic, separate-but-equal mentality whose major crit-

ical project seemed to be asserting the point: we too have writ-
ten and do write and some of our stuff deserves inclusion in
the mainstream.

By coincidence the two female writers who in separate
ways—one by her presence, the other by her absence—were
part of my first course would help transform African-American
literary studies. Toni Morrison—as writer-editor and Nobel
laureate—became point person of a band of awesomely tal-
ented women who would precipitate a flip-flop in African-
American letters so that women today, for better or worse,
dominate the field as much as men did thirty years ago. Zora
Neale Hurston's representation of the folk voice in her anthro-
pological work, autobiography and fiction expanded the idea
of what counts as literature, reframing the relationship between
spoken and written verbal art, high versus low culture, affirm-
ing folk voices, female voices. Hurston foregrounds creolized
language and culture in her fiction and nonfiction, dramatizing
vernacular ways of speaking that are so independent, dynamic,
self-assertive and expressive they cross over, challenge and trans-
form mainstream dialects. Creole languages refuse to remain
standing, hat in hand at the back door as segregated, second-
class, passive aspirants for marginal inclusion within the frame-
work of somebody else's literary aesthetic.

Though Africanized vernaculars of the rural American
South are not separate languages like the Creole of Haiti or
Martinique, they are distinctively different speech varieties
marked by systematic linguistic structures common to Creoles.
The *difference* of these Africanized vernaculars is complicated
by what could be called their "unwritability," their active resist-
ance to being captured in print.

> I began to write, that is: to die a little. As soon as my Es-
> ternome began to supply me the words, I felt death. Each
> of his sentences (salvaged in my memory, inscribed in the
> notebook) distanced him from me. With the notebooks

> piling up, I felt they were burying him once again. Each
> written sentence coated a little of him, his Creole
> tongue, his words, his intonation, his eyes, his airs with
> formaldehyde . . . The written words, my poor French
> words, dissipated the echo of his words forever and im-
> posed betrayal upon my memory . . . I was emptying my
> memory into immobile notebooks without having
> brought back the quivering of the living life. [Chamoi-
> seau: *Texaco* (321–2)]

All spoken language of course resists exact phonetic inscrip-
tion. But Creole's stubborn survivalist orality, its self-preserving
instinct to never stand still, to stay a step ahead, a step away, the
political challenge inherent in its form and function, increases
the difficulty of rendering it on the page.

The difference of vernacular speech has been represented at
one extreme by blackface minstrelsy and Hollywood's perpet-
uation of that fiction in the porn of race showcasing for the
viewer's gaze deviant clowns and outlaws whose comic, ob-
scene, violent speech (often the embodied fantasies of white
scriptwriters) stands as a barely intelligible mangling of the
master tongue. At the opposite end of the spectrum of imita-
tion is a self-aware, vital, independent, creative community that
speaks in Hurston's stories and the African-American narratives
she gathered for this collection: "I seen it so dry the fish came
swimming up the road in dust."

How speech is represented in writing raises more than ques-
tions of aesthetics. An ongoing struggle for authority and domi-
nation is present in any speech situation interfacing former slaves
with former masters, minority with majority culture, spoken with
written. Such interfaces bristle with extralinguistic tensions that
condition and usually diminish mutual intelligibility. Put in
another way, any written form of creolized language exposes the
site, evidence and necessity of struggle, mirrors America's deeply
seated refusal to acknowledge its Creole identity.

Traceable in court transcriptions of African testimony (see the Salem witch trials) and eighteenth-century comic drama, then refined and conventionalized by a Plantation school of highly popular nineteenth-century white writers (Sidney Lanier, Joel Chandler Harris, George Washington Cable), the so-called "eye dialects'" organized graphic signs such as italics, apostrophes, underlining, quotation marks, misspellings *tuh*, *gwine*, *dere*, *dem* along with tortured syntax, malapropisms, elisions, comic orthography, signifying, Joycean portmanteau words to *show* the sound of Black vernacular. Whatever else the mediating visualized scrim of eye dialect accomplished by its alleged rendering of Africanized speech, inevitably, given the means employed, it also suggested ignorant, illiterate southern darkies, a consequence bemoaned by African-American novelist Charles Waddell Chestnut. Ironically, because he used a conventional version of eye dialect (very similar to the look Hurston chooses for the voices of these Gulf narratives), his book *The Marrow of Tradition* was rejected out of hand by African-American students in my first Black Literature class. They found Chestnut's picturing of Black speech both embarrassing and taxing to decipher. Whether or not readers can see through the veil of eye dialects' incriminating constructions and ignore or resist the prejudice they embody remains an open question. Even here in these narratives.

So what does all the above tell us about reading this collection?

"Oral literature" is an oxymoron. Creole speech is approximated, at best, by any form of written transcription. In this context it is useful to read these folk-tales from the Gulf States as you would foreign poetry translated into English, grateful for a window into another culture, yet always keeping in mind that what you're consuming is vastly distanced from the original. Translation destroys and displaces as much as it restores and renders available. In the case of these oral narratives, some

major missing dimensions are the immediacy and sensuousness of face-to-face encounter, the spontaneous improvisation of call and response, choral repetition and echo, the voice played as a musical instrument, the kinesics of the speaker.

Translations ask us to forget as well as imagine an original. The nature of this forgetting varies depending on the theory of translation. The inevitable awkwardness of a literal rendering, emphasizing ideas and meaning, asks the reader to forget the evocative sonorities of rhythm and rhyme or rather recall their presence in the original as a kind of ennobling excuse for what often appears on the page as a fairly bare-bones, skimpy transmission of thought. Freer translations posit themselves as admirable objects of consideration within the literary tradition of the language into which they have been kidnapped, and to that extent ask readers to forget the original, except for acknowledging the original's status as a distant relative or celebrated ancestor.

So as your eyes read these folk narratives remember and forget selectively, judiciously, in order to enhance your enjoyment, your understanding of the particular species of verbal art they manifest. Imagine the situations in which these speech acts occur, the participants' multicolored voices and faces, the eloquence of nonverbal special effects employed to elaborate and transmit the text. Recall a front stoop, juke joint, funeral, wedding, barbershop, kitchen: the music, noise, communal energy and release. Forget for a while our learned habit of privileging the written over the oral, the mainstream language's hegemony over its competitors when we think "literature." Listen as well as read. Dream. Participate the way you do when you allow a song to transport you, all kinds of songs from hip-hop rap to Bach to Monk, each bearing its different history of sounds and silences.

What's offered in this volume is finally a way of viewing the world, a version of reality constructed by language that validates a worldview, and vice versa, a view that legitimizes a lan-

guage. Hurston is not curating a museum of odd, humorous negroisms. She's updating by looking backward, forward, all around, the continuous presence in America of an Africanized language that's still spoken, still going strong today. A language articulating an Africanized vision of reality: unsentimental, humorous, pantheistic, robustly visceral, syncretic, blending tradition and innovation, rooted in the body's immediate experience of pleasure and pain yet also cognizant of a long view, the slow, possibly just arc of time, the tribal as well as individual destiny.

Because Hurston is a product of that world, its language describes her and *is* her. As folklore collector she's not merely an outsider looking in, taking data away. She's both writer and subject, an insider, a cultural informant engaging in self-interrogation.

The doubleness of Hurston's stance as self-conscious subject of her writing requires the reader also to realign herself or himself. Any writer who chooses to break away, to cross over and occupy liminal turf between radically different linguistic modes, between two antagonistic ways of perceiving and naming the world, takes a great risk of betraying the integrity of his first cultural community and language. Breaking away can lead to assuming the role of guide and reporter (panderer) objectifying, introducing the exotic, erotic other to a reader's gaze. When she positions herself firmly, insistently within the language of her Africanized culture and her goal is self-knowledge, self-gratification as she recalls, reconstitutes, the pleasures of speaking and acting within the culture, Hurston accomplishes crossover with minimal damage to integrity. Her crossings are expressed through language and customs she shares with the people she interviews and invents. Hurston displays otherness to a perceptive reader not by packaging and delivering it as a commodity C.O.D. to the reader, but by remembering who she was, who she is, by listening, respecting, by staring clear-eyed at her self, her many selves past, future and present in the primal language, the language of feeling they speak.

A model for this self-conscious, self-appraising work mani-
fests itself in the critique of language contained in these Gulf
narratives. First, the folk-tales inhabit a pantheistic world where
everything talks—peas grunt when bursting through the hard
soil in which they're planted; corn gossips in a cemetery;
mules, alligators, horses, dogs, flies, cows, converse or sing. Lan-
guage resides in the boundless sea of Great Time. One summer
words frozen during a particularly severe winter thaw and sud-
denly the air is filled, like the air of Prospero's enchanted is-
land, with ghostly voices.

Language is treacherous, the tales school us. Interpretation,
translation of words, leads to dangerous misapprehensions or
not-so-funny comic predicaments, such as one slave bragging
to another that he got away with looking at Ole Missus' draw-
ers and the second slave receiving a painful thumping when he
tries to look at Ole Missus' drawers when they're not hanging
on the clothesline but wrapping her behind. The tales warn us
that anyone speaking must be eternally vigilant and circum-
spect. For one thing, tattlers' ears are everywhere and always
open. Even a prayer is liable to interception and subversion.

> Once there was a Negro. Every day he went under the
> hill to pray. So one day a white man went to see what he
> was doing. He was praying for God to kill all the white
> people; so the white man threw a brick on his head. The
> Negro said, "Lord can't you tell a white man from a
> Negro?"

A master's penchant for extravagant metaphorical overkill in
his speech is satirized by a slave who transposes the master's
style into an equally fanciful rhyming vernacular version and
fires it back at him, "You better git outa yo' flowery beds uh
ease, an put on yo' flying trapeze, cause yo' red ball uh simmons
done carried yo' flame uh flapperation tuh yo' high tall moun-
tain."

"What you say, Jack?"

The problematic relationship between oral and written is documented playfully in a tale quoting an illiterate father who chides his educated daughter because she can't write down in the letter he's dictating a mule-calling sound he clucks.

> Is you got dat down yit?
>> Naw sir, I aint' got it yit?
>> How come you ain't got it?
>> Cause I can't spell (clucking sound).
>> You mean tuh tell me you been off tuh school seven years and can't spell (clucking sound)? Well, I could almost spell dat myself.

Thus these narratives from the southern states instruct us that talk functions in African-American communities as it does in Zora Neale Hurston's fiction and life—as a means of having fun, getting serious, establishing credibility and consensus, securing identity, negotiating survival, keeping hope alive, suffering and celebrating the power language bestows.

—JOHN EDGAR WIDEMAN

Introduction

"I want to collect like a new broom."
—ZORA NEALE HURSTON[1]

"I am using the vacuum method, grabbing
everything I see."
—ZORA NEALE HURSTON[2]

Zora Neale Hurston is now famous—iconic even—as the author of the justly celebrated black female *bildungsroman*, *Their Eyes Were Watching God* (1937). But her first love was African-American folklore, and without an understanding of what she saw in it—a people's artistry and sensibility, their humor, their grievances, their worldview, "the first thing that man makes out of the natural laws that he finds around him"—her fiction, with its unexpected segues into folklore, magical realism, and myth, loses some of its force.

In February of 1927, after two years spent helping launch New York's celebrated Harlem Renaissance and studying anthropology as Barnard's only black scholar, Hurston headed to Jacksonville, Florida, to initiate an in-depth study of the rural, southern, African-American folklore she loved. She had a small ($1,400) grant from Carter Woodson's Association for the

Study of Negro Life and History, and the intellectual support
of Columbia University's renowned anthropologist Franz Boas.
Over the next two years she traveled to Florida, Alabama,
Georgia, New Orleans, and the Bahamas, collecting material
she would draw on for the rest of her life, recycling it often
and in various forms into her work, and attempting, in spite of
constant resistance, to bring authentic black folklore to main-
stream, popular audiences.

While she had to learn to build bridges between a heritage
among free-flowing storytellers exchanging dramatic "lies"
(folk-tales), and an academic training that emphasized objective
"facts" and cautioned against "the habit of talking all over your
face," Hurston ultimately amassed huge amounts of invaluable
material.[3] "I am getting some gorgeous material down here,
verse and prose, <u>magnificent</u>," she wrote to Langston Hughes.[4]
She collected so much material from just the American South
that she had the basis for seven volumes of American folklore:
"My plans: 1 volume of stories. 1 children's games. 1 Drama
and the Negro[.] 1 'Mules & Men[,]' a volume of work songs
with guitar arrangement[.] 1 on Religion. 1 on words &
meanings. 1 volume of love letters with an introduction on
Negro lore."[5] Had she published these seven volumes she
could certainly have laid claim to being *the* leading folklorist of
her generation. But doing so might also have derailed a career
as a major American novelist. Of the seven books she eventu-
ally did publish, four were novels, one was an autobiography,
and only two were folklore. The folklore books, *Mules and
Men*, a collection of American folk-tales and Hoodoo material
from New Orleans, and *Tell My Horse*, a study of Haitian and
Jamaican voodoo, were published in 1935 and 1938, respec-
tively. *Mules and Men* drew heavily on her fieldwork from the
twenties. But vast amounts of material collected at that time
seem to have disappeared.

According to her biographer, "the material [Hurston col-
lected] was so extensive that Thompson [Hurston's secretary]

often typed half the night."[6] Some of this material (games, songs, and an essay on religion) eventually found its way into *Mules and Men* and some reappears in Hurston's contribution to the Federal Writers Project's book-length study "The Florida Negro." But together they account for less than a third of the "gorgeous" stories Hurston originally vacuumed up.[7] Some of this missing material may still be found. After all, the full text of these stories Hurston considered "the life and color of my people" settled anonymously into a basement storage room at Columbia University for thirty years. It spent another twenty years at the Smithsonian, unrecognized as the vital core of Hurston's missing fieldwork, let alone as the "boiled-down juice of human living" she intended it to be.[8] This missing text is published here, in full, for the first time.

Hurston wanted to present authentic African-American folklore, not something doctored to suit either dominant aesthetics or stereotyped notions of black culture. "White people could not be trusted to collect the lore of others," she confided to Professor Alain Locke, one of the "midwives" (her term) of the Harlem Renaissance; they "take all the life and soul out of everything," she wrote her patron, Charlotte Osgood Mason.[9] In her view, "the god-maker, the creator of everything that lasts" was "his majesty, the man in the gutter."[10] The stakes of such collecting were high. Oral folklore was both crucial to cultural anthropology's legitimacy and a valuable tradition on its own terms, especially if those terms could be shook free of external pressures. Hurston feared that "the greatest cultural wealth of the continent was disappearing without the world ever realizing that it had ever been."[11] "It is fortunate that it is being collected now," she wrote Franz Boas; "the negro is [having his] . . . Negroness . . . rubbed off by close contact with white culture."[12]

Years later, Hurston reflected on the cultural meaning of black folklore:

In folklore, as in everything else that people create, the
world is a great, big, old serving-platter, and all the local
places are like eating-plates. Whatever is on the plate must
come out of the platter, but each plate has a flavor of its
own because the people take the universal stuff and sea-
son it to suit themselves on the plate. And this local flavor
is what is known as originality. . . . One fact stands out as
one examines the Negro folk-tales which have come to
Florida from various sources. There is no such thing as a
Negro tale which lacks point. Each tale brims over with
humor. The Negro is determined to laugh even if he has
to laugh at his own expense. By the same token, he spares
nobody else. His world is dissolved in laughter. His "boss-
man," his woman, his preacher, his jailer, his God, and
himself, all must be baptized in the stream of laughter.[13]

I thought about the tales I had heard as a child. How
even the Bible was made over to suit our imagination.
How the devil always outsmarted God and how that
over-noble hero Jack or John—not *John Henry*, who oc-
cupies the same place in Negro folklore that Casey Jones
does in white lore and if anything is more recent—out-
smarted the devil. Brer Fox, Brer Deer, Brer 'Gator, Brer
Dawg, Brer Rabbit, Ole Massa and his wife were walking
the earth like natural men way back in the days when
God himself was on the ground and men could talk with
him. Way back there before God weighed up the dirt to
make the mountains.[14]

Negro folklore is not a thing of the past. It is still in
the making. Its great variety shows the adaptability of the
black man: nothing is too old or too new, domestic or
foreign, high or low for his use. God and the devil are
paired, and are treated no more reverently than Rocke-
feller and Ford. Both of these men are prominent in folk-

lore, Ford being particularly strong, and they talk and act like good-natured stevedores or mill-hands. Ole Massa is sometimes a smart man and often a fool. The automobile is ranked alongside of the oxcart. The angels and the apostles walk and talk like section hands. And through it all walks Jack, the greatest culture hero of the South; Jack beats them all—even the Devil, who is often smarter than God.[15]

Hurston sought the most out-of-the-way locations for collecting. "Folklore is not as easy to collect as it sounds," she wrote. "The best source is where there are the least outside influences and these people being usually under-privileged are the shyest. They are most reluctant at times to reveal that which the soul lives by."[16]

Evidently, she cut an unusual figure: a single black woman, driving her own car, toting a gun, sometimes passing for a bootlegger, offering prize money for the best stories and "lies."[17] It's easy to romanticize Hurston with Model T and pistol, searching out his shy "majesty" and "woofing" in "Jooks" along the way. But the truth is that she worked hard under harsh conditions: traveling in blistering heat, sleeping in her car when "colored" hotel rooms couldn't be had, defending herself against jealous women, putting up with bedbugs, lack of sanitation, and poor food in some of the turpentine camps, sawmills, and phosphate mines she visited.

Hurston's situation was unusual. She was from the Alabama and Florida regions where she traveled, but her New York education and Columbia University pedigree made her seem an outsider. She was committed to the systematic study of folklore as an academic enterprise, but before any American university had yet to create such a department or program. Hurston's Harlem Renaissance art circles were steeped in notions of race "propaganda"—contesting white racism by showing black culture at its best (i.e., most middle-class). But the bawdy stories

Hurston collected from sawmills, small towns, dance halls, and turpentine camps were hardly what the "Talented Tenth" had in mind. Combined with a form of feminism that rattled some of her male colleagues, Hurston's unwavering commitment to a relatively unfamiliar folklore aesthetic may help account for the sharply negative reviews she received from peers like Richard Wright, who accused her of pandering to white audiences, or Alain Locke, who eventually charged her with "over-simplification."[18]

Most unusual in Hurston's situation was her funding. At the end of 1927, she signed a contract with a wealthy, white New York patron: Charlotte Osgood Mason, an eccentric, demanding woman who had supported Langston Hughes, Aaron Douglas, Alain Locke, and others, but who also thought nothing of directing their creativity as a self-appointed empress of art. Encouraged by Locke, Mason promised to support Hurston's folklore-collecting to the tune of $200 a month. For her part, Hurston saw Mason as someone who understood the importance of recording "the Negro farthest down" and she insisted that she and Mason shared a "psychic bond."[19] But their arrangement proved profoundly constricting. In the view of Hurston's biographer, Mason was both "soul mate" and "meddling patron."[20] Whereas Boas's cultural relativism sought to overturn the premises upon which "other" cultures were devalued, Mason was every bit the primitivist, convinced that African-Americans were emotionally and aesthetically superior to whites, but inferior in other ways. Louise Thompson, among others, viewed Mason's largesse as a way of "indulging her fantasies of Negroes."[21] The terms of the Hurston/Mason contract obliged Hurston to act as Mason's "agent" by collecting, *for Mason*, "all information possible, both written and oral, concerning the music, poetry, folk-lore, literature, hoodoo, conjure, manifestations of art and kindred subjects relating to and existing among the North American Negroes." Hurston's charge was "to return and lay before [Mason] all of said information, data, transcripts of music, etc., which she shall have

obtained."[22] Hurston was not even allowed "to make known to any other person, except one designated in writing by said first party any of said data or information."[23] This meant that while Hurston had *her* idea of African-American folklore, she had to answer to two outside powers with different ideas, one of whom sought control over every word she wrote.

Indeed, while Mason reportedly kept her copy of the manuscript Hurston called *Negro Folk-tales from the Gulf States* in her safe-deposit box, Hurston surreptitiously circulated other copies (possibly different ones) to Langston Hughes, Dorothy West, Helene Johnson, and Franz Boas.[24] Mason did eventually "press" publication of the stories, but only in her own edited version. "She says the dirty words must be toned down. Of course I knew that. But first I wanted to collect them as they are," Hurston told Hughes.[25] At the same time as she was juggling Mason's expurgations, Hurston was also trying to meet Boas's exacting standards for precise transcription:

> About the material I have been collecting. It is decided that the stories shall be one volume. . . . I have tried to be as exact as possible. Keep to the exact dialect as closely as I could, having the story teller to tell it to me word for word as I write it. This after it has been told to me off hand until I know it myself. But the writing down from the lips is to insure the correct dialect and wording so that I shall not let myself creep in unconsciously. . . . Now in the stories, I have omitted all Pat and Mike stories. It is obvious that these are not negroid, but very casual borrowings. The same goes for the Jewish and Italian stories.[26]

Boas encouraged scientific, uncensored publication, yet, ironically, he also wanted Hurston to contextualize the stories and provide a sense of " the intimate setting in the social life of the Negro," as he put it in his preface to *Mules and Men*, where he praised Hurston for providing the reader with "the charm of a loveable personality."

Apparently, what *Hurston* wanted was a volume of folklore that would stand on its own, without interference, interpretation, anthropological voice-over, or her own personal "charm." "I am leaving the story material almost untouched. I have only tampered with it where the storyteller was not clear. I know it is going to read different, but that is the glory of the thing, don't you think?" she wrote Langston Hughes.[27]

We cannot know exactly what stopped publication of the stories in 1929 when Mason first "pressed" ahead. Maybe she intervened. Maybe Boas did. Maybe publishers were the problem. According to Hemenway, Hurston's publishers "demanded something more than the mere transcription of collected tales."[28] Whatever the reason, the volume Hurston hoped for was scrapped. This is its first publication.

This manuscript turned up at the Smithsonian in the papers of William Duncan Strong, an American anthropologist known to have been a friend of Franz Boas's. There are a number of ways that Hurston and Strong might have crossed paths. In 1925 and 1926, while Hurston was studying with Boas, Strong worked as a research assistant in the Anthropology Department at Columbia. He left in 1926 to finish a Ph.D. at the University of California and then went to Chicago, Labrador, and the University of Nebraska. In the mid-1930s, he worked in Honduras, a country in which Hurston developed strong interests in the mid-1940s. In the late 1930s, Strong returned to Columbia University where he taught until 1962. Strong also served as the president of the American Ethnological Society, of which Hurston was a proud member. There is no mention of Strong in Hurston's known correspondence and he is unfamiliar to Hurston's biographer. Professor Akua Duku Anokye, who helped authenticate the manuscript in 1991, speculates that *Negro Folk-tales from the Gulf States* may have found its way into Strong's papers by accident. Suppose that Boas "kept it with other Department files which were later stored in the basement for lack of space. Later still the Strong papers were stored there

and all the stored papers transferred to the National Anthropo-
logical Archives in Washington."[29]

Unfortunately, nothing found with the manuscript indicates
exactly which version of the "stories" this was or through
whose hands it had passed. Hurston does not tell us how she
wanted it seen or where it fell in her publication plans for
Mules and Men. Readers, especially those already familiar with
Mules and Men, will now be able to compare the two volumes
and, in light of her letters, determine which book *they* think
Hurston would have preferred.[30]

Had there been less accident and outside interference in
Hurston's life, this volume might have appeared seventy years
earlier. How this would have changed Hurston's career can
only be a matter of conjecture. How seventy years with it
might have changed *our* views of African-American artistry is
also worth contemplation.

— CARLA KAPLAN

NOTES

[1]Zora Neale Hurston to Langston Hughes, April 12, 1928. *Zora Neale
Hurston: A Life in Letters*, Carla Kaplan, ed. (New York: Doubleday, 2002). All
letters cited in this introduction are from this volume.

[2]Zora Neale Hurston to Alain Locke, October 15, 1928.

[3]Zora Neale Hurston, *Dust Tracks on a Road* (New York: HarperCollins,
1991), p. 123.

[4]Zora Neale Hurston to Langston Hughes, March 17, 1927.

[5]Zora Neale Hurston to Langston Hughes, August 6, 1928.

[6]Robert Hemenway, *Zora Neale Hurston: A Literary Biography* (Urbana:
University of Illinois Press, 1977), p. 132.

[7]Almost every tale published in *Mules and Men* was intended, originally,
for publication in *Negro Folk-tales from the Gulf States*. Of the 122 sources
listed in *Negro Folk-tales from the Gulf States*, at least 17 are also listed as
sources for *Mules and Men*. Hurston appears, as well, to have recycled some

of that material and some of those sources in the mid-1930s, when she collected folklore with Alan Lomax and Mary Elizabeth Barnicle.

[8]Zora Neale Hurston to Langston Hughes, April 30, 1929; Zora Neale Hurston, "Folklore and Music," Cheryl Wall, ed., *Zora Neale Hurston: Folklore, Memoirs, and Other Writings* (New York: Library of America), p. 875. A slightly different version of "Folklore and Music" can be found, under the title "Go Gator and Muddy the Water," in Pamela Bordelon, ed., *Go Gator and Muddy the Water: Writings by Zora Neale Hurston from the Federal Writers Project* (New York: Norton, 1999).

[9]Zora Neale Hurston to Charlotte Osgood Mason, August 14, 1931.

[10]Zora Neale Hurston to Langston Hughes, September 20, 1928.

[11]Zora Neale Hurston to Thomas E. Jones, October 12, 1934.

[12]Zora Neale Hurston to Franz Boas, March 29, 1927.

[13]Hurston, "Folklore and Music," pp. 875, 892.

[14]Hurston, *Mules and Men* (New York: HarperCollins, 1990), p. 2.

[15]Zora Neale Hurston, "Characteristics of Negro Expression," Nancy Cunard, ed., *Negro: An Anthology*, (1934), abridged edition, Hugh Ford, ed. (New York: Ungar, 1970), p. 27.

[16]Zora Neale Hurston, *Mules and Men*, p. 3.

[17]Hemenway, p. 111.

[18]Richard Wright, "Between Laughter and Tears," *New Masses*, October 5, 1937; Alain Locke, review of *Their Eyes Were Watching God*, *Opportunity*, June 1, 1938.

[19]Hurston, *Dust Tracks on a Road*, pp. 129, 128.

[20]Hemenway, p. 109.

[21]Louise Thompson, as quoted by Hemenway, p. 107.

[22]Contract between Charlotte Osgood Mason and Zora Neale Hurston, December 8, 1927. Alain Locke papers, Moorland-Spingarn Center, Howard University.

[23]Contract between Zora Neale Hurston and Charlotte Osgood Mason; Zora Neale Hurston to Langston Hughes, March 28, 1928; and April 12, 1928.

[24]Zora Neale Hurston to Dorothy West, November 1928; Zora Neale Hurston to Franz Boas, December 27, 1928; Zora Neale Hurston to Langston Hughes, spring/summer 1929; Zora Neale Hurston to Langston Hughes, October 15, 1929.

[25]Zora Neale Hurston to Langston Hughes, October 15, 1929.

[26]Zora Neale Hurston to Langston Hughes, October 15, 1929; Zora Neale Hurston to Franz Boas, October 20, 1929.

[27]Zora Neale Hurston to Langston Hughes, April 30, 1929.

[28]Hemenway, p. 133.

[29]Akua Duku Anokye, *Linguistic Form and Social Function: A Discourse Analysis of Rhetorical and Narrative Structure in Oral and Written African American Folk Narrative Texts*, Ph.D. dissertation, City University of New York, 1991, p. 161. Dr. Anokye has done an extensive analysis of some of the folktales from this manuscript. I am grateful to her for her generosity in sharing her dissertation and her own story of authenticating Hurston's manuscript along with Professor Sally McLendon and James Glenn, then senior archivist of the National Anthropological Archives at the Smithsonian.

[30]I am grateful to John Homiak, archivist of the National Anthropological Archives, and to his staff, for gracious assistance with this manuscript and its history.

A Note to the Reader

As a fierce advocate of the folklore animating the lives of what she called "the Negro farthest down," Hurston believed that black people had wonderful stories that the world needed to hear. The manuscript she left was titled *Negro Folk-tales from the Gulf States*. The title under which it is now published, *Every Tongue Got to Confess*, comes from a short tale in her section of Preacher tales. "Every tongue got to confess; everybody got to stand in judgment for theyself; every tub got to stand on its own bottom," a preacher tells his congregation. Dissatisfied with being told what she's "got to" do, "one little tee-ninchy woman in de amen corner" snaps back: "Lordy, make my bottom wider." "Every Tongue Got to Confess" can be read in different ways. On the one hand, it suggests that everyone *has* something *worth* confessing, just as every tongue has a tale to tell. On the other hand, it begs for an ironic reading since Hurston did not believe in forced confessions—the coercions of preachers, politicians, and authorities. The phrase "Every Tongue Got to Confess" works as one of her many inside jokes about gender as well. "Don't you know you can't get de best of no woman in de talkin' game?" it asks. "Her tongue is all de weapon a woman

**Mules and Men* (New York: HarperCollins, 1990), p. 3.

got."* Any reader who expects to best Hurston in the talking game of her people has just been both fairly warned and also invited to play.

Hurston's undated manuscript appears to have been prepared for publication but not yet edited. It is evident that Hurston shuffled and reshuffled the material, adding a Table of Contents later (which is replicated on page three). The manuscript contains as many as six different pagination schemes, and her marked paginations do not generally correspond to those typed on her contents page. With few other exceptions, the manuscript is published here exactly as Hurston left it, in the order in which it was found. Hurston titled many of her tales, then crossed the titles out. This symbol † is used to indicate titles and/or text that Hurston had marked to be deleted in her original manuscript. When tales are included twice in the volume, in identical versions, the second version has been omitted and a footnote indicates where it appeared. Lists of Hurston's sources and a listing marked "Stories Kossula Told Me," originally placed at the front of the volume, have been moved to the appendices of this book. Hurston's underlined words are now replaced with italics. Editorial changes indicated by Hurston are typed in the manuscript and explained in footnotes. No corrections have been made to grammar, spelling, punctuation, syntax, or dialect. The language of the tales is reproduced exactly as it appears in Hurston's manuscript. Whenever possible, Hurston's own glossaries and footnotes—published elsewhere—have been used to annotate folk expressions and slang.

Negro
Folk-tales
from the
Gulf States

TABLE OF CONTENTS*

*On her manuscript, Hurston—or someone else—crossed off titles of four sections: "Massa and White Folks Tales" (originally, seventh); "Tall Hunting Tales" (originally, ninth); "Mosquito and Gnat Tales" (originally, tenth); and "Hidden Lover Tales" (originally, fourteenth). The "Tall Hunting Tales" are scattered within "Tall Tales."

God Tales

WHY GOD MADE ADAM LAST[†]

God wuz through makin' de lan' an' de sea an' de birds an' de animals an' de fishes an' de trees befo' He made man. He wuz intendin' tuh make 'im all along, but He put it off tuh de last cause if He had uh made Adam fust an' let him see Him makin' all dese other things, when Eve wuz made Adam would of stood round braggin' tuh her. He would of said: "Eve, do you see dat ole stripe-ed tagger (tiger) over dere? Ah made. See dat ole narrow geraffe (giraffe) over dere? Ah made 'im too. See dat big ole tree over dere? Ah made dat jus' so *you* could set under it."

God knowed all dat, so He jus' waited till everything wuz finished before he made man, cause He knows man will lie and brag on hisself tuh uh woman. Man ain't found out yet how things wuz made—he ain't meant tuh know.

—JAMES PRESLEY.

When God first put folks on earth there wasn't no dif-ference between men and women. They was all alike. They did de same work and everything. De man got tired uh fussin 'bout who gointer do this and who gointer do that.

So he went up tuh God and ast him tuh give him power over de woman so dat he could rule her and stop all dat arguin'.

He ast Him tuh give him a lil mo' strength and he'd do de heavy work and let de woman jus' take orders from him whut to do. He tole Him he wouldn't mind doing de heavy [work] if he could jus' boss de job. So de Lawd done all he ast Him and he went on back home—and right off he started tuh bossin' de woman uh-round.

So de woman didn't lak dat a-tall. So she went up tuh God and ast Him how come He give man all de power and didn't leave her none. So He tole her, "You never ast Me for none. I thought you was satisfied."

She says, "Well, I ain't, wid de man bossin' me round lak he took tuh doin' since you give him all de power. I wants half uh his power. Take it away and give it tuh me."

De Lawd shook His head. He tole her, "I never takes nothin' back after I done give it out. It's too bad since you don't like it, but you shoulda come up wid him, then I woulda 'vided it half and half!"

De woman was so mad she left dere spittin' lak a cat. She went straight tuh de devil. He tole her: "I'll tell you whut to do. You go right back up tuh God and ast Him tuh give you dat bunch uh keys hangin' by de mantle shelf; den bring 'em here tuh me and I'll tell you whut to do wid 'em, and you kin have mo' power than man."

So she did and God give 'em tuh her thout uh word and she took 'em back tuh de devil. They was three keys on dat ring. So de devil tole her whut they was. One was de key to de bedroom and one was de key to de cradle and de other was de kitchen key. He tole her not tuh go home and start no fuss, jus' take de keys and lock up everything an' wait till de man come in—and she could have her way. So she did. De man tried tuh ack stubborn at first. But he couldn't git no peace in de bed and nothin' tuh eat, an' he couldn't make no generations tuh

follow him unless he use his power tuh suit de woman. It wasn't doin' him no good tuh have de power cause she wouldn't let 'im use it lak he wanted tuh. So he tried tuh dicker wid her. He said he'd give her half de power if she would let him keep de keys half de time.

De devil popped right up and tole her naw, jus' keep whut she got and let him keep whut he got. So de man went back up tuh God, but He tole him jus' lak he done de woman.

So he ast God jus' tuh give him part de key tuh de cradle so's he could know and be sure who was de father of chillun, but God shook His head and tole him: "You have tuh ast de woman and take her word. She got de keys and I never take back whut I give out."

So de man come on back and done lak de woman tole him for de sake of peace in de bed. And thass how come women got de power over mens today.

—OLD MAN DRUMMOND.

God done pretty good when He made man, but He could have made us a lot more convenient. For instance: we only got eyes in de front uh our heads—we need some in de back, too, so nuthin' can't slip upon us. Nuther thing: it would be handy, too, ef we had one right on de end uv our dog finger (first finger). Den we could jest point dat eye any which way. Nuther thing: our mouths oughter be on top uv our heads 'stead uh right in front. Then, when I'm late tuh work I kin just throw my breakfast in my hat, an' put my hat on my head, an' eat my breakfast as I go on tuh work. Now, ain't dat reasonable, Miss? Besides, mouths ain't so pretty nohow.

—GEORGE BROWN.

One day Christ wuz going along wid His disciples an' He tole 'em all tuh pick up uh rock an' bring it along. All of 'em got one, but Peter happened tuh be sorta tired dat day, so he picked up uh pebble an' toted it.

When Christ got where He wuz going, He stopped under de shade of uh tree an' ast de disciples where wuz they rocks. They all showed 'em an' He turned 'em all tuh bread an' they set down an' et. Peter didn't have nothin' but uh pebble, so he didn't hardly have uh bite uh bread, an' he wuz *hungry*. He didn't lak de way things wuz goin' uh bit, neither.

Another time after dat, Jesus tole 'em all, "Well, we'se goin' for another walk t'day, an' I wants you all tuh bring long uh rock."

Peter wuzn't goin' tuh get left dis time, so he tore down half a mountain. He couldn't tote it, so he moved it along wid a pinch bar, but he wagged all day wid it till way after while Christ rested under uh tree. Then Christ said, "All right, now, everybody bring up yo' rocks." They did, and here come Peter wid his half a mountain. He turned round an' looked at all de rocks de disciples had done brought, an' He smiled when He saw de big, fine rock Peter had done toted, an' He said: "Peter, on *dis* rock I'm gointer build my church ..."

Peter said, "Naw you ain't, neither! I be damned if you is. You gointer turn *dis* rock intuh bread."

Christ did it, too. Den He took de leben other rocks an' stuck 'em together an' built His church on it, an' that's how come churches split up so much t'day (built on a pieced-up rock).

—CLIFFERT ULMER.

People wuz on earth uh long time, den God says He reckon He better give 'em something tuh do tuh keep 'em outa mischief. So He put two boxes down 'bout uh mile up de road and tole 'em, says they could race for de prizes. De

nigger out run de white man, but he wuz so tired dat he run fell up 'ginst de big box an' says: "Ah got it! Ah got de biggest one! Dis'n's mine! Ah got here first."

De white man says, "All right, I'll take yo' leavin's." He went and picked up de little box. He opened it an' it had uh pen an' ink an' some writin' paper. De nigger opened his an' it had uh ax an' grubbin'-hoe an' plow an' sich ez dat. De nigger been workin' hard ever since an' de white man been settin' down bossin' 'im.

—LARKINS WHITE.

WHY NEGROES HAVE NOTHING[†]

After God thew makin' de world an' rested Hisself uh little He called all de different nations uh people (races) up tuh Him an' ast 'em all whut dey wanted. De white man said he wanted tuh be pretty an' tuh boss everything; de Jew said he wanted all de money an' wealth; de Indian said he wanted tuh know all about rovin' de woods an' huntin' an' sich. De nigger didn't even come up tuh ast fuh nothin'. He wuz off somewhere restin'. Finally, God got tired uh waitin' an' sent one uh His angels tuh wake 'im up an' tell 'im tuh come on up an' git his, whutever he wanted.

He went on up an' God ast 'im, say, "Negro, whut do you want? Ah'm givin' de nations whutever dey wants, but dis is yo' las' chance. Now you better look all roun' an' see whut you want me tuh give yuh."

De nigger never moved out his tracks. He said, "Ah don't want nothin'," and went on back tuh sleep.

Thass how come we ain't got nothin'.

—LARKINS WHITE.

WHY NEGROES ARE BLACK[†]

The reason Negroes are black is because in the beginning God told everybody to be there at a certain time and get they color. Everybody went back at the right time but the Negroes. They went off somewhere and went to sleep. When they did get there they wuz so skeered they wouldn't get waited on they started to pushing and shoving and acting crazy, and God pushed them back and said, "Get back!" They misunderstood and got black.

—CHARLEY BRADLEY.

UNCLE IKE IN DE JUDGMENT[†]

Once an old man named Ike died and went to judgment. It was the great day and all the people in the world were coming up to be judged; but they were being judged by races—the whites, the yellow, the Indians and the blacks.

Ike used to work for some particular white folks and they had always taught him to be on time; so he was up at the throne dead on time. He saw the whites judged and sent to their doom or reward, then Gabriel turned over a new page for the Chinese and so on till everybody had been judged except the Negroes. They hadn't got to judgment yet. Gabriel turned over a new page for Negroes and called for them to come to the throne. Uncle Ike, he went on up and told the Lord that his race wasn't there, but he wanted to be judged; but the Lord told him he would have to wait until his race got there. He didn't judge by individuals. So Ike stood one side and waited.

God had two hours to wait; then he saw a great cloud of dust and He pushed Ike to one side so that he could see better. It was the colored folks coming to judgment. When they got up to the throne, God breathed on them and they said: "Just

give us anything you got—hell or heaven, but let us all go on together."

Us Negroes are just like crabs, you know. One can't get away from the rest; do, they'll pull him right back.

After they got quieted down, God judged them and said that He was sorry, but He had to send them all to hell because they were so late. Some of them cried; some of them begged Him to change His mind; and some of them said that they didn't care one or the other. When Ike heard the judgment he made God remember that he had been there on time, even before anybody had been judged; and God said that He thought He would have to give Ike some consideration, but He was wondering what to do with Ike when all the rest of the Negroes would be gone to hell.

Then all the Negroes began to holler and shout, "Let him come on wid us! He's a nigger just like us. How come he don't want to come on to hell with us? That's just like some old niggers—always trying to get away from their race! He come up here way ahead of time trying to pass for white, and if he ain't trying to pass, he's trying to act like white folks. Make him come on wid de rest of us, God."

God told them that Ike was on time and so He felt that He must fix him some place in heaven; but the colored folks set up such a racket that they woke up saints that had been sleep for thousands of years—way back in the back rooms of heaven, and they came out to see what was the trouble. God couldn't stand all that racket so He told them all to go on to hell where He had assigned them, but they didn't want to leave Ike up there. God sent a band of angels to shoo them on out, but some of the last ones grabbed Ike and dragged him on with them.

So you see, even on judgment day Negroes won't let one another get nowhere. We are too much like crabs.

—LOUISE NOBLE.

God made de cabbage and stood dere wid de hoe over his shoulder. And de Devil saw him, so he said he was going to make him a field of cabbage just like God. So he made it, but he couldn't git it straight and it made tobacco. So that's how come we got tobacco today.

—MRS. ANNIE KING.

Dere wuz once uh man an' he didn't count* nobody, not even God. So one day his son wuz out in de field and de lightning struck 'im. De man come running out de house hollering, "Don't come killing my son, pick on me, my shoulders is broad. I bet I'll take an . . ." Jes about dat time he got struck himself—not uh big stroke, jes enough tuh burn him uh little and skeer 'im. So he said, "Umph! God don't stand no joking dese days.

—JULIUS HENRY.

TWO BOYS, A SWEET POTATO AND GOD†

Two lil boys went tuh play in de woods once stayed too long, an' dark caught 'im, an' dey got lost in de woods.

So one uv de boys got down and prayed: "Dear Lawd, if you help me find de way home, I'll give you dat great big sweet potato we got home."

De lil brother got tuh cryin' when he heard dat and said: "Brother, you stop telling God dat, cause I want dat sweet potato myself."

—MARY DASH.

*"did not listen to anyone"; "did not account for others."

A man who was down on his knees praying for God to forgive him for stealing hogs said: "You might as well forgive me for that big ole turkey gobbler dat roosts in de chinaberry tree, too, Lord."

—EDWARD MORRIS.

Preacher
Tales

Once upon a time it wuz ah man and wife. Man wuz name Isaac and wife named Daphne. There wuz a convention going to be in town and the preacher ast Isaac to care for some of the delegates. He tole him he wasn't able. So de preacher tole him to trust in de Lord and whatsoever he ast de Lord for in faith that He would give it to 'im. So he tole him all right, he would take two delegates. The night before he went to church he tole his wife Daphne: "Lest make out an order for some groceries." So the Lord would have plenty time to have it here by morning. He tole her to call it out whilst he write it down.

"Lord, send us a sack of flour, a ham of cow, and a ham of hog, a bushel of meal, a barrel of black pepper, one barrel* of sugar, one barrel of lard."

So they went on to church to service and when service was over he brought the two preachers home that was to stop with him and taken them in the room. And then when they came out, him and Daphne went in de kitchen to see had they order

*Originally typed "package" but changed in the manuscript.

came. It wuzn't there, so they lied down. The next morning before day he went in agin to see had it come. It wasn't there. He got angry then and he got down on his knees and prayed agin.

"Say, Lord, I have these two brothers here and nothing for them to eat and you didn't do what you promised, and furthermore you are not a man to your word. So from this on, you be damned sho to tend to yo' own bizness and let Isaac tend to his own."

So de preachers heard him prayin' so loud they tole Sister Daphne to talk to him—that they think he wuz losin' his mind and she said: "Isaac ain't crazy. He's just a plain man. If uh man don't treat 'im right, Isaac 'll tell to dey teeth." 'Bout dat time I left.

—VIOLA BALLON.

GABRIEL'S TRUMPET[†]

One time uh preacher had uh church an' his members wuz pretty wicked, so he made up his mind tuh give 'em uh strong sermon tuh shake 'em up. So he preached on judgment day.

Somebody's parrot had done got away and had done flew up in de loft uh de church, but nobody didn't know it. So de preacher preached on till he got down to where de angel Gabrill would be blowin'. He said, "Brothers an' sisters, when Gabrill shall plant one foot on sea an' one on de dry land wid his trumpet in his hand an' shall cry dat Time shall be no mo'—whut'll you poor sinners do? When blows his trumpet, 'Tooot toot', whut *will* you do?"

Every time he said 'toot toot' de parrot would answer him; but he wuz so busy preachin' he didn't notice nothin'. But some of the people heard de parrot an' dey begin slippin' out a de church one an' two at uh time. Dey thought it wuz Gabrill

sho nuff. He kept on preachin' in uh strainin' voice wid his eyes shet tight, till he hollered 'toot, toot' and de parrot answered him so loud dat everybody heered 'im, an' everybody bolted for de door, de preacher, too. But he wuz way up in de pulpit and so he wuz de very las' one tuh reach de door. Justez he wuz goin' out de door de wind slammed it on his coattail and he hollered: "Aw naw, Gabrill, turn me loose! You 'low me de same chance you 'lowed dese others."

—JAMES PRESLEY.

A preacher wuz preaching and one ole woman kept on hollerin', "Let de Holy Ghost ride, let de Holy Ghost ride!"

When they went to lift collection de preacher says, "Now all y'all dat enjoyed de sermon so much, come up and put a dollar on de table."

De ole woman says, "Let de Holy Ghost walk."

—L. O. TAYLOR.

DE PREACHER AN' DE SHEEP'S TAILS†

Dere wuz uh man had uh pretty wife, an' de preacher wuz hangin' round her; but she wuzn't tumblin' fast.

He studied how tuh make her, so he started tuh spreadin' his flannel (his tongue) tuh make her think he had plenty power— so he up an' tole her one time dat he could change de color uh her baby from black tuh white, cause he wuz uh man uh God.

Her husban' wuz jus' outside an' heard 'im, but he didn't say nothin'—he jus' let dat ride.

De preacher had uh whole heap uh sheeps, so he jus' went on over tuh his place an' cut off de tails uh de sheeps an' put 'em down by de gate-post an' come on home an' went tuh bed.

De nex' day de preacher wuz all uhround rearin' an' cussin'

'bout his sheep. "If I jus' knowed who cut off my sheeps' tails I'd fix him. I'd give uh thousand dollars tuh know de seben-sided son of uh gun dat did it."

When he come tuh de man dat did it an' said dat, he tole 'im: "Well," he says, "if you kin turn black babies white, look lak you could tell who cut off yo' sheeps' tails."

—W. M. RICHARDSON.

A man and his wife had a colt that they thought a lot of. So they bought him a pretty new halter. Next Sunday they went to church and the preacher's text was: "There was an angel come down from heaven with a pair of tongs and taken a live coal from the altar."

The old lady said, "Come on, old man, let's git home just as quick as we kin."

He ast her why she wanted to leave the service and she said: "Didn't you hear what he said? He's preachin' 'bout our colt. He says 'There was a wild Indian from New Hampshire come and caught the colt by the tail and snatched his head out de halter."

TESTIMONY†

Dere wuz once uh woman who b'longded to de church an' she uster git up an' tell de greatest experience of anybody. No matter whut nobody said, she always carried it past 'em. So one Sunday when de Love-Feast wuz red hot, she got up and said: "Brothers and sisters, I jes been tuh heben in mah vision."

Chorus: "Amen."

Sister: "An' Gawd wuz in de beanpatch pickin' beans."

Chorus: "Amen."

Sister: "An' He tole me tuh go in de house and make myself tuh home. An' I went in de house in de many mentions (mansions) an' made myself tuh home. An' when He come in, He

tole me, says: 'Liza, Liza, go git yourself a long white robe.' I got it and put it on, and praise God, it fit.

"Den He tole me tuh git myself some golden slippers, and I put 'im on an' He says: "Liza, you sho looks good.'

"Den He tole me to go git myself uh starry crown. I put it on and, praise God, it fit.

"Den He tole me, He says: 'Liza, go get yourself some long white wings.' I got dem and put 'em on and flew and flew and flew so fast till I flew into God's tombstone an' knocked it down an' God stopped pickin' beans, an' pushed back His hat an' looked up an' He says: 'AHHH-HHHAHHAHH, didn't dat nigger fly-hi?'"

Uh man in de back uh de church says, "Yes, and didn't dat nigger lie?'"

An' dat broke up de meetin' in uh fight.

—MATTHEW BRAZZLE.

There was a great Sunday-school boy. He went to Sunday-school every Sunday. The boy was named Willie. Willie was very active about asking and answering questions until no one else could ask or answer a question. One Sunday his mother said, "Son, you want to give the others a chance and let them talk."

So the next Sunday the subject was Jacob's ladder. So Willie sat quietly until they was almost through. Willie saw the picture of Jacob's ladder and the angel going up and down. The superintendent said, "If there is nothing else we will close."

Willie held up his hand and said, "Mr. Superintendent, what in the hell does the angel need with a ladder when he's got wings?"

—CLIFFERT ULMER.

One time dere wuz a preacher wanted everybody to jine church and he went roun', my Lord, aroun'. He tole each an' everyone be down tuh de Economical River. Sunday evening he gwine tell you whut one of God's chillun gwine do.

Everybody dat heard about it was dere. He tole two deacons tuh build 'im a scaffold all de way cross de river under de water. De deacons only built it half way cross. He thowed up his hands and said, "All right, chillun, I'm gwinter sho you whut one of God's chilluns is gwinter do."

All right, he stepped out and went tuh singing his song, "I'm uh walkin' on de water, I'm uh walkin' on de water to be baptized. Oh water, to be baptized." About to de end of de scaffold dese deacons done built, he fell in. "I tole dem deacons tuh build dis scaffold all de way cross." (Gesture of swimming laboriously.)

—JAMES BROWN.

Once there wuz a preacher. He sent his boy over to a man name Paul to git him a half pint of shinny.* Boy stayed so long till when he got back his father wuz gone.

So he goes on over to the church and his father had taken his text in Paul. He wuz teaching about Paul and he ast: "Whut did Paul say?"

Little boy peep round de door every time he would say "What did Paul say?" Kept on asting whut did Paul say and de boy thought he wuz talking to him. The boy hollered out and tole him, "Paul say he wuzn't goin' send him a damn bit more till he pay for dat he got."

—WILL THOMAS.

*"Shine" or "moonshine."

There wuz uh woman who wuz always in church. Whenever her husban' looked for her she wuz there. One day she locked up de kitchen an' went on. She wuz in uh hurry tuh git dere cause dey wuz holdin' protracted meetin'. When her husban' come home she had him locked way from his rations, so he went down tuh de church an' peeped. He couldn't see her, but he knowed she wuz dere. He heered 'em singing': "Git on board, lil childen", so he answered 'em wid de nex' verse, "An' if my wife is in dere, jus' tell her this fuh me, jus' send dat doggone kitchen key an' stay on board, lil childen."

She had 'im locked way from his eatin's an' he wuz mad.
—LARKINS WHITE.

Once there was a man and the preacher came to his house to take dinner. Preacher saw the rooster on the yard and the man went into the garden to pick some greens. He cooked them and called the preacher to dinner. The preacher came to dinner and looked at the greens and said: "Uh! Say, I thought you were going to have chicken for dinner?"

The man said, "I be doggone if you are going to eat my rooster so I won't have any more eggs on my yard."
—ARTHUR HOPKINS.

Once an ole preacher was up preaching. An ole man sitting in the amen corner said, "God grant it!" to everything the preacher would say.

"What do you think about these fast trains running at the rate of one hundred fifty miles a hour?"

"God grant it!"

"What you think about these automobiles running at the rate of two hundred fifty miles a hour?"

"God grant it!"

"What you think about these ships on the water going at the rate of three hundred fifty miles a hour?"

"God grant it!"

"What you think about these airplanes going at the rate of four hundred fifty miles a hour?"

Old man died down and he said, "God damn it."

—Arthur Hopkins.

Once there wuz an ole lady died and her name wuz Aunt Dinah. Being she wuz so ole they thought they would have a prayer over her. So de ole deacon he call all of 'em round him and went down in prayer. He said, "Send your power down here and wake up dese cold, frozen hearts. I can't hear a moan and neither a groan." So he called again and nobody still didn't say nothing.

So he raised up and looked and everybody wuz gone but him and Aunt Dinah. She wuz sittin' up on de coolin' board, and so he called her. He said, "Aunt Dinah?"

She said, "Huh?"

He said, "Is dat you?"

She says, "Uh hunh."

He says, "Don't you move a damn peg, do I'll knock you dead on de coolin' board."

—Will Thomas.

Once there wuz another ole preacher. He wuz talkin' to some boys one day and de boys ast him would he be ready when Gabriel blow his trumpet. He told 'em, "Yeah, he'd be ready if Gabriel wuz to blow his trumpet dis minute."

So dat night he went on to church and he wuz asting de members, "Will you be ready when Gabriel blow his trumpet?" So whilst he wuz preaching, de boys begin to blow on a

horn back of a church and dey blowed de second time. He says, "Hush, I think I hear Gabriel blowing now. If it's him he'll blow de third time." So they blowed de third time. He stopped and said, "Wait dere, Gabriel, I ain't ready to go yet."

So he runned on home, told his wife to open de door. She wuz so slow 'bout opening de door he run round to de back. She ast him what wuz de matter. Says, "Gabriel begin to blow dat damn trumpet down yonder."

She says, "I speck you cussed, didn't you?"

He says, "Yes, you damn right I cussed and ain't thew cussin' yet."

—WILL THOMAS.

You know, too many folks is preaching dese days. Jes lak one man, he wuz grubbin' and cuttin' new ground, an' one day de sun got so hot, an' he got so tired. So he went and laid down on de shady side uh de log an' says: "Now, God, if you don't pick me up and throw me over dis log, I'll know you done called me tuh preach." De Lord never did, so he went and tole people he wuz called tuh preach.

—DAUGHTER SARAH SEWELL.

JUST DONE DAT TUH TRY YO' FAITH†

It wuz uh big revival meetin' goin' on and many souls wuz saved. De preacher really likes his women, you know. And there wuz one good-lookin' kinda plump-like girl at de mourner's bench he wuz likin'. You know, way back when folks uster lay under conviction, they uster stay at de church prayin' and singin' over de mourners all night long, 'specially them whut wuz layin' under conviction.

Dis girl wuz under conviction and she done fell out in de floor in front de altar rail all stretched out dere, and you could

see her fat legs. Way in de night when nearly everybody done went home, and them whut wuz dere wuz mostly bowed down sleep, de preacher looked all round and looked at dem legs, and eased on down out de pulpit and started tuh feelin' her legs.

It skeered her and she hollered out, "Oh, stop dat! Who dat grabbin' me by my leg?"

Dat skeered de preacher cause everybody woke up and begin lookin' right at 'im. So he started on back in de pulpit singin': "Oh, Ah jus' done dat to try yo' faith, Ah jus' done dat tuh try yo' faith."

—Cliffert Ulmer.

Uh preacher wuz up preachin'. He reared an' he pitched an' he had de church wid 'im, too. He says, "Ooooh, brothers an' sisters, when all de saints come marchin' up under de blood-stained banner uh Jesus Christ; when they go marchin', marchin', marchin', marchin', trompin', trompin', up tuh glory in dat ma-a-awni-ing; when Gabrull shall place one foot on de sea an' one on de land an' shall draw in de win' from de four corners uh de earth; when de rocks an' de mountains shall skip lak lambs; when de sun shall go down in blood and de moon shed tears lak uh weepin' woman; when Jesus Christ de Lamb of Gawd shall lead forth de forty-an'-four thousand dat's been redeemed by de blood uh de blood shed on Calvary for de sins uh de world; when de sinner man, de sinner woman shall run tuh de rocks and de mountains cryin', 'Who, who, who whoooo shall save me from de wrath of an angry God?'; when de rocks shall cry, 'Awwahhh! Git away! Ah'm burnin', too.'; when God shall step down from His throne an' say dat Time shall be no more—brothers an' sisters, will you be dere?"

Response: "Yes!"

Preacher: "Some of you got mothers gone on before."

Response: "Yes, Lord."

Preacher: "Some of you got fathers gone on tuh glory."

Response: "Yes, Yes."

Preacher: "Some of you got one child gone on before."

Response: "Yes, preach it!"

Preacher: "Some of you got two-oo children gone on before."

Response: "Yes, my God."

Preacher: "Some of you got three children, some got four."

Response: "Yes, I mean tuh see 'em, too!"

Preacher: "Some of you got seben children gone on tuh heben."

Response: "Lawd! I can't stand it!"

Preacher: "Some got ten children waitin' in glory."

Response: "My God, ain't it de truth!"

Preacher: "AN' DEY *ALL* GOT DIFFERENT DADDIES!"

You could uh heered uh pin drop in dat church. Not uh soul said amen on dat.

—LARKINS WHITE.

Preacher wuz going down to the water wid his candidates and uh sister wuz upon de bank and de people wuz singing: "Gimme dat ole time religion, gimme dat ole time religion, gimme dat ole time religion, it's good enough for me."

De sister upon de bank saw a big ole 'gator out behond de preacher, but the preacher didn't see him. So she wuz singing: "I don't lak dat red-eyed 'gator, I don't lak dat red-eyed 'gator, I don't lak dat red-eyed 'gator."

De preacher looked round and said, "No, by God, and I don't neither; he's too big and black for me."

—CARRIE MCCRAY.

De preacher was up preaching and he said: "Every tongue got to confess; everybody got to stand in judgment for theyself; every tub got to stand on its own bottom."

One little tee-ninchy* woman in de amen corner said: "Lordy, make my bottom wider."

—REBECCA CORBETT.

There wuz two deacons of de church, one Methodist and one Baptist. They went out sailing one night in a little boat and in de late watches of de night de water begin to git rough and stormy, and de tides begin to rise, and de boat begin to wheel and rock to ketch water; and de Methodist deacon said to the Baptist deacon: "Say dere, brother, we better git busy and begin to dip dis water out de boat wid a bucket."

So de Baptist deacon decided dat dipping de water out wid a bucket wuzn't gettin' much results. So de Baptist deacon decided dey better pray. So he said, "We better say our prayers."

The Methodist deacon said, "No, dem little God damn Our Fathers prayers ain't gointer do us any good, dip water."

—CARRIE MCCRAY.

A man wuz cussin' and damnin', an' a preacher come along and says tuh him: "Son, it's wrong tuh be talkin' 'bout fightin'. Let God fight your case."

So de man says: "All right." An' so he didn't fight.

'Bout uh week after dat de man met de preacher, an' he wuz all scratched up, an' his clothes all tore up. He said to de preacher: "God maybe all right in uh man fight, but He ain't worth uh damn in uh bear fight."

—GEORGE BROWN.

*"tiny."

A man wuz hongry and he ast de preacher to help him out. De preacher tole him just ast de Lawd for whut he wants and he'll git it. So de man went home and got down and ast de Lawd, says: "O Lawd, send me down a barrel of flour, a barrel of meal, a barrel of sugar, a tub of lard, ten hams, a side of meat, a barrel of pepper—hold on, dere a minute, God. Dat's too damn much pepper."

—NAT JAMES.

This was a great big woman. So she had done got religion and was going to be baptized in de river de next Sunday. So she went round and tole her friends she had better religion than anybody ever joined dat church and they better come see her baptized. So they did.

De preacher was a lil man, and de river was full of holes, and he got fretted when he heard how this big portly sister was going to rear and pitch out dere in dat water, so he got to studying 'bout dat thing.

So dat Sunday he tole de deacons to make her de last candidate and to stand close and give him aid and assistance wid her case. All de time he was baptizing de others, she was rearin' and pitchin' and hollerin' so de people on shore could take notice. When he got to her he said de words right quick and ducks her under and holds her under till she swallows a little water. She was so full when she come up she couldn't git her wind. She was steppin' out on de bank before she got straight to open her mouf, but she seen all de folks upon de bank she had done tole to come so she had to say something; but all she could git out was "Chris'mus gift".

—L. O. TAYLOR.

Two men wuz hoboing round an' come tuh uh town. They had done caught three pigeons an' wuz 'bout tuh kill 'em an' eat 'em when dey heard somebody say de church needed uh preacher. So they made it up for one of 'em to preach an' git holt uh some money.

They went on to de church house an' one of 'em took de pigeons an' clammed up in de loft, an' de other one took his seat in de pulpit.

When de people come, he tole 'em he wuz uh preacher an' uh God-sent man: so they let 'im preach.

Him an' his partner had done made it up dat everytime he call for uh pigeon from heben, de one up in de loft would send down one so de people would think it come from heben. Dey knowed dey wuz going tuh get uh good collection after that.

De one dat wuz preachin' reared an' he pitched. De church got all warmed up. After awhile he thowed back his head an' hollered, "If I be uh God-sent man, send me down uh pigeon from heben!"

De one up in de loft sent down uh pigeon. De people begin tuh shout.

He preached on awhile an' he hollered agin, "If I be uh God-sent man, send down another pigeon!"

Down come another pigeon. De people wuz goin' wild. Some of 'em even got skeered an' crep' out de church.

He preached some more, den he hollered de third time, "If I be uh God-sent man, send down another pigeon!"

De pigeon didn't come. He hollered agin, but no pigeon. He figgered his buddy mus' be sleep so he hollered still louder. De one up in de loft wuzn't sleep. Dat last pigeon had done got loose an' he wuz tryin' tuh ketch 'im, so when his buddy kept on hollerin', he hollered down, "You kin wait till I ketch 'im, cantcher?"

—CLIFFERT ULMER.

There was a church at my home that couldn't keep a pastor. So they changed pastors as regular as jumping checkers. So at last one of the deacons said, "I've found the man."

So on Saturday he come to preach Sunday, so the deacon advised him to be particular for he had a peculiar people to deal with.

He said, "Oh, I'll suit the people all right."

So on Sunday everybody was in a hurry to get to church. When he got up to address the congregation he said: "Brothers and sisters, it affords me no small source of pleasure of being with you today."

So his favorite deacon whispers to him and says, "Be careful, for God's sake! Don't tell a lie."

The preacher said, "I want to sing one of my favorite songs suited to common meter." So he gave it out—"O for a thousand tongues to sing my Great Redeemer's praise!"

One old deacon back in the corner said, "Come on down! Come on down from there! You have lied to start with—got a thousand tongues singing a song I can sing with one tongue. Come on down."

And that's all he got to say in that church, and when I left home they were still pastorless.

—JOE WILEY.

Once there wuz an ole lady so par'lyzed tuh not do nothing. One day she wuz in church, so de preacher put a man in de loft of de church and told him, when he say, "De Lawd is coming by", to go tuh tearin' off de shingles and make uh fuss.

He begin to preach. He said, "De Lawd is coming by," man begin to tear shingles and make a fuss. Everything begin to run, and this par'lyzed lady led de crowd hollerin', "De Lawd is coming by."

—EDWARD MORRIS.

There were once an old fellow, a farmer, and he had cleared some new ground, and he had a lil son and when he went to cultivate this land he put his son out to plow it with a very contrary mule; and de boy was plowing and de mule was going contrary, and de boy begin to curse and rear at de mule. So a preacher was passing at de time to revival meeting, and he heard the boy cussing and he ast de boy why did he cuss so bad and why didn't he pray. And de boy told him that a man couldn't pray and plow new ground, and so de preacher begged de boy to come to church dat night—which he did.

De preacher says, "You never hear me cuss, smoke, drink or lie, and if you ever hear or see me doing any of those things— you just whistle."

De preacher talked on and said, "Nothing could pick the grass as close to the ground as a goose," and when he said dat the lil boy raised up in de back of the church and whistled.

The preacher remembered that he had told the boy right immediately and after he finished preaching he ast de boy whut did he lie 'bout.

De lil boy tole him, "I heard you say dat nothin' could pick grass as close as a goose; but I must say dat a gander can pick it just as close as a goose."

—JERRY BENNETT.

Man loved preachers an' uster always have uh heap uh stump knockers* round all de time. He had uh boy dat wuz kinda mis*chee*vous an' one time he made de ole man so mad he tole 'im to git out an' go where he couldn't never see 'im no more. De boy jus' wanted tuh be aggravatin', so he ast 'im where he must go. De ole man wuz so mad he tole him tuh go tuh hell, cause he didn't keer whut become of 'im.

*"preachers."

De boy went on off an' thought he would jus' travel roun' an' see de world while he wuz on his way tuh hell. He traveled on till he come tuh de land uh de molly-moes (mile-or-mores). They is great big birds dat sticks they heads down in de ground when they see somebody comin' an' shake they feathers, an' you kin hear de wind whistlin' thew 'em fur uh mile or mo'.

He got by dem all right an' traveled on till he got tuh Head-and-Belly land. Dere all you had tuh do wuz tuh set down on de side uh de road an' wait, an' anything you want tuh eat would come by yuh. Uh baked hog wid uh knife an' fork in his side would come trottin' long an' all you had tuh do wuz tuh stop 'im an' eat all you want—then tell 'im tuh go on tuh de nex' one dat wanted some meat. Fried chickens an' everything come long, an' tater pies an' he et all he wanted; den he went on where he wuz gwine.

Way after while he got tuh hell, but everybody wuz back in de kitchen, an' so when he hailed he didn't git no answer. He didn't see no dogs, so he went on round tuh de back an' heered somebody talkin' in de kitchen an' he got skeered. He thought whut uh bad boy he uster be an' he wuz skeered de devil wuz gointer ketch 'im an' chunk 'im in de fire, but he didn't see de fire. Way after while he got up nerve tuh peep thew un crack an' he seen de devil settin' tuh de table playin' skin wid two or three preachers. One of 'em said: "Seem lak Ah hear somebody outside. Better go look."

De devil played on. De preacher tole 'im agin he thought he heered somebody outside, but de devil got mad an' tole 'im: "Say! you tryin' tuh git me tuh go outside so you kin shuffle dese cards tuh suit yo'self. But Ah ain't goin' no damn where till you fall."

De devil had uh big open fireplace wid taters roastin' in de ashes an' slices uh country cured ham broilin' on sticks an' uh big jug uh likker settin' on de table. Bad Boy wanted tuh git in dere so bad! He wanted de devil tuh ketch 'im after he seen all

dat, so he made some noise wid his feet. Afterwhile de devil says: "B'lieve I *do* hear somebody out dere, but it ain't nobody but uh preacher an' I got too many uh dem here now tuh eat up my rations an' drink up mah likker. He sho ain't gointuh git in. B'lieve I'll go sick de dogs on 'im."

De boy went on way from hell an' kept on travelin' fuh uh year uh two, den he come tuh uh place an' some crackers got 'im. They had uh way uh ketchin' niggers an' keerin' 'em cross on uh island an' makin' 'em work two or three years, an' den if youse uh good nigger, they'd give yuh uh pass an' let yuh go. They paid yuh all right, but you couldn't leave.

Well, de boy staid over dere three years an' saved all his money. Den he got intuh uh crap game an' won uh whole heap uh money, so he made up in his mind he wanted out. So he went on down tuh de boat an' de white man dat run de boat wuz settin' dere readin' uh paper wid his gun layin' on de groun' beside 'im. He had jus' cleaned it. He wouldn't eben look up at de nigger.

He say tuh de man: "Cap'n, Ah'd lak tuh go cross here tuh-day."

De white man didn't look up, still he jus' retched out his hand fuh de pass an' de boy says: "Ah ain't got no pass, cap'n, but Ah'm liable tuh give yuh uh couple hunded dollahs fur keerin' me cross."

De white man put down his paper an' looked at 'im an' said: "Oh, you got to, got to lick Venus, got to lick Venus an' her puppies (pistol and six bullets) or you can't cross here." (Sung to the tune of "You must have dat true religion.")

De boy reached in his shirt an' tole 'im, "Ah got uh thirty-two-twenty; b'lieve tuh mah soul it's uh doggone plenty. If dat ain't enough Ah got uh forty-four-forty an' uh pocket full uh cartidges an' Ah'm goin' cross here." (Sung to same air.)

Dat white man looked at dat pistol, begin tuh clap his hands an' says: "Oh, git on board, lil childen, git on board lil childen,

git on board lil childen, dere's room for many uh mo'." (Chorus of "Git on board".)

De boy come on cross an' kep' on travelin'. Way afterwhile he come home. He had done been off seben years when he got back. It wuz uh cold night when he come tuh de door an' knocked an' de ole man said: "Who is dat?"

An'de boy said: "It's me, John." De ole man let 'im in an' he looked so well de ole man wuz glad tuh see 'im, so he ast 'im where he been all dis time, an' he says: "You tole me to go tuh hell, didn't yuh? Well, Ah went." He looked round an' seen six preachers settin' tuh de fire.

"Naw! Whut wuz hell lak?"

"Jus' lak here. Ah couldn't git tuh de fire fuh de preachers."
—JAMES PRESLEY.

UNCLE JEFF AND THE CHURCH

During slavery there was an old slave named Jeff and he used to serve his old master so well that he used to give him his old clothes once in a while.

One time he gave Jeff a good pair of pants that he didn't like for some cause and Jeff decided—now that he had something nice to wear—to join the church, but he wanted to join the white church. So when Sunday came, he went and took a seat in the back of the church, and when they opened the doors of the church, he got up and told them he wanted to join.

You know they didn't want him in the church; but the preacher didn't exactly know how to turn him off; so he asked him, he said: "Jeff, do you think the Lord intended for you to join this church?"

Jeff said, "Why sho, He tole me to go unite myself wid a church, an' de niggers ain't got none; so He musta meant for me to join dis one."

"Jeff, I think you are mistaken. You didn't understand Him. I tell you what to do. You go back and ask him again, and if He tells you to come here again—why, then you can join."

Jeff knew that the preacher had just taken a way to get rid of him, so he waited a long time before he went back; but finally he did go, and when the doors of the church were opened, he went up again.

The preacher said, "Well, Jeff, what did the Lord tell you this time?"

"I went back and ast de Lawd agin lak you tole me about joinin' dis church."

"Well, what did He say, Jeff?"

"He say dat a good Christian lak me oughter been 'shamed of myself for even comin' here thinkin' 'bout joinin' dis church. He says He ain't never even joined here hisself. Fact is, He don't think He could git in if He wuz to try."

Then Jeff walked on out dat church and never came back.

—LOUISE NOBLE.

Preacher had a son that was just crazy 'bout card playin and gamblin. So one Sunday he was at it wid some of his friends and his old man come in. The boy was scared to let his pa ketch 'im so, you know in them days, preachers used to wear long dusters. So he had one hanging long side de wall. So de boy just stuck de cards in de pocket of de coat and make out he wasn't doing a thing. So de preacher put de coat on and went on down to de river to baptize some converts. De boy and his mama went too.

So when de preacher got out waist deep out come de ace. Next thing a king, next a queen and jack. Then de deuce. (A good poker hand)

De boy's mama hollered: "Oh, my husband done lost!" (She meant his soul, thinking he had taken to gambling.)

Boys says: "Well, mama, if papa lose wid a hand like that he don't deserve no sympathy."
—MACK C. FORD.

Once there was a preacher in the pulpit that had a handkerchief in his pocket. A man slipped a lamp eel in his pocket. The preacher reached his hand in his pocket to get his handkerchief, and grabbed the lamp eel by the head. He went to hollering and said, "What is it, what is it, what is it?"

An old sister in the church said, "I don't know what in the hell it is, but don't throw it on me."
—JOE WILEY.

There was a man went to church every Sunday and he would shout and run all over the church. One of the deacons of the church told the man if he would stop shouting and running around all over the church he would get him a pair of boots. The man stood it for about two Sundays. When the preacher was preaching, the man got happy and said: "Boots or no boots!" and started to shouting.
—DAVID LEVERETT.

Too many people say step out on de *word*. But all dem words don't say preach. Sometimes God writes and just as soon as God git to de letter P—they run off and go preach. God wuz gointer say 'plow', but they don't wait tuh see.

Now, one time uh jackass sent uh man tuh preach. They wuz two brothers and both of 'em wuz preaching and one always had big charges, so de other one went down in de woods and prayed to de Lord to know if he wuz called. About a mile or more through de woods uh man had a jackass and he wuz

hungry, so just as de man ast de Lord dat, he whickered: "Wa-a-anh Wanh! Go preach, go preach!"

De man jumped up and went and tole folks he wuz called to preach. But look like he never could git no good charges. He wuz always on turpentine stills and sawmill camps. So one day he met his brother and ast him how come, and his brother tole him, says: "You sho de Lord done called you to preach?" He tole him yeah, he heard de voice distinct. Says, "You better go ast Him agin."

So he went back to de same praying ground, but de woods wuz cut down. So when he ast de Lord dis time, de jackass whickered agin and de man looked up and seen him, and says: "Yes, youse de son of a gun* sent me off to preach last time."

—EUGENE OLIVER.

There was a little boy lived on a hill and it was a thicket between his home and the schoolhouse. One day he was coming from school. He was going up the hill and met a bear. The boy came running back down the hill and he met a preacher. The preacher saw him running and asked, "What's the matter, son?"

The boy told him that a bear got after him. The preacher asked him why didn't he stop and pray, and the boy said, "I didn't have time."

The preacher said, "I am going up there—watch me."

The boy watched the preacher. After while the preacher came running down. The boy asked what was the matter. The preacher said, "A bear got after me, son. A prayer is all right in prayer meeting, but it ain't worth a damn in bear-meeting."

—EDWARD MORRIS.

*Originally typed "son of a bitch," but changed in the manuscript.

My daddy was a great preacher. One Sunday he got to preaching and said: "When I get to heaven, I am going to fly around awhile, then I am going to put on my golden slippers and walk around awhile."

There was a bunch of boys standing around the church house peeping in the windows. So the preacher said, "I am going to see God for myself. I am going to tell him how you treated me. I am going to be on Hallelujah Street, and then I am going to have some fun." And he wanted to show the people how he was going to have fun. He started to sit down in the window, but it was up and he fell out on the ground. The boys came running around the church house to see what had happened. The preacher said, "What in the hell is you all coming around here for? The fun is all over now."

—L. O. TAYLOR.

There was two colored preachers went to Mississippi to run revival and ran their meeting for two weeks.

At the end of the meeting they had gained a lot of souls. So on their way back to Alabama they stopped to count money, and to their surprise they had a hundred bucks a-piece.

The younger preacher said to the old one, "Let's shoot some craps."

The older one said, "No, no, I've quit all that for twenty years."

So the younger one kept on persuading him until finally the game started. The younger preacher had a sharp shot they called the Hudson; the older preacher had the shot they call the Up-and-Out.

So him and him! The old preacher losing all the time. So when he got to his last dollar he opened his knife—(Soliloquy): "And as soon as the younger one make that point I am going to take my money back."

The younger one was watching him all the time, so he continued to shoot. As soon as the point was made the old one fastened

him around the neck and said: "Give me my money! I've 'hark from the tomb around your neck," not noticing the thirty-two–twenty the younger preacher had in his side. So the young preacher said, "Yes, but I've got the doleful sound."

So the old one looked and saw the gat and said, "The doleful sound gets it." So I being there, I asked the bushes to go my bond.*

—Joe Wiley.

I had the occasion of leaving Alabama and going to Georgia. While being in Georgia I attended a meeting runned by Reverend Fullbosom. So the meeting lasted one week.

So all the time meeting was going on, nobody wouldn't bow down, neither say "amen" to nothing said.

So the church had only one door and one window, and the window was in the pulpit behind the preacher. So the last night of the meeting, Reverend Fullbosom carried his fifty-six special; so when church begin Reverend said: "Brothers and sisters, we are about to end our meeting, so Brother Sexton, lock the door and bring me the key." So he did, the sexton being peg-legged.

About that time I was a mourner.

Reverend Fullbosom said, "I've preached to all of you one week and not a one of you have even bowed down." So he opened his grip and out with his fifty-six special and said: "Now, all of you thieves, and robbers, hoboes, cut-throats, and rounders, BOW DOWN!"

So they begin to bow. So the peg-leg man thought it was impossible for him to bend that peg, so he said: "Brother Pastor, me too?"

*As in, "headed for the hills."

Reverend said, "Yes, you peg-leg son of a gun, BOW DOWN!"

So when I looked around the sexton was on both knees singing: "If my wife is in this church, tell her to come here please; if she ain't got time to come, tell her to send me them keys."

So Reverend made three shots in the church and everybody went to run and made for the side of the church, and running so fast they carried it twenty-eight miles before they thought to turn it loose.

—JOE WILEY.

"Say, boy, where have you been?"

"I been to hell and everywheres else, mister."

"What did you see there?"

"I saw a preacher and some boys. The boys was shooting crap on Sunday. The preacher scolded them and told them they ought not to do that. So the boys told the preacher that they were going to find Jesus next Sunday. So the boys had dirty* under a hat and covered it up. The preacher was standing up and they all said, 'We have found Jesus.'

" 'Where is he,' said the preacher?

" 'You pick it up,' said the boys.

"So the preacher picked the hat up and said, 'Well, boys, Jesus done defecated and gone.' "

—EDWARD MORRIS.

*"incriminating evidence."

Devil Tales

The' passed the communion cup to a woman and she turned it up to her head and drunk it all up. She rubbed her belly and hand de cup back to de deacon and says: "Hah! I could drink uh quart uh dat wine for my sweet Jesus."

Baptis' and Meth'dis' always got a pick out at one 'nother.

One time two preachers—one Meth'dis' and de other Baptis' wuz on a train and de engine blowed up. When they started up in de air de Baptis' preacher hollered: "I bet I go higher than you."

A man had two sons. One was name Jack and de other one was name Frank. So they got grown and their father called 'em one day and says, "Now, y'all are grown. Here's five hundred dollars a piece. Go out for yourself."

Frank took his and went and bought him a farm and settled down.

Jack took his and went on down de road. He got into a crap game and bet his five hundred dollars and won. He bet five hundred more and won agin.

He went walking on down de road and met a man. "Good morning, my boy, what might be your name?"

"My name is Jack. Who are you?"

"Lie-a-road to ketch meddlers."

Jack says, "I speck youse de man I'm looking for to play me some five-up."

"All right, let's go."

So they set down and played and Jack lost. "I got five hundred more that says I'll win." They played and Jack lost agin. "Well," he says, "I got five hundred more." He lost dat.

Den de man says, "I tell you what I'll do. I'll play you a game for your life against all the money."

Jack lost again. So the man he says, "My name is the devil. My home is across the Atlantic ocean. If you gets there before this sun rises and goes down again I'll save your life. If not, you'll have to die."

Jack was down by de road crying and a ole mast ast him, "What you crying for?"

Jack says, "I played five-up wid de devil and he have won my life. He's gone back across the Atlantic Ocean. He told me if I'm not there before the sun rises and goes down again he's bound to take my life. I don't see no chance of getting there."

Old man says, "Youse in a pretty bad fix, all right. There's only one thing can cross de ocean in twelve hours. That's a bald eagle. She comes here every morning and dips herself in de ocean and walks out and plucks off her dead feathers. Now you be here tomorrow morning with a bull yearling; when she get through plucking her feathers she'll be ready to go. You mount her back wid dis bull yearling and every time she hollers, you put a piece of meat in her mouf and she'll carry you straight across de ocean by nine o'clock."

Jack was there de nex' morning wid de bull yearling and saw

de eagle when she dipped herself in de ocean and come out on shore to pick off her dead feathers. She dipped herself the second time and shook herself. When she rocked herself and made ready to mount the sky, Jack mounted her back wid his yearling.

After while she hollered, "Hah-ah! one quarter cross de ocean. I don't see nothing but blue water." Jack tore off one de hams of dat yearling and stuck it in her mouf and she flew on.

After a while, "Hah-ah! half way cross de ocean—don't see nothing but blue water, hah!" He give her de hind quarters and she flew on.

After while, "Hah-ah! mighty nigh cross de ocean—don't see nothing but blue water, Hah!" He give her de rest and pretty soon she landed. Jack hopped off and met an old black man with red eyes and ast him if he know where de devil live at. He told him, "Yeah, he live in de first little house down de road."

He knocked on de door and de devil opened it. "Well, you made it, didn't you? Come in and have breakfast with me."

After breakfast he says to Jack. "I got a lil job for you to do and if you do it, you can have my youngest daughter; but if you fail I'll hafta take yo' life. I got seventy-five acres of new ground—never a bush cut on it. Every bush, every tree, every stump got to be cut and piled up and burnt before twelve o'clock."

Jack went on down there and went to work; then he begin to cry and de devil's youngest daughter come down wid his breakfast. She says, "Whut's de matter, Jack?"

"Your father gimme a hard task. I can't clean all dis off by twelve o'clock."

"Eat yo' breakfast, Jack, and lay yo' head in my lap and go to sleep."

Jack done so, and when he woke up every bush, every tree, every stump was cut and piled up and burnt. So Jack went on back to de house.

"I got one more little hard task for you to do. If you do, you kin have my daughter; if you don't, I'll hafta take yo' life. I got a well three thousand feet deep—I want every drop of water dipped out and bring me whut you find on the bottom."

Jack went to dipping the water out de well, but it run in faster then he could dip it out; so he set down and went to crying. Here come de devil's daughter and ast him, "Whut's de matter, Jack?"

"Your father have give me another hard task. I can't do this work."

"Lay down and put your head in my lap and go to sleep."

Jack done so and after while she woke him up and hand him a ring and tole him: "Heah, take dis to papa. That's whut he want. Mama was walking out here de other day and lost her ring."

Devil says, "I got one more task for you to do and you kin have my youngest daughter. If you don't, I'll hafta take your life." De devil had some coconut palms three hundred fifty feet high. He tole Jack, "You kill these two geeses and go up dat palm tree and pick 'em and bring me back every feather."

Jack took de geeses and went on up de tree and de wind was blowing so strong he couldn't hardly stay up there. Jack started to cry. Pretty soon here come de devil's daughter. "Whut's de matter, Jack?"

"Your father have give me too hard a task. I can't do it."

"Just lay your head in my lap and go to sleep."

Jack done so and she caught the feathers that had got away from Jack and when he woke up she hand him every feather and de geese and says: Heah, take 'em to papa and let's get married."

So de devil give them a house to start housekeeping in.

That night the girl woke up and says: "Jack, father is coming after us. He's got two horses out in the barn and a bull. You hitch up de horses and turn their heads to us."

He hitched up de horses and she got in and off they went.

De devil misses 'em and run to git his horses. He seen they was gone, so he hitched up his bull. De horses could leap one thousand miles at every jump and de bull could jump five hundred. Jack was whipping up dem horses but de devil was coming fast behind them and de horses could hear his voice one thousand miles away. One of 'em was named Hallowed-Be-Thy-Name and the other one Thy-Kingdom-Come.

De devil would call, "Oh, Hallowed-Be-Thy-Name, Thy-Kingdom-Come! don't you hear your Master calling you? Jump Bull, jump five hundred miles." Every time he'd holler de horses would fall to their knees and de bull would gain on 'em.

De girl says, "Jack, get out de buggy and drag your heel nine steps backward and throw dirt over your left shoulder and git back in and let's go."

They did this three times before de horses got so far off they couldn't hear their master's voice. After dat they went so fast they got clean away. De devil kept right on coming and so he passed an old man and ast: "Did you see a girl black as coal, with eyes of fire, wid a young man in a buckboa'd?" He tole him yeah. "Where did you hear 'em say they were going?"

"On de mountain."

"I know 'tain't no use now, I can't ketch 'em. (Chant) Turn, bull, turn clean around, turn bull, turn clean around."

De bull turnt so short till he throwed de devil out and kilt him and broke his own neck."

That's why they say, "Jack beat the devil."

—JERRY BENNETT.

THE WOMAN AND THE DEVIL[†]

There was one man and his wife who always lived lovin'. They never had fussed since they had been married. Devil didn't like dat so he decided to break 'em up. He

tried and tried, but he was about to give up one day when he stopped a woman's house to get a drink of water. So she ast him why he looked so downhearted and he tole her he been trying to break up a couple for two years and they just wouldn't fuss.

So she says, "If you will gimme a new pair shoes, I betcher I kin git 'em to fussin' and quarrelin'."

So he tole her he would. So she quit whut she was doin' and went on over to de couple's house. De woman was sweepin' and singin'. De woman says, "You so happy, I'm sorry I come."

"How come? Don't you like to see folks happy?"

"Yes, thass how come I wish I hadn't come here. Youse too good a woman to have such a deceitful man. I ain't goin' tuh tell you whut he done, so don't ast me."

De woman says, "Nobody can't make me b'lieve my husband ain't right. Not even de devil hisself couldn't break us up."

"Oh, I ain't trying, thass how come I ain't goin' to tell you nothin'. But if you jus' watch you'll see for yourself. Nobody won't have to tell you if you keep yo' eyes open."

Then she left de woman and went on down in de fiel' where de man was plowin'. "Hello, brother, you sho is a smart man. That's whut makes me sorry to see a man like you wid a woman that keeps secrets from him."

"My wife ain't got no secrets from me. Thass one thing we don't do, is keep things from one 'nother."

"Well, all I got to say is, long as a person don't open up a box you can't tell whut they got in it. You jus' got to take they word for it. A secret wouldn't be a secret if ever body knowed it. Don't think I come to talk about nobody. I wouldn't tell you nothin', not even if you paid me. But if you keep yo' eyes open an' yo' mouf shet and nobody won't have to tell you nothin'."

So she went on 'bout her business. Devil hung round where he could watch. De man come in and never said a word. De wife got busy wid de cookin' and she never spoke. He took

down de wash pan and started to washin' his hands. She come snatched de towel out his hands and wiped her face with it. He set on de stoop and wouldn't ast her wuz dinner ready. She took de broom and swept all over him and wouldn't ast him to move.

He says, "Looka heah, ole nigger 'oman, whut de hell's de matter wid you? If you wanta know, I kin knock some uh dat hell out you anytime you git too high."

She up and tole 'im, "Looka here, Mr. Nappy-chin, I kin make out without you any day in the week. Gwan, hit me! I dare you!"

So they fought all over de house before they thought to git de thing straight. So de devil went on and give de woman de new pair of shoes.
—GENEVA WOODS.

Once I wuz travelin' huntin' uh job tuh work, and met uh man wid two horses. He ast me if I wanta work. I tole 'im, yes suh. He said, one of de horses was swift ez de wind and de other wuz a little bit swifter.

He tole me tuh go tuh his house and git his shotgun and one shell tuh kill enough birds to build uh bridge across de devil's trussle (trestle). I didn't do lak he tole me. I went an' got uh whole handful uh shells. He tole me after I build dat bridge dat I could have his daughter.

I went out dere and shot up one tree and all de birds flew out dat tree intuh another one. Went over and shot in de other tree, and by dat time the devil's daughter come out dere where I wuz. She ast me couldn't I kill 'em. I tole her naw.

She took de gun and shot and here come a bundle of birds fallin' down and she took de toes fur de nails, and she took de thighs fuh de logs to cross de bridge, and she took de backs fur de boards (floors), so she bilt de bridge and she tole me: "Papa ain't gointer let me go wid you." She tole me, "When you

come up dere tonight, when he snore so loud—he ain't sleep. Wait till he breathes easy. Then, you ketch dem two horses," says, "an' we'll go."

She give me one-half uh banana, and tole me to put dat in my pocket. She give me one-half uh peanut, and tole me to put dat in my pocket. She give me uh egg, and tole me to put dat in my pocket. And so she tole me, "When we go to my grandma's house, she got a lil fice (dog) and ef he kiss me, I won't see you no mo', and ef he kiss you, you won't see me no mo'."

He had an ole jumpin' bull jump five thousand miles every time he jump. De horses wuz named Three Color and Changeable. Every time you say "Changeable" he be changing states dat quick.

So when we saw her daddy coming, she tole me to han' her de egg. She threwed it crost her left shoulder and it made a great big river, and he had tuh go back home tuh git his blood hounds to drink up all de water so he could come on across.

Look back agin and saw him comin' on his bull, and so she tole me tuh hand her dat half uh banana. She threwed dat crost her left shoulder, and dere come a great big banana field. She said, "Papa love bananas, an' I know he'll hafter stop and git some of those."

He stopped and turnt roun' and carried some bananas back to de house. While he was carrying those bananas back to de house, we dodged him. So we got dere and we stopped and went in, an' so we wuz setten down talkin' and de lil ole fice come dere to play with me, and I pat 'im on de head. When I know anything, he had done kiss me "bap" in de mouth, and I ain't seen my gal no mo'.

—JULIUS HENRY.

WOMAN SMARTER THAN DEVIL[†]

There was a young man, very nice young man, raised nice, and he married a very nice girl and they loved one another dearly. And they lived so happy together and de Devil didn't like it, so he put in to break 'em up.

Every scheme the Devil would figure out their love would overcome. So de Devil met a woman named Sarah one day and she was barefooted. De Devil said to her: "Whut you doin barefooted?"

She says: "I ain't able to buy no shoes."

Devil says to her: "I got a job for you and if you 'complish dat job I'll give give you a pair of new shoes."

She says: "All right."

Devil says: "You know dat young man and his wife?"

She says: "Yes."

Devil says: "I been trying a long time to break 'em up, but every scheme I have don't take no effect. I give it up."

Woman says: "I'll break 'em up if you gimme dem shoes."

So de woman went to de house, de man was in de field plowing and she seen him before she got there. He had a mole on his neck. So she went to de house. Before he got there de woman was bragging about the husband. She says: "He is handsome, but there is one thing I don't like him. Dat mole on his neck. You cut dat off and he will be perfect."

So the wife ast: "How kin I cut it off and he won't know it?"

Sarah says: "Wait till he go to sleep and you take his razor and cut it off."

Wife says: "He is pretty now, but if anything will make him more pretty, I'll do it."

So after dinner de man went on back down in de field and went to plowing. So when de woman left she went on down in de fiel and she tole de man: "You know I found out something today."

He says: "Whut?"

She says: "You and yo wife been living together a nary a year and you love her, don't you?"

He says: "Yes".

"And she make out she love you, too, but tonight when you go to bed you stay wake and cover up yo' head and when she start to pull de cover off yo' head she gointer have yo' razor in her hand to cut yo' throat. Now don't say I told you. Don't call my name, but you'll see whut I'm tellin you is true."

So dat evening when he knocked off she had supper ready, he eat and went on to bed and covered up. When she thought he was sleep she went to easing the cover off and he looked up and saw de razor in her hand. He says: "Whut you doing wid dat razor. I done heard it today you was going to cut my throat. Good as I been to you, long as we been living together, too."

She says: "I just wanted to cut dat mole off yo' neck to make you mo' pretty."

"Oh, naw, you wuzn't—trying to cut my throat."

He put her out.

Next morning the woman she went over to the devil's house. He says: "Is dat you, Sarah?"

She says: "Yeah. I done whut I tole you. I done broke 'em up. I want my shoes."

Devil says: "All right, wait a minute."

He went down to de swamp and cut a long pole and tied de shoes on to it.

Says: Here's yo' shoes, but anybody slicker than me, I don't want 'em close to me. Git back. I don't want you close to me."

—M. C. FORD.

Once there was a man going with the devil's daughter and wanted to marry her. The devil told him he could, if he could tell her from the rest.

So he put all her seven sisters in a line with her and they were all exactly alike. But Mary had done told him she would move her feet, so he could tell her from the rest. So she did.

So he took her and married her and she used to fuss with him. One night in the bed he asked her what make her fuss so much when he was nice and kind to her and she said: "Honey, that's the devil. I got seven devils in me."

So he took a sledge hammer and knocked her on the head, and six devils jumped out, but one stayed in her. That's how come all lady people got the devil in them, because that one was left in her.

—ARTHER HOPKINS.

These people was vast rich. De devil had taken possession to such an extent dat all of 'em had died but de man and his daughter. So dey left de mansion and built another one not far off and made an offer to give any man de daughter to stay over night in dis*. Several tried it and couldn't stand de racket. At last two niggers came along and taken de job. They went upstairs and made them a fire. One sent de other down to get a couple of chickens. He stayed so long he went to look for him and found him dead at the foot of the stair. John didn't stop. He stepped over him and went on out to the coop and got de chickens and went back upstairs and picked 'em. By time he got in a good way picking 'em, in walked a man with a greasy sack and beard to waist. He ast John what's he doing.

"I'm picking my chicken."

He ast, "Kin I help you?"

Reply was, "Yes, if you behave yourself."

This party was de devil and he had sharp claws and he was

*Marked to supply missing word (probably "mansion") but word was not supplied.

tearing the chicken up. The man grabbed the chicken, taken it away and picked and cooked it. Devil ast, "Whut you going to do now?"

"Cook my chickens."

After cooked, "Whut you going to do now?"

"Eat."

"Kin I eat with you?"

"Yes, if you behave yourself." So they ate together; after supper they smoked. Now this sack dat devil had in his hand was full of imps. After they went to bed de devil turned 'em a-loose. They begin running all over de bed and house and in de meantime John had hid a hatchet under the pillow. He up wid it and lammed one of dese imps wid it and dat intempered de devil; so he jumped up and made a break for John and John made a break for de door and round de house, de woodshed and into de workshop, John on one side of de work bench and de devil on de other. Devil was reaching over after John and his whiskers got caught in the vice and John screwed up on them. He had him.

"Now you've got me, Now I'll not bother you, but stay off dat hill yonder. Don't you never come up dat hill."

So John won and married de girl. They gave him the girl and made him vast rich. One evening they went out driving in a buggy with a horse and saw a little white rabbit. Girl says, "Oh dear, git dat for me."

He spring out de buggy and run after de rabbit and de rabbit run right up dat hill. When he got up dere he turned back to de original devil. "I got you now. I tole you not to come upon dis hill."

"When I had you, I granted your request; now there's one request I want you to grant me—I want to go down and tell my wife good-bye—and you see her down dere in de buggy."

He goes down and got his wife and wrapped her in de rug and put her under his arm and walked on back. De devil saw him coming, ast him: "Whut's dat you got under your arm?"

"My vice." Devil tole him to gwan back—he didn't need him. Some years later John died and went to hell—devil looked through the iron gate and saw him. Give him some matches and tole him to go on back and build a hell of his own.

—L. O. TAYLOR.

A Negro and de devil had a bet of one thousand dollars to tell which one was the strongest. They brought out a five-ton hammer, placed it on the ground, and going to see which one could throw it the farthest. Devil picked up de hammer at nine A.M. and threw it. Turned to the Negro and said: "We'll go home—the hammer won't return until three days later."

On the third morning at nine A.M. the hammer fell. Knocked a hole in the ground big enough to place three counties in it. They took the hammer out and placed it on level again and it was then the Negro's time to throw it. The Negro looked straight towards the clouds and said: "Stand back, Rayfield (Raphael); move back, Abraham; watch your step, Jesus."

The devil walked up to the Negro and said to him: "Don't you throw my damn hammer up there. Some of my tools was left there when the Lord threw me down, and I ain't got 'em yet."

—JONATHAN HINES.

You know de devil don't do everything they say. One day uh man wuz on his way tuh church an' he wuz late, so he cut crost uh pasture. When he wuz gettin' under de barb-wire fence he snagged his pants, an' he said: "Oh shucks! de devil done dat."

Soon's he said dat he heard somebody snufflin' an' cryin' an' he looked up an' seen uh man settin' on uh fence post justa

cryin'. De man wuz sayin': "Ah sho do have uh hard time. Now there goes another man lyin' on me."

It wuz de devil!

—W. M. RICHARDSON.

WHY WE SAY "UNH HUNH"†

A widow lady had jus' one chile and it was a girl. She was mighty pretty. A man next door had four children.

So one day de Devil come stole 'em all. He put two chillen under each arm and put de pretty girl in his mouf.

De widow looked up and saw him flyin off wid her pretty daughter in his mouf so she thought up a way to git her back. So she hollered and ast: "Hey, old Satan, is you comin back after more?"

He says: "Yeah." Kerdap! De girl fell out his mouf and run back to her mama.

Next time he got somebody in his mouf they (the people) hollered and ast him: "Hey, Satan, is you comin back for more?"

He said: "Unh hunh" and kept right on.

—MACK C. FORD.

Witch and Hant* Tales

*"Hant" means "haunt" or "ghost."

DE WITCH WOMAN[†]

There was a witch woman wid a saddle-cat who could git out her skin and go ride people she didn't like. She had a great big looking-glass. When she git ready to go out she'd git befo dat glass naked. Jus befo she shake herself she would go and lay all her clothes out—stretch em out on de bed so she wouldn't have no trouble when she git back.

Then she'd go back befo de glass and shake herself and she'd say: "Gee whiz! Slip 'em and slip 'em agin!" And de old skin would slip off and she'd git out on her [illegible] and she'd look back and say "umph!! I forgot sumthin." And she'd go back to her keyhole and she blow and say, "Open door, lemme come in agin." And she'd go back and spread de old skin out at de fire place and tell de skin, "So remember who you are."

And one time her old use-to-be she used to love so hard was eave-dropping her and when she got away he slipped in and salts de hide wid pepper and salt. She couldn't find her old use-to-be at his house so she could ride him nowhere at no struggle of sleep, so she made her way back home. Says, "Umph! I'm de witch woman, but I b'lieve I'm done lost out."

So she goes and blows to de key hole in de door and de do'

got tighter. She squinch herself and blow, say: "Witchcraft, won't you let me in?"

Her old use-to-be come from behind de house and de door cracked and in she went. She looked all around. Everything looked all right. She said to de old skin, "Less go agin." When she tried de old skin on, de old skin begin to burn and sting. She laid it back down and looked at it. She picked it up agin and said: "Skin, oh skin, old skin, don't you know me?"

She tried it agin and it burned and stung her agin. Said: "Gee whiz! old skin, dis is me. I been goin and goin, but I think dis is my old use-to-be (who has conquered me)."

Her old use-to-be spoke behind de house and says: "You used to have me, but I got you now."

—A. D. FRAZIER.

THE FOUR STORY LOST LOT†

In Bullard County, Alabama, there was a haunted house and you had to spend the night so as you could tell whut happened during de night. The first guest come in had music to console him, gamblers and preachers, drunkards and other dissipated class to amuse one another and see whut happen.

The first thing come in at twelve o'clock was a big black cat and he would come sit by de hearth with his back to de fire and his face to de guests. Den for one hour de wind would blow and de lights would go out just as fast as you light 'em. So de guests would get skeered and run out and they couldn't tell nothin but "de black cat come in and de lights went out."

Some more guests come. This cat come in agin—back to fire and his face to de people. They begin to start de music to stay till day. De wind begin to blow and all de lights went out agin. They stood de hour through and de lights come on. When de wind riz de do' wuz already locked and thumb

bolted, but it flew open. In come a pair of white feets and stood before de fire wid de heels to de fire and they toes to de people. When de door opened again, de legs come in and joined to dem feet. De do' wuz still locked. Nex' time de thighs come in and joined to de legs. Nex' when de do' open agin in come de body and join on to de thighs. Nex' time in come de arms and joined on to de body. When de do' open agin, head come in and said: "Now, by God, we got de man."

Guests of people whut wuz there said: "No, by God, you got a hell of a run."

Next time five people tried it a old woman and her two daughters and the son-in-law and de baby. All four had a package but de baby. They set out on de porch wid they feets on second step from de top. Look at each other and every now and then the baby would cry. He was in de house on de bed. They would go and quiet de baby and go back on de porch.

Old lady said: "Lemme me go git de baby and git some water for it."

They all went out to de well, catch hold of the rope and begin to pull. Old lady said: "Lawd, dis bucket must be hung, it pulls so hard. Whut we goin do now?"

All drilled* back to de porch and set down agin. Come a big white man round de corner of de house. Old lady looks at him and say: "Lawd, whut you want here?"

He said to her: "Good that you spoke, If you hadna spoke I'd a 'stroyed de crowd." And he said to her, he said: "Y'all git up and follow me."

They followed him on down cross de weedy field. Old lady right behind de white man, and so on to de youngest. Carried 'em up in de pine thicket where there was a old chestnut tree and he caught on to one of de saplins and bent it down. After he got it down he told de old lady to tell her youngest girl to

*"walked," probably derived from militant marches.

come here. He said: "Now, before I tell y'all whut I want you
to do", he says to de young girl, "come ketch hold of de tip
top of dis sapling." He said: "Now lissen, at de root of dat tree
where dis saplin growed upon, I buried years and years of
money. You go to my old barn when I'm gone and you'll find
a bunch of tools tied up with chains. Everything I took (used)
to bury dis money is in dat chain. You'll find a steel box with
keys and you take it and get dis money for yourself. My home
is yo' home as long as you all live." Dat time de wind riz and
de lil girl holdin to de saplin top hit straightened in a flash of
wind and de old lady looked for her and she said: "Now, dat's
hell agin. But this is my home." They ain't never seen de girl
no more.

—A.D. FRAZIER.

THE ORPHAN BOY AND GIRL
AND THE WITCHES[†]

An orphan boy and girl lived in the house with their
grandmother, and one day she had to go a journey and
left them there alone. The little girl was sick and the boy went
to search for food for them both.

After he was gone, the girl felt stronger so she got out of
bed. She was walking in the house when he came back.

"Why do you get out of bed?" he asked her.

She said that she got out of bed because she smelt the
witches about. He laughed at her and persuaded her to eat
some yams. While they were eating, sure enough in came three
witches.

The witches wanted to eat them at once, but they begged to
be spared until their grandmother returned at sundown. The
witches didn't want to wait, so they said that they would not
eat them if they would go and get some water from the spring.
The children gladly said that they would go.

The witches gave them a sieve to fill with water, and told them that if they did not return at once with it, they would be eaten immediately.

The boy and girl went to the spring for the water and dipped and dipped to try to fill the sieve, but the water always ran out faster than they could fill it. At last they saw the witches coming. Their teeth were far longer than their lips.

The boy and girl were terribly frightened. He seized her hand said, "Let us run. Let us go across the deep river."

The children ran as fast they could. They saw the witches behind them coming so fast that they made a great cloud of dust that darkened the sun. The little girl stumbled and the witches gained so fast that they saw they could not reach the river before the witches, and so climbed a great tree.

The witches came to the foot of the tree and smelt their blood. They came with a broad-ax and began to chop down the tree. The little girl said: "Block eye, chip, block eye chip!" and the pieces that the witches chopped off would fly back into the witches' eyes and blind them.

The boy called his dogs. (Chant) "Hail Counter! Hail Jack! Hail Counter! Hail Jack!"

The witches at the foot of the tree chopping away said, (chant): O-ooo! Whyncher, whyncher! O-ooo! Whyncher, whyncher!" (Here it is understood that each actor in the drama is speaking, or chanting his lines without further indications.)

"Hail Counter, Hail Jack!"

"O-ooo! Whyncher, whyncher!"

"Block eye chip, block eye chip!"

The tree was toppling and the children was so scared, but the boy kept on calling: "Hail Counter, hail Jack!"

"Block eye chip, block eye chip!"

"O-ooo! Whyncher, whyncher!"

The little girl asked her brother: "Do you see the dogs coming yet?"

He said, "Not yet. Hail Counter! Hail Jack!" He didn't see the dogs coming and he began to sing: "I'm a little fellow here by myself for an hour."

"Block eye chip, block eye chip."

The dogs was tied at home. They heard his voice and wanted to come, but they were tied. The grandmother was asleep. She was very tired from her journey. She wondered where her grandchildren were. She did not hear the dogs whining to go to the aid of the boy. But a black fast-running snake heard the boy and ran to the house and struck the grandmother across the face with his tail and woke her, and she loosed the dogs.

"I'm a little fellow here by myself for an hour."

"Block eye, chip! Block eye, chip!"

"Hail Counter, hail Jack!"

"O-oooo! Whyncher, whyncher!"

By that time here come the dogs. The tree was falling. The boy and girl was so glad to see the dogs. He told one dog: "Kill 'em!" He told another one, "Suck their blood!" He told the last one, "Eat the bones!"

By that time I left. (Favorite way of ending a story.)

—HATTIE REEVES, born on Island of
Grand Command.

The old fortune-teller woman, you know. Dis old man and woman had been married for fifty years. And they lived a long ways from town and dis old fortune teller woman she lived on de road to town.

De old folks raised rice and hawgs and lived pretty good all they life.

Dis old fortune-teller woman she got out of produce so she figgered uh way to cut dis old man off on his way to town and git something off him to go upon.

She sees him comin down de road wid his team uh oxen so she got herself out where she could stop 'im. So she says to 'im:

"Brothah Ishum, I been dreamin bout you every night and de Lawd done tole me to tell you to watch yo' wife. Cause she's gointer cut yo' th'oat when you git back—thinkin youse wid other wimmen when youse in town. Whilst youse in town doin yo' shoppin think of me. When you start back home think of me."

Soon's he drives on off she gits her basket and sack and lights out to his house to see his old lady. She gits down to his Hannah's house and sets down and talks wid her and asts her why she don't never go to town wid her husband no time.

She tole her: "Lawd, chile, I ain't been to town in twenty year and I ain't feel like takin dat ride. I stay heah and take keer everything and have him a hot supper ready when he git back."

De old fortune-teller woman she say: "Lawd, Sister Hannah, you don't know Brer Ishum. He got a gal uptown. Thass how come it take him so long to go and come, and it wouldn't be *me*, Lawd, puttin up wid such."

So she gathered up her things and went on over to de fortune teller's house. She ast her: "Whut you do to yo' husband?"

Dat put de fortune teller in uh strain so she took her and carried her over to a neighbor's house.

Brer Ishum had done got lonesome for de old lady so when de witch woman got back home he wuz dere. He ast her: "Is you seen my old 'oman?"

She tole him: "No, I ain't seen 'em."

—A.D. Frazier.

A man sold hisself to de high chief devil. He give 'im his whole soul and body to do as he please wid it. He went out in dis drift of woods and lied down flat of his back

beyond all dese skull heads and bloody bones and said: "Go way, Lawd, and come heah Devil, and do as you please wid me, cause I wanta do everything in de world dat's wrong and never do nothin right."

And he dried up and died away on doin wrong. His meat all left his bones and de bones all wuz separated. And at dat time High Walker walked upon his skull head and kicked de old skull-head and kicked and kicked it on ahead of him a many and many times and said to it: "Rise up and shake yo'self. High Walker is here."

Old skull head wouldn't say nothin. He looked back over his shoulder, cause he heard a noise behind and said: "Bloody Bones, you won't say nothin yet."

Den de skull-head said: "My mouth brought me here, and if you don't mind, yours will bring you here."

High Walker and Bloody Bones went on back to his white folks and told de white man dat a dry skull-head wuz talkin in de drift today. White man say he didn't believe it.

So: "Well, if you don't believe it, come go with me and I'll prove it. And if hit don't speak you kin chop my head off right where hit at."

So de white man and High Walker went back in de drift to find dis old skull-head. So when he walked up to it, he begin to kick and kick de ole skull-head and it wouldn't say nothin. High Walker looked at de white man and de white man cut his head off. And de old dry skull-head said: "See dat now—I told you dat mouf brought me here and if you didn't mind it'd bring you heah."

So de Bloody Bones riz up and shook they selves and de white man said: "Whut you mean by dis?"

Bloody Bones say: "We got High Walker and we all bloody bones now in de drift together."

—A. D. FRAZIER.

HIGH WALKER AND BLOODY BONES[†]

This was a man. His name was High Walker. He walked into a boneyard with skull-heads and other bones. So he would call them: "Rise up, bloody bones and shake yo'self."

And they would rise up and come together and shake their selves and part and lay back down. Then he would say to his-self: "High Walker" and de bones would say: "Be walkin."

When he'd get off a little way he'd look back over his shoulder and shake hisself, say: "High Walker and bloody bones." And de bones would shake their selves. He knowed he had power.

—A. D. FRAZIER.

Heaven Tales

THE FIRST COLORED MAN IN HEBEN[†]

The first colored man that went to heben was John. So John goes up there walking. So he knocked. They ast him who he was. He said, "John."

"From where?"

"Alabama."

"Riding or walking?"

"Walking."

"Don't allow any walkers here."

So on his way back to Alabama he met a white man walking. He said, "Cap, where you going—to heben?"

He said yes.

"They don't allow no walkers there, so you ride me up there and we both will get in." So he rode John on up to heben and knocked.

"Who's that?"

"White man."

"From where?"

"Mississippi."

"Riding or walking?"

"Riding."

"Hitch your horse and come in."

Left John still out. Says the Good Book in heben no filth is found. So there was some old sacks outside of heben where they had been scrubbing the streets and the floors. So John began to study. So he taken one of the sacks and throwed it just as far in heben as he could. So the angels called him in to get that sack out of heben. So he goes in like he was going to get the sack (gesture of swift flight). And down Hallelujah Street! So down Amen Street picking them up and laying them down! So he come to Jerusalem Street and down the street! Throwing them in and curving round! So at the foot of Jerusalem Street was the Sea of Glass. Out on the Sea of Glass John went— breaking glass. The Lord was out there skating and asked, "What's the matter? What's the matter?"

They said, "This nigger throwed a sack in here and we was after him to make him take it out again."

The Lord said, "Never mind 'bout the sack. Just leave that nigger alone before he tear up heben."

—JOE WILEY.

DE FLYING NEGRO†

One time five niggers went tuh heben at one time, which is something don't happen often. Soon's dey got dere Gabull (Gabriel) fixed 'em all up wid robes an' wings an' everything, an' set 'em down in some golden cheers.

Four of 'em set dere; but one nigger tole 'em: "Shucks, Ah got tuh git up an' try out dese wings."

De others tole 'im, "You betta set down lak Gabull tole us. He'll tell us whut tuh do nex'."

"He don't need tuh tell me whut tuh do. He done gimme de wings, ain't he? They mine now, an' Ah'm gointer *use* 'em. Watch me skim roun' dat tree uh life thout tetchin' uh leaf."

He got up an' he flew thisa way an' thata way. They had a whole heap uh lights an' big vases settin' roun' an' de other

niggers says tuh him, "You betta be keerful, cause you liable tuh knock down some uh dem hangin' lamps uh knock over some uh dem fine vases!"

"Oh naw, I won't neither." He flew round an' round. He'd go way up, den fold his wings lak uh buzzard an' drop straight down; he'd dart under dem hangin' lights an' round dem vases. After while he says, "Watch me skim right cross de Sea uh Glass an' round de throne an' right cross God's nose thout tetchin' it. Jus' watch me."

He zipped off an' knocked down two or three lights an' fell intuh uh row uh dem vases an' knocked 'em all down an' skidded right upon de throne befo' he could git straight. God didn't say nothin'. He just looked at him. But Gabull knowed what to do. He come over tuh 'im an' snatched off his wings an' set 'im down so hard till it almost bust his robe, an' tole 'im: "Now, you set dere till I tell yuh to move, an' you ain't gointuh git no mo' wings neither."

His friends say, "Unhunh! We tole you you wuz gointuh keep on till you break somethin'. Now look at yuh. Ain't got no wings. Everybody got wings but you."

"Oh, I don't keer," he says, "but I sho wuz uh flyin' fool when I had 'em."
—CLIFFERT ULMER.

When all the prophets died and all of them went to heaven and they all got wings, one day one of the angels opened the door and let Simon Peter and all the rest out and told them to be back at two o'clock. All of the rest of the prophets came back at two o'clock except Simon Peter. At three o'clock Simon Peter came back and knocked at the door of heaven. The doorkeeper asked who it was. Simon Peter said, "Simon Peter." The doorkeeper told him that he couldn't come in and asked him where had he been. Simon Peter told him that he had been flying around. The doorkeeper asked him

then why didn't he come back with the others and told him that he had come too late and couldn't get in.

Simon Peter said, "I forgot what time to come back and I don't care if you don't let me in for I was a flying fool when I was in there."

—ED MORRIS.

Once a stingy man died and went up to heaven. When he got to the gates Peter ast him whut good had he ever done. He thought awhile then he says: "One time I saw a little girl crying and I ast her whut's de matter, and she says I lost my neckel, so I give her three cents and went on."

Peter says, "John, look on de books and see if that's on dere."

John looked and says, "Yes, he done it."

Peter says, "Is dat all de good ye ever done?"

Says, "No, another time I seen a little boy crying and I ast him whut wuz de matter, and he said I lost my nickel, so I give him two cents and went on."

"John, see if that's dere." So it was.

"So dat all you ever done good?" So he said yes.

John says, "Is you goin' let him in, Peter?"

Peter thought a while, "No, give him his damn nickel back and let him gwan to hell."

—CHRISTOPHER JENKINS.

Said there wuz a white man had a girl and she died, but he told her he would meet her in heaven. So after a while he went on up, but he couldn't git in.

Said there was a nigger up there flying around outside of heaven trying out his wings. So he met the white fellow. Tole the nigger boy, says, "Here's some dice. Let's shoot some for a dollar."

So the boy says he didn't have no dollar. White man says he'll shoot each wing for fifty cents. So he won the first fifty cents; so

he decided to shoot again, so he lost that one, too. So he says, "Guess I'll try my wings again," so he throwed twelve. So he says, "Didn't I win?" and the white fellow says, "No, you know damn well you crapped." So de poor boy lost—that's all of that.
—CHRISTOPHER JENKINS.

You know, when folks die an' go up tuh heben, they has tuh keer long uh piece uh crayon an' God got uh great big blackboard an' He makes you go tuh de blackboard while John reads off yo' sins out de Big Book, an' you has tuh write 'em down. Den God looks over 'em an' if they ain't many an' ain't too bad, He lets yuh stay in heben. If not, you get sent on tuh hell.

Well, my uncle died 'bout twenty years ago an' went on up. He wuz uh big preacher an' everybody said he sho wuz goin- ter git uh good seat on de right hand side, right up tuh de throne. But last week somebody died an' went up an' met my uncle on de way back to de earth tuh git some more chalk.
—LARKINS WHITE.

There was a man went to heaven and a man told him if he start to stealing he would go to hell. And he said, "Each person in the world has a lamp, and if your lamp is low you are going to hell."

The man seen that his lamp was low, and he went to stealing oil out of the people's lamps, puttin it in to his—and he went to hell.
—DAVIS LEVERETT.

One time a man died and had uh brother, and his brother loved him uh whole lots.

So after he wuz dead, his brother called up heaven on the

telephone and ast tuh speak tuh his brother. Peter tole him tuh wait uh minute cause he didn't remember nobody of dat description, so he tole him tuh hold de line uh minute.

He tole John tuh look on de book an' see if dat nigger wuz dere. John looked but he said he couldn't find no trace uv him.

So he tole him he had better call up hell and see ef he wuz dere. So he called up hell and ast if his brother wuz dere, and de devil tole him, yes, he wuz dere, and had done got tuh be de head fireman.

—CLIFFORD ULMER.

Uh nigger died and went tuh heben de same day dat President Harding died. He walked up to heben and knocked on de door. Ole Peter says, "Who comes?"

An' he tole him, "One."

An Peter ast him, "Walking or riding?"

An' he said, "Walking."

They tole him, "We can't take nobody in here walking, you hafter come ridin'." So de nigger turnt round and went back.

Soon after dat he met President Harding going up tuh heben. So he tole him, "You can't get in dere walking, so you might just as well turn back an' git something tuh ride."

Harding stopped a minute, den he said tuh de nigger, "I got uh good scheme, you let me ride you on up tuh heben, and when dey ask me if I'm ridin' or walkin', and I tell 'em I'm ridin', and they'll tell me to come on in, an' I'll ride you on in an' we both will be there."

So he rode de nigger on up dere, and de Lord ast him, "Ridin' or walkin?"

An' he tole him, "Ridin'."

So God said, "Hitch your horse on de outside an' come on in."

—CLIFFORD ULMER.

John and Massa Tales*

*Hurston's original title for this section was "John De Conqueror." John the Conqueror is a mythic figure, famous for his skill in outwitting his master or the Devil.

🌿 During slavery time Ole Massa had uh nigger name John an' he wuz uh faithful nigger an' Ole Massa lakked 'im, too.

Somebody got tuh stealin' Ole Massa's corn, so he sent John tuh ketch'im. John saw de somethin' in dere breakin' off de years uh corn an' kep' droppin' 'em on de groun'. It wuz uh bear, an' yuh know uh bear can't hold but three years at de time. If he break any mo' he'll drop all over three. John saw 'im keep breakin' corn an' droppin' one, so he walked up an' picked up one uh de years an' says: "Jus' you break another one now and see whut I'll do tuh yuh!"

He thought it wuz uh man all dis time. De bear thowed down de corn an' grabbed John, an' him an' dat bear! John finally got 'im by de tail an' de bear wuz tryin' tuh git tuh 'im, so dey walked roun' in uh ring all night long. He wuz skeered tuh turn de bear loose cause if he did, de bear would git 'im. He wuz holding de bear's tail an' de bear's nose jus' almost tuh tetch 'im in de back.

Daybreak Ole Massa come out tuh see 'bout John an' he seen de bear an' John walkin' roun' in de ring so tired dey wuz jus' creepin'. He run up an' says: "Lemme take holt of 'im, John, whilst you run git help."

John wuz so tired, he says: "Come here, Massa, now you run in quick an' grab 'im jus' so."

Ole Massa took holt uh de bear's tail an' tole John tuh hurry. John staggered off an' set down on de grass an' fanned hisself wid his hat. He wuzn't studyin' 'bout goin' fur no help. He wuz too tired.

Ole Massa looked over dere at John on de grass an' he hollered: "John, you better gwan git help or I'm gwinter turn 'im loose."

"Turn 'im loose, den. Dat's whut I tried tuh do all night long, but I couldn't."

—JAMES PRESLEY.

Once in olden times Ole Marster had two niggers, one named John and the other one, Bill. John was his favorite nigger. He was worth twice as much as Bill.

One day Bill ast his Marster for five dollars and Marster told him he ought not to did dat—he ought to ast for two dollars and a half, because he had to give John ten.

Then Bill ast Ole Marster for a suit of clothes and he said: "Bill, you ought not to ast for a suit of clothes—you ought to ast for a pair of pants or a coat, because now I have to give my favorite, John, two suits."

Bill went out into the crib and went to shelling corn and said: "Lord, tell me something to git away wid Ole Marster." He prayed a whole hour, but de Lord didn't tell him a thing. He went off and he said: "I know what I'm going to do. I'm going down amongst the cattle." And he said, "O devil, tell me something to git away wid Ole Marster."

De devil popped up right away and said, "Oh, hell! Tell Ole Marster to knock out one uh yo' eyes, and you know damn well he'll hafter knock out both uh John's."

—JOE WILEY (variant of tale from Chaucer).

In slavery time Ole Massa had uh nigger an' his name wuz John. He uster go stan' in de chimbley (chimney) corner of nights an' listen tuh whut Ole Massa say, den he'd go nex' day an' tell de other niggers whut tuh do. Ole Massa had done made 'im his foreman anyhow.

One night he heered 'im say, I'm gointuh have dem niggers plow dat bottom tuhmorrow." Soon ez John got out nex' mawnin' he tole de colored folks, "Well, Ole Massa wants y'all tuh plow dat bottom land dis mawnin'. Hit de grit."

In uh few minutes Ole Massa come out tuh give de orders fuh de day an' he said: "Well, John I wants you tuh have 'em plow dat bottom land tuhday. He says, "Dat's jus' whut I done tole 'em."

They all looked at one 'nother cause they couldn't understan' how John knowed whut Massa wuz gointer say. Massa didn't know hisself, an' John kept on doing dat till finally Massa ast John how he done it. John made b'lieve he could tell fortunes an' read de mind, an' Ole Massa b'lieved 'im.

One day he says tuh John, "John, looka here. I done bet mah whole plantation on you. Me an' one uh mah frien's got tuh arguin' 'bout you cause I tole 'im you could tell *anything*. He said he bet he could fix somethin' you couldn't tell thout seein' an' so we got it fixed. He's gointuh be here in uh few minutes an' if you make me lose mah plantation, Ah'll kill yuh."

Well, after while they called Ole John an' they had somethin' under uh turnt-down wash-pot, an' Ole Massa says tuh John, "Now, John, you tell us whut's under dat wash-pot."

John didn't have de least idee whut wuz under dat pot. He walked round an' round dat pot an' scratched his head an' tried tuh see if he could hear anything tuh give 'im uh lead; but he couldn't git de slightes' thing. So finally he give up an' said, "Well, you got de ole coon dis time."

He thought sho he wuz gointer git killed, but Ole Massa give uh whoop an' kicked over de pot and hollered: "I wins, I

knowed he could tell. John you gointuh git yo' freedom. Now I got two plantations 'stead uh one."

It wuz uh coon under de pot—but John didn't know it.
—LARKINS WHITE.*

After Massa winned offa John, he wanted tuh go way off on de water, an' he wanted John tuh stay wid Ole Missus; but John went tuh New York some way an' so when Massa stepped offa de train, dere wuz John waitin' fuh 'im in de station. He ast 'im, "How did *you* git here, John?"

"Ah run behin' dat train."

Massa wuz so took wid dat he didn't whup John. He jus' tole 'im tuh gwan back home an' stay wid Ole Miss. But John slipped on de boat an' hid hisself an' slipped off befo' Ole Massa did, an' wuz waitin' fuh 'im on de dock.

Ole Massa's eyes nearly popped outa his head when he saw John on de dock. He ast 'im, "John, how did you git cross de water?"

"Ah swimmed behind dat ship."

Massa called all de folks roun' dere to come see his John. He wuz wringin' wet jus' lak he been swimmin', but he had done wet hisself in de edge uh de water. Whilst they wuz all talkin' an' makin' 'mirations. John seed uh man out in de water uh swimmin' roun' an' cuttin' up. John hollered tuh 'im he said, "How long you been in dat water?"

Man tole 'im three hours. He said tuh Massa, "Massa, dat man can't swim none. Git me uh stove an' some wood an' rations cause Ah'm gointuh cook an' eat an' stay in dere uh month. Uh month ain't nothin' uh tall fuh me tuh swim."

He hollered tuh de man an' challenged 'im tuh swim wid

*In 1935, on a folklore expedition with Alan Lomax and Mary Barnicle, Hurston recorded John Davis's rendition of this tale.

'im. De man says he'll swim wid 'im cause he's de champeen over dere. Den John hollered back tuh ast 'im how much money he'd swim fuh an' de man says two thousan' dollars. By dat time Ole Massa b'lieves John kin do some swimmin' so he raises de man in de water tuh fifty thousan' dollars an' tole John tuh git ready an' if he lost his money he wuz gointuh kill 'im sho.

"Aw, Ah ain't gointuh lose yo' money, Massa. Jus' you git me de things Ah tole you, an' Ah'll beat 'im."

By dat time John wuz skeered tuh death cause everybody went tuh makin' preparations fuh de big swimmin' match, an' he couldn't swim uh lick. He hollered out tuh de man in de water, "Say, you betta git yo' self some vittles cause dis ain't gonna be one uh dem lil baby matches, jus' gittin out in de water an' playin' round six or seben hours. Cain't hardly git wet thew in dat lil time. Git yo' self some vittles tuh cook cause we gointuh be swimmin' fuh months, maybe uh year or two."

De man come out de water tuh look at John and he quit. He said he couldn't swim no whole day even—so John winned agin fuh Ole Massa on uh bluff.

—LARKINS WHITE.

There wuz a man in slavery time always meddling in everything he see. So finally de master said to him, "John, I want you to stay in this room all day and take keer of this box for me. Now, don't tetch it—don't bother it in no way, and I'll give you yo' freedom."

Ole Master had done put a young turkey under dat box, and left de window open so John could git some air. De box wuz restin' on a table.

Well, Master locked John up in de room and went off and set where he could watch.

John set there a little while, then he got to worrying about what wuz under dat box. First he come set side of de box.

Then he set on de box; last he got under de table trying to find out what's in de box.

Finally he couldn't stand it no longer and he lift up de box and out flew de turkey and right on out de window. John didn't know what to do.

After a little while Master came on in and said, "I see you can't mind yo' own business; so git back to hoeing."

—GEORGE MILLS.

BEAR IN DE CANE PATCH[†]

During slavery time Ole Master had uh cane patch and uh bear uster come stealing his cane. One night Ole Master see him himself. He had John along wid 'im, so John says, "Marsa, lemme go kill dat bear fer yuh."

"No, John, you might git hurt an' I don't want you all hurt up. You know I thinks uh whole heap uh you."

De nex' night ole John goes down dere atter dat bear unbeknownst tuh Ole Master. He had never seen uh bear up close, an' he didn't know how strong he wuz.

Dat bear grabbed John and wuz wearing him out er dis world, till John broke his holt and put out fuh de big house hollering "Ole Master" at every jump. Round and round dat house, John wid de bear right behind him. Ole Master heered de rookus and looked out and seed de bear an' shot 'im. Jes as soon as he done dat, John come on in de house and said, "Master, did yo' see de fine bear I brought you?"

"Why, John, I just killed uh bear I seen running round de house."

John made out he wuz so sorry. "Oh Master, you didn't kill mah bear, didja?"

"Why yes, John, why?"

"Why, Master, I had done conquered dat bear and wuz

bringing him up here tuh de house tuh be a plaything for yo' chillun."

—ROBERT WILLIAMS.

In slavery time Ole Marsa bought Jack an' took 'im home. Jack played green tuh everything.

While they wuz ridin' long they passed uh haystack an' Jack ast Ole Marsa whut it wuz. Marsa says, "Why, dat's my high tall mountain I feeds my cattle on."

When they got tuh de house de cat run out tuh meet Ole Marsa an' Jack ast 'im whut wuz dat. "Oh, dat's my red balls uh simmons, Jack."

They went inside de house an' dere wuz uh fire in de fireplace an' Jack ast 'im whut wuz dat. "Why, dat's my flames uh flapperation tuh keep me warm."

Ole Marsa went an' put on his bedroom slippers an' Jack ast 'im whut they wuz. "Why, dese are my flying trapeze."

Night come an' Jack saw Ole Marsa go tuh his bed an' he ast 'im whut wuz dat. "Why dat's my flowery beds of ease where I sleep. I ain't goin' tuh take you down tuh de quarters t'night. You kin sleep right in front uh my flames uh flapperation till mornin'—den I'll fix fuh yuh."

He made Jack down uh pallet on de floor in front uh de fire an' went on tuh bed. Jack went tuh sleep an' way afterwhile de cat come got on de pallet wid Jack an' he hauled off an' kicked her intuh de fire, an' she caught on fire an' shot outdoors an' right intuh dat haystack. Jack got up an' called Ole Marsa tuh tell 'im de haystack wuz on fire, so he said: "Marsa, Marsa!"

"Whut you want, Jack?"

"You better git outa yo' flowery beds uh ease, an' put on yo' flying trapeze, cause yo' red balls uh simmons done carried yo' flames uh flapperation tuh yo' high tall mountain."

"Whut you say, Jack?"

"I say you better git outa yo' flowery beds uh ease an' put on yo' flyin' trapeze, cause yo' red ball uh simmons done fell intuh yo' flames uh flapperation an' done carried it intuh yo' high tall mountain."

"I didn't understand whut you sayin', Jack."

"Aw, I said you better git out dat bed cause dat damn cat done set dat haystack afire."

—EUGENE OLIVER.

In slavery time Ole Massa wuzn't very good tuh John, so John got tired. So one day he made up a plot wid his buddy to fool Ole Massa. So dey put a whole heap uh groceries up a sycamore tree, so when Ole Massa come out tuh de field and started fussin' at John, John said:

"Ole Massa, I am tired de way you treats me. You works me befo' day an' after dark. I specks you gwinter be workin' me by de light uh de moon nex' thing. You don't half feed me. I'm gwine tuh God fur whut I want after dis."

"Well," said Ole Massa, "I feed you, don't I? God don't feed you, do He? So ef you don't do lak I say, you gwinter git plenty on yo' back an' starve, too."

John tole him, "No, I won't neither. I'm gwinter quit work right now an' go ask God for some rations."

So John went on over under de sycamore tree and fell down on his knees. His buddy wuz already up de tree. John begun tuh pray. He hollered, "O Lord, if I be your servant, send me down a sack uh flour." Down come de sack uh flour. "Now, Lord, please send your humble servant a side uh meat and a bag uh rice." Down come de rice and bacon. "Now, Lord, if I ask you tuh throw me down a sack uh meal and a sack uh sugar and a can uh lard and uh ham, if it be Thy holy and righteous will." Down come everything he ast fur.

Ole Massa's eyes wuz poppin'. He didn't know whut tuh do. John got up off his knees and tole Ole Massa, he said: "I'm

gwinter git back down on my knees and ast 'im tuh lam dis place wid uh bolt uh lightnin' and kill all dese weeked white folks. B'lieve I'l ast 'im to 'stroy de world."

Ole Massa got skeered and tole John, "Now, don't do dat, John. Ef you don't ast 'im dat, I'll give you your freedom and forty acres an' uh thousand dollars." So he give it tuh 'im and that's how niggers got they freedom.

—FRED COOPER.

BIG SIXTEEN†

Back in slavery time Marster had a Negro named John. John was such they named him Big Sixteen. He told Big Sixteen one morning to go down in his pasture and ketch him dat wild hawg and bring him to him. He run dat hawg down and brought him to him. Marster thought that wuz pretty good, so he thought he'd try him out agin.

So next morning he wanted to put some new blocks under his house, and he had some twelve by twelves in his cow lot and tole him to go bring him one. Big Sixteen goes and puts dat twelve by twelve on his shoulder and brings it to the house, and next morning Ole Marster decided to try him agin. He tole him to go ketch up all his chickens and he caught all dat was roosting in yard and tree. How many?—two thousand.

"That was all, John, I believe you can ketch de devil."

John tole him, "Yeah, Marster, I kin ketch him."

Nex' morning Marster tole him to go ketch de devil. John tole him, "All right, Marster. Gimme a shovel and a ten eb hammer."

Marster gits him de shovel and de ten eb hammer and John walks out about two hundred yards in front of de house and commenced digging in de dirt—digging dis hole. Finally he come to de devil's house and knocked on de door and his wife ast him who was it and he told her Big Sixteen. He ast her was Jack de Devil dere and she said, "Yes."

"Tell him I wants to see him."

Devil cracked de door and peeped out and John tapped him in de forehead wid dat hammer and kilt him, and run in and grabbed him up and throwed him crost his shoulder and carried him back to Ole Marster. His Marster tole him say, "I don't want dat ugly thing—take him back."

Big Sixteen took him back and throwed him in dat same hole dat he had dug and buried him. 'Bout two weeks later Big Sixteen died and he went to hell. Devil's wife and chillun saw him comin' and de chillun begin to run and hide, and de wife saw him coming so straight till she slammed de door herself. Big Sixteen walks up and knocks on de door and she ast who was it. He tole her Big Sixteen. She tole him, "Go way! Go back! We don't want you down here—you're too bad."

Big Sixteen goes on back. He goes to heben. When he got to heben he knocked on de gates. They ast who was it. He says Big Sixteen. They says, "Go on way from here. We don't want you here—you're too bad."

It was nowhere else for Big Sixteen to go. He had to come on back to de earth. His soul changed to a ball of fire. He is wandering round on de earth and they calls him Jack-o-Lanten; but it's nobody but Big Sixteen.

—JERRY BENNETT.

JOHN†

In slavery time there was a colored man by the name of John. One day him and his Ole Master was going along and John said, "Ole Massa, I can tell fortunes." Ole Massa didn't pay him no attention.

They went on to the next plantation and he told the owner, "I have a nigger that can tell fortunes."

He said, "I bet you my plantation and all my niggers against yours that he can't tell fortunes." So they called a notary public and signed up the bet.

John was in misery all that night for he knowed he couldn't tell no fortunes. Every morning John used to get up and saddle his mule and Ole Massa's horse. Ole Massa had to get him up that morning. Going over to the plantation where the bet was on, John had been riding side by side with Ole Massa; but this time he rode behind.

So the man on the plantation had went out that night and caught a coon and had it sealed up in a box. So there was a many one there to hear John tell what was in the box.

They brought John out and he pulled off his hat and scratched his head and said: "Well, white folks, you got the old coon at last."

He meant himself, but everybody hollered, "It's a coon sure enough. John sure can tell fortunes!" So he won for Ole Massa.

Going back home he said, "Ole Massa, I am not going to tell any more fortunes."

Massa said, "I don't care if you don't, because you have made me a rich man. Now I am going to New York and leave everything with you. So in the fall you can sell or keep everything until I come back."

Him and his wife left for the train, went to the next station and got off.

So John told what niggers that was there to get on the mules and one to ride three miles north, the other one to ride three miles south, one to ride three miles west and the other to ride three miles east. "Tell everybody to come here; there's going to be a ball here tonight. The rest of you go into the lot and kill hogs until you can walk on them."

So they did. He goes in and dressed up in Ole Massa's evening clothes, put on a collar and tie, got a box of cigars and put under his arm and one in his mouth. When the crowd

come that night and begin to dance, John told them he was
going to call figures.* So he got the big old rocking chair and
put it up in the bed and got up in the bed in the chair and
began to call figures. "Hands up four! Circle right! Half back!
Two ladies change!"

He puffed his cigar. When he went to say "Hands up four",
Ole Massa walked in and said: "John, look what you have
done. You have on my evening suit, up in my bed, done killed
all my hogs, and got all these niggers in my house. I am going
to take you out to that persimmon tree and break your neck."

"Ole Massa, can I have a word with Jack before you kill me?"

"Yes, but have it quick."

So he called Jack and told him, "Ole Massa is going to break
my neck. Get three matches and get in the top of that persim-
mon tree. When I pray and ask God to let it lightning I want
you to strike the matches."

So he got to the tree. Ole Massa had the rope around John's
neck and put it over a limb.

"Now, John, have you anything to say before I hang you?"

"Yes, sir. I want to pray."

"Well, pray and pray damn quick."

"O Lord, here I am at the foot of the persimmon tree. If you
are going to destroy Ole Massa tonight, his wife and all he has,
I want to see it lightning."

Jack striked a match. Ole Massa said, "John, don't pray no
more."

"Oh, yes, turn me loose so I can pray. O Lord, here I am at
the foot of the persimmon tree. O Lord, here I am tonight
calling on thee. If thou are going to destroy Ole Massa tonight,
his wife and all he has, I want to see it lightning again."

Jack struck another match and Ole Massa started to run. He

*As in "figure-eights"; to call out moves for square dancing.

run so fast till it took an express train running at the rate of ninety miles an hour six months to bring him back home.
—JOE WILEY.

During slavery time Old Marsa had uh slave name Jack an' his desire wuz chicken. Dere wuz one ole rooster uster jump upon de fence right in front uh Jack an' crow jes' 'bout time he wuz knockin' off. Jack wuz layin' for 'im, too, but he couldn't git uh good chance 'cause somebody wuz around. Old Marsa wuz watchin' *him* whilst he wuz watchin' de rooster, but he didn't know it.

At las' one evenin' Jack got de ole rooster, and he said (sang): "Dat ole rooster sittin' on de fence, got 'im in mah arms at las'."

Ole Marsa come up an' said, "Yes, an' dat ole whip wuz hangin' on de wall, Ah got it in mah hand at las'."
—JAMES PRESLEY.

Ole John, you know, been stealing Massa's hogs. Ole Massa said to 'im: "John, somebody been stealin' my hawgs. I'd give a thousand to know who done it."

"Massa, it musta been a bear. I goin' ketch 'im."

So next night ole Massa missed another hog. "John, I missed another hawg."

"Massa, I sho goin' git dat bear." So dat night when John went out tuh git him a pig an' there was a panter after *him* uh pig. John said, "Whut you doin' down there after Massa's pigs?" So de panter took after John.

John run round and round de crib, and de door were open and John run under de crib, and de panter thought he went in, so he darted in after. John shut de do' on 'im.

John run tuh de house, called his master up. He ast, "Whut is it, John?"

"I caught dat thing been stealin' yo' hogs."

"Whut wuz it, John?"

"It was a panter."

"Whut you do with 'im?"

"I put 'im in de barn."

"O, gwan, John, you ain't caught no panter."

"I be damn if I didn't caught 'im."

His wife said tuh 'im, "Git up and go an' see. John wouldn't cuss befo' me dat way ef it wuzn't something." So he went and looked. Sho nuff, dere wuz de panter. So he went round nex' day and told all his neighbors about it, whut his nigger, John, did. So dey didn't bleve it, so, "I will show you dat John will go in an' ketch 'im an' bring 'im out."

So dey betted so many thousand on John. His master betted his plantation and all his niggers. Then he tole John: "Now, John, you go in and git 'im and bring 'im out and I'll set you free."

John keep uh standin' round de crib dere and Ole Massa kept uh urgin' 'im to gwan in. Say, "Massa, wait till I git fixed."* (He went in.) As John opened de do', de panter made a leap at John and struck his head ginst de do' facin' an' broke his neck. John seen dat and grabbed 'im an' wrasseled wid 'im. "Oh, I got yo! You varmint. I'm bringin' 'im out, Massa. Oh, I done break his neck."

"John, I didn't mean for you tuh kill 'im."

"Well, Massa, you ortu been fuh tell me."

Well, Massa won de bet. One man says, "I will bet yo' a million I knows where's a wile man John can't handle."

"I'll betcher two million John kin whip 'im."

John knowed where de fightin' groun' wuz gointer be. He goes down an' cut de roots uh de oak trees. So dat nex' day de

*"prepared" or "ready."

fight wuz to come off. (John wuz tuh ride his master's horse down. So he tuk an' cut de bridle reins, so when he pulled on it, it would break.) So nex' day dey went down at de fightin' groun'. It wuz late when John come. De man said dat betted against John: "Look lak John ain't comin'."

"Yes, John be here in a few minutes." Tureckly*, here come John just whut he could come on de horse. He rared back on de bridle-reins and dey broke. Dat wild man looked. John jumped down. John looked round and said: "Looka here, Massa, is dis de fightin' groun'?"

His master tole him, "Why yes, John, what's de matter wid it?"

"Whuss de matter wid it? Can't yo' see 'tain't 'nough room for uh man tuh move roun' in? We better clear it off uh little."

John begin tuh grab up de trees by de roots an' toss 'em roun'. De wile man looked on, got skeered (gesture with hands as of a quick departure.) John winned agin for his master so he give 'im a thousand dollars and set 'im free."

—DELLA LEWIS.

JOHN IN THE SMOKE-HOUSE[†]

Some one continued tuh steal Mister George's meat out of the smoke-house. The rogues had cut uh hole in de wall for their convenience. Mister George keep er missin' his meat, so he sided he'd watch and ketch de nigger dat is stealin' his meat. He tole his wife tuh give him his gun and his sharpest hatchet. (His wife gave him the gun and hatchet.) Away Mister George went for the smoke-house. Mister George got dere and waited for one, two and three hours. After while he heard de rogues comin'. De rogues come nearer and nearer till dey got to de smoke-house, and den dey laid down

*"directly."

right by dat hole. Dese rogues wuz a white man an' a nigger named John.

Mister George heard de white man say, "John, you put your hand through and git a ham, and den I'll put mine through and git a ham."

John put his hand through and jerked it out quickly, placing it behind him and said: "Now, Master, I got a big one. Now you put yours through and git another one."

The white man put his hands through and jerked it out quickly and said: "I'll be damn if it ain't cut off."

John said, "Mine is, too, Massa."

The white man said, "Well, why the hell didn't you tell me?"

John said, "I wanted you to git just whut I got, so I didn't tell you nuthin."

—DELLA LEWIS.

JOHN AND DE HORSE[†]

Ole John, he wuz working fur Marster. You see, Master had uh horse an' had gi' John uh horse. John uster always hit Master's horse, but never hit his own horse. So then some white folks tole Master about John hitting his horse an' never hitting his own horse. So Master tole John if he ever hear tell of him hitting his horse, he wuz gwinter kill his (John's) horse. John tole 'im, "If you kill my horse, I'll beatcher makin' money."

One day ole John hit Marster's horse again. Dey went and tole Master about it. Marster come down dere wid a great big ole knife and cut John's horse's throat. John jumped down off de wagon and skint his horse and put de hide upon a stick and throwed it cross his shoulder.

John went downtown calling it a fortune teller. (He was a fortune teller hisself.) A man tole him, "Say, make it talk some,

John, an' I'll give you a sack of money and a horse and a saddle, and five head of cattle."

And John pulled out de stick and hit cross de horse hide and hold his head down dere. "Dere's a man in your bedroom behind de bed talking to your wife."

He went inside to see and come back out and said: "Yeah, John, you sho telling de truth. Well, make 'im talk some more."

"No, Master, he's tired now."

Then he said, "I will give you six head of sheep and four horses and four sacks of money."

He pulled out de stick an' hit down on it and held down his head to listen, and it said, "It's a man in de kitchen opening de stove." (De man went out tuh look.)

John went on by his Master's house driving his horse and sheeps an' hollering, "Yee! whoo pee! Crack! (Whip)

Master said, "John, where did you git all dat?"

John said, "I tole you if you kilt my horse, I'd beatcher makin' money."

Said tuh 'im, "Reckin if Ah killed my horse, I'd make dat much?"

"Yes, Master, I reckon so."

So Master went out and cut his horse's throat and took it to town. "Horse hide for sale! Horse hide for sale!"

One man said, "I'll give you twenty-five cents to put some bottom in some chairs."

Master said, "Youse crazy," an' went on.

Another man said, "I'll give you twenty cents to put bottoms in some chairs."

Master said, "You must be crazy, this hide is worth five thousand dollars." De people just laughed and he couldn't sell de horse hide.

So John, he's already rich, he didn't have to work, an' he went to driving horse and buggy for Master, and John let his grandma ride in dat buggy, and his Master said: "De nex' time I ketch your grandma in dat buggy, I'm goin' kill her."

John tole him, "If you kill my grandma, I'll beatcher making money."

Some white folks tole Master John wuz taking his grandma to town and hitting his horse, an' showing out wid 'im, so Master come out dere an' cut John's grandma's throat.

So John went and got his same ole horse hide and keered it uptown again. So John went uptown talking about, "Fortune teller! Fortune teller!"

One man tole 'im, "Why make 'im talk some, I'll give you six head of goats, six sheeps, an' a horse an' saddle to drive 'im wid."

John went on back by his master's house on his horse driving his sheeps and cattle. He jes' went by so Master could see 'im. So his Master said to 'im, "Oh, John, where did you git all dat?"

He said, "I tole you if you kill my grandma, I'd beatcher makin' money."

Master said, "You reckon if I kill mine, I'll make all dat?"

"Yes, Master, I reckon so."

So Master runned out dere and cut his grandma's throat and went uptown hollering, "Grandma for sale!"

Wouldn't nobody say nothin' to 'im. Dey thought he wuz crazy. He couldn't git nuthin' fur his grandma, so he tole John, "You made me kill my grandma, now I'm gwinter throw you in de river."

He got ole John in de sack and carried him down to de river, but he forgot his weights and while he wuz goin' after his weights uh toad frog come by dere and John tole 'im, "If you open dis sack and let me out, I'll give you uh dollar."

Toad frog let 'im out, so he got uh soft shell turtle and put it in de sack and two big ole bricks. So Master got his weights an' come back an' put 'em on de sack and throwed it in de river.

So ole John went back and got his ole horse hide and went back again calling it, "Fortune teller! Fortune teller!

One rich man said, "Make it talk some, John."

So John pulled out de stick and hit it an' said, "Uh man's in your kitchen in your meat safe."

De man went in de house and come back and said, "You sho kin tell de truth, make 'im talk some more, John."

"No, Master, he's tired now, I got tuh cair 'im home."

So John went back by his Master's house wid his horse an' uh sack uh money tied on de side of his horse. So ole Master said, "Oh John, where'd you git all dat?"

Say, "I tole you if you throw me in de river, I'd beatcher makin' money."

So he said to 'im, "Reckon if I let you throw me in dere, I'll make dat much money?"

John say, "Yes, Master, I know so."

John got Master in de sack an' carried 'im down to de river. John didn't ferget his weights. Put de weights on Ole Master, and just befo' he thowed 'im out, he said: "Good-bye, Master."

And dat wuz de last of Ole Master, cause he wuz crazy enough tuh let John throw 'im in de river.

—JULIUS HENRY (variant of a tale from
 Hans Andersen).

Master had got kinder good tuh Jack, an' let ole Jack stay in de house; an' he decided he'd go tuh town dat night—an' left Jack dere wid his wife.

While he wuz gone, Jack got in de bed wid his wife. Master forgot his pocketbook an' decided he wouldn't go dat night—he'd wait till tomorrow morning. So he turnt roun' an' came back an' hitched de horse an' knocked on de do', an' Jack says: "Who dat?"

"It's Marster."

Old Jack jumped up out de bed an' says: "Master, kin I have one of dem sweet potatoes?" He says, "Yes, an' one of dem but-

tered biscuits?" "Yes." He walked past an' said to Master's wife: "Wuzn't dat uh sharp turn?"

Master said to 'im: "Whut kinder sharp turn is dat yo' talkin' about?"

Jack says, "Nuthin, Master, just dropped mah biscuit and de butter side turned up."

—JULIUS HENRY.

Massa and White Folks Tales

SAMBO

One time Master had a nigger named Sambo. He had been working Sambo pretty hard. Sambo played sick for seven years and every time dey carried Sambo something tuh eat, he'd tell 'im, "Put de pan uh peas up, an' hand me down mah banjo. I done fooled Master seven years and specks tuh fool 'im seven mo'."

Sambo would have 'im up dere doin' de buzzard lope* and dancing, and den he'd have dem tuh pick de banjo and let 'im do de buzzard lope.

De people got tired uh totin' Sambo grub and tole Master 'bout it. Tole Master, Sambo wuzn't sick. Master didn't b'lieve it. He jes knowed Sambo wuz sick, and they tole him Sambo wuzn't sick cause he had dem up dere dancin' every day and picking de banjo, and tole 'im, say, "Ef, you don't b'lieve it, you go up dere tomorrow when we go tuh cair Sambo's dinner, and stand on de outside and listen."

So Massa went up dere and evedropped Sambo and heard him in dere dancing. So Massa walked in and Sambo stopped

*A plantation slave-dance imitating a buzzard in flight.

dancing and said, "Is dat you, Massa? I'm gwinter ketch de mule now."

—CHRISTOPHER JENKINS.

Another nigger and his sone stole some meat from de white folks. So they caught 'em. Ole Massa says, "I'm going to whip you niggers till you own up."

De ole nigger says to his boy, "Take two hundred and keep you mouf." They lit in on de boy and they lashed him. His daddy kept on hollern, "Stand up to him and don't talk." So de boy took two hundred lashes and never cheeped.

Then they grabbed de ole man and tied him down and begin to lay it on him. When they hit him five licks he says, "Untie me, white folks, and I'm gwine git your meat for you."

—BABY-FACE TURL.

Once in slavery time Ole Massa had his niggers out workin'. Man, he uster work his niggers, too. So one day when he wuz out in de fiel' uh big rain come up. They all run into de barn, Ole Massa wid 'em.

Massa says, "I hates dat rain come up. I wants tuh git uh heap uh work did tuhday."

Ole John over in de corner say, "Mo' rain, mo' rest."

Ole Massa say, "Whut you say, John?"

John say, "Mo' rain, mo' grass."

—EUGENE OLIVER.

Dis nigger wuz workin' for a white man down in de new ground cuttin' up logs for wood. He set down all day long till he hear de boss man coming, den he hit on de log wid de heel of de axe. "Clunk, clunk, clunk, clunk—think I'm working, but I ain't."

De white man seen 'im, but he didn't say nothing. Sat'day night Sam come up to git his wages. White man took out a handful of silver dollars and shook them in de nigger's face and says, "Unh hunh—clank, clank, clank—think I'm goin' pay you, but I ain't."

—JERRY BENNETT.

OLE MASSA'S GUN

Once in slavery, Ole Massa had uh nigger he uster pet. He tole 'im once tuh go out and get 'im a deer. Some more niggers went long wid him, but Ole Massa let his favorite take his best gun.

When dey got out in de woods, dey sprung uh deer. De man dat had Massa's new gun waited down de hill, and another went up de hill and headed de deer down. He hollered tuh de one wid de new gun, "Here he come, shoot 'im!"

De nigger didn't pay no 'tention tuh him. He hollered again, "Sam, he's coming down, shoot 'im!"

Still he didn't make uh move. De deer run on past 'im and got clean away. De other nigger come running down de hill and ast, "Say Sam, why didn't you kill dat deer?"

Sam say, "Nigger, is you crazy, think I'm gointer sprain Massa's gun shooting up hill wid it?"

—WILLIE ROBERTS.

Ole Massa took uh nigger deer-huntin' an' posted him in uh place an' tole 'im, he says, "Now, you wait right here an' keep yo' gun ready. Ah'm goin' roun' de hill an' skeer up de deer an' head 'im dis way. When he come past, you shoot 'im."

De nigger said, "Yessir, Ah sho will, Massa." He sot dere an' waited wid de gun all cocked an' after while de deer come on

past. Pretty soon de white man come on round de hill an' ast 'im did he kill de deer. De nigger says, "Ah ain't seed no deer pass here yit."

"Yes, you did, too, cause he come right disa way. You couldn't he'p but see 'im."

"Well Ah sho ain't seed none. All Ah seed wuz uh white man come long by here wid uh pack uh cheers on his head an' Ah tipped mah hat tuh 'im."

—LARKINS WHITE.

Once there wuz an old colored man and he walk long one day and he found a gold watch and chain. He didn't know whut it wuz, so the first thing he met wuz a white man and he ast de man whut wuz it. White man told him, "Lemme see it."

He give it to him and de white man put it in his own pocket and told him next time he found one like dat it wuz a gold watch, and the next thing he find kicking in the road put it in his pocket and sell it.

So he walked on down de road a piece further and walked upon a tarrypin kicking in de road. So he picked him up and tied a string on to him and put him in his pocket and let de string hang out.

So he met another colored fellow and fellow ast him, he says: "Cap, whut time you got?"

He pulled him out and told him, "Quarter to leben and kicking lak hell for twelve."

—WILL THOMAS.

Once uh white man took his nigger wid him tuh see his girl. He lef' de nigger outside in de buggy an' he went inside an' called on his girl. When he got ready tuh leave he ast fuh his hat, an' when he got tuh de door, he ast her fuh

uh kiss. She acted lak girls do an' tole 'im: "Ah can't do so now; but maybe when you come agin Ah'll be able tuh gratify yo' wishes."

He said good-bye tuh her an' got in de buggy an' de nigger drove 'im on home; but he had done noticed whut de white man done. De nigger gal dat dressed de white girl, she wuz listenin', too, an' she heered all her mistis had done tole her feller; so when dis coachman come tuh see her an' he set uh while, an' when he got his hat tuh go, he ast her fuh uh kiss. She tole 'im: "Ah can't do so now, but nex' time you comes Ah hopes tuh be able tuh grabble in yo' britches."

—LARKINS WHITE.

DE WHITE MAN'S PRAYER[†]

Well, it come uh famine an' all de crops wuz dried up an' Brother John had prayed last year for rain an' it rained; so they all 'sembled at de church an' called on John tuh pray, an' he got down an' prayed:

"Lord, first thing, I want you tuh understand that dis ain't no nigger talking tuh you. This is uh white man talking tuh you now an' I want you tuh *hear* me. I don't worry an' bother you all de time like dese niggers, an' when I do ast uh favor I want it *granted*. Now, Lord, I want some rain. Our crops is all burnin' up, an' I want you tuh send rain. I don't mean fuh you to come in uh hell of uh storm lak you done las' year. You kicked up as much racket as niggers at uh barbecue. I mean fuh you tuh come quiet an' easy. Now, another blessing I want tuh ast of you, Lord. Don't let dese niggers be as sassy as they have in the past. Keep 'em in their places, Lord. Amen."

—JAMES PRESLEY.

You know, niggers is so skeered uh white folks dat one time two men wuz roofin' uh house an' one of 'em slipped an' fell off de house. When he wuz half-way tuh de groun' he give up tuh die; but he seen he wuz 'bout tuh fall on uh white woman—so he turnt right roun' and fell back upon dat house.

—LARKINS WHITE.

'Twuz uh white lady walkin' cross de street. Uh colored man stood looking after her as she passed by. She looked nice tuh him, so he said: "Long dere's life dere's hopes."

He didn't see a white man standing right behind him. So de white man said, "Yes, an' long as dere's a limb, dere's ropes."

—RAYMOND MCGILL.

In Mississippi a black horse run away with a white lady. When they caught the horse they lynched him, and they hung the harness and burnt the buggy.

—ARTHUR HOPKINS.

A HUNTER

Uh man wuz hunting before hunting season. De game warden slipped upon 'im and said: "I hafter arrest you fer killing game dat you oughten tuh. No need looking so wild and so fear, I have a thirty-two hanging right here."

Dis is whut de nigger told him: "Mister Game Warden, would you 'rest me fur dat?"

"I'll hafter 'rest you. I know jest where you wuz at. I could have 'rest you when you wuz comin' through towm, but I knowed damn well I'd have tuh run you down."

He taken him up to de courthouse and de gam warden said: "I have uh man fur killin' uh squirrel."

Judge: "Yes, we're not going to give him a whirl."
Game Warden: "We have uh man for killing a deer."
Judge: "We'll just have to give him one year."
Game Warden: "We have uh man fur killin' a quail."
Judge: "Dat's white folks' meat. We'll put him under de jail."
—FLOYD THOMAS.

Durin' slavery time they didn't 'low niggers tuh eat biscuit bread; but Ole Miss had uh cook dat uster steal biscuits an' eat 'em. Ole Miss had uh parrot dat roosted out in de kitchen an' tole her all dat went on.

One day, jus' as she taken some biscuits out de pan, she heard Ole Miss comin' so she hid de biscuits under de cushion in de cheer an' made out lak she wuz busy doin' somethin' else. De parrot saw her, but she wuzn't payin' him no mind. Ole Miss started tuh set down in de cheer an' de parrot hollered: "Hot biscuits, Ole Miss! Burn yo' behind*!" He kept dat up till she looked under de cushion an' foun' de bread. Then she had forty lashes put on dat cook's back.

Dat made de cook mad wid dat ole parrot, so one day when Ole Miss wuz gone away, she turned her clothes up over her head an' backed up tuh de parrot an' it skeered 'im so bad till he dropped dead. Ever since den, if uh parrot sees uh naked behind he'll drop dead.

—BERTHA ALLEN.

BIG TALK[†]

During slavery time two ole niggers wuz talkin' an' one said tuh de other one: "Ole Massa made me so mad yistiddy till I give 'im uh good cussin' out. Man, I called 'im *everything* wid uh handle on it."

*Originally typed "buttocks" but changed in the manuscript.

De other one says, "You didn't cuss *Ole Massa,* didja? Good God! Whut did he do tuh yuh?"

"He didn't do *nothin'*, an' man, I laid one cussin' on 'im! I'm uh man lak dis, I won't stan' no hunchin! I betcha he won't bother *me* no mo'."

"Well, if you cussed 'im an' he didn't do nothin' tuh you, de nex' time he make me mad I'm goin' tuh lay uh hearin' on him."

Nex' day de nigger did somethin', Ole Massa got in behind 'im an' he turnt round an' give Ole Massa one good cussin'. An' Ole Massa had 'im took down an' whupped nearly tuh death. Nex' time he saw dat other nigger he says tuh 'im: "Thought you tole me you cussed Ole Massa out an' he never opened his mouf!"

"I did."

"Well, how come he never did nothin' tuh yuh? I did it an' he come nigh killin' uh *me*."

"Man, you didn't go cuss 'im tuh his face, didja?"

"Sho I did. Ain't dat whut you tole me you done?"

"Naw, I didn't say I cussed 'im tuh his face. You sho is crazy. Man, I thought you had mo' sense than dat. When I cussed Ole Massa he wuz settin' on de front porch an' I wuz down at de big gate."

De other nigger wuz mad, but he didn't let on. Way after-while he 'proached de nigger dat got 'im de beatin' an' tole 'im: "Know whut I done tuhday?"

"Naw, whut you done—give Ole Massa 'nother cussin'?"

"Naw, I ain't never goin' do dat no mo'. I peeped up under Ole Misses drawers."

"Man, hush yo' mouf! You knows you ain't looked up under Ole Misses clothes!"

"Yes I did, too. I looked right up intuh her very drawers!"

"You better hush dat talk! Somebody goin' hear you an' Ole Massa'll have you kilt."

"Well, I sho done it an' she never done nothin' neither."

"Well, whut did she say?"

"Not uh mumblin' word; an' I stopped an' looked jus' as long as I wanted tuh an' went on 'bout my business."

"Well, de nex' time I see her settin' out on de porch I'm goin' tuh look, too."

"Help yo'self."

Dat very day Ole Miss wuz settin' out on de proch in de cool uh de evenin' all dressed up in her starchy white clothes. She had her legs all crossed up an' de nigger walked up tuh de edge uh de porch an' peeped up under Ole Misses clothes. She took an hollered an' Ole Massa come out an' had dat nigger almost kilt alive.

When he wuz able tuh be about agin he said tuh de other nigger: "Thought you tole me you peeped up under Ole Misses drawers?"

"I sho did."

"Well, how come she never done nothin' tuh *you*? She got me nearly kilt."

"Man, when I looked up under Ole Misses drawers they wuz hangin' out on de clothes line. You didn't go look up in 'em while she had 'em on, didja? You sho is uh fool! I thought you had mo' sense than dat, I 'clare I did. It's uh wonder he didn't kill you dead. Umph, umph, umph! You sho ain't got no sense atall."

—CLIFFORD ULMER.*

MOUFY EMMA†

During slavery there was a girl who tattled to the white folks. If the Negroes said just the smallest thing, she would run and blab it, so they named her Moufy Emma.

When she was sent to the well for water, she would stand

*In 1935, on a folklore expedition with Alan Lomax and Mary Barnicle, Hurston recorded John Davis's rendition of this tale.

around to hear what the other slaves had to say so she could tell it when she went back to the big house. But one thing—she was crazy about pomegranites.

She had got some slaves whipped to death and some others beat up pretty bad; so they decided to get rid of her before she killed any more—so they poisoned a pomegranite and laid it on the well.

As soon as she came to the well and saw the pomegranite, she took it and ate it. By the time that she got back to the house she tried to tell Ole Miss that some of the Negroes had been picking her pomegranites, her lips began to turn wrong side out and she died.

The next day, when they took her to the place where slaves were buried, they began to sing a little song:

"Same way you done Brother Jefiries
Same way come back to you.
 Mouf is de cause of it all.

There's Brother Johnson laying over yonder
Same way come back to you.

There's Sister Clue, too, laying over yonder
Same way come back to you.
Oh, mouf is de cause of it all."

They sang about all the graves of the people Moufy Emma had got killed, then they buried her still singing; and when they threw the last lump of dirt on her they said: "Mouf is de cause of it all."

—Louise Noble.

Once in slavery time Ole Master had a slave named John. One day John stole one uh Ole Master's sheep and took 'im home. Befo' he could git it on de fire he seen Ole Master coming. So he took it an' hid it in de baby cradle, an' when Ole Master got dere he wuz sitting down rocking de sheep, making out it wuz uh baby.

Ole Master come on in de house. He seen John when he tool dat sheep but he didn't let on. John wuz juster rockin' away. Ole Master ast him, "John, whut you got in dat cradle?"

John kept on rocking away and tole him, "It's us baby, Massa, it's uh new baby we got."

"Lemme see 'im, John."

"Naw, Massa, I can't let you see 'im. De doctor say not tuh take de cover offen him till he say so."

"You better let me see 'im, John. I might kin cure 'im."

"Naw, you can't, Master. De doctor says not."

"Well, John, I don't care whut de doctor says, I'm gwinter see dat baby uh yours."

John got up ready tuh run, an' he says to Massa: "Well, Massa, I put dat in dere uh baby. I don't give a damn whut it done turnt to."

—JAMES MOSELEY.

Tall Tales

THE UGLIEST MAN†

 I seen a man so ugly he kin go behind a jimson weed
and hatch monkeys.
—ARTHUR HOPKINS.

 I seen a man so ugly he had to take a hammer to bed to
break day.
—JOE WILEY.

 I seen a man so ugly he could git behind a tombstone
and hatch hants (ghosts).
—F. BRADLEY.

 I seen a man so ugly they threw him in Dog River and
they could skim ugly for six months.
—ARTHUR HOPKINS.

 I saw a man so ugly he didn't die—he uglied away.

—GEORGE HARRIS.

 I saw a man so ugly till at night when he get ready to go to bed he have to take a gatling gun with him to keep ugly from sittin' on him and killin' him.

—ARTHUR HOPKINS.

 Hey, fellow, I am going to tell you the truth. I saw a man so ugly until he could turn sweet milk into cherry wine.

 There wuz uh man so ugly dat he could crack all de lookin' glasses in uh town as soon as he got off de train.

—CLIFFERT ULMER.

THE MEANEST MAN†

 A man was so mean he greased another man and swallowed him whole.

—GEORGE HARRIS.

 I seen a man so bad till he had to tote a pistol to the pump with him to keep from getting in a fight with himself.

—EDWARD MORRIS.

 I seen a man so bad till every time he set down he print "dangerous" in red on the chair.
—Lorenzo Morris.

I know a man was so hungry that he never ate no food, because it never would fill him up. He had to eat iron and bricks for his dinner, you know he was hungry.
—Arthur Hopkins.

No, man, that man wasn't hungry. I know a man was so hungry that he salted and peppered himself and swallowed himself and left nothing but his shadow.
—Edward Morris.

I saw a man shoot another with a gun and the bullet worked de man twice before he died and three times after. If you hold it high, it sweep the sky; if you hold it level, it will kill the devil.
—Arthur Hopkins.

Once I wuz an engineer on a train and I had a friend and his nose wuz so big I thought it was a tunnel, and I ran up his nose and ran into another train, and it was switching box cars in his nose.
—F. Bradley.

 I knowed a man so smart he had the seven year itch and scratched it out in three months.

 Whut's de fastest man you ever seed run? I seen uh man running so fast (away from de white folks) he turnt roun' and got in his own hip pocket, running so fast.
—MAE OLIVER.

 I've seen a man run so fast till de sheriff had to wire ahead tuh de people tuh hold 'im till his shadder got dere.
—F. BRADLEY.

 Once there was a man so lazy until he would pray to God if there was any work around his heart, please cast it into the river of forgetfulness where it would never rise to condemn him.
—ARTHUR HOPKINS.

THE TALLEST MAN†

 Whut is de tallest man you ever seen? De tallest man I ever seen could stand knee deep in hell an' shake hands wid Gabriel.
—EUGENE OLIVER.

 Whut's de biggest man you ever seen? Dat drives over me. I know a man so big dat when he went to whip his boy, de boy runned under his stomach and stayed hid under dere six months.
—MAE OLIVER.

THE SHORTEST MAN[†]

I seen a man so low he had to git on a ladder tuh pick sweet potatoes, an' den he tuh reach up an' pull 'im wid a hoe.
—JULIUS HENRY.

Whut is de shortest man you ever seen? I seen uh man so short he had tuh get upon uh box tuh look over uh grain uh sand.
—ARTHUR HOPKINS.

THE STINGIEST MAN[†]

There was a man so stingy he used to climb upon top of the house and chunk the wood down the stove pipe to keep from wearing out his stove door.
—WILL HOUSE.

I know a man who wouldn't walk on moonshine nights to keep from wearing out his shadow.

I seen uh man so stingy dat he wouldn't eat uh ham sandwich out in de sunlight—skeered his shadow might ast him fur some.
—WILLIE CLARKE.

I seen a man so stingy when he killed uh hawg, he throwed uh sack over his head to keep him from squealing. Said he wuz losing pork.

Whut's the stingiest man you ever seen? I seen a man so stingy he wouldn't give God uh honest prayer without snatching back amen.
—EUGENE OLIVER.

I knowed a man and he was foreman and he was so stingy that when three of his men on the job got blowed up, he docked 'em for the time they was up in the air.
—JOE WILEY.

THE BLACKEST MAN†

I seen a man so black till lightning bugs followed him at twelve o'clock in the day—thinking it's night.
—DAVID LEVRITT.

I seen a man so black till he could spit ink.

—LORENZO MORRIS.

I seen a man so black till he could go naked and every-body would think he was dressed in deep mourning.
—DAVID LEVRITT.

Ah seen a woman so black dat her husband had to spread a white sheet over her at night so sleep could slip upon her.
—FLOYD THOMAS.

A man had a wife and she was so small that she got in a storm and never got wet because she stepped between the drops.

—FLOYD THOMAS.

My old man had a cow. She give so much milk they had to build a platform under de calf to keep him from drowning.

—J. WILLIAMS.

I seen a cow so swaybacked that she could use de bushy part of her tail for a umbrella over her head.

—FRED COOPER.

THE FASTEST HORSE[†]

My father owned uh fast horse—I mean uh fast horse. We lived in Ocala. Mah mother took sick an' my father come an' said: "Skeet, you oughter wired yo' sister in St. Petersburg."

I tole 'im I just wired her an' he ast me whut I put in it, an' I tole 'im. He says: "Dat ain't right. I'm going ketch it."

He went out in de pasture an' caught de horse, shod 'im, curried 'im and breshed 'im and put de saddle on 'im, an' got on 'im an' caught de telegram, read it and took it tuh mah sister.

Mother said: "You chillun make uh fire in de stove an' fix somethin' for de ole man tuh eat." Befo' she could git de word out her mouf, him an' mah sister rid up tuh de do' an' said "whoa!"

That time uh flea ast me fur uh shoeshine—so I left.

—"NIGGER" HENRY BIRD.

My dad had a mare wid a lil colt and one day it come up a rain wid thunder and lightning and de lightning struck de mare and kilt her and run dat colt four days and nights and couldn't ketch him.
—JERRY BENNETT.

Dat same colt when he got bigger, my ole man hitched him to de plow to plow up some new ground, and he was so fast till he turned ten acres outside de fence.
—JERRY BENNETT.

THE POOREST HORSE†

Whut's de poorest horse you ever seen? I seen one so poor dat he had to stand in one place twice to make a shadder.

Oh, dat wuz a fat horse. I seen one so poor until de man drove him up in town in front o' de post office, an' got 'im uh letter and went round one side of de horse to read it in secret, looked roun'—twuz uh man on de other side de horse readin' de letter fast as he wuz.
—JULIUS HENRY.

I seen a horse so poor the man had to squat down to see if he wuz moving.
—JOE WILEY.

I seen a horse so poor you could wash clothes on his ribs and hang 'em up on his hips to dry.
—F. BRADLEY.

 I seen a mule so poor they had to feed him on muddy water to keep from seeing through him.
—RUSSELL SINGER.

 I saw a horse so poor they had to tie a knot in his tail to keep him from slipping through his collar.
—CLIFTON GREEN.

 Wonce (once) there was a hen. She cakel (cackled) so much that she give the rooster the blues.
—WILL HOWARD.

Whut is the biggest chickens you ever saw? My father had some chickens so big you couldn't feed 'em on earth. You had tuh shoot their food up to 'em wid uh britchloader (breechloading gun).
—JAMES PRESLEY.

"What's the best trained mule you ever seen?"
"I seen one so sensible he would carry letters, you didn't have to tell him where—he'd read de address and deliver it to de right place.

"I seen a mule could sit down and write letters to another mule and ast him how much corn he got."

"My paw had a mule working upon a fifty-story building and mule hauled off and fell off and got nearly to de ground. I said 'whoa' and he stopped right dere in de air and stood right there till somebody come rescued him."
—N. A. JAMES.

THE BIGGEST PUMPKIN†

Dis pumpkin wuz raised off of mosquito dust. My father went out in de woods tuh cut some timber, him and two three mo', an' uh rain come up. So dey went up under uh oak tree tuh keep out de rain.

It wuz uh great big ole tree. So big dat it took five or six men tuh reach round it. Well, my father wuz leaning up sidder de tree and uh big ole mosquito come upon de other side uv dat tree an' bored right through dat tree intuh my father's back an' got blood.

Dat made my father mad, so he bradded dat mosquito's bill right tuh de tree. By dat time, it had done stopped raining, so dey all went home.

De next day dey went tuh de woods and dat mosquito had clean up ten acres, dying. Dey went on home again, and about uh week after dat, my father went tuh de tree again an' he got enuff bones frum dat skeeter tuh fence in dat ten acres. An' dere wuz enuff dust frum dat skeeter tuh furtelize it.

So my father planted pumpkins de first year. He raised one pumpkin so big till he never could tell how high it wuz, an' we never did find how big around it wuz; even though we sent telegrams all round de world, nobody never did see de edge of dat pumpkin.

'Bout dat time my father lost uh fine brood sow wid leben pigs, an' we searched all over Florida and Georgie, and Alabama, an' everywhere, but we never could find her, till one day my father tole us boys tuh hitch up de double wagons and go haul one uv dem seeds to plant de nex' year.

When we dropped dat seed offen de wagon it bust and dere wuz dat sow an' two mo' broods, and everyone uh her pigs had pigs in dere.

—JULIUS HENRY.

My daddy raised a punkin so big we wuz six years building a shed over it. One day I dropped my hammer down in it and went down to look and I looked for two days. Then I went to a man and he ask me whut I wuz doing in dere and I tole him, and he said I might as well go back because he had been hunting for a mule and wagon for four days in dere and hadn't got no trace of 'em yet.

—N. A. JAMES.

My grandfather said that when he was a farmer he raised sugar cane so large that he would have to get an axe to cut it down; and that his watermelons would be so large until he would have to get a saw to saw the rind in two; and a pumpkin so large that Uncle Sam bought it to have the United States training camp in.

—JERRY BENNETT.

My father wuz a farmer and de most he raised wuz watermelons. He raised one so large he had to build a railroad down through de patch to load it on flatcars. When they got it loaded they sent it to Mississippi where it wuz awful dry. In unloading de melon out there it burst and the juice out of it caused the river to flood and drown all 'em people you read about.

—WILL HOUSE.

Whut's de biggest apple you ever seen? My pa raised a apple so big till they was shipping it out west and it fell in de Mississippi River, and it run cider for six months.

—JERRY BENNETT.

THE BIGGEST CABBAGE[†]

Whut is de biggest cabbage you ever saw? Ah seed one so big that it took de southern train twelve years tuh run round it. My papa growed dat cabbage.

Yes, an' my daddy built uh pot tuh hold dat lyin' cabbage yo' paw raised.

—NORA LEE AND LARKINS WHITE.

My daddy raised uh sweet potato so big they had to make a sawmill job out of it, an' all de houses was made outa tater slabs an' whut you reckon they did wid all dat sawdust? Made tater puddin'.

—JAMES PRESLEY.

THE BIGGEST TREE[†]

Dis William M. Richardson spreading his mess.

Whut's de biggest tree you've ever seen? Tell you 'bout one I saw. My ole man went out to clear some ground, and they wuz a tree out dere so big dat him and fo' mo' men wuz cutting on it uh week and hadn't got thew de bark; so he stopped chopping to rest a spell, and he went round to de other side and found ten men round dere been choppin' fuh six months and wuzn't half thew yet.

My other brother wuz a carpenter, and one day he went out in de woods and chopped down uh tree an' sawed it intuh timber and hauled it and built uh hundred story building, an' de man had done furnished it, and wuz suing some uh de people for back rent befo' de tree hit de ground.

—SODDY SEWELL.

In the year eighteen hundred my great-grandpa bought some land. And the land had a big tree on it. And my great-grandpa paid two men to saw the tree down. Before he died he gave it to my grandpa and the men was still a-sawing on the tree. Before grandpa died he give the land to my pa and the men was still a-sawing on the tree, and I got a letter today saying that the tree just fell.

—CLIFFERT ULMER.

RICH GROUND†

I have ground so rich until one day my father's mule died and he buried him out in the field. The next morning, guess what happened? The mule had sprouted little jackasses.

—JOE WILEY.

We wuz plantin' us crops very late dis year. Everybody had they stuff, but we wuz planting a mighty rich piece of ground. So he wuz a-dropping de corn and I wuz coming behind covering it, and by time we made one round a stalk de corn wuz coming up. I put my brother on it to hold it down. So de next day he drops me back a note, says: "Don't worry 'bout me cause I passed through heben yesterday at twelve o'clock selling roasting ears."

—LONNIE BARNES.

I seen ground so rich till dey plant corn on it and in a week's time, it done come up and have roasten ears on it. Roasten ears step down off de stalk and go tuh de mule lot and ketch de mules and hitch 'im up tuh de plow and lay by their ownself.

—CHRISTOPHER JENKINS.

This is T. Williams strowin' it.

Another time my ole man walked cross his farm wid uh cucumber seed in his pocket, and de land wuz so rich dat de air blowing over it sprouted dat seed in his pocket, and befo' he could git back in de house he had ripe cucumbers hangin' off 'im.

This is T. Williams strowin' it.

My father had a farm an' uh man give 'im uh grain uh corn tuh plant an' he took it an' planted it at de end of uh row, den he stuck uh stick dere fuh uh marker. Dat land wuz so rich dat nex' mornin' when he went out tuh look over de place, it wuz uh stalk uh corn wid ten ears on it an' three ears had done growed on de stick.

—T. WILLIAMS.

My daddy had some land an' it wuz so rich that one time he planted watermelons an' de vines growed so fast till they drug out de little melons.

—FLOYD THOMAS.

Down on Mississippi River I and my wife going fishing and it's a awful rich place on de river side. While fishing on one side, looking crost at de other, seen some good places to fish. But being there no way to get across, jes' thought of a seed I had in my pocket; so I dropped it into the rich soil and, going back after muh hooks jes' a few steps up de river, left my wife standing there where I dropped the seeds. When I got back to her, the seeds had come up and grown clear crost de Mississippi River and she had walked across de vine. When I got over dere on it too, she wuz over dere in de punkin on de vine; inside, lying down looking up de neck thinking about a sweet punkin tree.

—LONNIE BARNES.

THE POOREST GROUND

Ole Mitchell Field was de poorest land I ever seed. Dey bought uh lot on it tuh build a church. Built uh church, select de pastor, an' deacons, de members all together had to phone back to Jacksonville for ten sacks Commercinal to fertilize de ground befo' de could raise a hymn on it.—That's all.
—R. T. WILLIAMS.

I know an old colored man that had a plantation so poor it taken nine partridges to holler "bob white".
—JOE WILEY.

I seen a land so poor till dey had tuh put soda on people breast when dey bury dem so dey could rise in judgment.
—FLOYD THOMAS.

I saw a country so hilly till the squirrel had to put on britches to keep from breaking they neck.
—ARTHUR HOPKINS.

I saw a country so hilly till they had to shoot the corn into the hillside with a britch loader.
—ARTHUR HOPKINS.

HARD GROUND[†]

My daddy had a field where de ground wuz so hard dat one day he planted some peas, and a week later he went dere tuh see if de peas wuz growin', but he didn't see no peas; he went de next week, still no peas; and still no peas de third week; so de fourth week he went again and still he see no peas. But while he wuz standing looking around he heard something making a noise and he looked down, and it wuz de peas grunting, trying to git out of de hard ground.

—FLOYD THOMAS.

HARD WIND[†]

Seen de wind blow so hard whilst travelin along it blowed de crooked road straight and blowed a wash-pot wrong side outwards.

—WILL HOUSE.

One day de wind blowed so hard, till it blowed de sun four hours late.

—N. A. JAMES.

Another time it blowed so hard till it blowed South up North and had de North way down in Dixie.

—N. A. JAMES.

Another time it blowed so hard till a man had de catarrh and hadn't blowed his nose in fifteen years and it blowed his nose.

—N. A. JAMES.

What is the hardest wind you ever seen? I seen wind so hard till it blowed a man's nose off his face and onto the back of his neck and every time he sneeze, blow his hat off.
—N. A. James.

One day on de West Coast sich uh hard wind come up dat it blowed uh wash-pot wrong side out, an' scattered de days uh de week so bad till Sunday didn't come till late Tuesday evening.
—Charlie Jones.

I seen it rain so hard a barrel settin' in de yard wid no head in it swell up and burst.
—Lonnie Barnes.

I seen it rain so hard till a buzzard wuz up in de air flying and his shadder wuz on de ground barking.
—Catherine Hardy.

I seen it so dry the fish came swimming up the road in dust.
—Lonnie Barnes.

DE DARKEST NIGHT†

My daddy had a forty-five high-powered rifle. I heard a rumblin' in de woodpile. Stepped tuh de do', shot out. I heard somethin' zooning aroun' de house all night. Got up real soon de nex' mornin' tuh see whut it wuz. Jes as day began tuh break, I seen whut it wuz. It wuz de bullet goin' roun' de house waitin' fur day tuh see which way tuh go.
—R. T. Williams.

THE HOTTEST DAY†

 I seen it so hot dat de li'dwood knots wuz crawling off in de shade.

I seen it so hot till you had to feed the hens cracked ice to keep them from laying hard-boiled eggs.
—RICHARD EDWARDS.

Whut's de hottest day you ever seen? I seen uh day so hot dat when de train from Miami pulled intuh Tampa, two blue serge suits got off de train. De men whut wuz in 'em had done melted an' run out.
—W. M. RICHARDSON.

It wuz so hot once uh cake of ice walked away from de ice house and went down de street and fainted.
—RAYMOND McGILL.

THE COLDEST DAY†

 I seen it so cold till de fire wuz goin' somewhere to git warm.

 I seen it so cold till dey had to build a fire under de cow to warm de tits.

The coldest I ever seen it, while being the age of twenty-four I saw de moon toting a light for de sun to keep it warm and show it de way to go home.

—WILL HOUSE.

Hey, boy, how cold have you know it to get?

Big boy*, I have known it to get so cold that you would have to carry a bucket along so when some one talked to you, you would have to put the words in the bucket and carry them home and put the bucket on the stove and let the words melt.

That wasn't cold at all. I have known it to be so cold that the fire in hell would freeze and the sun froze so hard that the ice just melted today.

—EDWARD MORRIS.

Once it wuz so cold dat when people talked, de conversation froze up. My brother wuz down to de jook and dey wuz all skinnin' an cussin', an' damnin', but de words all froze up and fell tuh de floor lak hail.

My brother got 'im uh crocus sack and gathered up all dem frozen words and took 'em home and poured 'em out in front of de fire, an' when they commenced tuh thaw out, his wife up and left 'im.

—ROBERT WILLIAMS.

*In her "Glossary of Harlem Slang," Hurston defines "Big boy" as "stout fellow. But in the South, it means fool and is a prime insult."

What is the biggest gate that you have seen? I have seen a gate so big that it took a train six days to pass, and the train was running a hundred sixty miles an hour.
—JOE WILEY.

THE BLACKSMITH

My brother wuz uh blacksmith. An' one day he saw uh horse runnin' away. He wuz comin' straight towards my brother's blacksmith shop at de rate uv ninety-thousand miles uh hour, and my brother measured him and heated some iron and made uh shoe and put in on dat horse fo' he could pass de do'.
—SODDY SEWELL.

My father made a boiler so big dat when he dropped his hammer, de handle had done rotted out befo' it hit de bottom.
—SODDY SEWELL.

Ah wuz passin' long uh fence an' Ah heered uh turrible racket in uh fence corner an' whut you reckon it wuz? It wuz uh seed-tick down dere wid uh splinter in his toe an' uh red-bug wuz pickin' it out wid uh fence-rail.
—LARKINS WHITE.

Whut is de workenest pill you ever seen? I'm gwinter tell you whut kind of a pill it wuz and how much it did work. It wuz an ole man one time an' he had rheumatism so bad de po' boy didn't know whut to do. I tole 'im to go tuh town and git some uh dem conthartic pills. As he wuz coming

on back, he come through new ground where dey wuz clearin' up land. He opened his box and went to lookin' at his pills. He dropped one of dem down dere in his field. He got to de house and say, "Ole lady, look down yonder whut a big smoke," say, "whut is dat?"

She said, "I don't know."

"Well," he said, he guess he'd walk down dere and see what dat big smoke is down dere. He come back and says, "Guess whut it is? One of dem conthartic pills done worked all dem roots out de ground an' got 'em burning."

—JAMES BROWN.

Talking about fishing—I went to fishing the other day and set out my line. The water was very high; so that night the water fell and left two of my hooks and bait out of the water. And when I got there the next morning, a catfish had jumped up at the bait until he was washed down in sweat.

—JOE WILEY.

Once John D. Rockefeller and Henry Ford was woofing* at each other. Rockefeller told Henry Ford he could build a solid gold road around the world. Henry Ford told him if he would he would look at it and see if he liked it, and if he did he would buy it and put one of his tin lizzies on it.

—ARTHUR HOPKINS.

*In her "Glossary of Harlem Slang," Hurston defines "woofing" as "aimless talk, as a dog barks on a moonlight night."

My daddy went fishing one day and caught so many fish that he could not carry them home. And he was so bad that he called a alligator out of the water and made him carry him and those fish home. When he got home he told the alligator: "Now, rascal, you can go back."

—LOUIS ROBINSON.

My brother was so swift that the governor got him to work for the United States. And his job was sitting on the front of a train and turning the switch while the train was running.

Once we wuz on a train with some more boy friends and they got to talking about how fast the train wuz running which we didn't think it wuz running very fast; so I poked my head out de window to see how fast it wuz running and the steam from the locomotive wuz milking cows five miles from the railroad.

—ARTHUR HOPKINS.

I got on the train in New Orleans and ast the boys wuz the train running fast.

"Sho, sho."

"Why, no," I says, "this train ain't running fast."

We jumped off the train and run to Mobile and ast the ticket agent wuz we ahead of time. He says, "Why, yes."

We jumped up and run back and met the train half way and rode on back to Mobile.

—GENNIE MURRAY.

We seen the Alabama River running so fast till the fish had to back paddle with their fins to bite the people's hooks in Magazine Point.
—ARTHUR HOPKINS.

On a hobo trip out in Texas one rainy night we were going down de track thout orders and we had passed de station where we wuz stopped to get our orders. When we found we had passed de engine blowed for de orders at de next station. When we got to de next station it wuz too late for de engineerman to get them, so the conductor and de caboose got 'em, wondering how he wuz going to get 'em to the engineerman without stopping. So the brakeman told the conductor, "You got to go round dis bend." The engineer met de caboose at de other end and got de orders.
—WILL HOUSE.

I seen a railroad so crooked till de fireman be throwing coal in de headlight instead of de fire-box.
—ARTHUR HOPKINS.

My father sent me and my brother tuh de grist mill. We gits tuh de mill, but so much corn ahead uh us till it overlaid us and caused us tuh be night gittin' home.

On our way back home dat night, we passed a cane patch. I repeated tuh him, "Ooo brother, whut nice cane!" I said to 'im, "Say, looka here, we want some of dat cane."

He said, "We must have some," and we 'cided we'd go dere an' we went in. We cuts us a great turn of dat cane apiece, an' we started back into de car wid de cane. And between de cane patch and de highway, there wuz a mud-mash, and goin' thew dis mash de man fired uh gun, and firin' uh dis gun, we made

such uh dash forrunnin' dat us bogged down an' breaks our legs off even wid our knees. But we didn't stop—we kept right on runnin'. We built a fire an' we chewed thirty-five or forty stalks of cane apiece. After chewin' it, we decided tuh lie down, rise soon in de mornin' by de four o'clock whistle. Then finally we had missed our feets when we reached down tuh git our shoes—we had run so hard dat we had lost our feets in de mud-mash.

—ROBERT BAILEY.

I wuz gwine long one day cross de wood. I seen two blocks of ice come running and they were gatherin' li'dard knots to make up uh fire and warm. I had tuh go he'p 'em cause I wuz 'bout to freeze tuh death.

—JOHN BIRD.

There was once a man had a plantation up de country and de houses wuz built on each side of de creek, and they had a burning there—houses on both sides caught fire— and de creek got so hot, after the burning you walk along and pick up done (cooked) trouts.

—JOE WILEY.

Went down to the river today, took one match, set the river on fire. Burned it half up, took the other half of the water and put the fire out.

—JOE WILEY.

One day I was going through a field and I saw a man tie a butt-head cow's horns to a tree.

—CHARLEY BRADLEY.

I went down tuh de river wid my suit-case an' I couldn't get cross, an' I wuz in uh hurry, too. There wuzn't no bridge or nothin'. So I pulled out my forty-four forty an' fired it off an' jumped on de bullet an' went cross; but I had done lef' my suit-case. So I come back cross on de echo an' got it an' went back cross on de smoke.
—EUGENE OLIVER.

Once I wuz out batching, so I come in one evening, wuz kinda tired and made my fire. I forgot just how to put in mah seasoning, so I put in two boxes baking powder, one box soda, sack of salt, and made 'em up and put 'em in de oven and put mah lid on top mah oven. I went out to pick up some more splinters to put on top, and when I come back they wuz rising out through de top of de chimbley. So I went and got me a ladder to go on top de house to hold 'em down, and they riz so high wid me, took me twelve months to come down off de top of 'em, eating my way down.
—LONNIE BARNES.

I wuz lost in de woods, and I wuz lost teetotally. I heard uh racket over in de thicket. I looked behind a log. It wuz de moon changin'.
—RAYMOND MCGILL.

The largest sawmill I ever saw was thirteen stories high at a place by the name of Diddie War Diddie* owned by Jack. It had one band saw that extended through the thirteen

*In her "Glossary of Harlem Slang," Hurston defines "Diddy-wah-diddy" as "a far place, a measure of distance" and "another suburb of Hell, built since way before Hell wasn't no bigger than Baltimore."

stories. The fly was so large that every time it made a revolution it was pay-day, paying off by the month.

So being in this town I visited the plant. Jack weighed two thousand pounds and his wife nineteen hundred. While there, they had a son born to them weighing only four hundred pounds at birth. So Jack ordered him killed—said he didn't want no runts in the family.

So I goes up in the mill to the twelfth story and his daughter was setting head blocks on the carriage.

So one of the workmen taken me in the mess hall, and there was a molasses river running through the kitchen and a carriage hauling flapjacks and turning them with a steam nigger.

So it was payday and Jack had forty train loads of money switched in to pay off. Just after paying off, they started to playing the game they call skin*. So on that night John D. Rockefeller and J. P. Morgan came in and stopped the cards and said: "Put up a box car of money, two and one."

The boys that worked for Jack said, "You can go in the kitchen. The cook and chauffeur are back there spudding (playing for small change)."

—JOE WILEY.

One time my uncle he belongst to de church. He wuz an ole member of it. So dey thought dey's put him to doing something, him belongst to it so long. So dey put him to overseeing de young folks. So one night he says, "Son, less me and you go to church." So I tole him I didn't keer if we would.

So we went out and got in de ole Ford and he tole me to jump out and twist de tail. So I jumped out and twisted it—we

*Hurston includes a lengthy explanation of a "Georgia Skin Game" in the glossary for *Mules and Men*. The game involves "two 'principals' who do the dealing" and a group of players or "pikers."

drove on. So we got to church about ten o'clock, so wese comin' on back, it wuz two boys stayed in de house mighty rowdy. So he drove on by and stopped and he says, "Son, spose we go in here and see whuta all dis noise in here." I told him I didn't keer if we did.

So he went in and opened de door. First thing I looked at wuz uh forty-five pointed directly. So I curved round and in de old Ford. When I looked in de back, mah uncle wuz in dere, too. Course we didn't makin' but forty-five. I told my uncle I think we kin beat dis heah. So we runned de Ford outside and jumped out. Course we didn't run none but we passed some people whut wuz running. And so a Chrysler got in de way and hit stayed in de way 'bout fifteen minutes. So we got home and went on and went to bed. So I woke up 'bout four hours and fifteen minutes after I got dere and I saw something dartin' by de window. So I hunched my uncle. I tole him to wake up. He says, "Whut's de matter?"

I says, "Look to me lak we havin' trouble here."

He says, "Whut?"

I says, "Don't you see dem people dartin' by de window out dere?"

He said to me, "Git up and see whut 'tis." I looked at him and he looked at me. I tole him to make de thing more better less both of us git up and go see. So he looked up over de door and got his Winchester, cause he hadn't had it but 'bout seventy years, and I grabbed de do' and opened it wide and he thowed de Winchester right in de middle uh de do'. So we looked out and it wuz jes' our shadders four hours and fifteen minutes late getting home.

—WILL THOMAS.

Man went tuh huntin' wid one uh dese muzzle-loaders. He didn't have but one load uh ammunition an' he saw two wild turkeys settin' up in uh tree, an' right over in uh pond

he saw some wild ducks, an' over by de pond he saw uh deer an' he heard some noise back of him an' he looked round an' seen some partiges (quail). He wanted all of 'em an' he didn't know whut tuh do. So he stood an' thought an' thought. He took aim, but he didn't shoot at de turkeys, he shot at de limb they wuz settin' on an' de ball split dat limb an' let dem turkeys' feet drop right down thew de crack an' de limb shet up on 'em an' helt 'em right dere. De ball went on over an' fell intuh de pond an' kilt all dem ducks; de gun bust an' de barrel flew over an' kilt dat deer an' de stock kicked de man so hard till he fell backwards an' smothered all dem partiges.

He seen he couldn't tote all dat game home so he went home tuh git his team. He tole his wife tuh put on de pot cause plenty rations wuz comin'. He loaded up de wagon, but he didn't git in, cause he figgered de mule had enough tuh pull thout him. Jus' as he got his game loaded it commenced tuh rain, but he walked on side uh de mule tellin' 'im tuh come up till dey got home—about three miles.

When he got dere his wife ast 'im where wuz de game he wuz talkin' 'bout an' he looked back an' seen his wagon hadn't moved from where he loaded de game. De rain had done made dem traces stretch. So he jus' took de mule out an' wroped dem traces round de gate post an' put de mule up an' went on in de house. De nex' day it was dry an' de sun wuz hot an' it shrunk up dem traces an' about twelve o'clock they brought dat wagon home "cluck-cluck, cluck-cluck" right on up tuh de gate.

—LARKINS WHITE.

DE HONGRY BEAR†

My father wuz out huntin' an' he seen uh hongry bear makin' dead at 'im. He ups wid his gun an' fired, but he missed 'im an' de bear kept right on comin' so fast he didn't

have no time tuh load uhgin. When de bear made tuh grab
'im, he run his hand down de bear's throat and clear on thew
de bear and out de other end, an' caught hold uh de bear's tail
an' give sich uh jerk till he turnt dat bear wrong side out, an' he
wuz runnin' de other way (the bear was headed the other way.).
—JAMES PRESLEY.

Uh man went huntin' one day. He had one load, an' all
de shot he had wuz one bullet in de gun.

He saw fifteen wild turkeys on one limb. He wuz afraid he
would miss 'em, so he went on.

He saw a bear, and wuz afraid de bullet wouldn't kill de
bear—an' he went on.

He saw a cuvey of quails, and he wouldn't shoot at dem—
and he went on.

He saw a deer, and wouldn't shoot at him.

He 'cided he'd go back and try de turkeys. So he did.

He took a good aim and split de limb, and caught all de
turkeys by de feet. De ball went on and struck de bear, and in
his scuffle he killed all de quails. De ball went on and killed de
deer. De deer fell in de pond and knocked out fifty bushels of
fish. De ball went down de river swamp and cut down uh
honey tree. De tree fell cross de river and de honey sweetened
de river ten miles up and ten miles down.
—JOE WILEY.

My father wuz a hunter, and whenever he seen a deer
he would run along side of him tuh feel him to see if
he wuz fat uh-nuff 'fore he'd kill 'im.

Whenever he'd shoot in target practice, he'd shoot and den
go put up a target fur de bullet tuh hit after he shot. He uster
git round pretty fast.
—FLOYD THOMAS.

I seed de coach whip behind de race runner one day and dey was running so fast de race runner set de broom sage uh fire, and de coach whip wuz sweatin', and de coach whip put it out wid his sweat; and de race runner hopped in de river, and de coach whip hopped in behind him and they had to sprinkle de river, and outen de dust so he could swim. By that time de dust choked me so I had tuh leave.

—JOHN BIRD.

My pa had a gun dat shoot so far he had to put salt down de barrel before he shoot it, so de game he kilt wid it would keep till he got dere.

—E. EDWARDS.

A man went hunting and saw three thousand ducks in a pond. Just as he levelled his gun to fire, the weather turned cool and the water in the lake froze solid, and them ducks flew off wid de lake froze to their feet.

—PETER NOBLE.

Two mens went out rabbit huntin' an' after they went a lil way, one said tuh de other one: "We needs yo' dawg tuh jump dese rabbits fuh us. We ain't got no gun."

De other one says, "Thass all right. Ah got uh dawg in mah pocket dat'll jump all de rabbits we needs."

"Uh dawg in yo' pocket! Man, you cain't keer no dawg in yo' pocket dat kin ketch no rabbits."

"Thass all right, you jus' wait till we needs uh dawg an' you'll see."

After while dey seed uh rabbit an' de man retched in his pocket an' hauled out de dawg an' set 'im down on de ground.

He wuzn't no biggern yuh fist, but, man, he could cold* stroll behind uh cotton-tail. He got behind uh rabbit an' he wuz runnin' him so fast he run intuh uh tree an' split hisself wide open. De other man said, "Now, whut we goin' do?"

His friend said, "Thass all right, he kin be fixed."

He took an' picked dat dawg up an' stuck dem two sides uh dat dawg tuhgether; but he done it so quick dat he stuck one side upside-down, so dat he had two foots up an' two foots down, an' one-half uh his tail wuz stuck tuh one side uh his head—an' no matter which uh-way de rabbit run he didn't have tuh turn round a-tall—he wuz headed right data way.

—LARKINS WHITE.

*In her "Glossary of Harlem Slang," Hurston writes that "cold" means "exceeding, well, etc., as in 'He was cold on that trumpet!'"

[Mosquito and
Gnat Tales]

SKEETER AN' DE HOMINY POT[†]

One day down in Texas I went out huntin', but de mosquitoes wuz so bad till I had tuh run. After while I seen uh ole hominy pot an' I took an' run under it an' turnt it down over me tuh keep off de skeeters. But you know, one uh dem skeeters bored right thew dat pot an' bit me, an' dat made me mad; so I turnt round an' bradded his bill intuh dat pot an' he wuz so big he flew on off cross Galveston Bay wid dat pot bradded on his bill.

—LARKINS WHITE.

Once in my home, too, it wasn't any trees. That was between New York and Chicago, and so it had came a storm and had washed up the railroad track. So the train had to be there in fifteen minutes time and so they didn't know what they wuz gointer do, and up came a skeeter. He wuz so large that they decided to take this musskeeter and make the railroad track outa him. So they taken his feets and made de tires, and taken his bill and made de steel and so that throwed de train to be there in fifteen minutes time.

—LOUIS ROBINSON.

In Louisiana a man was clearing up new ground. The way he would do, he get out where the mosquito could see him, and when the mosquito got after him, he'd run and get behind a tree, and when the mosquito strike at him through the tree, he'd brad the bills and the mosquito would fly off wid de tree.

—Joe Wiley.

Another time we had some tin suits tuh keep de skeeters off us an' they went off an' fetched back can openers an' got us jus' de same.

—William Richardson.

Once there wuz a boiler across de river. They wanted to get the boiler on this side. Mosquitoes were so bad that nobody could stay over there no time. They had a reward of one thousand dollars for de one who brought it across.

So a man got him a sledge hammer and went over there and got into de boiler. Every time a mosquito would pop a bill into de boiler, he would brad it down. So many mosquitoes wuz there they picked up dat boiler and flew across de river.

—Edward Morris.

29 run a hot box between Lakeland and Plant City, and fireman wuz out helping him (the engineer) and de steam died down. He wuz trying to git up steam to make it to the station on time. Mosquito flew long an' blowed de train into Loughman.

—R. T. Williams.

It was a man who lived in the country. One day he was driving some oxen. So he drove the oxen up to the front of my door to get his supper. So he went in and ate his supper, and when he come out the mosquitoes had done ate up his oxen and was sitting on the wagon picking their teeth with the oxen horns.

—WILLIAM RICHARDSON.

I thought I heard an airplane. I looked up and seen it wuz a mosquito. He made at me. I dodged behind a tree. The mosquito broke off his bill in de tree and reached back in his pocket, got another one, screwed it on and went on 'bout his bizness.

—R. T. WILLIAMS.

Me an' my brother went off on uh journey an' when night come we stopped at uh house an' got uh room for de night.

Soon's we turned in de mosquitoes started tuh plagueing us. They was so big they sounded lak a bull lowing. We covered up all over, even our heads, under four blankets an' we could hear 'em flyin' roun' tryin' tuh git tuh us. T'reckly (directly) we heered 'em goin' on off but we was skeered tuh uncover ourselves. Pretty soon we heered 'em comin' back an' we peeped out. Everyone uh dem skeeters had uh little leather bag in his hand flyin' along. When they all got back in de room, they set down de bags an' screwed off them short bills an' took they long bills out them baggs an' screwed 'em on, an' bored right through dem blankets an' got us.

—WILLIAM RICHARDSON.

Me and my buddy went out on a hobo trip and so we come cross a logging camp, 'cided we'd work some, ast de man 'bout a job. So he give us a job loggin', give me uh five yoke ox team, my buddy a six ox team. So we goes into the woods and loads up waggins.

As we wuz coming on back we heard a little something coming through de woods singing. We stopped to see whut it wuz. Whilst we wuz stopped a little black gnat come along. He eat up de six ox team, de five ox team, got one of de horns, got upon de wagon, blowed for eleven more yokes.

—Lonnie Barnes.

I wuz coming from Birmingham going to Montgomery and a car passed me making eighty-five miles a hour. I looked under the steering wheel and I didn't see no man. Got in Montgomery a mosquito had held him up for over speeding. Looked on the steering wheel, it wuz a flea. Put him in jail and it cost him twenty-five dollars for speeding.

—Douglas Shine.

Neatest Trick
Tales

A man had three daughters and he was going out huntin' tuh git 'em something tuh eat. So he ast 'em all whut they wanted him tuh bring 'em back. De oldest one tole 'im, "I sho would love a nice rabbit tuh fry."

De nex' one tole 'im, "My mouf is just set tuh smack on a nice, fat cottontail."

De baby tole him, say, "If you don't bring me uh rabbit, I ain't gointer eat uh moufful uh nothin' else."

So he went on out tuh de woods wid his gun, but game wuz scarce. He didn't git but one rabbit and so he had tuh gwan home wid dat. When he got home they all ast him did he bring 'em uh rabbit. He tole 'em, "Well, I ain't got but one so y'all have tuh 'vide it de best way yuh kin."

They wouldn't do dat. Dey all wanted de whole rabbit, so he didn't know whut tuh do.

Way after while he tole de one whut did de sharpest trick could have de rabbit. They said all right.

De first one, she helt up a needle and urinated right through de eye and never touched de sides. De old man says, "Dat's uh sharp trick and I don't see how it kin be beat."

De next one, she urinated in uh thimble and never run it over. He thought dat was swell.

De last one she took uh hick'ry nut and thowed it up in de air and turned up her dress and broke wind and cracked de nut and blowed de goody right slap in de old man's mouf. He smacked his mouf, (gesture of tasting) and says, "You wins de rabbit."

—EUGENE OLIVER.

Once there was three girls went to huntin'. They saw a rabbit and all of them shot at the rabbit, and all of them said they killed it.

So they carried it to the court and the judge said that the one that done the sharpest trick could have the rabbit.

One girl up and poured water through a needle's eye and never touched the sides.

The next one poured a bucket of water in a thimble without running it over.

The last one picked up a hickory nut and throwed it up in the air and took aim and shot it and bust it open and spattered the goody in the judge mouth. He tasted it and says: "You win the rabbit."

—HENRY EDWARDS.

Once there was a man had a daughter and three fellows wuz courtin' her. All of 'em asked for her at de same time and they were all good clean boys. He didn't know what to do, so he said: "I'll give her to the one dat does the quickest trick."

De first one went out and cleaned up a forty acre new ground, broke it up and planted it and had roasting ears for breakfast.

The other one said, "I can beat that." He went one mile

down de road to a spring after water in a cedar bucket and
came back and caught de water before it hit the ground.

The other one said, "See what kin I do." He went into the
house and got a Winchester. He went out and shot de gun, laid
it down and run, overtaken de bullet and brought it back and
give it to de girl's pa. So he got de girl.

—LONNIE BARNES.

I wuz courtin' uh man's daughter once, me an' another
feller, an' her daddy caught us arguin' 'bout her one day,
an' so he said de one dat told de biggest lie could have her. So I
said, "Stick uh needle up in de ground an' put uh dime behind
it edgeways, an' I kin drive uh Ford right thew de eye uh dat
needle an' turn roun' on dat dime an' still have uh nickel
change."

—EUGENE OLIVER.

Me and my girl was sitting under a tree fishing one day.
A big rabbit jumped in front of us. My girl said, "Oh,
how I would like to have a ham off that rabbit."

I gave her my coat, I gave her my shoes, I shot my pistol, I
caught up with the bullet and told it to go back and get into
the pistol because I had the rabbit.

—PETER NOBLE.

"Mr. Hill doing it."

It wuz once an old man had three sons and they all
was off. One wuz naked, one wuz blind, one wuz armless. So
de one whut wuz blind he jumps a rabbit; one didn't have no
arms kotch 'im; one wuz naked grabbed 'im and put 'im in his
pocket.

So they wanted to know from the father which one the rab-

bit belong to. So he says, "Well, I don't know. The one that can do the sharpest trick."

One shot a rifle and beat the ball to the tree and cut a spot where it could hit. The other two says, "Father, we can do better than that."

So one of 'em says, "I see a red bug in England."

The other one says, "I see his eyes."

—LARKINS WHITE.

A man had seven sons and he sont 'em all off to school, and he had one girl.

An' he had called his boys up an' sont dem to school. One wuz schooled to be a machinist; one a blacksmith; one a mechanic; one a spier; one a crack-shot; and de other wuz a rogue; and one a gluer.

After dey returned back home, father axed dem did dey all have dere learnin'. Tole 'em dat since dey had been gone, de eagle had stole they sister.

Spier axed 'im which way did dey go. He tole 'im dat wuzn't no use to ast 'im cause he couldn't see dat fur.

He got up on top uh de house, put on his spy glasses and tole 'im, "Papa, I see 'im. Eagle has a place in uh fork of a limb cross de deep blue sea."

Tole his carpenter, "Great God, make me a boat!"

Tole his moulder, "Mould me uh motor."

Tole his gluer, "Glue it together."

"All right, boys, let's go cross."

Tole his spier to look see what de eagle wuz doin'. "Papa, she's watching de boat." Rogue axed 'im to stop de boat an' let him out.

Tole de spier look back see whut de eagle is doin'. "Papa, she's comin'."

Tole de crack-shot, "Gun in order."

Said, "Papa, I see 'im."

Tole de spier, "See how fur she is from us now."

"Papa, she's right over dere."

Crack-shot reformed his gun, shot de eagle, but he bust de boat and the gluer jumped down, glued it back together before air drop uv water got in it. That's all that is.

—R. T. WILLIAMS.

Mistaken Identity Tales

In slavery time there was a man by the name of Tom and he always had prayer before going to bed, and his prayers was always for God to take him to heben away from his hard taskmaster. And his master gone down through the quarters various times and listened to Tom's prayer.

So one night he decided to have some fun offa Tom. So when he was in this prayer, his master knocked on the door, representing himself as the Lord.

In a flat way Tom said to his wife, "Ast who dat."

His master said, "This is God Almighty come to keer Tom to heben."

Tom told his wife, "Tell God I'm not here."

His master, peeping through de hole in de door saw Tom run under de bed naked. He said, "I'm God Amighty and Tom don't come out from under dat bed I'm going to come in there and get him and carry him to heben anyhow."

Tom whispered to his wife to open de door wide. Tom run out from under de bed and out de door and right through the quarters naked as a rooster, wid his master right after him, who he thought was the Lord.

Tom's chile rose up and ast his mother a question, says, "Mama," says, "God's gointer ketch papa and carry him to heben?"

She set dere wid a head rag on her head patching. She clashed at de chile—tole him: "Shet up yo' mouf tellin' dem lies. Don't you know God ain't got no time wid yo' pa and he's barefooted, too."

—GEORGE MILLS.

THE RUNNING DEATH[†]

Massa had a slave once named Ike. Ike wuz always praying tuh be took into heaven alive. Every night he'd git down on his knees an' pray tuh be took jes like Enoch. One day Ole Massa heard him and made up his mind tuh try 'im out.

So one night he put on uh sheet, all white an' everything, an' went on down tuh Ike's house. Ike wuz down prayen and whoopin 'bout he wanted tuh gwan tuh heaven.

Massa knocked at de do'. (Gesture of knocking on door.)

Ike: "Who dat?"

Massa: "It's me, Ike, it's de Lord come tuh take you away frum dis hard working world."

Ike: (In whisper tuh his wife) "Tell 'im I ain't here."

Wife: "He ain't here, Lord."

Massa: "Then, Dinah, you'll do."

Dinah: (In whisper) "Ike, you come on out frum under dat bed and go on wid de Lord."

Ike: (Whispering) "Oh, go on wid de Lawd. Didn't you hear him say you will do?"

Dinah: "I ain't gwinter do nuthin uv de kind. Youse de one dat always whoopin' and hollerin' fur him tuh come git yuh. An' ef you don't come on out, I'm gwinter tell God you hiding under dat bed."

Massa: "Come on, Dinah."

Dinah: "Ike in here, Lawd, hidin' under de bed from you tuh keep from going on wid you tuh immortal glory."

Massa: "Come on, Ike an' go wid me." (Ike comes very slowly from under the bed.)

Massa: "Come on, Ike."

Ike: (Goes tuh do' and peeps out. He got so skeered when he seed whut he thought wuz death dat he didn't know whut tuh do. So he says tuh ole Massa): "Stand back a little way, Jesus, lemme come out by you." (Massa moved back uh little. He knowed whut Ike wuz up tuh, but he didn't let on. Ike done dat de third time. By den he figgered he had enough room, so he lit out dat door (gesture of swift running flight, passing one hand past the other quickly). He hollered back to Ole Massa: "Ef thou be uh running death, *ketch me!*"

—JAMES MOSELEY.

Once durin' slavery time Ole Marsa had uh nigger an' he uster go up under uh simmon tree tuh pray fuh God tuh come git him way from dis hardworkin' world. Young Marsa heard 'im an' clammed up de tree wid uh rope. When Jack got down under de tree an' begin tuh ast de Lawd tuh come git 'im, de white man said: "If you wanta go tuh heben wid me, Jack, stick you head in de loop."

He let down de rope so Jack could git his head in. Jack prayed on some more an' Marsa said: "Stick yuh head in de loop."

Jack heard 'im dat time an' stuck his head in de loop, an' de white man begin tuh pull. Dat rope got tighter an' tighter round Jack's goozle, an' Jack hollered up de tree: "Lawd, do you know everything?"

De man said, "Yes."

"Well," he said, "if thou be God an' know everything, you oughter know youse choking me tuh death."

—EUGENE OLIVER.

PRAYIN' WOMAN AN' DE BANJO MAN[†]

There uster be a woman dat went to de prayin' groun' every evenin' jestez soonez she come from de fiel'. You know in dem days niggers didn't have no churches, cause de white folks didn't 'low 'em. Dey uster slip off down in de woods tuh whut dey'd call de prayin' groun' an' have they little doings.

Dis woman, she uster go every day—she wuz so full uh reli-gion. Her husban' uster stay home an' play de banjo, cause he said all dat prayin' wuzn't doin' no good—de white folks wuz still in de lead. De ole woman thought dat wuz weeked an' sin-ful an' uster beg him tuh put down his music an' come wid her—but he wouldn't.

He made up his mind tuh break her uh all dat prayin' an' carryin' on, so he cut cross de woods an' beat her to de tree one day an' listened. She come on an' got down on her knees an' ast de Lord tuh send down His power tuh free de niggers an' tuh take her home wid Him. De husban' kept quiet and after she lef' he cut cross de woods an' beat her back home.

De nex' day he waited till she lef' home an' cut her off agin an' got some rocks an' hid 'em up de tree. When his wife got down an' ast de Lord tuh take her home wid Him, she said, "An' now, Lord, tuh show dat you got de powers tuh keer me home whole soul an' body, send down yo' power."

De man dropped a little rock down an' tapped her on de shoulder. She lak-ted dat, (liked). She raised her voice higher an' said: "Don't be sendin' down no little scraps uh yo' power. Send it so dese white folks'll know dey got tuh set us free—send it down in plenty."

De man dropped a great big rock dat time dat hit her on de head an' knocked her over. She got out from under dat tree an' tole Him, she said: "I didn't ast you for *all* yo' power at one time. I didn't ast you to crack my head wid it." She lit out for home.

De man took de short cut an' beat her home agin, but he didn't hardly have time to git uh seat an' git his banjo in his hands befo' she come in. Soon as she got in de house, she says, "Hurry an' chune up dat thing, ole man, an' less have some music. Ah done got enough power from de prayin' ground tuh las' me de rest uh my days."

—LARKINS WHITE.

GOD AN' DE DEVIL IN DE CEMETERY[†]

Two mens dat didn't know how tuh count good had been haulin' up cawn an' they stopped at de cemetery wid de las' load cause it wuz gittin' kinda dark. They thought they'd git through instead uh goin' way tuh one of 'ems barn. When they wuz goin' in de gate, two ears uh cawn dropped off de waggin, but they didn't stop tuh bother wid 'em jus' then. They wuz in uh big hurry tuh git home. They wuz justa 'vidin' it up, "You take dis'n, an' I'll take dat'un; you take dat'un an' I'll take dis'n."

An' ole nigger heard 'em while he wuz passin' de cemetery an' run home tuh tell ole massa 'bout it.

"Massa, de Lawd an' de devil is down in de cemetery 'vidin' up souls. Ah heard 'em. One say, 'You take that'un an' I'll take this'un.' "

Ole Massa wuz sick in de easy cheer, he couldn't git about by hisself, but he said: "Jack, Ah don't know whut dis folishness is, but Ah know you lyin'."

"Naw, Ah ain't neither. Ah swear it's so."

"Can't be, Jack, youse crazy."

"Naw, Ah ain't neither. If you don't b'lieve me, come see for yo'self."

"Guess Ah better go see whut you talkin' 'bout; but if you fool me Ah'm gointer have a hunded lashes put on yo' back in de mawnin', suh."

They went on down tuh de cemetery an' it wuz sho dark down dere, too. They stole up in de gate an' heard 'em jus' lak Jack said, but they couldn't see de two ears uh cawn layin' in de gate.

Sho nuff Ole Massa heard 'em sayin', "Ah'll take dis'n'" an' de other one say, "An' Ah'll take dis'n." Ole Massa got skeered hisself, but he wuzn't lettin on, an' Jack whispered tuh 'im, "Unh hunh, didn't Ah tell you de Lawd an' de devil wuz down here 'vidin' up souls?"

They waited awhile there in de gate listenin' den they heard 'em say, "Now, we'll go git dem two at de gate."

Jack says, "Ah knows de Lawd goin' take you, an' Ah ain't gwine let de devil git me—Ah'm gwine home." An' he did, an' lef' Ole Massa settin' dere at de cemetery gate in his rollin' cheer; but when he got home, Ole Massa had done beat 'im home an' wuz settin' by de fire smokin' uh seegar.

—LARKINS WHITE.

Once there was a Negro. Every day he went under the hill to pray. So one day a white man went to see what he was doing. He was praying for God to kill all the white people; so the white man threw a brick on his head. The Negro said, "Lord, can't you tell a white man from a Negro?"

—ARTHUR HOPKINS.

Once there was a man, he had a son and he died. Every night the man would go to the graveyard and pray to the Lord to let him see his son. One night a man decided to satisfy his wishes, so he hid in the graveyard. So that night the man went to pray. The other man rose up with a sheet over his head. The father said, "Go back, son, I have seen." The ghost came a little closer. "Go back, son, I have seen." The ghost came a little closer.

"Go back, son, go back, I tell you! That's the reason you are in the graveyard now—your head is so damn hard!"

—JOE WILEY.

A woman had a little boy who was always cussin'. She did everything to break him, but couldn't. So one time when he wuz sleep she got somebody to help her put him in a coffin to skeer him. Thought maybe that would break him. So they put him in de coffin and set de coffin in de cemetery and hid theyselves behind de tombstones to lissen. After while de lil boy woke up and set up in de coffin and looked all round and says, "Well, I'll be damned if this ain't judgment day and I'm de first son of a gun up."

—L. O. TAYLOR.

Once there was an old man, he had a son and two good dogs. They didn't have any guns, so every night they would go hunting. They would cut sticks. The man told the boy that a coon hollered like a man. The boy was afraid of the old man. One night the dogs chased a coon up a tree. The old man went up the tree and told the boy that when the coon fell down, to kill him with the stick. The old man fell out of the tree, and the boy began to beat him with the stick. The old man said, "Oh, Lordy, son, this is me."

The boy said, "Oh, hell, pa said a coon hollered like a man. I have you now."

So he beat the old man half to death before he knew it was his father.

—EDWARD MORRIS.

Once there were two men who was stealing old Master's hogs. They had a hole in the floor, and when the hogs come under, they would hit the hogs in the head with a stick. One day the man said, "Now, when a hog comes out, you hit him and kill him."

The hogs came out so fast that the man couldn't get a chance to kill a single one of them. The other fellow came crawling from under the house and said, "Did you get them?"

This man thought he was a hog, so he hit at him and hurt him so bad until he could not talk; but somehow he said: "I told you to notice *hogs* and you noticed *me*."

—WILL HOWARD.

PIG IN DE POKE†

One time way back a white man sent his Negro hand to another plantation to get a pig for him. He went and got it, but on the way back it was hot and he was tired, so he sat down to rest and dozed off to sleep. Some white men came along and saw him. They knew who he was and everything, so they thought it would be fun to take out the pig and put in a possum—so they did.

When he got home his boss asked him, "Well, Sam, did you get the pig?" "Yas suh, an' he sho is uh fine one, too. He kin crack corn already." "Well, let's see him." Sam poured the possum out of the bag, thinking it was the pig. He looked, the white man looked, neither one didn't want to believe his eyes. "Look here, Sam, is you dat big a fool to let 'em put a possum off on you for a pig?" "Boss, I 'clare dat wuz uhh pig when I put 'im in dere." "Well, you just turn round and go right back over the creek and get me a pig. Furthermore, you tell Hiram Bickerstaff he better not try any tricks on me, else I'll sink him wid lead."

The Negro went on back and he was awful tired by this

time, so he sat down at the same place and went to sleep again. The men saw him and knew what he was going back for, so they slipped the pig back into the bag and went away. When he woke up he heard the pig grunting in the bag and peeped in to see if it really was a pig again. He looked at the pig and scratched his head and said: "Pig, be somebody. Don't be switching back and forth. Either be a pig or a possum, but be whut you is."

—LOUISE NOBLE.

Fool Tales

THE SIX FOOLS[†]

A fellow went to court a girl. After he had courted her a long time, he began to talk of marriage. Her parents were very glad to hear him speak of it, for he was rich and strong. So they told the girl to go down in the cellar and draw some beer. They wanted to be merry, you know.

The girl took the pitcher and went down in the cellar to draw the beer. She turned the thing, you know, and let the beer run into the pitcher. While it was running, she got to thinking that if the young man *did* (should) propose to her in earnest, and she should accept him, and they get married and have a child—what would she name it?

She sat and thought and thought and the beer ran and ran. After a long time her mother wondered, what can be keeping our daughter? So she went down to see what was the matter. "What is the matter, daughter, you don't come on back with the beer?" "Mama, I just got to thinking, that if the young man should ask me to marry him, and if I should accept him, and if we should marry and have a child—what would we call it?" "Daughter, that *is* something to think about." So she sat down beside the girl and began to think, too. The beer was still running.

They thought and thought, and after a long time, the father came down to see what was the matter. "Wife! What are you doing letting all my good beer waste like this? I will be ruined! Our daughter hasn't married the young man yet, remember." "Well, we just been wondering what to name the baby if the young man does propose marriage to our daughter, and she should accept, and they should marry and have a child." "Now, that *is* something to study about. I never thought of that." So he sat down and began to think, too.

After a while, the young man got worried and came to see about them all. "What are all of you doing sitting here in a flood of beer?" The father said, "We are just studying what to name the baby in case you and daughter get married and have one." "Well," said the young man, "you are the three biggest fools that I ever heard talk of. I am going traveling for a year, and if I find three fools as big as you, I'll come back and marry the girl."

He traveled and traveled, and after a while he saw a man leaping up in the air before a bush with some clothes on it. The man just kept on jumping up in the air and falling back. "What are you doing?" the young man asked. "Those are my trousers on the bush and I am trying to get into them." "Well, why don't you take them in your hand and draw them on?" "I never thought of that," said the man and he did so. "That's *one* fool," said the young man, and went on.

Way after while he saw a man trying to pull a cow up on the roof of a barn by a rope around her neck. He pulled and pulled, but he could not pull the cow up on the barn. "What are you trying to do?" asked the young man. "See all that grass growing on top of the barn? I am trying to take the cow up there so that she can eat it." "Why don't you go up there and toss it down to her?" the young man asked the farmer. "Oh, I never thought of that." "That is two fools," the young man said and traveled on.

One day he saw a woman rushing in and out of her house,

pushing a wheelbarrow. She had a wide board placed in the door like a gangplank and was dashing in and out, in and out with the wheelbarrow. "What are you moving in that wheelbarrow? I can't see anything in it." "Oh, I have scoured my kitchen and I am trying to haul in some sunshine to dry it." "Why don't you open the doors and windows and let it dry?" "Oh, I never thought of that." "Well," said the young man, "I have found three fools as big as those I left, so I will go back and marry the girl."

By that time I left.

—HATTIE REEVES.

There was a ole man told his wife to make slop for the hogs. While he was out on the plantation working, she made the slop in de well. Caught all de hogs in de well and said, "Drink your food!"

When the husband come he wanted to know if de hogs had been fed. She said, "Yes, dem is de biggest fools me ever did see. Me put the hogs in de ole well, but dey wouldn't eat."

Ole man say, "You de biggest fool I ever did see." Dat de way wid geechies*.

—HATTIE GILES.

SAVING FOR MR. HARD TIME†

One time there was a man and he had a wife and she was sorta silly. He would save his earnings and his food and store it back, and tell her that he was saving it for Mr. Hard Time. So one day a man came along begging and told her he

*Or Gullah; a mix of West African and the coastal areas of Georgia and the Carolinas. May also be used as a derogatory term for an inarticulate Southerner.

was Mr. Hard Time. So she went and got all the money and all the food he had been saving and gave it to this man. When the husband came, he found so many things gone he asked her, "Where is my things I told you to put up for hard times?"

She said, "Lordy massa, Mr. Hard Time came by and I gin him dem things."

—HATTIE GILES.

Women Tales

Once there was a lady sitting by the fire. She and her little boy was making rolls out of cotton. So her sweetheart came, and later her husband.

So she placed her sweetheart in the basket and covered him with cotton. She and her old man started talking; but the little boy says, "Papa, I could raise hell here tonight."

The lady talked louder to drown the boy's voice, but the boy kept on saying, "Papa, I could raise hell here tonight."

After he had kept saying this a long time, the old man said, "Well, raise it then."

So the little boy reached into the fire and got out a red hot coal and throwed it into the basket, and the man caught on fire, and the man jumped out and took out down the road, and as far as you could see him you saw fire.

—CHARLEY BRADLEY.

Once there was a man who wanted to catch up with his wife. So he pretended he was going to work, and sent a little boy to his house to spend the night. His wife baked a cake of corn bread and fried some meat and gave it to the little boy

and sent him upstairs to bed. Then she baked a pig with an apple in his mouth, a sweet potato pone. By this time her sweetheart came, so she said: "You better eat, as we have plenty to eat this afternoon."

But he said, "Let us talk, we have plenty of time to eat."

So her husband knocked on the door and she told her sweetheart to get up the pot racks.

The old man asked her if a little boy had come to spend the night, and she said, "Yes, he is upstairs sleep."

The old man said, "Come down, little boy." The boy came down stretching as if he had been asleep. So the old man asked him what did he know.

The little boy said, "Well, I don't know much, but what I do know I'll tell that!"

"Once my father had a potato patch. Sow kept coming in there until it made my father mad, and father picked up a brick as big as that potato pone in that oven and knocked a pig out of that sow as big as that pig in the stove with that apple in his mouth. Every since then that sow has been afraid of my father as that man is of you up that pot rack."

—Arthur Hopkins.

There was another woman that had a sweetheart. So one night they retired and her husband come. So she put her sweetheart under the bed where she had a basket where a hen was setting on some eggs. The husband laid down in the bed and the hen pecked the sweetheart under the bed and he said, "Good God! I am snake bit!"

The woman said, "Hush! My husband will hear you."

The hen pecked him again and he said, "I am snake bit!"

The woman repeated "Hush, my husband will hear you."

But the man hollered "I don't care who in hell hears me, I say I'm snake bit."

—Charley Bradley.

A lady once married and her husband never would stay home, so she said she'd go to de hoodoo. So she went to the hoodoo and she ast de lady. So de lady said, "Here you come, and I know whut you come for. You havin' trouble with your husband."

"Yes, m'am, I certainly is." Says, "All right, whut kin ' do?"

Says, "All right, come take me to yo' house."

She goes and she walks in, says, "Tell you whut you do—" say, "get you some constrated lye, scrub yo' house, wash all yo' clothes, comb yo' head, powder yo' face, make up your bed, light and neat, and don't have a thing to say to him when he come in."

So de husband come in dat night. He walks in de house and looks all round. He looks at her and she was clean, head was combed, bed was turned back, and his water was fixed. They sits out on de porch a little while, then he walks in and says: "Dear, let's go to bed."

So they went to bed. She got up de next morning and went back to de hoodoo lady and paid what she charged and de hoodoo lady told her to jest keep dat up twice per week and her husband would always go to bed and go to sleep.

—J. W. WADE.

CRUEL WIFE[†]

This woman was so cruel till he couldn't please her no way he done. Las' one night he come in from makin' support for her, an' he said: "Oh baby doll, is you tired uh me?"

And she said, "Yes, I don't want you on no terms no matter whut you do."

"Well, I'll tell you how tuh get rid uh me."

Says, "All right, tell me."

He said to her, "Well, I got a brand new rope dere behind de head uh de bed. You take it and cair me soon in de mornin'

tuh de river bank, tie my hands behind my back, and get on de hillside and run and shove me overboard."

She says, "I really will."

So dat morning dey went on down and she tied his arms, roped 'em behind his back. So she got on de hillside and ran wid great speed, and jes' fo' getting' tuh him tuh make her shove, he made one step aside, an' overboard she went.

Hollered, "Save me, ole man, save me."

"How can I save you wid my arms tied behind my back?"

—ROBERT BAILEY.

There wuz uh woman once an' she didn't have no wash-pot; so she wuz always sending round tuh first one house an' another tuh borry they pot. But one day she got lucky an' bought herself uh pot; so she sent round tuh every-body: "Now, I got uh wash-pot uh my own an' I don't lend an' I don't borry."

Dat went on all right fuh uh spell till one day some devilish boys wuz chunkin'* an' dey struck her pot an' broke it. Den she sent round tuh everybody: "I lends an' borries, too."

—NIGGER BYRD.

There was a widow woman didn't have no husband. She been trying to get one for years. Every Sunday she uster dress up and put Cologne water on herself and primp her mouf up little to go to church.

After while a new preacher come to pastor there that didn't have no wife, and so dat Sunday she primped her mouf just so. So she was late for preaching, so she cut cross de field for de nigh cut, so she seen de mule was out and in de corn. So she

*Throwing or throwing rocks.

tried to drive him out without unfixing her mouf. So she says, "You mule, git out dat corn; oh, you mule, go on out de corn!"

De mule didn't pay her no mind, so she unprimped her mouf and says, "You damned ole crazy mule! git out dat corn 'fore I lam you wid lightning!"

And de mule went out. "Now look whut you done done! Done made me open my mouf wide. Now I got to go all de way back to de house and primp it agin befo' I kin go tuh meeting.

—L. O. TAYLOR.

The reason there ain't no women in de army is cause they squats to pea (urinate) and de minute one does it, they all wants to. De enemy would slip up and kill 'em all while they was squattin' down.

—E. EDWARDS.

Reason women folks always poke de fire if they set down by one is one time uh man wuz burnt up in uh fire, an' de women been searchin' fur his privates ever since.

—DAUGHTER SEWELL.

School Tales

 There wuz a woman who sent her boy to school to learn everything.

She had a young cow and went out to milk her, and the cow kicked all the milk out the bucket. She called her husband to assist her in milking the cow. He come out and felt responsible to help his wife, so he said: "I'll put a rope on her head."

He helt the cow while she milked her. She kicked the milk over again that she had given.

He said, "I know what! We sent our boy to school to learn everything—he'll know how to milk this cow."

So he calls the boy out and he comes out and ties the rope to a tree. He felt more responsible than his pa, so his mother began to milk again. The cow kicked that over and the boy said: "Father, she needs a weight on her back."

He looked all around but didn't see anything heavy to put on her back. So he had a long-legged father, and so he tole him to get up there on the cow's back. So he got up there and he tied his legs together under the cow's belly.

The cow begin to jump one side to the other, and he

wanted to get down. He hollered, "Cut the rope, son, cut the rope!"

And instead of cutting the rope from his father's legs so he could get down, he cut the rope to the tree. His father remained tied to the cow. She went running through the bushes.

There was a sister coming up through the woods. She saw him and said, "Wait a minute, brother, where you going?"

He said, "I don't know, sister. God and this cow knows."

—GEORGE MILLS.

Man sent his daughter off tuh school fur seven years. Den she come home all finished up. So he said tuh her: "Daughter, git you things an' write me uh letter tuh mah brother." So she did.

He says: "Head it up," an' she done so. "Dear brother, our chile is done come home from school all finished up, an' we is very proud of her." (To daughter): "You got dat?"

She tole 'im, "Yeah."

"Our dog is dead an' our mule is dead, but I got anuther mule, and when I say (the clucking tongue and teeth sound used to urge mules), he moves from de word . . . Is you got dat?" She told him, "Naw." He waited a while and he ast her again, "Is you got dat down yit?"

"Naw sir, I ain't got it yit."

"How come you ain't got it?"

"Cause I can't spell (clucking sound)."

"You mean tuh tell me you been off tuh school seven years and can't spell (clucking sound)? Well, I could almost spell dat myself. Well, jest say (sound) and go on."

—ROBERT WILLIAMS.

Man sent his son off to school for seven years. When he come home that morning they had breakfast. His pa said, "Son, pass me det taters."

De boy said, "Don't say taters, say po-tatoes."

After while de ma says, "Son, pass me de 'lasses."

Say, "Don't say 'lasses, say mo-lasses."

His pa says, "Our boy done gone off and lost his senses. He done come back here puttin' 'po' on taters and 'mo' on 'lasses."

—PETER NOBLE.

Miscellaneous Tales

GOOD-TIME WILLIE[†]

🌿 Once upon a time there wuz a man named Good-Time Willie. He wuz working in de army for seventy-five cents and so he quit de army and went on down de road. He met a man settin' on a stump and he had uh heap uh strops uh round him. Good-Time Willie said, "Ain't you all crippled up?" He say, "I got seventy-five cents you kin git half of dis."

The man told him to keep the money and Good-Time Willie asted him whut his name wuz. He say it wuz, "Disappear-And-Run-Out-Of-Sight." Good-Time Willie tole him there wuz a fortune at de end of de road for him and they both went on down de road and they soon met another man.

He wuz settin' upon a stump and Good-Time Willie asted him what he wuz doing settin' dere, and he tole him his name wuz "Change-De-Weather." He tole him to let him see some of his work and he set his hat on one side and started it to raining, and then he set his hat on top his head and it faired up.

Then Good-Time Willie tole him, "Come and go with us. There is a fortune at de end of de road for you."

They went on down de road and they saw another man in de ditch and Good-Time Willie asted him: "What wuz he

doing dere," and he said, "I blow water down de stream to grind de government corn."

So Good-Time Willie tole him to come and go with them, there was a fortune at de end of de road for him. All of 'em went on down the road. They met another man breaking down pine tree tops, throwing 'em over de mountain in his back yard. So Good-Time Willie asted him what he wuz doing and he said: "I'm breaking off pine tree tops throwing 'em over in my back yard."

So Good-Time Willie tole 'im: "Come and go wid us; there is uh fortune at de end of de road for you." All of 'em went on down de road till they got to de king's house, and so de king tole 'em: "If they had a man out dere could outrun his daughter to de well he could marry his daughter."

So Good-Time Willie tole Disappear to go and de king give both of 'em a bucket and he loosed one of his strops and disappeared and went out of sight.

So he got his bucket of water and laid down and went to sleep. De girl had done got her water and she wuz fixing to go up de step at home and Shoot-Well shot at Disappear and shaved his moustache off. He jumped up and got his bucket and beat de girl in de house.

De king said: "You have won my daughter—tell you what I'll do." He got some moonshine and he made 'em all half-drunk, and he tole 'em he'd give 'em a place to stay. That night he went and got seven firemen and started to burn 'em up.

Good-Time Willie woke up and shook Disappear, and Disappear shook Change-the-Weather and he tole 'em not to worry. So he started to making it hailing and storming, killed all de firemen and dat next day de king said: "Boys, I tried to harm you but I couldn't do you no harm. Tell you what I'll do—I'll give you three car load of gold."

So Stormy man got him a sack and sacked up all de gold he could and sent back down to king for three more carloads, and so de king come down dere to kill 'em. Blow-Stormy tole 'em

to git behind him and blowed 'em all up in de air and de king
said: "Let me down easy, kind Willie."

I stepped on a pin, de pin bent, and dat's de way de story went.
—A. C. WILLIAMS.

SCISSORS†

There was a man that [had] a contrary wife. I don't keer
what he suggested, she'd go jus' the other way.

One day he looked up at the sky and said it was time to mow
the hay, but she said it wasn't. They got into a fuss, but he jus' fi-
nally told her he was gointer mow it no matter what she said.

Then he looked around and said, "Where is my mower?"

She said, "There it is, but you don't need no mower to cut
no hay. It oughter be done with the scissors."

"Who did you ever see cut hay with scissors?"

"Everybody with any sense. Jus' because these fools round
here ain't got no better sense than to cut it with a mower is no
reason why YOU should be a bigger fool than you have to.
Cut it with scissors."

"Woman, do you want to make a fool outa me with your
scissors? No, I'm not going out to no hayfield with no scissors!
I'll take the mowing-machine and nothing else."

"And I'll take the scissors, you hammer-heel fool."

"No, you won't either. You won't go atall to worry me whill[e]
I work. You stay right home and use those scissors patching."

"Oh, yes, I will go too. You can't stop me, and I'm going to
cut hay, too, the way it should be cut—with scissors."

Sure 'nough, she went on with him hollering "scissors" in his
ear every step. He couldn't make her hush and he couldn't make
her go back, and she stayed on his heels no matter where he
walked. They got into a tussle on a little bridge they had to cross
and she fell overboard. She went down the first time and hollered
"scissors" when she come up. She hollered "scissors" the next

time she come up. The third time, she was so weak she couldn't say nothing—but she stuck up her hand with her fingers crossed.

She drowned, and when they found her body it was way upstream—she was too contrary to float downstream like other folks.

—ARMETTA JONES.

(European derivative)

De man wuz name Sam. He had been gone from home ten years an' he come up to this white man's place an' he hired him. He worked for twelve months for this white man for one hundred dollars. An' the end of the year he paid 'im de one hundred an' he tole him, say, "If yo' give me this one hundred dollars, I'll tell you something that will be worth two thousand dollars to you."

He give it to 'im. Says, "Well, now, I have worked twelve months an' I wanted tuh go home and I have nuthin' to go home with."

"Well, Sam, work another twelve months for another hundred dollars." So he worked another twelve months and so when the end uh de year he paid 'im this one hundred dollars.

He said, "Well, Sam, ef you give me this one hundred dollars, I'll tell you something that will be worth three thousand dollars tuh you." So he give it tuh 'im.

Says, "Well, now I want tuh go home, boss, and I haven't anything tuh go with. I know my wife is lookin' for me."

"Well, Sam," says, "work another twelve months fur another one hundred dollars." So he went tuh work and worked de twelve months.

At de end he says, "Give me dat one hundred dollars an' I'll tell you something dat will be worth ten thousand dollars tuh you." So he give it tuh 'im.

Says, "Well, boss, I must go home, money or no money."

"Well," he says, "ef you go, I haven't anything tuh give you

but uh loaf uh bread to take home wid you. Now, don't cut it. Break it. Now, on your way home, don't take a nigh cut. Keep de road home."

An' in travelin', when he come tuh the nigh path through de hammock, he started tuh take it, but he thought of what this man tole 'im, tuh keep de road. Jes' as he turnt back into the road, a peddler turned into this path an' in a short time heard de peddler screamin' and hollerin'. Somebody had done robbed 'im and put 'im to death. So he traveled on till that night. He come tuh somebody's residence and he thought of what de white man tole 'im—not to stop over night with uh ole man with uh young wife, so he got up and went out. Shortly after, he heard a noise in de room joining his, an' de ole man an' his wife wuz puttin' another traveler tuh death.

De next night he retched home and he went in de house and saw quite a young lad lying in de bed wid his wife. He went out doors and picked up de ax and went back in de house; but he thought of whut de white man said: "Don't do nuthin' in de night whut you might be sorry of next day." So he threw de ax down and went in and woke his wife and found out it wuz his son in de bed.

"Well, ole woman, I've been gone ten years or more and I come wid nuthin'. I worked three years for one man and all he give me wuz one loaf uh bread and he tole me not tuh cut de bread, but to ast de blessing and break it."

He ast de blessing and broke de bread, and he found three years' work in de bread. Den he tole her all de white man told 'im.

—DELLA LEWIS.

A man courted a woman once and married her. She was powerful pretty and he was proud. So that night after they had done got married it come time for them to go to bed.

So he went outside to give her time to git in de bed first. That's de way men always does wid a new wife.

Way after while he come in to git in hisself. De wife had done took off her wig and hung it on de bed-post. Her false teeth was layin' on de dresser, her cork leg was standin' over against de wall, and her cork arm was layin' cross a chair. One of her eyes was soakin' in a glass of water on de dresser.

He was so put out he didn't know whut to do. He looked at all her parts strowed around and he looked at de woman in de bed. He tole her, "I don't know whether to git in de bed wid dat half of yuh or to sit up wid de rest."

—ELIZA AUSTIN.

VARIANT ON A STORY TOLD
BY HATTIE REEVES†

One day de ole man decided to go git him uh load uh wood, and he got uh pail uh water and sat it in de yard and tole de old lady, "If dis pail uh water turn tuh blood, you turn dese dogs aloose, cause you most know I'm in trouble."

So de ole man, he got down in de woods and started tuh cut on uh tree. And uh bear got after 'im and he dropped his ax and run up de tree. De ole bear, he picked up de ax and looked at it. (The bear reads the name on the handle.) The bear says: "Dis name is Whimmer G. Martin." So he begin to chop on dat tree where de ole man was to de tune of de man's name: "De Whimmer G. Martin! de Whimmer G. Martin! de whim! De Whimmer G. Martin, de Whim!"

Ole man says, "Wait, Mr. Bear, lemme pray uh prayer befo' you kill me."

Ole bear says tuh 'im, "Pray it fast."

Man said (calling his dogs): "Come August, come Sparrow, come Bon Bon Pree!"

Bear says (chopping): "De Whimmer G. Martin, de Whimmer G. Martin, de Whim!"

Man says agin, "Wait, Mr. Bear, lemme pray one more prayer befo' you kill me."

"Pray it fast! Whimmer G. Martin, de Whim!"

Man said, "Come August, come Sparrow, come Bon Bon Pree!"

De tree wuz beginnin' to fall and de dogs wuz at de edge of de woods.

Bear says, "Whimmer G. Martin, de Whim!"

'Bout dat time de dogs jumped on de ole bear and kilt 'im. De ole man jumped down outa de tree and took de dogs, and de bear, home and tole his wife, "See how good my dogs is? Saved my life. If you hadn't turnt my dogs loose I'd be uh gone man, dat's all."

—JOHN SMITH.

MAN WITH THREE COUGHS[†]

Once uh man had de consumption real bad, an' he went tuh uh doctor tuh see whut he could do fur him, an' de doctor tole him, say: "Youse got it too bad tuh help. Fack is, you ain't got but three mo' coughs left an' you'll be dead. So you better be mighty keerful."

He went on home walkin' jes as keerful as he could, but he stumped his toe and it made 'im cough. He say, "Umph, dat's one of my coughs gone already."

Dat night he got in uh sorter draft and he coughed again. "Umph, umph, another cough gone!"

Next day he went tuh look over his field and he coughed de third time—so he says, "Well, I reckon I'm dead." So he laid down by uh log an' folded his hands. He laid dere a long time, when uh ole sow wid some pigs come long and begin tuh root

him. He wanted tuh make uh gwan off, but he figgered he couldn't. He kept on talkin' out de side uh his mouth: "Gwan! gwan! gwan! I say." But de ole sow kept on rootin' and rootin' till finally he hollered out loud, "Gwan way from here, you damned ole hawg! I'd git up from here and half kill you if I wuzn't dead."
—MARY DASH.

Uh nigger wuz cuttin' wood (cord wood). He got tired an' set down under a shade tree and went tuh sleep. When he woke up he saw a rattlesnake had rolled cross him. He looked up and saw de snake lickin' out his tongue. He wrote uh note and pinned it on his breast: "Found dead in de woods—bit by a rattlesnake." He folded his arms and died.
—GEORGE MILLS.

The boy courted the girl for a long time and then he married her. First night of married life, 'bout twelve o' clock, he ast her to tell him all the boys she had ever had and he would tell her all the girls he had had.

After she tole him, she called so many names he stopped her. He said, "That's enough. I don't want to hear no more, you ain't nothin' but a whore. I'm going to Alabama."

Early de nex' morning she went back home. Her pa met her at de gate. Ast her whut the matter wuz. She said, "Father, I can't tell you."

Father said, "I know dat trifling nigger ain't done beat you de first night. Wife, take our daughter upstairs and find out whut's de trouble.

While he staid downstairs and eve-dropped, she tole her mother, "My husband ast me to tell him how many boys I ever had and he would tell me how many girls he had courted, and when I tole him, he said I wuzn't nothin' but a whore and he wuz goin' to Alabama."

Mother said, "You sho wuz a fool. I been with your father over forty years, always have had twelve or fifteen men on him and he ain't never knowed nothin' about it."

De father says, "You kin bring me down my hat. Here's another damn fool Alabama bound."

—"Skinny" Floyd Thomas.

Once there was an old woman who went off once on a train with her little grandson and she didn't have the fare for the little boy. So she put him under her skirt. So the grandmother keep on fizzling on the little boy's head, so he got out from under her skirt. The conductor came around asked the boy where had he come from. The little boy told him, "I was up under grandma's skirt and you wouldn't have seen me if grandmother hadn't fizzled on my head."

—Cliffert Ulmer.

There was once an old man and a old woman who lived in the country with their little girl. So a man came from the city to visit them. They did not have but two beds, so the man had to sleep with the girl. The old woman put a pillow between the man and the girl. The next morning they got up and hitched the team up to go to town and took the old man's daughter. Riding along the wind blew the girl's hat off her head over the fence. The man got out to get the hat. She said, "Never mind, brother, I don't see how you can climb over a fence when you couldn't climb over the pillow last night."

—N. A. James.

G-r-a-s-s grass
H-o-p-p-e-r hopper
Never specks tuh stop
Till I git on top.
—NORA LEE WHITE.

Uh man tole uh tale on de boll weevil agin. Uh man wuz up on de hill an' he heered uh turrible racket down de hill, an' he went an' run down de hill tuh see whut it wuz—an' whut you reckon he found? Mister bool weevil wuz whuppin' lil boll weevil cause he couldn't keer two rows at a time.
—LARKINS WHITE.

BOLL WEEVIL†

White man wuz drivin' past uh cotton patch an' uh boll weevil flew onto his steerin' wheel an' said: "Lemme drive yo' car."

White man said, "Why, you can't drive it."

"Don't tell me Ah can't drive it! I drove in uh thousand last year an' Ah'm goin' tuh drive in two thousan' dis year."
—LARKINS WHITE.

JORDAN CAR†

De Jordan car is de only car not named after uh man. Know how come it tuh be lak dat? You know when dey make a car dey take it out on de road and try it out tuh see whut it will do. So de man got his car all made, and he had a nigger workin' for 'im. So he took 'im along tuh watch de speedometer.

He floored de accelerator an' she shot un tuh seventy. De nigger's eyes begin tuh pop out. De man ast him, "How am I doing, John?"

"You doing seventy, boss."

He floored de gas again and she shot up tuh eighty. By dat time John wuz shaking lak he had uh chill. He seen death comin' straight at him. So he hollered, "Git back, Jordan! Git away, death!" So de man named de car "Jordan".

—WILLIE ROBERTS.

Once there was an old man, woman and boy. They were eating, and the old man got through first and he got his pipe and went on the porch and sit on the bannister. He fell off and broke his neck. The boy was de next one got through eating and he went on the porch. He saw his grandfather had fell and broke his neck, so he went and told his grandmother about it and she said: "Wait till I git through eating and I will bellow for him."

—HENRY EDWARDS.

One ole couple wuz livin in uh house wid de kitchen built uh little off from de house, an' dey had dey lil granson livin' wid 'em.

De ole woman, she lakked her pipe. One night she wuz settin' dere smokin' when uh big blow uh wind come up, so she layed way her pipe an' went on intuh de house an' went tuh bed.

Pretty soon uh turrible wind come long an' blowed de kitchen down, an' kilt de ole man; but de lil boy got out an' run intuh de house an' tole his grandmaw:"Grandmaw! Grandmaw! De kitchen done blowed down an' kilt grandpaw!"

De ole lady says, "Umph, umph! An' Ah bet it broke mah pipe, too!!"

—HANDY PITTS.

"Say, boy, when you die, what you be thinking about?"

"Oh, man, I want to be buried in the center of the white folks' graveyard."

"Yes, what's that good for?"

"That's the last place the devil goes to look for a nigger."

"Yes, but when I die I want to be buried in a rubber coffin."

"What's that good for?"

"So I can go bouncing through hell."

—JERRY BENNETT.

FISHING ON SUNDAY[†]

There was a man that always went fishing on Sunday. The people told him not to go, but he went anyhow.

He baited his line and threw it overboard and tied the lines to his arm. The fish was so long in biting that he fell to sleep.

A catfish bit the line and he was so big till he jerked the man overboard and he was hollering. So the people came. He went down and came up. The last time he hollered, "Tell my wife—tell my wife to fear catfish and God."

—GEORGE HARRIS.

"Tomorrow is Sunday morning, if we should all live to see it. Tell Aunt Jane to tell Uncle Tom to tell de cow to tell de sweet milk, to tell de clabber to tell de buttermilk, to tell de butter to meet de biscuits in de morning on de breakfast table. Tell Aunt Jane to see to it."

—EUGENE OLIVER.

Once upon a time there was a poor ole lady and she didn't have no husband, but she had five children. One day she said: "Well, Lord, I ain't got no bread for my children to eat."

So she went out to find some bread for her children to eat. So de children were saying: "My belly ake, my belly shake, I wish I had some cornbread cake."

—LOUVENIA ENGLISH.

There was a man didn't know what corn was. So one day he was out walking and one of his friends asted him to dinner. He went in and sat to the table. He had corn for dinner. The man ate all of the corn off the cob and said: "Lady put some more beans on my stick."

—JOE WILEY.

Me and pa went to church. We started to church one Sunday and pa was late for church and he had a Ford car. He was driving pretty fast at the rate of eight miles a week. So pa went in church and went to sleep. A fat lady got to shouting and jumped in pa's lap and pa grabbed her around the waist and hollered, "Son, step on the zillerater (accelerator)! I got the steering wheel."

—ARTHUR HOPKINS.

Do you know how come the Amercans are not in war? No.

Because my father was a farmer. He raised most everything, but only one thing Uncle Sam could use. It was only sweet potatoes sent to France by the train load. But he raised one so big they couldn't get it in a box car. Had to load it on the flat.

So they sent it on to France and the Kiza (Kaiser) saw it, and he got hongry right then and ast for a piece; and the lutant (lieutenant) heard him and run and told his soldiers: "Hang up the sword and hang up the flag, for the Kiza done ask for peace."

—WILL HOWARD.

Once there were two men. One was larger than the other. They were traveling one day and they came to a pond of water which was too deep for the small man to cross. So the big man said, "Get on my back an' I will take you across."

So the little man did so. While they were in the middle of the stream the little man says, "Gee, yo' breath stinks like karn (carrion)."

The big man ast him, "Whut you say up dere?"

The little man says, "I says yo' breath smells like violets."

As soon as they got across, the little man jumped down and said: "Yo' breath stinks like a dead horse and I speck yo' body smells worse."

—F. BRADLEY.

One time uh man wuz drunk an' he had uh five gallon demijohn full uh whiskey totin' it home, an' he had tuh cross uh fence. De moon wuz shinin' bright an' he could see de fence, but he wuz too drunk tuh utilize hisself. When he got on top de fence he fell an' dropped his jug; but he fell on one side an' de jug on de other side. He wuz too fur under de weather tuh git up, an' heard de likker runnin' out de jug sayin', "goody, goody, goody."

He said, "I know yuh good, but I jus' can't git tuh you."

—CLIFFERT ULMER.

Five men want six orders. One order pig ears, one pig foot, one pig tail, one chittlings, two hawg snouts. Tell dat to de cook. Hey cook, git your grease hot, fixing to throw one at you, one walking, one flooping, one switching, snatch one from the rear, two rooting and let her roll.

I want a chocolate cake with icing and jelly roll smeared over the top. Tell dat to the cook. Say, cook, send me a brown-

skin lady wid a thin dress on, doing the shinny-she-wobble serving sweet jelly roll.*
—ARTHUR HOPKINS.

Once there were two men that would steal. They were rogues. They had done stole everything they could think of. So one day they went to a church. One of the men went up to the pulpit. All he could find was a Bible and the leaves turned and the reading said: "Thou shalt not steal."

The man called his buddy and said, "Read this."

So he read it and said, "Oh hell, I'll steal Thou."
—CHARLIE BRADLEY.

Once there was a man stole some sheep and they put him in jail. His lawyer told him he could clear him for fifty dollars. Say everything the judge ask him to say "ba-a."

And the judge asked him was he guilty of stealing sheep and he said, "Baa-aa."

So the judge said, "He is crazy; take him out of here."

As he was going out the lawyer asked him for his fifty dollars, and he told him "baa" and went on down the street saying, "Baa, baa."
—ARTHUR HOPKINS.

De police thinks so much of buzzards in Charleston dat one took uh ham sandwich outa my hand, and de police hit me up wid uh blackjack cause I looked lak I didn't lak it. De street cars turned wrong-side outers to keep from running over one.
—TARRYSON PARLOR.

*"vagina" or "sex."

THE NIGGER AND THE GOAT[†]

Once they tried a colored man in Mobile for stealing a hog. So he was very poorly dressed and somewhat dirty. So the judge told him, "Six months on the county road, you stink so bad."

A white man was standing there and he said, "Judge, he don't stink. I've got a nigger who smells worse than a billy goat." The judge told the man to bring the nigger over so he could smell him.

The next day the man took the billy goat and the nigger to the court house and sent the judge word that he had the nigger and the goat out there and which one did he want first. The judge told him to bring the goat. When he carried the goat in, the goat smelled so bad that the judge fainted. They got ice water and bathed the judge's face until he revived. Then he told them to bring in the nigger. So when they brought in the nigger, the goat fainted.

—JOE WILEY.

My father had a red silk shirt. He washed it and hung it out to dry so he could have it tuh wear tuh Sunday-school. De billy goat et up de shirt. My daddy got mad and tied de goat on de railroad track so de train could kill him. When he seen dat locomotive bearin' down on him, de goat coughed up de shirt and waved de train down.

—FLOYD THOMAS.

In de old days when folks was seeking religion they went to a mourning-ground. There was a big ole nigger name Ike used to lead all de mourners to de praying ground.

One right pretty gal wid big legs, she fell under conviction. So Ike didn't lead her, he thowed her crost his shoulder and

toted her on down thew de swamp to ground. It was getting on towards night and he wagged on thew de woods singing:

> It'll take us all night long, baby,
> It'll take us all night long—
> Drinking de wine.

He laid her down when he got there and got down on his knees. He was looking from side to side as hard as he could to see who saw 'im whilst he was easing up her dress.

Another man was out there seeking and he spied old Ike. He hollered at 'im, say: "Whut're you doin there, Ike?"

Ike says: "I ain't doin a damn thing, but you fixin to go off and tell a damn lie."

—Mack C. Ford.

DE LYING MULE[†]

A nigger name Sam useter work for a white man dat had a she mule. So he useter clam up on de edge of de crib and go wid de mule. He kept it up, every day, every day.

So one day another man dat could throw his voice caught him at it and he throwed his voice and made out like de mule said "Sam, git down off me and leave me alone, o' I'm gointer tell de boss on you."

Sam jumped down off de mule and fastened up his britches and went on up to de house. De white man was sittin on his porch smokin a seegar.

"Now, whut do you want, Sam?"

"Boss, I done heered 'em say dat mule uh yourn kin talk. If she come up here tellin her lies on me, dontcher b'lieve her."

A man said, "Hey, Sam, did you go tuh de campmeetin' like you said?"

"Yeah, man, I went."

"Did you see a pretty girl over dere wid a big pink hat on?"

"Yeah, I seen her."

"Well, I give her dat hat. Did you see dat swell dress she had on?"

"Yeah, I seen it. Sho was pretty."

"I give dat tuh her. Did you notice them swell slippers she had on her feet?"

"Yeah, I seen them, too."

"Well, I give 'em to her. And look, Sam did she have a fine fat baby in her arms?"

"Sho did."

"Well, I give dat tuh her, too."

—DAD BOYKIN.

One time after Jack Johnson and Jeffries fought, my pa said to me: "You hitch my mule to the buggy. I am going down and fight Jack Johnson."

I said, "Pa, don't do that. That's the champion of the world."

"You hitch my mule to the buggy."

So down the road we went and we met Jack Johnson. I said: "There he goes now."

Pa said, "I want to see you, Jack." So Jack got out of his car and pa got out of his buggy, and there was a fourteen feet wire fence on each side of the road. So pa said, "Jack, I'm going to whip you this morning." And he begin to motion at Jack Johnson. Jack hit pa a uppercut and knocked him over the fourteen feet fence. So pa got up and come to the fence and said, "Mr. Johnson?"

Jack said, "What is it?"

"Knock my mule and buggy and boy over the fence, please."

—JOE WILEY.

White Man: Hello, nigger, have you ever called a train?

Nigger: Yep, Cap, dass all I ever done. I mean nuthin but call trains.

(The train is coming and the nigger goes to the waiting room door.) Says he, "Hey, you fellows in dar, you better gitcher ticket if you gwine anywhar, cause dat train out dar gwine each an' everywhere. That's all."

—MARY DASH.

Geechies sho do love gold teeth. One time uh geechy married uh girl an' went off tuh work, an' she had uh baby whilst he wuz gone. When she wrote 'im de baby wuz born he come home right away tuh see if de youngun wuz his. He come in de house an' went straight tuh de bed an' looked at de baby. First thing he did wuz tuh open de baby's mouf an' look, den he says: "Dat ain't my baby. Naw, sir! Dat ain't no child uh mine."

Jus' like all de geechs he had uh mouf full uh gold teeth an' he looked at de baby agin. His wife said yes dat wuz his baby, too, an' wuz jus' like 'im. Everybody who wuz sittin' there said so, too; but he wouldn't have it dat way. "Well," he says, "if dat is my child, where is his gold teeth?"

—CLIFFORD ULMER.

THE MOBILE DISASTER†

Have you heard about the wreck? Dolphin run into Royal Street, skint up St. Francis Street, Conti layin' at de point of death.

—GEORGE HARRIS.

One day I was going down the road; I was real hungry. I heard something call me, "Hey, Mister, take me," so I looked around, couldn't see anything. It called again. I told it to come on. It was a ham of meat. I walked on down the road a piece further after I got the ham. I heard another call. I told it to come—it was a big pan of biscuits. So I walked on down further; I heard something call again, "Hey, take me." I told it to come on. It was a big can of syrup.

I decided to take lunch.

After I took lunch I got up and started on off. I heard something say, "Hey, Mister, are you a tooth dentist?" I told him no and asked him why. He said, "Oh, I wanted you to work on my wife's teeth. She wore them off eating grass."

—ARTHUR HOPKINS.

Two niggers went out stealing and they promised when they got thew stealing to meet each other at de forks of the road; and stid of meetin' his partner, he met de sheriff dere. He hollered, "Hey, Oh partner," fust and he says, "I beat you stealin' tonight."

Sheriff ast him whut did he steal. "I stole uh cow and sold her and I stole a mule an' sold him, and come by old lady Lan's and got dat big ole Shanghai rooster."

De sheriff helt him up and said, "You don't know who you talkin' to, do yuh? I am the sheriff."

Nigger says, "Well, do you know who I am, Mr. Sheriff?" and the sheriff said no. He says "I'm de lyingest nigger you ever met. I ain't stole nothin."

—BABY-FACE TURL.

Once it wuz hard times and two men wuz sworn buddies went out tuh hunt. Dey didn't ketch nothin, but when dey wuz most home dey seen uh deer layin' down sleep in uh cane patch.

One uh de men said: "Look here, de Lawd done blessed us. Look at dat big fine deer. Less shoot 'im."

De other said, "All right, but first less we 'vide 'im up."

"All right, I'll take one uh de hindquarters an' you take de other."

"Dat's all right wid me. Now I'm gointer give my wife's folks one front quarter."

"It's all right wid me; an I'm gointer give my uncle on my ole man's side uh front quarter."

"Dat's good, an' we kin sell de head tuh ole man Tody an' make uh stew outa de heart an' lights. Now who gointer git de liver?"

"I'll tell you whut! Less give it tuh my sister's husband."

"Naw indeed, he done me outa uh fat shoat one time an' I ain't had no use fur 'im since. Less we give it tuh de preacher."

"Naw, I wouldn't give 'im air if he wuz stopped up in uh jug. I caught 'im kissin' my side gal. Less give it tuh my nevvy (nephew)."

"Naw, I won't 'gree tuh dat neither. Whut's de matter wid you—always tryin' tuh git de big end uh things fuh yo' folks? Naw! naw! I mean NAW!! I'll fight yuh first."

Jus' den de deer heard 'im an' jumped up an' run off faster than de word uh God an' nobody didn't git de liver.

—JAMES PRESLEY.

Once there was an old man and an old woman who lived out in the woods. One day the old woman said to the old man. "Old man, what would you do if a bear would come?"

"I would take my gun and shoot his head off."

So after while a big grizzle bear came up in the yard. The old man jumped up and ran up in the lauf (loft), the old woman took the gun and killed the bear—then she called up to the old man: "Old man, old man, come on down. I done killed the bear."

The old man said: "The doggone bear done made me so mad that I messed all over myself. Bring me some more rags up here."

—ED MORRIS.

MAN & DE LION[†]

One day a man was riding uh horse down de road. He had him a shotgun an' uh pistol an' uh razor. He met uh bear an' de bear says tuh 'im, "Wait uh minute. They tell me dat you goin' round tellin' folks dat youse de king uh de world."

Man said, "Thass right. Don't you b'lieve it?"

"Naw, I don't b'lieve it. Git down and fight."

They went tuh fightin' an' de bear begin tuh squeeze an' squeeze, an' so de man knowed he couldn't stand dat long; so he out wid his razor and cut de bear in de side—cut 'im deep, too. De bear turnt loose and drug off in de bushes tuh try tuh git well. De man went on down de road.

De lion smelt de blood and come found de bear where he was layin' in de bushes and started tuh eat 'im. De bear hollered, "A-aw, Brother Lion, don't tetch me, please. Ah'm *so* sore I don't know whut to do. I met de king uh de world and he done cut me all up so Ah'm 'bout tuh die."

De lion roared at 'im. "Don't you lay dere an' tell me you done met de king uh de world when you ain't met *me*! Ah'm de king uh de world an' ever'body knows it! Arr-rr-rrr I got a good mind tuh tear yuh tuh pieces."

"Aw, Brother Lion, don't tetch me, please. If you hadda seen 'im you would of said he was de king, too."

"Where is he at? Jus' lemme see 'im an' Ah'll show him who is king uh de world."

"Well, you jus' set down here and wait awhile and he'll come long and you kin meet 'im."

So de lion set dere. After while he saw a old man comin' down de road. He jumped up and got ready. "Is dat him, Brother Bear?"

"Naw, dat's uh uster-be. Jus' wait uh lil while mo'."

After while a lil boy come down de road. De lion jumped up again and got ready tuh fight. "Is dat him?"

"Naw, dat's uh gointer-be. He'll be long here tureckly."

After while here come de man ridin' down de road. "Thass him! Thass him, Lion! Here he come!"

De lion jumped up and give his tail uh coupla cracks and run out in de middle of de road and got right in front de man. He hollered, "Hold on dere! They tell me you goin' round strowin' it youse de king uh de world?"

"I am, don't you b'lieve it?"

"Naw, come on let's fight."

De man didn't git down off his horse dis time—he jus' up wid his shotgun and let de lion have one barrel right in de face. That was too much for de lion. He wheeled tuh run. De man let him have de other barrel under his tail. De lion made it into de woods to where de bear was and tole 'im, say, "Move over dere an' give me uh place tuh lay down dere. I done met de king uh de world, I know it."

Bear ast 'im, "How did you know it, Lion?"

"Cause he made de lightning in my face and thunder in my hind parts ... So I know I done met de king."

—LOUIS CROOMS.

DE ANIMAL CONGRESS[†]

De elephant an' de monkey an' de wolf an' several other beasts had uh convention to find out which wuz de ugliest animal, and they said de one dat wuz voted de ugliest had tuh go tuh de well an' bring uh pail uh water. De monkey got up an' got de water bucket an' said: "I'll go git de water dis

time, but I don't crack." (He means to say he doesn't joke about personal appearances.)

—JAMES PRESLEY.

Every Friday all the mocking birds go to hell to carry a grain of sand to put out the fire; that is why no one ever hears a mocking bird sing on Friday.

—BERTHA ALLEN.

We wuz upon uh terbaccer truck goin' after terbaccer plants. When we wuz goin' we seen uh goat justa chewin'; when we come on back he wuz still chewin' an he ast us: "Whose truck is dat?"

We tole 'im, "Harly Moss, why?"

He say, "Oh, nothin'."

—NORA LEE WHITE.

Hurricane met de tornado in Fort Lauderdale. So they went and had breakfast together.

Hurricane ast de tornado, says: "Where you been and whut you been doing?"

Tornado says: "Oh, I been down in Cuba messin around. Where you been?"

"I been to Palm Beach kinda bumpin de bump. Tell you whut let's doo. Soon as we git thew breakfast, let's go down to Miami and let's shake dat thing."

—M. C. FORD, MIAMI.

WHY THE WAVES HAVE WHITE CAPS*

The Sea and the Wind was both women. They both had children. The Wind tole the Water, "My children is better than yours. Some flies in the air, some walks on the ground, and some swims the water. They got all kinds of pretty feathers. They kin sing. Yours can't do nothin' but swim."

The Water got mad at the Wind for talkin' like that, because she was mother of all the birds. So next time a lot of birds come down to drink, the Water caught 'em and drownded 'em. The Wind know she left her children down by the Water, so she keep passin' over callin' her children. Every time she calls 'em, they show they white feathers to let her know where they is, but de Water won't let 'em go. When it storms, the Sea and the Wind is fighting about the children.

—LILY MAY BEALE.

*This tale is repeated in a slightly different version, later.

Talking Animal Tales

De brother in black is lak de monkey. He wanter do everything he see somebody do. They was an engineer on de I. C. had a pet monkey and he use to let him ride wid him sometime. One day he stepped off to git his orders and de fireman to ketch air, and de monkey jumps up in de engineer's seat and opens de throttle and pulls her out. Down dat road him and dat wheeler. They sent wires ahead, "Look out ahead! Monkey on de rails." Well, he run her till his steam died down.

Another time he had his monkey on de ship and de monkey could talk, so he bet a million dollars his monkey could talk, and de man bet him a million different. So he tried to make dat monkey talk. Monkey wouldn't say a word. "Bet I'll make you talk." He tied dat monkey to de anchor chain. De chain wuz just running overboard. Way after while it jerked dat monkey up. When he got up to de rail he hollered, "Snub her, boss, snub her."
—JERRY BENNETT.

Man wuz goin' tuh give uh purleau supper, but he didn't have nothin'; so he went an' stole uh chicken an' brought it home. Well, he put on de water tuh clean it an'

his cat come up an' says: "Unhunh, I see you got uh chicken. Gimme de liver an' gizzard, please, m'am."

Thass de way cat got uh talkin'—they says "m'am" tuh ever'body, even uh man.

He never paid no 'tention tuh de cat. He took an' cooked dat hen wid uh plenty rice an' set it back till his friends come.

Being de man uh de house he wuz first one tuh dip in de pot an' he took de gizzard an' et it, an' it made 'im sick right off cause dat chicken wuz poisoned.

They called de doctor an' put 'im tuh bed an' uh rockin' cheer wuz standin' close up facin' de bed an' de cat got up in dat cheer an' set dere an' rocked, an' she tole de man: "I sho is glad I didn't eat none uh dat chicken. Goody, goody, goody! sho is glad I didn't eat none uh dat chicken. Thass whut you git fuh eatin' dat gizzard 'stead uh givin' me some." (The gizzard is believed to be the only dangerous part of a chicken fed on nux vomica.)

—"NIGGER" BIRD.

 Old feller one time had a mule. His name was Bill. Every morning he go to ketch 'im say, "Come round, Bill."

So one morning he slept late, so he decided while he wuz drinkin some coffee he'd send his son to ketch old Bill.

Told him, say, "Go down dere, boy, and bring me dat mule up here."

Boy, he such a fast aleck, he grabbed de bridle and went on down to de lot to ketch old Bill.

He say, "Come round, Bill." De mule looked round at him. He told de mule. " 'Tin't no use you rollin yo' eyes at me—pa want yuh dis mawnin. Come on round and stick yo' head in dis bridle."

Mule kept on lookin at him and said: "Every mawnin, it's come round, Bill—come round Bill. Don't hardly git no night rest before it's come round, Bill."

De boy thowed down dat bridle and flew back to de house and tole his pa, "Dat mule's talkin."

"Aw gwan, boy, tellin yo' lies. Gwan ketch dat mule."

"Naw, pa, dat mule's done gone to talkin. You hatta (have to) ketch dat mule. I ain't gwine."

Old man looked at old lady, say: "See whut uh lie dat boy's tellin."

So he gits out and goes down after de mule himself. When he got down dere he hollered: "Come round, Bill."

Old mule looked around and says: "Every mawnin it's 'come round Bill'."

De old man had a lil fice dog useter foller 'im everywhere he go, so he lit out wid de lil fice right behind 'im. So he told de lady: "De boy ain't tole much of a lie—dat mule sho is talkin. I never heered uh mule talk before."

Lil fice say: "Me neither. I got skeered." Right through de woods he went wid de fice right behind 'im. He nearly run hisself to death. He stopped and commenced blowin and he says: "I'm so tired I don't know whut to do." Lil dog run and set down in front of him and went to hasslin and he says, "me, too."

Dat man is runnin yit.

—A. D. FRAZIER.

Once the hounds wuz chasin' a fox and had run him all night long. And soon the next mornin' he wuz runnin' crost a mountain and looked back and seen the sun rising all red. He said to hisself: "Doggone my running soul! I done set de world on fire."*

—ARTHUR HOPKINS.

*Hurston repeats this tale later, attributing it to Eugene Oliver.

A cross-eyed gnat and a one-eyed fly had a collision, and they's suing each other yet.
—N. A. JAMES.

Once a lady had a polly* and he was awful bad. A man came along selling coal. The polly told him to drive around to the back and drive back this evening and get your pay. So the man came back that evening after his pay. The polly didn't answer, so the lady answered and the man said: "I came after the pay for the coal."

She said, "I haven't ordered any coal."

The man said, "I know you have!"

She thought about her polly and said, "I bet that old polly ordered that coal. She caught the polly and choked him and threw him back under the house. She had killed a rooster for dinner. The polly began to come to, so he raised up his head, looked at the rooster's head and said, "Hello friend, what are you doing under here—are you ordering coal, too."
—ARTHUR HOPKINS.

Man had a cat. Every evening he come home from work he bring a piece of meat for his supper. De cat meet him and ast: "Is dat ham?"

Man say: "Yeah, I'll give you a piece."

After while, times got tight. He got a lil piece of meat. Cat met him. "Is dat Ham?"

Man say: "Naw, God damn yuh, dis is bacon and you ain't gointer git a smell, neither."
—CLARENCE BEALE.

*A Gullah term, variant of "pollydo," or "polydore": a male friend or boyfriend; Apollo.

Animal Tales

ROOSTER AND FOX

A bunch of chickens and a rooster wasn't roosting very high. Fox would go there every morning and catch a hen till he caught all the hens. Rooster says: "I'm going to change my roosting place and roost higher."

So next morning Fox got dere before sunrise and rooster setting way up in de tree.

"Good morning, Brer Rooster."

"Good morning, Brer Fox."

Brer Fox says: "Brer Rooster, I got good news for you. Come down."

"No, I don't want to come down. It's too early. Whut is the news?"

"Come on down so I kin tell it to you."

"No, go ahead and tell it. I can hear you. Whut is the news?"

Fox says: "Law is now, fox eat no mo' roosters, hounds run no mo' foxes. Ain't dat good news?"

While they was talking they heard the hounds ow-ooo . . .

Fox says: "Hush, Brer Rooster, whut's dat I hear?"

Rooster say: "Dat ain't nothing but dem hounds."

Fox says: "Well, believe I'll go."

Rooster say: "Whut you skeered of? Didn't you say de new law say hounds run no more foxes?"

Fox says: "Yeah, but them hounds liable to run all over dat law and break it. Good-bye, Brer Rooster."

—M. C. FORD.

THE FROG AND THE MOLE

Frog used to have a long big tail and no eyes. Mole had eyes and no tail. So when one day de mole come up out de ground wid his eyes full of dirt he was just wiping his eyes and gittin de sand out. Soon's he looked round he seen de frog sittin up wid his big tail and no eyes. So he said: "Say, Brer Frog, whut you want wid dat big ole tail for? Tain't no good to you?"

Frog said: "Whut you want wid dem eyes and live in de dark all de time? Besides you roots yo' way and gits 'em full of dirt."

Mole says: "Les' swap, Brer Frog."

So they did. Now de frog got eyes and no tail and de mole got tail and no eyes.

—M. C. YARD.

WHY THE DOG HATES THE CAT

Cat and de dog wuz good friends one time. Both of 'em loved ham. So they put in together an' went to town an' bought 'em one. It wuz a great big ham. So de dog he toted it first. He said: "Our ham, our ham, ours, ours, ours."

Come time for de cat to tote it awhile. She says: "My ham, my ham, my ham."

Dog toted it agin. He says: "Ours, ours, ours."

Cat took agin. She says: "My ham, my ham."

Dog says: "Sis Cat, how come you always say 'my ham' when you totes de ham? I always say 'our ham'."

Cat didn't say nothin but when they got almost home de cat

sprung up de tree wid de ham and set up dere eatin it up.

Dog says: "Our friendship is broke up forever. I can't climb no tree, but you got to come down sometime and when you *do* . . ." (a significant shaking of the head).

—MACK C. FORD.

WHY DE DONKEY'S EARS IS LONG

Once upon a time there wuz a man he named all de animals. He named de lion, lion; he named de bear, bear; he named de tager, tager; he named de wolf, wolf; he named de fox, fox; de mule, mule; and all de other animals, so when he got to the donkey, donkey act stubborn. He caught de donkey by his ears and he pulled donkey's ears and dat's whut make de donkey's ears so long now.

—NATHANIEL BURNEY.

DE REASON DE WOODPECKER GOT UH RED HEAD

When all de animals wuz in de ark de woodpecker started tuh peckin' on de wood. Ole Nora tole 'im tuh stop cause he had done pecked uh hole nearly thew de wall, an' Ole Nora saw he wuz goin' tuh drown everybody; so he tole 'im tuh stop uhgin an' when he caught 'im peckin' de nex' time, he hauled off wid uh hammer an' hit de woodpecker on de head an' made it bleed. And that's how come de woodpecker got uh red top-knot t'day.

—CLIFFORD ULMER.

WHY DE BUZZARD AIN'T GOT NO HOME

Every time it rains the buzzard says: "Lawd, I wish I had a place to stay." But as soon as it fair off, he say: "Who want to be bothered wid any home? It's too nice flyin' 'round." But soon's it starts tuh rainin' again he says: "Lawd, I sho' wish I had a home. If it ever stops rainin' I'm sho' goin' build me a home." But he never do. So that's the reason the buzzard never have no home.

—ARMETTA JONES.

THE FOX AND THE HOUNDS

Once the hounds wuz chasin' a fox and had run him all night long. And soon the next mornin' he wuz runnin' crost a mountain and looked back and seen the sun rising all red. He said to hisself: "Doggone my running soul: I done set de world on fire."*

—EUGENE OLIVER.

WHY DE ALLIGATOR IS BLACK

De alligator was laying in the marsh sunning hisself and catching flies when Brother Rabbit dashed in and run right cross him and wake him up. That made Brother Alligator mad. He said: "Brother Rabbit, what you doing running over me that way and waking me up outa my rest?

Brother Rabbit say: "You'd run over somebody, too, if you'd been troubled like me. The hounds is behind me and I am in plenty of trouble."

*Hurston includes this tale earlier, attributing it to Arthur Hopkins.

Brother Alligator say: "Trouble? What's trouble?"

Brother Rabbit say: "Brother 'Gator, don't you know what trouble is?"

Brother 'Gator say: "No, I don't know nothing 'bout no trouble. I ain't never heard tell of it. What is it?"

Brother Rabbit say: "I'll show you." So he went off and took a lightwood torch and set that marsh afire all the way around. Then he went off and waited.

When the alligator felt that heat he made a break for de water, but no matter which way he run there was fire there. You know, before that, the 'gator was all pretty and white, but time that fire got thru scorching him he was black as a coal. Way after a while he burst thru the flame and heat and hit the water wham! An' where he had done got burnt black all over he's been black ever since.

And that is how the 'gator found out how trouble was.

—EUGENE OLIVER AND MARY DASH.

THE FLIES AND GOD

The flies was so small till everything trod on 'em you know and keep 'em back. And the flies held a conference—they wanted to know what to do. So they says: "We'll go up to heben and tell God about it." So they got one right after the other—one right after the other.

"Say, Lord, we ain't got no weapons to fight with and no way to protect ourselves, and we can't get nothing to eat."

So God said: "Go on back and when you get back I'll fix it so you'll git the first taste of everything."

So they did and they never fail.

—M. C. FORD.

WHY DE CAT HAS NINE LIVES

One time it was very hard times and de man had a wife an' five chillun an' dey didn't have nothin' to eat. Dey looked, but dere wasn't a dust of meal nor flour in de barrel, so he fixed him up a pole and dey all went down to de water. So he fished an' he fished till he caught seven fish; one for himself an' one for his wife an' one for everyone of his five chillun. Den he said: "I b'lieve I'll keep on fishin' till I catch one for de cat an' one for de dog." So he did. But jus' as he pulled out de las' fish, he broke his hook. So he said: "It's good I got a fish for everybody, 'cause I done broke my hook an' I ain't got no mo'."

So he went on up to the house an' dey cleaned dem fish and fixed dem. Then he seen he needed a bucket of water so him an' de ole lady went after de water, an' dey tole de chillun, "Don't let de cat touch de fish. He sho' will bother it if you don't watch 'im."

So while dey was gone, the children got to playin' an' forgot all 'bout de cat an' de cat took an' got up on de table an' et up seven of de fish. Dat was all he could hold.

When de man come back an' found out de cat had eat up de fish he said: "Dese two lil fish can't save us." He looked at the cat an' his stomach was so full it was 'bout to bust so de man knowed them other two fish would kill 'im. So he said to the cat: "Since you de cause of all de rest of us starvin' to death, I goin' make you eat dese two fish an' kill you."

So he made de cat eat de fish an' it bust him open and he died. So de man an' his wife an' his chillun an' de dog starved to death.

So dey all went up to heaven an' when dey got dere God put de man on de scales to weigh his soul an' de cat come up an' looked at 'im so funny till God knowed there was some-thin' between the man and the cat. So he asked de man: "What's between you an' dis cat?" So de man tole him whut de cat had done. So God tole Gabriel says: "Grab dat cat an'

throw him outa here." So because de cat had nine lives in his belly, he was fallin' for nine days befo' he landed in hell.

So dat's why de people say de cat has nine lives.

 Goat fell down an' skinned his chin
Great God-amighty, how de goat did grin.

WHY DE PORPOISE'S TAIL IS ON CROSSWISE

 Now, I want to tell you 'bout de porpoise. God had done made de world and everything. He set de moon and de stars in de sky. He got de fishes of de sea and the fowls of de air completed.

He made de sun and hung it up. Then he made a nice gold track for it to run on. Then He said: "Now, Sun, I got everything made but Time. That's up to you. I want you to start out and go round de world on dis track just as fast as you kin make it. And de time it takes you to go and come, I'm going to call day and night."

De Sun went zoonin' on cross de elements. Now, de porpoise was hanging round there and heard God what He tole de Sun, so he decided he'd take dat trip around de world hisself. He looked up and saw de Sun kytin' along, so he lit out too, (Gesture of swift flight), him and dat Sun!

So de porpoise beat de Sun round de world by one hour and three minutes. So God said: "Aw naw, this ain't gointer do! I didn't mean for nothin to be faster than de Sun!" So He run dat porpoise for 3 days before He caught dat porpoise and took his tail off and put it on crossways—still he's de fastest thing in de water.

—M. C. FORD.

THE LION AND THE RABBIT

De lion he lived in a rock cliff. He fooled de other varmints. Dasa way he had to git his livin' to keep him from gwine 'bout.

One day de rabbit he passed thata way and de lion said to him to come by and give him some water.

Rabbit he staid way out at de openin' and looked all round at de ground and everything. He told de lion, "I wouldn't mind comin' but I see dese tracks all gwine in and none comin' out. I'm kinda in a hurry anyhow, so I guess I betta go 'long."

De lion sorta had a taste for rabbit dat day, so he tried to hold him dere till he could git upon him. But de rabbit wuz jist ez slick ez he wuz sly. De lion den see he couldn't git de rabbit dat time, but he figgered he'd tole him on and lay for him; so he says: "Brer Rabbit, you mus' come set wid me some time. I laks to talk wid yuh. You comin' back dis way, aintcher?"

"If I have any business back dis way, I'm sho comin' back, but if I don't have no business, I sho' ain't comin' back. You down here 'stroyin' all de other varmints."

De rabbit went booky-ty-boo, booky-ty-book on down de road all day. 'Bout sundown he come to a clearin' where folks wuz workin'. It war a man and his ole lady and a passle of younguns. De man had a big ole shotgun. De rabbit laid low and watched him for a spell, keepin' outa wind of de dawgs. Dey passed on from de field to de house, and de rabbit wheeled and loped back to where de lion wuz laid up.

"Hello, Brer Rabbit, I see you come back. You come to set wid me dis time, I reckon. You know, I'm sorta po'ly. Don't look lak I'm goin' to mend a-tall."

"Naw, Brer Lion, ain't got time to set down. I got so much business. I jist come back by to let you know I seen a place yistiddy where's so many varmints, you'll be glad to let some of 'em live."

"Where dat at, Brer Rabbit?"

"Oh, 'bout a day's journey from here."

"Will you keer me dere?"

"Yeah, if you wanta go."

"All right, I'll be proud to go. Youse mah best friend, Brer Rabbit. Dese here other varmints see me lay dere 'bout to starve to death and dey won't come nigh me."

So he got hisself ready and followed de rabbit on off down de road, de rabbit keepin' his eye on him all de time and keepin' a safe distance ahead—never would let de lion git upon him close 'nough tuh harm him. Dey traveled and traveled till finally dey got to de fiel' de rabbit seed de day before. De rabbit stopped de lion and put him in de aidge of de woods.

"Lay down heah, now, right heah. Man be long after while."

"Whut *is* Man?" ast de lion, cause up tuh dat time he hadn't never seed no man.

"You'll see," de rabbit tole 'im.

"I ain't never heered tell nuh talk uh him befo'," de lion said.

De rabbit kept him low and dey waited till de man would knock off and start home. De sun wuz still high. Dey seen somebody comin' down de road.

"Whuss dat yonder comin'—dat Man?"

"No, no, lay down, Brer Lion."

"But whut is it?"

"Dass a lil boy—thass a will-be. Lay down."

By and by de horn blow for supper at de quarters and de man and his folks left de fiel' and start comin' cross a foot-log t'wards where de lion wuz hid.

"Rabbit, whuss dat yonder?"

"Shh-hh, dass Man."

A horn was hanging from his shoulder. De lion saw it and ast, "Whuss dat hangin' down on his shoulder?"

"Dat's his voice."

"Whut's dem all round him?"

"Dat's de imps dat his voice calls."

"Whuss dat long thing on his shoulder?"

"Dat's de stick he spits fire on de world wid."

De lion got his bristles all up and ast, "Do you know how I kin git in contack wid him?"

"Yas," de rabbit tole 'im, "go right down de hill and git on dat foot-log. He's bound to cross dere."

De lion romps down on de foot-log soon's he seen de man git on it. De dawgs tackled 'im, but he wuz too severe for de dawgs. De man ups wid his shotgun and cracks 'im off and blinded de lion. He wheeled and run. Man wuz too severe for him.

Dat rabbit lit out soon's he sont dat lion on to de foot-log. He done some fas' traveling back up de country.

Two or three days later de lion wundered on back to his old vicinity. De rabbit was dere all along, eatin' up whut wuz dere. He heered de lion groanin' on top of de hill and come out dere an' seen 'im. De rabbit had done took de lion's house.

"Who dat?" ast de rabbit.

"It's me, Rabbit. Go way f'om me, Rabbit. I don't want no mo' to do wid you. You got me in all dis trouble wid Man."

Ev'vy since den, Man been takin' de lions, but only de cubs; cause de ole lions is too severe to be took alive.

—WILLIAM JONES.*

*In her original manuscript, Hurston had prefaced this tale with the follow-ing statement about William Jones: "William Jones is an ex-slave. He tells many anecdotes of his share in the Civil War. By the gospel according to Jones, it would have availed the North little had they twenty U. S. Grants and had they not one William Jones on their side."

Biddy, biddy, ben
My story is end
Turn loose the rooster
And hold the hen.

De crane wuz hongry, so he caught uh eel and et him. But you know de crane ain't got no gizzard. He got a craw and dat's all. Soon's he swaller de eel he run right on through him out de other end and headed for de water. De crane seen him and caught him and swallowed him again. Right on through. De next time de crane swallowed him he backed up against a big ole tree and says, "Hot damn you! You won't git away dis time. I got dead wood on you now."

—JERRY BENNETT.

WHY THE WAVES HAVE WHITE CAPS*

The sea and the air was both women. They both had children. The air tole the water: "My children is better than yours. Some flies in the air, some walks on the ground, and some swims the water. Yours can't do nothin' but swim."

The water got mad at the air for talkin' like that because she was mother of all the birds. So next time a lot of birds come down to drink, the water caught 'em and drownded 'em. The wind knowed she left her children down by the water, so she keep passin' over callin' her children. Every time she call 'em, they show they white feathers to let her know where they is, but de water won't let 'em go. When it storms, the sea and the wind is fighting about the children.

—LILY MAY BEALE.

*Hurston includes this tale earlier, in a slightly different version.

*[Hurston's manuscript includes here a second—identical—version
of the tale "Why De Donkey's Ears Is Long."]*

HOW COME DE 'GATOR HATE DE DOG

God made both of 'em without a mouth, an' de 'gator
and de dog made up a plot to get each of 'em a mouth.
An' so de dog had de 'gator tuh cut his mouth first. So de dog
tole de 'gator tuh stop and de 'gator stopped.

And den de 'gator tole de dog tuh cut him uh mouth, and
de dog tuk de knife and went to cuttin' de 'gator mouth; and
de 'gator says, "Hold, Brer Dog," and de dog kept cutting right
on and cut de 'gator a great big mouth.

An' every since den, de 'gator been mad wid de dog.
—CHRISTOPHER JENKINS.

WHY DE 'GATOR GOT NO TONGUE

One time all de varmints wuz going tuh have uh big
frolic, but they didn't have no band; so de committee
went round seeing who would help out wid de music. De
dawg said he'd lend his horn—dat's whut he plays; an' de frog
said he'd lend his accordion; an' den Brer Dawg went tuh de
'gator tuh see if he would lend his tongue fur uh bass drum.
De 'gator lent it tuh 'em an' de dawg—he wuz de head uh de
committee—took it on down intuh de piney woods, an' they
frolicked all night long and played de drum an' danced till they
wore out Brer 'Gator's tongue; den de dawg wuz shame tuh
face de 'gator.

That's how come de 'gator been mad wid de dawg ever
since an' he eats all de dawgs he kin ketch, tryin' tuh find his
tongue.
—WILLIE MAY MCCLARY.

[Hurston's manuscript includes here a nearly identical version of "Why the Gator is Black," attributed to Willie May McClary.]

DE RABBIT WANTS UH TAIL

De rabbit saw de long bushy tail de squirrel got and he wanted one, too; so one day he says, "Squirrel, how did you git yo' long tail? Ah sho would be proud tuh own one lak dat."

"Well, Ah tell yuh, Rabbit. Ah did some tricks fuh Ole Master, an' He gimme dis tail."

"Well, Ah'm willin' tuh do some, too. B'lieve Ah'll go see 'im."

So he went tuh see Ole Master (God). He tole 'im, say, "Yes, you kin git uh long tail if you do some tricks for me."

Rabbit wuz so anxious he said, "Jus' tell me whut you want done an' Ah'll go do it—don't keer whut it is."

"Well," said Ole Master, "first thing Ah wants you tuh do is tuh go git me some rattlesnake teeth."

De rabbit didn't know where he wuz gointuh git dem rattlesnake teeth, so he cruised round awhile schemin'. But one day he saw de rattlesnake all quirreled up an' he said, "Brer rattler, Ah b'lieve de blacksnake is uh whole heap bigger an' longer dan you is, sho do."

"Naw, he ain't neither. You *know* he ain't bigger, an' Ah know Ah'm longer dan he is, even thout mah rattles."

"Ah hates tuh doubt yuh, Brer rattler, but Ah'm bound tuh think he's de longest. You better stretch out an' lemme measure yuh."

While de rattler wuz stretched out, de rabbit whammed 'im in de mouf wid uh club an' knocked out all his teeth and grabbed 'em up an' run back tuh Ole Master wid 'em.

"Thass pretty good, now go git me two bottles of deer eye-water."

Rabbit went on off to de woods an' set round tryin' tuh study up uh way tuh git deer-eye-water. At las' one day he seen de deer trottin' long, an' he stopped 'im.

"Say, brer deer, know whut Ah seen de other day?"

"Naw, whut did you see, brer rabbit?"

"Ah seen brer wolf leap right through dem two trees you see growin' over dere. Ah don't speck tuh see dat done no mo' whilst Ah lives. Fack is, nobody kin do dat but brer wolf."

De deer looked at de trees. They wuz two trees growin' right close together.

"Gwan, rabbit, you know Ah kin beat brer wolf an' anybody else jumpin'. Jes' you watch me."

He leaped through de trees and got stuck, so he couldn't git loose, so he looked round at brer rabbit an' said, "You better go git uh ax an' chop down one uh dese trees so Ah kin git loose."

"All right, brer deer, but lemme hang dese two bottles on yo' horns tuh keep from settin' 'em on de groun'."

He hung de two bottles on his horns jes' so they would hang at de corners of de deer's eyes. Den he went on round behind de deer wid uh big stick an' went tuh work on his hindquarters. He tole 'im, he said, "You gotta cry me some eye-water fo' Ah git you loose. Now you CRY!"

He worked on dat deer till he cried him up two bottles uh water. Den he took dem to de Ole Maker an' he said, "Thass jes' all right! Now take dis box an' keer (carry) it twelve mile out in de country befo' you open it an' you'll find yo' tail inside."

It wuz uh great big box an' de rabbit put it on uh wagon an' drove out in de country wid it. He counted de miles an' he wuz so anxious tuh git his tail dat he almost stopped two or three times, but he thought he better not cause de Ole Maker might take his tail back, so he drove thirteen miles for fear he had done missed countin' one. Den he took de box off de wagon an' set it down.

Soon as he done dat, he heard somethin' inside say "Urrrr!" He said, "Thass mah tail turnin' roun'." He jekked (jerked) off one uh de boards an' he heard dat noise agin. When he pulled off de las' board, out jumped two hounds an' took right after 'im. He beat 'em tuh uh dead holler log by uh inch, but hounds is been uh rabbit's tail ever since.

—JAMES PRESLEY.

[Hurston's manuscript includes here a second version, nearly identical, of "Why De Buzzard Has No Home."]

DIRT-DAUBER AND BEE

De dirt-dauber come to de bee one day to get him to teach him how to make honey. De bee went to work right away an' he tole de dirt-dauber to get some dust from de flowers an' he would show him whut to do with it. De dirt-dauber said, "I know, I know," (imitation of his song) and flew on off an' come right back wid a load uh dirt.

"Aw naw," de bee tole him, "you don't need dat to make honey! Go git some sweet dust from de roses an' flowers."

Dirt-dauber said, "I know, I know," and flew on off again an' back he come wid some more dirt. Bee sent him off agin an' he did it agin. After awhile de bee got tired uh foolin' wid dat dirt-dauber, an' he tole him, "Looka here, if you knowed how near you was in two*, you'd learn how to make honey instead of totin' dirt."

—ARMETTA JONES.

*The dirt-dauber has a very small waist.

The alligator and de rabbits was having a squabble. De rabbits said there was more rabbits than alligators, and the 'gators said there was more 'gators than rabbits. So they all lined up cross de creek like de rabbit told them (the 'gators). De rabbit said he was going to count de 'gators as he hopped across de creek on they noses. And so just as he got to de last 'gator, he said he didn't care nothin' 'bout countin' 'gators, he just wanted to git to de cabbage patch over on dat side. And just as he said dat, de 'gator said, "You ain't gone yet," and bit off his tail. And that's whut makes de rabbit's tail so short.

—CATHERINE WILLIAMS.

The snake went to God and said, "Please do something 'bout me. You put me on my belly in the dust and everything steps on me and tromps me down. They stomps on my chillen and 'stroys my generations."

God thought about it and tole de snake, "I don't want y'all tromped out so I am goin' to give you poison in your mouth so you'll be de most dangerous animal in de world." So He did.

The other animals come to God and said, "Do something about dat snake. He got poison in his mouth and he is 'stroying us every time we step in de bushes. He is 'stroying our generations. We all is skeered to walk."

God thought about that, so he sent for the snake and said, "I give you poison to protect yo'self from your enemies; but youse killin' everything dat moves."

Snake says, "Well, you knows I'm in de dust. All I kin see is feets comin' to tromp me and my generations. How kin I tell who is my enemy?"

God scratched His head and thought about that, so He says, "Put dis bell on de end of you tail and ring it every time you

see feets comin'. Yo' friends will be keerful after dey sees you. If it's yo' enemy, you and you."

Ever since then, snakes been had rattles.

—ARTHUR HOPKINS.

Once it wuz de rabbit an' de elephant an' de fox, an' dey were givin' uh frolic dat night, yuh know. It wuz uh girl dey all wanted tuh marry an' dey said de one dat danced de dust outa uh rock could have her.

Brother Rabbit had been workin' an' he wuz tired. So he cooked his supper, washed his feet, filled his shoes full uh ashes an' put 'em on an' den shined 'em an' went on tuh de dance.

Dey made de 'nouncement agin after he got dere dat de one whut danced de dust out de rock's gointer git de girl.

De fox danced fust. He cut an' he capered an' flung hisself head over heels, but he didn't raise uh speck uh dust.

De elephant he got up an' danced, but he didn't raise no dust. Den dey ast de rabbit tuh try. He helt back an' when dey kept on at 'im, he said: "Brother Elephant didn't dance it out big as he is, so Ah know Ah can't. Ah'm little an' he's big."

But after while he got up an' danced an' de house got so full uh dust dat dey couldn't see—so he got de girl.

—NORA LEE WHITE.

HOW THE GOPHER WAS CREATED

Cliffert Ulmer is doin' dis!

God was setting down by de ocean makin' all de fish and things and throwin' 'em in. De devil wuz settin' dere watchin' Him. He made de whale and He th'owed dat in. He made mullets and th'owed dem in. He th'owed in sharks and trouts stingaree (stinging ray) and after while He made uh tur-

tle and th'owed dat in, and it swimmed off like all de other things He had done th'owed in. De devil looked at de turtle and says, "Shux, I kin make one uh dem things."

God tole 'im, "Naw, you cain't neither."

"Aw, yes I kin, too. Who cain't make one uh dem things? They sho ain't nothin' to make. Anybody could make one, they jus' cain't blow de breath uh life in 'im."

"I know you cain't make none, but if you think you kin— go head and make it and I'll blow de breath uh life in it fuh you."

So de devil went on off and made it and brought it back and de Lawd blowed de breath uh life intuh it and th'owed it intuh de sea. It swum back out. You see, God wuz gittin' His dirt from by de water, but de devil had done got some high land dirt. Devil th'owed 'im back and he swum right back out agin. He th'owed him in *agin* and he swum back out de third time. God says, "Unh hunh, I tole you dat wuzn't no turtle."

"Yes, it is uh turtle, too."

"Naw, it ain't no turtle, neither."

"Yes, it is so uh turtle."

"Naw, it 'tain't neither. Dontcher see it won't stay in de water? All turtles likes de water. Dat ain't no turtle."

Devil say, "Yes, dat is uh turtle, too—anyhow it'll go for one." And dat's how come we got de go fors (gophers).
—CLIFFORD ULMER.

Once there was a rabbit and he had a good friend named Brother Fox. One day Brother Rabbit met Brother Fox and said to him, "Brother Fox, I know where there is a big piece of ham laying out there in the old field and all you got to do is to tie a string on him and carry him home for your wife and children."

So they went on down there and Brother Rabbit said, "There it is, Brother Fox." So they tied a rope on the big piece

of ham. Brother Rabbit broke him a little switch and hit the ham. Up jumped the horse and the way he did run. He ran as fast as the wind. Brother Rabbit said, "Hold him, Brother Fox, hold him."

"How can I hold him when my feet can't touch the ground?"

Brother Fox decided to get even with Brother Rabbit. He called all of his friends together and told them what had happened. He said that he was going to play like he was dead and he knew if Brother Rabbit knew he was dead they could catch him. He sent one of them after Brother Rabbit. He came up and looked at Brother Fox and shook his head and said the latest style was, if a man is dead, he would turn over and Brother Fox turned over. Brother Rabbit said that that was a lie as no dead man could turn over, and he left.

—L. O. TAYLOR.

 The snail wuz crossin' de road for seben years. Jus' as he got crost, a tree fell and jus' missed him. He said, "Gee! it's good to be fast."

 Know why possum ain't got no hair on his tail? Ham cut it off for banjo strings.

 Once a rabbit and a fox wanted to go with the same girl. The rabbit had told the girl already that Brother Fox was his riding horse. So one day Brother Fox went to Brother Rabbit's house and said, "Brother Rabbit, you going to see the girl today?"

"No," says Brother Rabbit, "I am sick, I can't go I tell you."

"Well, I'll tell you what I'll do, I will ride you half way down there."

"Then all right," says Brother Rabbit, "but you will have to let me put a saddle on your back."

"No, I can't do that."

"Well, I can't go."

"All right, you can put it on." So he put it on.

"I will have to have a bridle in your mouth."

"All right." He put it on.

"I need some spurs on me." He put those on. "Now I need a switch."

So they started to the girl's house—they ran and ran and ran. When Brother Fox saw the house about fifty feet away, he said: "Get off now," but Brother Rabbit put the spurs to him and away he ran right up to the house. Brother Rabbit jumped down and ran into the house and said: "I told you Brother Fox was my riding horse, I told you Brother Fox was my riding horse, I told you. Ha! Ha!"

—JERRY BENNETT.

DE GOPHER IN COURT

De gopher wuz called intuh court. De judge an' all de jury wuz all turtles. An' de gopher got up and looked around, an' ast de court could he be excused. De judge ast him why, an' he told de judge: "Blood is thicker dan water."

—MARTIN WHITE.

HAWG UNDER DE HOUSE

Ole man and woman was in de bed trying to sleep an' uh ole sow was under de house wid her pigs uh gruntin' an' scratchin' an' makin' so much noise till he said:

"Le's git up an pour some hot water through de hole an' run dat sow out from under dis house."

So they did an' when de hot water hit de sow, she said: "Whoosh! Shoosh! Who scald?"

De little pigs, they say, "Us, us, us, us, us, us."

—MARY DASH.

Once a ole goose uster live down in a holler log. She wuz settin' an' uh fox grabbed her. She tole him, "You don't wanta eat no ole po' settin' goose. Wait till I git fat, then I'll let you eat me and you kin git some meat off me. You kin eat de lil geeses, too."

De fox said all right. He kept on coming back every day or two to see if she wuz ready. De goose took her lil geeses and hid 'em, and went and got some dogs and hid 'em in de log. De fox come long pretty soon and says, "Ready or no ready I'm going to eat you today."

She says, "Don't eat me, eat dem tender lil geeses in de log."

So de fox went to de log and dashed in and turnt right round and tore out wid dem hounds right after him. De dogs says (chant): "Ah, ah, Ooo-ah . . . If you don't come go with me you won't get to town today."

De goose hollered, "Ketch him, ketch him," and geese been hollering dat ever since.

—JERRY BENNETT.

Tarrypin an' de fox run uh race for uh girl. It wuz uh five mile race. De tarrypin took an' fooled de fox. He got some uh his friends an' put one at each one uh de posts an' one at de startin' place; den he went on over tuh de girl's house an' set on de porch an' crossed his legs.

When dey set out on de race de fox sprung way ahead. He figgered he had done left de tarrypin way behind. He jus'

knowed he wuz gwine win dat race; but when he got tuh de fust mile post dere wuz de tarrypin scufflin' long uhead uh him. He hopped on past de tarrypin tuh de next mile post; but when he got dere, he seed de tarrypin uhgin. He strained on down de road cause he wuz sayin' tuh hisself: "Ah knows Ah kin beat dat ole tarrypin runnin'."

He lit out an' run lak lightnin' tuh de next post an' dere wuz de tarrypin waitin' agin. De fox laid out he wuz runnin' so fas' tuh beat de tarrypin tuh de house an' he took an' run up de steps an' fell down he wuz so tired, an' dere wuz de tarrypin settin' crossed legged on de porch laffin' an' talkin' wid de girl. De fox ast de tarrypin, he says: "Brer Tarrypin, Ah knows Ah kin beat you runnin'. How come you beat me tuh de house?"

De tarrypin lit uh seegar an' said: "Ah, Lawd! Uh heap sees, but uh few knows."

—LARKINS WHITE.

Once there was a rabbit and uh bear. The rabbit would go round to Brother Lamb and steal a lamb every evening for supper. So one evening he went round; they wuz eating and they begin to tell 'bout somebody been stealing they lambs.

So de rabbit told 'em every time he go to the bear's house he have roast lamb. So he told 'em that he wuz gointer make Brer Bear tell them the truth about it.

So he went and got his fiddle and went over to Brother Bear and told him that Brother Lamb wanted them to play for him tonight.

So they begin to practise and de rabbit says, "Did you, did you, did you?"

The bear says, "Yes, I, yes, I, yes, I."

They said dat twice, last verse was: "Didn't you steal Brother Lambkin's sheep?"

"Yes, by God, I did it."

So that night they both dressed and went over to Brother

Lamb's house. Brer Rabbit, he took a seat by the door and de bear over by de chimbley. So they begin to play. Rabbit said, "Did you, etc." Bear said, "Yes I, etc." Said dat twice. So last time Brer Rabbit said, "Did you steal Brother Lambkin's sheep?"

"Yes, by God, I did it."

So all de lambs jumped on Brother Bear and beat him, and the rabbit grabbed him uh lamb and run.

—EDWARD MORRIS.

When we lived in the country one day I went out in the field and I heard a noise, and I look around and saw a tick calling a red bug to get some trash out of his eyes. And the red bug got the rail off of my fence and got the trash out of the tick's eyes.*

—JERRY BENNETT.

THE SNAIL AND HIS WIFE

De snail's wife got sick. She was rollin' from side to side in her bed. So she tole her husban': "Oh Lawdy, I'm so sick. Please go get de doctor for me an' hurry up. I don't speck I'm goin' be here long."

So he said, "All right."

So she laid there seven years rollin' an tumblin' wid misery. So after seven years she heard a scufflin' at de door. So she said: "Oh, I'm so glad. Dat's my husban' done come back wid de doctor." So she hollered an' tole him: "Is dat you, baby, wid de doctor?"

He say: "Don't try to rush me. I ain't gone yet."

—PETER NOBLE.

*Hurston had written "Tall Tale" in the margin next to this tale.

THE SNAIL CROSSES THE ROAD

The snail was crossin' de road for seven years an' jus' as he got across a tree fell an' it would uh hit him if he'd a been where he was six months befo'. So he tole everybody: "See, dat tree jes' missed me. So that jes' goes to show you it's good to be fast."

—PETER NOBLE.

Appendix 1

Negro Folk-tales from the Gulf States*

Sources:

I. Alabama (Mobile & Suburbs, i.e. Plateau, Magazine Point, Prichard)

> Collected Dec. 16, 1927–Jan. 12, 1928
>
> June 4, 1928–Sept. 3, 1928

A locale of sawmills, lumber camps and fishermen. Illiterate and barely literate, except some school boys who told me tales.

II. Florida (Loughman Sawmill, Eatonville a purely Negro village, Lakeland, Mulberry, Pierce in the Phosphate Mines Country, Eau Gallie, a Truck-farm and fishing village; and Miami, a tourist town with more than half of the Negro population being Bahamians.)

> Collected: Loughman Sawmill:
>
> Jan. 15, 1928–March 20, 1928

*This second partial title page was originally page three of the Hurston manuscript.

Eatonville: March 20–April 18, 1928
Phosphate Country: April 19–June 2, 1928
Eau Gallie: April–Aug. 1929
Miami: Aug.–Nov. 1929

III. Louisiana—(New Orleans and Bogaloosa)
New Orleans is a huge and cosmopolitan city with many and marked characteristics. Very European, very American. Bogaloosa is a huge industrial center, sawmills, paper mills, chicken hatcheries and reforestation nurseries.

Collected: New Orleans: Sept. 1928–March 1929
Nov. 1929–March 1930
Bogaloosa: Nov. 1929

Appendix 2*

1. Della Lewis: An illiterate woman around 70 years old. Born in West Florida. Mother of 11 children by 9 different fathers. Has always lived in Florida. Occupation: Midwife.
2. Eugene Oliver: About 3rd grade education. About 20 in 1928. Occupation: Sawmill hand.
3. Mary Dash: About 35. Married, from Georgia. Domestic.
4. Tarryson Parlor: About middle age. Sawmill worker, from Miss.
5. Mae Oliver: Sister to Eugene Oliver, of about the same educational level. About 22 in 1928.
6. R. T. Williams: About 40. Works in an orange grove. Born in Georgia.
7. Julius Henry: Illiterate. About 14 in 1928. Born in the neighborhood.

*Hurston's list of 122 sources originally appeared at the front of her manuscript. Joe L. Wiley is not included on this list but is credited with many tales published here (and elsewhere) by Hurston.

8. Belle Williams: About 13 in 1928. Sister to Julius
 Henry. Married.
9. Robert Bailey: Middle age. From Georgia. Worker in
 orange grove, barely literate.
10. Fred Cooper: About 20 in 1928. Grove worker, barely
 literate. Born in South Florida. Grandson of Della
 Lewis.
11. Willie Roberts: Bootlegger. About 33. Born in
 Eatonville, Florida.
12. John Smith: About 33. Born in Georgia. Sawmill hand.
13. Christopher Jenkins: About 21. Born in Florida.
 Worker in phosphate mines.
14. Cliffert Ulmer: About 23. Born in Florida. Sawmill
 hand.
15. James Moseley: About 45. Born at Eatonville, Fla.
 Chauffeur and yard man.
16. Sarah Sewell: Born in Eatonville, Fla. Age 41. House-
 wife.
17. Matthew Brazzle: Born in Fla. About 70. Gardener
 and mayor of town.
18. Soddy Sewell: Born in Florida. About 21. School boy.
19. Isiah Hurston: Born in Alabama. Age 31. Preacher.
20. "Nigger" Bird: Born South Carolina. About 25.
 Grove worker.
21. George Brown: Florida. Truck gardener. Age 28.
22. Louvenia English: Born in Georgia. About 30. Do-
 mestic.
23. Jonathan Hines: Florida. About 29. Waiter.
24. Louis Black: Born in Pierce, Fla. (a phosphate mining
 camp). About 11, in 1928. In 4th grade.
25. Hattie Reeves: Born island of Grand Command, West
 Indies. About 50. Domestic.
26. Lillian Green: Born Florida. About 12. School girl.
27. Catherine Hardy: Born Fla. About 10. A school girl.

28. Geneva Woods: Born in Georgia. About 20. A house-wife.
29. Eliza Austin: Born in South Carolina. About 50. A laundress.
30. Charlie Jones: About 30. Born Florida. Laborer.
31. Dad Boykin: Born Georgia. About 80. Bum and roustabout.
32. L. O. Taylor: Tenn. About 30. Preacher.
33. Nora Lee White: South Carolina. About 23. House-wife.
34. Larkins White: Georgia. About 40. Sawmill hand.
35. James Presley: Musician, sawmill hand. About 40. Born in Georgia.
36. W. M. Richardson: Born in Florida. About 35. Orange picker and packer.
37. Handy Pitts: Middle Georgia. About 38. Sawmill hand.
38. Bertha Allen: Born in Georgia. About 55. Boarding-house keeper.
39. Ed Morris: Born Mobile, Ala. Age 15. 8th grade.
40. N. A. James: Born in Louisiana. About 40. YMCA secretary.
41. Peter Noble: North Alabama. About 22. Garage worker.
42. Jerry Bennett: Born in Louisiana. About 39. Sawmill hand.
43. J. Williams: Born in Mississippi. Sawmill hand. About 50.
44. Ed Edwards: Born in Alabama. About 17. About 6th grade.
45. Mrs. Louise Noble: About 48. Former country school-teacher. Born in Florida.
46. Baby Face Turl: About 65. Drives garbage wagon. Born in South Carolina.
47. Raymond McGill: About 35. Born in Florida. Works in phosphate mines.

48. Martin White: Born in Georgia. Age 50. Phosphate
 worker.
49. Floyd Thomas: Born in Florida. Age 23. Phosphate
 miner.
50. John Bird: Age 33. Born in Florida. Bootlegger and
 jail bird.
51. Carrie McCray: Prostitute. Born in South Carolina.
 Age 30.
52. Rebecca Corbett: Cook. Age 35. Born in Georgia.
53. Nathaniel Burney: Age 9. School. Born in Florida.
54. A. R. Cole: Laborer. Age 40. Born in Texas.
55. Louis Robinson: Age 11. School. Born in Florida.
56. Arthur Hopkins: Age 18. Born in Florida (reared in
 Alabama). School boy, but loads lumber at sawmill in
 summer.
57. George Mills: Born in South Carolina. Age 62.
 Deputy sheriff in Mobile, Ala.
58. David Leverett: Born in Alabama. Age 19. Sawmill.
59. Charley Bradley: Age 22. Sawmill hand. Born in Ala-
 bama.
60. Henry Edwards: Alabama. Age 19. Laborer.
61. George Harris: Farmer. Age 38. Alabama.
62. Douglash Shine: Age 26. Sawmill hand. Alabama.
63. Will Thomas: Boom-man. Age 28. Alabama.
64. Mannie Barnes: Born in Mississippi. Age 28. Sawmill
 hand.
65. Will House: Boom-man. Age 30. Georgia.
66. Hattie Giles: Age 39. Alabama. Housewife.
67. David Leverett: Age 19. Sawmill hand. Alabama.
68. Lorenzo Morris: Age 18. High School. Born in Ala-
 bama.
69. Richard Edwards: School boy. Age 15. Alabama born.
70. Armetta Jones: Domestic. Age 42. Georgia born.
71. Mack C. Ford: Age 55. Gardener. Florida.

72. Sarah Lou Potts. Born in Alabama. About 40. Tuskegee grad.
73. William Jones: Mobile, Ala. Ex-slave. Born near here.
74. Mrs. Sally Smith: Born in Tarkwa, Gold Coast. Brought to America in 1859.
75. Jessie Smith: Her son. About 60. Farmer of Bogue Chitts, Ala.
76. Russel Singer: About 17. Lumber mill. Alabama.
77. Clifton Green: About 20. Laborer. Alabama.
78. Uless Carter: About 20. Laborer.
79. Sam Hopkins: Born in Florida, reared in Alabama. About 14.
80. Gennie (Jenny) Murray: Born, Georgia. Moved to Ala. Age 40. Housewife.
81. Will Howard: Alabama. About 30. Lumber-mill hand.
82. Willie May McClary: Born Ga. Lives at Eatonville, Fla. Age 17 yrs.
83. Ed Langston: About 55. Born in W. Florida, now in Eau Gallie. R.R. section hand.
84. Clarence Beal: Eau Gallie. About 30. Garden hand.
85. Mrs. Annie King: Born in Florida. About 70. Cook.
86. Maybelle Frazier: Housewife, when out of jail. About 38. Born in Florida.
87. A. D. Frazier: Georgia. About 53. Barber when free.
88. Willie Fullwood: Turpentine worker. About 25.
89. Buster Williams: Age 20. Born in Georgia but reared in Mulberry, Florida.
90. Virginia Williams: Age 19. From Ga., but visited Mulberry, Fla.
91. Etta Lee Leonard: Pierce, Fla. School girl. 11 years old.
92. Jeannette Moore: Pierce, Fla. School girl. 10 years old.
93. Pearline Black: Pierce, Fla. School girl. 13 years old.
94. Catherine Williams: " " " 10 years old.
95. Pete Bryant: " " School boy. 11 years old.

96. Lulu Anderson: School boy. About 9.
97. Edward Frazier: Born, South Carolina, reared in Fla. Miner.
98. Tom Saunders: Age 42. Born, Va., keeps restaurant.
99. Rachael Moore: Age 60. Born Georgia. Laundress.
100. Marguerite Campbell: Age 22. Born in Florida. Domestic.
101. Lillian Green: Born Florida. Age 13. School girl.
102. Jessie Lee Hudson: Born Georgia. Age 28. Housewife.
103. Viola Ballon: Born in South Carolina. Age 33. Domestic.
104. C. S. McClendon: Florida. Age 40. Phosphate miner.
105. Louis Robinson: Born in Florida. Age 21. Laborer.
106. James Graham: Born in Miss. Age 42. Laborer.
107. Jesse Long: Age 56. Carpenter. Native of Tennessee.
108. Ed Davis: Bogaloosa, La. School boy, 17 years old.
109. Mrs. Fields: 1928 found her an invalid in New Orleans, Louisiana Hospital. She is about 70 years old.
110. Edith Knowles: School girl of Pierce, Fla. 11 years. old.
111. Gus Ramsey: Bahamian. Age 35. Laborer.
112. Ned Isaacs: Bahamian. Age 32. Sings.
113. Merle Wood: Bahamian girl. About 12 years old.
114. Dorothy Wood: Bahamian girl. About 14 years old.
115. Reuben Roker: Bahamian of Miami. Age 20.
116. Harold Tinker: Bahamian. Age 22.
117. William Weeks: Bahamian. Plantation owner.
118. Richard Barrett: Jamaica, B.W.I. Age 40. Chauffeur.
119. Mrs. Vera Taylor: Bahamian from Cat Island. Age 40.
120. Mrs. Sally Boles: Age 50. Born in Florida. Housewife.
121. Bunkie Rolls: Age 50. Truck gardener.
122. Horace Sharp: Age 55. Small shop-keeper.

Appendix 3

Stories Kossula Told Me[*]

1. Free men ain't got [illegible]
2. Four men who betrayed dey friend
3. The Monkey and the Camel
4. The Lion and the Rabbit
5. The Orphan Boy and Girl and the Witches
6. The Six Fools
7. The Man, the Woman and the Ready-to-Tame
8. The Devil and the Rabbit
9. Why the Bear Has No Tail
 Long Poem
10. Have you heard about the wreck?
11. I seen a man so black
12. I seen a man so ugly
13. I seen a man so ugly he didn't die

[*]Kossula, or Cudjo Lewis, one of the last surviving slaves of the ship *Chlotilde*, about whom Hurston wrote in "Cudjo's Own Story of the Last African Slaves," *Journal of Negro History*, 12 (Oct. 1927) and in her unpublished biography, *Barracoon*. Some of these tales seem to be included here, but Hurston's listing may be to establish cross-reference and, through Kossula, something of the age of the tales.

14. I saw a man so ugly till at night
15. I seen a railroad so crooked
16. I saw a country so hilly
17. I saw a country so hilly till they shoot the corn
18. I saw a man shoot another with a gun
19. I saw a man so ugly
20. Once there was a rabbit and uh bear
21. A man and his wife had a colt
22. A man had a wife and she was so small
23. A man went hunting
24. The First Man
25. In slavery time there was a man by the name of Tom
26. There wuz a man in slavery time always meddling
27. Once there was an old man, woman and boy
28. Once there was a man and the preacher came to his house
29. Man who stole hogs
30. The mule had sprouted little jackasses
31. Man who didn't know what corn was
32. "Son step on the zillerator!"
33. Saving for Mr. Hard Time
34. Old man, wife and hogs
35. Burning creek and trout
36. Man who bradded mosquito bills
37. I seen a man so ugly
38. " " "
39. I seen a horse so poor
40. I seen a horse so poor
41. I seen a mule so poor
42. I saw a horse so poor
43. Once I was an engineer on train
44. Rockefeller and Ford was woofing
45. There was a man so stingy
46. I knowed a man and he was formen and he was so stingy

47. Man so smart he had the 7 year itch
48. Once there was a man had a daughter
49. Sellin' roasting ears in heaven
50. Barrel swell up and burst wid rain
51. Once there wuz a boiler across de river
52. De Lawd is Comin' By
53. Mississippi River and de punkin tree
54. On hobo trip in Texas
55. Hard Wind
56. Juice of watermelon caused de rain flood
57. Moon toting a light for de sun
58. Fish came swimming up the road
59. Once I wuz out batching
60. De little black gnat
61. Paul and de ½ pint shinny
62. Ole colored man and de gold watch
63. Ant Dinah on de Coolin Board
64. De man who heard Gabriel and cussed
65. De men who beat dere shadders
66. Catfish who drowned in sweat
67. John, Bill, and de ole Master
68. Snail crossing the road
69. Story of de Jonah
70. How Disa Abraham, Fadda de Faithful
71. "Got 1000 tongues"
72. Rev. Full Bosom and the mourners
73. It taken 9 partridges to holler Bob White
74. 2 revival preachers and "the doleful sound"
75. Man who wanted to catchup with his wife
76. Little boy who raised hell in basket
77. "I am snake bit"
78. The butt head cow's horns
79. I have seen it so cold
80. "I tole you to notice hogs—"
81. "Your breath smells mighty dam bad"

82. In Miss. a black horse run away with white lady
83. Steam from locomotive wuz milkin' cows"—
84. Train in N. Orleans
85. Ala. River running so fast
86. "I done set de world on fire" (fox)
87. Five men want six orders
88. Car, mosquito, and flea
89. "Can't you tell a white man from a Negro"
90. "Shoot the gas to her son, I got the steering gear"
91. Ole Master and John and God dam
92. Colored man and billy goat
93. John and Ole Massa and lightnin
94. The boy and the cow
95. 3 girls, judge, and rabbit
96. The meanest man
97. Fishing on Sunday
98. Why Negroes are black
99. "God ain't worth a dam when a bear"—
100. Man who stole oil from heaven's lamps
101. Preacher and de lamp eel
102. Why Americans are not in war
103. Hen who gave rooster the blues
104. "Oh hell, I'll steal Thou"
105. Dady so small, bedbug pitcher
106. "Baa, ba"
107. Why all lady people got devil in them
108. "Boots or no boots"
109. Once there was a man so lazy
110. Took 1 match sit the river on fire
111. "I wanted you to work on my wife's teeth"
112. Lady and bad polly
113. The Tall Man
114. When he want it to rain
115. "God grant it"—"God dam it"
116. De witch who stole boy's money

117. John and Massa and whut's under de wash pot
118. John, Massa and swimming bluff
119. Rabbit, elephant, fox frolic
120. "Stay on board lil childen"
121. The Shortest Man
122. The Biggest Cabbage
123. The Hanted House
124. An dey all got different daddies
125. Ole Massa and nigger deer-hunting
126. Niggers is so skeered uh white folks
127. Uncle and heavenly blackboard
128. The seed-tick
129. Why Negroes Have Nothing
130. Mosquito bills
131. Tin suits tuh keep de skeeters off
132. De White Man's Prayer
133. What is the biggest chickens you ever saw
134. Uh sweet potato so big
135. "If Thou be God . . . Youse cholkin me tuh death"
136. Boll Weevil
137. 5 gallon demijohn—uh goody, goody, goody
138. The little boy and his grandma
139. Why de Gator Got No Tongue
140. Why de Gator is Black
141. Two men out huntin de little dog an de rabbit
142. Man and girl and picked chickens
143. Ole massa and nigger visitin' girl
144. Tarrypin an' fox run race for girl
145. The Boy from Hell
146. Why God Made Adam Last
147. Ole Massa and John an' de bear
148. Goat an' tobacco truck
149. If dat my child, where . . . gold teeth
150. Man went huntin' wid one uh dese muzzle-loaders
151. Cat an' de liver an' de gizzard

152. "I lends an' borries, too"
153. De Reason de Woodpecker Got Uh Red Head
154. De sworn hunter buddies an' de deer liver
155. "Yuh got tuh gum it lak hell"
156. De men dat melted in Miami
157. De devil don't do everything they say
158. De Hongry Bear
159. De Preacher an de Sheep's Tails
160. De bullet from de 44-40 an' de echo
161. Skeeter an' de Hominy Pot
162. De tallest man
163. "Stick uh needle up in de ground"—
164. There wuz uh man so ugly
165. [not legible in the original manuscript]
166. De Flyin' Negro
167. Why a parrot drops dead
168. Big Talk
169. The man who forgot God's name
170. "If you take up time ... you won't be nothin."
171. I'd go some here and keep books for somebody
172. 4 niggers and de blacksmith shop
173. "Papa's head so lousy"
174. 3 bluebirds
175. Why they use raw hide on mules
176. Monkey and dog
177. [not legible in the original manuscript]
178. "Raccoon"
179. Jesus Christ and de $98
180. "Don't send dat boy Jesus"
181. [not legible in the original manuscript]
182. Free slave and de panter
183. So dey had de picnic and not de wimming match
184. The Bull and God
185. Everytime ma cook eggs, pa cuts de Damn fool
186. "You kin have it I don't need it"

187. "Hold 'im Ned"
188. "6 months for yo' skillet"
189. "Squealin' Jenny"
190. 2 boys and de biggest lie
191. Cryin' for stale biscuit
192. Two mens and de bear
193. Why we Squinch (Screech) Owls
194. Ole Marster, corn field, and bear
195. John an' Massa's ridin' horse
196. Brer Rabbit and Brer Dog and Convention
197. " " " " "
198. Ole woman (Scat you rascal!)
199. Monkey: My people, my people"
200. "Tongue brought me here"—
201. From Pine to Pine
202. De brothers an' de persimmons
203. "Long as dere's limb, dere's ropes"
204. It wuz so hot once a cake of ice. . ."
205. It wuz de moon changin'
206. De Gopher in Court
207. When de weather gits hot de gopher—
208. Poor Land
209. Rich Land
210. De peas grunting trying to git out de ground—
211. A Hunter
212. A lady so cross-eyed
213. A woman so black
214. He'd shoot and den put up a target—
215. De honey sweetened de river
216. "Found dead in de woods—bit by a r. Snake"
217. Hog in de Cradle
218. I seen a man so black
219. I seen a man so tough
220. How come de gator hate de dog
221. Cat and dog race

222. Why we have Thanksgiving
223. The long horse and pig that died from old age
224. Lady with donkey, cat, rooster
225. Grandmother with large family
226. Beans and the Girl
227. [not legible in the original manuscript]
228. Cheap groceries in hell
229. Girl and mother and man who stole food
230. Little country boy and blessing
231. Why the ole man liked the camel best
232. Ole man and snake: "Oh, it is so hot"
233. Blind man, naked man, armless man on rock
234. Red bug had lost his eye and wrecked train
235. Lazy boy, smart boy, and bear
236. He saw sadness and joy
237. I've seen the wind blow so hard
238. Why we have kings and queens
239. Man and devil's daughter
240. Hairy man, little boy and little girl
241. Runaway slave and snake
242. Poor varmints don't rest on Monday
243. Devil, lil girl, lil boy, and her mother
244. Alligator and rabbit's squabble
245. Mosquito and monkey wrench
246. Lazy husband and woman and cake
247. Bear, woman and her baby
248. Woman and daughter and Devil
249. I seen it rain so hard
250. "My belly ake," etc.
251. Two preacher brothers
252. I seed de coachwhip behind de race runner, etc.
253. 2 blocks of ice gatherin' li'dard knots—
254. "I don't lak dat red-eyed 'gator"
255. Why the Donkey has long ears
256. "Lordy, make my bottom wider"

257. Baptist and Methodist deacons in sinking boat
258. Methodist and Baptist preacher
259. Good Time Willie
260. Long, long boy
261. 3 dogs, Thunder, Lightning, and Jack
262. Wolf at rabbit's funeral.
263. Difference in de climate—cucumber 4 ft. long
264. Fine Foot, Big Head, Big Gut, and apple tree
265. Sweet Papa Black
266. Wedding night
267. I'm the biggest liar you ever met
268. Buzzard and Hawk
269. "Job ain't never had a pair of britches"—
270. Preacher and woman making date
271. Brer Rabbit and Brer Frog
272. Johnny and the 7-headed lady
273. Brer Rabbit and de pea patch
274. Cleanest white woman in U.S.A.
275. Massa and Jack and fortune telling (variant)
276. Isaac and Daphne and grocery order for Lord
277. Dat dog dat eat out dat pan up in Canada
278. Negro, devil, bet of $1,000
279. De longest bullet and de deer
280. 3 sons: naked, blind, armless
281. Muskeeter and railroad track
282. Massa Martin and Ike and watermelon patch
283. Stingy man in heaven
284. White man and nigger shooting crap in heaven
285. Christopher spreading his mess
286. [not legible in the original manuscript]
287. Nigger and son and 200 lashes
288. 'Tater house
289. Bale of hay and a jack
290. "You mustn't say hide you must say skin"
291. Ole John and Massa's hogs

292. John in the Smoke-House
293. Jack and Massa's wife
294. Jack and de devil
295. John and de Horse
296. Ole Massa and John and groceries in sycamore tree
297. Bear in de cane-patch
298. Sheep in de cradle
299. Man with three coughs
300. 2 Boys, a Sweet Potato and God
301. Sam
302. Ole Massa's Gun
303. Sambo
304. "Didn't dat nigger fly"
305. The Running Death
306. Too many folks is preachin' dese days
307. Why women folks always poke in de fire
308. The Blacksmith
309. The Carpenter
310. My father made a boiler so big
311. I seen uh man so stingy
312. "He ain't worth uh damn in uh bear fight"
313. Spell: (clucking tongue & teeth sound used to urge mules)
314. Brother wuz de head fireman
315. Nigger and Pres. Harding at Heaven
316. "God, don't stand no jokin' dese days"
317. Dis punkin wuz raised offa mosquito dust
318. Buzzard in Charleston
319. Tell Aunt Jane to tell Uncle Tom to tell de cow
320. I seed uh man running so fast
321. I seen a man so stingy
322. I seen a man so stingy
323. I know a man who wouldn't walk—
324. I know a man so stingy
325. I know a man so big

326. Man and 7 sons and daughter and eagle
327. Mosquito and engineer
328. De poorest horse
329. Hosses: Three Color and Changeable
330. I seen a man so low
331. De train ran so fass
332. I'm uh walkin on de water, oh be baptized
333. Cruel Wife
334. I seen it so cold
335. Have you ever called a train
336. De workinest pill
337. The poorest ground I ever did see
338. De darkest night
339. Run so hard we lost our feets in de mud wash
340. Jordan Car
341. Whammer G. Martin's dogs, sparro, bon bon Pree
342. I seen ground so rich
343. Once it wuz so cold
344. "Chris'mus gift"
345. Father, John, Frank, and $5,000
346. Who had de right to meet de girl?
347. "A gander can pick it just close as a goose"
348. What is the hardest wind you ever seen
349. Best trained mule
350. Man so dangerous
351. Lady, husband, and hoodoo
352. "Clunk ... think I'm goin' pay you"
353. Massa and John and ketchin' de devil
354. "Dat's too d. much pepper"
355. De crane, eel
356. Lil cussin' boy and de coffin
357. Let the Holy Ghost ride—walk
358. Cross-eyed gnat
359. "Done make me open my mouf wide"
360. One day the wind blowed so hard

361. Another time it blowed so hard
362. Another time it blowed so hard
363. A punkin so big
364. School boy and "Mo" on 'lasses
365. De biggest apple
366. Platform under de calf
367. Gun shoot so far
368. Fastest colt
369. Why there ain't no women in the army
370. De brother in black is lak de monkey
371. Why geese holler "Ketch him"
372. Red bug, rail, trash in tick's eyes
373. John and de Devil and de Girl
374. Why possum ain't got no hair on his tail
375. Rabbit and Fox and same girl
376. Ole man, ole woman, and bear in loft
377. I know man so hungry
378. Down in Ga. ain't no brooms
379. Man with gold penis
380. Jack and Mary and father in tree
381. Preacher and boys and dirty under hat
382. Brother Rabbit and Brother Fox and piece of ham
383. "The fun is all over now"
384. I was a flying fool
385. Lil boy travelling, old man and woman and lil girl and Peas
386. Want to be buried in rubber coffin
387. I saw a man so ugly
388. Man falling on white woman
389. Country man and oxen
390. Man who fished alligator and took him home
391. My brother was so swift
392. Sugar cane so large
393. Bow-legged biscuits (I saw a man so hongry)
394. De biggest cabbage
395. Huntin' rabbit (fast bullet)

396. Man and hardheaded son ghost
397. Man, son, 2 dogs on coon hunt
398. Newlyweds and corn and rooster
399. Grandmother, lil boy on train
400. Old man and woman and girl and pillow
401. How cold have you known it
402. 3 boys going with same girl and dynamite
403. Lil boy and preacher and bear
404. Sawing down the big tree
405. "What angel need with ladder?"
406. Preacher had his congregation
407. "Naw, I ain't whistlin'—I'm pizen—"
408. Woman describing the fiddle
409. Woman and ginny-blue calico dress
410. Devil, man and gun
411. Why wimmen ain't had no whiskers
412. Why woman's vagina was moved
413. "Whut did he die wid Elder,"—
414. White man, son and nigger
415. How the gopher was created
416. Why churches are split today
417. Uh hard wind
418. Two hoboes and pigeons
419. Hawg Under de House
420. Uncle Ike in de Judgement
421. Uncle Jeff and the Church
422. Pig in de Poke
423. Gabriel's trumpet
424. The Monticello Legend
425. Moufy Emma
426. De Animal Congress
427. Every Friday . . . mocking birds
428. De Rabbit Wants Uh Tail
429. Why de buzzard has no home
430. Dirt dauber and bee

431. Massa and Jack and rooster
432. Prayin' woman an de banjo man
433. God an de devil in de cemetery
434. Scissors
435. Why de nigger been working hard
436. The devil and the daughter
437. Why mules have no colts
438. Why all animals look down
439. The Snake and the Gum Mallimie Tree
440. Why the dog has a small waist
441. "After all it was only a mouse"
442. Adam and Eve
443. The Solomon Cycle
444. Queen of Sheba, Solomon, and thirst
445. " " " and theft of water
446. How Man got his moustache
447. Devil in Cat Island; God in Bahamas
448. The Old Woman and Her Child
449. The Cane Field
450. The Farmyard
451. Brer Bookie and Brer Rabbit
452. The Devil And a Horse And Goat
453. The Sperrit House
454. Dog and Brer Goat
455. [number skipped in the original manuscript]
456. Why Women Talk So Much
457. The Three Sons
458. Why de Porpoise's Tail is on Crosswise
459. Why the Cat Has Nine Lives
460. How we got tobacco
461. Rooster and Fox
462. The Flies and God
463. Man and de Boy
464. Woman Smarter Than Devil
465. Cat, man, and ham (bacon)

466. How the storm came to Miami
467. "It'll take us all night long, baby"
468. Why we say "Unh Hunh"
469. De Lying Mule
470. The Four Story Lost Lot
471. Ole fortune-teller woman and Brer Ishum
472. High Walker and Bloody Bones
473. High Walker and Bloody Bones
474. De Witch Woman
475. "I could drink uh quart uh dat—"
476. "I bet I go Higher than you" (Bapt and Meth.)
477. Baptizing preacher and deck of cards
478. The Frog and the Mole
479. Farmer Courtin' a Girl
480. Why the Dog Hates the Cat
481. "Come round, Bill"
482. Why the Waves have White Caps

 Perennial

Books by Zora Neale Hurston:

EVERY TONGUE GOT TO CONFESS
Negro Folk-tales from the Gulf States
ISBN 0-06-093454-9 (paperback) • ISBN 0-694-52645-2 (unabridged audio)

A collection of Black folklore compiled from Hurston's anthropological travels through the American South in the 1920's. These 500 tales reflect the sorrows and joys of African American heritage with wit, wisdom, compassion, and style.

THEIR EYES WERE WATCHING GOD
ISBN 0-06-093141-8 (Perennial Classics paperback)
ISBN 1-559-94500-1 (abridged audio) • ISBN 0-694-52402-6 (unabridged audio)

In this American classic, Hurston tells with haunting sympathy and piercing immediacy the story of one black woman's evolving selfhood through three marriages.

"There is no book more important to me than this one." —Alice Walker

JONAH'S GOURD VINE
Foreward By Rita Dove
ISBN 0-06-091651-6 (paperback)

Hurston's first novel tells the story of John Buddy Pearson, "a living exultation" of a young man who loves too many women for his—and their—own good.

"A bold and beautiful book . . . priceless and unforgettable."—Carl Sandburg

MOSES, MAN OF THE MOUNTAIN
Foreward by Deborah McDowell
ISBN 0-06-091994-9 (paperback)

Taking off from the familiar story of the Exodus, Hurston blends the Moses of the Old Testament with the Moses of black folklore to create a powerful novel of the persecution of slavery and the dream of freedom.

"A narrative of great power." —*New York Times*

SERAPH ON THE SUWANEE
Foreward by Hazel V. Carby
ISBN 0-06-097359-5 (paperback)

A departure for Hurston, *Seraph on the Suwanee* is the story of two turn-of-the-century white "Florida Crackers" at once deeply in love, and deeply at odds.

"A simple, colorfully written, and moving novel." —*Saturday Review of Literature*

Available wherever books are sold, or call 1-800-331-3761 to order.

 Perennial

Books by Zora Neale Hurston:

MULES AND MEN
A Treasure of Black American Folklore
Foreword by Arnold Rampersad
ISBN 0-06-091648-6 (paperback)

"A classic in style and form. . . . Introduces the reader to the whole world of jook joints, lying contests, and tall tale sessions that make up the drama of the folk life of black people in the rural South." —Mary Helen Washington

TELL MY HORSE
Voodoo and Life in Haiti and Jamaica
Foreward by Ishmael Reed
ISBN 0-06-091649-4 (paperback)

Based on Hurston's visits to Haiti and Jamaica in the 1930's, this travelogue paints an authentic picture of ceremonies and customs of great cultural interest.

"Strikingly dramatic, yet simple and unrestrained . . . unusual and intensely interesting." —*New York Times Book Review*

DUST TRACKS ON A ROAD: REVISED
An Autobiography
Foreword by Maya Angelou
ISBN 0-06-092168-4 (paperback)

First published in 1942, this is Zora Neale Hurston's exuberant account of her rise from childhood poverty in the rural South to a prominent place among the leading artists and intellectuals of the Harlem Renaissance.

"Warm, witty, imaginative, and down-to-earth by turns, this is a rich and winning book by one of our genuine, Grade A, folk writers." —*The New Yorker*

THE COMPLETE STORIES
Introductions by Henry Louis Gates, Jr. & Sieglinde Lemke
ISBN 0-06-092171-4 (paperback)

This gathering of Hurston's short fiction—most of which appeared only in literary magazines during her lifetime—spans the years 1921-1955 and includes such works as "John Redding Goes to Sea," "Cock Robin Beale Street," "Hurricane," and "Book of Harlem."

Available wherever books are sold, or call 1-800-331-3761 to order.

MULE BONE

MULE BONE

A COMEDY OF NEGRO LIFE

LANGSTON HUGHES AND
ZORA NEALE HURSTON

Edited with Introductions by George Houston Bass
and Henry Louis Gates, Jr.
and the complete story of the *Mule Bone* Controversy

AMISTAD

An Imprint of HarperCollinsPublishers

FIRST PERENNIAL EDITION PUBLISHED 1991.
FIRST HARPER PERENNIAL MODERN CLASSICS EDITION PUBLISHED 2008.

Designed by Cassandra J. Pappas

The Library of Congress has catalogued the previous edition as follows:

Hughes, Langston, 1902–1967.
 Mule bone : a comedy of Negro life / by Langston Hughes and Zora Neale Hurston ; edited with introductions by George Houston Bass and Henry Louis Gates, Jr., and the complete story of the mule bone controversy.—1st ed.
 p. cm.
 ISBN 0-06-055301-4
 ISBN 0-06-096885-0 (pbk.)
 I. Hurston, Zora Neale. II. Bass, George Houston. III. Gates, Henry Louis. IV. Title.
 PS3515.U274M85 1991
 812'.52—dc20 90-55835

ISBN 978-0-06-165112-0 (pbk.)

21 22 LSC 10 9 8 7 6 5

For
George Houston Bass,
In Memoriam
1938–1990

CONTENTS

ACKNOWLEDGMENTS

T he editors would like to thank the estates of Langston Hughes and Zora Neale Hurston for permission to publish their play, and Robert Hemenway and Arnold Rampersad for permission to publish excerpts of their biographies of Hurston and Hughes. We would also like to thank the staffs at the Beinecke Rare Book and Manuscript Library at Yale and the Moorland-Spingarn Research Center at Howard for their advice and expertise in locating drafts of the play and relevant correspondence. Without this assistance, this publication would not have been possible.

PREFACE

Mule Bone is a three-act play, jointly written in 1930 by Langston Hughes and Zora Neale Hurston. Because of a dispute between the authors, the origins of which remain mysterious, the play was never performed during the authors' lifetimes. Indeed, only its third and final act was published, and this not until 1964. Drafts of the play were accessible only to scholars, through the Alain Locke Papers at the Moorland-Spingarn Research Center at Howard University and through the Langston Hughes Papers at the Beinecke Rare Book and Manuscript Library at Yale. But the quarrel surrounding the play's authorship has made it an object of great curiosity in Afro-American literary history.

I first heard of the play when reading Langston Hughes's autobiography, *The Big Sea* (1940); there, Hughes describes his perception of the affair in a chapter entitled "Literary Quarrel." Two careful and perceptive scholars, Robert Hemenway and Arnold Rampersad, present meticulous accounts of the controversy in their biographies of Hurston and Hughes.

These three accounts we reprint here, along with much of the archival sources upon which their accounts are based.

It is apparent to the editors that *Mule Bone* was written jointly by Hughes and Hurston, and that their quarrel not only interrupted a productive friendship, it also killed a most promising collaborative team in the theatre, which in turn stifled the development of an African-American theatre based upon black vernacular forms. We can only wonder at the directions that black theatre might have taken in America had *Mule Bone* been produced and published. However, it was not.

The first production of *Mule Bone* is scheduled, at this writing, for February 1991, at the Lincoln Center Theatre, thanks to Gregory Mosher, the Artistic Director; George Bass, executor of the Hughes Estate; and Clifford Hurston, executor of the Hurston Estate. The play has been copyrighted in the names of the authors.

Two days before the editing of this volume was completed, George Houston Bass died quite unexpectedly. Mr. Bass, a professor of Afro-American Studies and founder and Artistic Director of the Rites and Reason Theatre at Brown University, and Langston Hughes's secretary and confidant, had been especially excited about both this edition of *Mule Bone* and about its Lincoln Center premiere, exactly sixty-one years after it was written. Bringing this "lost" work of the Harlem Renaissance to the stage had preoccupied the last two years of his life. Mr. Bass and I designed together every aspect of this volume.

George Bass loved the theatre, as he loved all of literature, and life itself. He had recently edited the complete poems of Langston Hughes and was planning to edit Hughes's collected papers. His devotion to Hughes was total and unflinching. No author's legacy has been better served by an executor than Bass has served Hughes.

It is altogether fitting, then, that this edition of *Mule Bone* and its Lincoln Center premiere are dedicated to George Houston Bass.

H.L.G., Jr.
September 20, 1990

ANOTHER BONE
OF CONTENTION:

Reclaiming Our Gift of Laughter
George Houston Bass

In her writing of Afro-American folklore, Zora Neale Hurston has cited the art of laughter as one of black folk's gifts to American culture. Langston Hughes also recognized laughter as one of the great strengths of the Afro-American people. Hurston and Hughes, who combined their creative skills and appreciation for laughter in writing their play *Mule Bone,* are widely recognized masters of the art of "laughing to keep from crying" and of the blues sensibility which is so central to the comic imagination of Afro-American tradition. Hurston mastered the language and lore of southern black American landscape and Hughes claimed black folk sounds and rhythms of the urban north. Their appreciation for the

1

oral tradition of Afro-American people and their understand-
ing of black folk's use of laughter as a coping mechanism for
personal and group survival have made them primary sources
of instruction for students of Afro-American history and cul-
ture.

Hurston and Hughes adapted *Mule Bone* from a folktale,
"The Bone of Contention," which Hurston had collected
from her all-black hometown of Eatonville, Florida. The play-
script was written during the early months of 1930, a period
when images of black people in popular American culture
were still shaped by notions of primitivism, exoticism, and
minstrelsy. Unlike the contrived images of black folk-life pre-
sented in such plays as *The Emperor Jones, Porgy,* and *Green
Pastures,* the authors of *Mule Bone* envisioned their play as an
"authentic" portrayal of black comic characters and the rich
uses of language and laughter southern black folk had in-
vented as a way of creatively coping with the harshness of
being black in America. Unfortunately, the play was never
produced in the authors' lifetimes and in a real sense *Mule Bone*
is an unfinished work. The cover page of the draft of the
playscript in the Hughes papers at Yale University bears a
handwritten note by Langston Hughes that reads, "This play
was never done because the authors fell out."

In the spring of 1988, almost sixty years after the script
was written, Greg Mosher, Artistic Director of Lincoln Center
Theatre, expressed an interest in producing the first known
public performance of *Mule Bone.* It was thought that the
staging of an unproduced script by two of the most gifted
black writers of the twentieth century could make a significant
contribution to the American theatre. But, on close reading of
the script, it became very clear that a production of the 1930
draft of the text could become quite problematic in terms of
the current cultural, social, and political sensibilities of the
American public. Rites and Reason Theatre became a col-
laborator in the task of developing the playscript left by Hur-

ston and Hughes into a viable performance work for a popular theatre audience sixty years after the script was created.

One of the principal issues and creative challenges that has surfaced in the development of the script concerns the use of broad black comic types in the play which can be easily viewed in terms of the stigmas and offensive stereotypes of minstrel shows and the plantation tradition of American literature. A genuine appreciation for the richness of black folk culture and for the genius of Zora Neale Hurston and Langston Hughes has allowed us to look beyond the problematic aspects of the text and try to recognize the poetic insights and dramatic possibilities that could have been the thematic focus of the "Negro folk comedy" Hurston and Hughes wanted to create.

The expansion of moral and aesthetic consciousness that has occurred in American society since 1960 has produced a social climate that does not allow one to laugh easily at broad comic interpretations of black people. Many of the comic characters, comic devices, and forms of laughter that were sources of renewal and release within the black community before 1960 are now inhibited by the politics of race and gender. Forms of parody and self-parody which were once a way of dealing with the stress and pain of a bad situation and finding a way to change it are now quite often viewed as assaults and insults.

The millions of black folk who have endured cruel and dehumanizing situations as they inched their way through the years of slavery and Jim Crow laws to the years of the Civil Rights Movement and beyond knew how to use laughter as a tool for regeneration, transformation, and re-creation. They left folk tales, family stories, songs, rhymes, toasts, and jokes that document their great ability and skill in laughing at very ugly conditions. Obviously, they viewed the world quite differently from the black persons who in recent years found

little humor and no cause for laughter in George Wolfe's *The Colored Museum* and in Spike Lee's films.

In *Mule Bone*, Zora Neale Hurston and Langston Hughes have made very deliberate use of laughter and broad comic characters and devices from Afro-American tradition. The art of "lying" and telling tall tales as well as the art of "signifying" and "putting down" one's friends and neighbors in defining and refining one's sense of self and community are demonstrated by more than two dozen characters from Eatonville who know how to laugh away the overwhelming pains and burdens of hard times. The sense-meaning of their laughter holds the meaning and significance of the playscript Hurston and Hughes have left to us.

A TRAGEDY OF NEGRO LIFE

Henry Louis Gates, Jr.

This play was never done because the authors fell out.

—LANGSTON HUGHES, 1931

A nd fall out, unfortunately, they did, thereby creating the most notorious literary quarrel in African-American cultural history, and one of the most thoroughly documented collaborations in black American literature. Langston Hughes published an account entitled "Literary Quarrel" as the penultimate chapter—indeed, almost as a coda or an afterthought—in his autobiography, *The Big Sea* (1940). Robert Hemenway, Zora Neale Hurston's biographer, published a chapter in his biography entitled "Mule Bone," and Arnold Rampersad, Hughes's biographer, presents an equally detailed account in volume one of his *The Life of Langston Hughes*. Only Zora Neale Hurston, of the two principals, did not make public her views of the episode. But she did leave several letters (as did Hughes) in which she explains some of her behavior and feelings. In addition, Hurston left the manuscript of the short story, "The Bone of

5

Contention," upon which the play was based. These documents—letters, the short story, Hughes's account, and two accounts from careful and judicious scholars—as well as a draft of the text of the play, *Mule Bone: A Comedy of Negro Life,* comprise the full record of the curious history of this brilliant collaboration between two extraordinarily talented African-American writers. We have assembled this archival and published data here to provide contemporary readers with the fullest possible account of a complex and bizarre incident that will forever remain impossible to understand completely, beclouded in inexplicable motivation.

In a sense, this is a casebook of a crucial—and ugly—chapter in the history of the Harlem Renaissance, that extraordinarily rich period in American cultural history that witnessed the birth of jazz, the coming to fruition of the classic blues, and the first systematic attempt to generate an entire literary and cultural movement by black Americans. The Harlem Renaissance, also called "The New Negro Renaissance," is generally thought to have begun in the early 1920s and ended early on in the Great Depression, about the time when Hughes and Hurston had their dispute. The origins of the Renaissance are, of course, complex and have been written about extensively. It is clear, however, that the production of a rich and various black art, especially the written arts and the theatre, could very well help to reshape the public image of black people within American society and facilitate thereby their long struggle for civil rights, a struggle that commenced almost as soon as the last battle of the Civil War ended. As James Weldon Johnson put it in the "Preface" to his *Book of American Negro Poetry* (1922):

A people may be great through many means, but there is one by which its greatness is recognized and acknowledged. The final measure of the greatness of all peoples is the amount and standard of the

literature and art they produced. The world does
not know that a people is great until that people
produces great literature and art. No people that
has produced great literature and art has ever been
looked upon by the world as distinctly inferior.

If, then, African-Americans created a recognizable and valued
canon of literature, its effect would have enormous political
ramifications: "The status of the Negro in the United States,"
Johnson concluded, "is more a question of national mental
attitude toward the race than of actual conditions. And noth-
ing will do more to change that mental attitude and raise his
status than a demonstration of intellectual parity by the Negro
through the production of literature and art."

Johnson, by 1922 one of the venerable figures of the
black literary and theatrical traditions, effectively issued a call
to arms for the creation of a literary movement. Soon, political
organizations such as the National Association for the Ad-
vancement of Colored People (NAACP) and the National
Urban League, through their magazines, *The Crisis* and *Oppor-
tunity*, began to sponsor literary competitions, judged by
prominent members of the American literati, with the winners
receiving cash prizes, publication in the journals, and often
book contracts. At the prompting of Charles Johnson, the
editor of *Opportunity*, Hurston submitted two short stories—
"Spunk" and "Black Death"—and two plays—*Color Struck*
and *Spears*—for consideration in *Opportunity*'s annual literary
contests in 1925 and 1926. While "Spunk" and *Color Struck*
won second-place prizes, *Spears* and "Black Death" won hon-
orable mention. Two other short stories, "Drenched in Light"
and "Muttsy" would be published in *Opportunity*, along with
"Spunk." It was at the 1925 annual awards dinner that she met
another award winner, Langston Hughes, who took third
prize jointly with Countee Cullen and first prize for his great
poem, "The Weary Blues." It was a momentous occasion,

attended by "the greatest gathering of black and white literati ever assembled in one room," as Arnold Rampersad notes, and included among its judges Eugene O'Neill, John Farrar, Witter Bynner, Alexander Woolcott, and Robert Benchley. Hughes was quite taken with Hurston, Rampersad tells us: She " 'is a clever girl, isn't she?' he soon wrote to a friend; 'I would like to know her.' " Eventually, he would know her all too well.

II

Between 1925 and their collaboration on the writing of *Mule Bone* between March and June 1930, Hughes and Hurston came to know each other well. As Rampersad reports, by mid-summer of 1926, the two were planning a black jazz and blues opera. Hemenway calls it "an opera that would be the first authentic rendering of black folklife, presenting folk songs, dances, and tales that Hurston would collect." By the end of that summer, the two (along with Wallace Thurman, John P. Davis, Gwen Bennett, Bruce Nugent, and Aaron Douglass, all members of what was jokingly called "The Niggerati") decided to found a magazine, called *Fire!!*, the title taken from a Hughes poem. The following year, in July 1927, Hughes and Hurston met quite by accident in Mobile, Alabama, and decided to drive together to Manhattan in her car, "Sassy Susie." "I knew it would be fun travelling with her," Rampersad reports Hughes writing. "It was." The trip lasted about a month, with the two sharing notes on hoodoo, folktales, and the blues along the way, and even meeting Bessie Smith, the great classic blues singer. Shortly after this trip, Hughes introduced Hurston to his patron, Charlotte van der Veer Quick Mason, who would contribute about $75,000 to Harlem Renaissance writers, including $15,000 to Hurston. While Hughes received $150 per month, Hurston received $200. Ironically, their subsidies would end just about the time

of their feud over *Mule Bone;* although Hurston's contract ended March 30, 1931, she received "irregular" payments until September 1932; Hughes and she fell out late in 1930, just before his confrontation with Hurston in Cleveland.

A more natural combination for a collaboration among the writers of the Harlem Renaissance, one can scarcely imagine—especially in the theatre! Hurston wrote to Hughes often during the early period of her research in the South, collecting black folklore as part of her doctoral research in anthropology at Columbia under Franz Boas; Hemenway describes her correspondence as "frequent and conspiratorial," providing "an unintentional documentary of the expedition." In April 1928, she shared with Hughes her plans for a culturally authentic African-American theatre, one constructed upon a foundation of the black vernacular: "Did I tell you before I left about the new, the *real* Negro theatre I plan? Well, I shall, or rather we shall act out the folk tales, however short, with the abrupt angularity and naivete of the primitive 'bama Nigger. Quote that with native settings. What do you think?" They would share the burdens and the glory: "Of course, you know I didn't dream of that theatre as a one man stunt. I had you helping 50–50 from the start. In fact, I am perfectly willing to be 40 to your 60 since you are always so much more practical than I. But I know it is going to be *glorious!* A really new departure in the drama." Despite their enthusiasm for this idea, however, Mrs. Mason ("Godmother") disapproved; as Hurston wrote to Alain Locke, the veritable dean of the Harlem Renaissance and another beneficiary of Mrs. Mason's patronage: "Godmother was very anxious that I should say to you that the plans—rather the hazy dreams of the theatre I talked to you about should never be mentioned again. She trusts her three children [Hurston, Hughes, and Locke] to never let those words pass their lips again until the gods decree that they shall materialize."

Not only did the two share the dream of a vernacular

theatre and opera, but both had established themselves as creative writers and critics by underscoring the value of black folk culture, both of itself and as the basis for formal artistic traditions. By 1930, when, at last, the two would write *Mule Bone,* Hughes had published two brilliant, widely acclaimed, experimental books of poetry that utilized the blues and jazz as both form and content. And Hurston, though yet to publish a novel, had published sixteen short stories, plays, and essays, in prestigious journals such as *Opportunity, Messenger,* and the *Journal of Negro History,* and was pursuing a Ph.D. thesis in anthropology which was to be built around her extensive collection of Afro-American myths. With Hurston's mastery of the vernacular and compelling sense of story, and Hughes's impressive sense of poetic and theatrical structure, it would have been difficult to imagine a more ideal team to construct "a real Negro theatre." For, at ages twenty-eight and twenty-nine respectively,* Hughes and Hurston bore every promise of reshaping completely the direction of the development of African-American literature away from the blind imitation of American literature and toward a bold and vibrant synthesis of formal American literature and African-American vernacular.

III

The enormous potential of this collaborative effort was never realized, we know, because, as Hughes wrote on his manuscript copy of the text, "the authors fell out." Exactly *why* they "fell out" is not completely clear, despite the valiant attempts of Hemenway and Rampersad to reconstruct the curious series of events that led to such disastrous consequences. While we do know that Hughes and Hurston wrote acts one and

*Hurston, the scholar Cheryl Wall discovered, shaved ten years from her age. Actually, in 1930, she would have been thirty-nine, not twenty-nine, as she claimed.

three together, and, as Hemenway reports, "at least one scene
of the second act," it is impossible to ascertain who wrote
what. Hurston had conceived the plot, based as it was on her
short story, "The Bone of Contention" (published here for
the first time). Hughes would write that he "plotted out and
typed the play based on her story," and that Hurston "authen-
ticated and flavored the dialogue and added highly humorous
details." Rampersad's estimate is probably the most accurate:
"Hurston's contribution was almost certainly the greater to a
play set in an all-black town in the backwoods South (she drew
here on her childhood memories), with an abundance of tall
tales, wicked quips, and farcical styles of which she was abso-
lute master and Langston not much more than a sometimes
student. . . . Whatever dramatic distinction the play would
have, Hurston certainly brought to it." But, just as surely, it
was Hughes who shaped the material into a play, into comic
drama, with a plot, a dramatic structure, and a beginning,
middle, and end. While Hurston had published a play, and
Hughes had not yet completed his first play, Hughes was the
superior dramatist. Neither, however, would ever achieve the
results that they did, in close collaboration, with *Mule Bone*.

While we cannot explain Hurston's motivation for deny-
ing Hughes's collaboration, which caused the dispute and the
ending of their friendship, we can re-create the strange series
of events through the following chronology, which is based on
the accounts of Hemenway and Rampersad, printed in this
book:

Late February–early March 1930: Hughes meets Theresa Hel-
burn of the Dramatists Guild at a party; Helburn com-
plains about the lack of real comedies about blacks.
April–May 1930: Hughes and Hurston write the first draft of
"Mule Bone" in Westfield, New Jersey. Complete acts
one and three and at least scene one of act two, dictating
to Louise Thompson.

May 1930: Hughes's relation with patron, Mrs. Mason, begins to collapse.

June 1930: Hurston returns to the South, ostensibly to complete the trial scene of act two.

September 1930: Hurston returns, apparently without the scene completed.

October 1930: Hurston files for copyright of *Mule Bone* as sole author.

December 1930–January 1931: Hughes ends relationship with "Godmother," Mrs. Mason.

January 1931: Hughes returns to his mother's home in Cleveland, has tonsillectomy.

Winter 1930–31: Hurston gives Carl Van Vechten copy of play. Van Vechten sends it to Barrett Clark, reader for the Theatre Guild. Clark, an employee of Samuel French, the theatrical producer, contacts Rowena Jelliffe and sends script.

January 15, 1931: Hughes visits Rowena and Alexander Jelliffe, directors of the settlement playhouse "Karamu House," home of the black theatre troupe the Gilpin Players. Rowena Jelliffe explains that she has obtained the rights to a play entitled *Mule Bone* by Zora Neale Hurston.

January 16, 1931: Hughes phones Hurston to protest her action. Hurston denies knowledge of play being sent to French or to Jelliffe. Hughes incredulous.

January 16, 1931: Hughes writes to Carl Van Vechten asking for his advice.

January 17, 1931: Louise Thompson arrives in Cleveland, in her capacity as official of the American Interracial Seminar.

January 18, 1931: Hurston visits Van Vechten, and "cried and carried on no end."

January 19, 1931: Hughes mails copy of play to U.S. copyright office, in name of Hurston and himself. Received January 22.

January 20, 1931: Hughes receives Hurston's letter denying joint authorship and complaining about Louise Thompson's compensation.

January 20, 1931: French's company wires Jelliffe refusing Hurston's permission to authorize production. Demands return of script.

January 20–21, 1931: Hurston sends three telegrams reversing her decision; authorizes the production and agrees to collaborate with Hughes.

January 21, 1931: Hughes receives Hurston letter of January 18, denying Hughes's collaboration and revealing resentment over Hughes's friendship with Louise Thompson.

January 21–26, 1931: Hurston agrees to come to Cleveland to collaborate with Hughes on rewrites; first performance scheduled for February 15.

February 1, 1931: Hughes's twenty-ninth birthday. Hurston arrives in Cleveland, meets with Hughes, resolves differences, misses scheduled meeting with Gilpin Players. That evening, the Gilpin Players meet and vote to cancel play, but reconsider. All seems set for a Cleveland opening and a Broadway run.

February 2, 1931: Hurston learns that Louise Thompson has visited Cleveland and seen Hughes. Hurston berates Mrs. Jelliffe.

February 3, 1931: Hurston visits Hughes at his home and rudely cancels production.

August 1931: Wallace Thurman (estranged husband of Louise Thompson) hired to revise *Mule Bone.* Hughes writes to Dramatists Guild declaring joint authorship.

1940: Hughes publishes account in *The Big Sea.*

1964: Hughes publishes act three in *Drama Critique.*

This, in barest outline, is an account of the bizarre events of an extremely ugly affair. As Hemenway and Rampersad make clear, Hurston justified her denial of Hughes's collaboration by claiming anger over Hughes's apparent proposal that Louise Thompson be given a share of all royalties, and that she be made the business manager of any Broadway production that might evolve. In Hurston's words:

> In the beginning, Langston, I was very eager to do the play with you. ANYthing you said would go over big with me. But scarcely had we gotten underway before you made three propositions that shook me to the foundation of myself. First: that three way split with Louise. Now Langston, nobody has in the history of the world given a typist an interest in a work for typing it. Nobody would think of it unless they were prejudiced in favor of the typist.

If this seems scant reason, sixty years later, for Hurston's protest over Thompson's financial role to assume such an extreme form, her behavior was no doubt also motivated, as Hemenway and Rampersad argue, by Hughes's deteriorating relationship with Mrs. Mason and Hurston's desire to continue hers, even if at Hughes's expense. Hurston kept Mrs. Mason abreast of these developments over the play, and even sent her copies of Hughes's letters to her, all the while denying his claims to Mason. What seems clear, however, is that Hurston's behavior was not justified by her anger over Hughes's friendship with Thompson, and that her claim of sole authorship should not have been made. As Hughes concluded, "our art was broken," as was both their friendship and the promise of a new and bold direction in black theatre.

IV

Certainly one tragic aspect of the failure of Hughes and Hurston to produce and publish *Mule Bone* was the interruption of the impact that it might have had on the shape and direction of Afro-American theatre. Among all of the black arts, greater expectations were held for none more than for black theatre. As early as 1918, W. E. B. Du Bois, writing in *The Crisis,* argued that "the value of [a sustained Afro-American theatre] for Negro art can scarcely be overestimated." In 1925, Du Bois would help to found Krigwa, a black theatre group in Harlem, dedicated to drama that is "by," "for," "about," and "near *us,*" a self-contained and self-sustaining Afro-American theatre. Du Bois was just one of many critics who felt that the drama was the most crucial form of all of the arts for the future of black artistic development, and that it was precisely in this area that blacks had most signally failed. As Alain Locke put it, "Despite the fact that Negro life is somehow felt to be particularly rich in dramatic values, both as folk experience and as a folk temperament, its actual yield, so far as worthwhile drama goes, has been very inconsiderable." And, in another essay published in 1927, Locke wrote:

> In the appraisal of the possible contribution of the Negro to the American theatre, there are those who find the greatest promise in the rising drama of Negro life. Others see possibilities of a deeper, though subtler influence upon what is after all more vital, the technical aspects of the arts of the theatre. Until very recently the Negro influence upon American drama has been negligible, whereas even under the handicaps of second-hand exploitation and restriction to the popular amusement stage, the Negro actor has already considerably influenced our stage and its arts. One would do well to imagine

what might happen if the art of the Negro actor
should really become artistically lifted and liber-
ated. Transpose the possible resources of Negro
song and dance and pantomime to the serious stage,
envisage an American drama under the galvanizing
stimulus of a rich transfusion of essential folk-arts
and you may anticipate what I mean. ("The Negro
and the American Theatre")

There can be little doubt that Locke here voices the theory of
black drama that Hurston and Hughes sought to embody in
their unwritten black opera and in *Mule Bone*. (Hurston had,
by the way, once described the relationship among the three
as that of a triangle, with Hughes and her forming the base,
and Locke the apex.)

There are many reasons for the supposed primacy of the
theatre among the arts of the Harlem Renaissance. Many
scholars date the commencement of the Renaissance itself to
the phenomenal and unprecedented success of Eubie Blake's
and Noble Sissle's all-black Broadway musical, *Shuffle Along*,
which opened in 1921. (Blake and Sissle did the score, and
Aubrey Lyles and Flournoy Miller did the book.) As Bruce
Kellner informs us, "Often the week's first run business was
so heavy that the street on which it was playing had to be
designated for one-way traffic only." Josephine Baker, Flor-
ence Mills, and Paul Robeson were just a few of the perform-
ers who played in this musical.

Predictably, the success of *Shuffle Along* spawned a whole
host of imitators, including *Alabama Bound, Bandana Land,
Black Bottom Revue, Black Scandals, Blackbirds, Chocolate Blondes,
Chocolate Browns, Chocolate Dandies, Darktown Scandals, Dark-
town Strutters, Goin' White, Lucky Sambo, North Ain't South,
Raisin' Cane, Strut Miss Lizzie, Seven-Eleven, Dixie to Broadway,*
and *Runnin' Wild* (which introduced "The Charleston"), to
list just a few. Jazz, the dance, acting, and an extraordinarily

large white and sympathetic audience made the theatre an enormously promising venue for a black art that would transform the public image of the Negro. Its effect was both broad and immediate; there was not the sort of mediation necessary between artist and audience as is the case with a printed book. What's more, theatre as a combination of several arts—poetry, narrative, music, the dance, acting, the visual arts—allowed blacks to bring together the full range of their traditions, vernacular and formal, rather than just one. The great potential of the theatre was hard to resist.

Resistance, however, arose from tradition itself. The roots of black theatre in the twenties were buried in the soil of minstrelsy and vaudeville. Musicals such as *Shuffle Along* did indeed reach tens of thousands more Americans than would any book before *Native Son* (1940). But what image did they represent, and at what cost? Reviews of *Shuffle Along* often turned on phrases such as "extreme energy," "the sun of their good humor." Especially notable were the dancers' "jiggling," "prancing," "wiggling," and "cavorting." In other words, what this sort of black theatre did was to reinforce the stereotype of black people as happy-go-lucky, overly sensual bodies. And while it was (and remains) difficult to disrupt the integrity of jazz and Afro-American dance, even in association with quasi-minstrel forms, it is difficult to imagine how the *intelligence* of these artistic traditions could shine through the raucous humor of this kind of theatre. Broadway, in other words, stood as the counterpoint to the sort of written art that Hughes and Hurston were determined to create, even if they envied Broadway's potential and actual market. Accordingly, they decided to intervene, to do for the drama what Hughes had done for poetry and what Hurston would do (in *Jonah's Gourd Vine* [1934] and *Their Eyes Were Watching God* [1937]) for the novel, which was to shape a formal written art out of the vast and untapped black vernacular tradition.

Mule Bone was based on a Hurston short story, "The

Bone of Contention," which Hurston never published. For
the Hurston scholar, it is particularly fascinating as a glimpse
into Hurston's manner of revising or transforming the oral
tradition (she had collected the story in her folklore research)
and because of its representation of various characters (such
as Eatonville, an all-black town where Hurston was born, Joe
Clarke and his store, the yellow mule and his mock burial)
who would recur in subsequent works, such as *Mule Bone* and
Their Eyes Were Watching God.

The story's plot unfolds as follows: Dave Carter and Jim
Weston are hunting turkeys one evening. Carter claims to
have shot a turkey, while Weston is loading his gun. Weston
claims that it is his shot that killed the turkey. They struggle.
Jim Weston strikes Dave Carter on the head with "de hock-
bone" of a mule, Carter alleges, and steals his turkey.

The remainder of the plot depicts the trial, held at the
Baptist Church and presided over by Mayor Joe Clarke. Wes-
ton is a Methodist while Clarke is a Baptist, and the townspeo-
ple are equally divided between the two denominations. They
are also fiercely competitive, bringing a religious significance
to the quarrel. In fact, Carter and Weston would be repre-
sented in court by their ministers, Rev. Simms (Methodist)
and Elder Long (Baptist). "The respective congregations were
lined up behind their leaders," the text tells us.

The resolution of the dilemma turns on traditional Afri-
can-American biblical exegesis: can a mule-bone be a weapon?
If it can, then it follows that its use could constitute a criminal
act. Using Judges 15:16, Elder Long proves that since a don-
key is the father of a mule, and since Samson slew one thou-
sand Philistines with the jaw-bone of an ass, and since "de
further back on a mule you goes, do mo' dangerous he gits,"
then "by de time you gits clear back tuh his hocks hes rank
pizen." Jim Weston is banished from town.

The plot of *Mule Bone* is very similar. The play consists
of three acts, and includes Jim Weston and Dave Carter (best

friends), Joe Clarke, but now Daisy Taylor, over whom Weston and Clarke will, inevitably, quarrel. Weston will strike Carter with the hock-bone of "Brazzle's ole yaller mule," during an argument over Daisy on the front porch of Clarke's store. Weston is arrested, Carter is rushed off to be treated, leaving Daisy alone wondering who's going to walk her home.

Act Two consists of two scenes. The first reveals the subtext of the trial—the struggle between Joe Clarke and Elder Simms for mayor, and the class tension between the Baptists and the Methodists. Scene Two occurs mostly in the Macedonia Baptist Church, newly transformed into a courthouse, with Joe Clarke presiding. As in the short story, the Methodists and Baptists seat themselves on opposite sides, even singing competing hymns (Baptists, "Onward Christian Soldiers" and the Methodists, "All Hail the Power of Jesus's Name") when the mayor asks that the proceedings commence with a hymn. Act Two proceeds as does the short story, with Judges 18:18 coming to bear in exactly the same manner as had Judges 15:16. Jim Weston, found guilty, is banished from town for two years.

Act Three depicts the reconciliation of Jim and Dave, and Jim's return to Eatonville, following their joint rejection of Daisy, who as it turns out, wants her husband to "work for her white folks." What is most interesting about this scene is that the tension between Dave and Jim is resolved in a witty and sustained verbal dual, in which the two trade cleverly improvised hyperbolic claims of their love for Daisy, in an elaborate ritual of courtship. As Hemenway puts it:

> When Dave asks Jim how much time he would
> do for Daisy on the chain gang, Jim answers,
> "Twenty years and like it." Dave exults, "See dat,
> Daisy, Dat nigger ain't willin to do no time for you.
> I'd beg de judge to gimme life."

Again a significant stage direction interrupts
the dialogue. By telling us that "both Jim and Dave
laugh," Hurston and Hughes were trying to show
the sense of verbal play and rhetorical improvisa-
tion characteristic of Eatonville generally, and Joe
Clark's store-front porch specifically. . . . The con-
test is a ritual, designed to defuse the violence im-
plicit in the conflict, to channel the aggression into
mental rather than physical terms. The manner in
which the courting contest ends suggests its ritualis-
tic nature: Dave says to Daisy, "Don't you be
skeered, baby. Papa kin take keer o you [To Jim:
suiting the action to the word] Countin from de
finger back to de thumb. . . . Start anything, I got
you some." Jim is taken aback: "Aw, I don't want
no more fight wid you, Dave." Dave replies, "Who
said anything about fighting? We just provin who
love Daisy de best."

This courtship ritual, like so much of the verbal "signify-
ing" rituals in which the characters engage throughout the
play, are both reflections of historical folk rituals practiced by
African Americans as well as their extensions or elaborations.
As Hemenway shows so carefully in his essay appended to this
volume, often the characters' dialogues are taken directly
from the black vernacular tradition. As often, however,
Hughes and Hurston are *imitating* that tradition, improvising
upon a historical foundation of ritualized oral discourse, which
Hurston had been collecting as part of her graduate research
in anthropology with Franz Boas. Hughes and Hurston, in
other words, were drawing upon the black vernacular tradi-
tion both to "ground" their drama in that discourse but also
to "extend" the vernacular itself.

Mule Bone, then, was not a mere vehicle for black folk-
lore, rather, black folklore served as the basis, the foundation,

for what they hoped would be a truly new art form: an art form that would stand in relation to traditional American drama in the way that Hughes's "blues poetry" stood to American poetry and Hurston's vernacular fictions stood to the American novel. *Mule Bone,* in other words, was meant to be the dramatic embodiment of James Weldon Johnson's demand that "the colored poet in the United States needs to do . . . something like what Synge did for the Irish; he needs to find a form that will express the racial spirit by symbols from within rather than by symbols from without, such as the mere mutilation of English spelling and pronunciation. He needs a form that is freer and larger than dialect, but which will still hold the racial flavor; a form expressing the imagery, the idioms, the peculiar turns of thought, and the distinctive humor and pathos, too, of the Negro, but which will also be capable of voicing the deepest and highest emotions and aspirations, and allow of the widest range of subjects and the widest scope of treatment." Dialect, Johnson continued, was doomed by its racist textual heritage:

> Negro dialect is at present a medium that is not capable of giving expression to the varied conditions of Negro life in America, and much less is it capable of giving the fullest interpretation of Negro character and psychology. This is no indictment against the dialect as dialect, but against the mould of convention in which Negro dialect in the United States has been set.

Mule Bone was also a refutation of Johnson's claim that "Negro dialect" "is an instrument with but two full stops, humor and pathos," because of the racist minstrel and vaudeville representations of black characters and their language. This is what they meant when they subtitled their play "A Comedy of

Negro Life" and when they claimed that *Mule Bone* was "the first real Negro folk comedy."

By using the vernacular tradition as the foundation for their drama—indeed, as the basis for a new *theory* of black drama—Hughes and Hurston succeeded quite impressively in creating a play that implicitly *critiqued* and explicitly *reversed* the racist stereotypes of the ignorant dialect-speaking darky that had populated the stages of the minstrel and vaudeville traditions. Indeed, we can only wonder at the effect that a successful Broadway production of *Mule Bone* might have had on the subsequent development of black theatre, given the play's sheer novelty and freshness of language.

With their turn to the vernacular, however, Hurston and Hughes also seem at times to reinscribe the explicit sexism of that tradition, through the discussions of physical abuse and wife-beatings as agents of control, which the male characters on Joe Clarke's store-front porch seem to take for granted as a "natural" part of sexual relations. These exchanges are quite disturbing for our generation of readers, demanding as they do a forceful critique by the reader. Daisy's representation in a triangle of desire as the *object* of her lovers' verbal dueling rather than as one who duels herself, a mode of dueling that demands great intelligence, is also a concern, even if this concern is tempered somewhat by the fact that it is she who controls their complex relationship all along, as demonstrated when she dismisses them both when they will not accede to her demands that they get jobs and provide support for her own efforts at self-sufficiency: "Both of you niggers can git yo' hat on yo' heads and git on down de road. Neither one of y'all don't have to have me. I got a good job and plenty men beggin' for yo' change." Despite this, however, the depiction of female characters and sexual relations in *Mule Bone* almost never escapes the limitation of the social realities that the vernacular tradition reflects.

Mule Bone was never completed. Hurston, in a frantic

attempt to demonstrate to Hughes's lawyer, Arthur Spingarn, that she had indeed been the play's sole author, sent him more handwritten revisions of large sections of the play, creating still another version. We have reprinted here, however, the last version on which Hughes and Hurston collaborated. Despite its limitations as a work-in-progress, it stands as a daring attempt to resurrect black poetic language from the burial grounds of racist stereotypes. Had it been performed, the power of its poetic language could very well have altered forever the evolution of African-American drama enabling the theatre to fulfill its great—and still unfulfilled—potential among the African-American arts.

Selected Bibliography

Baker, Houston A., Jr. *Modernism and the Harlem Renaissance.* Chicago: University of Chicago Press, 1987.

Du Bois, W. E. B. "Can the Negro Save the Drama?" *Theatre Magazine* XXXVIII (July 1923): 12, 68.

Du Bois, W. E. B. "The Krigwa Players Little Negro Theatre." *Amsterdam News* (October 5, 1927) and *Crisis* XXXII, No. 3 (July 1926): 134–36.

Du Bois, W. E. B. "The Negro and the American Stage." *Crisis* XXVIII, No. 2 (June 1924): 55–60.

Du Bois, W. E. B. "The Negro Theatre." *Crisis* XV (February 1918): 165.

Fabre, Geneviève. *Drumbeats, Masks, and Metaphors: Contemporary Afro-American Theatre.* Cambridge, Mass.: Harvard University Press, 1983.

Hemenway, Robert. *Zora Neale Hurston: A Literary Biography.* Urbana, Ill.: University of Illinios, 1977.

Huggins, Nathan Irvin. *Harlem Renaissance.* New York: Oxford University Press, 1971.

Johnson, James Weldon. "Preface." In *The Book of American Negro Poetry.* New York: Harcourt, Brace, Jovanovich, 1931.

Kellner, Bruce. *The Harlem Renaissance: A Historical Dictionary of the Era.* New York: Methuen, 1987.

Lewis, David Levering. *When Harlem Was in Vogue.* New York: Alfred A. Knopf, 1981.

Locke, Alain. "The Drama of Negro Life." *Theatre Arts Monthly* 10 (October 1926): 701–6.

Locke, Alain. "The Negro and the American Stage." *Theatre Arts Monthly* 10 (February 1926): 112–20.

Rampersad, Arnold. *The Life of Langston Hughes. Vol. 1: 1902–1941: I, Too, Sing America.* New York: Oxford University Press, 1986.

"THE BONE OF CONTENTION"

a short story by

ZORA NEALE HURSTON

I

Eatonville Florida is a colored town and has its colored interests. It has not now, nor ever has had anything to rank Brazzle's yellow mule. His Yaller Highness was always mentioned before the weather, the misery of the back or leg, or the hard times.

The mule was old, rawbony and mean. He was so rawbony that he creaked as he ambled about the village street with his meanness shining out through every chink and cranny in his rattling anatomy. He worked little, ate heartily, fought every inch of the way before the plow and even disputed with Brazzle when he approached to feed him. Sale, exchange or barter was out of the question, for everybody in the county knew him.

But one day he died. Everybody was glad, including Brazzle. His death was one of those pleasant surprises that people hope for, but never expect to happen.

The city had no refuse plant so H.Y.H. went the way of

all other domestic beasts who died among us. Brazzle borrowed Watson's two grey plugs and dragged the remains out to the edge of the cypress swamp, three miles beyond the city limits and abandoned them to the natural scavengers. The town attended the dragging out to a man. The fallen gladiator was borne from the arena on his sharp back, his feet stiffly raised as if [in] a parting gesture of defiance. We left him on the edge of the cypress swamp and returned to the village satisfied that the only piece of unadulterated meanness that the Lord had ever made was gone from among us forever.

Three years passed and his bones were clean and white. They were scattered along the swamp edge. The children still found them sufficiently interesting to tramp out to gaze upon them on Sunday afternoons. The elders neglected his bones, but the mule remained with them in song and story as a simile, as a metaphor, to point a moral or adorn a tale. But as the mean old trouble-making cuss, they considered him gone for good.

II

It was early night in the village. Joe Clarke's store porch was full of chewing men. Some chewed tobacco, some chewed cane, some chewed straws, for the villager is a ruminant in his leisure. They sat thus every evening ostensibly waiting for the mail from Number 38, the south-bound express. It was seldom that any of them got any but it gave them a good excuse to gather. They all talked a great deal, and every man jack of them talked about himself. Heroes all, they were, of one thing or another.

Ike Pearson had killed a six-foot rattler in a mighty battle that grew mightier every time Ike told about it; Walter Thomas had chinned the bar twenty times without stopping; Elijah Moseley had licked a "cracker"; Brazzle had captured a live catamount; Hiram Lester had killed a bear; Sykes Jones

had won the soda-cracker eating contest; AND JOE CLARKE HAD STARTED THE TOWN!

Reverend Simms, the Methodist preacher, a resident of less than a year, had done nothing to boast of, but it was generally known that he aspired to the seat of Joe Clarke. He wanted to be the mayor. He had observed to some of his members that it wasnt no sense in one man staying in office all the time.

"Looka heah," Clarke cut across whoever it was that [was] talking at the time, "When Ah started dis town, Ah walked right up to de white folks an' laid down TWO HUN'DED DOLLAHS WID DIS RIGHT HAND YOU SEE BEFO' YOU AN' GOT MAH PAPERS AN' PUT DIS TOWN ON DE MAP! It takes uh powerful lot uh sense an' grit tuh start uh town, yessirree!"

"Whut map did you put it on, Joe?" Lindsay disrespectfully asked. "Ah aint seed it on no map."

Seeing Clarke gored to his liver, Rev. Simms let out a gloating snicker and tossed a cane knot to Tippy, the Lewis' dejected dog frame hovering about the group hoping for something more tempting to a dog's palate than cane chews and peanut shells might drop. He tossed the knot and waited for Clarke to answer. His Honor ignored the thrust as being too low for him to stoop to and talked on. Was he not mayor, postmaster, storekeeper and Pooh Bah general? Insults must come to him from at least the county seat.

"Nother thing," Clarke continued, giving Simms a meaning look, "There's a heap goin' on 'round heah under the cover dat Ahm gointer put a stop to. Jim Weston done proaged through mah hen house enough. Last Sat'day Ah missed three uh mah bes' layin' hens, an' Ah been tol' he buried feathers in his backyard the very next day. Cose Ah caint prove nothin', but de minute he crooks his little finger, he goes 'way from mah town. He aint de onliest one Ah got mah eye on neither."

Simms accepted the challenge thrown at him.

"Fact is, the town aint run lak it might be. We oughta stop dat foolishness of runnin' folks outa town. We oughta jail'em. They's got jails in all de other towns, an' we oughta bring ours up to date."

"Ah'll be henfired! Simms, you tries to know mo' 'bout runnin' de town than me! Dont you reckon a man thats got sense enough to start uh town, knows how tuh run it. Dont you reckon if de place had uh needed uh jailhouse Ah would have got one built 'long befo' you come heah?"

"We do so need a jail," Lindsay contended. "Jus' cause you stahted the town, dat dont make yo' mouf no prayer book nor neither yo' lips no Bible. They dont flap lak none tuh *me.*"

Lindsay was a little shriveled up man with grey hair and bow-legs. He was the smallest man in the village, who nevertheless did the most talk of fighting. That was because the others felt he was too small for them to hit. He was harmless, but known to be the nastiest threatener in the county.

Clarke merely snorted contemptuously at his sally and remarked dryly that the road was right there for all those who were not satisfied with the way he was running the town.

"Meaning to insult me?" Lindsay asked belligerently.

"Ah dont keer HOW yuh take it. Jus' take yo' rawbony cow an' gwan tuh de woods, fuh all I keer," Clarke answered.

Lindsay leaped from the porch and struck his fighting pose. "Jus' hit de ground an' Ah'll strow yuh all over Orange County! Aw, come on! Come on! Youse a big seegar, but Ah kin smoke yuh!"

Clarke looked at the little man, old, and less that half his size and laughed. Walter Thomas and 'Lige Moseley rushed to Lindsay and pretended to restrain him.

"That's right," Lindsay panted, "you better hold me offen him. Cause if I lay de weight uh dis right hand on him, he wont forget it long as he live."

"Aw, shet up, Lin'say, an' set down. If you could fight as

good as you kin threaten, you'd be world's champeen 'stead
uh Jack Dempsey. Some uh dese days when youse hollerin'
tuh be let loose, somebody's gointer take you at yo' word,
then it will be jus' too bad about yuh," Lester admonished.

"Who?—"

The war was about to begin all over on another front
when Dave Carter, the local Nimrod, walked, almost ran up
the steps of the porch. He was bareheaded, excited and even
in the poor light that seeped to the porch from the oil lamps
within, it was seen that he was bruised and otherwise unusu-
ally mussed up.

"Mist' Clarke, Ah wants tuh see yuh, Me said. "Come on
inside."

"Sholy, Dave, sholy." The mayor responded and fol-
lowed the young man into the store and the corner reserved
for City Administration. The crowd from the porch followed
to a man.

Dave wiped a bruise spot on his head. "Mist' Clarke, Ah
wants uh warrant took out fuh Jim Weston. Ahm gointer law
him outa dis town. He caint lam me over mah head wid no
mule bone and steal mah turkey and go braggin' about it!"

Under the encouraging quiz of the mayor, Dave told his
story. He was a hunter and fisherman, as everybody knew. He
had discovered a drove of wild turkeys roosting in the trees
along the edge of the cypress swamp near the spot where
Brazzle's old mule had been left. He had watched them for
weeks, had seen the huge gobbler that headed the flock and
resolved to get him.

"Yes," agreed Clarke, "you said something to me about
it yesterday when you bought some shells."

"Yes, and thats how Jim knowed Ah was goin' turkey
huntin'. He was settin' on de store porch and heard me talkin'
to you. Today when Ah started out, jes 'bout sundown—dats
de bes' time tuh get turkeys, when they goes tuh roost—he ups
and says he's goin' long. Ah didnt keer 'bout dat, but when

them birds goes tuh roost, he aint even loaded, so Ah had shot dat gobbler befo' he took aim. When he see dat great big gobbler fallin' he fires off his gun and tries tuh grab him. But Ah helt on. We got tuh pushin' and shovin' and tusslin' 'till we got to fightin'. Jim's a bully, but Ah wuz beatin' his socks offa him till he retched down and picked up de hock-bone of Brazzle's ol' mule and lammed me ovah mah head wid it and knocked me out. When Ah come to, he had done took mah turkey and gone. Ah wants uh warrant, Mist' Clarke. Ahm gointer law him outa dis town.''

"An' you sho gointer get, Dave. He oughter be run out. Comes from bad stock. Every last one of his brothers been run out as fast as they grow up. Daddy hung for murder.''

Clarke busied himself with the papers. The crowd looking on and commenting.

"See whut you Meth'dis' niggahs will do?'' asked Brazzle, a true Baptist. "Goin' round lammin' folks ovah the head an' stealin' they turkeys.''

"Cose everybody knows dem Westons is a set uh bullies, but you Baptists aint such a much,'' Elijah Moseley retorted.

"Yas, but Ah know yuh know,'' put in Lindsay. "No Baptis' aint never done nothin' bad as dat. Joe Clarke is right. Jail is too good fuh 'em. The last one uh these heah half-washed christians oughta be run 'way from heah.''

"When it comes tuh dat, theres jus' as many no count Baptists as anybody else. Jus' aint caught 'em,'' Thomas said, joining the fray.

"Yas,'' Lindsay retorted, "but we done kotched yo' Meth'dis' niggah. Kotched him knockin' people ovah de head wid mule bones an' stealin' they turkeys, an' wese gointer run him slap outa town sure as gun's iron. The dirty onion!''

"We dont know whether you will or no, Joe Lindsay. You Baptists aint runnin' this town exactly.''

"Trial set for three oclock tomorrow at de Baptis' church, that being the largest meetin' place in town,'' Clarke

announced with a satisfied smile and persuaded the men to go back to the porch to argue.

Clarke, himself, was a Methodist, but in this case, his interests lay with the other side. If he could get Jim to taste the air of another town, chicken mortality of the sudden and unexplained variety, would drop considerably, he was certain. He was equally certain that the ambitious Simms would champion Jim's cause and losing the fight, lose prestige. Besides, Jim was a troublesome character. A constant disturber of the village peace.

III

It was evident to the simplest person in the village long before three oclock that this was to be a religious and political fight. The assault and the gobbler were unimportant. Dave was a Baptist, Jim a Methodist, only two churches in the town and the respective congregations had lined up solidly.

At three the house was full. The defendant had been led in and seated in the amen corner to the left of the pulpit. Rev. Simms had taken his place beside the prisoner in the role of defense counsel. The plaintiff, with Elder Long, shepherd of the Baptist flock in the capacity of prosecution, was seated at the right. The respective congregations were lined up behind their leaders.

Mutual glances of despisement and gloating are exchanged across the aisle. Not a few verbal sorties were made during this waiting period as if they were getting up steam for the real struggle.

Wize Anderson (Meth) Look at ole Dave tryin' to make out Jim hurt his head! Yuh couldnt hurt a Baptist head wid a hammer—they're that hard.

Brother Poke (Bapt.) Well, anyhow we dont lie an' steal an' git run outa town lak de softhead Meth'dis niggahs.

Some Baptist wag looked over at Jim and crowed like a

rooster, the others took it up immediately and the place was full of hen-cackling and barnyard sounds. The implication was obvious. Jim stood up and said, "If I had dat mule bone heah, Ahd teach a few mo' uh you mud-turtles something."

Enter His Honor at this moment. Lum Boger pompously conducted him to his place, the pulpit, which was doing duty as the bench for the occasion. The assembly unconsciously moderated its tone. But from the outside could still be heard the voices of the children engaged in fisticuffy trials of the case.

The mayor began rapping for order at once. "Cote is set. Cote is set! Looka heah, DIS COTE IS DONE SET! Ah wants you folks tuh dry up."

The courtroom grew perfectly still. The mayor prepared to read the charge to the prisoner, when Brother Stringer (Meth.) entered, hot and perspiring with coat over his arm. He found a seat near the middle of the house against the wall. To reach it, he must climb over the knees of a bench length of people. Before seating himself, he hung his coat upon an empty lamp bracket above his head.

Sister Lewis of the Baptist persuasion, arose at once, her hands akimbo, her eyes flashing.

"Brothah Stringah, you take yo' lousy coat down off dese sacred walls! Aint you Methdis got no gumption in the house uh washup?"

Stringer did not answer her, but he cast over a glance that said as plain as day 'Just try and make me do it!

Della Lewis snorted, but Stringer took his seat complacently. He took his seat, but rose up again as if he had sat on a hot needle point. The reason for this was that Brother Hambo on the Baptist side, a nasty scrapper, rose and rolled his eyes to the fighting angle, looking at Stringer. Stringer caught the look, and hurriedly pawed that coat down off that wall.

Sister Taylor (M) took up the gauntlet dropped like a hot

potato by Stringer. "Some folks" she said with a meaning look, "is a whole lot mo' puhtic'lar bout a louse in they church than they is in they house." A very personal look at Sister Lewis.

"Well" said that lady, "mah house mought not be exactly clean. But nobody caint say *dat*"—indicating an infinitesimal amount on the end of her finger—"about my chaRACter! They didnt hafta git de sheriff to make Ike marry ME!"

Mrs. Taylor leaped to her feet and struggled to cross the aisle to her traducer but was restrained by three or four men. "Yas, they did git de sheriff tuh make Sam marry me!" She shouted as she panted and struggled, "And Gawd knows you sho oughter git him again and make *some* of these men marry yo' Ada."

Mrs. Lewis now had to be restrained. She gave voice and hard, bone-breaking words flew back and forth across the aisle. Each was aided and abetted by her side of the house. His Honor was all the time beating the pulpit with his gavel and shouting for order. At last he threatened to descend in person upon the belligerents.

"Heah! You moufy wimmen! Shet up. Aint Ah done said cote was set? Lum Boger, do yo' duty. Make them wimmen dry up or put 'em outa heah."

Marshall Boger who wore his star for the occasion was full of the importance of his office for nineteen is a prideful age; he hurried over to Mrs. Taylor. She rose to meet him. "You better gwan 'way from me, Lum Boger. Ah jes' wish you would lay de weight of yo' han' on me! Ahd kick yo' cloes up round yo' neck lak a horse collar. You impident limb you."

Lum retreated before the awful prospect of wearing his suit about his neck like a horse-collar. He crossed the aisle to the fiery Della and frowned upon her. She was already standing and ready to commence hostilities. One look was enough. He said nothing, but her threats followed him down the aisle as he retreated to the vestibule to shoo the noisy children

away. The women subsided and the Mayor began.

"We come heah on very important business," he said.
"Stan' up dere, Jim Weston. You is charged wid 'ssaultin'
Dave Carter here wid a mule bone, and robbin' him uh his
wild turkey. Is you guilty or not guilty?"

Jim arose, looked insolently around the room and an-
swered the charge: "Yas, Ah hit him and took de turkey cause
it wuz mine. Ah hit him and Ahll hit him agin, but it wasnt
no crime this time."

His Honor's jaw dropped. There was surprise on the
faces of all the Baptist section, surprise and perplexity. Gloat-
ing and laughter from the Methodists. Simms pulled Jim's
coattail.

"Set down Jim," he cooed, "youse one of mah lambs. Set
down. Yo' shepherd wil show them that walks in de darkness
wid sinners and republicans de light."

Jim sat down and the pastor got to his feet.

"Looka heah, Jim, this aint for no foolishness. Do you
realize dat if youse found guilty, youse gonna be run outa
town?"

"Yeah" Jim answered without rising. "But Ah aint
gonna be found no guilty. You caint find me." There was a
pleasurable stir on his side of the house. The Baptists were still
in the coma which Jim's first statement had brought on.

"Ah say too, he aint guilty," began Rev. Simms with
great unction in his tones. "Ah done been to de cot-house at
Orlando an' set under de voice of dem lawyers an' heard 'em
law from mornin' tell night. They says you got tuh have a
weepon befo' you kin commit uh 'ssault. Ah done read dis
heah Bible fum lid tuh lid (he made a gesture to indicate the
thoroughness of his search) and it aint in no Bible dat no mule
bone is a weepon, an' it aint in no white folks law neither.
Therefo' Brother Mayor, Ah ast you tuh let Jim go. You gotta
turn 'im loose, cause nobody kin run 'im outa town when he
aint done no crime."

A deep purple gloom settled down upon the Mayor and his followers. Over against this the wild joy of the Methodists. Simms already felt the reins of power in his hands. Over the protest of the Mayor he raised a song and he and his followers sang it with great gusto.

"Oh Mary dont you weep, dont you mourn
Oh Mary, dont you weep dont you mourn
Pharaoh's army got drownded,
O-O-oh Mary, dont you weep"

The troubled expression on the face of the Baptist leader, Elder Long, suddenly lifted. He arose while yet the triumphant defense is singing its hallelujah. Mayor Clarke quieted the tumult with difficulty. Simms saw him rise but far from being worried, he sank back upon the seat, his eyes half closed, hands folded fatly across his fat stomach. He smirked. Let them rave! He had built his arguments on solid rock, and the gates of Baptist logic could not prevail against it!

When at last Long got the attention of the assembly, he commanded Dave to stand.

"Ah jus want you all tuh take a look at his head. Anybody kin see dat big knot dat Jim put on dere." Jim, the Rev. Simms and all his communicants laughed loudly at this, but Long went on calmly. "Ah been tuh de cote-house tuh Orlando an' heard de white folks law as much as any body heah. And dey dont ast whether de thing dat a person gits hurt wid is uh weepon or not. All dey wants tuh fin' out is, 'did it hurt?' Now you all kin see dat mule bone did hurt Dave's head. So it must be a weepon cause it hurt 'im."

Rev. Simms had his eyes wide open now. He jumped to his feet.

"Never mind bout dem white folks laws at O'landa, Brother Long. Dis is a colored town. Nohow we oughter run

by de laws uh de Bible. Dem white folks laws dont go befo'
whuts in dis sacred book."

"Jes' hold yo' hot potater, Brother Simms, Ahm comin'
tuh dat part right now. Jes lemme take yo' Bible a minute."

"Naw indeed. You oughter brought one of yo' own if
you got one. Furthemo' Brother Mayor, we got work tuh do.
Wese workin' people. Dont keep us in heah too long. Dis case
is through wid."

"Oh, naw it aint" the Mayor disagreed, "you done talked
yo' side, now you got tuh let Brother Long talk his. So fur as
de work is concerned, it kin wait. One thing at a time. Come
on up heah in yo' pulpit an' read yo' own Bible, Brother Long.
Dont mind me being up heah."

Long ascended the pulpit and began to turn the leaves of
the large Bible. The entire assembly slid forward to the edges
of the seat.

"Ah done proved by de white folks law dat Jim oughter
be run outa town an' now Ahm gointer show by de Bible—"

Simms was on his feet again. "But Brother Mayor—"

"Set down Simms" was all the answer he got. "Youse
entirely outa order."

"It says heah in Judges 15:16 dat Samson slewed a thou-
sand Philistines wid de jaw-bone of a ass" Long drawled.

"Yas, but this wasnt no ass, this was a mule" Simms
objected.

"And now dat bring us to de main claw uh dis subjick.
It sho want no ass, but everybody knows dat a donkey is de
father of every mule what ever wuz born. Even little chillen
knows dat. Everybody knows dat dat little as a donkey is, dat
if he is dangerous, his great big mule son is mo' so. Everybody
knows dat de further back on a mule you goes, de mo' danger-
ous he gits. Now if de jawbone is as dangerous as it says heah,
in de Bible, by de time you gits clear back tuh his hocks hes
rank pizen."

"AMEN!! Specially Brazzle's ol' mule," put in Hambo.

"An' dat makes it double 'ssault an' batt'ry," Long continued. "Therefo' Brother Mayor, Ah ast dat Jim be run outa town fuh 'ssaultin Dave wid a deadly weepon an' stealin' his turkey while de boy wuz unconscious."

It was now the turn of the Baptists to go wild. The faint protests of Simms were drowned in the general uproar.

"I'll be henfired if he aint right!" The Mayor exclaimed when he could make himself heard. "This case is just as plain as day."

Simms tried once more. "But Brother Mayor—"

"Aw be quiet, Simms. You done talked yo'self all outa joint already." His Honor cut him short. "Jim Weston, you git right outa *mah* town befo sundown an' dont lemme ketch you back heah under two yeahs, neither. You folks dats so rearin' tuh fight, gwan outside an' fight all you wants tuh. But dont use no guns, no razors nor no mule-bones. Cote's dismissed."

A general murmur of approval swept over the house. Clarke went on, unofficially, as it were. "By ziggity, dat ol' mule been dead three years an' still kickin'! An' he done kicked more'n one person outa whack today." And he gave Simms one of his most personal looks.

THE END

MULE BONE
A COMEDY OF NEGRO LIFE

by

LANGSTON HUGHES

and

ZORA NEALE HURSTON

A Note on the Text

Several drafts of *Mule Bone* exist, housed at Howard and at Yale. The most complete draft, however, and the only one containing two scenes in Act Two, is that dated "Cleveland, 1931." It is this draft that we have published here.

Since the manuscript for *Mule Bone* was never copyedited during the authors' lifetimes, there are some apparent inconsistencies in characters' names and relationships to one another. For instance, Daisy Taylor is the daughter of Mrs. Blunt, and is seemingly unrelated to Mrs. Taylor. We have noted any name changes in the text.

CHARACTERS

Principal Characters

JIM WESTON: Guitarist, Methodist, slightly arrogant, aggressive, somewhat self-important, ready with his tongue.

DAVE CARTER: Dancer, Baptist, soft, happy-go-lucky character, slightly dumb and unable to talk rapidly and wittily.

DAISY TAYLOR: Methodist, domestic servant, plump, dark and sexy, self-conscious of clothes and appeal, fickle.

JOE CLARKE: The Mayor, storekeeper and postmaster, arrogant, ignorant and powerful in a self-assertive way, large, fat man, Methodist.

ELDER SIMMS: Methodist minister, newcomer in town, ambitious, small and fly, but not very intelligent.

ELDER CHILDERS: Big, loose-jointed, slow spoken but not dumb. Long resident in the town, calm and sure of himself.

KATIE CARTER: Dave's aunt, little old wisened dried-up lady.

MRS. MATTIE CLARKE: The Mayor's wife, fat and flabby mulatto, high-pitched voice.

THE MRS. REV. SIMMS: Large and aggressive.

THE MRS. REV. CHILDERS: Just a wife who thinks of details.

LUM BOGER: Young town marshall about twenty, tall, gangly, with big flat feet, liked to show off in public.

TEETS MILLER: Village vamp who is jealous of DAISY.

LIGE MOSELY: A village wag.

WALTER THOMAS: Another village wag.

ADA LEWIS: A promiscuous lover.

DELLA LEWIS: Baptist, poor housekeeper, mother of ADA.

BOOTSIE PITTS: A local vamp.

MRS. DILCIE ANDERSON: Village housewife, Methodist.

WILLIE NIXON: Methodist, short runt.

Minor Characters

HAMBO
GOODWIN
BRAZZLE
CODY
JONES
SAM MOSELY
TAYLOR
MRS. TAYLOR
MRS. JAKE ROBERTS
(VOICE OF MRS. MOSELY)
SENATOR BAILEY (BOY)
LITTLE MATILDA
OLD MAN
FRANK WARRICK
OLD WOMAN
SISTER THOMAS

SISTER JONES
MARY ELLA
SISTER PITTS
SISTER LUCAS
MRS. HAMBO
MRS. NIXON
MRS. BLUNT
(CHILDREN)
(LOUNGERS)

ACT ONE

SETTING: *The raised porch of* JOE CLARKE's *Store and the street in front. Porch stretches almost completely across the stage, with a plank bench at either end. At the center of the porch three steps leading from street. Rear of porch, center, door to the store. On either side are single windows on which signs, at left, "POST OFFICE", and at right, "GENERAL STORE" are painted. Soap boxes, axe handles, small kegs, etc., on porch on which townspeople sit and lounge during action. Above the roof of the porch the "false front", or imitation second story of the shop is seen with large sign painted across it "JOE CLARKE's GENERAL STORE". Large kerosine street lamp on post at right in front of porch.*

Saturday afternoon and the villagers are gathered around the store. Several men sitting on boxes at edge of porch chewing sugar cane, spitting tobacco juice, arguing, some whittling, others eating peanuts. During the act the women all dressed up in starched dresses parade in and out of store. People buying groceries, kids playing in the street, etc. General noise of conversation, laughter and children shouting. But when the curtain rises there is a momentary lull for cane-chewing. At left of porch four men are playing cards on a soap box, and seated on the edge of the porch at extreme right two children are engaged in a checker game, with the board on the floor between them.

When the curtain goes up the following characters are discovered on the porch: MAYOR JOE CLARKE, *the storekeeper;* DEACON HAMBO; DEACON GOODWIN; *Old Man* MATT BRAZZLE: WILL CODY; SYKES JONES: LUM BOGER, *the young town marshall:* LIGE MOSELY *and* WALTER THOMAS, *two village wags;* TOM NIXON *and* SAM MOSELY, *and several others, seated on boxes, kegs, benches and floor of the porch.* TONY TAYLOR *is sitting on steps of porch with empty basket.* MRS. TAYLOR *comes out with her arms full of groceries, empties them into basket and goes back in*

store. All the men are chewing sugar cane earnestly with varying facial expressions. The noise of the breaking and sucking of cane can be clearly heard in the silence. Occasionally the laughter and shouting of children is heard nearby off stage.

HAMBO: *(To* BRAZZLE*)* Say, Matt, gimme a jint or two of dat green cane—dis ribbon cane is hard.

LIGE: Yeah, and you ain't got de chears in yo' parlor you useter have.

HAMBO: Dat's all right, Lige, but I betcha right now wid dese few teeth I got I kin eat up more cane'n you kin grow.

LIGE: I know you kin and that's de reason I ain't going to tempt you. But youse gettin' old in lots of ways—look at dat bald-head—just as clean as my hand. *(Exposes his palm.)*

HAMBO: Don't keer if it tis—I don't want nothin'—not even hair—between me and God. *(General laughter—*LIGE *joins in as well. Cane chewing keeps up. Silence for a moment.)*

(Off stage a high shrill voice can be heard calling:)

VOICE: Sister Mosely, Oh, Sister Mosely! *(A pause)* Miz Mosely! *(Very irritated)* Oh, Sister Mattie! You hear me out here—you just won't answer!

VOICE OF MRS. MOSELY: Whoo-ee . . . somebody calling me?

VOICE OF MRS. ROBERTS: *(Angrily)* Never mind now—you couldn't come when I called you. I don't want yo' lil ole weasley turnip greens. *(Silence)*

MATT BRAZZLE: Sister Roberts is en town agin! If she was mine, I'll be hen-fired if I wouldn't break her down in de lines (loins)—good as dat man is to her!

HAMBO: I wish she was mine jes' one day—de first time she open her mouf to beg *anybody,* I'd lam her wid lightning.

JOE CLARKE: I God, Jake Roberts buys mo' rations out dis store than any man in dis town. I don't see to my Maker whut she do wid it all. . . . Here she come. . . .

(Enter MRS. JAKE ROBERTS, *a heavy light brown woman with a basket on her arm. A boy about ten walks beside her carrying a small child about a year old straddle of his back. Her skirts are sweeping the ground. She walks up to the step, puts one foot upon the steps and looks forlornly at all the men, then fixes her look on* JOE CLARKE.*)*

MRS. ROBERTS: Evenin', Brother Mayor.

CLARKE: Howdy do, Mrs. Roberts. How's yo' husband?

MRS. ROBERTS: *(Beginning her professional whine)* He ain't much and I ain't much and my chillun is poly. We ain't got 'nough to eat! Lawd, Mr. Clarke, gimme a lil piece of side meat to cook us a pot of greens.

CLARKE: Aw gwan, Sister Roberts. You got plenty bacon home. Last week Jake bought . . .

MRS. ROBERTS: *(Frantically)* Lawd, Mist' Clarke, how long you think dat lil piece of meat last me an' my chillun? Lawd, me and my chillun is *hongry!* God knows, Jake don't fee-eed me! *(*MR. CLARKE *sits unmoved.* MRS. ROBERTS *advances upon him)* Mist' Clarke!

CLARKE: I God, woman, don't keep on after me! Every time I look, youse round here beggin' for everything you see.

LIGE: And whut she don't see she whoops for it just de same.

MRS. ROBERTS: *(In dramatic begging pose)* Mist' Clarke! Ain't you goin' do nuthin' for me? And you see me and my poor chillun is starvin'. . . .

CLARKE: *(Exasperated, rises)* I God, woman, a man can't git no peace wid somebody like you in town. *(He goes angrily into the store followed by* MRS. ROBERTS. *The boy sits down on the edge of the porch sucking the baby's thumb.)*

VOICE OF MRS. ROBERTS: A piece 'bout dis wide. . . .

VOICE OF CLARKE: I God, naw! Yo' husband done bought you plenty meat, nohow.

VOICE OF MRS. ROBERTS: *(In great anguish)* Ow! Mist' Clarke! Don't you cut dat lil tee-ninchy piece of meat for me and my chillun! *(Sound of running feet inside the store.)* I ain't a going to tetch it!

VOICE OF CLARKE: Well, don't touch it then. That's all you'll git outa me.

VOICE OF MRS. ROBERTS: *(Calmer)* Well, hand it chear den. Lawd, me and my chillun is *so* hongry. . . . Jake don't fee-eed me. *(She re-enters by door of store with the slab of meat in her hand and an outraged look on her face. She gazes all about her for sympathy.)* Lawd, me and my poor chillun is *so* hungry . . . and some folks has *every*thing and they's so *stingy* and gripin'. . . . Lawd knows, Jake don't fee-eed me! *(She exits right on this line followed by the boy with the baby on his back.)*

(All the men gaze behind her, then at each other and shake their heads.)

HAMBO: Poor Jake . . . I'm really sorry for dat man. If she was mine I'd beat her till her ears hung down like a Georgy mule.

WALTER THOMAS: I'd beat her till she smell like onions.

LIGE: I'd romp on her till she slack like lime.

NIXON: I'd stomp her till she rope like okra.

VOICE OF MRS. ROBERTS: *(Off stage right)* Lawd, Miz Lewis, you goin' give me dat lil han'ful of greens for me and my chillun. Why dat ain't a eyefull. I ought not to take 'em . . . but me and my chillun is *so* hongry . . . Some folks is so stingy and gripin'! Lawd knows, Jake don't *feed* me!

(The noise of cane-chewing is heard again. Enter JOE LINDSAY *left with a gun over his shoulder and the large leg bone of a mule in the other hand. He approaches the step wearily.)*

HAMBO: Well, did you git any partridges, Joe?

JOE: *(Resting his gun and seating himself)* Nope, but I made de feathers fly.

HAMBO: I don't see no birds.

JOE: Oh, the feathers flew off on de birds.

LIGE: I don't see nothin' but dat bone. Look lak you done kilt a cow and et 'im raw out in de woods.

JOE: Don't y'all know dat hock-bone?

WALTER: How you reckon we gointer know every hock-bone in Orange County sight unseen?

JOE: *(Standing the bone up on the floor of the porch)* Dis is a hock-bone of Brazzle's ole yaller mule.

(General pleased interest. Everybody wants to touch it.)

BRAZZLE: *(Coming forward)* Well, sir! *(Takes bone in both hands and looks up and down the length of it)* If 'tain't my ole mule! This sho was one hell of a mule, too. He'd fight every inch in front of de plow . . . he'd turn over de mowing machine . . . run away wid de wagon . . . and you better not look like you wanter *ride* 'im!

LINDSAY: *(Laughing)* Yeah, I 'member seein' you comin' down de road just so . . . *(He limps wid one hand on his buttocks)* one day.

BRAZZLE: Dis mule was so evil he used to try to bite and kick when I'd go in de stable to feed 'im.

WALTER: He was too mean to git fat. He was so skinny you could do a week's washing on his ribs for a washboard and hang 'em up on his hip-bones to dry.

LIGE: I 'member one day, Brazzle, you sent yo' boy to Winter Park after some groceries wid a basket. So here he went down de road ridin' dis mule wid dis basket on his arm. . . . Whut you reckon dat ole contrary mule done when he got to dat crooked place in de road going round Park Lake? He turnt right round and went through de handle of dat basket . . . wid de boy still up on his back. *(General laughter)*

BRAZZLE: Yeah, he up and died one Sat'day just for spite . . . but he was too contrary to lay down on his side like a mule orter and die decent. Naw, he made out to lay down on his narrer contracted back and die wid his feets sticking straight up in de air just so. *(He gets down on his back and illustrates.)* We drug him out to de swamp wid 'im dat way, didn't we, Hambo?

JOE CLARKE: I God, Brazzle, we all seen it. Didn't we all go to de draggin' out? More folks went to yo' mule's draggin' out than went to last school closing . . . Bet there ain't been a thing right in mule-hell for four years.

HAMBO: Been dat long since he been dead?

CLARKE: I God, yes. He died de week after I started to cuttin' dat new ground. *(The bone is passing from hand to hand. At last a boy about twelve takes it. He has just walked up and is proudly handling the bone when a woman's voice is heard off stage right.)*

VOICE: Senator! Senator!! Oh, you Senator?

BOY: *(Turning, displeased, mutters)* Aw, shux. *(Loudly)* Ma'm?

VOICE: If you don't come here you better!

SENATOR: Yes ma'am. *(He drops bone on ground down stage and trots off frowning.)* Soon as we men git to doing something dese wimmen. . . . *(Exits, right.)*

(Enter TEETS and BOOTSIE left, clean and primped in voile dresses just alike. They speak diffidently and enter store. The men admire them casually.)

LIGE: Them girls done turned out to be right good-looking.

WALTER: Teets ain't as pretty now as she was a few years back. She used to be fat as a butter ball wid legs just like two whiskey-kegs. She's too skinny since she got her growth.

CODY: Ain't none of 'em pretty as dat Miss Daisy. God! She's pretty as a speckled pup.

LIGE: But she was sho nuff ugly when she was little . . . little ole hard black knot. She sho has changed since she been away up North. If she ain't pretty now, there ain't a hound dog in Georgy.

(Re-enter SENATOR BAILEY and stops on the steps. He addresses JOE CLARKE.)

SENATOR: Mist' Clarke. . . .

HAMBO: (To SENATOR) Ain't you got no manners? We all didn't sleep wid you last night.

SENATOR: (Embarrassed) Good evening, everybody.

ALL THE MEN: Good evening, son, boy, Senator, etc.

SENATOR: Mist' Clarke, mama said is Daisy been here dis evenin'?

JOE CLARKE: Ain't laid my eyes on her. Ain't she working over in Maitland?

SENATOR: Yessuh . . . but she's off today and mama sent her down here to get de groceries.

JOE CLARKE: Well, tell yo' ma I ain't seen her.

SENATOR: Well, she say to tell you when she come, to tell her ma say she better git hime and dat quick.

JOE CLARKE: I will. *(Exit* BOY *right.)*

LIGE: Bet she's off somewhere wid Dave or Jim.

WALTER: I don't bet it . . . I know it. She's got them two in de go-long.

(Re-enter TEETS *and* BOOTSIE *from store.* TEETS *has a letter and* BOOTSIE *two or three small parcels. The men look up with interest as they come out on the porch.)*

WALTER: *(Winking)* Whut's dat you got, Teets . . . letter from Dave?

TEETS: *(Flouncing)* Naw indeed! It's a letter from my B-I-T-sweetie! *(Rolls her eyes and hips.)*

WALTER: *(Winking)* Well, ain't Dave yo' B-I-T-sweetie? I thought y'all was 'bout to git married. Everywhere I looked dis summer 'twas you and Dave, Bootsie and Jim. I thought all of y'all would've done jumped over de broomstick by now.

TEETS: *(Flourishing letter)* Don't tell it to me . . . tell it to the ever-loving Mr. Albert Johnson way over in Apopka.

BOOTSIE: *(Rolling her eyes)* Oh, tell 'em 'bout the ever-loving Mr. Jimmy Cox from Altamont. Oh, I can't stand to see my baby lose.

HAMBO: It's lucky y'all girls done got some more fellers, cause look like Daisy done treed both Jim and Dave at once, or they done treed her one.

TEETS: Let her have 'em . . . nobody don't keer. They don't handle de "In God we trust" lak my Johnson. He's head bellman at de hotel.

BOOTSIE: Mr. Cox get money's grandma and old grandpa change. *(The girls exit huffily.)*

LINDSAY: *(To* HAMBO, *pseudo-seriously)* You oughtn't tease dem gals lak dat.

HAMBO: Oh, I laks to see gals all mad. But dem boys *is* crazy sho nuff. Before Daisy come back here they both had a good-looking gal a piece. Now they 'bout to fall out and fight over half a gal a piece. Neither one won't give over and let de other one have her.

LIGE: And she ain't thinking too much 'bout no one man. *(Looks off left.)* Here she come now. God! She got a mean walk on her!

WALTER: Yeah, man. She handles a lot of traffic! Oh, mama, throw it in de river . . . papa'll come git it!

LINDSAY: Aw, shut up, you married men!

LIGE: Man don't go blind cause he gits married, do he? *(Enter* DAISY *hurriedly. Stops at step a moment. She is dressed in sheer organdie, white shoes and stockings.)*

DAISY: Good evening, everybody. *(Walks up on the porch.)*

ALL THE MEN: *(Very pleasantly)* Good evening, Miss Daisy.

DAISY: *(To* CLARK*)* Mama sent me after some meal and flour and some bacon and sausage oil.

CLARKE: Senator been here long time ago hunting you.

DAISY: *(Frightened)* Did he? Oo . . . Mist' Clarke, hurry up and fix it for me. *(She starts on in the store.)*

LINDSAY: *(Giving her his seat)* You better wait here, Daisy. *(*WALTER *kicks* LIGE *to call his attention to* LINDSAY*'s attitude)* It's powerful hot in dat store. Lemme run fetch 'em out to you.

LIGE: *(to* LINDSAY*) Run!* Joe Lindsay, you ain't been able to run since de big bell rung. Look at dat gray beard.

LINDSAY: Thank God, I ain't gray all over. I'm just as good a man right now as any of you young 'uns. *(He hurries on into the store.)*

WALTER: Daisy, where's yo' two body guards? It don't look natural to see you thout nary one of 'em.

DAISY: *(Archly)* I ain't got no body guards. I don't know what you talkin' about.

LIGE: Aw, don' try to come dat over us, Daisy. You know who we talkin' 'bout all right . . . but if you want me to come out flat footed . . . where's Jim and Dave?

DAISY: Ain't they playin' somewhere for de white folks?

LIGE: *(To* WALTER*)* Will you listen at dis gal, Walter? *(To* DAISY*)* When I ain't been long seen you and Dave going down to de Lake.

DAISY: *(Frightened)* Don't y'all run tell mama where I been.

WALTER: Well, you tell us which one you laks de best and we'll wipe our mouf *(Gesture)* and say nothin'. Dem boys been de best of friends all they life, till both of 'em took after you . . . then good-bye, Katy bar de door!

DAISY: *(Affected innocence)* Ain't they still playin' and dancin' together?

LIGE: Yeah, but that's 'bout all they do 'gree on these days. That's de way it is wid men, young and old. . . . I don't keer how long they been friends and how thick they been . . . a woman kin come between 'em. David and Jonather never would have been friends so long if Jonather had of been any great hand wid de wimmen. You ain't never seen no two roosters that likes one another.

DAISY: I ain't tried to break 'em up.

WALTER: Course you ain't. You don't have to. All two boys need to do is go git stuck on de same girl and they done broke up . . . *right now!* Wimmen is something can't be divided equal.

(Re-enter JOE LINDSAY *and* CLARKE *with the groceries.* DAISY *jumps up and grabs the packages.)*

LIGE: *(To* DAISY*)* Want some of us . . . me . . . to go long and tote yo' things for you?

DAISY: *(Nervously)* Naw, mama is riding her high horse today. Long as I been gone it wouldn't do for me to come walking up wid nobody. *(She exits hurriedly right.)*

(All the men watch her out of sight in silence.)

CLARKE: *(Sighing)* I God, know whut Daisy puts me in de mind of?

HAMBO: No, what? *(They all lean together.)*

CLARKE: I God, a great big mango . . . a sweet smell, you know, with a strong flavor, but not something you could mash up like a strawberry. Something with a body to it.

(General laughter, but not obscene.)

HAMBO: *(Admiringly)* Joe Clarke! I didn't know you had it in you! *(MRS. CLARKE enters from store door and they all straighten up guiltily)*

CLARKE: *(Angrily to his wife)* Now whut do you want? I God, the minute I set down, here you come. . . .

MRS. CLARKE: Somebody want a stamp, Jody. You know you don't 'low me to bove wid de post office. *(HE rises sullenly and goes inside the store.)*

BRAZZLE: Say, Hambo, I didn't see you at our Sunday School picnic.

HAMBO: *(Slicing some plug-cut tobacco)* Nope, wan't there dis time.

WALTER: Looka here, Hambo. Y'all Baptist carry dis close-communion business too far. If a person ain't half drownded

in de lake and half et up by alligators, y'all think he ain't baptized, so you can't take communion wid him. Now I reckon you can't even drink lemonade and eat chicken perlow wid us.

HAMBO: My Lord, boy, youse just *full* of words. Now, in de first place, if this year's picnic was lak de one y'all had last year . . . you ain't had no lemonade for us Baptists to turn down. You had a big ole barrel of rain water wid about a pound of sugar in it and one lemon cut up over de top of it.

LIGE: Man, you sho kin mold 'em!

WALTER: Well, I went to de Baptist picnic wid my mouf all set to eat chicken, when lo and behold y'all had chitlings! Do Jesus!

LINDSAY: Hold on there a minute. There was plenty chicken at dat picnic, which I do know is right.

WALTER: Only chicken I seen was a half a chicken yo' pastor musta tried to swaller whole cause he was choked stiff as a board when I come long . . . wid de whole deacon's board beating him in de back, trying to knock it out his throat.

LIGE: Say, dat puts me in de mind of a Baptist brother that was crazy 'bout de preachers and de preacher was crazy 'bout feeding his face. So his son got tired of trying to beat dese stump-knockers to de grub on the table, so one day he throwed out some slams 'bout dese preachers. Dat made his old man mad, so he tole his son to git out. He boy ast him, "Where must I go, papa?" He says, "Go on to hell I reckon. . . . I don't keer where you go."

So de boy left and was gone seven years. He come back one cold, windy night and rapped on de door. "Who dat?" de

old man ast him. "It's me, Jack." De old man opened de door,
so glad to see his son agin, and tole Jack to come in. He did
and looked all round de place. Seven or eight preachers was
sitting round de fire eatin' and drinkin'.

"Where you been all dis time, Jack?" de old man ast him.

"I been to hell," Jack tole him.

"Tell us how it is down there, Jack."

"Well," he says, "It's just like it is here . . . you cain't git to
de fire for de preachers."

HAMBO: Boy, you kin lie just like de cross-ties from Jackson-
ville to Key West. De presidin' elder must come round on his
circuit teaching y'all how to tell 'em, cause you couldn't lie dat
good just natural.

WALTER: Can't nobody beat Baptist folks lying . . . and I
ain't never found out how come you think youse so important.

LINDSAY: Ain't we got de finest and de biggest church?
Macedonia Baptist will hold more folks than any two buildings
in town.

LIGE: Thass right, y'all got a heap more church than you got
members to go in it.

HAMBO: Thass all right . . . y'all ain't got neither de church
nor de members. Everything that's had in this town got to be
held in our church. (Re-enter JOE CLARKE.)

CLARKE: What you-all talkin'?

HAMBO: Come on out, Tush Hawg, lemme beat you some
checkers. I'm tired of fending and proving wid dese boys ain't
got no hair on they chest yet.

CLARKE: I God, you mean you gointer get beat. You can't handle me. . . . I'm a tush hawg.

HAMBO: Well, I'm going to draw dem tushes right now. *(To two small boys using checker board on edge of porch.)* Here you chilluns, let de Mayor and me have that board. Go on out an' play an' give us grown folks a little peace. *(The children go down stage and call out:)*

SMALL BOY: Hey, Senator. Hey, Marthy. Come on let's play chick-me, chick-me, cranie-crow.

CHILD'S VOICE: *(Off stage)* All right! Come on, Jessie! *(Enter several children, led by* SENATOR, *and a game begins in front of the store as* JOE CLARKE *and* HAMBO *play checkers.)*

JOE CLARKE: I God! Hambo, you can't play no checkers.

HAMBO: *(As they seat themselves at the checker board)* Aw, man, if you wasn't de Mayor I'd beat you all de time.

(The children get louder and louder, drowning out the men's voices.)

SMALL GIRL: I'm gointer be de hen.

BOY: And I'm gointer be de hawk. Lemme git maself a stick to mark wid.

(The boy who is the hawk squats center stage with a short twig in his hand. The largest girl lines up the other children behind her.)

GIRL: *(Mother Hen) (Looking back over her flock)* Y'all ketch holt of one 'nother's clothes so de hawk can't git yuz. *(They do.)* You all straight now?

CHILDREN: Yeah. *(The march around the hawk commences.)*

HEN AND CHICKS: Chick mah chick mah craney crow
Went to de well to wash ma toe
When I come back ma chick was
gone
What time, ole witch?

HAWK: *(Making a tally on the ground)* One!

HEN AND CHICKS: *(Repeat song and march.)*

HAWK: *(Scoring again)* Two! *(Can be repeated any number of times.)*

HAWK: Four. *(He rises and imitates a hawk flying and trying to catch a chicken. Calling in a high voice:)* Chickee.

HEN: *(Flapping wings to protect her young)* My chickens sleep.

HAWK: Chickee. *(During all this the hawk is feinting and darting in his efforts to catch a chicken, and the chickens are dancing defensively, the hen trying to protect them.)*

HEN: My chicken's sleep.

HAWK: I shall have a chick.

HEN: You shan't have a chick.

HAWK: I'm goin' home. *(Flies off)*

HEN: Dere's de road.

HAWK: My pot's a boilin'.

HEN: Let it boil.

HAWK: My guts a growlin'.

HEN: Let 'em growl.

HAWK: I must have a chick.

HEN: You shan't have n'airn.

HAWK: My mama's sick.

HEN: Let her die.

HAWK: Chickie!

HEN: My chicken's sleep. (HAWK *darts quickly around the hen and grabs a chicken and leads him off and places the captive on his knees at the store porch. After a brief bit of dancing he catches another, then a third, etc.)*

HAMBO: *(At the checker board, his voice rising above the noise of the playing children, slapping his sides jubilantly)* Ha! Ha! I got you now. Go ahead on and move, Joe Clarke . . . jus' go ahead on and move.

LOUNGERS: *(Standing around two checker players)* Ol' Deacon's got you now.

ANOTHER VOICE: Don't see how he can beat the Mayor like that.

ANOTHER VOICE: Got him in the Louisville loop. *(These remarks are drowned by the laughter of the playing children directly*

in front of the porch. MAYOR JOE CLARKE *disturbed in his concen-
tration on the checkers and peeved at being beaten suddenly turns
toward the children, throwing up his hands.)*

CLARKE: Get on 'way from here, you limbs of Satan, making
all that racket so a man can't hear his ears. Go on, go on! *(*THE
MAYOR *looks about excitedly for the town marshall. Seeing him
playing cards on the other side of porch, he bellows:)* Lum Boger,
whyn't you git these kids away from here! What kind of a
marshall is you? All this passle of young'uns around here
under grown people's feet, creatin' disorder in front of my
store. *(*LUM BOGER *puts his cards down lazily, comes down stage
and scatters the children away. One saucy little girl refuses to move.)*

LUM BOGER: Why'nt you go on away from here, Matilda?
Didn't you hear me tell you-all to move?

LITTLE MATILDA: *(Defiantly)* I ain't goin' nowhere. You
ain't none of my mama. *(Jerking herself free from him as* LUM
touches her.) My mama in the store and she told me to wait out
here. So take that, ol' Lum.

LUM BOGER: You impudent little huzzy, you! You must
smell yourself . . . youse so fresh.

MATILDA: The wind musta changed and you smell your
own top lip.

LUM BOGER: Don't make me have to grab you and take you
down a buttonhole lower.

MATILDA: *(Switching her little head)* Go ahead on and grab
me. You sho can't kill me, and if you kill me, you sho can't
eat me. *(She marches into the store.)*

SENATOR: *(Derisively from behind stump)* Ol' dumb Lum! Hey! Hey! *(LITTLE BOY at edge of stage thumbs his nose at the marshall.)* *(LUM lumbers after the small boy. Both exit.)*

HAMBO: *(To CLARKE who has been thinking all this while what move to make)* You ain't got but one move . . . go ahead on and make it. What's de matter, Mayor?

CLARKE: *(Moving his checker)* Aw, here.

HAMBO: *(Triumphant)* Now! Look at him, boys. I'm gonna laugh in notes. *(Laughing to the scale and jumping a checker each time)* Do, sol, fa, me, lo . . . one! *(Jumping another checker)* La, sol, fa, me, do . . . two! *(Another jump.)* Do, sol, re, me, lo . . . three! *(Jumping a third.)* Lo, sol, fa, me, re . . . four! *(The crowd begins to roar with laughter. LUM BOGER returns, looking on. Children come drifting back again playing chick-me-chick-me-cranie crow.)*

VOICE: Oh, ha! Done got the ol' tush hog.

ANOTHER VOICE: Thought you couldn't be beat, Brother Mayor?

CLARKE: *(Peeved, gets up and goes into the store mumbling)* Oh, I coulda beat you if I didn't have this store on my mind. Saturday afternoon and I got work to do. Lum, ain't I told you to keep them kids from playin' right in front of this store? *(LUM makes a pass at the nearest half-grown boy. The kids dart around him teasingly.)*

ANOTHER VOICE: Eh, heh . . . Hambo done run him in his store . . . done run the ol' coon in his hole.

ANOTHER VOICE: That ain't good politics, Hambo, beatin' the Mayor.

ANOTHER VOICE: Well, Hambo, you done got to be so hard at checkers, come on let's see what you can do with de cards. Lum Boger there got his hands full nursin' the chilluns.

ANOTHER VOICE: *(At the table)* We ain't playin' for money, nohow, Deacon. We just playin' a little Florida Flip.

HAMBO: Ya all can't play no Florida Flip. When I was a sinner there wasn't a man in this state could beat me playin' that game. But I'm a deacon in Macedonia Baptist now and I don't bother with the cards no more.

VOICE AT CARD TABLE: All right, then, come on here Tony *(To man with basket on steps.)* let me catch your jack.

TAYLOR: *(Looking toward door)* I don't reckon I got time. I guess my wife gonna get through buying out that store some time or other and want to go home.

OLD MAN: *(On opposite side of porch from card game)* I bet my wife would know better than expect me to sit around and wait for her with a basket. Whyn't you tell her to tote it on home herself?

TAYLOR: *(Sighing and shaking his head)* Eh, Lawd!

VOICE AT CARD TABLE: Look like we can't get nobody to come into this game. Seem like everybody's scared a us. Come on back here, Lum, and take your hand. (LUM *makes a final futile gesture at the children.)*

LUM: Ain't I tole you little haitians to stay away from here?

*(*CHILDREN *scatter teasingly only to return to their play in front of the store later on.* LUM *comes up on the porch and re-joins the card*

game. Just as he gets seated, MRS. CLARKE *comes to the door of the store and calls him.)*

MRS. CLARKE: *(Drawlingly)* Columbus!

LUM: *(Wearily)* Ma'am?

MRS. CLARKE: De Mayor say for you to go round in de back yard and tie up old lady Jackson's mule what's trampin' sup all de tomatoes in my garden.

LUM: All right. *(Leaving card game.)* Wait till I come back, folkses.

LIGE: Oh, hum! *(Yawning and putting down the deck of cards)* Lum's sho a busy marshall. Say, ain't Dave and Jim been round here yet? I feel kinder like hearin' a little music 'bout now.

BOY: Naw, they ain't been here today. You-all know they ain't so thick nohow as they was since Daisy Bailey come back and they started runnin' after her.

WOMAN: You mean since she started runnin' after them, the young hussy.

MRS. CLARKE: *(In doorway)* She don't mean 'em no good.

WALTER: That's a shame, ain't it now? *(Enter* LUM *from around back of store. He jumps on the porch and takes his place at the card box.)*

LUM: *(To the waiting players)* All right, boys! Turn it on and let the bad luck happen.

LIGE: My deal. *(He begins shuffling the cards with an elaborate fan-shape movement.)*

VOICE AT TABLE: Look out there, Lige, you shuffling mighty lot. Don't carry the cub to us.

LIGE: Aw, we ain't gonna beat you . . . we gonna beat you. *(He slams down the cards for* LUM BOGER *to cut.)* Wanta cut 'em?

LUM: No, ain't no need of cutting a rabbit out when you can twist him out. Deal 'em. *(*LIGE *deals out the cards.)*

CLARKE'S VOICE: *(Inside the store)* You, Mattie! *(*MRS. CLARKE, *who has been standing in the door, quickly turns and goes inside.)*

LIGE: Y-e-e-e! Spades! *(The game is started.)*

LUM: Didn't snatch that jack, did you?

LIGE: Aw, no, ain't snatched no jack. Play.

WALTER: *(*LUM'S *partner)* Well, here it is, partner. What you want me to play for you?

LUM: Play jus' like I'm in New York, partner. But we gotta try to catch that jack.

LIGE: *(Threateningly)* Stick out your hand and draw back a nub. *(*WALTER THOMAS *plays.)*

WALTER: I'm playin' a diamond for you, partner.

LUM: I done tole you you ain't got no partner.

LIGE: Heh, Heh! Partner, we got 'em. Pull off wid your king. Dey got to play 'em. *(When that trick is turned, triumphantly:)* Didn't I tell you, partner? *(Stands on his feet and slams down with his ace violently)* Now, come up under this ace. Aw, hah, look at ol' low, partner. I knew I was gonna catch 'em. *(When LUM plays)* Ho, ho, there goes the queen ... Now, the jack's a gentlemen. . . . Now, I'm playin' my knots. *(Everybody plays and the hand is ended.)* Partner, high, low, jack and the game and four.

WALTER: Give me them cards. I believe you-all done give me the cub that time. Look at me ... this is Booker T Washington dealing these cards. *(Shuffles cards grandly and gives them to LIGE to cut.)* Wanta cut 'em?

LIGE: Yeah, cut 'em and shoot 'em. I'd cut behind my ma. *(He cuts the cards.)*

WALTER: *(Turning to player at left, FRANK, LIGE's partner)* What you saying, Frank?

FRANK: I'm beggin'. *(LIGE is trying to peep at cards.)*

WALTER: *(Turning to LIGE)* Stop peepin' at them cards, Lige. *(To FRANK)* Did you say you was beggin' or standin'?

FRANK: I'm beggin'.

WALTER: Get up off your knees. Go ahead and tell 'em I sent you.

FRANK: Well, that makes us four.

WALTER: I don't care if you is. *(Pulls a quarter out of his pocket and lays it down on the box.)* Twenty-five cents says I know the best one. Let's go. *(Everybody puts down a quarter.)*

FRANK: What you want me to play for you partner?

LIGE: Play me a club. *(The play goes around to dealer, WALTER, who gets up and takes the card off the top of the deck and slams it down on the table.)*

WALTER: Get up ol' deuce of deamonds and gallop off with your load. *(To LUM)* Partner, how many times you seen the deck?

LUM: Two times.

WALTER: Well, then I'm gonna pull off, partner. Watch this ol' queen. *(Everyone plays)* Ha! Ha! Wash day and no soap. *(Takes the jack of diamonds and sticks him up on his forehead. Stands up on his feet.)* Partner, I'm dumping to you . . . play your king. *(When it comes to his play LUM, too, stands up. The others get up and they, too, excitedly slam their cards down.)* Now, come on in this kitchen and let me splice that cabbage! *(He slams down the ace of diamonds. Pats the jack on his forehead, sings:)* Hey, hey, back up, jenny, get your load. *(Talking)* Dump to that jack, boys, dump to it. High, low, jack and the game and four. One to go. We're four wid you, boys.

LIGE: Yeah, but you-all playin' catch-up.

FRANK: Gimme them cards . . . lemme deal some.

LIGE: Frank, now you really got responsibility on you. They's got one game on us.

FRANK: Aw, man, I'm gonna deal 'em up a mess. This deal's in the White House. *(He shuffles and puts the cards down for* WALTER *to cut.)* Cut 'em.

WALTER: Nope, I never cut green timber. *(*FRANK *deals and turns the card up.)*

FRANK: Hearts, boys. *(He turns up an ace.)*

LUM: Aw, you snatched that ace, nigger.

WALTER: Yeah, they done carried the cub to us, partner.

LIGE: Oh, he didn't do no such a thing. That ace was turned fair. We jus' too hard for you . . . we eats our dinner out a the blacksmith shop.

WALTER: Aw, you all cheatin'. You know it wasn't fair.

FRANK: Aw, shut up, you all jus' whoopin' and hollerin' for nothin'. Tryin' to bully the game. *(*FRANK *and* LIGE *rise and shake hands grandly.)*

LIGE: Mr. Hoover, you sho is a noble president. We done stuck these niggers full of cobs. They done got scared to play us.

LUM: Scared to play you? Get back down to this table, let me spread my mess.

LOUNGER: Yonder comes Elder Simms. You all better squat that rabbit. They'll be having you all up in the church for playin' cards.

*(*FRANK *grabs up the cards and puts them in his pocket quickly. Everybody picks up the money and looks unconcerned as the preacher*

enters. Enter ELDER SIMMS *with his two prim-looking little children by the hand.)*

ELDER SIMMS: How do, children. Right warm for this time in November, ain't it?

VOICE: Yes sir, Reverend, sho is. How's Sister Simms?

SIMMS: She's feelin' kinda po'ly today. *(Goes on in store with his children)*

VOICE: *(Whispering loudly)* Don't see how that great big ole powerful woman could be sick. Look like she could go bear huntin' with her fist.

ANOTHER VOICE: She look jus' as good as you-all's Baptist pastor's wife. Pshaw, you ain't seen no big woman, nohow, man. I seen one once so big she went to whip her little boy and he run up under her belly and hid six months 'fore she could find him.

ANOTHER VOICE: Well, I knowed a woman so little that she had to get up on a soap box to look over a grain of sand.

*(*REV. SIMMS *comes out of store, each child behind him sucking a stick of candy.)*

SIMMS: *(To his children)* Run on home to your mother and don't get dirty on the way. *(The two children start primly off down the street but just out of sight one of them utters a loud cry.)*

SIMMS'S CHILD: *(Off stage)* Papa, papa. Nunkie's trying to lick my candy.

SIMMS: I told you to go on and leave them other children alone.

VOICE ON PORCH: *(Kidding)* Lum, whyn't you tend to your business.

(TOWN MARSHALL rises and shoos the children off again.)

LUM: You all varmints leave them nice chillun alone.

LIGE: *(Continuing the lying on porch)* Well, you all done seen so much, but I bet you ain't never seen a snake as big as the one I saw when I was a boy up in middle Georgia. He was so big couldn't hardly move his self. He laid in one spot so long he growed moss on him and everybody thought he was a log, till one day I set down on him and went to sleep, and when I woke up that snake done crawled to Florida. *(Loud laughter.)*

FRANK: *(Seriously)* Layin' all jokes aside though now, you all remember that rattlesnake I killed last year was almost as big as that Georgia snake.

VOICE: How big, you say it was, Frank?

FRANK: Maybe not quite as big as that, but jus' about fourteen feet.

VOICE: *(Derisively)* Gimme that lyin' snake. That snake wasn't but four foot long when you killed him last year and you done growed him ten feet in a year.

ANOTHER VOICE: Well, I don't know about that. Some of the snakes around here is powerful long. I went out in my

front yard yesterday right after the rain and killed a great big ol' cottonmouth.

SIMMS: This sho is a snake town. I certainly can't raise no chickens for 'em. They kill my little biddies jus' as fast as they hatch out. And yes . . . if I hadn't cut them weeds out of the street in front of my parsonage, me or some of my folks woulda been snake-bit right at our front door. *(To whole crowd)* Whyn't you all cut down these weeds and clean up these streets?

HAMBO: Well, the Mayor ain't said nothin' 'bout it.

SIMMS: When the folks misbehaves in this town I think they oughta lock 'em up in a jail and make 'em work their fine out on the streets, then these weeds would be cut down.

VOICE: How we gonna do that when we ain't got no jail?

SIMMS: Well, you sho needs a jail . . . you-all needs a whole lot of improvements round this town. I ain't never pastored no town so way-back as this one here.

CLARKE: *(Who has lately emerged from the store, fanning himself, overhears this last remark and bristles up)* What's that you say 'bout this town?

SIMMS: I say we needs some improvements here in this town . . . that's what.

CLARKE: *(In a powerful voice)* And what improvements you figgers we needs?

SIMMS: A whole heap. Now, for one thing we really does need a jail, Mayor. We oughta stop runnin' these people out of town that misbehaves, and lock 'em up. Others towns has

jails, every town I ever pastored had a jail. Don't see how come we can't have one.

CLARKE: *(Towering angrily above the preacher)* Now, wait a minute, Simms. Don't you reckon the man who knows how to start a town knows how to run it? I paid two hundred dollars out of this right hand for this land and walked out here and started this town befo' you was born. I ain't like some of you new niggers, come here when grapes' ripe. I was here to cut new ground, and I been Mayor ever since.

SIMMS: Well, there ain't no sense in no one man stayin' Mayor all the time.

CLARKE: Well, it's my town and I can be mayor jus' as long as I want to. It was me that put this town on the map.

SIMMS: What map you put it on, Joe Clarke? I ain't seen it on no map.

CLARKE: *(Indignant)* I God! Listen here, Elder Simms. If you don't like the way I run this town, just' take your flat feets right on out and git yonder crost the woods. You ain't been here long enough to say nothin' nohow.

HAMBO: *(From a nail keg)* Yeah, you Methodist niggers always telling people how to run things.

TAYLOR: *(Practically unheard by the others)* We do so know how to run things, don't we? Ain't Brother Mayor a Methodist, and ain't the schoolteacher a . . . ? *(His remarks are drowned out by the others.)*

SIMMS: No, we don't like the way you're runnin' things. Now looka here, *(Pointing at the Marshall)* You got that lazy

Lum Boger here for marshall and he ain't old enough to be dry behind his ears yet . . . and all these able-bodied mens in this town! You won't 'low nobody else to run a store 'ceptin' you. And looka yonder *(happening to notice the street light)* only street lamp in town, you got in front of your place. *(Indignantly)* We pay the taxes and you got the lamp.

VILLAGER: Don't you-all fuss now. How come you two always yam-yamming at each other?

CLARKE: How come this fly-by-night Methodist preacher over here . . . ain't been here three months . . . tries to stand up on my store porch and tries to tell me how to run my town? *(*MATTIE CLARKE, *the Mayor's wife, comes timidly to the door, wiping her hands on her apron.)* Ain't no man gonna tell me how to run my town. I God, I 'lected myself in and I'm gonna run it. *(Turns and sees wife standing in door. Commandingly.)* I God, Mattie, git on back in there and wait on that store!

MATTIE: *(Timidly)* Jody, somebody else wantin' stamps.

CLARKE: I God, woman, what good is you? Gwan, git in. Look like between women and preachers a man can't have no peace. *(Exit* CLARKE.*)*

SIMMS: *(Continuing his argument)* Now, when I pastored in Jacksonville you oughta see what kinda jails they got there . . .

LOUNGER: White folks needs jails. We colored folks don't need no jail.

ANOTHER VILLAGER: Yes, we do, too. Elder Simms is right . . .

(The argument becomes a hubbub of voices.)

TAYLOR: *(Putting down his basket)* Now, I tell you a jail . . .

MRS. TAYLOR: *(Emerging from the store door, arms full of groceries, looking at her husband)* Yeah, and if you don't shut up and git these rations home I'm gonna be worse on you than a jail and six judges. Pickup that basket let's go. *(TONY meekly picks up the basket and he and his wife exit as the sound of an approaching guitar is heard off stage.)*

(Two carelessly dressed, happy-go-lucky fellows enter together. One is fingering a guitar without playing any particular tune, and the other has his hat cocked over his eyes in a burlesque, dude-like manner. There are casual greetings.)

WALTER: Hey, there, bums, how's tricks?

LIGE: What yo' sayin', boys?

HAMBO: Good evenin', sons.

LIGE: How did you-all make out this evening', boys?

JIM: Oh, them white folks at the party shelled out right well. Kept Dave busy pickin' it up. How much did we make today, Dave?

DAVE: *(Striking his pocket)* I don't know, boy, but feels right heavy here. Kept me pickin' up money just like this . . . *(As JIM picks a few dance chords, DAVE gives a dance imitation of how he picked up the coins from the ground as the white folks threw them.)* We count it after while. Woulda divided up with you already

if you hadn't left me when you seen Daisy comin' by. Let's sit down on the porch and rest now.

LIGE: She sho is lookin' stylish and pretty since she come back with her white folks from up North. Wearin' the swellest clothes. And that coal-black hair of hers jus' won't quit.

MATTIE CLARKE: *(In doorway)* I don't see what the mens always hanging after Daisy Taylor for.

CLARKE: *(Turning around on the porch)* I God, you back here again. Who's tendin' that store? (MATTIE *disappears inside.*)

DAVE: Well, she always did look like new money to me when she was here before.

JIM: Well, that's all you ever did get was a look.

DAVE: That's all you know! I bet I get more than that now.

JIM: You might git it but I'm the man to use it. I'm a bottom fish.

DAVE: Aw, man. You musta been walking round here fast asleep when Daisy was in this county last. You ain't seen de go I had with her.

JIM: No, I ain't seen it. Bet you didn't have no letter from her while she been away.

DAVE: Bet you didn't neither.

JIM: Well, it's just cause she can't write. If she knew how to scratch with a pencil I'd had a ton of 'em.

DAVE: Shaw, man! I'd had a post office full of 'em.

OLD WOMAN: You-all ought to be shame, carrying on over a brazen heifer like Daisy Taylor. Jus' cause she's been up North and come back, I reckon you cutting de fool sho 'nough now. She ain't studying none of you-all nohow. All she wants is what you got in your pocket.

JIM: I likes her but she won't git nothin' outa me. She never did. I wouldn't give a poor consumpted cripple crab a crutch to cross the River Jurdon.

DAVE: I know I ain't gonna give no woman nothin'. I wouldn't give a dog a doughnut if he treed a terrapin.

LIGE: Youse a cottontail dispute . . . both of you. You'd give her anything you got. You'd give her Georgia with a fence 'round it.

OLD MAN: Yeah, and she'd take it, too.

LINDSAY: Don't distriminate the woman like that. That ain't nothing but hogism. Ain't nothin' the matter with Daisy, she's all right. *(Enter* TEETS *and* BOOTSIE *tittering coyly and switching themselves.)*

BOOTSIE: Is you seen my mama?

OLD WOMAN: You know you ain't lookin' for no mama. Jus' come back down here to show your shape and fan around awhile. *(*BOOTSIE *and* TEETS *going into the store.)*

BOOTSIE & TEETS: No, we ain't. We'se come to get our mail.

OLD WOMAN: *(After girls enter store)* Why don't you all keep up some attention to these nice girls here, Bootsie and Teets. They wants to marry.

DAVE: Aw, who thinkin' 'bout marryin' now? They better stay home and eat their own pa's rations. I gotta buy myself some shoes.

JIM: The woman I'm gonna marry ain't born yet and her maw is dead. *(GIRLS come out giggling and exit.)* *(JIM begins to strum his guitar lightly at first as the talk goes on.)*

CLARKE: *(To DAVE and JIM)* Two of the finest gals that ever lived and friendly jus' like you-all is. You two boys better take 'em back and stop them shiftless ways.

HAMBO: Yeah, hurry up and do somethin'! I wants to taste a piece yo' weddin' cake.

JIM: *(Embarrassed but trying to be jocular)* Whut you trying to rush me up so fast? . . . Look at Will Cody here *(Pointing to little man on porch)* he been promising to bring his already wife down for two months . . . and nair one of us ain't seen her yet.

DAVE: Yeah, how you speck me to haul in a brand new wife when he can't lead a wagon-broke wife eighteen miles? Me, I'm going git one soon's Cody show me his'n. *(General sly laughter at CODY's expense.)*

WALTER: *(Snaps his fingers and pretends to remember something)* Thass right, Cody. I been intending to tell you . . . I know where you kin buy a ready-built house for you and yo' wife. *(Calls into the store.)* Hey, Clarke, come on out here and tell Cody 'bout dat Bradley house. *(To CODY.)* I know you wants to git a place of yo' own so you kin settle down.

HAMBO: He done moved so much since he been here till every time he walk out in his back yeard his chickens lay down and cross they legs.

LINDSAY: Cody, I thought you tole us you was going up to Sanford to bring dat 'oman down here last Sat'day.

LIGE: That ain't de way he tole me 'bout it. Look, fellers, *(Getting up and putting one hand on his hips and one finger of the other hand against his chin coquettishly)* Where you reckon I'll be next Sat'day night? . . . Sittin' up side of Miz Cody. *(Great burst of laughter.)*

SYKES JONES: *(Laughing)* Know what de folks tole me in Sanford? Dat was another man's wife. *(Guffaws.)*

CODY: *(Feebly)* Aw, you don't know whut you talkin' bout.

JONES: Naw, I don't know, but de folks in Sanford does. *(Laughing)* Day tell me when dat lady's husband come home Sat'day night, ole Cody jumped out de window. De man grabbed his old repeater and run out in de yard to head him off. When Cody seen him come round de corner de house *(Gesture)* he flopped his wings and flew up on de fence. De man thowed dat shotgun dead on him. *(Laughs)* Den, man! Cody flopped his wings lak a buzzard *(Gesture)* and sailed on off. De man dropped to his knees lak dis *(Gesture of kneeling on one knee and taking aim)* Die! die! die! *(Supposedly sound of shots as the gun is moved in a circle following the course of Cody's supposed flight)* Cody just flew right on off and lit on a hill two miles off. Then, man! *(Gesture of swift flight)* In ten minutes he was back here in Eatonville and in he bed.

WALTER: I passed there and seen his house shakin', but I didn't know how come.

HAMBO: Aw, leave de boy alone. . . . If you don't look out some of y'all going to have to break his record.

LIGE: I'm prepared to break it now. *(General laughter.)*

JIM: Well, anyhow, I don't want to marry and leave Dave . . . yet awhile. *(Picking a chord.)*

DAVE: And I ain't gonna leave Jim. We been palling around together ever since we hollered titty mama, ain't we, boy?

JIM: Sho is. *(Music of the guitar increases in volume.* DAVE *shuffles a few steps and the two begin to sing.)*

JIM: Rabbit on the log.
I ain't got no dog.
How am I gonna git him?
God knows.

DAVE: Rabbit on the log.
Ain't got no dog.
Shoot him with my rifle
Bam! Bam!

(Some of the villagers join in song and others get up and march around the porch in time with the music. BOOTSIE *and* TEETS *re-enter,* TEETS *sticking her letter down the neck of her blouse.* JOE LINDSAY *grabs* TEETS *and* WALTER THOMAS *grabs* BOOTSIE. *There is dancing, treating and general jollification. Little children dance the parse-me-la. The music fills the air just as the sun begins to go down. Enter* DAISY TAYLOR *coming down the road toward the store.)*

CLARKE: *(Bawls out from the store porch)* I God, there's Daisy again.

(Most of the dancing stops, the music slows down and then stops completely. DAVE *and* JIM *greet* DAISY *casually as she approaches the porch.)*

JIM: Well, Daisy, we knows you, too.

DAVE: Gal, youse jus' as pretty as a speckled pup.

DAISY: *(Giggling)* I see you two boys always playin' and singin' together. That music sounded right good floating down the road.

JIM: Yeah, child, we'se been playin' for the white folks all week. We'se playin' for the colored now.

DAVE: *(Showing off, twirling his dancing feet)* Yeah, we're standin' on our abstract and livin' on our income.

OLD MAN: Um-ump, but they ain't never workin'. Just round here playing as usual.

JIM: Some folks think you ain't workin' lessen you smellin' a mule. *(He sits back down on box and picks at his guitar.)* Think you gotta be beatin' a man to his barn every mornin'.

VOICE: Glad to be round home with we-all again, ain't you Daisy?

DAISY: Is I glad? I jus' got off special early this evenin' to come over here and see everybody. I was kinda 'fraid sundown would catch me 'fore I got round that lake. Don't know how I'm gonna walk back to my workin' place in the dark by muself.

DAVE: Don't no girl as good-lookin' as you is have to go home by herself tonight.

JIM: No, cause I'm here.

DAVE: *(To* DAISY*)* Don't you trust yourself round that like wid all them 'gators and moccasins with that nigger there, Daisy *(Pointing at* JIM*)* He's jus' full of rabbit blood. What you need is a real man . . . with good feet. *(Cutting a dance step.)*

DAISY: I ain't thinking 'bout goin' home yet. I'm goin' in the store.

JIM: What you want in the store?

DAISY: I want some gum.

DAVE: *(Starting toward door)* Girl, you don't have to go in there to git no gum. I'll go in there and buy you a carload of gum. What kind you want?

DAISY: Bubble gum. *(*DAVE *goes in the store with his hand in his pocket. The sun is setting and the twilight deepens.)*

JIM: *(Pulling package out of his pocket and laughing)* Here your gum, baby. What it takes to please the ladies, I totes it. I don't have to go get it, like Dave. What you gimme for it?

DAISY: A bushel and a peck, and a hug around the neck. *(She embraces* JIM *playfully. He hands her the gum, patting his shoulder as he sits on box.)* Oh, thank you. Youse a ready man.

JIM: Yeah, there's a lot of good parts to me. You can have West Tampa if you want it.

DAISY: You always was a nice quiet boy, Jim.

DAVE: *(Emerging from the store with a package of gum)* Here's your gum, Daisy.

JIM: Oh, youse late. She's done got gum now. Chaw that yourself.

DAVE: *(Slightly peeved and surprised)* Hunh, you mighty fast here now with Daisy but you wasn't that fast gettin' out of that white man's chicken house last week.

JIM: Who you talkin' 'bout?

DAVE: Hoo-oo? *(Facetiously)* You ain't no owl. Your feet don't fit no limb.

JIM: Aw, nigger, hush.

DAVE: Aw, hush, yourself. *(He walks away for a minute as DAISY turns to meet some newcomers. DAVE throws his package of gum down on the ground. It breaks and several children scramble for the pieces. An old man, very drunk, carrying an empty jug enters on left and staggers tipsily across stage.)* *(MAYOR JOE CLARKE emerges from the store and looks about for his marshall.)*

CLARKE: *(Bellowing)* Lum Boger!

LUM BOGER: *(Eating a stalk of cane)* Yessir!

CLARKE: I God, Lum, take your lazy self off that keg and go light that town lamp. All summer long you eatin' up my melon, and all winter long you chawin' up my cane. What you think this town is payin' you for? Laying round here doin' nothin'? Can't you see it's gettin' dark?

(LUM BOGER *rises lazily and takes the soap box down stage, stands on it to light the lamp, discovers no oil in it and goes in store. In a few moments he comes out of store, fills the lamp and lights it.*)

DAISY: *(Coming back toward* JIM) Ain't you all gonna play and sing a little somethin' for me? I ain't heard your all's music much for so long.

JIM: Play anything you want, Daisy. Don't make no difference what 'tis I can pick it. Where's that old coon, Dave? *(Looking around for his partner.)*

LIGE: *(Calling* DAVE, *who is leaning against post at opposite end of porch)* Come here, an' get warmed up for Daisy.

DAVE: Aw, ma throat's tired.

JIM: Leave the baby be.

DAISY: Come on, sing a little, Dave.

DAVE: *(Going back toward* JIM) Well, seeing who's asking . . . all right. What song you like, Daisy?

DAISY: Um-m. Lemme think.

VOICE ON PORCH: "Got on the train, didn't have no fare".

DAISY: *(Gaily)* Yes, that one. That's a good one.

JIM: *(Begins to tune up.* DAVE *touches* DAISY's *hand.)*

VOICE: *(In fun)* Hunh, you all wouldn't play at the hall last week when we asked you.

VOICE OF SPITEFUL OLD WOMAN: Daisy wasn't here then.

ANOTHER VOICE: *(Teasingly)* All you got to do to some men is to shake a skirt tail in their face and they goes off their head.

DAVE: *(To* JIM *who is still tuning up)* Come if you're comin' boy, let's go if you gwine. *(The full melody of the guitar comes out in a lively, old-fashioned tune.)*

VOICE: All right now, boys, do it for Daisy jus' as good as you do for dem white folks over in Maitland.

DAVE & JIM: *(Beginning to sing)*
 Got on the train,
 Didn't have no fare,
 But I rode some,
 I rode some.
 Got on the train,
 Didn't have no fare,
 But I rode some,
 But I rode some.
 Got on the train,
 Didn't have no fare,
 Conductor asked me what I'm doin' there,
 But I rode some!

 Grabbed me by the neck
 And led me to the door.
 But I rode some,
 But I rode some.
 Grabbed me by the neck
 And led me to the door.
 But I rode some,

But I rode some.
Grabbed me by the neck,
And led me to the door.
Rapped me cross the head with a forty-four,
But I rode some!

First thing I saw in jail
Was a pot of peas.
But I rode some,
But I rode some.
First thing I saw in jail
Was a pot of peas.
But I rode some,
But I rode some.
The peas was good,
The meat was fat,
Fell in love with the chain gang jus' for that,
But I rode some.

(DAVE *acts out the song in dancing pantomime and when it ends there are shouts and general exclamations of approval from the crowd.*)

VOICES: I don't blame them white folks for goin' crazy 'bout that . . .

OLD MAN: Oh, when I was a young boy I used to swing the gals round on that piece.

DAISY: *(To* JIM*)* Seem like your playin' gits better and better.

DAVE: *(Quickly)* And how 'bout my singin'? *(Everybody laughs.)*

VOICES IN THE CROWD: Ha! Ha! Ol' Dave's gittin' jealous when she speaks o' Jim.

JIM: *(To* DAVE, *in fun)* Ain't nothin' to it but my playin'. You ain't got no singin' voice. If that's singin', God's a go-pher.

DAVE: *(Half-seriously)* My singin' is a whole lot better'n your playin'. You jus' go along and fram. The reason why the white folks gives us money is cause I'm singin'.

JIM: Yeah?

DAVE: And you can't dance.

VOICE IN THE CROWD: You oughta dance. Big as your feet is, Dave.

DAISY: *(Diplomatically)* Both of you all is wonderful and I would like to see Dave dance a little.

DAVE: There now, I told you. What did I tell you. *(To* JIM*)* Stop woofing and pick a little tune there so that I can show Daisy somethin'.

JIM: Pick a tune? I bet if you fool with me I'll pick your bones jus' like a buzzard did the rabbit. You can't sing and now you wants to dance.

DAVE: Yeah, and I'll lam your head. Come on and play, good-for-nothing.

JIM: All right, then. You say you can dance . . . show these people what you can do. But don't bring that little stuff I been seein' you doin' all these years. *(*JIM *plays and* DAVE *dances,*

various members of the crowd keep time with their hands and feet,
DAISY *looks on enjoying herself immensely.)*

DAISY: *(As* DAVE *cuts a very fancy step)* I ain't seen nothin'
like this up North. Dave you sho hot.

(As DAVE *cuts a more complicated step the crowd applauds, but just
as the show begins to get good, suddenly* JIM *stops playing.)*

DAVE: *(Surprised)* What's the matter, buddy?

JIM: *(Envious of the attention* DAVE *has been getting from*
DAISY, *disgustedly)* Oh, nigger, I'm tired of seein' you cut the
fool. 'Sides that, I been playin' all afternoon for the white
folks.

DAISY: But I though you was playin' for me now, Jim.

JIM: Yeah, I'd play all night long for you, but I'm gettin' sick
of Dave round here showin' off. Let him git somethin' and
play for himself if he can. *(An* OLD MAN *with a lighted lantern
enters.)*

DAISY: *(Coyly)* Well, honey, play some more for me then,
and don't mind Dave. I reckon he done danced enough. Play
me "Shake That Thing".

OLD MAN WITH LANTERN: Sho, you ain't stopped, is you,
boy? Music sound mighty good floatin' down that dark road.

OLD WOMAN: Yeah, Jim, go on play a little more. Don't get
to acting so niggerish this evening.

DAVE: Aw, let the ol' darky alone. Nobody don't want to
hear him play, nohow. I know I don't.

JIM: Well, I'm gonna play. *(And he begins to pick "Shake That Thing".* TEETS *and* BOOTSIE *begin to dance with* LIGE MOSELY *and* FRANK WARRICK. *As the tune gets good,* DAVE *cannot resist the music either.)*

DAVE: Old nigger's evil but he sho can play. *(He begins to do a few steps by himself, then twirls around in front of* DAISY *and approaches her.* DAISY, *overcome by the music, begins to step rhythmically toward* DAVE *and together they dance unobserved by* JIM, *absorbed in picking his guitar.)*

DAISY: Look here, baby, at this new step I learned up North.

DAVE: You can show me anything, sugar lump.

DAISY: Hold me tight now. *(But just as they begin the new movement* JIM *notices* DAISY *and* DAVE. *He stops playing again and lays his guitar down.)*

VOICES IN THE CROWD: *(Disgustedly)* Aw, come on, Jim . . . You must be jealous . . .

JIM: No, I ain't jealous. I jus' get tired of seein' that ol' nigger clownin' all the time.

DAVE: *(Laughing and pointing to* JIM *on porch)* Look at that mad baby. Take that lip up off the ground. Got your mouth stuck out jus' because some one is enjoying themselves. *(He comes up and pushes* JIM *playfully.)*

JIM: You better go head and let me alone. *(To* DAISY*)* Come here, Daisy!

LIGE: That's just what I say. Niggers can't have no fun without someone getting mad . . . specially over a woman.

JIM: I ain't mad . . . Daisy, 'scuse me, honey, but that fool, Dave . . .

DAVE: I ain't mad neither . . . Jim always tryin' to throw off on me. But you can't joke him.

DAISY: *(Soothingly)* Aw, now, now!

JIM: You ain't jokin'. You means that, nigger. And if you tryin' to get hot, first thing, you can pull off my blue shirt you put on this morning.

DAVE: Youse a got that wrong. I ain't got on no shirt of yours.

JIM: Yes, you is got on my shirt, too. Don't tell me you ain't got on my shirt.

DAVE: Well, even if I is, you can just lift your big plantations out of my shoes. You can just foot it home barefooted.

JIM: You try to take any shoes offa me!

LIGE: *(Pacifying them)* Aw, there ain't no use of all that. What you all want to start this quarreling for over a little jokin'.

JIM: Nobody's quarreling . . . I'm just playin' a little for Daisy and Dave's out there clownin' with her.

CLARKE: *(In doorway)* I ain't gonna have no fussin' round my store, no way. Shut up, you all.

JIM: Well, Mayor Clarke, I ain't mad with him. We'se been friends all our lives. He's slept in my bed and wore my clothes and et my grub. . . .

DAVE: I et your grub? And many time as you done laid down with your belly full of my grandma's collard greens. You done et my meat and bread a whole lot more times than I et your stewed fish-heads.

JIM: I'd rather eat stewed fish-heads than steal out of other folkses houses so much till you went to sleep on the roost and fell down one night and broke up the settin' hen. *(Loud laughter from the crowd)*

DAVE: Youse a liar if you say I stole anybody's chickens. I didn't have to. But you . . . 'fore you started goin' around with me, playin' that little box of yours, you was so hungry you had the white mouth. If it wasn't for these white folks throwin' *me* money for *my* dancin', you would be thin as a whisper right now.

JIM: *(Laughing sarcastically)* Your dancin'! You been leapin' around here like a tailless monkey in a wash pot for a long time and nobody was payin' no 'tention to you, till I come along playing.

LINDSAY: Boys, boys, that ain't no way for friends to carry on.

DAISY: Well, if you all gonna keep up this quarrelin' and carryin' on I'm goin' home. 'Bout time for me to be gittin' back to my white folks anyhow. It's dark now. I'm goin', even if I have to go by myself. I shouldn't a stopped by here nohow.

JIM: *(Stopping his quarrel)* You ain't gonna go home by yourself. I'm goin' with you.

DAVE: *(Singing softly)*
 It may be so,

I don't know.
But it sounds to me
Like a lie.

WALTER: Dave ain't got as much rabbit blood as folks thought.

DAVE: Tell 'em 'bout me. *(Turns to DAISY)* Won't you choose a treat on me, Miss Daisy, 'fore we go?

DAISY: *(Coyly)* Yessir, thank you. I wants a drink of soda water.

(DAVE pulls his hat down over his eyes, whirls around and offers his arm to DAISY. They strut into the store, DAVE gazing contemptuously at JIM as he passes. Crowd roars with laughter, much to the embarrassment of JIM.)

LIGE: Ol' fast Dave jus' runnin' the hog right over you, Jim.

WALTER: Thought you was such a hot man.

LUM BOGER: Want me to go in there and put Daisy under arrest and bring her to you?

JIM: *(Sitting down on the edge of porch with one foot on the step and lights a cigarette pretending not to be bothered.)* Aw, I'll get her when I want her. Let him treat her, but see who struts around that lake and down the railroad with her by and by.

(DAVE and DAISY emerge from the store, each holding a bottle of red soda pop and laughing together. As they start down the steps DAVE accidentally steps on JIM's outstretched foot. JIM jumps up and pushes DAVE back, causing him to spill the red soda all over his white shirt front.)

JIM: Stay off my foot, you big ox.

DAVE: Well, you don't have to wet me all up, do you, and me in company? Why don't you put your damn foot in your pocket?

DAISY: *(Wiping* DAVE's *shirt front with her handkerchief)* Aw, ain't that too bad.

JIM: *(To* DAVE*)* Well, who's shirt did I wet? It's mine, anyhow, ain't it?

DAVE: *(Belligerently)* Well, if it's your shirt, then you come take it off me. I'm tired of your lip.

JIM: Well, I will.

DAVE: Well, put your fist where you lip is. *(Pushing* DAISY *aside.)*

DAISY: *(Frightened)* I want to go home. Now, don't you-all boys fight.

(JIM attempts to come up the steps. DAVE pushes him back and he stumbles and falls in the dust. General excitement as the crowd senses a fight.)

LITTLE BOY: *(On the edge of crowd)* Fight, fight, you're no kin. Kill one another, won't be no sin. Fight, fight, you're no kin.

(JIM jumps up and rushes for DAVE as the latter starts down the steps. DAVE meets him with his fist squarely in the face and causes him to step backward, confused.)

DAISY: *(Still on porch, half crying)* Aw, my Lawd! I want to go home.

(General hubbub, women's cries of "Don't let 'em fight." "Why don't somebody stop 'em?" "What kind of men is you all, sit there and let them boys fight like that." Men's voices urging the fight: "Aw, let 'em fight." "Go for him, Dave." "Slug him, Jim." JIM makes another rush toward the steps. He staggers DAVE, DAVE knocks JIM sprawling once more. This time JIM grabs the mule bone as he rises, rushes DAVE, strikes DAVE over the head with it and knocks him out. DAVE falls prone on his back. There is great excitement.)

OLD WOMAN: *(Screams)* Lawdy, is he kilt? *(Several men rush to the fallen man.)*

VOICE: Run down to the pump and get a dipper o' water.

CLARKE: *(To his wife in door)* Mattie, come out of that store with a bottle of witch hazely oil quick as you can. Jim Weston, I'm gonna arrest you for this. You Lum Boger. Where is that marshall? Lum Boger! *(LUM BOGER detaches himself from the crowd.)* Arrest Jim.

LUM: *(Grabs JIM's arm, relieves him of the mule bone and looks helplessly at the Mayor.)* Now I got him arrested, what's I going to do with him?

CLARKE: Lock him up back yonder in my barn till Monday when we'll have the trial in de Baptist Church.

LINDSAY: Yeah, just like all the rest of them Methodists . . . always tryin' to take undercurrents on people.

WALTER: Ain't no worse then some of you Baptists, nohow.

You all don't run this town. We got jus' as much to say as you have.

CLARKE: *(Angrily to both men)* Shut up! Done had enough arguing in front of my place. *(To* LUM BOGER*)* Take that boy on and lock him up in my barn. And save that mule bone for evidence.

*(*LUM BOGER *leads* JIM *off toward the back of the store. A crowd follows him. Other men and women are busy applying restoratives to* DAVE. DAISY *stands alone, unnoticed in the center of the stage.)*

DAISY: *(Worriedly)* Now, who's gonna take me home?

CURTAIN

ACT TWO

Scene I

SETTING: *Village street scene; huge oak tree upstage center; a house or two on back drop. When curtain goes up,* SISTER LUCY TAYLOR *is seen standing under the tree. She is painfully spelling it out. (Enter* SISTER THOMAS, *a younger woman [In her thirties] at left.)*

SISTER THOMAS: Evenin', Sis Taylor.

SISTER TAYLOR: Evenin'. *(Returns to the notice)*

SISTER THOMAS: What you doin'? Readin' dat notice Joe Clarke put up 'bout de meeting? *(Approaches tree)*

SISTER TAYLOR: Is dat whut it says? I ain't much on readin' since I had my teeth pulled out. You know if you pull out dem

eye teeth you ruins yo' eye sight. *(Turns back to notice)* Whut
it say?

SISTER THOMAS: *(Reading notice)* "The trial of Jim Weston
for assault and battery on Dave Carter wid a dangerous wee-
pon will be held at Macedonia Baptist Church on Monday,
November 10, at three o'clock. All are welcome. By order of
J. Clarke, Mayor of Eatonville, Florida." *(Turning to* SISTER
TAYLOR*)* Hit's makin' on to three now.

SISTER TAYLOR: You mean it's right *now. (Locks up at sun
to tell time)* Lemme go git ready to be at de trial 'cause I'm sho
goin' to be there an' I ain't goin' to bite my tongue neither.

SISTER THOMAS: I done went an' crapped a mess of collard
greens for supper. I better go put 'em on 'cause Lawd knows
when we goin' to git outa there an' my husband is one of them
dat's gointer eat don't keer whut happen. I bet if judgment day
was to happen tomorrow he'd speak I orter fix him a bucket
to carry long. *(She moves to exit, right)*

SISTER TAYLOR: All men favors they guts, chile. But whut
you think of all dis mess they got goin' on round here?

SISTER THOMAS: I just think it's a sin en' a shame befo' de
livin' justice de way dese Baptis' niggers is runnin' round here
carryin' on.

SISTER TAYLOR: Oh, they been puttin' out the brags ever
since Sat'day night 'bout shut they gointer do to Jim. They
thinks they runs this town. They tell me Rev. Childers
preached a sermon on it yistiddy.

SISTER THOMAS: Lawd help us! He can't preach em' let lone gittin' up dere tryin' to throw slams at us. Now all Elder Simms done wus to explain to us our rights . . . what you think 'bout Joe Clarke runnin' round here takin' up for these ole Baptist niggers?

SISTER TAYLOR: De puzzle-gut rascal . . . we oughter have him up in conference an' put him out de Methdis' faith. He don't b'long in there—wanter tun dat boy outa town for nothin'.

SISTER THOMAS: But we all know how come he so hot to law Jim outa town—hit's to dig de foundation out from under Elder Simms.

SISTER TAYLOR: Whut he wanta do dat for?

SISTER THOMAS: 'Cause he wants to be a God-know-it-all an' a God-do-it-all an' Simms is de onliest one in this town whut will buck up to him. *(Enter* SISTER JONES, *walking leisurely)*

SISTER JONES: Hello, Boyt, hello, Lucy.

SISTER TAYLOR: Goin' to de meetin'?

SISTER JONES: Done got my clothes on de line an' I'm bound to be dere.

SISTER THOMAS: Gointer testify for Jim?

SISTER JONES: Naw, I reckon—don't make such difference to me which way de drop fall. . . . 'Tain't neither one of 'em much good.

SISTER TAYLOR: I know it. I know it, Ida. But dat ain't de point. De crow we wants to pick is: Is we gointer set still an' let dese Baptist tell us when to plant an' when to pluck up?

SISTER JONES: Dat *is* something to think about when you come to think 'bout it. *(Starts to move on)* Guess I better go ahead—see y'all later an tell you straighter.

(Enter ELDER SIMMS, *right, walking fast, Bible under his arm, almost collides with* SISTER JONES *as she exits.)*

SIMMS: Oh, 'scuse me, Sister Jones. *(She nods and smiles and exits.)* How you do, Sister Taylor, Sister Thomas.

BOTH: Good evenin', Elder.

SIMMS: Sho is a hot day.

SISTER TAYLOR: Yeah, de bear is walkin' de earth lak a natural man.

SISTER THOMAS: Reverend, look like you headed de wrong way. It's almost time for de trial an' youse all de dependence we got.

SIMMS: I know it. I'm tryin' to find de marshall so we kin go after Jim. I wants a chance to talk wid him a minute before court sets.

SISTER TAYLOR: Y'think he'll come clear?

SIMMS: *(Proudly)* I *know* it! *(Shakes the Bible)* I'm goin' to law 'em from Genesis to Revelation.

SISTER THOMAS: Give it to 'em, Elder. Wear 'em out!

SIMMS: We'se liable to have a new Mayor when all dis dust settle. Well, I better scuffle on down de road. *(Exits, left.)*

SISTER THOMAS: Lord, lemme gwan home an' put dese greens on. *(Looks off stage left)* Here come Mayor Clarke now, wid his belly settin' out in front of him like a cow catcher! His name oughter be Mayor Belly.

SISTER TAYLOR: *(Arms skimbo)* Jus' look at him! Tryin' to look like a jigadier Breneral. *(Enter CLARKE hot and perspiring. They look at him coldly.)*

CLARKE: I God, de bear got me! *(Silence for a moment)* How y'all feelin', ladies?

SISTER TAYLOR: Brother Mayor, I ain't one of these folks dat bite my tongue an' bust my gall—what's inside got to come out! I can't see to my rest why you cloakin' in wid dese Baptist buzzards 'ginst yo' own church.

MAYOR CLARKE: I ain't cloakin' in wid *none.* I'm de Mayor of dis whole town. I stands for de right an' ginst de wrong—I don't keer who it kill or cure.

SISTER THOMAS: You think it's right to be runnin' dat boy off for nothin'?

CLARKE: I God! You call knockin' a man in de head wid a mule bone nothin'? 'Nother thing, I done missed nine of my best-layin' hens. I ain't sayin' Jim got 'em, but different people has tole me he burries a powerful lot of feathers in his back yard. I God, I'm a ruint man! *(He starts towards the right exit, but LUM BOGER enters right.)* I God, Lum, I bean lookin' for

you all day. It's almost three o'clock. *(Hands him a key from his ring)* Take dis key an' go fetch Jim Weston on to de church.

LUM: Have you got yo' gavel from de lodge-room?

CLARKE: I God, that's right, Lum. I'll go get it from de lodge room whilst you go git de bone an' de prisoner. Hurry up! You walk like dead lice droppin' off you. *(He exits right while* LUM *crosses stage towards left.)*

SISTER TAYLOR: Lum, Elder Simms been huntin' you—he's gone on down 'bout de barn. *(She gestures)*

LUM BOGER: I reckon I'll overtake him. *(Exit left.)*

SISTER THOMAS: I better go put dose greens on. My husband will kill me if he don't find no supper ready. Here come Mrs. Blunt. She oughter feel like a penny's worth of have-mercy wid all dis stink behind her daughter.

SISTER TAYLOR: Chile, some Folks don't keer. They don't raise they chillon, they drags 'em up. God knows if dat Daisy wus mine, I'd throw her down an' put a hundred lashes on her back wid a plow-line. Here she come in de store Sat'day night *(Acts coy and coquettish, burlesques* DAISY's *walk)* a wringing and a twisting!

*(*REV. CHILDERS *enters left with* DAVE *and* DEACON LINDSAY *and* SISTER LEWIS. *Very hostile glances from* SISTERS THOMAS *and* TAYLOR *towards the others.)*

CHILDERS: Good evenin', folks.

(Sisters THOMAS *and* TAYLOR *just grunt.* MRS. THOMAS *moves a step or two towards exit. Flirts her skirts and exits.)*

LINDSAY: *(Angrily)* What's de matter, y'all? Cat got yo' tongue?

MRS. TAYLOR: More matter than you kin scatter all over Cincinnatti.

LINDSAY: Go 'head on, Lucy Taylor. Go 'head on. You know a very little of yo' sugar sweetens my coffee. Go 'head on. Everytime you lift yo' arm you smell like a neet of yellow hammers.

MRS. TAYLOR: Go 'head on yo'self. Yo' head look like it done wore out three bodies. Talkin' 'bout *me* smellin'—you smell lak a nest of grand daddies yo'self.

LINDSAY: Aw rock on down de road, 'oman. Ah don't wantuh change words wid yuh. Youse too ugly.

MRS. TAYLOR: You ain't nobody's pretty baby, yo'self. You go ugly I betcha yo' wife have to spread uh sheet over yo' head tuh let sleep slip up on yuh.

LINDSAY: *(Threatening)* I done tole you I don't wanter break a breath wid you. It's uh whole heap better tuh walk off on yo' own legs than it is to be toted off. I'm tired of yo' achin' round here. You fool wid me now an' I'll knock you into doll rags, Tony or no Tony.

MRS. TAYLOR: *(Jumping up in his face)* Hit me! Hit me! I dare you tuh hit me. If you take dat dare, you'll steal uh hawg an' eat his hair.

LINDSAY: Lemme gunn down to dat church befo' you make me stomp you. *(He exits, right.)*

MRS. TAYLOR: You mean you'll *git* stomped. Ah'm goin' to
de trial, too. De nex trial gointer be *me* for kickin' some uh
you Baptist niggers around.

*(A great noise is heard off stage left. The angry and jeering voices of
children. MRS. TAYLOR looks off left and takes a step or two towards
left exit as the noise comes nearer.)*

VOICE OF ONE CHILD: Tell her! Tell her! Turn her up and
smell her. Yo' mama ain't got nothin' to do wid me.

MRS. TAYLOR: *(Hollering off left)* You lil Baptis' haitians
leave them chillun alone. If you don't, you better!

*(Enter about ten children struggling and wrestling in a bunch. MRS.
TAYLOR looks about on the ground for a stick to strike the children
with.)*

VOICE OF CHILD: Hey! Hey! He's skeered tuh knock it off.
Coward!

MRS. TAYLOR: If y'all don't git on home!

SASSY LITTLE GIRL: *(Standing akimbo)* I know you better not
touch me, do my mama will 'tend to you.

MRS. TAYLOR: *(Making as if to strike her)* Shet up you nasty
lil heifer, sassin' me! You ain't half raised. *(The little girl shakes
herself at MRS. TAYLOR and is joined by two or three others.)*

MRS. TAYLOR: *(Walkin' towards right exit)* I'm goin' on
down to de church an' tell yo' mammy. But she ain't been half
raised herself. *(She exits right with several children making faces
behind her.)*

MARY ELLA: Y'all ole Meth'dis' ain't got no window panes in yo' church down yonder in de swamp.

ANOTHER GIRL: *(Takes center of stand, hands akimbo and shakes her hips)* I don't keer whut y'all say, I'm a Meth'dis' bred an' uh Meth'dis' born an' when I'm dead there'll be uh Meth'-dis' gone.

MARY ELLA: *(Snaps fingers under other girl's nose and starts singing. Several join her.)*
> Oh Baptis', Baptis' is my name
> My name's written on high
> I got my lick in de Baptis' church
> Gointer eat up de Meth'dis' pie.

(The Methodist children jeer and make faces. The Baptist camp make faces back; for a full minute there is silence while each camp tries to outdo the other in face making. The Baptist makes the last face.)

METHODIST BOY: Oo e on, less us don't notice 'em. Less gwan down to de church an' hear de trial.

MARY ELLA: Y'all ain't de onliest ones kin go. We goin', too.

WILLIE: Aw, haw! Copy cats! *(Makes face)* Dat's right. Follow on behind us lak uh puppy dog tail. *(They start walking toward right exit, switching their clothes behind.)*

(Baptist children stage a rush and struggle to get in front of the Methodists. They finally succeed in flinging some of the Methodist children to the ground and come behind them and walk towards right exit haughtily switching their clothes.)

WILLIE: *(Whispers to his crowd)* Less go round by Mosely's lot an' beat 'em there!

OTHERS: All right!

WILLIE: *(Yellin' to Baptists)* We wouldn't walk behind no ole Baptists!

(The Methodists turn and walk off towards left exit, switching their clothes as the Baptists are doing.)

SLOW CURTAIN

ACT TWO

Scene II

SETTING: *Interior of Macedonia Baptist Church, a rectangular room. Windows on each side, two Amen Corners. Pulpit with a plush cover with heavy fringe, door in front of church, two oil brackets with reflectors on each side wall, with lamps missing on all but one. One big oil lamp in center.*

ACTION: *At the rise, church is about full. A buzz and hum fills the church. Voices of children angry and jeering heard from the street. The church bell begins to toll for death. Everybody looks shocked.*

SISTER LEWIS: Lawd! Is Dave done died from dat lick?

SISTER THOMAS: *(to her husband)* Walter, go see. *(He gets up and starts down the aisle to front door. Enter* DEACON HAMBO *by front door.)*

WALTER: Who dead?

HAMBO: *(Laughing)* Nobody. Jus' tollin' de bell for dat Meth'dis' gopher dat's gointer be long, long gone after dis trial. *(Laughter from Baptist side. Enter* TONY TAYLOR *and his wife.* TONY *is about to go to front of church but* MRS. TAYLOR *jerks him down into a seat on the aisle on the Methodist side.)*

WALTER: Y'all sho thinks you runs dis town, dontcher? But Elder Simms'll show you somethin' t'day. If he don't God's up gopher.

HAMBO: He can't show us nothin' cause he don't know nothin' hisself.

WALTER: He got mo' book-learnin' than Rev. Childers* got.

HAMBO: Childers mought be unletter-learnt, but he kin drive over Simms like a road plow.

METHODIST CHORUS: Aw naw! Dat's a lie!

(Enter REV. SIMMS *by front door with open* Bible *in hand. A murmur of applause rises on the Methodist side. Grunts on the Baptist side. Immediately behind him, comes* LUM BOGER *leading* JIM WESTON. *They parade up to the right Amen Corner and seat themselves on the same bench.* JIM *between the Marshall and preacher. A great rooster-crowing and hen-cackling arises on the Baptist side.* JIM WESTON *jumps angrily to his feet.)*

JIM: Wisht tuh God I had dat mule bone agin! Ah'd make some uh you mud turtles cackle out de other side yo' mouf. *(Loud laughter of derision from the Baptists.* LUM *looks scared.)*

*At this point in the original manuscript, for unknown reasons, the name *Childers* changed to *Singletary*. We have kept *Childers* for consistency.

SIMMS: Sit down, son; sit down. Be c'am.

(Enter by front door REV. CHILDERS *and* DAVE. DAVE's *head is bandaged, but he walks firmly and seems not ill at all. They sit in the left Amen Corner. Jeering grunts from the Methodist side.)*

SISTER THOMAS: Look at ol' Dave tryin' to make out he's hurt.

METHODIST VOICE: And Childers lookin' like ten cents worth of have-mercy.

BAPTIST VOICE: Yes, but you ought to heard that hell fire sermon he preached yesterday on fightin'.

METHODIST VOICE: Yeah, tryin de case fo' de trial come up.

BAPTIST VOICE: Well, sho is a sin to split a man's head, aint it?

LIGE: Everybody know uh Baptis' head is harder'n uh rock. Look like they'd be skeered tuh go in swimmin; do, they heads would drown 'em. *(General laughter on Methodist side.)*

SISTER TAYLOR: Some folks is a whole lot more keerful 'bout a louse in de church than dey is in dey house. *(Looks pointedly at Sister Lewis)*

SISTER LEWIS: *(bristling)* Whut you gazin' at me for? Wid your popeyes lookin' like skirt ginny-nuts?

SISTER TAYLOR: I hate to tell you whut yo' mouf looks like. I thinks you an' soap an' water musta had some words.

Evertime you lifts yo' arm you smell like a nest of yellow hammers.

SISTER LEWIS: Well, I ain't seen no bath tubs in your house.

SISTER TAYLOR: Mought not have no tub, but tain't no lice on me though.

SISTER LEWIS: Aw, you got just as many bed-bugs and chinces as anybody else. I seen de bed-bugs marchin' out of yo' house in de mornin', keepin' step just like soldiers drillin'.

SISTER TAYLOR: You got that wrong, I—

(Enter BROTHER NIXON with his junper jacket on his arm and climbs over the knees of a bench full of people and finds a seat against the wall directly beneath an empty lamp bracket. He looks around for some place to dispose of his coat. Sees the lamp-bracket and hangs the coat there. Hitches up his pants and sits down.)

SISTER LEWIS: Wait a minute (rising and glaring at NIXON) Shank Nixon, you take yo' lousy coat down off these sacred walls. Ain't you Meth'dis' niggers got no gumption in de house of wash-up!

(NIXON mocks her by standing akimbo and shaking himself like a woman. General laughter. He prepares to resume his seat, but looks over and sees DEACON HAMBO on his feet, and glaring angrily at him. He quickly reaches up and takes the coat down and folds it across his knee.)

SISTER TAYLOR: (Looks very pointedly at SISTER LEWIS, then takes a dip of snuff and looks sneering at LEWIS again.) If I kept

de dirty house you keeps ma mouth would be a closed book. *(Loud laughter from the Meth'dis' side.)*

SISTER LEWIS: *(furious, rises arms akimbo.)* Well, my house might not be exactly clean, but there's no fly-specks on my character! They didn't have to git de sheriff to make Willie marry *me* like they did to make Tony marry *you*.

SISTER TAYLOR: *(jumping up and starting across the aisle. She is pulled back out of the aisle by friends.)* Yeah, they got de sheriff to make Tony marry me, but he married me and made me a good husband too. I sits in my rocking cheer on my porch every Sat'day evenin' an' say: "Here come Tony and them"

SISTER LEWIS: *(scornfully)* Them what?

SISTER TAYLOR: Them dollars, that's what! Now you sho orter go git de sheriff and a shot gun and make some of dese men marry yo' daughter, Ada.

SISTER LEWIS: *(Jumpin' up an' startin' across the aisle. She is restrained, but struggles hard.)* Lemme go, Jim Merchant! Turn me go! I'm goin' to stomp her till she can't sit down.

SISTER TAYLOR: *(also struggling)* Let her come on! If I get my hands on her I'll turn her every way but loose.

SISTER LEWIS: Just come on out dis church, Lucy Taylor. I'll beat you on everything but yo' tongue, and I'll give dat a lick if you stick it out. *(to the men holding her)* Turn me go! I'm goin' to fix her so her own Mammy won't know her.

SISTER TAYLOR: *(trying to free herself.)* Why don't y'all turn dat ole twist mouth 'oman loose? All I wants to do is hit her

one lick. I betcha I'll take her 'way from here faster than de word of God.

SISTER LEWIS: *(to men holding Mrs. Taylor)* I don't see how come y'all won't let old Lucy Taylor a loose. Make out she so bad, now. She may be red hot but I kin cool her. I'll ride her just like Jesus rode a jackass.

(As they subside into their seats again, but glare at each other, MAYOR CLARKE comes thru the pulpit door. He is annoyed at the clamor going on. He tries to quell the noise with a frown.)

SISTER TAYLOR: Dat ain't nothin' but talk. You looks lak de Devil before day, but you ain't so bad; not half as bad as you smell.

MAYOR CLARKE: Order, please, court is set.

SISTER LEWIS: You looks like de devil's doll baby, but all I want you to do is put it where I kin git it an' I'll sho use it.

MAYOR CLARKE: *(booming)* Here! Here! *(feeling everywhere for the gavel)* Lum Boger! Where's dat gavel I done told you to put here?

LUM BOGER: *(from beside prisoner)* You said *you* was gonna bring it yo'self.

MAYOR CLARKE: *(going up in the air)* I God, Lum, you gointer stand there like a bump on a log and see I ain't got nothin' to open court wid? Go 'head an' fetch me dat gavel. Make haste quick before dese wimmen folks tote off dis church house. *(LUM exits by front door.)*

SISTER TAYLOR: *(to LEWIS)* Aw, shut up, you big ole he-

looking rascal you! Nobody don't know whether youse a man or a woman.

CLARKE: You wimmen, shut up! Hush! Just hush! *(He wipes his face with a huge handkerchief.)*

SISTER LEWIS: *(To* SISTER TAYLOR*)* Air Lawd! Dat ain't your trouble. They all knows whut you is eg-zackly.

LINDSAY: Aw? why don't you wimmen cut dat out in de church house? Jus' jawin' an chewin' de rag!

SISTER TAYLOR: Joe Lindsay, if you'd go home an' feed dat rawbony horse of yourn, you wouldn't have so much time to stick yo' bill in business that ain't yourn.

SISTER LEWIS: Joe Lindsay, don't you know no better than to strain wid folks ain't got sense enough to tote guts to a bear? If they ain't born wid no sense, you can't learn 'em none.

LINDSAY: You sho done tole whut God love now. *(glaring across the aisle)* Ain't got enough gumption to bell a buzzard. *(Enter* LUM *by front door with gavel in one hand and mule bone in the other. He walks importantly up the aisles and hands* CLARKE *the gavel and lays the bone atop the pulpit.)*

WALTER: Huh! Marshall had done forgot de bone.

METHODIST SISTER: It's a wonder he ain't forgot hisself.

CLARKE: *(rapping sharply with gavel)* Here! you moufy wimmen shut up. *(to* LUM*)* Lum you go on back there and shut dem wimmen up or put 'em outa here. They shan't contempt this court. *(He wipes his eye glasses.)*

(LUM *starts walking importantly down the aisle towards* SISTER TAYLOR. *She almost rises to meet him.*)

SISTER TAYLOR: Lum Boger, you fresh little snot you! Don't you dast to come here trying to put me out; many diapers as I done pinned on you! *(fiercely)* Git away from me before I knock every nap off of yo' head, one by one. (LUM BOGER *hurries away from her apologetically. He turns towards* MRS. LEWIS.)

MRS. LEWIS: *(calmly)* Deed God knows you better not lay de weight of yo' hand on me, Lum. Gwan way from here before I kick yo' clothes up round yo' neck like a horse collar. *(All the men laugh.* LUM *looks worried and finally goes back and takes his seat beside the prisoner.)*

CLARKE: *(glaring ferociously)* This court is set an' I'm bound to have some order or else. *(The talking ceases. Absolute quiet.)*

CLARKE: Now less git down to business. We got folks in dis town dat's just like a snake in de grass.

SISTER PITTS: Brother Mayor! We ain't got no business goin' into no trial for nothin' else 'thout a word of prayer to be sure de right spirit is wid us.

VOICE ON METHODIST SIDE: Thass right, Elder Simms. Give us a word of prayer. *(He rises hurriedly.)*

VOICE ON BAPTIST SIDE: This is a Baptist church an' de paster is sittin' right here. How come he can't pray in his own church?

TAYLOR: Y'all done started all dis mess, how you goin' to git de right spirit here? Go 'head Rev. Simms.

LEWIS: He cain't pray over me. Dis church says: One Lord, one faith, one Baptism, and a man that ain't never been baptised at all ain't got no business prayin' over nobody.

CLARKE: *(rapping with gavel)* Less sing. Somebody raise a tune.

VOICE ON BAPTIST SIDE: *(begins)* "Onward Christian Soldiers" *(and the others join in)*

VOICE ON METHODIST SIDE: *(Begins)* "All hail the power of Jesus name", *(and the Methodists join in. Both shout as loud as they can to the end of the verse. Clarke lifts his hands rapidly as if to bless a table.)*

CLARKE: *(Praying, quickly)* Lowd be with us and bless these few remarks we are about to receive amen. Now this court is open for business. All of us know we come here on serious business. This town is bout to be tore up by backbiting and malice and mouthy women. *(Glaring at the Sisters)* Now everybody that's a witness in this case, stand up. I wants the witness to take the front seat. *(Nearly everybody in the room rises. Clarke tries to count them.)*

HAMBO: *(Frowns across the aisle at* MRS. LUCAS, *who is standing.)* Whut you doing standing up for a witness? I know you wuzn't there.

SISTER LUCAS: I got just as much right to testify as you is. I don't keer if I wasn't there. Any man that treats they wife bad as you can't tell nobody else they eye is black. You clean round yo' own door before you go sweeping round other folks.

SISTER LINDSAY: *(to* NIXON*)* Whut you doing up there testifyin? When you done let yo' hawg root up all my p'tater patch?

NIXON: Aw, shut up woman. You ain't had no taters for no pig to root up.

SISTER LINDSAY: Who ain't had no taters? *(to* LIGE*)* Look here, Lige, didn't I git a whole crokus sack full of tater slips from yo' brother, Sam?

LIGE: *(Reluctantly)* Yeah.

SISTER LINDSAY: Course I had sweet p'taters! And if you stand up there and tell me I aint had no p'taters, I'll be all over you just like gravy over rice.

NIXON: AW, shut up. We ain't come here to talk about yo' tater vines. We come—

SISTER LINDSAY: *(to her husband)* Joe! Whut kind of a husband is you? Sit here and let Nixon 'buse me out lak dat.

WALTER THOMAS: How is Joe goin' give anybody a straightenin', when he needs straightenin' hisself?

SISTER HAMBO: Aw, you ain't got no right to talk, Walter. Not low down as you is. If somebody stump their toe in dis town you bolt over to Maitland an' puke yo' guts out to de white folks, and God knows I 'bominates a white folks nigger.

WALTER THOMAS: Aw, you jus' mad 'cause I wouldn't let your old starved-out cow eat up my cow-peas.

CLARKE: *(Pounding)* Hush and lemme count.

SISTER HAMBO: *(triumphantly)* UNhumh! I knowed you was the one knocked my cow's horn off! And you lied like a doodle-bug goin' backwards in his hole an' made out you didn't do it.

WALTER THOMAS: I didn't do no such a thing, woman.

SISTER HAMBO: I say you did, and I belong to Macedonia Baptist Church an' I can't lie.

DEACON HAMBO: Walter Thomas, talk dat biggity talk to me, not to my wife. Maybe you kin whip her, but if you can't whip me, too, don't bring de mess up.

CLARKE: *(rapping)* Y'all men folks shut up before I put you both under arrest. Come to order everybody.

LINDSAY: I just want a say this before we go any further. Nobody bet' not slur my wife in here. Do, I'll strow 'em over de country.

MRS. NIXON: Aw, youse de nastiest threatener in three states, but I ain't seen you do nothin'. De seat of yo' pants is too close to de ground for you to be crowin' so loud. You's so short you smell right earthy.

CLARKE: Shut up! We didn't come here to wash an' iron niggers! We come here for a trial. *(raps)*

MRS. NIXON: *(to CLARKE)* I ain't goin' to shut up nothin' of de kind.

CLARKE: Sister Nixon, shut up!

MRS. NIXON: You can't shut me up, not the way you live. When you quit beatin' Mrs. Mattie an' dominizing her all de time, then you kin tell other folks what to do. You ain't none of my boss, not de way you sells rancid bacon for fresh.

CLARKE: *(to* MARSHALL*)* Lum Boger, git me a pencil. *(to* MRS. NIXON*)* Big a bill as you owe ma store, you ain't gonna get nothin' else till you pay.

MRS. NIXON: Huh! I can trade in Maitland—an' see if I pays you now.

NIXON: AW, honey, hush a while, please, and less git started. You don't pay de bills no how. *(The men laugh.)*

JIM: Lawd! Lawd! We done set de whole town fightin'.

DAVE: Boy', we sho is!

CHILDERS: Son, don't talk wid yo' 'sailent. He's a wicked man.

DAVE: How come I can't talk wid him? Known him all ma life.

CHILDERS: Shss. He done tried to kill you.

DAVE: Was our fight, warn't it?

JIM: You niggers just tryin to get us messed up on some kind o' mess. Dave knows I ain't meant to hurt him.

SIMMS: *(to* JIM*)* Derserved to be hurt.

DAVE: No, he didn't. We's just friendly-fightin'-like.

CHILDERS: He sho tried to kill you!

(CLARKE raps. A momentary quiet falls on the place. MAYOR glowers all over the place.)

CLARKE: Here! Quiet till you's called on. *(Turns to LUM)* Lum, git a piece of paper an take de names of all de witnesses *who was there* while de fight was goin' on.

LUM: *(Pulling a small tablet and pencil out of his coat pocket)* I brought it with me.

CLARKE: Now everybody who was at de fight hold up yo' hands so Lum kin know who you are. *(Several hands go up. SISTER ANDERSON puts up her hand.)*

CLARKE: You wuzn't there, Sister Anderson, not at that time.

SISTER ANDERSON: I hadn't been gone more'n ten minutes.

CLARKE: But you didn't see it.

SISTER ANDERSON: It don't make no difference. My husband heered every word was spoke an' told me, jes' lak it happen. Don't tell me I can't testify.

DEACON HAMBO: Nobody can't testify but them what seen it.

SISTER ANDERSON: Dat's all right, but I know whut they was fightin' 'bout. It was Daisy Taylor*

*At this point in the original manuscript, for unknown reasons, Daisy *Taylor* is referred to as Daisy *Blunt*. We have kept *Taylor* for consistency. Likewise, *Dilcie* Anderson is referred to as *Becky*, and we have kept *Dilcie*.

MRS. BLUNT: Jus' you take my chile's name right out yo' mouf, Dilcie* Anderson. She was on her way back to her white folks when all this happen.

SISTER ANDERSON: Well, God knows if dat Daisy was mine, I'd throw her down an' put a hundred lashes on her back wid a plow-line. Here she come in de store Sat'day night *(Acts coy and coquettish, burlesques Daisy's walk).* A wringing and a twisting!

MRS. BLUNT: You better hush while you able! You niggers got my Daisy's name all mixed up in dis mess, an' she at work, can't defend herself.

MRS. TAYLOR: You musn't mind, Sister Blunt. People jus' *will* talk. They's talkin' in New York an' they's talkin' in Georgy an' they's talkin' in Italy.

SISTER PITTS: Chile, if you listen at folkses talk, they'll have you in de graveyard or in Chattahoochee—one. You can't pay no 'tention to talk.

MRS. BLUNT: Well, I know one thing. De man or woman, chick or child, grizzly or gray, that tells me to my face anythin' wrong 'bout *my* chile, I'm goin' to take *my* fist *(Rolling up right sleeve and gesturing with right fist)* and knock they teeth down they throat. *(She looks ferocious)* 'Case y'all know I raised my Daisy right round my feet till I let her go up North last year wid them white folks. I'd ruther her to be in de white folks' kitchen than walkin' de streets like some of dese gals round here. If I do say so, I done raised a lady. She can't help it if all dese mens get stuck on her.

MRS. TAYLOR: You'se tellin' de truth, Sister Blunt. That's whut I always say: Don't confidence dese niggers. Do, they'll sho put you in de street.

MRS. THOMAS: Naw indeed, never syndicate wid niggers.
Do, they will distriminate you.

MRS. BLUNT: Just as sho as you snore. An' they better leave
Daisy's name outa dis, too, an' Daisy better not leave them
white folks' house today to come traipsin' over here scornin'
her name all up wid dis nigger mess. Do, I'll kill her. No
daughter of mine ain't goin' be mixed up in nothin' like this.

MRS. THOMAS: That's right, Sister Blunt. I glory in yo'
spunk.

MAYOR CLARKE: Sit down, Sister Blunt an' shet up. Ain't
gonna mention Daisy a-tall. Ain't gonna drag no woman's
name in dis trial long as I's presidin'.

METHODIST SISTER: Dis ain't no trial. Dis is a mess!

REV. SIMMS: You sho said a mouthful, Sister. Dis sho is a
mess. Can't help from bein' uh mess. *(Glares at* MAYOR*)*
Holdin' a trial in de Baptist Church! Some folks ain't got sense
enough to do 'em till four o'clock, an' its way after half past
three right now.

MAYOR CLARKE: Shet up, dere, Simms! Set down! Who ast
yo' pot to boil, nohow? A church trial is de bes' trial they is,
anyhow, cause you better have a good experience here an' a
strong determination. *(Raps vigorously)* Now lemme tel *y'all*
somethin'. When de Mayor sets court, don't keer when I sets
it nor where I sets it, you got to git quiet and stay quiet till
I ast you tuh talk. Set down! All o' yuh! I God, you sound lak
a tree full uh blackbirds! Dis ain't no barbecue, nor neither no
camp meetin'. We 'sembled here tuh law uh boy on a serious
charge. *(A great buzz rises from the congregation.* MAYOR *raps
hard for order and glares all about him.)* Heah! Heah! All o' us

kin sing at de same time, but can't but one o' us talk at a time. I'm doin' de talkin' now, so de res' o' you dry up till I git through. I God, you sound lak uh passel uh dog fights! We ain't here for no form and no fashion and no outside show to de worl'. We'se here to law!

(For a moment, there is silence, then a small boy, peeping in window on the Methodist side says:)

BOY: *(Thru window, right)* Aw, haw! Y'all ole Baptis' ain't got no bookcase in yo' church.

SMALL GIRL: *(In window on opposite side, left, with other children)* Y'all ole Meth'dis' ain't got no window panes in yo' church down yonder in de swamp.

CLARKE: *(Booming)* You chillun shut up and get out o' them winders. You, Lum! (LUM *stops taking names to go shoo the children. The old people aid him, and the children on left run off singing:)*

CHILDREN: Oh, Baptis', Baptis' is my name,
 My name's written on high.
 I got my lick in de Baptis' Church,
 Gointer eat up de Meth'dis' pie.

CLARKE: *(Rapping)* You done got all de witnesses straight an' got they names down?

LUM: Yassuh, I got it all straightened out.

CLARKE: Well, read de names out and let de witnesses take de front seats. Who is they?

LUM: *(Reading)* Mrs. Lucy Taylor, Sister Katie Pitts, Sister Doll Nixon, Deacon Hambo, Brother Lige Mosely, Brother Joe Lindsay. . . .

LINDSAY: Brother, my eye!

LUM: *(Continuing the reading of the list)* Mr. Sykes Jones, Sister Laura Carter, Mr. Pat Jenkins. And they was lots mo' there but they say they ain't gonna witness. *(Those whose names were read begin to rise and start forward.)*

JIM: They better not neither.

SIMMS: Shsss! De devil can't hurt you, son. An' them what speaks against you is devils.

CLARKE: Won't witness, heh? Huh-um! Well, I see they's some witnessin' whut warn't there. Lucy Taylor, you know you left mah store fo' dat fight come off!

SISTER TAYLOR: *(In attitude of defiance)* Well, I'm gonna witness! An' I ain't gonna bit mah tongue neither. You knows you cheated me outa half a pound o' salt pork Sat'day night. I weighed dat piece when I got home, and 'twarn't no bigger'n mah fist here.

SISTER PITTS: Huh! Dat's a common thing, chile.

CLARKE: *(Calmly)* Is dat all?

SISTER TAYLOR: No, that ain't all. You waters yo' cider, an' yo' sells bag meal.

CLARKE: An' yo' been buyin' outa mah store fo' God knows how long. Yo' owes me Thirty-eight Dollars and Ten Cents,

an' can't nobody whuts in mah debt testify in this court. Set down!

SISTER TAYLOR: You'se a lie! You'se a . . . *(But the noise of the gavel drowns her out. In the meantime, the other witnesses are all seated at the front.)*

CLARKE: Now, we'll go on with this trial. We's tryin' Jim Weston fo' 'saultin' Dave Carter wid a dangerous weepon. Did he or did he not done it, that's what we got to fin' out? You, Lum! You was there. You'se de Marshall. You saw it. Now, what went on?

LUM: *(Startled, drawls)* Well . . .

DAVE: You better, "Well . . ." *(Mocking* LUM*)*

LUM: Daisy come. . . .

SISTER BLUNT: Uhm-uh! Not Daisy.

LUM: I mean *(turning to* CLARKE *in distress)* Well, you say I should take Jim and lock him up, an' that's whut I done, jus' like you tol' me.

CLARKE: You sho did, but I God, I ast you whut you seed befo' I told you to take Jim and lock him up? *(*DAVE, JIM *and* SISTER TAYLOR *eye* LUM *dangerously)*

LUM: *(Shifting nervously)* Well, I ain't seen much.

CLARKE: *(Rapping impatiently)* Whut did you see?

LUM: Well, ole lady Pitts' mule was tied in yo' back yard a-tearin' up Mis' Mattie's tomato vines, an' Mis' Mattie say,

'Lum, you go 'roun' an' tend to dat mule', an' I went, an' that mule sho drawed back to kick me.

CLARKE: *(To* SISTER PITTS*)* I God, yo' mule drawed a hoof on de marshall?

SISTER PITTS: Dat's a lie! Mah mule don't kick.

CLARKE: G'wan, Lum!

LUM: An' I was busy wid dat mule.

LIGE: Looks like de marshall warn't at de scene o' action.

SISTER LEWIS: Dat's de kin' o' men de Mayor hires to do de duties o' dis town.

CLARKE: Set down, Lum. Ain't worth de dust it took to make you. *(To* HAMBO*)* Hambo, you was settin' an' loafin' right on mah front porch all day Sat'day, and night, too. Get up an' tell whut you saw.

HAMBO: *(Rising)* Now, in de first place, Joe Clarke, I warn't loafin'. I'se a deacon in de church an' you knows I don't waste mah time wid dem low niggers whut hangs aroun' yo' store.

LIGE: Do you hear that?

HAMBO: An' furthermo', I don't know if I wuz there or not, now dat you so sure I wuz.

SISTER HAMBO: Make him prove it! Make him prove it!

CLARKE: I God, Hambo, you know you wuz there!

CHILDERS: *(Quickly)* He were there, yo' honery, but he warn't loafin'. *(To* HAMBO*)* You mah main witness, Brother Hambo. Now tell jus' how dis vileness was done. You sees our lamb all hurted here. *(Pointing to* DAVE's *head.* JIM *laughs.)*

DAVE: Hush, fool! You'se in court.

JIM: Boy, yo' head sho is soft.

HAMBO: *(To* JIM*)* An' you'll soon be gone. *(To the* MAYOR*)* Clarke, it were like dis. These two boys here started fightin' over Dais . . . *(sees* SISTER BLUNT *half rise in her seat)* over somethin' or nother o' no importance . . . *(*BAPTISTS *all murmur in agreement)* an' dat there triflin' rascal, for no cause whatinsoever, hit this boy in de head with a mule bone.

CLARKE: Um-hmmm! Dat's right.

SISTER THOMAS: Hear him, Lord! How he kin lie!

SISTER NIXON: An' then re-lie!

HAMBO: *(To* CLARKE*)* You 'lows dese 'ruptions in de court?

CLARKE: *(To* WOMEN, *rapping)* Hush! I say, hush! Hambo, is you through?

HAMBO: *(Sitting down pompously)* I is.

CLARKE: *(To* OLD WOMAN*)* Sister Pitts, le's hear whut you got to say!

SISTER PITTS: Brother Mayor, I wan't there, but I been knowin' this boy Dave since he was knee-high to a duck an' that boy wouldn't hurt nobody, but that varmint yonder *(Pointing to* JIM*)* is de crookedist limb of Satan that de Lawd ever made. He is a scoundrel, a rat, a low-down dog, a . . .

SIMMS: *(Jumping up)* I objects! I objects! Nobody's got de right to call my charge no names like dat. *(As* CLARKE *is silent and* SISTER PITTS *goes on, "rascal, heathen, etc.")* I objects! *(Dances in front of* MAYOR'*s face)* I objects!

CLARKE: I God, Simms, if you don't set down an' stop spittin' in mah face I'll lam you over de head wid dis mallet.

SIMMS: *(Weakly)* I objects.

CLARKE: Dat'll do! Dat'll do! Dry up, suh! *(Turning to* DAVE*)* Stand up, Dave. Since youse de one got hurted, you tell me jus' whut went on out dere. *(*DAVE *rises slowly)*

MRS. TAYLOR: Dat's right, Dave. Git up dere an' lie lak de cross ties from New York to Texas. You greasy rascal, you! You better go wash yo'self befo' you go testifyin' on people.

DAVE: *(Calmly)* I'm jus' as clean as you. *(*JIM *laughs)*

CHILDERS: *(Jumping to his feet)* Wait a minute! 'Tain't none o' y'all got no call to be thowin' off on dis boy. He come here to git justice, not to be slurred an' low-rated. He ain't 'ssaulted nobody. He ain't stole no chickens. He's a clean boy. He set at mah feet in Sunday School since he was so high *(Measures knee height)* and he come through religion under de sound of mah voice an' I baptized him an' I know he's clean.

MRS. TAYLOR: It'll take more'n uh baptizin' to clean dat nigger.

DAVE: I goes in swimmin' nearly every day. I'm jus' as clean as anybody else.

MRS. TAYLOR: (MAYOR *begins rapping for order.* SHE *shouts out*) Swimming! Dat ain't gointer clean de crust offa you. You ain't had a good bath since de devil was a hatchet.

CLARKE: I'm goin' to have order heah or else! G'wan, Dave!

DAVE: It's jus' lak you seen it Sat'day night. You-all was there.

CLARKE: Yeah, but dat wuz at de store. Dis is in court an' it's got to be tole.

SIMMS: Just uh minute, Brother Clarke, before we any further go, I wants to ast de witness uh question dat oughter be answered before he open his mouf.

CLARKE: Whut *kind* of a question is dat?

SIMMS: Dave, tell de truth. Ain't yo' heart full of envy an' malice 'gainst dis chile? (*Gestures towards* JIM. DAVE *shakes his head and starts to deny the charge, but* SIMMS *hurries on*) Wait a minute, now! Wait till I git thru. Didn't y'all used to run aroun' everywhere playin' an' singin' an' everythin' till you got so full of envy an' malice an' devilment till y'all broke up? Now, Brother Mayor, make him tell de truth.

DAVE: Yeah, I useter be crazy 'bout Jim, and we was buddies till he tried to back bite me wid my girl.

JIM: Yo' girl! Never *was* yo' girl, nohow! I reckon I ain't
none of yo' buddy. I ain't got no buddy, they kilt my buddy
tryin' to raise me. But I did useter lak you till you tried to root
me out wid Dais. . . .

SISTER BLUNT: Jes' dare!

MAYOR: Aw, table dat business, an' le's open up new busi-
ness. We ain't here to fin' out whose girl it is an' we ain't
gonna mention no woman's name. We wants to know 'bout
dis fight, an' who hit de first lick, an' how come. Go 'head on,
Dave, an' talk.

CHILDERS: Yes, Dave, talk, son.

DAVE: Well, we was all dancin' an' a singin' in front o' yo'
store, an' seem like Jim kinder got mad 'bout somethin' or
nother an' so I went in de store an' left de ole nigger. Well,
near as I can remember, when I come out seems like I kinder
step on his ole big foot whut had no business where it wuz
nohow. An' then he up and knocks mah soda all ovah mah
clean shirt.

JIM: Who's shirt?

DAVE: De shirt I had on. An' then I hits him. An' fo' I
knowed it, he done picked up that bone an' lammed me ovah
de head wid it.

CHILDERS: He hit you, didn't he?

DAVE: Yes, sir.

CHILDERS: He assaulted you, didn't he?

DAVE: I reckon he did.

CLARKE: Uh-humm!

(DAVE *resumes his seat and* JIM *drops his head for a moment then snatches it up arrogantly and glares at the* BAPTISTS. *The whole place is very silent for a moment. Then* MAYOR CLARKE *clears his throat, raps with his gavel and looks sternly at* JIM.)

Jim Weston, stand up, suh! (JIM *rises sullenly*) You'se charged wid 'ssaultin' Dave Carter wid uh dangerous weepon. You heard de charge. Guilty or not guilty?

JIM: (*Arrogantly*) Yeah, I hit him an' I'll hit him agin if he crowd me. But I ain't guilty of no crime. (HE *hitches up his pants and sits down arrogantly.*)

CLARKE: (*Surprised*) Whut's dat you say, Jim? (*Raps sharply*) Git up from there, sir! Whut's dat you say?

JIM: (*Rising*) I say, yeah, I lammed ole Dave wid de mule bone, but I ain't guilty uh nothin'. (*There is a stark silence for a few seconds. Then* CLARKE *raps nervously.*)

CLARKE: How come you ain't guilty?

SIMMS: (*To* JIM) Set down, Jim, and lemme show dese people dat walks in de darkness wid sinners an' republicans de light.

(JIM *sets down amid jubilant smiles of* METHODISTS. SIMMS *chuckles out loud and wipes his face with his handkerchief. He gets to his feet still laughing.*)

CHILDERS: You jus' as well tuh hush up befo' you start then, Simms. You can't show nobody uh light when you ain't got none tuh show.

HAMBO: Ain't dat de gospel?

NIXON: Aw, let de man talk! Y'all soun' lak uh tree full uh blackbirds. Go 'head on, Elder Simms.

WALTER THOMAS: Yeah, you can't teach 'em nothin', but talk on. We know whut you talkin' 'bout.

CLARKE: *(Rapping once or twice)* I God, tell it . . . whutever 'tis you got tuh tell!

SISTER NIXON: Law 'em from Genesis to Revelations, Elder.

SISTER LEWIS: Aw yeah, hurry up an' tell it. I know it ain't goin' tuh be nothin' after you git it tole, but hurry up an' say it so you kin rest easy.

THOMAS: Aw, shet up an' give de man uh chance.

SISTER LEWIS: My shetters ain't workin' good. Sposin' you come whet me up, Walter. Den you'll know it's done right.

LIGE: Aw, whyn't y'all ack lak folks an' leave de man talk!

CLARKE: *(Rapping repeatedly)* Order in dis court, I God, jus' like you wuz in Orlando! *(Silence falls)* Now, Simms, talk yo' chat.

SIMMS: *(Glances down into his open Bible, then looks all around the room with great deliberation. It is evident he enjoys being the center*

of attraction. He smiles smugly as he turns his face towards the pulpit. He speaks slowly and accents his words so that none will be lost on his audience.) De Bible says, be sho you're right, then go ahead. *(He looks all around to collect the admiration he feels he has earned.)* Now, we all done gathered an' 'sembled here tuh law dis young lad of uh boy on uh mighty serious charge. Uh whole passel of us is rarin' tuh drive him way from home lak you done drove off his daddy an' his brothers.

HAMBO: We never drove off his pappy. De white folks took an' hung him for killin' dat man in Kissimmee for nothin'.

SIMMS: Dat ain't de point, Brother Hambo.

HAMBO: It's jes' as good uh pint as any. If you gointer talk, tell de truth. An' if you can't tell de truth, set down an' leave Reverend Childers talk.

SIMMS: Brother Mayor, how come you let dese people run they mouf lak uh passel uh cowbells? Ain't I got de floor? I ain't no breath-an'-britches. I was *people* in middle Georgy befo' I ever come to Floridy. Whut kin' of chairman is you, nohow?

CLARKE: *(Angrily)* Heah! Heah! Don't you come tryin' show yo'self round me! I God, I don't keer whut you wuz in Georgy. I kin eat fried chicken when you cain't git rainwater tuh drink. Hurry up an' say what you got in yo' craw an' set down. We needs yo' space more'n we needs yo' comp'ny.

NIXON: Don't let him skeer yo', Elder Simms. You got plenty shoulders tuh back yo' fallin'.

HAMBO: Well, each an' every shoulder kin hit de groun' an' I'll git wid 'em.

THOMAS: Hambo, everybody in Orange county knows you love tuh fight. But dis is uh law hearin', not no wrassle.

HAMBO: Oh, you Meth'dis' niggers wants tuh fight, bad enough, but youse skeered. Youse jus' as hot as Tucker when de mule kicked his mammy. But you know you got plenty coolers.

SISTER TAYLOR: Aw, ain't nobody skeered uh you half-pint Baptists. God knows ah'm ready an' willin'. *(She glares at* MRS. LEWIS. SISTER LEWIS *jumps to her feet, but is pulled back into her seat.* MAYOR CLARKE *raps for order and the room gets quiet.)*

CLARKE: Aw right, now, Simms. I God, git through!

SIMMS: *(Pompously)* Now y'all done up an' took dis po' boy an' had him locked up in uh barn ever since Sat'day night an' done got him 'ccused uh 'ssault an' I don't know whut all, an' you ain't got no business wid yo' hands on him a-tall. He ain't done no crime, an' if y'all knowed anythin' 'bout law, I wouldn't have tuh tell you so.

CLARKE: I God, he *is* done uh crime an' he's gointer ketch it, too.

SIMMS: But not by law, Brother Mayor. You tryin' tuh lay uh hearin' on dis boy an' you can't do it 'cause he ain't broke no law. I don't keer whut he done so long as he don't break no law you can't touch him.

CHILDERS: He committed assault, didn't he? Dat sho is breakin' de law!

SIMMS: Naw, he ain't committed no 'ssault. He jus' lammed Dave over de head, dat's all. *(Triumphantly)* Yuh see y'all

don't know whut you talkin' 'bout. Now I done set in de court house an' heard de white folks law from mornin' till night. *(He flips his Bible shut.)* I done read dis book from lid tuh lid an' I knows de law. You got tuh have uh weepon tuh commit uh 'ssault. An' 'tain't in no white folks law an' 'tain't in dis Bible dat no mule bone is no weepon.

CLARKE: *(After a moment of dead silence)* I God, whut's dat you say?

SIMMS: *(Sitting down and crossing his legs and folding his hands upon his Bible.)* You heard me. I say you ain't got no case 'ginst dis boy an' you got tuh turn him loose.

CHILDERS: *(Jumping up)* Brother Chairman!

CLARKE: *(Raps once and nods recognition)* You got de floor.

CHILDERS: I ain't book-learnt an' I ain't rubbed de hair offen my head agin no college wall, but I know when uh 'ssault's been committed. I says Jim Weston did 'ssault Dave. *(He points at Dave's head.)*

SIMMS: *(Arrogantly)* Prove it!

CHILDERS: Stands silent and puzzled.

(The METHODIST *side breaks into a triumphant shout of* "Oh, Mary don't you weep, don't you moan, Pharaoh's Army got Drownded". CHILDERS *sinks into his seat. When they have shouted out three choruses,* SIMMS *rises to speak.)*

SIMMS: I move dat we sing doxology an' bring dis meetin' to uh close. We'se all workin' people, Brother Mayor. Dismiss

us so we kin g'wan back to our work. De sun is two hours high yet. *(Looks towards the* METHODIST *side.)* I second de motion.

CHILDERS: *(Arising slowly)* Hol' on there uh minute wid dat motion. Dis ain't no lodge meetin'. Dis is uh court an' bofe sides got uh right tuh talk. *(Motions towards* SIMMS's *Bible)* Youse uh letter-learnt man, but I kin read dat Bible some, too. Lemme take it uh minute.

SIMMS: I ain't uh gointer do it. Any preacher dat amounts to uh hill uh beans would have his own Bible.

CLARKE: I God, Childers, you right here in yo' own church. Come on up here an' read out yo' pulpit Bible. I God, don't mind me bein' up here. Come on up. *(A great buzzing breaks out all over the church for order.* CHILDERS *mounts the pulpit.* SIMMS *begins to turn the leaves of his Bible.)*

SIMMS: Brother Mayor, you oughter let us outa here. You ain't got no case 'ginst dis boy. Don't waste our time for nothin'. Leave us go home.

CLARKE: Aw, dry up, Simms, you done talked yo' talk. I God, leave Childers talk his. *(To* CHILDERS*)* Step on out when you ready, Reverend.

CHILDERS: *(Reading)* It says here in Judges 18:18 dat Samson slewed three thousand Philistines wid de jaw-bone of an ass.

SIMMS: *(On his feet)* Yeah, but dis wasn't no ass. Dis was uh mule, Brother Mayor. Dismiss dis meetin' an le's all go home.

CHILDERS: Yeah, but he was half-ass. A ass is uh mule's daddy, and he's bigger'n uh ass, too. *(Emphatic gestures)* Everybody knows dat, even de lil chillun.

SIMMS: *(Standing)* Yeah, but we didn't come here to talk about no asses, neither no half-asses, nor no mule daddies. *(Laughter from* METHODISTS*)* We come to law uh boy for 'ssault an' larceny.

CHILDERS: *(Very patiently)* We'se comin' to dat pint now. Dat's de second claw uh de sentence we'se expoundin'. I say Jim Weston did have uh weepon in his hand when he 'ssaulted Dave. 'Cause y'all knows if de daddy is dangerous, den de son is dangerous too. An y'all knows dat de further back you gits on uh mule de more dangerous he gits an' if de jaw-bone slewed three thousand people, by de time you gits back tuh his hocks, it's pizen enough tuh kill ten thousand. 'Tain't no knives nor no razors ever kilt no three thousand people. Now, folkses, I ast y'all whut kin be mo' dangerous dan uh mule bone? *(To* CLARKE*)* Brother Mayor, Jim didn't jes' lam Dave an' walk off . . . *(very emphatic)* he 'ssaulted him with de deadliest weepon there is in de worl' an' left him layin' unconscious. Brother Mayor, he's uh criminal an' oughter be run outa dis peaceful town! *(Great chorus of approval from Baptists.* CLARKE *begins to rap for order.)*

SIMMS: *(Standing)* Brother Mayor, I objects. I done studied jury and I know whut I'm talkin' 'bout.

CLARKE: Aw, dry up, Simms. You'se entirely out of order. You may be slick, but you kin stand another greasing. Reverend Childers is right. I God, I knows de law when I hear it. Stand up dere, Jim! *(*JIM *rises very slowly.* SIMMS *rises also.* DAVE *looks worried.)*

CLARKE: Set down, Simms! I God, I know where to find you when I want you. *(SIMMS sits.)* Jim, I find you guilty as charged an' I wants you to git outa my town an' stay gone for two years. *(To LUM)* Brother Marshall, you see dat he gits outa town befo' dark. An' you folks dat's so anxious to fight, fit on off dis church grounds befo' you starts. An' don't use no knives an' no guns an' no mule bones. Court's dismissed.

CURTAIN

ACT THREE

SETTING: *A high stretch of railroad track thru a luxurious Florida forest. It is near sundown.*

ACTION: *When the curtain rises there is no one on the stage, but there is a tremendous noise and hubbub off-stage right. There are yells of derision and shouts of anger. Part of the mob is trying to keep* JIM *in town, and part is driving him off. After a full minute of this,* JIM *enters with his guitar hanging around his neck and his coat over his shoulder. The sun is dropping low and red thru the forest. He is looking back angrily and shouting at the mob. A missile is thrown after him.* JIM *drops his coat and guitar and grabs up a piece of brick, and makes threatening gestures of throwing it.*

JIM: *(Running back the way he came and hurling the brick with all his might)* I'll kill some o' you old box-ankled niggers. *(Grabs up another piece of brick.)* I'm out o' your old town. Now just let some of you old half-pint Baptists let yo' wooden God and Cornstalk Jesus fool you into hittin' me. *(Threatens to throw again. There are some frightened screams and the mob is heard running back.)* I'm glad I'm out o' yo' ole town anyhow. I ain't never comin' back no mo', neither. You ole ugly-rump niggers done ruint de town anyhow.

(There is complete silence off stage. JIM *walks a few steps with his coat and guitar, then sits down on the railroad embankment facing the audience. He pulls off one shoe and pours the sand out. He holds the shoe in his hand a moment and looks wistfully back down the railroad track.)*

JIM: Lawd, folks sho is deceitful. *(He puts on the shoe and looks back down the track again.)* I never woulda thought people woulda acted like that. *(Laces up the shoe)* Specially Dave Carter, much as me and him done progue'd 'round together goin' in swimmin' an' playin' ball an' serenadin' de girls an' de white folks. *(He sits there gloomily silent for awhile, then looks behind him and picks up his guitar and begins to pick a tune. The music is very sad, but he trails off into, "YOU MAY LEAVE AN' GO TO HALIMUHFACKS, BUT MY SLOW DRAG WILL BRING YOU BACK." When he finishes he looks at the sun and picks up his coat.)*

JIM: Reckon I better git on down de road and git some-where. Lawd knows where. *(Stops suddenly in his tracks and turns back toward the village. Takes a step or two.)* All dat mess and stink for nothin'. Dave know good an' well I didn't meant to hurt him much. *(He takes off his cap and scratches his head thoroughly. Then turns again and starts on down the road left. Enter* DAISY, *left, walking fast and panting, her head down. They meet.)*

DAISY: Oh, hello, Jim. *(A little surprised and startled)*

JIM: *(Not expecting her)* Hello, Daisy. *(Embarrassed silence.)*

DAISY: I was just coming over town to see how you come out.

JIM: You don't have to go way over there to find dat out . . . you and Dave done got me run outa town for nothin'.

DAISY: *(Putting her hand on his arm)* Dey didn't run you outa town, did dey?

JIM: *(Shaking her hand off)* Whut you reckon I'm countin' Mr. Railroad's ties for . . . just to find out how many ties between here and Orlando?

DAISY: *(Hand on his arm again)* Dey *cain't* run you off like dat!

JIM: Take yo' hands off me, Daisy! How come they cain't run me off wid you and Dave an' . . . *every*body 'ginst me?

DAISY: I ain't opened my mouf 'gainst you, Jim. I ain't said one word . . . I wasn't even at de old trial. My madame wouldn't let me git off. I wuz just comin' to see 'bout you now.

JIM: Aw, go 'head on. You figgered I was gone too long to talk about. You was haulin' it over to town to see Dave . . . dat's whut you was doin' . . . after gittin' *me* all messed up.

DAISY: *(Making as if to cry)* I wasn't studyin' 'bout no Dave.

JIM: *(Hopefully)* Aw, don't tell me. *(Sings)* Ashes to ashes, dust to dust, show me a woman that a man can trust. *(DAISY is crying now.)*

JIM: What you crying for? You know you love Dave. I'm yo' monkey-man. He always could do more wid you that I could.

DAISY: Naw, you ain't no monkey-man neither. I don't want you to leave town. I didn't want y'all to be fightin' over me, nohow.

JIM: Aw, rock on down de road wid dat stuff. A two-timin'
cloaker like you don't keer whut come off. Me and Dave been
good friends ever since we was born till you had to go flounc-
ing yourself around.

DAISY: What did I do? All I did was to come over town to
see you and git a mouf-ful of gum. Next thing I know y'all is
fighting and carrying on.

JIM: *(Stands silent for a while)* Did you come over there Sat'-
day night to see me sho nuff, sugar babe?

DAISY: Everybody could see dat but you.

JIM: Just like I told you, Daisy, before you *ever* left from
round here and went up North. I could kiss you every
day . . . just as regular as pig-tracks.

DAISY: And I tole you I could stand it too—just as regular
as you could.

JIM: *(Catching her by the arm and pulling her down with him onto
the rail)* Set down, here, Daisy. Less talk some chat. You want
me sho nuff? Hones' to God?

DAISY: *(Coyly)* 'Member whut I told you out on de lake last
summer?

JIM: Sho nuff, Daisy? *(DAISY nods smilingly)*

JIM: *(Sadly)* But I got to go 'way. Whut we gointer do 'bout
dat?

DAISY: Where you goin', Jim?

JIM: *(Looking sadly down the track)* God knows.

(Off stage from the same direction from which JIM *entered comes the sound of whistling and tramping of feet on the ties.)*

JIM: *(Brightening)* Dat's Dave! *(Frowning)* Wonder whut he doin' walkin' dis track? *(Looks accusingly at* DAISY*)* I bet he's goin' to yo' work-place.

DAISY: Whut for?

JIM: He ain't goin' to see de madame—must be goin' to see you. *(He starts to rise petulantly as* DAVE *comes upon the scene.* DAISY *rises also.)*

DAVE: *(Looks accusingly from one to the other)* Whut y'all jumpin' up for? I . . .

JIM: Whut you gut to do wid us business? Tain't none of yo' business if we stand up, set down or fly like a skeeter hawk.

DAVE: Who said I keered? Dis railroad belongs to de *man*—I kin walk it good as you, cain't I?

JIM: *(Laughing exultantly)* Oh, yeah, Mr. Do-Dirty! You figgered you had done run me on off so you could git Daisy all by yo'self. You was headin' right for her work-place.

DAVE: I wasn't no such a thing.

JIM: You was. Didn't I hear you coming down de track all whistling and everything?

DAVE: Youse a big ole Georgy-something-ain't-so! I done got my belly full of Daisy Sat'day night. She can't snore in my ear no more.

DAISY: *(Indignantly)* Whut you come here low-ratin' me for, Dave Carter? I ain't done nothin' to you but treat you white. Who come rubbed yo' ole head for you yestiddy if it wasn't me?

DAVE: Yeah, you rubbed my head all right, and I lakted dat. But everybody say you done toted a pan to Joe Clarke's barn for Jim before I seen you.

DAISY: Think I was going to let Jim lay there 'thout nothing fitten for a dog to eat?

DAVE: That's all right, Daisy. If you want to pay Jim for knockin' me in de head, all right. But I'm a man in a class . . . in a class to myself and nobody knows my name.

JIM: *(Snatching Daisy around to face him)* Was you over to Dave's house yestiddy rubbing his ole head and cloaking wid him to run me outa town . . . and me looked up in dat barn wid de cows and mules?

DAISY: *(Sobbing)* All both of y'all hollerin' at me an' fussin' me just cause I tries to be nice . . . and neither one of y'all don't keer nothin' bout me.
(BOTH BOYS glare at each other over DAISY's head and both try to hug her at the same time. She violently wrenches herself away from both and makes as if to move on.)

DAISY: Leave me go! Take yo' rusty pams offen me. I'm going on back to my work-place. I just got off to see bout y'all and look how y'all treat me.

JIM: Wait a minute, Daisy. I love you like God loves Gabriel . . . and dat's His best angel.

DAVE: Daisy, I love you harder than de thunder can bump a sump . . . if I don't . . . God's a gopher.

DAISY: *(Brightening)* Dat's de first time you ever said so.

DAVE & JIM: Who?

JIM: Whut you hollering "Who" for? Yo' fat don't fit no limb.

DAVE: Speak when you spoken to . . . come when you called, next fall you'll be my coon houn' dog.

JIM: Table dat discussion. *(Turning to* DAISY*)* You ain't never give me no chance to talk wid you right.

DAVE: You made *me* feel like you was trying to put de Ned book on me all de time. Do you love me sho nuff, Daisy?

DAISY: *(Blooming again into coquetry)* Aw, y'all better stop dat. You know you don't mean it.

DAVE: Who don't mean it? Lemme tell you something, mama, if you was mine I wouldn't have you counting no ties wid *yo'* pretty lil toes. Know whut I'd do?

DAISY: *(Coyly)* Naw, whut would you do?

DAVE: I'd buy you a whole passenger train . . . and hire some mens to run it for you.

DAISY: *(Happily)* Oo-ooh, Dave.

JIM: *(To* DAVE*)* De wind may blow, de doorway slam
 Dat shut you shootin' ain't worth a dam.
(To DAISY*)* I'd buy you a great big ole ship . . . and
then, baby, I'd buy you a ocean to sail yo' ship on.

DAISY: *(Happily)* Oo-ooh, Jim.

DAVE: *(To* JIM*)* A long tain, a short caboose
 Dat lie whut you shootin', ain't no use.
(To DAISY*)* Miss Daisy, know what I'd do for you?

DAISY: Naw, whut?

DAVE: I'd come down de river riding a mud cat and loading
a minnow.

DAISY: Lawd, Dave, you sho is propaganda.

JIM: *(Peevishly)* Naw he ain't . . . he's just lying . . . he's a
noble liar. Know whut I'd do if you was mine?

DAISY: Naw, Jim.

JIM: I'd make a panther wash yl' dishes and a 'gater chop yo'
wood for you.

DAVE: Daisy, how come you let Jim lie lak dat? He's as big
as a liar as he is a man. But sho nuff now, laying all sides to
jokes, Jim there don't even know how to answer you. If you
don't b'lieve it . . . ast him something.

DAISY: *(To* JIM*)* You like me much, Jim?

JIM: *(Enthusiastically)* Yeah, Daisy I sho do.

DAVE: *(Triumphant)* See dat! I tole you he didn't know how to answer nobody like you. If he was talking to some of them ol' funny looking gals over town he'd be answering 'em just right. But he got to learn how to answer *you*. Now you ast *me* something and see how I answer you.

DAISY: Do you like me, Dave?

DAVE: *(Very properly in a falsetto voice)* Yes ma'am! Dat's de way to answer swell folks like you. Furthermore, less we prove which one of us love you do best right now. *(To* JIM*)* Jim, how much time would you do on de chain-gang for dis 'oman?

JIM: Twenty years and like it.

DAVE: See dat, Daisy? Dat nigger ain't willin' to do no time for you. I'd *beg* de judge to gimme life. *(Both* JIM *and* DAVE *laugh)*

DAISY: Y'all doin' all dis bookooin' out here on de railroad track but I bet y'all crazy 'bout Bootsie and Teets and a whole heap of other gals.

JIM: Cross my feet and hope to die! I'd ruther see all de other wimmen folks in de worl' dead than for you to have de tooth-ache.

DAVE: If I was dead and any other woman come near my coffin de undertaker would have to do his job all over . . . 'cause I'd git right up and walk off. Furthermore, Miss Daisy, ma'am, also ma'am, which would *you* ruther be a lark a flying or a dove a settin' . . . ma'am, also ma'am?

DAISY: 'Course I'd ruther be a dove.

JIM: Miss Daisy, ma'am, also ma'am . . . if you marry dis nigger over my head, I'm going to git me a green hickory club and season it over yo' head.

DAVE: Don't you be skeered, baby . . . papa kin take keer a *you*. (To JIM) Countin' from de finger (*Suiting the action to the word*) back to de thumb . . . start anything I got you some.

JIM: Aw, I don't want no more fight wid you, Dave.

DAVE: Who said anything about fighting? We just provin' who love Daisy de best. (*To* DAISY) Now, which one of us you think love you de best?

DAISY: Deed I don't know, Dave.

DAVE: Baby, I'd walk de water for you . . . and tote a mountain on my head while I'm walkin'.

JIM: Know what I'd do, honey babe? If you was a thousand miles from home and you didn't have no ready-made money and you had to walk all de way, walkin' till ye' feet start to rolling, just like a wheel, and I was riding way up in de sky, I'd step backwards offa dat aryplane just to walk home wid you.

DAISY: (*Falling on* JIM's *neck*) Jim, when you talk to me like dat I just can't stand it. Less us git married right now.

JIM: Now you talkin' like a blue-back speller. Less go!

DAVE: (*Sadly*) You gointer leave me lak dis, Daisy?

DAISY: (*Sadly*) I likes you, too, Dave, I sho do. But I can't marry both of y'all at de same time.

JIM: Aw, come on, Daisy . . . sun's gettin' low. *(He starts off pulling DAISY)*

DAVE: Whut's I'm gointer do? *(Walking after them)*

JIM: Gwan back and dance . . . you make out you don't need me to play none.

DAVE: *(Almost tearfully)* Aw, Jim, shucks! Where y'all going? *(DAISY comes to an abrupt halt and stops JIM)*

DAISY: That's right, honey. Where *is* we goin' sho nuff?

JIM: *(Sadly)* Deed I don't know, baby. They just sentenced me to go . . . they didn't say where and I don't know.

DAISY: How we goin' nohow to go when we don't know where we goin'?

(JIM looks at DAVE as if he expects some help but DAVE stands sadly silent. JIM takes a few steps forward as if to go on. DAISY makes a step or two, unwillingly, then looks behind her and stops. DAVE looks as if he will follow them.)

DAISY: Jim! *(HE stops and turns)* Wait a minute! Whut we gointer do when we git there?

JIM: Where?

DAISY: Where we goin'?

JIM: I done tole you I don't know where it is.

DAISY: But how we gointer git something to eat and a place to stay?

JIM: Play and dance . . . just like I been doin'.

DAISY: You can't dance and Dave ain't gointer be ther.

JIM: *(Looks appealingly at* DAVE, *then away quickly)* Well, I can't help *dat,* can I?

DAISY: *(Brightly)* I tell you whut, Jim! Less us don't go no-where. They sentenced you to leave Eatonville and youse more than a mile from de city limits already. Youse in Mait-land now. Supposin' you come live on de white folks' place wid me after we git married. Eatonville ain't got nothin' to do wid you livin' in Maitland.

JIM: Dat'a a good idea, Daisy.

DAISY: *(Jumping into his arms)* And listen, honey, you don't have to be beholden to Dave nor nobody else. You can throw dat ole box away if you want to. I know ehre you can get a *swell* job.

JIM: *(Sheepishly)* Doin' whut? *(Looks lovingly at his guitar)*

DAISY: *(Almost dancing)* Yard man. All you have to do is wash windows, and sweep de sidewalk, and scrub off de steps and porch and hoe up de weeds and rake up de leaves and dig a few holes now and then with a spade . . . to plant some trees and things like that. It's a good steady job.

JIM: *(After a long deliberation)* You see, Daisy, de Mayor and corporation told me to go on off and I oughter go.

DAISY: Well, I'm not going tippin' down no railroad track like a Maltese cat. I wasn't brought up knockin' round from here to yonder.

JIM: Well, I wasn't brought up wid no spade in my hand . . . and ain't going to start it now.

DAISY: But sweetheart, we got to live, ain't we? We got to git hold of money before we kin do anything. I don't mean to stay in de white folks' kitchen all my days.

JIM: Yeah, all dat's true, but you couldn't buy a flea a waltzing jacket wid de money *I'm* going to make wid a hoe and spade.

DAISY: *(Getting tearful)* You don't want me. You don't love me.

JIM: Yes, I do, darling, I love you. Youse de one letting a spade come between us. (HE *caresses her*) I loves you and you only. You don't see *me* dragging a whole gang of farming tools into us business, do you?

DAISY: *(Stiffly)* Well, I ain't going to marry no man that ain't going to work and take care of me.

JIM: I don't mind working if de job ain't too heavy for me. I ain't going to bother wid nothin' in my hands heavier than dis box . . . and I totes it round my neck 'most of de time.

*(*DAISY *makes a despairing gesture as* JIM *takes a step or two away from her. She turns to* DAVE *finally.)*

DAISY: Well, I reckon you loves me the best anyhow. You wouldn't talk to me like Jim did, would you, Dave?

DAVE: Naw, I wouldn't say what he said a-tall.

DAISY: *(Cuddling up to him)* Whut would *you* say, honey?

DAVE: I'd say dat box was too heavy for me to fool wid. I wouldn't tote nothing heavier than my hat and I feel like I'm 'busing myself sometime totin' dat.

DAISY: *(Outraged)* Don't you mean to work none?

DAVE: Wouldn't hit a lick at a snake.

DAISY: I don't blame *you,* Dave *(Looks down at his feet)* cause toting dem feet of yourn is enough to break down your constitution.

JIM: *(Airily)* That's all right . . . dem foots done put plenty bread in our moufs.

DAVE: Not by they selves though . . . wid de help of dat box, Jim. When you gits having fits on dat box, boy, my foots has hysterics. Daisy, you marry Jim cause I don't want to come between y'all. He's my buddy.

JIM: Come to think of it, Dave, she was yourn first. You take and handle dat spade for her.

DAVE: You heard her say it is all I can do to lift up dese feets and put 'em down. Where I'm going to git any time to wrassle wid any hoes and shovels? You kin git round better'n me. You done won Daisy . . . I give in. I ain't going to bite no fren' of mine in de back.

DAISY: Both of you niggers can git yo' hat an' yo' heads and git on down de road. Neither one of y'all don't have to have me. I got a good job and plenty men beggin for yo' chance.

JIM: Dat's right, Daisy, you go git you one them mens whut don't mind smelling mules . . . and beating de white folks to

de barn every morning. I don't wanta be bothered wid nothin' but dis box.

DAVE: And I can't strain wid nothin' but my feets.

(DAISY *walks slowly away in the direction from which she came. Both watch her a little wistfully for a minute. The sun is setting.*)

DAVE: Guess I better be gittin' on back . . . it's most dark. Where you goin', Jim?

JIM: I don't know, Dave. Down de road, I reckon.

DAVE: Whyncher come on back to town. 'Tain't no use you proguein' up and down de railroad track when you got a home.

JIM: They done lawed me way from it for hittin' you wid dat bone.

DAVE: Dat ain't nothin'. It was my head you hit. An' if I don't keer whut dem old ugly-rump niggers got to do wid it?

JIM: They might not let me come in town.

DAVE: *(Seizing* JIM*'s arm and facing him back toward the town)* They better! Look here, Jim, if they try to keep you out dat town we'll go out to dat swamp and git us a mule bone a piece and come into town and boil dat stew down to a low gravy.

JIM: You mean dat, Dave? (DAVE *nods his head eagerly*) Us wasn't mad wid one 'nother nohow. *(Beligerently)* Come on, less go back to town. Dem mallet-heads better leave me be, too. *(Picks up a heavy stick)* I wish Lum would come tellin' me 'bout de law when I got all dis law in *my* hands. And de rest

o' dem gator-faced jigs, if they ain't got a whóle sto' o' mule bones and a good determination, they better not bring no mess up. Come on, boy.

(THEY *start back together toward town,* JIM *picking a dance tune on his guitar, and* DAVE *cutting steps on the ties beside him, singing, prancing and happily, they exit, right, as*

THE CURTAIN FALLS.)

THE *MULE BONE*
CONTROVERSY

THE NARRATIVE
ACCOUNTS

FROM *THE BIG SEA* BY LANGSTON HUGHES

During the winter Zora Hurston came to Westfield from one
of her many trips into the deep South, and there began to
arrange her folk material, stacks and stacks of it—some of
which later appeared in *Mules and Men.* Together we also
began to work on a play called *Mule Bone,* a Negro folk
comedy, based on an amusing tale Miss Hurston had collected
about a quarrel between two rival church factions. I plotted
out and typed the play based on her story, while she authen-
ticated and flavored the dialogue and added highly humorous
details. We finished a first draft before she went South again,
and from this draft I was to work out a final version.

Zora, a very gay and lively girl, was seriously hemmed
in in village-like Westfield. But those backing her folk-lore
project felt that she should remain quietly in a small town and
not go galavanting gaily about New York while engaged in
the serious task of preparing her manuscripts. So she was
restless and moody, working in a nervous manner. And we

were both distressed at the growing depression—hearing of more and more friends and relatives losing jobs and becoming desperate for lack of work . . .

Of course, I knew I had no tapeworm all the time, so I decided to go home to Cleveland and get in bed. My mother then lived in three rooms in a basement on Carnegie Avenue, with my step-father and my brother. Very kindly my mother gave me the only bed and they slept on the davenport. My brother stayed with some cousins, because we had only two sleeping rooms and a kitchen.

. . . By now my brother was no longer in school in New England. Work was scarce in Cleveland, and my mother and dad were not doing so well. We were all in a rather bad way. The doctor in Cleveland said it was my tonsils that were poisoning my system, so he took them out—and that took the last money I had. Strangely enough, I still wouldn't tell any of the doctors I was just upset and emotionally confused. I guess I enjoyed paying for attention. And certainly I felt better as soon as the last penny left from Park Avenue was gone.

But to cap the climax, while I was in Cleveland, I had my first literary quarrel—although, basically, it was not really a literary quarrel.

On the evening that I arrived in Cleveland, the Gilpin Players, America's oldest Negro theater group, were performing a new play and I went to see it, thinking it might ease my mind. After the performance I was talking with the director, Rowena Jelliffe, and she told me that she had just received an excellent Negro folk comedy by a talented young woman named Zora Hurston. I expressed interest, so she went on to tell me that it was about a quarrel between two rival church factions in the deep South, that it was a very amusing play, and that it was called *Mule Bone*. She said it had just been turned down by the Theatre Guild in New York, but that an agent had sent a rough draft to her with permission to try it out in Cleveland.

From her description and the title, I knew it was the same play Zora Hurston and I had worked on together. But it was not finished and it did not seem to me it should be produced in that form.

I tried to telephone Miss Hurston, but could not reach her. I wired her, but got no answer. I wrote her three letters, and finally she replied from New York. She said, yes, she had sent the play to *her* agent because she felt that if the play were ever produced I would only take my half of the money and spend it on a girl she didn't like. Besides, the story was her story, the dialogue her dialogue, and the play her play—even if I had put it together, and she didn't want me to have any part in it.

Girls are funny creatures! By now the Gilpin Players were worried and wished her permission in writing, which they tried to secure. An answer came from her agent, giving the Gilpins permission to continue. I agreed to make a final draft, so the play was put into rehearsal, pending a written agreement from Miss Hurston, who as yet had sent no business word. Finally, Miss Hurston wrote that she was driving out to Cleveland to see the rehearsals and would then sign the agreement. Shortly she arrived.

We had a long talk and she agreed that whatever her personal feelings were about other things, the production could go ahead.

But overnight she changed her mind—or, rather, before 12 P.M. She heard that the girl she did not like had been in town, so at midnight she called up Mrs. Jelliffe and said that never, under any circumstances, would she permit any of her work to be linked with mine, nor her name with mine, and that there could be no production of our play, *Mule Bone.* By that time the Gilpin Players had put a sizable amount of money into scenery and costumes for the play. So Mrs. Jelliffe requested a joint conference with me and Miss Hurston the

following day. Nothing, she felt, could be settled over the phone at midnight.

Having recently had my tonsils out, I was forbidden by my doctor to leave bed, so the conference was called for my house. It was a cold and snowy day. Mr. and Mrs. Jelliffe arrived. Miss Hurston also came. But she would not talk about the play! Not at all. She would speak only of things that did not concern the drama in question, one way or another. She spoke passionately, long, and loud, until the Jelliffes begged to be excused. They went home. Miss Hurston then got the last word and left without saying good-bye to my mother, whom she had known for years. That made my mother angry, so she pursued Miss Hurston into the hall to give her a piece of her mind. I had to get up out of bed and restrain my mother. It was an exciting afternoon for a tonsillectomy patient.

That evening my fraternity brothers were giving a dance in my honor. I had informed them three days before that the doctor had forbidden me to leave my bed and that I could not come to any dance. But since it was all arranged, they went ahead with it just the same. In my honor, Miss Hurston, being a visiting celebrity, was invited to the party, since the brothers knew nothing of our literary quarrel. With a local young man, she went to the ball and told everyone how awful I was. Then she drove back to New York. As soon as I recovered my voice, I called up the local young man to tell him I meant to beat the hell out of him.

I never heard from Miss Hurston again. Unfortunately, our art was broken, and that was the end of what would have been a good play had it ever been finished—the first real Negro folk comedy—*Mule Bone.*

About that time, *Not Without Laughter* appeared and I received the Harmon Gold Award for Literature, given by the Federated Council of Churches—four hundred dollars and a gold medal. The week that I received the award, I wired Alain Locke, who knew the circumstances of our having written the

play and had, I believe, seen a first draft. I asked him kindly to talk to Miss Hurston for me. Alain Locke wired back, YOU HAVE HARMON AWARD SO WHAT MORE DO YOU WANT. Exactly ten cooling words.

I could not go to New York to receive the award, so they sent it to me by mail—a medal and a check. I put the medal away in my trunk. With the four hundred dollars I went to Haiti.

I needed sun.

FROM *ZORA NEALE HURSTON: A LITERARY BIOGRAPHY* BY ROBERT E. HEMENWAY

"Mule Bone" has never been produced, and only its third act has ever been published. Fewer than ten copies of the play survive, all deposited in private papers. Still, despite the fact that it has been read in full by only a few, it is a notorious work, the center of a quarrel that transformed Hughes and Hurston from intimate friends to lifelong enemies. "Mule Bone" is the reason Langston Hughes, a kind, gentle, forgiving man, never forgave Hurston for what he considered theft and dishonesty. "Mule Bone" caused Zora Hurston, who had high hopes of making their collaborative efforts famous, to accuse her partner of stealing ideas and of sabotaging the play's production. "Mule Bone" explains why, after February 3, 1931, Zora Neale Hurston and Langston Hughes avoided each other for the rest of their lives.

The "Mule Bone" episode is not so important in itself, perhaps, but it provides an intimate glimpse of the kinds of pressures Hurston struggled to control all her life. The tale is worth focusing on because its true history has gone unreported, and also because it illuminates complex tensions in Hurston's life that arose from patronage and personality. These tensions illustrate why Zora Hurston's career would be

at times controversial, at times puzzling, occasionally inconsistent.

The "Mule Bone" story is tangled, filled with bad behavior, shrill voices, and feigned innocence. When Hughes accused Hurston of claiming sole authorship of a play they had written together and of marketing it for the stage without consulting him, he acted from a legitimate sense of outrage. She had done both—whether out of misunderstanding, ambition, or malice, it is hard to say. Hughes's representation of the facts in *The Big Sea,* however—up to now the only public account of the dispute—oversimplifies an incredibly complicated affair. Hughes actually gave two versions of his side of things, one in his autobiography, another in correspondence with his lawyer. Hurston never gave a public account, and only a partial private one. The narrative that follows has been pieced together from a variety of sources, including the private correspondence of the principals.[1]

"Mule Bone" was written largely between March and June of 1930. Living near each other in rooming houses in New Jersey, seeing each other almost every day, Hughes and Hurston apparently talked about some of their plans for a "real Negro theatre." At a party in late February or early March, Hughes met Theresa Helburn of the Dramatists Guild; Helburn complained that practically all the plays about black people offered to the guild were serious problem dramas. Why didn't someone write a comedy—not a minstrel show, but a real comedy? Hughes took the idea back to Hurston, and they began to work, meeting at Zora's place in Westfield; they decided to build a three-act comedy around a folktale she had collected.

The tale was about two hunters who shot simultaneously at a wild turkey and then quarreled over who had killed it. In the ensuing fight, one hunter knocked the other unconscious with the hock bone of a mule found by happenstance during the struggle. The bone wielder was charged with assault and

battery and brought to trial. When it was asserted that a mule bone could hardly be considered a lethal weapon, a minister read to the jury the biblical story of Samson's slaying three thousand Philistines with the jawbone of an ass. Pointing out that a mule is more dangerous the farther to the rear one goes, the minister concluded that a bone from the hind legs must be considered a very dangerous weapon indeed. The hunter was convicted and expelled from town.

How Hughes and Hurston shaped this story into a comic play—the division of responsibility, who wrote what—is unknown. Hughes claimed that he was to do the construction, plot, some characterization, and some dialogue, and that Hurston was to provide the authentic Florida color, give the dialogue a true southern flavor, and insert turns of phrase and "highly amusing details" from her collecting trips. By early April they were working together intensely, dictating to Louise Thompson. The three of them had a wonderful time, Zora sometimes reducing the others to helpless laughter as she acted out all the parts. In four weeks they completed drafts of the first and third acts and at least one scene of the second act. The turkey was dropped (over Hurston's objections) and a girl made the root of the argument. The combatants became members of different churches, and the trial became part of a sectarian struggle. In May, Hurston left Westfield. In June she returned to the South for the summer, taking with her notes and outlines for the trial scene of act 2; she was to complete this act over the summer, and they would polish it in the fall.

Hughes contended that he saw nothing unusual in this departure just when things were nearing completion, and he claimed to be surprised and disappointed when Hurston returned in September and brushed him off when asked about beginning work again. According to him, she canceled appointments, said she had no time, and by early December was no longer seeing him at all. However, this autumn coldness was consistent with her breaking off work in late spring when

things were going smoothly; neither action had anything to do with the need for a trip south or the press of other business. She was angry over the growing friendship between Hughes and Louise Thompson, and she felt, rightly or wrongly, that Hughes was trying to make Thompson a part of their collaborative effort. Hurston broke off their partnership because she was angry over the way things were working out between them and their stenographer.

Her complaint, not voiced until later, was over Hughes's proposal that Thompson assume more than a stenographer's role in their effort, that perhaps she even be made business manager of any Broadway production. Hurston did not admit it, but this new partner was a considerable distraction to a creative collaboration looked forward to for years. She had already given up the racial opera they had talked about; Mrs. Mason* decided that Hughes could do it better with a composer, and she had sent him to Cuba to look for a new collaborator. Hughes later claimed that he attributed Hurston's behavior that fall to nerves and to the rush of getting her folklore collections organized for publication. It seems more likely that he knew what was bothering his co-worker and had concluded that it was best to let their long friendship cool.

The other factor complicating the Hughes-Hurston relationship at the time was Hughes's growing uneasiness with Mrs. Mason. During the fall and winter of 1930 Hughes began to feel guilty about eating caviar above Park Avenue while apple vendors hawked for survival on the street below. Hughes's poem "Advertisement for the Waldorf-Astoria" had addressed this feeling:

*Widow of the prominent physician Rufus Osgood Mason, Charlotte Louise Vandervere Quick Mason (1854–1946) was an influential philanthropist who invested more than $75,000 in the careers of young black artists such as Hughes and Hurston, as well as Aaron Douglas, Richmond Barthe, and Alain Locke. An opinionated patron, she involved herself in both the artistic and more personal aspects of her protégés' lives.

Have luncheon there this afternoon, all you jobless.
 Why not?
Dine with some of the men and women who got rich off
 of your Labor, who clip coupons with clean white
 fingers because your hands dug coal, drilled stone,
 sewed garments, poured steel to let other people
 draw dividends and live easy.

Mrs. Mason not only had clean white fingers, she also
clipped coupons regularly. She was bound to disapprove of
the poem, and Hughes probably knew it. Her disapproval led
to his rethinking their relationship, with the result that in late
December or early January he went off the payroll. There was
a final traumatic scene at 399 Park [the home of Mrs. Mason],
and the parting was bitter, Mrs. Mason accusing him of ingrati-
tude and disloyalty. Hurston knew about Hughes's dissatisfac-
tion and probably foresaw the breakup. It may be that she was
trying to protect her own relationship with her patron, hoping
that Mrs. Mason's unhappiness with Hughes would not rub off
on her. She had apparently made her peace with Mrs. Mason
and did not wish to sever the patronage arrangement until her
field work was organized. If this sounds as though Hurston
abandoned a friend, it is important to remember that Louise
Thompson—in Zora's mind at least—had already come be-
tween them. Complicating it all was Thompson's support from
Mrs. Mason while typing the play and her growing dissatisfac-
tion with Mrs. Mason's interest in black people as primitives.
Hurston herself was not entirely easy with this aspect of the
Mason personality, but she knew how to play to Godmother's
preferences. She once addressed Mrs. Mason as the "guard-
mother who sits in the twelfth heaven and shapes the destinies
of the primitives." Thompson, who was very close to Zora
before the "Mule Bone" blowup, remembers how, whenever
Mrs. Mason sent an exotic dress for Zora to wear, Zora called

Park Avenue to report that it looked stunning on her; then she would hang up and turn to her companion, remarking with a laugh that she would not think of wearing such a thing.

Hughes's reaction to the breakup with Mrs. Mason was to become psychosomatically ill. He spent his remaining money on doctors and radiologists who could find nothing wrong with him. One New York physician, a specialist in diagnosing Oriental ailments, identified his as a Japanese tapeworm. When Hughes returned home to Cleveland to live with his mother in early January, 1931, a general practitioner attempted to solve his problems by removing his tonsils. As Hughes admitted, his real illness was in his wallet; he began recovering the moment the last of Mrs. Mason's money was gone.

Hughes's tonsillitis did not stop him from visiting Cleveland's Karamu House shortly after his return. A settlement playhouse run by Rowena and Alexander Jelliffe, Karamu was the home of a black acting company called the Gilpin Players, nationally known for the quality and vigor of their productions. When Rowena Jelliffe told Hughes on January 15 that she had just obtained the rights to a play called "Mule Bone," a comedy of "Negro life" by Zora Neale Hurston, he was mystified. When the script arrived and proved to be clearly the play they had worked on together, he was angry. And when he could get no satisfactory explanation from Hurston by phone call or letter, he was outraged. He immediately copied act 2 from the script received, added his own copies of acts 1 and 3, and sent the play off to be copyrighted in both their names. He also sent Hurston a registered letter threatening litigation.

What actually happened was that Hurston had given the play to Carl Van Vechten to read. Although the script was in a very unfinished form, he had, without her knowledge, sent it to Barrett Clark, a reader for the Theatre Guild. Clark was sure that the guild would reject it, but in his capacity as an

employee of Samuel French, the theatrical producer, he had written Mrs. Jelliffe to ask if the Gilpin Players would be interested. When she said yes, he had sent the script on, indicating that a letter explaining rights to the play would follow.

Was Hurston thinking of marketing the play as her own? It seems likely, since the script read by the Theatre Guild carried only her name. Moreover, she, too, had submitted the play script for copyright, but in October of 1930, using her own second act, reinserting the turkey as the object of contention, and listing herself as the sole author. Still, she had not sent the play anywhere herself, and when she received an angry phone call from Hughes on January 16, she truthfully denied knowing anything about the play's being in an agent's hands or in Cleveland. Hughes found this hard to believe, and the phone conversation degenerated rapidly.

The Gilpin Players wanted very much to do the play. Mrs. Jelliffe was enthusiastic. Even though the script was in a rough state—the turkey had been reinserted, but the girl remained; there were two endings, with the suggestion that the performers take their pick—one of its authors was in Cleveland and available for rewriting. A number of phone calls followed, the upshot being that Barrett Clark promised Mrs. Jelliffe that he would try to obtain Hurston's permission for a production. On January 20, 1930, a wire came from French's saying that Hurston had refused to authorize the production and that the script should be returned at once. Within twenty-four hours, however, three wires came directly from Hurston authorizing the production and indicating that she would collaborate with Hughes on script changes. Within that same twenty-four-hour period, Hughes received a letter from Hurston, written on January 18, saying that no part of the play was his. Understandably confused, he contacted New York attorney Arthur Spingarn, one of the chief supporters of the NAACP, to protect his interests.

The letter that Hughes received from Hurston claiming he had no rights in the play was not vicious, although it undoubtedly angered him.[2] Hurston said that she wanted to have a heart-to-heart talk about the play, and finally expressed her resentment about Louise Thompson: "In the beginning, Langston, I was very eager to do the play with you. *ANY* thing you said would go over big with me. But scarcely had we gotten underway before you made three propositions that shook me to the foundation of myself. First: that three way split with Louise. Now Langston, nobody has in the history of the world given a typist an interest in a work for typing it. Nobody would think of it unless they were prejudiced in favor of the typist." According to Hurston, Hughes's second proposition was that Thompson be paid more than the usual typist's fee, and his third that she be made the business manager of the Broadway production. The effect, Hurston claimed, was to make her feel as though she were "among strangers, and the only thing to do was to go on away from there." (In a letter written two days later, she added a touch of melodrama to her exile: "I just went off to myself and tried to resolve to have no more friendships. Tears unceasing have poured down inside me.")

Having adopted the role of the betrayed partner, Hurston then told Hughes: "Now about the play itself. It was my story from beginning to end. It is my dialogue; my situations. But I am not concerned about that. Langston, with God as my judge, I don't care anything about the money it might make nor the glory. I'd be willing to give it all to you off-hand. But the idea of you, LANGSTON HUGHES, trying to use the tremendous influence that you knew you had with me that someone else might exploit me cut me to the quick." Then Hurston added her trump card, a veiled hint that although they both knew that her claim to the play was questionable, she had the money and power to back it up: "I told Godmother that I had

done my play all by myself, and so I did, and for the reasons stated before."

Godmother's entry into the proceedings was not by happenstance. She apparently knew that Zora was now working alone on a play that had been written in collaboration, and she chose to back Zora in the dispute. In the spring of 1930 the authors' uncertainty over whether Mrs. Mason would approve of their theatrical venture had led directly to one of their first arguments over Louise Thompson. Neither Zora nor Langston had enough money to pay her for the typing, and Thompson offered to wait for payment until the play was produced. This seems generous, but Zora saw it as a ploy; she complained to Hughes, "She resisted pay and tried to put it on a sentiment and royalty basis. Establishing the record of being the first stenog. [rapher] to try to collect royalties." Finally they spoke to Mrs. Mason about the play and obtained her permission to work together with Thompson as their typist.

Hurston's report to Hughes that Godmother was on her side was probably designed to scare him. They had already had a nasty telephone conversation during which Hughes threatened to sue her, and she was replying in kind. He was just now beginning to find some peace of mind after the breakup with his patron, and it must have been unsettling to think that Mrs. Mason might express her resentment toward him by backing Hurston's claim of authorship—perhaps even accusing him of trying to steal folklore material from her. Hurston, who knew of the anguish in his departure, may have been more than a little designing; but then, she also felt wronged. She told Arna Bontemps years later that she had been jealous of Louise Thompson, that this was a key to the dispute. Exactly what Hurston meant is unclear; she also told Bontemps that she was not in love with Hughes.[3] In a letter to Hughes, dated January 20, 1931, Zora said, with some feeling: "Now get this straight, Langston. You are still dear to me. I don't care whom you love nor whom you marry, nor

whom you bestow your worldly goods upon. I will never have any feeling about that part. I have always felt that if you had married anyone at all it would make no difference in our relationship. I *know* that no man on earth could change me towards you." She explained that she had gone off in June because "I couldn't hear myself saying unpleasant phrases to you." She had worked "the play out alone—carefully not using what was yours."

This claim to sole authorship melted away quickly when confronted by the good offices of Arthur Spingarn, when gentle persuasion brought the two friends back together again. Sorting out the sequence of events with help from Van Vechten, telling them they both were acting foolishly, Spingarn urged mutual apologies and a renewed attempt to polish the play; after all, it was a theatrical property that Van Vechten, at least, felt could be as great a popular success as *Green Pastures.* Things were smoothed over. Hurston consulted with her agent, Elizabeth Marbury, and although the preparation for the Cleveland production was tension filled, primarily because the signals from New York kept changing, it was finally agreed that Hurston would come to Cleveland by February 1 for last-minute work with Hughes. The first performance was scheduled for February 15.

Zora represented this accommodation to Godmother as a way for her to bring Langston to his senses and back into the Mason Holding Company. On January 20 she wrote Mrs. Mason that Hughes wanted to make up with his Godmother but was too emotional to come forth: "Personally I think that he has so much in him, that it is worth my swallowing and forgetting if by extending a friendly hand I can bring him back into the fold." She assured Mrs. Mason that Hughes "is ashamed of his attitude about the play," and that this enabled her to accept him once again as a co-author: "Godmother, I am so happy Langston has taken an honorable view of the thing, that I would give him part. I shant say that to him right

now, but it takes all the sting out of the thing. The money didn't mean anything, Godmother, really."

Hurston arrived in Cleveland on the first of February and in a meeting with Hughes resolved their differences. They agreed to the Gilpin Players production—provided the players still wanted to do it. The players had held a conference the same evening and voted to discontinue; they were uncertain of Hurston's attitude, and the whole production had become problematical. When Mrs. Jelliffe and the leader of the players promised to reconsider, all seemed settled. "Mule Bone" could be performed in Cleveland and, if financial backing was obtained, taken to Broadway; eventually, they hoped, it would become a movie.

Overnight, however, Hurston learned that Louise Thompson had recently been in Cleveland to visit Hughes. Although Thompson's visit was part of some interracial seminars she was conducting and had nothing to do with the play, it is logical that Zora Hurston would think otherwise. She concluded that Hughes and Thompson were scheming to pirate her play, and her reaction was total anger. According to Hughes, she called Mrs. Jelliffe and berated her. She went the next afternoon to a conference at Hughes's house, where his tonsillitis had confined him to bed, and berated him, the Gilpin Players, and the Jelliffes. She even complained about the playground next door to the settlement house. She abused Hughes's mother and generally stormed and raged. Since Hughes is the only participant who left a reminiscence of this event, publicly or privately, we are dependent on his account, which obviously would not be favorable to Hurston; it is doubtful if she was quite as emphatic as his descriptions imply, or, if she was, that her behavior was without provocation. Nevertheless, Hurston's capacity for outrage was considerable, and in this instance she felt deeply wronged. She told friends in New York that she would tear Louise Thompson limb from limb the next time she saw her. Carl Van Vechten

claimed that she once threw herself to the floor of his study in a tantrum over Hughes's betrayal. Needless to say, the production was called off. Hurston wired Mrs. Mason to tell of the betrayal, then left for New York, still angry, accusing Hughes of double-crossing her once again.[4]

Spingarn and Van Vechten did make some preliminary attempts to patch up the quarrel; Hurston became reconciled with Louise Thompson; and Zora and Hughes exchanged letters of a less hostile nature than their last meeting. Despite all this, "Mule Bone" was dead as a dramatic production. In March, 1931, in response to one of Spingarn's queries, Hurston replied acerbically, sending a copy of her letter to an approving Godmother:

> This is to deny your assertion that you have seen the original script. You have seen what your client *says* is the original script. You evidently forget that your client had my script out in Cleveland and I see did not hesitate to copy off some "emendations." The whole matter is absolutely without honor from start to finish and this latest evidence of trying to make a case by actual theft, "emendations" as you call them, makes me lose respect for the thin[g] altogether. From the very beginning it has been an attempt to build up a case by inference and construction rather than by fact. But all the liberal construction in the world cannot stand against certain things which I have in my possession.
>
> I think it would be lovely for your client to be a playwright but I'm afraid that I am too tight to make him one at my expense. You have written plays, why not do him one yourself? Or perhaps a nice box of apples and a well chosen corner. But never no play of mine.[5]

Hughes still had to assert his rights to the play as late as August, 1931, in conversations with Hurston's agent. In 1933 Hurston told Harold Jackman that she was thinking of revising "Mule Bone" again, and in January, 1934, she assured Van Vechten that a new version of the play was being prepared. But she more or less gave up hope for the play's production, as did Hughes. After Hurston's death he permitted the third act to be published in *Drama Critique,* but the play has never been performed or printed in full.[6]

Hughes's account of this whole episode in *The Big Sea* is discreet to the point of being self-serving. With his usual gallantry he chose not to mention Louise Thompson by name, and he nowhere suggests that a dispute over a typist was a central issue. He portrays Zora as a lively "girl," who was inhibited by village-like Westfield but made to stay there by "those backing her folklore project" who felt that it would be good for her to work quietly. He adds, "So she was restless and moody, working in a nervous manner. . . ." There are also factual errors in the *Big Sea* account, some probably resulting from slips of memory, some reflecting the interests of Hughes's case. Hughes leaves the impression that Mrs. Jelliffe had a copy of the script in hand when she first told him about it. Actually, he had to wait to see if it was the same script they had worked on together. He nowhere mentions that in the script sent to Cleveland, Hurston had somewhat rewritten all three acts. He denies that he talked with Hurston on the phone; yet he admitted privately that this was the first thing he did on January 16 when he saw the script. He does not mention that at one point he was willing to accept only a one-third interest in the play, granting that two-thirds of it was Hurston's work. He claims that Hurston's original folktale was about two rival church factions, but he told Arthur Spingarn that the tale was about two hunters and that the idea of making them representatives of the Baptist and Methodist faiths was his own. He also claims that there was a first draft

finished before Hurston went south and that it was he who was supposed to work out a final version. He reports that Hurston wrote him that she gave the play to her agent—she gave it only to Van Vechten—because he would "only take my half of the money and spend it on a girl she didn't like." He concludes in *The Big Sea,* "Girls are funny creatures."

Apart from the factual errors in this account, Hughes's construction of events is subtly designed to make Zora Hurston appear a fickle woman, representative of her sex, nervous and moody in New Jersey, and, above all, a "funny creature." In short, he presents a chauvinistic interpretation of their collaboration. Hughes's greatest omission, however, is his failure to admit that both parties were thinking of Mrs. Mason sitting in her throne-like chair on Park Avenue. When he reports in *The Big Sea* his dismay over Alain Locke's siding with Hurston, he presents Locke as a man who is as mysteriously unfair as Hurston is unstable. But Hughes knew that Locke had heard the story of the play only from Mrs. Mason and Zora. Hughes's fear of Mrs. Mason's power was such that when Spingarn reported that Locke was backing Hurston, Hughes came to doubt even Spingarn. Convinced that his lawyer was siding with the money and power in New York, at one point he asked for the return of his private papers from Spingarn's files. Zora kept Mrs. Mason abreast of the entire matter by letter—including copies of her letters to Hughes; a common refrain runs throughout: "I'd love for Langston to face me in your presence," and "I wish it were possible for Locke to get him before you and then call me in and let him state his claims."

What one is left with, finally, is speculation about an honest misunderstanding exacerbated by the special pressures both writers experienced at the time. Although Louise Thompson served as a typist, she was also a talented, brilliant woman, in the beginning a good friend to both Hughes and Hurston. She undoubtedly made suggestions as they dictated,

which Hughes, at least, appreciated. Hurston, seeing her as both a personal and an artistic rival, probably did not. On the other hand, she was primarily a typist, and Hurston had every right to resent Hughes's suggestions for her participation in the production. Yet one senses that Hughes's proposal probably arose as the two young writers grew excited about their play, imagined its Broadway production, and dreamed of its success. Envisioning fame and wealth for the authors, it seems perfectly plausible for Hughes to want the third person in the room not to feel left out. "And we'll make Louise business manager" seems a logical reaction, but one that a collaborator, already suspicious of that third person, might view skeptically. Since Louise Thompson had also been supported by Mrs. Mason while working with them on the play—and since both Hughes and Louise Thompson left Mrs. Mason in late 1930, shortly before the "Mule Bone" dispute, while Hurston stayed on—Mrs. Mason's presence had to have some effect on everyone's behavior. Arna Bontemps, working on a Hughes biography up to the time of his death, felt that Mrs. Mason was the key to the entire squabble and that Zora thought Louise Thompson might pose a threat to her relations with Mrs. Mason. Apparently the play arrived in Cleveland by pure happenstance, without Hurston's approval, making Hughes's initial willingness to accuse her of wrongdoing a bit unfair. Moreover, there is little question that most of the material in the play came from Hurston, including the basic characters and situation, which were Eatonville material. Still, though Hughes admitted that it was more hers than his, this does not justify her claim to sole authorship. At one point Hughes asked, with some exasperation, why she had not asked him to bow out of their work sessions if she was so convinced that the play was hers. Zora's reply was to accuse him of stealing from her for his first novel, *Not Without Laughter.*

None of this fully explains the behavior of all involved, and the circumstances surrounding the play will always remain

a mystery. Hurston and Hughes were never entirely candid about their motives. One wonders if the dispute had something to do with Hurston's officially going off the payroll in March of 1931. Zora did ask Bontemps in 1939 to tell Langston that their quarrel was "the cross of her life," but the bitterness stayed with Hughes to the end. Although he tried hard to be fair to her in his autobiography, he could not easily forget the pain she had caused. Hurston never really forgave, either; when Hughes went to Cuba to regain his health and try to forget the whole episode, she remarked to Godmother: "I know Langston says he was going to Cuba, but I suspect that he is really gone to hunt up Eatonville to pretend that he knew about it all along."

The play is the thing, however, and "Mule Bone" is an interesting attempt to transcend black dramatic stereotypes. The play is set in Eatonville, the porch of Joe Clarke's store serving as the set for the first act, and the village lifestyle providing the key to the action. "Mule Bone" tries to convey the humanity of this experience from its comic side. It rejects the stock comic types of the minstrel tradition, replacing them with real human beings who get a good deal of fun out of life, but who unconsciously order their existence and give it special meaning with elaborate verbal rituals. The play's effect depends largely on the devices of verbal improvisation—sounding, rhyming, woofing—that are central to Afro-American folklore.

The major characters of the play are described by the authors as follows:

> Jim Weston: Guitarist, Methodist, slightly arrogant, aggressive, somewhat self important, ready with his tongue.
> Dave Carter: Dancer, Baptist, soft, happy-go-lucky character, slightly dumb. . . .

Daisy Taylor: Methodist, domestic servant, plump, dark and sexy, self-conscious of clothes and appeal, fickle.

Joe Clark: The Mayor, storekeeper and postmaster, arrogant, ignorant and powerful in a self-assertive way, large fat man; Methodist.[7]

The setting is the raised porch of Joe Clark's general store and the street in front. The porch is to stretch almost completely across the stage, with a plank bench at either end. At the center of the porch three steps lead up from the street. At the rear of the porch, in the center, is a door with Post Office painted to the left and General Store to the right. Soap-boxes and small kegs are on the porch for townspeople to lounge on during the action. To one side is a large kerosene street lamp.

The time of the play is Saturday afternoon. "The villagers are gathered around the store. Several men sitting on boxes at edge of porch chewing sugar cane, spitting tobacco juice, arguing, some whittling, others eating peanuts. During the act the women all dressed up in starched dresses parade in and out of the store. People buying groceries, children playing in the street, etc. General noise of conversation, laughter and children shouting."

The first scene begins with a number of village men on the porch chewing their sugar cane and aimlessly talking. One of the regulars soon arrives carrying a hock bone of "Brazzle's ole yaller mule," an animal that is an Eatonville legend: "so skinny you could do a week's washin' on his ribs for a washboard, and hang 'em up on his hip bones to dry," so mean that he died on his back with his feet straight in the air, "too contra'y to lay down on his side like a mule orter and die decent." The bone was found down by the lake, where the village had gone to give the mule a mock burial only a few months earlier; its discovery produces a number of stories that

illustrate the verbal talents of the porch sitters and the mulish
nature of the animal. When the mule is finally buried as a
conversation topic, Daisy Taylor enters the scene, much to the
delight of the middle-aged men on the porch. She has a "mean
walk on her," prompting one of them to say, "Yeah, man. She
handles a lot of traffic! Oh, mama, throw it in de river . . .
papa'll come git it." Joe Clark says that Daisy puts him in mind
of "I God, a great big mango . . . a sweet smell, you know,
with a strong flavor, but not something you could mash up like
a strawberry. Something with body in it." The stage directions
at this point are particularly interesting: the authors feel com-
pelled to warn that the scene must be played to avoid sexual
stereotypes. After Joe Clark's remarks there is to be "general
laughter, but not obscene," and the actors are directed to
comment admiringly but not lasciviously on Daisy's sexuality.

The play's two major conflicts are introduced, first, when
the men remark on how Jim Weston and Dave Carter seem
to be losing their friendship over Daisy, an unavoidable cir-
cumstance since "wimmen is something can't be divided
equal," and second, when the Methodists and Baptists on the
porch begin playfully to dispute each other. One Methodist
says, "Y'all Baptist carry dis close-communion business too
far. If a person ain't half-drownded in de lake and half et up
by alligators, y'all think he ain't baptized, so you can't take
communion wid him." In response, one of the Baptists tells a
story about a Methodist minister's son who, because he can
never get enough to eat, leaves home and goes to hell. He
returns on a wintry day after seven years, and his father is
overjoyed to have him back. The father invites him into the
house where eight fellow Methodist pastors are sitting around
the fireplace and eating. The minister asks his son how hell
was, and his son replies, "It's just like it is here . . . you cain't
git to de fire for de preachers."

The major conflict in act 1 is between Jim and Dave.

They enter as the best of friends, good-natured rivals for Daisy's affection. When one of the men on the porch suggests that Daisy may be after their money, Jim assures him that there will be no gold dug from him, since he "wouldn't give a poor consumpted cripple crab a crutch to cross the river Jordan." Dave agrees that this will not work with him either, for he "wouldn't give a dog a doughnut if he treed a terrapin." In their attempt to impress Daisy they sing for her:

> Got on the train
> Didn't have no fare,
> But I rode some,
> I rode some.
> Got on de train,
> Didn't have no fare,
> But I rode some,
> But I rode some,
> Got on de train,
> Didn't have no fare,
> Conductor asked me what I'm doing there
> But I rode some.
>
> Grabbed me by the neck,
> And led me to the door
> But I rode some,
> But I rode some.
> Grabbed me by the neck
> And led me to the door
> But I rode some,
> But I rode some.
> Grabbed me by the neck,
> And led me to the door,
> Rapped me cross the head with a Forty-Four,
> But I rode some!

The two men begin to argue over Daisy, and their rivalry
becomes intense. A child calls out, "Fight, fight, you're no kin.
Kill one'nother, won't be no sin." The argument comes to
blows, and in the course of the fight Jim reaches down, picks
up the mule bone, and knocks Dave out. This causes an up-
roar. Some of the townspeople exit to minister to the wounded
Dave; the others arrest Jim and escort him to Joe Clark's barn,
where he will be kept until trial on Monday. Daisy is left in
stage center at the curtain, asking petulantly, "Now, who's
gonna take me home?"

The setting for act 2 is the interior of the Macedonia
Baptist church, where the trial will take place. The scene
begins with the townspeople filing in to take their places on
either one side of the church or the other, Jim's Methodist
supporters on the right and Dave's Baptists on the left. The
two groups begin to trade insults as they wait for the mayor
and the principals to arrive. When these men do enter, it is
suggested that the trial begin with a hymn, and the two con-
gregations rise to sing simultaneously—the Baptists using
"Onward Christian Soldiers" to try to drown out the Method-
ists' "All Hail the Power of Jesus' Name."

The legal niceties of the trial center around whether or
not a crime was committed. Jim admits to hitting Dave but
denies that it is a criminal offense. The Methodist minister
argues persuasively on this point: "Naw, he ain't committed
no 'ssault. He jus' lammed Dave over de head, dat's all. *(Tri-
umphantly)* Yuh see y'all don't know whut yuh talkin 'bout.
Now I done set in de court house an' heard de white folks law
from mornin till night. . . . You got tuh have uh weepon to
commit uh 'ssault. An' tain't in no white folks' law and tain't
in dis Bible dat no mule bone is no weepon."

The Methodists are not to have the final word, for the
Baptist minister then quotes Judges 18:18 about Samson's
warfare. Since the jawbone killed three thousand, the hock
bone, coming from the dangerous part of the animal, must be

a lethal weapon; thus there was a crime. The Methodist minister still objects, but is squelched when Joe Clark tells him to be quiet: "You may be slick, but you kin stand another greasin'." Jim is banished from the town for two years as punishment. The mayor ends the trial, and the act, by announcing that those in the audience who are near blows must get off the church grounds before they start to fight, and they can't "use no knives, an' no guns, an' no mule bones. Court Dismissed."

The setting for act 3 is a high stretch of railroad track through a luxuriant Florida forest. It is near sundown. At the rise of the curtain

> there is no one on stage, but there is a tremendous noise and hubbub off-stage right. There are yells of derision and shouts of anger. Part of the mob is trying to keep Jim in town and part is driving him off. After a full minute of this, Jim enters with his guitar hanging around his neck and his coat over his shoulder. The sun is dropping low and red through the forest. He is looking back angrily and shouting at the mob. A missile is thrown after him. Jim drops his coat and guitar and picks up a piece of brick and makes threatening gestures of throwing it. He runs back the way he came, hurling the brick with all his might.

Jim's opening speech indicates how drastically the town's harmony has been disrupted: "I'm out o' yo' ole town. Now just let some of you ole half-pint Baptists let yo' wooden God an' cornstalk Jesus fool you into hittin' me. . . . I'm glad I'm out o yo ole town anyhow. I ain't never comin back no mo, neither. You ole ugly-rump niggers done ruint de town anyhow. Lawd, folks sho is deceitful. I never woulda thought people woulda acted like that."

Before long Daisy enters, claiming that she has been

worried about him. He does not believe her: "Ashes to ashes, dust to dust, show me a woman that a man can trust." She convinces him of her affection, however, and they have made up by the time Dave enters. The two men, sobered by the violence of their quarrel, become involved in a courting ritual designed to prove to Daisy who loves her most. Dave says to Daisy, "I love you harder than de thunder can bump a stump—if I don't—God's a gopher." Jim complains to Daisy, "You ain't never give me no chance to talk wid you right," and Daisy says, "Aw, you'all better stop dat. You know you don't mean it." Dave responds, "Who don't mean it. Lemme tell you somethin', mama, if you was mine, I wouldn't have you countin' no ties wid you pretty lil toes. Know whut I'd do. . . . I'd buy a whole passenger train and hire some mens to run it for you." Jim is not about to be outdone: "De wind may blow, de door may slam, Dat stuff you shooting ain't worth a dam. I'd buy you a great big ole ship—and then, baby, I'd buy you a ocean to sail yo ship on." Dave's reply is in kind: "A long train, a short caboose, Dat lie whut you shootin, ain't no use. . . . Miss Daisy, know what I'd do for you? . . . I'd come down de river ridin' a mud cat and leadin' a minnow." But Jim will not be topped: "Naw he ain't—he's just lyin'—he's a noble liar. Know whut I'd do if you was mine? . . . I'd make a panther wash you dishes and a gator chop yo wood for you." This verbal play goes on for some time. When Dave asks Jim how much time he would do for Daisy on the chain gang, Jim answers, "Twenty years and like it." Dave exults, "See dat, Daisy, Dat nigger ain't willin' to do no time for you. I'd beg de judge to gimme life."

Again, a significant stage direction interrupts the dialogue. By telling us that "both Jim and Dave laugh," Hurston and Hughes were trying to show the sense of verbal play and rhetorical improvisation characteristic of Eatonville generally, and Joe Clark's store-front porch specifically. To use a term from the professional folklorist, Hurston and Hughes were

attempting to dramatize the "oral-aural worldview" of a black community that contrasts with the typographic-chirographic structure of white middle-class thought. The contest is a ritual, designed to defuse the violence implicit in the conflict, to channel the aggression into mental rather than physical terms. The manner in which the courting contest ends suggests its ritualistic nature: Dave says to Daisy, "Don't you be skeered, baby. Papa kin take keer o you [*To* JIM: *suiting the action to the word*] Countin' from de finger back to de thumb. . . . Start anything, I got you some." Jim is taken aback: "Aw, I don't want no more fight wid you, Dave." Dave replies, "Who said anything about fighting? We just provin' who love Daisy de best."

The courting rapidly ends when the men discover that Daisy expects that whoever she chooses will work for her white folks—washing windows, sweeping the sidewalk, hoe-ing, raking, and gardening. Although she has tentatively cho-sen Jim, the prospect of such employment causes her charms to diminish in his eyes. Dave has a similar reaction. The two men are reconciled, and Daisy is left without either of her lovers.

Daisy tells them, "Both of you niggers can git yo' hat on yo' heads and git on down de road. Neither one of y'all don't have to have me. I got a good job and plenty men beggin' for yo' chance." Jim heaves a sigh of relief: "Dat's right, Daisy, you go git you one them mens whut don't mind smellin' mules—and beatin' de white folks to de barn every mornin'. I don't wanta be bothered wid nothin' but dis box." Dave supports his buddy: "An' I can't strain wid nothin' but my feets." The good friends return to Eatonville, daring any townsman to deny them access to their community.

Although much could be said about this play, the most perti-nent commentary has to do with authorial intention. Hughes claimed that they were trying to create "the first real Negro

folk comedy"; what he meant, I think, was that the play could be contrasted with the black low-life comedy familiar to American theatergoers as the minstrel show. The minstrel stereotypes of the lazy, sensual, ignorant, laughing darky had been challenged by revue performers of the twenties such as Bert Williams; they had triumphed in spite of the tradition, on the basis of sheer talent rather than their stage roles. Hughes and Hurston, however, attempted to create a play that would be a part of what Larry Neal has called "a truly original Black literature," an attempt to portray the black folk in such a way as "to establish some new categories of perception; new ways of seeing a culture which had been caricatured by the white minstrel tradition, made hokey and sentimental by the nineteenth century local colorists, debased by the dialect poets, and finally made a 'primitive' aphrodisiac by the new sexualism of the twenties."[8] "Mule Bone" did not quite achieve this new mode of perception, but one wonders if its authors' continued collaboration might not have produced a breakthrough. The play that was originally titled "The Bone of Contention" turned out to be truer to its title than to its purposes.

One example will suffice to show the subtlety of the authors' attempt. The courting ritual in the final scene is a traditional mode of verbal lovemaking among southern rural black folk, very possibly African in origin. Some of the first recorded rituals appeared in 1895 in the *Southern Workman*, Hampton Institute's monthly magazine, written by a man remembering the tradition-bearer role that an old slave named Uncle Gilbert contributed to the quarters. Young slaves would go to Uncle Gilbert to learn "courtship's words and ways." The old man believed that to "git a gal wuth havin" a man 'mus' know how to talk fur her." Such talking involved a combination of testing the girl's availability, her willingness to be courted, her skill in solving riddles, and the suitor's ability to display verbal improvisation. Certain formulas and

rhymes were set, others improvised at the moment. The slave's proof of his affection is similar to Dave's purchase of a passenger train or Jim's buying an ocean; yet the point is not the implausibility, but the imagination that thought of the example: "Kin' lady, ef I was to go up between de heavens and de' yearth an drop down a grain of wheat over ten acres of land an' plow it up wid a rooster fedder, would you marry me?" Courtship testimony from the folklorist in 1895—"Dear Miss, ef I was starvin' an' had jes one ginger cake, I would give you half, an' dat would be de bigges' half"—is similar to "Mule Bone" 's "If I was dead and any other woman came near my coffin de undertaker would have to do his job all over—'cause I'd git right up and walk off." A direct connection between act 3 of "Mule Bone" and traditional courting rituals is found in Dave's question to Daisy following one of his boasts: "Miss Daisy, ma'am, also ma'am, which would you ruther be—a lark a flyin' or a dove a-settin', ma'am, also ma'am?" In 1895 Portia Smiley reported the following as a part of courting rituals in Alabama: "Kin' lady, are yo' a standin' dove or a flyin lark? Would you decide to trot in double harness, and will you give de most excrutish pleasure of rollin' de wheels of de axil, accordin' to your understandin'?" In *Negro Folk Rhymes* (1922), Thomas W. Talley includes a similar exchange in the section on courtship rhymes:

(He) Is you a flyin' lark or a settin' dove?
(She) I'se a flyin' lark, my honey Love.
(He) Is you a bird o' one fedder, or a bird o' two?
(She) I'se a bird o' one fedder, w'en it comes to you.
(He) Den, Mam:
 I has desire, an' quick temptation,
 To jine my fence to yo plantation.[9]

Hurston had collected such rituals and had sent some examples to Hughes. They were both aware that the genre

was traditional, and they were consciously trying to represent for the stage the folkloric context. If successful, they would be able to undermine the minstrel image of the ignorant black man using long words he did not understand, the stereotyped conception of black verbal art. If done well, the verbal duel would prove the rhyming ability, the ingenious improvisation, and the general wit of black folk, who were anything but ignorant or inarticulate. A play like "Mule Bone" could challenge racist preconceptions by remaining true to the traditions of "lowly" black peasants; it could destroy stereotypes by entertaining a "cultured" audience with the functional comedy of the Eatonville community. The courtship rituals were behavioral manifestations of a unique aspect of Afro-American subculture, and "Mule Bone" could represent that behavior in a way never realized on the stage before. Contrary to Van Vechten's hope that "Mule Bone" might become another *Green Pastures,* the effect of the play was intended to be quite different. *Green Pastures,* a well-meaning play by a white author, was redeemed from comic stereotypes by black actors. As Du Bois pointed out, it was "de Lawd," Richard Harrison, who had "guided a genial comedy into a great and human drama."[10] "Mule Bone" was "Negro folk comedy" written by two black authors who designed the play around the traditional verbal behavior of black people. Its comedy came not so much from the authors' wit as from the skillful verbal communication of the folk. It never came to the stage because of the authors' quarreling over authorship. Yet in a sense it was written by neither Hurston nor Hughes. Much of the language in the play belonged to the race itself, making the argument over its ownership even more ironic.

The "Mule Bone" quarrel took place at the same time Hurston was working hard to prepare her field notes for public attention, and the play was influenced by an uncertainty about the best medium for popular consumption of Afro-American

folklore. The presentation model offered by Boas and Locke was the scientific article—a most unliterary genre—in which the scholar subordinated personality in order to report factually on phenomena observed. The audience addressed was narrow and extraordinarily fickle, with a minimal capacity for an immediate effect on popular attitudes. Fretting scrutiny would follow the announcement of her findings, and even scholarly acceptance would be no guarantee of validity; as Hurston had seen with scientists like Odum and Johnson, truth was a culturally determined commodity. The adaptation of folklore for the stage in "real Negro theatre" was a possibility she had been drawn to for years. Yet the form necessarily compromised the authenticity of the lore; a hunter's quarrel had to become a lover's triangle to heighten dramatic conflict. The personal essay, published in forums accessible to the general public, had much to recommend it, but most mass-circulation magazines were controlled by whites, and if black material was accepted at all, it had to deal with the "race problem."

Hurston knew that her collections were unique and that she could write well enough to publish her findings in whatever form she chose. She spent considerable effort searching for the most appropriate medium. Songs and dances lost all life when confined to the written page. The communal participation in a tale-telling session disappeared when the folklorist intruded on the event. Yet a collector was not faceless. How did she report dispassionately on what she called the "boiled down juice of human living"? How did she camouflage a belief that "the greatest cultural wealth of the continent" was being ignored, and that she was the person who could save it from obscurity? Hurston used many presentational media in the next few years; all her efforts were characterized by an evangelical zeal for the form and substance of black folk art. Her missionary spirit was submerged in her scholarly attempts, left implicit in her career as a producer of folk drama, and proudly proclaimed in popular essays and *Mules and Men*.

Hurston came to speak for the esthetic consciousness of the "Negro farthest down," and her message was broadcast in many creative forms. "Mule Bone" was only one attempt to find an individual art commensurate with the native esthetics of her people.[11]

Notes

1. This chapter is based primarily on a file of letters and documents found in HUAL, including a twelve-page explanation of the entire "Mule Bone" episode written by Hughes and sent to Spingarn on Jan. 21, 1931; a complete version and other partial versions of "Mule Bone" in HUAL; LH, *The Big Sea* (New York: Hill and Wang, 1963), pp. 311–34; and my interview with LTP, June 22, 1976, in New York City. In reconstructing the episode from these materials and other published and unpublished sources, I have noted only those documents not in HUAL, and I have quoted directly only from Hurston's letters. My account comes chiefly from the following in HUAL: ZNH to LH, Jan. 18, Jan. 20 (two telegrams), Feb. 14, Mar. 18, 1931; ZNH to Mrs. Mason, Jan. 20, Mar. 25, Apr. 18, Aug. 14, 1931, Mar. 27, 1932; ZNH to AS, Mar. 25, 1931; ZNH to AL, Oct. 29, 1934; LH to ZNH, Jan. 16, 22, 27 (two letters); LH to AS, Jan. 21, 24, 26, 27, 30, Feb. 3, Mar. 6, 15, Aug. 14, 1931; LH to AL, Jan. 28, 1931; AL telegram to LH, Jan. 29, 1931; AS to LH, Jan. 24, 27, 28, Feb. 5, Mar. 5, 1931; LTP to LH, Jan. 28, 1931; Rowena Jelliffe to AS, Jan. 30, 1931; return receipt, registered mail, for LH to ZNH, Jan. 18, 1931; copyright notification for "Mule Bone," received Jan. 22, 1931.

2. This letter is not complete. Apparently Hughes kept the last page of the letter for personal reasons. As it has survived, the letter breaks off at this point: "I didn't intend to be evasive. With anyone else but you I could have said a plenty. Would have done so long ago but I have been thinking of you as my best friend for so long, and as I am not in love with anyone, that [rest of letter missing]."

3. Arna Bontemps to LH, Nov. 24, 1939 (JWJYale).

4. RH interview with LTP, June 22, 1976, New York City; Bruce Kellner (CVV's biographer) to RH, Sept. 1, 1972, quoting a letter from CVV to LH.

5. ZNH to AS, Mar. 25, 1931 (HUAL).

6. ZNH to Harold Jackman, Dec. 15, 1933; CVV, manuscript notes, "Introduction to the James Weldon Johnson Memorial Collection," p. 224; ZNH to CVV, Jan. 22, 1934 (JWJYale).

7. "Mule Bone: A Comedy of Negro Life," by LH and ZNH, mimeographed (HUAL).

8. Larry Neal, "A Profile: Zora Neale Hurston," *Southern Exposure,* 1 (Winter, 1974), 162.

9. Portia Smiley, "Folklore and Ethnography," *Southern Workman,* 24 (1895), 15; Frank D. Banks and Portia Smiley, "Old Time Courtship Conversation," ibid., pp. 14–15, 78, reprinted in *Mother Wit from the Laughing Barrel,* ed. Alan Dundes (Englewood Cliffs, N.J.: Prentice-Hall, 1973), pp. 251–57 (Dundes's notes to this article are especially valuable); Thomas W. Talley, *Negro Folk Rhymes* (New York: Macmillan, 1922), p. 135.

10. W. E. B. Du Bois, "Besides the Still Waters," *Crisis,* 38 (May, 1931), 169.

11. ZNH, "Folklore," typescript, Florida Federal Writers' Project, ca. 1938 (FHSP); ZNH to Thomas E. Jones, Oct. 12, 1934 (Fisk); ZNH, *Dust Tracks on a Road* (Philadelphia: J. B. Lippincott, 1942), p. 185.

FROM *THE LIFE OF LANGSTON HUGHES,* VOLUME I, BY ARNOLD RAMPERSAD

Back in Westfield, New Jersey, Hughes now had company. After a stay of over two years in the South (and a visit to the Bahamas) from which she had returned with a bonanza of notes on folklore, Zora Neale Hurston had moved into a roominghouse not far from his home at 514 Downer Street. Like Hughes, Hurston was there on their patron Mrs. Mason's orders. The two writers also would share the secretarial services of Louise Thompson, hired the previous September by Mrs. Mason to assist Hughes. As Thompson later recalled, Godmother had primed her for Hurston's coming: "She used to talk about Zora, about this wonderful child of nature who was so unspoiled, and what a marvellous person she was. And Zora did not disappoint me. She was a grand storyteller." Hughes himself, having found Westfield more than a little dull, also welcomed Hurston's vital, attractive presence. While she entertained him and Louise Thompson with tales of her escapades in the Florida wilds, imitating and parodying her folk subjects with almost uncanny theatrical gifts, he languidly awaited the arrival of proofs of his novel, *Not Without Laughter,* and copies of his *Four Lincoln Poets.*

Although Hurston had reported religiously from the South to Mrs. Mason and to Alain Locke, Hughes had emerged as her most dependable ally, a calm, strong force

essential (so Hurston often protested) to her growth as an artist, especially in their proposed collaboration on a folk opera. "Langston, Langston," Zora had written from Eaton-ville, Florida, in March, 1928, "this is going to be big. . . . Remember I am new and we want to do this tremendous thing with all the fire that genius can bring. I need your hand." Wanting him closer, she urged Hughes to join her for a care-free ramble in the South, like their journey in the summer of 1927. She offered to share fifty-fifty with him, even forty-sixty, any profits that came from their collaboration, since he was "so much more practical than I." Although Hughes did not join her, Hurston kept up her adulation. "Without flattery . . . you are the brains of this argosy," she insisted, "all the ideas have come out of your head." Months later, she was still praising Hughes. "You are always helpful," she declared, "in fact you are the expedition." Excited over the prospect of an artists' colony in Eau Gallie, Florida, for Negroes ("NO niggers," she vowed), Hurston envisioned them living and working there in an ideal community shared by Wallace Thurman, Aaron Douglas, and other gifted members of the "Nig-gerati."

Much of this praise, in fact, was nothing more than flat-tery, one of the less attractive habits in Hurston's effulgent way of life. Sometimes out of necessity, perhaps more often out of her own deep-seated sense of vulnerability, Hurston tended to live by her wits—and successfully so. Once, she had moved into a Manhattan apartment "with no furniture at all and no money" (Hughes recalled with wonder), and "in a few days friends had given her everything, from decorative silver birds, perched atop the linen cabinet, down to a footstool." One day, on her way to the Manhattan subway, Hurston fished a nickel from a blind man's cup. "I need money worse than you today," she assured him. "Lend me this! Next time, I'll give it back." On the other hand, Hurston matched Hughes in his deep regard for black folk culture; also, she genuinely

liked him. In turn, he looked out for her interests with God-mother. When Mrs. Mason grumbled about Zora's letters, he urged Hurston to write more often and in a different tone, and tipped her off about the kind of gift sure to please God-mother—wood carvings, driftwood, orange blossoms, and melons, like his own inspired gift of corn and evergreen branch ends (or a book such as Martha Beckwith's *Black Road-ways: A Study of Jamaican Folk Life,* which Hughes offered to Godmother as "Studies from Obeah Land"). Going further, he once warned Hurston to be more discreet with Alain Locke, who sometimes betrayed her confidences to God-mother. Unlike Hughes, Locke put no one before his lucrative relationship with Mrs. Mason; finding out that Godmother disliked his friend Wally Thurman, Locke offered to arrange a sneak attack on him in a publication. "The trouble with Locke," Hurston judged, "is that he is intellectually dishonest. He is too eager to be with the winner." Hughes, on the other hand, could be trusted to do his best to keep her in God-mother's good graces.

In Westfield together, Hughes and Hurston built on the goodwill developed in their correspondence; they were also frequently in New York at Louise Thompson's apartment at 435 Convent Avenue. Then, almost certainly from Locke, Godmother heard that there was too much playing and too little work going on in Westfield. Her displeasure was electric, and everyone felt the shock. Instead of upbraiding Hurston, Mrs. Mason snubbed her. When Hughes tried to soothe God-mother with a telephone call, he was brushed off by someone at her Park Avenue home obviously acting under instructions. Mainly on Hurston's behalf, he quickly drafted a calming letter. When Godmother relented, he sent a longer letter of apology—for what, he wasn't sure. He had been "terribly worried because Zora and I both felt that you had been dis-pleased, or hurt in some way about her work." Zora was "miserable," but he had been wrong to telephone and disturb

192192192The *Mule Bone* Controversy

Godmother. "I do care for you," he wrote, "and when I hurt you through stupidity or error, I cannot bear it. . . . Whatever happened last week to make you unhappy must have been my fault—not Zora's. . . . But maybe I'm all wrong—all tangled up. You will forgive me if I do not understand. Perhaps it is all 'nerves' on my part. 'Emotional instability' or whatever they call it."

Although Godmother forgave him, Hughes understood that he was being watched. Mrs. Mason was angry that he had not plunged into work immediately after his return from Cuba, but the idea that she would tell him when and where to work chilled him. The novel was one thing; his writing in general was another. A short time later, he would write to Mrs. Mason about his instinctive reaction to her despotism. "So far in this world," he declared, "only my writing has been my own, to do when I wanted to do it, to finish only when I felt it was finished, to put it aside or discard it completely if I chose. . . . I have washed thousands of hotel dishes, cooked, scrubbed decks, worked 12 to 15 hours a day on a farm, swallowed my pride for the help of philanthropy and charity— but nobody ever said to me 'you must write now. You must finish that poem tomorrow. You must begin to create on the first of the month'." Godmother had gone too far.

For the moment, however, he kept his resentment to himself. Sometime in April, about a month after his return from Cuba, he began to work on a play with Hurston. Shelving their plans for a high-toned folk opera, in response to a casual complaint from Theresa Helburn of the Dramatists Guild that most scripts about black life were too grimly earnest, they decided to write a folk comedy. The basic plot came from a story, "The Bone of Contention," collected by Hurston, about two hunters who quarrel over the question of which one has shot a turkey. After one knocks out the other with the hockbone of a mule, he is tried on charges of assault and battery. Before an excitable crowd of black townsfolk, the

example of Samson and the jawbone of an ass is invoked grandiloquently against the wielder of the mule bone, who is convicted and banished from the town. Uncertain how God-mother would react to such a project, Hughes and Hurston worked for a while without her permission. Hughes was responsible for "the plot, construction, and guiding the dialog toward the necessary ˌsituations and climaxes," he would recall; Hurston provided "the little story," gave the dialogue its Southern flavor and many of the 'wisecracks'." She had contributed a very brief play to *Fire!!* but did not feel very comfortable writing for the theater; with only the unfinished singing play about Haiti to his credit, Hughes nevertheless was more confident about his ability as a dramatist. Nevertheless, Hurston's contribution was almost certainly the greater to a play set in an all-black town in the backwoods South (she drew here on her childhood memories), with an abundance of tall tales, wicked quips, and farcical styles of which she was absolute master and Langston not much more than a sometime student. With Hughes and Louise Thompson laughing helplessly, she acted out male and female roles in a variety of voices. Whatever dramatic distinction the play would have, Hurston certainly brought to it. But "Mule Bone," as it was called, was at least as much a collaboration as, for example, that between Wallace Thurman and William Jourdan Rapp, who had tailored Thurman's *Harlem* into a Broadway property.

With Thompson typing almost as quickly as they invented, Hughes and Hurston made excellent progress. Then Zora seemed to grow tired of the project, becoming "restless and moody, working in a nervous manner." But, Langston reasoned, she had always been restless and moody. Moreover, while he was relatively unencumbered, Zora had to return to her massive folklore project and endure constant scrutiny from Locke and Mrs. Mason. Still, Hughes was very surprised when, with "Mule Bone" near completion but still in need of

serious work, Hurston suddenly left New Jersey and moved to Manhattan. She was en route, she said, back to the South, but promised to work further on one act of "Mule Bone."

Hughes's disappointment at Hurston's departure from Westfield was completely overshadowed near the end of May, however, by the collapse of his friendship with Godmother. While the precise cause of the rupture would remain unclear even to Hughes, he took it to be a result of Godmother's displeasure over his unwillingness to return to work following his return from Cuba. Certainly the new quarrel involved a trip late in May to Washington, D.C.; when Godmother argued that he should stay home and write, Hughes rebelled against her authority and committed himself to go. This time, as if primed for destruction, the enraged Mrs. Mason went much further than she had gone before, much further than he ever imagined she would go in accusing him of ingratitude and disloyalty. "The way she talked to Langston," Louise Thompson would remember from Hughes's account later that day, "is the way a woman talks when she's keeping a pimp. 'I bought those clothes you are wearing! I took care of you! I gave you this! I gave you that!' " Godmother counted out precisely to Hughes his cost to her—$225 a month, of which $150 comprised his stipend and $75 half of Louise Thompson's time; in return, he was giving her—nothing!

Nine years later, in a reticent account of their relationship, in which Hughes never identified Mrs. Mason by name (she was still alive), he did not hide his extreme pain in their last meeting:

> I cannot write here about that last half-hour in the big bright drawing-room high above Park Avenue one morning, because when I think about it, even now, something happens in the pit of my stomach that makes me ill. That beautiful room, that had been so full of light and help and understanding for

me, suddenly became like a trap closing in, faster
and faster, the room darker and darker, until the
light went out with a sudden crash in the dark, and
everything became like that night in Kansas when
I had failed to see Jesus and had lied about it after-
wards. Or that morning in Mexico when I suddenly
hated my father.

Shattered by her words, his body betraying a neurotic
turmoil that made his muscles twitch involuntarily and his
fingers curl into bizarre shapes, he rode the train to Washing-
ton. Although he made his rounds in the city (in one place
going over a gift copy of Nicolás Guillén's newly arrived
pamphlet of poems, *Motivos de Son,* with a Cuban acquaint-
ance), Godmother dominated his mind. To Alain Locke,
Hughes poured out his hurt and confusion; listening carefully,
Locke softly tendered advice. Whatever he counselled, when
Langston finally wrote Godmother he begged her to release
him, "or rather to release yourself from the burdens of my
own lack of wisdom." Hughes flogged himself unsparingly.
"The fault is mine. The darkness is mine. The search is mine.
The Gods have given me the . . . light of your kindness and
I do not know how to follow." He offered to settle all financial
accounts ($200 in the bank, $37.94 elsewhere). Then they
could go back to the happier time when money did not come
between them: "The beauty of your gifts and the things of
your spirit are written in my heart—not in an account book."
"I should adore coming to see you when ever you will me to,"
he promised Godmother, "and I know you have loved the
better part of my self with the most beautiful love . . . a being
can know in this world."
 To facilitate his financial break with Mrs. Mason he
turned to Carl Van Vechten, who lent him $200, then noted
Hughes's visit on May 26 in his diary: "His patron has failed
him & he borrows some money." . . .

. . . A new wave of illness overtook Hughes—a chronic toothache, tonsilitis, an upset stomach. With Godmother back in Manhattan after the summer, he moved cautiously. He sent her all the reviews of his novel from English and American papers; without enthusiasm, she acknowledged his letter, but advised him only to have his tonsils removed. Leaving Hedgerow near the end of October, he returned to Westfield in time to speak at an inter-racial conference at the recently opened Riverside Church in Manhattan, which the theologian Reinhold Niebuhr also addressed. At last, after several attempts, Hughes succeeded in reaching Zora Hurston, but when he begged her to resume work on their play, "Mule Bone," she was evasive, hesitated before settling on a meeting, then failed to keep their appointments. Still Hughes did not connect Hurston's behavior to his falling out with Godmother; Zora was notorious for unpunctuality even in Harlem. In fact, Hurston was looking for a dramatic stroke to sunder their link and affirm her total loyalty to Godmother. She made this desire clear in a letter to Mrs. Mason on November 25 from Asbury Park: "You love me. You have proved it. It is up to *me* now to let you see what my behavior of love looks like. So watch your sun-burnt child do some scuffling. That is the thing that I have lacked—the urge to push hard and insist on a hearing." She would be in town soon to see what "a certain person has to say to me." Her "scuffling," indeed, had already begun. . . .

. . . At last accepting as a fact that Godmother would not see him, Hughes planned to leave Westfield and the New York area—and without telling Mrs. Mason. After attending the usual parties in Manhattan, including one at Knopf's, he welcomed 1931 in Cleveland, to which his mother had just moved. Langston planned to stay at her home at 4800 Carnegie Avenue for only three weeks or so, then head south to Florida, with his trip financed from a check expected from Godmother early in January. But on January 10 Mrs. Mason

informed him that no check would be sent—as "by mere accident it came to me that you had gone and where you were. Dear child, what am I to believe, what am I to think under these circumstances? Will the sap rise in the trees that the blossoms may come in the spring?"

Without money to visit Florida, Hughes settled in with his mother for a stay that would last three months. Cleveland was a changed city. Most astonishing of all was the spread of blacks in the decade since his graduation; from 22nd to 110th Street and beyond, mile after mile of once-white blocks now teemed with blacks. Central High School, where he had been one of a handful of colored students, was now more than fifty percent black. Returning in glory, he read his poems to the students and teachers; he also spoke to school officials in the wealthy district of Shaker Heights. Lecturing on modern writing, Hughes argued the superiority of new writers such as Hemingway, Sandburg, Millay, and Masters over virtually all the established names in American literature, excepting Whitman and Dickinson. He also visited his old friends Rowena and Russell Jelliffe, whose drama troupe, the Gilpin Players, had become probably the outstanding amateur black theatrical organization in the nation. Mrs. Jelliffe shared some good news with him. Always on the look-out for suitable new plays for blacks, she had just been offered a rich folk comedy, written by a young woman in New York, which the Gilpins would open on February 15. Within seconds, Langston recognized "Mule Bone," his collaboration with Zora Hurston. But his name was nowhere on the script sent by the reputable Samuel French play agency to the Gilpin Players.

On November 14 of the previous year, Hughes soon discovered, Hurston had delivered the play to Van Vechten for a reading. Admiring it, but without informing her, Van Vechten had sent "Mule Bone" to the Theatre Guild for consideration. An official of the Guild, Barrett Clark, certain

that the Guild would not use "Mule Bone," had passed it on
with high praise to the Gilpins in his capacity as an employee
of the Samuel French agency. But why was Hughes's name not
on the script? Only later would he discover that the previous
October, while he was at Hedgerow, Zora Hurston had copy-
righted "Mule Bone" exclusively in her name; she had then
sent it to Van Vechten without mentioning Hughes's name.
This was the start of the "scuffling" she had promised God-
mother, and the main reason she had evaded Hughes in the
fall.

Astonished, Hughes wrote Hurston at once for an expla-
nation. By Friday, January 16, when she had not replied, he
wrote Van Vechten for advice: "Would you do anything, or
nothing, in the present situation, if you were me?" He was
"amazed" by Zora; "is there something about the very word
theater that turns people into thieves?" Friendly with both
writers, Van Vechten advised only that Hughes had to do
something. Hughes began gathering material and evidence; he
also wrote Hurston threatening litigation.

On Saturday, January 17, Louise Thompson arrived in
Cleveland. She was not there to see Langston or the Jelliffes
but travelling as part of her job with the American Interracial
Seminar, a non-partisan, non-propagandist group founded the
previous fall with the goal of improving race relations. To the
Jelliffes, Thompson backed Hughes's assertion of joint author-
ship. Then, later that day, Langston finally talked on the tele-
phone to Hurston. Genuinely surprised to learn that the play
was in Cleveland, she was not enthusiastic about an amateur
production; on this point she had the support of Van Vechten,
Fania Marinoff, Lawrence Langner, and other knowledgeable
theater persons. As for the matter of authorship, it was too
complicated to discuss on the telephone. She would write a
letter to Hughes.

The next day, when Hurston went to see Van Vechten,
she "cried and carried on no end," he wrote Hughes; years

later he would remember her throwing herself to his library floor in an absolute "tantrum." But she moved more coolly on another front. Sending Hughes's complaining letters to Mrs. Mason, Hurston insisted that in "Mule Bone," "I am not using one single solitary bit in dialogue, plot nor situation from him and yet he tries to muscle in." On January 20, when Langston received her promised letter, Hurston denied his claim of co-authorship. But she also claimed grounds for grievance. Langston, she accused, had taken Louise Thompson's side against her in Westfield, bettering Louise's working hours and allowing her to be late for work; then, after Thompson had tried to cut in (so Hurston said) on future royalties of the play, he had proposed her as its business manager, when the play was produced. "By this time," Zora asserted, "I had come to feel that I hadn't much of a chance in that combination." She capped these charges with protestations of affection for him, but made it clear that her interest was not romantic. He could have anything he wanted. "Tears unceasing have poured down inside me," she wailed. But the play was her own: "I told Godmother that I had done my play all by myself, and so I did, and for the reasons stated above."

This was not Hurston's first expropriation of another person's material; in October, 1927, for example, she had published an essay that was, according to her biographer, "25 percent original research and the rest shameless plagiarism." But the theft of the play was probably secondary. Either mistaking or deliberately misrepresenting the relationship between Hughes and Thompson, she had characterized it as an affair to Godmother, who carefully noted Hurston's information that Langston and Louise often "went off to his rooms" while Zora toiled, then would return and say, "Let's see how much you got done then—that's fine *we're* getting along splendidly." Unquestionably, Hurston had wanted Thompson fired. Instead, Zora caused something she probably had not expected—that Mrs. Mason would summarily banish Lang-

ston. And, in banishing him, frighten Hurston into not only
shunning his company but also denying that they had ever
collaborated on "Mule Bone." Thus it became essential to
Hurston to discredit both Hughes and Louise Thompson, al-
though her main target was Thompson. "It is just as we
know," she wrote Godmother, "Langston is weak. Weak as
water. When he has a vile wretch to push him he gets vile.
When he is under noble influences like yours, you know how
fine he can be." Perhaps he should have another chance. "He
is ashamed of his attitude about the play and apologized to me
for it."

Although Hurston had acted like a lover spurned, there
is no evidence either that an intimate relationship ever existed
between herself and Hughes, or that Hurston even wanted
one. And, according to Louise Thompson later, if Hurston
spoke of an affair between Louise and Langston, "well, she's
just lying. She's just lying. Because there was never any rela-
tionship between Langston and me other than as a brother.
. . . If Langston had approached me in another way, I might
have been receptive, but he never did. I accepted Langston on
that plane, that we were the best of friends and comrades."
(After knowing him most of his life, she would judge Hughes
to have been "asexual"; as for suggestions that he was a homo-
sexual, "*that* I felt was not true. I never had in any sense any
intimation that he was that way.") Hurston's suspicion of
Thompson seems to have been based on little more than a
general sense of insecurity with a woman younger, prettier,
more poised, and, although in a more orthodox way, as intelli-
gent as Hurston herself.

Most interesting of all, in what was in effect an unusual
emotional quadrangle, was Godmother's violent reaction to
Zora's insinuations. Mrs. Mason behaved either like someone
impossibly moral—or like a wronged, revengeful lover.

On January 20, the Samuel French agency wired the
Jelliffes that Hurston had denied permission for their produc-

tion. Langston then drew up an eleven-page letter to his lawyer, Arthur Spingarn, offering a compromise. Two-thirds of the royalties would go to Hurston, one-third to Hughes. But Zora had suddenly changed her position. Wiring her approval to the Jelliffes, she followed with two more affirmative telegrams and promised to come to Cleveland at the end of the month. Weary but relieved, Hughes wrote Van Vechten that "the split is over."

Langston had other troubles. He spent the night of January 21 in jail. With two black friends, he had left a car on busy Cedar Avenue to make a phone call. When they returned, a taxi driver accused them of denting the back of his cab. After two squad cars arrived, the police threatened the three with beatings unless they confessed. A paddy wagon took them to the station, where the owner of the car was roughed up and struck with clubs. But none "confessed"; they hadn't touched the cab. In jail overnight in a bitterly cold cell, with only a board to sleep on and no blanket, Hughes understood at last what Bessie Smith really meant in moaning of "Thirty days in jail / With ma back turned to de wall." In the morning they were released after signing "suspicious person" slips.

An even greater disappointment came later in the day. Hoping to publish his third book of verse with Knopf, Hughes had sent Van Vechten a collection of his poems, "The Singing Dark." But Van Vechten not only disparaged the title (people would call it, or Hughes, "The Singing Darkey")—the volume would add nothing to Langston's reputation, since it contained no single poem as fine as "The Weary Blues" or "Mulatto." "I shouldn't wonder," Van Vechten said pointedly, "if you are pretty nearly through with poetry." Having sent the poems apologetically, knowing well that he had written nothing really significant since the appearance of *Fine Clothes to the Jew,* Hughes was hurt but not surprised by Van Vechten's judgment. Still, he revised the manuscript and sent it as "A House in the World" to Knopf, where it was quickly

rejected. An editor, Bernard Smith, was "rather disappointed." The nonracial lyrics were "neither distinguished nor important"; all the best poems were in the section devoted to racial protest, but these were not enough. After the high quality of *Not Without Laughter,* the book would be "an act of retrogression."

The solitary bright note of the winter was the news that he had indeed been given the award for which Locke had nominated him—a prize of $400 and a gold medal for distinguished achievement among blacks in literature by the Harmon Foundation, established in 1922 to promote black participation in the fine arts; Cullen had won it in 1927, McKay in 1929. The largest single sum of money Hughes had ever possessed outright, the prize smelled now of freedom. Also encouraging, if also retrospective, was a request from Effie Lee Power, a white Cleveland librarian and a national adviser on children's books, for a selection of his poems suitable for younger people, who almost always responded keenly to Hughes's work. He sent her a selection that would be published by Knopf the following year (with an introduction by Power) as *The Dream Keeper.*

With "A House in the World" refused, Hughes needed the Gilpin production of "Mule Bone" to boost his morale. Thus he was glad to know that Zora Hurston planned to arrive in Cleveland on February 1, his twenty-ninth birthday. By this time, however, unknown to Hughes, she had a powerful ally against him—Alain Locke, who had just quietly and maliciously killed Louise Thompson's chances for a job with the economist Dr. Abram Harris at Howard University by describing her as indigent (as he let Godmother know). Assuring Mrs. Mason that he would back Hurston to the hilt against Hughes, Locke sadly reported the news of the Harmon award—"the tragedy is the credit will go to swell the false egotism that at present denies its own best insight." This "false egotism" was Hughes's attempts to alter his relationship with

Godmother, which Locke saw as endangering all her godchildren, especially himself.

Late on February 1, Hurston and Hughes met and apparently resolved their differences. Hurston, however, had nonchalantly missed a meeting she had promised to attend earlier that day with the Gilpin Players; fed up with the controversy, the group voted to cancel the play. Hurston was deeply offended. Russell and Rowena Jelliffe then decided to make a last attempt to salvage the production. Because Hughes was bedridden with influenza and tonsilitis, a meeting with Hurston was set for the afternoon of February 3 at his mother's home. Discovering, however, that Louise Thompson had been in Cleveland, Zora arrived at Hughes's home in an evil mood. "She made such a scene as you can not possibly imagine," he wrote Van Vechten the next day; "she pushed her hat back, bucked her eyes, ground her teeth, and shook manuscripts in my face particularly the third act which she claims she wrote alone by herself while Miss Thompson and I were off doing Spanish together. (And the way she said *Spanish* meant something else)." When Mrs. Jelliffe intervened, Hurston denounced her as a trickster, then ridiculed her sixteen years of community work in Cleveland. Throughout this tirade, the stricken Hughes did little more than gasp weakly; but when Hurston made to storm from the house, Carrie Clark suddenly leaped into the fray with some blistering words of her own. "Carrie was absolutely magnificent," Mrs. Jelliffe would recall; "for once she stood up for Langston and helped him. She let Zora have it in no uncertain terms. We were all very proud of her." But Hurston had achieved her goal. At 6:30 that evening she sent a triumphant telegram to Park Avenue: "DARLING GODMOTHER ARRIVED SAFELY HAVE PUT THE PERSON ON THE RUN PLAY STOPPED LOUISE THOMPSON HAD BEEN SENT FOR TO BOLSTER CASE I SMASHED THEM ALL BE HOME BY WEEKEND ALL MY LOVE ZORA."

"Do you think she is crazy, Carl?" Hughes inquired the next day of Van Vechten.

Knowing now what he was up against, Hughes made a deathbed appeal to Godmother. His appeal was denied. "What a sorrowful misguided way to have come!" Mrs. Mason mourned on February 12. "Has not the year spent tarnishing your wings proved that 'keeping accounts' had nothing to do with your failure to do creative writing? . . . Child, why build a labyrinth about yourself that causes you to wander in a miasma of untruth?"

Knocked into a relapse by her accusation of dishonesty, Hughes felt his whole body poisoned. He blamed his tonsils, but an astute doctor recommended the sun. After a week or so, Langston wrote a very brief note to "Dear Godmother": "When the sun shines again I will write you a long letter. Now, my thanks, and my love to you, as always."

Although he would never write this "long letter," Hughes could not say goodbye. When the Harmon medals came (there were actually two) he sent them like a child to her for her admiration. But she was like stone. "Langston," Mrs. Mason admonished him, alluding to the old woman of his novel, "do hurry to recognize the travail of Aunt Hagar to bring you face to face with yourself."

At 399 Park Avenue, Locke and Hurston hammered his coffin shut. When Hughes wired his favorite Harlem photographer, James L. Allen, for a set of portraits, Locke reported to Mrs. Mason that he evidently was preparing "a signed author's portrait racket." Hughes wrote a friend in Florida about a possible visit; Locke saw "a mad careening before a big fall." As for Langston's hopes to go to the Caribbean, "isn't that shameful—or rather shameless," Locke asked. "Well—he'll have a long rope—but eventually it will pull taut." To the Labarees at Lincoln, who heard of Hughes's illness, Locke intimated that he was having a nervous breakdown. To someone Langston challenged about the unautho-

rized use of his work, Locke apologized for Hughes's "real mean-ness." Against Van Vechten, who still befriended both Hurston and Hughes, Locke cried out to Mrs. Mason: "Why can't he die! Nothing seems to kill him." Not to be outdone, Hurston elbowed Locke out of the way to kneel behind Godmother. "Dear Godmother, the guard-mother who sits in the Twelfth Heaven and shapes the destiny of the primitives," one March letter began. And later: "Knowing you is like Sir Percival's glimpse of the holy grail. Next to Mahatma Gandhi, you are the most spiritual person on earth." Hurston stuck by her charges of Langston's corruption. "I can't conceive of such lying and falsehood," she sighed; "but then there are many things in earth and sky that I don't know about." A year later, more amusingly: "Honest Godmother it requires all my self-restraint to keep from tearing the gin-hound to pieces. If I followed my emotions I'd take a weapon and go around the ham-bone looking for meat." And to Arthur Spingarn, Langston's lawyer, Zora suggested that he should write a play for his client, if Hughes wanted one so badly. "Or perhaps a nice box of apples and a well chosen corner. But never no play of mine."

By this time, Hurston perhaps had internalized the conviction that Hughes had had no part in the play; how she was able to do so is a mystery, perhaps a part of her imaginative genius itself. Whether she ever regretted her deception is unclear. Eight years later, Arna Bontemps would report to Hughes that she was "a changed woman, still her old humorous self, but more level and poised. She told me that the cross of her life is the fact that there has been a gulf between you and her. She said she wakes up at night crying about it even yet." Certainly Hurston had matured as a writer; in the intervening years she would publish two novels, including her masterpiece, *Their Eyes Were Watching God,* about a black woman's experience first of a near-perfect love, then of the more profound satisfaction of a noble, feminist self-reliance.

Hurston's desire for a reconciliation with Hughes was probably wrecked by his droll, teasing treatment in *The Big Sea* of her quixotic behavior during the controversy; two years later, when Hurston published her own autobiography, *Dust Tracks on a Road,* she left out Hughes altogether. After "Mule Bone," the two writers apparently met only once. But, incredibly, when Hurston needed help during the most humiliating episode of her life, in which she faced prosecution on a sordid (but unfounded) morals charge, she would turn for a testament to her good character to—Langston Hughes.

Her self-deception, in any case, was in its way not much more bizarre than Hughes's pathetic enslavement by Mrs. Mason, which Louise Thompson, for one, could never understand. "He got sick," she would remember. "When I got over it, I got mad!" Mrs. Mason was "an old witch" whose behavior made Thompson "hate the power of money," the idea "that someone because they have money can do to you as they wish and talk to you as they want to. How *dare* they!" The reason for the difference between Langston's reaction to Mrs. Mason and her own, she guessed, was her mother's unceasing love of her and Langston's mother's neglect of him as a child. "Now I am ready to die," "Mother" Thompson had said when Louise graduated from college. "I can't imagine Carrie saying anything like that about Langston," Thompson judged flatly. The episode was as decisive as any other in urging her into an association for life with communism, just as it would drive Hughes almost as far to the left for many years, and in other ways affect the entire course of the rest of his life.

Nor was Hurston's self-deception less excusable than Mrs. Mason's abuse of her wealth, race, age, and intelligence in so torturing the lives of her blacks. In her case, the mitigating factors were that she exhibited a mental power so volatile, and cherished notions about Africa so novel for her class and race, that her inability to control herself was perhaps finally excusable. Only Locke's behavior was almost entirely repre-

hensible. For all his great learning he was a slippery character, too fond of intrigue and of the pleasures that Mrs. Mason's money assured. The tawdry "Mule Bone" affair rang down the curtain on one long era of Hughes's life. And in pitting black brother against sister, artist against artist, it marked just as conveniently the end of a cultural age. The highly sensitive Locke unconsciously caught a sense of this death of golden innocence in one of his reports to Godmother. "I hear almost no news now from New York," he confessed to her near the end of March; "a younger crowd of 'Newer Negroes' are dancing in the candle flame. The older ones are nursing their singed wings."

Notes

page 189 "She used to talk about Zora": Louise Thompson Patterson to author, interview, May 23, 1984.

pg 190 "Langston, Langston . . . this is going to be big": Zora Neale Hurston to LH, Mar. 8, 1928, LHP.

"so much more practical": Zora Neale Hurston to LH, May 1, 1928, LHP.

"Without flattery . . . you are the brains": Zora Neale Hurston to LH, July 10, 1928, LHP.

"You are always helpful": Zora Neale Hurston to LH, Apr. 30, 1929, LHP.

"NO niggers," she vowed: Zora Neale Hurston to LH, May 31, 1929, LHP.

"with no furniture at all": LH, *The Big Sea,* p. 239.

"I need money worse than you": LH, *The Big Sea,* p. 240.

page 191 "Studies from Obeah Land": In presentation copy, Aug. 12, 1929; courtesy of Thomas H. Wirth.

"The trouble with Locke": Zora Neale Hurston to LH, n.d., LHP.

"terribly worried because Zora and I": LH to Mrs. R. O. Mason, draft, n.d., LHP.

page 192 "So far in this world": LH to Mrs. R. O. Mason, draft, June 6 [1930], LHP.

page 193 "the plot, construction, and guiding the dialog": LH to Carl Van Vechten, Jan. 16, 1931, CVVP, Yale.

"restless and moody, working": LH, *The Big Sea,* p. 320.

page 194 "The way she talked to Langston": Louise Thompson Patterson to author, interview.

"I cannot write here": LH, *The Big Sea,* p. 325.

page 195 "or rather to release yourself": LH to Mrs. R. O. Mason, draft, n.d., LHP.

"His patron has failed him": Carl Van Vechten, Diary (May 26, 1930), CVVP, NYPL.

page 196 "You love me. You have proved": Zora Neale Hurston to Mrs. R. O. Mason, Nov. 25, 1930, ALLP, MSRC.

page 197 "by mere accident it came to me": Mrs. R. O. Mason to LH, Jan. 10, 1931, LHP.

page 198 "Would you do anything": LH to Carl Van Vechten, Jan. 16, 1931, CVVP, Yale.

"cried and carried on": Carl Van Vechten to LH, Jan. 20, 1931, LHP.

page 199 in an absolute "tantrum": Carl Van Vechten to LH, Aug. 17, 1942, LHP.

"I am not using one single solitary": Zora Neale Hurston to Mrs. R. O. Mason, Jan. 20, 1931, ALLP, MSRC.

"By this time . . . I had come to feel": Zora Neale Hurston to LH, n.d., LHP.

"25 percent original research": Robert E. Hemenway, *Zora Neale Hurston: A Literary Biography* (Urbana, Ill.: Univ. of Illinois, 1977), p. 96.

"went off to his rooms": Entry, Jan. 22, 1931, in Mrs. Mason's notebook, "1928 [*sic*] Data as we close 399 [Park Avenue]"; ALLP, MSRC.

page 200 "It is just as we know": Zora Neale Hurston to Mrs. R. O. Mason, Jan. 20, 1931, ALLP, MSRC.

"well, she's just lying": Louise Thompson Patterson to author, interview.

page 201 "the split is over": LH to Carl Van Vechten, Jan. 22, 1931, CVVP, Yale.

"Thirty days in jail": *Ibid.*

"I shouldn't wonder if you are": Carl Van Vechten to LH, Jan. 19, 1931, LHP.

page 202 An editor . . . was "rather disappointed": Alfred A. Knopf Inc. (Bernard Smith) to LH, Mar. 2, 1931, LHP.

"The tragedy is the credit will go": Alain Locke to Mrs. R. O. Mason, Jan. 29, 1931, ALLP, MSRC.

page 203 "She made such a scene": LH to Carl Van Vechten, Feb. 4, 1931, CVVP, Yale.

"Carrie was absolutely magnificent": Rowena Woodham Jelliffe to author, interview, Dec. 7, 1980.

"DARLING GODMOTHER ARRIVED SAFELY": Zora Neale Hurston to Mrs. R. O. Mason, Feb. 3, 1931, ALLP, MSRC.

page 204 "Do you think she is crazy": LH to Carl Van Vechten, Feb. 4, 1931, CVVP, Yale.

"What a sorrowful misguided way": Mrs. R. O. Mason to LH, Feb. 12, 1931, LHP.

"When the sun shines again": LH to Mrs. R. O. Mason, draft, Feb. 22, 1931, LHP.

"Langston . . . do hurry to recognize": Mrs. R. O. Mason to LH, Mar. 1, 1931, LHP.

"a signed author's portrait racket": Alain Locke to Mrs. R. O. Mason, Mar. 5, 1931, ALLP, MSRC.

"a mad careening": *Ibid.*

"isn't that shameful": Alain Locke to Mrs. R. O. Mason, Mar. 20, 1931, ALLP, MSRC.

page 205 Hughes's "real mean-ness": Alain Locke to Mrs. R. O. Mason, Apr. 16, 1931, ALLP, MSRC.

"Why can't he die!": Alain Locke to Mrs. R. O. Mason, Mar. 29, 1931, ALLP, MSRC.

"Dear Godmother, the guard-mother": Zora Neale Hurston to Mrs. R. O. Mason, Mar. 10, 1931, ALLP, MSRC.

"Knowing you is like Sir Percival's glimpse": Zora Neale Hurston to Mrs. R. O. Mason, Sept. 28, 1932, ALLP, MSRC.

"I can't conceive of such lying": Zora Neale Hurston to Mrs. R. O. Mason, Mar. 25, 1931, ALLP, MSRC.

"Honest Godmother it requires all my self-restraint": Zora Neale Hurston to Mrs. R. O. Mason, May 17, 1932, ALLP, MSRC.

"Or perhaps a nice box of apples": Zora Neale Hurston to Arthur B. Spingarn, Mar. 27, 1931, ABSP, MSRC.

she was "a changed woman": Arna Bontemps to LH, Nov. 24, 1939, LHP. In Charles H. Nichols, ed., *Arna Bontemps-Langston Hughes Letters: 1925–1967* (New York: Dodd, Mead, 1980), p. 44

page 206 "He got sick": Louise Thompson Patterson to author, interview.

page 207 "I hear almost no news": Alain Locke to Mrs. R. O. Mason, Mar. 29, 1931, ALLP, MSRC.

THE CORRESPONDENCE

HUGHES TO HURSTON January 16, 1931
[incomplete]

I'd also immensely like to know your attitude about our collaboration on the play. You were so strange and evasive the last time I saw you that I didn't know what you were about.
 Would you mind explaining it all to me?

Sincerely,
LH

43 W. 66th St.
 New York City
 January 18, 1931

DEAR LANGSTON,

I had written you a letter last week, but I have moved and in
my distraction I put it in the desk drawer and found it again
yesterday.

Now Langston, let us have a heart to heart chat about this
play business. Please believe that what I am saying is abso-
lutely sincere. I mean every word, so that you can bank upon
it.

In the beginning, Langston, I was very eager to do the
play with you. ANYthing you said would go over big with me.
But scarcely had we gotten under way before you made three
propositions that shook me to the foundation of myself. First:
That three-way split with Louise. Now Langston, nobody has
in the history of the world given a typist an interest in a work
for typing it. Nobody would think of it unless they were
prejudiced in favor of the typist. Not that I care what you give
of yourself and your things. As Kossula says, dat don't reaches
me. But I do object to having my work hi-jacked. There is no
other word for it. I don't see how, even if in your magnificent
gallantry you had offered it, she could have accepted it. But
next day she voiced the matter herself when the subject of her
pay came up. I offered to pay her five dollars a day and she
said to you, trying to look hurt, "Pay me, Langston! No, I
don't want a thing now, but when it goes over, then you all
can take care of me then." So then I saw that the thin[g] had
been agreed upon between you. First I was astounded that
such a suggestion should have come from you, and next I was
just plain hurt.

Then your argument that if we paid her money, that it
ought to be something fancy. I still don't follow your reason-

ing. First you give <u>me</u> no credit for intelligence at all. Knowing the current prices for typists, you must despise my mental processes to have broached the subject at all. You know what you said, so I don't need to go into that.

Then when these had failed you come forward with the Louise-for-business-manager plan. That struck me as merely funny. With all the experienced and capable agents on Broadway, <u>I</u> should put my business in the hands of some one who knows less about the subject than I.

From all these things I could not but get the idea that your efforts were bent on turning everything into a benefit for somebody else. I say again, I have nothing to do with what you do with your own things, but I choose to bestow mine where I will. Therefore, I felt that I was among strangers, and the only thing to do was to go on away from there.

Now about the play itself. It was my story from beginning to end. It is my dialogue; my situations. But I am not concerned about that. Langston, with God as my judge, I don't care anything about the money it might make nor the glory. I'd be willing to give it all to you off-hand. But the idea of <u>you</u>, LANGSTON HUGHES, trying to use the tremendous influence that you knew you had with me that some one else might exploit me cut me to the quick. I am only human, you know. I'll be willing to bet that if you told Mrs. Mason what you did exactly, she would agree with me.

I told Godmother that I had done my play all by myself, and so I did, and for the reasons stated before. Perhaps you know that a firm is bound by the contracts of any of its members. Therefore, with what had been proposed in mind, I realized that I could expect you to be promising many things that wouldn't do me a bit of good. That and that only is my reason for going it alone. I haven't gone happily. Just felt obliged to. I didn't intend to be evasive. With anyone else but you I could have said a plenty. Would have done so long ago but I have been thinking of you as my best friend for so long,

and as I am not in love with anyone, that naturally made you the nearest person to me on earth, and the things I had in mind seemed too awful to say to you, I just couldn't say them. I tried for a long time to bring the subject up with you, but I just couldn't. I just kept trying to make a joke of it to myself, but somehow the sentences in my mind wouldn't laugh themselves off. So now, it is all said.

I am sorry that you are having intestine trouble. That is what has harrassed [*sic*] me for a long time. I am glad that you are home with your mother so that you can get your stomach right. I have discovered that New York and ambition and the nervous condition that accompanies it are hard on stomachs.

Now, Langston, I have not wanted to grab things for myself. I don't want to thrust you forth or anything like that. It was just self-preservation. Suppose I had proposed such an arrangement with say, Harry Block as the beneficiary. No matter who it was, you would have acted to save yourself.

I didnt quite understand the wire from the Gilpin Players. I know no Mr. French and so I wondered what the reference meant. I don't know what you meant by it either. I should like to see the play worked out so that the things that read well but don't act well can be eliminated. I'd like to be there to offer explanations as to folk habits, etc. But I don't know how it could be arranged just now. At any rate I wonder if the producing of it would do much good. I wish to think it over. Let me hear from you about it.

With all good wishes, I am sincerely yours,

ZORA

P.S. First act recently rewritten. Synopsis of "Papa Passes" done for the first time.

You say over the phone 'my version of the play'. Are not both copies my version? I don't think that you can point out any

situations or dialogue that are yours. You made some suggestions, but they are not incorporated in the play.

HUGHES TO HURSTON 4800 Carnegie Ave.,
 Cleveland, Ohio.
 January 19, 1931.

DEAR ZORA,

I'm sorry the Guild turned down Mule-Bone—but I'm also sorry it won't to them in such a shape, and in such a way. . . . This is the Cleveland situation: The Gilpin Players here are probably the best Little Theatre Negro group in the country, and for ten years have been producing plays successfully. Each year they do a downtown season. In the past they have used such plays as Roseanne, In Abraham's Bosom, etc. They do try-out plays for New York producers also, and have been offered try-outs of plays the Guild was considering. New York scouts and agents attend their openings. This year they are to open downtown at the Theatre of Nations under the auspices of The Cleveland Plain Dealer, leading white paper out here, which would mean a great deal of assured publicity right there. Then later they will move to the Ohio, one of the leading legitimate downtown theatres here. All of which means an assured two-weeks run. This would in no way hurt a New York production. In fact, it would help it, because if the play is well-received out here, New York managers will be sure to bid for it—and I think that is our best bet, now that the Guild is out of the running. I hope you will agree for it to be done here, as I think it will mean much to us both. . . . I was in touch by phone today, through Mrs. Jelliffe, manager of the Gilpin Players, with Barrett Clark, the reader who handled your play. He thinks it will be swell when whipped into shape. Mrs. Jelliffe explained the entire situation

to him, and he also promised to get in direct touch with you
about it. I have also written two letters to Carl, since the play
seems to have reached the agent and eventually Cleveland
through him. . . . Since the Gilpin Players must open on the
15th of February, some work from you by wire at once would
be appreciated. I haven't your letter yet. . . . As you know, the
comedy reached here entirely without my knowledge, but
since it did get here, and since the Players are anxious to do
it, I would be interested in seeing it go through. They would
be glad to have you come out for rehearsals and the opening
if you cared to do so. . . . In any case, I do not think it would
be a bad beginning for our first play, and for the first Negro
folk-comedy ever written. . . . Let's not be niggers about the
thing, and fall out before we've even gotten started. Please
wire me.

Sincerely,
L.H.

VAN VECHTEN TO HUGHES 150 West Fifty-fifth Street
New York City
[January 19, 1931]

DEAR LANGSTON,

I read <u>The Singing Dark</u> some days ago, but have not had time
to write you about it. It may not subtract anything from your
reputation, but it certainly will not add to it. It contains no
outstanding poem like The Weary Blues or Mulatto. On the
other hand it contains a great many poems based on ideas that
have been better expressed by others. I shouldn't wonder if
you are pretty nearly through with poetry. However, I found
many of the poems admirable and some of them of almost a
mystic originality—almost all of those in the section entitled

Passing Love. And I think the book would gain in force and charm if it were reduced in volume. My choice for rejection (on the grounds of banality, etc.) would be the following: Walls, Old Lincoln Theatre, Barrel House (which I remember I never liked), Bodies, To a New Dancer (If you disagree about his one, Look up Karsavina: I do not think she is dead), African Dancer in Paris, For a Woman with Cancer, Burial, To Certain Intellectuals, Brothers, Terminal, Search. Indeed, I find the entire last section (The Singing Dark) weak. Of course, everybody will call the book The Singing Darkey! What shall I do with the ms.?

Zora's performance is not very pretty, but I am not surprised. I have seen some other strange behavior there. I do not know what you can do. Even if she has entirely rewritten the play in a version of her own, she had no moral right to do so without getting your permission. However, perhaps you had better <u>try</u> to do something. I think the play is fresh and amusing and authentic and <u>if properly produced</u> will be a success. Several members of the Guild liked it enormously. So, perhaps you had better put yourself on record by telling a few people what you have just told me so that if the play makes money you can claim part of it. After all, you have standing as a writer and Zora has not and people will believe you. If the Gilpin Players are going to do it, you might threaten suit unless your rights as co-author are recognized and unless you are financially reimbursed. This is not advice. This is all suggestion. If you have a lawyer friend, you might talk it over with him. Perhaps Chestnutt might be useful right here. I think also the stenographer might be a good witness.

George Schuyler's <u>Black No More</u> is in the house, but I haven't read it. I shall certainly read <u>God Sends Sunday,</u> as soon as possible.

If you want <u>Mule Bone</u> to succeed: i.e. if you establish your rights, it is my idea that it should be done with a certain stylized exaggeration in costume and gesture (violent colors,

with sunflower and watermelon backgrounds, like a Currier and Ives print) and with lots of music. This should be suggested rather than sung. What I mean is a couple o' bars here, a couple there, with some banjo strummings and a mouthorgan or two.

With Nora Holt and Donald I attended a superb drag in Harlem the other night, and then we went <u>everywhere</u>. Harlem is better than ever and wilder, and more English, and more everything, I guess. I love it! . . . I went to a party at Cora La Redd's that is probably the best party I ever went to. It was given for Harold Jackman (whom she had met the night before). So I gave a party for Harold myself, and had Billie Cain and Alma Smith and Al Moore and a few Ofays and this was rather good too . . . Eddie Wassermann went to Cuba and wanted some addresses, but this was before I heard from you and I didn't know where to reach you.

With 17 royal purple dachshunds (housebroken) with polished silver legs!

CARLO

<u>over</u>
<u>over</u>

!!!

[*handwritten on the back of the letter:*]

I have just dug out the letter Zora wrote me when she sent me the play on November 14. In it she says: "Langston and I started out together on the idea of the story I used to tell you about Eatonville, but being so much apart from rush of business I started all over again while in Mobile and this is the result of my work alone." Of course she should have written you to this effect.

DEAR CARLO,

Forgive me for worrying you to death—but once more the
Mule-Bone. Last night I talked to Zora by phone. She said she
knew nothing about French handling her play, or how it got
to Cleveland. I told her how it got here, and that it came in
a terribly tangled up version with two first-act endings, and
two different third acts—one our collaborated version we did
together, another evidently her new version—seemingly leav-
ing it up to the producer to decide which endings and which
acts he wanted. I told her the director here, Mrs. Jelliffe,
couldn't make head or tail of it as sent from French but, liking
the version I have here (the one we did together) she wishing
to put it on, and would Zora be willing that she do it, using
the script we had originally planned? Zora would not answer
yes or *no,* but kept stalling over the phone and asking what
good it would do her to produce it in Cleveland. Then I asked
Zora was she attempting to sell the play alone under her
name? She replied that at first she hadn't intended to, "but,
well—I'm writing you a letter." What she'll say in that letter,
I don't know. . . . Anyway, this morning Mrs. Jelliffe phoned
Barrett Clark, representative for French and also, I under-
stand, reader for the Guild. She explained the whole matter
to him, asking at the same time what he could do so that she
could go ahead with her production, as time is getting very
short. Barrett Clark said that he had gotten the manuscript
through your having first sent it in to the Guild and, feeling
that the Guild would refuse it, he had, some weeks ago offered
it to the Gilpin Players here; that he didn't know Zora Hur-
ston but that he would get in touch with her at once and see
if he could persuade her to allow the Cleveland production to

go through, and under our joint names, (since he had not been aware before that I had any thing to do with the play.) He is to wire Mrs. Jelliffe after he has talked with Zora. . . . Now, Carlo, the situation regarding the production here is this: The Gilpin Players, probably the best Little Theatre Negro group in the country, must open downtown with this play on February 15th, so you see how pushed for time they are. The play came to them through French quite without my knowledge, and bearing only Zora's name, but in such a confused form that I don't see how the Guild or anybody else read it. The Jelliffes are friends of mine and swell people, and realizing the predicament they are in for time, (and also being interested myself in seeing a trial production of the comedy) I am willing to overlook Zora's seeming attempt to get rid of the play without my knowledge, and to do my best to patch up the script using the two acts that I have, and the script of the second act from French which I had worked on with Zora before she went South, and thus enable the Gilpins to put it on out here and to begin rehearsals at once, doing the play under Zora and my names, as she and I had originally intended. This is what I tried to make Zora see over the phone last night but New York to Cleveland calls are expensive and I couldn't talk all night. The Gilpins plan a two-week season for this play, opening under the auspices of the <u>Cleveland Plain Dealer</u>'s Theatre of Nations downtown (which means a great deal of publicity through the <u>Plain Dealer</u>) and later moving to the <u>Ohio</u> one of the big legitimate downtown houses here, as they have done in past seasons with <u>Roseanne</u>, <u>In Abraham's Bosom</u>, and other plays, and with great success. This is their first Negro comedy downtown, and they feel that it would go over big, which would be fine for both Zora and I from the standpoint of both publicity and royalties. The Gilpin Players are in a sense a semi-professional group and have been offered try-outs by the Guild and other New York managers before, and a production here would mean that

representatives of the New York people would see it—which
is important to us too, since the Guild has turned it down,
from all I can discover. . . . So Carlo, would you, please, get
in touch with Zora and try to make her see all this. I am not
at all angry about her actions, because she always has been
strange in lots of ways, but I do hate to see a good Folk-play
go to waste, because for some reason I do not know, she no
longer wants to work with me. Tell her the Gilpins would be
happy to have her come out for rehearsals and the opening,
if she wants to. . . . This morning I got some legal advice on
the matter and with all the proof I have: a file of notes in my
own handwriting, pages of construction and situations, car-
bons of the first draft, and the testimony of the stenographer
who worked with us for three or four weeks, Zora can cer-
tainly do nothing at all with <u>Mule-Bone</u> without my permis-
sion. Why she should have set out to do so is beyond me.
. . . Of course, I know that you knew nothing of all this until
I wrote you, and I hope it won't be putting you to a great deal
of trouble, but would you do what you can to get it untangled,
and explain to Lawrence Langner or some of the Guild people
how sorry I am that such an unfinished version ever reached
them. . . . Since time is so pressing for the Gilpins, if you could
send me a night letter or something about Zora's attitude, I'd
appreciate it immensely. . . . Snowballs . . .

HUGHES TO HURSTON 4800 Carnegie Ave.,
 Cleveland, Ohio,
 January 20, 1931.

DEAR ZORA,

You know very well why paying Louise later was suggested
when we first began working on the play. You also know why
that suggestion lost its meaning and no longer held after we

disclosed the fact that we were doing the play. You know that Louise has been paid for her work and that she has, of course, no other interest in the play. You know also that after we disclosed our working together on the comedy, the idea that Louise was to have anything to do with the handling of it was also cancelled, and I myself made a personal appointment with Theresa Helburn of the Theatre Guild last June about the play, and that I said whenever it was ready I would take it to the Guild myself, and that if they turned it down then we would get a reputable Broadway agent. So don't be absurd about Louise—because you know better than that. . . . Certainly you know, at least, that never in any way did I attempt to deceive you, and that every idea that came to mind was disscussed with you, and Louise as well, since all three of us were engaged in working at the same place and time. So I didn't expect you to do the silent and uncalled-for thing that you did. However, I am quite willing to go back to our original bassis of collaboration, to do what I can to get the play in shape for presentation out here, and to work with you at any time or anywhere in the future that will be to the benifit of the play Mule-Bone. I think it would be a great shame for the first Negro comedy to go to pieces on account of selfish or foolish disagreement among us. If you want the larger share of the royalties which the play may earn, we can make a legal aggreement defining our shares, and you can take the biggest, (if that's your main trouble.) In any case, if you make any further attempts to dispose of any script based upon the play which we did together and now called Mule-Bone, it will be a matter for my lawyers and The Authors' Guild, to both of whom I have written full details. . . . I have also gotten legal advice here in Cleveland. . . . It would be much happier for all of us, if you would stick to our original agreement — because the play is ours, neither yours nor mine, and I feel it is too good to be lost. The Gilpin Players cordially invite you to Cleveland, and I'd be very happy to see you and to work with you here if you

come, and at the same time to prepare a script for New York sale that would at least be clean and readable. What do you mean that, "I made suggestions, but they are not incorporated in the play," when one of the two versions that the agent sent here is exactly the same third set that you and I did together, and to which I gave you a carbon in New York in November. It looks to me like the <u>same</u> carbon? You're an awfully amusing person, Zora.

Sincerely,
L.H.

HURSTON TO HUGHES 43 W. 66th St.
 New York City.
 January 20, 1931.

DEAR LANGSTON,

Gee, I was glad to get your letter!

I don't feel bad about the Guild refusing my offering, for I have learned that they thought well of it, and more things besides merit entered into the refusal. That is why Clark took it over to French's office—because he felt that it would not be hard to place, and that is why he gave it to Mrs(?) Jeliffe. However, it may be rotten as heck.

Now, I suppose that both of us got worked up unnecessarily. I have explained myself so that I see no need to rehash it. I know that you are nervously constituted like me and so the less emotion the better. I am busy smoothing out my lovely brow at present and returning to normal. I am in fault in the end and you were in fault in the beginning. I shall freely acknowledge my share at anytime and place. Somehow I don't mind re-versing myself, especially when it moves me towards pleasanter relationship. Perhaps I am just a coward who loves

to laugh at life better than I do to cry with it. But when I do get to crying, boy, I can roll a mean tear.

I shall write Godmother a letter leaving you in a white light. Not that you have been slandered, but she dotes so on our rock-bottom sincerity that she would be upset to know of a spat, however trivial it might turn out for us.

Hope to see you in Cleveland in a few days. Until then,

Most sincerely,
ZORA

P.S. How dare you use the word "nigger" to me. You know I don't use such a nasty word. I'm a refined lady and such a word simply upsets my conglomeration. What do you think I was doing in Washington all that time if not getting cultured. I got my foot in society just as well as the rest. Treat me refined.

VAN VECHTEN TO HUGHES 150 West Fifty-fifth Street
New York City
[January 20, 1931]

DEAR LANGSTON,

Zora came to see me yesterday and cried and carried on no end about how fond she was of you, and how she wouldn't have had this misunderstanding for the world. And she said she had written you six typewritten pages and talked to you over long distance and said she was going to write to you again. So I hope you are straightened out with her by now.

And she doesn't want the play done in Cleveland, and here I think she is wise. A semi-amateur production of this play will kill it completely. It needs the most careful and sympathetic production and casting and if it gets it, I think should

duplicate the success of <u>The Green Pastures.</u> And sooner or later I think it is quite certain to be produced.

Please keep my name out of any further conferences you may have with Zora about the matter. It wouldn't help any and I'd rather not become involved.

145 red crocodiles with golden tongues to you!

<div align="right">CARLO</div>

HUGHES MEMORANDUM January 20, 1931

JAN. 20—4:PM

Miss Hurston is invited by phone to come out for rehearsals after she says that her reason for not wishing the play to be done here is because she feels no one else understands it but her. The telephone conversation is conducted by Mr. Dubin of the <u>Cleveland Plain Dealer</u>, (as they are anxious to see the play done here).

HURSTON TO JELLIFFE [*via wire*] January 20, 1931

To Rowena Jelliffe—Sent 5:32

Okay

 Zora H.

To Rowena Jelliffe—Sent 7:04

Mr. Clark at French feels badly over complications thru unauthorized sending script but says you can be trusted for integrity of script material copyright not one word must be altered except by me script not to leave your hands N.Y. agent not available now but decision tomorrow.

HURSTON TO MASON January 20, 1931

DARLING GODMOTHER,

You will note that Langston makes no claim of authorship. In the letter, over the phone and thru his friends, he attempts to set up the claim that he is due something because I didn't tell him to get out. You can't talk about a work with a person and then do it alone unless you pay them.

Now I noted in his <u>Not Without Laughter</u> that he used several bits that I had given him. Now I am not using one single solitary bit in dialogue, plot nor situation from him and yet he tries to muscle in. I am enclosing the letter I wrote him and spoke to you about. I have since sent him a practical duplicate of it.

I wish it were possible for Locke to get him before you

and then call me in and let him state his claims.

But my nigger mess aside, I hope that you are well as can be expected and that your dear C. is the same. My heart goes out to Mrs. Biddle in her bad hour. She is being crushed like grapes in the press, but she has been singled out by the gods to bear heavenly fire to men. So she must suffer. Like Prometheus. Perhaps the grapes cry out under the press until a voice whispers, "Hush! The gods are making wine." Blessed and cursed is the bearer of heavenly fire.

The man is still haggling over the car. He wants me to pay for having the carbon ground and I am not going to do it. The price is too low anyway. Having made that sacrificing price, he concludes that I am lacking in a sense of values. But I won't give another inch.

All my love to you, Godmother. I told Langston that you knew that I had written the play. Take good care of your precious life.

Devotedly,
ZORA.

HURSTON TO MASON 43 W. 66th St.
 New York City
 January 20, 1931.

DEAREST GODMOTHER,

Things are happening hot and fast. Now it has developed that Langston did not start the bidding for the play to Cleveland. You know that Mr. MacGowan is connected with the Guild. So the play has been read there. It seems that they really want this company to try out the play. It has tried out other plays that the Guild was interested in. So it looks both to be a better proposition, and better for Langston than it did

at first glance. It came to his notice after it had been mentioned to the head of the organization out there.

AND BEHOLD! It begins to look like Langston has at last gotten one eye open. He seems to have gone to Cleveland to escape certain entanglements. He is staying on there indefinitely. He is a little pathetic in his wish to make up with you. He told me that in a registered letter I have just received, but someone else called me up to say that he is wretched and sick because he feels that he has fallen in the esteem of many folks, including me. He is fed up on New York for the time being. I thought he had a very hang-dog look the last time I saw him. He is highly emotional, and I can see how realization of how he looks to others would affect him, that is why he stays ill. At any rate, he wrote me a pathetic letter. It is just as we know, Langston is weak. Weak as water. When he has a vile wretch to push him he gets vile. When he is under noble influences like yours, you know how fine he can be. Personally, I think that he has so much in him, that it is worth my swallowing and forgetting if by extending a friendly hand I can bring him back into the fold. I think we are in a spot now to make a grand slam.

I hurry to send these lines to you, because I don't want to be unjust to anyone ever. Especially Langston. I did not get my facts about the play from him, however. I got them from the agency downtown that is connected with the Guild.

I shall write Langston at once. I am sure that if he felt that he could get your confidence again he would work hard to earn it. He is ashamed of his attitude about the play and apologized to me for it. Isn't that like the Langston of old? He says he feels so badly about going down to certain friends of his the way he did. I know just what happened. After he had spent a night or two in town and had been fed and flattered, he was told what a sucker he was not to fight for his rights. I was held up to him as a double-crossing monster. Plenty sighs went up over the fickleness of friends, etc. After all, Langston,

you are so fine and generous and the crass world robs you. I think it is just magnificent of you to love Zora the way you do, but you poor dear, nobody ever seems to love you. Lie down, let mama fix you some cocoa. Maybe you ought to have a cocktail. I'll run right out and fix you one. Umph! Umph! I forgot that all the liquor was gone. Better let me run get some. Now where is my purse? Oh, you'll get some? NO! I couldn't let you do that. You are so good to us. Well, if you will, but remember next time I do the buying. I wouldn't take advantage of you like others. Etc. By the third cocktail and the tenth ton of flattery, the Galahad goes forth to defend his rights, and tell that flat-foot sea buzzard of a Zora just where she gets off. "And while you are about it, dear, free yourself from the strings of these people who give you a few pennies just to dominate you."

Godmother, I am so happy that Langston has taken an honorable view of the thing, that I would give him part. I shan't say that to him right now, but it takes all the sting out of things. The money didn't mean anything, Godmother really. You know how I felt.

So Mr. [Barrett] Clark, one of the Guild people, thinks that I ought to go to Cleveland and work the thing out. I don't know, but it looks like a build-up for New York production. He says that it, the play, is so exotic that they would like to see how it works up.

Please see me with your inner vision, waving a fan gaily.

Lovingly,
ZORA.

HUGHES TO SPINGARN
4800 Carnegie Ave.,
Cleveland, Ohio,
January 21, 1931.

Mr. Arthur Spingarn,
19 West 44th Street,
New York, N. Y.

DEAR ARTHUR SPINGARN,

I am very happy that you are willing to do what you can for me in safeguarding my interest in a play of which I am half author. The play is now called <u>Mule-Bone</u>, and it was done by Miss Zora Hurston and myself in collaboration, largely by the dictation method to Miss Louise Thompson, our stenographer at the time. Miss Hurston, it appears, has recently attempted to dispose of the play under her name alone, and without my knowledge and permission. Here is the whole story:

Sometime last spring, I believe in late February or March Taylor Gordon gave a party, and there I met Theresa Helburn of the Theatre Guild. We had quite a talk about the theatre, and Negro plays. Among other things Miss Helburn said that practically all the plays by or about Negroes offered to the Guild were serious problem dramas, and that they would like very much to have a comedy. She suggested that I write one. At that time Zora Hurston was living in Westfield, N.J. working on a marvellous collection of folk-material that she had brought back with her from the South. A few days later, when I saw her, I repeated Miss Helburn's suggestion and proposed to Miss Hurston that we do a comedy together. She readily agreed, and in a short time we went to work, using as a basis a folk-tale that Miss Hurston had about one man who hit another in the head with a mule-bone in a quarrel over a turkey. There was a trial in the church and the culprit was

proven guilty by the minister grabbing the Bible and reading
about Samson and the Philistines, saying that if Samson could
kill ten thousand Philistines with the jaw-bone of an ass, a
mule-bone was much worse—and therefore this man should
be run out of town, which he was. I suggested using this tale
as our beginning. . . . It was agreed that I would do the
construction, plot, whatever characterization I could, and
guide the dialog. Miss Hurston was to put in the authentic
Florida color, give the dialog a true Southern flavor, and insert
many excellent turns of phrase and "wise-cracks" which she
had in her mind and among her collections. In conversation,
I suggested that we make the two men friends for years, one
a guitarist, the other a dancer, who made their living by play-
ing for the white folks who came to Florida from up North in
the winter, that they meet a girl, a fickle high-brown just come
down from New York with a white family as maid, that these
two boys both try to "make" the girl, that their life-long
friendship begins to go apart, that they finally fight over her
in front of the village store, and one hits the other in the head
with the mule-bone. One is knocked out, the other locked up,
and the girl is left standing alone in the excitement, saying,
"Now who's gonna take me home?" as the curtain falls for the
first act. . . . Act 2: The trial in the Baptist church. I said make
one boy a Methodist and the other a Baptist and let the whole
town split over the trial into two religious camps. Let the trial
be a loud and noisy rumpus between the Baptists and the
Methodists, and finally end in the folk-story manner, with the
minister, the Bible, and the man being run out of town.
. . . Act 3: On a lonesome stretch of railroad line outside of
town. The boy sits down and strums his guitar, his former
buddy follows him, anxious now to make up, but unwilling to
let on he is. They are about to patch up their differences, when
the girl comes along anxious to get back one or the other of
her lovers. There is a proposing contest, (Miss Hurston's sug-
gestion) and each fellow tries to out-do the other with the girl,

but more or less in a burlesque-serious manner. She accepts one of them, and then says that she will get him a job with her white folks. At the mention of the word <u>work</u> he backs out and turns her over to his buddy. The other boy doesn't want her either when he learns that he has to take care of her, so they both shy off, again leaving the girl forlorn. She goes off down the track in a huff, while both boys, friends again now, start singing and dancing their way back to town. Final curtain. . . . That's the gist of the story we decided to do together, largely worked out and constructed by myself, and the whole action outlined in my own handwriting. We sent for Miss Thompson who came from New York, sometimes commuting, sometimes staying over night with Miss Hurston, and in late March or April we three went to work by dictation to the stenographer, on the play. It moved along beautifully for some three or four weeks, during which time we completed drafts of the entire first and third acts, and a Scene 1 (short street scene before the trial) for the second act. About that time Miss Hurston had to leave Westfield, and later went back South for the summer, taking all the notes, outlines, etc. with her for the trial scene, with the understanding that she would finish a draft of that act down South while she was away. I did not see her again untill November in New York. In the meantime I had spent some weeks at the Hedgerow Theatre near Philadelphia, and while there had gotten some advice and help from Jasper Deeter on the first act. He did not read the third act which I also had with me, but from what he saw, he thought the thing would work out to be a swell comedy. . . . When I came back to New York in November and attempted to work with Miss Hurston, saying that we should put the play together and type out the final version, she gave me an appointment for work, but when I came, was not at home. Other appointments followed, but always she either was not home or had to go out at once as soon as I arrived; had no copies of the play in the house to work on; said she was

terribly busy and terribly nervous and couldn't work anyway; said she thought we ought to put the turkey back in the story and cut down on the girl-interest; finally gave me a copy of what she had done in the South, but demanded it back almost at once before I could make a copy of it for myself; said she had to go back South again almost at once; was not home for the last appointment that she gave me—and I have not seen her since. (That I believe was early December.) I thought her behavior strange, but since we have always been such good friends, and had had no disagreements about our work on the play together or anything else, I put down her actions to a rush of other work, and perhaps nerves. So I put the play aside and thought no more of it, except that we would finish it when she next came back to New York. . . . Imagine then my surprise when, some three weeks ago, attending a performance at the Little Theatre of the Gilpin Players here in Cleveland, I learned from Rowena Jelliffe, their manager, that they thought they were about to get the rights to do a swell Negro comedy called Mule-Bone, which Samuel French had offered them for their annual downtown production! Miss Zora Hurston was the author! . . . I was, of course, completely amazed, and told Mrs. Jelliffe that it was a play of which I knew a great deal. She then went on to tell me that they had not yet received the script because it was being considered by the Theatre Guild, but that Barrett Clark felt that the Guild would refuse it, and rather assured them here that the script would be forthcoming in a few days. So the Gilpins more or less went on the assumption that they would have it in time for production on the coming February 15th. In the meantime I at once sent for my copies of the play which I had left in Westfield. I also wrote Zora Hurston for an explanation. She did not answer. Last Friday, Jan. 16, Mrs. Jelliffe received from Samuel French a manuscript of Mule-Bone, saying that a letter regarding rights would follow later. Up to that point I had done nothing except to write Miss Hurston, because I was not

entirely sure it was our play. I thought there might be some mistake. But as soon as I saw the manuscript (bearing only Zora Hurston's name) I knew at once that it was what we had worked on together. It came here in very bad shape, as if hastily put together, and there is little wonder that the Guild refused it. It was in about the same shape as when we stopped work on it last spring (an unfinished second draft version) except that Miss Hurston had inserted the turkey, caused the fight to take place off-stage, thus changing the ending of the first act (and weakening her climax), and had also written a second slightly different ending which she sent along with the note attached that maybe it was better than the other. The second act sent here was the one of which I had no copy and which she herself put together in the South (with the aid of my notes, except that here again talk of the turkey appears). Of the third act two versions were sent, one the original that we did together last spring, the other a new version, based on and very much like the original. (An awful way to send out a manuscript, evidently leaving the producer his choice of acts and endings. In fact the whole thing is perfectly amazing. Maybe she has lost her mind!) But anyway—Mrs. Jelliffe immediately saw that the play French sent her and the one that I had (the first and third acts and complete out-line notes) were the same. She liked my version of the first act much the best (because it does have order and climax in construction, whereas Miss Hurston's insertion of the turkey threw the whole thing out of gear, as she simply put it in to an act that had not been written for it.) I at once got in touch with Miss Hurston by long distance phone to New York. She denied knowing anything about the play being in the hands of an agent, or that it had reached Cleveland; would give me no answer when I asked her if she were trying to sell the play herself, but said she would write me. Mrs. Jelliffe also got in touch with Barrett Clark, representative for French with whom she always deals, told him the whole story, said that she

wanted to produce the play, had very little time as rehearsals would have to start this week, and asked him over the phone what to do about it. He said he would try to get in touch with Miss Hurston. He also said that the play came to him in this way: Carl Van Vechten sent it to the Guild; Barrett Clark is a reader for the Guild, and also on the staff for French; the Guild turned down the play; he sent it to the Gilpin Players here, but he himself had never been in touch with the author or authors. However, he would do what he could to persuade Miss Hurston to allow the original collaborated version of the play to be done here. . . . On Jan. 20 a wire came from French saying Miss Hurston refused to authorize the production and to return the script at once. That, Mrs. Jelliffe did yesterday. But since then three wires have come from Miss Hurston after the <u>Plain Dealer</u> people talked with her by phone which seemingly authorize production here, and which indicate that she will again collaborate with me, so the Jelliffe's are going ahead today with the whole show, and have asked me to revise the second act so that it again comforms with the original play. Their lawyer here assures them that Miss Hurston's wires constitute a contract, and that the players will be safe now in going ahead with rehearsals. But if anything else should happen to delay or hinder the production, their downtown season would be ruined, as they must open on Feb. 15th. . . . When first I tried to phone you yesterday, I had just received a letter from Miss Hurston saying that no part of the play was mine, so I thought you had better do something at once about it, but when I finally reached you on the phone, two of the agreeable telegrams had arrived. Nevertheless, I think you had better know all this, and I hereby give you full authority to act as my personal representative in protecting my rights and interest in the play <u>Mule-Bone</u>. . . . It's all a very strange mess, and it's lucky for me that I happened to come home to my mother in Cleveland when I did, otherwise I probably would have known nothing of this until the play went on here. Mrs. Jelliffe

first heard of it from French's on December 17, so it must have been in the hands of an agent or the Guild at the very time when I was trying to work on it and make a final draft with Miss Hurston. At that time, I spoke of her strange behavior to your sister, Mrs. Amy Spingarn the day when she did her pencil drawing of me. Perhaps she can repeat to you what I told her then. . . . As to proofs of my statements: First, there is the stenographer, Miss Louise Thompson, 435 Convent Avenue, New York, who knows of the play and who worked with us from the very beginning last spring taking dictation and copying and recopying parts of it many times in the presence of both Miss Hurston and myself. Second, I have now in my possession in my own handwriting several pages of construction and characterization notes from which the present play was built, as well as a carbon of the first draft of the first act, containing insertions and corrections in mine and Miss Hurston's handwriting in pencil on this carbon. I have also clean copies of the first and third acts which I told Miss Hurston I would take to Hedgerow for Jasper Deeter's advice. Third, Jasper Deeter saw and read aloud to a part of his company the entire first act, which is practically the same as the act which Miss Hurston sent out as her own. Fourth, the day that Carl Van Vechten sailed for Europe last spring Miss Hurston and I went to bid him goodbye, and at that time told him we were doing a folk-comedy together—so he knew that we were working jointly on something. (Although I in no way blame him for the present situation, since he had no way of knowing that the play which Miss Hurston took to him alone was the one we did together.) Fifth, Miss Hurston's former landlady in Westfield, my landlady there, the boarding house keeper where Miss Hurston, Miss Thompson, and myself frequently ate, and others, all knew we were doing a play together. Sixth, a few of my friends, like Mrs. Spingarn, knew of it, either that spring or in the fall. But both Miss Hurston and myself had agreed to say very little about it until we had

finished—so that no one would be likely to get hold of our ideas. <u>Seventh</u>, I probably have in Westfield letters from Miss Hurston in the South last summer in which she mentions, or replies to questions of mine, how she is progressing on the second act which she had taken with her to finish up. . . . So with all that against her, I can't imagine why she would attempt to sell the play which we did together without any knowledge or consent on my part. . . . There are these details which you should know. The version which arrived here from French bore no copyright notice, so I immediately copied from it the second act which I had not possessed since last spring, except for a few hours loan in New York, and together with the original first and third acts that I ordered sent me from Westfield, I mailed the comedy off to be copyrighted on Monday (Jan. 19) in my name, but giving both our names as the authors. If she has already copyrighted the play in her name alone something must be done about that. . . . I have been as decent as possible about the matter, writing Miss Hurston only in the nicest way, and making no attempt to create a row about it, but trying to find out what's going on. I have not been successful, so if you could kindly check up on the whole business for me at once, I would appreciate it immensely. I have written Carl Van Vechten several letters asking his advice and giving him the same story I have set down here. Perhaps it would be wise for you to phone him about it, since he is a friend of both Miss Hurston and myself, and since it seems that he gave the play to someone connected with the Guild, and in that way it reached French. Then, too, perhaps you could get the whole story of its attempted sale from Barrett Clark who handled it for both the Guild and Samuel French, Inc. Jack Walsh at French's also seems to have had some knowledge of the business, as the correspondance shows which I am sending you. Undoubtedly you know where to find all these people except Miss Hurston. Her address is 43 West 66th Street, and her telephone is Endicott 2-2441. (I

do not know whether you will care to get in touch with her at once or not, but please do what you think is wise in regard to the whole matter) [*handwritten in margin:* Better talk to her if possible as to royalties—as explained below. I am writing her that you will represent me in New York now.] In all my letters to Miss Hurston I have said that I was perfectly willing to continue our colaboration, willing to work with her on the script for the production here, and to do everything I could for the future sale and success of "Mule-Bone." I am not particularly angry about what has happened, only puzzled, and I do not wish any legal entanglements, or to make things unneccessary unpleasant for her. We have always been good friends for the past six or eight years, since I first came to New York. But I do not want to see what may be a splendid play, and the first Negro folk-comedy to be written by Negroes, be torn apart before it has even gotten started. Carl Van Vechten writes me that several members of the Guild liked it very much, and that it is a sparkling and original play that, if properly produced, might be as successful as the *Green Pastures.* So you see what a shame it is for this sort of thing to come up. I hope Miss Hurston will see fit to continue our work together on this play so that it might be an artistic success. She has an amazing fund of folklore, wit, and knowledge of Southern life, and is marvellous at dialect and Southern turns of speech, but she has almost no sense of construction, (as the version which she tried to do herself shows) and little sense of continuity or form. She is a delightful person in many ways, and I think you would enjoy meeting her, if you don't already know her. Carl, Harry Block, T. R. Smith, Taylor Gordon, or most anybody could introduce you.

This is the situation here: I would never have thought of a Cleveland production myself, but since it was practically underway when I first heard of it, and since the Jelliffe's are old friends of mine from high school days, (marvellous white couple who have lived for fourteen years in the heart of the

Negro section here working and playing with the people, establishing art classes, clubs, a camp, and their fine theatre group, the Gilpin Players) and since they have been very kind and helpful in the present situation, I am perfectly willing to see them put the play on here, as Miss Hurston's agent seemed to think desirable when he sent out her script. And since it is to be produced under the auspices of the <u>Cleveland Plain Dealer</u> at the Theatre of Nations, and later move to the <u>Ohio</u>, for a week's run, a large legitimate playhouse downtown here, it will give Miss Hurston and I an excellent opportunity to study its faults, and if it is fairly successful here it will be a great help toward an opening in New York, as New York managers usually have representatives here in town, since Cleveland is a great try-out town for Broadway productions. . . . A production here would probably do us all good. Miss Hurston seems to have agreed to it by wire. But Mrs. Jelliffe has no contracts or anything of the sort, so far, from either of us. And Barrett Clark denies by phone that French is really her agent. She has my personal word that I agree to the production, and with that and Miss Hurston's wire, she is going ahead. She wants, of course, as soon as possible something signed and down on paper. So far, with Miss Hurston there has been no talk of royalties. I am writing her today about them. The royalties in the case of the Gilpin Players use of <u>Roseanne</u> for 14 performances amounted to $267.50, in the case of <u>In Abraham's Bosom</u>, $350.00 for 23 performances, but the size of the theatres varied in each case. Mrs. Jelliffe is willing to pay us as high a rate of royalty as has been paid on any other play. The Players are a non-comercial group, the money they make going toward the buying of a permanent scholarship for Negro students at the Cleveland School of Art and toward the improvement of their own little theatre made from an old pool hall on Central Avenue. Royalties are decided between the authors and the group, through Mrs. Jelliffe and the Ex. Com.

Could you get from Miss Hurston some sort of agree-

ment allowing me to act as her representative here for a tentative agreement on royalties for a two weeks run of the play Mule-Bone, all terms, of course, to be finally approved by her? . . . Again, I wish to make a personal agreement with Miss Hurston as to the division of royalties between us. Since from her letter to me she evidently feels that she is more author of the play than I am,—to keep the colaboration from going to pieces and to save an interesting play, I have written her that I was quite willing to accept the lesser share of the royalties we might make. She may have two-thirds of the joint royalties if she feels that she should, I will accept one-third—as a permanent agreement for all future productions of the play, should she not wish to split half and half. You may tell her that for me, and if you can get a signed agreement to that effect, I will also add my signature. I do not know how one goes about such matters, and since I am not in New York now, would you kindly advise me what to do, if you cannot attend to the royalty matters yourself? . . . I am enclosing copies of most of the correspondance. . . . I believe that is all. I am deeply grateful to you for helping me in this matter. I'm dead broke right now, but book royalties are due soon, and if Mule-Bone ever goes on in NEW YORK it may make something, so I trust I will be able to meet whatever fee you may charge. You may write or wire me at the above address at any time, or phone Endicott 9028. Mrs. Rowena Jelliffe may be reached at the Playhouse Settlement, 2239 East 38th St. Cleveland, or by phone Henderson 7798. . . . Thank you so much.

Sincerely,
LANGSTON HUGHES

HUGHES TO HURSTON 4800 Carnegie Avenue,
[incomplete] Cleveland, Ohio,
 January 22, 1931.

ZORA, MY DARLING,

Brazzle's mule is one ungodly beast. He's done a mean piece
of kicking lately, but I trust once more that the ghost of his
dead carcass is ready to repose in piece! We're all sorry! Last
night in jail with my back turned to the wall, I thought deeply
on the subject—because with a cousin of mine, I was mixed
up in a traffic run-in with a taxi driver who claimed we'd hit
his car—so I've just this morning come out of jail! . . . Well,
we're all glad you will come out here soon. I've told the
Jelliffe's what a grand person you are—even the New York
folk-tale about you and the blind man's tin cup. You see what
a famous person you are already, that folk-tales are made up
about you while you're still in your youth—not even dead yet.
. . . There's a matter of business to be taken up at once
regarding the production here. Since French is out of the
picture, there is no one to deal with except the authors direct
(which means we get all the royalties anyhow), but Mrs. Jel-
liffe wishes at once some signed right to the play from us as
to the royalties we will accept, etc. They are quite willing to
pay us the same rate they paid on Roseanne, their highest
royalty play so far. The royalty seems to vary with the size of
the theatre. In the case of Roseanne: 7 Little Theatre perform-
ances and Ohio Theatre performances netted to the author
$267.50. In the case of In Abraham's Bosom: 23 perform-
ances brought the author $350.00. Mrs. Jelliffe wishes that I
meet the Executive Comm. of the Players on the matter as
soon as possible. Would you be willing that I act as your
representative at this meeting to decide on our royalty rates
for the production here? The tentative decision which I might
accept due of course to your final O.K. and to have your

signature . . . Someone must merely act as a representative here for our interest. I have asked Mr. Arthur Spingarn to do that for me in New York, and I have asked him to see if he can formulate a personal agreement between you and myself as to division of royalties between us, either a temporary agreement for the Cleveland run, or a permanent one for whatever productions of the play there might be anytime in the future, (preferably I think a permanent one to cover all future income, since that would save everybody's time. If you feel that the major part of <u>Mule-Bone</u> is yours, I am quite willing that you have two-thirds of all incomes, myself accepting one-third, and have so informed Mr. Spingarn. His address is 19 West 44th Street. Maybe you know him. If not, you'll find him a very nice fellow, and I am sure, perfectly square. You might call him up and make an appointment. Or perhaps he will call you, but since this should be done soon, I hope you will get in touch with him. He has full authority to act as my personal representative. . . . I hope nothing will come out of this matter to worry Godmother. As you know, I had nothing to do with initiating this Cleveland production, so please get her straight on that point. The dated correspondance with French shows that the play had been offered here some weeks before I even thought of coming out this way. . . . I'm glad things seem to be straight again now. I hate mixups. Everybody's happy—so O.K. . . . It'll be great to see you. Maybe you'll like this big old dirty town. I hope so. There's a low-down night club that almost equals the Sugar Cane. . . .

HUGHES TO SPINGARN 4800 Carnegie Ave.,
 Cleveland, Ohio,
 January 24, 1931.

Mr. Arthur Spingarn,
19 West 44th Street,
New York, N. Y.

DEAR MR. SPINGARN,

Miss Hurston is expected here by February first to help the
Gilpin Players with their production, and she has written me
a very nice letter, so I guess everything is O.K. . . . I have your
note in response to my phone call, and I trust that you have
my letter by now in which I tell you all about the case, and a
second envelope containing copies of letters, wires, etc., in
regard to it. I posted them to you Wednesday. . . . Here are
the royalty terms which the Gilpin Players offer for the pro-
duction of Mule-Bone here, and which I have sent today to
Miss Hurston: The Gilpins, a working people's Little Theatre,
pay on all their plays what is known as "amateur royalties".
They are quite willing to pay us as high a rate as they have ever
paid on any other production. What they suggest now is as
follows: (This does not include the week they expect to do at
the Ohio Theatre—that being a professional legitimate house,
the arrangement is made through the management there, and
cannot be made until later, so Miss Hurston will probably be
here by that time.) But for the downtown opening under Plain
Dealer Theatre of Nations auspices, (one Art Scholarship per-
formance, and probably one Saturday night extra perform-
ance) and for five nights at their own Kamaru Theatre on
Central Avenue, with possibly three to six other performances
for special groups like the city librarians or the Art Museum

patrons who may buy out the house for their own private evenings, they offer either of the following propositions:

> Plain Dealer performances (some 750 seats)
>$50.00 per performance
> Kamaru performances (120 seats).$20.00 " "

Or:

> Plain Dealer performances. . .5% of profits per performance
> Kamaru performances. . . .20% " " " "

The first proposition would give the authors $150 for six performances, the minimum number to be given (exclusive of the Ohio). The second proposition would be a little less, (and a great deal less if the houses did not sell out) so I think we would be safer in taking the flat-rate proposition, which is agreeable to me, if it suits Miss Hurston. I have asked her to get in touch with you about the matter. So far the Gilpins have no signed agreement with anybody about the play (at the moment they are considering Miss Hurston's wires as constituting a contract) and if French is no longer acting as Miss Hurston's agent (or is he?) they must deal directly with us, and they wish to have something tangible as soon as possible, so I trust you can do something toward settling this royalty business. I hope so. . . . With best wishes to you,

Sincerely,
LANGSTON

SPINGARN TO HUGHES

January 24th, 1931
19 West 44th Street
New York City

Mr. Langston Hughes,
4800 Carnegie Avenue,
Cleveland, Ohio.

DEAR LANGSTON:—

As soon as I received your letter of Jan. 21st, I spoke to
Carl Van Vechten and he suggested that I ring up Miss Hur-
ston directly. Miss Hurston made an appointment for Friday,
which she was unable to keep on account of ill health, and I
saw her this morning at my office. In the meanwhile, Carl has
told me that he had heard from French that the script to
"Mule-Bone" had been returned to them, so I do not know
just what the status of the play is in Cleveland.

Miss Hurston insists that the account you gave me of
your collaboration in the play is grossly exaggerated and that
virtually all of the play was written by her. She says that you
should not have been surprised when the script arrived in
Cleveland with her name thereon as the sole author, as she
showed you this script last Fall with her name on it as sole
author and that you made no comment at the time, except to
say, couldn't there be two versions, so if we could not sell the
one, perhaps we could sell the other.

Miss Hurston says she is not so much concerned about
the matter of royalties, but feels that you have been unfair and
unjust in the matter. She feels that she cannot decide whether
or not the play should go on in Cleveland without consulting
her agent, Miss Elizabeth Marbury, who she expects to see this
afternoon. She has promised to let me know on Monday what

the decision is. As soon as I receive it, I shall communicate with you.

As to the royalties you should receive for your participation in the play, Miss Hurston thinks, and I agree with her, that this matter can be much better adjusted if you two meet face to face. Perhaps if the play goes on, she will go out to Cleveland and you can then talk it over, but if the play does not go on, when you come to New York you can then talk it over; preferably in the presence of some friend, either Carl Van Vechten or myself, or perhaps both. In the meanwhile, Miss Hurston will not take any action which will jeopardize your rights.

I may add that your letter of the 19th to Miss Hurston threatening litigation aroused her ire, and she has shown me a copy of the letter which she wrote to you and which I frankly told her was foolish, as I think your letter to her, which I have not seen, was probably also. Litigation is the last thing either of you should think of if it can possibly be avoided, not only for your own sakes, but for the sake of the group.

This letter is dictated in my office in Miss Hurston's presence.

Faithfully yours,
ARTHUR B. SPINGARN

HUGHES TO SPINGARN 4800 Carnegie Avenue,
 Cleveland, Ohio,
 January 26, 1931.

DEAR ARTHUR SPINGARN,

I regret very muich that Miss Hurston still does not wish to acknowledge our collaboration. I suggest that you get in touch

with the young lady who acted as our stenographer, and who took by dictation from us jointly practically the entire first and third acts, Miss Louise Thompson, 435 Convent Avenue, New York. During the working day she can be reached by phone at the office of Mr. Herring, who is in charge of the Caribbean Seminar, and the inter-racial seminar tours. His office is, I believe in East 19th Street. I am sure the address can be gotten from the N.A.A.C.P. or from Mrs. Thompson.

I am enclosing a carbon of my letter to Miss Hurston on January 20th, also her letter to me of the same date, the two letters having crossed one another. This letter of mine was written after three others over a period of some two weeks had been sent, none of them receiving a sensible response, nor could I get a definite answer by phone. Then it was that I turned the whole matter over to you, and wrote Miss Hurston that I was doing so, since I had no one else in New York to talk to her for me. Then when her letter arrived (the one enclosed) and the wires to the Jelliffe's saying Okay and Proceed I thought the whole thing was about settled, except for a royalty arrangement, and I wrote you January 24th saying so. This morning Mrs. Jelliffe received a letter from Elisabeth Marbury [*handwritten in the margin:* Could you discover what Mrs. Marbury believes herself to be negotiating for—the production of a play by Miss Hurston, or one by Miss Hurston and myself?] asking if she were willing to pay half of Miss Hurston's fare to Cleveland in lieu of royalties for the production of her play. The letter said nothing regarding the play as being ours, nor did it in any way mention my name. It was just as if the negotiations were being conducted entirely for a play by Miss Hurston alone—so again I do not know where matters stand, either in regard to the Cleveland production or to the authorship of the play. I am writing Miss Marbury now merely to say that I am part author, and that full details can be gotten from you.

* * *

Last night I mailed you a script of the first act of the play and will mail you the rest as soon as the Gilpins have made their copies. They are proceeding with the production on the strength of Miss Hurston's wires and my own verbal permission, which their lawyer interprets as our joint consent. As you know, the whole matter of this Cleveland production came through Barrett Clark and Samuel French, Inc., and I had nothing to do with it, nor knew of its likelihood, untill I arrived here just a short time before the script itself came from Barrett Clark, so Miss Hurston can in no way hold me responsible for beginning this business here. Then my consent to do the play here always, thereafter, hinged jointly with her own—if the Jelliffe's were able to get it. They felt that they had it after Mr. Dubin of the <u>Cleveland Plain Dealer</u> talked to her by phone, and they received her first wire OKAY, and a second the following day saying PROCEED GOOD LUCK.

Surely you are right—nobody wants litigation.

Sincerely,
LANGSTON

Enclosed with the above letter, Langston Hughes sent the following handwritten note as an introduction to Zora Neale Hurston's letter to him of January 18, 1931:

Miss Hurston's letter to me—Jan. 18th.

Please return

The first three pages are largely concerned with a personal matter over which Miss Hurston seems to be angry, and which she deliberately mistakes and exaggerates and offers for an excuse of her recent actions. The most definite statement about the play is in the Postscript!

HUGHES TO HURSTON 4800 Carnegie Ave.,
[incomplete] Cleveland, Ohio,
 January 27, 1931

DEAR ZO,

Everybody's happy about your announced coming. Lillian Smith's friends are all anxious to see you, and I believe it is being arranged for you to stop where Lillian used to stay. Mother is sorry our place is not large enough to have you stay with us. . . . Last night there was a reading of the first act, and it seemed to take pretty well with the company. They are mostly working people, and not many high-hats, as their theatre is located in the heart of the low-down colored district right on Central Avenue. And the Jelliffes are swell people. I think you'll like most of the group and I'm sure they'll like you. I told them the basis for the play is your folk material and home-town background, and said that all the color and wit belonged to you. . . . About royalties: The Gilpins, a Little Theatre, pay on all their plays what is known as "amateur royalties"—you can find out from French about the other plays they have rented from them—and as I told you, they are quite willing to pay us as high a rate as they have paid on any other production. What they offer immediately is as follows: (This does not include the week they expect to do at the Ohio Theatre. This being a professional legitimate house, the arrangement is made through the management there, and cannot be made until they have looked at the production, so you

will be here by that time.) But for the downtown opening
under Plain Dealer Theatre of Nations auspices, (one Art
Scholarship Performance, and probably one Saturday night
extra performance) and for five nights at their own Kamaru
Theatre on Central Avenue, with possibly three to six other
performances for special groups like the Library Club or the
Art Museum Group who may buy out the house for their own
evenings, they offer either of the following propositions:

Plain Dealer performances. . .$50.00 per perform-
ance
Kamaru performances.$20.00 per perform-
ance

Or:

Plain Dealer performances. . .5% of profits per perform-
ance

Kamaru performances. . . .20% of profits per "

The first proposition would net us $150.00 for six perform-
ances, (the minimum performances to be given). The second
proposition would be a little less for us (and a great deal less
if the house did not sell out). The Theatre of Nations seats
about 750 people, the Kamaru 120 people. . . . I think we
would be safer in taking the flat-rate proposition, which would
mean that we would get ours at all performances that might
be given, regardless of how the seats sold. Wire me if either
of these is agreeable to you. Besides this, of course, your fare
one way is to be paid, you will be housed with some member
of the company, (probably Lillian's friends) I believe, so that
your expenses here will not be large. . . . I am outlining these
two propositions to Mr. Spingarn, so if you decide to accept
one or the other at once without further correspondence, you
may get in touch with him and he will know about the legal

forms for you and I to comply with. Let me know when you're coming out. There is a grand [illegible] dramatic minister here that folks are crazy about . . . [illegible to end]

SPINGARN TO HUGHES 19 West 44th Street
 New York City
 January 27th, 1931

Mr. Langston Hughes,
4800 Carnegie Avenue,
Cleveland, Ohio.

DEAR LANGSTON:—

I received your letter of Jan. 24th yesterday afternoon when I returned from Court and to-day I spoke to Miss Hurston over the telephone. She tells me that her agent, Elizabeth Marbury, insists, if she is to handle the matter, that her office take charge of all arrangements as to royalties, etc., and that as she (Miss Hurston) knows nothing about these matters, she is leaving those arrangements to Miss Marbury's office. She says that she is writing to you directly and that she is going out to Cleveland, where you can discuss the whole situation face to face and in a friendly manner. I am sure that she is at bottom very friendly disposed toward you and that she really has been more hurt by what she thinks is an ungenerous attitude on your part than by anything else, but I believe and sincerely hope that when you see her, you will be able to straighten out the situation satisfactorily.

Last Sunday night Alain Locke came in to see me about the matter and told me a long story, the upshot of which was that he believed Miss Hurston was right and that you were wrong in the matter. I told him, naturally, that I would have

to suspend judgment until I saw you and talked over the situation. The typed script which you sent me reached me this morning.

In conclusion, let me send you my warmest congratulations on your well deserved award of the Harmon prize. I, in common with everybody who has read your book, cannot help being gratified at the admirable judgment of the Harmon committee.

As always,

> Sincerely yours,
> ARTHUR B. SPINGARN

HUGHES TO SPINGARN 4800 Carnegie Avenue,
 Cleveland, Ohio,
 January 27, 1931.

DEAR MR. SPINGARN,

I have received this morning a card from the Register of Copyrights granting me a copyright in my name for "The Mule-Bone, A Comedy of Negro Life in Three Acts, by Langston Hughes and Zora Hurston of the United States." Evidently, then, Miss Hurston had neglected to copyright the play before sending it out. As I told you, no copyright notice was attached to it when it arrived here from Barrett Clark, therefore I immediately sent it off to Washington to the Register of Copyrights. Knowing the thievery of the New York Theatre, that seemed to me the best immediate protection for both of us. . . . This morning a wire came to Mrs. Jelliffe from Miss Hurston saying that all future communications should be addressed her through her agent at the office of Elisabeth Marbury. Today the Gilpin Players are sending a contract form for the production of "Mule-Bone" here to that office.

The play has been cast and the first rehearsal is tonight.
. . . Do you think, from reading the first act which I sent you,
that the comedy seems amusing enough to merit all this rum-
pus? Miss Hurston and I wanted to make of it a play full of
the real folk quality, keeping it pure comedy.

<div style="text-align: right;">

Sincerely,
LANGSTON

</div>

THOMPSON TO The American Interracial Seminar
HUGHES 112 East 19th Street, New York
 Algonquin 4-9365
 January 28, 1931

DEAR LANG:

You have certainly had your time with Zora! However,
I would not be startled at anything now—so shoot the works.
No one has called me regarding it, but you count on me as a
very able witness should it be necessary.

Congratulations on the Harmon award. I suppose you
have guessed that that is why I wanted to know about you,
Hannah had asked me, but also had pressed silence upon me.
I am glad particularly because of the $400, as I don't think you
need the recognition. How about a little party!?!

I have been sick ever since I returned home with a cold
and have only today come to the office. I had to be fashionable
you know, as everybody is doing it.

I'll give Mary your message. She had a party of her
friends Monday night and felt she had a fine evening.

Kindly remember me to your Mother and all the others.
Tell her I certainly thank her for taking care of me during my
day in Cleveland.

I haven't been anywhere since I have been back as I have

been sick all the time. So I don't know any news to tell.

Success to the play and all matters pertaining thereto. It has truly become a bone of contention, hasn't it. The only thing I can say is that Zora is crazy, but unfortunately maliciously so.

Always,
LOU

HUGHES TO LOCKE January 28, 1931

WIRE TO ALAIN LOCKE, JAN. 28, 1931, 6:30 P.M.

Just received letter Arthur Spingarn please put me straight on Zoras attitude and your knowledge of matter by return wire collect I am afraid I don't understand

LANGSTON

Phone End. 9028.

SPINGARN TO HUGHES 19 West 44th Street
 New York City
 January 28th, 1931

Mr. Langston Hughes,
4800 Carnegie Ave.
Cleveland, Ohio.

DEAR LANGSTON:—

I have your letter of the 26th and also your letter of the
27th.

I did not question Miss Hurston on the subject, but she
volunteered the information that she had the play copyrighted
last October. My advice continues to be the same as in my last
letter to you; that you and she can best straighten the matter
out when you see each other face to face.

I certainly think the comedy can be made into a real
success; if not in its present form, at least after it has been
worked over a bit.

 Very sincerely yours,
 ARTHUR B. SPINGARN

HUGHES TO SPINGARN 4800 Carnegie Ave.,
 Cleveland, Ohio
 January 30, 1931

DEAR ARTHUR SPINGARN,

Thanks for your letters. Am in bed with the grippe, so
I haven't been so quick with an answer. I do not understand
Dr. Locke's zeal in upholding Miss Hurston's position—ex-

cept that they are both employed by the same patron. Miss
Hurston has probably claimed <u>Mule Bone</u> as entirely her own
before Dr. Locke and their patron; and Dr. Locke, knowing
only one side of the story, chooses to back Miss Hurston. So
far as I can recall, I have never spoken to Dr. Locke about our
comedy, nor was I aware, until I heard it from you, that he
ever knew Miss Hurston and I had worked on a play together.
I wired him asking for an explanation of his statements to you.
His answer was: "<u>Congratulations on the Harmon award but
what more do you want.</u>". . . . Isn't that annoying? . . .
Yesterday Mrs. Jelliffe received a letter from Mr. Paul Banks,
one of the Gilpin players at present visiting in New York for
some few weeks or so. Mr. Banks had just called on Miss
Hurston. He quotes her as saying that I have been stupidly
untruthful about the play; that she has convinced you that I am
wrong; that you are very much disillusioned about me and that
you will no longer represent me in New York; and that she
has Dr. Locke on her side. Further, that she will shortly leave
for Cleveland, but that she absolutely refuses to associate my
name with the production.

Of course, all this excited Mrs. Jelliffe anew. She tried to
reach both you and Miss Hurston yesterday by phone but
failed—so she tells me today that she has written you. The play
is in rehearsal here and has been announced by <u>The Plain
Dealer</u> as a Negro comedy by myself and Miss Hurston. Miss
Hurston, as I told you, authorized the production by her two
wires <u>Okay</u> and <u>Proceed Good Luck</u>. Now Mrs. Jelliffe does
not know what might happen from her present attitude as
expressed to Mr. Banks. Miss Hurston has never ordered the
production stopped here—but seemingly after I told her I had
put the matter in your hands she became angry and decided
to go back to her strange and stubborn policy of not admitting
our collaboration. Mrs. Jelliffe feels that she had better get
expert legal advice here to prevent anything happening at this
late date which would disrupt and spoil their downtown sea-

son, for that reason she asks me to get from you all correspondence of which I kept no copies! i.e. Miss Hurston's two letters to me, and anything else you may have, marked in red "Please return." So would you kindly send letters so marked back to me. . . . Also if you can aid me by giving Mrs. Jelliffe some expert advice about her touring it here when you answer her letter, I would appreciate it immensely, since I know nothing more to do or say about it myself. The check for Miss Hurston's fare to Cleveland has been sent to her—so maybe the face to face conference can be held soon. I hope so—as this strange and unpleasant business is beginning to get on my nerves. Judging from Mr. Banks's letter, New Yorkers are beginning to think that I am the robber instead of the robbed! Well, sir!! What next?

Sincerely,
LANGSTON

P.S. Would the copyright office be likely to copyright the same play twice by mistake? Is it possible to discover whether or not Miss Hurston did copyright Mule Bone last October by asking the question of the Register of Copyrights? If the play has been copyrighted twice, once by Miss Hurston with herself as sole author, again by myself this month with both of us as authors, what bearing would that have on the situation here regarding the impending Gilpin production—should it come to a matter of injunctions, etc. from Miss Hurston or her agents? The play was once tentatively called "The Bone of Contention"—and that's what it really has become. Miss Hurston has evidently decided to bluff her way through on the false stand that she has taken. Or else she is ashamed to back down before her New York friends. I'm sorry about the whole matter.

P.S. Am sending the II & III acts of the comedy as prepared for the Gilpin's production using the I and III acts done in

collaboration last spring, and the II act revised form the version Miss Hurston did last summer in the south with the use of my spring notes for its construction, and following my outline as to scenes and action, except that in her version the turkey incident was used instead of the girl. This had to be removed to conform with our original two acts. This is really a 2nd draft version of our collaborated play. I had wanted to work it over once more with Miss Hurston before we tried to sell it, or even tried it out here.

JELLIFFE TO SPINGARN The Neighborhood Association
2239 East 38th Street
Cleveland, Ohio
January 30, 1931

Mr. Arthur Spingarn,
19 West 44th Street,
New York, N. Y.

DEAR MR. SPINGARN:

There has, as you know, been a deal of controversy over a play by Zora Hurston and Langston Hughes called Mule Bone. I am necessarily involved in it, in as much as I am to produce and direct the play.

It seems to me that Miss Hurston has behaved very strangely. I know from Louise Thompson, who worked with them on the typing of the play that Langston Hughes did the construction of the play and that it was understood between them from the beginning that they were to be co-authors of the play. Moreover, I have seen and examined in detail the work-notes for the entire play in Mr. Hughes's own handwriting. I can see,

comparing his script with hers that she has made changes in an attempt perhaps to claim that she has re-written the play. But there's no question that it is the same play—and the changes are feeble.

Believing as I do, that Langston Hughes has rights in the matter, I will not produce it under her name alone. I think she has treated him very badly.

In one connection, Miss Hurston acknowledged his collaboration. Now, apparently, she repudiates it. One telegram says, "O.K.—Zora Hurston."—this in reply to a request to do the play, her name being used as co-author with that of Langston Hughes. Two hours later, I got another one calling it all off. The next morning, I have another one saying "Proceed. Good luck. Zora Hurston".

I am wondering whether she is not really too unreliable a person to deal with.

I have sent to her agent a confirmation of the agreement reached thru the telegrams to be signed, naming royalty terms, offering one-half rail fare here, and using her name jointly with that of Langston Hughes. Under the circumstances, I feel I cannot risk beginning the production until it is returned to me signed. And the date is near at hand.

Do you represent Langston Hughes in this affair? Do you believe that he has rights in the play?

Can Miss Hurston be dealt with? Can she or can she not be depended upon to keep a contract?

Would you care to have Louise Thompson's angle on the affair? Her address is 112 East 19th Street, New York City,

in care of The American Inter-racial Seminar. Hubert Herring
is Director of this organization. I know Miss Thompson and
believe implicitly in her integrity.

> Very truly yours,
> ROWENA WOODHAM
> JELLIFFE, DIRECTOR,
> THE GILPIN PLAYERS.

RWJ:A

HUGHES TO SPINGARN
4800 Carnegie Avenue,
Cleveland, Ohio.
February 3, 1931.

DEAR MR. SPINGARN,

Miss Hurston arrived in Cleveland, she says, on Sunday eve-
ning. Anyway she notified Mrs. Jelliffe of her presence here
on Monday, and we all had a conference together at the Play-
house on Monday afternoon. On Sunday evening, however,
because they had had no word from Miss Hurston, and the
agreement which they had sent her and her agent had not
been returned, the Gilpin Players voted to no longer continue
with the production, due to the uncertainty of her attitude.
However, when Miss Hurston showed up on Monday, Mrs.
Jelliffe felt that the group would perhaps reconsider their
action and continue with the play, so she asked Mr. Elmer
Cheeks, president of the Players to also come to the confer-
ence. We met at four o'clock. Miss Hurston and I had a talk
together alone first to straighten out our difficulties, so that we
could then confer in unity with the representatives of the
Gilpin Players. . . . In her talk with me, Miss Hurston's main
grievance seemed to be Miss Thompson. She seemed to feel

that by taking the play alone and go[ing] off with it she was thus protecting me and herself from what she chose to call "a gold digger." I told her that she and I both knew Miss Thompson had been paid for her typing last spring and she could have no further claim on the play in any way, of course. I asked her why she did not tell me of her ill feeling in the fall when I tried to resume work with her, and she said she could not bear to tell me. As to the play itself, Miss Hurston agreed that I had had some part in it's making, and she said she would sign an agreement to work together again jointly with me. She felt however that my part in the making of the play had been a very small one, and that her name should be first on the playbills, etc. I said that I had never claimed the play as even half mine, and in talking about it, had always said that the wit and color were in the main hers—but that I did not see how one could make a mathematical division of construction and characterization as opposed to dialect and wisecracks, the latter being clothing for the former. Miss Hurston insisted that the play which had been sent to Cleveland under her name had been a "new" play, anyhow, and that "there wasn't an idea of mine left in it." (That, of course, is untrue, as Mrs. Jelliffe could tell you. As I told you the play which came here was the same which we had outlined and planned and two-thirds finished together except for a rewritten ending to the first act, another secondary ending sent attached with a note saying either could be used, and the introduction of the turkey. One third act was the very same as we had done together. The rewritten third act, also sent, leaving it to the choice of the producer as to which would be used evidently, was built on the same construction lines . . . [type illegible] like type, leaving the similarity obvious.) Miss Hurston was very nice at this first conference, though, and we agreed that it was all over and settled and that we would sign together for a Gilpin production, should they re-decide to do it. We then called in Mrs. Jelliffe and Mr. Cheeks and told them of our agreement

and decision. They said they would call a meeting of the Players the following night (today, Tuesday). Zora said she was glad it all came out all right and that she would wire Carl at once and that I should wire you so that nobody in New York would any longer be in doubt about the matter. . . . That was last night! This morning early Miss Hurston called Mrs. Jelliffe by phone and began to abuse her, accusing her of acting on my word and in my behalf before she had gotten in touch with her, etc., Mrs. Jelliffe said she could hardly discuss the matter by phone that way, so it was agreed that we all get together again. This afternoon at five, then, at my house (because the doctor forbade me to go out as I've been down with tonsils for a week) Miss Hurston, Mrs. Jelliffe, a Mr. Banks whom Miss Hurston brought with her, and myself got together again. Miss Hurston was in a most angry and emotional mood. She began to berate Mrs. Jelliffe as being a dishonorable person saying that she didn't know what was going on here (when the facts are that she was informed by myself in two letters which remained unanswered for some ten days, as did Mrs. Jelliffe's wire to her when she failed to get any definite answer from French). Statements in any way disproving her wild assertions were absolutely disregarded. She implied that I was trying to steal the play from her. Kept bringing Miss Thompson into the conversation as a bad woman—and in general made a noisy and most undignified scene. She did, however, in the presence of Mrs. Jelliffe, admit that we had started the play together, and that certain characterizations such as making the two boys, one a dancer, the other a guitarist, work for the tourists, etc. were originally my ideas, and that one line in the first act had been mine—but that she had cut that out! . . . The whole thing was most absurd, like a scene in a play itself. Mr. Jelliffe stopped by to take his wife home for dinner, and hearing what was being said, asked her to no longer remain to be further insulted. Miss Hurston even insulted the city playground attached to the Playhouse Settle-

ment by saying that it was so muddy and dirty that it made her
sick to look at it when she had arrived yesterday for the first
conference. You can see from that how crazy and irrational the
afternoon was. Miss Hurston said that something she had
heard during the night before make her seek another under-
standing, as she hadn't come out to Cleveland to be made a
fool of; she said she didn't want the play to be done here now;
that whatever I had put in the hands of my lawyer could stay
there; and without even saying goodbye, she pushed her hat
on the back of her head and walked out. . . . So there is our
face to face ending! Of course there are a hundred other
remarks and sayings that were passed here that would take a
dozen more pages to put down, but you have here the gist of
what went on. (For one: Mr. Cheeks as President of the Play-
ers might have been more tactful in his handling of the situa-
tion. One of the first things he said to Miss Hurston was that
in ten years they had done plays by Paul Green, O'Neill, and
various other big people, and they'd never had the difficulties
with any one in regard to the permission to do or not do a play
as they had had with Miss Hurston!) And today's scene, of
course, made tonight's meeting of the Players to reconsider
the play, useless. . . . I also learn that she has said some
unpleasant things about me and the play in New York to
people whom I trust are friends—so it appears that she has
chosen to be as malicious and untrue about the matter as my
silence will allow her to be, making her version of the story
a public matter. In any case, the whole thing has come to the
ears of some of the colored newspaper reporters here. One of
them has promised to print nothing about the matter, but no
telling about some of the others may do. It's turned out to be
a most unpleasant mess here certainly, as the Gilpins will now
probably lose their downtown date and the money to pay on
the Art School scholarship. . . . As for myself, I see nothing
to do except to ask you to inform Elisabeth Marbury of my
claims as co-author of the play. (Raymond Crossett, I believe,

is the man who personally handles Miss Hurston's manuscripts there.) I have writen their office some days ago but have had no answer. I trust they will not attempt to sell the play until this is settled. If the play should ever be published or produced without my knowledge or consent, I feel that I have just proof, and ample grounds, on which to take action against the publishers or producers, as well as Miss Hurston—and after the disgraceful way in which she has acted, I certainly would wish to do so. . . . However, if she at any time again wishes to acknowledge our collaboration, or to work with me on the finishing of the play, I am perfectly willing to complete the play with her as regards the final polishing up and putting in shape which I feel that it needs. . . . At the moment I regret the loss of what I had considered her friendship, and the loss (I hope only temporarily) of what might have been an amusing comedy—but which really turned out to be A Bone Of Contention. . . . In the light of the face to face failure, I would appreciate your further advice on the matter. Aside from word to Marbury, I see nothing to do but let it all drop until Miss Hurston herself in some way brings it to life again. But I'd like to know what you think, too.

Sincerely,
[LANGSTON HUGHES]

SPINGARN TO HUGHES 19 West 44th Street
 New York City
 Feb. 3rd, 1931

Mr. Langston Hughes,
4800 Carnegie Ave.
Cleveland, Ohio.

DEAR LANGSTON:—

Your letter of Jan. 30th has just reached me and I am
returning herewith the papers previously sent to me and
which you ask for.

I did not tell Miss Hurston that I would not represent you
here in New York. What I did tell her was, that up to the
present I was acting, not as your lawyer but as your friend, in
an attempt to bring about an amicable adjustment and that, of
course, nothing she told me in my office would be used by me
in a legal capacity. This was, of course, the only ethical thing
to do, for if I were seeing her in a legal capacity, it would only
be proper that she be accompanied by her lawyer when she
saw me, but it had been my hope that in this matter the law
would not be resorted to.

I told Miss Hurston that I believed you were a strictly
honest person and that I resented your being described as
otherwise. When she gave me her detailed description of your
collaboration and other circumstances attending it, I told her,
as I wrote you and Mrs. Jelliffe, that I was not in a position to
controvert her statements without having a personal interview
with you, but that I felt your differences were largely tempera-
mental and emotional, and that I firmly believed that when she
got there you could adjust the matter between yourselves.

I also told Miss Hurston that no one would produce the
play without the consent of both of you and urged this as a

reason for a speedy settlement. She said that unless the matter could be settled "honestly" she would prefer to tear up the play. I told her this was foolish and that you doubtless could come to some accord. Likewise, when Dr. Locke came to see me, I made no comment further than to say that if the story told me were true, it was unfortunate, but that I was not in a position to pass on the matter without hearing your version.

As to the copyright, it is not unusual for the Copyright Office to copyright any material that is regularly presented to it. You can write to the Copyright office directly and ascertain the date on which Miss Hurston obtained her copyright.

By this time, you have seen Miss Hurston and I trust that my original belief that you could settle the matter amicably between you has been justified.

Believe me, as always,

Faithfully yours,
ARTHUR B. SPINGARN

Enclosures.

SPINGARN TO HUGHES 19 West 44th Street
 New York City
 February 5th, 1931

Mr. Langston Hughes,
4800 Carnegie Avenue,
Cleveland, Ohio.

DEAR LANGSTON:—

Your letter of February 3rd has just reached me and I am terribly sorry that the conference ended as it did.

The thing is particularly unfortunate, because unless you and Miss Hurston can come to some arrangement, the labors of both of you on the play will come to nought. On Miss Hurston's own statements at the Cleveland conference, you have some interests in the play and under the law, neither of you can dispose of the full rights to the play without the consent of the other. There are no steps for you to take now, inasmuch as the play is not going to be produced.

If you should ever learn of a production being contemplated, you would then be in a position to obtain an injunction. I understand from your letter that you have already notified Miss Marbury of your interest in the play, so there would be no point to my repeating the notice. I assume that you have kept a copy of the notice that you sent to her.

Perhaps when Miss Hurston has a chance to think further over this matter, you may again get together and collaborate on the manuscript and turn it into a really fine play. I sincerely hope this will come to pass.

In the meanwhile, with most cordial greetings, believe me to be, as always,

Faithfully yours,
ARTHUR B. SPINGARN

HURSTON TO HUGHES 43 W. 66th St.
 New York City
 February 14, 1931.

DEAR LANGSTON,

Arrived safely back in New York. Stopped in Westfield and got two books of mine that I needed. Asked Mrs. Peoples to tell you that I had taken them.

In case that my letter to Mrs. Jeliffe mis-carries, tell her

that I just found the check this afternoon. My nephew put part of the mail on my desk, and put the rest in the dresser drawer so I just found it, and am returning it to her. That is, I enclosed it in the letter I wrote her. In view of the fact that we did no business, I don't know whether I am due it. In addition it was incorrectly made out.

Sorry that you are having so much throat trouble. You are late on that again as you were on the intestinal trouble. I have wrassled with my throat for ages. Helene Johnson is in the hospital now having her tonsils out and I think I shall do the same before warm weather.

Lots of luck.
Sincerely,
Zora Neale Hurston

Spingarn to Hughes March 5th, 1931

Mr. Langston Hughes
4800 Carnegie Ave.
Cleveland, Ohio.

Dear Langston:—

Miss Hurston was in to see me this morning. She tells me that there is no possible chance of her ever collaborating with you on the play and that she wants to eliminate all parts of the play in which you claim collaboration, and make a new play in which you will have no interest, and she wants a release from you of your rights in this play.

I told Miss Hurston that Walter White had informed me that you were coming to New York shortly and that I could not take the matter up with you by correspondence, but that

when you came to New York, I would talk it over with you.

Will you please let me know by return mail what your plans are and when you expect to come to New York. I do not mean by this that you should come to New York on this account, but that you should let me know immediately when you expect to be here, so that I can inform Miss Hurston of the time when she may expect to hear your reaction from me.

In the meanwhile, with personal greetings, believe me to be, as always,

Sincerely yours,
ARTHUR B. SPINGARN

HUGHES TO SPINGARN 4800 Carnegie Ave.,
 Cleveland, Ohio,
 March 6, 1931

DEAR ARTHUR SPINGARN,

I hope to be in New York about March fifteenth. I will get in touch with you as soon as I arrive. I think it would be just as well to let Miss Hurston have the play, don't you? Or at least her part of it.

The copyright office informs us that Miss Hurston has not copyrighted the play (as she claimed she did in October). So I hold the only copyright. How would we dispose of that?

Thank you for writing me.

Sincerely,
LANGSTON HUGHES

HUGHES TO SPINGARN 4800 Carnegie Ave.,
 Cleveland Ohio,
 March 15, 1931

DEAR ARTHUR SPINGARN,

I cannot be in New York until next Monday, the 23rd. Have just had my tonsils out this week, so the doctor forbids my leaving until the end of next week. . . . I've finished a play of my own and want to ask your advice about a reliable agent when I see you. . . . With all good wishes,

 Sincerely,
 LANGSTON

HURSTON TO HUGHES 43 W. 66th St.
 New York City
 March 18, 1931

DEAR LANGSTON,

I got your clipping today. Thanks. I read it. I dont know whether you sent it to me so that I might know that this sort of thing happens to lots of folks, or whether some part of it appeared to you to fit the case.

At any rate, it was kind of you to want to help me. I am glad to hear that your throat is well. I have yet to undergo what you have just passed thru. I am feeling fine and well, but that throat is just waiting to spring on me again. I am calm again and went to a party and had a nice time. Hard at work on the African thing and plan to have it all done by next week.

Then I shall re-write the conjure book. I have a good scheme for doing it now.

Sincerely,
ZORA

HURSTON TO SPINGARN 43 W. 66 St.
 New York City
 March 25, 1931.

MY DEAR MR. SPINGARN,

This is to deny your assertion that you have seen the original script. You have seen what your client <u>says</u> is the original script. You evidently forget that your client had my script out in Cleveland and I see did not hesitate to copy off some "emendations." The whole matter is absolutely without honor from start to finish and this latest evidence of trying to make a case by actual theft, "emendations" as you call them, makes me lose respect for the thing altogether. From the very beginning it has been an attempt to build up a case by inference and construction rather than by fact. But all the liberal construction in the world cannot stand against certain things which I have in my possession.

I think it would be lovely for your client to be a playwright but I'm afraid that I am too tight to make him one at my expense. You have written plays, why not do him one yourself? Or perhaps a nice box of apples and a well chosen corner. But never no play of mine.

Most emphatically yours,
ZORA NEALE HURSTON

HURSTON TO MASON 43 West 66 St.
 New York City
 March 25, 1931.

DARLING GODMOTHER,

My work is coming along well. I have taken a great deal
of pains to rewrite certain passages and feel satisfied for the
moment with the introduction. I have done over two entire
chapters and now I am within a few paragraphs of the end of
the whole thing. Then for the final typing.

I found at the library an actual account of the raid as
Kossula said that it happened. Also the tribe name. It was
not on the maps because the entire tribe was wiped out by
the Dahomey troops. The king who conquered them pre-
served carefully the skull of Kossula's king as a most worthy
foe.

Harry's not being able to help me makes it unnecessary
to give him anything at present. I would want to offer him part
of my allowance as a gift if and when he does something for
me. He says that he cannot do anything until I have done it
over myself.

I find that Langston is in town and that he copied whole
hunks out of my play in Cleveland and NOW tries to say that
while he didn't write the thing in the beginning, he made all
those "emendations" on the play last Fall. I can't conceive of
such lying and falsehood. But then there are many things in
earth and sky that I don't know about.

All my love Godmother. I am very well and I have even
learned to live above Langston's vileness. So I am happy.

Love and love and love, and many prayers for your own
good health and happiness. I am making a supreme effort at

this time to make you happy and strengthen your faith in my creative ability.

Devotedly,
ZORA

I'd love for Langston to face me in your presence.

HURSTON TO MASON April 18, 1931

DARLING GODMOTHER,

At last "Barracoon" is ready for your eyes. I pray so earnestly that I have done something that can come somewhere near your expectations.

The pictures at the museum were magnificent. I am sending you the catalog so that you may know what the subjects are. The exhibit lasts until April 20th or thru that date.

I have been working on the Conjure book this week. It's getting easier now. I wrote Alain too. He is very busy I know but I hope for an answer.

Godmother darling, you don't know how the thought of you comforts me these devilish days. Sometimes what is inside me breaks out and destroys me for hours. Usually I am calm, but sometimes I need a refuge to run to. So I light a candle in your name and wait for you to send the peace.

The dress looks magnificent on me so I bought a hat to go with it. I am so grateful to you that you remember me always and try to drag me up to the light.

I saw Alta Douglas last week and she asked of you. This is the first time that she has said anything about you. She says she wants to write you but she knows you are not well.

I know that Langston says he was going to Cuba, but I

suspect that he is really gone to hunt up Eatonville to pretend that he knew about it all along.

When I look back on the three and a half years that I have known you, Godmother, I am amazed. I see all my terrible weakness and failures, my stark stupidity and lack of vision and I am amazed that your love and confidence has carried over. That is why I am plugging away so diligently now, so that your faith will have something to live on. I know that your perfect understanding of me will read all the volumes that are compressed in this paragraph.

I fear that the tonsils will have to come out soon. They stay sore and lower my vitality too much. I am only half of me at least a third of the time.

With a prayer for a greater understanding on my part, a continued love from you and some achievements from my person to nourish you, I am

> Your own
> ZORA

HUGHES TO SPINGARN 181 West 135th St.,
 New York, New York,
 August 14, 1931.

Mr. Arthur Spingarn,
19 West 44th Street,
New York, New York.

DEAR ARTHUR SPINGARN,

Yesterday morning, August 13, I went with my aunt, Mrs. Toy Harper, 2 East 127th Street, to the office of Elizabeth Marbury, where I had a talk with Raymond Crossett regarding

the comedy <u>Mule Bone</u> by Zora Hurston and myself. I told
Mr. Crossett that I had written his office last spring stating that
I was co-author with Miss Hurston of the play, and that they
had not answered my letter. Mr. Crossett said it was never
received by the Marbury office. I then proceeded to tell him
the facts of the collaboration. He said my story left him cold.
That I had no rights in the play. That he had absolute faith in
Miss Hurston. That he would continue to handle the play.
That I could get all the lawyers I choose. That they had one
of the best law-firms in town, (which he named). And that he
just loved fights. He further stated that he had laid the whole
case before the Dramatists Guild, and that he was well pro-
tected there. . . . When I left his office, I went to the Dramatists
Guild, where I am a member, and was informed that they had
never heard of the case there, and had never talked with
Crossett about it! They said Miss Hurston is not a member of
the Guild. And they advised me to write them a letter setting
forth the details. I am doing so today. . . . I am also writing
the Marbury office again, this time registered mail, so that they
cannot deny receiving my letter. The play has been for some
weeks in the hands of Wallace Thurman, whom the Marbury
office asked to revise it. Yesterday Mr. Thurman told me he
was returning the manuscript, having done no work on it, as
he did not wish to be involved in a controversy. . . . I am
enclosing a carbon of my letter to the Marbury office today.

Sincerely,
LANGSTON HUGHES

43 W. 66th St.
 New York City
 August 14, 1931

DARLING MY GODMOTHER,

 You have been with me every day in the spirit and I have
felt you there. My silence has neither been negligence nor
illness. Things have been in such a fluid condition from day
to day that there was not a statement I could safely make,
except to acknowledge your gift to me. For about 15 days the
revue "Fast and Furious" looked bad. Financial difficulties.
One day it would look hopeful, the next very black. Yesterday
the producer got the money and the house all settled. Some-
how my inner self tells me that even now something is not
well. Perhaps he and I shall disagree about changes in my
material. Godmother, they take all the life and soul out of
everything and make it fit what their idea of Broadway should
be like. It's sickening at times.
 Langston is back in town. I received an announcement
that he was to lecture on the West Indies, or his travels, to be
exact, under the auspices of the "Crisis." He went down to my
agent's with a long line of most malicious lies in an effort to
prejudice them against me. He took along some woman
whom he introduced as his aunt to help him talk. All he got
for his trouble was to be called a vicious liar to his face, a sneak
and a weakling. The woman was asked what she was doing
there and to keep her mouth shut or get out of the office. He
was made out a liar on five different counts, and told to do
anything that he wished, for there was able legal backing
behind me. So he finally slunk out telling Mr. Crossett that he
was collaborating on a play with Wallace Thurman and he
would like for the Marbury office to handle it. Mr. Crossett
told him that he handled Thurman's affairs, but that the office
would positively refuse to touch anything that he had anything

to do with as he had shown himself to be a person of no honor. Nobody had to convict him of being a liar. He convicted himself. With his own letter of Oct. 6, before Mr. Crossett in which he asks me to send him the second act of the play, he tells Mr. Crossett that he had written the play himself in January and I had stolen it and made a copy of his play and submitted it to the Guild. Then of course, Mr. C. showed him my copyright card of Oct. 29, 1930 and he all but fainted, for he thought he had played a sharp trick by making a copy while it was in Cleveland and getting copyrighted.

He tried to tell the agent these things which you had told me he was saying—that it was a personal affair and that I had taken his play because I was jealous of Louise. The agent of course cut him short and told him that he [had] no interest in anything except the authorship of the play, and that his place was an office and not a cleaning house for Harlem gossip. He wanted him to point out what he had done on the play. He [Hughes] said that he had taken a page and a half of my notes—all that there was of my story—and built it into seventy magnificent pages of a play. Whereupon he was again told that he was a stupid liar. He told him (I mean L. told C.) that I was a person of a most violent disposition and had called him and his Cleveland friends liars and crooks, etc. Mr. C. again reminded him that he was only interested in the business and commented that if his tactics were the same in Cleveland as they were in his office, I was more than justified and much too mild, really. So much for that. It no longer even annoys me. Give a calf enough rope—

Had a card from Alain. He gave me a nice bawling out. I loved it. It was the first time he had noticed me and I was so glad he had calmed down enough to speak to me at all. I shall write him c/o Cook's Place, Madelaine, Paris.

Now about the money, Godmother, darling. By the time for you to send me my next allowance, I shall be receiving money from the theatre. I should love to keep up our original

arrangement. I'd like to send you all monies and have you then give me an allowance as usual. If you say, "Now that you are earning money, go for yourself," I'll feel alone in the world again. And Godmother, that would be too awful.

What would happen if I were to jump in our car and come up to talk with you?

Thanks and thanks Godmother, darling. I love you truly.

<div align="right">Devotedly,
ZORA</div>

HURSTON TO LOCKE

<div align="right">The Young Womens
Christian Association
of Chicago
South Parkway Branch
and Residence
4559 South Parkway
October 29, 1934</div>

Dr. Alain Leroy Locke,
1326 R. Street,
Washington, D.C.

DEAR ALAIN:

I have written godmother for the permission to dedicate the new book.

Did I tell you in the last letter that it is being illustrated by Baldridge? It would have been off the press in November but for that. It will be out in January now.

Instead of feeling less need of godmother and more independent as success approaches me, I need her more and feel her great goodness to me more deeply. If I am acclaimed by

the world, and make a million in money, I would feel still that she was responsible for it. I have not written often because I did not get answers and thought she did not want to hear from me. Just did not understand. She shall have a weekly letter from me—from now on.

I do hope that you come to Chicago, within the next few days. I wish that you could be here for my concert on the 23rd of November. I would like very much to have you tell the audience what godmother has meant to Negro literature and art. She is where she can do no more, but before she passes I think there ought to be some acknowledgment to the world, from at least one of the people that she has saved or tried to save, and what she has meant to America.

There will be three performances, two evening performances on the 23rd and 24th of November and a matinee on the 24th.

I am beginning my third book as soon as the concert is over.

My play "Mule Bone" has been asked for by the Little Theatre in New York. Same director as for "Run Little Chillun." I am wondering whether to send it there or to produce it myself here. I have a very good opening. Since all funds for the play and everything else can be had right here, I am wondering if I could not do a better job of interpreting Negro material than any white director ever could.

<div style="text-align: right">

Most sincerely,
ZORA NEALE HURSTON

</div>

October
Twenty-ninth
1 9 3 4
ZNH/mp

VAN VECHTEN TO HUGHES James Weldon Johnson
 Memorial Committee
 Sixty-nine Fifth Avenue
 New York, NY
 [August 17, 1942]

Dear Langston, I've been away for a few days and when I come back I find your letter. . . . While away I have read a book called The Sabbath Has No End, by John Weld (ofay) a story of slave days on a plantation where the slaves were "well treated." Without much trouble, Mr. Weld shows you that it was impossible to treat slaves well and gives many intricate reasons in the course of his story. In many ways a vivid and extraordinary story. . . . I've also been reading many Negro letters for Yale, including the correspondence re Mule Bone which includes letters from YOU and Zora and Barrett H. Clark and Lawrence Langner and Theresa Helburn. It's a pretty complete tale and your letter regarding Zora's tantrum in your mother's room in Cleveland is wonderful. She had a tantrum in my library at 150 West 55 Street too and threw herself on the floor and screamed and yelled! Bit the dust in fact. You woulda loved it, had it not concerned you. . . . Something very important has happened, perhaps for the first time. *LIFE* in the August 17 issue has a couple of pages concerning the fire that destroyed part of the managery of the Ringling Brothers and it gives the name of the incendiary, but it does not say he is a Negro or print his picture! On my return I find a bundle (for Yale) a mile high from Walter White, another full of music from William Dawson, another smaller package from Verna Arvey and many letters promising help. Arna writes that he has already seen Georgette's manuscript and talked it over with her about a year ago. WHY will people behave in this fashion? She said she had never heard of him. Obviously I can't trust Miss Harvey on the next go-round. . . . Mr. Knollenberg has just given the Yale Collection some

terrific letters, including items of Lincoln, Frederick Douglass, and Harriet Beecher Stowe. And Ray Stannard Baker has given us a tremendous amount of important material. . . . I had already planned to write Mrs. Rapp but thought I would wait till Mr. Rapp had been dead a minute. . . . I guess people would walk into your life even if you didn't write poems, but perhaps the poems makes 'em walk in quicker. . . . MY LAST copy of Theatre Arts went to Noel, as you requested. Somebody told me the magazine was out of print, but I'll see what I can do. You shall have a copy if there is one! My reserved copy, of course, went to Yale. . . . I'm afraid Kenneth F. is somewhere in the catalogue as Miss Taggard's spouse. If so, this information came from You, you rascal! I haven't been to Fat Man in the Bronx though Eddie and his blonde wife asked me to the housewarming at their Love Nest. . . . It was too hot and too late a party, so I didn't go. Tita, Gate; is This Is The Army! And I have photographed the three leading Negroes. . . . In the Pennsylvania station last night there wasn't a single porter. Lugged a 90 pound bag (full of letters and books) about a mile in pitch blackness (the roof is glass and they keep the lights out). Your slow eating habits will be a distinct disadvantage to you in a boarding house where you are expected to talk. Better take vitamins. . . . The Everleigh Club in Chicago also had a fountain in the living room. Some of the best families used to fall in. Affection to you and FM even sends a kiss, after your "Tell Fania I love her!"

Monday (I'm off to the Canteen SOON)

CARLO!

ABOUT THE EDITORS

George Houston Bass (1938–1990), one of this country's leading authorities on Afro-American art and literature, was professor of Theatre Arts and Afro-American Studies at Brown University, and was founder and artistic director of Brown's Rites and Reason Theatre. He studied at Fisk (New York) and Yale Universities. Under his leadership, Rites and Reason Theatre won a citation from the New England Theatre Conference, and the Monarch Award from the National Council for Culture and Arts. Bass is the author of several plays including *Providence Garden Blues, Black Masque, Malacoff Blue,* and *Brer Rabbit Whole,* and Dr. Bass's research on the aesthetics of African-American performance tradition has appeared in many scholarly publications. He was editor of *The Langston Hughes Review,* the official publication of the Langston Hughes Society, published by Brown University's Afro-American Studies Program.

Henry Louis Gates, Jr., received his Ph.D. from the University of Cambridge in 1979. Duke University's John Spencer

Bassett Professor of English and Literature, he has also taught at Yale and Cornell Universities. His interests are in African and African-American literature and criticism. He is the general editor of *The Norton Anthology of Afro-American Literature,* and the editor of Oxford's thirty-volume series, *The Schomburg Library of Nineteenth-Century Black Women Writers.* His publications include *Figures in Black: Words, Signs, and the Racial Self* (Oxford, 1987) and *The Signifying Monkey: A Theory of Afro-American Literary Criticism* (Oxford, 1988), which won the American Book Award.

About the authors

About the book

Read on

Insights,
Interviews
& More...

Meet Zora Neale Hurston and Langston Hughes

LANGSTON HUGHES (1902–1967) ranks as one of the greatest American poets of the twentieth century. A landmark figure in the Harlem Renaissance, his work profoundly captures and celebrates the trials and triumphs of his exquisitely drawn characters. In addition to his poetry, he was also the author of the novels *Now Without Laughter* and *Something in Common*, the play *Mulatto*, and two volumes of autobiography.

ZORA NEALE HURSTON (1891–1960) was a novelist, folklorist, and anthropologist whose fictional and factual accounts of black heritage remain unparalleled. Her many books include *Dust Tracks on a Road*; *Their Eyes Were Watching God*; *Jonah's Gourd Vine*; *Seraph on the Suwannee*; *Moses, Man of the Mountain*; and *Every Tongue Got to Confess*.

She *Was* the Party

by Valerie Boyd

ZORA NEALE HURSTON knew how to make an entrance. On May 1, 1925, at a literary awards dinner sponsored by *Opportunity* magazine, the earthy Harlem newcomer turned heads and raised eyebrows as she claimed four awards: a second-place fiction prize for her short story "Spunk," a second-place award in drama for her play *Color Struck*, and two honorable mentions.

The names of the writers who beat out Hurston for first place that night would soon be forgotten. But the name of the second-place winner buzzed on tongues all night, and for days and years to come.

Lest anyone forget her, Hurston made a wholly memorable entrance at a party following the awards dinner. She strode into the room—jammed with writers and arts patrons, black and white—and flung a long, richly colored scarf around her neck with dramatic flourish as she bellowed a reminder of the title of her winning play: ▶

Author photograph by Carl Van Vechten, courtesy of the Van Vechten Trust

3

"Coloooooor Struuckkkk!" Her exultant entrance literally stopped the party for a moment, just as she had intended. In this way, Hurston made it known that a bright and powerful presence had arrived.

By all accounts, Zora Neale Hurston could walk into a roomful of strangers and, a few minutes and a few stories later, leave them so completely charmed that they often found themselves offering to help her in any way they could.

Gamely accepting such offers—and employing her own talent and scrappiness—Hurston became the most successful and most significant black woman writer of the first half of the twentieth century. Over a career that spanned more than thirty years, she published four novels, two books of folklore, an autobiography, numerous short stories, and several essays, articles, and plays.

Born on January 7, 1891, in Notasulga, Alabama, Hurston moved with her family to Eatonville, Florida, when she was still a toddler. Her writings reveal no recollection of her

Alabama beginnings. For Hurston, Eatonville was always home.

Established in 1887, the rural community near Orlando was the nation's first incorporated black township. It was, as Hurston described it, "a city of five lakes, three croquet courts, three hundred brown skins, three hundred good swimmers, plenty guavas, two schools, and no jailhouse."

In Eatonville, Zora was never indoctrinated in inferiority, and she could see the evidence of black achievement all around her. She could look to town hall and see black men, including her father, John Hurston, formulating the laws that governed Eatonville. She could look to the Sunday schools of the town's two churches and see black women, including her mother, Lucy Potts Hurston, directing the Christian curricula. She could look to the porch of the village store and see black men and women passing worlds through their mouths in the form of colorful, engaging stories.

Growing up in this culturally affirming setting in an eight- ▶

❝ In Eatonville, Zora was never indoctrinated in inferiority, and she could see the evidence of black achievement all around her. ❞

room house on five acres of land, Zora had a relatively happy childhood, despite frequent clashes with her preacher-father, who sometimes sought to "squinch" her rambunctious spirit, she recalled. Her mother, on the other hand, urged young Zora and her seven siblings to "jump at de sun." Hurston explained, "We might not land on the sun, but at least we would get off the ground."

Hurston's idyllic childhood came to an abrupt end, though, when her mother died in 1904. Zora was only thirteen years old. "That hour began my wanderings," she later wrote. "Not so much in geography, but in time. Then not so much in time as in spirit."

After Lucy Hurston's death, Zora's father remarried quickly— to a young woman whom the hotheaded Zora almost killed in a fistfight—and seemed to have little time or money for his children. "Bare and bony of comfort and love," Zora worked a series of menial jobs over the ensuing years, struggled to finish her schooling, and eventually joined a Gilbert & Sullivan

66 Zora had a relatively happy childhood, despite frequent clashes with her preacher-father, who sometimes sought to 'squinch' her rambunctious spirit. 99

6

traveling troupe as a maid to the lead singer. In 1917, she turned up in Baltimore; by then, she was twenty-six years old and still hadn't finished high school. Needing to present herself as a teenager to qualify for free public schooling, she lopped ten years off her life—giving her year of birth as 1901. Once gone, those years were never restored: from that moment forward, Hurston would always present herself as at least ten years younger than she actually was.

Apparently, she had the looks to pull it off. Photographs reveal that she was a handsome, big-boned woman with playful yet penetrating eyes, high cheekbones, and a full, graceful mouth that was never without expression.

Zora also had a fiery intellect, an infectious sense of humor, and "the gift," as one friend put it, "of walking into hearts." Zora used these talents—and dozens more—to elbow her way into the Harlem Renaissance of the 1920s, befriending such luminaries as poet Langston Hughes and popular singer-actress Ethel Waters. ▶

Though Hurston rarely drank, fellow writer Sterling Brown recalled, "When Zora was there, she *was* the party." Another friend remembered Hurston's apartment—furnished by donations she solicited from friends—as a spirited "open house" for artists. All this socializing didn't keep Hurston from her work, though. She would sometimes write in her bedroom while the party went on in the living room.

By 1935, Hurston—who'd graduated from Barnard College in 1928—had published several short stories and articles, as well as a novel, *Jonah's Gourd Vine*, and a well-received collection of black Southern folklore, *Mules and Men*. But the late thirties and early forties marked the real zenith of her career. She published her masterwork, *Their Eyes Were Watching God*, in 1937; *Tell My Horse*, her study of Haitian Voodoo practices and Caribbean culture, in 1938; and another masterful novel, *Moses, Man of the Mountain*, in 1939. When her autobiography, *Dust Tracks on a Road*, was

66 'When Zora was there, she *was* the party.' 99

published in 1942, Hurston finally received the well-earned acclaim that had long eluded her. That year, she was profiled in *Who's Who in America*, *Current Biography*, and *Twentieth Century Authors*. She went on to publish another novel, *Seraph on the Suwanee*, in 1948.

Still, Hurston never received the financial rewards she deserved. (The largest royalty she ever earned from any of her books was $943.75.) So, when she died on January 28, 1960—at age sixty-nine, after suffering a stroke—her neighbors in Fort Pierce, Florida, had to take up a collection for her February 7 funeral. The collection didn't yield enough to pay for a headstone, however, and Hurston was buried in a grave that remained unmarked until 1973.

That summer, a young writer named Alice Walker traveled to Fort Pierce to place a marker on the grave of the author who had so inspired her own work. Walker found the Garden of Heavenly Rest, a segregated cemetery at the dead end of North Seventeenth ▸

66 Hurston was buried in a grave that remained unmarked until 1973. 99

Street, abandoned and overgrown with yellow-flowered weeds.

Back in 1945, Hurston had foreseen the possibility of dying without money—and she'd proposed a solution that would have benefited her and countless others. Writing to W. E. B. Du Bois, whom she called the "Dean of American Negro Artists," Hurston suggested "a cemetery for the illustrious Negro dead" on one hundred acres of land in Florida. "Let no Negro celebrity, no matter what financial condition they might be in at death, lie in inconspicuous forgetfulness," she urged. "We must assume the responsibility of their graves being known and honored." Du Bois, citing practical complications, wrote a curt reply discounting her argument.

As if impelled by Hurston's words, Walker bravely entered the snake-infested cemetery where the writer's remains had been laid to rest. Wading through waist-high weeds, she soon stumbled upon a sunken rectangular patch of ground that she determined to be Hurston's grave. Unable to

> 66 Wading through waist-high weeds, Alice Walker stumbled upon a sunken rectangular patch of ground that she determined to be Hurston's grave. 99

afford the marker she wanted—
a tall, majestic black stone called
"Ebony Mist"—Walker chose
a plain gray headstone instead.
Borrowing from a Jean Toomer
poem, she dressed the marker
up with a fitting epitaph: "Zora
Neale Hurston: A Genius of the
South." ∼

*Valerie Boyd is the author of
the award-winning* Wrapped in
Rainbows: The Life of Zora Neale
Hurston. *Formerly the arts editor at
the* Atlanta Journal-Constitution,
*she is a professor at the University
of Georgia's Grady College of
Journalism and Mass
Communication.*

"The First Real Negro Folk Comedy"?

by Robert E. Hemenway

The following is excerpted from Robert E. Hemenway's Zora Neale Hurston: A Literary Biography *(The University of Illinois Press, 1977) and is reprinted by permission of the University of Illinois Press.*

ALTHOUGH much could be said about this play, the most pertinent commentary has to do with authorial intention. [Langston] Hughes claimed that they were trying to create "the first real Negro folk comedy"; what he meant, I think, was that the play could be contrasted with the black low-life comedy familiar to American theatergoers as the minstrel show. The minstrel stereotypes of the lazy, sensual, ignorant, laughing darky had been challenged by revue performers of the twenties such as Bert Williams; they had triumphed in spite of the tradition, on the basis of sheer talent rather than their stage roles. Hughes and Hurston, however,

attempted to create a play that would be a part of what Larry Neal has called "a truly original Black literature," an attempt to portray the black folk in such a way as "to establish some new categories of perception; new ways of seeing a culture which had been caricatured by the white minstrel tradition, made hokey and sentimental by the nineteenth-century local colorists, debased by the dialect poets, and finally made a 'primitive' aphrodisiac by the new sexualism of the twenties."* *Mule Bone* did not quite achieve this new mode of perception, but one wonders if its authors' continued collaboration might not have produced a breakthrough. The play that was originally titled *The Bone of Contention* turned out to be truer to its title than to its purposes.

One example will suffice to show the subtlety of the authors' attempt. The courting ritual in the final scene is a traditional mode of verbal lovemaking among southern rural black folk, very possibly African in origin. Some ▶

66 Hughes and Hurston ... attempted to create a play that would be a part of what Larry Neal has called 'a truly original Black literature.' 99

* Larry Neal, "A Profile: Zora Neale Hurston," *Southern Exposure*, 1 (Winter, 1974), 162.

of the first recorded rituals appeared in 1895 in the *Southern Workman*, Hampton Institute's monthly magazine, written by a man remembering the tradition-bearer role that an old slave named Uncle Gilbert contributed to the quarters. Young slaves would go to Uncle Gilbert to learn "courtship's words and ways." The old man believed that to "git a gal wuth havin" a man "mus' know how to talk fur her." Such talking involved a combination of testing the girl's availability, her willingness to be courted, her skill in solving riddles, and the suitor's ability to display verbal improvisation. Certain formulas and rhymes were set, others improvised at the moment. The slave's proof of his affection is similar to Dave's purchase of a passenger train or Jim's buying an ocean; yet the point is not the implausibility, but the imagination that thought of the example: "Kin' lady, ef I was to go up between de heavens and de' yearth an drop down a grain of wheat over ten acres of land an' plow it

up wid a rooster fedder, would you marry me?" Courtship testimony from the folklorist in 1895—"Dear Miss, ef I was starvin' an' had jes one ginger cake, I would give you half, an' dat would be de bigges' half"—is similar to *Mule Bone*'s "If I was dead and any other woman came near my coffin de under taker would have to do his job all over—'cause I'd git right up and walk off." A direct connection between act 3 of *Mule Bone* and traditional courting rituals is found in Dave's question to Daisy following one of his boasts: "Miss Daisy, ma'am, also ma'am, which would you ruther be—a lark a flyin' or a dove a-settin, ma'am, also ma'am?" In 1895 Portia Smiley reported the following as a part of courting rituals in Alabama: "Kin' lady, are yo' a standin' dove or a flyin lark? Would you decide to trot in double harness, and will you give de most excrutish pleasure of rollin' de wheels of de axil, accordin' to your understandin'?" In *Negro Folk Rhymes* (1922), Thomas W. Talley includes a similar exchange in the section on courtship rhymes: ▶

"The First Real Negro Folk Comedy"?
(continued)

(He) Is you a flyin' lark or a
 settin' dove?
(She) I'se a flyin' lark, my
 honey Love.
(He) Is you a bird o' one
 fedder, or a bird o' two?
(She) I'se a bird o' one fedder,
 w'en it comes to you.
(He) Den, Mam:
I has desire, an' quick
 temptation,
To jine my fence to yo
 plantation.*

Hurston had collected such rituals and had sent some examples to Hughes. They were both aware that the genre was traditional, and they were consciously trying to represent for the stage the folkloric context. If successful, they would be able

" If successful, they [Hughes and Hurston] would be able to undermine the minstrel image of the ignorant black man using long words he did not understand, the stereotyped conception of black verbal art. "

* Portia Smiley, "Folklore and Ethnography," *Southern Workman*, 24 (1895), 15; Frank D. Banks and Portia Smiley, "Old Time Courtship Conversation," ibid., pp. 14–15, 78, reprinted in *Mother Wit from the Laughing Barrel*, ed. Alan Dundes (Englewood Cliffs, N.J.: Prentice-Hall, 1973), pp. 251–57 (Dundes's notes to this article are especially valuable); Thomas W. Talley, *Negro Folk Rhymes* (New York: Macmillan, 1922), p. 135.

to undermine the minstrel image of the ignorant black man using long words he did not understand, the stereotyped conception of black verbal art. If done well, the verbal duel would prove the rhyming ability, the ingenious improvisation, and the general wit of black folk, who were anything but ignorant or inarticulate. A play like *Mule Bone* could challenge racist preconceptions by remaining true to the traditions of "lowly" black peasants; it could destroy stereotypes by entertaining a "cultured" audience with the functional comedy of the Eatonville community. The courtship rituals were behavioral manifestations of a unique aspect of Afro-American subculture, and *Mule Bone* could represent that behavior in a way never realized on the stage before. Contrary to Van Vechten's hope that *Mule Bone* might become another *Green Pastures*, the effect of the play was intended to be quite different. *Green Pastures*, a well-meaning play by a white author, was redeemed from ▶

comic stereotypes by black actors.
As Du Bois pointed out, it was "de
Lawd," Richard Harrison, who had
"guided a genial comedy into a
great and human drama." * *Mule
Bone* was "Negro folk comedy"
written by two black authors
who designed the play around
the traditional verbal behavior
of black people. Its comedy came
not so much from the authors'
wit as from the skillful verbal
communication of the folk. It
never came to the stage because
of the authors' quarreling over
authorship. Yet in a sense it was
written by neither Hurston nor
Hughes. Much of the language in
the play belonged to the race itself,
making the argument over its
ownership even more ironic. ∾

* W. E. B. Du Bois, "Besides the Still Waters,"
Crisis, 38 (May, 1931), 169.

Have You Read?
More by Zora Neale Hurston

JONAH'S GOURD VINE

Zora Neale Hurston's first novel
tells the story of John Buddy
Pearson, a young minister who
loves too many women for his own
good even though he is married
to Lucy, his one true love. In this
sympathetic portrait of a man and
his community, Hurston shows
that faith, tolerance, and good
intentions cannot resolve the
tension between the spiritual
and the physical.

THEIR EYES WERE WATCHING GOD

The epic tale of Janie Crawford,
whose quest for identity takes
her on a journey during which
she learns what love is, experiences
life's joys and sorrows, and comes
home to herself in peace. Her
passionate story prompted Alice
Walker to say, "There is no book
more important to me than
this one."

MULES AND MEN

The fruit of Hurston's labors as a folklorist and anthropologist, this celebrated treasury of black American folklore includes stories, "big old lies," songs, Voodoo customs, superstitions—all the humor and wisdom that is the matchless heritage of American blacks.

THE COMPLETE STORIES

This landmark gathering of Zora Neale Hurston's short fiction— most of which appeared only in literary magazines during her lifetime and some of which has never before been published— reveals the evolution of one of the most important African American writers. Spanning her career from 1921 to 1955, these stories attest to Hurston's tremendous range and establish themes that recur in her longer fiction. The stories in this collection map, in rich language and imagery, Hurston's development and concerns as a writer and provide an invaluable reflection of the mind and imagination of the author of the

acclaimed novel *Their Eyes Were Watching God*.

TELL MY HORSE

This firsthand account of the mysteries of Voodoo is based on Hurston's personal experiences in Haiti and Jamaica, where she participated as an initiate and not just an observer of Voodoo practices in the 1930s. Of great cultural interest, her travelogue paints a vividly authentic picture of ceremonies, customs, and superstitions.

MOSES, MAN OF THE MOUNTAIN

Based on the familiar story of the Exodus, Hurston blends the Moses of the Old Testament with the Moses of black folklore and song to create a compelling allegory of power, redemption, and faith.

DUST TRACKS ON THE ROAD

First published in 1942 at the crest
of her popularity as a writer, this
is Hurston's imaginative and
exuberant account of her rise
from childhood poverty in the
rural South to a prominent place
among the leading artists and
intellectuals of the Harlem
Renaissance. It is a book full of
the wit and wisdom of a proud
and spirited woman who started
off low and climbed high.

SERAPH ON THE SUWANEE

Set among the community of
"Florida Crackers" at the turn of
the twentieth century, Hurston's
novel marks a daring departure
for the author famous for her
complex accounts of black culture
and heritage. Hurston explores the
evolution of a marriage full of love
but very little communication and
the desires of a young woman in
search of herself and her place in
the world.

African American folklore was Zora Neale Hurston's first love. Collected in the late 1920s, these hilarious, bittersweet, often saucy folktales—some of which date back to the Civil War—provide a fascinating, verdant slice of African American life in the rural South at the turn of the twentieth century. Arranged according to subject—from God Tales, Preacher Tales, and Devil Tales to Heaven Tales, White-Folk Tales, and Mistaken Identity Tales—they reveal attitudes about slavery, faith, race relations, family, and romance that have been passed on for generations. They capture the heart and soul of the vital, independent, and creative community that so inspired Zora Neale Hurston.

THE COMPLETE STORIES

The
Complete Stories

Zora Neale Hurston

*With an Introduction by Henry Louis Gates, Jr.,
and Sieglinde Lemke*

AMISTAD

An Imprint of HarperCollinsPublishers

Contents

PREVIOUSLY UNPUBLISHED STORIES
(IN ALPHABETICAL ORDER)

Acknowledgments

The editors would like to thank the following scholars for their editorial assistance: Cynthia Bond, Lisa Gates, Michael Roy, Richard Newman, Jennifer James, Mary Anne Boelcskevy, and Michael Vazquez. Joanne Kendall expertly and enthusiastically prepared this manuscript. To Jennifer Burton a note of special thanks for assiduously comparing the galleys with the original manuscripts, and for overseeing the editorial apparatus of this volume.

Acknowledgments

Introduction

ZORA NEALE HURSTON: ESTABLISHING THE CANON

*Hurston's black characters do not suffer from the sort of
alternative black self-hatred/prideful self-love/hate-envy
of white and black that characterizes many other
Harlem Renaissance fictional creations.* —MARGARET PERRY

Since 1990, HarperCollins has committed itself to publishing the
complete works of the great American novelist and anthropolo-
gist, Zora Neale Hurston (1891–1960). Between 1990 and 1994,
we have published, in a uniform edition, the seven books that
Hurston published during her lifetime, as well as her previously
unpublished play, *Mule Bone*, which she coauthored with Lang-
ston Hughes. These eight texts, ranging from her pioneering an-
thropological studies of African-American myth and ritual, *Mules
and Men* and *Tell My Horse*, to her canonical novel, *Their Eyes
Were Watching God*, demonstrate for a new generation of readers
the astonishingly broad range of Hurston's literary talents. In-
deed, using any measure, by the time that she published her third
novel, *Seraph on the Suwanee*, Zora Neale Hurston had estab-
lished herself as a major person of letters in American culture.
Within African-American culture, she had few peers.

Hurston "disappeared" from the African-American canon be-
tween the mid-1940s—when the naturalism of Richard Wright

and the naturalist-feminism of Ann Petry dramatically dominated the black literary landscape, in stark contrast to the lyrical modernism epitomized by Hurston's masterpiece, *Their Eyes Were Watching God*—and the mid-1970s, when a nascent black feminist movement led by Alice Walker and Mary Helen Washington seized upon her as *the* canonical black foremother. Hurston's recovery is one of the most curious instances of canon reformation in the recent history of American letters. A fuller account of Hurston's career and its fate appears in the Afterword.

Under the direction of Miss Hurston's heirs, we have decided to publish an additional seven volumes of Hurston's uncollected and unpublished works, including complete editions of her short stories, her essays, and her plays, as well as a fully restored edition of her autobiography, *Dust Tracks on a Road*, which we are publishing jointly with the Library of America. In this way, we hope to establish Hurston's own canon of texts, so that students and scholars can continue the necessary task of evaluating Hurston's place—both for our generation of readers and, ultimately, for generations to come—in the American literary tradition. We have decided to inaugurate this series of Miss Hurston's uncollected and unpublished works with this edition of her collected short fictional and folkloric narratives and character sketches.

As early as 1931, Zora Neale Hurston's capacities as a master of the short story were widely acknowledged. Otelia Cromwell, Lorenzo Dow Turner, and Eva B. Dykes—three of the most sophisticated black literary critics writing at the time—identified Hurston, in their well-regarded anthology, *Readings From Negro Authors*—as one of the best-known black writers of the short story. This, despite the fact that by 1931, Hurston had published only eight short stories and had not yet published her two great novels, *Jonah's Gourd Vine* (1934) and *Their Eyes Were Watching God* (1937). But Cromwell, Turner, and Dykes were correct: Her command of narrative voice and plotting, her concern with the themes of divine and human justice, her delight in the Southern black vernacular voice as a vehicle for narration, and the use

of the complex dynamics among a small group of characters set in her native Eatonville as the site for the unfolding of these themes—all of these signal elements that would assume such magnificent full-blown form in her first two novels are present in these early short narratives. Clearly, Hurston used these stories, perhaps unconsciously, the way an artist uses a sketch for a larger work of art.

What strikes the contemporary reader is that Hurston was deeply passionate about the people whose dreams and desires, whose traumas and foibles she describes with such élan, and that she loved the fictional language in which she cloaks their tales; hers is not the urgency of the essayist or the columnist, intent upon reducing human complexity to a sociological or political *point*. Above all else, Hurston is concerned to register a distinct sense of space—an African-American cultural space. The Hurston voice of these stories is never in a hurry or a rush, pausing over—indeed, luxuriating in—the nuances of speech or the timbre of voice that give a storyteller her or his distinctiveness.

For example, in her story "The Bone of Contention," Hurston narrates the tale that she and Langston Hughes would use as the basis of the plot of their play, *Mule Bone*, which was largely written in 1930 but remained unpublished and unperformed until 1991, when a production premiered at Lincoln Center Theater in New York. Unlike so many of her contemporaries, Hurston frequently commented explicitly on the nature of figurative language, as well as on the process of fiction-making. Her remarks about this story are no exception: "The elders neglected his bones," she writes, "but the mule remained with them in song and story as a simile, as a metaphor, to point a moral or adorn a tale." This level of attention both to the nature of narration and to the functions of figurative language underscores Hurston's determination to represent black culture in the art of fictional narrative rather than primarily in sociological or political terms. Even the anthropologically based narratives that we have chosen to reprint here—her well-known "Eatonville Anthology," her tales about the mythical figure High John De Conquer, and her character

sketches "Mother Catherine" and "Uncle Monday"—reveal Hurston to be the storyteller first, the anthropologist second. She is far more interested in human motivation and the idiosyncracies of character as manifested in language-use than in what we might broadly think of as "the nature of the Negro" or the struggle for civil rights.

We have selected for publication here nineteen narratives that Hurston published between 1921 and 1951, including three that she excerpted from her novels *Their Eyes Were Watching God* and *Moses: Man of the Mountain*, as well as seven unpublished stories, including "The Woman in Gaul" and "The Seventh Veil," both of which were clearly intended to be part of her unpublished novel, *Herod the Great*, which was severely damaged in a fire. In these stories, Hurston demonstrates an exceptionally broad range of narrative concerns and skills. Some seem to be dress rehearsals for scenes that she would develop in her novels.

For example, in "Drenched in Light," the second short story that Hurston published (1924), Isis Watt, a playful young girl, is continuously reprimanded by her grandmother for sitting at the gate post and waving at people driving by, whistling, playing with the household boys, and of course sitting with her knees separated. Since she is the only girl, Isis has to wash the dishes and do most of the chores. In spite of her repressive grandmother, Isis retains a certain joyful spirit and keeps dreaming of a better world, one in which she wears golden robes and rides white horses.

One afternoon when Grandma takes her nap, Isis and her brother decide that they will give Grandma a shave. Joel lathers her carefully while Isis holds the razor. Just as the two are to commence their ritual of retribution, Grandma awakes and flees the house, screaming.

Isis steals out the gate and follows a marching band on its way to the festivities that were arranged for the benefit of the new hall. She is delighted to dance and is captivated by the band, which she follows in a parade toward a campground picnic. Suddenly, she realizes that her dress is dirty and torn and runs back to the house, takes Grandma's new red tablecloth, and drapes it around herself

like a Spanish shawl. At the picnic grove, her appearance and her dancing attract the attention of all the visitors, who begin to surround the little brown girl. When she hears Grandma yell from afar, "Mah Gawd, Mah brand new tablecloth Ah jus' brought f'um O'landah!," sensibly, Isis flees into the woods.

Loathing the beating that she is bound to receive, the little girl wants to drown herself. As she walks into the creek, a car pulls up. A white couple who had watched Isis dance ask her what she is up to. Isis responds that she is going to kill herself because of Grandma. They laugh and ask her to show them the way back to the Park Hotel. Isis sits next to the driver as they drive. When they come to the child's house, they stop reluctantly; they do not like the thought of giving her up. The white woman whispers to Isis that she will help her by confronting her grandmother. Listening to her complaints about the tablecloth and the silver dollar she had spent on it, the woman gives her five dollars and says she wants Isis to go to the hotel with her and dance on the tablecloth. "I can stand a little light today," the woman says. "I want brightness and this Isis is joy itself. Why, she's drenched in light." Grandma consents to this right away, scarcely able to conceal the fact that she is proud of her grandchild. Isis dances in exalted joy over her fate.

The story resembles a fairy tale in its contrasts of the evil grandmother and the sweet, innocent young girl who has to suffer from her tyranny but who ultimately outwits the evil old witch. The girl's bondage has not stopped her from dreaming and being joyful. She is high-spirited, a characteristic that simultaneously causes her trouble but also secures her liberation. The final sentence spoken by the rich white lady echoes a key trope of primitivism. "I want a little of her sunshine to soak my soul. I need it," she says.

Isis is represented as the natural happy-go-lucky black girl—and her capacity to entertain the white woman saves her from being beaten to death by her harsh grandmother. This reversal of roles—evil black woman and "benevolent" white woman—is noteworthy for showing that Hurston was intent upon breaking

with the tradition of using black literature primarily as propaganda in the nascent civil rights struggle. In today's terms Hurston was politically incorrect, which would earn her the ire of contemporaries such as Richard Wright, Sterling Brown, and Ralph Ellison, among others.

In "Spunk" (1925), we encounter Elijah, Walter, and Joe, characters who will reappear throughout Hurston's fiction. Elijah Mosley and Walter Thomas are inside the general store watching Spunk Banks striding along the main road with Joe's wife on his arm. They express their admiration for Spunk—a large and burly man who is physically strong and so courageous that he dares to take another man's wife out publicly. Joe—small and timid— enters the store, angry, hands trembling, swearing to take revenge.

Joe confronts Spunk. Spunk retorts that Lena is his wife from now on. When Joe sees in her eyes the love for this other man, he leaves without saying a word. Days later, when Joe—goaded by the other men—tries to stab Spunk from behind with a razor, Spunk shoots him.

The court considers the murder an act of self-defense and finds Spunk innocent. Consequently, Spunk and Lena move into a house together. On their first night, a black cat howls, making such a ruckus that Spunk takes his gun to kill it. But when he looks into its eyes, he thinks he sees Joe's ghost. Walter's comment on this incident—that Joe was actually braver than Spunk— is met with disapproval by the other men. The next time they meet is to discuss the latest news: the sudden death of Spunk Banks who had been caught in a big saw. On his deathbed, Spunk claims that Joe pushed him. In the final scene, Lena is in despair and the village gathers at the funeral where "the men coarsed conjectures between guzzles of whiskey."

"Spunk" is structurally complex. There are many jumps in the story. The reader never knows how much time has passed between paragraphs in the story's four sections. There are also many unresolved, vague, and indeterminate aspects of the plot. We don't know whether the men identify with Spunk or with Joe,

who could not prevent this bully from taking his wife. What is also interesting about "Spunk" is the framing of the story: It is told through the eyes of the men in the store. And the perspective shifts from the protagonists, Joe and Spunk, who narrate in direct speech, to the direct speech of Walter and Elijah. The story also uses an omniscient narrator saying things such as "The men gathered the next evening in a different mood, no laughter, no badinage this time." Hence, there are three levels of narration: action (the two protagonists over Lena); judgment (the men watching them and reflecting); and the narrator's comments.

There is a sense of tragedy to this story about love, jealousy, guilt, superstition, and death, themes to which Hurston would return again and again, culminating in her masterpiece, *Their Eyes Were Watching God*. In "Magnolia Flower" (1925), for instance, a river tells a brook the story of Bentley, a strong ex-slave who builds a big house on the banks of the Savannah River and marries a Cherokee woman. They settle down and he hires many black employees who hate him because he is so cruel. He himself hates many things, particularly all that reminds him of his oppressors, whose oppression he has internalized. But Bentley loves his daughter Magnolia, and builds a schoolhouse so that she and the other children of Bentley's village can learn how to read and write. The schoolteacher, a light-skinned young man, soon falls in love with Magnolia and they have several clandestine meetings at the river. When John proposes to her and Magnolia confesses her love to him, he decides to ask Mr. Bentley for her hand in marriage, in spite of Magnolia's warning that her father would never agree to her marrying a man who was so light.

When John confronts Bentley, Bentley is enraged, but John holds his ground. Bentley demands that John be locked up and hanged the next day. He locks Magnolia up in the parlor and wants her to be married to crazy Joe, so they can have very dark children. Yelling and hammering against the door does not help; Magnolia spends the night in desolation. A watch-guard pities her and opens the door so she can escape. Magnolia, however, refuses to leave without her lover. To free him, she has to sneak into

Bentley's bedroom and steal the key out of his trouser pocket. The couple manages to flee that night. When Bentley awakes the next morning and realizes that the two have escaped, he orders the hanging of his wife and the guard for allowing them to flee. Bentley dies from his own rage.

"Magnolia Flower" is about the triumph of love over evil. The couple is determined and courageous and rewarded with freedom. The conflict between father and daughter is more prominent than racial conflicts; Magnolia loves John in spite of his light skin color. The powerless daughter's victory over her cruel father also echoes the plot of "Drenched in Light," but the peculiarity of this story is that it is told by the river. The story opens with the brook disturbing the river and urging him to tell one of the many stories he has witnessed during the ages. This framing adds a matter-of-fact tone to the story; the constant flow of the water coincides with the flow of human tragedy and happiness. The river makes mocking comments about the human notions of wealth and time: " 'No matter, no matter,' scolded the river, 'I have seen millions of lovers, child. I have borne them up and down, listened to those things that are uttered more with breath than with lips, gathered infinite tears. . . .' " This aloofness and irony and the use of personification would become hallmarks of Hurston's penchant for allegorical narrative.

This volume includes seven unpublished stories. In addition to "The Bone of Contention," Hurston's story "Black Death" is one of special interest. Docia Boger, a chambermaid at the Park Hotel, is in love with Beau Diddley. They spend a few happy months together. When she becomes pregnant, he refuses to marry her. Beau gets angry at her for attempting to make him settle down and mentions that he is married already. When Docia confronts him with the fact that he had said he was not, he responds that he did not feel obliged to be honest to a girl like her. Docia's heart is broken. She has lost faith in the person she loved. She also pities herself for being a fallen woman.

Docia's mother wants to take revenge for her daughter's misery and goes to see Old Man Morgan, the Hoodoo doctor. Dr. Morgan

does not allow her to tell her story but asks her how she wants to kill Beau Diddley. Mrs. Boger decides to shoot him. She looks into a mirror, waits until she sees Beau's image, then fires at him. The mirror collapses, grows misty, and then clears.

The next day, the news spreads that Beau dropped dead while making love to a chambermaid: While bragging about his conquest of Docia, he suddenly clutched his heart and died. The verdict was death by natural causes. Mrs. Boger and Docia move to Jacksonville, where Docia marries happily.

Although this is another story with a happy ending that once again celebrates the triumph of the powerless over evil oppressors, this time success is dependent on outside forces. This story is about the power of hoodoo, superstition, and conjure. Although there are only black protagonists, the narrative frame explicitly refers to the blacks' magic and the whites' ignorance: "The Negroes in Eatonville know a number of things that the hustling, bustling white man never dreams of. He is a materialist with little ears for overtones." Moreover, "White folks are very stupid about some things. They can think mightily but cannot feel."

This stark contrast between cerebral white folks and the black villagers who *knew* can be extended to the received oppositions between reason and emotion. But Hurston suggests that whites are not knowing because they don't believe in a knowledge that goes beyond pure reason. The message of this story is not that blacks have feeling, but that they have another kind of knowledge, which is usually dismissed as superstition. This story is also about black justice outside of the white man's law.

In "The Gilded Six-Bits" (1933), Hurston continues this theme. Every Saturday, Miss May would put special care into cleaning the house and preparing a delicious dinner while waiting for her husband, Joe, to come home from work. Always while getting dressed, she would hear the sound of nine silver dollars hitting the wooden floor. This was the opening to a ritual that began with her demanding: "Who dat chunkin' money in mah do'way?" Then Miss May would track Joe down behind the jasmine tree and chase him around the house. When she caught him in the kitchen,

they would start a mock battle. Their shouting, laughing, twisting, and turning would end in Miss May's reaching into Joe's pockets to get the candy kisses he has put there for her. Exhausted from their play-fighting, Joe would take a bath and then they would eat dinner.

One day, Miss May cooks a glorious dinner of ham hocks, new potatoes, stringbeans, and potato pudding. Joe suggests that they go to the ice-cream parlor that has just opened. He wants the new owner, Otis D. Slemmons, to meet his beautiful wife. Although Joe has neither a big belly nor gold jewelry, like Slemmons has, he has a wife he loves more than anything. And Miss May loves him more than anything in this world. When Joe expresses his feelings of inferiority in talking about all those prestigious things Otis brags about—white women lovers and wealth—Miss May responds, "Dat stray nigger jes' tell y'all anything and y'all b'lieve it."

Miss May manages to console her husband, and their happy marriage continues with its weekly mock battles. But apparently she is just as impressed as Joe by that shining gold chain Otis would not allow anybody to touch because one day Joe comes home to find his wife and Otis in bed. To Joe, a world has broken apart. And from that day on, the romance and the ritual are over. Their love has lost its mystique.

They do not break up, but regret on her part and dismay on his predominate; their life becomes a practical arrangement: "No laughter, no banter." They are polite but aloof and do not touch one another for three months. Then Joe complains about a backache and Miss May rubs his back and they make love once again. Soon after, Miss May finds out that Otis's gold chain was only a gilded half-dollar coin.

Months later, after Miss May delivers a son, a strong boy who looks just like Joe, the couple return to their old routine. Joe buys candies with the gilded coin and Miss May, who has awaited him, cries, "Joe Banks, Ah hear you chinkin' money in mah do'way. You wait Ah got mah strength back and Ah'm gointer fix you for dat."

This fetching story is the magic that is produced by two people,

a play they have written and performed themselves for themselves. What Hurston called elsewhere a fundamental characteristic of Negro expression—the tendency to dramatize and the art of lovemaking—makes up the allure of this narrative. A love that seems to be stronger than money, however, is broken because Miss May seeks the gleaming gold chain of a "rich" man, thereby jeopardizing a sweet and pristine relationship. The tragic moment of Joe walking in on an act of adultery—the moment when "the great belt on the wheel of time slipped and eternity stood still"—is the culmination point of the story. Due to the happy ending—the fact that their love could be retrieved and reactivated—the story teaches us about the importance of an emotional attachment over material wealth, about a justice that transcends grief, and about the power of reconciliation.

"High John De Conquer" was published in 1943. Originally, High John De Conquer was not a natural person; he was the "wish to find something worthy of laughter and song." He had come walking on the waves of sound from Africa. And when he became a real man, he worked on the plantations where everybody knew him for his laughter and his drumming. Whenever the work was most dreadful and cruel, High John De Conquer helped the slaves to endure. John, the personification of hope, was superior to everything and everybody, including Old Massa. Moreover, he made a "way-out-of-no-way" because he was "winning with the soul of a black man whole and free." One day, John decided to leave the plantation and find a "particular piece of singing." After initial reluctance, because of the slaves' fear of being caught, they decided to join him and all mounted on the back of a big crow. They flew to several places and had many adventures. They stopped off in Hell, where John not only married the Devil's daughter but also roasted the Devil himself, becoming the High Chief Devil. The group was delighted over John's power, but since they were trying to find their song, they decided to move on to Heaven. When they reached that splendid place and met the Old Maker, He made them a tune without words and put it in their mouths.

All of a sudden Heaven turned dark and they heard a voice shouting: "Get up from there and get on back to the field." It was Old Massa calling them back to finish chopping cotton. This made them feel bad but then they heard John's voice saying, "Don't pay what he say no mind. You know where you got something finer than this plantation and anything it's got on it, put away. Ain't that funny? Us got all that and he don't know nothing at all about it. Do't tell him nothing. Nobody don't have to know where us gets our pleasure from." These words were so consoling that they felt neither the heat nor the burden of working. The song they had sought returned to them in their memories.

This story is about a famous black mythological figure and represents the power of the seemingly powerless. The capacity to be ironic and to laugh makes the workers superior to their apparently better-off master. John is the figure of courage and faith. He embodies joy over misery and he is the hero who shows that all that counts is in the soul and in the imagination. Those who are deprived of material wealth discover that their principal asset is spiritual wealth, rhythm, and laughter.

This reemerging theme in Hurston's fiction reaches its fullest form in the character of Tea Cake in her novel *Their Eyes Were Watching God*. In fact, it seems that Hurston draws on this folk hero as a basis for a certain philosophy of life. An anti-materialist and carefree attitude, she suggests, offers political and economic power. This view, implying that blacks had not succumbed to a culture of poverty, is at the core of the accusations against Hurston that she was not politically correct (see the Afterword).

Instead of criticizing discrimination directly, as Richard Wright did, for example, Hurston constructed a myth—she invented an enabling fiction—that would depend upon a reversal of the roles between blacks and whites. Instead of lamenting, she urged a pride in cultural features that were, according to her, characteristic of being a Negro. The joy of life, rhythm, and singing were key to "the Negro" Hurston had in mind. "High John de Conquer" is about the power of imagination, creativity, and memory.

Furthermore, "High John de Conquer" returns to Hurston's

great theme of justice. Those who are physically and economically humiliated are spiritually exalted. Hence, it fits into the general theme of her short stories: the focus on the nature of justice, either attained by hoodoo, as in Docia's case, or by a desire for love, as in Magnolia's case, or due to personal abilities, such as Isis's joyous, beautiful, and sunny self or Laura's integrity and loyalty. The concern for justice beyond race, class, or gender seems to be at the center of so very much of Hurston's fiction and her fascination with myth.

Hurston published her last original short story, "The Conscience of the Court," in the *Saturday Evening Post* in 1950. This story, like "Black Death," is concerned with the quality of justice. Laura Lee Kimble, the black maid of Mrs. Celestine Clairborne, has been charged with felonious aggravated assault. In the courtroom Clement Beasley, who appears to be in pain from severe fractures, testifies that he had lent $600 to Mrs. Clairborne. He reports that one day he came to the house to collect the money, but Mrs. Clairborne had left. When he saw the maid packing away the silver, he decided to protect his loan by taking at least the furniture. On entering the house, he was attacked by the maid and beaten almost to death, Beasley complains.

Laura Lee, who has no defender, is called into the witness stand to give her testimony. Calling herself an unlearned and ignorant woman, she starts out defending her employer, saying that she would never try to escape the obligation of repaying a loan and that her furniture was worth far more than $600. In her version of the story, Mr. Beasley had come to the house when Mrs. Clairborne was away at Miami Beach and she promised to give him her address so he could get in touch with her. When Mr. Beasley returned the next day with a truck, determined to take the furniture, Laura stood in his way to stop him from taking her employer's property. When he tried to enter forcefully and hit Laura, she attacked him so hard that he was unable to stand up.

Laura leaves the question of whether or not she is guilty to the jury. On the one hand, she feels that it was right to protect Mrs. Clairborne's property; on the other hand, Laura thinks of her

husband who had always complained about her excessive devotion to other people. Laura then talks about her relationship to Mrs. Clairborne, whom she has cared for ever since she was born. Laura's love for her was so strong that she decided to marry a man who worked for the Clairbornes. And when they had to move, Laura and her own husband, Tom, followed them in spite of his objections. When Tom died, Mrs. Clairborne paid for the transportation of his coffin to his home town, which is why she had to borrow money from Beasley.

The note for the loan, which Beasley had withheld, is finally submitted to the jury. It reveals that the due date of the loan was three months away. The judge accuses Mr. Beasley of attempted burglary and of insulting the court for appealing to it to justify an attempted theft. After the judge has given a long speech on the American constitution and civilization, he expresses his respect for the defendant. The story ends with the jury congratulating Laura Lee for her integrity.

This story is about altruism, about a woman who loved so much that she almost went to prison because of her devotion to her employer. It is also about an idea of justice and the fact that the court was on the side of a simple black woman. Good is being rewarded—even in a black skin—and those who mean well will be rewarded in the end. In most of Hurston's stories, the good guys win and the bad guys fail. Actually, morality is the issue in most of her stories, which usually end happily for the disenfranchised and powerless. The moral values that Hurston cherishes are loyalty, justice, and love. Structurally, most of her narratives are framed tales, with a story within a story, as in *Their Eyes Were Watching God*. And direct speech is prominent—as if it would bring alive, in the guise of the language of fiction, the empirical reality of what troubles, and indeed defines and delights, a culture, while the narrative frame raises the broader ethical issues, especially the complex reaction between divine or supernatural and legal retribution—an African-American version of the tension between Themis (Divine Justice) and Dike (Human Justice).

* * *

The stories gathered here allow us to examine the evolution of Hurston's skills at fiction-making, from her earliest experiments at the height of the Harlem Renaissance to the eve of the Korean War and the civil rights movement half a century later. Taken together, they attest to Hurston's sustained concern with the structures of myth and allegory as vehicles for the representation of the conflicts and dilemmas that African-Americans share with all other human beings. Above all else, Hurston's great themes—obsessions, really—are love, betrayal, and death, the great themes of modernism, which she elaborated upon so eloquently for the African-American tradition.

Henry Louis Gates, Jr.
Sieglinde Lemke

John Redding Goes to Sea

The Villagers said that John Redding was a queer child. His mother thought he was too. She would shake her head sadly, and observe to John's father: "Alf, it's too bad our boy's got a spell on 'im."

The father always met this lament with indifference, if not impatience.

"Aw, woman, stop dat talk 'bout conjure. Tain't so nohow. Ah doan want Jawn tuh git dat foolishness in *him*."

"Cose you allus tries tuh know mo' than me, but Ah ain't so ign'rant. Ah knows a heap mahself. Many and many's the people been drove outa their senses by conjuration, or rid tuh deat' by witches."

"Ah keep on telling yuh, woman, tain's so. B'lieve it all you wants tuh, but dontcha tell mah son none of it."

Perhaps ten-year-old John *was* puzzling to the simple folk there in the Florida woods for he was an imaginative child and fond of day-dreams. The St. John River flowed a scarce three hundred feet from his back door. On its banks at this point grow numerous palms, luxuriant magnolias and bay trees with a dense undergrowth of ferns, cat-tails and rope-grass. On the bosom of the stream float millions of delicately colored hyacinths. The little brown boy loved to wander down to the water's edge, and, casting in dry twigs, watch them sail away down stream to Jacksonville, the sea, the wide world and John Redding wanted to follow them.

1

Sometimes in his dreams he was a prince, riding away in a gorgeous carriage. Often he was a knight bestride a fiery charger prancing down the white shell road that led to distant lands. At other times he was a steamboat captain piloting his craft down the St. John River to where the sky seemed to touch the water. No matter what he dreamed or who he fancied himself to be, he always ended by riding away to the horizon; for in his childish ignorance he thought this to be farthest land.

But these twigs, which John called his ships, did not always sail away. Sometimes they would be swept in among the weeds growing in the shallow water, and be held there. One day his father came upon him scolding the weeds for stopping his sea-going vessels.

"Let go mah ships! You ole mean weeds you!" John screamed and stamped impotently. "They wants tuh go 'way. You let 'em go on!"

Alfred laid his hand on his son's head lovingly. "What's mattah, son?"

"Mah ships, pa," the child answered weeping. "Ah throwed 'em in to go way off an' them ole weeds won't let 'em."

"Well, well, doan cry. Ah thought youse uh grown up man. Men doan cry lak babies. You mustn't take it too hard 'bout yo' ships. You gotta git uster things gittin' tied up. They's lotser folks that 'ud go on off too ef somethin' didn' ketch 'em an' hol' 'em!"

Alfred Redding's brown face grew wistful for a moment, and the child noticing it, asked quickly: "Do weeds tangle up folks too, pa?"

"Now, no, chile, doan be takin' too much stock of what ah say. Ah talks in parables sometimes. Come on, les go on tuh supper."

Alf took his son's hand, and started slowly toward the house. Soon John broke the silence.

"Pa, when ah gets as big as you Ah'm goin' farther than them ships. Ah'm goin' to where the sky touches the ground."

"Well, son, when Ah wuz a boy Ah said Ah wuz goin' too, but heah Ah am. Ah hopes you have bettah luck than me."

"Pa, Ah betcha Ah seen somethin' in th' woodlot you ain't seen!"

"Whut?"

"See dat tallest pine tree ovah dere how it looks like a skull wid a crown on?"

"Yes, indeed!" said the father looking toward the tree designated. "It do look lak a skull since you call mah 'tention to it. You 'magine lotser things nobody else evah did, son!"

"Sometimes, Pa dat ole tree waves at me just aftah th' sun goes down, an' makes me sad an' skeered, too."

"Ah specks youse skeered of de dahk, thas all, sonny. When you gits biggah you won't think of sich."

Hand in hand the two trudged across the plowed land and up to the house, the child dreaming of the days when he should wander to far countries, and the man of the days when he might have—and thus they entered the kitchen.

Matty Redding, John's mother, was setting the table for supper. She was a small wiry woman with large eyes that might have been beautiful when she was young, but too much weeping had left them watery and weak.

"Matty," Alf began as he took his place at the table, "dontcha know our boy is different from any othah chile roun' heah. He 'lows he's goin' to sea when he gits grown, an' Ah reckon Ah'll let 'im."

The woman turned from the stove, skillet in hand. "Alf, you ain't gone crazy, is you? John kain't help wantin' tuh stray off, cause he's got a spell on 'im; but *you* oughter be shamed to be encouragin' him."

"Ain't Ah done tol' you forty times not tuh tahk dat low-life mess in front of mah boy?"

"Well, ef tain't no conjure in de world, how come Mitch Potts been layin' on his back six mont's an' de doctah kain't do 'im no good? Answer me dat. The very night John wuz bawn, Granny seed ole Witch Judy Davis creepin outer dis yahd. You know she had swore tuh fix me fuh marryin' you, 'way from her darter Edna. She put travel dust down fuh mah chile, dat's whut she

done, tuh make him walk 'way fum me. An' evuh sence he's been able tuh crawl, he's been tryin tuh go.''

"Matty, a man doan need no travel dust tuh make 'im wanter hit de road. It jes' comes natcheral fuh er man tuh travel. Dey all wants tuh go at some time or other but they kain't all get away. Ah wants mah John tuh go an' see cause Ah wanted to go mah self. When he comes back Ah kin see them furrin places wid his eyes. He kain't help wantin' tuh go cause he's a man chile!''

Mrs. Redding promptly went off into a fit of weeping but the man and boy ate supper unmoved. Twelve years of married life had taught Alfred that far from being miserable when she wept, his wife was enjoying a bit of self-pity.

Thus John Redding grew to manhood, playing, studying and dreaming. He attended the village school as did most of the youth about him, but he also went to high school at the county seat where none of the villagers went. His father shared his dreams and ambitions, but his mother could not understand why he should wish to go strange places where neither she nor his father had been. No one of their community had ever been farther away than Jacksonville. Few indeed had ever been there. Their own gardens, general store, and occasional trips to the county seat— seven miles away—sufficed for all their needs. Life was simple indeed with these folk.

John was the subject of much discussion among the country folk. Why didn't he teach school instead of thinking about strange places and people? Did he think himself better than any of the "gals" there about that he would not go a-courting any of them? He muss be "fixed" as his mother claimed, else where did his queer notions come from? Well, he was always queer, and one could not expect the man to be different from the child. They never failed to stop work at the approach of Alfred in order to be at the fence and inquire after John's health and ask when he expected to leave.

"Oh," Alfred would answer. "Jes' as soon as his mah gits reconciled to th' notion. He's a mighty dutiful boy, mah John is. He doan wanna hurt her feelings.''

The boy had on several occasions attempted to reconcile his mother to the notion, but found it a difficult task. Matty always took refuge in self-pity and tears. Her son's desires were incomprehensible to her, that was all. She did not want to hurt him. It was love, mother love, that made her cling so desperately to John.

"Lawd knows," she would sigh, "Ah nevah wuz happy an' nevah specks tuh be."

"An' from yo' actions," put in Alfred hotly, "you's determined *not* to be."

"Thas right, Alfred, go on an' 'buse me. You allus does. Ah knows Ah'm ign'rant an' all dat, but dis is mah son. Ah bred an' born 'im. He kain't help from wantin' to go rovin' cause travel dust been put down fuh him. But mebbe we kin cure 'im by disincouragin' the idee."

"Well, Ah wants mah son tuh go; an' he wants tuh go too. He's a man now, Matty. An' we mus' let John hoe his own row. If it's travelin' twon't be foh long. He'll come back to us bettah than when he went off. What do you say, son?"

"Mamma," John began slowly, "it hurts me to see you so troubled over my going away; but I feel that I must go. I'm stagnating here. This indolent atmosphere will stifle every bit of ambition that's in me. Let me go mamma, please. What is there here for me? Why, sometimes I get to feeling just like a lump of dirt turned over by the plow—just where it falls there's where it lies—no thought or movement or nothing. I wanter make myself something—not just stay where I was born."

"Naw, John, it's bettah for you to stay heah and take over the school. Why don't you marry and settle down?"

"I don't *want* to, mamma. I want to go away."

"Well," said Mrs. Redding, pursing her mouth tightly, "you ainta goin' wid *mah* consent!"

"I'm sorry mamma, that you won't consent. I am going nevertheless."

"John, John, mah baby! You wouldn't kill yo' po' ole mamma, would you? Come, kiss me, son."

The boy flung his arms about his mother and held her closely

while she sobbed on his breast. To all of her pleas, however, he answered that he must go.

"I'll stay at home this year, mamma, then I'll go for a while, but it won't be long. I'll come back and make you and papa oh so happy. Do you agree, mamma dear?"

"Ah reckon tain' nothin' tall fuh me to do else."

Things went on very well around the Redding home for some time. During the day John helped his father about the farm and read a great deal at night.

Then the unexpected happened. John married Stella Kanty, a neighbor's daughter. The courtship was brief but ardent—on John's part at least. He danced with Stella at a candy-pulling, walked with her home and in three weeks had declared himself. Mrs. Redding declared that she was happier than she had ever been in her life. She therefore indulged in a whole afternoon of weeping. John's change was occasioned possibly by the fact that Stella was really beautiful; he was young and red-blooded, and the time was spring.

Spring-time in Florida is not a matter of peeping violets or bursting buds merely. It is a riot of color in nature—glistening green leaves, pink, blue, purple, yellow blossoms that fairly stagger the visitor from the north. The miles of hyacinths lie like an undulating carpet on the surface of the river and divide reluctantly when the slow-moving alligators push their way log-like across. The nights are white nights for the moon shines with dazzling splendor, or in the absence of that goddess, the soft darkness creeps down laden with innumerable scents. The heavy fragrance of magnolias mingled with the delicate sweetness of jasmine and wild roses.

If time and propinquity conquered John, what then? These forces have overcome older men.

The raptures of the first few weeks over, John began to saunter out to the gate to gaze wistfully down the white dusty road; or to wander again to the river as he had done in childhood. To be sure he did not send forth twig-ships any longer, but his thoughts would in spite of himself, stray down river to Jacksonville, the sea,

the wide world—and poor home-tied John Redding wanted to follow them.

He grew silent and pensive. Matty accounted for this by her ever-ready explanation of "conjuration." Alfred said nothing but smoked and puttered about the barn more than ever. Stella accused her husband of indifference and made his life miserable with tears, accusations and pouting. At last John decided to bring matters to a head and broached the subject to his wife.

"Stella, dear, I want to go roving about the world for a spell. Would you stay here with papa and mamma and wait for me to come back?"

"John, is you crazy sho' nuff? If you don't want me, say so an' I kin go home to mah folks."

"Stella, darling, I do want you, but I want to go away too. I can have both if you'll let me. We'll be *so* happy when I return . . ."

"Naw, John, you kain't rush me off one side like that. You didn't hafta marry me. There's a plenty othahs that would have been glad enuff tuh get me; you know Ah wan't educated befo' han'."

"Don't make me too conscious of my weakness, Stella. I know I should never have married with my inclinations, but it's done now, no use to talk about what is past. I love you and want to keep you, but I can't stifle that longing for the open road, rolling seas, for peoples and countries I have never seen. I'm suffering too, Stella, I'm paying for my rashness in marrying before I was ready. I'm not trying to shirk my duty—you'll be well taken care of in the meanwhile."

"John, folks allus said youse queer and tol' me not to marry yuh, but Ah jes' loved yuh so Ah couldn't help it, an' now to think you wants tuh sneak off an' leave me."

"But I'm coming back, darling . . . listen Stella."

But the girl would not. Matty came in and Stella fell into her arms weeping. John's mother immediately took up arms against him. The two women carried on such an effective war against him for the next few days that finally Alfred was forced to take his son's part.

"Matty, let dat boy alone, Ah tell you! Ef he wuz uh homebuddy he'd be drove 'way by you all's racket."

"Well, Alf, dat's all we po' wimmen kin do. We wants our husbands an' our sons. John's got uh wife now, an' he ain't got no business to be talkin' 'bout goin' nowheres. I 'lowed dat marrin' Stella would settle him."

"Yas, dat's all you wimmen study 'bout—settlin' some man. You takes all de get-up out of 'em. Jes' let uh fellah mak uh motion lak gettin' somewhere, an' some 'oman'll begin tuh hollah, 'Stop theah! where's you goin'? Don't fuhgit you b'longs tuh me.' "

"My Gawd! Alf! Whut you reckon Stella's gwine do? Let John walk off an' leave huh?"

"Naw, git outer huh foolishness an' go 'long wid him. He'd take huh."

"Stella ain't got no call tuh go crazy 'cause John is. She ain't no woman tuh be floppin' roun' from place tuh place lak some uh dese reps follerin' uh section gang."

The man turned abruptly from his wife and stood in the kitchen door. A blue haze hung over the river and Alfred's attention seemed fixed upon this. In reality his thoughts were turned inward. He was thinking of the numerous occasions upon which he and his son had sat on the fallen log at the edge of the water and talked of John's proposed travels. He had encouraged his son, given him every advantage his own poor circumstances would permit. And now John was home-tied.

The young man suddenly turned the corner of the house and approached his father.

"Hello, papa."

" 'Lo, son."

"Where's mamma and Stella?"

The older man merely jerked his thumb toward the interior of the house and once more gazed pensively toward the river. John entered the kitchen and kissed his mother fondly.

"Great news, mamma.' "

"What now?"

"Got a chance to join the Navy, mamma, and go all around the world. Ain't that grand?"

"John, you shorely ain't gointer leave me an' Stella, is yuh?"

"Yes, I think I am. I know how both of you feel, but I know how *I* feel, also. You preach to me the gospel of self-sacrifice for the happiness of others, but you are unwilling to practice any of it yourself. Stella can stay here—I am going to support her and spend all the time I can with her. I am going—that's settled, but I want to go with your good will. I want to do something worthy of a strong man. I have done nothing so far but look to you and papa for everything. Let me learn to strive and think—in short, be a man."

"Naw, John, Ah'll nevah give mah consent. I know yous hard-headed jes' lak yo' paw; but if you leave dis place ovah mah head, Ah nevah wants you tuh come back heah no mo. Ef Ah wuz laid on de coolin' board, Ah doan want yuh standin' ovah me, young man. Doan even come neah mah grave, you ongrateful wretch!"

Mrs. Redding arose and flung out of the room. For once, she was too incensed to cry. John stood in his tracks, gone cold and numb at his mother's pronouncement. Alfred, too, was moved. Mrs. Redding banged the bed-room door violently and startled John slightly. Alfred took his son's arm, saying softly: "Come, son, let's go down to the river."

At the water's edge they halted for a short space before seating themselves on the log. The sun was setting in a purple cloud. Hundreds of mosquito hawks darted here and there, catching gnats and being themselves caught by the lightning-swift bullhats. John abstractly snapped in two the stalk of a slender young bamboo. Taking no note of what he was doing, he broke it into short lengths and tossed them singly into the stream. The old man watched him silently for a while, but finally he said: "Oh, yes, my boy, some ships get tangled in the weeds."

"Yes, papa, they certainly do. I guess I'm beaten—might as well surrender."

"Nevah say die. Yuh nevah kin tell what will happen."

"What *can* happen? I have courage enough to make things

happen; but what can I do against mamma! What man wants to go on a long journey with his mother's curses ringing in his ears? She doesn't understand. I'll wait another year, but I am going because I must.''

Alfred threw an arm about his son's neck and drew him nearer but quickly removed it. Both men instantly drew apart, ashamed for having been so demonstrative. The father looked off to the woodlot and asked with a reminiscent smile: ''Son, do you remember showin' me the tree dat looked lak a skeleton head?''

''Yes, I do. It's there still. I look at it sometimes when things have become too painful for me at the house, and I run down here to cool off and think. And every time I look at it, papa, it laughs at me like it had some grim joke up its sleeve.''

''Yuh wuz always imagin' things, John; things that nobody else evah thought on!''

''You know, papa, sometimes—I reckon my longing to get away makes me feel this way. . . . I feel that I am just earth, *soil* lying helpless to move myself, but *thinking*. I seem to hear herds of big beasts like horses and cows thundering over me, and rains beating down; and winds sweeping furiously over—all acting upon me, but me, well, just soil, *feeling* but not able to take part in it all. Then a soft wind like love passes over and warms me, and a summer rain comes down like understanding and softens me, and I push a blade of grass or a flower, or maybe a pine tree— that's the ground thinking. Plants are ground thoughts, because the soil can't move itself. Whenever I see little whirls of dust sailing down the road I always step aside—I don't want to stop 'em 'cause they're on their shining way—moving! Oh, yes, I'm a dreamer. . . . I have such wonderfully complete dreams, papa. They never come true. But even as my dreams fade I have others.''

''Yas, son, Ah have them same feelings exactly, but Ah can't find no words lak you do. It seems lak you an' me see wid de same eyes, hear wid de same ears an' even feel de same inside. Only thing you kin talk it an' Ah can't. But anyhow you speaks for me, so whut's the difference?''

The men arose without more conversation. Possibly they feared to trust themselves to speech. As they walked leisurely toward the house Alfred remarked the freshness of the breeze.

'It's about time the rains set in,'' added his son. "The year is wearin' on.''

After a gloomy supper John strolled out into the spacious front yard and seated himself beneath a China-berry tree. The breeze had grown a trifle stronger since sunset and continued from the south-east. Matty and Stella sat on the deep front porch, but Alfred joined John under the tree. The family was divided into two armed camps and the hostilities had reached that stage where no quarter could be asked or given.

About nine o'clock an automobile came flying down the dusty white road and halted at the gate. A white man slammed the gate and hurried up the walk toward the house, but stopped abruptly before the men beneath the China-berry. It was Mr. Hill, the builder of the new bridge that was to span the river.

"Howdy John, Howdy Alf. I'm mighty glad I found you. I am in trouble.''

"Well now, Mist' Hill,'' answered Alfred slowly but pleasantly. "We'se glad you foun' us too. What trouble could *you* be having now?''

"It's the bridge. The weather bureau says that the rains will be upon me in forty-eight hours. If it catches the bridge as it is now, I'm afraid all my work of the past five months will be swept away, to say nothing of a quarter of a million dollars' worth of labor and material. I've got all my men at work now and I thought to get as many extra hands as I could to help out tonight and tomorrow. We can make her weather tight in that time if I can get about twenty more.''

"I'll go, Mister Hill,'' said John with a great deal of energy. "I don't want papa out on that bridge—too dangerous.''

"Good for you, John!'' cried the white man. "Now if I had a few more men of your brawn and brain, I could build an entirely new bridge in forty-eight hours. Come on and jump into the car. I am taking the men on down as I find them.''

"Wait a minute. I must put on my blue jeans. I won't be long."

John arose and strode to the house. He knew that his mother and wife had overheard everything, but he paused for a moment to speak to them.

"Mamma, I am going to work all night on the bridge."

There was no answer. He turned to his wife.

"Stella, don't be lonesome. I will be home at day-break."

His wife was as silent as his mother. John stood for a moment on the steps, then resolutely strode past the women and into the house. A few minutes later he emerged clad in his blue overalls and brogans. This time he said nothing to the silent figures rocking back and forth on the porch. But when he was a few feet from the steps he called back: "Bye, mamma; bye, Stella," and hurried on down the walk to where his father sat.

"So long, papa. I'll be home around seven."

Alfred roused himself and stood. Placing both hands upon his son's broad shoulders he said softly: "Be keerful, son, don't fall or nothin'."

"I will, papa. Don't *you* get into a quarrel on my account."

John hurried on to the waiting car and was whirled away.

Alfred sat for a long time beneath the tree where his son had left him and smoked on. The women soon went indoors. On the night breeze were borne numerous scents: of jassamine, of roses, of damp earth of the river, of the pine forest near by. A solitary whip-poor-will sent forth his plaintive call from the nearby shrubbery. A giant owl roared and boomed from the wood lot. The calf confined in the barn would bleat and be answered by his mother's sympathetic "moo" from the pen. Away down in Lake Howell Creek the basso profundo of the alligators boomed and died, boomed and died.

Around ten o'clock the breeze freshened, growing stiffer until midnight when it became a gale. Alfred fastened the doors and bolted the wooden shutters at the windows. The three persons sat about a round deal table in the kitchen upon which stood a bulky kerosene lamp, flickering and sputtering in the wind that came in through the numerous cracks in the walls. The wind rushed down

the chimney blowing puffs of ashes about the room. It banged the cooking utensils on the walls. The drinking gourd hanging outside by the door played a weird tattoo, hollow and unearthly, against the thin wooden wall.

The man and the women sat silently. Even if there had been no storm they would not have talked. They could not go to bed because the women were afraid to retire during a storm and the man wished to stay awake and think with his son. Thus they sat: the women hot with resentment toward the man and terrified by the storm; the man hardly mindful of the tempest but eating his heart out in pity for his boy. Time wore heavily on.

And now a new element of terror was added. A screech-owl alighted on the roof and shivered forth his doleful cry. Possibly he had been blown out of his nest by the wind. Matty started up at the sound but fell back in her chair, pale and trembling: "My Gawd!" she gasped, "dat's a sho' sign uh death."

Stella hurriedly thrust her hand into the salt-jar and threw some into the chimney of the lamp. The color of the flame changed from yellow to blue-green but this burning of salt did not have the desired effect—to drive away the bird from the roof. Matty slipped out of her blue calico wrapper and turned it wrong side out before replacing it. Even Alfred turned one sock.

"Alf," said Matty, "what do you reckon's gonna happen from this?"

"How do Ah know, Matty?"

"Ah wisht John hadn't went way from heah tuh night."

"Humh."

Outside the tempest raged. The palms rattled dryly and the giant pines groaned and sighed in the grip of the wind. Flying leaves and pine-mast filled the air. Now and then a brilliant flash of lightning disclosed a bird being blown here and there with the wind. The prodigious roar of the thunder seemed to rock the earth. Black clouds hung so low that the tops of the pines were among them moving slowly before the wind and made the darkness awful. The screech-owl continued his tremulous cry.

After three o'clock the wind ceased and the rain commenced.

Huge drops clattered down upon the shingle roof like buckshot and ran from the eaves in torrents. It entered the house through the cracks in the walls and under the doors. It was a deluge in volume and force but subsided before morning.

The sun came up brightly on the havoc of the wind and rain calling forth millions of feathered creatures. The white sand everywhere was full of tiny cups dug out by the force of the falling raindrops. The rims of the little depressions crunched noisily underfoot.

At daybreak Mr. Redding set out for the bridge. He was uneasy. On arriving he found that the river had risen twelve feet during the cloudburst and was still rising. The slow St. John was swollen far beyond its banks and rushing on to sea like a mountain stream, sweeping away houses, great blocks of earth, cattle, trees—in short anything that came within its grasp. Even the steel framework of the new bridge was gone!

The siren of the fibre factory was tied down for half an hour, announcing the disaster to the country side. When Alfred arrived therefore he found nearly all the men of the district there.

The river, red and swollen, was full of floating debris. Huge trees were swept along as relentlessly as chicken coops and fence rails. Some steel piles were all that was left of the bridge.

Alfred went down to a group of men who were fishing members of the ill-fated construction gang out of the water. Many were able to swim ashore unassisted. Wagons backed up and were hurriedly driven away loaded with wet shivering men. Two men had been killed outright, others seriously wounded. Three men had been drowned. At last all had been accounted for except John Redding. His father ran here and there asking for him, or calling him. No one knew where he was. No one remembered seeing him since daybreak.

Dozens of women had arrived at the scene of the disaster by this time. Matty and Stella, wrapped in woolen shawls, were among them. They rushed to Alfred in alarm and asked where was John.

"Ah doan know," answered Alfred impatiently, "that's what Ah'm trying to fin' out now."

"Do you reckon he's run away?" asked Stella thoughtlessly.
Matty bristled instantly.

"Naw," she answered sternly, "he ain't no sneak."

The father turned to Fred Mimms, one of the survivors and
asked him where John was and how had the bridge been de-
stroyed.

"Yuh see," said Mimms, "when dat turrible win' come up we
wuz out 'bout de middle of de river. Some of us wuz on de bridge,
some on de derrick. De win' blowed so hahd we could skeercely
stan' and Mist' Hill tol' us tuh set down fuh a spell. He's 'fraid
some of us mought go overboard. Den all of a sudden de lights
went out—guess de wires wuz blowed down. We wuz all skeered
tuh move for slippin' overboard. Den dat rain commenced—an'
Ah nevah seed such a down-pour since de flood. We set dere and
someone begins tuh pray. Lawd how we did pray tuh be spared!
Den somebody raised a song an' we sung, you hear me, we sung
from de bottom of our hearts till daybreak. When the first light
come we couldn't see nothin' but fog everywhere. You couldn't
tell which wuz water an' which wuz lan'. But when de sun come
up de fog begin to liff, an' we could see de water. Dat fog wuz so
thick an' heavy dat it wuz huggin' dat river lak a windin' sheet.
And when it rose we saw dat de river had rose way up durin' the
rain. My Gawd, Alf! it wuz runnin' high—so high it nearly teched
de span of de bridge—an' red as blood! So much clay, you know
from lan' she done overflowed. Comin' down stream, as fas' as
'press train wuz three big pine trees. De first one wuzn't fohty feet
from us and there wasn't no chance to do nothin' but pray. De fust
one struck us and shook de whole works an' befo' it could stop
shakin' the other two hit us an' down we went. Ah thought Ah'd
never see home again."

"But, Mimms, where's John?"

'Ah ain't seen him, Alf, since de logs struck us. Mebbe he's
swum ashore, mebbe dey picked him up. What's dat floatin' way
out dere in de water?"

Alfred shaded his eyes with his gnarled brown hand and gazed
out into the stream. Sure enough there was a man floating on a

piece of timber. He lay prone upon his back. His arms were outstretched, and the water washed over his brogans but his feet were lifted out of the water whenever the timber was buoyed up by the stream. His blue overalls were nearly torn from his body. A heavy piece of steel or timber had struck him in falling for his left side was laid open by the thrust. A great jagged hole wherein the double fists of a man might be thrust, could plainly be seen from the shore. The man was John Redding.

Everyone seemed to see him at once. Stella fell to the wet earth in a faint. Matty clung to her husband's arm, weeping hysterically. Alfred stood very erect with his wife clinging tearfully to him, but he said nothing. A single tear hung on his lashes for a time then trickled slowly down his wrinkled brown cheek.

"Alf! Alf!" screamed Matty, "dere's our son. Ah knowed when Ah heard dat owl las' night. . . ."

"Ah see 'im, Matty," returned her husband softly.

"Why is yuh standin' heah? Go git mah boy."

The men were manning a boat to rescue the remains of John Redding when Alfred spoke again.

"Mah po' boy, his dreams never come true."

"Alf," complained Matty, "why doantcher hurry an' git my boy—doantcher see he's floatin' on off?"

Her husband paid her no attention but addressed himself to the rescue-party.

"You all stop! Leave my boy go on. Doan stop 'im. Doan' bring im back for dat ole tree to grin at. Leave him g'wan. He wants tuh go. Ah'm happy 'cause dis mawnin' mah boy is goin' tuh sea, *he's goin' tuh sea.*"

Out on the bosom of the river, bobbing up and down as if waving good bye, piloting his little craft on the shining river road, John Redding floated away toward Jacksonville, the sea, the wide world—at last.

Drenched
in Light

"You Isie Watts! Git 'own offen dat gate post an' rake up dis yahd!"

The little brown figure perched upon the gate post looked yearningly up the gleaming shell road that led to Orlando, and down the road that led to Sanford and shrugged her thin shoulders. This heaped kindling on Grandma Potts' already burning ire.

"Lawd a-mussy!" she screamed, enraged—"Heah Joel, gimme dat wash stick. Ah'll show dat limb of Satan she kain't shake huhseff at *me*. If she ain't down by de time Ah gets dere, Ah'll break huh down in de lines" (loins).

"Aw Gran'ma, Ah see Mist' George and Jim Robinson comin' and Ah wanted to wave at 'em," the child said petulantly.

"You jes wave dat rake at dis heah yahd, madame, else Ah'll take you down a button hole lower. You'se too 'oomanish jumpin' up in everybody's face dat pass."

This struck the child in a very sore spot for nothing pleased her so much as to sit atop of the gate post and hail the passing vehicles on their way South to Orlando, or North to Sanford. That white shell road was her great attraction. She raced up and down the stretch of it that lay before her gate like a round eyed puppy hailing gleefully all travelers. Everybody in the country, white and colored, knew little Isis Watts, the joyful. The Robinson brothers, white cattlemen, were particularly fond of her and always extended a stirrup for her to climb up behind one of them for a short

17

ride, or let her try to crack the long bull whips and yee whoo at the cows.

Grandma Potts went inside and Isis literally waved the rake at the "chaws" of ribbon cane that lay so bountifully about the yard in company with the knots and peelings, with a thick sprinkling of peanut hulls.

The herd of cattle in their envelope of gray dust came alongside and Isis dashed out to the nearest stirrup and was lifted up.

"Hello theah Snidlits, I was wonderin' wheah you was," said Jim Robinson as she snuggled down behind him in the saddle. They were almost out of the danger zone when Grandma emerged.

"You Isie-s!" she bawled.

The child slid down on the opposite side from the house and executed a flank movement through the corn patch that brought her into the yard from behind the privy.

"You lil' hasion you! Wheah you been?"

"Out in de back yahd," Isis lied and did a cart wheel and a few fancy steps on her way to the front again.

"If you doan git tuh dat yahd, Ah make a mommuk of you!" Isis observed that Grandma was cutting a fancy assortment of switches from peach, guana and cherry trees.

She finished the yard by raking everything under the edge of the porch and began a romp with the dogs, those lean, floppy eared 'coon hounds that all country folks keep. But Grandma vetoed this also.

"Isie, you set 'own on dat porch! Uh great big 'leben yeah ole gal racin' an' rompin' lak dat—set 'own!"

Isis impatiently flung herself upon the steps.

"Git up offa dem steps, you aggavatin' limb, 'fore Ah git dem hick'ries tuh you, an' set yo' seff on a cheah."

Isis petulantly arose and sat down as violently as possible in a chair, but slid down until she all but sat upon her shoulder blades.

"Now look atcher," Grandma screamed. "Put yo' knees together, an' git up offen yo' backbone! Lawd, you know dis hellion is gwine make me stomp huh insides out."

Isis sat bolt upright as if she wore a ramrod down her back and began to whistle. Now there are certain things that Grandma Potts felt no one of this female persuasion should do—one was to sit with the knees separated, "settin' brazen" she called it; another was whistling, another playing with boys, neither must a lady cross her legs.

Up she jumped from her seat to get the switches.

"So youse whistlin' in mah face, huh!" She glared till her eyes were beady and Isis bolted for safety. But the noon hour brought John Watts, the widowed father, and this excused the child from sitting for criticism.

Being the only girl in the family, of course she must wash the dishes, which she did in intervals between frolics with the dogs. She even gave Jake, the puppy, a swim in the dishpan by holding him suspended above the water that reeked of "pot likker"—just high enough so that his feet would be immersed. The deluded puppy swam and swam without ever crossing the pan, much to his annoyance. Hearing Grandma she hurriedly dropped him on the floor, which he tracked up with feet wet with dishwater.

Grandma took her patching and settled down in the front room to sew. She did this every afternoon, and invariably slept in the big red rocker with her head lolled back over the back, the sewing falling from her hand.

Isis had crawled under the center table with its red plush cover with little round balls for fringe. She was lying on her back imagining herself various personages. She wore trailing robes, golden slippers with blue bottoms. She rode white horses with flaring pink nostrils to the horizon, for she still believed that to be land's end. She was picturing herself gazing over the edge of the world into the abyss when the spool of cotton fell from Grandma's lap and rolled away under the whatnot.

Isis drew back from her contemplation of the nothingness at the horizon and glanced up at the sleeping woman. Her head had fallen far back. She breathed with a regular "snark" intake and soft "poosah" exhaust. But Isis was a visual minded child. She

heard the snores only subconsciously but she saw straggling beard on Grandma's chin, trembling a little with every "snark" and "poosah." They were long gray hairs curled here and there against the dark brown skin. Isis was moved with pity for her mother's mother.

"Poah Gran-ma needs a shave," she murmured, and set about it. Just then Joel, next older than Isis, entered with a can of bait.

"Come on Isie, les' we all go fishin'. The perch is bitin' fine in Blue Sink."

"Sh-sh—" cautioned his sister, "Ah got to shave Gran'ma."

"Who say so?" Joel asked, surprised.

"Nobody doan hafta tell me. Look at her chin. No ladies don't weah no whiskers if they kin help it. But Gran'ma gittin' ole an' she doan know how to shave like me."

The conference adjourned to the back porch lest Grandma wake.

"Aw, Isie, you doan know nothin' 'bout shavin' a-tall—but a *man* lak *me*—"

"Ah do so know."

"You don't not. Ah'm goin' shave her mahseff."

"Naw, you won't neither, Smarty. Ah saw her first an' thought it all up first," Isis declared, and ran to the calico covered box on the wall above the wash basin and seized her father's razor. Joel was quick and seized the mug and brush.

"Now!" Isis cried defiantly, "Ah got the razor."

"Goody, goody, goody, pussy cat, Ah got th' brush an' you can't shave 'thout lather—see! Ah know mo' than you," Joel retorted.

"Aw, who don't know dat?" Isis pretended to scorn. But seeing her progress blocked for lack of lather she compromised.

"Ah know! Les' we all shave her. You lather an' Ah shave."

This was agreeable to Joel. He made mountains of lather and anointed his own chin, and the chin of Isis and the dogs, splashed the walls and at last was persuaded to lather Grandma's chin. Not that he was loath but he wanted his new plaything to last as long as possible.

Isis stood on one side of the chair with the razor clutched cleaver fashion. The niceties of razor-handling had passed over her head. The thing with her was to *hold* the razor—sufficient in itself.

Joel splashed on the lather in great gobs and Grandma awoke.

For one bewildered moment she stared at the grinning boy with the brush and mug but sensing another presence, she turned to behold the business face of Isis and the razor-clutching hand. Her jaw dropped and Grandma, forgetting years and rheumatism, bolted from the chair and fled the house, screaming.

"She's gone to tell papa, Isis. You didn't have no business wid his razor and he's gonna lick yo hide," Joel cried, running to replace mug and brush.

"You too, chuckle-head, you, too," retorted Isis. "You was playin' wid his brush and put it all over the dogs—Ah seen you put it on Ned an' Beulah." Isis shaved some slivers from the door jamb with the razor and replaced it in the box. Joel took his bait and pole and hurried to Blue Sink. Isis crawled under the house to brood over the whipping she knew would come. She had meant well.

But sounding brass and tinkling cymbal drew her forth. The local lodge of the Grand United Order of Odd Fellows led by a braying, thudding band, was marching in full regalia down the road. She had forgotten the barbecue and log-rolling to be held today for the benefit of the new hall.

Music to Isis meant motion. In a minute razor and whipping forgotten, she was doing a fair imitation of the Spanish dancer she had seen in a medicine show some time before. Isis' feet were gifted—she could dance most anything she saw.

Up, up went her spirits, her brown little feet doing all sorts of intricate things and her body in rhythm, hand curving above her head. But the music was growing faint. Grandma nowhere in sight. She stole out of the gate, running and dancing after the band.

Then she stopped. She couldn't dance at the carnival. Her dress

was torn and dirty. She picked a long stemmed daisy and thrust it behind her ear. But the dress, no better. Oh, an idea! In the battered round topped trunk in the bedroom!

She raced back to the house, then, happier, raced down the white dusty road to the picnic grove, gorgeously clad. People laughed good naturedly at her, the band played and Isis danced because she couldn't help it. A crowd of children gathered admiringly about her as she wheeled lightly about, hand on hip, flower between her teeth with the red and white fringe of the table-cloth—Grandma's new red table-cloth that she wore in lieu of a Spanish shawl—trailing in the dust. It was too ample for her meager form, but she wore it like a gypsy. Her brown feet twinkled in and out of the fringe. Some grown people joined the children about her. The Grand Exalted Ruler rose to speak; the band was hushed, but Isis danced on, the crowd clapping their hands for her. No one listened to the Exalted one, for little by little the multitude had surrounded the brown dancer.

An automobile drove up to the Crown and halted. Two white men and a lady got out and pushed into the crowd, suppressing mirth discreetly behind gloved hands. Isis looked up and waved them a magnificent hail and went on dancing until—

Grandma had returned to the house and missed Isis and straightway sought her at the festivities expecting to find her in her soiled dress, shoeless, gaping at the crowd, but what she saw drove her frantic. Here was her granddaughter dancing before a gaping crowd in her brand new red table-cloth, and reeking of lemon extract, for Isis had added the final touch to her costume. She *must* have perfume.

Isis saw Grandma and bolted. She heard her cry: "Mah Gawd, mah brand new table-cloth Ah jus' bought f'um O'landah!" as she fled through the crowd and on into the woods.

II

She followed the little creek until she came to the ford in a rutty wagon road that led to Apopka and laid down on the cool grass at the roadside. The April sun was quite hot.

Misery, misery and woe settled down upon her and the child wept. She knew another whipping was in store for her.

"Oh, Ah wish Ah could die, then Gran'ma an' papa would be sorry they beat me so much. Ah b'leeve Ah'll run away an' never go home no mo'. Ah'm goin' drown mahseff in th' creek!" Her woe grew attractive.

Isis got up and waded into the water. She routed out a tiny 'gator and a huge bull frog. She splashed and sang, enjoying herself immensely. The purr of a motor struck her ear and she saw a large, powerful car jolting along the rutty road toward her. It stopped at the water's edge.

"Well, I declare, it's our little gypsy," exclaimed the man at the wheel. "What are you doing here, now?"

"Ah'm killin' mahseff," Isis declared dramatically, "cause Gran'ma beats me too much."

There was a hearty burst of laughter from the machine.

"You'll last sometime the way you are going about it. Is this the way to Maitland? We want to go to the Park Hotel."

Isis saw no longer any reason to die. She came up out of the water, holding up the dripping fringe of the table-cloth.

"Naw, indeedy. You go to Maitlan' by the shell road—it goes by mah house—an' turn off at Lake Sebelia to the clay road that takes you right to the do'."

"Well," went on the driver, smiling furtively, "could you quit dying long enough to go with us?"

"Yessuh," she said thoughtfully, "Ah wanta go wid you."

The door of the car swung open. She was invited to a seat beside the driver. She had often dreamed of riding in one of these heavenly chariots but never thought she would, actually.

"Jump in then, Madame Tragedy, and show us. We lost ourselves after we left your barbecue."

During the drive Isis explained to the kind lady who smelt faintly of violets and to the indifferent men that she was really a princess. She told them about her trips to the horizon, about the trailing gowns, the gold shoes with blue bottoms—she insisted on the blue bottoms—the white charger, the time when she was

Hercules and had slain numerous dragons and sundry giants. At last the car approached her gate over which stood the umbrella China-berry tree. The car was abreast of the gate and had all but passed when Grandma spied her glorious tablecloth lying back against the upholstery of the Packard.

"You Isie-e!" she bawled. "You lil' wretch you! Come heah *dis instunt.*"

"That's me," the child confessed, mortified, to the lady on the rear seat.

"Oh, Sewell, stop the car. This is where the child lives. I hate to give her up though."

"Do you wanta keep me?" Isis brightened.

"Oh, I wish I could, you shining little morsel. Wait, I'll try to save you a whipping this time."

She dismounted with the gaudy lemon flavored culprit and advanced to the gate where Grandma stood glowering, switches in hand.

"You're gointuh ketchit f'um yo' haid to yo' heels m'lady. Jes' come in heah."

"Why, good afternoon," she accosted the furious grandparent. "You're not going to whip this poor little thing, are you?" the lady asked in conciliatory tones.

"Yes, Ma'am. She's de wustest lil' link that ever drawed bref. Jes' look at mah new table-cloth, dat ain't never been washed. She done traipsed all over de woods, uh dancin' an' uh prancin' in it. She done took a razor to me t'day an' Lawd knows whut mo'."

Isis clung to the white hand fearfully.

"Ah wuzn't gointer hurt Gran'ma, miss—Ah wuz jus' gointer shave her whiskers fuh huh 'cause she's old an' can't."

The white hand closed tightly over the little brown one that was quite soiled. She could understand a voluntary act of love even though it miscarried.

"Now, Mrs. er—er—I didn't get the name—how much did your table-cloth cost?"

"One whole big silvah dollar down at O'landah—ain't had it a week yit."

"Now here's five dollars to get another one. The little thing loves laughter. I want her to go on to the hotel and dance in that table-cloth for me. I can stand a little light today—"

"Oh, yessum, yessum," Grandma cut in. "Everything's alright, sho' she kin go, yessum."

The lady went on: "I want brightness and this Isis is joy itself, why she's drenched in light!"

Isis for the first time in her life, felt herself appreciated and danced up and down in an ecstasy of joy for a minute.

"Now, behave yo'seff, Isie, ovah at de hotel wid de white folks," Grandma cautioned, pride in her voice, though she strove to hide it. "Lawd, ma'am, dat gal keeps me so frackshus, Ah doan know mah haid f'um mah feet. Ah orter comb huh haid, too, befo' she go wid you all."

"No, no, don't bother. I like her as she is. I don't think she'd like it either, being combed and scrubbed. Come on, Isis."

Feeling that Grandma had been somewhat squelched did not detract from Isis' spirit at all. She pranced over to the waiting motor and this time seated herself on the rear seat between the sweet, smiling lady and the rather aloof man in gray.

"Ah'm gointer stay wid you all," she said with a great deal of warmth, and snuggled up to her benefactress. "Want me tuh sing a song fuh you?"

"There, Helen, you've been adopted," said the man with a short, harsh laugh.

"Oh, I hope so, Harry." She put her arm about the red draped figure at her side and drew it close until she felt the warm puffs of the child's breath against her side. She looked hungrily ahead of her and spoke into space rather than to anyone in the car. "I want a little of her sunshine to soak into my soul. I need it."

Spunk

A giant of a brown skinned man sauntered up the one street of the Village and out into the palmetto thickets with a small pretty woman clinging lovingly to his arm.

"Looka theah, folkses!" cried Elijah Mosley, slapping his leg gleefully. "Theah they go, big as life an' brassy as tacks."

All the loungers in the store tried to walk to the door with an air of nonchalance but with small success.

"Now pee-eople!" Walter Thomas gasped. "Will you look at 'em!"

"But that's one thing Ah likes about Spunk Banks—he ain't skeered of nothin' on God's green foot-stool—*nothin'!* He rides that log down at saw-mill jus' like he struts round wid another man's wife—jus' don't give a kitty. When Tes' Miller got cut to giblets on that circle-saw, Spunk steps right up and starts ridin'. The rest of us was skeered to go near it."

A round-shouldered figure in overalls much too large, came nervously in the door and the talking ceased. The men looked at each other and winked.

"Gimme some soda-water. Sass'prilla Ah reckon," the new-comer ordered, and stood far down the counter near the open pickled pig-feet tub to drink it.

Elijah nudged Walter and turned with mock gravity to the new-comer.

"Say Joe, how's everything up yo' way? How's yo' wife?"

Joe started and all but dropped the bottle he held in his hands. He swallowed several times painfully and his lips trembled.

"Aw 'Lige, you oughtn't to do nothin' like that," Walter grumbled. Elijah ignored him.

"She jus' passed heah a few minutes ago goin' thata way," with a wave of his hand in the direction of the woods.

Now Joe knew his wife had passed that way. He knew that the men lounging in the general store had seen her, moreover, he knew that the men knew *he* knew. He stood there silent for a long moment staring blankly, with his Adam's apple twitching nervously up and down his throat. One could actually *see* the pain he was suffering, his eyes, his face, his hands and even the dejected slump of his shoulders. He set the bottle down upon the counter. He didn't bang it, just eased it out of his hand silently and fiddled with his suspender buckle.

"Well, Ah'm goin' after her today. Ah'm goin' an' fetch her back. Spunk's done gone too fur."

He reached deep down into his trouser pocket and drew out a hollow ground razor, large and shiny, and passed his moistened thumb back and forth over the edge.

"Talkin' like a man, Joe. Course that's *yo'* fambly affairs, but Ah like to see grit in anybody."

Joe Kanty laid down a nickel and stumbled out into the street.

Dusk crept in from the woods. Ike Clarke lit the swinging oil lamp that was almost immediately surrounded by candle-flies. The men laughed boisterously behind Joe's back as they watched him shamble woodward.

"You oughtn't to said whut you did to him, 'Lige,—look how it worked him up," Walter chided.

"And Ah hope it did work him up. Tain't even decent for a man to take and take like he do."

"Spunk will sho' kill him."

"Aw, Ah doan' know. You never kin tell. He might turn him up an' spank him fur gettin' in the way, but Spunk wouldn't shoot no unarmed man. Dat razor he carried outa heah ain't gonna run Spunk down an' cut him, an' Joe ain't got the nerve to go up to

Spunk with it knowing he totes that Army 45. He makes that break outa heah to bluff us. He's gonna hide that razor behind the first likely palmetto root an' sneak back home to bed. Don't tell me nothin' 'bout that rabbit-foot colored man. Didn't he meet Spunk an' Lena face to face one day las' week an' mumble sumthin' to Spunk 'bout lettin' his wife alone?''

"What did Spunk say?'' Walter broke in—"Ah like him fine but tain't right the way he carries on wid Lena Kanty, jus' cause Joe's timid 'bout fightin.' ''

"You wrong theah, Walter. 'Tain't cause Joe's timid at all, it's cause Spunk wants Lena. If Joe was a passel of wile cats Spunk would tackle the job just the same. He'd go after *anything* he wanted the same way. As Ah wuz sayin' a minute ago, he tole Joe right to his face that Lena was his. 'Call her,' he says to Joe. 'Call her and see if she'll come. A woman knows her boss an' she answers when he calls.' 'Lena, ain't I yo' husband?' Joe sorter whines out. Lena looked at him real disgusted but she don't answer and she don't move outa her tracks. Then Spunk reaches out an' takes hold of her arm an' says: 'Lena, youse mine. From now on Ah works for you an' fights for you an' Ah never wants you to look to nobody for a crumb of bread, a stitch of close or a shingle to go over yo' head, but *me* long as Ah live. Ah'll git the lumber foh owah house tomorrow. Go home an' git yo' things together!' 'Thass mah house,' Lena speaks up. 'Papa gimme that.' 'Well,' says Spunk, 'doan give up whut's yours, but when youse inside don't forgit youse mine, an' let no other man git outa his place wid you!' Lena looked up at him with her eyes so full of love that they wuz runnin' over an' Spunk seen it an' Joe seen it too, and his lips started to tremblin' and his Adam's apple was galloping up and down his neck like a race horse. Ah bet he's wore out half a dozen Adam's apples since Spunk's been on the job with Lena. That's all he'll do. He'll be back heah after while swallowin' an' workin' his lips like he wants to say somethin' an' can't.''

"But didn't he do *nothin'* to stop 'em?''

"Nope, not a frazzlin' thing—jus' stood there. Spunk took Lena's arm and walked off jus' like nothin' ain't happened and he

stood there gazin' after them till they was outa sight. Now you know a woman don't want no man like that. I'm jus' waitin' to see whut he's goin' to say when he gits back.''

II

But Joe Kanty never came back, never. The men in the store heard the sharp report of a pistol somewhere distant in the palmetto thicket and soon Spunk came walking leisurely, with his big black Stetson set at the same rakish angle and Lena clinging to his arm, came walking right into the general store. Lena wept in a frightened manner.

"Well," Spunk announced calmly, "Joe come out there wid a meatax an' made me kill him."

He sent Lena home and led the men back to Joe—Joe crumple and limp with his right hand still clutching his razor.

"See mah back? Mah close cut clear through. He sneaked up an' tried to kill me from the back, but Ah got him, an' got him good, first shot," Spunk said.

The men glared at Elijah, accusingly.

"Take him up an' plant him in 'Stoney lonesome,' " Spunk said in a careless voice. "Ah didn't wanna shoot him but he made me do it. He's a dirty coward, jumpin' on a man from behind."

Spunk turned on his heel and sauntered away to where he knew his love wept in fear for him and no man stopped him. At the general store later on, they all talked of locking him up until the sheriff should come from Orlando, but no one did anything but talk.

A clear case of self-defense, the trial was a short one, and Spunk walked out of the court house to freedom again. He could work again, ride the dangerous log-carriage that fed the singing, snarling, biting, circle-saw; he could stroll the soft dark lanes with his guitar. He was free to roam the woods again; he was free to return to Lena. He did all of these things.

III

"Whut you reckon, Walt?" Elijah asked one night later. "Spunk's gittin' ready to marry Lena!"

"Naw! Why Joe ain't had time to git cold yit. Nohow Ah didn't figger Spunk was the marryin' kind."

"Well, he is," rejoined Elijah. "He done moved most of Lena's things—and her along wid 'em—over to the Bradley house. He's buying it. Jus' like Ah told yo' all right in heah the night Joe wuz kilt. Spunk's crazy 'bout Lena. He don't want folks to keep on talkin' 'bout her—thass reason he's rushin' so. Funny thing 'bout that bob-cat, wan't it?"

"Whut bob-cat, 'Lige? Ah ain't heered 'bout none."

"Ain't cher? Well, night befo' las' was the fust night Spunk an' Lena moved together an' jus' as they was goin' to bed, a big black bob-cat, black all over, you hear me, *black*, walked round and round that house and howled like forty, an' when Spunk got his gun an' went to the winder to shoot it, he says it stood right still an' looked him in the eye, an' howled right at him. The thing got Spunk so nervoused up he couldn't shoot. But Spunk says twan't no bob-cat nohow. He says it was Joe done sneaked back from Hell!"

"Humph!" sniffed Walter, "he oughter be nervous after what he done. Ah reckon Joe come back to dare him to marry Lena, or to come out an' fight. Ah bet he'll be back time and agin, too. Know what Ah think? Joe wuz a braver man than Spunk."

There was a general shout of derision from the group.

"Thass a fact," went on Walter. "Lookit whut he done; took a razor an' went out to fight a man he knowed toted a gun an' wuz a crack shot, too; 'nother thing Joe wuz skeered of Spunk, skeered plumb stiff! But he went jes' the same. It took him a long time to get his nerve up. 'Tain't nothin' for Spunk to fight when he ain't skeered of nothin'. Now, Joe's done come back to have it out wid the man that's got all he ever had. Y'all know Joe ain't never had nothin' nor wanted nothin' besides Lena. It musta been a h'ant cause ain' nobody never seen no black bob-cat."

" 'Nother thing," cut in one of the men, "Spunk wuz cussin' a

blue streak today 'cause he 'lowed dat saw wuz wobblin'—almos'
got 'im once. The machinist come, looked it over an' said it wuz
alright. Spunk musta been leanin' t'wards it some. Den he claimed
somebody pushed 'im but 'twant nobody close to 'im. Ah wuz
glad when knockin' off time come. I'm skeered of dat man when
he gits hot. He'd beat you full of button holes as quick as he's look
atcher.''

IV

The men gathered the next evening in a different mood, no laugh-
ter. No badinage this time.

"Look 'Lige, you goin' to set up wid Spunk?"

"Naw, Ah reckon not, Walter. Tell yuh the truth, Ah'm a lil bit
skittish. Spunk died too wicket—died cussin' he did. You know he
thought he wuz done outa life.''

"Good Lawd, who'd he think done it?"

"Joe."

"Joe Kanty? How come?"

"Walter, Ah b'leeve Ah will walk up thata way an' set. Lena
would like it Ah reckon.''

"But whut did he say, 'Lige?"

Elijah did not answer until they had left the lighted store and
were strolling down the dark street.

"Ah wuz loadin' a wagon wid scantlin' right near the saw when
Spunk fell on the carriage but 'fore Ah could git to him the saw got
him in the body—awful sight. Me an' Skint Miller got him off but
it was too late. Anybody could see that. The fust thing he said wuz:
'He pushed me, 'Lige—the dirty hound pushed me in the back!'—
He was spittin' blood at ev'ry breath. We laid him on the sawdust
pile with his face to the East so's he could die easy. He helt mah
han' till the last, Walter, and said: 'It was Joe, 'Lige—the dirty
sneak shoved me . . . he didn't dare come to mah face . . . but Ah'll
git the son-of-a-wood louse soon's Ah get there an' make hell too
hot for him. . . . Ah felt him shove me . . . !' Thass how he died.''

"If spirits kin fight, there's a powerful tussle goin' on some-
where ovah Jordan 'cause Ah b'leeve Joe's ready for Spunk an'

ain't skeered anymore—yas, Ah b'leeve Joe pushed 'im mahself.''

They had arrived at the house. Lena's lamentations were deep and loud. She had filled the room with magnolia blossoms that gave off a heavy sweet odor. The keepers of the wake tipped about whispering in frightened tones. Everyone in the Village was there, even old Jeff Kanty, Joe's father, who a few hours before would have been afraid to come within ten feet of him, stood leering triumphantly down upon the fallen giant as if his fingers had been the teeth of steel that laid him low.

The cooling board consisted of three sixteen-inch boards on saw horses, a dingy sheet was his shroud.

The women ate heartily of the funeral baked meats and wondered who would be Lena's next. The men whispered coarse conjectures between guzzles of whiskey.

Magnolia Flower

The brook laughed and sang. When it encountered hard places in its bed, it hurled its water in sparkling dance figures up into the moonlight.

It sang louder, louder; danced faster, faster, with a coquettish splash! at the vegetation on its banks.

At last it danced boisterously into the bosom of the St. John's, upsetting the whispering hyacinths who shivered and blushed, drunk with the delight of moon kisses.

The Mighty One turned peevishly in his bed and washed the feet of the Palmetto palms so violently that they awoke and began again the gossip they had left off when the Wind went to bed. A palm cannot speak without wind. The river had startled it also, for the winds sleep on the bosom of waters.

The palms murmured noisily of seasons and centuries, mating and birth and the transplanting of life. Nature knows nothing of death.

The river spoke to the brook.

"Why, O Young Water, do you hurry and hurl yourself so riotously about with your chatter and song? You disturb my sleep."

"Because, O Venerable One," replied the brook, "I am young. The flowers bloom, the trees and wind say beautiful things to me: there are lovers beneath the orange trees on my banks,—but most of all because the moon shines upon me with a full face."

"That is not sufficient reason for you to disturb my sleep," the river retorted. "I have cut down mountains and moved whole valleys into the sea, and I am not so noisy as *you* are."

The river slapped its banks angrily.

"But," added the brook diffidently, "I passed numbers of lovers as I came on. There was also a sweet-voiced night-bird."

"No matter, no matter!" scolded the river. "I have seen millions of lovers, child. I have borne them up and down, listened to those things that are uttered more with the breath than with the lips, gathered infinite tears, and some lovers have even flung themselves upon the soft couch I keep in my bosom, and slept."

"Tell me about some of them!" eagerly begged the brook.

"Oh, well," the river muttered, "I am wide awake now, and I suppose brooks must be humored."

THE RIVER'S STORY

"Long ago, as men count years, men who were pale of skin held a dark race of men in a bondage. The dark ones cried out in sorrow and travail,—not here in my country, but farther north. Many rivers carried their tears to the sea and the tide would bring some of them to me. The Wind brought cries without end.

"But there were some among the slaves who did not weep, but fled in the night to safety,—some to the far north, some to the far south, for here the red man, the panther, and the bear alone were to be feared. One of them from the banks of the Savannah came here. He was large and black and strong. His heart was strong and thudded with an iron sound in his breast. The forest made way for him, the beasts were afraid of him, and he built a house. He gathered stones and bits of metal, yellow and white—such as men love and for which they die—and grew wealthy. How? I do not know. Rivers take no notice of such things. We sweep men, stones, metal—all, ALL to the sea. All are as grass; all must to the sea in the end.

"He married Swift Deer, a Cherokee Maiden, and five years—as men love to clip Time into bits—passed.

"They had now a daughter, Magnolia Flower they called her, for she came at the time of their opening.

"When they had been married five years, she was four years old.

"Then the tide brought trouble rumors to me of hate, strife and destruction,—war, war, war.

"The blood of those born in the North flowed to sea, mingled with that of the southern-born. Bitter Waters, Troubled Winds. Rains that washed the dust from Heaven but could not beat back the wails of anguish, the thirst for blood and glory; the prayers for that which God gives not into the hands of man—Vengeance,—fires of hate to sear and scorch the ground: wells of acid tears to blight the leaf.

"Then all men walked free in the land, and Wind and Water again grew sweet.

"The man-made time notches flew by, and Magnolia Flower was in full-bloom. Her large eyes burned so brightly in her dark-brown face that the Negroes trembled when she looked angrily upon them. 'She curses with her eyes,' they said. 'Some evil surely will follow.'

"Black men came and went now as they pleased and the father had many to serve him, for now he had built a house such as white men owned when he was in bondage.

"His heart, of the ex-slave Bentley, was iron to all but Magnolia Flower. Swift Deer was no longer swift. Too many kicks and blows, too many grim chokings had slowed her feet and heart.

"He had done violence to workmen. There was little law in this jungle, and that was his,—'Do as I bid you or suffer my punishment.'

"He was hated, but feared more.

"He hated anything that bore the slightest resemblance to his former oppressors. His servants must be black, very black or Cherokee.

"The flower was seventeen and beautiful. Bentley thought often of a mate for her now, but one that would not offend him either in spirit or flesh. He must be full of humility, and black.

"One day, as the sun gave me a good-night kiss and the stars began their revels, I bore a young Negro yet not a Negro, for his skin was the color of freshly barked cypress, golden with the curly black hair of the white man.

"There were many Negroes in Bentley's Village and he wished to build a school that would teach them useful things.

"Bentley hated him at once; but ordered a school-house to be built, for he wished Magnolia to read and write.

"But before two weeks had passed, the teacher had taught the Flower to read strange marvels with her dark eyes, and she had taught the teacher to sing with his eyes, his hands, his whole body in her presence or whenever he thought of her,—not in her father's house, but beneath that clump of palms, those three that bathe their toes eternally and talk.

"They busied themselves with dreams of creation, while Bentley swore the foundation of the school-room into place.

" 'Nothing remains for me to do, now that I have your consent, but to ask your father for your sweet self. I know I am poor, but I have a great Vision, a high purpose, and he shall not be ashamed of me!'

"She clung fearfully to him.

" 'No, don't, John, don't. He'll say 'Naw!' and cuss. He—he don't like you at all. Youse too white.'

" 'I'll get him out of that, just trust me, precious. Then I can just *own* you—just let me talk to him!'

"She wept and pleaded with him—told him of Bentley's terrible anger and his violence, begged him to take her away and send her father word; but he refused to hear her, and walked up to her house and seated himself upon the broad verandah to wait for the father of Magnolia Flower.

"She flew to Swift Deer and begged her to persuade her lover not to brave Bentley's anger. The older woman crept out and tearfully implored him to go. He stayed.

"At dusk Bentley came swearing in. It had been a hot day; the men had cut several poor pieces of timber and seemed all bent on driving him to the crazy-house, he complained.

"Swift Deer slunk into the house at his approach, dragging her daughter after her.

"What followed was too violent for words to tell,—strength against strength, steel against steel. Threats bellowed from Bentley's bull throat seemed no more than little puffs of air to the lover. Of course, he would leave Bentley's house; but he would stay in the vicinity until he was told to leave by the Flower,—his Flower of sweetness and purity—and he would marry her unless hell froze over.

" 'Better eat up dem words an' git out whilst ah letcher,' the old man growled.

"Bentley drew up his lips in a great roll glare.

" 'No!' John shouted, giving him glare for his rage boiling and tumbling out from behind these ramparts, as it were. His eye reddened, a vessel in the center of his forehead stood out, gorged with blood, and his great hands twitched. For good or evil, Bentley was a strong man, mind and body.

"Swift Deer could no longer restrain her daughter. Magnolia Flower burst triumphantly upon the verandah.

" 'Well, papa, you don't say that I haven't picked a man. No one else in forty miles round would stand up to you like John!'

" 'Ham! Jim! Israel!' Bentley howled, on the verge of apoplexy. The men appeared. 'Take dis here yaller skunk an' lock him in dat back-room. I'm a gonna hang 'im high as Hamon come sun up, law uh no law.'

"A short struggle, and John was tied hand and foot.

" 'Stop!' cried Magnolia Flower, fighting, clawing, biting, kicking like a brown fiend for her lover. One brawny worker held her until John was helplessly bound.

"But when she looked at all three of the men with her eye of fire, they shook in superstitious fear.

" 'Oh, Moh Gawd!' breathed Ham, terrified. 'She's cussing us, she's cussing us all wid her eyes. Sump'm sho gwine happen.'

"Her eye was indeed something to affright the timid and even give the strong heart pause. A woman robbed of her love is more terrible than an army with banners.

" 'Oh, I wish I could!' she uttered in a voice flat with intensity. 'You'd all drop dead on the spot.'

"Swift Deer had crept out and stood beside the child. She screamed and clasped her hands over her daughter's lips.

" 'Say not such words, Magnolia,' " she pleaded. 'Take them back into your bosom unsaid.'

" 'Leave her be,' Bentley laughed acidly. 'Ah got a dose uh mah medicine ready for her too. Befo' ah hangs dis yaller pole-cat ahm gwinter marry her to crazy Joe, an' John kin look on; den ah'll hang *him*, and she kin look on. Magnolia and Joe oughter have fine black chillen. Ha! Ha!'

"The girl never uttered a sound. She smiled with her lips but her eyes burned every bit of courage to cinders in those who saw her.

"John was locked in the stout back-room. The windows were guarded and Ham sat with a loaded gun at the door.

"Magnolia was locked in the parlor where she ran up and down, tearing her heavy black hair. She beat helplessly upon the doors, she hammered the windows, making little mewing noises in her throat like a cat deprived of her litter.

"The house grew grimly still. Bentley had forced his wife to accompany him to their bedroom. She lay fearfully awake but he slept peacefully, if noisily.

" 'Magnolia Flower!' Ham called softly as he turned the key stealthily in the lock of her prison. 'Come on out. Ah caint stan' dis here weekedness uh yo pappy!'

" 'No thank you, Ham. I'll stay right here and make him kill me long with John, if you don't let him out too.'

" 'Lawd a mussy knows ah wisht ah could, but de ole man's got de key in his britches.'

" 'I'm going and get it, Ham,' she announced as she stepped over the threshold to freedom.

" 'Lawd! He'll kill me sho's you born.'

"Her feet were already on the stairs.

" 'I'll have that key or die. Ham, you put some victuals in that rowboat.'

"Half for love, half for fear, Ham obeyed.

"No one but Magnolia Flower would have entered Bentley's bed-room as she did, under the circumstances but to her the circumstances were her reasons for going. The big horse pistol under his pillow, the rack of guns in the hall, and her father's giant hands—none of these stopped her. She knew three lives,—her own, her lover's, and Ham's—hung on her success; but she went and returned with that key.

"One minute more and they flew down the path to the three leaning palms into the boat away northward.

"The morning came. Bentley ate hugely. The new rope hung ominously from the arm of the giant oak in the yard. Preacher Ike had eaten his breakfast with Bentley and the idiot, Crazy Joe, had forced himself into a pair of clean hickory pants.

"Bentley turned the key and flung open the door, stood still a moment in a grey rage and stalked to the back-room door, feeling for the key meanwhile.

"When he had fully convinced himself that the key was gone, he did not bother to open the door.

" 'Ham, it 'pears dat Magnolia an' dat yaller dog aint heah dis mawnin', so you an' Swift Deer will hafta do, being ez y'all let 'em git away.' He said this calmly and stalked toward the gun rack; but his anger was too large to be contained in one human heart. His arteries corded his face, his eyes popped, and he fell senseless as he stretched his hand for the gun. Rage had burst his heart at being outwitted by a girl.

"This all happened more than forty years ago, as men reckon time. Soon Swift Deer died, and the house built by strong Bentley fell to decay. White men came and built a town and Magnolia Flower and her eyes passed from the hearts of people who had known her."

The brook had listened, tensely thrilled to its very bottom at times. The river flowed calmly on, shimmering under the moon as it moved ceaselessly to the sea.

An old couple picked their way down to the water's edge. He

had once been tall—he still bore himself well. The little old woman clung lovingly to his arm.

"It's been forty-seven years, John," she said sweetly, her voice full of fear. "Do you think we can find the place?"

"Why yes, Magnolia, my Flower, unless they have cut down our trees; but if they are standing, we'll know 'em—couldn't help it."

"Yes, sweetheart, there they are. Hurry and let's sit on the roots like we used to and trail our fingers in the water. Love is wonderful, isn't it, dear?"

They hugged the trunks of the three clustering palms lovingly; then hugged each other and sat down shyly upon the heaped up roots.

"You never have regretted, Magnolia?"

"Of course not! But, John, listen, did you ever hear a river make such a sound? Why it seems almost as if it were talking—that murmuring noise, you know."

"Maybe, it's welcoming us back. I always felt that it loved you and me, somehow."

Muttsy

The piano in Ma Turner's back parlor stuttered and wailed. The pianist kept time with his heel and informed an imaginary deserter that "she might leave and go to Halimufack, but his slow-drag would bring her back," mournfully with a memory of tom-toms running rhythm through the plaint.

Fewclothes burst through the portieres, a brown chrysalis from a dingy red cocoon, and touched the player on the shoulder.

"Say, Muttsy," he stage whispered. "Ma's got a new lil' biddy in there—just come. And say—her foot would make all of dese Harlem babies a Sunday face."

"Whut she look like?" Muttsy drawled, trying to maintain his characteristic pose of indifference to the female.

"Brown skin, patent leather grass on her knob, kinder tallish. She's a lil' skinny," he added apologetically, "but ah'm willing to buy corn for that lil' chicken."

Muttsy lifted his six feet from the piano bench as slowly as his curiosity would let him and sauntered to the portieres for a peep:

The sight was as pleasing as Fewclothes had stated—only more so. He went on in the room which Ma always kept empty. It was her receiving room—her "front."

From Ma's manner it was evident that she was very glad to see the girl. She could see that the girl was not overjoyed in her presence, but attributed that to southern greenness.

"Who you say sentcher heah, dearie?" Ma asked, her face

41

trying to beam, but looking harder and more forbidding.

"Uh-a-a man down at the boat landing where I got off—North River. I jus' come in on the boat."

Ma's husband from his corner spoke up.

"Musta been Bluefront."

"Yeah, musta been him," Muttsy agreed.

"Oh, it's all right, honey, we New Yorkers likes to know who we'se takin' in, dearie. We has to be keerful. Whut did you say yo' name was?"

"Pinkie, yes, mam, Pinkie Jones."

Ma stared hard at the little old battered reticule that the girl carried for luggage—not many clothes if that was all—she reflected. But Pinkie had everything she needed in her face—many many trunks full. Several of them for Ma. She noticed the cold-reddened knuckles of her bare hands too.

"Come on upstairs to yo' room—thass all right 'bout the price—we'll come to some 'greement tomorrow. Jes' go up and take off yo things."

Pinkie put back the little rusty leather purse of another generation and followed Ma. She didn't like Ma—her smile resembled the smile of the Wolf in Red Riding Hood. Anyway back in Eatonville, Florida, "ladies," especially old ones, didn't put powder and paint on the face.

"Forty-dollars-Kate sure landed a pippin' dis time," said Muttsy, sotto voce, to Fewclothes back at the piano. "If she ain't, then there ain't a hound dawk in Georgy. Ah'm goin' home an' dress."

No one else in the crowded back parlor let alone the house knew of Pinkie's coming. They danced on, played on, sang their "blues" and lived on hotly their intense lives. The two men who had seen her—no one counted ole man Turner—went on playing too, but kept an ear cocked for her coming.

She followed Ma downstairs and seated herself in the parlor with the old man. He sat in a big rocker before a copper-lined gas stove, indolence in every gesture.

"Ah'm Ma's husband," he announced by way of making conversation.

"Now you jus' shut up!" Ma commanded severely. "You gointer git yo' teeth knocked down yo' throat yit for runnin' yo' tongue. Lemme talk to dis gal—dis is *mah* house. You sets on the stool un do nothin' too much tuh have anything tuh talk over!"

"Oh, Lawd," groaned the old man feeling a knee that always pained him at the mention of work. "Oh, Lawd, will you sen' yo' fiery chariot an' take me 'way from heah?"

"Aw shet up!" the woman spit out. "Lawd don't wantcher—devil wouldn't have yuh." She peered into the girl's face and leaned back satisfied.

"Well, girlie, you kin be a lotta help tuh me 'round dis house if you takes un intrus' in things—oh Lawd!" She leaped up from her seat. "That's mah bread ah smell burnin! . . ."

No sooner had Ma's feet cleared the room than the old man came to life again. He peered furtively after the broad back of his wife.

"Know who she is," he asked Pinkie in an awed whisper. She shook her head. "You don't? Dat's Forty-dollars-Kate!"

"Forty-dollars-Kate?" Pinkie repeated open eyed. "Naw, I don't know nothin' 'bout her."

"Sh-h," cautioned the old man. "Course you don't. I fuhgits you aint nothin' tall but a young 'un. Twenty-five years ago they all called her dat 'cause she *wuz* 'Forty-dollars-Kate.' She sho' wuz some p'utty 'oman—great big robus' lookin' gal. Men wuz glad 'nough to spend forty dollars on her if dey had it. She didn't lose no time wid dem dat didn't have it."

He grinned ingratiatingly at Pinkie and leaned nearer.

"But you'se better lookin' than she ever wuz, you might—taint no tellin' whut you might do ef you git some sense. I'm a gointer teach you, hear?"

"Yessuh," the girl managed to answer with an almost paralyzed tongue.

"Thass a good girl. You jus' lissen to me an' you'll pull thew alright."

He glanced at the girl sitting timidly upon the edge of the chair and scolded.

"Don't set dataway," he ejaculated. "Yo' back bone ain't no ram rod. Kinda scooch down on the for'ard edge uh de chear lak dis." (He demonstrated by "scooching" forward so far that he was almost sitting on his shoulder-blades.) The girl slumped a trifle.

"Is you got a job yit?"

"Nawsuh," she answered slowly, "but I reckon I'll have one soon. Ain't been in town a day yet."

"You looks kinda young—kinda little biddy. Is you been to school much?"

"Yessuh, went thew eight reader. I'm goin' again when I get a chance."

"Dat so? Well ah reckon ah kin talk some Latin tuh yuh den." He cleared his throat loudly. "Whut's you entitlum?"

"I don't know," said the girl in confusion.

"Well, den, whut's you entrimmins," he queried with a bit of braggadocio in his voice.

"I don't know," from the girl, after a long awkward pause.

"You chillun don't learn nothin' in school dese days. Is you got to 'goes into' yit?"

"You mean long division?"

"Ain't askin' 'bout de longness of it, dat don't make no difference," he retorted. "Sence you goin' stay heah ah'll edgecate yuh—do yuh know how to eat a fish—uh nice brown fried fish?"

"Yessuh," she answered quickly, looking about for the fish.

"How?"

"Why, you jus' eat it with corn bread," she said, a bit disappointed at the non-appearance of the fish.

"Well, ah'll tell yuh," he patronized. "You starts at de tail and liffs de meat off de bones sorter gentle and eats him clear tuh de head on dat side; den you turn 'im ovah an' commence at de tail agin and eat right up tuh de head; den you push *dem* bones way tuh one side an' takes another fish an' so on 'till de end—well, 'till der ain't no mo'!"

He mentally digested the fish and went on. "See," he pointed accusingly at her feet, "you don't even know how tuh warm yoself! You settin' dere wid yo' feet ev'y which a way. Dat ain't de way tuh git wahm. Now look at *mah* feet. Dass right put bofe big toes right togethah—now shove 'em close up tuh de fiah; now lean back so! Dass de way. Ah knows uh heap uh things tuh teach yuh sense you gointer live heah—ah learns all of 'em while de ole lady is paddlin' roun' out dere in de yard."

Ma appeared at the door and the old man withdrew so far into his rags that he all but disappeared. They went to supper where there was fried fish but forgot all rules for eating it and just ate heartily. She helped with the dishes and returned to the parlor. A little later some more men and women knocked and were admitted after the same furtive peering out through the nearest crack of the door. Ma carried them all back to the kitchen and Pinkie heard the clink of glasses and much loud laughter.

Women came in by ones and twos, some in shabby coats turned up about the ears, and with various cheap but showy hats crushed down over unkempt hair. More men, more women, more trips to the kitchen with loud laughter.

Pinkie grew uneasy. Both men and women stared at her. She kept strictly to her place. Ma came in and tried to make her join the others.

"Come on in, honey, a lil' toddy ain't gointer hurt nobody. Evebody knows *me*, ah wouldn't touch a hair on yo' head. Come on in, dearie, all th' men wants tuh meetcher."

Pinkie smelt the liquor on Ma's breath and felt contaminated at her touch. She wished herself back home again even with the ill treatment and squalor. She thought of the three dollars she had secreted in her shoe—she had been warned against pickpockets—and flight but where? Nowhere. For there was no home to which *she* could return, nor any place else she knew of. But when she got a job, she'd scrape herself clear of people who took toddies.

A very black man sat on the piano stool playing as only a Negro can with hands, stamping with his feet and the rest of his body keeping time.

Ahm gointer make me a graveyard of mah own
Ahm gointer make me a graveyard of mah own
Carried me down on de smoky Road—

Pinkie, weary of Ma's maudlin coaxing caught these lines as she was being pulled and coaxed into the kitchen. Everyone in there was shaking shimmies to music, rolling eyes heavenward as they picked imaginary grapes out of the air, or drinking. "Folkes," shouted Ma, "look a heah! Shut up dis racket! Ah wantcher tuh meet Pinkie Jones. She's de bes' frien' ah got." Ma flopped into a chair and began to cry into her whiskey glass.

"Mah comperments!" The men almost shouted. The women were less, much less enthusiastic.

"Dass de las' run uh shad," laughed a woman called Ada, pointing to Pinkie's slenderness.

"Jes' lak a bar uh soap aftah uh hard week's wash," Bertha chimed in and laughed uproariously. The men didn't help.

"Oh, Miss Pinkie," said Bluefront, removing his Stetson for the first time, "Ma'am, also Ma'am, ef you wuz tuh see me settin' straddle of uh Mud-cat leadin' a minner whut ud you think?"

"I-er, oh, I don't know, suh. I didn't know you-er anybody could ride uh fish."

"Stick uh roun' me, baby, an' you'll wear diamon's." Bluefront swaggered. "Look heah, lil' Pigmeat, youse *some* sharp! If you didn't had but one eye ah'd think you wuz a needle—thass how sharp you looks to me. Say, mah right foot is itchin'. Do dat mean ah'm gointer walk on some strange ground wid you?"

"Naw, indeedy," cut in Fewclothes. "It jes' means you feet needs to walk in some strange water—wid a lil' red seal lye thowed in."

But he was not to have a monopoly. Fewclothes and Shorty joined the chase and poor Pinkie found it impossible to retreat to her place beside the old man. She hung her head, embarrassed that she did not understand their mode of speech; she felt the unfriendly eyes of the women, and she loathed the smell of liquor

that filled the house now. The piano still rumbled and wailed that same song—

> *Carried me down on de Smoky Road*
> *Brought me back on de coolin' board*
> *Ahm gointer make me a graveyard of mah own.*

A surge of cold, fresh air from the outside stirred the smoke and liquor fumes and Pinkie knew that the front door was open. She turned her eyes that way and thought of flight to the clean outside. The door stood wide open and a tall figure in an overcoat with a fur collar stood there.

"Good Gawd, Muttsy! Shet 'at do'," cried Shorty. "Dass a pure razor blowing out dere tonight. Ah didn't know you wuz outa here nohow."

> *Carried me down on de Smoky Road*
> *Brought me back on de coolin' board*
> *Ahm gointer make me a graveyard of mah own,*

sang Muttsy, looking as if he sought someone and banged the door shut on the last words. He strode on in without removing hat or coat.

Pinkie saw in this short space that all the men deferred to him, that all the women sought his notice. She tried timidly to squeeze between two of the men and return to the quiet place beside old man Turner, thinking that Muttsy would hold the attention of her captors until she had escaped. But Muttsy spied her through the men about her and joined them. By this time her exasperation and embarrassment had her on the point of tears.

"Well, whadda yuh know about dis!" he exclaimed, "A real lil' pullet."

"Look out dere, Muttsy," drawled Dramsleg with objection, catching Pinkie by the arm and trying to draw her toward him. "Lemme tell dis lil' Pink Mama how crazy ah is 'bout her mahself. Ah ain't got no lady atall an'—"

"Aw, shut up Drams," Muttsy said sternly, "put yo' pocket-

book where yo' mouf is, an' somebody will lissen. Ah'm a heavy-sugar papa. Ah eats fried chicken when the rest of you niggers is drinking rain water.''

He thrust some of the others aside and stood squarely before her. With her downcast eyes, she saw his well polished shoes, creased trousers, gloved hands and at last timidly raised her eyes to his face.

"Look a heah!" he frowned, "you roughnecks done got dis baby ready tuh cry.''

He put his forefinger under her chin and made her look at him. And for some reason he removed his hat.

"Come on in the sittin' room an' le's talk. Come on befo' some uh dese niggers sprinkle some salt on yuh and eat yuh clean up lak uh radish.'' Dramsleg looked after Muttsy and the girl as they swam through the smoke into the front room. He beckoned to Bluefront.

"Hey, Bluefront! Ain't you mah fren'?''

"Yep,'' answered Bluefront.

"Well, then why cain't you help me? Muttsy done done me dirt wid the lil' pig-meat—throw a louse on 'im.''

Pinkie's hair was slipping down. She felt it, but her selfcon-sciousness prevented her catching it and down it fell in a heavy roll that spread out and covered her nearly to the waist. She followed Muttsy into the front room and again sat shrinking in the corner. She did not wish to talk to Muttsy nor anyone else in that house, but there were fewer people in this room.

"Phew!'' cried Bluefront, "dat baby sho got some righteous moss on her keg—dass reg'lar 'nearrow mah Gawd tuh thee' stuff.'' He made a lengthy gesture with his arms as if combing out long, silky hair.

"Shux,'' sneered Ada in a moist, alcoholic voice. "Dat ain't nothin.' Mah haih useter be so's ah could set on it.''

There was general laughter from the men.

"Yas, ah know it's de truth!'' shouted Shorty. "It's jes' ez close tuh yo' head *now* ez ninety-nine is tuh uh hund'ed.''

"Ah'll call Muttsy tuh you,'' Ada threatened.

"Oh, 'oman, Muttsy ain't got you tuh study 'bout no mo' cause he's parkin' his heart wid dat lil' chicken wid white-folks' haih. Why, dat lil' chicken's foot would make you a Sunday face."

General laughter again. Ada dashed the whiskey glass upon the floor with the determined stalk of an angry tiger and arose and started forward.

"Muttsy Owens, uh nobody else ain't to gointer make no fool outer *me*. Dat lil' kack girl ain't gointer put *me* on de bricks—not much."

Perhaps Muttsy heard her, perhaps he saw her out of the corner of his eye and read her mood. But knowing the woman as he did he might have known what she would do under such circumstances. At any rate he got to his feet as she entered the room where he sat with Pinkie.

"Ah know you ain't lost yo' head sho' 'nuff, 'oman. 'Deed, Gawd knows you bettah go 'way f'um me." He said this in a low, steady voice. The music stopped, the talking stopped and even the drinkers paused. Nothing happened, for Ada looked straight into Muttsy's eyes and went on outside.

"Miss Pinkie, Ah votes you g'wan tuh bed," Muttsy said suddenly to the girl.

"Yes-suh."

"An' don't you worry 'bout no job. Ah knows where you kin git a good one. Ah'll go see em first an' tell yuh tomorrow night."

She went off to bed upstairs. The rich baritone of the piano-player came up to her as did laughter and shouting. But she was tired and slept soundly.

Ma shuffled in after eight the next morning. "Darlin', ain't you got 'nuff sleep yit?"

Pinkie opened her eyes a trifle. "Ain't you the puttiest lil' trick! An' Muttsy done gone crazy 'bout yuh! Chile, he's lousy wid money an' diamon's an' everything— Yuh better grab him quick. Some folks has all de luck. Heah ah is—got uh man dat hates work lak de devil hates holy water. Ah gotta make dis house pay!"

Pinkie's eyes opened wide. "What does Mr. Muttsy do?"

"Mah Gawd, chile! He's de bes' gambler in three states, cards,

craps un hawses. He could be a boss stevedore if he so wanted. The big boss down on de dock would give him a fat job—just begs him to take it cause he can manage the men. He's the biggest hero they got since Harry Wills left the waterfront. But he won't take it cause he makes so much wid the games.''

"He's awful good-lookin'," Pinkie agreed, "an' he been mighty nice tuh me—but I like men to work. I wish he would. Gamblin' ain't nice."

"Yeah, 'tis, ef you makes money lak Muttsy. Maybe yo ain't noticed dat diamon' set in his tooth. He picks women up when he wants tuh an' puts 'em down when he choose."

Pinkie turned her face to the wall and shuddered. Ma paid no attention.

"You doan hafta git up till you git good an' ready, Muttsy says. Ah mean you kin stay roun' the house 'till you come to, sorter."

Another day passed. Its darkness woke up the land east of Lenox—all that land between the railroad tracks and the river. It was very ugly by day, and night kindly hid some of its sordid homeliness. Yes, nighttime gave it life.

The same women, or others just like them, came to Ma Turner's. The same men, or men just like them, came also and treated them to liquor or mistreated them with fists or cruel jibes. Ma got half drunk as usual and cried over everyone who would let her.

Muttsy came alone and went straight to Pinkie where she sat trying to shrink into the wall. She had feared that he would not come.

"Howdy do, Miss Pinkie."

"How'do do, Mistah Owens," she actually achieved a smile. "Did you see bout m'job?"

"Well, yeah—but the lady says she won't needya fuh uh week yet. Doan' worry. Ma ain't gointer push yuh foh room rent. Mah wrist ain't got no cramps."

Pinkie half sobbed: "Ah wantsa job now!"

"Didn't ah say dass alright? Well, Muttsy doan lie. Shux! Ah

might jes' es well tell yuh—ahm crazy 'bout yuh—money no objeck.''

It was the girl herself who first mentioned "bed" this night. He suffered her to go without protest.

The next night she did not come into the sitting room. She went to bed as soon as the dinner things had been cleared. Ma begged and cried, but Pinkie pretended illness and kept to her bed. This she repeated the next night and the next. Every night Muttsy came and every night he added to his sartorial splendor; but each night he went away, disappointed, more evidently crestfallen than before.

But the insistence for escape from her strange surroundings grew on the girl. When Ma was busy elsewhere, she would take out the three one dollar bills from her shoe and reconsider her limitations. If that job would only come on! She felt shut in, imprisoned, walled in with these women who talked of nothing but men and the numbers and drink, and men who talked of nothing but the numbers and drink and women. And desperation took her.

One night she was still waiting for the job—Ma's alcoholic tears prevailed. Pinkie took a drink. She drank the stuff mixed with sugar and water and crept to bed even as the dizziness came on. She would not wake tonight. Tomorrow, maybe, the job would come and freedom.

The piano thumped but Pinkie did not hear; the shouts, laughter and cries did not reach her that night. Downstairs Muttsy pushed Ma into a corner.

"Looky heah, Ma. Dat girl done played me long enough. Ah pays her room rent, ah pays her boahd an' all ah gets is uh hunk of ice. Now you said you wuz gointer fix things—you tole me so las' night an' heah she done gone tuh bed on me agin.''

"Deed, ah caint do nothin' wid huh. She's thinkin' sho' nuff you goin' git her uh job and she fret so cause tain't come, dat she drunk uh toddy un hits knocked her down jes lak uh log.''

"Ada an' all uh them laffin—they say ah done crapped.'' He felt injured. "Caint ah go talk to her?''

"Lawdy, Muttsy, dat gal dead drunk an' sleepin' lak she's buried."

"Well, caint ah go up an'—an' speak tuh her jus' the same." A yellow backed bill from Muttsy's roll found itself in Ma's hand and put her in such good humor that she let old man Turner talk all he wanted for the rest of the night.

"Yas, Muttsy, gwan in. Youse *mah* frien'."

Muttsy hurried up to the room indicated. He felt shaky inside there with Pinkie, somehow, but he approached the bed and stood for awhile looking down upon her. Her hair in confusion about her face and swinging off the bedside; the brown arms revealed and the soft lips. He blew out the match he had struck and kissed her full in the mouth, kissed her several times and passed his hand over her neck and throat and then hungrily down upon her breast. But here he drew back.

"Naw," he said sternly to himself, "ah ain't goin' ter play her wid no loaded dice." Then quickly he covered her with the blanket to her chin, kissed her again upon the lips and tipped down into the darkness of the vestibule.

"Ah reckon ah bettah git married." He soliloquized. "B'lieve me, ah will, an' go uptown wid dicties."

He lit a cigar and stood there on the steps puffing and thinking for some time. His name was called inside the sitting room several times but he pretended not to hear. At last he stole back into the room where slept the girl who unwittingly and unwillingly was making him do queer things. He tipped up to the bed again and knelt there holding her hands so fiercely that she groaned without waking. He watched her and he wanted her so that he wished to crush her in his love; crush and crush and hurt her against himself, but somehow he resisted the impulse and merely kissed her lips again, kissed her hands back and front, removed the largest diamond ring from his hand and slipped it on her engagement finger. It was much too large so he closed her hand and tucked it securely beneath the covers.

"She's *mine!*" he said triumphantly. "All mine!"

He switched off the light and softly closed the door as he went

out again to the steps. He had gone up to the bed room from the sitting room boldly, caring not who knew that Muttsy Owens took what he wanted. He was stealing forth afraid that someone might *suspect* that he had been there. There is no secret love in those barrens; it is a thing to be approached boisterously and without delay or dalliance. One loves when one wills, and ceases when it palls. There is nothing sacred or hidden—all subject to coarse jokes. So Muttsy re-entered the sitting room from the steps as if he had been into the street.

"Where you been Muttsy?" whined Ada with an awkward attempt at coyness.

"What *you* wanta know for?" he asked roughly.

"Now, Muttsy you know you ain't treatin' me right, honey. How come you runnin' de hawg ovah me lak you do?"

"Git outa mah face 'oman. Keep yo' han's offa me." He clapped on his hat and strode from the house.

Pinkie awoke with a gripping stomach and thumping head.

Ma bustled in. "How yuh feelin' darlin'? Youse jes lak a li'l doll baby."

"I got a headache, terrible from that ole whiskey. Thass mah first und las' drink long as I live." She felt the ring.

"Whut's this?" she asked and drew her hand out to the light.

"Dat's Muttsy' ring. Ah seen him wid it fuh two years. How'd y'all make out? He sho is one thur'bred."

"Muttsy? When? I didn't see no Muttsy."

"Dearie, you doan' hafta tell yo' bizniss ef you doan wanta. Ahm a hush-mouf. Thass all right, keep yo' bizniss to yo' self." Ma bleared her eyes wisely. "But ah know Muttsy wuz up heah tuh see yuh las' night. Doan' mine *me* honey, gwan wid 'im. He'll treat yuh right. Ah *knows* he's crazy 'bout yuh. An' all de women is crazy 'bout *him*. Lawd! lookit dat ring!" Ma regarded it greedily for a long time, but she turned and walked toward the door at last. "Git up darlin'. Ah got fried chicking fuh breckfus' un mush melon."

She went on to the kitchen. Ma's revelation sunk deeper, then

there was the ring. Pinkie hurled the ring across the room and leaped out of bed.

"He ain't goin' to make *me* none of his women—I'll die first! I'm goin' outa this house if I starve, lemme starve!"

She got up and plunged her face into the cold water on the washstand in the corner and hurled herself into the shabby clothes, thrust the three dollars which she had never had occasion to spend, under the pillow where Ma would be sure to find them and slipped noiselessly out of the house and fled down Fifth Avenue toward the Park that marked the beginning of the Barrens. She did not know where she was going, and cared little so long as she removed herself as far as possible from the house where the great evil threatened her.

At ten o'clock that same morning, Muttsy Owens dressed his flashiest best, drove up to Ma's door in a cab, the most luxurious that could be hired. He had gone so far as to stick two one hundred dollar notes to the inside of the windshield. Ma was overcome.

"Muttsy, dearie, what you doin' heah so soon? Pinkie sho has got you goin'. Un in a swell cab too—gee!"

"Ahm gointer git mah'ried tuh de doll baby, thass how come. An' ahm gointer treat her white too."

"Umhumh! Thass how come de ring! You oughtn't never fuhgit me, Muttsy, fuh puttin' y'all together. But ah never thought you'd mah'ry *nobody*—you allus said you wouldn't."

"An' ah wouldn't neither ef ah hadn't of seen *her*. Where she is?"

"In de room dressin'. She never tole me nothin' 'bout dis."

"She doan' know. She wuz sleep when ah made up mah mind an' slipped on de ring. But ah never miss no girl ah wants, you knows me."

"Everybody in this man's town knows you gets whut you wants."

"Naw, ah come tuh take her to brek'fus 'fo we goes tuh de cote-house."

"An' y'all stay heah and eat wid me. You go call her whilst ah set de grub on table."

Muttsy, with a lordly stride, went up to Pinkie's door and

rapped and waited and rapped and waited three times. Growing impatient or thinking her still asleep, he flung open the door and entered.

The first thing that struck him was the empty bed; the next was the glitter of his diamond ring upon the floor. He stumbled out to Ma. She was gone, no doubt of that.

"She looked awful funny when ah tole her you wuz in heah, but ah thought she wuz puttin' on airs," Ma declared finally.

"She thinks ah played her wid a marked deck, but ah didn't. Ef ah could see her she'd love me. Ah know she would. 'Cause ah'd make her," Muttsy lamented.

"I don't know, Muttsy. She ain't no New Yorker, and she thinks gamblin' is awful."

"Zat all she got against me? Ah'll fix that up in a minute. You help me find her and ah'll do anything she says jus' so she marries me." He laughed ruefully. "Looks like ah crapped this time, don't it, ma?"

The next day Muttsy was foreman of two hundred stevedores. How he did make them work. But oh how cheerfully they did their best for him. The company begrudged not one cent of his pay. He searched diligently, paid money to other searchers, went every night to Ma's to see if by chance the girl had returned or if any clues had turned up.

Two weeks passed this way. Black empty days for Muttsy.

Then he found her. He was coming home from work. When crossing Seventh Avenue at 135th Street they almost collided. He seized her and began pleading before she even had time to recognize him.

He turned and followed her; took the employment office slip from her hand and destroyed it, took her arm and held it. He must have been very convincing for at 125th Street they entered a taxi that headed uptown again. Muttsy was smiling amiably upon the whole round world.

A month later, as Muttsy stood on the dock hustling his men to greater endeavor, Bluefront flashed past with his truck. "Say, Muttsy, you don't know what you missin' since you quit de game.

Ah cleaned out de whole bunch las' night." He flashed a roll and laughed. "It don't seem like a month ago you wuz king uh de bones in Harlem." He vanished down the gangplank into the ship's hold.

As he raced back up the gangplank with his loaded truck Muttsy answered him. "And now, I'm King of the Boneheads—which being interpreted means stevedores. Come on over behind dis crate wid yo' roll. Mah wrist ain't got no cramp 'cause ah'm married. You'se gettin' too sassy."

"Thought you wuzn't gointer shoot no mo'!" Bluefront temporized.

"Aw Hell! Come on back heah," he said impatiently. "Ah'll shoot you any way you wants to—hard or soft roll—you'se trying to stall. You know ah don't crap neither. Come on, mah Pinkie needs a fur coat and you stevedores is got to buy it."

He was on his knees with Bluefront. There was a quick movement of Muttsy's wrist, and the cubes flew out on a piece of burlap spread for the purpose—a perfect seven.

"Hot dog!" he exulted. "Look at dem babies gallop!" His wrist quivered again. "Nine for point!" he gloated. "Hah!" There was another quick shake and nine turned up again. "Shove in, Bluefront, shove in dat roll, dese babies is crying fuh it."

Bluefront laid down two dollars grudgingly. "You said you wuzn't gointer roll no mo' dice after you got married," he grumbled.

But Muttsy had tasted blood. His flexible wrist was already in the midst of the next play.

"Come on, Bluefront, stop bellyachin'. Ah shoots huy for de roll!" He reached for his own pocket and laid down a roll of yellow bills beside Bluefront's. His hand quivered and the cubes skipped out again. "Nine!" He snapped his fingers like a trap-drum and gathered in the money.

"Doxology, Bluefront. Git back in de line wid yo' truck an' send de others roun' heah one by one. What man can't keep one li'l wife an' two li'l bones? Hurry 'em up, Blue!"

'Possum or
Pig?

Before freedom there was a house slave very much in the confidence of the Master. But young pigs began to disappear, and for good reasons the faithful house slave fell under suspicion.

One night, after his duties at the "big house" were over, he was sitting before his cabin fire. From a pot was seeping the odor of young pig. There was a knock at the door.

"Who dat?" he asked cautiously.

"It's me, John," came the Master's voice.

"Lawd, now, Massa, whut you want way down heah?"

"I'm cold, John. I want to come in."

"Now, Massa, ah jes' lef' a lovely hot fire at de big house. You aughter gwan up dere an' git warm."

"I want to come in, John."

"Massa, whut you wanta come in po' niggah's house an' you got dat fine big house up yander?"

"John, if you don't open this door, I'll have you whipped tomorrow."

John went to the door grumbling about rich white folks hanging around po' niggahs' cabins.

The white man sat down before the blazing fire. The pot boiled and breathed of delicious things within.

After a while he said, "I'm hungry, John. What have you got in that pot?"

"Lawd, now, Massa, whut you wanter eat mah po' vittles fuh

and Mistis got roas' chicken an' ham an' chine-bone pie an' everything up to de house? White folks got de funniest ways.''

"What's in that pot, John?''

"It's one lil' measly possum, Massa, ah'm bilin' tuh keep fuh a cold snack.''

"I want some of it.''

"Naw, Massa, you don't want none uh dat dirty lil' possum.''

"Yes I do, and if you don't give me some, I'll have you whipped.''

John slowly arose and got a plate, knife and fork and opened the pot.

"Well,'' he said resignedly before dipping in. "Ah put dis heah critter in heah a possum,—if it comes out a pig, 'tain't mah fault.''

Stepped on a tin, mah story ends.

The Eatonville Anthology

THE PLEADING WOMAN

Mrs. Tony Roberts is the pleading woman. She just loves to ask for things. Her husband gives her all he can rake and scrape, which is considerably more than most wives get for their housekeeping, but she goes from door to door begging for things.

She starts at the store. "Mist' Clarke," she sing-songs in a high keening voice, "gimme lil' piece uh meat tuh boil a pot uh greens wid. Lawd knows me an' mah chillen is SO hongry! Hits uh SHAME! Tony don't fee-ee-eee-ed me!"

Mr. Clarke knows that she has money and that her larder is well stocked, for Tony Roberts is the best provider on his list. But her keening annoys him and he arises heavily. The pleader at this shows all the joy of a starving man being seated at a feast.

"Thass right Mist' Clarke. De Lawd loveth de cheerful giver. Gimme jes' a lil' piece 'bout dis big (indicating the width of her hand) an' de Lawd'll bless yuh."

She follows this angel-on-earth to his meat tub and superintends the cutting, crying out in pain when he refuses to move the knife over just a teeny bit mo'.

Finally, meat in hand, she departs, remarking on the meanness of some people who give a piece of salt meat only two-fingers wide when they were plainly asked for a hand-wide piece. Clarke puts it down to Tony's account and resumes his reading.

With the slab of salt pork as a foundation, she visits various homes until she has collected all she wants for the day. At the Piersons, for instance: "Sister Pierson, plee-ee-ease gimme uh han'ful uh collard greens fuh me an' mah po' chillen! 'Deed, me an' mah chillen is SO hongry. Tony doan' fee-ee-eed me!"

Mrs. Pierson picks a bunch of greens for her, but she springs away from them as if they were poison. "Lawd a mussy, Mis' Pierson, you ain't gonna gimme dat lil' eye-full uh greens fuh me an' mah chillen, is you? Don't be so graspin'; Gawd won't bless yuh. Gimme uh han'full mo'. Lawd, some folks is got everything, an' theys jes' as gripin' an stingy!"

Mrs. Pierson raises the ante, and the pleading woman moves on to the next place, and on and on. The next day, it commences all over.

II
TURPENTINE LOVE

Jim Merchant is always in good humor—even with his wife. He says he fell in love with her at first sight. That was some years ago. She has had all her teeth pulled out, but they still get along splendidly.

He says the first time he called on her he found out that she was subject to fits. This didn't cool his love, however. She had several in his presence.

One Sunday, while he was there, she had one, and her mother tried to give her a dose of turpentine to stop it. Accidently, she spilled it in her eye and it cured her. She never had another fit, so they got married and have kept each other in good humor ever since.

III

Becky Moore has eleven children of assorted colors and sizes. She has never been married, but that is not her fault. She has never stopped any of the fathers of her children from proposing, so if she

has no father for her children it's not her fault. The men round about are entirely to blame.

The other mothers of the town are afraid that it is catching. They won't let their children play with hers.

IV
TIPPY

Sykes Jones' family all shoot craps. The most interesting member of the family—also fond of bones, but of another kind—is Tippy, the Jones' dog.

He is so thin, that it amazes one that he lives at all. He sneaks into village kitchens if the housewives are careless about the doors and steals meats, even off the stoves. He also sucks eggs.

For these offenses he has been sentenced to death dozens of times, and the sentences executed upon him, only they didn't work. He has been fed bluestone, strychnine, nux vomica, even an entire Peruna bottle beaten up. It didn't fatten him, but it didn't kill him. So Eatonville has resigned itself to the plague of Tippy, reflecting that it has erred in certain matters and is being chastened.

In spite of all the attempts upon his life, Tippy is still willing to be friendly with anyone who will let him.

V
THE WAY OF A MAN WITH A TRAIN

Old Man Anderson lived seven or eight miles out in the country from Eatonville. Over by Lake Apopka. He raised feed-corn and cassava and went to market with it two or three times a year. He bought all of his victuals wholesale so he wouldn't have to come to town for several months more.

He was different from us citybred folks. He had never seen a train. Everybody laughed at him for even the smallest child in Eatonville had either been to Maitland or Orlando and watched a train go by. On Sunday afternoons all of the young people of the

village would go over to Maitland, a mile away, to see Number 35 whizz southward on its way to Tampa and wave at the passengers. So we looked down on him a little. Even we children felt superior in the presence of a person so lacking in worldly knowledge.

The grown-ups kept telling him he ought to go see a train. He always said he didn't have time to wait so long. Only two trains a day passed through Maitland. But patronage and ridicule finally had its effect and Old Man Anderson drove in one morning early. Number 78 went north to Jacksonville at 10:20. He drove his light wagon over in the woods beside the railroad below Maitland, and sat down to wait. He began to fear that his horse would get frightened and run away with the wagon. So he took him out and led him deeper into the grove and tied him securely. Then he returned to his wagon and waited some more. Then he remembered that some of the train-wise villagers had said the engine belched fire and smoke. He had better move his wagon out of danger. It might catch afire. He climbed down from the seat and placed himself between the shafts to draw it away. Just then 78 came thundering over the trestle spouting smoke, and suddenly began blowing for Maitland. Old Man Anderson became so frightened he ran away with the wagon through the woods and tore it up worse than the horse ever could have done. He doesn't know yet what a train looks like, and says he doesn't care.

VI

COON TAYLOR

Coon Taylor never did any real stealing. Of course, if he saw a chicken or a watermelon or muskmelon or anything like that that he wanted he'd take it. The people used to get mad but they never could catch him. He took so many melons from Joe Clarke that he set up in the melon patch one night with his shotgun loaded with rock salt. He was going to fix Coon. But he was tired. It is hard work being a mayor, postmaster, storekeeper and everything. He dropped asleep sitting on a stump in the middle of the patch. So

he didn't see Coon when he came. Coon didn't see him either, that is, not at first. He knew the stump was there, however. He had opened many of Clarke's juicy Florida Favorite on it. He selected his fruit, walked over to the stump and burst the melon on it. That is, he thought it was the stump until it fell over with a yell. Then he knew it was no stump and departed hastily from those parts. He had cleared the fence when Clarke came to, as it were. So the charge of rock-salt was wasted on the desert air.

During the sugar-cane season, he found he couldn't resist Clarke's soft green cane, but Clarke did not go to sleep this time. So after he had cut six or eight stalks by the moonlight, Clarke rose up out of the cane strippings with his shotgun and made Coon sit right down and chew up the last one of them on the spot. And the next day he made Coon leave his town for three months.

VII
VILLAGE FICTION

Joe Lindsay is said by Lum Boger to be the largest manufacturer of prevarications in Eatonville; Brazzle (late owner of the world's leanest and meanest mule) contends that his business is the largest in the state and his wife holds that he is the biggest liar in the world.

Exhibit A—He claims that while he was in Orlando one day he saw a doctor cut open a woman, remove everything—liver, lights and heart included—clean each of them separately; the doctor then washed out the empty woman, dried her out neatly with a towel and replaced the organs so expertly that she was up and about her work in a couple of weeks.

VIII

Sewell is a man who lives all to himself. He moves a great deal. So often, that 'Lige Moseley says his chickens are so used to moving that every time he comes out into his backyard the chickens lie down and cross their legs, ready to be tied up again.

He is baldheaded; but he says he doesn't mind that, because he wants as little as possible between him and God.

IX

Mrs. Clarke is Joe Clarke's wife. She is a soft-looking, middle-aged woman, whose bust and stomach are always holding a get-together.

She waits on the store sometimes and cries every time he yells at her which he does every time she makes a mistake, which is quite often. She calls her husband "Jody." They say he used to beat her in the store when he was a young man, but he is not so impatient now. He can wait until he goes home.

She shouts in Church every Sunday and shakes the hand of fellowship with everybody in the Church with her eyes closed, but somehow always misses her husband.

X

Mrs. McDuffy goes to Church every Sunday and always shouts and tells her "determination." Her husband always sits in the back row and beats her as soon as they get home. He says there's no sense in her shouting, as big a devil as she is. She just does it to slur him. Elijah Moseley asked her why she didn't stop shouting, seeing she always got a beating about it. She says she can't "squinch the sperrit." Then Elijah asked Mr. McDuffy to stop beating her, seeing that she was going to shout anyway. He answered that she just did it for spite and that his fist was just as hard as her head. He could last just as long as she. So the village let the matter rest.

XI
DOUBLE-SHUFFLE

Back in the good old days before the World War, things were very simple in Eatonville. People didn't fox-trot. When the town

wanted to put on its Sunday clothes and wash behind the ears, it put on a "breakdown." The daring younger set would two-step and waltz, but the good church members and the elders stuck to the grand march. By rural canons dancing is wicked, but one is not held to have danced until the feet have been crossed. Feet don't get crossed when one grand marches.

At elaborate affairs the organ from the Methodist church was moved up to the hall and Lizzimore, the blind man, presided. When informal gatherings were held, he merely played his guitar assisted by any volunteer with mouth organs or accordions.

Among white people the march is as mild as if it had been passed on by Volstead. But it still has a kick in Eatonville. Everybody happy, shining eyes, gleaming teeth. Feet dragged 'shhlap, shhlap! to beat out the time. No orchestra needed. Round and round! Back again, parse-me-la! shlap! shlap! Strut! Strut! Seaboard! Shlap! Shlap! Tiddy bumm! Mr. Clarke in the lead with Mrs. Moseley.

It's too much for some of the young folks. Double shuffling commences. Buck and wing. Lizzimore about to break his guitar. Accordion doing contortions. People fall back against the walls, and let the soloist have it, shouting as they clap the old, old double shuffle songs.

> Me an' mah honey got two mo' days,
> Two mo' days tuh do de buck.

Sweating bodies, laughing mouths, grotesque faces, feet drumming fiercely. Deacons clapping as hard as the rest.

> Great big nigger, black as tar
> Trying tuh git tuh hebben on uh 'lectric car.
>
> Some love cabbage, some love kale
> But I love a gal wid a short skirt tail.
>
> Long tall angel—steppin' down,
> Long white robe an' starry crown.

Ah would not marry uh black gal (bumm bumm!)
Tell yuh de reason why
Every time she comb her hair
She make de goo-goo eye.

Would not marry a yaller gal (bumm bumm!)
Tell yuh de reason why
Her neck so long an' stringy
Ahm 'fraid she'd never die.

"Would not marry uh preacher
Tell yuh de reason why
Every time he comes tuh town
He makes de chicken fly.

When the buck dance was over, the boys would give the floor to the girls and they would parse-me-la with a sly eye out of the corner to see if anybody was looking who might "have them up in church" on conference night. Then there would be more dancing. Then Mr. Clarke would call for everybody's best attention and announce that *'freshments was served! Every gent'man would please take his lady by the arm and scorch her right up to de table fur a treat!*

Then the men would stick their arms out with a flourish and ask their ladies: "You lak chicken? Well, then, take a wing." And the ladies would take the proffered "wings" and parade up to the long table and be served. Of course most of them had brought baskets in which were heaps of jointed and fried chicken, two or three kinds of pies, cakes, potato pone and chicken purlo. The hall would separate into happy groups about the baskets until time for more dancing.

But the boys and girls got scattered about during the war, and now they dance the fox-trot by a brand new piano. They do waltz and two-step still, but no one now considers it good form to lock his chin over his partner's shoulder and stick out behind. One night just for fun and to humor the old folks, they danced, that is, they grand marched, but everyone picked up their feet. *Bah!!*

XII

THE HEAD OF THE NAIL

Daisy Taylor was the town vamp. Not that she was pretty. But sirens were all but non-existent in the town. Perhaps she was forced to it by circumstances. She was quite dark, with little brushy patches of hair squatting over her head. These were held down by shingle-nails often. No one knows whether she did this for artistic effect or for lack of hair-pins, but there they were shining in the little patches of hair when she got all dressed for the afternoon and came up to Clarke's store to see if there was any mail for her.

It was seldom that anyone wrote to Daisy, but she knew that the men of the town would be assembled there by five o'clock, and some one could usually be induced to buy her some soda-water or peanuts.

Daisy flirted with married men. There were only two single men in town. Lum Boger, who was engaged to the assistant school-teacher, and Hiram Lester, who had been off to school at Tus-kegee and wouldn't look at a person like Daisy. In addition to other drawbacks, she was pigeon-toed and her petticoat was al-ways showing so perhaps he was justified. There was nothing else to do except flirt with married men.

This went on for a long time. First one wife then another com-plained of her, or drove her from the preserves by threat.

But the affair with Crooms was the most prolonged and serious. He was even known to have bought her a pair of shoes.

Mrs. Laura Crooms was a meek little woman who took all of her troubles crying, and talked a great deal of leaving things in the hands of God.

The affair came to a head one night in orange picking time. Crooms was over at Oneido picking oranges. Many fruit pickers move from one town to the other during the season.

The *town* was collected at the store-postoffice as is customary on Saturday nights. The *town* has had its bath and with its week's pay in pocket fares forth to be merry. The men tell stories and

treat the ladies to soda-water, peanuts and peppermint candy.

Daisy was trying to get treats, but the porch was cold to her that night.

"Ah don't keer if you don't treat me. What's a dirty lil nickel?" She flung this at Walter Thomas. "The everloving Mister Crooms will gimme anything atall Ah wants."

"You better shet up yo' mouf talking 'bout Albert Crooms. Heah his wife comes right now."

Daisy went akimbo. "Who? Me! Ah don't keer whut Laura Crooms think. If she ain't a heavy hip-ted Mama enough to keep him, she don't need to come crying to me."

She stood making goo-goo eyes as Mrs. Crooms walked upon the porch. Daisy laughed loud, made several references to Albert Crooms, and when she saw the mail-bag come in from Maitland she said, "Ah better go in an' see if Ah ain't got a letter from Oneido."

The more Daisy played the game of getting Mrs. Crooms' goat, the better she liked it. She ran in and out of the store laughing until she could scarcely stand. Some of the people present began to talk to Mrs. Crooms—to egg her on to halt Daisy's boasting, but she was for leaving it all in the hands of God. Walter Thomas kept on after Mrs. Crooms until she stiffened and resolved to fight. Daisy was inside when she came to this resolve and never dreamed anything of the kind could happen. She had gotten hold of an envelope and came laughing and shouting, "Oh, Ah can't stand to see Oneido lose!"

There was a box of ax-handles on display on the porch, propped up against the door jamb. As Daisy stepped upon the porch, Mrs. Crooms leaned the heavy end of one of those handles heavily upon her head. She staggered from the porch to the ground and the timid Laura, fearful of a counter-attack, struck again and Daisy toppled into the town ditch. There was not enough water in there to do more than muss her up. Every time she tried to rise, down would come that ax-handle again. Laura was fighting a scared fight. With Daisy thoroughly licked, she retired to the store porch and left her fallen enemy in the ditch. None of the men helped

Daisy—even to get out of the ditch. But Elijah Moseley, who was some distance down the street when the trouble began, arrived as the victor was withdrawing. He rushed up and picked Daisy out of the mud and began feeling her head.

"Is she hurt much?" Joe Clarke asked from the doorway.

"I don't know," Elijah answered, "I was just looking to see if Laura had been lucky enough to hit one of those nails on the head and drive it in."

Before a week was up, Daisy moved to Orlando. There in a wider sphere, perhaps, her talents as a vamp were appreciated.

XIII
PANTS AND CAL'LINE

Sister Cal'line Potts was a silent woman. Did all of her laughing down inside, but did the thing that kept the town in an uproar of laughter. It was the general opinion of the village that Cal'line would do anything she had a mind to. And she had a mind to do several things.

Mitchell Potts, her husband, had a weakness for women. No one ever believed that she was jealous. She did things to the women, surely. But most any townsman would have said that she did them because she liked the novel situation and the queer things she could bring out of it.

Once he took up with Delphine—called Mis' Pheeny by the town. She lived on the outskirts on the edge of the piney woods. The town winked and talked. People don't make secrets of such things in villages. Cal'line went about her business with her thin black lips pursed tight as ever, and her shiny black eyes unchanged.

"Dat devil of a Cal'line's got somethin' up her sleeve!" The town smiled in anticipation.

"Delphine is too big a cigar for her to smoke. She ain't crazy," said some as the weeks went on and nothing happened. Even Pheeny herself would give an extra flirt to her over-starched petticoats as she rustled into church past her of Sundays.

Mitch Potts said furthermore, that he was tired of Cal'line's foolishness. She had to stay where he put her. His African soup-bone (arm) was too strong to let a woman run over him. 'Nough was 'nough. And he did some fancy cussing, and he was the fanciest cusser in the county.

So the town waited and the longer it waited, the odds changed slowly from the wife to the husband.

One Saturday, Mitch knocked off work at two o'clock and went over to Maitland. He came back with a rectangular box under his arm and kept straight on out to the barn and put it away. He ducked around the corner of the house quickly, but even so, his wife glimpsed the package. Very much like a shoe-box. So!

He put on the kettle and took a bath. She stood in her bare feet at the ironing board and kept on ironing. He dressed. It was about five o'clock but still very light. He fiddled around outside. She kept on with her ironing. As soon as the sun got red, he sauntered out to the barn, got the parcel and walked away down the road, past the store and out into the piney woods. As soon as he left the house, Cal'line slipped on her shoes without taking time to don stockings, put on one of her husband's old Stetsons, worn and floppy, slung the axe over her shoulder and followed in his wake. He was hailed cheerily as he passed the sitters on the store porch and answered smiling sheepishly and passed on. Two minutes later passed his wife, silently, unsmilingly, and set the porch to giggling and betting.

An hour passed perhaps. It was dark. Clarke had long ago lighted the swinging kerosene lamp inside.

XIV

Once 'way back yonder before the stars fell all the animals used to talk just like people. In them days dogs and rabbits was the best of friends—even tho' both of them was stuck on the same gal—which was Miss Nancy Coon. She had the sweetest smile and the prettiest striped and bushy tail to be found anywhere.

They both run their legs nigh off trying to win her for them-

selves—fetching nice ripe persimmons and such. But she never give one or the other no satisfaction.

Finally one night Mr. Dog popped the question right out. "Miss Coon," he says, "Ma'am, also Ma'am which would you ruther be—a lark flyin' or a dove a settin'?"

Course Miss Nancy she blushed and laughed a little and hid her face behind her bushy tail for a spell. Then she said sorter shy like, "I does love yo' sweet voice, brother dawg—but—but I ain't jes' exactly set in my mind yit."

Her and Mr. Dog set on a spell, when up comes hopping Mr. Rabbit wid his tail fresh washed and his whiskers shining. He got right down to business and asked Miss Coon to marry him, too.

"Oh, Miss Nancy," he says, "Ma'am, also Ma'am, if you'd see me settin' straddle of a mud-cat leadin' a minnow, what would you think? Ma'am also Ma'am?" Which is a out and out proposal as everybody knows.

"Youse awful nice, Brother Rabbit and a beautiful dancer, but you cannot sing like Brother Dog. Both you uns come back next week to gimme time for to decide."

They both left arm-in-arm. Finally Mr. Rabbit says to Mr. Dog. "Taint no use in me going back—she ain't gwinter have me. So I mought as well give up. She loves singing, and I ain't got nothing but a squeak."

"Oh, don't talk that a' way," says Mr. Dog, tho' he is glad Mr. Rabbit can't sing none.

"Thass all right, Brer Dog. But if I had a sweet voice like you got, I'd have it worked on and make it sweeter."

"How! How! How!" Mr. Dog cried, jumping up and down.

"Lemme fix it for you, like I do for Sister Lark and Sister Mocking-bird."

"When? Where?" asked Mr. Dog, all excited. He was figuring that if he could sing just a little better Miss Coon would be bound to have him.

"Just you meet me t'morrer in de huckleberry patch," says the rabbit and off they both goes to bed.

The dog is there on time next day and after a while the rabbit comes loping up.

"Mawnin', Brer Dawg," he says kinder chippy like. "Ready to git yo' voice sweetened?"

"Sholy, sholy, Brer Rabbit. Let's we all hurry about it. I wants tuh serenade Miss Nancy from de piney woods tuh night."

"Well, den, open yo' mouf and poke out yo' tongue," says the rabbit.

No sooner did Mr. Dog poke out his tongue than Mr. Rabbit split it with a knife and ran for all he was worth to a hollow stump and hid himself.

The dog has been mad at the rabbit ever since.

Anybody who don't believe it happened, just look at the dog's tongue and he can see for himself where the rabbit slit it right u the middle.

Stepped on a tin, mah story ends.

Sweat

It was eleven o'clock of a Spring night in Florida. It was Sunday. Any other night, Delia Jones would have been in bed for two hours by this time. But she was a washwoman, and Monday morning meant a great deal to her. So she collected the soiled clothes on Saturday when she returned the clean things. Sunday night after church, she sorted them and put the white things to soak. It saved her almost a half day's start. A great hamper in the bedroom held the clothes that she brought home. It was so much neater than a number of bundles lying around.

She squatted in the kitchen floor beside the great pile of clothes, sorting them into small heaps according to color, and humming a song in a mournful key, but wondering through it all where Sykes, her husband, had gone with her horse and buckboard.

Just then something long, round, limp and black fell upon her shoulders and slithered to the floor beside her. A great terror took hold of her. It softened her knees and dried her mouth so that it was a full minute before she could cry out or move. Then she saw that it was the big bull whip her husband liked to carry when he drove.

She lifted her eyes to the door and saw him standing there bent over with laughter at her fright. She screamed at him.

"Sykes, what you throw dat whip on me like dat? You know it would skeer me—looks just like a snake, an' you knows how skeered Ah is of snakes."

"Course Ah knowed it! That's how come Ah done it." He slapped his leg with his hand and almost rolled on the ground in his mirth. "If you such a big fool dat you got to have a fit over a earth worm or a string, Ah don't keer how bad Ah skeer you."

"You aint got no business doing it. Gawd knows it's a sin. Some day Ah'm gointuh drop dead from some of yo' foolishness. 'Nother thing, where you been wid mah rig? Ah feeds dat pony. He aint fuh you to be drivin' wid no bull whip."

"You sho is one aggravatin' nigger woman!" he declared and stepped into the room. She resumed her work and did not answer him at once. "Ah done tole you time and again to keep them white folks' clothes outa dis house."

He picked up the whip and glared down at her. Delia went on with her work. She went out into the yard and returned with a galvanized tub and sat it on the washbench. She saw that Sykes had kicked all of the clothes together again, and now stood in her way truculently, his whole manner hoping, *praying*, for an argument. But she walked calmly around him and commenced to re-sort the things.

"Next time, Ah'm gointer kick 'em outdoors," he threatened as he struck a match along the leg of his corduroy breeches.

Delia never looked up from her work, and her thin, stooped shoulders sagged further.

"Ah aint for no fuss t'night, Sykes. Ah just come from taking sacrament at the church house."

He snorted scornfully. "Yeah, you just come from de church house on a Sunday night, but heah you is gone to work on them clothes. You ain't nothing but a hypocrite. One of them amen-corner Christians—sing, whoop, and shout, then come home and wash white folks clothes on the Sabbath."

He stepped roughly upon the whitest pile of things, kicking them helter-skelter as he crossed the room. His wife gave a little scream of dismay, and quickly gathered them together again.

"Sykes, you quit grindin' dirt into these clothes! How can Ah git through by Sat'day if Ah don't start on Sunday?"

"Ah don't keer if you never git through. Anyhow, Ah done

promised Gawd and a couple of other men, Ah aint gointer have it in mah house. Don't gimme no lip neither, else Ah'll throw 'em out and put mah fist up side yo' head to boot.''

Delia's habitual meekness seemed to slip from her shoulders like a blown scarf. She was on her feet; her poor little body, her bare knuckly hands bravely defying the strapping hulk before her.

''Looka heah, Sykes, you done gone too fur. Ah been married to you fur fifteen years, and Ah been takin' in washin' fur fifteen years. Sweat, sweat, sweat! Work and sweat, cry and sweat, pray and sweat!''

''What's that got to do with me?'' he asked brutally.

''What's it got to do with you, Sykes? Mah tub of suds is filled yo' belly with vittles more times than yo' hands is filled it. Mah sweat is done paid for this house and Ah reckon Ah kin keep on sweatin' in it.''

She seized the iron skillet from the stove and struck a defensive pose, which act surprised him greatly, coming from her. It cowed him and he did not strike her as he usually did.

''Naw you won't,'' she panted, ''that ole snaggle-toothed black woman you runnin' with aint comin' heah to pile up on *mah* sweat and blood. You aint paid for nothin' on this place, and Ah'm gointer stay right heah till Ah'm toted out foot foremost.''

''Well, you better quit gittin' me riled up, else they'll be totin' you out sooner than you expect. Ah'm so tired of you Ah don't know whut to do. Gawd! how Ah hates skinny wimmen!''

A little awed by this new Delia, he sidled out of the door and slammed the back gate after him. He did not say where he had gone, but she knew too well. She knew very well that he would not return until nearly daybreak also. Her work over, she went on to bed but not to sleep at once. Things had come to a pretty pass!

She lay awake, gazing upon the debris that cluttered their matrimonial trail. Not an image left standing along the way. Anything like flowers had long ago been drowned in the salty stream that had been pressed from her heart. Her tears, her sweat, her blood. She had brought love to the union and he had brought a longing after the flesh. Two months after the wedding, he had given her

the first brutal beating. She had the memory of his numerous trips to Orlando with all of his wages when he had returned to her penniless, even before the first year had passed. She was young and soft then, but now she thought of her knotty, muscled limbs, her harsh knuckly hands, and drew herself up into an unhappy little ball in the middle of the big feather bed. Too late now to hope for love, even if it were not Bertha it would be someone else. This case differed from the others only in that she was bolder than the others. Too late for everything except her little home. She had built it for her old days, and planted one by one the trees and flowers there. It was lovely to her, lovely.

Somehow, before sleep came, she found herself saying aloud: "Oh well, whatever goes over the Devil's back, is got to come under his belly. Sometime or ruther, Sykes, like everybody else, is gointer reap his sowing." After that she was able to build a spiritual earthworks against her husband. His shells could no longer reach her. *Amen*. She went to sleep and slept until he announced his presence in bed by kicking her feet and rudely snatching the cover away.

"Gimme some kivah heah, an' git yo' damn foots over on yo' own side! Ah oughter mash you in yo' mouf fuh drawing dat skillet on me."

Delia went clear to the rail without answering him. A triumphant indifference to all that he was or did.

The week was as full of work for Delia as all other weeks, and Saturday found her behind her little pony, collecting and delivering clothes.

It was a hot, hot day near the end of July. The village men on Joe Clarke's porch even chewed cane listlessly. They did not hurl the cane-knots as usual. They let them dribble over the edge of the porch. Even conversation had collapsed under the heat.

"Heah come Delia Jones," Jim Merchant said, as the shaggy pony came 'round the bend of the road toward them. The rusty buckboard was heaped with baskets of crisp, clean laundry.

"Yep," Joe Lindsay agreed. "Hot or col', rain or shine, jes ez

reg'lar ez de weeks roll roun' Delia carries 'em an' fetches 'em on
Sat'day.''

"She better if she wanter eat," said Moss. "Sykes Jones aint
wuth de shot an' powder hit would tek tuh kill 'em. Not to *huh*
he aint."

"He sho' aint," Walter Thomas chimed in. "It's too bad, too,
cause she wuz a right pritty li'l trick when he got huh. Ah'd uh
mah'ied huh mahseff if he hadnter beat me to it."

Delia nodded briefly at the men as she drove past.

"Too much knockin' will ruin *any* 'oman. He done beat huh
'nough tuh kill three women, let 'lone change they looks," said
Elijah Moseley. "How Sykes kin stommuck dat big black greasy
Mogul he's layin' roun' wid, gits me. Ah swear dat eight-rock
couldn't kiss a sardine can Ah done thowed out de back do' 'way
las' yeah."

"Aw, she's fat, thass how come. He's allus been crazy 'bout fat
women," put in Merchant. "He'd a' been tied up wid one long
time ago if he could a' found one tuh have him. Did Ah tell yuh
'bout him come sidlin' roun' *mah* wife—bringin' her a basket uh
pee-cans outa his yard fuh a present? Yessir, mah wife! She tol'
him tuh take 'em right straight back home, cause Delia works so
hard ovah dat washtub she reckon everything on de place taste lak
sweat an' soapsuds. Ah jus' wisht Ah'd a' caught 'im 'roun' dere!
Ah'd a' made his hips ketch on fiah down dat shell road."

"Ah know he done it, too. Ah sees 'im grinnin' at every 'oman
dat passes," Walter Thomas said. "But even so, he useter eat
some mighty big hunks uh humble pie tuh git dat lil' 'oman he got.
She wuz ez pritty ez a speckled pup! Dat wuz fifteen yeahs ago. He
useter be so skeered uh losin' huh, she could make him do some
parts of a husband's duty. Dey never wuz de same in de mind."

"There oughter be a law about him," said Lindsay. "He aint fit
tuh carry guts tuh a bear."

Clarke spoke for the first time. "Taint no law on earth dat kin
make a man be decent if it aint in 'im. There's plenty men dat
takes a wife lak dey do a joint uh sugar-cane. It's round, juicy an'
sweet when dey gits it. But dey squeeze an' grind, squeeze an'

grind an' wring tell dey wring every drop uh pleasure dat's in 'em out. When dey's satisfied dat dey is wrung dry, dey treats 'em jes lak dey do a cane-chew. Dey thows 'em away. Dey knows whut dey is doin' while dey is at it, an' hates theirselves fuh it but they keeps on hangin' after huh tell she's empty. Den dey hates huh fuh bein' a cane-chew an' in de way.''

"We oughter take Sykes an' dat stray 'oman uh his'n down in Lake Howell swamp an' lay on de rawhide till they cain't say 'Lawd a' mussy.' He allus wuz uh ovahbearin' niggah, but since dat white 'oman from up north done teached 'im how to run a automobile, he done got too biggety to live—an' we oughter kill 'im,'' Old Man Anderson advised.

A grunt of approval went around the porch. But the heat was melting their civic virtue and Elijah Moseley began to bait Joe Clarke.

"Come on, Joe, git a melon outa dere an' slice it up for yo' customers. We'se all sufferin' wid de heat. De bear's done got *me!*''

"Thass right, Joe, a watermelon is jes' whut Ah needs tuh cure de eppizudicks.'' Walter Thomas joined forces with Moseley. "Come on dere, Joe. We all is steady customers an' you aint set us up in a long time. Ah chooses dat long, bowlegged Floridy favorite.''

"A god, an' be dough. You all gimme twenty cents and slice away,'' Clarke retorted. "Ah needs a col' slice m'self. Heah, everybody chip in. Ah'll lend y'all mah meat knife.''

The money was quickly subscribed and the huge melon brought forth. At that moment, Sykes and Bertha arrived. A determined silence fell on the porch and the melon was put away again.

Merchant snapped down the blade of his jack-knife and moved toward the store door.

"Come on in, Joe, an' gimme a slab uh sow belly an' uh pound uh coffee—almost fuhgot 'twas Sat'day. Got to git on home.'' Most of the men left also.

Just then Delia drove past on her way home, as Sykes was ordering magnificently for Bertha. It pleased him for Delia to see.

"Git whutsoever yo' heart desires, Honey. Wait a minute, Joe. Give huh two botles uh strawberry soda-water, uh quart uh parched ground-peas, an a block uh chewin' gum."

With all this they left the store, with Sykes reminding Bertha that this was his town and she could have it if she wanted it.

The men returned soon after they left, and held their water-melon feast.

"Where did Sykes Jones git dat 'oman from nohow?" Lindsay asked.

"Ovah Apopka. Guess dey musta been cleanin' out de town when she lef'. She don't look lak a thing but a hunk uh liver wid hair on it."

"Well, she sho' kin squall," Dave Carter contributed. "When she gits ready tuh laff, she jes' opens huh mouf an' latches it back tuh de las' notch. No ole grandpa alligator down in Lake Bell aint got nothin' on huh."

Bertha had been in town three months now. Sykes was still paying her room rent at Della Lewis'—the only house in town that would have taken her in. Sykes took her frequently to Winter Park to "stomps." He still assured her that he was the swellest man in the state.

"Sho' you kin have dat lil' ole house soon's Ah kin git dat 'oman outa dere. Everything b'longs tuh me an' you sho' kin have it. Ah sho' 'bominates uh skinny 'oman. Lawdy, you sho' is got one portly shape on you! You kin git *anything* you wants. Dis is *mah* town an' you sho' kin have it."

Delia's work-worn knees crawled over the earth in Gethsemane and up the rocks of Calvary many, many times during these months. She avoided the villagers and meeting places in her efforts to be blind and deaf. But Bertha nullified this to a degree, by coming to Delia's house to call Sykes out to her at the gate.

Delia and Sykes fought all the time now with no peaceful inter-ludes. They slept and ate in silence. Two or three times Delia had attempted a timid friendliness, but she was repulsed each time. It was plain that the breaches must remain agape.

* * *

The sun had burned July to August. The heat streamed down like
a million hot arrows, smiting all things living upon the earth. Grass
withered, leaves browned, snakes went blind in shedding and men
and dogs went mad. Dog days!

Delia came home one day and found Sykes there before her.
She wondered, but started to go on into the house without speak-
ing, even though he was standing in the kitchen door and she must
either stoop under his arm or ask him to move. He made no room
for her. She noticed a soap box beside the steps, but paid no
particular attention to it, knowing that he must have brought it
there. As she was stooping to pass under his outstretched arm, he
suddenly pushed her backward, laughingly.

"Look in de box dere Delia, Ah done brung yuh somethin'!"

She nearly fell upon the box in her stumbling, and when she saw
what it held, she all but fainted outright.

"Sykes! Sykes, mah Gawd! You take dat rattlesnake 'way from
heah! You *gottuh*. Oh, Jesus, have mussy!"

"Ah aint gut tuh do nuthin' uh de kin'—fact is Ah aint got tuh
do nothin' but die. Taint no use uh you puttin' on airs makin' out
lak you skeered uh dat snake—he's gointer stay right heah tell he
die. He wouldn't bite me cause Ah knows how tuh handle 'im.
Nohow he wouldn't risk breakin' out his fangs 'gin *yo'* skinny
laigs."

"Naw, now Sykes, don't keep dat thing 'roun' heah tuh skeer
me tuh death. You knows Ah'm even feared uh earth worms.
Thass de biggest snake Ah evah did see. Kill 'im Sykes, please."

"Doan ast me tuh do nothin' fuh yuh. Goin' 'roun' tryin' tuh be
so damn astorperious. Naw, Ah aint gonna kill it. Ah think uh
damn sight mo' uh him dan you! Dat's a nice snake an' anybody
doan lak 'im kin jes' hit de grit."

The village soon heard that Sykes had the snake, and came to
see and ask questions.

"How de hen-fire did you ketch dat six-foot rattler, Sykes?"
Thomas asked.

"He's full uh frogs so he caint hardly move, thass how Ah eased

up on 'm. But Ah'm a snake charmer an' knows how tuh handle 'em. Shux, dat aint nothin'. Ah could ketch one eve'y day if Ah so wanted tuh.''

"Whut he needs is a heavy hick'ry club leaned real heavy on his head. Dat's de bes 'way tuh charm a rattlesnake.''

"Naw, Walt, y'all jes' don't understand dese diamon' backs lak Ah do,'' said Sykes in a superior tone of voice.

The village agreed with Walter, but the snake stayed on. His box remained by the kitchen door with its screen wire covering. Two or three days later it had digested its meal of frogs and literally came to life. It rattled at every movement in the kitchen or the yard. One day as Delia came down the kitchen steps she saw his chalky-white fangs curved like scimitars hung in the wire meshes. This time she did not run away with averted eyes as usual. She stood for a long time in the doorway in a red fury that grew bloodier for every second that she regarded the creature that was her torment.

That night she broached the subject as soon as Sykes sat down to the table.

"Sykes, Ah wants you tuh take dat snake 'way fum heah. You done starved me an' Ah put up widcher, you done beat me an Ah took dat, but you done kilt all mah insides bringin' dat varmint heah.''

Sykes poured out a saucer full of coffee and drank it deliberately before he answered her.

"A whole lot Ah keer 'bout how you feels inside uh out. Dat snake aint goin' no damn wheah till Ah gits ready fuh 'im tuh go. So fur as beatin' is concerned, yuh aint took near all dat you gointer take ef yuh stay 'roun' *me*.''

Delia pushed back her plate and got up from the table. "Ah hates you, Sykes,'' she said calmly. "Ah hates you tuh de same degree dat Ah useter love yuh. Ah done took an' took till mah belly is full up tuh mah neck. Dat's de reason Ah got mah letter fum de church an' moved mah membership tuh Woodbridge—so Ah don't haftuh take no sacrament wid yuh. Ah don't wantuh see yuh 'roun' me a-tall. Lay 'roun' wid dat 'oman all yuh wants tuh, but

gwan 'way fum me an' mah house. Ah hates yuh lak uh suck-egg dog.''

Sykes almost let the huge wad of corn bread and collard greens he was chewing fall out of his mouth in amazement. He had a hard time whipping himself up to the proper fury to try to answer Delia.

"Well, Ah'm glad you does hate me. Ah'm sho' tiahed uh you hangin' ontuh me. Ah don't want yuh. Look at yuh stringey ole neck! Yo' rawbony laigs an' arms is enough tuh cut uh man tuh death. You looks jes' lak de devvul's doll-baby tuh *me.* You cain't hate me no worse dan Ah hates you. Ah been hatin' *you* fuh years."

"Yo' ole black hide don't look lak nothin' tuh me, but uh passel uh wrinkled up rubber, wid yo' big ole yeahs flappin' on each side lak uh paih uh buzzard wings. Don't think Ah'm gointuh be run 'way fum mah house neither. Ah'm goin' tuh de white folks bout *you,* mah young man, de very nex' time you lay yo' han's on me. Mah cup is done run ovah." Delia said this with no signs of fear and Sykes departed from the house, threatening her, but made not the slightest move to carry out any of them.

That night he did not return at all, and the next day being Sunday, Delia was glad that she did not have to quarrel before she hitched up her pony and drove the four miles to Woodbridge.

She stayed to the night service—"love feast"—which was very warm and full of spirit. In the emotional winds her domestic trials were borne far and wide so that she sang as she drove homeward,

> *Jurden water, black an' col'*
> *Chills de body, not de soul*
> *An' Ah wantah cross Jurden in uh calm time.*

She came from the barn to the kitchen door and stopped.

"Whut's de mattah, ol' satan, you aint kickin' up yo' racket?" She addressed the snake's box. Complete silence. She went on into the house with a new hope in its birth struggles. Perhaps her threat to go to the white folks had frightened Sykes! Perhaps he was sorry! Fifteen years of misery and suppression had brought

Delia to the place where she would hope *anything* that looked towards a way over or through her wall of inhibitions.

She felt in the match safe behind the stove at once for a match. There was only one there.

"Dat niggah wouldn't fetch nothin' heah tuh save his rotten neck, but he kin run thew whut Ah brings quick enough. Now he done toted off nigh on tuh haff uh box uh matches. He done had dat 'oman heah in mah house, too."

Nobody but a woman could tell how she knew this even before she struck the match. But she did and it put her into a new fury.

Presently she brought in the tubs to put the white things to soak. This time she decided she need not bring the hamper out of the bedroom; she would go in there and do the sorting. She picked up the pot-bellied lamp and went in. The room was small and the hamper stood hard by the foot of the white iron bed. She could sit and reach through the bedposts—resting as she worked.

"Ah wantah cross Jurden in uh calm time." She was singing again. The mood of the "love feast" had returned. She threw back the lid of the basket almost gaily. Then, moved by both horror and terror, she sprung back toward the door. *There lay the snake in the basket!* He moved sluggishly at first, but even as she turned round and round, jumped up and down in an insanity of fear, he began to stir vigorously. She saw him pouring his awful beauty from the basket upon the bed, then she seized the lamp and ran as fast as she could to the kitchen. The wind from the open door blew out the light and the darkness added to her terror. She sped to the darkness of the yard, slamming the door after her before she thought to set down the lamp. She did not feel safe even on the ground, so she climbed up in the hay barn.

There for an hour or more she lay sprawled upon the hay a gibbering wreck.

Finally she grew quiet, and after that, coherent thought. With this, stalked through her a cold, bloody rage. Hours of this. A period of introspection, a space of retrospection, then a mixture of both. Out of this an awful calm.

"Well, Ah done de bes' Ah could. If things aint right, Gawd knows taint mah fault."

She went to sleep—a twitchy sleep—and woke up to a faint gray sky. There was a loud hollow sound below. She peered out. Sykes was at the wood-pile, demolishing a wire-covered box.

He hurried to the kitchen door, but hung outside there some minutes before he entered, and stood some minutes more inside before he closed it after him.

The gray in the sky was spreading. Delia descended without fear now, and crouched beneath the low bedroom window. The drawn shade shut out the dawn, shut in the night. But the thin walls held back no sound.

"Dat ol' scratch is woke up now!" She mused at the tremendous whirr inside, which every woodsman knows, is one of the sound illusions. The rattler is a ventriloquist. His whirr sounds to the right, to the left, straight ahead, behind, close under foot—everywhere but where it is. Woe to him who guesses wrong unless he is prepared to hold up his end of the argument! Sometimes he strikes without rattling at all.

Inside, Skyes heard nothing until he knocked a pot lid off the stove while trying to reach the match safe in the dark. He had emptied his pockets at Bertha's.

The snake seemed to wake up under the stove and Skyes made a quick leap into the bedroom. In spite of the gin he had had, his head was clearing now.

"Mah Gawd!" he chattered, "ef Ah could on'y strack uh light!"

The rattling ceased for a moment as he stood paralyzed. He waited. It seemed that the snake waited also.

"Oh fuh de light! Ah thought he'd be too sick"—Skyes was muttering to himself when the whirr began again, closer, right underfoot this time. Long before this, Skyes' ability to think had been flattened down to primitive instinct and he leaped—onto the bed.

Outside Delia heard a cry that might have come from a maddened chimpanzee, a stricken gorilla. All the terror, all the horror,

all the rage that man possibly could express, without a recogniz-
able human sound.

A tremendous stir inside there, another series of animal
screams, the intermittent whirr of the reptile. The shade torn
violently down from the window, letting in the red dawn, a huge
brown hand seizing the window stick, great dull blows upon the
wooden floor punctuating the gibberish of sound long after the
rattle of the snake had abruptly subsided. All this Delia could see
and hear from her place beneath the window, and it made her ill.
She crept over to the four-o'clocks and stretched herself on the
cool earth to recover.

She lay there. "Delia, Delia!" She could hear Skyes calling in a
most despairing tone as one who expected no answer. The sun
crept on up, and he called. Delia could not move—her legs were
gone flabby. She never moved, he called, and the sun kept rising.

"Mah Gawd!" she heard him moan. "Mah Gawd fum Heben!"
She heard him stumbling about and got up from her flower-bed.
The sun was growing warm. As she approached the door she
heard him call out hopefully, "Delia, is dat you Ah heah?"

She saw him on his hands and knees as soon as she reached the
door. He crept an inch or two toward her—all that he was able,
and she saw his horribly swollen neck and his one open eye shin-
ing with hope. A surge of pity too strong to support bore her away
from that eye that must, could not, fail to see the tubs. He would
see the lamp. Orlando with its doctors was too far. She could
scarcely reach the Chinaberry tree, where she waited in the grow-
ing heat while inside she knew the cold river was creeping up and
up to extinguish that eye which must know by now that she knew.

The Gilded
Six-Bits

It was a Negro yard around a Negro house in a Negro settlement that looked to the payroll of the G. and G. Fertilizer works for its support.

But there was something happy about the place. The front yard was parted in the middle by a sidewalk from gate to door-step, a sidewalk edged on either side by quart bottles driven neck down into the ground on a slant. A mess of homey flowers planted without a plan but blooming cheerily from their helter-skelter places. The fence and house were whitewashed. The porch and steps scrubbed white.

The front door stood open to the sunshine so that the floor of the front room could finish drying after its weekly scouring. It was Saturday. Everything clean from the front gate to the privy house. Yard raked so that the strokes of the rake would make a pattern. Fresh newspaper cut in fancy edge on the kitchen shelves.

Missie May was bathing herself in the galvanized washtub in the bedroom. Her dark-brown skin glistened under the soapsuds that skittered down from her wash rag. Her stiff young breasts thrust forward aggressively like broad-based cones with the tips lacquered in black.

She heard men's voices in the distance and glanced at the dollar clock on the dresser.

"Humph! Ah'm way behind time t'day! Joe gointer be heah 'fore Ah git mah clothes on if Ah don't make haste."

She grabbed the clean meal sack at hand and dried herself hurriedly and began to dress. But before she could tie her slippers, there came the ring of singing metal on wood. Nine times.

Missie May grinned with delight. She had not seen the big tall man come stealing in the gate and creep up the walk grinning happily at the joyful mischief he was about to commit. But she knew that it was her husband throwing silver dollars in the door for her to pick up and pile beside her plate at dinner. It was this way every Saturday afternoon. The nine dollars hurled into the open door, he scurried to a hiding place behind the cape jasmine bush and waited.

Missie May promptly appeared at the door in mock alarm.

"Who dat chunkin' money in mah do'way?" she demanded. No answer from the yard. She leaped off the porch and began to search the shrubbery. She peeped under the porch and hung over the gate to look up and down the road. While she did this, the man behind the jasmine darted to the china berry tree. She spied him and gave chase.

"Nobody ain't gointer be chunkin' money at me and Ah not do 'em nothin'," she shouted in mock anger. He ran around the house with Missie May at his heels. She overtook him at the kitchen door. He ran inside but could not close it after him before she crowded in and locked with him in a rough and tumble. For several minutes the two were a furious mass of male and female energy. Shouting, laughing, twisting, turning, tussling, tickling each other in the ribs; Missie May clutching onto Joe and Joe trying, but not too hard, to get away.

"Missie May, take yo' hand out mah pocket!" Joe shouted out between laughs.

"Ah ain't, Joe, not lessen you gwine gimme whateve' it is good you got in yo' pocket. Turn it go, Joe, do Ah'll tear yo' clothes."

"Go on tear 'em. You de one dat pushes de needles round heah. Move yo' hand Missie May."

"Lemme git dat paper sack out yo' pocket. Ah bet it's candy kisses."

"Tain't. Move yo' hand. Woman ain't got no business in a man's clothes nohow. Go way."

Missie May gouged way down and gave an upward jerk and triumphed.

"Unhhunh! Ah got it. It 'tis so candy kisses. Ah knowed you had somethin' for me in yo' clothes. Now Ah got to see whut's in every pocket you got."

Joe smiled indulgently and let his wife go through all of his pockets and take out the things that he had hidden there for her to find. She bore off the chewing gum, the cake of sweet soap, the pocket handkerchief as if she had wrested them from him, as if they had not been bought for the sake of this friendly battle.

"Whew! dat play-fight done got me all warmed up," Joe exclaimed. "Got me some water in de kittle?"

"Yo' water is on de fire and yo' clean things is cross de bed. Hurry up and wash yo'self and git changed so we kin eat. Ah'm hongry." As Missie said this, she bore the steaming kettle into the bedroom.

"You ain't hongry, sugar," Joe contradicted her. "Youse jes' a little empty. Ah'm de one whut's hongry. Ah could eat up camp meetin', back off 'ssociation, and drink Jurdan dry. Have it on de table when Ah git out de tub."

"Don't you mess wid mah business, man. You git in yo' clothes. Ah'm a real wife, not no dress and breath. Ah might not look lak one, but if you burn me, you won't git a thing but wife ashes."

Joe splashed in the bedroom and Missie May fanned around in the kitchen. A fresh red and white checked cloth on the table. Big pitcher of buttermilk beaded with pale drops of butter from the churn. Hot fried mullet, crackling bread, ham hock atop a mound of string beans and new potatoes, and perched on the window-sill a pone of spicy potato pudding.

Very little talk during the meal but that little consisted of banter that pretended to deny affection but in reality flaunted it. Like when Missie May reached for a second helping of the tater pone. Joe snatched it out of her reach.

After Missie May had made two or three unsuccessful grabs at

the pan, she begged, "Aw, Joe gimme some mo' dat tater pone."

"Nope, sweetenin' is for us men-folks. Y'all pritty lil frail eels don't need nothin' lak dis. You too sweet already."

"Please, Joe."

"Naw, naw. Ah don't want you to git no sweeter than whut you is already. We goin' down de road a lil piece t'night so you go put on yo' Sunday-go-to-meetin' things."

Missie May looked at her husband to see if he was playing some prank. "Sho nuff, Joe?"

"Yeah. We goin' to de ice cream parlor."

"Where de ice cream parlor at, Joe?"

"A new man done come heah from Chicago and he done got a place and took and opened it up for a ice cream parlor, and bein' as it's real swell, Ah wants you to be one de first ladies to walk in dere and have some set down."

"Do Jesus, Ah ain't knowed nothin' 'bout it. Who de man done it?"

"Mister Otis D. Slemmons, of spots and places—Memphis, Chicago, Jacksonville, Philadelphia and so on."

"Dat heavy-set man wid his mouth full of gold teethes?"

"Yeah. Where did you see 'im at?"

"Ah went down to de sto' tuh git a box of lye and Ah seen 'im standin' on de corner talkin' to some of de mens, and Ah come on back and went to scrubbin' de floor, and he passed and tipped his hat whilst Ah was scourin' de steps. Ah thought Ah never seen *him* befo'."

Joe smiled pleasantly. "Yeah, he's up to date. He got de finest clothes Ah ever seen on a colored man's back."

"Aw, he don't look no better in his clothes than you do in yourn. He got a puzzlegut on 'im and he so chuckle-headed, he got a pone behind his neck."

Joe looked down at his own abdomen and said wistfully, "Wisht Ah had a build on me lak he got. He ain't puzzle-gutted, honey. He jes' got a corperation. Dat make 'm look lak a rich white man. All rich mens is got some belly on 'em."

"Ah seen de pitchers of Henry Ford and he's a spare-built man

and Rockefeller look lak he ain't got but one gut. But Ford and Rockefeller and dis Slemmons and all de rest kin be as many-gutted as dey please, Ah'm satisfied wid you jes lak you is, baby. God took pattern after a pine tree and built you noble. Youse a pritty man, and if Ah knowed any way to make you mo' pritty still Ah'd take and do it.''

Joe reached over gently and toyed with Missie May's ear. "You jes' say dat cause you love me, but Ah know Ah can't hold no light to Otis D. Slemmons. Ah ain't never been nowhere and Ah ain't got nothin' but you.''

Missie May got on his lap and kissed him and he kissed back in kind. Then he went on. "All de womens is crazy 'bout 'im every-where he go.''

"How you know dat, Joe?''

"He tole us so hisself.''

"Dat don't make it so. His mouf is cut cross-ways, ain't it? Well, he kin lie jes' lak anybody else.''

"Good Lawd, Missie! You womens sho is hard to sense into things. He's got a five-dollar gold piece for a stick-pin and he got a ten-dollar gold piece on his watch chain and his mouf is jes' crammed full of gold teethes. Sho wisht it wuz mine. And whut make it so cool, he got money 'cumulated. And womens give it all to 'im.''

"Ah don't see whut de womens see on 'im. Ah wouldn't give 'im a wink if de sheriff wuz after 'im.''

"Well, he tole us how de white womens in Chicago give 'im all dat gold money. So he don't 'low nobody to touch it at all. Not even put dey finger on it. Dey tole 'im not to. You kin make 'miration at it, but don't tetch it.''

"Whyn't he stay up dere where dey so crazy 'bout 'im?''

"Ah reckon dey done made 'im vast-rich and he wants to travel some. He say dey wouldn't leave 'im hit a lick of work. He got mo' lady people crazy 'bout him than he kin shake a stick at.''

"Joe, Ah hates to see you so dumb. Dat stray nigger jes' tell y'all anything and y'all b'lieve it.''

"Go 'head on now, honey and put on yo' clothes. He talkin'

'bout his pritty womens—Ah want 'im to see *mine.*''

Missie May went off to dress and Joe spent the time trying to make his stomach punch out like Slemmons' middle. He tried the rolling swagger of the stranger, but found that his tall bone-and-muscle stride fitted ill with it. He just had time to drop back into his seat before Missie May came in dressed to go.

On the way home that night Joe was exultant. "Didn't Ah say ole Otis was swell? Can't he talk Chicago talk? Wuzn't dat funny whut he said when great big fat ole Ida Armstrong come in? He asted me, 'Who is dat broad wid de forte shake?' Dat's a new word. Us always thought forty was a set of figgers but he showed us where it means a whole heap of things. Sometimes he don't say forty, he jes' say thirty-eight and two and dat mean de same thing. Know whut he tole me when Ah wuz payin' for our ice cream? He say, 'Ah have to hand it to you, Joe. Dat wife of yours is jes' thirty-eight and two. Yessuh, she's forte!' Ain't he killin'?''

"He'll do in case of a rush. But he sho is got uh heap uh gold on 'im. Dat's de first time Ah ever seed gold money. It lookted good on him sho nuff, but it'd look a whole heap better on you.''

"Who, me? Missie May youse crazy! Where would a po' man lak me git gold money from?''

Missie May was silent for a minute, then she said, "Us might find some goin' long de road some time. Us could.''

"Who would be losin' gold money round heah? We ain't even seen none dese white folks wearin' no gold money on dey watch chain. You must be figgerin' Mister Packard or Mister Cadillac goin' pass through heah.''

"You don't know whut been lost 'round heah. Maybe somebody way back in memorial times lost they gold money and went on off and it ain't never been found. And then if we wuz to find it, you could wear some 'thout havin' no gang of womens lak dat Slemmons say he got.''

Joe laughed and hugged her. "Don't be so wishful 'bout me. Ah'm satisfied de way Ah is. So long as Ah be yo' husband, Ah don't keer 'bout nothin' else. Ah'd ruther all de other womens in

de world to be dead than for you to have de toothache. Less we go to bed and git our night rest.''

It was Saturday night once more before Joe could parade his wife in Slemmons' ice cream parlor again. He worked the night shift and Saturday was his only night off. Every other evening around six o'clock he left home, and dying dawn saw him hustling home around the lake where the challenging sun flung a flaming sword from east to west across the trembling water.

That was the best part of life—going home to Missie May. Their white-washed house, the mock battle on Saturday, the dinner and ice cream parlor afterwards, church on Sunday nights when Missie out-dressed any woman in town—all, everything was right.

One night around eleven the acid ran out at the G. and G. The foreman knocked off the crew and let the steam die down. As Joe rounded the lake on his way home, a lean moon rode the lake in a silver boat. If anybody had asked Joe about the moon on the lake, he would have said he hadn't paid it any attention. But he saw it with his feelings. It made him yearn painfully for Missie. Creation obsessed him. He thought about children. They had been married more than a year now. They had money put away. They ought to be making little feet for shoes. A little boy child would be about right.

He saw a dim light in the bedroom and decided to come in through the kitchen door. He could wash the fertilizer dust off himself before presenting himself to Missie May. It would be nice for her not to know that he was there until he slipped into his place in bed and hugged her back. She always liked that.

He eased the kitchen door open slowly and silently, but when he went to set his dinner bucket on the table he bumped it into a pile of dishes, and something crashed to the floor. He heard his wife gasp in fright and hurried to reassure her.

''Iss me, honey. Don't git skeered.''

There was a quick, large movement in the bedroom. A rustle, a thud, and a stealthy silence. The light went out.

What? Robbers? Murderers? Some varmint attacking his help-

less wife, perhaps. He struck a match, threw himself on guard and stepped over the door-sill into the bedroom.

The great belt on the wheel of Time slipped and eternity stood still. By the match light he could see the man's legs fighting with his breeches in his frantic desire to get them on. He had both chance and time to kill the intruder in his helpless condition—half in and half out of his pants—but he was too weak to take action. The shapeless enemies of humanity that live in the hours of Time had waylaid Joe. He was assaulted in his weakness. Like Samson awakening after his haircut. So he just opened his mouth and laughed.

The match went out and he struck another and lit the lamp. A howling wind raced across his heart, but underneath its fury he heard his wife sobbing and Slemmons pleading for his life. Offering to buy it with all that he had. "Please, suh, don't kill me. Sixty-two dollars at de sto'. Gold money."

Joe just stood. Slemmons looked at the window, but it was screened. Joe stood out like a rough-backed mountain between him and the door. Barring him from escape, from sunrise, from life.

He considered a surprise attack upon the big clown that stood there laughing like a chessy cat. But before his fist could travel an inch, Joe's own rushed out to crush him like a battering ram. Then Joe stood over him.

"Git into yo' damn rags, Slemmons, and dat quick."

Slemmons scrambled to his feet and into his vest and coat. As he grabbed his hat, Joe's fury overrode his intentions and he grabbed at Slemmons with his left hand and struck at him with his right. The right landed. The left grazed the front of his vest. Slemmons was knocked a somersault into the kitchen and fled through the open door. Joe found himself alone with Missie May, with the golden watch charm clutched in his left fist. A short bit of broken chain dangled between his fingers.

Missie May was sobbing. Wails of weeping without words. Joe stood, and after awhile he found out that he had something in his hand. And then he stood and felt without thinking and without

seeing with his natural eyes. Missie May kept on crying and Joe kept on feeling so much and not knowing what to do with all his feelings, he put Slemmons' watch charm in his pants pocket and took a good laugh and went to bed.

"Missie May, whut you cryin' for?"

"Cause Ah love you so hard and Ah know you don't love *me* no mo'."

Joe sank his face into the pillow for a spell then he said huskily, "You don't know de feelings of dat yet, Missie May."

"Oh Joe, honey, he said he wuz gointer give me dat gold money and he jes' kept on after me——"

Joe was very still and silent for a long time. Then he said, "Well, don't cry no mo', Missie May. Ah got yo' gold piece for you."

The hours went past on their rusty ankles. Joe still and quiet on one bed-rail and Missie May wrung dry of sobs on the other. Finally the sun's tide crept upon the shore of night and drowned all its hours. Missie May with her face stiff and streaked towards the window saw the dawn come into her yard. It was day. Nothing more. Joe wouldn't be coming home as usual. No need to fling open the front door and sweep off the porch, making it nice for Joe. Never no more breakfast to cook; no more washing and starching of Joe's jumper-jackets and pants. No more nothing. So why get up?

With this strange man in her bed, she felt embarrassed to get up and dress. She decided to wait till he had dressed and gone. Then she would get up, dress quickly and be gone forever beyond reach of Joe's looks and laughs. But he never moved. Red light turned to yellow, then white.

From beyond the no-man's land between them came a voice. A strange voice that yesterday had been Joe's.

"Missie May, ain't you gonna fix me no breakfus'?"

She sprang out of bed. "Yeah, Joe. Ah didn't reckon you wuz hongry."

No need to die today. Joe needed her for a few more minutes anyhow.

Soon there was a roaring fire in the cook stove. Water bucket

full and two chickens killed. Joe loved fried chicken and rice. She didn't deserve a thing and good Joe was letting her cook him some breakfast. She rushed hot biscuits to the table as Joe took his seat.

He ate with his eyes in his plate. No laughter, no banter.

"Missie May, you ain't eatin' yo' breakfus'."

"Ah don't choose none, Ah thank yuh."

His coffee cup was empty. She sprang to refill it. When she turned from the stove and bent to set the cup beside Joe's plate, she saw the yellow coin on the table between them.

She slumped into her seat and wept into her arms.

Presently Joe said calmly, "Missie May, you cry too much. Don't look back lak Lot's wife and turn to salt."

The sun, the hero of every day, the impersonal old man that beams as brightly on death as on birth, came up every morning and raced across the blue dome and dipped into the sea of fire every evening. Water ran down hill and birds nested.

Missie knew why she didn't leave Joe. She couldn't. She loved him too much, but she could not understand why Joe didn't leave her. He was polite, even kind at times, but aloof.

There were no more Saturday romps. No ringing silver dollars to stack beside her plate. No pockets to rifle. In fact the yellow coin in his trousers was like a monster hiding in the cave of his pockets to destroy her.

She often wondered if he still had it, but nothing could have induced her to ask nor yet to explore his pockets to see for herself. Its shadow was in the house whether or no.

One night Joe came home around midnight and complained of pains in the back. He asked Missie to rub him down with liniment. It had been three months since Missie had touched his body and it all seemed strange. But she rubbed him. Grateful for the chance. Before morning, youth triumphed and Missie exulted. But the next day, as she joyfully made up their bed, beneath her pillow she found the piece of money with the bit of chain attached.

Alone to herself, she looked at the thing with loathing, but look she must. She took it into her hands with trembling and saw first thing that it was no gold piece. It was a gilded half dollar. Then she

knew why Slemmons had forbidden anyone to touch his gold. He trusted village eyes at a distance not to recognize his stick-pin as a gilded quarter, and his watch charm as a four-bit piece.

She was glad at first that Joe had left it there. Perhaps he was through with her punishment. They were man and wife again. Then another thought came clawing at her. He had come home to buy from her as if she were any woman in the long house. Fifty cents for her love. As if to say that he could pay as well as Slemmons. She slid the coin into his Sunday pants pocket and dressed herself and left his house.

Half way between her house and the quarters she met her husband's mother, and after a short talk she turned and went back home. Never would she admit defeat to that woman who prayed for it nightly. If she had not the substance of marriage she had the outside show. Joe must leave *her*. She let him see she didn't want his old gold four-bits too.

She saw no more of the coin for some time though she knew that Joe could not help finding it in his pocket. But his health kept poor, and he came home at least every ten days to be rubbed.

The sun swept around the horizon, trailing its robes of weeks and days. One morning as Joe came in from work, he found Missie May chopping wood. Without a word he took the ax and chopped a huge pile before he stopped.

"You ain't got no business choppin' wood, and you know it."

"How come? Ah been choppin' it for de last longest."

"Ah ain't blind. You makin' feet for shoes."

"Won't you be glad to have a lil baby chile, Joe?"

"You know dat 'thout astin' me."

"Iss gointer be a boy chile and de very spit of you."

"You reckon, Missie May?"

"Who else could it look lak?"

Joe said nothing, but he thrust his hand deep into his pocket and fingered something there.

It was almost six months later Missie May took to bed and Joe went and got his mother to come wait on the house.

Missie May was delivered of a fine boy. Her travail was over

when Joe came in from work one morning. His mother and the old women were drinking great bowls of coffee around the fire in the kitchen.

The minute Joe came into the room his mother called him aside.

"How did Missie May make out?" he asked quickly.

"Who, dat gal? She strong as a ox. She gointer have plenty mo'. We done fixed her wid de sugar and lard to sweeten her for de nex' one."

Joe stood silent awhile.

"You ain't ast 'bout de baby, Joe. You oughter be mighty proud cause he sho is de spittin' image of yuh, son. Dat's yourn all right, if you never git another one, dat un is yourn. And you know Ah'm mighty proud too, son, cause Ah never thought well of you marryin' Missie May cause her ma used tuh fan her foot round right smart and Ah been mighty skeered dat Missie May wuz gointer git misput on her road."

Joe said nothing. He fooled around the house till late in the day then just before he went to work, he went and stood at the foot of the bed and asked his wife how she felt. He did this every day during the week.

On Saturday he went to Orlando to make his market. It had been a long time since he had done that.

Meat and lard, meal and flour, soap and starch. Cans of corn and tomatoes. All the staples. He fooled around town for awhile and bought bananas and apples. Way after while he went around to the candy store.

"Hello, Joe," the clerk greeted him. "Ain't seen you in a long time."

"Nope, Ah ain't been heah. Been round in spots and places."

"Want some of them molasses kisses you always buy?"

"Yessuh." He threw the gilded half dollar on the counter. "Will dat spend?"

"Whut is it, Joe? Well, I'll be doggone! A gold-plated four-bit piece. Where'd you git it, Joe?"

"Offen a stray nigger dat come through Eatonville. He had it on his watch chain for a charm—goin' round making out iss gold

money. Ha ha! He had a quarter on his tie pin and it wuz all golded up too. Tryin' to fool people. Makin' out he so rich and everything. Ha! Ha! Tryin' to tole off folkses wives from home.''

"How did you git it, Joe? Did he fool you, too?''

"Who, me? Naw suh! He ain't fooled me none. Know whut Ah done? He come round me wid his smart talk. Ah hauled off and knocked 'im down and took his old four-bits way from 'im. Gointer buy my wife some good ole lasses kisses wid it. Gimme fifty cents worth of dem candy kisses.''

"Fifty cents buys a mighty lot of candy kisses, Joe. Why don't you split it up and take some chocolate bars, too. They eat good, too.''

"Yessuh, dey do, but Ah wants all dat in kisses. Ah got a lil boy chile home now. Tain't a week old yet, but he kin suck a sugar tit and maybe eat one them kisses hisself.''

Joe got his candy and left the store. The clerk turned to the next customer. "Wisht I could be like these darkies. Laughin' all the time. Nothin' worries 'em.''

Back in Eatonville, Joe reached his own front door. There was the ring of singing metal on wood. Fifteen times. Missie May couldn't run to the door, but she crept there as quickly as she could.

"Joe Banks, Ah hear you chunkin' money in mah do'way. You wait till Ah got mah strength back and Ah'm gointer fix you for dat.''

Mother
Catherine

One must go straight out St. Claude below the Industrial Canal and turn south on Flood Street and go almost to the Florida Walk. Looking to the right one sees a large enclosure walled round with a high board fence. A half-dozen flags fly bravely from eminences. A Greek cross tops the chapel. A large American flag flies from the huge tent.

A marsh lies between Flood Street and that flag-flying enclosure, and one must walk. As one approaches, the personality of the place comes out to meet one. No ordinary person created this thing.

At the gate there is a rusty wire sticking out through a hole. That is the bell. But a painted notice on the gate itself reads: "Mother Seal is a holy spirit and must not be disturbed."

One does not go straight into the tent, into the presence of Mother Catherine (Mother Seal). One is conducted into the chapel to pray until the spirit tells her to send for you. A place of barbaric splendor, of banners, of embroideries, of images bought and images created by Mother Catherine herself; of an altar glittering with polished brass and kerosene lamps. There are 356 lamps in this building, but not all are upon the main altar.

The walls and ceilings are decorated throughout in red, white and blue. The ceiling and floor in the room of the Sacred Heart are striped in three colors and the walls are panelled. The panels contain a snake design. This is not due to Hoodoo influence but to

African background. I note that the African loves to depict the grace of reptiles.

On a placard: *Speak so you can speak again.*

It would take a volume to describe in detail all of the things in and about this chapel under its Greek cross. But we are summoned by a white-robed saint to the presence.

Mother Catherine holds court in the huge tent. On a raised platform is her bed, a piano, instruments for a ten-piece orchestra, a huge coffee urn, a wood stove, a heater, chairs and rockers and tables. Backless benches fill the tent.

Catherine of Russia could not have been more impressive upon her throne than was this black Catherine sitting upon an ordinary chair at the edge of the platform within the entrance to the tent. Her face and manner are impressive. There is nothing cheap and theatrical about her. She does things and arranges her dwelling as no occidental would. But it is not for effect. It is for feeling. She might have been the matriarchal ruler of some nomad tribe as she sat there with the blue band about her head like a coronet; a white robe and a gorgeous red cape falling away from her broad shoulders, and the box of shaker salt in her hand like a rod of office. I know this reads incongruous, but it did not look so. It seemed perfectly natural for me to go to my knees upon the gravel floor, and when she signalled to me to extend my right hand, palm up for the dab of blessed salt, I hurried to obey because she made me feel that way.

She laid her hand upon my head.

"Daughter, why have you come here?"

"Mother, I come seeking knowledge."

"Thank God. Do y'all hear her? She come here lookin for wisdom. Eat de salt, daughter, and get yo mind with God and me. You shall know what you come to find out. I feel you. I felt you while you was sittin in de chapel. Bring her a veil."

The veil was brought and with a fervent prayer placed upon my head. I did not tell Mother then that I wanted to write about her. That came much later, after many visits. When I did speak of it she

was very gracious and let me photograph her and everything behind the walls of her Manger.

I spent two weeks with her, and attended nightly and Sunday services continuously at her tent. Nothing was usual about these meetings. She invariably feeds the gathering. Good, substantial food too. At the Sunday service the big coffee urn was humming, and at a certain point she blessed bread and broke it, and sprinkled on a bit of salt. This she gave to everyone present. To the adults she also gave a cup of coffee. Every cup was personally drawn, sweetened and tasted by her and handed to the communicants as they passed before the platform. At one point she would command everyone to file past the painted barrel and take a glass of water. These things had no inner meaning to an agnostic, but it did drive the dull monotony of the usual Christian service away. It was something, too, to watch the faith it aroused in her followers.

All during her sermons two parrots were crying from their cages. A white cockatoo would scream when the shouting grew loud. Three canary birds were singing and chirping happily all through the service. Four mongrel dogs strolled about. A donkey, a mother goat with her kid, numbers of hens, a sheep—all wandered in and out of the service without seeming out of place. A Methodist or Baptist church—or one of any denomination whatever—would have been demoralised by any one of these animals. Two dogs fought for a place beside the heater. Three children under three years of age played on the platform in the rear without distracting the speaker or the audience. The blue and red robed saint stood immobile in her place directly behind the speaker and the world moved on.

Unlike most religious dictators Mother Catherine does not crush the individual. She encourages originality. There is an air of gaiety about the enclosure. All of the animals are treated with tenderness.

No money is ever solicited within the enclosure of the Manger. If you feel to give, you may. Mother wears a pouch suspended from her girdle. You may approach the platform at any time and

drop your contribution in. But you will be just as welcome if you have nothing. All of the persons who live at the Manger are there at Mother Catherine's expense. She encourages music and sees that her juveniles get off to school on time.

There is a catholic flavor about the place, but it is certainly not catholic. She has taken from all the religions she knows anything about any feature that pleases her.

Hear Mother Seal: "Good evening, Veils and Banners!

"God tells me to tell you *(invariable opening)* that He holds the world in the middle of His hand.

"There is no hell beneath this earth. God wouldn't build a hell to burn His breath.

"There is no heaven beyond dat blue globe. There is a between-world between this brown earth and the blue above. So says the beautiful spirit.

"When we die, where does the breath go? Into trees and grass and animals. Your flesh goes back to mortal earth to fertilise it. So says the beautiful spirit.

"Our brains is trying to make something out of us. Everybody can be something good.

"It is right that a woman should lead. A womb was what God made in the beginning, and out of that womb was born Time, and all that fills up space. So says the beautiful spirit.

"Some are weak to do wisdom things, but strong to do wicked things.

"He could have been born in the biggest White House in the world. But the reason He didn't is that He knowed a falling race was coming what couldn't get to no great White House, so He got born so my people could all reach.

"God is just as satisfied with the damnation of men as He is with their salvation. So says the beautiful spirit.

"It is not for people to know the whence.

"Don't teach what the apostles and the prophets say. Go to the tree and get the pure sap and find out whether they were right.

"No man has seen spirit—men can see what spirit does, but no man can see spirit."

As she was ready to grant blessings an evil thought reached her and she sat suddenly on a chair and covered her face with her hands, explaining why she did so. When it passed she rose, "Now I will teach you again."

Here the food was offered up but not distributed until the call came from the spirit.

St. Prompt Succor brought the basin and towel at a signal. She washed her hands and face.

It is evident that Mother Seal takes her stand as an equal with Christ.

No nailing or building is done on Friday. A carpenter may saw or measure, but no nailing or joining.

She heals by the laying on of hands, by suggestion and copious doses of castor oil and Epsom salts. She heals in the tent and at great distances. She has blessed water in the barrel for her followers, but she feels her divinity to such an extent that she blesses the water in the hydrants at the homes of her followers without moving out of her tent.

No one may cross his legs within the Manger. That is an insult to the spirit.

Mother Catherine's conception of the divinity of Christ is that Joseph was his foster father as all men are foster fathers, in that all children are of God and all fathers are merely the means.

All of her followers wear her insignia. The women wear a veil of unbleached muslin; the men, an arm-band. All bear the crescent and M.C.S. (Mother Catherine's Saints). They must be worn everywhere.

In late February and early March it rained heavily and many feared a flood. Mother Seal exhorted all of her followers to pin their faith in her. All they need do is believe in her and come to her and eat the blessed fish she cooked for them and there would be no flood. "God," she said, "put oars in the fishes' hands. Eat this fish and you needn't fear the flood no more than a fish would."

All sympathetic magic. Chicken, beef, lamb are animals of pleasing blood. They are used abundantly as food and often in

healing. A freshly killed chicken was split open and bound to a sore leg.

All of her followers, white and colored, are her children. She has as many of one race as the other.

"I got all kinds of children, but I am they mother. Some of 'em are saints; some of 'em are conzempts (convicts) and jailbirds; some of 'em kills babies in their bodies; some of 'em walks the streets at night—but they's all my children. God got all kinds, how come I cain't love all of mine? So says the beautiful spirit.

"Now y'all go home in faith. I'm going to appear to you all in three days. Don't doubt me. Go home in faith and pray."

There is a period in the service given over to experiences.

One woman had a vision. She saw a flash of lightning on the wall. It wrote, "Go to Mother Seal." She came with pus on the kidneys and was healed.

A girl of fourteen had a vision of a field of spinach that turned to lilies with one large lily in the middle. The field was her church and the large lily was Mother Catherine.

Most of the testimony has to do with acknowledging that they have been healed by Mother's power, or relating how the wishes they made on Mother came true.

Mother Catherine's religion is matriarchal. Only God and the Mother count. Childbirth is the most important element in the creed. Her compound is called the Manger, and is dedicated to the birth of children in or out of wedlock.

Over and over she lauds the bringing forth. *There is no sinful birth.* And the woman who avoids it by abortion is called a "damnable extrate."

Mother Catherine was not converted by anyone. Like Christ, Mohammed, Buddha, the call just came. No one stands between her and God.

After the call she consecrated her body by refraining from the sex relation, and by fasting and prayer.

She was married at the time. Her husband prayed two weeks before he was converted to her faith. Whereupon she baptised him in a tub in the backyard. They lived together six months as a

holy man and woman before the call of the flesh made him elope
with one of her followers.

She held her meetings first on Jackson Avenue, but the crowds
that swarmed about her made the authorities harry her. So some
of her wealthy followers bought the tract of land below the Indus-
trial Canal where the Manger now is.

God sent her into the Manger over a twelve-foot board fence—
not through a gate. She must set no time for her going but when
the spirit gave the word. After her descent through the roof of the
chapel she has never left the grounds but once, and that was not
intentional. She was learning to drive a car within the enclosure.
It got out of control and tore a hole through the fence before it
stopped. She called to her followers to "Come git me!" (She must
not set her foot on the unhallowed ground outside the Manger.)
They came and reverently lifted her and bore her back inside. The
spot in the yard upon which she was set down became sacred, for
a voice spoke as her feet touched the ground and said, "Put down
here the Pool of Gethsemane so that the believers may have holy
water to drink." The well is under construction at this writing.

Uncle Monday

People talk a whole lot about Uncle Monday, but they take good pains not to let him hear none of it. Uncle Monday is an out-and-out conjure doctor. That in itself is enough to make the people handle him carefully, but there is something about him that goes past hoodoo. Nobody knows anything about him, and that's a serious matter in a village of less than three hundred souls, especially when a person has lived there for forty years and more.

Nobody knows where he came from nor who his folks might be. Nobody knows for certain just when he did come to town. He was just there one morning when the town awoke. Joe Lindsay was the first to see him. He had some turtle lines set down on Lake Belle. It is a hard lake to fish because it is entirely surrounded by a sooky marsh that is full of leeches and moccasins. There is plenty of deep water once you pole a boat out beyond the line of cypress pines, but there are so many alligators out there that most people don't think the trout are worth the risk. But Joe had baited some turtle lines and thrown them as far as he could without wading into the marsh. So next morning he went as early as he could see light to look after his lines. There was a turtle head on every line, and he pulled them up cursing the 'gators for robbing his hooks. He says he started on back home, but when he was a few yards from where his lines had been set something made him look back,

and he nearly fell dead. For there was an old man walking out of
the lake between two cypress knees. The water there was too deep
for any wading, and besides, he says the man was not wading, he
was walking vigorously as if he were on dry land.

Lindsay says he was too scared to stand there and let the man
catch up with him, and he was too scared to move his feet; so he
just stood there and saw the man cross the marshy strip and come
down the path behind him. He says he felt the hair rise on his head
as the man got closer to him, and somehow he thought about an
alligator slipping up on him. But he says that alligators were in the
front of his mind that morning because first, he had heard bull
'gators fighting and bellowing all night long down in this lake, and
then his turtle lines had been robbed. Besides, everybody knows
that the father of all 'gators lives in Belle Lake.

The old man was coming straight on, taking short quick steps
as if his legs were not long enough for his body, and working his
arms in unison. Lindsay says it was all he could do to stand his
ground and not let the man see how scared he was, but he
managed to stand still anyway. The man came up to him and
passed him without looking at him seemingly. After he had
passed, Lindsay noticed that his clothes were perfectly dry, so he
decided that his own eyes had fooled him. The old man must have
come up to the cypress knees in a boat and then crossed the marsh
by stepping from root to root. But when he went to look, he found
no convenient roots for anybody to step on. Moreover, there was
no boat on the lake either.

The old man looked queer to everybody, but still no one would
believe Lindsay's story. They said that he had seen no more than
several others—that is, that the old man had been seen coming
from the direction of the lake. That was the first that the village
saw of him, way back in the late 'eighties, and so far, nobody
knows any more about his past than that. And that worries the
town.

Another thing that struck everybody unpleasantly was the fact
that he never asked a name nor a direction. Just seemed to know

who everybody was, and called each and every one by their right name. Knew where everybody lived too. Didn't earn a living by any of the village methods. He didn't garden, hunt, fish, nor work for the white folks. Stayed so close in the little shack that he had built for himself that sometimes three weeks would pass before the town saw him from one appearance to another.

Joe Clarke was the one who found out his name was Monday. No other name. So the town soon was calling him Uncle Monday. Nobody can say exactly how it came to be known that he was a hoodoo man. But it turned out that that was what he was. People said he was a good one too. As much as they feared him, he had plenty of trade. Didn't take him long to take all the important cases away from Ant Judy, who had had a monopoly for years.

He looked very old when he came to the town. Very old, but firm and strong. Never complained of illness.

But once, Emma Lou Pittman went over to his shack early in the morning to see him on business, and ran back with a fearsome tale. She said that she noticed a heavy trail up to his door and across the steps, as if a heavy, bloody body had been dragged inside. The door was cracked a little and she could hear a great growling and snapping of mighty jaws. It wasn't exactly a growling either, it was more a subdued howl in a bass tone. She shoved the door a little and peeped inside to see if some varmint was in there attacking Uncle Monday. She figured he might have gone to sleep with the door ajar and a catamount, or a panther, or a bob-cat might have gotten in. He lived near enough to Blue Sink Lake for a 'gator to have come in the house, but she didn't remember ever hearing of them tracking anything but dogs.

But no; no varmint was inside there. The noise she heard was being made by Uncle Monday. He was lying on a pallet of pine-straw in such agony that his eyes were glazed over. His right arm was horribly mangled. In fact, it was all but torn away from right below the elbow. The side of his face was terribly torn too. She called him, but he didn't seem to hear her. So she hurried back for some men to come and do something for him. The men came as fast as their legs would bring them, but the house was locked from

the outside and there was no answer to their knocking. Mrs. Pittman would have been made out an awful liar if it were not for the trail of blood. So they concluded that Uncle Monday had gotten hurt somehow and had dragged himself home, or had been dragged by a friend. But who could the friend have been?

Nobody saw Uncle Monday for a month after that. Every day or so, someone would drop by to see if hide or hair could be found of him. A full month passed before there was any news. The town had about decided that he had gone away as mysteriously as he had come.

But one evening around dusk-dark Sam Merchant and Jim Gooden were on their way home from a squirrel hunt around Lake Belle. They swore that, as they rounded the lake and approached the footpath that leads towards the village, they saw what they thought was the great 'gator that lives in the lake crawl out of the marsh. Merchant wanted to take a shot at him for his hide and teeth, but Gooden reminded him that they were loaded with bird shot, which would not even penetrate a 'gator's hide, let alone kill it. They say the thing they took for the 'gator then struggled awhile, pulling off something that looked like a long black glove. Then he scraped a hole in the soft ground with his paws and carefully buried the glove which had come from his right paw. Then without looking either right or left, he stood upright and walked on towards the village. Everybody saw Uncle Monday come thru the town, but still Merchant's tale was hard to swallow. But, by degrees, people came to believe that Uncle Monday could shed any injured member of his body and grow a new one in its place. At any rate, when he reappeared his right hand and arm bore no scars.

The village is even sceptical about his dying. Once Joe Clarke said to Uncle Monday, "I'god, Uncle Monday, aint you skeered to stay way off by yo'self, old as you is?"

Uncle Monday asked, "Why would I be skeered?"

"Well, you liable to take sick in de night sometime, and you'd be dead befo' anybody would know you was even sick."

Uncle Monday got up off the nail keg and said in a voice so low

that only the men right close to him could hear what he said, "I have been dead for many a year. I have come back from where you are going." Then he walked away with his quick short steps, and his arms bent at the elbow, keeping time with his feet.

It is believed that he has the singing stone, which is the greatest charm, the most powerful "hand" in the world. It is a diamond and comes from the mouth of a serpent (which is thought of as something different from an ordinary snake) and is the diamond of diamonds. It not only lights your home without the help of any other light, but it also warns its owner of approach.

The serpents who produce these stones live in the deep waters of Lake Maitland. There is a small island in this lake and a rare plant grows there, which is the only food of this serpent. She only comes to nourish herself in the height of a violent thunderstorm, when she is fairly certain that no human will be present.

It is impossible to kill or capture her unless nine healthy people have gone before to prepare the way with THE OLD ONES, and then more will die in the attempt to conquer her. But it is not necessary to kill or take her to get the stone. She has two. One is embedded in her head, and the other she carries in her mouth. The first one cannot be had without killing the serpent, but the second one may be won from her by trickery.

Since she carries this stone in her mouth, she cannot eat until she has put it down. It is her pilot, that warns her of danger. So when she comes upon the island to feed, she always vomits the stone and covers it with earth before she goes to the other side of the island to dine.

To get this diamond, dress yourself all over in black velvet. Your assistant must be dressed in the same way. Have a velvet-covered bowl along. Be on the island before the storm reaches its height, but leave your helper in the boat and warn him to be ready to pick you up and flee at a moment's notice.

Climb a tall tree and wait for the coming of the snake. When she comes out of the water, she will look all about her on the ground to see if anyone is about. When she is satisfied that she is alone,

she will vomit the stone, cover it with dirt and proceed to her feeding ground. Then, as soon as you feel certain that she is busy eating, climb down the tree as swiftly as possible, cover the mound hiding the stone with the velvet-lined bowl and flee for your life to the boat. The boatman must fly from the island with all possible speed. For as soon as you approach the stone it will ring like chiming bells, and the serpent will hear it. Then she will run to defend it. She will return to the spot, but the velvet-lined bowl will make it invisible to her. In her wrath she will knock down grown trees and lash the island like a hurricane. Wait till a calm fair day to return for the stone. She never comes up from the bottom of the lake in fair weather. Furthermore, a serpent who has lost her mouth-stone cannot come to feed alone after that. She must bring her mate. The mouth-stone is their guardian, and when they lose it they remain in constant danger unless accompanied by one who has the singing stone.

They say that Uncle Monday has a singing stone, and that is why he knows everything without being told.

Whether he has the stone or not, nobody thinks of doubting his power as a hoodoo man. He is feared, but sought when life becomes too powerful for the powerless. Mary Ella Shaw backed out on Joe-Nathan Moss the day before the wedding was to have come off. Joe-Nathan had even furnished the house and bought rations. His people, her people, everybody tried to make her marry the boy. He loved her so, and besides he had put out so much of his little cash to fix for the marriage. But Mary Ella just wouldn't. She had seen Caddie Brewton, and she was one of the kind who couldn't keep her heart still after her eye had wandered.

So Joe-Nathan's mama went to see Uncle Monday. He said, "Since she is the kind of woman that lets her mind follow her eye, we'll have to let the snake-bite cure itself. You go on home. Never no man will keep her. She kin grab the world full of men, but she'll never keep one any longer than from one full moon to the other."

Fifteen years have passed. Mary Ella has been married four times. She was a very pretty girl, and men just kept coming, but

not one man has ever stayed with her longer than the twenty-eight days. Besides her four husbands, no telling how many men she has shacked up with for a few weeks at a time. She has eight children by as many different men, but still no husband.

John Wesley Hogan was another driver of sharp bargains in love. By his own testimony and experience, all women from eight to eighty were his meat, but the woman who was sharp enough to make him marry her wasn't born and her mama was dead. They couldn't frame him and they couldn't scare him.

Mrs. Bradley came to him nevertheless about her Dinkie. She called him out from his work-place and said, "John Wesley, you know I'm a widder-woman and I aint got no husband to go to de front for me, so I reckon I got to do de talkin' for me and my chile. I come in de humblest way I know how to ast you to go 'head and marry my chile befo' her name is painted on de signposts of scorn."

If it had not made John Wesley so mad, it would have been funny to him. So he asked her scornfully, " 'Oman, whut you take me for? You better git outa my face wid dat mess! How you reckon *I* know who Dinkie been foolin roun wid? Don't try to come dat mess over *me*. I been all over de North. I aint none of yo' fool. You must think I'm Big Boy. They kilt Big Boy shootin after Fat Sam so there aint no mo' fools in de world. Ha, ha! All de wimmen *I* done seen! I'll tell you like de monkey tole de elephant—don't bull me, big boy! If you want Dinkie to git married off so bad, go grab one of dese country clowns. I aint yo' man. Taint no use you goin runnin to de high-sheriff neither. I got witness to prove Dinkie knowed more'n I do."

Mrs. Bradley didn't bother with the sheriff. All he could do was to make John Wesley marry Dinkie; but by the time the interview was over that wasn't what the stricken mother wanted. So she waited till dark, and went on over to Uncle Monday.

Everybody says you don't have to explain things to Uncle Monday. Just go there, and you will find that he is ready for you when you arrive. So he set Mrs. Bradley down at a table, facing a huge mirror hung against the wall. She says he had a loaded pistol and

a huge dirk lying on the table before her. She looked at both of the weapons, but she could not decide which one she wanted to use. Without a word, he handed her a gourd full of water and she took a swallow. As soon as the water passed over her tongue she seized the gun. He pointed towards the looking-glass. Slowly the form of John Wesley formed in the glass and finally stood as vivid as life before her. She took careful aim and fired. She was amazed that the mirror did not shatter. But there was a loud report, a cloud of bluish smoke and the figure vanished.

On the way home, Brazzle told her that John Wesley had dropped dead, and Mr. Watson had promised to drive over to Orlando in the morning to get a coffin for him.

ANT JUDY BICKERSTAFF

Uncle Monday wasn't the only hoodoo doctor around there. There was Ant Judy Bickerstaff. She was there before the coming of Uncle Monday. Of course it didn't take long for professional jealousy to arise. Uncle Monday didn't seem to mind Ant Judy, but she resented him, and she couldn't hide her feelings.

This was natural when you consider that before his coming she used to make all the "hands" around there, but he soon drew off the greater part of the trade.

Year after year this feeling kept up. Every now and then some little incident would accentuate the rivalry. Monday was sitting on top of the heap, but Judy was not without her triumphs.

Finally she began to say that she could reverse anything that he put down. She said she could not only reverse it, she could throw it back on *him*, let alone his client. Nobody talked to him about her boasts. People never talked to him except on business anyway. Perhaps Judy felt safe in her boasting for this reason.

Then one day she took it in her head to go fishing. Her children and grandchildren tried to discourage her. They argued with her about her great age and her stiff joints. But she had her grandson to fix her a trout pole and a bait pole and set out for Blue Sink, a lake said to be bottomless by the villagers. Furthermore, she

didn't set out till near sundown. She didn't want any company. It was no use talking, she felt that she just must go fishing in Blue Sink.

She didn't come home when dark came, and her family worried a little. But they reasoned she had probably stopped at one of her friends' houses to rest and gossip, so they didn't go to hunt her right away. But when the night wore on and she didn't return, the children were sent out to locate her.

She was not in the village. A party was organised to search Blue Sink for her. It was after nine o'clock at night when the party found her. She was in the lake. Lying in shallow water and keeping her old head above the water by supporting it on her elbow. Her son Ned said that he saw a huge alligator dive away as he shined the torch upon his mother's head.

They bore Ant Judy home and did everything they could for her. Her legs were limp and useless and she never spoke a word, not a coherent word, for three days. It was more than a week before she could tell how she came to be in the lake.

She said that she hadn't really wanted to go fishing. The family and the village could witness that she never had fooled round the lakes. But that afternoon she *had* to go. She couldn't say why, but she knew she must go. She baited her hooks and stood waiting for a bite. She was afraid to sit down on the damp ground on account of her rheumatism. She got no bites. When she saw the sun setting she wanted to come home, but somehow she just couldn't leave the spot. She was afraid, terribly afraid down there on the lake, but she couldn't leave.

When the sun was finally gone and it got dark, she says she felt a threatening, powerful evil all around her. She was fixed to the spot. A small but powerful whirlwind arose right under her feet. Something terrific struck her and she fell into the water. She tried to climb out, but found that she could not use her legs. She thought of 'gators and otters, and leeches and gar-fish, and began to scream, thinking maybe somebody would hear her and come to her aid.

Suddenly a bar of red light fell across the lake from one side to

the other. It looked like a fiery sword. Then she saw Uncle Monday walking across the lake to her along this flaming path. On either side of the red road swam thousands of alligators, like an army behind its general.

The light itself was awful. It was red, but she never had seen any red like it before. It jumped and moved all the time, but always it pointed straight across the lake to where she lay helpless in the water. The lake is nearly a mile wide, but Ant Judy says Uncle Monday crossed it in less than a minute and stood over her. She closed her eyes from fright, but she saw him right on thru her lids.

After a brief second she screamed again. Then he growled and leaped at her. "Shut up!" he snarled. "Part your lips just one more time and it will be your last breath! Your bragging tongue has brought you here and you are going to stay here until you acknowledge my power. So you can throw back my work, eh? I put you in this lake; show your power and get out. You will not die, and you will not leave this spot until you give consent in your heart that I am your master. Help will come the minute you knuckle under."

She fought against him. She felt that once she was before her own altar she could show him something. He glowered down upon her for a spell and then turned and went back across the lake the way he had come. The light vanished behind his feet. Then a huge alligator slid up beside her where she lay trembling and all her strength went out of her. She lost all confidence in her powers. She began to feel if only she might either die or escape from the horror, she would never touch another charm again. If only she could escape the maw of the monster beside her! Any other death but that. She wished that Uncle Monday would come back so that she might plead with him for deliverance. She opened her mouth to call, but found that speech had left her. But she saw a light approaching by land. It was the rescue party.

Ant Judy never did regain the full use of her legs, but she got to the place where she could hobble about the house and yard. After relating her adventure on Lake Blue Sink she never called the name of Uncle Monday again.

The rest of the village, always careful in that respect, grew almost as careful as she. But sometimes when they would hear the great bull 'gator, that everybody knows lives in Lake Belle, bellowing on cloudy nights, some will point the thumb in the general direction of Uncle Monday's house and whisper, "The Old Boy is visiting the home folks tonight."

The Fire
and the Cloud

Moses sat upon his new made grave on Mount Nebo. His back stooped wearily, but his strong gaze leaped the Jordan and travelled over the land of Canaan.

A lizard popped out of a hole under a rock directly before Moses.

"Good morning, O brother-of-insufficient walking legs. I find you at waking where I left you at sun-rest." So the reptile greeted Moses.

With his eyes still in Canaan, Moses answered. "Ah yes, little kin who-uses-all-his-legs-for-walking, the labor has been long. This is the thirtieth day that I have sojourned upon this mountain." He waved at the mound of stone. "Behold, friend, it is finished."

From the top of a low bush near the left foot of Moses the lizard studied the work. "It is good. But you have been a long time in the building of your nest. Your female must be near death from retaining her eggs."

"No fecund female awaits this labor."

"A male alone!"

"A male alone."

"Perhaps you are a widower also. It is very sad, but you must know that fat lizards have may sudden-striking enemies." A tear dewed the leaf beneath him.

"I am alone, O lizard, because I am alone."

The lizard felt that Moses' answer lacked reason and he would

117

have taught him how to make answer as do the great ones in the council of lizards, but when he lifted his head to speak, he beheld the head of Moses enveloped in a dense white cloud. "The gods have borne away the head of the rock-lifter," he thought aloud, and scurried to his hole in quivering awe. He slept and memory fled away. So soon he emerged and looked into the benign eyes of the nation-maker from the same bush.

"The lizard says that the present hour is much hotter than the tender ones of morning," he began abruptly.

"The lizard is wise," Moses answered casually.

"The words of lizards are full of truth," the reptile went on cunningly. "But even so, O friend-who-digs-his-hole-above-ground, the greatest among us has no rod that can summon fly-swarms at will." The lizard said this and looked at Moses under-eyed.

"That is true," Moses agreed with his thoughts at a distance.

"All your works accumulate praise. Twenty and nine days you have been with me upon this mountain, and each day you have called forth a swarm of flies at the hour when I am most hungry."

"Pardon me, friend," Moses said humbly. "The thirtieth day shall be as the twenty-nine." He lifted his rod ever so slightly and flies swarmed over the bush upon which the lizard rested. "Sup."

The lizard ate. The last fly of the swarm was just enough. Every day it had been so. He looked at Moses in admiration.

"Whence do you come, O Master?"

Moses pointed to the plain of Moab where the tents of Israel crowded the horizon.

"How do you say that you are alone if of your kind such hosts of multitudes be at hand?"

"I am that I am and so I am alone. I am Moses, The-drawn-out. It is given me to call God by his power-compelling names. I bear his rod. The blind and the mute have companionship, but I am a leader."

"I see that your leadership has galled your shoulders. Why then did you go before?"

"I went because I was sent. In my agony I cried into nothing-

ness and enquired 'Why am I called?' There was no answer. Only the voice that again said 'Go!' "

"How long O mighty Moses, have you led?"

"Forty years and more. From the mountain of God I returned to Egypt, and with my stretched-out arm I confounded the Pharaoh, and led my people forth with a mighty hand. From the Nile, where we were bondsmen, to beyond the Jordan, where they shall rule."

"Ah Moses, because you have so exalted your kind and kindred, their love for you must exceed this great mountain in thickness and the height would not be less."

"Lizard, love is not created by service to mankind. But if the good be deemed sufficiently great, man sometimes erects little mountains of stone to the doer called monuments. They do this so that in the enjoyment of the benefit they forget not the benefactor. The heart of man is an ever empty abyss into which the whole world shall fall and be swallowed up."

"Do none of the hosts love their deliverer?"

"Who shall know? However, Joshua is strong in soul and body. He shall follow me. He gives thought to me. If I do not return to my tent before another day begins, he will ascend this mountain in search of me."

"Your labors have brought little joy."

"Lizard, forty years ago I led a horde of slaves out of Egyptian bondage and held them in the wilderness until I grew men. Look now upon the plain of Moab. A great people! They shall rule over nations and dwell in cities they have not builded. Yet they have rebelled against me ever. A stiff-necked race of people. They murmur against me anew because I have held them before the Jordan for forty days. Their taste would humble them before the armies of Canaan. They must wait yet another thirty days. I have not striven with God, with the wilderness, with rebellion and my own soul for forty years to bring them to a new bondage in the land beyond the Jordan. They shall wait for strength."

"How then, Moses will you hold your horde of murmurers on

the brink of the Jordan when their eyes already feast on the good land?''

"If a leader dies in Israel, the hosts mourn thirty days."

Again the head of Moses disappeared in cloud and a sleep fell upon the lizard. But the cloud-splitting eye of Moses carried to the silver gilt hills of Canaan lying half in the late light, and half in shadows of the setting sun, and his soul wandered beyond the Jordan for the space of half an hour. When it returned to him upon Nebo he gazed down upon the tented nation beneath him, and the nation-maker sorrowing, wept over Israel. But Israel, unknowing, sang and danced, hammered its swords, milked its cows, got born and died.

"Ah Moses," the lizard observed on waking. "You shall yet rejoice. Soon your hosts will triumph beyond the Jordan, and you shall be called king of kings."

"I have already known the palaces of the Pharaohs, lizard, but I was not happy in the midst of them."

"You were an alien in the Egyptian palaces, but the mansions in Canaan shall be of your kindred."

"When the Israelites shall erect palaces, God shall raise up abundant palace-dwellers to fill them. I have taught them statutes and judgments fit for the guidance of kings and shepherds alike."

"But will they remember your laws?"

"If I tarry within this that I have erected on Nebo, then shall they remember my laws in Canaan. People value monuments above men, and signs above works."

The lizard travelled around the tomb and studied its contours.

"But Moses, your splendid new dwelling has no hole by which you may enter. A queer dwelling. A hole above ground—no entrance."

"This is no dwelling, lizard. It is a place of burial."

"I am no longer young, Moses, perhaps, I nodded. What buried you there?"

"No, you did not witness it, but here is interred the voice of Sinai, the stretched-out arm of Moses, the lawgiver, the nation-maker."

"Those are your words, but I behold you sitting as you sat at sunrise."

"Those are your thoughts, but you see the old man of the wilderness sitting upon the tomb of Moses."

Whereupon Moses arose and took one long look at the tented nation in the valley, and his face shone as it had done at Sinai when even Aaron had feared to look upon it. He took one dragging look beyond the Jordan, then wrapped his mantle closely about him.

"Sun is set," he said in low rumbles. "I depart."

He laid his rod upon the new-made tomb, set his face sternly towards the wilderness and walked away, leaning lightly on a new-cut staff.

"But wait, O Moses!" the lizard squeaked after him. "You have left your rod behind."

"Oh, Joshua will pick it up," he called back and strode on.

Cock Robin
Beale Street

Uncle July was mad clear through. A'nt Dooby could tell by the way he threw down the load of kindling in the corner behind the kitchen stove. Anyhow, if he wasn't really mad, he was letting on like it. It was an off day with her and she didn't feel like no fussing, so she started in right away to head him off.

"July, don't you come in here starting none of your foolishness wid me this day and year of our Lawd! I done told you now!"

"Who's starting any fussing? I know 'tain't none of me, I ain't broke a breath wid you, 'oman. You better go 'head and leave me be."

A'nt Dooby braced herself for the storm. She plunked her fat fists on her abundant hips and glared him round the room. July could see names like "mule" "fool" "sea-buzzard" "groundhog" and things like that swimming around in her eyes. So he sat down, pulled off one shoe, looked at it hard, then pulled off the other one, wiggled his toes and lit his pipe.

"Hit's a sin before de living jestice!" July exploded. "Dese white folks ought to talk whut dey know, and testify to whut see."

"Whut's de matter now?" Dooby asked, full of suspicion.

"Going 'round letting on dat Cock Robin was a bird! Jest heard Miz Pendleton reading out of some kind of a book how Cock Robin was a real-true bird wid feathers on him and got kilt wid a arrow. Hit's a sin and a shame! 'Tain't a word of it so! I knowed

Cock Robin well—was right dere when he got kilt wid a forty-four, and was at de funeral.''

A'nt Dooby was unimpressed.

"I ain't knowed nothing 'bout no Cock Robin gitting kilt and you must a' sneaked off to de funeral and never told me nothing 'tall about it.''

"Oh, dat was back dere in Memphis. I used to git around right smart before I was saved. Long before I and you made a wed. And den it wasn't exactly no funeral neither. Dere was some talk about funeralizing him, but it didn't amount to nothing.

"Cock Robin was a high-flier if ever I seed one. Sung solo in de choir, and got round right smart wid de lady-people. Comed to Memphis from off somewhere like a whole heap of us done. Big doings in Memphis in dem days.

"Well, late one evening just 'fore sundown everybody was down 'round Beale Street sort of catching de cool breezes off de gutter wid de Grease Spot doing a heap of business, de pool-room was full, and somebody was jooking on de piano in de Shimmy Shack, dat was a high class hotel run by Sister Buzzard, slap on Beale.

"Quite a few folks was scattered around de place upstairs and down, when all of a suddent we heard three pistol shots down 'round de front. Everybody run to de windows and looked down on de street. Dere was Cock Robin laying on de sidewalk in front of de hotel wid three bullet holes in him.

"Brother Owl, he was around so he naturally took charge and went to asking folks, 'Who kilt Cock Robin?' Not expecting to git much of a answer.

" 'I kilt Cock Robin,' Bull Sparrow says, pushing up front in de crowd. 'Who is it wants to know?' He had his gun wide open in his hand.

" 'Not dat we cares, Brother Sparrow,' Brother Owl sort of simmerized. 'Us just asked for a little information to find out how come.'

" 'Well, it's like dis,' Bull Sparrow told him, and sort of reared

back on his dew-claws. 'You all knows dat I am a sparrow, and all my folks was sparrows from way back.'

" 'Dat sho is de truth,' they told him, 'De spitting image of your paw.'

" 'And furthermore, you all know dat sparrows don't never lay nothing but plain white eggs. My great-great-great grandma, she laid white eggs. My mama laid white eggs.'

" 'Dat sho is de truth!' Sister Buzzard put in. 'Your maw and your paw did they nesting right here in my Shimmy Shack.'

" 'Well, now when me and my wife first started to nesting, she never laid nothing but plain white eggs. But things done changed, ever since dat Cock Robin been 'round here. Now, every time I go off on a worm hunt, when I get back, I find another blue egg in my nest.'

" 'Dere now!' Brother Crow hollered and jumped clear up in de air. 'You done got *me* to scratching where I don't itch. Seem like to me, I seen a bluish egg or two 'round my nest, too.'

" 'Tain't no ifs and ands about it,' Brother Bull snorted, 'Cock Robin was in de egg business. Whilst I sympathizes wid Brother Sparrow, I'm glad we don't have no egg-laying 'round our place.'

" 'You mean Cock Robin been laying eggs?' Brother Fly asked.

." 'Aw, naw! You know no rooster don't lay no eggs. Us leaves things like dat to de hen-folks.' Brother Owl hooted. 'But he was too mixified just de same.'

" 'You done right, Brother Sparrow.' Everybody told him. 'Kilt him in de first degree and finished de job off well.'

" 'All we got to do now is to funeralize him,' Brother Owl said, and got him a high chair to sit on. 'He was sort of unfinancial, so we got to do 'round to fix things up.'

"Wid that, he took and signed different ones to do and to fix until he had a burial robe and everything fixed up down to de chief mourner, which was Sister Dove. She was a widow 'oman and used to mourning, and she really could mourn. Den he took up de hall he was going to be funeralized from.

"Right dere was where he throwed de fat in de fire 'cause Brother Cock Robin belonged to every fraternal and benevolent

society round dere. De Night-Stepping Owls allowed dat he was a brother in good standing, and naturally dey would parade him to de graveyard. De Never-Been-Caught Fishes, De Ever-Blooming Blackbirds, De Muckty-Ducky Beetle-Bugs, De High-Roosting Crows, and Fun-Feeling Flies all hollered dat dey put on de best funerals in town. Dey argued, and went home and got into regalia to show Brother Owl how dey paraded, and brought along de bands and put de thing on. Brother Owl couldn't say for not knowing which one of dem was de best. Brother Bull, he stood dere by Brother Owl and said, 'I don't care who gits de deceasted. I aim to march in front.'

" 'How come, Brother Bull?' Dey all wanted to know. 'You don't belong to none of de orders.'

" 'Matters a difference about dat,' he told 'em. 'You know dat bull goes in front of everything. *I aims to march in front.* I got my parading stick all ready and my strutting hat.'

"Brother Owl scratched his head all over two or three more times and den he said, 'Everybody parades de best. So as not to have no hard feeling, who ever pays de funeral expenses can have de body. Dat's fair.'

"De unfairness of de thing took everybody by surprise, so nobody couldn't say a word for a long time. Finally, Sister Blackbird up and told him, 'Brother Owl, if you was talking about money all dis time, how come you never told nobody? Here you done got us all dressed up to funeralize our dear deceasted, and now you come talking about money. My people! My people!'

" 'Yeah, and had us gitting up bands to march by and everything,' Sparrow told him. Everybody was good and mad at Brother Owl.

"Brother Crow snapped his fingers and said, 'Folkses and feathers, I clean forgot! Sister Speckled-Hen is having a big fish fry and barbecue down on Front Street and Beale dis evening. She told me to tell everybody, but all dis mess 'bout Cock Robin put it clean out of my head.' He rolled his eyes at Brother Owl. Everybody begin to get more lively right away, so Brother Crow went on. 'Since we is all 'sembled right here together, and in regalia, how come we

don't all form one big amalgamated, contaminated parade down to Sister Speckled-Hen's place and enjoy de consequences?'

"Dat sounded like a good idea to everybody, so dey agreed all at one time. Nobody was de first to agree, and nobody was de last. Brother Owl dusted hisself off and got ready. Brother Bull halted everything until he got his strutting hat set over one eye so it looked like it couldn't stay on, but was just too mean to fall off. He whirled his parading stick and told de professor of de band to turn it on.

"But Sister Buzzard raised a ruckus. Dey wasn't going to leave Cock Robin in front of *her* hotel, giving the place a bad name. Naw sir! Dey was going to take him up from dere and bury him.

"Feathers begin to crumple. Dey tried to make dis one and dat one do de burying, but everybody was otherwise engaged. 'Way after while Brother Owl told her, 'Oh, leave de white folks bury him! Dey always loves to take charge.'

"De band hit a hatful of notes at one lick, and Brother Bull led off. Sister Speckled-Hen sho done herself proud dat night. Lawd! I ain't never had dat much fun before nor since."

Uncle July looked kind of sheepish at Dooby. "Since I been saved, I forgot all about such doings. Never would have remembered it no more if dese white folks had of got de thing like it was sho 'nough.''

"Humph!" A'nt Dooby snorted. "Old coon for cunning; young coon for running. Now tell me whut you done wid your wages. I know you been up to something. Tell me! You and your Muckty-Duckty Beetle-Bugs!"

Story
in Harlem
Slang*

Wait till I light up my coal-pot and I'll tell you about this Zigaboo called Jelly. Well, all right now. He was a sealskin brown and papa-tree-top-tall. Skinny in the hips and solid built for speed. He was born with this rough-dried hair, but when he laid on the grease and pressed it down overnight with his stocking-cap, it looked just like that righteous moss, and had so many waves you got seasick from looking. Solid, man, solid!

His mama named him Marvel, but after a month on Lenox Avenue, he changed all that to Jelly. How come? Well, he put it in the street that when it came to filling that long-felt need, sugar-curing the ladies' feelings, he was in a class by himself and nobody knew his name, so he had to tell 'em. "It must be Jelly, 'cause jam don't shake." Therefore, his name was Jelly. That was what was on his sign. The stuff was there and it was mellow. Whenever he was challenged by a hard-head or a frail eel on the right of his title he would eye-ball the idol-breaker with a slice of ice and put on his ugly-laugh, made up of scorn and pity, and say: "Youse just dumb to the fact, baby. If you don't know what you talking 'bout, you better ask Granny Grunt. I wouldn't mislead you, baby. I don't need to—not with the help I got."

*In her original manuscript, Hurston entitled this story "Now You Cookin' with Gas" (see page 233).

Then he would give the pimps'[1] sign, and percolate on down the Avenue. You can't go behind a fact like that.

So this day he was airing out on the Avenue. It had to be late afternoon, or he would not have been out of bed. All you did by rolling out early was to stir your stomach up. That made you hunt for more dishes to dirty. The longer you slept, the less you had to eat. But you can't collar nods all day. No matter how long you stay in bed, and how quiet you keep, sooner or later that big gut is going to reach over and grab that little one and start to gnaw. That's confidential right from the Bible. You got to get out on the beat and collar yourself a hot.

So Jelly got into his zoot suit with the reet pleats and got out to skivver around and do himself some good. At 132nd Street, he spied one of his colleagues on the opposite sidewalk, standing in front of a café. Jelly figured that if he bull-skated just right, he might confidence Sweet Back out of a thousand on a plate. Maybe a shot of scrap-iron or a reefer. Therefore, Jelly took a quick backward look at his shoe soles to see how his leather was holding out. The way he figured it after the peep was that he had plenty to get across and maybe do a little more cruising besides. So he stanched out into the street and made the crossing.

"Hi there, Sweet Back!" he exploded cheerfully. "Gimme some skin!"

"Lay de skin on me, pal!" Sweet Back grabbed Jelly's out-stretched hand and shook hard. "Ain't seen you since the last time, Jelly. What's cookin'?"

"Oh, just like de bear—I ain't nowhere. Like de bear's brother, I ain't no further. Like de bear's daughter—ain't got a quarter."

Right away, he wished he had not been so honest. Sweet Back gave him a top-superior, cut-eye look. Looked at Jelly just like a showman looks at an ape. Just as far above Jelly as fried chicken is over branch water.

[1]In Harlemese, *pimp* has a different meaning than its ordinary definition as a procurer for immoral purposes. The Harlem pimp is a man whose amatory talents are for sale to any woman who will support him, either with a free meal or on a common law basis; in this sense, he is actually a male prostitute.

"Cold in hand, hunh?" He talked down to Jelly. "A red hot pimp like you *say* you is, ain't got no business in the barrel. Last night when I left you, you was beating up your gums and broadcasting about how hot you was. Just as hot as July-jam, you told me. What you doing cold in hand?"

"Aw, man, can't you take a joke? I was just beating up my gums when I said I was broke. How can I be broke when I got de best woman in Harlem? If I ask her for a dime, she'll give me a ten dollar bill: ask her for drink of likker, and she'll buy me a whiskey still. If I'm lying, I'm flying!"

"Gar, don't hang out dat dirty washing in my back yard! Didn't I see you last night with dat beat chick, scoffing a hot dog? Dat chick you had was beat to de heels. Boy, you ain't no good for what you live."

"If you ain't lying now, you flying. You ain't got de first thin. You ain't got nickel one."

Jelly threw back the long skirt of his coat and rammed his hand down into his pants pocket. "Put your money where your mouth is!" he challenged, as he mock-struggled to haul out a huge roll. "Back your crap with your money. I bet you five dollars!"

Sweet Back made the same gesture of hauling out non-existent money.

"I been raised in the church. I don't bet, but I'll doubt you. Five rocks!"

"I thought so!" Jelly crowed, and hurriedly pulled his empty hand out of his pocket. "I knowed you'd back up when I drawed my roll on you."

"You ain't drawed no roll on me, Jelly. You ain't drawed nothing but your pocket. You better stop dat boogerbooing. Next time I'm liable to make you do it." There was a splinter of regret in his voice. If Jelly really had had some money, he might have staked him. Sweet Back, to a hot. Good Southern cornbread with a piano on a platter. Oh, well! The right broad would, or might, come along.

"Who boogerbooing?" Jelly snorted. "Jig, I don't have to. Talking about *me* with a beat chick scoffing a hot dog! You must of not

seen me, 'cause last night I was riding round in a Yellow Cab, with a yellow gal, drinking yellow likker and spending yellow money. Tell 'em 'bout me, tell 'em!''

"Git out of my face, Jelly! Dat broad I seen you with wasn't no pe-ola. She was one of them coal-scuttle blondes with hair just as close to her head as ninety-nine is to a hundred. She look-ted like she had seventy-five pounds of clear bosom, guts in her feet, and she look-ted like six months in front and nine months behind. Buy you a whiskey still! Dat broad couldn't make the down payment on a pair of sox.''

"Sweet Back, you fixing to talk out of place." Jelly stiffened.

"If you trying to jump salty, Jelly, that's your mammy.''

"Don't play in de family, Sweet Back. I don't play de dozens. I done told you.''

"Who playing de dozens? You trying to get your hips up on your shoulders 'cause I said you was with a beat broad. One of them lam blacks.''

"Who? Me? Long as you been knowing me, Sweet Back, you ain't never seen me with nothing but pe-olas. I can get any frail eel I wants to. How come I'm up here in New York? You don't know, do you? Since youse dumb to the fact, I reckon I'll have to make you hep. I had to leave from down south 'cause Miss Anne used to worry me so bad to go with me. Who, me? Man, I don't deal in no coal. Know what I tell 'em? If they's white, they's right! If they's yellow, they's mellow! If they's brown, they can stick around. But if they come black, they better git way back! Tell 'em bout me!''

"Aw, man, you trying to show your grandma how to milk ducks. Best you can do is to confidence some kitchen-mechanic out of a dime or two. Me, I knocks de pad with them cack-broads up on Sugar Hill, and fills 'em full of melody. Man, I'm quick death and easy judgment. Youse just a home-boy, Jelly. Don't try to follow me.''

"Me follow *you!* Man, I come on like the Gang Busters, and go off like The March of Time! If dat ain't so, God is gone to Jersey City and you know He wouldn't be messing 'round a place like

that. Know what my woman done? We hauled off and went to church last Sunday, and when they passed 'round the plate for the *penny* collection, I throwed in a dollar. De man looked at me real hard for dat. Dat made my woman mad, so she called him back and throwed in a twenty dollar bill! Told him to take dat and go! Dat's what he got for looking at me 'cause I throwed in a dollar.''

"Jelly, de wind may blow and de door may slam; dat what you shooting ain't worth a damn!''

Jelly slammed his hand in his bosom as if to draw a gun. Sweet Back did the same.

"If you wants to fight, Sweet Back, the favor is in me.''

"I was deep-thinking then, Jelly. It's a good thing I ain't short-tempered. 'T'aint nothing to you, nohow. You ain't hit me yet.''

Both burst into a laugh and changed from fighting to lounging poses.

"Don't get too yaller on me, Jelly. You liable to get hurt some day.''

"You over-sports your hand your ownself. Too blamed astor-perious. I just don't pay you no mind. Lay de skin on me!''

They broke their handshake hurriedly, because both of them looked up the Avenue and saw the same thing. It was a girl and they both remembered that it was Wednesday afternoon. All of the domestics off for the afternoon with their pay in their pockets. Some of them bound to be hungry for love. That meant a dinner, a shot of scrap-iron, maybe room rent and a reefer or two. Both went into the pose and put on the look.

"Big stars falling!'' Jelly said out loud when she was in hearing distance. "It must be just before day!''

"Yeah, man!'' Sweet Back agreed. "Must be a recess in Heaven—pretty angel like that out on the ground.''

The girl drew abreast of them, reeling and rocking her hips.

"I'd walk clear to Diddy-Wah-Diddy to get a chance to speak to a pretty lil' ground-angel like that,'' Jelly went on.

"Aw, man, you ain't willing to go very far. Me, I'd go slap to Ginny-Gall, where they eat cow-rump, skin and all.''

The girl smiled, so Jelly set his hat and took the plunge.

"Baby," he crooned, "what's on de rail for de lizard?"

The girl halted and braced her hips with her hands. "A Zigaboo down in Georgy, where I come from, asked a woman that one time and the judge told him 'ninety days.' "

"Georgy!" Sweet Back pretended to be elated. "Where 'bouts in Georgy is you from? Delaware?"

"Delaware?" Jelly snorted. "My people! My people! Free schools and dumb jigs! Man, how you going to put Delaware in Georgy? You ought to know dat's in Maryland."

"Oh, don't try to make out youse no northerner, you! Youse from right down in 'Bam your ownself!" The girl turned on Jelly.

"Yeah, I'm *from* there and I aims to stay from there."

"One of them Russians, eh?" the girl retorted. "Rushed up here to get away from a job of work."

That kind of talk was not leading towards the dinner table.

"But baby!" Jelly gasped. "Dat shape you got on you! I bet the Coca Cola Company is paying you good money for the patent!"

The girl smiled with pleasure at this, so Sweet Back jumped in.

"I know youse somebody swell to know. Youse real people. You grins like a regular fellow." He gave her his most killing look and let it simmer in. "These dickty jigs round here tries to smile. S'pose you and me go inside the café here and grab a hot?"

"You got any money?" the girl asked, and stiffened like a ram-rod. "Nobody ain't pimping on me. You dig me?"

"Aw, now, baby!"

"I seen you two mullet-heads before. I was uptown when Joe Brown had you all in the go-long last night. Dat cop sure hates a pimp! All he needs to see is the pimps' salute, and he'll out with his night-stick and whip your head to the red. Beat your head just as flat as a dime!" She went off into a great blow of laughter.

"Oh, let's us don't talk about the law. Let's talk about us," Sweet Back persisted. "You going inside with me to holler 'let one come flopping! One come grunting! Snatch one from de rear!' "

"Naw indeed!" the girl laughed harshly. "You skillets is trying to promote a meal on me. But it'll never happen, brother. You

barking up the wrong tree. I wouldn't give you air if you was stopped up in a jug. I'm not putting out a thing. I'm just like the cemetery—I'm not putting out, I'm taking in! Dig?"

"I'll tell you like the farmer told the potato—plant you now and dig you later."

The girl made a movement to switch on off. Sweet Back had not dirtied a plate since the day before. He made a weak but desperate gesture.

"Trying to snatch my pocketbook, eh?" she blazed. Instead of running, she grabbed hold of Sweet Back's draping coat-tail and made a slashing gesture. "How much split you want back here? If your feets don't hurry up and take you 'way from here, you'll *ride* away. I'll spread my lungs all over New York and call the law. Go ahead. Bedbug! Touch me! And I'll holler like a pretty white woman!"

The boys were ready to flee, but she turned suddenly and rocked on off with her ear-rings snapping and her heels popping.

"My people! My people!" Sweet Back sighed.

"I know you feel chewed," Jelly said, in an effort to make it appear that he had had no part in the fiasco.

"Oh, let her go," Sweet Back said magnanimously. "When I see people without the periodical principles they's supposed to have, I just don't fool with 'em. What I want to steal her old pocketbook with all the money I got? I could buy a beat chick like her and give her away. I got money's mammy and Grandma change. One of my women, and not the best one I got neither, is buying me ten shag suits at one time."

He glanced sidewise at Jelly to see if he was convincing. But Jelly's thoughts were far away. He was remembering those full, hot meals he had left back in Alabama to seek wealth and splendor in Harlem without working. He had even forgotten to look cocky and rich.

GLOSSARY OF HARLEM SLANG

Air out leave, flee, stroll

Astorperious haughty, biggity

Aunt Hagar Negro race *(also Aunt Hagar's chillun)*

Bad hair Negro type hair

Balling having fun

'Bam, and *down in 'Bam* down South

Battle-hammed badly formed about the hips

Beating up your gums talking to no purpose

Beluthahatchie next station beyond Hell

Big boy stout fellow. But in the South, it means fool and is a prime insult.

Blowing your top getting very angry; occasionally used to mean, "He's doing fine!"

Boogie-woogie type of dancing and rhythm. For years, in the South, it meant secondary syphilis.

Brother-in-black Negro

Bull-skating Bragging

Butt sprung a suit or a skirt out of shape in the rear

Coal scuttle blonde black woman

Cold exceeding, well, etc., as in "He was cold on that trumpet!"

Collar a nod sleep

Collar a hot eat a meal

Color scale high yaller, yaller, high brown, vaseline brown, seal brown, low brown, dark black

Conk buster cheap liquor; also an intellectual Negro

Cruising parading down the Avenue. Variations: *oozing, percolating,* and *free-wheeling.* The latter implies more briskness.

Cut doing something well

Dark black a casually black person. Superlatives: *low black,* a blacker person; *lam black,* still blacker; and *damn black,* blackest man, of whom it is said: "Why, lightning bugs follow him at 12 o'clock in the day, thinking it's midnight."

Dat thing sex of either sex

Dat's your mammy same as, "So is your old man."

Diddy-Wah-Diddy a far place, a measure of distance. (2) another suburb of Hell, built since way before Hell wasn't no bigger than Baltimore. The folks in Hell go there for a big time.

Dig understand. "Dig me?" means, "Do you get me? Do you collar the jiver?"

Draped down dressed in the height of Harlem fashion; also *togged down.*

Dumb to the fact "You don't know what you're talking about."

Dusty butt cheap prostitute

Eight-rock very black person

Every postman on his beat kinky hair

First thing smoking a train. "I'm through with this town. I mean to grab the first thing smoking."

Frail eel pretty girl

Free schools a shortened expression of deprecation derived from "free schools and dumb Negroes," sometimes embellished with "free schools, pretty yellow teachers and dumb Negroes."

Function a small, unventilated dance, full of people too casually bathed

Gator-faced long, black face with big mouth

Getting on some stiff time really doing well with your racket

Get you to go power, physical or otherwise, to force the opponent to run

Ginny Gall a suburb of Hell, a long way off

Git up off of me quit talking about me, leave me alone

Go when the wagon comes another way of saying, "You may be acting biggity now, but you'll cool down when enough power gets behind you."

Good hair Caucasian-type hair

Granny Grunt a mythical character to whom most questions may be referred

Ground rations sex, also under rations

Gum beater a blowhard, a braggart, idle talker in general

Gut-bucket low dive, type of music, or expression from same

Gut-foot bad case of fallen arches

Handkerchief-head sycophant type of Negro; also an Uncle Tom

Hauling fleeing on foot. "Man! He cold hauled it!"

I don't deal in coal "I don't keep company with black women."

I'm cracking but I'm facking "I'm wisecracking, but I'm telling the truth."

Inky dink very black person

I shot him lightly and he died politely "I completely outdid him."

Jar head Negro man

Jelly sex

Jig Negro, a corrupted shortening of Zigaboo

Jook a pleasure house, in the class of gut-bucket; now common all over the South

Jooking playing the piano, guitar, or any musical instrument in the manner of the Jooks (pronounced like "took") (2) dancing and 'scronching,' ditto

Juice liquor

July jam something very hot

Jump salty get angry

Kitchen mechanic a domestic

Knock yourself out have a good time

Lightly, slightly and politely doing things perfectly

Little sister measure of hotness: "Hot as little sister!"

Liver-lip pendulous, thick purple lips

Made hair hair that has been straightened

Mammy a term of insult. Never used in any other way by Negroes.

Miss Anne a white woman

Mister Charlie a white man

Monkey chaser a West Indian

Mug Man small-time thug or gangster

My people! My people! Sad and satiric expression in the Negro language; sad when a Negro comments on the backwardness of some members of his race; at other times, used for satiric or comic effect.

Naps kinky hair

Nearer my God to Thee good hair

Nothing to the bear but his curly hair "I call your bluff," or "Don't be afraid of him; he won't fight."

Now you cookin' with gas now you're talking, in the groove, etc.

Ofay white person

Old cuffee Negro (genuine African word for the same thing)

Palmer House walking flat-footed, as from fallen arches

Pancake a humble type of Negro

Park ape an ugly, underprivileged Negro

Peckerwood poor and unloved class of Southern whites

Peeping through my likkers carrying on even though drunk

Pe-ola a very white Negro girl

Piano spare ribs (white rib-bones suggest piano keys)

Pig meat young girl

Pilch house or apartment; residence

Pink toes yellow girl

Playing the dozens low-rating the ancestors of your opponent

Red neck poor Southern white man

Reefer marijuana cigarette, also *a drag*

Righteous mass or grass good hair

Righteous rags the components of a Harlem-style suit

Rug-cutter originally a person frequenting house-rent parties, cutting up the rugs of the host with his feet; a person too cheap or poor to patronize regular dance halls; now means a good dancer.

Russian a Southern Negro up north. "Rushed up here," hence a Russian.

Scrap iron cheap liquor

Sell out run in fear

Sender he or she who can get you to go, i.e., has what it takes. Used often as a compliment: "He's a solid sender!"

Smoking, or *smoking over* looking someone over

Solid perfect

Sooner anything cheap and mongrel, now applied to cheap clothes, or a shabby person

Stanch, or stanch out to begin, commence, step out

Stomp low dance, "but hat man!"

Stormbuzzard shiftless, homeless character

Stroll doing something well

Sugar Hill northwest sector of Harlem, near Washington Heights, site of the newest apartment houses, mostly occupied by professional people. (The expression has been distorted in the South to mean a Negro red light district.)

The bear confession of poverty

The big apple, also *the big red apple* New York City

The man the law, or powerful boss

Thousand on a plate beans

Tight head one with kinky hair

Trucking strolling. (2) dance step from the strolling motif

V and X five-and-ten-cent store

West Hell another suburb of Hell, worse than the original

What's on the rail for the lizard? suggestion for moral turpitude

Whip it to the red beat your head until it is bloody

Woofing aimless talk, as a dog barks on a moonless night

Young suit ill-fitting, too small. Observers pretend to believe you're breaking in your little brother's suit for him.

Your likker told you misguided
 behavior
Zigaboo a Negro
*Zoot suit with the reet
 pleat* Harlem style suit, padded shoulders, 43-inch trousers at the knee with cuff so small it needs a zipper to get into, high waistline, fancy lapels, bushels of buttons, etc.

High John
De Conquer

Maybe, now, we used-to-be black African folks can be of some help to our brothers and sisters who have always been white. You will take another look at us and say that we are still black and, ethnologically speaking, you will be right. But nationally and culturally, we are as white as the next one. We have put our labor and our blood into the common causes for a long time. We have given the rest of the nation song and laughter. Maybe now, in this terrible struggle, we can give something else—the source and soul of our laughter and song. We offer you our hope-bringer, High John de Conquer.

High John de Conquer came to be a man, and a mighty man at that. But he was not a natural man in the beginning. First off, he was a whisper, a will to hope, a wish to find something worthy of laughter and song. Then the whisper put on flesh. His footsteps sounded across the world in a low but musical rhythm as if the world he walked on was a singing-drum. The black folks had an irresistible impulse to laugh. High John de Conquer was a man in full, and had come to live and work on the plantations, and all the slave folks knew him in the flesh.

The sign of this man was a laugh, and his singing-symbol was a drum-beat. No parading drum-shout like soldiers out for show. It did not call to the feet of those who were fixed to hear it. It was an inside thing to live by. It was sure to be heard when and where the work was the hardest, and the lot the most cruel. It helped the

slaves endure. They knew that something better was coming. So they laughed in the face of things and sang, "I'm so glad! Trouble don't last always." And the white people who heard them were struck dumb that they could laugh. In an outside way, this was Old Massa's fun, so what was Old Cuffy laughing for?

Old Massa couldn't know, of course, but High John de Conquer was there walking his plantation like a natural man. He was treading the sweat-flavored clods of the plantation, crushing out his drum tunes, and giving out secret laughter. He walked on the winds and moved fast. Maybe he was in Texas when the lash fell on a slave in Alabama, but before the blood was dry on the back he was there. A faint pulsing of a drum like a goat-skin stretched over a heart, that came nearer and closer, then somebody in the saddened quarters would feel like laughing, and say, "Now, High John de Conquer, Old Massa couldn't get the best of *him*. That old John was a case!" Then everybody sat up and began to smile. Yes, yes, that was right. Old John, High John could beat the unbeatable. He was top-superior to the whole mess of sorrow. He could beat it all, and what made it so cool, finish it off with a laugh. So they pulled the covers up over their souls and kept them from all hurt, harm and danger and made them a laugh and a song. Night time was a joke, because daybreak was on the way. Distance and the impossible had no power over High John de Conquer.

He had come from Africa. He came walking on the waves of sound. Then he took on flesh after he got here. The sea captains of ships knew that they brought slaves in their ships. They knew about those black bodies huddled down there in the middle passage, being hauled across the waters to helplessness. John de Conquer was walking the very winds that filled the sails of the ships. He followed over them like the albatross.

It is no accident that High John de Conquer has evaded the ears of white people. They were not supposed to know. You can't know what folks won't tell you. If they, the white people, heard some scraps, they could not understand because they had nothing to hear things like that with. They were nct looking for any hope in those days, and it was not much of a strain for them to find

something to laugh over. Old John would have been out of place for them.

Old Massa met our hope-bringer all right, but when Old Massa met him, he was not going by his right name. He was traveling, and touristing around the plantations as the laugh-provoking Brer Rabbit. So Old Massa and Old Miss and their young ones laughed with and at Brer Rabbit and wished him well. And all the time, there was High John de Conquer playing his tricks of making a way out of no-way. Hitting a straight lick with a crooked stick. Winning the jack pot with no other stake but a laugh. Fighting a mighty battle without outside-showing force, and winning his war from within. Really winning in a permanent way, for he was winning with the soul of the black man whole and free. So he could use it afterwards. For what shall it profit a man if he gain the whole world, and lose his own soul? You would have nothing but a cruel, vengeful, grasping monster come to power. John de Conquer was a bottom-fish. He was deep. He had the wisdom tooth of the East in his head. Way over there, where the sun rises a day ahead of time, they say that Heaven arms with love and laughter those it does not wish to see destroyed. He who carries his heart in his sword must perish. So says the ultimate law. High John de Conquer knew a lot of things like that. He who wins from within is in the "Be" class. *Be* here when the ruthless man comes, and *be* here when he is gone.

Moreover, John knew that it is written where it cannot be erased, that nothing shall live on human flesh and prosper. Old Maker said that before He made any more sayings. Even a man-eating tiger and lion can teach a person that much. His flabby muscles and mangy hide can teach an emperor right from wrong. If the emperor would only listen.

II

There is no established picture of what sort of looking-man this John de Conquer was. To some, he was a big, physical-looking man like John Henry. To others, he was a little, hammered-down, low-built man like the Devil's doll-baby. Some said that they never

heard what he looked like. Nobody told them, but he lived on the plantation where their old folks were slaves. He is not so well known to the present generation of colored people in the same way that he was in slavery time. Like King Arthur of England, he has served his people, and gone back into mystery again. And, like King Arthur, he is not dead. He waits to return when his people shall call again. Symbolic of English power, Arthur came out of the water, and with Excalibur, went back into the water again. High John de Conquer went back to Africa, but he left his power here, and placed his American dwelling in the root of a certain plant. Only possess that root, and he can be summoned at any time.

"Of course, High John de Conquer got plenty power!" Aunt Shady Anne Sutton bristled at me when I asked her about him. She took her pipe out of her mouth and stared at me out of her deeply wrinkled face. "I hope you ain't one of these here smart colored folks that done got so they don't believe nothing, and come here questionizing me so you can have something to poke fun at. Done got shamed of the things that brought us through. Make out 'tain't no such thing no more."

When I assured her that that was not the case, she went on.

"Sho John de Conquer means power. That's bound to be so. He come to teach and tell us. God don't leave nobody ignorant, you child. Don't care where He drops you down, He puts you on a notice. He don't want folks taken advantage of because they don't know. Now, back there in slavery time, us didn't have no power of protection, and God knowed it, and put us under watch-care. Rattlesnakes never bit no colored folks until four years after freedom was declared. That was to give us time to learn and to know. 'Course, I don't know nothing about slavery personal like. I wasn't born till two years after the Big Surrender. Then I wasn't nothing but a infant baby when I was born, so I couldn't know nothing but what they told me. My mama told me, and I know that she wouldn't mislead me, how High John de Conquer helped us out. He had done teached the black folks so they knowed a hundred years ahead of time that freedom was coming. Long

before the white folks knowed anything about it at all.

"These young Negroes reads they books and talk about the war freeing the Negroes, but Aye, Lord! A heap sees, but a few knows. 'Course, the war was a lot of help, but how come the war took place? They think they knows, but they don't. John de Conquer had done put it into the white folks to give us our freedom, that's what. Old Massa fought against it, but us could have told him that it wasn't no use. Freedom just *had* to come. The time set aside for it was there. That war was just a sign and a symbol of the thing. That's the truth! If I tell the truth about everything as good as I do about that, I can go straight to Heaven without a prayer."

Aunt Shady Anne was giving the inside feeling and meaning to the outside laughs around John de Conquer. He romps, he clowns, and looks ridiculous, but if you will, you can read something deeper behind it all. He is loping on off from the Tar Baby with a laugh.

Take, for instance, those words he had with Old Massa about stealing pigs.

Old John was working in Old Massa's house that time, serving around the eating table. Old Massa loved roasted young pigs, and had them often for dinner. Old John loved them too, but Massa never allowed the slaves to eat any at all. Even put aside the left-over and ate it next time. John de Conquer got tired of that. He took to stopping by the pig pen when he had a strong taste for pig-meat, and getting himself one, and taking it on down to his cabin and cooking it.

Massa began to miss his pigs, and made up his mind to squat for who was taking them and give whoever it was a good hiding. So John kept on taking pigs, and one night Massa walked him down. He stood out there in the dark and saw John kill the pig and went on back to the "big house" and waited till he figured John had it dressed and cooking. Then he went on down to the quarters and knocked on John's door.

"Who dat?" John called out big and bold, because he never dreamed that it was Massa rapping.

"It's me, John," Massa told him. "I want to come in."

"What you want, Massa? I'm coming right out."

"You needn't to do that, John. I want to come in."

"Naw, naw, Massa. You don't want to come into no old slave cabin. Youse too fine a man for that. It would hurt my feelings to see you in a place like this here one."

"I tell you I want to come in, John!"

So John had to open the door and let Massa in. John had seasoned that pig *down*, and it was stinking pretty! John knowed Old Massa couldn't help but smell it. Massa talked on about the crops and hound dogs and one thing and another, and the pot with the pig in it was hanging over the fire in the chimney and kicking up. The smell got better and better.

Way after while, when that pig had done simbled down to a low gravy, Massa said, "John, what's that you cooking in that pot?"

"Nothing but a little old weasly possum, Massa. Sickliest little old possum I ever did see. But I thought I'd cook him anyhow."

"Get a plate and give me some of it, John. I'm hungry."

"Aw, naw, Massa, you ain't hongry."

"Now, John, I don't mean to argue with you another minute. You give me some of that in the pot, or I mean to have the hide off of your back tomorrow morning. Give it to me!"

So John got up and went and got a plate and a fork and went to the pot. He lifted the lid and looked at Massa and told him, "Well, Massa, I put this thing in here a possum, but if it comes out a pig, it ain't no fault of mine."

Old Massa didn't want to laugh, but he did before he caught himself. He took the plate of brownded-down pig and ate it up. He never said nothing, but he gave John and all the other house servants roast pig at the big house after that.

III

John had numerous scrapes and tight squeezes, but he usually came out like Brer Rabbit. Pretty occasionally, though, Old Massa won the hand. The curious thing about this is, that there are no bitter tragic tales at all. When Old Massa won, the thing ended up in a laugh just the same. Laughter at the expense of the slave, but

laughter right on. A sort of recognition that life is not one-sided. A sense of humor that said, "We are just as ridiculous as anybody else. We can be wrong, too."

There are many tales, and variants of each, of how the Negro got his freedom through High John de Conquer. The best one deals with a plantation where the work was hard, and Old Massa mean. Even Old Miss used to pull her maids' ears with hot fire-tongs when they got her riled. So, naturally, Old John de Conquer was around that plantation a lot.

"What we need is a song," he told the people after he had figured the whole thing out. "It ain't here, and it ain't no place I knows of as yet. Us better go hunt around. This has got to be a particular piece of singing."

But the slaves were scared to leave. They knew what Old Massa did for any slave caught running off.

"Oh, Old Massa don't need to know you gone from here. How? Just leave your old work-tired bodies around for him to look at, and he'll never realize youse way off somewhere, going about your business."

At first they wouldn't hear to John, that is, some of them. But, finally, the weak gave in to the strong, and John told them to get ready to go while he went off to get something for them to ride on. They were all gathered up under a big hickory nut tree. It was noon time and they were knocked off from chopping cotton to eat their dinner. And then that tree was right where Old Massa and Old Miss could see from the cool veranda of the big house. And both of them were sitting out there to watch.

"Wait a minute, John. Where we going to get something to wear off like that. We can't go nowhere like you talking about dressed like we is."

"Oh, you got plenty things to wear. Just reach inside yourselves and get out all those fine raiments you been toting around with you for the last longest. They is in there, all right. I know. Get 'em out, and put 'em on."

So the people began to dress. And then John hollered back for them to get out their musical instruments so they could play music

on the way. They were right inside where they got their fine raiments from. So they began to get them out. Nobody remembered that Massa and Miss were setting up there on the veranda looking things over. So John went off for a minute. After that they all heard a big sing of wings. It was John come back, riding on a great black crow. The crow was so big that one wing rested on the morning, while the other dusted off the evening star.

John lighted down and helped them, so they all mounted on, and the bird took out straight across the deep blue sea. But it was a pearly blue, like ten squillion big pearl jewels dissolved in running gold. The shore around it was all grainy gold itself.

Like Jason in search of the golden fleece, John and his party went to many places, and had numerous adventures. They stopped off in Hell where John, under the name of Jack, married the Devil's youngest daughter and became a popular character. So much so, that when he and the Devil had some words because John turned the dampers down in old Original Hell and put some of the Devil's hogs to barbecue over the coals, John ran for High Chief Devil and won the election. The rest of his party was overjoyed at the possession of power and wanted to stay there. But John said no. He reminded them that they had come in search of a song. A song that would whip Old Massa's earlaps down. The song was not in Hell. They must go on.

The party escaped out of Hell behind the Devil's two fast horses. One of them was named Hallowed-Be-Thy-Name, and the other, Thy-Kingdom-Come. They made it to the mountain. Somebody told them that the Golden Stairs went up from there. John decided that since they were in the vicinity, they might as well visit Heaven.

They got there a little weary and timid. But the gates swung wide for them, and they went in. They were bathed, robed, and given new and shining instruments to play on. Guitars of gold, and drums, and cymbals and wind-singing instruments. They walked up Amen Avenue, and down Hallelujah Street, and found with delight that Amen Avenue was tuned to sing bass and alto. The west end was deep bass, and the east end alto. Hallelujah Street

was tuned for tenor and soprano, and the two promenades met right in front of the throne and made harmony by themselves. You could make any tune you wanted to by the way you walked. John and his party had a very good time at that and other things. Finally, by the way they acted and did, Old Maker called them up before His great workbench, and made them a tune and put it in their mouths. It had no words. It was a tune that you could bend and shape in most any way you wanted to fit the words and feelings that you had. They learned it and began to sing.

Just about that time a loud rough voice hollered, "You Tunk! You July! You Aunt Diskie!" Then Heaven went black before their eyes and they couldn't see a thing until they saw the hickory nut tree over their heads again. There was everything just like they had left it, with Old Massa and Old Miss sitting on the veranda, and Massa was doing the hollering.

"You all are taking a mighty long time for dinner," Massa said. "Get up from there and get on back to the field. I mean for you to finish chopping that cotton today if it takes all night long. I got something else, harder than that, for you to do tomorrow. Get a move on you!"

They heard what Massa said, and they felt bad right off. But John de Conquer took and told them, saying, "Don't pay what he say no mind. You know where you got something finer than this plantation and anything it's got on it, put away. Ain't that funny? Us got all that, and he don't know nothing at all about it. Don't tell him nothing. Nobody don't have to know where us gets our pleasure from. Come on. Pick up your hoes and let's go."

They all began to laugh and grabbed up their hoes and started out.

"Ain't that funny?" Aunt Diskie laughed and hugged herself with secret laughter. "Us got all the advantage, and Old Massa think he got us tied!"

The crowd broke out singing as they went off to work. The day didn't seem hot like it had before. Their gift song came back into their memories in pieces, and they sang about glittering new robes and harps, and the work flew.

IV

So after a while, freedom came. Therefore High John de Conquer has not walked the winds of America for seventy-five years now. His people had their freedom, their laugh and their song. They have traded it to the other Americans for things they could use like education and property, and acceptance. High John knew that that was the way it would be, so he could retire with his secret smile into the soil of the South and wait.

The thousands upon thousands of humble people who still believe in him, that is, in the power of love and laughter to win by their subtle power, do John reverence by getting the root of the plant in which he has taken up his secret dwelling, and "dressing" it with perfume, and keeping it on their person, or in their houses in a secret place. It is there to help them overcome things they feel that they could not beat otherwise, and to bring them the laugh of the day. John will never forsake the weak and the helpless, nor fail to bring hope to the hopeless. That is what they believe, and so they do not worry. They go on and laugh and sing. Things are bound to come out right tomorrow. That is the secret of Negro song and laughter.

So the brother in black offers to these United States the source of courage that endures, and laughter. High John de Conquer. If the news from overseas reads bad, and the nation inside seems like it is stuck in the Tar Baby, listen hard, and you will hear John de Conquer treading on his singing-drum. You will know then, that no matter how bad things look now, it will be worse for those who seek to oppress us. Even if your hair comes yellow, and your eyes are blue, John de Conquer will be working for you just the same. From his secret place, he is working for all America now. We are all his kinfolks. Just be sure our cause is right, and then you can lean back and say, "John de Conquer would know what to do in a case like this, and then he would finish it off with a laugh."

White America, take a laugh out of our black mouths, and win! We give you High John de Conquer.

Hurricane*

Since Tea Cake and Janie had friended with the Bahaman workers in the 'Glades, they, the "Saws," had been gradually drawn into the American crowd. They quit hiding out to hold their dances when they found that their American friends didn't laugh at them as they feared. Many of the Americans learned to jump and liked it as much as the "Saws." So they began to hold dances night after night in the quarters, usually behind Tea Cake's house. Often now, Tea Cake and Janie stayed up so late at the fire dances that Tea Cake would not let her go with him to the field. He wanted her to get her rest.

So she was home by herself one afternoon when she saw a band of Seminoles passing by. The men walking in front and the laden, stolid women following them like burros. She had seen Indians several times in the 'Glades, in twos and threes, but this was a large party. They were headed towards the Palm Beach road and kept moving steadily. About an hour later another party appeared and went the same way. Then another just before sundown. This time she asked where they were all going and at last one of the men answered her.

"Going to high ground. Saw-grass bloom. Hurricane coming."

Everybody was talking about it that night. But nobody was worried. The fire dance kept up till nearly dawn. The next day,

*From *Their Eyes Were Watching God*

149

more Indians moved east, unhurried but steady. Still a blue sky
and fair weather. Beans running fine and prices good, so the
Indians could be, *must* be, wrong. You couldn't have a hurricane
when you're making seven and eight dollars a day picking beans.
Indians are dumb anyhow, always were. Another night of Stew
Beef making dynamic subtleties with his drum and living, sculp-
tural, grotesques in the dance. Next day, no Indians passed at all.
It was hot and sultry and Janie left the field and went home.

Morning came without motion. The winds, to the tiniest, lisping
baby breath had left the earth. Even before the sun gave light,
dead day was creeping from bush to bush watching man.

Some rabbits scurried through the quarters going east. Some
possums slunk by and their route was definite. One or two at a
time, then more. By the time the people left the fields the proces-
sion was constant. Snakes, rattlesnakes began to cross the quar-
ters. The men killed a few, but they could not be missed from the
crawling horde. People stayed indoors until daylight. Several
times during the night Janie heard the snort of big animals like
deer. Once the muted voice of a panther. Going east and east. That
night the palm and banana trees began that long distance talk with
rain. Several people took fright and picked up and went in to Palm
Beach anyway. A thousand buzzards held a flying meet and then
went above the clouds and stayed.

One of the Bahaman boys stopped by Tea Cake's house in a car
and hollered. Tea Cake came out throwin' laughter over his shoul-
der into the house.

"Hello Tea Cake."

"Hello 'Lias. You leavin', Ah see."

"Yeah man. You and Janie wanta go? Ah wouldn't give nobody
else uh chawnce at uh seat till Ah found out if you all had any way
tuh go."

"Thank yuh ever so much, 'Lias. But we 'bout decided tuh
stay."

"De crow gahn up, man."

"Dat ain't nothin'. You ain't seen de bossman go up, is yuh?
Well all right now. Man, de money's too good on de muck. It's

liable tuh fair off by tuhmorrer. Ah wouldn't leave if Ah wuz you.''

"Mah uncle come for me. He say hurricane warning out in Palm Beach. Not so bad dere, but man, dis muck is too low and dat big lake is liable tuh bust.''

"Ah naw, man. Some boys in dere now talkin' 'bout it. Some of 'em been in de 'Glades fuh years. 'Tain't nothin' but uh lil blow. You'll lose de whole day tuhmorrer tryin' tuh git back out heah.''

"De Indians gahn east, man. It's dangerous.''

"Dey don't always know. Indians don't know much uh nothin', tuh tell de truth. Else dey'd own dis country still. De white folks ain't gone nowhere. Dey oughta know if it's dangerous. You better stay heah, man. Big jumpin' dance tuhnight right heah, when it fair off.''

'Lias hesitated and started to climb out, but his uncle wouldn't let him. "Dis time tuhmorrer you gointuh wish you follow crow,'' he snorted and drove off. 'Lias waved back to them gaily.

"If Ah never see you no mo' on earth, Ah'll meet you in Africa.''

Others hurried east like the Indians and rabbits and snakes and coons. But the majority sat around laughing and waiting for the sun to get friendly again.

Several men collected at Tea Cake's house and sat around stuffing courage into each other's ears. Janie baked a big pan of beans and something she called sweet biscuits and they all managed to be happy enough.

Most of the great flame-throwers were there and naturally, handling Big John de Conquer and his works. How he had done everything big on earth, then went up tuh heben without dying atall. Went up there picking a guitar and got all de angels doing the ring-shout round and round de throne. Then everybody but God and Old Peter flew off on a flying race to Jericho and back and John de Conquer won the race; went on down to hell, beat the old devil and passed out ice water to everybody down there. Somebody tried to say that it was a mouth organ harp that John was playing, but the rest of them would not hear that. Don't care how good anybody could play a harp, God would rather to hear a guitar. That brought them back to Tea Cake. How come he

couldn't hit that box a lick or two? Well, all right now, make us know it.

When it got good to everybody, Muck-Boy woke up and began to chant with the rhythm and everybody bore down on the last word of the line:

> Yo' mama don't wear no Draws
> Ah seen her when she took 'em Off
> She soaked 'em in alcoHol
> She sold 'em tuh de Santy Claus
> He told her 'twas aginst de Law
> To wear dem dirty Draws

Then Muck-Boy went crazy through the feet and danced himself and everybody else crazy. When he finished he sat back down on the floor and went to sleep again. Then they got to playing Florida flip and coon-can. Then it was dice. Not for money. This was a show-off game. Everybody posing his fancy shots. As always it broiled down to Tea Cake and Motor Boat. Tea Cake with his shy grin and Motor Boat with his face like a little black cherubim just from a church tower doing amazing things with anybody's dice. The others forgot the work and the weather watching them throw. It was art. A thousand dollars a throw in Madison Square Garden wouldn't have gotten any more breathless suspense. It would have just been more people holding in.

After a while somebody looked out and said, "It ain't gitting no fairer out dere. B'lieve Ah'll git on over tuh mah shack." Motor Boat and Tea Cake were still playing so everybody left them at it.

Sometime that night the winds came back. Everything in the world had a strong rattle, sharp and short like Stew Beef vibrating the drum head near the edge with his fingers. By morning Gabriel was playing the deep tones in the center of the drum. So when Janie looked out of her door she saw the drifting mists gathered in the west—that cloud field of the sky—to arm themselves with thunders and march forth against the world. Louder and higher and lower and wider the sound and motion spread, mounting, sinking, darking.

It woke up old Okechobee and the monster began to roll in his bed. Began to roll and complain like a peevish world on a grumble. The folks in the quarters and the people in the big houses further around the shore heard the big lake and wondered. The people felt uncomfortable but safe because there were the seawalls to chain the senseless monster in his bed. The folks let the people do the thinking. If the castles thought themselves secure, the cabins needn't worry. Their decision was already made as always. Chink up your cracks, shiver in your wet beds and wait on the mercy of the Lord. The bossman might have the thing stopped before morning anyway. It is so easy to be hopeful in the day time when you can see the things you wish on. But it was night, it stayed night. Night was striding across nothingness with the whole round world in his hands.

A big burst of thunder and lightning that trampled over the roof of the house. So Tea Cake and Motor stopped playing. Motor looked up in his angel-looking way and said, "Big Massa draw him chair upstairs."

"Ah'm glad y'all stop dat crap-shootin' even if it wasn't for money," Janie said. "Ole Massa is doin' *His* work now. Us oughta keep quiet."

They huddled closer and stared at the door. They just didn't use another part of their bodies, and they didn't look at anything but the door. The time was past for asking the white folks what to look for through that door. Six eyes were questioning God.

Through the screaming wind they heard things crashing and things hurtling and dashing with unbelievable velocity. A baby rabbit, terror ridden, squirmed through a hole in the floor and squatted off there in the shadows against the wall, seeming to know that nobody wanted its flesh at such a time. And the lake got madder and madder with only its dikes between them and him.

In a little wind-lull, Tea Cake touched Janie and said, "Ah reckon you wish now you had of stayed in yo' big house 'way from such as dis, don't yuh?"

"Naw."

"Naw?"

"Yeah, naw. People don't die till dey time come nohow, don't keer where you at. Ah'm wid mah husband in uh storm, dat's all."

"Thanky, Ma'am. But 'sposing you wuz tuh die, now. You wouldn't git mad at me for draggin' yuh heah?"

"Naw. We been tuhgether round two years. If you kin see de light at daybreak, you don't keer if you die at dusk. It's so many people never seen de light at all. Ah wuz fumblin' round and God opened de door."

He dropped to the floor and put his head in her lap. "Well then, Janie, you meant whut you didn't say, 'cause Ah never *knowed* you wuz so satisfied wid me lak dat. Ah kinda thought—"

The wind came back with triple fury, and put out the light for the last time. They sat in company with the others in other shanties, their eyes straining against crude walls and their souls asking if He meant to measure their puny might against His. They seemed to be staring at the dark, but their eyes were watching God.

As soon as Tea Cake went out pushing wind in front of him, he saw that the wind and water had given life to lots of things that folks think of as dead and given death to so much that had been living things. Water everywhere. Stray fish swimming in the yard. Three inches more and the water would be in the house. Already in some. He decided to try to find a car to take them out of the 'Glades before worse things happened. He turned back to tell Janie about it so she could be ready to go.

"Git our insurance papers tuhgether, Janie. Ah'll tote mah box mahself and things lak dat."

"You got all de money out de dresser drawer, already?"

"Naw, git it quick and cut uh piece off de tablecloth tuh wrap it up in. Us liable tuh git wet tuh our necks. Cut uh piece uh dat oilcloth quick fuh our papers. We got tuh go, if it ain't too late. De dish can't bear it out no longer."

He snatched the oilcloth off the table and took out his knife. Janie held it straight while he slashed off a strip.

"But Tea Cake, it's too awful out dere. Maybe it's better tuh stay heah in de wet than it is tuh try tuh—"

He stunned the argument with half a word. "Fix," he said and fought his way outside. He had seen more than Janie had.

Janie took a big needle and ran up a longish sack. Found some newspaper and wrapped up the paper money and papers and thrust them in and whipped over the open end with her needle. Before she could get it thoroughly hidden in the pocket of her overalls, Tea Cake burst in again.

" 'Tain't no cars, Janie."

"Ah thought not! Whut we gointuh do now?"

"We got tuh walk."

"In all dis weather, Tea Cake? Ah don't b'lieve Ah could make it out de quarters."

"Oh yeah you kin. Me and you and Motor Boat kin all lock arms and hold one 'nother down. Eh, Motor?"

"He's sleep on de bed in yonder," Janie said. Tea Cake called without moving.

"Motor Boat! You better git up from dere! Hell done broke loose in Georgy. Dis minute! How kin you sleep at uh time lak dis? Water knee deep in de yard."

They stepped out in water almost to their buttocks and managed to turn east. Tea Cake had to throw his box away, and Janie saw how it hurt him. Dodging flying missiles, floating dangers, avoiding stepping in holes and warmed on the wind now at their backs until they gained comparatively dry land. They had to fight to keep from being pushed the wrong way and to hold together. They saw other people like themselves struggling along. A house down, here and there, frightened cattle. But above all the drive of the wind and the water. And the lake. Under its multiplied roar could be heard a mighty sound of grinding rock and timber and a wail. They looked back. Saw people trying to run in raging waters and screaming when they found they couldn't. A huge barrier of the makings of the dike to which the cabins had been added was rolling and tumbling forward. Ten feet higher and as far as they could see the muttering wall advanced before the braced-up waters like a road crusher on a cosmic scale. The monstropolous beast had left his bed. The two hundred miles an hour

wind had loosed his chains. He seized hold of his dikes and ran forward until he met the quarters; uprooted them like grass and rushed on after his supposed-to-be conquerors, rolling the dikes, rolling the houses, rolling the people in the houses along with other timbers. The sea was walking the earth with a heavy heel.

"De lake is comin'!" Tea Cake gasped.

"De lake!" In amazed horror from Motor Boat, "De lake!"

"It's comin' behind us!" Janie shuddered. "Us can't fly."

"But we still kin run," Tea Cake shouted and they ran. The gushing water ran faster. The great body was held back, but rivers spouted through fissures in the rolling wall and broke like day. The three fugitives ran past another line of shanties that topped a slight rise and gained a little. They cried out as best they could, "De lake is comin'!" and barred doors flew open and others joined them in flight crying the same as they went. "De lake is comin'!" and the pursuing waters growled and shouted ahead, "Yes, Ah'm comin'!" and those who could fled on.

They made it to a tall house on a hump of ground and Janie said, "Less stop heah. Ah can't make it no further. Ah'm done give out."

"All of us is done give out," Tea Cake corrected. "We'se goin' inside out dis weather, kill or cure." He knocked with the handle of his knife, while they leaned their faces and shoulders against the wall. He knocked once more then he and Motor Boat went round to the back and forced a door. Nobody there.

"Dese people had mo' sense than Ah did," Tea Cake said as they dropped to the floor and lay there panting. "Us oughta went on wid 'Lias lak he ast me."

"You didn't know," Janie contended. "And when yuh don't know, yuh just don't know. De storms might not of come sho nuff."

They went to sleep promptly but Janie woke up first. She heard the sound of rushing water and sat up.

"Tea Cake! Motor Boat! De lake is comin'!"

The lake was coming on. Slower and wider, but coming. It had trampled on most of its supporting wall and lowered its front by

spreading. But it came muttering and grumbling onward like a tired mammoth just the same.

"Dis is uh high tall house. Maybe it won't reach heah at all," Janie counselled. "And if it do, maybe it won't reach tuh de upstairs part."

"Janie, Lake Okechobee is forty miles wide and sixty miles long. Dat's uh whole heap uh water. If dis wind is shovin' dat whole lake disa way, dis house ain't nothin' tuh swaller. Us better go. Motor Boat!"

"Whut you want, man?"

"De lake is comin'!"

"Aw, naw it 'tain't."

"Yes, it is so comin'! Listen! You kin hear it way off."

"It kin jus' come on. Ah'll wait right here."

"Aw, get up, Motor Boat! Less make it tuh de Palm Beach road. Dat's on uh fill. We'se pretty safe dere."

"Ah'm safe here, man. Go ahead if yuh wants to. Ah'm sleepy."

"What you gointuh do if de lake reach heah?"

"Go upstairs."

"S'posing it come up dere?"

"Swim, man. Dat's all."

"Well, uh, good bye, Motor Boat. Everything is pretty bad, yuh know. Us might git missed of one 'nother. You sho is a grand friend fuh uh man tuh have."

"Good bye, Tea Cake. Y'all oughta stay here and sleep, man. No use in goin' off and leavin' me lak dis."

"We don't wanta. Come on wid us. It might be night time when de water hem you up in heah. Dat's how come Ah won't stay. Come on, man."

"Tea Cake Ah got tuh have mah sleep. Definitely."

"Good bye, then, Motor. Ah wish you all de luck. Goin' over tuh Nassau fuh dat visit widja when all dis is over."

"Definitely, Tea Cake. Mah mama's house is yours."

Tea Cake and Janie were some distance from the house before they struck serious water. Then they had to swim a distance, and Janie could not hold up more than a few strokes at a time, so Tea

Cake bore her up till finally they hit a ridge that led on towards the fill. It seemed to him the wind was weakening a little so he kept looking for a place to rest and catch his breath. His wind was gone. Janie was tired and limping but she had not had to do that hard swimming in the turbulent waters, so Tea Cake was much worse off. But they couldn't stop. Gaining the fill was something but it was no guarantee. The lake was coming. They had to reach the six-mile bridge. It was high and safe perhaps.

Everybody was walking the fill. Hurrying, dragging, falling, crying, calling out names hopefully and hopelessly. Wind and rain beating on old folks and beating on babies. Tea Cake stumbled once or twice in his weariness and Janie held him up. So they reached the bridge at Six Mile Bend and thought to rest.

But it was crowded. White people had pre-empted that point of elevation and there was no more room. They could climb up one of its high sides and down the other, that was all. Miles further on, still no rest.

They passed a dead man in a sitting position on a hummock, entirely surrounded by wild animals and snakes. Common danger made common friends. Nothing sought a conquest over the other.

Another man clung to a cypress tree on a tiny island. A tin roof of a building hung from the branches by electric wires and the wind swung it back and forth like a mighty ax. The man dared not move a step to his right lest this crushing blade split him open. He dared not step left for a large rattlesnake was stretched full length with his head in the wind. There was a strip of water between the island and the fill, and the man clung to the tree and cried for help.

"De snake won't bite yuh," Tea Cake yelled to him. "He skeered tuh go intuh uh coil. Skeered he'll be blowed away. Step round dat side and swim off!"

Soon after that Tea Cake felt he couldn't walk anymore. Not right away. So he stretched long side of the road to rest. Janie spread herself between him and the wind and he closed his eyes and let the tiredness seep out of his limbs. On each side of the fill was a great expanse of water like lakes—water full of things living and dead. Things that didn't belong in water. As far as the eye

could reach, water and wind playing upon it in fury. A large piece of tar-paper roofing sailed through the air and scudded along the fill until it hung against a tree. Janie saw it with joy. That was the very thing to cover Tea Cake with. She could lean against it and hold it down. The wind wasn't quite so bad as it was anyway. The very thing. Poor Tea Cake!

She crept on hands and knees to the piece of roofing and caught hold of it by either side. Immediately the wind lifted both of them and she saw herself sailing off the fill to the right, out and out over the lashing water. She screamed terribly and released the roofing which sailed away as she plunged downward into the water.

"Tea Cake!" He heard her and sprang up. Janie was trying to swim but fighting water too hard. He saw a cow swimming slowly towards the fill in an oblique line. A massive built dog was sitting on her shoulders and shivering and growling. The cow was approaching Janie. A few strokes would bring her there.

"Make it tuh de cow and grab hold of her tail! Don't use yo' feet. Jus' yo' hands is enough. Dat's right, come on!"

Janie achieved the tail of the cow and lifted her head up along the cow's rump, as far as she could above water. The cow sunk a little with the added load and thrashed a moment in terror. Thought she was being pulled down by a gator. Then she continued on. The dog stood up and growled like a lion, stiff-standing hackles, stiff muscles, teeth uncovered as he lashed up his fury for the charge. Tea Cake split the water like an otter, opening his knife as he dived. The dog raced down the back-bone of the cow to the attack and Janie screamed and slipped far back on the tail of the cow, just out of reach of the dog's angry jaws. He wanted to plunge in after her but dreaded the water, somehow. Tea Cake rose out of the water at the cow's rump and seized the dog by the neck. But he was a powerful dog and Tea Cake was over-tired. So he didn't kill the dog with one stroke as he had intended. But the dog couldn't free himself either. They fought and somehow he managed to bite Tea Cake high up on his cheek-bone once. Then Tea Cake finished him and sent him to the bottom to stay there. The cow relieved of a great weight was landing on the fill with

Janie before Tea Cake stroked in and crawled weakly upon the fill again.

Janie began to fuss around his face where the dog had bitten him but he said it didn't amount to anything. "He'd uh raised hell though if he had uh grabbed me uh inch higher and bit me in mah eye. Yuh can't buy eyes in de store, yuh know." He flopped to the edge of the fill as if the storm wasn't going on at all. "Lemme rest awhile, then us got tuh make it on intuh town somehow."

It was next day by the sun and the clock when they reached Palm Beach. It was years later by their bodies. Winters and winters of hardship and suffering. The wheel kept turning round and round. Hope, hopelessness and despair. But the storm blew itself out as they approached the city of refuge.

Havoc was there with her mouth wide open. Back in the Everglades the wind had romped among lakes and trees. In the city it had raged among houses and men. Tea Cake and Janie stood on the edge of things and looked over the desolation.

"How kin Ah find uh doctor fuh yo' face in all dis mess?" Janie wailed.

"Ain't got de damn doctor tuh study 'bout. Us needs uh place tuh rest."

A great deal of their money and perseverance and they found a place to sleep. It was just that. No place to live at all. Just sleep. Tea Cake looked all around and sat heavily on the side of the bed.

"Well," he said humbly, "reckon you never 'spected tuh come tuh dis when you took up wid me, didja?"

"Once upon uh time, Ah never 'spected nothin' Tea Cake but bein' dead from the standin' still and tryin' tuh laugh. But you come 'long and made somethin' outa me. So Ah'm thankful fuh anything we come through together."

"Thanky, Ma'am."

"You was twice noble tuh save me from dat dawg. Tea Cake, Ah don't speck you seen his eyes lak Ah did. He didn't aim fuh jus' bite me, Tea Cake. He aimed tuh kill me stone dead. Ah'm never tuh fuhgit dem eyes. He wuzn't nothin' all over but pure hate. Wonder where he come from?"

"Yeah, Ah did see 'im too. It wuz frightenin'. Ah didn't mean tuh take his hate neither. He had tuh die uh me one. Mah switch blade said it wuz him."

"Po' me, he'd tore me tuh pieces, if it wuzn't fuh you, honey."

"You don't have tuh say, if it wuzn't fuh me, baby, cause Ah'm *heah,* and then Ah want yuh tuh know it's uh man heah."

The Conscience of the Court

The clerk of the court took a good look at the tall brown-skinned woman with the head rag on. She sat on the third bench back with a husky officer beside her.

"The People versus Laura Lee Kimble!"

The policeman nudged the woman to get to her feet and led her up to the broad rail. She stood there, looking straight ahead. The hostility in the room reached her without her seeking to find it.

Unpleasant things were ahead of Laura Lee Kimble, but she was ready for this moment. It might be the electric chair or the rest of her life in some big lonesome jail house, or even torn to pieces by a mob, but she had passed three long weeks in jail. She had come to the place where she could turn her face to the wall and feel neither fear nor anguish. So this here so-called trial was nothing to her but a form and a fashion and an outside show to the world. She could stand apart and look on calmly. She stood erect and looked up at the judge.

"Charged with felonious and aggravated assault. Mayhem. Premeditated attempted murder on the person of one Clement Beasley. Obscene and abusive language. Laura Lee Kimble, how do you plead?"

Laura Lee was so fascinated by the long-named things that they were accusing her of that she stood there tasting over the words. *Lawdy me!* she mused inside herself. *Look like I done every crime excepting habeas corpus and stealing a mule.*

162

"Answer the clerk!" The officer nudged Laura Lee. "Tell him how you plead."

"Plead? Don't reckon I make out just what you all mean by that." She looked from face to face and at last up at the judge, with bewilderment in her eyes. She found him looking her over studiously.

The judge understood the look in her face, but he did not interfere so promptly as he ordinarily would have. This was the man-killing bear cat of a woman that he had heard so much about. Though spare of fat, she was built strongly enough, all right. An odd Negro type. Gray-green eyes, large and striking, looking out of a chestnut-brown face. A great abundance of almost straight hair only partially hidden by the high-knotted colored kerchief about her head. Somehow this woman did not look fierce to him at all. Yet she had beaten a man within an inch of his life. Here was a riddle to solve. With the proud, erect way she held herself, she might be some savage queen. The shabby housedress she had on detracted nothing from this impression. She was a challenge to him somehow or other.

"Perhaps you don't understand what the clerk means, Laura," the judge found himself saying to her in a gentle voice. "He wants you to say whether you are guilty of the charges or not."

"Oh, I didn't know. Didn't even know if he was talking to me or not. Much obliged to you, sir." Laura Lee sent His Honor a shy smile. " 'Deed I don't know if I'm guilty or not. I hit the man after he hit me, to be sure, Mister Judge, but if I'm guilty I don't know for sure. All them big words and all."

The clerk shook his head in exasperation and quickly wrote something down. Laura Lee turned her head and saw the man on the hospital cot swaddled all up in bandage rags. Yes, that was the very man who caused her to be here where she was.

"All right, Laura Lee," the judge said. "You can take your seat now until you are called on."

The prosecutor looked a question at the judge and said, "We can proceed." The judge nodded, then halted things as he looked down at Laura Lee.

"The defendant seems to have no lawyer to represent her."
Now he leaned forward and spoke to Laura Lee directly. "If you
have no money to hire yourself a lawyer to look out for your
interests, the court will appoint one for you."

There was a pause, during which Laura Lee covered a lot of
ground. Then she smiled faintly at the judge and answered him.
"Naw sir, I thank you, Mister Judge. Not to turn you no short
answer, but I don't reckon it would do me a bit of good. I'm
mighty much obliged to you just the same."

The implications penetrated instantly and the judge flushed.
This unlettered woman had called up something that he had not
thought about for quite some time. The campus of the University
of Virginia and himself as a very young man there, filled with a
reverence for his profession amounting to an almost holy dedica-
tion. His fascination and awe as a professor traced the more than
two thousand years of growth of the concepts of human rights and
justice. That brought him to his greatest hero, John Marshall, and
his inner resolve to follow in the great man's steps, and even add
to interpretations of human rights if his abilities allowed. No, he
had not thought about all this for quite some time. The judge
flushed slowly and deeply.

Below him there, the prosecutor was moving swiftly, but some-
how his brisk cynicism offended the judge. He heard twelve
names called, and just like that the jury box was filled and sworn
in.

Rapidly now, witnesses took the stand, and their testimony was
all damaging to Laura Lee. The doctor who told how terribly
Clement Beasley had been hurt. Left arm broken above the elbow,
compound fracture of the forearm, two ribs cracked, concussion
of the brain and various internal injuries. Two neighbors who had
heard the commotion and arrived before the house in time to see
Laura Lee fling the plaintiff over the gate into the street. The six
arresting officers all got up and had their say, and it was very bad
for Laura Lee. A two-legged she-devil no less.

Clement Beasley was borne from his cot to the witness stand,
and he made things look a hundred times blacker. His very ap-

pearance aroused a bumble of pity, and anger against the defendant. The judge had to demand quiet repeatedly. Beasley's testimony blew strongly on the hot coals.

His story was that he had come in conflict with this defendant by loaning a sizable sum of money to her employer. The money was to be repaid at his office. When the date was long past due, he had gone to the house near the river, just off Riverside Drive, to inquire why Mrs. Clairborne had not paid him, nor even come to see him and explain. Imagine his shock when he wormed it out of the defendant that Mrs. Clairborne had left Jacksonville. Further, he detected evidence that the defendant was packing up the things in the house. The loan had been made, six hundred dollars, on the furnishings of the entire house. He had doubted that the furnishings were worth enough for the amount loaned, but he had wanted to be generous to a widow lady. Seeing the defendant packing away the silver, he was naturally alarmed, and the next morning went to the house with a moving van to seize the furniture and protect the loan. The defendant, surprised, attacked him as soon as he appeared at the front door, injured him as he was, and would have killed him if help had not arrived in time.

Laura Lee was no longer a spectator at her own trial. Now she was in a flaming rage. She would have leaped to her feet as the man pictured Miz' Celestine as a cheat and a crook, and again as he sat up there and calmly lied about the worth of the furniture. All of those wonderful antiques, this man making out that they did not equal his minching six hundred dollars! That lie was a sin and a shame! The People was a meddlesome and unfriendly passel and had no use for the truth. It brought back to her in a taunting way what her husband, Tom, had told her over and over again. This world had no use for the love and friending that she was ever trying to give.

It looked now that Tom could be right. Even Miz' Celestine had turnt her back on her. She was here in this place, the house of The People, all by herself. She had ever disbelieved Tom and had to get to be forty-nine before she found out the truth. Well, just as the old folks said, "It's never too long for a bull frog to wear a stiff-bosom

shirt. He's bound to get it dirtied some time or other.''

"You have testified," Laura Lee heard the judge talking, "that you came in contact with the defendant through a loan to Mrs. J. Stuart Clairborne, her employer, did you not?''

"Yes, Your Honor," Beasley answered promptly and glibly.

"That being true, the court cannot understand why that note was not offered in evidence.''

Beasley glanced quickly at the prosecutor and lowered his eyes. "I—I just didn't see why it was necessary, Your Honor. I have it, but——''

"It is not only pertinent, it is of the utmost importance to this case. I order it sent for immediately and placed in evidence.''

The tall, lean, black-haired prosecutor hurled a surprised and betrayed look at the bench, then, after a pause, said in a flat voice, "The State rests.''

What was in the atmosphere crawled all over Laura Lee like reptiles. The silence shouted that her goose was cooked. But even if the sentence was death, she didn't mind. Celestine Beaufort Clairborne had failed her. Her husband and all her folks had gone on before. What was there to be so happy to live for any more? She had writ that letter to Miz' Celestine the very first day that she had been placed in jail. Three weeks had gone by on their rusty ankles, and never one word from her Celestine. Laura Lee choked back a sob and gritted her teeth. You had to bear what was placed on your back for you to tote.

"Laura Lee Kimble," the judge was saying, "you are charged with serious felonies, and the law must take its course according to the evidence. You refused the lawyer that the court offered to provide for you, and that was a mistake on your part. However, you have a right to be sworn and tell the jury your side of the story. Tell them anything that might help you, so long as you tell the truth.''

Laura Lee made no move to get to her feet and nearly a minute passed. Then the judge leaned forward.

"Believe it or not, Laura Lee, this is a court of law. It is needful to hear both sides of every question before the court can reach a

conclusion and know what to do. Now, you don't strike me as a person that is unobliging at all. I believe if you knew you would be helping me out a great deal by telling your side of the story, you would do it.''

Involuntarily Laura Lee smiled. She stood up. "Yes, sir, Mister Judge. If I can be of some help to you, I sure will. And I thank you for asking me.''

Being duly sworn, Laura Lee sat in the chair to face the jury as she had been told to do.

"You jury-gentlemens, they asked me if I was guilty or no, and I still don't know whether I is or not. I am a unlearnt woman and common-clad. It don't surprise me to find out I'm ignorant about a whole heap of things. I ain't never rubbed the hair off of my head against no college walls and schooled out nowhere at all. All I'm able to do is to tell you gentlemens how it was and then you can tell me if I'm guilty or no.

"I would not wish to set up here and lie and make out that I never hit this plaintive back. Gentlemens, I ain't had no malice in my heart against the plaintive. I seen him only one time before he come there and commenced that fracas with me. That was three months ago, the day after Tom, my husband, died. Miz' Celestine called up the funeral home and they come and got Tom to fix him up so we could take him back to Georgia to lay him to rest. That's where us all come from, Chatham County—Savannah, that is.

"Then now, Miz' Celestine done something I have never knowed her to do be-fore. She put on her things and went off from home without letting me know where she was bound for. She come back afterwhile with this plaintive, which I had never seen before in all my borned days. I glimpsed him good from the kitchen where I was at, walking all over the dining room and the living room with Miz' Celestine and looking at things, but they was talking sort of low like, and I couldn't make out a word what they was talking about. I figgered that Miz' Celestine must of been kind of beside herself, showing somebody look like this plaintive all her fine things like that. Her things is fine and very scarce old antiques, and I know that she have been offered vast sums of

money for 'em, but she would never agree to part with none. Things that been handed down in both the Beaufort and the Clairborne families from way back. That little old minching six hundred dollars that the plaintive mentioned wouldn't even be worth one piece of her things, not to mention her silver. After a while they went off and when Miz' Celestine come back, she told me that everything had been taken care of and she had the tickets to Savannah in her purse.

"Bright and soon next morning we boarded the train for Savannah to bury Tom. Miz' Celestine done even more than she had promised Tom. She took him back like she had promised, so that he could be buried in our family lot, and he was covered with flowers, and his church and his lodges turned out with him, and he was put away like some big mogul of a king. Miz' Celestine was there sitting right along by my side all the time. Then me and Miz' Celestine come on back down here to Jacksonville by ourselves.

"And Mrs. Clairborne didn't run off to keep from paying nobody. She's a Clairborne, and before that, she was born a Beaufort. They don't owe nobody, and they don't run away. That ain't the kind of raising they gets. Miz' Clairborne's got money of her own, and lives off of the interest which she receives regular every six months. She went off down there to Miami Beach to sort of refresh herself and rest up her nerves. What with being off down here in Florida, away from all the folks she used to know, for three whole years, and cooped up there in her house, and remembering her dear husband being dead, and now Tom gone, and nobody left of the old family around excepting her and me, she was nervous and peaked like. It wasn't her, it was me that put her up to going off down there for a couple of months so maybe she would come back to herself. She never cheeped to me about borrowing no money from nobody, and I sure wasn't packing nothing up to move off when this plaintive come to the door. I was just gleaming up the silver to kill time whilst I was there by myself.

"And, gentlemens, I never tackled the plaintive just as soon as he mounted the porch like he said. The day before that, he had come there and asked-ed me if Miz' Clairborne was at home. I told

him no, and then he asked-ed me just when I expected her back.
I told him she was down at Miami Beach, and got the letter that
she had sent me so he could get her right address. He thanked me
and went off. Then the next morning, here he was back with a
great big moving wagon, rapped on the door and didn't use a bit
of manners and politeness this time. Without even a 'Good morn-
ing' he says for me to git out of his way because he come to haul
off all the furniture and things in the house and he is short for
time.

"You jury-gentlemens, I told him in the nicest way that I
knowed how that he must of been crazy. Miz' Celestine was off
from home and she had left me there as a kind of guardeen to look
after her house and things, and I sure couldn't so handy leave
nobody touch a thing in Mrs. Clairborne's house unlessen she was
there and said so.

"He just looked at me like I was something that the buzzards
laid and the sun hatched out, and told me to move out of his way
so he could come on in and get his property. I propped myself and
braced one arm across the doorway to bar him out, reckoning he
would have manners enough to go on off. But, no! He flew just as
hot as Tucker when the mule kicked his mammy and begun to
cuss and double-cuss me, and call me all out of my name, some-
thing nobody had never done be-fore in all my borned days. I took
it to keep from tearing up peace and agreement. Then he balled
up his fistes and demanded me to move 'cause he was coming in.

" 'Aw, naw you ain't,' I told him. 'You might think that you's
going to grow horns, but I'm here to tell you you'll die butt-
headed.'

"His mouth slewed one-sided and he hauled off and hit me in
my chest with his fist two times. Hollered that nothing in the
drugstore would kill me no quicker than he would if I didn't git
out of his way. I didn't, and then he upped and kicked me.

"I jumped as salty as the 'gator when the pond went dry. I
stretched out my arm and he hit the floor on a prone. Then, that
truck with the two men on it took off from there in a big hurry.
All I did next was to grab him by his heels and frail the pillar of the

porch with him a few times. I let him go, but he just laid there like a log.

" 'Don't you lay there, making out you's dead, sir!' I told him. 'Git up from there, even if you is dead, and git on off this place!'

"The contrary scamp laid right there, so I reached down and muscled him up on acrost my shoulder and toted him to the gate, and heaved him over the fence out into the street. None of my business what become of him and his dirty mouth after that.

"I figgered I done right not to leave him come in there and haul off Miz' Celestine's things which she had left there under my trust and care. But Tom, my husband, would have said I was wrong for taking too much on myself. Tom claimed that he ever loved me harder than the thunder could bump a stump, but I had one habit that he ever wished he could break me of. Claimed that I always placed other folks's cares in front of my own, and more expecially Miz' Celestine. Said that I made out of myself a wishbone shining in the sun. Just something for folks to come along and pick up and rub and pull and get their wishes and good luck on. Never looked out for nothing for my ownself.

"I never took a bit of stock in what Tom said like that until I come to be in this trouble. I felt right and good, looking out for Miz' Celestine's interest and standing true and strong, till they took me off to jail and I writ Miz' Celestine a letter to please come see 'bout me and help me out, and give it to the folks there at the jail to mail off for me."

A sob wrestled inside Laura Lee and she struck silence for a full minute before she could go on.

"Maybe it reached her, and then maybe again it didn't. Anyhow, I ain't had a single scratch from Miz' Celestine, and here I is. But I love her so hard, and I reckon I can't help myself. Look, gentlemens, Celestine was give to me when I was going on five—"

The prosecutor shot up like a striking trout and waved his long arm. "If the court please, this is not a street corner. This is a court of law. The witness cannot be allowed to ramble—"

The judge started as if he had been shaken out of a dream. He looked at the prosecutor and shook his head. "The object of a

trial, I need not remind you, is to get at the whole truth of a case. The defendant is unlearned, as she has said. She has no counsel to guide her along the lines of procedure. It is important to find out why an act was committed, as you well know. Please humor the court by allowing the witness to tell her story in her own way.'' The judge looked at Laura Lee and told her to go ahead. A murmur of approval followed this from all over the room.

"I don't mean that her mama and papa throwed her away. You know how it used to be the style when a baby was born to place it under the special care of a older brother or sister, or somebody that had worked on the place for a long time and was apt to stay. That's what I mean by Celestine was give to me.

"Just going on five, I wasn't yet old enough to have no baby give to me, but that I didn't understand. All I did know that some way I loved babies. I had me a old rag doll-baby that my mama had made for me, and I loved it better'n anything I can mention.

"Never will forget the morning mama said she was going to take me upstairs to Miz' Beaufort's bedroom to lemme see the new baby. Mama was borned on the Beaufort place just like I was. She was the cook, and everything around the place was sort of under her care. Papa was the houseman and drove for the family when they went out anywhere.

"Well, I seen that tee-ninchy baby laying there in a pink crib all trimmed with a lot of ribbons. Gentlemens, it was the prettiest thing I had ever laid my eyes on. I thought that it was a big-size doll-baby laying there, and right away I wanted it. I carried on so till afterwhile Miz' Beaufort said that I could have it for mine if I wanted it. I was so took with it that I went plumb crazy with joy. I ask-ed her again, and she still said that she was giving it to me. My mama said so too. So, for fear they might change they minds, I said right off that I better take my baby home with me so that I could feed it my ownself and make it something to put on and do for it in general.

"I cried and carried on something terrible when they wouldn't leave me take it on out to the little house where we lived on the

place. They pacified me by telling me I better leave it with Miz' Beaufort until it was weaned.

"That couldn't keep me from being around Celestine every chance I got. Later on I found out how they all took my carrying-on for jokes. Made out they was serious to my face, but laughing fit to kill behind my back. They wouldn't of done it if they had knowed how I felt inside. I lived just to see and touch Celestine—my baby, I thought. And she took to me right away.

"When Celestine was two, going on three, I found out that they had been funning with me, and that Celestine was not my child at all. I was too little to have a baby, and then again, how could a colored child be the mother of a white child? Celestine belonged to her papa and mama. It was all right for me to play with her all I wanted to, but forget the notion that she was mine.

"Jury-gentlemens, it was mighty hard, but as I growed on and understood more things I knowed what they was talking about. But Celestine wouldn't allow me to quit loving her. She ever leaned on me, and cried after me, and run to me first for every little thing.

"When I was going on sixteen, papa died and Tom Kimble, a young man, got the job that papa used to have. Right off he put in to court me, even though he was twelve years older than me. But lots of fellows around Savannah was pulling after me too. One wanted to marry me that I liked extra fine, but he was settling in Birmingham, and mama was against me marrying and settling way off somewhere. She ruthered for me to marry Tom. When Celestine begin to hang on me and beg and beg me not to leave her, I give in and said that I would have Tom, but for the sake of my feelings, I put the marriage off for a whole year. That was my first good chance to break off from Celestine, but I couldn't.

"General Beaufort, the old gentleman, was so proud for me to stay and pacify Celestine, that he built us a nice house on the place and made it over to us for life. Miz' Beaufort give me the finest wedding that any colored folks had ever seen around Savannah. We stood on the floor in the Beaufort parlor with all the trimmings.

"Celestine, the baby, was a young lady by then, and real pretty with reddish-gold hair and blue eyes. The young bloods was hanging after her in swarms. It was me that propped her up when she wanted to marry young J. Stuart Clairborne, a lawyer just out of school, with a heap of good looks, a smiling disposition, a fine family name and no money to mention. He did have some noble old family furniture and silver. So Celestine had her heart's desire, but little money. They was so happy together that it was like a play.

"Then things begin to change. Mama and Miz' Beaufort passed on in a year of each other. The old gentleman lingered around kind of lonesome, then one night he passed away in his sleep, leaving all he had to Celestine and her husband. Things went on fine for five years like that. He was building up a fine practice and things went lovely.

"Then, it seemed all of a sudden, he took to coughing, and soon he was too tired all the time to go to his office and do around like he used to. Celestine spent her money like water, sending her husband and taking him to different places from one end of the nation to the other, and keeping him under every kind of a doctor's care.

"Four years of trying and doing like that, and then even Celestine had to acknowledge that it never did a bit of good. Come a night when Clairborne laid his dark curly head in her lap like a trusting child and breathed his last.

"Inside our own house of nights, Tom would rear and pitch like a mule in a tin stable, trying to get me to consent to pull out with him and find us better-paying jobs elsewhere. I wouldn't hear to that kind of a talk at all. We had been there when times was extra good, and I didn't aim to tear out and leave Miz' Celestine by herself at low water. This was another time I passed up my chance to cut aloose.

"The third chance wasn't too long a-coming. A year after her husband died, Miz' Celestine come to me and told me that the big Beaufort place was too much for her to keep up with the money she had on hand now. She had been seeking around, and she had

found a lovely smaller house down at Jacksonville, Florida. No big grounds to keep up and all. She choosed that instead of a smaller place around Savannah because she could not bear to sing small where she had always led off. An' now she had got hold of a family who was willing to buy the Beaufort estate at a very good price.

"Then she told me that she wanted me to move to Florida with her. She realized that she had no right to ask me no such a thing, but she just could not bear to go off down there with none of her family with her. Would I please consent to go? If I would not go with her, she would give Tom and me the worth of our property in cash money and we could do as we pleased. She had no call to ask us to go with her at all, excepting for old-time love and affection.

"Right then, jury-gentlemens, I knowed that I was going. But Tom had ever been a good husband to me, and I wanted him to feel that he was considered, so I told her that I must consult my pillow. Give her my word one way or another the next day.

"Tom pitched a acre of fits the moment that it was mentioned in his hearing. Hollered that we ought to grab the cash and, with what we had put away, buy us a nice home of our own. What was wrong with me nohow? Did I aim to be a wishbone all my days? Didn't I see that he was getting old? He craved to end his days among his old friends, his lodges and his churches. We had a fine cemetery lot, and there was where he aimed to rest.

"Miz' Celestine cried when he told her. Then she put in to meet all of Tom's complaints. Sure, we was all getting on in years, but that was the very reason why we ought not to part now. Cling together and share and lean and depend on one another. Then when Tom still helt out, she made a oath. If Tom died before she did, she would fetch him back and put him away right at her own expense. And if she died before either of us, we was to do the same for her. Anything she left was willed to me to do with as I saw fit.

"So we put in to pack up all the finest pieces, enough and plenty to furnish up our new home in Florida, and moved on down here to live. We passed three peaceful years like that, then Tom died."

Laura Lee paused, shifted so that she faced the jury more directly, then summed up.

"Maybe I is guilty sure enough. I could be wrong for staying all them years and making Miz' Celestine's cares my own. You gentlemens is got more book-learning than me, so you would know more than I do. So far as this fracas is concerned, yeah, I hurted this plaintive, but with him acting the way he was, it just couldn't be helped. And 'tain't nary one of you gentlemens but what wouldn't of done the same."

There was a minute of dead silence. Then the judge sent the prosecutor a cut-eye look and asked, "Care to cross-examine?"

"That's all!" the prosecutor mumbled, and waved Laura Lee to her seat.

"I have here," the judge began with great deliberation, "the note made by Mrs. J. Stuart Clairborne with the plaintiff. It specifies that the purpose of the loan was to finance the burial of Thomas Kimble." The judge paused and looked directly at Laura Lee to call her attention to this point. "The importance to this trial, however, is the due date, which is still more than three months away."

The court officers silenced the gasps and mumbles that followed this announcement.

"It is therefore obvious why the plaintiff has suppressed this valuable piece of evidence. It is equally clear to the court that the plaintiff knew that he had no justification whatsoever for being upon the premises of Mrs. Clairborne."

His Honor folded the paper and put it aside, and regarded the plaintiff with cold gray eyes.

"This is the most insulting instance in the memory of the court of an attempt to prostitute the very machinery of justice for an individual's own nefarious ends. The plaintiff first attempts burglary with forceful entry and violence and, when thoroughly beaten for his pains, brazenly calls upon the law to punish the faithful watch-dog who bit him while he was attempting his trespass. Further, it seems apparent that he has taken steps to prevent

any word from the defendant reaching Mrs. Clairborne, who certainly would have moved heaven and earth in the defendant's behalf, and rightfully so."

The judge laced the fingers of his hands and rested them on the polished wood before him and went on.

The protection of women and children, he said, was inherent, implicit in Anglo-Saxon civilization, and here in these United States it had become a sacred trust. He reviewed the long, slow climb of humanity from the rule of the club and the stone hatchet to the Constitution of the United States. The English-speaking people had given the world its highest concepts of the rights of the individual, and they were not going to be made a mock of, and nullified by this court.

"The defendant did no more than resist the plaintiff's attempted burglary. Valuable assets of her employer were trusted in her care, and she placed her very life in jeopardy in defending that trust, setting an example which no decent citizen need blush to follow. The jury is directed to find for the defendant."

Laura Lee made her way diffidently to the judge and thanked him over and over again.

"That will do, Laura Lee. I am the one who should be thanking you."

Laura Lee could see no reason why, and wandered off, bewildered. She was instantly surrounded by smiling, congratulating strangers, many of whom made her ever so welcome if ever she needed a home. She was rubbed and polished to a high glow.

Back at the house, Laura Lee did not enter at once. Like a pilgrim before a shrine, she stood and bowed her head. "I ain't fitten to enter. For a time, I allowed myself to doubt my Celestine. But maybe nobody ain't as pure in heart as they aim to be. The cock crowed on Apostle Peter. Old Maker, please take my guilt away and cast it into the sea of forgetfulness where it won't never rise to accuse me in this world, nor condemn me in the next."

Laura Lee entered and opened all the windows with a ceremonial air. She was hungry, but before she would eat, she made a ritual of atonement by serving. She took a finely wrought silver platter from the massive old sideboard and gleamed it to perfection. So the platter, so she wanted her love to shine.

Escape
from Pharaoh*

Africa has her mouth on Moses . . .

Night came walking through Egypt swishing her black dress. The palace and the peasant slept. Pharaoh and the servants of Pharaoh had assured the Egyptians that the terrors of Moses were ended. He had said that Moses must cease and the word of Pharaoh was enough. So the nation slept its sleep untroubled.

In Goshen the blind-eyed goddess of night huddled close, and families stayed inside their houses and waited. A bloody bunch of hyssop had swished against every door in Goshen three times—once on the lintel overhead and once on the door facing at either side. Then the people had gone inside and sat behind the blood and waited as Moses had ordered. Their new god, who had chosen them through Moses, was going to fight Pharaoh for their sake. He had asked the sign of the three bloody marks on the door and the people had done their part. The rest was for Moses and God to do. So the dark stillness in Goshen was not sleeping darkness. It meant waiting. The lamb had been sacrificed and eaten in every house in the land and his signal blood guarded the doors. The night went on its way.

Darkness balanced up on midnight looking both ways for day. Then the great cry arose in Egypt. They cried and died in Egypt. It was the great cry that had issued first from the throat of Israel years before and spread to the rim bones of the world and come

*From *Moses: Man of the Mountain*

178

back again. And now it poured out through the mouth of the Egyptian nation. It was such a cry that there was none like it since the morning stars sang together, and never shall be another like it as long as heaven is happy. Egypt cried out at the death of the first-born. Every house in Egypt was bloody. Blood outside the door in Goshen, blood inside every other house in Egypt.

Pharaoh looked upon his first-born and wept. His son was dead and the son of his son was dead in his own blood. There were snorts and bellows from his stables from the smell of animal blood. So Pharaoh cried for his dead with all of his voice. Every house in Egypt strained its voice trying to express its bereavement. The noise of it struck the sky and came back to the Nile and ran with it to the sea, the Egyptian chorus of sorrow indoors.

Outside, the paths and pavements were full of soft, swift feet fleeing into Goshen with its listening ears. These were the sounds of the night, sounds without words.

With the sunrise, Princes and people said, "This is the hand, the right hand of Moses." They lifted their dead from beds and said in awe, "Moses and the God of the Israelites." They rolled their dead from straw mats and pallets and said, "Moses and his right hand." They crowded in and around the palace and shouted, "Get Moses and the Hebrews out of Egypt. If you don't, everybody in Egypt will be dead."

So Pharaoh sent for Moses to dismiss him, his God and his people from Egypt. He was no longer proud Pharaoh with the masklike face. He was a man whose son was dead. But Moses refused to go see Pharaoh all that day. Burials went on and burials went out from houses all day in long lines and solemn weeping, and all Egypt was in tears. Pharaoh sent messengers to Moses again telling him not that the Hebrews might go, but that they must go.

Moses heard the message sitting in his house but he didn't say a word right then. The news was too big to speak at once. He had to sit with his feelings for a while. Afterwards he called his leaders to him and told them, "Your slavery is over. Pharaoh is broken at

last. We march out of Egypt with a free people. We march out with a high hand.''

The people cried when Moses told them. He had expected wild clamor; the sound of cymbals and exultant singing and dancing. But the people wept out of their eyes. Goshen was very still. No songs and shouts.

''Free at last! Free at last! Thank God Almighty I'm free at last! No more toting sand and mixing mortar! No more taking rocks and building things for Pharaoh! No more whipping and bloody backs! No more slaving from can't see in the morning to can't see at night! Free! Free! So free till I'm foolish!'' They just sat with centuries in their eyes and cried. A few could express themselves like that. But the majority just sat in the doors of their dwellings staring out at life.

But Moses put a stop to all of that. ''You won't be free for long if you keep that up. Stop that shouting, and stop that sitting, people! Get everything you got together and let's go, and that quick.''

''Why, Moses?'' some of them asked. ''We're free now and we can take our own time about everything.''

''You people been around Pharaoh all this time and don't know him no better than that? He is scared today and so he says you can go. Tomorrow or next day he will realize what he's losing and send his army into Goshen to put you back to work. Grab up your things right now. Tonight we leave Egypt forever.''

''Good gracious!'' somebody grumbled, ''I was figuring on going fishing tomorrow morning. I don't want to be bothered with no packing up today. It's too much like work and I just got free this morning.''

''That's the heaven's truth, too,'' plenty of others chimed in. ''Looks like we done swapped one bossman for another one. I don't want nobody giving me no orders no more.''

''But it was Moses that got us free,'' Joshua told them. ''If it hadn't been for him we would be hauling rocks right this minute.''

''Oh, I don't know about that. This God that done chose us

would have got us free anyhow. I never did much care for this Moses like some of you all.''

''What's the matter with Moses? He got us free all right.''

''Oh, I have every confidence in the man, I just don't trust him.''

But Moses himself moved from place to place urging hurry and everybody, unwilling or not, did what he said. The women told Miriam's committee that they just couldn't get ready because it was baking day. ''We got dough set to rise and we can't disturb it or it won't be light.'' Miriam went back and told Moses what they said and he went to see about it himself. ''Mix your dough,'' Moses told them, ''but don't put your seasoning in it so it won't spoil, and while you are at it, mix enough for a week. And that is just part of what I want done. Everybody roast a lamb so that everybody in Goshen can eat a full meal with some greens to settle the stomach. We got a long, hard march in front of us tonight!''

Finally Moses got them ready in the spirit so everywhere in Goshen the people were saying, ''Tonight!''

Everybody said it according to their thought and their feelings. Some talked it with the edge of their lips. Some rolled it deep in their throats. Some throbbed it inside their hearts and let their bodies move with the rhythm. Some said it with their eyes, with a gleam, with future-searching gazes. Some said it with a question, ''Tonight?''

They fixed and they did around and got ready. Nothing was still. Children hunted the bitter herbs. Men slaughtered beasts and tied bundles. Women mixed dough and cooked. And all the time everybody thought back over the years and every now and then they breathed, ''Tonight!'' Moses had inspired them for the journey and they were going.

The God of the two horizons took flight beyond the western line and the frenzied hurry of the day took shape. Flocks and herds gathered and ready. Bundles tied. Every group had met its leader and been told.

''Now,'' Moses said to a group of men under Nun, ''go quickly to the tomb of Joseph and bring me the casket with his bones. He

brought Israel into Egypt and Israel must take him out of a land that is no longer fit for his dust. Hurry!''

The gorgeous carved and painted casket of Joseph rested on a pedestal before the house of Moses, and its bearers were appointed. So Moses told everybody to eat in haste, leaving nothing to eat behind them when they were ready to go.

They sang a song. Now that they were ready to go and going, it was triumphant but it was sad. It was a long time since Israel had done any singing much and they had forgotten how to shout. Moses noticed that their glad notes broke on wails. Israel was used to wailing now. They had forgotten how to laud. His heart hurt for them. So he said to himself that they should see glory mountains and shiny valleys and they should learn to sing.

He led them out of Goshen with a high hand. Out and out the tread of the tribes behind him. A great horde of mixed-blooded people grabbed up their things and joined the hosts of Israel. "Let us be free too," they begged and Moses said yes to them. His fighting men in front and behind with Joshua's volunteer boys in the center to give aid and assistance to women and children. Out and out he led. People cried and died and stayed where they fell. Aged ones hobbled and were partly carried, old ones, crippled by the generations behind them and blinded by the look ahead, grasped and clutched at young shoulders and gasped, "Don't leave me behind." Babies borned themselves and joined the procession out. Out was such a big word in Egypt to the Hebrews.

"Which way, Moses?" Aaron asked.

"By the wilderness of the Red Sea."

"It's a whole heap shorter through the land of the Philistines."

"I know, Aaron. But our people are leaving slavery. It takes free men for fighting. The Philistines might let us through without fighting but it's too much of a risk. If these people see an army right now they would turn right around and run back into Goshen. So let's head them for the Red Sea."

The soft murmur of sandals and bare feet kept up in the night without a moon as Moses and his hosts moved on.

"On our way at last," Aaron said happily to Nun.

"After four hundred and thirty years to the day. It still seems like it ain't so to me, Aaron. Ain't but one thing I'm sorry about."

"What is that, Nun? I can't imagine any sorrows connected with the thing."

"I sure hate to miss seeing those Egyptians doing our work in all that hot sun."

"I hadn't thought of that, Nun, but it sure would be a lovely sight. I never want to even see a brick again—not even a brick house to live in."

"Me neither. Where we going now?"

"Out, Nun, out!"

"I don't mean that. I mean just exactly where we're going to live permanent when we get out?"

"Moses may know, but if he does he ain't told nobody yet."

"You reckon it's all right to ask him?"

"I guess so. You can ask him if you want to."

"Where is he now?"

"He was just ahead of us a few minutes ago."

The two men looked up and became conscious of a changed rhythm in the multitudes around them and behind them. It was a sort of spontaneous mass halt and they saw the reason right away. Ahead of them at a short distance was a column of fire. What it consumed was hard to understand for it towered up steady and solid as no flame they had ever seen. It was like an illumination that glowed but never flamed. It brightened the countryside, but never grew more nor less.

"What is that?" Nun asked in fear.

"It must be where Moses is. You think it is his right hand shining like that?"

"It could be. Is nothing impossible to Moses?"

"It don't look like it. Let's go ahead to see what it is."

The two leaders marching ahead of the host hurried nearer the fiery column and stopped. It was moving ahead as if it was borne but nothing was holding it up. Its many colored lights just moved along ahead of Moses like a vertical beam.

"Moses! Moses!" Aaron gasped. "What is that?"

"The pillar of fire that will always go in front of us at night. It is the sign of the Presence. In the daytime it will be a cloud. Go tell the people not to be afraid."

With the fiery sign the people marched all night and camped next day far from the city of Rameses at Pihahiroth on the shore of the sea to rest and eat. Moses gazed across the water and exulted.

Next morning Pharaoh woke up and looked out of the window on the city, new and fine, its towers, its parks and streets, which the Hebrews had built for his father and him. He had a strange feeling of newness as if he had not seen these sights for a long time. As if he had awakened among familiar surroundings after a long, horrid dream. Then he noticed something. No work was going on around the half-finished public building near the palace grounds. He called a servant right away and asked about it. The servant didn't know.

"Well, go find out," Pharaoh snapped and ordered his breakfast. After a while the servant came back and said that no Hebrews had been seen that morning by anybody except a very sick old Hebrew found by the road by some fishermen. No work had been done for two whole days.

"Two days! You must be wrong.

"Send to Goshen and find out what's the matter. Some more foolishness out of that Moses, I reckon. If it is, I'm through playing with that man. He dies today, him and all his magic. I don't see why I stood him as long as I did."

The word came back, "A great song was heard, then the whole host of the Israelites were seen marching out, driving their flocks and herds, two days ago. Nobody has heard from them since."

"Oh, that worship they were talking about. I did say that they could go. I was too worried about the funeral of the first-born to notice things. It is a terrible thing to lose a son." Then Pharaoh became alarmed. "Do you suppose those Hebrews have run away?"

"A lot of people are saying the same thing, and they want their work done and they aren't getting a bit done today."

Pharaoh thought a minute and his blood jumped salty. He was angry with himself. He could have killed Moses and saved himself this trouble. But he had yearned to humble the man first. To outwit him and shame him. Then would have come death for Moses. But the man had made a fool of him instead before the whole nation, and now he was gone with the Hebrews as he had threatened. Pharaoh was resolved on his death if he could lay hands on him now. He rose up with a great scowl on his face. "That's my trouble," he said, "I'm too good-natured."

"That's right, you certainly are," all the servants and courtiers agreed.

"I must have been out of my head to let those people go off and now we have nobody to work for us. That is, I mean that just because I was grieved down at the death of my son and my grandson and the first-born of all the other people and said things, this man Moses takes advantage of my good nature and runs off with our Hebrews."

"And why should we let them stop working for us and go off like that?" one of the courtiers asked. "It's a sin and a shame when you come to think about it. Them Hebrews off doing nothing and our work going undone."

"It's worse than that," one of the others agreed. "And they could be stopped, you know. They couldn't be very far by now, and them on foot, too."

"Get me my war chariots!" Pharaoh shouted. "Six hundred fighting chariots and men to fill them and have them ready in half an hour. I'm going after those Hebrews and I'm going to bring 'em back. And so far as that Moses is concerned I mean to kill him with my own hands. That rascal has been imposing on me for thirty-odd years. Always some trick up his sleeve. Get me my fighting chariots and do it now!"

People scurried in every direction and Pharaoh began to dress himself for war.

"My finest sword and javelin! I am a man of war today and it is the happiest day of my life. I have been tricked and tricked and made a fool of by that Moses ever since he was weaned from his

nurse. He is facing me today for the last time. Where are my chariots and men?''

With a kill-mad cry, the six hundred chariots with Pharaoh in the lead thundered out of the city before a cloud of road dust, and raced down the road to way off.

It was late afternoon of the second day when Moses came down to the sea. He ordered rest overnight and plenty cooking and eating to keep up the strength of the hosts. Some people grumbled about sore feet and some missed their beds and houses. Moses let the Elders take care of that. He went down to look at the sea. He studied the wind and sky and looked at the sea and beyond.

That was the way things were when Joshua came running and shouting, "Pharaoh! The Egyptians! They are coming down behind us. Chariots!''

Moses hurried back to the Israelites. By now the thunder of hoofs and the growl of chariot wheels were easy to hear.

Women screamed in open-mouthed terror and whimpered in fear. Men cursed, cried out and milled about in great whorls. Some tried to run away to the woods to hide, others just stood or squatted on the ground in dumb fear. When they saw Moses come among them they crowded about him. Some clung to him while others screamed at him. He shook them off roughly and kept marching towards the rear.

"I always told my husband not to bother with this mess," one woman sobbed. "I tried to tell him we was getting along all right under the Egyptians. But he was so hard-headed he had to go and get mixed up in it.''

Voices broke out everywhere and all were sprung with fear. The war chariots of Pharaoh were in plain view now though distant on the plain. Moses could hear many things as he shoved through the camp.

"Couldn't that man find graves enough in Egypt to bury us all without dragging us out here in the wilderness to die?''

"Didn't I say all along that this Moses was some fake prophet? That god he made up out of his own head—''

"Didn't I always tell you all that them Egyptians was nice people to work for? You couldn't find better bossmen nowhere."

"The idea of coming and fooling people off from home and leaving 'em with no protection. I mean to tell Pharaoh just how it was."

"Didn't I always say we was better off in slavery than we would be wandering all over the wilderness following after some stray man that nobody don't know nothing about? Tell the truth, didn't I always say that?"

"I told you all a long time ago that we had enough gods in Egypt without messing with some fool religion that nobody don't know nothing about but Moses. You all just let him make a fool out of you. I always knowed it was some trick in it. That man is a pure Egyptian and Pharaoh is his brother. He just told us off so his brother could butcher us in the wilderness. I told you all so."

"You heard me at the meeting distinctly tell that man to leave us alone and let us serve our Egyptian masters in peace, didn't you? We was getting along fine—plenty to eat and a place to sleep and everything. We wouldn't be in the fix we're in right now if that Moses had of let us alone."

"Who asked him to butt in nohow? Our business didn't concern him, did it? It was our backs they was beating. It wasn't none of his and if we was satisfied he ought to been tickled to death. Now Pharaoh is going to kill us all."

"Great Ra! Great Horus! Great Thoth! Great Isis and the forty-two gods of the double justice! Save us."

Slowed down by the weight of the chariots over the rough ground, the horses were coming in a walk. Moses reached the rear of his great huddle of trembling humanity and took his stand, between danger and his charges. Again, he was one against all Egypt. Listening and thinking back, it was hard to keep his feelings from flying to his head. He had but to step aside and leave them to Pharaoh and his servants. But Pharaoh himself was driving the first chariot as the cavalcade approached, and he wanted to face him and beat him one last time. He laughed to himself as he thought, "Pharaoh thinks he's pursuing me, but it's the other

way around. I been on his trail for thirty years, and now I got the old coon at last, as Jericho would say. Let me fuddle him all up for a night and then I will raise my hand. First and last, I'm showing him my ugly laugh."

As the chariots drew near the panic grew in Israel. They committed every kind of folly and showed their inside weakness. Then Moses showed his power again. He turned his back on the Egyptian horde and spoke to his people. Spoke to them in their own dialect as one of them.

"Stand still!" he commanded in a sterner voice than they had ever heard before. "Stand still, every last one of you and stop that screaming and yelling. You haven't got a thing to be scared of. That ain't nobody but Pharaoh and his army and we done beat them too many times before. Don't get so excited about nothing! The Lord is going to fight for you just as He's been doing all along. Stand still and see the salvation of the Lord which He is going to show you today. See those Egyptians there? Take a good look at 'em, because those Egyptians that you are looking at today, you're never going to see *them* no more as long as you live. And nobody else won't be seeing them either. Stand still and keep quiet is all I ask you to do."

Moses didn't lift his hand while he talked but the command in his voice was calming. Suddenly everybody felt secure and brave.

Moses just stood and looked and the pillar of cloud that went before the host moved around from the sea and spread itself like a great plumey curtain between the Israelites and Pharaoh and hid each camp from the other. The Israelites felt shut in and safe. The Egyptians felt shut out and puzzled. They were afraid to attack until they could know what went on behind that cloud screen, so Pharaoh ordered his forces to camp until next day and then to attack with vigor.

"They can't get away from us so we might as well get some sleep. Our horses need freshening too," Pharaoh ordered. "We got them in a trap—between us and the sea. We'll close the trap in the morning." So they turned in and rested so they could have plenty of vim to butcher Hebrews in the morning.

But Moses never slept. The signal pillar of fire glowed behind the cloud screen and lighted the camp of Israel. Moses himself went back to the sea and stood. When the hour came he called up the east wind and stretched out his hand. They broke the head of the eastern drum and marched out on the sea. The retreating tidal waters did not creep on as was their habit; they fell back from the strait on either side like two mighty armies in retreat. Both sides shrank away from the uplifted hand like lambs before a lion. The waters fled back and back and back and stood in a solid wall on either side and waited on the powers to close them up again.

Then Moses ordered the march. In the same order in which they had come down to the sea, Moses told his hosts to cross over. Flocks first, then women and children followed by the six hundred thousand men of fighting age armed with whatever Moses could find in Egypt to put in their hands—clubs, spears, javelins, old swords, sticks and anything that could wound and tear.

The bones of Joseph crossed over after the women and children. Then Moses challenged Pharaoh. The smoky cloud screen lifted. The fiery pillar again went before the hosts and the sentries of the Egyptian army saw that the children of Israel were escaping across the sea and ran to wake up the camp. "Wake up! The Hebrews have broke camp and are gone."

The camp woke up by degrees. Nobody could believe the sentry at first. They had to get to their feet and get their heads clear of dreams first, and then the peeping dawn did the rest. It was hard to believe, but the sea was really divided and the Hebrews were tramping across on dry land.

"Well, I'll be—" Pharaoh began, then sprang to action. "Get up and harness the horses! Don't let 'em get away! A palace and high houses to the man who overtakes Moses and hands him over to me alive! Get up and get after our slaves."

In a few minutes the camp was furiously alive. Leaping into chariots, shouts, cries, plunging and neighing of horses, clash of arms on shields, posing Pharaoh's chariot with its three Arabian horses in front of the forces and the furious charge to the sea crossing while the last ranks of the Hebrews were still in sight.

Moses heard the commotion in the Egyptian camp and knew that his movements had been seen as he intended them to be. He hurried across after the last man and waited. He saw the mad charge down the beach. He saw them hesitate there to debate the wisdom of trying the unusual crossing. Then he deliberately showed himself to Pharaoh and the frenzied pursuit was on. The six hundred chariots dashed down into the sea ten and twenty abreast. The Egyptians shouted in triumph as they viewed the cowering Israelites on the opposite shore.

Then when the Egyptians had thoroughly committed themselves to the sea bed and wagered their lives and their vengeance on it, Moses stood on the opposite shore and looked hard at his pursuers. He could distinguish the royal chariot with its fiery Arabians well in the lead. Those were fine horses, Moses recognized, and a splendid chariot. But Ta-Phar had always thought too well of chariots. He could not see his uncle's face at that distance and read its expression, but he could feel it, the hatred, the bafflement and the lust for vengeance. Behind him the Israelites were already over their joy at the miraculous crossing and were beginning to cry out in fear.

"Moses! The Egyptians are coming after us! Ain't no more seas for us to cross."

"I see them. Don't worry."

What he knew must come, happened. Away from the smooth sand of the shore, the horses and the heavy chariots struck rough going. Horses began to flounder and fall as they stepped into holes and soft clay. Chariots swerved, overturned, and control was lost. Chariots coming after plunged into the tangle and were themselves overturned. Then Moses lifted his hand.

The gripping east wind loosed its mighty fingers and the sea water came rushing back to its bed. It was a moving time. There was the outspoken voice of the wind going east; the mad grumble and shout of the waves as they raced back to embrace each other over the clamor of men in fright, the scream of drowning horses, the last mad struggle of the chariots. That all made a boiling place in the sea for a space. Then there was just the heaving Red Sea

with its two shores. Egypt on one side and Moses and his mission on the other. Moses stood and looked on the sea. It was a long time before he thought to change his rod from his right hand to his left and let the wind and the sea subside.

Behind him he heard the people exulting. "Didn't we outdo old Pharaoh, though?" Miriam was asking everybody. "It was a great victory for our God," Aaron was saying. "The Lord is a man of war. The Lord is His name." "Old Pharaoh thought he knew who to fool with and who to let alone." "We showed him something. Yeah, he's dead out there in the ocean and there ain't no help for it. That's one old Pharaoh won't have no great big old tombstone over him."

"Well, he's got the great big sea over him, and I reckon that's big enough to suit anybody."

They made a song on that and danced it off. A man with a good voice got out in the center of the ring and sang.

"Old Pharaoh's dead!"

And the chorus answered, "How did he die?"

And the solo man went to dancing and said: "Well, he died like this!" and he danced that off. Then he sang another part and everybody went on dancing and shouting.

> *Oh, he died in his chariot and he died in the sea*
> *And he wouldn't have died at all if he let us be.*

They sang that over and over and danced on it until they got tired. Then Miriam took the cymbal and some more women went behind her and they went all over the camp singing:

> *Oh, Miriam played the cymbal over the Red Sea*
> *Miriam played the cymbal over the Red Sea*
> *Miriam played the cymbal over the Red Sea.*
> *Oh, Miriam played the cymbal right over.*

And they clapped time on that with their hands and danced and double clapped it off like they did the other song because everybody was happy and felt like clapping and dancing. Then Moses told them to make camp for the night.

Moses strolled down the beach a little way and sat down on the same boulder that he had sat down on after the first crossing so many years ago. It was another morning and another crossing and so he thought thoughts again. This time he had crossed over safely with a nation behind him and no weapon worth talking about but his right hand. Well, the present was an egg laid by the past that had the future inside its shell. So Moses sat on the rock and said, "You, Voice, you told me to lead out, and by the hardest, I did it. So I'm down here by the Red Sea with these people. You know more about 'em than I do, Lord. What must I do with them now?"

A little tee-nincy voice raised up in the back of his mind and said: "Old Rameses is dead. Ta-Phar is dead. The set who bucked against you and hated you are dead. You know one time you were the idol of Egypt. The army still thinks you are the biggest man they ever made. Moses, you can go back to Egypt and be King. You can do even better than that. You can control the army which controls the King. The Voice told you to lead out and you have led out with a high hand. You have done your duty. The Israelites are out of Egypt and they are free. If they fall into slavery again somewhere else that's none of your business. You set them free. Moses, there is Egypt right over there and the King is dead in the sea."

Moses sat on the rock and thought back. He had sat on this rock when he fled from Pharaoh the first time and something had shown him clearly the futility of a life of war. Right on this rock he had forsworn the sword and glory. He got to his feet and looked earnestly at the camp for a while, then he said, "Which way, Lord, which way must I lead Your people?"

The Tablets of the Law*

Moses lifted the freshly chiseled tablets of stone in his hands and gazed down the mountain to where Israel waited in the valley. He knew a great exultation. Now men could be free because they could govern themselves. They had something of the essence of divinity expressed in order. They had the chart and compass of behavior. They need not stumble into blind ways and injure themselves. This was bigger than Israel itself. It comprehended the world. Israel could be a heaven for all men forever, by these sacred stones.

With flakes of light still clinging to his face, Moses turned down the mountain with the tablets of testimony in his hands. He heard nothing earthly nor sensed anything about him until he descended to where Joshua waited for him. With his eyes turned inward, he sat down on a stone opposite Joshua to rest.

"Joshua, I have laws. Israel is going to know peace and justice."

Moses indicated the sacred stones on his lap.

Then from far off a sound, a noise made up of many sounds, came up to Moses and he listened. And his ears accepted what his soul refused. It was a wild and savage shout of voices and drums that Moses heard, but his spirit rejected it, because it injured his vision of destiny for Israel. It clashed with his exalted forty days.

*From *Moses: Man of the Mountain*

It soiled what had passed between him and God. So for a long time Moses sat silent and listened, hoping that he dreamed. Finally he asked Joshua, "Do I hear shouting and singing, Joshua, or is it just a ringing in my ears?"

"It's shouting and singing, Moses."

Moses sat sodden and sad for a long while and then a new hope crept into his voice.

"Do *you* hear anything that sounds like singing and cymbals, Joshua, or does it just sound like that to me because I'm tired and sort of frazzled out?"

Joshua looked at the face of Moses and pitied him.

"I hear a mighty loud noise down below," Joshua evaded.

Moses looked down at the stones in his lap and passed his hand over the carved figures reverently and then he looked back up the mountain as if he would retreat up there. Then he brought his attention back to the tumult below.

"Does it sound like the voice of the people shouting for victory, Joshua? Maybe the Amalekites have come up against Israel while we've been up here with God."

"No, Moses, it's not the voice of mastery that I hear. It's the voice of Israel, but they are not shouting for conquering anybody."

Moses sat and listened for a while longer, shutting his heart against what he feared.

"Well, Joshua," he said haltingly, "do they sound to you like they are crying out for help? They could be overcome, you know, by some nation that might attack, with both of us away."

Joshua listened carefully for a moment. "No, it's not the voice of them that cry for being overcome."

"What do you reckon could have happened to Israel, Joshua?" Moses tried to persevere in his hopes.

"Oh, that's singing and dancing that I hear. Sounds like the dance songs to Apis, the Bull-god, to me. Listen at those drums!"

Moses snatched his face away from Joshua and the last glimmer of light that had clung to his face from God died to ashes.

"Oh, no, Joshua, they couldn't do a thing like that. Not after all

we have been through from Egypt on! Not after they cried to God
to deliver them from Egypt and its sorrows! Not after the God of
the mountain sent me to save them from all harm and danger, and
brought them here to the mountain to give them laws and pledges!
No, Joshua, they wouldn't be back in unforgetfulness and ingrati-
tude here at the foot of Sinai. They couldn't be howling in idolatry
in the very ears of God."

"It certainly is the sound of drumming and chanting to Apis that
I hear."

Moses stood up and closed his eyes with the tablets clasped
tightly to his breast. Then he started slowly up the mountainside
again. "I better go back and talk to God again about Israel. He'd
know better what to do than I would." He left Joshua behind him
and struggled on back toward God.

But he didn't get far. At first he thought it was the wind scuffling
around in the brush. Then he knew it was the Voice that spoke
and halted him.

"Moses," it said like a strong breeze in the pine tops, "don't
come up here to Me. Hurry down!"

"Lord," Moses sobbed, "have they betrayed You?"

"They have betrayed Me. They have betrayed you, and most of
all they have dirtied their souls by betraying themselves. Go down,
Moses, and halt them in their headlong flight. The people that you
have brought out of Egypt have soiled themselves and tempted Me
to destroy them. They are worshiping a calf of gold and giving it
the credit for bringing them out of the land of Egypt, and out of
the house of bondage. Go stop them before I get too tired of their
ingratitude and kill them."

The Voice was gone and the light was gone and Moses turned
cold and heavy and went down the mountain like God descending
into Eden. First it was the mountain top and then the high shoul-
der and then the heavy hips of the mountain and then the crum-
bling ankles of the mountain and then the plain where Israel
waited for a sign from God.

So Moses stood before the altar of the golden calf with the tables
of stone in his hands. Drunken shouts filled his ears; bodies drunk

on the liquor of feeling rocked and reeled and contorted about him with eyes glazed and covered. Aaron with his bearded chin stuck out in front of him was presiding at the altar. His two oldest sons, Abihu and Nadab, chief acolytes in the dance and revel, were shouting and leaping, and thumping their naked bodies and urging the people on.

"Aaron!" Moses cried at him with a stern voice. "Aaron, do you hear me?" Moses had to call three times before Aaron really saw him standing before the altar with the law from Sinai in his hands. Aaron took one long comprehending look and sunk behind the altar on his knees. The eyes of Moses had gutted him. Aaron hid himself behind the pagan altar while Moses towered tall and grim before it with the tablets of God in his hands. All around the spot the tumult boiled, for few had seen with their eyes or heard.

The calf and all its meaning and all the thoughts it collected glimmered and winked at Moses from its altar and suddenly Moses raised one of the tablets with its fine writings and hurled it at the graven image and saw the golden calf topple over on its side. The force of the impact shattered the sacred stone and crumbled it in pieces. Moses lifted the other stone and hurled it, and the calf broke in pieces and the pieces scattered around the altar. But in breaking the calf, the tablets of testimony had been broken to crumbling stone. Moses stood in his wrath and considered. The law from Sinai had broken the idol of Egypt, but the sacred tablets had themselves been destroyed in the clash. Egypt against Sinai. It was going to be a hard struggle.

The crash of stone on metal had attracted attention. Drums faltered and stopped. Dancers paused and looked and saw Moses destroying Apis and froze to sculpture in poses, which broke into flight. Some ran heedless. Some crept off slowly with dazed faces to hiding places. Before Apis and Aaron they were clothed in joy and license. Before Moses and Sinai they were naked to their souls. They slunk into places of concealment as best they could. Moses strode over the huge vacant square of celebration with Joshua at his heels, looking, looking and seeing. Looking inside of people by their outward appearance and sickening at what he

saw. He circled and circled and came back to the naked altar and stopped.

Moses found Aaron squatting down behind the altar trying to hide himself. Moses kicked over the altar and snatched Aaron to his feet and looked him dead in the eye. He looked at the man and saw him as he was, stripped of the imitation of dignity that he affected lately; saw him naked of the imitation of himself that he wore as best he might.

"Aaron," he said, "what on earth did these people do to you to make you bring such a sin on everybody like you did?"

Aaron tried to back off but Moses had him by his whiskers and he wouldn't let him go. So Aaron cringed and fawned and said, "Lord, Moses, you're my bossman, and I know it. I wouldn't think of putting myself on an equal with you. You're a great big high cockadoo and I ain't nothing. So you oughtn't to be wasting your time getting mad with me. You done been round these people long enough to know 'em. You know they ain't nothing and if you and God fool with 'em you won't be nothing neither."

"Aaron, you haven't said a thing yet to excuse yourself for what you have done. Tell me and tell me quick why you have betrayed God and the people in the way you have done."

Aaron lifted his hand as if to break Moses' grip on his beard, but the eye of Moses forbade him. He winced and said, "You oughtn't to hold my whiskers like that, Moses, the people are looking at us, and me being a leader—"

"The people are looking at you naked and capering around like an old goat, too. Let's forget about that while you answer me."

Moses did not miss the look of hatred born of hurt vanity in Aaron's eyes as he sought to placate Moses by dissembling.

"Now, Moses, you know these people is always up for something that ain't no good. They don't mean nobody no good including theirselves. Know what they did? When you didn't come back right away they was going round behind your back running you down and scandalizing your name and making out you was dead or done run on off and they took and brought me all them ornaments, just because they knowed I used to work in gold, and they

told me, we don't know what become of that man Moses. Make us some gods to march in front of us instead of that cloud. And they shoved all them earrings and things in my hands and naturally I didn't want to be bothered with the things, so just to get 'em out of my hands I took and threw 'em in the fire and what you reckon, boss? All I did was to fling them earrings into the fire, and out come that calf.''

''Aaron, you haven't said a thing yet and that is because you haven't thought a thing yet, nor felt anything except your own importance. Your whole body is nothing but a big bag to tote your littleness in.''

Moses thrust Aaron from him so roughly that he all but fell. Then Moses strode away, noting as he went how many people who had taken no part in the ceremony to the bull. There was open disgust on the faces of many and that made Moses think. Some were here because of Sinai and all that it meant and some were just here. A divided people, and that would never do, not at this point in their history. So Moses made a decision. He straightened his shoulders and marched to the gate of the camp and lifted both hands in the air.

People saw Moses standing like a crucifix and came. Moses still stood and they kept coming and questioning each other and coming. When a great multitude stood before him, Moses began to speak and cried out, ''Who is on the Lord's side? Who is on the Lord's side?'' Moses kept crying until the words became a chant. ''Who is on the Lord's side?'' Israel's ears were wrung. ''Who is on the Lord's side?'' It woke up fear in the guilty. Israel was stung. ''Who is on the Lord's side?'' It freshened hope in the hearts of the just. Israel was called. ''Who is on the Lord's side?'' And some young Levites were the first to come closer and say, ''We are, Moses, we are for the Lord of Sinai.'' Then others joined until thousands upon thousands stood by Moses. Then he said, ''You who are on the Lord's side, take your swords in your hands and come to me.'' The surging multitudes of young men gathered around Moses with ready swords. So Aaron saw one of his sons, Eleazar, and all the other Levites go to Moses with swords and he

was afraid to stay away. He came to Moses also with his sword and his censer in his hand and stood.

Moses said, "You all know what a foul thing has happened in Israel today. You know better than I do who the leaders and the agitators were. If this is to be a great nation, it must be purged of such evildoers, or all Israel must perish. You have your eager weapons, men. Spare not a soul who is guilty." Their swords leaped out of their scabbards like day out of dawn.

The struggle began. Drunken people in hidden places roused from a stupor with their eyes wide open in judgment. Aaron saw two of his sons dragged forth and cut down before his eyes. He dropped his sword and swung his censer in wide arcs to call to the minds of the avengers that he was a priest. He stood between the living and the dead with his censer in his hand, weeping and quaking and cursing. He was afraid to fight, afraid to run and ashamed to cry out loud.

For hours there was fleeing and screaming and hiding and bloody swords. Then there was quiet again in the camp. It only remained to bury the dead. Aaron came creeping and looked down into the faces of Nadab and Abihu, his two dead sons, and wept. The men buried his sons with the other thousand leaders of the revolt slain by the sons of Levi. Aaron started a little song in his heart that went like this: "It's your time now, be mine after while. Oh, it's your time now, but be mine after while, oh, it's your time now, but it'll be mine after while." And from that minute on till the hour he died Aaron kept his eyes on Moses in secret and waited his chance. All he needed was the strength to seize his hour for vengeance. His hate was strong but his heart was weak. From then on for forty years the underhand struggle went on. Sometimes he made an open attack upon Moses when Aaron thought he could succeed, but always the secret struggle went on to destroy him and have Aaron in the saddle. And always the strength of Moses trampled down the weak cunning of Aaron.

Moses was hard on Israel, after that. He felt that only discipline would save what he had begun and so he chastened the people severely. They suffered epidemics of ailments and many discom-

forts. It was then that he established the House of God. It was called the Tabernacle of the Congregation and Moses set it apart from all other tents, even his own. He pitched it far outside the camp. And when Moses went out to the tabernacle everybody saw him go and everybody was afraid. Would he lift his rod against them? Would he raise that right hand? As Moses went the people stood in their tent doors and watched him pass. And every eye in Israel followed him in fear.

They watched him go inside the door of the new tabernacle and they saw the shimmering cloudy pillar descend and they saw it stand at the door of the tabernacle and in awe they rose as one man and worshiped the God who had chosen to live among them. They heard the Lord talking to Moses from the cloud like two friends talking face to face. They heard Moses tell the Lord, "If you don't go with us, don't send me by myself, Lord. Other people will make a fool out of us."

So the Lord told him, "I'll always be there, Moses, because I love you and I know you by your name."

"Thank you, Lord. One favor more I want to ask you while I am still on pleading terms with mercy."

"What is it, Moses?"

"Lord, I done seen your pillar of fire and your pillar of cloud and heard your voice in rumbling thunder. I done seen the cloudy cloak that hides your glory, but I ain't never seen your glory itself. Lord, be so pleased in your tender mercy as to show me your glory."

The Lord answered Moses and told him, "Moses, I will make all My goodness pass before you. And I will proclaim the name of the Lord before you and I will be gracious to whom I will be gracious, and show mercy unto whom I will show mercy, but, Moses, you just can't see My face, for no man can see My face and live. But, Moses, since it is you that ask me, look, see there is a place by Me and you go and stand upon that certain rock and when My Glory passes by, I'll take you and put you in a crack in the rock, and I will cover you with My hand while I pass by, then I will move My

hand and you shall see the back parts of My Glory, but My face you shall never see."

So Moses thanked the Lord for letting him see that much and God told him, "Moses, get you two more nice smooth pieces of stone and bring it up to the top of the mountain so I can put those same laws that you broke upon that golden calf down again. These people need laws and rules to go by."

Moses got up early next morning and took the stones and went up to the top of the mountain and kept company with God again. And when he came down with the law in his hands, the skin of his face was iridescent and shining, but Moses didn't know it himself, that is, until the people gazed at him in awe and talked about his shining face. So they knew that God had covered Moses with His hand in the cleft of the rock and passed His Glory by Moses.

And Moses took the tables of testimony into the tabernacle and the pillar of cloud went in behind Moses and rested on the altar. So that was the first time that God had come inside the house to live with people.

Black Death

The Negroes in Eatonville know a number of things that the hustling, bustling white man never dreams of. He is a materialist with little ears for overtones.

For instance, if a white person were halted on the streets of Orlando and told that Old Man Morgan, the excessively black Negro hoodoo man, can kill any person indicated and paid for, without ever leaving his house or even seeing his victim, he'd laugh in your face and walk away, wondering how long the Negro will continue to wallow in ignorance and superstition. But no black person in a radius of twenty miles will smile, not much. They *know*.

His achievements are far too numerous to mention singly. Besides many of his curses or "conjures" are kept secret. But everybody knows that he put the loveless curse on Della Lewis. She has been married seven times but none of her husbands have ever remained with her longer than the twenty-eight days that Morgan had prescribed as the limit.

Hiram Lester's left track was brought to him with five dollars and when the new moon came again, Lester was stricken with paralysis while working in his orange grove.

There was the bloody-flux that he put on Lucy Potts; he caused Emma Taylor's teeth to drop out; he put the shed skin of a black snake in Horace Brown's shoes and made him as the Wandering

Jew; he put a sprig of Lena Merchant's hair in a bottle, corked it and threw it into a running stream with the neck pointing up stream, and she went crazy; he buried Lillie Wilcox's finger-nails with lizard's feet and dried up her blood.

All of these things and more can easily be proved by the testimony of the villagers. They ought to know.

He lives alone in a two-room hut down by Lake Blue Sink, the bottomless. His eyes are reddish and the large gold hoop ear-rings jangling on either side of his shrunken black face make the children shrink in terror whenever they meet him on the street or in the woods where he goes to dig roots for his medicines.

But the doctor does not spend his time merely making folks ill. He has sold himself to the devil over the powerful black cat's bone that alone will float upstream, and many do what he wills. Life and death are in his hands—he sometimes kills.

He sent Old Lady Grooms to her death in the Lake. She was a rival hoodoo doctor and laid claims to equal power. She came to her death one night. That very morning Morgan had told several that he was tired of her pretenses—he would put an end to it and prove his powers.

That very afternoon near sundown, she went down to the lake to fish, telling her daughter, however, that she did not wish to go, but something seemed to be forcing her. About dusk someone heard her scream and rushed to the Lake. She had fallen in and drowned. The white coroner from Orlando said she met her death by falling into the water during an epileptic fit. But the villagers *knew*. White folks are very stupid about some things. They can think mightily but cannot *feel*.

But the undoing of Beau Diddely is his masterpiece. He had come to Eatonville from up North somewhere. He was a waiter at the Park House Hotel over in Maitland where Docia Boger was a chamber-maid. She had a very pretty brown body and face, sang alto in the Methodist Choir and played the blues on her guitar. Soon Beau Diddely was with her every moment he could spare from his work. He was stuck on her all right, for a time.

They would linger in the shrubbery about Park Lane or go for long walks in the woods on Sunday afternoon to pick violets. They are abundant in the Florida woods in winter.

The Park House always closed in April and Beau was planning to go North with the white tourists. It was then Docia's mother discovered that Beau should have married her daughter weeks before.

"Mist' Diddely," said Mrs. Boger, "Ah'm a widder 'oman an' Deshy's all Ah got, an' Ah know youse gointer do what you orter." She hesitated a moment and studied his face. " 'Thout no trouble. Ah doan wanta make no talk 'round town."

In a split second the vivacious, smiling Beau had vanished. A very hard vitriolic stranger occupied his chair.

"Looka heah, Mis' Boger. I'm a man that's travelled a lot—been most everywhere. Don't try to come that stuff over me—What I got to marry Docia for?"

" 'Cause—'Cause"—the surprise of his answer threw the old woman into a panic. "Youse the cause of her condition, aintcher?"

Docia, embarrassed, mortified, began to cry.

"Oh, I see the little plot now!" He glanced maliciously toward the girl and back again to her mother. "But I'm none of your down-South-country-suckers. Go try that on some of these clod-hoppers. Don't try to lie on *me*—I got money to fight."

"Beau," Docia sobbed, "you ain't callin' me a liah, is you?" And in her misery she started toward the man who through four months' constant association and assurance she had learned to love and trust.

"Yes! You're lying—you sneaking little—oh you're not even good sawdust! Me marry you! Why I could pick up a better woman out of the gutter than you! I'm a married man anyway, so you might as well forget your little scheme!"

Docia fell back stunned.

"But, but Beau, you said you wasn't," Docia wailed.

"Oh," Beau replied with a gesture of dismissal of the whole affair. "What difference does it make? A man will say anything at

times. There are certain kinds of women that men always lie to.''

In her mind's eye Docia saw things for the first time without her tinted glasses and real terror seized her. She fell upon her knees and clasped the nattily clad legs of her seducer.

"Oh Beau," she went, struggling to hold him, as he, fearing for the creases in his trousers, struggled to free himself—"You made—you—you promised"—

"Oh, well, you ought not to have believed me—you ought to have known I didn't mean it. Anyway I'm not going to marry you, so what're you going to do? Do whatever you feel big enough to try—my shoulders are broad."

He left the house hating the two women bitterly, as we only hate those we have injured.

At the hotel, omitting mention of his shows of affection, his pleas, his solemn promises to Docia, he told the other waiters how that piece of earth's refuse had tried to inveigle, to coerce him into a marriage. He enlarged upon his theme and told them all, in strict confidence, how she had been pursuing him all winter; how she had waited in a bush time and again and dragged him down by the Lake, and well, he was only human. It couldn't have happened with the *right* kind of girl, and he thought too much of himself to marry any other than the country's best.

So the next day Eatonville knew; and the scourge of tongues was added to Docia's woes.

Mrs. Boger and her daughter kept strictly indoors, suffering, weeping, growing bitter.

"Mommer, if he jus' hadn't tried to make me out a bad girl, I could look over the rest in time, Mommer, but—but he tried to make out—ah—"

She broke down weeping again.

Drip, drip, drip, went her daughter's tears on the old woman's heart, each drop calcifying a little the fibers till at the end of four days the petrifying process was complete. Where once had been warm, pulsing flesh was now cold heavy stone, that pulled down pressing out normal life and bowing the head of her. The woman

died, and in that heavy cold stone a tiger, a female tiger—was born.

She was ready to answer the questions Beau had flung so scornfully at her old head: "Well, what are you going to do?"

Docia slept, huddled on the bed. A hot salt tear rose to Mrs. Boger's eyes and rolled heavily down the quivering nose. Must Docia awake always to that awful desolation? Robbed of *everything*, even faith. She knew then that the world's greatest crime is not murder—its most terrible punishment is meted to her of too much faith—too great a love.

She turned down the light and stepped into the street.

It was near midnight and the village slept. But she knew of one house where there would be light; one pair of eyes still awake.

As she approached Blue Sink she all but turned back. It was a dark night but the Lake shimmered and glowed like phosphorous near the shore. It seemed that figures moved about on the quiet surface. She remembered that folks said Blue Sink the bottomless, was Morgan's graveyard and all Africa awoke in her blood.

A cold prickly feeling stole over her and stood her hair on end. Her feet grew heavy and her tongue dry and stiff.

In the swamp at the head of the Lake, she saw Jack-O-Lanteren darting here and there and three hundred years of America passed like the mist of morning. Africa reached out its dark hand and claimed its own. Drums, tom, tom, tom, tom, tom, beat her ears. Strange demons seized her. Witch doctors danced before her, laid hands upon her alternately freezing and burning her flesh, until she found herself within the house of Morgan.

She was not permitted to tell her story. She opened her mouth but the old man chewed a camphor leaf or two, spat into a small pail of sand and asked:

"How do yuh wants kill 'im? By water, by sharp edge, or a bullet?"

The old woman almost fell off the chair in amazement that he knew her mind. He merely chuckled a bit and handed her a drinking gourd.

"Dip up a teeny bit of water an' po' hit on de flo',—by dat time you'll know."

She dipped the water out of a wooden pail and poured it upon the rough floor.

"Ah wanta shoot him, but how kin ah' 'thout . . . ?"—

"Looka heah." Morgan directed and pointed to a huge mirror scarred and dusty. He dusted its face carefully. "Look in dis glass 'thout turnin' yo' head an' when he comes, you shoot tuh kill. Take a good aim!"

Both faced about and gazed hard into the mirror that reached from floor to ceiling. Morgan turned once to spit into the pail of sand. The mirror grew misty, darker, near the center, then Mrs. Boger saw Beau walk to the center of the mirror and stand looking at her, glaring and sneering. She all but fainted in superstitious terror.

Morgan thrust the gun into her hand. She saw the expression on Beau Diddely's face change from scorn to fear and she laughed.

"Take good aim," Morgan cautioned. "You cain't shoot but once."

She leveled the gun at the heart of the apparition in the glass and fired. It collapsed; the mirror grew misty again, then cleared.

In horror she flung her money at the old man who seized it greedily, and fled into the darkness, dreading nothing, thinking only of putting distance between her and the house of Morgan.

The next day Eatonville was treated to another thrill.

It seemed that Beau Diddely, the darling of the ladies, was in the hotel yard making love to another chamber-maid. In order that she might fully appreciate what a great victory was here, he was reciting the Conquest of Docia, how she loved him, pursued him, knelt down and kissed his feet, begging him to marry her,—when suddenly he stood up very straight, clasped his hand over his heart, grew rigid, and fell dead.

The coroner's verdict was death from natural causes—heart failure. But they were mystified by what looked like a powder burn directly over the heart.

But the Negroes knew instantly when they saw that mark, but everyone agreed that he got justice. Mrs. Boger and Docia moved to Jacksonville where she married well.

And the white folks never knew and would have laughed had anyone told them,—so why mention it?

The
Bone of
Contention

Eatonville, Florida is a colored town and has its colored interests. It has not now, nor ever has had anything to rank Brazzle's yellow mule. His Yaller Highness was always mentioned before the weather, the misery of the back or leg, or the hard times.

The mule was old, rawbony and mean. He was so rawbony that he creaked as he ambled about the village street with his meanness shining out through every chink and cranny in his rattling anatomy. He worked little, ate heartily, fought every inch of the way before the plow and even disputed with Brazzle when he approached to feed him. Sale, exchange or barter was out of the question, for everybody in the county knew him.

But one day he died. Everybody was glad, including Brazzle. His death was one of those pleasant surprises that people hope for, but never expect to happen.

The city had no refuse plant so H.Y.H. went the way of all other domestic beasts who died among us. Brazzle borrowed Watson's two grey plugs and dragged the remains out to the edge of the cypress swamp, three miles beyond the city limits and abandoned them to the natural scavengers. The town attended the dragging out to a man. The fallen gladiator was borne from the arena on his sharp back, his feet stiffly raised as if in a parting gesture of defiance. We left him to the village. Satisfied that the only piece of unadulterated meanness that the Lord had ever made was gone from among us forever.

* * *

Three years passed and his bones were clean and white. They were scattered along the swamp edge. The children still found them sufficiently interesting to tramp out to gaze upon them on Sunday afternoons. The elders neglected his bones, but the mule remained with them in song and story as a simile, as a metaphor, to point a moral or adorn a tale. But as the mean old trouble-making cuss, they considered him gone for good.

II

It was early night in the village. Joe Clarke's store porch was full of chewing men. Some chewed tobacco, some chewed cane, some chewed straws, for the villager is a ruminant in his leisure. They sat thus every evening ostensibly waiting for the mail from Number 38, the south-bound express. It was seldom that any of them got any but it gave them a good excuse to gather. They all talked a great deal, and every man jack of them talked about himself. Heroes all, they were, of one thing or another.

Ike Pearson had killed a six-foot rattler in a mighty battle that grew mightier every time Ike told about it; Walter Thomas had chinned the bar twenty times without stopping; Elijah Moseley had licked a "cracker"; Brazzle had captured a live catamount; Hiram Lester had killed a bear; Sykes Jones had won the soda-cracker eating contest; AND JOE CLARKE HAD STARTED THE TOWN!

Reverend Simms, the Methodist preacher, a resident of less than a year, had done nothing to boast of, but it was generally known that he aspired to the seat of Joe Clarke. He wanted to be the mayor. He had observed to some of his members that it wasnt no sense in one man staying in office all the time.

"Looka heah," Clarke cut across whoever it was that was talking at the time, "when Ah started dis town, Ah walked right up to de white folks an' laid down TWO HUN'DED DOLLAHS WID DIS RIGHT HAND YOU SEE BEFO' YOU AN' GOT MAH PAPERS AN' PUT DIS TOWN ON DE MAP! It takes uh powerful lot uh sense an' grit tuh start uh town, yessirree!"

"Whut map did you put it on, Joe?" Lindsay disrespectfully asked. "Ah aint seed it on no map."

Seeing Clarke gored to his liver, Rev. Simms let out a gloating snicker and tossed a cane knot to Tippy, the Lewis' dejected dog frame hovering about the group hoping for something more tempting to a dog's palate than cane chews and peanut shells might drop. He tossed the knot and waited for Clarke to answer. His Honor ignored the thrust as being too low for him to stoop, and talked on. Was he not mayor, postmaster, storekeeper and Pooh Bah general? Insults must come to him from at least the county seat.

"Nother thing," Clarke continued, giving Simms a meaning look, "there's a heap goin' on 'round heah under the cover dat Ahm gointer put a stop to. Jim Weston done proaged through mah hen house enough. Last Sat'day Ah missed three uh mah bes' layin' hens, an' Ah been tol' he buried feathers in his backyard the very next day. Cose Ah caint prove nothin', but de minute he crooks his little finger, he goes 'way from mah town. He aint de onliest one Ah got mah eye on neither."

Simms accepted the challenge thrown at him.

"Fact is, the town aint run lak it might be. We oughta stop dat foolishness of runnin' folks outa town. We oughta jail 'em. They's got jails in all de other towns, an' we oughta bring ours up to date."

"Ah'll be henfired! Simms, you tries to know mo' 'bout runnin' de town than me! Dont you reckon a man thats got sense enough to start uh town, knows how tuh run it. Dont you reckon if de place had uh needed uh jailhouse Ah would have got one built long befo' you come heah?"

"We do so need a jail," Lindsay contended. "Jus' cause you stahted the town, dat dont make yo' mouf no prayer book nor neither yo' lips no Bible. They dont flap lak none tuh *me*."

Lindsay was a little shriveled up man with grey hair and bow-legs. He was the smallest man in the village, who nevertheless did the most talk of fighting. That was because the others felt he was

too small for them to hit. He was harmless, but known to be the nastiest threatener in the county.

Clarke merely snorted contemptuously at his sally and remarked dryly that the road was right there for all those who were not satisfied with the way he was running the town.

"Meaning to insult me?" Lindsay asked belligerently.

"Ah dont keer HOW yuh take it. Jus' take yo' rawbony cow an' gwan tuh de woods, fuh all I keer," Clarke answered.

Lindsay leaped from the porch and struck his fighting pose. "Jus' hit de ground an' Ah'll strow yuh all over Orange County! Aw, come on! Come on! Youse a big seegar, but Ah kin smoke yuh!"

Clarke looked at the little man, old, and less than half his size and laughed. Walter Thomas and 'Lige Moseley rushed to Lindsay and pretended to restrain him.

"That's right," Lindsay panted, "you better hold me offen him. Cause if I lay de weight uh dis right hand on him, he wont forget it long as he live."

"Aw, shet up, Lin'say, an' set down. If you could fight as good as you kin threaten, you'd be world's champeen'stead uh Jack Dempsey. Some uh dese days when youse hollerin' tuh be let loose, somebody's gointer take you at yo' word, then it will be jus' too bad about yuh," Lester admonished.

"Who?—"

The war was about to begin all over on another front when Dave Carter, the local Nimrod, walked, almost ran up the steps of the porch. He was bareheaded, excited and even in the poor light that seeped to the porch from the oil lamps within, it was seen that he was bruised and otherwise unusually mussed up.

"Mist' Clarke, Ah wants tuh see yuh," he said. "Come on inside."

"Sholy, Dave, sholy." The mayor responded and followed the young man into the store and the corner reserved for City Administration. The crowd from the porch followed to a man.

Dave wiped a bruise spot on his head. "Mist' Clarke, Ah wants uh warrant took out fuh Jim Weston. Ahm gointer law him outa

dis town. He caint lam me over mah head wid no mule bone and steal mah turkey and go braggin' about it!''

Under the encouraging quiz of the mayor, Dave told his story. He was a hunter and fisherman, as everybody knew. He had discovered a drove of wild turkeys roosting in the trees along the edge of the cypress swamp near the spot where Brazzle's old mule had been left. He had watched them for weeks, had seen the huge gobbler that headed the flock and resolved to get him.

''Yes,'' agreed Clarke, ''you said something to me about it yesterday when you bought some shells.''

''Yes, and thats how Jim knowed Ah was goin' turkey huntin'. He was settin' on de store porch and heard me talkin' to you. Today when Ah started out, jes 'bout sundown—dats de bes' time tuh get turkeys, when they goes tuh roost—he ups and says he's goin' long. Ah didnt keer 'bout dat, but when them birds goes tuh roost, he aint even loaded, so Ah had shot dat gobbler befo' he took aim. When he see dat great big gobbler fallin' he fires off his gun and tries tuh grab him. But Ah helt on. We got tuh pushin' and shovin' and tusslin' 'till we got to fightin'. Jim's a bully, but Ah wuz beatin' his socks offa him till he retched down and picked up de hock-bone of Brazzle's ol' mule and lammed me ovah mah head wid it and knocked me out. When Ah come to, he had done took mah turkey and gone. Ah wants uh warrant, Mist' Clarke. Ahm gointer law him outa dis town.''

''An' you sho gointer get, Dave. He oughter be run out. Comes from bad stock. Every last one of his brothers been run out as fast as they grow up. Daddy hung for murder.''

Clarke busied himself with the papers. The crowd looking on and commenting.

''See whut you Meth'dis' niggahs will do?'' asked Brazzle, a true Baptist. ''Goin' round lammin' folks ovah the head an' stealin they turkeys.''

''Cose everybody knows dem Westons is a set uh bullies, but you Baptists aint such a much,'' Elijah Moseley retorted.

''Yas, but Ah know yuh know,'' put in Lindsay. ''No Baptis' aint never done nothin' bad as dat. Joe Clarke is right. Jail is too good

fuh 'em. The last one uh these heah half-washed christians oughta
be run 'way from heah.''

"When it comes tuh dat, theres jus' as many no count Baptists
as anybody else. Jus' aint caught 'em,'' Thomas said, joining the
fray.

"Yas,'' Lindsay retorted, "but we done kotched yo' Meth'dis'
niggah. Kotched him knockin' people ovah de head wid mule
bones an' stealin' they turkeys, an' wese gointer run him slap outa
town sure as gun's iron. The dirty onion!''

"We dont know whether you will or no, Joe Lindsay. You
Baptists aint runnin' this town exactly.''

"Trial set for three oclock tomorrow at de Baptis' church, that
being the largest meetin' place in town,'' Clarke announced with
a satisfied smile and persuaded the men to go back to the porch
to argue.

Clarke himself was a Methodist, but in this case, his interests lay
with the other side. If he could get Jim to taste the air of another
town, chicken mortality of the sudden and unexplained variety
would drop considerably, he was certain. He was equally certain
that the ambitious Simms would champion Jim's cause and losing
the fight, lose prestige. Besides, Jim was a troublesome character.
A constant disturber of the village peace.

III

It was evident to the simplest person in the village long before
three oclock that this was to be a religious and political fight. The
assault and the gobbler were unimportant. Dave was a Baptist,
Jim a Methodist, only two churches in the town and the respective
congregations had lined up solidly.

At three the house was full. The defendant had been led in and
seated in the amen corner to the left of the pulpit. Rev. Simms had
taken his place beside the prisoner in the role of defense counsel.
The plaintiff, with Elder Long, shepherd of the Baptist flock in the
capacity of prosecution, was seated at the right. The respective
congregations were lined up behind their leaders.

Mutual glances of despisement and gloating are exchanged

across the aisle. Not a few verbal sorties were made during this waiting period as if they were getting up steam for the real struggle.

Wize Anderson (Meth.) Look at ole Dave tryin' to make out how Jim hurt his head! Yuh couldnt hurt a Baptist head wid a hammer—they're that hard.

Brother Poke (Bapt.) Well, anyhow we dont lie an' steal an' git run outa town lak de softhead Meth'dis' niggahs.

Some Baptist wag looked over at Jim and crowed like a rooster, the others took it up immediately and the place was full of hen-cackling and barnyard sounds. The implication was obvious. Jim stood up and said, "If I had dat mule bone heah, Ahd teach a few mo' uh you mud-turtles something." Enter His Honor at this moment. Lum Boger pompously conducted him to his place, the pulpit, which was doing duty as the bench for the occasion. The assembly unconsciously moderated its tone. But from the outside could still be heard the voices of the children engaged in fisticuffy trials of the case.

The mayor began rapping for order at once. "Cote is set. Cote is set! Looka heah, DIS COTE IS DONE SET! Ah wants you folks tuh dry up."

The courtroom grew perfectly still. The mayor prepared to read the charge to the prisoner, when Brother Stringer (Meth.) entered, hot and perspiring with coat over his arm. He found a seat near the middle of the house against the wall. To reach it, he must climb over the knees of a bench length of people. Before seating himself, he hung his coat upon an empty lamp bracket above his head.

Sister Lewis of the Baptist persuasion arose at once, her hands akimbo, her eyes flashing.

"Brothah Stringah, you take yo' lousy coat down off dese sacred walls! Aint you Meth'dis' got no gumption in the house uh washup?"

Stringer did not answer her, but he cast over a glance that said as plain as day, "Just try and make me do it!"

Della Lewis snorted, but Stringer took his seat complacently.

He took his seat, but rose up again as if he had sat on a hot needle point. The reason for this was that Brother Hambo on the Baptist side, a nasty scrapper, rose and rolled his eyes to the fighting angle, looking at Stringer. Stringer caught the look, and hurriedly pawed that coat down off that wall.

Sister Taylor (M.) took up the gauntlet dropped like a hot potato by Stringer. "Some folks," she said with a meaning look, "is a whole lot moh puhtic'lar bout a louse in they church than they is in they house." A very personal look at Sister Lewis.

"Well," said that lady, "mah house mought not be exactly clean. But nobody caint say *dat*"—indicating an infinitesimal amount on the end of her finger—"about my chaRACter! They didn't hafta git de sheriff to make Sam marry ME!"

Mrs. Taylor leaped to her feet and struggled to cross the aisle to her traducer but was restrained by three or four men. "Yas, they did git de sheriff tuh make Sam marry me!" She shouted as she panted and struggled, "And Gawd knows you sho oughter git him agin and make *some* of these men marry yo' Ada."

Mrs. Lewis now had to be restrained. She gave voice and hard, bone-breaking words flew back and forth across the aisle. Each was aided and abetted by her side of the house. His Honor was all the time beating the pulpit with his gavel and shouting for order. At last he threatened to descend in person upon the belligerents.

"Heah! You moufy wimmen! Shet up. Aint Ah done said cote was set? Lum Boger, do yo' duty. Make them wimmen dry up or put 'em outa heah."

Marshall Boger who wore his star for the occasion was full of the importance of his office for nineteen is a prideful age; he hurried over to Mrs. Taylor. She rose to meet him. "You better gwan 'way from me, Lum Boger. Ah jes' wish you would lay de weight of yo' han' on me! Ahd kick yo' cloes up round yo' neck lak a horse collar. You impident limb you."

Lum retreated before the awful prospect of wearing his suit about his neck like a horse collar. He crossed the aisle to the fiery Della and frowned upon her. She was already standing and ready to commence hostilities. One look was enough. He said nothing,

but her threats followed him down the aisle as he retreated to the vestibule to shoo the noisy children away. The women subsided and the Mayor began.

"We come heah on very important business," he said. "Stan' up dere, Jim Weston. You is charged wid 'ssaultin' Dave Carter here wid a mule bone, and robbin' him uh his wild turkey. Is you guilty or not guilty?"

Jim arose, looked insolently around the room and answered the charge: "Yas, Ah hit him and took de turkey cause it wuz mine. Ah hit him and Ahll hit him agin, but it wasnt no crime this time."

His Honor's jaw dropped. There was surprise on the faces of all the Baptist section, surprise and perplexity. Gloating and laughter from the Methodists. Simms pulled Jim's coattail.

"Set down Jim," he cooed, "youse one of mah lambs. Set down. Yo' shepherd will show them that walks in de darkness wid sinners and republicans de light."

Jim sat down and the pastor got to his feet.

"Looka heah, Jim, this aint for no foolishness. Do you realize dat if youse found guilty, youse gonna be run outa town?"

"Yeah," Jim answered without rising. "But Ah aint gonna be found no guilty. You caint find me." There was a pleasurable stir on his side of the house. The Baptists were still in the coma which Jim's first statement had brought on.

"Ah say too, he aint guilty," began Rev. Simms with great unction in his tones. "Ah done been to de cot-house at Orlando an' set under de voice of dem lawyers an' heard 'em law from mornin' tell night. They says you got tuh have a weepon befo' you kin commit uh 'ssault. Ah done read dis heah Bible fum lid tuh lid" (he made a gesture to indicate the thoroughness of his search) "and it aint in no Bible dat no mule bone is a weepon, an' it aint in no white folks law neither. Therefo' Brother Mayor, Ah ast you tuh let Jim go. You gotta turn 'im loose, cause nobody kin run 'im outa town when he aint done no crime."

A deep purple gloom settled down upon the Mayor and his followers. Over against this the wild joy of the Methodists. Simms already felt the reins of power in his hands. Over the protest of the

Mayor he raised a song and he and his followers sang it with great gusto.

> *Oh Mary dont you weep, dont you mourn*
> *Oh Mary, dont you weep dont you mourn*
> *Pharaoh's army got drownded,*
> *O-O-oh Mary, dont you weep*

The troubled expression on the face of the Baptist leader, Rev. Long, suddenly lifted. He arose while yet the triumphant defense is singing its hallelujah. Mayor Clarke quieted the tumult with difficulty. Simms saw him rise but far from being worried, he sank back upon the seat, his eyes half closed, hands folded fatly across his fat stomach. He smirked. Let them rave! He had built his arguments on solid rock, and the gates of Baptist logic could not prevail against it!

When at last he got the attention of the assembly, he commanded Dave to stand.

"Ah jus want you all tuh take a look at his head. Anybody kin see dat big knot dat Jim put on dere." Jim, the Rev. Simms and all his communicants laughed loudly at this, but Long went on calmly. "Ah been tuh de cote-house tuh Orlando an' heard de white folks law as much as any body heah. And dey dont ast whether de thing dat a person gits hurt wid is uh weepon or not. All dey wants tuh fin' out is, 'did it hurt?' Now you all kin see dat mule bone did hurt Dave's head. So it must be a weepon cause it hurt him.—"

Rev. Simms had his eyes wide open now. He jumped to his feet.

"Never mind bout dem white folks laws at O'landa, Brother Long. Dis is a colored town. Nohow we oughter run by de laws uh de Bible. Dem white folks laws dont go befo' whuts in dis sacred book."

"Jes' hold yo' hot potater, Brother Simms, Ahm comin' tuh dat part right now. Jes lemme take yo' Bible a minute."

"Naw indeed. You oughter brought one of yo' own if you got one. Furthemo' Brother Mayor, we got work tuh do—Wese wor-

kin' people. Dont keep us in heah too long. Dis case is through wid."

"Oh, naw it aint," the Mayor disagreed, "you done talked yo' side, now you got tuh let Brother Long talk his. So fur as de work is concerned, it kin wait. One thing at a time. Come on up heah in yo' pulpit an' read yo' own Bible, Brother Long. Dont mind me being up heah."

Long ascended the pulpit and began to turn the leaves of the large Bible. The entire assembly slid forward to the edges of the seat.

"Ah done proved by de white folks law dat Jim oughter be run outa town an' now Ahm gointer show by de Bible—"

Simms was on his feet again. "But Brother Mayor—"

"Set down Simms" was all the answer he got. "Youse *entirely* outa order."

"It says heah in Judges 15:16 dat Samson slewed a thousand Philistines wid de jaw-bone of a ass," Long drawled.

"Yas, but this wasnt no ass, this was a mule," Simms objected.

"And now dat bring us to de main claw uh dis subjick. It sho want no ass, but everybody knows dat a donkey is de father of every mule what ever wuz born. Even little chillen knows dat. Everybody knows dat little as a donkey is, dat if he is dangerous, his great big mule son is mo' so. Everybody knows dat de further back on a mule you goes, de mo' dangerous he gits. Now if de jawbone is as dangerous as it says heah, in de Bible, by de time you gits clear back tuh his hocks hes rank pizen."

"AMEN!! Specially Brazzle's ol' mule," put in Hambo.

"An' dat makes it double 'ssault an' batt'ry," Long continued. "Therefo' Brother Mayor, Ah ast dat Jim be run outa town fuh 'ssaultin Dave wid a deadly weepon an' stealin' his turkey while de boy wuz unconscious."

It was now the turn of the Baptists to go wild. The faint protests of Simms were drowned in the general uproar.

"I'll be henfired if he aint right!" the Mayor exclaimed when he could make himself heard. "This case is just as plain as day."

Simms tried once more. "But Brother Mayor—"

"Aw be quiet, Simms. You done talked yo'self all outa joint already." His Honor cut him short. "Jim Weston, you git right outa *mah* town befo sundown an' dont lemme ketch you back heah under two yeahs, neither. You folks dats so rearin' tuh fight, gwan outside an' fight all you wants tuh. But dont use no guns, no razors nor no mule-bones. Cote's dismissed."

A general murmur of approval swept over the house. Clarke went on; unofficially, as it were. "By ziggity, dat ol' mule been dead three years an' still kickin'! An' he done kicked more'n one person outa whack today." And he gave Simms one of his most personal looks.

Book
of Harlem

1. A pestilence visiteth the land of Hokum, and the people cry out.
4. Toothsome, a son of Georgia returns from Babylon, and stirreth
up the Hamites. 10. Mandolin heareth him and resolveth to see
Babylon. 11. He convinceth his father and departs for Babylon. 21.
A red-cap toteth his bag, and uttereth blasphemy against Mandolin.
26. He lodgeth with Toothsome, and trieth to make the females of
Harlem, but is scorned by them. 28. One frail biddeth him sit upon
a tack. 29. He taketh council with Toothsome and is comforted. 33.
He goeth to an hall of dancing, and meeting a damsel there, shaketh
vehemently with her. 42. He discloseth himself to her and she telleth
him what to read. 49. He becometh Panic. 50. The Book of Harlem.

1. And in those days when King Volstead sat upon the throne
in Hokum, then came a mighty drought upon the land, many
cried out in agony thereof.

2. Then did the throat parch and the tongue was thrust into
the cheek of many voters.

3. And men grew restless and went up and down in the land
saying, "We are verily the dry-bones of which the prophet Ezekiel
prophesied."

4. Then returned one called Toothsome unto his town of Stan-
dard Bottom, which is in the province of Georgia. And he was of
the tribe of Ham.

5. And his raiment was very glad, for he had sojourned in the

city of Babylon, which is ruled by the tribe of Tammany. And his garments putteth out the street lamps, and the vaseline upon his head, yea verily the slickness thereof did outshine the sun at noonday.

6. And the maidens looked upon him and were glad, but the men gnasheth together their bridgework at sight of him. But they drew near unto him and listened to his accounts of the doings of Babylon, for they all yearned unto that city.

7. And the mouth of Toothsome flapped loudly and fluently in the marketplace, and the envy of his hearers increased an hundredfold.

8. Then stood one youth before him, and his name was called Mandolin. And he questioned Toothsome eagerly, asking ''how come'' and ''wherefore'' many times.

9. And Toothsome answered him according to his wit. Moreover he said unto the youth, ''Come thou also to the city as unto the ant, and consider her ways and be wise.''

10. And the heart of Mandolin was inflamed, and he stood before his father and said, ''I beseech thee now, papa, to give unto me now my portion that I may go hence to great Babylon and see life.''

11. But his father's heart yearned towards him, and he said, ''Nay, my son, for Babylon is full of wickedness, and thou art but a youth.''

12. But Mandolin answered him saying, ''I crave to gaze upon its sins. What do you think I go to see, a prayer-meeting?''

13. But his father strove with him and said, ''Why dost thou crave Babylon when Gussie Smith, the daughter of our neighbor, will make thee a good wife? Tarry now and take her to wife, for verily she is a mighty biscuit cooker before the Lord.''

14. Then snorted Mandolin with scorn and he said, ''What care I for biscuit-cookers when there be Shebas of high voltage on every street in Harlem? For verily man liveth not by bread alone, but by every drop of banana oil that drippeth from the tongue of the lovely.''

15. Then strove they together all night. But at daybreak did

Mandolin touch the old man upon the hip, yea verily upon the pocket-bearing joint, and triumphed.

16. So the father gave him his blessing, and he departed out of Standard Bottom on his journey to Babylon.

17. And he carried with him of dreams forty-and-four thousands, and of wishes ten thousands, and of hopes ten thousands.

18. But of tears or sorrows carried he none out of all that land. Neither bore he any fears away with him.

19. And journeyed he many days upon the caravan of steel, and came at last unto the city of Babylon, and got him down within the place.

20. Then rushed there many upon him who wore scarlet caps upon the head, saying "Porter? Shall I tote thy bags for thee?"

21. And he marvelled greatly within himself, saying, "How charitable are the Babylons, seeing they permit no stranger to tote his own bag! With what great kindness am I met!"

22. And he suffered one to prevail and tote his bag for him. Moreover he questioned him concerning the way to Harlem which is a city of Ham in Babylonia.

23. And when he of the scarlet cap had conducted Mandolin unto a bus, then did Mandolin shake hands with him and thank him greatly for his kindness, and stepped upon the chariot as it rolled away, and took his way unto Harlem.

24. Then did the bag-toter blaspheme greatly, saying, "Oh, the cock-eyed son of a wood louse! Oh, the hawg! Oh, the sea-buzzard! Oh, the splay-footed son of a doodle bug and cockroach! What does he take me for? The mule's daddy! The clod-hopper! If only I might lay my hands upon him, verily would I smite him, yea, until he smelt like onions!"

25. But Mandolin journeyed on to Harlem, knowing none of these things.

26. And when he had come unto the place, he lodged himself with Toothsome, and was glad.

27. And each evening stood he before the Lafayette theatre and a-hemmed at the knees that passed, but none took notice of him.

28. Moreover one frail of exceeding sassiness bade him go to

and cook a radish, and seat himself upon a tack, which being interpreted is slander.

29. Then went he unto his roommate and saith, "How now doth the damsel think me? Have I not a smiling countenance, and coin in my jeans? My heart is heavy for I have sojourned in Harlem for many weeks, but as yet I have spoken to no female."

30. Then spoke Toothsome, and answered him saying, "Seek not swell Shebas in mail-order britches. Go thou into the market-place and get thee Oxford bags and jacket thyself likewise. Pro-cure thee shoes and socks. Yea, anoint thy head with oil until it runneth over so that thou dare not hurl thyself into bed unless thou wear weed chains upon the head, lest thou skid out again."

31. "Moreover lubricate thy tongue with banana oil, for from the oily lips proceedeth the breath of love."

32. And Mandolin hastened to do all that his counsellor bade him.

33. Then hied him to the hall of dancing where many leaped with the cymbal, and shook with the drums.

34. And his belly was moved, for he saw young men seize upon damsels and they stood upon the floor and "messed around" meanly. Moreover many "bumped" them vehemently. Yea, there were those among them who shook with many shakings.

35. And when he saw all these things, Mandolin yearned within his heart to do likewise, but as yet he had spoken to no maiden.

36. But one damsel of scarlet lips smiled broadly upon him, and encouraged him with her eyes, and the water of his knees turned to bone, and he drew nigh unto her.

37. And his mouth flew open and he said, "See now how the others do dance with the cymbal and harp, yea, even the saxo-phone? Come thou and let us do likewise."

38. And he drew her and they stood upon the floor. Now this maiden was a mighty dancer before the Lord; yea, of the mightiest of all the tribe of Ham. And the shakings of the others were as one stricken with paralysis beside a bowl of gelatine. And the heart of the youth leaped for joy.

39. And he was emboldened, and his mouth flew open and the

banana oil did drip from his lips, yea even down to the floor, and the maiden was moved.

40. And he said, "Thou sure art propaganda! Yea, verily thou shakest a wicked ankle."

41. And she being pleased, answered him, "Thou art some sheik thyself. I do shoot a little pizen to de ankle if I do say so myself. Where has thou been all my life that I have not seen thee?"

42. Then did his mouth fly open, and he told her everything of Standard Bottom, Georgia, and of Babylon, and of all those things which touched him.

43. And her heart yearned towards him, and she resolved to take him unto herself and to make him wise.

44. And she said unto him, "Go thou and buy the books and writings of certain scribes and Pharisees which I shall name unto you, and thou shalt learn everything of good and of evil. Yea, thou shalt know as much as the Chief of the Niggerati, who is called Carl Van Vechten."

45. And Mandolin diligently sought all these books and writings that he was bidden, and read them.

46. Then was he sought for all feasts, and stomps, and shakings, and none was complete without him. Both on 139th Street and on Lenox Avenue was he sought, and his fame was great.

47. And his name became Panic, for they asked one of the other, "Is he not a riot in all that he doeth?"

48. Then did he devise poetry, and played it upon the piano, saying:

> *Skirt by skirt on every flirt*
> *They're getting higher and higher*
> *Day by day in every way*
> *There's more to admire*
> *Sock by sock and knee by knee*
> *The more they show, the more we see*
> *The skirts run up, the socks run down*
> *Jingling bells run round and round*

Oh week by week, and day by day
Let's hope that things keep on this way
Let's kneel right down and pray.

49. And the women all sought him, and damsels and the matrons and the grandmothers and all those who wear the skirt, and with them his name was continually Panic.

50. Of his doings and success after that, is it not written in The Book of Harlem?

Harlem
Slanguage*

Sugar Hill, the northwest corner of Harlem near Washington Heights where most of the newest-occupied large apartment houses for Negroes are. Mostly occupied by professional Negroes. Walter White and others of his financial standing live at 409 Edgecombe. NOTE: It is interesting to note that many expressions that come from the South, as this one does, have been distorted. In numerous southern towns, the Negro red-light district is called "Sugar Hill." The term was probably overheard without understanding its original meaning.

Pilch, house or apartment, residence

Scooter-pooker, a professional at sex

Scooter-pooking, practising, or the act of sex

Jelly, sex

Jelly bean, a man who lives by sex, a pimp

P.I., a pimp

Sweet-back, a pimp

Bull-diker, a flatter, a Lesbian

Flatter, Lesbian

Scrap iron, cheap likker

Conk buster, cheap likker

Reefer, marijuana cigarette

Drag, a reefer

Monkey chaser, a West Indian

Miss Anne, a white woman

Mister Charlie, white man

Ofay, white person

A Pan-cake, humble type of Negro

Handkerchief-head, sycophant type of Negro

Uncle Tom, same as above

Jar Head, Negro man

Zigaboo, Negro

*"Harlem Slanguage" is Hurston's unedited glossary as it appears in her original manuscript. In addition to the terms being alphabetized and condensed, many of the explicitly sexual definitions were eliminated before the list was published as the "Glossary of Harlem Slang" at the end of "Story in Harlem Slang."

Jig, Negro, a corrupted shortening of zigaboo

Aunt Hagar, Negro race

Aunt Hagar's Chillun, Negro race

Old cuffee, Negro (genuine African word for the same thing)

Smoking, or *Smoking over*, looking someone over

Gut-bucket, low dive, type of music or expression from same

Solid, perfect

Cut, doing something well

Stroll, doing something well

Cold, exceeding well, etc. "Yeah man! He was cold strolling on that trumpet!"

Palmer House, walking flat-footed as from fallen arches

Boogie-woogie, type of dancing and rhythm. For years in the South it meant secondary syphilis.

Park ape, an ugly under-privileged Negro

Can, rump

Stuff, sex, or excretion, according to how used

Butt sprung, a suit or a skirt out of shape in the rear

Battle-hammed, badly formed about the hips

Gator-faced, long black face with big mouth

Gut-foot, bad case of fallen arches

Liver-lip, pendulous, thick, purple lips

The Wagon, police patrol

The Man, the law, or powerful boss

Get you to go, power, physical or otherwise to force the opponent to run

Sell out, run in fear

Go when the wagon comes, another way of saying "You may be talking or acting biggity now, but you will cool down when enough power gets behind you. They all go when the wagon comes."

Sender, he or she who can get you to go, i.e. got what it takes. It is used often as a compliment. "Solid sender!!"

Jook, a pleasure house in the class of gut-bucket. The houses originated in the lumber, turpentine and railroad camps of Florida. Now common all over the South, even in the towns. They are the cradle of the Blues, and most of the dance steps that finally migrate north.

Jooking, playing the piano, guitar, or any musical instrument in the manner of the Jooks (pronounced like "took"). 2. Dancing and "schronching" in the manner. A player may be "getting low-down" at the piano and his listeners may yell out in admiration, "Jook it, papa! Jook!"

Sooner, anything cheap and mongrel. Once applied to mongrel dog who would eat anything, even excretion. "He'd sooner eat stuff as pork

chops.'' Now it applies to cheap clothes, shabby man or woman, etc.

Dark black, a casually black person

Low black, a blacker person

Lam black, still blacker person

Damn black, blackest. "Why, lightning bugs follows him at twelve o'clock in the day, thinking it's midnight."

Balling, having fun

July jam, something very hot. "Hot as July jam."

Little sister, measure of hotness. "Hot as little sister!"

Peeping through my likkers, carrying on even though drunk

Your likker told you, misguided behavior, Dutch courage

Ginny Gall, a suburb of Hell, long way off. "Way off in Ginny Gall, where you have to eat cow cunt, skin and all."

West Hell, another suburb of Hell, worse than the original

Beluthahatchie, next station beyond Hell

Diddy-wah-diddy, a far place, measure of distance. 2. Another suburb of Hell, built on since way before Hell wasn't no bigger than Baltimore. Where the folks in Hell go for a big time. All the good jooking, barbecues, fish-frys, etc. are held.

Free schools, a shortened expression of deprecation. When something particularly stupid is done, a sad shake of the head, "Free schools, and dumb Negroes." Sometimes it is embellished with "Free schools, pretty yellow teachers, and dumb Negroes."

I'm cracking but I'm facking, "I am wise-cracking (supposedly joking) but I'm telling the truth."

Nothing to the bear but his curly hair, "I call your bluff." Or "Don't be afraid of him. He won't fight."

Dumb to the fact, "You don't know what you're talking about."

Lightly, slightly, and politely, doing things perfectly

I shot him lightly and he died politely, "I completely out-did him."

Georgia jumping-root, male sex organ

I don't deal in coal, "I don't keep company with black women. I prefer the mulatto kind."

Juice, another name for likker

My people! My people!, the saddest and the funniest expression in the Negro language. It is a sad sign when a progressive Negro observes the backwardness of some members, and realizes that there is nothing that he or she can do about it. For instance, seeing and hearing some loud-mouthed Negroes making themselves thoroughly disgusting in places common to both white and black. At other times it is used with hilarious

effect. One story built around it goes like this:

A monkey was sitting in the middle of the highway playing with his tail and toes, when a Cadillac full of white people came along. Seeing the happy little monkey, they carefully drove off on the shoulder of the road to pass him without disturbing him. The monkey kept on playing. A Buick full of some more white folks came by and did the same. The monkey kept on playing. Then a T Model Ford came rattling down the road full of Negroes. Instead of trying not to disturb the monkey, they tried to run over him, and almost succeeded. The monkey leaped to the side of the road just in time to save his life. He watched the Ford rattling off with the driver cursing at him, and shook his head sadly and sighed, "My people! My people!!!" Some say that the monkey has stopped saying "my people, my people!" They say that he is now saying, "Those people! Those people!!"

Big Boy, stout fellow. But in the South it means fool and is a prime insult. Here again, it took up in the North without being understood. It is a fighting word in the South. If you call a Negro Big Boy, he will tell you something like this: "Don't you call me no Big Boy. Elephant is bigger than me, and he got a name. Taint no more Big Boy. (There are no more fools.) They kilt Big Boy shooting at Fat Sam."

Zoot suit with the reet pleat, Harlem style suit, padded shoulders, 43-inch trousers at the knee with cuff so small it needs a zipper to get into, high waist line, fancy lapels, bushels of buttons, etc.

Drapes, same thing as Zoot

Shags, same as above

Draped down, dressed in the height of Harlem mood

Togged down, same as above

Righteous rags, shags, zoots, drapes, etc.

Young suit, ill fitting, too small. You are supposed to be breaking in your little brother's suit for him. That is what the observers pretend to believe on seeing it.

Cabbage, female sex organ. "Oh, she cooks good cabbage."

Bread, female sex. "Good bread!"

Dat thing, sex of either sex

Ground rations, sex

Under rations, sex

Poontang, boody

Boody, female sex organ. "I hold my dress up to my knees, and I give my poontang to who I please. I hold my dress up in the back and I give my boody to white and black. Oh Poooooontang!!"

Rug-cutter, person who frequents house-rent parties, cutting up the rugs of the host with his feet. Now means a good dancer. Originally meant a person too cheap or too poor to patronize regular dance halls.

Stanch, or Stanch out, to begin, commence, step out

Air out, leave, flee, stroll

Russian, a southern Negro up North. "Rushed up here from Georgy," hence a rushian.

The bear, confession of poverty:
Just like de bear,
I ain't nowhere (broke).
Like de bear's brother,
I ain't no further.
Like de bear's daughter,
ain't got a quarter.

Function, from funk, a small unventilated dance full of people too casually bathed

Peckerwood, poor, and unloved class of southern whites

First thing smoking, a train. "Yeah man! I'm through with this town. I mean to grab the first thing smoking."

Hauling, fleeing on foot. "Man! He cold hauled it!"

Kitchen mechanic, domestic

Broad, girl or woman

Frail eel, pretty girl

Red neck, poor southern white man

Mack, a P.I., a jelly bean

Percolating, parading down the Avenue

Cruising, same as above

Oozing, same as above

Free-wheeling, same as above but more briskness is implied

Git up off of me!, quit talking about me, leave me alone

Now you cookin' with gas!, now you're talking, in the groove, etc.

Getting on some stiff time, really laying your racket

Spreading your jenk, same as above

Jump salty, get angry

Knock yourself out, have a good time

Dig, understand. "Dig me?" means do you get me? Do you collar the jive?

Collar a nod, sleep

I'll do like a farmer, plant you now and dig you later

Collar a hot, eat a meal

Gum beater, a blow-hard, a braggart, idle talker in general

Beating up your gums, talking to no purpose

Trucking, strolling; (2) dance step from the strolling motif

Dusty butt, cheap whore

Storm buzzard, shiftless, homeless character

V and X, Ten-Cent store

Good hair, Caucasian-type hair

Bad hair, Negro-type hair

Righteous moss or grass, good hair

Nearer my God to thee, good hair

Naps, kinky hair

Made hair, hair that has been straightened

Tight head, one with kinky hair

Every postman on his beat, kinky hair

Coal-scuttle blonde, black woman

Pink toes, yellow girl

Pig meat, young girl

Color scale:
 a. High yaller
 b. Yaller
 c. High brown
 d. Vaseline brown
 e. Seal brown
 f. Low brown
 g. Dark black (see blacks)

Knocking the pad, committing sex

Granny Grunt, a mythical character to whom moot questions may be referred

Baby, how is the drawbridge? Any boats passing? Suggestions for moral turpitude

What's on the rail for the lizard, same as above

Brother in black, Negro

Hambone, male sex organ

Getting my hambone boiled, committing sex

Stomp, low dance, but hot, man!

8-rock, very black person

Inky dink, same as above

The Big Apple, the Big Red Apple, New York City

Bam, Down in Bam, down South

Whip it to the red, beat your head until it is bloody

Playing the dozens, low-rating the ancestors of your opponent. Most unsafe game unless you are well armed.

Dat's your mammy, playing the dozens, same as "So is your old man"

Mammy, a term of insult. Never used by Negroes in any other way.

Girls as commented on in Harlemese:
 If she is white,
 she's all right.
 If she is yellow,
 she's mellow.
 If she is brown,
 she can stick around.
 If she's black,
 she better get 'way back!

Now You
Cookin'
with Gas*

Wait till I light up my coal-pot, and I'll tell you about this Zigaboo called Jelly.

Well, all right now. He was a seal-skin brown and papa-tree-top-tall. Skinny in the hips and solid built for speed. He was born with this rough-dried hair, but when he laid on the grease and pressed it down over night with his stocking-cap, it looked just like that righteous moss, and had so many waves till you got seasick from looking. Solid, man, solid!

His mama named him Marvel, but after a month on Lennox Avenue, he changed all that to Jelly. How come? Well, he put it in the street that when it came to filling that long-felt need, sugar-curing the ladies' feelings, pimping, sweet-backing, he was in a class by himself and nobody knew his name, so he had to tell 'em. "It must be Jelly, 'cause jam dont shake." Therefore, his name was Jelly. He was a Scooter-pooker from way back. That was what was on his sign. The stuff was there, and it was mellow. Whenever he was challenged by a hard-head or a frail eel on the right of his title, he would eye-ball idol-breaker with a slice of ice, and put on his ugly-laugh, made up out of scorn and pity and say, "Youse just dumb to the fact, baby. If you dont know what you

*"Now You Cookin' with Gas" is Hurston's unedited version of the story that appeared as "Story in Harlem Slang" in 1942 in *The American Mercury* (see page 127). This original version includes numerous sections that were edited out of the published version, including a reference to the killing of a white police officer.

talking 'bout, you better ask Granny Grunt. I wouldnt mislead you, baby. I don't need to,—not with the help I got." Then he would give the pimps' sign, and percolate on down the avenue. You can't go behind a fact like that.

So this day he was airing out on the Avenue. It had to be late afternoon, or he would not have been out of bed. All you did by rolling out early was to stir your stomach up. That made you hunt for more dishes to dirty. The longer you slept, the less you had to eat. But you cant collar nods all day. No matter how long you stayed in bed, and how quiet you kept, sooner or later that big gut is going to reach over and grab that little one and start to gnaw. Thats confidential right from the Bible. You got to get out on the beat and collar yourself a hot.

So Jelly got into his zoot suit with the reet pleats and got out to skivver around and do himself some good. At 132nd Street, he spied one of his colleagues across the street, standing in front of a cafe. Jelly figured that if he bull-skated just right, he might confidence Sweet-Back out of a thousand on a plate. Maybe a shot of scrap-iron or a reefer. Therefore, Jelly took a quick backwards look at his shoesoles to see how his leather was holding out. The way he figured it after the peep was that he had plenty to get across and maybe do a little more cruising besides. So he stanched out into the street and made the crossing.

"Hi there, Sweet Back!" he exploded cheerfully, "Gimme some skin!"

"Lay de skin on me, pal!" Sweet Back grabbed Jelly's out-stretched hand and shook hard. "Aint seen you since the last time, Jelly. Whats cookin'?"

"Oh, just like de bear—I aint nowhere. Like de bear's brother,—I aint no further. Like de bear's daughter—aint got a quarter."

Right away, he wished he had not been so honest. Sweet Back gave him a top-superior cut-eye look. Looked at Jelly just like a showman looks at an ape. Just as far above Jelly as fried chicken is over branch water.

"Cold in hand, hunh?" He talked down to Jelly. "A red hot

pimp like you say you is, aint got no business in the barrel. Last night when I left you, you was beating up your gums and broadcasting about how hot you was. Just as hot as July-jam, you told me. What you doing cold in hand?"

"Aw, man, cant you take a joke? I was just beating up my gums when I said I was broke. How can I be broke when I got de best woman in Harlem? If I ask her for a dime, she'll give me a ten dollar bill; ask her for a drink of likker, and she'll buy me a whiskey still. If I'm lying, I'm flying!"

"Gar, dont hang out dat dirty washing in my back yard! Didnt I see you last night with dat beat chick scoffing a hot dog? Dat chick you had was bet to de heels. Boy, you aint no good for what you live."

"If you aint lying now, you flying. You aint got de first thin. You aint got nickel one."

Jelly threw back the long skirt of his coat and rammed his hand down into his pants pocket.

"Put your money where your mouth is!" he challenged as he mock-struggled to haul out a huge roll. "Back your crap with your money. I bet you five dollars!"

Sweet Back made the same gesture of hauling out non-existent money.

"I been raised in the church. I dont bet, but I'll doubt you. Five rocks!"

"I thought so!" Jelly crowed and hurriedly pulled his empty hand out of his pocket." I knowed you'd back up when I drawed my roll on you."

"You ain't drawed no roll on me, Jelly. You aint drawed nothing but your pocket. You better stop dat boogerbooing. Next time I'm liable to make you do it." There was a splinter of regret in his voice. If Jelly really had had some money, he might have staked him, Sweet Back to a hot. Good southern cornbread with a piano on a platter. Oh, well! The right browd would, or might come along.

"Who boogerbooing?" Jelly snorted. "Jig, I dont have to. Talking about *me* with a beat chick scoffing a hot dog! Heh, heh! You

must of not seen me, 'cause last night I was riding round in a Yellow Cab, with a yellow gal, drinking yellow likker and spending yellow money. Humph! Tell 'em 'bout me!''

"Git out of my face with that crap, Jelly! Dat broad I seen you with wasnt no pe-ola. She was one of them coal-scuttle blondes with hair just as close to her head as ninety-nine is to a hundred. She look-ted like she had seventy-five pounds of clear bosom, guts in her feet, and she look-ted like six months in front and nine months behind. Buy you a whiskey still! Humph! Dat broad couldnt make the down payment on a pair of sox.''

"Sweet Back, you fixing to talk out of place." Jelly stiffened.

"If you trying to jump salt, Jelly, thats your mammy.''

"Dont play in de family, Sweet Back. I dont play de dozens. I done told you.''

"Who playing de dozens? You trying to get your hips up on your shoulders cause I said you was with a beat broad. One of them lam blacks.''

"Who? Me? Long as you been knowing me, Sweet Back, you aint never seen me with nothing but pe-olas. I can get any frail eel I wants to. I can lay it! How come I'm up here in New York? You dont know, do you? Since youse dumb to the fact, I reckon I'll have to make you hep. I had to leave from down south cause Miss Anne used to worry me so bad to go with me. Who, Me? Man, I don't deal in no coal. Know what I tell 'em? If they's white, they's right! If they's yellow, they's mellow! If they's brown, they can stick around. But if they come black, they better git way back! Tell 'em bout me!''

"Aw, man, you trying to show your grandma how to milk ducks. Best you can do is to confidence some kitchen-mechanic out of a dime or two. Me, I knocks de pad with them cack-broads up on Sugar Hill, and fills 'em full of melody. Man, I'm quick death and easy judgment. Youse just a home-boy, Jelly. Dont try to follow me.''

"Me follow *you!* Man, I come on like the Gang-Busters, and go off the MARCH OF TIME! If dat aint so, God is gone to Jersey City, and you know He wouldnt be messing round a place like

that. Know what my woman done? We hauled off and went to church last Sunday, and when they passed round the plate for the *penny* collection, I throwed in a dollar. De man looked at me real hard for dat. Dat made my woman mad, so she called him back and throwed in a twenty dollar bill! Told him to take dat and go! Dats what he got for looking at me cause I throwed in a dollar.''

"Jelly, de wind may blow and de door may slam; dat what you shooting aint worth a damn!"

Jelly slammed his hand in his bosom as if to draw a gun. Sweet Back did the same.

"If you wants to fight, Sweet Back, the favor is in me."

"I was deep-thinking then, Jelly. Its a good thing I aint short-tempered. Taint nothing to you. You aint hit me yet."

"Oh, I flies hot quick" Jelly said "But I'm mighty easy cooled if de man I'm salty with is bigger than me."

Both burst into a hearty laugh and changed from fighting to lounging poses.

"Dont get too yaller on me, Jelly. You liable to get hurt some day."

"You over-sports your hand your ownself. I just dont pay you no mind. I know taint nothing to de bear but his curly hair. Lay de skin on me!"

They broke their hand-shake hurriedly because both of them looked up the Avenue and saw the same thing. It was a girl, and they both remembered that it was Wednesday afternoon. All of the domestics off for the afternoon with their pay in their pockets. Some of them bound to be hungry for love. That meant a dinner, a shot of scrap-iron, maybe room-rent and a reefer or two. Well, it did happen sometimes, so that gave vapor to hope that some women would buy them forty zoot suits, a Packard, and plenty of money to flash. This one looked prosperous. Both of the Scooter-Pookers hoped that the other one had other fish to fry, but neither retired. Both went into the pose, set lapels and put on the look.

"Big stars falling!" Jelly said out loud when she was in hearing distance. "It must be just before day!" He put all the awe and admiration he could in his voice.

"Yeah Man!" Sweet Back agreed. "Must be a recess in Heaven—pretty angel like that out on the ground."

The girl drew abreast of them, long ear-rings swinging, reeling and rocking in her hips.

"I'd walk clear to Diddy-Wah-Diddy to get a chance to speak to a pretty lil' ground-angel like that." Jelly went on.

"Aw, man, you aint willing to go very far. Me, I'd go slap to Ginny-Gall, where they eat cow-rump, skin and all."

The girl smiled, so Jelly set his hat like it was hanging on one louse-leg and just too mean to fall off, and took the plunge.

"Baby," he crooned, "Whats on de rail for de lizard?"

The girl halted and braced her hips with her hands. "A Zigaboo down in Georgy where I come from asked a woman that one time, and the judge told him 'ninety days' ".

"Georgy!" Sweet Back pretended to be elated. "Where 'bouts in Georgy is you from? Delaware?"

"Delaware?" Jelly snorted. "My people! My people!! Free schools and dumb jigs! Man, how you going to put Delaware in Georgy? You ought to know dats in Maryland. Hah! Hah! Hah!"

"I never heard nothing about no Delaware—not in the part of Georgy I come from."

"We dont care nothing bout no Delaware. Lets me and you go back down there in Georgy and settle down." Sweet Back cooed.

"Go down in Georgy!" Jelly snorted. "You crazy in the head? Christ walked de water to go *around* Georgy. What you want to go in it for?"

"Oh dont try to make out youse no northerner, you! Youse from right down in Bam your ownself!" The girl turned on Jelly.

"Yeah, I'm *from* there, and I aims to stay from there.

"One of them Russians, eh?" The girl retorted. "Rushed up here to get away from a job of work."

"De work didnt worry me. Mister Charlie down there plays too rough to suit me. I aint none of them cowards like them shines down in Bam. I'm *mean!* I got Indian blood in *me*. Them pecker-woods down there liable to make me hurt some of 'em. So I just come on off to keep from killing somebody."

"I know its de truth!" The girl snorted and laughed.

But that kind of talk was not leading towards the dinner table.

"But Baby!" Jelly gasped. "Dat shape you got on you!" He dragged his eyes from her head to her feet." I bet the CocaCola Company is paying you good money for the patent!"

Their girl smiled with pleasure at this, so Sweet Back jumped in.

"I know youse somebody swell to know. Youse real people. You grins like a regular fellow." He gave her his most killing look and let it simmer in. "These dickty jigs round here tries to smile. Spose you and me go inside the cafe here and grab a hot?"

"You got any money?" The girl asked and stiffened like a ramrod. Nobody aint pimping on me. You dig me?"

"Aw, now, Baby!"

"I seen you two mullet-heads before. I was uptown when Joe Brown had you all in the go-long last night. Ha! Ha! Dat cop sure hates a pimp! All he needs to see is the pimps' salute, and he will out with his night-stick and whip your head to the red. Beat your head just as flat as a dime!" She went off into a great blow of laughter.

"Aw, I wasnt scared of him" Sweet Back tried to be casual. "I just know de fool is crazy. De way he carries on. You would think I been fooling with some of his wives. He never hit *me*. He just hit where I was."

"You all really did turn on the fan!" The gile kept on laughing, and both of the men jumped salty. But nothing they said showed it.

"Oh, seeing that he is one of my color, I let him go and call him lucky." Sweet Back went on. "A cracker cop down in Georgy got in my face one time and I shot him lightly and he died politely."

"I know its de truth!" The girl smiled salty like. "I bet you come away from there so fast till your hip pockets was dipping sand."

"Oh, lets us dont talk about the law. Lets talk about us." Sweet Back persisted. "You going inside with me to holler 'let one come flopping! One come grunting! Snatch one from de rear!"

"Naw indeed!" The girl laughed harshly. "You skillets is trying to promote a meal on me. But it will never happen, brother. You

barking up the wrong tree. I wouldn't give you air if you was stopped up in a jug. I'm not putting out a thing. I'm just like the cemetery—I'm not putting out, I'm taking in!'' She reared back and regarded the two with scorn. ''Dig?''

''I'll tell you like the farmer told the potato—plant you now and dig you later.''

The girl made a movement to switch on off. Sweet Back had not dirtied a plate since the day before. He made a weak but significant gesture.

''Trying to snatch my pocket-book, eh?'' She blazed. Instead of running, she grabbed hold of Sweet Back's draping coat-tail and made a slashing gesture. ''How much split you want back here? If your feets dont hurry up and take you way from here you'll *ride* away. I'll spread my lungs all over New York and call the law. Go ahead, Bedbug! Touch me and I'll holler like a pretty white woman!''

The boys were ready to flee, but she turned suddenly and rocked on off with her ear-rings snapping and her heels popping.

''My people! My people!!'' Sweet Back sighed when he was calm enough to speak.

''I know you feel chewed,'' Jelly said in an effort to make it appear that he had had no part in the fiasco.

''Oh, let her go.'' Sweet Back said magnanimously. ''When I see people without the periodical principles they's supposed to have, I just dont fool with 'em. What I want to steal her old pocket-book with all the money I got? I could buy a beat chick like her and give her away. I got money's mammy and Grandma's change. One of my women, and not the best one I got neither, is buying me ten shag suits at one time. All I got to do is to go round to the tailor shop and try 'em on.''

He glanced sidewise at Jelly to see if he was convincing. But Jelly's thoughts were far away. He was remembering those full, hot meals he had left back in Alabama to seek wealth and splendor in Harlem without working. He had even forgotten to look cocky and rich. He was thinking corroding thoughts about the white folks in this man's town—so cold and finicky about jobs. So mean

about folks being on time and things had to be done just so. They would call you 'Mister' all right, just like he had been told that they would. But they kept their old clothes and wore them themselves. You better not never ask them about a loan before pay-day. Then too, these Harlem landladies! They didnt want a thing out of you but your rent. One thing had been over-rated. These lady-people wasnt as lonesome for love as somebody had told him. His hunger brought him back to the present. He decided he had better mooch on around to a certain hair-dressing parlor. The woman who ran it usually gave him a dime or two if he ran errands for her, which was more work than he wanted to do, but which he did when the hunting was poor.

"Well, I better get on down town and see if them folks at de car place got my Packard ready for me. My woman just would buy it. Told her I didnt want to be bothered with no car." Jelly said this casually as if it bored him to death.

"Same here," Sweet Back came back snappily. "Okay, Jelly. See you in the funny papers. If I dont see you no more in this world, I'll meet you in Africa."

"Abyssinia," Jelly said. "Dont get into no more scrapes like you done just now."

"Oh, well, Jelly, if you dont bite, you dont taste."

Both of them stiffened their arms at their sides, pointed their first fingers rigidly at the ground in the pimps' salute and went their separate ways.

The Seventh
Veil

The commanding officer emerged from the great gate of the Roman fort at Lyons. He was accompanied by a subordinate officer who had arrived only the day before—sent out with two additional legions to beef up the staff of this important post. He was being taken for a stroll around the Fort.

"But look," he indicated to the left of the road, a short distance from the entrance. "What wretchedness! Ignorance and poverty show there plainly on that old couple. Yet they have a neat cottage and a handsome though small orchard."

"And that confirms the deceptive nature of appearances." The commander answered quickly that the old man dressed in the clothing of a peasant is Antipas, prince of Judea, son of Herod the Great, and once possessed of one of the greatest fortunes in the empire, highly educated in Rome by the most eminent of our scholars and accustomed to the most luxurious living that Romans stationed in Asia took it as a high honor to be invited to be his guest in his white marble palace on the Lake of Galilee.

"By the fortune of Caesar! What brought a man like that to such a state?"

"The well known greed and corruption of Caligula and a bit of desert patriotism on the part of the prince. There was a slavish boot-licking brother of the wife of the prince—she is called Herodias, after her celebrated grandfather—who betrayed the patriotism of Antipas, who had once been imprisoned for his lack of

morals by Tibernius, who was set free by Caligula who was of the same patterns and made king in the place of Antipas but fortunately did not live long to enjoy his evil-gotten gains.''

"Good. But Caligula has been dead many years. Why has the prince not sued for the return of his fortune and his power?''

"Many have asked that and urged it upon Antipas, but he no longer desires it, it appears. He is content to sit there waiting for a religious prophet which he calls John the Baptist, who he is convinced will appear in Gaul one day.''

"You certain it is not this Jesus Christ show followers are causing such disturbance in Rome at present?''

"No, John the Baptist is the name he states. And as decayed as that man and woman appear now, he was a robust figure of handsome face once, and this Herodias was rated as one of the most beautiful and elegantly dressed women who ever appeared in Rome and moved among the Patricians and Royal circles.''

"Oh, how tragic! I am moved to go over and make them a present of money.''

"No, you will only offend them. They desire nothing but the simplest things, and besides it is whispered that there are chests of gold and silver in that small cottage. Caligula did not completely succeed in his purpose. Those two want no more of luxuries. The money is for John the Baptist to distribute to the poor when he appears, or to found a mutual help for his followers.''

"That is dedication. I should like to talk with them sometime.''

"There is something more. Rumor has it that those two have lived a romantic life that may well be one of the great love affairs of the inhabitable world. Someday minstrels may sing of their love, who knows?''

"And now, Gallentins,'' the young officer nodded, "I remember seeing the old woman down at the Wharf when our ships docked on the Rhone peering eagerly at the faces of the passengers as they disembarked, then turning away at last in disappointment. Perhaps she was seeking this John the Baptist.''

"Certainly they do that for every ship that comes up either of the two streams the Rhone and the Saone. And they watch the

roads which come here from every part of Gaul the same way. It is truly remarkable.''

Herodias was seated in a rude chair whose seat was covered by a goat skin with the hair still on it, beside Antipas in an identical chair, before their simple cottage of four rooms. There were flowers blooming in the yard. A vineyard began at the rear of the house and extended for a hundred yards and off to the left of the house in front a vegetable garden where a man worked. To the right an animal enclosure with goats, sheep, fowls and in a separate enclosure, a magnificent Arabian stallion.

She was aware that they were the subject of discussion of the Roman officers. But they attracted attention at the Fort often. There were men there who had known them in their prime and even a few oldsters who had known of Herod the Great. Being an object of curiosity did not disturb her. The drowsing Antipas was not even aware of the men on the opposite side of the great highway.

Antipas had selected and bought this small homestead with great care. Just a short way north of the main entrance to the Roman fort. Nobody could enter nor leave it without his observation if he cared to watch. The fort of Lyons was the most important outside of Italy itself. It was just across the mountains and roads to every other point in Gaul ran from there. This arrangement had been made by Agrippa, 43 B.C. Augustus Caesar had built the ample aqueducts and other improvements and Lyons became the center of things beyond the Alps. Caligula had exiled Antipas to Lyons, believing he would be carefully watched there and not allowed to flee back to Asia and seize his former power. It was not because Antipas was so carefully watched, for few were sympathetic with Caligula, but that Antipas had no wish to return to power.

But the years went by and no John the Baptist appeared in Gaul, but Antipas would not give up hope and Herodias would not give up Antipas.

With her once luxuriant head of hair thinned and discolored by age and the contour of her face drooping and dripping down

under her chin, she sat there in the afternoon sunlight beside Antipas, indifferent to stares and comment. Often she spent time retracing her steps to where she had come, this small but clean and comfortable cottage at the confluence of the Rhone and the Saone in Gaul. Passion, passion for a man, had brought her here, but she had no regrets. She still possessed Antipas, son of Herod the Great, and that was all she had ever *really* wanted in her turbulent life.

She remembered clearly how it all had begun. Her grandfather, Herod the Great, was on his death bed and his sons who were in school in Rome had been summoned back to Jerusalem.

From the chatter of hopeful mothers, Herodias heard the names of the returners but shut in the women's apartment she did not even glimpse them immediately. It was in the late afternoon of that day when a tall figure emerged from the door of the King's apartment into the huge enclosed rectangle that held some rose trees, shrubbery, two fountains and the houses of Herod's beloved doves.

This was a magnificent figure of a young man, beautiful of hair and face who bore himself with great confidence. He visited the dove houses, then glanced about the shrubbery lovingly, then precise he, headed towards the entrance of the women's apartment.

By that time, the little Herodias, aged 12, was in love. She wanted to rush to the door and fling herself into the arms of this Antipas. She knew it was he because his mother the very gentle Malthrace, the Samaritan, cried out, "It is Antipas my son who comes to see his mother!" The woman ran to the door, flung it open and herself into a tight embrace with the handsome young man. He was very tender with his mother and when the embrace was over presented her with a magnificent brooch and a chain for her neck of very fine gold and cunning workmanship, and another kiss on the cheek.

"Oh what a loving, tender, splendid and thoughtful son God has given me!" Malthrace buried her face again on the shoulder of Antipas. "But where is my first born?"

"Ah, after going in to our father Archelaus hurried off into the city to renew the acquaintance of his old association, Mother. I am certain that he will come in to see you presently."

And now Antipas saluted each of the wives of Herod respectfully by name, and the children in a group, which was a vast disappointment to the palpitating Herodias who had hoped to be greeted in the same emotion that she felt for her handsome young uncle. Then Antipas left by the same door by which he had entered, recrossed the garden and returned to the bedside of the King.

He left the women's apartment in a turmoil, for every mother there with a son had hopes for her offspring, and each hated the other for her hopes. Rumors flew thick and fast. It was known that Salome, the sister of Herod and his most trusted advisor, was with him constantly and that the King was writing his will.

Herodias saw Antipas again the following afternoon when every member of the royal house was summoned to appear in the King's private apartment to hear the reading of the will.

Salome made it known immediately that Herod favored Antipas as his successor because of his generous spirit and tender heart. He would be kind and considerate to the people, but since Jewish custom demanded the succession of the first born, he was naming Archelaus. It was explained why this prince or that one was passed over. Then it came to the disposition of every member of the family and who was to be mated with whom and the amount of money settled upon each.

Herodias was aflame with hope that she would be given to the handsome and kindly Antipas, but he was mated with the daughter of the King of Arabia Petra, as Herod wished to bind the two nations together.

The old woman seated before the little house in distant Gaul felt a tremor over her whole body and her toes grip at the soles of her sandals at the memory. She had the impulse to leap to her feet and cry out in protest to the King propped up by many pillows in his enormous bed. But a glimpse at the face of Salome warned her. It reminded her that she was the daughter of Aristobulus who was

the second son of Miriamne of the power-greedy Asamoneans, who had plotted with his brother Alexander to murder their father Herod to obtain the government. And while the King was tenderness itself with his grandchildren made fatherless by the execution of the two conspirators, the inhabitants of the women's apartment did not spare them. She was accustomed to frequent slighting remarks intended to wound which were made about murderers so vile that they would treacherously slay their own father, so what could you look forward to in the offspring of such foul ingrates? The overflowing kindness in the face of Antipas on his short visit to the women's apartment and the fact that he did not look at her nor others of the children of the conspirators any different than the other children endeared him further and made her want to take refuge in him, until by this hour Antipas seemed necessary to her very existence.

But the inexorable voice of the King went on, "Herod son of Miriamne, the daughter of Simon the high priest, and Herodias, daughter of Aristobulus, son of Miriamne, of the Asamoneans will please come to me and join hands in marriage and may the blessing of God be upon you and go with you."

And Herodias managed to follow the command without fainting. She glanced at Antipas seeking dissatisfaction in his face, but there was none. He appeared utterly indifferent to the undeveloped girl who was being pledged to his half brother, who was several years his senior. This Herod, son of the famous Alexandrian beauty who had captured the heart of Herod after the execution of that first Miriamne, was handsome enough but weak of face and somewhat lacking in personality. At one time he had been considered as the successor of the King, but his mother was found to be in a conspiracy against the King and excluded from the throne. As in each case the amount of money settled upon each was announced.

Herodias was grateful that her marriage was near the end of the list so that she could flee the room now hateful to her. She was given to uninteresting Herod and Antipas did not even care! Oh but he would! When she was grown, he would repent his indiffer-

ence of this hour. She would make him love her.

The old woman turned her head and gazed at the old man sitting beside her with great satisfaction. "And I made him love me. That I did. Few women of the world have been so loved."

In retrospect Herodias skipped over those years during which she and Herod dwelt in Rome and lived in luxury as members of the Patrician society and received at the palace. Herodias was looked upon as among the reigning beauties and distinctive dressers of Rome. Herod was the rich husband of Herodias. She bore him a daughter in her sixteenth year, a beautiful, sprightly auburn-haired little being which Herod ignored more or less because it was not a son. And seeing the child with so much personality as well as beautiful, Herodias thought it fitting to name her after her own grandmother Salome, who was the sister of the late King, Herod the Great.

Little Salome was in her second year and walking well, when Antipas Tetrarch of Galilee came to Rome on business, and on the urging of his brother made their home his own during his stay in Rome.

Six years had passed since the elaborate funeral of Herod the Great and when she had last seen Antipas. And she now considered that God had granted her the opportunity she had prayed for. And she had no intention of wasting it. She dressed for him and acted to catch his attention and to please him. She now had a matured body to fight with, and she made the most of it. It so happened that they both were fond of the theatre and Herod was not, so they attended together. Antipas was particularly devoted to the dance and they took in all that Rome was offering at the time, attracting much attention and admiration by the splendid appearance that they made as a couple.

Then Herodias found that fate had provided her with another weapon. Antipas, like his father, was very fond of children and his marriage with the daughter of Aretas had provided him with none so he began to shower great affection upon the little Salome. Herodias continually threw them together when they did not go out. Both she and Antipas had keen senses of humor and shared

lots of jokes which went right over the head of her husband. Antipas had an abundance of old friends in Rome and Herodias encouraged him to entertain them in her home as if it were his own and no function was too elaborate for her to prepare for him for his friends.

Then when she deemed that the time was ripe, one day when Antipas reclined on a long seat in the little garden with Salome cuddled in his arms, she put matters to a test.

"You hurt me terribly on one occasion, O Antipas."

"It was certainly not intentional, O beauteous Herodias. Tell me how and when it happened."

"On the occasion when the King was mating us all up. I yearned desperately to be given to you, but the King gave me to Herod. I looked at your face to see if you were as displeased and disappointed as I was, but you appeared utterly indifferent and it broke my heart."

"But you were nothing but a child at the time, O Herodias. You can be certain that I am no longer indifferent to such a great treasure. By the fortune of Caesar, I now desire you more than any other woman of the world, and want you to be my wife."

"More than your Arabian princess?"

"I said more than any woman of the inhabitable earth, and if it is pleasing to you, I will divorce her and marry you and be a faithful and devoted husband to you and a kind loving father to your child."

Herodias ran across to the bench and flung herself in his arms and covered his face with kisses.

"You have my answer, Beloved, and I will quickly divorce Herod. The King did what was expedient. None of our feelings were taken into account. I do not believe that Herod ever loved me anymore than I do him. There is a certain Roman matron to whom I feel he is devoted. So let it be."

"Very well, when I have finished my business with the palace, I will return to Galilee and divorce my wife, and you must follow me and share my fortunes what ever they may be."

Their right hands clasped tightly.

"Whatever happens to you, my beloved, happens to me, till death do us part. That I swear, Antipas," and once more Herodias fell to kissing and embracing the man on the marble bench.

Just at that moment, Herod emerged upon the portico, but Herodias did not spring away from her embrace.

"How fortunate that you have appeared at this moment, Herod. I am desperately in love with Antipas, and am now asking you to divorce me so that I can marry him."

At that moment Herod's chariot drew up at the door.

"As you will," Herod said in a flat tone of voice. "And you can take with you all the money which the King gave her, any of the household furnishings that she desires she can take."

"Oh no, brother," Antipas interjected. "I have planned a new and splendid city on the shores of Lake Galilee which I shall name after the emperor Tiberius, and there I shall build a palace for myself sparing no expenses to make it truly magnificent. It will be furnished exactly as Herodias wishes—to the last detail. She will require nothing from you."

"As you will," said Herod with indifference, and stepping into his chariot was driven away swiftly.

The Tetrarch of Galilee was not so fortunate with his Arabian princess. He kept his new alliance secret or so he thought; until he could return her to her father with all formality and dignity, but some how she got wind of it and fled to Petra Arabia and told her story. Therefore, shortly after Herodias joined Antipas in Galilee, Aretas marched against Antipas with a great army.

Here Antipas was confronted with a matter of conscience. He was a man deeply in love and had no intention of abandoning Herodias, but he had a feeling of guilt as regarding Aretas and of violating the plan made by his father. What to do? As a matter of diplomatic appeasement, he summoned few troops, fought faintly and so Aretas could boast of a victory over him and march back to Arabia consoled. So far as Herodias was concerned, he lost nothing. He did not give her up, and fought a battle for her. She was exalted and felt herself deeply loved.

In time, the white marble palace was duly completed. It had a

land and a water entrance. The long eastern portico had steps which dipped down into the waters of Lake Galilee, so that the boats of Antipas could discharge and take on passengers there. He was extremely fond of boating and boats. He had a very luxurious seafaring vessel which he kept at Caesarea. It was a pleasure to Herodias to stretch herself on a couch on this eastern portico and listen to the little waves slapping at the stone steps and watch the movement of fishing and pleasure boats out on the lake.

Then came this John the Baptist. He was a barrel-chested, heavily bearded man of about her own age from among the River bathers from a spot known as the Desert of Quietude on the eastern shore of the Jordan just before it entered the Dead Sea. They belonged to the sect of the Essenes.

Herodias never knew what moved this man to come northward to Galilee and denounce her marriage to Antipas, unless the fact that Herod the Great had a sort of affiliation with the Essenes. They walked in and out of his palace at will, ate, and took what they wanted and scolded the King as if he were no more than a common workman if they saw fit. Herod's submission to the Essenes was so complete that the Pharisees complained that "Herod treated the Essenes with a greater reverence than their mortal nature requires."

So the young Essene erupted into Galilee, to reprove the Tetrarch for his divorce and remarriage to his former sister-in-law, feeling, no doubt, that the public scolding would be accepted by the son of Herod the Great in the spirit it was given.

The reports of the denunciation of her great happiness were brought to her by many.

"I am not at all distressed by this man," Herodias assured her maid. "For the Tetrarch will punish his vile insolence with instant death. Did he not fight a war with the King of Arabia on my account?"

"But that is just the difficulty, O beautiful Herodias. The Tetrarch appears not to be offended by this religious fanatic, but accepts the charge as no more than the scoldings of a father to a son. He consorts with him and listens humbly."

"Consorts with him—listens humbly."

These words burned like tongues of flames across the brain of Herodias. And a great fear arose in her soul. Could this hairy monster from the Desert of Quietude exert a power that was greater than all others even her own over the Tetrarch? Antipas was a worshiper and imitator of his father who was known to be a subject of the River Bretheren. How far had Antipas committed himself to their doctrines? Could he be persuaded to put her away? She had not defense if he decided to do so.

Herodias was sipping some fresh pressed grapes from Italy when Antipas appeared about two agonizing hours later. And pretending to be calm and unconcerned, when she broached the matter.

"Of course you will order this monster slain for the insults that he has offered to you as the ruler of Galilee and to your wife."

"Oh no, my beloved Herodias. I cannot lay violent hands upon such a holy man."

"Holy man!" Herodias leaped to her feet. "What sacrilege! Do you no longer love me, my beloved?"

"More than anybody or anything else on earth, Herodias. But I revere him. I am not certain that these Essenes are just mortal men. Maybe they are reflections of spirits in Heaven. I fear to touch that man. Let him scold away. I will never put you away. You can be sure of that, but I will never slay this prophet either."

"Then I will!" Herodias screamed. "This beast who would deprive me of the only happiness I have ever known. I will kill him like any other raving beast! I will shed his blood with my own hands!"

"That I cannot permit, Herodias. But do not distress yourself further. He cannot turn me from you."

Antipas would not discuss the matter further, and the next day he disappeared and did not return until the third day. What troubled Herodias was that John the Baptist vanished from Galilee at the same time and none could tell what had become of him. She sent out spies, but none could find a trace of the Essene, and

Antipas refused to answer any of her questions concerning the man.

"But Beloved," Herodias protested, "when did you become so pious? I have never noted it in you previously."

"There was no occasion for it. This is a very serious matter, song of my soul. Think of being privileged to meet a deity in the flesh."

"Pooh! deity indeed! Nothing more than a hairy rustic from that waste place, the Desert of Quietude where nothing lives but an abundance of little owls and Essenes, I am told. In fact this John the Baptist has a pet, one which rides about on his shoulder and sleeps in his thick matted hairs. Deity indeed! Just let me get my hands upon him and I will show you how mortal he is!"

"It is my responsibility to see to it that he does not come into your hands, Beloved. What a sacrilege you contemplate! And what a tremendous honor you would deprive me of—the earthly arm of a new and true religion. Forget your petty spite and look carefully after the instruction of our daughter. How does she do with the Seven Veils?"

"If anything better than her celebrated teacher. The child is a genius at the dance. I am quite proud of her."

"I am eager to see her performance, but have not the time at present, but oh, how I love her. She's the jewel of my life."

"Very strange to hear you say that my dear, when you allow this John the Baptist to destroy the very foundations of her life."

"You willfully misinterpret the facts, my beautiful Herodias. Because I will not lay violent hands upon a deity that does not mean that I no longer love my family."

Herodias sought to pull him down upon the many-cushioned couch with embraces, but Antipas prevented her.

"I must hasten away, song of my soul. Many important things to be attended to if Asia is ever to cast off the yoke of Rome. Under the rule of my noble father, Rome was the friend of southwest Asia, so it must be weakness on my part if this Pilate can play the vicious and obscene tricks on Judea and Samaria. He has even molested Galileans, who were placed under my special care and

protection by my father. He flashed his sword in protection of Galilee and always loved it best of all. He exacted a solemn oath from me that I would protect the Galileans well, and I gave my solemn word.''

"But you are ruler of Galilee only, not of Judea and Samaria."

"Every Jew in the inhabitable world can claim my sympathy and protection, Herodias, and as you know, my mother is a Samaritan. Mt. Zion and Mount Gerizzim are one in my heart. Pilate's outrages against both has my blood boiling. But just words mean nothing if you are powerless to strike. We have at present the arms and equipment for 70,000 men; when we can field 100,000 I shall make a strong protest to Tibernius and if we are not treated with respect, we shall fight. Nor have I concealed my rage at the shameful abuse of my people from Pilate. He fears that I shall place the matter before Tibernius, but I will not until I am prepared to fight. I leave you again today Beloved to confer with other potent men of Asia who share my views."

"And where will you meet, object of my soul?"

"That I am not permitted to reveal." Antipas turned sharply on his heel. "I must hasten away. Do not expect my return under seven days, Beloved."

Herodias went to the west portico to wave him good-bye as usual and in less than an hour he thundered off without looking in on Salome's dancing instructions, which was strange indeed.

Herodias returned to the eastern portico to watch the activity on the lake. But fear had grown in her until it all but choked her. And fear is the mother of hatred. The more she feared for her security with Antipas the more she hated John the Baptist. She said to herself, "All right, he has put me away, now what is my life?" But she could not conjure up any compensating benefits, spiritual nor material. Oh, she would not be poor. There untouched were the two chests of money inherited from her grandfather, but what benefit to her derived from spending it, separated from Antipas. He was her life, her very breath and blood. This was love in its purest form. She could not be deprived of Antipas without giving up her very existence. And she was prepared to

fight to the death for him. But let her get her hands on this John the Baptist and he would not disturb the happiness of any other woman. That hairy beast and his owl! Oh how she hated!

She heard a chariot make a furious stop at the western portico and was on her feet in an instant and running through the great hall of reception. She was deflated when she saw that it was her brother Agrippa, who had been staying with them for several months now. He was a tall, handsome ne'er-do-well who would spend his last coin to entertain someone like the kin of royalty—make an impression and leave nothing to support his wife and children who were at present in Ituraea being cared for by her family, while Agrippa, who was to be known later as King Agrippa, lived with Herodias and Antipas.

"Oh, it is only you," Herodias said flatly. "I thought that my husband might have turned back for some reason."

"No chance of that, my proud and arrogant sister. He has important matters to attend to. I am his trusted assistant in the matter. A new shipment of arms from the east is coming across the lake this night. I was left behind to see them safely across the lake and stored in the palace."

"It is time you did something to justify the enormous expenses of your extravagances, Agrippa. You will impoverish my generous husband."

"Nonsense! With what his father willed to him and his enormous revenues coming from his office as Tetrarch, his is one of the biggest fortunes in the empire."

"Which a sycophant of a waster like you envy him."

"Frankly I wish I had even a half of it." Agrippa was possessed of great charm of manner and he knew it. Now he illuminated his features and continued, "I would be extremely grateful for a mere talent of seven right now and the loan of the pale pair of arabian horses and the chariot of white and gold. I promised some friends to meet them at an inn in Caesarea the day after tomorrow."

"I am very glad that it is I and not my open-handed husband that you approach, my wastrel of a brother, for I can and do refuse you with a firm voice. I was lamenting that Antipas did not

tell me where he was going, so now, not knowing, I cannot tell you where to find him."

"That I already know. I know that he left here to meet others at the Fort of Macherus: that he hides there also John the Baptist with whom he converses at every opportunity and feasts every evening."

Herodias could not quite suppress a gasp of surprise and pleasure, then covered her failure by flipping.

"Oh, that I know of—I mean the presence of the prophet at Macherus. A good place for him to be confined too."

"You knew no such thing, insolent sister. You think I have not heard of your frantic efforts to find this John the Baptist and lay hands upon him. I told you because I thought you might give me some of the generous sums you promise others to locate him, even though I betray Antipas by letting it slip."

"Very well, Agrippa, 100 shekels of silver from my own purse, but not the horses and chariot of my husband."

"Why not? He would never know. I would be back long before he finishes with the conspirators at Macherus."

"Are you insane, Agrippa? You are only my brother, and that by an accident of nature, but Antipas, greatly beloved, is my husband, and I will allow none to exploit him. I am his wife."

"Very well. I will accept the mira and hire a rig and be off to the coast. You are indeed a husband-worshipping female if ever one existed."

"That is my glorious privilege to worship at the feet of Antipas. What created woman could wish for more? I would prefer death to the loss of him."

"Antipas talks that kind of drivel concerning you, but I thought you were more sensible."

"Thank God, I am not. Now, go away and let me enjoy my thoughts of my husband while my maid rubs me down with that youth preserving ointment that Antipas bought for me in Alexandria. How thoughtful, kind and indulgent is Antipas! He built and furnished this palace to my wishes and specifications, my clothes and ornaments leave nothing to be desired to say nothing of what

he lavishes upon my daughter—the expensive dancing teacher, the bands of musicians to accompany her movements, her costumes, and ornaments. And would I sit like a dolt and allow some hairy prophet with the one the Romans call a bubo riding him around like a charioteer, and no doubt this owl is the source of his divine instruction part no one from another under the name of righteousness, when in fact pure love like ours is the highest virtue? I will not allow it. No! Nothing but death shall part me from my Antipas."

"I am willing to go, my sister, but where is the talent of silver that you promised me?"

"One moment, and you shall have it." She turned to her maid. "Fetch me my purse from my apartment, Iris, and make haste, so this wastrel and drunkard may be on his way to the coast. The very presence of this eternal beggar offends me."

She all but flung the heavy purse in her brother's face and turned on her face for two reasons. The obvious one being to allow the maid to massage her back, but the real one that the triumph in her face might not be observed. Aha! Antipas was check-mated. She had come upon his secret, now this John the Baptist would be brought to justice and dealt with according to his deserts. This would-be Wrecker of perfect love blotted from the earth.

But to get hold of him and get him in her power? Herodias dwelt upon these questions until around sundown when she summoned Salome to the east portico with its 20 Corinthian columns, its couches piled high with silk cushions and potted plants, and told her, "My beautiful daughter, light of my life, do you want to please your father very much?"

"Oh yes, Mother, you know that I do. My love for him consumes me."

"Good! Then have your most elaborate dance costumes packed and we shall take your musicians and set out to where he is and you shall dance for him and his eminent guests."

Salome flung her slender arms around Herodias and embraced her warmly.

"Oh, Mother! Nothing would please me more. I love to dance

at any rate, and if I were not the daughter of a Tetrarch and a princess I would make it my profession. And Antipas is such a connoisseur of the dance, and when I please him, I am most exalted. I shall exert myself to satisfy him and his guests, you can be assured. Oh, Mother!''

"That is what I desire and expect of you, my beautiful. It is of the greatest importance that your performance please Antipas completely, who has expended such extravagant sums upon your instruction. I might persuade him to allow you to perform publicly.''

"I'd love that more than anything in the world, adored mother. And I am certain that I can please him now my instructor has repeatedly declared that she has nothing more to teach me.''

"Well, make ready to depart before dawn of tomorrow, my precious love.''

"Oh, glorious!'' the girl exclaimed, executed a perfect whirl and vanished.

At sunrise the party was rounding the southern end of the lake to cross the Jordan entrance at Gadara. There they would wing southward by the road that paralleled the river along its eastern shore as the captain of the guard considered they would be less likely to encounter bandits there than on the road which ran along the Jordan to the west. They were traveling through what was known as the Decapolis—the Ten Greek cities. They were in the deep, hot, narrow valley of the Jordan, the result of some violent upheaval of nature which dropped this gulch many hundred feet below sea-level and ended in what is known as the Dead Sea. On the urgings of Herodias, the cavalcade moved at a smart pace, so that in the early afternoon, it passed through the Desert of Quietude and ahead of the community of the River Bretheren, the one to which John the Baptist belonged. A cultivated spot of green in otherwise grayness.

"I suggest we make camp here briefly for rest and refreshment,'' the captain said as he dropped back and rode beside Herodias.

"No! I want nothing to do with religious fanatics and owls.''

"It is not necessary to enter the community, but it is safest in this vicinity."

To this Herodias agreed. The party halted, had bread, meat and wine and set out again with the hope of reaching the mountainous area that fronted three ways: Midia, Arabia and Judea. Herod the Great had created an impregnable fortress called Macherus on this strategic spot.

And now they entered the dirty gray salt deposits of fantastic hills and hummocks rising from the shores of the Jordan before it gave up its life and everything living in the Dead Sea. They knew that Fort Macherus was near and could be reached before darkness fell.

Now the way was upward and their mounts labored as they climbed. Suddenly the scowling ramparts of Macherus appeared above them, and Herodias was surprised to find that those in the fort were not surprised but had had her party under observation for nearly an hour. So well was this fort planned and constructed. The Tetrarch was merely astonished to find his wife and daughter there.

"How did you know where to find me, Beloved of my soul?" Antipas inquired as he embraced Herodias warmly, "and why have you come to this terrible place?"

"Oh, the intuition bred of love, my beloved husband, and I yearned so for the sight of you, and Salome came to dance for you and to entertain your distinguished guests. She thought it might please you and so persuaded me to undertake the journey."

Antipas expressed great pleasure at this and said that at the end of the feast in the banquet hall of the fort, he would be delighted to have Salome perform for his guests and himself.

Herodias and Salome were promptly installed in the quarters of the commanding officer, and Antipas left them and went about his official affairs.

The strange sight in a grim fort was Herodias and Salome, arrayed in the elegance that would have befitted the royal palace in Rome, waiting around in their suite for the fateful hour, which seemed a very long time coming for both Herodias and Salome,

Herodias for her vengeance and the slim Salome for her triumph. She already saw herself a public performer and the toast of Rome, Alexandria and Corinth. Her ever tender and indulgent father would not refuse her when she pled after a marvelous performance of the Seven Veils. That was his favorite ballet because of the tender beauty of the themes.

The Woman
in Gaul*

Herodias, wife of Antipas, who was Tetrarch of Galilee, reclined her beautiful body on a rich couch on the portico of the white marble palace at Tiberias, the magnificent city which her husband had built on the shores of the body of water that originally was called the Lake of Gennesareth, then the Sea of Galilee, and now Lake of Tiberias, after the Roman Emperor, Tiberius, with whom Antipas was in great favor.

This portico was both deep and long, and decorated by Corinthian columns. It was the water gate to the white marble palace. It was appropriately furnished with marble benches, elegant chairs, and this rich couch on which Herodias spent frequent hours when the weather was warm. It jutted out into the lake, for Antipas was a boating enthusiast, and this portico was his landing.

Now, on this afternoon, Herodias lounged on the couch with a serving maid of her body sitting crossed-legged on the stone floor tinting her her toe-nails with henna in the Egyptian fashion. This Egyptian maid worked gently on the feet of Herodias while she

*The manuscript of this unpublished story was partially burned in the fire that destroyed some of Hurston's manuscripts shortly after her death. The edges of five pages of the original manuscript, now housed in the department of Rare Books and Manuscripts of the University of Florida Library, are badly charred. In this edition, the missing words have been represented by brackets, with the space in between the brackets corresponding to the amount of text that has been lost. As with all of the previously unpublished material, Hurston's own misspellings, typos, and textual errors have been left uncorrected.

read, or pretended to read from an elegantly produced scroll, a play by Euripides. It was not that Herodias experienced any difficulty with reading the script, for all members of the family of Herod the Great were educated to a degree, Herod the Great having that passion for learning, and Greek learning in particular. Herodias was very proficient.

It was very difficult for the wife of the Tetrarch to concentrate this day. She now impatiently waited for the return of a trusted steward of her house named Callimander, whom she had sent on a confidential mission many days before, and was suffering tortures now because she had had no word from him as yet.

Now the skilled maid, finished with the tinting of the nails of Herodias, began to massage her feet and legs with a fragrant lotion obtainable only at Alexandria, Egypt. Herodias had recently acquired this one and another from Egypt to attend her body, because Egypt had the reputation of producing women and men who the most skilled in creating and preserving beauty than any nation in the then known world. Herodias had felt the necessity for such expert care only in the last year, for she was nearer forty than she cared to think about, and besides, things had occurred during that time to cause her to fear that she might lose her trememndous hold over the heart of the Tetrarch.

From the apartment of Salome, her beautiful teen-aged daughter, came the strain of the plaintive tune which accompanied the temple dance of the Seven Veils. So she knew that Salome was at her dancing lessons. The music produced by wood-wind and strings, came from an orchestra of six men whom Antipas had gathered in Canetha, one of the cities of the Decapolis—the ten Greek cities east of the Jordan—where there was a famous theater. There also Antipas had found the celebrated dancer whom he had immediately engaged to instruct his step-daughter. The sounds lightened the spirits of Herodias, for it called to her mind how her husband had exhibited no decrease in his fondness and indulgence of her daughter. And how delighted he was in Salome's rapid progress in the dance, and particularly in her mastery

of the dance of the Seven Veils. This was a pantomime, and acting out the story of the love of the goddess Ashtar for her husband, Adonis. So profound was her passion that when Adonis died, she set out to pass the seven barriers down into Hades to obtain some of the water of life that would restore him to life. It was a tense, but beautiful drama when skillfully performed. Antipas was already declaring that his daughter already showed greater skill and talent than her famous teacher. So Herodias smiled wanly. Antipas was such a doting father that anybody would think that Salome was his child, instead of the child of his half-brother.

"Replace my sandals," she now ordered the maid, "and go to the apartment of my daughter and say to her that her mother thinks that she gives too many hours to her dancing lessons. And say that I wish her to come here and keep me company."

In a few minutes, Salome appeared, but with a protesting face. She sat down petulantly on a carved stool, but said nothing.

"My beloved daughter," Herodias began after a long silence, "you do not appear grateful that I attempt to prevent you from wearing your beauty away at these dancing lessons. The Tetrarch says you are already perfect. Why continue?"

"But I am not so perfect as he makes me out to be. He is a loving and indulgent father to me, and so he sees perfection before it is accomplished."

Herodias smiled with satisfaction.

"Yes, having no child of his own, he has proved himself a most affectionate father to you. Much better than that society-mad Philip who begot you. He was a cold and indifferent man indeed. So long as he was immersed in the social life of the Roman patricians, and a guest at all their affairs, he was fulfilled. His horses, his clubs, and the dancing girls of the taverns were his life. Antipas is fond of his family as his royal father was." Herodias halted and studied the face of Salome. "I thought you might care to rest from your studies for a while by going for a sail on the lake with me."

"It would be pleasant if I were not so eager to work on my movements at the last barrier some more. Where I make the prayer for the water of life to the King of Hades. Now—"

At that moment, the young man who always stood at the front entrance to the palace entered, genuflected and when Herodias gave him permission to speak, announced that Callimander was returned and was most urgent to speak to Herodias.

"Then return to your lessons, since you are so eager, my beloved daughter," Herodias told her hastily. "You seem never to want to go on the lake unless Antipas manages the small boat. Since he is not here, perhaps I will not go either. Go, my child."

Callimander really had news for Herodias. She could detect it in his eyes as he stepped out upon the portico and cut through all formality to save time.

"You have found where that monster hides who would part me from my beloved husband?"

"Yes, noble-born Herodias. John the Baptist does not really hide himself, but is hidden by Antipas."

"Where?" Herodias shouted in wild triumph.

"In the strong fort of Macherus, there on the border of Moab, and from its great elevation, that over-looks the mountains of Arabia. The place made so strong as not to be taken by your grandfather, Herod the Great."

"You do not deceive me and raise my hopes in vain?"

"I would not so betray your confidence in me, nor yet would I dare to be found deceiving you."

"It would be very dangerous to you to do so, Callimander. But tell me all that you have learned. You may seat yourself."

"He is imprisoned by Antipas at Macherus but it is not for his punishment, but his safety from you. Antipas has shown him every kindness and sworn to protect him. He is furnished with every delicacy of diet—the fat tails of sheep, every sort of fruits and vegetables, wines, and an abundance of bread and cakes. However, he consumes little of the rich foods, being very austere in his diet, and only used to rough foods. But it has been provided by your husband anyway, to show his admiration of the man. And, for his greater satisfaction, and that his imprisonment may not weigh heavily upon this John the Baptist, has sent to his associates in that dismal spot, the Desert of Quietude along the

lower Jordan and brought three of these men to bear him company.''

"What?" Herodias almost screamed. "This barbarous creature has indeed bewitched the mind of my husband! Antipas will be persuaded at last to do anything which this John advises. Oh, what will become of me and my daughter? How many days will pass before he resolves to put me away from him? Herod the Great, his father and my grandfather, indeed had a great reverence for these river bretheren all his life, and Antipas imitates his father as far as he can in all things. But never did the King allow those fanatics to interfere in his home. That is, if they ever tried, which I never heard of. However, the King was often persuaded by them in matters of government.''

A sick silence prevailed for a time, then Herodias reflected in a bitter voice.

"So that is where my husband has been for the eight days that he has been absent from me, taking delight in the rude discourses of that hairy monster. I will have the head of that beast and in no long time. Somehow, I will find a way.''

"You are mistaken, O noble Herodias. He has been there for only the last three days. He was somewhere east of the Jordan before, I [] told. The guard at the entrance of the fort—who was grateful for the present of money that I made him, told me that. Antipas was going about summoning potent men to be guests at his birthday celebration three days from this day.''

"That is true, Callimander. He spoke to me of that. This year he will not observe the feast here at his palace as formerly. I had forgotten, but I had assumed that he would celebrate his birthday at his palace at Jerusalem.''

Herodias was not truthful when she said this. Except in the case of John the Baptist, Antipas confided everything to her. Therefore she was only too aware that her husband was to meet certain rulers in that part of Asia and other influential friends at Macherus on his birthnight. The meeting was to further the plans of Antipas to attack and slay Pontius Pilate, and if possible, to deliver Pales-

tine from Roman rule. The son of Herod the Great was grim and determined on this.

The reason for his rage was that the cruelly sadistic Pilate had manufactured occasions for butchering hundreds of Jews, Samaritans and Galileans. His father had tenderly left the care of Galilee, his favored province to Antipas, and charging him earnestly to take the best possible care of the people there. His mother, Malthrace, had been a Samaritan, and Pilate had rejoiced in slaughtering hundreds of them at Mount Gerizzim needlessly. Recalling that his father had offered to fight Sosius, the Roman general who aided Herod in the war against Antigonus, last of the Asamonean claimants to the throne of Judea, which Rome had conferred on Herod, if Sosius allowed his Roman soldiers to enter the temple, plunder Jerusalem, or to touch even one Jewish woman, Antipas was convinced that he would be despicable if he did not avenge Galilee and Samaria. He was implementing his rage by secretly collecting arms. Already, he had secured enough to arm 50,000 men, and planned to attack when he had 100,000 under arms. Most of these weapons had been bought beyond the Euphrates, and arriving under the cover of night on the eastern shore of the lake, were brought across by Galilean fishermen while it was still night to the landing of the palace, and stored by them in a great storaged beneath the palace before dawn. Herodias knew all of this, and was [] and encouraging. She knew also that her husband was now securing others to aid him in the plot, but she had not the slightest intention of confiding in Callimander, a Greek out of Corinth, in the matter. After a few minutes of cold rage, she said, you have done well, Callimander.''

"I am overcome with pleasure at your words, O daughter of a noble house.''

"I shall have pulled down that small house which you now occupy and have built one more suited to you faithfulness and abilities. The moment that my husband returns, it shall be done.''

With Callimander thus bound to secrecy, Herodias gave him permission to leave her and fell into deep thought as how to bring about the death of the man who so threatened her way of life.

There was no denying that this hairy meddler, John the Baptist, has some mysterious power to so affect the mind of her husband. This [] who had valued her to the extent of wresting her from his half-bro[ther] Philip, divorcing the Arabian princess for her sake, and fightin[g] war with Aretas, her father, for sending his daughter, humiliate[d] being discarded, back to Petra, the rose-red capital of Arabia. [] is, Antipas had refused to change his plans nor apologize to Areta[s] sending his daughter back and stood up to him in battle. He had made her daughter his own, and had, all these years, been the most affect[ionate] and indulgent husband in the known world.

For example, her weaving women were never required to weave for her body, nor that of her daughter. Antipas provided an abundance of the finest linen from Egypt, and rare, expensive silk from the island of Cos for them. Nor was there any shortage of purple for dying, and other colors. Their ornaments were of unusual design because Antipas had stewards to be present when great caravans from the east passed along the ancient highway, and likewise those moving north from Egypt, or south from India and Persia, and to bring for her inspection what they thought she might like. No rare perfumes nor ointments were too costly for him to indulge her in. Therefore this influence of the preacher from the river bottoms was something most formidable. Yes, this man must die. When months before she had come to realize that Antipas, rather than resenting his criticism of their marriage, had taken it as a son being corrected by his father, she had sensed the danger she was in. It was then that she had sworn to her husband to destroy the man, and she meant it. She was a hundred-fold more determined now that Antipas had deceived her and prevented the man from being punished for meddlesome audacity by concealing him from her just indignation. John the Baptist was going to lose his head.

The how of it came to Herodias almost immediately. The triumphant burst of music that went with the movements of the last barrier of the story and signified that Ashtar had gained the flask of the water of life came to her ears.

That was it! The pleasure of Antipas in the performance of his daughter would do excellently for a weapon. She would surprise him by being a guest at his birth-day banquet.

By noon the next day, Herodias and her party, which included Salome and the orchestra, were far along the highway that ran along the Jordan but east of that river. What with the military escort, the wagons of provisions to refresh them along the way, her servitors and all, the entourage was over three hundred.

Herodius []ed that Salome was no longer sullen. She was enjoying the trip since she had her musicians along and could rehearse while she was there. More than that, Herodius stimulated her daughter by telling her how pleased Antipas would be that she had come this distance to dance for him at his banquet. Mother and daughter rode along in high spirits, but for different reasons. Salome, because she was going to give great pleasure to the man who had been an affectionate and indulgent father to her, and allowed her artistic inclinations scope. Herodias, because she was going to outwit that same man. With his head separated from his body, no more would that foul mouth utter words that could destroy her utterly. Shortly, she would procure his death. Dead men do not meddle.

So the dismal streth south of Jericho did not depress her spirits, but rather held a fascination for her. Down here below sea-level the heat was oppressive, and the great cubes of dirty salt where no vegetation existed was awful in implication. Great hills of dirty-gray salt rose up from the shallow water on either side; great cubes of it, and she did not wonder at the title the river bretheren had given it was understandable. It could not avoid being a "Desert of Quietude" being what it was. Who or what, except fanatical preachers could find any reason for being there?

On the morning of the birthday, the caravan began to climb the frowning ramparts of the Fort, situated so high up in the mountains, passed the hot springs of Callahorhe, and in mid-afternoon, was at the entrance of the impregnable fort.

To say that Antipas was surprised when he, seated down in the dungeon conversing with John the Baptist was told that his wife

was there would be a vast understatement. He came up to receive them, and have installed in the royal apartment that his father had built into the fort. These rooms were luxurious and large. Preparations were going on in the great banquet hall for the celebration. Herodias, knowing that women could not be present by custom, went on into the other part and went to bed to rest her body.

The celebration had been going on for a full hour before she sent for Salome and directed her to prepare for her dance. Then she sent word to Antipas to let him know that Salome was going to dance for him. Soon the musicians were stationed and the dance began.

At the end, Antipas was transported as were his guests. It was then that he told his daughter the she could have anything, ANYTHING, that she might demand.

The innocent girl, having everything that she had ever wished for, did not know what to say. She therefore ran down the corridor to the room where Herodias reclined, and smiling happily, asked her mother what to demand. This was the moment that Herodias had hoped and longed for. This was her hour of triumph.

"Demand the head of John the Baptist."

Flushed with victory, the unthinking girl, now with a robe about her, raced back to the banqueting hall and like a child asking for a toy, smilingly asked for what her mother had told her. Only when the dead silence enveloped the room did she begin to realize that something dreadful had happened. The look of horror on the face of Antipas, succeeded by deep gloom, began to penetrate her exhiliration. And only when the horrid gift on the salver was in her hands, did the full realization reach her. Overwhelmed by horror and disgust, Salome fled down the corridor and thrust the grisley object into her mother's willing hands and ran weeping to her own room.

Herodias sat triumphant in spite of her daughter with the great silver platter resting heavily upon her lap and gazed in triumphant hatred into the dead face of John the Baptist. But her victory was brief. She had only time to spit upon the head of the man she had

so hated and feared and slap the cheeks spitefully twice when she heard the tread of several feet marching down the corridor and approaching her door. There was a repeated rap, and when she demanded to know who knocked, the voice of an officer answered her.

"Antipas, Tetrarch of Galilee, governor of Perea sends us for the head of the prophet John the Baptist, so that it may be joined again to his body and receive decent burial."

This formal demand struck cold fear into the heart of Herodias. Her husband had not come himself to speak with her about the matter. He had sent a dozen soldiers, led by a captain to get it. Had she lost entirely by her victory?

The armed men tramped away with the head and Herodias shook with fright for an hour before she could even muster enough composure to send for her daughter. The servant returned to say that Salome could not come because she was in bed with an illness of her head.

Herodias suffered for an hour more, then got up and went into the room of Salome. She found her daughter with swollen eyes, stretched on the bed, with her serving maid rubbing her face with a liquid made from the balm of the trees that were native to the Jericho area.

"O you stupid little prig, you! Self-righteous little upstart. You lie there in judgment of your own mother. Because you are familiar with Meander and Euripides, the poets and the dance like the hetairai of the coastal cities that you know everything that is to be known of life. But wait until you find yourself lonely and neglected, even secretly despised as I was after my father had been strangled for conspiring to murder his father. Many to fawn upon you openly, but despise you secretly, then to find one who truly and warmly loves you as did Antipas, and see if you will allow yourself to be separated from him lightly. O you—"

"Please be quiet, Mother," the slender girl on the bed, begged. "I have no wish to, nor do I sit in judgment upon your actions. As for myself, I shall never dance again. You and Antipas have made a betrothal between Philip, governor of Batania and Trachopitis,

and half-brother to Antipas. But yesterday I felt I could wait a year to consummate my marriage because I loved the dance. Now, I beg of you to marry me to him as quickly as possible. Please, dear mother.''

The plea was a crushing stone against the temple of Herodias. This daughter upon whom she had rained so much love and affection was afraid of her as if she were some murderous monster with the blood of God and man upon her hands. Involuntarily, she lifted and examined her hands for blood, then becoming conscious of the act, lowered them guiltily. With tremendous effort she regained composure and spoke with dignity.

"Yes, I understand. Philip is called the beneficent and the just, and you wish to flee to him. As you know, your dowrey and the household goods required in marriage have been ready for nearly a year. You can complete your marriage as soon as we can return to Tiderias. I will go and tell the Tetrarch of your wishes at once.''

Herodias almost raced along the corridor. Her feet were hastened by another consideration. What was her status with the Tetrarch now? Was it divorce, banishment of a place in the dungeon which John the Baptist had just vacated? She must know. The suspense was worse than death.

She found the banquet hall not only deserted, but utterly dark. Dark and abominally still. A nothingness that affrighted the soul. She fled back to her chamber which was lighted by eight clusters of candles and found it a haven of delight.

Summoning a guard, she ordered him to go and say to the Tetrarch that she wished to speak to him at once on a matter of importance.

The expression on the face of the man told her that he took cruel pleasure in telling her: "does not the noble-born wife of the Tetrarch know that he is no longer in the fort? Dressed in humble clothing, he departed the fort immediately after the head of the River Brother was returned. He went with the two live bretheren and twelve men of his guard up the Jordan to buy a sepulcre and give this John the Baptist a proper burial. He appeared most grieved at the death of this man.''

When Herodias regained her composure, she said, "I dismiss you for the present."

Herodias and Salome had been back at the palace in Tiberias for ten full days when Antipas returned. They had been ten days of terror and agony for Antipas. Even if her husband had the intention of ordering her execution, which he had the power to do, she would noy have cared so long as the agonising suspense was ended. Antipas returned by a fisherman's boat well after midnight, and was dressed in the clothing of a workman.

Herodias was awakened by a cheerful greeting as he entered her bedchamber. She leaped from her bed and prostrated herself before and began to beg his pardon.

"But you are mistaken, flower of my heart," Antipas raised her tenderly. "Whatever you might have intended, you did not bring about the death of John the Baptist, my Beloved, for he is not dead."

"He is not dead? But that is impossible. I saw and touched—"

"Ah, yes, but John the Baptist is not a mere man. We shall see him again and in good health. Think no more of the matter, Beloved Herodias. Through your action, you have brought me an experience with divinity. Prepare your tenderest carresses for me. I am going into the bath and return to you very shortly."

The Tetrarch hurried to his own apartment, leaving Herodias dazed with puzzlement and trembling with fright.

"What deceit is this that my husband practices on me? He holds something terrible in his heart as a punishment for me. What does he intend?"

But Antipas soon returned and embraced her warmly. And never did he bring up that night at Macherus to her. His silence tortured her like the point of a javelin into the arm-pit.

So a great change came over the white marble palace on the lake. Where once Antipas had humored Herodias like a baby and bowed to her every wish, she now humbled herself and behaved with the insecurity of a concubine. She was jealous in seeking ways and opportunity to please him and bind him closer to her.

Herodias suffered terribly in silence the night during the Pass-

over when the guards brought Jesus Christ to their palace in Jerusalem from Pilate for Antipas to pass on His guilt.

"I have heard much of this man in Galilee," Antipas said, leaping from his bed to interview him. "It is my opinion that he is none other than John the Baptist. I am most eager to talk with him, and question him concerning the miracles that he performs."

No sooner did Antipas cross the doorsill of the room and head for his Audience Hall, than Herodias creep from bed, throw on a loose robe and follow to near enough where she could overhear what was said.

"Are you not John the Baptist?" she heard Antipas ask eagerly. But this bound and beaten man said nothing. During the entire interview this Jesus gave no information that Antipas could use to defend him. So he soon ended the audience, and returned to his bed a disappointed man.

"That man is not John the Baptist, Beloved, though there is a slight resemblance. Had it been John, I would have freed him even if I had to use my Galilean troops to achieve it. But I believe that he knows where John is hiding. Oh, well. He will reappear when he wills."

"Will I never be quit of this John the Baptist and feel secure with my husband again?" Herodias conversed inwardly with her self.

And so she became more zealous in binding Antipas to her through gratitude, and her zeal brought on the final catastrophe in Galilee.

Tiberius, step-son of Augustus Caesar, that tough old veteran of the wars in Gaul, had passed away. He had been a suspicious, puritanical ruler, and had imprisoned the gay, gambling and drinking Agrippa for saying to his equally dissolute nephew, Caligula, that he wished that Tiberius would hurry and die so that his more accommodating friend, this Caligula could become emperor. By malevolent chance, now, Caligula had succeeded Tiberius, and immediately freed Agrippa, brother of Herodias, and made him King of Judea.

Herodias was enraged when the news reached her. A drinking, gambling, squanderer of a snob and sychophant like Agrippa rul-

ing over the territory which had been so ably governed by her gifted grandfather Herod the Great? And when her noble and able husband, and one who had a better claim to the dignity was over-looked? It was simply not to be borne.

Partly to place Antipas in her debt, but also because she really considered the appointment an outrage, Herodias began to goad her easy-going husband to sail for Rome and protest to Caligula. Go there and demand that he himself be made king instead of Agrippa. It did no good for Antipas to insist that he was satisfied where he was, and moreover that when and if his secret plan matured, the Romans would no longer be in position to shove their favorites, however callous and inept, over Palestine. Herodias kept right on needling him until Antipas reluctantly agreed with her.

But Agrippa, hearing of the resolve of Antipas, and realizing that his uncle-brother-in-law did have a more valid claim, hastened off a long letter to his [b n] companion in which among other charges he made against Antipas, tattled what he knew about the secret accumulation of arms, the purpose of them, and where they were concealed.

So when Antipas berthed his luxurious yacht at Brundisium and raced behind his four fine horses to Rome, Caligula was ready for him. In the audience chamber of the Caesars, Antipas was accused as an enemy of Rome, harshly questioned, and finally sentenced to be stripped of his wealth and banished to Lugdunum (Lyons, France now) in Gaul. Caligula then ordered him to be led from the room.

Although Caius Caesar, called Caligula, was yet a young man, he was already notorious for his seductions of married women. All the time that he was examining Antipas, he was stealing glances at Herodias and assessing her good points, and Herodias was in possession of some most excellent good points. She was one of those rare, late developing women like her maternal grand-mother, Salome, who seem to lie fallow during her maiden years, only to develop into a woman truly disturbing to men in middle age.

So now Caius Caligula looked hard at her and said, "Since you are the sister of my beloved friend, Agrippa, I grant you pardon for all charges, Herodias. Nor are you required to accompany your seditious husband, Antipas into banishment. Caius Caesar, Imperator, grants you permission to remain here at Rome where you have relatives and friends, Further, you are granted permission to retain the considerable sum of money which Herod the Great, your noble grandfather willed to you."

A dramatic hush fell upon the chamber at this surprising announcement. Romans being a highly materialistic nation of people, few in the room expected Herodias to reject such generous terms. A short pause found Herodias on her feet and standing very erect. Then she opened her mouth.

"I am most grateful for your generosity, O noble Caesar, but since I have had the good fortune to be the companion of Antipas, son of the Great Herod during his years of enormous wealth and power, I will not desert him now that he has been reduced to poverty and exile. In fact, I look upon it as an honorable privilege to accompany him.

The hall was saturated with applause, but the ominous glare of Caius Caligula prevented it from expression with the hands.

"Then you also, Herodias, shall be stripped of your money."

"So be it, O Caligula," Herodias uttered proudly, and with head erect, she marched out to join here husband. By midnight, Herodias was the heroine of a great love story all over Rome.

The truth is, however, that they were not to face the grim poverty that Caligula and Agrippa intended. Antipas was more capable of devious tricks than either of them, and so he embarked for Lugdunum with 20 talents in coined gold and a great part of their expensive ornaments and wearing apparel aboard. That was because the palms of Roman officials eternally itched for graft. In addition, the cold, coarse dissolute Caligula's reign of two years had caused him to be thoroughly hated by all except his close associates. His assassination which came about two years later was already predicted.

Lugdunum, now known as Lyins, France, struck admiration

from both Herodias and her husband. ''What a magnificent site to build a great city!'', Antipas exclaimed. He gazed and gazed upon the great rock fully two miles in width at the confluence of the two rivers, the Rhone and the Saone. The Saone made a great circle, or half circle about this elevation then joined the Rhone which flowed down the western side of the rock, joined it briefly, then parted again as both the streams ran south for a long stretch towards the Mediterranean.

Their ship had ascended the Rhone, and immediately on the arrival at the warf, they were conducted to the governor of this important military post within the fort which was upon the rocky eminence, about 500 feet above the shores of the two rivers. From there, they could look out over the country for miles in every direction.

Agrippa, the military commander-in-chief of Augustus, had chosen this location as the first Roman post in Gual. From Lugdunum, fanned out the four great highways that touched all of Gallia Cometa, the sixty cities in Gaul under Roman rule. Augustus Caesar had built the city, the great acqueducts, one coming 52 miles, and pouring 11,000,000 gallons of excellent water a day into the city. He built also temples and a theatre, gave it a senate, and made it the seat of an annual assembly of deputies from all over Gaul. It gained great importance and grew rapidly. Looking about them now, Herodias and Antipas agreed that banishment to this spot was no severe punishment.

The governor received them, registered them, and when Antipas had tactfully made him the present of money always expected by Roman officials in the provinces, assigned them a comfortable and attractive villa on the banks of the Rhône where most of his officers lived. A short time later, he permitted Antipas to buy a piece of ground on the elevated section, a little north of the fort, out of consideration that the communities along the river banks were sometimes inundated by the spring rains, and because Antipas had earned the reputation of generosity. Nor were Herodias and Antipater here unknown as they thought they would be. Few there were among the officers and men of means who had not

heard the name of Herod the Great, close friend and associate of both Augustus Caesar and Agrippa. Numerous of the men had known Antipater himself when he was a student at Rome, or had met him on his numerous visits to Rome later, and his unmatched stable of fine horses were celebrated as the first in the empire. And being banished by Caligula hurt his prestige not at all. Numerous men of high character and family had been banished. To an extent, it was a testimony of honor.

"But this is troublesome to me," Antipater complained to Herodias. "When my real plan is to build a small in there at the divergence of the four great roads where I have bought the land."

"Inn?" screamed Herodias. "Small inn? What does the son of a great king do with an inn?"

"Await there the coming of John the Baptist. Somehow, I feel that someday he will come along this road that branches out to all parts of Europe. You know that this sect of Christians are being persecuted in Rome, and some are fleeing to all parts of the known world from there. Some have already penetrated into Gual. What, then, is more natural than that John the Baptist to come on a journey of proselyting? I will build an inn just where the four highways begin and wait for him there."

Herodias groaned internally. Even here, that disturber of her life threatened her. He was more tenacious dead than alive. Death concealed his human traits and permitted him to become a god. And there was nothing that she could do against a bodyless being. But perhaps, being a political prisoner in a way, the governor would not permit Antipas to build an inn.

But her hopes were immediately dashed. The governor rather urged him on, saying that a good, roomy inn which served good food and wines was just what had been lacking so far. It was impossible to furnish accomodations now that Rome had so extended itself in Gaul, for all the parties of important officials who came to Lugdunum now, let alone those who stopped there on their way to distant points in Gaul. And who had better taste in living, and more concepts in building than Antipas? He was just the man. And as governor, he could assist in the matter by cutting

the cost of building by sending all offenders among the common soldiers to do the rough work of construction, such as digging foundations and mixing mortar and lifting stones.

So the inn was built, though not the small, plain thing that Antipas had contemplated. The nature of Antipas also got the better of him, and when finished, the inn had a small garden with flowering things and a fountain playing. There were extensive stables, servant quarters, and a well-stocked wine cellar and pantry. Rare delicacies from all parts of the world could be found there.

Herodias felt content that the expectation of the Fore-Runner would be driven from the mind of Antipas now, but she was shocked to find that in addition to the twenty spacious apartments for lodging that entourages of the mighty, there was a small room eternally reserved for John the Baptist. No matter how crowded the inn might become, that room was never rented. Her chagrin was great.

The inn was an instant success. It became the meeting place at night of all the high officials of the city and fort, the men of commerce as well as those passing through. After expensive meals, they lounged and discussed the news of the day or indulged in philosophical discussions in which Antipas could hold his own with the best. In fact, the host lent luster to the place. He had so entrenched himself with the powerful, that when the news came of the assassination of Caligula, some urged him to appeal to Caligula's successor for reinstatement as Tetrarch of Galilee, while others cried that he could not be spared where he was. When shortly after, the report came of the sudden death of Kibg Agrippa, he was urged again to vindicate himself, but Herodius was surprised to find that neither herself nor Antipas wanted to go. Instead, they decided to send to Arabia for six choice young palomino mares and a stallion and breed Arabian horses to satisfy the demands of numerous wealthy officials there, and the love of horses of Antipas himself. That was the only lack with them.

Then, one morning, Herodias noticed that the movements of her husband had become slow and uneven. Antipas was old. And

while she was fifteen years younger than he, her metal mirror told her that she was old herself. The tracks of time were all over her face and body.

The thought of being deprived of the company of her husband in her old age was too devastating. She became more tender, and urged Antipas to take better care of himself.

"But I can hardly do less, Beloved." Antipas pointed out. "My steward looks after all the business, you know, and hands over the earnings of the inn on the first day of every month. But the dignateries who patronize the place expect to see me there. As you know, I am the great attraction to the inn. And now I fear that I must exert myself for a time, for the Emperor Nero is reported to be coming into gaul about three months from now, when the snow has completely vanished from the roads. We shall require at least double the lodging space that we have now. Another dining pavillion will be necessary also, for we are always over taxed for space there as it is."

Herodias did not like this, but there was nothing she could do, what with the governor urging and depending upon Antipas. She knew that his passion for building, she knew that she could not constrain him from the planning and over-seeing the work.

And out of his fertile imagination, something entrancing emerged. He did not extend the building at the back, as was taken for granted, nor add the conventional wings. Out of his ancestry he produced a large circular structure on either side that resembled the tents of black goat hair of Arabia reproduced in stone with glass windows. From Parthia he had brought rich rugs of excellent design that were hung between the windows and covered the floors deeply. These rooms were furnished with pillows instead of chairs. Long, thick pillows for reclining to eat, and round ones for sitting. These cushions were rich and very comfortable. For the food, tables of fine wood that rose no more than two feet from the floor. Elegant silk hangings supplemented the rugs hung on the walls.

No detail was neglected. From his background, Antipas knew how to command and get things done. A vast amount of oysters

arrived from Britain. Thousands of live quail from southern Pales-
tine, peacocks from Greece and Italy. The wines of Gaul being
admired as [] superior of all on earth, they were brought in in
great quantity [] north and south of the Rhine. Geese,
ducks, and fat [] goats were also available in Gaul and
they were on hand [] a great quantity of sausages from the
Germans north of the [] entertainment, he hired dancing girls
and strolling makers [] with their instruments to be handy.

 Nero had summoned the governors of the sixty cities in Gaul,
they arrived before the Emperor, and were on hand to give him
a g[] reception. He was swept off his feet as soon as he beheld
the inn [] Antipas and with the most important men present,
lodged there. He declared all to be more than perfect there and
gorged himself continuously on the fare. On his third night of
residence, as he reclined on a long cushion, one of the strolling
singers accompanied himself on a lyre as he presented a song in
praise of Nero which he had composed. At the finish of it, Nero
sprang up, took the lyre and for a half hour sang songs of his own
composition. His face was flushed with pleasure when he ended.

 ''Antipater, son of Herod the Great shows himself to be a []
of numerous talents. Some years ago, this man was falsely ac-
cused of being an enemy of Rome. I, Nero, Imperator, declare this
to be a lie. He is in spirit a Roman, and a patrician Roman. I will
[] be Tetrarch of Galilee, or even King of all the territories
which his noble father governed, at any time thaat he desires. But
[] he would prefer not to further involve himself with that
[] naation of religious fanatics who show themselves the
enemies of mankind. They are creating disturbances in Rome at
this moment [] in the Empire.

 Antipater thanked him, but declined on the [] of his age.
He said that he no longer desired to be annoyed with [] of
government. And neither had he a son to succeed him.

 Nero then paid Antipas other compliments. The inn [] dwell-
ing of Antipas were the only structures in Lugdunum fit to look at
or to live in. The others were not fit for anything but swine.

 Two days before the departure of Nero for Rome, the city

[] on fire as if by accident, and burned to the ground. The inn and [] home of Antipas were north of the city, and so were not injured. Nero ordered Lugdunum rebuilt in a much improved manner, and left for Rome.

Herodias was very happy to see Nero go, and deeply regretted that he had ever come, though the inn prospered at the rate of more than a talent a day for the two weeks that he had been there, for she accused him of driving Antipas to his death-bed. Utterly exhausted, he was forced to take to his bed.

Herodias hovered about him with tears in her eyes, and refu[sed] to allow her servants to do anything for him, continually waited on him herself. Antipas lay there following her every movement while he was awake.

"Come to me, perfume of my soul," Antipas murmured to her on the fourth day in bed. "Come sit beside me on the bed."

Herodias sat so that she could cradle his head in her lap and sat there gently stroking it and looking down into his face.

"Perhaps I shall never leave this bed, beloved—"

"And John the Baptist has not arrived," she finished for him.

"No, but I no longer expect him. I am convinced he is dead."

"Dead, Antipas?"

"Yes, for if he were alive, as diligently as I have searched [] some trace of him. I was attracted to him first [] at Jerusalem had become so cold and cynical [] required something more. I yearned for a revival of goodness. [] attracted for the same reason that my father revered the Essenes. [] that at one time I considering abandoning my gov[] and becoming one of them. But there was a barrier to that."

"What barrier, my love?"

"You. Their way of life bars the association with women as an expression of daily love, and—well, you remember my disappearance on that night at Macherus?"

"Can I ever forget it?"

"Overwhelmed by his death, I resolved to abandon everything and to join them. Almost instantly I felt the hunger for your love and beseeched them to allow you to join me. That they refused.

Do you recall that I returned in the dress of a workman?''

"Yes, I remember everything."

"That was the dress I would have to wear as a disciple. But when I was certain that they would not admit you, I left them and returned to you."

"You never considered divorcing me, then?"

"Never. I so told John the Baptist months before his death. He knew that I would not. We talked earnestly of starting another sect where people lived simply and pure, but where women also were included."

With this information sinking in, Herodias sat numb and silent. The doing away with John the Baptist, and all that had followed in its train to bring her to Gaul and this bed-side—all through not knowing.

"The world, especially public life," Antipas continued, "seemed so full of evil that I longed for escape to simplicity, but my love for you was so strong that I could not face it. Torn between love and a wish to escape, I have suffered as few men have. But no matter what, love was ever the stronger. The two have only been reconciled since I have been here. And strangely enough, I became more and more bound to you as we grew older. You grow more beautiful all the time."

The thinned, pale eyelids closed weakly and wearily, and Herodias sat hovering and contemplated. Her husband's skull was now asserting itself. In fact, his whole, tall frame outlined beneath the sheets appeared to be dismissing the flesh as something temporary taking its leave. But then, the flesh of her body was no longer firm either. But involved as she was, the infirmity of the body of her husband was somehow mingled up with his youthful years and all the beauty of [] In spite of all the years of fear and doubt and warmth and glory and misery, she knew that she would choose this man again if she had the opportunity again. She had really known love.

But what was love? It surely was not happiness. She thought and thought as Antipas breathed in a way that indicated sleep.

"He suffered; I suffered; he accepted all things, including my

slaying of a man and causing him to lose a kingdom and banishment to be with me. I suffered to keep him." Herodias sighed deeply and bent to gently press her lips upon his, and sighed again.

Perhaps love is a compelling necessity imposed on man by God that has something to do with suffering."

Afterword

ZORA NEALE HURSTON:
"A NEGRO WAY OF SAYING"

The Reverend Harry Middleton Hyatt, an Episcopal priest whose five-volume classic collection, *Hoodoo, Conjuration, Witchcraft, and Rootwork*, more than amply returned an investment of forty years' research, once asked me during an interview in 1977 what had become of another eccentric collector whom he admired. "I met her in the field in the thirties. I think," he reflected for a few seconds, "that her first name was Zora." It was an innocent question, made reasonable by the body of confused and often contradictory rumors that make Zora Neale Hurston's own legend as richly curious and as dense as are the black myths she did so much to preserve in her classic anthropological works, *Mules and Men* and *Tell My Horse*, and in her fiction.

A graduate of Barnard College, where she studied under Franz Boas, Zora Neale Hurston published seven books—four novels, two books of folklore, and an autobiography—and more than fifty shorter works between the middle years of the Harlem Renaissance and the end of the Korean War, when she was the dominant black woman writer in the United States. The dark obscurity into which her career then lapsed reflects her staunchly independent political stances rather than any deficiency of craft or vision. Virtually ignored after the early 1950s, even by the Black Arts movement in the 1960s, an otherwise noisy and intense spell of black image- and myth-making that rescued so many black writers from remaindered oblivion, Hurston embodied a more or less harmoni-

ous but nevertheless problematic unity of opposites. It is this complexity that refuses to lend itself to the glibness of categories such as "radical" or "conservative," "black" or "Negro," "revolutionary" or "Uncle Tom"—categories of little use in literary criticism. It is this same complexity, embodied in her fiction, that, until Alice Walker published her important essay ("In Search of Zora Neale Hurston") in *Ms.* magazine in 1975, had made Hurston's place in black literary history an ambiguous one at best.

The rediscovery of African-American writers has usually turned on larger political criteria, of which the writer's work is supposedly a mere reflection. The deeply satisfying aspect of the rediscovery of Zora Neale Hurston is that black women generated it primarily to establish a maternal literary ancestry. Alice Walker's moving essay recounts her attempts to find Hurston's unmarked grave in the Garden of Heavenly Rest, a segregated cemetery in Fort Pierce, Florida. Hurston became a metaphor for the black woman writer's search for tradition. The craft of Alice Walker, Gayl Jones, Gloria Naylor, and Toni Cade Bambara bears, in markedly different ways, strong affinities with Hurston's. Their attention to Hurston signifies a novel sophistication in black literature: They read Hurston not only for spiritual kinship inherent in such relations but because she used black vernacular speech and rituals, in ways subtle and various, to chart the coming to consciousness of black women, so glaringly absent in other black fiction. This use of the vernacular became the fundamental framework for all but one of Hurston's novels and is particularly effective in her classic work *Their Eyes Were Watching God*, published in 1937, which is more closely related to Henry James's *The Portrait of a Lady* and Jean Toomer's *Cane* than to Langston Hughes's and Richard Wright's proletarian literature, so popular in the Depression.

The charting of Janie Crawford's fulfillment as an autonomous imagination, *Their Eyes* is a lyrical novel that correlates the need of her first two husbands for ownership of progressively larger physical space (and the gaudy accoutrements of upward mobility) with the suppression of self-awareness in their wife. Only with her

third and last lover, a roustabout called Tea Cake whose unstruc-
tured frolics center around and about the Florida swamps, does
Janie at last bloom, as does the large pear tree that stands beside
her grandmother's tiny log cabin:

> She saw a dust bearing bee sink into the sanctum of a bloom; the
> thousand sister calyxes arch to meet the love embrace and the
> ecstatic shiver of the tree from root to tiniest branch creaming in
> every blossom and frothing with delight. So this was a marriage!

To plot Janie's journey from object to subject, the narrative of
the novel shifts from third to a blend of first and third person
(known as "free indirect discourse"), signifying this awareness of
self in Janie. *Their Eyes* is a bold feminist novel, the first to be
explicitly so in the African-American tradition. Yet in its concern
with the project of finding a voice, with language as an instrument
of injury and salvation, of selfhood and empowerment, it suggests
many of the themes that inspirit Hurston's oeuvre as a whole.

One of the most moving passages in American literature is Zora
Neale Hurston's account of her last encounter with her dying
mother, found in a chapter entitled "Wandering" in her autobiog-
raphy, *Dust Tracks on a Road* (1942):

> As I crowded in, they lifted up the bed and turned it around so that
> Mama's eyes would face the east. I thought that she looked to me
> as the head of the bed reversed. Her mouth was slightly open, but
> her breathing took up so much of her strength that she could not
> talk. But she looked at me, or so I felt, to speak for her. She de-
> pended on me for a voice.

We can begin to understand the rhetorical distance that sepa-
rated Hurston from her contemporaries if we compare this pas-
sage with a similar scene published just three years later in *Black
Boy* by Richard Wright, Hurston's dominant black male contem-
porary and rival: "Once, in the night, my mother called me to her
bed and told me that she could not endure the pain, and she
wanted to die. I held her hand and begged her to be quiet. That

night I ceased to react to my mother; my feelings were frozen."
If Hurston represents her final moments with her mother in terms
of the search for voice, then Wright attributes to a similar experi-
ence a certain "somberness of spirit that I was never to lose,"
which "grew into a symbol in my mind, gathering to itself . . . the
poverty, the ignorance, the helplessness. . . ." Few authors in the
black tradition have less in common than Zora Neale Hurston and
Richard Wright. And whereas Wright would reign through the
1940s as our predominant author, Hurston's fame reached its
zenith in 1943 with a *Saturday Review* cover story honoring the
success of *Dust Tracks*. Seven years later, she would be serving as
a maid in Rivo Alto, Florida; ten years after that she would die in
the County Welfare Home in Fort Pierce, Florida.

How could the recipient of two Guggenheims and the author of
four novels, a dozen short stories, two musicals, two books on
black mythology, dozens of essays, and a prizewinning autobiog-
raphy virtually "disappear" from her readership for three full
decades? There are no easy answers to this quandary, despite the
concerted attempts of scholars to resolve it. It is clear, however,
that the loving, diverse, and enthusiastic responses that Hurston's
work engenders today were not shared by several of her influen-
tial black male contemporaries. The reasons for this are complex
and stem largely from what we might think of as their "radical
ideologies."

Part of Hurston's received heritage—and perhaps the para-
mount received notion that links the novel of manners in the
Harlem Renaissance, the social realism of the 1930s, and the
cultural nationalism of the Black Arts movement—was the idea
that racism had reduced the black people to mere ciphers, to
beings who only react to an omnipresent racial oppression, whose
culture is "deprived" where different, and whose psyches are in
the main "pathological." Albert Murray, the writer and social
critic, calls this "the Social Science Fiction Monster." Socialists,
separatists, and the civil rights advocates alike have been de-
voured by this beast.

Hurston thought this idea degrading, its propagation a trap, and

railed against it. It was, she said, upheld by "the sobbing school of Negrohood who hold that nature somehow has given them a dirty deal." Unlike Hughes and Wright, Hurston chose deliberately to ignore this "false picture that distorted. . . ." Freedom, she wrote in *Moses, Man of the Mountain*, "was something internal. . . . The man himself must make his own emancipation." And she declared her first novel a manifesto against the "arrogance" of whites assuming that "black lives are only defensive reactions to white actions." Her strategy was not calculated to please.

What we might think of as Hurston's mythic realism, lush and dense within a lyrical black idiom, seemed politically retrograde to the proponents of a social or critical realism. If Wright, Ellison, Brown, and Hurston were engaged in a battle over ideal fictional modes with which to represent the Negro, clearly Hurston lost the battle.

But not the war.

After Hurston and her choice of style for the black novel were silenced for nearly three decades, what we have witnessed since is clearly a marvelous instance of the return of the repressed. For Zora Neale Hurston has been "rediscovered" in a manner unprecedented in the black tradition: Several black women writers, among whom are some of the most accomplished writers in America today, have openly turned to her works as sources of narrative strategies, to be repeated, imitated, and revised, in acts of textual bonding. Responding to Wright's critique, Hurston claimed that she had wanted at long last to write a black novel, and "not a treatise on sociology." It is this urge that resonates in Toni Morrison's *Song of Solomon* and *Beloved,* and in Alice Walker's depiction of Hurston as our prime symbol of "racial health—a sense of black people as complete, complex, *undiminished* human beings, a sense that is lacking in so much black writing and literature." In a tradition in which male authors have ardently denied black literary paternity, this is a major development, one that heralds the refinement of our notion of tradition: Zora and her daughters are a tradition-within-the-tradition, a black woman's voice.

* * *

Rereading Hurston, I am always struck by the density of intimate experiences she cloaked in richly elaborated imagery. It is this concern for the figurative capacity of black language, for what a character in *Mules and Men* calls "a hidden meaning, jus' like de Bible . . . de inside meanin' of words," that unites Hurston's anthropological studies with her fiction. For the folklore Hurston collected so meticulously as Franz Boas's student at Barnard became metaphors, allegories, and performances in her novels, the traditional recurring canonical metaphors of black culture. Always reading more like novels than social science, even Hurston's academic collections center on the quality of imagination that makes these lives whole and splendid. But it is in the novel that Hurston's use of the black idiom realizes its fullest effect. In *Jonah's Gourd Vine,* her first novel, for instance, the errant preacher, John, as described by her biographer Robert Hemenway, "is a poet who graces his world with language but cannot find the words to secure his own personal grace." This concern for language and for the "natural" poets who "bring barbaric splendor of word and song into the very camp of the mockers" not only connects her two disciplines but also makes of "the suspended linguistic moment" a thing to behold indeed. Invariably, Hurston's writing depends for its strength on the text, not the context, as does John's climactic sermon, a tour de force of black image and metaphor. Image and metaphor define John's world; his failure to interpret himself leads finally to his self-destruction. As Hemenway concludes, "Such passages eventually add up to a theory of language and behavior."

Using "the spy-glass of Anthropology," her work celebrates rather than moralizes; it shows rather than tells, such that "both behavior and art become self-evident as the tale texts and hoodoo rituals accrete during the reading." As author she functions as "a midwife participating in the birth of a body of folklore, . . . the first wondering contacts with natural law." The myths she describes so accurately are in fact "alternative modes for perceiving reality," and never just condescending depictions of the quaint. Hurston

sees "the Dozens," for example, the age-old black ritual of grace-
ful insult as, among other things, a verbal defense of the sanctity
of the family, conjured through ingenious plays on words. Though
attacked by Wright and virtually ignored by his literary heirs,
Hurston's ideas about language and craft undergird many of the
most successful contributions to African-American literature that
followed.

We can understand Hurston's complex and contradictory legacy
more fully if we examine *Dust Tracks on a Road*, her own contro-
versial account of her life. Hurston did make significant parts of
herself up, like a masquerader putting on a disguise for the ball,
like a character in her own fictions. In this way, Hurston *wrote*
herself, and sought in her works to rewrite the "self" of "the
race" in its several private and public guises, largely for ideologi-
cal reasons. That which she chooses to reveal is the life of her
imagination, as it sought to mold and interpret her environment.
That which she silences or deletes, similarly, is all that her reader-
ship would draw upon to delimit or pigeonhole her life as a synec-
doche of "the race problem," an exceptional part standing for the
debased whole.

Hurston's achievement in *Dust Tracks* is twofold. First, she
gives us a *writer's* life, rather than an account, as she says, of "the
Negro problem." So many events in this text are figured in terms
of Hurston's growing awareness and mastery of books and lan-
guage, language and linguistic rituals as spoken and written both
by masters of the Western tradition and by ordinary members of
the black community. These two "speech communities," as it
were, are Hurston's great source of inspiration not only in her
novels but also in her autobiography.

The representation of her sources of language seems to be her
principal concern, as she shifts back and forth between her "liter-
ate" narrator's voice and a highly idiomatic black voice found in
wonderful passages of free indirect discourse. Hurston moves in
and out of these distinct voices effortlessly, seamlessly, just as she
does in *Their Eyes* to chart Janie's coming to consciousness. It is

this usage of a *divided* voice, a double voice unreconciled, that strikes me as her great achievement, a verbal analogue of her double experiences as a woman in a male-dominated world and as a black person in a nonblack world, a woman writer's revision of W.E.B. Du Bois's metaphor of "double consciousness" for the hyphenated African-American.

Her language, variegated by the twin voices that intertwine throughout the text, retains the power to unsettle:

> There is something about poverty that smells like death. Dead dreams dropping off the heart like leaves in a dry season and rotting around the feet; impulses smothered too long in the fetid air of underground caves. The soul lives in a sickly air. People can be slave-ships in shoes.

Elsewhere she analyzes black "idioms" used by a culture "raised on smile and invective. They know how to call names," she concludes, then lists some, such as "gator-mouthed, box-ankled, puzzle-gutted, shovel-footed: Eyes looking like skint-ginny nuts, and mouth looking like a dishpan full of broke-up crockery!"

Immediately following the passage about her mother's death, she writes:

> The Master-Maker in His making had made Old Death. Made him with big, soft feet and square toes. Made him with a face that reflects the face of all things, but neither changes itself, nor is mirrored anywhere. Made the body of death out of infinite hunger. Made a weapon of his hand to satisfy his needs. This was the morning of the day of the beginning of things.

Language, in these passages, is not merely "adornment," as Hurston described a key black linguistic practice; rather, manner and meaning are perfectly in tune: She says the thing in the most meaningful manner. Nor is she being "cute," or pandering to a condescending white readership. She is "naming" emotions, as she says, in a language both deeply personal and culturally specific.

The second reason that *Dust Tracks* succeeds as literature arises from the first: Hurston's unresolved tension between her double voice signifies her full understanding of modernism. Hurston uses the two voices in her text to celebrate the psychological fragmentation both of modernity and of the black American. As Barbara Johnson has written, hers is a rhetoric of division, rather than a fiction of psychological or cultural unity. Zora Neale Hurston, the "real" Zora Neale Hurston that we long to locate in this text, dwells in the silence that separates these two voices: she is both, and neither; bilingual, and mute. This strategy helps to explain her attraction to so many contemporary critics and writers, who can turn to her works again and again only to be startled at her remarkable artistry.

But the life that Hurston could write was not the life she could live. In fact, Hurston's life, so much more readily than does the standard sociological rendering, reveals how economic limits determine our choices even more than does violence or love. Put simply, Hurston wrote well when she was comfortable, wrote poorly when she was not. Financial problems—book sales, grants and fellowships too few and too paltry, ignorant editors and a smothering patron—produced the sort of dependence that affects, if not determines, her style, a relation she explored somewhat ironically in "What White Publishers Won't Print." We cannot oversimplify the relation between Hurston's art and her life; nor can we reduce the complexity of her postwar politics, which, rooted in her distaste for the pathological image of blacks, were markedly conservative and Republican.

Nor can we sentimentalize her disastrous final decade, when she found herself working as a maid on the very day the *Saturday Evening Post* published her short story "The Conscience of the Court" and often found herself without money, surviving after 1957 on unemployment benefits, substitute teaching, and welfare checks. "In her last days," Hemenway concludes dispassionately, "Zora lived a difficult life—alone, proud, ill, obsessed with a book she could not finish."

The excavation of her buried life helped a new generation read

Hurston again. But ultimately we must find Hurston's legacy in her art, where she "ploughed up some literacy and laid by some alphabets." Her importance rests with the legacy of fiction and lore she constructed so cannily. As Hurston herself noted, "Roll your eyes in ecstasy and ape his every move, but until we have placed something upon his street corner that is our own, we are right back where we were when they filed our iron collar off." If, as a friend eulogized, "She didn't come to you empty," then she does not leave black literature empty. If her earlier obscurity and neglect today seem inconceivable, perhaps now, as she wrote of Moses, she has "crossed over."

Henry Louis Gates, Jr.

Bibliography

Abbott, Dorothy. "Recovering Zora Neale Hurston's Work." *Frontiers: A Journal of Women Studies* (1991): 174–81.

Abel, Elizabeth. "Black Writing, White Reading: Race and the Politics of Feminist Interpretation." *Critical Inquiry* (Spring 1993): 470(29).

Academic Conference of the Zora Neale Hurston Festival of the Arts (1990, Eatonville, Florida). *All About Zora: Views and Reviews by Colleagues and Scholars,* (ed. by Alice Morgan Grant. Four-G: Winter Park FL, 1991).

Alps, Sandra. "Concepts of Selfhood in *Their Eyes Were Watching God* and *The Color Purple.*" *Pacific Review* (Spring 1986): 106–112.

Awkward, Michael. " 'The inaudible voice of it all': Silence, Voice, and Action in *Their Eyes Were Watching God.*" In Weixlmann, Joe and Houston A. Baker, Jr., eds., *Black Feminist Criticism and Critical Theory* (Penkevill: Greenwood, FL, 1988): 57–109.

———. *Inspiring Influences: Tradition, Revision, and Afro-American Women's Novels.* Columbia University Press: New York, 1991.

———, ed., *New Essays on Their Eyes Were Watching God.* (Cambridge University Press: Cambridge, 1990): 29–49.

Batker, Carol J. *Ethnic Women's Literature and Politics: The Cultural Construction of Gender in Early Twentieth-Century America.* 1993.

Bauer, Margaret D. "The Sterile New South: An Intertextual Reading of *Their Eyes Were Watching God* and *Absalom, Absalom!*" CLA Journal (June 1993): 384(22).

Behar, Ruth. "Dare We Say 'I?' Bringing the Personal into Scholarship." *Chronicle of Higher Education* (June 1994): B1(2).

Benesch, Klaus. "Oral Narrative and Literary Text: Afro-American Folklore in *Their Eyes Were Watching God.*" *Callaloo* (Summer 1988): 627–35.

Bethel, Lorraine. " 'This Infinity of Conscious Pain': Zora Neale Hurston and the Black Female Literary Tradition." In Hull, Gloria and Barbara Smith, eds. and introds.; Patricia Bell Scott, ed.; Mary Berry (foreword), *All the Women Are White, All the Blacks Are Men, but Some of Us Are Brave: Black Women's Studies* (Feminist Press: Old Westbury, NY, 1982): 176–188.

Bigsby, Chris. "A Rage in Harlem: Black American Culture Has Built on Foundations Laid in the Jazz Age." *New Statesman & Society* (July 1991): 28(2).

Bloom, Harold, ed. *Zora Neale Hurston.* Chelsea: New York, 1986.

———, ed. *Zora Neale Hurston's Their Eyes Were Watching God.* Chelsea: New York, 1987.

Boi, Paola. "Moses, Man of Power, Man of Knowledge: A 'Signifying' Reading of Zora Neale Hurston (Between a Laugh and a Song)." In Diedrich, Maria and Dorothea Fischer-Hornung, eds., *Women and War: The Changing Status of American Women from the 1930's to the 1950's.* (Berg: New York, 1990): 107–26.

Bone, Robert. *The Negro Novel in America.* Yale University Press: New Haven, 1958.

Borders, Florence Edwards. "Zora Neale Hurston: Hidden Woman." *Callaloo* (May 1979): 89–92.

Bray, Rosemary. "Now Our Eyes Are Watching Her." *The New York Times Book Review* (Feb. 25, 1990): 11.

Brock, Sabine and Anne Koenen. "Alice Walker in Search of Zora Neale Hurston: Rediscovering a Black Female Tradition." In Lenz, Gunter H., ed., *History and Tradition in Afro-American Culture* (Campus: Frankfurt, 1984): 167–80.

Brown, Elizabeth Abigail. *A Porch of Her Own: The Politics of Domestic Space in Chopin, Hurston and McCullers.* 1991.

Brown, Lloyd W. "Zora Neale Hurston and the Nature of the Female Perceptions." *Obsidian* (1978): 39–45.

Burke, Virginia M. "Zora Neale Hurston and Fannie Hurst as They Saw Each Other." *CLA Journal* (June 1977): 435–47.

Bus, Heiner. "The Establishment of Community in Zora Neale Hurston's *The Eatonville Anthology* (1926) and Rolando Hinojosa's *Estampas del Valle* (1973)." In Febre, Genevieve, ed., *European Perspectives on Hispanic Literature of the United States* (Arte Publico: Houston, 1988): 66–81.

Bush, Trudy Bloser. "Transforming Vision: Alice Walker and Zora Neale Hurston." *The Christian Century* (Nov. 16, 1988): 1035–40.

Byrd, James W. "Zora Neale Hurston: A Negro Folklorist." *Tennessee Folklore Society Bulletin.* (June 1955): 37–41.

Byrd, James W. "Black Collectors of Black Folklore: An Update on Zora Neale Hurston and J. Mason Brewer." *Louisiana Folklore Miscellany* (1986–87): 1–7.

Byrd, Rudolph P. "Shared Orientation and Narrative Acts in *Cane, Their Eyes Were Watching God*, and *Meridian*." *Melus* (Winter 1991): 41(16).

Callahan, John F. " 'Mah Tongue Is in Mah Friend's Mouf': The Rhetoric of Intimacy and Immensity in *Their Eyes Were Watching God*." In Bloom, Harold, ed., *Zora Neale Hurston's Their Eyes Were Watching God* (Chelsea: New York, 1987): 87–113.

Cantrow, Ellen. "Sex, Race and Criticism: Thoughts of a White Feminist and Kate Chopin and Zora Neale Hurston." *Radical Teacher* (Sept. 1978): 30–33.

Caputi, Jane. " 'Specifying Fannie Hurst: Langston Hughes's *Limitations of Life*, Zora Neale Hurston's *Their Eyes Were Watching God*, and Toni Morrison's *The Bluest Eye* as Answers to Hurst's 'Imitation of Life.' " *Black American Literature Forum* (Winter 1990): 697(20).

Carby, Hazel V. "The Politics of Fiction, Anthropology, and the Folk: Zora Neale Hurston." In Awkward, Michael, ed., *New Essays on Their Eyes Were Watching God* (Cambridge University Press: Cambridge, 1990): 71–93.

Carr, Glynis. "Storytelling as Building in Zora Neale Hurston's *Their Eyes Were Watching God*." *CLA Journal* (Dec. 1987): 189–200.

Cassidy, Thomas. "Janie's Rage: The Dog and the Storm in *Their Eyes Were Watching God*." *CLA Journal* (March 1993): 260(10).

Christian, Barbara. *Black Women Novelists: The Development of a Tradition 1892–1976*. Greenwood Press: Westport CT, 1980.

Coleman, Ancilla. "Mythological Structure and Psychological Significance in Hurston's 'Seraph on the Suwanee.' " *Publications of the Mississippi Philological Association* (1988): 21–27.

Crabtree, Claire. "The Confluence of Folklore, Feminism, and Black Self-Determination in Zora Neale Hurston's *Their Eyes Were Watching God*." *Southern Literary Journal* (Spring 1985): 54–66.

Dalgarno, Emily. "Words Walking Without Masters: Ethnography and Creative Process in *Their Eyes Were Watching God*." *American Literature* (Sept. 1992): 519(23).

Dance, Daryl C.. "Zora Neale Hurston." In Duke, Maurice; Jackson R. Bryer, and M. Thomas Inge, eds., *American Women Writers: Bibliographical Essays* (Greenwood: Westport CT, 1983): 321–51.

Davies, Kathleen. "Zora Neale Hurston's Poetics of Embalmment: Articulating the Rage of Black Women and Narrative Self-Defense." *African American Review* (Spring 1992): 147(13).

Davis, Jane. *"The Color Purple:* A Spiritual Descendant of Hurston's *Their Eyes Were Watching God." Griot* (Summer 1987): 79–96.

Deck, Alice. "Zora Neale Hurston, Noni Jabavu, and Cross-Disciplinary Discourse." *Black American Literature Forum* (Summer 1990): 237–57.

Dickerson, Vanessa D. " 'It Takes Its Shape from de Shore It Meets': The Metamorphic God in Hurston's *Their Eyes Were Watching God." Lit: Literature Interpretation Theory* (1991): 221–30.

Dolby-Stahl, Sandra. "Literary Objectives: Hurston's Use of Personal Narrative in *Mules and Men." Western Folklore* (Jan. 1992): 51(13).

duCille, Ann. "The Intricate Fabric of Feeling: Romance and Resistance in *Their Eyes Were Watching God." The Zora Neale Hurston Forum* (Spring 1990): 1–16.

DuPlessis, Rachel Blau. "Power, Judgment, and Narrative in a Work of Zora Neale Hurston: Feminist Cultural Studies." In Awkward, Michael, ed., *New Essays on Their Eyes Were Watching God* (Cambridge University Press: Cambridge, 1990): 95–123.

Dutton, Wendy. "The Problem of Invisibility: Voodoo and Zora Neale Hurston." *Frontiers* (Summer 1992): 131(22).

Fannin, Alice. "A Sense of Wonder: The Pattern for Psychic Survival in *Their Eyes Were Watching God* and *The Color Purple." The Zora Neale Hurston Forum* (Fall 1986): 1–11.

Faulkner, Howard J. "Mules and Men: Fiction as Folklore." *CLA Journal* (March 1991): 331–40.

Ferguson, SallyAnn. "Folkloric Men and Female Growth in *Their Eyes Were Watching God." Black American Literature Forum* (Spring-Summer 1987): 185–97.

Flores, Toni. "Claiming and Making: Ethnicity, Gender, and the Common Sense in Leslie Marmon Silko's *Ceremony* and Zora Neale Hurston's *Their Eyes Were Watching God."* (*Frontiers:* 1989): 52–58.

Foreman, Gabrielle. "Looking Back from Zora, or Talking Out Both Sides My Mouth for Those Who Have Two Ears." *Black American Literature Forum* (Winter 1990): 649–67.

Fox-Genovese, Elizabeth. "To Write My Self: The Autobiographies of Afro-American Women." In Benstock, Shari, ed., and Catharine R. Stimpson, introd., *Feminist Issues in Literary Scholarship* (Indiana University Press: Bloomington, 1987): 161–80.

———. "My Statue, My Self: Autobiographical Writings of Afro-American Women." In Benstock, Shari, ed., *The Private Self: Theory and Practice of Women's Autobiographical Writings* (University of North Carolina Press: Chapel Hill, 1988): 63–89.

———. "Myth and History: Discourse of Origins in Zora Neale Hurston and Maya Angelou." *Black American Literature Forum* (Summer 1990): 221–36.

Freeman, Alma S. "Zora Neale Hurston and Alice Walker: A Spiritual Kinship." *SAGE* (Spring 1985): 37–40.

Gates, Henry Louis, Jr. "Why the *Mule Bone* Debate Goes On." *New York Times* (Feb. 10, 1991): II, 5:1.

Giovanni, Nikki. "Sisters, Too; Great Women in African-American History." *The Black Collegian* (Jan.–Feb. 1992): 60–64.

Glassman, Steve and Kathryn Lee Seidel, eds., *Zora in Florida*. University of Central Florida Press: Orlando; University Presses of Gainesville, Florida, 1991.

Grant, Alice Morgan. *Jump at the Sun: Zora Neale Hurston and Her Eatonville Roots: A Guide for Teachers*. Association to Preserve Eatonville Community: Eatonville, FL, 1991.

Hale, David G. "Hurston's 'Spunk' and Hamlet." (Summer 1993): 397(2).

Hattenhauer, Darryl. "Hurston's *Their Eyes Were Watching God*." *The Explicator* (Winter 1992): 111(2).

Hemenway, Robert. *The Harlem Renaissance Remembered*. ("Zora Neale Hurston and the Eatonville Anthropology") ed. by Arna Bontemps. Dodd, Mead and Co., New York, 1972.

———. "Folklore Field Notes From Zora Neale Hurston." *Black Scholar* (1976): 39–46.

———. *Zora Neale Hurston: A Literary Biography*. University of Illinois Press: Chicago, 1977.

———. *Dust Tracks on a Road: An Autobiography*, 2nd ed. University of Illinois Press: Urbana, 1984.

———. "The Personal Dimension in *Their Eyes Were Watching God*." In Awkward, Michael, ed., *New Essays on Their Eyes Were Watching God* (Cambridge University Press: Cambridge, 1990): 29–49.

Hite, Molly. "Romance, Marginality, Matrilineage: Alice Walker's *The Color Purple* and Zora Neale Hurston's *Their Eyes Were Watching God*." *Novel* (Spring 1989): 257–73.

Holloway, Karla F.C. *The Character of the Word: The Texts of Zora Neale Hurston*. Greenwood Press: New York, 1987.

hooks, bell. "Zora Neale Hurston: A Subversive Reading." *Matatu* (1989): 5–23.

Howard, Lillie P., ed. *Alice Walker and Zora Neale Hurston: The Common Bond*. Westport, Conn.: Greenwood Press, 1993.

———. "Marriage: Zora Neale Hurston's System of Values." *CLA Journal* (Dec. 1977): 256–68.

———. *Zora Neale Hurston*. Twayne Publishers: Boston, 1980.

Hubbard, Dolan. " '. . . Ah said Ah'd save de text for you': Recontextualizing the Sermon to Tell (Her) Story in Zora Neale Hurston's *Their Eyes Were Watching God*." *African American Review* (Summer 1993): 167(12).

Hudson, Gossie Harold. "Zora Neale Hurston and Alternative History." *MAWA Review* (Summer-Fall 1982): 60–64.

Hughes, Carl Milton. *The Negro Novelist*. (Citadel Press: New York, 1953): 172–78.

Hurst, Fannie. "Zora Neale Hurston: A Personality Sketch." *Yale University Library Gazette* (1960): 17–22.

Hurston, Zora Neale. "Self-Help—Hoodoo Style: How to Ward Off Enemies and Make Love Charms." Excerpted from *Journal of American Folklore* (1931), 174. Published in: *Utne Reader* (May–June 1990): 121(2).

Isaacs, D.S. "Zora Neale Hurston: Critical Perspectives Past and Present." *Choice* (Jan 1994): 785(1).

Johnson, Barbara. "Metaphor, Metonymy, and Voice in *Their Eyes Were Watching God*." In Gates, Henry Louis, Jr., ed., *Black Literature and Literary Theory* (Methuen, New York, 1984): 205–19.

Johnson, Lonnell E. "The Defiant Black Heroine: Ollie Miss and Janie Mae—Two Portraits from the 30's." *The Zora Neale Hurston Forum* (Spring 1990): 41–46.

Jones, Evora W. "The Pastoral and the Picaresque in Zora Neale Hurston's 'The Gilded Six-Bits.' " *CLA Journal* (March 1992): 316(9).

Jones, Kirkland C. "Folk Humor as Comic Relief in Hurston's *Jonah's Gourd Vine*." *The Zora Neale Hurston Forum* (Fall 1986): 26–31.

Jordan, Jennifer. "Feminist Fantasies: Zora Neale Hurston's *Their Eyes Were Watching God*." *Tulsa Studies in Women's Literature* (Spring 1988): 105–17.

Jordan, June. "On Richard Wright and Zora Neale Hurston: Notes Toward a Balance of Love and Hatred." *Black World* (Aug 1974): 4–8.

Kalb, John D. "The Anthropological Narrator of Hurston's *Their Eyes Were Watching God*." *Studies in American Fiction* (Fall 1988): 169–80.

Kim, Myung Ja. "Zora Neale Hurston's Search for Self: *Their Eyes Were Watching God*." *The Journal of English Language and Literature* (Fall 1990): 491–513.

King, Sigrid. "Naming and Power in Zora Neale Hurston's *Their Eyes Were Watching God.*" *Black American Literature Forum* (Winter 1990): 683–97.

Kitch, Sally L. "Gender and Language: Dialect, Silence, and the Disruption of Discourse." *Women's Studies* (1987): 66–78.

Krasner, James. "The Life of Women: Zora Neale Hurston and Female Autobiography." *Black American Literature Forum* (Spring 1989): 113–27.

Kubitschek, Missy Dehn. " 'Tuh de Horizon and Back': The Female Quest in *Their Eyes Were Watching God.*" *Black American Literature Forum* (Fall 1983): 109–15.

Lenz, Gunter H. "Southern Exposure: The Urban Experience and the Re-Construction of Black Folk Culture and Community in the Works of Richard Wright and Zora Neale Hurston." *New York Folklore* (Summer 1981): 3–39.

LeSeur, Geta. "Janie as Sisyphus: Existential Heroism in *Their Eyes Were Watching God.*" *The Zora Neale Hurston Forum* (Spring 1990): 33–40.

Lewis, Vashti Crutcher. "The Declining Significance of the Mulatto Female as Major Character in the Novels of Zora Neale Hurston." *CLA Journal* (Dec. 1984): 127–49.

Lindberg-Seyersted, Brita. "The Color Black: Skin Color as Social, Ethical, and Esthetic Sign in Writings by Black American Women." *English Studies* (Feb. 1992): 51(1-7).

Lindroth, James R. "Generating the Vocabulary of Hoodoo: Zora Neale Hurston and Ishmael Reed." *The Zora Neale Hurston Forum* (Fall 1987): 27–34.

Love, Theresa R. "Zora Neale Hurston's America." *Papers on Language and Literature* (Fall 1976): 422–37.

Lowe, John. "Hurston, Humor, and the Harlem Renaissance." In Kramer, Victor A., ed., *The Harlem Renaissance Re-Examined* (AMS: New York, 1987): 283–313.

———. *Jump at the Sun: Zora Neale Hurston's Cosmic Comedy.* University of Illinois Press, Urbana, 1995.

Lupton, Mary Jane. "Zora Neale Hurston and the Survival of the Female." *Southern Literary Journal* (Fall 1982): 45–54.

———. "Black Women and Survival in Comedy: American Style and *Their Eyes Were Watching God.*" *The Zora Neale Hurston Forum* (Fall 1986): 38–44.

MacKethan, Lucinda H. "Mother Wit: Humor in Afro-American Women's Autobiography." *Studies in American Humor* (Spring-Summer 1985): 51–61.

Marks, Donald R. "Sex, Violence and Organic Consciousness in Zora Neale Hurston's *Their Eyes Were Watching God.*" *Black American Literature Forum* (Winter 1985): 152–57.

Matza, Diane. "Zora Neale Hurston's *Their Eyes Were Watching God* and Toni Morrison's *Sula:* A Comparison." *MELUS* (Fall 1985): 43–54.

McCredie, Wendy J. "Authority and Authorization in *Their Eyes Were Watching God.*" *Black American Literature Forum* (Spring 1982): 25–28.

McKay, Nellie. " 'Crayon Enlargements of Life': Zora Neale Hurston's *Their Eyes Were Watching God* as Autobiography." In Awkward, Michael, ed., *New Essays on Their Eyes Were Watching God* (Cambridge University Press: Cambridge, 1990): 51–70.

Mikell, Gwendoly. "When Horses Talk: Reflections on Zora Neale Hurston's Haitian Anthropology." *Phylon* (Sept 1982): 218–30.

Nathiri, N. Y. *Zora! Zora Neale Hurston, a Woman and Her Community.* Sentinel Communications Co.: Orlando, 1991.

Naylor, Carolyn A. "Cross-Gender Significance of the Journey Motif in Selected Afro-American Fiction." *Colby Library Quarterly* (March 1982): 26–38.

Neal, Carry. "Eatonville's Zora Neale Hurston: A Profile." In *Black Review* Vol. 2. William Morrow Publishers: New York, 1972.

Newson, Adele S. " 'The Fiery Chariot': A One-Act Play by Zora Neale Hurston." *The Zora Neale Hurston Forum* (Fall 1986): 32–37.

————. *Zora Neale Hurston: A Reference Guide.* G. K. Hall: Boston MA, 1987.

Olaniyan, Tejumola. "God's Weeping Eyes: Hurston and the Anti-Patriarchal Form." *Obsidian II* (Summer 1990): 30–45.

Paquet, Sandra Pouchet. "The Ancestor as Foundation in *Their Eyes Were Watching God* and *Tar Baby.*" *Callaloo* (Summer 1990): 499–515.

Peterson, Dale E. "Response and Call: The African American Dialogue with Bakhtin." *American Literature* (Dec. 1993): 761(15).

Plant, Deborah G. "The Folk Preacher and Folk Sermon Form in Zora Neale Hurston's *Dust Tracks on a Road.*" *Folklore Forum* (1988): 3–19.

Pondrom, Cyrena N. "The Role of Myth in Hurston's *Their Eyes Were Watching God.*" *American Literature* (May 1986): 181–202.

Raynaud, Claudine. "Autobiography as a 'Lying' Session: Zora Neale Hurston's *Dust Tracks on a Road.*" In Weixlmann, Joe and Houston

A. Baker, Jr., eds., *Black Feminist Criticism and Critical Theory* (Penkevill, Greenwood, FL, 1988): 111–38.

Rayson, Ann L. "The Novels of Zora Neale Hurston." *Studies in Black Literature* (Winter 1974): 1–11.

Reich, Alice. "Phoeby's Hungry Listening." *Women's Studies* (1986): 163–69.

Robey, Judith. "Generic Strategies in Zora Neale Hurston's *Dust Tracks on a Road.*" Black American Literature Forum (Winter 1990): 667–83.

Robinson, Wilhelmena. *Historical Negro Biographies.* (Publisher's Co.: New York, 1967): 208–10.

Roemer, Jule. "Celebrating the Black Female Self: Zora Neale Hurston's American Classic *(Their Eyes Were Watching God)."* English Journal (Nov. 1989): 70–73.

Rosenblatt, Jean. "Charred Manuscripts Tell Zora Neale Hurston's Poignant and Powerful Story." *The Chronicle of Higher Education* (June 5, 1991): B4.

Ryan, Bonnie Crarey. "Zora Neale Hurston—A Checklist of Secondary Sources." *Bulletin of Bibliography* (March 1988): 33–39.

Sadoff, Dianne F. "Black Matrilineage: The Case of Alice Walker and Zora Neale Hurston." *Signs* (Fall 1985): 4–26.

Saunders, James Robert. "Womanism as the Key to Understanding Zora Neale Hurston's *Their Eyes Were Watching God* and Alice Walker's *The Color Purple.*" The Hollins Critic (Oct. 1988): 1–11.

Schmidt, Rita T. "The Fiction of Zora Neale Hurston: An Assertion of Black Womanhood." *Ilha do Desterro* (1985): 53–70.

Schwalbenberg, Peter. "Time as Point of View in Zora Neale Hurston's *Their Eyes Were Watching God."* Negro American Literature Forum (Fall 1976): 104–108.

Setterberg, Fred. "Zora Neale Hurston in the Land of 1,000 Dances." *The Georgia Review* (Winter 1992): 627(17).

Sheffey, Ruthe T. "Zora Neale Hurston's *Moses, Man of the Mountain:* A Fictionalized Manifesto on the Imperatives of Black Leadership." *CLA Journal* (Dec. 1985): 206–20.

Sheppard, David M. "Living by Comparisons: Janie and Her Discontents." *English Language Notes* (Dec. 1992): 63(13).

Smith-Wright, Geraldine. "Revision as Collaboration: Zora Neale Hurston's *Their Eyes Were Watching God* as Source for Alice Walker's *The Color Purple.*" SAGE (Fall 1987): 20–25.

Sollors, Werner. "Of Mules and Mares in a Land of Difference; or, Quadrupeds All?" *American Quarterly* (June 1990): 167–91.

Speisman, Barbara. "A Tea with Zora and Marjorie: A Series of Vignettes Based on the Unique Friendship of Zora Neale Hurston and Marjorie Kinnan Rawlings." *Rawlings Journal* (1988): 67–100.

St. Clair, Janet. "The Courageous Undertow of Zora Neale Hurston's 'Seraph on the Suwanee.' " *Modern Language Quarterly* (March 1989): 38–57.

Stadler, Quandra Prettyman. "Visibility and Difference: Black Women in History and Literature: Pieces of a Paper and Some Ruminations." In Eisenstein, Hester, ed. and introd.; Alice Jardine, ed. and pref., *The Future of Difference* (Hall, Boston, 1980): 239–46.

Stetson, Erlene. "*Their Eyes Were Watching God:* A Woman's Story." *Regionalism and the Female Imagination* (1979): 30–36.

Story, Ralph D. "Gender and Ambition: Zora Neale Hurston in the Harlem Renaissance." *The Black Scholar* (May–July 1989): 25(7).

———. "Patronage and the Harlem Renaissance: You Get What You Pay For." *CLA Journal* (March 1989): 284–95.

Sundquist, Eric J. *The Hammers of Creation: Folk Culture in Modern African-American Fiction.* University of Georgia Press: Athens, 1992.

Thomas, Marion A. "Reflections on the Sanctified Church as Portrayed by Zora Neale Hurston." *Black American Literature Forum* (Spring 1991): 35–42.

Thornton, Jerome E. " 'Goin' on de Muck': The Paradoxical Journey of the Black American Hero" (notes) *CLA Journal* (March 1988): 261–80.

Turner, Darwin. *Minor Chord: Three Afro-American Writers and Their Search for Identity.* Southern Illinois University Press: Carbondale, 1971.

Urgo, Joseph R. "The Tune is the Unity of the Thing: Power and Vulnerability in Zora Hurston's *Their Eyes Were Watching God.*" *The Southern Literary Journal* (Spring, 1991): 40–55.

Wald, Priscilla. "Becoming 'Colored': The Self-Authorized Language of Difference in Zora Neale Hurston." *American Literary History* (Spring 1990): 79–100.

Walker, Alice. "In Search of Zora Neale Hurston." *Ms* (March 1975): 74–82.

———, and Mary Helen Washington, *I Love Myself When I Am Laughing . . . and Then Again When I Am Looking Mean and Impressive: A Zora Neale Hurston Reader.* Feminist Press: New York, 1979.

———. "Looking for Zora." In Ascher, Carol; Louise DeSalvo, and Sara Ruddick, eds., *Between Women: Biographers, Novelists, Critics,*

Teachers, and Artists Write about Their Work on Women (Beacon Press: Boston, 1984): 431–47.

Walker, S. Jay. "Zora Neale Hurston and *Their Eyes Were Watching God:* Black Novel of Sexism." *Modern Fiction Studies* (Winter 1975): 519–27.

Wall, Cheryl A. "Mules and Men and Women: Zora Neale Hurston's Strategies of Narration and Visions of Female Empowerment." *Black American Literature Forum* (Winter 1989): 661–80.

Welsh-Asante, Dariamu. "Dance as Metaphor in Zora Neale Hurston's *Their Eyes Were Watching God." The Zora Neale Hurston Forum* (Spring 1990): 18–31.

Wilentz, Gay. "White Patron, and Black Artist: The Correspondence of Fannie Hurst and Zora Neale Hurston." *Library Chronicle of the University of Texas* (1986): 20–43.

———. "Defeating the False God: Janie's Self-Determination in Zora Neale Hurston's *Their Eyes Were Watching God."* In Kessler-Harris, Alice and William McBrien, eds., *Faith of a (Woman) Writer* (Greenwood: Westport CT, 1988): 28.

Williams, Delores S. "Black Women's Literature and the Task of Feminist Theory." In Atkinson, Clarissa W. and Constance H. Buchanan, eds. and prefs.; Margaret R. Miles, ed., pref., and intro., *Immaculate and Powerful: The Female in Sacred Image and Social Reality* (Beacon Press: Boston, 1985): 88–110.

Williams, Donna M. "Our Love/Hate Relationship with Zora Neale Hurston." *The Black Collegian* (Jan–Feb 1994): 86(3).

Williams, Sherley Ann, Ruby Dee, and Jerry Pinkney, *Their Eyes Were Watching God.* University of Illinois Press: Urbana, 1991.

Willis, Miriam DeCosta. "Folklore and the Creative Artist: Lydia Cabrera and Zora Neale Hurston." *CLA Journal* (Sept. 1983): 81–90.

Insights,
Interviews
& More . . .

"In Search of Zora Neale Hurston"

by Alice Walker

The work of Zora Neale Hurston was relatively unknown in 1975, when Alice Walker, beloved author of The Color Purple, *wrote her groundbreaking essay "In Search of Zora Neale Hurston" (Ms.* magazine, *March 1975). In this seminal piece, reprinted here in its entirety, Walker illuminates her idol's life and work.*

"ON JANUARY 16, 1959, Zora Neale Hurston, suffering from the effects of a stroke and writing painfully in longhand, composed a letter to the 'editorial department' of Harper & Brothers inquiring if they would be interested in seeing 'the book I am laboring upon at the present—a life of Herod the Great.' One year and twelve days later, Zora Neale Hurston died without funds to provide for her burial, a resident of the St. Lucie County, Florida, Welfare Home. She lies today in an unmarked grave in a segregated cemetery in Fort Pierce, Florida, a resting place generally symbolic of the black writer's fate in America.

"Zora Neale Hurston is one of the most significant unread authors in America, the author of two minor classics and four other major books."

—*Robert Hemenway, "Zora Hurston and the Eatonville Anthropology," from* The Harlem Renaissance Remembered, *edited by Arna Bontemps (Dodd, 1972)*

Courtesy of the Estate of Carl Van Vechten, Joseph Solomon, Executor

ON AUGUST 15, 1973, I wake up just as the plane is lowering over Sanford, Florida, which means I am also looking down on Eatonville, Zora Neale Hurston's birthplace. I recognize it from Zora's description in *Mules and Men*: "the city of five lakes, three croquet courts, three hundred brown skins, three hundred good swimmers, plenty guavas, two schools, and no jailhouse." Of course I cannot see the guavas, but the five lakes are still there, and it is the lakes I count as the plane prepares to land in Orlando.

From the air, Florida looks completely flat, and as we near the ground this impression does not change. This is the first time I have seen the interior of the state, which Zora wrote about so well, but there are the acres of orange groves, the sand, mangrove trees, and scrub pine that I know from her books. Getting off the plane I walk through the hot moist air of midday into the tacky but air-conditioned airport. I search for Charlotte Hunt, my companion on the Zora Hurston expedition. She lives in Winter Park, Florida, very near Eatonville, and is writing her graduate dissertation on Zora. I see her waving—a large pleasant-faced white woman in dark glasses. We have written to each other for several weeks, swapping our latest finds (mostly hers) on Zora, and trying to make sense out of the mass of information obtained (often erroneous or simply confusing) from Zora herself—through her stories and autobiography—and from people who wrote about her.

Eatonville has lived for such a long time in my imagination that I can hardly believe it will be found existing in its own right. But after twenty minutes on the expressway, Charlotte turns off and I see a small settlement of ▶

"In Search of Zora Neale Hurston" *(continued)*

houses and stores set with no particular pattern in the sandy soil off the road. We stop in front of a neat gray building that has two fascinating signs: EATONVILLE POST OFFICE and EATONVILLE CITY HALL.

Inside the Eatonville City Hall half of the building, a slender, dark, brown-skin woman sits looking through letters on a desk. When she hears we are searching for anyone who might have known Zora Neale Hurston, she leans back in thought. Because I don't wish to inspire foot-dragging in people who might know something about Zora they're not sure they should tell, I have decided on a simple, but I feel profoundly *useful*, lie.

"I am Miss Hurston's niece," I prompt the young woman, who brings her head down with a smile.

"I think Mrs. Moseley is about the only one still living who might remember her," she says.

"Do you mean *Mathilda* Moseley, the woman who tells those 'woman-is-smarter-than-man' lies in Zora's book?"

"Yes," says the young woman. "Mrs. Moseley is real old now, of course. But this time of day, she should be at home."

I stand at the counter looking down on her, the first Eatonville resident I have spoken to. Because of Zora's books, I feel I know something about her; at least I know what the town she grew up in was like years before she was born.

"Tell me something," I say, "do the schools teach Zora's books here?"

"No," she says, "they don't. I don't think most people know anything about Zora Neale

Hurston, or knew about any of the great things she did. She was a fine lady. I've read all of her books myself, but I don't think many other folks in Eatonville have."

"Many of the church people around here, as I understand it," says Charlotte in a murmured aside, "thought Zora was pretty loose. I don't think they appreciated her writing about them."

"Well," I say to the young woman, "thank you for your help." She clarifies her directions to Mrs. Moseley's house and smiles as Charlotte and I turn to go.

"The letter to Harper's does not expose a publisher's rejection of an unknown masterpiece, but it does reveal how the bright promise of the Harlem Renaissance deteriorated for many of the writers who shared in its exuberance. It also indicates the personal tragedy of Zora Neale Hurston: Barnard graduate, author of four novels, two books of folklore, one volume of autobiography, the most important collector of Afro-American folklore in America, reduced by poverty and circumstance to seek a publisher by unsolicited mail."
 —*Robert Hemenway*

"Zora Neale Hurston was born in 1901, 1902, or 1903—depending on how old she felt herself to be at the time someone asked."
 —*Librarian, Beinecke Library, Yale University*

THE MOSELEY HOUSE is small and white and snug, its tiny yard nearly swallowed up by oleanders and hibiscus bushes. Charlotte and I knock on the door. I call out. But there is no ▶

5

answer. This strikes us as peculiar. We have had time to figure out an age for Mrs. Moseley—not dates or a number, just old. I am thinking of a quivery, bedridden invalid when we hear the car. We look behind us to see an old black-and-white Buick—paint peeling and grillwork rusty—pulling into the drive. A neat old lady in a purple dress and white hair is straining at the wheel. She is frowning because Charlotte's car is in the way.

Mrs. Moseley looks at us suspiciously. "Yes, I knew Zora Neale," she says, unsmilingly and with a rather cold stare at Charlotte (who I imagine feels very *white* at that moment), "but that was a long time ago, and I don't want to talk about it."

"Yes ma'am," I murmur, bringing all my sympathy to bear on the situation.

"Not only that," Mrs. Moseley continues, "I've been sick. Been in the hospital for an operation. Ruptured artery. The doctors didn't believe I was going to live, but you see me alive, don't you?"

"Looking well, too," I comment.

Mrs. Moseley is out of her car. A thin, sprightly woman with nice gold-studded false teeth, uppers and lowers. I like her because she stands there *straight* beside her car, with a hand on her hip and her straw pocketbook on her arm. She wears white T-strap shoes with heels that show off her well-shaped legs.

"I'm eighty-two years old, you know," she says. "And I just can't remember things the way I used to. Anyhow, Zora Neale left here to go to school and she never really came back to live. She'd come here for material for her

books, but that was all. She spent most of her time down in South Florida."

"You know, Mrs. Moseley, I saw your name in one of Zora's books."

"You did?" She looks at me with only slightly more interest. "I read some of her books a long time ago, but then people got to borrowing and borrowing and they borrowed them all away."

"I could send you a copy of everything that's been reprinted." I offer. "Would you like me to do that?"

"No," says Mrs. Moseley promptly. "I don't read much any more. Besides, all of that was *so* long ago. . . ."

Charlotte and I settle back against the car in the sun. Mrs. Moseley tells us at length and with exact recall every step in her recent operation, ending with: "What those doctors didn't know—when they were expecting me to die (and they didn't even think I'd live long enough for them to have to take out my stitches!)—is that Jesus is the best doctor, and if *He* says for you to get well, that's all that counts."

With this philosophy, Charlotte and I murmur quick assent: being Southerners and church bred, we have heard that belief before. But what we learn from Mrs. Moseley is that she does not remember much beyond the year 1938. She shows us a picture of her father and mother and says that her father was Joe Clarke's brother. Joe Clarke, as every Zora Hurston reader knows, was the first mayor of Eatonville; his fictional counterpart is Jody Starks of *Their Eyes Were Watching God*. We also get directions to where Joe Clarke's store *was*—where Club ▶

"In Search of Zora Neale Hurston" *(continued)*

Eaton is now. Club Eaton, a long orange-beige nightspot we had seen on the main road, is apparently famous for the good times in it regularly had by all. It is, perhaps, the modern equivalent of the store porch, where all the men of Zora's childhood came to tell "lies," that is, black folktales, that were "made and used on the spot," to take a line from Zora. As for Zora's exact birthplace, Mrs. Moseley has no idea.

After I have commented on the healthy growth of her hibiscus bushes, she becomes more talkative. She mentions how much she *loved* to dance, when she was a young woman, and talks about how good her husband was. When he was alive, she says, she was completely happy because he allowed her to be completely free. "I was so free I had to pinch myself sometimes to tell if I was a married woman."

Relaxed now, she tells us about going to school with Zora. "Zora and I went to the same school. It's called Hungerford High now. It *was* only to the eighth-grade. But our teachers were so good that by the time you left you knew college subjects. When I went to Morris Brown in Atlanta, the teachers there were just teaching me the same things I had already learned right in Eatonville. I wrote Mama and told her I was going to come home and help her with her babies. I wasn't learning anything new."

"Tell me something, Mrs. Moseley," I ask, "why do you suppose Zora was against integration? I read somewhere that she was against school desegregation because she felt it was an insult to black teachers."

"Oh, one of them [white people] came

around asking me about integration. One day I was doing my shopping. I heard 'em over there talking about it in the store, about the schools. And I got on out of the way because I knew if they asked me, they wouldn't like what I was going to tell 'em. But they came up and asked me anyhow. 'What do you think about this integration?' one of them said. I acted like I thought I had heard wrong. 'You're asking *me* what *I* think about integration?' I said. 'Well, as you can see I'm just an old colored woman'—I was seventy-five or seventy-six then—'and this is the first time anybody ever asked me about integration. And nobody asked my grandmother what she thought, either, but her daddy was one of you all.'" Mrs. Moseley seems satisfied with this memory of her rejoinder. She looks at Charlotte. "I have the blood of three races in my veins," she says belligerently, "white, black, and Indian, and nobody asked me *anything* before."

"Do you think living in Eatonville made integration less appealing to you?"

"Well, I can tell you this: I have lived in Eatonville all my life and I've been in the governing of this town. I've been everything but Mayor and I've been *assistant* Mayor. Eatonville was and is an all-black town. We have our own police department, post office, and town hall. Our own school and good teachers. Do I need integration?

"They took over Goldsboro, because the black people who lived there never incorporated like we did. And now I don't even know if any black folks live there. They built big houses up there around the lakes. But we didn't let that happen in Eatonville, ▶

and we don't sell land to just anybody. And
you see, we're still here."

When we leave, Mrs. Moseley is standing
by her car, waving. I think of the letter Roy
Wilkins wrote to a black newspaper blasting
Zora Neale for her lack of enthusiasm about
the integration of schools. I wonder if he knew
the experience of Eatonville she was coming
from. Not many black people in America have
come from a self-contained, all-black
community where loyalty and unity are taken
for granted. A place where black pride is
nothing new.

There is, however, one thing Mrs. Moseley
said that bothered me.

"Tell me, Mrs. Moseley," I had asked, "Why
is it that thirteen years after Zora's death, no
marker has been put on her grave?"

And Mrs. Moseley answered: "The reason
she doesn't have a stone is because she wasn't
buried here. She was buried down in South
Florida somewhere. I don't think anybody
really knew where she was."

"Only to reach a wider audience, need she ever
write books—because she is a perfect book of
entertainment in herself. In her youth she was
always getting scholarships and things from
wealthy white people, some of whom simply
paid her just to sit around and represent the
Negro race for them, she did it in such a racy
fashion. She was full of sidesplitting
anecdotes, humorous tales, and tragicomic
stories, remembered out of her life in the
South as a daughter of a traveling minister of
God. She could make you laugh one minute
and cry the next. To many of her white friends,
no doubt, she was a perfect 'darkie,' in the nice

meaning they give the term—that is, a naïve, childlike, sweet, humorous, and highly colored Negro.

"But Miss Hurston was clever, too—a student who didn't let college give her a broad 'a' and who had great scorn for all pretentions, academic or otherwise. That is why she was such a fine folklore collector, able to go among the people and never act as if she had been to school at all. Almost nobody else could stop the average Harlemite on Lenox Avenue and measure his head with a strange-looking, anthropological device and not get bawled out for the attempt, except Zora, who used to stop anyone whose head looked interesting, and measure it."

—*Langston Hughes,* The Big Sea *(Knopf)*

"What does it matter what white folks must have thought about her?"

—*Student, Black Women Writers Class,*
Wellesley College

MRS. SARAH PEEK PATTERSON is a handsome, red-haired woman in her late forties, wearing orange slacks and gold earrings. She is the director of Lee-Peek Mortuary in Fort Pierce, the establishment that handled Zora's burial. Unlike most black funeral homes in Southern towns that sit like palaces among the general poverty, Lee-Peek has a run-down, *small* look. Perhaps this is because it is painted purple and white, as are its Cadillac chariots. These colors do not age well. The rooms are cluttered and grimy, and the bathroom is a tiny, stale-smelling prison, with a bottle of black hair dye (apparently used to touch up

the hair of the corpses) dripping into the face bowl. Two pine burial boxes are resting in the bathtub.

Mrs. Patterson herself is pleasant and helpful.

"As I told you over the phone, Mrs. Patterson," I begin, shaking her hand and looking into her penny-brown eyes, "I am Zora Neale Hurston's niece, and I would like to have a marker put on her grave. You said, when I called you last week, that you could tell me where the grave is."

By this time I am, of course, completely into being Zora's niece, and the lie comes with perfect naturalness to my lips. Besides, as far as I'm concerned, she *is* my aunt—and that of all black people as well.

"She was buried in 1960," exclaims Mrs. Patterson. "That was when my father was running this funeral home. He's sick now or I'd let you talk to him. But I know where she's buried. She's in the old cemetery, the Garden of the Heavenly Rest, on Seventeenth Street. Just when you go in the gate there's a circle, and she's buried right in the middle of it. Hers is the only grave in that circle—because people don't bury in that cemetery any more."

She turns to a stocky, black-skinned woman in her thirties, wearing a green polo shirt and white jeans cut off at the knee. "This lady will show you where it is," she says.

"I can't tell you how much I appreciate this," I say to Mrs. Patterson, as I rise to go. "And could you tell me something else? You see, I never met my aunt. When she died I was still a junior in high school. But could you tell me what she died of, and what kind of funeral she had?"

"I don't know exactly what she died of," Mrs. Patterson says, "I know she didn't have any money. Folks took up a collection to bury her. . . . I believe she died of malnutrition."

"*Malnutrition?*"

Outside, in the blistering sun, I lean my head against Charlotte's even more blistering cartop. The sting of the hot metal only intensifies my anger. "*Malnutrition?*" I manage to mutter. "Hell, our condition hasn't changed *any* since Phillis Wheatley's time. *She* died of malnutrition!"

"Really?" says Charlotte, "I didn't know that."

"One cannot overemphasize the extent of her commitment. It was so great that her marriage in the spring of 1927 to Herbert Sheen was short-lived. Although divorce did not come officially until 1931, the two separated amicably after only a few months, Hurston to continue her collecting, Sheen to attend Medical School. Hurston never married again."

—*Robert Hemenway*

"WHAT IS YOUR NAME?" I ask the woman who has climbed into the back seat.

"Rosalee," she says. She has a rough, pleasant voice, as if she is a singer who also smokes a lot. She is homely, and has an air of ready indifference.

"Another woman came by here wanting to see the grave," she says, lighting up a cigarette. "She was a little short, dumpy white lady from one of these Florida schools. Orlando or Daytona. But let me tell you something before we get started. All I know is where the ▶

cemetery is. I don't know one thing about that grave. You better go back in and ask her to draw you a map."

A few moments later, with Mrs. Patterson's diagram of where the grave is, we head for the cemetery.

We drive past blocks of small, pastel-colored houses and turn right onto Seventeenth Street. At the very end, we reach a tall curving gate, with the words "Garden of Heavenly Rest" fading into the stone. I expected, from Mrs. Patterson's small drawing, to find a small circle—which would have placed Zora's grave five or ten paces from the road. But the "circle" is over an acre large and looks more like an abandoned field. Tall weeds choke the dirt road and scrape against the sides of the car. It doesn't help either that I step out into an active anthill.

"I don't know about y'all," I say, "but I don't even believe this." I am used to the haphazard cemetery-keeping that is traditional in most Southern black communities, but this neglect is staggering. As far as I can see there is nothing but bushes and weeds, some as tall as my waist. One grave is near the road, and Charlotte elects to investigate it. It is fairly clean, and belongs to someone who died in 1963.

Rosalee and I plunge into the weeds; I pull my long dress up to my hips. The weeds scratch my knees, and the insects have a feast. Looking back, I see Charlotte standing resolutely near the road.

"Aren't you coming?" I call.

"No," she calls back. "I'm from these parts and I know what's out there." She means snakes.

"Shit," I say, my whole life and the people I love flashing melodramatically before my eyes. Rosalee is a few yards to my right.

"How're you going to find anything out here?" she asks. And I stand still a few seconds, looking at the weeds. Some of them are quite pretty, with tiny yellow flowers. They are thick and healthy, but dead weeds under them have formed a thick gray carpet on the ground. A snake could be lying six inches from my big toe and I wouldn't see it. We move slowly, very slowly, our eyes alert, our legs trembly. It is hard to tell where the center of the circle is since the circle is not really round, but more like half of something round. There are things crackling and hissing in the grass. Sandspurs are sticking to the inside of my skirt. Sand and ants cover my feet. I look toward the road and notice that there are, indeed, *two* large curving stones, making an entrance and exit to the cemetery. I take my bearings from them and try to navigate to exact center. But the center of anything can be very large, and a grave is not a pinpoint. Finding the grave seems positively hopeless. There is only one thing to do:

"Zora!" I yell as loud as I can (causing Rosalee to jump), "are you out here?"

"If she is, I sho hope she don't answer you. If she do, I'm gone."

"Zora!" I call again, "I'm here. Are you?"

"If she is," grumbles Rosalee, "I hope she'll keep it to herself."

"Zora!" Then I start fussing with her. "I hope you don't think I'm going to stand out here all day, with these snakes watching me and these ants having a field day. In fact, I'm going to ▶

call you just one or two more times." On a clump of dried grass, near a small busy tree, my eye falls on one of the largest bugs I have ever seen. It is on its back, and is as large as three of my fingers. I walk toward it, and yell "Zo-ra!" and my foot sinks into a hole. I look down. I am standing in a sunken rectangle that is about six feet long and about three or four feet wide. I look up to see where the two gates are.

"Well," I say, "this is the center, or approximately anyhow. It's also the only sunken spot we've found. Doesn't this look like a grave to you?"

"For the sake of not going no farther through these bushes," Rosalee growls, "yes, it do."

"Wait a minute," I say, "I have to look around some more to be sure this is the only spot that resembles a grave. But you don't have to come."

Rosalee smiles—a grin, really—beautiful and tough.

"Naw," she says, "I feels sorry for you. If one of these snakes got a hold of you out here by yourself I'd feel *real* bad." She laughs. "I done come this far, I'll go on with you."

"Thank you, Rosalee," I say. "Zora thanks you too."

"Just as long as she don't try to tell me in person," she says, and together we walk down the field.

"The gusto and flavor of Zora Neal[e] Hurston's storytelling, for example, long before the yarns were published in *Mules and Men* and other books, became a local legend which might . . . have spread further under different conditions. A tiny shift in the

center of gravity could have made them best-sellers."

—*Arna Bontemps,* Personals *(Paul Bremen, Ltd., London; 1963)*

"Bitter over the rejection of her folklore's value, especially in the black community, frustrated by what she felt was her failure to convert the Afro-American world view into the forms of prose fiction, Hurston finally gave up."

—*Robert Hemenway*

WHEN CHARLOTTE AND I drive up to the Merritt Monument Company, I immediately see the headstone I want.

"How much is this one?" I ask the young woman in charge, pointing to a tall black stone. It looks as majestic as Zora herself must have been when she was learning voodoo from those root doctors down in New Orleans.

"Oh, *that* one," she says, "that's our finest. That's Ebony Mist."

"Well, how much is it?"

"I don't know. But wait," she says, looking around in relief, "here comes somebody who'll know."

A small, sunburned man with squinty green eyes come sup. He must be the engraver, I think, because his eyes are contracted into slits as if he has been keeping stone dust out of them for years.

"That's Ebony Mist," he says. "That's our best."

"How much is it?" I ask, beginning to realize I probably *can't* afford it. ▶

He gives me a price that would feed a dozen Sahelian drought victims for three years. I realize I must honor the dead, but between the dead great and the living starving, there is no choice.

"I have a lot of letters to be engraved," I say, standing by the plain gray marker I have chosen. It is pale and ordinary, not at all like Zora, and makes me momentarily angry that I am not rich.

We got into his office and I hand him a sheet of paper that has:

ZORA NEALE HURSTON
"A GENIUS OF THE SOUTH"
NOVELIST FOLKLORIST
ANTHROPOLOGIST
1960

"A genius of the South" is from one of Jean Toomer's poems.

"Where is this grave?" the monument man asks. "If it's in a new cemetery, the stone has to be flat."

"Well, it's not a new cemetery and Zora—my aunt—doesn't need anything flat because with the weeds out there, you'd never be able to see it. You'll have to go out there with me."

He grunts.

"And take a long pole and 'sound' the spot," I add. "Because there's no way of telling it's a grave, except that it's sunken."

"Well," he says, after taking my money and writing up a receipt, in the full awareness that he's the only monument dealer for miles, "you take this flag" (he hands me a four-foot-long pole with a red-metal marker on top) "and take it out to the

cemetery and put it where you think the grave is. It'll take us about three weeks to get the stone out there."

I wonder if he knows he is sending me to another confrontation with the snakes. He probably does. Charlotte has told me she will cut my leg and suck out the blood, if I am bit.

"At least send me a photograph when it's done, won't you?"

He says he will.

"Hurston's return to her folklore-collecting in December of 1927 was made possible by Mrs. R. Osgood Mason, an elderly white patron of the arts, who at various times also helped Langston Hughes, Alain Locke, Richmond Barthe, and Miguel Covarrubias. Hurston apparently came to her attention through the intercession of Locke, who frequently served as a kind of liaison between the young black talent and Mrs. Mason. The entire relationship between this woman and the Harlem Renaissance deserves extended study, for it represents much of the ambiguity involved in white patronage of black artists. All her artists were instructed to call her 'Godmother'; there was a decided emphasis on the 'primitive' aspects of black culture, apparently a holdover from Mrs. Mason's interest in the Plains Indians. In Hurston's case there were special restrictions imposed by her patron: although she was to be paid a handsome salary for her folklore collecting, she was to limit her correspondence and publish nothing of her research without prior approval."

—*Robert Hemenway* ▶

"In Search of Zora Neale Hurston" *(continued)*

"You have to read the chapters Zora *left out* of her autobiography."
—*Student, Special Collections Room*
Beinecke Library, Yale University

Dr. Benton, a friend of Zora's and a practicing M.D. in Fort Pierce, is one of those old, good-looking men whom I always have trouble not liking. (It no longer bothers me that I may be constantly searching for father figures; by this time, I have found several and dearly enjoyed knowing them all.) He is shrewd, with steady brown eyes under hair that is almost white. He is probably in his seventies, but doesn't look it. He carries himself with dignity, and has cause to be proud of the new clinic where he now practices medicine. His nurse looks at us with suspicion, but Dr. Benton's eyes have the penetration of a scalpel cutting through skin. I guess right away that if he knows anything at all about Zora Hurston, he will not believe I am her niece. "Eatonville?" Dr. Benton says, leaning forward in his chair, looking first at me, then at Charlotte. "Yes, I know Eatonville, I grew up not far from there. I knew the whole bunch of Zora's family." (He looks at the shape of my cheekbones, the size of my eyes, and the nappiness of my hair.) "I knew her daddy. The old man. He was a hardworking, Christian man. Did the best he could for his family. He was the mayor of Eatonville for a while, you know.

"My father was the mayor of Goldsboro. You probably never heard of it. It never incorporated like Eatonville did, and has just about disappeared. But Eatonville is still all-black."

He pauses and looks at me. "And you're Zora's niece," he says wonderingly.

"Well," I say with shy dignity, yet with some tinge, I hope, of a nineteenth-century blush, "I'm illegitimate. That's why I never knew Aunt Zora."

I love him for the way he comes to my rescue. "You're *not* illegitimate!" he cries, his eyes resting on me fondly. "All of us are God's children! Don't you even *think* such a thing!"

And I hate myself for lying to him. Still I ask myself, would I have gotten this far toward getting the headstone and finding out about Zora Hurston's last days without telling my lie? Actually I probably would have. But I don't like taking chances that could get me stranded in Central Florida.

"Zora didn't get along with her family. I don't know why. Did you read her autobiography, *Dust Tracks on a Road*?"

"Yes, I did," I say. "It pained me to see Zora pretending to be naïve and grateful about the old white 'Godmother' who helped finance her research, but I loved the part where she ran off from home after falling out with her brother's wife.

Dr. Benton nodded. "When she got sick, I tried to get her to go back to her family, but she refused. There wasn't any real hatred; they just never had gotten along and Zora wouldn't go to them. She didn't want to go to the country home, either, but she had to, because she couldn't do a thing for herself."

"I was surprised to learn she died of malnutrition."

Dr. Benton seems startled. "Zora *didn't* die of malnutrition," he says indignantly. ▶

"In Search of Zora Neale Hurston" *(continued)*

"Where did you get that story from? She had a stroke and she died in the welfare home." He seems particularly upset, distressed, but sits back reflectively in his chair: "She was an incredible woman," he muses. "Sometimes when I closed my office, I'd go by her house and just talk to her for an hour or two. She was a well-read, well-traveled woman and always had her own ideas about what was going on . . ."

"I never knew her, you know. Only some of Carl Van Vechten's photographs and some newspaper photographs. . . . What did she look like?"

"When I knew her, in the fifties, she was a big woman, *erect*. Not quite as light as I am [Dr. Benton is dark beige], and about five foot, seven inches, and she weighed about two hundred pounds. Probably more. She . . ."

"What! Zora was *fat!* She wasn't in Van Vechten's pictures!"

"Zora loved to eat," Dr. Benton says complacently. "She could sit down with a mound of ice cream and just eat and talk till it was all gone."

While Dr. Benton is talking, I recall that the Van Vechten pictures were taken when Zora was still a young woman. In them she appears tall, tan, and healthy. In later newspaper photographs—when she was in her forties—I remembered that she seemed heavier and several shades lighter. I reasoned that the earlier photographs were taken while she was busy collecting folklore materials in the hot Florida sun.

"She had high blood pressure. Her health

wasn't good. . . . She used to live in one of my houses—on School Court Street. It's a block house . . . I don't recall the number. But my wife and I used to invite her over to the house for dinner. *She always ate well*," he says emphatically.

"That's comforting to know," I say, wondering where Zora ate when she wasn't with the Bentons.

"Sometimes she would run out of groceries—after she got sick—and she'd call me. 'Come over here and see 'bout me,' she'd say. And I'd take her shopping and buy her groceries.

"She was always studying. Her mind—before the stroke—just worked all the time. She was always going somewhere, too. She once went to Honduras to study something. And when she died, she was working on that book about Herod the Great. She was so intelligent!

And really had perfect expressions. Her English was beautiful." (I suspect that is a clever way to let me know Zora herself didn't speak in the "black English" her characters used.)

"I used to read all of her books," Dr. Benton continues, "but it was a long time ago. I remember one about . . . it was called, I think, 'The Children of God' [*Their Eyes Were Watching God*], and I remember Janie and Teapot [Teacake] and the mad dog riding on the cow in that hurricane and bit old Teapot on the cheek. . . ."

I am delighted that he remembers even this much of the story, even if the names are wrong, but seeing his affection for Zora I ▶

23

feel I must ask him about her burial. "Did she *really* have a pauper's funeral?"

"She *didn't* have a pauper's funeral!" he says with great heat. "Everybody around here *loved* Zora."

"We just came back from ordering a headstone," I say quietly, because he *is* an old man and the color is coming and going on his face, "but to tell the truth, I can't be positive what I found is the grave. All I know is the spot I found was the only grave-size hole in the area."

"I remember it wasn't near the road," says Dr. Benton, more calmly. "Some other lady came by here and we went out looking for the grave and I took a long iron stick and poked all over that part of the cemetery but we didn't find anything. She took some pictures of the general area. Do the weeds still come up to your knees?"

"And beyond," I murmur. This time there isn't any doubt. Dr. Benton feels ashamed.

As he walks us to our car, he continues to talk about Zora. "She couldn't really write much near the end. She had the stroke and it left her weak; her mind was affected. She couldn't think about anything for long.

"She came here from Daytona, I think. She owned a houseboat over there. When she came here, she sold it. She lived on that money, then she worked as a maid—for an article on maids she was writing—and she worked for the *Chronicle* writing the horoscope column.

"I think black people here in Florida got mad at her because she was for some politician they were against. She said this

politician *built* schools for blacks while the one they wanted just talked about it. And although Zora wasn't egotistical, what she thought, she thought; and generally what she thought, she said."

When we leave Dr. Benton's office, I realize I have missed my plane back home to Jackson, Mississippi. That being so, Charlotte and I decide to find the house Zora lived in before she was taken to the country welfare home to die. From among her many notes, Charlotte locates a letter of Zora's she has copied that carries the address: 1734 School Court Street. We ask several people for directions. Finally, two old gentlemen in a dusty gray Plymouth offer to lead us there. School Court Street is not paved, and the road is full of mud puddles. It is dismal and squalid, redeemed only by the brightness of the late afternoon sun. Now I can understand what a "block" house is. It is a house shaped like a block, for one thing, surrounded by others just like it. Some houses are blue and some are green or yellow. Zora's is light green. They are tiny—about fifty by fifty feet, squatty with flat roofs. The house Zora lived in looks worse than the others, but that is its only distinction. It also has three ragged and dirty children sitting on the steps.

"Is this where y'all live?" I ask, aiming my camera.

"No, ma'am" they say in unison, looking at me earnestly. "We live over yonder. This Miss So-and-So's house; but she in the hospital."

We chatter inconsequentially while I take more pictures. A car drives up with a young ▶

black couple in it. They scowl fiercely at Charlotte and don't look at me with friendliness, either. They get out and stand in their doorway across the street. I go up to them to explain. "Did you know Zora Hurston used to live right across from you?" I ask.

"Who?" They stare at me blankly, then become curiously attentive, as if they think I made the name up. They are both Afro-ed and he is somberly dashiki-ed.

I suddenly feel frail and exhausted. "It's too long a story," I say, "but tell me something, is there anybody on this street who's lived here for more than thirteen years?"

"That old man down there," the young man says, pointing. Sure enough, there is a man sitting on his steps three houses down. He has graying hair and is very neat, but there is a weakness about him. He reminds me of Mrs. Turner's husband in *Their Eyes Were Watching God*. He's rather "vanishing"-looking, as if his features have been sanded down. In the old days, before black was beautiful, he was probably considered attractive, because he has wavy hair and light-brown skin; but now, well, light skin has ceased to be its own reward.

After the preliminaries, there is only one thing I want to know: "Tell me something," I begin, looking down at Zora's house, "did Zora like flowers?"

He looks at me queerly. "As a matter of fact," he says, looking regretfully at the bare, rough yard that surrounds her former house, "she was crazy about them. And she was a great gardener. She loved azaleas, and that

running and blooming vine [morning glories], and she really loved that night-smelling flower [gardenia]. She kept a vegetable garden year-round, too. She raised collards and tomatoes and things like that.

"Everyone in this community thought well of Miss Hurston. When she died, people all up and down this street took up a collection for her burial. We put her away nice."

"Why didn't somebody put up a headstone?"

"Well, you know, one was never requested. Her and her family didn't get along. They didn't even come to the funeral."

"And did she live there by herself?"

"Yes, until they took her away. She lived with—just her and her companion, Sport."

My ears perk up. "Who?"

"Sport, you know, her dog. He was her only companion. He was a big brown-and-white dog."

When I walk back to the car, Charlotte is talking to the young couple on their porch. They are relaxed and smiling.

"I told them about the famous lady who used to live across the street from them," says Charlotte as we drive off. "Of course they had no idea Zora ever lived, let alone that she lived across the street. I think I'll send some of her books to them."

"That's real kind of you," I say.

"I am not tragically colored. There is no great sorrow dammed up in my soul, nor lurking behind my eyes. I do not mind at all. I do not belong to the sobbing school of Negrohood who hold that nature somehow has given them a lowdown dirty deal and whose feelings ▶

are all hurt about it. . . . No, I do not weep at the world—I am too busy sharpening my oyster knife."

> —*Zora Neale Hurston, "How It Feels to Be Colored Me,"* World Tomorrow, *1928*

THERE ARE TIMES—and finding Zora Hurston's grave was one of them—when normal responses of grief, horror, and so on, do not make sense because they bear no real relation to the depth of the emotion one feels. It was impossible for me to cry when I saw the field full of weeds where Zora is. Partly this is because I have come to know Zora through her books and she was not a teary sort of person herself; but partly, too, it is because there is a point at which even grief feels absurd. And at this point laughter gushes up to retrieve sanity.

It is only later, when the pain is not so direct a threat to one's own existence that what was learned in that moment of comical lunacy is understood. Such moments rob us of both youth and vanity. But perhaps they are also times when greater disciplines are born.

Alice Walker is the author of Revolutionary Petunias and Other Poems *(Harcourt), which was nominated for a National Book Award, and* In Love & Trouble: Stories of Black Women *(Harcourt), which received the Rosenthal Foundation Award from the National Institute of Arts and Letters.*

Rescued from the Flames
Typescript of "The Woman in Gaul"

AFTER ZORA NEALE HURSTON died on January 28, 1960, in a Fort Pierce, Florida, hospital, her papers were ordered to be burned. A law officer and friend, Patrick DuVal, passing by the house where she had lived, stopped and put out the fire, thus saving an invaluable collection of literary documents for posterity. The original manuscript of "The Woman in Gaul," an unpublished story, was partially burned in the fire. Following are two charred pages from the manuscript, now preserved in the Department of Special and Area Studies Collections at the University of Florida.

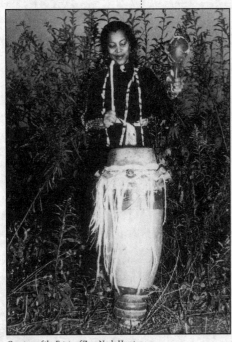

Courtesy of the Estate of Zora Neale Hurston

Zora drumming on her trip to Haiti, where she penned *Their Eyes Were Watching God* and collected information on Vodou for her nonfiction work *Tell My Horse*.

29

THE WOMAN IN GAUL

"Am I to be disposed of like a dishonest servant - I, the grand-daughter of Herod the Great, and with the royal blood of the Asamoneans coursing in my veins?" Herodias, wife of Antipas, Tetrarch of Galilee reclined on an elaborately draped couch on the East Portico of the white marble palace beside the Lake of Tiberias. " It is not to be borne!" In her left hand was an exquisetely worked scroll of a drama by Euripides which she now flung to the marble floor of the portico. " If Antipas thinks that he can discard me as he did the daughter of Aretas of Arabia, he deceives himself. Am I to be exorcised from his bed and house like an evil spirit by that desert-dwelling, hairy monster, John the Bapt- ist? It is not to be borne! Does Antipas forget that I have made a vow to destroy that monster? I have made a vow to God to behead that John the Baptist if and when he is found. And that I will do, in spite of my weak-hearted husband."

Sitting on a tasselled cushion near the lapping water of the lake was Asenath, the Egyptian ladies-maid of Herodias. She sat with her legs crossed under her like a scribe. She had lifted her eyes for the tenth part of a second when Herodias began her outburst, the dropped them and fixed her gaze as if in deep contemplation of the wide ex- panse of the lake. Now she moved her head quickly towards her mistress as if she had only that moment become aware that Herodias had spoken, leaped to her feet, and ran to kneel beside the couch which stood against the house wall. She struck a convincing pose of guilt and contrition and spoke.

" The reprimand which you gave me is just and merciful. born Herodias. I do not forget that you paid a most magnif at Alexandria to obtain my services, and that you are generous to me.

Page 1, typescript of "The Woman in Gaul"

But I, wretch that I am, sat here being fed on the beauty of the lake
and the movement of the boats of fishermen far out there, when I should
have been ministering to your comfort. Chastize me as you will."

For a minute, Herodias was struck dumb. Her outburst had indeed
been involuntary - forced out by the termendous emotional pressure from
.thin - and she had expected that it could not escape being overheard
..r maid. Now, she breathed deeply in relief that Asenath had not

But Herodias was mistaken. Egypt of her time had the reputation
more secrets for cultivating and preserving beauty than any
.. known world, and the college of beauty at Alexan-
The graduates were eagerly seized
around the .st and most powerful ladies
cosmetics, massage .le of ointments,
knowledge of the affairs
Asenath had merely reacted to her in .us.
heard and seen nothing, which in this inst
complished acting.

" I grant you my pardon this time," Herodias no .ere
said indulgently. " As you know, I myself spend many hours on this por-
tico when the weather is pleasant, gazing upon the lake. It steals the
entire attention."

" I am thankful for your kind understanding, O beaute ous
mistress. What was it that you were commanding me to do for you?"

" To do something, O skilled Egyptian maiden, to increase my
beauty. Call upon the most valued and potent secrets in your knowledge
and work your great skill upon me." Asenath could see th
building up in Herodias again. " I am nearer forty th
think about. I have a daughter well past her nubil
that I am no longer very young. I was reminding
very negligent of me today."

Less than an hour before, Asenath had finis
ment which was supposed to preserve - indeed re

Page 2, typescript of "The Woman in Gaul"

Have You Read?
More by
Zora Neale Hurston

JONAH'S GOURD VINE

Zora Neale Hurston's first novel tells the story of John Buddy Pearson, a young minister who loves too many women for his own good even though he is married to Lucy, his one true love. In this sympathetic portrait of a man and his community, Hurston shows that faith and tolerance and good intentions cannot resolve the tension between the spiritual and the physical.

MULES AND MEN

The fruit of Hurston's labors as a folklorist and anthropologist, this celebrated treasury of black American folklore includes stories, "big old lies," songs, Vodou customs, superstitions—all the humor and wisdom that is the matchless heritage of American blacks.

TELL MY HORSE

This firsthand account of the mysteries of Vodou is based on Hurston's personal experiences in Haiti and Jamaica, where she participated as an initiate and not just an observer of Vodou practices in the 1930s. Of great cultural interest, her travelogue paints a vividly authentic picture of ceremonies, customs, and superstitions.

MOSES, MAN OF THE MOUNTAIN

Based on the familiar story of the Exodus, Hurston blends the Moses of the Old Testament with the Moses of black folklore and song to create a compelling allegory of power, redemption, and faith.

DUST TRACKS ON A ROAD

First published in 1942 at the crest of her popularity as a writer, this is Hurston's imaginative and exuberant account of her rise from childhood poverty in the rural South to a prominent place among the leading artists and intellectuals of the Harlem Renaissance. It is a book full of the wit and wisdom of a proud and spirited woman who started off low and climbed high.

SERAPH ON THE SUWANEE

Hurston's novel of turn-of-the-century white Florida "crackers" marks a daring departure for the author famous for her complex accounts of black culture and heritage. Hurston explores the evolution of a marriage full of love but very little communication and the desires of a young woman in search of herself and her place in the world.

EVERY TONGUE GOT TO CONFESS

African American folklore was Zora Neale
Hurston's first love. Collected in the late 1920s,
these hilarious, bittersweet, often saucy folk-
tales—some of which date back to the Civil
War—provide a fascinating, verdant slice of
African American life in the rural South at the
turn of the twentieth century. Arranged
according to subject—from God Tales,
Preacher Tales, and Devil Tales to Heaven
Tales, White-Folk Tales, and Mistaken
Identity Tales—they reveal attitudes about
slavery, faith, race relations, family, and
romance that have been passed on for
generations. They capture the heart and soul of
the vital, independent, and creative
community that so inspired Zora Neale
Hurston.

MULE BONE

In 1930, two giants of African American
literature—Zora Neale Hurston and Langston
Hughes—joined forces to create a lively,
insightful, often wildly farcical look inside a
rural Southern black community, the three-act
play *Mule Bone*. In this hilarious story, Jim and
Dave are a struggling song-and-dance team,
and when a woman comes between them,
chaos ensues in their tiny Florida hometown.
This extraordinary theatrical work broke new
ground while triggering a bitter controversy
between the collaborators that kept it out of the
public eye for sixty years.

Discover great
authors, exclusive offers,
and more at hc.com.

ALSO BY
ZORA NEALE HURSTON

THE COMPLETE STORIES
Introduction by Henry Louis Gates, Jr., and Sieglinde Lemke
978-0-06-135018-4 (paperback)
This gathering of Hurston's short fiction—most of which appeared only in literary
magazines during her lifetime—spans the years 1921-1955 and includes such works as
"John Redding Goes to Sea," "Cock Robin Beale Street," "Hurricane," and "Book of
Harlem."

DUST TRACKS ON A ROAD: REVISED
An Autobiography
Foreword by Maya Angelou
978-0-06-085408-9 (paperback)
First published in 1942, this is Zora Neale Hurston's exuberant account of her rise from
childhood poverty in the rural South to a prominent place among the leading artists and
intellectuals of the Harlem Renaissance.
"Warm, witty, imaginative, and down-to-earth by turns, this is a rich and winning book
 by one of our genuine, Grade A folk writers." —*The New Yorker*

EVERY TONGUE GOT TO CONFESS
Negro Folk-tales from the Gulf States
Foreword by John Edgar Wideman
Edited and with an Introduction by Carla Kaplan
978-0-06-093454-5 (paperback) • 978-0-694-52645-1 (unabridged cassette)
A collection of African American folklore compiled from Hurston's anthropological trav-
els through the American South in the 1920s. These 500 tales reflect the sorrows and joys
of African American heritage with wit, wisdom, compassion, and style.

JONAH'S GOURD VINE
Foreword by Rita Dove
978-0-06-091651-0 (paperback) • 978-0-06-135019-1 (paperback)
Hurston's first novel tells the story of John Buddy Pearson, "a living exultation" of a
young man who loves too many women for his—and their—own good.
"A bold and beautiful book . . . priceless and unforgettable."—Carl Sandburg

MOSES, MAN OF THE MOUNTAIN
Foreword by Deborah McDowell
978-0-06-091994-8 (paperback)
Taking off from the familiar story of the Exodus, Hurston blends the Moses of the Old
Testament with the Moses of black folklore to create a powerful novel of the persecution
of slavery and the dream of freedom.
"A narrative of great power." —*New York Times*

MULE BONE
A Comedy of Negro Life in Three Acts
978-0-06-096885-4 (paperback)

This three-act play is the only collaboration between the brightest lights of the Harlem Renaissance—Zora Neale Hurston and Langston Hughes. This volume contains the play, the Hurston short story on which it was based, and a detailed account of the literary dispute between Hurston and Hughes which delayed the introduction of this revolutionary piece of African American drama to readers.

MULES AND MEN
A Treasure of Black American Folklore
Foreword by Arnold Rampersad
978-0-06-135017-7 (paperback)

"A classic in style and form. . . . Introduces the reader to the whole world of jook joints, lying contests, and tall-tale sessions that make up the drama of the folk life of black people in the rural South." —Mary Helen Washington

SERAPH ON THE SUWANEE
Foreword by Hazel V. Carby
978-0-06-097359-9 (paperback)

A departure for Hurston, *Seraph on the Suwanee* is the story of two turn-of-the-century white "Florida Crackers" at once deeply in love, and deeply at odds.
"A simple, colorfully written, and moving novel." —*Saturday Review of Literature*

TELL MY HORSE
Voodoo and Life in Haiti and Jamaica
Foreword by Ishmael Reed
978-0-06-091649-7 (paperback)

Based on Hurston's visits to Haiti and Jamaica in the 1930s, this travelogue paints an authentic picture of ceremonies and customs of great cultural interest.
"Strikingly dramatic, yet simple and unrestrained . . . unusual and intensely interesting."
—*New York Times Book Review*

THEIR EYES WERE WATCHING GOD
978-0-06-083867-6 (paperback) • 978-0-06-112006-0 (deluxe paperback)
978-0-06-147037-0 (large print) • 978-0-06-077653-4 (unabridged CD)
978-1-559-94500-4 (abridged cassette)

In this American classic, Hurston tells with haunting sympathy and piercing immediacy the story of one black woman's evolving selfhood through three marriages.
"There is no book more important to me than this one." —Alice Walker

HARPER ● PERENNIAL